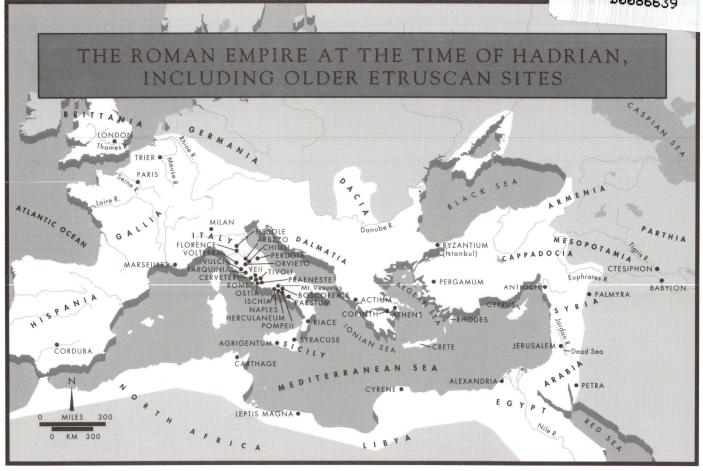

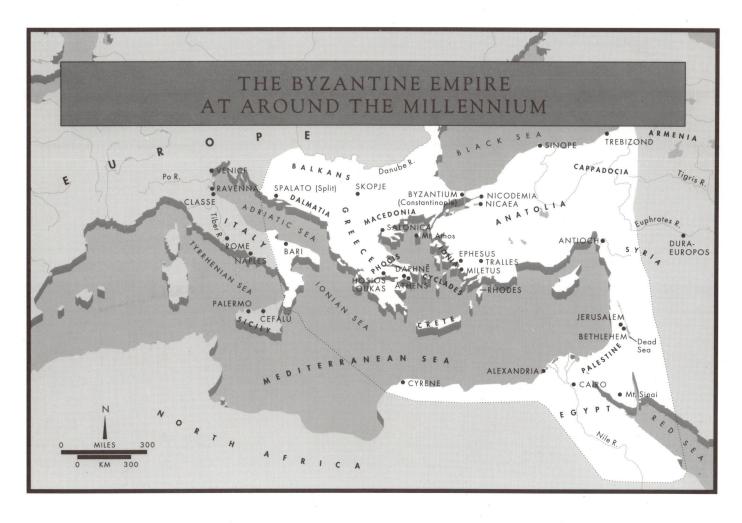

HISTORY OF ART

FIFTH EDITION REVISED

HISTORYOFART

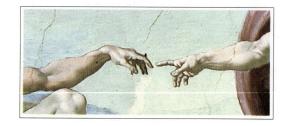

FIFTH EDITION REVISED

H. W. JANSON ANTHONY F. JANSON

HARRY N. ABRAMS, INC., PUBLISHERS

Project director: JULIA MOORE

Editor: JOANNE GREENSPUN

Assistant editor: MONICA MEHTA

Picture editor: JENNIFER BRIGHT

Art director: Lydia Gershey

Designers:
Lydia Gershey with Yonah Schurink
of Communigraph

Library of Congress Cataloging-in-Publication Data

Janson, H. W. (Horst Woldemar), 1913-82

History of art / H.W. Janson, Anthony F. Janson.—5th ed. rev. / Anthony F. Janson.

p. cm.

Includes bibliographical references and index.

ISBN-0-8109-3442-6

1. Art—History. I. Janson, Anthony F.

II. Title.

N5300.J3 1997

709—dc21

96-49963

Copyright © 1991, 1995, 1997 Harry N. Abrams, Inc.

Published in 1997 by Harry N. Abrams, Incorporated, New York

All rights reserved. No part of the contents of this book may be reproduced without the written permission of the publisher.

Printed and bound in Japan

Harry N. Abrams, Inc. 100 Fifth Avenue New York, N.Y. 10011 www.abramsbooks.com

Note on the picture captions:

Each illustration is placed as close as possible to its first discussion in the text. Measurements are given throughout, except for objects that are inherently large: architecture, architectural sculpture, interiors, and wall paintings. Height precedes width. A probable measuring error of more than one percent is indicated by "approx." Titles of works are those designated by the institutions owning the works, where applicable, or by custom. Dates are based on documentary evidence, unless preceded by "c."

First Edition 1962, revised and enlarged, 1969 Second Edition 1977 Third Edition 1986 Fourth Edition 1991 Fifth Edition 1995, revised 1997

CONTENTS

PREFACES AND ACKNOWLEDGMENTS 12
PRELUDE 14

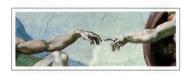

INTRODUCTION 16
ART AND THE ARTIST 16
LOOKING AT ART 25

PART ONE THE ANCIENT WORLD 44

Map 48

CHAPTER ONE PREHISTORIC ART 50
THE OLD STONE AGE 50
THE NEW STONE AGE 54

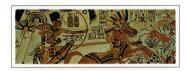

CHAPTER TWO EGYPTIAN ART 60
THE OLD KINGDOM 60
THE MIDDLE KINGDOM 71
THE NEW KINGDOM 72

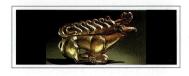

CHAPTER THREE ANCIENT NEAR EASTERN ART 78

SUMERIAN ART 78 ASSYRIAN ART 88 PERSIAN ART 92

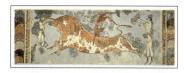

CHAPTER FOUR AEGEAN ART 98 CYCLADIC ART 98 MINOAN ART 99 MYCENAEAN ART 106

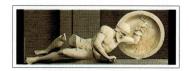

CHAPTER FIVE GREEK ART 110

GEOMETRIC STYLE 111
ORIENTALIZING STYLE 112 The Greek Gods and Goddesses 113
ARCHAIC VASE PAINTING 114 The Hero in Greek Legend 117
ARCHAIC SCULPTURE 118
ARCHITECTURE 124
CLASSICAL SCULPTURE 139
Music in Ancient Greece 142 Theater in Ancient Greece 146
CLASSICAL PAINTING 151
FOURTH-CENTURY SCULPTURE 154
HELLENISTIC SCULPTURE 158

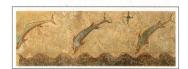

COINS 162

CHAPTER SIX ETRUSCAN ART 166

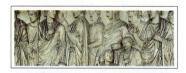

CHAPTER SEVEN ROMAN ART 176

ARCHITECTURE 177
SCULPTURE 188
PAINTING 203
Theater and Music in Ancient Rome 209

Primary Sources for Part One 212 Timeline One 220

PART TWO THE MIDDLE AGES 224

Map 228

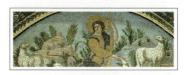

CHAPTER ONE EARLY CHRISTIAN AND BYZANTINE ART 230

EARLY CHRISTIAN ART 233

The Liturgy of the Mass 235 Versions of the Bible 241
The Life of Jesus 246 Biblical, Church, and Celestial Beings 248
BYZANTINE ART 249

CHAPTER TWO EARLY MEDIEVAL ART 270

CAROLINGIAN ART 275
Guilds: Masters and Apprentices 276
OTTONIAN ART 282

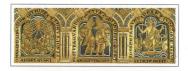

CHAPTER THREE ROMANESQUE ART 292

ARCHITECTURE 293

Monasticism and Christian Monastic Orders 296

SCULPTURE 304

PAINTING AND METALWORK 313

Hildegard of Bingen 316

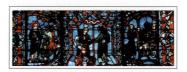

CHAPTER FOUR GOTHIC ART 320

ARCHITECTURE 321 Medieval Music and Theater 326 SCULPTURE 344 PAINTING 358

Primary Sources for Part Two 382 Timeline Two 396

PART THREE THE RENAISSANCE THROUGH THE ROCOCO 402

Map 406

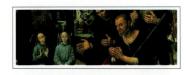

CHAPTER ONE THE EARLY RENAISSANCE IN ITALY 408

FLORENCE: 1400–1450 409 CENTRAL AND NORTHERN ITALY: 1450–1500 434 Early Italian Renaissance Theater and Music 442

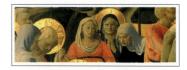

CHAPTER TWO THE HIGH RENAISSANCE IN ITALY 452

Theater and Music During the High Renaissance 464

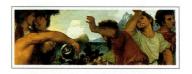

CHAPTER THREE MANNERISM AND OTHER TRENDS 482

PAINTING 483 Music and Theater in the Age of Mannerism 486 SCULPTURE 496 ARCHITECTURE 498

CHAPTER FOUR "LATE GOTHIC" PAINTING, SCULPTURE, AND THE GRAPHIC ARTS 504

RENAISSANCE VERSUS "LATE GOTHIC" PAINTING 504

Music in Fifteenth-Century Flanders 517

"LATE GOTHIC" SCULPTURE 521

THE GRAPHIC ARTS 523 Printmaking 524

CHAPTER FIVE THE RENAISSANCE IN THE NORTH 527

GERMANY 527 Music and Theater in the Northern Renaissance 535 THE NETHERLANDS 539 FRANCE 544

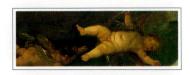

CHAPTER SIX THE BAROQUE IN ITALY AND SPAIN 548

PAINTING IN ITALY 549
Baroque Music in Italy 558
ARCHITECTURE IN ITALY 560
Baroque Theater in Italy and Spain 569
SCULPTURE IN ITALY 564
PAINTING IN SPAIN 569

CHAPTER SEVEN THE BAROQUE IN FLANDERS AND HOLLAND 574

FLANDERS 574
HOLLAND 581 Music and Theater in Holland 586

CHAPTER EIGHT THE BAROQUE IN FRANCE AND ENGLAND 594

FRANCE: THE AGE OF VERSAILLES 594

Baroque Theater and Music in France 600

ENGLAND 607 Baroque Theater and Music in England 607

CHAPTER NINE THE ROCOCO 610

FRANCE 610
ENGLAND 616
GERMANY AND AUSTRIA 621
Rococo Music 622 Modern Harmony 624
ITALY 625 Rococo Theater 628

Primary Sources for Part Three 630 Timeline Three 644

PART FOUR THE MODERN WORLD 650

Map 656

CHAPTER ONE NEOCLASSICISM AND ROMANTICISM 658

NEOCLASSICISM 658

PAINTING 659 SCULPTURE 664
ARCHITECTURE 667 Neoclassical Theater 667 Neoclassical Music 670
THE ROMANTIC MOVEMENT 672

PAINTING 672 New Printmaking Techniques 674
The Romantic Movement in Literature and Theater 694
SCULPTURE 698 Romanticism in Music 702 ARCHITECTURE 706
DECORATIVE ARTS 712 PHOTOGRAPHY 712

CHAPTER TWO REALISM AND IMPRESSIONISM 718

PAINTING 718 Nationalism in Mid-Nineteenth-Century Music 730

SCULPTURE 734 ARCHITECTURE 738

Realism in Mid-Nineteenth-Century Theater 740 OTHER FIELDS 743

CHAPTER THREE POST-IMPRESSIONISM, SYMBOLISM, AND ART NOUVEAU 746

PAINTING 746 Music in the Post-Impressionist Era 758 SCULPTURE 765 Theater in the Post-Impressionist Era 766 ARCHITECTURE 768 PHOTOGRAPHY 774

CHAPTER FOUR TWENTIETH-CENTURY PAINTING 780

PAINTING BEFORE WORLD WAR I 780
EXPRESSIONISM 781 ABSTRACTION 788

Music Before World War I 790 Theater Before World War I 795
FANTASY 796 REALISM 799
PAINTING BETWEEN THE WARS 800
Theater Between the Wars 812 Music Between the Wars 816

Theater Between the Wars 812 Music Between the Wars 816
PAINTING SINCE WORLD WAR II 818 Theater Since World War II 824
LATE MODERNISM 836 Music Since World War II 838

CHAPTER FIVE TWENTIETH-CENTURY SCULPTURE 844

SCULPTURE BEFORE WORLD WAR I 844 SCULPTURE BETWEEN THE WARS 847 SCULPTURE SINCE 1945 855

CHAPTER SIX TWENTIETH-CENTURY ARCHITECTURE 872

ARCHITECTURE BEFORE WORLD WAR I 872
ARCHITECTURE BETWEEN THE WARS 876 DESIGN 883
ARCHITECTURE FROM 1945 TO 1980 884

CHAPTER SEVEN TWENTIETH-CENTURY PHOTOGRAPHY 894

THE FIRST HALF-CENTURY 894 PHOTOGRAPHY SINCE 1945 908

CHAPTER EIGHT POSTMODERNISM 914 POSTMODERN ART 916 ARCHITECTURE 916

SCULPTURE 923 PAINTING 927
Postmodernism in Music and Theater 928 PHOTOGRAPHY 929

Postmodernism in Music and Theater 928 PHOTOGRAPHY 929
POSTSCRIPT: POSTMODERN THEORY 931

Primary Sources for Part Four 934 Timeline Four 950

BOOKS FOR FURTHER READING 956
GLOSSARY 965
ART AND ARCHITECTURE WEB SITE GAZETTEER 972
INDEX 977
CREDITS 999

PREFACE AND ACKNOWLEDGMENTS TO THE FIRST EDITION

The title of this book has a dual meaning: it refers both to the events that make the history of art, and to the scholarly discipline that deals with these events. Perhaps it is just as well that the record and its interpretation are thus designated by the same term. For the two cannot be separated, try as we may. There are no "plain facts" in the history of art—or in the history of anything else for that matter, only degrees of plausibility. Every statement, no matter how fully documented, is subject to doubt and remains a "fact" only so long as nobody questions it. To doubt what has been taken for granted, and to find a more plausible interpretation of the evidence, is every scholar's task. Nevertheless, there is always a large body of "facts" in any field of study; they are the sleeping dogs whose very inertness makes them landmarks on the scholarly terrain. Fortunately, only a minority of them can be aroused at the same time, otherwise we should lose our bearings; yet all are kept under surveillance to see which ones might be stirred into wakefulness and locomotion. It is these "facts" that fascinate the scholar. I believe they will also interest the general reader. In a survey such as this, the sleeping dogs are indispensable, but I have tried to emphasize that their condition is temporary, and to give the reader a fairly close look at some of the wakeful ones.

I am under no illusion that my account is adequate in every respect. The history of art is too vast a field for anyone to encompass all of it with equal competence. If the shortcomings of my book remain within tolerable limits, this is due to the many friends and colleagues who have permitted me to tax their kindness with inquiries, requests for favors, or discussions of doubtful points. I am particularly indebted to Bernard Bothmer, Richard Ettinghausen, M. S. Ïpsiroğlu, Richard Krautheimer, Max Loehr, Wolfgang Lotz, Alexander Marshack, and Meyer Schapiro, who reviewed various aspects of the book and generously helped in securing photographic material. I must also record my gratitude to the American Academy in Rome, which made it possible for me, as art historian in residence during the spring of 1960, to write the chapters on ancient art under ideal conditions, and to the Academy's indefatigable librarian, Nina Langobardi. Irene Gordon, Celia Butler, and Patricia Egan have improved the book in countless ways. Patricia Egan also deserves the chief credit for the reading list. I should like, finally, to acknowledge the admirable skill and patience of Philip Grushkin, who is responsible for the design and layout of the volume; my thanks go to him and to Adrienne Onderdonk, his assistant.

> H. W. J. 1962

PREFACE AND ACKNOWLEDGMENTS TO THE FIFTH EDITION REVISED

This Revised Fifth Edition of H. W. Janson's *History of Art* continues the process of broad change that was inaugurated in the previous edition. Whereas the changes to the Fifth Edition concentrated on art from Mannerism through the art of the twentieth century, this time the focus is on art before 1520. The differences are less sweeping, but readers familiar with earlier editions will note some significant changes in emphasis. I have brought the scholarship on ancient art up to date. In this regard I had the benefit of numerous suggestions made by Professor Andrew Stewart and Dr. Mary Ellen Soles. In several instances, however, I have followed an independent approach to ongoing controversies. Some of them are relatively minor (for example, Which battle does the Nike of Samothrace commemorate?). The most important, however, is the vexing question of the debt of Roman painting to Greek art, to which I devoted a year's study before siding with those specialists who see it as essentially Roman in character. I have also rethought a good deal of medieval art. I am indebted to the helpful comments of Professor Dale Kinney, who served as reader. Thus, I examined afresh the contribution of Abbot Suger in the formation of Gothic architecture, which has been undergoing a major reevaluation of late, although again I have taken a different stand on the issue from many other writers. I have also emphasized what I regard as the critical role of Byzantium in preserving the heritage of early Christian art and transmitting it to the Latin world, where it provided the foundation for the revolution in Gothic painting and sculpture. Finally, I have reorganized the historical background in the Introduction to Part Two and included additional information within each chapter.

So far as the Renaissance is concerned, I have added more iconography than before, such as the inspiration of Poliziano in Botticelli's *Birth of Venus* and Raphael's *Galatea*, and the symbolism of Giorgione's *The Tempest*. The presentation of High Renaissance art has been altered, particularly in the case of Michelangelo, and more subtly when it comes to Leonardo and Raphael.

This addition also completes the process of transforming the book into purely a history of Western art. It has been done with regret, and I was especially reluctant to relinquish Islamic art. When that chapter was written, it represented the state of the art, and although our understanding has increased greatly in recent years, it would not have been difficult to bring the scholarship up to date. Nevertheless, I have decided to give it up in order to accommodate changes that I felt were imperative to strengthen the treatment of other areas.

Perhaps the biggest change to the book has been the incorporation of new sections on the history of music and theater. They are frankly experimental, for although books on other disciplines have often included material on art, art-history surveys have avoided reciprocating the honor. I confess to misgivings about such an interdisciplinary approach, which is perhaps better suited to the expert than the beginner, and about the risk of committing a naïveté often shown by colleagues in other fields when they have ventured into art. I have nonetheless decided to add them so as to suggest the larger cultural context in which the visual arts have existed. I have

done so out of a deeply felt love for music and drama. However, my account is necessarily slanted to those aspects that illuminate the main content of this book. As this is by no means intended to be a general humanities book, I have placed less emphasis on the history of literature and philosophy, which are vast subjects in themselves, except insofar as they are directly relevant to the discussion.

I must also admit that I have tried to act as an advocate of modern music and theater because I appreciate the resistance that most people feel toward them, just as they do to modern art. I, too, have felt that resistance to modern culture, and I am more than sympathetic to the plight of many readers. From my own experience, I can attest that the only way to come to terms with these demanding art forms is to immerse oneself in them fully, however forbidding that may seem. The rewards are more than worth the effort.

In addition to the new sections on music and theater, the reader will also find a number of other boxed texts that appear throughout the book as supplements to the main text. These deal with such subjects as classical and Christian iconography, the religious orders, the guilds, and printmaking techniques. The Greek chapter, for example, includes discussions of the Greek gods and goddesses and the hero in Greek legend. In the chapter on Early Christian and Byzantine art, there are texts on the liturgy of the Mass, the various versions of the Bible, the life of Jesus, and biblical, church, and celestial beings. Monasticism is explored in the Romanesque art chapter, and the various printmaking techniques are explained in the chapters on fifteenth- and nineteenth-century art.

Putting this book together is a mammoth undertaking. I can honestly say that this time around was by far the smoothest, thanks to the experienced and amicable "dream team" at Abrams, which has worked so well together on previous editions of this and other Janson volumes. Julia Moore once again served as project manager and developmental respondant and Joanne Greenspun as editor, with the assistance of project editor Monica Mehta and photo editor Jennifer Bright. Lydia Gershey and Yonah Schurink of Communigraph are responsible for the excellent design and prepress, and Shun Yamamoto oversaw the production process. Paul Gottlieb, Abrams' great publisher and editor-in-chief, was unfailingly supportive.

I would like to dedicate this edition to the memory of my father, who wrote the original survey of art history 35 years ago. I am keenly aware of the very broad changes I have introduced over the past several editions. He would undoubtedly be as surprised as I am by how extensive they are. They reflect changes in scholarship, as well as the inevitable differences in taste and outlook between two authors, no matter how closely related they may be. Yet my goal has always been to maintain the identity and integrity of the book as he originally conceived it. It is my hope that he would recognize the book as his. Fortunately, my mother is still alive, and since she played an integral role in its inception (not to mention mine), this edition is happily dedicated to her as well.

A. F. J.

PRELUDE

The art-historical approach of this book is often labeled formalistic insofar as it is concerned with the evolution of style, yet this use of the label should not be taken to mean the visual analysis of aesthetic qualities. It also draws on iconography, that is, the meaning of a work of art, and what Erwin Panofsky called iconology, its cultural context. Thus, it embodies what might be called the classical approach to art history as defined by three generations of mainly German-born scholars, including H. W. Janson, who was himself a student of Panofsky's. It is well suited to introducing beginners to art history by providing the framework for how to look at and respond to art in museums and galleries—something both authors have themselves greatly enjoyed throughout their lifetimes.

Nonetheless, readers should be aware that there are other approaches that have benefitted art history and are worthy of attention. The oldest is Marxism, which examines art in terms of the social and political conditions determined by the prevailing economic system. It has been especially useful in treating art since the Industrial Revolution, which created the historical circumstances analyzed so tellingly by Karl Marx in the middle of the nineteenth century. It remains to be seen what will become of Marxist art history in the wake of the collapse of communist governments in Russia and Eastern Europe.

Psychology, too, has added many insights to the private meaning that works of art have held for their creators, particularly when that meaning has been hidden even to the artists themselves. Although the more extreme attempts at psychoanalyzing Leonardo and Michelangelo, for instance, have caused some scholars to distrust this method, works such as Fuseli's *The Nightmare* (whose meaning was analyzed by H. W. Janson in a pioneering article) are incomprehensible without it. Another case in point: at my editor's suggestion, I have traced the theme of a woman holding a mirror from the sixteenth century to modern times as a "textbook" example of iconography, using works by Hans Buldung Grien, Simon Vouet, François Boucher, Pablo Picasso, Erich Heckel, and Cindy Sherman as examples. But the meaning of this fascinating image is vastly enriched by knowing that is a classic rep-

resentation of the anima, one of the psychological archetypes defined by Freud's former disciple Carl Jung, which personifies the feminine tendencies in the male psyche and acts as a guide to the inner realm. This discovery opens up a field of analysis that I invite readers to explore on their own.

Three new approaches—feminism, multiculturalism, and deconstruction—are perhaps the most radical of all. Feminism reexamines art history from the point of view of gender. Depictions of the woman with a mirror virtually call for a feminist treatment, which yields a very different understanding of their covert significance, as readers may readily ascertain by questioning these works themselves. Because it is embedded in current gender politics in Western society, there is risk that a major shift in social outlook might call some if its conclusions into questions. In principle, however, feminist theory is applicable to the full scope of art history. It has certainly forced everyone to reconsider what is "good" art. After all, when this book first appeared, not a single woman was represented nor, I hasten to add, was one to be found in any other art-history survey for that matter. Today, such omissions seem nothing short of astonishing.

Feminism in turn may be seen as part of the larger shift to multiculturalism, which addresses a very real gap in our understanding of the art of nontraditional and non-Western cultures. Why, indeed, should one not include artists who embody very different sensibilities from that of the European and American mainstream? There is, in principle, no reason to exclude them. However, I have decided to limit this edition to Western art for reason both practical and philosophical. To compensate, the representation of African-American artists has been significantly increased. In doing so, however, I have taken a stand about what art I think is most significant, and not all readers will agree with it, since it favors universality over ethnocentricity. This position reflects in part my own sensitivities about the stereotyping that the latter fosters on both sides of the racial fence. In my opinion, it forces a cultural dead end, although I do not deny that art with a racial "edge" has a legitimate place. Feminism and multiculturalism have both

attacked the "canon" of masterpieces in this and similar book as embodying a traditional chauvinism and colonialist attitudes. I will leave readers to judge the issue for themselves.

Because they are so central to Postmodernist thought, I have attempted to summarize semiotics and deconstruction toward the end of this book, knowing full well that their followers will never be satisfied, partly because each treatment is necessarily brief and partly because I am not a convert to either cause. I took on the task in order to help the reader gain a little better understanding of the world of ideas we live in. I have to say that I enjoyed drinking from the cup of Postmodernism, even though it is ultimately not to my taste. It provided a brisk a refreshing tonic, hardly the poisonous brew that I might have expected. Rather than emerging gloomy from the experience, I find myself surprisingly optimistic as we fly headlong into the new millennium.

Let me add that I am fundamentally sympathetic to semiotics, which became an interest of mine more than 20 years ago, though I ultimately find Noam Chomsky's theory of linguistics to be more satisfying. Deconstruction has likewise made art historians reconsider meaning in new ways that have breathed fresh life into the field. Nevertheless, I know from classroom experience that semiotics is nearly impossible for the art history novice to comprehend. Deconstruction, which has taken scholarship by storm in recent years, is even more taxing. What began as an internecine feud between two schools of French semiologists has spread to art history, where it pits older, mostly German-trained scholars against a younger generation using deconstruction as a way of finding their place in the sun. And that is perhaps the point. People are constantly recasting art history in their image. But if art history reflects our time, the reader may well wonder how it can have any claim to objectivity and, hence, validity. In actual fact, people's understanding of history has always changed with the times. How could it be otherwise? Indeed, it seems almost necessary for each generation to reinvent history to understand both the past and the present. The danger is that the intrusion of ideology, regardless of noble intent, will undermine the search for Truth, no matter how relative it may be. Such a thing happened during the 1930s, when scholarship was made to serve the political ends of dictatorships—and which led Panofsky and Janson to leave Germany.

Neither author of the present volume is an ideologue. Both are humanists who believe that the study of the humane letters is an enjoyable and enriching experience. Such a view carries with it the implicit charge (admittedly not always honored in the observance) that scholarly discourse be temperate, though it is rarely dispassionate. I would encourage the reader to examine all forms of art history with an open mind. One cannot view something so rich and complex from a single perspective any more than it is possible to see a diamond from one angle. Each approach has something to contribute to our understanding. To be sure, a plea for tolerance may be seem an anachronism at a time when art history, like all fields, has become so contentious. In this regard, scholarship is simply the mirror of the rapid political change, social unrest, ideological intolerance, and religious fanaticism that characterize postindustrial society and the new world order that is emerging in its wake.

Let me end these rather personal remarks with a surprising admission. For nearly 40 years, both authors have given a great deal of thought to this book, which is written in the authoritative tones that intellectuals habitually adopt as their public voice. It is difficult, of course, to resist the temptation to pontificate—to hand down the "cannon" as if it were immutable law. Yet, if the truth be told, the experience of surveying such a broad field as art history provides a lesson in humility. One becomes only too aware of the painful omissions and how little one knows about any given subject in this age of increasing specialization. If it requires the egotism of the gods to undertake such a project in the first place, in the end one sees it clearly for what it is: an act of hubris. It also requires a faith in the power of reason to produce such a synthesis, something that is in short supply in this skeptical era.

A. F. J. 1997

INTRODUCTION

ART AND THE ARTIST

"What is art?" Few questions provoke such heated debate and provide so few satisfactory answers. If definitive conclusions are impossible, there is still a good deal that can be said. Art is first of all a *word*, which itself acknowledges both the idea and the fact of art. Without a word, one might well ask whether art exists in the first place. The term, after all, is not found in every society. Yet art is *made* everywhere. Art, therefore, is also an object, but it is not just any kind of object. Art is an *aesthetic object*. It is meant to be looked at and appreciated for its intrinsic value. Its special qualities set art apart, so that it is often placed away from everyday life—in museums, caves, or churches.

What does aesthetic mean? By definition, aesthetic is "that which concerns the beautiful." Of course, not all art is beautiful to each person's eyes, but it is art nonetheless. No matter how unsatisfactory, the term will have to do for lack of a better one. Aesthetics is, strictly speaking, a branch of philosophy which has occupied thinkers from Plato to the present day. Like all matters philosophical, it is subject to debate. During the last hundred years, aesthetics has also become a field of psychology, a field which has come to equally little agreement. Why should this be so? On the one hand, people the world over make much the same fundamental judgments. Our brains and nervous systems are the same because, according to recent theory, everyone is descended from one woman who lived in Africa a quarter-million years ago. On the other hand, taste is conditioned solely by culture, which is so varied that it is impossible to reduce art to any one set of precepts. It would seem, therefore, that absolute qualities in art must elude us, that we cannot escape viewing works of art in the context of time and circumstance, whether past or present. How indeed could it be otherwise, so long as art is still being created all around us, opening our eyes almost daily to new experiences and forcing us to readjust our understanding?

Imagination

We all dream. That is imagination at work. To imagine means simply to make an image—a picture—in our minds. Human beings are not the only creatures who have imagination. Even animals dream. However, there is a profound difference between human and animal imagination. Humans are the only creatures who can tell one another about imagination in words or pictures. No other animal has ever been observed to draw a recognizable image spontaneously in the wild. In fact, their only images have been produced under carefully controlled laboratory conditions that tell us more about the experimenter than they do about art. There can be little doubt, on the other hand, that people possess an artistic faculty. By the age of five every normal child has drawn a moon pie-face. The ability to make art is one of our most distinctive features; it separates us from all other creatures across an evolutionary gap that is unbridgeable.

Just as an embryo retraces much of the human evolutionary past, so budding artists reinvent the first stages of art. Soon, however, they complete that process and begin to respond to the culture around them. Thus even children's art is subject to the taste and outlook of the society that shapes his or her personality. In fact, children's art is generally judged according to the same criteria as adult art, only in appropriately simpler terms, and with good reason. The youngster must develop all the skills that go into adult art: coordination, intellect, personality, imagination, creativity, and aesthetic judgment. Seen this way, the making of a youthful artist is a process as fragile as growing up itself, and one that can be stunted at any step by the vicissitudes of life. No wonder that so few continue their creative aspirations into adulthood.

The imagination is one of our most mysterious facets. It can be regarded as the connector between the conscious and the subconscious, where most of our brain activity takes place. It is the very glue that holds our personality, intellect, and

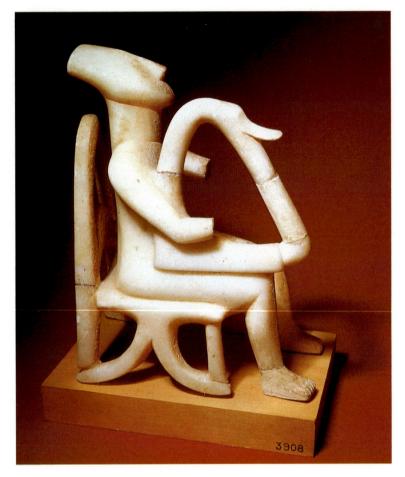

1. *Harpist*, so-called Orpheus. Marble statuette from Amorgos in the Cyclades. Latter part of the 3rd millennium B.C. Height 8¹/2" (21.5 cm). National Archaeological Museum, Athens

spirituality together. Because the imagination responds to all three, it acts in lawful, if unpredictable, ways that are determined by the psyche and the mind. Even the most private artistic statements can be understood on some level, if only an intuitive one. The imagination is important, as it allows us to conceive of all kinds of possibilities in the future and to understand the past in a way that has real survival value. It is an essential part of our makeup. The ability to make art, in contrast, must have been acquired relatively recently in the course of evolution. The record of the earliest art is lost. Human beings have been walking the earth for nearly 4.5 million years, although our own species (homo sapiens) is much younger than that. By comparison, the oldest known prehistoric art was made only about 35,000 years ago, but it was undoubtedly the culmination of a long development no longer traceable. Even the art found today in the simplest traditional culture represents a late stage of development within a stable society.

Who were the first artists? In all likelihood, they were shamans. Like the legendary Greek poet Orpheus, who sang his words while playing the lyre, they were magicians who were believed to have divine powers of inspiration and to be able to enter the underworld of the subconscious in a death-like trance, but, unlike ordinary mortals, they were then able

to return to the realm of the living. Just such a figure seems to be represented by *Harpist* (fig. 1) from nearly 5,000 years ago. A work of unprecedented complexity for its time, it was carved by a remarkably gifted artist who makes the beholder feel the visionary rapture of a bard as he sings his legend. With this unique ability to penetrate the unknown and rare talent for expressing it through art, the artist-shaman gained control over the forces hidden in human beings and nature. Even today the artist remains a magician whose work can mystify and move us—an embarrassing fact to civilized people, who do not readily relinquish their veneer of rational control.

In a larger sense art, like science and religion, fulfills humanity's innate urge to comprehend itself and the universe. This function makes art especially significant and, hence, worthy of our attention. Art has the power to penetrate to the core of our being, which recognizes itself in the creative act. For that reason, art represents its creator's deepest understanding and highest aspirations. At the same time, artists often play an important role as the articulators of our shared beliefs and values, which they express through an ongoing tradition to their audience.

Given the many factors that feed into it, art must play a very special role in the artist's personality. Sigmund Freud, the founder of modern psychiatry, conceived of art primarily in

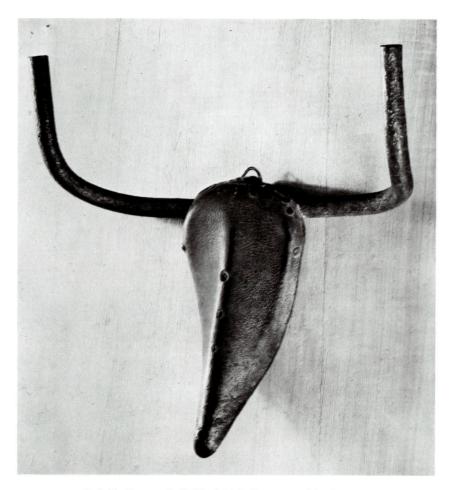

2. Pablo Picasso. Bull's Head. 1943. Bronze cast bicycle parts, height $16^{1}/8$ " (41 cm). Musée Picasso, Paris

terms of sublimation outside of consciousness. Such a view hardly does justice to artistic creativity, since art is not simply a negative force at the mercy of our neuroses but a positive expression that integrates diverse aspects of personality. Indeed, when we look at the art of someone who is mentally ill, we may be struck by its vividness; but we instinctively sense that something is wrong, because the expression is incomplete. Artists may sometimes be tortured by the burden of their genius, but they can never be fully creative under the thrall of psychosis.

Creativity

What is meant by making art? At the very least, a work of art must be a tangible thing shaped by human hands. (This definition eliminates the confusion of treating as works of art such natural phenomena as flowers, seashells, or sunsets, which are raised to their status as art when they are depicted in still lifes and landscapes.) It is a far from sufficient definition, to be sure, since human beings make countless things other than works of art. Still, it will serve as a starting point. Now let us look at the striking *Bull's Head* by Picasso (fig. 2), which seems to consist of nothing but the seat and handlebars of an old bicycle. How meaningful is our formula here? Of course the materials used by Picasso are fabricated, but it would be absurd to insist that

Picasso must share the credit with the manufacturer, since the seat and handlebars in themselves are not works of art.

While we feel a certain jolt when we first recognize the ingredients of this visual pun, we also sense that it was a stroke of genius to put them together in this unique way, and we cannot very well deny that it is a work of art. Yet the handiwork—the mounting of the seat on the handlebars—is ridiculously simple. What is far from simple is the leap of the imagination by which Picasso recognized a bull's head in these unlikely objects. That is something only he could have done. Clearly, then, the making of a work of art should not be confused with manual skill or craftsmanship. Some works of art may demand a great deal of technical discipline; others do not. And even the most painstaking piece of craft does not deserve to be called a work of art unless it involves a leap of the imagination.

But if this is true, did not the real making of the *Bull's Head* take place in the artist's mind? No, that is not so, either. Suppose that, instead of actually putting the two pieces together and showing them to us, Picasso merely said, "You know, today I saw a bicycle seat and handlebars that looked just like a bull's head to me." Then there would be no work of art and his remark would not even strike us as an interesting bit of conversation. Moreover, Picasso himself would not have felt the satisfaction of having created something on the basis of

his leap of the imagination alone. Once he had conceived his visual pun, he could never be sure that it would really work unless he put it into effect.

Thus the artist's hands, however modest the task they may have to perform, play an essential part in the creative process. Picasso's *Bull's Head* is, of course, an ideally simple case, involving only one leap of the imagination and a manual act in response to it: once the seat had been properly placed on the handlebars (and then cast in bronze), the job was done. The leap of the imagination is sometimes experienced as a flash of inspiration, but only rarely does a new idea emerge full-blown like the Greek goddess Athena from the head of her father, Zeus. Instead, it is usually preceded by a long gestation period in which all the hard work is done without finding the key to the solution to the problem. At the critical point, the imagination makes connections between seemingly unrelated parts and recombines them.

Ordinarily, artists do not work with ready-made parts but with materials that have little or no shape of their own. The creative process consists of a long series of leaps of the imagination and the artist's attempts to give them form by shaping the material. In painting, for example, the hand tries to carry out the commands of the imagination and puts down a brushstroke, but the result may not be quite what had been expected, partly because all matter resists the human will, partly because the image in the artist's mind is constantly shifting and changing, so that the commands of the imagination cannot be very precise. In fact, the mental image begins to come into focus only as the artist "draws the line somewhere." That line then becomes part—the only fixed part of the image. The rest of the image, as yet unborn, remains fluid. Each time the artist adds another line, a new leap of the imagination is needed to incorporate that line into the evergrowing mental image. If the line cannot be incorporated, it is discarded and a new one put down.

In this way, by a constant flow of impulses back and forth between the mind and the partly shaped material, the artist gradually defines more and more of the image, until at last all of it has been given visible form. Needless to say, artistic creation is too subtle and intimate an experience to permit an exact step-by-step description. Only artists can observe it fully, but they are so absorbed by it that they have great difficulty explaining it to us. The metaphor of birth comes closer to the truth than would a description of the process in terms of a transfer or projection of the image from the artist's mind, for the making of a work of art is both joyous and painful, replete with surprises, and in no sense mechanical. There is, moreover, ample testimony that artists themselves tend to look upon their creation as living things. Perhaps that is why creativity was once a concept reserved for god, as only he could give material form to an idea. Indeed, the artist's labors are much like the Creation told in the Bible; but this divine ability was not fully realized until Michelangelo described the anguish and glory of the creative experience when he spoke of "liberating the figure from the marble that imprisons it." Evidently he started the process of carving a statue by trying to visualize a figure in the rough, rectilinear block as it came to him from the quarry. (At times he may even have done so while picking out his material on the spot.)

At first Michelangelo did not see the figure any more clearly than one can see an unborn child inside the womb, but he may have believed that he could see isolated "signs of life" within the marble—a knee or an elbow pressing against the surface. To get a firmer grip on this dimly felt, fluid image, he was in the habit of making numerous drawings, and sometimes small models in wax or clay, before he dared to assault the "marble prison" itself. For that, he knew, was the final contest between himself and his material. Once he started carving, every stroke of the chisel would commit him more and more to a specific conception of the figure hidden in the block, and the marble would permit him to free the figure whole only if his guess as to its shape was correct.

Sometimes he did not guess well enough. The stone refused to give up some essential part of its prisoner, and Michelangelo, defeated, left the work unfinished, as he did with his *Awakening Slave* (fig. 3), whose very gesture seems to record the vain struggle for liberation. Looking at the block, we may get some inkling of Michelangelo's difficulties here. But could he not have finished the statue in *some* fashion? Surely there is enough material left for that. Well, he probably could have, but perhaps not in the way he wanted, and so he abandoned the sculpture.

Clearly, then, the making of a work of art has little in common with what is ordinarily meant by "making." It is a strange and risky business in which the makers never quite know what they are making until they have actually made it. Or, to put it another way, it is a game of find-and-seek in which the seekers are not sure what they are looking for until they have found it. In the case of the Bull's Head it is the bold "finding" that impresses us most; in the *Awakning Slave*, the strenuous "seeking." To the non-artist, it seems hard to believe that this uncertainty, this need to take a chance, should be the essence of the artist's work. We all tend to think of "making" in terms of artisans or manufacturers who know exactly what they want to produce from the very outset, pick the tools best suited to the task, and are sure of what they are doing at every step. Such "making" is a two-phase affair: first, artisans make a plan, then they act on it. And because they—or their customers—have made all the important decisions in advance, they have to worry only about the means, rather than the ends, while carrying out this plan. There is thus comparatively little risk in their endeavors, which as a consequence tend to become routine. It may even be replaced by the mechanical labor of a machine.

No machine, on the other hand, can replace the artist. In art, conception and execution go hand in hand and are so completely interdependent that they cannot be separated from each other. Whereas artisans generally attempt what they know to be possible, artists are driven to attempt the impossible—or at least the improbable or seemingly unimaginable. Who, after all, would have conceived that a bull's head was hidden in the seat and handlebars of a bicycle until Picasso discovered it? Did he not, almost literally, "make a silk purse out of a sow's ear"? No wonder the artist's way of working is so resistant to any set rules, while the artisan's tends to encourage standardization and regularity. The difference is that the artist *creates* instead of merely *makes* something, although the word has been done to death by overuse, and every child and fashion designer is labeled "creative."

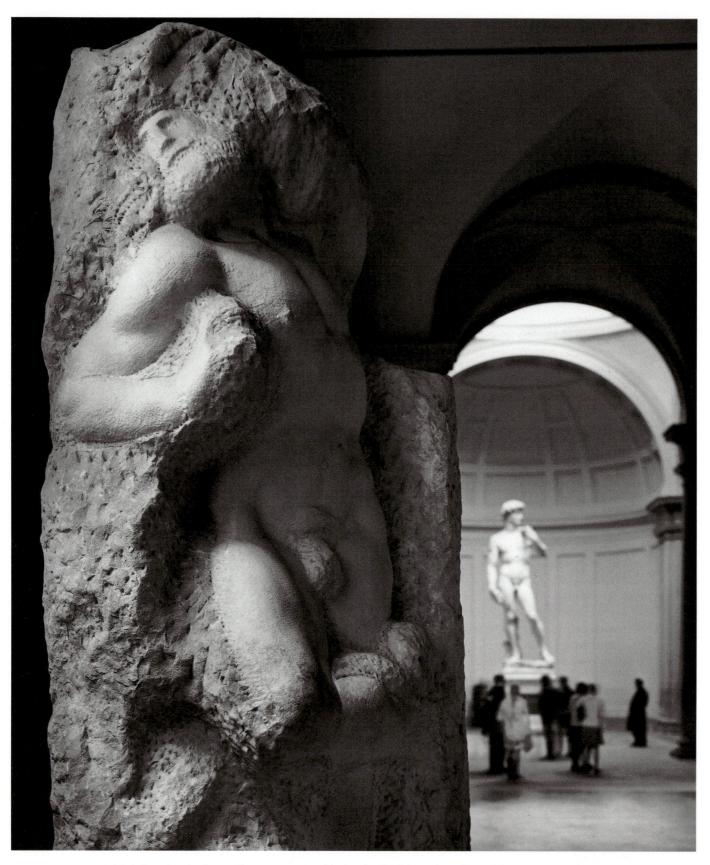

3. Michelangelo. Awakening Slave. c. 1525. Marble, height 8'11" (2.7 m). Galleria dell'Accademia, Florence

Needless to say, there have always been many more artisans than artists, since people's need for the familiar and expected far exceeds their capacity to absorb the original but often deeply unsettling experiences they get from works of art. The urge to penetrate unknown realms, to achieve something original, may be felt by every one of us now and then. To that extent, we can all fancy ourselves potential artists—mute, inglorious Miltons as it were. What sets the real artist apart is not so much the desire to *seek*, but that mysterious ability to *find*, which is called talent. It is often called a "gift," implying that it is a sort of present from some higher power; or as "genius," a term which originally meant that a higher power—a kind of "good demon"—inhabits and acts through the artist.

Talent must not be confused with aptitude. Aptitude is what the artisan needs. It means a better-than-average knack for doing something. An aptitude is fairly constant and specific. It can be measured with some success by means of tests that permit us to predict future performance. Creative talent, on the other hand, seems utterly unpredictable. It can be spotted only on the basis of *past* performance. Even past performance is not enough to ensure that a given artist will continue to produce on the same level. Some artists reach a creative peak quite early in their careers and then "go dry," while others, after a slow and unpromising start, may achieve astonishingly original work in middle age or even later.

Originality

Originality is what ultimately distinguishes art from craft. It is the yardstick of artistic greatness or importance. Unfortunately, it is also very hard to define. The usual synonyms—uniqueness, novelty, freshness—do not help us very much, and the dictionaries tell us only that an original work must not be a copy. If we want to rate works of art on an "originality scale," the problem does not lie in deciding whether or not a given work is original (the obvious copies and reproductions are for the most part easy enough to eliminate) but in establishing exactly *how* original it is.

Straightforward copies can usually be recognized as such on internal evidence alone. If the copyists are merely conscientious, they produce works of craft. The execution strikes us as pedestrian and out of tune with the conception of the work. There are also likely to be small slipups that can be spotted in much the same way as misprints in a text. But what happens when great artists copy each other? In such cases, they do not simply produce copies in the accepted sense of the word, since they do not try to achieve the effect of a duplicate. Rather, they do so purely for their own instruction, transcribing their models accurately, yet with their own inimitable rhythm, and are not the least constrained or intimidated by the other work of art. In other words, they "represent" (they do not copy) their models.

Ordinarily, though, the link is not immediately obvious. Édouard Manet's famous painting *Luncheon on the Grass (Le Déjeuner sur l'herbe;* fig. 4, page 22) seemed so revolutionary a work when first exhibited more than 130 years ago that it caused a scandal; the artist had dared to show an undressed young woman next to two men in fashionable contemporary dress. People assumed that Manet had intended to represent an actual event. Not until many years later did an art historian

discover the source of these figures: a group of classical deities from an engraving by Marcantonio Raimondi after a design supplied to him by Raphael (fig. 5). The relationship, so striking once it has been pointed out to us, had escaped attention, for Manet did not *copy* or *represent* the Raphael composition. He merely *borrowed* its main outlines while translating the figures into modern terms.

Had his contemporaries known of this, the *Luncheon* would have seemed a rather less disreputable kind of outing to them, since then the hallowed shade of Raphael could be seen to hover nearby as a sort of chaperon. For us, the main effect of the comparison is to make the cool, formal quality of Manet's figures even more conspicuous. But does it decrease our respect for his originality? True, he is "indebted" to Raphael; yet his way of bringing the forgotten old composition back to life is in itself so original and creative that he may be said to have more than repaid his debt. As a matter of fact, Raphael's figures are just as "derivative" as Manet's. They stem from still older sources which lead us back to ancient Roman art and beyond (compare the relief of *River Gods*, fig. 6).

Thus Manet, Raphael, and the Roman river-gods form three links in a chain of relationships that arises out of the distant past and continues into the future—for the *Luncheon* on the Grass has in turn served as a source of more recent works of art. Nor is this an exceptional case. All works of art anywhere—yes, even such works as Picasso's Bull's Head—are part of similar chains that link them to their predecessors. If it is true that "no man is an island," the same can be said of works of art. The sum total of these chains makes a web in which every work of art occupies its own specific place. This is known as tradition. Without tradition—the word means "that which has been handed down to us"-no originality would be possible. It is clear that Manet took tradition as his starting point and intended to link his painting to the past through wellhidden quotations in his "scandalous" group, as well as in the figure of the woman bathing and the landscape. Tradition provides, as it were, the firm platform from which artists make their leap of the imagination. The place where they land will then become part of the web and serve as a point of departure for further leaps.

And for us, too, the web of tradition is equally essential. Whether we are aware of it or not, tradition is the framework within which we inevitably form our opinions of works of art and assess their degree of originality. A masterpiece is a work that contributes to our vision of life and leaves us profoundly moved. Yet, it can also bear the closest scrutiny and withstand the test of time. Let us not forget, however, that such assessments should always remain subject to revision. In fact, tastes have varied greatly over time. Works that were once regarded as cornerstones of tradition have been discarded, while others that were ignored or even despised appear to be important works in their own right. Thus the "canon," or core body, of Western art is constantly shifting, rather than being static and immutable. One reason for this change is overexposure, which has reduced the greatest masterpieces to commodities through mass-merchandising in popular culture. Leonardo's Mona Lisa, Rodin's The Thinker, and Munch's The Scream are found everywhere in advertisements, humorous cards, and the like, so that they have become victims of their fame.

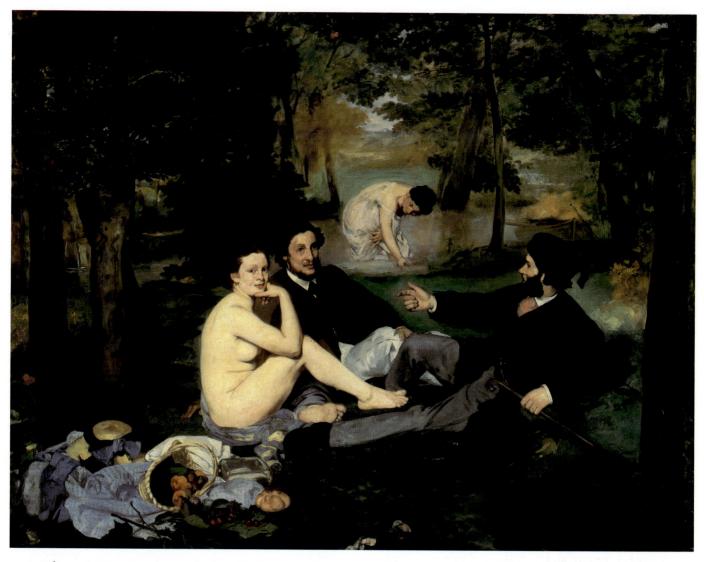

4. Édouard Manet. Luncheon on the Grass (Le Déjeuner sur l'herbe). 1863. Oil on canvas, 7' x 8'10" (2.1 x 2.6 m). Musée d'Orsay, Paris

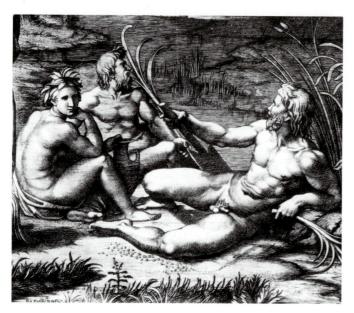

5. Marcantonio Raimondi, after Raphael. The Judgment of Paris (detail). c. 1520. Engraving. The Metropolitan Museum of Art, New York Rogers Fund, 1919

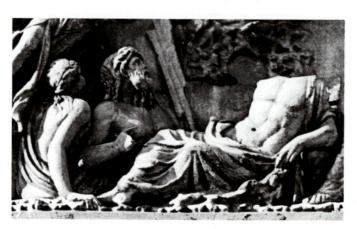

6. River Gods. Detail of Roman sarcophagus. 3rd century A.D. Villa Medici, Rome

If originality distinguishes art from craft, tradition serves as the common meeting ground of the two. Most beginning artists start out on the level of craft by imitating other works of art. In this way, they gradually absorb the artistic tradition of their time and place until they have gained a firm footing in it. But only the truly gifted ever leave that stage of conventional competence and become creators in their own right. No one, after all, can be taught how to create—only how to go through the motions of creating. The aspiring artist of talent will eventually achieve the real thing. What the apprentice or art student learns are skills and techniques: established ways of drawing, painting, carving, designing—established ways of seeing.

Nevertheless, one of the attributes that distinguishes great artists is their consummate technical command. This superior talent is recognized by other artists, who admire their work and seek to emulate it. This is not to say that facility alone is sufficient. Far from it! The academic painters and sculptors of the nineteenth century were as a group among the most proficient artists in history—as well as the dullest. Still, complete technical command is a requisite of masterpieces, which are distinguished by their superior execution.

When would-be artists sense that their talents are not great enough to succeed in the fine arts as painters, sculptors, or architects, many of them take up one of the special fields known collectively as "the applied arts," for which they can be rewarded in less artistically risky work: illustration, typographic design, industrial design, and interior design, for example. The applied arts are more deeply enmeshed in our everyday lives and thus cater to a far wider public than do painting and sculpture. Their purpose, as the name suggests, is to beautify the useful—an important and valued end. They provide some scope for originality to their more ambitious practitioners, but the flow of creative endeavor is cramped by such factors as the cost and availability of materials or manufacturing processes, as well as accepted notions of what is useful, fitting, or desirable.

Nevertheless, it is often difficult to maintain the distinction between fine and applied art. Medieval painting, for instance, is to a large extent "applied," in the sense that it embellishes surfaces which serve other, practical purposes as well—walls, book pages, windows, furniture. The same may be said of much ancient and medieval sculpture. Greek vases, although functional pottery, were sometimes decorated by artists of very impressive talent. Indeed, the history of applied art is filled with artists of considerable stature. How can this be so, if art and the crafts are so separate? The reason is that what defines art is not any difference in materials or techniques from the applied arts but the willingness to take risks in the quest for bold, new ideas. In architecture the distinction between art and applied art breaks down altogether, since the design of every building, from country cottage to cathedral, reflects external limitations imposed upon it by the practical purpose of the structure, by the site, by cost factors, materials, and technology. (The only "pure" architecture is imaginary, unbuilt architecture.) Thus architecture is, almost by definition, an applied art, but it is also a major art (as against the other applied arts, which are often called the "minor arts").

The graphic arts, which comprise the pictorial arts outside painting, especially those that rely on line rather than color, form a special case of their own. Drawings are original works of art; that is, they are entirely by the artist's own hand. With prints, however, the relationship between artist and image is more complex. Prints are not unique images but multiple impressions of images made by mechanical means on paper or other suitable material. Perhaps the distinction between original and copy is not so critical in printmaking after all. Printmakers must usually copy onto the plate a composition that was first worked out in a drawing, whether their own or someone else's. From the beginning, many prints have been made, at least in part, by artisans whose technical skill is necessary to ensure the outcome. Woodcuts and engraving in particular were traditionally dependent on craftsmanship, which may explain why so few creative geniuses have made them and have generally been content to let others produce prints from their designs. Although it does not require the artist's intervention at every step of the way, printmaking usually involves the artist's supervision and even active participation, so that the process can be thought of as a collaborative effort. The Judgment of Paris in figure 5 is an example of this type of work. Raphael had such admiration for Marcantonio's sensitive interpretations of his paintings that he began to make drawings for him to translate into engravings—a privilege enjoyed by no other printmaker. Because the design was conceived expressly with him in mind, Marcantonio's contribution was just as essential as, and hence no less original than, Raphael's.

Meaning and Style

Why do people create art? Surely one reason is an irresistible urge to adorn themselves and decorate the world around them. Both are part of a larger desire, not to remake the world in their image but to recast themselves and their environment in ideal form. Art is, however, much more than decoration. It is laden with meaning, even if that content is sometimes slender or obscure. What do we mean by content? The word encompasses not only the subject matter and literal meaning (its iconography) but its appearance as well, for the visual elements are themselves filled with significance. Art enables us to communicate our understanding in ways that cannot be expressed otherwise. In art, as in language, human beings are above all inventors of symbols that convey complex thoughts in new ways. We must think of art not in terms of everyday prose but of poetry, which is free to rearrange conventional vocabulary and syntax in order to convey new, often multiple, meanings and moods. A work of art likewise suggests much more than it states. It communicates partly by implying meanings through pose, facial expression, allegory, and the like. And like a poem, the value of art lies equally in what it says and how it says it.

But what is art trying to say? Artists often provide no clear explanation, since the work is the statement itself. If they could say what they mean in words, they would surely be writers instead. Fortunately, certain visual symbols and responses occur so regularly over time and place that they can be regarded as virtually universal. Nevertheless, their exact meaning is specific to each particular culture, giving rise to art's incredible diversity.

The meaning, or content, of art is inseparable from its formal qualities, its style. The word *style* is derived from *stilus*, the

writing instrument of the ancient Romans. Originally, it referred to distinctive ways of writing—the shape of the letters as well as the choice of words. Now, style is used loosely to mean the distinctive way a thing is done in any field of human endeavor. It is a term of praise in most cases: "to have style" means to have distinction, to stand out. A thing that has style also has inner coherence, or unity.

In the visual arts, style means the particular way in which the forms that make up any given work of art are chosen and fitted together. To art historians the study of styles is of great importance. It not only enables them to find out, by means of careful analysis and comparison, when, where, and by whom something was produced, but it also leads them to understand the artist's intention as expressed through the work's style, the way it looks. This intention depends on both the artist's personality and the context of time and place. Accordingly, art historians speak of "period styles" if they are concerned with those features which distinguish, let us say, Egyptian art as a whole from Greek art. Within these broad period styles they in turn distinguish the styles of particular phases, such as the Egyptian Old Kingdom. And wherever it seems appropriate, they differentiate national or local styles within a period, until they arrive at the personal styles of individual artists. Even these may need to be subdivided further into the various phases of an artist's development. The extent to which they are able to categorize effectively depends on the degree of internal coherence, and on how much of a sense of continuity there is in the body of material they are dealing with. Thus art, like language, requires that we learn the style and outlook of a country, period, and artist if it is to be understood properly.

Style needs only be appropriate to the *intent* of the work. This idea is not always easy to accept. Westerners are accustomed to a tradition of naturalism, in which art imitates nature as closely as possible. But the accurate reproduction of visual phenomena, called illusionism, is just one vehicle for expressing an artist's understanding of reality. Truth, it seems, is indeed relative, for it is a matter not simply of what our eyes tell us but also of the concepts through which our perceptions are filtered. There is, then, no reason to place a premium on realism (a term that is sometimes taken to mean truth to life, in contradistinction to naturalism, though most people use them interchangeably). The advantage of realism at face value is that it seems easier to understand. The disadvantage is that representational art, like prose, is always bound to the literal meaning and appearance of the everyday world, at least to some extent. Actually, realism is exceptional in the history of art and is not even necessary to its purposes. Any image is a separate and self-contained reality which has its own ends and responds to its own imperatives as determined by the artist's creativity. Even the most convincing illusion is the product of the artist's imagination and understanding, so that we must always ask why this subject was chosen and made in this way rather than in some other way.

Self-Expression and Audience

The birth of a work of art is an intensely private experience, so much so that many artists can work only when completely alone and refuse to show their unfinished pieces to anyone. Yet

it must, as a final step, be shared by the public in order for the birth to be successful. Artists do not create merely for their own satisfaction, but want their work validated by others. In fact, the creative process is not completed until the work has found an audience. In the end, works of art exist in order to be liked rather than to be debated.

This seeming paradox can be resolved once we understand what artists mean by "public." They are concerned not with the public as a statistical entity but with their particular public, their audience; quality rather than wide approval is what matters to them. At a minimum, this audience needs to consist of only one or two people whose opinions they value. Ordinarily, artists also need patrons among their audience who will purchase their work, thus combining moral and financial support. In contrast to customers of applied art, for example, who know from previous experience what they will get when they buy the products of craftsmanship, the "audience" for art merits such adjectives as critical, fickle, receptive, engaged. It is uncommitted, free to accept or reject, so that anything placed before it is on trial—nobody knows in advance how it will receive the work. Hence, there is a tension between artist and audience that has no counterpart in the relationship of artisan and customer.

The audience whose approval looms so large in artists' minds is a limited and special one. Its members may be other artists as well as patrons, friends, critics, and interested viewers. The one quality they all have in common is an informed love of works of art—an attitude at once discriminating and enthusiastic that lends particular weight to their judgments. They are, in a word, experts, people whose authority rests on experience and knowledge. In reality, there is no sharp break, no difference in kind, between the expert and the layperson, only a difference in degree.

Tastes

Deciding what is art and rating a work of art are two separate problems. If there were an absolute method for distinguishing art from non-art, it would not necessarily help in measuring quality. People tend to compound the two problems into one. Often when they ask, "Why is that art?" they mean, "Why is that good art?" How often have we heard this question asked before a strange, disquieting work in a museum or art exhibition? There usually is an undertone of exasperation, for the question implies that the viewer doesn't think he or she is looking at a work of art, but that the experts—the critics, museum curators, art historians—must suppose it to be one, or why else would they put it on public display? Clearly, their standards are very different from others. People wish for a few simple, clear-cut rules to go by. Then maybe they would learn to like what they see-they would know "why it is art." But the experts do not post exact rules, and the lay person is apt to fall back upon a final line of defense: "Well, I don't know anything about art, but I know what I like."

It is a formidable roadblock, this stock phrase, in the path of understanding between expert and lay audience. Until not so very long ago, there was no great need for the two parties to communicate with each other. The general public had little voice in matters of art and therefore could not challenge the judgment of the expert few. Today both sides are aware of the barrier between them and the need to level it. Let us examine the roadblock and the various unspoken assumptions that buttress it.

The fact that art is a complex and in many ways mysterious human activity about which even the experts can hope to offer only tentative and partial conclusions can be taken as confirming the belief that "I don't know anything about art." But are there really people who know nothing about art? The answer must be no for nearly all adults, who cannot help knowing something about it, just as everybody knows something about politics and economics, no matter how indifferent one may be to the issues of the day. Art is so much a part of the fabric of daily life that it is encountered all the time, even if the contacts are limited to magazine covers, advertising posters, war memorials, television, and the buildings where we live, work, and worship. Much of this art, to be sure, is pretty shoddy—art at third- and fourth-hand, worn out by endless repetition, representing the common denominator of popular taste. Still, it is art of a sort, and since it is the only art most people experience, it molds their ideas on art in general. When they say, "I know what I like," they may really mean, "I like what I know (and I am uncomfortable with whatever fails to match the things I am familiar with)." Such likes are not in truth so much theirs as those imposed by habit and culture without any personal choice. To like what we know and to distrust what we do not know is an age-old human trait. The past tends to be "the good old days," while the future seems fraught with danger.

But why should so many people cherish the notion of making personal choices in art when in fact they do not? There is another unspoken assumption at work here that goes something like this. "Since art is such an 'unruly' subject that even the experts keep disagreeing with each other, my opinion is as good as theirs. It's all a matter of subjective preference. In fact, my opinion may be better than theirs, because as a lay person I react to art in a direct, straightforward fashion, without having my view obstructed by a lot of complicated facts and theories. There must be something wrong with a work of art if it takes an expert to appreciate it." On the contrary, experts appreciate art more than other people precisely because of their greater knowledge. Expertise requires only an open mind and a capacity to absorb new experiences. So as their understanding grows, most people find themselves liking a great many more things than they had thought possible at the start. They gradually acquire the courage of their own convictions, until they are able to say, with some justice, that they know what they like.

LOOKING AT ART

The Visual Elements

We live in a sea of images conveying the culture and learning of modern civilization. Fostered by an unprecedented media explosion, this "visual background noise" has become so much a part of our daily lives that we take it for granted. In the process, we have become desensitized to art as well. Anyone can buy cheap paintings and reproductions to decorate a room, where they often hang virtually unnoticed, perhaps deservedly so. It is small wonder that we look at the art in museums with equal casualness. We pass rapidly from one object to another, sampling them like dishes in a cafeteria line. We may pause briefly before a famous masterpiece that we have been told we are supposed to admire, then ignore the gallery full of equally beautiful and important works around it. We will have seen the art but not really looked at it. Looking at great art is not such an easy task, for art rarely reveals its secrets readily. While the experience of a work can be immediately electrifying, we sometimes do not realize its impact until it has had time to filter through the recesses of our imaginations. It even happens that something that at first repelled or confounded us emerges only many years later as one of the most important artistic events of our lives. Because so much goes into art, it makes much the same demands on our faculties as it did on the person who created it. For that reason, we must be able to respond to it on many levels. If we are going to get the most out of art, we will have to learn how to look and think for ourselves in an intelligent way, which is perhaps the hardest task of all. After all, we will not always have someone at our side to help us. In the end, the confrontation of viewer and art remains a solitary act.

Understanding a work of art begins with a sensitive appreciation of its appearance. Art can be approached and appreciated for its purely visual elements: line, color, light, composition, form, and space. These may be present in any work of art. Their effects, however, vary widely according to medium (the physical materials of which the artwork is made) and technique, which together help to determine the possibilities and limitations of what the artist can achieve. For that reason, our discussion is merged with an introduction to four major arts: graphic arts, painting, sculpture, and architecture. (The technical aspects of the major mediums are treated in sections within the main body of the text and in the glossary toward the end of the book.) Just because line is discussed with drawing, however, does not mean that it is not equally important in painting and sculpture. And although form is introduced with sculpture, it is just as essential to painting, drawing, and architecture.

Visual analysis can help us to appreciate the beauty of a masterpiece, but we must be careful not to use a formulaic approach that would trivialize it. Every aesthetic "law" advanced so far has proven of dubious value, and usually gets in the way of our understanding. Even if a valid "law" were to be found—and none has yet been discovered—it would probably be so elementary as to prove useless in the face of art's complexity. We must also bear in mind that art appreciation is more than enjoyment of aesthetics. It is learning to understand the meaning of a work of art. And finally, let us remember that no work can be understood outside its historical context.

LINE. Line may be regarded as the most basic visual element. A majority of art is initially conceived in terms of contour line. Its presence is often implied even when it is not actually used to describe form. And because children start out by scribbling, line is generally considered the most rudimentary component of art—although as anyone knows who has watched a youngster struggle to make a stick figure with pencil or crayon, drawing is by no means as easy as it seems. Line

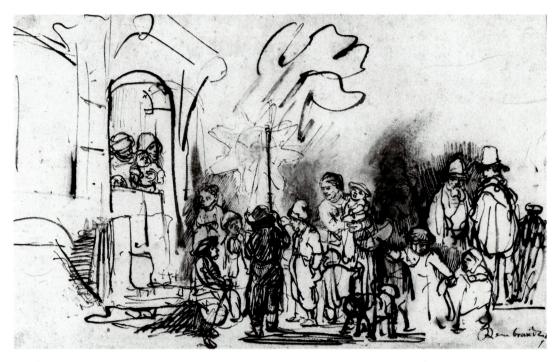

7. Rembrandt. *The Star of the Kings*. c. 1642. Pen and bistre, wash on paper, 8 x 12³/4" (20.3 x 32.4 cm). The British Museum, London

has traditionally been admired for its descriptive value, so that its expressive potential is easily overlooked. Yet line is capable of creating a broad range of effects.

Drawings represent line in its purest form. The appreciation of drawings as works of art dates from the Renaissance, when the artist's creative genius first came to be valued and paper began to be made in quantity. Drawing style can be as personal as handwriting. In fact, the term *graphic art*, which designates drawings and prints, comes from the Greek word for writing, *graphos*. Collectors treasure drawings because they seem to reveal the artist's inspiration with unmatched freshness. Their role as records of artistic thought also makes drawings uniquely valuable to the art historian, for they help in documenting the evolution of a work from its inception to the finished piece.

Artists themselves commonly treat drawings as a form of note-taking. Some of these notes are discarded as fruitless, while others are tucked away to form a storehouse of motifs and studies for later use. Rembrandt was a prolific draftsman who was constantly jotting down observations of daily life and other ideas for further development. His use of line was highly expressive. Many of his sketches were done in pen and ink, a medium that captured his most intimate thoughts with admirable directness. In *The Star of the Kings* (fig. 7), one of his most elaborate sheets, Rembrandt rendered the essence of each pose and expression with remarkable succinctness—the dog, for example, consists of no more than a few strokes of the pen—yet every figure emerges as an individual character. Rembrandt's draftsmanship is so forceful that it allows us to

mentally trace the movements of the master's hand with astonishing vividness.

Once a basic idea is established, an artist may develop it into a more complete study. Michelangelo's studies (fig. 8) of the Libyan Sibyl for the Sistine Chapel ceiling is a drawing of great beauty. For this sheet, he chose the softer medium of red chalk over the scratchy line of pen and ink that he used in rough sketches. His chalk approximates the texture of flesh and captures the play of light and dark over the nude forms, giving the figure a greater sensuousness. The emphatic outline that defines each part of the form is so fundamental to the conceptual genesis and design process in all of Michelangelo's paintings and drawings that ever since his time line has been closely associated with the "intellectual" side of art.

In accordance with the practice of the day, it was Michelangelo's habit to base his female figures on male nudes drawn from life. To him, moreover, only the heroic male nude possessed the physical monumentality necessary to express the awesome power of figures such as this mythical prophetess. In common with other sheets like this by him, Michelangelo's focus here is on the torso. He studied the musculature at length before turning his attention to details like the hand and toes. Since there is no sign of hesitation in the pose, we can be sure that the artist already had the conception firmly in mind. (Probably it had been established in a preliminary drawing.) Why did he go to so much trouble when the finished sibyl is mostly clothed and must be viewed from a considerable distance below? Evidently Michelangelo believed that only by describing the anatomy completely

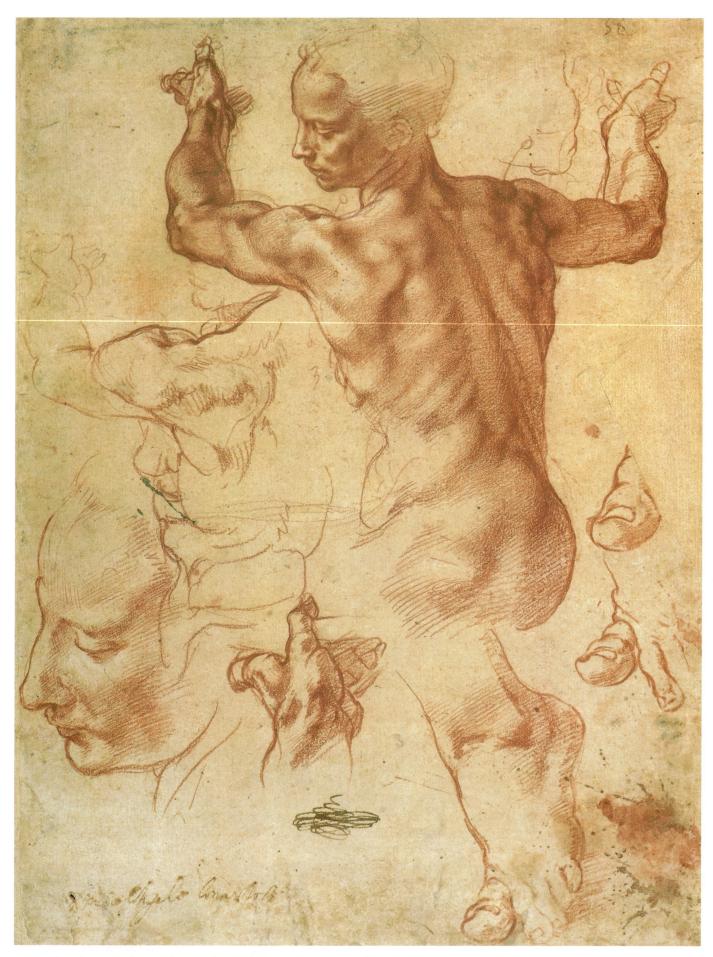

8. Michelangelo. Studies for the Libyan Sibyl. c. 1511. Red chalk on paper, 11³/8 x 8³/8" (28 x 21.3 cm). The Metropolitan Museum of Art, New York Purchase, Joseph Pulitzer Bequest, 1924

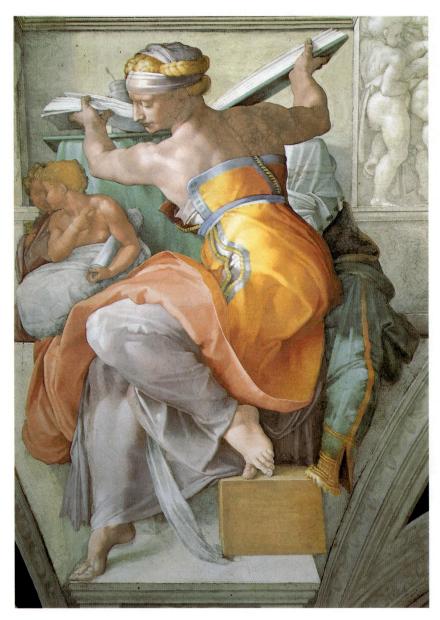

9. Michelangelo. *Libyan Sibyl*, portion of the Sistine Ceiling. 1508–12. Fresco. Sistine Chapel, The Vatican, Rome

could he be certain that the figure would be convincing. In the final painting (fig. 9) she communicates a superhuman strength, lifting her massive book of prophecies with the utmost ease.

COLOR. The world is alive with color, and because color is an adjunct element to graphics and sometimes sculpture, it is indispensable to virtually all forms of painting. This is true even of tonalism, which emphasizes dark, neutral hues like gray and brown. Of all the visual elements, color is undoubtedly the most expressive—as well as the most intractable. Perhaps for that reason, it has attracted the wide attention of researchers and theorists since the mid-nineteenth century. Along with the Post-Impressionists and, more recently, Op artists, color theorists have tried to set down their understanding of colors as perceptual and artistic laws equivalent to those of optical physics. Both Van Gogh and Seurat developed elaborate color systems, one entirely personal in its

meaning, the other claiming to be "scientific." We often read that red seems to advance, while blue recedes; or that the former is a violent or passionate color, the latter a sad one. Like a recalcitrant child, however, color in art refuses to be governed by any rules. They work only when the painter consciously applies them.

Notwithstanding this large body of theory, the role of color in art rests primarily on its sensuous and emotive appeal, in contrast to the more cerebral quality generally associated with line. The merits of line versus color have been the subject of a debate that first arose between partisans of Michelangelo and Titian, Michelangelo's great contemporary in Venice. Titian himself was a fine draftsman and absorbed the influence of Michelangelo. He nevertheless stands at the head of the coloristic tradition that descends through Rubens and Van Gogh to the Abstract Expressionists of the twentieth century. In fact, *Danäe* (fig. 10), painted in the middle of Titian's long career during a sojourn in Rome, shows the

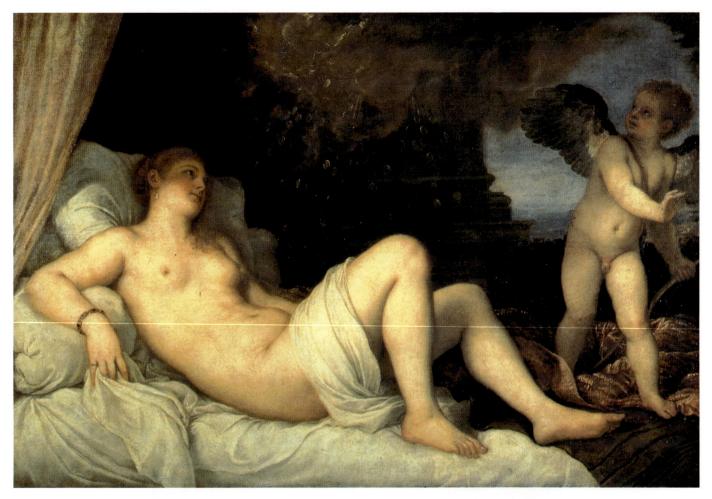

10. Titian. Danaë. c. 1544-46. Oil on canvas, 471/4 x 673/4" (120 x 172 cm). Museo e Gallerie Nazionale di Capodimonte, Naples

impact of Michelangelo's figure of Night on the Tomb of Giuliano de' Medici (fig. 616). After seeing it, Michelangelo is said to have praised Titian's coloring and style but criticized his sense of design. We can readily understand Michelangelo's discomfort, for Titian has rephrased his sculpture in utterly sensuous terms through the painterly application of sonorous color that is characteristic of his work.

Though Titian no doubt worked out the essential features of the composition in preliminary drawings, none have survived. Nor evidently did he transfer the design onto the canvas but worked directly on the surface, making subtle adjustments as he went along. By varying the consistency of his pigments, the artist was able to capture the texture of Danäe's flesh with uncanny accuracy, while distinguishing it clearly from bed sheets and covers. To convey these tactile qualities, Titian built up his surface in thin coats, known as glazes. The interaction between these layers produces unrivaled richness and complexity of color; yet the medium is so filmy as to become nearly translucent as the cloud, in which guise Jupiter appears to the mortal young woman, trails off into the gossamer sky.

Color is so potent that it does not need a system to work its magic in art. From the heavy outlines, it is apparent that Picasso must have originally conceived Girl Before a Mirror (fig. 11) in terms of form; yet the picture makes no sense in black and white. He has treated his shapes much like the

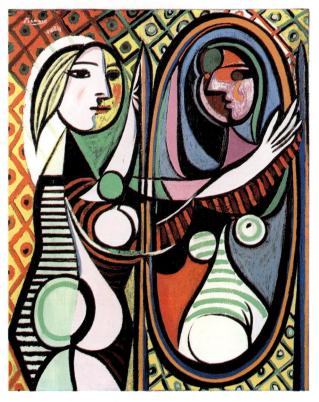

11. Pablo Picasso. Girl Before a Mirror. March 1932. Oil on canvas, 64 x 51¹/4" (162.3 x 130.2 cm). The Museum of Modern Art, New York Gift of Mrs. Simon Guggenheim

12. Caravaggio. David with the Head of Goliath. 1607 or 1609/10. Oil on canvas, $49^{1/4} \times 39^{3/8}$ " (125.1 x 100.1 cm). Galleria Borghese, Rome

enclosed, flat panes of a stained-glass window to create a lively decorative pattern. The motif of a young woman contemplating her beauty goes all the way back to antiquity, but rarely has it been depicted with such disturbing overtones. Picasso's girl is anything but serene. On the contrary, her face is divided into two parts, one with a somber expression, the other with a masklike appearance whose color nevertheless betrays passionate feeling. She reaches out to touch the image in the mirror with a gesture of longing and apprehension.

Now we all feel a jolt when we unexpectedly see ourselves in a mirror, which often gives back a reflection that upsets our self-conception. Picasso here suggests this visionary truth in several ways. Much as a real mirror introduces changes of its own and does not reflect the simple truth, so this one alters the way the girl looks, revealing a deeper reality. She appears not so much to be examining her physical appearance as to be exploring her sexuality. The mirror is a sea of conflicting emotions signified above all by the color scheme of her reflection. Framed by strong blue, purple, and green hues, her features stare back at her with fiery intensity. Clearly discernible is a tear on her cheek. But it is the masterstroke of the green spot, shining like a beacon in the middle of her forehead, that con-

veys the anguish of the girl's confrontation with her inner self. Picasso was probably aware of the theory that red and green are complementary colors which intensify each other. However, this "law" can hardly have dictated his choice of green to stand for the girl's psyche. That was surely determined as a matter of pictorial and expressive necessity.

LIGHT. For the most part, art is concerned with reflected light effects rather than with radiant light. (Among the few exceptions are modern light installations such as laser displays.) Artists have several ways of representing radiant light. Divine light, for example, is sometimes indicated by golden rays, at other times by a halo or aura. A candle or torch may be depicted as the source of light in a dark interior or night scene. The most common method is not to show radiant light directly but to suggest its presence through a change in the value of reflected light from dark to light. Sharp contrast (known as *chiaroscuro*, the Italian word for light-dark) is identified with the Baroque artist Caravaggio, who made it the cornerstone of his style. In *David with the Head of Goliath* (fig. 12), he employed it to heighten the drama. An intense raking light from an unseen source at the left is used to model

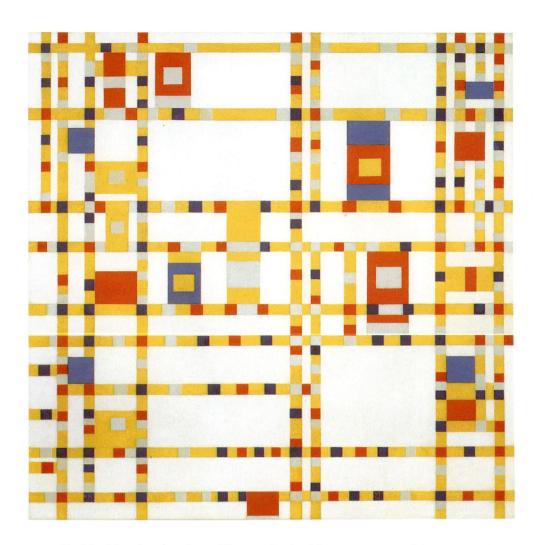

13. Piet Mondrian. *Broadway Boogie Woogie*. 1942–43. Oil on canvas, 50 x 50" (127 x 127 cm).

The Museum of Modern Art, New York

Given anonymously

forms and create textures. The selective highlighting endows the lifesize figure of David and the gruesome head with a startling presence. Light here serves as a device to create the convincing illusion that David is standing before us. With its indeterminate depth, the pictorial space, which extends beyond the picture plane, becomes continuous with ours, despite the fact that the frame cuts off the figure. Thus the foreshortened arm with Goliath's head seems to extend out to the viewer from the dark background. For all its obvious theatricality, the painting is surprisingly muted: David seems to contemplate Goliath with a mixture of sadness and pity. The severed head is a self-portrait, and the disturbing image communicates a tragic personal vision that was soon fulfilled. Not long after the *David* was painted, Caravaggio killed another man in a duel, which forced him to spend the rest of his short life on the run.

Light can also be implied through color. Piet Mondrian uses white and the three primary colors—red, yellow, and blue—to signify radiant light in *Broadway Boogie Woogie* (fig. 13), a painting that immortalizes his fascination with the culture he found in America after emigrating from his native Holland during World War II. The play of color evokes with

striking success the jaunty rhythms of light and music found in New York's nightclub district during the jazz age. *Broadway Boogie Woogie* is as flat as the canvas it is painted on. Mondrian has laid out his colored "tiles" along a grid system that appropriately resembles a city map. As in a medieval manuscript decoration (fig. 352), the composition relies entirely on surface pattern.

COMPOSITION. Composition is the organization of forms in art. It is of fundamental importance, because all art requires order. Otherwise its message would emerge as visually garbled. To accomplish this, the artist must control space within the framework of a unified composition. Moreover, pictorial space must work across the picture plane, as well as behind it. Since the Early Renaissance, we have become accustomed to experiencing paintings as windows onto separate illusionistic realities. The Renaissance invention of one-point perspective—also called linear or scientific perspective—provided a geometric system for the convincing representation of architectural and open-air settings. By having the orthogonals (shown as diagonal lines) converge at a vanishing point on the horizon, it enabled the artist to gain command over every aspect of his

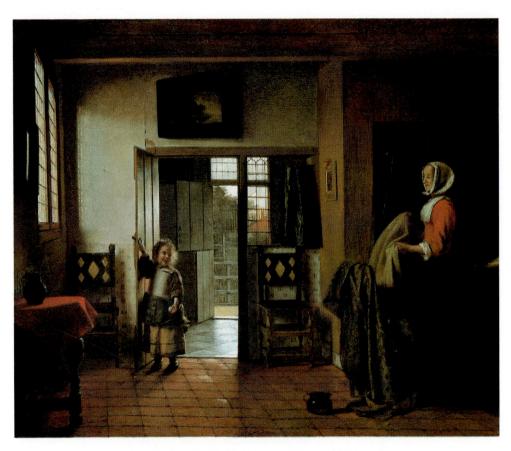

14. Pieter de Hooch. *The Bedroom.* c. 1658–60. Oil on canvas, 20 x $23^{1/2}$ " (51 x 60 cm). National Gallery of Art, Washington, D.C. Widener Collection

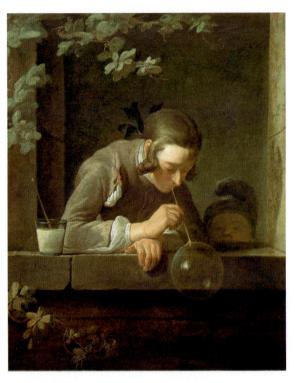

15. Jean-Baptiste-Siméon Chardin. Soap Bubbles. c. 1733–34. Oil on canvas, $36^5/8 \times 29^3/8$ " (93 x 74.6 cm). National Gallery of Art, Washington, D.C. Gift of Mrs. John Simpson

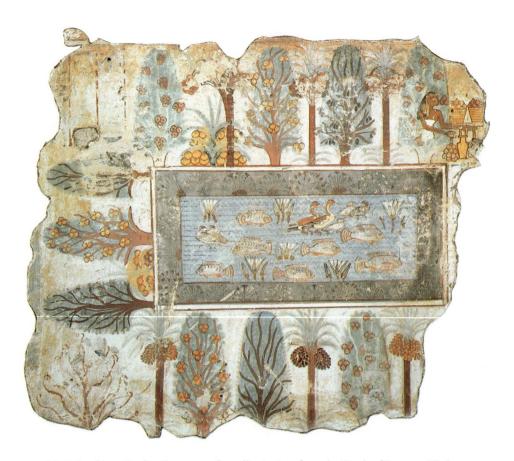

16. A Pond in a Garden. Fragment of a wall painting, from the Tomb of Ramose, Thebes.c. 1400 B.C. The British Museum, London

composition, including the rate of recession and placement of figures. Pieter de Hooch, the Dutch Baroque artist, used one-point perspective in organizing *The Bedroom* (fig. 14). Nevertheless, the problems he faced in composing the three-dimensional space of his work were not so very different from those later confronted by Mondrian. (The surface geometry of De Hooch's painting is basically similar in design to *Broadway Boogie Woogie*.) Each part of the house is treated as a separate pocket of space and as a design element that is integrated into the scene as a whole.

Artists will usually dispense with aids like perspective and rely on their own eyes. This does not mean that they merely transcribe optical reality. Soap Bubbles by the French painter Jean-Baptiste-Siméon Chardin (fig. 15) depends in good measure on a satisfying composition for its success. The motif had been a popular one in earlier Dutch genre scenes, where bubbles symbolized life's brevity and, hence, the vanity of all earthly things. No such meaning can be attached to Chardin's picture, which is disarming in its simplicity. The interest lies solely in the seemingly insignificant subject and in the sense of enchantment imparted by the children's rapt attention to the moment. We know from a contemporary source that Chardin painted the youth "carefully from life and . . . tried hard to give him an ingenuous air." The results are anything but artless, however. The triangular shape of the boy leaning on the ledge gives stability to the painting, which helps to suspend the fleeting instant in time. To fill out the composition, the artist includes the toddler peering intently over the ledge at the bubble, which is about the same size as his head. Chardin has carefully thought out every aspect of his arrangement. The honeysuckle in the upper left-hand corner, for example, echoes the contour of the adolescent's back, while the two straws are virtually parallel to each other. Even the crack in the stone ledge has a purpose: to draw attention to the glass of soap by setting it slightly apart.

Often artists paint not what they see but what they imagine. A wall painting from Thebes (fig. 16) presents a flattened view of a delightful garden in which everything is shown in profile except for the pond, which is seen from above. In order to provide the clearest, most complete idea of the scene, the Egyptian artist treated each element as an entity unto itself. Instead of using standard devices such as scale and overlapping, space is treated vertically, so that we read the trees at the bottom as being "closer" to us than those at the top, even though they are the same size. Despite the multiple vantage points and implausible bird's-eye view, the image works because it constitutes a self-contained reality. The picture, moreover, has an aesthetically satisfying decorative unity. The geometry underlying the composition reminds us once more of Broadway Boogie Woogie. At the same time, the presentation has such clarity that we feel as if we were seeing nature with open eyes for the first time.

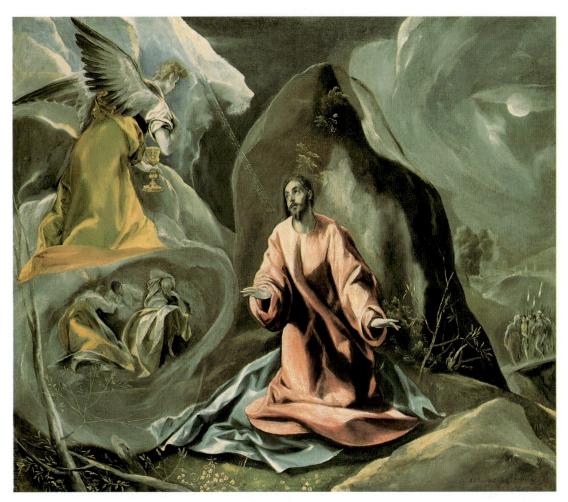

17. El Greco. *The Agony in the Garden.* 1597–1600. Oil on canvas, $40^{1}/4 \times 44^{3}/4$ " (102.2 x 113.6 cm). The Toledo Museum of Art, Toledo, Ohio Gift of Edward Drummond Libbey

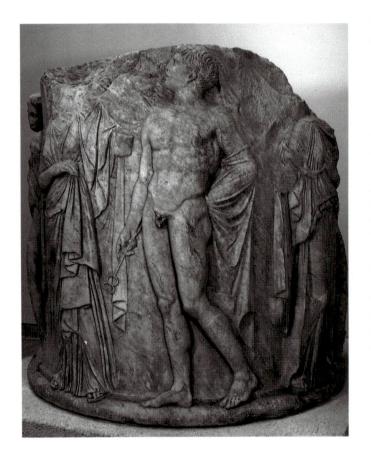

Pictorial space need not conform to either conceptual or visual reality. El Greco's *The Agony in the Garden* (fig. 17) uses contradictory, irrational space to help conjure up a mystical vision that instead represents a spiritual reality. Jesus, isolated against a large rock that echoes his shape, is comforted by the angel bearing a golden cup, symbol of the Passion (the suffering of Jesus in his last days). The angel appears to kneel on a mysterious oval cloud, which envelops the sleeping disciples. In the distance to the right we see Judas and the soldiers coming to arrest the Lord. The composition is balanced by two giant clouds on either side. The entire landscape resounds with Jesus' agitation, represented by the sweep of supernatural forces. The elongated forms, eerie moonlight, and expressive colors—all hallmarks of El Greco's style—help to heighten our sense of identification with Jesus' suffering.

FORM. Line creates shape. Every shape that we encounter in art is a counterpart to form. The only difference between them is that shape is flat, whereas form has volume, though it also has a characteristic shape defined by its contour. There is a vast difference between drawing or painting forms and sculpting them. The one transcribes, the other brings them to life, as it were. They require fundamentally different talents and atti-

18. Alkestis Leaving Hades. Lower column from the Temple of Artemis, Ephesus. c. 340 B.C. Marble, height 71" (180.3 cm).

The British Museum, London

Praxiteles (attr.). Standing Youth, found in the sea off Marathon.
 c. 350–325 B.C. Bronze, height 51" (129.5 cm).
 National Archaeological Museum, Athens

tudes toward material as well as subject matter. Although a number of artists have been competent in both painting and sculpture, only a handful managed to bridge the gap between them with complete success.

Sculpture is categorized according to whether it is carved or modeled and whether it is a relief or a free-standing statue. Relief remains tied to the background, from which it only partially emerges, in contrast to free-standing sculpture, which is fully liberated from it. A further distinction is made between low (bas) relief and high (alto) relief, depending on how much the carving projects. However, since scale as well as depth must be taken into account, there is no single guideline, so that a third category, middle (mezzo) relief, is sometimes added.

Low reliefs often share characteristics with painting. In Egypt, where low-relief carving attained unsurpassed subtlety, many reliefs were originally painted and included elaborate settings. High reliefs largely preclude this kind of pictorialism. The figures on a column from a Greek temple (fig. 18) have become so detached from the background that the addition of landscape or architecture elements would be both unnecessary and unconvincing. The neutral setting, moreover, is in keep-

20. Gianlorenzo Bernini. *Apollo and Daphne*. 1622–24. Marble, height 8' (2.43 m). Galleria Borghese, Rome

ing with the mythological subject, which takes place in an indeterminate time and place. In compensation, the sculptor has treated the limited free space atmospherically, yet the figures remain imprisoned in stone.

Free-standing sculpture—that is, sculpture that is carved or modeled fully in the round—is made by either of two methods. One is modeling, an additive process using soft materials such as plaster, clay, or wax. Since these materials are not very durable, they are usually cast in a more lasting medium: anything that can be poured, including molten metal, cement, even plastic. Modeling encourages "open" forms with the aid of metal armatures to support their extension into space. This in conjunction with the development of lightweight hollow-bronze casting enabled the Greeks to experiment with daring poses in monumental sculpture before attempting them in marble. In contrast to the figure of Hades on the column, the bronze youth in figure 19 is free to move about, lending him a lifelike presence that is further enhanced by his dancing pose. His inlaid eyes and soft patina, accentuated by oxidation and corrosion (he was found in the Aegean Sea off the coast of Greece, near Marathon), make him even more credible in a way that marble statues, with their

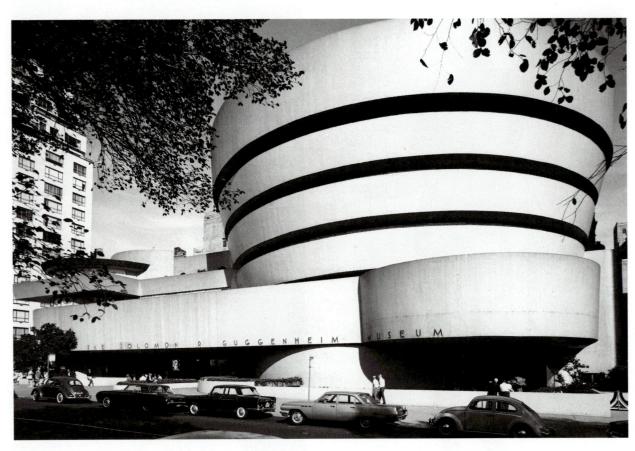

21. Frank Lloyd Wright. Solomon R. Guggenheim Museum, New York. 1956-59

seemingly cold and smooth finish, rarely equal, despite their more natural color (compare fig. 20).

Carving is the very opposite of modeling. It is a subtractive process that starts with a solid block, usually stone, which is highly resistant to the sculptor's chisel. The brittleness of stone and the difficulty of cutting it tend to result in the compact, "closed" forms seen in Michelangelo's Awakening Slave (fig. 3). One of the most daring attempts at overcoming the tyranny of mass over space is Apollo and Daphne by the Baroque sculptor Gianlorenzo Bernini (fig. 20). The dancelike pose of Apollo and graceful torsion of Daphne create the impression that they are moving in a carefully choreographed ballet. Time and motion have almost, but not quite, come to a standstill as the nymph begins to change into a tree rather than succumb to the god's amorous advances. The sculpture is an amazing technical achievement. Bernini is completely successful in distinguishing between the soft flesh of Daphne and the rough texture of the bark and leaves. The illusion of change is so convincing that we share Apollo's shock at the metamorphosis.

Like most monumental sculpture, *Apollo and Daphne* was intended for a specific location. It was originally placed along the wall to the left of the doorway, rather than in the middle

of the room as now. Thus despite the fact that it is fully carved, the back side was never meant to be seen and provides little additional visual information. The statue demands our direct participation in order to experience the drama. The action unfolds gradually as we walk around the sculpture (our illustration shows the most characteristic view), reaching its climax almost directly in front of Daphne, where her transformation has its greatest "shock effect." Bernini's ingenuity in creating this theatrical display is fully characteristic of the Baroque.

SPACE. In our discussions of pictorial and sculptural space, we have repeatedly referred to architecture, for it is the principal means of organizing space. Of all the arts, it is also the most practical. Architecture's parameters are defined by utilitarian function and structural system, but there is almost always an aesthetic component as well, even when it consists of nothing more than a decorative veneer. A building proclaims the architect's concerns by the way in which it weaves these elements into a coherent program.

Architecture becomes memorable only when it expresses a transcendent vision, whether personal, social, or spiritual. Such buildings are almost always important public places that require the marshaling of significant resources and serve the

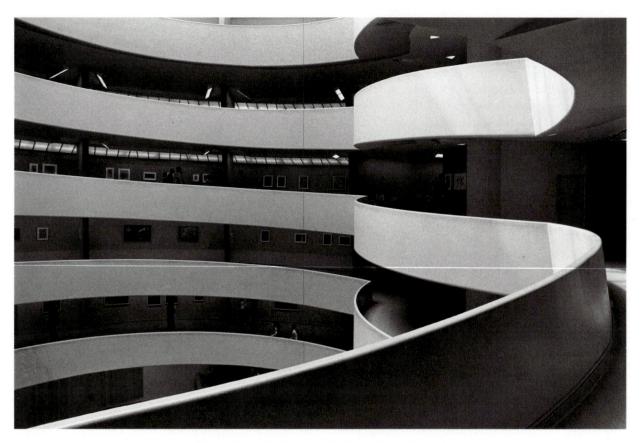

22. Interior of the Solomon R. Guggenheim Museum

purpose of bringing people together to share common goals, pursuits, and values. An extreme case is the Solomon R. Guggenheim Museum in New York by the architect Frank Lloyd Wright. Scorned when it was first erected in the late 1950s, it is a brilliant, if idiosyncratic, creation by one of the most original architectural minds of the century. The sculptural exterior (fig. 21) announces that this can only be a museum, for it is self-consciously a work of art in its own right. As a piece of design, the Guggenheim Museum is remarkably willful. In shape it is as defiantly individual as the architect himself and refuses to conform to the boxlike apartments around it. From the outside, the structure looks like a gigantic snail, reflecting Wright's interest in organic shapes. The office area forming the "head" to the left is connected by a narrow passageway to the "shell" containing the main body of the museum.

The outside gives us some idea of what to expect inside (fig. 22), yet nothing quite prepares us for the extraordinary sensation of light and air in the main hall after being ushered through the unassuming entrance. The radical design makes it clear that Wright had completely rethought the purpose of an art museum. The exhibition area is a kind of inverted dome with a huge glass-covered eye at the top. The vast, fluid space

creates an atmosphere of quiet harmony while actively shaping our experience by determining how art shall be displayed. After taking an elevator to the top of the building, the visitor begins a leisurely descent down the gently sloping ramp. The continuous spiral provides for uninterrupted viewing, conducive to studying art. At the same time, the narrow confines of the galleries prevent us from becoming passive observers by forcing us into a direct confrontation with the works themselves. Sculpture takes on a heightened physical presence which demands that we look at it. Even paintings acquire a new prominence by protruding slightly from the curved walls, instead of receding into them. Viewing exhibitions at the Guggenheim is like being conducted through a predetermined stream of consciousness, where everything merges into a total unity. Whether one agrees with this approach or not, the building testifies to the strength of Wright's vision by precluding any other way of seeing the art.

Meaning in Context

Art has been called a visual dialogue, for though the object itself is mute, it expresses its creator's intention just as surely as if it were speaking to us. For there to be a dialogue, however, our active participation is required. If we cannot literally talk to a work of art, we can learn how to respond to it and question it in order to fathom its meaning. Finding the right answers usually involves asking the right questions. Even if we are not sure which question to ask, we can always start with, "What would happen if the artist had done it another way?" And when we are through, we must question our explanation according to the same test of adequate proof that applies to any investigation: have we taken into account *all* the available evidence, and arranged it in a logical and coherent way? There is, alas, no step-by-step method to guide us, but this does not mean that the process is entirely mysterious. We can illustrate it by looking at some examples together; the demonstration will help us gain courage to try the same analysis the next time we enter a museum.

The great Dutch painter Jan Vermeer has been called the Sphinx of Delft, for all his paintings have a degree of mystery. In Woman Holding a Balance (fig. 23), a young woman, richly dressed in at-home wear of the day, is contemplating a balance in her hand, with strings of pearls and gold coins spread out on the table before her. The canvas is painted entirely in gradations of cool, neutral tones, except for a bit of the red dress visible beneath her jacket. The soft light from the partly open window is concentrated on her face and the cap framing it. Other beads of light reflect from the pearls and her right hand. The serene atmosphere is sustained throughout the stable composition. Vermeer places us at an intimate distance within the relatively shallow space, which has been molded around the figure. The underlying grid of horizontals and verticals is modulated by the gentle curves of the woman's form and the heap of blue drapery in the foreground, as well as by the oblique angles of the mirror. The design is so perfect that we cannot move a single element without upsetting the delicate balance.

The composition is controlled in part by perspective. The vanishing point of the diagonals formed by the top of the mirror and the right side of the table lies at the juncture of the woman's little finger and the picture frame. If we look carefully at the bottom of the frame, we see that it is actually lower on the right than on the left, where it lies just below her hand. The effect is so carefully calculated that the artist must have wanted to guide our eye to the painting in the background. Though difficult to read at first, it depicts Christ at the Last Judgment, when every soul is weighed. The parallel of this subject to the woman's activity tells us that, contrary to our initial impression, this cannot be simply a scene of everyday life. The painting, then, is testimony to the artist's faith, for he was a Catholic living in Protestant Holland, where his religion was officially banned, although worship in private houses was tolerated.

The meaning is nevertheless far from clear. Because Vermeer treated forms as beads of light, it was assumed until recently that the balance holds items of jewelry and that the woman is weighing the worthlessness of earthly possessions in the face of death; hence, the painting was generally called *The Pearl Weigher* or *The Gold Weigher*. However, we can see that the pans actually contain nothing. This is confirmed by infrared photography, which also reveals that Vermeer changed the position of the balance: to make the picture more harmonious, he placed them parallel to the picture plane instead of allow-

ing them to recede into space. What, then, is she doing? If she is weighing temporal against spiritual values, it can be only in a symbolic sense, because nothing about the figure or the setting betrays a sense of conflict. What accounts for this inner peace? Perhaps it is self-knowledge, symbolized here by the mirror. It may also be the promise of salvation through her faith. In Woman Holding a Balance, as in Caravaggio's The Calling of St. Matthew (fig. 726), light might therefore serve not only to illuminate the scene but also to represent religious revelation. In the end, we cannot be sure, because Vermeer's approach to his subject proves as subtle as his pictorial treatment. He avoids any anecdote or symbolism that might limit us to a single interpretation. There can be no doubt, however, about his fascination with light. Vermeer's mastery of light's expressive qualities elevates his concern for the reality of appearance to the level of poetry, and subsumes its visual and symbolic possibilities. Here, then, we have found the real "meaning" of Vermeer's art.

The ambiguity in Woman Holding a Balance serves to heighten our interest and pleasure, while the carefully organized composition expresses the artist's underlying concept with singular clarity. But what are we to do when a work deliberately seems devoid of apparent meaning? Modern artists can pose a gap between their intention and the viewer's understanding. The gap is, however, often more apparent than real, for the meaning is usually intelligible to the imagination at some level. Still, we feel we must comprehend intellectually what we perceive intuitively. We can partially solve the personal code in Jasper Johns' Target with Four Faces (fig. 24) by treating it somewhat like a rebus. Where did he begin? Surely with the target, which stands alone as an object, unlike the long box at the top, particularly when its hinged door is closed. Why a target in the first place? The size, texture, and colors inform us that this is not to be interpreted as a real target. The design is nevertheless attractive in its own right, and Johns must have chosen it for that reason. When the wooden door is up, the assemblage is transformed from a neutral into a loaded image, bringing out the nascent connotations of the target. Johns has used the same plaster cast four times, which lends the faces a curious anonymity. Then he cut them off at the eyes, "the windows of the soul," rendering them even more enigmatic. Finally, he crammed them into their compartments, so that they seem to press urgently out toward us. The results are disquieting, aesthetically as well as expressively.

Something so disturbing cannot be without significance—but what? We may be reminded of prisoners trying to look out from small cell windows, or perhaps "blindfolded" targets of execution. Whatever our impression, the claustrophobic image radiates an aura of menacing danger. Unlike Picasso's joining of a bicycle seat and handlebars to form a bull's head, *Target with Four Faces* combines two disparate components in an open conflict that we cannot reconcile, no matter how hard we try. The intrusion of this ominous meaning creates an extraordinary tension with the dispassionate investigation of the target's formal qualities. It is, then, this disparity between form and content that must have been Johns' goal.

How do we know we are right? After all, this is merely our "personal" interpretation, so we turn to the critics for help. We find them divided about the meaning of this work, although

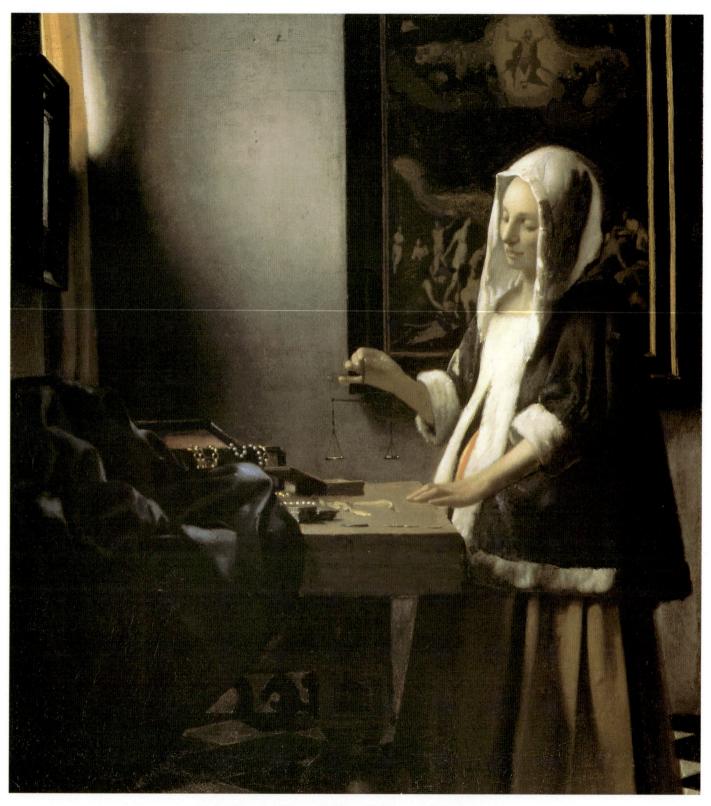

23. Jan Vermeer. Woman Holding a Balance. c. 1664. Oil on canvas, $16^3/4 \times 15$ " (42.5 x 38.1 cm). National Gallery of Art, Washington, D.C. Widener Collection

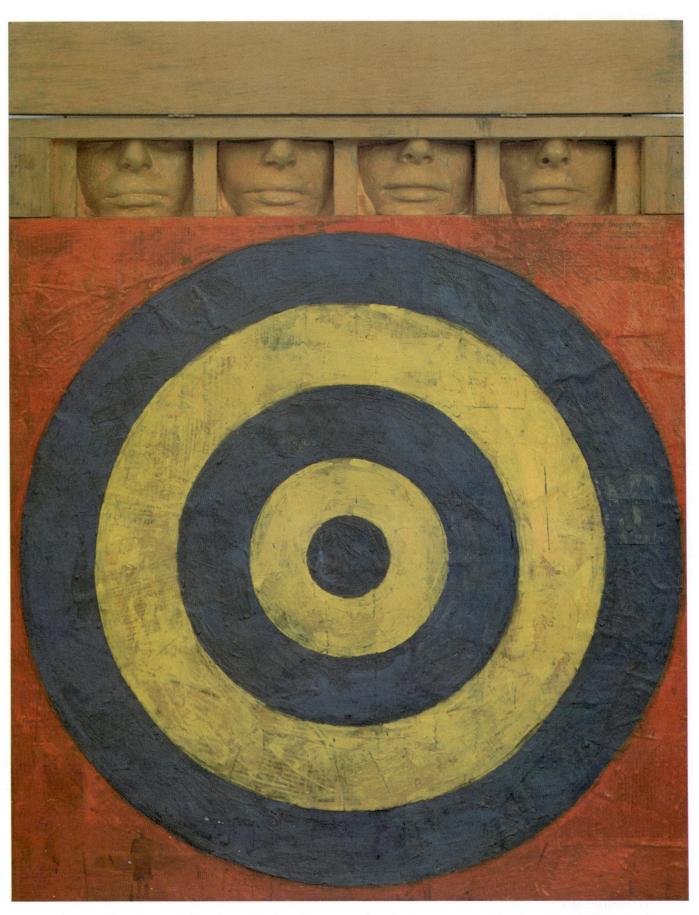

24. Jasper Johns. Target with Four Faces. 1955. Assemblage: encaustic and collage on canvas with objects, 26 x 26" (66 x 66 cm) surmounted by four tinted plaster faces in wood box with hinged front. Box, closed 3³/₄ x 26 x 3¹/₂" (9.5 x 66 x 8.9 cm); overall dimensions with box open, $33^5/8 \times 26 \times 3$ " (85.3 x 66 x 7.6 cm). The Museum of Modern Art, New York Gift of Mr. and Mrs. Robert C. Scull

25. John Singleton Copley. Paul Revere. c. 1768–70.
Oil on canvas, 35 x 28¹/2" (88.9 x 72.3 cm). Museum of Fine Arts, Boston Gift of Joseph W., William B., and Edward H. R. Revere

they agree it must have one. Johns, on the other hand, has insisted that there is none! Whom are we to believe, the critics or the artist himself? The more we think about it, the more likely it seems that both sides may be right. The artist is not always aware why he has made a work. That does not mean that there were no reasons, only that they were unconscious ones. Under these circumstances, the critic may well know the artist's mind better than he does and explain his creation more clearly. We can now understand that to Johns the leap of his imagination in *Target with Four Faces* remains as mysterious as it first seemed to us. Our account reconciles the artist's aesthetic concerns and the critics' search for meaning, and while we realize that no ultimate solution is possible, we have arrived at a satisfactory explanation by looking and thinking for ourselves.

It is all too easy to overlook the obvious, and this is especially true in looking at portraits. Those of famous people have a special appeal, for they seem to bridge a gap of time and place and to establish a personal link. In their faces we read a thousand insights about character which no amount of historical data can satisfy nearly as well. Our interest arises no doubt from the remnant of a primitive belief that an image captures not merely the likeness but also the soul of a sitter. In the age of photography, we have come to see portraits as mere likenesses, and we readily forget that they call on all our skill to grasp their meaning. *Paul Revere*, painted by the American

artist John Singleton Copley around 1770 (fig. 25), gives rise to questions we cannot solve with on-the-spot observations, so we must look elsewhere to answer them. The fruit of our investigation must agree with our observations; otherwise we cannot be sure that we are right.

Silversmith, printmaker, businessman, and patriot, Revere has acquired legendary status thanks to Henry Wadsworth Longfellow's long poem about his midnight ride, and Copley's painting has become virtually an American icon. It has generally been treated as a workingman's portrait, so to speak. By all rights, however, such a portrait ought to be much more straightforward than this and, hence, less memorable. Revere has a penetrating glance and thoughtful pose which are heightened by the sharp light, lending him an unusually forceful presence. He looks out at us with astonishing directness, as if he were reading us with the same intensity that we bring to bear on his strongly modeled features. Clearly, Revere is a thinker possessing an active intelligence, and we will recognize the pose of hand on chin as an old device used since antiquity to represent philosophers. This is certainly no ordinary craftsman here, and we may also wonder whether this is really his working outfit. Surely no silversmith would have carried out his craft in what are probably Revere's best business clothes. Simply by looking at the picture we have raised enough doubts to challenge the traditional view of this famous painting.

26. John Singleton Copley. Nathaniel Hurd. c. 1765. Oil on canvas, 30 x 251/2" (76.2 x 64.8 cm). The Cleveland Museum of Art Gift of the John Huntington Art and Polytechnic Trust

At this point, our questioning of the picture's surface comes to an end, for the portrait fails to yield up further clues. Once we have posed the problem of this "artisan's" portrayal, we feel compelled to investigate it further. The more we pursue the matter, the more fascinating it becomes. Copley, we discover, had painted only a few years earlier a portrait of another Boston silversmith, Nathaniel Hurd (fig. 26). Yet this one is so different that we would never guess the sitter's trade. Hurd is wearing a casual robe and turban, and before him are two books, one of them devoted to heraldry from which he culled the coats of arms he needed for his work. Why, then, did Copley show Revere at a workbench with his engraving tools spread out before him, holding a teapot as the object of his contemplation and offering it to us for our inspection? In light of Hurd's portrait, Revere's work as a silversmith hardly explains these attributes and actions, natural as they seem. Oddly enough, the question has never been raised; yet surely the differences between the two paintings cannot be accidental.

Perhaps we can find the answer in the antecedents for each. Hurd's image can be traced back to informal portraits that originated in France in the early eighteenth century and soon became popular as well in England, where there was a rage for portraits of well-known men and women. This type of portrait was customarily reserved for artists, writers, and the like. In turn, the type gave rise to a distinctive offshoot that showed a sculptor at work in his studio with his tools prominently displayed (fig. 27). Sometimes an engraver is seen instead. There is another possible precedent: moralizing portraits, the descendants of pictures of St. Jerome, that show their subjects holding or pointing to skulls, much as Revere has the teapot in his hand. Copley was surely familiar with all of these kinds of images from the portrait engravings that we know he collected, but his exact sources for the Revere painting remain a mystery and may never be discovered. For after 1765 Copley freely adapted and combined motifs from different prints in his paintings, often disguising their origins so completely that we cannot be certain which they were. It is

27. Francis Xavier Vispré (attr.). Portrait of Louis-François Roubiliac.
 c. 1750. Pastel on paper laid on canvas, 24¹/2 x 21¹/2" (62.2 x 54.6 cm).
 Yale Center for British Art, New Haven, Connecticut
 Paul Mellon Collection

likely that he conflated two or three in Revere's portrait. In any case, it is apparent that Copley has transformed Revere from a craftsman into an artist-philosopher.

Let us now look at this portrait in its larger historical and cultural context. In Europe, the artisan's inferior position to the artist had been asserted since the Renaissance, except in England, where the newly founded Royal Academy first drew the distinction in 1768, about when Copley painted Hurd's portrait. But in the Colonies there was, as Copley himself complained, no distinction between the trades of artist and artisan. Indeed, except for portraiture, it can be argued that the decorative arts were the fine arts of America.

It is significant that Copley's portrait probably dates from around the time of Revere's first efforts at making engravings, a form of art that arose, interestingly enough, out of silver- and goldsmith decorating during the late Middle Ages. Revere was then already involved with libertarianism, a cause which Copley himself did not share. This difference in their points of view did not prevent Copley from endowing Revere's portrait

with an ingenious significance and penetrating characterization. The painter and the silversmith must have known each other well. (Copley ordered various pieces of silver, and even false teeth, from Revere.) The portrait stands as Copley's compelling tribute to a fellow artist—and as an invaluable statement about the culture of the Colonial era.

Obviously, not everyone is in a position to undertake this kind of research. Only the art historian and the most interested lay person do. But this does not mean that "there must be something wrong with a work of art if it takes an expert to appreciate it." On the contrary, research serves only to affirm the portrait of Paul Revere as a masterpiece. Reacting to the portrait in "a direct, straightforward fashion," without the benefit of additional knowledge, precludes the understanding necessary for full appreciation. Critics, scholars, and curators are not the public's adversaries. In sharing their expertise and knowledge of art's broader contexts, they expand our general capacity for appreciating art, and provide a model for our own seek-and-find experiences.

PART ONE

THE ANCIENT WORLD

rt history is more than a stream of art objects created over time. It is in-

timately related to history itself, that is, the recorded evidence of human events. For that reason, we must consider the *concept* of history, which, we are often told, begins with the invention of writing some 5,000 years ago. And, indeed, the invention of writing was an early accomplishment of the "historic" civilizations of Mesopotamia and Egypt. Without writing, the growth we have known would have been impossible. We do not know the earliest phases of its development, but writing seems to have been several hundred years in the making—between 3300 and 3000 B.C., roughly speaking, with Mesopotamia in the lead—after the new societies were already past their first stage. Thus "history" was well under way by the time writing could be used to record events.

The invention of writing makes a convenient landmark, for the absence of written records is surely one of the key differences between prehistoric and historic societies. But as soon as we ask why this is so, we face some intriguing problems. First of all, how valid is the distinction between "prehistoric" and "historic"? Does it merely reflect a difference in our knowledge of the past? (Thanks to the invention of writing, we know a great deal more about history than about prehistory.) Or was there a genuine change in the way things happened, and of the kinds of things that happened, after "history" began? Obviously, prehistory was far from uneventful. Yet changes in the human condition that mark this road, decisive though they are, seem incredibly slow-paced and gradual when measured against the events of the last 5,000 years. The beginning of "history," then, means a sudden increase in the speed of events, a shifting from low gear to high gear, as it were. It also means a change in the kind of events. Historic societies quite literally make history. They not only bring forth "great individuals and great deeds" (one traditional definition of history) by demanding human effort on a large scale, but they make these achievements memorable. And for an event to be memorable, it must be more than "worth remembering." It must also be accomplished quickly enough to be grasped by human memory, and not spread over countless centuries. Collectively, memorable events have caused the ever-quickening pace of change during the past five millenniums, which begin with what we call the ancient world.

This period was preceded by a vast prehistoric era of which we know practically nothing until the last Ice Age in Europe, which lasted from about 40,000 to 8000 B.C. (There had been at least three previous ice ages, alternating with periods of

subtropical warmth, at intervals of about 25,000 years.) At that time, the climate between the Alps and Scandinavia resembled that of present-day Siberia or Alaska. Huge herds of reindeer and other large herbivores roamed the plains and valleys, preyed upon by the ferocious ancestors of today's lions and tigers, as well as by our own ancestors. These people liked to live in caves or in the shelter of overhanging rocks wherever they could find them. Many such sites have been discovered, mostly in Spain and in southern France. This phase of prehistory is known as the Old Stone Age, or Paleolithic era, because tools were exclusively made from stone. Adapted almost perfectly to the special conditions of the receding Ice Age, it was a way of life that could not survive beyond then.

What brought the Old Stone Age to a close has been termed the Neolithic Revolution, which ushered in the New Stone Age. And a revolution it was indeed, although its course extended over several thousand years. It first occurred in the Near East an area encompassing the modern countries of Turkey, Iraq, Iran, Jordan, Israel, Lebanon, and Syria—sometime about 8000 B.C., with the first successful attempts to domesticate animals and food grains. The cultivation of regular food sources was one of the truly epoch-making achievements of human history. People in Paleolithic societies had led the unsettled life of the hunter and food gatherer, reaping where nature sowed and thus at the mercy of forces that they could neither understand nor control. But having learned how to assure a food supply by their own efforts, they now settled down in permanent village communities. A new discipline and order also entered their lives. There is, then, a very basic difference between the Neolithic and the Paleolithic, despite the fact that both still depended on stone as the material of their main tools and weapons. The new mode of life brought forth a number of important new crafts and inventions long before the earliest appearance of metals: pottery, weaving and spinning, as well as basic methods of architectural construction in wood, brick, and stone. It must also have been accompanied by profound changes in the people's view of themselves and the world.

The Neolithic Revolution placed us on a level at which we might well have remained indefinitely. The forces of nature would never again challenge men and women as they had Paleolithic peoples. In a few places, however, the Neolithic balance between humans and nature was upset by a new threat posed not by nature but by people themselves. The earliest monument to that threat is seen in the earliest Neolithic fortifications, constructed almost 9,000 years ago in the Near East. What

was the source of the human conflict that made these defenses necessary? Competition for grazing land among groups of herders or for arable soil among farming communities? The basic cause, we suspect, was that the Neolithic Revolution had been too successful in this area, permitting population groups to grow beyond the available food supply. This situation might have been resolved in a number of ways. Constant warfare could have reduced the population. Or the people could have united in larger and more disciplined social units for the sake of ambitious group efforts that no loosely organized society would have been able to achieve. Fortifications are an enterprise of this kind, requiring sustained and specialized labor over a long period.

We do not know the outcome of the struggle in the region (future excavations may tell us how far the urbanizing process extended) but about 3,000 years later, similar conflicts, on a larger scale, arose in the Nile Valley and again in the plains of the Tigris and Euphrates rivers. The pressures that forced the inhabitants of both regions to abandon the pattern of Neolithic village life may well have been the same. These conflicts generated enough pressure to produce a new kind of society, organized into much larger units of cities and city-states that were far more complex and efficient than had ever existed before. (The word "civilization" derives from the Latin term for city, civilis.) First in Mesopotamia and Egypt, somewhat later in neighboring areas, and in the Indus Valley and along the Yellow River in China, people were to live in a more dynamic world, where their capacity to survive was challenged not by the forces of nature but by human forces—by tensions and conflicts arising either within society or as the result of competition between societies. These efforts to cope with human environment have proved a far greater challenge than the earlier struggle with nature. The problems and pressures faced by historic societies are thus very different from those that confronted peoples in the Paleolithic or Neolithic eras.

They also spurred the development of new technologies in what we designate the Bronze Age and the Iron Age. Like the Neolithic, the Bronze and Iron ages are not distinct eras, but stages. People first began to cast bronze, an alloy of copper and tin, in the Middle East around 3500 B.C., at the same time that the earliest cities arose in Egypt and Mesopotamia. And the smelting and forging of iron were invented about 2000–1500 B.C. by the Hittites, an Indo-European–speaking people who settled in Cappadocia (today's east central Turkey), a high plateau with abundant copper and iron ore. Indeed, it was the competition for mineral resources that helped create the conflicts that beset civilizations everywhere.

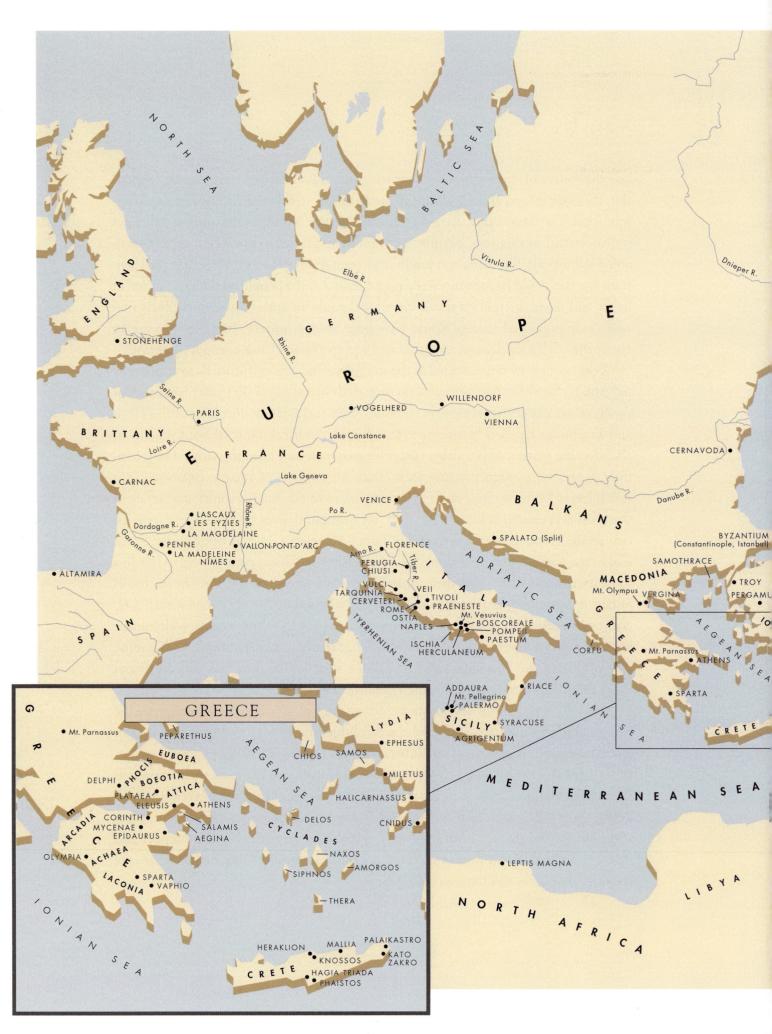

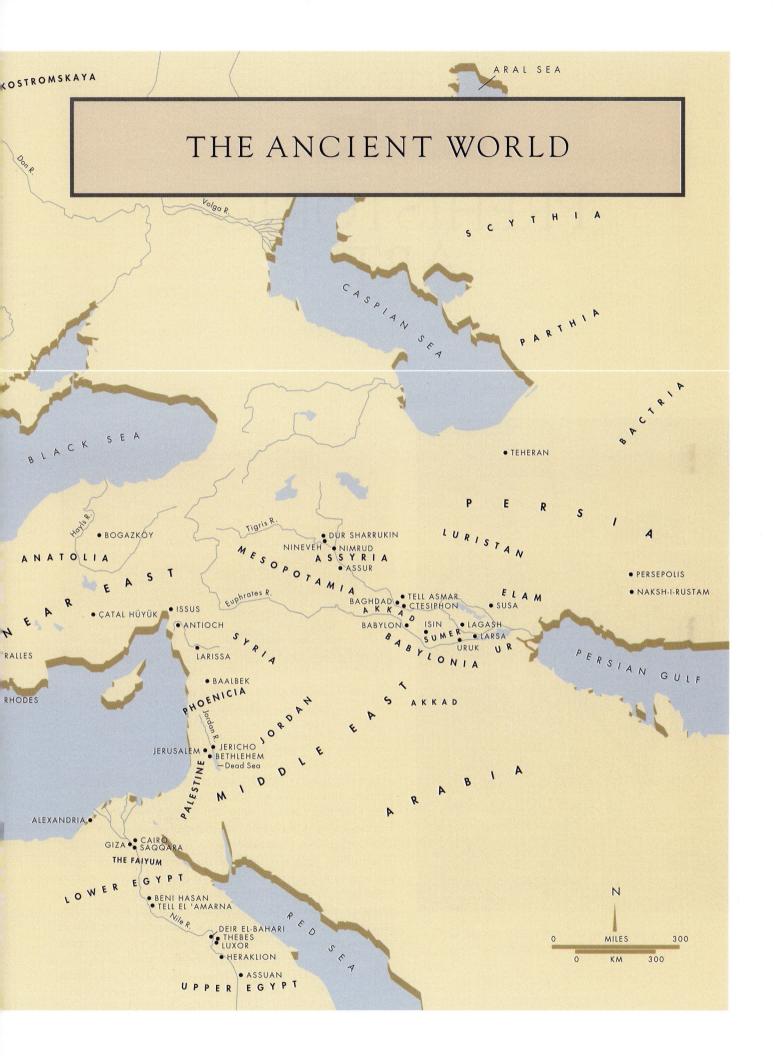

CHAPTER ONE

PREHISTORIC ART

28. Horses. Cave painting. c. 28,000 B.C. Chauvet cave, Vallon-pont-d'Arc, Ardèche gorge, France

29. Wounded Bison. Cave painting. c. 15,000-10,000 B.C. Altamira, Spain

THE OLD STONE AGE

When did human beings start creating works of art? What prompted them to do so? What did these earliest works of art look like? Every history of art must begin with these questions—and with the admission that we cannot answer them. Our earliest-known ancestors began to walk on two feet about four million years ago, but how they were using their hands remains unknown to us. Not until more than two million years later do we meet the earliest evidence of toolmaking. Humans must have been using tools all along, however. After all, apes will pick up a stick to knock down a banana or a stone to throw at an enemy. The making of tools is a more complex matter. It demands first of all the ability to think of sticks or stones as "fruit knockers" or "bone crackers," not only when they are needed for such purposes but at other times as well.

Once humans were able to do this, they gradually discovered that some sticks or stones had a handier shape than oth-

30. Axial Gallery, Lascaux (Montignac, Dordogne), France

ers, and they put them aside for future use. They selected and "appointed" certain sticks or stones as tools because they had begun to connect form and function. The sticks, of course, have not survived, but a few of the stones have. They are large pebbles or chunks of rock that show the marks of repeated use for the same operation, whatever that may have been. The next step was to try chipping away at these tools-by-appointment in order to improve their shape. This is the first craft of which we have evidence, and with it we enter a phase of human development known as the Paleolithic, or Old Stone Age, which lasted from about 40,000 to 10,000 B.C.

Cave Art

CHAUVET. The most striking works of Paleolithic art are the images of animals incised, painted, or sculptured on the rock surfaces of caves. In the recently discovered Chauvet cave in southeastern France, we meet the earliest paintings known to us, dating from more than 30,000 years ago. Ferocious lions, panthers, rhinoceroses, bears, reindeer, and mammoths

are depicted with extraordinary vividness, along with bulls, horses, birds, and occasionally humans. These paintings already show an assurance and refinement far removed from any humble beginnings. What a vivid, lifelike image is the depiction of horses seen in figure 28! We are amazed not only by the keen observation and the assured, vigorous outlines, but even more perhaps by the power and expressiveness of these creatures. Unless we are to believe that images such as this came into being in a single, sudden burst, we must assume that they were preceded by thousands of years of development about which we know nothing at all.

ALTAMIRA AND LASCAUX. On the basis of differences among the tools and other remains found there, scholars have divided up later "cavemen" into several groups, each named after a characteristic site. Of these it is the so-called Aurignacians and Magdalenians who stand out for the gifted artists they produced and for the important role art must have played in their lives. Besides Chauvet, the major sites are at Altamira, in northern Spain (fig. 29), and Lascaux, in the Dordogne

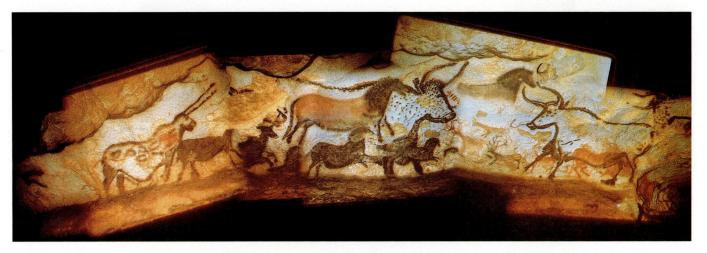

31. Cave paintings. 15,000-10,000 B.C. Lascaux

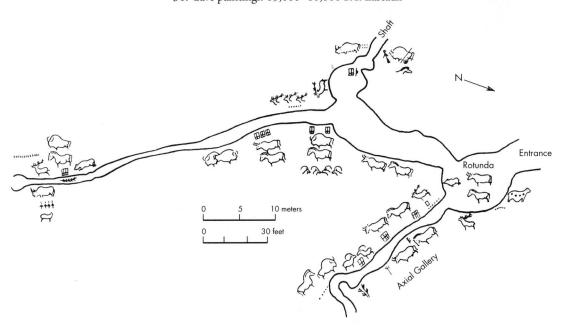

32. Schematic plan of Lascaux

region of France (figs. 30 and 31). At Lascaux, as at Chauvet, bison, deer, horses, and cattle race across walls and ceiling in wild profusion. Some of them are simply outlined in black, others filled in with bright earth colors, but all show the same uncanny sense of life. No less important, the style remains essentially the same between the two caves, despite the gap of thousands of years—testimony to the remarkable stability of Paleolithic culture. Gone, however, are the fiercest of beasts.

How did this extraordinary art happen to survive intact over so many thousands of years? The question can be answered easily enough. The pictures never occur near the mouth of a cave, where they would be open to easy view and destruction, but only in the darkest recesses, as far from the entrance as possible (fig. 32). Some can be reached only by crawling on hands and knees, and the path is so intricate that one would soon be lost without an expert guide. In fact, the cave at Lascaux was discovered purely by chance in 1940 by some neighborhood boys whose dog had fallen into a hole that led to the underground chamber.

What purpose did these images serve? Hidden away as they

are in the bowels of the earth, to protect them from the casual intruder, they must have been considered far more serious than decoration. There can be little doubt that they were produced as part of a magic ritual. But of what kind? The traditional explanation is that their origin lies in hunting magic. According to this theory, in "killing" the image of an animal, people of the Old Stone Age thought they had killed its vital spirit; this later evolved into fertility magic, practiced deep within the bowels of the earth. But how are we to account for the presence at Chauvet of lions and other dangerous creatures that we know were not hunted? Perhaps initially cavemen assumed the identity of lions and bears to aid in the hunt. Although it cannot be disproved, this proposal is not completely satisfying. In addition to being highly speculative, it fails to explain many curious features of cave art.

There is a growing consensus that cave paintings must incorporate a very early form of religion. If so, the creatures found in them embody a spiritual meaning that makes of them the distant ancestors of the animal divinities and their half-human, half-animal cousins we shall meet throughout the

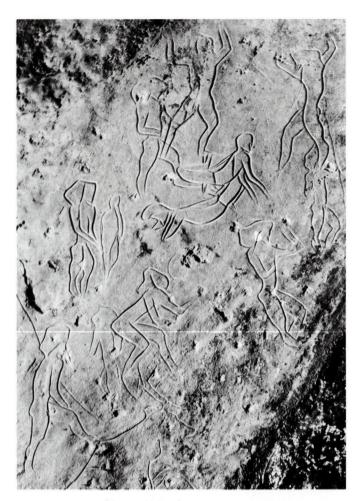

33. Ritual Dance (?). Rock engraving. c. 10,000 B.C. Height of figures approx. 10" (25.4 cm). Cave of Addaura, Monte Pellegrino (Palermo), Sicily

Near East and the Aegean. Indeed, how else are we to account for their existence? Moreover, such a hypothesis accords as well with the belief that nature is filled with spirits. This belief was found the world over in the ethnographic societies that survived intact until recently.

The existence of cave rituals relating to both human and animal fertility would seem to be confirmed by a unique group of Paleolithic drawings found in the 1950s on the walls of the cave of Addaura, near Palermo in Sicily (fig. 33). These images, incised into the rock with quick and sure lines, show human figures in dancelike movements, along with some animals; and, as at Lascaux, we again find several layers of images superimposed on one another. Here, then, we seem to be on the verge of that fusion of human and animal identity that distinguishes the earliest historical religions of Egypt and Mesopotamia.

POSSIBLE ORIGINS. Some of the cave pictures may even provide a clue to the origin of this tradition of fertility magic. In a good many instances, the shape of the animal seems to have been suggested by the natural formation of the rock, so that its body coincides with a bump, or its contour follows a vein or crack as far as possible. We all know how our imagination sometimes makes us see many sorts of images in chance formations such as clouds or blots. Perhaps at first the Stone Age artist merely reinforced the outlines of such images with a charred stick from the fire. It is tempting to think that those

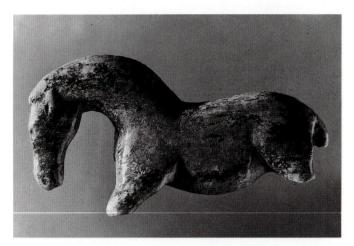

34. *Horse*, from Vogelherd cave. c. 28,000 B.C. Mammoth ivory, length 2¹/₂" (6.4 cm). Private collection

who proved particularly good at finding such images were given a special status as artist-magicians so that they could perfect their image-hunting, until finally they learned how to make images with little or no help from chance formations, though they continued to welcome such aid.

Carved and Painted Objects

Apart from large-scale cave art, the people of the Upper Paleolithic also produced small, hand-sized drawings and carvings in bone, horn, or stone, skillfully cut by means of flint tools. The earliest of these found so far are small figures of mammoth ivory from a cave in southwestern Germany, made 30,000 years ago. Even they, however, are already so accomplished that they too must be the fruit of an artistic tradition many thousands of years old. The graceful, harmonious curves of a running horse (fig. 34) could hardly be improved upon by a more recent sculptor. Many years of handling have worn down some details of the tiny animal. (The two converging lines on the shoulder, indicating a dart or wound, were not part of the original design.)

Some of these carvings suggest that the objects may have originated with the recognition and elaboration of some chance resemblance. Earlier Stone Age people were content to collect pebbles in whose natural shape they saw something that apparently rendered them "magic." Echoes of this approach can sometimes be felt in later, more fully worked

35. "Venus" of Willendorf. c. 25,000–20,000 B.C. Limestone, height 4³/8" (111 cm); shown actual size. Naturhistorisches Museum, Vienna

pieces. The so-called "Venus" of Willendorf (fig. 35), one of many such female figurines, has a bulbous roundness of form that recalls an egg-shaped "sacred pebble." Her navel, the central point of the design, is a natural cavity in the stone. She and like carvings are often considered fertility figures, based on the spiritual beliefs of "preliterate" societies of modern times. Although the idea is tempting, we cannot be certain that such parallels existed in the Old Stone Age. Likewise, the masterful Bison (fig. 36) of reindeer horn owes its compact, expressive outline in part to the contours of the palm-shaped piece of antler from which it was carved. It is a worthy companion to the splendid beasts at Altamira, Lascaux, and Chauvet.

THE NEW STONE AGE

The art of the Old Stone Age in Europe as we know it today marks the highest achievements of a way of life that began to decline soon afterward. Adapted almost perfectly to the special conditions of the receding Ice Age, that way of life could not survive beyond then.

Unfortunately, the tangible remains of Neolithic settlements tell us very little, as a rule, of the spiritual condition of Neolithic culture. Uncovered by excavation, they include stone implements of ever greater technical refinement and

36. Bison, from La Madeleine near Les Eyzies (Dordogne). c. 15,000–10,000 B.C. Reindeer horn, length 4" (10.1 cm). Musée des Antiquités Nationales, St.-Germain-en-Laye, France

beauty of shape, and an infinite variety of clay vessels covered with abstract ornamental patterns, but hardly anything comparable to the painting and sculpture of the Paleolithic. The changeover from hunting to husbandry must nonetheless have been accompanied by profound changes in the people's view of themselves and the world, and it seems impossible to believe that these did not find expression in art. There may be a vast chapter in the development of art here that is largely lost to us simply because Neolithic artists worked in wood or other impermanent materials. Perhaps excavations in the future will help to fill the gap.

JERICHO. Prehistoric Jericho (now in the West Bank territory), the most extensively excavated site thus far, has yielded tantalizing discoveries, which include a group of impressive sculptured heads dating from about 7000 B.C. (fig. 37). They are actual human skulls whose faces have been "reconstituted" in tinted plaster, with pieces of seashell for the eyes. The subtlety and precision of the modeling, the fine gradation of planes and ridges, and the feeling for the relationship of flesh and bone would be remarkable enough in themselves, quite apart from the early date. The features, moreover, do not conform to a single type, for each has a strongly individual cast. Mysterious as they are, those Neolithic heads clearly point forward to Mesopotamian art (compare fig. 88). They are the first harbingers of a phenomenon of portraiture that will continue unbroken until the collapse of the Roman Empire.

Unlike Paleolithic art, which had grown from the perception of chance images, the Jericho heads are not intended to "create" life but to perpetuate it beyond death by replacing the transient flesh with a more enduring substance. From the circumstances in which these heads were found, we gather that they were displayed above ground while the rest of the body was buried beneath the floor of the house. Presumably they belonged to venerated ancestors whose beneficent presence was thus assured. Paleolithic societies, too, had buried their dead, but we do not know what ideas they associated with the grave. Was death merely a return to the womb of mother earth, or did they have some conception of the beyond?

37. Neolithic plastered skull, from Jericho. c. 7000 B.C. Lifesize. Archaeological Museum, Amman, Jordan

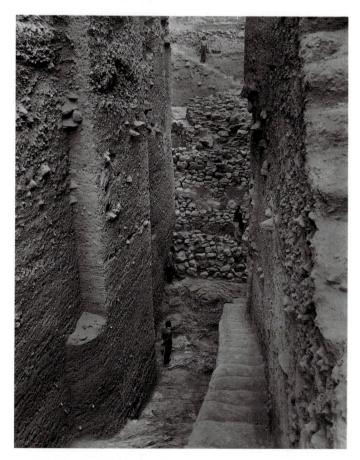

38. Early Neolithic wall and tower, Jericho, Jordan. c. 7000 B.C.

The Jericho heads suggest that some peoples of the Neolithic era believed in a spirit or soul, located in the head, that could survive the death of the body. Thus, it could assert its power over the fortunes of later generations and had to be appeared or controlled. The preserved heads apparently were

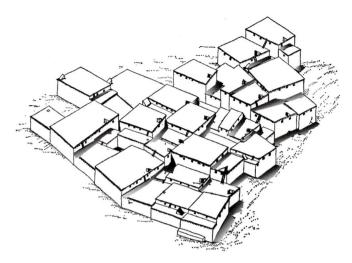

39. Houses and shrines in terraces. Çatal Hüyük, Turkey (schematic reconstruction of Level VI after Mellaart). c. 6000 B.C.

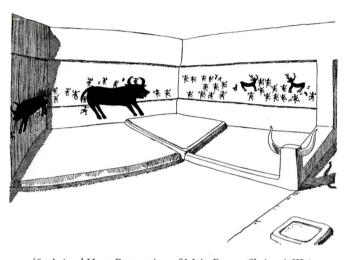

40. Animal Hunt. Restoration of Main Room, Shrine A.III.1, Çatal Hüyük (after Mellaart). c. 6000 B.C. 27 x 65" (68.5 x 165 cm)

"spirit traps" designed to keep the spirit in its original dwelling place. They express in visible form the sense of tradition, of family or clan continuity, that sets off the settled life of husbandry from the roving existence of the hunter. And Neolithic Jericho was a settled community of the most emphatic sort: the people who treasured the skulls of their forebears lived in stone houses with neat plaster floors, within a fortified town protected by walls and towers of rough but strong masonry construction (fig. 38). Amazingly enough, they had no pottery. The technique of baking clay in a kiln, it seems, was not invented until later.

ÇATAL HÜYÜK. Excavations at Çatal Hüyük in Anatolia (modern Turkey) brought to light another Neolithic town, roughly a thousand years younger than Jericho. Its inhabitants lived in houses built of mud bricks and timber, clustered around open courtyards (fig. 39). There were no streets, since the houses had no doors; people apparently entered through the roof. The settlement included a number of religious shrines, the earliest found so far, and on their plaster-covered walls we encounter the earliest paintings on a man-made surface. Animal hunts, with small running figures surrounding huge bulls or stags (fig. 40), evoke echoes of cave paintings.

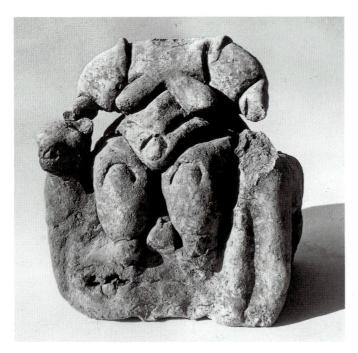

41. Fertility Goddess, from Shrine A.II.1, Çatal Hüyük. c. 6000 B.C. Baked clay, height 8" (20.3 cm). Archaeological Museum, Ankara, Turkey

42. View of Town and Volcano. Wall painting, Shrine VII.14, Çatal Hüyük. c. 6000 B.C.

This is an indication that the Neolithic Revolution must have been a recent event at the time, but the balance has already shifted: these hunts have the character of rituals honoring the deity to whom the bull and stag were sacred, rather than of an everyday activity necessary for survival. They therefore continue the transformation of animals into gods that began in the Old Stone Age.

Compared to the animals of the cave paintings, those at Çatal Hüyük are simplified and immobile. Here it is the hunters who are in energetic motion. Animals associated with

female deities display an even more rigid discipline. A pair of leopards forms the sides of the throne of a fertility goddess (fig. 41). Among the wall paintings at Çatal Hüyük, the most surprising one is a view of the town itself, with the twin cones of an erupting volcano above it (fig. 42). The densely packed rectangles of the houses are seen from above, while the mountain is shown in profile, its slope covered with dots representing blobs of lava. Such a volcano is still visible today from Çatal Hüyük. Its eruption must have been a terrifying event for the inhabitants. How could they have viewed it as any-

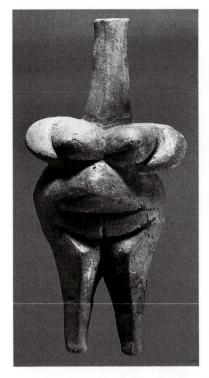

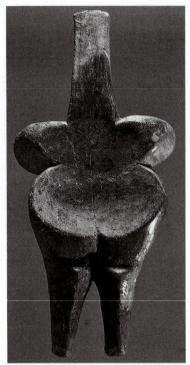

43, 44. *Fertility Goddess* (front and back), from Cernavoda, Romania. c. 5000 B.C. Baked clay, height 6 ¹/₄" (16 cm). National Museum, Bucharest.

thing except a manifestation of a deity's power? Nothing less could have brought forth this image, halfway between a map and a landscape.

Neolithic Europe

The Near East became the cradle of civilization: to be civilized, after all, means to live as a citizen, a town dweller. Meanwhile, the Neolithic Revolution progressed at a very much slower pace in Europe. About 5000 B.C., Near Eastern influences began to spread to the northern shore of the Mediterranean. Baked clay figurines of fertility goddesses found in the Balkans, such as the striking one from Cernavoda (figs. 43 and 44), have their closest relatives in Asia Minor. What makes the Cernavoda *Fertility Goddess* so memorable is the sculptor's ability to simplify the shapes of a woman's body and yet retain its salient features (which, to him, did not include the face). The smoothly concave back sets off the ballooning convexity of thighs, belly, arms, and breasts on the front.

DOLMENS AND CROMLECHS. North of the Alps, Near Eastern influence cannot be detected until a much later time. In Central and Northern Europe, a sparse population continued to lead the simple tribal life of small village communities even after the introduction of bronze and iron, until a few hundred years before the birth of Christ. Thus Neolithic Europe never reached the level of social organization that produced the masonry architecture of Jericho or the dense urban community of Çatal Hüyük. Instead we find there monumental stone structures of a different kind, called megalithic because

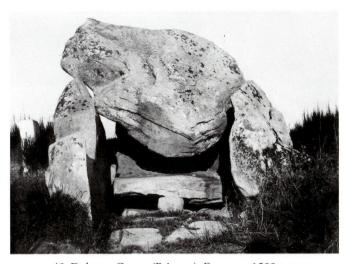

45. Dolmen, Carnac (Brittany), France. c. 1500 B.C.

they consist of huge blocks or boulders placed upon each other without mortar. Their purpose was religious, rather than civic or utilitarian. Apparently, the sustained and coordinated effort they required could be compelled only by the authority of religious faith—a faith that almost literally demanded the moving of mountains. Even today these megalithic monuments have an awe-inspiring, superhuman air about them, as if they were the work of a forgotten race of giants.

Some, known as dolmens, are tombs resembling "houses of the dead," with upright stones for walls and a single giant slab for a roof (fig. 45). Others, the so-called cromlechs, form

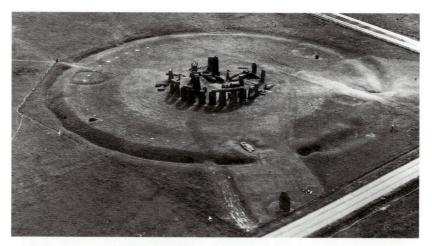

46. Stonehenge (aerial view), Salisbury Plain (Wiltshire), England. c. 2000 B.C. Diameter of circle 97' (29.6 m)

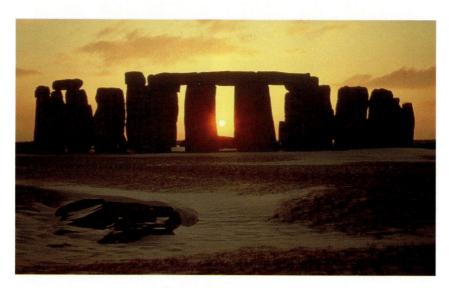

47. Stonehenge at sunset

the setting of religious observances. The most famous of these, Stonehenge in southern England (figs. 46 and 47), has a great outer circle of evenly spaced uprights (posts) supporting horizontal slabs (lintels) and two inner circles similarly marked, with an altarlike stone at the center (fig. 48). The entire structure is oriented toward the exact point at which the sun rises on the day of the summer solstice. As our illustration suggests, it probably served a sun-worshiping ritual.

Whether a monument such as this should be termed architecture is a matter of definition. Nowadays, we tend to think of architecture in terms of enclosed interiors, but we also have landscape architects, who design gardens, parks, and playgrounds. Nor would we want to deny the status of architecture to open-air theaters or sports stadiums. To the ancient Greeks, who coined the term, "archi-tecture" meant something higher than ordinary "tecture" (that is, "construction" or "building"), much as an archbishop ranks above a bishop. Thus it is a structure distinguished from the practical, everyday kind by its scale, order, permanence, or solemnity of purpose. A Greek would certainly have acknowledged Stonehenge as architecture. We, too, shall have no difficulty in doing so once we understand that it is not necessary to enclose space in order to

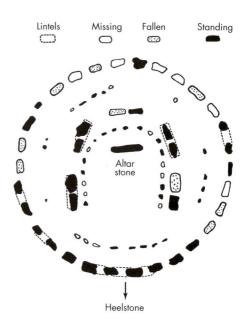

48. Diagram of original arrangement of stones at Stonehenge (after F. Hoyle)

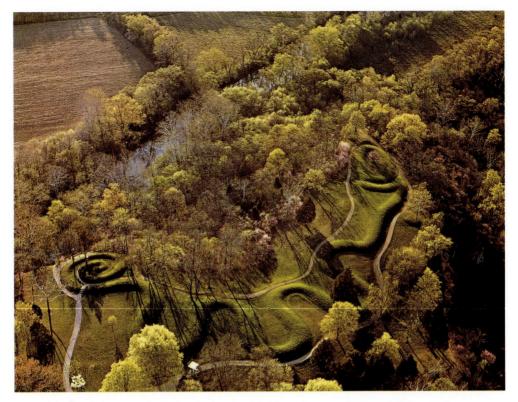

49. Great Serpent Mound, Adams County, Ohio. c. 1070 A.D. Length 1,400' (426.7 m)

define or articulate it. If architecture is "the art of shaping space to human needs and aspirations," then Stonehenge more than meets the test.

Neolithic America

The "earth art" of the prehistoric Indians of North America, the so-called Mound Builders, is comparable to the megalithic monuments of Europe in terms of the effort involved. The term is misleading, since these mounds vary greatly in shape and purpose as well as in date, ranging from about 2000 B.C.

to the time of the Europeans' arrival in the late fifteenth century. Of particular interest are the "effigy mounds" in the shape of animals, presumably the totems of the tribes that produced them. The most spectacular is the Great Serpent Mound (fig. 49), a snake some 1,400 feet long that slithers along the crest of a ridge by a small river in southern Ohio. The huge head, its center marked by a heap of stones that may once have been an altar, occupies the highest point. Evidently it was the natural formation of the terrain that inspired this extraordinary work of landscape architecture, as mysterious and moving in its way as Stonehenge.

CHAPTER TWO

EGYPTIAN ART

Egyptian civilization has long been regarded as the most rigid and conservative ever. Plato said that Egyptian art had not changed in 10,000 years. Perhaps "enduring" and "continuous" are better terms for it, although at first glance all Egyptian art between 3000 and 500 B.C. does tend to have a certain sameness. There is a kernel of truth in this: the basic pattern of Egyptian institutions, beliefs, and artistic ideas was formed during the first few centuries of that vast span of time and kept reasserting itself until the very end. We shall see, however, that over the years this basic pattern went through ever more severe crises that challenged its ability to survive. Had it been as inflexible as supposed, it would have succumbed long before it finally did. Egyptian art alternates between conservatism and innovation, but is never static. Some of its great achievements had a decisive influence on Greek and Roman art, and thus we can still feel ourselves linked to the Egypt of 5,000 years ago by a continuous, living tradition.

THE OLD KINGDOM

DYNASTIES. The history of Egypt is divided into dynasties of rulers, in accordance with ancient Egyptian practice, beginning with the First Dynasty shortly after 3000 B.C. (The dates of the earliest rulers are difficult to translate exactly into our calendar; the dating system used in this book is that of French Egyptologist Nicolas Grimal.) The transition from prehistory to the First Dynasty is referred to as the predynastic period.

The next major period, known as the Old Kingdom, lasted from about 2700 B.C. until about 2190 B.C., with the end of the Sixth Dynasty. This method of counting historic time by dynasties conveys at once the strong Egyptian sense of continuity and the overwhelming importance of the pharaoh (king), who was not only the supreme ruler but also a god. The pharaoh transcended all people, for his kingship was not a duty or privilege derived from a superhuman source, but was absolute, divine. This belief remained the key feature of Egyptian civilization and largely determined the character of Egyptian art. We do not know exactly the steps by which the early pharaohs established their claim to divinity, but we know their historic achievements: molding the Nile Valley from the first cataract at Assuan to the Delta into a single, effective state, and increasing its fertility by regulating the river waters through dams and canals.

TOMBS AND RELIGION. Of these vast public works nothing remains today, and very little has survived of ancient Egyptian palaces and cities. Our knowledge of Egyptian civilization rests almost entirely on the tombs and their contents. This is no accident, since these tombs were built to last forever, yet we must not make the mistake of concluding that the Egyptians viewed life on this earth mainly as a road to the grave. Their preoccupation with the cult of the dead is a link with the Neolithic past, but the meaning they gave it was new and different: the dark fear of the spirits of the dead which dominates primitive ancestor cults seems entirely absent.

50. People, Boats, and Animals. Reconstruction drawing of wall painting in predynastic tomb. c. 3200 B.C. Hierakonpolis, Egypt

Instead, the Egyptian attitude was that each person must provide for his or her own happy afterlife. [See Primary Sources, no. 1, page 212.] The ancient Egyptians would equip their tombs as a kind of shadowy replica of their daily environment for their spirits (*ka*) to enjoy. They would make sure that the *ka* had a body to dwell in (their own mummified corpse or, if that should become destroyed, a statue of themselves).

There is a curious blurring of the sharp line between life and death here, and perhaps that was the essential impulse behind these mock households. People who knew that after death their *kas* would enjoy the same pleasures they did, and who had provided these pleasures in advance by their own efforts, could look forward to active and happy lives without being haunted by fear of the great unknown. In a sense, then, the Egyptian tomb was a kind of life insurance, an investment in peace of mind. Such, at least, is the impression one gains of Old Kingdom tombs. Later on, the serenity of this concept of death was disturbed by a tendency to subdivide the spirit or soul into two or more separate identities and by the introduction of a sort of judgment, a weighing of souls. Only then do we also find expressions of the fear of death.

HIERAKONPOLIS. An early stage in the development of Egyptian funerary customs, and of Egyptian art, can be seen in the fragment of a wall painting from Hierakonpolis of about 3200 B.C. (fig. 50). The design is still decidedly primitive in its character—an even scattering of forms over the entire surface. It is instructive to note, however, that the

human and animal figures tend to become standardized, abbreviated "signs," almost as if they were on the verge of turning into hieroglyphics (such as we see in fig. 83). The large white shapes are boats. Their significance here seems to be that of funeral barges, or "vehicles of the soul," since that is their role in later tombs. The black-and-white figures above the topmost boat are mourning women, their arms spread out in a gesture of grief. For the rest, the picture does not appear to have any coherence as a scene or any symbolic import. At first glance, it seems simply an early attempt at those typical scenes of daily life that we meet several centuries later in Old Kingdom tombs (compare figs. 68 and 69). However, the figure flanked by a pair of heraldic lions at the bottom center of our illustration is such a striking anticipation of the mythical hero on a Mesopotamian lyre 600 years later (see fig. 92) that the scene may well have a meaning we have yet to decipher.

Egyptian Style and the Palette of King Narmer

At the time of the Hierakonpolis mural, Egypt was in the process of learning the use of bronze tools. The country, we may assume, was ruled by a number of local sovereigns not too far removed from the status of tribal chiefs. The fight scenes between black-bodied and white-bodied men in the painting probably reflect local wars or raids. Out of these emerged two rival kingdoms, Upper and Lower Egypt. The struggle between them ended when the Upper Egyptian kings conquered Lower Egypt and combined the two realms.

51, 52. Palette of King Narmer (both sides), from Hierakonpolis. c. 3150-3125 B.C. Slate, height 25" (63.5 cm). Egyptian Museum, Cairo

One of these was King Menes (Narmer), who appears on the impressive object in figures 51 and 52, a ceremonial slate palette probably celebrating a victory over Lower Egypt, though the precise meaning is under dispute. (Note the different crowns worn by the king.) It, too, comes from Hierakonpolis, but otherwise has little in common with the wall painting. In many ways, the Narmer palette can claim to be the oldest historic work of art we know. Not only is it the earliest surviving image of a historic personage identified by name, but its character is clearly no longer primitive. In fact, it already shows most of the features of late Egyptian art. If only we had enough preserved material to trace step-by-step the evolution that led from the wall painting to this palette!

Let us first "read" the scenes on both sides. The fact that we are able to do so is another indication that we have left prehistoric art behind. The meaning of these reliefs is made clear and explicit not only by means of hieroglyphic labels, but also through the use of a broad range of visual symbols conveying precise messages to the beholder and—most important of all—through the disciplined, rational orderliness of the design. In figure 51 Narmer has seized a fallen enemy by the hair and is about to slay him with his mace. Two more defeated enemies are placed in the bottom compartment. (The small rectangular shape next to the man on the left stands for a fortified town or citadel.) Facing the king in the upper right we see a complex bit of picture writing: a falcon standing above a clump of papyrus plants holds a tether attached to a human

head that "grows" from the same soil as the plants. This composite image actually repeats the main scene on a symbolic level. The head and papyrus plant stand for Lower Egypt, while the victorious falcon is Horus, the local god of Upper Egypt. The parallel is plain. Horus and Narmer are the same; a god triumphs over human foes. Hence, Narmer's gesture must not be taken as representing a real fight. The enemy is helpless from the very start, and the slaying is a ritual rather than a physical effort. We gather the ritual import from the fact that Narmer has taken off his sandals (the court official behind him carries them in his right hand), an indication that he is standing on holy ground.

On the other side of the palette (fig. 52), the king again appears barefoot, followed by the sandal carrier, as he walks in solemn procession behind a group of standard-bearers to inspect the decapitated bodies of prisoners. (The same notion recurs in the Old Testament, apparently as the result of Egyptian influence, when the Lord commands Moses to remove his shoes before he appears to him in the burning bush.) The bottom compartment reenacts the victory once again on a symbolic level, with the pharaoh represented as a strong bull trampling an enemy and knocking down a citadel. (A bull's tail hanging down from his belt is shown in both images of Narmer; it was to remain a part of pharaonic ceremonial garb for the next 3,000 years.) Only the center section fails to convey an explicit meaning. The intertwined snake-necked lions and their two attendants have no identifying attributes. How-

ever, similar beasts are found in protoliterate Mesopotamian art of about 3300–3200 B.C. (see Chapter Three). There they combine the lioness attribute of the mother goddess with the copulating snakes signifying the god of fecundity to form a fertility symbol that unites the female and male principles in nature. Do they perhaps contain another reference to the union of Upper and Lower Egypt? Whatever their meaning on Narmer's palette, their presence provides evidence of the extensive contact between the two emerging civilizations at an early and critical stage of their development. In any event, they do not reappear in Egyptian art.

LOGIC OF EGYPTIAN STYLE. The new inner logic of the Narmer palette's style becomes readily apparent in contrast to the predynastic wall painting. What strikes us first is its strong sense of order. The surface of the palette has been divided into horizontal bands, or registers, and each figure stands on a line or strip denoting the ground. The only exceptions are the attendants of the long-necked beasts, whose role seems mainly ornamental; the hieroglyphic signs, which belong to a different level of reality; and the dead enemies. The latter are seen from above, whereas the standing figures are seen from the side. Obviously, the modern notion of representing a scene as it would appear to a single observer at a single moment is as alien to Egyptian artists as it had been to their Neolithic predecessors. They strive for clarity, not illusion, and therefore pick the most telling view in each case.

But they impose a strict rule on themselves. When the angle of vision changes, it must be by 90 degrees, as if sighting along the edges of a cube. As a consequence, only three views are possible: full face, strict profile, and vertically from above. Any intermediate position is embarrassing. (Note the oddly rubberlike figures of the fallen enemies at the bottom of figure 51.) Moreover, the standing human figure does not have a single main profile but two competing profiles, so that, for the sake of clarity, these views must be combined. The method of doing this (which was to survive unchanged for 2,500 years) is clearly shown in the large figure of Narmer in figure 51: eye and shoulders in frontal view, head and legs in profile. Apparently this formula was worked out so as to show the pharaoh (and all persons of significance who move in the aura of his divinity) in the most complete way possible. And since the scenes depict solemn and, as it were, timeless rituals, our artist did not have to concern himself with the fact that this method of representing the human body made almost any kind of movement or action practically impossible. In fact, the frozen quality of the image would seem especially suited to the divine nature of the pharaoh. Ordinary mortals act; he simply is.

Whenever physical activity demanding any sort of effort or strain must be depicted, the Egyptian artist does not hesitate to abandon the composite view if necessary, for such activity is always performed by underlings whose dignity does not have to be preserved. Thus in our palette the two animal trainers and the four men carrying standards are shown in strict profile, except for the eyes. The Egyptian style of representing the human figure, then, seems to have been created specifically for the purpose of conveying in visual form the majesty of the divine king. It must have originated among the artists working for the

53. Portrait Panel of Hesy-ra, from Saqqara. c. 2660 B.C. Wood, height 45" (114.3 cm). Egyptian Museum, Cairo

royal court. It never lost its ceremonial, sacred flavor, even when, in later times, it had to serve other purposes as well.

Third Dynasty

The beauty of the style which we saw in the Narmer palette did not develop fully until about five centuries later, during the Third Dynasty, and especially under the reign of King Djoser, its greatest figure. From the Tomb of Hesy-ra, one of Djoser's high officials, comes the masterly wooden relief (fig. 53) showing

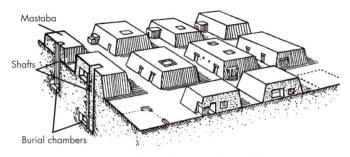

54. Group of mastabas (after A. Badawy). 4th Dynasty

the deceased with the emblems of his rank. These include writing materials, since the position of scribe was a highly honored one. The view of the figure corresponds exactly to that of Narmer on the palette, but the proportions are far more balanced and harmonious, and the carving of the physical details shows keen observation as well as great delicacy of touch.

TOMBS. When we speak of the Egyptians' attitude toward death and afterlife as expressed in their tombs, we must be careful to make it clear that we do not mean the attitude of the average Egyptian but only that of the small aristocratic caste clustered around the royal court. The tombs of the members of this class of high officials, who were often relatives of the royal family, are usually found in the immediate neighborhood of the pharaohs' tombs. Their shape and contents reflect, or are related to, the funerary monuments of the divine kings. We still have a great deal to learn about the origin and significance of Egyptian tombs, but there is reason to believe that the concept of afterlife we find in the so-called private tombs did not apply to ordinary mortals but only to the privileged few because of their association with the immortal pharaohs. [See Primary Sources, no. 2, page 212.]

MASTABAS. The standard form of these tombs was the mastaba, a squarish mound faced with brick or stone, above the

burial chamber, which was deep underground and linked to the mound by a shaft (figs. 54 and 55). Inside the mastaba is a chapel for offerings to the *ka* and a secret cubicle for the statue of the deceased. Royal mastabas grew to conspicuous size as early as the First Dynasty, and their exteriors could be elaborated to resemble a royal palace. During the Third Dynasty, they developed into step pyramids. The best known (and probably the first) is that of King Djoser (fig. 56), built over a traditional mastaba (see figs. 55 and 57). The pyramid itself, unlike later examples, is a completely solid structure whose only purpose seems to have been memorial.

FUNERARY DISTRICTS. The modern imagination, enamored of "the silence of the pyramids," is apt to create a false picture of these monuments. They were not erected as isolated structures in the middle of the desert, but were part of vast funerary districts, with temples and other buildings that were the scene of great religious celebrations during the pharaoh's lifetime as well as after. The most elaborate of these is the funerary district around the Step Pyramid of Djoser (fig. 57). Enough of its architecture has survived to enable us to understand why its creator, Imhotep, came to be deified in later Egyptian tradition. He is the first artist whose name has been recorded in history, and deservedly so. His achievement remains impressive not only for its scale but also for its unity, which embodies the concept of the pharaoh to perfection. Imhotep must have possessed remarkable intellect and outstanding ability. In this he set an important precedent for all the great architects who followed in his footsteps. Even architects today address the important ideas and issues of their time.

COLUMNS. Egyptian architecture had begun with structures made of mud bricks, wood, reeds, and other light materials. Imhotep used cut-stone masonry, but his repertory of architectural forms still reflected shapes or devices developed for less enduring materials. Thus we find columns of several kinds—always engaged (set into the wall) rather than free-

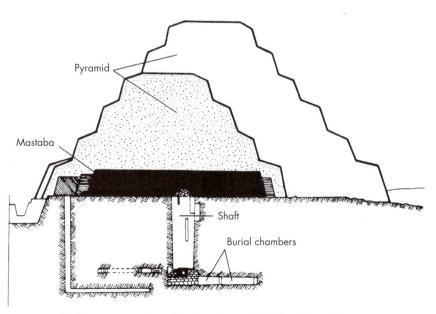

55. Transverse section of the Step Pyramid of King Djoser, Saqqara

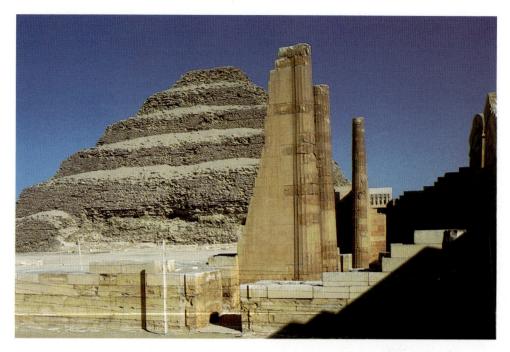

56. Imhotep. Step Pyramid of King Djoser, Saqqara. 3rd Dynasty. c. 2681–2662 B.C.

57. Plan of the funerary district of King Djoser, Saqqara (M. Hirmer after J. P. Lauer). 1) pyramid (m=mastaba); 2) funerary temple; 3, 4, 6) courts; 5) entrance hall; 7) small temple; 8) court of North Palace; 9) court of South Palace; 10) southern tomb

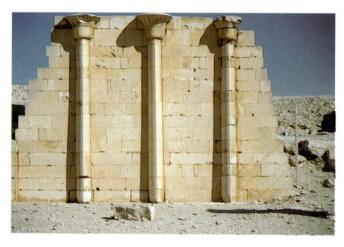

58. Papyrus half-columns, North Palace, Funerary district of King Djoser, Saqqara

standing—which echo the bundles of reeds or the wooden supports that used to be set into mud-brick walls in order to strengthen them. But the very fact that these members no longer had their original functional purpose made it possible for Imhotep and his fellow architects to redesign them so as to make them serve a new, expressive purpose. The notion that architectural forms can express anything may seem difficult to grasp at first. Today we tend to assume that unless these forms have a clear-cut structural service to perform, such as supporting or enclosing, they are mere surface decoration. But let us look at the slender, tapering, fluted columns in figure 56, or the papyrus-shaped half-columns in figure 58. These do not simply decorate the walls to which they are attached, but interpret them and give them life. Their proportions, the feeling of strength or resilience they convey, their spacing, the degree to which they project—all share in this task.

We shall learn more about their expressive role when we discuss Greek architecture, which took over the Egyptian stone column and developed it further. For the time being, let us note one additional factor that may enter into the design and use of such columns: announcing the symbolic purpose of the building. The papyrus half-columns in figure 58 are linked with Lower Egypt (compare the papyrus plants in fig. 51); hence they appear in the North Palace of Djoser's funerary district. The South Palace has columns of different shape to evoke its association with Upper Egypt.

Fourth Dynasty

PYRAMIDS OF GIZA. Djoser's successors soon adapted the step pyramid to the familiar smooth-sided shape. The development of the pyramid reaches its climax during the Fourth

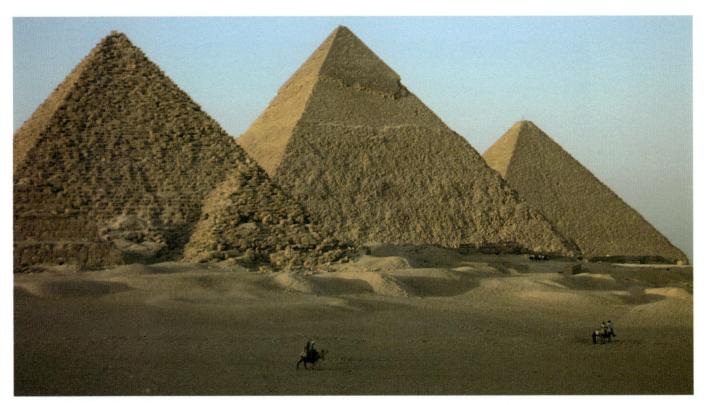

59. The Pyramids of Menkaure (c. 2533-2515 B.C.), Khafre (c. 2570-2544 B.C.), and Khufu (c. 2601-2528 B.C.), Giza

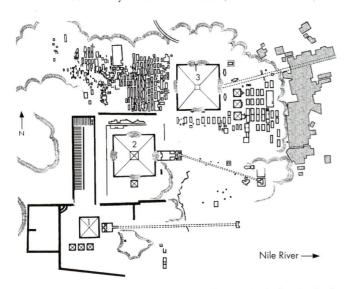

60. Plan of the pyramids at Giza. 1) Menkaure; 2) Khafre; 3) Khufu

Dynasty in the famous triad of great pyramids at Giza (figs. 59 and 60). They originally had an outer casing of carefully dressed stone, which has disappeared except near the top of the Pyramid of Khafre. Each of the three differs slightly from the others in details of design and construction, but the essential features are shown in the section of the earliest and largest, that of Khufu (fig. 61). The burial chamber is now near the center of the structure rather than below ground, as in the Step Pyramid of Djoser. This placement of the chamber was a vain attempt to safeguard it from robbers.

According to recent theory, the three pyramids are arranged in the same configuration as the stars in the constellation Orion, which was identified with the god Osiris, the mythical founder of Egypt. One of the mysterious "airshafts" in the king's chamber of the Pyramid of Khufu pointed to the permanently visible polar stars in the north; the other lined up in

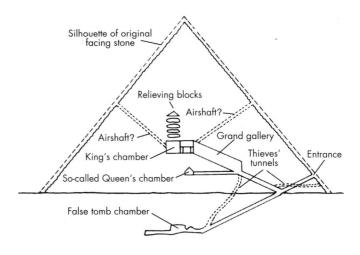

61. North-south section of Pyramid of Khufu (after L. Borchardt)

ancient times with Orion when it was visible in the southern sky after an absence of some two months, so that it acted as a kind of spiritual "escape hatch" which enabled the pharaoh to ascend and assume his place as a star in the cosmos. Another hidden shaft in the queen's chamber was aligned with the star of Isis (today's Sirius), Osiris' consort, and was evidently used in the ritual of fertilization and rebirth described in the Egyptian *Book of the Dead*. The hypothesis, though controversial, is tantalizing, for it helps to explain many puzzling features of the pyramids in light of the *Pyramid Texts* of the two dynasties that followed. [See Primary Sources, no. 1, page 212.]

Clustered about the three great pyramids are several smaller ones and a large number of mastabas for members of the royal family and high officials, but the unified funerary district of Djoser has given way to a simpler arrangement. Adjoining each of the great pyramids to the east is a funerary temple,

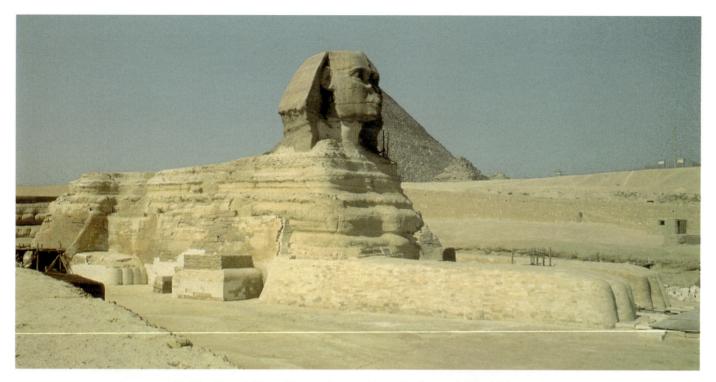

62. The Great Sphinx, Giza. c. 2570-2544 B.C. Sandstone, height 65' (19.8 m)

from which a processional causeway leads to a second temple at a lower level, in the Nile Valley, at a distance of about a third of a mile. This new arrangement represents the decisive final step in the evolution of kingship in Egypt. It links the pharaoh to the eternal cosmic order by connecting him physically and ritually to the Nile River, whose annual cycles give life and dictate its rhythm in Egypt to this very day.

THE GREAT SPHINX. Next to the valley temple of the Pyramid of Khafre stands the Great Sphinx carved from the live rock (fig. 62). It is, if anything, an even more impressive embodiment of divine kingship than the pyramids themselves. The royal head rising from the body of a lion towers to a height of 65 feet and once bore, in all probability, the features of Khafre. (Damage inflicted upon it during Islamic times has obscured the details of the face.) Its awesome majesty is such that a thousand years later it could be regarded as an image of the sun-god.

Enterprises of this huge scale mark the high point of pharaonic power. After the end of the Fourth Dynasty, less than two centuries later, they were never attempted again, although much more modest pyramids continued to be built. The world has always marveled at the sheer size of the great pyramids as well as at the technical accomplishment they represent. They have also come to be regarded as symbols of slave labor, with thousands of men forced by cruel masters to serve the aggrandizement of absolute rulers. Such a picture may well be unjust. Certain records indicate that the labor was paid for, so that we are probably nearer the truth if we regard these monuments as vast public works providing economic security for a good part of the population.

PORTRAITURE. Apart from its architectural achievements, the chief glories of Egyptian art during the Old Kingdom and later are the portrait statues recovered from funerary temples and tombs. One of the finest is that of Khafre, from the valley temple of his pyramid (fig. 63). Carved of diorite, a stone of

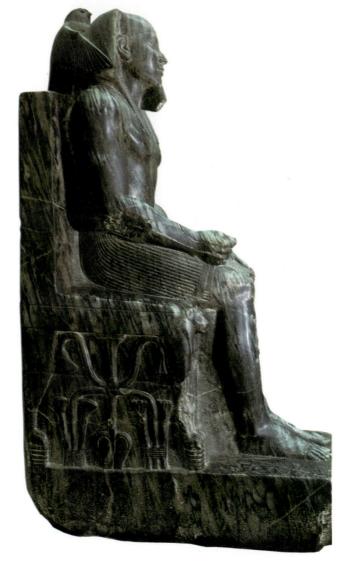

63. Khafre, from Giza. c. 2500 B.C. Diorite, height 66" (167.7 cm). Egyptian Museum, Cairo

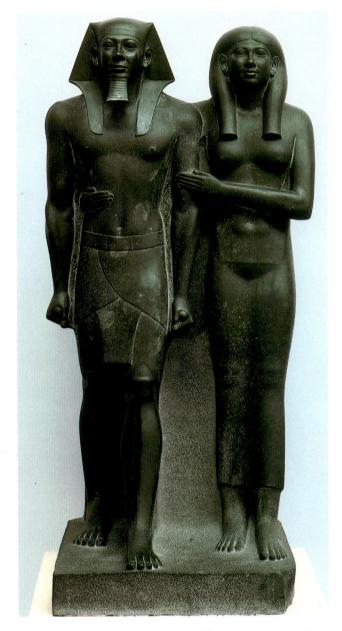

64. Menkaure and His Wife, Queen Khamerernebty, from Giza. c. 2515 B.C. Slate, height 54½" (138.4 cm). Museum of Fine Arts, Boston. Harvard–Museum of Fine Arts Expedition

extreme hardness, it shows the king enthroned, with the falcon of the god Horus enfolding the back of the head with its wings. (The pharaoh was equated with Horus as the son of Osiris and Isis; we encountered the association, in different form, in the Narmer palette; fig. 51.)

Here the Egyptian sculptor's "cubic" view of the human form appears in full force. After marking the faces of the rectangular block with a grid, the artist drew the front, top, and side views of the statue, then worked inward until these views met. This approach also encouraged the development of systematic proportions. The result is a figure almost overpowering in its three-dimensional firmness and immobility. Truly it is a magnificent vessel for the spirit! The body, at once idealized and powerfully built, is completely impersonal. Only the face suggests some individual traits, as will be seen if we compare it with that of Menkaure (fig. 64),

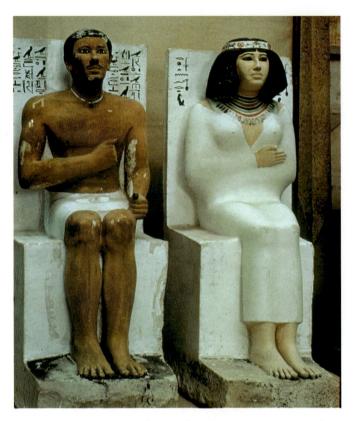

65. Prince Rahotep and His Wife Nofret. c. 2580 B.C. Painted limestone, height 47 1/4" (120 cm). Egyptian Museum, Cairo

Khafre's successor and the builder of the third and smallest pyramid at Giza.

Menkaure, accompanied by his queen, Khamerernebty, is standing. Both have the left foot placed forward, yet there is no hint of a forward movement. These are idealized portraits: a similar group, showing Menkaure between two goddesses, hardly differs in appearance. Since both figures are almost of the same height, they afford an interesting comparison of male and female beauty as interpreted by one of the finest of Old Kingdom sculptors, who knew not only how to contrast the structure of the two bodies but also how to emphasize the soft, swelling forms of the queen through her light, close-fitting gown.

The sculptor who carved the statues of Prince Rahotep and his wife Nofret (fig. 65) was less subtle in this respect. They owe their strikingly lifelike appearance to their vivid coloring, which they must have shared with other such statues but which has survived completely intact only in a few instances. The darker body color of the prince has no individual significance; it is the standard masculine complexion in Egyptian art. The eyes have been inlaid with shining quartz to make them look as alive as possible, and the portrait character of the faces is very pronounced.

Standing and seated figures comprise the basic repertory of Egyptian large-scale sculpture in the round. At the end of the Fourth Dynasty, a third pose was added, as symmetrical and immobile as the first two: that of the scribe sitting cross-legged on the ground. The finest of these scribes dates from the beginning of the Fifth Dynasty (fig. 66). The name of the sitter (in whose tomb at Saqqara the statue was found) is unknown, but we must not think of him as a secretary waiting

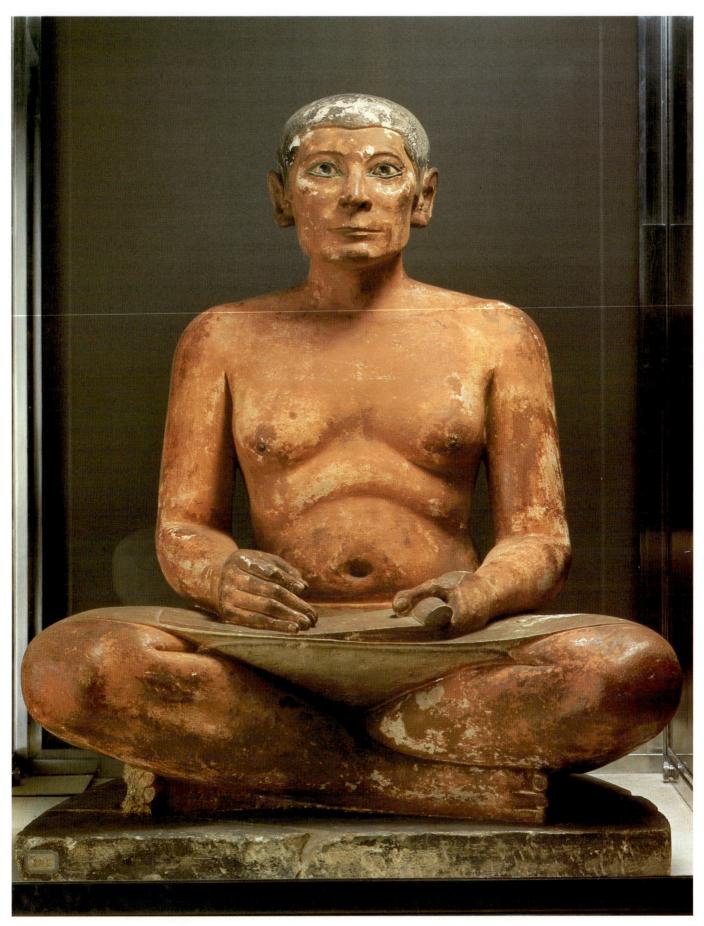

66. Seated Scribe, from Saqqara. c. 2400 B.C. Limestone, height 21" (53.3 cm). Musée du Louvre, Paris

67. Bust of Vizier Ankh-haf, from Giza. c. 2520 B.C. Limestone, partially molded in plaster, height 21" (53.3 cm). Museum of Fine Arts, Boston. Harvard–Museum of Fine Arts Expedition

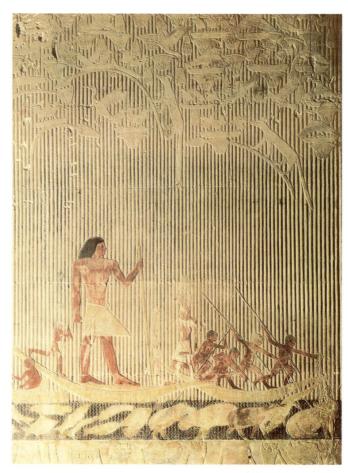

68. *Ti Watching a Hippopotamus Hunt.* c. 2510–2460 B.C. Painted limestone relief, height approx. 45" (114.3 cm). Tomb of Ti, Saqqara

to take dictation. Rather, the figure represents a high court official, a "master of sacred—and secret—letters." The solid, incisive treatment of form bespeaks the dignity of his station, which in the beginning seems to have been restricted to the sons of pharaohs. Our example stands out for the vividly alert expression of the face and for the individual handling of the torso, which records the somewhat flabby body of a man past middle age.

Another invention of Old Kingdom art was the portrait bust, a species of sculpture so familiar that we tend to take it for granted; yet its origin is puzzling. Was it simply an abbreviated statue, a cheaper substitute for a full-length figure? Or did it have a distinct purpose of its own, perhaps as a remote echo of the Neolithic custom of keeping the head of the deceased separate from the rest of his body (see pages 54–55)? Be that as it may, the earliest of these busts (fig. 67) is also the finest. Indeed, it is one of the great portraits of all time. In this noble head, we find a memorable image of the sitter's individual character as well as a most subtle differentiation between the solid, immutable shape of the skull and its soft, flexible covering of flesh, abetted by the well-preserved color.

TOMB DECORATION. Before we leave the Old Kingdom, let us look briefly at some of the scenes of daily life from the offering chambers of nonroyal tombs, such as that of the architectural overseer Ti at Saqqara. The hippopotamus hunt in figure 68 is of special interest to us because of its landscape set-

ting. The background of the relief is formed by a papyrus thicket. The stems of the plants make a regular, rippling pattern that erupts in the top zone into an agitated scene of nesting birds menaced by small predators. The water in the bottom zone, marked by a zigzag pattern, is equally crowded with struggling hippopotamuses and fish. All these, as well as the hunters in the first boat, are acutely observed and full of action. Only Ti himself, standing in the second boat, is immobile, as if he belonged to a different world. His pose is that of the funerary portrait reliefs and statues (compare fig. 53), and he towers above the other men, since he is more important than they.

His size also lifts him out of the context of the hunt. He neither directs nor supervises it, but simply observes. His passive role is characteristic of the representations of the deceased in all such scenes from the Old Kingdom. It seems to be a subtle way of conveying the fact that the body is dead but the spirit is alive and aware of the pleasures of this world, though the man can no longer participate in them directly. We should also note that these scenes of daily life do not represent the dead man's favorite pastimes. If they did, he would be looking back, and such nostalgia is quite alien to the spirit of Old Kingdom tombs. It has been shown, in fact, that these scenes form a seasonal cycle, a sort of perpetual calendar of recurrent human activities for the spirit of the deceased to watch year in and year out. For the artist, on the other hand, these scenes, which partake of both sculpture and painting, offered a welcome opportation.

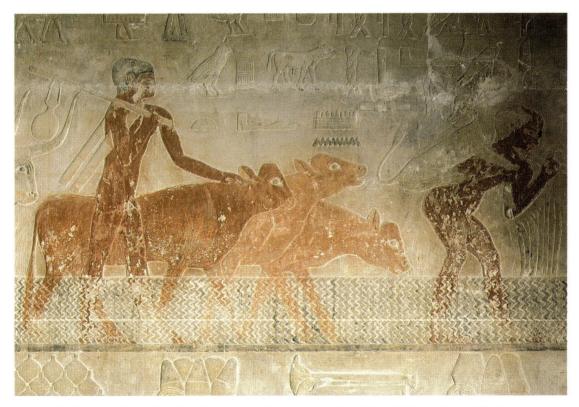

69. Cattle Fording a River. Detail of a painted limestone relief. c. 2510-2460 B.C. Tomb of Ti, Saqqara

tunity to widen his powers of observation, so that in details we often find astounding bits of realism.

Another relief from the Tomb of Ti shows some cattle fording a river (fig. 69). One of the herders carries a newborn calf on his back to keep it from drowning, and the frightened animal turns its head to look back at its mother, who answers with an equally anxious glance. Such sympathetic portrayal of an emotional relationship is as delightful as it is unexpected in Old Kingdom art. It will be some time before we encounter anything similar in the human realm. But eventually we shall even see the deceased abandoning his passive, timeless stance to participate in scenes of daily life.

THE MIDDLE KINGDOM

After the collapse of centralized pharaonic power at the end of the Sixth Dynasty, Egypt entered a period of political disturbances and ill fortune that was to last almost 700 years. During most of this time, effective authority lay in the hands of local or regional overlords, who revived the old rivalry of Upper and Lower Egypt. Many dynasties followed one another in rapid succession, but only two, the Eleventh and Twelfth, are worthy of note. The latter constitute the Middle Kingdom (2040–1674 B.C.), when a series of able rulers managed to reassert themselves against the provincial nobility. However, the spell of divine kingship, having once been broken, never regained its old effectiveness, and the authority of the Middle Kingdom pharaohs tended to be personal rather than institutional. Soon after the close of the Twelfth Dynasty, the weakened country was invaded by the Hyksos, a western Asiatic people of somewhat mysterious origin, who seized the Delta area and ruled it for 150 years until their expulsion by the princes of Thebes about 1552 B.C.

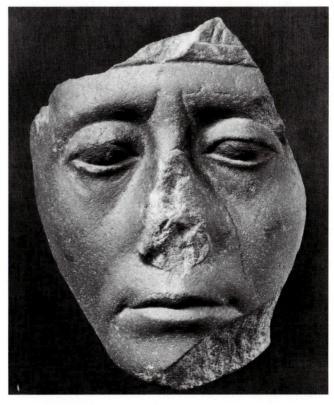

70. Portrait of Sesostris III (fragment). c. 1850 B.C. Quartzite, height 6 ¹/₂" (16.5 cm). The Metropolitan Museum of Art, New York. Carnaryon Collection, Gift of Edward S. Harkness, 1926

PORTRAITURE. The unquiet spirit of the times is well reflected in Middle Kingdom art. We find it especially in the new type of royal portrait that marks the Twelfth Dynasty, such as the one in figure 70. There is a real sense of shock on first encountering this strangely modern face. The serene

assurance of the Old Kingdom has given way to a brooding, troubled expression that bespeaks a new level of self-awareness. Lacking its royal trappings, our fragment displays so uncompromising a realism, physical as well as psychological, that at first glance the link with the sculptural tradition of the past seems broken entirely. Here is another enduring achievement of Egyptian art, destined to live on in Roman portraiture and in the portraiture of the Renaissance.

PAINTING AND RELIEF. A loosening of established rules also makes itself felt in Middle Kingdom painting and relief, where it leads to all sorts of interesting departures from convention. They occur most conspicuously in the decoration of the tombs of local princes at Beni Hasan, which have survived destruction better than most Middle Kingdom monuments because they are carved into the living rock. The mural Feeding the Oryxes (fig. 71) comes from one of these rock-cut tombs, that of Khnum-hotep. (As the emblem of the prince's domain, the oryx antelope seems to have been a sort of honored pet in his household.) According to the standards of Old Kingdom art, all the figures ought to share the same groundline, or the second oryx and its attendant ought to be placed above the first. Instead, the painter has introduced a secondary ground-line only slightly higher than the primary one, and as a result the two groups are related in a way that closely approximates normal appearances. His interest in exploring spatial effects can also be seen in the awkward but quite bold foreshortening of the shoulders of the two attendants. If we cover up the hieroglyphic signs, which emphasize the flatness of the wall, we can "read" the forms in depth with surprising ease.

THE NEW KINGDOM

The 500 years following the expulsion of the Hyksos, and comprising the Eighteenth, Nineteenth, and Twentieth dynasties, represent the third and final flowering of Egypt. The country, once more united under strong and efficient kings, extended its frontiers far to the east, into Palestine and Syria; hence this period is also known as the Empire. During the climactic period of power and prosperity, between about 1500 B.C. and the end of the reign of Ramesses III in 1145 B.C., tremendous architectural projects were carried out, centering on the region of the new capital, Thebes, while the royal tombs reached unequaled material splendor.

The divine kingship of the pharaohs was now asserted in a new way: by association with the god Amun, whose identity had been fused with that of the sun-god Ra, and who became the supreme deity, ruling the lesser gods much as the pharaoh towered above the provincial nobility. This very development produced an unexpected threat to royal authority: the priests of Amun grew into a caste of such wealth and power that the pharaoh could maintain his position only with their consent. Amenhotep IV, the most remarkable figure of the Eighteenth Dynasty, tried to defeat them by proclaiming his faith in a single god, the sun disk Aten. He changed his name to Akhenaten, closed the Amun temples, and moved the capital to central Egypt, near the modern Tell el'Amarna. His attempt to place himself at the head of a new monotheistic faith, however, did not outlast his reign (1348–1336/5 B.C.), and under his suc-

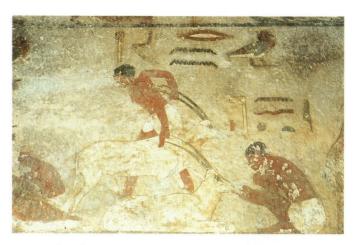

71. Feeding the Oryxes. c. 1928–1895 B.C. Detail of a wall painting. Tomb of Khnum-hotep, Beni Hasan

cessors orthodoxy was speedily restored. During the long decline that began about 1000 B.C., the country became increasingly priest-ridden, until, under Greek and Roman rule, Egyptian civilization ended in a welter of esoteric religious doctrines.

New Kingdom art covers a wide range of styles and quality, from rigid conservatism to brilliant inventiveness, from oppressively massive ostentation to the most delicate refinement. As with the art of Imperial Rome 1,500 years later, it is almost impossible to summarize in terms of a representative sampling. Different strands are interwoven into a fabric so complex that any choice of monuments is bound to seem arbitrary. All we can hope is to convey some of the flavor of its variety.

Architecture

TEMPLE OF HATSHEPSUT. Among the architectural enterprises that have survived from the early years of the New Kingdom, the outstanding one is the Funerary Temple of Queen Hatshepsut, built by her *vizier* (overseer) Senenmut about 1478–1458 B.C. against the rocky cliffs of Deir el-Bahari (figs. 72 and 73) and dedicated to Amun and several other deities. The worshiper is led toward the holy of holies—a small chamber driven deep into the rock—through three large courts on ascending levels, linked by ramps among long colonnades. They form a processional road reminiscent of those at Giza, but with the mountain instead of a pyramid at the end. It is this magnificent union of architecture and nature (note how ramps and colonnades echo the shape of the cliff) that makes Hatshepsut's temple the rival of any of the Old Kingdom monuments.

TEMPLE AT LUXOR. The later rulers of the New Kingdom continued to build funerary temples, but an ever greater share of their architectural energies was devoted to huge imperial temples of Amun, the supreme god whom the reigning monarch traditionally claimed as his father. The temple complex at Luxor, on the Nile at the site of ancient Thebes, dedicated to Amun, his wife Mut, and their son Khonsu, was begun about 1350 B.C. by Amenhotep III but was extended and completed more than a century later. Its plan is characteristic of the general pattern of later Egyptian temples. The facade consists of two massive walls, with sloping sides, that flank the entrance. This unit, which is known as the gateway or pylon (fig. 74, far

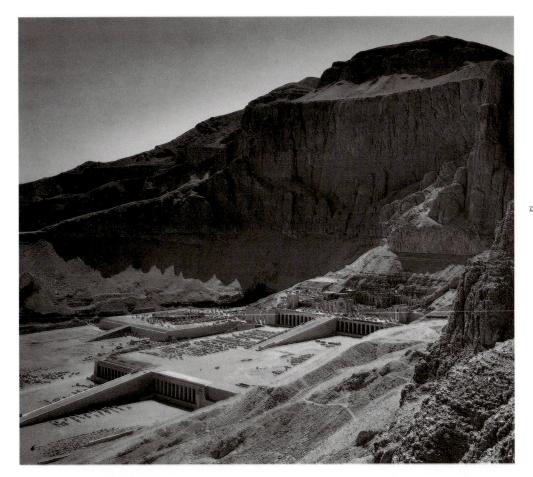

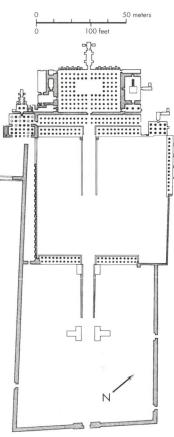

73. Plan of Funerary Temple of Queen Hatshepsut (after Lange)

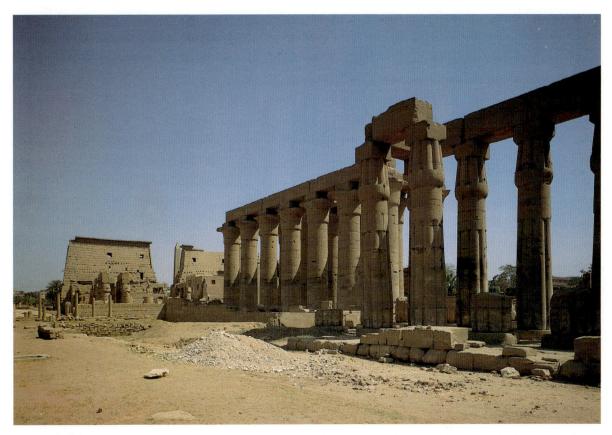

74. Court and pylon of Ramesses II (c. 1279–1212 B.C.) and colonnade and court of Amenhotep III (c. 1350 B.C.), Temple complex of Amun-Mut-Khonsu, Luxor

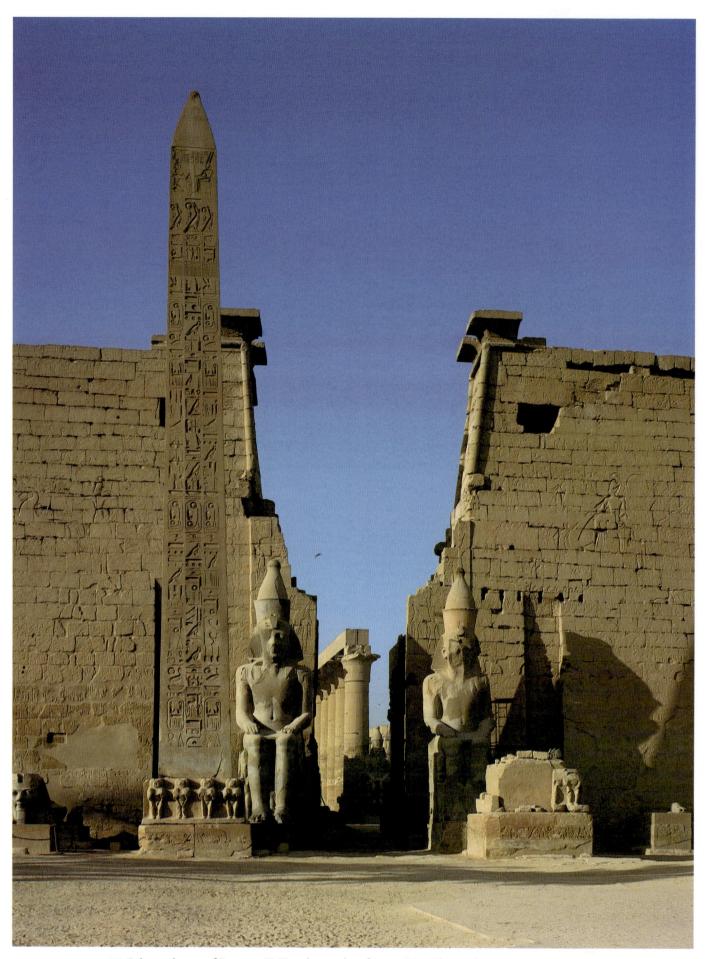

75. Pylon and court of Ramesses II, Temple complex of Amun-Mut-Khonsu, Luxor. c. 1279–1212 B.C.

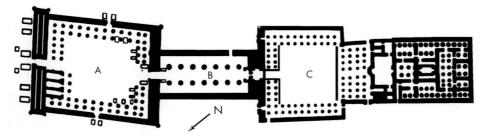

76. Plan of the Temple of Amun, Luxor (after N. de Garis Davies)

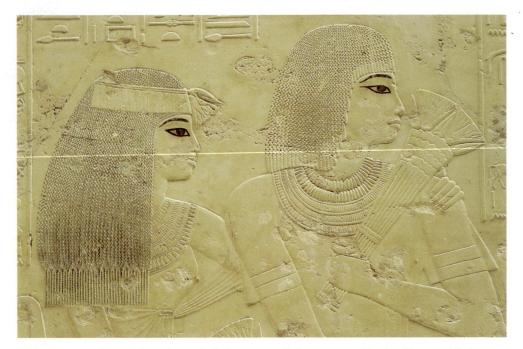

77. Mai and His Wife Urel. Detail of a limestone relief. c. 1375 B.C. Tomb of Ramose, Thebes

left, and fig. 75), leads to the court (fig. 76, A). The court, in this case, is a parallelogram, because Ramesses II, who added it to the temple that had been planned under Amenhotep III, changed the axis of his court slightly so as to conform with the direction of the Nile. We then enter a pillared hall, which brings us to the second court (fig. 76, B and C; fig. 74, center and right). On its far side we find another pillared hall. Beyond it, the temple proper begins: a series of symmetrically arranged halls and chapels shielding the holy of holies, a square room with four columns (fig. 76, extreme right).

The entire sequence of courts, halls, and temple was enclosed by high walls that shut off the outside world. Except for the monumental pylon (fig. 75), such a structure is designed to be experienced from within. Ordinary worshipers were confined to the courts and could but marvel at the forest of columns that screened the dark recesses of the sanctuary. The columns had to be closely spaced, for they supported the stone lintels of the ceiling, and these had to be short to keep them from breaking under their own weight. Yet the architect has consciously exploited this condition by making the columns far heavier than they need be. As a result, the beholder feels almost crushed by their sheer mass. The effect is certainly impressive, but also rather coarse when measured against the earlier masterpieces of Egyptian architecture. We need only compare the papyrus columns of the colonnade of Amenhotep III with their remote ancestors in Djoser's North Palace (fig. 58) in order to

realize how little of the genius of Imhotep has survived at Luxor.

Akhenaten

Of the great projects built by Akhenaten hardly anything remains above ground. He must have been a revolutionary not only in his religious beliefs but in his artistic tastes as well, consciously fostering a new style and a new ideal of beauty in his choice of masters. The contrast with the past becomes strikingly evident if we compare a head in low relief from the Tomb of Ramose, done at the end of the reign of Amenhotep III (fig. 77, following page), with a low-relief portrait of Akhenaten that is some 30 to 40 years later in date (fig. 78, following page). Figure 77 shows the traditional style at its best. The wonderful subtlety of the carving and the precision and refinement of its lines make the head of Akhenaten seem at first glance like a brutal caricature. And the latter work is indeed an extreme statement of the new ideal, with its oddly haggard features and overemphatic, undulating outlines. Still, we can perceive its kinship with the justly famous bust of Akhenaten's queen, Nefertiti (fig. 79), one of the masterpieces of the "Akhenaten style."

What distinguishes this style is not greater realism so much as a new sense of form that seeks to unfreeze the traditional immobility of Egyptian art. Not only the contours but the plastic shapes, too, seem more pliable and relaxed, antigeometric. We find these qualities again in the delightful fragment

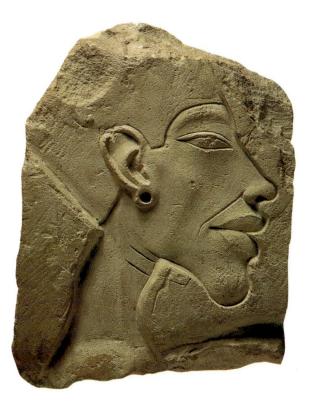

78. Akhenaten (Amenhotep IV). c. 1348–1336/5 B.C. Limestone, height 3¹/8" (7.9 cm). Staatliche Museen zu Berlin, Preussischer Kulturbesitz, Ägyptisches Museum

of a wall painting showing the daughters of Akhenaten (fig. 80). Their playful gestures and informal poses seem in defiance of all rules of pharaonic dignity.

The old religious tradition was quickly restored after Akhenaten's death, but the artistic innovations he encouraged could be felt in Egyptian art for some time to come. The scene of workmen struggling with a heavy beam (fig. 81), from the Tomb of Horemheb at Saqqara, shows a freedom and expres-

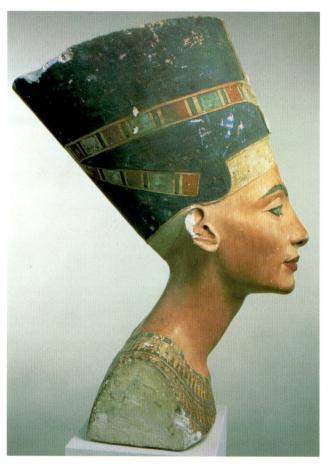

79. *Queen Nefertiti*. c. 1348–1336/5 B.C. Limestone, height 19" (48.3 cm). Staatliche Museen zu Berlin, Preussischer Kulturbesitz, Ägyptisches Museum

siveness that would have been unthinkable in earlier times.

Tutankhamen

Even the face of Akhenaten's successor, Tutankhamen, as it appears on his gold coffin cover, betrays an echo of the Akhenaten style (fig. 82). Tutankhamen, who died at the age of 18, owes his fame entirely to the accident that his is the only

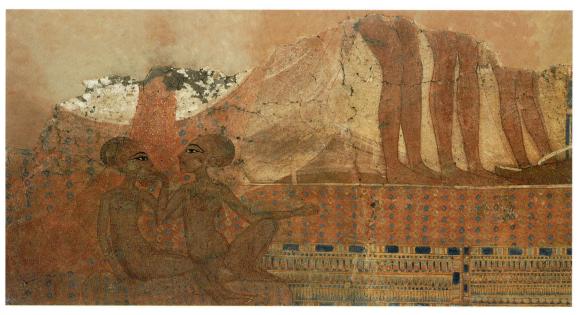

80. The Daughters of Akhenaten. c. 1360 B.C. Detail of a wall painting. 113/4 x 16" (30 x 40.7 cm). Ashmolean Museum, Oxford, England

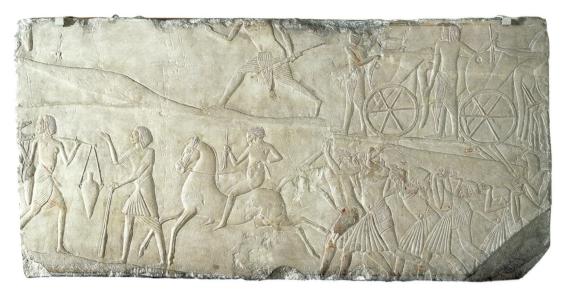

81. Workmen Carrying a Beam. Detail of a relief, from the Tomb of Horemheb, Saqqara. c. 1325 B.C. Museo Civico, Bologna

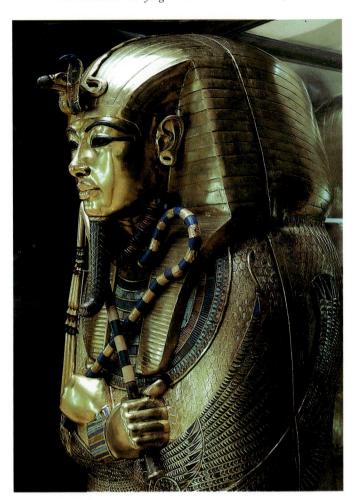

82. Cover of the coffin of Tutankhamen. c. 1327 B.C. Gold inlaid with enamel and semiprecious stones, height of whole 6'7/8" (1.85 m). Egyptian Museum, Cairo

pharaonic tomb discovered in our times with most of its contents undisturbed. The sheer material value of the tomb (Tutankhamen's gold coffin alone weighs 250 pounds) makes it understandable that grave robbing has been practiced in Egypt ever since the Old Kingdom. To us, the exquisite workmanship of the coffin cover, with the rich play of colored inlays against the polished gold surfaces, is even more impressive.

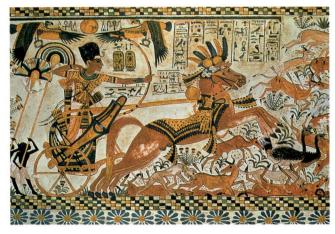

83. *Tutankhamen Hunting*. Detail from a painted chest found in the king's tomb, Thebes. c. 1336/5–1327 B.C. Length of scene approx. 20" (50.7 cm). Egyptian Museum, Cairo

As unique in its way as the gold coffin is a painted chest from the same tomb, showing the youthful king in battle and hunting scenes (fig. 83). These subjects, which were intended to glorify Tutankhamen (hunting was of primarily ritual significance), had been traditional since the late years of the Old Kingdom, but here they are done with astonishing freshness, at least so far as the animals are concerned. While the king and his horse-drawn chariot remain frozen against the usual blank background filled with hieroglyphs, the same background in the right-hand half of the scene suddenly turns into a desert. The surface is covered with stippled dots to suggest sand, desert plants are strewn across it in considerable variety, and the animals stampede over it helter-skelter, without any ground-lines to impede their flight.

Here is an aspect of Egyptian painting that we rarely see on the walls of tombs. Perhaps this lively scattering of forms against a landscape background existed only on the miniature scale of the scenes on Tutankhamen's chest, and even there it became possible only as a result of the Akhenaten style. How these animals-in-landscape endured in later Egyptian painting we do not know, but they must have survived somehow, for their resemblance to Islamic miniatures done more than 2,000 years later is far too striking to be ignored.

CHAPTER THREE

ANCIENT NEAR EASTERN ART

SUMERIAN ART

It is an astonishing fact that human civilization should have emerged into the light of history in two separate places at just about the same time. Between 3500 and 3000 B.C., when Egypt was being united under pharaonic rule, another great civilization arose in Mesopotamia, the "land between the rivers." And for close to 3,000 years, the two centers retained their distinct characters, even though they had contact with each other from their earliest beginnings and their destinies were interwoven in many ways. The pressures that forced the inhabitants of both regions to abandon the pattern of Neolithic village life may well have been the same (see fig. 38). But the valley of the Tigris and Euphrates rivers, unlike that of the Nile, is not a narrow fertile strip protected by deserts on either side. It resembles a wide, shallow trough with few natural defenses, crisscrossed by two great rivers and their tributaries, and easily encroached upon from any direction.

Thus the facts of geography tended to discourage the idea of uniting the entire area under a single head. Rulers who had this ambition did not appear, so far as we know, until about a thousand years after the beginnings of Mesopotamian civilization, and they succeeded in carrying it out only for brief periods and at the cost of almost continuous warfare. As a consequence, the political history of ancient Mesopotamia has no underlying theme of the sort that divine kingship provides for Egypt. Local rivalries, foreign incursions, the sudden upsurge and equally sudden collapse of military power—these are its substance. Against such a disturbed background, the continuity of cultural and artistic traditions seems all the more remarkable. This common heritage is very largely the creation of the founders of Mesopotamian civilization, whom we call Sumerians after the region of Sumer, which they inhabited, near the confluence of the Tigris and Euphrates rivers.

The origin of the Sumerians remains obscure. Their language is unrelated to any other known tongue. Sometime before 4000 B.C., they came to southern Mesopotamia from Persia, and there, within the next thousand years, they founded a number of city-states and developed their distinctive form of writing in cuneiform (wedge-shaped) characters on clay tablets. This transitional phase, corresponding to the predynastic period in Egypt, is called "protoliterate"; it leads to the early dynastic period, from about 3000 to 2340 B.C.

ARCHAEOLOGICAL CONDITIONS. The first evidence of Bronze Age culture is seen in Sumer about 4000 B.C. Unfortunately, the tangible remains of Sumerian civilization are extremely scanty compared to those of ancient Egypt. Building stone being unavailable in Mesopotamia, the Sumerians used mud brick and wood, so that almost nothing is left of their architecture except the foundations. Nor did they share the Egyptians' concern with the hereafter, although some richly endowed tombs in the shape of vaulted chambers below ground from the early dynastic period have been found in the city of Ur. Our knowledge of Sumerian civilization thus depends very largely on chance fragments brought to light by excavation, including vast numbers of inscribed clay tablets. Yet we have learned enough to form a general picture of the achievements of this vigorous, inventive, and disciplined people.

RELIGION. Each Sumerian city-state had its own local god, who was regarded as its "king" and owner. It also had a human ruler, the steward of the divine sovereign, who led the people in serving the deity. The local gods, in return, were expected to plead the cause of their subjects among the other deities who controlled the forces of nature, such as wind and weather, water, fertility, and the heavenly bodies. Nor was the idea of divine ownership treated as a mere pious fiction. The god was quite literally believed to own not only the territory of the

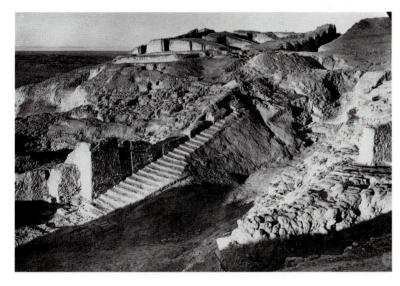

84. Remains of the "White Temple" on its ziggurat, Uruk (Warka), Iraq. c. 3500–3000 B.C.

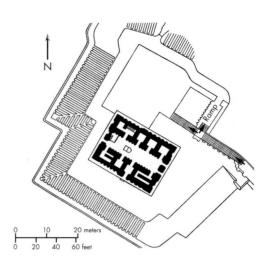

85. Plan of the "White Temple" on its ziggurat (after H. Frankfort)

city-state but also the labor power of the population and its products. All these were subject to his commands, transmitted to the people by his human steward. The result was an economic system that has been dubbed "theocratic socialism," a planned society whose administrative center was the temple. The temple controlled the pooling of labor and resources for communal enterprises, such as the building of dikes or irrigation ditches, and it collected and distributed a considerable part of the harvest. All this required the keeping of detailed written records. Hence we need not be surprised to find that the texts of early Sumerian inscriptions deal very largely with economic and administrative rather than religious matters, although writing was a priestly privilege.

ARCHITECTURE. The dominant role of the temple as the center of both spiritual and physical existence is strikingly conveyed by the layout of Sumerian cities. The houses were clustered about a sacred area that was a vast architectural complex embracing not only shrines but workshops, storehouses, and scribes' quarters as well. In their midst, on a raised platform, stood the temple of the local god. These platforms soon reached the height of true mountains, comparable to the pyramids of Egypt in the immensity of effort required and in their effect as great landmarks that tower above the featureless plain. They are known as ziggurats.

The most famous of them, the biblical Tower of Babel, has been completely destroyed, but a much earlier example, built shortly before 3000 B.C. and thus several centuries older than the first of the pyramids, survives at Warka, the site of the Sumerian city of Uruk (called Erech in the Bible). The mound, its sloping sides reinforced by solid brick masonry, rises to a height of 40 feet. Stairs and ramps lead up to the platform on which stands the sanctuary, called the "White Temple" because of its whitewashed brick exterior (figs. 84 and

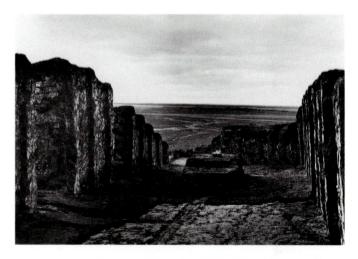

86. Interior of the cella, "White Temple"

85). Its heavy walls, articulated by regularly spaced projections and recesses, are sufficiently well preserved to suggest something of the original appearance of the structure. The main room, or cella (fig. 86), where sacrifices were offered before the statue of the god, is a narrow hall that runs the entire length of the temple and is flanked by a series of smaller chambers. But the main entrance to the cella is on the southwest side, rather than on the side facing the stairs or on one of the narrow sides of the temple, as one might expect. In order to understand the reason for this, we must view the ziggurat and temple as a whole. The entire complex is planned in such a way that the worshiper, starting at the bottom of the stairs on the east side, is forced to go around as many corners as possible before reaching the cella. The processional path, in other words, resembles a sort of angular spiral.

This "bent-axis approach" is a fundamental characteristic of Mesopotamian religious architecture, in contrast to the straight, single axis of Egyptian temples (see fig. 76). During the following 2,500 years, it was elaborated into ever taller and more towerlike ziggurats rising in multiple stages. The one built by King Urnammu at Ur about 2100 B.C. and dedicated

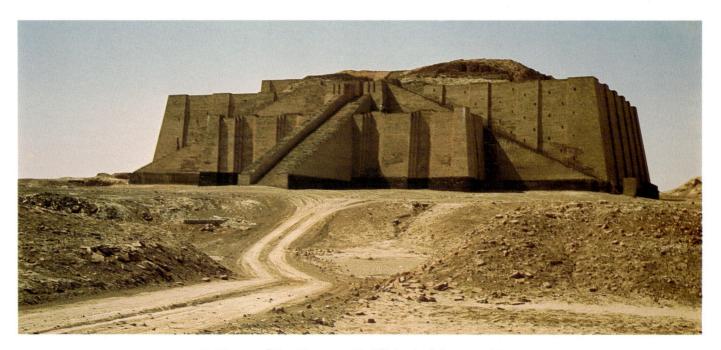

87. Ziggurat of King Urnammu, Ur (El Muqeiyar), Iraq. c. 2100 B.C.

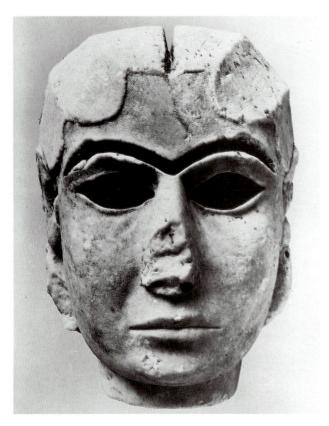

88. Female Head, from Uruk (Warka). c. 3500–3000 B.C. Limestone, height 8" (20.3 cm). Iraq Museum, Baghdad

to the moon-god Nanna had three levels (fig. 87). Little is left of the upper two stages, but the bottom one, some 50 feet high, has survived fairly well, and its facing of brick has been restored. What was the impulse behind these structures? Certainly not the kind of pride attributed to the builders of the Tower of Babel in the Old Testament. They reflect, rather, the widespread belief that mountaintops are the dwelling places of the gods. (We need only think of the Mount Olympus of the Greeks.) The Sumerians felt they could provide a fit residence for a deity only by creating their own artificial mountains.

STONE SCULPTURE. The image of the god to whom the "White Temple" was dedicated is lost—it was probably Anu, the god of the sky—but a splendid female head from the same period at Uruk (Warka) may well have belonged to another cult statue (fig. 88). It is carved from limestone, and the hair, eyes, and eyebrows were originally inlaid with colored materials. The rest of the figure, which must have been close to lifesize, was probably of wood. As an artistic achievement, this head is on a par with the finest works of Egyptian Old Kingdom sculpture. The softly swelling cheeks, the delicate curves of the lips, combined with the steady gaze of the huge eyes, create a balance of sensuousness and severity that seems worthy of any goddess.

It was the geometric and expressive aspects of the Uruk head, rather than the realistic ones, that survived in the stone sculpture of the early dynastic period, as seen in a group of figures from Tell Asmar (fig. 89) carved about five centuries later than the head. Although the two tallest figures have traditionally been thought to represent Abu, the god of vegetation, and a mother goddess, it is likely that all are votive statues of priests and worshipers. Despite the disparity in size, each has the same pose of humble worship, save for the kneeling figure to the lower right. The enormous eyes of all the figures communicate a sense of awe entirely appropriate before the often-terrifying deities they worshiped. Their insistent stare is emphasized by colored inlays, which are still in place. The entire group must have stood in the cella of the Abu temple, the priests and worshipers communicating with the god through their eyes.

"Representation" here had a very direct meaning: the gods were believed to be present in their images, and the statues of the worshipers served as stand-ins for the persons they portrayed, offering prayers or transmitting messages to the deity in their stead. Yet none of them indicates any attempt to achieve a real likeness. The bodies as well as the faces are rigorously simplified and schematic, in order to avoid distracting attention from the eyes, "the windows of the soul." If the Egyptian sculptor's sense of form was essentially cubic, that of the Sumerian was based on the cone and cylinder. Arms and legs have the roundness of pipes, and the long skirts worn by

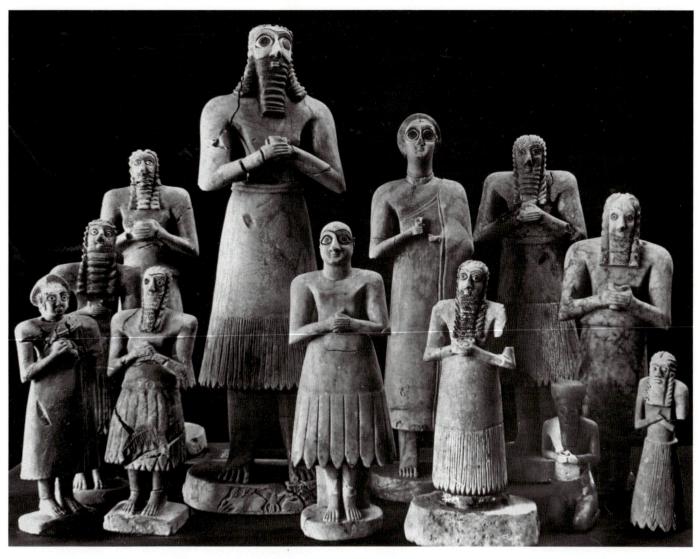

89. Statues, from the Abu Temple, Tell Asmar, Iraq. c. 2700–2500 B.C. Limestone, alabaster, and gypsum, height of tallest figure approx. 30" (76.3 cm). Iraq Museum, Baghdad, and The Oriental Institute Museum of The University of Chicago

all these figures are as smoothly curved as if they had been turned on a lathe. This preference for curvilinear forms may initially have been determined in part by the shape of the blocks supplied from afar, but even in later times, when Mesopotamian sculpture had acquired a far richer repertory of shapes, the same quality asserted itself again and again.

BRONZE OR ASSEMBLED SCULPTURE. The coniccylindrical simplification of the Tell Asmar statues is characteristic of the carver, who works by cutting forms out of a solid block. A far more flexible and realistic style prevails among the Sumerian sculpture that was made by addition rather than subtraction (that is, either modeled in soft materials for casting in bronze or put together by combining such varied substances as wood, gold leaf, and lapis lazuli). Some pieces of the latter kind, roughly contemporary with the Tell Asmar figures, have been found in the tombs at Ur which we mentioned earlier. They include the fascinating object shown in figure 90, an offering stand in the shape of a ram rearing up

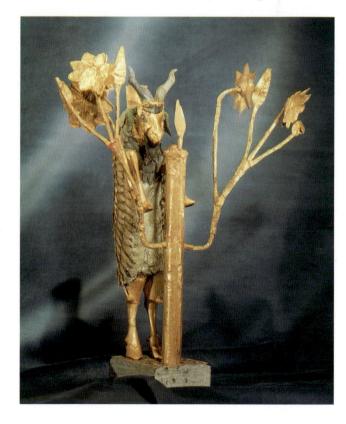

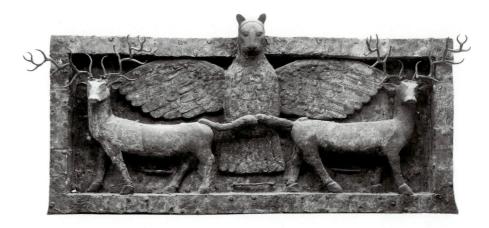

91. Imdugud and Two Stags. c. 2500 B.C. Copper over wood, 3'61/8" x 7'10" (1 x 2.3 m). The British Museum, London

against a flowering tree. The animal, marvelously alive and energetic, has an almost demonic power of expression as it gazes at us from between the branches of the symbolic tree. And well it might, for it is sacred to the god Tammuz and thus embodies the male principle in nature. Even more astonishing is the copper relief of the storm god Imdugud in the guise of a lion-headed eagle between two heraldically arranged stags (fig. 91), which probably came from a lintel over a doorway. Here the awesome power of Mesopotamian gods and goddesses becomes terrifyingly clear.

Such an association of animals with deities is a carry-over from prehistoric times (see pages 52-53). We find it not only in Mesopotamia but in Egypt as well (see the falcon of Horus in fig. 51). What distinguishes the sacred animals of the Sumerians is the active part they play in mythology. Much of this lore, unfortunately, has not come down to us in written form, but tantalizing glimpses of it can be caught in pictorial representations such as those on an inlaid panel from a harp (fig. 92) that was recovered together with the offering stand at Ur. The hero embracing two human-headed bulls in the top compartment was so popular a subject that its design has become a rigidly symmetrical, decorative formula. The other sections, however, show animals performing a variety of human tasks in surprisingly lively and precise fashion. The wolf and the lion carry food and drink to an unseen banquet, while the ass, bear, and deer provide musical entertainment. (The bull-headed harp is the same type as the instrument to which the inlaid panel was attached.) At the bottom, a scorpion-man and a goat carry some objects they have taken from a large vessel.

The skillful artist who created these scenes was far less constrained by rules than the Egyptian. Even though the figures, too, are placed on ground-lines, there is no fear of overlapping forms or foreshortened shoulders. However, we must be careful not to misinterpret the intent. What strikes the modern eye as delightfully humorous was probably meant to be viewed with perfect seriousness. If we only knew the context in which these actors play their roles! The animals, which probably descend from tribal totems or worshipers wearing masks, presumably represent deities engaged in familiar

92. Inlay panel from the soundbox of a lyre, from Ur. c. 2600 B.C. Shell and bitumen, 12½4 x 4½" (31.1 x 11.3 cm). University of Pennsylvania Museum, Philadelphia

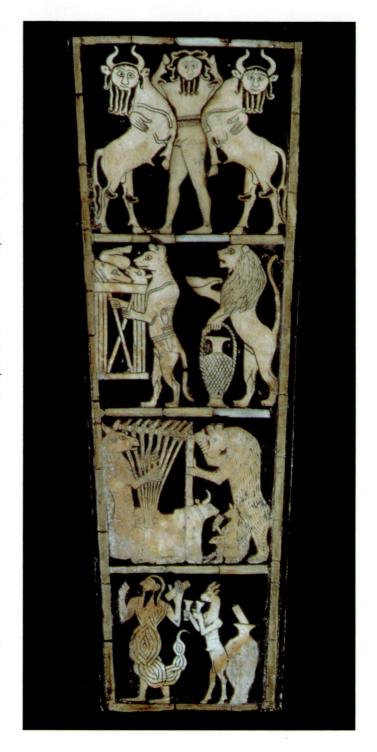

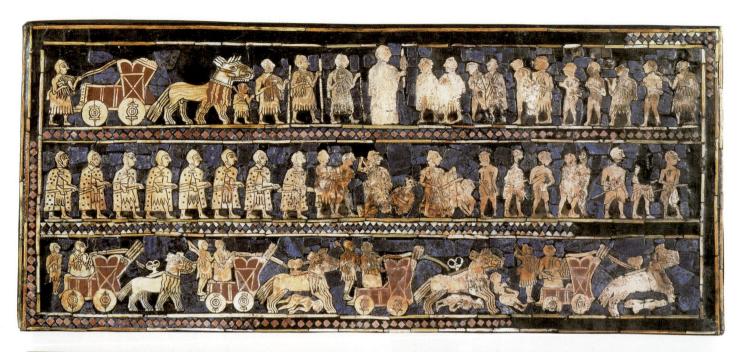

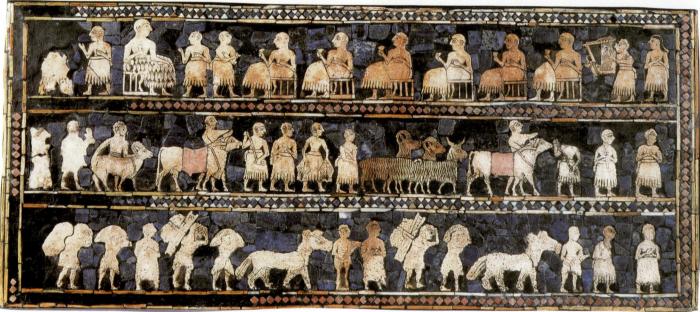

93. Standard of Ur, front and back sides. c. 2600 B.C. Wood inlaid with shell, limestone, and lapis lazuli, height 8" (20.3 cm). The British Museum, London

human activities. Nevertheless, we are entitled to regard them as the earliest known ancestors of the animal fable that flourished in the West from Aesop to La Fontaine. The ass with the harp and the hero between two animals survived as fixed images, and we encounter them almost 4,000 years later in medieval sculpture.

The royal *Standard of Ur*, which celebrates an important military victory, attests to the Sumerian artist's sophistication at inlaywork (fig. 93). The side depicting "war" records the conquest itself in fascinating detail, including costume elements and a row of chariots pulled by wild asses known as onagers, with a driver and spearman in each chariot; the "peace" side shows officials in celebration as animals are shepherded in for the feast, while onagers and other booty are being brought back on the bottom register. The triangular end panels of the standard also had animal scenes. The figures have the same squat proportions and rounded forms as the statues from

Tell Asmar. Here the artist observes the combination of profile and frontal views familiar to us from Egyptian art, which became the convention in Mesopotamia as well.

Akkadian

Toward the end of the early dynastic period, the theocratic socialism of the Sumerian city-states began to decay. The local "stewards of the god" had in practice become reigning monarchs, and the more ambitious among them attempted to enlarge their domain by conquering their neighbors. At the same time, the Semitic-speaking inhabitants of northern Mesopotamia drifted south in ever larger waves, until they outnumbered the Sumerian peoples in many places. These newer arrivals had adopted many features of Sumerian civilization but were less bound to the tradition of the city-state. So it is perhaps not surprising that Sargon of Akkad (his name

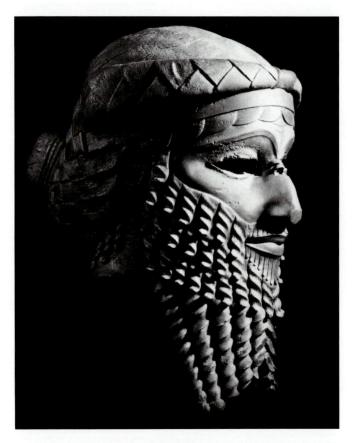

94. *Head of an Akkadian Ruler*, from Nineveh (Kuyunjik), Iraq. c. 2300–2200 B.C. Bronze, height 12" (30.7 cm). Iraq Museum, Baghdad

means "true king") and his successors (2340–2180 B.C.) were the first Mesopotamian rulers who openly called themselves kings and proclaimed their ambition to rule the entire earth.

Sargon reorganized the Sumerian and Akkadian gods and goddesses into a new pantheon to help unite the country and break down the traditional identification between cities and their deities. Under these Akkadians, Sumerian art faced a new task: the personal glorification of the sovereign. The most impressive work of this kind that has survived is a magnificent royal portrait head in bronze from Nineveh (fig. 94). Despite the gouged-out eyes (once inlaid with precious materials), it remains a persuasive likeness, majestic and humanly moving at the same time. Equally admirable is the richness of the surfaces framing the face. The plaited hair and the finely curled strands of the beard are shaped with incredible precision, yet without losing their organic character and becoming mere ornament. The complex technique of casting and chasing has been handled with an assurance that bespeaks true mastery. This head could hold its own in the company of the greatest works of any period.

STELE OF NARAM-SIN. Sargon's grandson, Naram-Sin, had himself and his victorious army immortalized in relief on a large stele (fig. 95)—an upright stone slab used as a marker—which owes its survival to the fact that at a later time it was carried off as booty to Susa, where modern archaeologists discovered it. Here rigid ground-lines have been discarded, and we see the king's forces advancing among the trees on a mountainside. Above them, Naram-Sin alone stands trium-

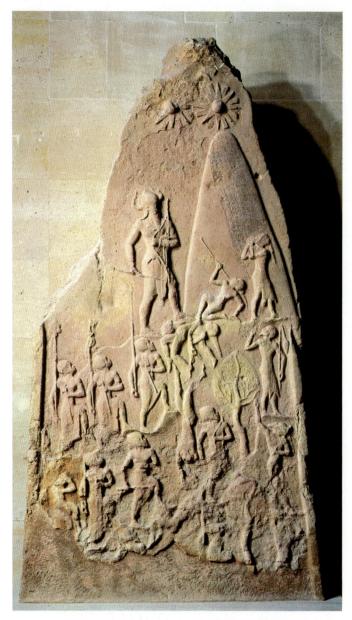

95. Victory Stele of Naram-Sin. c. 2300–2200 B.C. Stone, height 6'6" (2 m). Musée du Louvre, Paris

phant, as the defeated enemy soldiers plead for mercy. He is as vigorously active as his men, but his size and his isolated position endow him with superhuman status. Moreover, he wears the horned crown hitherto reserved for the gods. There is nothing above him except the mountaintop and the celestial bodies, his "good stars."

Ur

The rule of the Akkadian kings came to an end when tribesmen from the northeast descended into the Mesopotamian plain and gained mastery of it for more than half a century. They were driven out in 2125 B.C. by the kings of Ur, who reestablished a united realm that was to last a hundred years.

GUDEA. During the period of foreign dominance, Lagash (the modern Telloh), one of the lesser Sumerian city-states, managed to retain local independence. Its ruler, Gudea, was

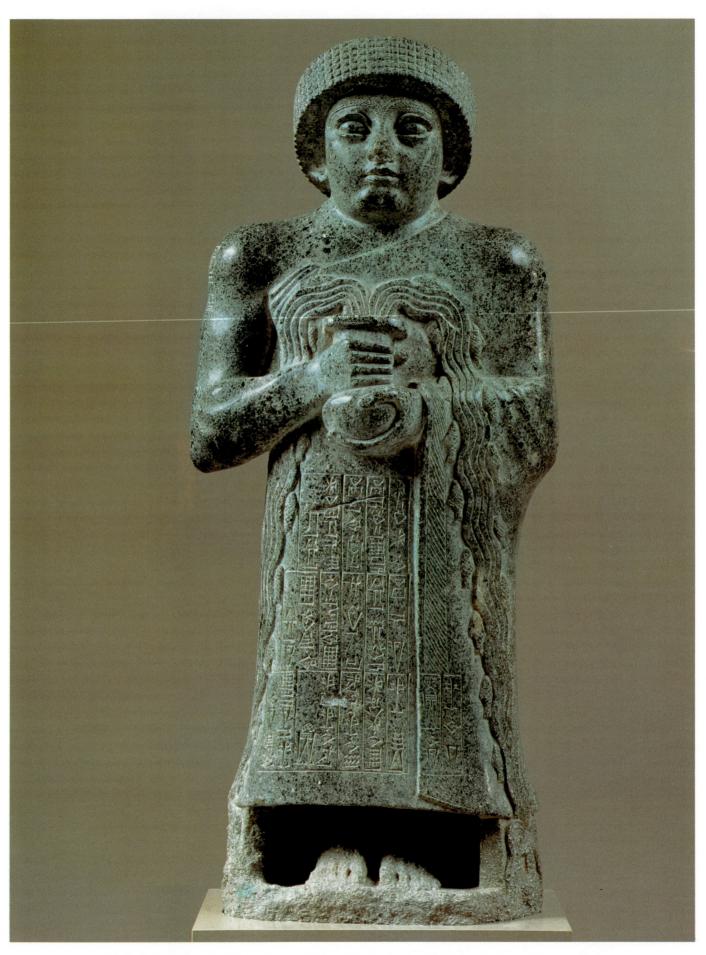

96. Gudea, from Lagash (Telloh), Iraq. c. 2120 B.C. Diorite, height 29" (73.7 cm). Musée du Louvre, Paris

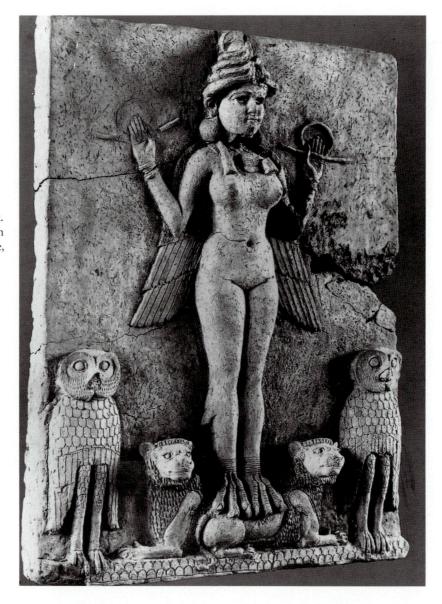

97. Inanna-Ishtar. c. 2025–1763 B.C. Terracotta, height approx. 20" (50.8 cm). Collection Colonel Norman Colville, United Kingdom

careful to reserve the title of king for the city-god, whose cult he promoted by an ambitious rebuilding of his temple. [See Primary Sources, no. 3, pages 212–13.] Of this architectural enterprise nothing remains today, but Gudea also had numerous statues of himself placed in the shrines of Lagash, and some twenty examples, all obviously of the same general type, have been found so far. Carved of diorite, an extremely hard stone favored by Egyptian sculptors, they are much more ambitious works than their predecessors from Tell Asmar. Even Gudea, however devoted he was to the traditional pattern of the Sumerian city-state, seems to have inherited something of the sense of personal importance that we felt in the Akkadian kings, although he prided himself on his intimate relations with the gods rather than on secular power.

The head in a statue of Gudea (fig. 96) appears much less distinctly individualized when compared with that of the Akkadian ruler, yet its fleshy roundness is far removed from the geometric simplicity of the Tell Asmar statues. Gudea holds a vase from which flow two streams of life-giving water representing the Tigris and Euphrates. (Mesopotamia was known as the Land of the Two Rivers.) This attribute was otherwise reserved for water goddesses and female votive figures, although the statue was dedicated to Geshtinanna, the goddess of poetry and interpreter of dreams. It probably alludes to the king's

important role in providing irrigation canals for his people and attests to his beneficent rule. The stone has been worked to a high and subtly accented finish, inviting a wonderful play of light upon the features. The figure makes an instructive contrast with such Egyptian statues as in figures 63 and 65. The Sumerian carver has rounded off all the corners to emphasize the cylindrical quality of the forms. Equally characteristic is the muscular tension in Gudea's bare arm and shoulder, compared with the passive, relaxed limbs of Egyptian statues.

Babylonian

The second millennium B.C. was a time of almost continuous turmoil in Mesopotamia. The ethnic upheaval that brought the Hyksos to Egypt had an even more disruptive effect on the valley of the Tigris and Euphrates, where the invasion of the Elamites from the east and Amorites from the northwest gave rise to the rival city-states of Isin and Larsa after 2025 B.C. As we might expect, the art and architecture that have come down to us from this period of turmoil are unassuming. Sculpture consists for the most part of small terracotta reliefs.

Among them is a cult statue of remarkable quality (fig. 97). The sculpture is modeled so deeply as to be nearly in the round, lending it a monumentality that belies the modest size.

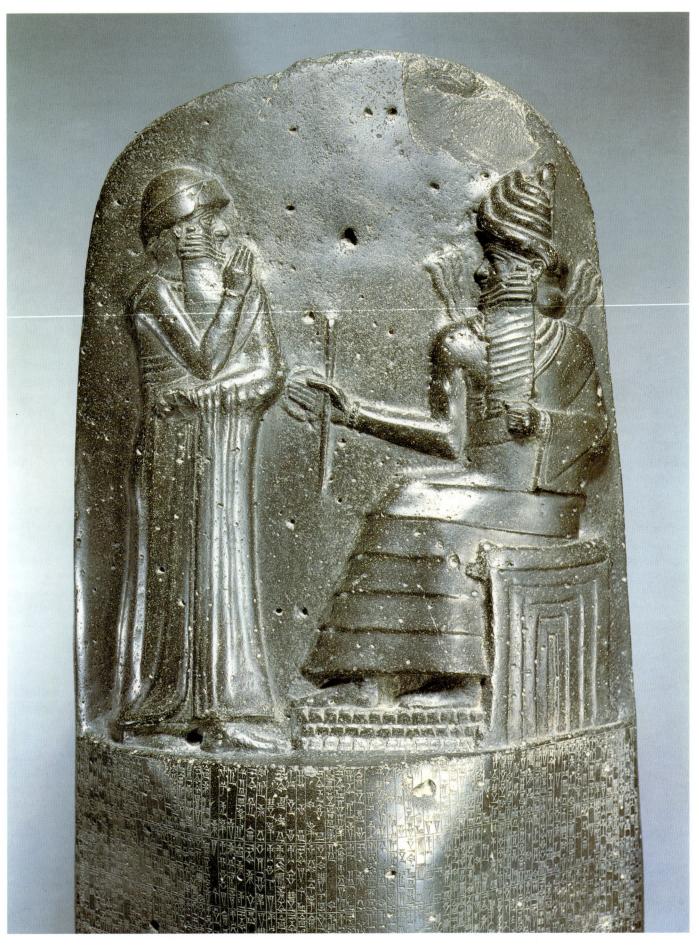

98. Upper part of stele inscribed with the Law Code of Hammurabi. c. 1760 B.C. Diorite, height of stele approx. 7' (2.1 m); height of relief 28" (71 cm). Musée du Louvre, Paris

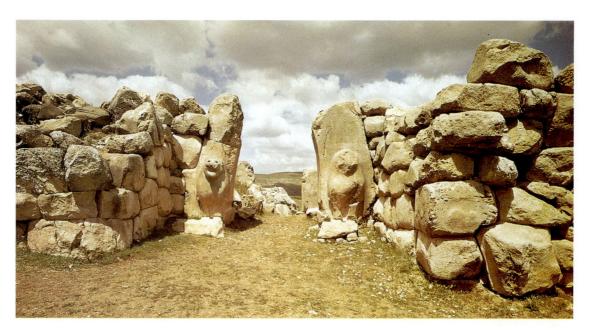

99. The Lion Gate, Bogazköy, Anatolia, Turkey. c. 1400 B.C.

Who can this winged creature with taloned feet be? She is Inanna-Ishtar, whose emblem is the lion. One of the most widely worshiped of all Mesopotamian deities, she unites the Sumerian goddess of fertility with the winged Semitic goddess of war and hunting. The four-horned headdress is a sign of divinity. Characteristic of Ishtar in her guise as the goddess of love, identified with the planet Venus, is the figure's voluptuous nudity. Missing, however, are Ishtar's key attributes: weapons in her hands and sprouting from her shoulders. Instead, she bears in each hand the rod and ring of kingship, which she brought with her in her descent into the underworld for her consort Tammuz's return. The myth of Ishtar's descent into the underworld is a paradigm of feminine selfdiscovery and empowerment: in it, she is stripped by the goddess of death of all her vestments, which are eventually returned to her, and she emerges transformed by the experience. She is, then, also a goddess of death and resurrection, further denoted by the owl, which also establishes her as Kilili, the forerunner of the Assyrian storm goddess Lilitu and the Semitic demon Lilith. This conflation of identities is typical of Sumerian religion as the ancient deities were united into a comprehensive pantheon. Yet the image, unprecedented in Mesopotamian art, remains unique, for it is never found again.

Central power by native rulers prevailed only from about 1760 to 1600 B.C., when Babylon assumed the role formerly played by Akkad and Ur. Hammurabi (c. 1792–1750 B.C.), the founder of the Babylonian dynasty, is by far the greatest figure of the age. Combining military prowess with a deep respect for Sumerian tradition, he saw himself as "the favorite shepherd" of the sun-god Shamash, whose mission was "to cause justice to prevail in the land." Under him and his successors, Babylon became the cultural center of Sumer. The city was to retain this prestige for more than a thousand years after its political power had waned.

CODE OF HAMMURABI. Hammurabi's most memorable achievement is his law code, justly famous as among the earliest uniform written bodies of laws and amazingly rational and

humane in conception. He had it engraved on a tall diorite stele whose top shows Hammurabi confronting the sun-god, seen holding the ring and rod of kingship, which here stand for justice as well (fig. 98). The ruler's right arm is raised in a speaking gesture, as if he were reporting his work of codification to the divine king. Although this scene was carved four centuries after the Gudea statues, it is closely related to them in both style and technique. In fact, the relief here is so high that the two figures almost give the impression of statues sliced in half when we compare them with the pictorial treatment of the Naram-Sin stele (fig. 95). As a result, the sculptor has been able to render the eyes in the round, so that Hammurabi and Shamash gaze at each other with a force and directness unique in representations of this kind. They make us recall the statues from Tell Asmar (see fig. 89), whose enormous eyes indicate an attempt to establish the same relationships between humans and god in an earlier phase of Sumerian civilization.

ASSYRIAN ART

The city-state of Assur on the upper course of the Tigris owed its rise to power to a strange chain of events. During the earlier half of the second millennium B.C., Asia Minor had been invaded from the east by people of Indo-European language. One group, the Mitannians, created an independent kingdom in Syria and northern Mesopotamia, including Assur, while another, the Hittites, established themselves farther north on the rocky plateau of Anatolia. Their capital, near the present-day Turkish village of Bogazköy, was protected by impressive fortifications built of large, roughly cut stones. Flanking the gates were lions or other guardian figures protruding from the enormous blocks that formed the jambs of the doorway (fig. 99).

About 1360 B.C., the Hittites attacked the Mitannians, who were allies of the Egyptians. But the latter, because of the internal crisis provoked by the religious reforms of Akhenaten (see page 72), could send no effective aid. Consequently, the Mitannians were defeated and Assur regained its independence. Under a series of able rulers, the Assyrian domain grad-

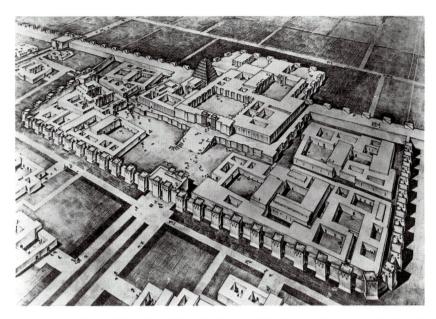

100. Citadel of Sargon II, Dur Sharrukin (Khorsabad), Iraq. 742–706 B.C. (reconstruction by Charles Altman)

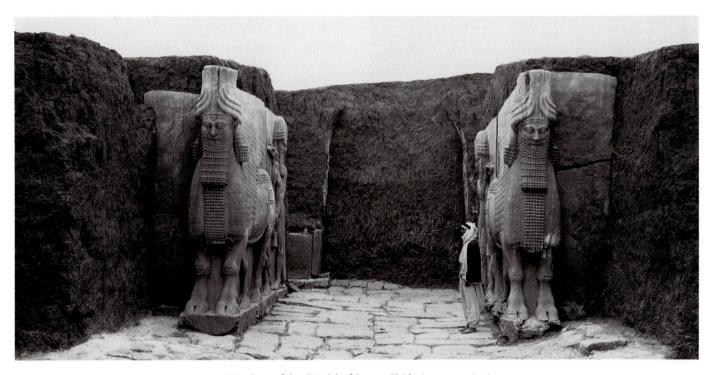

101. Gate of the Citadel of Sargon II (during excavation)

ually expanded until it embraced not only Mesopotamia proper but the surrounding regions as well. At the height of its power, from about 1000 to 612 B.C., the Assyrian empire stretched from the Sinai peninsula to Armenia. Even Lower Egypt was successfully invaded about 670 B.C.

Palaces and Their Decoration

The Assyrians, it has been said, were to the Sumerians what the Romans were to the Greeks. Assyrian civilization drew on the achievements of the south but reinterpreted them to fit its own distinct character. Thus the temples and ziggurats they built were adapted from Sumerian models, while the palaces of Assyrian kings grew to unprecedented size and magnificence.

DUR SHARRUKIN. One of these, that of Sargon II (died 705 B.C.) at Dur Sharrukin (the modern Khorsabad), dating from the second half of the eighth century B.C., has been explored sufficiently to permit a reconstruction (fig. 100). It was surrounded by a citadel with turreted walls that shut it off from the rest of the town. Figure 101 shows one of the two gates of the citadel in the process of excavation. Although the Assyrians, like the Sumerians, built in brick, they liked to line gateways and the lower walls of important interiors with great slabs of stone (which were less difficult to procure in northern Mesopotamia). These slabs were either decorated with low reliefs or, as in our case, elaborated into guardian demons that are an odd combination of relief and sculpture in the round. They must have been inspired by Hittite examples such as the

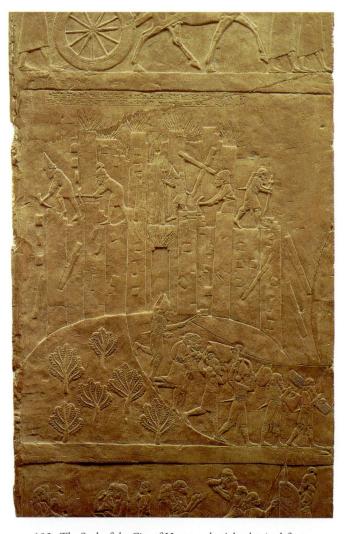

102. The Sack of the City of Hamanu by Ashurbanipal, from the Palace of Ashurbanipal, Nineveh (Kuyunjik), Iraq. c. 650 B.C. Limestone, $36 \times 24^{1/2}$ " (92.7 x 62.2 cm). The British Museum, London

Lion Gate at Bogazköy (fig. 99). Awesome in size and appearance, the gates were meant to impress the visitor with the power and majesty of the king.

Inside the palace, the same impression was reinforced by long series of reliefs illustrating the conquests of the royal armies. Every campaign is described in detail, with inscriptions supplying further data. The Assyrian forces, relentlessly efficient, always seem to be on the march, meeting the enemy at every frontier of the overextended empire, destroying his strong points and carrying away booty and prisoners. There is neither drama nor heroism in these scenes—the outcome of the battle is never in doubt—and they are often depressingly repetitious. Yet, as the earliest large-scale efforts at narrative in the history of art, they represent an achievement of great importance. To describe the progress of specific events in time and space had been outside the scope of earlier Sumerian art; even the scene on the stele of Naram-Sin is symbolic rather than historic. The Assyrian artist thus had to develop an entirely new set of devices in order to cope with the requirements of pictorial storytelling.

NINEVEH. If the artist's results can hardly be called beautiful, they achieve their main purpose: to be clearly readable. This is certainly true of our example (fig. 102), from the Palace of Ashurbanipal (died 626? B.C.), at Nineveh (now Kuyunjik), which shows the sack of the Elamite city of Hamanu in the main register. Assyrian soldiers with pickaxes and crowbars are demolishing the fortifications (notice the falling timbers and bricks in midair) after they have set fire to the town itself. Still others are marching away from it, down a wooded hill, laden with booty. The latter group poses a particularly interesting problem in representation, for the road on which they walk widens visibly as it approaches the foreground, as if the artist had meant to render it in perspective. Yet the same road also serves as a curved band that frames the marchers. This may seem an odd mixture of modes, but it is an effective device for

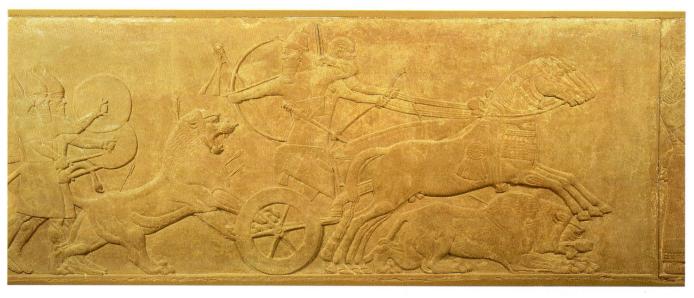

103. Ashurnasirpal II Killing Lions, from the Palace of Ashurnasirpal II, Nimrud (Calah), Iraq. c. 850 B.C. Limestone, 3'3" x 8'4" (1 x 2.5 m). The British Museum, London

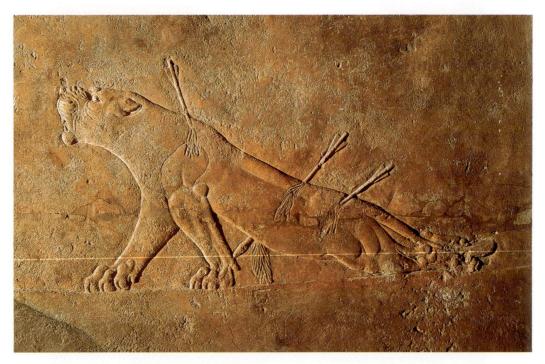

104. *Dying Lioness*, from Nineveh (Kuyunjik), Iraq. c. 650 B.C. Limestone, height of figure 13³/4" (35 cm). The British Museum, London

linking foreground and background. Below the main scene, we observe the soldiers at camp, relaxing with food and drink, while one of them, at far right, stands guard.

LION HUNTS. The mass of descriptive detail in the reliefs of military campaigns often leaves little room for the personal glorification of the king. This purpose is served more directly by another recurrent subject, the royal lion hunts. As in Egypt, whence they derive (see fig. 83), they were more in the nature of ceremonial combats than actual hunts: the animals for the king to kill were released from cages into a square formed by troops with shields. (Presumably, at a much earlier time, the hunting of lions in the field had been an important duty of Mesopotamian rulers as the "shepherds" of the communal flocks.) Here the Assyrian relief sculptor rises to his greatest heights. In figure 103, from the Palace of Ashurnasirpal II (died 860? B.C.) at Nimrud (Calah), the lion attacking the royal chariot from the rear is clearly the hero of the scene. Of magnificent strength and courage, the wounded animal seems to embody all the dramatic emotion that we miss in the pictorial accounts of war. The dying lion on the right is equally impressive in its agony. How differently the Egyptian artist (see fig. 83) had interpreted the same composition! We need only compare the horses: the Assyrian ones are less graceful but very much more energetic and alive as they flee from the attacking lion, their ears folded back in fear. The lion hunt reliefs from Nineveh, about two centuries later than those of Nimrud, are the finest of all. Despite the shallowness of the actual carving, the bodies have a greater sense of weight and volume because of the subtle gradations of the surface. Images such as the dying lioness (fig. 104) have an unforgettable tragic grandeur.

Neo-Babylonian

The Assyrian empire came to an end in 612 B.C., when Nineveh fell before the combined onslaught of Medes and Scythians from the east. At that time the commander of the Assyrian army in southern Mesopotamia made himself king of Babylon. Under him and his successors the ancient city had a final brief flowering between 612 and 539 B.C., before it was conquered by the Persians. The best known of these Neo-Babylonian rulers was Nebuchadnezzar (died 562 B.C.), the builder of the Tower of Babel. That famous structure represented only one part of a very large architectural complex comparable to the Citadel of Sargon II at Dur Sharrukin.

Whereas the Assyrians had used carved stone slabs, the Neo-Babylonians (who were farther removed from the sources of such slabs) substituted baked and glazed brick. This technique, too, had been developed in Assyria, but now it was used on a far larger scale, both for surface ornament and for architectural reliefs. Its distinctive effect becomes evident if we compare the gate of Sargon's citadel (fig. 101) with the Ishtar Gate of Nebuchadnezzar's sacred precinct in Babylon, which

105. Ishtar Gate (restored), from Babylon, Iraq. c. 575 B.C. Glazed brick. Staatliche Museen zu Berlin, Preussischer Kulturbesitz, Vorderasiatisches Museum

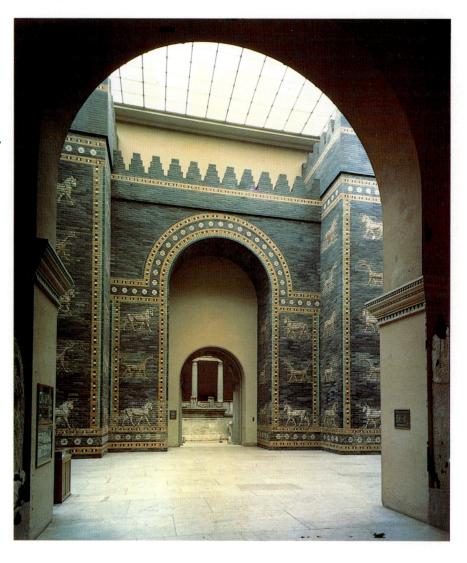

has been rebuilt from the thousands of individual glazed bricks that covered its surface (fig. 105). The stately procession of bulls, dragons, and other animals of molded brick within a framework of vividly colored ornamental bands has a grace and gaiety far removed from the ponderous guardian monsters of the Assyrians. Here, for the last time, we sense again that special genius of ancient Mesopotamian art for the portrayal of animals which we noted in early dynastic times.

PERSIAN ART

Persia, the mountain-fringed high plateau to the east of Mesopotamia, takes its name from the people who occupied Babylon in 539 B.C. and became the heirs of what had been the Assyrian empire. Today the country is called Iran, its older and more suitable name, since the Persians, who put the area on the map of world history, were latecomers who had arrived on the scene only a few centuries before they began their epochal conquests. Inhabited continuously since prehistoric times, Iran seems always to have been a gateway for migratory tribes from the Asiatic steppes to the north as well as from India to the east. The new arrivals would settle down for a while, dominating or intermingling with the local population, until they in turn were forced to move on—to Mesopotamia,

to Asia Minor (roughly, Asian Turkey), to southern Russia by the next wave of migrants.

These movements form a shadowy area of historical knowledge; all available information is vague and uncertain. Since nomadic tribes leave no permanent monuments or written records, we can trace their wanderings only by a careful study of the objects they buried with their dead. Such objects, of wood, bone, or metal, represent a distinct kind of portable art which we call the nomad's gear: weapons, bridles for horses, buckles, fibulas and other articles of adornment, cups, bowls, and the like. They have been found over a vast area, from Siberia to Central Europe, from Iran to Scandinavia. They have in common not only a jewellike concentration of ornamental design but also a repertory of forms known as the "animal style." And one of the sources of this animal style appears to be ancient Iran.

ANIMAL STYLE. Its main feature, as the name suggests, is the decorative use of animal motifs in a rather abstract and imaginative manner. We find its earliest ancestors on the prehistoric painted pottery of western Iran, such as the fine beaker in figure 106, which shows an ibex (a wild mountain goat) reduced to a few sweeping curves, so that the body of the animal becomes a mere appendage of the huge horns. The racing

106. Painted beaker, from Susa. c. 5000–4000 B.C. Height 11¹/₄" (28.3 cm). Musée du Louvre, Paris

hounds above the ibex are little more than horizontal streaks, and on closer inspection the striations below the rim turn out to be long-necked birds. In the historic art of Sumer, this style soon gave way to an interest in the organic unity of animal bodies (see figs. 90 and 92), but in Iran it survived despite the powerful influence of Mesopotamia.

Several thousand years later, in the tenth to seventh centuries B.C., the style reappears in the small bronzes that may come from the Luristan region in western Iran, though the origin and date are by no means certain. The pole-top ornament (fig. 107) represents nomad's gear of a particularly resourceful kind. It consists of a symmetrical pair of rearing ibexes with vastly elongated necks and horns. Originally, we suspect, they were pursued by a pair of lions, but the bodies of the latter have been absorbed into those of the ibexes, whose necks have been pulled out to dragonlike slenderness. By and for whom the Luristan bronzes were produced remains something of a mystery. There can be little doubt, however, that they are somehow linked with the animal-style metalwork of the Asiatic steppes, such as the splendid Scythian gold stag from southern Russia, which is somewhat later in date (fig. 108). The animal's body here shows far less arbitrary distortion, and the smoothly curved sections divided by sharp ridges have no counterpart among Luristan bronzes; yet the way the antlers have been elaborated into an abstract openwork ornament betrays a similar feeling for form. In its compact form we will recognize the descendant of the prehistoric *Bison* from La Madeleine (fig. 36).

Whether or not this typically Scythian piece reflects Central Asiatic sources independent of the Iranian tradition, the Scythians surely learned a good deal from the bronze casters of Luristan during their stay in Iran; as we shall see, they con-

107. Pole-top ornament, from Luristan(?), western Iran. 10th–7th century B.C. Bronze, height $7^{1/2}$ " (19 cm). The British Museum, London

108. *Stag*, from Kostromskaya. Scythian. 7th–6th century B.C. Chased gold, height approx. 12" (30.5 cm). Hermitage Museum, St. Petersburg

tributed something in return to Persian art. The Scythians belonged to a group of nomadic Indo-European tribes, including the Medes and the Persians, that began to filter into the country soon after 1000 B.C. An alliance of Medes and Scythians, it will be recalled, had crushed Nineveh in 612 B.C. The Persians at that time were vassals of the Medes, but only 60 years later, under Cyrus the Great of the family of the Achaemenids, they reversed this situation.

109. (*left*) Plan of the Palace of Darius and Xerxes, Persepolis. 518–460 B.C. Solid triangles show the processional route taken by Persian and Mede notables; open triangles indicate the way taken by heads of delegations and their suites

Achaemenid

After conquering Babylon in 539 B.C., Cyrus (c. 600-529 B.C.) assumed the title king of Babylon along with the ambitions of the Assyrian rulers. The empire he founded continued to expand under his successors. Egypt as well as Asia Minor fell to them, and Greece escaped the same fate only by the narrowest of margins. At its high tide, under Darius I (c. 550-486 B.C.) and Xerxes (519-465 B.C.), the Persian empire was far larger than its Egyptian and Assyrian predecessors together. Moreover, this huge domain endured for two centuries, and during most of its life it was ruled both efficiently and humanely. For an obscure tribe of nomads to have achieved all this is little short of miraculous. Within a single generation, the Persians not only mastered the complex machinery of imperial administration but also evolved a monumental art of remarkable originality to express the grandeur of their rule. Despite their genius for adaptation, the Persians retained their own religious beliefs drawn from the prophecies of Zoroaster. This faith was based on the dualism of Good and Evil, embod-

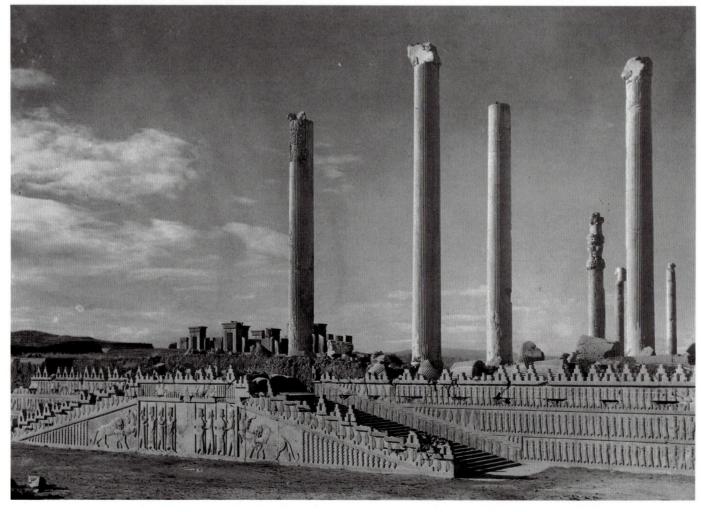

110. Audience Hall of Darius and Xerxes, Persepolis, Iran. c. 500 B.C.

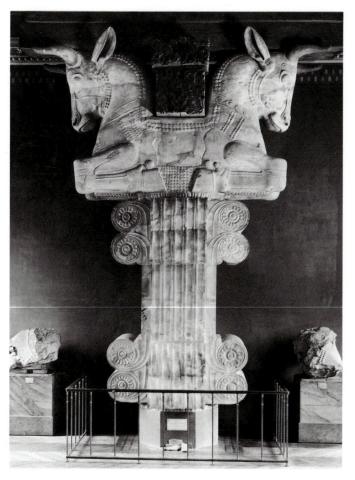

111. Bull capital, from Persepolis. c. 500 B.C. Musée du Louvre, Paris

ied in Ahuramazda (Light) and Ahriman (Darkness). Since the cult of Ahuramazda centered on fire altars in the open air, the Persians had no religious architecture. Their palaces, on the other hand, were huge and impressive structures.

PERSEPOLIS. The most ambitious palace, at Persepolis, was begun by Darius I in 518 B.C. Its general layout as shown in figure 109—a great number of rooms, halls, and courts assem-

bled on a raised platform—recalls the royal residences of Assyria (see fig. 100). Assyrian traditions are the strongest single element throughout. Yet they do not determine the character of the building, for they have been combined with influences from every corner of the empire in such a way that the result is a new, uniquely Persian style. Thus at Persepolis columns are used on a grand scale. The Audience Hall of Darius and Xerxes, a room 250 feet square, had a wooden ceiling supported by 36 columns 40 feet tall, a few of which are still standing (fig. 110). Such a massing of columns suggests Egyptian architecture (compare fig. 74), and Egyptian influence does indeed appear in the ornamental detail of the bases and capitals, but the slender, fluted shaft of the Persepolis columns is derived from the Ionian Greeks in Asia Minor, who are known to have furnished artists to the Persian court. Entirely without precedent in earlier architecture is the strange "cradle" for the beams of the ceiling, composed of the front parts of two bulls or similar creatures, that crowns the Persepolis columns (fig. 111). While the animals themselves are of Assyrian origin, the way they are combined suggests nothing so much as an enormously enlarged version of the pole-top ornaments of Luristan. This seems to be the only instance of Persian architects drawing upon their native artistic heritage of nomad's gear (fig. 107).

The double stairway leading up to the Audience Hall is decorated with long rows of solemnly marching figures in low relief (fig. 110). Their repetitive, ceremonial character emphasizes a subservience to the architectural setting that is typical of all Persian sculpture. We find it even in scenes of special importance, such as *Darius and Xerxes Giving Audience* (fig. 112). Here the expressive energy and narrative skill of Assyrian relief have been deliberately rejected.

PERSIAN STYLE. The style of these Persian carvings seems at first glance to be only a softer and more refined echo of the Mesopotamian tradition. Even so, we discover that the Assyrian-Babylonian heritage has been enriched in one important respect. There is no precedent in Near Eastern sculpture for the layers of overlapping garments, for the play of finely pleated folds such as we see in the Darius and Xerxes relief. Another

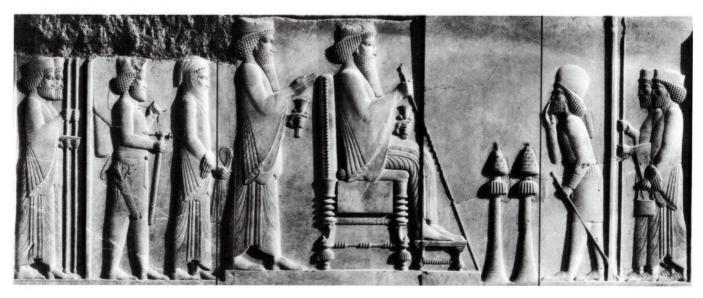

112. Darius and Xerxes Giving Audience. c. 490 B.C. Limestone, height 8'4" (2.5 m). Archaeological Museum, Teheran

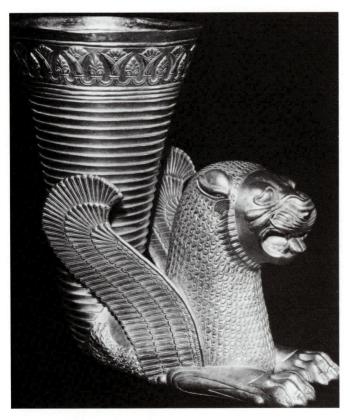

113. Gold rhyton. Achaemenid. 5th–3rd century B.C. Archaeological Museum, Teheran

surprising effect is the way the arms and shoulders of these figures press through the fabric of the draperies. These innovations stem from the Ionian Greeks, who had created them in the course of the sixth century B.C.

Persian art under the Achaemenids, then, is a remarkable synthesis of many diverse elements. Yet it lacked a capacity for growth. The style formulated under Darius I about 500 B.C. continued without significant change until the end of the empire. The Persians, it seems, maintained a preoccupation with decorative effects regardless of scale, a carry-over from their nomadic past that they never discarded. There is no essential difference between the bull capital (fig. 111) and the rhyton (drinking cup) in figure 113, which maintains the virtues of the animal style in its wonderfully imaginative transformation of the lion sprouting griffin's wings. The ferocious beast, descended from the magnificent animals of Assyrian reliefs (figs. 103 and 104), has been tamed, thanks to the small scale and fine goldsmith's work, which reveals a debt to the Scythian stag (fig. 108). The tradition of portable art in Achaemenid Persia, unlike that of monumental architecture and sculpture, somehow managed to survive the more than 500 years during which the Persian empire was under Greek and Roman domination, so that it could flower once more when Persia regained its independence.

Sassanian

The Achaemenids were toppled by Alexander the Great (356–323 B.C.) in 331 B.C. Following his death eight years

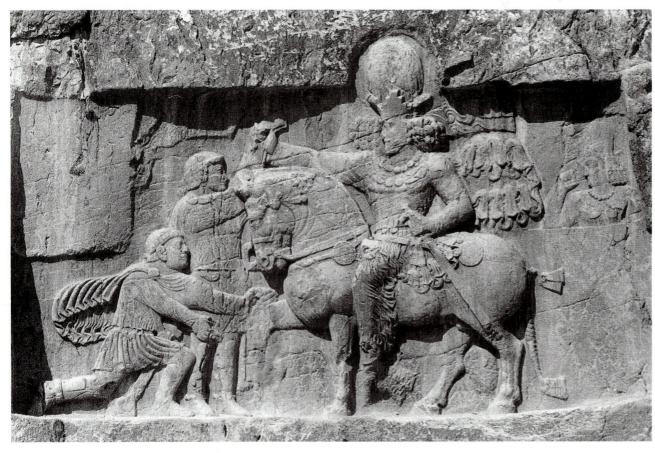

114. Shapur I Triumphing over the Emperors Philippus the Arab and Valerian. 260–72 A.D. Naksh-i-Rustam (near Persepolis), Iran

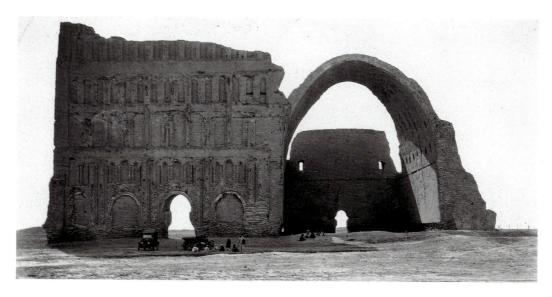

115. Palace of Shapur I, Ctesiphon, Iraq. 242-72 A.D.

later, his realm was divided among his generals. Seleucis (reigned 312–281 B.C.) received much of the Near East except Egypt, which was given to Ptolemy (died 284 B.C.). The Seleucids were succeeded by the Parthians, who established their control over the region in 238 B.C. The Parthians were ferocious fighters, who successfully fended off the Romans until the time of Trajan in the second century A.D. Although their power subsequently declined, it was not until 224 A.D. that Artabanus V, the last Parthian king, was overthrown by one of his governors, Ardashir (died 240 A.D.), who set up the Sassanian dynasty, which endured until it fell to the Arabs in 651 A.D. Throughout the Parthian and Sassanian eras, Mesopotamia was part of the Greek and Roman world, though it retained elements of its ancient culture.

The greatest Sassanian ruler, Shapur I (died 272 A.D.) had the political and artistic ambitions of Darius. At Naksh-i-Rustam, the burial place of the Achaemenid kings not far from Persepolis, he commemorated his victory over two Roman emperors in an enormous relief hewn into the rock (fig. 114). The formal source of this scene of triumph is a well-known composition in Roman sculpture, with the emperors now in the role of the humiliated barbarians. The style, too, is Roman (compare fig. 272), but the flattening of the volumes and the ornamental elaboration of the draperies indicate a revival of Persian qualities. The two elements hold each other in balance, and that is what makes the relief so strangely impressive. A blending of Roman and Near Eastern elements can also be observed in Shapur's palace at Ctesiphon, near Babylon, with its enormous brick-vaulted audience hall (fig. 115). The blind arcades of the facade, strikingly Roman in flavor (compare fig. 245), again emphasize decorative surface pattern.

But monumental art under Sassanian rule proved as incapable of further evolution as it had under the Achaemenids. Metalwork and textiles, on the other hand, continued to flourish. The chief glory of Sassanian art—and a direct echo of the ornamental tradition reaching back more than a thousand years to the Luristan bronzes—is its woven silks, such as the splendid example in figure 116. They were copiously exported both to Constantinople and to the Christian West, and we

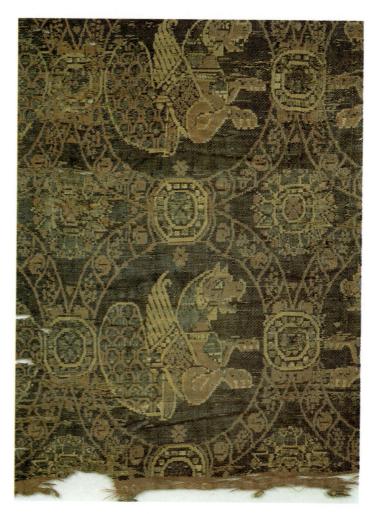

116. Woven silk. Sassanian. c. 6th century A.D. Museo Nazionale del Bargello, Florence. Franchetti Collection

shall see that their wealth of colors and patterns exerted an important stimulus upon the art of the Middle Ages. And since their manufacture was resumed after the Sassanian realm fell to the Arabs in the mid-seventh century, they provided an essential treasury of design motifs for Islamic art as well.

CHAPTER FOUR

AEGEAN ART

If we sail from the Nile Delta northwestward across the Mediterranean, our first glimpse of Europe will be the eastern tip of Crete. Beyond it, we find a scattered group of small islands, the Cyclades, and, a little farther on, the mainland of Greece, facing the coast of Asia Minor across the Aegean Sea. To archaeologists, "Aegean" is not merely a geographical term. They have adopted it to designate the civilizations that flourished in this area during the third and second millenniums B.C., before the development of Greek civilization proper. There are three of these, closely interrelated yet distinct from each other: that of Crete, called Minoan after the legendary Cretan King Minos; that of the small islands north of Crete (Cycladic); and that of the Greek mainland (Helladic), which includes Mycenaean civilization. Each of them has in turn been divided into three phases, Early, Middle, and Late, which correspond, very roughly, to the Old, Middle, and New Kingdoms in Egypt. The most important remains, and the greatest artistic achievements, date from the latter part of the Middle phase and from the Late phase.

Aegean civilization was long known only from Homer's account of the Trojan War in the *Iliad* and the *Odyssey*, as well as from Greek legends centering on Crete. The earliest excavations (by Heinrich Schliemann during the 1870s in Asia Minor and Greece and by Sir Arthur Evans in Crete shortly before 1900) were undertaken to test the factual core of these tales. Since then, a great amount of fascinating material has been brought to light—far more than the literary sources would lead us to expect. But even now our knowledge of Aegean civilization is very much more limited than our knowledge of Egypt or the ancient Near East. Unfortunately, our reading of the archaeological evidence has so far received limited aid from the written records of the Aegeans.

MINOAN SCRIPT AND LINEAR B. In Crete a system of writing was developed about 2000 B.C. A late form of this Minoan script, called Linear B, which was in use about six cen-

turies later both in Crete and on the Greek mainland, was deciphered in the early 1950s. The language of Linear B is Greek, yet this apparently was not the language for which Minoan script was used before the fifteenth century B.C., so that being able to read Linear B does not help us to understand the great mass of earlier Minoan inscriptions. Moreover, the Linear B texts are largely palace inventories and administrative records, although they do reveal something about the history, religion, and political organization of the people who composed them. We thus lack a great deal of the background knowledge necessary for an understanding of Aegean art. Its forms, although linked both to Egypt and the Near East on the one hand and to later Greek art on the other, are no mere transition between these two worlds. They have a haunting beauty of their own that belongs to neither. Among the many strange qualities of Aegean art, and perhaps the most puzzling, is its air of freshness and spontaneity, which makes us forget how little we know of its meaning.

CYCLADIC ART

After about 2800 B.C. the people who inhabited the Cycladic Islands often buried their dead with marble sculptures of a peculiarly impressive kind. Almost all of them represent a nude female figure with arms folded across the chest (fig. 117). They also share a distinctive shape, which at first glance recalls the angular, abstract qualities of Paleolithic and Neolithic sculpture: the flat, wedge shape of the body, the strong, columnar neck, the tilted, oval shield of the face, and the long, ridgelike nose. (Other features were painted in.) Within this narrowly defined and stable type, however, the Cycladic figures show wide variations in scale and form. This lends them a surprising individuality.

The best of these Cycladic figures, such as that in figure 117, represent a late, highly developed phase around 2500–2400 B.C. Our example has a disciplined refinement

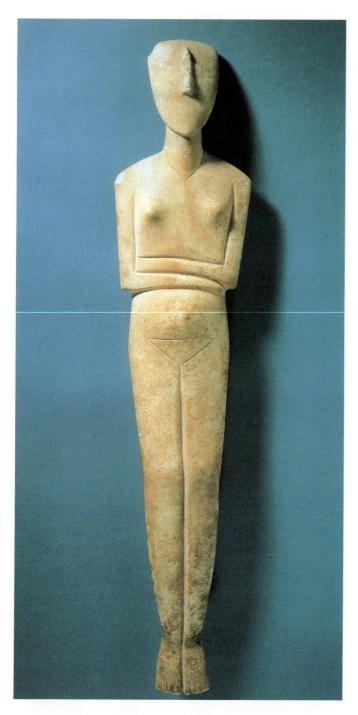

117. Figure, from Amorgos, Cyclades. c. 2500 B.C. Marble, height 30" (76.3 cm). Ashmolean Museum, Oxford, England

utterly beyond the range of Paleolithic or Neolithic art. The longer we study this piece, the more we come to realize that its qualities can only be defined as "elegance" and "sophistication," however incongruous such terms may seem in this context. What an extraordinary feeling for the organic structure of the body there is in the delicate curves of the outline, in the hints of convexity marking the knees and abdomen! Even if we discount its deceptively modern look, the figure seems a bold departure from anything we have seen before. There is no dearth of earlier female figures, but almost all of them betray their descent from the bulbous, heavy-bodied type of the Old Stone Age (fig. 35). In fact, the earliest Cycladic figurines, too, were of that kind.

We do not know what led Cycladic sculptors to adopt the lithe, "girlish" ideal of figure 117. The transformation was presumably related to a change in religious beliefs and practices away from the mother and fertility goddess known to us from Asia Minor and the ancient Near East, whose ancestry reaches far back to the Old Stone Age. The largest figures were probably cult statues to a female divinity who may have been identified with the sun in the great cycle of life and death, while the smaller ones might have been displayed in household shrines or even used as votive offerings. Although their meaning and function remain far from clear, their purpose was not simply funereal. Rather, they were important objects that were included in graves with others from everyday life, as either presents for the deity or provisions for the afterlife. Rarely were they free-standing. Most have been found in a reclining position, but they may also have been propped upright during normal use.

Be that as it may, the Cycladic sculptors of the third millennium B.C. produced the oldest large-scale figures of the female nude we know, and for many hundreds of years they were the only ones to do so. In Greek art, we find very few nude female statues until the middle of the fourth century B.C., when Praxiteles and others began to create cult images of the nude Aphrodite (see fig. 206). It can hardly be coincidence that the most famous of these Venuses were made for sanctuaries on the Aegean Islands or the coast of Asia Minor, the region where the Cycladic idols had flourished.

MINOAN ART

Minoan civilization is by far the richest, as well as the strangest, of the Aegean world. What sets it apart, not only from Egypt and the Near East but also from the Classical civilization of Greece, is a lack of continuity that appears to have been caused by archaeological accidents, as well as historical forces. The different phases appear and disappear so abruptly that their fate must have been determined by sudden violent changes affecting the entire island. Yet the character of Minoan art, which is gay, even playful, and full of rhythmic motion, conveys no hint of such threats.

Architecture

The first of these unexpected shifts occurred about 2000 B.C. Until that time, during the thousand years of the Early Minoan era, the Cretans had not advanced much beyond the Neolithic level of village life, even though they seem to have engaged in some overseas trade that brought them contact with Egypt. Then they created not only their own system of writing but an urban civilization as well, centering on several great palaces. At least three of them, at Knossos, Phaistos, and Mallia, were built in short order. Little is left today of this sudden spurt of large-scale building activity. The three early palaces were all destroyed at the same time, about 1700 B.C., demolished, it seems, by a catastrophic earthquake. After a short interval, new and even larger structures appeared on the same sites, only to suffer destruction, in their turn, by another earthquake about 1450 B.C. These were abandoned, except for the palace at Knossos, which was

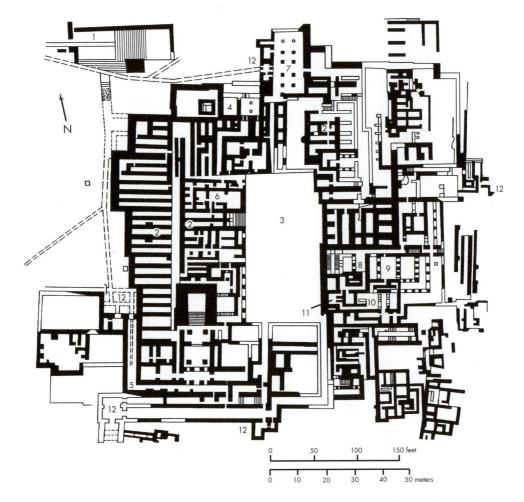

118. Plan of the Palace of Minos, Knossos, Crete. The palace is organized in two wings, to east and west of a central court, and is on several levels: 1) stairway and theater area; 2) storerooms; 3) central court; 4) antechamber; 5) corridor of the procession; 6) throne room;7) north pillar hall; 8) hall of the colonnade; 9) hall of the double axes; 10) queen's megaron; 11) queen's bath; 12) entrances and atriums

occupied by the Mycenaeans, who took over the island almost immediately.

Minoan civilization, therefore, has a complicated chronology. Archaeologists divide the period that concerns us into the Old Palace period, comprising Middle Minoan I and Middle Minoan II, which together lasted from 2000 B.C. until about 1700 B.C. The New Palace period includes Middle Minoan III (1700–1670 B.C.), Late Minoan IA (1670–1620 B.C.), and Late Minoan IB (1620–1490/1450 B.C.). The eruption of the volcano on the island of Thera (Santorini) occurred during the New Palace period, at the end of Late Minoan IA. It did little damage to Crete, however, and ushered in the Late Minoan IB period, which marked the peak of Minoan civilization. For our purposes, we need only remember that the Old Palace period coincides very roughly with the Middle Kingdom and the New Palace period with the onset of the New Kingdom in Egypt.

The "new" palaces are our main source of information on Minoan architecture. The one at Knossos, called the Palace of Minos, was the most ambitious, covering a large territory and composed of so many rooms that it survived in Greek legend as the labyrinth of the Minotaur (see fig. 118). It has been carefully excavated and partly restored. We cannot recapture the appearance of the building as a whole, but we can assume that the exterior probably did not look impressive compared with Assyrian or Persian palaces (see figs. 100 and 110). There was

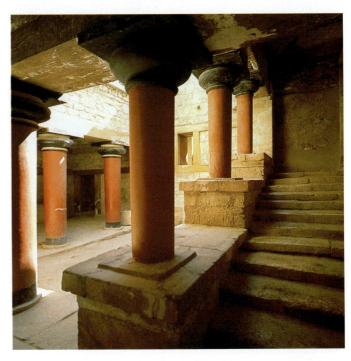

119. Staircase, east wing, Palace of Minos, Knossos, Crete. c. 1500 B.C.

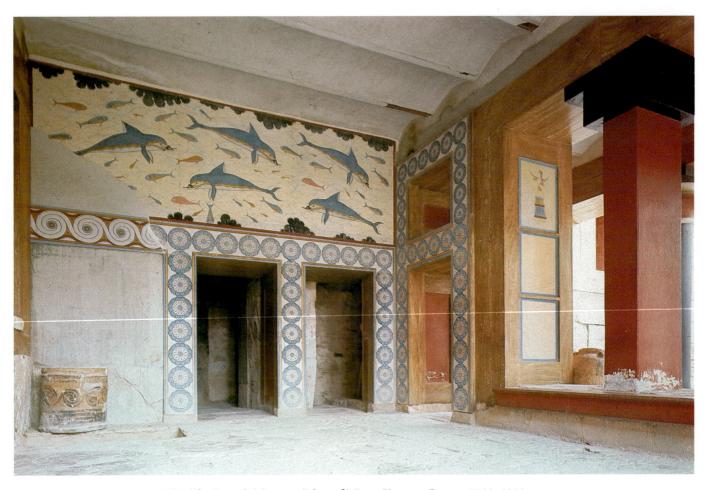

120. The Queen's Megaron, Palace of Minos, Knossos, Crete. c. 1700-1300 B.C.

no striving for unified, monumental effect. The individual units are generally rather small and the ceilings low (figs. 119 and 120), so that even those parts of the structure that were several stories high could not have seemed very tall.

Nevertheless, the numerous porticoes, staircases, and air-shafts must have given the palace a pleasantly open, airy quality. Some of the interiors, with their richly decorated walls, retain their atmosphere of intimate elegance to this day. The masonry construction of Minoan palaces is excellent throughout, but the columns were always of wood. Although none has survived (those in fig. 119 are reconstructions), their characteristic form (the smooth shaft tapering downward and topped by a wide, cushion-shaped capital) is known from representations in painting and sculpture. About the origins of this type of column, which in some contexts could also serve as a religious symbol, or about its possible links with Egyptian architecture, we can say nothing at all.

Who were the rulers that built these palaces? We do not know their names or deeds, except for the legendary Minos, but the archaeological evidence permits a few conjectures. They were not warrior princes, since no fortifications have been found anywhere in Minoan Crete, and military subjects are almost unknown in Minoan art. Nor is there any hint that they were sacred kings on the Egyptian or Mesopotamian model, although they may well have presided at religious fes-

tivals. The palaces certainly functioned as centers of religious life. However, the only parts that can be identified as places of worship are small chapels, suggesting that religious ceremonies took place out of doors, as well as at outlying shrines. On the other hand, the many storerooms, workshops, and "offices" at Knossos indicate that the palace was not only a royal residence but a great center of administrative and commercial activity. Shipping and trade formed an important part of Minoan economic life, to judge from elaborate harbor installations and from Cretan export articles found in Egypt and elsewhere. Perhaps, then, the king should be viewed as the head of a merchant aristocracy. Just how much power he wielded and how far it extended are still open to debate.

Sculpture

The religious life of Minoan Crete is even harder to define than the political or social order. It centered on certain sacred places, such as caves or groves; and its chief deity (or deities?) was female, akin to the mother and fertility goddesses we have encountered before. Since the Minoans had no temples, we are not surprised to find that they lacked large cult statues as well, but even on a small scale, religious subjects in Minoan art are few in number and of uncertain significance. Two statuettes of about 1650 B.C. from Knossos must represent the goddess in

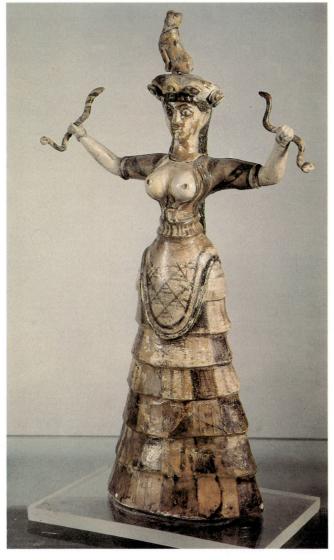

121. "Snake Goddess." c. 1650 B.C. Faience, height 11⁵/8" (29.5 cm). Archaeological Museum, Heraklion, Crete

one of her several identities. One of them (fig. 121) shows her with three long snakes wound around her arms, body, and headdress. The meaning is clear: snakes are associated with earth deities and male fertility in many ancient religions, just as the bared breasts of our statuette suggest female fertility. Although the costume endows her with a secular, "fashionable" air, there can be little doubt that she is a goddess (compare fig. 123). The style of the statuette hints at a possible foreign source: the voluptuous bosom, the emphatically conical quality of the figure, and the large eyes and heavy, arched eyebrows suggest a kinship—remote and indirect, perhaps through Asia Minor—with Mesopotamian art (compare fig. 97).

Minoan civilization also featured a cult centering on bulls (see below). One of them is shown tamed on a splendid rhyton (drinking horn; fig. 122) carved from serpentine stone, with incised lines to indicate its shaggy fur, painted crystal eyes, and a shell-inlay muzzle, which create an astonishingly lifelike impression, despite its small size. (The horns are restored.) Not since the offering stand from Ur (fig. 90) have we seen such a magnificent beast in the round. Can it be that the Minoans learned how to carve from the artistic descendants of Mesopotamians more than a thousand years earlier?

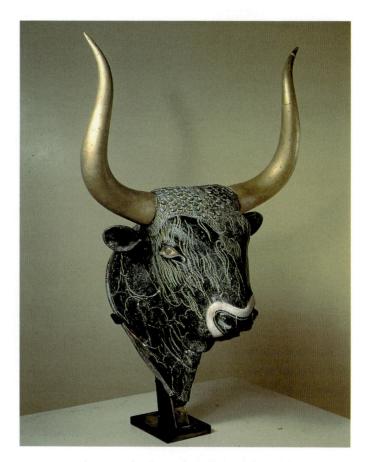

122. Rhyton in the shape of a bull's head, from Knossos. c. 1500–1450 B.C. Serpentine, crystal, and shell inlay (horns restored), height 8 ¹/8" (20.6 cm). Archaeological Museum, Heraklion, Crete

Paintings, Pottery, and Reliefs

After the catastrophe that had wiped out the earlier palaces, there was what seems to our eyes an explosive increase in wealth and a remarkable outpouring of creative energy that produced most of what we have in Minoan architecture, sculpture, and painting. The most surprising aspect of this sudden efflorescence, however, is its great achievement in painting. Unfortunately, the murals that covered the walls of the new palaces have survived mainly in fragments, so that we rarely have a complete composition, let alone the design of an entire wall.

Amazingly enough, the settlement at Akrotiri on the island of Thera has been extensively excavated and a large number of frescoes recovered—the earliest Minoan examples we have. They belong to the Late Minoan IA period (that is, 1670–1620 B.C.), although they vary considerably in subject and style. Of these, the most remarkable is the scene of a young woman offering crocuses (the source of saffron) to a snake goddess, nicknamed "The Mistress of the Animals," who is seated on an altar with an oil jar (fig. 123). What an astonishing achievement it is, despite its fragmentary condition and the artist's difficulty with anatomy. Yet the contrast between the girlish charm of the crocus bearer and the awesomeness of the goddess

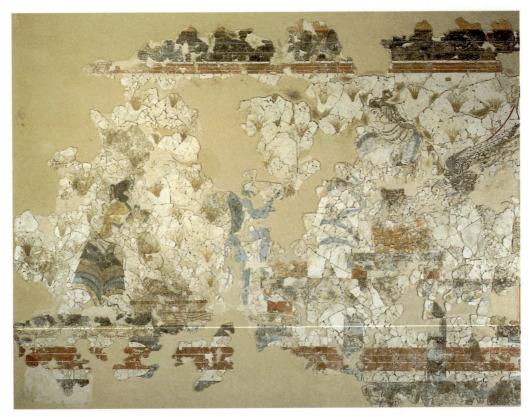

123. Crocus Girl (left) and "The Mistress of the Animals" (right). Mural fragments from Akrotiri, Thera (Santorini). c. 1670–1620 B.C. National Archaeological Museum, Athens

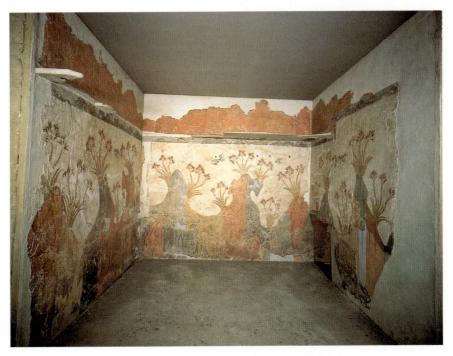

124. Landscape. Fresco from Akrotiri, Thera. c. 1600-1500 B.C. National Archaeological Museum, Athens

could hardly be more telling. We would recognize the latter's special status even without her elevated position on the altar and the snake in her hair—which makes her a clear forerunner of the Medusa—or the griffin behind her.

The flat forms, silhouetted against the landscape, recall Egyptian painting, and the acute observation of plants also suggests Egyptian art. If Minoan wall painting owes its origin to Egyptian influence, it betrays an attitude of mind very differ-

ent from that of the Nile Valley. To the Minoans, nature was an enchanted realm that provided the focus of their attention from the very beginning, whereas Egyptian painters could explore it only by loosening the rules that governed them. The frescoes at Akrotiri include the first pure landscape paintings we know of. Not even the most adventurous Egyptian artist of the Middle Kingdom would have dared to devote an entire composition to the out-of-doors. Our example (fig. 124) is a surprisingly

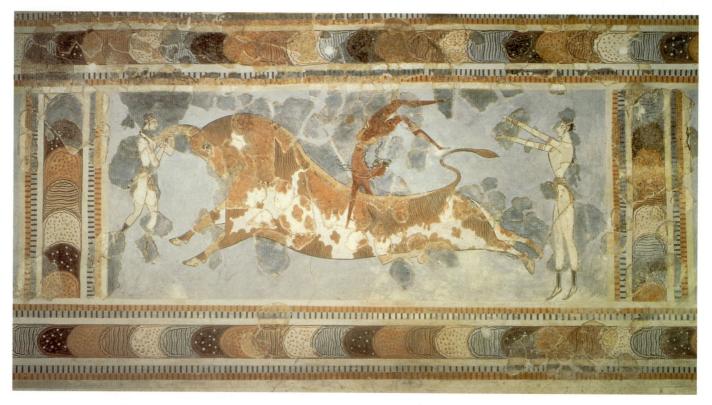

125. "The Toreador Fresco." c. 1500 B.C. Height including upper border approx. 24 1/2" (62.3 cm). Archaeological Museum, Heraklion, Crete

126. Beaked jug (Kamares style), from Phaistos. c. 1800 B.C. Height 10⁵/8" (27 cm). Archaeological Museum, Heraklion, Crete

successful evocation of the dunes along the coast of Thera, but the artist has invested the scene with a lively fantasy and sense of beauty that bespeak the same sense of wonderment we found in the confrontation between mortal and divinity.

Marine life (as seen in the fish and dolphin fresco in fig. 120) was a favorite subject of Minoan painting after 1600 B.C., and the marine feeling pervades everything else as well. Instead of permanence and stability, we find a passion for rhythmic, undulating movement, and the forms themselves have an oddly weightless quality. They seem to float, or sway, in a world without gravity, as if the scene took place under water, even though a great many of them show animals and birds among luxuriant vegetation, as well as creatures of the sea. We sense this even in "The Toreador Fresco," the most dynamic Minoan mural recovered so far (fig. 125). (The darker patches are the original fragments on which the restoration is based.) The conventional title should not mislead us. What we see here is not a bullfight but a ritual game in which the performers vault over the back of the animal. Two of the slimwaisted athletes are girls, differentiated (as in Egyptian art) mainly by their lighter skin color.

That the bull was a sacred animal and that bull-vaulting played an important role in Minoan religious life are beyond doubt. Scenes such as this still echo in the Greek legend of the youths and maidens sacrificed to the minotaur, a half-animal, half-human creature. The three figures in all likelihood show successive phases of the same action. But if we try to "read" the fresco as a description of what actually went on during these performances, we find it strangely ambiguous. This does not mean that the Minoan artist was deficient. It would be absurd to find fault for failing to accomplish what was never intended in the first place. Fluid, effortless ease of movement was clearly more important than factual precision or dramatic power. The

127. "Octopus Vase," from Palaikastro, Crete. c. 1500 B.C. Height 11" (28 cm). Archaeological Museum, Heraklion, Crete

128. Leaping Mountain Goat, on a vase from the palace at Kato Zakro. c. 1500 B.C. Limestone, originally covered with gold foil, length of goat approx. 4" (10.3 cm).

Archaeological Museum, Heraklion, Crete

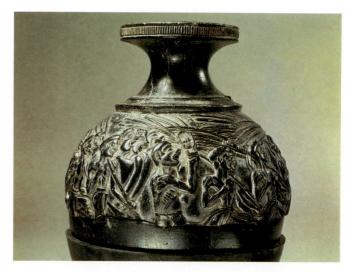

129. *Harvester Vase*, from Hagia Triada. c. 1550–1500 B.C. Steatite, width 4 ½" (11.3 cm). Archaeological Museum, Heraklion, Crete

painting, as it were, idealizes the ritual by stressing its harmonious, playful aspect to the point that the participants behave like dolphins gamboling in the sea.

The floating world of Minoan wall painting was an imaginative creation so rich and original that its influence can be felt throughout Minoan art during the era of the new palaces. At the time of the earlier palaces, between 2000 and 1700 B.C., Crete had developed a type of pottery (known as Kamares ware after the center where it was discovered) that was famous for its technical perfection and its dynamic, swirling ornament, consisting of organic abstractions filled with life (fig. 126). This in no way prepares us for the new repertory of designs drawn from plant and animal life. Some vessels are covered entirely with fish, shells, and octopuses, as if the ocean itself had been caught within them (fig. 127).

Monumental sculpture, had there been any, might have retained its independence, but the small-scale works to which the Minoan sculptor was confined are often closely akin to the style of the murals. The splendidly observed mountain goat carved on a stone vase (fig. 128) leaps in the same "flying" movement as the bull of "The Toreador Fresco." (These mountain goats, too, were sacred animals.) Even more vivid is the relief on the so-called Harvester Vase (fig. 129; the lower part is lost): a procession of slim, muscular men, nude to the waist, carrying long-handled implements that look like a combination of scythe and rake. A harvest festival? Quite probably, although here again the lively rhythm of the composition takes precedence over descriptive clarity.

Our view of the scene includes three singers led by a fourth who is swinging a sistrum (a rattle of Egyptian origin). They are bellowing with all their might, especially the "choirmaster," whose chest is so distended that the ribs press through the skin. What makes the entire relief so remarkable—in fact, unique—is its emphasis on physical strain, its energetic, raucous gaiety, which combines sharp observation with a consciously humorous intent. How many works of this sort, we wonder, did Minoan art produce? Only once have we met anything at all like it: in the relief of workmen carrying a beam (see fig. 81), carved almost two centuries later under the impact of the Akhenaten style (see pages 76–77). Is it possible

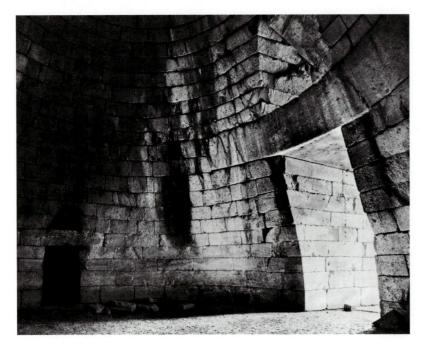

130. (*left*) Interior, Treasury of Atreus, Mycenae, Greece. c. 1300–1250 B.C.

131. (below) Section, Treasury of Atreus

that pieces similar to the *Harvester Vase* stimulated Egyptian artists during that brief but important period?

MYCENAEAN ART

Along the southeastern shores of the Greek mainland there were, during Late Helladic times (c. 1400–1100 B.C.), a number of settlements that corresponded in many ways to those of Minoan Crete. They, too, were grouped around palaces. Their inhabitants have come to be called Mycenaeans, after Mycenae, the most important of these settlements. Since the works of art unearthed there by excavation often showed a strikingly Minoan character, the Mycenaeans were at first regarded as having come from Crete, but it is now agreed that they were the descendants of the earliest Greek clans, who had entered the country soon after 2000 B.C.

Tombs and Their Contents

For some 400 years, these people had led an inconspicuous pastoral existence in their new homeland. Their modest tombs have yielded only simple pottery and a few bronze weapons. Toward 1600 B.C., however, they suddenly began to bury their dead in deep shaft graves and, a little later, in conical stone chambers, known as beehive tombs. This development reached its height toward 1300 B.C. in impressive structures such as the one shown in figures 130 and 131, built of concentric layers of precisely cut stone blocks that taper inward toward the highest point. (This method of spanning space is called corbeling.) Its discoverer thought it far too ambitious for a tomb and gave it the misleading name Treasury of Atreus. Burial places as elaborate as this can be matched only in Egypt during the same period.

The Treasury of Atreus had been robbed of its contents long ago, but other Mycenaean tombs were found intact, and what they yielded up caused even greater surprise: alongside the royal dead were placed masks of gold or silver, presumably to cover their faces. If so, these masks were similar in purpose

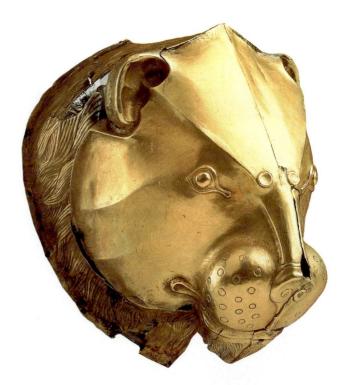

132. Rhyton in the shape of a lion's head, from a shaft grave at Mycenae. c. 1550 B.C. Gold, height 8" (20.3 cm).

National Archaeological Museum, Athens

(if not in style) to the masks found in pharaonic tombs of the Middle and New Kingdoms (compare fig. 82). There was considerable personal equipment—drinking vessels, jewelry, weapons—much of it gold and exquisite in workmanship. Some of these pieces, such as the magnificent gold vessel in the shape of a lion's head (fig. 132), show a boldly expressive style of smooth planes bounded by sharp ridges which suggests contact with the Near East, while others are so Minoan in flavor that they might be imports from Crete.

Of the latter kind are the two famous gold cups from a Mycenaean tomb at Vaphio (figs. 133 and 134). They must

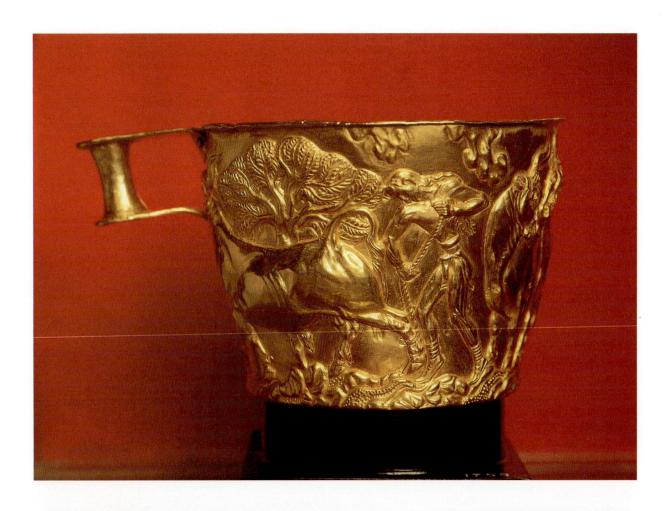

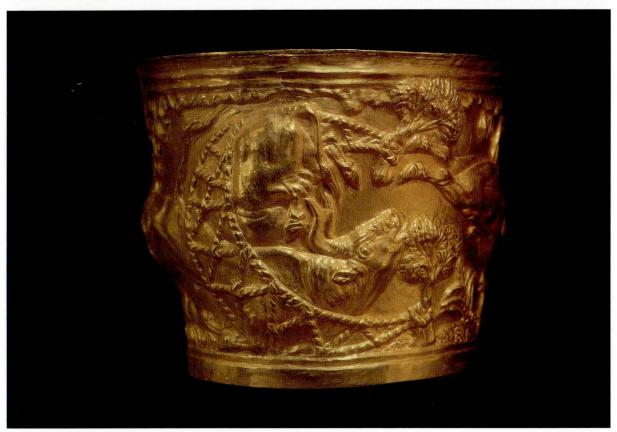

133, 134. Vaphio Cups. c. 1500 B.C. Gold, heights 3"; 3 ½" (7.5; 9 cm). Shown actual size. National Archaeological Museum, Athens

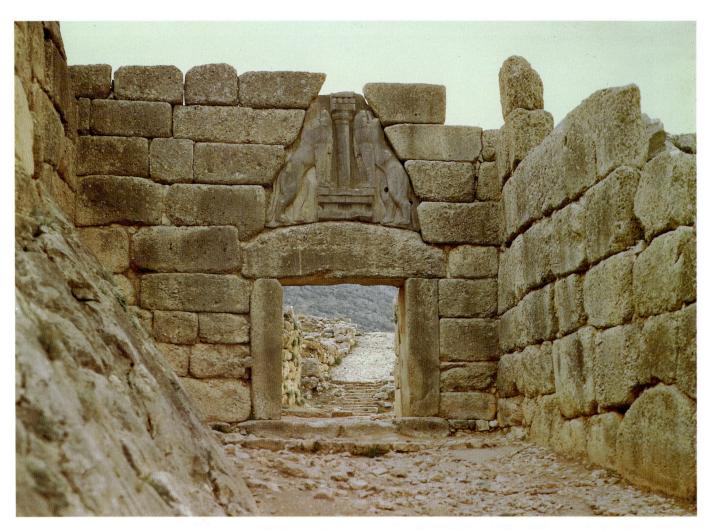

135. The Lioness Gate, Mycenae, Greece. 1250 B.C.

have been made about 1500 B.C., a few decades after the lion vessel, but where, for whom, and by whom? Here the problem "Minoan or Mycenaean?" becomes acute. The dispute is not as idle as it may seem, for it tests our ability to differentiate between the two neighboring cultures. It also forces us to consider every aspect of the cups. Do we find anything in their style or content that is un-Minoan? Our first impulse, surely, is to note the similarity of the human figures to those on the Harvester Vase, and the similarity of the bulls to the animal in "The Toreador Fresco." To be sure, the men on the Vaphio Cups are not engaged in the Cretan bull-vaulting game but in the far more mundane business of catching the animals on the range. However, this subject also occurs in Minoan art. On the other hand, we cannot overlook the fact that the design on the cups does not quite match the continuous rhythmic movement of Minoan compositions and that the animals, for all their physical power, have the look of cattle rather than of sacred animals. They nevertheless differ only in degree, not kind, from the wonderfully sturdy leaping goat in figure 128. It would seem, on balance, that the cups are by a Minoan artist working for Mycenaean patrons.

MYCENAE, CRETE, AND EGYPT. In the sixteenth century B.C., Mycenae thus presents a strange picture. What appears to be an Egyptian influence on burial customs is combined with a strong artistic influence from Crete and with an

136. Plan of a Mycenaean megaron

extraordinary material wealth as expressed in the lavish use of gold. What we need is a triangular explanation that involves the Mycenaeans with Crete as well as Egypt about a century before the destruction of the new palaces. Such a theory fascinating and imaginative, if hard to confirm in detail—runs about as follows: between 1700 and 1580 B.C., the Egyptians were trying to rid themselves of the Hyksos, who had seized the Nile Delta (see page 71). For this they gained the aid of warriors from Mycenae, who returned home laden with gold (of which Egypt alone had an ample supply) and deeply impressed with Egyptian funerary customs. The Minoans, not military but famous as sailors, ferried the Mycenaeans back and forth, so that they, too, had a new and closer contact with Egypt. This may help to account for their sudden prosperity toward 1600 B.C., as well as for the rapid development of naturalistic wall painting at that time. In fact, such a theory is supported by the recent discovery of a large group of Minoan frescoes in Egypt. The close relations between Crete and Mycenae, once established, were to last a long time.

Architecture

The great monuments of Mycenaean architecture were all built between 1400, when Linear B script began to appear, and 1200 B.C. Apart from such details as the shape of the columns or decorative motifs of various sorts, Mycenaean architecture owes little to the Minoan tradition. The palaces on the mainland were hilltop fortresses surrounded by defensive walls of huge stone blocks, a type of construction quite unknown in Crete but similar to the Hittite fortifications at Bogazköy (see fig. 99). The Lioness Gate at Mycenae (fig. 135) is the most impressive remnant of these massive ramparts, which inspired such awe in the Greeks of later times that they were regarded as the work of the Cyclopes, a mythical race of one-eyed giants. Even the Treasury of Atreus, although built of smaller and more precisely shaped blocks, has a Cyclopean lintel (see fig. 130).

Another aspect of the Lioness Gate foreign to the Minoan tradition is the great stone relief over the doorway. The two lionesses flanking a symbolic Minoan column have the same grim, heraldic majesty as the golden lion's head we encountered in figure 132. Their function as guardians of the gate, their tense, muscular bodies, and their symmetrical design again suggest an influence from the ancient Near East. We may at this point recall the Trojan War, which brought the Mycenaeans to Asia Minor soon after 1200 B.C. It seems likely, however, that they began to sally eastward across the Aegean, for trade or war, much earlier than that.

The center of the palace, at Mycenae and other mainland sites, was the royal audience hall, called the megaron. Only its plan is known for certain: a large rectangular room with a round hearth in the middle and four columns to support the roof beams (fig. 136). It was entered through a deep porch with two columns and an antechamber. This design is in essence no more than an enlarged version of the simple houses of earlier generations, for its ancestry can be traced back to Middle Helladic times. There may have been a rich decorative scheme of wall paintings and ornamental carvings to stress its dignity as the king's abode.

Sculpture

As in Crete, Mycenaean temple architecture was confined to modest structures with cult statues set apart from the palaces, which also included small shrines. A wide variety of gods were worshiped in them, although their exact identity is sometimes a matter of dispute. Mycenaean religion incorporated not only Minoan elements but also influences from Asia Minor, as well as deities of Greek origin inherited from their own forebears, including a number of the later Olympian gods, such as Poseidon. But gods have an odd way of merging or exchanging their identities, so that the religious images in Mycenaean art are hard to interpret.

What, for instance, are we to make of the exquisite little ivory group (fig. 137) unearthed at Mycenae in 1939? The

137. *Three Deities*, from Mycenae. c. 1500–1400 B.C. Ivory, height 3" (7.5 cm). National Archaeological Museum, Athens

style of the piece—its richly curved shapes and easy, flexible body movements—still echoes Minoan art, though the carving has an unmistakably Near Eastern air (compare figs. 88 and 98). The subject, however, is strange indeed. Two kneeling women, closely united, tend a single child. But whose is he? The natural interpretation would be to regard the now headless figure as the mother, since the child clings to her arm and turns toward her; the second woman, whose left hand rests on the other's shoulder, would then be the grandmother. Such three-generation family groups are a well-known subject in Christian art, in which we often find St. Anne, the Virgin Mary, and the Infant Christ combined in similar fashion.

It is the memory of these later works that colors our view of the Mycenaean ivory. Yet we search in vain for a subject in ancient religion that fits our reading of the group. On the other hand, there is a very widespread myth about the divine child who is abandoned by his mother and reared by nymphs, goddesses, or even animals. His name varies from place to place and includes Bacchus and Jupiter. We are thus forced to conclude that our ivory in all likelihood shows a motherless child god with his nurses. The real mystery, however, lies deeper: it is the tender play of gestures, the intimate human feeling, that binds the three figures together. Nowhere in the entire range of ancient art before the Greeks do we find gods—or people, for that matter—expressing affection with such warmth and eloquence.

Something quite basically new is reflected here, a familiar view of divine beings that makes even the Minoan snake goddess (fig. 121) seem awesome and remote. Was this change of attitude, and the ability to express it in art, a Mycenaean achievement? Or did they inherit it from the Minoans? However that may be, our ivory group opens up a dimension of experience that had never been accessible to Egypt or Mesopotamia.

CHAPTER FIVE

GREEK ART

To people of European heritage, the works of art we have come to know so far seem like fascinating strangers because of their "alien" background and the "language difficulties" they present, occasioned by the vast gap in time and culture. Greek architecture, sculpture, and painting, by contrast, appear not as strangers but as relatives, older members of a family that are immediately recognizable. A Greek temple will remind us at a glance of the bank around the corner, a Greek statue will bring to mind countless other statues we have seen somewhere, and a Greek coin will make us want to reach for the small change in our own pockets. The continuous tradition linking us with the ancient Greeks can be a handicap as well as an advantage in looking at Greek originals, whose contribution is sometimes obscured by familiarity with later imitations. However, we shall find that Greek art was indebted to its predecessors in countless ways, so that we may consider them, too, among the direct ancestors of Western civilization.

Another complication peculiar to the study of Greek art arises from the fact that we have three separate, and sometimes conflicting, sources of information on the subject. There are, first of all, the monuments themselves, a reliable but often woefully inadequate source. Then we have various copies made in Roman times that tell us something about important Greek works that would otherwise be lost to us entirely. These copies, however, always pose a problem. Some are of such high quality that we cannot be sure that they really are copies. Others make us wonder how faithfully they follow their model—especially if we have several copies, all slightly different, of the same lost original.

Finally, there are the literary sources. The Greeks were the first people in history to write at length about their own artists, and their accounts were eagerly collected by the Romans, who handed them down to us. From them we learn what the Greeks themselves considered their most important achievements in architecture, sculpture, and painting. This written testimony has helped us to identify some celebrated artists and monuments, but much of it deals with works of which no visible trace remains today, while other works, which do survive and which strike us as among the greatest masterpieces of their

time, are not mentioned at all. To reconcile the literary evidence with that of the copies and that of the original monuments, and to weave these strands into a coherent picture of the development of Greek art, is a difficult task indeed, despite the enormous amount of work that has been done since the beginnings of archaeological scholarship some 250 years ago.

Who were the Greeks? We have met some of them before, such as the Mycenaeans, who came to Greece about 2000 B.C. Other Greek-speaking tribes entered the peninsula from the north toward 1100 B.C., overwhelmed and absorbed the Mycenaean stock, and gradually spread to the Aegean Islands and Asia Minor. It was these tribes who during the following centuries created the great civilization for which we now reserve the name Greek. We do not know how many separate tribal units there were in the beginning, but three main groups, who settled mainland Greece, the coast of Asia Minor, and the Aegean Islands, stand out: the Aeolians, who took over the north; the Dorians, who inhabited the south, including the Cyclades; and the Ionians, who colonized Attica, Euboea, most of the Aegean Islands and the central coast of nearby Asia Minor. In the eighth century B.C., the Greeks also spread westward, founding important settlements in Sicily and southern Italy.

Despite a strong sense of kinship based on language and common beliefs, expressed in such traditions as the four great Panhellenic (all-Greek) festivals, the Greeks remained divided into many small, independent city-states. The pattern may be viewed as an echo of age-old tribal loyalties, as an inheritance from the Mycenaeans, or as a response to the geography of Greece, whose mountain ranges, narrow valleys, and jagged coastline would have made political unification difficult in any event. Perhaps all of these factors reinforced one another. The intense military, political, and commercial rivalry of these states undoubtedly stimulated the growth of ideas and institutions.

Our own thinking about government continues to make use of a number of key terms of Greek origin which reflect the evolution of the city-state: monarchy, aristocracy, tyranny, democracy, and, most important, politics (derived from *polites*, the citizen of the *polis*, or city-state). In the end, however, the Greeks paid dearly for their inability to broaden the

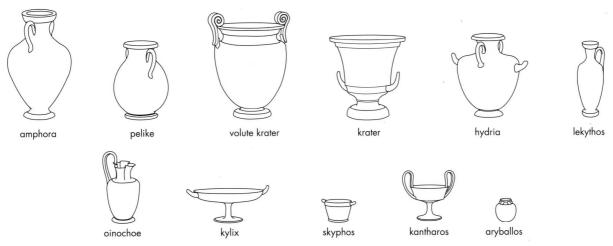

138. Some common Greek vessel forms

concept of the state beyond the local limits of the *polis:* they engaged in almost continuous warfare. The Peloponnesian War (431–404 B.C.), in which the Spartans and their allies defeated the Athenians, was only the most notable among the series of conflicts that left Greece so weak that it was easily defeated by Alexander the Great in the late fourth century B.C.

GEOMETRIC STYLE

The formative phase of Greek civilization embraces about 400 years, from about 1100 to 700 B.C. Of the first three centuries of this period we know very little, but after about 800 B.C. the Greeks rapidly emerge into the full light of history. The earliest specific dates that have come down to us are from that time: 776 B.C., the founding of the Olympic Games and the starting point of Greek chronology, as well as several slightly later dates recording the founding of various cities. That time also saw the full development of the oldest characteristically Greek style in the fine arts, the so-called Geometric. We know it only from painted pottery and small-scale sculpture. (Monumental architecture and sculpture in stone did not appear until the seventh century.) The two forms are intimately related. The pottery was often adorned with figurines indistinguishable in form from sculpture, which was made of clay or bronze. These early bronzes leave little doubt that the Greeks learned the technique directly from the Mycenaeans.

Greek potters quickly developed a considerable variety of shapes. (The basic ones are shown in fig. 138.) Chief among these was the amphora, a two-handled vase for storing wine or oil. Variants were the pelike and stamnos, used for wine or water; these could also be dispensed from a type of jar known as an oinochoe. The principal vessel for water was the hydria. Wine was always heavily diluted with water in a krater, which came in assorted shapes. This mixture was drunk from a shallow cup, the kylix; a deeper one called a kantharos; or the bowl-shaped skyphos. The main oil bottles were the lekythos, often used for sepulchral offerings, and the tiny aryballos. Each type was wonderfully adapted to its function, which was aptly reflected in its form. Consequently, each shape presented unique challenges to a painter, and some became specialists at decorating certain types of vases, though the larger pots generally attracted the best artists because they proved more generous fields to work on. Since each was a complex and

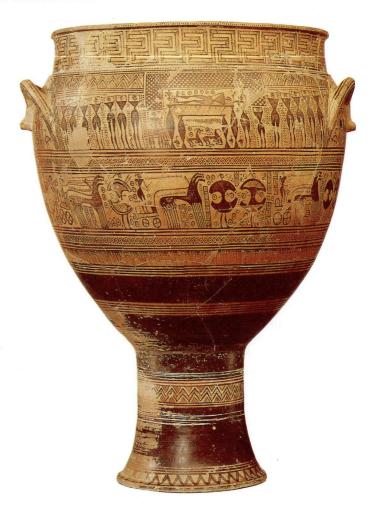

139. Dipylon Vase. 8th century B.C. Height $40^{1}/2$ " (102.8 cm). The Metropolitan Museum of Art, New York. Rogers Fund, 1914

demanding process in its own right, the making and decorating of vases were separate professions, but the finest painters were sometimes potters as well.

DIPYLON VASE. At first the pottery was decorated only with abstract designs: triangles, checkers, concentric circles. Toward 800 B.C. human and animal figures began to appear within the geometric framework, and in the most mature examples these figures could form elaborate scenes. Our specimen (fig. 139), from the Dipylon cemetery in Athens,

belongs to a group of very large vases that served as grave monuments. Its bottom has holes through which liquid offerings could filter down to the dead below. On the body of the vessel we see the deceased lying in state, flanked by figures with their arms raised in a gesture of mourning, and a funeral procession of chariots and warriors on foot.

The most remarkable thing about this scene is that it contains no reference to an afterlife. Its purpose is purely commemorative. Here lies a worthy man, it tells us, who was mourned by many and had a splendid funeral. Did the Greeks, then, have no conception of a hereafter? They did, but the realm of the dead to them was a colorless, ill-defined region where the souls, or "shades," led a feeble and passive existence without making any demands upon the living. When Odysseus, in the Homeric poem, conjures up the shade of Achilles, all the dead hero can do is mourn his own demise: "Speak not conciliatorily of death, Odysseus. I'd rather serve on earth the poorest man . . . than lord it over all the wasted dead." If the Greeks nevertheless marked and tended their graves, and even poured libations over them, they did so in a spirit of pious remembrance, rather than to satisfy the needs of the dead. Clearly, they had refused to adopt the elaborate burial customs of the Mycenaeans (see page 106). Nor is the Geometric style an outgrowth of the Mycenaean tradition but a fresh, and in some respects quite primitive, start. Yet it also owes a great deal to Near Eastern art: the repertory of forms can be traced back to prehistoric Mesopotamian pottery, though how they survived to be transmitted to the Greeks is as yet unknown.

Given the limited repertory of shapes, the artist who painted our vase has achieved an astonishingly varied effect. The spacing of the bands, their width and density, show a rather subtle relationship to the structure of the vessel. His interest in representation, however, is as yet very limited. The figures or groups, repeated at regular intervals, are little more than another kind of ornament, part of the same over-all texture, so that their size varies in accordance with the area to be filled. Organic and geometric elements still coexist in the same field, and the distinction between them is often difficult. Lozenges indicate legs, whether of a man, a chair, or a bier. Circles with dots may or may not be human heads. The chevrons, boxed triangles, and so on between the figures may be decorative or descriptive—we cannot tell.

Geometric pottery has been found not only in Greece but in Italy and the Near East as well, a clear indication that Greek traders were well established throughout the eastern Mediterranean in the eighth century B.C. What is more, they had already adopted the Phoenician alphabet and reshaped it for their own use, as we know from the inscriptions on these same vases. The greatest Greek achievements of this era, however, are the two Homeric epics, the *Iliad* and the *Odyssey*. The scenes on Geometric vases contain barely a hint of the narrative power of these poems. If our knowledge of eighth-century Greece were based on the visual arts alone, we would inevitably think of it as a far simpler and more provincial society than the literary evidence suggests.

There is a paradox here that needs to be resolved. Perhaps, at this particular time, Greek civilization was so language-minded that painting and sculpture played a less important role than they were to assume in the following centuries. In

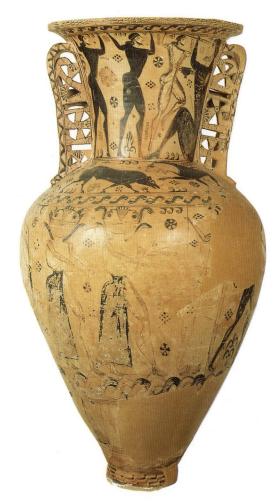

140. The Blinding of Polyphemus and Gorgons, on a Proto-Attic amphora. c. 675–650 B.C. Height 56" (142.3 cm). Archaeological Museum, Eleusis, Greece

that event, the Geometric style may well have been something of an anachronism in the eighth century, a conservative tradition about to burst at the seams. Representation and narrative demand greater scope than the style could provide. The dam finally burst toward 700 B.C., when Greek art entered another phase, which we call the Orientalizing style, and new forms came flooding in.

ORIENTALIZING STYLE

As its name implies, the new style reflects powerful influences from Egypt and the Near East, stimulated by increasing trade with these regions. Between about 725 and 650 B.C. Greek art absorbed a host of Oriental motifs and ideas and was profoundly transformed in the process. It would be difficult to overestimate the contribution of these outside influences. Whereas earlier Greek art is Aegean in flavor, the Orientalizing phase is characterized by a new monumentality and variety that is wildly exuberant as painters and sculptors struggled to master the new forms that came in waves, like immigrants from afar. The subsequent development of Greek art is unthinkable without this vital period of experimentation. Some of the subjects and motifs that we think of as typically Greek were, in fact, derived from Mesopotamia and Egypt, where

The Greek Gods and Goddesses

All early civilizations and preliterate cultures had creation myths

to explain the origin of the universe and humanity's place in it. Over time, these myths were elaborated into complex cycles that represent a comprehensive attempt to understand the world. The Greek stories of the gods and heroes—the myths and legends—were the result of combining local Doric and Ionic deities and folktales with the pantheon of Olympian gods. These tales had been brought to Greece from the ancient Near East through successive waves of immigration. The gods and goddesses, though immortal, were very human in behavior. They quarreled, and had children with each other's spouses and often with mortals as well. They were sometimes threatened and even overthrown by their own children. The principal Greek gods and goddesses, with their Roman counterparts in parentheses, are given below.

Zeus (Jupiter), god of sky and weather, was the king of the Olympian deities. His parents were Kronos and Rhea. It had been prophesied that one of Kronos' children would overthrow him, and Kronos had thus taken the precaution of eating his children as soon as they were born. After Zeus' birth, Rhea hid him so that he would not suffer the same fate as his siblings. Zeus later tricked Kronos into disgorging his other children, who then overthrew their father with the help of the earth goddess, Gaea. Gaea was both the mother and wife of the sky god Uranus and the wife of Pontus, god of the sea. She was also the mother of the Cyclopes, who forged the weapons of the Olympians, as well as the Titans and Hundred-Handed Ones. The descendants of the Titans included Atlas (who was credited with holding up the earth), Hecate (an underworld goddess), Selene (goddess of the moon), Helios (a god of the sun), and Prometheus (a demigod, who gave humanity the gift of fire and was severely punished for doing so). After the defeat of Kronos, Zeus divided the universe by lot with his brothers Poseidon (Neptune), who ruled the sea, and Hades (Pluto), who became lord of the underworld.

Zeus fathered Ares (Mars, the god of war), Hephaestus (Vulcan, the god of armor and the forge), and Hebe (the goddess of youth) with his queen, Hera (Juno), goddess of marriage and fruitfulness, who was both his wife and sister. He also had numerous children through his love affairs with other goddesses and with mortal women. Chief among his children was Athena (Minerva), goddess of war. She was born of the liaison between Metis and Zeus, who swallowed her alive because, like his own father, he was told he would

be toppled by one of his offspring. Athena later emerged

fully armed from the head of Zeus when it was split open by Hephaestus. Although a female counterpart to the war god Ares, Athena was also the goddess of peace, a protector of heroes, a patron of arts and crafts (especially spinning and weaving), and, later, of wisdom. She became the patron goddess of Athens, an honor she won in a contest with Poseidon. Her gift to the city was an olive tree, which she caused to sprout on the Acropolis. Poseidon had offered a useless saltwater spring.

Zeus sired other goddesses, perhaps the most notable of whom was Aphrodite (Venus), the goddess of love, beauty, and fertility. She became the wife of Hephaestus and a lover of Ares, by whom she bore Harmonia, Eros, and Anteros. Aphrodite was also the mother of Hermaphroditus (with Hermes), Priapus (with Dionysus), and Aeneas (with the Trojan prince Anchises). Artemis (Diana), who with her twin brother Apollo was born of Leto and Zeus, was the virgin goddess of the hunt. She was also sometimes considered a moon goddess with Selene and Hecate.

Zeus begat other major gods as well. Hermes (Mercury), son of Maia, was the messenger of the gods, conductor of souls to Hades, and the god of travelers and commerce. He was sometimes credited with inventing the lyre and the shepherd's flute. The main god of civilization (including art, music, poetry, law, and philosophy) was the sun-god Apollo (Helios), who was also the god of prophecy and medicine, flocks and herds. Apollo was opposite in temperament to Dionysus (Bacchus), the son of Zeus and of either Persephone (Proserpina), queen of the underworld, or the moon goddess Semele. Dionysus was raised on Mount Nysa, where he invented wine making. His followers, the half-man, halfgoat satyrs (the oldest of whom was Silenus, the tutor of Dionysus) and their female companions, the nymphs and humans known as maenads (bacchantes), were given to orgiastic excess. However, there was a temperate side to Dionysus. As the god of fertility, he was also the god of vegetation, as well as the god of peace, hospitality, and the civi-

In its inspiration and grandeur, Greek civilization represented a fusion of contrasting sensibilities—the Apollonian and the Dionysian. The origins of Classical tragedy lay in Dionysiac rites tempered by rational Apollonian influence. Fifth-century B.C. Greek playwrights such as Aeschylus, Sophocles, and Euripides recast the ancient myths and legends into dramatic form.

they had a long history reaching back to the very dawn of Near Eastern civilization. It was the merging with Aegean tendencies and the distinctive Greek cast of mind that soon gave rise to what we think of as Greek art proper.

ELEUSIS AMPHORA. The change becomes very evident if we compare the large amphora from Eleusis (fig. 140) with the *Dipylon Vase* of a hundred years earlier (fig. 139). Geometric ornament has not disappeared from this vase altogether, but it is confined to the peripheral zones: the foot, the handles, and

the lip. New, curvilinear motifs—such as spirals, interlacing bands, palmettes, and rosettes—are conspicuous everywhere. On the shoulder of the vessel we see a frieze of fighting animals, derived from the repertory of Near Eastern art. The major areas, however, are given over to narrative, which has become the dominant element.

Narrative painting tapped a nearly inexhaustible source of subjects from Greek myths and legends (see box above). These tales were the result of mixing local Doric and Ionic deities and heroes into the pantheon of Olympian gods and Homeric

141. Proto-Corinthian perfume vase. c. 650 B.C. Height 2" (5 cm). Musée du Louvre, Paris

sagas. They also represent a comprehensive attempt to understand the world. Such an interest in heroes and deities also helps to explain the strong appeal exerted on the Greek imagination by Oriental lions and monsters. These terrifying creatures embodied the unknown forces of life faced by the hero. This fascination is clearly seen on the Eleusis amphora. The figures have gained so much in size and descriptive precision that the decorative patterns scattered among them can no longer interfere with their actions. Ornament of any sort now belongs to a separate and lesser realm, clearly distinguishable from that of representation.

As a result, the blinding of the giant one-eyed cyclops Polyphemus, a son of Poseidon, by Odysseus and his companions, whom Polyphemus had imprisoned, is enacted with memorable directness and dramatic force. (This scene on the neck of the amphora is taken from Homer's *Odyssey*.) If these men lack the beauty we will later expect of epic heroes in art, their movements have an expressive vigor that makes them seem thoroughly alive. The slaying of another monstrous creature is depicted on the body of the vase, the main part of which has been badly damaged so that only two figures have survived intact. They are Gorgons, the sisters of the snake-haired, terrible-faced Medusa whom Perseus (partly seen running away to the right) killed with the aid of the gods. Even here we notice an interest in the articulation of the body far beyond the limits of the Geometric style.

The Eleusis vase belongs to a group called Proto-Attic, the ancestors of the great tradition of vase painting that was soon to develop in Attica, the region around Athens. A second family of Orientalizing vases is known as Proto-Corinthian, since

it points toward the later pottery production of Corinth. These vessels, noted for their spirited animal motifs, show particularly close links with the Near East. Some of them, such as the perfume vase in figure 141, are molded in the shape of animals. The enchanting little owl, streamlined to fit the palm of a lady's hand and yet so animated in pose and expression, helps us to understand why Greek pottery came to be in demand throughout the Mediterranean world.

ARCHAIC VASE PAINTING

The Orientalizing phase of Greek art was a period of experiment and transition, in contrast to the stable and consistent Geometric style. Once the new elements from the East had been fully assimilated, there emerged another style, as well defined as the Geometric but infinitely greater in range: the Archaic, which lasted from the later seventh century to about 480 B.C., the time of the famous Greek victories over the Persians at Salamis and Plataea. During the Archaic period, we witness the unfolding of the artistic genius of Greece not only in vase painting but also in monumental architecture and sculpture. While Archaic art lacks the balance, the sense of perfection of the Classical style of the later fifth century, it has such freshness that many people consider it the most vital phase in the development of Greek art.

Greek architecture and sculpture on a large scale must have begun to develop long before the mid-seventh century. Until that time, however, both were mainly of wood, and nothing of them has survived except the foundations of a few buildings. The desire to build and sculpt in stone, for the sake of permanence, was the most important new idea that entered Greece during the Orientalizing period. Moreover, the revolution in material and technique must have brought about decisive changes of style as well, so that we cannot safely reconstruct the appearance of the lost wooden temples or statues on the basis of later works. In vase painting, on the other hand, there was no such break in continuity. It thus seems best to deal with Archaic vases before we turn to the sculpture and architecture of the period.

The significance of Archaic vase painting is in some ways completely unique. Decorated pottery, however great its value as an archaeologist's tool, rarely enters the mainstream of the history of art. We think of it, in general, as a craft or industry. This remains true even of Minoan vases, despite their exceptional beauty and technical refinement, and the same may be said of the vast bulk of Greek pottery. Yet if we study such pieces as the *Dipylon Vase* or the amphora from Eleusis, they are impressive not only by virtue of their sheer size but as vehicles of pictorial effort, and we cannot escape the feeling that they are among the most ambitious works of art of their day.

There is no way to prove this, of course—far too much has been lost—but it seems obvious that these are objects of highly individual character, rather than routine ware produced in quantity according to set patterns. Archaic vases are generally a good deal smaller than their predecessors, since pottery vessels no longer served as grave monuments (which were now made of stone). Their painted decoration, however, shows a far greater emphasis on pictorial subjects (fig. 143). Scenes from mythology, legend, and everyday life appear in endless

variety, and the artistic level is often very high indeed, especially among Athenian vases.

After the middle of the sixth century, the finest vases frequently bear the signatures of the artists who made them. This indicates not only that individual potters, as well as painters, took pride in their work, but also that they could become famous for their personal style. To us, such signatures in themselves do not mean a great deal. They are no more than convenient labels unless we know enough of an artist's work to gain some insight into his personality. Remarkably enough, that is possible with a good many Archaic vase painters. Some of them have so distinctive a style that their artistic "handwriting" can be recognized even without the aid of a signature. In a few cases we are lucky enough to have dozens (in one instance, over 200) of vases by the same hand, so that we can trace one master's development over a considerable period. Archaic vase painting thus introduces us to the first clearly defined personalities in the entire history of art. While it is true that signatures occur in Archaic sculpture and architecture as well, they have not helped us to identify the personalities of individual masters.

Archaic Greek painting was, of course, not confined to vases. There were murals and panels, too. Although nothing has survived of them except a few poorly preserved fragments, we can form a fair idea of what they looked like from the wall paintings in Etruscan tombs of the same period (see figs. 226 and 227). How, we wonder, were these large-scale works related to the vase pictures? We do not know, but one thing seems certain: all Archaic painting was essentially drawing filled in with solid, flat color, and therefore murals could not have been very different in appearance from vase pictures.

According to the literary sources, Greek wall painting did not come into its own until about 475–450 B.C., after the Persian wars, through the gradual discovery of modeling and spatial depth. [See Primary Sources, no. 4, page 213.] From that time on, vase painting became a lesser art, since depth and modeling were beyond its limited technical means, and by the end of the fifth century its decline was obvious. The great age of vase painting, then, was the Archaic era. Until about 475 B.C., good vase painters enjoyed as much prestige as other artists. Whether or not their work directly reflects the lost wall paintings, it deserves to be viewed as a major achievement.

BLACK-FIGURED STYLE. The difference between Orientalizing and Archaic vase painting is one of artistic discipline. In the amphora from Eleusis (fig. 140), the figures are shown partly as solid silhouettes, partly in outline, or as a combination of both. Toward the end of the seventh century, Attic vase painters resolved these inconsistencies by adopting the "blackfigured" style, which means that the entire design is silhouetted in black against the reddish clay. Internal details are scratched in with a needle, and white and purple may be added on top of the black to make certain areas stand out. The virtues of this procedure, which favors a decorative, two-dimensional effect, are apparent in figure 142, a kylix (drinking cup) by Exekias of about 540 B.C. The slender, sharp-edged forms have a lacelike delicacy, yet also resilience and strength, so that the composition adapts itself to the circular surface without becoming mere ornament. Dionysus reclines in his boat (the sail

142. Exekias. *Dionysus in a Boat.* Interior of an Attic black-figured kylix. c. 540 B.C. Diameter 12" (30.5 cm). Staatliche Antikensammlungen, Munich

was once entirely white). It moves with the same ease as the dolphins, whose lithe forms are counterbalanced by the heavy clusters of grapes.

But why is he at sea? What does the happy poetry of Exekias' image mean? According to a Homeric hymn, the god of wine had once been abducted by pirates, whereupon he caused vines to grow all over the ship and frightened his captors until they jumped overboard and were turned into dolphins. We see him here on his return journey—an event to be gratefully recalled by every Greek drinker—accompanied by seven dolphins and seven bunches of grapes for good luck.

If the spare elegance of Exekias retains something of the spirit of Geometric pottery, the work of the slightly younger Psiax is the direct outgrowth of the forceful Orientalizing style of the blinding of Polyphemus in the Eleusis amphora. Herakles killing the Nemean lion, the first of his 12 labors (see box page 117), on an amphora attributed to Psiax (fig. 143), reminds us of the hero on the soundbox of the harp from Ur (see fig. 92). Both show a hero facing the unknown forces of life embodied by terrifying mythical creatures. The lion also serves to underscore the hero's might and courage against demonic forces. The scene is all grimness and violence. The two heavy bodies are truly locked in combat, so that they almost grow together into a single, compact unit. Incised lines and subsidiary colors have been added with utmost economy in order to avoid breaking up the massive expanse of black. Yet both figures show such a wealth of knowledge of anatomical structure and skillful use of foreshortening that they give an

143. Psiax. *Herakles Strangling the Nemean Lion,* on an Attic black-figured amphora from Vulci, Italy. c. 525 B.C. Height 19¹/2" (49.5 cm). Museo Civico dell'Età Cristiana, Brescia

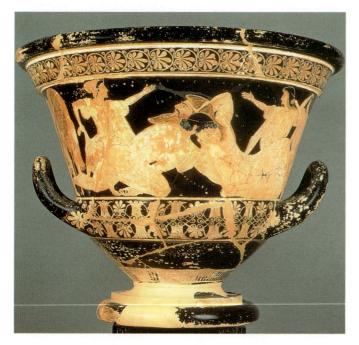

144. Euphronios. *Herakles Wrestling Antaios*, on an Attic red-figured krater. c. 510 B.C. Height 19" (48 cm). Musée du Louvre, Paris

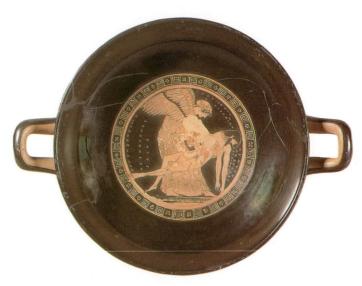

145. Douris. *Eos and Memnon*. Interior of an Attic red-figured kylix. c. 490–480 B.C. Diameter 10¹/₂" (26.7 cm). Musée du Louvre, Paris

amazing illusion of existing in the round. (Note the way the abdomen and shoulders of Herakles are rendered.) Only in such details as the eye of Herakles do we still find the traditional combination of front and profile views.

RED-FIGURED STYLE. Psiax must have felt that the silhouettelike black-figured technique made the study of foreshortening unduly difficult, for in some of his vases he tried the reverse procedure, leaving the figures red and filling in the background. This red-figured technique gradually replaced the older method toward 500 B.C. Its advantages are well shown in figure 144, a krater of about 510 B.C. by Euphronios showing Herakles wrestling Antaios. The details are now freely drawn with the brush, rather than laboriously incised, so the picture depends far less on the profile view than before. Instead, the artist exploits the internal lines that permit him to show boldly foreshortened and overlapping limbs, precise details of costume (note the pleated dresses of the giant's two sisters), and

intense facial expressions. He is so fascinated by all these new effects that he has made the figures as large as he possibly could. They almost seem to burst from the field of the vase!

A similar striving for monumental effect, but with more harmonious results, may be seen in the *Eos and Memnon* by Douris (fig. 145), one of the masterpieces of late Archaic vase painting. It shows the goddess of dawn holding the body of her son, who had been killed and despoiled of his armor by Achilles. In this moving evocation of grief, Greek art touches a mood that seems strangely prophetic of the Christian *Pietà* (see fig. 479). Notable, too, is the expressive freedom of the draftsmanship: the lines are as flexible as if they had been done with a pen. Douris knows how to trace the contours of limbs beneath the drapery and how to contrast vigorous, dynamic outlines with thinner and more delicate secondary strokes, such as those indicating the anatomical details of Memnon's body. This vase also has a special interest because of its elaborate inscription, which includes the signatures of both painter

The early Greeks grasped the meaning of events in terms of fate

and human character rather than as accidents of history, in which they had little interest before about 500 B.C. The main focus in the writings of Greek authors was on explaining why the legendary heroes of the past seemed incomparably greater than contemporary men and women. Some of these heroes were historical figures, but all were believed to be descendants of the gods, who often had children with mortals. Such a lineage helped to explain the hero's extraordinary power. This power (called *arete* by the Greeks) could, in excess, lead to overweening pride (*hubris*) and consequently to error (*hamartia*). The tragic results of such pride were the

The Hero in Greek Legend

subject of many Greek plays, especially those by Sophocles.

The Greek ideal became moderation in all things, personified by Apollo, the god of art and civilization. Arete came to be identified over time with personal and civic virtues, such as modesty and piety.

The greatest of all Greek heroes was Herakles (Hercules to the Romans). The son of Zeus and the princess Alcmene, he became the only mortal ever to ascend to Mount Olympus upon his immolation on Mount Oite. His greatest exploits were the 12 labors undertaken during his dozen years at the court of King Eurystheus in Tiryns. They were done to atone for killing his wife and children.

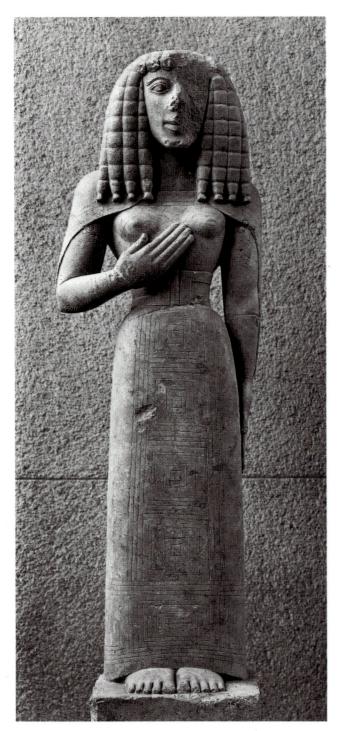

146. Female Figure (Kore). c. 650 B.C. Limestone, height 24¹/2" (62.3 cm). Musée du Louvre, Paris

ARCHAIC SCULPTURE

The new motifs that distinguish the Orientalizing style from the Geometric—fighting animals, winged monsters, scenes of combat—had reached Greece mainly through the importation of ivory carvings and metalwork from Phoenicia or Syria, pieces that reflected Mesopotamian as well as Egyptian influences. Such objects have actually been found on Greek soil, so that we can regard this channel of transmission as well

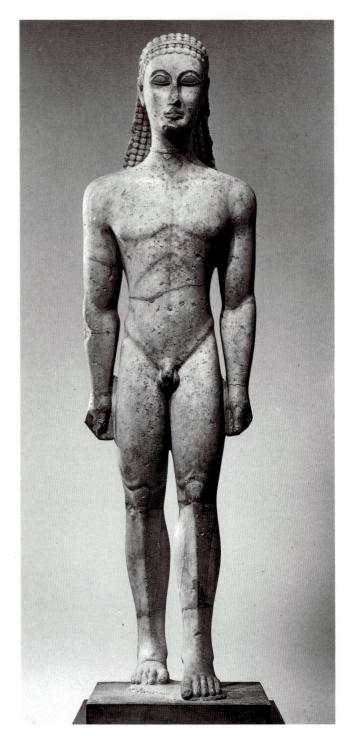

147. Standing Youth (Kouros). c. 600 B.C. Marble, height 6'1¹/2" (1.88 m). The Metropolitan Museum of Art, New York. Fletcher Fund, 1932

established. They do not help us, however, to explain the rise of monumental architecture and sculpture in stone about 650 B.C., which must have been based on acquaintance with Egyptian works that could be studied only on the spot. We know that small colonies of Greeks existed in Egypt at the time, but why, we wonder, did Greece suddenly develop a taste for monumentality, and how did her artists acquire so quickly the Egyptian mastery of stone carving? All the earliest Greek sculpture we know from the Geometric period consists of simple clay or bronze figurines of animals and warriors only a few inches in size. The mystery may never be cleared up, for the oldest surviving Greek stone sculpture and architecture show that

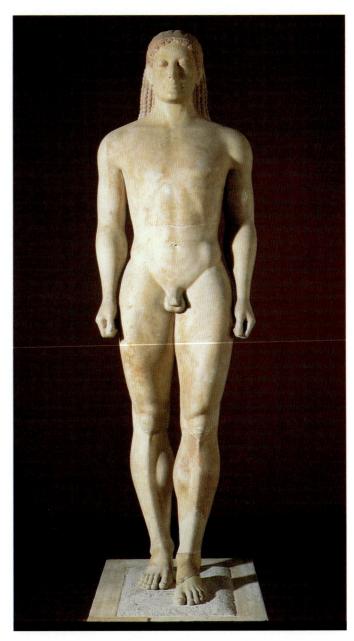

148. Kroisos (Kouros from Anavysos). c. 525 B.C. Marble, height 6'4" (1.9 m). National Archaeological Museum, Athens

the Egyptian tradition had already been well assimilated and Hellenized, though their link with Egypt is still clearly visible.

Kouros and Kore

Let us consider two very early Greek statues, a small female figure of about 650 B.C. (fig. 146) and a lifesize nude youth of about 600 B.C. (fig. 147), and compare them with their Egyptian predecessors (fig. 64). The similarities are certainly striking. We note the block-conscious, cubic character of all four statues, the slim, broad-shouldered silhouette of the male figures, the position of their arms, their clenched fists, the way they stand with the left leg forward, the emphatic rendering of the kneecaps. The formalized, wiglike treatment of the hair, the close-fitting garment of the female figure, and her raised arm are further points of resemblance. Judged by Egyptian standards, the Archaic statues seem somewhat primitive: rigid, oversimplified, awkward, less close to nature. Whereas the

Egyptian sculptor allows the legs and hips of the female figure to press through the skirt, the Greek shows a solid, undifferentiated mass from which only the toes protrude.

But the Greek statues also have virtues of their own that cannot be measured in Egyptian terms. First of all, they are truly free-standing—the earliest large stone images of the human form in the entire history of art of which this can be said. The Egyptian carver had never dared to liberate such figures completely from the stone. They remain immersed in it to some degree, so that the empty spaces between the legs and between the arms and the torso (or between two figures in a double statue, as in fig. 64) always remain partly filled. There are never any holes in Egyptian stone figures. In that sense, they do not rank as sculpture in the round but as an extreme case of high relief. The Greek carver, on the contrary, does not mind holes in the least. The arms are separated from the torso and the legs from each other, unless they are encased in a skirt, and the carver goes to great lengths to cut away every bit of dead material. (The only exceptions are the tiny bridges between the fists and the thighs of the nude youth.) Apparently it is of the greatest importance to the sculptor that a statue consist only of stone that has representational meaning within an organic whole. The stone must be transformed; it cannot be permitted to remain inert, neutral matter.

This is not, we must insist, a question of technique but of artistic intention. The act of liberation achieved in our two figures endows them with a spirit basically different from that of any of the Egyptian statues. While the latter seem becalmed by a spell that has released them from every strain for all time to come, the Greek images are tense, full of hidden life. The direct stare of their huge eyes offers the most telling contrast to the gentle, faraway gaze of the Egyptian figures.

Whom do they represent? We call the female statues by the general name of Kore (Maiden), the male ones Kouros (Youth)—noncommittal terms that gloss over the difficulty of identifying them further. Nor can we explain why the Kouros is always nude while the Kore is clothed. Whatever the reason, both types were produced in large numbers throughout the Archaic era, and their general outlines remained extraordinarily stable. Some are inscribed with the names of artists ("Soand-so made me") or with dedications to various deities. These, then, were votive offerings. But whether they represent the donor, the deity, or a divinely favored person such as a victor in athletic games remains uncertain in most cases. Others were placed on graves, yet they can be viewed as representations of the deceased only in a broad (and completely impersonal) sense. This odd lack of differentiation seems part of the essential character of these figures. They are neither gods nor mortals but something in between, an ideal of physical perfection and vitality shared by mortal and immortal alike, just as the heroes of the Homeric epics dwell in the realms of both history and mythology.

If the type of Kouros and Kore is narrowly circumscribed, its artistic interpretation shows the same inner dynamic we have traced in Archaic vase painting. The pace of this development becomes strikingly clear from a comparison of the Kouros of figure 147 with another carved some 75 years later (fig. 148) and identified by the inscription on its base as the funerary statue of Kroisos, who had died a hero's death in the

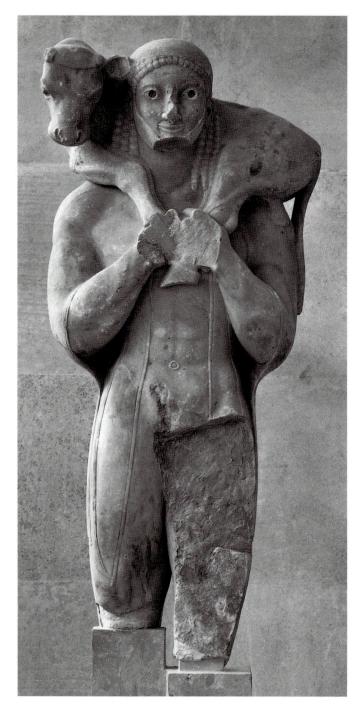

149. *Calf-Bearer.* c. 570 B.C. Marble, height of entire statue 65" (165 cm). Acropolis Museum, Athens

front line of battle. Like all such figures, it was originally painted. (Traces of color can still be seen in the hair and the pupils of the eyes.) Instead of the sharply contoured, abstract planes of the older statue, we now find swelling curves. The whole body displays a greater awareness of massive volumes, but also a new elasticity, and countless anatomical details are more functionally rendered than before. The style of the *Kroisos* thus corresponds exactly to that of Psiax's *Herakles* (fig. 143). Here we witness the transition from black-figured to red-figured in sculptural terms.

There are numerous statues from the middle years of the sixth century marking previous way stations along the same road. The magnificent *Calf-Bearer* of about 570 B.C. (fig. 149) is a votive figure representing the donor with the sacrificial ani-

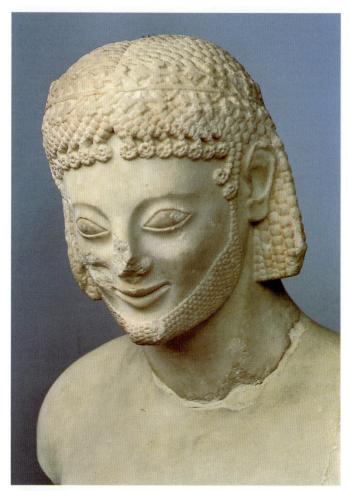

150. Rampin Head. c. 560 B.C. Marble, height 11¹/2" (29.3 cm). Musée du Louvre, Paris

mal he is offering to Athena. Needless to say, it is not a portrait, any more than the Kroisos is, but it shows a type: the beard indicates a man of mature years. The Calf-Bearer originally had the Kouros standing pose, and the body conforms to the Kouros ideal of physical perfection. Its vigorous, compact forms are emphasized, rather than obscured, by the thin cloak, which fits them like a second skin, detaching itself only momentarily at the elbows. The face, effectively framed by the soft curve of the animal, no longer has the masklike quality of the early Kouros. The features have, as it were, caught up with the rest of the body in that they, too, are permitted a gesture, a movement expressive of life: the lips are drawn up in a smile. We must be careful not to impute any psychological meaning to this "Archaic smile," for the same radiant expression occurs throughout sixth-century Greek sculpture, even on the face of the dead hero Kroisos. Only after 500 B.C. does it gradually fade out.

One of the most famous instances of this smile is the wonderful *Rampin Head* (fig. 150), which probably belonged to the body of a horseman. Slightly later than the *Calf-Bearer*, it shows the black-figured phase of Archaic sculpture at its highest stage of refinement. Hair and beard have the appearance of richly textured beaded embroidery that sets off the subtly accented planes of the face.

The Kore type is somewhat more variable than that of the Kouros, although it follows the same pattern of development. A clothed figure by definition, it poses a different problem: how to relate body and drapery. It is also likely to reflect chang-

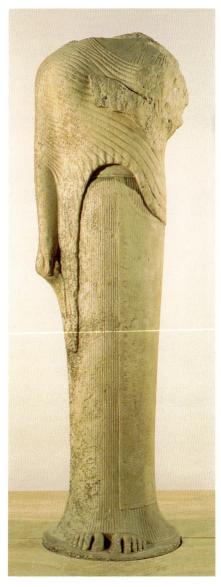

151. "Hera," from Samos. c. 570–560 B.C. Marble, height 6'4" (1.9 m). Musée du Louvre, Paris

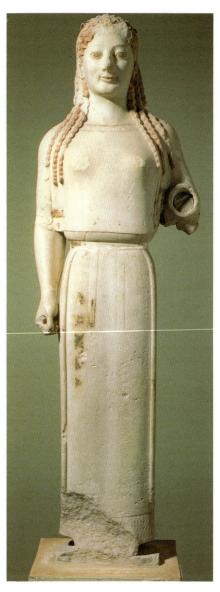

152. Kore in Dorian Peplos. c. 530 B.C. Marble, height 48" (122 cm). Acropolis Museum, Athens

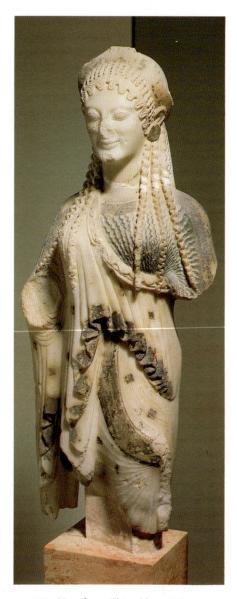

153. *Kore*, from Chios (?). c. 520 B.C. Marble, height 21⁷/8" (55.3 cm). Acropolis Museum, Athens

ing habits or local differences of dress. Thus, the impressive statue in figure 151, carved about the same time as the Calf-Bearer, does not represent a more evolved stage of the Kore in figure 146 but an alternative approach to the same basic task. She was found in the Temple of Hera on the island of Samos and may well have been an image of the goddess because of her great size as well as her extraordinary dignity. If the earlier Kore echoes the planes of a rectangular slab, the "Hera" seems like a column come to life. Instead of clear-cut accents, such as the nipped-in waist in figure 146, we find here a smooth, continuous flow of lines uniting limbs and body. Yet the majestic effect of the statue depends not so much on its abstract quality as on the way the abstract form blossoms forth into the swelling softness of a living body. The great upward sweep of the lower third of the figure gradually subdivides to reveal several separate layers of garments, and its pace is slowed further (but never fully stopped) as it encounters the protruding shapes of arms, hips, and torso. In the end, the drapery, so completely architectonic up to the knee region, turns into a second skin of the kind we have seen in the Calf-Bearer.

The Kore of figure 152, in contrast, seems a linear descendant of our first Kore, even though she was carved a full century later. She, too, is blocklike rather than columnar, with a strongly accented waist. The simplicity of her garments is new and sophisticated, however. The heavy cloth forms a distinct, separate layer over the body, covering but not concealing the solidly rounded shapes beneath. And the left hand, which originally was extended forward, offering a votive gift of some sort, must have given the statue a spatial quality quite beyond the two earlier Kore figures we have discussed. Equally new is the more organic treatment of the hair, which falls over the shoulders in soft, curly strands, in contrast to the massive, rigid wig in figure 146. Most noteworthy of all, perhaps, is the full, round face with its enchantingly gay expression—a softer, more natural smile than any we have seen hitherto. Here, as in the Kroisos, we sense the approaching red-figured phase of Archaic art.

Our final Kore (fig. 153), about a decade later, has none of the severity of figure 152, though both were found on the Acropolis of Athens. In many ways she seems more akin to the

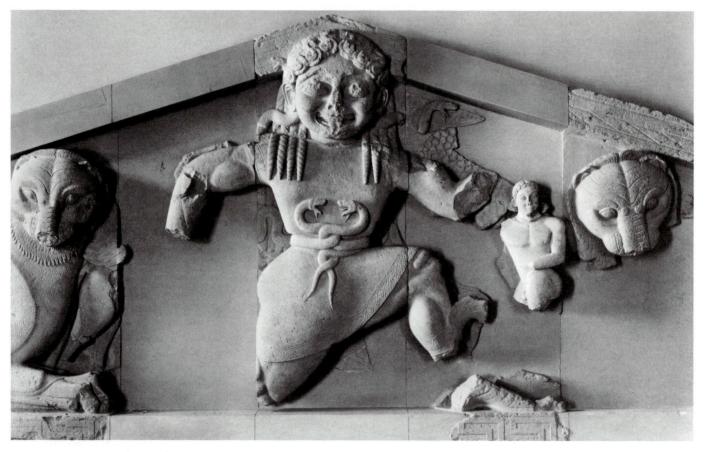

154. Central portion of the west pediment of the Temple of Artemis at Corfu, Greece. c. 600–580 B.C. Limestone, height 9'2" (2.8 m). Archaeological Museum, Corfu, Greece

"Hera" from Samos. In fact, she probably came from Chios, another island of Ionian Greece. The architectural grandeur of her ancestress, though, has given way to an ornate refined grace. The garments still loop around the body in soft diagonal curves, but the play of richly differentiated folds, pleats, and textures has almost become an end in itself. Color must have played a particularly important role in such works, and we are fortunate that so much of it survives in this example.

Architectural Sculpture

When the Greeks began to build their temples in stone, they also fell heir to the age-old tradition of architectural sculpture. The Egyptians had been covering the walls and even the columns of their buildings with reliefs since the time of the Old Kingdom, but these carvings were so shallow (for example, figs. 68 and 81) that they left the continuity of the wall surface undisturbed. They had no weight or volume of their own, so that they were related to their architectural setting only in the same limited sense as Egyptian wall paintings, with which they were, in practice, interchangeable. This is also true of the reliefs on Assyrian, Babylonian, and Persian buildings (for example, figs. 103 and 112). There existed, however, another kind of architectural sculpture in the ancient Near East, originated, it seems, by the Hittites: the great guardian monsters protruding from the blocks that framed the gateways of fortresses or palaces (see figs. 99 and 101). This tradition

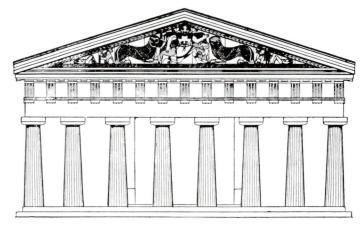

155. Reconstruction drawing of the west front of the Temple of Artemis at Corfu (after Rodenwaldt)

must have inspired, albeit perhaps indirectly, the carving over the Lioness Gate at Mycenae (see fig. 135). We must nevertheless note one important feature that distinguishes the Mycenaean guardian figures from their predecessors. Although they are carved in high relief on a huge slab, this slab is thin and light compared to the enormously heavy, Cyclopean blocks around it. In building the gate, the Mycenaean architect left an empty triangular space above the lintel, for fear that the weight of the wall above would crush it, and then filled the hole with the comparatively lightweight relief panel. Here,

then, we have a new kind of architectural sculpture: a work integrated with the structure yet also a separate entity rather than a modified wall surface or block.

TEMPLE OF ARTEMIS, CORFU. That the Lioness Gate relief is the direct ancestor of Greek architectural sculpture becomes evident when we compare it with the facade of the early Archaic Temple of Artemis on the island of Corfu, erected soon after 600 B.C. (figs. 154 and 155). Here again the sculpture is confined to a zone that is framed by structural members but is itself structurally empty: the triangle between the horizontal ceiling and the sloping sides of the roof. This area, called the pediment, need not be filled in at all except to protect the wooden rafters behind it against moisture. It demands not a wall but merely a thin screen. And it is against this screen that the pedimental sculpture is displayed.

Technically, these carvings are in high relief, like the guardian lionesses at Mycenae. Characteristically enough, however, the bodies are strongly undercut so as to detach them from the background. Even at this early stage of development, the Greek sculptor wanted to assert the independence of his figures from their architectural setting. The head of the central figure actually overlaps the frame. Who is this frightening creature? Not Artemis, surely, although the temple was dedicated to that goddess. As a matter of fact, we have met her before: she is a Gorgon, a descendant of those on the Eleusis amphora (fig. 140). Her purpose here was to serve as a guardian, along with the two huge lions, warding off evil from the temple and the sacred image of the goddess within. (The other pediment, of which only small fragments survive, had a similar figure.) She might be defined, therefore, as an extraordinarily monumental and still rather frightening hex sign. On her face, the Archaic smile appears as a hideous grin. And to emphasize further how alive and real she is, she has been represented running, or rather flying, in a pinwheel stance that conveys movement without locomotion.

The symmetrical, heraldic arrangement of the Gorgon and the two animals reflects an Oriental scheme which we know not only from the Lioness Gate at Mycenae but from many earlier examples as well (see fig. 50, bottom center, and fig. 92, top). Because of its ornamental character, it fits the shape of the pediment to perfection. Yet the early Archaic designer was not content with that. The pediment must contain narrative scenes. Therefore a number of smaller figures have been added in the spaces left between or behind the huge main group. The design of the whole thus shows two conflicting purposes in uneasy balance. As we might expect, narrative will soon win out over heraldry.

Aside from the pediment, there were not many places that the Greeks deemed suitable for architectural sculpture. They might put free-standing figures (often of terracotta) above the ends and the center of the pediment to break the severity of its outline. And they often placed reliefs in the zone immediately below the pediment. In Doric temples such as that at Corfu (fig. 155), this "frieze" consists of alternating triglyphs (blocks with three vertical markings) and metopes. The latter were originally the empty spaces between the ends of the ceiling beams; hence they, like the pediment, could be filled with sculpture. In Ionic architecture, the triglyphs were omitted,

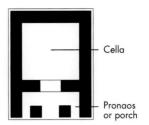

156. Plan of the Treasury of the Siphnians

157. Reconstruction drawing of the Treasury of the Siphnians. Sanctuary of Apollo at Delphi. c. 525 B.C.

and the frieze became what the term usually conveys to us, a continuous band of painted or sculptured decoration. The Ionians would also sometimes elaborate the columns of a porch into female statues, which is not a very surprising development in view of the columnar quality of the "Hera" from Samos (fig. 151).

SIPHNIAN TREASURY, DELPHI. All these possibilities are combined in the Treasury (a miniature temple for storing votive gifts) erected at Delphi shortly before 525 B.C. by the inhabitants of the Ionian island of Siphnos. Although the building no longer stands, we can get a general idea of its appearance from the reconstruction in figures 156 and 157. Of its lavish sculptural décor, the most impressive part is the splendid frieze. The detail reproduced here (fig. 158) shows part of the battle of the Greek gods against the giants. On the extreme left, two lions (who pull the chariot of Cybele) are tearing apart an anguished giant. In front of them, Apollo and Artemis advance together, shooting their arrows. A dead giant, despoiled of his armor, lies at their feet, while three others enter from the right.

The high relief, with its deep undercutting, recalls the Corfu pediment, but the Siphnian sculptor has taken full advantage of the spatial possibilities offered by this technique. The projecting ledge at the bottom of the frieze is used as a

158. Battle of the Gods and Giants, from the north frieze of the Treasury of the Siphnians. c. 530 B.C. Marble, height 26" (66 cm). Archaeological Museum, Delphi

stage on which he can place his figures in depth. The arms and legs of those nearest the beholder are carved completely in the round. In the second and third layers, the forms become shallower, yet even those farthest removed from us are never permitted to merge with the background. The result is a limited and condensed but very convincing space that permits a dramatic relationship between the figures such as we have never seen before in narrative reliefs. Any comparison with older examples (such as figs. 69, 102, 129, and 133) will show us that Archaic art has indeed conquered a new dimension here, not only in the physical but also in the expressive sense.

TEMPLE OF APHAIA, AEGINA. Meanwhile, in pedimental sculpture, relief has been abandoned altogether. Instead, we find separate statues placed side by side in complex dramatic sequences designed to fit the triangular frame. The most ambitious ensemble of this kind, that of the east pediment of the Temple of Aphaia at Aegina, was created about 490 B.C., and thus brings us to the final stage in the evolution of Archaic sculpture. The figures were found in pieces on the ground. The position of each within the pediment, however, can be determined, since their height (but not their scale) varies with the sloping sides of the triangle (fig. 159). The center is accented by the standing goddess Athena, who presides over the battle between Greeks and Trojans that rages to either side of her in symmetrically diminishing fashion.

The correspondence in the poses of the fighters on the two halves of the pediment makes for a balanced and orderly design. Yet it also forces us to see the statues as elements in an ornamental pattern and thus robs them of their individuality to some extent. They speak most strongly to us when viewed one by one. Among the most impressive are the fallen warrior from the left-hand corner (fig. 160) and the kneeling Herakles, who once held a bronze bow, from the right-hand half (fig. 161). Both are lean, muscular figures whose bodies seem marvelously functional and organic. That in itself, however, does

not explain their great beauty, much as we may admire the artist's command of the human form in action. What really moves us is their nobility of spirit, whether in the agony of dying or in the act of killing. These men, we sense, are suffering—or carrying out—what fate has decreed, with tremendous dignity and resolve. And this communicates itself to us in the very feel of the magnificently firm shapes of which they are composed.

ARCHITECTURE

Orders and Plans

In architecture, the Greek achievement has been identified since ancient Roman times with the creation of the three classical architectural orders: Doric, Ionic, and Corinthian. [See Primary Sources, no. 8, page 215.] Actually, there are only two, the Corinthian being a variant of the Ionic. (The dentils, or toothlike blocks, are sometimes found in the Doric and Ionic orders as well.) The Doric, so named because its home is a region of the Greek mainland, may well claim to be the basic order, since it is older and more sharply defined than the Ionic, which developed on the Aegean Islands and the coast of Asia Minor.

What do we mean by "architectural order"? By common agreement, the term is used only for Greek architecture (and its descendants); and rightly so, for none of the other architectural systems known to us produced anything like it. Perhaps the simplest way to make clear the unique character of the Greek orders is this: there is no such thing as "the Egyptian temple" or "the Gothic church." The individual buildings, however much they may have in common, are so varied that we cannot distill a generalized type from them. But "the Doric temple" is a real entity that inevitably forms in our minds as we examine the monuments themselves. We must be careful, of course, not to think of this abstraction as an ideal that permits us to measure

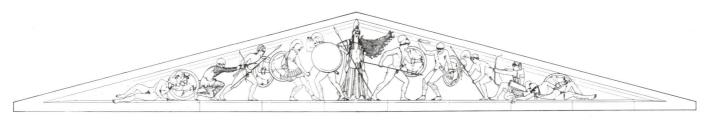

159. Reconstruction drawing of the east pediment of the Temple of Aphaia, Aegina (after Ohly)

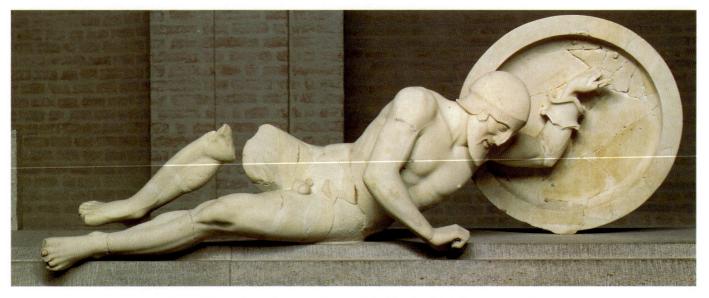

160. Dying Warrior, from the east pediment of the Temple of Aphaia, Aegina. c. 490 B.C. Marble, length 6' (1.83 m). Staatliche Antikensammlungen und Glyptothek, Munich

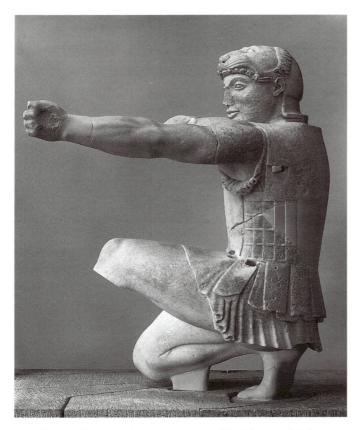

161. Herakles, from the east pediment of the Temple of Aphaia, Aegina. c. 490 B.C. Marble, height 31" (78.7 cm). Staatliche Antikensammlungen und Glyptothek, Munich

the degree of perfection of any given Doric temple. It simply means that the elements of which a Doric temple is composed are extraordinarily constant in number, in kind, and in their relation to one another. As a result of this narrowly circumscribed repertory of forms, Doric temples all belong to the same clearly recognizable family, just as the Kouros statues do. And like the Kouros statues, they show an internal consistency, a mutual adjustment of parts, that gives them a unique quality of wholeness and organic unity.

DORIC ORDER. The term Doric order refers to the standard parts, and their sequence, constituting the exterior of any Doric temple. Its general outlines are already familiar to us from the facade of the Temple of Artemis at Corfu (fig. 155). The diagram in figure 162 shows it in detail, along with the names of all the parts. To the nonspecialist, the detailed terminology may seem something of a nuisance. Yet a good many of these terms have become part of our general architectural vocabulary, to remind us of the fact that analytical thinking, in architecture as in countless other fields, originated with the Greeks. Let us first look at the three main divisions: the stepped platform (consisting of the stylobate and stereobate), the columns, and the entablature (which includes all the horizontal components that rest on the columns). The Doric column consists of the shaft, marked by shallow vertical grooves known as flutes, and the capital, which is made up of the flaring, cushionlike echinus and a square tablet called the abacus. The entablature is the most complex of the three major units.

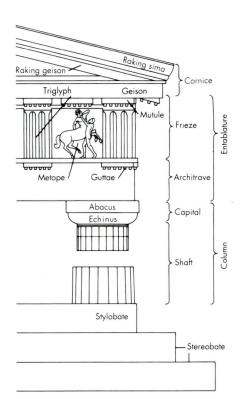

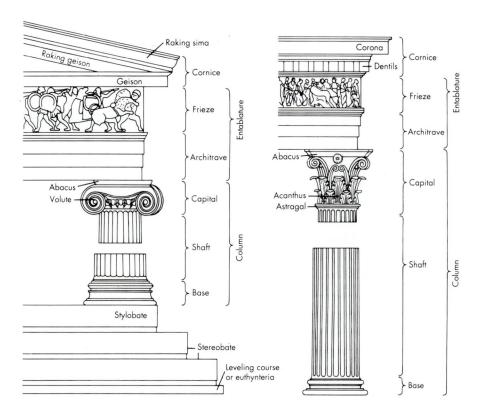

162. Doric, Ionic, and Corinthian orders

It is subdivided into the architrave (a series of stone blocks directly supported by the columns), the frieze with its triglyphs and metopes, and the projecting cornice, or geison, which may include a gutter (sima). The entablature in turn supports the triangular pediment and roof elements (the raking geison and raking sima).

The entire structure is built of stone blocks fitted together without mortar. They had to be shaped with extreme precision to achieve smooth joints. Where necessary, they were fastened together by means of metal dowels or clamps. Columns, with very rare exceptions, are composed of sections, called drums (clearly visible in fig. 165). The roof consisted of terracotta tiles supported by wooden rafters, and wooden beams were used for the ceiling, so that the threat of fire was constant.

TEMPLE PLANS. The plans of Greek temples are not directly linked to the orders (which, as we have seen, concern the elevation only). They may vary according to the size of the building or regional preferences, but their basic features are so much alike that it is useful to study them from a generalized "typical" plan (fig. 163). The nucleus is the cella or naos (the room in which the image of the deity is placed) and the porch (pronaos) with its two columns flanked by pilasters (antae). The Siphnian Treasury shows this minimal plan (see fig. 156). Often we find a second porch added behind the cella, to make

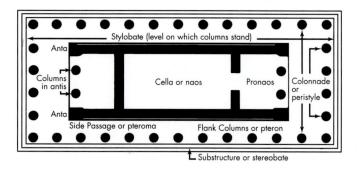

163. Ground plan of a typical Greek peripteral temple (after Grinnell)

the design more symmetrical. In the larger temples, this central unit is surrounded by a colonnade, called the peristyle, and the structure is then known as peripteral. The very largest temples of Ionian Greece may even have a double colonnade. The entrance to a Greek temple customarily faces east, toward the rising sun—an orientation that reaches back to Stonehenge (see fig. 47) and is continued in Christian basilicas (see page 234–35), which also face east but were entered from the west.

Doric Temples

How did the Doric originate? What factors shaped the rigid and precise vocabulary of the Doric order? These fascinating questions have occupied archaeologists for many years, but even now they can be answered only in part, for we have hardly any remains from the time when the system was still in process of formation. The earliest stone temples known to us, such as that of Artemis at Corfu, show that the essential features of the Doric order were already well established soon after 600 B.C. How these features developed, individually and in combination, why they congealed into a system as rapidly as they seem to have done, remains a puzzle to which we have few reliable clues.

The early Greek builders in stone apparently drew upon three distinct sources of inspiration: Egypt, Mycenae, and pre-Archaic Greek architecture in wood and mud brick. The Mycenaean contribution is the most tangible, although probably not the most important, of these. The central unit of the Greek temple, the cella and porch, clearly derives from the megaron (see fig. 136), either through a continuous tradition or by way of revival. There is something oddly symbolic about the fact that the Mycenaean royal hall should have been converted into the dwelling place of the Greek gods. The entire Mycenaean era had become part of Greek mythology, as attested by the Homeric epics, and the walls of the Mycenaean fortresses were believed to be the work of mythical giants, the Cyclopes. The religious awe the Greeks felt before these remains also helps us to understand the relationship between the Lioness Gate relief at Mycenae and the sculptured pediments on Doric temples. Finally, the flaring, cushionlike capital of the Minoan-Mycenaean column is a good deal closer to the Doric echinus and abacus than is any Egyptian capital. The shaft of the Doric column, on the other hand, tapers upward, not downward as does the Minoan-Mycenaean column, and this definitely points to Egyptian influence.

Perhaps we will recall now—with some surprise—the fluted columns (or rather half-columns) in the funerary district of Djoser at Saggara (see fig. 56) that had approximated the Doric shaft more than 2,000 years before its appearance in Greece. Moreover, the very notion that temples ought to be built of stone, and that they required large numbers of columns, must have come from Egypt. It is true, of course, that the Egyptian temple is designed to be experienced from the inside, while the Greek temple is arranged so that the impressive exterior matters most. (Few people were allowed to enter the dimly lit cella, and religious ceremonies usually took place at altars erected out-of-doors, with the temple facade as a backdrop.) A peripteral temple might be interpreted as the columned court of an Egyptian sanctuary turned inside-out. The Greeks also must have acquired much of their stonecutting and masonry techniques from the Egyptians, along with architectural ornament and the knowledge of geometry needed in order to lay out temples and to fit the parts together. Yet we cannot say just how they went about all this, or exactly what they took over, technically and artistically, although there can be little doubt that they owed more to the Egyptians than to the Minoans or the Mycenaeans.

DOES FORM FOLLOW FUNCTION? The problem of origins becomes acute when we consider a third factor: to what extent the Doric order can be understood as a reflection of wooden structures. Those historians of architecture who believe that form follows function—that an architectural form

will inevitably reflect the purpose for which it was devised—have pursued this line of approach at great length, especially in trying to explain the details of the entablature. Up to a point, their arguments are convincing. It seems plausible to assume that at one time the triglyphs did mask the ends of wooden beams, and that the droplike shapes below, called guttae (see fig. 162), are the descendants of wooden pegs. The peculiar vertical subdivisions of the triglyphs are perhaps a bit more difficult to accept as an echo of three half-round logs. And when we come to the flutings of the column, our doubts continue to rise. Were they really developed from adz marks on a tree trunk, or did the Greeks take them over ready-made from the "proto-Doric" stone columns of Egypt?

As a further test of the functional theory, we would have to ask how the Egyptians came to put flutes in their columns. They, too, after all, had once had to translate architectural forms from impermanent materials into stone. Perhaps it was they who turned adz marks into flutes? But the predynastic Egyptians had so little timber that they seem to have used it only for ceilings. The rest of their buildings consisted of mud brick, fortified by bundles of reeds. And since the proto-Doric columns at Saggara are not free-standing but are attached to walls, their flutings might represent a sort of abstract echo of bundles of reeds. (There are also columns at Saggara with convex rather than concave flutes that come a good deal closer to the notion of a bundle of thin staves.) On the other hand, the Egyptians may have developed the habit of fluting without reference to any earlier building techniques at all. Perhaps they found it an effective way to disguise the horizontal joints between the drums and to stress the continuity of the shaft as a vertical unit. Even the Greeks did not flute the shafts of their columns drum by drum, but waited until the entire column was assembled and in position. Be that as it may, fluting certainly enhances the expressive character of the column. A fluted shaft looks stronger, more energetic and resilient, than a smooth one. This, rather than its manner of origin, surely accounts for the persistence of the habit.

Why then did we enter at such length into an argument that seems at best inconclusive? Mainly in order to suggest the complexity, as well as the limitations, of the technological approach to problems of architectural form. The question, always a thorny one, of how far stylistic features can be explained on a functional basis will face us again and again. Obviously, the history of architecture cannot be fully understood if we view it only as an evolution of style in the abstract, without considering the actual purposes of building or its technological basis. But we must likewise be prepared to accept the purely aesthetic impulse as a motivating force. At the very start, Doric architects certainly imitated in stone some features of wooden temples, if only because these features were deemed necessary in order to identify a building as a temple. Thus, the trigylyphs were derived from the ends of ceiling beams decorated with three grooves and secured with wooden pegs, whose shape is dimly echoed in the guttae. Metopes evolved out of the boards that filled in the gaps between the triglyphs to guard against the elements. Likewise, mutules (flat projecting blocks) reflect the rafter ends of wooden roofs. When Greek architects enshrined them in the Doric order, however, they did not do so from blind conservatism or force of habit, but because the

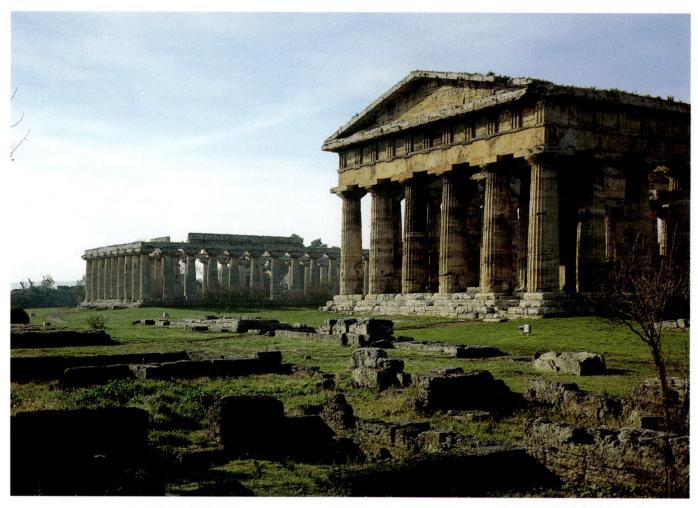

164. The "Basilica," c. 550 B.C., and the "Temple of Poseidon," c. 460 B.C. Paestum, Italy

wooden forms had by now been so thoroughly transformed that they were an organic part of the stone structure.

TEMPLES AT PAESTUM. We must confront the problem of function once more when we consider the best-preserved sixth-century Doric temple, the so-called "Basilica" at Paestum in southern Italy (fig. 164, left; fig. 165), in relation to its neighbor, the so-called "Temple of Poseidon" (fig. 164, right), which was built almost a century later. Both are Doric, but we at once note striking differences in their proportions. The "Basilica" seems low and sprawling (and not only because so much of the entablature is missing), while the "Temple of Poseidon" looks tall and compact. Even the columns themselves are different. Those of the older temple taper far more emphatically, their capitals are larger and more flaring. Why the difference?

The peculiar shape of the columns of the "Basilica" (peculiar, that is, compared to fifth-century Doric) has been explained as being due to overcompensation. The architect, not yet fully familiar with the properties of stone as compared with wood, exaggerated the taper of the shaft for greater stability and enlarged the capitals so as to narrow the gaps to be spanned by the blocks of the architrave. Maybe so, but if we accept this interpretation in itself as sufficient to account for the design of

these Archaic columns, do we not judge them by the standards of a later age? To label them primitive or awkward would be to disregard the particular expressive effect that is theirs and theirs alone.

The "Basilica's" columns seem to be more burdened by their load than those of the "Temple of Poseidon," so that the contrast between the supporting and supported members of the order is dramatized rather than harmoniously balanced, as it is in the later building. Various factors contribute to this impression. The echinus of the "Basilica's" capitals is not only larger than its counterpart in the "Temple of Poseidon," but it also seems more elastic and hence more distended by the weight it carries, almost as if it were made of rubber. And the shafts not only show a more pronounced taper but also a particularly strong bulge or curve along the line of taper, so that they, too, convey a sense of elasticity and compression compared with the rigidly geometric blocks of the entablature. This curve, called entasis, is a basic feature of the Doric column. Although it may be very slight, it endows the shaft with a muscular quality unknown in Egyptian or Minoan-Mycenaean columns.

The "Temple of Poseidon" (figs. 164, 166, and 167)—it was probably dedicated to Hera—is among the best preserved of all Doric sanctuaries. Of special interest are the interior

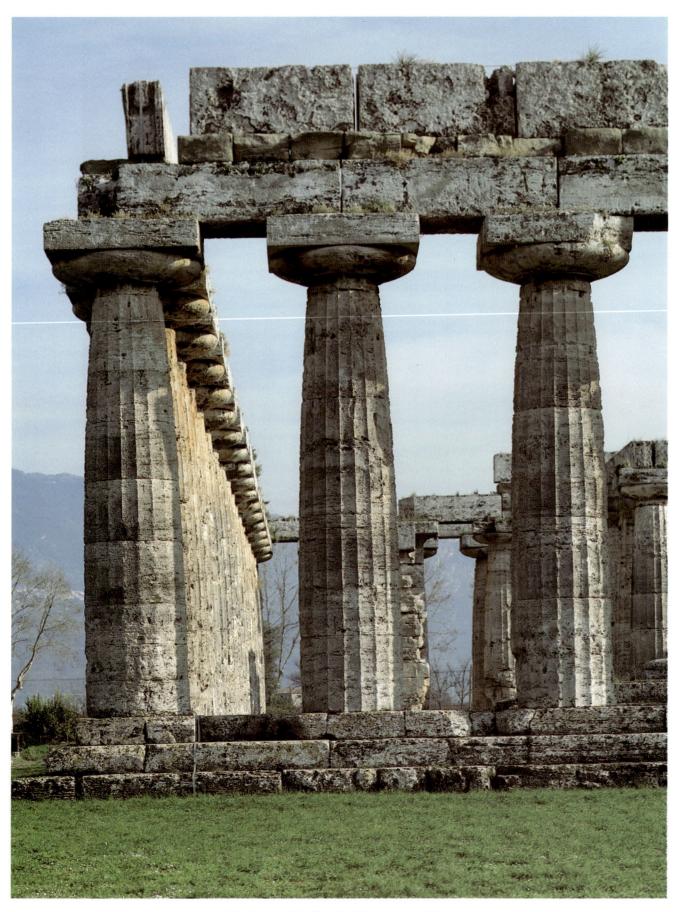

165. Corner of the "Basilica," Paestum. c. 550 B.C.

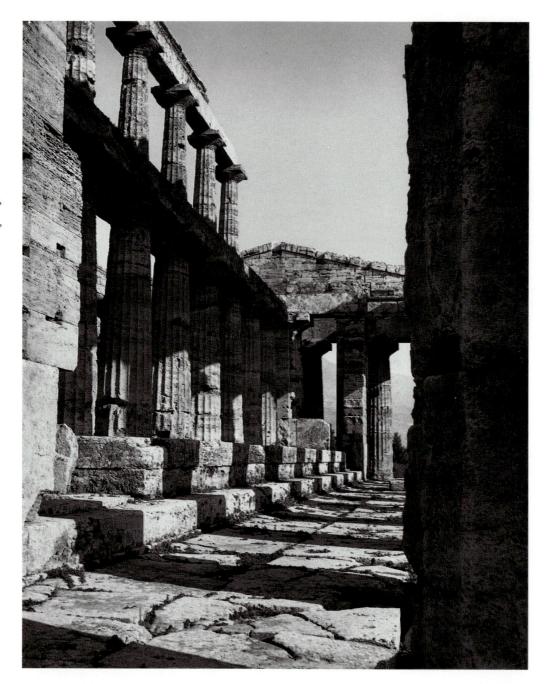

166. Interior, "Temple of Poseidon," Paestum. c. 460 B.C.

supports of the cella ceiling (fig. 166), two rows of columns, each supporting a smaller set of columns in a way that makes the tapering seem continuous despite the architrave in between. Such a two-story interior became a practical necessity for the cellas of the larger Doric temples. It is first found at the Temple of Aphaia at Aegina around the beginning of the fifth century, shown here in a reconstruction drawing to illustrate its construction scheme (fig. 168).

ATHENS, PERICLES, AND THE PARTHENON. In 480 B.C., shortly before their defeat, the Persians had destroyed the temple and statues on the Acropolis, the sacred hill above Athens which had been a fortified site since Mycenaean times. (For modern archaeologists, this disaster has turned out to be a blessing in disguise, since the debris, which was subsequently used as fill, has yielded many fine Archaic pieces, such as those in figures 149, 150, 152, and 153, which would hardly

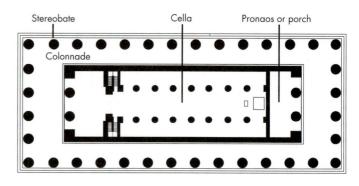

167. Plan of the "Temple of Poseidon"

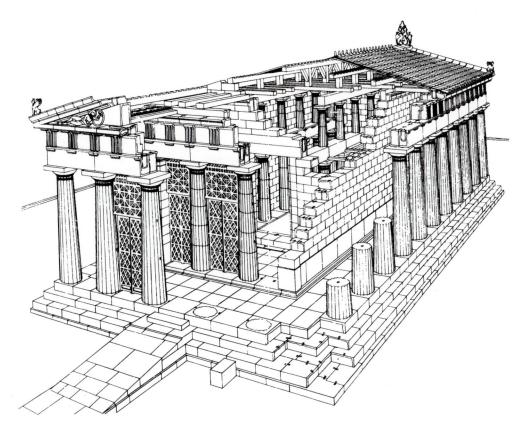

168. Sectional view (restored) of the Temple of Aphaia, Aegina

have survived otherwise.) The rebuilding of the Acropolis under the leadership of Pericles during the later fifth century was the most ambitious enterprise in the history of Greek architecture. [See Primary Sources, no. 12, page 216.] This is all the more surprising in light of the fact that, by today's standards, Athens was only a modest city, even at the height of its power. The Acropolis nevertheless represents the artistic climax of Greek art. Individually and collectively, these structures exemplify the Classical phase of Greek art in full maturity. The inspiration for such a complex can have come only from Egypt. So must Pericles' idea of treating it as a vast public works project, for which he spared no expense.

The greatest temple, and the only one to be completed before the Peloponnesian War (431–404 B.C.), is the Parthenon (figs. 169 and 170), dedicated to the virginal Athena, the patron deity in whose honor Athens was named. Built of marble on the most prominent site along the southern flank of the Acropolis, it dominates the city and the surrounding countryside, a brilliant landmark against the backdrop of mountains to the north. The history of the Parthenon is as extraordinary as its artistic significance. It is the only sanctuary we know that has served four different faiths in succession. The architects Ictinus, Callicrates, and Karpion erected it between 448 and 432 B.C., an amazingly brief span of time for a project of this size.

In order to meet the huge expense of building the largest and most lavish temple on the Greek mainland, Pericles delved into funds collected from states allied with Athens for mutual defense against the Persians. He may have felt that the danger was no longer a real one, and that Athens, the chief victim and victor at the climax of the Persian wars in 480–478 B.C., was

justified in using the money to rebuild what the Persians had destroyed. His act did weaken the position of Athens, however, and contributed to the disastrous outcome of the Peloponnesian War. (Thucydides openly reproached him for adorning the city "like a harlot with precious stones, statues, and temples costing a thousand talents.") In Christian times, the Virgin Mary displaced the virginal Athena: the Parthenon became first a Byzantine church, then a Catholic cathedral. Finally, under the Turks, it was a mosque. It has been a ruin since 1687, when a store of gunpowder the Turks had put into the cella exploded during a siege.

The Parthenon is unconventional in plan (see fig. 171). The cella is unusually wide and somewhat shorter than in other temples, so as to accommodate a second room behind it. The pronaos and its counterpart at the western end have almost disappeared, but there is an extra row of columns in front of either entrance. The architrave above these columns is more Ionic than Doric, since it has no triglyphs and metopes but a continuous sculptured frieze that encircles the entire cella (fig. 170). As the perfect embodiment of Classical Doric architecture, the Parthenon makes an instructive contrast with the "Temple of Poseidon" (fig. 164). Despite its greater size, it seems far less massive. Rather, the dominant impression it creates is one of festive, balanced grace within the austere scheme of the Doric order. This has been achieved by a general lightening and readjustment of the proportions. The entablature is lower in relation to its width and to the height of the columns, and the cornice projects less. The columns themselves are a good deal more slender, their tapering and entasis less pronounced, and the capitals are smaller and less flaring; yet the

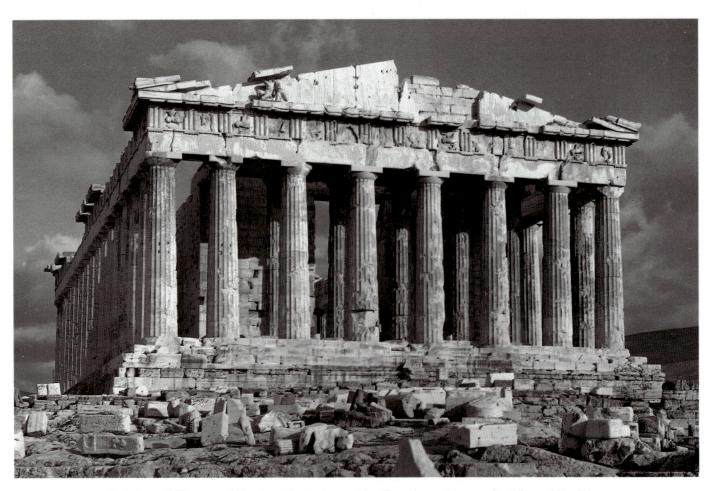

169. Ictinus, Callicrates, and Karpion. The Parthenon (view from the west), Acropolis, Athens. 448–432 B.C.

170. Frieze above the western entrance of the cella of the Parthenon

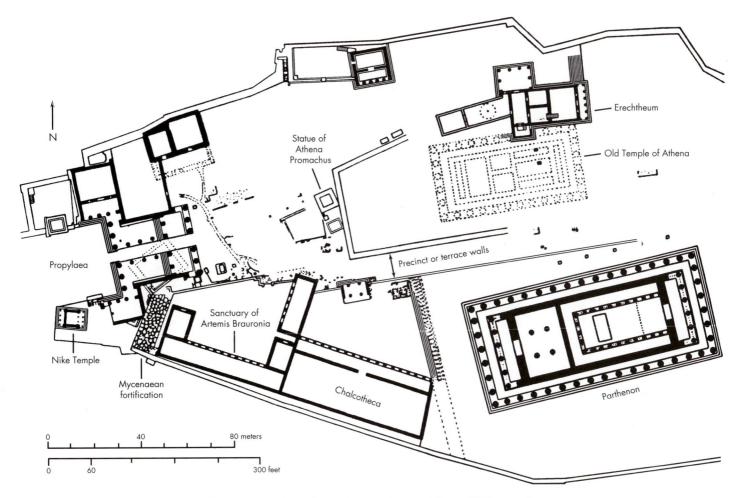

171. Plan of the Acropolis at Athens in 400 B.C. (after A. W. Lawrence)

spacing of the columns has become wider. We might say that the load carried by the columns has decreased, and consequently the supports can fulfill their task with a new sense of ease.

THE PARTHENON'S REFINEMENTS. These so-called refinements, intentional departures from the strict geometric regularity of the design for aesthetic reasons, are another feature of the Classical Doric style that can be observed in the Parthenon better than anywhere else. Thus the stepped platform and the entablature are not absolutely straight but slightly curved, so that the center is a bit higher than the ends; the columns lean inward; the interval between the corner column and its neighbors is smaller than the standard interval adopted for the colonnade as a whole; and every capital of the colonnade is slightly distorted to fit the curving architrave.

A great deal has been written about these deviations from mechanical exactitude. That they are planned rather than accidental is beyond doubt, but why did the architects go to the enormous trouble of carrying them through, since they are not a matter of necessity? They used to be regarded as optical corrections designed to produce the illusion of absolutely straight horizontals and verticals. Unfortunately, this functional explanation does not work. If it did, we should be unable to perceive the deviations except by careful measurement. Yet the fact is that, though unobtrusive, they are visible to the naked eye, even in photographs such as our figure 169. Moreover, in temples that do not have these refinements, the columns do

not give the appearance of leaning outward, nor do the horizontal lines look "dished." Plainly, then, the deviations were built into the Parthenon because they were thought to add to its beauty. They are a positive element that is meant to be noticed. And they do indeed contribute, in ways that are hard to define, to the integral, harmonious quality of the structure. These intentional departures from strict geometric regularity give us visual reassurance that the points of greatest stress are supported and provided with a counterstress as well.

Even this explanation fails to account fully for the Parthenon's remarkable persuasiveness, which has never been surpassed. The Roman architect Vitruvius records that Ictinus based his design on carefully considered proportions. But accurate measurements reveal them to be anything but simple or rigid. They, too, are replete with subtle adjustments, which lend the temple its surprisingly organic quality. In this respect the Parthenon closely parallels the underlying principles of Classical sculpture (see pages 139–40). Indeed, with its sculpture in place the Parthenon must have seemed animated with the same inner life that informs the pediment figures, such as the *Three Goddesses* (fig. 192).

PROPYLAEA. Immediately after the completion of the Parthenon, Pericles commissioned another splendid and expensive edifice, the monumental entry gate at the western end of the Acropolis, called the Propylaea (see plan, fig. 171). It was begun in 437 B.C. under the architect Mnesicles, who

172. Mnesicles. The Propylaea (view from the east), Acropolis, Athens. 437-432 B.C.

completed the main part in five years; the remainder had to be abandoned because of the Peloponnesian War. Again the entire structure was built of marble and included refinements comparable to those of the Parthenon. It is fascinating to see how the familiar elements of a Doric temple have been adapted to a totally different task, on an irregular and steeply rising site. Mnesicles has indeed acquitted himself nobly. His design not only fits the difficult terrain but also transforms it from a rough passage among rocks into a splendid overture to the sacred precinct on which it opens.

Of the two porches (or facades) at either end, only the eastern one is in fair condition today (fig. 172). It resembles a Classical Doric temple front, except for the wide opening between the third and fourth columns. The western porch was flanked by two wings (figs. 173 and 174). The one to the north, considerably larger than its companion, included a picture gallery (*pinakotheke*), the first known instance of a room especially designed for the display of paintings. Along the central roadway that passes through the Propylaea, we find two rows of columns which are Ionic rather than Doric. Apparently at that time the trend in Athenian architecture was toward using Ionic elements inside Doric structures. (We recall the sculptured frieze of the Parthenon cella.)

Ionic Temples

Athens, with its strong Aegean orientation, had shown itself hospitable to the eastern Greek style of building from the

mid-fifth century on, and the finest surviving examples of the Ionic order are to be found among the structures of the Acropolis. The previous development of the order is known only in very fragmentary fashion. Of the huge Ionic temples that were erected in Archaic times on Samos and at Ephesus, little has survived except the plans. The Ionic vocabulary, however, seems to have remained fairly fluid, with strong affinities to the Near East (see figs. 110 and 111), and it did not really become an order in the strict sense until the Classical period. Even then it continued to be rather more flexible than the Doric order. Its most striking features are the continuous frieze, which lacks the alternating triglyphs and metopes of the Doric order, and the Ionic column, which differs from the Doric not only in body but also in spirit (see fig. 162). The Ionic column rests on an ornately profiled base of its own, perhaps used initially to protect the bottom from rain. The shaft is more slender, and there is less tapering and entasis. The capital shows a large double scroll, or volute, below the abacus, which projects strongly beyond the width of the shaft.

That these details add up to an entity very distinct from the Doric column becomes clear as soon as we turn from the diagram to an actual building (fig. 177). How shall we define it? The Ionic column is lighter and more graceful than its mainland cousin. It lacks the latter's muscular quality. Instead, it evokes a growing plant, something like a formalized palm tree. This vegetal analogy is not sheer fancy, for we have early ancestors, or relatives, of the Ionic capital that bear it out

173. The Propylaea (with *pinakotheke*), western entrance

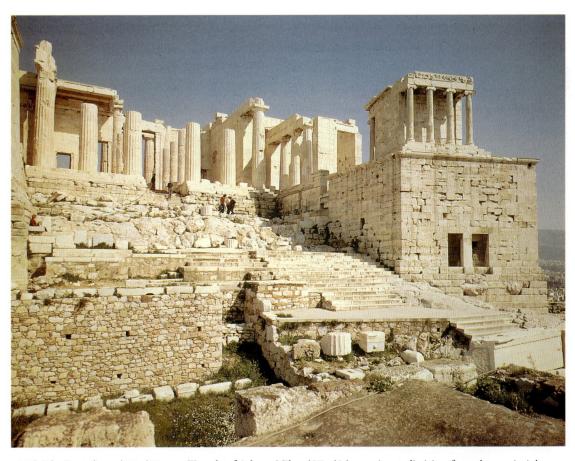

174. The Propylaea, 437–432 B.C.; Temple of Athena Nike, 427–424 B.C., Acropolis (view from the west), Athens

(fig. 175). If we were to pursue these plantlike columns all the way back to their point of origin, we would eventually find ourselves at Saqqara, where we encounter not only "proto-Doric" supports but also the wonderfully graceful papyrus half-columns of figure 58, with their curved, flaring capitals. It may well be, then, that the form of the Ionic column, too, had its ultimate source in Egypt, but instead of reaching Greece by sea, as we suppose the proto-Doric column did, it traveled a slow and tortuous path by land through Syria and Asia Minor.

In pre-Classical times, the only Ionic structures on the Greek mainland had been the small treasuries built by eastern Greek states at Delphi in the regional styles (see fig. 157). Hence the Athenian architects who took up the Ionic order about 450 B.C. at first thought of it as suitable only for small temples of simple plan. Such a building is the little Temple of Athena Nike on the southern flank of the Propylaea (fig. 174),

175. *(far left)* Aeolian capital, from Larissa. c. 600 B.C. Archaeological Museum, Istanbul, Turkey

176. (*left*) Corinthian capital, from the Tholos at Epidaurus. c. 350 B.C. Museum, Epidaurus, Greece

probably built between 427 and 424 B.C. from a design prepared 20 years earlier by Callicrates.

ERECHTHEUM. Larger and more complex is the Erechtheum (fig. 177 and plan, fig. 171) on the northern edge of the Acropolis opposite the Parthenon. It was erected between 421 and 405 B.C., probably by Mnesicles. Like the Propylaea, it is masterfully adapted to an irregular, sloping site. The area had various associations with the mythical founding of Athens, so that the Erechtheum served several religious functions at once. Apparently there were four rooms, in addition to a basement on the western side, although their exact purpose is under dispute. One held a statue of Erechtheus, a legendary king of Athens, who promoted the worship of Athena and from whom the building derives its name. The Erechtheum may have covered the spot where the contest between Athena and Poseidon, depicted on the east pediment of the Parthenon, was believed to have taken place. In any event, the eastern room was dedicated to Athena Polias (Athena the City Goddess) and contained the old statue replaced by Phidias, while another room was dedicated to Poseidon.

Instead of a west facade, the Erechtheum has two porches attached to its flanks, a very large one facing north and a small

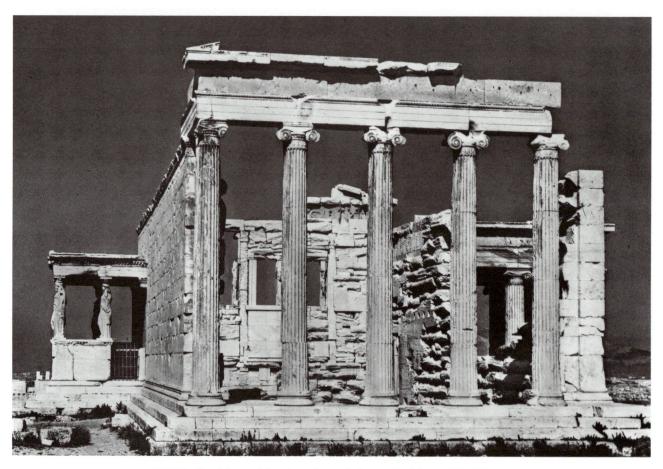

177. The Erechtheum (view from the east), Acropolis, Athens. 421-405 B.C.

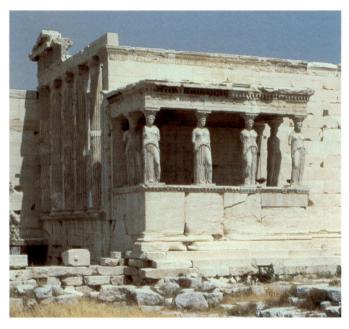

178. Porch of the Maidens, the Erechtheum, Acropolis, Athens. 421–405 B.C.

one toward the Parthenon. The latter is the famous Porch of the Maidens (fig. 178), so named because its roof is supported by six female figures (caryatids) on a high parapet, instead of regular columns (compare fig. 157). Here the exquisite refinement of the Ionic order conveys what Vitruvius might have called a "feminine" quality, compared with the "masculinity" of the Parthenon across the way. [See Primary Sources, no. 8, page 215.] Apart from the caryatids, sculptural decoration on the Erechtheum was confined to the frieze, of which very little survives. The pediments remained bare, perhaps for lack of funds at the end of the Peloponnesian War. However, the ornamental carving on the bases and capitals of the columns, and on the frames of doorways and windows, is extraordinarily delicate and rich. Its cost, according to the accounts inscribed on the building, was higher than that of figure sculpture.

CORINTHIAN CAPITAL. Such emphasis on ornament seems characteristic of the late fifth century. It was at this time that the Corinthian capital was invented as an elaborate substitute for the Ionic. (For a comparison of Doric, Ionic, and Corinthian capitals, see fig. 162.) Its shape is that of an inverted bell covered with the curly shoots and leaves of the acanthus plant, which seem to sprout from the top of the column shaft (fig. 176). At first, Corinthian capitals were used only for interiors. Not until a century later do we find them replacing Ionic capitals on the exterior. The earliest known instance is the Monument of Lysicrates in Athens (fig. 179), built soon after 334 B.C. It is not really a building in the full sense of the term the interior, though hollow, has no entrance—but an elaborate support for a tripod won by Lysicrates in a contest. The round structure, resting on a tall base, is a miniature version of a tholos, a type of circular building of which several earlier examples are known to have existed. The columns here are engaged rather than free-standing, to make the monument more compact. Soon after, the Corinthian capital came to be employed on the exteriors of large buildings as well, and in Roman times it was the standard capital for almost any purpose.

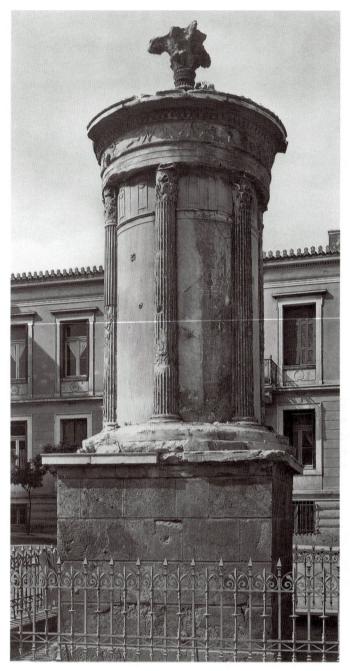

179. Monument of Lysicrates, Athens. c. 334 B.C.

TOWN PLANNING AND THEATERS. During the three centuries between the end of the Peloponnesian War and the Roman conquest, Greek architecture shows little further development. Even before the time of Alexander the Great, the largest volume of building activity was to be found in the Greek cities of Asia Minor. There we encounter some structures of a new kind, often under Oriental influence, such as the huge Tomb of Mausolus at Halicarnassus (see figs. 202-204) and the Great Pergamum Altar (see figs. 211-13). Town planning on a rectangular grid pattern, first introduced at Miletus in the mid-fifth century, assumed new importance, as did the municipal halls (stoas) lining the marketplaces where the civic and commercial life of Greek towns was centered. Private houses, too, became larger and more ornate than before. Yet the architectural vocabulary, aesthetically as well as technically, remained essentially that of the temples of the late fifth century.

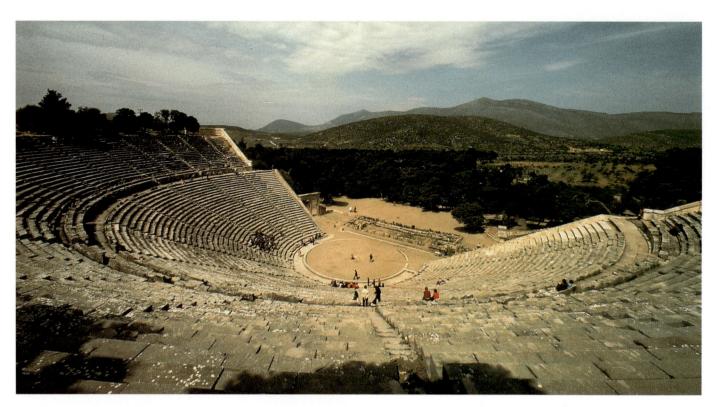

180. Theater, Epidaurus. c. 350 B.C.

The basic repertory of Greek architecture increased in one respect only: the open-air theater achieved a regular, defined shape. Before the fourth century, the auditorium had simply been a natural slope, preferably curved, equipped with stone benches. Now the hillside was provided with concentric rows of seats and with staircase-aisles at regular intervals, as at Epidaurus (figs. 180 and 181). In the center is the orchestra, where most of the action took place.

Contribution of Greek Architecture

In the end, the greatest achievement of Greek architecture was much more than just beautiful buildings. Greek temples are governed by a structural logic that makes them look stable because of the precise arrangement of their parts. The Greeks tried to regulate their temples in accordance with nature's harmony by constructing them of measured units which were so proportioned that they would all be in perfect agreement. ("Perfect" was as significant an idea to the Greeks as "forever" was to the Egyptians.) Now architects could create organic unities, not by copying nature, not by divine inspiration, but by design. Thus their temples seem to be almost alive. They achieved this triumph chiefly by expressing the structural forces active in buildings, known as architectonics. In the Classical period, expressions of force and counterforce in both Doric and Ionic temples were proportioned so exactly that their opposition produced the effect of a perfect balancing of forces and harmonizing of sizes and shapes. This, then, is the real reason why, for so many centuries, the orders have been considered the only true basis for beautiful architecture. They are so perfect that they could not be surpassed, only equaled.

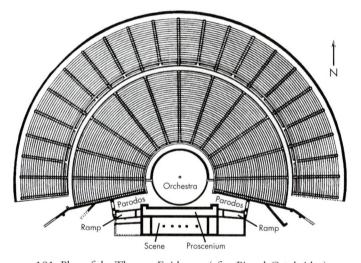

181. Plan of the Theater, Epidaurus (after Picard-Cambridge)

Limitations of Greek Architecture

How are we to account for the fact that Greek architecture did not grow significantly beyond the stage it had reached at the time of the Peloponnesian War? After all, neither intellectual life nor the work of sculptors and painters show any tendency toward staleness during the last 300 years of Greek civilization. Are we perhaps misjudging her architectural achievements after 400 B.C.? Or were there inherent limitations that prevented Greek architecture from continuing the pace of development it had maintained in Archaic and Classical times? A number of such limitations come to mind: the concern with monumental exteriors at the expense of interior space, the concentration of effort on temples of one particular type, and the lack of inter-

est in any structural system more advanced than the post-andlintel (uprights supporting horizontal beams). Until the late fifth century, these had all been positive advantages. Without them, the great masterpieces of the Periclean age would have been unthinkable. But the possibilities of the traditional Doric temple were nearly exhausted by then, as indicated by the attention lavished on expensive refinements.

What Greek architecture needed after the Peloponnesian War was a breakthrough, a revival of the experimental spirit of the seventh century, that would create an interest in new building materials, vaulting, and interior space. What prevented the breakthrough? Could it have been the architectural orders, or rather the cast of mind that produced them? The suspicion will not go away that it was the very coherence and rigidity of these orders which made it impossible for Greek architects to break from the established pattern. What had been their great strength in earlier days became a tyranny. It remained for later ages to adapt the Greek orders to brick and concrete, to arched and vaulted construction. Such adaptation necessitated doing a certain amount of violence to the original character of the orders, something the Greeks, it seems, were incapable of.

CLASSICAL SCULPTURE

KRITIOS BOY. Among the statues excavated from the debris the Persians had left behind on the Acropolis, there is one Kouros (fig. 182) that stands apart from the rest. It must have been carved very shortly before the fateful year 480 B.C. This remarkable work, which some have attributed to the Athenian sculptor Kritios and which therefore has come to be known as the *Kritios Boy,* differs subtly but importantly from the Archaic Kouros figures we discussed above (figs. 147 and 148): it is the first statue we know that *stands* in the full sense of the word. Of course, the earlier figures also stand, but only in the sense that they are in an upright position and are not reclining, sitting, kneeling, or running. Their stance is really an arrested walk, with the weight of the body resting evenly on both legs. Thus, early Greek statues have an unintentional military air, as if they were soldiers standing at attention.

The Kritios Boy, too, has one leg placed forward, yet we never doubt for an instant that he is standing still. Just as in military drill, this is simply a matter of allowing the weight of the body to shift from equal distribution on both legs. When we compare the left and right half of his body, we discover that the strict symmetry of the Archaic Kouros has given way to a calculated nonsymmetry. The knee of the forward leg is lower than the other, the right hip is thrust down and inward, and the left hip up and outward. If we trace the axis of the body, we realize that it is not a straight vertical line but a faint, S-like curve (or, to be exact, a reversed S-curve). Taken together, all these small departures from symmetry tell us that the weight of the body rests mainly on the left leg and that the right leg plays the role of an elastic prop or buttress to make sure that the body keeps its balance.

CONTRAPPOSTO. The *Kritios Boy*, then, not only stands, he stands at ease. The artist has masterfully observed the balanced nonsymmetry of this relaxed natural stance. To describe

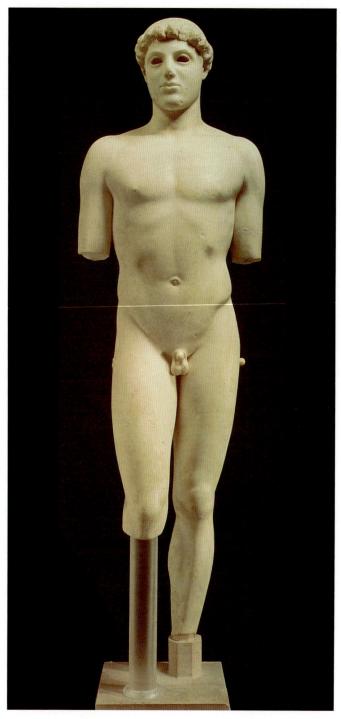

182. Standing Youth (Kritios Boy). c. 480 B.C. Marble, height 46" (116.7 cm). Acropolis Museum, Athens

it, we use the Italian word *contrapposto* (counterpoise). The leg that carries the main weight is commonly called the engaged leg; the other, the free leg. These terms are a useful shorthand, for from now on we shall have frequent occasion to mention contrapposto. It was a very basic discovery. Only by learning how to represent the body at rest could the Greek sculptor gain the freedom to show it in motion. But is there not plenty of motion in Archaic art? There is indeed (see figs. 154, 158, 160, and 161), but it is somewhat mechanical and inflexible in kind. We read it from the poses without really feeling it.

In the Kritios Boy, on the other hand, we sense for the first

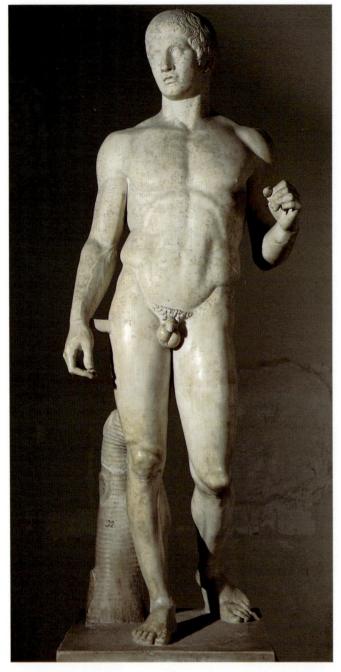

183. *Doryphorus (Spear Bearer)*. Roman copy after an original of c. 450–440 B.C. by Polyclitus. Marble, height 6'6" (2 m). Museo Archeologico Nazionale, Naples

time not only a new repose but an animation of the body structure that evokes the experience we have of our own body, for contrapposto brings about all kinds of subtle curvatures: the bending of the free knee results in a slight swiveling of the pelvis, a compensating curvature of the spine, and an adjusting tilt of the shoulders. Like the refined details of the Parthenon, these variations have nothing to do with the statue's ability to maintain itself erect but greatly enhance its lifelike impression. In repose, it will still seem capable of movement; in motion, of maintaining its stability. Life now suffuses the entire figure, so

that the Archaic smile, the "sign of life," is no longer needed. It has given way to a serious, pensive expression characteristic of the early phase of Classical sculpture (or, as it is often called, the Severe style). Once the Greek statue was free to move, as it were, it became free to think, not merely to act. The two are inseparable aspects of Greek classicism.

The new articulation of the body that appears in the *Kri*tios Boy was to reach its full development within half a century in the mature Classical style of the Periclean era. The most famous Kouros statue of that time, the Doryphorus (Spear Bearer) by Polyclitus (fig. 183), is known to us only through Roman copies, which must convey little of the beauty of the original. Still, it makes an instructive comparison with the Kritios Boy. Everything is a harmony of complementary opposites. The contrapposto is now much more emphatic. The differentiation between the halves of the body can be seen in every muscle, and the turn of the head, barely hinted at in the Kritios Boy, is pronounced. The "working" left arm is balanced by the "engaged" right leg in the forward position, and the relaxed right arm by the "free" left leg. This studied poise, the precise anatomical details, and above all the harmonious proportions of the figure made the *Doryphorus* renowned as the standard embodiment of the Classical ideal of beauty. The ideal here must be understood in a dual sense as perfect model and universal prototype. According to one ancient writer, it was known simply as the Canon (rule, measure). [See Primary Sources, no. 5, pages 213–14.]

The Doryphorus was not simply an exercise in abstract geometry. It embodied not only symmetria (proportion), but also rhythmos (composition, movement), both fundamental aspects of Greek aesthetics derived from music and dance (see box pages 142-43). A faith in ratio can be found throughout Greek philosophy from the Pythagoreans, who believed that the harmony of the universe, like musical harmony, was expressible mathematically, to Plato, who made numbers the basis of his doctrine of ideal forms and acknowledged that the concept of beauty was commonly based on proportion. Moreover, Polyclitus' faith in numbers had a moral dimension: contemplation of harmonious proportions was equated with contemplation of the good. Rather than being opposed to naturalism, this elevated conception was inseparably linked to a more careful treatment of form that endows the human figure with a heightened liveliness as well as greater realism. Classical Greek sculpture appeals equally to the mind and the eye, so that human and divine beauty become one. No wonder that figures of victorious athletes have sometimes been mistaken for gods!

We can get some idea of what the *Doryphorus* might have looked like in its bronze original from a pair of impressive figures that created a sensation when they were found in the sea near Riace, Italy, in 1972 (figs. 184 and 185). They owe their importance to their fine workmanship and the extreme rarity of intact monumental bronze statues from ancient Greece. Miraculously, they still have their ivory and glass-paste eyes, bronze eyelashes, and copper lips, which combine with the detailed anatomy to create an astonishingly lifelike presence. They challenge our understanding of Greek sculpture in many ways. What or whom do these statues represent? When and where were they made? What purpose did they serve? To such questions we have as yet no certain answers. From both the

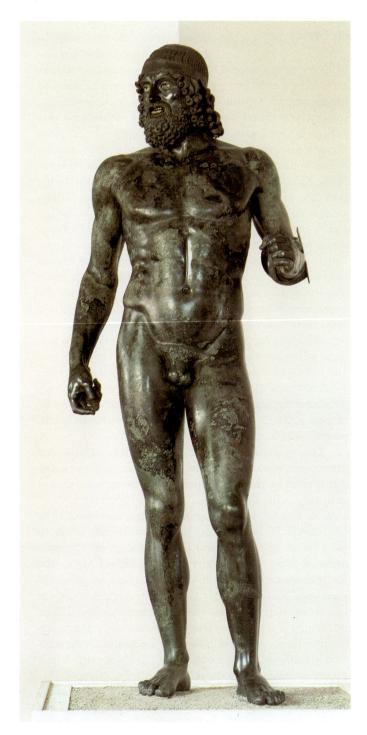

184. *Riace Warrior A*, found in the sea off Riace, Italy. c. 450 B.C. Bronze, height 6'8" (2.03 m). Museo Archeologico, Reggio Calabria, Italy

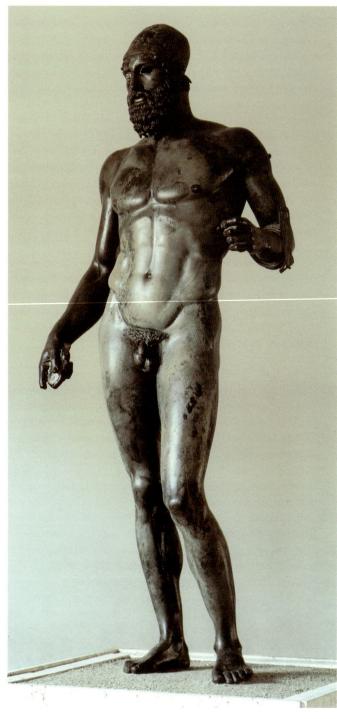

185. *Riace Warrior B*, found in the sea off Riace. c. 450 B.C. Bronze, height 6'8" (2.03 m). Museo Archeologico, Reggio Calabria

stylistic and technical evidence, they would seem to have been made around the same time as the *Doryphorus*. Although they have sometimes been dated slightly earlier, our sculptor may well have been an older artist who was accustomed to working in the Severe style and had not fully adapted to the new Classicism. (Compare the heads to that of *Zeus* in fig. 188.)

A tantalizing clue is provided by the statue in figure 185, which conforms to a widespread type right down to the proportions. (Examples of the second figure, however, are otherwise unknown.) He is, it appears, a warrior rather than an

athlete, in contrast to the *Doryphorus*. Still to be explained is the extraordinary realism of the heads, so out of keeping with the idealization characteristic of Greek art as a whole. Were they meant to commemorate two heroes? It is tempting to think so. If that is the case, why were their names not recorded by ancient historians? Moreover, portraits are unknown from this time. Perhaps, then, their features were varied merely to distinguish the two among a larger group of unprecedented size, although free-standing groups of more than two figures are not recorded before the Late Classical era.

Although the earliest surviving evidence of Greek culture can be

traced back to the eighth century B.C., it must have been preceded by at least 400 years now lost to us. In the eighth century we find the earliest remnants of Greek sculpture, painting, and architecture, however primitive they may be; the beginnings of Greek philosophy at Miletus; and, above all, the creation of two epic poems, the *lliad* and the *Odyssey* (which probably treat an actual war of about 1200 B.C.), out of preexisting material. Homer, to whom these poems are attributed, lived in Asia Minor and chanted his poetry while playing a lyre. This unity of words and music, epitomized by the legendary bard Orpheus, whose music, it was said, could move even stones, was to be a constant feature of Greek poetry and theater.

Early Greek music as sung by the bards was of a very rudimentary sort called stithic: melodies consisted of only three or four notes sung repetitively in lines of simple rhythm and unchanging length. There was also a strophic form that could be closed (small, using a few basic meters, and clear in structure) or open (larger, more complex, with no fixed meter). Early Greek vocal music was accompanied by lyres having but a few strings ("lyric" poetry was sung to a lyre) or a primitive form of the aulos, an oboelike reed instrument that was always played in pairs. The harp, an import from Lydia and Ionia in Asia Minor, was preferred by Sappho of Lesbos (early sixth century B.C.) and remained chiefly an instrument for women, though it was also taken up by Alcaeus.

Because it involved only four notes, early Greek music was organized in tetrachords. At first, it was governed by the "enharmonic" (in tune) genus, meaning that the two inner (moving) notes were lower than the two outer (standing) ones and were separated by about a quarter-tone. By the fifth century B.C., a second genus, chromaticism, in which the moving notes of the tetrachord are separated by a semitone, began to gain favor because it was easier to play. Chromaticism virtually displaced the enharmonic genus toward the end of the fourth century B.C. Even easier was the diatonic genus, using full and half-tones, which was used for most late Greek music, as it has been for the vast majority of Western music since then. Two successive tetrachords were joined by a common note to form a seven-note scale, which gave rise to the standard seven-string kithara (lyre). Not until the early seventh century B.C. was the scale extended to the modern octave by Terpander. The concordant intervals nevertheless remained the fourth and the fifth, not the third and fifth

These scales, with their varying intervals, were the basis of the modes. Although the notes can be reconstructed readily enough, each mode had certain rhythms, meters, and melodies associated with it that lent it a distinctive character

(ethos) but that can only be guessed at, since all that remains

of Greek music is some 51, mostly late, fragments supplemented by a small but crucial body of theory. The standard modes were the Dorian, used for invocations, lamentations, tragedy, and choral songs; the Phrygian, introduced into Athens by Sophocles, which could be cheerful and pious according to the philosopher Plato (427?-347 B.C.), or wildly emotional (orgiastic) according to his successor, Aristotle (384–322 B.C.); the Lydian, a "slack" (soft) mode used by the poet Anacreon (c. 570–c. 485 B.C.) at symposia that perhaps arose from the aulos airs composed by Olympus in the late eighth century B.C.; the Mixolydian, a highly emotional mode used by Sappho and deemed especially suitable for laments, which was the main tragic mode with the Dorian before the time of Sophocles; and the Ionian, a slack mode that was derived from Asiatic laments and was therefore also appropriate for tragedy. All other modes were likely derived from these five, whose names attest to the fact that Greece was a vast melting pot both musically and ethnically. In fact, there were rival musical centers throughout Greece. Sparta and Lesbos were the leaders throughout the seventh century B.C., only to be succeeded by Argos during the sixth century B.C., until Syracuse emerged as the capital of Greek music around 450 B.C., though Thebes continued to maintain its preeminence in the aulos.

The modes could be varied through modulations of genus, scale, key, and ethos. The growing complexity of music was spurred by the rise of instrumental music independent of singing. It began in Phrygia in the late eighth century B.C. with the first aulos player (*aulete*), variously considered to be Olympus or Hyagnis (Agnis), and was sufficiently advanced for a piper's contest (agones) to be added to the Phrygian games in 586 B.C., which was won by Sakada of Argos. The first kithara contest was added to the Phrygian games 28 years later. No longer tied to words, instrumental music was free to develop ever more novel, complex forms. It also underwent a change in character toward the ecstatic, serpentine music still found in the Near East today. By the midfifth century B.C., the emphasis was on virtuosity, which inevitably influenced vocal music as well. For example, Pindar (518?-c. 438 B.C.), the great composer of odes (music meant to be sung by a chorus), emphasized the intricacy and variety of his music. This trend reached its zenith in the late fifth century B.C. under Melanippides of Melos, a composer who created a more expressive singing style shaped to the words, and Timotheus the Milesian, whose Persians strikingly anticipates The Battle of Issus (fig. 199) in its representation of the sounds and color of combat. These innovations, however, met with stiff resistance from conservatives, who decried the loss of simplicity and dignity in favor of corrupt styles catering to popular taste. After the invention in the sixth century B.C. of sophisticated lyres and auloi that could change modes without retuning, it became essential to unify the scales. The first coherent system was devised in the fourth century B.C. by Aristoxenus of Tarentum, a pupil of Aristotle, who devised a 13-note scale that was eventually superseded by a 15-note "perfect system," despite the attempt of Ptolemy in the second century B.C. to reduce the number back to seven. Surprisingly, the great age of Greek music was soon over. By the early fourth century, composers were replaced by star performers, who relied for the most part on the music of the past.

Music was of great importance in ancient Greece. The word *music* derives from *muse*, the personification and inspiration of the nine branches of art and learning. Thus, an educated person was a "musical" person. Music was closely linked to art through philosophy. Pythagoras (c. 582-c. 507 B.C.), who believed that the universe was governed by numbers, is generally credited with discovering that an octave is exactly half the length of the next lower one on a monochord over a graduated rule (kanon), although it may have actually been invented by the fifth-century theorist Simos. Also during the sixth century, Epigonos used a zither divided into quarter-tones to determine the relationships between the modal scales. From then on, Greek aesthetics as a branch of formal philosophical inquiry was founded on the belief in harmonious proportion, despite the fact that musical theory for the most part continued to be based on tonal intervals, which do not bear a simple mathematical relationship to each other. The importance of ratio was acknowledged by the great philosopher Plato, to whom we also owe the phrase "the music of the spheres," which was represented by eight Sirens taken from the eight notes of the standard diatonic scale.

During the fifth century B.C., moreover, Greek sculptors sought to infuse their work with inner life by investing it with rhythmos (composition, movement) and symmetria (proportion), terms taken from music and dance with strong philosophical connotations. Moreover, beauty itself was regarded by Plato and his successor, Aristotle, the teacher of Alexander the Great, as having inherent ethical associations and educative functions. This concept, too, was rooted in music. It was first adumbrated in the 440s by Damon, Pericles' teacher, who spelled out a comprehensive theory of modes according to their expressive effect and impact on character. Damon warned against revolutions in music as bad for society, an idea taken up as well by Plato, who had studied music under Damon's pupil Dracon. While it was challenged by the Epicurean philosophers in particular, the concept of musical ethos reached its height with Ptolemy, whose system of cosmic proportions was founded very much on his belief in the "tuning" of the soul.

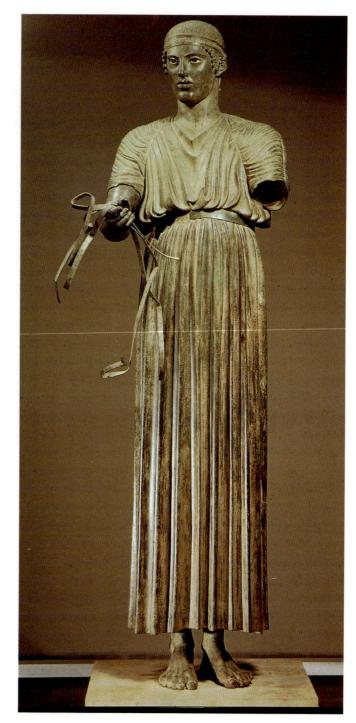

186. *Charioteer*, from the Sanctuary of Apollo at Delphi. c. 470 B.C. Bronze, height 71" (180 cm). Archaeological Museum, Delphi

This might help to explain why they seem to embody such a distinctive ethnic type. Conceptually, they are not altogether satisfying: the contrast between the individuality of the faces and the generalized treatment of the bodies is at once fascinating and disturbing. Were there similar statues about which we are ignorant simply because they have not survived? Our view of Greek sculpture may be as distorted by the incomplete record as was that of the poet Goethe, who could not accommodate the Aegina statues of Greek art into his understanding.

SEVERE STYLE. The splendid *Charioteer* from Delphi (fig. 186), one of the earliest surviving large bronze statues in

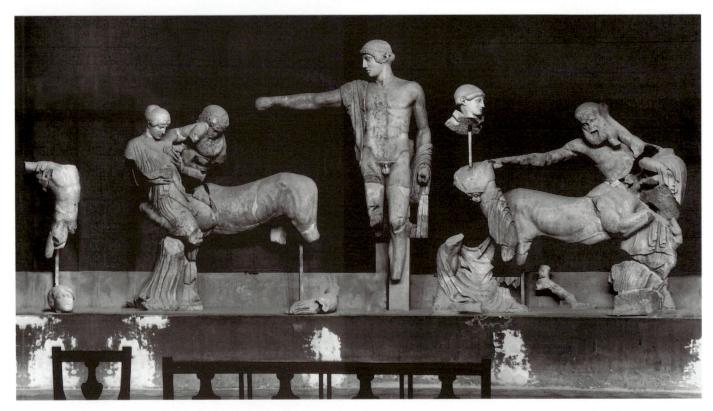

187. Photographic reconstruction (partial) of the *Battle of the Lapiths and Centaurs*, from the west pediment of the Temple of Zeus at Olympia. c. 460 B.C. Marble, slightly over-lifesize. Archaeological Museum, Olympia

Greek art, shows why the Severe style has been chosen as the term to describe the character of Greek sculpture during the years between about 480 and 450 B.C. It must have been made about a decade later than the *Kritios Boy*, as a votive offering after a race: the young victor originally stood on a chariot drawn by four horses. Despite the long, heavy garment, we sense a hint of contrapposto in the body. The feet are carefully differentiated so as to inform us that the left leg is the engaged one, and the shoulders and head turn slightly to the right. The garment is severely simple, yet compared with Archaic drapery the folds seem softer and more pliable. We feel (probably for the first time in the history of sculpture) that they reflect the behavior of real cloth.

Not only the body but the drapery, too, has been transformed by a new understanding of functional relationships, so that every fold is shaped by the forces that act upon it: the downward pull of gravity, the shape of the body underneath, and the belts or straps that constrict its flow. The face has the pensive, somewhat faraway look we saw in the *Kritios Boy*, but the color inlay of the eyes (fortunately preserved in this instance), as well as the slightly parted lips, give it a more animated expression. The bearing of the entire figure conveys the solemnity of the event it commemorates, for chariot races and similar contests at that time were competitions for divine favor, not sporting events in the modern sense.

TEMPLE OF ZEUS, OLYMPIA. The greatest sculptural ensemble of the Severe style is the pair of pediments of the Temple of Zeus at Olympia, carved about 460 B.C. and now

reassembled in the local museum. In the west pediment, the more mature of the two, we see the victory of the Lapiths over the Centaurs. Centaurs were the offspring of Ixion, king of the Lapiths, and a phantom of Hera, whom he tried to seduce while in Olympus, where Zeus brought him to be purified for having murdered his father-in-law in order to avoid paying for his bride. In punishment for his impiety, Ixion was chained forever to a fiery wheel in Tartarus. Since they were the half-brothers of the Lapiths, the Centaurs were invited to the wedding of the Lapith king Peirithoös and Hippodamia, but because they were half-animals, they became drunk and got into a brawl with the Lapiths, who eventually subdued them.

The action takes place under the aegis of Apollo, who forms the center of the composition (fig. 187). His commanding figure is part of the drama and yet above it. The outstretched right arm and the strong turn of the head show his active intervention. He wills the victory but, as befits a god, does not physically help to achieve it. Nevertheless, there is a tenseness, a gathering of forces, in this powerful body that makes its outward calm doubly impressive. The forms themselves are massive and simple, with soft contours and undulating, continuous surfaces. In the group of the Centaur king, Eurytion, who has seized Hippodamia, we witness another achievement of the Severe style. The passionate struggle is expressed not only through action and gesture but through the emotions mirrored in the face of the Centaur, whose pain and desperate effort contrast vividly with the stoic calm on the face of the woman.

To the Greek, pose and expression conveyed character and feeling, which revealed the inner person and, with it, *arete*

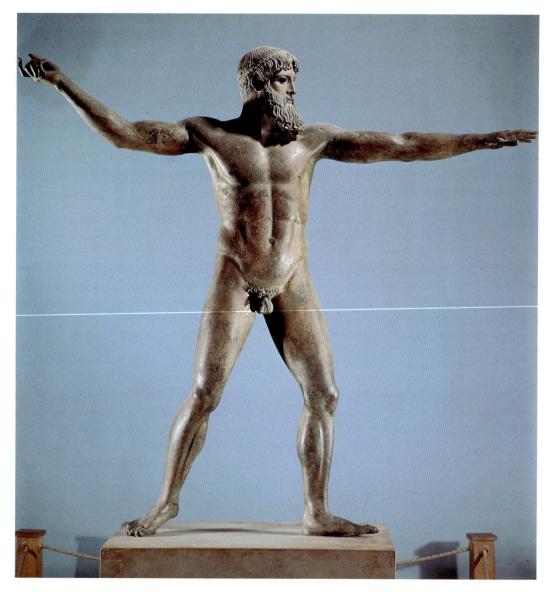

188. Zeus. c. 460-450 B.C. Bronze, height 6'10" (2.08 m). National Archaeological Museum, Athens

(excellence or virtue). The pediment makes a clear moral distinction in the contrast between the bestial Centaurs and the human protagonists, who partake of Apollo's nobility. Thus it is Apollo, as the god of music and poetry, who emerges as the real hero by ensuring the triumph of civilization. In general, the pediment stands for the victory of humanity's rational and moral sides over its animal nature. More specifically, however, it refers to the military threat of the Persians under Darius and his son, Xerxes I, which was repulsed by the Athenian navy at Marathon and Greek forces at the pass of Thermopylae in 480 B.C.

MOVEMENT IN STATUES. No Archaic artist would have known how to combine the two figures of Hippodamia and the Centaur into a group so compact, so full of interlocking movements. Strenuous action, of course, had already been investigated in pedimental sculpture of the late Archaic period (see figs. 160 and 161). However, such figures, although technically carved in the round, are not free-standing. They represent, rather, a kind of super-relief, since they are designed

to be seen against a background and from one direction only. To infuse the same freedom of movement into genuinely free-standing statues was a far greater challenge. Not only did it run counter to an age-old tradition that denied mobility to these figures, but also the unfreezing had to be done in such a way as to safeguard their all-around balance and self-sufficiency. The problem could not really be tackled until the concept of contrapposto had been established, but once this was done, the solution no longer presented serious difficulties.

Large, free-standing statues in motion are the most important achievement of the Severe style. The finest figure of this kind was recovered from the sea near the coast of Greece (fig. 188): a magnificent nude bronze, almost seven feet tall, of Zeus throwing a thunderbolt. Here, stability in the midst of action becomes outright grandeur. The pose is that of an athlete, yet it is not so much the arrested phase of a continuous succession of movements as an awe-inspiring gesture that reveals the power of the god. Hurling a weapon thus becomes a divine attribute here, rather than a specific act aimed at a particular adversary.

Greek tragic theater combined not only words and music but

dance as well, reflecting its origin in rites, known as dithyrambs, which began in the ninth century B.C. as part of the orgies held four times yearly in honor of the wine god Dionysus (see page 113). (Tragedy meant goat song in ancient Greek.) These theatrical presentations were improvised until the early sixth century B.C., when they began to be set down in literary form by Arion of Corinth (c. 625-585 B.C.), which also claimed to have invented comedy. But the main development of Greek theater began in 534 B.C., the year Athens reorganized the Dionysian festival and held the first drama contest, won by Thespis, who added spoken texts to what had previously been sung. (Thespis, who was also the first actor, is honored with the term thespian to denote actors and actresses.) Unfortunately, we have only 31 plays out of the more than 1,000 that are recorded. These were composed by four writers in Athens during the fifth century B.C., all of whom possessed very different personalities. Of these authors, Aeschylus (c. 523-456) was the most philosophical, Sophocles (c. 496-406) the most pyschologically penetrating, and Euripides (c. 480-406) the most modern and gripping, albeit the least skillful. Despite their great differences, they all relied on past myths and history, which they freely altered.

Initially the author was also the principal actor, but this practice became unnecessary, as well as undesirable, after Aeschylus introduced a second actor, to which Sophocles added a third. In addition to writing and directing his play, each author was generally responsible for composing his own music, training the actors and chorus, and devising his own choreography for the annual contests. Even when the number of festivals was increased over time, acting never became a full-time profession, and the chorus was always made up solely of amateurs, though their training was as rigorous as a soldier's. Despite the fragmentary remains, we know that substantial portions of Greek tragedies were set to music: the Greek chorus, for example, intoned its lines to musical accompaniment while moving in intricate patterns on the stage. Although Sophocles introduced new musical modes and Euripides promoted chromaticism, drama generally followed the lead of the dithyrambs and citharodes (kithara players) in musical matters. Thus, Agathon, who won his first tragedy contest in 416, was an unabashed modernist noted for his sensuous and intricate melodies.

Our understanding of Greek tragedy is largely formed by Aristotle's *Poetics*, which were derived from his lectures at the Lyceum in Athens around 335 B.C. With his inquisitive mind, everything became the subject of systematic philo-

sophical thought. Aristotle's argument proceeds from the belief

that tragedy is the highest form of drama and that Oedipus Rex by Sophocles is its greatest representative. His theory is based on the complex idea of imitation, by which he means "not of men but of life, an action," which is conveyed by plot, words, song, costumes, and scenery. Plot is the very soul of tragedy, for through it is revealed the moral character (ethos) of the protagonist. In "complex" dramas, the protagonist achieves a new understanding (peripety) as a consequence of a reversal in fortune, which is brought about by error (hamartia) rather than evil intent. To be successful, the plot must have unity of action and preferably take place within one day, though not necessarily in the same place, as later theorists proclaimed. The concept of overweening pride (hubris) ascribed to Aristotle is nowhere to be found in the *Poetics*, and the importance of emotional release (*kathar*sis) has been overstated, thanks to Sigmund Freud, the founder of early-twentieth-century psychiatry.

Comedy was represented by the bawdy satyr play, the distant ancestor of modern burlesque theater, which was apparently invented by Pratinas in the late sixth century B.C. The only surviving examples are Euripides' *Cyclops* and a fragment from Sophocles' *The Trackers*, which are parodies of tragic dramas. Entirely different in character and perhaps origin are the comic plays of Aristophanes (c. 448–c. 388 B.C.), which are commentaries on the contemporary scene: society, politics, war, and literature. No subject was too sacred for his irreverent satire. His favorite targets were philosophers and his fellow dramatists. Nothing of later Greek comedy remains, but we know from other documents that it centered on the daily life of the middle class.

Perhaps surprisingly, the visual arts contributed little to Greek theater, which made sparse use of scenery. (The term derives from skena, the hut where actors changed their costumes.) Scene painting probably began around the middle of the fifth century B.C. and is variously credited to Aeschylus or Sophocles. According to the first century B.C. Roman architect and historian Vitruvius, scene painting consisted of architectural designs on a flat surface; it also made use of pinakes (painted panels) and periaktoi (triangular prisms) that were rotated. However, like the poet Horace, who wrote about Greek tragedy and comedy, Vitruvius looked on the Classical past through distinctly Roman eyes. In actual fact, scenery was probably very simple and changes minimal. Indeed, the advances sometimes attributed to Greek scenographers, especially in illusionism, appear to have been much later developments made in Roman times not long before Vitruvius himself.

Some years after the *Zeus*, about 450 B.C., Myron created his famous bronze statue of the *Discobolus (Discus Thrower)*, which came to enjoy a reputation comparable to that of the *Doryphorus*. Like the latter, it is known to us only from Roman copies (fig. 189). [See Primary Sources, no. 5, pages 213–14.] Here the problem of how to condense a sequence of movements into a single pose without freezing it is a much more complex one. It involves a violent twist of the torso in order to

bring the arms into the same plane as the action of the legs. The pose conveys the essence of the action by presenting the fully coiled figure in perfect balance. (The copy makes the design seem harsher and less poised than it was in the original.)

CLASSICAL STYLE. The *Discobolus* brings us to the threshold of the second half of the century, the era of the mature Classical style. The conquest of movement in a free-standing

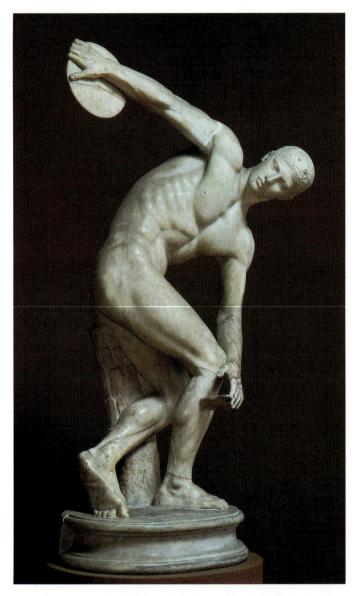

189. *Discobolus (Discus Thrower)*. Roman marble copy after a bronze original of c. 450 B.C. by Myron. Lifesize. Museo delle Terme, Rome

statue now exerted a liberating influence on pedimental sculpture as well, endowing it with a new spaciousness, fluidity, and balance. The *Dying Niobid* (fig. 190), a work of the 440s, was carved for the pediment of a Doric temple but is so richly three-dimensional, so self-contained, that we hardly suspect her original context. Niobe, according to legend, had humiliated the mother of Apollo and Artemis by boasting of her seven sons and seven daughters, whereupon the two gods killed all of Niobe's children. Our Niobid has been shot in the back while running. Her strength broken, she sinks to the ground while trying to extract the fatal arrow. The violent movement of her arms has made her garment slip off. Her nudity is thus a dramatic device, rather than a necessary part of the story.

The *Niobid* is the earliest known large female nude in Greek art. The artist's primary motive in devising it was to display a beautiful female body in the kind of strenuous action hitherto reserved for the male nude. Still, we must not misread the intent. It was not a detached interest in the physical aspect

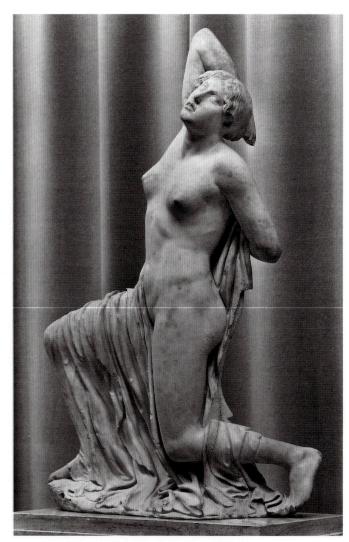

190. Dying Niobid. c. 450–440 B.C. Marble, height 59" (150 cm). Museo delle Terme, Rome

of the event alone but the desire to unite motion and emotion and thus to make the beholder experience the suffering of this victim of a cruel fate. Looking at the face of the *Niobid*, we feel that here, for the first time, human feeling is expressed as eloquently in the features as in the rest of the figure.

A brief glance backward at the wounded warrior from Aegina (fig. 160) will show us how very differently the agony of death had been conceived only half a century before. What separates the Niobid from the world of Archaic art is a quality summed up in the Greek word pathos, which means suffering, but particularly suffering conveyed with nobility and restraint so that it touches rather than horrifies us. Late Archaic art may approach it now and then, as in the Eos and Memnon group (fig. 145). Yet the full force of pathos can be felt only in Classical works such as the Niobid. Perhaps, in order to measure the astonishing development we have witnessed since the beginnings of Greek monumental sculpture less than two centuries before, we ought to compare the Niobid with the earliest pedimental figure we came to know, the Gorgon from Corfu (fig. 154). As we do so, we suddenly realize that these two, worlds apart as they may be, do in fact belong to the same artistic tradition, for the Niobid, too, shows the pinwheel stance, even though its meaning has been radically reinter-

191. Dionysus, from the east pediment of the Parthenon. c. 438-432 B.C. Marble, over-lifesize. The British Museum, London

192. Three Goddesses, from the east pediment of the Parthenon. c. 438-432 B.C. Marble, over-lifesize. The British Museum, London

preted. Once we recognize the ancient origin of her pose, we understand better than before why the *Niobid*, despite her suffering, remains so monumentally self-contained.

THE PARTHENON. The largest, as well as the greatest, group of Classical sculptures at our disposal consists of the remains of the marble decoration of the Parthenon, most of them, unfortunately, in battered and fragmentary condition. Much of the sculpture was removed between 1801 and 1803 by Lord Elgin; the Elgin Marbles are today housed in the British Museum. The centers of both pediments are gone completely, and of the figures in the corners only those from the east pediment are sufficiently well preserved to convey

something of the quality of the ensemble. They represent various deities, most in sitting or reclining poses, witnessing the birth of Athena from the head of Zeus (figs. 191 and 192). (The west pediment was devoted to the struggle of Athena and Poseidon for Athens.)

Here, even more than in the case of the *Dying Niobid*, we marvel at the spaciousness, the complete ease of movement of these statues even in repose. There is neither violence nor pathos in them, indeed no specific action of any kind, only a deeply felt poetry of being. We find it equally in the relaxed masculine body of Dionysus and in the soft fullness of the three goddesses, enveloped in thin drapery that seems to share the qualities of a liquid substance as it flows and eddies around

193. Jacques Carrey. Drawings of the east pediment of the Parthenon. 1674. Bibliothèque Nationale, Paris

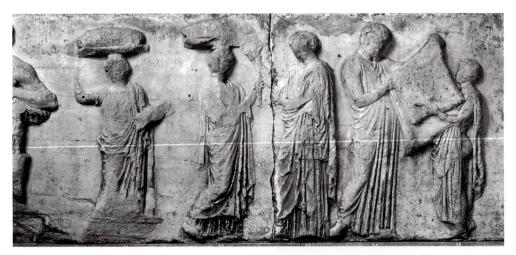

194. The Sacrifice of King Erechtheus' Daughters, from the east frieze of the Parthenon. c. 440 B.C. Marble, height 43" (109.3 cm). The British Museum, London

the forms underneath. Though all are seated or half-reclining, the turning of the bodies under the elaborate folds of their costumes makes them seem anything but static. Indeed, the "wet" drapery unites them in one continuous action, so that they seem in the process of arising.

The figures are so freely conceived in depth that they create their own aura of space. It is hard to imagine them "shelved" upon the pediment. Evidently the great master who achieved such lifelike figures also found this incongruous, for the composition as a whole (fig. 193) suggests that the triangular field is treated as no more than a purely physical limit. For example, two horses' heads are placed in the sharp angles at the corners at the feet of Dionysus and the reclining goddesses. They are meant to represent the chariots of the rising sun and the waning moon emerging into and dipping below the pedimental space, but visually the heads are merely two fragments arbitrarily cut off by the frame. Clearly, we are approaching the moment when the pediment will be rejected altogether as the focal point of Greek architectural sculpture. In fact, the sculptural decoration of later buildings tends to be placed in areas where it would seem less boxed in, as well as more readily visible.

The frieze of the Parthenon, a continuous band 525 feet in length (fig. 170), was long assumed to show a procession honoring Athena in the presence of the other Olympic gods. According to recent theory, however, the main scene depicts the sacrifice by King Erechtheus of his three daughters, as demanded by the oracle at Delphi, in order to save Athens from its enemies, though he himself was to perish during his victory over Eumolpos, the son of Poseidon (fig. 194). The subject was

especially significant to the city following its victory over the Persians, who had desecrated the old Temple of Athena. It also integrates the frieze into the rest of the program of the Parthenon, which includes the struggle of Athena and Poseidon, and helps to explain why the Erechtheum was built on the Acropolis. Remarkably, the frieze is of the same high rank as the pedimental sculptures. In a somewhat different way it, too, suffered from its subordination to the architectural setting, for it must have been poorly lit and difficult to see, placed as it was immediately below the ceiling. The depth of the carving and the concept of relief are not radically different from the frieze of the Siphnian Treasury (figs. 157 and 158), but the illusion of space and of rounded form is now achieved with sovereign ease. The most remarkable quality of the Parthenon frieze is the rhythmic grace of the design, particularly striking in the spirited movement of the groups of horsemen.

The metopes, which date from the 440s, are very different in character from the rest of the sculpture on the Parthenon in showing violent action. We have encountered two of the subjects before: the combat of the gods and giants and the battle of Lapiths and Centaurs (see figs. 158 and 187). It is the other two subjects that provide the key to their meaning. They are the Sack of Troy by the Greeks, and Greeks fighting Amazons, who, according to legend, had desecrated the Acropolis. The entire cycle forms an extended allegory of the Athenian victory over the Persians, who likewise destroyed the Acropolis. But rather than presenting the war as historical fact, the Greek mind insisted on cloaking it in the guise of myth and legend in order to explain the outcome, as if preordained.

Although the metopes do not form a fully coherent

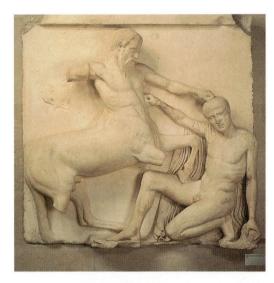

195. *Lapith and Centaur*, metope from the south side of the Parthenon. c. 440 B.C. Marble, height 56" (142.2 cm). The British Museum, London

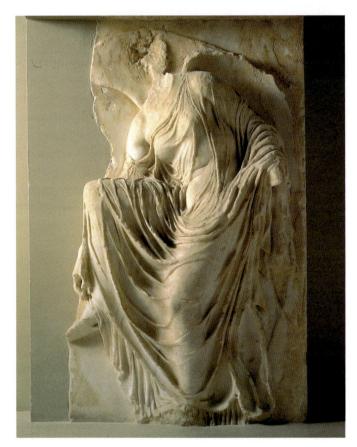

196. *Nike*, from the balustrade of the Temple of Athena Nike. c. 410–407 B.C. Marble, height 42" (106.7 cm). Acropolis Museum, Athens

program and vary in the quality of their execution, the best of them, such as our scene of a Lapith fighting a Centaur (fig. 195), have a compelling dramatic force that is still grounded in the pediment at Olympia almost 20 years earlier (see fig. 187). Our sculptor has been remarkably successful in overcoming the obstacles presented by the metope. Because it was

placed high above the ground, where it could barely be seen, the figures fill as much of the limited field as possible and are carved so deeply as to appear nearly in the round. If the action seems somewhat forced in both pose and expression, it has been beautifully choreographed for maximum clarity and impact.

PHIDIAS. Who was responsible for this magnificent array of sculptures? They have long been associated with the name of Phidias, the chief overseer of all artistic enterprises sponsored by Pericles. [See Primary Sources, no. 12, page 216.] According to ancient writers, Phidias was particularly famous for a huge ivory-and-gold statue of Athena he made for the cella of the Parthenon, a colossal figure of Zeus in the same technique for the temple of that god in Olympia, and an equally large bronze statue of Athena that stood on the Acropolis facing the Propylaea. None of these survives, and small-scale representations of them in later times are utterly inadequate to convey the artist's style. It is hard to imagine that enormous statues of this sort, burdened with the requirements of cult images and the demands of a difficult technique, shared the vitality of the Elgin Marbles. The admiration they elicited may have been due to their size, the preciousness of the materials, and the aura of religious awe surrounding them. Phidias' personality thus remains oddly intangible. He may have been simply a very able coordinator and supervisor, but more likely he was a great genius, comparable to Imhotep (see pages 64-65), capable of giving powerful expression to the ideas that motivated his patron, Pericles.

The term *Phidian style* used to describe the Parthenon sculptures is no more than a generic label; undoubtedly, a large number of masters were involved, since the frieze and the two pediments were executed in less than ten years (c. 440–432 B.C.). Albeit of questionable accuracy, it is justified by its convenience. The Phidian ideal was not merely artistic but no doubt extended to life itself: it denotes a distinctive attitude in which the gods are aware of, yet aloof from, human affairs as they fulfill their cosmic roles. This is an attitude that came to be widely shared among Greek philosophers, especially of the fourth century B.C.

It is hardly surprising that the Phidian style should have dominated Athenian sculpture until the end of the fifth century and beyond, even though large-scale sculptural enterprises gradually came to a halt because of the Peloponnesian War. The last of these was the balustrade erected around the small Temple of Athena Nike about 410-407 B.C. Like the Parthenon frieze, it shows a festive procession, but the participants are winged Nike figures (personifications of victory) rather than citizens of Athens. One Nike (fig. 196) is taking off her sandals in conformity with an age-old tradition, indicating that she is about to step on holy ground (see page 62). Her wings—one open, the other closed—are effectively employed to help her keep her balance, so that she performs this normally awkward act with consummate elegance of movement. Her figure is more strongly detached from the relief ground than are those on the Parthenon frieze, and her garments, with their deeply cut folds, cling to the body. (We have seen an earlier phase of this "wet" drapery in the Three Goddesses of the Parthenon, fig. 192.)

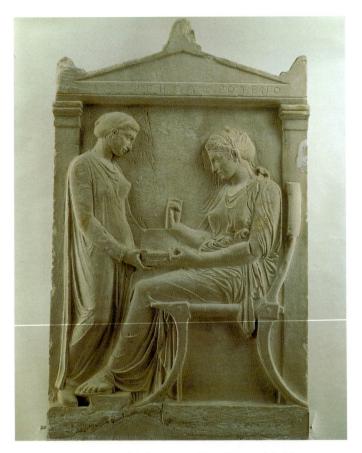

197. *Grave Stele of Hegeso.* c. 410–400 B.C. Marble, height 59" (150 cm). National Archaeological Museum, Athens

198. *The Abduction of Proserpine*. Detail of a wall painting in Tomb I, Vergina, Macedonia. c. 340–330 B.C.

"Phidian," too, and also from the last years of the century, is the beautiful Grave Stele of Hegeso (fig. 197). Memorials of this kind were produced in large numbers by Athenian sculptors, and their export must have helped to spread the Phidian style throughout the Greek world. Few of them, however, can match the harmonious design and the gentle melancholy of our example. The deceased is represented in a simple domestic scene that was a standard subject for sculptured and painted memorials of young women. She has picked a necklace from the box held by the girl servant and seems to be contemplating it as if it were a keepsake. The delicacy of the carving can be seen especially well in the forms farthest removed from the beholder, such as the servant's left arm supporting the lid of the jewel box, or the veil behind Hegeso's right shoulder. Here the relief merges almost imperceptibly with the background, so that the ground no longer appears as a solid surface but assumes something of the transparency of empty space. This novel effect was probably inspired by paintings.

CLASSICAL PAINTING

Documentary sources tell us a great deal about how Classical painting evolved, but rarely in sufficient detail for us to know what it looked like. The great age of Greek painting began in the Early Classical period with Polygnotos of Thasos and his collaborator, Mikon of Athens, who were sculptors as well. Polygnotos was the first artist to place figures at various heights

in a landscape setting and to depict women in transparent drapery. But, above all, he inaugurated the "representation of emotion and character [and the] use of patterns of composition," which became as central to Classical painting as it was to sculpture. An important advance came a hundred years later with the invention of shading by Apollodoros of Athens.

Painting reached its zenith in the fourth century B.C., when it was recognized as one of the liberal arts. This period witnessed an explosion of rival schools as panel painting gradually supplanted wall painting. Among the leading masters mentioned by the Roman writer Pliny are Zeuxis of Herakleia, a master of texture; Parrhasios of Ephesus, who "first gave proportion to painting . . . and was supreme in painting contour lines, which is the most subtle aspect of painting"; Apelles of Kos, Alexander the Great's favorite artist and the most famous painter of his day, distinguished for his grace; and Nikomachos of Athens, renowned for his rapid brush.

We get a tantalizing glimpse of Classical painting, albeit just one facet, in *The Abduction of Proserpine* (fig. 198) from a Macedonian tomb at Vergina of about 340–330 B.C. Discovered only in 1976, it assumes great importance as one of the very few wall paintings to come to light in Greece itself. The subject is especially appropriate to the funereal setting. Proserpine, goddess of vegetation, was abducted by Hades, ruler of the underworld, to be his queen but, thanks to Zeus' intervention, was permitted to return to earth six months of every year. The painting may well be based on a famous work by

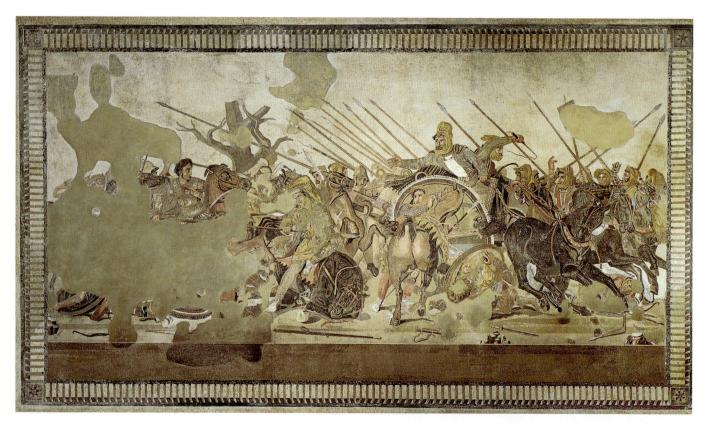

199. The Battle of Issus or Battle of Alexander and the Persians. Mosaic copy from Pompeii of a Hellenistic painting of c. 315 B.C. 8'11" x 16'9¹/₂" (2.7 x 5.1 m). Museo Archeologico Nazionale, Naples

Nikomachos of Athens. The forceful expressiveness more than makes up for any technical deficiencies of the artist, who was clearly not of the first rank: the scene has a magnificent sweep that captures the frenzy of the moment. The technique reflects the main tradition of Greek painting, which emphasized line, although there was also a competing coloristic tendency.

We can get some further idea of what Greek wall painting looked like from Roman copies and imitations, although their relation is extremely problematic (see pages 208–11). According to the Roman writer Pliny, Philoxenos of Eretria at the end of the fourth century painted the victory of Alexander the Great over Darius at Issus. [See Primary Sources, no. 4, pages 213.] The same subject—or, at any rate, another battle of Alexander's war against the Persians—is shown in an exceptionally large and technically accomplished floor mosaic from a Pompeian house of about 100 B.C. Figure 199 shows Darius and the fleeing Persians on the right, and, in the badly damaged left-hand portion, the figure of Alexander.

While there is no special reason to link this mosaic with Pliny's account (several others are recorded), we can hardly doubt that it is a copy—and an astonishingly proficient one—of a Hellenistic painting from the late fourth century B.C. The picture follows the four-color scheme (yellow, red, black, and white) that is known to have been widely used at that time. The crowding, the air of frantic excitement, the powerfully modeled and foreshortened forms, and the precise cast shadows make the scene far more complicated and dramatic than any other work of Greek art from the period. And for the first time it shows something that actually happened, without the symbolic overtones of *Herakles Strangling the Nemean Lion* or the *Battle of the Lapiths and Centaurs* (figs. 143 and 187). In

character and even in appearance, it is close to Roman reliefs commemorating specific historic events (see figs. 271–73). Yet, there can be little doubt that the mosaic was executed by a Greek, as this technique originated in Hellenistic times and remained a specialty of Greek artists to the end.

According to literary sources, Greek painters of the Classical period achieved a great breakthrough in mastering illusionistic space—a claim partially supported by murals discovered in Macedonia. [See page 151 and Primary Sources, no. 4, page 213, and no. 13, pages 216–17.] Vase painting by its very nature could echo the new concept of pictorial space only in rudimentary fashion. Still, there are vessels that form an exception to this rule. We find them mostly in the lekythoi (oil jugs) used as funerary offerings. These had a white coating on which painters could draw as freely and with the same spatial effect as their modern successors using pen and paper. The white ground is treated as empty space from which the forms seem to emerge—if the draftsman knows how to achieve this.

Not many lekythos painters were capable of bringing off the illusion. Foremost among them is the unknown artist, nicknamed the "Achilles Painter," who drew the woman in figure 200. Although some 25 years older than the Hegeso stele, this vase shows a similar scene, and there is the same mood of "Phidian" reverie, as a woman (perhaps a poetess seeking inspiration) listens to the muse playing her lyre on Mount Helikon accompanied by a nightingale. Our chief interest, however, is in the masterly draftsmanship. With a few lines, sure, fresh, and fluid, the artist not only creates a three-dimensional figure but reveals the body beneath the drapery as well. What persuades us that these shapes exist in depth rather than merely on the surface of the vase? First of all, the command of foreshorten-

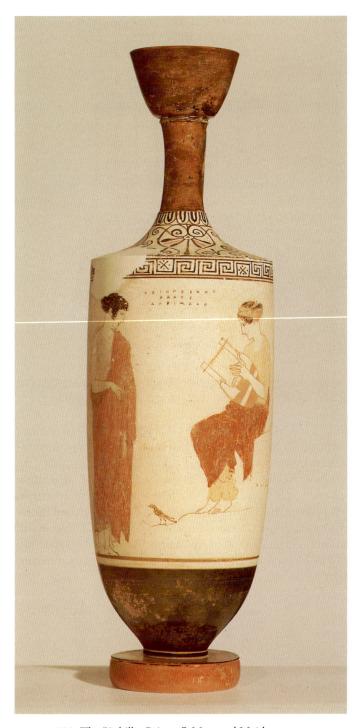

200. The "Achilles Painter." *Muse and Maiden*, on an Attic white-ground lekythos. c. 440–430 B.C. Height 16" (40.7 cm). Staatliche Antikensammlungen, Munich

ing. But the "internal dynamics" of the lines are equally important. Their swelling and fading make some contours stand out boldly while others merge with one another or disappear into the white ground. The effect is completed by the color, unusually elaborate for a lekythos: vermilion for the himations and the muse's head scarf, ocher for her chiton. The artist has made skillful use of the white ground to enliven the "empty" space by adding an inscription: "Axiopeithes, the son of Alkimachos, is beautiful."

Considering its artistic advantages, we might expect a more general adoption of the white-ground technique. Such, how-

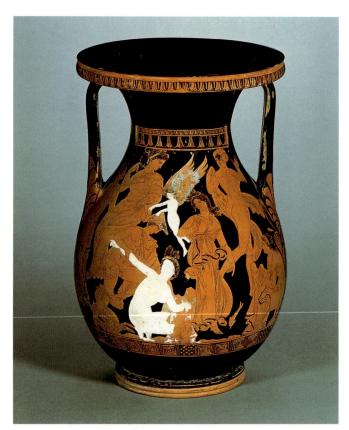

201. The "Marsyas Painter." *Peleus and Thetis*, on a Kerch-style pelike. c. 340 B.C. Height 16³/4" (42.5 cm). The British Museum, London

ever, was not the case. Instead, from the mid-fifth century on, the impact of monumental painting gradually transformed vase painting as a whole into a satellite art that tried to reproduce large-scale compositions in a kind of shorthand dictated by its own limited technique. The result, more often than not, was spotty and overcrowded.

Even the finest examples suffer from this defect, as we can see in figure 201, which is taken from a vase produced near the end of the Classical period by an Athenian master known as the "Marsyas Painter." It shows Thetis, who is about to bathe in the sea, being abducted by Peleus as two of her maidservants flee in panic. The main figures are placed on a firm groundline, with a bit of wavy water to suggest the spatial setting of the scene. The others, intended to be farther away, seem suspended in midair. Although the turning poses are a further attempt to create the illusion of space, the effect remains flat and silhouettelike, because of the obtrusive black background.

In an attempt to enlarge the color range, the body of Thetis has been painted white, as has that of Eros crowning Peleus. (Thetis' dress has been filled in with green as well.) This expedient, too, fails to solve the problem, since the medium does not permit shading or modeling. Our artist must therefore rely on the network of lines to hold the scene together and create a maximum of dramatic excitement—and, being a spirited draftsman, almost succeeds. Still, it is a success at second hand, for the composition must have been inspired by a mural or panel picture. The "Marsyas Painter" is, as it were, battling for a lost cause. We have reached the effective end of Greek vase painting, which disappeared altogether by the end of the century.

FOURTH-CENTURY SCULPTURE

This Athenian style, so harmonious in both feeling and form, did not long survive the defeat of Athens by Sparta in the Peloponnesian War. Building and sculpture continued in the same tradition for another three centuries, but without the subtleties of the Classical age whose achievements we have just discussed. There is, unfortunately, no single word, like Archaic or Classical, that we can use to designate this third and final phase in the development of Greek art, which lasted from about 400 to the first century B.C. The 75-year span between the end of the Peloponnesian War and the rise of Alexander the Great used to be labeled "Late Classical," and the remaining two centuries and a half "Hellenistic," a term meant to convey the spread of Greek civilization southeastward to Asia Minor and Mesopotamia, Egypt, and the borders of India. It was perhaps natural to expect that the world-shaking conquests of Alexander between 333 and 323 B.C. would also effect an artistic revolution. However, the history of style is not always in tune with political history. Although the center of Greek thought shifted to Alexandria, the city founded by Alexander in Egypt, we have come to realize that there was no decisive break in the tradition of Greek art at the end of the fourth century. The art of the Hellenistic era is the direct outgrowth of developments that occurred, not at the time of Alexander, but during the preceding 50 years.

Here, then, is our dilemma: "Hellenistic" is a concept so closely linked with the political and cultural consequences of Alexander's conquest that we cannot very well extend it backward to the early fourth century, although there is wide agreement now that the art of the years 400 to 325 B.C. can be far better understood if we view it as pre-Hellenistic rather than as Late Classical. Until the right word is found and wins general acceptance, we shall have to make do with the existing

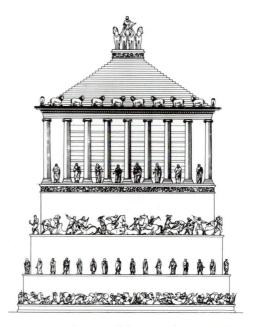

202. Reconstruction drawing of the Mausoleum at Halicarnassus. 359–351 B.C.

terms as best we can, always keeping in mind the essential continuity of the third phase that we are about to examine.

THE MAUSOLEUM AT HALICARNASSUS. The contrast between Classical and pre-Hellenistic is strikingly demonstrated by the only project of the fourth century that corresponds to the Parthenon in size and ambition. It is not a temple but a huge tomb—so huge, in fact, that its name, Mausoleum, has become a generic term for all oversized funerary monuments. It was designed by Pytheos of Priene and erected at Halicarnassus in Asia Minor just before and after 360 B.C. by Mausolus, who ruled the area as a satrap of the Persians,

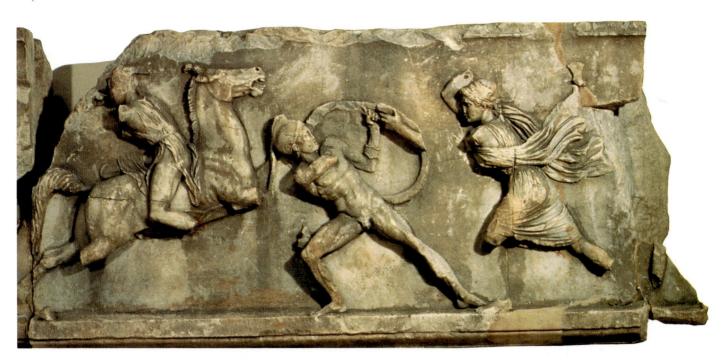

203. Scopas (?). Battle of the Greeks and Amazons, from the east frieze of the Mausoleum, Halicarnassus. 359–351 B.C. Marble, height 35" (89 cm). The British Museum, London

and his widow, Artemisia. The structure itself is completely destroyed, but its dimensions and general appearance can be reconstructed on the basis of ancient descriptions and the excavated fragments, including a good deal of sculpture. [See Primary Sources, no. 6, page 214.]

The drawing in figure 202 does not pretend to be exact in detail. We do know, however, that the building rose in three stages to a height of about 160 feet. A tall rectangular base 117 feet wide and 82 feet deep supported a colonnade of Ionic columns 40 feet tall, and above this rose a pyramid crowned by a chariot with statues of Mausolus and Artemisia. The sculptural program consisted of two friezes showing Greeks battling Persians and Greeks fighting Amazons, each as long as the Parthenon frieze, with a row of Greek and Persian figures in between. Along the colonnade were 36 large statues of Mausolus' family. The roof featured a row of carved guardian lions and was surmounted by a huge quadriga, presumably with statues of the deceased.

The commemorative and retrospective character of the monument, based on the idea of human life as a glorious struggle or chariot race, is entirely Greek. Yet we immediately notice the un-Greek way it has been carried out. The huge size of the tomb, and more particularly the pyramid, derive from Egypt. They imply an exaltation of the ruler far beyond ordinary human status. His kinship with the gods may have been hinted at. Apparently Mausolus took this view of himself as a divinely ordained sovereign from the Persians, who in turn had inherited it from the Assyrians and Egyptians, although he seems to have wanted to glorify his individual personality as much as his high office. The structure embodying these ambitions must have struck his contemporaries as impressive and monstrous at the same time, with its multiple friezes and the receding faces of a pyramid in place of pediments above the colonnade.

SCOPAS. According to ancient sources, the sculpture on each of the four sides of the monument was entrusted to a different master, chosen from among the best of the time. Scopas, the most famous, did the main side, the one to the east. His dynamic style has been recognized in some portions of the Amazon frieze, such as the portion in figure 203. The Parthenon tradition can still be felt here, but there is also a decidedly un-Classical violence, physical as well as emotional, conveyed through strained movements and passionate facial expressions. (Deep-set eyes are a hallmark of Scopas' style.) As a consequence, we no longer find the rhythmic flow of the Parthenon frieze. Continuity and harmony have been sacrificed so that each figure may have greater scope for sweeping, impulsive gestures. Clearly, if we are to do justice to this explosive, energetic style we must not judge it by Classical standards. What the composition lacks in unity, it more than makes up for in bold innovation (note, for instance, the Amazon seated backward on her horse) and heightened expressiveness. In a sense, Scopas turned backward as well to the scenes of violent action so popular in the Archaic period. We will recognize its ancestor in the Siphnian Battle of the Gods and Giants (fig. 158), although he clearly learned from the example of the Parthenon metopes as well (see fig. 195).

The "pre-Hellenistic" flavor is even more pronounced in one of the portrait statues, sometimes presumed to represent

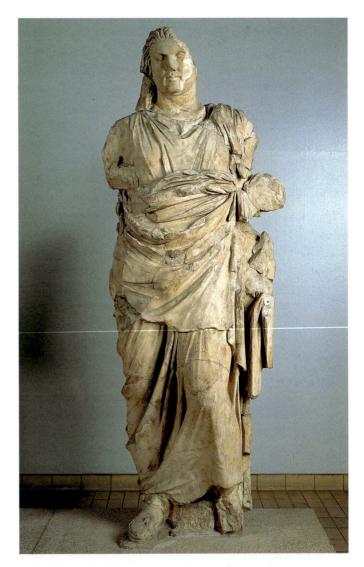

204. "Mausolus," from the Mausoleum at Halicarnassus. c. 360 B.C. Marble, height 9'10" (3.1 m). The British Museum, London

Mausolus himself (fig. 204), from the colonnade. The figure must be the work of a man younger than Scopas and even less encumbered by Classical standards, probably Bryaxis, the master of the north side. Through Roman copies, we know of some Greek portraits of Classical times, but they seem to represent types rather than individuals. Such is probably the case here, for he is a distinctly non-Greek sort; not until Hellenistic times were individual likenesses to play an important part. The figure nevertheless possesses a surprisingly personal character in the head, with its heavy jaws and small, sensuous mouth—features later found in the Hellenistic portrait head from Delos (fig. 216). The thick neck and broad, fleshy body seem equally individual. The massiveness of the forms is further emphasized by the sharp-edged and stiff-textured drapery, which might be said to encase, rather than merely clothe, the body. The great volumes of folds across the abdomen and below the left arm seem designed for picturesque effect more than for functional clarity.

PRAXITELES. Some of the features of the Mausoleum sculpture recur in other important works of the period. Foremost among these is the wonderful seated figure of the goddess

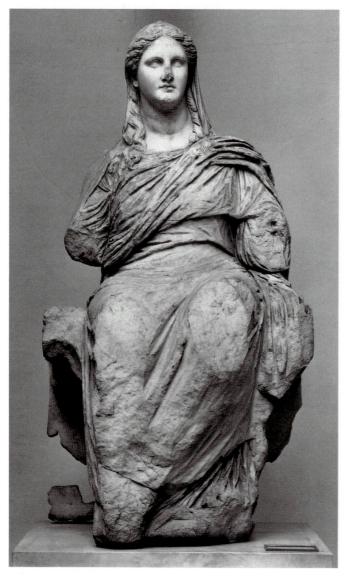

205. *Demeter*, from Cnidus. c. 330 B.C. Marble, height 60" (152.3 cm). The British Museum, London

Demeter from her temple at Cnidus (fig. 205), a work closely related to the "Mausolus." Here again the drapery, though more finely textured, has an impressive volume of its own, while motifs such as the S-curve of folds across the chest form an effective counterpoint to the shape of the body beneath. The deep-set eyes gaze into the distance with an intensity that suggests the influence of Scopas. The modeling of the head, on the other hand, has a veiled softness that points to an altogether different source: Praxiteles, the master of feminine grace and sensuous evocation of flesh.

The *Demeter* is probably only slightly later in date than Praxiteles' most acclaimed statue, an *Aphrodite* (fig. 206), which was likewise made for Cnidus about 340–330 B.C. [See Primary Sources, no. 6, page 214.] Hence, the sculptor who carved the *Demeter* would have had no difficulty incorporating some Prax-

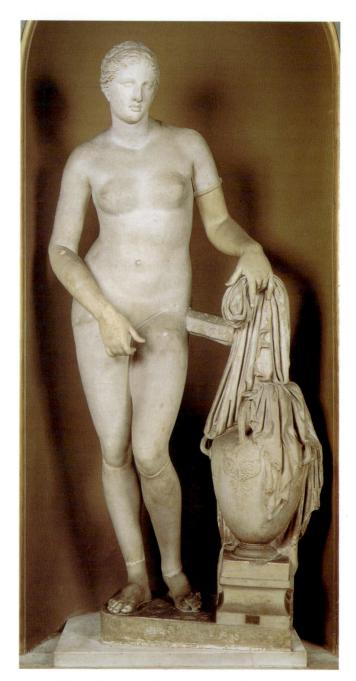

206. Cnidian Aphrodite. Roman copy after an original of c. 340–330 B.C., by Praxiteles. Marble, height 6'8" (2 m). Musei Vaticani, Museo Pio Clementino, Gabinetto delle Maschere, Città del Vaticano, Rome

itelean qualities into his own work. The *Cnidian Aphrodite* by Praxiteles achieved such fame that she is often referred to in ancient literature as a synonym for absolute perfection. To what extent her renown was based on her beauty, or on the fact that she was (so far as we know) the first completely nude cult image of the goddess, is difficult to say, for the statue is known to us only through Roman copies that can be no more than pallid reflections of the original. The viewer "discovers" her in the midst of bathing, yet through her pose and expression she maintains a chaste modesty so as to disarm any critic.

A more faithful embodiment of Praxitelean beauty is the group of Hermes with the infant Bacchus (fig. 207). Pausanias mentions seeing such a statue by Praxiteles at the Temple of Hera at Olympia, where this marble was excavated in 1877. It is of such high quality that it was long regarded as Praxiteles'

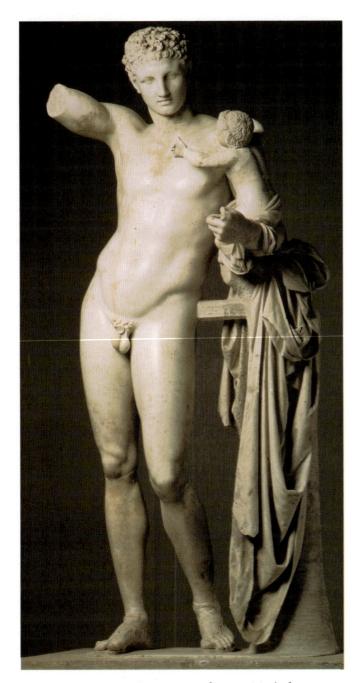

207. Hermes. Roman copy after an original of c. 320–310 B.C., by Praxiteles. Marble, height 7'1" (2.16 m). Archaeological Museum, Olympia

own work, though most scholars now believe it to be a very fine later Greek copy because of the strut support and unfinished back. The dispute is of little consequence for us, except perhaps in one respect: it emphasizes the unfortunate fact that we do not have a single undisputed original by any of the famous sculptors of Greece. Nevertheless, the *Hermes* is the most completely Praxitelean statue we know. The sensuousness, the lithe proportions, the sinuous curve of the torso, the play of gentle curves, the sense of complete relaxation (enhanced by the use of an outside support for the figure to lean against), all agree well enough with the character of the *Cnidian Aphrodite*. We also find many refinements here that are ordinarily lost in a copy, such as the caressing treatment of the marble, the faint smile, the meltingly soft, "veiled" modeling of the features. Even the hair, left comparatively rough

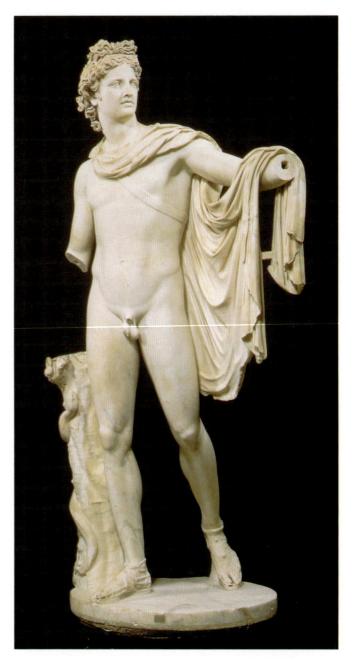

208. Apollo Belvedere. Roman marble copy, probably of a Greek original of the late 4th century B.C. Height 7'4" (2.3 m). Musei Vaticani, Museo Pio Clementino, Cortile Ottagono, Città del Vaticano, Rome

for contrast, shares the silky feel of the rest of the work. Here, for the first time, is an attempt to modify the stony look of a statue by giving to it the illusion of an enveloping atmosphere.

APOLLO BELVEDERE. The same qualities recur in many other statues, all of them Roman copies of Greek works in a more or less Praxitelean vein. The best known is the *Apollo Belvedere* (fig. 208), which enjoyed tremendous popularity during the eighteenth and nineteenth centuries. Johann Joachim Winckelmann, Goethe, and other champions of the Greek Revival found it the perfect exemplar of Classical beauty. Plaster casts or reproductions of it were considered indispensable for all museums, art academies, or liberal arts colleges, and generations of students grew up in the belief that it embodied the essence of the Greek spirit. This enthusiasm tells us a good deal,

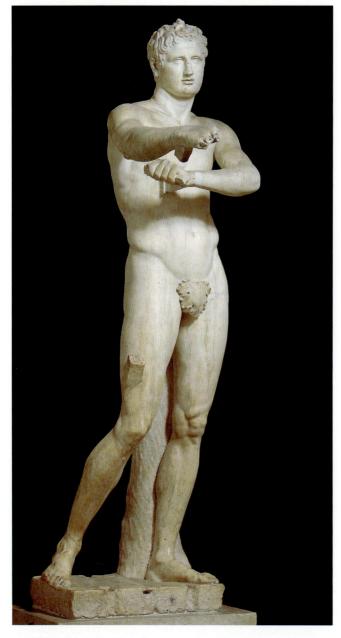

209. Apoxyomenos (Scraper). Roman marble copy, probably after a bronze original of c. 330 B.C. by Lysippus. Height 6'9" (2.1 m). Musei Vaticani, Museo Pio Clementino, Gabinetto dell'Apoxyomenos, Città del Vaticano, Rome

not about the qualities of the *Apollo Belvedere* but about the character of the Greek Revival, although our own time takes a less enthusiastic view of the statue.

LYSIPPUS. Besides Scopas and Praxiteles, there is another great name in pre-Hellenistic sculpture: Lysippus, whose career may have begun as early as about 370 B.C. and continued to the end of the century. The main features of his style, however, are more difficult to grasp than those of his two famous contemporaries, because of the contradictory evidence of the Roman copies that are assumed to reproduce his work. Ancient authors praised him for replacing the canon of Polyclitus with a new set of proportions that produced a more slender body and a smaller head. [See Primary Sources, no. 5, pages 213–14.] His realism, too, was proverbial: he is said to have had no master other than nature. But these statements describe little more than a

general trend toward the end of the fourth century. Certainly the proportions of Praxiteles' statues are "Lysippic" rather than "Polyclitan." Nor could Lysippus have been the only artist of his time to conquer new aspects of reality.

Even in the case of the *Apoxyomenos* (fig. 209), the statue most insistently linked with his name, the evidence is far from conclusive. It shows a young athlete cleaning himself with a scraper, a motif often represented in Greek art from Classical times on. Unlike all other versions, here the arms are horizontally extended in front of the body. This bold thrust into space, at the cost of obstructing the view of the torso, is a noteworthy feat, whether or not we credit it to Lysippus. It endows the figure with a new capacity for spontaneous three-dimensional movement. A similar freedom is suggested by the diagonal line of the free leg. Even the unruly hair reflects the new trend toward spontaneity.

HELLENISTIC SCULPTURE

Of the artistic enterprises sponsored by Alexander the Great, such as the numerous portraits of the great conqueror by Lysippus, no direct evidence survives. In fact, we know very little of the development of Greek sculpture as a whole during the first hundred years of the Hellenistic era. Even after that, we have few fixed points of reference. Only a small fraction of the large number of works at our disposal can be securely identified as to date and place of origin. Moreover, Greek sculpture was now being produced throughout such a vast territory that the interplay of local and international currents must have formed a complex pattern, of which we can trace only some isolated strands.

Hellenistic sculpture nevertheless possesses a markedly different character from that of the Classical era. It has a more pronounced realism and expressiveness, as well as a greater variety of drapery and pose, which is often marked by extreme torsion. This willingness to experiment should be seen as a valid, even necessary, attempt to extend the subject matter and dynamic range of Greek art in accordance with a new temperament and outlook.

DYING TRUMPETER. The more human conception that characterizes the age is represented by the bronze groups dedicated by Attalus I of Pergamum (a city in northwestern Asia Minor) between about 240 and 200 B.C. to celebrate his victories over the Celts, who kept raiding the Greek states from Galatia, the area around present-day Ankara, until Attalus forced them to settle down. The bronze statues commemorating the Celts' defeat were reproduced in marble for the Romans, who may have had a special interest in them because of their own troubles with Celtic tribes in northwestern Europe. A number of these copies have survived, including the famous *Dying Trumpeter* (fig. 210), which presumably replicates a statue by Epigonos of Pergamum mentioned in Pliny's *Natural History*.

The sculptor must have known the Celts well, for the ethnic type is carefully rendered in the facial structure and in the bristly shock of hair. The torque around the neck is another characteristically Celtic feature. Otherwise, he shares the heroic nudity of Greek warriors, such as those on the Aegina pedi-

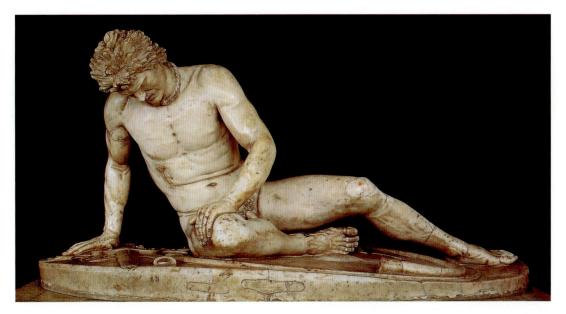

210. Epigonos of Pergamum (?). *Dying Trumpeter.* Roman copy after a bronze original of c. 230–220 B.C. Marble, lifesize. Museo Capitolino, Rome

211. The west front of the Great Pergamum Altar (restored). Staatliche Museen zu Berlin, Preussischer Kulturbesitz, Antikensammlung

212. Plan of the Great Pergamum Altar (after J. Schrammen)

ments (see fig. 160). If his agony seems infinitely more realistic in comparison, it still has considerable dignity and pathos. Clearly, the Celts were not considered unworthy foes. "They knew how to die, barbarians though they were," is the idea conveyed by the statue. Yet we also sense something else, an animal quality that had never before been part of Greek images of men. Death, as we witness it here, is a very concrete physical process. No longer able to move his legs, the Trumpeter puts all his waning strength into his arms, as if to prevent some tremendous invisible weight from crushing him against the ground.

PERGAMUM ALTAR. Some four decades later, we find a second sculptural style flourishing at Pergamum. About

213. Athena and Alcyoneus, from the east side of the Great Frieze of the Great Pergamum Altar. c. 166–156 B.C. Marble, height 7'6" (2.29 m). Staatliche Museen zu Berlin, Preussischer Kulturbesitz, Antikensammlung

180 B.C., Eumenes II, the son and successor of Attalus I, had a mighty altar erected on a hill above the city to commemorate the victory of Rome and her allies over Antiochus the Great of Syria that had given him much of the Seleucid empire eight years earlier. A large part of the sculptural decoration has been recovered by excavation, and the entire west front of the altar, with its monumental flight of stairs leading to the entrance, has been reconstructed in Berlin (fig. 211). It is an impressive structure indeed. The altar proper occupies the center of a rectangular court surrounded by an Ionic colonnade, which rises on a tall base about 100 feet square (fig. 212). Altar structures of such great size seem to have been an Ionian tradition since Archaic times, but the Pergamum Altar is the most elaborate of all, as well as the only one of which considerable portions have survived. Its boldest feature is the great frieze covering the base, 400 feet long and over 7 feet tall. The huge figures, cut to such a depth that they seem almost detached from the background, have the scale and weight of pedimental statues, but freed from the confining triangular frame and transported to a frieze—a unique compound of two separate traditions that represents a thundering climax in the development of Greek architectural sculpture (fig. 213).

The carving of the frieze, though not very subtle in detail, has tremendous dramatic force. The heavy, muscular bodies rush at each other, and the high relief creates strong accents of light and dark, while the beating wings and windblown garments are almost overwhelming in their dynamism. A writhing movement pervades the entire design, down to the last lock of hair, linking the victors and the vanquished in a single continuous rhythm. This sense of unity disciplines the

physical and emotional violence of the struggle and keeps it—but just barely—from exploding its architectural frame. Indeed, the action spills out onto the stairs, where several figures are locked in mortal combat.

The subject, the battle of the gods and giants, is a traditional one for Ionic friezes. (We saw it before on the Siphnian Treasury, fig. 158.) At Pergamum, however, it has a novel significance. It promotes Pergamum as a new Athens—the patron goddess of both cities was Athena, who figures prominently in the great frieze. Moreover, it almost surely incorporates a sophisticated cosmological program whose meaning, however, remains under dispute. Finally, the victory of the gods is meant to symbolize Eumenes' own victories. Such a translation of history into mythology had been an established device in Greek art for a long time (see page 149). But to place Eumenes in analogy with the gods themselves implies an exaltation of the ruler that is Oriental rather than Greek in origin. This association was reinforced by a second frieze, entirely different in character, along the interior of the altar depicting the life of Telephos, the legendary founder of Pergamum and the son of Herakles, who was himself born of Zeus. After the time of Mausolus, who may have been the first to introduce it on Greek soil, the idea of divine kingship had been adopted by Alexander the Great and the lesser sovereigns who divided his realm, including the rulers of Pergamum. It later became central to Imperial Rome from Augustus onward (see page 190).

NIKE OF SAMOTHRACE. Equally dramatic in its impact is another great victory monument of the early second century B.C., the *Nike of Samothrace* (fig. 214), which perhaps com-

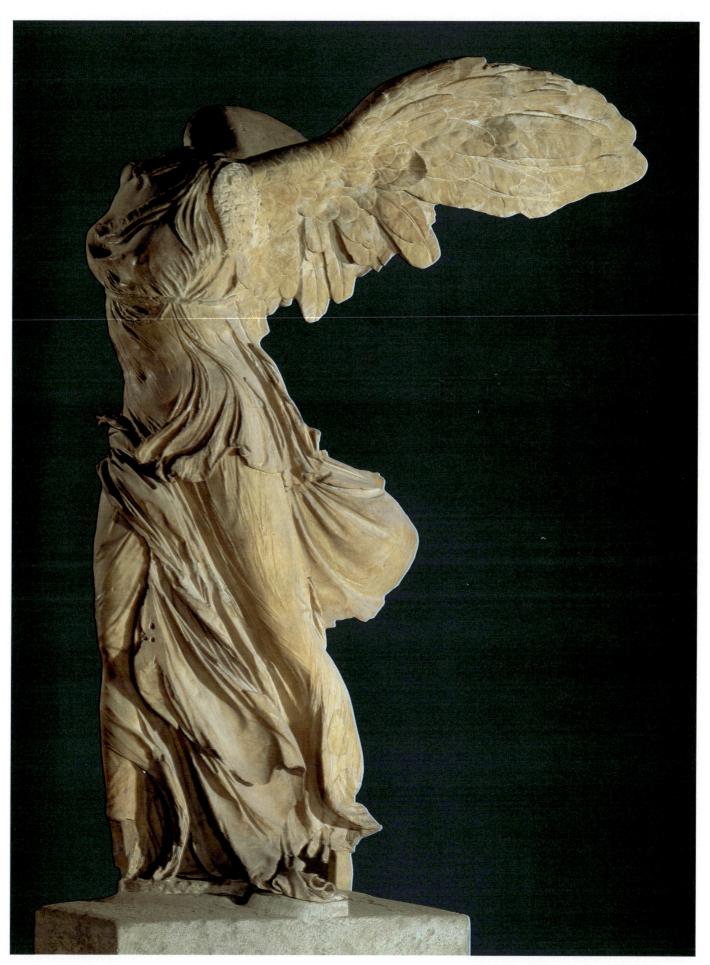

214. Pythokritos of Rhodes (?). Nike of Samothrace. c. 200–190 B.C. Marble, height 8' (2.4 m). Musée du Louvre, Paris

memorates the naval victory in 190 B.C. over Antiochus the Great by Eudamos of Rhodes. The style is Rhodian, and the statue may well have been carved by the island's leading sculptor, Pythokritos. The goddess has just descended to the prow of a ship. Her great wings spread wide, she is still partly airborne by the powerful head wind against which she advances. The invisible force of onrushing air here becomes a tangible reality. It not only balances the forward movement of the figure but also shapes every fold of the wonderfully animated drapery. As a result, there is an active relationship—indeed, an interdependence—between the statue and the space that envelops it, such as we have never seen before. By comparison, all earlier examples of active drapery seem inert. This is true even of the three goddesses from the Parthenon (fig. 192), whose wet drapery responds not to the atmosphere around it but to an inner impulse independent of all motion. Nor shall we see its like again for a long time to come. The Nike of Samothrace deserves all of her fame as the greatest masterpiece of Hellenistic sculpture.

LAOCOÖN. Until the *Nike* was discovered over 100 years ago, the most admired work of Hellenistic statuary had been a group showing the death of Laocoön and his two sons (fig. 215). [See Primary Sources, no. 6, page 214, and no. 14, pages 217–18.] It was found in Rome in 1506 and made a tremendous impression on Michelangelo and many others. The history of its fame is like that of the *Apollo Belvedere*. The two were treated as complementary, the *Apollo* exemplifying harmonious beauty, the *Laocoön* sublime tragedy. (Laocoön was the priest punished by the gods for telling the Trojans not to admit the Greeks' wooden horse into the city, but his warning went unheeded, which led to the Trojans' defeat.) Today we tend to find the pathos of the group somewhat calculated and rhetorical, and its meticulous surface finish strikes us as a display of virtuoso technique.

In style, including the relieflike spread of the three figures, it clearly descends from the Pergamum frieze, although its dynamism has become rather self-conscious. It was long accepted as a Greek original and identified with a group by Agesander, Athenodorus, and Polydorus of Rhodes that the Roman writer Pliny mentions in the palace of the emperor Titus; they, we now know, were skilled copyists active just before or after the birth of Christ. The subject must have held a special meaning for the Romans. Laocoön's fate forewarned Aeneas of the fall of Troy, prompting him to flee in time. Since Aeneas was believed to have come to Italy and to have been the ancestor of Romulus and Remus, the death of Laocoön could be viewed as the first link in a chain of events that ultimately led to the founding of Rome.

PORTRAITS. Individual likenesses were inconceivable in Classical art, which sought a timeless ideal. [See Primary Sources, no. 15, page 218.] Portraiture first arose as an important branch of Greek sculpture only in the mid-fourth century and continued to flourish in Hellenistic times. Its achievements, however, are known to us only indirectly, for the most part through Roman copies. One of the few originals is the extraordinarily vivid bronze head from Delos, a work of the early first century B.C. (fig. 216). It was not made as a bust but rather, in accordance with Greek custom, as part of a full-

length statue. The identity of the sitter is unknown, but whoever he was, his individual likeness has been fused with a distinctive Hellenistic type (compare the face of Alcyoneus in figure 213) to provide an intensely private view of him that captures the character of the age.

The distant stare of the "Mausolus" (fig. 204) has been replaced by a troubled look. The fluid modeling of the somewhat flabby features, the uncertain, plaintive mouth, and the unhappy eyes under furrowed brows reveal an individual beset by doubts and anxieties—an extremely human, unheroic personality. There are echoes of noble pathos in these features, but it is a pathos translated into psychological terms of unparalleled immediacy. People of such inner turmoil had certainly existed earlier in the Greek world, just as they do today. Yet it is significant that their complex character could be conveyed in art only when Greek independence was about to come to an end, culturally as well as politically.

STATUETTES. Before we leave Hellenistic sculpture, we must cast at least a passing glance at another aspect of it, represented by the enchanting bronze statuette of a veiled dancer (fig. 217). She introduces us to the wide variety of small-scale works produced for private ownership, which comprise a special category unto themselves. They are often called Tanagra figures, after the site where many have been found. Such pieces were collected in much the same way as painted vases had been in earlier times. Like vase paintings, they show a range of subject matter far broader than that of monumental sculpture. Besides the familiar mythological themes, we encounter a wealth of everyday subjects: beggars, street entertainers, peasants, young ladies of fashion. The grotesque, the humorous, the picturesque—qualities that rarely enter into Greek monumental art—play a conspicuous role here. Most of these figurines are routine decorative pieces mass-produced in clay or bronze. But at their best, as in our example, they have an imaginative freedom rarely matched on a larger scale. The bold spiral twist of the veiled dancer, reinforced by the diagonal folds of the drapery, creates a multiplicity of interesting views that practically forces the beholder to turn the statuette in his hands. No less extraordinary is the rich interplay of concave and convex forms, the intriguing contrast between the compact silhouette of the figure and the mobility of the body within.

COINS

We rarely think of coins as works of art, and the great majority of them surely are not. The study of their history and development, known as numismatics, offers many rewards, but visual delight is the least of these. If many Greek coins form an exception to this general rule, it is not simply because they are the earliest. (The idea of stamping metal pellets of standard weight with an identifying design originated in Ionian Greece sometime before 600 B.C.) After all, the first postage stamps were no more distinguished than their present-day descendants. The reason, rather, is the persistent individualism of Greek political life. Every city-state had its own coinage, adorned with its particular emblem, and the designs were changed at frequent intervals so as to take account of treaties, victories, or other occasions for local pride. As a consequence,

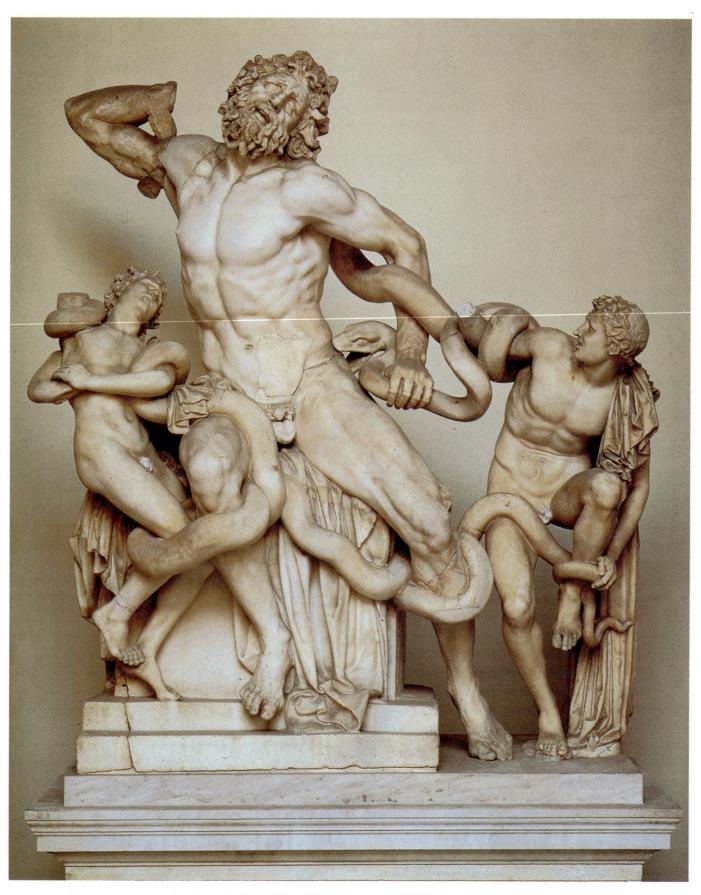

215. *The Laocoön Group*. Perhaps by Agesander, Athenodorus, and Polydorus of Rhodes (present state, former restorations removed). 1st century B.C. Marble, height 7' (2.1 m). Musei Vaticani, Museo Pio Clementino, Cortile Ottagono, Città del Vaticano, Rome

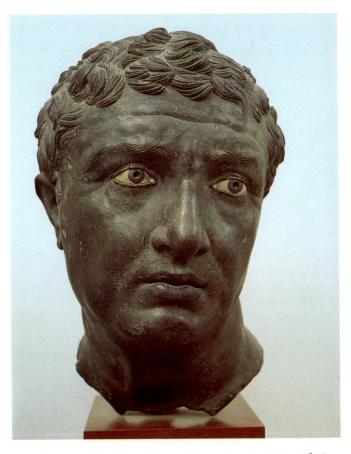

216. *Portrait Head*, from Delos. c. 80 B.C. Bronze, height 12³/4" (32.4 cm). National Archaeological Museum, Athens

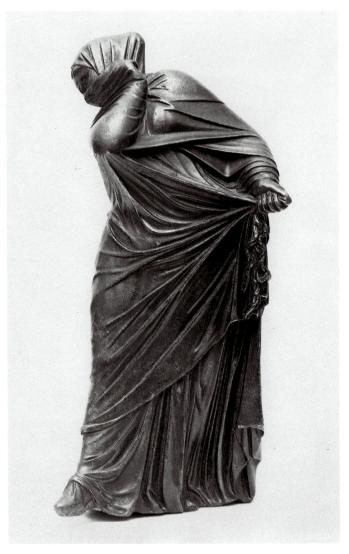

217. Veiled Dancer. c. 200 B.C.? Bronze statuette, height 8 1/8" (20.6 cm). The Metropolitan Museum of Art, New York.

Bequest of Walter C. Baker, 1971

the number of coins struck at any one time remained relatively small, while the number of coinages was large.

The constant demand for new designs produced highly skilled specialists who took such pride in their work that they sometimes signed it. Greek coins thus are not only an invaluable source of historical knowledge but an authentic expression of the changing Greek sense of form. Within their own compass, they illustrate the development of Greek sculpture from the sixth to the second century B.C. as faithfully as the larger works we have examined. And since they form a continuous series, with the place and date of almost every item well established, they reflect this development more fully in some respects than do the works of monumental art.

Oddly enough, the finest coins of Archaic and Classical Greece were usually produced not by the most powerful states such as Athens, Corinth, or Sparta, but by the lesser ones along the periphery of the Greek world. Our first example (fig. 218), from the Aegean island of Peparethus, reflects the origin of

coinage: a square die deeply embedded in a rather shapeless pellet, like an impression in sealing wax. The winged god, his pinwheel stance so perfectly adapted to the frame, is a summary-in-miniature of Archaic art, down to the ubiquitous smile (see fig. 154). On the coin from Naxos in Sicily (fig. 219), almost half a century later, the die fills the entire area of the coin. The astonishingly monumental figure shows the articulation and organic vitality of the Severe style (compare fig. 187). Our third coin (fig. 220) was struck in the Sicilian town of Catana toward the end of the Peloponnesian War. It is signed with the name of its maker, Herakleidas, and it well deserves to be, for it is one of the true masterpieces of Greek coinage. Who would have thought it possible to endow the full-face view of a head in low relief with such plasticity! This radiant image of Apollo has all the swelling roundness of the mature Classical style. Its grandeur completely transcends the limitations of the tiny scale of a coin.

From the time of Alexander the Great onward, coins began

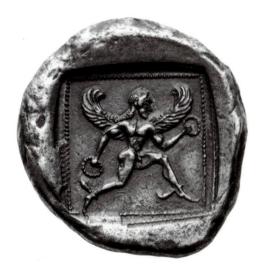

218. *Winged God.* Silver coin from Peparethus. c. 500 B.C. Diameter 1¹/₂" (3.7 cm). The British Museum, London

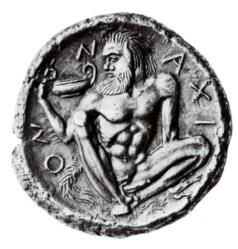

219. Silenus. Silver coin from Naxos. c. 460 B.C. Diameter 1¹/₄" (3.3 cm). The British Museum, London

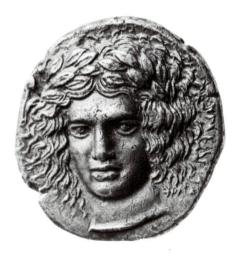

220. *Apollo*. Silver coin from Catana. c. 415–400 B.C. Diameter 1¹/8" (3 cm). The British Museum, London

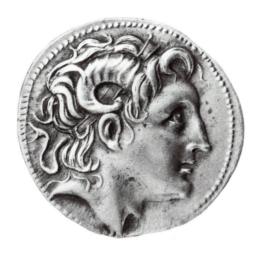

221. Alexander the Great with Amun Horns.
 Four-drachma silver coin issued by Lysimachus.
 c. 297–281 B.C. Diameter 1¹/₈" (3 cm)

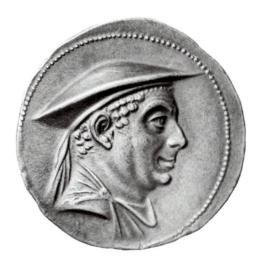

222. Antimachus of Bactria. Silver coin. c. 185 B.C. Diameter 1¹/4" (3.3 cm). The British Museum, London

to show profile portraits of rulers. The successors of Alexander at first put his features on their coins to emphasize their link with the deified conqueror. Such a piece is shown in figure 221. Alexander here displays the horns identifying him with the ram-headed Egyptian god Amun. His "inspired" expression, conveyed by the half-open mouth and the upward-looking eyes, is characteristic of the emotionalism of Hellenistic art, as are the fluid modeling of the features and the agitated, snakelike hair. As a likeness, this head can have only the most tenuous relation to the way Alexander actually looked. Yet this idealized image of the all-conquering genius projects the flavor of the new era more eloquently than do the large-scale portraits of Alexander.

Once the Hellenistic rulers started putting themselves on their coins, the likenesses became more individual. Perhaps the most astonishing of these (fig. 222) is the head of Antimachus of Bactria (present-day Afghanistan), which stands at the opposite end of the scale from the Alexander-Amun. Its mobile features show a man of sharp intelligence and wit, a bit skeptical perhaps about himself and others, and, in any event, without any desire for self-glorification. This penetratingly human portrait seems to point the way to the bronze head from Delos (fig. 216) a hundred years later. It has no counterpart in the monumental sculpture of its own time and thus helps to fill an important gap in our knowledge of Hellenistic portraiture.

CHAPTER SIX

ETRUSCAN ART

The Italian peninsula did not emerge into the light of history until fairly late. The Bronze Age, which dawned first in Mesopotamia about 4000 B.C., came to an end in the Italian peninsula around 1100 B.C., when the Villanovan people brought an early Iron Age culture from Central Europe. They were succeeded by the Etruscans in the eighth century B.C., about the time the earliest Greeks began to settle along the southern shores of Italy and in Sicily. Interestingly, the Romans believed that their city had been founded in 753 B.C. by the descendants of refugees from Troy (see page 162) in Asia Minor. According to the Classical Greek historian Herodotus, however, the Etruscans had left their homeland of Lydia in Asia Minor about 1200 B.C. and settled in the area between Florence and Rome, which to this day is known as Tuscany, the country of the Tusci or Etrusci.

Herodotus' claim was already disputed in Roman times by the Greek historian Dionysius of Halicarnassus. Be that as it may, the Etruscans were strongly linked with Asia Minor and the ancient Near East culturally and artistically. Yet they also show many traits for which no parallels can be found anywhere. The sudden flowering of Etruscan civilization resulted in large part from the influx of Greek culture. For example, the Etruscans borrowed their alphabet from the Greeks toward the end of the eighth century. Nevertheless, their language, of

which our understanding is still very limited, has no kin among any known tongues. The only Etruscan writings that have come down to us are brief funerary inscriptions and a few somewhat longer texts relating to religious ritual, though Roman authors tell us that a rich Etruscan literature once existed. We would, in fact, know practically nothing about the Etruscans at first hand were it not for their elaborate tombs. They were not molested when the Romans destroyed or rebuilt Etruscan cities and therefore have survived intact until modern times.

Italian Bronze Age burials had been of the modest sort found elsewhere in prehistoric Europe. The remains of the deceased, contained in a pottery vessel or urn, were placed in a simple pit along with the equipment they required in an afterlife: weapons for men, jewelry and household tools for women. In Mycenaean Greece, this primitive cult of the dead had been elaborated under Egyptian influence, as shown by the monumental beehive tombs. Something very similar happened eight centuries later in Tuscany. Toward 700 B.C., Etruscan tombs began to imitate, in stone, the interiors of actual dwellings, covered by great conical mounds of earth. They could be roofed by vaults or corbeled domes built of horizontal, overlapping courses of stone blocks, as was the Treasury of Atreus at Mycenae (see fig. 130). At the same time, the pot-

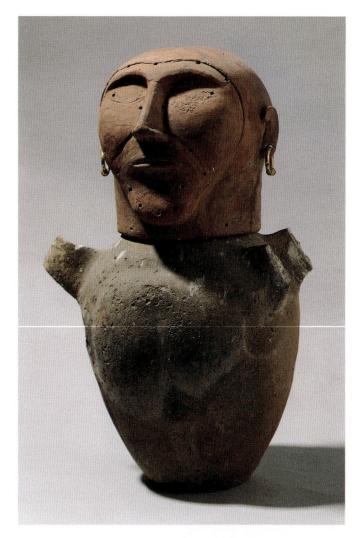

223. Human-headed cinerary urn. c. 675–650 B.C. Terracotta, height 25¹/2" (64.7 cm). Museo Etrusco, Chiusi, Italy

tery urns gradually took on human shape. The lid grew into the head of the deceased, and body markings appeared on the vessel itself, which could be placed on a sort of throne to indicate high rank (fig. 223). Alongside the modest beginnings of funerary sculpture, we find sudden evidence of great wealth in the form of exquisite goldsmiths' work decorated with motifs familiar from the Orientalizing Greek vases of the same period (see fig. 141), intermingled with precious objects imported from the ancient Near East.

The seventh and sixth centuries B.C. saw the Etruscans at the height of their power. Their cities rivaled those of the Greeks; their fleet dominated the western Mediterranean and protected a vast commercial empire that competed with the Greeks and Phoenicians; and their territory extended as far as Naples in the south and the lower Po Valley in the north. Rome itself was ruled by Etruscan kings for about a century, until the establishment of the Republic in 510 B.C. The kings threw the first defensive wall around the seven hills, drained the swampy plain of the Forum, and built the original temple on the Capitoline Hill, thus making a city out of what had been little more than a group of villages before.

But the Etruscans, like the Greeks, never formed a unified nation. They were no more than a loose federation of individual city-states given to quarreling among themselves and slow to unite against a common enemy. During the fifth and fourth centuries B.C., one Etruscan city after another succumbed to the Romans. By the end of the third century, all of them had lost their independence, although many continued to prosper, if we are to judge by the richness of their tombs during the period of political decline.

Tombs and Their Decoration

The flowering of Etruscan civilization thus coincides with the Archaic age in Greece. During this period, especially near the end of the sixth and early in the fifth century B.C., Etruscan art showed its greatest vigor. Greek Archaic influence had displaced the Orientalizing tendencies (many of the finest Greek vases have been found in Etruscan tombs of that time) but Etruscan artists did not simply imitate their Hellenic models. Working in a very different cultural setting, they retained their own clear-cut identity.

One might expect to see the Etruscan cult of the dead wane under Greek influence. On the contrary, tombs and equipment grew more elaborate as the skills of the sculptor and painter increased. The deceased could now be represented full-length, reclining on the lids of sarcophagi shaped like couches, as if they were participants in a festive repast, an Archaic

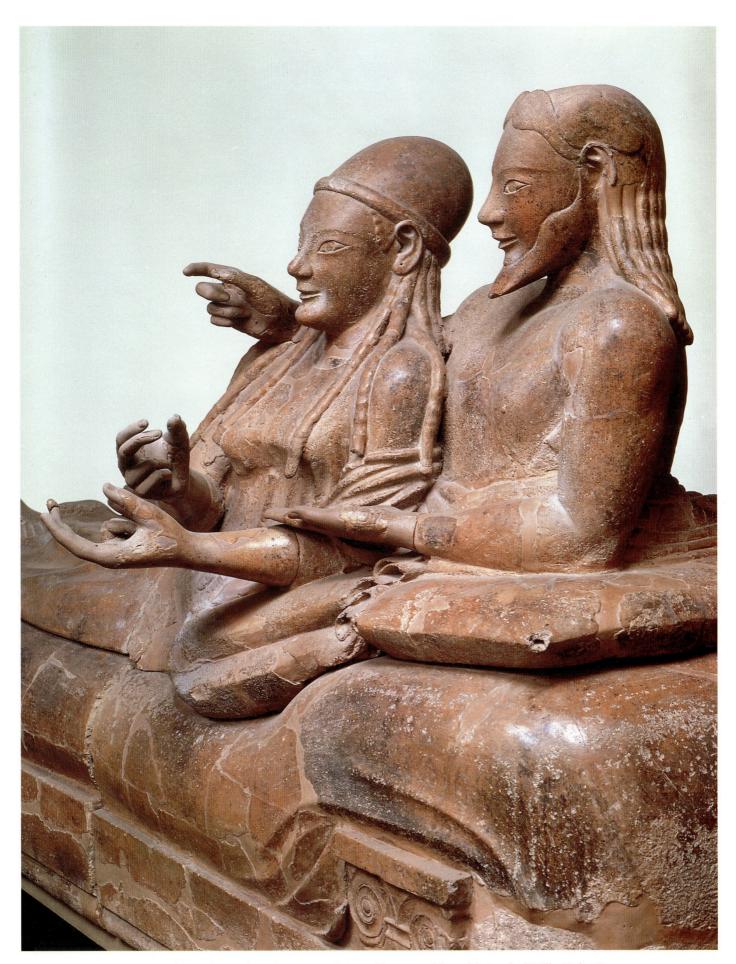

224. Detail of sarcophagus, from Cerveteri. c. 520 B.C. Terracotta. Museo Nazionale di Villa Giulia, Rome

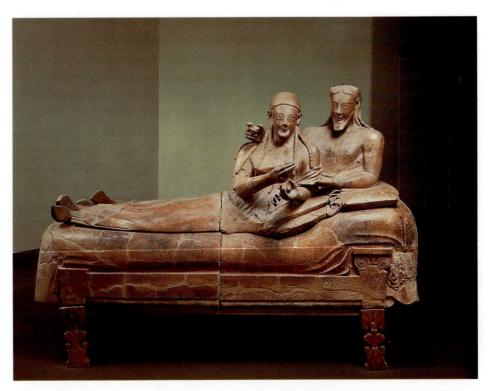

225. Sarcophagus, from Cerveteri. c. 520 B.C. Terracotta, length 6'7" (2 m). Museo Nazionale di Villa Giulia, Rome

smile about their lips. The monumental example in figures 224 and 225 shows a husband and wife side by side, strangely gay and majestic at the same time. The entire work is of terracotta and was once painted in bright colors. The smoothly rounded, elastic forms betray the Etruscan sculptor's preference for modeling in soft materials, in contrast to the Greek love of stone carving. There is less formal discipline here but an extraordinary directness and vivacity characteristic of Etruscan art as a whole.

EARLY FUNERARY BELIEFS. We do not know precisely what ideas the Archaic Etruscans held about the afterlife. Effigies such as our reclining couple, which for the first time in history represent the deceased as thoroughly alive and enjoying themselves, suggest that they regarded the tomb as an abode not only for the body but for the soul as well (in contrast to the Egyptians, who thought of the soul as roaming freely and whose funerary sculpture therefore remained "inanimate"). How else are we to understand the purpose of the wonderfully rich array of murals in these funerary chambers? Since nothing of the sort has survived in Greek territory, they are uniquely important, not only as an Etruscan achievement but also as a possible reflection of Greek wall painting.

TOMB OF HUNTING AND FISHING. Perhaps the most astonishing murals are found in the Tomb of Hunting and Fishing at Tarquinia of about 520 B.C. Figure 226 shows a great marine panorama at one end of the low chamber: a vast, continuous expanse of water and sky in which the fishermen and the hunter with his slingshot play only an incidental part. The free, rhythmic movement of birds and dolphins is strangely reminiscent of Minoan painting of a thousand years earlier (see fig. 120), but the weightless, floating quality of Cretan art is absent. We might also recall Exekias' Dionysus in a Boat (see fig. 142) as the closest Greek counterpart to our scene. The differences, however, are as revealing as the similarities, and one wonders if any Greek Archaic artist knew how to place human figures in a natural setting as effectively as the Etruscan painter did. Could the mural have been inspired by Egyptian scenes of hunting in the marshes, such as the one in figure 68? They seem the most convincing precedent for the general conception of our subject. If so, the Etruscan artist has brought the scene to life, just as the reclining couple in figure 225 has been brought to life compared with Egyptian funerary statues.

TOMB OF THE LIONESSES. A somewhat later example

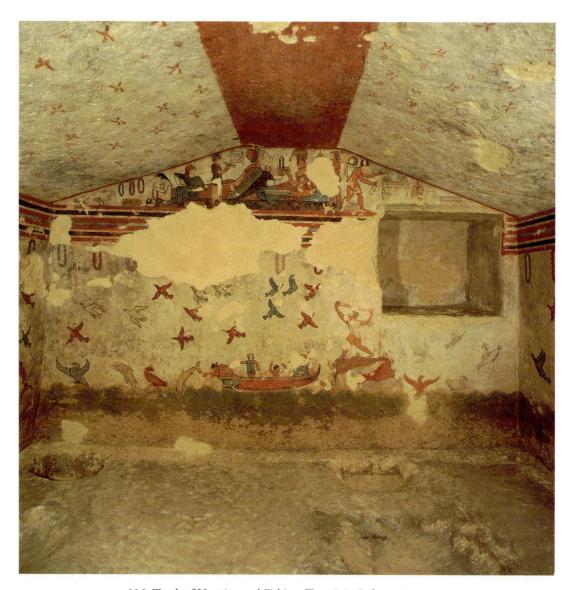

226. Tomb of Hunting and Fishing, Tarquinia, Italy. c. 520 B.C.

from another tomb in Tarquinia (fig. 227) shows a pair of ecstatic dancers. The passionate energy of their movements again strikes us as uniquely Etruscan rather than Greek in spirit. Of particular interest is the transparent garment of the woman, which lets the body shine through. In Greece, this differentiation appears only a few years earlier, during the final phase of Archaic vase painting. The contrasting body color of the two figures continues a practice introduced by the Egyptians more than 2,000 years before (see fig. 65).

LATER FUNERARY BELIEFS. During the fifth century, the Etruscan view of the hereafter must have become a good deal more complex and less festive. We notice the change immediately if we compare the group in figure 228, a cinerary container carved of soft local stone soon after 400 B.C., with its

predecessor in figure 225. The woman now sits at the foot of the couch, but she is not the wife of the young man. Her wings indicate that she is the demon of death, and the scroll in her left hand records the fate of the deceased. The young man is pointing to it as if to say, "Behold, my time has come." The thoughtful, melancholy air of the two figures may be due to some extent to the influence of Classical Greek art which pervades the style of our group (compare fig. 197). A new mood of uncertainty and regret is felt. Human destiny is in the hands of inexorable supernatural forces, and death is now the great divide rather than a continuation, albeit on a different plane, of life on earth.

In later tombs, the demons of death gain an even more fearful aspect. Other, more terrifying demons enter the scene, often battling against benevolent spirits for possession of the soul of the deceased. One of these demons appears in the

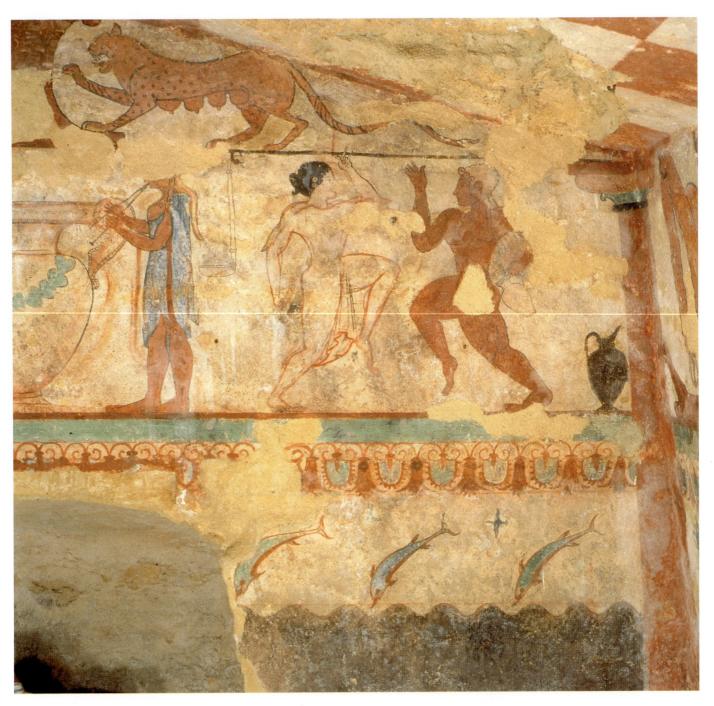

227. Musicians and Two Dancers. Detail of a wall painting. c. 480-470 B.C. Tomb of the Lionesses, Tarquinia, Italy

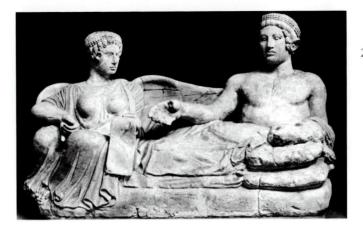

228. Youth and Demon of Death.
Cinerary container.
Early 4th century B.C. Stone
(pietra fetida), length 47"
(119.4 cm). Museo
Archeologico Nazionale,
Florence

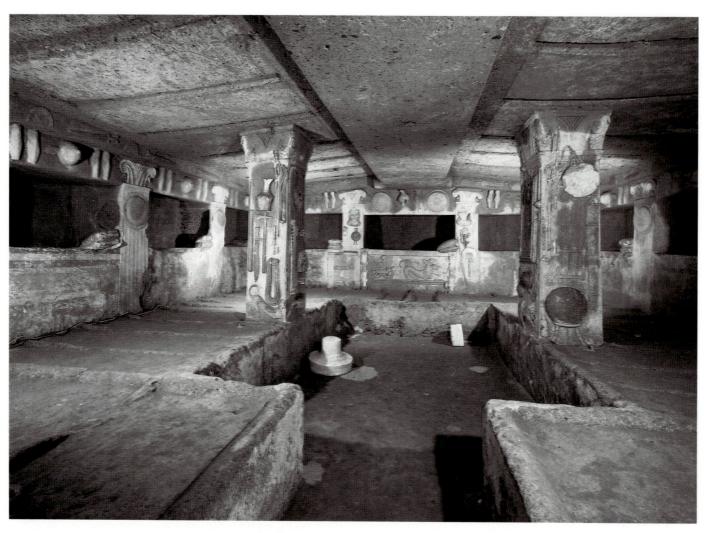

229. Burial chamber. Tomb of the Reliefs, Cerveteri, Italy. 3rd century B.C.

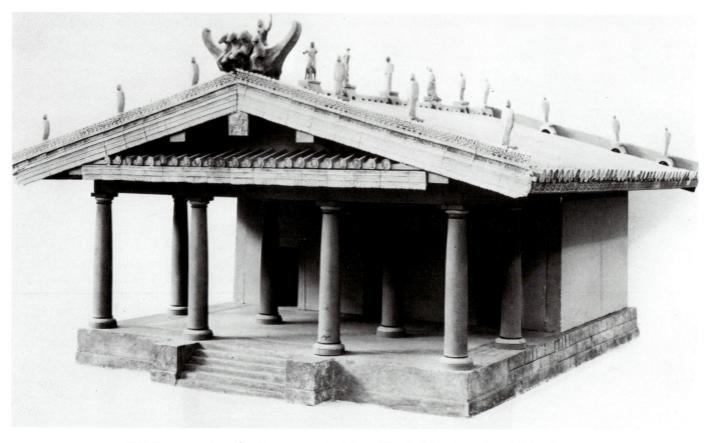

230. Reconstruction of an Etruscan temple. Museo delle Antichità Etrusche e Italiche, Rome

center of figure 229, a tomb of the third century B.C. at Cerveteri, richly decorated with stucco reliefs rather than paintings. The entire chamber, cut into the live rock, closely imitates the interior of a house, including the beams of the roof. The sturdy pilasters (note the capitals, which recall the Aeolian type from Asia Minor in fig. 175), as well as the wall surfaces between the niches, are covered with exact reproductions of weapons, armor, household implements, small domestic animals, and busts of the deceased. In such a setting, the snakelegged demon and his three-headed hound (whom we recognize as Cerberus, the guardian of the infernal regions) seem particularly disquieting.

Temples and Their Decoration

Only the stone foundations of Etruscan temples have survived, since the buildings themselves were built of wood. Apparently the Etruscans, although they were masters of masonry construction for other purposes, rejected for religious reasons the use of stone in temple architecture. The design of their sanctuaries bears a general resemblance to the simpler Greek temples (fig. 230), but with several distinctive features, some of them later perpetuated by the Romans. The entire structure rests on a tall base, or podium, that is no wider than the cella and has steps only on the south side; these lead to a deep porch, supported by two rows of four columns each, and to the cella beyond. The cella is generally subdivided into three compartments, for Etruscan religion was dominated by a triad of gods, the predecessors of the Roman Juno, Jupiter, and Minerva. The Etruscan temple, then, must have been of a squat, squarish shape compared to the graceful Greek sanctuaries, and more closely linked with domestic architecture. Needless to say, it provided no place for stone sculpture. The decoration usually consisted of terracotta plaques covering the architrave and the edges of the roof. Only after 400 B.C. do we occasionally find large-scale terracotta groups designed to fill the pediment above the porch.

VEII. We know, however, of one earlier attempt—and an astonishingly bold one—to find a place for monumental sculpture on the exterior of an Etruscan temple. The so-called Temple of Apollo at Veii, not very far north of Rome, was a structure of standard type in every other respect, but it also had four lifesize terracotta statues on the ridge of its roof (seen also in the reconstruction model, fig. 230). They formed a dramatic group of the sort we might expect in Greek pedimental sculpture: the contest of Hercules and Apollo for the sacred hind (female deer), in the presence of other deities. The best preserved of these figures is the Apollo (fig. 231), acknowledged to be the masterpiece of Etruscan Archaic sculpture. His massive body, completely revealed beneath the ornamental striations of the drapery; the sinewy, muscular legs; the hurried, purposeful stride—all these betray an expressive power that has no counterpart in free-standing Greek statues of the same date.

That Veii was indeed a sculptural center at the end of the sixth century seems to be confirmed by the Roman tradition that the last of the Etruscan rulers of the city called on a master from Veii to make the terracotta image of Jupiter for the temple on the Capitoline Hill. This image has disappeared, but an

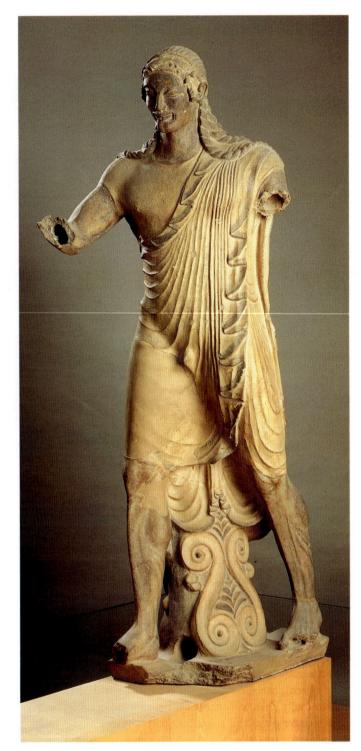

231. *Apollo*, from Veii. c. 510 B.C. Terracotta, height 69" (175.3 cm). Museo Nazionale di Villa Giulia, Rome

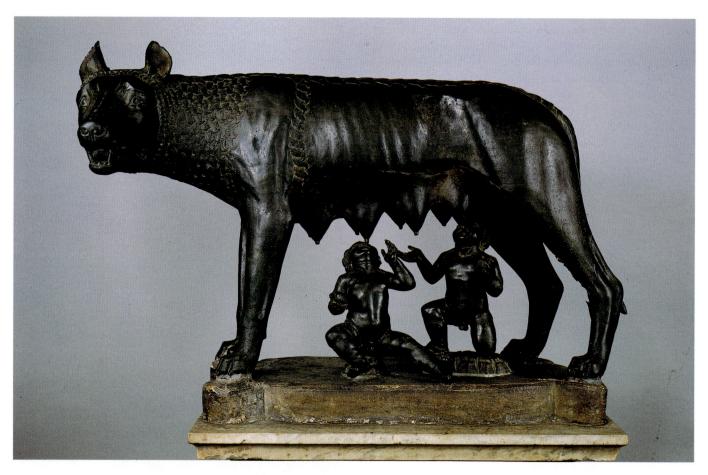

232. She-Wolf. c. 500 B.C. Bronze, height 331/2" (85 cm). Museo Capitolino, Rome

even more famous symbol of Rome, the bronze figure of the she-wolf that nourished Romulus and Remus, is still in existence (fig. 232). [See Primary Sources, no. 16, page 218.] The two babes are Renaissance additions, and the early history of the statue is obscure; some scholars, therefore, have even suspected it of being a medieval work. Nevertheless, it is almost surely an Etruscan Archaic original, for the wonderful ferocity of expression, the latent physical power of the body and legs, have the same awesome quality we sense in the *Apollo* from Veii. In any event, the she-wolf as the totemic animal of Rome has the strongest links with Etruscan mythology, in which wolves seem to have played an important part from very early times.

Portraiture and Metalwork

The Etruscan concern with effigies of the deceased might lead us to expect an early interest in individual portraiture. Yet the features of such funerary images as those in figures 225 and 228 are entirely impersonal, and it was only toward 300 B.C., under the influence of Greek portraiture, that individual likenesses began to appear in Etruscan sculpture. The finest of them are not funerary portraits, which tend to be rather crude and perfunctory, but the heads of bronze statues. *Portrait of a Boy* (fig. 233) is a real masterpiece of its kind. The firmness of modeling lends a special poignancy to the sensitive mouth and the gentle, melancholy eyes.

No less impressive is the very high quality of the casting

and finishing, which bears out the ancient fame of the Etruscans as master craftsmen in metal. Their ability in this respect was of long standing, for the wealth of Etruria was founded on the exploitation of copper and iron deposits. From the sixth century on, they produced large quantities of bronze statuettes, mirrors, and such, both for export and domestic consumption. The charm of these small pieces is well displayed by the engraved design on the back of a mirror done soon after 400 B.C. (fig. 234). Within an undulating wreath of vines, we see a winged old man, identified as Chalchas, examining a roundish object. The draftsmanship is so beautifully balanced and assured that we are tempted to assume that Classical Greek art was the direct source of inspiration.

DIVINATION. So far as the style of our piece is concerned, this may well be the case, but the subject is uniquely Etruscan, for the winged genius is gazing at the liver of a sacrificial animal. We are witnessing a practice that loomed as large in the lives of the Etruscans as the care of the dead: the search for omens or portents. The Etruscans believed that the will of the gods manifested itself through signs in the natural world, such as thunderstorms or the flight of birds, and that by reading them people could find out whether the gods smiled or frowned upon their enterprises. The priests who knew the secret language of these signs enjoyed enormous prestige. Even the Romans were in the habit of consulting them before any major public or private event. Divination (as the Romans

233. *Portrait of a Boy.* Early 3rd century B.C. Bronze, height 9" (23 cm). Museo Archeologico Nazionale, Florence

234. Engraved back of a mirror. c. 400 B.C. Bronze, diameter 6" (15.3 cm). Musei Vaticani, Museo Gregoriano Etrusco, Città del Vaticano, Rome

called the art of interpreting omens) can be traced back to ancient Mesopotamia, and the practice was not unknown in Greece, but the Etruscans carried it further than any of their predecessors. They put especial trust in the livers of sacrificial animals, on which, they thought, the gods had inscribed the hoped-for divine message. In fact, they viewed the liver as a sort of microcosm, divided into regions that corresponded, in their minds, to the regions of the sky.

Arcane and irrational as they were, these practices became part of our cultural heritage, and echoes of them persist to this day. True, we no longer try to tell the future by watching the flight of birds or examining animal livers, but tea leaves and horoscopes are still prophetic to many people. And we speak of auspicious events, that is, of events indicating a favorable future, unaware that "auspicious" originally referred to a favorable flight of birds. Perhaps we do not believe very seriously that four-leaf clovers bring good luck and black cats bad luck, yet a surprising number of us admit to being superstitious.

The Architecture of Cities

According to Roman writers, the Etruscans were masters of architectural engineering, and of town planning and surveying. That the Romans learned a good deal from them can hardly be doubted, but exactly how much the Etruscans con-

tributed to Roman architecture is difficult to say, since very little Etruscan or early Roman architecture remains standing above ground. Roman temples certainly retained many Etruscan features, and the atrium, the central hall of the Roman house (see fig. 255), likewise originated in Etruria. In town planning and surveying, too, the Etruscans have a good claim to priority over the Greeks.

The original homeland of the Etruscans, Tuscany, was too hilly to encourage geometric schemes. However, when they colonized the flatlands south of Rome in the sixth century, they laid out their newly founded cities as a network of streets centering on the intersection of two main thoroughfares, the cardo (which ran north and south) and the decumanus (which ran east and west). The four quarters thus obtained could be further subdivided or expanded, according to need. This system, which the Romans adopted for the new cities they were to found throughout Italy, western Europe, and North Africa, may have been derived from the plan of Etruscan military camps. Yet it also seems to reflect the religious beliefs that made the Etruscans divide the sky into regions according to the points of the compass and place their temples along a north-south axis. The Etruscans must also have taught the Romans how to build fortifications, bridges, drainage systems, and aqueducts, but hardly anything remains of their enterprises in these fields.

CHAPTER SEVEN

ROMAN Art

Among the civilizations of the ancient world, that of the Romans is far more accessible to us than any other. We can trace its history with a wealth of detail that continues to amaze us: the growth of the Roman domain from city-state to empire; its military and political struggles; its changing social structure, the development of its institutions; and the public and private lives of its leading personalities. Nor is this a matter of chance. The Romans themselves seem to have wanted it that way. Articulate and posterity-conscious, they have left a vast literary legacy, from poetry and philosophy to humble inscriptions recording everyday events, and an equally huge mass of visible monuments that were scattered throughout their empire, from England to the Persian Gulf, from Spain to Romania. Yet, paradoxically, there are few questions more difficult to answer than "What is Roman art?" The Roman genius, so clearly recognizable in every other sphere of human activity, becomes oddly elusive when we ask whether there was a characteristic Roman style in the fine arts, particularly painting and sculpture.

Why is this so? The most obvious reason is the great admiration the Romans had for Greek art of every period and variety. They imported originals of earlier date—Archaic, Classical, and Hellenistic-by the thousands and had them copied in even greater numbers. In addition, their own production was clearly based on Greek sources, and many of their artists, from Republican times (509-27 B.C.) to the end of the Empire (27 B.C.-A.D. 395), were of Greek origin. Moreover, Roman authors show little concern with the art of their own time. They tell us a good deal about the development of Greek art as described in Greek writings on the subject. Or they speak of artistic production during the early days of the Roman Republic, of which not a trace survives today, but rarely about contemporary works. While anecdotes or artists' names may be mentioned incidentally in other contexts, the Romans never developed a rich literature on the history, theory, and criticism of art such as had existed among the Greeks. Nor do we hear of Roman artists who enjoyed individual

fame, although the great names of Greek art—Polyclitus, Phidias, Praxiteles, Lysippus—were praised as highly as ever.

One might be tempted to conclude, therefore, that the Romans themselves looked upon the art of their time as being in decline compared with the great Greek past, whence all important creative impulses had come. This, indeed, was the prevalent attitude among scholars until not very long ago. Roman art, they claimed, is essentially Greek art in its final decadent phase—Greek art under Roman rule. Hence, there is no such thing as Roman style, only Roman subject matter. Yet the fact remains that, as a whole, the art produced under Roman auspices does look distinctly different from Greek art. Otherwise the "problem" would not have arisen. If we insist on evaluating this difference by Greek standards, it will appear as a process of decay. If, on the other hand, we interpret it as expressing different, un-Greek intentions, we are likely to see it in a less negative light.

Once we admit that art under the Romans had positive un-Greek qualities, we cannot very well regard these innovations as belonging to the final phase of Greek art, no matter how many artists of Greek origin we may find in Roman records. Actually, the Greek names of these men do not signify much. Most of the artists, it seems, were thoroughly Romanized. In any event, the great majority of Roman works of art are unsigned, and their makers, for all we know, may have come from any part of the far-flung Roman domain.

The Roman Empire was a cosmopolitan society in which national or regional traits were soon absorbed into the common all-Roman pattern set by the capital, the city of Rome. From the very start Roman society proved astonishingly tolerant of alien traditions. It had a way of accommodating them all, so long as they did not threaten the security of the state. The populations of newly conquered provinces were not forced into a uniform straitjacket but, rather, were put into a fairly low-temperature melting pot. Law and order, and a token reverence for the symbols of Roman rule, were imposed

on them. At the same time, however, their gods and sages were

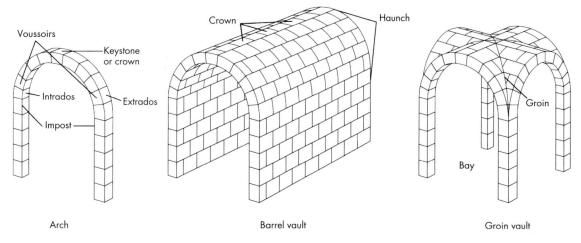

235. Arch, barrel vault, and groin vault

hospitably received in the capital, and eventually they themselves would be given the rights of citizenship. Roman civilization and Roman art thus acquired not only the Greek heritage but, to a lesser extent, that of the Etruscans, and of Egypt and the Near East as well. All this made for an extraordinarily complex and open society, homogeneous and diverse at the same time. The sanctuary of Mithras accidentally unearthed in the center of London offers a striking illustration of the cosmopolitan character of Roman society. The god is Persian in origin but he had long since become a Roman "citizen," and his sanctuary, now thoroughly and uniquely Roman in form, can be matched by hundreds of others throughout the empire.

Under such conditions, it would be little short of a miracle if Roman art were to show a consistent style such as we found in Egypt, or the clear-cut evolution that distinguishes the art of Greece. Its development, to the extent that we understand it today, might be likened to a counterpoint of divergent tendencies that may exist side by side, even within a single monument, and none of them ever emerges as overwhelmingly dominant. The "Roman-ness" of Roman art must be found in this complex pattern, rather than in a single and consistent quality of form—and that is precisely its strength.

ARCHITECTURE

If the originality of Roman sculpture and painting has been questioned, Roman architecture is a creative feat of such magnitude as to silence all doubts about its distinctive Roman character. Its growth, moreover, from the very start reflected a specifically Roman way of public and private life. Greek models, though much admired, no longer sufficed to accommodate the sheer numbers of people in large public buildings necessitated by the empire. And when it came to supplying the citizenry with everything it needed, from water to entertainment on a grand scale, radical new forms had to be invented, and cheaper materials and quicker methods had to be used.

From the beginning, the growth of Rome is hardly thinkable without the arch and the vaulting systems derived from it: the barrel vault, a half-cylinder; the groin vault, which consists of two barrel vaults intersecting each other at right angles;

and the dome (see figs. 235 and 325). True arches are constructed of wedge-shaped blocks, called voussoirs, each pointing toward the center of the semicircular opening. Such an arch is strong and self-sustaining, in contrast to the "false" arch composed of horizontal courses of masonry or brickwork (like the opening above the lintel of the Lioness Gate at Mycenae. fig. 135). The true arch, and its extension, the barrel vault, had been discovered in Egypt as early as about 2700 B.C., but the Egyptians had used it mainly in underground tomb structures and in utilitarian buildings, never in temples. Apparently they thought it unsuited to monumental architecture. In Mesopotamia the true arch was used for city gates and perhaps elsewhere as well, but to what extent we cannot determine for lack of preserved examples. The Greeks knew the principle from the fifth century on, but they confined the use of the true arch to underground structures or to simple gateways, because they refused to combine it with the elements of the architectural orders.

No less vital to Roman architecture was concrete, a mixture of mortar and gravel with rubble (small pieces of building stone and brick). Concrete construction had been invented in the Near East more than a thousand years earlier, but the Romans developed its potential until it became their chief building technique. The advantages of concrete are obvious: strong, cheap, and flexible, it alone made possible the vast architectural enterprises that are still the chief reminders of "the grandeur that was Rome." The Romans knew how to hide the unattractive concrete surface by adding a facing of brick, stone, or marble, or by covering it with smooth plaster. Today, this decorative skin has disappeared from the remains of most Roman buildings, leaving the concrete core exposed and thus depriving these ruins of the appeal that those of Greece have for us.

Religious Architecture

"TEMPLE OF FORTUNA VIRILIS." Any elements borrowed from the Etruscans or Greeks were soon marked with an unmistakable Roman stamp. These links with the past are strongest in the temple types developed during the Republican period (510–60 B.C.), the heroic age of Roman expansion.

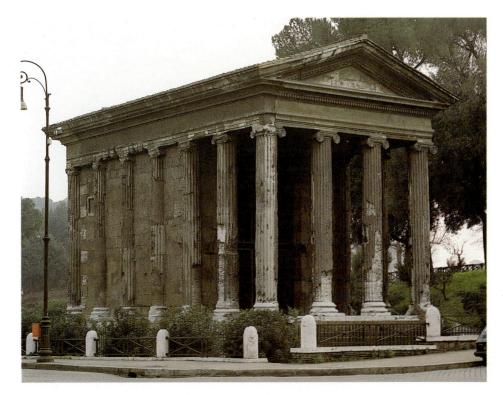

236. "Temple of Fortuna Virilis," Rome. Late 2nd century B.C.

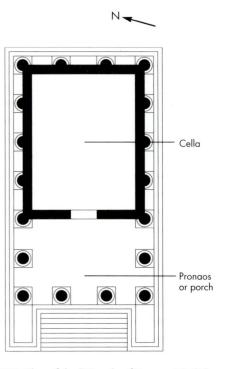

237. Plan of the "Temple of Fortuna Virilis"

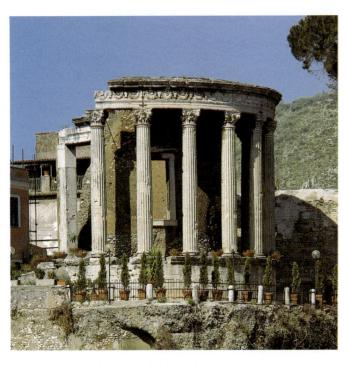

238. "Temple of the Sibyl," Tivoli. Early 1st century B.C.

The delightful small "Temple of Fortuna Virilis" is the oldest well-preserved example of its kind (fig. 236). (The name is sheer fancy, for the sanctuary seems to have been dedicated to the Roman god of harbors, Portunus.) Built in Rome during the last years of the second century B.C., it suggests, in the elegant proportions of its Ionic columns and entablature, the wave of Greek influence following the Roman conquest of Greece in 146 B.C. Yet it is not simply a copy of a Greek temple, for we recognize a number of Etruscan elements: the high

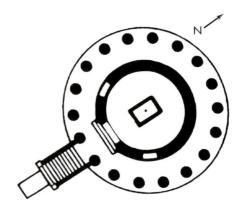

239. Plan of the "Temple of the Sibyl"

podium, the deep porch, and the wide cella, which engages the columns of the peristyle. However, the cella is no longer subdivided into three compartments as it had been under the Etruscans; it now encloses a single unified space (fig. 237).

The Romans needed spacious temple interiors, since they used them not only for the image of the deity but also for the display of trophies (statues, weapons, etc.) brought back by their conquering armies. The "Temple of Fortuna Virilis" thus represents a well-integrated new type of temple designed for Roman requirements, not a haphazard cross of Etruscan and Greek elements. It was to have a long life. Numerous examples of it, usually large and with Corinthian columns, can be found as late as the second century A.D., both in Italy and in the provincial capitals of the empire.

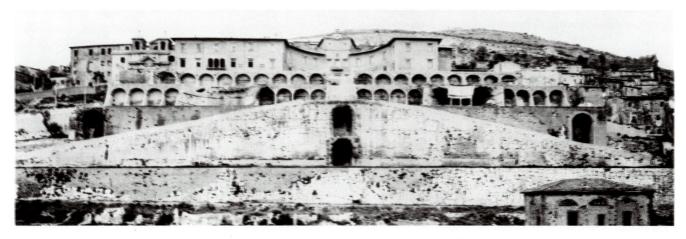

240. Sanctuary of Fortuna Primigenia, Praeneste (Palestrina). Early 1st century B.C.

TEMPLE OF THE SIBYL. Another type of Republican temple is seen in the so-called "Temple of the Sibyl" at Tivoli (figs. 238 and 239), erected a few decades later than the "Temple of Fortuna Virilis." It, too, was the result of the merging of two separate traditions. Its original ancestor was a structure in the center of Rome in which the sacred flame of the city was kept. This building at first had the shape of the traditional round peasant huts in the Roman countryside. Later on it was redesigned in stone, under the influence of Greek structures of the tholos type (see page 106), and thus became the model for the round temples of late Republican times. Here again we find the high podium, with steps only opposite the entrance, and a graceful Greek-inspired exterior. As we look closely at the cella, we notice that while the door and window frames are of cut stone, the wall is built in concrete, visible now that the marble facing that once disguised it is gone.

SANCTUARY OF FORTUNA PRIMIGENIA. Roman buildings characteristically speak to us through their massive size and boldness of conception. The oldest monument in which these qualities are fully in evidence is the Sanctuary of Fortuna Primigenia at Palestrina, in the foothills of the Apennines east of Rome (fig. 240). Here, in what was once an important Etruscan stronghold, a strange cult had been established since early times, dedicated to Fortuna (Fate) as a mother deity and combined with a famous oracle. The Roman sanctuary dates from the early first century B.C. Its size and shape were almost completely hidden by the medieval town that had been built over it, until a bombing attack in 1944 destroyed most of the later houses and thus laid bare the remains of the huge ancient temple precinct. (The semicircular edifice is of much later date.)

The site originally had a series of ramps leading up to a broad colonnaded terrace, and the entire structure was crowned by a great colonnaded court (fig. 241). Arched openings, framed by engaged columns and architraves, played an important part in the second terrace, just as semicircular recesses did in the first. These openings were covered by barrel vaults, another characteristic feature of the Roman archi-

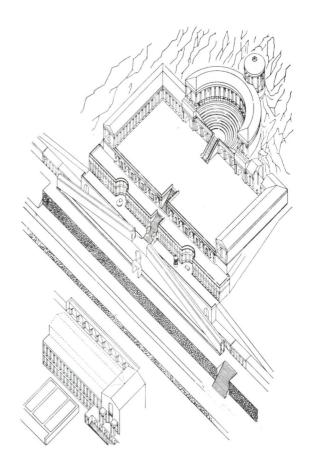

241. Axonometric reconstruction of the Sanctuary of Fortuna Primigenia, Praeneste

tectural vocabulary. Except for a niche with the columns and entablature on the lower terrace, all the surfaces now visible are of concrete, like the cella of the round temple at Tivoli. Indeed, it is hard to imagine how a complex as enormous as this could have been constructed otherwise.

What makes the sanctuary at Palestrina so imposing, however, is not merely its scale but the superb way it fits the site.

242. Plan of the Forums, Rome. 1) Temple of Capitoline Jupiter;
2) Temple of Trajan;
3) Basilica Ulpia;
4) Market of Trajan;
5) Temple of Venus Genetrix;
6) Forum of Trajan;
7) Temple of Mars Ultor;
8) Forum of Augustus;
9) Forum of Julius Caesar;
10) Senate Chamber;
11) Temple of Concord;
12) Roman Forum;

13) Sacred Way; 14) Basilica Julia; 15) Temple of Castor and Pollux; 16) Arch of Augustus; 17) Temple of Vesta;

18) Temple of Julius Caesar; 19) Basilica Aemilia;

20) Temple of Antoninus and Faustina;
21) House of the Vestal Virgins;
22) Temple of Romulus;
23) Basilica of Maxentius and Constantine;
24) Forum of Vespasian;
25) Temple of Minerva;
26) Forum of Nerva

An entire hillside, comparable to the Acropolis of Athens in its commanding position, has been transformed and articulated so that the architectural forms seem to grow out of the rock, as if human beings had simply completed a design laid out by nature itself. Such a molding of great open spaces had never been possible, or even desired, in the Classical Greek world. The only comparable projects are found in Egypt (see the Temple of Queen Hatshepsut, figs. 72 and 73). Nor did it express the spirit of the Roman Republic. Significantly enough, the Palestrina sanctuary dates from the time of Sulla, whose absolute dictatorship (82-79 B.C.) marked the transition from Republican government to the one-man rule of Julius Caesar and his Imperial successors. Since Sulla had won a great victory against his enemies in the civil war at Palestrina, it is tempting to assume that he personally ordered the sanctuary built, both as an offering to Fortuna and as a monument to his own fame.

243. (below) Pont du Gard, Nîmes, France. Early 1st century A.D.

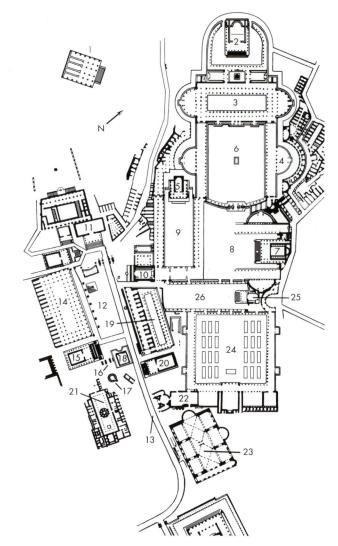

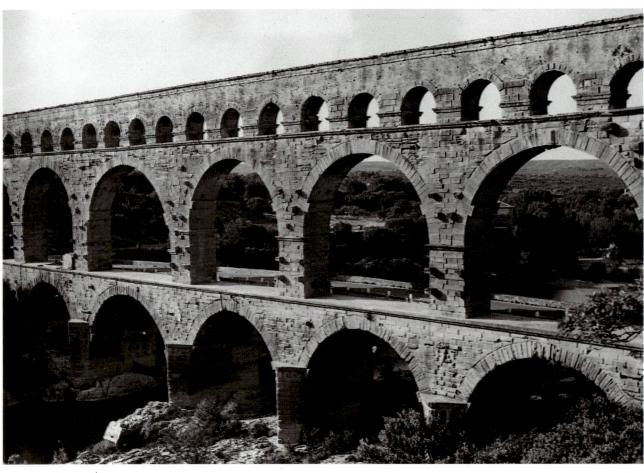

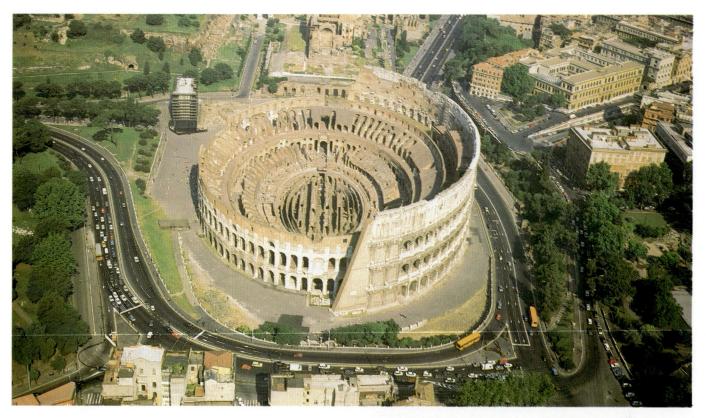

244. The Colosseum (aerial view), Rome. 72-80 A.D.

FORUMS. Perhaps inspired by the Palestrina complex, Julius Caesar, near the end of his life, sponsored a project planned on a similar scale in Rome itself: the Forum Julium, a great architecturally framed square adjoining the Temple of Venus Genetrix, the mythical ancestress of Caesar's family. Here the merging of religious cult and personal glory is even more overt. The Forum of Caesar set the pattern for all the later Imperial forums, which were linked to it by a common major axis, forming the most magnificent architectural sight of the Roman world (fig. 242). Unfortunately, nothing is left of the forums today but a field of ruins that conveys little of their original splendor.

Secular Architecture

The arch and vault, which we encountered at Palestrina as an essential part of Roman monumental architecture, also formed the basis of construction projects such as sewers, bridges, and aqueducts, designed for efficiency rather than beauty. The first enterprises of this kind were built to serve the city of Rome as early as the end of the fourth century B.C., but only traces of them survive today. There are, however, numerous others of later date throughout the empire, such as the exceptionally well-preserved aqueduct at Nîmes in southern France known as the Pont du Gard (fig. 243). Its rugged, clean lines that span the wide valley are a tribute not only to the high caliber of Roman engineering but also to the sense of order and permanence that inspired these efforts. It is these qualities, one may argue, that underlie all Roman architecture and define its unique character.

COLOSSEUM. They impress us again in the Colosseum, the enormous amphitheater for gladiatorial games in the center of Rome (figs. 244 and 245). Completed in 80 A.D., it is,

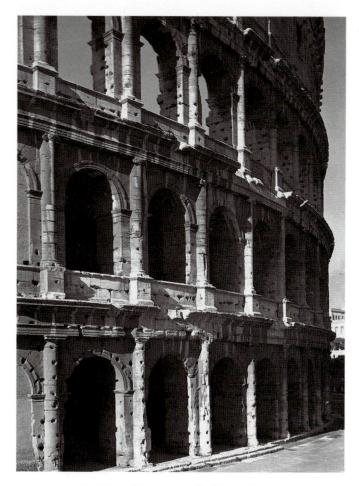

245. View of the outer wall of the Colosseum

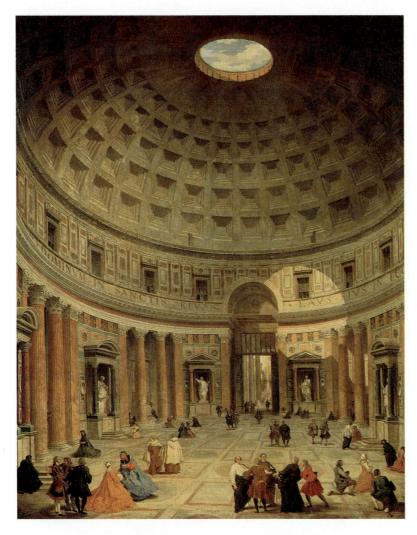

246. Giovanni Paolo Panini. *The Interior of the Pantheon.* c. 1740. Oil on canvas, 50½ x 39" (128.3 x 99.1 cm). National Gallery of Art, Washington, D.C. Samuel H. Kress Collection

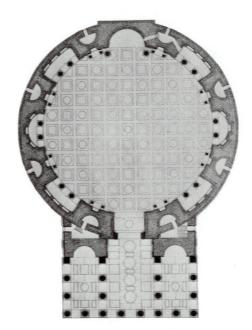

247. Plan of the Pantheon

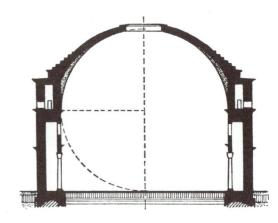

248. Transverse section of the Pantheon

Interiors

Arches, vaults, and concrete permitted the Romans to create huge uninterrupted interior spaces for the first time in the history of architecture. These were explored especially in the great baths, or thermae, which had become important centers of social life in Imperial Rome. The experience gained there could then be applied to other, more traditional types of buildings, sometimes with revolutionary results.

PANTHEON. Perhaps the most striking example of this process is the famous Pantheon in Rome, a very large round temple of the early second century A.D. whose interior is the best preserved, as well as the most impressive, of any surviving Roman structure (figs. 246–49). There had been round temples long before this time, but their shape, as represented by the "Temple of the Sibyl" (see figs. 238 and 239), is so different from that of the Pantheon that the latter could not possibly have been derived from them. On the outside, the cella of the Pantheon appears as an unadorned cylindrical drum, surmounted by a gently curved dome. The entrance is emphasized by a deep porch of the kind familiar to us from standard

in terms of sheer mass, one of the largest single buildings anywhere; when intact, it accommodated more than 50,000 spectators. The concrete core, with its miles of stairways and barrel- and groin-vaulted corridors, is an outstanding feat of engineering efficiency devised to ensure the smooth flow of traffic to and from the arena. It utilizes both the familiar barrel vault and a more complex form, the groin vault (see fig. 235). The exterior, dignified and monumental, reflects the interior articulation of the structure but clothes and accentuates it in cut stone. There is a fine balance between vertical and horizontal elements in the framework of engaged columns and entablatures that contains the endless series of arches. The three Classical orders are superimposed according to their intrinsic "weight": Doric, the oldest and most severe, on the ground floor, followed by Ionic and Corinthian. The lightening of the proportions, however, is barely noticeable, for the orders in their Roman adaptation are almost alike. Structurally, they have become ghosts; yet their aesthetic function continues unimpaired. It is through them that this enormous facade becomes related to the human scale.

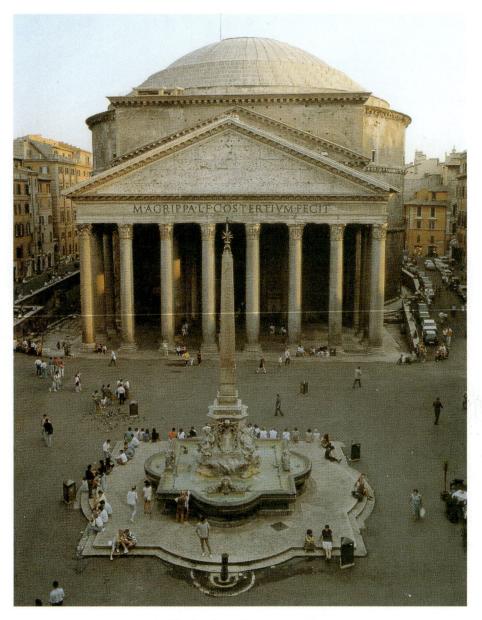

249. The Pantheon, Rome. 118-25 A.D.

Roman temples such as "Fortuna Virilis" (figs. 236 and 237).

The junction of these two elements seems rather abrupt, but we must remember that we no longer see the building raised high on a podium as it was meant to be seen. Today the level of the surrounding streets is a good deal higher than it was in antiquity, so that the steps leading up to the porch are now submerged. Moreover, the porch was designed to form part of a rectangular, colonnaded forecourt, which must have had the effect of detaching it from the rotunda. So far as the cella is concerned, therefore, the architect apparently discounted the effect of the exterior, putting all the emphasis on the great domed space that opens before us with dramatic suddenness as we step through the entrance.

That the architects did not have an easy time with the engineering problems of supporting the huge dome may be deduced from the heavy plainness of the exterior wall. Nothing on the outside, however, gives any hint of the interior. Indeed, its airiness and elegance are utterly different from what the rather forbidding exterior would lead us to expect. The impact

of the interior, awe-inspiring and harmonious at the same time, is impossible to convey in photographs. Even the painting (fig. 246) that we use to illustrate it fails to do it justice.

The dome is a true hemisphere of ingenious design. The interlocking ribs form a structural cage that permits the use of relatively lightweight coffers arranged in five rings. The circular opening in its center (called the oculus, or eye) admits an ample and wonderfully even flow of light. The height from the floor to the eye is 143 feet, which is also the diameter of the dome's base and the interior (fig. 248). Dome and drum are likewise of equal heights, so that all the proportions are in exact balance. On the exterior, this balance could not be achieved, for the outward thrust of the dome had to be contained by making its base considerably heavier than the top. (The thickness of the dome increases downward from 6 feet to 20 feet.) The weight of the dome does not rest uniformly on the drum but is concentrated on the eight wide "pillars" (see fig. 247). Between them, niches are daringly hollowed out of the massive concrete, and although they are closed in back,

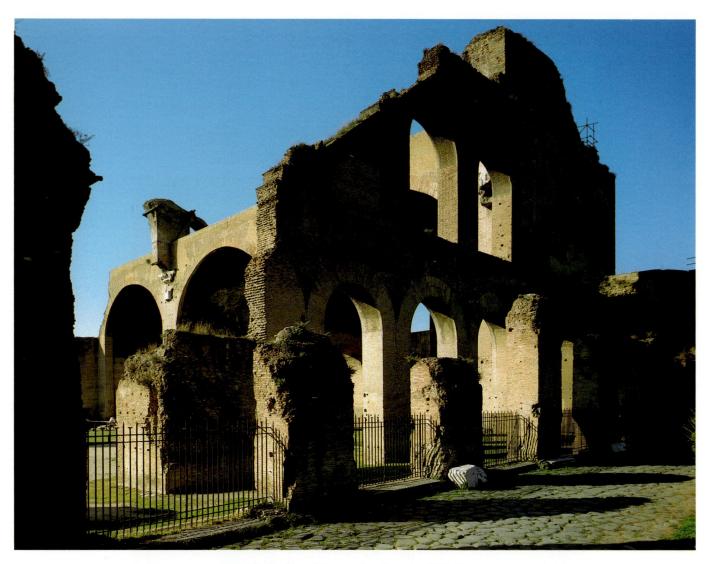

250. The Basilica of Constantine, Rome. c. 307-20 A.D.

251. Reconstruction drawing of the Basilica of Constantine (after Huelsen)

the screen of columns gives them the effect of openings that lead to adjoining rooms. This sense of open space behind the supports helps to prevent us from feeling imprisoned inside the Pantheon and makes us feel that the walls are less thick and the dome much lighter than is actually the case. The columns, the colored marble paneling of the wall surfaces, and the floor

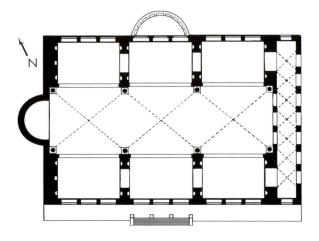

252. Plan of the Basilica of Constantine

remain essentially as they were in Roman times. Originally, however, the recessed coffers were gilded to make the dome resemble "the golden Dome of Heaven."

As its name suggests, the Pantheon was dedicated to all the gods or, more precisely, to the seven planetary gods. (There are seven niches.) It seems reasonable, therefore, to assume that

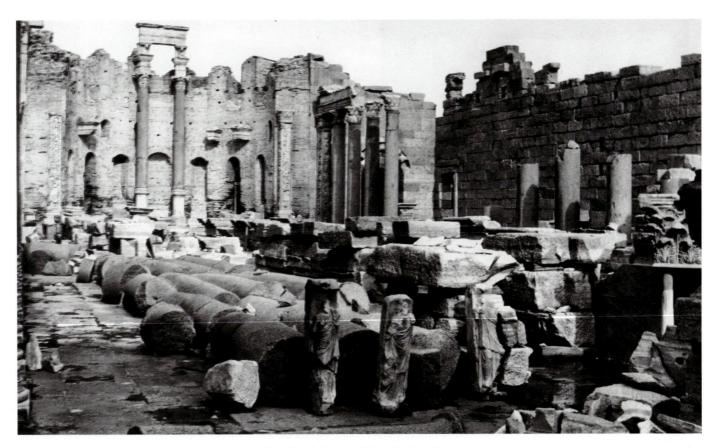

253. Basilica, Leptis Magna, Libya. Early 3rd century A.D.

the golden dome had a symbolic meaning, that it represented the Dome of Heaven. Yet this solemn and splendid structure grew from rather humble antecedents. The Roman architect Vitruvius, writing more than a century earlier, describes the domed steam chamber of a bathing establishment that anticipates (undoubtedly on a very much smaller scale) the essential features of the Pantheon: a hemispherical dome, a proportional relationship of height and width, and the circular opening in the center (which could be closed by a bronze shutter on chains to adjust the temperature of the steam room).

BASILICAS. The Basilica of Constantine, from the early fourth century A.D., is an even more direct example of how thermae were transformed in new applications. Unlike other basilicas, which we will discuss below, the Basilica of Constantine (it was actually begun by his predecessor, Maxentius) derives its shape from the main hall of the public baths built by two earlier emperors, Caracalla and Diocletian, but it is constructed on an even grander scale. It must have been the largest roofed interior in all of Rome. Today only the north aisle, consisting of three huge barrel-vaulted compartments, is still standing (fig. 250). The center tract, or nave, covered by three groin vaults (figs. 251 and 252), rose a good deal higher. Since a groin vault resembles a canopy, with all the weight and thrust concentrated at the four corners (see fig. 235), the upper walls of the nave could be pierced by large windows (called the clerestory), so that the interior of the basilica must have had a light and airy quality despite its enormous size. We meet its echoes in many later buildings, from churches to railway stations. The Basilica of Constantine was entered through

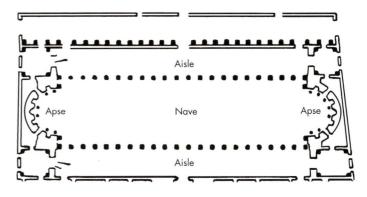

254. Plan of the Basilica, Leptis Magna

the entrance hall, or narthex, at the east end and terminated in a semicircular niche, called an apse, where the colossal statue of Constantine was found (see fig. 283). Perhaps to accommodate his cult statue, Constantine modified the building by adding a second entrance to the south and a second apse opposite it where he could sit as emperor.

Basilicas, long halls serving a variety of civic purposes, had first been developed in Hellenistic Greece. Under the Romans, they became a standard feature of every major town, where one of their chief functions was to provide a dignified setting for the courts of law that dispensed justice in the name of the emperor. [See Primary Sources, no. 9, page 215.] Rome itself had a number of basilicas, but very little remains of them today. Those in the provinces have fared somewhat better. The outstanding one at Leptis Magna in North Africa (figs. 253 and 254) has most of the characteristics of the standard type.

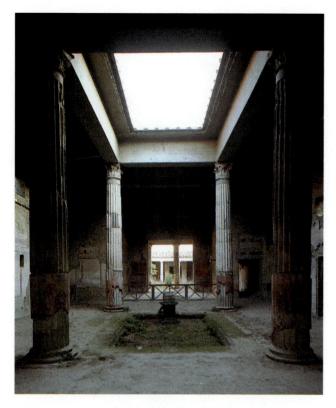

255. Atrium, House of the Silver Wedding, Pompeii. Early 1st century A.D.

The long nave terminates in a semicircular apse at either end. Its walls rest on colonnades to provide access to the side aisles, which are lower than the nave to permit clerestory windows in the upper part of the nave wall.

These basilicas had wooden ceilings instead of masonry vaults, for reasons of convenience and tradition rather than technical necessity. They were thus subject to destruction by fire. The one at Leptis Magna, sadly ruined though it is, counts among the best-preserved examples. The Basilica of Constantine in Rome was a daring attempt to create a novel, vaulted type, but the design seems to have met with little public favor, as it had no direct successors. Perhaps people felt that it lacked dignity because of its obvious resemblance to the public baths. Whatever the reason, the Christian basilicas of the fourth century were modeled on the older, wooden-roofed type (see fig. 299). Not until 700 years later did vaulted basilican churches become common in western Europe.

Domestic Architecture

One of the delights in studying Roman architecture is that it includes not only great public edifices but also a wide variety of residential dwellings, from Imperial palaces to the quarters of the urban poor. If we disregard the extremes of this scale, we are left with two basic types that account for most of the domestic architecture that has survived. The *domus* is a single-family house based on ancient Italic tradition. Its distinctive feature is the atrium, a square or oblong central hall lit by an opening in the roof, around which the other rooms are grouped. In Etruscan times, it had been a rural dwelling, but the Romans "citified" and elaborated it into the typical home of the well-to-do.

Many examples of the domus in various stages of development have come to light at Herculaneum and Pompeii, the

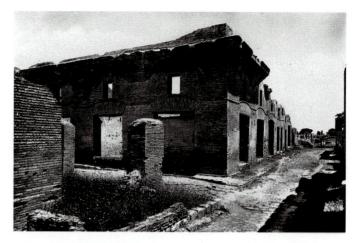

256. Insula of the House of Diana, Ostia. c. 150 A.D.

two towns that were buried under volcanic ash during an eruption of Mount Vesuvius in 79 A.D. As we enter the socalled House of the Silver Wedding at Pompeii, we see the view in figure 255, taken from the vestibule, along the main axis of the domus. Here the atrium has become a room of impressive size. The four Corinthian columns at the corners of the opening in the roof give it the quality of an enclosed court. There is a shallow basin in the center to catch the rainwater (the roof slants inward). The atrium was the traditional place for keeping portrait images of the ancestors of the family. At its far end, to the right, we see a recess for keeping family records (the tablinum) and beyond it the garden, surrounded by a colonnade (the peristyle). In addition to the chambers grouped around the atrium, there may be further rooms attached to the back of the house. The entire establishment is shut off from the street by windowless walls. Obviously, privacy and self-sufficiency were important to the wealthy Roman. [See Primary Sources, no. 10, page 215.]

Less elegant than the domus, and decidedly urban from the very start, is the *insula*, or city block, which we find mainly in Rome itself and in Ostia, the ancient port of Rome near the mouth of the Tiber. The insula anticipates many features of the modern apartment house. It is a good-sized concrete-and-brick building (or a chain of such buildings) around a small central court, with shops and taverns open to the street on the ground floor and living quarters for numerous families above. Some insulae had as many as five stories, with balconies above the second floor (fig. 256). The daily life of the artisans and shop-keepers who inhabited such an insula was oriented toward the street, as it still is to a large extent in modern Italy. The privacy of the domus was reserved for the minority who could afford it.

Late Roman Architecture

In discussing the new forms based on arched, vaulted, and domed construction, we have noted the continued allegiance to the Classical Greek orders. If they no longer relied on them in the structural sense, Roman architects remained faithful to their spirit by acknowledging the aesthetic authority of the post-and-lintel system as an organizing and articulating principle. Column, architrave, and pediment might be merely superimposed on a vaulted brick-and-concrete core, but their shape, as well as their relationship to each other, was still determined by the original grammar of the orders.

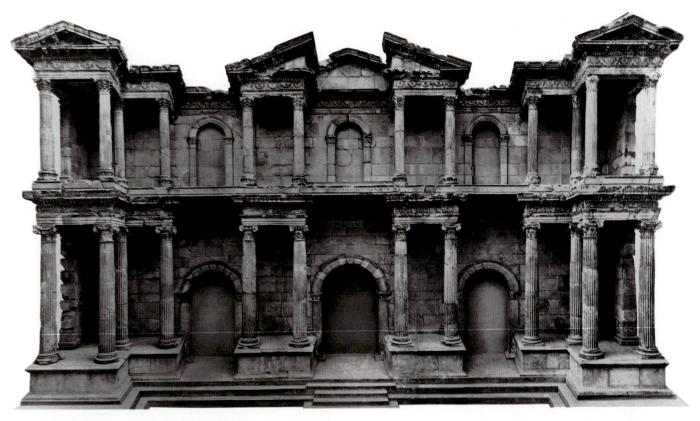

257. Market Gate from Miletus (restored). c. 160 A.D. Staatliche Museen zu Berlin, Preussischer Kulturbesitz, Antikensammlung

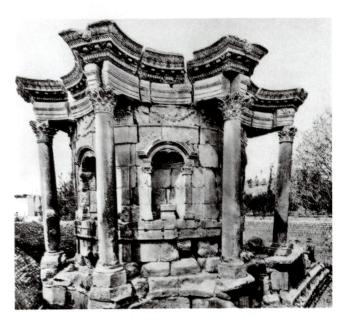

258. Temple of Venus, Baalbek, Lebanon. First half of the 3rd century A.D.

This orthodox, reverential attitude toward the architectural vocabulary of the Greeks prevailed, generally speaking, from the Roman conquest of Greece until the end of the first century A.D. After that, we find increasing evidence of a contrary trend, of a taste for imaginative, "ungrammatical" transformations of the Greek vocabulary. Just when and where it began is still a matter of dispute. There is some evidence that it may go back to late Hellenistic times in the Near East. The tendency certainly was most pronounced in the Asiatic and African provinces of the empire. A characteristic example is the Market Gate from Miletus of about 160 A.D. (rebuilt in the

259. Schematic reconstruction of Temple of Venus, Baalbek

state museums in Berlin; fig. 257). One might refer to it as display architecture in terms both of its effect and of its ancestry, for the picturesque facade, with its alternating recesses and projections, derives from the architectural stage backgrounds of the Roman theater. The continuous in-and-out rhythm has even seized the pediment above the central doorway, breaking it into three parts.

Equally astonishing is the small Temple of Venus at Baalbek, probably built in the early second century A.D. and refurbished in the third (figs. 258 and 259). The convex curve of the cella is effectively counterbalanced by the concave niches

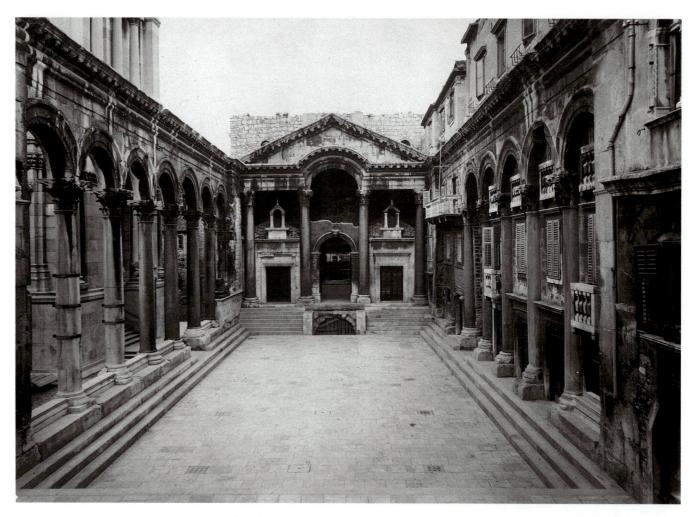

260. Peristyle, Palace of Diocletian, Spalato (Split), Croatia. c. 300 A.D.

and the scooped-out base and entablature, introducing a new play of forces into the conventional ingredients of the round temple (compare figs. 238 and 239).

By the late third century, unorthodox ideas such as these had become so well established that the traditional grammar of the Greek orders was in process of dissolution everywhere. At the end of the peristyle in the Palace of Diocletian (fig. 260) at Spalato (Split), the architrave between the two center columns is curved to create a novel effect by echoing the arch of the doorway below. On either side we see an even more revolutionary device: a series of arches resting directly on columns. A few isolated instances of such an arcade can be found earlier, but it was only now, on the eve of the victory of Christianity, that the marriage of arch and column became fully legitimate. The union, indispensable to the future development of architecture, seems so natural to us that we can hardly understand why it was ever opposed.

SCULPTURE

The dispute over the question "Is there such a thing as a Roman style?" has centered largely on the field of sculpture, and for quite understandable reasons. Even if we discount the wholesale importing and copying of Greek originals, the reputation of the Romans as imitators seems borne out by large quantities of works that are probably adaptations and variants

of Greek models of every period. While the Roman demand for sculpture was tremendous, much of it may be attributed to a taste for antiquities, both the learned and the fashionable variety, and to a taste for sumptuous interior decoration. There are thus whole categories of sculpture produced under Roman auspices that deserve to be classified as "deactivated" echoes of Greek creations, emptied of their former meaning and reduced to the status of highly refined works of craftsmanship. At times this attitude extended to Egyptian sculpture as well, creating a vogue for pseudo-Egyptian statuary. On the other hand, there can be no doubt that some kinds of sculpture had serious and important functions in ancient Rome. They represent the living sculptural tradition, in contradistinction to the antiquarian-decorative trend. We shall concern ourselves here mainly with those aspects of Roman sculpture that are most conspicuously rooted in Roman society: portraiture and narrative relief.

Republican

We know from literary accounts that from early Republican times on, meritorious political or military leaders were honored by having their statues put on public display. The habit was to continue until the end of the empire a thousand years later. Its beginnings may well have derived from the Greek custom of placing votive statues of athletic victors and other

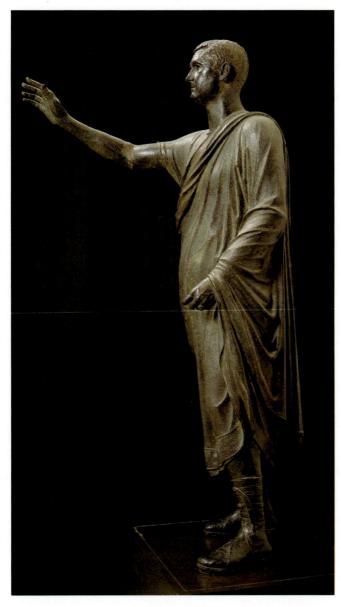

261. Aulus Metellus (L'Arringatore). Early 1st century B.C. Bronze, height 71" (280 cm). Museo Archeologico Nazionale, Florence

important individuals in the precincts of such sanctuaries as Delphi and Olympia (see fig. 186). Unfortunately, the first 400 years of this Roman tradition are a closed book to us. Not a single Roman portrait has yet come to light that can be dated before the first century B.C. with any degree of confidence. How were those early statues related to Etruscan or Greek sculpture? Did they ever achieve any specifically Roman qualities? Were they individual likenesses in any sense, or were their subjects identified only by pose, costume, attributes, and inscriptions?

L'ARRINGATORE. Our sole clue in answer to these questions is the lifesize bronze statue of an orator called *L'Arringatore* (fig. 261), once assigned to the second century B.C. but now generally placed in the early years of the first. It comes from southern Etruscan territory and bears an Etruscan inscription that includes the name Aule Metele (Aulus Metellus in Latin), presumably the name of the official represented. He must have been a Roman, or at least a Roman-appointed

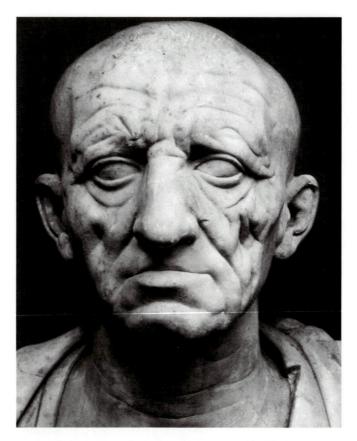

262. *Portrait of a Roman.* c. 80 B.C. Marble, lifesize. Palazzo Torlonia, Rome

official. The workmanship is evidently Etruscan, as indicated by the inscription. But the gesture, which denotes both address and salutation, recurs in hundreds of Roman statues of the same sort. The costume, an early kind of toga, is Roman as well. One suspects, therefore, that our sculptor tried to conform to an established Roman type of portrait statue, not only in these externals but in style as well. We find very little here of the Hellenistic flavor characteristic of the later Etruscan tradition. What makes the figure remarkable is its serious, prosaically factual quality, down to the neatly tied shoelaces. The term "uninspired" suggests itself, not as a criticism but as a way to describe the basic attitude of the artist in contrast to the attitude of Greek or Etruscan portraitists.

PORTRAITS. That seriousness was consciously intended as a positive value becomes clear when we familiarize ourselves with Roman portrait heads of the years around 75 B.C., which show it in its most pronounced form. Apparently the creation of a monumental, unmistakably Roman portrait style was achieved only in the time of Sulla, when Roman architecture, too, came of age (see pages 179–80). We see it at its most impressive perhaps in the features of the unknown Roman of figure 262, contemporary with the fine Hellenistic portrait from Delos in figure 216. A more telling contrast could hardly be imagined. Both are extremely persuasive likenesses, yet they seem worlds apart. Whereas the Hellenistic head impresses us with its subtle grasp of the sitter's psychology, the Roman may strike us at first glance as nothing but a detailed record of facial topography. The sitter's character emerges only incidentally, as it were. Yet this is not really the case. The wrinkles are true to life, no

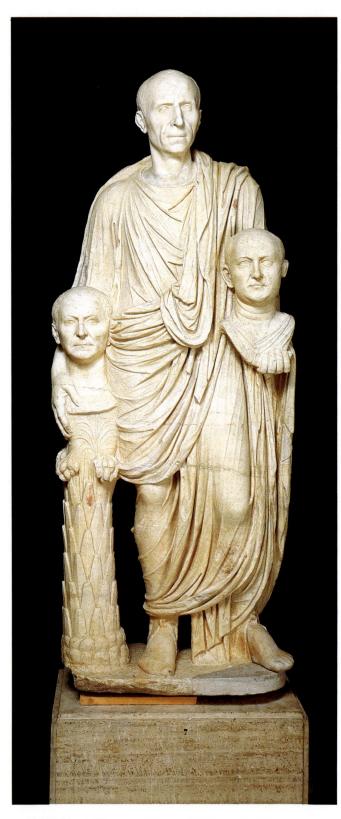

263. A Roman Patrician with Busts of His Ancestors. Late 1st century B.C. Marble, lifesize. Museo Capitolino, Rome

doubt, but the carver has nevertheless treated them with a selective emphasis designed to bring out a specifically Roman personality—stern, rugged, iron-willed in its devotion to duty. It is a "father image" of frightening authority, and the minutely observed facial details are like individual biographical data that differentiate this father image from others.

Its peculiar flavor reflects a patriarchal Roman custom of considerable antiquity. [See Primary Sources, no. 17, pages 218–19.] At the death of the head of the family, a waxen image was made of his face, which was then preserved in a special shrine, or family altar. At funerals, these ancestral images were carried in the procession. The patrician families of Rome clung to this custom well into Imperial times. The images were, of course, records rather than works of art, and because of the perishability of wax they probably did not last more than a few decades. Thus the desire to have them duplicated in marble seems natural enough, but the demand did not arise until the early first century B.C. Perhaps the patricians, feeling their leadership endangered, wanted to make a greater public display of their ancestors, as a way of emphasizing their ancient lineage.

Such display certainly is the purpose of the statue in figure 263, carved about half a century later than our previous example. It shows an unknown man holding two busts of his ancestors, presumably his father and grandfather. The work has little distinction, though the somber face of our dutiful Roman is strangely affecting. Yet the "father-image" spirit can be felt even here. Needless to say, this quality was not present in the wax images themselves. It came to the fore when they were translated into marble, a process that not only made the ancestral images permanent but monumentalized them in the spiritual sense as well. Nevertheless, the marble heads retained the character of records, of visual documents, which means that they could be freely duplicated. What mattered was only the facial "text," not the "handwriting" of the artist who recorded it. The impressive head in figure 262 is itself a copy, made some 50 years later than the lost original, and so are the two ancestors in figure 263. (Differences in style and in the shape of the bust indicate that the original of the head on the left in fig. 263 is about 30 years older than that of its companion.) Perhaps this Roman lack of feeling for the uniqueness of the original, understandable enough in the context of their ancestor cult, also helps to explain why they developed so voracious an appetite for copies of famous Greek statues.

Imperial

PORTRAITS. As we approach the reign of the emperor Augustus (27 B.C.–14 A.D.), we find a new trend in Roman portraiture that reaches its climax in the images of Augustus himself. In his splendid statue from Primaporta (fig. 264), we may be uncertain at first glance whether it represents a god or a human being. This doubt is entirely appropriate, for the figure is meant to be both. Here, on Roman soil, we meet a concept familiar to us from Egypt and the ancient Near East: the divine ruler. It had entered the Greek world in the fourth century B.C. (see fig. 204). Alexander the Great then made it his own, as did his successors, who modeled themselves after him. The latter, in turn, transmitted it to Julius Caesar and the Roman emperors, who at first encouraged the worship of themselves only in the eastern provinces, where belief in a divine ruler was a long-established tradition.

The idea of attributing superhuman stature to the emperor, thereby enhancing his authority, soon became official policy, and while Augustus did not carry it as far as later emperors, the

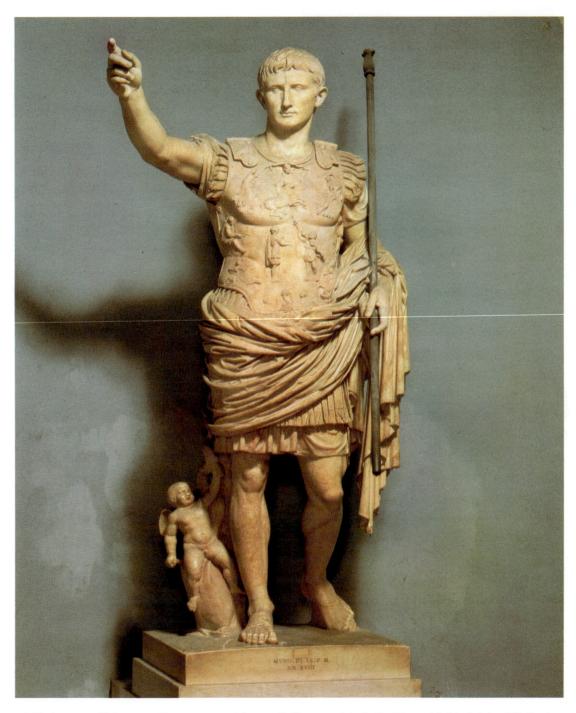

264. Augustus of Primaporta. Roman copy c. 20 A.D. of a Roman original of c. 15 B.C. Marble, height 6'8" (2 m). Musei Vaticani, Braccio Nuovo, Rome

Primaporta statue clearly shows him enveloped in an air of divinity. (He also was the chief priest of the state religion.) The heroic, idealized body is obviously derived from the *Doryphorus* of Polyclitus (fig. 183), while the Cupid at his feet suggests the infant Bacchus in Praxiteles' *Hermes* (fig. 207). However, the statue has an unmistakably Roman flavor. The emperor's gesture is familiar from *Aulus Metellus* (fig. 261). The head is idealized, or, better perhaps, "Hellenized." Small physiognomic details are suppressed, and the focusing of attention on the eyes gives it something of the "inspired" look we find in portraits of Alexander the Great (compare fig. 221). Nevertheless, the face is a definite likeness, elevated but clearly individual, as we know by comparison with the numerous other

portraits of Augustus. All Romans would have recognized it immediately, for they knew it from coins and countless other representations. In fact, the emperor's image soon came to acquire the symbolic significance of a national flag.

Although it was found in the villa of Augustus' wife, Livia, the Primaporta statue is probably a later copy of a lost original: the bare feet indicate that he has been deified, so that the sculpture was made after his death. Myth and reality are compounded to glorify the emperor. The little Cupid on a dolphin serves both to support the heavy marble figure and as a reminder of the claim that the Julian family was descended from Venus; he has also been seen as a representation of Gaius Caesar, Augustus' nephew. The costume has a concreteness of

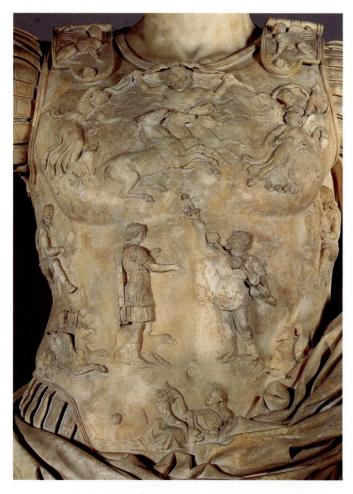

265. Augustus of Primaporta. Detail of breastplate

surface texture that conveys the actual touch of cloth, metal, and leather. The breastplate (fig. 265) illustrates Augustus' victory over the Parthians in 39–38 B.C., which avenged a Roman defeat at their hands nearly 15 years earlier.

Characteristically enough, however, the event is shown as an allegory: the presence of gods and goddesses raises it to cosmic significance, while the rich symbolic program proclaims that this triumph, which Augustus regarded as pivotal, inaugurated an era of peace and plenty. Representing their respective armies, a Parthian returns the captured military standard to a Roman. Are they merely personifications, as seems likely, or historical figures—Phraates IV and either Augustus himself or his stepson and successor Tiberius, who, according to Suetonius, was his intermediary? The issue may never be resolved.

NARRATIVE RELIEF. Imperial art, however, was not confined to portraiture. The emperors also commemorated their outstanding achievements in narrative reliefs on monumental altars, triumphal arches, and columns. Similar scenes are familiar to us from the ancient Near East (see figs. 95, 102, and 112) but not from Greece. Historical events—that is, events which occurred only once, at a specific time and in a particular place—had not been dealt with in Classical Greek sculpture. If a victory over the Persians was to be commemorated, it would be represented indirectly as a mythical event outside any space-time context: a combat of Lapiths and Centaurs or Greeks and Amazons (see figs. 195 and 203). Even in Hellenistic times, this attitude persisted, although not quite as

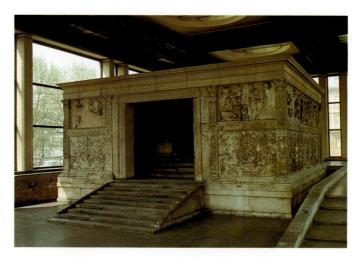

266. Ara Pacis. c. 13–9 B.C. Marble, width of altar approx. 35' (10.7 m). Museum of the Ara Pacis, Rome

absolutely. When the kings of Pergamum celebrated their victories over the Celts, the latter were represented faithfully (see fig. 210) but in typical poses of defeat rather than in the framework of a particular battle.

Greek painters, on the other hand, had depicted historical subjects such as the Battle of Salamis as early as the mid-fifth century, although we do not know how specific these pictures were in detail. As we have seen, the mosaic from Pompeii showing the Battle of Issus (fig. 199) probably reflects a famous Hellenistic painting of about 315 B.C. depicting the defeat of the Persian king Darius by Alexander the Great. In Rome, too, historic events had been depicted from the third century B.C. on. A victorious military leader would have his exploits painted on panels that were carried in his triumphal procession, or he would show such panels in public places. These pictures seem to have had the fleeting nature of posters advertising the hero's achievements. None has survived. Sometime during the late years of the Republic, the temporary representations of such events began to assume more monumental and permanent form. They were no longer painted, but carved and attached to structures intended to last indefinitely. They were thus a ready tool for the glorification of Imperial rule, and the emperors did not hesitate to use them on a large scale.

ARA PACIS. Since the leitmotif of his reign was peace, Augustus preferred to appear in his monuments as the "Prince of Peace" rather than as the all-conquering military hero. The most important of these monuments was the Ara Pacis (Altar of Peace), voted by the Roman Senate in 13 B.C. and completed four years later. It is probably identical with the richly carved Augustan altar that bears this name today. The entire structure (fig. 266) recalls the Pergamum Altar, though on a much smaller scale (compare figs. 211 and 213). On the wall that screens the altar proper, a monumental frieze depicts allegorical and legendary scenes, as well as a solemn procession led by the emperor himself.

Here the "Hellenic," classicizing style we noted in the *Augustus of Primaporta* reaches its fullest expression. Nevertheless, a comparison of the Ara Pacis frieze (fig. 267) with that of the Parthenon (figs. 170 and 268) shows how different they

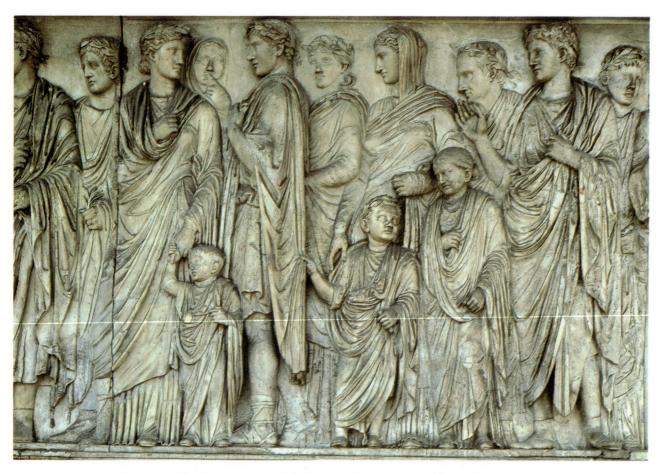

267. Imperial Procession, a portion of the frieze of the Ara Pacis. Marble, height 63" (160 cm)

268. *Procession*, a portion of the east frieze, Parthenon. c. 440 B.C. Marble, height 43" (109.3 cm). Musée du Louvre, Paris

really are, despite all surface similarities. The Parthenon frieze belongs to an ideal, timeless world. It represents a procession that took place in the remote, mythic past, beyond living memory. What holds it together is the great formal rhythm of the ritual itself, not its variable particulars. On the Ara Pacis, in contrast, we see a procession in celebration of one particular recent event—probably the founding of the altar in 13 B.C.—idealized to evoke something of the solemn air that surrounds the Parthenon procession, yet filled with concrete details of a remembered event. The participants, at least so far as they belong to the Imperial family, are meant to be identifiable as portraits, including those of children dressed in

miniature togas but who are too young to grasp the significance of the occasion. (Note how the little boy in the center of our group is tugging at the mantle of the young man in front of him while the somewhat older child to his left smilingly seems to be telling him to behave.) The Roman artist also shows a greater concern with spatial depth than his Classical Greek predecessor. The softening of the relief background, which we first observed in the much earlier *Grave Stele of Hegeso* (see fig. 197), has been carried so far that the figures farthest removed from us seem partly immersed in the stone, such as the woman on the left whose face emerges behind the shoulder of the young mother in front of her.

269. Allegorical and ornamental panels of the Ara Pacis

270. Stucco decoration from the vault of a Roman house. Late 1st century B.C. Museo delle Terme, Rome

The same interest in space appears even more strongly in the allegorical panel in figure 269, showing Mother Earth flanked by two personifications of winds. The embodiment of human, animal, and plant fertility, she also serves as a symbol of Augustus' reign that reflected a time of peace and plenty. Here the figures are placed in a real landscape setting of rocks, water, and vegetation, and the blank background clearly stands for the empty sky. Whether this pictorial treatment of space is a Hellenistic or Roman invention remains a matter of dispute. There can be no question, however, about the Hellenistic look of the three personifications, which represent not only a different level of reality but also a different, and less distinctly Roman, style from the Imperial procession. The acanthus ornament on the pilasters and the lower part of the wall, on the other hand, has no counterpart in Greek art, although the acanthus motif as such derives from Greece. The plant forms are wonderfully graceful and alive. Yet the design as a whole, with its emphasis on bilateral symmetry, never violates the discipline of surface decoration and thus serves as an effective foil for the spatially conceived reliefs above.

STUCCO DECORATION. Much the same contrast of flatness and depth occurs in the stucco decoration of a Roman house, a casual but enchanting product of the Augustan era

(fig. 270). The modeling, as suits the light material, is delicate and sketchy throughout, but the content varies a great deal. On the bottom strip of our illustration are two winged genii with plant ornament. Here depth is carefully avoided, since this zone belongs to the framework. Above it, we see what can only be described as a "picture painted in relief," an idyllic landscape of great charm and full of atmospheric depth, despite the fact that its space is merely suggested rather than clearly defined. The whole effect echoes that of painted room decorations (see fig. 290).

ARCH OF TITUS. The spatial qualities of the Ara Pacis reliefs reached their most complete development in the two large narrative panels on the triumphal arch erected in 81 A.D. to commemorate the victories of the emperor Titus. One of them (fig. 271) shows part of the triumphal procession celebrating the conquest of Jerusalem. The booty displayed includes the seven-branched menorah, or candlestick, and other sacred objects. The movement of a crowd of figures in depth is conveyed with striking success, despite the mutilated surface. On the right, the procession turns away from us and disappears through a triumphal arch placed obliquely to the background plane so that only the nearer half actually emerges from the background—a radical but effective compositional device.

271. Spoils from the Temple in Jerusalem. Relief in passageway, Arch of Titus, Rome. 81 A.D. Marble, height 7'10" (2.4 m)

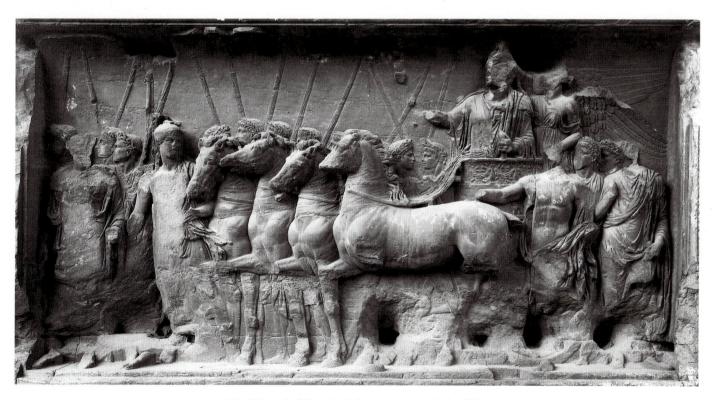

272. Triumph of Titus. Relief in passageway, Arch of Titus

The companion panel (fig. 272) avoids such experiments, although the number of layers of relief is equally great here. We also sense that its design has an oddly static quality, despite the fact that this is simply another part of the same procession. The difference must be due to the subject, which shows the emperor himself in his chariot, crowned by the winged Victory behind him. Apparently the sculptor's first concern was to dis-

play this set image, rather than to keep the procession moving. Once we try to read the Imperial chariot and the surrounding figures in terms of real space, we become aware of how strangely contradictory the spatial relationships are. Four horses, shown in strict profile view, move in a direction parallel to the bottom edge of the panel, but the chariot is not where it ought to be if they were really pulling it. Moreover, the bodies of the

273. Lower portion of the Column of Trajan, Rome. 106–13 A.D. Marble, height of relief band approx. 50" (127 cm)

emperor and of most of the other figures are represented in frontal view, rather than in profile. These seem to be fixed conventions for representing the triumphant emperor which our artist felt constrained to respect, though they were in conflict with the desire to create the kind of consistent movement in space achieved so well in figure 271.

COLUMN OF TRAJAN. Just how incompatible the purposes of Imperial art, narrative or symbolic, could sometimes be with a realistic treatment of space becomes fully evident in the Column of Trajan, which was erected between 106 and 113 A.D. to celebrate that emperor's victorious campaigns against the Dacians (the ancient inhabitants of Romania). Single, free-standing columns had been used as commemorative monuments from Hellenistic times on; their ultimate source may have been the obelisks of Egypt. The Column of Trajan is distinguished not only by its great height (125 feet, including the base) but by the continuous spiral band of relief covering its surface (fig. 273) and recounting, in epic breadth, the history of the Dacian wars. The column was crowned by a statue of the emperor (destroyed in the Middle Ages), and the base served as a burial chamber for his ashes. If we could unwind the relief band, it would be 656 feet long, two-thirds the combined length of the three friezes of the Mausoleum at Halicarnassus and a good deal longer than the Parthenon frieze. In terms of the number of figures and the density of the narrative, however, our relief is by far the most ambitious frieze composition attempted up to that time. It is also the most frustrating, for viewers must "run around in circles like a circus horse" (to borrow the apt description of one scholar) if they want to follow the narrative, and can hardly see the wealth of detail above the fourth or fifth turn without binoculars.

One wonders for whose benefit this elaborate pictorial account was intended. In Roman times, the monument formed the center of a small court flanked by public buildings at least two stories tall, but even that does not quite answer our question. Nor does it explain the evident success of our column, which served as the model for several others of the same type. But let us take a closer look at the scenes visible in our figure 273. In the center of the bottom strip, we see the upper part of a large river-god representing the Danube. To the left are some riverboats laden with supplies, and a Roman town on the rocky bank, while to the right, the Roman army crosses the river on a pontoon bridge. The second strip shows Trajan addressing his soldiers (to the left) and the building of fortifications. The third depicts the construction of a garrison camp and bridge as the Roman cavalry sets out on a reconnaissance mission (on the right). In the fourth strip, Trajan's foot soldiers are crossing a mountain stream (center); to the right, the emperor addresses his troops in front of a Dacian fortress. These scenes are a fair sampling of the events depicted on the column. Among the more than 150 separate episodes, actual combat occurs only rarely, while the geographic, logistic, and political aspects of the campaign receive detailed attention, much as they do in Julius Caesar's famous account of his conquest of Gaul.

Only at one other time have we seen this matter-of-fact visualization of military operations—in Assyrian reliefs such as that in figure 102. Was there an indirect link between the two? And, if so, of what kind? The question is difficult to answer, especially since no examples of the Roman antecedents for our reliefs survive: the panels showing military conquests that were carried in triumphal processions (see page 192). At any rate, the spiral frieze on the Column of Trajan was a new and demanding framework for historic narrative, which imposed a number of difficult conditions upon the sculptor. Since there could be no clarifying inscriptions, the pictorial account had to be as self-sufficient and explicit as possible, which meant that the spatial setting of each episode had to be worked out with great care. Visual continuity had to be preserved without destroying the inner coherence of the individual scenes. And the actual depth of the carving had to be much shallower than in reliefs such as those on the Arch of Titus. Otherwise the shadows cast by the projecting parts would make the scenes unreadable from below.

Our artist has solved these problems with great success, but at the cost of sacrificing all but the barest remnants of illusionistic spatial depth. Landscape and architecture are reduced to abbreviated "stage sets," and the ground on which the figures stand is tilted upward. All these devices had already been employed in Assyrian narrative reliefs. Here they assert themselves once more, against the tradition of foreshortening and perspective space. In another 200 years, they were to become dominant, and we shall find ourselves at the threshold of medieval art. In this respect, the relief band on the Column of Trajan is curiously prophetic of both the end of one era and the beginning of the next.

274. *Apotheosis of Sabina*. 136–38 A.D. Marble. Museo dei Conservatori, Rome

APOTHEOSIS OF SABINA. Trajan's successor, Hadrian, who was educated in Athens, led a Classical revival that relied heavily on allegory for largely personal reasons. First, he proclaimed the beautiful youth Antinous a god and erected cult statues of him as Apollo throughout the empire. (One is

depicted in a medallion on the Arch of Constantine, which was taken from a Hadrianic monument; see fig. 285, right). Then he had his wife, Sabina, deified. In her apotheosis relief (fig. 274) we see the deceased empress being borne aloft from her funeral pyre by the female genius of Eternity (identified by her torch), as Hadrian and the personification of the Campus Martius, where the royal cremation took place, witness the event to make it official. It is a strange sight indeed, yet it is rendered plausible by the Classical style, which permits allegory and reality to mingle with surprising ease.

SARCOPHAGUS OF MELEAGER. The time of Hadrian witnessed a major change in the attitude toward death as well. Sarcophagi quickly replaced cinerary urns as part of a new belief in an afterlife. In response to the sudden demand for sarcophagi, patterns for decorating them were based at first on Greek examples, but new designs were soon passed from shop to shop, probably in illustrated manuscripts. Preferences changed over time. For example, battle sarcophagi enjoyed a vogue under Marcus Aurelius. Later, in the third century, biographical and historical scenes projected the deceased's ideal of life, frequently with moral overtones. But the most popular scenes remained those taken from Classical mythology. Since these occur on sarcophagi and nowhere else, they must possess symbolic significance and not just antiquarian interest. Their general purpose seems to have been to glorify the deceased through visual analogy to the legendary heroes of the past.

Here, too, Hadrian took the lead. A second medallion on the Arch of Constantine (fig. 285, left) shows him slaying a wild boar as testimony not simply to his love of the chase but also his strength and courage in battle, for which hunting serves as a metaphor. Yet a third tondo on the other side showing a sacrifice to Hercules equates celebrated deeds with victory over death (fig. 284, far right). This explains the prevalence of Meleager on sarcophagi. In Homer's account, Meleager saved Calydon from a huge boar sent by Artemis to ravage his father's

275. Sarcophagus of Meleager. c. 180 A.D. Marble. Galleria Doria Pamphili, Rome

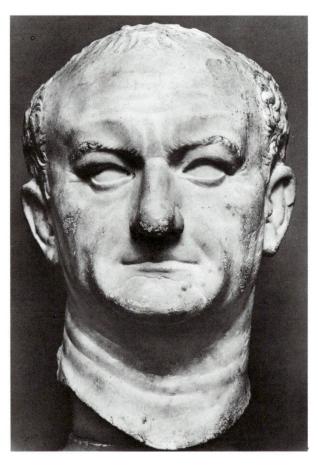

276. *Vespasian*. c. 75 A.D. Marble, lifesize, with damaged chin repaired. Museo delle Terme, Rome

land, but then died in the battle over its pelt. He thus provided an exemplar of noble *virtus*, or virtue, a concept akin to the Greek *arete* (see page 117): heroism and death in the service of country, for which he earned immortality. Figure 275 reproduces the finest example of the type. (The top shows the fallen Meleager being carried from the field of combat.) It is skillfully executed in a style indebted to Scopas (see fig. 203), but now the poses are a bit stiff in the joints and the expressions filled with the exaggerated pathos of Hellenistic sculpture. Characteristic of Roman reliefs is the crowding of the entire surface with figures (compare fig. 267).

PORTRAITS. The Ara Pacis, the Arch of Titus, and the Column of Trajan are monuments of key importance for the art of Imperial Rome at the height of its power. To single out equally significant works among the portraits of the same period is much more difficult. Their production was vast, and the diversity of types and styles mirrors the ever more complex character of Roman society. If we regard the Republican ancestral image tradition and the Greek-inspired *Augustus of Primaporta* as opposite extremes, we can find almost any variety of interbreeding between the two. The fine head of the emperor Vespasian, of about 75 A.D., is a case in point (fig. 276). He was the first of the Flavian emperors, a military man who came to power after the Julio-Claudian (Augustan) line had died out and who must have viewed the idea of emperor worship with considerable skepticism. (When he was dying, he is reported

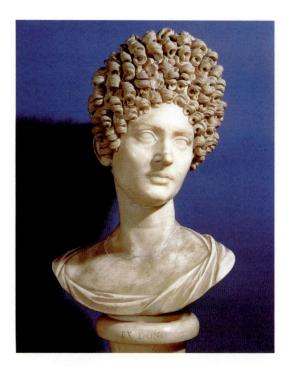

277. *Portrait of a Lady.* c. 90 A.D. Marble, lifesize. Museo Capitolino, Rome

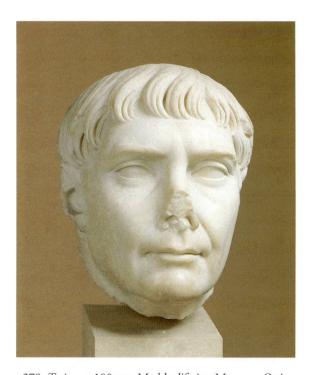

278. Trajan. c. 100 A.D. Marble, lifesize. Museum, Ostia

to have said, "It seems I am about to become a god.") His humble origin and simple tastes may be reflected in the anti-Augustan, Republican flavor of his portrait. The soft, veiled quality of the carving, on the other hand, with its emphasis on the texture of skin and hair, is so Greek that it immediately recalls the seductive marble technique of Praxiteles and his school (compare fig. 207).

A similar refinement can be felt in the surfaces of the slightly later bust of a lady (fig. 277), probably the subtlest portrait

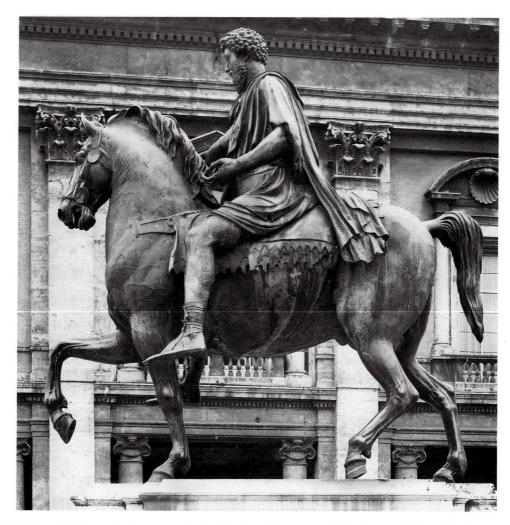

279. Equestrian Statue of Marcus Aurelius. 161–180 A.D. Bronze, over-lifesize. Piazza del Campidoglio, Rome

of a woman in all of Roman sculpture. The graceful tilt of the head and the glance of the large eyes convey a gentle mood of reverie. And how effectively the silky softness of skin and lips is set off by the many corkscrew curls of the fashionable coiffure! The wonderful head of Trajan (fig. 278), of about 100 A.D., is another masterpiece of portraiture. Its firm, rounded forms recall the *Augustus of Primaporta* (see fig. 264), as does the commanding look of the eyes, dramatized by the strongly projecting brows. The face radiates a strange emotional intensity that is difficult to define—a kind of Greek pathos transmuted into Roman nobility of character (compare fig. 216).

Trajan still conformed to age-old Roman custom by being clean-shaven. His successors, in contrast, adopted the Greek fashion of wearing beards as an outward sign of admiration for the Hellenic heritage. It is therefore not surprising to find a strong neo-Augustan, classicistic trend, often of a peculiarly cool, formal sort, in the sculpture of the second century A.D. This is especially true during the reigns of Hadrian and Marcus Aurelius, both of them private men deeply interested in Greek philosophy. We can sense this introspective quality in the equestrian bronze statue of Marcus Aurelius (fig. 279), which is remarkable not only as the sole survivor of this class of monument but as one of the few Roman statues that

remained on public view throughout the Middle Ages. The image showing the mounted emperor as the all-conquering lord of the earth had been a firmly established tradition ever since Julius Caesar permitted an equestrian statue of himself to be erected in the forum that he built. As depicted here, Marcus Aurelius, too, was meant to characterize the emperor as ever-victorious, for beneath the right front leg of the horse (according to medieval accounts) there once crouched a small figure of a bound barbarian chieftain. The wonderfully spirited and powerful horse expresses this martial spirit. But the emperor himself, without weapons or armor, presents a picture of stoic detachment. He is a bringer of peace rather than a military hero, for so he indeed saw himself and his reign (161–180 A.D.).

The late second century A.D. was the calm before the storm, for the third century saw the Roman Empire in almost perpetual crisis. Barbarians endangered its far-flung frontiers while internal conflicts undermined the authority of the Imperial office. To retain the throne became a matter of naked force, succession by murder a regular habit. The "soldier emperors," who were mercenaries from the outlying provinces of the realm, followed one another at brief intervals. The portraits of some of these men, such as Philippus the Arab

280. Philippus the Arab. 244 – 49 A.D. Marble, lifesize. Musei Vaticani, Braccio Nuovo, Città del Vaticano, Rome

281. *Portrait Head* (probably Plotinus). Late 3rd century A.D. Marble, lifesize. Museum, Ostia

(fig. 280; see fig. 114), who reigned from 244 to 249 A.D., are among the most powerful likenesses in all of art. Their facial realism is as uncompromising as that of Republican portraiture, but its aim is expressive rather than documentary. All the dark passions of the human mind—fear, suspicion, cruelty—suddenly stand revealed here, with a directness that is almost unbelievable. The face of Philippus mirrors all the violence of the time. Yet in a strange way it also moves us to pity. There is a psychological nakedness about it that recalls a brute creature, doomed and cornered. Clearly, the agony of the Roman world was not only physical but spiritual. That Roman art should have been able to create an image of a man embodying this crisis is a tribute to its continued vitality.

The results will remind us of the head from Delos (fig. 216). Let us note, however, the new plastic means through which the impact of these portraits is achieved. We are struck, first of all, by the way expression centers on the eyes, which seem to gaze at some unseen but powerful threat. The engraved outline of the iris and the hollowed-out pupils, devices alien to earlier portraits, serve to fix the direction of the glance. The hair, too, is rendered in thoroughly un-Classical fashion as a close-fitting, textured cap. The beard has been replaced by a stubble that results from roughing up the surfaces of the jaw and mouth with short chisel strokes.

A somewhat later portrait, probably that of the Greek philosopher Plotinus, suggests a different aspect of the third-century crisis (fig. 281). Plotinus' thinking—abstract, speculative, and strongly tinged with mysticism—marked a retreat from concern with the outer world that seems closer to the Middle Ages than to the Classical tradition of Greek philosophy. [See Primary Sources, no. 18, page 219.] It sprang from the same mood that, on a more popular level, expressed itself in the spread of Oriental mystery cults throughout the Roman

empire. How trustworthy a likeness our head represents is hard to say. The ascetic features, the intense eyes and tall brow, may well portray inner qualities more accurately than outward appearance. According to his biographer, Plotinus was so contemptuous of the imperfections of the physical world that he refused to have any portrait made of himself. The body, he maintained, was an awkward enough likeness of the true, spiritual self. Why bother to make an even more awkward "likeness of a likeness"?

Such a view presages the end of portraiture as we have known it so far. If a physical likeness is worthless, a portrait becomes meaningful only as a visible symbol of the spiritual self. It is in these terms that we must view the statue of the Tetrarchs, who jointly ruled the four corners of the Roman Empire for a decade (fig. 282). To emphasize their equality, all are identical in appearance: they are of the same height, wear the same clothes, and bear the same features, nominally those of the emperor Diocletian, who conceived this unique form of government. Each Augustus embraces his Caesar, or junior partner, who was his designated successor and son-in-law. That this is the image they intended to project is beyond doubt: it is made of porphyry, an extremely hard Egyptian stone which was reserved for Imperial portraits. Yet the effect is hardly what was expected. They appear huddled together, as if seeking strength against the turbulent times, to which they lent a measure of stability.

Stranger still is the head of Constantine the Great, the first Christian emperor and reorganizer of the Roman state, who was named a tetrarch in 307 but became sole ruler only in 324 (fig. 283). Although it shows more individuality, the face is hardly a portrait in the proper sense of the term. No mere bust, this head is one of several remaining fragments of a huge statue from the apse of Constantine's gigantic basilica (see fig.

282. *The Tetrarchs*. c. 305 A.D. Porphyry, height 51" (129.5 cm). St. Mark's, Venice

251). Although imperial sculptures, including other colossal statues of the period, show the ruler standing, this one probably depicted him seated nude in the manner of Jupiter, with a mantle draped across his legs. It is probably the large statue mentioned by Bishop Eusebius, Constantine's friend and biographer, that held a cross-scepter, called a *labarum*, in its right hand. Following Constantine's conversion in 312, this Imperial device, originally a Roman military standard, became a Christian symbol through the addition of the Chi Rho insignia with a wreath. (Chi and Rho are the first two letters of Christ's name in Greek.) Thus, the colossal statue represented Constantine as a Christian ruler of the world, although the surviving hand points straight up. (The other hand most likely held an orb.) At the same time, it served as a cult statue to the emperor himself.

The head alone is eight feet tall. Everything is so out of proportion to the scale of ordinary people that we feel crushed by its immensity. The impression of being in the presence of some unimaginable power was deliberate. We may call it superhuman, not only because of its enormous size, but even more so perhaps as an image of Imperial majesty. It is reinforced by the massive, immobile features out of which the huge, radiant eyes stare with hypnotic intensity. All in all, the colossal head conveys little of Constantine's actual appearance, but it does tell us a great deal about his view of himself and his exalted office.

283. *Constantine the Great.* Early 4th century A.D. Marble, height 8' (2.4 m). Museo dei Conservatori, Rome

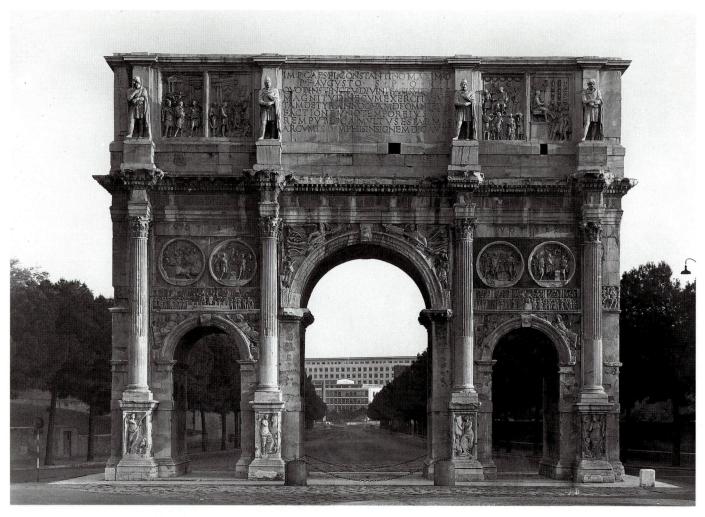

284. Arch of Constantine, Rome. 312-15 A.D.

ARCH OF CONSTANTINE. Constantine's conception of his role is clearly reflected in his triumphal arch (fig. 284), erected near the Colosseum between 312 and 315 A.D. One of the largest and most elaborate of its kind, it is decorated for the most part with sculpture taken from earlier Imperial monuments. This procedure has often been viewed as dictated by haste and by the poor condition of the sculptural workshops of Rome at that time. These may have been contributory factors, but there appears to be a conscious and carefully considered plan behind the way the earlier pieces were chosen and employed. All of them come from a related group of monuments dedicated to Trajan, Hadrian, and Marcus Aurelius, and the portraits of these emperors have been systematically reworked into likenesses of Constantine. Does this not convey Constantine's view of himself as the restorer of Roman glory, the legitimate successor of the "good emperors" of the second century? [See Primary Sources, no. 19, page 219.]

The arch also contains a number of reliefs made especially for it, however, such as the friezes above the lateral openings, and these show the new Constantinian style in full force. If we compare the medallions of figure 285, carved in Hadrian's time, with the relief immediately below them, the contrast is such that they seem to belong to two different worlds. The scene represents Constantine, after his entry into Rome in 312 A.D., addressing the Senate and the people from the rostrum in the Forum.

The first thing we notice here is the avoidance of all the numerous devices developed since the fifth century B.C. for creating spatial depth. We find no oblique lines, no foreshortening, and only the barest ripple of movement in the listening crowds. The architecture has been flattened out against the relief background, which thus becomes a solid, impenetrable surface. The rostrum and the people on or beside it form an equally shallow layer: the second row of figures appears simply as a series of heads above those of the first. The figures themselves have an oddly doll-like quality. The heads are very large, while the bodies seem not only dwarfish because of the thick, stubby legs, but they also appear to be lacking in articulation. The mechanism of contrapposto has disappeared completely, so that these figures no longer stand freely and by their own muscular effort. Rather, they seem to dangle from invisible strings.

Judged from the Classical point of view, all the characteristics we have described so far are essentially negative. They represent the loss of many hard-won gains—a throwback to earlier, more primitive levels of expression. Yet such an approach does not really advance our understanding of the new style. The Constantinian panel cannot be explained as the result of a lack of ability, for it is far too consistent within itself to be regarded as no more than a clumsy attempt to imitate earlier Roman reliefs. Nor can it be viewed as a return to

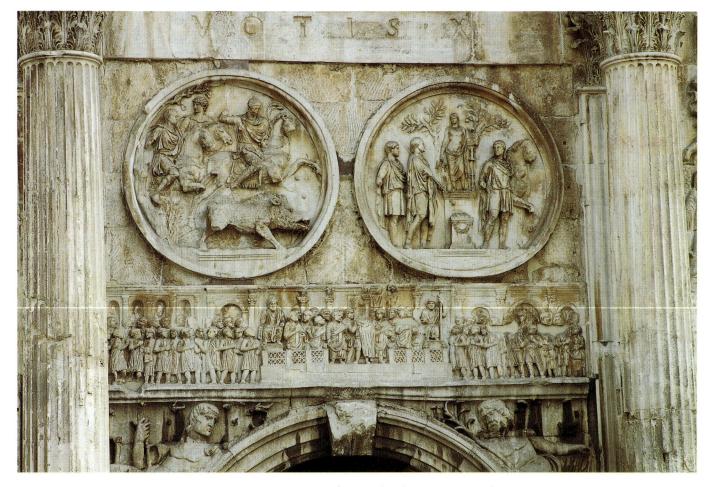

285. Medallions (117–38 A.D.) and frieze (early 4th century), Arch of Constantine

Archaic art, since there is nothing in pre-Classical times that looks like it. No, the Constantinian sculptor must have had a positive new purpose of his own that we can only surmise. Perhaps we can approach it best by stressing one dominant feature of our relief: its sense of self-sufficiency.

The scene fills the available area, and fills it completely. (Note how all the background buildings are made to have the same height.) Any suggestion that it continues beyond the frame is carefully avoided. It is as if our artist had asked, "How can I get all of this complicated ceremonial event into my panel?" In order to do so, an abstract order has been imposed upon the world of appearances. The middle third of the strip is given over to the rostrum with Constantine and his entourage, the rest to the listeners and the buildings that identify the Roman Forum as the scene of the action. They are all quite recognizable, even though their scale and proportions have been drastically adjusted. The symmetrical design also makes clear the unique status of the emperor. Constantine not only occupies the exact center, he is shown full-face (his head, unfortunately, has been knocked off), while all the other figures turn their heads toward him to express their dependent relationship. That the frontal pose is indeed a position of majesty reserved for sovereigns, human or divine, is nicely demonstrated by the seated figures at the corners of the rostrum, the only ones besides Constantine to face us directly.

These figures are statues of emperors—the same "good emperors" we met elsewhere on the arch, Hadrian and Marcus Aurelius. Looked at in this way, our relief reveals itself as a bold and original creation. It is the harbinger of a new vision that will become basic to the development of Christian art.

PAINTING

The modern viewer, whether expert or amateur, is apt to find painting the most exciting, as well as the most baffling, aspect of art under Roman rule. It is exciting because it represents the only large body of ancient painting after the Etruscan murals and because much of it, having come to light only in modern times, has the charm of the unfamiliar. Yet it remains baffling because we know much less about it than we do about Roman architecture or sculpture. The surviving material, with few exceptions, is severely limited in range. Almost all of the surviving examples consist of wall paintings, and the majority of these come from Pompeii, Herculaneum, and other settlements buried by the eruption of Mount Vesuvius in 79 A.D., or from Rome and its environs. Their dates cover a span of less than 200 years, from the end of the second century B.C. to the late first century A.D. What happened before remains largely a matter of guesswork, but Roman painting seems to have stagnated thereafter. And since we have no original Classical Greek

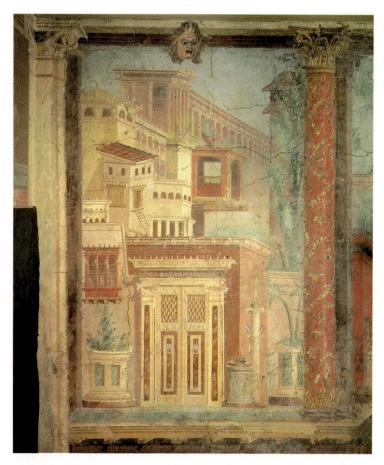

286. Architectural View. Wall painting from a villa at Boscoreale, near Naples. 1st century B.C. The Metropolitan Museum of Art, New York. Rogers Fund, 1903

or Hellenistic wall paintings on Greek soil, except for a handful of Macedonian tombs from Alexander's time, the problem of singling out the Roman element as against the Greek is far more difficult than in sculpture or architecture.

Four phases of Roman wall painting have been distinguished, but the differences among them are not always clear, and there seems to have been considerable overlapping in their sequence. The earliest phase, known from a few examples of the late second century B.C., must have been widespread in the Hellenistic world, since examples of it have also been found in the eastern Mediterranean. Unfortunately, it is not very informative for us, as it consists entirely of the imitation of colored marble paneling. About 100 B.C., this so-called First Style began to be displaced by a far more ambitious and elaborate style that sought to open up the flat surface of the wall by means of illusionistic architectural perspectives and "window effects," including landscapes and figures. [See Primary Sources, no. 7, page 214.]

The architectural vistas typical of the Second Style are represented by figure 286. Our artist is clearly a master of modeling and surface textures. The forms framing the vista—the lustrous, richly decorated columns, moldings, and mask at the top—have an extraordinary degree of three-dimensional reality. They effectively set off the distant view of buildings, which is flooded with light to convey a sense of free, open-air space. But as soon as we try to penetrate this architectural maze, we find ourselves lost. The individual structures cannot be disentangled from each other, and their size and relation-

ship are obscure. We quickly realize that the Roman painter has no systematic grasp of spatial depth, that the perspective is haphazard and inconsistent within itself. Apparently we were never intended to enter this space. Like a promised land, it remains forever beyond us.

When landscape takes the place of architectural vistas, exact foreshortening becomes less important, and the virtues of the Roman painter's approach outweigh his limitations. This is most strikingly demonstrated by the famous Odyssey Landscapes, a continuous stretch of landscape subdivided into eight compartments by a framework of pilasters. Each section illustrates an episode of the adventures of Odysseus (Ulysses). Vitruvius informs us that such cycles were common. [See Primary Sources, no. 11, page 216.] However, the narrative has large gaps, which suggests that the scenes have been excerpted from a larger cycle. In the adventure with the Laestrygonians (fig. 287), the airy, bluish tones create a wonderful feeling of atmospheric, light-filled space that envelops and binds together all the forms within this warm Mediterranean fairyland, where the human figures seem to play no more than an incidental role. Only upon further reflection do we realize how frail the illusion of coherence is. If we tried to map this landscape, we would find it just as ambiguous as the architectural perspective discussed above. Its unity is not structural but poetic, like that of the stucco landscape in figure 270.

The Odyssey Landscapes contrast with another approach to nature that we know from the murals in a room of the Villa of Livia at Primaporta (fig. 288), which have no precedent in

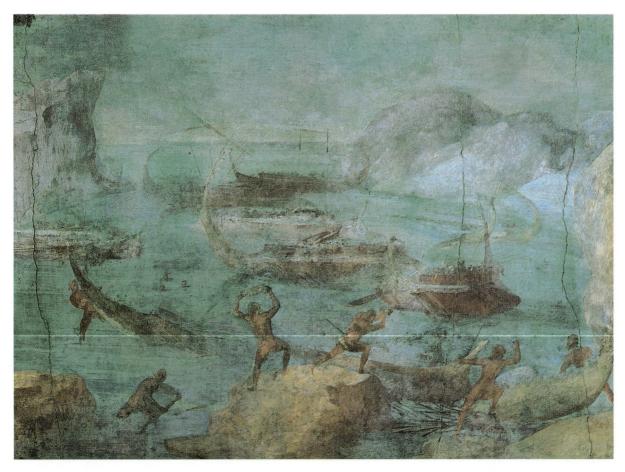

287. The Laestrygonians Hurling Rocks at the Fleet of Odysseus. Wall painting from a house on the Esquiline Hill, Rome. Late 1st century B.C. Biblioteca Apostolica Vaticana, Città del Vaticano, Rome

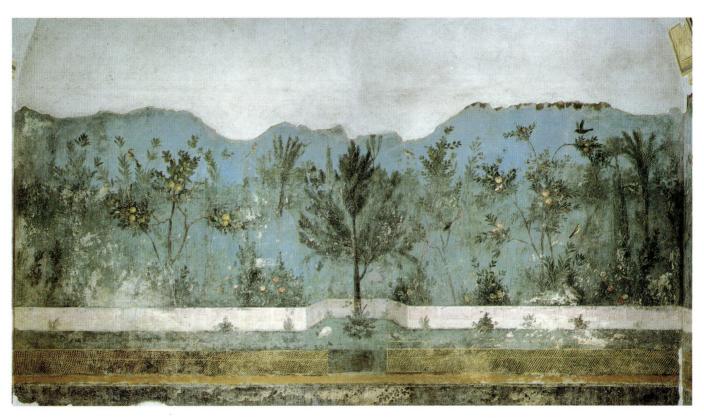

288. View of a Garden. Wall painting from the Villa of Livia at Primaporta. c. 20 B.C. Museo delle Terme, Rome

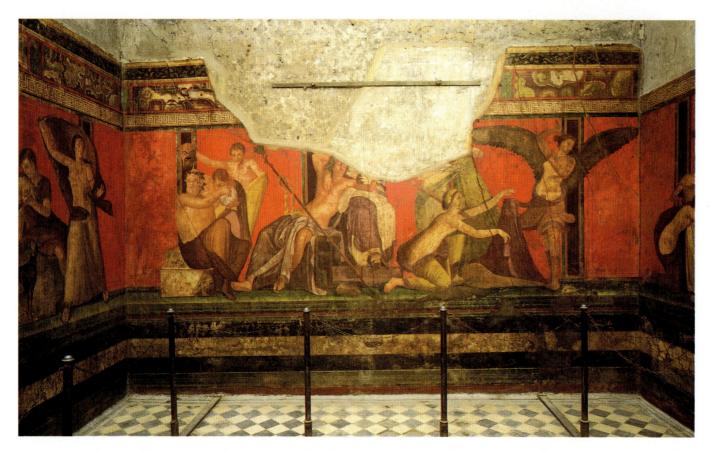

289. Scenes of a Dionysiac Mystery Cult. Mural frieze. c. 50 B.C. Villa of the Mysteries, Pompeii

Greek art. Here the architectural framework has been dispensed with altogether, and the entire wall is given over to a view of a delightful, serene garden full of colorful flowers, fruit trees, and birds. These charming details have the same tangible quality, the same concreteness of color and texture as the architectural framework of figure 286, and their apparent distance from the beholder is also about the same: they seem to be within arm's reach. At the bottom is a low trellis, beyond it a narrow strip of lawn with a tree in the center, then a low wall, and immediately after that the garden proper begins. Oddly enough, however, we cannot enter it. Behind the front row of trees and flowers lies an opaque mass of greenery that shuts off our view as effectively as a dense hedge. This garden, then, is another promised land made only for looking. The wall has not really been opened up but merely pushed back a few feet and replaced by a wall of plants. It is this very limitation of spatial depth that endows our mural with its unusual degree of coherence.

VILLA OF THE MYSTERIES. The great frieze in one of the rooms in the Villa of the Mysteries just outside Pompeii (fig. 289), like the garden view from the Villa of Livia, dates from the latter part of the first century B.C., when the Second Style was at its height. So far as the treatment of the wall space is concerned, the two works have more in common with each other than with other Second Style murals, for both of them are conceived in terms of rhythmic continuity and arm's-length depth. The result is a sweeping grandeur of design and

a coherence of style that is nearly unique in Roman painting.

The artist who created the frieze in the Villa of the Mysteries has placed his figures on a narrow ledge of green against a regular pattern of red panels separated by strips of black, a kind of running stage on which they enact their strange and solemn ritual. Who are they, and what is the meaning of the cycle? Many details remain puzzling, but the program as a whole represents various rites of the Dionysiac mysteries, a semisecret cult of very ancient origin that had been brought to Italy from Greece. The sacred rituals are performed, perhaps as part of an initiation into womanhood or marriage, in the presence of Dionysus and Ariadne, with their train of satyrs and sileni, so that human and mythical reality tend to merge into one. We sense the blending of these two spheres in the qualities all the figures have in common: their dignity of bearing and expression, the wonderful firmness of body and drapery, and the rapt intensity with which they participate in the drama of the ritual.

The Third Style, from about 20 B.C. until at least the middle of the first century A.D., eschewed illusionism altogether in favor of essentially flat, decorative surfaces with broad planes of intense color sometimes relieved by imitation panel paintings. By contrast, the Fourth Style, which prevailed at the time of the eruption of Mount Vesuvius in 79 A.D., was the most intricate of all. It united aspects of all three preceding styles to extravagant effect. The Ixion Room in the House of the Vettii at Pompeii (fig. 290) combines imitation marble paneling, conspicuously framed mythological scenes intended to give

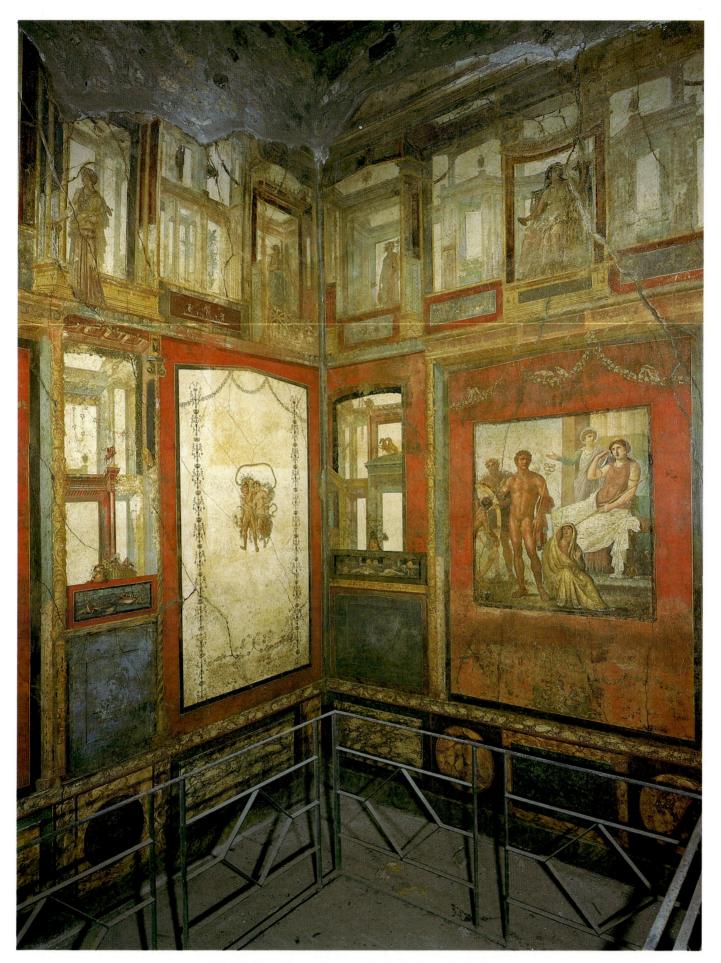

290. The Ixion Room, House of the Vettii, Pompeii. 63-79 A.D.

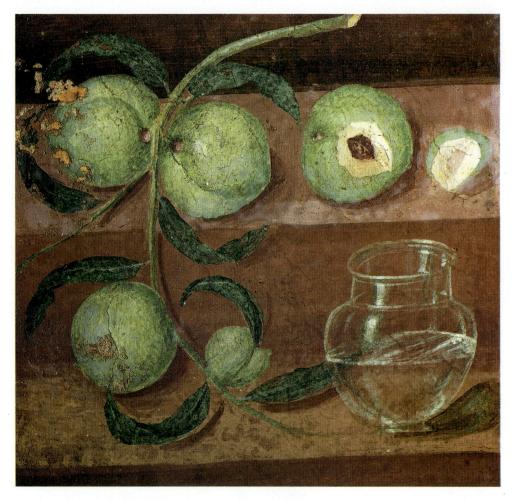

291. Peaches and Glass Jar. Wall painting from Herculaneum. c. 50 A.D. Museo Archeologico Nazionale, Naples

the effect of panel pictures set into the wall, and fantastic architectural vistas seen through make-believe windows, creating the effect of a somewhat disjointed compilation of motifs from various sources. This architecture has a strangely unreal and picturesque quality that is believed to reflect the architectural backdrops of the theaters of the time. It often anticipates effects such as that of the Market Gate of Miletus (see fig. 257), which shares the same source.

A unique feature of Roman mural decoration is the still lifes that sometimes make their appearance within the intricate architectural schemes of the Fourth Style. These usually take the form of make-believe niches or cupboards, so that the objects, which are often displayed on two levels, remain close to us. Our example (fig. 291) is particularly noteworthy for the rendering of the translucent glass jar half-filled with water. The reflections are so acutely observed that we feel the painter must have copied them from an actual jar illuminated in just this way. But if we try to determine the source and direction of the light in the picture, we find that this cannot be done, because the shadows cast by the various objects are not con-

sistent with each other. Nor do we have the impression that the jar stands in a stream of light. Instead, the light seems to be imprisoned within the jar.

Clearly, the Roman artist, despite striving for illusionistic effects, is no more systematic in the approach to light than in the handling of perspective. However sensuously real the details, the work nearly always lacks a basic unifying element in its overall structure. In the finest examples, this lack is amply compensated for by other qualities, so that our observation must not be regarded as condemning the Roman artist to an inferior status. Like the preference for shallow illusionistic space, the absence of a consistent view of the visible world should be thought of instead as a fundamental characteristic that distinguishes Roman painting.

Greek Sources

Since we have so few Classical Greek or Hellenistic wall murals on Greek soil and no panels whatsoever, the problem of singling out the Roman element as against the Greek is far more

Theater and Music in Ancient Rome

According to contemporary sources, the Romans adopted

Greek music, including its system of modes, with little modification. Roman theater, by contrast, was very different in many respects from that of Greece, for its origins lay even more in the region of Etruria. The Roman writer Livy (59 B.C.-17 A.D.) states that the first performances were held in 364 B.C., when musicians and dancers were imported from Etruria during a plague. Moreover, Tarquin the Elder, the Etruscan ruler of Rome between about 616 and 578 B.C., established the religious festivals known as ludi Romani (Roman games) to honor Jupiter each September; plays were part of the program. Perhaps more important, he introduced the Etruscan taste for spectacle and built the first Circus Maximus for horse races and similar events. Most Roman theater, in fact, fell into the category of modern carnival and circus acts, called mimus, or mime. A late form of popular theater was pantomine (all mime)—introduced from Greece in 22 B.C.—which involved a single dancer who acted out all the roles of a tragedy by changing masks.

Serious drama began in 240 B.C. with Livius Andronicus, a freed slave from south Italy, who produced a Latin translation of two Greek plays for the *ludi Romani* and became the first writer of Greek-style tragedies in Latin. Because Roman tragedies, which were always associated with religious festivals, reflected the stringent moral values of Republican Rome, they died out during the empire. The greatest author of comedies was Caecilius Statius (c. 219–168 B.C.) but, as

with Livius Andronicus, none of his works is left. During the

first century B.C., Roman comic theater was taken over by the Fabula Atellana (named for the town of Atella near Naples). It was a coarse variety of farce that relied for its appeal on stock subjects with happy endings in the manner of late Greek comedy and was likewise accompanied by music.

All that remains of Roman theater are 21 comedies by Plautus (c. 254–184 B.C.), six comedies by the freed African slave Terence (190–156 B.C.), and nine tragedies by Seneca (4 B.C.–65 A.D.), the teacher of the emperor Nero, which may never have been performed. These writers exercised enormous influence on sixteenth-century Elizabethan theater by providing models of plot and style that were used by William Shakespeare and Christopher Marlowe. Roman playwrights have fallen into unjust neglect today, especially Seneca, whose works—far from being dry imitations of Greek prototypes—are powerful dramas with penetrating characterizations revealed in soliloquies fully the equal of Shakespeare's.

The architect and historian Vitruvius, writing in the late first century B.C., has left us a detailed account of Roman theater practices. He suggests that Roman architectural backdrops and painted scenery were considerably more elaborate than those of Greece. We can get a good idea of their probable appearance from the illusionistic treatment of architecture in Roman wall paintings (see fig. 290).

difficult in painting than in sculpture or architecture. That Greek designs were copied, and that Greek paintings as well as painters were imported, nobody will dispute. It is tempting to link Roman paintings with lost works recorded by Pliny, Vitruvius, and others. But *The Battle of Issus* (fig. 199) is one of the rare instances where this can be convincingly demonstrated.

For the most part, Roman painting appears to have been a specifically Roman development. Despite the fact that the characters' names are given in Greek, there is no reason to assume a Greek origin for the Odyssey Landscapes any more than for the *View of a Garden* from the Villa of Livia, although the latter's distant ancestor can be seen in the landscape fresco from Thera (fig. 124). Likewise, still-life painting began in Greece, but even when certain Classical Greek motifs were adopted, the form in which we know it is distinctively Roman, as can be ascertained by the changes in style and repertoire it underwent. Finally, the illusionistic tendencies that gained the upper hand in Roman murals during the first century B.C. represent a dramatic breakthrough without precedent in Greek art so far as we know.

The issue is more complex when it comes to narrative painting. Although not a trace of it exists, we can hardly doubt that Greek painting continued to evolve after the Classical era, much as Italian painting did after the High Renaissance. In fact, narrative painting underwent a decline in the late Hellenistic period, when earlier "Old Master" panels

were highly prized by collectors. It was revived, so Pliny tells us, around the middle of the first century B.C. by Timomachus of Byzantium, who "restored its ancient dignity to the art of painting." This is the same time as the frescoes in the Villa of the Mysteries (fig. 289), which provide a test case of what is Roman in Roman painting. Many of the poses and gestures are taken from the repertory of Classical Greek art, yet they lack the studied and self-conscious quality we call classicism. An artist of exceptional greatness of vision has filled these forms with new life. Our painter was the legitimate heir of the Greeks in the same sense that the finest Latin poets of the Augustan age were the legitimate heirs to the Greek poetic tradition.

Roman painting as a whole shows the same genius for adapting Greek examples to Roman needs as do sculpture and architecture. This is true even of seemingly reproductive or imitative works. The mythological panels that occur like islands in the Third and Fourth Styles (see fig. 290) sometimes give the impression of relatively straightforward copies after Hellenistic originals. In several cases, however, we possess more than one variant of the same composition derived ultimately from the same, presumably Greek, source, and the divergences attest to how readily the original was copied and changed. Moreover, a closer reading shows that such panels, too, underwent a clear-cut evolution that reflects the changing taste of Roman artists and their patrons. Figures were

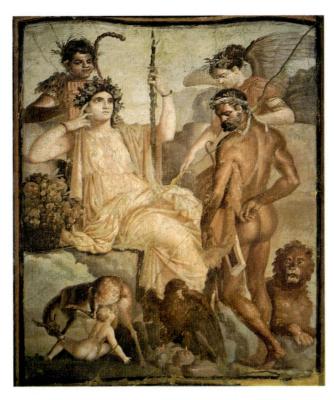

292. *Herakles and Telephos*. Wall painting from Herculaneum. c. 70 A.D. Museo Archeologico Nazionale, Naples

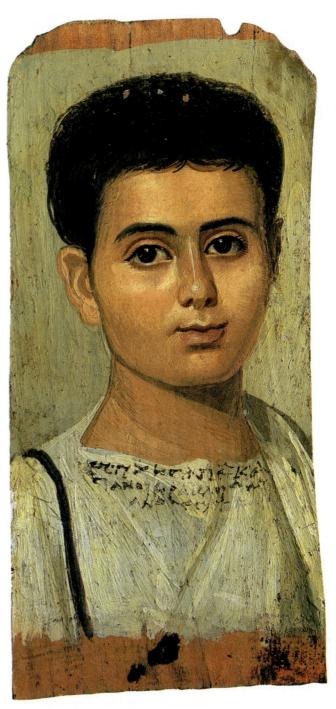

293. *Portrait of a Boy,* from the Faiyum, Lower Egypt.

2nd century A.D. Encaustic on panel, 15³/8 x 7¹/2" (39 x 19 cm).

The Metropolitan Museum of Art, New York

Gift of Edward S. Harkness, 1918

freely altered, rearranged, and recombined, often within very different settings, suggesting that they were made available in pattern books much like those for sarcophagi (see page 197). Thus, whatever the relation to the famous masterpieces of Greece that are lost to us forever, scenes such as Hermes overseeing the punishment of Ixion in figure 290 represent the highly electic Roman approach to painting, and it is likely that most were of recent vintage as well.

These pictures often have the rather disjointed character of compilations of motifs from diverse sources. A characteristic

example of the latter is the picture of Herakles discovering the infant Telephos in Arcadia, from the basilica at Herculaneum (fig. 292). It may reflect a painting made in Pergamum, since a similar composition occurs in fragmentary form on the Great Altar (see pages 159–60). What stamps this as the handiwork of a Roman painter is its oddly unstable style. Almost everything here has the look of a "quotation," so that not only the forms, but even the brushwork vary from one figure to the next. Thus the personification of Arcadia, seated in the center, seems as cold, immobile, and tightly modeled as a statue,

whereas Herakles, although his pose is equally statuesque, exhibits a broader and more luminous technique. Or compare the Nemean Lion, emblem of Herakles, and the eagle of Jupiter, his father, which are painted in sketchy, agitated dabs, with the precise and graceful outlines of the doe and the suckling child. The sparkling highlights on the basket of fruit are derived from yet another source: still lifes such as figure 291. And the mischievously smiling young Pan in the upper left-hand corner is composed of quick, feathery brushstrokes that have an altogether different character. We recognize the same peculiarly Roman operating principle at work here as in the shifting decorative system of the Fourth Style as a whole, with its ambivalent perspective and inconsistent light.

PORTRAITS. Portrait painting, according to Pliny, was an established custom in Republican Rome, serving the ancestor cult as did the portrait busts discussed earlier (see pages 189–90). None of these panels has survived, and the few portraits found on the walls of Roman houses in Pompeii may well derive from a different, specifically Hellenistic, tradition. The only coherent group of painted portraits at our disposal comes instead from the Faiyum district in Lower Egypt. The earliest of them found so far seem to date from the second century A.D. We owe them to the survival (or revival) of an ancient Egyptian custom, that of attaching a portrait of the deceased to the wrapped, mummified body. Originally, these portraits

had been sculpted (compare fig. 82), but they were replaced in Roman times by painted ones such as the very fine and well-preserved wooden panel that is shown in figure 293.

The amazing freshness of its colors is due to the fact that it was done in a medium of great durability called encaustic, which means that the pigments are suspended in hot wax. The mixture can be opaque and creamy, like oil paint, or thin and translucent. At their best, these portraits have an immediacy and sureness of touch that have rarely been surpassed, thanks to the need to work quickly before the hot wax set. Our darkhaired boy is as solid, sparkling, and lifelike a piece of reality as anyone might wish. The style of the picture—and it does have style, otherwise we could not tell it from a snapshotbecomes apparent only when we compare it with other Faiyum portraits. Since they were produced quickly and in large numbers, they tend to have many elements in common, such as the emphasis on the eyes, the placing of the highlights and shadows, and the angle from which the face is seen. Over time, these conventional elements stiffen into a fixed type, whereas here they merely furnish a flexible mold within which to cast individual likeness. The artist has emphasized certain features, for example the eyes, but in this happy instance, the stylization has been made with the intention only of recalling the attractive personality of a beloved child. This way of painting was revived four centuries later in the earliest Byzantine icons, which were considered "portraits" of the Madonna and Child.

Primary Sources for Part One

The following is a selection of excerpts, in modern translations, from original texts by historians or writers from Egyptian times through the Roman era. These readings supplement the main text and are keyed to it. Their full citations are given in the Credits section at the end of the book.

The Pyramid Texts, from Utterance 373

This text is an "utterance" of Pharaoh Teti, who reigned in the Sixth Dynasty (2350–2190 B.C.). Inscriptions on Fifth- and Sixth-Dynasty pyramids at Saqqara are an important source of information about Egyptian ideas of the afterlife. They contain incantations ("utterances") intended to effect the resurrection of the pharaoh and his ascent to the realm of the gods.

Oho! Oho! Rise up, O Teti!
Take your head,
Collect your bones,
Gather your limbs,
Shake the earth from your flesh!
Take your bread that rots not,
Your beer that sours not,
Stand at the gates that bar the common people!
The gatekeeper comes out to you,
He grasps your hand,
Takes you into heaven, to your father Geb [earth god],
He rejoices at your coming,
Gives you his hands,
Kisses you, caresses you,
Sets you before the spirits, the imperishable stars.

From The Story of Sinuhe

The Story of Sinuhe is the fictionalized Middle Kingdom account of a courtier who flees from Egypt to another country upon the death of the reigning pharaoh. He rises to prominence in a new land but longs to return to Egypt to die. Hearing of his plight, Pharaoh Sesostris I (1971–1928 B.C.) recalls Sinuhe to Egypt and provides lavishly for his funeral and tomb.

A night is made for you with ointments and wrappings from the hand of Tait [goddess of weaving]. A funeral procession is made for you on the day of burial; the mummy case is of gold, its head of lapis lazuli. The sky is above you as you lie in the hearse, oxen drawing you, musicians going before you. The dance . . . is done at the door of your tomb; the offeringlist is read to you; sacrifice is made before your offering-stone. Your tomb-pillars, made of white stone, are among (those of) the royal children. You shall not die abroad! . . .

A stone pyramid was built for me in the midst of the pyramids. The masons who build tombs constructed it. A master draughtsman designed in it. A master sculptor carved in it. The overseers of construction in the necropolis busied themselves with it. All the equipment that is placed in a tomb-shaft was supplied. Mortuary priests were given me. A funerary domain was made for me. It had fields and a garden in the right place, as is done for a Companion of the first rank. My statue was overlaid with gold, its skirt with electrum. It was his majesty who ordered it made. There is no commoner for whom the like has been done. I was in the favor of the king, until the day of landing came.

From Cylinder A of Gudea

Gudea's rebuilding of the temple, called Eninnu, to the god Ningirsu was recounted on three inscribed clay cylinders of about 2125 B.C. Cylinder A describes the construction of the temple. Gudea is presented as the architect, helped by Nidaba (goddess of writing, here representing the use of written sources) and Enki (god of builders).

did Enki put right the design of the house. To the house . . . did Gudea pace from south to north on the fired [purified] mound, . . . laid the measuring cord down on what was a true acre, put in pegs at its sides, verified them himself. It was cause of rejoicing for him. . . . In the brick-mold shed he performed the pouring of water, and the water sounded to the ruler as cymbals and alu lyres playing for him; on the brick pit and its bricks he drenched the top layer, hoed in honey, butter, and sweet princely oil; . . . into the brick mold Gudea put the clay, made "the proper thing" appear, was establishing his name, making the brick of the house appear. . . .

For . . . Gudea . . . did Nidaba open

the house of understanding,

He placed the brick, paced off the house, laid out the plan of the house, (as) a very Nidaba knowing the inmost (secrets) of numbers, and like a young man building his first house, sweet sleep came not unto his eyes; like a cow keeping an eye on its calf, he went in constant worry to the houselike a man who eats food sparingly he tired not from going. . . . Gudea made Ningirsu's house come out like the sun from the clouds, had it grow to be like sparkling foothills; like foothills of white alabaster he had it stand forth to be marveled at . . . the house's stretching out along (substructure) walltops, was like the heights of heaven awe-inspiring; the roofing of the house, like a white cloud, was floating in the midst of heaven. Its gate through which the owner entered was like a lammergeier [vulture] espying a wild bull, its curved gateposts standing at the gate were like the rainbow standing in the sky. . . . It (the house) kept an eye on the country; no arrogant one could walk in its sight, awe of Eninnu covered all lands like a cloth.

Pliny the Elder (23–79 A.D.)

Natural History,
from Book 35 (on Greek painting)

The earliest preserved history of art appears in the work of the Roman naturalist and historian Pliny, who lived at the beginning of the Roman Imperial period and died in the eruption of Mount Vesuvius that destroyed Pompeii. Pliny says nothing about vase painting. For him the great era of painting began in the fifth century B.C., and its high point came in the fourth century B.C. Pliny lists the names and works of many artists who are otherwise unknown today. His anecdotes reveal the primacy placed on illusionism by Greeks and Romans. Pliny's work influenced Renaissance writers of art history, including Ghiberti and Vasari.

The origin of painting is obscure. . . . All, however, agree that painting began with the outlining of a man's shadow; this was the first stage, in the second a single colour was employed, and after the discovery of more elaborate methods this style, which is still in vogue, received the name of monochrome. . . .

Four colours only—white from Melos, Attic yellow, red from Sinope on the Black Sea, and the black called 'atramentum'—were used by Apelles, Aetion, Melanthios and Nikomachos in their . . . works; illustrious artists, a single one of whose pictures the wealth of a city could hardly suffice to buy. . . .

Apollodoros of Athens [in 408–405 B.C.] was the first to give his figures the appearance of reality. [He] opened the gates of art through which Zeuxis of Herakleia passed [in 397 B.C.]. The story runs that Parrhasios and Zeuxis entered into competition, Zeuxis exhibiting a picture of some grapes, so true to nature that the birds flew up to the wall of the stage. Parrhasios then displayed a picture of a linen curtain, realistic to such a degree that Zeuxis, elated by the verdict of the birds, cried out that now at last his rival must draw the curtain and show his picture. On discovering his mistake he surrendered the prize to Parrhasios, admitting candidly that he had deceived the birds, while Parrhasios had deluded himself, a painter. . . .

Apelles of Kos [in 332–329 B.C.] excelled all painters who came before or after him. He of himself perhaps contributed more to painting than all the others together; he also wrote treatises on his theory of art. . . .

Nikomachos'... pupils were his brother Ariston, his son Aristeides and Philoxenos of Eretria, who painted for king Kassander the battle between Alexander and Dareios, a picture second to none [compare fig. 199].

Pliny the Elder Natural History, from Book 34 (on bronze)

Many of the best known Greek sculptors worked primarily in bronze, though their works are known to us in marble copies. This is true of Polyclitus, Myron, and Lysippus. Following the Roman conquest of Greece in the second century B.C., a number of these precious bronze originals were brought to Rome.

Besides his Olympian Zeus, a work which has no rival, Pheidias made in ivory the Athena at Athens, which stands erect in the Parthenon. . . . He is rightly held to have first revealed the capabilities of sculpture and indicated its methods.

Polykleitos... made an athlete binding the diadem about his head, which was famous for the sum of one hundred talents which it realized. This... has been described as 'a man, yet a boy': the... spear-bearer [fig. 183] as 'a boy, yet a man.' He also made the statue which sculptors call the 'canon,' referring to it as to a standard from which they can learn the first rules of their art. He is the only man who is held to have embodied

the principles of his art in a single work. . . . He is considered to have brought the scientific knowledge of statuary to perfection, and to have systematized the art of which Pheidias had revealed the possibilities. It was his peculiar characteristic to represent his figures resting their weight on one leg; . . .

Myron . . . [made an] athlete hurling the disk [fig. 189], a Perseus, . . . and the Herakles which is near the great Circus in the temple of the great Pompeius. . . . He was more productive than Polykleitos, and a more diligent observer of symmetry. Still he too only cared for the physical form, and did not express the sensations of the mind, . . .

Lysippos produced more works than any other artist, possessing, as I have said, a most prolific genius. Among them is the man scraping himself [fig. 209]. . . . In this statue the Emperor Tiberius took a marvellous delight, . . . he could not refrain from having the statue removed into his private chamber, substituting another in its place. . . . His chief contributions to the art of sculpture are said to consist in his vivid rendering of the hair, in making the heads smaller than older artists had done, and the bodies slimmer and with less flesh, thus increasing the apparent height of his figures. There is no word in Latin for the canon of symmetry which he was so careful to preserve, bringing innovations which had never been thought of before into the square canon of the older artists, and he often said that the difference between himself and them was that they represented men as they were, and he as they appeared to be. His chief characteristic is extreme delicacy of execution even in the smallest details.

Pliny the Elder Natural History, from Book 36 (on marble)

Among the sculptors famous for their work in marble, Pliny mentions Praxiteles and Scopas. He also describes the collaborative Laocoön Group (fig. 215).

The art of [marble] sculpture is much older than that of painting or of bronze statuary, both of which began with Pheidias. . . .

Praxiteles... outdid even himself by the fame of his works in marble.... Famous... throughout the whole world, is the Aphrodite which multitudes have sailed to Knidos to look upon [fig. 206]. He had offered two statues of Aphrodite for sale at the same time, the second being a draped figure, which for that reason was preferred by the people of Kos with whom lay the first choice; the price of the two figures was the same, but they flattered themselves they were giving proof of a severe modesty. The rejected statue, which was bought by the people of Knidos, enjoys an immeasurably greater reputation. King Nikomedes subsequently wished to buy it from them, offering to discharge the whole of their public debt, which was enormous. They, however, preferred to suffer the worst that

could befall, and they showed their wisdom, for by this statue Praxiteles made Knidos illustrious. . . .

Bryaxis, Timotheos, and Leochares were rivals and contemporaries of Skopas, and must be mentioned with him, as they worked together on the Mausoleion [figs. 202 and 203]. This is the tomb erected by Artemisia in honour of her husband Mausolos, . . . and its place among the seven wonders of the world is largely due to these great sculptors. The length of the south and north sides is 163 feet; the two façades are shorter, and the whole perimeter is 440 feet; its height is 25 cubits [37½ feet], and it has thirty-six columns. . . . The sculptures of the eastern front are carved by Skopas, those on the north by Bryaxis, on the south by Timotheos, and on the west by Leochares. . . . Above the colonnade is a pyramid, of the same height as the lower structure, consisting of twenty-four retreating steps rising into a cone. On the apex stands a chariot and four horses in marble made by Pythis. . . .

In the case of certain masterpieces the . . . number of the collaborators is an obstacle to their individual fame, since neither can one man take to himself the whole glory, nor have a number so great a claim to honour. This is the case with the Laokoon in the palace of the Emperor Titus, a work superior to all the pictures and bronzes of the world [compare fig. 215]. Out of one block of marble did the illustrious artists Hagesander, Polydoros, and Athanodoros of Rhodes, after taking counsel together, carve Laokoon, his children, and the wondrous coils of the snakes.

Pliny the Elder Natural History, from Book 35 (on Roman painting)

Pliny's account of the history of painting privileges the ancient Greeks, while Romans are relatively neglected. He does mention Studius, as well as several women painters whose works have not been identified. In judging Roman painters, Pliny puts a high value on speed of execution.

Studius, a painter of the days of Augustus, . . . introduced a delightful style of decorating walls with representations of villas, harbours, landscape gardens, sacred groves, woods, hills, fishponds, straits, streams and shores, any scene in short that took the fancy. . . .

Women too have been painters: . . . Iaia of Kyzikos, who remained single all her life, worked at Rome. . . . She painted chiefly portraits of women, and also a large picture of an old woman at Naples, and a portrait of herself, executed with the help of a mirror. No artist worked more rapidly than she did, and her pictures had such merit that they sold for higher prices than those of [other] well-known contemporary painters, whose works fill our galleries.

8

Vitruvius (1st century B.C.) On Architecture, from Book IV (on the Doric and Corinthian orders)

Vitruvius, like Pliny, was a Roman writer who admired the achievements of the Greeks. His treatise on architecture (c. 35–25 B.C.) reflects the classicizing taste of his time. Vitruvius' work was a principal source for Renaissance architects seeking the revival of antiquity. His account of the origin of the Greek orders is partly mythic, partly rational conjecture (see fig. 162).

For in Achaea and over the whole Peloponnese, Dorus . . . was king; by chance he built a temple . . . at the old city of Argos, in the sanctuary of Juno. . . . Afterwards [Greeks in Ionia] . . . established a temple as they had seen in Achaea. Then they called it Doric because they had first seen it built in that style. When they wished to place columns in that temple, not having their proportions, . . . they measured a man's footstep and applied it to his height. Finding that the foot was the sixth part of the height in a man, they applied this proportion to the column. Of whatever thickness they made the base of the shaft they raised it along with the capital to six times as much in height. So the Doric column began to furnish the proportion of a man's body, its strength and grace. . . .

But the third order, which is called Corinthian, imitates the slight figure of a maiden; because girls are represented with slighter dimensions because of their tender age, and admit of more graceful effects in ornament. Now the first invention of that capital is related to have happened thus. A girl, a native of Corinth, already of age to be married, was attacked by disease and died. After her funeral, the goblets which delighted her when living, were put together in a basket by her nurse, carried to the monument, and placed on the top. That they might remain longer, exposed as they were to the weather, she covered the basket with a tile. As it happened the basket was placed upon the root of an acanthus. Meanwhile about spring time, the root of the acanthus, being pressed down in the middle by the weight, put forth leaves and shoots. The shoots grew up the sides of the basket, and, being pressed down at the angles by the force of the weight of the tile, were compelled to form the curves of volutes at the extreme parts. . . .

Workmen of old, . . . when they had put beams reaching from the inner walls to the outside parts, built in the spaces between the beams. . . . Then they cut off the projections of the beams, as far as they came forward, to the line and perpendicular of the walls. But since this appearance was ungraceful, they fixed tablets shaped as triglyphs now are, against the cut-off beams, and painted them with blue wax, in order that the cut-off beams might be concealed so as not to offend the eyes. Thus in Doric structures, the divisions of the

beams being hidden began to have the arrangement of the triglyphs, and, between the beams, of metopes. Subsequently other architects in other works carried forward over the triglyphs the projecting rafters, and trimmed the projections. . . . In the Doric style the detail . . . of the triglyphs . . . arose from this imitation of timber work.

9

Vitruvius On Architecture, from Book V (on public buildings)

Vitruvius' description of basilicas indicates that the proportional design prescribed for temples was expected of other columned buildings as well.

The sites of basilicas ought to be fixed adjoining the fora in as warm a quarter as possible, so that in the winter, business men may meet there without being troubled by the weather. And their breadth should be fixed at not less than a third, nor more than half their length, unless the nature of the site is awkward and forces the proportions to be changed. When the site is longer than necessary, the committee rooms are to be placed at the end of the basilica. . . . The columns of basilicas are to be of a height equal to the width of the aisle. The aisle is to have a width one third of the nave.

Vitruvius On Architecture, from Book VI (on private buildings)

We must go on to consider how, in private buildings, the rooms belonging to the family, and how those which are shared with visitors, should be planned. For into the private rooms no one can come uninvited, such as the bedrooms, dining-rooms, baths and other apartments which have similar purposes. The common rooms are those into which, though uninvited, persons of the people can come by right, such as vestibules, courtyards, peristyles and other apartments of similar uses. Therefore magnificent vestibules and alcoves and halls are not necessary to persons of a common fortune, because they pay their respects by visiting among others, and are not visited by others. . . . The houses of bankers and farmers of the revenue should be more spacious and imposing and safe from burglars. . . . For persons of high rank who hold office and magistracies, and whose duty it is to serve the state, we must provide princely vestibules, lofty halls and very spacious peristyles, plantations and broad avenues finished in a majestic manner.

11

Vitruvius On Architecture, from Book VII (on ornamentation)

Vitruvius' conservative taste approved of wall painting like the First and Second Styles, but disliked the kinds of fantasy that typify the Fourth Style.

The ancients who first used polished stucco, began by imitating the variety and arrangement of marble inlay; then the varied distribution of festoons, ferns, coloured strips.

Then they proceeded to imitate the contours of buildings, the outstanding projections of columns and gables; in open spaces, like exedrae, they designed scenery on a large scale in tragic, comic, or satyric style; in covered promenades, because of the length of the walls, they used for ornament the varieties of landscape gardening, . . . some have also the anatomy of statues, the images of the gods, or the representations of legends; further, the battles of Troy and the wanderings of Ulysses over the countryside [compare fig. 287] with other subjects taken in like manner from Nature.

But these which were imitations based upon reality are now disdained by the improper taste of the present. On the stucco are monsters rather than definite representations taken from definite things. Instead of columns there rise up stalks; instead of gables, striped panels with curled leaves and volutes. Candelabra uphold pictured shrines and above the summits of these, clusters of thin stalks rise from their roots in tendrils with little figures seated upon them at random. Again, slender stalks with heads of men and of animals attached to half the body [compare fig. 290].

Such things neither are, nor can be, nor have been. On these lines the new fashions compel bad judges to condemn good craftsmanship for dullness. For how can a reed actually sustain a roof, or a candelabrum the ornaments of a gable? . . . Pictures cannot be approved which do not resemble reality. Even if they have a fine and craftsmanlike finish, they are only to receive commendation if they exhibit their proper subject without transgressing the rules of art.

12

Plutarch (c. 46-after 119 A.D.) Parallel Lives of Greeks and Romans, from the lives of Pericles and Fabius Maximus

A Greek author of the Roman period, Plutarch wrote the Parallel Lives to show that ancient Greece matched or exceeded Rome in its great leaders. Comparing Pericles (died 429 B.C.) with Fabius Maximus (died 203 B.C.), he concludes that Pericles' buildings

surpass all the architecture of the Romans. Plutarch is the only ancient source to say that Phidias was the overseer of Pericles' works.

But that which brought most delightful adornment to Athens, and the greatest amazement to the rest of mankind; that which alone now testifies for Hellas that her ancient power and splendour, of which so much is told, was no idle fiction,—I mean his construction of sacred edifices. . . . For this reason are the works of Pericles all the more to be wondered at; they were created in a short time for all time. Each one of them, in its beauty, was even then and at once antique; but in the freshness of its vigour it is, even to the present day, recent and newly wrought. Such is the bloom of perpetual newness, as it were, upon these works of his, which makes them ever to look untouched by time, as though the unfaltering breath of an ageless spirit had been infused into them.

His general manager and general overseer was Pheidias, although the several works had great architects and artists besides. Of the Parthenon, for instance, with its cella of a hundred feet in length, Callicrates and Ictinus were the architects. . . .

By the side of the great public works, the temples, and the stately edifices, with which Pericles adorned Athens, all Rome's attempts at splendour down to the times of the Caesars, taken together, are not worthy to be considered, nay, the one had a towering pre-eminence above the other, both in grandeur of design, and grandeur of execution, which precludes comparison.

Plato (c. 427–347 B.C.) The Republic, from Book X

At the end of his treatise on the ideal state, the philosopher Plato attacks poets and painters. He claims that painters are only imitators of appearances, rather than of essences (forms or ideas), and therefore dishonest; he concludes that they must be banished from the state. Implicit in this argument is a condemnation of the new illusionistic practices in Greek art. The treatise is written in Socratic dialogue form, which consists of a series of questions designed to elicit clear and rational answers.

"Could you tell me what imitation in general is? . . . We are, presumably, accustomed to set down some one particular form for each of the particular 'manys' to which we apply the same name. Or don't you understand?"

"I do."

"Then let's now set down any one of the 'manys' you please; for example, if you wish, there are surely many couches and tables."

"Of course."

"But as for ideas for these furnishings, there are presumably

two, one of couch, one of table."

"Yes."

"Aren't we also accustomed to say that it is in looking to the *idea* of each implement that one craftsman makes the couches and another the chairs we use, and similarly for other things? For presumably none of the craftsmen fabricates the idea itself. How could he?"

"In no way."

"Well, now, see what you call this craftsman here."

"Which one?"

"He who makes everything that each one of the manual artisans makes separately. . . . This same manual artisan is not only able to make all implements but also makes everything that grows naturally from the earth, . . . all animals, . . . and everything in heaven and everything in Hades under the earth."

"That's quite a wonderful sophist you speak of," he said.

"... Aren't you aware that you yourself could in a certain way make all these things?"

"And what," he said, "is that way?"...

"You could fabricate them quickly, . . . if you are willing to take a mirror and carry it around everywhere; quickly you will make the sun and the things in heaven; quickly, the earth; and quickly, yourself and the other animals and implements and plants. . . . "

"Yes," he said, "so that they look like they *are*; however, they surely *are* not the truth."

"Fine," I said, "and you attack the argument at just the right place. For I suppose the painter is also one of these craftsmen, isn't he?"

"Of course he is."

"But I suppose you'll say that he doesn't truly make what he makes. And yet in a certain way the painter too does make a couch, doesn't he?"

"Yes," he said, "he too makes what looks like a couch."

"And what about the couchmaker? Weren't you just saying that he doesn't make the form, which is what we, of course, say a couch is, but a certain couch?"

"Yes," he said. . . .

"Do you," I said, "want us . . . to investigate who this imitator is?"

"If you want to," he said.

"There turn out, then, to be these three kinds of couches: one that *is* in nature, which we would say, I suppose, a god produced. . . . And then one that the carpenter produced."

"Yes," he said.

"And the one that the painter produced, isn't that so?"

"Let it be so." . . .

"Now, the god . . . made only one, that very one which is a couch [that is, the essence of a couch]. . . . Do you want us to address him as [the couch's] nature-begetter or something of the kind?"

"That's just, at any rate," he said, "since by nature he has made both this and everything else."

"And what about the carpenter? Isn't he a craftsman of

a couch?"

"Yes."

"And is the painter also a craftsman and a maker of such a thing?"

"Not at all."

"But what of a couch will you say he is?"

"In my opinion," he said, "he would most sensibly be addressed as an imitator of that of which these others are craftsmen."

"All right," I said, "do you, then, call the man at the third generation from nature an imitator?"

"Most certainly," he said. . . .

"Now tell me this about the painter. In your opinion, does he in each case attempt to imitate the thing itself in nature, or the works of the craftsmen?"

"The works of the craftsmen," he said.

"Such as they are or such as they look? For you still have to make that distinction."

"How do you mean?" he said.

"Like this. Does a couch, if you observe it from the side, or from the front, or from anywhere else, differ at all from itself? Or does it not differ at all but only look different, and similarly with the rest?"

"The latter is so," he said. "It looks different, but isn't."

"Now consider this very point. Toward which is painting directed in each case—toward imitation of the being as it is or toward its looking as it looks? Is it imitation of looks or of truth?"

"Of looks," he said.

"Therefore, imitation is surely far from truth; and, as it seems, it is due to this that it produces everything—because it lays hold of a certain small part of each thing, and that part is itself only a phantom. For example, the painter, we say, will paint for us a shoemaker, a carpenter, and the other craftsmen, although he doesn't understand the arts of any one of them. But, nevertheless, if he is a good painter, by painting a carpenter and displaying him from far off, he would deceive children and foolish human beings into thinking that it is truly a carpenter."

"Of course."

14 Vergil (70–19 B.C.) The Aeneid, from Book II

Vergil was the greatest Latin poet and the chief exponent of the Augustan age in literature. The Aeneid is an epic poem about the hero Aeneas, who fled Troy when it was destroyed by the Greeks and settled in Italy. Book II tells of the fall of Troy, including the punishment by Minerva of Laocoön for trying to warn the Trojans against the trick wooden horse. The sculptural rendition of Laocoön shown in figure 215 closely resembles Vergil's description.

The Vatican Vergil (fig. 310) contains the complete Aeneid as well as other poetry by Vergil.

Laocoön, by lot named priest of Neptune, was sacrificing then a giant bull upon the customary altars, when two snakes with endless coils, from Tenedos strike out across the tranquil deep. . . . They lick their hissing jaws with quivering tongues. We scatter at the sight, our blood is gone. They strike a straight line toward Laocoön. At first each snake entwines the tiny bodies of his two sons in an embrace, then feasts its fangs on their defenseless limbs. The pair next seize upon Laocoön himself, who nears to help his sons, carrying weapons. They wind around his waist and twice around his throat. They throttle him with scaly backs; their heads and steep necks tower over him. He struggles with his hands to rip their knots, his headbands soaked in filth and in dark venom, while he lifts high his hideous cries to heaven, just like the bellows of a wounded bull.

Aristotle (384–322 B.C.) The Politics, from Book VIII

The Politics is a counterpart to Plato's Republic, a treatment of the constitution of the state. Books VII and VIII discuss the education prescribed for good citizens. Drawing is included as a liberal art—that is, a skill not only useful but also conducive to higher activities. Yet painting and sculpture are said to have only limited power to move the soul.

There is a sort of education in which parents should train their sons, not as being useful or necessary, but because it is liberal or noble. . . . Further, it is clear that children should be instructed in some useful things—for example, in reading and writing—not only for their usefulness, but also because many other sorts of knowledge are acquired through them. With a like view they may be taught drawing, not to prevent their making mistakes in their own purchases, or in order that they may not be imposed upon in the buying or selling of articles [works of art], but perhaps rather because it makes them judges of the beauty of the human form. To be always seeking after the useful does not become free and exalted souls. . . .

The habit of feeling pleasure or pain at mere representations is not far removed from the same feeling about realities; for example, if any one delights in the sight of a statue for its beauty only, it necessarily follows that the sight of the original will be pleasant to him. The objects of no other sense, such as taste or touch, have any resemblance to moral qualities; in visible objects there is only a little, for there are figures which are of a moral character, but only to a slight extent, and all do not participate in the feeling about them. Again, figures and colours are not imitations, but signs, of character, indications which the body gives of states of feeling. The connexion of them with morals is slight, but in so far as there is any, young men should be taught to look . . . at [the works] of Polygnotus, or any other painter or sculptor who expresses character.

Livy (59 B.C.–17 A.D.) From the Founding of the City, from Book I

Livy, a historian, was a contemporary of Vitruvius and Vergil and also moved in the circle of the emperor Augustus. His history of Rome begins with Aeneas and includes the legend of the she-wolf that suckled Romulus and Remus (compare fig. 232).

The Vestal [Virgin, Rhea Silvia] was ravished, and having given birth to twin sons, named Mars as the father of her doubtful offspring. . . . But neither gods nor men protected the mother herself or her babes from the king's cruelty; the priestess he ordered to be manacled and cast into prison, the children to be committed to the river. . . . The story persists that when the floating basket in which the children had been exposed was left high and dry by the receding water, a shewolf, coming down out of the surrounding hills to slake her thirst, turned her steps towards the cry of the infants, and with her teats gave them suck so gently, that the keeper of the royal flock found her licking them with her tongue. . . . He carried the twins to his hut and gave them to his wife Larentia to rear.

Polybius (c. 200–c. 118 B.C.) Histories, from Book VI

Polybius was a Greek historian active during the Roman conquest of his homeland. His Histories recount the rise of Rome from the third century B.C. to the destruction of Corinth in 146 B.C. In Book VI he considers cultural and other factors explaining Rome's success.

Whenever any illustrious man dies, . . . they place the image of the departed in the most conspicuous position in the house, enclosed in a wooden shrine. This image is a mask reproducing with remarkable fidelity both the features and complexion of the deceased. On the occasion of public sacrifices they display these images, and decorate them with much care, and when any distinguished member of the family dies they take

them to the funeral, putting them on men who seem to them to bear the closest resemblance to the original in stature and carriage. These representatives wear togas, with a purple border if the deceased was a consul or praetor, whole purple if he was a censor, and embroidered with gold if he had celebrated a triumph or achieved anything similar. They all ride in chariots preceded by the fasces, axes, and other insignia . . . and when they arrive at the rostra they all seat themselves in a row on ivory chairs. There could not easily be a more ennobling spectacle for a young man who aspires to fame and virtue. For who would not be inspired by the sight of the images of men renowned for their excellence, all together and as if alive and breathing? . . . By this means, by this constant renewal of the good report of brave men, the celebrity of those who performed noble deeds is rendered immortal. . . . But the most important result is that young men are thus inspired to endure every suffering for the public welfare in the hope of winning the glory that attends on brave men.

Plotinus (205–270 A.D.) Enneads, from Book I.6, "On Beauty"

A Greek philosopher who taught in Rome, Plotinus was a Neo-Platonist, the last great pagan expositor of the thought of Plato. Mystical in outlook, he conceived the cosmos as a hierarchical descent from the ineffable One (God) to matter. His reference to "images, traces, shadows" is a clear echo of Plato's argument in The Republic and indicates his distrust of images. As the lowest form of existence in his scheme, matter could not be the site of true beauty. Plotinus' teachings were Christianized and transmitted to the Middle Ages by writers like Pseudo-Dionysius.

Beauty is mostly in sight, but it is to be found too in things we hear, in combinations of words and also in music . . . and for those who are advancing upwards from sense-perception ways of life and actions and characters and intellectual activities are beautiful, and there is the beauty of virtue. . . .

How can one see the "inconceivable beauty" which . . . does not come out where the profane may see it? Let him who can . . . leave . . . the sight of his eyes . . . When he sees the beauty in bodies he must not run after them; we must know that they are images, traces, shadows, and hurry away to that

which they image. For if a man runs to the image and wants to seize it as if it was the reality . . . [he] will, . . . in soul, . . . sink down into the dark depths where intellect has no delight, and stay blind in Hades. . . . Shut your eyes, and change to and wake another way of seeing, which everyone has but few use. . . .

First of all . . . look at beautiful ways of life: then at beautiful works, not those which the arts produce, but the works of men who have a name for goodness: then look at the souls of the people who produce the beautiful works.

Ammianus Marcellinus (c. 330–395 A.D.) *History*, from Book 16

The surviving books of the History cover the years from 353 to 378 A.D. The author's description of the first sight of Rome by the emperor Constantius II, the son of Constantine the Great, in 357 shows how enormously impressive the ancient city was.

So then he [the emperor] entered Rome, the home of empire and of every virtue, and when he had come to the Rostra, the most renowned forum of ancient dominion, he stood amazed; and on every side on which his eyes rested he was dazzled by the array of marvellous sights. . . . As he surveyed the sections of the city and its suburbs, lying within the summits of the seven hills, along their slopes, or on level ground, he thought that whatever first met his gaze towered above all the rest: the sanctuaries of Tarpeian Jove so far surpassing as things divine excel those of earth; the baths built up in the manner of provinces; the huge bulk of the amphitheatre [Colosseum], strengthened by its framework of Tiburtine stone, to whose top human eyesight barely ascends; the Pantheon like a rounded city-district, vaulted over in lofty beauty. . . . But when he came to the Forum of Trajan, a construction unique under the heavens, as we believe, and admirable even in the unanimous opinion of the gods, he stood fast in amazement, turning his attention to the gigantic complex about him, beggaring description and never again to be imitated by mortal men. . . . When the emperor had viewed many objects with awe and amazement, he complained of Fame as either incapable or spiteful, because while always exaggerating everything, in describing what there is in Rome, she becomes shabby.

	35,000–3500 B.C.	3500-3000 в.с.	3000-2500 в.с.
HISTORY AND POLITICS	c. 35,000 First Paleolithic societies c. 4000 Predynastic period in Egypt	dom, are artworks in which the conn- cal power, religious ideology, and the particularly clear. Intentionally grandi- viewer with their monumentality and the pharaohs who built them. The a power directly in the hands of the mon- reaucracy able to mobilize tens of tho astronomical calculations and the late plumb line and the A-frame). The py-	built in Egypt during the Old King- ection of public architecture to politi- e development of high technology is iose, they were designed to impress the l to represent the might and wealth of newly centralized government placed harch, administered by an efficient bu- busands of workers and apply accurate st in surveying techniques (such as the tramids display a high degree of skill in
RELIGION		tombs for Egypt's rulers, they and thei	asonry. Built in as little as 30 years as r attendant temples and sculptures exury idea of the divinity of the pharaoh.
	(left) "Venus" of Willendorf, c. 25,000–20,000 B.C. (center) Cave painting, Altamira, c. 15,000–10,000 B.C.	(right) Female Head, Uruk, c. 3500–3000 B.C.	Inlay panel, Ur, c. 2600 B.C.
MUSIC, LITERATURE, AND PHILOSOPHY			c. 3000–2500 Epic of Gilgamesh, early Sumerian heroic tale
SCIENCE AND TECHNOLOGY	c. 8000 Husbandry and farming develop in the Near East	c. 3500–3000 Wheeled carts in Sumer c. 3500 Sailboats used on the Nile c. 3300–3000 Invention of writing by Sumerians; use of potter's wheel and organic dyes	

2500-2000 в.с.	2000-1500 в.с.	1500-1000 в.с.
Sargon of Akkad, Akkadian ruler (r. 2340–2305), unifies Mesopotamian region and organizes first empire, encompassing land in Persia, Africa, and the Aegean c. 2125 Gudea rules in Mesopotamia; c. 2060–1950, Third Dynasty of Ur comes to power in Sumeria, ushering in a period of great cultural development 2040–1674 Middle Kingdom in Egypt. After a period of chaos, Egyptian pharaohs strengthen the country, institute a centralized government, and conquer neighboring Nubia (present-day Ethiopia)	c. 2000–750 Bronze Age in Europe c. 1760–1600 Babylonian Empire, founded by Hammurabi, flourishes	 c. 1500–1145 New Kingdom in Egypt (Dynasties 18–20) 1478–1458 Queen Hatshepsut rules Egypt c. 1450 Mycenaean forces conquer the Minoan city of Knossos on Crete c. 1350 Assyrian Empire founded in Mesopotamia by Ashuruballit I; empire endures until 612 Pharaoh Akhenaten (r. 1348–1336/5) attempts radical alteration of Egyptian society. Deposed by Tutankhamen (r. 1336/5–1327) c. 1319–1145 Ramesside period in Egypt (Dynasty 19), epitomized by Pharaoh Ramesses II, whose frequent wars against invaders bring about great expansion of Egyptian territory and influence c. 1250 (traditional) Moses and Israelites flee to Palestine from Egypt to escape persecution 1184 (traditional) Attack on Troy in Asia Minor by united Greek armies under Agamemnon
		c. 1345 Akhenaten institutes a new monotheistic religion in Egypt c. 1000 Hebrews in Palestine accept monotheism
The Great Sphinx, Egypt, c. 2570–2544 B.C.	(left) Inanna-Ishtar, Mesopotamia, c. 2025–1763 B.C. (right) Stonehenge, England, c. 2000 B.C.	(top) "The Toreador Fresco," Crete, c. 1500 B.C. (bottom) Tutankhamen Hunting, detail of a painted chest, Egypt, c. 1336/5–1327 B.C.
c. 2350 The Pyramid Texts, early religious writings found on walls of Egyptian tombs	c. 1900 The Story of Sinuhe, a Middle Kingdom Egyptian tale c. 1760 Code of Hammurabi, first known legal document, carved on a stone monolith for the Babylonian king	c. 1500 Book of the Dead, first manuscripts (on papyrus), encapsulating Egyptian religious thought
	c. 2000 Iron used for tools and weapons in Asia Minor c. 1725 Hyksos tribes introduce horse-drawn vehicles into Egypt c. 1700 Babylonian mathematics flourish under Hammurabi: use of whole numbers, fractions, and square roots	c. 1500 Chinese develop silk production c. 1400 First Greek writing, known as Linear B, in general use in the Aegean

	1000-600 в.с.	600-200 в.с.	200 B.C 1 A.D.
HISTORY AND POLITICS	 c. 1000–961 Israelite kingdom established by King David. Reign of his son, Solomon (961–922), is a time of legendary peace, justice, and stability 753 (traditional) Founding of Rome by Romulus By 700 (traditional) Theseus unifies Athenian state Nebuchadnezzar, Neo-Babylonian king (r. 605–562). Under his rule the empire, based in Babylon, reaches its greatest extent, conquering Egypt (605) and Jerusalem (586) 	 539 Persians conquer Babylonian Empire and Egypt (525). Expansion of Persian Empire 510 Roman Republic established c. 510–508 Greece establishes the first government based on democratic principles c. 499 Persians invade Greece; 490, defeated by Athenians at the Battle of Marathon 431–404 Peloponnesian War pits Greek citystates against one another; Athens is defeated by Sparta and its fleet destroyed at Syracuse 356–323 Alexander the Great leads Greek army in conquest of Egypt (333), Palestine, Phoenicia, and Persia (331) 264–201 Punic Wars waged between Rome and North Africa. Carthaginian general Hannibal marches from Spain and invades Italy (218), threatening Rome (211). He is defeated, and Roman expansion continues; Rome annexes Spain (201), by 147 dominates Asia Minor, Syria, Egypt, and Greece (146). Carthage destroyed (146) 	 82–79 Sulla becomes first dictator of Roman state. Institutes substantial legal and legislative reforms 73–71 Slave rebellion led by the ex–gladiator Spartacus in Rome 51–30 Cleopatra, descendant of the Ptolemys, rules in Egypt 49–44 Julius Caesar (c. 101–44), Roman general, becomes dictator of Rome, after a military career in the provinces. Assassinated by a group of senators who fear his usurpation of power 31 Sea battle of Actium, on the western coast of Greece, in which Julius Caesar's cousin Octavian defeats Marc Antony, a rival, and consolidates the Roman Empire under his control. Octavian takes the name Augustus Caesar and rules with Imperial powers, 27 B.C.–14 A.D. Golden Age of Rome, the <i>Pax Romana</i>. Henceforth Roman emperors are hereditary, although the senate retains some powers
RELIGION	776 First Olympic Games, established as a religious festival in Olympia, Greece	 c. 563 Siddhartha (Gautama Buddha), founder of Buddhism, born in Nepal c. 250 Mithraism, worship of an ancient Persian warrior hero, grows in Roman Empire 	4 Birth of Jesus Christ, crucified c. 30 A.D.
	Detail of Ashurnasirpal II Killing Lions, from the Palace of Ashurnasirpal II, Nimrud, Iraq, c. 850 B.C.	(left) The "Marsyas Painter" Red-figured pelike, Greece, c. 340 B.C (right) Nike of Samothrace, c. 200–190 B.C.	Imperial Procession, from the Ara Pacis, Rome, c. 13–9 B.C.
MUSIC, LITERATURE, AND PHILOSOPHY	c. 750–700 (traditional) Homer composes the epics <i>Iliad</i> and <i>Odyssey</i>	Confucius (551–c. 479), Chinese philosopher Pythagoras (c. 520), Greek philosopher c. 500–400 Greek drama: Aeschylus (523–456), Sophocles (496–406), Euripides (480–406), Aristophanes (c. 448–385) c. 450–300 Classical Greek philosophy: Socrates (470–399), Plato (c. 427?–c. 347), Aristotle (384–322) Demosthenes (384–322), Greek philosopher and orator	Cicero (106–43), Roman statesman and orator Vergil (70–19), Roman author of <i>The Aeneid</i> , epic poem narrating the mythic origins of the Romans Livy (59 B.C.–17 A.D.), author of <i>From the Founding of the City</i> , a history of Rome c. 50 <i>Commentaries</i> , by Julius Caesar, detail the progress of his wars in France Ovid (43 B.C.–17 A.D.), poet of <i>The Metamorphoses</i> , amorous and mythological tales
SCIENCE AND TECHNOLOGY	 c. 800 Adoption of the Phoenician alphabet, ancestor of that of modern European languages, by Greeks c. 700–600 Phoenician sailors circumnavigate African continent; c. 700, horseshoes invented in Europe by Celtic tribes c. 650 Coins for currency imported from Asia Minor to Greece 	 c. 500 Greek advances in metal working; invention of metal-casting and ore-smelting techniques c. 300 Euclid, geometrician in Alexandria, writes <i>Elements</i>, fundamental text of mathematics and reasoning Pytheas, Greek explorer, travels the Atlantic coast of Europe, reaching points beyond Britain Archimedes (287–212), Greek mathematician 	 c. 200 Standing army maintained by the Romans; development of the professional soldier; use of concrete as building material in the Roman Empire c. 100 Earliest waterwheels Vitruvius' On Architecture, late first century B.C. manual of classical building methods and styles 46 Julius Caesar establishes the Julian calendar, in use until the 16th century A.D.

1 A.D100 A.D.	100-200 A.D.	200 –300 a.d.
Claudius (r. 41–54), reluctant emperor of Rome, reconquers Britain In the reign of the emperor Nero (r. 54–68), a fire destroys most of Rome, which is soon rebuilt; first persecutions of Christians Emperor Trajan (r. 98–117) brings the Roman Empire to its greatest expansion, venturing into Persian territory and northern Germany. The city of Rome has an estimated population of one million 79 Eruption of Mount Vesuvius in southern Italy; destruction of cities of Pompeii and Herculaneum by lava and ash	132–135 Jewish Diaspora begins; Jews expelled from Jerusalem Marcus Aurelius, emperor of Rome (r. 161–180), repulses the growing flood of Goth and Hun invaders from Northern Europe Pompeii The sudden destruction of Pompeii by lava from Mount Vesuvius in 79 A.D. preserved intact an entire city. Private houses, public buildings, shops, plumbing systems, and even bits of furniture were encased in lava and mud. Pompeii was a town of modest importance in first-century Rome; it thus affords a remarkable view of daily life—both high and low—in the Empire. Grooves in paved streets mark the passage of carts and chariots. On the walls of fine villas are brightly colored paintings; on those of cheaper lodgings are scrawled political slogans and graffiti. Among the finest wall paintings, otherwise rare, are those of the luxurious villas of wealthy Pompeiians decorated lavishly with complex architectural scenes, figures, and landscape vistas. With ornate mosaic floors and elegant architecture, the Pompeiian villas illustrate the refinement of aristocratic Roman life.	
c. 45–50 St. Paul spreads Christianity in Asia Minor and Greece St. Peter (died c. 64), first Bishop of Rome	c. 130–68 Dead Sea Scrolls written; early manuscripts of Judaism and Christianity	c. 250–302 Widespread persecution of Christians in Roman Empire
Spoils from the Temple in Jerusalem, from the Arch of Titus, Rome, 81 A.D.	(left) Pantheon, Rome, 118–125 A.D. (right) Portrait of a Boy, Egypt, 2nd century A.D.	
Seneca (4 B.C.–65 A.D.), prominent Roman Stoic philosopher and adviser to Emperor Nero Plutarch (c. 46–after 119), Greek essayist, author of <i>Parallel Lives of Greeks and Romans</i> c. 47–49 Epistles of St. Paul, written during his missionary work in Asia Minor Tacitus (55–118), Roman historian and political commentator		Plotinus (205–270), Neo-Platonic Greek philosopher and author of the <i>Enneads</i> , teaches in Rome
c. 77 Pliny the Elder (23–79) writes his <i>Natural History</i> , an encyclopedic history, including a history of art Ptolemy (85–160), influential geographer and astronomer in Alexandria, popularizes the theory that the earth is at the center of the universe	c. 100 Early glass-blowing techniques developed in Syria Galen (c. 130–200), Greek physician whose writings form the foundation of the study of human physiology	By 200 Over 50,000 miles of paved roads built by Romans

PART TWO

THE MIDDLE AGES

hen we think of great Western civilizations of the past, we tend to do so

in terms of visible monuments that have come to symbolize the distinctive character of each: the pyramids of Egypt, the ziggurats of Babylon, the Parthenon of Athens, the Colosseum of Rome. The Middle Ages, in such a review of climactic achievements, would be represented by a Gothic cathedral—Notre-Dame in Paris, perhaps, or the cathedral of Chartres in France, or Salisbury Cathedral in England. We have many to choose from, but whichever one we pick, it will be well north of the Alps (although in territory that formerly belonged to the Roman Empire). And if we were to spill a bucket of water in front of the cathedral of our choice, this water would eventually make its way to the English Channel rather than to the Mediterranean Sea. Here, then, we have perhaps the most important single fact about the Middle Ages—the center of gravity of European civilization has shifted to what had been the northern boundaries of the Roman world. The Mediterranean, for so many centuries the great highway of commercial and cultural exchange binding together all the lands along its shores, has become a barrier, a border zone.

How did this dramatic shift come about? In 323 A.D. Constantine the Great made a fateful decision, the consequences of which are still felt today. He resolved to move the capital of the Roman Empire to the Greek town of Byzantium, which came to be known then as Constantinople and today as Istanbul. Six years later, after an energetic building campaign, the transfer was officially completed. In taking this step, the emperor acknowledged the growing strategic and economic importance of the eastern provinces, a development that had been evolving for some time. The new capital also symbolized the new Christian basis of the Roman state, since it was in the heart of the most thoroughly Christianized region of the empire.

Constantine could hardly have foreseen that shifting the seat of imperial power would result in splitting the realm. In 395, less than 75 years after the capital was relocated in the East, the division of the Roman Empire into the Eastern and Western empires was official and permanent. That separation eventually led to a religious split as well.

By the end of the fifth century, the bishop of Rome, who derived his authority from St. Peter, regained independence from the emperor and reasserted his claim as the acknowledged head—the pope—of the Christian Church. His claim to preeminence, however, soon came to be disputed by the Eastern counterpart to the pope, the patriarch of Constantinople. Differences in doctrine began to develop, and eventually the division of Christendom into a Western, or Catholic, and an Eastern, or Orthodox, Church became all but final. Institutionally, the differences between them went very deep. Roman Catholicism maintained its autonomy from imperial or any other state authority and became an international institution, reflecting its character

as the Universal Church. The Orthodox Church, on the other hand, was based on the union of spiritual and secular authority in the person of the emperor, who appointed the patriarch. It thus remained dependent on the power of the State, exacting a double allegiance from the faithful and sharing the vicissitudes of political power. This tradition did not die even with the fall of Constantinople to the Ottoman Turks in 1453. The czars of Russia claimed the mantle of the Byzantine emperors, Moscow became "the third Rome," and the Russian Orthodox Church was as closely tied to the State as was its Byzantine parent body.

Under Justinian (ruled 527–65), the Eastern (or Byzantine) Empire reached new power and stability after riots in 532 nearly deposed him. In contrast, the Latin West soon fell prey to invading Germanic peoples: Visigoths, Vandals, Franks, Ostrogoths, and Lombards. By the end of the sixth century, the last vestige of centralized authority had disappeared even though the emperors at Constantinople did not relinquish their claim to the western provinces. Yet these invaders, once they had settled in their new environment, accepted the framework of late Roman, Christian civilization, however imperfectly. The local kingdoms they founded—the Vandals in North Africa, the Visigoths in Spain, the Franks in Gaul, the Ostrogoths and Lombards in Italy—were all Mediterranean-oriented, provincial states on the periphery of the Byzantine Empire, subject to the pull of its military, commercial, and cultural power. As late as 630, after the Byzantine armies had recovered Syria, Palestine, and Egypt from the Sassanid Persians, the reconquest of the lost western provinces remained a serious possibility. Ten years later, the chance had ceased to exist, for a tremendous and completely unforeseen new force had made itself felt in the East: Islam.

Under the banner of Islam, the Arabs overran the African and Near Eastern parts of the Empire, and by 732, a century after Mohammed's death, they had absorbed Spain as well and threatened to add southwestern France to their conquests. In the eleventh century, the Turks occupied much of Asia Minor, while the last Byzantine possessions in the West (in southern Italy) fell to the Normans, from northwestern France. The Eastern Empire, with its domain reduced to the Balkan peninsula, including Greece, held on until 1453, when the Turks finally conquered Constantinople itself.

Islam had created a new civilization stretching to the Indus Valley (now Pakistan) in the East, a civilization that reached its highest point far more rapidly than did that of the medieval West. Baghdad, on the Tigris, the most important city of Islam in the eighth century, rivaled the splendor of Byzantium. Islamic art, learning, and crafts were to have a far-ranging influence on the European Middle Ages, from arabesque ornament, the manufacture of paper, and Arabic numerals to the transmission of Greek philosophy and science through the writings of Arab scholars. (The English language records this debt in such words of Arabic origin as *algebra* and *alcohol.*)

It would be difficult to exaggerate the impact of the lightning-like advance of Islam

on the Christian world. The Byzantine Empire, deprived of its western Mediterranean bases, concentrated all its efforts on keeping Islam at bay in the East. Byzantium's impotence in the West, where it retained only a precarious foothold on Italian soil, left the European shore of the western Mediterranean, from the Pyrenees to Naples, exposed to Arabic raiders from North Africa and Spain. Western Europe was thus forced to develop its own resources—political, economic, and spiritual.

The process was slow and difficult, however. The early medieval world, beset by unremitting upheaval, presents a constantly shifting picture. Not even the Frankish kingdom, ruled by the Merovingian dynasty from about 500 to 751, was capable of imposing more than temporary order. As the only international organization of any sort, Christianity was to play a critical role in promoting a measure of stability. Yet it, too, was divided between the papacy, whose influence was limited, and the monastic orders that spread quickly throughout Europe but remained largely independent of the Church in Rome.

This rapid expansion of Christianity, like that of Islam, cannot be explained simply in institutional terms, for the Church was at best an imperfect embodiment of Christian ideals. Moreover, its success was hardly guaranteed. In fact, its position was often precarious under Constantine's Latin successors. Instead, Christianity must have exercised an extraordinarily persuasive appeal, spiritual as well as moral, on the masses of people who heard its message.

Church and State gradually discovered that cooperation worked to their mutual advantage and that, in fact, they could not live without each other. What was needed, however, was an alliance between a strong central secular authority and a united church. This link was forged when the Catholic church, which had now gained the allegiance of the religious orders, broke its last ties with the East and turned for support to the Germanic north. There the energetic leadership of Charlemagne and his heirs—the Carolingian dynasty—made the Frankish kingdom into the leading power during the second half of the eighth century after overturning the Merovingian dynasty. In 800, the pope solemnized the new order of things by bestowing the title of emperor upon Charlemagne.

In placing himself and all of Western Christianity under the protection of the king of the Franks and Lombards, the pope nevertheless did not subordinate himself to the newly created Catholic emperor, whose legitimacy depended on the pope. (Formerly it had been the other way around: the emperor in Constantinople had ratified the newly elected pope.) This interdependent dualism of spiritual and political authority, of Church and State, was to distinguish the West from both the Orthodox east and the Islamic south. Its outward symbol was the fact that though the emperor had to be crowned in Rome, he did not reside there. Charlemagne built his capital at the center of his effective power, in Aachen, located, on the present-day map of Europe, in Germany and close to France, Belgium, and the Netherlands.

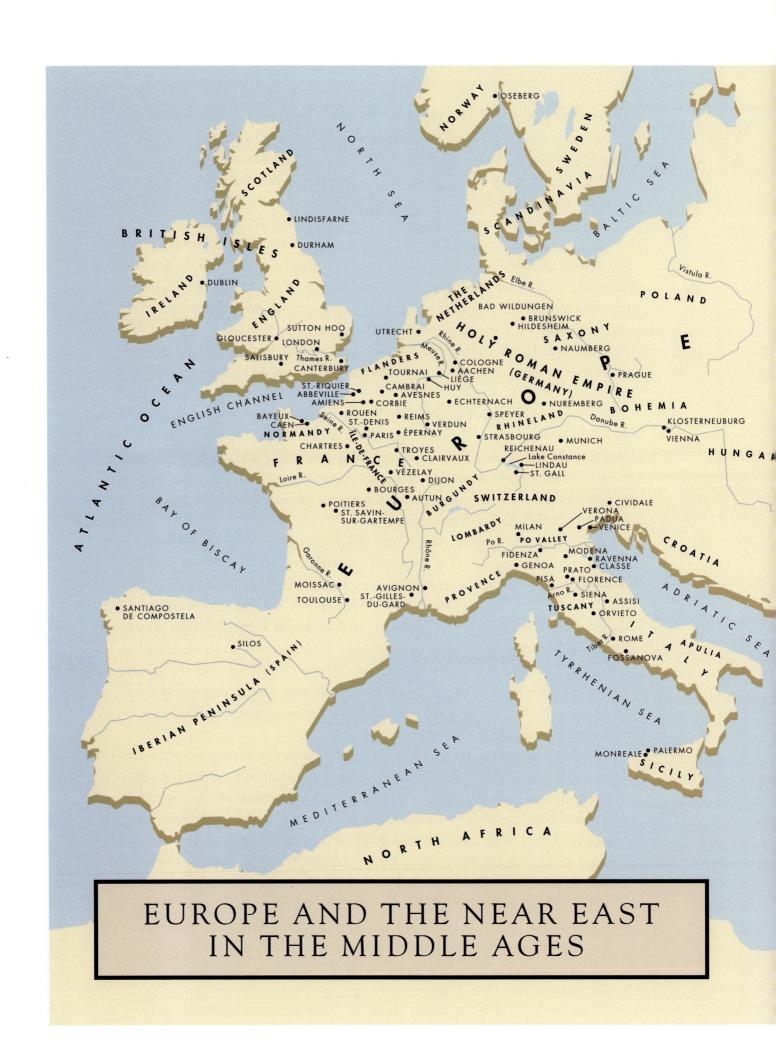

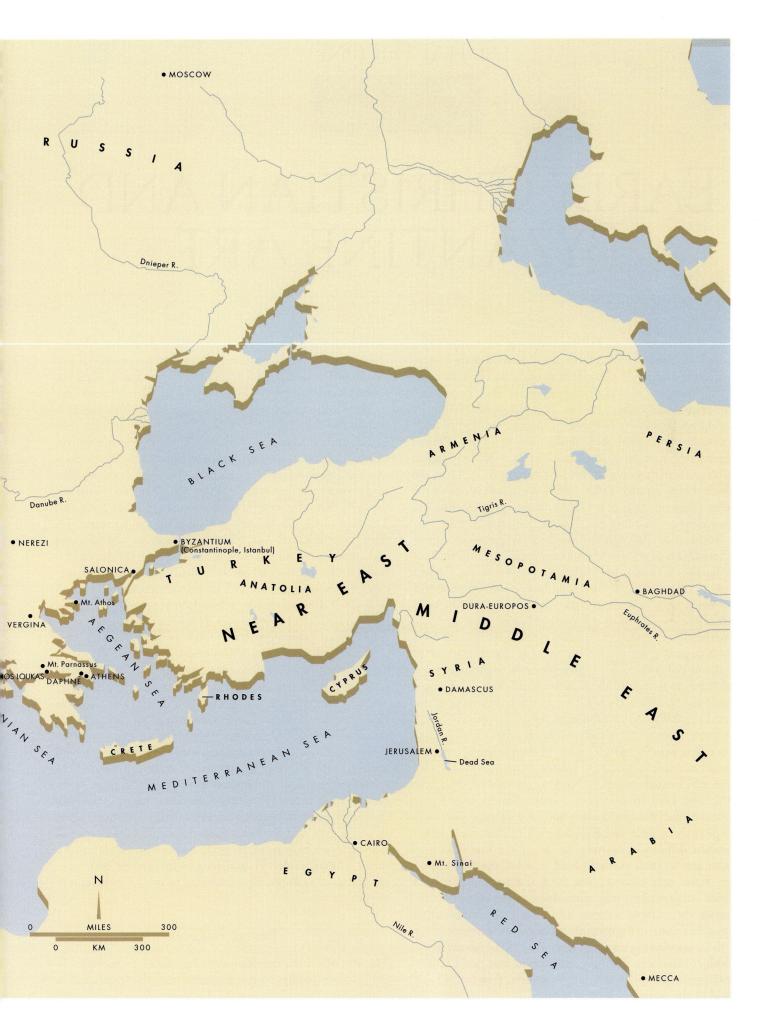

CHAPTER ONE

EARLY CHRISTIAN AND BYZANTINE ART

In the third century A.D., the Roman world was gripped by a spiritual crisis that reflected broad social turmoil as the empire gradually disintegrated. Characteristic of the mood of the times was the spread of Oriental mystery religions. They were of various origins—Egyptian, Persian, Semitic—and their early development naturally centered in their home territory, the southeastern provinces and border regions of the Roman Empire. Although based on traditions in effect long before the conquest of these ancient lands by Alexander the Great, the cults had been strongly influenced by Greek ideas during the Hellenistic period. It was, in fact, to this fusion of Oriental and Greek elements that they owed their vitality and appeal.

At that time, the Near East was a vast religious and cultural melting pot where all of the many competing faiths (including Judaism, Christianity, Mithraism, Manichaeism, Gnosticism, and many more) tended to influence each other, so that they had a number of things in common, whatever their differences of origin, ritual, or nomenclature. Most of them shared such features as an emphasis on revealed truth, the hope of salvation, a chief prophet or messiah, the dichotomy of good and evil, a ritual of purification or initiation (baptism), and the duty to seek converts among "unbelievers." The last and, in the Near East, the most successful development of this period was Islam, which dominates the area to this day.

The growth of the Graeco-Oriental religions under Roman rule is difficult to trace, since many of them were underground movements that have left few tangible remains. This is true of Christianity as well. The Gospels of Mark, Matthew, Luke, and John (their probable chronological order) were written in the later first century and present somewhat varying pictures of Jesus and his teachings; in part, these reflect doctrinal differences between St. Peter, the first bishop of Rome, and St. Paul, a tireless proselytizer and the most important of the early converts. For the first three centuries after Christ, congregations were disinclined to worship in public. Instead, their simple services, held at best at portable altars with a minimum of implements or vestments (garments worn by those conducting services), took place in the houses of the wealthier members. The new faith spread first to the Greekspeaking communities, notably Alexandria, then to the Latin world by the end of the second century.

Even before it was declared a lawful religion in 261 by the emperor Gallienus, Christianity was rarely persecuted. It suffered chiefly under Diocletian, whose successor, Galerius, issued an edict of toleration in 309. Nevertheless, it had little standing until the conversion of Constantine the Great in 312, despite the fact that nearly one-third of Rome was by then Christian. According to Bishop Eusebius of Caesarea, based on Constantine's own account late in life, on the eve of the decisive battle against Constantine's rival Maxentius at the Milvian Bridge over the Tiber River in Rome, there appeared in the sky the sign of the cross with the inscription "In this sign, conquer." The next night, Christ came to Constantine in a dream with the sign (undoubtedly the Chi Rho monogram, the *labarum*) and commanded him to copy it, whereupon he had it emblazoned on his helmet and on the military standards of his soldiers. Following his victory, Constantine accepted the faith, if he had not done so already, although he was baptized only on his deathbed. The following year, 313, he and his fellow emperor, Licinius, promulgated the Edict of Milan, which proclaimed freedom of religion throughout the empire.

Constantine never declared Christianity the official state religion. Still, it enjoyed special status under his patronage. The emperor championed its cause and played an active role in shaping its theological program, partly in an effort to settle doctrinal disputes. Unlike his pagan predecessors, Constantine could no longer command the status of a deity, but he did claim that his authority was granted directly from God. Thus he retained a unique and exalted role by placing himself at the head of the Church as well as of the State. We recognize this claim as the adaptation of an ancient heritage: the divine kingship of Egypt and the Near East. Although the sincerity of Constantine's faith is not to be doubted, he set a pattern for future Christian rulers in using religion for personal and imperial ends, for example, by continuing to promote the cult of the emperor.

Eastern Religions

The area where the development of the Graeco-Oriental religions took place has been a theater of war and destruction so many times over the centuries that major finds, such as the

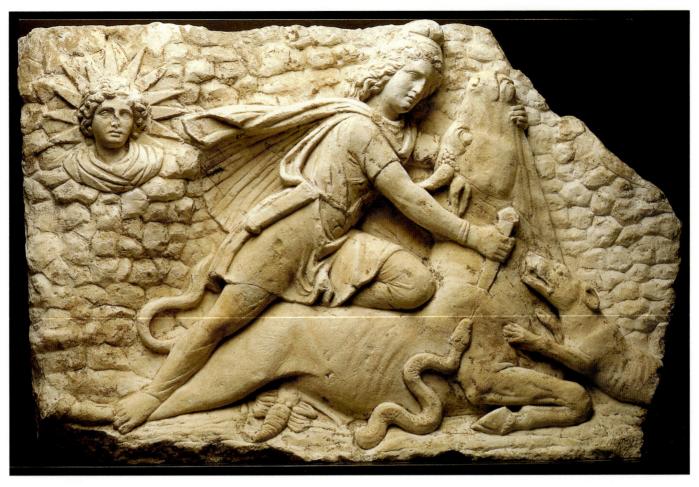

294. Mithras Slaying the Sacred Bull. c. 150–200 A.D. Limestone, 24⁵/8 x 37 ¹/2" (62.5 x 95.2 cm). Cincinnati Art Museum. Gift of Mr. and Mrs. Fletcher E. Nyce (1968.112)

discovery of the *Dead Sea Scrolls* in 1947, are rare events indeed. There is sufficient evidence, however, to indicate that the new faiths also gave birth to a new style in art, and that this style, too, resulted from a fusion of Graeco-Roman and Oriental elements.

MITHRAS. Mithras Slaying the Sacred Bull (fig. 294) shows an early stage in this process. It depicts the central myth of the cult: the god Mithras captures and sacrifices the bull, which was associated with spring, thereby releasing its vital life-giving forces to the snake, symbol of earth, as the scorpion, the astrological sign of autumn, is shown sapping the bull's strength. Originally a minor figure in the pantheon of the Persian prophet Zoroaster (Zarathustra; c. 628-c. 551 B.C.), Mithras emerged as the principal deity of Persia; from there Mithraism spread, eventually becoming the leading mystical sect of the Roman Empire during the second century, when our relief was carved. The image encompasses the principal features of the religion: the ceaseless struggle of good versus evil, and the triumph of life over death. These dualistic forces were represented by light and darkness, portrayed by the Roman sun-god Helios to the left and his counterpart, the moon goddess Luna, unfortunately missing at the right.

The composition is indebted to Late Classical reliefs (compare fig. 203), in which similar Persian figures appear in hunting scenes and battles against the Greeks. Indeed, Helios is

astonishingly close to the head of the *Apollo Belvedere* (see fig. 208). The whole nevertheless has an exotic character that is unmistakably Oriental. This is not only evident in the subject and costume but is also inherent in the composition. The juxtaposition of hero and beast has an ancient history in the Near East, where the ancestry of the clear layout, with its symbolic intent, can also be found (compare figs. 92 and 97). So, too, does the sympathetic portrayal of the splendid bull in its death throes (see fig. 104), which is echoed as well in the struggling cows on the *Vaphio Cups* (figs. 133 and 134).

The sophisticated technique and classical style indicate that the Mithraic relief was carved in Rome itself, where it was found. These features are nevertheless unusual. For the most part, the artists who wrestled with the task of coining images to express the contents of these faiths were not among the most gifted of their time. They were provincial craftsmen of modest ambition who drew upon whatever visual sources happened to be available to them, adapting, combining, and reshaping these as best they could. Their efforts are often clumsy, yet it is here that we find the beginnings of a tradition that was to become of basic importance for the development of medieval art.

DURA-EUROPOS. The most telling illustrations of this new compound style have been found in the Mesopotamian town of Dura-Europos on the upper Euphrates, a Roman

295. The Consecration of the Tabernacle and Its Priests, from the Assembly Hall of the Synagogue at Dura-Europos. 245–56 A.D. Mural, 4'8 ¹/₄" x 7'8 ¹/₄" (1.4 x 2.3 m). National Museum, Damascus, Syria

frontier station that was captured by the resurgent Persians under Shapur I about 256 A.D. (see page 97) and abandoned by its population soon after. Its ruins have yielded the remains of sanctuaries of several religions, including Mithraism and Christianity, decorated with murals which all show essentially the same Graeco-Oriental character. The finest and best preserved are those from the assembly hall of a synagogue, painted about 250 A.D. Of their numerous compartments, we illustrate the one representing the consecration of the tabernacle (fig. 295).

It is characteristic of the melting-pot conditions described above that even Judaism should have been affected by them. Momentarily, at least, the age-old injunction against images as idolatrous was relaxed so that the walls of the assembly hall could be covered with a richly detailed visual account of the history of the Chosen People and their Covenant with the Lord. [See Primary Sources, no. 20, page 382.] The new attitude seems to have been linked with a tendency to change Judaism from a national to a universal faith by missionary activity among the non-Jewish population. (Interestingly, some of the inscriptions on the murals, such as the name Aaron in figure 295, are in Greek.) In any event, we may be sure that the artists who designed these pictures faced an unaccustomed task, just as did the painters who worked for the earliest Christian communities. They had to cast into visible form what had hitherto been expressed only in words. How did they go about it? Let us take a closer look at our illustration. We can read the details—animals, human beings, buildings, cult objects—without trouble, but their relationship eludes us. There is no action, no story, only an assembly of forms and figures confronting us in the expectation that we will be able to establish the proper links between them. The frieze in the Villa of the Mysteries (fig. 289) presents a similar difficulty. There, too, the beholder is supposed to know what is represented. Yet it strikes us as much less puzzling, for the figures have an eloquence of gesture and expression that makes them meaningful even though we may not understand the context of the scenes.

If the synagogue painter fails to be equally persuasive, must we attribute this to a lack of competence, or are there other reasons as well? The question is rather like the one we faced when discussing the Constantinian relief in figure 285, which resembles the Dura-Europos mural in a number of ways. The synagogue painter exhibits the same sense of self-sufficiency, of condensation for the sake of completeness, but the subject is far more demanding. The mural had to represent an historical event of great religious importance: the consecration of the tabernacle and its priests, which began the reconciliation of humanity and God, as described in detail in the Holy Scriptures. And it had to do so in such a way as to suggest that this was also a timeless, recurrent ritual. Thus the picture is burdened with a wealth of significance far greater and more rigidly defined than that of the Dionysiac frieze or the Constantinian relief. Nor did the artist have a well-established tradition of Jewish religious painting at his disposal to help him visualize the tabernacle and the consecration ceremony.

No wonder our painter has fallen back on a sort of symbolic shorthand composed of images borrowed from other, older traditions. The tabernacle itself, for instance, is shown as a Classical temple simply because our artist could not imagine it, in accordance with the biblical description, as a tentlike construction of poles and goat's-hair curtains. The attendant and the red heifer in the lower left-hand corner are derived from Roman scenes of animal sacrifice; hence, they show remnants of foreshortening not found among the other figures. Other echoes of Roman painting appear in the perspective view of the altar table next to the figure of Aaron, in the perfunctory modeling here and there, and in the rudimentary cast shadows attached to some of the figures. Did the painter still understand the purpose of these shadows? They seem to be mere empty gestures, since the rest of the picture betrays no awareness of either light or space in the Roman sense. Even the occasional overlapping of forms appears largely accidental.

The sequence of things in space is conveyed by other means: the seven-branched candlestick, or menorah, the two incense burners, the altar, and Aaron are to be understood as behind, rather than on top of, the crenellated wall that shields the precinct of the tabernacle. Their size, however, is governed by their importance, not by their position in space. Aaron, as the principal figure, is not only larger than the attendants but

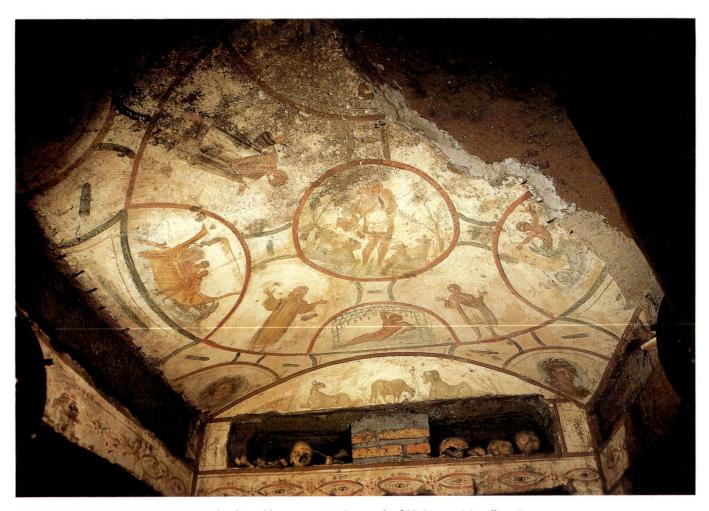

296. Painted ceiling. 4th century A.D. Catacomb of SS. Pietro e Marcellino, Rome

also more rigid and abstract. His costume, because of its ritual significance, is diagramed in detail, at the cost of obliterating the body underneath. The attendants, on the other hand, still show a residue of mobility and three-dimensional existence. Their garments, surprisingly enough, are Persian, an indication not only of the odd mixture of civilizations in this border area but of possible artistic influences from Persia.

Our synagogue mural, then, combines—in none-too-skillful a fashion—a considerable variety of formal elements whose only common denominator is the religious message of the whole. In the hands of a great artist, this message might have been a stronger unifying force, but even then the shapes and colors would have been no more than a humble, imperfect simile of the spiritual truth they were meant to serve. That, surely, was the outlook of the authorities who supervised the execution of the mural cycle and controlled its program. The essential quality of these pictures can no longer be understood in the framework of ancient art. They express an attitude that seems far closer to the Middle Ages. If we were to sum up their purpose in a single phrase, we could hardly do better than to quote a famous dictum justifying the pictorial representation of Christian themes: Quod legentibus scriptura, hoc idiotis . . . pictura. Translated freely it means: painting conveys the Word of God to the unlettered. [See Primary Sources, no. 21, page 382.]

EARLY CHRISTIAN ART

When and where the first Christian works of art were produced remain a matter of conjecture. Of the surviving monuments, none can be dated earlier than about 200 A.D., so that we lack all direct knowledge of art in the service of Christianity before that time. In fact, there is little we know for certain about Christian art until we reach the reign of Constantine the Great, because the third century, too, is poorly represented. The only Christian house found at Dura Europos has murals that are far less extensive or developed than the synagogue frescoes. The painted decorations of the Roman catacombs, the underground burial places of the Christians, provide the only sizable and coherent body of material, but these are only one among various possible kinds of Christian art that may have existed.

Catacombs

The catacomb paintings tell us a good deal about the spirit of the communities that sponsored them, even if the dearth of material from the eastern provinces of the empire makes it difficult to judge their position within the early development of Christian art. The burial rite and the safeguarding of the tomb were of vital concern to the early Christian, whose faith rested on the hope of eternal life in paradise. In the painted ceiling in figure 296, the imagery of the catacombs clearly expresses

this otherworldly outlook, although the forms are in essence still those of pre-Christian mural decoration. We recognize the division of the ceiling into compartments as a late and highly simplified echo of the illusionistic architectural schemes in Pompeian painting. The modeling of the figures, as well as the landscape settings, betray their descent from the same Roman idiom, which here, in the hands of an artist of very modest ability, has become debased by endless repetition. But the catacomb painter has used this traditional vocabulary to convey a new, symbolic content, and the original meaning of the forms is of little interest to him. Even the geometric framework shares in this task, for the great circle suggests the Dome of Heaven, inscribed with the Cross, the basic symbol of the faith. In the central medallion we see a youthful shepherd, with a sheep on his shoulders, in a pose that can be traced back as far as Greek Archaic art (compare fig. 149). He stands for Christ the Saviour, the Good Shepherd who gives his life for his flock.

The semicircular compartments tell the story of Jonah. On the left he is cast from the ship, on the right he emerges from the whale, and at the bottom he is safe again on dry land, meditating upon the mercy of the Lord. This Old Testament miracle, often juxtaposed with New Testament miracles, enjoyed great favor in Early Christian art as proof of the Lord's power to rescue the faithful from the jaws of death. The standing figures may represent members of the Church, with their hands raised in prayer, pleading for divine help. The entire scheme, though small in scale and unimpressive in execution, has a consistency and clarity that set it apart from its Graeco-Roman ancestors, as well as from the synagogue murals of Dura-Europos (see fig. 295). Here is, if not the reality, at least the promise of a truly monumental new form (compare fig. 341).

Architecture

Constantine's decision to sanction Christianity as a legal religion of the Roman Empire had a profound impact on Christian art. Now, almost overnight, an impressive architectural setting had to be created for the newly approved faith, so that the Church might be visible to all. Constantine himself devoted the full resources of his office to this task, and within a few years an astonishing number of large, imperially sponsored churches arose, not only in Rome but also in Constantinople, the Holy Land, and other important centers.

THE BASILICA. These structures were a new type, now called the Early Christian basilica, that provided the basic model for the development of church architecture in western Europe. Unfortunately, none of them has survived in its original form, but the plan of the greatest Constantinian church, Old St. Peter's in Rome, is known with considerable accuracy (figs. 297 and 298). [See Primary Sources, no. 22, page 382.] For an impression of the interior, we must draw upon the slightly later basilica of St. Paul Outside the Walls, built on the same pattern, which remained essentially intact until it was wrecked by fire in 1823 (fig. 299). The Early Christian basilica, as exemplified in these two monuments, has features of assembly hall, temple, and private house. It also has the qualities of an original creation that cannot be wholly explained in terms of its sources.

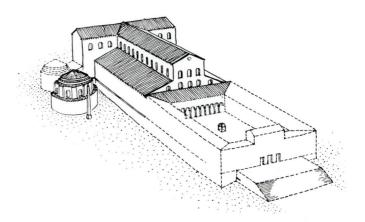

297. Reconstruction of Old St. Peter's, Rome. Begun c. 333 A.D. (after Frazer)

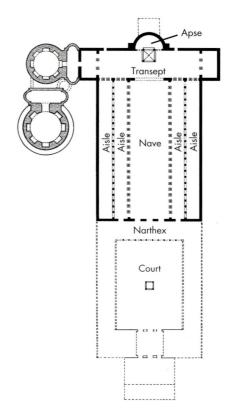

298. Plan of Old St. Peter's (after Frazer)

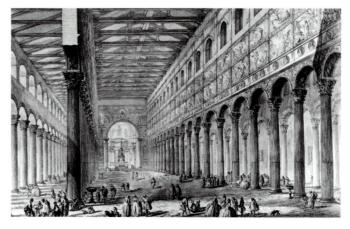

299. Interior, St. Paul Outside the Walls, Rome. Begun 386 A.D. (etching by G. B. Piranesi, 1749)

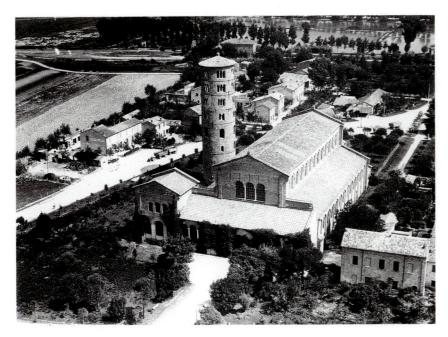

300. S. Apollinare in Classe, Ravenna, Italy. 533-49 A.D.

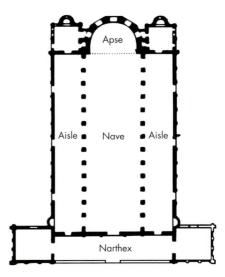

301. Plan of S. Apollinare in Classe (after De Angelis d'Ossat)

The Early Christian basilica owes the long nave flanked by aisles and lit by clerestory windows, the apse, and the wooden roof to the imperial basilicas, such as that at Leptis Magna, erected a hundred years earlier (figs. 253 and 254). The Roman basilica was by no means unique to Christianity. It had already been employed by pagan cults and Judaism. It was nevertheless a suitable model for Constantinian churches, since it combined the spacious interior demanded by Christian ritual with imperial associations that proclaimed the privileged status of Christianity. But a church had to be more than an assembly hall. In addition to enclosing the community of the faithful, it was the sacred House of God, the Christian successor to the temples of old. In order to express this function, the basilica had to be redesigned. The plan of the Early Christian basilica (fig. 298) was given a new focus, the altar, which was placed in front of the apse at the eastern end of the nave, while the entrances, which in earlier basilicas had usually been on the flanks, were shifted to the western end. The Christian basilica was thus oriented along a single, longitudinal axis that

is curiously reminiscent of the layout of Egyptian temples (compare fig. 76).

Before entering the church proper, we traverse a colonnaded court, the atrium (a feature derived from the domus; see fig. 255), the far side of which forms an entrance hall, the narthex. Only when we step through the nave portal do we gain the view presented in figure 299. The steady rhythm of the nave arcade pulls us toward the great arch at the eastern end, which frames the altar and the vaulted apse beyond. As we come closer, we realize that the altar stands in a separate compartment of space placed at right angles to the nave and aisles forming a cross plan, the transept. (This feature is frequently omitted, especially in the lesser basilican churches.)

One essential aspect of Early Christian religious architecture has not yet emerged from our discussion: the contrast between exterior and interior. It is strikingly demonstrated in the sixth-century church of S. Apollinare in Classe (Classe is the seaport of Ravenna), which still retains its original appearance for the most part (figs. 300–302). Our view, taken from

The central rite of many Christian churches is the Eucharist or

communion service, a ritual meal that reenacts Jesus' Last Supper. In the Catholic church and in a few Protestant churches as well, this service is known as the Mass (from the Latin words *Ite, missa est,* "Go, [the congregation] is dismissed" at the end of the Latin service). The Mass was first codified by Pope Gregory the Great about 600. Each Mass consists of the "ordinary"—those prayers and hymns that are the same in all masses—and the "proper," the parts that vary, depending on the occasion. In addition to a number of specific prayers, the "ordinary" consists of five hymns: the *Kyrie Eleison* (Greek for "Lord have mercy on us"); the *Gloria in Excelsis* (Latin for "Glory in the highest"); *Credo* (Latin for "I believe," a statement of faith also called the Creed); *Sanctus* (Latin for "Holy"); and *Agnus Dei* (Latin for "Lamb of

The Liturgy of the Mass

God"). The "proper" of the Mass consists of prayers, two readings

from the New Testament (one from the Epistles and one from the Gospels); a homily, or sermon, on these texts; and hymns, all chosen specifically for the day.

Musical settings for the five "ordinary" hymns, also called a mass, have been a major compositional form from 1400 into the twentieth century, although these masses follow no set tradition and have considerable variety. Many of the greatest composers have written masses, including Josquin Des Prés, Bach, Haydn, Mozart, Beethoven, Verdi, Stravinsky, Britten, and Bernstein. These works often depart rather freely from liturgical requirements of the Mass, as they were written for special occasions, such as the Requiem Mass for the dead, the Nuptial Mass for weddings, and the Coronation Mass.

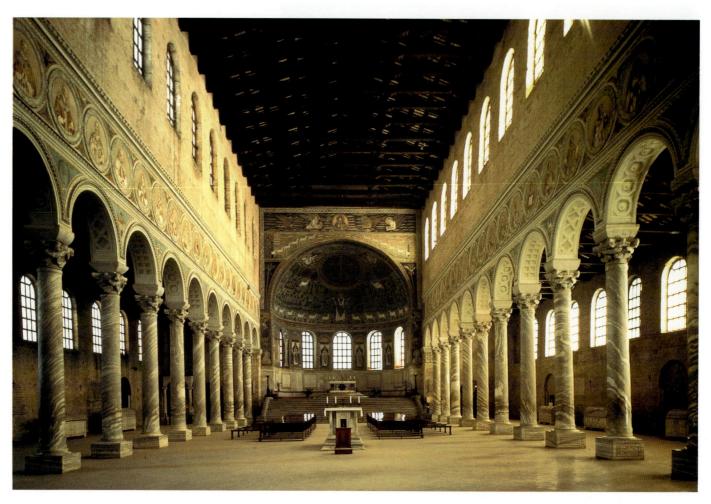

302. Interior (view toward the apse), S. Apollinare in Classe, Ravenna. 533-49 A.D.

the west, shows the narthex but not the atrium, which was torn down a long time ago. (The round bell tower, or campanile, is a medieval addition.) As the plan reveals, the church lacks a transept. The plain brick exterior remains conspicuously unadorned. It is only a shell whose shape reflects the interior space it encloses—the exact opposite of the Classical temple. This ascetic, antimonumental treatment of the exterior gives way to the utmost richness as we enter the church. Having left the everyday world behind, we find ourselves in a shimmering realm of light and color where precious marble surfaces and the brilliant glitter of mosaics evoke the spiritual splendor of the Kingdom of God.

DOMED STRUCTURES. We must take note of another type of structure that entered the tradition of Christian architecture in Constantinian times: round or polygonal buildings crowned with a dome. Also known as central-plan churches, they developed out of the elaborate Roman baths. (The design of the Pantheon, we will recall, was derived from that source; see pages 182–85.) Similar structures had been built by Roman emperors to serve as monumental tombs, or mausoleums. In the fourth century, this type of building was given a Christian meaning in the baptisteries (where the bath became the sacred rite of baptism) and in the funerary chapels (where the hope for eternal life was expressed) that were linked with basilican churches. Because of these symbolic associations, central-plan

churches became widely adopted. Most were derived from a handful of venerated sites, such as the Church of the Holy Sepulchre in Jerusalem, but these served only as a point of departure, so that considerable liberties were taken with them. The sense of geometry was surprisingly loose. The shape could be round or polygonal and need incorporate only one or two significant features and measurements to establish the identity with its model. Symbolism even played an important role in the number of elements and their configuration. Octagons were favored, for example, because the number eight was a symbol of resurrection. This free approach was typical of Early Christian architecture as a whole. Thus we find wide variation from building to building—not only domed structures but basilican churches as well.

The finest surviving example is Sta. Costanza (figs. 303–5), the mausoleum of Constantine's daughter Constantia, originally attached to the (now ruined) Roman church of St. Agnes Outside the Walls. In contrast to its predecessors, it shows a clear articulation of the interior space into a domed cylindrical core lit by clerestory windows—the counterpart of the nave of a basilican church—and a ring-shaped "aisle" or ambulatory covered by a barrel vault. Once again the mosaic decoration plays an essential part in setting the mood of the interior. Here the motifs are secular in the ambulatory but Christian in the two apsidal chapels, a striking contrast that attests to how long the two motifs coexisted.

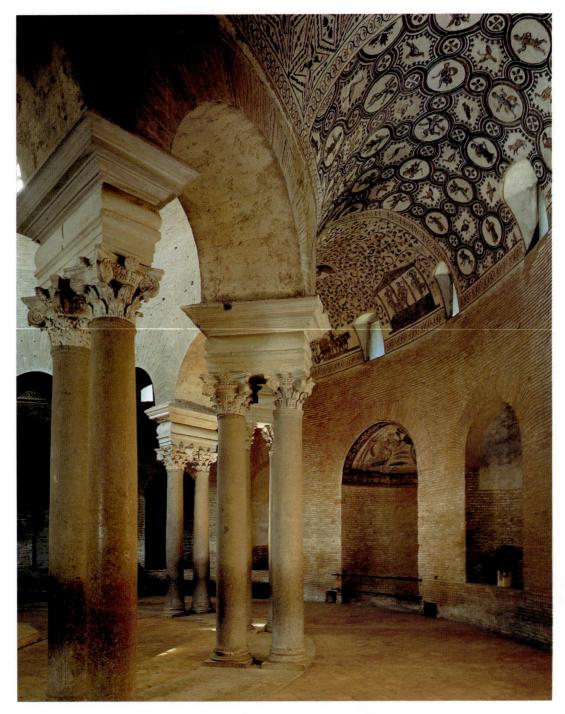

303. Interior, Sta. Costanza, Rome. c. 350 A.D.

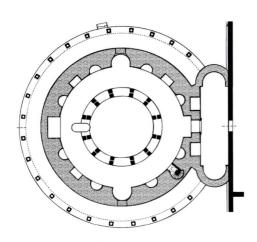

304. Plan of Sta. Costanza

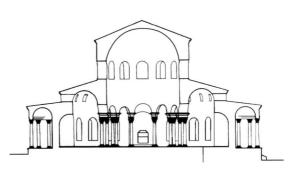

305. Section of Sta. Costanza

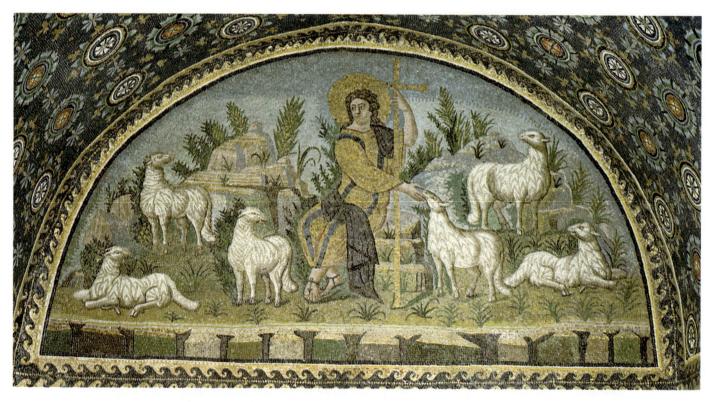

306. Good Shepherd. 425-50. Mosaic. Mausoleum of Galla Placidia, Ravenna

Mosaics

The rapid growth of Christian architecture on a large scale had a revolutionary effect on the development of Early Christian painting. All of a sudden, huge wall surfaces had to be covered with images worthy of their monumental framework. Who was equal to this challenge? Certainly not the humble artists who had decorated the catacombs with their limited stock of types and subjects. They were superseded by masters of greater ability—recruited, we may suppose, under imperial auspices, as were the architects of the new basilicas. Unfortunately, so little of the decoration of fourth-century churches has survived that its history cannot be traced in detail.

WALL MOSAICS. Out of this process emerged a great new art form, the Early Christian wall mosaic, which to a large extent replaced the older and cheaper medium of mural painting. Mosaics—designs composed of small pieces of colored material set in plaster—had been used by the Sumerians as early as the third millennium B.C. to embellish architectural surfaces. The Hellenistic Greeks and the Romans, employing small cubes of marble called tesserae, had refined the technique to the point that it could reproduce paintings, as in *The Battle of Issus* (see fig. 199). But these were mostly floor mosaics, and the color scale, although rich in gradations, lacked brilliance, since it was limited to the various kinds of colored marble found in nature. The Romans would also produce wall mosaics occasionally, but only for special purposes and on a limited scale.

The extensive and intricate wall mosaics of Early Christian art thus are essentially without precedent. The same is true of their material, for they consist of tesserae made of colored glass. These, too, were not entirely unknown to the Romans, yet their

special virtues had never been exploited before. They offered colors, including gold, of far greater range and intensity than marble tesserae, but lacked the fine gradations in tone necessary for imitating painted pictures. Moreover, the shiny (and slightly irregular) faces of glass tesserae act as tiny reflectors, so that the overall effect is that of a glittering, immaterial screen rather than of a solid, continuous surface. All these qualities made glass mosaic the ideal complement of the new architectural aesthetic that confronts us in Early Christian basilicas.

The guiding principle of Graeco-Roman architecture, we recall, had been to express a balance of opposing forces, rather like the balance within the contrapposto of a Classical statue. The result was a muscular, physical display of active and passive, supporting and supported members, whether these were structurally real or merely superimposed on a concrete core. Viewed in such terms, Early Christian architecture is strangely inexpressive, even antimonumental. The tangible, material structure has become subservient to the creation and definition of immaterial space. Walls and vaults have the quality of weightless shells, their actual thickness and solidity hidden rather than emphasized as before. The brilliant color, the lightfilled brightness of gold, the severe geometric order of the images in a mosaic complex such as that of S. Apollinare in Classe (fig. 302) fit the spirit of these interiors to perfection. One might say, in fact, that Early Christian and Byzantine churches demand mosaics the way Greek temples demand architectural sculpture.

EARLY SOURCES. Apparently, great pictorial cycles were spread over the nave walls, the triumphal arch, and the apse from the very start, first in painting, then in mosaic. These

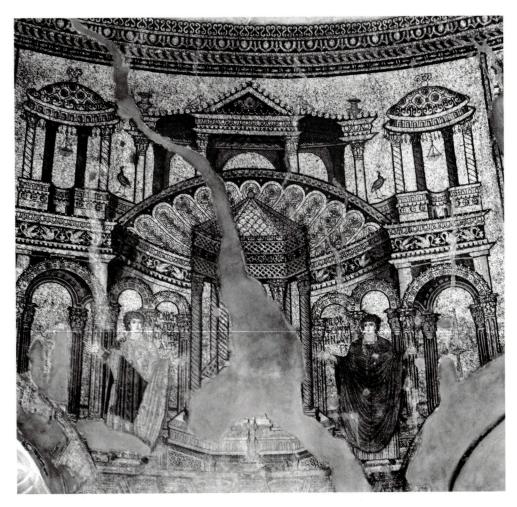

307. Dome mosaic (detail). Late 4th century A.D. St. George, Salonica, Greece

cycles must have drawn upon a great variety of earlier sources, reflecting the whole range of Graeco-Roman painting as well as the art of other centers of Christianity. Before Constantine's reign, Rome did not embody the faith. Older and larger Christian communities existed in the great cities of North Africa and the Near East, such as Alexandria and Antioch. They had probably developed separate artistic traditions of their own, but few traces of them exist today. Paintings in an Orientalizing style similar to that of the extraordinary murals in the synagogue at Dura-Europos (see fig. 295) may have decorated the walls of Christian places of worship in Syria and Palestine, since the earliest Christian congregations were formed by dissident members of the Jewish community. Moreover, during the first or second century A.D., Alexandria, the home of a large and thoroughly Hellenized Jewish colony, may have produced illustrations of the Old Testament in a style akin to that of Pompeian murals. We meet echoes of such scenes in Christian art later on, but we cannot be sure when or where they originated, or by what paths they entered the Christian tradition. The importance of Judaic sources for Early Christian art is hardly surprising: the new faith also incorporated many aspects of the Jewish service into its own liturgy, including hymns, which were to provide the basis for medieval chants.

Be that as it may, the heritage of the past was not only absorbed but also transformed so as to make it fit its new environment physically and spiritually. A characteristic example is the *Good Shepherd* mosaic in the mausoleum of Galla Placidia

(fig. 306), the sister of Honorius, who initiated the first ambitious building program in Ravenna. The figure of the shepherd seated in a landscape expands the central subject of our catacomb painting (fig. 296) by being both more elaborately and more formally treated. In accordance with the preference of the time, Christ is depicted as a young man in the familiar pose of a philosopher. (We shall meet him again as a youthful philosopher in the *Sarcophagus of Junius Bassus*; see fig. 312.) The rest of his attributes, however, have been adapted from Imperial art, which provided a ready supply of motifs that was mined heavily in the early fifth century, when Christian imagery underwent intensive development. The halo was taken from representations of the emperor as sun-king, and even the cross had been an Imperial device.

CONTRASTS WITH GRAECO-ROMAN PAINTING. Roman mural painting had developed elaborate illusionistic devices in order to suggest a reality beyond the surface of the wall. In Early Christian mosaics the flatness of the wall surface is also denied, but for the purpose of achieving an "illusion of unreality," a luminous realm populated by celestial beings or symbols. The difference in intent becomes particularly striking whenever these mosaics make use of the old formulas of spatial illusionism. Figure 307 shows a section of the magnificent dome mosaics from the church of St. George at Salonica, done at the end of the fourth century. Two saints, their hands raised in prayer, stand against a background that clearly betrays its

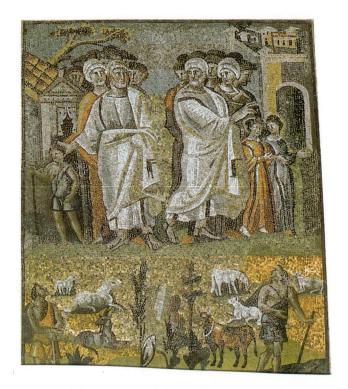

308. The Parting of Lot and Abraham. c. 430 A.D. Mosaic. Sta. Maria Maggiore, Rome

descent from the perspective vistas of "stage architecture" in Pompeian painting (see figs. 286 and 290). The foreshortening, to be sure, seems somewhat askew, but a surprising amount of it survives intact. Even so, the structure no longer seems real, for it lacks all physical substance. Its body consists of the same gold as the background, so that the entire building becomes translucent. (Other colors, mainly purple, blue, and green, are used only in the shaded portions and the ornament.) This is not a stage set but a piece of symbolic, otherworldly architecture meant to evoke such concepts as the Heavenly Jerusalem, the City of God. Here the disparity between pagan and Christian that we sensed in Sta. Costanza has been bridged by adapting the classical past for new spiritual ends.

The Parting of Lot and Abraham (fig. 308) is a scene from the oldest and most important surviving cycle of this kind, executed about 430 in the church of Sta. Maria Maggiore in Rome. Abraham, his son Isaac, and the rest of his family occupy the left half of the composition as they depart for the land of Canaan; Lot and his clan, including his two small daughters, turn toward the city of Sodom on the right. The task of the artist who designed our panel is comparable to that faced by the sculptors of the Column of Trajan (see fig. 273): how to condense complex actions into a visual form that would permit them to be read at a distance. In fact, many of the same "shorthand" devices are employed, such as the abbreviative formulas for house, tree, and city, or the trick of showing a crowd of people as a "grape-cluster of heads" behind the foreground figures. But in the Trajanic reliefs, these devices could be used only to the extent that they were compatible with the realistic aim of the scenes, which re-create actual historic events.

The mosaics in Sta. Maria Maggiore, on the other hand, depict the history of salvation, beginning with Old Testament scenes along the nave (in this instance from Genesis 13) and

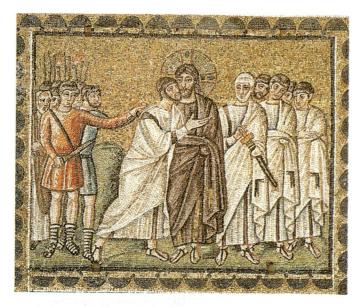

309. *The Betrayal of Christ.* c. 500 A.D. Mosaic. S. Apollinare Nuovo, Ravenna

culminating in the life of Jesus as the Messiah on the triumphal arch across the nave. The scheme constitutes not only an historical cycle but, above all, a unified symbolic program that presents a higher reality—the Word of God. Hence, the artist need not clothe the scene with the concrete details of historic narrative. Glances and gestures are more important than theatrical movement or three-dimensional form. The symmetrical composition, with its cleavage in the center, makes clear the significance of this parting: the way of righteousness represented by Abraham, as against the way of evil, signified by the city of Sodom, which was destroyed by the Lord.

S. APOLLINARE NUOVO, RAVENNA. The challenge of inventing a body of Christian imagery brought forth an extraordinary creative outpouring, and by the end of the sixth century the process was essentially complete. It had taken less than 175 years to lay the foundation for a completely new artistic tradition—a remarkably short time indeed! The earliest cycle of mosaics to survive intact (preceded by others in Rome) are those in S. Apollinare Nuovo in Ravenna. Originally a naval station on the Adriatic, it had become the capital first of the West Roman emperors in 402 and then, at the end of the century, of Theodoric, king of the Ostrogoths, whose tastes were patterned after those of Constantinople. Under Justinian, Ravenna became the main stronghold of Byzantine rule in Italy. S. Apollinare Nuovo was originally built around 500 by Theodoric as his palace church and received its present name only in the ninth century. Along the nave are rows of male and female martyrs surmounted by prophets, patriarchs, and apostles between the windows. It is, however, the scenes depicting the ministry of Christ and the Passion that interest us, for although they have been relegated to a narrow band above the clerestory, they are of great importance.

The selection of subjects is unusual, perhaps reflecting Theodoric's Arian persuasion. In any event, The Betrayal of Christ (fig. 309) remains an astonishing achievement. We immediately recognize the kinship with *The Parting of Lot and* Abraham at Sta. Maria Maggiore (fig. 308). The figures still betray their Roman ancestry as well (compare figs. 267 and 268). Yet we are struck not by any debt to the past but by the newness of the scene, which is without precedent in Greek or Roman art. Its originality lies not so much in the particulars as in the approach. The drama has a clarity that is surprisingly intense. The protagonists are isolated between two equal groups of soldiers and disciples, so that we are forced to concentrate our attention on the central event and, above all, its meaning. So persuasive is the result that the scene became "classic" in its own right: it is the ancestor of countless others not only in Byzantium but also in the West, from Giotto through El Greco and Van Dyck.

Roll, Book, and Illustration

From what source did the designers of narrative mosaic cycles such as those of Sta. Maria Maggiore and S. Apollinare Nuovo derive their compositions? They were certainly not the first to illustrate scenes from the Bible in extensive fashion (see box below). For certain subjects, they could have found models among the catacomb murals, but some prototypes may have

come from illustrated manuscripts. Because of their portability, the latter have been assigned an important role in disseminating religious imagery. In certain well-identified cases, manuscript illustrations unquestionably served as models for wall paintings, while in others it is apparent they must have been derived from frescoes. But in many more instances than have been acknowledged, the similarities between two pictures point to a common source that was probably a lost mural, not a manuscript.

As a scriptural religion, founded on the Word of God as revealed in Holy Writ, the early Christian Church must have sponsored the duplicating of the sacred text on a large scale. Every copy of it was handled with a reverence quite unlike the treatment of any book in Graeco-Roman civilization. But when did these copies become works of pictorial art as well? And what did the earliest Bible illustrations look like?

Books, unfortunately, are frail things. Thus their history in the ancient world is known to us largely from indirect evidence. It begins in Egypt (we do not know exactly when) with the discovery of a suitable material, paperlike but rather more brittle, made from the papyrus plant. Books of papyrus were made in the form of rolls throughout antiquity. Not until late Hellenistic times did a better substance become available: parchment, or vellum (thin, bleached animal hide), which is far more durable than papyrus. Vellum was strong enough to be creased without breaking, and thus made possible the kind

The word *bible* is derived from the Greek word for books, since it

was originally a compilation of a number of sacred texts. Over time, the books of the Bible came to be regarded as a unit, and thus the Bible is now generally considered a single book.

There is considerable disagreement between Christians and Jews, and among various Christian and Jewish sects, over which books should be considered canonical—that is, accepted as legitimate parts of the biblical canon, the standard list of authentic texts. However, every version of the Bible includes the Hebrew torah, or the Law (also called the Pentateuch, or Books of Moses), as the first five books. Also universally accepted by both Jews and Christians are the books known as the Prophets (which include texts of Jewish history as well as prophecy). There are also a number of other books known simply as the Writings, which include history, poetry (the Psalms and the Song of Songs), prophecy, and even folktales, some universally accepted, some accepted by one group, and some accepted virtually by no one. Books of doubtful authenticity are known as apocryphal books, or simply, Apocrypha, from a Greek word meaning obscure. The Jewish Bible or Hebrew Canon—the books which are accepted as authentic Jewish scripture—was agreed upon by Jewish scholars sometime before the beginning of the Christian era.

The Christian Bible is divided into two major sections, the Old Testament and the New Testament. The Old Testament contains many, but not all, of the Jewish scripture, while the New Testament, originally written in Greek, is specifically Christian. It contains four gospels—each written in the first century A.D. by one of the Early Christian mis-

Versions of the Bible

sionaries known as the four evangelists, Mark, Matthew, Luke,

and John. The Gospels tell, from slightly different points of view, the story of the life and teachings of Jesus of Nazareth. The Gospels are followed by the Epistles, letters written by Paul and a few other Christian missionaries to various congregations of the church. The final book is the Apocalypse, by John the Divine, also called the Book of Revelation, which foretells the end of the world.

Jerome (342–420), the foremost scholar of the early Church, selected the books considered canonical for the Christian Bible from a large body of Early Christian writings. It was due to his energetic advocacy that the Church accepted the Hebrew scriptures as representing the Word of God as much as the Christian texts, and therefore worthy to be included in the Bible. Jerome then translated the books he had chosen from Hebrew and Greek into Latin, the spoken language of Italy in his time. This Latin translation of the Bible was—and is—known as the Vulgate, because it was written in the vernacular (Latin vulgaris) language. The Vulgate remained the Church's primary text for the Bible for more than a thousand years. It was regarded with such reverence that in the fourteenth century, when early humanists first translated it into the vernacular languages of their time, they were sometimes suspected of heresy for doing so. The writings rejected for inclusion in the Bible by Jerome are known as Christian Apocrypha. Although not canonical, some of these books, such as the Life of Mary and the Gospel of James, were nevertheless used by artists and playwrights during the Middle Ages as sources for stories to illustrate and dramatize.

310. Miniature, from the *Vatican Vergil*. Early 5th century A.D. Biblioteca Apostolica Vaticana, Rome

of bound book we know today, technically called a codex.

Between the first and the fourth century A.D., the vellum codex gradually replaced the roll, whether vellum or papyrus. This change must have had an important effect on the growth of book illustration. As long as the roll form prevailed, illustrations seem to have been mostly line drawings, since layers of pigment would soon have cracked and come off in the process of rolling and unrolling. Only the vellum codex permitted the use of rich colors, including gold, that was to make book illustration—or, as we usually say, manuscript illumination—the small-scale counterpart of murals, mosaics, and panel pictures. There are still unsettled problems: when, where, and at what pace the development of pictorial book illumination took place; whether biblical, mythological, or historical subjects were primarily depicted; and how much of a carry-over there might have been from roll to codex.

VATICAN VERGIL. There can be little question that the earliest illuminations, whether Christian, Jewish, or classical, were done in a style strongly influenced by the illusionism of Hellenistic-Roman painting of the sort we met at Pompeii. One of the oldest illustrated manuscript books known, the *Vatican Vergil*, reflects this tradition, although the quality of the miniatures is far from inspired. The book was probably made in Italy about the time of the Sta. Maria Maggiore mosaics, to which it is closely linked in style. The picture (fig. 310), separated from the rest of the page by a heavy frame, has the effect of a window, and in the landscape we find remnants of deep space, perspective, and the play of light and shade.

VIENNA GENESIS. The oldest illustrated Bible manuscripts discovered thus far apparently belong to the early sixth century (except for one fragment of five leaves that seems related to the *Vatican Vergil*). They, too, contain echoes of the Hellenistic-Roman style, in various stages of adaptation to

religious narrative and often with a Near Eastern flavor that at times recalls the Dura-Europos murals (see fig. 295). The most important example, the Vienna Genesis, is a far more striking work than the Vatican Vergil. Written in silver (now turned black) on purple vellum and adorned with brilliantly colored miniatures, this Greek translation of the first book of the Bible achieves a sumptuous effect not unlike that of the mosaics we have seen. Figure 311 shows a number of scenes from the story of Jacob. (In the foreground, for example, we see him wrestling with the angel, then receiving the angel's benediction.) The picture thus does not show a single event but a whole sequence, strung out along a single U-shaped path, so that progression in space becomes progression in time. This method, known as continuous narration, has a complex and much debated history going back as far as ancient Egypt and Mesopotamia. Its appearance in miniatures such as ours may well reflect earlier illustrations made for books in roll form: our picture certainly looks like a frieze turned back upon itself.

For manuscript illustration, the continuous method offers the advantage of spatial economy. It permits the painter to pack a maximum of narrative content into the area at his disposal. Our artist evidently thought of his picture as a running account to be read like lines of text, rather than as a window demanding a frame. The painted forms are placed directly on the purple background that holds the letters, emphasizing the importance of the page as a unified field.

Sculpture

Compared to painting and architecture, sculpture played a secondary role in Early Christian art. The biblical prohibition of graven images in the Second Commandment was thought to apply with particular force to large cult statues, the idols worshiped in pagan temples. If religious sculpture was to avoid the taint of idolatry, it had to eschew lifesize representations of the human figure. It thus developed from the very start in an antimonumental direction: away from the spatial depth and massive scale of Graeco-Roman sculpture toward shallow, small-scale forms and lacelike surface decoration.

The earliest works of Christian sculpture are marble sarcophagi. These evolved from the pagan sarcophagi that replaced cinerary urns for the deceased in Roman society around the time of Hadrian, when belief in an afterlife arose as part of a major change in the attitude toward death. Patterns for decorating them were quickly set, probably by passing designs from shop to shop in illustrated manuscripts. The most popular scenes were taken from classical mythology which, since they occur on sarcophagi and nowhere else, must possess symbolic significance, not just antiquarian interest. Their general purpose seems to have been to glorify the deceased through visual analogy to the great legendary heroes of the past. Later, in the third century, biographical and historical scenes projected the deceased's ideal of life, often with moral overtones. From the middle of the third century on, sarcophagi were also produced for the more important members of the Christian Church. Before the time of Constantine, their decoration consisted mostly of the same limited repertory of themes familiar from catacomb murals—the Good Shepherd, Jonah and the

311. Page with Jacob Wrestling the Angel, from the Vienna Genesis. Early 6th century A.D. Tempera and silver on dyed vellum, $13\frac{1}{4} \times 9\frac{1}{2}$ " (33.6 x 24 cm). Österreichische Nationalbibliothek, Vienna

Whale, and so forth—but within a framework clearly borrowed from secular sarcophagi. Not until a century later do we find a significantly broader range of subject matter and form.

SARCOPHAGUS OF JUNIUS BASSUS. The finest Early Christian sarcophagus is the richly carved *Sarcophagus of Junius Bassus*, made for a prefect of Rome who died in 359 (figs. 312 and 313, page 246). Its colonnaded front, divided into ten square compartments, shows a mixture of Old and New Testament scenes. In the upper row we see (left to right) the Sacrifice of Isaac, St. Peter Taken Prisoner, Christ Enthroned between Sts. Peter and Paul, Christ before Pontius Pilate (two compartments); in the lower row are the Misery of Job, the Temptation of Adam and Eve (The Fall of Man), Christ's Entry

into Jerusalem, Daniel in the Lions' Den, and St. Paul Led to His Martyrdom. This choice, somewhat strange to the modern beholder, is characteristic of the Early Christian way of thinking, which stresses the divine rather than the human nature of Christ. Hence his suffering and death are merely hinted at. He appears before Pilate as a youthful, long-haired philosopher expounding the true wisdom (note the scroll), and the martyrdom of the two apostles is represented in the same discreet, nonviolent fashion. The two central scenes are also devoted to Christ (see box pages 246–47). Enthroned above Jupiter as the personification of the heavens, he dispenses the Law to Sts. Peter and Paul; below, he enters Jerusalem as Conquering Saviour (compare fig. 279). Adam and Eve, the original sinners, denote the burden of guilt redeemed by Christ, while the

312. Sarcophagus of Junius Bassus. c. 359 A.D. Marble, 3'101/2" x 8' (1.2 x 2.4 m). Museo Storico del Capitolino di S. Pietro, Rome

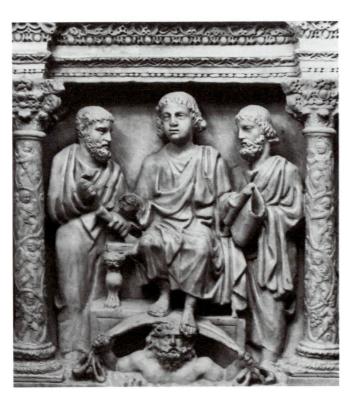

313. Christ Enthroned (detail of fig. 312)

Sacrifice of Isaac is the Old Testament prefiguration of Christ's sacrificial death and resurrection. Job and Daniel carry the same message as Jonah in the catacomb painting (fig. 296): they fortify the hope of salvation.

When measured against the frieze on the Arch of Constantine, carved almost half a century before (see fig. 285), the Sarcophagus of Junius Bassus retains a veneer of classicism. The figures in their deeply recessed niches still recall the statuesque dignity of the Greek and Roman tradition. (Compare Eve to the Cnidian Aphrodite of Praxiteles; fig. 206). Yet beneath this superimposed classicism we sense a basic kinship to the Constantinian style in the doll-like bodies, the large heads, and the oddly becalmed, passive air of scenes calling for dramatic action. The events and personages confronting us are no longer intended to tell their own story, physically or emotionally, but to call to our minds a higher, symbolic meaning that binds them together.

CLASSICISM. Classicizing tendencies of this sort seem to have been a recurrent phenomenon in Early Christian sculpture from the mid-fourth to the early sixth century. Their causes have been explained in various ways. During this period paganism still had many important adherents who may have fostered such revivals as a kind of rear-guard action. Recent converts (including Junius Bassus himself, who was not baptized until shortly before his death) often kept their allegiance to values of the past, artistic and otherwise. There

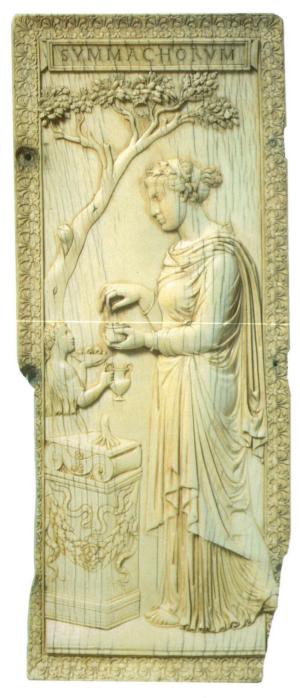

314. *Priestess of Bacchus*. Leaf of a diptych. c. 390–400 A.D. Ivory, $11^{3/4} \times 5^{1/2}$ " (30 x 14 cm). Victoria & Albert Museum, London

315. *The Archangel Michael.* Leaf of a diptych. Early 6th century A.D. Ivory, $17 \times 5^{1}/2$ " (43.3 x 14 cm). The British Museum, London

were also important leaders of the Church who favored a reconciliation of Christianity with the heritage of classical antiquity, and with good reason: Early Christian theology depended a great deal on Greek and Roman philosophers, not only recent thinkers such as Plotinus (see fig. 281) but also Plato, Aristotle, and their predecessors. The imperial courts, too, both East and West, always remained aware of their institutional links with pre-Christian times, and could thus become centers for revivalist impulses. Whatever its roots in any given instance, classicism remained of considerable importance during this age of transition.

IVORY DIPTYCHS. This holds particularly true for a class of objects whose artistic importance far exceeds their physi-

cal size: ivory panels and other small-scale reliefs in precious materials. Designed for private ownership and meant to be enjoyed at close range, they often mirror a collector's taste, a refined aesthetic sensibility not found among the large, official enterprises sponsored by Church or State. Such a piece is the ivory (fig. 314) forming the right half of a hinged two-leaved tablet, or diptych, that was carved about 390–400, probably on the occasion of a wedding between the Nicomachi and Symmachi, two aristocratic Roman families. (The other half is poorly preserved.) The conservative outlook of this piece is reflected not only in the pagan subject (a priestess of Bacchus and her assistant before an altar of Jupiter) but also in the design, which harks back to the era of Augustus (compare fig. 267). At first glance, we might well mistake it

The Life of Jesus

Events in the life of Jesus, from his birth through his ascension to Heaven, are traditionally grouped in cycles, each with numerous episodes. The scenes most frequently depicted in European art are presented here.

INCARNATION CYCLE AND THE CHILDHOOD OF JESUS

These episodes concern Jesus' conception, infancy, and youth.

Annunciation. The archangel Gabriel tells Mary that she will bear God's son. The Holy Spirit, shown usually as a dove, represents the Incarnation, the miraculous conception.

Visitation. The pregnant Mary visits her older cousin, Elizabeth, who is to bear John the Baptist and who is the first to recognize the divine nature of the baby Mary is carrying.

Nativity. Just after the birth of Jesus, the Holy Family— Mary, his foster father Joseph, and the child—is usually depicted in a stable or, in Byzantine representations, in a cave.

Annunciation to the Shepherds and Adoration of the Shepherds. An angel announces the night birth of Jesus to shepherds in the field. They then appear at the birthplace.

Adoration of the Magi. Wise men from the East (called the three kings in the Middle Ages), the Magi follow a bright star for 12 days until they find the Holy Family and present their precious gifts to the Infant Jesus.

Presentation in the Temple. Mary and Joseph take the baby Jesus to the Temple in Jerusalem, where Simeon, a high priest, and Anna, a prophetess, foresee Jesus' messianic (saviour's) mission and martyr's death.

Massacre of the Innocents and Flight into Egypt. King Herod orders all babies killed to preclude his being murdered by a rival newborn king. The Holy Family flees to Egypt.

PUBLIC MINISTRY CYCLE

Baptism. John the Baptist baptizes Jesus in the Jordan River, recognizing Jesus' incarnation as the Son of God and marking the beginning of his ministry.

Calling of Matthew. A tax collector, Matthew, becomes Jesus' first disciple (apostle) when Jesus calls to him, "Follow me."

Jesus Walking on the Water. During a storm, Jesus walks on the water to reach his apostles in a little boat.

Raising of Lazarus. Jesus brings his friend Lazarus back to life four days after Lazarus' death and burial.

Delivery of the Keys to Peter. Jesus names the apostle Peter his successor by giving him the keys to the kingdom of Heaven.

Transfiguration. As Jesus' closest disciples watch, God transforms Jesus into a dazzling vision and proclaims him to be his own son.

Cleansing the Temple. Enraged, Jesus clears the Temple of moneychangers and animal traders.

PASSION CYCLE

The Passion (from *passio*, Latin for suffering) cycle relates Jesus' death, resurrection from the dead, and ascension to Heaven.

Entry into Jerusalem. Welcomed by crowds as the Messiah, Jesus rides an ass into Jerusalem.

Last Supper. At the Passover seder, Jesus tells his disciples of his impending death and lays the foundation for the Christian rite of Eucharist: the taking of bread and wine in remembrance of Christ. (Jesus is called Jesus until he leaves his earthly physical form, after which he is called Christ.)

Jesus Washing the Disciples' Feet. Following the Last Supper, Jesus washes the feet of his disciples to demonstrate humility.

Agony in the Garden. In Gethsemane, the disciples sleep while Jesus wrestles with his mortal dread of suffering and dying.

Betrayal (Arrest). Disciple Judas Iscariot takes money to identify Jesus to Roman soldiers. Jesus is arrested.

Denial of Peter. As Jesus predicted, Peter denies knowing Jesus three times when questioned in the presence of the high priest Caiaphas.

Jesus Before Pilate. Jesus is charged with treason by the Roman governor Pontius Pilate for calling himself King of the Jews.

for a much earlier work, until we realize, from small spatial incongruities such as the priestess's right foot overlapping the frame, that these forms are quotations from earlier examples, reproduced with loving care but no longer fully understood. Significantly enough, the pagan theme did not prevent our panel from being incorporated into the shrine of a saint many

centuries later; its cool perfection had an appeal for the Middle Ages as well.

Our second ivory (fig. 315, page 247) was done soon after 500 in the eastern Roman Empire. It shows a classicism that has become an eloquent vehicle of Christian content. The majestic archangel is a descendant of the winged Victories of

Flagellation (Scourging). Jesus is whipped by Romans.

Jesus Crowned with Thorns (Mocking). Pilate's soldiers make fun of Jesus by dressing him in robes, crowning him with thorns, and calling him King of the Jews.

Carrying of the Cross (Road to Calvary). Jesus carries the wooden cross on which he will be executed from Pilate's house to the hill of Golgatha, "the place of the skull."

Crucifixion. Jesus is nailed to the cross by his hands and feet and dies after much physical suffering.

Descent from the Cross (Deposition). Jesus' followers lower his body from the cross and wrap it for burial. Also present are the Virgin, the apostle John, and in some accounts Mary Magdalen.

Lamentation (*Pietà* or *Vesperbild*). The grief-stricken followers gather around Jesus' body. In the *Pietà*, his body lies across the lap of the Virgin.

Entombment. The Virgin and others place the wrapped body in a sarcophagus, a rock tomb.

Descent into Limbo (Harrowing of Hell). Christ descends to Hell, or limbo, to free deserving souls.

Resurrection (Anastasis). Christ rises from the dead on the third day after his entombment.

The Marys at the Tomb. As terrified soldiers look on, Christ's female followers (the Virgin Mary, Mary Magdalen, and Mary, mother of the apostle James) discover the empty tomb.

Noli me tangere, Supper at Emmaus, Doubting of Thomas. In three episodes during the 40 days between his resurrection and ascent into Heaven, Christ tells Mary Magdalen not to touch him (Noli me tangere); shares a supper with his disciples at Emmaus; and invites the apostle Thomas to touch the lance wound in his side.

Ascension. As his disciples watch, Christ is taken into Heaven from the Mount of Olives.

Graeco-Roman art, down to the richly articulated drapery (see fig. 196). Yet the power he heralds is not of this world, nor does he inhabit an earthly space. The architectural niche against which he appears has lost all three-dimensional reality. Its relationship to him is purely symbolic and ornamental, so that he seems to hover rather than to stand (notice the position of the

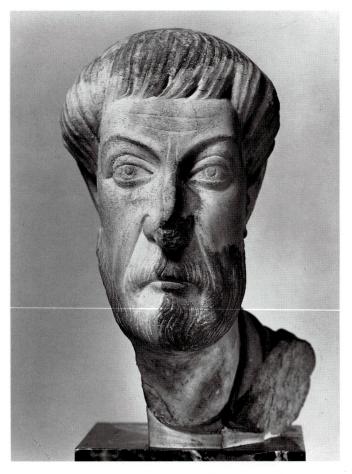

316. Portrait of Eutropios. c. 450 A.D. Marble, height $12^{1}/2$ " (31.7 cm). Kunsthistorisches Museum, Vienna

feet on the steps). It is this disembodied quality, conveyed through harmonious forms, that gives him so compelling a presence.

PORTRAITURE. If monumental statuary was discouraged by the Church, it retained, for a while at least, the patronage of the State. Emperors, consuls, and high officials continued the old custom of erecting portrait statues of themselves in public places as late as the reign of Justinian (527–65), and sometimes later than that. (The last recorded instance is in the late eighth century.) Here, too, we find retrospective tendencies during the latter half of the fourth century and the early years of the fifth, with a revival of pre-Constantinian types and a renewed interest in individual characterization. From about 450 on, however, the outward likeness gives way to the image of a spiritual ideal, sometimes intensely expressive, but increasingly impersonal. There were not to be any more portraits, in the Graeco-Roman sense of the term, for almost a thousand years to come.

The process is strikingly exemplified by the head of Eutropios from Ephesus (fig. 316), one of the most memorable of its kind. It reminds us of the strangely sorrowful features of "Plotinus" and of the masklike colossal head of Constantine (see figs. 281 and 283), but both of these have a physical concreteness that seems almost overwhelming compared to the extreme attentuation of Eutropios. The face is frozen in visionary ecstasy, as if the sitter were a hermit saint. It looks, in fact, more like that of a specter than of a being of flesh and blood.

Biblical, Church, and Celestial Beings

Much of Western art deals with biblical persons and celestial beings. Their names appear in titles of paintings and sculpture and in discussions of subject matter. Following is a brief guide to some of the most commonly encountered persons and beings in Christian art.

Patriarchs. Literally, head of a family, ruler of a tribe. Old Testament patriarchs are Abraham, Isaac, Jacob, and Jacob's 12 sons. Patriarch also refers to the bishops of the five chief bishoprics of Christendom: Alexandria, Antioch, Constantinople, Jerusalem, and Rome.

Prophets. In Christian art, prophets usually mean the Old Testament figures whose writings were seen to foretell the coming of Christ. The so-called major prophets are Isaiah, Jeremiah, and Ezekiel. The minor prophets are Hosea, Joel, Amos, Obadiah, Jonah, Micah, Nahum, Habakkuk, Zephaniah, Haggai, Zechariah, and Malachi.

Trinity. Central to Christian belief is the doctrine that One God exists in Three Persons: Father, Son (Jesus Christ), and Holy Spirit. The Holy Spirit is often represented as a dove.

Holy Family. The infant Jesus, his mother Mary, and his foster father Joseph constitute the Holy Family.

John the Baptist. The precursor of Jesus Christ, John is regarded by Christians as the last prophet before the coming of the Messiah, Jesus. John was an ascetic who baptized his disciples in the name of the coming Messiah; he recognized Jesus as that Messiah when he saw the Holy Spirit descend on Jesus at the moment of baptism.

Evangelists. There are four: Matthew, John, Mark, and Luke—each an author of one of the Gospels. The first two were among Jesus' 12 apostles. The latter two wrote in the second half of the first century.

Apostles. The apostles are the 12 disciples Jesus asked to convert nations to his faith. They are Peter (Simon Peter), Andrew, James the Greater, John, Philip, Bartholomew, Matthew, Thomas, James the Less, Jude (or Thaddaeus), Simon the Canaanite, and Judas Iscariot. After Judas betrayed Jesus, his place was taken by Matthias.

Disciples. See Apostles.

Angels and Archangels. Beings of a spiritual nature, angels are spoken of in the Old and New Testaments as having been created by God to be heavenly messengers between God and human beings, Heaven and earth. Spoken of first by the apostle Paul, archangels, unlike angels, have names: Michael, Gabriel, Tobias, and Raphael.

Cherubim and Seraphim. The celestial hierarchy devised

by Pseudo-Dionysius about 500 A.D. had cherubim (with six wings) and seraphim (four wings) at the peak, encircling the throne of God and the Ark of the Covenant. After the Middle Ages, a cherub came to be represented as a rosy-cheeked, plump, and winged child.

Saints. Persons are declared saints only after death. The pope acknowledges sainthood by canonization, a process based on meeting rigid criteria of authentic miracles and beatitude. He ordains a public cult of the new saint throughout the Catholic church.

Martyrs. Originally, martyrs referred to all the apostles. Later, it signified those persecuted for their faith. Still later, the term was reserved for those who died in the name of Christ.

Pope. Meaning "father," the term refers to the bishop of Rome, the spiritual head of the Roman Catholic church. The pope dwells in and heads an independent state, Vatican City, within the city of Rome. His chief attribute is a shepherd's staff; he dresses in white.

Cardinals. Priests or higher religious officials chosen to help the pope administer the Church. They are of two types: those who live in Rome (the Curia), and those who remain in their dioceses. Together they constitute the Sacred College. One of their duties is to elect a pope after the death or removal of a sitting pope. They dress in red garments and wear broad-brimmed hats tied under the chin.

Diocese. A territorial unit administered in the Western church by a bishop and in the Eastern church by a patriarch. A cathedral is the diocese church and the seat of the bishop.

Bishops and Archbishops. A bishop is the highest order of minister in the Catholic church, with his administrative territory being the diocese. Bishops are ordained by archbishops, who also have the authority to consecrate kings. Bishops carry an elaborately curved staff called a crozier and wear a three-pointed hat.

Priests and Parishes. Priests did not exist in the early Church, because only bishops were authorized to offer the Eucharist and receive confession. As the Church grew, church officials called presbyters were designated by bishops to perform the Eucharist and ablutions in smaller administrative units, called parishes, and they became priests.

Abbots and Abbesses. Heads of large monasteries (called abbeys) and convents (nunneries).

Monks and Nuns. Men and women living in religious communities who have taken vows of poverty, chastity, and obedience to the rules of their orders. The avoidance of solid volumes has been carried so far that the features are for the most part indicated only by thin ridges or shallow engraved lines. Their smooth curves emphasize the elongated oval of the head and thus reinforce its abstract, otherworldly character. Not only the individual person but the human body itself has ceased to be a tangible reality here—and with that the Greek tradition of sculpture in the round has reached the end of the road.

BYZANTINE ART

Early Byzantine Art

Since there is no clear-cut line of demarcation between Early Christian and Byzantine art, it could be argued that a Byzantine style (that is, a style associated with the imperial court of Constantinople) becomes discernible within Early Christian art as early as the beginning of the fifth century, soon after the effective division of the empire. However, we have avoided making this distinction, for East Roman and West Romanor, as some scholars prefer to call them, Eastern and Western Christian—characteristics are often difficult to separate before the sixth century. Until that time, both areas contributed to the development of Early Christian art, although the leadership tended to shift more and more to the East as the position of the West declined. During the reign of Justinian this shift was completed. Constantinople not only reasserted its political dominance over the West but became the undisputed artistic capital as well. Justinian himself was an art patron on a scale unmatched since Constantine's day. The works he sponsored or promoted have an imperial grandeur that fully justifies the acclaim of those who have termed his era a golden age. They also display an inner unity of style that links them more strongly with the future development of Byzantine art than with the art of the preceding centuries.

S. VITALE, RAVENNA. The richest array of early Byzantine monuments survives today not in Constantinople, where much has been destroyed, but on Italian soil, in the town of Ravenna. The most important church of that time, S. Vitale, was begun by Bishop Ecclesius in 526, just before Theodoric's death, but built chiefly in 540-47 under Bishop Maximian, who also consecrated S. Apollinare in Classe two years later (see figs. 300-302). The structure of S. Vitale is of a type derived mainly from Constantinople. We find only the barest remnants of the longitudinal axis of the Early Christian basilica. Toward the east is a cross-vaulted compartment for the altar, backed by an apse; and on the other side a narthex, whose odd, nonsymmetrical placement has never been fully accounted for. We recognize its octagonal plan, with the domed central core (figs. 317-20), as a descendant of the mausoleum of Sta. Costanza in Rome (see figs. 303-5), but the intervening development seems to have taken place in the East, where domed churches of various kinds had been built during the previous century.

Remembering S. Apollinare in Classe (see figs. 300–302), built at the same time on a straightforward basilican plan, we are particularly struck by the different character of S. Vitale. How did it happen that the East favored a type of church

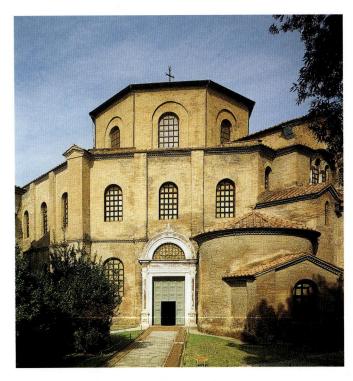

317. S. Vitale, Ravenna. 526-47 A.D.

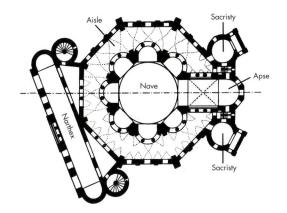

318. Plan of S. Vitale

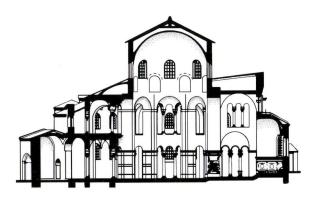

319. Transverse section of S. Vitale

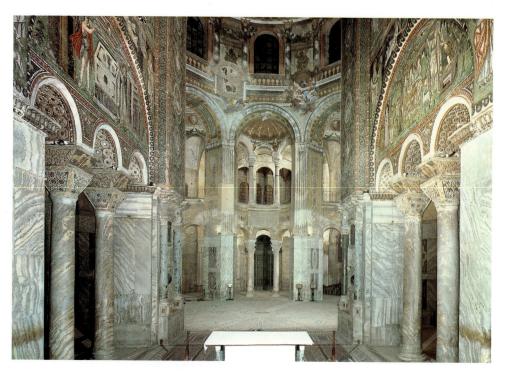

320. Interior (view from the apse into the choir), S. Vitale

building (as distinct from baptisteries and mausoleums) so radically different from the basilica? A number of different reasons have been suggested: practical, religious, political. All of them may be relevant, but if the truth be told, they fall well short of a really persuasive explanation. After all, the design of the basilica had been backed by the authority of Constantine; yet it never enjoyed the popularity that it had in the Latin West since early Imperial times. Moreover, it was Constantine who erected the first central-plan churches in Constantinople, thereby helping to establish the preference for the type in the eastern part of the Empire. In any event, domed, central-plan churches were to dominate the world of Orthodox Christianity as thoroughly as the basilican plan dominated the architecture of the medieval West.

Compared to Sta. Costanza, S. Vitale is both larger in scale and very much richer in its spatial effect (fig. 320). Below the clerestory, the central space turns into a series of semicircular niches that penetrate into the aisle and thus link it to the nave in a new and intricate way. The aisle itself has been given a second story: the galleries, which may have been reserved for women. A new economy in the construction of the vaulting permits large windows on every level, which flood the interior with light. The complexity of the interior is matched by its lavish decoration.

S. Vitale's link with the Byzantine court is manifest in the two famous mosaics flanking the altar (figs. 321 and 322), which depict Justinian and his empress, Theodora, accompanied by officials, the local clergy, and ladies-in-waiting. Although they did not attend the actual ceremonies, the royal couple are shown as present at the consecration of S. Vitale to demonstrate their authority over Church and State, as well as their support for their archbishop, Maximianus, who was initially unpopular with the citizens of Ravenna. In these large panels, whose design most likely came directly from the impe-

rial workshop, we find an ideal of human beauty quite different from the squat, large-headed figures we encountered in the art of the fourth and fifth centuries.

We have caught a glimpse of this emerging new ideal occasionally (figs. 296, 314, and 315), but only now do we see it complete: extraordinarily tall, slim figures, with tiny feet, small almond-shaped faces dominated by their huge, staring eyes, and bodies that seem to be capable only of slow ceremonial gestures and the display of magnificently patterned costumes. Every hint of movement or change is carefully excluded. The dimensions of time and earthly space have given way to an eternal present amid the golden translucency of Heaven, as the solemn, frontal images in the mosaics seem to present a celestial rather than a secular court. This union of political and spiritual authority accurately reflects the "divine kingship" of the Byzantine emperor. We are invited to see Justinian and Theodora as analogous to Christ and the Virgin. On the hem of Theodora's mantle (fig. 322) is conspicuous embroidery showing the three Magi carrying their gifts to Mary and the newborn King; Justinian (fig. 321) is flanked by 12 companions—the imperial equivalent of the 12 apostles (six are soldiers, crowded behind a shield with the monogram of Christ).

Justinian, Theodora, and their immediate neighbors were surely intended to be individual likenesses, and their features are indeed differentiated to a degree (those of Maximianus and Julianus Argentarius, the banker who underwrote the building, more so than the rest), but the ideal has molded the faces as well as the bodies, so that they all have a curious family resemblance. We shall meet the same large dark eyes under curved brows, the same small mouths and long, narrow, slightly aquiline noses countless times from now on in Byzantine art. As we turn from these mosaics to the interior space of the church, we realize that it, too, shares the quality of dematerialized, soaring slenderness that endows the figures with their air of mute exaltation.

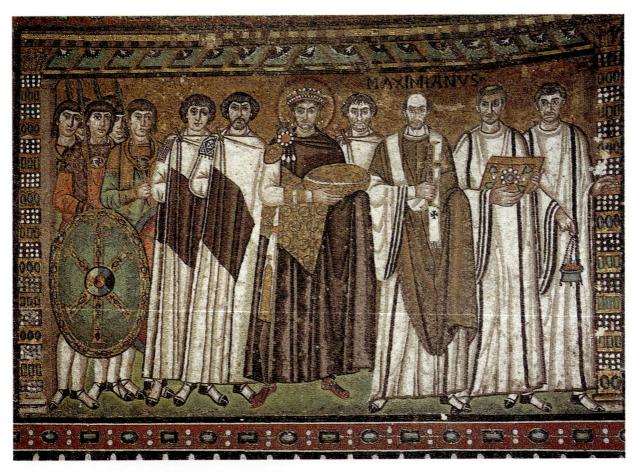

321. Emperor Justinian and His Attendants. c. 547 A.D. Mosaic. S. Vitale

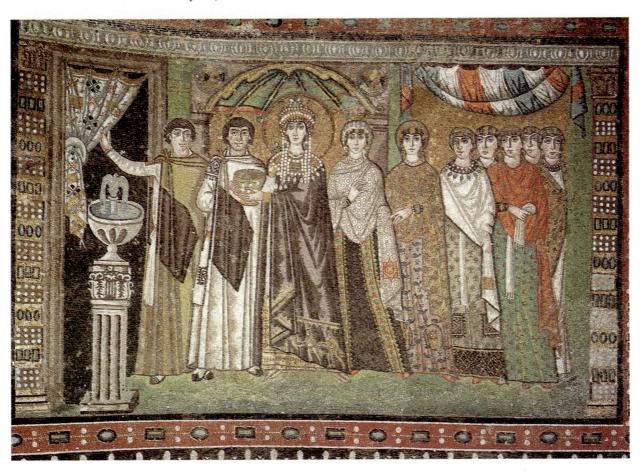

322. Empress Theodora and Her Attendants. c. 547 A.D. Mosaic. S. Vitale

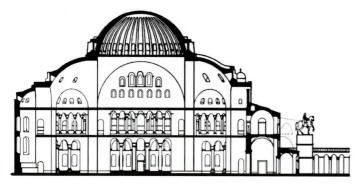

323. Section of Hagia Sophia (after Gurlitt)

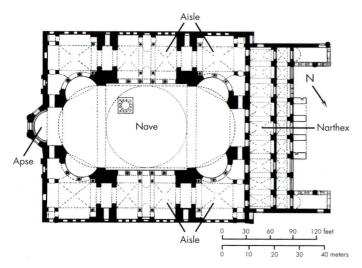

324. Plan of Hagia Sophia (after v. Sybel)

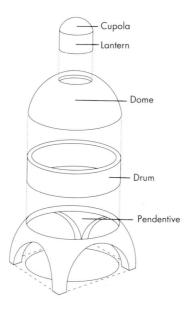

325. Parts of a dome

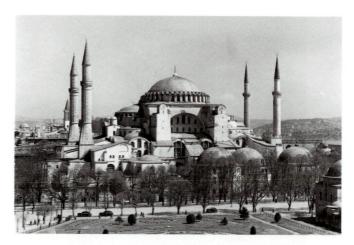

326. Anthemius of Tralles and Isidorus of Miletus. Hagia Sophia, Istanbul, Turkey. 532-37 A.D.

327. Capital, Hagia Sophia

HAGIA SOPHIA, ISTANBUL. Among the surviving monuments of Justinian's reign in Constantinople, the most important by far is Hagia Sophia (Church of Holy Wisdom), the architectural masterpiece of the era and one of the great creative triumphs of any age (figs. 323, 324, 326-28). The previous church, begun by Constantine and finished in 360, was destroyed, along with several other monuments, in the riots of 532 that almost deposed Justinian, who immediately rebuilt it. Completed in only five years, Hagia Sophia achieved such fame that the names of the architects, too, were remembered: Anthemius of Tralles, an expert in geometry and the theory of statics and kinetics, and Isidorus of Miletus, who taught physics and wrote on vaulting techniques. [See Primary Sources, no. 23, page 383.] After the Turkish conquest in 1453, it became a mosque (the four minarets were added then) and the mosaic decoration was largely hidden under whitewash. Some of the mosaics were uncovered in our century, after the building was turned into a museum (see fig. 338).

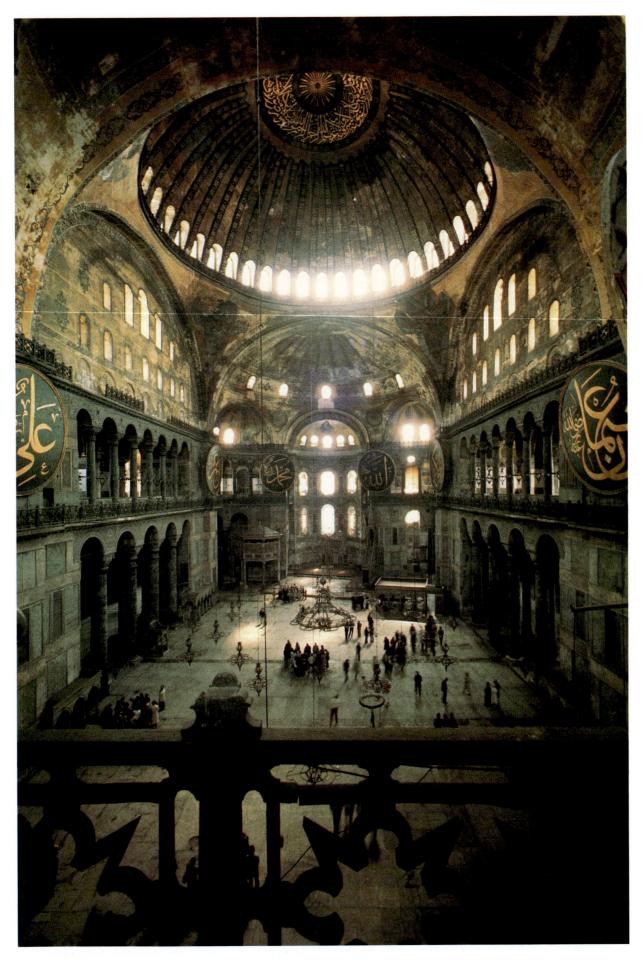

328. Interior, Hagia Sophia

The design of Hagia Sophia presents a unique combination of elements. It has the longitudinal axis of an Early Christian basilica, but the central feature of the nave is a square compartment crowned by a huge dome and abutted at either end by half-domes, so that the nave becomes a great ellipse. Attached to these half-domes are semicircular niches with open arcades, similar to those in S. Vitale. One might say, then, that the dome of Hagia Sophia has been inserted between the two halves of a central-plan church. The dome rests on four arches that carry its weight to the great piers at the corners of the square, so that the walls below the arches have no supporting function at all. The transition from the square formed by these arches to the circular rim of the dome is achieved by spherical triangles called pendentives (see fig. 325); hence we speak of the entire unit as a dome on pendentives. In conjunction with a new technique to build domes utilizing thin bricks embedded in mortar, this device permits the construction of taller, lighter, and more economical domes than the older method (seen in the Pantheon, Sta. Costanza, and S. Vitale) of placing the dome on a round or polygonal base. Where or when the dome on pendentives was invented we do not know. Hagia Sophia is the earliest case we have of its use on a monumental scale, and its example must have been of epoch-making importance. From that time on the dome on pendentives became a basic feature of Byzantine architecture and, somewhat later, of Western architecture as well.

There is, however, still another element that entered into the design of Hagia Sophia. The plan, the buttressing of the main piers, and the huge scale of the whole recall the Basilica of Constantine (figs. 250–52), the most ambitious achievement of Imperial Roman vaulted architecture and the greatest monument associated with a ruler for whom Justinian had particular admiration. Hagia Sophia thus unites East and West, past and future, in a single overpowering synthesis. Its massive exterior, firmly planted upon the earth like a great mound, rises by stages to a height of 184 feet—41 feet higher than the Pantheon—and therefore its dome, although its diameter is somewhat smaller (112 feet), stands out far more boldly.

Once we are inside, all sense of weight disappears, as if the material, solid aspects of the structure had been banished to the outside. Nothing remains but an expanding space that inflates, like so many sails, the apsidal recesses, the pendentives, and the dome itself. Here the architectural aesthetic we saw taking shape in Early Christian architecture (see pages 234–37) has achieved a new, magnificent dimension. Even more than previously, light plays a key role: the dome seems to float—"like the radiant heavens," according to a contemporary description of the building—because it rests upon a closely spaced ring of windows, and the nave walls are pierced by so many openings that they have the transparency of lace curtains.

The golden glitter of the mosaics must have completed the "illusion of unreality." We can sense the new aesthetic even in ornamental details such as moldings and capitals (fig. 327). The scrolls, acanthus foliage, and the like are motifs that derive from classical architecture, but their effect is radically different. Instead of actively cushioning the impact of heavy weight upon the shaft of the column, the capital has become a sort of openwork basket whose delicate surface pattern belies the strength and solidity of the stone.

THRONE OF MAXIMIANUS. Beyond architectural decorations and some sarcophagi, early Byzantine sculpture consists mainly of reliefs in ivory and silver, which survive in considerable numbers. Not surprisingly, they share characteristics with the capitals at Hagia Sophia, as we can see from the *Throne of Maximianus* (fig. 329). This magnificent episcopal chair (or *cathedra*) is covered with ivory panels (some are later replacements) devoted to the infancy of Christ (on the backrest), the story of Joseph in Egypt (on the sides), and John the Baptist flanked by the four evangelists (on the front). They are embedded in strips of the most luxurious ornamentation festooned with lacy foliage, including clusters of grapes, and inhabited by lions, stags, peacocks, and other creatures.

Considering its size, it is probable that the throne was the work of several people of outstanding ability from diverse backgrounds operating under royal patronage in Constantinople, which summoned the finest artists from around the Empire. In all likelihood, it was a gift from Justinian to Maximianus, the archbishop of Ravenna, upon the dedication of S. Vitale. Its origin at the Byzantine court is assured not only by the quality but also the style of the Baptist and his companions, which echoes the classicism of *The Archangel Michael* (fig. 315) while conforming to the aristocratic ideal of the S. Vitale mosaics (figs. 321 and 322), with its flattened forms. The arcade with frontal figures, derived from sarcophagi, was to have a long life: it is found on nearly all metal reliefs and ivory carvings (particularly book covers) through the Romanesque era.

JUSTINIAN DIPTYCH. The last vestiges of classicism can still be seen in the beautifully carved diptych of Justinian as Conqueror (fig. 330), from about the same time as the throne, which celebrates his victories in Italy, North Africa, and Asia. The subject is a restatement of the allegorical scene on the breastplate of the Augustus of Primaporta in appropriately Christian terms (see fig. 265). The figure of Victory appears twice: below the emperor, to his right, and as a statuette held by the Roman general at the left, who no doubt was mirrored in the missing panel at the right. Scythians, Indians, even ferocious lions and elephants offer gifts and pay homage, while a figure personifying Earth supports Justinian's foot to signify his dominion over the entire world. His role as triumphant general and ruler of the empire is blessed from Heaven above by Christ (note the sun, moon, and star), whose symbolic image is carried in a medallion by two heraldically arranged angels. Despite their ancestry, the stubby figures are hardly classical in style. They will remind us of Constantinian reliefs (compare fig. 285), but with a distinctly Oriental cast derived from the eastern provinces. The large head and bulging features of Justinian brim with the same energy as his charging steed. He is anything but the calm philosopher portrayed on the equestrian statue of Marcus Aurelius (fig. 279), from which the image derives.

ICONS. In the late sixth century, icons—paintings of Christ, the Enthroned Madonna, or saints—came to vie with relics as objects of veneration. They were considered "portraits," and understandably so, for such pictures had developed in Early Christian times out of Graeco-Roman portrait panels. One of the chief arguments in their favor was the claim that Christ

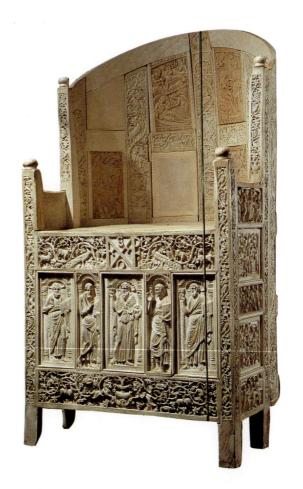

329. Throne of
Maximianus. c. 547.

Ivory over wood,
59 x 23 ½"
(149.8 x 59.7 cm).

Archepiscopal Museum,
Ravenna

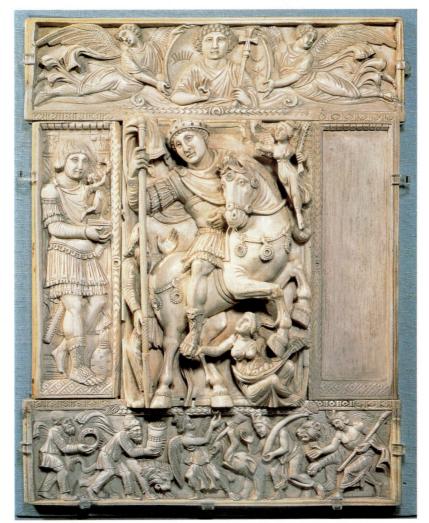

330. *Justinian as Conqueror.* c. 525–50

A.D. Ivory, 13 ¹/₂ x 10 ¹/₂"
(34.2 x 26.8 cm).

Musée du Louvre, Paris

331. Virgin and Child Enthroned between Saints and Angels. Late 6th century A.D. Encaustic on panel, 27 x 19³/8" (68.5 x 49.2 cm). Monastery of St. Catherine, Mount Sinai, Egypt

had appeared with the Virgin to St. Luke and permitted him to paint their portrait, and that other portraits of Christ or of the Virgin had miraculously appeared on earth by divine fiat. These original, "true" sacred images were supposedly the source for the later, man-made ones. Little is known about their origins, for examples antedating the Iconoclastic Controversy are extremely scarce (see page 257).

Of the few discovered so far, the most revealing is the *Virgin and Child Enthroned between Saints and Angels* (fig. 331). Like late Roman murals (see pages 203–08), it is a compilation painted in several styles at once. Its link with Graeco-Roman portraiture is evident not only from the use of encaustic, a medium that went out of use after the Iconoclastic Controversy, but also from the fine gradations of light and shade in the Virgin's face, which is similar in treatment to that

of the little boy in our Faiyum portrait (fig. 293). She is flanked by the warrior saints Theodore on the left and George to the right, who recall the stiff mannequins accompanying Justinian in S. Vitale (fig. 321). Typical of early icons, however, their heads are too massive for their doll-like bodies. Behind them are two angels who come closest in character to Roman art (compare the personification of Arcadia in fig. 292), although their lumpy features show that classicism is no longer a living tradition. Clearly these figures are quotations from different sources, so that the painting marks an early stage in the development of icons. Yet it is typical of the conservative icon tradition that the unknown artist has tried to remain as faithful as possible to his sources, in order to preserve the likenesses of these holy figures. While hardly an impressive achievement in itself, it is worthy of our attention: this is the earliest

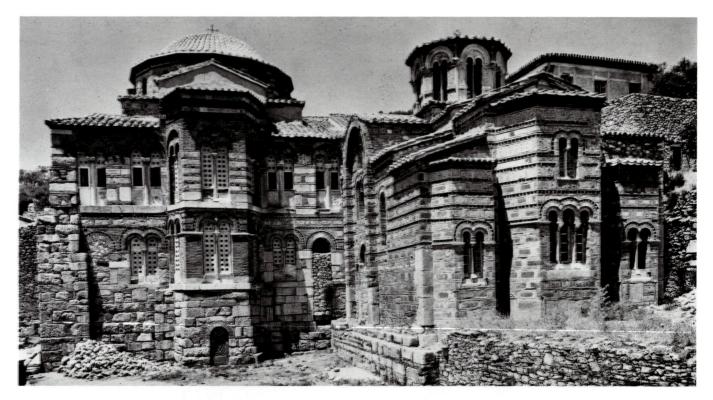

332. Churches of the Monastery of Hosios Loukas (St. Luke of Stiris), Greece. Early 11th century

representation we have of the Madonna and Child. We shall encounter its descendants again and again in the history of art.

Middle Byzantine Art

After the age of Justinian, the development of Byzantine art, not only painting and sculpture but architecture as well, was disrupted by the Iconoclastic Controversy, which began with an imperial edict of 726 prohibiting religious images. It raged for more than a hundred years, dividing the population into two hostile groups. The image-destroyers (Iconoclasts), led by the emperor and supported mainly in the eastern provinces of the realm, insisted on a literal interpretation of the biblical ban against graven images as conducive to idolatry; they wanted to restrict religious art to abstract symbols and plant or animal forms. Their opponents, the Iconophiles, were led by the monks and centered in the western provinces, where the imperial edict remained ineffective for the most part. [See Primary Sources, no. 20, page 382, and no. 24, pages 383-84.] The roots of the conflict went very deep. On the plane of theology they involved the basic issue of the relationship of the human and the divine in the person of Christ. Socially and politically, they reflected a power struggle between Church and State. The controversy also caused an irrevocable break between Catholicism and the Orthodox faith, although the two churches remained officially united until 1054, when the pope excommunicated the eastern patriarch for heresy.

Had the edict been enforceable throughout the Empire, it might well have dealt Byzantine religious art a fatal blow. It did succeed in greatly reducing the production of sacred images, but failed to wipe it out altogether, so that after the victory of the Iconophiles in 843 under the empress Theodora there was a fairly rapid recovery. Spearheaded by Basil I the Macedonian, this recovery lasted from the late ninth to the eleventh century.

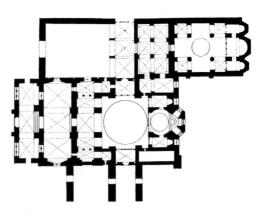

333. Plan of churches of the Monastery of Hosios Loukas (after Diehl)

MONASTIC ARCHITECTURE. Byzantine architecture never produced another structure to match the scale of Hagia Sophia. The churches built after the Iconoclastic Controversy were modest in size, and monastic rather than imperial or urban in spirit. Most were constructed for small groups of monks living in isolated areas. Their usual plan is that of a Greek cross (that is, a cross with arms of equal length) contained in a square, with a narthex added on one side and an apse (sometimes with flanking chapels) on the other. The central feature is a dome on a square base. It often rests on a cylindrical or octagonal drum with tall windows, which raises it high above the rest of the building, as in both churches of the Monastery of Hosios Loukas in Greece (figs. 332–34). They also show other characteristics of later Byzantine architecture: a tendency toward more elaborate exteriors, in contrast to the extreme severity we observed earlier (compare fig. 317), and a preference for elongated proportions. The full impact of this verticality, however, strikes us only when we enter the church

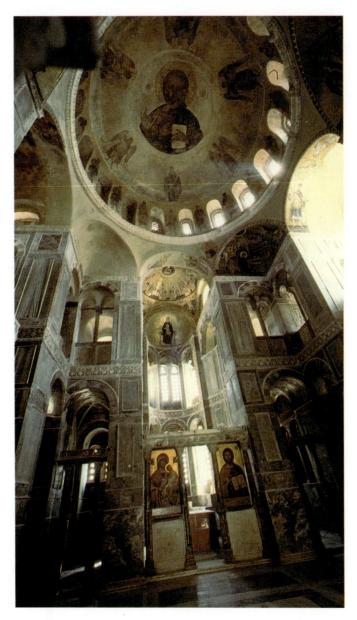

334. Interior, Katholikon, Hosios Loukas

(fig. 334 shows the interior of the Katholikon, on the left in figs. 332 and 333). The tall, narrow space compartments produce a sense of crowdedness, almost of compression, which is dramatically relieved as we raise our glance toward the luminous pool of space beneath the dome.

ST. MARK'S, VENICE. The largest and most lavishly decorated church of the period surviving today is St. Mark's in Venice, begun in 1063. The present structure, modeled on the Church of the Holy Apostles in Constantinople, which had been rebuilt by Justinian following the Nika riots and later destroyed, replaced two earlier churches of the same name on the site. The Venetians had long been under Byzantine sovereignty and remained artistically dependent on the East well after they had become politically and commercially powerful in their own right. St. Mark's, too, has the Greek-cross plan inscribed within a square, but here each arm of the cross is emphasized by a dome of its own (figs. 335 and 336). These domes are not raised on drums. Instead, they have been

encased in bulbous wooden helmets covered by gilt copper sheeting and topped by ornate lanterns, to make them appear taller and more conspicuous at a distance. They make a splendid landmark for the seafarer. The spacious interior, which is famous for its mosaics, shows that it was meant to receive the citizenry of a large metropolis and not just a small monastic community, as at Hosios Loukas.

ST. BASIL, MOSCOW. Byzantine architecture also spread to Russia, along with the Orthodox faith. There the basic type of the Byzantine church underwent an amazing transformation through the use of wood as a structural material. The most famous product of this native trend is the Cathedral of St. Basil adjoining the Kremlin in Moscow (fig. 337). Built during the reign of Ivan the Terrible, it seems as unmistakably Russian as that extraordinary ruler. The domes, growing in amazing profusion, have become fantastic towerlike structures as vividly patterned as the rest of the building. The total effect is extremely impressive. The church nevertheless conveys a

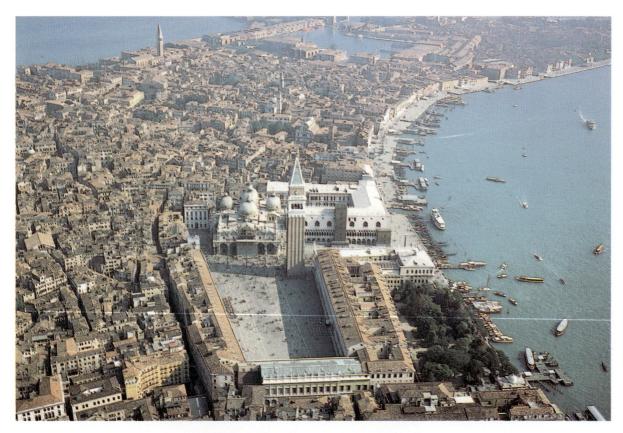

335. St. Mark's (aerial view), Venice. Begun 1063

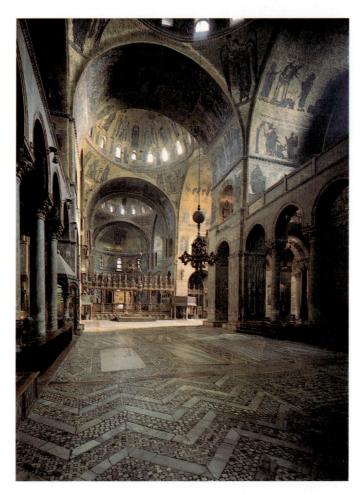

336. Interior, St. Mark's, Venice.

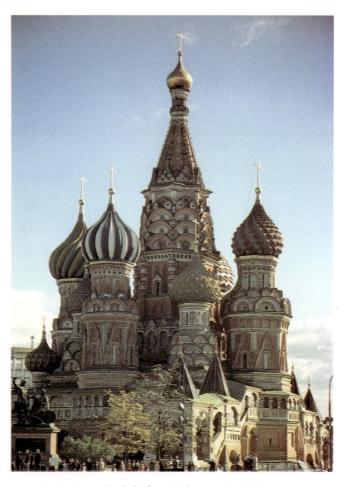

337. Cathedral of St. Basil, Moscow. 1554-60

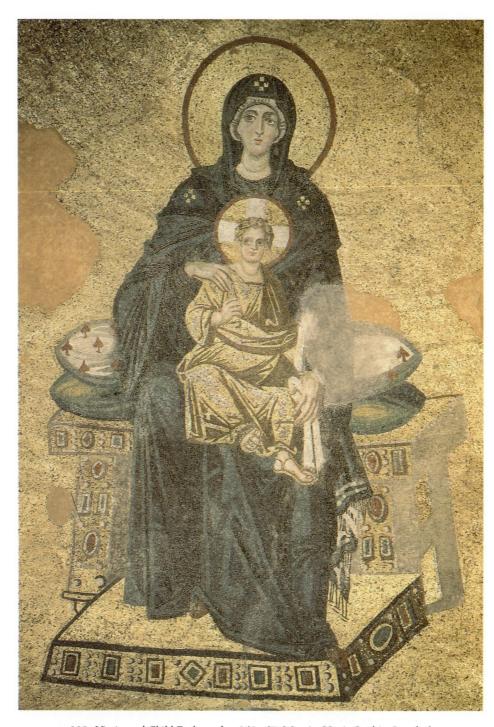

338. Virgin and Child Enthroned. c. 843-67. Mosaic. Hagia Sophia, Istanbul

sense of the miraculous that is derived from the more austere miracles of Byzantine architecture.

ORTHODOX REVIVAL. We know little for certain about how the Byzantine artistic tradition managed to survive from the early eighth to the mid-ninth century, but survive it did. The most direct proof is the mosaic of the *Virgin and Child Enthroned* in Hagia Sophia (fig. 338). We know it was made sometime between the end of the Iconclastic Controversy in 843 and 867, when it was unveiled to celebrate the triumph of Orthodoxy. It adheres closely to the earliest icon of the same subject (see fig. 331). Remarkably, the subtlety of modeling and color manages to perpetuate the best tradition of early

Byzantine art. Perhaps most important, there is a new human quality in the fullness of the figures, the more relaxed poses, and their more natural expressions that we have not seen before.

CLASSICAL REVIVAL. Basil I reopened the university in Constantinople, which led to an astonishing revival of classical learning, literature, and art. Much of it occurred in the early tenth century under Constantine VII, who was emperor in name only for most of his life and turned to classical scholarship and art. This renewed interest helps to explain the reappearance of Late Classical motifs in middle Byzantine art. *David Composing the Psalms* (fig. 339) is one of eight

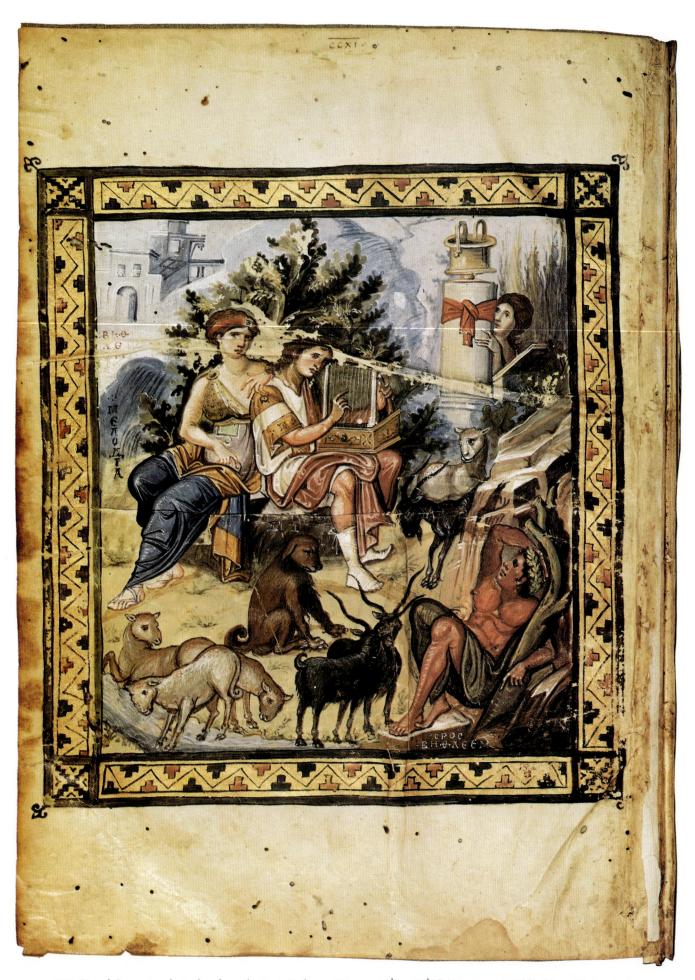

339. David Composing the Psalms, from the Paris Psalter. c. 900 A.D. $14^{1}/8 \times 10^{1}/4$ " (36 x 26 cm). Bibliothèque Nationale, Paris

340. The Crucifixion. 11th century. Mosaic. Monastery Church, Daphné, Greece

341. Dome mosaics. 11th century. Monastery Church, Daphné, Greece

full-page scenes in the so-called *Paris Psalter*. These scenes illustrating his life introduce the Psalms (which David was thought to have composed). The psalter was probably illuminated about 900, although the temptation to put it earlier is almost irresistible. Not only do we find a landscape that recalls Pompeian murals, but the figures, too, obviously derive from Roman models. David himself could well be mistaken for Orpheus charming the beasts with his music, and his companions prove even more surprising, since they are allegorical figures that have nothing at all to do with the Bible: the young woman next to David is Melody, the one coyly hiding behind a pillar is Echo, and the male figure with a tree trunk personifies the mountains of Bethlehem. The late date of the picture is evident only from certain qualities of style such as the abstract zigzag pattern of the drapery covering Melody's legs.

DAPHNÉ. The *Paris Psalter* betrays an almost antiquarian enthusiasm for the traditions of classical art. Such a direct revival, however, is an extreme case. More commonly classicism is harmoniously merged with the spiritualized ideal of human beauty we encountered in the art of Justinian's reign. Among these, the *Crucifixion* mosaic in the Greek monastery church at Daphné (fig. 340) enjoys special fame. Its classical qualities are more fundamental, and more deeply felt, than those of the *Paris Psalter*, yet they are also completely Christian. There is no attempt to re-create a realistic spatial setting, but the composition has a balance and clarity that are truly monumental. Classical, too, is the statuesque dignity of

the figures, which seem extraordinarily organic and graceful compared to those of the Justinian mosaics at S. Vitale (figs. 321 and 322).

The most important aspect of these figures' classical heritage, however, is emotional rather than physical. The gestures and facial expressions convey a restrained and noble suffering of the kind we first met in Greek art of the fifth century B.C. (see pages 146–48). When and where this human interpretation of the Saviour made its first appearance we cannot say, but it seems to have developed primarily in the wake of the Iconoclastic Controversy, and reached its height during the Ducas and Comnene dynasties that ruled Byzantium from the middle of the eleventh through the late twelfth centuries. There are, to be sure, a few earlier examples of it, but none of them appeals to the emotions of the beholder so powerfully as the Daphné *Crucifixion*. To have introduced this compassionate view of Christ into sacred art was perhaps the greatest achievement of middle Byzantine art.

Early Christian art had been quite devoid of this quality. It stressed the Saviour's divine wisdom and power rather than his sacrificial death, so that the Crucifixion was depicted only rarely and in a notably unpathetic spirit. Alongside the new emphasis on the Christ of the Passion, however, the image of the Pantocrator (Ruler of the Universe), as we saw it on the Sarcophagus of Junius Bassus and above the apse of S. Apollinare in Classe (figs. 312 and 302), retained its importance. Staring down from the center of the majestic dome at Daphné is an awesome mosaic image of Christ the Pantocrator against a gold background (fig. 341), its huge scale emphasized by the

342. *Nativity.* Early 11th century. Mosaic. Monastery of Hosios Loukas

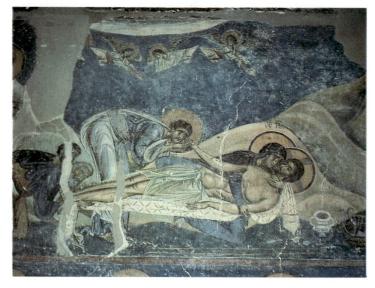

343. Lamentation. 1164. Fresco. St. Panteleimon, Nerezi, Macedonia

much smaller figures of the 16 Old Testament prophets between the windows. [See Primary Sources, no. 25, page 384.] Although it descends from images of Zeus, the mature, bearded visage of Jesus was first defined during the sixth century in the Mandylion, a "true portrait" on cloth that, according to legend, Jesus sent to King Agbar. Later it provided the basis for the miraculous image that appeared on the veil (*sudarium*) of St. Veronica (*vera icona*, or true image). Because of its historical "authenticity," the bearded Christ quickly replaced the youthful philosopher in art.

In the corners of the dome, we see four scenes revealing the divine and human natures of Christ: the Annunciation (bottom left) followed in counterclockwise order by the Birth, Baptism, and Transfiguration. The entire cycle represents a theological program perfectly in harmony with the geometric relationship of the images. A similarly strict order governs the distribution of subjects throughout the rest of the interior. The basic scheme probably dates back to the time of Basil I, who ordered decorations added to the Nea and the Church of the Apostles in Constantinople, both now destroyed.

HOSIOS LOUKAS. Byzantine art had managed somehow to preserve these and other biblical subjects from Early Christian times. In the eleventh century they enjoyed a revival, which thoroughly explored their narrative and pictorial potential. The *Nativity* in figure 342 from Hosios Loukas, which

employs the same composition as at Daphné but is somewhat earlier in date and in better condition, has a greater complexity than previous renderings. Instead of focusing simply on the Virgin and Child, the mosaicist used continuous narrative to include not only midwives bathing the newborn infant but also a host of angels and the Adoration of the Magi and the Annunciation to the Shepherds. The great variety of pose and expression lends a heightened sense of drama to the scene. Despite its schematic rendering, the mountainous landscape shows a new interest in illusionistic space as well. Missing only is the tender exchange of glances and gestures that is the most precious legacy of Daphné.

NEREZI. The emphasis on human content reaches its climax in the paintings at the church of St. Panteleimon in Nerezi, Macedonia. It was built by members of the Byzantine royal family and decorated by a team of artists summoned from Constantinople. From the beginning of Byzantine art in the sixth century, mural painting had served as a less expensive alternative to mosaic, which was preferred whenever possible. The best painters nevertheless participated fully in the new style; in some cases, they even felt free to introduce innovations of their own. The artist responsible for the Lamentation over the dead Christ (fig. 343) was a great master who expanded the latest advances. The gentle sadness of the Daphné *Crucifixion* has been replaced by a grief of almost unbearable

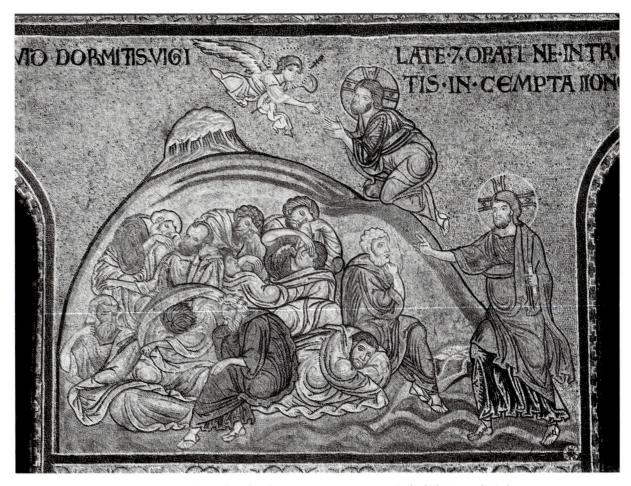

344. Christ in the Garden of Gethsemane. c. 1183. Mosaic. Cathedral, Monreale, Italy

intensity. The style remains the same, but its expressive qualities have been emphasized by subtle adjustments in the proportions and features. The subject seems to have been of recent invention, for it is otherwise unknown in earlier Byzantine art. Even more than the Daphné *Crucifixion*, its origins lie in Classical art: *Eos and Memnon* by Douris (fig. 145), which it echoes in composition and mood. Yet nothing prepares us for the Virgin's anguish as she clasps her dead son or the deep sorrow of St. John holding Christ's lifeless hand. We have entered a new realm of religious feeling that was to be further explored in the West.

MONREALE. The Byzantine manner was soon transmitted to Italy, where it was called the "Greek style" and had a decisive impact on Gothic painting (see pages 362–63). Sometimes it was carried by miniature mosaic diptychs from Constantinople, but most often it was brought directly by visiting Byzantine artists. It made its first appearance in Sicily, a former Byzantine holding, which was taken from the Moslems in 1091 by the Normans and was united with southern Italy. The new style is seen throughout the magnificent churches and monasteries erected in Palermo, the island's capital. The Norman kings considered themselves the equals of the Byzantine emperors and called in teams of mosaicists from Constantinople to decorate their splendid religious buildings. The mosaics at the Cathedral of Monreale, the last to be executed,

are in a thoroughly up-to-date Byzantine style, although the selection and disposition of subjects are purely Western in approach. *Christ in the Garden of Gethsemane* (fig. 344) is an astonishing premonition of El Greco's painting of the same subject (see fig. 17). The scene shows Christ comforted by the angel of the Lord (above); he then admonishes Peter and the sleeping disciples (below), who appear enclosed by the mountain behind them in order to conflate the two episodes within a single image. Even more important than the striking composition is the attention paid to the figures, each of which is far more individualized than before. The artist's growing ability to investigate subtleties of characterization traces the progress of Byzantine art.

IVORIES. Monumental sculpture, as we saw earlier (page 242), tended to disappear completely from the fifth century on. In Byzantine art, large-scale statuary died out with the last imperial portraits, and stone carving was confined almost entirely to architectural ornament (see fig. 327). But small-scale reliefs, especially in ivory and metal, continued to be produced in considerable numbers.

Their extraordinary variety of content, style, and purpose is suggested by the two examples shown here, both of which date from the tenth century. One is *The Harbaville Triptych*, a small portable altar shrine with two hinged wings of the kind a high dignitary might carry for his private devotions while

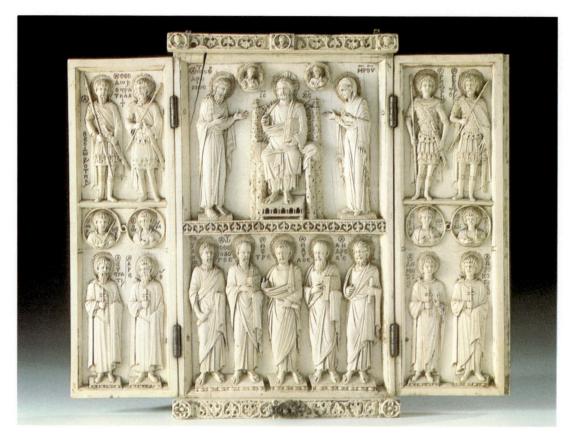

345. The Harbaville Triptych. Late 10th century. Ivory, 91/2 x 11" (24 x 28 cm). Musée du Louvre, Paris

346. The Sacrifice of Iphigenia. Detail of ivory casket. 10th century. Victoria & Albert Museum, London

traveling (fig. 345). In the upper half of the center panel we see Christ Enthroned, flanked by St. John the Baptist and the Virgin, who plead for divine mercy on behalf of humanity. Below is John the Baptist flanked by the four apostles arranged in strictly frontal view. Only in the upper tier of each wing is this formula relaxed. There, surprisingly, we find an echo of Classical contrapposto in the poses of the two inner military saints. The exquisite refinement of this icon-in-miniature recalls the style of the Daphné *Crucifixion* (fig. 340).

Our second example, slightly later in date, is the Veroli

Casket (fig. 346), meant for a wedding gift, which, rather surprisingly, is decorated with scenes of Greek mythology. Even more than the miniatures of the *Paris Psalter*, it illustrates the antiquarian aspects of Byzantine classicism after the Iconclastic Controversy. The subject, the Sacrifice of Iphigenia, comes from a famous Greek drama by Euripides. The panel shows a major change in style that features deep undercutting of the relief. The composition (which nevertheless remains curiously shallow) probably derives from an illustrated manuscript rather than from a sculptural source. Though drained of all

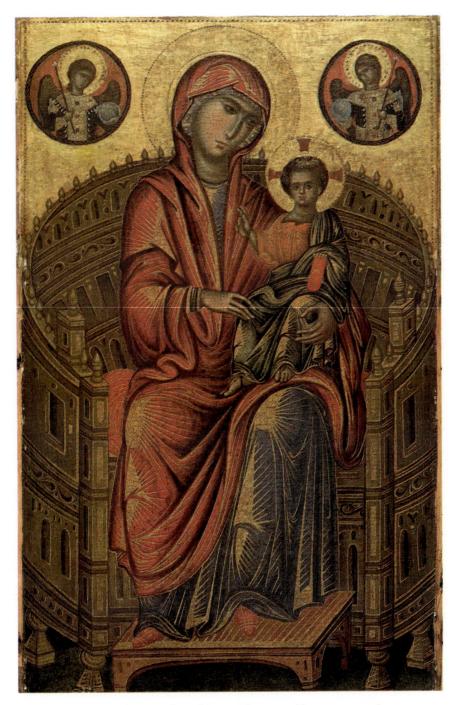

347. Madonna Enthroned. Late 13th century. Tempera on panel, 32 1 /8 x 19 3 /8" (81.9 x 49.3 cm). National Gallery of Art, Washington, D.C. Andrew Mellon Collection

tragic emotion and reduced to a level of ornamental playfulness, these knobby little figures, with their distinctive grapecluster hair, form a coherent visual quotation from ancient art.

Late Byzantine Art

In 1204 Byzantium sustained an almost fatal defeat when the armies of the Fourth Crusade, instead of warring against the Turks, assaulted and took the city of Constantinople. For more than 50 years, the core of the Eastern Empire remained in Western hands. Byzantium, however, survived this catastrophe. In 1261 it once more regained its sovereignty under the Palaeo-

logue dynasty, and the fourteenth century saw a last flowering of Byzantine painting, with a distinct and original flavor of its own, before the Turkish conquest in 1453.

ICONS. Because of the veneration in which they were held, icons had to conform to strict formal rules, with fixed patterns repeated over and over again. As a consequence, the majority of them are more conspicuous for exacting craftsmanship than for artistic inventiveness. Although painted in the thirteenth century, the *Madonna Enthroned* (fig. 347) reflects a much earlier type. Echoes of middle Byzantine art abound: the graceful pose, the rich play of drapery folds, the tender melancholy of

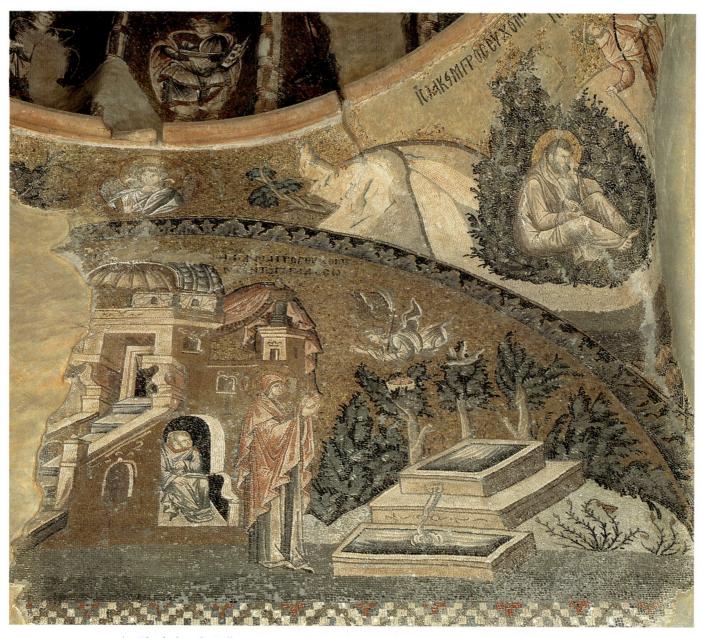

348. Elizabeth at the Well. c. 1310. Mosaic. Kariye Camii (Church of the Saviour in Chora), Istanbul

the Virgin's face, and the elaborate architectural perspective of the throne (which looks rather like a miniature replica of the Colosseum). But all these elements have become oddly abstract. The throne, despite its foreshortening, no longer functions as a three-dimensional object, and the highlights on the drapery resemble ornamental sunbursts, in sharp contrast to the soft shading of hands and faces. The total effect is neither flat nor spatial but transparent, somewhat like that of a stained-glass window. The shapes look as if they were lit from behind. Indeed, the highly reflective gold background against which they are set and the gold highlights are so brilliant that even the shadows never seem wholly opaque.

This all-pervading celestial radiance, we will recall, is a quality first encountered in Early Christian mosaics (compare fig. 307). Panels such as ours, therefore, should be viewed as the aesthetic equivalent, on a smaller scale, of mosaics, and not simply as the descendants of the ancient panel painting tradi-

tion. In fact, some of the most precious Byzantine icons are miniature mosaics done on panels, rather than paintings.

MOSAICS AND MURAL PAINTING. Kariye Camii (the former Church of the Saviour in Chora) in Istanbul contains the finest extant cycle of late Byzantine mosaics, done about 1310–20. They present the climax of the humanism that emerged in middle Byzantine art, and with good reason: like Constantine VII, the emperor Theodore Metochites, who restored the church and paid for its decorations, was a scholar and poet. The unprecedented variety of poses and expressions in *Elizabeth at the Well* (fig. 348) shows the growing Byzantine fascination with storytelling. As part of this lively narrative, the setting has blossomed quite literally into a full landscape, complete with illusionistically rendered architecture. The scene resurrects a landscape style that had flourished in sixth-century secular mosaics and had been all but lost over the intervening

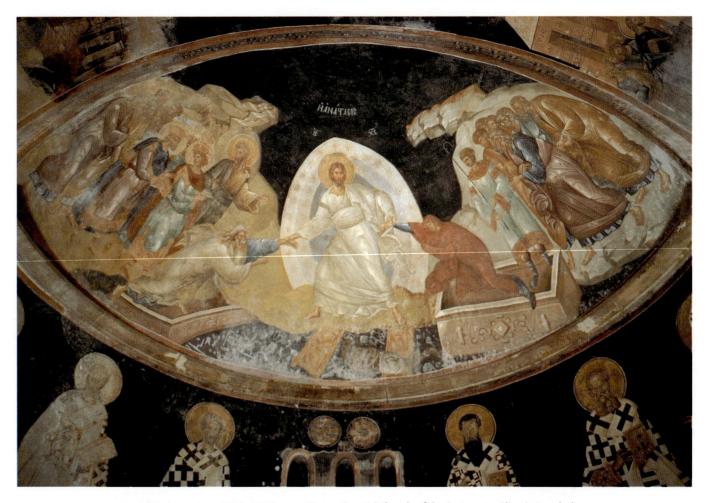

349. Anastasis. c. 1310-20. Fresco. Kariye Camii (Church of the Saviour in Chora), Istanbul

centuries. It reflects an illusionism familiar to us from Pompeian painting, which was also preserved in manuscripts of the classical revival of the tenth century (compare fig. 339).

Equally impressive are the paintings in the mortuary chapel attached to Kariye Camii. Because of the impoverished state of the greatly shrunken empire, murals often took the place of mosaics, but at Kariye Camii they exist on an even footing. In figure 349 we reproduce the Anastasis, which is Greek for resurrection. (Actually the scene depicts the traditional Byzantine image of this subject, an event before Christ's Resurrection on earth that Western Christians call Christ's Descent into Limbo or the Harrowing of Hell to rescue souls.) Surrounded by a radiant gloriole, the Saviour has vanquished Satan and battered

down the gates of Hell, and is raising Adam and Eve from the dead. (Note the bound Satan at his feet, in the midst of an incredible profusion of hardware.) What amazes us about this central group is its dramatic force, a quality we would hardly expect to find on the basis of what we have seen of Byzantine art so far. Christ here moves with extraordinary physical energy, tearing Adam and Eve from their graves, so that they appear to fly through the air-a magnificently expressive image of divine triumph. Such dynamism had been unknown in the earlier Byzantine tradition. Coming in the fourteenth century, it shows that eight hundred years after Justinian, when this subject made its first appearance, Byzantine art still had all its creative powers.

CHAPTER TWO

EARLY MEDIEVAL ART

The labels used for historical periods tend to be like the nicknames of people. Once established, they are almost impossible to change, even though they may no longer be suitable. Those who coined the term *Middle Ages* thought of the entire thousand years from the fifth to the fifteenth century as an age of darkness, an empty interval between classical antiquity and its rebirth, the Renaissance in Europe. Since then, our view of the Middle Ages has changed completely. We no longer think of the period as "benighted" but as a time of great cultural change and considerable creative activity. During the 200-year interval between the death of Justinian and the reign of Charlemagne, as we have already pointed out, the center of gravity of European civilization shifted northward from the Mediterranean Sea, and the economic, political, and spiritual framework of the Middle Ages began to take shape. We shall now see that the same centuries also gave rise to some important artistic achievements.

Celtic-Germanic Style

ANIMAL STYLE. The Celtic-Germanic style was a result of the widespread migrations after the fall of the Roman Empire. The Celts, who had settled the area later known to the Romans as Gaul in southwest Germany and eastern France during the second millennium B.C., spread across much of Europe and into Asia Minor, where they battled the Greeks (see page 158). Pressed by neighboring Germanic peoples, who originated in the Baltic region, they crossed the English Channel in the fourth century B.C. and colonized Britain and Ireland, where they were joined in the fifth century by the Angles and Saxons from today's Denmark and northern Germany. In 376 the Huns, who had pressed beyond the Black Sea from Central Asia, became a serious threat to Europe, first pushing the Visigoths westward into the Roman Empire from the Danube, and then under Attila (died 453) invading Gaul in 451 before attacking Rome a year later. These Germanic peoples from the east carried with them, in the form of nomads' gear, an ancient and widespread artistic tradition, the so-called animal style. We have encountered early examples of

it in the Luristan bronzes of Iran and the Scythian gold ornaments from southern Russia (see page 93 and figs. 107 and 108). This style, with its combination of abstract and organic shapes, of formal discipline and imaginative freedom, merged with the intricate ornamental metalwork of the Celts to create Celtic-Germanic art. An excellent example of this "heathen" style is the gold-and-enamel purse cover (fig. 350) from the grave at Sutton Hoo of an East Anglian king who died between 625 and 633.

On it are four pairs of symmetrical motifs. Each has its own distinctive character, an indication that the motifs have been assembled from four different sources. One motif, the standing man between confronted animals, has a very long history indeed—we first saw it in Egyptian art more than 3,800 years earlier (see fig. 50). The eagles pouncing on ducks bring to mind similar pairings of carnivore-and-victim in Luristan bronzes. The design above them, at center, on the other hand, is of more recent origin. It consists of fighting animals whose tails, legs, and jaws are elongated into bands forming a complex interlacing pattern. The fourth motif, interlacing bands as an ornamental device, on the top left and right, occur in Roman and Early Christian art, especially along the southern shore of the Mediterranean. However, their combination with the animal style, as shown here, seems to be an invention of Celtic-Germanic art, not much before the date of our purse cover.

Metalwork, in a variety of materials and techniques and often of exquisitely refined craftsmanship, had been the principal medium of the animal style. Such metal objects, small, durable, and eagerly sought after, account for the rapid diffusion of this idiom's repertory of forms. These forms migrated not only in the geographic sense but also technically and artistically, in the mediums used: from metal into wood, stone, and even pigment in manuscript illumination.

Wooden specimens, as we might expect, have not survived in large numbers. Most of them come from Scandinavia, where the animal style flourished longer than anywhere else. The splendid animal head of the early ninth century in figure 351 is the terminal, or decorated end, of a post that was found, along with much other equipment, in a buried Viking ship at

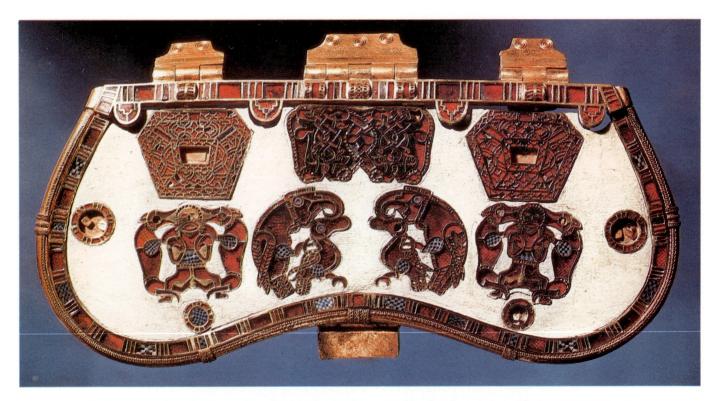

350. Purse cover, from the Sutton Hoo ship burial. 625–33 A.D. Gold with garnets and enamels, length 8" (20.3 cm). The British Museum, London

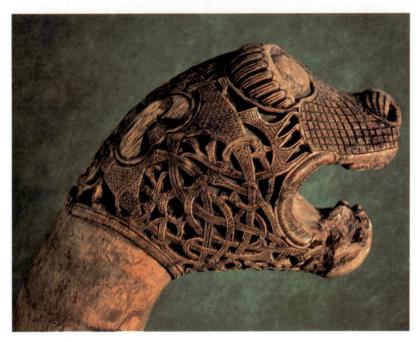

351. *Animal Head*, from the Oseberg ship burial. c. 825 A.D. Wood, height approx. 5" (12.7 cm). Institute for Art History and Classical Archaeology, University of Oslo, Norway

Oseberg in southern Norway. Like the motifs on the Sutton Hoo purse cover, it shows a peculiarly composite quality. The basic shape of the head is surprisingly realistic, as are certain details (teeth, gums, nostrils). But the surface has been spun over with interlacing and geometric patterns that betray their derivation from metalwork. Snarling monsters such as this used to rise from the prows of Viking ships, which endowed

them with the character of mythical sea dragons.

The earliest Christian works of art made north of the Alps also reflected the Germanic version of the animal style. In order to understand how they came to be produced, however, we must first acquaint ourselves with the important role played by the Irish (Hibernians), who assumed the spiritual and cultural leadership of western Europe during the early Middle Ages. The period 600 to 800 A.D. deserves, in fact, to be called the Golden Age of Ireland. Unlike their English neighbors, the Irish had

Hiberno-Saxon Style

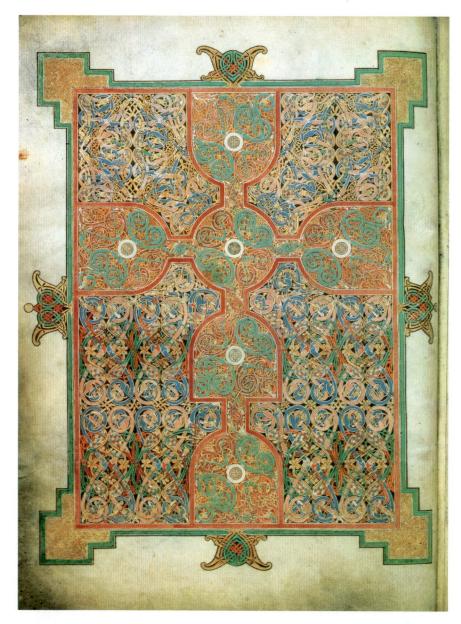

352. Cross page, from the Lindisfarne Gospels. c. 700 A.D. Tempera on vellum, 13 1/2 x 9 1/4" (34.3 x 23.5 cm). The British Library, London

never been part of the Roman Empire. Thus the missionaries who carried the Gospel to them from England in the fifth century found a Celtic society entirely barbarian by Roman standards. The Irish readily accepted Christianity, which brought them into contact with Mediterranean civilization, but they did not become Rome-oriented. Rather, they adapted what they had received in a spirit of vigorous local independence.

The institutional framework of the Roman Church, being essentially urban, was ill-suited to the rural character of Irish life. Irish Christians preferred to follow the example of the desert saints of Egypt and the Near East who had left the temptations of the city to seek spiritual perfection in the solitude of the wilderness. Groups of such hermits, sharing the ideal of ascetic discipline, had founded the earliest monasteries in Egypt and now did so in Ireland. By the fifth century, monasteries had spread as far north as western Britain, but only in Ireland did monasticism take over the leadership of the Church from the bishops.

Irish monasteries, unlike their Egyptian prototypes, soon became seats of learning and the arts. They developed a missionary fervor that sent Irish monks to preach to the heathen and to found monasteries not only in northern Britain but also on the European mainland, from present-day France to Austria. These Irish monks speeded the conversion to Christianity of Scotland, northern France, the Netherlands, and Germany. Further, they established the monastery as a cultural center throughout the European countryside. Although their Continental foundations were taken over before long by the monks of the Benedictine order, who were advancing north from Italy during the seventh and eighth centuries, Irish influence was to be felt within medieval civilization for several hundred years to come.

MANUSCRIPTS. In order to spread the Gospel, the Irish monasteries had to produce copies of the Bible and other Christian books in large numbers. Their scriptoria (writing workshops) also became centers of artistic endeavor, for a manuscript containing the Word of God was looked upon as a sacred object whose visual beauty should reflect the importance of its contents. Irish monks must have known Early

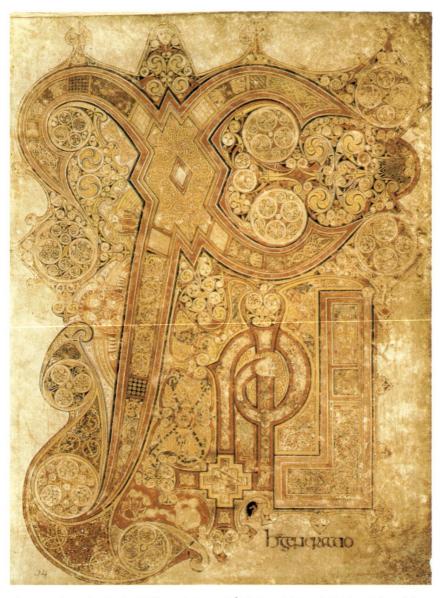

353. Chi-Rho page, from the Book of Kells. c. 800? 13 x 9 1/2" (33 x 24.1 cm). Trinity College Library, Dublin

Christian illuminated manuscripts, but here, as in other respects, they developed an independent tradition instead of simply copying their models. While pictures illustrating biblical events held little interest for them, they devoted great effort to decorative embellishment. The finest of these manuscripts belong to the Hiberno-Saxon style—that Christian form which evolved from heathen Celtic-Germanic art and flourished in the monasteries founded by Irishmen in Saxon England. [See Primary Sources, no. 26, page 384.]

The Cross page in the *Lindisfarne Gospels* (fig. 352) is an imaginative creation of breathtaking complexity. The miniaturist, working with a jeweler's precision, has poured into the compartments of the geometric frame an animal interlace so dense and yet so full of controlled movement that the fighting beasts on the Sutton Hoo purse cover seem simple in comparison. It is as if these biting and clawing monsters had suddenly been subdued by the power of the Cross. In order to achieve this effect, our artist has had to work within an extremely severe discipline, following "rules of the game." These rules demand, for instance, that organic and geometric shapes must be kept separate and that within the animal compartments every line must turn out to be part of an animal's body, if we take the trou-

ble to trace it back to its point of origin. There are other rules, too complex to go into here, concerning symmetry, mirrorimage effects, and repetitions of shapes and colors. Only by working these out for ourselves by intense observation can we hope to enter into the spirit of this strange, mazelike world.

Irish manuscripts reached a climax a hundred years later in the Book of Kells, the most varied and elaborate codex of Celtic art. Once renowned as "the chief relic of the Western world," it was done at the monastery on the island of Iona and left incomplete when the island was invaded by Vikings between 804 and 807. Its many pages present a summa of early medieval illumination, reflecting a wide array of influences from the Mediterranean to the English Channel. The justly famous Chi-Rho monogram (standing for Christ; fig. 353) has much the same swirling design as the Cross page from the Lindisfarne Gospels, but now the rigid geometry has been relaxed somewhat and, with it, the ban against human representation. Suddenly the pinnacle of the X-shaped Chi sprouts a thoroughly recognizable face, while along its shaft are three winged angels. And in a touch of enchanting fantasy, the tendrillike P-shaped Rho ends in a monk's head. More surprising still is the introduction of the natural world. Nearly hidden in

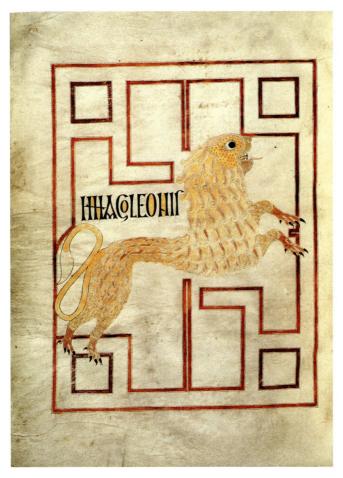

354. Symbol of St. Mark, from the Echternach Gospels. c. 690 A.D. $12^{3}/4 \times 10^{3}/8$ " (32.4 x 26.4 cm). Bibliothèque Nationale, Paris

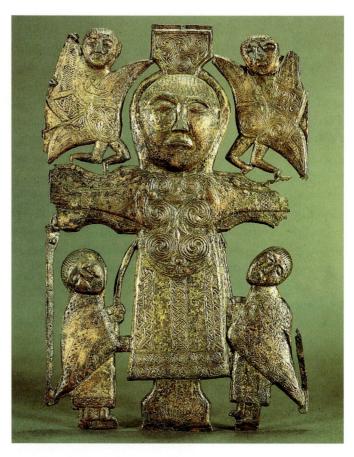

355. *Crucifixion*, plaque from a book cover (?). 8th century A.D. Bronze, height 8 ¹/₄" (21 cm). National Museum of Ireland, Dublin

the profuse ornamentation, as if playing a game of hide-andseek, are cats and mice, butterflies, even otters catching fish. No doubt they perform some as yet unclear symbolic function in order to justify their presence. Nevertheless, their appearance here is nothing short of astounding.

Of the representational images they found in Early Christian manuscripts, the Hiberno-Saxon illuminators generally retained only the symbols of the four evangelists, since these could be translated into their ornamental idiom without much difficulty. These symbols—the man (St. Matthew), the lion (St. Mark), the eagle (St. John), and the ox (St. Luke) were derived from the Revelation of St. John the Divine and assigned to the evangelists by St. Augustine. The lion of St. Mark in the Echternach Gospels (fig. 354), sectioned and patterned like the enamel inlays of the Sutton Hoo purse cover, is animated by the same curvilinear sense of movement we saw in the animal interlaces of our previous illustration. Here again we marvel at the masterly balance between the shape of the animal and the geometric framework on which it has been superimposed (and which, in this instance, includes the inscription, imago leonis).

On the other hand, Celtic and Germanic artists showed little interest in the human figure for a long time. The bronze plaque of the *Crucifixion* (fig. 355), probably made for a book cover, shows a continuing concentration on flat patterns, even when faced with the image of a man. Although the composi-

tion is Early Christian in origin, the artist has conceived the human frame as a series of ornamental compartments, so that the figure of Jesus is disembodied in the most literal sense: the head, arms, and feet are all separate elements joined to a central pattern of whorls, zigzags, and interlacing bands. Clearly, there is a wide gulf between the Celtic-Germanic and the Mediterranean traditions, a gulf that the Irish artist who modeled the *Crucifixion* saw no need to bridge.

Lombard Style

The situation was much the same in Continental Europe. We even find it among the Lombards in northern Italy. The Germanic stone carver who did the marble balustrade relief in the Cathedral Baptistery at Cividale (fig. 356) was just as perplexed as the Irish by the problem of representation. The evangelists' symbols are strange creatures indeed. All four of them have the same spidery front legs, and their bodies consist of nothing but head, wings, and (except for the angel) a little spiral tail. Apparently the artist did not mind violating their integrity by forcing them into their circular frames in this Procrustean fashion. On the other hand, the panel as a whole has a well-developed sense of ornament. The flat, symmetrical pattern is an effective piece of decoration, rather like an embroidered cloth. It may, in fact, have been derived in part from Oriental textiles (compare fig. 116).

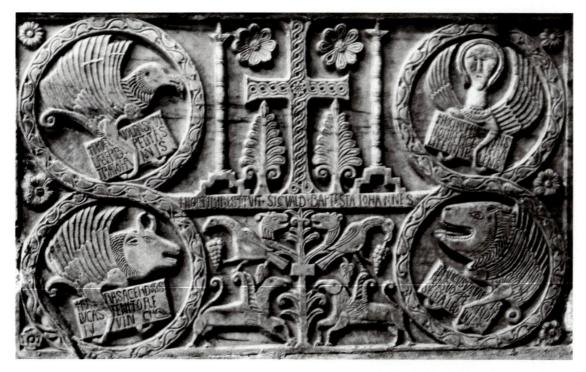

356. Balustrade relief inscribed by the Patriarch Sigvald (762–76 A.D.), probably carved c. 725–50 A.D. Marble, approx. 36 x 60" (91.3 x 152.3 cm). Cathedral Baptistery, Cividale, Italy

CAROLINGIAN ART

The cultural achievements of Charlemagne's reign have proved far more lasting than his empire, which began to disintegrate even before his death in 814. This very page would look different without them, for it is printed in letters whose shapes derive from the script in Carolingian manuscripts. The fact that these letters are known today as "Roman" rather than Carolingian recalls another aspect of the cultural reforms sponsored by Charlemagne: the collecting and copying of ancient Roman literature. The oldest surviving texts of a great many classical Latin authors are to be found in Carolingian manuscripts, which, until not very long ago, were mistakenly regarded as Roman; hence their lettering, too, was called Roman.

This interest in preserving the classics was part of an ambitious attempt to better the education of the court and the clergy as part of a larger reform program. Charlemagne's goals were to improve the administration of his realm and the teaching of Christian truths. Toward that end, he summoned a glittering array of the best minds from around the realm to his court, including Alcuin of York, the most learned scholar of the day, to restore ancient Roman learning and to establish a system of schools at every cathedral and monastery. The emperor, who could read but not write, took an active hand in this renewal, which went well beyond mere antiquarianism. To an astonishing extent, he succeeded. Thus, the "Carolingian revival" may be termed the first, and in some ways most important, phase of a genuine fusion of the Celtic-Germanic spirit with that of the Mediterranean world.

Architecture

During the Middle Ages, the word architect (which derives from the Greek word for master builder and was defined in its modern sense of designer and theoretician by the Roman writer Vitruvius during the first century A.D.) came to have different meanings. During the eighth century the distinction between design and construction, theory and practice, became increasingly blurred. As a result, the term nearly disappeared in northern Europe by the tenth century, and was replaced by a new vocabulary, in part because the building trades were strictly separated under the guild system. When it was used, architect could apply not only to masons, carpenters, and even roofers, but also to the person who commissioned or supervised a building. We know that in some instances the head abbot of a community of monks was the actual designer. Consequently, the design of churches became increasingly subordinate to liturgical and practical considerations. Their actual appearance, however, was largely determined by an organic construction process. Roman architectural principles and construction techniques, such as the use of cement, had been largely forgotten and were recovered only through cautious experimentation by builders of inherently conservative persuasion. Thus vaulting remained rudimentary and was limited to short spans, mainly the aisles, if it was used at all.

Not until about 1260 did Thomas Aquinas revive Aristotle's definition of architect as the person of intellect who leads or conducts, as opposed to the artisan who makes. In doing so, he acknowledged a change in practice that had

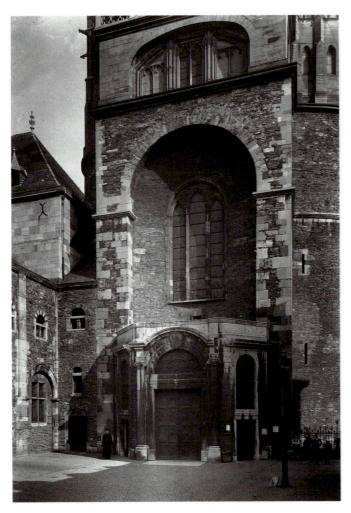

357. Entrance, Palace Chapel of Charlemagne, Aachen, Germany. 792–805 A.D.

occurred over the previous 150 years. Within a century the term was used by the humanist Petrarch to designate the artist in charge of a project. Petrarch thus acknowledged what had already become established practice in Florence, where first the painter Giotto and then the sculptors Andrea Pisano and Francesco Talenti were placed in charge of Florence Cathedral

(see page 341). The decisive step, however, came only in the early fifteenth century with the rediscovery of Vitruvius' writings, which provided the foundation for Renaissance theory.

PALACE CHAPEL, AACHEN. The achievement of Charlemagne's famous Palace Chapel (figs. 357-59) is all the more spectacular seen in this light. On his visits to Italy, he had become familiar with the architectural monuments of the Constantinian era in Rome and with those of the reign of Justinian in Ravenna. Charlemagne felt that his new capital at Aachen (the site was chosen for its mineral baths) must convey the majesty of empire through buildings of an equally impressive kind. The Palace Chapel, part of a large imperial complex, was inspired, in part, by S. Vitale (see figs. 317–20). The debt is particularly striking in cross section (compare fig. 359 to fig. 319). To erect such a structure on Northern soil was a difficult undertaking that was supervised by Einhard, Charlemagne's trusted adviser and biographer. Columns and bronze gratings had to be imported from Italy, and expert stonemasons must have been hard to find. The design, by Odo of Metz (probably the earliest architect north of the Alps known to us by name), is by no means a mere echo of S. Vitale but a vigorous reinterpretation, with piers and vaults of Roman massiveness and a geometric clarity of the spatial units very different from the fluid space of the earlier structure.

Equally significant is Odo's scheme for the western entrance, now largely obscured by later additions and rebuilding (fig. 357). At S. Vitale, the entrance consists of a broad, semidetached narthex with twin stair turrets, at an odd angle to the main axis of the church (see fig. 318), while at Aachen these elements have been molded into a tall, compact unit, in line with the main axis and closely attached to the chapel proper. This monumental entrance structure, known as a westwork (from the German Westwerk), makes one of its first known appearances here, and already holds the germ of the two-tower facade familiar from so many later medieval churches. Charlemagne's throne was placed behind the great window above the entrance, where it faced an altar dedicated to Christ, who confers his blessing to the emperor from the dome mosaic. Thus, although contemporary documents say little about its function, the westwork seems to have served initially as a royal loge

In the Middle Ages, the word master (Latin, magister) was a title

conferred by a trade organization, or guild, signifying a member who had achieved the highest level of skill in the guild's profession or craft. In each city, trade guilds virtually controlled commercial life by establishing quality standards, setting prices, defining the limits of each guild's activity, and overseeing the admission of new members. The earliest guilds were formed in the eleventh century by merchants; but craftsmen, too, soon organized themselves in similar professional societies, whose power continued well into the sixteenth century. Most guilds admitted only men, but some, such as the painters' guild of Bruges, occasionally admitted women also. Guild membership established a certain level of social status for townspeople, who were neither

Guilds: Masters and Apprentices

nobility, clerics (people in religious life), nor peasantry.

A boy would begin as an apprentice to a master in his chosen guild, and after many years might advance to the rank of journeyman. In most guilds this meant that he was then a full member of the organization, capable of working without direction, and entitled to receive full wages for his work. Once he became a master, the highest rank, he could direct the work of apprentices and manage his own workshop, hiring journeymen to work with him.

In architecture, the master mason (sometimes called master builder) generally designed the building, that is, acted in the role of architect. In church-building campaigns, teams of carpenters (joiners), metalworkers, and glaziers (glassworkers) labored under the direction of the master builder.

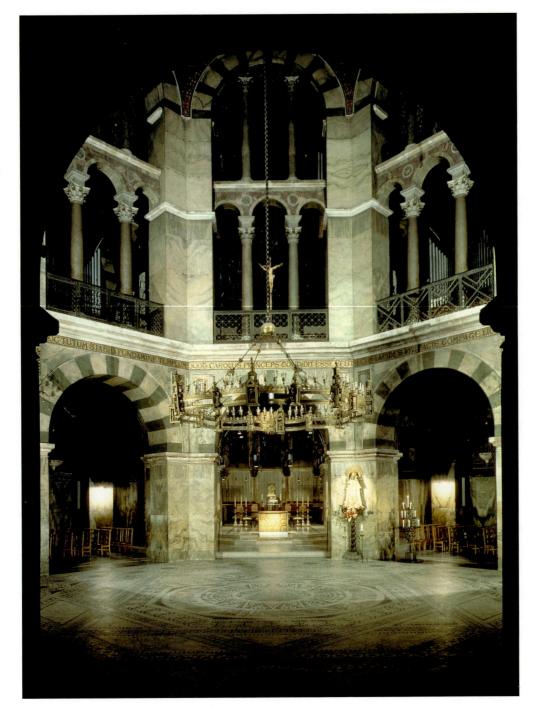

358. Interior of the Palace Chapel of Charlemagne, Aachen

or chapel, but both here and elsewhere it may have been used for a variety of other liturgical functions as the need arose.

ST.-RIQUIER, ABBEVILLE. An even more elaborate westwork formed part of the greatest basilican church of Carolingian times, that of the monastery of St.-Riquier (also called Centula), near Abbeville in northeastern France. Named for a monk who died in 645, it was established in 790 by Abbot Angilbert, a poet and scholar close to Charlemagne whose nickname at the court was Homer. The monastery has been

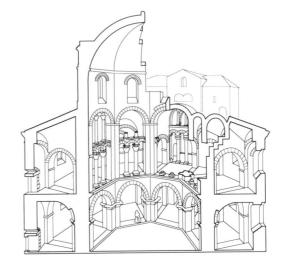

359. (right) Cross section of the Palace Chapel of Charlemagne (after Kubach)

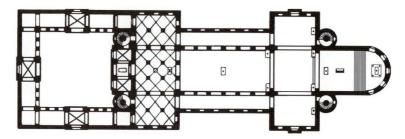

360. Plan of the Abbey Church of St.-Riquier, France. Consecrated 799 A.D. (after Effmann, 1912)

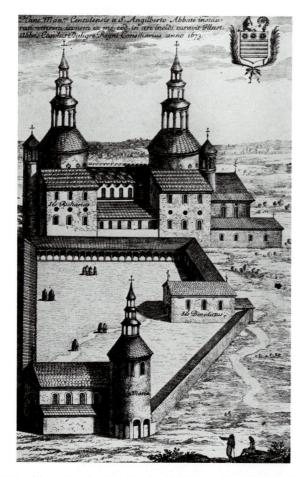

361. Abbey Church of St.-Riquier (1673 engraving after a 1612 view by Petau, from an 11th-century manuscript illumination)

completely destroyed, but its design is known in detail from drawings and descriptions (figs. 360 and 361). [See Primary Sources, nos. 27–29, pages 384–85.] Several innovations in the church were to become of basic importance for the future. The westwork leads into a vaulted narthex, which is in effect a western transept. Its crossing (the area where the transept intersects the nave) was crowned by a tower, as was the crossing of the eastern transept. Both transepts, moreover, featured a pair of round stair towers. The apse, unlike that of Early Christian basilicas (compare fig. 298), is separated from the eastern transept by a square compartment, called the choir. St.-Riquier was widely imitated in other Carolingian monastery churches, but these, too, have been destroyed or rebuilt in later times.

PLAN OF A MONASTERY, ST. GALL. The importance of monasteries and their close link with the imperial court are

vividly suggested by a unique document of the period, the large drawing on five sheets of vellum of a plan for a monastery preserved in the chapter library at St. Gall in Switzerland (fig. 362). Its basic features seem to have been determined at a council held near Aachen in 816–17 that established the Benedictines as the official order under the Carolingians. This copy was then sent by Abbot Haito of Reichenau to Gozbert, the abbot of St. Gall, for "you to study only" in rebuilding the monastery. We may regard it, therefore, as a standard plan, intended to be modified according to local needs.

The monastery plan shows a complex, self-contained unit, filling a rectangle about 500 by 700 feet (fig. 363). The main path of entrance, from the west, passes between stables and a hostelry toward a gate that admits the visitor to a colonnaded semicircular portico flanked by two round towers—an early instance of a monumental western church front, or westwork—that loom impressively above the low outer buildings. The plan emphasizes the church as the center of the monastic community. The church is a basilica, with a transept and choir in the east but an apse and altar at either end. The nave and aisles, containing numerous other altars, do not form a single continuous space but are subdivided into compartments by screens. There are numerous entrances: two beside the western apse, others on the north and south flanks.

This entire arrangement reflects the functions of a monastery church, designed for the liturgical needs of the monks rather than for a lay congregation. Adjoining the church to the south is an arcaded cloister, around which are grouped the monks' dormitory (on the east side), a refectory (dining hall) and kitchen (on the south side), and a cellar. The three large buildings north of the church are a guesthouse, a school, and the abbot's house. To the east are the infirmary, a chapel and quarters for novices (new members of the religious community), the cemetery (marked by a large cross), a garden, and coops for chickens and geese. The south side is occupied by workshops, barns, and other service buildings. There is, needless to say, no monastery exactly like this plan anywhere—even in St. Gall the design was not carried out as drawn—yet its layout conveys an excellent notion of such establishments throughout the Middle Ages. [See Primary Sources, no. 30, pages 385–86.]

SPAIN. Outside of Germany, the vast majority of early medieval churches were small in size, simple in plan, and provincial in style. The best examples, such as Sta. Maria de

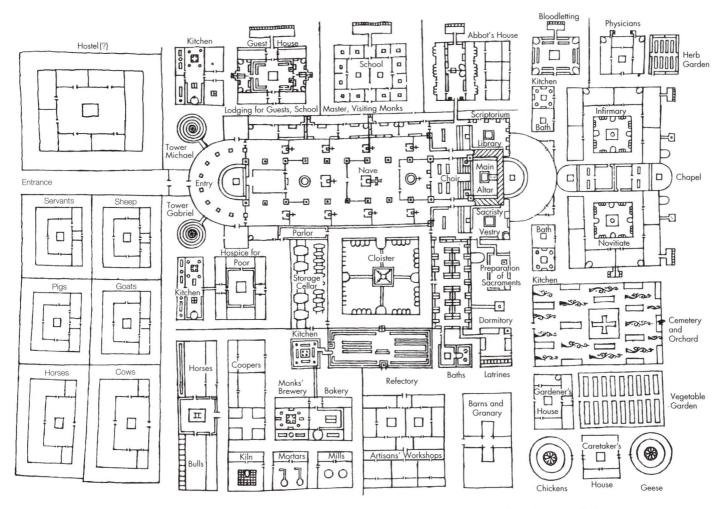

362. Plan of a monastery. Redrawn, with inscriptions translated into English from the Latin, from the original of c. 820 A.D. Red ink on parchment, 28 x 44 ¹/8" (71.1 x 112.1 cm). Stiftsbibliothek, St. Gall, Switzerland

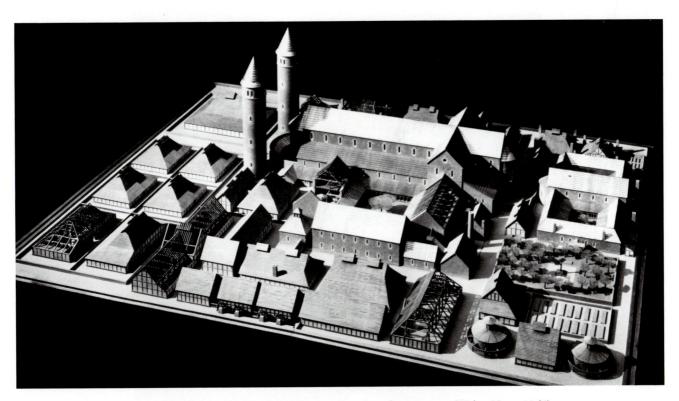

363. Reconstruction model, after the c. 820 A.D. plan of a monastery (Walter Horn, 1965)

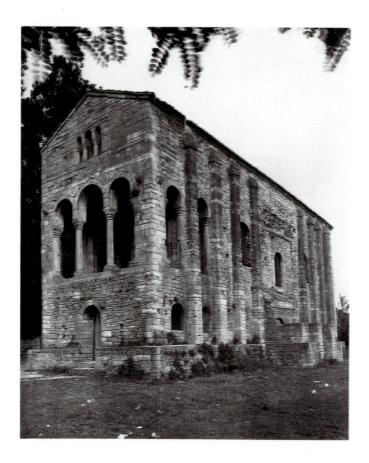

364. Sta. Maria de Naranco, Oviedo, Spain. Dedicated 848

Naranco (fig. 364), are in Spain and owe their survival to their remote locations. Built by Ramiro I about 848 as part of his palace near Oviedo, it is, like Charlemagne's Palace Chapel, an audience hall and chapel (it even included baths) but on a much more modest scale. Remarkably, it features a tunnel vault along the upper story and arcaded loggias at either end that were clearly inspired by the interior of the Palace Chapel (fig. 358). The construction, however, is far more rudimentary, built of crudely carved, irregular blocks instead of the carefully dressed masonry (called ashlar) found at Aachen. We need only glance at S. Apollinare in Classe (fig. 300) to realize how much of the architectural past had been lost in only 300 years.

Manuscripts and Book Covers

GOSPEL BOOK OF CHARLEMAGNE. From the start, the fine arts played an important role in Charlemagne's cultural program. We know from literary sources that Carolingian churches contained murals, mosaics, and relief sculpture, but these have disappeared almost entirely. Illuminated manuscripts, carved ivories, and goldsmiths' work, on the other hand, have survived in considerable numbers. They demonstrate the impact of the Carolingian revival even more strikingly than the architectural remains of the period. The former Imperial Treasury in Vienna contains a Gospel Book said to have been found in the Tomb of Charlemagne and, in any event, is closely linked with his court at Aachen. Looking at the picture of St. Matthew from that manuscript (fig. 365), we can hardly believe that such a work could have been executed in northern Europe about the year 800. Were it not for the

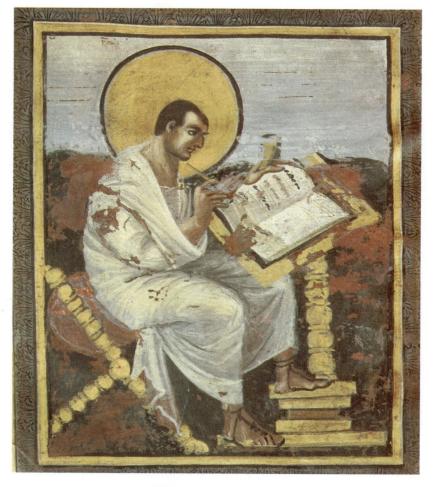

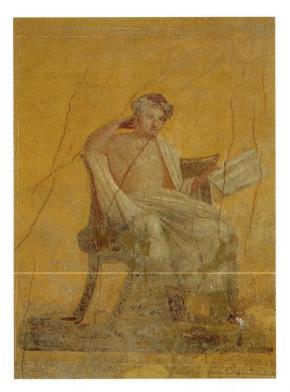

366. *Portrait of Menander.* c. 70 A.D. Wall painting. House of Menander, Pompeii

large golden halo, the evangelist Matthew might almost be mistaken for a classical author's portrait like the one of Menander (fig. 366), painted at Pompeii almost eight centuries earlier. Whether Byzantine, Italian, or Frankish, the artist plainly was fully conversant with the Roman tradition of painting, down to the acanthus ornament on the wide frame, which emphasizes the "window" treatment of the picture.

GOSPEL BOOK OF ARCHBISHOP EBBO. This St. Matthew represents the initial and most conservative phase of the Carolingian revival. It is the visual counterpart of copying the text of a classical work of literature. More typical is a slightly later miniature of St. Mark, painted some three decades later for the Gospel Book of Archbishop Ebbo of Reims (fig. 367), that shows the classical model translated into a Carolingian idiom. It must have been based on an evangelist's portrait of the same style as the St. Matthew, but now the entire picture is filled with a vibrant energy that sets everything into motion. The drapery swirls about the figure, the hills heave upward, the vegetation seems to be tossed about by a whirlwind, and even the acanthus pattern on the frame assumes a strange, flamelike character. The evangelist himself has been transformed from a Roman author setting down his own thoughts into a man seized with the frenzy of divine inspiration, an instrument for recording the Word of God. His gaze is fixed not upon his book but upon his symbol (the winged lion with a scroll), which acts as the transmitter of the sacred text. This dependence on the Word, so powerfully expressed here, characterizes the contrast between classical and medieval images of humanity. But the *means* of expression—the dynamism of line

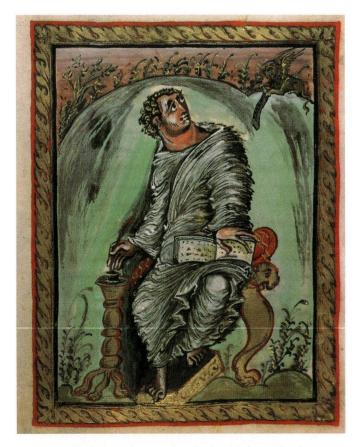

367. *St. Mark*, from the *Gospel Book of Archbishop Ebbo of Reims*. 816–35 A.D. Ink and colors on vellum, $10^{1}/4 \times 8^{3}/16$ " (26 x 20.8 cm). Bibliothèque Municipale, Épernay, France

that distinguishes our miniature from its predecessor—recalls the passionate movement in the ornamentation of Irish manuscripts (figs. 352 and 354).

UTRECHT PSALTER. The Reims School also produced the most extraordinary of all Carolingian manuscripts, the Utrecht Psalter (fig. 368, page 282). It displays the style of the Ebbo Gospels in an even more energetic form, since the entire book is illustrated with pen drawings. Here again the artist has followed a much older model, as indicated by the architectural and landscape settings of the scenes, which are strongly reminiscent of those on the Arch of Titus (see fig. 271), and by the use of Roman capital lettering, which had gone out of general use several centuries before. The wonderfully rhythmic quality of his draftsmanship, however, gives to these sketches a kind of emotional coherence that could not have been present in the earlier pictures. Without it, the drawings of the Utrecht Psalter would carry little conviction, for the poetic language of the Psalms does not lend itself to illustration in the same sense as the narrative portions of the Bible.

The Psalms can be illustrated only by taking each phrase literally and then by visualizing it in some manner. Thus, toward the bottom of the page, we see the Lord reclining on a bed, flanked by pleading angels, an image based on the words, "Awake, why sleepest thou, Oh Lord?" On the left, the faithful crouch before the Temple, "for . . . our belly cleaveth unto the earth," and at the city gate in the foreground they are killed "as sheep for the slaughter." In the hands of a pedestrian artist, this procedure could well turn into a wearisome charade. Here it has the force of a great drama.

368. Illustrations to Psalms 43 and 44, from the Utrecht Psalter. c. 820-32 A.D. University Library, Utrecht, The Netherlands

LINDAU GOSPELS COVER. The style of the Reims School can still be felt in the reliefs of the jeweled front cover of the Lindau Gospels (fig. 369), a work of the third quarter of the ninth century. This masterpiece of the goldsmith's art shows how splendidly the Celtic-Germanic metalwork tradition adapted itself to the Carolingian revival. The clusters of semi-precious stones are not mounted directly on the gold ground but raised on claw feet or arcaded turrets, so that the light can penetrate beneath them to bring out their full brilliance. Interestingly enough, the crucified Jesus betrays no hint of pain or death. He seems to stand rather than to hang, his arms spread

out in a solemn gesture. To endow him with the signs of human suffering was not yet conceivable, even though the means were at hand, as we can see from the eloquent expressions of grief among the small figures in the adjoining compartments.

OTTONIAN ART

Upon the death of Charlemagne's son, Louis I, in 843, the empire built by Charlemagne was divided into three parts by his grandsons: Charles the Bald, the West Frankish king, who established the French Carolingian dynasty; Louis the Ger-

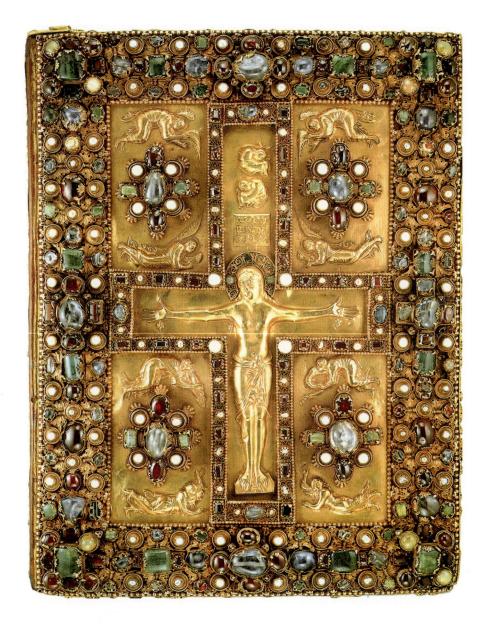

369. Front cover of binding, *Lindau Gospels.* c. 870 A.D.

Gold and jewels, 13³/4 x 10 ¹/2" (35 x 26.7 cm).

The Pierpont Morgan Library, New York

man, the East Frankish king, whose domain corresponded roughly to the Germany of today; and Lothair I, who inherited the middle kingdom and the title of Holy Roman Emperor. By dividing the king's domain among his heirs, the Carolingian dynasty made the same fatal mistake as its predecessors, the Merovingians. Charlemagne had tried to impose unified rule by placing his friends in positions of power throughout the realm, but they naturally became increasingly independent over time. During the late ninth and early tenth centuries this loose arrangement gradually gave way to the decentralized political and social system known today as feudalism in France and Germany, where it had deep historical roots. Knights (originally cavalry officers) held fiefs, or feuds, as their land was called, in return for service to their lords, to whom they were associated through a complex system of personal bonds—termed vassalage—that extended all the way to the king. The land itself was worked by the large class of generally downtrodden peasants (serfs and esnes), who were utterly powerless.

The Carolingians finally became so weak that Continental Europe once again lay exposed to attack. In the south, the Moslems resumed their depredations; Slavs and Magyars advanced from the east; and Vikings from Scandinavia rav-

aged the north and west. The Vikings (the Norse ancestors of today's Danes and Norwegians) had been raiding Ireland and Britain by sea from the late eighth century on. Now they invaded northwestern France as well and occupied the area that ever since has been called Normandy. Once established there, they soon adopted Christianity and Carolingian civilization, and from 911 on their leaders were recognized as dukes nominally subject to the authority of the king of France. During the eleventh century, the Normans assumed a role of major importance in shaping the political and cultural destiny of Europe, with William the Conqueror becoming king of England, while other Norman nobles expelled the Arabs from Sicily and the Byzantines from southern Italy.

In Germany, meanwhile, after the death of the last Carolingian monarch in 911, the center of political power had shifted north to Saxony. Beginning with Henry I, the Saxon kings (919–1024) reestablished an effective central government, and the greatest of them, Otto I, also revived the imperial ambitions of Charlemagne. After marrying the widow of a Lombard king, he extended his rule over most of Italy and in 962 was crowned emperor by Pope John XII, at whose request he conquered Rome and whom he subsequently deposed for conspiring against him. From then on the Holy

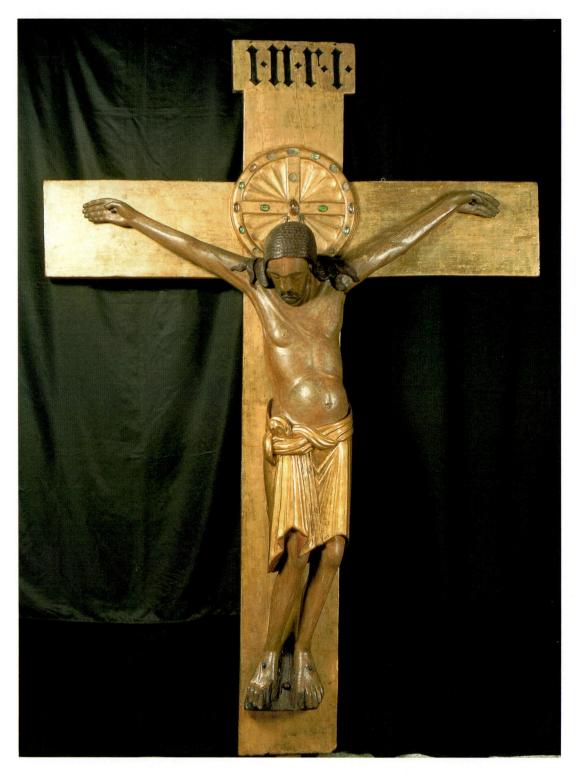

370. The Gero Crucifix. c. 975-1000 A.D. Wood, height 6'2" (1.88 m). Cathedral, Cologne, Germany

Roman Empire was to be a German institution—or perhaps we ought to call it a German dream, for Otto's successors never managed to consolidate their claim to sovereignty south of the Alps. Yet this claim had momentous consequences, since it led the German emperors into centuries of conflict with the papacy and local Italian rulers, linking North and South in a lovehate relationship whose echoes can be felt to the present day.

Sculpture

THE GERO CRUCIFIX. During the Ottonian period, from the mid-tenth century to the beginning of the eleventh,

Germany was the leading nation of Europe, artistically as well as politically. German achievements in both areas began as revivals of Carolingian traditions but soon developed new and original traits.

The change of outlook is impressively brought home to us if we compare the Christ on the cover of the *Lindau Gospels* with *The Gero Crucifix* (fig. 370) in the Cathedral at Cologne, which was done for Archbishop Gero of that city. The two works are separated by little more than a hundred years' interval, but the contrast between them suggests a far greater span. In *The Gero Crucifix* we meet an image of the crucified Saviour new to Western art: monumental in scale, carved in pow-

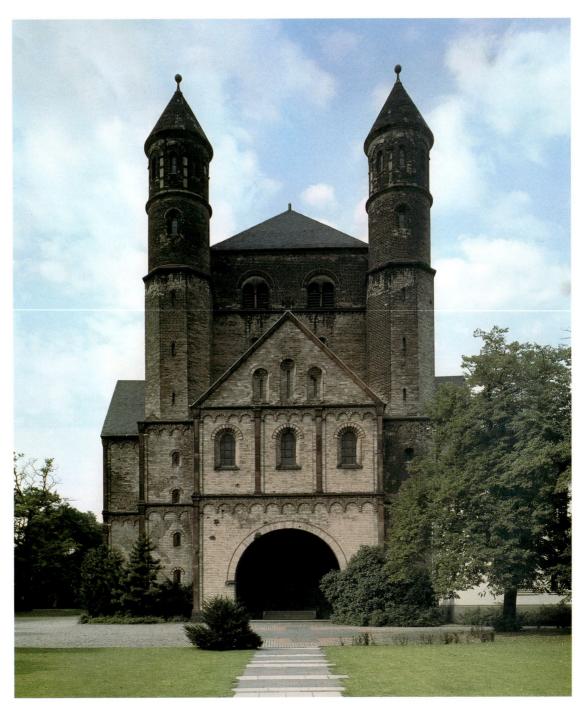

371. Westwork, St. Pantaleon, Cologne. Consecrated 980 A.D.

erfully rounded forms, and filled with a deep concern for the sufferings of the Lord. Particularly striking is the forward bulge of the heavy body, which makes the physical strain on arms and shoulders seem almost unbearably real. The face, with its deeply incised, angular features, has turned into a mask of agony, from which all life has fled.

How did the Ottonian sculptor arrive at this startlingly bold conception? *The Gero Crucifix* was clearly influenced by middle Byzantine art, which, we will recall, had created the compassionate view of Christ on the Cross (see fig. 340). Byzantine influence was strong in Germany at the time, for Otto II had married a Byzantine princess, establishing a direct link between the two imperial courts. The source alone is not sufficient to explain the results. It remained for the Ottonian artist to trans-

late the Byzantine image into large-scale sculptural terms and to replace its gentle pathos with an expressive realism that has been the main strength of German art ever since.

Architecture

Cologne was closely connected with the imperial house through its archbishop, Bruno, the brother of Otto I, who left a strong mark on the city through the numerous churches he built or rebuilt. His favorite among these, the Benedictine abbey of St. Pantaleon, became his burial place as well as that of the wife of Otto II. Only the monumental westwork (fig. 371) has retained its original shape essentially unchanged until modern times. We recognize it as a massive and well-proportioned successor to

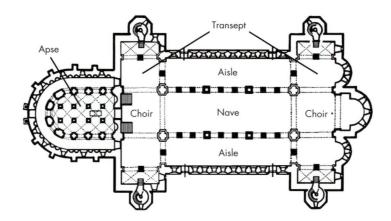

372. Reconstructed plan, Hildesheim Cathedral (St. Michael's), Germany. 1001–33 (after Beseler)

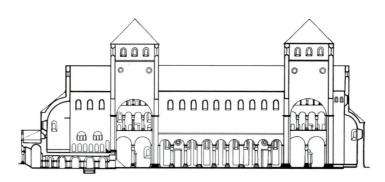

373. Reconstructed longitudinal section, Hildesheim Cathedral (after Beseler)

Carolingian westworks, with the characteristic tower over the crossing of the western transept and a deep porch flanked by tall stair turrets (compare fig. 361).

ST. MICHAEL'S, HILDESHEIM. Judged in terms of surviving works, however, the most ambitious patron of architecture and art in the Ottonian age was Bernward, who became bishop of Hildesheim after having been court chaplain and one of the tutors of Otto III during the regency of the empress Theophano. His chief monument is another Benedictine abbey church, St. Michael's (figs. 372–74). The plan, with its two choirs and lateral entrances, recalls the monastery church of the St. Gall plan (see fig. 362). But in St. Michael's the symmetry is carried much further. Not only are there two identical transepts, with crossing towers and stair turrets (see figs. 372 and 373), but the supports of the nave arcade, instead of being uniform, consist of pairs of columns separated by square piers. This alternate system divides the arcade into three equal units of three openings each. Moreover, the first and third units are correlated with the entrances, thus echoing the axis of the transepts. And since the aisles and nave are unusually wide in relation to their length, the architect's intention must have been to achieve a harmonious balance between the longitudinal and transverse axes throughout the structure.

The exterior as well as the choirs of Bernward's church have been disfigured by rebuilding, but the interior of the nave (figs. 373 and 374), with its great expanse of wall space between arcade and clerestory, retains the majestic spatial feeling of the original design following its recent restoration. (The capitals of the columns date from the twelfth century, the painted wooden ceiling from the thirteenth.) The Bernwardian western choir, as reconstructed in our plan, is particularly interesting. Its floor was raised above the level of the rest of the church to accommodate a half-subterranean basement chapel, or crypt, apparently a special sanctuary of St. Michael, which could be entered both from the transept and from the west. The crypt was roofed by groin vaults resting on two rows of columns, and its walls were pierced by arched openings that linked it with the U-shaped corridor, or ambulatory, wrapped around it. This ambulatory must have been visible above ground, enriching the exterior of the western choir, since there were windows in its outer wall. Such crypts with ambulatories, usually housing the venerated tomb of a saint, had been introduced into the repertory of Western church architecture during Carolingian times. But the Bernwardian design stands out for its large scale and its carefully planned integration with the rest of the building.

Metalwork

BRONZE DOORS OF BISHOP BERNWARD. How much importance Bernward himself attached to the crypt at St. Michael's can be gathered from the fact that he commissioned a pair of richly sculptured bronze doors that were probably meant for the two entrances leading from the transept to

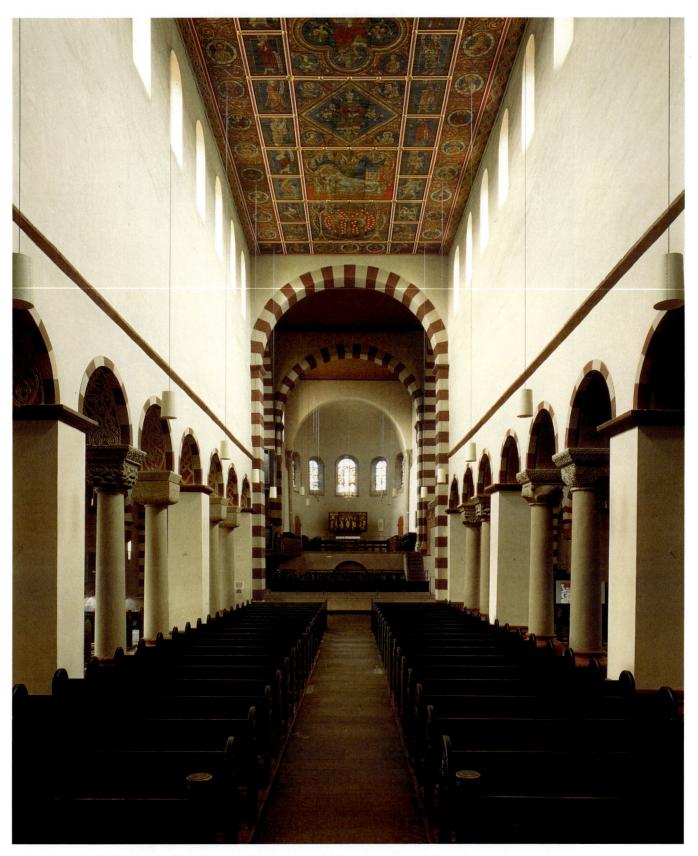

374. Interior (view toward the apse, after restoration of 1950-60), Hildesheim Cathedral

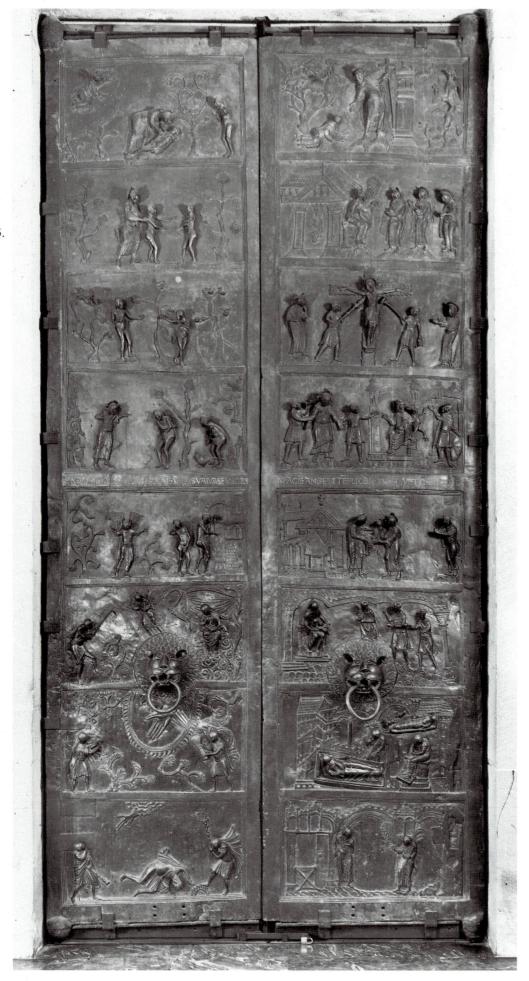

375. Doors of Bishop Bernward. 1015. Bronze, height approx. 16' (4.8 m). Hildesheim Cathedral

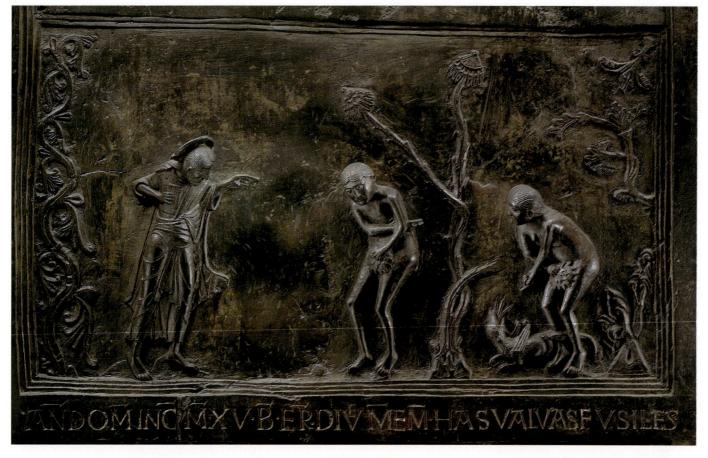

376. Adam and Eve Reproached by the Lord, from the Doors of Bishop Bernward. Bronze, approx. 23 x 43" (58.3 x 109.3 cm)

the ambulatory (fig. 375). They were finished in 1015, the year the crypt was consecrated. Bernward, according to his biographer, Thangmar of Heidelberg, excelled in the arts and crafts. The idea may have come to him as a result of his visit to Rome, where he could have seen ancient Roman (and perhaps Byzantine) bronze doors. The Bernwardian doors, however, differ from their predecessors. They are divided into broad horizontal fields rather than vertical panels, and each field contains a biblical scene in high relief. The subjects, taken from Genesis (left door) and the Life of Christ (right door), depict the origin and redemption of sin.

Our detail (fig. 376) shows Adam and Eve after the Fall. Below it, in inlaid letters remarkable for their classical Roman character, is part of the dedicatory inscription, with the date and Bernward's name. In these figures we find nothing of the monumental spirit of *The Gero Crucifix*. They seem far smaller than they actually are, so that one might easily mistake them for a piece of goldsmith's work such as the Lindau Gospels cover (compare fig. 369). The composition must have been derived ultimately from an illuminated manuscript, since very similar scenes are found in medieval Bibles. Even the oddly stylized bits of vegetation have a good deal of the twisting, turning movement we recall from Irish miniatures. Yet this is no slavish imitation, for the story is conveyed with splendid directness and expressive force. The accusing finger of the Lord, seen against a great void of blank surface, is the focal point of the drama. It points to a cringing Adam, who passes the blame to his mate, while Eve, in turn, passes it to the serpent at her feet.

Manuscripts

GOSPEL BOOK OF OTTO III. The same intensity of glance and of gesture found in the Bernwardian bronze doors characterizes Ottonian manuscript painting, which blends Carolingian and Byzantine elements into a new style of extraordinary scope and power. The most important center of manuscript illumination at that time was the Reichenau Monastery, on an island in Lake Constance, on the borders of modern-day Germany, Switzerland, and Austria. Perhaps its finest achievement—and one of the great masterpieces of medieval art—is the *Gospel Book of Otto III*, from which we reproduce two full-page miniatures (figs. 377 and 378).

The scene of Jesus washing the feet of St. Peter contains notable echoes of ancient painting, transmitted through Byzantine art. The soft pastel hues of the background recall the illusionism of Graeco-Roman landscapes (see figs. 287 and 288), and the architectural frame around Jesus is a late descendant of the kind of architectural perspectives we saw in the mural from Boscoreale (see fig. 286). These elements have been reformulated by the Ottonian artist, who has put them to a new use: what was once an architectural vista now becomes the Heavenly City, the House of the Lord filled with golden celestial space as against the atmospheric earthly space without.

The figures have undergone a similar transformation. In ancient art, this composition had been used to represent a doctor treating a patient. Now St. Peter takes the place of the sufferer, and Jesus that of the physician. (Note that Jesus is still the beardless young philosopher type here.) As a consequence, the emphasis has shifted from physical to spiritual action, and this

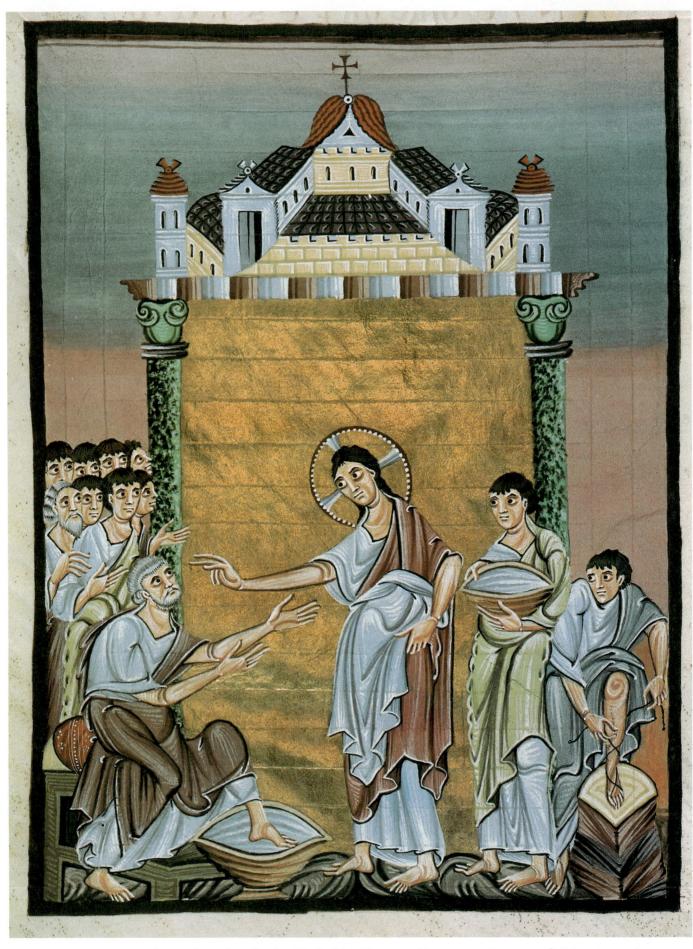

377. Jesus Washing the Feet of Peter, from the Gospel Book of Otto III. c. 1000. Tempera on vellum, $13 \times 9^3/8$ " (33 x 23.8 cm). Staatsbibliothek, Munich

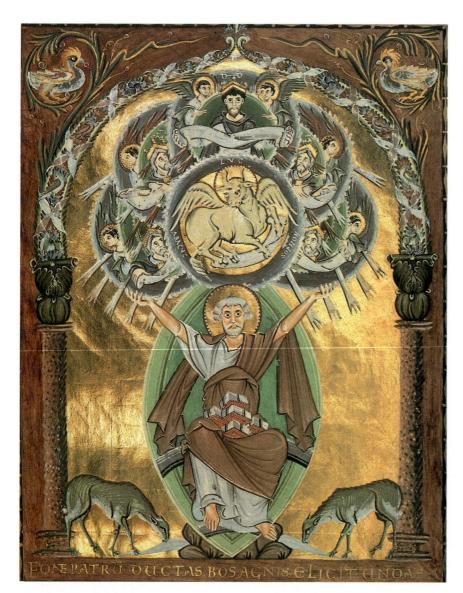

378. *St. Luke*, from the *Gospel Book of Otto III*. c. 1000. Tempera on vellum, 13 x 9³/8" (33 x 23.8 cm). Staatsbibliothek, Munich

379. Moses Receiving the Law and The Doubting of Thomas. Early 11th century. Ivory, each
 95/8 x 4" (24.5 x 10.2 cm). Staatliche Museen zu
 Berlin, Preussischer Kulturbesitz, Museum für Spätantike und Byzantische Kunst

new kind of action is not only conveyed through glances and gestures, it also governs the scale of things. Jesus and St. Peter, the most active figures, are larger than the rest; Jesus' "active" arm is longer than his "passive" one; and the eight apostles, who merely watch, have been compressed into a tiny space, so that we see little more than their eyes and hands. Even the fanlike Early Christian crowd from which this derives (see fig. 308) is not so literally disembodied. The scene straddles two eras. On the one hand, the nearly perfect synthesis of Western and Byzantine elements represents the culmination of the early medieval manuscript tradition; on the other, the expressive distortions look forward to Romanesque art, which incorporated them in heightened form to telling effect.

The other miniature, the painting of St. Luke, is a symbolic image of overwhelming grandeur. Unlike his Carolingian predecessors (see figs. 365 and 367), the evangelist is no longer shown writing. Instead, his Gospel lies completed on his lap. Enthroned on two rainbows, he holds aloft an awesome cluster of clouds from which tongues of light radiate in every direction. Within it we see his symbol, the ox, surrounded by five Old Testament prophets and an outer circle of angels. At the bottom, two lambs drink the life-giving waters that spring from beneath the evangelist's feet. The key to the entire design is in the inscription: Fonte patrum ductas bos agnis elicit undas—"From the source of the fathers the ox brings forth a flow of water for the

lambs"—that is, St. Luke makes the prophets' message of salvation explicit for the faithful. The Ottonian artist has truly "illuminated" the meaning of this terse and enigmatic phrase.

IVORY DIPTYCHS. Closely related in style to the Gospel Book of Otto III is an ivory diptych with Moses Receiving the Law in the left panel and The Doubting of Thomas in the right (fig. 379). These two panels, which may have come from the abbey of Kues on the Mosel River, were probably done in nearby Trier, then a leading art center. It is certain that the artist was familiar with Byzantine ivories, among them the diptych of Justinian as Conqueror (fig. 330), which is known to have made its way to Trier as early as the seventh century. The artist, a great master, nevertheless avoids the Byzantine influences that continued to find favor in Ottonian art, and prefers instead the physical distortions, fluid drapery, and architectural treatment seen in Jesus Washing the Feet of Peter. These devices are used to squeeze an amazing amount of action into the two scenes, which adopt the format of The Archangel Michael (fig. 315) but depart entirely from its classicism. They also lend an impressive power to both panels that makes us feel the full force of the confrontation between mortal and God in divine and in human form, as the awestruck Moses strains to receive the Ten Commandments from Heaven and Thomas reaches up to touch the wound of Christ.

CHAPTER THREE

ROMANESQUE ART

Looking back over the ground we have covered in this book so far, a thoughtful reader will be struck by the fact that almost all of our chapter headings and subheadings might serve equally well for a general history of civilization. Some are based on technology (for example, the Old Stone Age), others on geography, ethnology, religion. Whatever the source, they have been borrowed from other fields, even though in our context they also designate artistic styles. There are only two important exceptions to this rule: Archaic and Classical are primarily terms of style. They refer to qualities of form rather than to the setting in which these forms were created. Why don't we have more terms of this sort? We do, as we shall see—but only for the art of the past 900 years.

Those who first conceived the idea of viewing the history of art as an evolution of styles started out with the conviction that art in the ancient world developed toward a single climax: Greek art from the age of Pericles to that of Alexander the Great. This style they called Classical (that is, perfect). Everything that came before was labeled Archaic, to indicate that it was still old-fashioned and tradition-bound, not-yet-Classical but striving in the right direction, while the style of post-Classical times did not deserve a special term since it had no positive qualities of its own, being merely an echo or a decadence of Classical art.

The early historians of medieval art followed a similar pattern. To them, the great climax was the Gothic style, from the thirteenth century to the fifteenth. For whatever was not-yet-Gothic they adopted the label Romanesque. In doing so, they were thinking mainly of architecture. Pre-Gothic churches, they noted, were round-arched, solid, and heavy, as against the pointed arches and the soaring lightness of Gothic structures. It was rather like the ancient Roman style of building, and the term "Romanesque" was meant to convey just that. In this sense, all of medieval art before 1200 could be called Romanesque insofar as it shows any link with the Mediterranean tradition. Some scholars speak of medieval art before

Charlemagne as pre-Romanesque, and of Carolingian and Ottonian as proto- or early Romanesque. They are right to the extent that Romanesque art proper—that is, medieval art from about 1050 to 1200—would be unthinkable without the contributions of these earlier styles. On the other hand, if we follow this practice we are likely to do less than justice to those qualities that make the art of the early Middle Ages and of Carolingian and Ottonian times different from the Romanesque.

Carolingian art, we will recall, was brought into being by Charlemagne and his circle, as part of a conscious revival policy, and even after his death, it remained strongly linked with his imperial court. Ottonian art, too, had this sponsorship, and a correspondingly narrow base. The Romanesque, in contrast, sprang up all over western Europe at about the same time. It consists of a large variety of regional styles, distinct yet closely related in many ways, and without a central source. In this respect, it resembles the art of the early Middle Ages rather than the Carolingian and Ottonian court styles that had preceded it, although it includes that tradition along with a good many other, less clearly traceable ones, such as Late Classical, Early Christian, and Byzantine elements, some Islamic influence, and the Celtic-Germanic heritage.

What welded all these different components into a coherent style during the second half of the eleventh century was not any single force but a variety of factors that made for a new burgeoning of vitality throughout the West. The millennium came and went without the Apocalypse (described in the Book of Revelation of St. John the Divine) that many had predicted. Christianity had at last triumphed everywhere in Europe. The Vikings, still largely heathen in the ninth and tenth centuries when their raids terrorized the British Isles and the Continent, had entered the Catholic fold, not only in Normandy but in Scandinavia as well. The Caliphate of Cordova had disintegrated in 1031 into many small Moslem states, opening the way for the reconquest of the Iberian Peninsula. And the Magyars had settled down in Hungary.

There was a growing spirit of religious enthusiasm, reflected in the greatly increased pilgrimage traffic to sacred sites and culminating, from 1095 on, in the crusades to liberate the Holy Land from Moslem rule. Equally important was the reopening of Mediterranean trade routes by the navies of Venice, Genoa, Amalfi, Pisa, and Rimini; the revival of trade and travel, which linked Europe commercially and culturally; and the consequent growth of urban life. During the turmoil of the early Middle Ages, the towns of the West Roman Empire had shrunk greatly in size. (The population of Rome, about one million in 300 A.D., fell to less than fifty thousand at one point.) Some cities were deserted altogether. From the eleventh century on, they began to regain their former importance. New towns sprang up everywhere, and, like the cities, they gained their independence thanks to a middle class of artisans and merchants who established itself between the peasantry and the landed nobility as an important factor in medieval society.

In many respects, then, western Europe between 1050 and 1200 became a great deal more "Roman-esque" than it had been since the sixth century, recapturing some of the international trade patterns, the urban quality, and the military strength of ancient imperial times. The central political authority was lacking, to be sure. Even the empire of Otto I did not extend much farther west than modern Germany does. But the central spiritual authority of the pope took its place to some extent as a unifying force. The monasteries of the Cistercians and Benedictines rivaled the wealth and power of secular rulers. Indeed, it was now the pope who sought to unite Europe into a single Christian realm. The international army that responded to Pope Urban II's call in 1095 for the First Crusade to liberate the Holy Land from Moslem rule was more powerful than anything a secular ruler could have raised for the purpose. The pope's authority was spiritual, not just temporal, as he was forced to combat the heresies that mushroomed throughout the Catholic realm. Papal assertion of dogmatic supremacy led to the final break (known as the Great Schism) with the Byzantine Orthodox church in 1054.

ARCHITECTURE

The most conspicuous difference between Romanesque architecture and that of the preceding centuries is the amazing increase in building activity. An eleventh-century monk, Raoul Glaber, summed it up well when he triumphantly exclaimed that the world was putting on a "white mantle of churches." These churches were not only more numerous than those of the early Middle Ages, they were also generally larger, more richly articulated, and more "Roman-looking." Their naves now had vaults instead of wooden roofs; their exteriors, unlike those of Early Christian, Byzantine, Carolingian, and Ottonian churches, were decorated with both architectural ornament and sculpture. Geographically, Romanesque monuments of the first importance are distributed over an area that might well have represented the world—the Catholic world, that is-to Raoul Glaber: from northern Spain to the Rhineland, from the Scottish-English border to central Italy. The richest examples, the greatest variety of regional types, and the most adventurous ideas are to be found in France. If we

add to this group those destroyed or disfigured buildings whose original designs are known to us through archaeological research, we have a wealth of architectural invention unparalleled by any previous era.

Southwestern France

ST.-SERNIN, TOULOUSE. We begin our survey of Romanesque churches with St.-Sernin, in the southern French town of Toulouse (figs. 380–83), one of a group of great churches of the "pilgrimage type," so called because they were built along the roads leading to the pilgrimage center of Santiago de Compostela in northwestern Spain. [See Primary Sources, no. 31, pages 386–87.] The plan immediately strikes us as much more complex and more fully integrated than the designs of earlier structures such as St.-Riquier, or St. Michael's at Hildesheim (see figs. 360 and 372). It is an emphatic Latin cross, with the center of gravity at the eastern end. Clearly this church was designed to serve not only a monastic community but also, like Old St. Peter's in Rome (fig. 297), to accommodate large crowds of lay worshipers in its long nave and transept.

The nave is flanked by two aisles on each side. The inner aisle continues around the arms of the transept and the apse, thus forming a complete ambulatory circuit anchored to the two towers of the west facade. The ambulatory, we will recall, had developed as a feature of the crypts of earlier churches such as St. Michael's. Now it has emerged above ground, where it is linked with the aisles of nave and transept and enriched with apsidal chapels that seem to radiate from the apse and continue along the eastern face of the transept. (Apse, ambulatory, and radiating chapels form a unit known as the pilgrimage choir.) The plan also shows that the aisles of St.-Sernin are groin-vaulted throughout. In conjunction with the features already noted, this imposes a high degree of regularity upon the entire design. The aisles are made up of square bays, which serve as a basic module for the other dimensions, so that the nave and transept bays equal two such units, the crossing and the facade towers four units. The spiritual harmony conveyed by the repetition of these units is perhaps the most striking achievement of the pilgrimage church.

On the exterior, this rich articulation, or interrelationship of elements, is further enhanced by the different roof levels that set off the nave and transept against the inner and outer aisles, the apse, the ambulatory, and the radiating chapels. This effect is enhanced by the buttresses, which reinforce the walls between the windows, to contain the outward thrust of the vaults. The windows and portals are further emphasized by decorative framing. The great crossing tower was completed later, in Gothic times, and is taller than originally intended. The two facade towers, unfortunately, have never been finished and remain stumps.

As we enter the nave, we are impressed with its tall proportions, the elaboration of the nave walls, and the dim, indirect lighting, all of which create a sensation very different from the ample and serene interior of St. Michael's, with its simple and clearly separated blocks of space (see figs. 373 and 374). If the nave walls of St. Michael's look Early Christian (see fig. 299), those of St.-Sernin seem more akin to structures

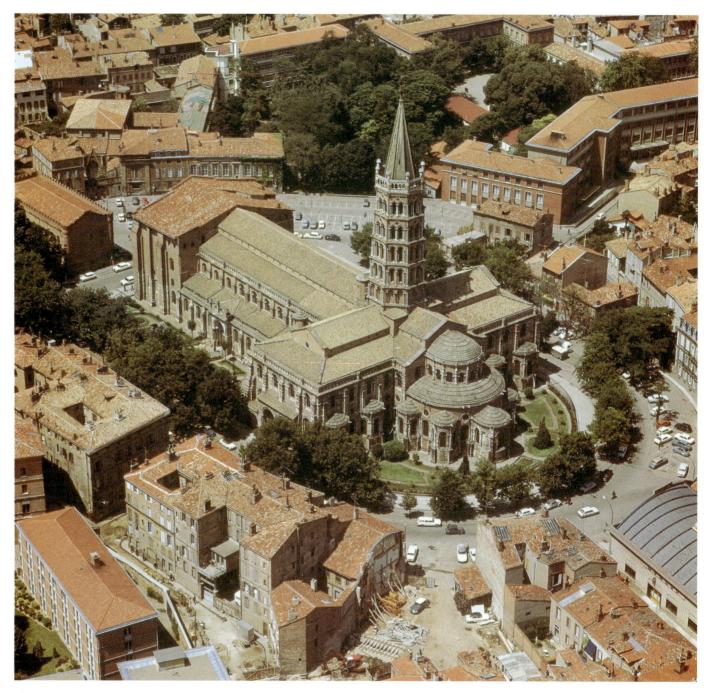

380. St.-Sernin, Toulouse, France (aerial view). c. 1080-1120

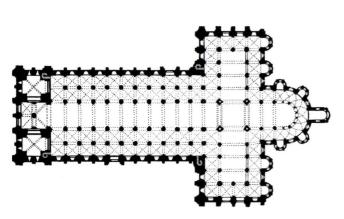

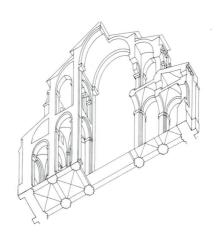

382. Axonometric projection of nave, St.-Sernin (after Choisy)

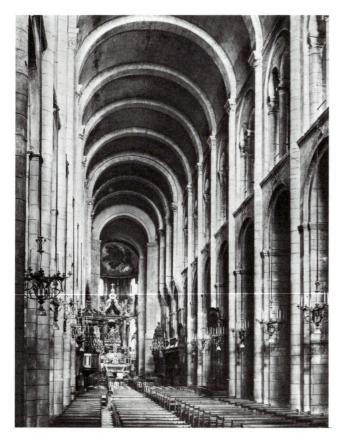

383. Nave and choir, St.-Sernin

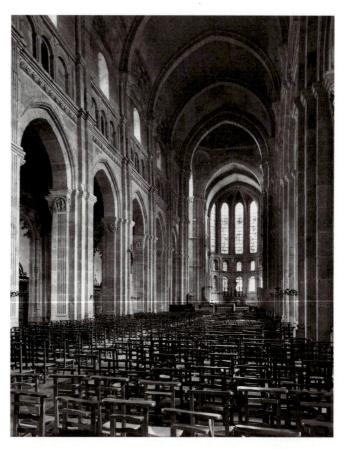

384. Nave wall, Autun Cathedral, France. c. 1120-32

such as the Colosseum (see fig. 245). The syntax of ancient Roman architecture—vaults, arches, engaged columns, and pilasters firmly knit together into a coherent order—has indeed been recaptured here to a remarkable degree. Yet the forces whose interaction is expressed in the nave of St.-Sernin are no longer the physical, muscular forces of Graeco-Roman architecture but spiritual forces of the kind we have seen governing the human body in Carolingian and Ottonian miniatures. The half-columns running the entire height of the nave wall would appear just as unnaturally drawn-out to an ancient Roman beholder as the arm of Jesus in figure 377. The columns seem to be driven upward by some tremendous, unseen pressure, hastening to meet the transverse arches that subdivide the barrel vault of the nave. Their insistently repeated rhythm propels us toward the eastern end of the church, with its light-filled apse and ambulatory (now obscured by a huge altar of later date).

In thus describing our experience we do not, of course, mean to suggest that the architect consciously set out to achieve this effect. Beauty and engineering were inseparable. Vaulting the nave to eliminate the fire hazard of a wooden roof was not only a practical aim; it provided a challenge to make the House of the Lord grander and more impressive. Since a vault becomes more difficult to sustain the farther it is from the ground, every resource had to be strained to make the nave as tall as possible. However, the clerestory was sacrificed for safety's sake. Instead, galleries are built over the inner aisles to abut the lateral pressure of the nave vault in the hope that

enough light would filter through them into the central space. St.-Sernin serves to remind us that architecture, like politics, is "the art of the possible," and that its success, here as elsewhere, is measured by the degree to which the architect has explored the limits of what seemed possible under those particular circumstances, structurally and aesthetically.

Burgundy and Western France

AUTUN CATHEDRAL. The builders of St.-Sernin would have been the first to admit that their answer to the problem of the nave vault was not a final one, impressive though it is in its own terms. The architects of Burgundy arrived at a more elegant solution, as evidenced by the Cathedral of Autun (fig. 384), which was begun by a Cluniac bishop, Étienne de Bage, and consecrated in 1132. Here the galleries are replaced by a blind arcade (called a triforium, since it often has three openings per bay) and a clerestory. What made this three-story elevation possible was the use of the pointed arch for the nave vault. The pointed arch probably reached France from Islamic architecture, where it had been employed for some time. (For reasons of harmony, it also appears in the nave arcade, where it is not needed for additional support.) By eliminating the part of the round arch that responds the most to the pull of gravity, the two halves of a pointed arch brace each other. The pointed arch thus exerts less outward pressure than the semicircular arch, so that not only can it be made as steep as possible, the walls can be perforated. The potentialities of the

People of many times, places, and religious faiths have renounced

the world and wholly devoted themselves to a spiritual way of life. Some have chosen to live alone as hermits, often in isolated places, where they have led harsh ascetic existences. Others have come together in monasteries—religious communities—to share their faith and religious observance. Hermits have been especially characteristic of Hinduism, while the monastic life has been more common in Buddhism and Islam. Among the Jews of the first century B.C., there were both hermits, or anchorites (John the Baptist was one of these), and a kind of monasticism practiced by a sect known as the Essenes. Both forms are found in Christianity throughout most of its history as well. Their basis can be found in Scripture. On the one hand, Jesus urged giving up all earthly possessions as the road to salvation. On the other, the book of Acts in the Bible records that his followers came together in their faith after the Crucifixion.

The earliest monasticism practiced by Christians was the hermit's life. Chosen by a number of pious men and women who lived alone in the Egyptian desert in the second and third centuries A.D., this way of life was to remain fundamental to the Eastern Church, especially in Syria. But early on, communities emerged when colonies of disciples—both men and women—gathered around the most revered of the hermits, such as St. Anthony (fourth century), who achieved such fame as a holy man that he was pursued by people asking him to act as a divine intercessor on their behalf.

Monasteries (including communities for women, which are often called convents or nunneries) soon came to assume great importance in early Christian life. The earliest-known monastery was founded by Pachomius along the Nile around 320, which blossomed into nine monasteries and two nunneries by the time of his death a quarter-century later. Similar ones quickly followed in Syria, where monachism flourished until the 638 conquest by the Arabs. Syrian monasteries were for the most part sites along pilgrimage routes leading to the great monastery Qal'at Sim'ân, where Simeon Stylites (born 390) spent the last 30 years of his long life atop a tall column in almost ceaseless prayer.

Eastern monasticism was founded by Basil the Great (c. 330-379), bishop of Caesarea in Asia Minor. A remarkable man, he was the brother of Gregory of Nyssa and St. Macrina, successor to Eusebius as bishop of Caesarea, and one of the four Fathers of the Greek Church, along with his close friend Gregory Nazianzen. Basil's rules for this life established the basic characteristics of Christian monasticism: temperance, chastity, and humility. They emphasized prayer, scriptural reading, and work, not only within the monastery, but also for the good of lay people in the world beyond its walls, so that monasticism now assumed a social role. The oldest rules in the West are those of St. Augustine (354-430), who spread monasticism to Africa, where it proved short-lived due to the Vandal conquests. Monasticism had been brought even earlier to France by St. Martin of Tours (c. 316–397) around the middle of the fourth century and to Ireland by St. Patrick (c. 385-461) in the fifth century. Ireland wholeheartedly adopted a harsh form of anchoritism during the sixth century.

The most important figure in Western monasticism was Benedict of Nursia (c. 480–c. 553), the founder of the abbey at Monte Cassino in southern Italy. His rule, which was patterned after Basil's, divided the monk's day into periods of private prayer, communal ritual, and labor, and also mandated a moderate form of communal life, however strictly governed it may have been. This was the beginning of the Benedictine order, the first of the great monastic orders (or societies) of the Western church. The Benedictines thrived with the strong support of Pope Gregory the Great, himself a former monk, who codified the Western liturgy and the forms of Gregorian chant (see pages 326–27).

Because of their organization and continuity, monasteries were considered ideal seats of learning and administration under the Frankish kings of the eighth century, and they were even more strongly supported by Charlemagne and his heirs, who gave them land, money, and royal protection. As a result, they became rich and powerful, even exercising influence on international affairs. Monasteries and convents provided a place for the younger children of the nobility, and even talented members of the lower classes, to pursue challenging, creative, and useful lives as teachers, nurses, writers, and artists, opportunities that generally would have been closed to them in secular life (see "Hildegard of Bingen," page 316). Although they initially had considerable independence, the various orders eventually gave their loyalty to Pope Gregory the Great, thereby becoming a major source of power for the papacy in return for its protection. Through these linkages, Church and State over time became intertwined institutionally to their mutual benefit, thereby promoting growing stability.

Besides the Benedictines, the other important monastic orders of the West included the Cluniacs, the Cistercians, the Carthusians, the Franciscans, and the Dominicans. The Cluniac order (named after its original monastery at Cluny, in France) was founded as a renewal of the original Benedictine rule in 909 by Berno of Baume and 12 brethren on farmland donated by William of Aquitaine. It quickly emerged as the leading international force in Europe, thanks to its unique charter, which made it answerable only to the papacy, then at a low ebb in its power, even as it enjoyed close connections to the Ottonian rulers. Indeed, under the abbots Odilo (ruled 994-1049) and Hugh of Semur (ruled 1049-1109), its authority became so great that it could determine papal elections and influence imperial policy on the one hand while calling for crusades and the reconquest of Spain on the other.

Partly in reaction to the wealth and secular power of the Cluniac order and other church institutions, the Cistercian order was founded in 1098 by Robert of Molesme as a return to the Benedictine rule. The order, headquartered at Cîteaux, reached its apogee under St. Bernard (1090–1153), whose abbey in Clairvaux, settled with 12 brethren, came to surpass Cluny in population and power by the time of his death. Cistercian monasteries were deliberately sited in

remote places, where the monks would come into minimal contact with the outside world, and the rules of daily life were particularly strict. In keeping with this austerity, the order developed an architectural style known as Cistercian Gothic, recognizable by its simplicity and lack of ornamentation (see pages 336, 339).

The Carthusian order was founded by Bruno, an Italian monk, in 1084. Carthusians are in effect hermits, each monk or nun living alone in a separate cell, vowed to silence and devoted to prayer and meditation. The members of each house come together only for religious services and for communal meals several times a year. Because of the extreme austerity and piety of this order, several powerful dukes in the fourteenth and fifteenth centuries established Carthusian houses (charterhouses; French, *chartreuses*), so that the monks could pray perpetually for the souls of the dukes after they died. The most famous of these was the Chartreuse de Champmol, built in 1385 near Dijon, France, as the funerary church of Philip the Bold of Burgundy (see page 352) and his son, John the Fearless.

Eventually the conflict between poverty and work led to the creation of two orders of wandering friars: the Franciscans and the Dominicans. Founded with the blessing of Pope Innocent III, to whom they swore obedience, both orders became arms of papal policy and grew with astonishing rapidity until they inevitably became rivals, thanks in part to their contrasting missions: the Franciscans were devoted to spiritual reform by example, while the purpose of the Dominicans was to combat heresy. The Franciscan order was founded in 1209 by St. Francis of Assisi (c. 1181-1226) as a preaching community. Francis, who was perhaps the most saintly character since Early Christian times, insisted on a life of complete poverty, not only for the members personally, but for the order as a whole. The Poor Clares, established by Francis and St. Clare (1194-1253) near Assisi, was an enclosed order of nuns that followed the ascetic life while ministering to the sick. It, too, underwent spectacular growth, especially in Spain, where it was sponsored by the royal house. Franciscan monks and nuns were originally mendicant—that is, they begged for a living. However, this rule was revised in the fourteenth century.

The Dominican order was established in 1220 by St. Dominic (c. 1170–1221), a Spanish monk who had been a member of the Cistercians. Besides preaching, the Dominicans devoted themselves to the study of theology. They were considered the most intellectual of the religious orders in the late Middle Ages and the Early Renaissance. Whereas the Dominicans were well organized from the start, the Franciscan community did not become a formal order until a papal bull of 1230, and achieved its greatest prominence only under St. Bonaventure (1221–1274), who was, with the Dominican St. Thomas Aquinas (1225–1274), one of the great Doctors of the church. They even taught together at the University of Paris for a while during the early 1250s.

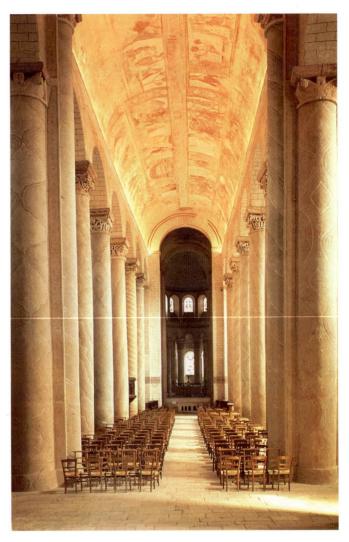

385. Choir (c. 1060–75) and nave (1095–1115), St.-Savin-sur-Gartempe, France

engineering advances that grew out of this discovery were to make possible the soaring churches of the Gothic period (see, for example, figs. 434, 437, and 438). Like St.-Sernin, Autun comes close to straining the limits of the possible. The upper part of the nave wall shows a slight but perceptible outward lean under the pressure of the vault, a warning against any further attempts to increase the height of the clerestory or to enlarge the windows.

HALL CHURCHES. A third alternative, with virtues of its own, appears in the west of France, in such churches as that of St.-Savin-sur-Gartempe (fig. 385). The nave vault here lacks the reinforcing arches, since it was meant to offer a continuous surface for murals (see fig. 416 for this cycle, the finest of its kind). Its great weight rests directly on the nave arcade, which is supported by a majestic set of columns. Yet the nave is fairly well lit, for the two aisles are carried almost to the same height, making it a "hall church," and their outer walls have generously sized windows. At the eastern end of the nave, there is a pilgrimage choir (happily unobstructed in this case) beyond the crossing tower.

The nave and aisles of hall churches are covered by a single roof, as at St.-Savin. The west facade, too, tends to be low and wide, and may become a richly sculptured screen. Notre-

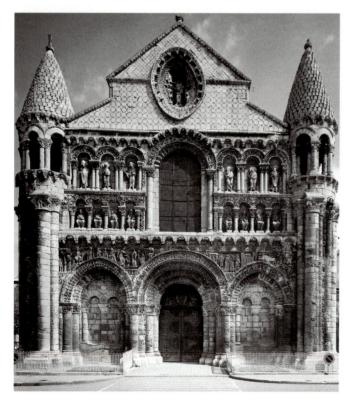

386. West facade, Notre-Dame-la-Grande, Poitiers, France. Early 12th century

Dame-la-Grande at Poitiers (fig. 386), due west from St.-Savin, is particularly noteworthy in this respect. The sculptural program spread out over this entire area is a visual exposition of Christian doctrine that is a feast for the eyes as well as the mind. Below the elaborately bordered arcades housing large seated or standing figures, a wide band of relief stretches across the facade. Essential to the rich sculptural effect is the doorway, which is deeply recessed and framed by a series of arches resting on stumpy columns. Taller bundles of columns enhance the turrets; their conical helmets nearly match the height of the gable in the center, which rises above the actual height of the roof behind it.

Normandy and England

The next major development took place farther north, in Normandy, and for good reason. Ruled by a succession of weak Carolingians before being ceded by the aptly named Charles the Simple to the Danes in 911, the duchy developed under the Capetian dynasty into the most dynamic force in Europe by the middle of the eleventh century. Although it came late, Christianity was enthusiastically supported by the Norman dukes and barons, who played an active role in monastic reform and established numerous abbeys. Normandy soon became a cultural center of international importance.

ST.-ÉTIENNE, CAEN. The architecture of southern France was assimilated and merged with local traditions to produce a new school that evolved in an entirely different direction. The west facade of the abbey church of St.-Étienne at Caen (fig.

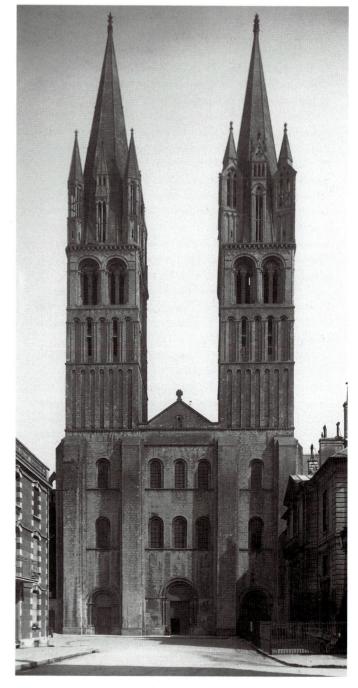

387. West facade, St.-Étienne, Caen, France. Begun 1068

387), founded by William the Conqueror a year or two after his invasion of England in 1066, offers a striking contrast with that of Notre-Dame-la-Grande. Decoration is at a minimum. Four huge buttresses divide the front of the church into three vertical sections, and the vertical impetus continues triumphantly in the two splendid towers, whose height would be impressive enough even without the tall Early Gothic helmets. St.-Étienne is cool and composed: a structure to be appreciated, in all its refinement of proportions, by the mind rather than the eye. The interior is equally remarkable, but in order to understand its importance we must first turn to the extraordinary development of Anglo-Norman architecture in Britain during the last quarter of the eleventh century.

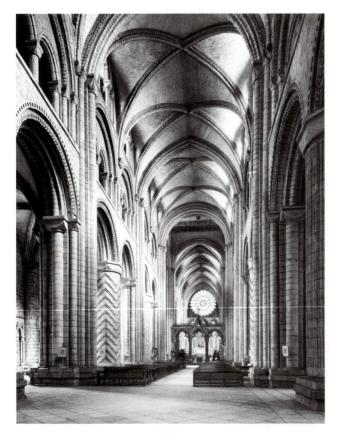

388. Nave (looking east), Durham Cathedral, England. 1093-1130

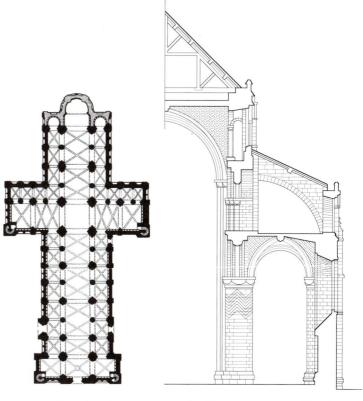

389. Plan of Durham Cathedral (after Conant)

390. Transverse section of Durham Cathedral (after Acland)

DURHAM CATHEDRAL. Its most ambitious product is the Cathedral of Durham (figs. 388-90), just south of the Scottish border, begun in 1093. Though somewhat more austere in plan, it has a nave one-third wider than St.-Sernin's, and a greater overall length (400 feet), which places it among the largest churches of medieval Europe. The nave may have been designed to be vaulted from the start. The vault over its eastern end had been completed by 1107, a remarkably short time, and the rest of the nave, following the same pattern, was finished by 1130. This vault is of great interest, for it represents the earliest systematic use of a ribbed groin vault over a three-story nave, and thus marks a basic advance beyond the solution we saw at Autun. Looking at the plan, we see that the aisles consist of the usual groin-vaulted compartments closely approaching a square, while the bays of the nave, separated by strong transverse arches, are decidedly oblong and groinvaulted in such a way that the ribs form a double-design, dividing the vault into seven sections rather than the conventional four. Since the nave bays are twice as long as the aisle bays, the transverse arches occur only at the odd-numbered piers of the nave arcade, and the piers therefore alternate in size, the larger ones being of compound shape (that is, bundles of column and pilaster shafts attached to a square or oblong core), the others cylindrical.

Perhaps the easiest way to visualize the origin of this peculiar system is to imagine that the architect started out by designing a barrel-vaulted nave, with galleries over the aisles and without a clerestory, as at St.-Sernin, but with the trans-

verse reinforcing arches spaced more widely. The realization suddenly dawned that putting groin vaults over the nave as well as the aisles would gain a semicircular area at the ends of each transverse vault which could be broken through to make a clerestory, because it had no essential supporting functions (fig. 391, left). Each nave bay is intersected by two transverse barrel vaults of oval shape, so that it contains a pair of Siamesetwin groin vaults that divide it into seven compartments. The outward thrust and weight of the whole vault are concentrated at six securely anchored points on the gallery level. The ribs were necessary to provide a stable skeleton for the groin vault, so that the curved surfaces between them could be filled in with masonry of minimum thickness, thus reducing both weight and thrust. We do not know whether this ingenious scheme was actually invented at Durham, but it could not have been created much earlier, for it is still in an experimental stage. While the transverse arches at the crossing are round, those to the west of it are slightly pointed, indicating a continuous search for improvements.

There were other advantages to this system as well. Aesthetically, the nave at Durham is among the finest in all Romanesque architecture. The wonderful sturdiness of the alternating piers makes a splendid contrast with the dramatically lighted, saillike surfaces of the vault. This lightweight, flexible system for covering broad expanses of great height with fireproof vaulting without sacrificing the ample lighting of a clerestory marks the culmination of the Romanesque and the dawn of the Gothic.

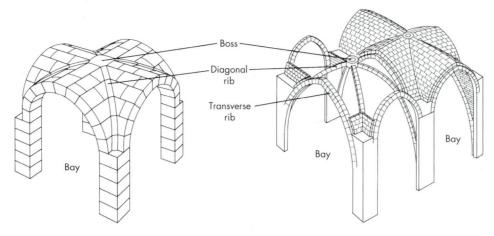

391. Rib vaults (after Acland)

ST.-ÉTIENNE, CAEN. Let us now return to the interior of St.-Étienne at Caen (fig. 392). The nave, it seems, had originally been planned to have galleries and a clerestory, with a wooden ceiling. After the experience of Durham, it became possible, in the early twelfth century, to build a groined nave vault instead, with only slight modifications of the wall design. But the bays of the nave here are approximately square, so that the double-X rib pattern could be replaced by a single X with an additional transverse rib (see fig. 391, right), producing a groin vault of six sections instead of seven. These sexpartite vaults are no longer separated by heavy transverse arches but by simple ribs—another saving in weight that also gives a stronger sense of continuity to the nave vault as a whole and makes for a less emphatic alternating system of piers. Compared to Durham, the nave of St.-Étienne creates an impression of graceful, airy lightness closely akin to the quality of the Gothic choir that was added in the thirteenth century. And structurally, too, we have here reached the point where Romanesque merges into Early Gothic.

Lombardy

We might have expected central Italy, which had been part of the heartland of the original Roman Empire, to have produced the noblest Romanesque of them all, since surviving classical originals were close at hand. Such was not the case, however. All of the rulers having ambitions to revive "the grandeur that was Rome," with themselves in the role of emperor, were in the north of Europe. The spiritual authority of the pope, reinforced by considerable territorial holdings, made imperial ambitions in Italy difficult to achieve. New centers of prosperity, whether arising from seaborne commerce or local industries, tended to consolidate a number of small principalities, which competed among themselves or aligned themselves from time to time, if it seemed politically profitable, with the pope or the German emperor. Lacking the urge to recreate the old empire, and furthermore having Early Christian church buildings as readily accessible as classical Roman architecture, the Tuscans were content to continue what are basically Early Christian forms, but enlivened them with decorative features inspired by pagan architecture.

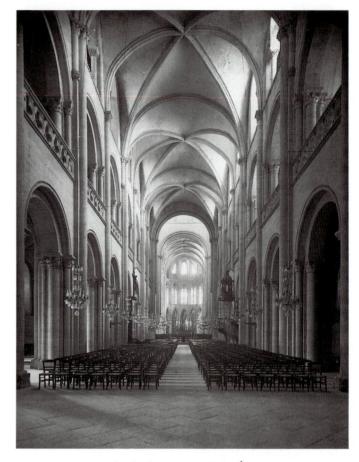

392. Nave (vaulted c. 1115-20), St.-Étienne, Caen

S. AMBROGIO, MILAN. Instead, the lead in developing the Romanesque in Italy was taken by Lombardy, where ancient cities had once again grown large and prosperous. At the time when the Normans and Anglo-Normans constructed their earliest ribbed groined nave vaults, the same problem was being explored in and around Milan, which had devised a rudimentary system of vaulting in the late ninth century during the so-called First Romanesque. Lombard Romanesque architecture was both nourished and impeded by a continuous building tradition reaching back to Roman and Early Christian times and including the monuments of Ravenna. We sense this background as we approach one of its most venerable and important structures, S. Ambrogio in Milan (figs.

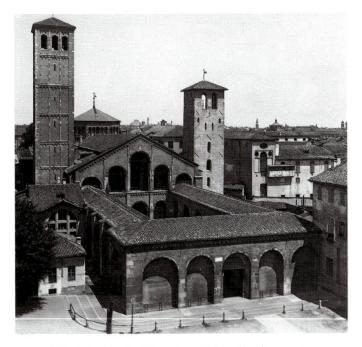

393. S. Ambrogio, Milan. Late 11th and 12th centuries

393 and 394), on a site that had been occupied by a church since the fourth century. The present building was begun in the late eleventh century, except for the apse and southern tower, which date from the tenth. The brick exterior, though more ornate and far more monumental, recalls the proportions and the geometric simplicity of the Ravenna churches

(see S. Apollinare in Classe and S. Vitale; figs. 300 and 317).

Upon entering the atrium, we are confronted by the severely handsome facade, with its deeply recessed arcades. Just beyond it are two bell towers, separate structures just touching the outer walls of the church. We had seen a round tower of this kind on the north side of S. Apollinare in Classe, probably the earliest surviving example, of the ninth or tenth century. Most of its successors are square, but the tradition of the free-standing bell tower, or campanile, remained so strong in Italy that they hardly ever became an integral part of the church proper.

The nave of S. Ambrogio, low and broad (it is some ten feet wider than that at Durham), consists of four square bays separated by strong transverse arches. There is no transept, but the easternmost nave bay carries an octagonal, domed crossing tower or lantern. This was an afterthought, but we can easily see why it was added. The nave has no clerestory and the windows of the lantern provide badly needed illumination. As at Durham, or Caen, there is an alternate system of nave piers, since the length of each nave bay equals that of two aisle bays. The latter are groin-vaulted, like the first three of the nave bays, and support galleries. The nave vaults, however, differ significantly from their northern counterparts. Constructed of brick and rubble, in a technique reminiscent of Roman groin vaults such as those in the Basilica of Constantine, they are a good deal heavier. The diagonal ribs, moreover, form true halfcircles (at Durham and Caen, they are flattened), so that the vaults rise to a point considerably above the transverse arches.

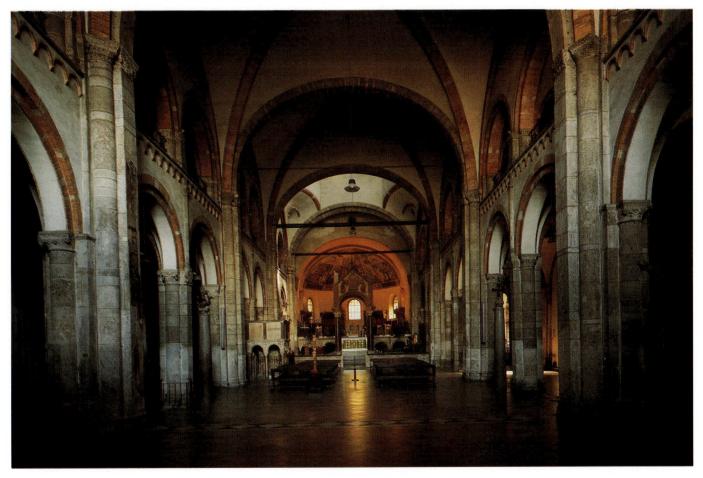

394. Interior, S. Ambrogio

Apart from further increasing the height of the vault, this produces a domed effect and gives each bay the appearance of a separate entity.

On a smaller scale, the Milanese architect might have attempted a clerestory instead of galleries. But the span of the nave was determined by the width of the tenth-century apse, and Lombardy had a taste for ample interior proportions, like those of Early Christian basilicas (compare fig. 302), instead of height and light, as in contemporary Norman churches. Under these circumstances, there was no reason to take risks by experimenting with more economical shapes and lighter construction, so that the ribbed groin vault in Lombardy remained conservative and never approached the proto-Gothic stage.

Germany and the Low Countries

SPEYER CATHEDRAL. German Romanesque architecture, centered in the Rhineland, was equally conservative. Because Speyer was an imperial church, its conservatism reflects the persistence of Carolingian-Ottonian rather than earlier traditions. Begun about 1030, Speyer was not completed until more than a century later. It has a westwork (now sheathed by a modern reconstruction) and an equally monumental eastern grouping of crossing tower and paired stair towers (fig. 395). As on many German facades of the same period, the architectural detail derives from the First Romanesque in Lombardy (compare S. Ambrogio), long a focus of German imperial ambitions. However, the tall proportions are northern, and the scale is so great as to dwarf every other church of the period. The nave, one-third taller and wider than that of

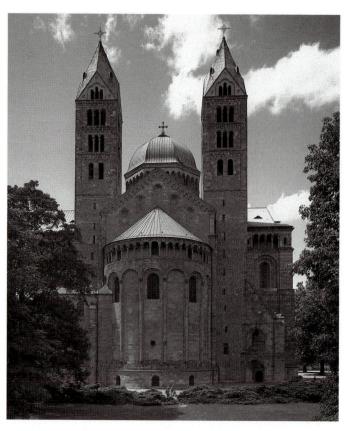

395. Speyer Cathedral, Germany, from the east. Begun 1030

Durham, has a generous clerestory, since it was planned for a wooden roof. Only in the early twelfth century was it divided into square bays and covered with heavy, unribbed groin vaults akin to the Lombard rather than the Norman type.

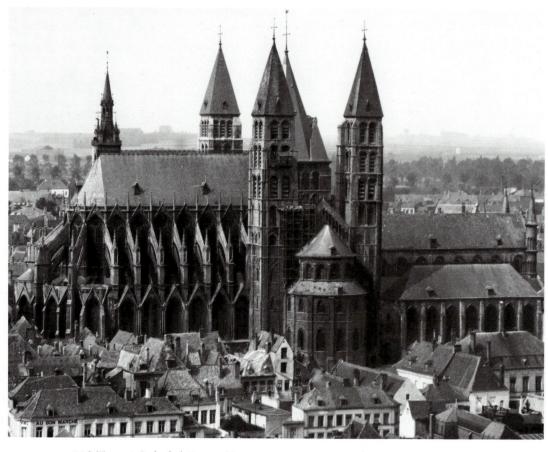

396. Tournai Cathedral, France. Nave, 1110-71; transept and crossing, c. 1165-1213

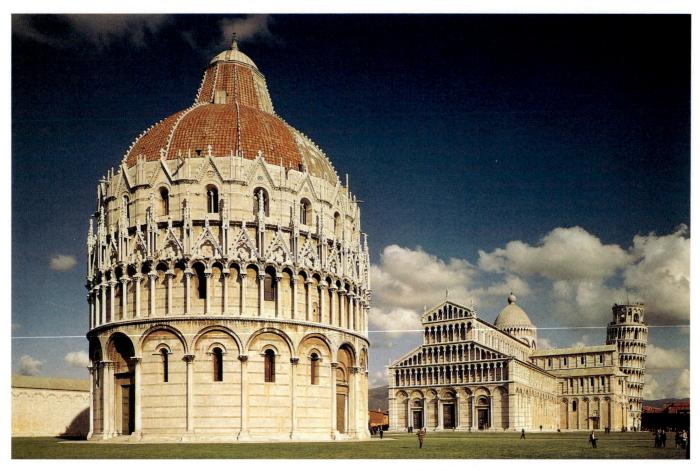

397. Pisa Baptistery, Cathedral, and Campanile (view from the west). 1053–1272

TOURNAI CATHEDRAL. The impressive eastern end of Speyer Cathedral is echoed in a number of churches of the Rhine Valley and the Low Countries. In the Cathedral of Tournai (fig. 396), it occurs twice, at either end of the transept. The result is the most memorable massing of towers anywhere in Romanesque architecture. Originally, there were to have been four more: two at the west facade (later reduced to turrets) and two flanking the eastern apse (replaced by a huge Gothic choir). Such multiple towers had been firmly established in medieval church design north of the Alps since the time of Charlemagne (see fig. 361), although few complete sets were ever finished and even fewer have survived. Their popularity can hardly be accounted for on the basis of their practical functions (whether stair towers, bell towers, or watchtowers). In a way not easily fathomed today, they expressed medieval man's relation to the supernatural, as the ziggurats had done for the ancient Mesopotamians. (The story of the Tower of Babel fascinated the people of the Middle Ages.) Perhaps their symbolic meaning is best illustrated by a "case history." A certain count had a quarrel with the people of a nearby town, led by their bishop. He finally laid siege to the town, captured it, and, to express his triumph and humiliate his enemies, he lopped the top off their cathedral tower. Evidently, loss of tower meant loss of face, for towers were considered architectural symbols of strength, power, and authority.

Tuscany

CAMPANILE, BAPTISTERY, AND CATHEDRAL, PISA. The most famous tower of all owes its renown to an accident:

the Leaning Tower of Pisa (or, more precisely, the Campanile of Pisa Cathedral), designed by the sculptor Bonanno Pisano (active 1174–86), began to assume its present angle, because of poor foundations, even before completion (fig. 397). The tower forms part of a magnificent ensemble on an open site north of the city that includes the Cathedral and the circular, domed Baptistery to the west of it. They represent the most ambitious monument of the Tuscan Romanesque, reflecting the wealth and pride of the city-republic of Pisa after its naval victory at Palermo in 1062.

Far more than Lombardy, with its strong northward connections, Tuscany retained an awareness of its classical heritage throughout the Middle Ages. If we compare Pisa Cathedral, on the one hand, with S. Apollinare in Ravenna and, on the other, with St.-Sernin in Toulouse (see figs. 300 and 380), we are left in little doubt that the latter is its closer relation. But the essential features and even the detached bell tower still continue much as we see them in S. Apollinare. The plan of Pisa Cathedral is essentially that of an Early Christian basilica, elaborated into a Latin cross by the addition of two transept arms that resemble smaller basilicas in themselves, with apses of their own. The crossing is marked by a dome, but the rest of the church is wooden-roofed except for the aisles (four in the nave, two in the transept arms), which have groin vaults. The interior (fig. 398) has somewhat taller proportions than an Early Christian basilica, because there are galleries over the aisles, as well as a clerestory. Yet the splendid files of classical columns supporting the nave and aisle arcades inevitably recall such Roman structures as St. Paul Outside the Walls (see fig. 299).

The only deliberate revival of the antique Roman style in

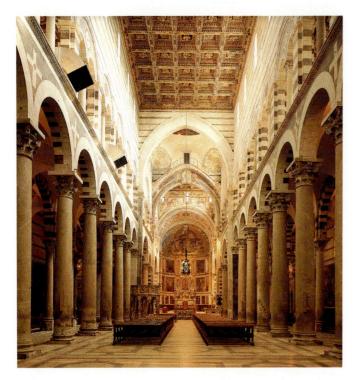

398. Interior, Pisa Cathedral

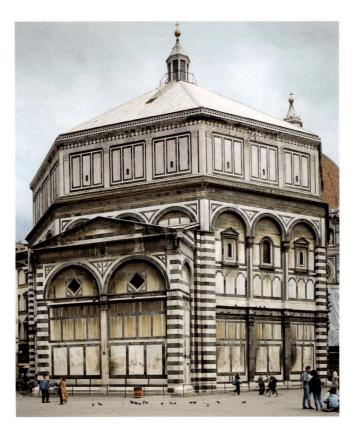

399. Baptistery of S. Giovanni, Florence. c. 1060-1150

Tuscan architecture was in the use of a multicolored marble "skin" on the exteriors of churches. Little of this is left in Rome, a great deal of it having literally been "lifted" for the embellishment of later structures, but the interior of the Pantheon still gives us some idea of it (see fig. 246). We can recognize the desire to emulate such marble inlay in Pisa

Cathedral and its companions, which are sheathed entirely in white marble inlaid with horizontal stripes and ornamental patterns in dark-green marble. It is combined with blind arcades and galleries, producing a lacelike richness of texture and color very different from the austerely simple Early Christian exteriors. But by now the time had long passed when it might be thought undesirable for a church to compete with the outward splendor of classical temples.

BAPTISTERY OF S. GIOVANNI, FLORENCE. In Florence, which was to outstrip Pisa commercially and artistically, the greatest achievement of the Tuscan Romanesque is the Baptistery (fig. 399), opposite the Cathedral. It is a domed octagonal structure of impressive size. Here the green-and-white marble paneling follows severe geometric lines, and the blind arcades are extraordinarily classical in proportion and detail. The entire building, in fact, exudes so classical an air that the Florentines themselves came to believe, a few hundred years later, that it had originally been a temple of Mars. And even today the controversy over its date has not yet been settled to everyone's satisfaction. We shall return to this baptistery a number of times, since it was destined to play an important role in the Renaissance.

SCULPTURE

The revival of monumental stone sculpture is even more surprising than the architectural achievements of the Romanesque era, since neither Carolingian nor Ottonian art had shown any tendencies in this direction. Free-standing statues, we will recall, all but disappeared from Western art after the fifth century. Stone relief in turn survived only in the form of architectural ornament or surface decoration, with the depth of the carving reduced to a minimum. Thus the only continuous sculptural tradition in early medieval art was that of sculpturein-miniature: small reliefs and occasional statuettes, in metal or ivory. Ottonian art, in works such as the bronze doors of Bishop Bernward (see fig. 375), had enlarged the scale of this tradition but not its spirit. Moreover, its truly large-scale sculptural efforts, represented by the impressive Gero Crucifix (fig. 370), were limited almost entirely to wood. What little stone carving there was in western Europe before the mid-eleventh century hardly went beyond the artistic and technical level of the Sigvald relief (fig. 356).

Southwestern France

Fifty years later, the situation had changed dramatically. Just when and where the revival of stone sculpture began we cannot say with certainty, but the earliest surviving examples are found in southwestern France and northern Spain, along the pilgrimage roads leading to Santiago de Compostela. The link with the pilgrimage traffic seems logical enough, for architectural sculpture, especially when applied to the exterior of a church, is meant to appeal to the lay worshiper rather than to the members of a closed monastic community.

ST.-SERNIN, TOULOUSE. As in Romanesque architecture, the rapid development of stone sculpture shortly before

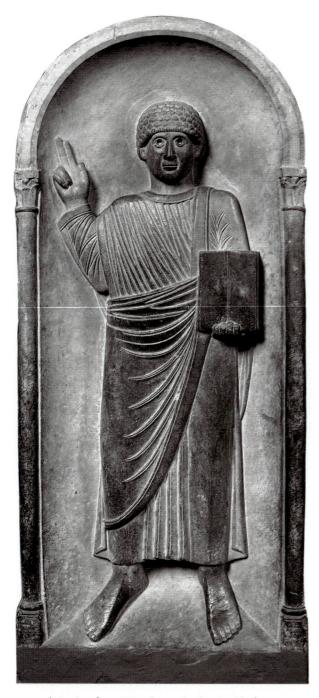

400. Apostle. c. 1090. Stone. St.-Sernin, Toulouse

1100 coincides with the growth of religious fervor among the lay population in the decades before the First Crusade. St.-Sernin at Toulouse contains several important examples probably carved about 1090, including the *Apostle* in figure 400. This panel is now in the ambulatory; its original location remains uncertain, but it perhaps decorated the front of an altar. Where have we seen its like before? The solidity of the forms has a strongly classical air, indicating that our artist must have had a close look at late Roman sculpture, of which there are considerable remains in southern France. But the solemn frontality of the figure and its placement in the architectural frame show that the design as a whole must derive from a Byzantine source, in all likelihood an ivory panel descended from the *Archangel Michael* in figure 315.

In enlarging such a miniature, the carver of our relief has also reinflated it. The niche is a real cavity, the hair a round, close-fitting cap, the body severe and blocklike. Our *Apostle* has, in fact, much the same dignity and directness as the sculpture of Archaic Greece. The figure, somewhat more than half-lifesize, was not intended for viewing at close range only. Its impressive bulk and weight "carry" over a considerable distance. This emphasis on massive volume hints at what may well have been the main impulse behind the revival of large-scale sculpture. A stone-carved image, being tangible and three-dimensional, is far more "real" than a painted one. To the mind of a cleric steeped in the abstractions of theology, this might seem irrelevant, or even dangerous. For the unsophisticated laity, any large sculpture had something of the quality of an idol, and it was this fact that gave it such great appeal.

ST.-PIERRE, MOISSAC. Another important early center of Romanesque sculpture was the abbey at Moissac, some distance north of Toulouse. In figure 401 we see the magnificent trumeau (the center post supporting the lintel) and the western jamb of the south portal. (The parts of typical medieval portals are shown in fig. 403.) Both have a scalloped profileapparently a bit of Moorish influence—and the shafts of the half-columns applied to jambs and trumeau follow this scalloped pattern, as if they had been squeezed from a giant pastry tube. Human and animal forms are treated with the same incredible flexibility, so that the spidery prophet on the side of the trumeau seems perfectly adapted to his precarious perch. (Notice how he, too, has been fitted into the scalloped outline.) He even remains free to cross his legs in a dancelike movement and to turn his head toward the interior of the church as he unfurls his scroll.

But what of the crossed lions that form a symmetrical zigzag on the face of the trumeau—do they have a meaning? So far as we know, they simply "animate" the shaft, just as the interlacing beasts of Irish miniatures (whose descendants they are) animate the compartments assigned to them. In manuscript illumination, this tradition had never died out. Our sculpture has undoubtedly been influenced by it, just as the agitated movement of the prophet has its ultimate origin in miniature painting (see fig. 414). The crossed lions reflect another source as well. We can trace them through textiles to Persian metalwork (although not in this towerlike formation), whence they can be traced back to the confronted animals of ancient Near Eastern art (see figs. 50, 92, and 135). Yet we cannot fully account for their presence at Moissac in terms of their effectiveness as ornament. They belong to an extensive family of savage or monstrous creatures in Romanesque art that retain their demoniacal vitality even though they are compelled, like our lions, to perform a supporting function. (A similar example may be seen in fig. 407.) Their purpose is thus not only decorative but expressive. They embody dark forces that have been domesticated into guardian figures or banished to a position that holds them fixed for all eternity, however much they may snarl in protest.

The south portal at Moissac displays the same richness of invention that St. Bernard of Clairvaux condemned in his famous letter of 1127 to Abbot William of St. Thierry about the sculpture of Cluny. [See Primary Sources, no. 32, pages

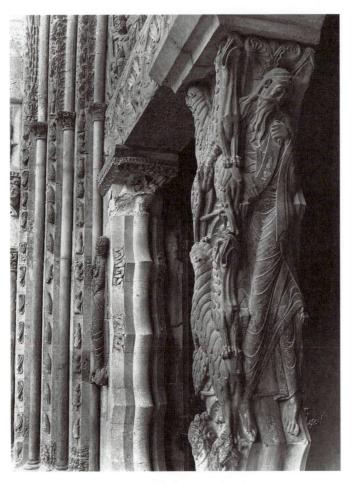

401. South portal (portion), St.-Pierre, Moissac, France. Early 12th century

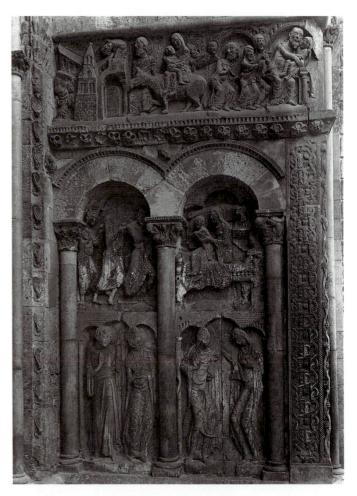

402. East flank, south portal, St.-Pierre, Moissac (the angel of the *Annunciation*, bottom left, is modern)

387–88.] Although he did not object specifically to the role of art in teaching the unlettered, St. Bernard had little use for church decoration. He would surely have disapproved of the Moissac portal's excesses, which were clearly meant to appeal to the eye—as Bernard's begrudging admiration for the cloister at Cluny so eloquently attests.

The portal proper at Moissac is preceded by a deep porch, with lavishly sculptured sides. Within the arcade on the east flank (fig. 402) we see the *Annunciation* and *Visitation*, as well as the *Adoration of the Magi*. Other events from the early life of Christ are shown on the frieze above. Here we find the same thin limbs, the same eloquent gestures we saw in the prophet on the trumeau. (Note especially the wonderful play of hands in the *Visitation* and *Annunciation*.) Only the proportions of the bodies and the size of the figures vary with the architectural context. What matters is the vividness of the narrative, rather than consistency of treatment.

Burgundy

AUTUN CATHEDRAL. The tympanum (the lunette above the lintel) of the main portal of Romanesque churches usually holds a composition centered on the Enthroned Christ, most often the Apocalyptic Vision, or the Last Judgment, the most awesome scene of Christian art. At Autun Cathedral, this subject has been visualized with singularly expressive force by Giselbertus (fig. 404), who probably based his imagery on a contemporary account rather than relying on the Revelation of St. John the Divine. The apostles, at the viewer's left, observe the weighing of souls to the right. Four angels in the corners sound the trumpets of the Apocalypse. At the bottom, the dead rise from their graves in fear and trembling; some are already beset by snakes or gripped by huge, clawlike hands. Above, their fate quite literally hangs in the balance, with devils yanking at one end of the scales and angels at the other. The saved souls cling like children to the angels for protection before their ascent to the Heavenly Jerusalem (far left), while the condemned, seized by grinning devils, are cast into the mouth of Hell (far right).

These devils betray the same nightmarish imagination we observed in the Romanesque animal world. They are composite creatures, human in general outline but with spidery, birdlike legs, furry thighs, tails, pointed ears, and enormous, savage mouths. Their violence, unlike that of the animal monsters, is unchecked, and they enjoy themselves to the full in their grim occupation. No visitor, having "read in the marble" here (to speak with St. Bernard of Clairvaux), could fail to enter the church in a chastened spirit.

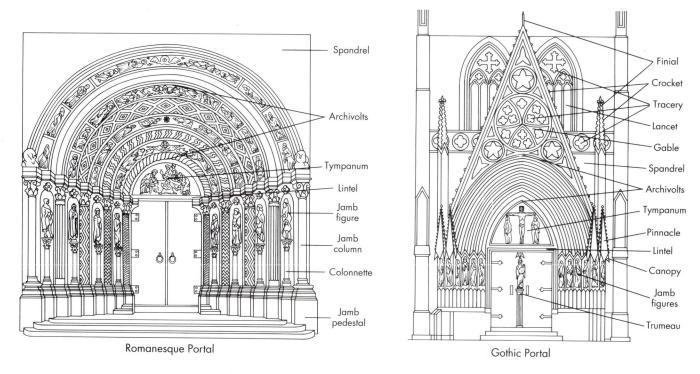

403. Romanesque and High Gothic portal ensembles

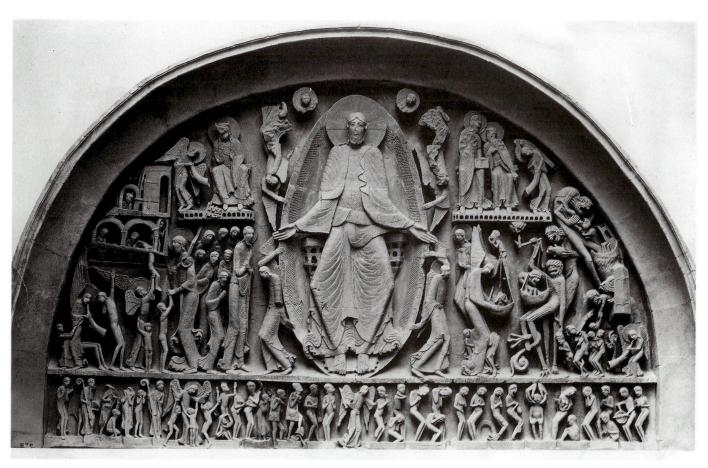

404. Giselbertus. Last Judgment, west tympanum, Autun Cathedral. c. 1130–35

405. Giselbertus. *Eve*, right half of lintel, north portal, from Autun Cathedral. Musée Rolin, Autun

The emergence of distinct artistic personalities in the twelfth century is a phenomenon that is rarely acknowledged, perhaps because it contradicts the widespread notion that all medieval art is anonymous. It does not happen very often, of course, but it is no less significant for all that. Giselbertus is not an isolated case. He cannot even claim to be the earliest. He is among a number of Romanesque sculptors who are

known to us by name; nor is this an accident. Their highly individual styles made theirs the first identities worthy of being recorded since Anthemius of Tralles and Isidorus of Miletus a half-millennium earlier.

The work of Giselbertus is distinguished from that of his contemporaries by its unusually wide range. As at Moissac, it varies according to subject and location. His *Eve* (fig. 405) is as whimsical as the *Last Judgment* is terrifying. She is delicately plucking the apple from the Tree of Knowledge with an irresistible come-hither look at the missing Adam, who no doubt faced her. The languorous pose, necessitated by the door lintel she adorns, allows Giselbertus to model her figure with captivating—and surprisingly sensual—beauty.

STE.-MADELEINE, VÉZELAY. Giselbertus began his career at Cluny (see pages 316–17), where he may have served as chief assistant to the unknown master responsible for perhaps the most beautiful of all Romanesque tympanums, that of Ste.-Madeleine in Vézelay, not far from Autun (fig. 406). [See Primary Sources, no. 31, pages 386–87.] Its subject, the Mission of the Apostles, had a special meaning for this age of crusades, since it proclaims the duty of every Christian to spread the Gospel to the ends of the earth. From the hands of the majestic ascending Christ we see the rays of the Holy Spirit pouring down upon the apostles, all of them equipped with copies of the Scriptures in token of their mission. The lintel and the compartments around the central group are filled with representatives of the heathen world, a veritable encyclopedia

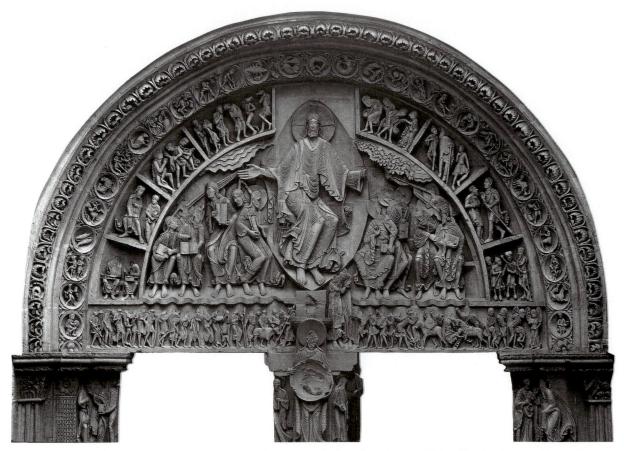

406. The Mission of the Apostles, tympanum of center portal of narthex, Ste.-Madeleine, Vézelay, France. 1120-32

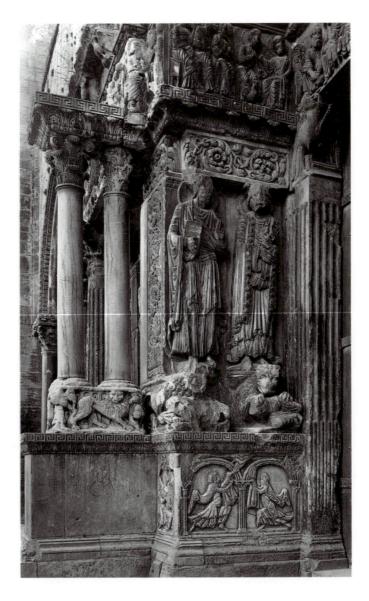

407. North jamb, center portal, St.-Gilles-du-Gard, France. Second quarter of the 12th century

of medieval anthropology which includes all sorts of legendary races. On the archivolt (the arch framing the tympanum) we recognize the signs of the zodiac and the labors appropriate to every month of the year, to indicate that the preaching of the Faith is as unlimited in time as it is in space.

Romanesque Classicism

PROVENCE. The portal sculpture at Moissac, Autun, and Vézelay, although varied in style, has many qualities in common: intense expression, unbridled fantasy, and a nervous agility of form that owes more to manuscript illumination and metalwork than to the sculptural tradition of antiquity. The *Apostle* from St.-Sernin, in contrast, had impressed us with its stoutly "Roman" flavor. The influence of classical monuments was particularly strong in Provence, the coastal region of southeastern France, which had been part of the Graeco-Roman world far longer than the rest of the country and is full of splendid Roman remains. Perhaps for this reason, the Romanesque style persisted longer in these areas than elsewhere. Looking at the center portal of the church at St.-Gilles-du-Gard (fig. 407), one of the great masterpieces of Romanesque art, we are struck

immediately by the classical flavor of the architectural framework, with its free-standing columns, meander patterns, and fleshy acanthus ornament. The two large statues, carved almost in the round, have a sense of weight and volume akin to that of the *Apostle* from St.-Sernin, although, being half a century later in date, they also display the richness of detail we have observed in the intervening monuments. They stand on brackets supported by crouching beasts of prey, and these, too, show a Roman massiveness, while the small figures on the base (Cain and Abel) recall the style of Moissac.

Spain and Italy

STO. DOMINGO DE SILOS. The French style soon spread to Spain, first to Santiago da Compostela, where the sculpture has unfortunately been much rearranged, then to Sto. Domingo de Silos, which became an important destination in its own right, even though it lies some 60 miles off the pilgrimage route. Among the reliefs in the cloister of Sto. Domingo, which were probably carved in the second quarter of the twelfth century, is the splendid *Doubting of Thomas* in figure 408. The composition, with its apostles who appear to have been cut from the

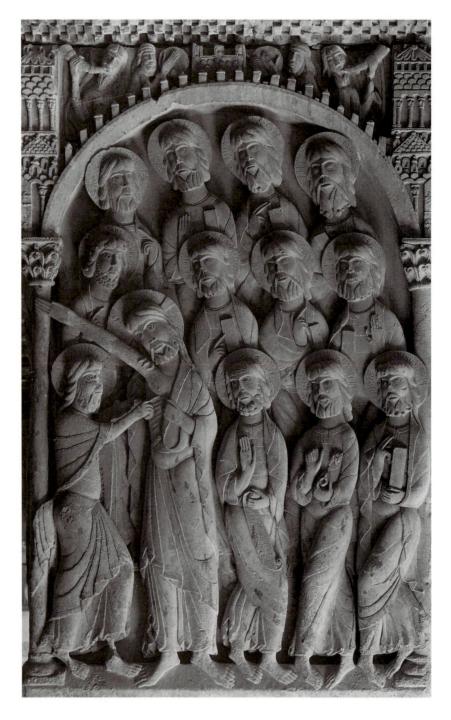

408. The Doubting of Thomas. c. 1130–40. Marble. Cloister, Sto. Domingo de Silos, Spain

same mold, is indebted to Ottonian art (compare fig. 377). The subtle carving technique owes something to France as well, in particular the corner piers of the cloister at Moissac. It shares other features found in Romanesque sculpture outside Spain: the elongated forms, angular poses, and emphatic gestures. Yet we cannot account for the appearance of this work solely in terms of external influences. *The Doubting of Thomas* is, in fact, a highly original achievement, for there is nothing like it elsewhere. The unaffected plainness is both disarming and deceptive—the extreme stylization lends the scene an expressiveness that is as moving as it is direct. Like the Gregorian chants for which Silos is still renowned, this relief is a testimony to faith of unmatched eloquence. They share similar formal means as well: both rely on the repetition of unadorned motifs in simple cadence for their cumulative effect.

WILIGELMO. Although the French style quickly became international, it was modified through interaction with local tradition. We see this process in the work of Wiligelmo, whose reliefs from Genesis (fig. 409) on the facade of Modena Cathedral are rightly credited with inaugurating Romanesque sculpture in Italy. The scenes show a surprising kinship to the doors of Bishop Bernward at Hildesheim (fig. 375), which suggests that Wiligelmo perhaps hailed from Germany, where he may have been trained as a goldsmith under the name Wilhelm. If so, he must also have been familiar with the Romanesque style then emerging in Burgundy, as a glance at the frieze depicting the early life of Christ along the porch at Moissac attests (fig. 402). Nevertheless, the figures show a knowledge of the nude that can have been gained only in Italy itself. Moreover, they have a ponderousness, derived from

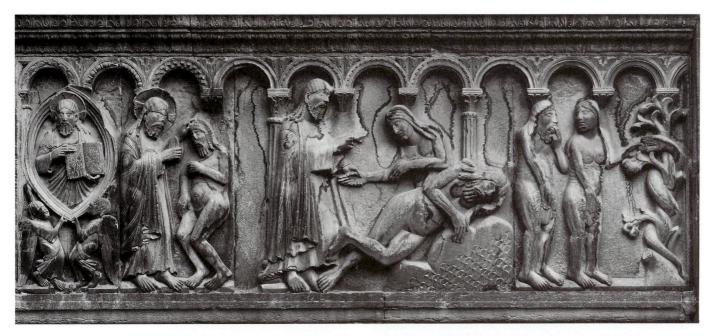

409. Wiligelmo. Scenes from Genesis. c. 1106-20. Marble, height approx. 36" (91.5 cm). Cathedral, Modena, Italy

Early Christian ivory panels done in Italy, that seems all the more astonishing in comparison to the spindly Adam and Eve at Hildesheim, from which they descend. This solidity in turn lends the scenes a solemn dignity, as against the urgent drama seen on Bernward's doors (compare fig. 376). The artist was proud of his work, and justly so: an inscription boasts, "Among sculptors, your work shines through, Wiligelmo." That Italian sculpture was revived by a German is by no means surprising: the tradition had all but died out by the middle of the eighth century, while northern Italy remained in the hands of German rulers, who also acted as protectors of the papacy in Rome.

ANTELAMI. The nascent classicism of Wiligelmo reaches its height toward the end of the twelfth century in the splendid figure of King David from the facade of Fidenza Cathedral in Lombardy (fig. 410) by Benedetto Antelami, the greatest sculptor of Italian Romanesque art. As we have seen, artists' signatures are far from rare in Romanesque times. What makes Antelami exceptional is the fact that his work shows a much greater degree of individuality than is evident in other artists' work, so that, for the first time since the ancient Greeks, we can begin to speak (though with some hesitation) of a personal style. Furthermore, unlike Wiligelmo he is a monumental sculptor at heart, not a relief carver. Thus, his King David approaches the ideal of the self-sufficient statue more closely than any medieval work we have seen so far. The Apostle from St.-Sernin is one of a series of figures, all of them immutably fixed to their niches, while Antelami's King David stands physically free and even shows an attempt to recapture the classical contrapposto. To be sure, he would look awkward if placed on a pedestal in isolation. He demands the architectural framework for which he was made, but certainly to a far lesser extent than do the two statues at St.-Gilles, to which he is otherwise kin. Nor is he subject to the group discipline of a series; his only companion is a second niche statue on the other side of the

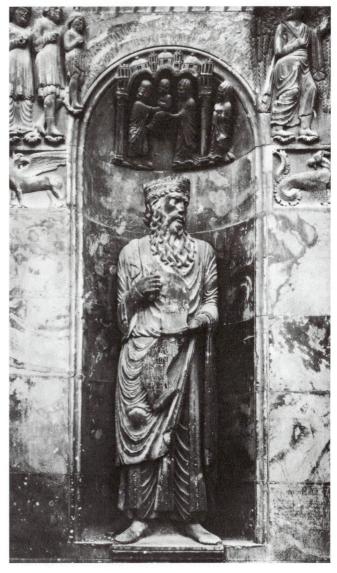

410. Benedetto Antelami. *King David.* c. 1180–90. West facade, Fidenza Cathedral, Italy

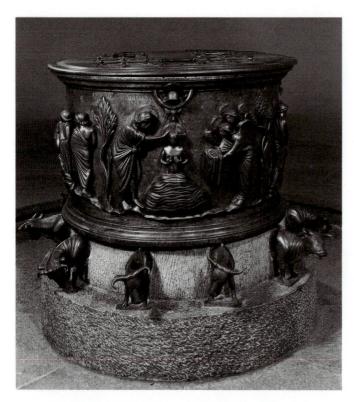

411. Renier of Huy. Baptismal Font. 1107–18. Bronze, height 25" (63.5 cm). St.-Barthélemy, Liège, Belgium

portal. We note, too, that the figure is lost in thought. Indeed, such expressiveness, new to Romanesque sculpture, is characteristic of Benedetto's work as a whole. We shall meet it again in the statues of Donatello. The *King David* is an extraordinary achievement indeed, especially if we consider that less than a hundred years separate it from the beginnings of the sculptural revival.

The Meuse Valley

The revival of individuality is also found in one particular region of the north, the valley of the Meuse River, which runs from northeastern France into Belgium and Holland. This region had been the home of the classicizing Reims style in Carolingian times (see figs. 367 and 368), and that awareness of classical sources pervades its art (called Mosan) during the Romanesque period. Here again, interestingly enough, the revival of individuality is linked with the influence of ancient art, although this influence did not produce works on a monumental scale.

Mosan Romanesque sculpture excelled in metalwork, such as the splendid baptismal font of 1107–18 in Liège (fig. 411), which is also the masterpiece of the earliest among the individually known artists of the region, Renier of Huy. The vessel rests on 12 oxen (symbols of the 12 apostles), like Solomon's basin in the Temple at Jerusalem as described in the Bible. The reliefs make an instructive contrast with those of Bernward's doors (see fig. 376), since they are about the same height. Instead of the rough expressive power of the Ottonian panel, we find here a harmonious balance of design, a subtle control of the sculptured surfaces, and an understanding of organic structure that, in medieval terms, are amazingly classical. The

412. Lion Monument. 1166. Bronze, length approx. 6' (1.8 m). Cathedral Square, Brunswick, Germany

figure seen from the back (beyond the tree on the left in our illustration), with its graceful turning movement and Greeklooking drapery, might almost be taken for an ancient work.

Germany

The one monumental free-standing statue of Romanesque art—perhaps not the only one made, but the only one that has survived—is that of an animal, and in a secular rather than a religious context: the lifesize bronze lion on top of a tall shaft that Duke Henry the Lion of Saxony had placed in front of his palace at Brunswick in 1166 (fig. 412). The wonderfully ferocious beast personifies the duke, or at least that aspect of his personality that earned him his nickname. It will remind us in a curious way of the archaic bronze she-wolf of Rome (see fig. 232). Perhaps the resemblance is not entirely coincidental, since the she-wolf was on public view in Rome at that time and must have had a strong appeal for Romanesque artists.

The more immediate relatives of the Brunswick lion, however, are the countless bronze water ewers in the shape of lions, dragons, griffins, and such, that came into use in the twelfth century for the ritual washing of the priest's hands during Mass. These vessels, another instance of monsters doing menial service for the Lord, were of Near Eastern inspiration. The beguiling specimen reproduced in figure 413 still betrays its descent from the winged beasts of Persian art, transmitted to the West through trade with the Islamic world.

413. Ewer. Mosan. c. 1130. Gilt bronze, height $7^{1/4}$ " (18.5 cm). Victoria & Albert Museum, London

PAINTING AND METALWORK

Unlike architecture and sculpture, Romanesque painting shows no sudden revolutionary developments that set it apart immediately from Carolingian or Ottonian. Nor does it look more "Roman" than Carolingian or Ottonian painting. This does not mean, however, that in the eleventh and twelfth centuries painting was any less important than it had been during the earlier Middle Ages. The absence of dramatic change merely emphasizes the greater continuity of the pictorial tradition, especially in manuscript illumination.

France

GOSPEL BOOK, CORBIE. Nevertheless, soon after the year 1000 we find the beginnings of a painting style that corresponds to—and often anticipates—the monumental qualities of Romanesque sculpture. The new attitude is clearly evident in the St. Mark (fig. 414), from a Gospel Book probably done toward 1050 at the monastery of Corbie in northern France. The twisting and turning movement of the lines, which pervades not only the figure of the evangelist but the winged lion, the scroll, and the curtain, recalls Carolingian miniatures of the Reims School such as the Ebbo Gospels (see fig. 367). This very resemblance helps us see the differences between the two works. In the Corbie manuscript, every trace of classical illusionism has disappeared. The fluid modeling of the Reims School, with its suggestion of light and space, has been replaced by firmly drawn contours filled in with bright, solid colors, so that the three-dimensional aspects of the picture are reduced to overlapped planes. Even Ottonian painting (see figs. 377 and 378) seems illusionistic in comparison. Yet

414. *St. Mark*, from a Gospel Book produced at Corbie. c. 1050. Bibliothèque Municipale, Amiens, France

by sacrificing the last remnants of modeling in terms of light and shade, the Romanesque artist has endowed his work with an abstract clarity and precision that had not been possible in Carolingian or Ottonian times. Only now can we truly say that the representational, the symbolic, and the decorative elements of the design are knit together into a single, unified structure.

This style of rhythmic lines and planes eschews all effects that might be termed specifically pictorial, including not only tonal values but the rendering of textures and highlights such as we still find in Ottonian painting. For that very reason, however, it gains a new universality of scale. The evangelists of the *Ebbo Gospels*, the drawings of the *Utrecht Psalter*, and the miniatures in the *Gospel Book of Otto III* are made up of open, spontaneous flicks and dashes of brush or pen that have an intimate, handwritten flavor. They would certainly look strange if copied on a larger scale or in another medium. The Corbie miniature, on the contrary, might be translated into a mural, a stained-glass window, a tapestry, or a relief panel without losing any of its essential qualities.

415. *The Battle of Hastings.* Detail of the *Bayeux Tapestry.* c. 1073–83. Wool embroidery on linen, height 20" (50.7 cm). Centre Guillaume le Conquerant, Bayeux, France

BAYEUX TAPESTRY. This monumentality is much the same as in the Vézelay tympanum (fig. 406), where similar pleated drapery patterns are rendered in sculptural terms. It is found again in the so-called Bayeux Tapestry, an embroidered frieze 230 feet long illustrating William the Conqueror's invasion of England. In our detail (fig. 415), portraying the Battle of Hastings, the designer has integrated narrative and ornament with consummate ease. The main scene is enclosed by two border strips that perform a framing function. The upper tier with birds and animals is purely decorative, but the lower strip is full of dead warriors and horses and thus forms part of the story. Although told in a direct style devoid of such pictorial devices of classical painting as foreshortening and overlapping (see fig. 199), the tapestry gives us an astonishingly vivid and detailed account of warfare in the eleventh century. The massed forms of the Graeco-Roman scene are gone, replaced by a new kind of individualism that makes of each combatant a potential hero, whether by force or cunning. (Observe how the soldier who has fallen from the horse that is somersaulting with its hind legs in the air is, in turn, toppling his adversary by yanking at the saddle girth of his mount.) The stylistic kinship with the Corbie manuscript is apparent in the lively somersaults of the falling horses, so strikingly like the pose of the lion in the miniature.

ST.-SAVIN-SUR-GARTEMPE. The firm outlines and a strong sense of pattern found in the English Channel region are equally characteristic of Romanesque wall painting in southwestern France. The Building of the Tower of Babel (fig. 416) is part of the most impressive surviving cycle, on the nave vault of the church at St.-Savin-sur-Gartempe (compare fig. 385). It is an intensely dramatic design, crowded with strenuous action. The Lord himself, on the far left, participates directly in the narrative as he addresses the builders of the colossal structure. He is counterbalanced, on the right, by the giant Nimrod, the leader of the enterprise, who frantically hands blocks of stone to the masons atop the tower, so that the entire scene becomes a great test of strength between God and human. The heavy dark contours and the emphatic play of gestures make the composition eminently readable from a distance. Yet, as we shall see, the same qualities occur in the illuminated manuscripts of the region, which can be equally monumental despite their small scale.

Where did the idea come from to cover such a vast area with murals? Surely not from France itself, which had no tradition of monumental painting, but from Byzantium (see fig. 349)—probably by way of Italy, which had strong ties to the East (see pages 238–40). Toward the end of the eleventh century, Greek artists decorated the newly constructed basilican church of

416. The Building of the Tower of Babel. Detail of painting on the nave vault, St.-Savin-sur-Gartempe. Early 12th century

417. The Arrest of Christ. c. 1085. Fresco. S. Angelo in Formis, Capua, Italy

the Benedictine monastery at Monte Cassino with mosaics at the invitation of Abbot Desiderius (later Pope Victor III). Although they no longer survive, their impact can be seen in the frescoes painted a short time later in the church of S. Angelo in Formis near Capua, also built by Desiderius. *The Arrest of Christ*, along the nave (fig. 417), is a counterpart to the mosaics and murals that line the arcades of Early Christian

basilicas, whose splendor Desiderius sought to recapture (compare fig. 299). The painting shows its Byzantine heritage, but it has been adapted to Latin liturgical requirements and taste. What it lacks in sophistication this monumental style more than makes up for in expressive power. That very quality appealed to Western artists, as it was in keeping with the vigorous art that emerged at the same time in the *Bayeux Tapestry*.

The late tenth through the twelfth century witnessed the unprece-

dented rise of women, first as patrons of art and then as artists. This remarkable chapter began with the Ottonian dynasty, which forged an alliance with the Church by placing members of the family in prominent positions. Thus, Mathilde, Otto I's granddaughter, became abbess of the Holy Trinity convent at Essen in 974; later, the sister, daughters, and granddaughter of Otto II also served as abbesses of major convents. Hardly less important, though not of royal blood, were Hrosvitha, canoness at the monastery of Gandersheim, who was the first woman dramatist we know of, and the two abbesses of Niedermünster, both named Uota. They paved the way for Herrad of Hohenberg (died 1195), author of *The Garden of Delights*, an encyclopedia of knowledge and history compiled for the education of her nuns.

Most remarkable of all was the Benedictine abbess Hildegard of Bingen (1098-1179). Among the most brilliant women in history, she was in close contact with leaders throughout Europe. In addition to a musical drama in Latin, the Ordo Virtutum, about the struggle between the forces of good and evil, she composed almost 80 vocal works that rank with the finest of the day. She also wrote some 13 books on theology, medicine, and science. But she is known above all for her books of visions, which made her one of the great spiritual voices of her day. Although one (To Know the Ways of God) is now known only in facsimile (it was destroyed in 1945) and the other (The Book of Divine Works) in a later reproduction, it seems likely that the originals were executed under her direct supervision by nuns in her convent along the Rhine. It has also been argued that they were done by monks at nearby monasteries.

Hildegard of Bingen

That there were women artists in the twelfth century is certain,

although we know only a few of their names. In one instance, an initial in a manuscript includes a nun bearing a scroll inscribed, "Guda, the sinful woman, wrote and illuminated this book"; another book depicts Claricia, evidently a lay artist, swinging as carefree as any child from the letter Q she has decorated. Without these author portraits, we might never suspect the involvement of women illuminators.

"The Fountain of Life," detail from *Liber divinorum* operum, Vision 8, fol. 132r. 13th century. Tempera on vellum, 13¹/₈ x 5⁵/₈" (33.3 x 14.4 cm). Biblioteca statale di Lucca, Italy

By the middle of the twelfth century Byzantine influences were in evidence everywhere, from Italy and Spain in the south to France, Germany, and England in the north. How were they disseminated? The principal conduit was most likely the Benedictine order, then at the height of its power. A Byzantine style must have been an important feature of the decorations in the abbey church at Cluny, the seat of Benedictine monasticism in France and the largest one ever built in Romanesque Europe. Unfortunately, the great church was almost completely destroyed after the French Revolution, but the Cluniac style is echoed in the early-twelfth-century frescoes at nearby Berzéla-Ville; these have distinct Byzantine overtones that relate them directly to the paintings at S. Angelo in Formis.

The Channel Region

Although Romanesque painting, like architecture and sculpture, developed a wide variety of regional styles throughout western Europe, its greatest achievements emerged from the monastic scriptoria of northern France, Belgium, and southern England. The works from this area are so closely related in style that it is impossible at times to be sure on which side of the English Channel a given manuscript was produced.

GOSPEL BOOK OF ABBOT WEDRICUS. Thus, the style of the wonderful miniature of St. John (fig. 418) has been linked with both Cambrai, France, and Canterbury, England. Here the abstract linear draftsmanship of the Corbie manuscript (fig. 414) has been influenced by the Byzantine style (note the ropelike loops of drapery, whose origin can be traced back to such works as the *Crucifixion* at Daphné in fig. 340 and even further, to the ivory leaf in fig. 315), but without losing its energetic rhythm. It is the precisely controlled dynamics of every contour, both in the main figure and in the frame, that unite the varied elements of the composition into a coherent whole. This quality of line still betrays its ultimate source, the Celtic-Germanic heritage.

If we compare our miniature with one from the *Lindisfarne Gospels* (fig. 352), we see how much the interlacing patterns of the early Middle Ages have contributed to the design of the St. John page. The drapery folds and the clusters of floral ornament have an impulsive yet disciplined aliveness that echoes the intertwined snakelike monsters of the animal style, even though the foliage is derived from the classical acanthus and the human figures are based on Carolingian and Byzantine models. The unity of the entire page, however, is conveyed not only by the forms but by the content as well. The

418. St. John the Evangelist, from the Gospel Book of Abbot Wedricus. c. 1147. Tempera on vellum, 14 x 9 ½" (35.5 x 24 cm). Société Archéologique et Historique, Avesnes-sur-Helpe, France

evangelist "inhabits" the frame in such a way that we could not remove him from it without cutting off his ink supply (offered by the donor of the manuscript, Abbot Wedricus), his source of inspiration (the dove of the Holy Spirit in the hand of God), or his identifying symbol (the eagle). The other medallions, less directly linked with the main figure, show scenes from the life of St. John.

PORTRAIT OF A PHYSICIAN. Soon after the middle of the twelfth century, however, an important change began to make itself felt in Romanesque manuscript painting on both sides of the English Channel. The Portrait of a Physician (fig. 419), from a medical manuscript of about 1160, is surprisingly different from the St. John miniature, although it was produced in the same region. Instead of abstract patterns, we suddenly find lines that have regained the ability to describe three-dimensional shapes. The drapery folds no longer lead an ornamental life of their own but suggest the rounded volume of the body underneath. There is even a renewed interest in foreshortening. At last, then, we see an appreciation for the achievements of antiquity missing in the murals at S. Angelo in Formis, as it is in those at St.-Savin-sur-Gartempe. Here again, the lead was taken by Cluny, which was an important center of manuscript production.

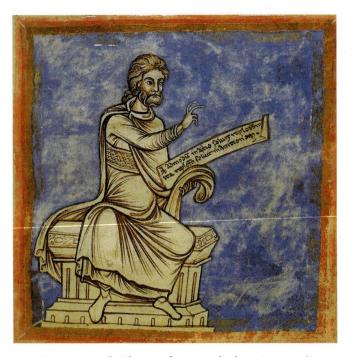

419. *Portrait of a Physician,* from a medical treatise. c. 1160. The British Museum, London

This style, too, stemmed from Byzantine art, which saw a revival of classicism during the tenth and eleventh centuries, but it was perhaps transmitted through Germany where, as we have seen, Byzantine elements had long been present in manuscript painting (compare figs. 365 and 377). The physician, seated in the pose of Christ as philosopher (compare fig. 313), will remind us of David from the *Paris Psalter* (see fig. 339), but he has been utterly transformed. The sharp, deliberate lines look as if they had been engraved in metal, rather than drawn with pen or brush. Thus our miniature is the pictorial counterpart of the classicism we saw earlier in the baptismal font of Renier of Huy at Liège (see fig. 411). In fact, it was probably done at Liège, too.

NICHOLAS OF VERDUN. That a new way of painting should have originated in metalwork is perhaps less strange than it might seem at first, for the style's essential qualities are sculptural rather than pictorial. Moreover, metalwork (which includes not only cast or embossed sculpture but also engraving, enameling, and goldsmithing) had been a highly developed art in the Meuse Valley area since Carolingian times. Its greatest practitioner after Renier of Huy was Nicholas of Verdun, in whose work the classicizing, three-dimensional style of draftsmanship reaches full maturity.

The Klosterneuburg Altar, which he completed in 1181 for provost Wernher, consists of numerous engraved and

420. Nicholas of Verdun. Klosterneuburg Altar. 1181. Gold and enamel, height approx. 28" (71.1 cm). Klosterneuburg Abbey, Austria

enameled plaques originally in the form of a pulpit but rearranged as a triptych after a fire in 1330 (fig. 420). Laid out side by side like a series of manuscript illuminations from the Old and New Testaments to form a complex program, they have a sumptuousness that recalls, on a miniature scale, the glittering play of light across mosaics (compare fig. 340). Our detail of *The Crossing of the Red Sea* (fig. 421) clearly belongs to the same tradition as the Liège miniature, but the figures, clothed in rippling, "wet" draperies familiar to us from countless classical statues, have achieved so high a degree of organic body structure and freedom of movement that we tend to think of them as harbingers of Gothic art rather than as the final phase of the Romanesque. Whatever we choose to call it, the style of the Klosterneuburg Altar was to have a profound impact upon both painting and sculpture during the next 50 years (see figs. 469 and 470).

Equally revolutionary is a new expressiveness that unites all the figures, and even the little dog perched on the bag carried by one of the men, through the exchange of glances and gestures within the tightly knit composition. Not since late Romań times have we seen such concentrated drama, though its intensity is uniquely medieval. Indeed, the astonishing humanity of Nicholas of Verdun's art is linked to an appreciation of the beauty of ancient works of art, as well as a new regard for classical literature and mythology.

CARMINA BURANA. The general reawakening of interest in humanity and the natural world throughout northwestern Europe sometimes was expressed as a greater readiness to acknowledge the enjoyment of sensuous experience. This aspect is reflected particularly in such lighthearted poetry as the well-known *Carmina Burana*, composed during the later twelfth century and preserved in an illuminated manuscript

of the early thirteenth that was produced at a Benedictine monastery in Upper Bavaria. That a collection of verse devoted largely, and at times very frankly, to the delights of nature, love, and drinking should have been embellished with illustrations is significant in itself. We are even more surprised, however, to find that one of the miniatures (fig. 422), coupled with a poem praising summer, represents a land-scape—the first, so far as we know, in Western art since Late Classical times.

Echoes of ancient landscape painting, derived from Early Christian and Byzantine sources, can be found in Carolingian art (see figs. 367 and 368), but only as background for the human figure. Later on, these remnants had been reduced still further, even when the subject required a landscape setting. For example, the Garden of Eden on Bernward's doors (see fig. 376) is no more than a few strangely twisted stems and bits of foliage. Thus the *Carmina Burana* illustrator, called upon to depict the life of nature in summertime, must have found the task a rather perplexing one. It has been solved in the only way possible at the time: by filling the page with a sort of anthology of Romanesque plant ornament interspersed with birds and animals.

The trees, vines, and flowers remain so abstract that we cannot identify a single species. The birds and animals, probably copied from a zoological treatise, are far more realistic. Yet they have an uncanny vitality of their own that makes them seem to sprout and unfold as if the growth of an entire season were compressed into a few frantic moments. These giant seedlings convey the exuberance of early summer, of stored energy suddenly released, far more intensely than any normal vegetation could. Our artist has created a fairytale landscape, but his enchanted world nevertheless evokes an essential underlying reality.

421. Nicholas of Verdun. *The Crossing of the Red Sea*, from the Klosterneuburg Altar. 1181. Enamel on gold plaque, height $5^{1}/2$ " (14 cm). Klosterneuburg Abbey

422. *(right)* Page with *Summer Landscape,* from a manuscript of *Carmina Burana*. Early 13th century. 7 x 4 ⁷/8" (17.8 x 12.5 cm). Bayerische Staatsbibliothek, Munich

CHAPTER FOUR

GOTHIC ART

Time and space, we have been taught, are interdependent. Yet we tend to think of history as the unfolding of events in time without sufficient awareness of their unfolding in space. We visualize it as a stack of chronological layers, or periods, each layer having a specific depth that corresponds to its duration. For the more remote past, where our sources of information are scanty, this simple image works reasonably well. It becomes less and less adequate as we draw closer to the present and our knowledge grows more precise. Thus we cannot define the Gothic era in terms of time alone; we must consider the changing surface area of the layer as well as its depth.

At the start, about 1140, this area was small indeed. It embraced only the province known as the Île-de-France (that is, Paris and vicinity), the royal domain of the French kings. A hundred years later, most of Europe had "gone Gothic," from Sicily to Iceland, with only a few Romanesque pockets left here and there. Through the crusaders, the new style had even been introduced to the Near East. About 1450, the Gothic area began to shrink (it no longer included Italy) and by about 1550 had disappeared almost entirely. The Gothic layer, then, has a rather complicated shape, with its depth varying from close to 400 years in some places to a minimum of 150 in others. This shape, moreover, does not emerge with equal clarity in all the visual arts.

The term *Gothic* was first coined for architecture, and it is in architecture that the characteristics of the style are most easily recognized. Although we speak of Gothic sculpture and painting, there is, as we shall see, some uncertainty about the exact limits of the Gothic style in these fields. This evolution of our concept of Gothic art suggests the way the new style actually grew. It began with architecture, and for a century—from about 1150 to 1250, during the Age of the Great Cathedrals—architecture retained its dominant role. Gothic sculpture, at first severely architectural in spirit, tended to become less and less so after 1200; its greatest achievements are between the years 1220 and 1420. Painting, in turn, reached a climax of creative endeavor between 1300 and 1350 in central Italy.

North of the Alps, it became the leading art from about 1400 on. We thus find, in surveying the Gothic era as a whole, a gradual shift of emphasis from architecture to painting or, better perhaps, from architectural to pictorial qualities. Characteristically, Early Gothic sculpture and painting both reflect the discipline of their monumental setting, while Late Gothic architecture and sculpture strive for "picturesque" effects rather than clarity or firmness.

Overlying this broad pattern is another one: international diffusion as against regional independence. Starting as a local development in the Île-de-France, Gothic art radiates from there to the rest of France and to all Europe, where it comes to be known as opus modernum or opus francigenum (modern or French work). In the course of the thirteenth century, the new style gradually loses its imported flavor, and regional variety begins to reassert itself. Toward the middle of the fourteenth century, we notice a growing tendency for these regional achievements to influence each other until, about 1400, a surprisingly homogeneous "International Gothic" style prevails almost everywhere. Shortly thereafter, this unity breaks apart. Italy, with Florence in the lead, creates a radically new art, that of the Early Renaissance, while north of the Alps, Flanders assumes an equally commanding position in the development of Late Gothic painting and sculpture. A century later, finally, the Italian Renaissance becomes the basis of another international style.

This development roughly parallels what happened in the political arena. Supported by shifting alliances with the papacy, the kings of France and England emerged as the leading powers at the expense of the Germans in the early thirteenth century, which was generally a time of peace and prosperity. Under these ideal conditions the new Franciscan and Dominican orders were established, and Catholicism found its greatest intellect, St. Thomas Aquinas, since St. Augustine and St. Jerome some 850 years earlier. After 1290, however, the balance of power quickly broke down, resulting in the exile of the papacy to Avignon, France, in 1305 for more than 70 years.

423. Ambulatory, Abbey Church of St.-Denis, Paris. 1140-44

424. Plan of the choir and ambulatory of St.-Denis (Peter Kidson)

ARCHITECTURE

France

ST.-DENIS AND ABBOT SUGER. We can pinpoint the origin of no previous style as exactly as that of Gothic. It was born between 1137 and 1144 in the rebuilding by Abbot Suger of the royal Abbey Church of St.-Denis just outside the city of Paris. If we are to understand how Gothic architecture happened to come into being at this particular spot, we must first acquaint ourselves with the special relationship between St.-Denis, Suger, and the French monarchy. The kings of France derived their claim to authority from the Carolingian tradition, although they belonged to the Capetian line (founded by Hugh Capet after the death of the last Carolingian in 987). But their power was eclipsed by that of the nobles who, in theory, were their vassals. The only area they ruled directly was the Île-de-France, and they often found their authority challenged even there. Not until the early twelfth century did the royal power begin to expand, and Suger, as chief adviser to Louis VI, played a key role in this process. It was he who forged the alliance between the monarchy and the Church, which brought the bishops of France (and the cities under their authority) to the king's side, while the king, in turn, supported the papacy in its struggle against the German emperors.

Suger championed the monarchy not only in practical politics but also in "spiritual politics." By investing the royal office

with religious significance and glorifying it as the strong right arm of justice, he sought to rally the nation behind the king. His architectural plans for the abbey of St.-Denis must be understood in this context, for the church, founded in the late eighth century, enjoyed a dual prestige that made it ideally suitable for Suger's purpose. It was the shrine of St.-Denis, the Apostle of France and special protector of the realm, as well as the chief memorial of the Carolingian dynasty. Both Charlemagne and his father, Pepin, had been consecrated kings there, and it was also the burial place of Charles Martel, Pepin, and Charles the Bald. Suger wanted to make the abbey the spiritual center of France, a pilgrimage church to outshine the splendor of all the others, the focal point of religious as well as patriotic emotion. But in order to become the visible embodiment of such a goal, the old edifice had to be enlarged and rebuilt. The great abbot himself has described the campaign in considerable detail. Unfortunately, the west facade and its sculpture are sadly mutilated today, and the choir at the east end, which Suger regarded as the most important part of the church, retains its original appearance only in the ambulatory (figs. 423 and 424). [See Primary Sources, nos. 33 and 34, pages 388–89.]

The ambulatory and radiating chapels surrounding the arcaded apse are familiar elements from the Romanesque

pilgrimage choir (compare fig. 381), yet they have been integrated in strikingly novel fashion. The chapels, instead of remaining separate entities, are merged so as to form, in effect, a second ambulatory, and ribbed groin vaulting based on the pointed arch is employed throughout. (In the Romanesque pilgrimage choir, only the ambulatory had been groin-vaulted.) As a result, the entire plan is held together by a new kind of geometric order. It consists of seven nearly identical wedge-shaped units fanning out from the center of the apse. (The central chapel, dedicated to the Virgin, and its neighbors on either side are slightly larger, presumably because of their greater importance.) We experience this double ambulatory not as a series of separate compartments but as a continuous (though articulated) space, whose shape is outlined for us by the network of slender arches, ribs, and columns that sustains the vaults.

What distinguishes this interior immediately from its predecessors is its lightness, in both senses. The architectural forms seem graceful, almost weightless, as against the massive solidity of the Romanesque, and the windows have been enlarged to the point that they are no longer openings cut into a wall—they fill the entire wall area, so that they themselves become translucent walls. If we now examine the plan once more, we realize what makes this abundance of light possible. The outward pressure of the vaults is contained by heavy buttresses jutting out between the chapels. (In the plan, they look like stubby black arrows pointing toward the center of the apse.) The main weight of the masonry construction is concentrated there, visible only from the outside. No wonder, then, that the interior appears so amazingly airy and weightless, since the heaviest members of the structural skeleton are beyond our view. The same impression would be even more striking if we could see all of Suger's choir, for the upper part of the apse, rising above the double ambulatory, had very large, tall windows. The effect, from the nave, must have been similar to that of the somewhat later choir of Notre-Dame in Paris (see fig. 426).

SUGER AND GOTHIC ARCHITECTURE. In describing Suger's choir, we have also described the essentials of Gothic architecture. Yet none of the individual elements that entered into its design is really new. The pilgrimage choir plan, the pointed arch, and the ribbed groin vault can be found in various regional schools of the French and Anglo-Norman Romanesque, even though we never encounter them all combined in the same building until St.-Denis. The Île-de-France had failed to develop a Romanesque tradition of its own, so that Suger (as he himself tells us) had to bring together artisans from many different regions for his project. We must not conclude from this, however, that Gothic architecture originated as no more than a synthesis of Romanesque traits. If it were only that, we would be hard pressed to explain the new spirit that strikes us so forcibly at St.-Denis: the emphasis on geometric planning and the quest for luminosity. Suger's account of the rebuilding of his church stresses both of these as the highest values achieved in the new structure. "Harmony" (that is, the perfect relationship among parts in terms of mathematical proportions or ratios) is the source of all beauty, since it exemplifies the laws according to which divine reason has constructed the universe. Thus, it is suggested, the "miraculous" light that floods the choir through the "most sacred" windows becomes the Light Divine, a revelation of the spirit of God.

This symbolic interpretation of light and of numerical harmony had been established over the centuries in Christian thought. It derived in part from the writings of a fifth-century Greek theologian who, in the Middle Ages, was believed to have been Dionysius the Areopagite, an Athenian disciple of St. Paul. Through this identification, the works of another fifthcentury writer, known as the Pseudo-Dionysius, came to be vested with great authority. In Carolingian France, however, Dionysius the disciple of St. Paul was identified both with the author of the Pseudo-Dionysian writings and with St.-Denis. Although these writings were available to Suger at St.-Denis, his debt to them seems rather general at best. Suger was not a scholar but a man of action, who was conventional in his thinking. It is probable that he consulted the contemporary theologian Hugh of St.-Victor, who was steeped in Dionysian thought, for the most obscure part of his program at the west end of the church. This does not mean that Suger's own writings are little more than a justification after the fact. On the contrary, he clearly knew his own mind. What, then, was he trying to achieve? Like the three blind men attempting to describe an elephant by touching different parts of the animal, scholars have come to surprisingly little agreement. For Suger, the material realm was the stepping stone for spiritual contemplation. Thus, the actual experience of dark, jewellike light that disembodies the material world lies at the heart of Suger's mystical intent, which was to be transported to "some strange region of the universe which neither exists entirely in the slime of earth nor entirely in the purity of Heaven."

SUGER AND THE MEDIEVAL ARCHITECT. The success of the choir design at St.-Denis is proved not only by its inherent qualities but also by its extraordinary impact. Every visitor, it seems, was overwhelmed by the achievement, and within a few decades the new style had spread far beyond the confines of the Île-de-France. The how and why of Suger's success are a good deal more difficult to explain. Here we encounter a controversy we have met several times beforethat of form versus function. To the advocates of the functionalist approach, Gothic architecture has seemed the result of advances in architectural engineering, which made it possible to build more efficient vaults, to concentrate their thrust at a few critical points, and thus eliminate the solid walls of the Romanesque church. Suger, they would argue, was fortunate in securing the services of an architect who evidently understood the principles of ribbed groin vaulting better than anybody else at that time. If the abbot chose to interpret the resulting structure as symbolic of Dionysian theology, he was simply expressing his enthusiasm over it in the abstract language of the churchman, so that his account does not help us to understand the origin of the new style.

As the careful integration of its components suggests, the choir of St.-Denis is more rationally planned and constructed than any Romanesque church. The pointed arch (which can be "stretched" to reach any desired height regardless of the width of its base) has now become an integral part of the ribbed groin vault. As a result, these vaults are no longer restricted to square or near-square compartments. They have

425. Gerard Horenbout (Master of James IV of Scotland). Elijah Begging for Fire from Heaven (miniature) and The Construction of the Tower of Babel (border), from Spinola Hours. Flemish, c. 1510–20. Tempera on vellum, 91/8 x 61/2" (23.2 x 16.6 cm). The J. Paul Getty Museum, Los Angeles. Ms. Ludwig IX 18, fol. 32

gained a flexibility that permits them to cover areas of almost any shape (such as the trapezoids and pentagons of the ambulatory). The buttressing of the vaults, too, is more fully understood than before. How could Suger's ideas have led to these technical advances, unless we are willing to assume that he was a professionally trained architect? If we grant that he was not, can he claim any credit at all for the style of what he so proudly calls "his" new church? Oddly enough, there is no contradiction here. As we have seen (page 275), the term architect was understood in a very different way from the modern sense, which derives from Greece and Rome by way of the Italian Renaissance. To the medieval mind, he was the overall leader of the project, not the master builder responsible for its construction—as Suger's account makes abundantly clear, which is why he remains so silent about his helper. Furthermore, professional architectural training as we know it did not exist at the time.

Perhaps the question poses a false alternative, somewhat like the conundrum of the chicken and the egg. The function of a church, after all, is not merely to enclose a maximum of space with a minimum of material but to communicate the great religious ideas that lie behind it. For the master who built the choir of St.-Denis, the technical problems of vaulting must have been inextricably bound up with such ideas, as well as considerations of form—beauty, harmony, fitness, and so forth. As a matter of fact, the design includes various elements that express function without actually performing it, such as the slender shafts (called responds) that seem to carry the weight of the vaults to the church floor.

But in order to know what concepts to convey, the medieval architect needed the guidance of ecclesiastical authority. At a minimum, such guidance might be a simple directive to follow some established model, but in the case of Suger, it

amounted to a more active role. It seems that he began with one master builder at the west end but was disappointed in the results and had it torn down. This not only indicates Suger's participation in the design process but also confirms his position as the architect of St.-Denis in the medieval sense. Suger's views no doubt helped to determine his choice of a second master of Norman background to translate them into the kind of structure he wanted, not simply as a matter of design preference. This great artist must have been singularly responsive to the abbot's objectives. Together, they created the Gothic. We have seen this kind of close collaboration between patron and architect before: it existed between Djoser and Imhotep, Pericles and Phidias, just as it does today.

CONSTRUCTING ST.-DENIS. Fittingly enough, St.-Denis required marshaling the combined resources of Church and State. Building such a large church was a hugely expensive and complex undertaking. For example, Suger used stone from quarries near Pontoise for the ambulatory columns and lumber from the forest of Yveline for the roof; both had to be transported by land and river over considerable distances, a slow and costly process. The master builder in charge of construction probably employed several hundred stonemasons and two or three times that many laborers. He was aided by advances in technology spurred by warfare. Of particular importance were improved cranes powered by windlasses or treadwheels that used counterweights and double pulleys for greater efficiency. These were easily put up and taken down, allowing for lighter scaffolding suspended from the wall instead of resting on the ground. Such enhancements permitted the construction techniques illustrated in the border of figure 425, and were essential to the construction of the new rib vaults.

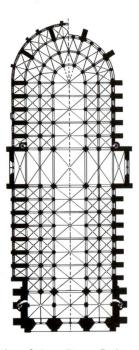

426. (above) Plan of Notre-Dame, Paris. 1163–c. 1250
427. (right) Nave and choir, Notre-Dame, Paris
428. (below) Notre-Dame (view from the southeast), Paris

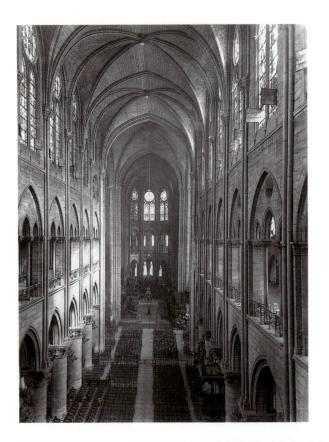

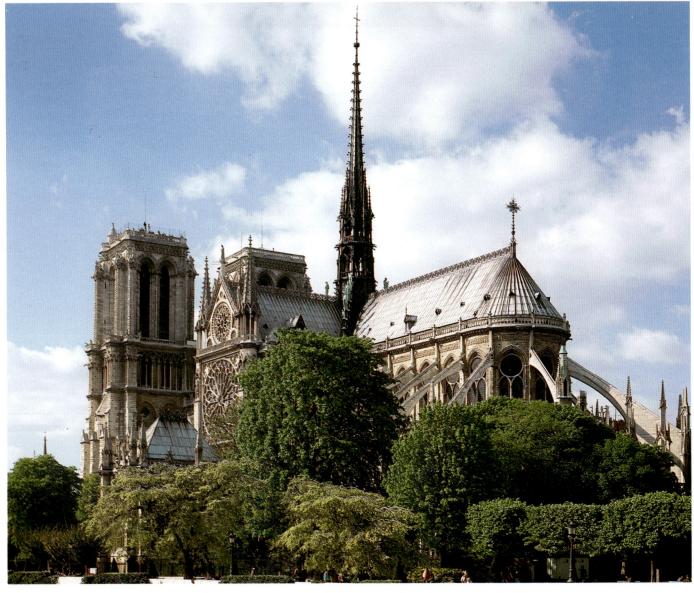

324 GOTHIC ART

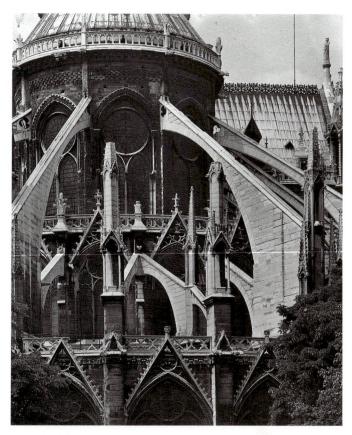

429. Flying arches and flying buttresses, Notre-Dame, Paris

NOTRE-DAME, PARIS. Although St.-Denis was an abbey, the future of Gothic architecture lay in the towns rather than in rural monastic communities. There had been a vigorous revival of urban life, we will recall, since the early eleventh century. This movement continued at an accelerated pace, and the growing weight of the cities made itself felt not only economically and politically but in countless other ways as well. Bishops and the city clergy rose to new importance. Cathedral schools and universities took the place of monasteries as centers of learning, while the artistic efforts of the age culminated in the great cathedral churches. (A cathedral is the seat of a bishopric, or see.)

Notre-Dame ("Our Lady," the Virgin Mary) at Paris, begun in 1163, reflects the salient features of Suger's St.-Denis more directly than does any other church (figs. 426–30). The plan (fig. 426), with its emphasis on the longitudinal axis, is extraordinarily compact and unified compared to that of major Romanesque churches. The double ambulatory of the choir continues directly into the aisles, and the stubby transept barely exceeds the width of the facade. The sexpartite nave vaults over squarish bays, although not identical with the "Siamese-twin" groin vaulting in Durham Cathedral (see fig. 388), continue the kind of structural experimentation that was begun by the Norman Romanesque.

Inside (fig. 427) we find other echoes of the Norman Romanesque: sexpartite nave vaults over squarish bays, and galleries above the inner aisles. The columns of the nave arcade are another conservative feature. Here, too, the use of pointed

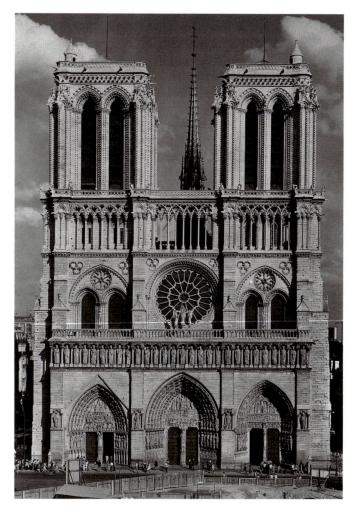

430. West facade, Notre-Dame, Paris

ribbed arches, which was pioneered in the western bays of the nave at Durham, has become systematic throughout the building. Yet the large clerestory windows and the lightness and slenderness of the forms create the weightless effect that we associate with Gothic interiors and make the nave walls seem thin. Gothic, too, is the verticality of the interior space. This depends less on the actual proportions of the nave—some Romanesque naves are equally tall relative to their width—than on the constant accenting of the verticals and on the soaring ease with which the sense of height is attained. Romanesque interiors (such as that in fig. 383), by contrast, emphasize the great effort required in supporting the weight of the vaults.

In Notre-Dame, as in Suger's choir, the buttresses (the "heavy bones" of the structural skeleton) are not visible from the inside. (The plan shows them as massive blocks of masonry that stick out from the building like a row of teeth.) Above the aisles, these piers turn into flying buttresses—arched bridges that reach upward to the critical spots between the clerestory windows where the outward thrust of the nave vault is concentrated (fig. 428). This method of anchoring vaults, a characteristic feature of Gothic architecture, certainly owed its origin to functional considerations. Even the flying buttress, however, soon became aesthetically important, and its shape could express support (apart from actually providing it) in a variety of ways, according to the designer's sense of style (fig. 429).

The most monumental aspect of the exterior of Notre-Dame is the west facade (fig. 430). Except for its sculpture,

Medieval Music and Theater

As in ancient Greece, music and theater were intimately connected

during the Middle Ages. Indeed, medieval theater was in large part a direct outgrowth of music. The only musical texts that survive from the Middle Ages before the late eleventh century are religious. Like Early Christian visual art, they bring together Roman, Greek, Jewish, and Syrian elements. Early medieval pieces, or chants, were in the form of plainsong, a single, unaccompanied line of melody in free rhythm. Plainsong continued many of the features of the ancient Greek modes (see pages 142-43), thanks mainly to the philosopher Boethius (c. 480–524), whose musical theories, set down around 500, were based on those of Pythagoras and other ancient Greek writers that are now mostly lost to us. By that time, however, Greek music was no longer a living tradition, having been modified by the Romans, so that it was adopted in altered form. One of the most important early medieval composers was Ambrose, a fourth-century bishop of Milan, who introduced an early variety of plainsong now known as Ambrosian chant. (He also converted the equally music-loving St. Augustine to Catholicism.) Over the next two centuries, Ambrosian chant was developed further, especially by the choir of the papal chapel in Rome. Around 600, Pope Gregory the Great (590-604) codified the Church's liturgy (the prescribed form for various worship services and other rites), including the music to be sung in each kind of service and the prayer hours to be observed by the monastic orders. The plainsong style in use in Rome at the time, which is still sung in many Catholic services, is popularly known as Gregorian chant.

At first, medieval chant was sung in unison, one word to a note, but gradually more notes were added for some syllables. Eventually some of these multinote passages were elaborated into long musical phrases (melismas), until there were so many notes for each word that additional, often unrelated, texts could be inserted into the work. These interpolated texts (tropes, from the Latin *tropus*, for "added melody") ultimately developed into medieval drama. The introduction of dramatic elements was also an outgrowth of the interplay between two choruses (antiphons), or between a soloist and a choir (responses).

The burgeoning complexity of medieval music stimulated the gradual evolution of music theory—an organized code of rules comparable to the grammar of a spoken language—that culminated in the thirteenth century, when a

system for musical notation was perfected. The development of

this body of theory may be compared to the gradual evolution of architectural principles during the Romanesque and Gothic eras, as musicians sought a comprehensive structure for their work. Of the many centers of chant, the most important was the Cathedral of Notre-Dame in Paris, where a new type of polyphonic music (music in parts), called organum, developed from the late ninth to the thirteenth century. Organum might have two or more voices, which sang the same words and melody a given interval apart, often with a plainsong underpinning (cantus firmus). During the late twelfth century, these pieces became so complex under Master Léonin and his pupil Master Pérotin, the first Western composers whose names and works we know, that around 1200 each voice was assigned its own text and melodic line. The resulting multivoiced composition, sometimes with instrumental accompaniment, was called a motet (from French mot, "word"). The motet was such an appealing form that it was quickly secularized, when vernacular verses, chiefly love poems, were substituted for religious texts.

Like Gothic architecture, the Notre-Dame style quickly spread throughout Europe, and lasted until about 1400. It was gradually replaced after 1325 by a new musical style, called ars nova (new art), which featured polyphony of evergreater complexity and subtlety, especially in its elaborate rhythms. Despite its name, ars nova, like the Gothic paintings of Giotto, remained rooted in the past while looking to the future. The greatest exponent of ars nova was Guillaume de Machaut (c. 1300–1377), a cleric who served the kings of Bohemia and France and was also considered the finest poet of his day. A perfect blend of religious and secular talents characteristic of the Gothic era as a whole, Guillaume de Machaut represented a new figure in European culture: the professional composer. During the twelfth and thirteenth centuries, courtly music had been composed by aristocratic amateurs (called trouvères, troubadours, or Minnesingers) who wrote songs chiefly on the theme of courtly love, but often left the actual performance to minstrels, or jongleurs. Because of its sophistication, however, ars nova increasingly required professional musicians to compose and play it. In its elaboration, ars nova paralleled the complexly ornamented late phase of Gothic architecture. It may also be seen as a musical counterpart to late medieval Scholasticism, which presented an equally complex blend of theology and philosophy.

which suffered heavily during the French Revolution and is for the most part restored, it retains its original appearance. The design reflects the general disposition of the facade of St.-Denis, which in turn had been derived from Norman Romanesque facades such as that of St.-Étienne at Caen (see fig. 387). Comparing the latter with Notre-Dame, we note the persistence of some basic features: the pier buttresses that reinforce the corners of the towers and divide the facade into three main parts, the placing of the portals, and the three-story arrangement. The rich sculptural decoration, however, recalls the facades of western France (see fig. 386) and the elaborately

carved portals of Burgundy, such as that at Vézelay.

Much more important than these resemblances are the qualities that distinguish the facade of Notre-Dame from its Romanesque ancestors. Foremost among these is the way all the details have been integrated into a wonderfully balanced and coherent whole. The meaning of Suger's emphasis on harmony, geometric order, and proportion becomes evident here even more strikingly than in St.-Denis itself. This formal discipline also embraces the sculpture, which is no longer permitted the spontaneous (and often uncontrolled) growth so characteristic of the Romanesque but has been assigned a pre-

Because of its pagan associations, theater was regarded as disreputable by early Christianity, and actors were forbidden to become members of the Church or to receive the sacraments, although Theodora, the wife of the Byzantine emperor Justinian, was a mime actress. Gradually, however, theater became associated with the great religious feasts, such as Christmas and Easter, although it, too, came eventually to rely on vernacular texts. Liturgical drama flourished at many of the same monasteries and churches that contributed to the development of medieval art and music, such as St. Gall in Switzerland. Not surprisingly, theater and music shared many of the same subjects, such as the Passion cycle. The close affiliation between them is illustrated by the career of such composer-playwrights as Hildegard of Bingen (see box page 316). Another link of the two performing arts to religious life was architectural: music and drama were presented exclusively inside churches before 1200. Religious plays, acted by the priests and choirboys, often involved intricate self-contained architectural sets called mansions. In the early thirteenth century, performances became so elaborate and independent that they were moved outdoors to the churchyards, where they were taken over by civic institutions. At the same time, secular plays and farces illustrating moral lessons began to develop out of religious drama.

During the late Middle Ages, theater flourished as towns grew prosperous and the major guilds began to shoulder the costs of staging religious pageants. The dramas best known today—such as the vast Corpus Christi cycle performed at York, England, the great Passion plays, and morality plays like Everyman—date from the fourteenth century and later. These were community affairs, mounted in town squares, in which guild members assumed all the roles, so that there was no clear distinction between religious and popular theater. The medieval tradition of music and theater continued well into the Renaissance, especially in the North. It was epitomized by Hans Sachs (1494-1576), the head of the shoemakers' guild in Nuremberg. A master singer and composer immortalized by Richard Wagner in his nineteenth-century German opera Der Meistersinger, Sachs wrote thousands of songs, fables, verses, religious plays, and secular farces.

cisely defined role within the architectural framework. At the same time, the cubic solidity of the facade of St.-Étienne at Caen has been transformed into its very opposite. Lacelike arcades, huge portals and windows, dissolve the continuity of the wall surfaces, so that the total effect approximates that of a weightless openwork screen. How rapidly this tendency advanced during the first half of the thirteenth century can be seen by comparing the west front of Notre-Dame with the somewhat later facade of the south transept, visible in the center of figure 428. In the west facade, the rose window in the center is still deeply recessed and, as a result, the stone tracery

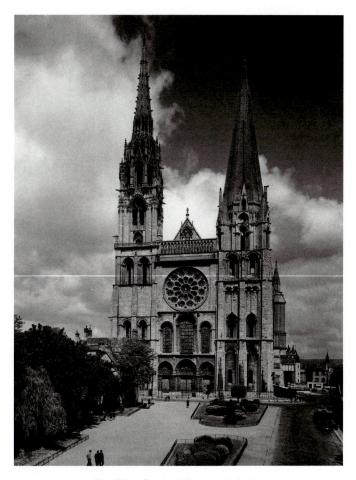

431. West facade, Chartres Cathedral (north spire is from 16th century). 1145–1220

that subdivides the opening is clearly set off against the surrounding wall surface. On the transept facade, in contrast, we can no longer distinguish the rose window from its frame, as a single network of tracery covers the entire area.

CHARTRES CATHEDRAL. Toward 1145 the bishop of Chartres, who befriended Abbot Suger and shared his ideas, began to rebuild his cathedral in the new style. [See Primary Sources, no. 35, page 389.] Fifty years later, all but the west facade, which provided the main entrance to the church, and the east crypt were destroyed by a fire (for sculpture of the west portals, see figs. 466 and 467). A second rebuilding was begun in 1194 (fig. 431), and as the result of a huge campaign was largely accomplished within the astonishingly brief span of 26 years. The basic design is so unified that it must have been planned by a single master builder. However, because the construction proceeded in several stages and was never entirely finished, the church incorporates an evolutionary, rather than a systematic, harmony. For example, the two west towers, though similar, are by no means identical. Moreover, their spires are radically different: the north spire on the left dates from the early sixteenth century, nearly 300 years later than the other.

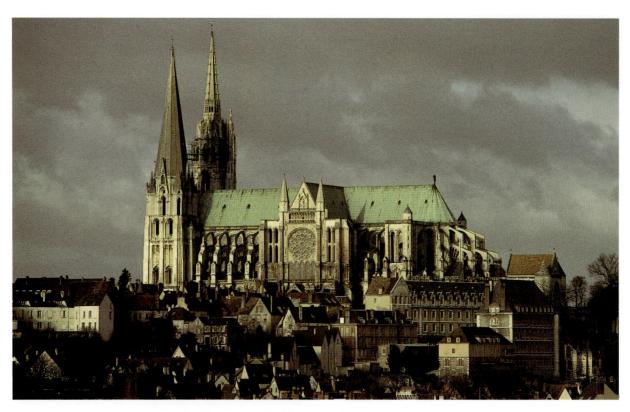

432. Chartres Cathedral

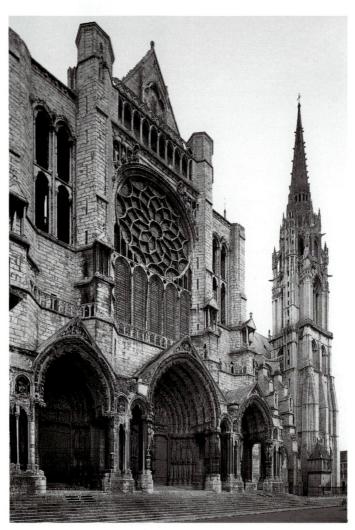

433. Portals, north transept, Chartres Cathedral (see also fig. $469)\,$

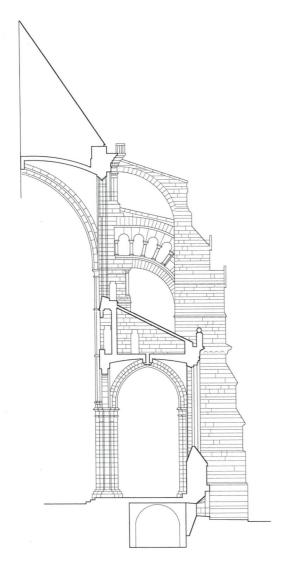

434. Transverse section of Chartres Cathedral (after Acland)

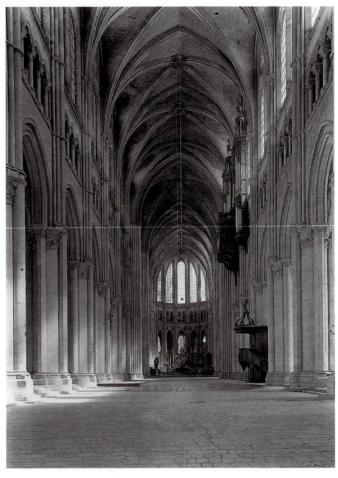

435. Nave and choir, Chartres Cathedral

The church was erected on the highest point in town and the spires can be seen for miles in the surrounding farmland (fig. 432). Had the seven other spires been completed as originally planned, Chartres would convey a less insistent directionality. Both arms of the transept have three deeply recessed portals lavishly embellished with sculpture and surmounted by an immense rose window over five smaller lancets (fig. 433). Perhaps the most striking feature of the flanks is the flying buttresses, whose massing lends a powerfully organic presence to the semicircular apse at the east end, with its seven subsidiary chapels (figs. 432 and 434).

The impressive west facade, divided into units of two and three, is a model of lucidity. Its soaring verticality and punctuated surface are important in shaping our expectations about the interior. The shape of the doors tells us that we will first be ushered into a low chamber. As soon as we enter the narthex (the covered anteroom) we have left the temporal world completely behind. It takes some time for our eyes to adjust to the darkness of the interior. The noise of daily life has been shut out as well; at first, sounds are eerily muffled, as if

swallowed up with light by the void. Once we recover from the disorienting effect of this cavernous realm, we become aware of a glimmering light, which guides us into the full height of the church.

Conceived one generation after the nave of Notre-Dame in Paris, the rebuilt nave (fig. 435) represents the first masterpiece of the mature, or High Gothic, style. The openings of the pointed nave arcade are taller and narrower (see fig. 427). They are joined to a clerestory of the same height by a short triforium screening the galleries, which have now been reduced to a narrow wall. Responds have been added to the columnar supports to stress the continuity of the vertical lines and guide our eye upward to the quadripartite vaults, which appear as diaphanous webs stretched across the slender ribs. Because there are so few walls, the vast interior space of Chartres Cathedral initially seems indeterminate. It is made to seem even larger by the sense of disembodied sound. The effect is so striking that it may well have been thought of from the beginning with music in mind, both antiphonal choirs and large pipe organs, which

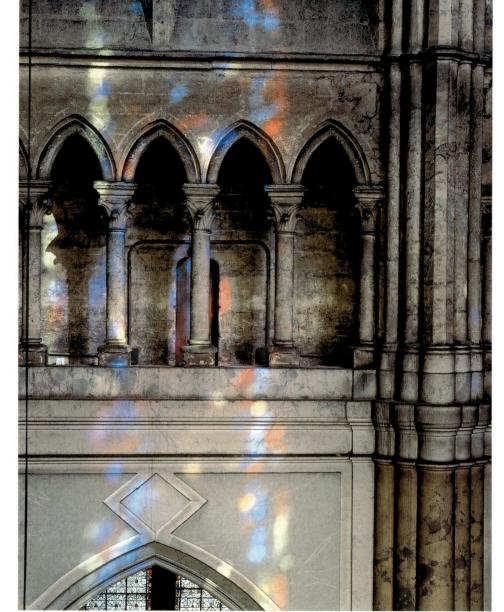

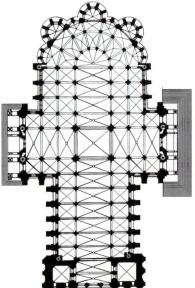

436. Plan, Chartres Cathedral

437. Triforium wall of the nave, Chartres Cathedral

had already been in use for more than two centuries in some parts of Europe.

The alternating sequence of round and octagonal piers that demark each bay extends down the nave toward the apse, where the liturgy is performed. Beneath the apse is the crypt, which houses Chartres' most important possession: remnants of the robe said to have been worn by the Virgin Mary, to whom the cathedral is dedicated. The venerable relic, which miraculously survived the great fire of 1194, drew pilgrims from all over Europe. In order to accommodate large numbers of visitors without disturbing worshipers, the church

incorporates a wide aisle running the length of the nave and around the transept; it is joined at the choir by a second aisle, forming an ambulatory that connects the apsidal chapels (see plan, fig. 436).

Alone among all major Gothic cathedrals, Chartres still retains most of its more than 180 original stained-glass windows (see fig. 494). The magic of the colored light streaming down from the clerestory through the large windows is unforgettable to anyone who has experienced their intense, jewellike hues (fig. 437). The windows admit far less light than one might expect. They act mainly as multicolored dif-

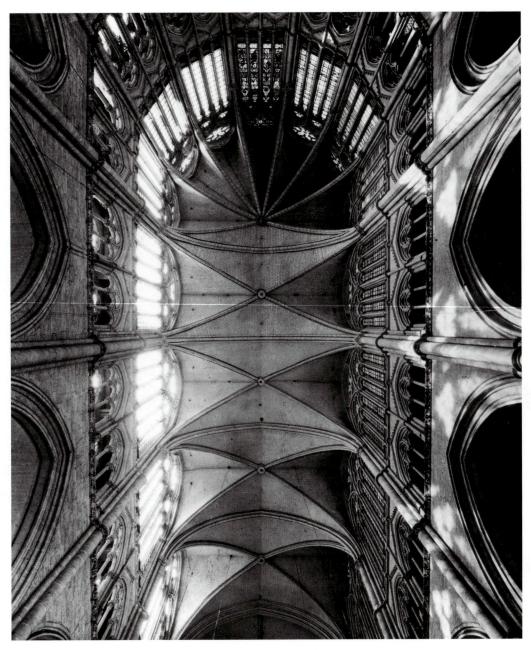

438. Choir vault, Amiens Cathedral. Begun 1220

fusing filters that change the quality of ordinary daylight, endowing it with the poetic and symbolic values—the "miraculous light"—so highly praised by Abbot Suger. The sensation of ethereal light, which dissolves the physical solidity of the church and, hence, the distinction between the temporal and the divine realms, creates the intensely mystical experience that lies at the heart of Gothic spirituality. The aisles, however, are considerably darker because the stained-glass windows on the outer walls, though relatively large, are nevertheless smaller and located at ground level, where they let in less light than at the clerestory level.

AMIENS CATHEDRAL. The High Gothic style defined at Chartres reaches its climax a generation later in the interior of Amiens Cathedral (figs. 438 and 439). Breathtaking height becomes the dominant aim, both technically and aesthetically (see fig. 440). The relatively swift progression toward verticality in French Gothic cathedral architecture is clearly seen in figure 442, while figure 443 shows how both height and large expanses of window were achieved. At Amiens, skeletal construction is carried to its most precarious limits. The inner logic of the system forcefully asserts itself in the shape of the vaults, taut and thin as membranes, and in the expanded

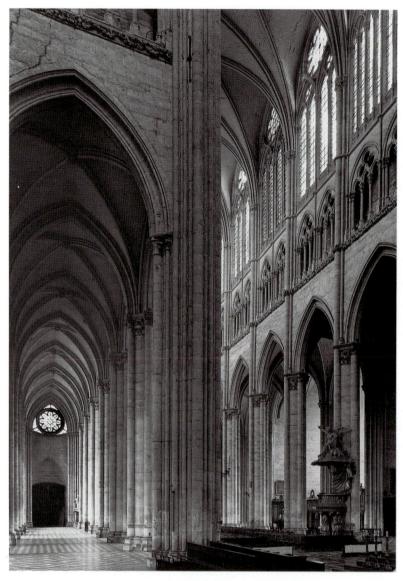

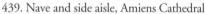

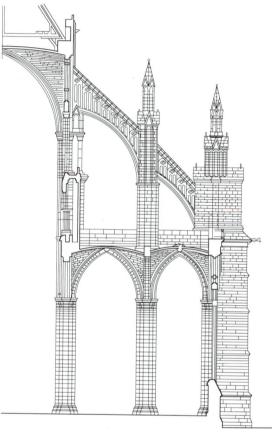

440. Transverse section, Amiens Cathedral (after Acland)

window area, which now includes the triforium so that the entire wall above the nave arcade becomes a clerestory.

REIMS CATHEDRAL. The same emphasis on verticality and translucency can be traced in the development of the High Gothic facade. The most famous of these, at Reims Cathedral (fig. 441), makes an instructive contrast with the west facade of Notre-Dame in Paris, even though its basic design was conceived only about 30 years later. Many elements are common to both (as the Coronation Cathedral of the kings of France, Reims was closely linked to Paris), but in the later structure they have been reshaped into a very different ensemble. The portals, instead of being recessed, are projected forward as gabled porches, with windows in place of tympanums above the doorways. The gallery of royal statues, which in Paris forms an incisive horizontal band between the first and second stories, has been raised until it merges with the third-story arcade. Every detail except the rose window has become taller and narrower than before. A multitude of pinnacles further accentuates the restless upward-pointing movement. The sculptural decoration, by far the most lavish of its kind (see figs. 471 and 472), no longer remains in clearly marked-off zones. It has now spread to so many hitherto unaccustomed perches, not only on the facade but on the flanks as well, that the exterior of the cathedral begins to look like a dovecote for statues.

LATER THIRTEENTH-CENTURY GOTHIC. The High Gothic cathedrals of France represent a concentrated expenditure of effort such as the world has rarely seen before or since. They are truly national monuments, whose immense cost was borne by donations collected all over the country and from all classes of society—the tangible expression of that merging of religious and patriotic fervor that had been the goal of Abbot Suger. As we approach the second half of the thirteenth century, we sense that this wave of enthusiasm has passed its crest. Work on the vast structures begun during the first half now proceeds at a slower pace. New projects are fewer and generally on a far less ambitious scale. Lastly, the highly organized teams of masons and sculptors that had developed at the sites

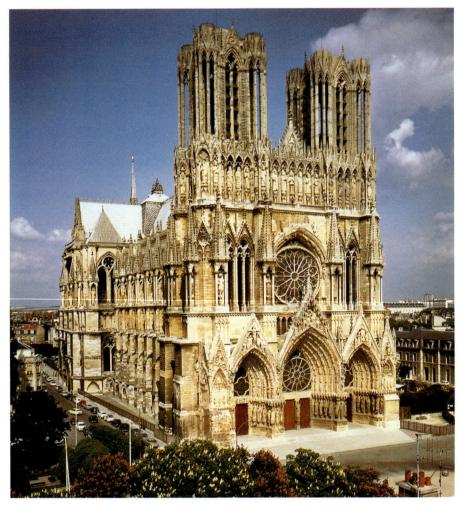

441. West facade, Reims Cathedral. c. 1225-99

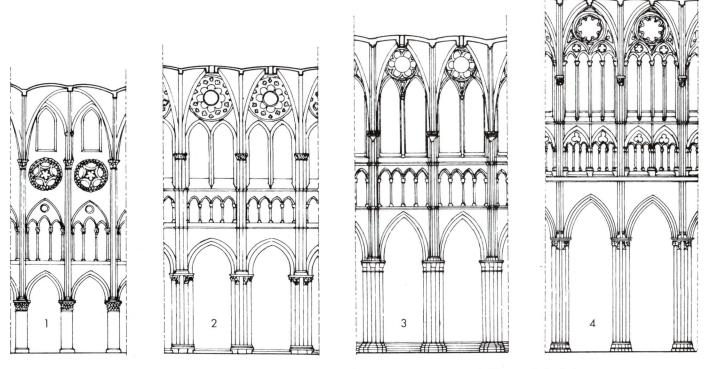

442. Comparison of nave elevations in same scale. 1) Notre-Dame, Paris; 2) Chartres Cathedral; 3) Reims Cathedral; 4) Amiens Cathedral (after Grodecki)

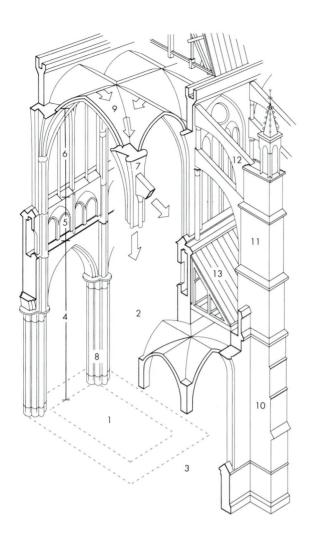

443. (*left*) Axonometric projection of a High Gothic cathedral (after Acland). 1) Bay; 2) Nave; 3) Side aisle; 4) Nave arcade; 5) Triforium; 6) Clerestory; 7) Pier; 8) Compound pier; 9) Sexpartite vault;

10) Buttress; 11) Flying buttress; 12) Flying arch; 13) Roof

of the great cathedrals during the preceding decades gradually break up into smaller units.

A characteristic church of the later years of the century, St.-Urbain in Troyes (figs. 444 and 445), leaves no doubt that the heroic age of the Gothic style is past. Refinement of detail, rather than towering monumentality, has become the chief concern. By eliminating the triforium and simplifying the plan, the designer has created a delicate glass cage (the choir windows begin ten feet above the floor), sustained by flying buttresses so thin as to be hardly noticeable. The same spiny, attenuated elegance can be felt in the architectural ornament.

FLAMBOYANT GOTHIC. In some respects, St.-Urbain is prophetic of the Late, or Flamboyant, phase of Gothic architecture. The beginnings of Flamboyant Gothic do indeed seem to go back to the late thirteenth century, but its growth was delayed by the Hundred Years' War (1338–1453) with England, so that we do not meet any full-fledged examples of it until the early fifteenth. Its name, which means flamelike, refers to the undulating patterns of curve and countercurve that are a prevalent feature of Late Gothic tracery, as at St.-Maclou in Rouen (fig. 446). Structurally, Flamboyant Gothic shows no significant developments of its own. What distinguishes St.-Maclou from such churches as St.-Urbain in

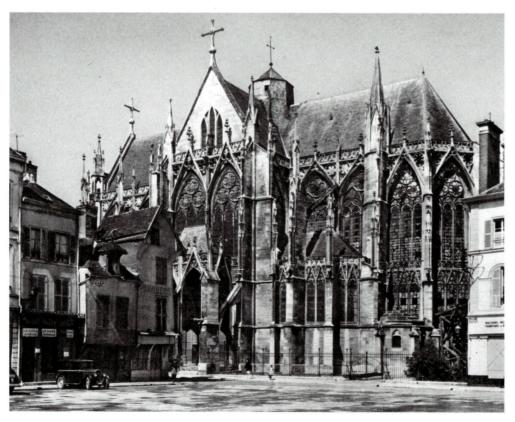

444. St.-Urbain, Troyes, France. 1261-75

Troyes is the luxuriant profusion of ornament. The architect has turned into a virtuoso who overlays the structural skeleton with a web of decoration so dense and fanciful as to obscure it almost completely. It becomes a fascinating game of hide-and-seek to locate the "bones" of the building within this picturesque tangle of lines.

SECULAR ARCHITECTURE. Since our account of medieval architecture is mainly concerned with the development of style, we have until now confined our attention to religious structures, the most ambitious as well as the most representative efforts of the age. Secular building reflects the same general trends, but these are often obscured by the diversity of types, ranging from bridges and fortifications to royal palaces, from barns to town halls. Moreover, social, economic, and practical factors play a more important part here than in church design, so that the useful life of the buildings is apt to be much briefer and their chance of preservation correspondingly less. (Fortifications, indeed, are often made obsolete by even minor advances in the technology of warfare.) As a consequence, our knowledge of secular structures of the pre-Gothic Middle Ages remains extremely fragmentary, and most of the surviving examples from Gothic times belong to the latter half of the period. This fact, however, is not without significance. Nonreligious architecture, both private and public, became far more elaborate during the fourteenth and fifteenth centuries than it had been before.

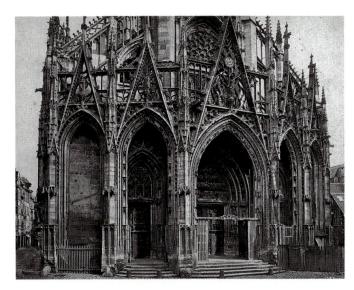

446. St.-Maclou, Rouen, France. Begun 1434

The history of the Louvre in Paris provides a telling example. The original building, erected about 1200, followed the severely functional plan of the castles of that time. It consisted mainly of a stout tower, the donjon or keep, surrounded by a heavy wall. In the 1360s, King Charles V had it built as a sumptuous royal residence. Although this second Louvre, too, has now disappeared, we know what it looked like from a fine miniature painted in the early fifteenth century (see fig. 522).

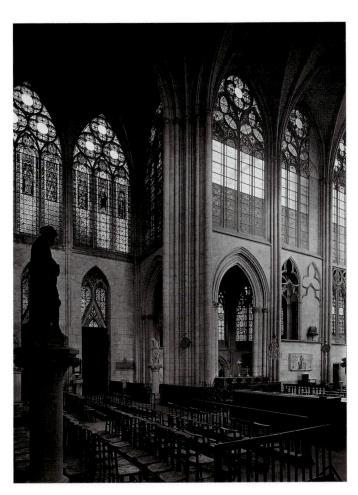

445. Interior toward northeast, St.-Urbain

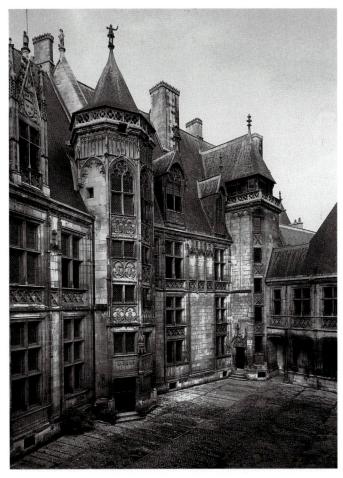

447. Court, House of Jacques Coeur, Bourges, France. 1443-51

There is still a defensive outer wall, but the great structure behind it has far more the character of a palace than of a fortress. Symmetrically laid out around a square court, it provided comfortable quarters for the royal family and household (note the countless chimneys) as well as lavishly decorated halls for state occasions.

If the exterior of the second Louvre still has some of the forbidding qualities of a stronghold, the sides toward the court displayed a wealth of architectural ornament and sculpture. The same contrast also appears in the house of Jacques Coeur in Bourges, built in the 1440s. We speak of it as a house, not a palace, only because Jacques Coeur was a silversmith and merchant, rather than a nobleman. Since he also was one of the richest men of his day, he could well afford an establishment obviously modeled on the mansions of the aristocracy. The courtyard (fig. 447), with its high-pitched roofs, its pinnacles and decorative carvings, suggests the picturesque qualities familiar to us from Flamboyant church architecture (fig. 446). That we should find an echo of the Louvre court in a merchant's residence is striking proof of the importance attained by the urban middle class during the later Middle Ages.

England

Among the astonishing things about Gothic art is the enthusiastic response this "royal French style of the Paris region" evoked abroad. Even more remarkable was its ability to acclimate itself to a variety of local conditions—so much so, in fact, that the Gothic monuments of England and Germany have become objects of intense national pride in modern times, and critics in both countries have acclaimed Gothic as a peculiarly native style. A number of factors contributed to the rapid spread of Gothic art: the superior skill of French architects and stone carvers; the great intellectual prestige of French centers of learning, such as the Cathedral School of Chartres and the University of Paris; and the influence of the Cistercians, the reformed monastic order energized by St. Bernard of Clairvaux. In conformity with his ascetic ideals, Cistercian abbey churches were of a distinctive, severe type. Decoration of any sort was held to a minimum, and a square choir took the place of apse, ambulatory, and radiating chapels. For that very reason, however, Cistercian architects put special emphasis on harmonious proportions and exact craftsmanship. Their "anti-Romanesque" outlook also prompted them to adopt certain basic features of the Gothic style, even though Cistercian churches remained strongly Romanesque in appearance. During the latter half of the twelfth century, as the reform movement gathered momentum, this austere Cistercian Gothic came to be known throughout western Europe.

Still, one wonders whether any of the explanations we have mentioned really go to the heart of the matter. The ultimate reason for the international victory of Gothic art seems to have been the extraordinary persuasive power of the style itself, its ability to kindle the imagination and to arouse religious feeling even among people far removed from the cultural climate of the Île-de-France.

That England should have proved particularly receptive to the new style is hardly surprising. Yet English Gothic did not grow directly from Anglo-Norman Romanesque but rather from the Gothic of the Île-de-France, which was introduced in 1175 by the French architect who rebuilt the choir of Canterbury Cathedral, and from that of the Cistercians. Within less than 50 years, it developed a well-defined character of its own, known as the Early English style, which dominated the second quarter of the thirteenth century. Although there was a great deal of building activity during those decades, it consisted mostly of additions to Anglo-Norman structures. Many English cathedrals had been begun about the same time as Durham (see figs. 388–90) but remained unfinished. They were now completed or enlarged. As a consequence, we find few churches that are designed in the Early English style throughout.

SALISBURY CATHEDRAL. Among cathedrals, only Salisbury meets this requirement (figs. 448–50). We realize immediately how different the exterior is from its counterparts in France—and how futile it would be to judge it by French Gothic standards. Compactness and verticality have given way to a long, low, sprawling look. (The great crossing tower, which provides a dramatic unifying accent, was built a century later than the rest and is much taller than originally planned.) Since there is no straining after height, flying buttresses have been introduced only as an afterthought. The west facade has become a screen wall, wider than the church itself and stratified by emphatic horizontal bands of ornament and statuary, while the towers have shrunk to stubby turrets. The plan, with its strongly projecting double transept, retains the segmented quality of Romanesque structures, but the square east end derives from Cistercian architecture.

As we enter the nave, we recognize the same elements familiar to us from French interiors of the time, such as Chartres (see fig. 435), but the English interpretation of these elements produces a very different total effect. As on the facade, the horizontal divisions are stressed at the expense of the vertical, so that we see the nave wall not as a succession of bays but as a continuous series of arches and supports. These supports, carved of dark marble, stand out against the rest of the interior. This method of stressing their special function is one of the hallmarks of the Early English style. Another insular feature is the steep curve of the nave vault. The ribs ascend all the way from the triforium level. As a result, the clerestory gives the impression of being tucked away among the vaults. At Durham, more than a century earlier, the same treatment had been a technical necessity (compare fig. 390). Now it has become a matter of style, thoroughly in keeping with the character of English Early Gothic as a whole. This character might be described as conservative in the positive sense. It accepts the French system but tones down its revolutionary aspects so as to maintain a strong sense of continuity with the Anglo-Norman past.

PERPENDICULAR STYLE. The contrast between the bold upward thrust of the crossing tower and the leisurely horizontal progression throughout the rest of Salisbury Cathedral suggests that English Gothic had developed in a new direction during the intervening hundred years. The change becomes very evident if we compare the interior of Salisbury with the choir of Gloucester Cathedral, built in the second quarter of the next century (fig. 451). This is a striking example of

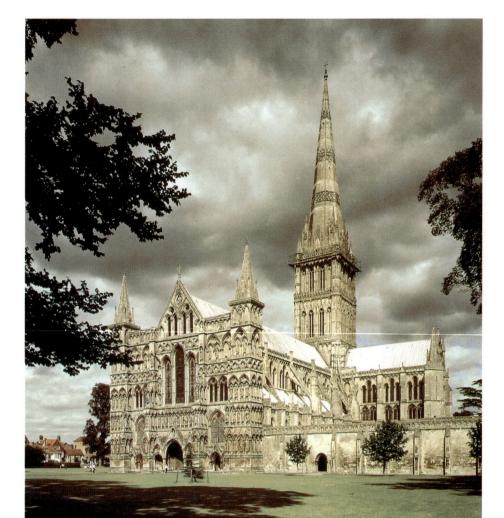

448. (*left)* Salisbury Cathedral, England. 1220–70

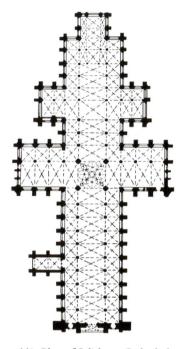

449. Plan of Salisbury Cathedral

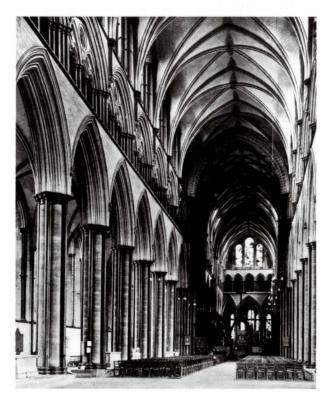

450. Nave and choir, Salisbury Cathedral

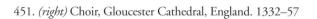

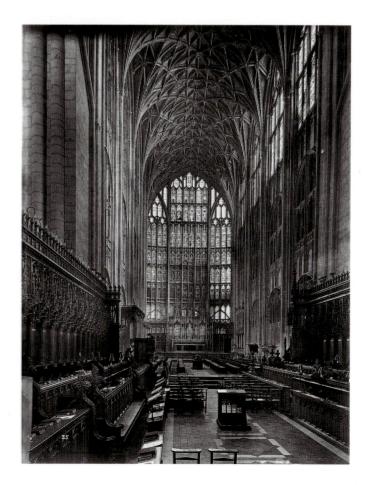

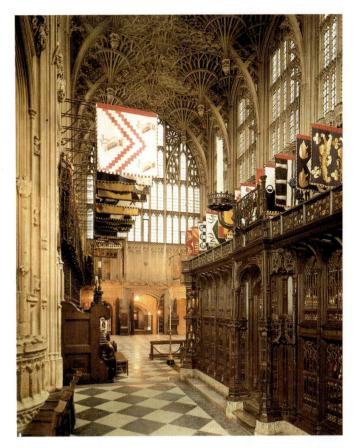

452. Chapel of Henry VII (view toward west), Westminster Abbey, London. 1503–19

English Late Gothic, also called "Perpendicular." The name certainly fits, since we now find the dominant vertical accent that is so conspicuously absent in the Early English style. (Note the responds running in an unbroken line from the vault to the floor.) In this respect Perpendicular Gothic is much more akin to French sources, yet it includes so many features we have come to know as English that it would look very much out of place on the Continent. The repetition of small uniform tracery panels recalls the bands of statuary on the west facade at Salisbury. The plan simulates the square east end of earlier English churches. And the upward curve of the vault is as steep as in the nave of Salisbury.

The ribs of the vaults, on the other hand, have assumed an altogether new role. They have been multiplied until they form an ornamental network that screens the boundaries between the bays and thus makes the entire vault look like one continuous surface. This, in turn, has the effect of emphasizing the unity of the interior space. Such decorative elaboration of the "classic" quadripartite vault is characteristic of the so-called Flamboyant style on the Continent as well, but the English started it earlier and carried it to greater lengths. The ultimate is reached in the amazing pendant vault of Henry VII's Chapel at Westminster Abbey, built in the early years of the sixteenth century (figs. 452 and 453), with its lanternlike knobs hanging from conical "fans." This fantastic scheme merges ribs and tracery patterns in a dazzling display of architectural pageantry.

Germany

In Germany, Gothic architecture took root a good deal more slowly than in England. Until the mid-thirteenth century, the

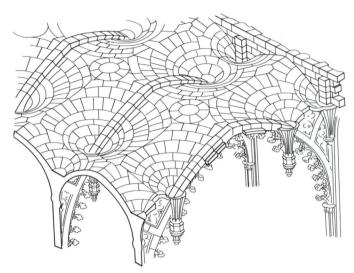

453. Diagram of vault construction, Chapel of Henry VII, Westminster Abbey (after Swaan)

Romanesque tradition, with its persistent Ottonian reminiscences, remained dominant, despite the growing acceptance of Early Gothic features. From about 1250 on, however, the High Gothic of the Île-de-France had a strong impact on the Rhineland. Cologne Cathedral (begun in 1248) represents an ambitious attempt to carry the full-fledged French system beyond the stage of Amiens. Significantly enough, however, the building remained a fragment until it was finally completed in modern times. Nor did it have any successors.

HALL CHURCHES. Far more characteristic of German Gothic is the development of the hall church, or *Hallenkirche*. Such churches, with aisles and nave of the same height, are familiar to us from Romanesque architecture (see fig. 385). For reasons not yet well understood, the type found particular favor on German soil, where its artistic possibilities were very fully explored. The large hall choir added between 1361 and 1372 to the church of St. Sebald in Nuremberg (fig. 454) is one of many fine examples from central Germany. The space here has a fluidity and expansiveness that enfold us as if we were standing under a huge canopy. There is no pressure, no directional command to prescribe our path. And the unbroken lines of the pillars, formed by bundles of shafts which gradually diverge as they turn into ribs, seem to echo the continuous movement that we feel in the space itself.

Italy

Italian Gothic architecture stands apart from that of the rest of Europe. Judged by the formal criteria of the Île-de-France, most of it hardly deserves to be called Gothic at all. Yet the

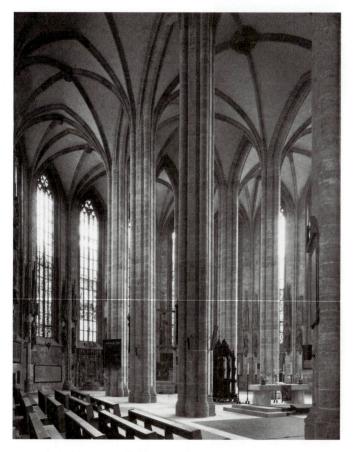

454. Choir, St. Sebald, Nuremberg, Germany. 1361-72

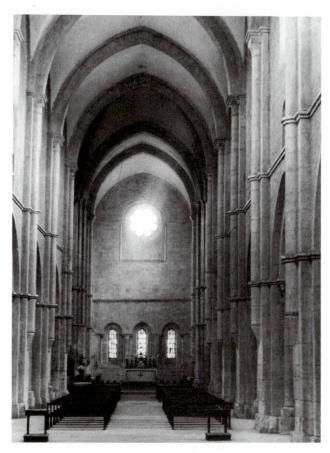

455. Nave and choir, Abbey Church of Fossanova, Italy. Consecrated 1208

Gothic in Italy produced structures of singular beauty and impressiveness that cannot be understood as continuations of the local Romanesque. We must be careful, therefore, to avoid too rigid or technical a standard in approaching these monuments, lest we fail to do justice to their unique blend of Gothic qualities and Mediterranean tradition. It was the Cistercians, rather than the cathedral builders of the Île-de-France, who provided the chief exemplars on which Italian architects based their conception of the Gothic style. As early as the end of the twelfth century, Cistercian abbeys sprang up in both northern and central Italy, their designs patterned directly after those of the French abbeys of the order.

ABBEY CHURCH, FOSSANOVA. One of the finest buildings, at Fossanova, some 60 miles south of Rome, was consecrated in 1208 (figs. 455 and 456). Without knowing its location, we would be hard put to decide where to place it on a map—it might as well be Burgundian or English. The plan looks like a simplified version of Salisbury, and the finely proportioned interior bears a strong family resemblance to all Cistercian abbeys of the Romanesque and Gothic eras. There are no facade towers, only a lantern over the crossing, as befits the Cistercian ideal of austerity prescribed by the order's founder, St. Bernard of Clairvaux. The groin vaults, while based on the pointed arch, have no diagonal ribs; the windows are small; and the architectural detail retains a good deal of Romanesque solidity. Nevertheless, the flavor of the whole is unmistakably Gothic.

Churches such as the one at Fossanova made a deep impression upon the Franciscans, the monastic order founded by St. Francis of Assisi in the early thirteenth century. As mendicant friars dedicated to poverty, simplicity, and humility, they were the spiritual kin of St. Bernard, and the severe beauty of Cistercian Gothic must have seemed to them to express an ideal closely related to theirs. Thus, their churches from the first reflected Cistercian influence and played a leading role in establishing Gothic architecture in Italy.

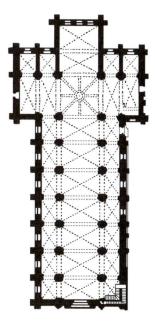

456. Plan of the Abbey Church of Fossanova

457. *(left)* Nave and choir, Sta. Croce, Florence. Begun c. 1295

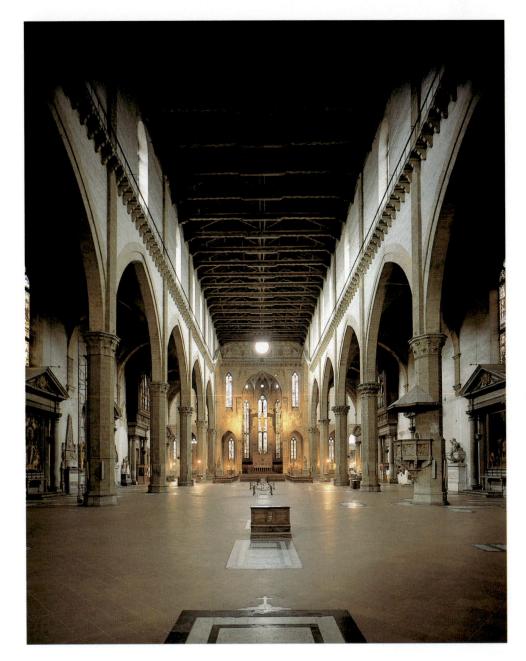

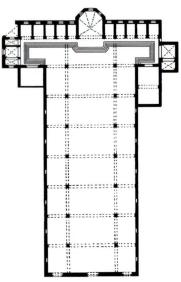

458. Plan of Sta. Croce

STA. CROCE, FLORENCE. Sta. Croce in Florence, begun about a century after Fossanova, may well claim to be the greatest of all Franciscan structures (figs. 457 and 458). It is also a masterpiece of Gothic architecture, even though it has wooden ceilings instead of groin vaults, except in the choir. There can be no doubt that this was a matter of deliberate choice, rather than of technical or economic necessity. The choice was made not simply on the basis of local practice. (Wooden ceilings, we will recall, were a feature of the Tuscan Romanesque.) It also sprang perhaps from a desire to evoke the simplicity of Early Christian basilicas and, in doing so, to link Franciscan poverty with the traditions of the early Church. The plan, too, combines Cistercian and Early Christian features. We note, however, that it shows no trace of the Gothic structural system, except for the groin-vaulted apse. Hence, in contrast to Fossanova, there are no longer any buttresses, since the wooden ceilings do not require them. The walls thus remain intact as continuous surfaces. Indeed, Sta. Croce owes part of its fame to its wonderful murals. (Some of

these are visible on the transept and apse in our illustration.)

Why, then, do we speak of Sta. Croce as Gothic? Surely the use of the pointed arch is not sufficient to justify the term. A glance at the interior will dispel our misgivings, for we sense immediately that this space creates an effect fundamentally different from that of either Early Christian or Romanesque architecture. The nave walls have the weightless, "transparent" quality we saw in Northern Gothic churches, and the dramatic massing of windows at the eastern end conveys the dominant role of light as forcefully as Abbot Suger's choir at St.-Denis. Judged in terms of its emotional impact, Sta. Croce is Gothic beyond doubt. It is also profoundly Franciscan—and Florentine—in the monumental simplicity of the means by which this impact has been achieved.

FLORENCE CATHEDRAL. If in Sta. Croce the architect's main concern was an impressive interior, Florence Cathedral was planned as a monumental landmark to civic pride towering above the entire city (figs. 459 and 460). The original

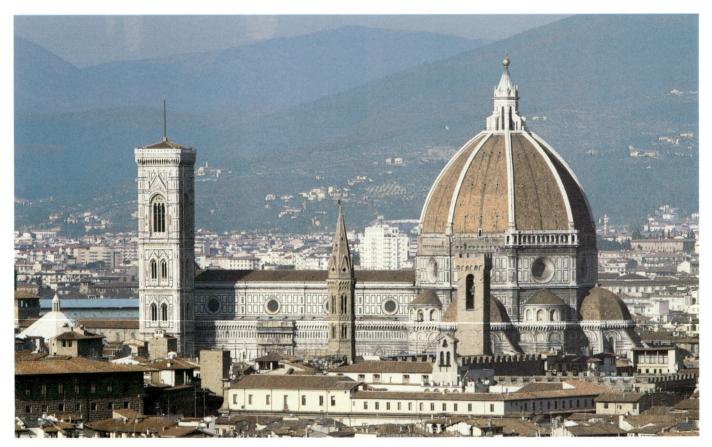

459. Florence Cathedral (Sta. Maria del Fiore). Begun by Arnolfo di Cambio, 1296; dome by Filippo Brunelleschi, 1420–36

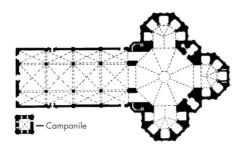

460. Plan of Florence Cathedral and Campanile

design, by the sculptor Arnolfo di Cambio (c. 1245–c. 1310), which dates from 1296, a little after Sta. Croce was begun, is not known in detail. Although somewhat smaller than the present building, it probably showed the same basic plan. The building as we know it is based largely on a design by Francesco Talenti, who took over about 1343. The most striking feature is the great octagonal dome with its subsidiary halfdomes, a motif ultimately of late Roman origin (see figs. 247, 248, and 303–5). It may have been thought of at first as an oversize dome above the crossing of nave and transept, but it soon grew into a huge central pool of space that makes the nave look like an afterthought. The basic characteristics of the dome were set by a committee of leading painters and sculptors in 1367. The actual construction, however, belongs to the early fifteenth century.

Apart from the windows and the doorways, there is nothing Gothic about the exterior of Florence Cathedral. (Flying buttresses to sustain the nave vault may have been planned but proved unnecessary.) The solid walls, encrusted with

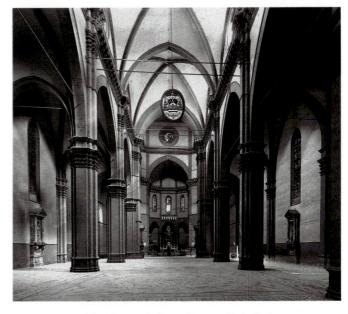

461. Nave and choir, Florence Cathedral

geometric marble inlays, are a perfect match for the Romanesque Baptistery nearby (see fig. 399). The interior, on the other hand, recalls Sta. Croce, even though the dominant impression is one of chill solemnity rather than lightness and grace. The ribbed groin vault of the nave rests directly on the nave arcade, producing an emphasis on width instead of height, and the architectural detail has a massive solidity that seems more Romanesque than Gothic (fig. 461). Thus the unvaulted interior of Sta. Croce reflects the spirit of the new style more faithfully than does the Cathedral, which,

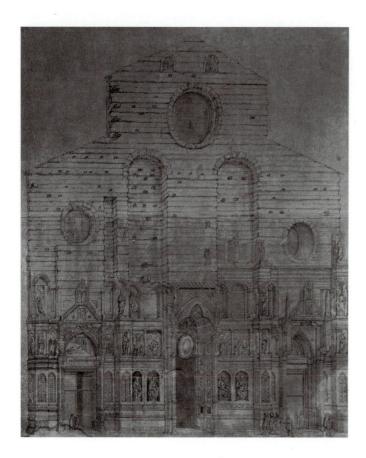

462. (left) Bernardino Poccetti. Drawing of Arnolfo di Cambio's unfinished design for the facade of Florence Cathedral. c. 1587. Museo dell'Opera di S. Maria del Fiore, Florence

on the basis of its structural system, ought to be the more Gothic of the two.

Typical of Italy, a separate campanile takes the place of the facade towers familiar to us in Northern Gothic churches. It was begun by the great painter Giotto (see pages 365–70), who managed to finish only the first story, and continued by the sculptor Andrea Pisano (see page 358), who was responsible for the niche zone. The rest represents the work of Talenti, who completed it by about 1360.

The west facade, so dramatic a feature in French cathedrals, never achieved the same importance in Italy. It is remarkable how few Italian Gothic facades were ever carried to completion before the onset of the Renaissance. Those of Sta. Croce and Florence Cathedral both date from the nineteenth century. Fortunately, Arnolfo's design for the latter is preserved in a drawing made by Bernardino Poccetti just before being demolished in 1587 (fig. 462). Only the bottom half of the decorations is shown in detail, but it provides us with a clear idea of what an Italian Gothic facade would

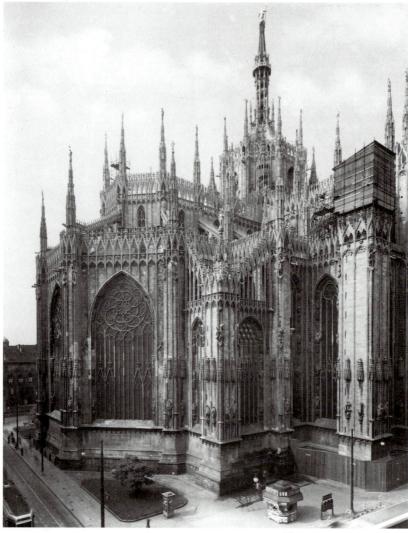

463. Milan Cathedral (apse). Begun 1386

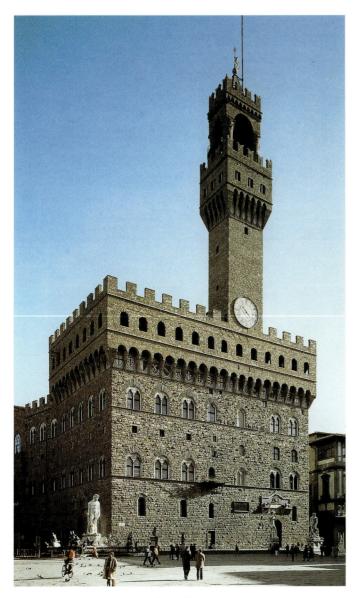

464. Palazzo Vecchio, Florence. Begun 1298

have looked like, though it is not without later alterations. Arnolfo devised an ornate scheme of pilasters and niches with sculptures to articulate the surface, which was further embellished by mosaics. The over-all effect must have been a dazzling fusion of sculpture and architecture, classical severity, and Gothic splendor.

MILAN CATHEDRAL. Work on Italian Gothic churches often continued for hundreds of years. Such was the case with Milan Cathedral, by far the largest Gothic church on Italian soil as well as the one most nearly comparable to Northern structures. Begun in 1386, it was completed only in 1910. Its structural design was the subject of a famous dispute between the local architects and consulting experts from France and Germany. Only the apse, begun first, retains the original flavor of the building, which belongs to the late, Flamboyant phase of Gothic architecture (fig. 463). Otherwise the decoration strikes us as an overly elaborate piling up of detail applied in mechanical fashion over the centuries without any unity of feeling.

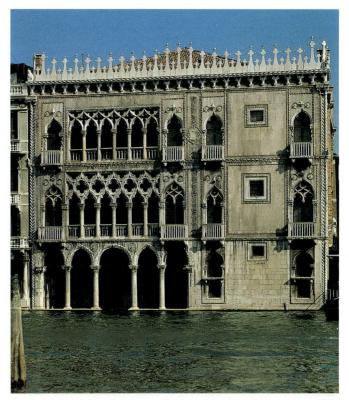

465. Ca' d'Oro, Venice. 1422-c. 1440

SECULAR ARCHITECTURE. The secular buildings of Gothic Italy convey as distinct a local flavor as the churches. There is nothing in the cities of northern Europe to match the impressive grimness of the Palazzo Vecchio (fig. 464), the town hall of Florence. Fortresslike structures such as this reflect the factional strife among political parties, social classes, and prominent families so characteristic of life within the Italian city-states. The wealthy man's home (or palazzo, a term denoting any large urban house) was quite literally his castle, designed both to withstand armed assault and to proclaim the owner's importance. The Palazzo Vecchio, while larger and more elaborate than any private house, follows the same pattern. Behind its battlemented walls, the city government could feel well protected from the wrath of angry crowds. The tall tower not only symbolizes civic pride but has an eminently practical purpose: dominating the city as well as the surrounding countryside, it served as a lookout against enemies from without or within.

Among Italian cities Venice alone was ruled by a merchant aristocracy so firmly established that internal disturbances were the exception rather than the rule. As a consequence, Venetian palazzi, unhampered by defensive requirements, developed into graceful, ornate structures such as the Ca' d'Oro (fig. 465). There is more than a touch of the Orient in the delicate latticework effect of this facade, even though most of the decorative vocabulary derives from the Late Gothic of northern Europe. Its rippling patterns, ideally designed to be seen against their own reflection in the water of the Grand Canal, have the same fairy-tale quality we recall from the exterior of St. Mark's (see fig. 335).

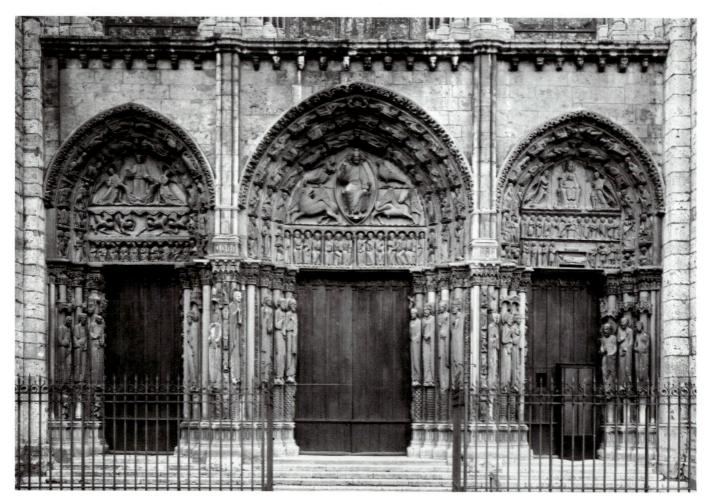

466. West portal, Chartres Cathedral. c. 1145-70

SCULPTURE

France

Abbot Suger must have attached considerable importance to the sculptural decoration of St.-Denis, although his story of the rebuilding of the church does not deal at length with that aspect of the enterprise. The three portals of his west facade were far larger and more richly carved than those of Norman Romanesque churches. Unhappily, their condition today is so poor that they do not tell us a great deal about Suger's ideas of the role of sculpture within the total context of the structure he had envisioned.

CHARTRES CATHEDRAL, WEST PORTALS. We may assume, however, that Suger's ideas had prepared the way for the admirable west portals of Chartres Cathedral (fig. 466), begun about 1145 under the influence of St.-Denis, but even more ambitious. They probably represent the oldest full-fledged example of Early Gothic sculpture. Comparing them with Romanesque portals, we are impressed first of all with a new sense of order, as if all the figures had suddenly come to attention, conscious of their responsibility to the architectural framework. The dense crowding and the frantic movement of Romanesque sculpture have given way to an emphasis on symmetry and clarity. The figures on the lintels, archivolts, and

tympanums are no longer entangled with each other but stand out as separate entities, so that the entire design carries much further than that of previous portals.

Particularly striking in this respect is the novel treatment of the jambs (fig. 467), which are lined with tall figures attached to columns. Similarly elongated figures, we recall, had occurred on the jambs or trumeaux of Romanesque portals (see figs. 401 and 407), but they had been conceived as reliefs carved into or protruding from the masonry of the doorway. The Chartres jamb figures, in contrast, are essentially statues, each with its own axis. They could, in theory at least, be detached from their supports. Here, then, we witness a development of truly revolutionary importance: the first basic step toward the reconquest of monumental sculpture in the round since the end of classical antiquity. Apparently, this step could be taken only by borrowing the rigid cylindrical shape of the column for the human figure, with the result that these statues seem more abstract than their Romanesque predecessors. Yet they will not retain their immobility and unnatural proportions for long. The very fact that they are round endows them with a more emphatic presence than anything in Romanesque sculpture, and their heads show a gentle, human quality that

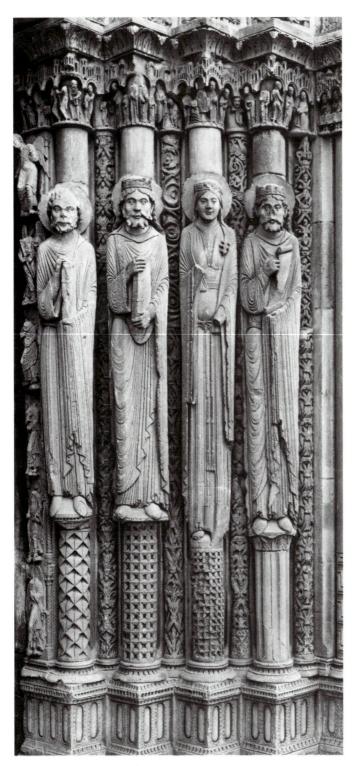

467. Jamb statues, west portal, Chartres Cathedral

Betokens the fundamentally realistic trend of Gothic sculpture.

Realism is, of course, a relative term whose meaning varies greatly according to circumstances. On the Chartres west portals, it appears to spring from a reaction against the fantastic and demoniacal aspects of Romanesque art. This response may be seen not only in the calm, solemn spirit of the figures and their increased physical bulk (compare the Christ of the center tympanum with that at Vézelay, fig. 406) but also in the rational discipline of the symbolic program underlying the entire scheme. While the subtler aspects of this program are accessible only to a mind fully conversant with the theology of

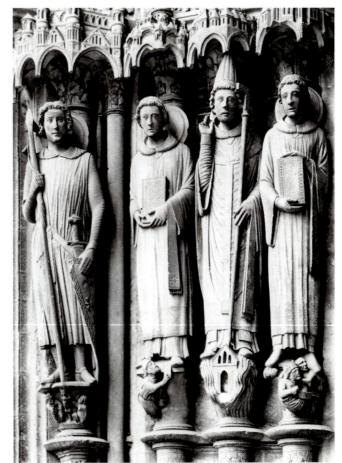

468. Jamb statues, south transept portal, Chartres Cathedral. c. 1215–20

the Chartres Cathedral School, its main elements can be readily understood.

The jamb statues form a continuous sequence linking all three portals (fig. 466). Together they represent the prophets, kings, and queens of the Bible. Their purpose is both to acclaim the rulers of France as the spiritual descendants of Old Testament royalty and to stress the harmony of spiritual and secular rule, of priests (or bishops) and kings—ideals insistently put forward by Abbot Suger. Christ himself appears enthroned above the main doorway as Judge and Ruler of the universe, flanked by the symbols of the four evangelists, with the apostles assembled below and the 24 elders of the Apocalypse in the archivolts. The right-hand tympanum shows Christ's incarnation: the Birth, the Presentation in the Temple, and the Infant Christ on the lap of the Virgin, who also stands for the Church. In the archivolts above are the personifications and representatives of the liberal arts as human wisdom paying homage to the divine wisdom of Christ. Finally, in the left-hand tympanum, we see the timeless Heavenly Christ (the Christ of the Ascension) framed by the ever-repeating cycle of the year: the signs of the zodiac and their earthly counterparts, the labors of the 12 months.

NORTH PORTALS. When Chartres Cathedral was rebuilt after the fire of 1195, the so-called Royal Portals of the west facade must have seemed rather small and old-fashioned in relation to the rest of the new edifice. Perhaps for that reason, the two transept facades each received three large and lavishly

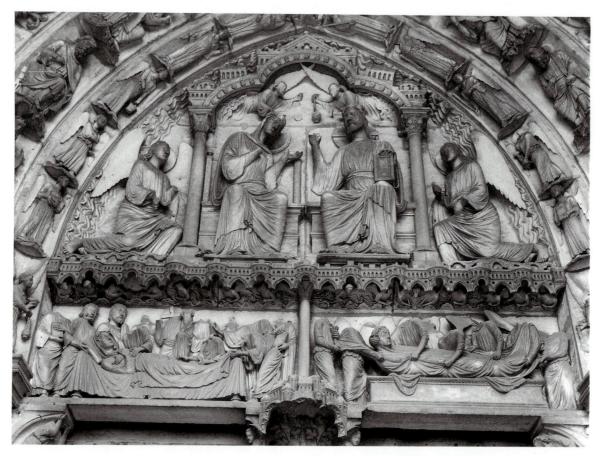

469. Coronation of the Virgin (tympanum), Dormition and Assumption of the Virgin (lintel), north portal, Chartres Cathedral. c. 1230

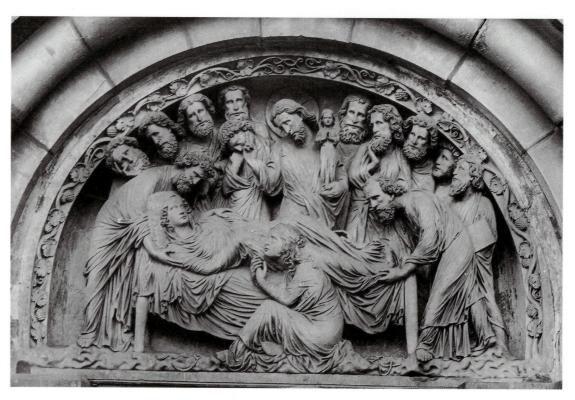

470. Death of the Virgin, tympanum of the south transept portal, Strasbourg Cathedral, France. c. 1220

carved portals preceded by deep porches. The north transept (fig. 469) is devoted to the Virgin. She had already appeared over the right portal of the west facade in her traditional guise as the Mother of God seated on the Throne of Divine Wisdom (fig. 466). Her new prominence reflects the increasing importance of the cult of the Virgin, which had been actively promoted by the Church since the Romanesque era. The growth of Mariology, as it is known, was linked to a new emphasis on divine love, which was enthusiastically embraced by the faithful as part of the more human view that became increasingly popular throughout the Gothic era. The cult of the Virgin received special emphasis about 1204, when Chartres, which is dedicated to her, received the head of her mother, St. Anne, as a relic.

Our tympanum depicts events associated with the Feast of the Assumption (celebrated on August 15), when Mary was transported to Heaven: the Death (Dormition), Assumption, and Coronation of the Virgin, which, with the Annunciation (see fig. 471), were to become the most characteristic subjects relating to her life. The appearance of all three here is extraordinary. It identifies Mary with the Church as the Bride of Christ and the Gateway to Heaven, in addition to her old role as divine intercessor. More important, it stresses her equality with Christ. Like him, she is transported to Heaven, where she becomes not only his companion (The Triumph of the Virgin) but also his Queen! Unlike earlier representations, which rely on Byzantine prototypes, the compositions here are of Western invention. The figures have a monumentality unprecedented in medieval sculpture, while the treatment is so pictorial that the scenes are virtually independent of the architectural setting into which they have been crammed.

GOTHIC CLASSICISM. The *Coronation of the Virgin* exemplifies an early phase of High Gothic sculpture. The jamb statues of these portals, such as the group shown in figure 468, show a similar evolution. By now, the symbiosis of statue and column has begun to dissolve. The columns are quite literally put in the shade by the greater width of the figures, by the strongly projecting canopies above, and by the elaborately carved bases of the statues.

In the three saints on the right, we still find echoes of the rigid cylindrical shape of Early Gothic jamb statues, but even here the heads are no longer strictly in line with the central axis of the body. St. Theodore, the knight on the left, already stands at ease, in a semblance of classical contrapposto. His feet rest on a horizontal platform, rather than on a sloping shelf as before, and the axis of his body, instead of being straight, describes a slight but perceptible S-curve. Even more astonishing is the abundance of precisely observed detail in the weapons and in the texture of the tunic and chain mail. Above all, there is the organic structure of the body. Not since Imperial Roman times have we seen a figure as thoroughly alive as this. Yet the most impressive quality of the statue is not its realism. It is, rather, the serene, balanced image which this realism conveys. In this ideal portrait of the Christian Soldier, the spirit of the crusades has been cast into its most elevated form.

The style of the *St. Theodore* could not have evolved directly from the elongated columnar statues of Chartres' west facade. It incorporates another, equally important tradition:

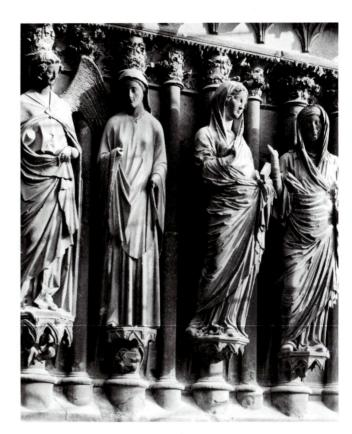

471. Annunciation and Visitation, west portal, Reims Cathedral. c. 1225–45

the classicism of the Meuse Valley, which we traced in the previous chapter from Renier of Huy to Nicholas of Verdun (compare figs. 411, 420, and 421). At the end of the twelfth century this trend, hitherto confined to metalwork and miniatures, began to appear in monumental stone sculpture as well, transforming it from Early Gothic to Classic High Gothic. The link with Nicholas of Verdun is striking in the *Death of the Virgin* (fig. 470), a tympanum at Strasbourg Cathedral slightly later than the Chartres north transept portals. Here the draperies, the facial types, and the movements and gestures have a classical flavor that immediately recalls the Klosterneuburg Altar (fig. 420).

What marks it as Gothic rather than Romanesque, however, is the deeply felt tenderness pervading the entire scene. We sense a bond of shared emotion among the figures, an ability to communicate by glance and gesture that surpasses even the Klosterneuburg Altar. This quality, too, has a long heritage reaching back to antiquity. We recall that it entered Byzantine art during the eleventh century as part of a renewed classicism (see figs. 340 and 343). Gothic expressiveness is unthinkable without such examples. But how much warmer and more eloquent it is at Strasbourg than at Chartres! What appears as merely one episode within the larger doctrinal statement of the earlier work now becomes the sole focus of attention—and the vehicle for an outpouring of emotion such as had never been seen in the art of western Christendom.

The climax of Gothic classicism is reached in some of the statues at Reims Cathedral. The most famous among them is the *Visitation* group (fig. 471, right). To have a pair of jamb figures enact a narrative scene such as this would have been

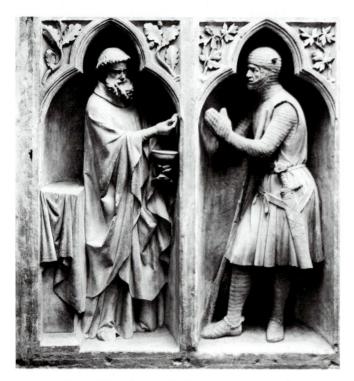

472. Melchizedek and Abraham, interior west wall, Reims Cathedral. After 1251

unthinkable in Early Gothic sculpture. The fact that they can do so now shows how far the sustaining column has receded into the background. Now the S-curve resulting from the pronounced contrapposto is much more conspicuous than in the St. Theodore. It dominates the side view as well as the front view, and the physical bulk of the body is further emphasized by horizontal folds pulled across the abdomen. The relationship of the two women shows the same human warmth and sympathy we found in the Strasbourg tympanum, but their classicism is of a far more monumental kind. They remind us so forcibly of ancient Roman matrons (compare fig. 267) that we wonder if the artist could have been inspired directly by large-scale Roman sculpture.

The vast scale of the sculptural program for Reims Cathedral made it necessary to call upon the services of masters and workshops from various other building sites, and so we encounter several distinct styles among the Reims sculpture. Two of these styles, both clearly different from the classicism of the *Visitation*, appear in the *Annunciation* group (fig. 471, left). The Virgin exhibits a severe manner, with a rigidly vertical body axis and straight, tubular folds meeting at sharp angles, a style probably invented about 1220 by the sculptors of the west portals of Notre-Dame in Paris; from there it traveled to Reims as well as Amiens (see fig. 474, top center). The

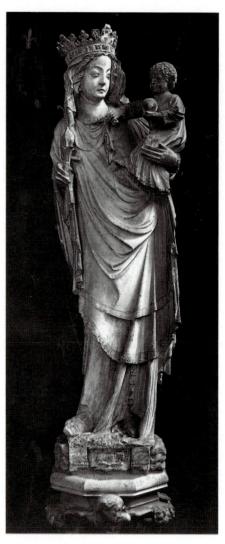

473. *The Virgin of Paris*. Early 14th century. Stone. Notre-Dame, Paris

angel, in contrast, is conspicuously graceful. We note the tiny, round face framed by curly locks, the emphatic smile, the strong S-curve of the slender body, the ample, richly accented drapery. This "elegant style," created around 1240 by Parisian masters working for the royal court, was to spread far and wide during the following decades. It soon became, in fact, the standard formula for High Gothic sculpture. We shall feel its effect for many years to come, not only in France but abroad.

A characteristic instance of the elegant style is the fine group of *Melchizedek and Abraham*, carved shortly after the middle of the century for the interior west wall of Reims Cathedral (fig. 472). Abraham, in the costume of a medieval knight, still recalls the vigorous realism of the *St. Theodore* at Chartres. Melchizedek, however, shows clearly his descent from the angel of the Reims *Annunciation*. His hair and beard are even more elaborately curled, the draperies more lavishly ample, so that the body almost disappears among the rich play of folds. The deep recesses and sharply projecting ridges betray a new awareness of effects of light and shadow that seem more pictorial than sculptural. The same may be said of the way the figures are placed in their cavernous niches.

A half-century later every trace of classicism has disappeared from Gothic sculpture. The human figure itself now becomes strangely abstract. Thus the famous *Virgin of Paris*

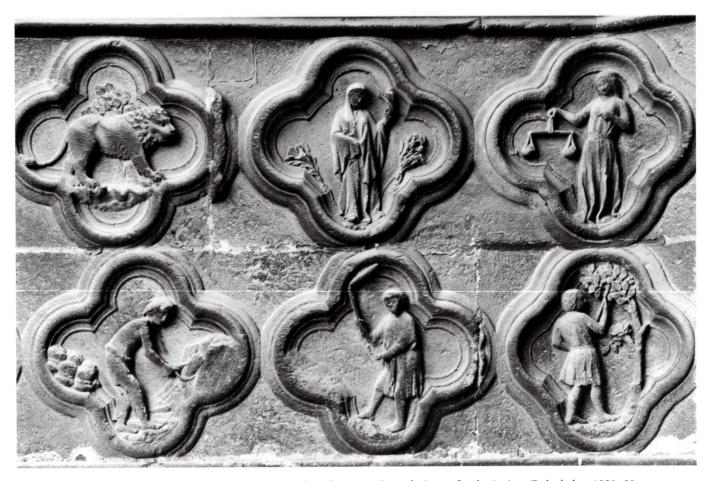

474. Signs of the Zodiac and Labors of the Months (July, August, September), west facade, Amiens Cathedral. c. 1220-30

(fig. 473) in Notre-Dame Cathedral consists largely of hollows, the projections having been reduced to the point where they are seen as lines rather than volumes. The statue is quite literally disembodied—its swaying stance no longer bears any relationship to the classical contrapposto. Compared to such unearthly grace, the angel of the Reims *Annunciation* seems solid and tangible indeed. Yet it contains the seed of the very qualities so strikingly expressed in *The Virgin of Paris*.

When we look back over the century and a half that separates *The Virgin of Paris* from the Chartres west portals, we cannot help wondering what brought about this graceful manner. The new style was certainly encouraged by the royal court of France and thus had special authority, but smoothly flowing, calligraphic lines came to dominate Gothic art, not just in France but throughout northern Europe from about 1250 to 1400. It is clear, moreover, that the style of *The Virgin of Paris* represents neither a return to the Romanesque nor a complete repudiation of the earlier realistic trend.

Gothic realism had never been of the all-embracing, systematic sort. Rather, it had been a "realism of particulars," focused on specific details rather than on the over-all structure of the visible world. Its most characteristic products are not the classically oriented jamb statues and tympanum compositions of the early thirteenth century but small-scale carvings, such

as the *Labors of the Months* in quatrefoil frames on the facade of Amiens Cathedral (fig. 474), with their delightful observation of everyday life. This intimate kind of realism survives even within the abstract formal framework of *The Virgin of Paris*. We see it in the Infant Christ, who appears here not as the Saviour-in-miniature austerely facing the beholder, but as a thoroughly human child playing with his mother's veil. Our statue thus retains an emotional appeal that links it to the Strasbourg *Death of the Virgin* and to the Reims *Visitation*. It is this appeal, not realism or classicism as such, that is the essence of Gothic art.

England

The spread of Gothic sculpture beyond the borders of France began only toward 1200, so that the style of the Chartres west portals had hardly any echoes abroad. Once under way, however, it proceeded at an astonishingly rapid pace. England may well have led the way, as it did in evolving its own version of Gothic architecture. Unfortunately, so much English Gothic sculpture was destroyed during the Reformation that we can study its development only with difficulty. Our richest materials are the tombs, which did not arouse the iconoclastic zeal of anti-Catholics. They include a type, illustrated by the

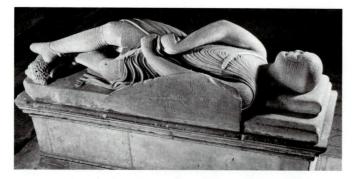

475. Tomb of a Knight. c. 1260. Stone. Dorchester Abbey, Oxfordshire, England

splendid example in figure 475, that has no counterpart on the other side of the Channel. It shows the deceased, not in the quiet repose found on the vast majority of medieval tombs, but in violent action, as a fallen hero fighting to the last breath. According to an old tradition, these dramatic figures honor the memory of crusaders who died in the struggle for the Holy Land. As the tombs of Christian Soldiers, they carry a religious meaning that helps to account for their compelling expressive power. Their agony, which so oddly recalls the *Dying Trumpeter* (see fig. 210), makes them among the finest achievements of English Gothic sculpture.

Germany

In Germany, the growth of Gothic sculpture can be traced more easily. From the 1220s on, German masters trained in the sculptural workshops of the great French cathedrals transplanted the new style to their homeland, although German architecture at that time was still predominantly Romanesque. Even after the middle of the century, however, Germany failed to emulate the large statuary cycles of France. As a consequence, German Gothic sculpture tended to be less closely linked with its architectural setting. (The finest work was often done for the interiors rather than the exteriors of churches.) This, in turn, permitted it to develop an individuality and expressive freedom greater than that of its French models.

THE NAUMBURG MASTER. These qualities are strikingly evident in the style of the Naumburg Master, an artist of real genius whose best-known work is the magnificent series of statues and reliefs of about 1240–50 for Naumburg Cathedral. The *Crucifixion* (fig. 476) forms the central feature of the choir screen; flanking it are statues of the Virgin and John the Baptist. Enclosed by a deep, gabled porch, the three figures frame the opening that links the nave with the sanctuary. Rather than placing the group above the screen, in accordance with the usual practice, our sculptor has brought the sacred subject down to earth both physically and emotionally. The suffering of Christ thus becomes a human reality because of the emphasis on the weight and volume of his body. Mary and John, pleading with the beholder, convey their grief more eloquently than ever before.

The pathos of these figures is heroic and dramatic, as against the lyricism of the Strasbourg tympanum or the Reims *Visitation* (see figs. 470 and 471). If the Classic High Gothic

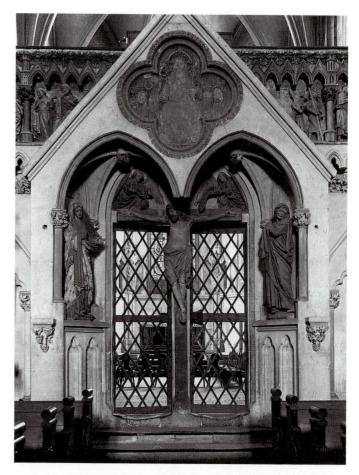

476. *Crucifixion*, on the choir screen, Naumburg Cathedral, Germany. c. 1240–50. Stone

477. *The Kiss of Judas*, on the choir screen, Naumburg Cathedral. c. 1240–50. Stone

sculpture of France evokes comparison with Phidias, the Naumburg Master might be termed the temperamental kin of Scopas (see page 155). The same intensity of feeling dominates the Passion scenes, such as *The Kiss of Judas* (fig. 477), with its unforgettable contrast between the meekness of Christ and the violence of the sword-wielding St. Peter. Attached to the responds inside the choir are statues of nobles associated with the founding of the cathedral. These men and women

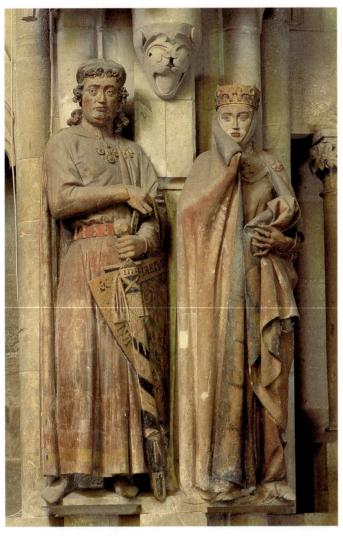

478. Ekkehard and Uta. c. 1240-50. Stone. Naumburg Cathedral

were not of the artist's own time, so that they were only as names in a chronicle. Yet the famous pair *Ekkehard and Uta* (fig. 478) are personalities as distinctive and forceful as if they had been portrayed from life. In this regard, they make an instructive contrast with the idealized portrait of *St. Theodore* at Chartres (see fig. 468, left).

THE PIETÀ. Gothic sculpture, as we have come to know it so far, reflects a desire to endow the traditional themes of Christian art with greater emotional appeal. Toward the end of the thirteenth century, this tendency gave rise to a new kind of religious imagery, designed to serve private devotion. It is often referred to by the German term Andachtsbild (contemplation image), since Germany played a leading part in its development. The most characteristic and widespread type of Andachtsbild was the Pietà (an Italian word derived from the Latin pietas, the root word for both pity and piety): a representation of the Virgin grieving over the dead Christ. No such scene occurs in the scriptural account of the Passion. The Pietà conflates two iconic types: the Madonna and Child and the Crucifixion, which were often paired as objects of veneration once they became familiar to Europeans following the conquest of Constantinople in 1204. Exactly where or when it

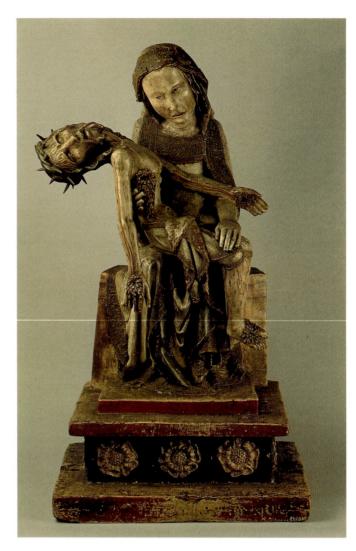

479. Roettgen Pietà. Early 14th century. Wood, height $34\,^1\!/^2$ " (87.5 cm). Rheinisches Landesmuseum, Bonn

was invented we do not know, but it represents one of the Seven Sorrows of the Virgin, a tragic counterpart to the familiar motif of the Madonna and Child, which depicts one of her Seven Joys. [See Primary Sources, no. 36, pages 389–90.]

The Roettgen Pietà, reproduced in figure 479, is carved of wood, with a vividly painted surface. Like most such groups, this large cult statue was meant to be placed on an altar. The style, like the subject, responds to the emotional fervor of lay religiosity, which emphasized a personal relationship with the deity as part of the tide of mysticism that swept the fourteenth century. Realism here has become purely a vehicle of expression to enhance its impact. The agonized faces convey an almost unbearable pain and grief. The blood-encrusted wounds of Christ are enlarged and elaborated to an almost grotesque degree. The bodies and limbs have become puppetlike in their thinness and rigidity. The purpose of the work, clearly, is to arouse so overwhelming a sense of horror and pity that the faithful will share completely in Christ's suffering and identify their own feelings with those of the grief-stricken Mother of God. The ultimate goal of this emotional bond is a spiritual transformation that comprehends the central mystery of God in human form through compassion (which means "to suffer with").

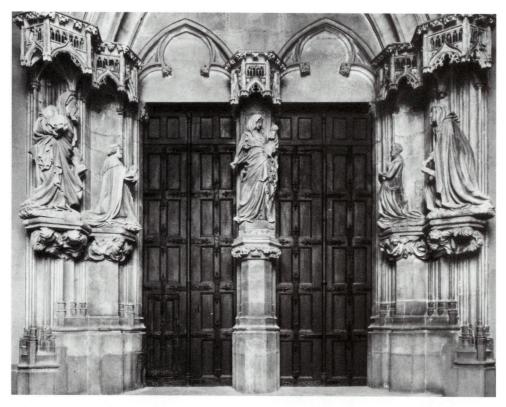

480. Claus Sluter. Portal of the Chartreuse de Champmol, Dijon, France. 1385-93. Stone

At a glance, our *Pietà* would seem to have little in common with *The Virgin of Paris* (fig. 473), which dates from the same period. Yet they share both a lean, "deflated" quality of form and a strong emotional appeal to the viewer that characterize the art of Northern Europe from the late thirteenth century to the midfourteenth. Only after 1350 do we again find an interest in weight and volume, coupled with a renewed impulse to explore tangible reality as part of a larger change in religious sensibility.

The International Style in the North

SLUTER. The climax of this new trend came about 1400, during the period of the International Style (see pages 377–81). Its greatest exponent was Claus Sluter, a sculptor of Netherlandish origin working at Dijon for the king's brother Philip the Bold, the duke of Burgundy. The portal of the charterhouse of Carthusian monks known as the Chartreuse de Champmol (fig. 480), which he decorated between 1385 and 1393, recalls the monumental statuary on thirteenth-century cathedral portals, but the figures have grown so large and expansive that they almost overpower their architectural framework. This effect is due not only to their size and the bold three-dimensionality of the carving, but also to the fact that the jamb statues (showing the duke and his wife, accompanied by their patron saints) are turned toward the Madonna on the trumeau, so that the five figures form a single, coherent unit, like the Crucifixion group at Naumburg. In both instances, the sculptural composition has simply been superimposed, however skillfully, on the shape of the doorway, not developed from it as at Chartres, Notre-Dame, or Reims. Significantly enough, the Champmol portal

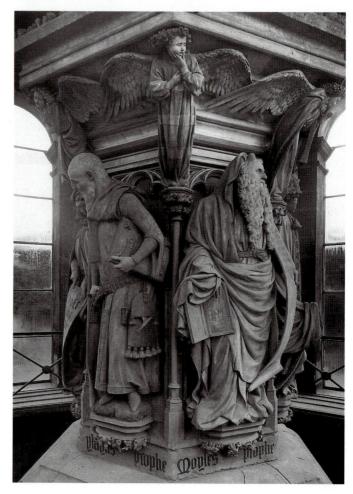

481. Claus Sluter. *The Moses Well.* 1395–1406. Stone, height of figures approx. 6' (1.8 m). Chartreuse de Champmol, Dijon

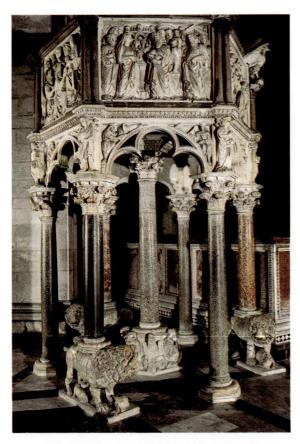

482. Nicola Pisano. Pulpit. 1259–60. Marble, height 15' (4.6 m). Baptistery, Pisa

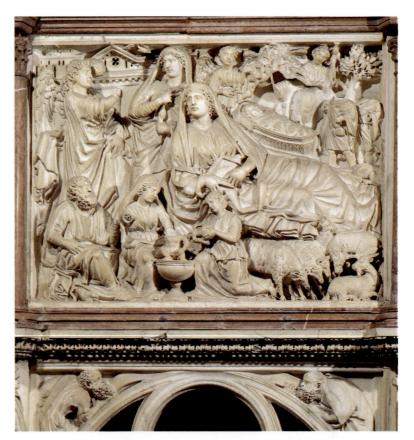

483. Nativity, detail of the pulpit by Nicola Pisano. Baptistery, Pisa

Italy

did not pave the way for a revival of architectural sculpture. Instead, it remained an isolated effort.

Sluter's other works belong to a different category that, for lack of a better term, we must label church furniture (tombs, pulpits, and the like), which combine large-scale sculpture with a small-scale architectural setting. The most impressive of these is The Moses Well at the Chartreuse de Champmol (fig. 481), a symbolic well surrounded by statues of Old Testament prophets and once surmounted by a crucifix. The majestic Moses epitomizes the same qualities we find in Sluter's portal statues. Soft, lavishly draped garments envelop the heavy-set body like an ample shell, and the swelling forms seem to reach out into the surrounding space, determined to capture as much of it as possible. (Note the outward curve of the scroll, which reads: "The children of Israel do not listen to me.") The effect must have been enhanced greatly by the polychromy added by Jean Malouel (see page 378), which has largely disappeared. At first glance, Moses seems a startling premonition of the Renaissance. (Compare Michelangelo's treatment of the same subject in fig. 608.) Only upon closer inspection do we realize that in his vocabulary Sluter remains firmly allied to the Gothic.

In the Isaiah, facing left in our illustration, what strikes us is the precise and masterful realism of every detail, from the minutiae of the costume to the texture of the wrinkled skin. The head, unlike that of Moses, has all the individuality of a portrait. Nor is this impression deceiving: Sluter has left us two splendid examples in the heads of the duke and duchess on the Chartreuse portal. This attachment to the tangible and specific distinguishes his realism from that of the thirteenth century.

We have left a discussion of Italian Gothic sculpture to the last, for here, as in Gothic architecture, Italy stands apart from the rest of Europe. The earliest Gothic sculpture on Italian soil was probably produced in the extreme south, in Apulia and Sicily, the domain of the German emperor Frederick II, who employed Frenchmen and Germans along with native artists at his court. Of the works he sponsored little has survived, but there is evidence that his taste favored a strongly classical style derived from the sculpture of the Chartres transept portals and the *Visitation* group at Reims (see figs. 468 and 471). This style not only provided a fitting visual language for a ruler who saw himself as the heir of the Caesars of old, it also blended easily with the classical tendencies in Italian Romanesque sculpture (see page 311).

NICOLA PISANO. Such was the background of Nicola Pisano (c. 1220/5–1284), who went to Tuscany from southern Italy about 1250 (the year of Frederick II's death). Ten years later he completed the marble pulpit in the Baptistery of Pisa Cathedral (fig. 482). His work has been well defined as that of "the greatest—and in a sense the last—of medieval classicists." Whether we look at the architectural framework or the sculptured parts, the classical flavor is indeed so strong in the Pisa Baptistery pulpit that the Gothic elements are at first hard to detect. But we do find such elements in the design of the arches, in the shape of the capitals, and in the standing figures at the corners, which look like small-scale descendants of the jamb statues on French Gothic cathedrals.

Most striking, perhaps, is the Gothic quality of human feeling in the reliefs of scenes such as the *Nativity* (fig. 483). The

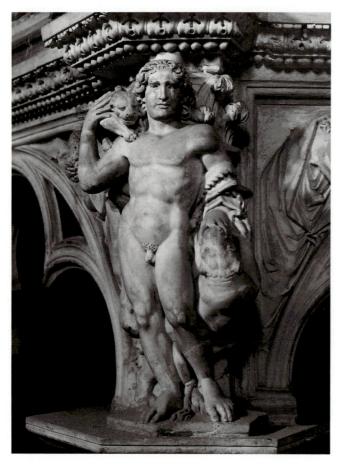

484. Fortitude, detail of the pulpit by Nicola Pisano

dense crowding of figures, on the other hand, has no counterpart in Northern Gothic sculpture. Aside from the Nativity, the panel also shows the Annunciation and the shepherds in the fields receiving the glad tidings of the birth of Christ. This treatment of the relief as a shallow box filled almost to the bursting point with solid, convex shapes tells us that Nicola Pisano must have been thoroughly familiar with Roman sarcophagi (compare fig. 312).

The figures atop the columns ringing the pulpit include an even more startling manifestation of Nicola's classicism: a nude male (fig. 484), instantly recognizable as Herakles by the lion cub on his shoulder and the skin of the Nemean lion he slew with his bare hands (compare fig. 143). But what is he doing here? He is the personification of Fortitude. Whenever we meet the unclothed body, from 800 to 1400, we may be sure, except for a few special cases, that such nudity has a moral significance, whether negative (Adam and Eve, or sinners in Hell) or positive (the nudity of the Christ of the Passion, of saints being martyred or mortifying the flesh). Herakles' presence as one of the seven Cardinal Virtues was therefore perfectly acceptable to the medieval mind.

We may also be sure that such figures are derived, directly or indirectly, from classical sources, no matter how unlikely this may seem in some instances. Such is the case with Nicola's *Herakles*, who betrays his descent from Praxiteles' *Hermes* (fig. 207). However, classical must be understood in a relative sense, for Herakles' nearest ancestors are miniature figures of Daniel in the lions' den on Early Christian sarcophagi of the fifth century, which have the same squat proportions;

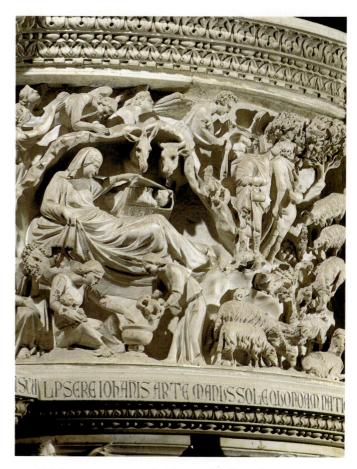

485. Giovanni Pisano. *The Nativity*, detail of pulpit. 1302–10. Marble. Pisa Cathedral

his appearance here is thus based on eminently respectable sources. Like all medieval nudes, even the most accomplished, it is devoid of the sensual appeal that we take for granted in every nude of classical antiquity. This quality was purposely avoided rather than unattainable, for to the medieval mind the physical beauty of the ancient "idols," especially nude statues, embodied the insidious attraction of paganism. As seen in the bulging features and lumpy anatomy, Nicola's style remains Gothic, tempered as it were by classicism, despite his obvious fascination with antique sculpture.

GIOVANNI PISANO. Half a century later, Nicola's son Giovanni (1245/50-after 1314), who was an equally gifted sculptor, carved a marble pulpit for Pisa Cathedral. [See Primary Sources, no. 37, page 390.] It, too, includes a Nativity (fig. 485). Both panels have a good many things in common, as we might well expect, yet they also offer a sharp—and instructive—contrast. Giovanni's slender, swaying figures, with their smoothly flowing draperies, recall neither classical antiquity nor the Visitation group at Reims. Instead, they reflect the elegant style of the royal court at Paris that had become the standard Gothic formula during the later thirteenth century. And with this change there has come about a new treatment of relief: to Giovanni Pisano, space is as important as plastic form. The figures are no longer tightly packed together. They are now spaced far enough apart to let us see the landscape setting that contains them, and each figure has been allotted its own pocket of space. If Nicola's *Nativity* strikes us as essentially a sequence of bulging, rounded masses, Giovanni's

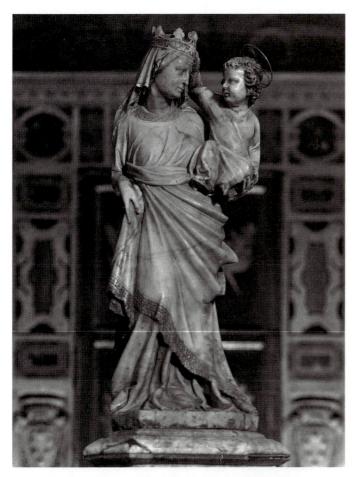

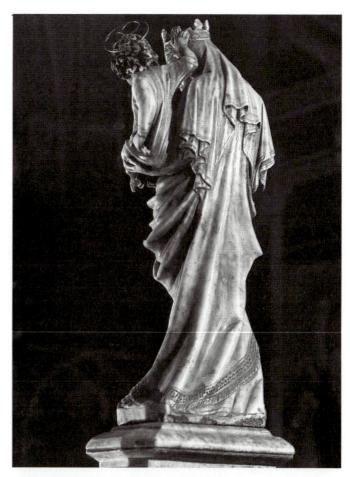

486, 487. Giovanni Pisano. Madonna. c. 1315. Marble, height 27" (68.7 cm). Prato Cathedral

appears to be made up mainly of cavities and shadows.

Giovanni Pisano, then, follows the same trend toward disembodiment that we encountered north of the Alps around 1300, only he does so in a more limited way. Compared to *The Virgin of Paris* (fig. 473), his *Madonna* at Prato Cathedral (figs. 486 and 487) immediately evokes memories of Nicola's style. The three-dimensional firmness of the modeling is further emphasized by the strong turn of the head and the thrust-out left hip. We also note the heavy, buttresslike folds that anchor the figure to its base. Yet there can be no doubt that the Prato statue derives from a French prototype which must have been rather like *The Virgin of Paris*. The back view, with its suggestion of "Gothic sway," reveals the connection more clearly than the front view, which hides the pose beneath a great swathe of drapery.

CHURCH FACADES. Italian Gothic church facades generally do not rival those of the French cathedrals as focal points of architectural and sculptural endeavor. The French Gothic portal, with its jamb statues and richly carved tympanum, never found favor in the south. Instead, we often find a survival of Romanesque traditions of architectural sculpture, such as statues in niches or small-scale reliefs overlaying the wall surfaces (compare figs. 410 and 462).

At Orvieto Cathedral, Lorenzo Maitani (before 1270–1330) covered the wide pilasters between the portals with relief carvings of such lacelike delicacy that we become aware of them only if we see them at close range. The tortures of the damned from *The Last Judgment* on the southernmost pilaster (fig. 488)

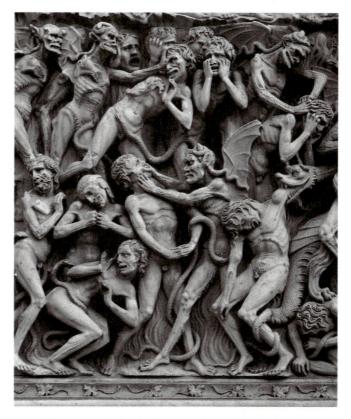

488. Lorenzo Maitani. *The Last Judgment* (detail), from the facade of Orvieto Cathedral, Italy. c. 1320

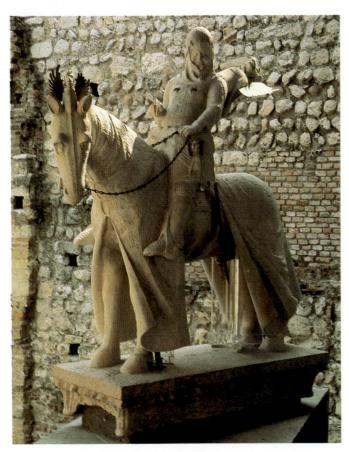

489. Equestrian Statue of Can Grande della Scala, from his tomb. 1330. Stone. Museo di Castelvecchio, Verona, Italy

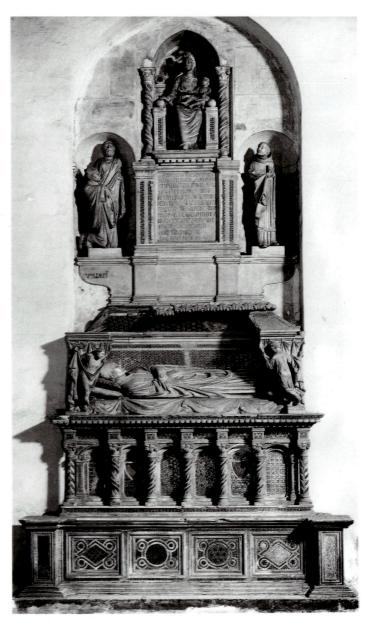

490. Arnolfo di Cambio. Tomb of Guglielmode Braye. 1282. Marble. S. Domenico, Orvieto

make an instructive comparison with similar scenes in Romanesque art (such as fig. 404). The hellish monsters are as vicious as ever, but the sinners now evoke compassion rather than sheer horror. Even here, we feel the spirit of human sympathy that distinguishes the Gothic from the Romanesque.

TOMBS. If Italian Gothic sculpture failed to emulate the vast sculptural programs of Northern Europe, it excelled in the field that we have called church furniture, such as pulpits, screens, shrines, and tombs. Perhaps the most remarkable of all tombs is the monument of Can Grande della Scala, the lord of Verona. A tall structure built out-of-doors next to the church of Sta. Maria Antica and now in the courtyard of the Castelvecchio, it consists of a vaulted canopy housing the sarcophagus and surmounted by a truncated pyramid which in turn supports an equestrian statue of the deceased (fig. 489). The ruler, astride his richly caparisoned mount, is shown in

full armor, sword in hand, as if he were standing on a windswept hill at the head of his troops—and, in a supreme display of self-confidence, he wears a broad grin. Clearly, this is no Christian Soldier, no crusading knight, no embodiment of the ideals of chivalry, but a frank glorification of power.

Can Grande, remembered today mainly as the friend and protector of Dante, was indeed an extraordinary figure. [See Primary Sources, no. 38, pages 390–91.] Although he held Verona as a fief from the German emperor, he styled himself "the Great Khan," thus asserting his claim to the absolute sovereignty of an Asiatic potentate. His free-standing equestrian statue—a form of monument traditionally reserved for emperors (see fig. 279)—conveys the same ambition in visual terms.

ARNOLFO DI CAMBIO. The late thirteenth century witnessed the development of a new kind of tomb for leaders of the Catholic church. Its origins lie in French royal tombs, but

491. Jacobello and Pierpaolo dalle Masegne. *Apostles*, on the choir screen. c. 1394. Marble, height approx. 53" (134.6 cm). St. Mark's, Venice

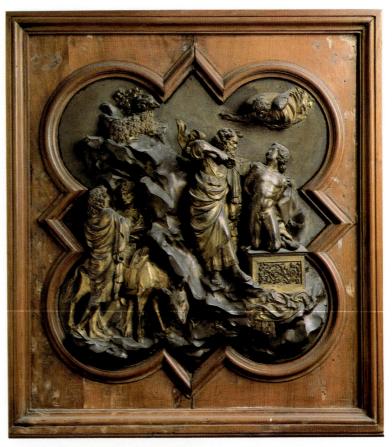

492. Lorenzo Ghiberti. *The Sacrifice of Isaac*. 1401–2. Gilt bronze, 21×17 " (53.3 x 43.4 cm). Museo Nazionale del Bargello, Florence

the type spread quickly to Italy, where Arnolfo di Cambio (1245-1302?) gave it definitive form. Arnolfo had been an assistant to Nicola Pisano, under whom he developed a classicizing style that became even more emphatic after he moved to Rome. There he entered the employment of Charles of Anjou, which exposed him directly to French influences. The monument of Cardinal Guglielmo de Braye (fig. 490) reflects the artist's diverse background, for it is a compound of previously separate prototypes: a carved effigy resting upon a sarcophagus and surmounted by a tableau of St. Mark presenting the deceased to the Virgin and Child. The ensemble was originally housed in an elaborate tabernacle (now lost) rather than in its present shallow niche. Arnolfo's solution proved so satisfying that it immediately became the model followed by all other Italian sculptors for sepulchral monuments. Even without its architectural setting, the tomb has a grandeur befitting a prince of the church. The two angels solemnly drawing the curtains to a close add a human note that is as unexpected as it is touching.

The International Style in the South

During the later fourteenth century, northern Italy proved particularly hospitable to artistic influences from across the Alps, not only in architecture (see Milan Cathedral, fig. 463), but in sculpture as well. The *Apostles* atop the choir screen of

St. Mark's in Venice (fig. 491), carved by Jacobello and Pierpaolo dalle Masegne about 1394, reflect the trend toward greater realism and the renewed interest in weight and volume that culminated in the work of Claus Sluter, even though these qualities are not yet fully developed here. Both figures betray a marked "Gothic sway" as well. Yet their kinship with Benedetto Antelami's *King David* (fig. 410) of a century earlier is equally apparent. With the *Apostles* from St. Mark's, then, we are on the threshold of the "International Style," which flourished throughout western Europe about 1400 to 1420.

GHIBERTI. The outstanding representative of the International Style in Italian sculpture was Lorenzo Ghiberti (c. 1381–1455), a Florentine who as a youth must have had close contact with French art. We first encounter him in 1401–2, when he won a competition for a pair of richly decorated bronze doors for the Baptistery of S. Giovanni in Florence. (It took him more than two decades to complete these doors, which fill the north portal of the building.) Each of the competing artists had to submit a trial relief, in a Gothic quatrefoil frame, representing the Sacrifice of Isaac. [See Primary Sources, no. 41, page 392.] Ghiberti's panel (fig. 492) strikes us first of all with the perfection of its craftsmanship, which reflects his training as a goldsmith. The silky shimmer of the surfaces and the wealth of beautifully articulated detail make it easy to understand why this entry was awarded the prize. If

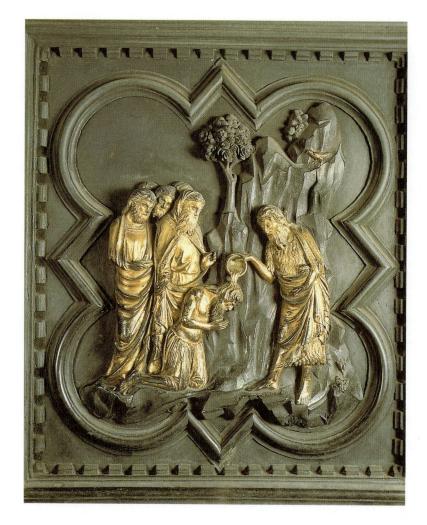

493. Andrea da Pisano. The Baptism of Christ, from the south doors, Baptistery of S. Giovanni, Florence. 1330–36. Gilt bronze

the composition seems somewhat lacking in dramatic force, that is characteristic of Ghiberti's calm, lyrical temper, which was very much to the taste of the period. Indeed, the figures, in their softly draped, ample garments, retain an air of courtly elegance even when they enact scenes of violence.

Ghiberti's doors were not the first ones on the Florence Baptistery. Some 70 years earlier Andrea da Pisano (no relation to Nicola or Giovanni Pisano; c. 1290-1348?) had received a commission for the south doors to rival those of Pisa Cathedral. In *The Baptism of Christ* (fig. 493), Andrea reveals himself an able follower of the painter Giotto (compare fig. 506). Ghiberti's doors are a direct outgrowth of Andrea's, which exercised great influence on Florentine art and helped to determine the appearance of Ghiberti's doors. Whatever the debt, the differences are equally important. Andrea's reliefs must have seemed hopelessly old-fashioned to Ghiberti in their stiff, angular poses and simplified compositions. Although both artists were strongly influenced by French metalwork, Ghiberti's work shows the fluid grace and the tactile reality of International Style sculpture. These are characteristics that also grew out of French manuscript painting (compare fig. 516), whose intimacy also appealed to Ghiberti.

However much his work may owe to French influence, Ghiberti proves himself thoroughly Italian in one respect: his admiration for ancient sculpture, as evidenced by the beautiful nude torso of Isaac. Here our artist revives a tradition of classicism that had reached its highest point in Nicola Pisano but had gradually died out during the fourteenth century. But Ghiberti is also the heir of Giovanni Pisano. In Giovanni's *Nativity* panel (fig. 485) we noted a bold new emphasis on the spatial setting. The trial relief carries this same tendency a good deal further, achieving a far more natural sense of recession. For the first time since classical antiquity, we are made to experience the background of the panel not as a flat surface but as empty space from which the sculpted forms emerge toward the beholder, so that the angel in the upper right-hand corner seems to hover in midair. This pictorial quality relates Ghiberti's work to the painting of the International Style, where we find a similar concern with spatial depth and atmosphere (see pages 377–81). While not a revolutionary himself, he prepares the ground for the great revolution that will mark the second decade of the fifteenth century in Florentine art and that we call the Early Renaissance.

PAINTING

France

STAINED GLASS. Although Gothic architecture and sculpture began so dramatically at St.-Denis and Chartres, Gothic painting developed at a rather slow pace in its early stages. The new architectural style sponsored by Abbot Suger gave birth to a new conception of monumental sculpture almost at once but did not demand any radical change of style in painting. Suger's account of the rebuilding of his church, to be sure, places a great deal of emphasis on the miraculous effect of

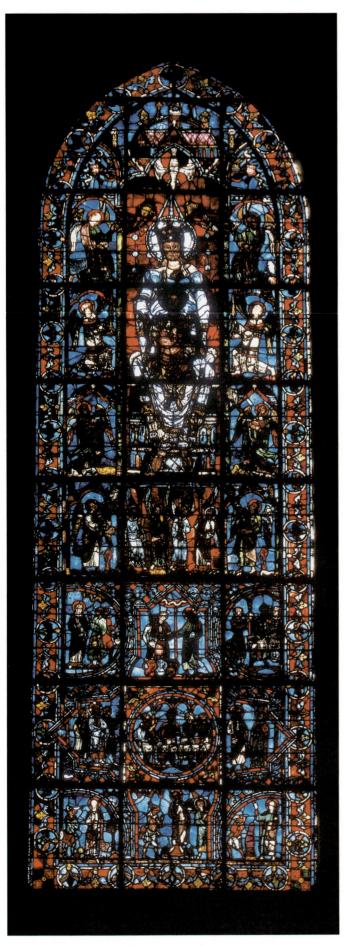

494. *Notre Dame de la Belle Verrière.* c. 1170. Stained-glass window, height approx. 14' (4.27 m). Chartres Cathedral

stained-glass windows, with their "continuous light" flooding the interior. Stained glass was thus an integral element of Gothic architecture from the very beginning. Yet the technique of stained-glass painting had already been perfected in Romanesque times, and the style of stained-glass designs (especially single figures) sometimes remained Romanesque for nearly another hundred years. Nonetheless, the "many masters from different regions" whom Suger assembled to do the choir windows at St.-Denis faced a larger task and a more complex pictorial program than before.

During the next half-century, as Gothic structures became ever more skeletal and clerestory windows grew to huge size, stained glass displaced manuscript illumination as the leading form of painting. Since the production of stained glass was so intimately linked with the great cathedral workshops, the designers came to be influenced more and more by architectural sculpture. The majestic *Notre Dame de la Belle Verrière* (fig. 494) at Chartres Cathedral, the finest early example of this process, lacks some of the sculptural qualities of its relief counterpart on the west portal of the church (fig. 466) and still betrays its Byzantine ancestry. By comparison, however, even the mosaic of the same subject in Hagia Sophia (fig. 338) seems remarkably solid. The stained glass dissolves the group into a weightless mass that hovers effortlessly in indeterminate space.

The window consists of hundreds of small pieces of tinted glass bound together by strips of lead. The maximum size of these pieces was severely limited by the primitive methods of medieval glass manufacture, so that the design could not simply be "painted on glass." Rather, the window was painted with glass, by assembling it somewhat the way one would a mosaic or a jigsaw puzzle, out of odd-shaped fragments cut to fit the contours of the forms. Only the finer details, such as eyes, hair, and drapery folds, were added by actually painting—or, better perhaps, drawing—in black or gray on the glass surfaces. [See Primary Sources, no. 43, pages 392–93.] This process encourages an abstract, ornamental style, which tends to resist any attempt to render three-dimensional effects. Only in the hands of a great master could the maze of lead strips resolve itself into figures having such monumentality.

Apart from the peculiar demands of their medium, the stained-glass workers who filled the windows of the great Gothic cathedrals also had to face the difficulties arising from the enormous scale of their work. No Romanesque painter had ever been called upon to cover areas so vast or so firmly bound into an architectural framework. The task required a technique of orderly planning for which the medieval painting tradition could offer no precedent.

VILLARD DE HONNECOURT. Only architects and stonemasons knew how to deal with this problem, and it was their methods that the stained-glass workers borrowed in mapping out their own compositions. Gothic architectural design, as we recall from our discussion of the choir of St.-Denis (see figs. 423 and 424), uses a system of geometric relationships to establish numerical harmony. The same rules could be used to control the design of stained-glass windows, through which shines the Light Divine, or even of an individual figure.

We gain some insight into this procedure from the drawings in a notebook compiled about 1240 by the architect

bela delof let figuret de le roce & forume-weet let ou- i magenes

495. Villard de Honnecourt. *Wheel of Fortune.* c. 1240. Bibliothèque Nationale, Paris

496. Villard de Honnecourt. Front View of a Lion. c. 1240. Bibliothèque Nationale, Paris

Villard de Honnecourt. [See Primary Sources, no. 44, page 393.] What we see in the *Wheel of Fortune* (fig. 495) is not the final version of the design but the scaffolding of circles and triangles on which the image is to be constructed. The pervasiveness of these geometric schemes is well illustrated by another drawing from the same notebook, the *Front View of a Lion* (fig. 496). According to the inscription, Villard has portrayed the animal from life, but a closer look at the figure will convince us that he was able to do so only after he had laid down a geometric pattern: a circle for the face (the dot between the eyes is its center) and a second, larger circle for the body. To Villard, then, drawing from life meant something far different from what it does to us: it meant filling in an abstract framework with details based on direct observation.

The period 1200–1250 might be termed the golden age of stained glass. After that, as architectural activity declined and the demand for stained glass began to slacken, manuscript illumination gradually recaptured its former position of leadership. By then, however, miniature painting had been thoroughly affected by the influence of both stained glass and stone sculpture, the artistic pacemakers of the first half of the century.

ILLUMINATED MANUSCRIPTS. The resulting change of style can be seen in figure 497, from a psalter done about 1260 for King Louis IX (St. Louis) of France. The scene illustrates I Samuel 11:2, in which Nahash the Ammonite threatens the Jews at Jabesh. We notice first of all the careful symmetry of the framework, which consists of flat, ornamented panels and of an architectural setting remarkably similar to the choir screen by the Naumburg Master (see fig. 476). The latter recalls the canopies above the heads of jamb statues (see fig.

467) and the arched twin niches enclosing the relief of *Melchizedek and Abraham* at Reims (fig. 472).

Against this emphatically two-dimensional background, the figures are "relieved" by smooth and skillful modeling. But their sculptural quality stops short at the outer contours, which are defined by heavy dark lines rather like the lead strips in stained-glass windows. The figures themselves show all the characteristics of the elegant style originated about 20 years before by the sculptors of the royal court: graceful gestures, swaying poses, smiling faces, neatly waved strands of hair (compare the Annunciation angel in figure 471 and Melchizedek in figure 472). Our miniature thus exemplifies the subtle and refined taste that made the court art of Paris the standard for all Europe. Of the expressive energy of Romanesque painting we find no trace (figs. 352 and 354).

Until the thirteenth century, the production of illuminated manuscripts had been centered in the scriptoria of monasteries. Now, along with a great many other activities once the special preserve of monasteries, it shifted ever more to urban workshops organized by laymen, the ancestors of the publishing houses of today. Here again the workshops of sculptors and stained-glass painters may have set the pattern.

Some members of this new, secular breed of illuminator are known to us by name, such as Master Honoré of Paris, who in 1295 did the miniatures in the *Prayer Book of Philip the Fair*.

497. (opposite) Nahash the Ammonite Threatening the Jews at Jabesh, from the Psalter of St. Louis. c. 1260. $5 \times 3^{1/2}$ " (17.7 \times 8.9 cm). Bibliothèque Nationale, Paris

498. Master Honoré. *David and Goliath*, from the *Prayer Book of Philip the Fair.* 1295. Bibliothèque Nationale, Paris

Our sample (fig. 498) shows him working in a style derived from the *Psalter of St. Louis*. Significantly, however, the framework no longer dominates the composition. The figures have become larger, and their relieflike modeling is more emphatic. They are even permitted to overlap the frame, a device that helps to detach them from the flat pattern of the background and thus introduces a certain, though very limited, spatial range into the picture.

Italy

We must now turn our attention to Italian painting, which at the end of the thirteenth century produced an explosion of creative energy as spectacular, and as far-reaching in its impact on the future, as the rise of the Gothic cathedral in France. A single glance at Giotto's *Lamentation* (fig. 506) will convince us that we are faced with a truly revolutionary development. How, we wonder, could a work of such intense dramatic power be conceived by a contemporary of Master Honoré? What were the conditions that made it possible? Oddly enough, as we inquire into the background of Giotto's art, we find that it arose from the same "old-fashioned" attitudes we met in Italian Gothic architecture and sculpture.

Medieval Italy, although strongly influenced by Northern

art from Carolingian times on, had always maintained contact with Byzantine civilization. As a consequence, panel painting, mosaic, and murals—mediums that had never taken firm root north of the Alps—were kept alive on Italian soil. Indeed, a new wave of influences from Byzantine art, which enjoyed a major resurgence during the thirteenth century, overwhelmed the lingering Romanesque elements in Italian painting at the very time when stained glass became the dominant pictorial art in France.

There is a certain irony in the fact that this neo-Byzantine style made its appearance soon after the conquest of Constantinople by the armies of the Fourth Crusade in 1204. (One thinks of the way Greek art had once captured the taste of the victorious Romans of old.) In any event, this "Greek manner," as the Italians disparagingly called it, prevailed almost until the end of the thirteenth century. Giorgio Vasari, the chronicler of Renaissance art, later wrote that in the mid-thirteenth century, "Some Greek painters were summoned to Florence by the government of the city for no other purpose than the revival of painting in their midst, since that art was not so much debased as altogether lost."

There is probably more truth to this statement than is often acknowledged. The Byzantine tradition had preserved Early Christian narrative art virtually intact. When transmitted to the

499. Cimabue. *Madonna Enthroned.* c. 1280–90.
Tempera on panel,
12'7¹/2" x 7'4" (3.9 x 2.2 m).
Galleria degli Uffizi, Florence

West this tradition led to an explosion of subjects and compositions that had been essentially lost for nearly 700 years. Many of them had been available all along in the mosaic cycles of Rome and Ravenna, and there had been successive waves of Byzantine influence throughout the early Middle Ages and the Romanesque period. Nevertheless, they lay dormant, so to speak, until interest in them was reawakened through closer relations with Constantinople, which enabled Italian painters to absorb Byzantine art far more thoroughly than ever before. During this same period, we recall, Italian architects and sculptors followed a very different course: untouched by the Greek manner, they were assimilating the Gothic style. Eventually, toward 1300, Gothic influence spilled over into painting as well, and the interaction of this element with the neo-Byzantine produced the revolutionary new style.

TEMPERA. Altarpieces during the Gothic era were painted on wood panel in tempera, an egg-based medium that dries

quickly to form an extremely tough surface. The preparation of the panel was a complex, time-consuming process. First it was planed and coated with a mixture of plaster and glue known as gesso, which was sometimes reinforced with linen. Once the design had been drawn, the background was almost invariably filled in with gold leaf over red sizing. Then the underpainting, generally a green earth pigment (*terra verde*), was added. The image itself was executed in multiple layers of thin tempera with very fine brushes, a painstaking process that placed a premium on neatness, since few corrections were possible.

CIMABUE. Among the painters of the Greek manner, the Florentine master Cimabue (c. 1250–after 1300), who Vasari claims was apprenticed to a Greek painter and who in turn may have been Giotto's teacher, enjoyed special fame. His huge altar panel, *Madonna Enthroned* (fig. 499), rivals the finest Byzantine icons or mosaics (compare figs. 338 and 347). What distinguishes it from them is mainly a greater severity of

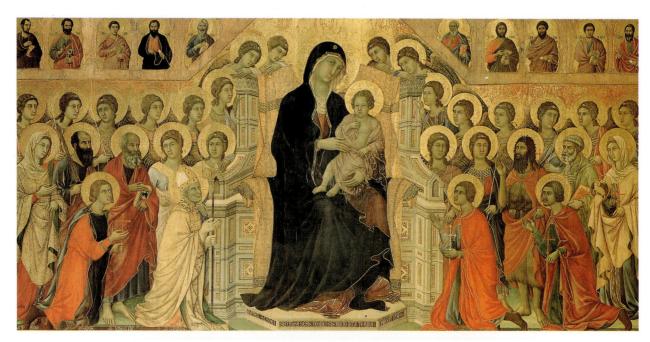

500. Duccio. *Madonna Enthroned*, center of the *Maestà Altar.* 1308–11. Tempera on panel, height 6'10¹/₂" (2.1 m). Museo dell'Opera del Duomo, Siena

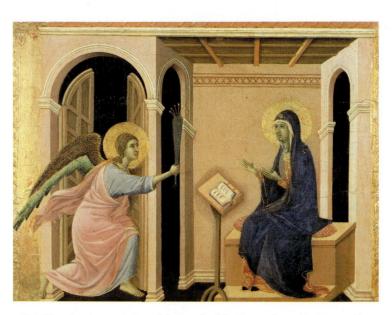

501. Duccio. Annunciation of the Death of the Virgin, from the Maestà Altar

design and expression, which befits its huge size. Panels on such a monumental scale had never been attempted in the East. Equally un-Byzantine is the picture's gabled shape and the way the throne of inlaid wood seems to echo it. The geometric inlays, like the throne's architectural style, remind us of the Florence Baptistery (see fig. 399).

DUCCIO. The *Madonna Enthroned* (fig. 500), painted a quarter century later by Duccio of Siena (c. 1255–before 1319) for the main altar of Siena Cathedral, was honored by being called the *Maestà* (majesty) to identify the Virgin's role

here as the Queen of Heaven surrounded by her celestial court of saints and angels. [See Primary Sources, no. 45, page 393.] At first glance, the picture may seem much like Cimabue's, since both follow the same basic scheme. Yet the differences are important. They reflect not only two contrasting personalities and contrasting local tastes—the gentleness of Duccio is characteristic of Siena—but also the rapid evolution of style.

In Duccio's hands, the Greek manner has become unfrozen. The rigid, angular draperies have given way to an undulating softness. The abstract shading-in-reverse with lines of gold is reduced to a minimum. The bodies, faces, and hands are beginning to swell with a subtle three-dimensional life. Clearly, the heritage of Hellenistic-Roman illusionism that had always been part of the Byzantine tradition, however dormant or submerged, is asserting itself once more. But there is also a half-hidden Gothic element here. We sense it in the fluency of the drapery, the appealing naturalness of the Infant Christ, and the tender glances by which the figures communicate with each other. The chief source of this Gothic influence must have been Giovanni Pisano (see pages 354–55), who was in Siena from 1285 to 1295 as the sculptor-architect in charge of the cathedral facade.

Apart from the *Madonna*, the *Maestà* includes many small compartments with scenes from the lives of Christ and the Virgin on the reverse side. In these panels, the most mature works of Duccio's career, the cross-fertilization of Gothic and Byzantine elements has given rise to a development of fundamental importance: a new kind of picture space and, with it, a new treatment of narrative. The *Annunciation of the Death of the Virgin* (fig. 501) shows us something we have never seen before in the history of painting: two figures enclosed by an architectural interior.

Ancient painters and their Byzantine successors were quite unable to achieve this space. Their architectural settings always stay behind the figures, so that their indoor scenes tend to look as if they were taking place in an open-air theater, on a stage without a roof. Duccio's figures, in contrast, inhabit a space that is created and defined by the architecture, as if the artist had carved a niche into his panel. Perhaps we will recognize the origin of this spatial framework: it derives from the architectural "housing" of Gothic sculpture (compare especially figs. 472 and 476). Northern Gothic painters, too, had tried to reproduce these architectural settings, but they could do so only by flattening them out completely (as in the Psalter of St. Louis, fig. 497). The Italian painters of Duccio's generation, on the other hand, trained as they were in the Greek manner, had acquired enough of the devices of Hellenistic-Roman illusionism (see fig. 290) to let them render such a framework without draining it of its three-dimensional qualities. Duccio, however, is not interested simply in space for its own sake. The architecture is used to integrate the figures within the drama more tellingly than ever before.

Even in the outdoor scenes on the back of the *Maestà*, such as *Christ Entering Jerusalem* (fig. 502), the architecture keeps its space-creating function. The diagonal movement into depth is conveyed not by the figures, which have the same scale throughout, but by the walls on either side of the road leading to the city, by the gate that frames the crowd, and by the structures beyond. Whatever the shortcomings of Duccio's perspective, his architecture demonstrates its capacity to contain and enclose, and for that reason seems more intelligible than similar vistas in ancient or Byzantine art (compare figs. 286 and 348).

GIOTTO. Turning from Duccio to Giotto (1267?–1336/7), we meet an artist of far bolder and more dramatic temper. Ten to 15 years younger than Duccio, Giotto was less close to the Greek manner from the start, despite his probable apprenticeship under Cimabue. [See Primary Sources, nos. 39, 42, and 46, pages 391–94.] As a Florentine, he fell heir to

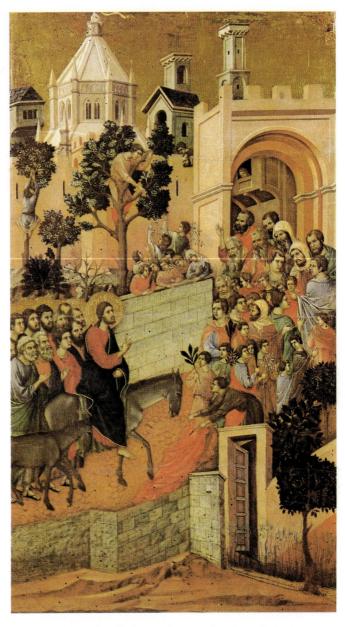

502. Duccio. *Christ Entering Jerusalem,* from the back of the *Maestà Altar.* 1308–11. Tempera on panel, $40^{1/2} \times 21^{1/8}$ " (103 x 53.7 cm). Museo dell'Opera del Duomo, Siena

Cimabue's sense of monumental scale, which made him a wall painter by instinct, rather than a panel painter. The art of Giotto is nevertheless so daringly original that its sources are far more difficult to trace than those of Duccio's style. Apart from his Florentine background as represented by the Greek manner of Cimabue, the young Giotto seems to have been familiar with the work of neo-Byzantine masters of Rome, among whom was Cimabue's contemporary Pietro Cavallini (documented 1272–1303), who practiced both mosaic and fresco. Cavallini's style is an astonishing blend of Byzantine, Roman, and Early Christian elements. The figures

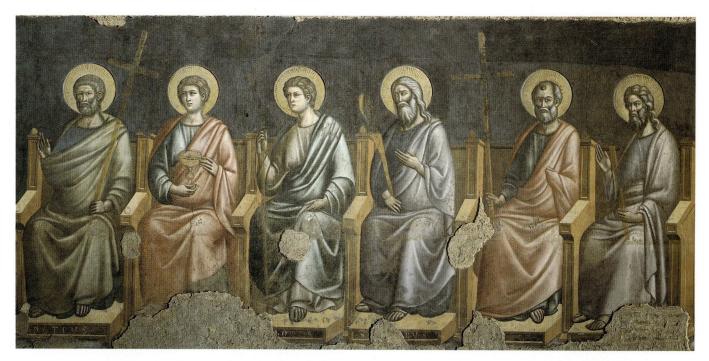

503. Pietro Cavallini. Seated Apostles, from The Last Judgment. c. 1290. Fresco. Sta. Cecilia in Trastevere, Rome

in his *Last Judgment* (fig. 503) are in the best up-to-date manner of late Byzantine art (compare the *Anastasis* in fig. 349), but he has modeled them in a soft daylight that can only have come from exposure to antique wall painting (see fig. 292). (He was also employed as a fresco restorer.) The result is an almost sculptural monumentality that is remarkably classical. Indeed, these saints have the same calm air and gentle gravity found on the *Sarcophagus of Junius Bassus* (fig. 312), but with the relaxed naturalness of the Gothic.

Cavallini set an important example for Giotto. In Rome Giotto, too, must have become acquainted with Early Christian and ancient Roman mural decoration. Classical sculpture likewise seems to have left an impression on him. More fundamental than any of these, however, was the influence of late medieval Italian sculptors: Nicola and Giovanni Pisano and especially Arnolfo di Cambio. They were the chief intermediaries through whom Giotto first came in contact with the world of Northern Gothic art. The latter remains the most important of all the elements that entered into Giotto's style. Indeed, Northern works such as those illustrated in figure 478 or figure 486 are almost certainly the ultimate source of the emotional impact that distinguishes his work from that of Cavallini and all others.

Of Giotto's surviving murals, those in the Arena Chapel in Padua, done in 1305–6, are the best preserved as well as the most characteristic. The decorations are devoted principally to scenes from the life of Christ, laid in a carefully arranged program consisting of three tiers of narrative scenes (fig. 505) and culminating in the *Last Judgment* at the west end of the chapel. [See Primary Sources, no. 40, page 391.] Giotto depicts many of the same subjects that we find on the reverse of Duccio's

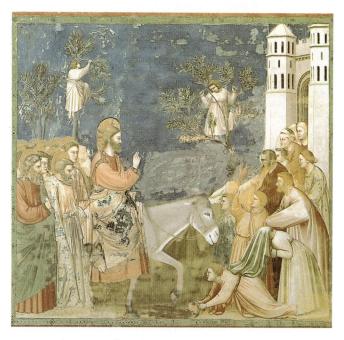

504. Giotto. *Christ Entering Jerusalem*. 1305–6. Fresco. Arena (Scrovegni) Chapel, Padua, Italy

Maestà, including Christ Entering Jerusalem (fig. 504). But where Duccio has enriched the traditional scheme, spatially as well as in narrative detail, Giotto subjects it to a radical simplification. The two versions have many elements in common, since they both ultimately derive from Byzantine sources. The difference is that Giotto's version must be based on a prototype of the early sixth century, while Duccio's is nearly 500 years later. In Giotto's painting, the action proceeds parallel to the picture plane. Landscape, architecture, and figures have been reduced to the essential minimum. The austerity of Giotto's art is further emphasized by the sober medium of fresco

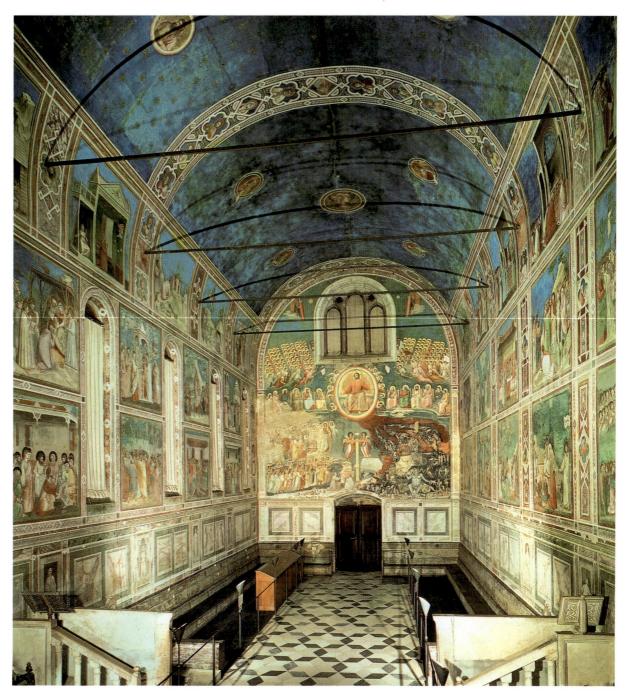

505. Interior, Arena (Scrovegni) Chapel, Padua, Italy. 1305-6

painting, with its limited range and intensity of tones. By contrast, Duccio's picture, which is executed in egg tempera on gold ground, has a jewellike brilliance and sparkling colors. Yet Giotto's work has the far more powerful impact of the two. It makes us feel so close to the event that we have a sense of being participants rather than distant observers.

How does the artist achieve this extraordinary effect? He does so, first of all, by having the entire scene take place in the foreground. Even more important, he presents it in such a way that the beholder's eye level falls within the lower half of the picture. Thus we can imagine ourselves standing on the same ground plane as these painted figures, even though we see

them from well below, whereas Duccio makes us survey the scene from above in "bird's-eye" perspective. The consequences of this choice of viewpoint are truly epoch-making. Choice implies conscious awareness—in this case, awareness of a relationship in space between the beholder and the picture. Duccio, certainly, does not yet conceive his picture space as continuous with the beholder's space. Hence we have the sensation of vaguely floating above the scene, rather than of knowing where we stand. Even ancient painting at its most illusionistic provides no more than a pseudo-continuity in this respect (see figs. 286 and 290). Giotto, on the other hand, tells us where we stand. Above all, he also endows his forms with a

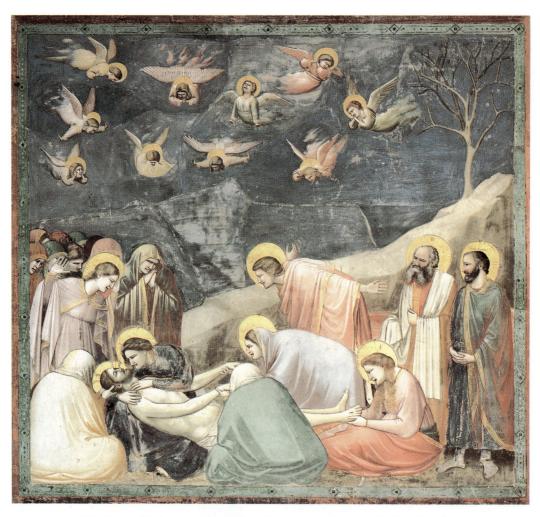

506. Giotto. The Lamentation. 1305-6. Fresco. Arena (Scrovegni) Chapel, Padua

three-dimensional reality so forceful that they seem as solid and tangible as sculpture in the round.

With Giotto it is the figures, rather than the architectural framework, that create the picture space. As a result, this space is more limited than Duccio's—its depth extends no further than the combined volumes of the overlapping bodies in the picture—but within its limits it is very much more persuasive. To Giotto's contemporaries, the tactile quality of his art must have seemed a near-miracle. It was this quality that made them praise him as equal, or even superior, to the greatest of the ancient painters, because his forms looked so lifelike that they could be mistaken for reality itself. Equally significant are the stories linking Giotto with the claim that painting is superior to sculpture. This was not an idle boast, as it turned out, for Giotto does indeed mark the start of what might be called "the era of painting" in Western art. The symbolic turning point is the year 1334, when he was appointed head of the Florence Cathedral workshop, an honor and responsibility hitherto reserved for architects or sculptors.

Giotto's aim was not simply to transplant Gothic statuary into painting. By creating a radically new kind of picture space, he had also sharpened his awareness of the picture surface. When we look at a work by Duccio (or his ancient and medieval predecessors), we tend to do so in installments, as it were. Our glance travels from detail to detail at a leisurely pace

until we have surveyed the entire area. Giotto, on the contrary, invites us to see the whole at one glance. His large, simple forms, the strong grouping of his figures, the limited depth of his "stage," all these factors help endow his scenes with an inner coherence such as we have never found before. Notice how dramatically the massed verticals of the "block" of apostles on the left are contrasted with the upward slope formed by the welcoming crowd on the right, and how Christ, alone in the center, bridges the gulf between the two groups. The more we study the composition, the more we come to realize its majestic firmness and clarity. Thus the artist has rephrased the traditional pattern of Christ's entry into Jerusalem to stress the solemnity of the event as the triumphal procession of the Prince of Peace.

Giotto's achievement as a master of design does not fully emerge from any single work. Only if we examine a number of scenes from the Padua fresco cycle do we understand how perfectly the composition in each instance is attuned to the emotional content of the subject. *The Lamentation* (fig. 506) was clearly inspired by a Byzantine example similar to the Nerezi fresco (see fig. 343), which was known in Italy early on. The tragic mood is brought home to us by the formal rhythm of the design as much as by the gestures and expressions of the participants. [See Primary Sources, no. 36, pages 389–90.] The very low center of gravity, and the hunched, bending fig-

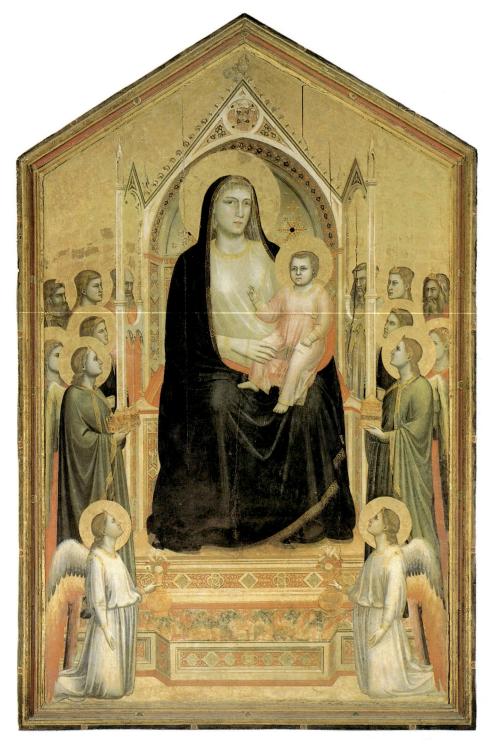

507. Giotto. Madonna Enthroned. c. 1310. Tempera on panel, 10'8" x 6'8" (3.3 x 2 m). Galleria degli Uffizi, Florence

ures communicate the somber quality of the scene and arouse our compassion even before we have grasped the specific meaning of the event depicted. With extraordinary boldness, Giotto sets off the frozen grief of the human mourners against the frantic movement of the weeping angels among the clouds, as if the figures on the ground were restrained by their collective duty to maintain the stability of the composition while the angels, small and weightless as birds, do not share this burden.

Once again the impact of the drama is heightened by the severely simple setting. The descending slope of the hill acts as a unifying element and at the same time directs our glance toward the heads of Christ and the Virgin, which are the focal point of the scene. Even the tree has a twin function. Its barrenness and isolation suggest that all of nature somehow shares in the Saviour's death. Yet it also invites us to ponder a more precise symbolic message: it alludes (as does Dante in a passage in the *Divine Comedy*) to the Tree of Knowledge, which the sin of Adam and Eve had caused to wither and which was to be restored to life through the sacrificial death of Christ.

What we have said of the Padua frescoes applies equally to the *Madonna Enthroned* (fig. 507), the most important among the small number of panel paintings by Giotto. Done about

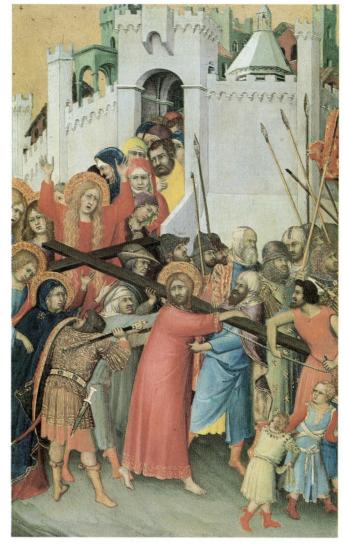

508. Simone Martini. *The Road to Calvary.* c. 1340. Tempera on panel, 97/8 x 61/8" (25 x 15.5 cm). Musée du Louvre, Paris

the same time as Duccio's *Maestà*, it illustrates once again the difference between Florence and Siena. Its architectural severity clearly derives from Cimabue (see fig. 499). The figures, however, have the same overpowering sense of weight and volume we saw in the frescoes in the Arena Chapel, and the picture space is just as persuasive—so much so, in fact, that the golden halos look like foreign bodies in it.

The throne, of a design based on Italian Gothic architecture, has now become a nichelike structure that encloses the Madonna on three sides and thus "insulates" her from the gold background. Its lavish ornamentation includes one feature of special interest: the colored marble surfaces of the base and of the quatrefoil within the gable. Such make-believe stone textures had been highly developed by ancient painters (see figs. 286 and 290), but the tradition had died out in Early Christian times. Its sudden reappearance here offers concrete evidence of Giotto's familiarity with whatever ancient murals could still be seen in medieval Rome.

MARTINI. There are few artists in the entire history of art who equal the stature of Giotto as a radical innovator. His very greatness, however, tended to dwarf the next generation of Florentine painters, which produced only followers rather than new leaders. Their contemporaries in Siena were more fortunate in this respect, since Duccio never had the same overpowering impact. As a consequence, it was they, not the Florentines, who took the next decisive step in the development of Italian Gothic painting. Simone Martini (c. 1284–1344), who painted the tiny but intense *The Road to Calvary* (fig. 508) about 1340, may well claim to be the most distinguished of Duccio's disciples. He spent the last years of his life in Avignon, the town in southern France that served as the residence-in-exile of the popes during most of the fourteenth century. Our panel, originally part of a small altar, was probably done there, as it was commissioned by Philip the Bold of Burgundy for the Chartreuse de Champmol.

In its sparkling colors, and especially in the architectural background, it still echoes the art of Duccio (see fig. 502). The vigorous modeling of the figures, on the other hand, as well as their dramatic gestures and expressions, betray the influence of Giotto. While Simone Martini is not much concerned with spatial clarity, he proves to be an extraordinarily acute observer. The sheer variety of costumes and physical types and the wealth of human incident create a sense of down-to-earth reality very different from both the lyricism of Duccio and the grandeur of Giotto.

THE LORENZETTI BROTHERS. This closeness to everyday life also appears in the work of the brothers Pietro and Ambrogio Lorenzetti (both died 1348?), but on a more monumental scale and coupled with a keen interest in problems of space. The boldest spatial experiment is Pietro's triptych of 1342, the Birth of the Virgin (fig. 509), where the painted architecture has been correlated with the real architecture of the frame in such a way that the two are seen as a single system. Moreover, the vaulted chamber where the birth takes place occupies two panels. It continues unbroken behind the column that divides the center from the right wing. The left wing represents an anteroom which leads to a large and only partially glimpsed architectural space suggesting the interior of a Gothic church. What Pietro Lorenzetti achieved here is the outcome of a development that began three decades earlier in the work of Duccio (compare fig. 502): the conquest of pictorial space. Only now, however, does the painting surface assume the quality of a transparent window through which not on which—we perceive the same kind of space we know from daily experience. Duccio's work alone is not sufficient to explain Pietro's astonishing breakthrough. It became possible, rather, through a combination of the architectural picture space of Duccio and the sculptural picture space of Giotto.

The same procedure enabled Ambrogio Lorenzetti to unfold a comprehensive view of the entire town before our eyes in his frescoes of 1338–40 in the Siena city hall (fig. 510). [See Primary Sources, no. 47, page 394.] We are struck by the distance that separates this precisely articulated "portrait" of Siena from Duccio's Jerusalem (fig. 502). Ambrogio's mural forms part of an elaborate allegorical program depicting the contrast of good and bad government. To the right on the far wall of figure 510, we see the Commune of Siena guided by Faith, Hope, and Charity and flanked by a host of other

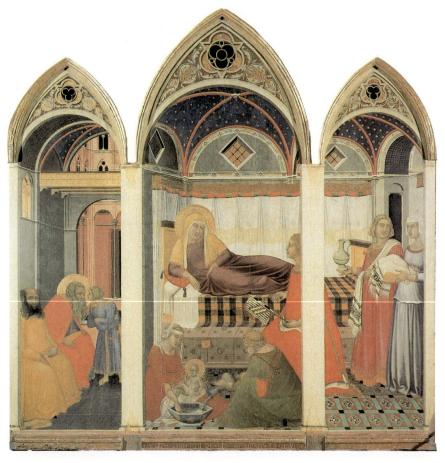

509. Pietro Lorenzetti. Birth of the Virgin. 1342. Tempera on panel, 6'11/2" x 5'111/2" (1.9 x 1.8 m). Museo dell'Opera del Duomo, Siena

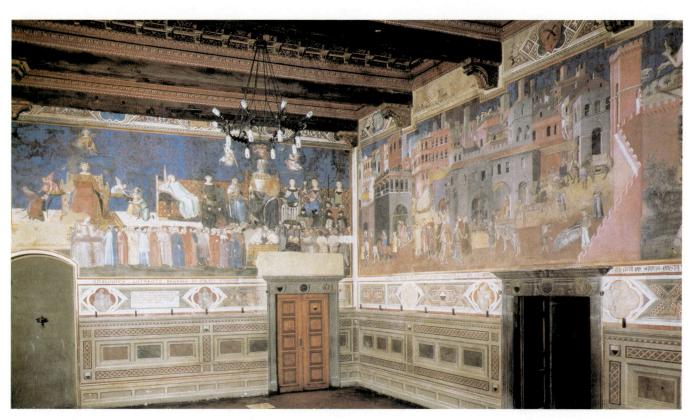

510. Ambrogio Lorenzetti. *The Commune of Siena* (left), *Good Government in the City* and portion of *Good Government in the Country* (right). 1338–40. Frescoes in the Sala della Pace, Palazzo Pubblico, Siena

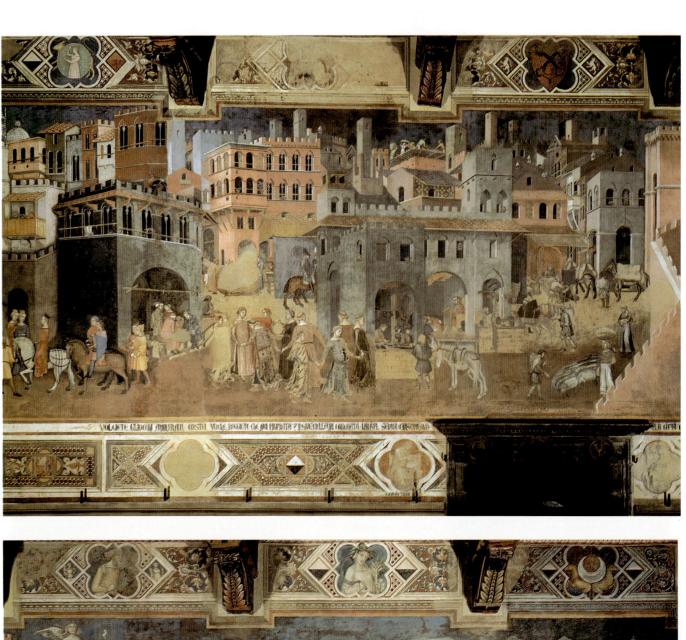

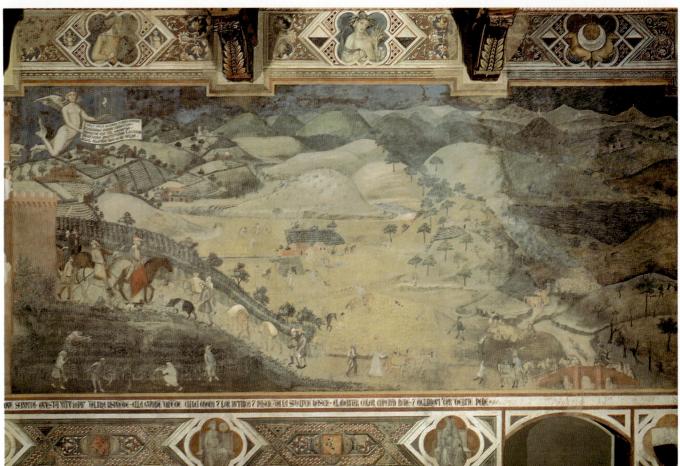

511. (opposite, above) Ambrogio Lorenzetti. Good Government in the City. Fresco, width of entire wall 46' (14 m). Palazzo Pubblico, Siena

512. (opposite, below) Ambrogio Lorenzetti. Good Government in the Country. Palazzo Pubblico, Siena

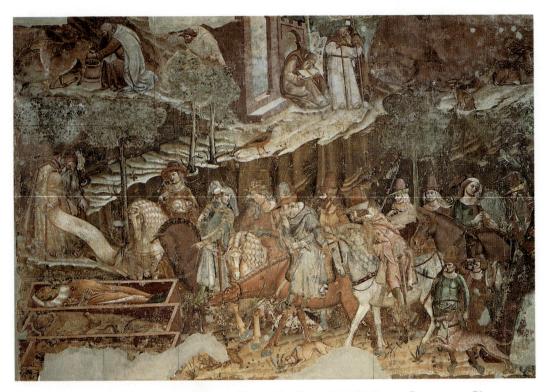

513. Francesco Traini. The Triumph of Death (detail). c. 1325-50. Fresco. Camposanto, Pisa

symbolic figures. The artist, in order to show the life of a well-ordered city-state, had to fill the streets and houses with teeming activity (fig. 511). The bustling crowd gives the architectural vista its striking reality by introducing the human scale. On the right, outside the city walls, the Good Government fresco provides a view of the Sienese countryside, fringed by distant mountains (fig. 512). It is a true landscape—the first since ancient Roman times—full of sweeping depth yet distinguished from its classical predecessors (such as fig. 287) by an ingrained orderliness, which lends it a domesticated air. Here the presence of people is not accidental. They have taken full possession of nature, terracing the hillsides with vineyards, patterning the valleys with the geometry of fields and pastures. In such a setting, Ambrogio observes the peasants at their seasonal labors, recording a rural Tuscan scene so characteristic that it has hardly changed during the past 600 years.

THE BLACK DEATH. The first four decades of the four-teenth century in Florence and Siena had been a period of political stability and economic expansion as well as of great artistic achievement. In the 1340s both cities suffered a series of catastrophes whose echoes were to be felt for many years. Banks and merchants went bankrupt by the score, internal upheavals shook the government, there were repeated crop failures, and in 1348 the epidemic of bubonic plague—the

Black Death—that spread throughout Europe wiped out more than half their urban population. [See Primary Sources, no. 48, page 394.] The popular reaction to these calamitous events was mixed. Many people regarded them as signs of divine wrath, warnings to a sinful humanity to forsake the pleasures of this earth; in such people the Black Death engendered a mood of otherworldly exaltation. To others, such as the gay company in Boccaccio's *Decameron*, the fear of sudden death merely intensified the desire to enjoy life while there was yet time. These conflicting attitudes are reflected in the pictorial theme of the Triumph of Death.

TRAINI. The most impressive version of this subject is an enormous fresco, attributed to the Pisan master Francesco Traini (documented c. 1321–1363), in the Camposanto, the cemetery building next to Pisa Cathedral. In a particularly dramatic detail (fig. 513), the elegantly costumed men and women on horseback have suddenly come upon three decaying corpses in open coffins. Even the animals are terrified by the sight and smell of rotting flesh. Only the hermit, having renounced all earthly pleasures, points out the lesson of the scene. But will the living accept the lesson, or will they, like the characters of Boccaccio, turn away from the shocking spectacle more determined than ever to pursue their hedonistic ways? The artist's own sympathies seem curiously divided. His style,

514. Francesco Traini. Sinopia drawing for *The Triumph of Death* (detail). Camposanto, Pisa

far from being otherworldly, recalls the realism of Ambrogio Lorenzetti, although the forms are harsher and more expressive.

In a fire that occurred in 1944, Traini's fresco was badly damaged and had to be detached from the wall in order to save what was left of it. This procedure exposed the first, rough coat of plaster underneath, on which the artist had sketched out his composition (fig. 514). These drawings, of the same size as the fresco itself, are amazingly free and sweeping. They reveal Traini's personal style more directly than the painted version, which was carried out with the aid of assistants. Because they are done in red, these underdrawings are called *sinopie* (an Italian word derived from ancient Sinope, in Asia Minor, which was famous as a source of brick-red earth pigment).

FRESCO PAINTING. Sinopie serve to introduce us to the standard technique of painting frescoes in the fourteenth century. After the first coat of plaster (arriccio or arricciato) had dried, the wall was divided into squares using a ruler or chalk lines tied to nails. The design was then brushed in with a thin ocher paint, and the outline developed further in charcoal, with the details being added last in sinopia. During the Renaissance, sinopie were replaced by cartoons: sheets of heavy paper or cardboard (cartone) on which the design was drawn in the studio. The design was then pricked with small holes and transferred to the wall by dusting ("pouncing") it with chalk. In the High Renaissance, however, the contours were often simply pressed through the paper with a stylus. Be that as it may, each section of the wall was covered with just enough fresh plaster (intonaco) to last the current session, in order for the water-based paints to sink in. (Some insoluble pigments could only be applied a secco to dry plaster.) Each

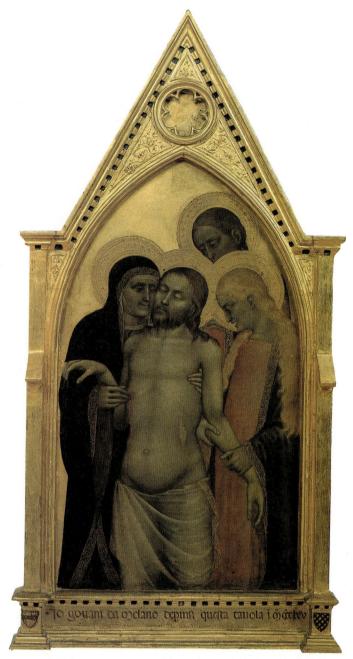

515. Giovanni da Milano. *Pietà*. 1365. Oil on panel, 48 x 22³/4" (122 x 57.5 cm). Galleria dell'Accademia, Florence

day's work progressed in this manner. Since the work had to be done on a scaffold, it was carried out from the top down, usually in horizontal strips. Needless to say, fresco painting was a slow process requiring numerous assistants for large projects.

GIOVANNI DA MILANO. Traini still retains a strong link with the great masters of the second quarter of the century. More characteristic of Tuscan painting after the Black Death are the painters who reached maturity around the 1350s. None of them can compare with the earlier artists whose work we have discussed. Their style, in comparison, seems dry and formula-ridden. Yet they were capable, at their best, of expressing the somber mood of the time with memorable intensity. The *Pietà* of 1365 (fig. 515) by Giovanni da Milano (documented 1346–1369) has all the emotional appeal of a German *Andachtsbild* (compare fig. 479), although the heritage of Giotto can be clearly felt even here.

516. Jean Pucelle. *The Betrayal of Christ* and *Annunciation*, from the *Hours of Jeanne d'Evreux*. 1325–28. Tempera and gold leaf on parchment, each page, $3^{1/2} \times 2^{7/16}$ " (8.9 x 6.2 cm). Shown larger than actual size. The Metropolitan Museum of Art, New York. The Cloisters Collection, Purchase, 1954

North of the Alps

ILLUMINATED MANUSCRIPTS. We are now in a position to turn once more to Gothic painting north of the Alps. What happened there during the latter half of the fourteenth century was determined in large measure by the influence of the great Italians. Some examples of this influence can be found even earlier, such as the *Annunciation* (fig. 516) from the private prayer book—called a "book of hours"—illuminated by Jean Pucelle in Paris about 1325–28 for Jeanne d'Evreux, queen of France. The style of the figures still recalls Master Honoré (see fig. 498), but the delicate *grisaille* (painting in gray) lends them a soft plasticity that was not explored by other artists for another 50 years. This is not Pucelle's only contribution: the architectural interior clearly derives from Duccio (fig. 501). It had taken less than 20 years for the fame of the *Maestà* to spread from Tuscany to the Île-de-France.

In taking over the new picture space, however, Jean Pucelle had to adapt it to the special character of a manuscript page, which lends itself far less readily than a panel to being treated as a window. The Virgin's chamber no longer fills the entire picture surface. It has become an ethereal cage that floats on the blank parchment background (note the supporting angel on the right) like the rest of the ornamental framework, so that the entire page forms a harmonious unit. As we explore the

details of this framework, we realize that most of them have nothing to do with the religious purpose of the manuscript: the kneeling queen inside the initial D is surely meant to be Jeanne d'Evreux at her devotions, but who could be the man with the staff next to her? He seems to be listening to the lute player perched on the tendril above him. The page is filled with other enchanting vignettes. A rabbit peers from its burrow beneath the girl on the left, and among the foliage leading up to the initial we find a monkey and a squirrel.

DRÔLERIE. These fanciful marginal designs—or *drôleries*—are a characteristic feature of Northern Gothic manuscripts. They had originated more than a century before Jean Pucelle in the regions along the English Channel, whence they spread to Paris and all the other centers of Gothic art. [See Primary Sources, no. 49, page 395.] Their subjects encompass a wide range of motifs: fantasy, fable, and grotesque humor, as well as acutely observed scenes of everyday life, appear side by side with religious themes. The essence of drôlerie is its playfulness, which marks it as a special domain where the artist enjoys almost unlimited freedom. It is this freedom, comparable to the license traditionally claimed by the court jester, that accounts for the wide appeal of drôlerie during the later Middle Ages.

517. Italian follower of Simone Martini (Matteo Giovannetti?). Scenes of Country Life (detail). c. 1345. Fresco. Palace of the Popes, Avignon

The innocent facade of Pucelle's drôleries nevertheless hides a serious intent. The four figures at the bottom of the right-hand page are playing a game of tag called Froggy in the Middle, a reference to the Betrayal of Christ on the opposite page. We will recognize this dramatic scene as the descendant, however indirect, of the mosaic in S. Apollinare Nuovo (see fig. 309). Below the *Betrayal* are two knights on goats jousting at a barrel. We may see in this image not only a mockery of courtly chivalry but also a veiled reference to Christ as a "scapegoat" and the spear of Longinus that will piece his side at the Crucifixion.

FRESCOES AND PANEL PAINTINGS. As we approach the middle years of the fourteenth century, Italian influence becomes ever more important in Northern Gothic painting. Sometimes this influence was transmitted by Italian artists active on northern soil, for example, Simone Martini (see page 370), who worked at the Palace of the Popes near Avignon (fig. 517).

One gateway of Italian influence was the city of Prague, the capital of Bohemia, thanks to Emperor Charles IV (1316–1378), the most remarkable ruler since Charlemagne. Charles received an excellent education in Paris at the French court of Charles IV, whose daughter he married and in whose

518. Bohemian Master. *Death of the Virgin.* 1355–60. Tempera on panel, $39^{3/8}$ x 28" (100 x 71 cm). Museum of Fine Arts, Boston.

William Francis Warden Fund; Seth K. Sweetser Fund, The Henry C. and Martha B. Angell Collection, Juliana Cheney Edwards Collection, Gift of Martin Brimmer, and Mrs. Frederick Frothingham; by exchange

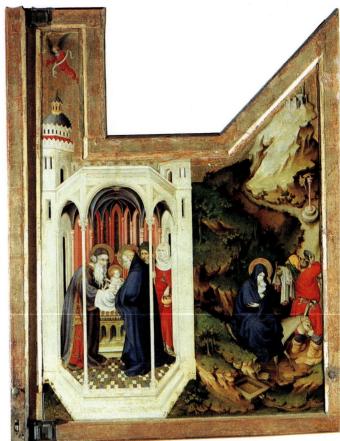

519. Melchior Broederlam. *Annunciation* and *Visitation; Presentation in the Temple;* and *Flight into Egypt.* 1394–99. Tempera on panel, each 65 x 49 ¹/₄" (167 x 125 cm). Musée des Beaux-Arts, Dijon, France

honor he changed his name from Wenceslaus. He returned to Prague and eventually succeeded his father as king of Bohemia in 1346. As a result of Charles' alliance with Pope Clement VI, who resided at Avignon during the papal exile, Prague became an independent archbishopric. It was also through Clement's intervention that Charles was elevated to Holy Roman Emperor at Aachen in 1349 by the German Electors. This title was confirmed by coronations in Milan and Rome six years later. In exchange, Charles supported Pope Urban V's return to Rome in 1367.

Like Charlemagne before him, Charles sought to make his capital a center of learning, and in 1348 he established a university along the lines of that in Paris, which attracted many of the best minds from throughout Europe. He also became an active patron of the arts, which he supported by founding an artists' guild. Prague rapidly developed into an international cultural center second only to Paris itself. Charles was nevertheless impressed most by the art he saw during his two visits to Italy. (He is known to have commissioned works by several Italian painters.) Thus, the Death of the Virgin (fig. 518), made by a Bohemian master about 1355-60, brings to mind the achievements of the great Sienese painters. Its glowing richness of color recalls Simone Martini, who, it will be remembered, had worked at Avignon. The carefully articulated architectural interior further betrays its descent from such works as Pietro Lorenzetti's Birth of the Virgin (fig. 509), but it lacks the spaciousness of its Italian models. Italian, too, is the vigorous modeling of the heads and the overlapping of the figures, which reinforces the three-dimensional quality of the design but raises the awkward question of what to do with the halos. (Giotto, we will remember, had faced the same problem in his *Madonna Enthroned*; compare fig. 507). Still, the Bohemian master's picture is not just an echo of Italian painting. The gestures and facial expressions convey an intensity of emotion that represents the finest heritage of Northern Gothic art. In this respect, our panel is far more akin to the *Death of the Virgin* at Strasbourg Cathedral (fig. 470) than to any Italian work.

The International Style

BROEDERLAM. Toward the year 1400, the merging of Northern and Italian traditions gave rise to a single dominant style throughout western Europe. This International Style was not confined to painting—we have used the same term for the sculpture of the period—but painters clearly played the main role in its development. Among the most important was Melchior Broederlam (flourished c. 1387-1409), a Fleming who worked for the court of the duke of Burgundy in Dijon, where he would have known Simone Martini's The Road to Calvary (fig. 508). Figure 519 shows the panels of a pair of shutters for an altar shrine that Broederlam did in 1394-99 for the Chartreuse de Champmol. (The interior consists of an elaborately carved relief by Jacques de Baerze showing the Adoration of the Magi, the Crucifixion, and the Entombment.) Each wing is really two pictures within one frame. Landscape and architecture stand abruptly side by side, even though the artist has

520. Jean Malouel and Henri Bellechose. *Martyrdom of St. Denis* with the Trinity. c. 1415. Tempera on panel, 5'3³/8" x 6'10⁵/8" (1.61 x 2.1 m). Musée du Louvre, Paris

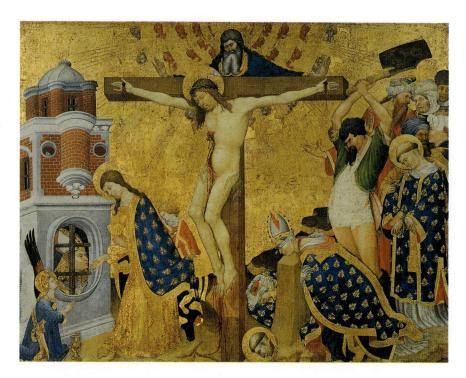

tried to suggest that the scene extends around the building.

Compared to paintings by Pietro and Ambrogio Lorenzetti, Broederlam's picture space still strikes us as naïve in many ways. The architecture looks like a doll's house, and the details of the landscape are quite out of scale with the figures. Yet the panels convey a far stronger feeling of depth than we have found in any previous Northern work. The reason for this is the subtlety of the modeling. The softly rounded shapes and the dark, velvety shadows create a sense of light and air that more than makes up for any shortcomings of scale or perspective. This soft, pictorial quality is a hallmark of the International Style. It appears as well in the ample, loosely draped garments with their fluid curvilinear patterns of folds, which remind us of Sluter and Ghiberti (see figs. 481 and 492).

Our panels also exemplify another characteristic of the International Style: its "realism of particulars." It is the same kind of realism we encountered first in Gothic sculpture (see fig. 474) and somewhat later among the marginal drôleries of manuscripts. We find it in the left panel in the carefully rendered foliage and flowers of the enclosed garden to the left, and in the clear distinction between the Gothic antechamber and the Romanesque temple. We see it as well in the right panel, in the delightful donkey (obviously drawn from life), and in the rustic figure of St. Joseph, who looks and behaves like a simple peasant and thus helps to emphasize the delicate, aristocratic beauty of the Virgin. This painstaking concentration on detail gives Broederlam's work the flavor of an enlarged miniature rather than of a large-scale painting, even though the panels are more than five feet tall.

The expansion of subject matter during the International Style was allied to a comparable growth in symbolism. In the left panel, for example, the lily signifies Mary's virginity, as does the enclosed garden next to her, while the contrasting Romanesque and Gothic architecture stands for the Old and New Testaments, respectively. This important development paves the way for the dramatic elaboration of symbolic mean-

ing that occurs a mere 25 years later under the Master of Flémalle.

MALOUEL AND BELLECHOSE. More monumental still is the somewhat later Martyrdom of St Denis (fig. 520), also from the Chartreuse de Champmol, which was probably begun by the court painter Jean Malouel (Jan Maelwel; active 1386–1415), but completed after his death by his successor, Henri Bellechose (died 1440/44), who likewise was born in the Netherlands. The subject of the painting is unique: it equates Denis' martyrdom with the Crucifixion. At the left Christ himself administers the last rites to Denis, while to the right we see the decapitation of the saint and his companions. Malouel also worked as an illuminator, but he was clearly a panel painter at heart. Although the oddly diminutive prison is a remnant of manuscript illustrations, the figures combine typically French gracefulness with an impressive bulk that can have come only from Italian art (compare fig. 515). The more robust figures, such as the executioner, were probably done by Bellechose, though the difference is one primarily of temperament than of style.

THE BOUCICAUT MASTER. Despite the growing importance of panel painting, book illumination remained the leading form of painting in northern Europe at the time of the International Style. Among the finest of the many manuscript painters employed by French courts was the Boucicaut Master, who was perhaps the Bruges artist Jacques Coen. In *The Story of Adam and Eve* (fig. 521) the promise of the Broederlam panels has been fulfilled, as it were: landscape and architecture are united in deep, atmospheric space, although the perspective is skewed. Even such intangible things as the starry sky have become paintable. Note, too, how the sky becomes lighter toward the horizon—the earliest-known example of atmospheric perspective. Every detail, be it divine or natural, is rendered as if it were a miraculous revelation. Stemming

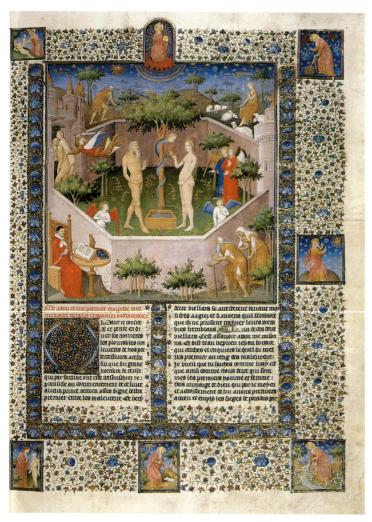

521. The Boucicaut Master. *The Story of Adam and Eve*, from Giovanni Boccaccio, *Des cas des nobles hommes et femmes* (The Fates of Illustrious Men and Women). Paris c. 1415. Gold leaf, gold paint, and tempera on vellum, $16^{3}/4 \times 11^{1}/2$ " (42.5 x 29.3 cm). The J. Paul Getty Museum, Los Angeles. Ms. 63, fol. 3

from St. Augustine, who considered the temporal realm a metaphor of the spiritual, this attitude represents a decisive change that soon leads to Late Gothic art.

THE LIMBOURG BROTHERS. The International Style reached its most advanced phase in the luxurious book of hours known as *Les Très Riches Heures du Duc de Berry*, produced for the brother of the king of France, a man of far from admirable character but the most lavish art patron of his day. The artists were Pol de Limbourg and his two brothers, Flemings all who were introduced to the court by their uncle, who was none other than Jean Malouel. They must have visited Italy, for their work includes numerous motifs and whole compositions borrowed from the great masters of Tuscany.

The most remarkable pages of *Les Très Riches Heures* are those of the calendar, with their elaborate depiction of the life of humanity and nature throughout the months of the year. Such cycles, originally consisting of 12 single figures each performing an appropriate seasonal activity, had long been an established tradition in medieval art (compare fig. 474). Jean Pucelle had enriched the margins of the calendar pages of his

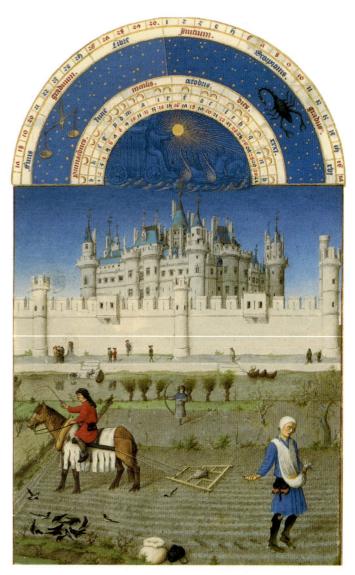

522. The Limbourg Brothers. *October*, from *Les Très Riches Heures du Duc de Berry.* 1413–16. 8 7/8 x 5 3/8" (22.5 x 13.7 cm). Musée Condé, Chantilly, France

books of hours by emphasizing the changing aspects of nature in addition to the labors of the months. The Limbourg brothers, however, integrated all these elements into a series of panoramas of human life in nature.

The illustration for the month of October (fig. 522) shows the sowing of winter grain. It is a bright, sunny day, and the figures—for the first time since classical antiquity—cast visible shadows on the ground. We marvel at the wealth of realistic detail, such as the scarecrow in the middle distance or the footprints of the sower in the soil of the freshly plowed field. The sower is memorable in other ways as well. His tattered clothing, his unhappy air, go beyond mere description. Although peasants were often caricatured in Gothic art, the portrayal here is surprisingly sympathetic, as it is throughout this book of hours. He is meant to be a pathetic figure, to arouse our awareness of the miserable lot of the peasantry in contrast to the life of the aristocracy, as symbolized by the splendid castle on the far bank of the river. (The castle, we will recall, is a "portrait" of the Gothic Louvre, the most lavish structure of its kind at that time; see pages 335–36.)

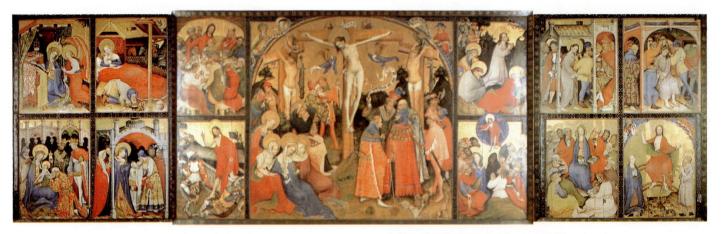

523. Konrad von Soest. The Wildunger Altarpiece. 1403? Panels, height 6'63/4" (2 m). Church, Bad Wildungen, Germany

SOEST. The International Style spread to Germany from France and Bohemia primarily along the Rhine and Danube rivers until it eventually converged on Cologne and nearby Westphalia. The greatest representative of this regional style was Konrad von Soest (active 1394-1422) of Dortmund, whose Wildunger Altarpiece (fig. 523) is a truly international blend of elements drawn from throughout Europe. The Crucifixion is descended from Duccio's Maestà altar by way of Paris, which accounts for the willowy Christ and delicate Mary. Her grief is sweetly lyrical, in contrast to the anguished despair of St. John behind her. The genteel, courtly throng to the left of Christ (the "sinister" side) is patently wicked, however, and the contrast between the two groups could hardly be more telling. The side panels, however, derive entirely from Bohemian art. Densely packed with figures, they have a drama that is uniquely German but with the refinement characteristic of the International Style as a whole.

MASTER FRANCKE. This intensely expressive manner culminates in the paintings of Master Francke, a Netherlander who probably worked in Paris and Westphalia before settling in Hamburg as a member of the Dominican order. *Christ Carrying the Cross* (fig. 524) on the *Englandfahrer Altarpiece*, completed in 1424, has the physical brutality we encountered in the Naumburg Master's *Kiss of Judas* (fig. 477), but now it is matched by an expressive violence that makes us feel the full force of Jesus' suffering at the hands of the malevolent crowd, with its coarse, leering faces. Not until Hieronymus Bosch nearly a hundred years later will we again encounter such a pervasive sense of evil. Yet in the sorrowful faces to the left we can sense Master Francke's continuing allegiance to the elegant manner of the International Style.

GENTILE DA FABRIANO. Italy was also susceptible to the International Style, although it gave more than it received. The altarpiece with the three Magi and their train by Gentile da Fabriano (c. 1370–1427; fig. 525), the greatest Italian painter of the International Style, shows that he

524. Master Francke. *Christ Carrying the Cross,* from the *Englandfahrer Altarpiece.* 1424. Panel, 39 x 35" (99 x 88.9 cm). Kunsthalle, Hamburg

knew the work of the Limbourg brothers. The costumes here are as colorful, the draperies as ample and softly rounded, as in Northern painting. The Holy Family on the left almost seems in danger of being overwhelmed by the festive pageant pouring down upon it from the hills in the far distance. The foreground includes more than a dozen marvelously well-observed animals, not only the familiar ones but hunting leopards, camels, and monkeys. (Such creatures were eagerly collected by the princes of the period, many of whom kept private zoos.) The Oriental background of the Magi is fur-

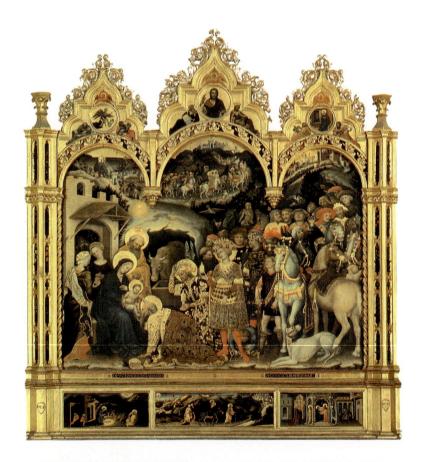

525. Gentile da Fabriano. *The Adoration of the Magi.* 1423. Oil on panel, 9'10¹/₈" x 9'3" (3 x 2.8 m). Galleria degli Uffizi, Florence

526. Gentile da Fabriano. *The Nativity,* from the predella of the *Adoration of the Magi.* 1423. 12¹/4 x 29¹/2" (31 x 75 cm). Galleria degli Uffizi, Florence

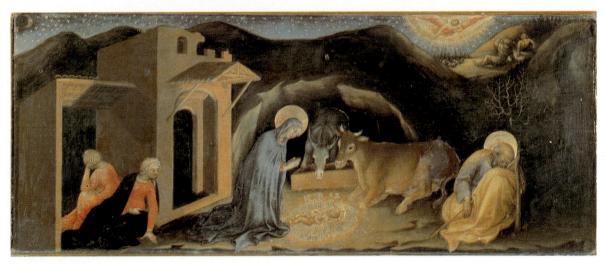

ther emphasized by the Mongolian facial cast of some of their companions. It is not these exotic touches, however, that mark our picture as the work of an Italian master but something else, a greater sense of weight, of physical substance, than we could hope to find among the Northern representatives of the International Style.

Despite his love of fine detail, Gentile is obviously a painter used to working on a large scale, rather than a manuscript illuminator at heart. The panels decorating the base, or predella, of the altarpiece have a monumentality that belies their small size. Gentile was thoroughly familiar with Sienese art. Thus, the *Flight into Egypt* in the center panel is indebted to Ambrogio Lorenzetti's frescoes in the Siena city hall (fig. 510), while the *Presentation in the Temple* to the right is based on another scene by the same artist that was also ultimately the source of Broederlam's depiction. They nevertheless show that Gentile, too, commanded

the delicate pictorial effects of a miniaturist when he wanted to.

Although he was not the first artist to depict it, the night scene in *The Nativity* in the left panel (fig. 526), partly based on the vision received by the fourteenth-century Swedish princess St. Bridget in Bethlehem, has an unprecedented poetic intimacy. The entire picture is dominated by the new awareness of light as an independent factor, separate from form and color, that we first observed in the October page of *Les Très Riches Heures*. Even though the main sources of illumination are the divine radiance of the newborn Child ("the light of the world") and of the angel bringing the glad tidings to the shepherds in the fields, their effect is as natural as if the Virgin were kneeling by a campfire. (Note the strong cast shadows.) Yet, the new world of artistic possibilities it opened up were not to be fully explored until two centuries later—characteristically enough, by Northern artists.

Primary Sources for Part Two

The following is a selection of excerpts, in modern translations, from original texts by poets, historians, religious figures, and artists of the Early Christian and Byzantine eras through the Middle Ages. These readings are intended to supplement the main text and are keyed to it. Their full citations are given in the Credits section at the end of the book.

The Holy Bible, Exodus 20:1–5

Exodus, the second book of the Old Testament, is one of five books traditionally attributed to Moses (these five are the Hebrew Torah). Exodus tells of the departure of the Jews from Egypt in the thirteenth century B.C. In chapter 20, God speaks to Moses on Mount Sinai and gives him the Ten Commandments. The second commandment pertains to images.

And the Lord spoke all these words: I am the Lord thy God, who brought thee out of the land of Egypt. . . .

Thou shalt not have strange gods before me.

Thou shalt not make to thyself a graven thing, nor the likeness of any thing that is in heaven above, or in the earth beneath, nor of those things that are in the waters under the earth.

Thou shalt not adore them, nor serve them.

21

Pope Gregory I (reigned 590–604) From a letter to Serenus of Marseille

Bishop Serenus apparently moved to discourage excessive acts of devotion to paintings in his church by having the images destroyed. In this letter of 600 A.D., Pope Gregory the Great reprimands him, reminding him that images serve to teach those who cannot read. This remained the standard defense of figural painting and sculpture in the Western church through the Middle Ages.

Word has . . . reached us that you . . . have broken the images of the saints with the excuse that they should not be adored. And indeed we heartily applaud you for keeping them from being adored, but for breaking them we reproach you. . . . To adore images is one thing; to teach with their help what should be adored is another. What Scripture is to the educated, images are to the ignorant, who see through them what

they must accept; they read in them what they cannot read in books. This is especially true of the pagans. And it particularly behooves you, who live among pagans, not to allow yourself to be carried away by just zeal and so give scandal to savage minds. Therefore you ought not to have broken that which was placed in the church not in order to be adored but solely in order to instruct the minds of the ignorant. It is not without reason that tradition permits the deeds of the saints to be depicted in holy places.

22

The Book of the Popes (Liber Pontificalis), from the life of Pope Sylvester I

This text is an official history of the Roman papacy from St. Peter (died c. 64 A.D.) to the twelfth century. Its biographies of the early popes were compiled from archival documents, for example this list of gifts to Old St. Peter's by the emperor Constantine in the time of Pope Sylvester I (314–335 A.D.). Lavish imperial donations like these set a standard which subsequent popes and other prelates continued to match.

Constantine Augustus built the basilica of blessed Peter, the apostle, . . . and laid there the coffin with the body of the holy Peter; the coffin itself he enclosed on all sides with bronze. . . . Above he set porphyry columns for adornment and other spiral columns which he brought from Greece. He made a vaulted apse in the basilica, gleaming with gold, and over the body of the blessed Peter, above the bronze which enclosed it, he set a cross of purest gold, ... He gave also 4 brass candlesticks, 10 feet in height, overlaid with silver, with figures in silver of the acts of the apostles, . . . 3 golden chalices, . . . 20 silver chalices, ... 2 golden pitchers, ... 5 silver pitchers, ... a golden paten with a turret of purest gold and a dove, . . . a golden crown before the body, that is a chandelier, with 50 dolphins, . . . 32 silver lamps in the basilica, with dolphins, . . . for the right of the basilica 30 silver lamps, . . . the altar itself of silver overlaid with gold, adorned on every side with gems, 400 in number, . . . a censer of purest gold adorned on every side with jewels.

23

Procopius of Caesarea (6th century) From *Buildings*

Procopius was an historian during the reign of Emperor Justinian. He wrote an entire book (c. 550 A.D.?) about the fortifications, aqueducts, churches, and other public buildings constructed by Justinian throughout the Byzantine Empire. The book begins with the greatest of these, Hagia Sophia (figs. 326–28).

The Emperor, disregarding all considerations of expense, . . . raised craftsmen from the whole world. It was Anthemius of Tralles, the most learned man in the discipline called engineering, . . . that ministered to the Emperor's zeal by regulating the work of the builders and preparing in advance designs of what was going to be built. He had as partner another engineer called Isidore, a native of Miletus. . . .

So the church has been made a spectacle of great beauty, stupendous to those who see it and altogether incredible to those who hear of it. . . . It subtly combines its mass with the harmony of its proportions, having neither any excess nor any deficiency, inasmuch as it is more pompous than ordinary [buildings] and considerably more decorous than those which are huge beyond measure; and it abounds exceedingly in gleaming sunlight. You might say that the [interior] space is not illuminated by the sun from the outside, but that the radiance is generated within, so great an abundance of light bathes this shrine all round. . . . In the middle of the church there rise four man-made eminences which are called piers, two on the north and two on the south, . . . each pair having between them exactly four columns. The eminences are built to a great height. . . . As you see them, you could suppose them to be precipitous mountain peaks. Upon these are placed four arches so as to form a square, their ends coming together in pairs and made fast at the summit of those piers, while the rest of them rises to an immense height. Two of the arches, namely those facing the rising and the setting sun, are suspended over empty air, while the others have beneath them some kind of structure and rather tall columns. Above the arches the construction rises in a circle. . . . Rising above this circle is an enormous spherical dome which makes the building exceptionally beautiful. It seems not to be founded on solid masonry, but to be suspended from heaven by that golden chain and so cover the space. All of these elements, marvellously fitted together in mid-air, suspended from one another and reposing only on the parts adjacent to them, produce a unified and most remarkable harmony in the work, and yet do not allow the spectators to rest their gaze upon any one of them for a length of time, but each detail readily draws and attracts the eye to itself. Thus the vision constantly shifts round, and the beholders are quite unable to select any particular element which they might admire more than all the others. No matter how much they concentrate their attention on this side and that, and examine everything with contracted eyebrows, they are unable to understand the craftsmanship and always depart from there amazed by the perplexing spectacle.

24

St. Theodore the Studite (759–826 A.D.) From Second and Third Refutations of the Iconoclasts

Theodore of the Stoudios monastery in Constantinople was a principal defender of icons against the Iconoclasts. He refuted their charges of idolatry by examining how an image is and is not identical to its prototype (the person portrayed). Some of his arguments reflect the Neo-Platonic theory expounded by Plotinus that the sense-world is related to the divine by emanation.

The holy Basil [St. Basil the Great, c. 329–379 A.D.] says, "The image of the emperor is also called 'emperor,' yet there are not two emperors, nor is his power divided, nor his glory fragmented. Just as the power and authority which rules over us is one, so also the glorification which we offer is one, and not many. Therefore the honor given to the image passes over to the prototype." . . . In the same way we must say that the icon of Christ is also called "Christ," and there are not two Christs; nor in this case is the power divided, nor the glory fragmented. The honor given the image rightly passes over to the prototype. . . .

Every image has a relation to its archetype; the natural image has a natural relation, while the artificial image has an

artificial relation. The natural image is identical both in essence and in likeness with that of which it bears the imprint: thus Christ is identical with His Father in respect to divinity, but identical with His mother in respect to humanity. The artificial image is the same as its archetype in likeness, but different in essence, like Christ and His icon. Therefore there is an artificial image of Christ, to whom the image has its relation. . . .

It is not the essence of the image which we venerate, but the form of the prototype which is stamped upon it, since the essence of the image is not venerable. Neither is it the material which is venerated, but the prototype is venerated together with the form and not the essence of the image. . . .

If every body is inseparably followed by its own shadow, and no one in his right mind could say that a body is shadowless, but rather we can see in the body the shadow which follows, and in the shadow the body which precedes: thus no one could say that Christ is imageless, if indeed He has a body with its characteristic form, but rather we can see in Christ His image existing by implication and in the image Christ plainly visible as its prototype. . . .

By its potential existence even before its artistic production we can always see the image in Christ; just as, for example, we can see the shadow always potentially accompanying the body, even if it is not given form by the radiation of light. In this manner it is not unreasonable to reckon Christ and His image among things which are simultaneous. . . .

If, therefore, Christ cannot exist unless His image exists in potential, and if, before the image is produced artistically, it subsists always in the prototype: then the veneration of Christ is destroyed by anyone who does not admit that His image is also venerated in Him.

25

Nicholas Mesarites (c. 1163–after 1214) From Description of the Church of the Holy Apostles

The Church of the Holy Apostles in Constantinople, destroyed in the fifteenth century, was decorated with mosaics by the artist Eulalios in the twelfth century. As at Daphnē, the central dome displayed an image of the Pantocrator. In this text a contemporary author offers an interpretation of the placement of the image in the dome, its bust form, and its expression.

This dome . . . exhibits an image of the God-man Christ looking down, as it were, from the rim of heaven towards the floor of the church and everything that is in it. He is not [represented] full-length and entire, and this, I think, is a very profound conception that the artist has had in his mind and has expressed by means of his art to the unhurried spectator: first,

methinks, because at present our knowledge of things concerning Christ and His ways is but partial, as in a riddle or in a glass; second, because the God-man is going to appear to us from heaven once again at the time of His Second Coming to earth, and the time until that happens has not yet entirely elapsed, and because He both dwells in heaven in the bosom of His Father, and wishes to associate with men on earth together with His Father. . . . Wherefore He may be seen, to quote her who sings [in the Canticle], looking forth through the windows, leaning out down to his navel through the lattice which is near the summit of the dome, after the manner of irresistibly ardent lovers. . . . His eyes are joyful and welcoming to those who have a clean conscience . . . but to those who are condemned by their own judgment, they are wrathful and hostile. . . . The right hand blesses those who walk a straight path, while it admonishes those who do not and, as it were, checks them and turns them back from their disorderly course.

Lindisfarne Gospels Colophon

Colophons are notes written at the end of some manuscripts recording who wrote them, when, for whom, etc. The colophon at the end of the Lindisfarne Gospels (c. 700 A.D.) was written some 250 years after the text, but most scholars believe that its information is accurate. It names the scribe, the binder, the maker of the metal ornaments on the binding, and the author of the English translation of the Latin text, but no painter. The painting seems to have been done by Eadfrith, the scribe.

Eadfrith, Bishop of the Lindisfarne Church, originally wrote this book, for God and for Saint Cuthbert and . . . for all the saints whose relics are in the Island. And Ethelwald, Bishop of the Lindisfarne islanders, impressed it on the outside and covered it—as he well knew how to do. And Billfrith, the anchorite, forged the ornaments which are on it on the outside and adorned it with gold and with gems and also with gilded-over silver—pure metal. And Aldred, unworthy and most miserable priest, glossed it in English between the lines with the help of God and Saint Cuthbert. . . .

Hariulf (c. 1060–1143)
From History of the Monastery
of St.-Riquier

Hariulf was a monk at St.-Riquier until 1105, when he became abbot of St. Peter's at Oudenbourg in Belgium.

The church dedicated to the Saviour and St. Richarius . . . was among all other churches of its time the most famous. . . . The eastern tower is close to the sepulchre of St. Richarius. . . . The western tower is especially dedicated to the Saviour. . . .

If one surveys the place, one sees that the largest church, that of St. Richarius, lies to the north. The second, somewhat smaller one, which has been built in honor of our Lady on this side of the river, lies to the south. The third one, the smallest, lies to the east. The cloisters of the monks are laid out in a triangular fashion, one roof extending from St. Richarius' to St. Mary's, one from St. Mary's to St. Benedict's and one from St. Benedict's to St. Richarius'. . . . The monastery is so arranged that, according to the rule laid down by St. Benedict, all arts and all necessary labors can be executed within its walls. The river flows through it, and turns the mill of the brothers.

St. Angilbert (c. 750–814) From Customary for the Different Devotions

Angilbert, a member of Charlemagne's court, became lay abbot of St.-Riquier in 781 and sponsored the monastery's rebuilding. His description reveals how the resident monks moved from one part of the basilica to another while chanting the devotions prescribed in the Rule of St. Benedict.

When the brethren have sung Vespers and Matins at the altar of the Saviour, then one choir should descend on the side of the holy Resurrection, the other one on the side of the holy Ascension, and having prayed there the processions should in the same fashion as before move singing towards the altars of St. John and St. Martin. After having prayed they should enter from both sides through the arches in the middle of the church and pray at the holy Passion. From there they should go to the altar of St. Richarius. After praying they should divide themselves again as before and go to the altars of St. Stephen and St. Lawrence and from there go singing and praying to the altar of the Holy Cross. Thence they should go again to the altar of St. Maurice and through the long gallery to the church of St. Benedict.

20

From Inventory of the Treasury of Centula

The fabulously rich adornment of the monastery church, recorded in this document of 831 A.D., harks back to the imperial endowment of Old St. Peter's and anticipates the equally extravagant commissions by Abbot Suger for St.-Denis.

In the main church are three altars, . . . made out of marble, gold, silver, gems, and various kinds of stones. Over the three altars stand three canopies of gold and silver, and from them

hang three crowns, one for each, made of gold and costly stones with little golden crosses and other ornaments. In the same church are three lecterns, made of marble, silver and gold. Thirty reliquaries, made of gold, silver and ivory, five large crosses and eight smaller ones. . . . Fifteen large candlesticks of metal with gold and silverwork, seven smaller ones. Seven circular chandeliers of silver, seven of gilded copper, six silver lamps, six lamps of gilded copper. . . . Eight censers of gilded silver and one of copper. A silver fan. Sidings around the head end of the shrine of St. Richarius, and two small doors made of silver, gold and precious stones, six small doors made of gold and silver around the foot of his shrine, and six others which are similar. . . . One gospel book, written in gold and its silver box set with jewels and gems. Two other boxes for gospel books, of silver and gold, and a folding chair made of silver, belonging to them. Four golden chalices, two large silver chalices and thirteen small ones. Two golden patens, four large silver patens and thirteen smaller ones. . . . One large silver bowl, four small silver bowls, one brass bowl. . . . One golden staff, fitted with silver and crystal. One crook of crystal.

30

St. Benedict of Nursia (c. 480–c. 553) From *The Rule*

Monastic communities generally had a rule, or set of regulations, prescribing the discipline of their members' daily life. The rule written by St. Benedict for his community at Monte Cassino in southern Italy was admired by Pope Gregory the Great and by Charlemagne, who obtained an exact copy of it when he visited Monte Cassino in 787. The plan of St. Gall was part of a Carolingian effort to impose the Benedictine rule on all monasteries in France and Germany. The Rule requires complete renunciation of the world in order to maintain a routine of collective prayer and chanting seven times a day, about four hours of reading and meditation on the Bible, and some manual labor.

CHAPTER 16:

The Day Office

The prophet says: "Seven times daily I have sung Your praises" (Ps. 119:164). We will cleave to this sacred number if we perform our monastic duties at Lauds, Prime, Tierce, Sext, None, Vespers and Compline.

CHAPTER 17:

The number of psalms said in the Day Office

Three psalms are to be chanted for Prime, each with a separate Gloria. An appropriate hymn is sung, before the psalms. . . . After the psalms a lesson from the apostle is recited, and the Hour is finished with the versicle, the Kyrie and dismissal. The Hours of Tierce, Sext and None are to be conducted in the same order.

CHAPTER 22:

How the monks are to sleep

All the monks shall sleep in separate beds. . . . If possible they should all sleep in one room. However, if there are too many for this, they will be grouped in tens or twenties, a senior in charge of each group. Let a candle burn throughout the night. They will sleep in their robes, belted but with no knives, thus preventing injury in slumber. The monks then will always be prepared to rise at the signal and hurry to the Divine Office. But they must make haste with gravity and modesty.

The younger brothers should not be next to each other. Rather their beds should be interspersed with those of their elders. When they arise for the Divine Office, they ought encourage each other, for the sleepy make many excuses.

CHAPTER 48:

Daily manual labor

Idleness is an enemy of the soul. Therefore, the brothers should be occupied according to schedule in either manual labor or holy reading. . . . From Easter to October, the brothers shall work at manual labor from Prime until the fourth hour. From then until the sixth hour they should read. After dinner they should rest (in bed) in silence. However, should anyone desire to read, he should do so without disturbing his brothers.

None should be chanted at about the middle of the eighth hour. Then everyone shall work as they must until Vespers. If conditions dictate that they labor in the fields (harvesting), they should not be grieved for they are truly monks when they must live by manual labor, as did our fathers and the apostles. Everything should be in moderation, though, for the sake of the timorous. . . .

All shall read on Saturdays except those with specific tasks. If anyone is so slothful that he will not or cannot read or study, he will be assigned work so as not to be idle.

CHAPTER 53:

The reception of guests

The kitchen of the abbot and guests should be separate from that of the community so as not to disturb the brothers, for the visitors, of whom there are always a number, come and go at irregular hours. . . .

No one may associate or converse with guests unless ordered. If one meets or sees a guest, he is to greet him with humility . . . and ask a blessing. If the guest speaks, the brother is to pass on, telling the guest that he is not permitted to speak.

CHAPTER 55:

Clothing and shoes

Each monk needs only two each of tunics and cowls, so he will be prepared for night wear and washing. Anything else is superfluous and should be banished. . . . Bedding shall consist of a mattress, coverlet, blanket and pillow. The abbot will make frequent inspections of the bedding to prevent hoarding. Any infractions are subject to the severest discipline and, so that this vice of private ownership may be cut away at the roots, the abbot is to furnish all necessities: cowl, tunic, shoes, stockings, belt, knife, pen, needle, towel and writing tablet.

CHAPTER 57:

Artisans and craftsmen

Craftsmen present in the monastery should practice their crafts with humility, as permitted by the abbot. But if anyone becomes proud of his skill and the profit he brings the community, he should be taken from his craft and work at ordinary labor. This will continue until he humbles himself and the abbot is satisfied. If any of the works of these craftsmen are sold, the salesman shall take care to practice no fraud. . . .

In pricing, they should never show greed, but should sell things below the going secular rate.

CHAPTER 66:

The porter of the monastery

The monastery should be planned, if possible, with all the necessities—water, mill, garden, shops—within the walls. Thus the monks will not need to wander about outside, for this is not good for their souls.

From Pilgrim's Guide to Santiago de Compostela

The Pilgrim's Guide, written in the mid-twelfth century, gives a vivid account of the routes and what was to be met along them by pilgrims to the shrine of the Apostle James in Compostela. Describing Ste.-Madeleine (the church of St. Mary Magdalen) at Vézelay (fig. 406), the Guide recounts a medieval legend that Mary Magdalen journeyed to France after Christ's death and died in Aix-en-Provence.

There are four roads which, leading to Santiago, converge to form a single road at Puente la Reina, in Spanish territory. One crosses Saint-Gilles [fig. 407], Montpellier, Toulouse [figs. 380–83] and the pass of Somport; another goes through Notre-Dame of Le Puy, Sainte-Foy of Conques and Saint-Pierre of Moissac [figs. 401 and 402]; another traverses Sainte-Marie-Madeleine of Vézelay [fig. 406], Saint Léonard in the Limousin as well as the city of Périgueux; still another cuts through Saint-Martin of Tours, Saint-Hilaire of Poitiers, Saint-Jean-d'Angély, Saint-Eutrope of Saintes and the city of Bordeaux. . . .

One needs three more days of march, for people already tired, to traverse the Landes of the Bordelais.

This is a desolate region deprived of all good: there is here no bread, wine, meat, fish, water or springs; villages are rare here. The sandy and flat land abounds none the less in honey, millet, panic-grass, and wild boars. If perchance you cross it in summertime, guard your face diligently from the enormous flies that greatly abound there and which are called in the vulgar wasps or horseflies; and if you do not watch your feet carefully, you will rapidly sink up to the knees in the sea-sand copiously found all over.

Having traversed this region, one comes to the land of Gascon rich in white bread and excellent red wine. . . . The Gascons are fast in words, loquacious, given to mockery, libidinous, drunkards, prodigal in food. . . . However, they are well-trained in combat and generous in the hospitality they provide for the poor. . . .

They have the habit of eating without a table and of drinking all of them out of one single cup. In fact, they eat and drink a lot, wear rather poor clothes, and lie down shamelessly on a thin and rotten straw litter, the servants together with the master and the mistress.

On leaving that country, . . . on the road of St. James, there are two rivers. . . . There is no way of crossing them without a raft. May their ferrymen be damned! . . . They have the habit of demanding one coin from each man, whether poor or rich, whom they ferry over, and for a horse they ignominiously extort by force four. . . . When boarding . . . one must be most careful not to fall by chance into the water. . . .

Many times the ferryman, having received his money, has such a large troop of pilgrims enter the boat that it capsizes and the pilgrims drown in the waves. Upon which the boatmen, having laid their hands upon the spoils of the dead, wickedly rejoice.

ST. MARY MAGDALENE

On the route that through Saint-Léonard stretches towards Santiago, the most worthy remains of the Blessed Mary Magdalene must first of all be rightly worshipped by the pilgrims. She is . . . that glorious Mary who, in the house of Simon the Leprous, watered with her tears the feet of the Savior, wiped them off with her hair, and anointed them with a precious ointment while kissing them most fervently. . . . It is she who, arriving after the Ascension of the Lord from the region of Jerusalem . . . went by sea as far as the country of Provence, namely the port of Marseille.

In that area she led for some years . . . a celibate life and, at the end, was given burial in the city of Aix. . . . But, after a long time, a distinguished man called Badilon, beatified in monastic life, transported her most precious earthly remains from that city to Vézelay, where they rest up to this day in a much honored tomb. In this place a large and most beautiful basilica as well as an abbey of monks were established [fig. 406]. Thanks to her love, the faults of the sinners are here remitted by God, vision is restored to the blind, the tongue of the mute is untied, the lame stand erect, the possessed are

delivered, and unspeakable benefices are accorded to many. Her sacred feast is celebrated on July 22.

THE STONECUTTERS OF THE CHURCH [OF ST. JAMES] AND THE BEGINNING AND COMPLETION OF THEIR WORK

The master stonecutters that first undertook the construction of the basilica of the Blessed James were called Master Bernard the elder—a marvelously gifted craftsman—and Robert, as well as other stonecutters, about fifty in number, who worked assiduously under the most faithful administration of Don Wicart, the head of the chapter Don Segeredo, and the abbot Don Gundesindo, during the reign of Alphonso king of Spain and during the bishopric of Don Diego I, a valiant soldier and a generous man.

The church was begun in the year 1116 of the era.... And from the year that the first stone of the foundations was laid down until such a time that the last one was put in place, forty-four years have elapsed.

37

St. Bernard of Clairvaux (1090–1153) From Apologia to Abbot William of St.-Thierry

Bernard of Clairvaux was a member of the Cistercians, an ascetic order founded in the eleventh century in opposition to the increasing opulence of the Benedictines. His letter to the Benedictine abbot William of St.-Thierry of about 1127 denounces all monastic luxury, especially the presence of art in cloisters. Like many others, Bernard believed that monks were spiritually superior to the "carnal" layfolk and so should not need material inducements to devotion.

As a monk, I put to monks the same question that a pagan used to criticize other pagans: "Tell me, priests," he said, "what is gold doing in the holy place?" I, however, say, . . . "Tell me, poor men, if indeed you are poor men, what is gold doing in the holy place?" For certainly bishops have one kind of business, and monks another. We [monks] know that since they [bishops] are responsible for both the wise and the foolish, they stimulate the devotion of a carnal people with material ornaments because they cannot do so with spiritual ones. But we who have withdrawn from the people, we who have left behind all that is precious and beautiful in this world for the sake of Christ, we who regard as dung all things shining in beauty, soothing in sound, agreeable in fragrance, sweet in taste, pleasant in touch—in short, all material pleasures-... whose devotion, I ask, do we strive to excite in all this? . . .

Does not avarice . . . cause all this . . .? Money is sown with such skill that it may be multiplied. . . . The very sight of these costly but wonderful illusions inflames men more to give than

to pray. In this way wealth is derived from wealth. . . . Eyes are fixed on relics covered with gold and purses are opened. The thoroughly beautiful image of some male or female saint is exhibited and that saint is believed to be the more holy the more highly colored the image is. People rush to kiss it, they are invited to donate, and they admire the beautiful more than they venerate the sacred. . . . What do you think is being sought in all this? The compunction of penitents, or the astonishment of those who gaze at it? O vanity of vanities . . . ! The Church is radiant in its walls and destitute in its poor. . . . It serves the eyes of the rich at the expense of the poor. The curious find that which may delight them, but those in need do not find that which should sustain them. . . .

But apart from this, in the cloisters, before the eyes of the brothers while they read—what is that ridiculous monstrosity doing, an amazing kind of deformed beauty and yet a beautiful deformity? What are the filthy apes doing there? The fierce lions? The monstrous centaurs? The creatures, part man and part beast? The striped tigers? The fighting soldiers? The hunters blowing horns? You may see many bodies under one head, and conversely many heads on one body. On one side the tail of a serpent is seen on a quadruped, on the other side the head of a quadruped is on the body of a fish. Over there an animal has a horse for the front half and a goat for the back; here a creature which is horned in front is equine behind. In short, everywhere so plentiful and astonishing a variety of contradictory forms is seen that one would rather read in the marble than in books, and spend the whole day wondering at every single one of them than in meditating on the law of God. Good God! If one is not ashamed of the absurdity, why is one not at least troubled at the expense?

33 Suger of St.-Denis (1081–1151) From On the Consecration of the Church of St.-Denis

Abbot Suger left two accounts of his rebuilding of the Abbey Church of St.-Denis: a booklet that describes the entire campaign from its conception to the consecration of the new east end on June 11, 1144; and a record of the precious outfittings, including the stained-glass windows, in a review of his accomplishments as abbot. In these excerpts from the first text (1144-47), Suger justifies his enlargement of the Carolingian building with reference to its overcrowding on religious holidays, and he recounts the auspicious discovery of a local quarry and the appearance of the workmen needed to execute his project. After rebuilding the west end of the Carolingian church, he destroyed its eastern apse and built a much larger, more elaborate choir over

the old crypt. Suger notes as his principal innovation the radiating chapels filled with stained glass.

Through a fortunate circumstance . . . —the number of the faithful growing and frequently gathering to seek the intercession of the Saints—the [old] basilica had come to suffer grave inconveniences. Often on feast days, completely filled, it disgorged through all its doors the excess of the crowds as they moved in opposite directions, and the outward pressure of the foremost ones not only prevented those attempting to enter from entering but also expelled those who had already entered. At times you could see . . . that no one among the countless thousands of people because of their very density could move a foot; that no one, because of their very congestion, could [do] anything but stand like a marble statue, stay benumbed or, as a last resort, scream. The distress of the women . . . was so great and so intolerable that you could see . . . how they cried out horribly . . . how several of them, . . . lifted by the pious assistance of men above the heads of the crowd, marched forward as though upon a pavement; and how many others, gasping with their last breath, panted in the cloisters of the brethren to the despair of everyone. . . .

Through a gift of God a new quarry, yielding very strong stone, was discovered such as in quality and quantity had never been found in these regions. There arrived a skillful crowd of masons, stonecutters, sculptors and other workmen, so that-thus and otherwise-Divinity relieved us of our fears and favored us with Its goodwill by comforting us and by providing us with unexpected [resources]. I used to compare the least to the greatest: Solomon's riches could not have sufficed for his Temple any more than did ours for this work had not the same Author [God] of the same work abundantly supplied His attendants. The identity of the author and the work provides a sufficiency for the worker. . . .

Upon consideration, then, it was decided to remove that vault, unequal to the higher one, which, overhead, closed the apse containing the bodies of our Patron Saints, all the way [down] to the upper surface of the crypt to which it adhered; so that this crypt might offer its top as a pavement to those approaching by either of the two stairs, and might present the chasses [reliquaries] of the Saints, adorned with gold and precious gems, to the visitors' glances in a more elevated place. Moreover, it was cunningly provided that—through the upper columns and central arches which were to be placed upon the lower ones built in the crypt—the central nave of the old [church] should be equalized, by means of geometrical and arithmetical instruments, with the central nave of the new addition; and, likewise, that the dimensions of the old sideaisles should be equalized with the dimensions of the new side-aisles, except for that elegant and praiseworthy extension, in [the form of] a circular string of chapels, by virtue of which the whole [church] would shine with the wonderful and uninterrupted light of most luminous windows, pervading the interior beauty.

34

Suger of St.-Denis From On What Was Done Under His Administration

St.-Denis was a Benedictine abbey, though its church was open to layfolk and attracted them in large numbers. The ostentatious embellishment of the church was the type of material display deplored by St. Bernard of Clairvaux. Suger's descriptions of it, recorded between 1144 and 1149, suggest a sensuous love of precious materials, but also a belief that contemplation of these materials could lead the worshiper to a state of heightened spiritual awareness. Like the Byzantine rationale for icons, the notion of "anagogical" transportation to another dimension is indebted to Neo-Platonism.

We insisted . . . that the adorable, life-giving cross . . . should be adorned. . . . Therefore we searched around everywhere by ourselves and by our agents for an abundance of precious pearls and gems. . . . One merry but notable miracle which the Lord granted us in this connection we do not wish to pass over. . . . For when I was in difficulty for want of gems and could not sufficiently provide myself with more (for their scarcity makes them very expensive): then, lo and behold, [monks] from three abbeys of two Orders—that is, from Cîteaux and another abbey of the [Cistercian] Order, and from Fontevrault . . . offered us for sale an abundance of gems such as we had not hoped to find in ten years, hyacinths, sapphires, rubies, emeralds, topazes. Their owners had obtained them from Count Thibaut for alms; and he in turn had received them, through the hands of his brother Stephen, King of England [reigned 1135-54], from the treasures of his uncle, the late King [Henry I, reigned 1100-1135], who had amassed them throughout his life in wonderful vessels. We, however, freed from the worry of searching for gems, thanked God and gave four hundred pounds for the lot though they were worth much more. . . .

We hastened to adorn the Main Altar of the blessed Denis where there was only one beautiful and precious frontal panel from Charles the Bald [843–77], the third Emperor; for at this [altar] we had been offered to the monastic life. . . .

The rear panel, of marvelous workmanship and lavish sumptuousness (for the barbarian artists were even more lavish than ours), we ennobled with chased relief work equally admirable for its form as for its material. . . . Much of what had been acquired and more of such ornaments of the church as we were afraid of losing—for instance, a golden chalice that was curtailed of its foot and several other things—we ordered to be fastened there. . . .

Often we contemplate . . . these different ornaments both new and old When . . . the loveliness of the many-colored

gems has called me away from external cares, and worthy meditation has induced me to reflect, transferring that which is material to that which is immaterial, on the diversity of the sacred virtues: then it seems to me that I see myself dwelling, as it were, in some strange region of the universe which neither exists entirely in the slime of the earth nor entirely in the purity of Heaven; and that, by the grace of God, I can be transported from this inferior to that higher world in an anagogical manner. . . .

We [also] caused to be painted, by the exquisite hands of many masters from different regions, a splendid variety of new windows. . . .

Because [these windows] are very valuable on account of their wonderful execution and the profuse expenditure of painted glass and sapphire glass, we appointed an official master craftsman for their protection and repair.

35

Robert de Torigny (died 1186) From *Chronicle*

Chartres Cathedral burned twice in the twelfth century, in 1134 and 1194. This contemporary notice of the rebuilding of the west front (fig. 431) in the 1140s stresses the participation of masses of lay volunteers. This kind of piety was later referred to as the "cult of the carts."

In this same year, primarily at Chartres, men began, with their own shoulders, to drag the wagons loaded with stone, wood, grain, and other materials to the workshop of the church, whose towers were then rising. Anyone who has not witnessed this will not see the like in our time. Not only there, but also in nearly the whole of France and Normandy and in many other places, [one saw] everywhere . . . penance and the forgiveness of offenses, everywhere mourning and contrition. One might observe women as well as men dragging [wagons] through deep swamps on their knees, beating themselves with whips, numerous wonders occurring everywhere, canticles and hymns being offered to God.

36

From Meditations on the Life of Christ

This late-thirteenth-century text, addressed to a Franciscan nun, represents a long-standing tendency to embellish the New Testament account of Christ's life with apocryphal detail. Unlike earlier such embellishments, this one dwells especially on the

emotions of the participants in the story. From the twelfth century on, worshipers (especially women) were encouraged to experience Scripture through visualization and emotion rather than as words alone. In its purpose the Meditations is related to such two-and three-dimensional representations as figures 479 and 506.

Attend diligently and carefully to the manner of the Deposition. Two ladders are placed on opposite sides of the cross. Joseph [of Arimathea] ascends the ladder placed on the right side and tries to extract the nail from His hand. But this is difficult . . . and it does not seem possible to do it without great pressure on the hand of the Lord. . . . The nail pulled out, John makes a sign to Joseph to extend the said nail to him, that the Lady [Virgin Mary] might not see it. Afterwards Nicodemus extracts the other nail from the left hand and similarly gives it to John. Nicodemus descends and comes to the nail in the feet. Joseph supported the body of the Lord: happy indeed is this Joseph, who deserves thus to embrace the body of the Lord! . . . The nail in the feet pulled out, Joseph descends part way, and all receive the body of the Lord and place it on the ground. The Lady supports the head and shoulders in her lap, the Magdalen the feet at which she had formerly found so much grace. The others stand about, all making a great bewailing over Him: all most bitterly bewail Him, as for a first-born son.

After some little time, when night approached, Joseph begged the Lady to permit them to shroud Him in linen cloths and bury Him. She strove against this, saying, "My friends, do not wish to take my Son so soon; or else bury me with Him." She wept uncontrollable tears; she looked at the wounds in His hands and side, now one, now the other; she gazed at His face and head and saw the marks of the thorns, the tearing of His beard, His face filthy with spit and blood, His shorn head; and she could not cease from weeping and looking at Him. . . . The hour growing late, John said, "Lady, let us bow to Joseph and Nicodemus and allow them to prepare and bury the body of our Lord. . . . " She resisted no longer, but blessed Him and permitted Him to be prepared and shrouded.... The Magdalen ... seemed to faint with sorrow. . . . She gazed at the feet, so wounded, pierced, dried out, and bloody: she wept with great bitterness. . . . Her heart could hardly remain in her body for sorrow; and it can well be thought that she would gladly have died, if she could, at the feet of the Lord.

37

Inscriptions on the pulpit in Pisa Cathedral by Giovanni Pisano

Giovanni Pisano's pulpit (1302–10) in Pisa Cathedral has two lengthy inscriptions, one of which is visible in figure 485. In the first inscription Giovanni praises his own talent; in the second,

on the base of the pulpit, he laments that his work is not properly appreciated.

I praise the true God, the creator of all excellent things, who has permitted a man to form figures of such purity. In the year of Our Lord thirteen hundred and eleven the hands of Giovanni, son of the late Nicola, by their own art alone, carved this work. . . . Giovanni who is endowed above all others with command of the pure art of sculpture, sculpting splendid things in stone, wood and gold . . . would not know how to carve ugly or base things even if he wished to do so. There are many sculptors, but to Giovanni remain the honours of praise. . . .

Giovanni has encircled all the rivers and parts of the world endeavouring to learn much and preparing everything with heavy labour. He now exclaims: 'I have not taken heed. The more I have achieved the more hostile injuries have I experienced. But I bear this pain with indifference and a calm mind.' That I (the monument) may free him from this envy, mitigate his sorrow and win him recognition, add to these verses the moisture (of your tears).

38

Dante Alighieri (1265–1321) The Divine Comedy: Paradise, from Canto XVII

When Dante wrote the three books of The Divine Comedy, he placed many of his contemporaries in Hell, Purgatory, and Paradise. In Paradise he meets his ancestor Cacciaguida, who describes Dante's exile from Florence for political reasons and his protection by Bartolommeo della Scala, father of Can Grande della Scala (fig. 489). Dante stayed at Can Grande's court in Verona from 1314 to 1317.

"Your first abode, your first refuge, will be the courtesy of the great Lombard lord [Bartolommeo della Scala] who[se coat of arms] bears the sacred bird [the eagle] upon the ladder,

and he will hold you in such high regard that in your give and take relationship the one will give before the other asks.

With him you shall see one [Can Grande] who at his birth was stamped so hard with this star's [Mars'] seal that all of his achievements will win great renown.

The world has not yet taken note of him; he is still very young, for Heaven's wheels have circled round him now for just nine years. But even before the Gascon [Pope Clement V] tricks proud Henry [Emperor Henry VII, reigned 1308–13], this one [Can Grande] will show some of his mettle's sparks by scorning wealth and making light of toil.

Knowledge of his munificence will yet be spread abroad: even his enemies will not be able to deny his worth.

Look you to him, expect from him good things.

Through him the fate of many men shall change, rich men and beggars changing their estate.

Now write this in your mind but do not tell the world"—and he said things concerning him incredible even to those who see

them all come true. . . .

39

Dante Alighieri The Divine Comedy: Purgatory, from Canto XI

In the first circle of Purgatory are those guilty of the sin of pride. Dante meets a famous manuscript illuminator who has learned the vanity of pride and the fleeting nature of fame, illustrated by the rapidity with which Giotto eclipsed Cimabue.

"Oh!" I said, "you must be that Oderisi, honor of Gubbio, honor of the art which men in Paris call 'Illuminating.'"

"The pages Franco Bolognese paints," he said, "my brother, smile more radiantly; *his* is the honor now—mine is far less.

Less courteous would I have been to him, I must admit, while I was still alive and my desire was only to excel.

For pride like that the price is paid up here; I would not even be here, were it not that, while I still could sin, I turned to God.

Oh, empty glory of all human power! How soon the green fades from the topmost bough, unless the following season shows no growth! Once Cimabue thought to hold the field as painter; Giotto now is all the rage, dimming the lustre of the other's fame."

40

Dante Alighieri The Divine Comedy: Hell, from Canto XVII

In the seventh circle of Hell, Dante encounters the usurers, who are identified by the coats of arms on the purses that hang around their necks. Among them is Rinaldo Scrovegni of Padua, the father of Enrico Scrovegni, who was the patron of the Arena Chapel, painted in fresco by Giotto (figs. 504–6). Many scholars believe that Enrico sponsored the chapel to expiate his father's sins.

I carefully examined several faces among this group caught in the raining flames and did not know a soul, but I observed that around each sinner's neck a pouch was hung, each of a different color, with a coat of arms, and fixed on these they seemed to feast their eyes.

And while I looked about among the crowd, I saw something in blue on a yellow purse that had the face and bearing of a lion;

and while my eyes continued their inspection I saw another purse as red as blood exhibiting a goose more white than butter.

And one [Rinaldo Scrovegni] who had a blue sow, pregnantlooking, stamped on the whiteness of his moneybag asked me: "What are you doing in this pit?

Get out of here! And since you're still alive, I'll tell you that my neighbor Vitaliano will come to take his seat on my left side.

Among these Florentines I sit, one Paduan: time after time they fill my ears with blasts of shouting: 'Send us down the sovereign knight

who will come bearing three goats on his pouch.'"
As final comment he stuck out his tongue—
as far out as an ox licking its nose.

41

Lorenzo Ghiberti (c. 1381–1455) The Commentaries, from Book 2

Ghiberti's incomplete Commentaries is an important early document of art history. The first book consists largely of extracts from Pliny and Vitruvius; the second is about art in Italy in the thirteenth and fourteenth centuries, and ends with an account of his own work (fig. 492). Like Giovanni Pisano, Ghiberti was not reluctant to praise himself.

Whereas all gifts of fortune are given and as easily taken back, but disciplines attached to the mind never fail, but remain fixed to the very end, . . . I give greatest and infinite thanks to my parents, who . . . were careful to teach me the art, and the one that cannot be tried without the discipline of letters. . . . Whereas therefore through parents' care and the learning of rules I have gone far in the subject of letters or learning in philology, and love the writing of commentaries, I have furnished my mind with these possessions, of which the final fruit is this, not to need any property or riches, and most of all to desire nothing. . . . I have tried to inquire how nature proceeds . . . and how I can get near her, how things seen reach the eye and how the power of vision works, and how visual [word missing] works, and how visual things move, and how the theory of sculpture and painting ought to be pursued.

In my youth, in the year of Our Lord 1400, I left Florence because of both the bad air and the bad state of the country. ... My mind was largely directed to painting. ... Nevertheless . . . I was written to by my friends how the board of the temple of St. John the Baptist was sending for well-versed masters, of whom they wanted to see a test piece. A great many very well qualified masters came through all the lands of Italy to put themselves to this test. . . . Each one was given four bronze plates. As the demonstration, the board of the temple wanted each one to make a scene . . . [of] the sacrifice of Isaac. . . . These tests were to be carried out in a year. . . . The competitors were . . . : Filippo di ser Brunellesco, Simone da Colle, Niccolo D'Arezzo, Jacopo della Quercia from Siena, Francesco da Valdambrino, Nicolo Lamberti. . . . The palm of victory was conceded to me by all the experts and by all those who took the test with me. The glory was conceded to me universally, without exception. Everyone felt I had gone beyond the others in that time, without a single exception, with a great consultation and examination by learned men. . . . The judges were thirty-four, counting those of the city and the surrounding areas; the endorsement in my favor of the victory was given by all, and by the consuls and board and the whole body of the merchants' guild, which has the temple of St. John the Baptist in its charge. It was . . . determined that I should do this bronze door for this temple, and I executed it with great diligence. And this is the first work; with the frame around it, it added up to about twenty-two thousand florins.

42

Lorenzo Ghiberti The Commentaries, from Book 2

Ghiberti, and Vasari after him, traced the origins of modern painting to Giotto. Giotto is presented here as a natural genius and hence unfettered by the "Greek manner" of his teacher.

The art of painting began to arise [again] in Etruria. In a village near the city of Florence, called Vespignano, a boy of marvelous genius was born. He was drawing a sheep from life, and the painter Cimabue, passing on the road to Bologna, saw the boy sitting on the ground and drawing a sheep on a flat rock. He was seized with admiration. . . . And seeing he had his skill from nature, he asked the boy what his name was. He answered and said, I am called Giotto by name, my father is called Bondone and lives in this house close by. Cimabue went with Giotto to his father; he made a very fine appearance. He asked the father for the boy; the father was very poor. He handed the boy over to him and Cimabue took Giotto with him and he was Cimabue's pupil. He [Cimabue] used the Greek manner, and in that manner he was very famous in Etruria. And Giotto grew great in the art of painting.

He brought in the new art, . . . and many pupils were taught on the level of the ancient Greeks. Giotto saw in art what no others added. He brought in natural art, and grace with it. . . . He was . . . the inventor and discoverer of much learning that had been buried some six hundred years.

43

Theophilus Presbyter On Divers Arts, from Book II: The Art of the Worker in Glass

"Theophilus" may have been the pseudonym of Roger of Helmarshausen, a Benedictine monk and metalworker. Metalwork is the subject of the third book of this treatise, following books on painting and stained glass. Theophilus' text, written in the twelfth century, is the first in the Western tradition to give a practitioner's account of the technology of art production.

CHAPTER 17: LAYING OUT WINDOWS

When you want to lay out glass windows, first make yourself a smooth flat wooden board. . . . Then take a piece of chalk,

scrape it with a knife all over the board, sprinkle water on it everywhere, and rub it all over with a cloth. When it has dried, take the measurements . . . of one section in a window, and draw it on the board with a rule and compasses. . . . Draw as many figures as you wish, first with [a point made of] lead or tin, then with red or black pigment, making all the lines carefully, because, when you have painted the glass, you will have to fit together the shadows and highlights in accordance with [the design on] the board. Then arrange the different kinds of robes and designate the color of each with a mark in its proper place; and indicate the color of anything else you want to paint with a letter.

After this, take a lead pot and in it put chalk ground with water. Make yourself two or three brushes out of hair from the tail of a marten, badger, squirrel, or cat or from the mane of a donkey. Now take a piece of glass of whatever kind you have chosen, but larger on all sides than the place in which it is to be set, and lay it on the ground for that place. Then you will see the drawing on the board through the intervening glass, and, following it, draw the outlines only on the glass with chalk.

CHAPTER 18. GLASS CUTTING

Next heat on the fireplace an iron cutting tool, which should be thin everywhere except at the end, where it should be thicker. When the thicker part is red-hot, apply it to the glass that you want to cut, and soon there will appear the beginning of a crack. If the glass is hard [and does not crack at once], wet it with saliva on your finger in the place where you had applied the tool. It will immediately split and, as soon as it has, draw the tool along the line you want to cut and the split will follow.

Villard de Honnecourt (13th century) From *Sketchbook*

The first inscription below addresses the user of Villard's sketchbook and suggests what the book might be for. The others appear on the leaves shown in figures 495 and 496.

Villard de Honnecourt greets you and begs all who will use the devices found in this book to pray for his soul and remember him. For in this book will be found sound advice on the virtues of masonry and the uses of carpentry. You will also find strong help in drawing figures according to the lessons taught by the art of geometry.

Here is a lion seen from the front. Please remember that he was drawn from life. This is a porcupine, a little beast that shoots its quills when aroused.

Here below are the figures of the Wheel of Fortune, all seven of them correctly pictured.

Agnolo di Tura del Grasso From *History*

Duccio's Maestà (figs. 500–502) stood on the main altar of Siena Cathedral until 1506, when it was removed to the transept. It was sawn apart in 1771, and some panels were acquired subsequently by museums in Europe and the United States. This local history of about 1350 describes the civic celebration that accompanied the installation of the altarpiece in 1311.

This [the Maestà] was painted by master Duccio di Niccolò, painter of Siena, who was in his time the most skillful painter one could find in these lands. The panel was painted outside the Porta a Stalloreggi . . . in the house of the Muciatti. The Sienese took the panel to the cathedral at noontime on the ninth of June [1311], with great devotions and processions, with the bishop of Siena, ... with all of the clergy of the cathedral, and with all the monks and nuns of Siena, and the Nove, with the city officials, the Podestà and the Captain, and all the citizens with coats of arms and those with more distinguished coats of arms, with lighted lamps in hand. . . . The women and children went through Siena with much devotion and around the Campo in procession, ringing all the bells for joy, and this entire day the shops stayed closed for devotions, and throughout Siena they gave many alms to the poor people, with many speeches and prayers to God and to his mother, Madonna ever Virgin Mary, who helps, preserves and increases in peace the good state of the city of Siena and its territory, . . . and who defends the city from all danger and all evil. And so this panel was placed in the cathedral on the high altar. The panel is painted on the back . . . with the Passion of Jesus Christ, and on the front is the Virgin Mary with her son in her arms and many saints at the side. Everything is ornamented with fine gold; it cost three thousand florins.

Franco Sacchetti (1332?–1400)
From *Three Hundred Stories*

Like Boccaccio, Sacchetti composed a collection of stories, many of which feature contemporary or historical figures of Italy. This tale about Giotto and his sense of humor is representative of a growing interest in artists' personalities.

Whoever is acquainted with Florence knoweth that upon the first Sunday of each month it is the custom for men and women to go to [the church of] San Gallo in company, and they go there rather to make merry than for the Pardon. Upon one of these Sundays Giotto started out to go thither with his companions. And having halted a moment in the street called Cocomero to relate a certain tale, there passed by some pigs of St. Anthony, and one of these, running violently, ran between Giotto's legs in such a manner that Giotto fell to the ground. Rising up of his own accord, [he] shook himself, and neither cursed the pigs nor cried out at them, but turning to his companions, half-smiling, he said: "Are they not in the right? For I in my day have earned many thousands of lire with their bristles, and never have I given unto them even a dish of swill."

47

Inscriptions on the frescoes in the Palazzo Pubblico, Siena

The first inscription is painted in a strip below the fresco of Good Government (figs. 511 and 512), which is dated between 1338 and 1340. The second is held by the personification of "Security" who hovers over the landscape in figure 512.

Turn your eyes to behold her, you who are governing, [Justice] who is portrayed here, crowned on account of her excellence, who always renders to everyone his due.

Look how many goods derive from her and how sweet and peaceful is that life of the city where is preserved this virtue who outshines any other.

She guards and defends those who honor her, and nourishes and feeds them. From her light is born Requiting those who do good and giving due punishment to the wicked.

Without fear every man may travel freely and each may till and sow, so long as this commune shall maintain this lady [Justice] sovereign, for she has stripped the wicked of all power.

48

Giovanni Boccaccio (1313–1375) Decameron, from The First Day

The young people who tell the 100 stories of Boccaccio's Decameron have fled Florence to escape the bubonic plague. At the beginning of the book, Boccaccio describes the horror of the disease and the immensity of the epidemic, as well as the social dissolution it produced.

The years of the fruitful Incarnation of the Son of God had attained to the number of one thousand three hundred and forty-eight, when into the notable city of Florence, fair over every other of Italy, there came the death-dealing pestilence, . . . through the operation of the heavenly bodies or of our own iniquitous doings, being sent down upon mankind for our correction by the just wrath of God. . . . In men and women alike there appeared, at the beginning of the malady, certain swellings, either on the groin or under the armpits, whereof some waxed to the bigness of a common apple, others to the size of an egg, . . . and these the vulgar named

plague-boils. From these two parts the aforesaid death-bearing plague-boils proceeded, in brief space, to appear and come indifferently in every part of the body; wherefrom, after awhile, the fashion of the contagion began to change into black or livid blotches. . . .

Well-nigh all died within the third day from the appearance of the aforesaid signs, this one sooner and that one later, and for the most part without fever or other complication. . . . The mere touching of the clothes or of whatsoever other thing had been touched or used by the sick appeared of itself to communicate the malady to the toucher. . . .

Well-nigh all tended to a very barbarous conclusion, namely, to shun and flee from the sick and all that pertained to them... Some there were who conceived that to live moderately and keep oneself from all excess was the best defense; ... they lived removed from every other, taking refuge and shutting themselves up in those houses where none were sick and where living was best. ... Others, inclining to the contrary opinion, maintained that to carouse and make merry and go about singing and frolicking and satisfy the appetite in everything possible and laugh and scoff at whatsoever befell was a very certain remedy for such an ill. . . .

The common people (and also, in great part, . . . the middle class) . . . fell sick by the thousand daily and being altogether untended and unsuccored, died well-nigh all without recourse. Many breathed their last in the open street, by day and by night, while many others, though they died in their homes, made it known to the neighbors that they were dead rather by the stench of their rotting bodies than otherwise; and of these and others who died all about, the whole city was full. . . . The consecrated ground not sufficing for the burial of the vast multitude of corpses . . . there were made throughout the churchyards, . . . vast trenches, in which those who came . . . were laid by the hundred, . . . being heaped up therein by layers, as goods are stowed aboard ship. . . .

So great was the cruelty of heaven . . . that, between March and the following July, . . . it is believed for certain that

upward of a hundred thousand human beings perished within the walls of the city of Florence. . . . Alas, how many great palaces, how many goodly houses, how many noble mansions, once full of families, of lords and of ladies, remained empty even to the meanest servant! How many memorable families, how many ample heritages, how many famous fortunes were seen to remain without lawful heir! How many valiant men, how many fair ladies, how many sprightly youths, . . . breakfasted in the morning with their kinsfolk, comrades and friends and that same night supped with their ancestors in the other world!

Christine de Pizan (c. 1363–c. 1430) From *The Book of the City of Ladies*

Born in Venice but active in Paris and the courts of France, Christine de Pizan was a learned and well-known writer who championed the cause of women. This passage from her history of women (1404–5) mentions a manuscript illuminator who would have been a contemporary of the Limbourg brothers.

Regarding what you say about women expert in the art of painting, I know a woman today, named Anastasia, who is so learned and skilled in painting manuscript borders and miniature backgrounds that one cannot find an artisan in all the city of Paris—where the best in the world are found—who can surpass her, nor who can paint flowers and details as delicately as she does, nor whose work is more highly esteemed, no matter how rich or precious the book is. People cannot stop talking about her. And I know this from experience, for she has executed several things for me which stand out among the ornamental borders of the great masters.

	300-600	600 –700	700 – 750
HISTORY AND POLITICS	Constantine the Great (r. 306–37) reunites Roman Empire, moving capital Constantinople, formerly Byzantium; 313, proclaims Edict of Milan, allowing religious toleration; c. 312, converts to Christianity. The religion spreads rapidly through the Roman world 410 Sack of Rome by the Visigoth Alaric 451 Attila, leader of the Huns, invades Gaul from Eastern Europe and, in 452, Italy 476 Western Roman Empire falls, its territories divided among local rulers c. 493 Theodoric, Eastern Roman Emperor, establishes Ostrogoth kingdom in Italy Justinian, Eastern Roman Emperor (r. 527–65) with Empress Theodora. Their reign is marked by peace, legal reforms, and attempts to reunite the Empire 568 Lombard kingdom created in northern Italy	600–800 Golden Age of Celtic culture 669–690 Theodore of Tarsus begins organization of English rival groups; period of Greco-Roman cultural revival 697 (traditional) First doge of Venice elected by governing council	 711–15 Conquest of North Africa and Spain by Moslems; much of the Mediterranean controlled by the Arabs 717 Leo III, Byzantine emperor (r. 717–41) defeats Arab invaders and establishes a period of peace; 726, his prohibition of images in churches sparks the Iconoclastic Controversy
HISTORY A		Iconoclasm From the earliest days of Christianity, painted and carved images were used in churches as decorations, representing holy figures, biblical narratives, miracles, and other pious scenes. Such works of art have usually been considered precious and were sometimes venerated as holy themselves; but at some moments in history they have been attacked as idolatrous. In the eighth century the Byzantine emperor Leo III harshly criticized such images, placing himself in opposition to the pope, who declared them sacred. In 726 Leo issued a decree prohibiting images in churches. This touched off a power struggle between the Eastern emperor and the	
RELIGION	 395 Christianity becomes official religion of the Roman Empire 432 St. Patrick (died c. 461) founds Celtic church in Ireland 529 St. Benedict (c. 480–c. 553), founds Benedictine monastic order 	Western papacy. The controversy raise garding the interpretation of the Bib course of it, Leo's followers, called Icor tine art that existed at the time in chur oclastic Controversy was no small eve	ed fundamental religious questions re- ble and the divinity of Christ. In the noclasts, destroyed much of the Byzan- rches, especially in the East. The Icon- nt: cities revolted; battles were fought,
	Virgin and Child Enthroned Between Saints and Angels, Monastery of St. Catherine, Mount Sinai, late 6th century	a clash of the political forces of chur ages—their power to move and stir pe An effect of the ban on pious imag porarily channeled into secular and p manuscripts for private use. The deba in 843, when image-worship was e Grand cycles of mosaics like those for	may have mainly been the excuse for rich and state, the importance of impople—should not be underestimated, ges was that artistic energies were temperivate art—for example, illuminated ate was settled in favor of holy images stablished by the pope as doctrinal. Formerly found in Byzantine churches danew humanism derived from the oclastic period.
MUSIC, LITERATURE, AND PHILOSOPHY	Ammianus Marcellinus (c. 330–95), Roman historian Boethius (c. 480–524), Roman philosopher whose <i>Consolation of Philosophy</i> held the struggle for knowledge to be the highest expression of love of God	c. 600 Gregorian chants widely used in Catholic Mass Isidore of Seville (died 636), encyclopedist The Venerable Bede (673–735), English writer and historian, primary member of Theodore of Tarsus' intellectual group	Early 700s Beowulf, English epic
SCIENCE, TECHNOLOGY, AND EXPLORATION	 c. 410 First records of alchemical experiments, in which science and myth are utilized to try to create gold from metal c. 550 Procopius of Caesarea writes <i>Buildings</i>, on architecture and public works of the Byzantine Empire c. 600 Chinese invent woodblock printing 	c. 600 Stirrup introduced in Western Europe 604 First church bell made in Rome	

	•	
750-800	800-850	850-900
756 Pepin the Short, king of the Franks (r. 747–68), defeats the Lombards in Italy and destroys their kingdom. His gift of conquered Central Italian lands to the pope (the Papal States) allows the papacy to be independent and earns France a privileged position Charlemagne (r. 768–814), Pepin's successor, establishes control of most of Europe. His organization of European society into semiau-	800–900 Invasions by Scandinavian peoples in the North, Moslems in the Mediterranean, and Magyars from the East destabilize much of Europe, which suffers extended warfare 804–807 Vikings invade Ireland and, 856–75, British Isles. By 878, Danes control Scotland	c. 850–900 Angkor Thom, capital of the Khmer people, founded in what is now Cambodia. The moated city covers five square miles and has elaborate temples and palaces c. 900 Toltec people settle in Mexico; they clash with the Maya in Yucatan
tonomous regional centers (called marks) becomes the basis for feudal society; 800, crowned Holy Roman Emperor by the pope. Charlemagne's empire is divided after his death into eastern and western Frankish kingdoms (approximately present-day France and Germany) Irene, first empress of Byzantium (r. 797–802)	of what is now France, Germany, Ital dom, with his court at Aachen in Gerhad not been under one rule since Ror in Rome in 800 was clearly understood power over the papacy and the streng as a threat by the Byzantine Empire in finitive division of the Christian worl was a great founder of schools, mona	th of his position. As such, it was seen a Constantinople, and signaled the de- ld into two rival realms. Charlemagne asteries, and systems of civil adminis- med for his dynasty, the arts flourished
St. Angilbert (c. 750–814), monk at Charlemagne's court, rebuilds StRiquier abbey St. Boniface (died 755) converts Germanic peoples to Christianity St. Theodore the Studite (759–826) defends use of icons	as they often do in times of relative st	ability.
(left) Crucifixion, bronze plaque from a book cover(?), Ireland, 8th century (right) Chi-Rho page, from the Book of Kells, Ireland, c.800?	Virgin and Child Enthroned, mosaic, Hagia Sophia, Constantinople, c. 843–67	Lindau Gospels, upper cover of binding, c. 870
Hrabanus Maurus (784–856), German ency- clopedist	 c. 800 Carolingian schools chartered by Charlemagne, encouraging study of Latin texts c. 800 First version of <i>The Thousand and One Nights</i>, a collection of Arabian stories of the court of Hārūn al-Rashīd 	
	822 Earliest documented church organ, Aachen	c. 850 Horse collar adopted in Western Europe for draft work 860 Danish Vikings discover Iceland; c. 866, they attack England; c. 980, they find Greenland

-	900-950	950-1000	1000–1050
HISTORY AND POLITICS	907 In China, the Five Dynasties period sees the land politically divided	962 Otto I the Great, ruler of Germany (r. 936–73), defeats Magyar invaders and assumes crown of the Holy Roman Empire Capetian kings (later, kings of France, 987–1792) come to power in Frankish kingdom with Hugh Capet (r. 987–96)	1016 Normans arrive in Italy from northern France, establishing a kingdom in the south, 1071, by taking Bari; between 1072 and 1091 they take Sicily, evicting the Arabs who had possessed the island First kings of Scotland; Duncan I (r. 1034–40), murdered by the usurper Macbeth (r. 1040–57), himself defeated by Malcolm Canmore (r. 1057–93). Beginning of Anglicization of Scotland Henry III the Black (r. 1039–56) aggressively asserts German imperial authority by personally nominating new popes and mastering the duchies of Poland, Hungary, and Bohemia
RELIGION	c. 900 Russia converts to Christianity under the Eastern Orthodox church 910 Abbey of Cluny founded in France. Cluniac organization of monasteries and reforming methods spread through Europe	Bishop Bernward (bishop 993–1022) makes Hildesheim, in Germany, a cultural and artistic center	
	Monasteries The great European monastic orders of the Middle Ages were founded during a time of weak governments and economic uncertainty; neither education nor literacy was common. Financed by kings, private patrons, and the papacy, abbeys such as Lindisfarne in England (635), Cluny (910) and Clairvaux (1115) in France, Hildesheim in Germany (1001–33), and Assisi in Italy (1209)	(left) Interior, Hildesheim Cathedral, 1001–33 (right) The Harbaville Triptych, ivory altar, late 10th century	The Crucifixion, mosaic, Greece, 11th century
MUSIC, LITERATURE, AND PHILOSOPHY	were stable, self-contained societies in which strict religious observance was combined with intellectual and artistic experimentation, in a blend peculiar to the Middle Ages. Exempt from taxation, they became wealthy and powerful. Monastic life was dedicated to the fur-		c. 1000 Ottonian revival in Germany c. 1000 Development of modern music notation system in Europe Solomon ibn Gabirol (1020–70) Jewish poet and philosopher active in Moslem Spain
SCIENCE, TECHNOLOGY, AND EXPLORATION	the me was dedicated to the full thering of Christian doctrine; this often meant not only pious works but the search for knowledge. Monks copied and wrote books; studied architecture, engineering, mathematics, medicine, and philosophy; painted frescos and panels, and illuminated manuscripts.	Ibn Sînâ (Avicenna) (980–1037?), Arab physician and interpreter of Aristotle, active in Persia and the Middle East; chief medical authority of the Middle Ages	c. 1000 Urban development of Europe begins; cities grow steadily in importance and size throughout the Middle Ages. Use of abacus for computation in Europe 1002 Leif Ericson sails to North America and establishes a settlement

1050 - 11001100-1150 1150-1200 1066 French Normans under William the Foundation of the crusading orders of knight-1171 Salah al-Din (Saladin), ruler of Egypt, Conqueror, duke of Normandy, invade hood: 1113, Knights Hospitalers; 1118, Temdominates Damascus and captures Syria; England and defeat local forces under King plars; 1190, Teutonic Knights 1187, he recaptures Jerusalem for Islam Harold at Battle of Hastings. William 1189-92 Third Crusade, a fruitless attempt to 1122 Suger becomes abbot of St.-Denis, near crowned king of England Paris, and adviser to kings Louis VI and Louis regain Jerusalem, led by Frederick I Barba-1083 Henry IV, Holy Roman Emperor (ruler rossa, Holy Roman Emperor, King Richard I 1147-49 Second Crusade called, urged by the of Germany), invades Italy in a dispute with the Lionhearted, of England, and King Philip the pope; 1084, Rome sacked by Normans. preaching of St. Bernard of Clairvaux; it II of France, all of them rivals; the papacy is Ensuing political chaos results in increased achieves little. Suger is regent of France largely excluded. Project ends with capture power of individual German principates and of English king Richard I. The crusading weakening of papacy armies, unable to oust Saladin from Palestine, 1096 First Crusade, called by Pope Urban II in conclude a pact with him that permits Chris-1095, to retake the Holy Land from the tian pilgrims to visit Jerusalem unmolested Moslems for Christianity. A disorganized mass of mostly French, Norman, and Flemish nobles and peasants, 30,000 or more, leaves Europe for Palestine in several Suger, St.-Denis, and Architectural Symbolism The prelate Suger, made waves; an estimated 12,000 are killed in Asia abbot in 1122 of the Abbey Church of St.-Denis, was regent of France while Minor; 1097-99, the crusading force takes King Louis VII was away on the Second Crusade. As such, his rebuilding of Nicaea, Antioch, and Jerusalem, which they sack the church, begun c. 1140, was more than a simple architectural project. It set the standard for Gothic churches and is an early example of architecture used to represent political power and a philosophical idea. 1054 Final schism between Eastern (Orthodox) The aesthetic design of the building has been attributed to Suger's interand Western (Catholic) Christian Churches est in Scholasticism and Neo-Platonism. Thus, the individual parts of the c. 1115 St. Bernard (1090-1153) heads the asbuilding support the entire structure, much as the individual believer upcetic Cistercian order at the abbey of Clairvaux, in northern France holds the Christian faith as a whole. St.-Denis was intended to be seen as the Christian universe in microcosm, an architectural experience of beauty through which the visitor comes to an emotional understanding of Christ. Technological innovations allowed the walls to be pierced with large windows that filled the interior with brilliant colored light. In Neo-Platonist terms, the stupendous stained-glass windows of the choir were meant not merely to illuminate the altar but to represent divine light itself, the ineffable spirit of God made visible. In addition, as depository of holy relics and burial place of the kings of France, the Abbey Church had an important political function. Suger's new design served to glorify the nascent French state and to affirm the role of the monarch as defender of the faith. The building was thus created as a network of religious, aesthetic, and political ideas. (left) Speyer Cathedral, Germany, begun 1030 (right) The Arrest of Christ, fresco, S. Angelo in Formis, Capua, c. 1085 c. 1050 Chanson de Roland, French epic tale c. 1100 Chrétien de Troyes, French poet, c. 1160 Nibelungenleid, German epic Hariulf (c. 1060-1143), a monk at St.-Riquier, writes Arthurian romances Nicholas Mesarites (c. 1163-after 1214), Byzauthor of a history of the monastery Omar Khayyam (c. 1100), Persian poet antine chronicler Peter Abelard (1079?-1144), French Nominal-Early 1100s Troubadour poetry and music, a Late 1100s Carmina Burana, a collection of ist philosopher at the University of Paris, aucourtly, intricate style, often on the theme of popular secular poems thor of Sic et Non, a theological inquiry, and love, popular in France and Italy Albertus Magnus (1192-1280), German Schoopponent of St. Bernard of Clairvaux Ibn Rushd (Averroës) (c. 1126-98), Spanish lastic philosopher Moslem physician and philosopher, author of Matthew Paris (c. 1200-59), French historian treatises on Plato and Aristotle 1086 Domesday survey in England, first full 1100s Moorish paper mills in operation; use in c. 1150 Crossbow, more effective than the census of a population, for taxation purposes. Italy of lateen sail for improved sailing; soap standard bow and arrow, in widespread use Domesday Book, containing collected data, in widespread use; Theophilus Presbyter, c. 1170 Leonardo of Pisa, Italian mathemati-German scholar, publishes manual on buildcompiled cian, introduces Hindu mathematics, geoing and decorating a cathedral metry, and algebra 1180-1223 Philip II of France embarks on a rebuilding of Paris. Roads are paved, walls erected, and, c. 1200, the Louvre palace is

begun

1193 First merchant guild, England

1200–1225		1225-1250	1250-1275
HISTORY AND POLITICS	in Venetian ships. Diverted to Christian Constantinople, crusaders sack the city; entire enterprise excommunicated by the pope; 1208–74, numerous other crusades shift possession of lands in the Middle East from one of the Western powers to another, and confront the Moslems, who nevertheless hold Jerusalem from 1244 until 1917 1206–23 Mongol ruler Genghis Khan crosses Asia and Russia, threatening Europe 1215 Magna Carta, a pact between the English monarch and the feudal barons, signed by King John. The document, limiting the absolute powers of the monarchy, is the genesis of a new constitution that places the law over the will of the king, contains new legal, religious, and taxation rights for the individual, including the right to a trial and other reforms, and establishes a parliament	Louis IX, king of France (St. Louis, r. 1226–70), leads Seventh and Eighth Crusades	1254–73 Period of strife in Germany, with contested claims to the throne of the Holy Roman Empire, confirms fractured nature of individual German states and signals the end of the empire as a political power By 1263 Papal grant to trade awarded to Teutonic Knights, originally a crusading order of chivalry. The order grows powerful in the absence of any strong monarch and controls much of Prussia, northern Germany, and parts of Lithuania and Poland. Founds numerous independent cities as a mercantile corporation; these later form part of the Hanseatic League of free trading cities of Northern Europe 1271–95 The trader Marco Polo travels from Venice to the court of Kublai Khan. His journeys through India, China, Burma, and Persia open the first diplomatic relations between European and Asian nations
RELIGION	1215 Fourth Lateran Council of bishops, in Rome, establishes major Catholic doctrines: transubstantiation, practice of confession, and worship of relics 1223 St. Francis of Assisi founds Franciscan monastic order, emphasizing poverty (left) Interior, Chartres Cathedral, c. 1194–1220 (right) Notre-Dame, Paris, 1163–c. 1250	minations, small personal dip epitomize one aesthetic thread scale and great elegance of thes France, of a class of wealthy no traveling required art to be bot books of hours containing dail Gospels were fashionable item piety, good taste, and conno graceful, decorative style was a lar, romantic, and written in coeducated Latin of previous growing Provençal, the <i>Roman de la Ros</i>	tional Style Intricate miniature illutychs, and precious, jeweled objects of the fourteenth century. The small e works reflect the rise, particularly in obles whose refined taste and habit of h beautiful and portable. Illuminated ly prayers, calendars, and parts of the is that advertised the owner's wealth, isseurship. Contemporary with this parallel new style in literature—secuntemporary language, rather than the enerations; the troubadour poets in e in French, and much of Dante's and examples. Poems and paintings alike of the material world.
MUSIC, LITERATURE, AND PHILOSOPHY	1200 Foundation of the University of Paris (called the Sorbonne after 1257); 1209, University of Valencia; 1242, University of Salamanca; these become centers for interchange between Arabs and Christians	St. Thomas Aquinas (1225–74), Italian Scholastic philosopher. His <i>Summa Theologica</i> , a founding text of Catholic teaching, examines the relationship between faith and intellect, religion and society	Vincent of Beauvais (died 1264), French encyclopedist Dante Alighieri (1265–1321), author of <i>The Divine Comedy</i> , in Tuscan vernacular. The poem is immensely influential for the development of the Italian language 1266–83 <i>The Golden Legend</i> , a collection of apocryphal religious stories by the Italian prelate Jacopo da Voragine (c. 1228–98)
SCIENCE, TECHNOLOGY, AND EXPLORATION	1200s Use of coal gains over wood fuel; mining begins in Liège, France. Advances in seafaring: sternpost rudder and compass in use in Europe; spinning wheel and gunpowder introduced	Roger Bacon (died 1292), English scientist who utilized observation and experiment in study- ing natural forces	

1275–1300	1300–1325	1325–1350
 1289 John of Montecorvino establishes a permanent Christian mission in China 1290 Jews expelled from England; 1306, from France 1295 King Edward I of England institutes the Model Parliament, first bicameral English parliament 	 1302 First known convocation of French estates-general, parliamentary assembly of the crown, clergy, and commons, to support Philip IV the Fair in his struggle with Pope Boniface VIII over questions of papal authority 1305 Fearing political anarchy and desperate conditions in Rome, Pope Clement V establishes Avignon as the primary residence of the papacy; beginning of the so-called Babylonian Captivity (to 1376) 1310–13 Holy Roman Emperor Henry VII invades Italy to reestablish imperial rule 	1325 Foundation of the city of Tenochtitlán by the Aztecs 1337 Hundred Years' War between England and France begins (until 1453) 1347–50 Black Death in Europe. Bubonic plague kills an estimated one-third of population
Europe and the East The relationsh non-Christian nations had been altern Moslem conquest of the Mideast an scholarship and technology were community through trade and travel, and the crust of Arab culture in the West, but the known. European contacts with Asia unthirteenth century, after the Venetian courts of the Mongol emperor Kubbrought back the first accurate account Asia grew, trade routes and trading Christian missions. Lured by the prose exotic spices, and gold, as well as by act to these previously hostile nations in the later crusades has been attributed opportunity to open trade routes and countries. The effect on European culbecame a thriving center for trade from cities; these cities became not only mentioned of arts and ideas. The influentimages as the English heraldic lion, we nese dragon figure, no doubt woven it	JEAN PUCELLE Illuminated pages from the Hours of Jeanne d'Evreux, Paris, 1325–28	
c. 1297 Publication of Marco Polo's <i>Book of Various Experiences</i> . These enormously popular tales of travels in the Far East fostered a general interest in foreign lands	c. 1300 The Roman de la Rose, satire on society written in vernacular French William of Ockham (c. 1300–49), English Nominalist philosopher, stresses mystical experience over rational understanding Petrarch (1304–74), Italian humanist scholar and poet Giovanni Boccaccio (1313–75), Italian author of The Decameron, a collection of tales	1325–27 Ibn Batutah (1304–c. 1368), Arab traveler and scholar, visits North Africa, the Mideast, and Persia; 1334, reaches India and later, 1342, China; his memoirs contain commentary on political and social customs Franco Sacchetti (1332?–1400), Italian poet and author of <i>Three Hundred Stories</i> Geoffrey Chaucer (1340–1400), English diplomat and author of <i>The Canterbury Tales</i>
Late 1200s Arabic numerals introduced in Europe c. 1286 Spectacles invented	Early 1300s Earliest cast iron in Europe; gun- powder first used for launching projectiles	 1335–45 Artillery first used on ships 1340 Francesco Pegolotti writes The Merchant's Handbook, an Italian manual for traders 1346 Longbow replaces crossbow: at the Battle of Crécy the English use it to defeat the French, including cavalry; greater participation of foot soldiers in warfare follows

PART THREE

THE RENAISSANCE THROUGH THE ROCOCO

n discussing the transition from classical antiquity to the Middle Ages, we

were able to point to a great crisis—the rise of Islam—marking the separation between the two eras. No comparable event sets off the Middle Ages from the Renaissance. The fifteenth and sixteenth centuries, to be sure, witnessed far-reaching developments: the fall of Constantinople and the Turkish conquest of southeastern Europe; the journeys of exploration that led to the founding of overseas empires in the New World, in Africa and Asia, with the subsequent rivalry of Spain and England as the foremost colonial powers; and the deep spiritual crises of the Reformation and Counter Reformation. But none of these events, however great their effects, can be said to have produced the new era. By the time they happened, the Renaissance was well under way. Even if we disregard the minority of scholars who would deny the existence of the period altogether, we are left with an extraordinary diversity of views on the Renaissance. Perhaps the only essential point on which most experts agree is that the Renaissance had begun when people realized they were no longer living in the Middle Ages.

This statement is not as simple-minded as it sounds. It brings out the undeniable fact that the Renaissance was the first period in history to be aware of its own existence and to coin a label for itself. Medieval people did not think they belonged to an age distinct from classical antiquity. The past, to them, consisted simply of "B.C." and "A.D.," the era "under the Law" (that is, of the Old Testament) and the era "of Grace" (that is, after the birth of Jesus). From their point of view, then, history was made in Heaven rather than on earth. The Renaissance, by contrast, divided the past not according to the divine plan of salvation, but on the basis of human achievements. It saw classical antiquity as the era when civilization had reached the peak of its creative powers, an era brought to a sudden end by the barbarian invasions that destroyed the Roman Empire. During the thousand-year interval of "darkness" that followed, little was accomplished, but now, at last, this "time in-between" or "Middle Age" had been superseded by a revival of all those arts and sciences that flourished in classical

antiquity. The present, the "New Age," could thus be fittingly labeled a "rebirth"— *rinascita* in Italian (from the Latin *renascere*, to be reborn), *renaissance* in French and, by adoption, in English.

The origin of this revolutionary view of history can be traced back to the 1330s in the writings of the Italian poet Francesco Petrarca, the first of the great individuals who made the Renaissance. Petrarch, as we call him, thought of the new era mainly as a "revival of the classics," limited to the restoration of Latin and Greek to their former purity and the return to the original texts of ancient authors. During the next two centuries, this concept of the rebirth of antiquity grew to embrace almost the entire range of cultural endeavor, including the visual arts. The latter, in fact, came to play a particularly important part in shaping the Renaissance, for reasons that we shall explore later.

That the new historic orientation (to which, let us remember, we owe our concepts of the Renaissance, the Middle Ages, and classical antiquity) should have had its start in the mind of one man is itself a telling comment on the new era, although it was soon taken up by many others. Individualism—a new self-awareness and self-assurance—enabled Petrarch to proclaim, against all established authority, his own conviction that the "age of faith" was actually an era of darkness, while the "benighted pagans" of antiquity really represented the most enlightened stage of history. Such readiness to question traditional beliefs and practices was to become profoundly characteristic of the Renaissance as a whole. Humanism, to Petrarch, meant a belief in the importance of what we still call "the humanities" or "humane letters" (rather than divine letters, or the study of Scripture): the pursuit of learning in languages, literature, history, and philosophy for its own end, in a secular rather than a religious framework.

We must not assume, however, that Petrarch and his successors wanted to revive classical antiquity lock, stock, and barrel. By interposing the concept of "a thousand

years of darkness" between themselves and the ancients, they acknowledged (unlike the medieval classicists) that the Graeco-Roman world was irretrievably dead. Its glories could be revived only in the mind, by nostalgic and admiring contemplation across the barrier of the "dark ages," by rediscovering the full greatness of ancient achievements in art and thought, and by endeavoring to compete with these achievements on an ideal plane.

The aim of the Renaissance was not to duplicate the works of antiquity but to equal and, if possible, to surpass them. In practice, this meant that the authority granted to the ancient models was far from unlimited. Writers strove to express themselves with Ciceronian eloquence and precision, but not necessarily in Latin. Architects continued to build the churches demanded by Christian ritual, not to duplicate pagan temples; but their churches were designed *all'antica*, "in the manner of the ancients," using an architectural vocabulary based on the study of classical structures. The humanists, however great their enthusiasm for classical philosophy, did not become neo-pagans but went to great lengths trying to reconcile the heritage of the ancient thinkers with Christianity.

The people of the Renaissance, then, found themselves in the position of the legendary sorcerer's apprentice who set out to emulate his master's achievements and in the process released far greater energies than he had bargained for. But since their master was dead, rather than merely absent, they had to cope with these unfamiliar powers as best they could, until they became masters in their own right. This process of forced growth was replete with crises and tensions. The Renaissance must have been an uncomfortable, though intensely exciting, time to live in. Yet these very tensions, it seems, called forth an outpouring of creative energy such as the world had never experienced. It is a fundamental paradox that the desire to return to the classics, based on a rejection of the Middle Ages, brought to the new era not the rebirth of antiquity but the birth of modern civilization.

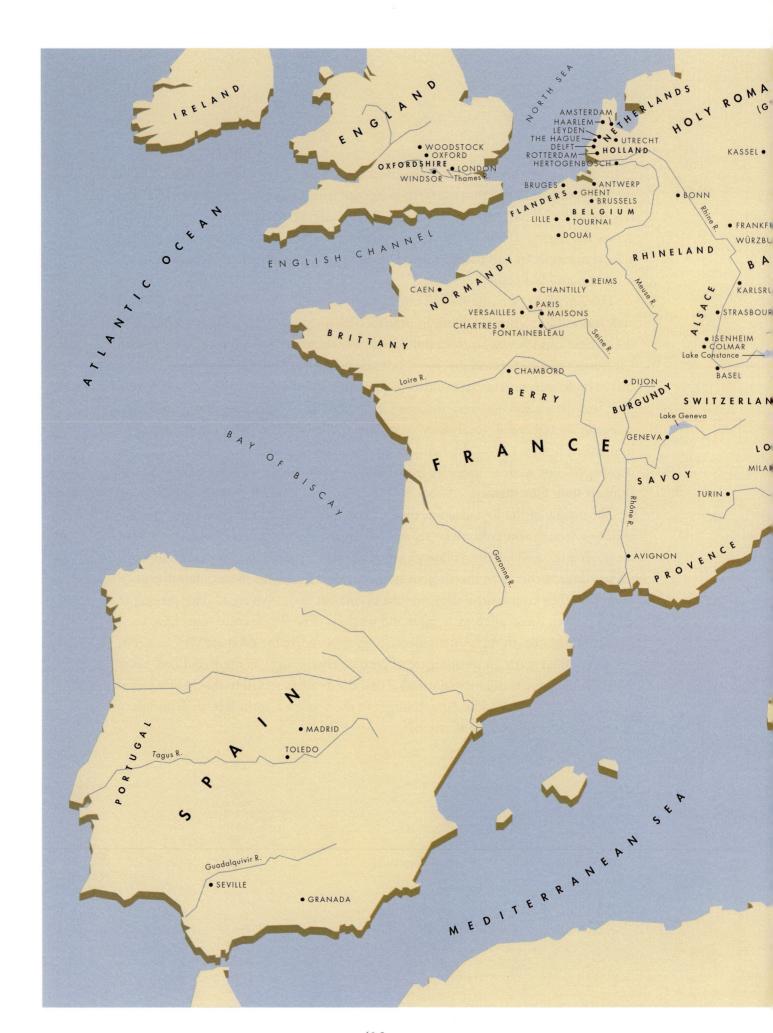

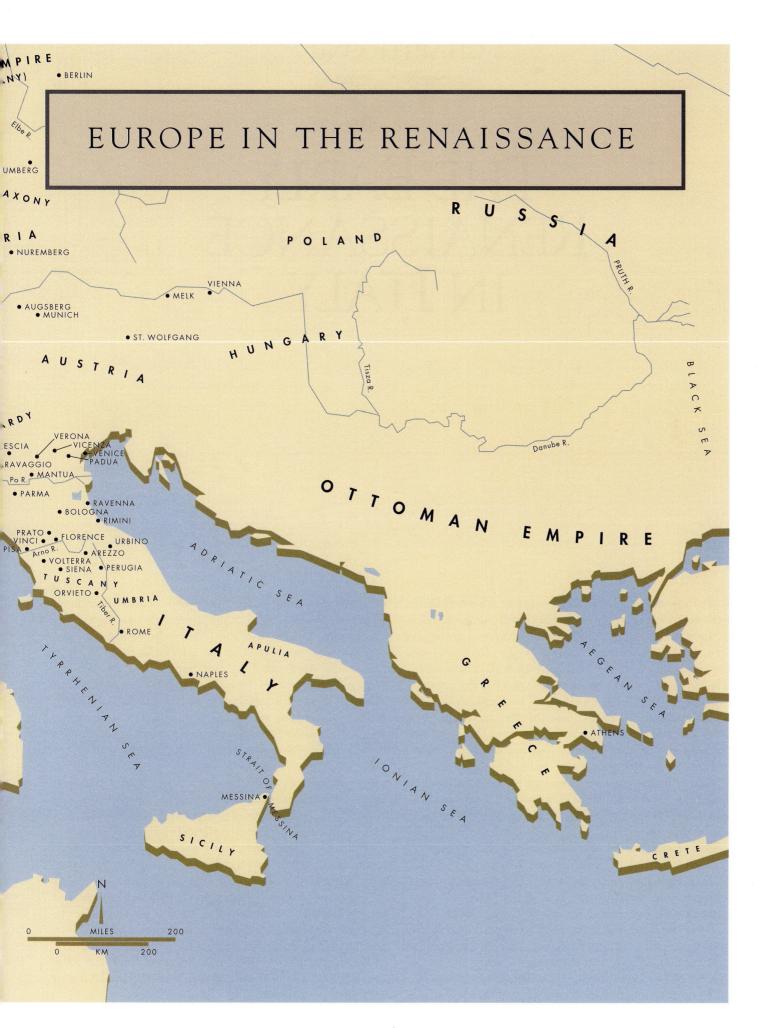

CHAPTER ONE

THE EARLY RENAISSANCE IN ITALY

As we narrow our focus from the Renaissance as a whole to the Renaissance in the fine arts, we are faced with some questions that are still under debate. When did Renaissance art begin? Did it, like Gothic art, originate in a specific center or in several places at the same time? Should we think of it as one coherent style or as an attitude that might be embodied in more than one style? "Renaissance-consciousness," we know, was an Italian idea, and there can be no doubt that Italy played the leading role in the development of Renaissance art, at least until the early sixteenth century. This fact does not necessarily mean, however, that the Renaissance was confined to the South.

So far as architecture and sculpture are concerned, modern scholarship agrees with the traditional view, first expressed more than 500 years ago, that the Renaissance began soon after 1400 in Florence. For painting, however, an even older tradition claims that the new era began with Giotto, who, as Boccaccio wrote about 1350, "restored to light this art which had been buried for many centuries." We cannot disregard such testimony. Yet if we accept it at face value, we must assume that the Renaissance in painting dawned about 1300, a full generation before Petrarch. Giotto himself certainly did not reject the past as an age of darkness. After all, the two chief sources of his own style were the Byzantine tradition and the influence of Northern Gothic. The artistic revolution he created from these elements does not inherently place him in a

new era, since revolutionary changes had occurred in medieval art before. Nor is it fair to credit this revolution to him alone, disregarding Duccio and the other great Sienese masters. Petrarch was well aware of the achievements of all these artists—he wrote admiringly of both Giotto and Simone Martini—but he never claimed that they had restored to light what had been buried during the centuries of darkness. And, in fact, such a thing was inherently impossible, because neither could have known classical painting.

How, then, do we account for Boccaccio's statement about Giotto? We must understand that Boccaccio (1313–1375), an ardent disciple of Petrarch, was chiefly concerned with advancing humanism in literature. In his defense of the status of poetry, he found it useful to draw analogies with painting. Had not the ancients themselves proclaimed that the two arts were alike, in Horace's famous dictum that art must conform to the example of poetry (ut pictura poesis)? Boccaccio thus cast Giotto in the role of "the Petrarch of painting," taking advantage of his already legendary fame. Boccaccio's view of Giotto as a Renaissance artist is, then, a bit of intellectual strategy, rather than a trustworthy reflection of Giotto's own attitude. Nevertheless, what he has to say interests us because he was the first to apply Petrarch's concept of "revival after the dark ages" to one of the visual arts, even though he did so somewhat prematurely.

Boccaccio's way of describing Giotto's achievement is also noteworthy. It was he who claimed that Giotto depicted every aspect of nature so truthfully that people often mistook his paintings for reality itself. Here he implies that the revival of antiquity means for painters an uncompromising realism. This, as we shall see, was to become a persistent theme in Renaissance thought, justifying the imitation of nature as part of the great movement "back to the classics" and tending to minimize the possible conflict between these two aims. After all, Classical Greek art was itself based on a synthesis of naturalism and ideal proportions.

FLORENCE: 1400-1450

There were special circumstances that help to explain why the Early Renaissance was born in Florence at the beginning of the fifteenth century, rather than elsewhere or at some other time. In the years around 1400, Florence faced an acute threat to its independence from the powerful duke of Milan, who was trying to bring all of Italy under his rule. He had already subjugated the Lombard plain and most of the Central Italian city-states. Florence remained the only serious obstacle to his ambition. The city put up a vigorous and successful defense on the military, diplomatic, and intellectual fronts. Of these three, the intellectual was by no means the least important. The duke had eloquent support as a new Caesar, bringing peace and order to the country. Florence, in turn, rallied public opinion by proclaiming itself as the champion of freedom against unchecked tyranny.

This propaganda war was waged on both sides by humanists, the heirs of Petrarch and Boccaccio, but the Florentines gave by far the better account of themselves. Their writings, such as *Praise of the City of Florence* (1402–3) by Leonardo Bruni (see fig. 577), give renewed focus to the Petrarchanideal of a rebirth of the Classics. The humanist, speaking as the citizen of a free republic, asks why, among all the states of Italy, Florence alone had been able to defy the superior power of Milan. He finds the answer in her institutions, her cultural achievements, her geographical situation, the spirit of her people, and her descent from the city-states of ancient Etruria. Florence, he concludes, assumes the same role of political and intellectual leadership as that of Athens at the time of the Persian Wars.

The patriotic pride, the call to greatness, implicit in this image of Florence as the "new Athens" must have aroused a deep response throughout the city, for just when the forces of Milan threatened to engulf them, the Florentines embarked on an ambitious campaign to finish the great artistic enterprises begun a century before at the time of Giotto. Following the competition of 1401–2 for the bronze doors of the Baptistery of S. Giovanni, another extensive program continued the sculptural decoration of Florence Cathedral and other churches, while deliberations were resumed on how to build the dome of the Cathedral, the largest and most difficult project of all. The campaign lasted more than 30 years; it gradually petered out after the completion of the dome in 1436. Although difficult to express in present-day financial terms, its total cost was comparable to the cost of rebuilding the Acropolis in Athens. The huge investment was itself not a guarantee of artistic quality, but, stirred by such civic enthusiasm, it provided a splendid opportunity for the emergence of creative talent and the coining of a new style worthy of the "new Athens."

From the start, the visual arts were considered essential to the resurgence of the Florentine spirit. Throughout antiquity and the Middle Ages, they had been classed with the crafts, or "mechanical arts." It cannot be by chance that the first explicit statement claiming a place for them among the liberal arts occurs around 1400 in the writings of the Florentine chronicler Filippo Villani. A century later, this claim was to win general acceptance throughout most of the Western world. What does it imply? The liberal arts were defined by a tradition going back to Plato and comprised the intellectual disciplines necessary for a "gentleman's" education: mathematics (including musical theory), dialectics, grammar, rhetoric, and philosophy. The fine arts were excluded because they were "handiwork" lacking a theoretical basis. Thus when artists gained admission to this select group, the nature of their work had to be redefined. They were acknowledged as people of ideas, rather than mere manipulators of materials, and works of art came to be viewed more and more as the visible records of their creative minds. This meant that works of art need notindeed, should not-be judged by fixed standards of craftsmanship. Soon everything that bore the imprint of a great master was eagerly collected, regardless of its incompleteness: drawings, sketches, fragments, unfinished pieces.

The outlook of artists, too, underwent important changes as well. Now in the company of scholars and poets, they themselves often became learned and literary. They might write poems, autobiographies, or theoretical treatises. As another consequence of their new social status, artists tended to develop into one of two contrasting personality types: the person of the world, self-controlled, polished, at ease in aristocratic society; or the solitary genius, secretive, idiosyncratic, subject to fits of melancholy, and likely to be in conflict with patrons. It is remarkable how soon this modern view of art and artists became a living reality in the Florence of the Early Renaissance. However, such an attitude did not take immediate hold everywhere, nor did it apply equally to all artists. England, for example, was slow to grant them special status, and women in general were denied the professional training and opportunities available to men.

In addition to humanism and historical forces, we must acknowledge the decisive importance of individual genius in the birth of Renaissance art. It originated with three men of exceptional ability-Filippo Brunelleschi, Donatello, and Masaccio. It is hardly a coincidence that these founders knew each other. Moreover, they faced the same fundamental task: to reconcile Classical form with Christian content in creating the new style. Yet each possessed a unique artistic personality that enabled him to solve this problem in a distinctive way. Thanks to them, Florentine art retained the undisputed leadership of the movement during the first half of the fifteenth century, which became the heroic age of the Early Renaissance. To trace its beginnings, we must discuss sculpture first, for although Brunelleschi was perhaps the central figure, the sculptors had earlier and more plentiful opportunities than the architects or the painters to meet the challenge of the "new Athens."

527. Nanni di Banco. Four Saints (Quattro Coronati). c. 1410–14. Marble, about lifesize. Or San Michele, Florence

Sculpture

GHIBERTI. The artistic campaign had opened with the competition for the Baptistery doors, and for some time it consisted mainly of sculptural projects. Ghiberti's trial relief, we recall, does not differ significantly from the International Gothic (see fig. 492); nor do the completed Baptistery doors, even though their execution took another 20 years. Only in the trial panel can Ghiberti's admiration for ancient art, as demonstrated by the torso of Isaac, be linked with the classicism of the Florentine humanists around 1400. Similar instances occur in other Florentine sculpture at that time. But such quotations of ancient sculpture, isolated and small in scale, merely recapture what Nicola Pisano had done a century before (see fig. 483).

NANNI DI BANCO. A decade after the trial relief, we find that this limited medieval classicism has been surpassed by a somewhat younger artist, Nanni di Banco (c. 1384-1421). The four saints, called the Quattro Coronati (fig. 527), which he made about 1410–14 for one of the niches on the exterior of the church of Or San Michele, demand to be compared not with the work of Nicola Pisano but with the Reims Visitation (see fig. 471). The saints represent four Christian sculptors who were executed for not carving the statue of a pagan god ordered by Diocletian—a story later conflated with that of four martyrs who refused to worship in the god's temple. The figures in both groups are approximately lifesize, yet Nanni's give the impression of being a good deal larger than those at Reims. Their quality of mass and monumentality was quite beyond the range of medieval sculpture, even though Nanni depended less directly on ancient models than had the sculptor of the Visitation or Nicola Pisano. Only the heads of the second and third of the Coronati directly recall examples of Roman sculpture, specifically those memorable portrait heads of the third century A.D. (see figs. 528 and 529). Nanni was obviously impressed by their realism and their agonized expressions. His ability to retain the essence of both these qualities indicates a new attitude toward ancient art, which unites classical form and content, instead of separating them as medieval classicists had done.

DONATELLO'S EARLY WORKS. Early Renaissance art sought an attitude toward the human body similar to that of classical antiquity. The artist who did most to reestablish this attitude was Donatello, the greatest sculptor of his time. Born in 1386, several years after Nanni di Banco, he died in 1466, outliving Nanni by 45 years. Among the founders of the new style, he alone survived well past the middle of the century. Together with Nanni, Donatello spent the early part of his career working on commissions for Florence Cathedral and Or San Michele. They often faced the same artistic problems, yet the personalities of the two masters had little in common.

Their different approaches are strikingly illustrated in Nanni's Quattro Coronati and Donatello's St. Mark (fig. 530). Both are located in deep Gothic niches, but Nanni's figures cannot be divorced from the architectural setting and still seem attached, like jamb statues, to the pilasters behind them. The St. Mark, however, no longer needs such shelter. Perfectly balanced and self-sustaining, he would lose nothing of his immense authority if he were deprived of his present enclosure. Here is the first statue since antiquity capable of standing by itself—or, to put it another way, the first statue to recapture the full meaning of the classical contrapposto. In a performance that truly marks an epoch, the young Donatello has mastered at one stroke the central achievement of ancient sculpture. He treats the human body as an articulated structure, capable of movement, and its drapery as a separate and secondary element that is determined by the shapes underneath rather than by patterns imposed from without. Unlike the Coronati, the St. Mark looks as if he could take off his clothes, yet he is not at all classicistic—that is, ancient motifs are not quoted as they are in Nanni's figures. Perhaps "classic" is a better word for him instead.

528. Four Saints (Quattro Coronati), head of second figure from left in fig. 527

529. *Portrait of a Roman.* Early 3rd century A.D. Marble, lifesize. Staatliche Museen zu Berlin, Antikensammlung

530. Donatello. *St. Mark.* 1411–13. Marble, 7'9" (2.4 m). Or San Michele, Florence

531. Donatello. St. George Tabernacle, from Or San Michele, Florence. c. 1415–17. Marble, height of statue 6'10" (2.1 m). Museo Nazionale del Bargello, Florence

532. St. George and the Dragon, relief below St. George (fig. 531). Marble, height 153/4" (40 cm)

A few years later, about 1415–17, Donatello carved another statue for Or San Michele, the famous *St. George* (fig. 531). The niche is shallower than that of the *St. Mark*, so that the young warrior saint actually protrudes from it slightly. Although encased in armor, his body and limbs are not rigid but wonderfully elastic. His stance, with the weight placed on the forward leg, conveys his readiness for combat. (The right hand originally held a lance or sword.) The controlled energy of his body is reflected in his eyes, which seem to scan the horizon for the approaching enemy. *St. George* is the Christian Soldier in his Early Renaissance version, spiritually akin to the *St. Theodore* at Chartres (see fig. 468), but he is also the proud defender of the "new Athens."

Below St. George's niche is a relief panel (fig. 532) showing the hero's best-known exploit, the slaying of a dragon. (The maiden on the right is the captive princess whom the saint had come to liberate.) Here Donatello produces another revolutionary work, devising a new kind of relief that is physically shallow (called schiacciato, "flattened-out"). Yet it creates an illusion of infinite pictorial depth. This had already been achieved to some degree in certain Greek and Roman reliefs, as well as by Ghiberti (compare with figs. 197, 267-72, and 492). In all these cases, however, the actual carved depth is roughly proportional to the apparent depth of the space represented. The forms in the front plane are in very high relief, while those more distant become progressively lower, seemingly immersed in the background of the panel. Donatello discards this relationship altogether. Behind the figures, the amazing windswept landscape consists entirely of delicate surface modulations that cause the marble to catch light from varying angles. Every tiny ripple becomes endowed with a descriptive power infinitely greater than its real depth, and the chisel, like a painter's brush, becomes a tool for creating shades of light and dark. Yet Donatello cannot have borrowed his landscape from any painting, for no painter at the time he did the St. George relief had achieved so coherent and atmospheric a view of nature.

When the campanile of Florence Cathedral was built between 1334 and 1357, a row of tall Gothic niches had been designed for statues (barely visible above the rooftops in fig. 459). Half of these niches were still empty, but between 1416 and 1435 Donatello filled five of them. The most impressive statue of his series (fig. 533) is the unidentified prophet nicknamed *Zuccone* ("pumpkin-head"), made a dozen years after

533. Donatello. *Prophet (Zuccone)*, on the campanile of Florence Cathedral. 1423–25. Marble, height 6'5" (2 m). Original now in the Museo dell'Opera del Duomo, Florence

the St. Mark. The figure has long enjoyed special fame as a striking example of the master's realism. There can be no question that it is indeed realistic, far more so than any ancient statue or its nearest rivals, the prophets on Sluter's Moses Well (see fig. 481). But, we may ask, what kind of realism have we here? Donatello has not followed the conventional image of a prophet (a bearded old man in Oriental-looking costume, holding a large scroll). Rather, he has invented an entirely new type, and it is difficult to account for his impulse in terms of realism. Why did he not simply reinterpret the old image from a realistic point of view, as Sluter had done? Donatello obviously felt that the established type was inadequate for his own conception of the subject. But how did he conceive it anew? Surely not by observing the people around him. More likely, he imagined the personalities of the prophets from what he had read about them in the Old Testament. He gained an impression, we may assume, of divinely inspired orators lecturing the multitude. This, in turn, reminded him of the Roman orators he had seen in ancient sculpture. Hence the classical costume of the Zuccone, whose mantle falls from one shoulder like those of the toga-clad patricians in figures 263 and 267. Hence, too, the fascinating head, ugly yet noble, like Roman portraits of the third century A.D. (compare figs. 280 and 281).

To shape all these elements into a coherent whole was a revolutionary feat that required an almost visible struggle. Donatello himself seems to have regarded the *Zuccone* as a particularly hard-won achievement. It is the first of his surviving works to carry his signature. He is said to have sworn "by the Zuccone" when he wanted to emphasize a statement and to have shouted at the statue while working on it, "Speak, speak, or the plague take you!"

Donatello had learned the technique of bronze sculpture as a youth by working under Ghiberti on the first Baptistery doors. By the 1420s, he began to rival his former teacher in that medium. The Feast of Herod (fig. 534), which he made about 1425 for the baptismal font of S. Giovanni (the Baptistery of Siena Cathedral), shows the same exquisite surface finish as Ghiberti's panels (see fig. 492), but also an expressive power that we could expect only of the master of the *Zuccone*. By classical or medieval standards, the main scene is poorly composed. The focus of the drama (the executioner presenting the head of St. John to Herod) is far to the left, while the dancing Salome and most of the spectators are massed on the right, and the center remains empty. Yet we see at once why Donatello created this gaping hole. It conveys, more effectively than the witnesses' gestures and expressions, the impact of the shocking sight. Moreover, the centrifugal movement of the figures helps persuade us that the picture space does not end within the panel but continues indefinitely in every direction. Hence the frame becomes a window through which we see this particular segment of unlimited, continuous reality. The arched openings within the panel serve to frame additional segments of the same reality, luring us farther into the depths of the palace.

SCIENTIFIC PERSPECTIVE. This architecture, with its round arches, its fluted columns and pilasters, is not Gothic at all, but reflects the new style launched by Filippo Brunelleschi, whose architectural achievements will occupy us soon. Although it is not certain, Brunelleschi probably also invent-

534. Donatello. *The Feast of Herod.* c. 1425. Gilt bronze, $23^{1}/2$ " (59.7 cm) square. Baptismal font, Siena Cathedral

ed linear, or scientific, perspective, and *The Feast of Herod* is seemingly the earliest surviving example of a picture space constructed by this method. The system is a geometric procedure for projecting space onto a plane, analogous to the way the lens of a photographic camera projects a perspective image on the film. Its central feature is the vanishing point, toward which any set of parallel lines will seem to converge. If these lines are perpendicular to the picture plane, their vanishing point will be on the horizon, corresponding exactly to the position of the beholder's eye. Brunelleschi's discovery in itself was scientific rather than artistic, but it immediately became highly important to Early Renaissance artists because, unlike the perspective practices of the past, it was objective, precise, and rational. In fact, it soon became an argument for upgrading the fine arts into the liberal arts.

While empirical methods could also yield striking results, scientific perspective made it possible now to represent threedimensional space on a flat surface in such a way that all the distances remained measurable. This meant, in turn, that by reversing the procedure the plan could be derived from the perspective picture of a building. On the other hand, the scientific implications of the new perspective demanded that it be consistently applied, a requirement that artists could not always live up to, for practical as well as aesthetic reasons. Since the method presupposes that the beholder's eye occupies a fixed point in space, a perspective picture automatically tells us where we must stand to see it properly. Thus the artist who knows in advance that his work will be seen from above or below, rather than at ordinary eye level, ought to make his perspective construction correspond to these conditions. If, however, these are so abnormal that he must foreshorten his entire design to an extreme degree, he may disregard them and assume instead an ideal beholder, normally located. Such is the case in The Feast of Herod. Our eye should be on a line perpendicular to the center of the panel, but in the Baptistery we must crouch low to see it correctly, as the basin to which our relief is attached is only a few feet high. (For a further discussion of scientific perspective and the problems it raises, see pages 423–25.)

DONATELLO'S DAVID. Donatello's bronze *David* (fig. 535) is an equally revolutionary achievement: the first free-standing lifesize nude statue since antiquity. The Middle Ages would surely have condemned it as an idol, and Donatello's contemporaries must also have felt uneasy about it. For many years it remained the only work of its kind. The early history of the figure is unknown, but it must have been meant for an open space. It probably stood on top of a column in the garden of Cosimo de' Medici, the most powerful figure in Florence, where it would have been visible from every side.

The key to its significance is the elaborate helmet of Goliath with visor and wings, which was derived from depictions of the Roman wind god Zephyr, an evil and destructive figure who killed the young boy Hyacinth. This unique and otherwise implausible feature can only refer to the dukes of Milan, who had threatened Florence about 1400 and were now warring against it once more in the mid-1420s. The statue, then, must be understood as a civic-patriotic public monument identifying David—weak but favored by the Lord with Florence, and Goliath with Milan. David's nudity is most readily explained as a reference to the classical origin of Florence, and his wreathed hat as the opposite of Goliath's helmet: peace versus war. Donatello chose to model an adolescent boy, not a full-grown youth like the athletes of Greece, so that the skeletal structure here is less fully enveloped in swelling muscles. Nor does he articulate the torso according to the classical pattern (compare figs. 182 and 183). Rather, he treats it with a soft sensuousness reminiscent of cult statues of the Roman youth Antinous (compare fig. 285, right). However, his David resembles an ancient statue mainly in its beautifully poised contrapposto. If the figure conveys a profoundly Classical air, the reason lies beyond its anatomical perfection. The impassive expression signifies the virtue humility, which triumphs over the sinful pride of Goliath. It was inspired by Classical examples, which equate the lowered gaze with modesty and virtue. As in ancient statues, it is nevertheless the body that speaks to us more eloquently than the face, which by Donatello's standards is strangly devoid of individuality.

DONATELLO'S GATTAMELATA. Donatello was invited to Padua in 1443 to produce the Equestrian Monument of Gattamelata, portraying the recently deceased commander of the Venetian armies (fig. 536). This statue, the artist's largest free-standing work in bronze, still occupies its original position on a tall pedestal near the facade of the church dedicated to St. Anthony of Padua. We already know its two chief precedents, the mounted Marcus Aurelius in Rome and the Can Grande in Verona (see figs. 279 and 489). Without directly imitating the former, the Gattamelata shares its material, its impressive scale, and its sense of balance and dignity. Donatello's horse, a heavy-set animal fit to carry a man in full armor, is so large that the rider must dominate it by his authority of command, rather than by physical force. The link with the Can Grande monument, though less obvious, is equally significant. Both statues were made to stand next to a church facade, and both are memorials to the military prowess of the deceased. But the Gattamelata, in the new Renaissance fashion, is not part of a tomb. It was designed solely to immortalize the fame of a great soldier. Nor is it the

535. Donatello. *David.* c. 1425–30. Bronze, height 62¹/4" (158 cm). Museo Nazionale del Bargello, Florence

self-glorifying statue of a sovereign, but a monument authorized by the Republic of Venice in special honor of distinguished and faithful service. To this purpose, Donatello has coined an image that is a complete union of the ideal and the real. The general's armor combines modern construction with classical detail, and the head is powerfully individual, yet endowed with a truly Roman nobility of character.

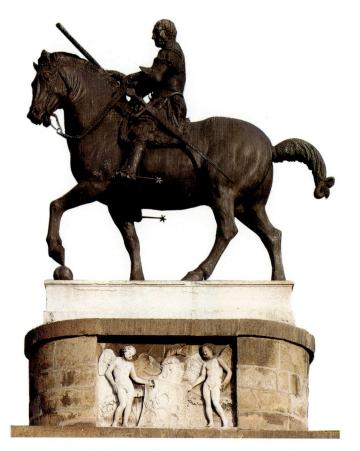

536. Donatello. *Equestrian Monument of Gattamelata.* 1445–50. Bronze, approx. 11' x 13' (3.35 x 3.96 m). Piazza del Santo, Padua

DONATELLO'S LATER WORKS. When Donatello went home to Florence after a decade's absence, he must have felt like a stranger. The political and spiritual climate had changed, and so had the taste of artists and public (see page 409). His subsequent works, between 1453 and 1466, stand apart from the dominant trend. Perhaps that is why their fierce expressiveness and personal quality exceed anything the master had revealed before. The extreme individualism of his late works confirms Donatello's reputation as the earliest "solitary genius" among the artists of the new age.

In contrast to the *David* of some 20 years earlier, the wood *Mary Magdalen* (fig. 537) seems so far from Renaissance ideals that at first we are tempted to see in this statue a return to such Gothic devotional images as the Bonn *Pietà* (see fig. 479). But when we look back at the intensity of Donatello's *Zuccone* (fig. 533), we realize that it is not basically different from his earlier work. *Mary Magdalen* conveys a profound insight into religious experience: the ravaged features and wasted body make her the very embodiment of penitence, so that we fully share her anguish and longing for redemption.

GHIBERTI. At the same time that Donatello made *The Feast of Herod*, Ghiberti was commissioned to do a second pair of bronze doors for the Baptistery in Florence. This set (fig. 538), so beautiful that they were soon dubbed the "Gates of Paradise," is decorated with ten large reliefs in square frames, which provided a more generous field than the 28 small panels in quatrefoil frames of the earlier doors. They mark the artist's successful conversion, under the influence of Donatello and the other pioneers of the new style, to the Early Renaissance point of view. The only lingering elements of the Gothic style are to

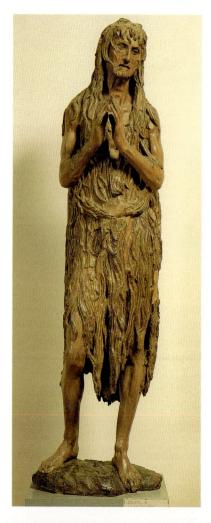

537. (left)
Donatello. Mary
Magdalen.
c. 1455. Wood,
partially gilded,
height 6'2"
(1.88 m).
Museo dell'Opera del
Duomo,
Florence

538. (opposite)
Lorenzo
Ghiberti.
"Gates of
Paradise," east
doors of the
Baptistery of
S. Giovanni,
Florence.
c. 1435. Gilt
bronze, height
15' (4.57 m)

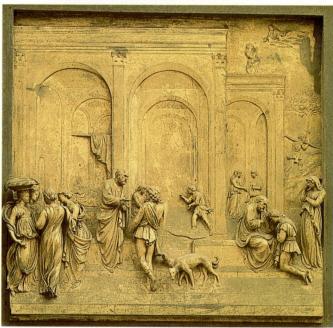

539. Lorenzo Ghiberti. *The Story of Jacob and Esau*, panel of the "*Gates of Paradise.*" c. 1435. Gilt bronze, 31¹/4" (79.5 cm) square. Baptistery of S. Giovanni, Florence

be found in the figures, whose gentle and graceful classicism still reminds us of the International Style. The "Gates of Paradise" show the new pictorialism that distinguishes Renaissance reliefs. The hint of spatial depth we saw in *The Sacrifice of Isaac* (fig. 492) has grown in *The Story of Jacob and Esau* (fig. 539)

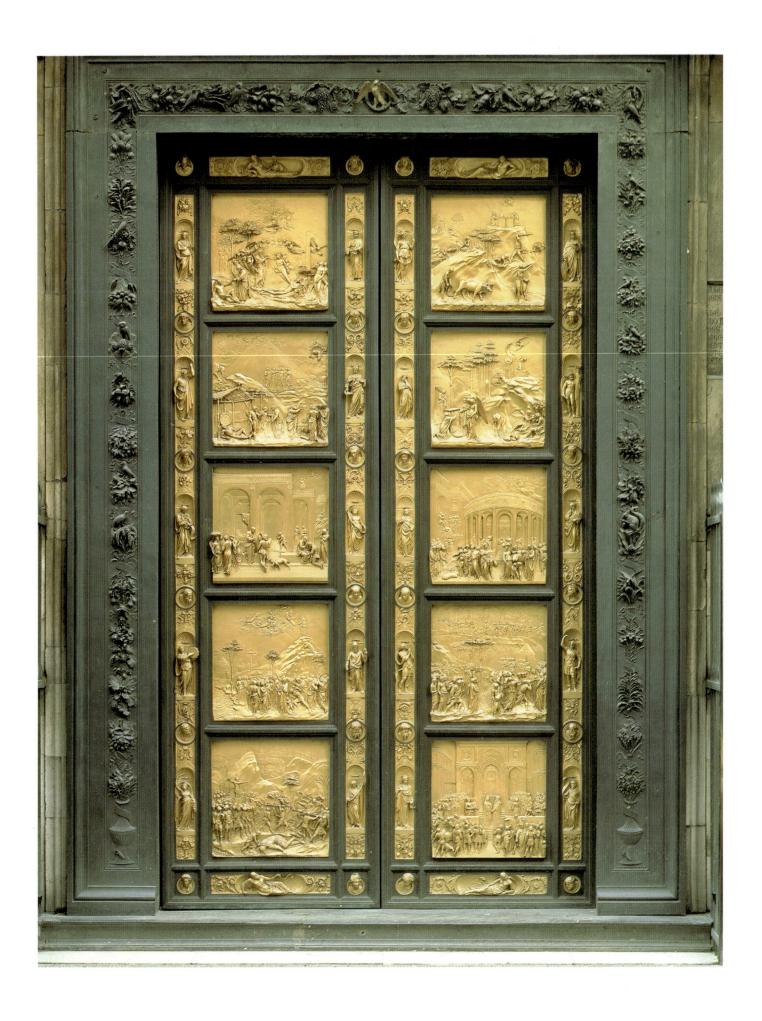

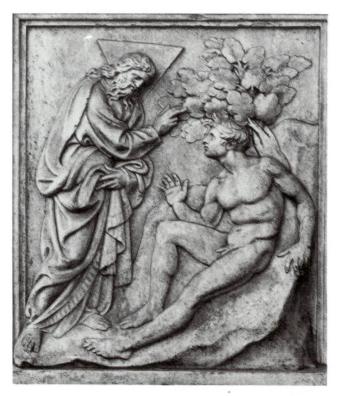

540. Jacopo della Quercia. *The Creation of Adam.* c. 1430. Marble, $34^{1}/2 \times 27^{1}/2$ " (87.7 x 69.8 cm). Main portal, S. Petronio, Bologna

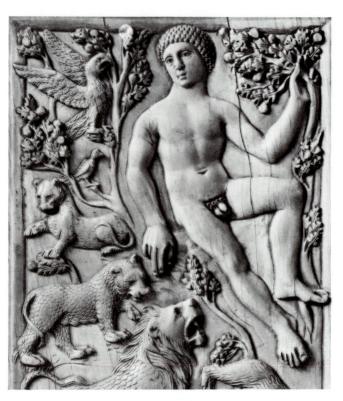

541. *Adam in Paradise*, detail of an ivory diptych. c. 400 A.D. Museo Nazionale del Bargello, Florence

into a complete setting for the figures that goes back as far as the eye can reach. We can imagine the figures leaving the scene, for the deep, continuous space of this "pictorial relief" in no way depends on their presence. Ghiberti's spacious hall is a fine example of Early Renaissance architectural design reflecting the mature art of Brunelleschi. Because *The Story of Jacob and Esau* is about a decade later than *The Feast of Herod* by Donatello, its perspective construction is more easy and assured. In the meantime, Brunelleschi's discovery had been formulated in writing by Leone Battista Alberti, the author of the first Renaissance treatise on painting and later an important architect in his own right (see pages 434–37).

JACOPO DELLA QUERCIA. Outside Florence, the only major sculptor at that time was Jacopo della Quercia of Siena (c. 1374–1438). Like Ghiberti, he changed his style from Gothic to Early Renaissance in mid-career, mainly through contact with Donatello. Had he grown up in Florence, he might have been one of the great leaders of the new movement from the start, but his forcefully individual art remained outside the main trend. It had no effect on Florentine art until the very end of the century, when the young Michelangelo fell under its spell.

Michelangelo's admiration was aroused by the scenes from Genesis framing the main portal of the church of S. Petronio in Bologna, among them *The Creation of Adam* (fig. 540). The relief modeling of these panels is conservative—Jacopo had little interest in pictorial depth—but the figures are daring and profoundly impressive. Adam slowly rising from the ground,

as a statue brought to life might rise from its mold, recaptures the heroic beauty of a classical athlete. Here the nude body once again expresses the dignity and power of the individual as it did in classical antiquity. As he faces the Lord, Jacopo's *Adam* contains a hint of incipient conflict that will lead to Original Sin. He will surely fall, but in pride of spirit rather than as a hapless victim of the Evil One.

It is instructive to compare Jacopo's *Adam* with the work that probably inspired it, an *Adam in Paradise* from an Early Christian ivory diptych (fig. 541). The latter figure represents a classicizing trend around 400 A.D. (compare fig. 314), a final attempt to preserve the Greek ideal of physical beauty within a Christian context. Adam appears as the Perfect Man, divinely appointed to "have dominion . . . over every living thing," but the classic form has already become a formula, a mere shell. It was left to the fifteenth century to rediscover the sensuous beauty of the unclothed body. Jacopo's *Adam* is clearly nude, in the full classical sense.

Architecture

BRUNELLESCHI. Although Donatello was its greatest and most daring master, he did not create the Early Renaissance style in sculpture all by himself. The new architecture, on the other hand, owed its existence to one person, Filippo Brunelleschi (1377–1446). Ten years older than Donatello, he, too, had begun his career as a sculptor. After failing to win the competition of 1401–2 for the first Baptistery doors, Brunel-

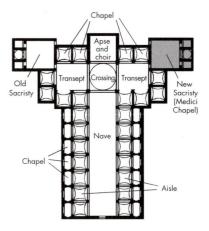

543. Plan of S. Lorenzo. Gray area indicates Michelangelo's later addition

leschi reportedly went to Rome with Donatello. He studied the architectural monuments of the ancients and seems to have been the first to take exact measurements of these structures. His discovery of scientific perspective (see page 414) may well have grown out of his search for an accurate method of recording their appearance on paper. What else he did during this long gestation period we do not know, but between 1417 and 1419 we again find him competing with Ghiberti, this time for the job of building the Florence Cathedral dome (see figs. 459 and 460). Its design had been established half a century earlier and could be altered only in details, but its vast size posed a difficult problem of construction. Brunelleschi's proposals, although contrary to all traditional practice, so impressed the authorities that this time he won out over his rival. Thus the dome deserves to be called the first work of postmedieval architecture, as an engineering feat if not for style.

Brunelleschi's main achievement was to build the dome in two separate shells which are ingeniously linked to reinforce each other, rather than in one solid mass. As the total weight of the structure was thereby lightened, he could dispense with the massive and costly wooden trusswork required by the older method of construction. Instead of having building materials carried up on ramps to the required level, he designed hoisting machines. His entire scheme reflects a bold, analytical mind, always discarding conventional solutions if better ones could be devised. This fresh approach distinguishes Brunelleschi from the Gothic stonemason-architects, with their time-honored procedures.

In 1419, while he was working out the final plans for the Cathedral dome, Brunelleschi received his first opportunity to create buildings entirely of his own design. It came from the head of the Medici family, one of the leading merchants and bankers of Florence, who commissioned him to add a sacristy to the Romanesque church of S. Lorenzo. His plans for this sacristy (which was to serve also as a burial chapel for the Medici) were so successful that he was immediately asked to develop a new design for the entire church. The construction, begun in 1421, was often interrupted, so that the interior was not completed until 1469, more than 20 years after the architect's death. The exterior itself remains unfinished to this day. Nevertheless, the building in its present form is essentially what Brunelleschi had envisioned about 1420, and thus represents the first full statement of his architectural aims (figs. 542 and 543).

The plan may not seem very novel, at first glance. Its general arrangement recalls Cistercian Gothic churches (see fig. 456), while the unvaulted nave and transept link it to Sta. Croce (see fig. 457). What distinguishes it is a new emphasis on symmetry and regularity. The entire design consists of square units. Four large squares form the choir, the crossing, and the arms of the transept. Four more are combined into the nave. Other squares, one-fourth the size of the large ones, make up the aisles and the chapels attached to the transept. (The oblong chapels outside the aisles were not part of the original design.) As we examine the plan, we realize that Brunelleschi must have first decided to make the floor area of the choir equal to four of the small square units. The nave and

transept were thus to be twice as wide as the aisles or chapels. In other words, Brunelleschi conceived S. Lorenzo as a grouping of abstract "space blocks," the larger ones being simple multiples of the standard unit. Once we understand this, we realize how revolutionary he was, for his clearly defined, separate space compartments represent a radical departure from the Gothic architect's way of thinking. In fixing this system, he was not concerned with the thickness of the walls between these compartments, so that the transept arms are slightly longer than they are wide, and the length of the nave is not four but four and one-half times its width.

The interior bears out our expectations. Cool, static order has replaced the emotional warmth, the flowing spatial movement of Gothic church interiors. S. Lorenzo does not sweep us off our feet. It does not even draw us forward after we have entered it, and we are quite content to remain near the door. From that vantage point, our view seems to take in the entire structure, almost as if we were confronted with a particularly clear and convincing demonstration of scientific perspective (compare fig. 539). The total effect recalls the "old-fashioned" Tuscan Romanesque, such as Pisa Cathedral (see fig. 398), as well as Early Christian basilicas (compare fig. 299). These monuments, to Brunelleschi, exemplified the church architecture of classical antiquity. They inspired his return to the use of the round arch and of columns, rather than piers, in the nave arcade. Yet these earlier buildings lack the transparent lightness, the wonderfully precise articulation of S. Lorenzo. Unlike Brunelleschi's, their columns are larger and more closely spaced, tending to screen off the aisles from the nave. Only the arcade of the Florentine Baptistery is as gracefully proportioned as that of S. Lorenzo, but it is a *blind* arcade, without any supporting function (see fig. 399). The Baptistery, we will recall, was thought in Brunelleschi's day to have once been a classical temple. Hence, it was an appropriate source of inspiration for him.

Clearly, then, Brunelleschi did not revive the architectural vocabulary of the ancients out of mere antiquarian enthusiasm. The very quality that attracted him to the component parts of classical architecture must have seemed, from the medieval point of view, their chief drawback: inflexibility. A classical column, unlike a medieval column or pier, is strictly defined and self-sufficient, and its details and proportions can be varied only within narrow limits. (The ancients thought of it as an organic structure comparable to the human body.) The classical round arch, unlike any other arch (horseshoe, pointed, and so forth), has only one possible shape, a semicircle. The classical architrave and the classical repertory of profiles and ornaments are all subject to similarly strict rules. Not that the classical vocabulary is completely rigid. If it were, it could not have persisted from the seventh century B.C. to the fourth century A.D. in the ancient world. But the disciplined spirit of the Greek orders, which can be felt even in the most original Roman buildings, demands regularity and consistency and discourages sudden, arbitrary departures from the norm.

Without the aid of such a "standardized" vocabulary, Brunelleschi would have found it impossible to define the shape of his "space blocks" so convincingly. With remarkable logic, he emphasizes the edges or "seams" of the units without disrupting their rhythmic sequence. To single out a particularly noteworthy example, consider the vaulting of the aisles. The transverse arches rest on pilasters attached to the outer wall (corresponding to the columns of the nave arcade), but a continuous architrave intervenes between arch and pilaster, linking all the bays. We would expect these bays to be covered by groin vaults of the classical, unribbed type. Instead, we find a novel kind of vault, the curved surface of which is formed from the upper part of a hemispherical dome. (Its radius equals half the diagonal of the square compartment.) Avoiding the ribs and even the groins, Brunelleschi has created a "one-piece" vault, strikingly simple and geometrically regular, that makes of each bay a distinct unit.

At this point we may well ask: if the new architecture consists essentially of separate elements added together, be they spaces, columns, or vaults, how did Brunelleschi relate these elements to each other? What makes the interior of S. Lorenzo seem so beautifully integrated? There is indeed a controlling principle that accounts for the harmonious, balanced character of his design. The secret of good architecture, Brunelleschi was convinced, lay in giving the "right" proportions—that is, proportional ratios expressed in simple whole numbers—to all the significant measurements of a building. The ancients had possessed this secret, he believed, and he tried to rediscover it by painstakingly surveying the remains of their monuments. What he found, and how he applied his theory to his own designs, we do not know for sure. He may have been the first to think out what would be explicitly stated a few decades later in Leone Battista Alberti's Treatise on Architecture: that the mathematical ratios determining musical harmony must also govern architecture, for they recur throughout the universe and are thus divine in origin.

Similar ideas, ultimately derived from the Greek philosopher Pythagoras, had been current during the Middle Ages, but they had not before been expressed so radically, directly, and simply. When Gothic architects "borrowed" the ratios of musical theory, they did so with the aid of the theologians and far less consistently than their Renaissance successors. But even Brunelleschi's faith in the universal validity of harmonious proportions did not tell him how to allot these ratios to the parts of any given building. It left him many alternatives, and his choice among them was necessarily subjective. We may say, in fact, that the main reason S. Lorenzo strikes us as the product of a single great mind is the very individual sense of proportion permeating every detail.

In the revival of classical forms, Renaissance architecture found a standard vocabulary. The theory of harmonious proportions provided it with the kind of syntax that had been mostly absent in medieval architecture. Lest this comparatively inflexible order be misinterpreted as an architectural impoverishment, we might carry our linguistic analogy a bit further. It is tempting to see a parallel between the "unclassical" flexibility of medieval architecture, proliferating in regional styles, and the equally "unclassical" attitude at that time toward language, as evidenced by its barbarized Latin and the rapid growth of regional vernaculars, the ancestors of our modern Western tongues. The revival of Latin and Greek in the Renaissance did not stunt these languages. On the contrary, the classical influence made them so much more stable, precise, and articulate that Latin before long lost the dominant

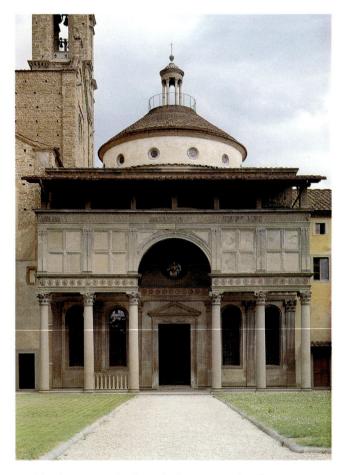

544. Filippo Brunelleschi and others. Pazzi Chapel, Sta. Croce, Florence. Begun 1430–33

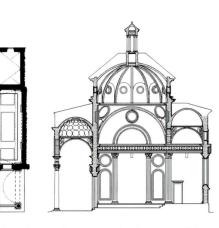

546. Plan of the Pazzi Chapel

547. Longitudinal section of the Pazzi Chapel

position it had maintained throughout the Middle Ages as the language of intellectual discourse. It is not by chance that today we can still read Renaissance literature in Italian, French, English, or German without much trouble, while texts of a century or two before can often be understood only by scholars. Similarly, the revival of classical forms and proportions enabled Brunelleschi to transform the architectural "vernacular" of his region into a stable, precise, and articulate system. The new rationale underlying his buildings soon spread to the rest of Italy and later to all of Northern Europe.

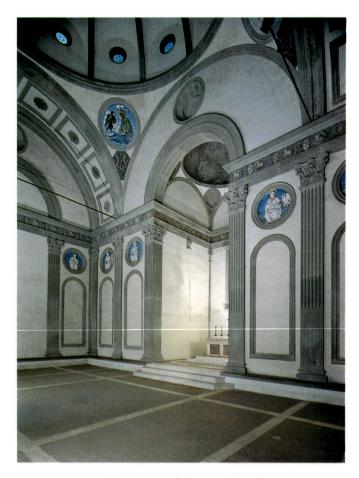

545. Interior of the Pazzi Chapel

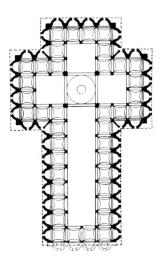

548. Filippo Brunelleschi. Plan of Sto. Spirito, Florence. Begun 1434–35

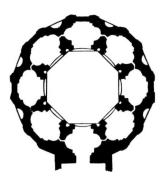

549. Filippo Brunelleschi. Plan of Sta. Maria degli Angeli, Florence. 1434–37

Among the surviving structures by Brunelleschi, not one exterior shows his original design unaltered by later hands, not even the facade of the Pazzi Chapel (fig. 544). The chapel was begun about 1430, but Brunelleschi (who died in 1446) could not have planned the front in its present form. It dates from about 1460, and the top story remains incomplete. Nevertheless, it is a most original creation, totally unlike any medieval facade. A porch, reminiscent of the narthex of Early Christian churches (see fig. 298), precedes the chapel, making the facade seem to screen the main

body of the structure. The central arch linking two sections of a classical colonnade is a prime innovation. It frames the portal behind and draws attention to the dome. The plan (fig. 546) shows us that the interrupted architrave supports two barrel vaults, which in turn help to support a small dome above the central opening.

Inside the chapel, we find the same motif on a larger scale—two barrel vaults flanking the dome—and a third dome, like that over the entrance but twice its diameter, above the square compartment housing the altar (figs. 545 and 547). Interior surfaces are articulated much as in S. Lorenzo but their effect is richer and more festive. Here we also find some sculpture. On the four pendentives of the central dome are large roundels with reliefs of the evangelists, and on the walls 12 smaller ones of the apostles. These reliefs, however, are not essential to the design of the chapel. Brunelleschi provided the frames, but he need not have intended them to be filled with sculpture. Indeed, the medallions may very well have been planned "blind," like the recessed panels below them. In any case, the medieval interdependence of architecture and sculpture (never as strong in Italy as in Northern Europe) had ceased to exist. Donatello had liberated the statue from its setting, and Brunelleschi's conception of architecture as the visual counterpart of musical harmonies did not permit sculpture to play a more prominent role than the roundels in the Pazzi Chapel.

In the early 1430s, when the Cathedral dome was nearing completion, Brunelleschi's development as an architect entered a decisive new phase. His design for the church of Sto. Spirito (fig. 548) might be described as a perfected version of S. Lorenzo. All four arms of the cross are alike, with the nave being distinguished from the others only by its greater length, and the entire structure is now enveloped by an unbroken sequence of aisles and chapels. These chapels are the most surprising feature of Sto. Spirito. Brunelleschi had always shunned the apsidal shape before, but now he used it to express more dynamically the relation between interior space and its boundaries, for the wall seems to bulge under the outward pressure of the space. Unhappily, this novel feature was later walled over.

In the church of Sta. Maria degli Angeli, which Brunelleschi began about the same time as Sto. Spirito, this new direction reaches its ultimate conclusion (fig. 549): a domed, central-plan church—the first of the Renaissance—inspired by the round and polygonal structures of Roman and Early Christian times. Financial difficulties interfered with completing the project above the ground floor, so that we cannot be sure of the design of the upper part, or even of some details in the plan. It is nevertheless clear that Brunelleschi has recaptured here the ancient Roman principle of the "sculptured" wall. The dome was to rest on eight heavy piers of complex shape, which belong to the same mass of masonry from which the eight chapels have been "excavated." Wall and space are both charged with energy, and the plan records the precarious balance of their pressures and counterpressures. As a conception, Sta. Maria degli Angeli was so far in advance of Brunelleschi's previous work that it must have utterly bewildered his contemporaries. It had, in fact, no echoes until the end of the century.

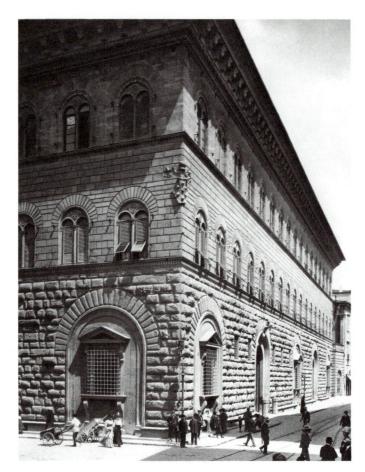

550. Michelozzo. Palazzo Medici-Riccardi, Florence. Begun 1444

MICHELOZZO. The massive "Roman" style of the church of Sta. Maria degli Angeli may explain the great disappointment of Brunelleschi's final years: the rejection by his old patrons, the Medici, of his design for their new palace. The family had risen, since the 1420s, to such power that they were in practice, if not in theory, the rulers of Florence. For that very reason they thought it prudent to avoid any ostentation that might antagonize the public. If Brunelleschi's plan for their palace followed the style of Sta. Maria degli Angeli, it probably had such Imperial Roman magnificence that the Medici could not safely afford so grand an edifice. They awarded the commission to a younger and much less distinguished architect, Michelozzo (1396–1472); actual construction began in 1444, two years before Brunelleschi's death.

Michelozzo's design for the Palazzo Medici-Riccardi (fig. 550) still recalls the fortresslike Florentine palaces of old (the windows on the ground floor were added by Michelangelo 75 years later), but the type has been transformed by Brunelleschian principles (compare fig. 464). The three stories are in a graded sequence, each complete in itself. The lowest is built of rough-hewn, "rustic" masonry like the Palazzo Vecchio; the second has smooth-surfaced blocks with "rusticated" (indented) joints; and the third an unbroken surface. On top of the structure rests, like a lid, a strongly projecting cornice inspired by those of Roman temples, emphasizing the finality of the three stories.

Painting

MASACCIO. Although Early Renaissance painting did not appear until the early 1420s, a decade later than Donatello's *St. Mark* and some six years after Brunelleschi's first designs for S. Lorenzo, its inception was the most extraordinary of all. This new style was launched single-handedly by a young genius named Masaccio (1401–1428), who was only 21 years old at the time and who died just six years later. The Early Renaissance was already well established in sculpture and architecture by then, making Masaccio's task easier than it would have been otherwise. His achievement remains stupendous nevertheless.

His first fully mature work is a fresco of 1425 in Sta. Maria Novella (fig. 551) which shows the Holy Trinity accompanied by the Virgin, St. John the Evangelist, and two donors who kneel on either side. The lowest section of the fresco, linked with a tomb below, represents a skeleton lying on a sarcophagus, with the inscription (in Italian): "What you are, I once was; what I am, you will become." Here we seem to plunge into a new environment. But Masaccio's world is a realm of monumental grandeur rather than the lyrical grace of the International Gothic. It seems hard to believe that only two years before, in this city of Florence, Gentile da Fabriano had completed *The Adoration of the Magi* (see fig. 525). What the *Trinity* fresco brings to mind is not the style of the immediate past, but Giotto's art, with its sense of large scale, its compositional severity and sculptural volume. Masaccio's renewed allegiance to Giotto was only a starting point, however. For Giotto, body and drapery form a single unit, as if both had the same substance. In contrast, Masaccio's figures, like Donatello's, are "clothed nudes," whose drapery falls like real fabric. The Christ adheres to the example established by Duccio's Maestà altarpiece, but the nearly sculptural treatment suggests a knowledge of an early Crucifixion by Brunelleschi that translates the same model into three dimensions—no small feat, easy though it may seem. Like Donatello and Brunelleschi, Masaccio shows a thorough understanding of anatomy not seen since Roman art.

The fully up-to-date setting reveals an equally complete command of Brunelleschi's new architecture and of scientific perspective. For the first time in history, we are given all the data needed to measure the depth of this painted interior, to draw its plan, and to duplicate the structure in three dimensions. It is, in short, the earliest example of a rational picture space. For Masaccio, like Brunelleschi, it must have also been a symbol of the universe ruled by divine reason. This barrelvaulted chamber is not a niche, but a deep space in which the figures could move freely if they so wished. As in Ghiberti's later relief panel The Story of Jacob and Esau (see fig. 539), the picture space is independent of the figures. They inhabit it but do not create it. Take away the architecture and you take away the figures' space. We could go even further and say that scientific perspective depends not just on architecture, but on this particular kind of architecture, so different from Gothic.

First we note that all the lines perpendicular to the picture plane converge upon a point below the foot of the Cross, on the platform that supports the kneeling donors. To see the fresco properly, we must face this point, which is at normal eye

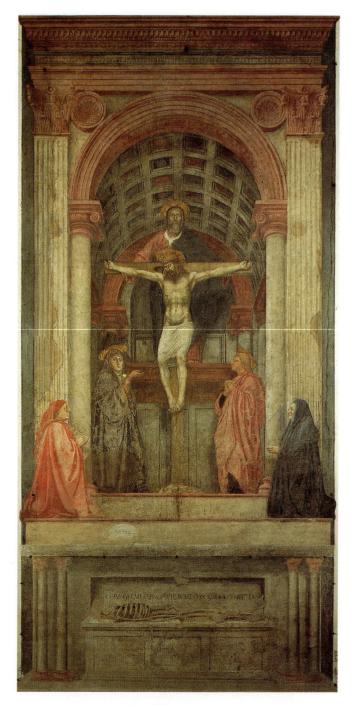

551. Masaccio. The Holy Trinity with the Virgin, St. John, and Two Donors. 1425. Fresco. Sta. Maria Novella, Florence

552. Plan of The Holy Trinity

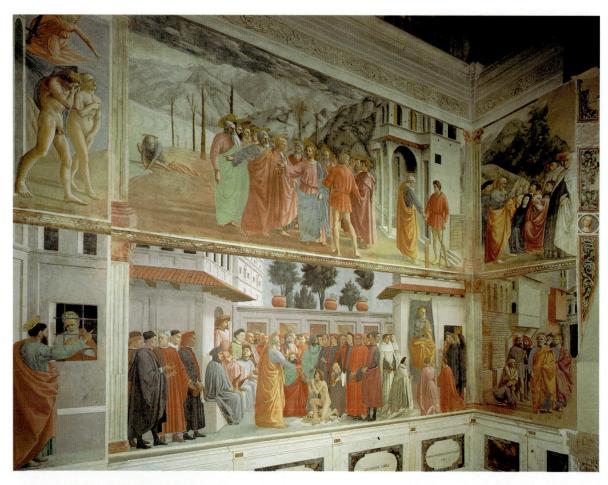

553. Left wall of Brancacci Chapel, with frescoes by Masaccio. Sta. Maria del Carmine, Florence

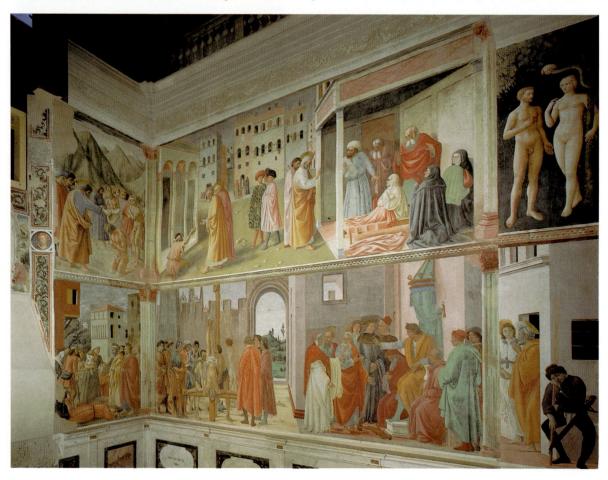

554. Right wall of Brancacci Chapel, with frescoes by Masolino and Filippino Lippi. Sta. Maria del Carmine, Florence

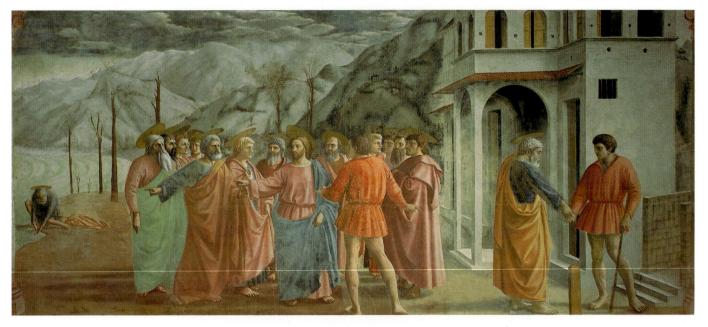

555. Masaccio. The Tribute Money. c. 1427. Fresco. Brancacci Chapel, Sta. Maria del Carmine, Florence

level, somewhat more than five feet above the floor of the church. The figures within the vaulted chamber are five feet tall, slightly less than lifesize, while the donors, who are closer to us, are fully lifesize. The exterior framework is therefore "lifesize," too, since it is directly behind the donors. The distance between the pilasters corresponds to the span of the barrel vault, and both are seven feet. The circumference of the arc over this span measures 11 feet. That arc is subdivided by eight square coffers and nine ridges, the coffers being one foot wide and the ridges four inches. Applying these measurements to the length of the barrel vault (it consists of seven coffers, the nearest one of which is invisible behind the entrance arch) we find that the vaulted area is nine feet deep.

We can now draw a complete floor plan (fig. 552). A puzzling feature may be the place of God the Father. His arms support the Cross, close to the front plane, while his feet rest on a ledge attached to a wall. How far back is this surface? If it is the rear wall of the chamber, God would appear to be exempt from the laws of perspective. But in a universe ruled by reason, this cannot be so. Hence Masaccio must have intended to locate the ledge directly behind the Cross. The strong shadow that St. John casts on the wall beneath the ledge bears this out.

The largest group of Masaccio's works to come down to us are frescoes in the Brancacci Chapel in Sta. Maria del Carmine (figs. 553 and 554), devoted to the life of St. Peter. *The Tribute Money*, in the upper tier (fig. 555), is the most famous of these. It illustrates the story in the Gospel of Matthew (17:24–27) by the age-old method known as "continuous narration" (see page 314). In the center, Christ instructs Peter to catch a fish, whose mouth will contain the tribute money for the tax collector. On the far left, in the distance, Peter takes the coin from the fish's mouth, and on the right, he gives it to

the tax collector. Since the lower edge of the fresco is almost 14 feet above the floor of the chapel, Masaccio could not here coordinate his perspective with our actual eye level. Instead, he expects us to imagine that we are looking directly at the central vanishing point, which is located behind the head of Christ. Oddly enough, this feat is so easy that we take note of it only if we are in an analytical frame of mind. But then, pictorial illusion of any sort is always an imaginary experience. No matter how eager we are to believe in a picture, we never mistake it for reality itself, just as we are hardly in danger of confusing a statue with a living thing.

If we could see *The Tribute Money* from the top of a suitable ladder, the painted surface would be more visible, of course, but the illusion of reality would not improve markedly. This illusion depends to only a minor degree on Brunelleschian perspective. Masaccio controls the flow of light (which comes from the right, where the window of the chapel is actually located), and he uses atmospheric perspective in the subtly changing tones of the landscape. We now recall Donatello's preview of such a setting, a decade earlier, in his small relief of St. George (compare fig. 532).

The figures in *The Tribute Money*, even more than those in the *Trinity* fresco, display Masaccio's ability to merge the weight and volume of Giotto's figures with the new functional view of body and drapery. All stand in beautifully balanced contrapposto, and close inspection reveals fine vertical lines scratched in the plaster by the artist, establishing the gravitational axis of each figure from the head to the heel of the engaged leg. In accord with this dignified approach, the figures seem rather static. The narrative is conveyed to us by intense glances and a few emphatic gestures, rather than by physical movement. But in another fresco of the Brancacci

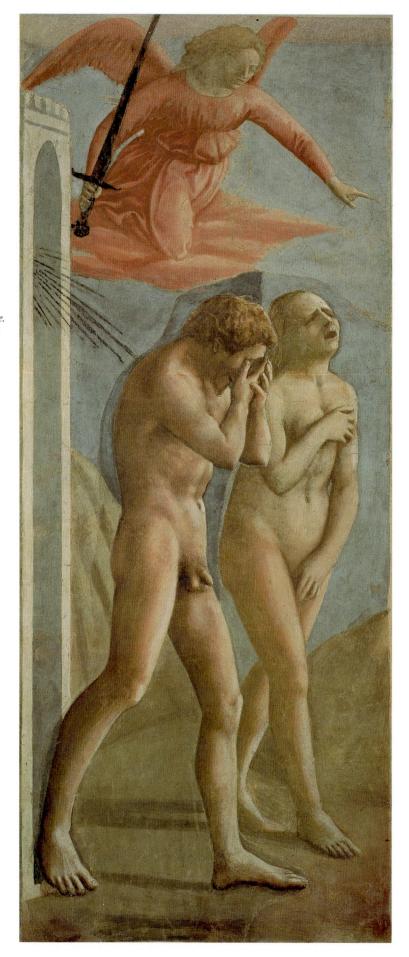

556. Masaccio.

The Expulsion from Paradise.
c. 1427. Fresco. Brancacci
Chapel, Sta. Maria del
Carmine, Florence

Chapel, *The Expulsion from Paradise* (fig. 556), Masaccio proves decisively his ability to display the human body in motion. The tall, narrow format leaves little room for a spatial setting. The gate of paradise is only indicated, and in the background are a few shadowy, barren slopes. Yet the soft, atmospheric modeling, and especially the forward-moving angel, boldly foreshortened, suffice to convey a free, unlimited space. In conception this scene is clearly akin to Jacopo della Quercia's Bolognese reliefs (see fig. 540). Masaccio's grief-stricken Adam and Eve, though less dependent on ancient models, are equally striking exemplars of the beauty and power of the nude human form.

Masaccio divided the work on the Brancacci Chapel with a much older artist, Masolino (documented 1423-died 1440), who had been decisively influenced by Gentile da Fabriano. Remarkably enough, the two cooperated well and even collaborated on several frescoes (the head of Christ in The Tribute Money is by Masolino, for instance), although the difference in their styles was great. Masaccio's impact notwithstanding, Masolino retained an allegiance to the International Style. Thus the figures in the upper tier of the right wall (fig. 554) are simply larger versions of those in Pietro Lorenzetti's Birth of the Virgin (see fig. 509). The setting, too, remains Gothic in character, despite the scientific perspective (compare fig. 511). Masolino constructs a self-consciously theatrical space that remains separate from his figures, whereas Masaccio's are fully integrated into their surroundings, both visually and dramatically.

Nowhere is the sharp contrast between their styles more striking than in *The Temptation* by Masolino (visible in the upper right of fig. 554), which forms an enchanting companion to the unprecedented anguish in Masaccio's *Expulsion from Paradise*. Regardless of their contrapposto, the figures of Adam and Eve are no more classical than Adam in our figure 541. Indeed, they may well derive from a similar source, for Masolino was utterly incapable of treating the nude in convincing organic terms. The comparison is telling: Masaccio's contribution, like Donatello's, was to recapture the substance of antiquity without relying on external forms. Masaccio left for Rome before he could finish the Brancacci Chapel, and Masolino's work, too, was interrupted for several years. It was finally completed toward the end of the century by Filippino Lippi (1457/8–1504), who was responsible for the lower tier to either side.

While he had a mural painter's temperament, Masaccio was skilled in panel painting. His large many-paneled altarpiece, or polyptych, made in 1426 for the Carmelite church in Pisa, has since been dispersed among various collections. Its center panel (fig. 557) is a more fully developed restatement of his earliest known work. The *Madonna Enthroned* is of the monumental Florentine type introduced by Cimabue and reshaped by Giotto (see figs. 499 and 507). The usual components, including the gold ground, are still present: a large, high-backed throne dominates the composition and on either side are adoring angels (here only two). Despite these traditional elements, the painting is revolutionary in several respects. The kneeling angels in Giotto's *Madonna* have become lute players, seated on the lowest step of the throne, and the Christ Child is no longer blessing us but eating a bunch of

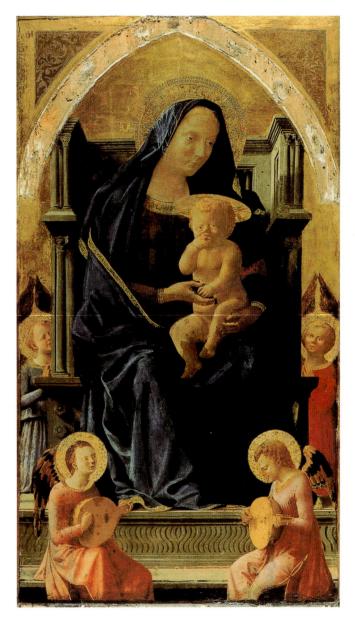

557. Masaccio. *Madonna Enthroned.* 1426. Oil on panel, 56 x 29" (142 x 73.6 cm). The National Gallery, London Reproduced by courtesy of the Trustees

grapes, a symbolic act that alludes to the Passion. (The grapes refer to wine, which represents the Saviour's blood in the sacrament of the Eucharist.) Above all, the figures have powerful proportions which make them infinitely more concrete and impressive than any that had preceded them, even Giotto's, although they are hardly beautiful by the elegant standards of the International Style.

It is no surprise, in light of the *Trinity* fresco, that Masaccio replaces Giotto's ornate but frail Gothic throne with a solid and austere stone seat in the style of Brunelleschi, or that he uses perspective expertly. (Note especially the two lutes.) We are perhaps less prepared by the murals to find such delicacy and precision in painting the light on the surfaces. Within the picture, sunlight enters from the left—not the brilliant glare of noontime but the softer glow of the setting sun. (Some of the shadows on the throne permit us to determine its exact angle.) There are consequently no harsh contrasts between

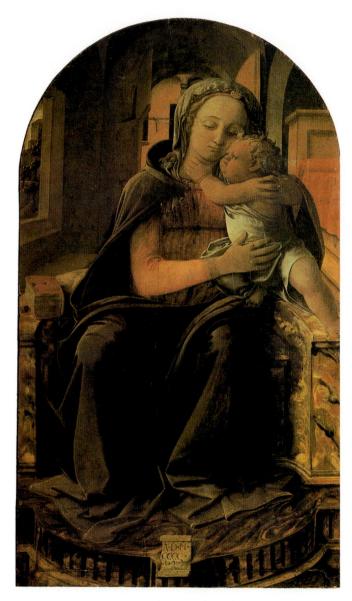

558. Fra Filippo Lippi. *Madonna Enthroned.* 1437. Oil on panel, $45 \times 25^{1}/2$ " (114.7 x 64.8 cm). Galleria Nazionale d'Arte Antica, Rome

light and shade. Subtle half-shadows intervene, producing a rich scale of transitional hues. The light retains its full descriptive function, while acting as an independent force that imposes a common tonality, as well as a common mood, on all the forms it touches.

TEMPERA AND OIL. These new refinements were made possible by oil painting. The basic medium of medieval panel painting had been tempera, in which the finely ground pigments were mixed ("tempered") with diluted egg yolk. It produced a thin, tough, quick-drying coat admirably suited to the medieval taste for high-keyed, flat color surfaces. However, in tempera the different tones on the panel cannot be blended smoothly, and the continuous progression of values necessary for three-dimensional effects was difficult to achieve. Furthermore, the darks tended to look muddy and undifferentiated. These were serious drawbacks that were overcome by substituting oil for the water-and-egg-yolk mixture. In a purely

material sense, oil was not unfamiliar to medieval artists, but it had been used only for special purposes, such as the coating of stone surfaces or painting on metal. Its artistic potential was first discovered around the 1420s by the Master of Flémalle and his contemporaries in the North (see page 506). Oil, a viscous, slow-drying medium, is capable of producing a wide variety of effects, from thin, translucent films (called "glazes") to the thickest impasto (that is, a thick layer of creamy, heavybodied paint). The hues can also yield a continuous scale of tones, including rich, velvety dark shades previously unknown. The medium offers a unique advantage over egg tempera, encaustic, and fresco: oils give the artist the unprecedented ability to change his mind almost at will. Without oil, the conquest of visible reality would have been much more limited. The oil medium spread quickly to Italy, where it became the foundation of modern painting. Although it continued to be mixed with tempera for some time, oil has been the basic medium ever since.

FRA FILIPPO LIPPI. Masaccio's early death left a gap that was not filled for some time. Among his younger contemporaries only Fra Filippo Lippi (c. 1406–1469) seems to have had close contact with him ("fra" means "brother"; Lippi was a friar). Fra Filippo's earliest dated work, the Madonna Enthroned of 1437 (fig. 558), evokes Masaccio's earlier Madonna in several important ways: the lighting, the heavy throne, the massive three-dimensional figures, the drapery folds over the Virgin's legs. Nevertheless, the picture lacks Masaccio's monumentality and severity. In fact, it seems decidedly cluttered by comparison, for Lippi reduces the divine to the mundane. The background is a domestic interior (note the Virgin's bed on the right), and the vividly patterned marble throne displays a prayer book and a scroll inscribed with the date. Such a quantity of realistic detail, as well as the rather undisciplined perspective, indicates an artistic temperament very different from Masaccio's. It also suggests that Fra Filippo must have seen Flemish paintings (perhaps during his visit to northeastern Italy in the mid–1430s).

Finally, we note the painter's interest in movement, which is evident in the figures and, even more strikingly, in parts of the drapery. The curly, fluid edge of the Virgin's headdress and the curved folds of her mantle streaming to the left, which accentuate her own turn to the right, show an interest in graceful decorative effects that will later become an end in itself. Such effects are found earlier in the relief sculpture of Donatello and Ghiberti: compare the dancing Salome in The Feast of Herod (fig. 534) and the maidens in the lower left-hand corner of The Story of Jacob and Esau (fig. 539). It is not surprising that these two artists should have so strongly affected Florentine painting in the decade after Masaccio's death. Age, experience, and prestige gave them authority unmatched by any painter then active in the city. Their influence, and that of the Flemish masters, in modifying Fra Filippo's early Masacciesque outlook was particularly significant, because he lived until 1469 and played a decisive role in setting the course of Florentine painting during the second half of the century.

FRA ANGELICO. Fra Filippo's slightly older contemporary, Fra Angelico (c. 1400–1455), was also a friar, but, unlike Fra

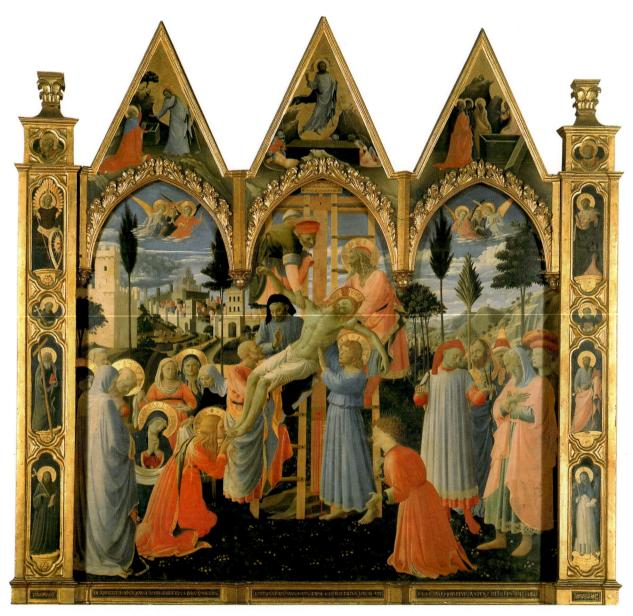

559. Fra Angelico. Deposition. Probably early 1440s. Oil on panel, 9'1/4" x 9'41/4" (275 x 285 cm). Museo di S. Marco, Florence

Filippo, he took his vows seriously and rose to a responsible position within his order. We sense this immediately in the large Deposition (fig. 559), which was painted in all likelihood for the same chapel as Gentile da Fabriano's Adoration of the Magi (see fig. 525). Fra Angelico took over the commission from Gentile's Florentine contemporary, Lorenzo Monaco, who was responsible for the Gothic shape of the frame and the triangular pinnacles but who died before he could complete the altar. It has been dated about 1435 by some scholars, to the early 1440s by others. Either date is plausible, for this artist, like Ghiberti, developed slowly, and his conservative style underwent no decisive changes upon reaching maturity. We are clearly in a different world from Fra Filippo's. This *Deposition* is an object of devotion. Fra Angelico preserves the very aspects of Masaccio that Fra Filippo had rejected: his dignity, directness, and spatial order. Thus Fra Angelico's dead Christ is the true heir of the monumental figure in Masaccio's Trinity.

Fra Angelico's art is something of a paradox. The deeply

reverential attitude presents an admixture of traditional Gothic piety (compare fig. 515) and Renaissance grandeur bestilled by contemplative calm. The elaborate setting spreads behind the figures like a tapestry. The landscape, with the town in the distance, harks back to the Allegory of Good Government by Ambrogio Lorenzetti (see figs. 511 and 512). Our artist also shows a clear awareness of the achievements of Northerners such as the Limbourg brothers (compare fig. 522), for he evokes a brilliant sunlit day with striking success. Yet the scene does not strike us as Gothic in the least. It has the same quality of natural light that produces softly modeled, sculptural forms in Masaccio's Madonna Enthroned (fig. 557). This light suffuses the entire landscape with a sense of wonderment before God's creation that is wholly Renaissance in spirit. We shall meet it again in the work of Giovanni Bellini (see fig. 592). At the same time, the bright, enamellike hues, although remnants of the International Style, look forward to the colorism of Domenico Veneziano.

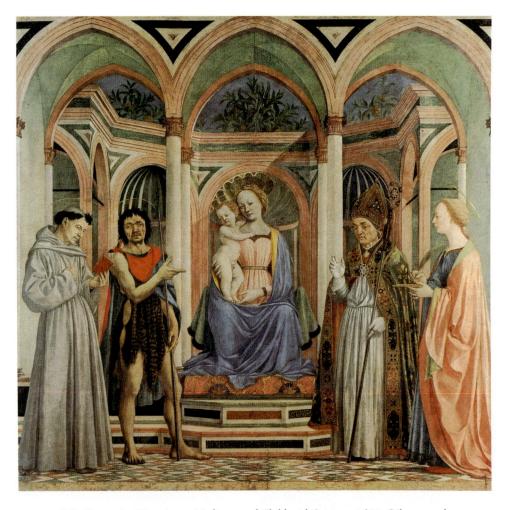

560. Domenico Veneziano. *Madonna and Child with Saints.* c. 1455. Oil on panel, 6'10" x 7' (2.08 x 2.13 m). Galleria degli Uffizi, Florence

DOMENICO VENEZIANO. In 1439 a gifted painter from Venice, Domenico Veneziano, settled in Florence. We can only guess at his age (he was probably born about 1410 and he died in 1461), training, and previous work. He must, however, have been in sympathy with the spirit of Early Renaissance art, for he quickly became a thoroughgoing Florentine-by-choice and a master of great importance in his new home. His *Madonna and Child with Saints*, shown in figure 560, is one of the earliest examples of a new kind of altar panel that was to prove popular from the mid-fifteenth century on, the so-called *sacra conversazione* ("sacred conversation"). The type includes an enthroned Madonna framed by architecture and flanked by saints, who may converse with her, with the beholder, or among themselves.

Looking at Domenico's panel, we can understand the wide appeal of the sacra conversazione. The architecture and the space it defines are supremely clear and tangible, yet elevated above the everyday world. The figures, while echoing the formal solemnity of their setting, are linked with each other and with us by a thoroughly human awareness. We are admitted to their presence, but they do not invite us to join them. Like spectators in a theater, we are not allowed "on stage." In Flemish painting, by way of contrast, the picture space seems a direct extension of the viewer's everyday environment (compare fig. 671).

The basic elements of our panel were already present in Masaccio's *Holy Trinity* fresco. Domenico must have studied it carefully, for his St. John looks at us while pointing toward the Madonna, repeating the glance and gesture of Masaccio's Virgin. Domenico's perspective setting is worthy of the earlier master, although the slender proportions and colored inlays of his architecture are less severely Brunelleschian. His figures, too, are balanced and dignified like Masaccio's, but without the same weight and bulk. The slim, sinewy bodies of the male saints, with their highly individualized, expressive faces, show Donatello's influence (fig. 533).

In his use of color, however, Domenico owes nothing to Masaccio. Unlike the great Florentine master, he treats color as an integral part of his work, and the sacra conversazione is as remarkable for its color scheme as for its composition. The blond tonality, its harmony of pink, light green, and white set off by strategically placed spots of red, blue, and yellow, reconciles the decorative brightness of Gothic panel painting with the demands of perspective space and natural light. Ordinarily, a sacra conversazione is an indoor scene, but this one takes place in a kind of loggia (a covered open-air arcade) flooded with sunlight streaming in from the right, as we can tell from the cast shadow behind the Madonna. The surfaces of the architecture reflect the light so strongly that even the shadowed areas glow with color. Masaccio had achieved a

similar quality of light in his *Madonna* of 1426, which Domenico surely knew. In this sacra conversazione, the discovery has been applied to a far more complex set of forms and integrated with Domenico's exquisite color sense. The influence of its distinctive tonality can be felt throughout Florentine painting of the second half of the century.

PIERO DELLA FRANCESCA. When Domenico Veneziano settled in Florence, he had a young assistant from southeastern Tuscany named Piero della Francesca (c. 1420–1492), who became his most important disciple and one of the truly great artists of the Early Renaissance. Surprisingly, however, Piero left Florence after a few years, never to return. The Florentines seem to have regarded his work as somewhat provincial and old-fashioned, and from their point of view they were right. Piero's style, even more strongly than Domenico's, reflected the aims of Masaccio. He retained this allegiance to the founder of Italian Renaissance painting throughout his long career, whereas Florentine taste developed in a different direction after 1450.

Piero's most impressive achievement is the fresco cycle in the choir of S. Francesco in Arezzo, which he painted from about 1452 to 1459 (fig. 561). Its many scenes represent the legend of the True Cross (that is, the story of the Cross used for Christ's crucifixion). The section in figure 562 shows the empress Helena, the mother of Constantine the Great, discovering the True Cross and the two crosses of the thieves who died beside Christ (all three had been hidden by enemies of the Faith). On the left, they are being lifted out of the ground, and on the right, the True Cross is identified by its power to bring a dead youth back to life.

Piero's link with Domenico Veneziano is readily apparent from his colors. The tonality of this fresco, although less luminous than in Domenico's sacra conversazione, is similarly blond, evoking early morning sunlight in much the same way. Since the light enters the scene at a low angle, in a direction almost parallel to the picture plane, it serves both to define the

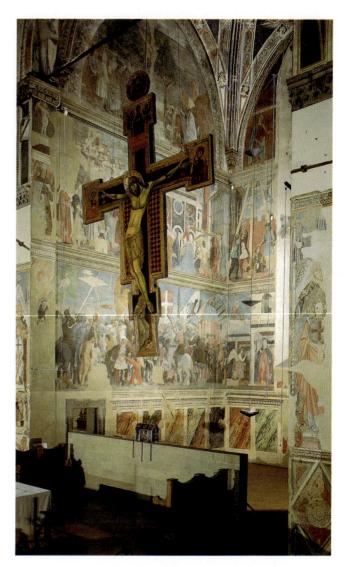

561. View into main chapel, with frescoes by Piero della Francesca. S. Francesco, Arezzo

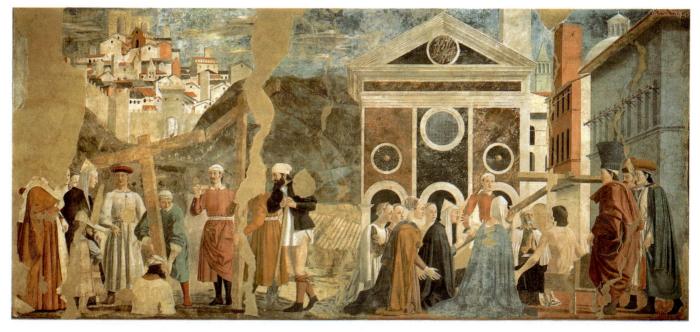

562. Piero della Francesca. The Discovery and Proving of the True Cross. c. 1455. Fresco. S. Francesco, Arezzo

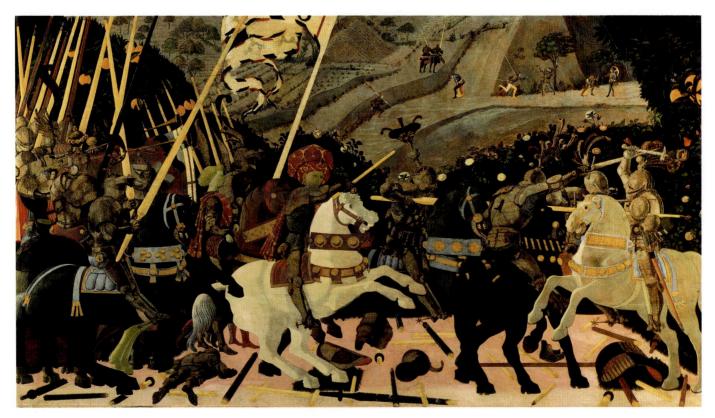

563. Paolo Uccello. *Battle of San Romano.* c. 1455.

Tempera and silver foil on wood panel, 6' x 10'5³/4" (1.8 x 3.2 m). The National Gallery, London Reproduced by courtesy of the Trustees

three-dimensional character of every shape and to lend drama to the narrative. But Piero's figures have a harsh grandeur that recalls Masaccio, or even Giotto, more than Domenico. These men and women seem to belong to a lost heroic race, beautiful and strong—and silent. Their inner life is conveyed by glances and gestures, not by facial expressions. They have a gravity, both physical and emotional, that makes them seem kin to Greek sculpture of the Severe style (see fig. 187).

How did Piero arrive at these memorable images? Using his own testimony, we may say that they were born of his passion for perspective. More than any other artist of his day, Piero believed in scientific perspective as the basis of painting. In a rigorous mathematical treatise, the first of its kind, he demonstrated how it applied to stereometric bodies and architectural shapes, and to the human form. This mathematical outlook permeates all his work. When he drew a head, an arm, or a piece of drapery, he saw them as variations or compounds of spheres, cylinders, cones, cubes, and pyramids, thus endowing the visible world with some of the impersonal clarity and permanence of stereometric bodies. The medieval artist, in contrast, had used the opposite procedure, building natural forms on geometric scaffoldings (see fig. 495). We may regard Piero as the earliest ancestor of the abstract artists of our own time, for they, too, work with systematic simplifications of natural forms. It is not surprising that Piero's fame is greater today than ever before.

UCCELLO. In mid-fifteenth-century Florence there was only one painter who shared, and may have helped to inspire, Piero's devotion to perspective: Paolo Uccello (1397–1475), whose *Battle of San Romano* (fig. 563) perhaps influenced the battle scenes in Piero's frescoes at Arezzo (fig. 561). Uccello's

design shows an extreme preoccupation with stereometric shapes. The ground is covered with a gridlike design of discarded weapons and pieces of armor, forming a display of perspective studies neatly arranged to include one fallen soldier. The landscape, too, has been subjected to a process of stereometric abstraction, matching the foreground. Despite these strenuous efforts, however, the panel has none of the crystalline order and clarity of Piero della Francesca's work. In the hands of Uccello, perspective produces strangely disquieting, fantastic effects. What unites his picture is not its spatial construction but its surface pattern, decoratively reinforced by spots of brilliant color and the lavish use of gold.

Uccello had been trained in the Gothic International Style of painting. It was only in the 1430s that he was converted to the Early Renaissance outlook by the new science of perspective. This he superimposed on his earlier style like a straitjacket. The result is a fascinating and highly unstable mixture. As we study this panel we realize that surface and space are more at war than the mounted soldiers, who get entangled with each other in all sorts of implausible ways.

CASTAGNO. The third dimension held no difficulties for Andrea del Castagno (c. 1423–1457), the most gifted Florentine painter of Piero della Francesca's own generation. Less subtle but more forceful than Domenico Veneziano, Castagno recaptures something of Masaccio's monumentality in his Last Supper (fig. 564), one of the frescoes he painted in the refectory of the convent of S. Apollonia. The event is set in a richly paneled alcove designed as an extension of the real space of the refectory. As in medieval representations of the subject, Judas sits in isolation opposite Christ on the near side of the

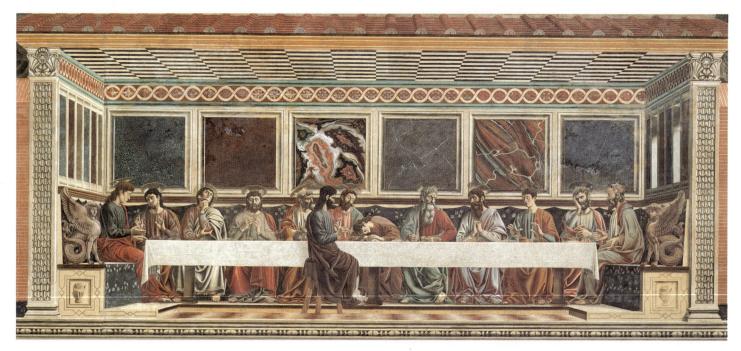

564. Andrea del Castagno. The Last Supper. c. 1445-50. Fresco. S. Apollonia, Florence

table. The rigid symmetry of the architecture, emphasized by the colorful inlays, enforces a similar order among the figures and threatens to imprison them. There is so little communication among the apostles—only a glance here, a gesture there—that a brooding silence hovers over the scene.

Castagno, too, must have felt confined by a scheme imposed on him by the rigid demands of both tradition and perspective, for he used a daringly original device to break the symmetry and focus the drama of the scene. Five of the six panels on the wall behind the table are filled with subdued varieties of colored marble, but above the heads of St. Peter, Judas, and Christ, the marble panel has a veining so garish and explosive that a bolt of lightning seems to descend on Judas' head. When Giotto revived the ancient technique of illusionistic marble textures (see fig. 507), he hardly anticipated that it could hold such expressive significance.

Some five years after *The Last Supper*, between 1450 and 1457 (the year of his death), Castagno produced the remarkable David in figure 565. It is painted on a leather shield that was to be used for display, not protection. Its owner probably wanted to convey an analogy between himself and the biblical hero, since David is here defiant as well as victorious. This figure differs fundamentally from the apostles of The Last Supper. Solid volume and statuesque immobility have given way to graceful movement, conveyed by both the pose and the windblown hair and drapery. The modeling of the earlier figures has been minimized and the forms are now defined mainly by their outlines, so that the David seems to be in relief rather than in the round. This dynamic linear style has important virtues, but it is far removed from Masaccio's. During the 1450s, the artistic climate of Florence changed greatly. Castagno's David is early evidence of the outlook that was to dominate the second half of the century.

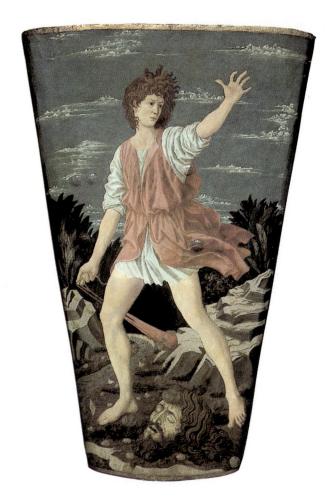

565. Andrea del Castagno. *David.* c. 1450–57. Leather, surface curved, height 45¹/2" (115.8 cm). National Gallery of Art, Washington, D.C. Widener Collection

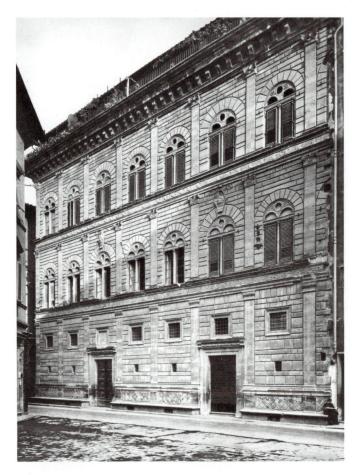

566. Leone Battista Alberti, Palazzo Rucellai, Florence, 1446-51

CENTRAL AND NORTHERN ITALY: 1450–1500

As the founders of Early Renaissance art and their immediate heirs disappeared one by one in the middle years of the fifteenth century, a younger generation began to assert itself. At the same time, the seeds planted by Florentine masters in other regions of Italy were beginning to flower. (We recall Donatello's stay in Padua.) When some of these regions, notably the northeast, produced distinctive versions of the new style, Tuscany ceased to have the privileged position it had previously enjoyed.

Architecture

ALBERTI. In architecture, the death of Brunelleschi in 1446 brought to the fore Leone Battista Alberti (1404–1472), whose career as a practicing architect, like Brunelleschi's own, had been long delayed. Until he was 40, Alberti seems to have been interested in the fine arts only as an antiquarian and theorist. He studied the monuments of ancient Rome, composed the earliest Renaissance treatises on sculpture and painting, and began a third treatise, far more exhaustive than the others, on architecture. [See Primary Sources, nos. 50 and 51, page 630.] After about 1430, he was close to the leading artists of his day: *On Painting* is dedicated to Brunelleschi and refers to "our dear friend" Donatello. Alberti began to practice art as a dilettante, eventually becoming a professional architect of outstanding

ability. Highly educated in classical literature and philosophy, he exemplifies both the humanist and the person of the world.

The design for the Palazzo Rucellai (fig. 566) may be Alberti's critique of the slightly earlier Medici Palace by Michelozzo (see fig. 550). Again we meet the heavy cornice and the three-story scheme, but the articulation of the facade is more strict and more self-consciously classical. It consists of three superimposed orders of pilasters, separated by wide architraves, in imitation of the Colosseum (see fig. 245). Yet Alberti's pilasters are so flat that they remain part of the wall, and the entire facade seems to be one surface on which the artist projects a linear diagram of the Colosseum exterior.

If we are to grasp the logic of this curiously abstract and theoretical design, we must understand that Alberti has met here an issue that became fundamental to Renaissance architecture: how to apply a classical system of articulation to the exterior of a nonclassical structure. Whether Brunelleschi ever coped with this problem is difficult to say. Only his exterior design for the Pazzi Chapel survives (fig. 544), but not unaltered, and it is too special a case to permit general conclusions. Be that as it may, Alberti's solution acknowledges the primacy of the wall, reducing the classical system to a network of incised lines. For his first church exterior, Alberti tried a radically different alternative. Sigismondo Malatesta, lord of the town of Rimini, engaged him toward 1450 to turn the Gothic church of S. Francesco into a "temple of fame" and a burial site for himself, his wife, and the humanists of his court. Alberti encased the older building in a Renaissance shell. The sides consist of austere, deeply recessed arched niches containing stone sarcophagi (figs. 567 and 568). The facade has three similar niches: the large one framing the central portal and the other two (now filled in) intended to receive the sarcophagi of Sigismondo and his wife.

The facade niches are flanked by columns, a scheme clearly derived from the triumphal arches of ancient Rome (see fig. 284). Unlike the pilasters of the Palazzo Rucellai, these columns are not part of the wall. Although partly embedded in it, they project so strongly that we see them as separate entities. We notice, too, that they are set on separate blocks, rather than on the platform supporting the walls, and that they would have nothing to support if the entablature had not been made to project above each capital. These projections make the vertical divisions of the facade more conspicuous than the horizontal ones, and we expect each column to support some important element of the upper story. Yet Alberti planned only one such feature: an arched niche (which remains incomplete) above the portal, with a window and framed by pilasters. Thus the second story fails to fulfill the promise of the first. Perhaps Alberti would have modified this aspect of his design in the end, but the whole enterprise was never finished, and the great dome, projected as its crowning feature, was never built.

Alberti's goal was to superimpose a classical temple front on the traditional basilican church facade. If the classical system of the Palazzo Rucellai is in danger of being devoured by the wall, that of S. Francesco retains too much of its ancient Roman character to fit the basilican shape. (For the medieval approach to this task, see the facade of Pisa Cathedral in fig. 397.) Only toward the end of his career did he succeed in accomplishing this seemingly impossible feat. In the majestic facade of S. Andrea at Mantua (fig. 569), his last work, designed in 1470,

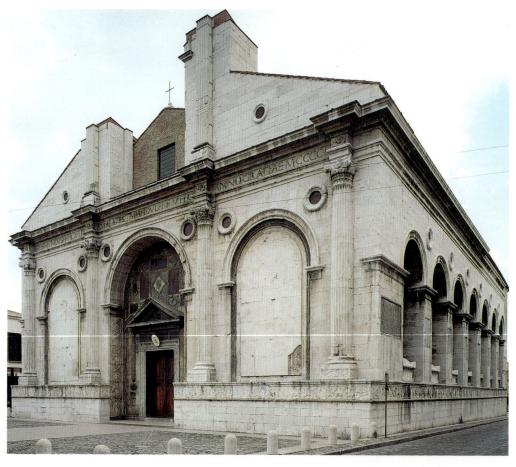

567. Leone Battista Alberti. S. Francesco, Rimini. Facade designed 1450

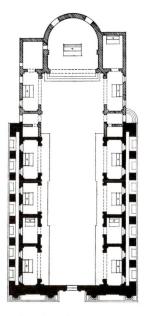

568. Plan of S. Francesco

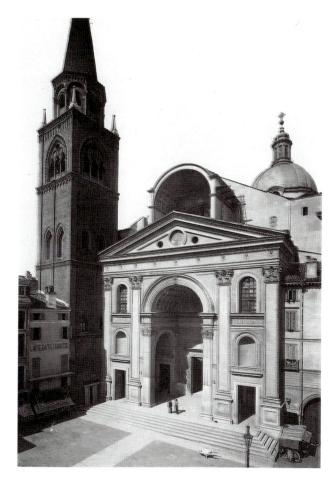

569. Leone Battista Alberti. S. Andrea, Mantua. Designed 1470

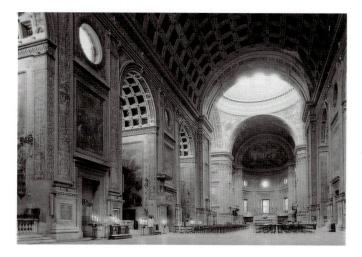

570. Leone Battista Alberti. Interior of S. Andrea

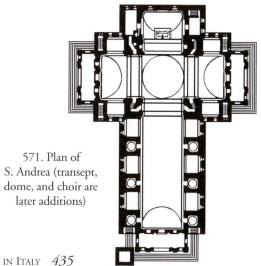

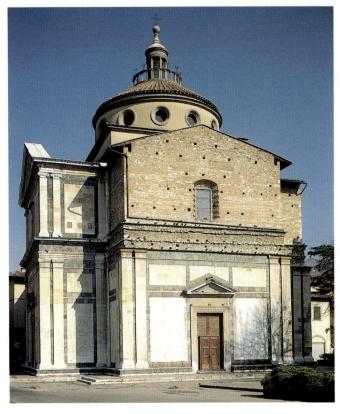

572. Giuliano da Sangallo. Sta. Maria delle Carceri, Prato. Begun 1485

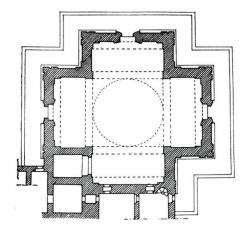

573. Plan of Sta. Maria delle Carceri

he superimposed the triumphal-arch motif—now with a huge center niche—upon a classical temple front, and projected this combination onto the wall. He again uses flat pilasters that acknowledge the primacy of the wall surface, but these pilasters, unlike those of the Palazzo Rucellai, are clearly differentiated from their surroundings. They are of two sizes. The smaller ones sustain the arch over the huge center niche. The larger ones are linked with the unbroken architrave and the strongly outlined pediment and form what is known as a "colossal" order for all three stories of the facade wall, balancing exactly the horizontal and vertical impulses within the design.

So intent was Alberti on stressing the inner cohesion of the facade that he inscribed the entire design within a square, even though it is appreciably lower in height than the nave of the church. (The effect of the west wall protruding above the pediment is more disturbing in photographs than at street level, where it is nearly invisible.) While the facade is physically distinct from the main body of the structure, it offers a "preview" of the interior, where the same colossal order, the same proportions, and the same triumphal-arch motif reappear on the nave walls (fig. 570, page 435).

Comparing the plan (fig. 571) with that of Brunelleschi's Sto. Spirito (fig. 548), we are struck by its revolutionary compactness. Had the church been completed as planned, the difference would be even stronger, for Alberti's design had no transept, dome, or choir, only a nave terminating in an apse.

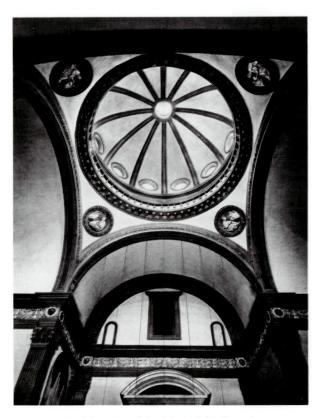

574. Interior of Sta. Maria delle Carceri

The aisles are replaced by chapels alternately large and small, and there is no clerestory. The colossal pilasters and the arches of the large chapels support a barrel vault of impressive span (the nave is as wide as the facade). Here Alberti has drawn upon his memories of the massive vaulted halls in ancient Roman baths and basilicas, yet he interprets his classical models as freely as in his facade design. They no longer embody an absolute authority that must be quoted literally, but serve as a valuable store of motifs to be utilized at will. With this sovereign attitude toward his sources, he was able to create a structure that truly deserves to be called a "Christian temple."

CENTRAL-PLAN CHURCHES. Because it occupies the site of an older basilican church (note the Gothic campanile next to the facade), with consequent limitations on the designer's freedom, S. Andrea does not conform to the ideal shape of sacred buildings as defined in Alberti's Treatise on Architecture. There he explains that the plan of such structures should be either circular, or of a shape derived from the circle (square, hexagon, octagon, and so forth), because the circle is the perfect, as well as the most natural, figure and therefore a direct image of divine reason. This argument rests, of course, on Alberti's faith in the God-given validity of mathematically determined proportions (discussed on page 420). How could he reconcile it with the historical evidence? After all, the standard form of both ancient temples and Christian churches was longitudinal. But, he reasoned, the basilican church plan became traditional only because the early Christians worshiped in private Roman basilicas. Since pagan basilicas were associated with the dispensing of justice (which originates from God), he admitted that their shape has some relationship to sacred architecture, but since they cannot rival the sublime beauty of the temple, their purpose is human rather than divine.

In speaking of temples, Alberti arbitrarily disregarded the standard form and relied instead on the Pantheon (see figs. 246–49), the round temple at Tivoli (see figs. 238 and 239), and the domed mausoleums, which he mistook for temples. Moreover, he asked, had not the early Christians themselves acknowledged the sacred character of these structures by converting them to their own use? Here he could point to such monuments as Sta. Costanza (see figs. 303–5), the Pantheon itself (which had been used as a church ever since the early Middle Ages), and the Baptistery in Florence (then thought to be a former temple of Mars).

Alberti's ideal church, then, demands a design so harmonious that it would be a revelation of divinity and would arouse pious contemplation in the worshiper. It should stand alone, elevated above the surrounding everyday life, and light should enter through openings placed high, for only the sky should be seen through them. That such an isolated, central-plan structure was ill-adapted to the requirements of Catholic ritual made no difference to Alberti. A church, he believed, must be a visible embodiment of "divine proportion," which the central plan alone could attain.

When Alberti formulated these ideas in his treatise, about 1450, he could have cited only Brunelleschi's revolutionary, but unfinished, Sta. Maria degli Angeli as a modern example of a central-plan church (fig. 549). Toward the end of the century, after his treatise became widely known, the central-plan church

gained general acceptance. Between 1500 and 1525 it became a vogue reigning supreme in High Renaissance architecture.

GIULIANO DA SANGALLO. It is no coincidence that Sta. Maria delle Carceri in Prato (figs. 572-74), an early and distinguished example of this trend, was begun in 1485, the date of the first printed edition of Alberti's treatise. Its architect, Giuliano da Sangallo (c. 1443-1516), must have been an admirer of Brunelleschi. Many features of the interior and the plan recall the Pazzi Chapel (see figs. 545 and 546). The basic shape of his structure, however, conforms closely to Alberti's ideal. Except for the dome, the entire church would fit neatly inside a cube, since its height (up to the drum) equals its length and width. By cutting into the corners of this cube, as it were, Giuliano has formed a Greek cross (a plan he preferred for its symbolic value). The arms are barrel-vaulted, and the dome rests on these vaults. Yet the dark ring of the drum does not quite touch the supporting arches, making the dome seem to hover weightlessly, like the pendentive domes of Byzantine architecture (compare fig. 336). There can be no doubt that Giuliano wanted his dome to accord with the age-old tradition of the Dome of Heaven. The single round opening in the center and the 12 on the perimeter clearly refer to Christ and the apostles. Brunelleschi had anticipated this feature in the Pazzi Chapel, but Giuliano's dome, crowning a perfectly symmetrical structure, conveys its symbolic value far more strikingly.

Sculpture

Donatello left Florence for Padua in 1443. His ten-year absence had an effect similar to that of Brunelleschi's death, but whereas Alberti took Brunelleschi's place in architecture, there was no young sculptor of comparable stature to take Donatello's. As a consequence, the other sculptors remaining in the city gained greater prominence. The new talents who grew up under their influence brought about the changes between 1443 and 1453 that Donatello must have seen with dismay when he returned to Florence.

LUCA DELLA ROBBIA. Ghiberti aside, the only significant sculptor in Florence after Donatello left was Luca della Robbia (1400–1482). He had made his reputation in the 1430s with the marble reliefs of the *Cantoria* (singers' pulpit) in the Cathedral. The *Trumpet Players* panel reproduced here (fig. 575) shows the beguiling mixture of sweetness and gravity characteristic of all of Luca's work but leavened by an unusual note of exuberance. Its style has very little to do with Donatello. Instead, it recalls the classicism of Nanni di Banco (see fig. 527), with whom Luca may have worked as a youth. We also sense a touch of Ghiberti here and there, as well as the powerful influence of classicistic Roman reliefs (such as fig. 267). Unfortunately, Luca lacked a capacity for growth, despite his great gifts. So far as we know, he never did a free-standing statue, and the *Cantoria* remained his most ambitious achievement.

For the rest of his long career, he devoted himself almost exclusively to sculpture in terracotta, a cheaper and less demanding medium than marble, which he covered with enamellike glazes to mask its surface and make it impervious to weather. His finest works in this technique, which include *The*

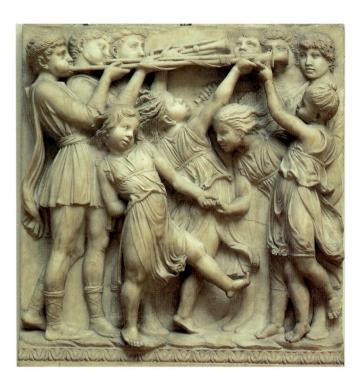

575. Luca della Robbia. *Trumpet Players*, from the *Cantoria*. c. 1435. Marble, 40⁵/8" x 36⁷/8" (103 x 93.5 cm). Museo dell'Opera del Duomo, Florence

576. Luca della Robbia. *The Resurrection.* 1442–45. Glazed terracotta, 5'3" x 7'3¹/₂" (1.6 x 2.22 m). Museo Nazionale del Bargello, Florence

Resurrection in figure 576, have the dignity and charm of the Cantoria panels. The white glaze creates the impression of marble, with a deep blue for the background of the lunette. Other colors were confined almost entirely to the decorative framework of Luca's reliefs. This restraint, however, lasted only while he was in active charge of his workshop. Later, the quality of the modeling deteriorated and the simple harmony of white and blue often gave way to an assortment of more vivid hues. At the end of the century, the Della Robbia shop had become a factory, turning out small Madonna panels and garish altarpieces for village churches by the score.

Because of Luca's almost complete withdrawal from the domain of carving, there was a real shortage of capable marble sculptors in the Florence of the 1440s. By the time Donatello returned, this gap had been filled by a group of men, most of them still in their twenties, from the little hill towns to the north and east of Florence that had long supplied the city with stonemasons and carvers. Now, because the exceptional circumstances gave them special opportunities, the most gifted of them developed into artists of considerable importance.

BERNARDO ROSSELLINO. The oldest of these, Bernardo Rossellino (1409–1464), seems to have begun as a sculptor and architect in Arezzo. He established himself in Florence about 1436, but received no commissions of real consequence until some eight years later, when he was entrusted with the Tomb of Leonardo Bruni (fig. 577). This great humanist and statesman had played a vital part in the city's affairs ever since the beginning of the century (see page 409). When he died in 1444, he received a grand funeral "in the manner of the ancients." His monument was probably ordered by the city government of Florence. Since Bruni had been born in Arezzo, his native town also wished to honor him and may have helped to secure the commission for Bernardo because of his earlier activity there. (One wonders, however, what chance Bernardo would have had if Donatello had been available.)

Although the Bruni monument is not the earliest Renaissance tomb, nor even the earliest large-scale tomb of a humanist, it can claim to be the first memorial that fully expresses the spirit of the new era. Echoes of Bruni's funeral all'antica are everywhere. The deceased reclines on a bier supported by Roman eagles, his head wreathed in laurel and his hands enfolding a volume (presumably his own History of Florence, rather than a prayer book). The monument is a fitting tribute to the man who, more than any other, had helped to establish the new historical perspective of the Florentine Early Renaissance. On the classically severe sarcophagus, two winged genii display an inscription very different from those on medieval tombs. Instead of recording the name, rank, and age of the deceased and the date of his death, it refers only to his timeless accomplishments: "At Leonardo's passing, history grieves, eloquence is mute, and it is said that the Muses, Greek and Latin alike, cannot hold back their tears." The religious aspect of the tomb is confined to the lunette, where the Madonna is adored by angels.

The entire monument may thus be viewed as an attempt to reconcile two contrasting attitudes toward death: the retrospective, commemorative outlook of the ancients (see page 155), and the Christian concern with afterlife and salvation. Bernardo's design, adapted from the Tomb of Guglielmo de Braye by Arnolfo di Cambio (fig. 490), is admirably suited to such a program, balancing architecture and sculpture within a compact, self-contained framework. Its dominant motif, the two pilasters supporting a round arch resting on a strongly accented architrave, suggests Alberti, who employed it repeatedly. It is derived from the doorway to the Pantheon (see fig. 249), which accounts for its use in church portals such as that of S. Andrea in Mantua (fig. 569). While Bernardo may have adopted it for the Bruni tomb on purely aesthetic grounds, it is possible that he also meant to convey a symbolic meaning: the deceased on his bier, pausing at the gateway between one life and the next. Perhaps he even wanted us to associate the motif with the Pantheon, the "temple of the immortals" for

577. Bernardo Rossellino. Tomb of Leonardo Bruni. c. 1445–50. Marble, height 20' (6.1 m to top of arch). Sta. Croce, Florence

pagans and Christians alike. (Once dedicated to all the gods of the Roman world, it had been rededicated to all the martyrs when it became a church, and in the High Renaissance it was to receive the remains of yet another breed of immortals: such famous artists as Raphael.)

All the tombs, tabernacles, and the reliefs of the Madonna produced in Florence between 1450 and 1480 have a common ancestor in the Bruni monument. Nevertheless its sculptural style is not easy to define, since its components vary a good deal in quality. Broadly speaking, it reflects the classicism of Ghiberti and Luca della Robbia; echoes of Donatello are few and

578. Desiderio da Settignano. *St. John the Baptist.* c. 1455–60. Marble, height 63" (160 cm). Museo Nazionale del Bargello, Florence

indirect. By the same token, we do not yet have a clear conception of Bernardo's style as a sculptor. He surely employed assistants here, as he did in his subsequent commissions. During the later 1440s, his workshop was the only training ground for ambitious young marble sculptors, such as his very gifted younger brother Antonio (1417–1470) and other members of the same generation. Their share in Bernardo's sculptural projects is hard to identify, however, for their personalities were not distinct until they began to work independently.

DESIDERIO DA SETTIGNANO. Of the many sculptors who passed through the Rossellino shop, the most gifted was Desiderio da Settignano (1429/30–1464), who came from a family of stonemasons. It was nevertheless the influence of Donatello, to whom he was probably apprenticed in the early 1440s, that proved decisive. Indeed, the *St. John the Baptist* in figure 578 was long considered to be by Donatello himself but

579. Antonio del Pollaiuolo. Hercules and Antaeus.c. 1475. Bronze, height 18" (45.8 cm, with base).Museo Nazionale del Bargello, Florence

is now recognized as the work of Desiderio. Although he is remembered for his beautiful Madonnas and enchanting children, no other sculptor of the day was so attuned to the ascetic side of Donatello's later sculpture. Desiderio's *Baptist* was manifestly inspired by Donatello's *Mary Magdalen* (fig. 537), but the differences are equally important, for Desiderio has magnified the visionary expressiveness by turning it inward. The young St. John has a disturbing, haunted look, as if lacerated by a spiritual experience of almost unbearable intensity. The effect is heightened by the subtlety of the carving, so refined that it is small wonder the statue passed as Donatello's.

POLLAIUOLO. By 1450 the great civic campaign of art patronage came to an end, and Florentine artists had to depend mainly on private commissions. This put the sculptors at a disadvantage because of the high costs involved in their work. Since the monumental tasks were few, they concentrated on works of moderate size and price for individual patrons, such as bronze statuettes. The collecting of sculpture,

widely practiced in ancient times, had ceased during the Middle Ages. The taste of kings, feudal lords, and others who could afford to collect for personal pleasure ran to gems, jewelry, goldsmith's work, illuminated manuscripts, and precious fabrics. The habit was reestablished in fifteenth-century Italy as part of the "revival of antiquity." Humanists and artists first collected ancient sculpture, especially small bronzes (such as fig. 217), which were numerous and of convenient size. Before long, contemporary artists began to cater to the spreading vogue, with portrait busts and small bronzes of their own "in the manner of the ancients."

A particularly fine piece of this kind is Hercules and Antaeus (fig. 579) by Antonio del Pollaiuolo (1431-1498), who represents a sculptural style very different from that of the marble carvers we discussed above. Trained as a goldsmith and metalworker, probably in the Ghiberti workshop, he was deeply impressed by the late styles of Donatello and Castagno, as well as by ancient art. From these sources, he evolved the distinctive manner that appears in our statuette. To create a freestanding group of two figures in violent struggle, even on a small scale, was a daring idea in itself. Even more astonishing is the way Pollaiuolo has endowed his composition with a centrifugal impulse. Limbs seem to radiate in every direction from a common center, and we see the full complexity of their movements only when we examine the statuette from all sides. Despite its strenuous action, the group is in perfect balance. To stress the central axis, Pollaiuolo in effect grafted the upper part of Antaeus onto the lower part of his adversary.

There is no precedent for this design among earlier statuary groups of any size, ancient or Renaissance. Pollaiuolo himself was a painter and engraver as well as a bronze sculptor, and we know that about 1465 he did a large picture of Hercules and Antaeus, which is now lost but whose design is preserved in a smaller replica, made for the Medici, who also owned the statuette. For the first time, a sculptural group has acquired the pictorial quality that had characterized reliefs since the early years of the Renaissance.

Few of his paintings have survived, and only a single engraving (see page 524), the Battle of the Ten Naked Men (fig. 580). This print, however, is of great importance, since it represents Pollaiuolo's most elaborate pictorial design. Its subject, undoubtedly a classical one, has not yet been convincingly identified, but that matter is not so significant. The primary purpose of the engraving obviously was to display Pollaiuolo's mastery of the nude body in action. About 1465-70, when the print must have been produced, this was still a novel problem, and Pollaiuolo contributed more than any other master to its solution. An interest in movement, coupled with slender proportions and an emphasis on outline rather than on modeling, had been seen in Castagno's David (fig. 565), which in these respects is clearly the progenitor of the *Ten Naked Men*. Pollaiuolo also drew upon the action poses he found in certain types of Greek vases (compare fig. 201). But he realized that a full understanding of bodily movement demands a detailed knowledge of anatomy, down to the last muscle and sinew. These ten naked men, in fact, have an oddly "flayed" appearance, as if their skin had been stripped off to reveal the play of muscles underneath, and so, to a somewhat lesser degree, do the two figures of our statuette.

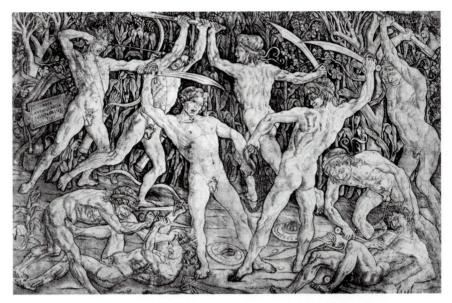

580. Antonio del Pollaiuolo. Battle of the Ten Naked Men. c. 1465–70. Engraving, $15^{1}/8 \times 23^{1}/4$ " (38.3 x 59 cm). The Metropolitan Museum of Art, New York Joseph Pulitzer Bequest, 1917

Artists may have begun to study human anatomy from dissected cadavers as early as 1425, and the practice was almost certainly established during the 1450s by Andrea Mantegna, among others, but this is the clearest visual evidence we have of a custom that was to be followed by artists through the High Renaissance. Equally novel are the facial expressions, as strained as the bodily movements. We have already encountered contorted features in the work of Donatello and Masaccio (see figs. 534, 537, and 556). But the anguish they convey is inner and does not arise from or accompany the extreme physical action of Pollaiuolo's struggling nudes.

VERROCCHIO. Although Pollaiuolo did two monumental bronze tombs for St. Peter's in Rome during the late years of his career, he never had an opportunity to execute a large-scale free-standing statue. For such works we must turn to his slightly younger contemporary Andrea del Verrocchio (1435–1488), the greatest sculptor of his day and the only one to share some of Donatello's range and ambition. A modeler as well as a carver—we have works of his in marble, terracotta, silver, and bronze—he combined elements from Antonio Rossellino and Antonio del Pollaiuolo into a unique synthesis. He was also a respected painter and the teacher of Leonardo da Vinci, which is unfortunate, as he has been overshadowed ever since.

Like *Hercules and Antaeus* by Pollaioulo, Verrocchio's *The Doubting of Thomas* (fig. 581) is closely related to a painting: a *Baptism of Christ*, painted with the assistance of the young Leonardo. The result is a pictorialism unique in monumental sculpture of the Early Renaissance, one surpassing even Donatello's efforts in this vein. In contrast to the *Quattro Coronati* of Nanni di Banco (fig. 527), the subject is a narrative. Moreover, Verrocchio's group does not quite fit its niche on Or San Michele, for it replaced a single figure by Donatello that had been moved; hence, the statues have no backs in order to accommodate them within the shallow tabernacle, which consequently acts as a foil rather than a container.

581. Andrea del Verrocchio. *The Doubting of Thomas*. 1465–83. Bronze, lifesize. Or San Michele, Florence

582. Andrea del Verrocchio. *Equestrian Monument of Colleoni*. c. 1483–88. Bronze, height 13' (3.9 m). Campo SS. Giovanni e Paolo, Venice

Although the biblical text is inscribed on the drapery, the drama is conveyed by the eloquent poses and bold exchange of gestures between Christ and Thomas. It is heightened by the active drapery, with its deep folds, which echo the contrasting states of mind. *The Doubting of Thomas* is of extraordinary importance in the history of sculpture. The work was immediately admired for its great beauty, especially the head of Christ, which was to inspire Michelangelo. To the young Leonardo it served as a prototype of figures whose actions express the passions of the mind. And the sculpture of Bernini is virtually unthinkable without its example (compare fig. 753).

By a strange coincidence, the crowning achievement of Verrocchio's career, as of Donatello's, was a bronze equestrian statue: the monument of a Venetian army commander, Bartolommeo Colleoni (fig. 582). In his will, Colleoni had requested such a statue and, by way of encouragement, had left a sizable fortune to the Republic of Venice. He obviously knew the Gattamelata monument and wanted to ensure the same honor for himself. Verrocchio, too, must have regarded Donatello's work as the prototype of his own statue, yet he did not simply imitate his illustrious model. He reinterpreted the theme less subtly perhaps, but no less impressively. The horse, graceful and spirited rather than robust and placid, is modeled with the same sense of anatomy-in-action that we saw in the nudes of Pollaiuolo. Its thin hide reveals every vein, muscle, and sinew, in strong contrast to the rigid surfaces of the armored figure bestriding it. Since the horse is also smaller in relation to the rider than Gattamelata's, Colleoni looms in the saddle like the very embodiment of forceful dominance. Legs rigidly straight, one shoulder thrust forward, he surveys the scene before him with the utter concentration of Donatello's St. George (fig. 531), but his lip is now contemptuously curled.

Medieval theater continued with little change until around 1500

(see "Medieval Music and Theater," page 326). Unlike other literary forms, theater was slow to show the influence of humanism, which dominated so much of Italian Renaissance intellectual life. This seems surprising, since the earliest humanist tragedy and comedy date from about 1390. (Both were written in Latin, and neither was actually performed.) Perhaps the main reason that new forms of drama were slow to develop in the Renaissance was that the works of the Greek and Roman dramatists were only gradually rediscovered in the West. Although the plays of Seneca (see page 209) were known in the Middle Ages, Plautus' secondcentury B.C. comedies were not rediscovered until 1429. Further, when Constantinople fell to the Turks in 1453, fleeing Greek scholars brought the manuscripts of many previously unknown classical dramas with them to Italy. Renaissance theater was further revolutionized when the printing press was introduced into Italy in 1465. As a result, between 1471 and 1518 all of the known Greek and Roman plays were published.

Italian humanists were always interested more in philosophy and theory than in actual practice. Plautus' *Menaechmi*

Early Italian Renaissance Theater and Music

was first staged only in 1486, then again five years later, but

Seneca's Hippolytus had to wait until 1509. This emphasis on theory rather than practice also helped to inhibit the development of music, for Italy was slow to produce a composer of stature. Until the middle of the sixteenth century, the popes and the rulers of the Italian cities imported French and Flemish musicians to occupy all the important positions for composers in churches and at ducal courts. Since the goal of the humanists was to revive Latin and Greek, few of them were interested in writing poetry in Italian. Consequently, there were very few good writers for composers to work with, especially on secular motets and songs, which were fertile soil for experimentation. The first humanist to write extensively in Italian was Angelo Poliziano (1454-1494), a member of the Medici circle in Florence; his poetry inspired paintings by Botticelli and Raphael (see figs. 583 and 627). He also collaborated with the Flemish-born composer Heinrich Isaac (c. 1450–1517), and he wrote a play about the legendary Greek bard Orpheus with musical accompaniment in imitation of the antique; though the music is now lost, the stage design by the young Leonardo da Vinci still exists.

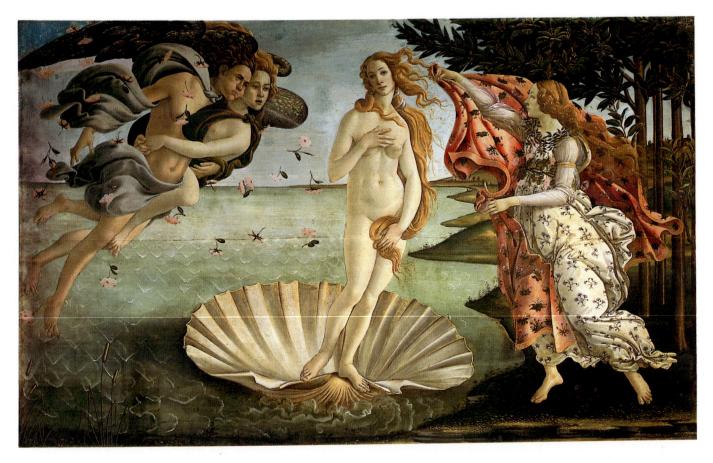

583. Sandro Botticelli. The Birth of Venus. c. 1480. Tempera on canvas, 5'87/8" x 9'17/8" (1.8 x 2.8 m). Galleria degli Uffizi, Florence

Neither *Gattamelata* nor *Colleoni* is a portrait in the specific sense of the term. Both project an idealization of the personality that each artist associated with successful leadership in war. If *Gattamelata* conveys steadfast purpose and nobility of character, *Colleoni* radiates an almost frightening sense of power. As an image of awesome self-assurance, it recalls the *Can Grande* (see fig. 489) rather than the *Gattamelata* monument. Perhaps Verrocchio visited the tomb of the Can Grande (who was well remembered in Florence as the patron of Dante) and decided to translate the wonderful arrogance of the statue into the style of his own day. In any case, Colleoni got a great deal more than he had bargained for in his will.

Painting

BOTTICELLI. In Florence, the trend forecast by Castagno's *David* substitutes energetic, graceful movement and agitated linear contours for the stable monumentality of Masaccio's style. Its climax comes in the final quarter of the century, in the art of Sandro Botticelli (1444/5–1510). He was trained by Fra Filippo Lippi, whose *Madonna Enthroned* (fig. 558) already had undercurrents of linear movement, and was strongly influenced by Pollaiuolo. Botticelli soon became the favorite painter of the so-called Medici circle: those patricians, literati, scholars, and poets surrounding Lorenzo the Magnificent, the head of the Medici family and, for all practical purposes, the real ruler of the city.

For Lorenzo de Medici (it once hung in his summer villa), Botticelli did The Birth of Venus (fig. 583), his most famous picture. Its kinship with Pollaiuolo's Battle of the Ten Naked *Men* (fig. 580) is unmistakable. The shallow modeling and the emphasis on outline produce an effect of low relief rather than of solid, three- dimensional shapes. In both we note a lack of concern with deep space. The ornamentalized thicket forms a screen behind the naked men much like the grove on the righthand side of the Venus. But the differences are just as striking. Botticelli obviously does not share Pollaiuolo's passion for anatomy. His bodies are more attenuated and drained of all weight and muscular power. Indeed, they seem to float even when they touch the ground. All this seems to deny the basic values of the founders of Early Renaissance art, yet the picture does not look medieval. The bodies, ethereal though they be, retain their voluptuousness. They are genuine nudes (see the discussion on pages 415 and 418) enjoying full freedom of movement.

NEO-PLATONISM. Botticelli's *Venus* derives from a variant of the *Cnidian Aphrodite* of Praxiteles (fig. 206), but the subject itself was inspired by the Homeric *Hymn to Aphrodite*, which begins: "I shall sing of beautiful Aphrodite . . . who is obeyed by the flowery sea-girt land of Cyprus, whither soft Zephyr and the breeze wafted her in soft foam over the waves. Gently the golden-filleted Horae received her, and clad her in divine garments." Yet no single literary source accounts for the pictorial conception. It owes something as well to Ovid and

the humanist poet Angelo Poliziano who was, like Botticelli, a member of the Medici circle and may well have advised him on the painting, as he undoubtedly did in other instances.

The subject of the picture is clearly meant to be serious, even solemn. How could such images be justified in a Christian civilization, without subjecting both artist and patron to the accusation of neo-paganism? To understand this paradox, we must consider the meaning of our picture, and the general use of classical subjects in Early Renaissance art. During the Middle Ages, classical form had become divorced from classical subject matter. Artists could only draw upon the ancient repertory of poses, gestures, expressions, and types by changing the identity of their sources. Philosophers became apostles, Orpheus turned into Adam, Herakles was now Samson. When medieval artists had occasion to represent the pagan gods, they based their pictures on literary descriptions rather than visual models. This was the situation, by and large, until the mid-fifteenth century. Only with Pollaiuolo—and Mantegna in northern Italy—does classical form begin to rejoin classical content. Pollaiuolo's lost paintings of the Labors of Herakles (about 1465) mark the earliest instance, so far as we know, of large-scale subjects from classical mythology depicted in a style inspired by ancient monuments.

In the Middle Ages, classical myths had at times been interpreted didactically, however remote the analogy, as allegories of Christian precepts. Europa abducted by the bull, for instance, could be declared to signify the soul redeemed by Christ. But such pallid constructions were hardly an adequate excuse for reinvesting the pagan gods with their ancient beauty and strength. To fuse the Christian faith with ancient mythology, rather than merely relate them, required a more sophisticated argument. This was provided by the Neo-Platonic philosophers, whose foremost representative, Marsilio Ficino, enjoyed tremendous prestige during the later years of the fifteenth century and after. Ficino, who was also an ordained priest, based his thought as much on the mysticism of Plotinus (see page 200) as on the authentic works of Plato. He believed that the life of the universe, including human life, was linked to God by a spiritual circuit continuously ascending and descending, so that all revelation, whether from the Bible, Plato, or classical myths, was one. Similarly, he proclaimed that beauty, love, and beatitude, being phases of this same circuit, were one. Thus, Neo-Platonists could invoke the "celestial Venus" (that is, the nude Venus born of the sea, as in our picture) interchangeably with the Virgin Mary, as the source of "divine love" (meaning the recognition of divine beauty).

This celestial Venus, according to Ficino, dwells purely in the sphere of Mind, while her twin, the ordinary Venus, engenders "human love." Of her Ficino wrote to the young Medici prince: "Venus . . . is a nymph of excellent comeliness, born of heaven and more than others beloved by God all highest. Her soul and mind are Love and Charity, her eyes Dignity and Magnanimity, the hands Liberality and Magnificence, the feet Comeliness and Modesty. The whole, then, is Temperance and Honesty, Charm and Splendor. Oh, what exquisite beauty! . . . a nymph of such nobility has been wholly given into your hands! If you were to unite with her in wedlock and claim her as yours she would make all your years sweet." In

both form and content this passage follows odes to the Virgin by medieval church fathers.

Once we understand that Botticelli's picture has this quasireligious meaning, it seems less astonishing that the wind god Zephyr and the breeze goddess Aura on the left look so much like angels and that the Hora personifying Spring on the right, who welcomes Venus ashore, recalls the traditional relation of St. John to the Saviour in the Baptism of Christ (compare fig. 411). As baptism is a "rebirth in God," so the birth of Venus evokes the hope for "rebirth" from which the Renaissance takes its name. Thanks to the fluidity of Neo-Platonic doctrine, the number of possible associations to be linked with our painting is almost limitless. All of them, however, like the celestial Venus herself, "dwell in the sphere of Mind," and Botticelli's deity would hardly be a fit vessel for them if she were less ethereal. Thus, rather than being merely decorative, it is the highly stylized treatment of the surface that elevates the picture to allegory.

Neo-Platonic philosophy and its expression in art were obviously too complex to become popular outside the select and highly educated circle of its devotees. In 1494, the suspicions of ordinary people were aroused by the friar Girolamo Savonarola, an ardent advocate of religious reform, who gained a huge following with his sermons attacking the "cult of paganism" in the city's ruling circle. [See Primary Sources, no. 52, pages 630–31.] Botticelli himself was perhaps a follower of Savonarola and reportedly burned a number of his "pagan" pictures. In his last works he returned to traditional religious themes but with no essential change in style. He seems to have given up painting entirely after 1500, even though the apocalyptic destruction of the world predicted by Savonarola at the millennium-and-a-half was not fulfilled.

A similar meaning can be assigned to *Primavera* (fig. 584), which was likewise painted by Botticelli for Lorenzo's country retreat. The large canvas was nominally inspired by Poliziano's light-hearted poem about the birth of love in spring. At the same time, there are elements that cannot be explained by this source alone and were surely derived from Ovid and the Roman poet Lucretius. We see Venus in her sacred grove, with Eros flying overhead, her companions the Three Graces and Hermes to the left, and to the right Zephyr grasping for the nymph Chloris whom he subsequently transforms into Flora, the goddess of flowers. That the painting has a hidden meaning is suggested once more by the decorative treatment of the surface and the disjunctive groupings, which appear curiously frozen despite their graceful rhythms.

In a recent interpretation, *Primavera* can be understood on several levels based on Ficino's writings. It is first a metaphor of Platonic love between two friends: Mercury points the way to divine love in the guise of Venus, which is born of the Three Graces symbolizing beauty, in contrast to physical love represented by Flora, who often had lascivious connotations in Renaissance thought. On another plane, it signifies the immortality of the soul through death and rebirth by analogy of the Rape of Chloris to the Rape of Persephone, which was the subject of a poem by the Roman author Claudian that enjoyed great popularity in humanist circles at the time. Accordingly, Venus becomes Demeter/ Ceres of the Eleusian mysteries, with Mercury as the god of the dead, and Eros the

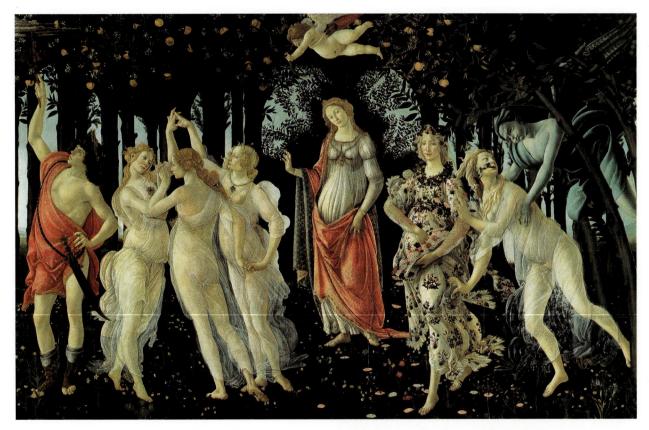

584. Sandro Botticelli. Primavera. c. 1482. Tempera on wood panel, 6'8" x 10'4" (2.03 x 3.15 m). Galleria degli Uffizi, Florence

vehicle of divine revelation, while the Three Graces stand for the soul. Finally, it denotes the Last Judgment, in which Venus assumes the role of Mary the Divine Intercessor, Mercury of St. Michael, and Eros of the Holy Spirit; the Three Graces are seen as the Saved, as well as the three virtues Faith, Hope, and Love, and Zephyr depicts Satan snatching up the Damned, personified by Chloris, even as Flora, content with earthly pleasures, remains as oblivious to her ultimate fate as do the fashionable couples in Traini's *The Triumph of Death* (see fig.513). Even if we do not agree with every detail, this reading accords well in spirit with Ficino's lofty neo-Platonism, and provides the most satisfactory explication today of Botticelli's complex work.

GHIRLANDAIO. The fresco cycles of Domenico Ghirlandaio (1449–1494), another contemporary of Botticelli, have so many portraits that they almost serve as family chronicles of the wealthy patricians who sponsored them. Among his most touching individual portraits is the panel *An Old Man and His Grandson* (fig. 585). The precise attention to surface texture and facial detail emphasizes the disfigurement of the old man's nose by rosacea. Ghirlandaio has rendered the tender relationship between the little boy and his grandfather with unprecedented human understanding. Psychologically, our panel plainly bespeaks its Italian origin.

PERUGINO. Rome, long neglected during the papal exile in Avignon (see page 370), once more became an important center of art patronage in the later fifteenth century. As the papacy regained its political power on Italian soil, the occupants of the Chair of St. Peter began to beautify both the Vatican and

585. Domenico Ghirlandaio. *An Old Man and His Grandson.* c. 1480. Tempera and oil on wood panel, 24¹/8 x 18" (61.2 x 45.5 cm). Musée du Louvre, Paris

586. Pietro Perugino. The Delivery of the Keys. 1482. Fresco. Sistine Chapel, The Vatican, Rome

the city, in the conviction that the monuments of Christian Rome must outshine those of the pagan past. The most ambitious pictorial project of those years was the decoration of the walls of the Sistine Chapel beginning around 1482. Among the artists who carried out this large cycle of Old and New Testament scenes we encounter most of the important painters of central Italy, including Botticelli and Ghirlandaio, although these frescoes do not, on the whole, represent their best work.

There is, however, one notable exception: The Delivery of the Keys (fig. 586) by Pietro Perugino (c. 1450-1523) must rank as his finest achievement. Born near Perugia in Umbria (the region southeast of Tuscany), Perugino maintained close ties with Florence. His early development had been decisively influenced by Verrocchio, as the statuesque balance and solidity of the figures in *The Delivery of the Keys* suggest. The grave, symmetrical design conveys the special importance of the subject in this particular setting: the authority of St. Peter as the first pope, and that of all his successors, rests on his having received the keys to the Kingdom of Heaven from Christ himself. A number of contemporaries, with powerfully individualized features, witness the solemn event. Equally striking is the vast expanse of the background. Its two Roman triumphal arches (both modeled on the Arch of Constantine; fig. 284) flank a domed structure in which we recognize the ideal church of Alberti's *Treatise on Architecture*. The spatial clarity, achieved by the mathematically exact perspective of this view, is the heritage of Piero della Francesca, who spent much of his later life working for Umbrian clients, notably the duke of Urbino. Also from Urbino, shortly before 1500, Perugino received a pupil whose fame would soon outshine his own: Raphael, the most classic master of the High Renaissance.

SIGNORELLI. The Sistine frescoes were completed by Luca Signorelli (1445/50–1523), who was linked to Perugino by a similar background, although his personality was far more dramatic. Of provincial Tuscan origin, he had been a disciple of Piero della Francesca before coming to Florence in the 1470s. Like Perugino, Signorelli was strongly impressed by Verrocchio, but he also admired the energy, expressiveness, and anatomic precision of Pollaiuolo's nudes. Combining these influences with Piero's cubic solidity of form and mastery of perspective foreshortening, Signorelli achieved a style of epic grandeur that later made a lasting imprint on Michelangelo. He reached the climax of his career just before 1500 with a series of monumental frescoes on the walls of the S. Brizio Chapel in Orvieto Cathedral representing the end of the world.

The commission from Pope Alexander VI was an important one, rewarding the city for its faithfulness to the Vatican. The cycle conforms to the typology established by St. Augustine, but it is further rooted in St. Thomas Aquinas and Dante, as well as fifteenth-century Dominican theologians, especially St. Vincent Ferrer. The 1490s were a time of great hardship for Orvieto. It was beset by the plague, political upheaval, economic decline, and fear of the Turks, who crushed the Christian forces at Lepanto, Greece, in 1499—a defeat that was to be avenged in a second, more famous battle at the same site in 1571. This turmoil is vividly reflected in Signorelli's The Rule of the Antichrist (fig. 587), which is flanked by The End of the World and The Coronation of the Elect. Representing the chaos caused by political leaders and the "infidel" forces of Islam, the false Christ is Satan's chief ally, who rules the world before being defeated by St. Michael (seen in the upper left-hand

587. Luca Signorelli. The Rule of the Antichrist. 1499–1500. Fresco. S. Brizio Chapel, Orvieto Cathedral

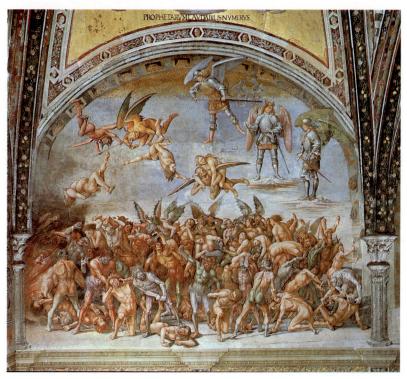

588. Luca Signorelli. The Damned Cast into Hell. 1499–1500. Fresco. S. Brizio Chapel, Orvieto Cathedral

corner of the painting). He appears before the third Temple of Solomon, the center of his fiendish realm, which is presented in a skewed view that contrasts pointedly with the rational calm of Perugino's *The Delivery of the Keys* (fig. 586).

The most dynamic of the Orvieto frescoes is *The Damned Cast into Hell* (fig. 588). What most strikes us is not the harsh

style, which is fully appropriate to the tumultuous scene, or Signorelli's use of the nude body as an expressive instrument, even though he far surpasses his predecessors in this respect, but the pervasive sense of tragedy. Signorelli's Hell, the exact opposite of Bosch's (compare fig. 684), is illuminated by the full light of day, without nightmarish machines of torture or grotesque

monsters. The damned retain their dignity, and even the devils are less demonic. Even in Hell, it seems, the Renaissance faith in humanity does not lose its force.

VENICE AND PADUA. We must now consider the growth of Early Renaissance art in northern Italy. The International Style in painting and sculpture lingered there until mid-century, and architecture retained a strongly Gothic flavor long after the adoption of a classical vocabulary. As a result, there were hardly any achievements of major significance in these fields, but between 1450 and 1500 a great tradition was born in Venice and its dependent territories that was to flourish for the next three centuries. The Republic of Venice, although more oligarchic and unique in its eastward orientation, had many ties with Florence. It is therefore not surprising that Venice, rather than the duchy of Milan, should have become the leading center of Early Renaissance art in northern Italy.

MANTEGNA. Florentine masters had been carrying the new style to Venice and to the neighboring city of Padua since the 1420s. Fra Filippo Lippi, Uccello, and Castagno had worked there at one time or another. Still more important was Donatello's ten-year sojourn. Their presence, however, evoked only rather timid local responses until, shortly before 1450, the young Andrea Mantegna (1431-1506) emerged as an independent master. He was first trained by a minor Paduan painter, but his early development was decisively shaped by the impressions he received from locally available Florentine works and, we may assume, by personal contact with Donatello. Next to Masaccio, Mantegna was the most important painter of the Early Renaissance. He, too, was a precocious genius, fully capable at 17 of executing commissions of his own. Within the next decade, he reached artistic maturity, and during the next half-century (he died at the age of 75) he broadened the range of his art but never departed, in essence, from the style he had formulated in the 1450s.

The greatest achievement of Mantegna's early career, the frescoes in the Church of the Eremitani in Padua, was almost entirely destroyed by an accidental bomb explosion in 1944—a more grievous loss than the murals of the Pisa Camposanto (see fig. 513). St. James Led to His Execution (fig. 589) is the most dramatic scene of the cycle because of its daring "worm's-eye view" perspective, which is based on the beholder's actual eye level. (The central vanishing point is below the bottom of the picture, somewhat to the right of center.) The architectural setting consequently looms large, as in Masaccio's Trinity fresco (see fig. 551). Its main feature is a huge triumphal arch which, although not a copy of any known Roman monument, looks so authentic in every detail that it might as well be.

Here Mantegna's devotion to the visible remains of antiquity, almost like that of an archaeologist, shows his close association with the learned humanists at the University of Padua, who had the same reverence for every word of ancient literature. No Florentine painter or sculptor of the time could have transmitted such an attitude to him. The same desire for authenticity can be seen in the costumes of the Roman soldiers (compare fig. 264). It even extends to the use of "wet" drapery patterns, an invention of Classical Greek sculpture inher-

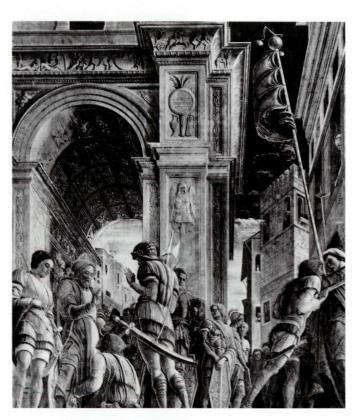

589. Andrea Mantegna. *St. James Led to His Execution.* c. 1455. Fresco. Ovetari Chapel, Church of the Eremitani, Padua. Destroyed 1944

590. Andrea Mantegna. *St. James Led to His Execution.* c. 1455. Pen drawing, 6½ x 9½ (15.7 x 23.5 cm). Collection G. M. Gathorne-Hardy, Donnington Priory, Newbury, Berkshire, England

ited by the Romans (see fig. 267). But the tense figures, lean and firmly constructed, and especially their dramatic interaction, clearly derive from Donatello. Mantegna's subject hardly demands this agitated staging. The saint, on the way to his execution, blesses a paralytic and commands him to walk. Many of the bystanders express by glance and gesture how deeply the miracle has stirred them. The large crowd generates an extraordinary emotional tension that erupts into real physical violence on the far right, as the great spiral curl of the banner echoes the turbulence below.

By rare good luck, a sketch for this fresco has survived (fig. 590), the earliest instance we know of a drawing that permits us to compare the preliminary and final versions of such

a design. (Among the drawings by earlier masters, none, it seems, is related to a known picture in the same way.) This sketch differs from sinopie (full-scale drawings on the wall; see fig. 514) in its tentative, unsettled quality. The composition has not yet taken full shape. Still growing, as it were, the image in our drawing is "unfinished" both in the conception and the quick, shorthand style. We note, for example, that here the perspective is closer to normal, indicating that the artist worked out the exact scheme only on the wall. Our drawing also offers proof of what we suspected in the case of Masaccio: that Early Renaissance artists actually conceived their compositions in terms of nude figures. The group on the right is still in that first stage, and in the others the outlines of the body show clearly beneath the costume. But the drawing is more than a document. It is a work of art in its own right. The very quickness of its "handwriting" gives it an immediacy and rhythmic force that are necessarily lost in the fresco.

On the evidence of these works, we would hardly expect Mantegna to be much concerned with light and color. The *St. Sebastian* panel reproduced in figure 591, painted only a few years after the Paduan frescoes, shows that he was, however. In the foreground, to be sure, we find the familiar array of classical remains (including, this time, the artist's signature in Greek). The saint, too, looks more like a statue than a living body. But beyond we see a wonderfully atmospheric landscape and a deep blue sky dotted with the softest of white clouds. The entire scene is bathed in the warm radiance of late afternoon sunlight, which creates a gently melancholy mood, making the pathos of the dying saint doubly poignant. The background of our panel shows the influence, direct or indirect, of the Van Eycks (compare fig. 672, left).

Some works of the great Flemish masters had surely reached Florence as well as Venice between 1430 and 1450, and must have been equally admired in both cities. But in Venice they had more immediate effect, evoking the interest in lyrical, light-filled landscapes that became an ingrained part of Venetian Renaissance painting.

BELLINI. In the painting of Giovanni Bellini (c. 1431-1516), Mantegna's brother-in-law, we trace the further growth of the Flemish tradition. Bellini was slow to mature, and his finest pictures, such as St. Francis in Ecstasy (fig. 592), date from the last decades of the century or later. The subject is unique. The saint has left his wooden pattens behind and stands barefoot on holy ground, like Moses in the Lord's presence (see page 62). Despite the absence of the crucified seraph that appeared to him on Mount Alverna, the painting seemingly shows Francis receiving the stigmata (the wounds of Christ) on the Feast of the Holy Cross in 1224, although they are barely visible even in person. However, it also "illustrates" the Hymn of the Sun, which he composed the following year after his annual fast at a hermitage near his hometown of Assisi. During that time he could not bear the sight of light and was plagued as well by mice. The monk finally emerged from these torments after being assured by the Lord that he would enter the Kingdom of Heaven. We see him looking ecstatically up at the sun. (Note the direction of the shadows.) In the background is a magnificent expanse of Italian countryside. Yet this is no ordinary landscape. It represents the

591. Andrea Mantegna. *St. Sebastian.* c. 1455–60. Tempera on panel, $26^{3}/4 \times 11^{7}/8$ " (68 x 30.6 cm). Kunsthistorisches Museum, Vienna

Heavenly Jerusalem, inspired by the Revelation of St. John the Divine. It lies across the river, separated from the everyday realm by the bridge to the left. Behind looms Mount Zion, where the Lord dwells. How, then, shall we enter the gate to paradise, shown as a large tower?

For Francis, the road to salvation lay in the ascetic life, signified by the cave, which also connects him symbolically to St. Jerome, the first great hermit saint. The donkey is a symbol of

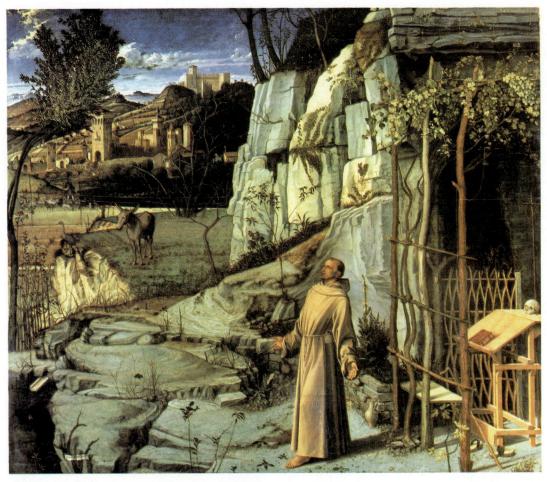

592. Giovanni Bellini. *St. Francis in Ecstasy.* c. 1485. Oil and tempera on panel, 49 x 55⁷/8" (124 x 141.7 cm). The Frick Collection, New York Copyright The Frick Collection

St. Francis himself, who referred to his body as Brother Ass, which must be disciplined. The other animals (difficult to discern in our illustration) are, like monks, solitary creatures in Christian lore: the heron, bittern, and rabbit.

The complex iconography is not sufficient in itself to explain the picture. Far more important is the treatment of the landscape. St. Francis is here so small in comparison to the setting that he seems almost incidental. Yet his mystic rapture before the beauty of the visible world sets our own response to the view that is spread out before us, ample and intimate at the same time. St. Francis revered nature as the Lord's handiwork, made for humanity's benefit. Our artist shares his tender lyricism, expressed in the Hymn of the Sun:

Be praised, my Lord, with all Your creatures, Above all Brother Sun, Who gives the day and by whom You shed light on us. And he is beautiful and radiant with great splendor. Of Thee, Most High, he is a symbol.

Bellini's contours are less brittle than those of Mantegna, the colors softer and the light more glowing. He has as well the concern of the great Flemings for every detail and its symbolism. Unlike the Northerners, however, he can define the beholder's spatial relationship to the landscape. The rock formations of the foreground are structurally clear and firm, like architecture rendered by the rules of scientific perspective.

As the foremost painter of the city of Venice, Bellini pro-

duced a number of formal altar panels of the sacra conversazione type. The last and most monumental one of the series is the *Madonna and Saints* of 1505 in S. Zaccaria (fig. 593). Compared to Domenico Veneziano's sacra conversazione of 50 years earlier (fig. 560), the architectural setting is a good deal simpler but no less impressive. We stand in the nave of a church, near the crossing (which is partly visible), with the apse filling almost the entire panel. The figures appear in front of the apse, however, under the great vaulted canopy of the crossing. The structure is not a real church, for its sides are open and the entire scene is flooded with gentle sunlight, just as Domenico Veneziano had placed his figures in a semioutdoor setting. The Madonna's solid, high-backed throne and the music-making angel on its lowest step are derived (through many intermediaries, no doubt) from Masaccio's *Madonna Enthroned* of 1426 (see fig. 557).

What differentiates this altar immediately from its Florentine ancestors is not merely the ample spaciousness of the design but its wonderfully calm, meditative mood. Instead of "conversation," we sense the figures' deep communion, which makes all rhetorical gestures unnecessary. We shall encounter this quality again and again in Venetian painting. Here, we see it as through a diffusing filter of atmosphere, for the aged master has bathed the entire scene in a delicate aerial haze. All harsh contrasts are eliminated, light and shadow blend in almost imperceptible gradations, and colors glow with a new richness and depth. In this magical moment, Bellini unites Florentine grandeur with Venetian poetic intimacy.

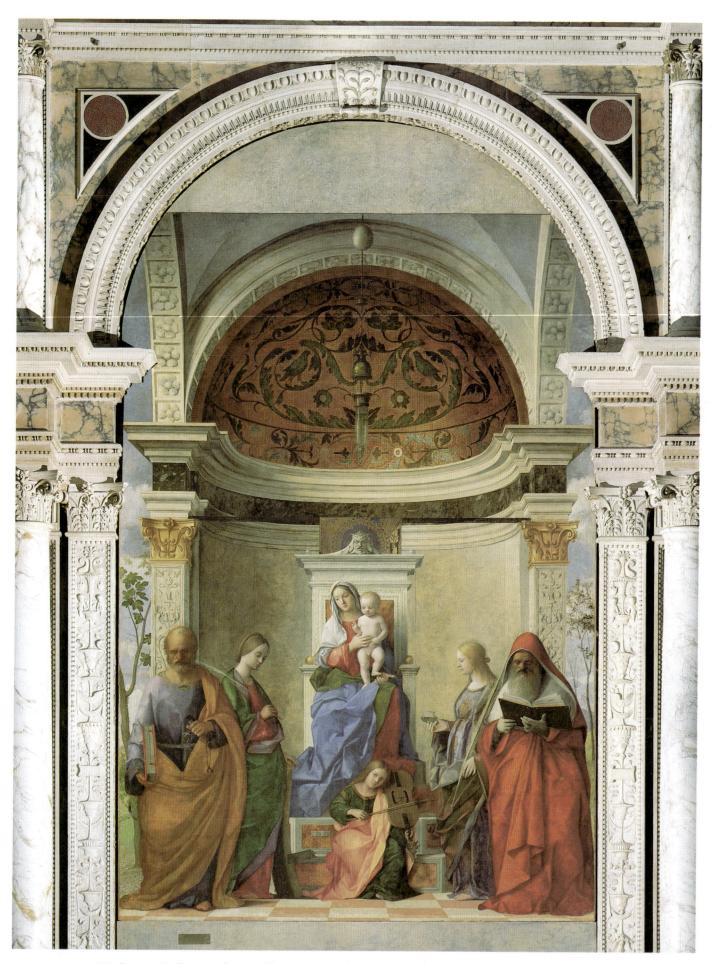

593. Giovanni Bellini. $\it Madonna\ and\ Saints.$ 1505. Oil on panel, $16'5^{1}/8" \times 7'9"$ (5 x 2.4 m). S. Zaccaria, Venice

CHAPTER TWO

THE HIGH RENAISSANCE IN ITALY

It used to be taken for granted that the High Renaissance followed upon the Early Renaissance as naturally and inevitably as night follows day. The great masters of the sixteenth century—Leonardo, Bramante, Michelangelo, Raphael, Giorgione, Titian—were thought to have shared the ideals of their predecessors, but to have expressed them so completely that their names became synonyms for perfection. They represented the climax, the classic phase, of Renaissance art, just as Phidias had brought the art of ancient Greece to its highest point. This view could also explain why these two classic phases, though 2,000 years apart, were so short. If art is assumed to develop along the pattern of a ballistic curve, its highest point cannot be expected to last more than a moment.

Since the 1920s, art historians have come to realize the shortcomings of this scheme. When we apply it literally, the High Renaissance becomes so absurdly brief, for example, that we wonder whether it happened at all. Moreover, we hardly increase our understanding of the Early Renaissance if we regard it as a "not-yet-perfect High Renaissance," any more than an Archaic Greek statue can be satisfactorily viewed from a Phidian standpoint. Nor is it very useful to insist that the subsequent post-Classical phase, whether Hellenistic or "Late Renaissance," must be decadent. The image of the ballistic curve has now been abandoned, and we have gained a less assured, but also less arbitrary, estimate of what, for lack of another term, we still call the High Renaissance.

In some fundamental respects, we shall find that the High Renaissance was indeed the culmination of the Early Renaissance, while in other respects it represented a significant departure. Certainly the tendency to view artists as sovereign geniuses, rather than as devoted artisans, was never stronger than during the first half of the sixteenth century. Plato's concept of genius—the spirit entering into poets that causes them to compose in a "divine frenzy"—had been broadened by Marsilio Ficino and his fellow Neo-Platonists to include architects, sculptors, and painters. For Giorgio Vasari, individuals

of genius were thought to be set apart from ordinary artists by "grace," in the sense of both divine grace, a gift from God, and gracefulness, which reflected it. To him, this concept had moral and spiritual significance, inspired in good measure by Dante's Inferno. Building further on Petrarch's scheme of history (see page 404), he saw the High Renaissance as superior even to antiquity, for it belonged to the Christian era of grace (tempus gratia), in contrast to the Old Testament of God's law as received by Moses (tempus legem), which had not been revealed to the pagans. Thus in his Lives of the Painters (1550-68), Vasari extolls the "gracious," virtuous personalities of Michelangelo, Leonardo, and Raphael, as a way of accounting for their universal talent. Grace served, moreover, to justify his treatment of his close friend and idol Michelangelo as the greatest artist of all time, a view that remains with us to this very day, although Michelangelo's character was far from admirable in all respects.

What set these artists apart was the inspiration guiding their efforts, which was worthy of being called "divine," "immortal," and "creative." (Before 1500 creating, as distinct from making, was the privilege of God alone.) To Vasari, the painters and sculptors of the Early Renaissance, like those of the Late Gothic, had learned only to imitate coarse nature, whereas the geniuses of the High Renaissance had conquered nature by ennobling, transcending, or subjecting it to art. In actual fact, the High Renaissance remained thoroughly grounded in nature. Its achievement lay in the creation of a new classicism through abstraction. It was an act of the imagination, not the intellect, for the result was a poetic ideal informed by a spirit of ineffable harmony.

Faith in the divine origin of inspiration led artists to rely on subjective, rather than objective, standards of truth and beauty. If Early Renaissance artists felt bound by what they believed to be universally valid rules, such as the numerical ratios of musical harmony and the laws of linear perspective, their High Renaissance successors were less concerned with

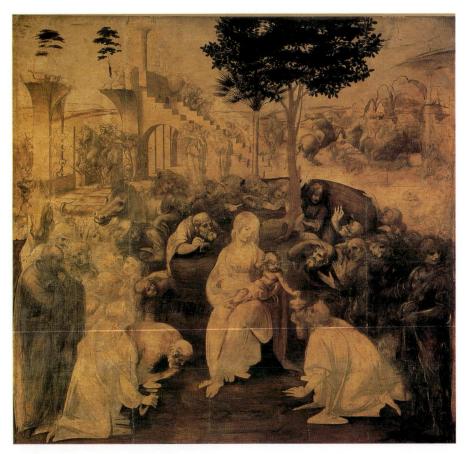

594. Leonardo da Vinci. Adoration of the Magi. 1481-82. Monochrome on panel, 8' x 8'1" (2.43 x 2.46 m). Galleria degli Uffizi, Florence

rational order than with visual effectiveness. They evolved a new drama and a new rhetoric to engage the emotions of the beholder, whether sanctioned or not by classical precedent. Indeed, the works of the great High Renaissance masters immediately became classics in their own right, their authority equal to that of the most renowned monuments of antiquity. At the same time, this cult of the genius had a profound effect on the artists of the High Renaissance. It spurred them to vast and ambitious goals, and prompted their awed patrons to support such enterprises. Since these ambitions often went beyond the humanly possible, they were apt to be frustrated by external as well as internal difficulties, leaving artists with a sense of having been defeated by a malevolent fate.

Here we encounter a contradiction: if the creations of genius are viewed as unique by definition, they cannot be successfully imitated by lesser artists, however worthy they may seem of such imitation. Unlike the founders of the Early Renaissance, the leading artists of the High Renaissance did not set the pace for a broadly based "period style" that could be practiced on every level of quality. The High Renaissance produced astonishingly few minor masters. It died with those who had created it, or even before. Of the six great personalities mentioned above, only Michelangelo and Titian lived beyond 1520.

External conditions after that date were undoubtedly less favorable to the High Renaissance style than those of the first two decades of the sixteenth century. Yet the High Renaissance might well have ended soon even without the pressure of circumstances. Its harmonious grandeur was inherently unstable, a balance of divergent qualities. Only these quali-

ties, not the balance itself, could be transmitted to the artists who reached maturity after 1520. In pointing out the limited and precarious nature of the High Renaissance we do not mean to deny its tremendous impact upon later art. For most of the next 300 years, the great personalities of the early sixteenth century loomed so large that the achievements of their predecessors seemed to belong to a forgotten era. Even when the art of the fourteenth and fifteenth centuries was finally rediscovered, people still acknowledged the High Renaissance as the turning point, and referred to all painters before Raphael as "the Primitives."

Leonardo da Vinci

One important reason why the High Renaissance rightfully deserves to be called a period is the fact that its key monuments were all produced between 1495 and 1520, despite the great differences in age of the artists who created them. Bramante, the oldest, was born in 1444, Raphael in 1483, and Titian about 1488–90. Yet the distinction of being the earliest High Renaissance master belongs to Leonardo da Vinci (1452–1519), not to Bramante. Born in the little Tuscan town of Vinci, Leonardo was trained in Florence by Verrocchio. Conditions there must not have suited him. At the age of 30 he went to work for the duke of Milan as a military engineer, and only secondarily as an architect, sculptor, and painter.

ADORATION OF THE MAGI. Leonardo left behind, unfinished, the most ambitious work he had then begun, a large *Adoration of the Magi* (fig. 594), for which he had made

several preliminary studies. The design of the ruins shows a geometric order and a precisely constructed perspective that recall Florentine painting in the wake of Masaccio, rather than the style prevailing about 1480, which is reflected solely in the gracefulness of the Madonna and Child. Yet the structure is so peculiar as to heighten the contrast with the landscape. The result is a spatial disjunctiveness that is nearly hallucinatory. Without the trees to anchor it, the composition would consist of two wholly separate parts. The background is inexplicable in rational terms. What are we to make of the figures who inhabit the stairs of the wrecked building, or the combat of horsemen to either side? The foreground is no less visionary. The main figures are contained within a triangle surrounded by the sweeping arc of onlookers. The scene is framed by a philosopher lost in thought to the left and by a young soldier on the right looking outside the picture to something that has caught his attention. They undoubtedly represent ideal types—but what do they signify? The contemplative and active lives surely, youth and old age as well, perhaps moral and physical beauty, as one critic has suggested. Within these contrasts lies a duality of mind and body that Leonardo sought to resolve in his mature work. The inchoate assembly is as spellbinding as it is strange. The future is already writ within it, for it contains the germinal form of figures found in Leonardo's later paintings.

The most striking, and indeed revolutionary, aspect of the panel is the way it is executed, although Leonardo had not even completed the underpainting. The forms seem to materialize softly and gradually, never quite detaching themselves from a dusky realm. Leonardo, unlike Pollaiuolo or Botticelli, thinks not of outlines, but of three-dimensional bodies made visible in varying degrees by the incidence of light. In the shadows, these shapes remain incomplete. Their contours are only implied instead. In this method of modeling (called *chiaro*scuro, the Italian word for "light and dark"), the forms no longer stand abruptly side by side but partake of a new pictorial unity, for the barriers between them have been partially broken down. There is a comparable emotional continuity as well. The gestures and faces of the crowd convey with touching eloquence the reality of the miracle they have come to behold. We will recognize the influence of both Pollaiuolo and Verrocchio in the mobile expressiveness of these figures, but Leonardo may also have been impressed by the breathless shepherds in *The Portinari Altarpiece*, then newly installed in Florence (see fig. 682).

THE VIRGIN OF THE ROCKS. Soon after arriving in Milan, Leonardo did *The Virgin of the Rocks* (fig. 595), another altar panel, which suggests what the *Adoration* would have looked like had it been completed. Here the figures emerge from the semidarkness of the grotto, enveloped in a moisture-laden atmosphere that delicately veils their forms. This fine haze, called *sfumato*, is more pronounced than similar effects in Flemish and Venetian painting. It lends a peculiar warmth and intimacy to the scene. It also creates a remote, dreamlike quality, and makes the picture seem a poetic vision rather than an image of reality. The subject—the infant St. John adoring the Infant Christ in the presence of the Virgin and an angel—is without immediate precedent. The story of their meeting is

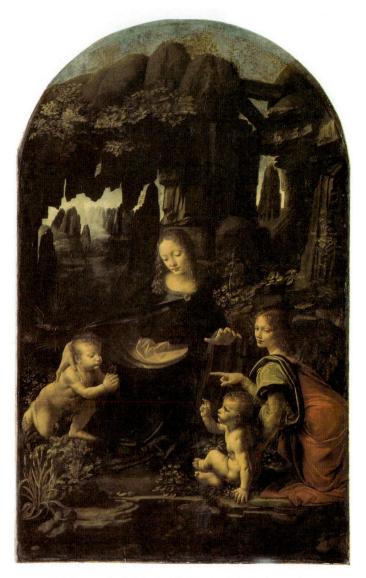

595. Leonardo da Vinci. *The Virgin of the Rocks.* c. 1485. Oil on panel transferred to canvas, 6'6" x 4' (1.9 x 1.2 m). Musée du Louvre, Paris

one of the many legends that arose to satisfy the abiding curiosity about the "hidden" early life of Christ, which is hardly mentioned in the Bible. (According to a similar legend, St. John, about whom equally little is known, spent his childhood in the wilderness; hence he is shown wearing a hair shirt.)

Leonardo was the first to depict this scene, but the treatment is mysterious in many ways: the secluded, rocky setting, the pool in front, and the plant life, carefully chosen and exquisitely rendered, all hint at levels of meaning that are somehow hard to define. How are we to interpret the relationships among the four figures, signified by the conjunction of gestures? Protective, pointing, blessing, they convey the wonderment of St. John's recognition of Christ as the Saviour, but with a tenderness that raises the scene above the merely doctrinal. The gap between these hands and St. John makes the exchange all the more telling. Although present in germinal form in *The Doubting of Thomas* by Leonardo's teacher, Verrocchio (fig. 581), the elegant gestures and the refined features are the first mature example of that High Renaissance "grace" signifying a spiritual state of being.

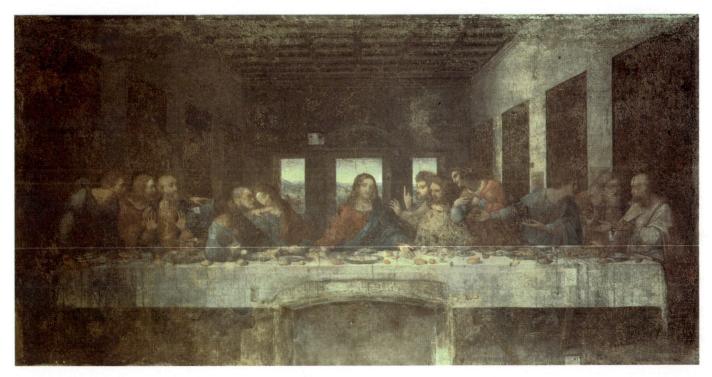

596. Leonardo da Vinci. The Last Supper. c. 1495–98. Tempera wall mural, 15'2" x 28'10" (4.6 x 8.8 m). Sta. Maria delle Grazie, Milan

THE LAST SUPPER. Despite their originality, the *Adoration* and the Virgin of the Rocks do not yet differ clearly in conception from the aims of the Early Renaissance. But Leonardo's Last Supper, later by a dozen years, has always been recognized as the first classic statement of the ideals of High Renaissance painting (fig. 596). Unfortunately, the famous mural began to deteriorate a few years after its completion. The artist, dissatisfied with the limitations of the traditional fresco technique, experimented in an oil-tempera medium that did not adhere well to the wall. We thus need some effort to imagine its original splendor. Yet what remains is more than sufficient to account for its tremendous impact. Viewing the composition as a whole, we are struck at once by its balanced stability. Only afterward do we discover that this balance has been achieved by the reconciliation of competing, even conflicting, aims such as no previous artist had attempted.

A comparison with Castagno's *Last Supper* (fig. 564), painted half a century before, is particularly instructive here. The spatial setting in both cases seems like an annex to the real interior of the refectory (dining hall), but Castagno's architecture has a strangely oppressive effect on the figures, unlike Leonardo's. The reason for this becomes clear when we realize that in the earlier work the space has been conceived autonomously. It was there before the figures entered and would equally suit another group of diners. Leonardo, in contrast, began with the figural composition, and the architecture had no more than a supporting role from the start. His perspective is an ideal one.

Leonardo's painting, high up on the refectory wall, assumes a vantage point some 15 feet above the floor and 30 feet back—an obvious impossibility, yet we readily accept it nonetheless. The central vanishing point, which governs our view of the interior, is located behind the head of Jesus in the exact middle of the picture and thus becomes charged with symbolic significance. Equally plain is the symbolic function of the main opening in the back wall: its projecting pediment acts as the architectural equivalent of a halo. We thus tend to see the perspective framework of the scene almost entirely in relation to the figures, rather than as a preexisting entity. How vital this relationship is we can easily test by covering the upper third of the picture. The composition then takes on the character of a frieze, the grouping of the apostles is less clear, and the calm triangular shape of Jesus becomes merely passive, instead of acting as a physical and spiritual force. At the same time, the perspective system helps to "lock" the composition in place, lending the scene an eternal quality without making it appear static in any way.

The Saviour, presumably, has just spoken the fateful words, "One of you shall betray me," and the disciples are asking, "Lord, is it I?" We actually see nothing that contradicts this interpretation, but to view the scene as one particular moment in a psychological drama hardly does justice to Leonardo's intentions. These went well beyond a literal rendering of the biblical narrative, for he crowded together all the disciples on the far side of the table, in a space quite inadequate for so many people. He clearly wanted to condense his subject

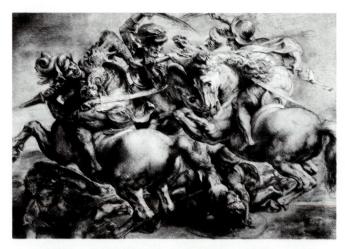

597. Peter Paul Rubens. Drawing after Leonardo's cartoon for *The Battle of Anghiari*. c. 1600. Cabinet des Dessins, Musée du Louvre, Paris

physically by the compact, monumental grouping of the figures, and spiritually by presenting many levels of meaning at one time. Thus the gesture of Jesus is one of submission to the divine will, and of offering. It is a hint at Jesus' main act at the Last Supper, the institution of the Eucharist, in which bread and wine become his body and blood through transubstantiation. The apostles do not simply react to these words. Each of them reveals his own personality, his own relationship to the Saviour. (Note that Judas is no longer segregated from the rest; his dark, defiant profile sets him apart well enough.) Leonardo has carefully calculated each pose and expression so that the drama unfolds across the picture plane. The figures exemplify what the artist wrote in one of his notebooks, that the highest and most difficult aim of painting is to depict "the intention of man's soul" through gestures and movements of the limbs—a dictum to be interpreted as referring not to momentary emotional states but to the inner life as a whole.

THE BATTLE OF ANGHIARI. In 1499, the duchy of Milan fell to the French, and Leonardo returned to Florence after brief trips to Mantua and Venice. He must have found the cultural climate very different from his recollections of it. The Medici had been expelled, and the city was briefly a republic again, until their return. For a while, Leonardo seems to have been active mainly as an engineer and surveyor, but in 1503 the city commissioned him to do a mural of some famous event from the history of Florence for the council chamber of the Palazzo Vecchio. Leonardo chose the Battle of Anghiari, where the Florentine forces had once defeated the Milanese army. He completed the cartoon (a full-scale drawing) and had just begun the mural itself when he returned once more to Milan in 1506 at the request of the French, abandoning the commission.

The cartoon for *The Battle of Anghiari* survived for more than a century and enjoyed enormous fame. Today we know it only through Leonardo's preliminary sketches and through copies of the cartoon by later artists, notably a splendid drawing by Peter Paul Rubens (fig. 597; see page 574). Leonardo had started with the historical accounts of the engagement. As his plans crystallized, however, he abandoned factual accuracy and created a monumental group of soldiers on horseback that

represents a condensed, timeless image of the spirit of battle, rather than any specific event. His concern with "the intention of man's soul" is even more evident here than in *The Last Supper*. In this case, a savage fury has seized not only the combatants but the animals as well, so that they become one with their riders. *The Battle of Anghiari* stands at the opposite end of the scale from Uccello's *Battle of San Romano* (fig. 563), where nothing has been omitted except the fighting itself; yet Leonardo's battle scene is not one of uncontrolled action. Its dynamism is held in check by the hexagonal outline that stabilizes this seething mass. Once again, balance has been achieved by the reconciliation of competing claims.

MONA LISA. While working on The Battle of Anghiari, Leonardo painted the Mona Lisa (fig. 598). The delicate sfumato of The Virgin of the Rocks is here so perfected that it seemed miraculous to the artist's contemporaries. The forms are built from layers of glazes so gossamer-thin that the entire panel seems to glow with a gentle light from within. But the fame of the Mona Lisa comes not from this pictorial subtlety alone. Even more intriguing is the psychological fascination of the sitter's personality. Why, among all the smiling faces ever painted, has this particular one been singled out as "mysterious"? Perhaps the reason is that, as a portrait, the picture does not fit our expectations. The features are too individual for Leonardo to have simply depicted an ideal type, yet the element of idealization is so strong that it blurs the sitter's character. Once again the artist has brought two opposites into harmonious balance. The smile, also, may be read in two ways: as the echo of a momentary mood, and as a timeless, symbolic expression, akin to the "Archaic smile" of the Greeks (see figs. 152 and 153). The Mona Lisa seemingly embodies a quality of maternal tenderness which was to Leonardo the essence of womanhood. Even the landscape in the background, composed mainly of rocks and water, suggests elemental generative forces. Who was the sitter for this, the most famous portrait in the world? Her identity remained a mystery until very recently. We now know that she was the wife of a Florentine merchant born in 1479 and dead before 1556. This is not the only painting of the Mona Lisa: Leonardo also painted a nude version that once belonged to the king of France.

DRAWINGS. In his later years, Leonardo devoted himself more and more to his scientific interests. Art and science, we recall, were first united in Brunelleschi's discovery of systematic perspective. Leonardo's work is the climax of this trend. The artist, he believed, must know not only the rules of perspective but all the laws of nature, and the eye was to him the perfect instrument for gaining such knowledge. The extraordinary scope of his own inquiries is attested in the hundreds of drawings and notes that he hoped to incorporate into an encyclopedic set of treatises. [See Primary Sources, no. 53, page 631.] How original he was as a scientist is still a matter of debate, but in one field his importance remains undisputed: he created the modern scientific illustration, an essential tool for anatomists and biologists. A drawing such as the Embryo in the Womb (fig. 599) combines his own vivid observation with the analytic clarity of a diagram—or, to paraphrase Leonardo's own words, sight and insight.

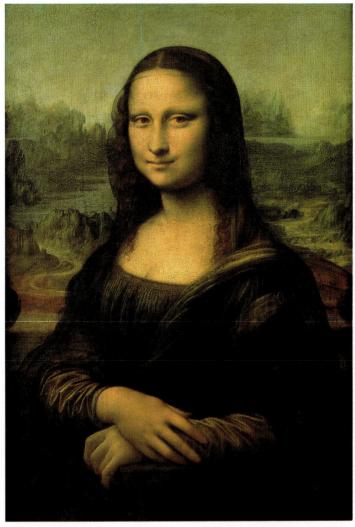

598. Leonardo da Vinci. *Mona Lisa.* c. 1503–5. Oil on panel, 30¹/4 x 21" (77 x 53.5 cm). Musée du Louvre, Paris

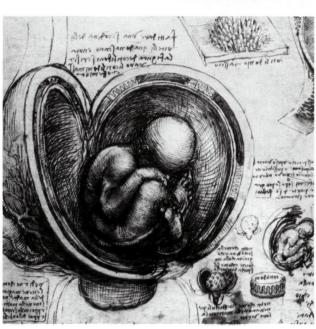

599. Leonardo da Vinci. *Embryo in the Womb.* c. 1510. Detail of pen drawing, 11⁷/8 x 8³/8" (30.4 x 21.5 cm). Windsor Castle, Royal Library © 1991. Her Majesty Queen Elizabeth II

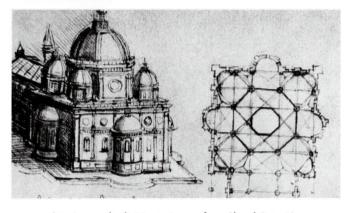

600. Leonardo da Vinci. *Project for a Church* (Ms. B). c. 1490. Pen drawing. Bibliothèque de l'Arsenal, Paris

Contemporary sources show that Leonardo was esteemed as an architect. Actual building seems to have concerned him less, however, than problems of structure and design. The numerous architectural projects in his drawings were intended, for the most part, to remain on paper. Yet these sketches, especially those of his Milanese period, have great historic importance, for only in them can we trace the transition from the Early to the High Renaissance in architecture.

The domed, centrally planned churches of the type illustrated in figure 600 hold particular interest for us. The plan recalls Brunelleschi's Sta. Maria degli Angeli (see fig. 549), but the new relationship of the spatial units is more complex,

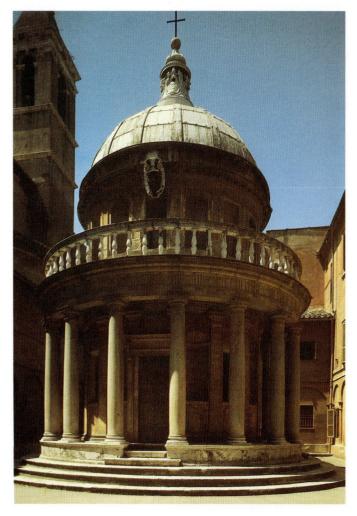

601. Donato Bramante. The Tempietto, S. Pietro in Montorio, Rome. 1502-11

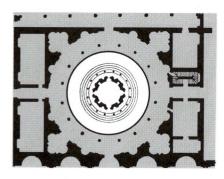

602. Plan of the Tempietto (after Serlio, in Regole generali di Architettura). Gray indicates unbuilt sections

while the exterior, with its cluster of domes, is more monumental than any Early Renaissance structure. In conception, this design stands halfway between the dome of Florence Cathedral and the most ambitious structure of the sixteenth century, the new basilica of St. Peter's in Rome (compare figs. 459, 603, and 604). It gives evidence, too, of Leonardo's close contact, during the 1490s, with the architect Donato Bramante (1444–1514), who was then also working for the duke of Milan. Bramante went to Rome after Milan fell to the French, and it was in Rome, during the last 15 years of his life, that he became the creator of High Renaissance architecture.

Bramante

THE TEMPIETTO. The new style is shown fully formed in Bramante's Tempietto at S. Pietro in Montorio (figs. 601 and 602), designed soon after 1500. This chapel, which marks the site of St. Peter's crucifixion, was planned to be surrounded by a circular, colonnaded courtyard. The Tempietto would then have appeared less isolated from its environment than it does today, for Bramante intended it to be set within a "molded" exterior space, a conception as bold and novel as the design of the chapel itself. Its nickname, "little temple," is well deserved. In the three-step platform and the severe Doric order of the colonnade, Classical temple architecture is more directly recalled than in any fifteenth-century structure. Equally striking is Bramante's application of the "sculptured wall" in the Tempietto itself and the courtyard. Not since Brunelleschi's Sta. Maria degli Angeli have we seen such deeply recessed niches "excavated" from heavy masses of masonry. These cavities are counterbalanced by the convex shape of the dome and by strongly projecting moldings and cornices. As a result, the Tempietto has a monumentality that belies its modest size.

ST. PETER'S, ROME. The Tempietto is the earliest of the great achievements that made Rome the center of Italian art during the first quarter of the sixteenth century. Most of them belong to the decade 1503–13, the papacy of Julius II. It was he who decided to replace the old basilica of St. Peter's, which had been in precarious condition, with a church so magnificent as to overshadow all the monuments of ancient Imperial Rome. The task fell to Bramante, the foremost architect in the city. His original design of 1506 is known only from a plan (fig. 603) and from the medal commemorating the start of the building campaign (fig. 604), which shows the exterior in rather imprecise perspective. These are sufficient, however, to bear out the words Bramante reportedly used to define his aim: "I shall place the Pantheon on top of the Basilica of Constantine."

To surpass the two most famous structures of Roman antiquity by a Christian edifice of unexampled grandeur nothing less would have satisfied Julius II, a pontiff of enormous ambition, who wanted to unite all Italy under his command and thus to gain a temporal power matching the spiritual authority of his office. Bramante's design is indeed of truly imperial magnificence. A huge hemispherical dome, similar to that of the Tempietto, crowns the crossing of the barrel-vaulted arms of a Greek cross, with four lesser domes and tall corner towers filling the angles. This plan fulfills all the demands laid down by Alberti for sacred architecture (see

603. Donato Bramante. Original plan for St. Peter's, Rome. 1506 (after Geymuller)

604. Caradosso. Bronze medal showing Bramante's design for St. Peter's. 1506. The British Museum, London

605. Plan of Brunelleschi's S. Lorenzo, Florence, reproduced at the same scale as figure 603

page 437). Based entirely on the circle and the square, it is so rigidly symmetrical that we cannot tell which apse was to hold the high altar. Bramante envisioned four identical facades like that on the medal of 1506, dominated by the same repertory of severely classical forms we saw in the Tempietto: domes, half-domes, colonnades, pediments.

These simple geometric shapes, however, do not prevail inside the church. Here the sculptured wall reigns supreme. The plan shows no continuous surfaces, only great, oddly shaped "islands" of masonry that have been well described by one critic as giant pieces of toast half-eaten by a voracious space. The actual size of these islands can be visualized only if we compare the measurements of Bramante's church with those of earlier buildings. S. Lorenzo in Florence, for instance, has a length of 268 feet, less than half that of the new St. Peter's (550 feet). Figure 605, which reproduces the plan of S. Lorenzo on the same scale as Bramante's plan (fig. 603), proves that Bramante's reference to the Pantheon and the Basilica of Constantine was no idle boast. His plan dwarfs these monuments, as well as every Early Renaissance church. (Each arm of the Greek cross has about the same dimensions as the Basilica of Constantine.)

How did he propose to build a structure of such overwhelming size? Cut stone and brick, the materials favored by medieval architects, would not do, for technical and economic reasons. Only construction in concrete, as used by the Romans but largely forgotten during the Middle Ages, was strong and cheap enough to fill Bramante's needs (see page 177). By reviving this ancient technique, he opened a new era in the history of architecture, for concrete permitted designs of far greater flexibility than the building methods of the medieval masons. The possibilities of the material, however, were not fully exploited for some time to come. The construction of St. Peter's progressed so slowly that in 1514, when Bramante died, only the four crossing piers had actually been built. For the next three decades the campaign was carried on hesitantly by architects trained under Bramante, who modified his design in a number of ways. A new and decisive phase in the history of St. Peter's began only in 1546, when Michelangelo took charge, and the present appearance of the church (fig. 622) is largely shaped by his ideas. But this must be considered in the context of Michelangelo's career as a whole.

Michelangelo

The concept of genius as divine inspiration, a superhuman power granted to a few rare individuals and acting through them, is nowhere exemplified more fully than in the life and work of Michelangelo (Michelangelo di Lodovico Buonarroti Simoni, 1475–1564). Not only his admirers viewed him in this light. He himself, steeped in Neo-Platonist tradition (see pages 443–44), accepted the idea of his genius as a living reality, although it seemed to him at times a curse rather than a blessing. The element that brings continuity to his long and stormy career is the sovereign power of his personality, his faith in the subjective rightness of everything he created. Conventions, standards, and traditions might be observed by lesser spirits, but he could acknowledge no authority higher than the dictates of his genius.

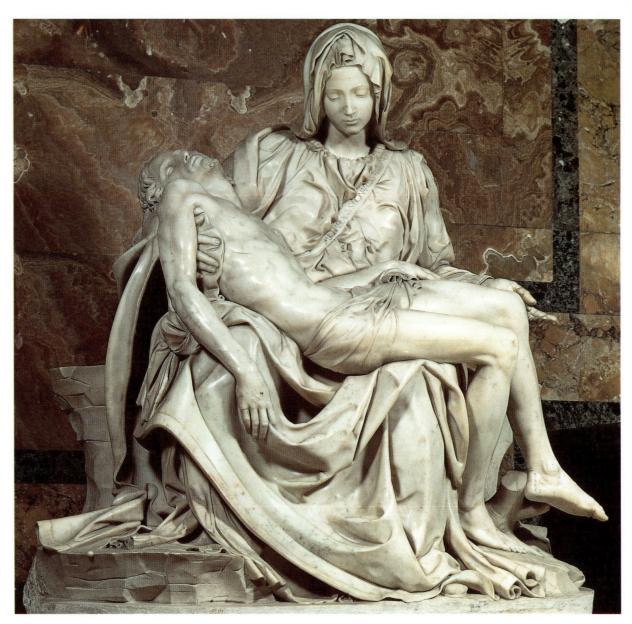

606. Michelangelo. Pietà. c. 1500. Marble, height 681/2" (173.9 cm). St. Peter's, Rome

Unlike Leonardo, for whom painting was the noblest of the arts because it embraced every visible aspect of the world, Michelangelo was a sculptor—more specifically, a carver of marble statues—to the core. Art, for him, was not a science but "the making of men," analogous (however imperfectly) to divine creation. Hence the limitations of sculpture that Leonardo decried were essential virtues in Michelangelo's eyes. Only the "liberation" of real, three-dimensional bodies from recalcitrant matter could satisfy his urge. (See his *Awakening Slave* fig. 3). Painting, for him, should imitate the roundness of sculptured forms, and architecture, too, must partake of the organic qualities of the human figure.

Michelangelo's faith in the human image as the supreme vehicle of expression gave him a sense of kinship with Classical sculpture closer than that of any Renaissance artist. Among recent masters, he admired Giotto, Masaccio, Donatello, and Della Quercia more than the men he knew as a youth in Florence. Yet his mind was decisively shaped by the cultural climate of Florence during the 1480s and 1490s. Both the Neo-Platonism of Marsilio Ficino and the religious reforms of Savonarola affected him profoundly. These conflicting influences reinforced the tensions within Michelangelo's personality, his violent changes of mood, his sense of being at odds with himself and with the world. As he conceived his statues to be human bodies released from their marble prison, so the body was the earthly prison of the soul—noble, but a prison nevertheless. This dualism of body and spirit endows his figures with extraordinary pathos. Outwardly calm, they seem stirred by an overwhelming psychic energy that has no release in physical action.

PIETÀ. We sense none of these struggles in the *Pietà* commissioned in 1497 by a French cardinal for his tomb chapel in St. Peter's (fig. 606). The subject, of Northern origin (see page 351), is rare, though not unknown, in Italy before this time. One of the Seven Sorrows of the Virgin, it owed its sudden

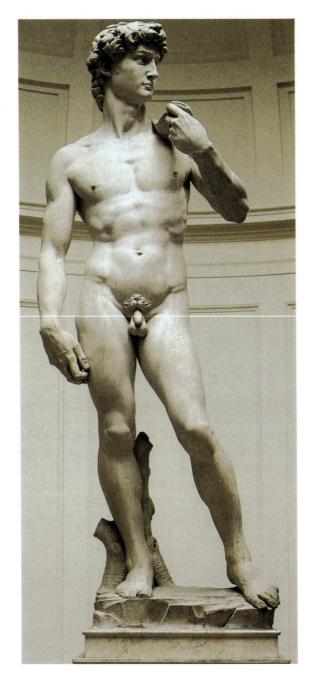

607. Michelangelo. *David.* 1501–4. Marble, height 13'5" (4.08 m). Galleria dell'Accademia, Florence

popularity at the end of the fifteenth century to the growing veneration of Mary. Seated on Golgatha, the extraordinarily lovely and youthful Madonna stands for the Church and serves as the gateway to Heaven. If this Lamentation lacks the pathos of the German *Andachtsbild* (compare fig. 479), it is because we are meant to contemplate the central mystery of Christian faith with the same serenity as Mary herself: Jesus as God in human form who sacrificed himself to redeem our sins.

Spiritually as well as aesthetically, this *Pietà* still belongs to the fifteenth century. It is indebted to two of Michelangelo's predecessors: Jacopo della Quercia, for the figure of the Virgin, and Andrea Verrocchio, for the nobility of the faces and the highly ornamental treatment of the drapery. The cloak flowing like a river over the Madonna enables Michelangelo to resolve her physically and visually awkward relationship with

her dead son—a problem that evidently was of little interest to the German Gothic artist, who instead turned it to his expressive advantage. Michelangelo succeeded in his ambition of carving "the most beautiful work of marble in Rome, one that no living artist could better." To Vasari it "was a revelation of all the potentialities and force of the art of sculpture."

DAVID. The unique qualities of Michelangelo's art do not emerge fully until his *David* (fig. 607), the earliest monumental statue of the High Renaissance. Commissioned of the artist in 1501 as the symbol of the Florentine republic (see fig. 464), the huge figure was designed to be placed high above the ground, on one of the buttresses of Florence Cathedral. However, a committee of civic leaders and artists decided instead to put it in front of the Palazzo Vecchio. [See Primary Sources, no. 54, pages 631–32.]

We can well understand the decision. Because the head of Goliath has been omitted, Michelangelo's David looks challenging. Here is not a victorious hero but the champion of a just cause. To Michelangelo, he embodied Fortitude—the same virtue celebrated by the diminutive "Herakles" on Nicola Pisano's pulpit (fig. 484), which the David curiously resembles, but here the figure has a civic-patriotic rather than a moral significance. Vibrant with pent-up energy, he faces the world like Donatello's St. George (see fig. 531), although his nudity links him to the older master's bronze David as well. The style of the sculpture proclaims an ideal very different from the wiry slenderness of Donatello's youths. Michelangelo had just spent several years in Rome, where he had been deeply impressed with the emotion-charged, muscular bodies of Hellenistic sculpture. Their heroic scale, their superhuman beauty and power, and the swelling volume of their forms became part of Michelangelo's own style and, through him, of Renaissance art in general.

Whereas his earlier work could sometimes be taken for ancient statues, in the *David* Michelangelo competes with antiquity on equal terms and replaces its authority with his own. This resolute individualism is partly indebted to Leonardo da Vinci, who had recently returned to Florence. (As with all of Michelangelo's great peers, they soon became arch rivals.) So is the expressive attitude of the figure, which conveys the "intention of man's soul." In Hellenistic works (compare fig. 213) the body "acts out" the spirit's agony, while the *David*, at once calm and tense, shows the action-in-repose so characteristic of Michelangelo.

TOMB OF JULIUS II. This feature persists in the *Moses* (fig. 608) and the two "Slaves" (figs. 609 and 610) of about ten years later. They were part of the ambitious sculptural program for the Tomb of Julius II, which would have been Michelangelo's greatest achievement had he been able to carry it out as originally planned. (The unfinished *Awakening Slave* in fig. 3 is from a later plan for the tomb.) The majestic *Moses*, meant to be seen from below, has the awesome force which the artist's contemporaries called *terribilità*—a concept akin to the sublime. His pose, both watchful and meditative, suggests a man capable of wise leadership as well as towering wrath. The "Slaves" are more difficult to interpret. They seem to have belonged to a series representing the arts, now shackled by the

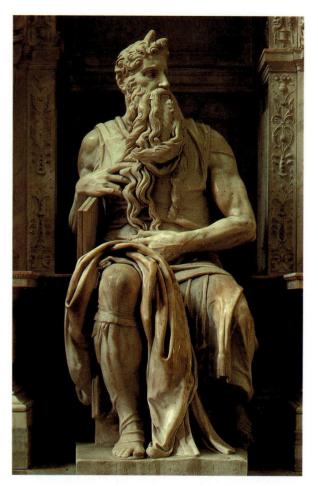

608. Michelangelo. *Moses.* c. 1513–15. Marble, height $7'8^{1}/2''$ (2.35 m). S. Pietro in Vincoli, Rome

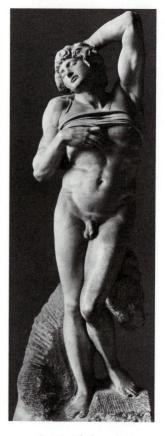

609. Michelangelo. "The Dying Slave." 1513–16. Marble, height 7'6" (2.28 m). Musée du Louvre, Paris

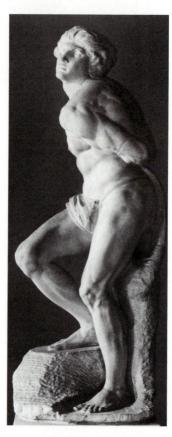

610. Michelangelo. "The Rebellious Slave." 1513–16. Marble, height 7' (2.13 m). Musée du Louvre, Paris

death of their greatest patron. Later, apparently, they came to signify the territories conquered by Julius II. Be that as it may, Michelangelo has treated the two figures as a contrasting pair, the "Dying Slave" (fig. 609) yielding to his bonds, the "Rebellious Slave" (fig. 610) struggling to free himself. Perhaps their allegorical meaning mattered less to him than their expressive content, so evocative of the Neo-Platonic image of the body as the earthly prison of the soul. They represent humanity's spiritual condition, with all its inner conflicts. In them we may recognize the influence of *The Laocoön Group* (fig. 215), whose unearthing Michelangelo witnessed in 1506, although these figures were first conceived the previous year.

THE SISTINE CEILING. Julius II interrupted Michelangelo's labors on the tomb project at an early stage. He decided to enlarge St. Peter's, initially, it seems, to house his tomb, an idea that was soon abandoned. When the undertaking was turned over to Bramante (see page 458), Michelangelo left Rome in anger. Two years later, the pope half-forced, half-cajoled the reluctant artist to return to paint frescoes on the ceiling of the Sistine Chapel in the Vatican (fig. 611). Driven by his desire to resume work on the tomb, Michelangelo completed the entire ceiling in four years, between 1508 and 1512.

[See Primary Sources, no. 56, pages 632–33.] He produced a work of truly epochal importance. The ceiling is a huge organism with hundreds of figures rhythmically distributed within the painted architectural framework, dwarfing the earlier murals (fig. 586) by its size, and still more by its compelling inner unity. In the central area, subdivided by five pairs of girders, are nine scenes based on the Old Testament Book of Genesis, from the Creation of the World (at the far end of the chapel) to the Drunkenness of Noah.

The theological scheme of these scenes and the rich program accompanying them—the nude youths, the medallions, the prophets and sibyls, the scenes in the spandrels—have not been fully explained, but we know that they link early history and the coming of Jesus. What greater theme could Michelangelo wish than the creation, destruction, and salvation of humanity? We do not know how much responsibility he had for the program. The artist was not someone to submit to dictation, and the subject matter of the ceiling fits his cast of mind so perfectly that his own desires cannot, in any event, have conflicted strongly with those of his patron.

A detailed survey of the ceiling would fill a book, and we shall have to be content with two of the four major scenes in the center portion. Of these, the *Creation of Adam* (fig. 612)

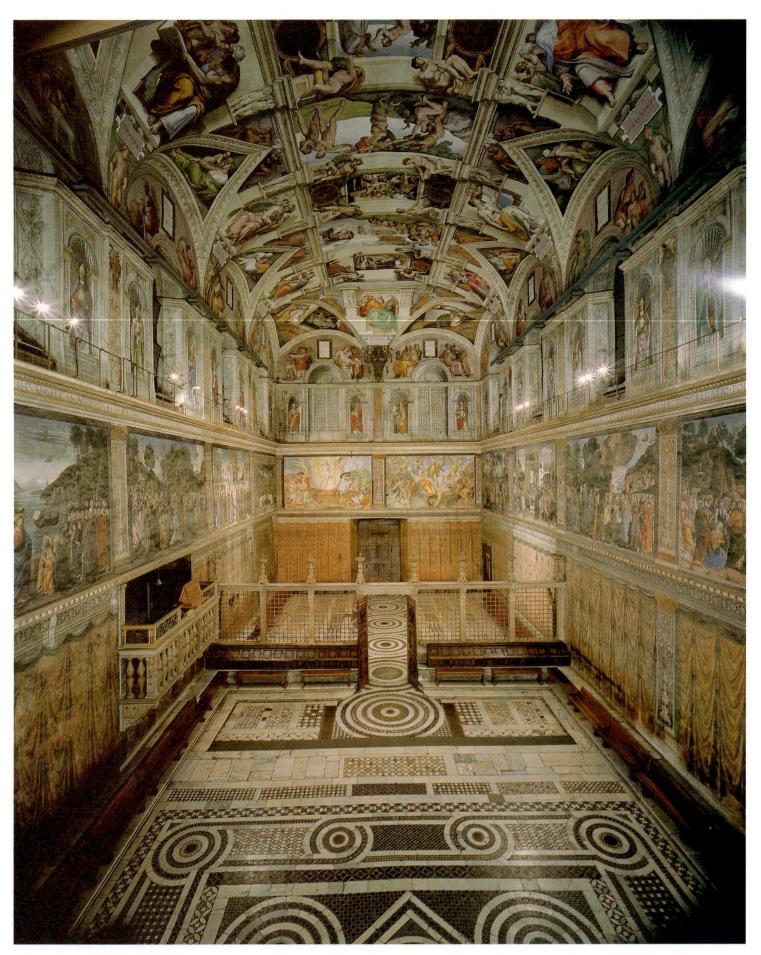

611. Interior of the Sistine Chapel showing Michelangelo's ceiling fresco. The Vatican, Rome

must have stirred Michelangelo's imagination most deeply. It shows not the physical molding of Adam's body but the passage of the divine spark—the soul—and thus achieves a dramatic juxtaposition unrivaled by any other artist. Della Quercia had approximated it in his relief panel (see fig. 540), which Michelangelo is known to have admired. But Michelangelo's design has a dynamism that contrasts the earth-bound Adam, who has been likened to an awakening river-god (compare fig. 6), and the figure of God rushing through the sky. This relationship assumes even more meaning when we realize that Adam strains not only toward his Creator but toward Eve, whom he sees, yet unborn, in the shelter of the Lord's left arm.

Michelangelo has been regarded as a poor colorist—unjustly, as the recent cleaning of the frescoes has revealed. *The Fall of Man* and *The Expulsion from the Garden of Eden* (fig. 613) show the bold, intense hues typical of the whole ceiling. The range of his palette is astonishing. Contrary to what had been thought, the heroic figures have anything but the quality of painted sculpture. Full of life, they act out their epic roles in illusionistic "windows" that puncture the architectural setting. Michelangelo does not simply color the areas within the

contours but builds up his forms from broad and vigorous brushstrokes in the tradition of Giotto and Masaccio. In fact, *The Expulsion* is particularly close to Masaccio's (see fig. 556) in its intense drama. *The Fall,* by contrast, has the astonishing elegance of the *Libyan Sibyl* (fig. 9), the last of her breed to be executed on the ceiling. This surely is not merely an expression of beauty but of a spiritual state as well.

Figure 613 also permits us to glimpse the garland-bearing nude youths that accompany the main sections of the ceiling. These wonderfully animated figures, recurring at regular intervals, play an important role in Michelangelo's design: they form a kind of chain linking the Genesis scenes. Yet their significance remains uncertain. Do they represent the world of pagan antiquity? Are they angels or images of human souls? They seem ideal beings, but ones who have not yet attained a state of grace and thus yearn for salvation. Whatever the answer, they clearly belong to the same category as the "Slaves" from the Tomb of Julius II, to which they are closely related visually and conceptually. Again the symbolic intent is overpowered by the wealth of expression Michelangelo has poured into these figures.

Although the term applies specifically to art, the High Renaissance was intimately connected to liter-

ature, theater, and music. Indeed, these arts created the cultural climate that made the High Renaissance possible in the first place. The early sixteenth century ushered in the first great age of Italian literature since the time of Dante and Petrarch some 200 years earlier. It centered on the poet Ludovico Ariosto (1474–1533), whose masterpiece, Orlando Furioso (1532), used the story of the crusade knight Roland to glorify his patron, the d'Este family of Ferrara. As early as 1508, Ariosto had written the first comedy along classical lines in Italian: The Chest, which initiated the genre known as commedia erudita (learned or serious comedy). Even Niccolò Machiavelli (1469-1527), who is best known for his manual of power and courtly life, The Prince (published posthumously in 1532), wrote a comedy, The Mandrake. The first vernacular tragedy, Sofonisba (1515) by Giangiorgio Trissino (1478–1550), was written in the Greek style to combat the influence of Seneca, thus setting off a debate that was effectively won by partisans of Latin drama in 1541, when Orbecche by Giambattista Cinthio (1504-1573) became the first Italian tragedy actually to be produced.

The High Renaissance counterpart to Ariosto in music was the Fleming Josquin Des Prés (c. 1440–1521), who became the most celebrated composer of his time. Artistically he belonged to the same generation as Leonardo da Vinci, though he was even older. Despite his notorious artistic temperament, he was employed at one time or another by all the leading courts in Italy and France, and enjoyed the patronage of no fewer than three popes. (He was present at the Vatican when Perugino and Botticelli were decorating the walls of the Sistine Chapel.) Josquin was regarded with much the same awe as Michelangelo came to be by his peers. The first true musical genius we know of, Josquin was a vir-

Theater and Music During the High Renaissance

tuoso equally at ease in secular and religious music. His work represented the perfect marriage

of Flemish composition and Italian humanism, which, inspired by Greek accounts, sought unity between text and music. He thus found his ideal outlet in song (*chanson*) and the motet, which made an entire realm of human action and feeling available to him that lay outside the scope of the traditional Mass. He cultivated a smooth, homogenous style that has aptly been compared to the art of Raphael as the embodiment of the classical ideal in its calm, balanced perfection. He was also important for beginning to lead music away from the system of modes used throughout the Middle Ages and Early Renaissance.

Josquin became famous throughout Europe, thanks not only to his travels but also to the invention of music publication using movable type by the Venetian Ottaviano Petrucci (1466–1539) in 1498, a development that proved as revolutionary as printing had been for books and printmaking. Petrucci enjoyed such success that during the 1520s and 1530s France, Germany, and the Netherlands emerged as rival centers of music publishing. The diffusion of music and ideas in print helped to elevate composers in humanist circles. Like artists, they now became "learned" and joined in debates over matters of theory with other intellectuals. Their status was further enhanced by the appearance of the first primers, which taught amateurs how to play instruments and set off a new wave of enthusiasm for music.

It is a sign of the growing importance of music that courts competed eagerly for the leading composers and musicians, who commanded high salaries. Moreover, the ideal prince or courtier was expected to cultivate some musical ability in addition to his other talents. That consummate courtier Leonardo da Vinci was himself an accomplished musician, as were Giorgione and Titian.

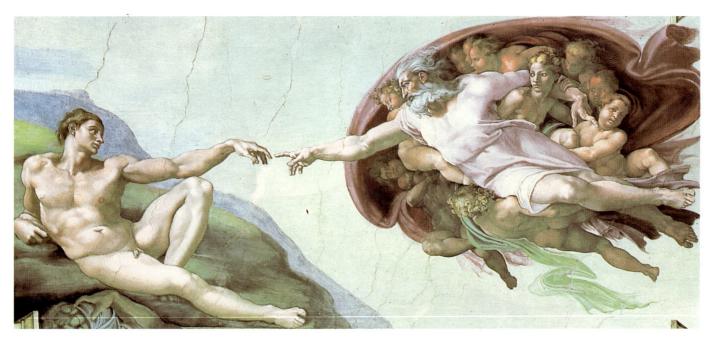

612. Michelangelo. The Creation of Adam, portion of the Sistine Ceiling. 1508–12. Fresco

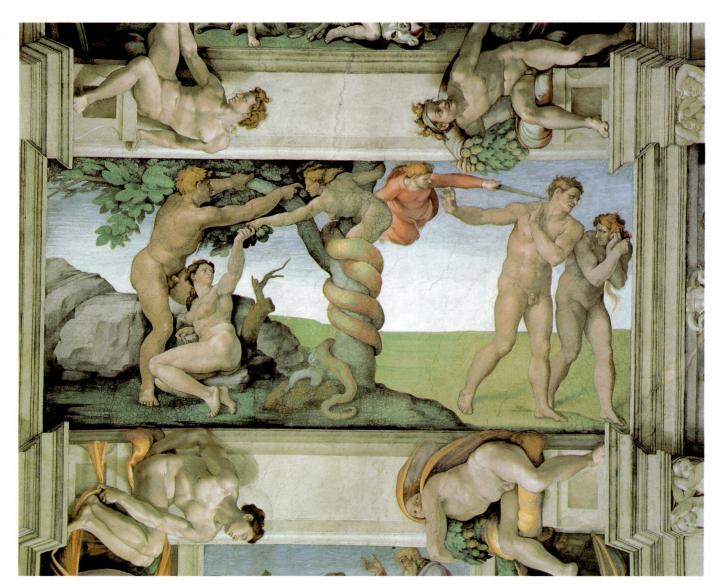

613. Michelangelo. The Fall of Man and The Expulsion from the Garden of Eden, portion of the Sistine Ceiling. 1508–12. Fresco

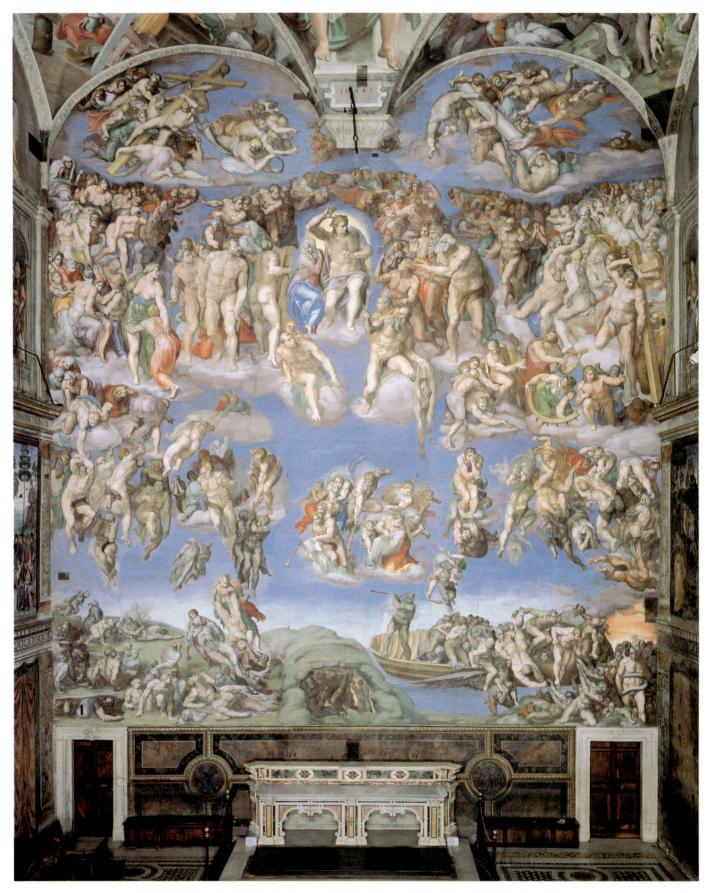

614. Michelangelo. The Last Judgment. 1534-41. Fresco. Sistine Chapel, The Vatican, Rome

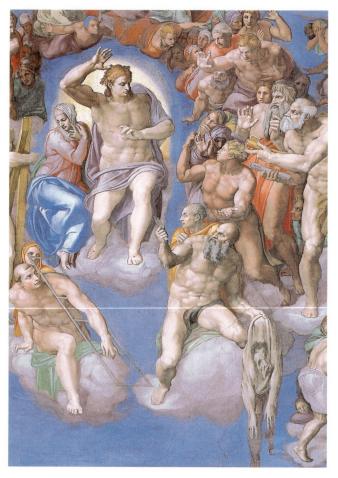

615. Michelangelo. The Last Judgment (detail, with self-portrait)

THE LAST JUDGMENT. When Michelangelo returned to the Sistine Chapel in 1534, more than 20 years after completing the ceiling fresco, the Western world was enduring the spiritual and political crisis of the Reformation (see page 539). Michelangelo's religious beliefs had changed as well. We see the new mood with shocking directness as we turn from the radiant vitality of Michelangelo's ceiling fresco to the somber vision of his *Last Judgment* (fig. 614; reproduced here freshly cleaned), which illustrates Matthew 24:29–31.

How unlike the well-ordered, majestic treatment of Giotto (compare fig. 505), whose conception of Hell in the lower right-hand corner is still closely related to that on the west tympanum at Autun (see fig. 404). Michelangelo must have looked partly to Luca Signorelli's frescoes for Orvieto Cathedral (fig. 587). In the Sistine Chapel, however, the agony has become essentially spiritual, as expressed through violent physical contortions within the turbulent atmosphere. The Blessed and Damned alike huddle together in tight clumps, pleading for mercy before a wrathful God. All traces of classicism have disappeared, save for the Apollolike figure of the Lord. Straddling a cloud just below him is the apostle Bartholomew (fig. 615), holding a human skin to represent his martyrdom (he had been flayed). The face on that skin, however, is not the saint's but Michelangelo's own. In this grimly sardonic self-portrait, so well hidden that it was recognized only in modern times, the artist has left his personal confession of guilt and unworthiness.

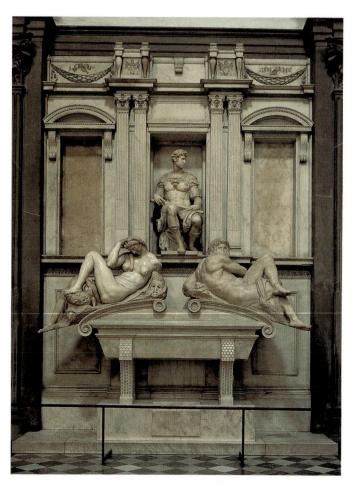

616. Michelangelo. Tomb of Giuliano de' Medici. 1524–34. Marble, height of central figure 71" (180.5 cm). New Sacristy, S. Lorenzo, Florence

THE MEDICI CHAPEL. The interval between the Sistine Ceiling and The Last Judgment coincides with the papacies of Leo X (1513-21) and Clement VII (1523-34). Both were members of the Medici family and preferred to employ Michelangelo in Florence. His activities centered on the Medici church of S. Lorenzo. A century after Brunelleschi's revolutionary design for the sacristy (see pages 419-20), Leo X decided to build a matching structure, the New Sacristy, to house the tombs of Lorenzo the Magnificent, Lorenzo's brother Giuliano, and two younger members of the family, also named Lorenzo and Giuliano (see fig. 543). These tombs are nearly mirror-images of each other. Michelangelo took early charge of this project and worked on it for 14 years. He managed to complete the architecture and two of the tombs, those for the lesser Lorenzo and Giuliano (fig. 616). The New Sacristy was thus conceived as an architectural-sculptural ensemble. It is the only work of the artist where his statues remain in the setting planned specifically for them, although their exact placement is problematic.

Michelangelo's plans for the Medici tombs underwent many changes of program and form while the work was underway. Other figures and reliefs were planned, but never executed. The present state of the monuments can hardly be the final solution, but the dynamic process of design was halted when the artist left permanently for Rome in 1534.

The tomb of Giuliano remains a compelling visual unit,

although the niche is too narrow and too shallow to accommodate the seated figure comfortably. The great triangle of the statues is held in place by a network of verticals and horizontals whose slender, sharp-edged forms heighten the roundness and weight of the sculpture. The design still shows some kinship with such Early Renaissance tombs as that of Leonardo Bruni (see fig. 577), but the differences weigh more heavily. There is no inscription, and the effigy has been replaced by two allegorical figures—Day on the right and Night on the left in our illustration. What is the meaning of this triad? The question, put countless times, has never found a satisfactory answer. Some lines penned on one of Michelangelo's drawings suggest a possible answer: "Day and Night speak, and say: We with our swift course have brought the Duke Giuliano to death . . . It is only just that the Duke takes revenge [for] he has taken the light from us; and with his closed eyes has locked ours shut, which no longer shine on earth."

Giuliano, the ideal image of the prince, is a younger and more pensive counterpart of the *Moses*. The statue, in classical military garb, bears no resemblance to the deceased Medici. ("A thousand years from now, nobody will know what he looked like," Michelangelo is said to have remarked.) Originally the base of each tomb was to have included a pair of rivergods. The reclining figures, themselves derived from ancient river-gods (compare fig. 6), contrast in mood like the "*Slaves*." They embody the quality of action-in-repose more dramatically than any other works by Michelangelo. In the brooding menace of *Day*, whose face was left deliberately unfinished, and in the disturbed slumber of *Night*, the dualism of body and soul is expressed with unforgettable grandeur.

LAURENTIAN LIBRARY. The Tomb of Giuliano de' Medici is squeezed uncomfortably within an architectural framework that takes considerable liberties with the syntax of classicism. The New Sacristy inspired Vasari to write that "all artists are under a great and permanent obligation to Michelangelo, seeing that he broke the bonds and chains that had previously confined them to the creation of traditional forms." However, his full powers as a creator of new architectural forms are fully displayed for the first time only in the vestibule (fig. 617) to the Laurentian Library, adjoining S. Lorenzo. This library was built concurrently with the New Sacristy to house, for the public, the huge collection of books and manuscripts belonging to the Medici family.

By the standards of the 1520s, based on the classical ideal of Bramante, everything in the vestibule is wrong. The pediment above the door is broken, the pilasters of the niches taper downward, the columns belong to no recognizable order, and the scroll brackets sustain nothing. Most paradoxical of all from the point of view of established practice are the recessed columns. Though structurally logical—the columns support heavy piers, which in turn support the roof beams (fig. 618)—this feature upsets a hallowed rule of architectural propriety. In the classical post-and-lintel system the columns (or pilasters) and entablature must project from the wall on which they have been superimposed, to stress their separate identities. The system could be reduced to a linear pattern (as in the Palazzo Rucellai; fig. 566), but no one before Michelangelo had dared to defy it by incorporating columns into the wall.

617. Michelangelo. Vestibule of the Laurentian Library, Florence. Begun 1524; stairway designed 1558–59

618. Axonometric diagram of structural system, Vestibule of the Laurentian Library (after Ackerman)

The purpose of these innovations is, of course, expressive rather than functional. The walls push inward between the columns to make of the vestibule a kind of "compression chamber" where the beholder experiences an almost physical stress. Our unease is heightened by the blank stare of the empty niches and by the nightmarish stairway, whose solution came, appropriately enough, to Michelangelo in a dream many years later. The steps, constructed from his design by Bartolommeo Ammannati (see page 499), flow downward and outward so relentlessly that we wonder if we dare brave the current by mounting them.

619. Michelangelo. The Campidoglio (engraving by Étienne Dupérac, 1569)

620. Plan of the Campidoglio, Rome

CAMPIDOGLIO. During the last 30 years of Michelangelo's life, architecture became his main preoccupation. In 1537–39, he received the most ambitious commission of his career: to reshape the Campidoglio, the top of Rome's Capitoline Hill, into a square with a monumental frame worthy of this venerable site, which once had been the symbolic center of ancient Rome. At last he could plan on a grand scale, and he took full advantage of the opportunity. Although not completed until long after his death, the project was carried out essentially as he had designed it. The Campidoglio remains the most imposing civic center ever built, and a model for countless 'others. Pope Paul III took the initiative by transferring the equestrian monument of Marcus Aurelius (see fig. 279) to the Campidoglio, and Michelangelo designed its base. The statue became the focal point of his entire scheme, placed at the apex of a gently rising oval mound that serves to integrate the space.

Three sides of the piazza are defined by palace facades, so that visitors, after ascending the flight of steps on the fourth side, find themselves enclosed in a huge "outdoor room." The effect of the ensemble cannot be rendered by photographs. Even the best view, an engraving based on Michelangelo's design (fig. 619), conveys it very imperfectly. The print shows the complete bilateral symmetry of the scheme and the energetic sense of progression along the main axis toward the Senators' Palace. However, it distorts the shape of the piazza, which is not a rectangle but a trapezoid (see fig. 620). This peculiarity was imposed on Michelangelo by the existing site. The Senators' Palace and the Conservators' Palace on the right were actually older buildings that had to be preserved behind newly designed exteriors, and they were placed at an angle of 80 instead of 90 degrees. But Michelangelo turned into an asset what would have hindered a less imaginative architect:

621. Michelangelo. Palazzo dei Conservatori, Campidoglio, Rome. Designed c. 1545

the divergence of the flanks makes the Senators' Palace look larger than it is, so that it dramatically dominates the piazza.

The whole conception has the visual effectiveness of a stage set: in the engraving the "New Palace" on the left is only a show front with nothing behind it. Yet this facade and its twin on the opposite side are not shallow screens, but vigorously three-dimensional structures (fig. 621) with the most muscular juxtaposition of voids and solids, of horizontals and verticals, to be found in any piece of architecture since Roman antiquity (compare fig. 257). They share the striking feature of an open portico which links the piazza and facades, just as a courtyard is related to the arcades of a cloister.

The columns and stone beams of the porticoes are inscribed within a colossal order of pilasters that supports a heavy cornice topped by a balustrade. We have encountered these elements on the facades of the Pazzi Chapel by Brunelleschi and Alberti's S. Andrea, and in the Tempietto of Bramante (see figs. 544, 569, and 601), but it was Michelangelo who welded them into a coherent system. For the Senators' Palace he employed the colossal order and balustrade above a tall basement, which emphasizes the massive quality of the building. The single entrance at the top of the huge doubleramped stairway seems to gather all the spatial forces set in motion by the oval mound and the divergent flanks, and thus provides a dramatic climax for the visitor traversing the piazza.

ST. PETER'S. With the Campidoglio, the colossal order became firmly established in the repertory of monumental architecture. Michelangelo himself used it again with even more impressive results on the exterior of St. Peter's (fig. 622). He took over the design of the church in 1546 upon the death of the previous architect, Antonio da Sangallo the Younger (the nephew of his close friend Giuliano da Sangallo but a rival nonetheless), whose work he completely recast. The system of the Conservators' Palace, with windows now replacing the open loggias and an attic instead of the balustrade, could be adapted perfectly here to the jagged contour of the plan. Unlike Bramante's manylayered elevation (see fig. 604), the colossal order emphasized the compact body of the structure, thus setting off the dome more dramatically. The same desire for compactness and organic unity led Michelangelo to simplify the interior, without changing its centralized character (figs. 623 and 624). He brought the complex spatial sequences of Bramante's plan (see fig. 602) into one cross-and-square, and defined its main axis by modifying the exterior of the eastern apse and projecting a portico for it. This part of his design was never carried out. The dome, however, reflects his ideas in every important respect, although it was largely built after his death and has a steeper pitch. (Compare the engraving after his original design, fig. 624.)

Bramante had planned his dome as a stepped hemisphere above a narrow drum, which would have seemed to press down on the church below. Michelangelo's plan conveys the opposite sensation, a powerful thrust that draws energy upward from the main body of the structure. The high drum, the strongly projecting buttresses accented by double columns, the ribs, the raised curve of the cupola, the tall lantern, all contribute to the insistent verticality. Michelangelo borrowed not only the double-shell construction but the Gothic profile from the Florence Cathedral dome (see fig. 459), yet the effects are

622. Michelangelo. St. Peter's, Rome, seen from the west. 1546–64 (dome completed by Giacomo della Porta, 1590)

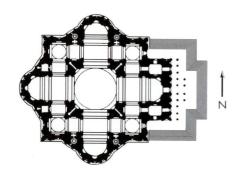

623. Michelangelo. Plan for St. Peter's

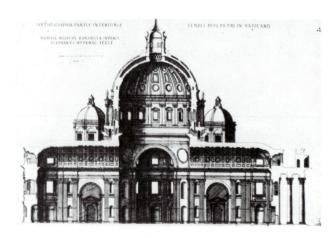

624. Longitudinal section of St. Peter's (engraving by Étienne Dupérac, 1569)

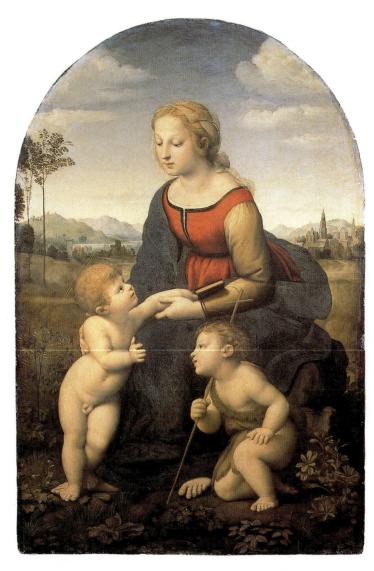

625. Raphael. *La Belle Jardinière*. 1507. Oil on panel, 48 x 31¹/2" (122 x 80 cm).

Musée du Louvre, Paris

very different. The smooth planes of Brunelleschi's dome give no hint of the internal stresses. Michelangelo, in contrast, finds a sculptured shape for these contending forces and relates it to the rest of the building. The impulse of the paired colossal pilasters below is taken up by the double columns of the drum, continues in the ribs, and culminates in the lantern. The logic of this design is so persuasive that few domes built between 1600 and 1900 fail to acknowledge it in some way.

Michelangelo's magnificent assurance in handling such projects as the Campidoglio and St. Peter's seems to belie his portrayal of himself as a limp skin in *The Last Judgment*. It is indeed difficult to reconcile these contrasting aspects of his personality. Perhaps toward the end of his life he found greater fulfillment in architecture than in shaping human bodies, for we have no finished sculpture from his hand after 1545, when he at last completed the Tomb of Julius II. He devoted much of his final two decades to poetry and drawings of a religious and Neo-Platonic sort that are intensely personal in their content. [See Primary Sources. no. 55, page 632.] The statues undertaken for his own purposes, including a *Pietà* intended for his own tomb that was partly destroyed by his hand, show him groping for new forms, as if his earlier work had become meaningless to him.

Raphael

If Michelangelo exemplifies the solitary genius, Raphael (Raffaello Sanzio, 1483–1520) belongs just as surely to the

opposite type: the artist as a person of the world. In consequence, they were natural antagonists. The contrast between the two was as clear to their contemporaries as it is to us. Although each had his defenders, they enjoyed equal fame. Twentieth-century sympathies have been less evenly divided, thanks to Vasari, Michelangelo's chief partisan, as well as to the authors of historical novels and fictionalized biographies. Michelangelo still fascinates people today, while Raphael is usually discussed only by historians of art, although his life was also the subject of a fanciful account. The younger artist's career seems too much a success story, his work too marked by effortless grace, to match the tragic heroism of Michelangelo. Raphael also appears to have been less of an innovator than Leonardo, Bramante, and Michelangelo, whose achievements were basic to his. Nevertheless, he is the central painter of the High Renaissance. Our conception of the entire style rests more on his work than on any other artist's.

The genius of Raphael was a unique power of synthesis that enabled him to merge the qualities of Leonardo and Michelangelo, creating an art at once lyric and dramatic, pictorially rich and sculpturally solid. This power is already present in the Madonnas he painted in Florence (1504–8), after he completed his apprenticeship with Perugino. The meditative calm of *La Belle Jardinière* (fig. 625) still reflects the style of his teacher (compare fig. 586), but the forms are ampler and enveloped in Leonardesque sfumato. The Virgin, grave and tender, makes us think of the *Mona Lisa* without engendering

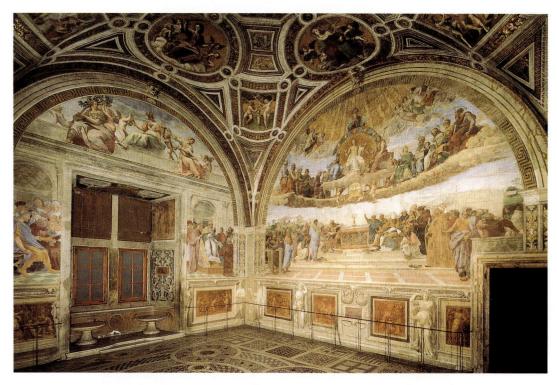

626. Stanza della Segnatura, with frescoes by Raphael. Vatican Palace, Rome

any of her mystery. What is arcane in Leonardo becomes credibly human in Raphael, yet informed by a sensibility no less exquisite. At the same time, the insistent idealization of form already shows the grace and perfection that are the hallmarks of Raphael's style. The enigmatic gestures in *The Virgin of the Rocks* (fig. 595) are replaced by a gentle, rhythmic interplay, and the intricate grouping by a stable pyramid whose severity is relieved by Mary's billowing cape. Most striking is the beautiful landscape which, unlike any by Leonardo, is carefully observed. The human forms, too, have a firmness that further attests to his dedication to nature.

THE SCHOOL OF ATHENS. One of the reasons *La Belle Jardinière* looks different from *The Virgin of the Rocks*, to which it is otherwise so clearly indebted, is Michelangelo's influence. Its full force can be felt only in Raphael's Roman works, however. In 1508, at the time Michelangelo began to paint the Sistine ceiling, Julius II summoned the younger artist from Florence. At first Raphael mined ideas he had developed somewhat earlier, but the experience of Rome transformed him as an artist, and he underwent an astonishing growth. This metamorphosis is seen in the Stanza della Segnatura (Room of the Seal), the first in a series of private rooms he was called on to decorate at the Vatican Palace. The stanza housed the pope's library, but it was also where the tribunal of the seal (*segnatura*), presided over by the pope, dispensed canon and civil law.

Raphael's cycle of frescoes on its walls and ceiling refers to the four domains of learning: theology, philosophy, law, and the arts. The program, derived from St. Bonaventure, had no doubt already been provided by a Franciscan at the papal court, but the realization is Raphael's alone. To the right in our view (fig. 626) is the *Disputa*, or *Disputation over the Sacrament*, in which Jesus sits enthroned between the Virgin and St. John the Baptist, with God the Father behind him, saints and prophets to either side, and the Holy Spirit hovering over the Eucharist below. In the lunette over the door to the left are represented *The Three Legal Virtues*; beneath are *The Granting of Civil Law* (left) and *The Granting of Canon Law* (right). The opposite doorway depicts *Parnassus*, the sacred mountain of Apollo and the Muses.

Of these frescoes, *The School of Athens* (fig. 627), facing the *Disputa*, has long been acknowledged as Raphael's masterpiece and the perfect embodiment of the classical spirit of the High Renaissance. Its subject is "the Athenian school of thought," a group of famous Greek philosophers gathered around Plato and Aristotle, each in a characteristic pose or activity. Raphael must have already seen the Sistine ceiling, then nearing completion. He evidently owes to Michelangelo the expressive energy, the physical power, and the dramatic grouping of his figures. Yet Raphael has not simply borrowed Michelangelo's repertory of gestures and poses. He has absorbed it into his own style, and thereby given it different meaning.

Body and spirit, action and emotion, are now balanced harmoniously, and all members of this great assembly play their roles with magnificent, purposeful clarity. The total conception of *The School of Athens* suggests the spirit of Leonardo's *The Last Supper* (fig. 596) rather than the Sistine ceiling. This holds true of the way Raphael makes each philosopher reveal "the intention of his soul," distinguishes the relations among

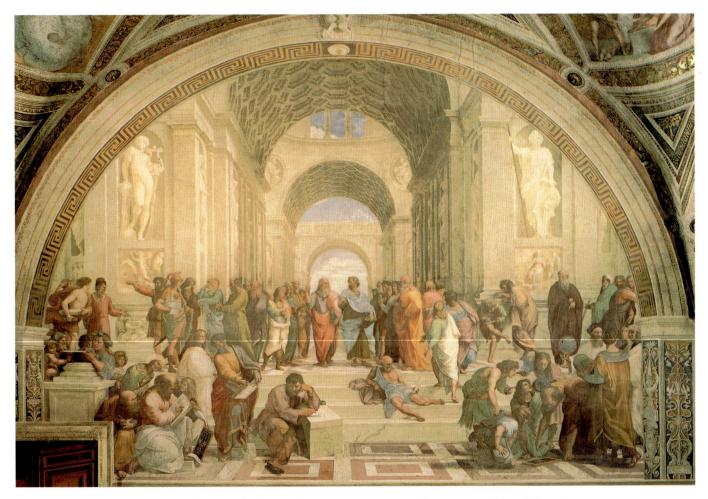

627. Raphael. The School of Athens. 1510-11. Fresco. Stanza della Segnatura, Vatican Palace, Rome

individuals and groups, and links them in formal rhythm. The artist carefully worked out the poses in a series of drawings, many of them from life. Also Leonardesque is the centralized, symmetrical design, as well as the interdependence of the figures and their architectural setting. But Raphael's edifice shares far more of the compositional burden than the hall of The Last Supper. With its lofty dome, barrel vault, and colossal statuary, it is classical in spirit without being at all Greek in appearance. Inspired by Bramante, it seems like an advance view of the new St. Peter's. (Bramante was born in Urbino, the same birthplace as Raphael, and even posed for the figure of Pythagoras, seen holding a book in the foreground to the lower left. Michelangelo was added at the last minute, just to the right, as Heraclitus writing on the steps.) The geometric precision and spatial grandeur of this setting bring to a climax the tradition begun by Masaccio (see fig. 551) and transmitted to Raphael by his teacher Perugino, who had inherited it from Piero della Francesca. What is new is the active role played by the architecture in creating narrative space. This innovation was of such fundamental importance that it had a profound impact on the course of painting far beyond the sixteenth century.

GALATEA. Raphael rarely set so splendid an architectural stage again. To create pictorial space, he relied increasingly on the movement of human figures, rather than perspective vistas.

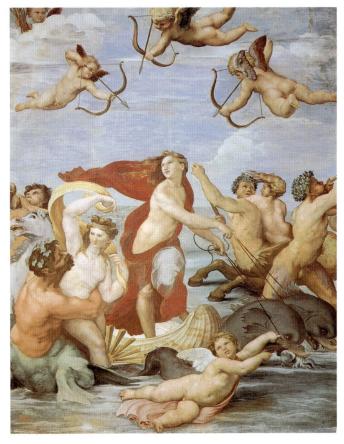

628. Raphael. *Galatea*. 1513. Fresco, 9'8¹/8" x 7'4" (3 x 2.2 m). Villa Farnesina, Rome

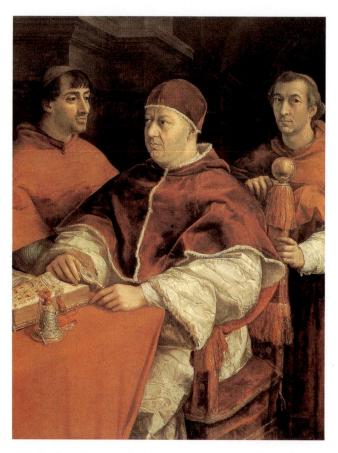

629. Raphael. *Pope Leo X with Giulio de' Medici and Luigi de' Rossi.* c. 1518. Oil on panel, 60⁵/8 x 46⁷/8" (154 x 119 cm). Galleria degli Uffizi, Florence

In the Galatea of 1513 (fig. 628), the subject is again classical: the beautiful nymph Galatea, vainly pursued by the giant Polyphemus, belongs to Greek mythology. Like the verse by Angelo Poliziano that inspired it, the painting celebrates the light-hearted, sensuous aspect of antiquity, in contrast to the austere idealism of *The School of Athens*. [See Primary Sources, no. 58, page 633.] If the latter presents an ideal concept of the antique past, Galatea captures its pagan spirit as if it were still a living force. The composition recalls Botticelli's *The Birth of* Venus (fig. 583), a picture Raphael knew from his Florentine days, which shares a debt to Poliziano (see page 443). Yet their very resemblance emphasizes their profound dissimilarity. Raphael's full-bodied, dynamic figures take on their expansive spiral movement from the vigorous *contrapposto* of Galatea. In Botticelli's picture, the movement is not generated by the figures but imposed on them from without by the decorative, linear design, so that it never detaches itself from the surface of the canvas.

PORTRAITS. Given his adherence to nature, it is not surprising that Raphael had a special talent for portraiture. It is another tribute to his genius for synthesis that he combined the realism of fifteenth-century portraits (such as fig. 585)

with the human ideal of the High Renaissance, which in the Mona Lisa nearly overpowers the sitter's individuality. Raphael did not flatter or conventionalize his subjects. Surely Pope Leo X (fig. 629) looks here no handsomer than he did in reality. The sullen, heavy-jowled features of this most hedonistic pope have been recorded in concrete detail. Nevertheless, the pontiff has a commanding presence, his aura of power and dignity emanating more from his inner being than from his exalted office. Raphael, we feel, has not falsified the sitter's personality but ennobled and focused it, as if he had been fortunate enough to observe Leo X in his finest hour. The two cardinals, who lack this balanced strength although they are studied with equal care, enhance by contrast the sovereign quality of the main figure. Even the pictorial treatment shows a similar gradation: Leo X has been set off from his companions, his reality heightened by intensified light, color, and texture.

LATER WORKS. When Michelangelo was dispatched to Florence by Leo X in 1516 to work on the Medici Chapel (see page 467), Raphael assumed undisputed leadership of art in Rome. He had already been named Bramante's successor at St. Peter's—Michelangelo was not put in charge of it until 30 years later—and appointed superintendent of antiquities in

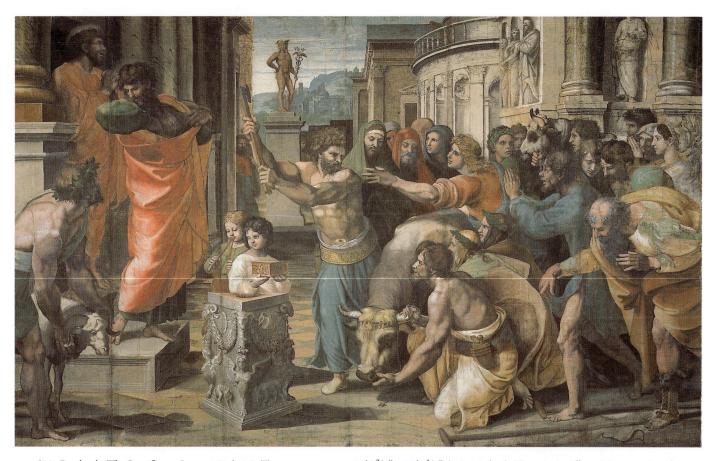

630. Raphael. The Sacrifice at Lystra. 1514–15. Tempera on paper, 11'53/4" x 17'81/2" (3.5 x 5.4 m). Victoria & Albert Museum, London

Rome. Now he was flooded with commissions, and of necessity came to rely increasingly on his growing workshop. As a consequence, few of Raphael's later works, other than portraits such as that of Leo X, are entirely by his own hand. Thus, his achievement is partially obscured by the increasing participation of assistants, who adulterated his intent, as well as by the intervention of later restorers. The final phase of his brief career is nevertheless extraordinarily rich and complex.

Raphael elevated narrative painting to a new plane by greatly expanding its pictorial and expressive range. This unprecedented variety is marked by a creative tension between grandiose rhetoric and high theater that pushes classicism to its limits, and sometimes beyond. At times these forces coexist in an uneasy truce, but in *The Sacrifice at Lystra* (fig. 630), one of a series of tapestry cartoons for the Sistine Chapel that placed him in direct competition with Michelangelo, they are held in a state of dynamic equilibrium that is masterful. The scene, taken from Acts 14, shows Paul admonishing a crowd not to sacrifice animals in his honor after he had healed a cripple (to the far right in our illustration) and been mistaken for Mercury—hence, the statue of the god at upper center in the background. The architectural setting, reconstructed from the Antique with the passion of an archaeologist, is disposed

linearly across the picture plane, partly in imitation of Roman reliefs (compare fig. 273). In addition to framing the action, it plays an important expressive role by echoing the agitation of the surging crowd and the dignified strength of the saint and his companion, Barnabas.

Raphael has left a telling gap that serves not only to highlight the figure of Mercury but also to heighten the contrast between the two groups. The drama partakes of Leonardo's and Michelangelo's, but is of a different order, thanks to Raphael's unique power of concentration. In this work the artist has exhausted the possibilities that classicism had to offer him. What steps he might have taken next we shall never know, as his life was cut short at the critical juncture of the High Renaissance. Yet it is significant that some of the leading Mannerists of the next generation emerged from his atelier.

Giorgione

The distinction between Early and High Renaissance art, so marked in Florence and Rome, is far less sharp in Venice. Giorgione (Giorgione da Castelfranco, 1478–1510), the first Venetian painter to belong to the new era, left the orbit of Giovanni Bellini only during the final years of his short career.

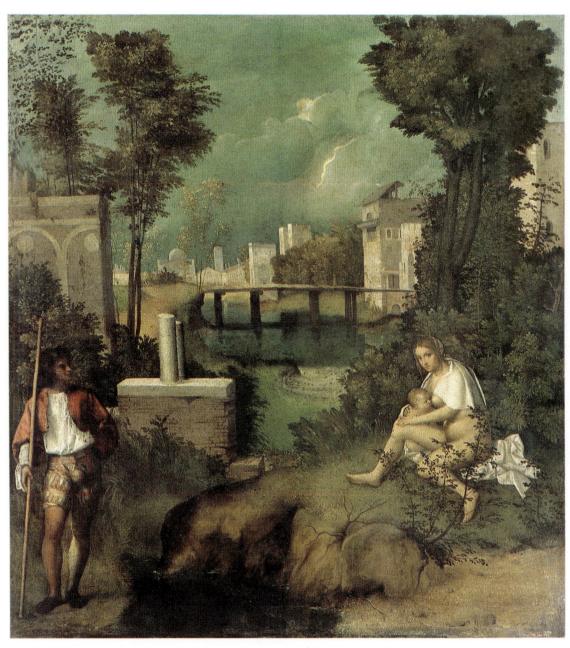

631. Giorgione. *The Tempest.* c. 1505. Oil on canvas, $31^{1/4}$ x $28^{3/4}$ " (79.5 x 73 cm). Galleria dell'Accademia, Venice

THE TEMPEST. Among his few mature works, *The Tempest* (fig. 631) is both the most singular and the most enigmatic. There have been many attempts to explain this peculiar image. Perhaps the most persuasive one is that the painting represents Adam and Eve after the Fall. Their fate as decreed by God, whose awesome voice is represented by the lightning bolt, is that man shall till the ground from which he was taken, and that woman shall bring forth children in sorrow. Adam, dressed in contemporary Venetian costume, is seen resting from his labors, while Eve, whose draped nudity signifies shame and carnal knowledge, suckles Cain, her first-born son. In the distance is a bridge over the river surrounding the city of the earthly paradise, from which they have been expelled. Barely visible near the rock at river's edge is a snake, signifying the Temptation. The broken columns complete the tragic vision: they stand for death, the ultimate punishment of Original Sin.

The Tempest was probably commissioned by the wealthy merchant Gabriele Vendramin, one of Venice's greatest patrons of the arts, who owned the picture when it was first recorded in 1530. It certainly reflects the predilection for learned humanist allegories in Venetian painting, whose subjects are often obscured, as here, by static poses and alien settings. The iconography does not tell us the whole story of *The Tempest,* however. It is the landscape, rather than Giorgione's figures, that interprets the scene for us. Belonging themselves to nature, Adam and Eve are passive victims of the thunderstorm seemingly about to engulf them. The contrast to Bellini's St. Francis in Ecstasy (fig. 592) is striking. Bellini's landscape is meant to be seen through the eyes of the saint, as a piece of God's creation. Despite its biblical subject, the mood in *The Tempest* is subtly, pervasively pagan. The scene is like an enchanted idyll, a dream of pastoral beauty soon to be swept

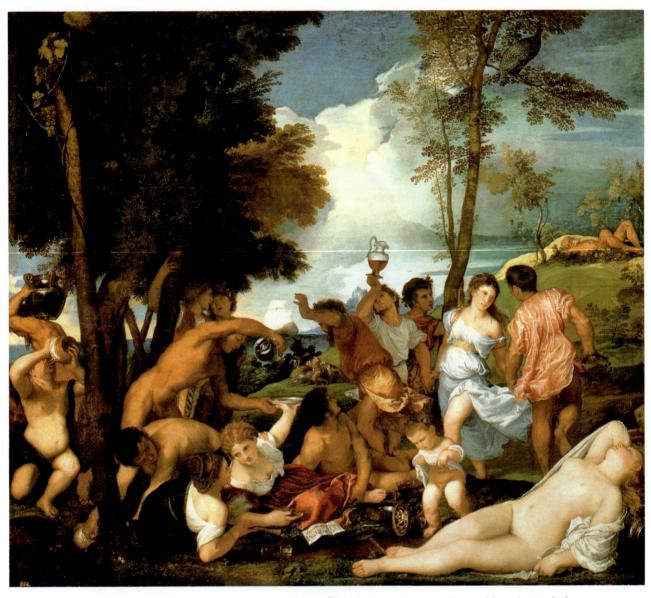

632. Titian. Bacchanal. c. 1518. Oil on canvas, 5'87/8" x 6'4" (1.7 x 1.9 m). Museo del Prado, Madrid

away. Only poets had hitherto captured this air of nostalgic reverie. Now, it entered the repertory of the painter. Indeed, the painting is very similar in its mood to the poem *Arcadia* by Jacopo Sannazaro, a pastoral poem about unrequited love that was popular in Giorgione's day. Thus, *The Tempest* initiates what was to become an important new tradition.

Titian

Giorgione died before he could explore in full the sensuous, lyrical world he had created in *The Tempest*. This task was taken up by Titian (Tiziano Vecellio, 1488/90–1576), an artist of comparable gifts who was decisively influenced by Giorgione and who dominated Venetian painting for the next half-century. [See Primary Sources, no. 57, page 633.]

BACCHANAL. Titian's Bacchanal of about 1518 (fig. 632) is frankly pagan, inspired by an ancient author's description of such a revel. The landscape, rich in contrasts of cool and warm tones, has all the poetry of Giorgione, but the figures are of another breed. Active and muscular, they move with a joyous freedom that recalls Raphael's Galatea (fig. 628). By this time, many of Raphael's compositions had been engraved (see fig. 5), and from these reproductions Titian became familiar with the Roman High Renaissance. A number of the celebrants in his Bacchanal also reflect the influence of classical art. Titian's approach to antiquity, however, is very different from Raphael's. He visualizes the realm of classical myths as part of the natural world, inhabited not by animated statues but by beings of flesh and blood. The figures of the Bacchanal are idealized just enough beyond everyday reality to persuade us that they belong to a long-lost golden age. They invite us to share

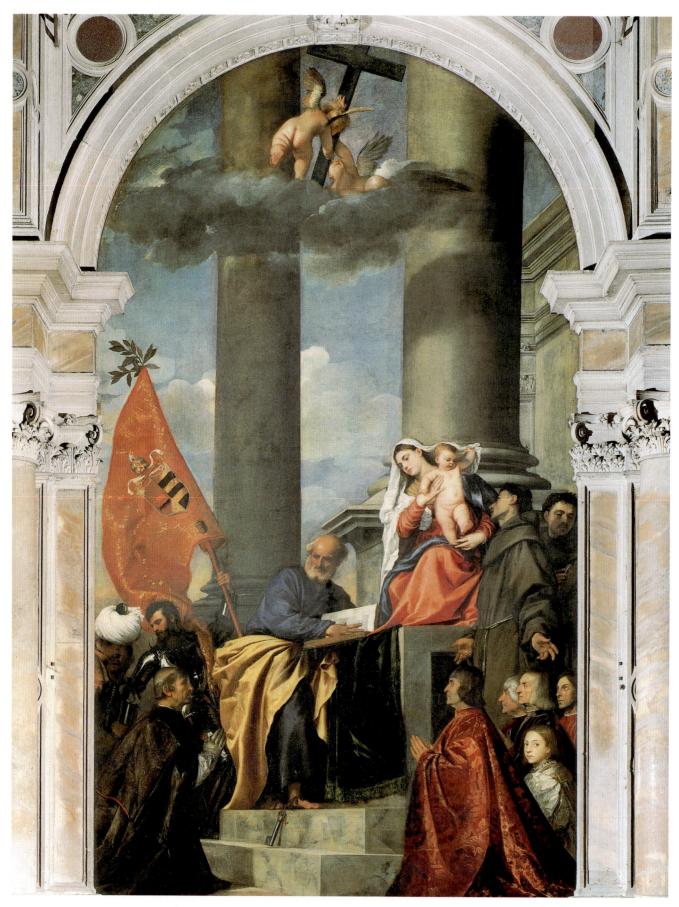

633. Titian. Madonna with Members of the Pesaro Family. 1526. Oil on canvas, $16' \times 8'10''$ (4.9 x 2.7 m). Sta. Maria del Gloriosa dei Frari, Venice

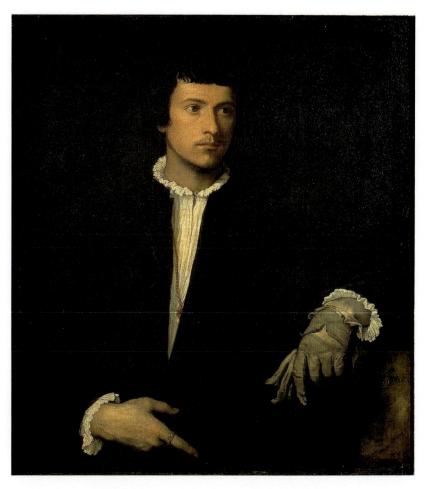

634. Titian. *Man with the Glove.* c. 1520. Oil on canvas, 39½ x 35" (100.3 x 89 cm). Musée du Louvre, Paris

their blissful state in a way that makes Raphael's *Galatea* seem cold and remote by comparison.

THE PESARO MADONNA. This quality of festive animation reappears in many of Titian's religious paintings, such as the *Madonna with Members of the Pesaro Family* (fig. 633). Although we recognize the subject as a variant of the sacra conversazione, Titian has thoroughly transformed it. For the first time, we feel that the participants are actually sharing in a dialogue. The Holy Family is no longer timeless and remote, as in Veneziano's prototype (compare fig. 560). The Infant Jesus is as natural as the child in the artist's *Bacchanal*, while the Virgin and St. Joseph now turn to the donor, Jacopo Pesaro, kneeling in devotion at the left. Joseph himself marks an innovation: instead of being the simple-minded old man of tradition, he is shown as a learned philosopher—an idea that had become current only a few years earlier.

Much of the picture's effectiveness is due to the composition, which replaces the familiar frontal view with an oblique one that is far more active. The Virgin is now enthroned in a great barrel-vaulted hall open on either side, a High Renaissance counterpart of the architectural setting in Bellini's *Madonna and Saints* in S. Zaccaria (fig. 593). The elevated columns, which are the key to the setting, represent the gateway to Heaven, identified with Mary herself; they are a sym-

bol of both eternal life and the Immaculate Conception (the belief that she was conceived without Original Sin). Because the view is diagonal, open sky and clouds now fill most of the background. Except for the kneeling donors, every figure is in motion—turning, leaning, gesturing—while the officer with the flag seems almost to lead a charge up the steps. (He is probably St. Maurice, namesake of the battle at Santa Mauro where the Venetian navy, which included the papal fleet commanded by Pesaro, prevailed against the Turks in 1502—note the turbaned figure beside him.) Yet the design remains harmoniously self-contained despite the strong element of drama. Brilliant sunlight makes every color and texture sparkle, in keeping with the joyous spirit of the altar. The only hint of tragedy is the cross of the Passion held by two angel-putti, hidden by clouds from the participants in the sacra conversazione but not from us, adding a note of poignancy to the scene.

PORTRAITS. After Raphael's death, Titian became the most sought-after portraitist of the age. His prodigious gifts, evident in the donors' portraits in the *Pesaro Madonna*, are even more striking in the *Man with the Glove* (fig. 634). The dreamy intimacy of this portrait, with its soft outline and deep shadows, still reflects the style of Giorgione. Lost in thought, the young man seems quite unaware of us. This slight melancholy

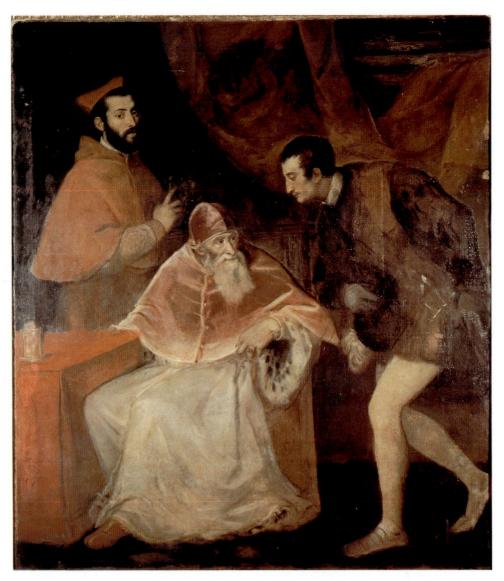

635. Titian. Pope Paul III and His Grandsons. 1546. Oil on canvas, 6'10" x 5'8" (2.1 x 1.7 m). Museo di Capodimonte, Naples

in his features conjures up the poetic appeal of *The Tempest*. The breadth and power of form, however, go far beyond Giorgione's. In Titian's hands, the possibilities of the oil technique—rich, creamy highlights, deep dark tones that are transparent and delicately modulated—now are fully realized, and the separate brushstrokes, hardly visible before, become increasingly free.

We can see the rapid pace of Titian's development by turning from the *Man with the Glove* to the papal group portrait *Pope Paul III and His Grandsons* (fig. 635), painted a quartercentury later, whose formal composition is derived from Raphael's *Pope Leo X* (fig. 629). The quick, slashing strokes here endow the entire canvas with the spontaneity of a first sketch (some parts of it are, in fact, unfinished). In the freer technique, Titian's uncanny grasp of human character also comes out. The tiny figure of the pope, shriveled with age, dominates his tall attendants with awesome authority. Comparing these two portraits by Titian, we see that a change of pictorial technique is not a surface phenomenon. It reflects a change of the artist's aim.

LATE WORKS. This correspondence of form and technique, which we have already seen in Titian's *Danaë* (fig. 10), is even clearer in Christ Crowned with Thorns (fig. 636), the most awesome work of Titian's old age. To what does the canvas owe its power? Surely not to its large scale or dramatic composition, though these are contributing factors. (The painting is a variant of one he had made a quarter-century earlier that is considerably less successful.) The answer lies in the artist's technique. The shapes emerging from the semidarkness now consist wholly of light and color. Despite the heavy impasto, the shimmering surfaces have lost every trace of material solidity and seem translucent, as if aglow from within. The violent action has been miraculously suspended. What lingers in our minds is the strange mood of serenity engendered by deep religious feeling rather than the drama. As a result, we contemplate not Jesus' physical suffering but its purpose: the redemption and salvation of humanity. The painting's ethereality participates in a widespread visionary tendency that was shared by other late-sixteenth-century Venetian artists. We shall meet it again in the work of Tintoretto and El Greco.

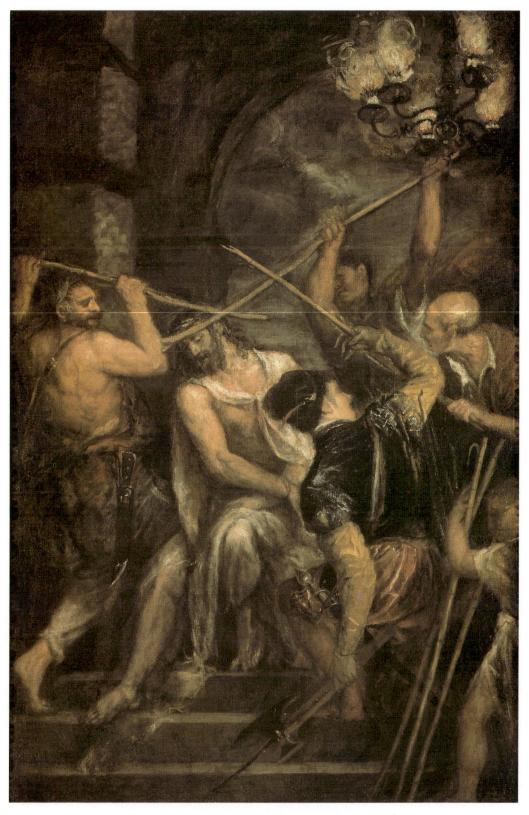

636. Titian. *Christ Crowned with Thorns.* c. 1570. Oil on canvas, 9'2" x 6' (2.8 x 1.8 m). Alte Pinakothek, Munich

CHAPTER THREE

MANNERISM AND OTHER TRENDS

What happened after the High Renaissance? Eighty years ago the answer would have been simply that after the High Renaissance came the Late Renaissance, which lasted until the Baroque style emerged at the end of the sixteenth century. Today we take a far more positive view of the artists who reached maturity after 1520, and generally discard the term "Late Renaissance" as misleading. Yet we have still to agree on a name for the 75 years separating the High Renaissance from the Baroque. Any one label implies that the period has one style, but there is no single style in the years 1525 to 1600. Why, then, should this span be regarded as a period at all? This difficulty can be resolved by thinking of the period as a time of crisis that gave rise to several competing tendencies rather than one dominant ideal.

Although they had taken place during the High Renaissance, the great voyages of discovery—Columbus' landing in the New World in 1492, followed by Amerigo Vespucci's exploration of South America seven years later and Magellan's voyage to circumnavigate the globe beginning in 1519—had far-reaching consequences that were to reverberate until the end of the sixteenth century. The most immediate consequence was the rise of the great European colonial powers, which vied with each other for commercial supremacy around the world. The Spanish (as well as the Portuguese) quickly established themselves in the Americas: Mexico was conquered by Hernán Cortés in 1519-21, Peru by Francisco Pizarro during the following decade. By 1585, however, Sir Walter Raleigh had established the first English settlement in North America, and the French soon followed with outposts of their own. An unexpected effect was the explosion of knowledge as explorers brought back a host of natural and artistic wonders never before seen in Europe. Dazzled by these revelations, avid collectors formed Kunst- und Wunderkammern (literally, art and wonder rooms) to display exotic treasures from every corner of the earth. As Europeans struggled to assimilate this profusion of new discoveries into old categories of thought, the science inherited from ancient Greece and Rome by the Early Renaissance was largely discarded as inadequate by 1650 in favor of a new body of learning.

At almost the same time, the Protestant Reformation was launched by Martin Luther, a former Augustinian friar who had become professor of theology at the University of Wittenberg. At face value, the 95 theses he nailed to the Wittenberg Castle church door on All Saints' Eve in October 1517 were little more than a broadside against the sale of indulgences promising redemption of sins. More fundamentally they constituted a wholesale attack against Catholic dogma, for he claimed that the Bible and natural reason were the sole bases of religious authority. Freed from traditional doctrine, the Protestant movement rapidly developed splinter groups. Within a few years the Swiss pastor Huldreich Zwingli sought to reduce religion to its essentials by preaching an even more radical fundamentalism, denouncing the arts as distractions and denying the validity of even the Eucharist as a rite, which led to a split with Luther that was never healed. Even within Zwingli's camp there were rifts: the Anabaptists accepted only adult baptism.

What divided the reformers were the twin issues of grace and free will in attaining faith and salvation. These issues had been spelled out with the aid of the humanists, who initially counted Luther and Zwingli among their number; many of them, however, eventually turned against the Reformation because of its extremism. By the time of Zwingli's death at the hands of the Catholic forces at the Battle of Kappel in 1531, the essential corpus of Protestant theology had been defined. It was codified around mid-century by John Calvin of Geneva, who tried to mediate between Luther and Zwingli while adopting the puritanical beliefs of the Anabaptists.

The Catholic church soon inaugurated a reform movement of its own, generally known today as the Counter Reformation. It was spearheaded following the Council of Trent in 1545–47 by the Society of Jesus, the Jesuit order representing the Church militant, which had been founded by the Spanish St. Ignatius of Loyola in 1534. The internal reforms were carried out mainly by Pope Paul IV after he ascended the throne of St. Peter in 1555, and by St. Carlo Borromeo, who initiated the model reform as bishop of Milan five years later. The Reformation and Counter Reformation quickly became bound up in the political upheavals and social unrest sweeping Europe. Although they were sometimes passionate in their beliefs, rulers usually allied themselves with either movement depending on dynastic and economic self-interest. Thus Henry VIII of England established the Church of England in 1534 in order to make divorce easier so that he could produce a male heir. Later, Philip II of Spain made the Catholic cause part of the Hapsburg ambitions, cloaking his true motives in the mantle of a crusade for the true faith.

PAINTING

Mannerism in Florence and Rome

Among the various trends in art in the wake of the High Renaissance, Mannerism is the most significant, as well as the most problematic. In scope, the original meaning of the term was narrow and derogatory, designating a group of mid-sixteenth-century painters in Rome and Florence whose self-consciously "artificial" style (maniera) was derived from certain aspects of the work of Raphael and Michelangelo. This phase has since been recognized as part of a wider movement that had begun around 1520. Keyed to a sophisticated, even rarefied taste, early Mannerism had appealed to a small circle around aristocratic patrons such as Cosimo I, the grand duke of Tuscany. The style soon became international as a number of events—including the plague of 1522 and, above all, the Sack of Rome by Spanish forces in 1527—disrupted its development and displaced it abroad, where most of its next phase took place.

This new phase, High Mannerism, was the assertion of a purely aesthetic ideal. Through formulaic abstraction, it translated expression into a style of the utmost refinement, emphasizing grace, variety, and virtuoso display at the expense of content, clarity, and unity. This taste for mannered elegance and bizarre conceits appealed to a small but sophisticated audience, but in a larger sense Mannerism signified a major shift in Italian culture. In part, it resulted from the High Renaissance quest for originality as a projection of the individual's personality, which had given artists license to explore their imaginations freely. This investigation of new modes was

ultimately healthy, but the Mannerist style itself came to be regarded by many as decadent, and no wonder: given such subjective freedom, it produced extreme personalities that today seem the most "modern" of all sixteenth-century painters.

The seemingly cold and barren formalism of High Mannerist work was part of a wider movement that placed inner vision, however private or fantastic, above the twin standards of nature and the ancients. Hence, some scholars have broadened the definition of Mannerism to include the later style of Michelangelo, who could himself acknowledge no artistic authority higher than his own genius. Mannerism is often considered a reaction against the normative ideal created by the High Renaissance as well. Save for a brief initial phase, however, Mannerism did not consciously reject the tradition from which it stemmed. Although the subjectivity inherent in this aesthetic was necessarily unclassical, it was not deliberately anticlassical, except in its more extreme manifestations. Even more conspicuous than Mannerism's anticlassicism is its insistent antinaturalism.

The relation of Mannerism to religious trends was equally paradoxical. Notwithstanding the intense religious feeling that informs many works by the first generation of artists, it has rightly been observed that Mannerism as a whole illustrates the spiritual bankruptcy of the age. In particular, the extreme worldliness of the next generation, the High Mannerists, was fundamentally antithetical to both the Reformation, with its stern morality, and the Counter Reformation, which demanded a strict adherence to doctrine. However, after midcentury there was a Counter Mannerist trend, which adapted the vocabulary of Mannerism for Counter Reformation ends. At the same time, the subjective latitude of Mannerism became valued for its visionary power as part of a larger shift in religious sensibility.

ROSSO. The first indications of disquiet in the High Renaissance appear shortly before 1520 in Florence. Art had been left in the hands of a younger generation that could refine but not further develop the styles of the great innovators who had spent their early careers there before leaving the city. Having absorbed the lessons of the leading artists at one remove, the first generation of Mannerists was free to apply High Renaissance formulas to a new aesthetic divorced from its previous content. By 1521, Rosso Fiorentino (1495-1540), the most eccentric member of this group, expressed the new attitude with full conviction in the Descent from the Cross (fig. 637). Nothing has prepared us for the shocking impact of this latticework of spidery forms spread out against the dark sky. The figures are agitated yet rigid, as if congealed by a sudden, icy blast. Even the draperies have brittle, sharp-edged planes. The acid colors and the light, brilliant but unreal, reinforce the nightmarish effect of the scene. Here is clearly a full-scale revolt against the classical balance of High Renaissance art: a profoundly disquieting, willful, visionary style that indicates a deep inner anxiety.

PONTORMO. Pontormo (1494–1556/7), a friend of Rosso's, had an equally strange personality. Introspective, willful, and shy, he worked only when and for whom he pleased, and he would shut himself up in his quarters for weeks on end, remaining inaccessible even to his closest friends. Pontormo's

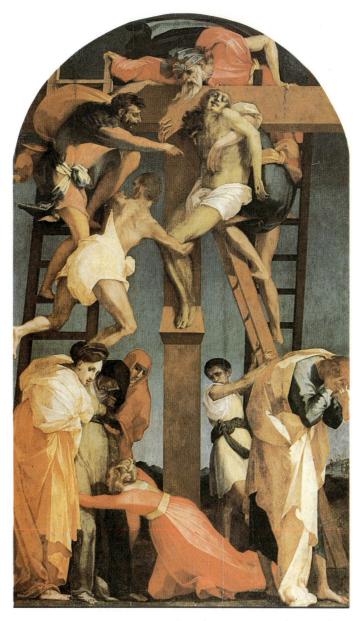

637. Rosso Fiorentino. *Descent from the Cross.* 1521. Oil on panel, 11' x 6'5¹/2" (3.4 x 2 m). Pinacoteca Communale, Volterra

Deposition (fig. 638) well reflects these facets of his character. The painting contrasts sharply with Rosso's Descent from the Cross, but is no less disturbing. Unlike Rosso's attenuated forms, Pontormo's have a nearly classical beauty and sculptural solidity inspired by Michelangelo, who in turned admired his art. Yet the figures are confined to a stage so claustrophobic as to cause acute discomfort in the viewer. The very implausibility of the image renders it convincing in spiritual terms. Indeed, this visionary quality is essential to its meaning, which is communicated by formal means alone. We have entered a world of innermost contemplation in which every pictorial element responds to a purely subjective impulse. Everything is subordinate to the play of graceful linear rhythms created by the tightly interlocking forms. These patterns unify the surface and impart a poignancy unlike any we have seen. Although they act in concert, the mourners are lost in a grief too personal to share with each other—or us. In this hushed atmosphere, anguish is transmuted into a lyrical expression of exquisite sensitivity. The entire scene is as haunted as Pontormo's selfportrait just to the right of the swooning Madonna. The artist, moodily gazing into space, seems to shrink from the outer

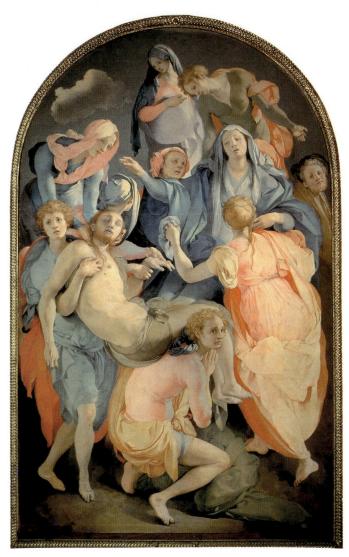

638. Pontormo. *Deposition.* c. 1526–28. Oil on panel, $10'3" \times 6'4"$ (3.1 x 1.9 m). Sta. Felicita, Florence

world, as if scarred by the trauma of some half-remembered experience, and into one of his own invention.

PARMIGIANINO. The first phase of Mannerism was soon replaced by one less overtly anticlassical, less laden with subjective emotion, but equally far removed from the confident, stable world of the High Renaissance. The Self-Portrait (fig. 639) by Parmigianino (Girolamo Francesco Maria Mazzuoli, 1503 – 1540) suggests no psychological turmoil. The artist's appearance is bland and well groomed. The features, painted with Raphael's smooth perfection, are veiled by a delicate Leonardesque sfumato. The distortions, too, are objective, not arbitrary, for the picture records what Parmigianino saw as he gazed at his reflection in a convex mirror. Why was he so fascinated by this view "through the looking glass"? Earlier painters who used the mirror as an aid to observation had "filtered out" the distortions, except when the mirror image was contrasted with a direct view of the same scene (see fig. 677). But Parmigianino substitutes his painting for the mirror itself, even employing a specially prepared convex panel. Perhaps he wanted to demonstrate that there is no single "correct" reality, that distortion is as natural as the normal appearance of things. The painting bespeaks an interest in magic as well: the convex mirror was valued in the Renaissance for its visionary effects, which

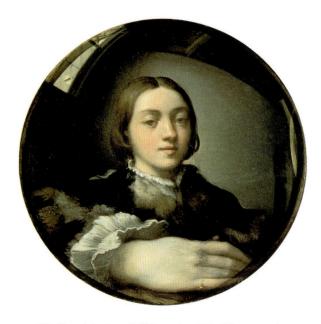

639. Parmigianino. *Self-Portrait*. 1524. Oil on panel, diameter 9⁵/8" (24.7 cm). Kunsthistorisches Museum, Vienna

seemed to reveal the future, as well as hidden aspects of the past and present.

This may help to explain why Parmigianino's scientific detachment soon changed into its very opposite. Vasari tells us that Parmigianino, as he neared the end of his brief career (he died at 37), was obsessed with alchemy and became "a bearded, long-haired, neglected, and almost savage or wild man." Certainly his strange imagination is evident in his most famous work, *The Madonna with the Long Neck* (fig. 640), painted after he had returned to his native Parma following several years in Rome. He had been deeply impressed with the rhythmic grace of Raphael's art (compare fig. 628), but he has transformed the older artist's figures into a remarkable new breed. Their limbs, elongated and ivory-smooth, move with effortless languor, embodying an ideal of beauty as remote from nature as any Byzantine figure.

The pose of the Christ Child balanced precariously on the Madonna's lap echoes that of a *Pietà* (compare fig. 606). Although it has antecedents in Byzantine icons, this unusual device is of Parmigianino's own invention, and helps to explain the setting, which is not as arbitary as it may seem. The gigantic column alludes to the flagellation of the Lord during the Passion, reminding us of his sacrifice, which the tiny figure of a prophet foretells on his scroll. But it also serves to disrupt our perception of space, which is strangely disjointed. Parmigianino seems determined to prevent us from measuring anything in this picture by the standards of ordinary experience. Here we have approached that "artificial" style for which the term *Mannerism* was originally coined. *The Madonna with the Long Neck* is a vision of unearthly perfection, its cold elegance no less arresting than the violence in Rosso's *Descent*.

Parmigianino is important as a printmaker as well as a painter. He was the first artist to explore the possibilities of etching seriously. Although the technique was introduced in the North shortly after 1510 (see page 524), it took the Italian Mannerists to appreciate the new medium. We can see why in Parmigianino's *The Entombment* (fig. 641): the print looks very much like his ink drawings in retaining a sketchlike immediacy that conveys the agitation of the scene. For that reason, etching

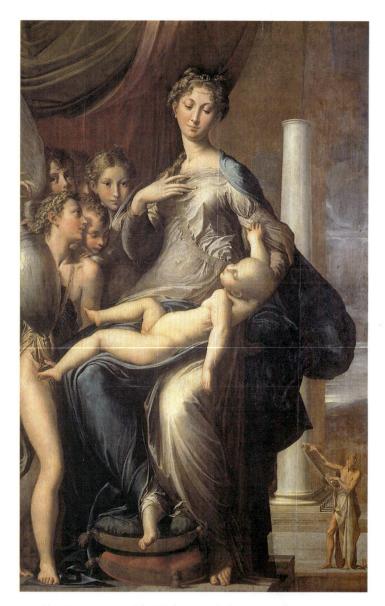

640. Parmigianino. *The Madonna with the Long Neck.* c. 1535. Oil on panel, 7'1" x 4'4" (2.2 x 1.3 m). Galleria degli Uffizi, Florence

641. Parmigianino. *The Entombment*. c. 1535. Etching printed in brown ink, 12¹/4 x 9³/8" (31.3 x 23.8 cm). Los Angeles County Museum of Art. Collection of Mary Stansburg Ruiz

The music and theater of Italy between 1530 and 1600 reflect the

same rich variety found in art. The most characteristic musical form after about 1530 was the madrigal, which was an outgrowth of French and Italian popular songs. It was similar to the motet in that all the voices were equally important, but it was livelier and more expressive. The madrigal was also closely connected to the resurgence of Italian poetry in the work of Ludovico Ariosto (see page 464) and Torquato Tasso (1544–1595), Ariosto's successor as court poet to the ruling d'Este family of Ferrara. Tasso also treated the crusades in Jerusalem Delivered (1575), which remained the most popular poem of its kind through the seventeenth century. Although at first the best composers of madrigals were Flemish, after 1575 Italians dominated the form. Foremost among them was Carlo Gesualdo (c. 1560-1613), an aristocrat whose music was as bold and flamboyant as his personality. His madrigals, like those of Luca Marenzio (1553–1599), are full of complex verbal and musical conceits that make them counterparts to the paintings of the High Mannerists.

The church dignitaries at the Council of Trent (1545–63), which spearheaded the Counter Reformation in the Catholic church, objected to the growing use of secular melodies in sacred music, as well as to elaborate polyphony that obscured the words of the liturgy. In response, Giovanni Palestrina (c. 1525–1594) based his masses on traditional Gregorian chants. In many respects, however, his works are the successors of Josquin Des Prés' in their seamless texture and the perfect balance of melodic and harmonic values—that is, the beauty both of the principal melody and the other notes that accompany it, known as harmony. Palestrina, who held all the important musical posts in Rome during his lifetime, had special authority because of the backing of the papacy, and his style became "classic": it was held up as a model for imitation into the twentieth century.

Venice, unlike Rome, was ruled by secular authorities, so that Venetian music differed greatly from that composed for the pope. The vast spaces of St. Mark's church—which was the palace chapel of the Doges—encouraged the colorful music of Palestrina's contemporary, Andrea Gabrieli (1510–1586), who had studied under the Fleming Adrian Willaert (c. 1490–1562), and his nephew and pupil, Giovanni Gabrieli (1557–1612). The compositions of the Gabrielis emphasized sensuous effects of sound over counterpoint (different melodic lines moving independently, or "counter"

to each other). Giovanni was also the first composer to specify

which instruments should play which parts, to include dynamic markings in his music as indications of loudness and softness, and to make use of harmonies that sound "modern" to our ears, although Palestrina had effectively abandoned the modes except insofar as they were an inescapable part of church music. Much of Giovanni's music was purely instrumental. Instrument-only music in the late sixteenth century began to achieve its independence from vocal music by adapting popular dance tunes, often treated as a theme with variations. Such dances had been performed for centuries, although they were rarely written down. This development coincided with the creation of new families of instruments, such as viols and recorders, whose rangessoprano, contralto, tenor, and bass-approximated those of human voices. These instruments lent Late Renaissance music a wonderfully diverse and distinctive sound.

The principal theatrical performances in sixteenthcentury Italy were public spectacles paid for by the aristocracy. The most splendid were produced in Florence to glorify the Medici family in allegorical terms: Masque of the Genealogy of the Gods (1566), with sets and costumes designed by Giorgio Vasari, and The Battle of the Argonauts, mounted in 1608 on the Arno River. These displays spurred the development of more elaborate and sophisticated scenery design at the Medici court under Bernardo Buontalenti (1536–1608) and his pupil Giulio Parigi (c. 1570–1635), as well as in Ferrara, Mantua, Urbino, Milan, Parma, and Rome. Scenography initially relied on the accounts of Roman theater in the architectural treatise of Vitruvius, which was published in 1486, the same year that the humanist antiquarian Pomponius Laetus (1424–1498) began to produce ancient plays at the Roman Academy. Even more important was the influence of Leon Battista Alberti's linear perspective (see pages 459-62). Sebastiano Serlio (1475-1554) published an architectural treatise in 1545, which included a number of stage designs that made use of Alberti's perspective system to visualize Vitruvius' descriptions of Roman theaters. Serlio's designs proved so influential throughout Europe that they were often used to illustrate later editions of Vitruvius.

The occasional nature of dramatic presentations meant that few permanent theaters were built during the sixteenth century. The first court theater was erected by Buontalenti for the Medici in Florence. More important was the first

was ideally suited to capturing the artist's highly individual style and nervous temperament—traits prized above all others by the Mannerists.

BRONZINO. The second generation of Mannerists, with whom High Mannerism is identified, congealed the style they inherited from Rosso, Pontormo, and Parmigianino into a cool perfection that filtered out the last vestige of their intensely personal sensibility. As a consequence, they produced few master-pieces. In their best works, however, formal beauty becomes the aesthetic counterpart to recondite thought. Nowhere is this better seen than in the *Allegory of Venus* (fig. 642) painted by

Agnolo Bronzino (1503–1572), Pontormo's favorite pupil, as a gift to Francis I of France from Cosimo I de' Medici. The central motif of Cupid embracing Venus was suggested by a lost *Triumph of Love* by Michelangelo that Pontormo and Bronzino are both known to have copied. However, as with so much else in Mannerism, it has been corrupted in content and treatment. Father Time tears back the curtain from Fraud in the upper left-hand corner to uncover Venus and Cupid in an incestuous embrace, to the delight of Folly, who is armed with roses, and the dismay of Jealousy, who tears her hair, as Pleasure, half-woman and half-snake, proffers a honeycomb. The moral is that folly blinds one to the jealousy and fraud of

public theater, built in 1565 in Venice, which immediately established its leadership in theater writing and production. Twenty years later the architect Andrea Palladio (see pages 500–2) designed a theater for the Olympic Academy in Vicenza, which opened with a performance of Sophocles' *Oedipus Rex.* Although the theater was soon abandoned, its construction is a measure of sixteenth-century interest in serious classical theater.

After 1550, Renaissance theories of drama centered on Horace's Art of Poetry and Aristotle's Poetics, which had been published in a Latin translation in 1498. Drawing on these sources, Giulio Cesare Scaliger (1484-1558) and Lodovico Castelvetro (1505?-1571) insisted that both tragedy and comedy be presented in five acts and that they obey the "unities" of time, space, and action sanctioned as inviolable rules by Classical precedent: the events portrayed had to take place in roughly the same time as it took to present them (or at least within one day); in a space approximately the size of the actual stage; and with the story line revolving around a single incident or problem. The new body of theory also promoted the concept of verisimilitude, incorporating realism, morality, and universality (typical, normative traits). These ideas in turn led to an insistence on decorum: strict adherence to what was considered appropriate to the age, sex, temperament, and social status of each character. Drama was further divided into tragedy and comedy along class lines. Tragedy involved the actions of noble, that is, aristocratic, characters, while comedy was devoted to the buffooneries of the lower classes. However, the few plays written according to these rules met with a mixed reception in sixteenth-century Italy.

Among the most popular forms of theater were pastoral plays. These shared a common story line, in which a sophisticated young man or woman—in Torquato Tasso's *Aminta* (1573) this was actually the god Cupid—is forced by circumstance to spend some time among simple rural folk. The healthy manner of living and innocent goodness of the country people teach an important moral lesson and send the protagonist back to normal life refreshed in spirit. Also popular were comic interludes (*intermezzi*) between the acts of dramas, which featured such sensational scenery, costumes, music, dance, and special effects that they eventually became more important than the plays themselves.

sensual love which time reveals. The literal unmasking of this deceit revels in the very lasciviousness it purports to condemn. The painting is thus a perversion of the elevated humanism that informs Botticelli's *Birth of Venus* (fig. 583). With its extreme stylization, Bronzino's subtle elegance proclaims an equally refined erotic ideal that reduces passion to a genteel exchange of serpentine gestures between figures as polished as marble.

VASARI. Bronzino's figures are indebted to Michelangelo in their sculptural quality (compare the Venus to *Night* in fig. 616). Those in *Perseus and Andromeda* (fig. 643) by Giorgio ⁷asari (1511–1574), the chronicler of the Italian Renaissance

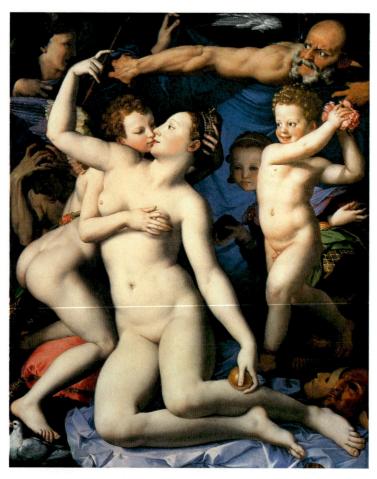

642. Agnolo Bronzino. *Allegory of Venus.* c. 1546. Oil on panel, $57^{1/2} \times 45^{1/4}$ " (146.1 x 116.2 cm). The National Gallery, London Reproduced by courtesy of the Trustees

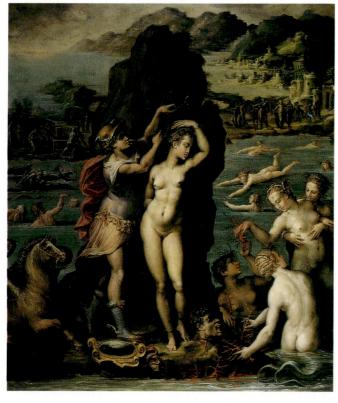

643. Giorgio Vasari. *Perseus and Andromeda.* 1570–72. Oil on slate, 45¹/₂ x 34" (115.6 x 86.4 cm). Palazzo Vecchio, Florence

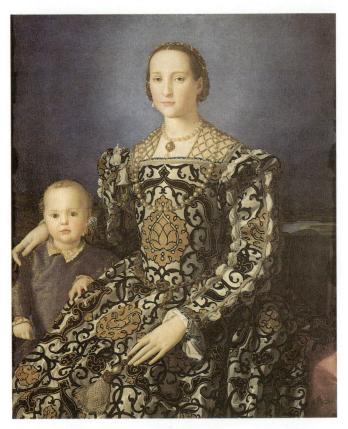

644. Agnolo Bronzino. *Eleanora of Toledo and Her Son Giovanni de' Medici.* c. 1550. Oil on panel, 45¹/₄ x 37³/₄" (115 x 96 cm). Galleria degli Uffizi, Florence

who worked in the same chill vein, owe more to Raphael, although he esteemed Michelangelo above all others. The painting, one of the artist's last works, is a play on the Galatea (see fig. 628). It forms part of the rich decorative scheme Vasari devised for the study of Francesco I de' Medici of Florence. The program, by the humanist Vincenzo Borghini, is devoted to the four elements. Vasari has chosen to represent water with the story of coral, which according to legend was formed by the blood of the monster slain by Perseus in rescuing the fair Andromeda. The subject provided an excuse to show voluptuous nudes, but in his hands the story has become an enchanting fantasy. In keeping with this lighthearted treatment, the Nereids, annealed versions of Raphael's mythological creatures, frolic with bits of coral they have discovered in the sea. Vasari's painting became a model in its own right: it spawned a host of imitations by minor artists in the waning years of Mannerism.

PORTRAITS. The Mannerists also produced splendid portraits in the same highly cultivated style, like Bronzino's painting of Eleanora of Toledo (fig. 644), the wife of Cosimo I de' Medici and Bronzino's main patron. The sitter here appears as a member of an exalted social caste, not as an individual personality. Frozen into immobility behind the barrier of her lavishly ornate costume, Eleanora seems more akin to Parmigianino's *Madonna* (compare the hands) than to ordinary flesh and blood.

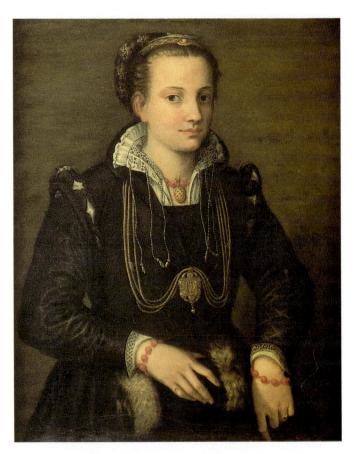

645. Sofonisba Anguissola. *Portrait of the Artist's Sister Minerva*. c. 1559. Oil on canvas, 33 ¹/₂ x 26" (85 x 66 cm). Milwaukee Art Museum, Layton Art Collection

Gift of the Family of Mrs. Fred Vogel, Jr.

ANGUISSOLA. So far, this book has not treated a named woman artist, although this does not mean that there were none. Pliny, for example, mentions in his Natural History (Book 35) the names and describes the work of women artists in Greece and Rome, and there are records of women manuscript illuminators during the Middle Ages. We must remember, however, that the vast majority of all artists remained anonymous until the late fourteenth century, so that all but a few works specifically by women have proved impossible to identify. Women began to emerge as distinct artistic personalities about 1550. The first of these to be widely recognized in her own lifetime was Sofonisba Anguissola (c. 1535–1625). The oldest of six artistic daughters from a prominent family in Cremona, she showed a precocious talent and at an early age exchanged drawings with Michelangelo. After establishing her reputation as a portraitist while still a young woman, she was called to Madrid, where she spent 20 years as a court painter until marriage brought her back to Italy. She became such a celebrity that her self-portraits, often showing her playing a spinet, were in considerable demand. Anguissola was highly regarded throughout her lifetime-Van Dyck drew her likeness shortly before her death—and her success was an important inspiration to other women artists. While her commissioned portraits follow the formal conventions of the day, she was at her best in more intimate paintings of her family, like the charming portrait she made of her sister Minerva shortly before leaving for Spain (fig. 645).

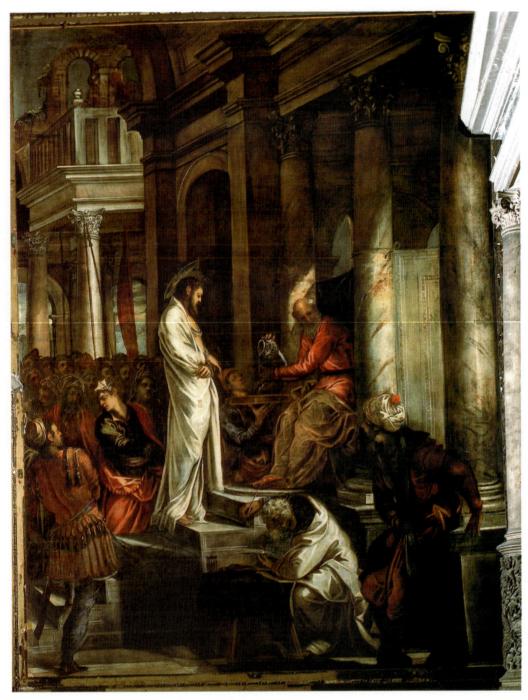

646. Jacopo Tintoretto. *Christ Before Pilate*. 1566–67. Wall painting, approx. 18'1" x 13'3¹/2" (5.5 x 4.1 m). Scuola di San Rocco, Venice

Mannerism in Venice

TINTORETTO. Not until mid-century did Mannerism appear in Venice, where it became allied with the visionary tendencies already manifest in Titian's late work. Its leading exponent, Jacopo Tintoretto (1518–1594), was an artist of prodigious energy and inventiveness, who combined qualities of both its anticlassical and elegant phases in his work. He reportedly wanted "to paint like Titian and to design like Michelangelo," but his relationship to these two masters, though real enough, was as peculiar as Parmigianino's was to Raphael. *Christ Before Pilate* (fig. 646), one of his many huge

canvases for the Scuola di San Rocco, the home of the Confraternity of St. Roch, contrasts tellingly with Titian's *Christ Crowned with Thorns* (see fig. 636). The bold brushwork, the glowing colors, and the sudden lights and shadows show what Tintoretto owed to the older artist, and indeed the entire composition recalls the *Madonna with Members of the Pesaro Family* (see fig. 633). Yet the total effect is unmistakably Mannerist. The feverish emotionalism of the flickering, unreal light, and the ghostly Christ, pencil-slim and motionless among the agitated Michelangelesque figures, remind us of Rosso's *Descent*.

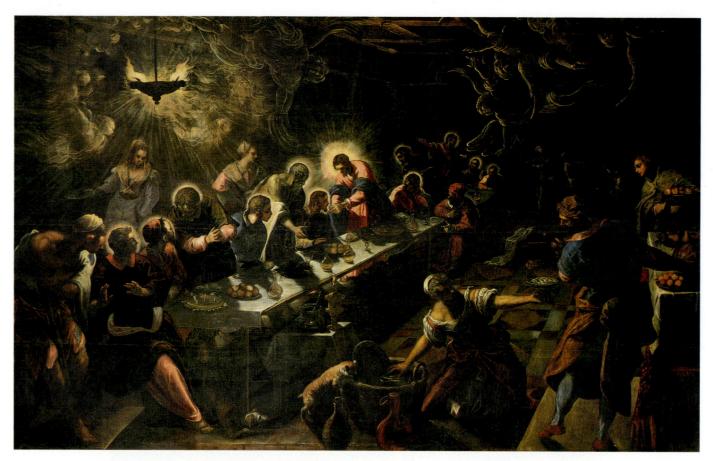

647. Jacopo Tintoretto. The Last Supper. 1592-94. Oil on canvas, 12' x 18'8" (3.7 x 5.7 m). S. Giorgio Maggiore, Venice

Tintoretto's final major work, *The Last Supper* (fig. 647), is also his most spectacular. At first, this canvas seems to deny in every possible way the classic values of Leonardo's version (see fig. 596), painted almost exactly a century before. Christ, to be sure, still occupies the center of the composition, but his small figure in the middle distance is distinguishable mainly by the brilliant halo, while the table is placed at a sharp angle to the picture plane in exaggerated perspective. In fact, this arrangement was designed to relate the scene to the space of the chancel of the church for which it was commissioned, and to be seen by the faithful as they knelt at the altar rail to receive Communion.

Tintoretto has gone to great lengths to give the event an everyday setting, cluttering the scene with attendants, containers of food and drink, and domestic animals. There are also celestial attendants who converge upon Christ just as he offers his body and blood, in the form of bread and wine, to the disciples. The smoke from the blazing oil lamp miraculously turns into clouds of angels, blurring the distinction between the natural and the supernatural and turning the scene into a magnificently orchestrated vision. Tintoretto barely hints at the human drama of Judas' betrayal, so important to Leonardo. Judas can be seen isolated on the near side of the table, but his role is so insignificant that he could almost be mistaken for an attendant. The artist's main concern has been to make visible the miracle of the Eucharist—the transubstantiation of earthly into divine food—the institution central to Catholic doctrine, which was reasserted during the Counter Reformation.

EL GRECO. The last, and today most famous, Mannerist painter was also trained in the Venetian School. Domenikos Theotocopoulos (1541–1614), called El Greco, came from Crete, which was then under Venetian rule. His earliest training must have been from a Cretan artist still working in the Byzantine tradition. Soon after 1560 El Greco arrived in Venice and quickly absorbed the lessons of Titian, Tintoretto, and other artists. A decade later, in Rome, he came to know the art of Raphael, Michelangelo, and the Central Italian Mannerists. In 1576/77 he went to Spain, settling in Toledo for the rest of his life. There he became established in the leading intellectual circles of the city, then a major center of learning as well as the seat of Catholic reform in Spain. Although it provides the content of his work, Counter Reformation theology does not account for the exalted emotionalism that informs his painting. [See Primary Sources, no. 59, pages 633-34.] The spiritual tenor of El Greco's mature work was primarily a response to mysticism, which was especially intense in Spain. Contemporary Spanish painting, however, was too provincial to affect him. His style had already been formed before he arrived in Toledo. Nor did he forget his Byzantine background. Until the very end of his career, he signed his pictures in Greek.

The largest and most resplendent of El Greco's major commissions, and the only one for a public chapel, is *The Burial of Count Orgaz* (figs. 648 and 649) in the church of Sto. Tomé. The program, which was given at the time of the commission, emphasizes the traditional role of good works in salvation and of the saints as intercessors with Heaven. This huge canvas honors a medieval benefactor so pious that St. Stephen and St.

648. Chapel with *The Burial of Count Orgaz.* 1586. Sto. Tomé, Toledo, Spain

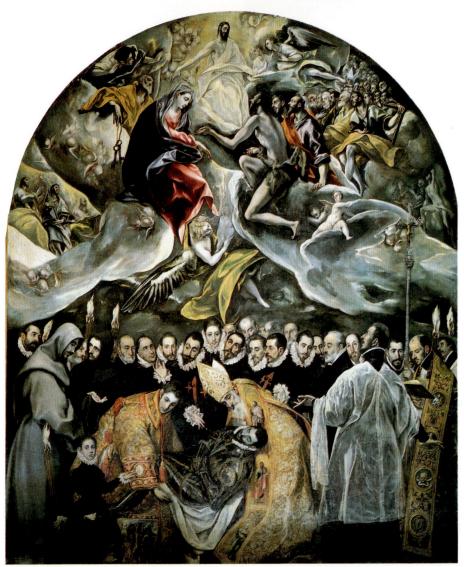

649. El Greco.

The Burial of Count
Orgaz. 1586.
Oil on canvas,
16' x 11'10" (4.9 x
3.6 m). Sto. Tomé,
Toledo, Spain

Mannerism and Other Trends 491

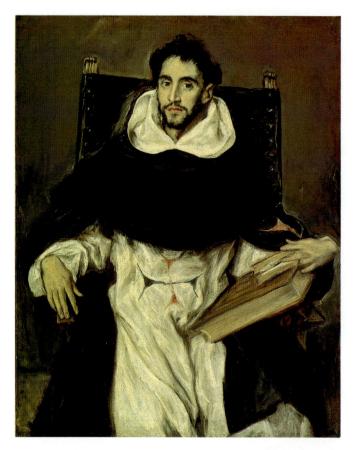

650. El Greco. *Fray Felix Hortensio Paravicino*. c. 1605. Oil on canvas, 44 ¹/₂ x 33³/₄" (112.5 x 85.5 cm). Museum of Fine Arts, Boston

Isaac Sweetser Fund

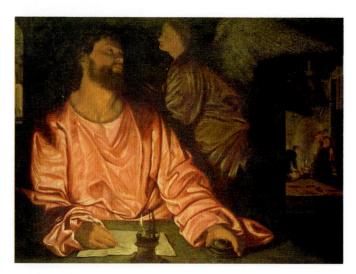

651. Girolamo Savoldo. *St. Matthew and the Angel.* c. 1535. Oil on canvas, 36³/4 x 49" (93.3 x 124.5 cm). The Metropolitan Museum of Art, New York

Marquand Fund, 1912

Augustine miraculously appeared at his funeral and themselves lowered the body into its grave. The burial took place in 1323, but El Greco presents it as a contemporary event, portraying among the attendants many of the local nobility and clergy. The dazzling display of color and texture in the armor and vestments could hardly have been surpassed by Titian himself. Directly above, the count's soul (a small, cloudlike figure like the angels in Tintoretto's Last Supper) is carried to Heaven by an angel. The celestial assembly filling the upper half of the picture is painted very differently from the lower half: every form—clouds, limbs, draperies—takes part in the sweeping, flamelike movement toward the distant figure of Christ. Here, even more than in Tintoretto's art, the entire range of Mannerism fuses into a single ecstatic vision.

The full import of the work, however, becomes clear only when we see it in its original setting. Like an enormous window, it fills one entire wall of its chapel. The bottom of the canvas is 6 feet above the floor, and as the chapel is only about 18 feet deep, we must look sharply upward to see the upper half of the picture. El Greco's violent foreshortening is calculated to achieve an illusion of boundless space above, while the lower foreground figures appear as on a stage. (Their feet are cut off by the molding just below the picture.) The large stone plaque set into the wall also belongs to the ensemble, representing the front of the sarcophagus into which the two saints lower the body of the count; it thus explains the action within the picture. The beholder, then, perceives three levels of reality: the grave itself, supposedly set into the wall at eye level

and closed by an actual stone slab; the contemporary reenactment of the miraculous burial; and the vision of celestial glory witnessed by some of the participants. El Greco's task here was analogous to Masaccio's in his *Trinity* mural (see fig. 551). But whereas the Renaissance painter creates the illusion of reality through his command of rational pictorial space that appears continuous with ours, El Greco summons an apparition that remains essentially separate from its architectural surroundings. The contrast measures the dynamic evolution of Western art since the Early Renaissance.

El Greco has created a spiritual counterpart to his imagination, in contrast to Counter Reformation images, which were given a convincing physical presence to convey their doctrinal message as clearly as possible. Every passage is alive with his peculiar religiosity, which is felt as a nervous exaltation occurring as the dreamlike vision is conjured up. This kind of mysticism is very similar in character to the Spiritual Exercises of Ignatius of Loyola. St. Ignatius sought to make visions so real that they would seem to appear before the very eyes of the faithful. Such mysticism could be achieved only through strenuous devotion. That effort is mirrored in the intensity of El Greco's work, which fully retains a feeling of spiritual struggle.

From El Greco's Venetian training came his mastery of portraiture. We generally know little of his relationship to his sitters, but in his memorable portrait of Fray Felix Hortensio Paravicino (fig. 650), the sitter, an important scholar and poet, was also a friend who praised El Greco's genius in several son-

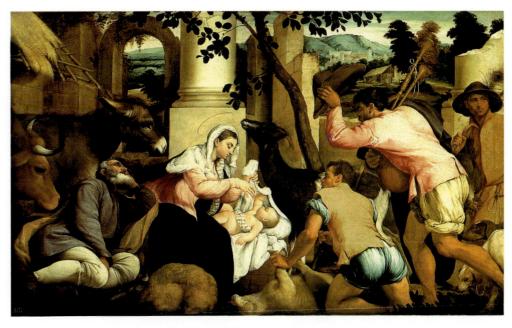

652. Jacopo Bassano. *The Adoration of the Shepherds.* 1542–47. Oil on canvas, 4'7" x 7'2¹/4" (1.39 x 2.19 m). The Royal Collection © 1993 Her Majesty Queen Elizabeth II

nets. This portrait is an artistic descendant of Titian's *Man with the Glove* and the self-portrait in Pontormo's *Deposition* (see figs. 634 and 638). Yet the mood is one of neither reverie nor withdrawal. Paravicino's frail, expressive hands and the pallid face, with its sensitive mouth and burning eyes, convey a spiritual ardor of compelling intensity. Such, we like to think, were the saints of the Counter Reformation—mystics and intellectuals at the same time.

Realism

Although Mannerism spread to Venice and other cities, as a style it failed to establish dominance outside Florence and Rome. Elsewhere it competed with other tendencies. In towns along the northern edge of the Lombard plain, such as Brescia and Verona, there were a number of artists who worked in a style based on Giorgione and Titian, but with a stronger interest in everyday reality.

SAVOLDO. One of the earliest and most attractive of these North Italian realists was Girolamo Savoldo (c. 1480–1550) from Brescia, whose *St. Matthew and the Angel* (fig. 651) must be contemporary with Parmigianino's *Madonna with the Long Neck*. The broad, fluid manner of painting reflects the dominant influence of Titian, yet the great Venetian artist would never have placed the evangelist in so thoroughly domestic an environment. The humble scene in the background shows the saint's milieu to be lowly indeed and makes the presence of the angel doubly miraculous. This tendency to visualize sacred events among ramshackle buildings and simple people had been characteristic of Gothic painting, especially in the North, and Savoldo must have acquired it from that source. The nocturnal lighting, too, recalls such Gothic pictures as the *Nativity* by Gentile da Fabriano (see fig. 526). But whereas the main

illumination in Gentile's panel is the divine radiance of the child, Savoldo uses an ordinary oil lamp for his similarly magic and intimate effect.

BASSANO. A different form of realism is found in the paintings of Jacopo da Ponte (c. 1510-1592), called Bassano after the town 30 miles northwest of Venice where he passed virtually his entire career. He inevitably fell under the influence of Titian, but equally important to the formation of his style were prints by Germans such as Albrecht Dürer, who had twice visited Venice (see page 529), and by the Mannerists, notably Parmigianino. In The Adoration of the Shepherds (fig. 652), Bassano's most characteristic subject, the landscape will remind us of the setting in Titian's Bacchanal, but the figures show the impact of Parmigianino: their interlocking rhythms, the gentle grace of the Madonna, the gesture of the Infant Christ, the seemingly arbitrary column, all can be found in The Madonna with the Long Neck. The pose of the shepherd doffing his hat, too, has its specific source in Parmigianino's etching The Entombment. The high-pitched color is decidedly Mannerist as well.

The role of Northern art seems less immediately apparent, until we realize that the tender relationship between the Virgin and Child has an intimacy that can have come only from German prints (compare fig. 695), not Italian painting. The humble setting indicates that he must also have known a similar composition by Martin Schongauer (see page 525). And the mountains in the distance find their nearest counterpart in the watercolor *Italian Mountains* (see fig. 699) that Dürer sketched on his way back from Venice, rather than any work by Titian. Unlike Dürer's, Jacopo's landscape is a "portrait," showing Mount Grappa near Bassano. *The Adoration of the Shepherds* is more than a synthesis of diverse sources, however. What is novel in all this is the pastoral quality of the scene. The

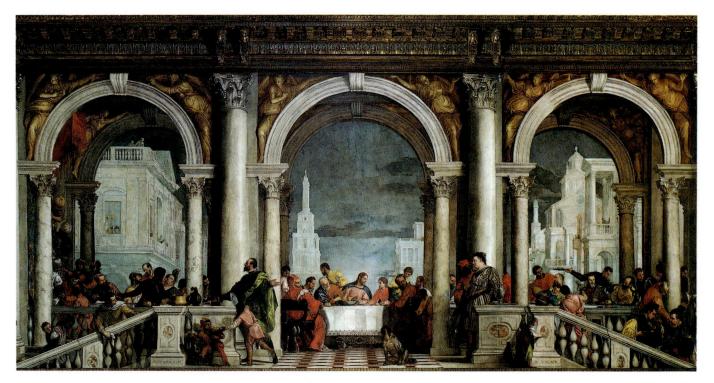

653. Paolo Veronese. Christ in the House of Levi. 1573. Oil on canvas, 18'2" x 42' (5.5 x 12.8 m). Galleria dell'Accademia, Venice

654. Correggio. *The Assumption of the Virgin* (portion). c. 1525. Fresco. Dome, Parma Cathedral

artist includes peasants of the sort he must have encountered around his native town. Andrea Mantegna and the Fleming Hugo van der Goes had been among the few to show such coarse, simple people (see fig. 682). Yet for Bassano they were an essential feature of his work. His realism, then, is not one of specific details but of general type, which offsets the self-conscious artificiality of his style.

VERONESE. In the work of Paolo Veronese (Paolo Caliari, 1528-1588), North Italian realism takes on the splendor of a pageant. Born and trained in Verona, Veronese became, after Tintoretto, the most important painter in Venice. Both found favor with the public, although they were utterly unlike each other in style. The contrast is strikingly evident if we compare Tintoretto's Last Supper (fig. 647) and Veronese's Christ in the House of Levi (fig. 653), which have similar subjects. Veronese avoids all reference to the supernatural. His symmetrical composition harks back to paintings by Leonardo and Raphael, while the festive mood of the scene reflects examples by Titian of the 1520s, so that at first glance the picture looks like a High Renaissance work born 50 years too late. Missing, however, is one essential element: the elevated, ideal conception of humanity underlying the High Renaissance. Veronese paints a sumptuous banquet, a true feast for the eyes, but not "the intention of man's soul."

Significantly, we are not even sure which event from the life of Jesus he originally meant to depict, for he gave the canvas its present title only after he had been summoned by the religious tribunal of the Inquisition on the charge of filling his picture with "buffoons, drunkards, Germans, dwarfs, and

similar vulgarities" unsuited to its sacred character. The account of this trial shows that the tribunal thought the painting represented the Last Supper, but Veronese's testimony never made clear whether it was the Last Supper or the Supper in the House of Simon. To him this distinction made little difference. In the end, he settled on a convenient third title, Christ in the House of Levi, which permitted him to leave the offending incidents in place. He argued that they were no more objectionable than the nudity of Jesus and the Heavenly Host in Michelangelo's *Last Judgment*, but the tribunal failed to see the analogy on the grounds that "in the Last Judgment it was not necessary to paint garments, and there is nothing in those figures that is not spiritual." [See Primary Sources, no. 60, pages 634–35.]

The Inquisition, of course, considered only the impropriety of Veronese's art, not its lack of concern with spiritual depth. His dogged refusal to admit the justice of the charge, his insistence on his right to introduce directly observed details, however "improper," and his indifference to the subject of the picture spring from an attitude so startlingly "extroverted" that it was not generally accepted until the nineteenth century. The painter's domain, Veronese seems to say, is the entire visible world, and here he acknowledges no authority other than his senses.

Proto-Baroque Painting

A third trend that emerged about 1520 in northern Italy has been labeled Proto-Baroque, as much because it eludes convenient categories as because it embodies so many features that would later characterize the Baroque style, although such a term hardly does justice to its highly individual qualities. This tendency centers largely on Correggio, although later in the century it has a counterpart in architecture (see pages 502–3).

CORREGGIO. Correggio (Antonio Allegri da Correggio, 1489/94–1534), a phenomenally gifted North Italian painter, spent most of his brief career in Parma, which lies to the west along the Lombard plain. Consequently, he absorbed a wide range of influences: first Leonardo and the Venetians, then Michelangelo and Raphael, but their ideal of classical balance did not attract him. Correggio's work partakes of North Italian realism but applies it with the imaginative freedom of the Mannerists, though we do not find any hint of his fellow resident Parmigianino in his style. His largest work, the fresco of The Assumption of the Virgin in the dome of Parma Cathedral (fig. 654), is a masterpiece of illusionistic perspective, a vast, luminous space filled with soaring figures. Although they move with such exhilarating ease that the force of gravity seems not to exist for them, these are healthy, energetic beings of flesh and blood, not disembodied spirits, and they frankly delight in their weightless condition.

There was little difference between spiritual and physical ecstasy for Correggio, who thereby established an important precedent for Baroque artists such as Gianlorenzo Bernini (see page 567). We can see this by comparing *The Assumption of the Virgin* with his *Jupiter and Io* (fig. 655), one canvas in a series illustrating the loves of the classical gods. The nymph,

655. Correggio. *Jupiter and Io.* c. 1532. Oil on canvas, 64¹/₂ x 27³/₄" (163.8 x 70.5 cm). Kunsthistorisches Museum, Vienna

swooning in the embrace of a cloudlike Jupiter, is the direct kin of the jubilant angels in the fresco. Leonardesque sfumato, combined with a Venetian sense of color and texture, produces an effect of exquisite voluptuousness that far exceeds Titian's in his *Bacchanal* (see fig. 632). Correggio had no immediate successors, nor did he have any lasting influence on the art of his century, but toward 1600 his work began to be widely appreciated. For the next century and a half he was admired as the equal of Raphael and Michelangelo, while the Mannerists, so important before, were largely forgotten.

SCULPTURE

Italian sculptors of the later sixteenth century fail to match the achievements of the painters. Perhaps Michelangelo's overpowering personality discouraged new talent in this field, but the dearth of challenging new tasks is a more plausible reason. In any case, the most interesting sculpture of this period was produced outside of Italy, and in Florence—after the death of Michelangelo in 1564—the leading sculptor was a Northerner.

Mannerism, First and Second Phases

BERRUGUETE. If the anticlassical phase of Mannerism, represented by the style of Rosso and Pontormo, has no sculptural counterpart, the work of the Spaniard Alonso Berruguete (c. 1489–1561) most closely approaches it. Berruguete had been associated with the founders of the anticlassical trend in Florence about 1520; his *St. John the Baptist* (fig. 656), one of the reliefs carved 20 years later for the wood choir stalls of Toledo Cathedral, still reflects this experience. The angular, emaciated body, clawlike hands, and fixed, wide-eyed stare recall the otherworldly expressiveness of Rosso's *Descent from the Cross* (see fig. 637).

CELLINI. The second, elegant phase of Mannerism appears in countless sculptural examples in Italy and abroad. The best-known representative of the style is Benvenuto Cellini (1500–1571), the Florentine goldsmith and sculptor who owes much of his fame to his picaresque autobiography. The gold saltcellar for Francis I of France (fig. 657), Cellini's only major work in precious metal to escape destruction, displays the virtues and limitations of his art. To hold condiments is obviously the lesser function of this lavish conversation piece. Because salt comes from the sea and pepper from the land, Cellini placed the boat-shaped salt container under the guardianship of Neptune, while the pepper, in a tiny triumphal arch, is watched over by a personification of Earth. On the base are figures representing the four seasons and the four parts of the day.

The entire object thus reflects the cosmic significance of the Medici tombs (compare fig. 616), but on this miniature scale Cellini's program turns into playful fancy. We recognize it as a conceit on the same order as Vasari's *Perseus and Andromeda* (fig. 643). Cellini wants to impress us with his ingenuity and skill. Earth, he wrote, is "fashioned like a woman with all the beauty of form, the grace and charm, of which my art was capable." The allegorical significance of the design is simply a pretext for this display of virtuosity. When he tells us, for instance,

656. Alonso Berruguete. *St. John the Baptist. c.* 1540. Wood, 31¹/2 x 19¹/4" (80 x 49 cm). Toledo Cathedral, Spain

that Neptune and Earth each have a bent and a straight leg to signify mountains and plains, form is completely divorced from content. Despite his boundless admiration for Michelangelo, Cellini creates elegant figures that are as elongated, smooth, and languid as Parmigianino's (see fig. 640).

PRIMATICCIO. Parmigianino also strongly influenced Francesco Primaticcio (1504-1570), Rosso's assistant and successor at the royal château of Fontainebleau. A man of many talents, Primaticcio designed the interior decoration of some of the main rooms, which combine painted scenes and a richly sculptured stucco framework. The section shown in figure 658 caters to the same aristocratic taste that admired the Saltcellar of Cellini, who was Primaticcio's rival at the court of Francis I in 1540-45. The four maidens are not burdened with any specific allegorical significance—their role recalls the nudes of the Sistine ceiling—but perform a task for which they seem equally ill-fitted: they reinforce the piers that sustain the ceiling. These willowy caryatids epitomize the studied nonchalance of second-phase Mannerism. The painting is nearly lost in the luxurious ornamentation. Executed by assistants from Primaticcio's design, it shows Apelles painting the abduction of Campaspe by Alexander the Great, who presented his favorite concubine to the artist when he fell in love with her. Such a heady mixture of violence and eroticism appealed greatly to the Mannerists; yet the story was interpreted as a gesture of uncommon respect and magnanimity by the Roman historian Pliny, which justified the subject.

657. Benvenuto Cellini. Saltcellar of Francis I. 1539–43. Gold with enamel, $10^{1/4}$ x $13^{1/8}$ " (26 x 33.3 cm). Kunsthistorisches Museum, Vienna

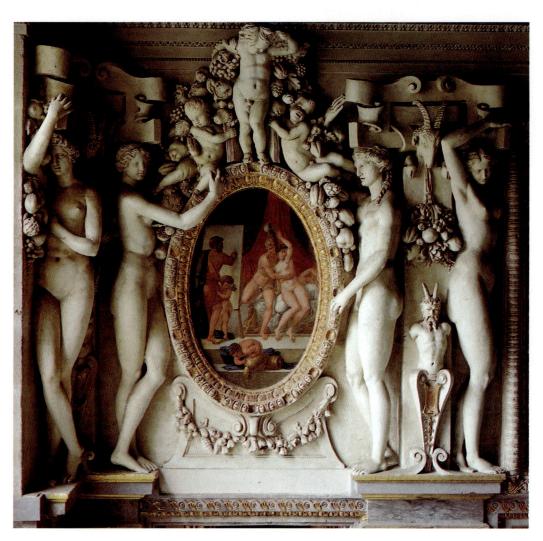

658. Francesco Primaticcio. *Stucco Figures*. c. 1541–45. Room of the Duchesse d'Estampes, Château of Fontainebleau, France

659. Giovanni Bologna. *The Abduction of the Sabine Woman.* Completed 1583. Marble, height 13'6" (4.1 m). Loggia dei Lanzi, Florence

GIOVANNI BOLOGNA. Cellini, Primaticcio, and the other Italians employed by Francis I at Fontainebleau made Mannerism the dominant style in mid-sixteenth-century France. Their influence went far beyond the royal court. It reached Jean de Bologne (1529–1608), a gifted young sculptor from Douai in northern France, who went to Italy about 1555 for further training. He stayed and became, under the Italianized name of Giovanni Bologna, the most important sculptor in Florence during the last third of the century. His over-lifesize marble group, *The Abduction of the Sabine Woman* (fig. 659), won particular acclaim, and still has its place of honor near the Palazzo Vecchio.

The subject, drawn from the legends of ancient Rome, seems an odd choice for statuary. The city's founders, an adventurous band of men from across the sea, so the story goes, tried vainly to find wives among their neighbors, the Sabines, and resorted at last to a trick. Having invited the entire Sabine tribe into Rome for a peaceful festival, they fell upon them with arms, took the women away by force, and thus ensured the future of their race. Actually, the artist designed the group with no specific subject in mind, to silence

those critics who doubted his ability as a monumental sculptor in marble. He selected what seemed to him the most difficult feat, three figures of contrasting character united in a common action. Their identities were disputed among the learned connoisseurs of the day, who finally settled on *The Abduction of the Sabine Woman* as the most suitable title.

Here, then, is another artist who is noncommittal about subject matter, although his unconcern had a different motive from Veronese's. Like Cellini's, Bologna's purpose was virtuoso display. His self-imposed task was to carve in marble, on a massive scale, a sculptural composition that was to be seen not from one but from all sides; this had previously been attempted only in bronze and on a much smaller scale (see fig. 579). He has solved this purely formal problem, but at the cost of insulating his group from the world of human experience. These figures, spiraling upward as if confined inside a tall, narrow cylinder, perform their well-rehearsed choreographic exercise with ease; yet, like much Hellenistic sculpture (compare fig. 213), it is ultimately devoid of emotional meaning. We admire their discipline but we find no trace of genuine pathos.

ARCHITECTURE

Mannerism

The term *Mannerism* was first coined to describe painting of the period. We have not encountered any difficulty in applying it to sculpture. But can it be usefully extended to architecture as well? And if so, what qualities must we look for? These questions have proved surprisingly difficult to answer precisely. The reasons are all the more puzzling, because the important Mannerist architects were leading painters and sculptors. Reflecting our dilemma, only a few structures are generally acknowledged today as Mannerist. Such a building is the Palazzo del Te, Mantua, by Giulio Romano (c. 1499-1566), Raphael's chief assistant. The courtyard facade (fig. 660) features unusually squat proportions and coarse rustication. The massive and utterly useless keystones of the windows have been "squeezed" up by the force of the triangular lintels—an absurd impossibility, since there are no true arches except over the central doorway, which is surmounted by a pediment in violation of classical canon. Even more bizarre is how the metope midway between each pair of columns "slips" downward in defiance of all logic and accepted practice, creating the uneasy sense that the frieze might collapse before our eyes.

The reliance on idiosyncratic gestures that depart from Renaissance norms does not in itself provide a viable definition of Mannerism as an architectural period style. What, then, are the qualities we must look for? Above all, form is divorced from content for the sake of surface effect. The emphasis instead is on picturesque devices, especially encrusted decoration, with the occasional distortion of form and novel, even illogical, rearrangement of space. Thus Mannerist architecture lacks a consistent integration between elements.

VASARI. The Palazzo degli Uffizi in Florence, by Giorgio Vasari, whom we have already encountered as a painter and

660. Giulio Romano. Courtyard of the Palazzo del Te, Mantua. 1527-34

biographer, consists of two long wings—originally intended, as the name Uffizi suggests, for offices—facing each other across a narrow court and linked at one end by a loggia (fig. 661). Vasari's inspiration is not far to seek: the "tired" scroll brackets and the peculiar combination of column and wall have their source in the vestibule of the Laurentian Library. We will recall Vasari's praise for Michelangelo's unorthodox use of the classical vocabulary (see page 468). Does this mean that the Laurentian Library itself is Mannerist? The case can be argued both ways. On the one hand, Michelangelo's design is as willful a subversion of High Renaissance classicism as Rosso's Descent from the Cross (see fig. 637); on the other, these devices serve a powerful expressive purpose in the Laurentian Library that responds to the imperative of Michelangelo's genius, whereas in Vasari's paraphrase they have been reduced to empty gestures. Whichever side one takes (they are not mutually exclusive), the differences in the results are plain enough. The Uffizi loggia lacks the sculptural power and eloquence of its model; rather, it forms a screen as weightless as the facade of the Pazzi Chapel (see fig. 544). What is tense in Michelangelo's design becomes merely ambiguous. The architectural members seem as devoid of energy as the human figures in Vasari's Perseus and Andromeda (fig. 643), and their relationships as studiedly "artificial."

AMMANATI. The same is true of the courtyard of the Palazzo Pitti (fig. 662) by Michelangelo's protégé, the sculptor Bartolommeo Ammanati (1511–1592), despite its display of muscularity. Here the three-story scheme of superimposed orders, derived from the Colosseum, has been overlaid with an extravagant pattern of rustication that "imprisons" the columns, reducing them to an oddly passive role. These welts disguise rather than enhance the massiveness of the masonry, the overall corrugated texture making us think of the fancies of a pastry cook.

Ammanati had worked under Jacopo Sansovino in Venice, and the Palazzo Pitti stands in the same relation to Sansovino's

661. Giorgio Vasari. Loggia of the Palazzo degli Uffizi, Florence (view from the Arno River). Begun 1560

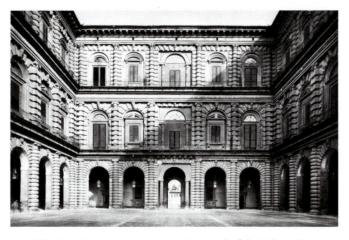

662. Bartolommeo Ammanati. Courtyard of the Palazzo Pitti, Florence. 1558–70

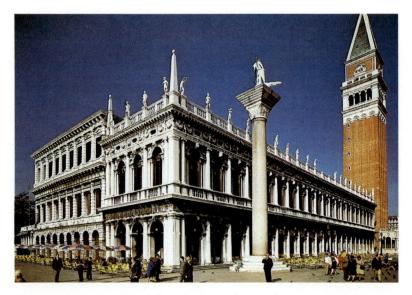

663. Jacopo Sansovino. Mint (left) and Library of St. Mark's, Venice. Begun c. 1535/7

Mint (fig. 663) as Vasari's Palazzo degli Uffizi does to Michelangelo's Laurentian Library.

Other Trends

SANSOVINO. We have not encountered the architecture of Venice since the Ca' d'Oro (see fig. 465), for it remained outside the mainstream of the Renaissance. Its essential characteristics were defined by Jacopo Sansovino (1486-1570), a minor Florentine sculptor of incipient Mannerist persuasion from the circle of Raphael who settled there after the Sack of Rome in 1527 and established himself as the chief architect of the city. Not surprisingly, his buildings are remarkably sculptural in treatment. Indeed, his masterpiece, the Library of St. Mark's (fig. 663) facing the Piazzetta along the Grand Canal, looks like nothing so much as a huge wedding cake, so luxurious is the sculptural encrustation. The street-level arcade consists of the Roman Doric order, inspired by the Colosseum (see fig. 244), while the upper one shows an unusually elaborate treatment of the Ionic order (including triple engaged columns) surmounted by a garlanded entablature. The ensemble is capped off by a balustrade, with lifesize statues over every column cluster and obelisks at each corner. The facade, with its extravagant ornamentation, creates an effect of ponderous opulence that proclaims the Venetian republic as a new Rome. The Library set a new standard for lavish architecture. Sansovino's style was so authoritative that it enjoyed classic status and was followed in Venice for the remainder of the century. Nevertheless, we have left the commanding logic of the High Renaissance far behind.

Stranger still is the Mint to the left of the Library. Once again the facade has been penetrated wherever possible, but the results are yet more massive. Though of equal height, the rusticated arcade seems barely able to sustain the weight of the upper two stories (the top story was added belatedly around 1560), which feature unique corkscrew columns and support heavy cornices. We seem on the verge of Mannerism, but a glance at Ammanati's Pitti courtyard (see fig. 662) will con-

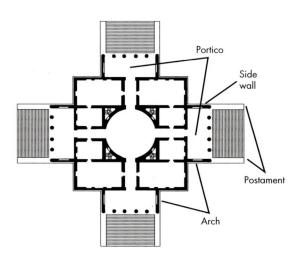

664. Plan of the Villa Rotonda

vince us of the differences. Art historians have yet to find a term adequate to Sansovino's grandiose style.

PALLADIO. Most later sixteenth-century architecture can hardly be called Mannerist at all. Although he, too, drew inspiration from Sansovino, Andrea Palladio (1518–1580), next to Michelangelo the most important architect of the century, belongs to the tradition of the humanist and theoretician Leone Battista Alberti (see page 434).

Although Palladio's career centered on Vicenza, his native town, his buildings and theoretical writings brought him international status. [See Primary Sources, no. 61, page 000.] Palladio insisted that architecture must be governed by reason and by certain rules that were perfectly exemplified by the buildings of the ancients. He thus shared Alberti's basic outlook and his faith in the cosmic significance of numerical ratios (see page 437). But the two differed in how each related theory and practice. With Alberti, this relationship had been loose and flexible, whereas Palladio believed quite literal-

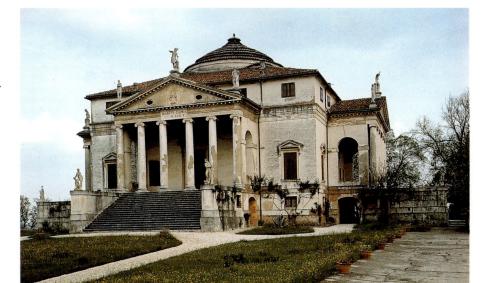

665. Andrea Palladio. Villa Rotonda, Vicenza. c. 1567–70

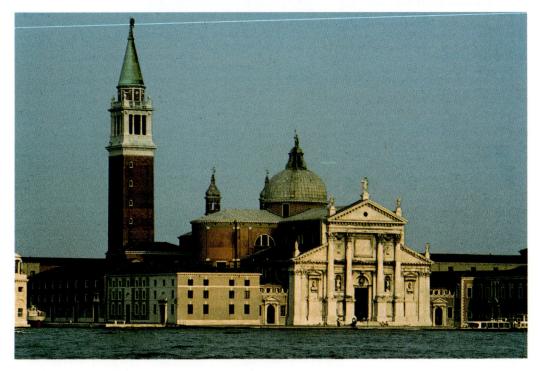

666. Andrea Palladio. S. Giorgio Maggiore, Venice. Designed 1565

667. Plan of S. Giorgio Maggiore

ly in practicing what he preached. His architectural treatise *The Four Books of Architecture* (1570) is consequently more practical than Alberti's, which helps to explain its huge success, while his buildings are linked more directly with his theories. It has even been said that Palladio designed only what was, in his view, sanctioned by ancient precedent. Indeed, the usual term for both Palladio's work and theoretical attitude is "classicistic," to denote a conscious striving for classic qualities, though the results are not necessarily classical in style.

The Villa Rotonda (figs. 664 and 665), one of Palladio's finest buildings, perfectly illustrates the meaning of his classicism. An aristocratic country residence near Vicenza, it consists of a square block surmounted by a dome and is faced on all four sides with identical porches in the shape of temple fronts. Alberti had defined the ideal church as such a completely symmetrical, centralized design (see page 437), and it is evident that

Palladio found in the same principles the ideal country house. How could he justify a context so purely secular for the solemn motif of the temple front? Like Alberti, he sought support in a selective interpretation of the historical evidence. He was convinced, on the basis of ancient literary sources, that Roman private houses had porticoes like these (excavations have since proved him wrong; see page 186). But Palladio's use of the temple front here is not mere antiquarianism. He probably persuaded himself that it was legitimate because he regarded this feature as desirable for both beauty and utility. Beautifully correlated with the walls behind, the porches of the Villa Rotonda are an organic part of his design that lends the structure an air of serene dignity and festive grace.

The facade of S. Giorgio Maggiore in Venice (fig. 666), of about the same date as the Villa Rotonda, adds to the same effect a new sumptuousness and complexity. Palladio's

problem here was how to create a classically integrated facade for a basilican church. He surely knew Alberti's solution at S. Andrea in Mantua (see fig. 569): a temple front enclosing a triumphal arch. But this design, although impressively logical and compact, did not fit the cross section of a basilica and really circumvented the problem. Palladio, again following what he believed to be ancient precedent, found a different answer. He superimposed a tall, narrow temple front on another low, wide one to reflect the different heights of nave and aisles. Theoretically, it was a perfect solution. In practice, however, he found that he could not keep the two systems as separate as his classicistic conscience demanded and still integrate them into a harmonious whole. This conflict, which makes ambiguous those parts of the design that have a dual allegiance, might be interpreted as a Mannerist quality. The plan (fig. 667), too, suggests a duality. The main body of the church is strongly centralized—the transept is as long as the nave—but the longitudinal axis reasserts itself in the separate compartments for the main altar and the chapel beyond.

Proto-Baroque Architecture

VIGNOLA AND DELLA PORTA. Palladio's immense authority as a designer keeps the conflicting elements in the facade and plan of S. Giorgio from actually clashing. In less assured hands, such a precarious union would break apart. The most widely accepted solution was evolved just at that time in Rome by Giacomo Vignola (1507–1573) and Giacomo della Porta (c. 1540–1602), architects who had assisted Michelangelo at St. Peter's and were still using his architectural vocabulary. Il Gesù (Jesus) is a building whose importance for subsequent church architecture can hardly be exaggerated. Since Il Gesù was the mother church of the Jesuits, its design must have been closely supervised so as to conform to the aims of the militant new order, founded in 1534. We may thus view it as the architectural embodiment of the spirit of the Counter Reformation.

The planning stage of the structure began in 1550, only five years after the Council of Trent (see page 483). Michelangelo himself once promised a design, but apparently never furnished it. The present ground plan, by Vignola, was adopted in 1568 (fig. 668). Il Gesù contrasts in almost every possible respect with Palladio's S. Giorgio. It is a basilica, strikingly compact, dominated by its mighty nave. The aisles have been replaced by chapels, thus herding the congregation quite literally into one large, hall-like space directly in view of the altar. The attention of this audience is positively directed toward altar and pulpit, as our view of the interior shows (fig. 669). (The painting indicates how the church would look from the street if the center part of the facade were removed. For the later, High Baroque decoration of the nave vault, see fig. 737.) We also see here an unexpected feature that the ground plan cannot show: the dramatic contrast between the dim illumination in the nave and the abundant light beyond, in the eastern part of the church, supplied by the large windows in the drum of the dome. Light has been consciously exploited for its expressive possibilities—a novel device, "theatrical" in the best sense of the term—to give Il Gesù a stronger emotional focus than we have yet found in a church interior.

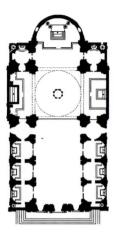

668. Giacomo Vignola. Plan of Il Gesù, Rome. 1568

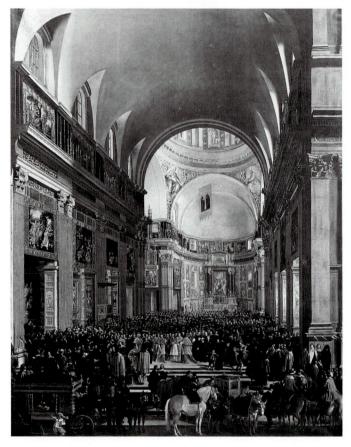

669. Andrea Sacchi and Jan Miel. *Urban VIII Visiting Il Gesù*. 1639–41. Oil on canvas. Galleria Nazionale d'Arte Antica, Rome

Despite its great originality, the plan of Il Gesù is not entirely without precedent (see fig. 571). The facade by Giacomo della Porta (fig. 670) is as bold as the plan, although it, too, has its earlier sources. The paired pilasters and broken architrave on the lower story are clearly derived from the colossal order on the exterior of St. Peter's (compare fig. 622), and with good reason, for it was Della Porta who completed Michelangelo's dome. In the upper story the same pattern recurs on a somewhat smaller scale, with four instead of six pairs of supports. The difference in width is bridged by two scroll-shaped buttresses. This novel device, also taken from Michelangelo, forms a graceful transition to the large pediment crowning the facade, which retains

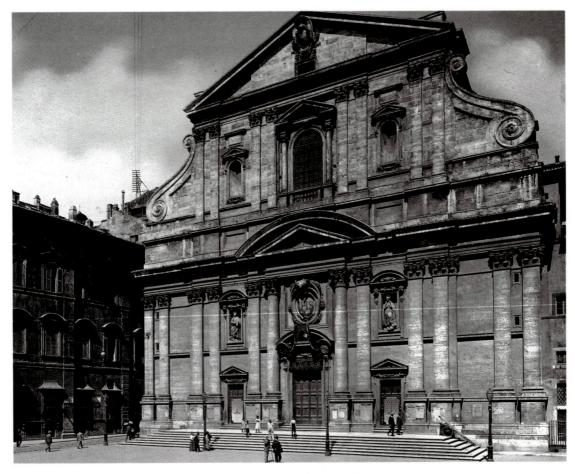

670. Giacomo della Porta. Facade of Il Gesù, Rome. c. 1575-84

the classic proportions of Renaissance architecture (the height equals the width).

What is fundamentally new here is the very element that was missing in the facade of S. Giorgio: the integration of all the parts into one whole. Della Porta, freed from classicistic scruples by his allegiance to Michelangelo, gave the same vertical rhythm to both stories of the facade. This rhythm is obeyed by all the horizontal members (note the broken entablature), but the horizontal divisions in turn determine the size of the vertical members (hence no colossal order). Equally important is the emphasis on the main portal: its double frame—two pediments resting on coupled pilasters and columns—projects beyond the rest of the facade and gives strong focus to the entire design. Not since Gothic architecture has the entrance to a church received such a dramatic con-

centration of features, attracting the attention of the beholder outside the building much as the concentrated light beneath the dome channels that of the worshiper inside.

What are we to call the style of Il Gesù? Obviously, it has little in common with Palladio, and it shares with Vasari's architecture only the influence of Michelangelo. But this influence reflects two very different phases of the great master's career: the contrast between the Uffizi and Il Gesù is hardly less great than that between the vestibule of the Laurentian Library and the exterior of St. Peter's. If we label the Uffizi Mannerist, the same term will not serve us for Il Gesù. As we shall see, the design of Il Gesù became basic to Baroque architecture. By calling it Proto-Baroque, we suggest both its germinal importance for the future and its special place in relation to the past.

CHAPTER FOUR

"LATE GOTHIC" PAINTING, SCULPTURE, AND THE GRAPHIC ARTS

RENAISSANCE VERSUS "LATE GOTHIC" PAINTING

Should we think of the Renaissance as one coherent style or as an attitude that might be embodied in more than one style? "Renaissance-consciousness," we know, was an Italian idea, and there can be no doubt that Italy played the leading role in the development of Renaissance art, at least until the early sixteenth century. This fact does not necessarily mean, however, that the Renaissance was confined to the South. When Boccaccio praised Giotto's imitation of nature, he was not in a position to know how many aspects of reality Giotto and his contemporaries had failed to investigate. These, we recall, were further explored by the painters of the International Style, albeit in somewhat tentative fashion. To advance beyond Gothic realism required a second revolution, which began simultaneously and independently in Italy and in the Netherlands about 1420. We must think of two events linked by a common aim—the conquest of the visible world—yet sharply divided in almost every other respect.

The Italian, or Southern, revolution, which originated in Florence and which we call the Early Renaissance, was the more systematic and, in the long run, the more fundamental, since it included architecture and sculpture as well as painting. Art historians are still of two minds about the scope and significance of the Northern focus of the revolution and its relation to the Renaissance as a whole. The new style emerged in Flanders around 1420, but we lack a satisfactory explanation why it took place at that particular time and in that particular area. This does not mean, however, that no explanation is possible. Unless we believe in sheer fate or chance, we find it difficult to place the entire burden of responsibility on the great masters who gave birth to it. There must, we feel, be some link between their accomplishment and the social, political, and cultural setting in which they worked, but it is not yet well understood.

Many scholars treat fifteenth-century Northern painting as the counterpart of the Early Renaissance in Italy. It is because the Flemish artists had an impact that went far beyond their own region. In Italy they were admired as greatly as the leading Italian artists of the period. Their intense realism had a conspicuous influence on Early Renaissance painting, for the Italians, as we have already noted, associated the exact imitation of nature in painting with a "return to the classics." To Italian eyes, then, "Late Gothic" painting appeared definitely post-medieval.

Nevertheless, Italian Renaissance art made very little impression north of the Alps during the fifteenth century. Not until the final decades did humanism begin to play an important role in Northern thought, which it changed decisively. Nor do we find an interest in the art of classical antiquity before that time. Rather, the artistic and cultural environment of Northern painters clearly remained "Late Gothic." The term suggests the continuity with the world view of the late Middle Ages. Moreover, the creators of the new style, unlike their Italian contemporaries, did not entirely reject the International Style. Instead, they took it as their point of departure, so that the break with the past was less abrupt in the North than in the South. Would it not be more reasonable to regard their work, despite its great importance, as the final phase of Gothic painting? "Late Gothic" also reminds us that fifteenthcentury architecture and sculpture outside Italy remained firmly rooted in the Gothic tradition.

We have, in fact, no satisfactory name to designate the new Flemish painting. Whatever we choose to call the style, we shall find that it has some justification. For the sake of convenience, we shall use the customary label, "Late Gothic," but with quotation marks to indicate its doubtful status, as the

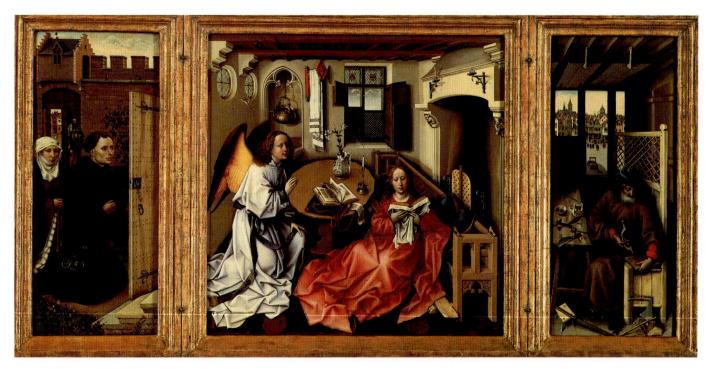

671. Master of Flémalle (Robert Campin?). *Mérode Altarpiece*. c. 1425–30. Oil on panel, center 25³/16 x 24⁷/8" (64.3 x 62.9 cm); each wing approx. 25³/8 x 10⁷/8" (64.5 x 27.4 cm). The Metropolitan Museum of Art, New York. The Cloisters Collection, 1956

term hardly does justice to the special character of Northern fifteenth-century art as a whole.

Netherlandish Painting

THE MASTER OF FLÉMALLE. The first, and perhaps most decisive, phase of the pictorial revolution in Flanders is represented by an artist whose name we do not know for certain. We call him the Master of Flémalle (after the fragments of a large altar from Flémalle), but he was probably Robert Campin, the foremost painter of Tournai, whose career we can trace in documents from 1406 to his death in 1444. His finest work is the Mérode Altarpiece (fig. 671), which he must have done soon after 1425. Comparing it with its nearest relatives, the Franco-Flemish pictures of the International Style (see figs. 519–22), we see that it falls within the same tradition. Yet we also recognize in it a new pictorial experience. Here, for the first time, we have the sensation of actually looking through the surface of the panel into a spatial world that has all the essential qualities of everyday reality: unlimited depth, stability, continuity, and completeness. The painters of the International Style, even at their most adventurous, had never aimed at such consistency, and their commitment to reality was far from absolute. The pictures they created have the enchanting quality of fairy tales, in which the scale and relationship of things can be shifted at will, and fact and fancy mingle without conflict. The Master of Flémalle, in contrast, has undertaken to tell the truth, the whole truth, and nothing but the truth. To be sure, he does not yet do it with total ease. His objects, overly foreshortened, tend to jostle each other in space. But with almost obsessive determination, he defines every last detail of every object to give it maximum concreteness: its individual shape and size; its color, material, surface textures; its degree of rigidity; and its way of responding to illumination. The artist even distinguishes between the diffused light creating soft shadows and delicate gradations of brightness, and the direct light entering through the two round windows, which produces the twin shadows sharply outlined in the upper part of the center panel and the twin reflections on the brass vessel and candlestick.

The *Mérode Altarpiece* transports us from the aristocratic world of the International Style to the household of a Flemish burgher. The Master of Flémalle was no court painter, but a townsperson catering to the tastes of such well-to-do fellow citizens as the two donors piously kneeling outside the Virgin's chamber. This is the earliest Annunciation in panel painting that occurs in a fully equipped domestic interior, as well as the first to honor Joseph, the humble carpenter, by showing him at work next door.

This bold departure from tradition forced upon our artist a problem no one had faced before: how to transfer supernatural events from symbolic settings to an everyday environment, without making them look either trivial or incongruous. He has met this challenge by the method sometimes known as "disguised symbolism," which means that almost any detail within the picture, however casual, may carry a symbolic message. We saw its beginnings during the International Style in the Annunciation by Melchior Broederlam (see page 383), but his symbolism seems rudimentary in comparison with the profusion of hidden meanings in the Mérode Altarpiece. Thus, the flowers are associated with the Virgin: in the left wing the roses denote her charity and the violets her humility, while in the center panel the lilies symbolize her chastity. The shiny water basin and the towel on its rack are not ordinary household equipment either but further tributes to Mary as the "vessel most clean" and the "well of living waters." Perhaps the most intriguing symbol of this sort is the candle next to the vase of lilies. It was extinguished only moments before, as we can tell from the glowing wick and the curl of smoke. But why had it been lit in broad daylight, and what made the flame go out? Has the divine radiance of the Lord's presence overcome the material light? Or did the flame of the candle itself represent the divine light, now extinguished to show that God has become human, that in Jesus "the Word was made flesh"?

Clearly, the entire wealth of medieval symbolism survives in our picture, but it is so completely immersed in the world of everyday appearances that we are often left to doubt whether a given detail demands symbolic interpretation. Observers long wondered, for instance, about the boxlike object on Joseph's workbench (and a similar one on the ledge outside the open window), until one scholar identified them as mousetraps intended to convey a specific theological message. According to St. Augustine, God had to appear on earth in human form so as to fool Satan: "The Cross of the Lord was the devil's mousetrap."

Since iconographic explanations of this sort require much scholarly ingenuity, we tend to think of the *Mérode Altarpiece* and similar pictures as embodying a special kind of puzzle. And so they often do to the modern beholder, although they can be enjoyed apart from knowing all their symbolic content. But what about the patrons for whom these works were painted? Did they immediately grasp the meaning of every detail? They would have had no difficulty with such well-established symbols in our picture as the flowers, and they probably understood the significance of the water basin. The message of the extinguished candle and the mousetrap could not have been common knowledge even among the well-educated, however.

These two symbols—and from their incongruity we can hardly doubt that they are symbols—make their earliest appearance in the *Mérode Altarpiece*. They must be unusual, too, for St. Joseph with the mousetrap has been found in only one other picture, and the freshly extinguished candle does not recur elsewhere, so far as we know. Apparently, the Master of Flémalle introduced them into the visual arts, yet hardly any artists adopted them despite his great influence. If the candle and the mousetrap were difficult to understand even in the fifteenth century, why are they in our picture at all? Was the artist told to put them in by the patron, who may have been exceptionally erudite? This would be possible if it were the only case of its kind, but since there are countless instances of equally subtle or obscure symbolism in "Late Gothic" painting, it seems more likely that the initiative came from the artists, rather than from their patrons.

We have reason to believe, therefore, that the Master of Flémalle was either a man of unusual learning himself, or had contact with the theologians and other scholars who could supply him with the references that suggested the symbolic meanings of things such as the extinguished candle and the mousetrap. In other words, the artist did not simply continue the symbolic tradition of medieval art within the framework of the new realistic style. He expanded and enriched it by his own efforts. To him, even more than Broederlam (see pages 383–84), realism and symbolism were interdependent. We might say that the Master of Flémalle needed a growing symbolic repertory because it encouraged him to explore features

of the visible world never represented before, such as a candle immediately after it has been blown out or the interior of a carpenter's shop, which provided the setting for the mousetraps. For him to paint everyday reality, he had to "sanctify" it with a maximum of spiritual significance.

This deeply reverential attitude toward the physical universe as a mirror of divine truths helps us to understand why in the Mérode panels the smallest and least conspicuous details are rendered with the same concentrated attention as the sacred figures. Potentially, at least, everything is a symbol and thus merits an equally exacting scrutiny. The disguised symbolism of the Master of Flémalle and his successors was not an external device grafted onto the new realistic style, but ingrained in the creative process. Their Italian contemporaries must have sensed this, for they praised both the miraculous realism and the "piety" of the Flemish masters.

If we compare our illustration of the Mérode Annunciation with those of earlier panel paintings (figs. 508, 518, 519, and 525), we see vividly that, all other differences aside, its distinctive tonality makes the Master of Flémalle's picture stand out from the rest. The jewellike brightness of the older works, their patterns of brilliant hues and lavish use of gold, have given way to a color scheme far less decorative but much more flexible and differentiated. The subdued tints of muted greens, bluish- or brownish-grays show a new subtlety, and the scale of intermediate shades is smoother and has a wider range. All these effects are essential to the realistic style of the Master of Flémalle. They were made possible by the use of oil, the medium he was among the first to exploit.

JAN AND HUBERT VAN EYCK. Needless to say, the full range of effects made possible by oil was not discovered all at once, nor by any one individual. The Master of Flémalle contributed less than Jan van Eyck, a somewhat younger and much more famous artist who was long credited with the actual "invention" of oil painting. [See Primary Sources, no. 62, pages 635–36.] We know a good deal about Jan's life and career. Born about 1390, he worked in Holland from 1422 to 1424, in Lille from 1425 to 1429, and thereafter in Bruges, where he died in 1441. He was both a townsman and a court painter, highly esteemed by Duke Philip the Good of Burgundy, who occasionally sent him on confidential diplomatic errands. After 1432, we can follow Jan's career through a number of signed and dated pictures.

The inscription on the frame of the great *Ghent Altarpiece* (see figs. 673–75) tells us that Jan completed it in that year, after it had been begun by his older brother, Hubert, who had died in 1426. Jan's earlier development, however, remains disputed. There are several "Eyckian" works, obviously older than the *Ghent Altarpiece*, that may have been painted by either of the two brothers. The most fascinating of these is a pair of panels showing the *Crucifixion* and the *Last Judgment* (fig. 672). Scholars agree that their date is between 1420 and 1425, whichever brother, Jan or Hubert, was the author. The style of these paintings has many qualities in common with that of the *Mérode Altarpiece*: the all-embracing devotion to the visible world, the unlimited depth of space, and the angular drapery folds, less graceful but far more realistic than the unbroken loops of the International Style. At the same time, the indi-

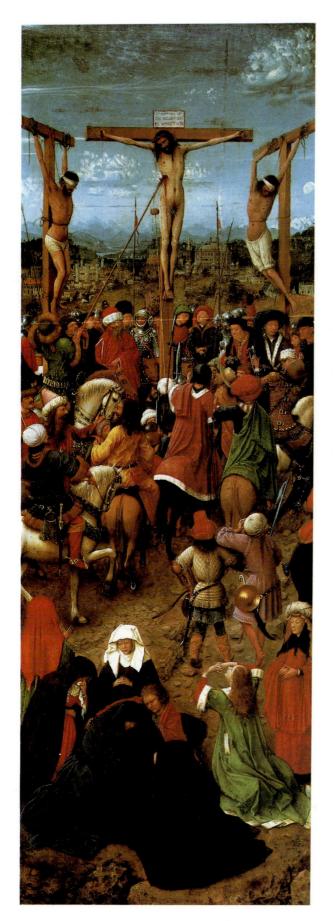

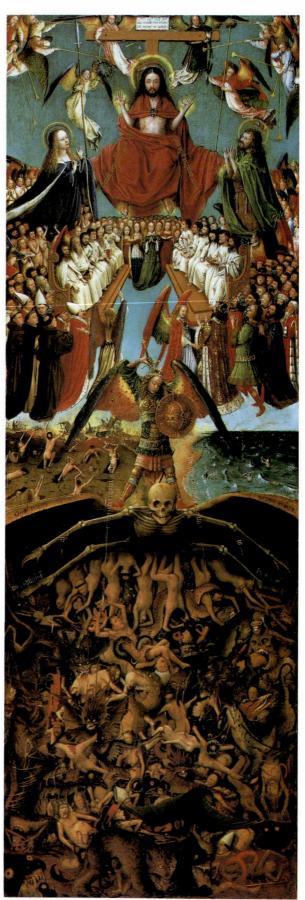

672. Hubert and/or Jan van Eyck. *The Crucifixion; The Last Judgment.* c. 1420–25. Tempera and oil on canvas, transferred from panel; each panel $22^{1/4} \times 7^{3/4}$ " (56.5 x 19.4 cm). The Metropolitan Museum of Art, New York Fletcher Fund, 1933

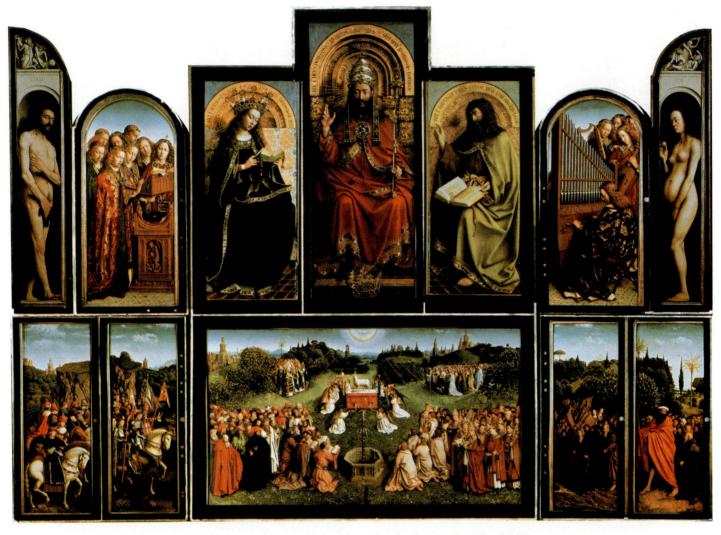

673. Hubert and Jan van Eyck. *Ghent Altarpiece* (open). Completed 1432. Oil on panel, $11'3" \times 14'5" (3.4 \times 4.4 \text{ m})$. Church of St. Bavo, Ghent, Belgium

vidual forms are not starkly tangible, like those characteristic of the Master of Flémalle, and seem less isolated, less "sculptural." The sweeping sense of space is the result not so much of violent foreshortening as of subtle changes of light and color. If we inspect the *Crucifixion* panel closely, we see a gradual decrease in the intensity of local colors and in the contrast of light and dark, from the foreground figures to the far-off city of Jerusalem and the snow-capped peaks beyond. Everything tends toward a uniform tint of light bluish-gray, so that the farthest mountain range merges imperceptibly with the color of the sky.

This optical phenomenon is known as "atmospheric perspective." The Van Eycks were the first to utilize the effect fully and systematically, although the Boucicaut Master and the Limbourg brothers had already been aware of it. The atmosphere is never wholly transparent. Even on the clearest day, the air between us and what we are looking at acts as a hazy screen that interferes with our ability to see distant shapes clearly. As we approach the limit of visibility, it swallows them altogether. Atmospheric perspective is more fundamental to our perception of deep space than linear perspective, which records the diminution in the apparent size of objects as their distance from the observer increases. It is effective not only in faraway

vistas. In the *Crucifixion* panel, even the foreground seems enveloped in a delicate haze that softens contours, shadows, and colors. Thus the entire scene has a continuity and harmony quite beyond the pictorial range of the Master of Flémalle.

How did the Van Eycks achieve this effect? Their exact technical procedure is difficult to reconstruct, but there can be no question that they used the oil medium with extraordinary refinement. By alternating opaque and translucent layers of paint, they were able to impart to their pictures a soft, glowing radiance of tone that has never been equaled, probably because it depends fully as much on their individual sensibilities as it does on their skillful craftsmanship.

Seen as a whole, the *Crucifixion* seems singularly devoid of drama, as if the scene had been gently becalmed by some magic spell. Only when we concentrate on the details do we become aware of the violent emotions in the faces of the crowd beneath the Cross, and the restrained but profoundly touching grief of the Virgin Mary and her companions in the foreground. In the *Last Judgment* panel, this dual quality of the Eyckian style takes the form of two extremes. Above the horizon, all is order, symmetry, and calm; below it, on earth and in the subterranean realm of Satan, violent chaos prevails. The two states thus correspond to Heaven and Hell, contemplative

674. Adam and Eve, details of Ghent Altarpiece, left and right wings

bliss as against physical and emotional turbulence. The lower half, clearly, was the greater challenge to the artist's imaginative powers. The dead rising from their graves with frantic gestures of fear and hope, the damned being torn apart by devilish monsters more frightful than any we have seen before (compare fig. 404), all have the awesome reality of a nightmare, but a nightmare "observed" with the same infinite care as the natural world of the *Crucifixion* panel.

The *Ghent Altarpiece* (figs. 673–75), the greatest monument of early Flemish painting, presents problems so complex that our discussion must be limited to bare essentials. We have already mentioned the inscription informing us that the work,

675. Ghent Altarpiece (closed)

begun by Hubert, was completed by Jan in 1432. Since Hubert died in 1426, the altarpiece was presumably made in the seven-year span between 1425 and 1432. We may therefore expect it to introduce to us the next phase of the new style we have discussed so far. Its basic arrangement is a triptych a central body with two hinged wings—the standard format of altarpieces. In addition, each of the three units consists of four separate panels. And since the wings are also painted on both sides, the altarpiece has a total of 20 components of assorted shapes and sizes. The ensemble makes what has rightly been called a "super-altar," overwhelming but far from harmonious, which could not have been planned this way from the start. Apparently Jan took over a number of panels left unfinished by Hubert, completed them, added some of his own, and assembled them at the behest of the wealthy donor whose portrait we see on one of the outer panels of the altar.

To reconstruct this train of events, and to determine each brother's share, is an interesting but difficult game. Suffice it to say that Hubert remains a somewhat shadowy figure. His style, overlaid with retouches by Jan, can probably be found in the four central panels inside, although they did not belong together originally. The upper three, whose huge figures in the final arrangement crush the multitude of small ones below, were intended, it seems, to form a self-contained triptych: the Lord between the Virgin Mary and St. John the Baptist. The lower panel and the four flanking it probably

676. Jan van Eyck. *Man in a Red Turban (Self-Portrait?)*. 1433. Oil on panel, 10¹/₄ x 7¹/₂" (26 x 19 cm). The National Gallery, London

Reproduced by courtesy of the Trustees

formed a separate altarpiece, the Adoration of the Lamb, symbolizing Jesus' sacrificial death. The two panels with music-making angels may have been planned by Hubert as a pair of organ shutters.

If this hypothesis is correct, the two tall, narrow panels showing Adam and Eve (fig. 674) are the only ones on the interior added by Jan to Hubert's stock. They certainly are the most daring of all: these, the earliest monumental nudes of Northern panel painting (hardly less than lifesize), are magnificently observed and caressed by the most delicate play of light and shade. Their quiet dignity and prominent place in the altar suggest that they should remind us not so much of Original Sin as of our creation in God's own image. Actual evil, by contrast, is represented in the small, violently expressive scenes above, which show the story of Cain and Abel. Even more extraordinary is the fact that the Adam and Eve were designed specifically for their present positions in the ensemble. Jan van Eyck has established a new, direct relationship between picture space and real space by depicting the two figures as they would really appear to the spectator, whose eye level is below the bottom of the panels.

The outer surfaces of the two wings (fig. 675) were evidently planned by Jan as one coherent unit. Here, as we would normally expect, the largest figures are not above, but in the lower tier. The two St. Johns (painted in grays to simulate

sculpture, like the scenes of Cain and Abel), the donor, and his wife, each in a separate niche, are the immediate kin of the *Adam* and *Eve* panels. The upper tier has two pairs of panels of different width. The artist has made a virtue of this awkward necessity by combining all four into one interior. Such an effect, we recall, had first been created by Pietro Lorenzetti almost a century earlier (compare fig. 509). Not content with perspective devices alone, Jan heightens the illusion by painting the shadows cast by the frames of the panels on the floor of the Virgin's chamber. Interestingly enough, this Annunciation resembles, in its homely detail, the *Mérode Altarpiece*, thus providing an important link between the two great pioneers of Flemish realism.

Donors' portraits of splendid individuality occupy conspicuous positions in both the Mérode and the Ghent altarpieces. A renewed interest in realistic portraiture had developed in the mid-fourteenth century, but until about 1420 its best achievements were in sculpture (see fig. 480). Painters usually confined themselves to silhouettelike profile views. Not until the Master of Flémalle, the first artist since antiquity to have real command of a close-up view of the human face from a three-quarter view, did the portrait play a major role in Northern painting.

In addition to donors' portraits, we now begin to encounter a growing number of small, independent likenesses whose intimacy suggests that they were treasured keepsakes, pictorial substitutes for the real presence of the sitter. One of the most compelling is Jan van Eyck's Man in a Red Turban of 1433 (fig. 676), which may well be a self-portrait. (The slight strain about the eyes seems to come from gazing into a mirror.) The sitter is bathed in the same gentle, clear light as Adam and Eve on the Ghent Altarpiece. Every detail of shape and texture has been recorded with almost microscopic precision. Jan does not suppress the sitter's personality, yet this face, like all of Jan's portraits, remains a psychological puzzle. It might be described as "even-tempered" in the most exact sense of the term: its character traits are balanced against each other so perfectly that none can assert itself at the expense of the rest. As Jan was fully capable of expressing emotion—we need only recall the faces of the crowd in the Crucifixion, or the scenes of Cain and Abel in the Ghent Altarpiece—the stoic calm of his portraits surely reflects his conscious ideal of human character rather than indifference or lack of insight.

The Flemish cities of Tournai, Ghent, and Bruges, where the new style of painting flourished, rivaled those of Italy as centers of international banking and trade. Their foreign residents included many Italian businessmen. Jan van Eyck probably painted his remarkable portrait in figure 677 to celebrate the alliance of two of these families that were active in Bruges and Paris. It represents in all likelihood the betrothal of Giovanni Arnolfini and Giovanna Cenami in the main room of the bride's house, rather than an exchange of marriage vows in the privacy of the bridal chamber, as commonly thought. The young couple touches hands in espousal as he raises his right hand in solemn oath. (In accordance with Northern custom, the actual wedding no doubt took place later in front of a church, when the young couple's right hands were literally joined in holy matrimony.) They seem to be quite alone, but in the mirror conspicuously placed behind them is the reflection

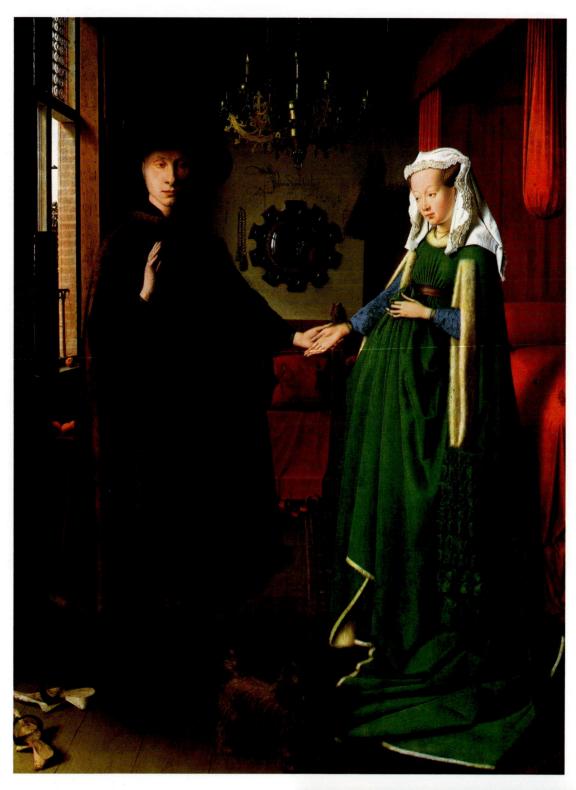

677. Jan van Eyck. *The Arnolfini Portrait.* 1434. Oil on panel, 33 x 22¹/2" (83.7 x 57 cm). The National Gallery, London Reproduced by courtesy of the Trustees

of two other people who have entered the room (fig. 678). One of them is presumably the bride's father, who by tradition gives her to the groom. The other must be the artist, since the words above the mirror, in florid lettering, tell us that "Johannes de eyck fuit hic" (Jan van Eyck was here) in the year 1434.

Jan's role, then, is that of a witness to the event, which also entailed a legal and financial contract between the two families.

678. (right) Jan van Eyck. The Arnolfini Portrait (detail)

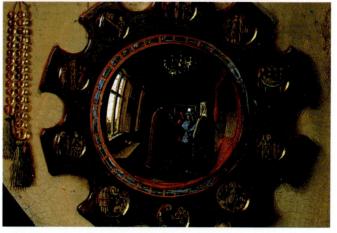

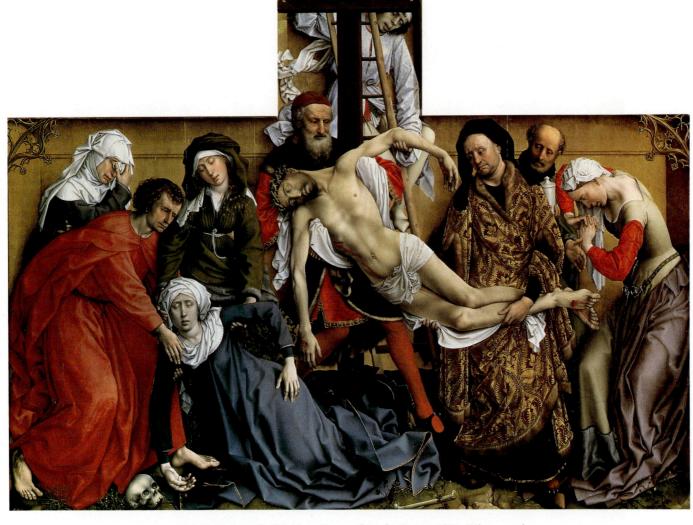

679. Rogier van der Weyden. *Descent from the Cross.* c. 1435. Oil on panel, 7'25/8" x 8'7¹/8" (2.2 x 2.6 m). Museo del Prado, Madrid

The picture claims to show exactly what he saw. Given its secular nature, we may wonder whether the picture is filled with the same sort of disguised symbolism as the Mérode Altarpiece, where the natural world contains the world of the spirit so completely that the two actually become one. Or does the pervasive realism serve simply as an accurate record of the domestic setting? The elaborate bed, the main piece of furniture in the wellappointed living room of the day, was used not for sleeping but for greeting new mothers and paying final respects to the deceased. May it not also contain a discreet allusion to the physical consummation that validated marriage? Has the couple taken off their shoes merely as a matter of custom, or to remind us that they are standing on "holy ground"? (For the origin of the theme, see page 62.) By the same token, is the little dog no more than a beloved pet or an emblem of fidelity? (The words dog and fidelity share the same root with betrothal in the Latin fides.) The other furnishings of the room pose similar problems of interpretation. What is the role of the single candle in the chandelier, burning in broad daylight (compare page 505)? And is the convex mirror, the frame of which is decorated with

scenes from the Passion, not a Vanitas symbol (see fig. 678, page 511)? Clearly Jan was so intrigued by its unusual visual effects that he incorporated it into two other paintings as well.

ROGIER VAN DER WEYDEN. In the work of Jan van Eyck, the exploration of the reality made visible by light and color reached a level that was not to be surpassed for another two centuries. Rogier van der Weyden (1399/1400-1464), the third great master of early Flemish painting, set himself a different though equally important task: to recapture the emotional drama and the pathos of the Gothic past within the framework of the new style created by his predecessors. We see this greater expressive immediacy in his early masterpiece, Descent from the Cross (fig. 679), which dates from about 1435 when the artist was in his mid-thirties. Here the modeling is sculpturally precise, with brittle, angular drapery folds recalling those of his teacher, the Master of Flémalle. The soft halfshadows and rich, glowing colors show his knowledge of Jan van Eyck, with whom he may also have been in contact. Yet Rogier is far more than a follower of the two older artists.

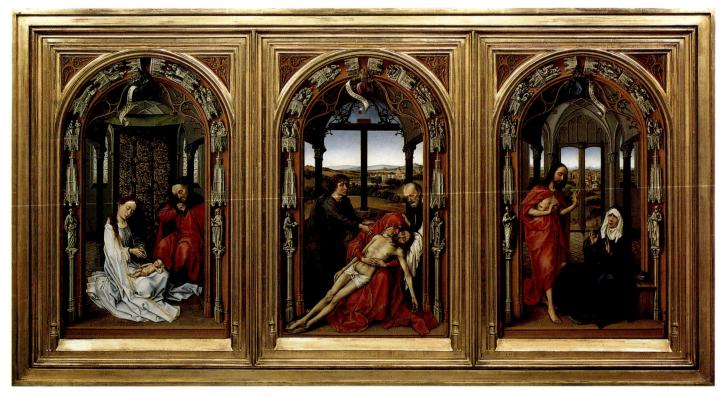

680. Rogier van der Weyden. *The Miraflores Altarpiece.* c. 1440–44. Oil on panel, each panel 28 x 16⁷/8" (71.1 x 42.8 cm). Staatliche Museen zu Berlin, Gemäldegalerie

Whatever he owes to them (and it is obviously a great deal) he uses for purposes that are not theirs but his. The external events (in this case, the lowering of Jesus' body from the Cross) concern him less than the world of human feeling: "the inner desires and emotions . . . whether sorrow, anger, or gladness," in the words of an early account. The visible world in turn becomes a means toward that same end.

Rogier's art has been well described as "at once physically barer and spiritually richer than Jan van Eyck's." This *Descent*, judged for its expressive content, could well be called a *Lamentation*. The Virgin's swoon echoes the pose and expression of her son. So intense is her pain and grief that it inspires in the viewer the same compassion. Rogier has staged his scene in a shallow architectural niche or shrine, and not against a land-scape background. This bold device gives him a double advantage in heightening the effect of the tragic event. It focuses the viewer's entire attention on the foreground, and allows the artist to mold the figures into a coherent group. It seems uniquely fitting that Rogier treats his figures as if they were colored statues, for the artistic ancestry of these grief-stricken gestures and faces

is in sculpture rather than in painting. The panel descends from the Strasbourg *Death of the Virgin* (fig. 470), to which it bears a strong similarity in both composition and mood.

Truly "Late Gothic," Rogier's art never departs from the spirit of the Middle Ages. Yet visually it belongs just as clearly to the new era, so that the past is inevitably restated in contemporary terms. Thus, *The Miraflores Altarpiece* (fig. 680) is replete with self-conscious archaisms but looks thoroughly up to date. By now the artist was in great demand, and his work involved the participation of assistants: such is the case with our altar, named for the convent near Burgos that received it by 1445. (The composition is known in a second, equally fine version from his shop.) As the inscriptions on the scrolls tell us, the triptych celebrates the purity, faith, and perseverance of the Virgin, which are related in turn to the theme of her joys, sorrows, and glories.

A simulated portal provides the doorway into each scene, which is confined to the foreground of a small niche, despite the suggestion of space around it. This old-fashioned device once again creates the impression of figures as colored sculpture

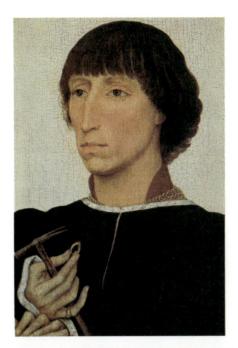

681. Rogier van der Weyden. *Francesco d'Este.* c. 1455. Tempera and oil on panel, 11³/4 x 8" (29.8 x 20.3 cm). The Metropolitan Museum of Art, New York The Friedsam Collection. Bequest of Michael Friedsam, 1931

in an architectural setting (see the Naumburg *Crucifixion*, fig. 476). The effect is heightened by the reliefs lining the archivolts, which carry much of the narrative and symbolic burden by depicting events from the life of Jesus related to the main subject below. The Virgin adoring the Christ Child in the left panel recalls a traditional Nativity (compare fig. 521) transferred to an indoor setting, which indicates that this Madonna of Humility is also the Queen of Heaven. The center panel similarly combines the Byzantine motif of the Last Kiss with the time-honored German *Pietà* (fig. 479). However, the Final Appearance of Jesus to his Mother, in the right panel, is unusu-

al in both subject and treatment. It is reminiscent of the more familiar *Noli me tangere*, where he appears to the Magdalen. Like *The Deposition, The Miraflores Altar* may be thought of as an enlarged Gothic *Andachtsbild* that is meant to be revered as an object of spiritual devotion. The figures bespeak the aristocratic ideal of the International Style. Attenuated and elegant, they represent Rogier's definitive type. He uses them to convey a remarkable range of emotion not simply through gesture and expression but also through purely formal means—the precise quality of line, form, and color—which communicate their intent with powerful conviction.

What is true of Rogier's religious works applies equally well to his portraits. The likeness of Francesco d'Este (fig. 681), an Italian nobleman resident at the Burgundian court, may strike us as less lifelike than Jan van Eyck's. Modeling is reduced to a minimum, and much descriptive detail has been simplified or omitted altogether. The gracefully elongated forms render an aristocratic ideal rather than the sitter's individual appearance. Yet this face, compared with that of the Man in a Red Turban (fig. 676), conveys a more vivid sense of character. Instead of striving for the psychologically "neutral" calm of Jan's portraits, Rogier interprets the human personality by suppressing some traits and emphasizing others through such features as the set of the eyes and mouth. As a result, he tells us more about the inner life of his sitters and less about their outward appearance. They are so self-contained as to remain enigmatic. Consequently, we are hard pressed to define their state of mind, witness the widely varying responses they evoke.

Neverthless, Rogier was accessible to people still imbued with a medieval outlook. No wonder he set an example for countless other artists. When he died in 1464, after 30 years as the foremost painter of Brussels, his influence was supreme throughout Europe north of the Alps. Its impact continued to be felt almost everywhere outside Italy, in painting as well as sculpture, until the end of the fifteenth century, such was the authority of his style.

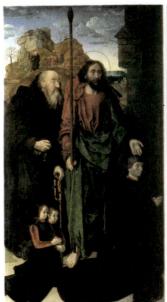

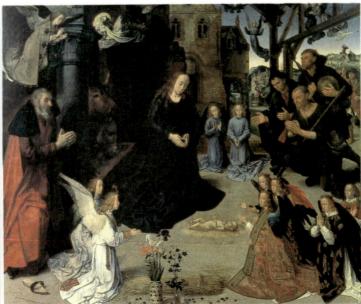

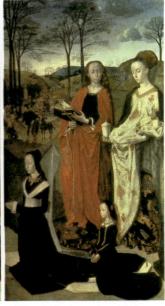

682. Hugo van der Goes. *The Portinari Altarpiece* (open). c. 1476. Tempera and oil on panel, center $8'3^{1}/2" \times 10' (2.5 \times 3.1 \text{ m})$, wings each $8'3^{1}/2" \times 4'7^{1}/2" (2.5 \times 1.4 \text{ m})$. Galleria degli Uffizi, Florence

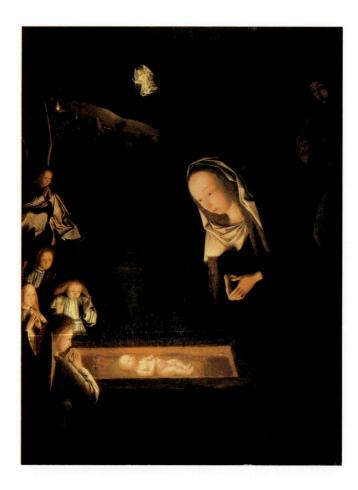

683. Geertgen tot Sint Jans. *Nativity*. c. 1490. Oil on panel, 13¹/₂ x 10" (34.3 x 25.7 cm). The National Gallery, London Reproduced by courtesy of the Trustees

HUGO VAN DER GOES. Among the artists who followed Rogier van der Weyden, few succeeded in escaping from the great master's shadow. To them his paintings offered a choice between intense drama on the one hand and delicate restraint on the other. Most opted for the latter, and their work is marked by a fragile charm. The most dynamic of Rogier's disciples was Hugo van der Goes (c. 1440–1482), an unhappy genius whose tragic end suggests an unstable personality especially interesting to us today. After a spectacular rise to fame in the cosmopolitan atmosphere of Bruges, he decided in 1475, when he was nearly 35 years of age, to enter a monastery as a lay brother. [See Primary Sources, no. 63, pages 636–37.] He continued to paint for some time, but increasing fits of depression drove him to the verge of suicide, and four years later he was dead.

Van der Goes' most ambitious work, the huge altarpiece commissioned by Tommaso Portinari in 1475, is an awesome achievement (fig. 682). While we need not search here for hints of Hugo's future mental illness, it nonetheless evokes a nervous and restless personality. There is a tension between the artist's devotion to the natural world and his concern with the supernatural. Hugo has rendered a wonderfully spacious and atmospheric landscape setting, with a wealth of precise detail. Yet the disparity in the size of the figures seems to contradict this realism. In the wings, the kneeling members of the Portinari family are dwarfed by their patron saints, whose gigantic size characterizes them as being of a higher order. The latter figures are not meant to be "larger than life," however, for they

share the same huge scale with Joseph, the Virgin Mary, and the shepherds of the Nativity in the center panel, whose height is normal in relation to the architecture and to the ox and ass. The angels are drawn to the same scale as the donors, and thus appear abnormally small.

This variation of scale stands outside the logic of everyday experience affirmed in the environment the artist has provided for his figures. Although it originated with Rogier van der Weyden and has a clear symbolic purpose, Hugo exploited the incongruity for expressive effect. There is another striking contrast between the hushed awe of the shepherds and the ritual solemnity of all the other figures. These field hands, gazing in breathless wonder at the newborn Child, react to the dramatic miracle of the Nativity with a wide-eyed directness new to Flemish art. They aroused particular admiration in the Italian painters who saw the work after it arrived in Florence in 1483.

GEERTGEN TOT SINT JANS. During the last quarter of the fifteenth century there were no painters in Flanders comparable to Hugo van der Goes, and the most original artists appeared farther north, in Holland. To one of these, Geertgen tot Sint Jans of Haarlem, who died at the age of 28, about 1495, we owe the enchanting *Nativity* reproduced in figure 683, a picture as daring in its quiet way as the center panel of the *Portinari Altarpiece*. The idea of a nocturnal Nativity, illuminated mainly by radiance from the Christ Child, goes back to the International Style (see fig. 526), but Geertgen, applying the pictorial discoveries of Jan van Eyck, gives new, intense

684. Hieronymus Bosch. *The Garden* of Delights. c. 1510–15. Oil on panel, center 7'2¹/2" x 6'4³/4" (2.19 x 1.95 m); wings, each 7'2¹/2" x 3'2" (2.19 x .96 m). Museo del Prado, Madrid

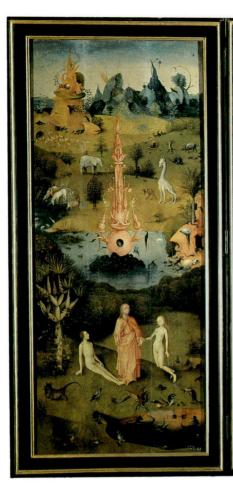

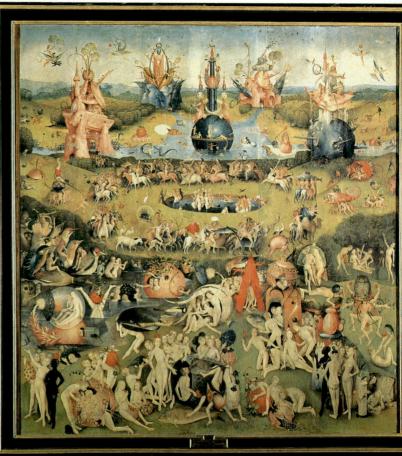

reality to the theme. The magic effect of his little panel is greatly enhanced by the smooth, simplified shapes that record the play of light with striking clarity. The heads of the angels, the Infant, and the Virgin are all as round as objects turned on a lathe, while the manger is a rectangular trough.

BOSCH. If Geertgen's uncluttered forms seem surprisingly modern to us today, another Dutch artist, Hieronymus Bosch, appeals to our interest in the world of dreams. Little is known about Bosch except that he came from a family of painters named Van Aken, spent his life in the provincial town of 's Hertogenbosch, and died, an old man, in 1516. His work, full of weird and seemingly irrational imagery, has proved difficult to interpret.

We can readily see why when we study the triptych known as *The Garden of Delights* (fig. 684), the richest and most puzzling of Bosch's pictures. [See Primary Sources, no. 64, page 637.] Its peculiar qualities may be owing in part to the fact that this is not a traditional altarpiece but a secular work: it was probably commissioned by Henry III of Nassau for his palace in Brussels, where it was hanging immediately after Bosch's death. Henry would have been familiar with Bosch's work in 's Hertogenbosch, the royal summer residence. Many ingenious proposals have been put forward by scholars to explicate the enigmatic painting: for example, that it represents the days of Noah, or that it is a heretical allegory of redemption through

the acceptance of humanity's natural state before the Fall.

Much of the imagery in *The Garden of Delights* derives from treatises on astrology and alchemy, which Bosch would have known through his father-in-law, a well-to-do pharmacist. These unite the humors with the zodiac in a universal scheme of good and evil paralleling Neo-Platonism, which was itself interested in magic in this prescientific era. Yet, if the truth be told, none of these explanations is wholly satisfactory. In the end, we must take the character of the painting itself into account; moreover, any interpretation must be consistent with Bosch's work as a whole.

Of the three panels, only the left one has a clearly recognizable subject: the Garden of Eden, where the Lord introduces Adam to the newly created Eve. The landscape, almost Eyckian in its airy vastness, is filled with animals, among them such exotic creatures as an elephant and a giraffe, as well as hybrid monsters of odd and sinister kinds. The distant rock formations behind them are equally strange. They are perhaps a reference to the alchemical furnace, in which foul gases are purified. The right wing, a nightmarish scene of burning ruins and fantastic instruments of torture, surely represents Hell. But what of the center panel, a detail of which is seen in figure 685?

Here is a landscape much like that of the Garden of Eden, populated with countless nude men and women engaged in a variety of peculiar activities. In the center, they parade around a circular basin on the backs of all sorts of beasts. Many frolic

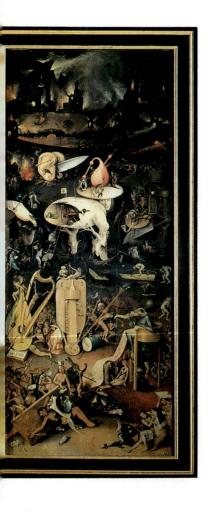

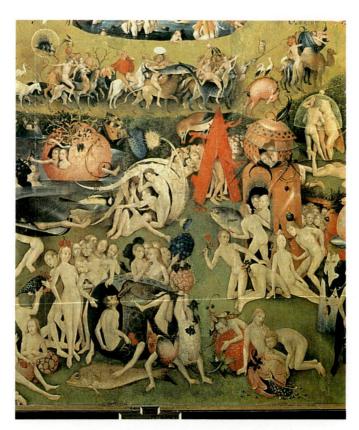

685. Hieronymus Bosch. *The Garden of Delights.*Detail of center panel

The brilliance of the fifteenthcentury Flemish painters had a

close parallel in the field of music. After about 1420, The Netherlands produced a school of composers—Guillaume Dufay (c. 1400-1474), Johannes Ockeghem (c. 1420-1495), Josquin Des Prés (c. 1440-1521), and Adrian Willaert (c. 1490–1562)—so revolutionary as to dominate the development of music throughout Europe for the next 125 years. How much the new style was appreciated can be gathered from the words of the Flemish theorist Johannes Tinctoris (1446?–1511), who wrote of these composers in 1477: "Although it seems beyond belief, nothing worth listening to had been composed before their time." Except for the absence of any reference to the revival of antiquity, this remark, with its sweeping rejection of medieval music, shows a Flemish "Renaissance consciousness" much like that of the Italian humanists of the same period. In fact, Des Prés and Willaert held important positions in Italy, and Dufay had spent nearly a decade there early in his career. In Italy, during the High Renaissance, they were revered as the greatest composers of their day (see page 464). The main contribution of these Flemings was the invention of the fugue, the passing of a short theme from one voice to another of equal weight (think of "Three Blind Mice"), a technique that was

Music in Fifteenth-Century Flanders

to become highly developed in the sixteenth century.

Tinctoris credited the English composer John Dunstable (c. 1385-1453), active in France between 1422 and 1435, with beginning a revolution that replaced the complexities of Gothic polyphony with a simpler style. Dufay carried Dunstable's innovations further by placing the main melody, which earlier had been sung by the tenor, in the soprano voice. This simple change gave greater prominence to the melodic line and emphasized its beauty. Dufay also led a movement to replace plainsong in sacred music with themes from secular songs, which were more flexible than chant and more appealing to contemporary taste. In the sixteenth century, these innovations evolved into a form called the parody mass, in which most of the themes were taken from popular songs, freely modified, and connected with newly composed passages. Ockeghem completed the musical revolution toward a more mellifluous style. Though less well known today than Dufay, Ockeghem was highly honored in his own time. The humanist Erasmus wrote of him, "His golden voice caressed the ears of the angels, and swayed the hearts of men to their depths," and his passing was mourned by his pupil Josquin in the lament Nymphs of the Woods.

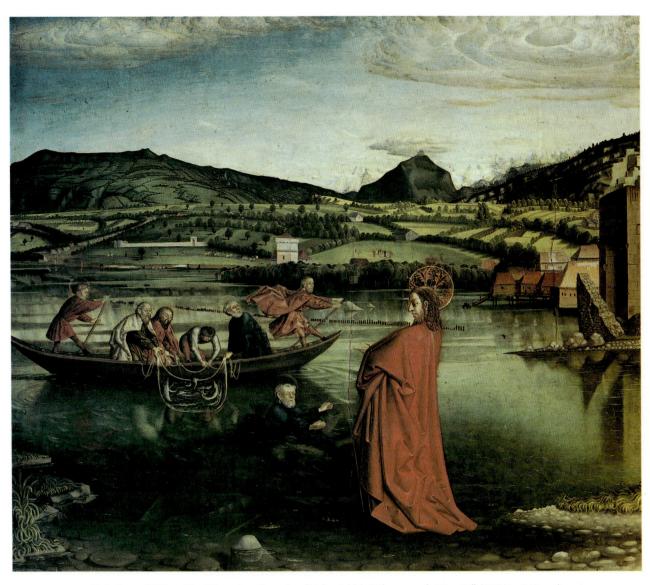

686. Conrad Witz. *The Miraculous Draught of Fishes.* 1444. Oil on panel, 51 x 61" (129.7 x 155 cm). Musée d'Art et d'Histoire, Geneva, Switzerland

in pools of water. Most of them are closely linked with enormous birds, fruit, flowers, or marine animals. Only a few are openly engaged in lovemaking, but there can be no doubt that the delights in this "garden" are those of carnal desire, however oddly disguised. The birds, fruit, and the like are symbols or metaphors which Bosch uses to depict life on earth as an unending repetition of the Original Sin of Adam and Eve, which dooms us to be prisoners of our appetites. Nowhere does the artist even hint at the possibility of salvation. Corruption, on the animal level at least, had already asserted itself in the Garden of Eden before the Fall, and we are all destined for Hell, the Garden of Satan, with its grisly and refined instruments of torture.

Bosch conveys a profoundly pessimistic attitude about humanity. We nevertheless sense a fundamental ambiguity in the central panel. There is an innocence, even a haunting poetic beauty, in this panorama of human sinfulness. Consciously, Bosch was a stern moralist who intended his pictures to be visual sermons, every detail packed with didactic meaning. Unconsciously, however, he must have been so enraptured by the sensuous appeal of the world of the flesh that the images

he coined in such abundance tend to celebrate what they are meant to condemn. That, surely, is the reason why *The Garden of Delights* still evokes so strong a response today, even though we no longer understand every word of the sermon.

Swiss, German, and French Painting

We must now glance briefly at fifteenth-century art in the rest of Northern Europe. After about 1430, the new realism of the Flemish masters began to spread into France and Germany until, by the middle of the century, its influence prevailed everywhere from Spain to the Baltic. Among the countless artists (many of them still anonymous) who turned out provincial adaptations of Netherlandish painting, only a few were gifted enough to impress us with a distinctive personality.

WITZ. One of the earliest and most original of these masters was Conrad Witz of Basel (1400/10–1445/6), whose altarpiece for Geneva Cathedral, painted in 1444, includes the remarkable panel shown in figure 686. To judge from the drapery, with its tubular folds and sharp, angular breaks, he

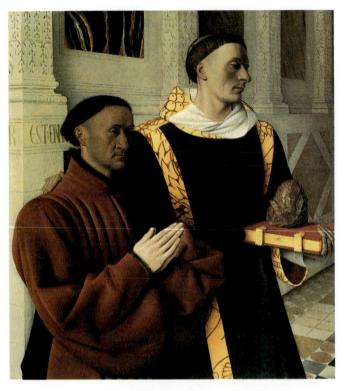

687. Jean Fouquet. Étienne Chevalier and St. Stephen, left wing of the Melun Diptych. c. 1450. Oil on panel, 36½ x 33½" (92.7 x 85 cm). Staatliche Museen zu Berlin, Gemäldegalerie

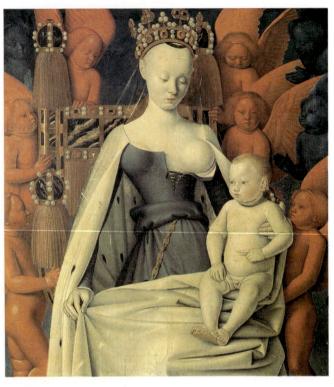

688. Jean Fouquet. *Madonna and Child*, right wing of the *Melun Diptych*. c. 1450. Oil on panel, 36 ⁵/8 x 33 ¹/2" (93 x 85 cm). Musée Royal des Beaux-Arts, Antwerp, Belgium

must have had close contact with the Master of Flémalle. But the setting, rather than the figures, attracts our interest, and here the influence of the Van Eycks seems dominant. Witz, however, did not simply follow these great pioneers. An explorer himself, he knew more about the optical appearances of water than any other painter of his time, as we can see the bottom of the lake in the foreground. The landscape, too, is an original contribution. Representing a specific part of the shore of the Lake of Geneva, it is among the earliest landscape "portraits" that have come down to us.

FOUQUET. In France, the leading painter was Jean Fouquet (c. 1420–1481) of Tours, some 20 years younger than Witz. He had the exceptional fortune of a lengthy visit to Italy around 1445, soon after he had completed his training, so that his work represents a unique blend of Flemish and Early Renaissance elements, although it remains basically Northern. Étienne Chevalier and St. Stephen, the left wing of the Melun Diptych (fig. 687), his most famous work, shows his mastery as a portraitist. Remarkably, the head of the saint seems no less individual than that of the donor. Italian influence can be seen

in the style of the architecture and, less directly, in the statuesque solidity and weight of the two figures. According to an old tradition, the Madonna in the right wing (fig. 688) is also a portrait: that of Agnes Sorel, Charles VII's mistress, whose estate Chevalier represented as executor upon her death in 1450, when our diptych may have been painted. If so, it presents a highly idealized image of courtly beauty, as befits the Queen of Heaven, seen wearing a crown and robe amidst a choir of angels.

Here we see the beginnings of that tendency toward intellectual lucidity and abstraction which were to become distinctive to French art. This emphasis extends to the treatment of the background, which is very different in the two panels, not out of disregard for visual perspective but in order to distinguish clearly between the temporal and spiritual realms. Thus, each half of the diptych constitutes a separate, self-contained world. By the same token, pictorial space for Fouquet exists independently of the viewer's "real" space.

Manuscript painting continued to flourish on both sides of the Alps well into the sixteenth century, and Fouquet was justly the most famous illuminator of the day in the North. *The*

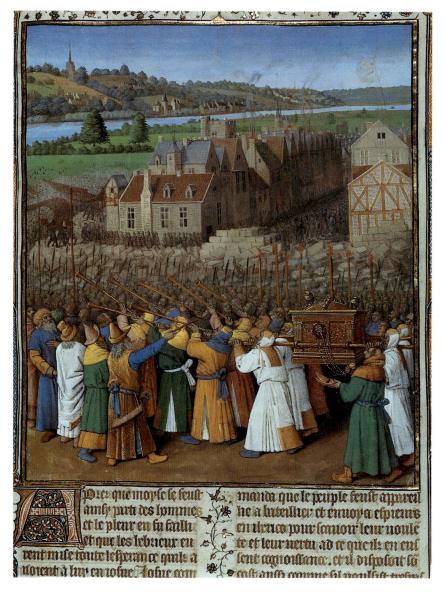

689. Jean Fouquet. *The Fall of Jerusalem*, from Josephus, *Les Antiquités Judaïques*. c. 1470–75. Illumination, 16⁷/8 x 11³/4" (42.8 x 29.8 cm). Bibliothèque Nationale, Paris

Fall of Jerusalem (fig. 689) shows him to be literally the inheritor of the Gothic: it comes from a copy of Josephus' Les Antiquités Judaïques that was started around 1410 for the duke of Berry and fell to our artist to complete some 60 years later. The scene, which closely follows Josephus' text, depicts the forces of the Babylonian king Nebuchadnezzar under general Nebuzar-Adar overrunning the city and destroying the Temple of Solomon in 586 B.C. Fouquet's mastery of outdoor space and atmospheric perspective is no less refined than in the October page of Les Très Riches Heures du Duc du Berry (fig. 522). Yet Fouquet was more than an imitator of the Limbourg brothers, no matter how great his admiration for them may have been.

The landscape is painted in the up-to-date style of Conrad Witz and presents a stunningly realistic evocation of a contemporary French town. It is hardly surprising that the page imitates effects found in panels, which had become the dominant vehicle for painting. Yet the quality of the narrative itself belongs to the tradition of manuscript illustration. Even here Fouquet reveals himself to be an innovator. The scene is not entirely without precedent among earlier illuminations, notably those by Jan van Eyck, who excelled in this sphere. Yet its closest relative is, surprisingly enough, *The Building of the*

Tower of Babel at St.-Savin-sur-Gartempe (fig. 416), which presents a similar subject in reverse, so to speak. They share the same monumental spirit, despite the vast difference in size—truly a remarkable achievement!

AVIGNON PIETÀ. A Flemish style influenced by Italian art also characterizes the most famous of all fifteenth-century French pictures, the Avignon Pietà (fig. 690). As its name indicates, the panel comes from the extreme south of France and is attributed to an artist of that region, Enguerrand Quarton (c. 1410-c. 1466). He must have been thoroughly familiar with the art of Rogier van der Weyden, for the figure types and the expressive content of the Avignon Pietà could be derived from no other source. At the same time, the magnificently simple and stable design is Italian rather than Northern. These are qualities we first saw in the art of Giotto. Southern, too, is the bleak, featureless landscape emphasizing the monumental isolation of the figures. The distant buildings behind the donor on the left have an unmistakably Islamic flavor, suggesting that the artist meant to place the scene in an authentic Near Eastern setting. From these various features he has created an unforgettable image of heroic pathos.

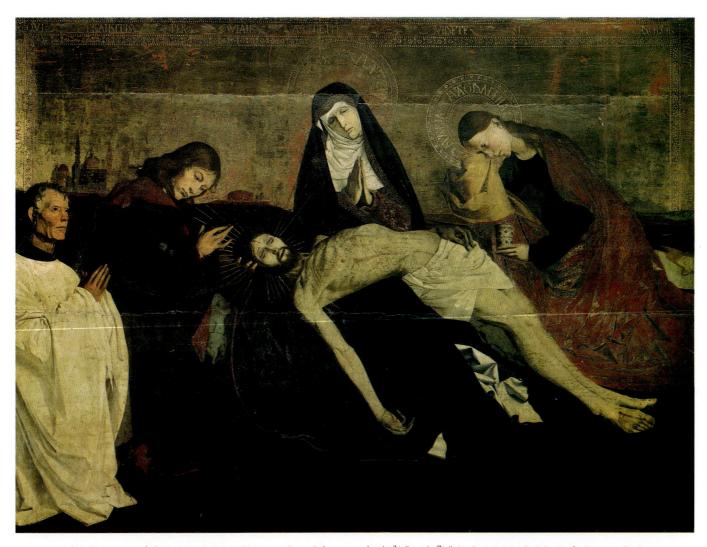

690. Enguerrand Quarton. Avignon Pietà. c. 1470. Oil on panel, 5'33/4" x 7'17/8" (1.61 x 2.17 m). Musée du Louvre, Paris

"LATE GOTHIC" SCULPTURE

If we had to describe fifteenth-century art north of the Alps in a single phrase, we might label it "the first century of panel painting," which so dominated the art of the period between 1420 and 1500 that its standards apply to manuscript illumination, stained glass, and even, to a large extent, sculpture. After the later thirteenth century, we will recall, the emphasis had shifted from architectural sculpture to the more intimate scale of devotional images, tombs, pulpits, and the like. Claus Sluter, whose art is so impressive in weight and volume, had briefly recaptured the monumental spirit of the High Gothic. However, he had no real successors, although echoes of his style can be felt in French art for the next 50 years.

It was the influence of the Master of Flémalle and Rogier van der Weyden that ended the International Style in the sculpture of Northern Europe. The carvers, who quite often were also painters, began to reproduce in stone or wood the style of these artists, and continued to do so until about 1500.

PACHER. The most characteristic works of the "Late Gothic" carvers are wooden altar shrines, often large in size and incred-

ibly intricate in detail. Such shrines were especially popular in the Germanic countries. One of the richest examples is the *St. Wolfgang Altarpiece* (fig. 691) by the Tyrolean sculptor and painter Michael Pacher (c. 1435–1498). [See Primary Sources, no. 65, page 638.] Its lavishly gilt and colored forms make a dazzling spectacle as they emerge from the shadowy depth of the shrine under Flamboyant canopies. We enjoy it, but in pictorial rather than plastic terms. We have no experience of volume, either positive or negative. The figures and setting in the central panel, showing the *Coronation of the Virgin*, seem to melt into a single pattern of agitated, twisting lines that permits only the heads to stand out as separate entities.

Surprisingly, when we turn to the paintings of scenes from the life of the Virgin on the interior of the wings, we enter a different realm, one that already commands the vocabulary of the Northern Renaissance. Here the artist provides a deep space in scientific perspective that takes the viewer's vantage point into account, so that the upper panels are represented slightly from below. Paradoxically, the figures, powerfully modeled by the clear light, seem far more "sculptural" than the

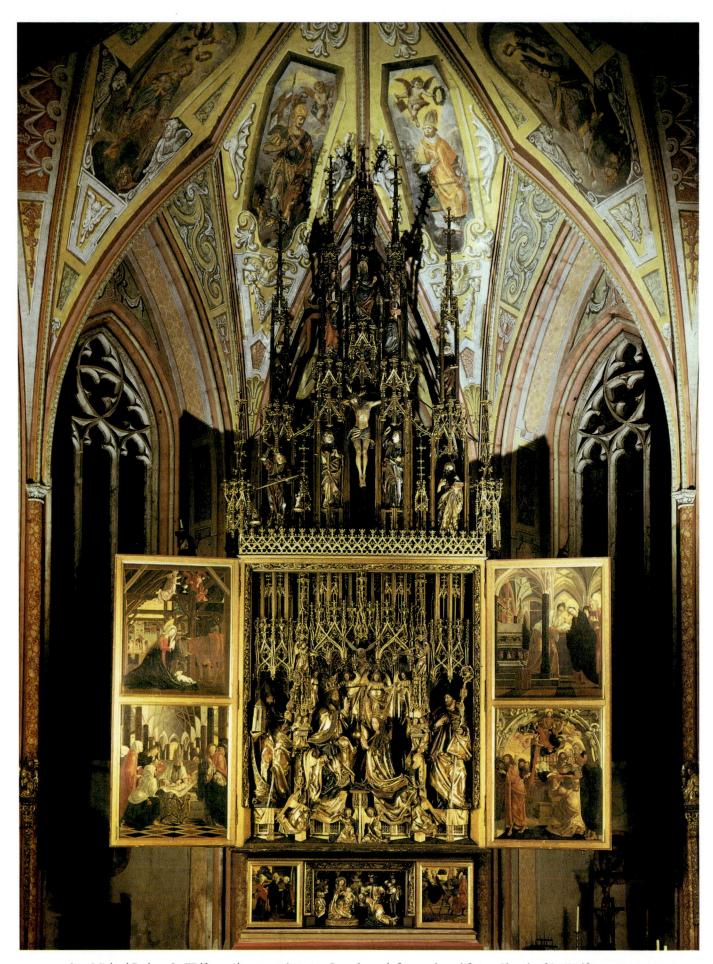

691. Michael Pacher. St. Wolfgang Altarpiece. 1471–81. Carved wood, figures about lifesize. Church of St. Wolfgang, Austria

692. St. Dorothy. c. 1420. Woodcut, 10⁵/8 x 7¹/2" (27 x 19 cm). Staatliche Graphische Sammlung, Munich

693. Woodcut of St. Christopher, detail from an Annunciation by Jacques Daret (?). c. 1435. Musées Royaux d'Art et d'Histoire, Brussels, Belgium

694. Martin Schongauer. *The Temptation of St. Anthony*. c. 1480–90. Engraving, 11¹/₂ x 8⁵/₈" (29.2 x 21.8 cm). The Metropolitan Museum of Art, New York

Rogers Fund, 1920

carved ones, despite the fact that they are a good deal smaller. It is as if Pacher, the "Late Gothic" sculptor, felt unable to compete with Pacher the painter in the rendering of three-dimensional bodies and therefore chose to treat the *Coronation of the Virgin* in pictorial terms, by extracting the maximum of drama from contrasts of light and shade.

THE GRAPHIC ARTS

WOODCUTS. We must now take note of another important event north of the Alps: the development of printmaking. (For the various techniques of printing, for pictures as well as books, see page 524.) The idea of printing pictorial designs from blocks of wood onto paper seems to have originated in Northern Europe at the very end of the fourteenth century. Many of the oldest surviving examples of such prints, called woodcuts,

are German, others are Flemish, and some may be French; but all show the familiar qualities of the International Style. The designs were probably furnished by painters or sculptors. The actual carving of the wood blocks, however, was done by specially trained artisans, who also produced wood blocks for textile prints. As a result, early woodcuts, such as the *St. Dorothy* in figure 692, have a flat, ornamental pattern. Forms are defined by simple, heavy lines, and there is little concern for three-dimensional effects, as indicated by the absence of hatching or shading. Since the outlined shapes were meant to be filled in with color, these prints often recall stained glass (compare fig. 494) more than the miniatures they replaced.

Despite their aesthetic appeal to modern eyes, we should remember that fifteenth-century woodcuts were popular art, on a level that did not attract artists of great ability until shortly before 1500. A single wood block yielded thousands of Printmaking

The earliest printed books in the modern sense were produced in

the Rhineland soon after 1450. (It is doubtful whether Johann Gutenberg deserves the priority long claimed for him.) The new technique quickly spread all over Europe and developed into an industry that had a profound effect on Western civilization, ushering in the era of increased literacy. Printed pictures had hardly less importance, for without them the printed book could not have replaced the work of the medieval scribe and illuminator so quickly and completely. The pictorial and literary aspects of printing were indeed closely linked from the start. But where is the start? When, and by whom, was printing invented?

The beginnings of the story lie in the ancient Near East 5,000 years ago. Mechanically speaking, the Sumerians were the earliest "printers," for their relief impressions on clay from stone seals were carved with both pictures and inscriptions. From Mesopotamia the use of seals spread to India and eventually to China. The Chinese applied ink to their seals in order to impress them on wood or silk, and, in the second century A.D., they invented paper. By the ninth century, they were printing pictures and books on paper from wooden blocks carved in relief, and 200 years later they developed movable type. Some of the products of Chinese printing surely reached the medieval West—through the Arabs, the Mongols, or travelers such as Marco Polo—although we lack direct evidence.

The technique of manufacturing paper, too, came to Europe from the East, and Chinese silk and porcelain were imported in small quantities from the fourteenth century on. Paper and printing from wood blocks were both known in the West during the later Middle Ages. However, paper gained ground very slowly as a cheap alternative to parchment, while printing was used only for ornamental patterns on cloth. All the more astonishing is the development, beginning about 1400, of a printing technology that within the century surpassed that of the Far East and proved of far wider cultural importance. After 1500, in fact, no basic changes were made in this field until the Industrial Revolution.

WOODCUT. In a woodcut, lines are ridges left by gouging out the block. The thinner they are, the more difficult they are to carve. Hence, the work was often left to specialists. Inscriptions are frequently found on early woodcuts, the letters having been either added by hand or printed from the same block as the picture. But to carve lines of text backward in relief on a wooden block was a wearisome and particularly risky task—a single slip could ruin an entire page. It is little wonder, then, that printers soon had the idea of putting each letter on its own small block. Wooden movable type carved by hand worked well for letters of large size but not for small ones. Moreover, it was too expensive to use for printing long texts such as the Bible. By 1450, this problem had been solved through the introduction of metal type cast from molds, and the stage was set for book production as we know it today.

ENGRAVING. Whoever first thought of metal type probably

had the aid of goldsmiths and armorers to work out the technical production problems. This is all the more likely since many goldsmiths had already entered the field of printmaking as engravers. The technique of engraving—of embellishing metal surfaces with incised pictures—was developed in classical antiquity (see fig. 234) and continued to be practiced throughout the Middle Ages (see fig. 421, where the engraved lines are filled in with enamel). Thus, no new skill was required to engrave a plate that was to serve as the "matrix" for a paper print.

The idea of making an engraved print apparently came from the desire for an alternative, more refined and flexible, to woodcuts. In an engraving, lines are V-shaped grooves incised with a tool (called a burin) into a metal plate, usually copper, which is relatively soft and easy to work. The subsequent printing is done by rubbing ink into the grooves, wiping off the surface of the plate, covering it with a damp sheet of paper, and putting it through the press.

DRYPOINT. A variant of this technique is known as drypoint. It permitted artists to draw almost as freely as with a pen on a sheet of paper by scratching their designs into the copperplate with a fine steel needle. The needle, of course, did not cut grooves as deep as those made by the burin, so that a drypoint plate wore out after yielding a relative handful of impressions, whereas an engraved plate lasted through hundreds of printings. But the drypoint technique preserved the artist's personal "handwriting" and permitted soft, atmospheric effects—velvety shadows, delicate, luminous distances—unattainable with the burin.

ETCHING. Eventually the techniques of woodcut and engraving were employed mainly to reproduce other works. The creative printmakers came to prefer etching, often combined with drypoint. This technique, too, must have originated with goldsmiths and armorers in the North. An etching is made by coating a copperplate with resin to make an acid-resistant "ground," through which the design is scratched with a needle, laying bare the metal surface underneath. The plate is then bathed in an acid that etches (or "bites") the lines into the copper. The depth of these grooves varies with the strength and duration of the bath, and the biting is usually by stages. After a brief immersion in the acid bath the etcher will apply a protective coating to the plate in those areas where the lines should be faint. The plate is then immersed until it is time to protect the less delicate lines, and so on. To scratch a design into the resinous ground is, of course, an easier task than to scratch it into the copperplate itself. Hence, an etched line is smoother and more flexible than a drypoint line. An etched plate is also more durable; it yields a far greater number of prints than a drypoint plate. Its chief virtue is its wide tonal range, including velvety dark shades not possible in engraving or woodcut.

copies, to be sold for a few pennies apiece, bringing the individual ownership of pictures within everyone's reach for the first time in history. What people did with these prints is illustrated in figure 693, a detail from a Flemish *Annunciation* panel of about 1435, where a tattered woodcut of St. Christopher is pinned up above the mantel. Perhaps it is a hint at the Virgin's journey to Bethlehem (St. Christopher was the patron saint of travelers), but this charmingly incongruous feature must also be understood as a disguised symbol of her humility, for only the poor would have such an object on their walls. The *St. Christopher* woodcut has two lines of lettering—a short prayer, presumably—at the bottom. Such woodcuts combining image and text were sometimes assembled into popular picture books, called block books.

ENGRAVINGS. Engravings appealed from the first to a smaller and more sophisticated public. The oldest examples we know, dating from about 1430, already show the influence of the great Flemish painters. Their forms are systematically modeled with fine hatched lines and often convincingly foreshortened. Nor do engravings share the anonymity of early woodcuts. Individual hands can be distinguished almost from the beginning, dates and initials appear shortly, and most of the important engravers of the last third of the fifteenth century are known to us by name. Even though the early engravers were usually goldsmiths by training, their prints are so closely linked to local painting styles that we may determine their geographic origin far more easily than for woodcuts. Especially in the Upper Rhine region, we can trace a continuous tradition of fine engravers from the time of Conrad Witz to the end of the century.

SCHONGAUER. The most accomplished of the Upper Rhenish engravers was Martin Schongauer (c. 1430–1491), the first printmaker whom we also know as a painter, and the first to gain international fame. Schongauer might be called the Rogier van der Weyden of engraving. After learning the goldsmith's craft in his father's shop, he must have spent considerable time in Flanders, for he shows a thorough knowledge of Rogier's art. His prints are filled with Rogierian motifs and expressive devices, and they reveal a deep temperamental affinity to the great Fleming. Yet Schongauer had his own impressive powers of invention. His finest engravings have a complexity of design, spatial depth, and richness of texture that make them fully equivalent to panel paintings. In fact, lesser artists often found inspiration in them for large-scale pictures.

The Temptation of St. Anthony (fig. 694), one of Schongauer's most famous works, masterfully combines savage expressiveness and formal precision, violent movement and ornamental stability. The longer we look at it, the more we marvel at its range of tonal values, the rhythmic beauty of the engraved line, and the artist's ability to render every conceivable surface—spiky, scaly, leathery, furry—by varying the burin's attack upon the plate. He was not to be surpassed by any later engraver in this respect.

695. The Master of the Housebook. *Holy Family by* the Rosebush. c. 1480–90. Drypoint, 5⁵/8 x 4¹/2" (14.2 x 11.5 cm). Rijksprentenkabinet, Rijksmuseum, Amsterdam

THE MASTER OF THE HOUSEBOOK. For originality of conception and technique, Schongauer had only one rival among the printmakers of his time, the Master of the Housebook (so called after a book of drawings attributed to him). Although he was probably of Dutch origin, he seems to have spent most of his career, from about 1475 to 1490, in the Rhineland. The very individual style of this artist is the opposite of Schongauer's. His prints—such as the Holy Family by the Rosebush (fig. 695)—are small, intimate in mood, and spontaneous, almost sketchy, in execution, which lends them a quaint charm that makes up for their naïveté. Even his tools were different from the standard engraver's equipment. Instead of submitting to the somewhat impersonal discipline demanded by the burin, the Master of the Housebook scratched his designs into the copperplate with a fine steel needle, a technique known as drypoint. The Master of the Housebook knew how to take full advantage of the medium. He was a pioneer in the use of a tool that was to become the supreme instrument of Rembrandt's graphic art a century and a half later.

CHAPTER FIVE

THE RENAISSANCE IN THE NORTH

North of the Alps, as we have seen, most fifteenth-century artists remained indifferent to Italian forms and ideas. Since the time of the Master of Flémalle and the Van Eycks they had looked to Flanders, rather than to Tuscany, for leadership. This relative isolation ended suddenly toward the year 1500. As if a dam had burst, Italian influence flowed northward in an ever wider stream, and Northern Renaissance art began to replace the "Late Gothic." That term, however, has a far less well-

defined meaning than "Late Gothic," which at least refers to a single, clearly recognizable stylistic tradition, however questionable the name may otherwise be. The diversity of trends north of the Alps is even greater than in Italy during the sixteenth century. Nor does Italian influence provide a common denominator, for this influence is itself diverse: Early Renaissance, High Renaissance, and Mannerist, all are to be found in regional variants from Lombardy, Venice, Florence, and Rome.

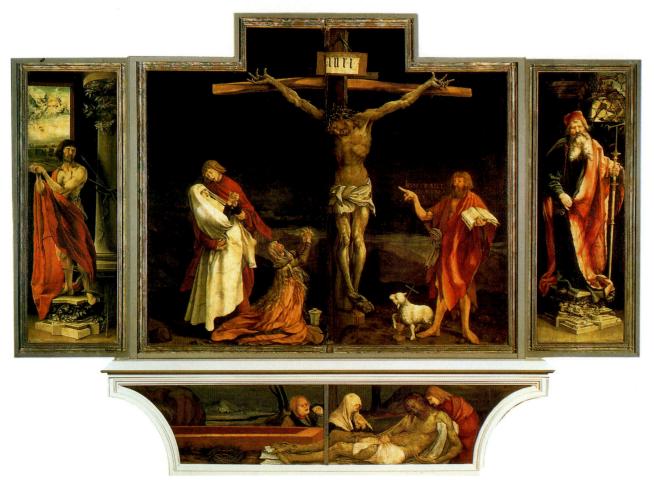

696. Matthias Grünewald. St. Sebastian; The Crucifixion; St. Anthony Abbot; predella: Lamentation. Isenheim Altarpiece (closed). c. 1510–15. Oil on panel, main body 9'9¹/2" x 10'9" (2.97 x 3.28 m), predella 2'5¹/2" x 11'2" (0.75 x 3.4 m). Musée Unterlinden, Colmar, France

Its effects, too, vary greatly. They may be superficial or profound, direct or indirect, specific or general. Nevertheless, we may speak for the first time of a Renaissance proper in the North. Like its cousin in Italy, it is distinguished by an interest in humanism, albeit with equally inconsistent results.

The "Late Gothic" tradition remained very much alive, if no longer dominant, and its encounter with Italian art resulted in a protracted conflict among styles that ended only when the Baroque emerged as an international movement in the early seventeenth century. The full history of this contest is yet to be written. Its course was decisively affected by the Reformation, which had a far more immediate impact on art north of the Alps than in Italy, but the major issues are nevertheless hard to trace. Our account, then, necessarily emphasizes the main phases.

GERMANY

Painting and the Graphic Arts

Let us begin with Germany, the home of the Reformation, where the first major stylistic developments took place during the first quarter of the century. Between 1475 and 1500, it had produced such important artists as Michael Pacher and Martin Schongauer (see figs. 691 and 694), but they hardly prepare us for the astonishing burst of creative energy that was to

follow. The range of achievements of this period, which was comparable in its brevity and brilliance to the Italian High Renaissance, is measured by the contrasting personalities of its greatest artists: Matthias Grünewald and Albrecht Dürer. Both died in 1528, probably at about the same age, although we know only Dürer's birth date (1471). Dürer quickly became internationally famous, while Grünewald, who was born about 1470–80, remained so obscure that his real name, Mathis Gothart Nithart, was discovered only at the end of the nineteenth century.

GRÜNEWALD. Grünewald's fame, like that of El Greco, has developed almost entirely within our own century. His main work, the *Isenheim Altarpiece*, is unique in the Northern art of his time in its ability to overwhelm us with something like the power of the Sistine ceiling. Long believed to be by Dürer, it was painted between 1509/10 and 1515 for the monastery church of the Order of St. Anthony at Isenheim, in Alsace, and is now in the museum of the nearby city of Colmar.

This extraordinary altarpiece is a carved shrine with two sets of movable wings, which give it three stages, or "views." The first of these views, formed when all the wings are closed, shows *The Crucifixion* in the center panel (fig. 696)—the most impressive ever painted. In one respect it is very medieval. Jesus' terrible agony and the desperate grief of the Virgin, St. John, and Mary Magdalen recall the older German

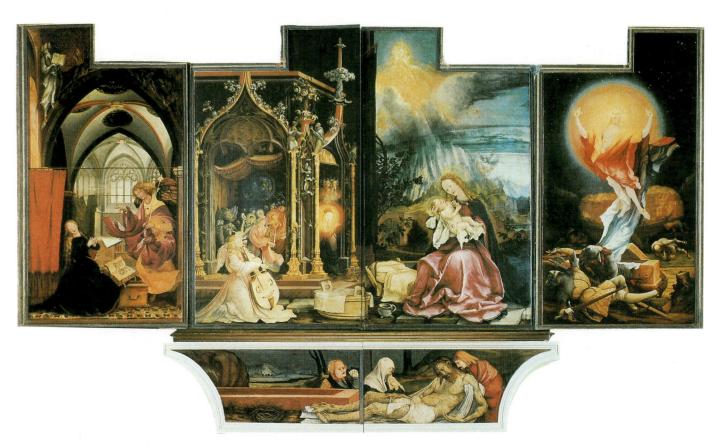

697. Matthias Grünewald. *The Annunciation; Madonna and Child with Angels; The Resurrection.* Second view of the *Isenheim Altarpiece.* c. 1510–15. Oil on panel, each wing 8'10" x 4'8" (2.69 x 1.42 m); center panel 8'10" x 11'2¹/2" (2.69 x 3.41 m). Musée Unterlinden, Colmar, France

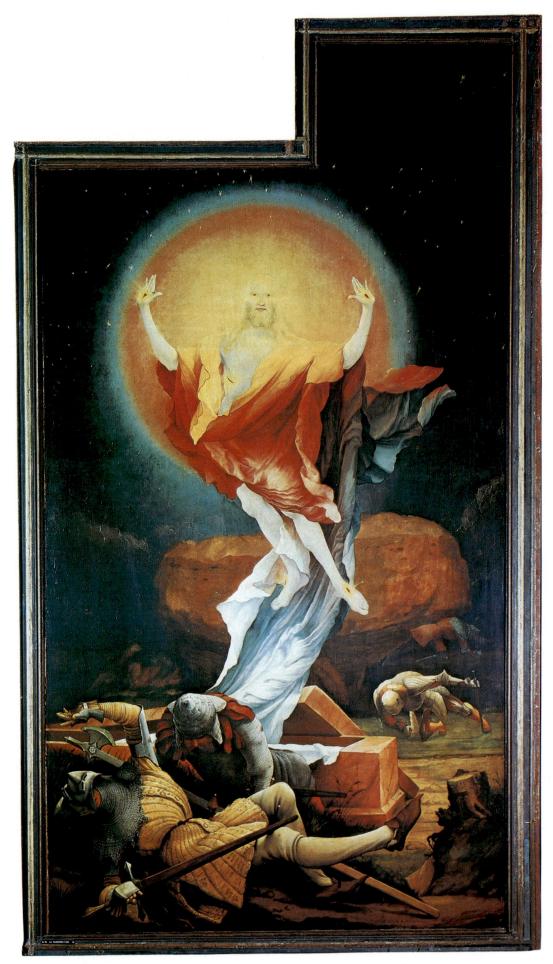

698. Matthias Grünewald. The Resurrection, from second view of the Isenheim Altarpiece

Andachtsbild (see fig. 479). But the pitiful body on the Cross with its twisted limbs, its countless lacerations, its rivulets of blood, is on a heroic scale that raises it beyond the human and thus reveals the two natures of Jesus. The same message is conveyed by the flanking figures. The three historic witnesses on the left mourn Jesus' death as a man, while John the Baptist, on the right, points with calm emphasis to him as the Saviour. Even the background suggests this duality. Golgotha here is not a hill outside Jerusalem, but a mountain towering above lesser peaks. The Crucifixion, lifted from its familiar setting, thus becomes a lonely event silhouetted against a deserted, ghostly landscape and a blue-black sky. Darkness is over the land, in accordance with the Gospel, yet brilliant light bathes the foreground with the force of sudden revelation. This union of time and eternity, of reality and symbolism, gives Grünewald's Crucifixion its awesome grandeur.

When the outer wings are opened, the mood of the *Isenheim Altarpiece* changes dramatically (fig. 697). All three scenes in this second view—the Annunciation, the Angel Concert for the Madonna and Child, and the Resurrection (fig. 698)—celebrate events as jubilant in spirit as the Crucifixion is austere. Most striking in comparison with "Late Gothic" painting is the sense of movement pervading these panels. Everything twists and turns as though it had a life of its own. The angel of the Annunciation enters the room like a gust of wind that blows the Virgin backward, and the Risen Jesus leaps from his grave with explosive force. This vibrant energy is matched by the ecstatic vision of heavenly glory in celebration of Jesus' birth, seen behind the Madonna and Child, who are surely the most tender and lyrical in all of Northern art.

In contrast to the brittle, spiky contours and angular drapery patterns of "Late Gothic" art, Grünewald's forms are soft, elastic, fleshy. His light and color show a corresponding change. Commanding all the resources of his great Flemish predecessors, he employs them with extraordinary boldness and flexibility. His color scale is richly iridescent, its range matched only by the Venetians. Indeed, his exploitation of colored light is altogether without parallel at that time. Grünewald's genius has achieved miracles through light that were never to be surpassed in the luminescent angels of the Concert, the apparition of God the Father and the Heavenly Host above the Madonna, and, most spectacularly, the rain-bow-hued radiance of the Risen Jesus.

How much did Grünewald owe to Italian art? Nothing at all, we are first tempted to say, yet he must have learned from the Renaissance in more ways than one. His knowledge of perspective (note the low horizons) and the physical vigor of some of his figures cannot be explained by the "Late Gothic" tradition alone, and occasionally his pictures show architectural details of Southern origin. Perhaps the most important effect of the Renaissance on him, however, was psychological. We know little about his career, but he apparently did not lead the settled life of an artisan-painter controlled by guild rules. He was also an architect, an engineer, something of a courtier, and an entrepreneur. Moreover, he worked for many different patrons and stayed nowhere for very long. He was in sympathy with Martin Luther even though as a painter he depended on Catholic patronage. [See Primary Sources, no. 66, page 638.]

In a word, Grünewald seems to have shared the free, indi-

699. Albrecht Dürer. *Italian Mountains*. c. 1495 or 1505–6. Brush drawing in watercolor, 8¹/4 x 12¹/4" (21 x 31.2 cm). Ashmolean Museum, Oxford, England

vidualistic spirit of Italian Renaissance artists. The daring of his pictorial vision likewise suggests a reliance on his own resources. The Renaissance, then, had a liberating influence on him but did not change the basic cast of his imagination. Instead, it helped him to epitomize the expressive aspects of the "Late Gothic" in a style of unique intensity and individuality.

DÜRER. For Albrecht Dürer (1471–1528), the Renaissance held a richer meaning. Attracted to Italian art while still a young journeyman, he visited Venice in 1494/5 and returned to his native Nuremberg with a new conception of the world and the artist's place in it. The unbridled fantasy of Grünewald's art was to him "a wild, unpruned tree" (a phrase he used for painters who worked by rules of thumb, without theoretical foundations) that needed the discipline of the objective, rational standards of the Renaissance. Taking the Italian view that the fine arts belong among the liberal arts, he also adopted the ideal of the artist as a gentleman and humanistic scholar. [See Primary Sources, no. 67, pages 638–39.] By steadily cultivating his intellectual interests he came to encompass in his lifetime an unprecedented variety of subjects and techniques. And since he was the greatest printmaker of the time, he had a wide influence on sixteenth-century art through his woodcuts and engravings, which circulated everywhere in Europe.

In Italy Dürer made copies after Mantegna and other Early Renaissance masters that display his eager and intuitive grasp of the essentials of their alien style. Equally astonishing are his watercolors painted on the way back from Venice, such as the one inscribed "Italian Mountains" (fig. 699). He was the first serious artist to work in watercolor, which acquired new importance as a sketching medium thanks to his experiments. Yet, significantly, Dürer did not record the name of the spot here or in his other sheets; the specific location had no interest for him. The title he jotted down seems exactly right, for this is not a "portrait," but a "study from the model" perceived in timeless freshness. The calm rhythm of this panorama of softly rounded slopes conveys a view of nature in its organic wholeness that was matched in those years only by Leonardo's landscapes (compare the background in the *Mona Lisa*; fig. 598).

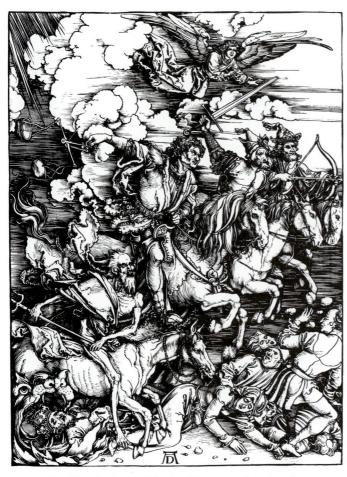

700. Albrecht Dürer. The Four Horsemen of the Apocalypse. c. 1497–98. Woodcut, 15¹/2 x 11¹/8" (39.3 x 28.3 cm). The Metropolitan Museum of Art, New York Gift of Junius S. Morgan, 1919

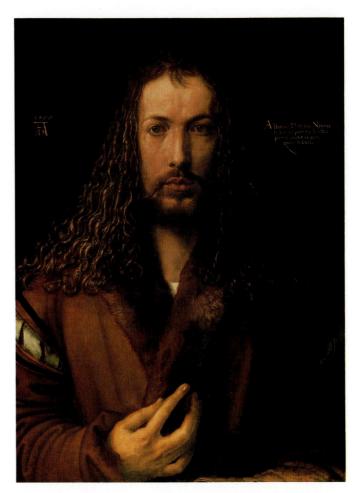

701. Albrecht Dürer. *Self-Portrait.* 1500. Oil on panel, 26 ¹/₄ x 19 ¹/₄ " (66.3 x 49 cm). Alte Pinakothek, Munich

After the breadth and lyricism of the *Italian Mountains*, the expressive violence is doubly shocking in the woodcuts illustrating the Apocalypse, Dürer's most ambitious graphic work of the years following his return from Venice. The gruesome vision of The Four Horsemen (fig. 700) seems at first to return completely to the "Late Gothic" world of Martin Schongauer's Temptation of St. Anthony (see fig. 694). Yet the physical energy and solid, full-bodied volume of these figures would have been impossible without Dürer's earlier experience in copying the works of such artists as Mantegna (compare fig. 589). At this stage, Dürer's style has much in common with Grünewald's. The comparison with Schongauer, however, is instructive from another point of view. It shows how thoroughly Dürer has redefined his medium—the woodcut—by enriching it with the linear subtleties of engraving. In his hands, woodcuts lose their former charm as popular art (see fig. 692), but gain the precise articulation of a fully matured graphic style. He set a standard that soon transformed the technique of woodcuts all over Europe.

The first artist to be fascinated by his own image, Dürer was in this respect more of a Renaissance personality than any Italian artist. His earliest known work, a drawing made at 13, is a self-portrait, and he continued to produce self-portraits throughout his career. Most impressive, and uniquely revealing, is the panel of 1500 (fig. 701). Pictorially, it belongs to the

Flemish tradition (compare Jan van Eyck's *Man in a Red Turban*; fig. 676), but the solemn, frontal pose and the Christlike idealization of the features assert an authority quite beyond the range of ordinary portraits. The picture looks, in fact, like a secularized icon, reflecting not so much Dürer's vanity as the seriousness with which he regarded his mission as an artistic reformer. (One thinks of Martin Luther's "Here I stand; I cannot do otherwise.")

The didactic aspect of Dürer's art is clearest perhaps in the engraving *Adam and Eve* of 1504 (fig. 702), where the biblical subject serves as a pretext for the display of two ideal nudes: Apollo and Venus in a Northern forest (compare figs. 206 and 208). No wonder they look somewhat out of place. Unlike the picturesque setting and its animal inhabitants, Adam and Eve are not observed from life, but constructed according to what Dürer believed to be perfect proportions. Here, for the first time, both the form and the substance of the Italian Renaissance enter Northern art, but adapted to the unique cultural climate of Germany. That is why his ideal male and female figures, though very different from their classical exemplars, were to become models in their own right to countless Northern artists.

The same approach, now applied to the body of a horse, is evident in *Knight, Death, and Devil* (fig. 703), one of the artist's finest prints. This time, however, there is no incon-

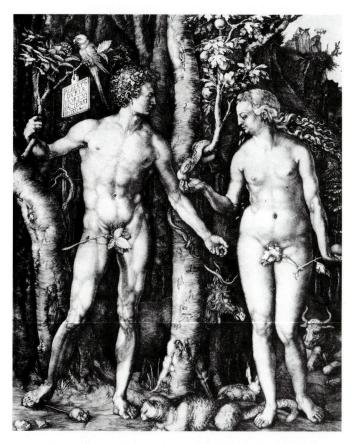

702. Albrecht Dürer. *Adam and Eve.* 1504. Engraving, 9⁷/8 x 7⁵/8" (25.2 x 19.4 cm). Museum of Fine Arts, Boston Centennial Gift of Landon T. Clay

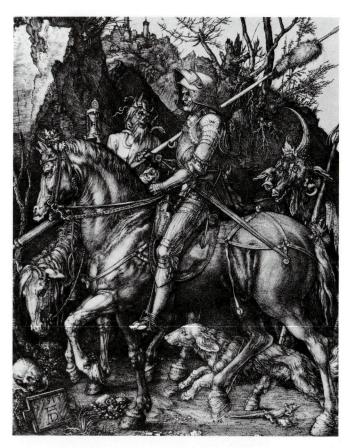

703. Albrecht Dürer. *Knight, Death, and Devil.* 1513. Engraving, $9^{7/8} \times 7^{1/2}$ " (25.2 x 19.4 cm). Museum of Fine Arts, Boston Gift of Mrs. Horatio Greenough Curtis in memory of her husband

gruity. The knight on his beautiful mount, poised and confident as an equestrian statue, embodies an ideal both aesthetic and moral. He is the Christian Soldier steadfast on the road of faith toward the Heavenly Jerusalem, undeterred by the hideous rider threatening to cut him off or the grotesque devil behind him. The dog, symbol of fidelity, loyally follows its master despite the lizards and skulls in their path. Italian Renaissance form, united with the heritage of "Late Gothic" symbolism (whether open or disguised), here takes on a new, characteristically Northern significance.

Dürer's convictions were essentially those of Christian humanism. He seems to have derived the subject of *Knight*, *Death*, *and Devil* from the *Manual of the Christian Soldier* by Erasmus of Rotterdam, the greatest of Northern humanists. It is the first of three engravings that were probably conceived as a unified program, as Dürer often sold them as a set. Taken together, they are an unusually personal statement. A *St. Jerome in His Study* complements the knight of action, who carries his faith into the world, with one who pursues it through private meditation.

The last of the trilogy, *Melencolia I* (fig. 704), is the very antithesis of the other two. One of the Four Temperaments, she holds the tools of geometry, yet is surrounded by chaos. She thinks but cannot act, while the infant scrawling on the slate, who symbolizes Practical Knowledge, can act but not

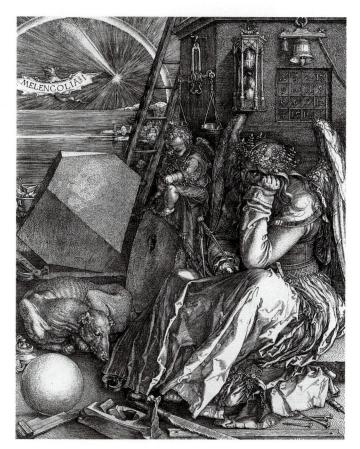

704. Albrecht Dürer. *Melencolia I.* 1514. Engraving, 9³/8 x 6⁵/8" (23.8 x 16.8 cm). National Gallery of Art, Washington, D.C.

Rosenwald Collection

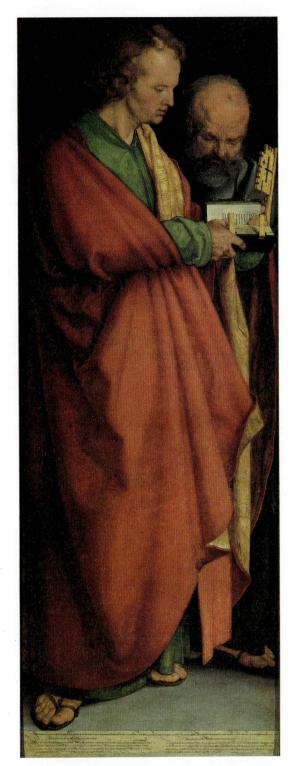

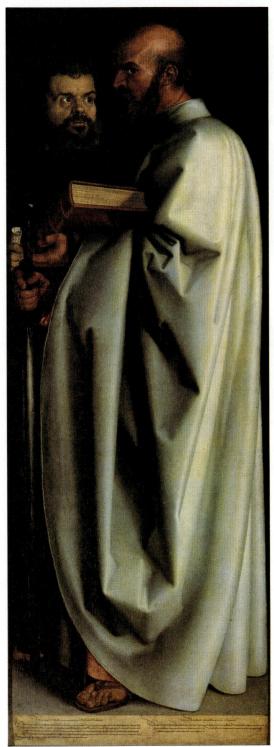

705. Albrecht Dürer. The Four Apostles. 1523–26. Oil on panel, each 7'1" x 2'6" (2.16 x .76 m). Alte Pinakothek, Munich

think. This is, then, the melancholia of an artist, perhaps Dürer himself. He cannot achieve perfect beauty, which is known only to God, because he cannot extend his thinking beyond the limits of space and the physical world. The conception of this disturbing image comes from the humanist Marsilio Ficino, who esteemed melancholia (to which he was himself subject) as the source of divine inspiration. He tied it to Saturn, the Mind of the World, which, as the oldest and highest of the planets, he deemed superior even to Jupiter, the Soul of the World. It is evident, however, that in contrasting

the ineffectiveness of *Melencolia*, who derives her tools from Saturn, to the spiritual achievements of the knight and saint, Dürer asserts the superiority of faith over reason.

Not surprisingly, Dürer became an early and enthusiastic follower of Martin Luther, although, like Grünewald, he continued to work for Catholic patrons. His new faith can be sensed in the growing austerity of style and subject in his religious works after 1520. The climax of this trend is represented by *The Four Apostles* (fig. 705), paired panels containing what has rightly been termed Dürer's artistic testament.

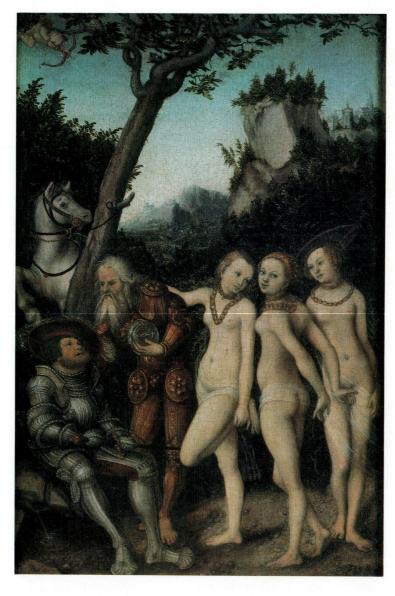

706. Lucas Cranach the Elder. *The Judgment of Paris.* 1530. Oil on panel, 13¹/2 x 9¹/2" (34.3 x 24.2 cm). Staatliche Kunsthalle, Karlsruhe, Germany

Dürer presented the panels in 1526 to the city of Nuremberg, which had joined the Lutheran camp the year before. The chosen apostles are basic to Protestant doctrine: John and Paul face one another in the foreground, with Peter and Mark behind. Quotations from their writings, inscribed below in Luther's translation, warn the city government not to mistake human error and pretense for the will of God. They plead against Catholics and ultrazealous Protestant radicals alike. But in another, more universal sense, the figures represent the Four Temperaments and, by implication, the other cosmic quartets—the seasons, the elements, the times of day, and the ages of life—encircling, like the cardinal points of the compass, the Deity who is at the invisible center of this "triptych." In keeping with their role, the apostles have a cubic severity and grandeur such as we have not encountered since Masaccio and Piero della Francesca. That the style of The Four Apostles has evoked the names of these great Italians is no coincidence, for Dürer devoted a good part of his last years to the theory of art, including a treatise on geometry based on a thorough study of Piero della Francesca's discourse on perspective.

CRANACH THE ELDER. Dürer's hope for a monumental art embodying the Protestant faith remained unfulfilled.

Other German painters, notably Lucas Cranach the Elder (1472-1553), also tried to cast Luther's doctrines into visual form, but created no viable tradition. On his way to Vienna around 1500, Cranach had probably visited Dürer in Nuremberg. In any event, he fell early on under the influence of Dürer's work, which he turned to for inspiration throughout his career but invested with a highly individual expression. In 1504 Cranach left Vienna for Wittenberg, then a center of humanist learning. There he became court painter to Frederick the Wise of Saxony, as well as a close friend of Martin Luther, who even served as godfather to one of his children. Like Grünewald and Dürer, Cranach relied on Catholic patronage, but some of his altars have a Protestant content; ironically, they lack the fervor of those he painted before his conversion. Such efforts to embody Luther's doctrines in art were doomed, since the spiritual leaders of the Reformation looked upon religious images with indifference or, more often, outright hostility, even though Luther himself seems to have been relatively tolerant of them.

Cranach is best remembered today for his portraits and his delightfully incongruous mythological scenes. In *The Judgment of Paris* (fig. 706), nothing could be less classical than the three coquettish damsels, whose wriggly nakedness fits the

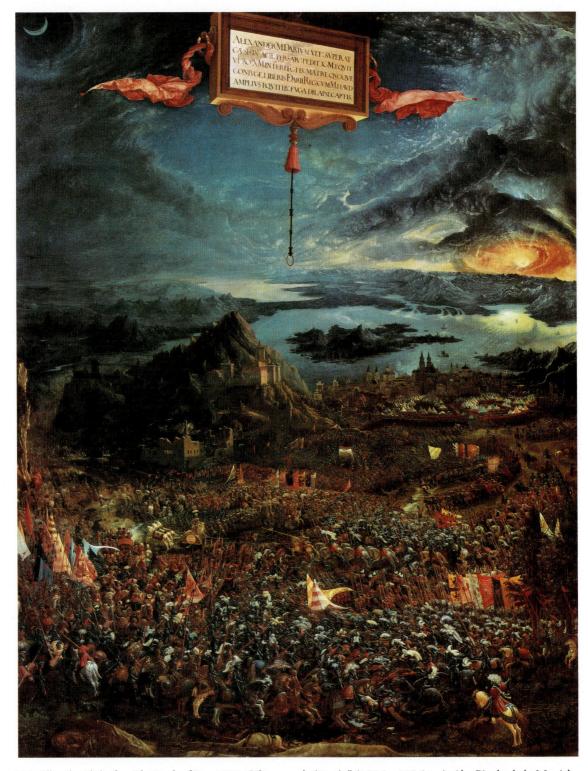

707. Albrecht Altdorfer. The Battle of Issus. 1529. Oil on panel, 62 x 47" (157.5 x 119.5 cm). Alte Pinakothek, Munich

Northern background better than does the nudity of Dürer's *Adam and Eve.* Paris is a German knight clad in fashionable armor, indistinguishable from the nobles at the court of Saxony who were the artist's patrons. The playful eroticism, small size, and precise, miniaturelike detail of the picture make it plainly a collector's item, attuned to the tastes of a provincial aristocracy.

Cranach's contribution lies above all in the handling of the landscape, which lends Dürer's naturalism a lively fantasy through the ornate treatment of forms, such as the crinkly veg-

etation. Cranach had formulated this manner soon after arriving in Vienna. It played a critical role in the formation of the Danube School, which culminated in the work of Albrecht Altdorfer (c. 1480–1538), a somewhat younger artist than Cranach who spent most of his career in Bavaria.

ALTDORFER. As remote from the classic ideal, but far more impressive, is Altdorfer's *Battle of Issus* (fig. 707). We could not possibly identify the subject, Alexander's victory over Darius, without the text on the tablet suspended in the sky and the

inscriptions on the banners (they were probably written by the Regensburg court humanist Aventinus) or the label on Darius' fleeing chariot. The artist has tried to follow ancient descriptions of the actual number and kind of combatants in the battle. To accomplish this, he adopts a bird's-eye view, so that the two protagonists are lost in the antlike mass of their own armies. (Contrast the Hellenistic representation of the same subject in fig. 199.)

However, the soldiers' armor and the fortified town in the distance are unmistakably of the sixteenth century. The picture commemorates a major contemporary battle that took place in 1529, the year this panel was painted. At that time the Turks unsuccessfully invaded Vienna after gaining control over much of Eastern Europe. (They were to threaten the imperial city repeatedly for another 250 years.) Neither the Hapsburg emperor Charles V, the most powerful leader in

Europe, nor Suleiman the Magnificent, the Turkish sultan, was present at this battle; yet, the painting proclaims Charles a new Alexander in his victory over Suleiman, the modern-day counterpart to Darius, who likewise became the ruler of a vast empire before his defeat at Issus.

To suggest its importance, Altdorfer treats the event as allegory: the sun triumphantly breaks through the clouds of the spectacular sky and "defeats" the moon, representing the Turkish Crescent. We have seen the same battle of good versus evil symbolized by the sun and moon in the Zoroastrian relief of *Mithras Slaying the Sacred Bull* (fig. 294). The celestial drama above a vast Alpine landscape, obviously correlated with the human contest below, raises the scene to the cosmic level. This is strikingly similar to the vision of the Heavenly Host above the Virgin and Child in the *Isenheim Altarpiece* (see fig. 697) by Grünewald, who influenced Altdorfer earlier in his career.

The most significant musical development of the Reformation was the introduction of congrega-

tional singing in the services of the Protestant churches. The reformer Martin Luther, himself a singer and composer, admired the sophisticated polyphony of Josquin Des Prés, whose music he retained for use by choirs in the Latin Mass. Luther also believed strongly in the educational value of music, and he wanted every member of the church to participate in the service by singing. So in 1524 he wrote a German Mass with chorales—simple hymns to be sung by the congregation—based on traditional chants and secular songs for use especially in parishes without professional choirs. The Swiss reformer John Calvin, on the other hand, objected to hymns based on new poems, and insisted that only the Word of God be sung in church. The result was the Calvinist psalter: Old Testament psalms set to traditional melodies, generally sung in unison. Another form of Protestant music was the English anthem, a kind of motet that could be "full" (sung by the choir a cappella, "without accompaniment") or "verse" (for soloists with chorus and instruments).

In secular music, the most popular form throughout Northern Europe was the madrigal. Its chief exponent was Roland de Lassus (1532–1594), a Fleming who had lived in Italy as a youth, but spent most of his career in Munich. Widely regarded as the leading composer of his day, he was the equal of Giovanni Palestrina as a writer of religious music; but because his temperament was more secular, many of his religious compositions are parody masses (see page 517). In his later years he devoted himself chiefly to madrigals and motets. In its impulsive leaps, irregular rhythms, and dramatic harmonies, his style anticipates the bold brilliance of Carlo Gesualdo (see page 558). During the reign of Elizabeth I (1558-1603), the English developed a distinguished madrigal school under Thomas Morley (1557-c. 1602), Thomas Weelkes (c. 1575-1623), John Wilbye (1574-1638), and John Dowland (1563–1626), whose lute songs are sensitive settings of poems by Shakespeare and his contemporaries.

It is utterly remarkable that English theater developed into greatness during the late sixteenth century. Its tradition was deeply rooted in medieval religious drama, and secular

Music and Theater in the Northern Renaissance

theater reached back only to about 1520. When Queen Elizabeth suppressed religious theater

in the 1570s, secular theater came to the fore under humanist influence at schools, universities, and inns-colleges where young men completed their education—despite the fact that theater was strictly regulated by the Master of the Revels. Yet neither the decline of religious theater nor the influence of the humanists can account satisfactorily for the enthusiastic support of theater throughout the realm ten public outdoor theaters were built in London between 1567 and 1642, in addition to numerous private indoor theaters—or the sudden appearance of four very fine playwrights within just a few years. Thomas Kyd (1558-1594) inaugurated the theme of revenge with The Spanish Tragedy (c. 1587); Christopher Marlowe (1564–1593) presented the great morality play of the day in Dr. Faustus (c. 1588); John Lyly (c. 1553-1606) used classical mythology to flatter the queen in Endimion (c. 1588); and Robert Greene (c. 1558-1592) helped to introduce the history, or chronicle, drama with James IV (c. 1591). Shortly before, William Shakespeare (1564-1616) had written Henry VI (1590). Of these playwrights, Shakespeare was incomparably the finest. His plays featured bold plots (many of them drawn from English history and patterned after Roman dramas), and they refrained from conventional moralizing and traditional happy endings in favor of tragedy of unrelenting darkness. His greatness lies in his use of blank verse (unrhymed, although metrical composition), which he perfected into a poetic language of infinite richness and subtlety able to express any thought or mood on a transcendent, indeed universal, plane.

Shakespeare's only serious rival in popularity was Ben Jonson (1572–1637), the leading classicist of the 1590s, whose theories followed those of Giulio Scaliger and Lodovico Castelvetro (see page 607). It was Jonson who published the first integrated edition of Shakespeare's works upon his death in 1616, thereby establishing the primacy of the playwright as a literary figure. Nevertheless, Jonson primarily wrote tragi-comedies for reforming behavior based on Italian examples, which made him a great favorite at the court of James I, Elizabeth's successor.

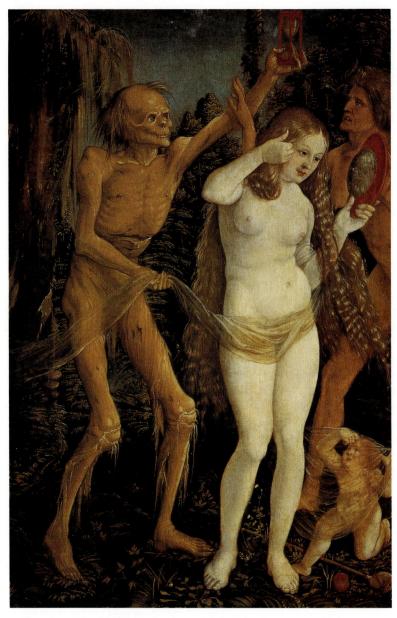

708. Hans Baldung Grien. *Death and the Maiden.* c. 1510. Oil on panel, 15³/4 x 12³/4" (40 x 32.4 cm). Kunsthistorisches Museum, Vienna

Altdorfer may indeed be viewed as a later, and lesser, Grünewald. Although Altdorfer, too, was an architect, well acquainted with perspective and the Italian stylistic vocabulary, his paintings show the unruly imagination already familiar from the work of the older painter. But Altdorfer is also unlike Grünewald. He treats the human figure with ironic intent by making it incidental to the spatial setting, whether natural or architectural. The tiny soldiers of *The Battle of Issus* have their counterpart in his other late pictures, and he painted at least one landscape with no figures at all—the earliest "pure" landscape we know of since antiquity. (Dürer's sketch, *Italian Mountains*, fig. 699, after all, is not a finished work of art.)

BALDUNG GRIEN. Altdorfer's fantastic landscape partakes of the imaginative qualities to be found in paintings by Hans Baldung Grien (1484/5–1545). This former apprentice of

Dürer spent much of his career in Strasbourg, which is not far from Isenheim and, like Nuremberg and Wittenberg, was a center of humanism. Yet he was fascinated above all with the magical and the demonic, which exemplify the dark side of the Renaissance. Humanism and the occult may be viewed as two sides of the same coin. Since the late thirteenth century, humanists had been nearly as interested in the treatises of the ancients on magic as in their literature and learning. In fact, the key text of Renaissance magic, the Corpus Hermeticum, was translated by the humanist Marsilio Ficino. But whereas the occult only rarely makes an appearance in Italian art, it was the object of continuing fascination in the North. Nowhere is this better seen than in Baldung Grien's *Death and* the Maiden (fig. 708). Clearly based on Dürer's Eve (see fig. 702), she is the personification of Vanitas, signifying the triumph of Death over Beauty. The three ages of life—infancy,

adulthood, old age—are repeated in the mirror, where three heads stare out at the young woman, who nevertheless examines her features serenely.

The painting epitomizes the prophetic and demonic powers of the convex mirror. In antiquity, mirrors had often served as attributes of goddesses and sometimes of mortal women, such as brides. The motif of a woman contemplating her beauty reappeared in Gothic cycles of the Vices and Virtues. This moralizing tradition was revived after 1500 as part of a widespread renewal of Gothic piety and mysticism during the Reformation. It was closely linked in turn to resurgent occultism at a time when rationalism seemed inadequate to explain the world. Because of their association with light, mirrors have often had mystical connotations throughout history, and reflected images were widely valued for their revelatory power. At the same time, supernatural qualities were attributed to them in folklore as a means of effecting hexes and other forms of black magic.

Initially the convex mirror expressed the "Late Gothic" fascination with the visible world, as we have seen in Jan van Eyck's *Arnolfini Portrait* (fig. 677), which was painted within a few decades after mirrors began to be manufactured from polished metal. After 1500 the convex mirror came to be used almost exclusively as a Vanitas symbol, due to its extreme distortions, which heighten visionary reality; this, too, had its origin in another work by Jan. In Baldung Grien's painting, the characteristic image became a nude woman holding a convex mirror. It is used to convey a tragic vision of life to chilling effect through the striking contrast between the sensual nude and the grinning corpse, who holds an hourglass above her head as the horrified man vainly tries to stay Death's hand.

Portraiture

HOLBEIN. Gifted though they were, Cranach and Altdorfer both evaded the main challenge of the Renaissance so bravely faced, if not always mastered, by Dürer: the human image. Their style, antimonumental and miniaturelike, set the pace for dozens of lesser masters. Perhaps the rapid decline of German art after Dürer's death was due to a failure of ambition among artists and patrons alike. The career of Hans Holbein the Younger (1497–1543), the one painter of whom this is not true, confirms the general rule. The son of an important artist, he was born and raised in Augsburg, a center of international commerce in southern Germany particularly open to Renaissance ideas, but left at the age of 18 with his brother to seek work in Switzerland. Thanks in large part to the help of humanist patrons, he was firmly established in Basel by 1520 as a designer of woodcuts, a splendid decorator, and an incisive portraitist. Holbein took Dürer as his point of departure, but almost from the beginning his religious paintings and portraits show a keen interest in the Italian Renaissance, including the latest tendencies, especially from Venice and Rome.

Holbein's likeness of Erasmus of Rotterdam (fig. 709), painted soon after the famous author had settled in Basel, gives us a truly memorable image, at once intimate and monumental. This kind of profile view had been popular during the

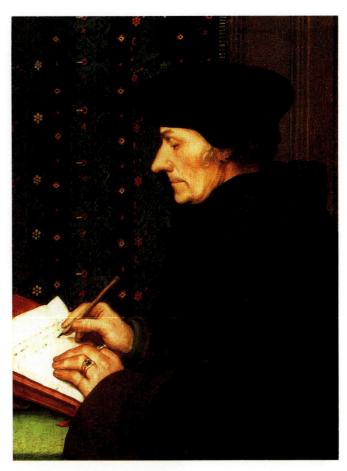

709. Hans Holbein the Younger. *Erasmus of Rotterdam.* c. 1523. Oil on panel, $16^{1/2} \times 12^{1/2}$ " (42 x 31.4 cm). Musée du Louvre, Paris

Early Renaissance. Here it has been reinterpreted with a characteristically Northern emphasis on tangible reality to convey the sitter's personality that is nevertheless thoroughly in keeping with High Renaissance ideas. The very ideal of the humanist scholar, this doctor of humane letters has a calm rationality that lends him an intellectual authority formerly reserved for the Doctors of the Church.

Holbein spent 1523-24 traveling in France, apparently with the intention of offering his services to Francis I. When he returned two years later, Basel was in the throes of the Reformation crisis, and he went to England, hoping for commissions at the court of Henry VIII. He bore with him the portrait of Erasmus in figure 709 as a gift to the humanist Thomas More, who became his first patron in London. (Erasmus, recommending him to More, wrote: "Here [in Basel] the arts are out in the cold.") On his return to Basel in 1528, he saw fanatical Protestant mobs destroying religious images as "idols," and reluctantly abandoned Catholicism. Despite the entreaties of the city council, Holbein departed for London four years later. He went back to Basel only once, in 1538, while traveling on the Continent as court painter to Henry VIII, who had More beheaded in 1525 for refusing to consent to the Act of Supremacy that made the king the head of the Church of England. The council made a last attempt to keep Holbein at home, but he had become an artist of international fame to whom Basel now seemed provincial indeed.

710. Hans Holbein the Younger. *Henry VIII*. 1540. Oil on panel, 32¹/2 x 29" (82.6 x 74.5 cm). Galleria Nazionale d'Arte Antica, Rome

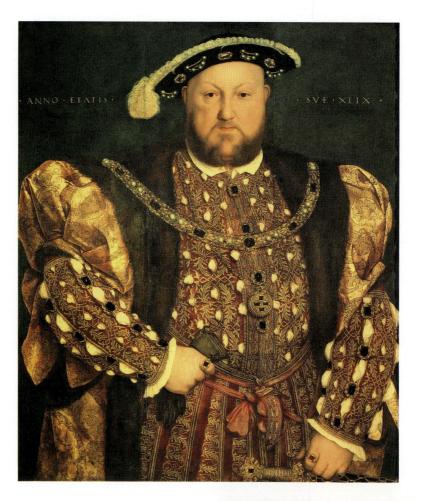

Holbein's style, too, had gained an international flavor. His portrait of Henry VIII (fig. 710) has the rigid frontality of Dürer's self-portrait (see fig. 701), but its purpose is to convey the almost divine authority of the absolute ruler. The monarch's physical bulk creates an overpowering sensation of his ruthless, commanding presence. The portrait of the king shares with Bronzino's Eleanora of Toledo (see fig. 644) the immobile pose, the air of unapproachability, and the precisely rendered costume and jewels. Holbein's picture, unlike Bronzino's, does not yet reflect the Mannerist ideal of elegance, but both clearly belong to the same species of court portrait. The link between the two may lie in such French works as Jean Clouet's Francis I (fig. 711), which Holbein could have seen on his travels. (For Francis I as a patron of Italian Mannerists, see page 496.) The type evidently was coined at the royal court of France, where its ancestry can be traced back as far as Jean Fouquet (see fig. 687). It gained international currency between 1525 and 1550 as reflecting a new aristocratic ideal.

Although Holbein's pictures molded British taste in aristocratic portraiture for decades, he had no English disciples of real talent. The Elizabethan genius was more literary and musical than visual, and the demand for portraits in the later sixteenth century continued to be filled largely by visiting foreign artists.

HILLIARD. The most notable English painter of the period was Nicholas Hilliard (1547–1619), a goldsmith who also

711. Jean Clouet. Francis I. c. 1525–30. Tempera and oil on panel, $37^3/4 \times 29$ " (96 x 74.5 cm). Musée du Louvre, Paris

712. Nicholas Hilliard. *A Young Man Among Roses.* c. 1588. Oil on parchment, shown at actual size, $5^3/8 \times 2^3/4$ " (13.7 x 7 cm). Victoria & Albert Museum, London

specialized in miniature portraits on parchment, tiny keep-sakes often worn by their owners as jewelry. These "portable portraits" had been invented in antiquity and were revived in the fifteenth century. Holbein, too, produced miniature portraits, which Hilliard acknowledged to be his model. We see this link with the older artist in the even lighting and meticulous detail of *A Young Man Among Roses* (fig. 712), but the elongated proportions and the pose of languorous grace come from Italian Mannerism, probably via Fontainebleau (compare fig. 658). Our lovesick youth also strikes us as the descendant of the fashionable attendants at the court of the duke of Berry. We can imagine him besieging his lady with sonnets and madrigals before presenting her with this exquisite token of devotion.

THE NETHERLANDS

Painting

The Netherlands in the sixteenth century had the most turbulent and painful history of any country north of the Alps.

When the Reformation began, they were part of the far-flung empire of the Hapsburgs under Charles V, who was also king of Spain. Protestantism quickly became powerful in The Netherlands, and the attempts of the crown to suppress it led to open revolt against foreign rule. After a bloody struggle, the northern provinces (today's Holland) emerged at the end of the century as an independent state, while the southern ones (roughly corresponding to modern Belgium) remained in Spanish hands.

The religious and political strife might have had catastrophic effects on the arts, yet this, astonishingly, did not happen. The art of the period, to be sure, does not equal that of the fifteenth century in brilliance, nor did it produce any pioneers of the Northern Renaissance comparable to Dürer and Holbein. This region absorbed Italian elements more slowly than Germany, but more steadily and systematically, so that instead of a few isolated peaks of achievement we find a continuous range. Between 1550 and 1600, their most troubled time, The Netherlands produced the major painters of Northern Europe, who paved the way for the great Dutch and Flemish masters of the next century.

Two main concerns, sometimes separate, sometimes interwoven, characterize Netherlandish sixteenth-century painting: to assimilate Italian art from Raphael to Tintoretto (albeit in an often dry and didactic manner), and to develop a repertory supplementing, and eventually replacing, the traditional religious subjects.

"MANNERISM" AND ROMANISM. When Flanders passed from Burgundy to Spain in 1482, Antwerp, with its deep harbor, superseded Ghent and Bruges as the political, commercial, and artistic capital of The Netherlands. Flemish artists spent the next quarter-century largely imitating earlier Netherlandish painting. Then, around 1507, we find two important new developments. "Antwerp Mannerism" is the misleading label applied to the largely anonymous school of painters which first arose in that city. Their preference for elongated forms, decorative surfaces, and arbitrary space seems to reassert Late Gothic tendencies, although the similarities are superficial at best. Actually, the style bore no direct relation to either the Renaissance or Mannerism in Italy. Still, the term is not without foundation. It suggests the peculiar flavor of their work, for it represented a "mannered" response to the "classics" by Jan van Eyck, Rogier van der Weyden, and their successors. Almost simultaneously, a second group of Netherlandish artists, the so-called Romanists, began to visit Italy in the wake of Albrecht Dürer and returned home with the latest tendencies. The preceding generation of Flemish painters had already shown a growing interest in Renaissance art and humanism, but none ventured below the Alps, so that they assimilated both at second hand.

GOSSAERT. The greatest of the Romanists, Jan Gossaert (c. 1478–1532; nicknamed Mabuse, for his hometown), was also the first to travel south. In 1508 he accompanied Philip of Burgundy to Italy, where the Renaissance and antiquity made a deep impression on him. He nevertheless viewed this experience through characteristically Northern eyes. Except for their greater monumentality, his religious subjects were

713. Jan Gossaert. *Danaë*. 1527. Oil on panel, $44^{1/2}$ x $37^{3/8}$ " (113 x 95 cm). Alte Pinakothek, Munich

based on fifteenth-century Netherlandish art, and he often found it easier to assimilate Italian classicism through the intermediary of Dürer's prints. Danaë (fig. 713), painted toward the end of Gossaert's career, is his most thoroughly Italianate work. In true humanist fashion, the subject of Jupiter's seduction of the mortal is treated as a pagan equivalent of the Annunciation, so that the picture may be seen as a chaste counterpart to Correggio's Jupiter and Io (fig. 655). The god enters Danaë's chambers, where she has been confined by her father against all suitors, disguised as a shower of gold comparable to the miraculous stream of light in the Mérode Altarpiece (fig. 671). Her partial nudity notwithstanding, she appears as modest as the Virgin in any Annunciation. Indeed, she hardly differs in type from Gossaert's paintings of the Madonna and Child, inspired equally by Van Eyck and Raphael. She even wears the blue robe traditional to Mary. The linear perspective of the architectural fantasy, compiled largely from Italian treatises, marks a revolution. Never before

have we encountered such a systematic treatment of space in The Netherlands.

STILL LIFE, LANDSCAPE, GENRE. Later religious art in The Netherlands presents a fusion of Antwerp Mannerism and Romanism, which produced a distinctive strain of Northern Mannerism that persisted until the end of the century. After 1550, however, narrative painting was largely supplanted by the secular themes that loom so large in Dutch and Flemish painting of the Baroque era: landscape, still life, and genre (scenes of everyday life). The process was gradual—it began around 1500 and was not complete until 1600—and was shaped less by the genius of individual artists than by the need to cater to popular taste as church commissions became steadily scarcer. (Protestant iconoclastic zeal was particularly widespread in The Netherlands.) Still life, landscape, and genre had been part of the Flemish tradition since the Master of Flémalle and the brothers Van Eyck. In the *Mérode Altar*-

714. Joachim Patinir. Landscape with St. Jerome Removing the Thorn from the Lion's Paw. c. 1520. Oil on panel, $29^{1/8} \times 35^{7/8}$ " (74 x 91 cm). Museo del Prado, Madrid

piece (fig. 671) we remember the objects grouped on the Virgin's table and the scene of Joseph in his workshop, or think of the setting of the Van Eyck *Crucifixion* (fig. 672). But these had remained ancillary elements, governed by the principle of disguised symbolism and subordinated to the devotional purpose of the whole. Now they acquired a new independence, until they became so dominant that the religious subject could be relegated to the background.

PATINIR. We see the beginnings of this approach in the paintings of Joachim Patinir (c. 1485–1524). Landscape with St. Jerome Removing the Thorn from the Lion's Paw (fig. 714) reveals him as the heir of Bosch in both his treatment of nature and choice of subject, but without the strange demonic overtones of The Garden of Delights (see fig. 684). Although the landscape dominates the scene, the figures, rather than being incidental, are central to it, both visually and iconographically. The landscape has been constructed around the hermit in

his cave, which could exist happily in another setting, whereas the picture would be incomplete without it. St. Jerome is an allegory of the pilgrimage of life, contrasting the way of the world with the road to salvation through ascetic withdrawal. (Note the two pilgrims wending their way up the hill to the right, past the lion hunt which takes place unnoticed by them.) The church on the mountain represents the Heavenly Jerusalem, which can be reached only by passing directly through the hermit's cave (compare fig. 592). Like Bosch, Patinir reveals a fundamental ambivalence toward his subject, for the vista in the background, with its well-kept fields and tidy villages, is enchanting in its own right. Yet, he seems to tell us, we should not be distracted from the path of righteousness by these temptations.

AERTSEN. Pieter Aertsen (1508/9–1575) is remembered today mainly as a pioneer of still lifes, but he seems to have first painted such pictures as a sideline, until he saw many of his

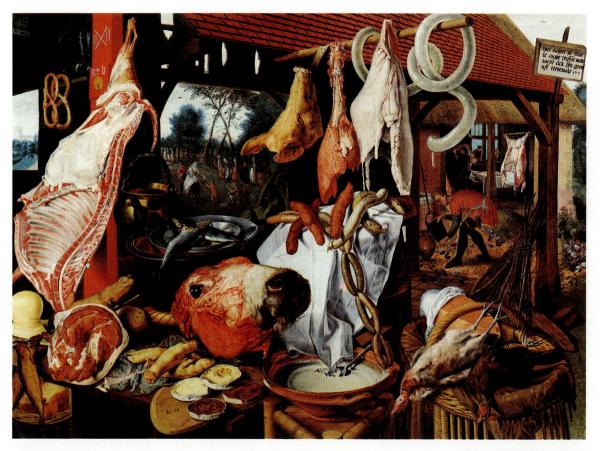

715. Pieter Aertsen. The Meat Stall. 1551. Oil on panel, 481/2 x 59" (123.3 x 150 cm). University Art Collections, Uppsala University, Sweden

altarpieces destroyed by iconoclasts. *The Meat Stall* (fig. 715), done a few years before he moved from Antwerp to Amsterdam, seems at first glance to be an essentially secular picture. The tiny, distant figures are almost blotted out by the avalanche of edibles in the foreground. We see little interest here in selection or formal arrangement. The objects, piled in heaps or strung from poles, are meant to overwhelm us with their sensuous reality (the panel is nearly lifesize). Here the still life so dominates the picture that it seems independent of the religious subject. The latter, however, is not merely a pretext to justify the painting; it must be integral to the meaning of the scene. In the background to the left we see the Virgin on the Flight into Egypt giving bread to the poor, who are ignored by the faithful lined up for church, while to the right is a tavern scene with the prodigal son.

The Northern Mannerists often relegated subject matter to a minor position within their compositions. This "inverted" perspective was a favorite device of Aertsen's younger contemporary, Pieter Bruegel the Elder, who treated it with ironic intent in his landscapes. Aertsen belonged to the same tradition, whose greatest representative was the humanist Erasmus of Rotterdam (see page 531). *The Meat Stall* is, then, a moralizing sermon on charity and gluttony. Not until around 1600 was this vision replaced as part of a larger change in world view (see page 540). Only then did it no longer prove necessary to include religious or historical scenes in still lifes and landscapes.

BRUEGEL THE ELDER. The only genius among these Netherlandish painters, Pieter Bruegel the Elder (1525/30–1569), explored landscape and peasant life. Although his career was spent in Antwerp and Brussels, he may have been born near's Hertogenbosch, the home of Hieronymus Bosch.

Certainly Bosch's work impressed him deeply, and he is in many ways as puzzling to us as the older master. What were his religious convictions, his political sympathies? We know little about him, but his preoccupation with folk customs and the daily life of humble people seems to have sprung from a complex philosophical attitude. Bruegel was highly educated, the friend of humanists, who, with wealthy merchants, were his main clients, though he was also patronized by the Hapsburg court. Yet he apparently never worked for the Church, and when he dealt with religious subjects he did so in a strangely ambiguous way.

His attitude toward Italian art is also hard to define. A trip to the South in 1552–53 took him to Rome, Naples, and the Strait of Messina, but the famous monuments admired by other Northerners seem not to have interested him. He returned instead with a sheaf of magnificent landscape drawings, especially Alpine views. He was probably much impressed by landscape painting in Venice, above all its integration of figures and scenery and the progression in space from foreground to background (see figs. 631 and 632).

Out of this experience came such sweeping landscapes in Bruegel's mature style as *The Return of the Hunters* (fig. 716), one of a set depicting the months. (He typically composed in series.) Such cycles, we recall, had begun with medieval calendar illustrations, and Bruegel's winter scene shows its descent from *Les Très Riches Heures du Duc de Berry*. Now, however, nature is more than a setting for human activities. It is the main subject of the picture. Men and women in their seasonal occupations are incidental to the majestic annual cycle of death and rebirth that is the breathing rhythm of the cosmos.

The Peasant Wedding (fig. 717) is Bruegel's most memo-

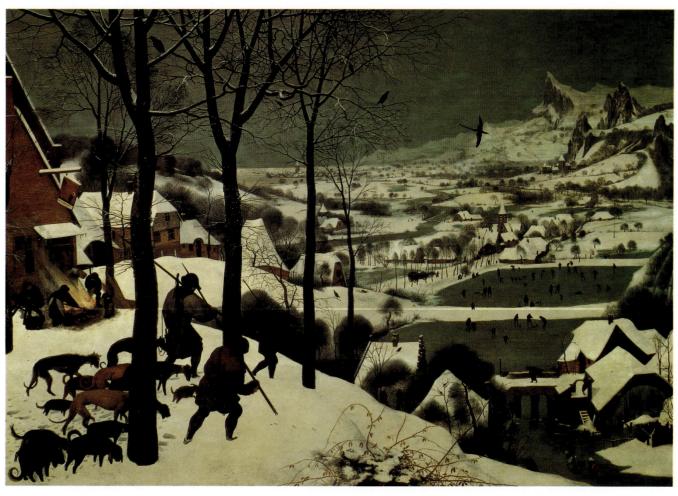

716. Pieter Bruegel the Elder. The Return of the Hunters. 1565. Oil on panel, $46^{1/2}$ x $63^{3/4}$ " (117 x 162 cm). Kunsthistorisches Museum, Vienna

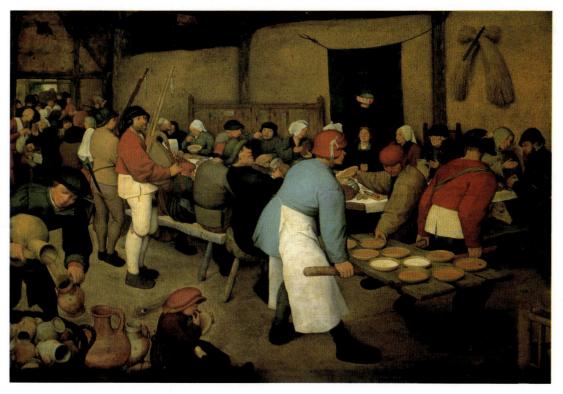

717. Pieter Bruegel the Elder. Peasant Wedding. c. 1565. Oil on panel, $44^7/8 \times 64^\circ$ (114 x 162.5 cm). Kunsthistorisches Museum, Vienna

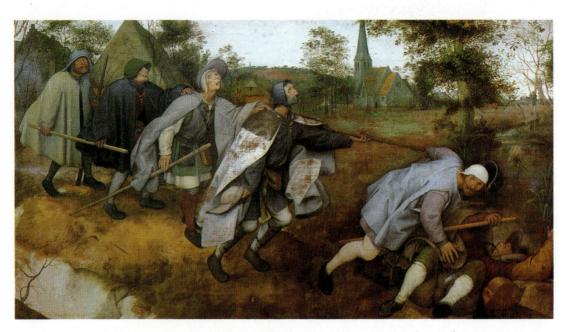

718. Pieter Bruegel the Elder. The Blind Leading the Blind. c. 1568. Oil on panel, $34^{1/2} \times 60^{5/8}$ " (85 x 154 cm). Museo di Capodimonte, Naples

rable scene of peasant life. These are stolid, crude folk, heavybodied and slow, yet their very clumsiness gives them a strange gravity that commands our respect. Painted in flat colors with minimal modeling and no cast shadows, the figures nevertheless have a weight and solidity that remind us of Giotto. Space is created in assured perspective, and the entire composition is as monumental and balanced as that of any Italian master. Why, we wonder, did Bruegel endow this commonplace ceremony with the solemnity of a biblical event? It is because he saw in the life of these rural people the natural condition of humanity. We know from his biographer, Karel van Mander (the Netherlandish "Vasari"), that Bruegel and his patron Hans Franckert often disguised themselves as peasants and joined them in their revelries. There Bruegel would draw them from life. In his hands, they become types whose follies he knew at first hand, yet whose dignity remains intact. For him, Everyman occupies an important place in the scheme of things.

Bruegel's philosophical detachment, which was shared by his fellow humanists, also informs one of his last pictures, *The Blind Leading the Blind* (fig. 718). Its source is the Gospels (Matthew 15:12–19): Jesus, speaking of the Pharisees, says, "And if the blind lead the blind, both shall fall into the ditch." This parable of human folly recurs in humanistic as well as popular literature, and we know it in at least one earlier representation, but the tragic depth of Bruegel's forceful image gives new urgency to the theme. He has used continuous narrative to ingenious effect. Each succeeding pose becomes progressively more unstable along the downward diagonal, leaving us in little doubt that everyone will end up in the ditch with the

leader. (The gap behind him is especially telling.) Perhaps he found the biblical context of the parable specially relevant to his time, which was marked by religious and political fanaticism, for Jesus continued: "Out of the heart proceed evil thoughts, murders . . . blasphemies." Could Bruegel have thought that this applied to the controversies then raging over details of religious ritual?

FRANCE

Architecture and Sculpture

It took the Northern countries longer to assimilate Italian forms in architecture and sculpture than in painting. France was more closely linked with Italy than the rest. We will recall that it had conquered Milan in 1499, and that King Francis I had shown his admiration for Italian art earlier by inviting first Leonardo and then several Mannerists to France (see page 483). As a consequence, France began to assimilate Italian art somewhat earlier than the other countries and was the first to achieve an integrated Renaissance style. We shall therefore confine our discussion to French monuments.

SOHIER. As we might expect, architects still trained in the Gothic tradition could not adopt the Italian style all at once. They readily used its classical vocabulary, but its syntax gave them trouble for many years. One glance at the choir of St.-Pierre at Caen (fig. 719), built by Hector Sohier, shows that he followed the basic pattern of French Gothic church choirs (compare fig. 430), simply translating flamboyant decoration

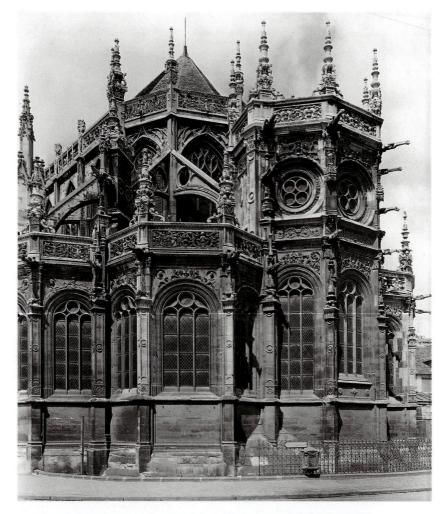

719. Hector Sohier. Choir of St.-Pierre, Caen, France. 1528–45

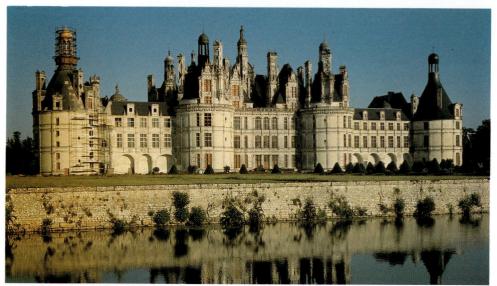

721. Plan of center portion, Château of Chambord (after Du Cerceau)

into the vocabulary of the new language. Finials become candelabra, pier buttresses are shaped like pilasters, and the round-arched windows of the ambulatory chapels have geometric tracery.

CHÂTEAU OF CHAMBORD. The Château of Chambord (fig. 720) is stylistically more complicated. Its plan, and the

turrets, high-pitched roofs, and tall chimneys, recall the Gothic Louvre. Yet the design, though greatly modified by later French builders, was originally by an Italian pupil of Giuliano da Sangallo, and his was surely the plan of the center portion (fig. 721), which is quite unlike its French predecessors. This square block, developed from the keep of medieval castles (see page 335), has a central staircase fed by four corridors. These

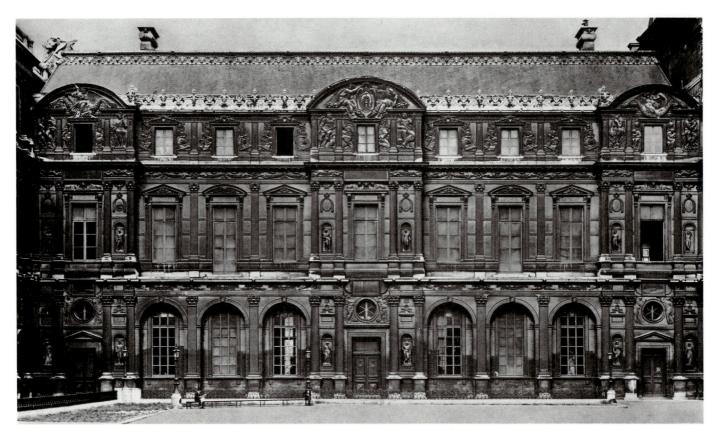

722. Pierre Lescot. Square Court of the Louvre, Paris. Begun 1546

form a Greek cross dividing the interior into four square sections. Each section is further subdivided into one large and two smaller rooms, and a closet, forming a suite, or apartment, in modern parlance. The functional grouping of these rooms, originally imported from Italy, was to become a standard pattern in France. It represents the starting point of all modern "designs for living."

LESCOT. Francis I, who built Chambord, decided in 1546 to replace the old Gothic royal castle, the Louvre, with a new palace on the old site. The project had barely begun at the time of his death, but his architect, Pierre Lescot (c. 1515–1578), continued it under Henry II, quadrupling the size of the court. This enlarged scheme was not completed for more than a century. Lescot built only the southern half of the court's west side (fig. 722), which represents its "classic" phase, so called to distinguish it from the style of such buildings as Chambord. This distinction is well warranted. The

Italian vocabulary of Chambord and St.-Pierre at Caen is based on the Early Renaissance, whereas Lescot drew on the work of Bramante and his successors. Lescot's design is classic in another sense as well: it is the finest surviving example of Northern Renaissance architecture.

The details of Lescot's facade do indeed have an astonishing classical purity, yet we would not mistake it for an Italian structure. Its distinctive quality comes not from Italian forms superficially applied, but from a genuine synthesis of the traditional château with the Renaissance palazzo. Italian are the superimposed classical orders (see figs. 566 and 662), the pedimented window frames, and the arcade on the ground floor. But the continuity of the facade is interrupted by three projecting pavilions that have supplanted the château turrets, and the high-pitched roof is also traditionally French. The vertical accents thus overcome the horizonal ones (note the broken architraves), an effect reinforced by the tall, narrow windows.

723, 724. Jean Goujon. Reliefs from the Fontaine des Innocents, Paris. 1548-49

GOUJON. Equally un-Italian is the rich sculptural decoration covering almost the entire wall surface of the third story. These reliefs, admirably adapted to the architecture, are by Jean Goujon (c. 1510-1565?), the finest French sculptor of the mid-sixteenth century. Unfortunately, they have been much restored. To get a more precise idea of Goujon's style we must turn to the relief panels from the Fontaine des Innocents

(two are shown in figs. 723 and 724), which have survived intact, although their architectural framework by Lescot is lost. These graceful figures recall the Mannerism of Cellini (see fig. 657) and, even more, Primaticcio's decorations at Fontainebleau (see fig. 658). Like Lescot's architecture, their design combines classical details of remarkable purity with a delicate slenderness that gives them a uniquely French air.

CHAPTER SIX

THE BAROQUE IN ITALY AND SPAIN

What is Baroque? Like Mannerism, the term was originally coined to disparage the very style it designates. It meant "irregular, contorted, grotesque." Art historians otherwise remain divided over its definition. Should Baroque be used only for the dominant style of the seventeenth century, or should it include other tendencies, such as classicism, to which it bears a complex relationship? Should the time frame be extended to cover the period 1700–1750, known as the Rococo? More important, is the Baroque an era distinct from both Renaissance and modern, or the final phase of the Renaissance? Although a good case can be made for viewing the Baroque as the end of the Renaissance, we shall, for convenience, look at it here as a distinct era. Which of the alternatives is adopted is perhaps less important than an understanding of the factors that must enter into our decision.

The fact is that the Baroque eludes simple classification. Rather, it was a time full of inner contradictions, not unlike the present, and thus peculiarly fascinating to us. Hence, we run into a series of paradoxes typical of the conflicting nature of the Baroque. It has been claimed that the Baroque style expresses the spirit of the Counter Reformation, which, however, had already done its work by 1600. Catholicism had recaptured much of its former territory, and Protestantism was on the defensive, so that neither side any longer had the power to upset the new balance. As if to signify the triumph of the old faith, in 1622 the heroes of the Counter Reformation—Ignatius of Loyola, Francis Xavier (both Jesuits), Theresa of Avila, Filippo Neri, and Isidoro Agricola—were named saints (Carlo Borromeo had been made one in 1610), beginning a wave of canonizations that lasted through the mid-eighteenth century. In contrast to the piety and good deeds of these reformers, the new princes of the Church who supported the growth of Baroque art were known primarily for worldly splendor.

Another reason why we should guard against overemphasizing the Baroque's ties to the Counter Reformation is that, unlike Mannerism, the new style was not specifically Italian, although historians generally agree that it was born in Rome during the final years of the sixteenth century. Nor was it confined to religious art. Baroque elements quickly penetrated the Protestant North, where they were applied primarily to other subjects.

Equally problematic is the assertion that Baroque is "the style of absolutism," reflecting the centralized state ruled by an autocrat of unlimited powers. Although absolutism reached its climax during the reign of Louis XIV in the later seventeenth century, it had been in the making since the 1520s (under Francis I in France and the Medici dukes in Tuscany). Moreover, Baroque art flourished in bourgeois Holland no less than in the absolutist monarchies, and the style officially sponsored under Louis XIV was a notably subdued, classicistic kind of Baroque.

It is nevertheless tempting to see the turbulent history of the era reflected in Baroque art, where the tensions of the era often seem to erupt into open conflict. The seventeenth century was one of almost continuous warfare, which involved virtually every nation in a complex web of shifting alliances. The Thirty Years' War (1618–1648) was fueled by the dynastic ambitions of the kings of France, who sought to exert their domination over Europe, and the Hapsburgs, who ruled Spain, The Netherlands, and Austria. Though fought largely in Germany, the war eventually engulfed nearly all of Europe, even absorbing the Dutch struggle for independence from Spain, which had been waged since 1581. After the Treaty of

Westphalia formally ended the war and granted their freedom, the United Provinces—as the independent Netherlands was known—entered into a series of battles with England and France for commercial and maritime supremacy that lasted until 1679. Yet, other than in Germany, which was left in ruins, there is little correlation between these rivalries and the art of the period. It is a remarkable fact that the seventeenth century has been called the Golden Age of painting in France, Holland, Flanders, and Spain. We look in vain, moreover, for the impact of these wars on Baroque imagery. Its chief manifestation is the etchings of Jacques Callot (see fig. 790), though we occasionally catch an indirect glimpse of it in Dutch militia scenes, such as Rembrandt's *Night Watch* (fig. 777).

We encounter similar difficulties when we try to relate Baroque art to the science and philosophy of the period. A direct link did exist in the Early and High Renaissance, when an artist then could also be a humanist and a scientist. During the seventeenth century, however, scientific and philosophical thought became too complex, abstract, and systematic for the artist to share. Gravitation and calculus could not stir the artist's imagination any more than Descartes' famous motto *Cogito, ergo sum* (I think, therefore I am).

There is nevertheless a relationship between Baroque art and science which, though subtle, is essential to an understanding of the entire age. The complex metaphysics of the humanists, which endowed everything with religious import, was replaced by a new physics, beginning with Copernicus, Kepler, and Galileo, and culminating in Descartes and Newton. They instituted a cosmology that severed the ties between sensory perception and science. By placing the sun, not the earth (and humanity), at the center of the universe, it contradicted what our eyes (and common sense) tell us: that the sun revolves around the earth. Scientists now defined underlying relationships in mathematical and geometrical terms as part of the simple, orderly system of mechanics. Not only was the seventeenth century's world view fundamentally different from what had preceded it, but its understanding of visual reality was forever altered by the new science, thanks to advances in optical physics and physiology. Thus we may say that the Baroque literally saw with new eyes.

The attack on Renaissance science and philosophy, which could trace their origins (and authority) back to antiquity, also had the effect of supplanting natural magic, a precursor of modern science that included both astrology and alchemy. The difference was that natural magic sought to exercise practical control of the world through prediction and manipulation, by uncovering nature's "secrets" instead of her laws. To be sure, traditional magic, linked as it was to religion and morality, continued to live on in popular literature and folk-lore long afterward.

In the end, Baroque art was not simply the result of religious, political, or intellectual developments. Let us therefore think of it as one among other basic features that distinguish the period from what had gone before: the refortified Catholic faith, the absolutist state, and the new role of science. These factors are combined in volatile mixtures that give Baroque its fascinating variety. Such diversity was perfectly suited to express the expanding view of life. What ultimately unites this refractory era is a reevaluation of humanity and its relation to

the universe. Central to this image is the new psychology of the Baroque. A prominent role was now assigned by philosophers to human passion, which encompasses a wider range of emotions and social levels than ever before. The scientific revolution culminating in Newton's unified mechanics responded to the same impulses, for it assumes a more active role in our ability to understand and in turn affect the world around us. Remarkably, the Baroque remained an age of great religious faith, however divided it may have been in its loyalties. The counterpoint between the passions, intellect, and spirituality may be seen as forming a dialogue which has never been truly resolved.

PAINTING IN ITALY

Around 1600 Rome became the fountainhead of the Baroque, as it had of the High Renaissance a century before, by gathering artists from other regions to perform challenging new tasks. The papacy patronized art on a large scale with the aim of making Rome the most beautiful city of the Christian world "for the greater glory of God and the Church." This campaign had begun as early as 1585, but the artists then on hand were Late Mannerists of feeble distinction. Soon, however, it attracted ambitious young artists, especially from northern Italy, who created the new style.

CARAVAGGIO. Foremost among them was a painter of genius, Michelangelo Merisi, called Caravaggio after his birthplace near Milan (1571–1610). His first important religious commission was for a series of three monumental canvases devoted to St. Matthew that he painted for the Contarelli chapel in S. Luigi dei Francesi from 1599 to 1602 (fig. 725). As decorations they perform the same function that fresco cycles had in the Renaissance (compare fig. 561). Our view of the chapel includes St. Matthew and the Angel, in which the illiterate tax collector turns dramatically for inspiration to the angel who dictates the gospel. *The Calling of St. Matthew* (fig. 726), the most extraordinary picture of all, is remote from both Mannerism and the High Renaissance. Its only antecedent is the "North Italian realism" of artists like Savoldo (see fig. 651). But Caravaggio's realism is of a new and radical kind. According to contemporary accounts, Caravaggio painted directly on the canvas from the live model. He depicted the world he knew, so that his canvases are filled with ordinary people. Indeed, his pictures are often surprisingly autobiographical (see page 31).

Never have we seen a sacred subject depicted so entirely in terms of contemporary lowlife. Matthew, the tax gatherer, sits with some armed men (evidently his agents) in what is a common Roman tavern as two figures approach from the right. The arrivals are poor people, their bare feet and simple garments contrasting strongly with the colorful costumes of Matthew and his companions. For Caravaggio, however, naturalism is not an end in itself but a means of conveying profoundly religious content. Why do we sense a religious quality in this scene and do not mistake it for an everyday event? The answer is that Caravaggio's North Italian realism is wedded to elements derived from his study of Renaissance art in Rome, which lend the scene its surprising dignity. His style, in other

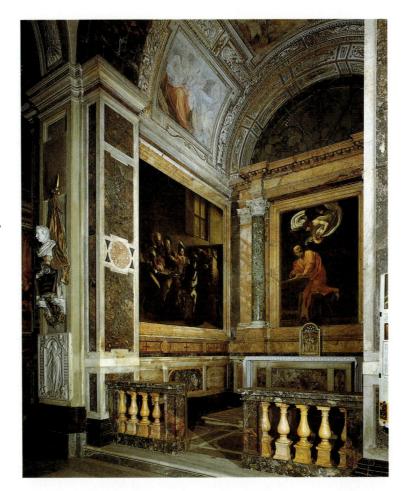

725. *(right)* Contarelli Chapel, S. Luigi dei Francesi, Rome

726. (below) Caravaggio.
The Calling of St. Matthew.
c. 1599–1602.
Oil on canvas.11'1" x 11'5"
(3.4 x 3.5 m).
Contarelli Chapel, S. Luigi dei Francesi, Rome

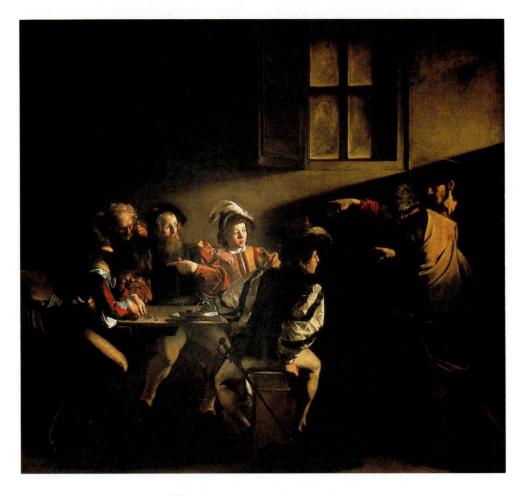

550 The Baroque in Italy and Spain

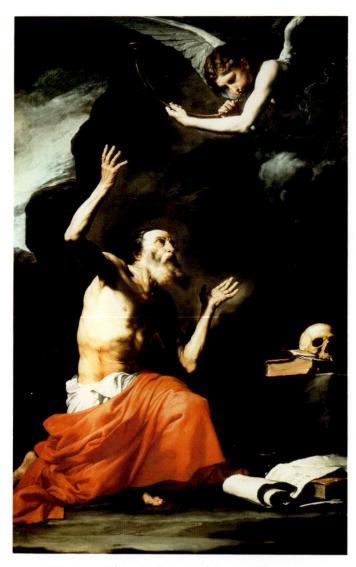

727. Jusepe Ribera. *St. Jerome and the Angel of Judgment.*Oil on canvas, 8'7¹/8" x 5'4¹/2" (2.62 x 1.64 m). Museo e Gallerie Nazionali di Capodimonte, Naples

words, is classical, without being classicizing. The composition, for example, is disposed across the picture surface and its forms sharply highlighted, much as in a relief (see fig. 267). What identifies one of the figures as Christ? It is surely not the Saviour's halo, the only supernatural feature in the picture, which is an inconspicuous gold band that we might well overlook. Our eyes fasten instead upon his commanding gesture, borrowed from Michelangelo's *Creation of Adam* (fig. 612), which "bridges" the gap between the two groups and is echoed by Matthew, who points questioningly at himself.

Most decisive is the strong beam of sunlight above Jesus that illuminates his face and hand in the gloomy interior, thus carrying his call across to Matthew. Without this light, so natural yet so charged with symbolic meaning, the picture would lose its magic, its power to make us aware of the divine presence. Caravaggio here gives moving, direct form to an attitude shared by certain great saints of the Counter Reformation: that

the mysteries of faith are revealed not by intellectual speculation but spontaneously, through an inward experience open to all people. What separates the Baroque from the later Counter Reformation is the externalization of the mystic vision, which appears to us complete, without any signs of the spiritual struggle in El Greco's art (see pages 490–93).

Caravaggio's paintings have a "lay Christianity" that appealed to Protestants no less than Catholics. This quality made possible his strong, though indirect, influence on Rembrandt, the greatest religious artist of the Protestant North. In Italy, Caravaggio fared less well. His work was acclaimed by artists and connoisseurs, but the ordinary people for whom it was intended resented meeting their own kind in these paintings; they preferred religious imagery of a more idealized and rhetorical sort. Conservative critics, moreover, regarded it as lacking decorum: the propriety and reverence demanded of religious subjects. For these reasons, Caravaggism largely ran its course by 1630, when it was assimilated into other Baroque tendencies.

RIBERA. Caravaggio's style lived on only in Naples, then under Spanish rule, where he fled from Rome after killing a man in a duel over a ball game. His main disciple in Naples was the Spaniard Jusepe Ribera (1591-1652), who settled there after having first absorbed Caravaggio's style in Rome and who in turn spawned a school of his own. Especially popular were his paintings of saints, prophets, and ancient beggar philosophers. The asceticism for which they were known appealed strongly to the otherworldliness of Spanish Catholicism. At the same time, such pictures reflected the learned humanism of the Spanish nobility who ruled Naples and were the artist's main patrons. Most of Ribera's figures are middleaged or elderly men, who possess the unique blend of inner strength and intensity seen in St. Jerome and the Angel of Judgment (fig. 727), his masterpiece in this vein. The fervent characterization owes its expressive force to both the dramatic composition, inspired by Caravaggio (compare St. Matthew and the Angel in fig. 725), and the raking light, which lends the figure a powerful presence by heightening the realism and emphasizing the vigorous surface textures.

GENTILESCHI. It was in the Baroque era that women first began to play an important role in the arts. However, the obstacles they met in getting instruction in figure drawing and anatomy effectively barred them from painting narrative subjects. Hence, women artists were largely restricted to painting portraits, genre scenes, and still lifes until the middle of the nineteenth century. Many nevertheless carved out successful careers, often emerging as the equals or superiors of the men in whose styles they were trained (see page 488). The exceptions to this general rule were certain Italian women born into artistic families, for whom painting came naturally. The most significant contribution of all was made by Artemisia Gentileschi (1593–c. 1653). [See Primary Sources, no. 68, page 639.]

The daughter of Caravaggio's follower Orazio Gentileschi (1563–1639), she was born in Rome and became one of the leading painters and personalities of her day. Her characteristic subjects are Bathsheba, the tragic object of King David's passion, and Judith, who saved her people by beheading the

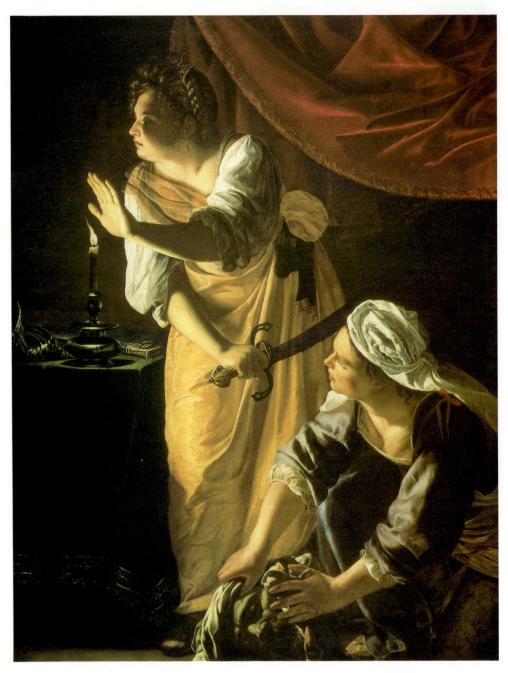

728. Artemisia Gentileschi. *Judith and Maidservant with the Head of Holofernes*. c. 1625. Oil on canvas, 6'1/2" x 4'7" (1.84 x 1.41 m). The Detroit Institute of Arts

Gift of Leslie H. Green

Assyrian general Holofernes. Both subjects were popular during the Baroque era, which delighted in erotic and violent scenes. Artemisia's frequent depictions of these biblical heroines throughout her restless career suggest a fundamental ambivalence toward men that was rooted in her life, which was as turbulent as Caravaggio's. While Gentileschi's early paintings of Judith take her father's and Caravaggio's work as their points of departure, our example (fig. 728) is a fully mature, independent work. The inner drama is uniquely hers, and no less powerful for its restraint in immortalizing Judith's courage.

Rather than the decapitation itself, the artist shows the instant after. Momentarily distracted, Judith gestures theatrically as her servant stuffs Holofernes' head into a sack. The object of their attention remains hidden from view, heightening the air of intrigue. The hushed, candlelit atmosphere in turn establishes a mood of exotic mystery that conveys Judith's complex emotions with unsurpassed understanding.

ANNIBALE CARRACCI. The conservative wishes of every-day people in Italy were met by artists less radical, and less tal-

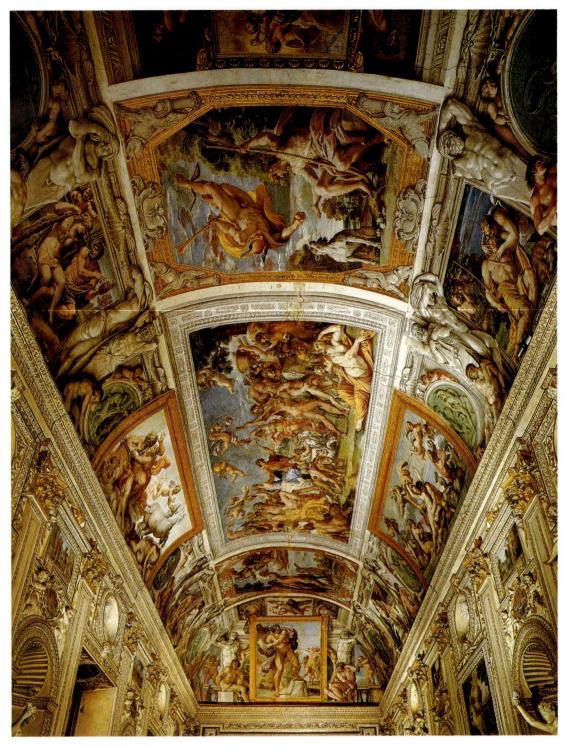

729. Annibale Carracci. Ceiling fresco. 1597–1601. Gallery, Palazzo Farnese, Rome

ented, than Caravaggio. They took their lead instead from Annibale Carracci (1560–1609), another recent arrival in Rome. Annibale came from Bologna where, since the 1580s, he and two other members of his family had evolved an anti-Mannerist style based on North Italian realism and Venetian art. He was a reformer rather than a revolutionary. Like Caravaggio, who apparently admired him, it was his experience of Roman classicism that transformed his art. He, too, felt that art must return to nature, but his approach emphasized a revival of the classics, which to him meant the art of antiquity,

and of Raphael, Michelangelo, Titian, and Correggio. At his best, he succeeded in fusing these diverse elements, although their union always remained somewhat precarious.

Between 1597 and 1604 Annibale produced the ceiling fresco in the gallery of the Farnese Palace (fig. 729), his most ambitious work, which soon became so famous that it ranked behind only the murals of Michelangelo and Raphael. [See Primary Sources, no. 69, pages 639–40.] Commissioned to celebrate a wedding in the family, it wears its humanist subject, the Loves of the Classical Gods, lightly. The historical significance

730. Annibale Carracci. Ceiling fresco (detail). Gallery, Palazzo Farnese, Rome

731. Annibale Carracci. Landscape with the Flight into Egypt. c. 1603. Oil on canvas, $4'^{1}/4" \times 8'^{2}/2" (1.22 \times 2.50 \text{ m})$. Galleria Doria Pamphili, Rome

of the Farnese Gallery is great indeed. Our detail (fig. 730) shows Annibale's rich and intricate design. The narrative scenes, like those of the Sistine ceiling, are surrounded by painted architecture, simulated sculpture, and nude, garland-holding youths. The Farnese Gallery does not rely solely on Michelangelo's masterpiece. The style of the main panels is reminiscent of Raphael's *Galatea* (see fig. 628), and the whole is held together by an illusionistic scheme that reflects Annibale's knowledge of Correggio and the great Venetians. Carefully foreshortened and illuminated from below (as we can judge from the shadows), the nude youths and the simulated sculpture and architecture appear real. Against this background the mythologies are presented as simulated easel pictures, a solution adopted from Raphael. Each of these levels of reality

is handled with consummate skill, and the entire ceiling has an exuberance that sets it apart from both Mannerism and High Renaissance art.

The sculptured precision of the Farnese Gallery does not do justice to the important Venetian element in Annibale Carracci's style. This is most striking in his landscapes, such as the monumental *Landscape with the Flight into Egypt* (fig. 731). Its pastoral mood and the soft light and atmosphere hark back to Giorgione and Titian (see figs. 631 and 632). The figures, however, play a far less conspicuous role here. They are, indeed, as small and incidental as in any Northern landscape (compare fig. 716). Nor does the character of the panorama at all suggest the Flight into Egypt. It would be equally suitable for almost any story, sacred or profane. Still, we feel that the

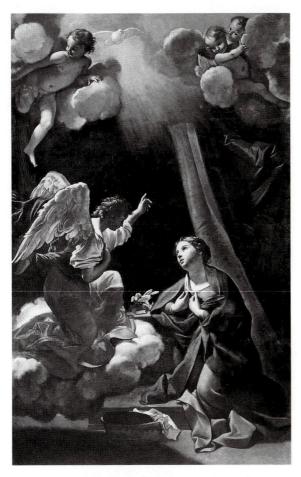

732. Giovanni Lanfranco. *Annunciation*. c. 1616. Oil on canvas, 9'8¹/2" x 6' (2.96 x 1.83 m). S. Carlo ai Catinari, Rome

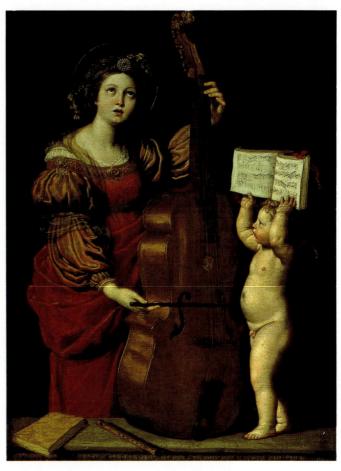

733. Domenichino. *St. Cecilia.* c. 1617–18. Oil on canvas, $62^{5/8} \times 46^{1/8}$ " (159 x 117 cm; enlarged). Musée du Louvre, Paris

figures could not be removed altogether (though we can imagine them replaced by others). This is not the untamed nature of Northern landscapes. The old castle, the roads and fields, the flock of sheep, the ferryman with his boat, all show that this "civilized," hospitable countryside has been inhabited for a long time. Hence the figures, however tiny, do not appear lost or dwarfed into insignificance, because their presence is implicit in the orderly, domesticated quality of the setting. This firmly constructed "ideal landscape" evokes a vision of nature that is gentle yet austere, grand but not awesome. We shall meet its descendants again and again in the next two centuries.

LANFRANCO; DOMENICHINO. The seeds of the reaction against Carracci's classicism were to be found within his own studio. The way was led by Giovanni Lanfranco (1582–1647), a native of Parma, whose *Annunciation* (fig. 732) unites Correggio's colorism with Caravaggio's drama. The result is an emotive style that announces the arrival of the High Baroque. Lanfranco's expressive intensity was the very opposite of the measured economy of Domenichino (1581–1641), Carracci's favorite pupil, who thought out every gesture and expression with impressive logic. Today, however, Domenichino is

remembered more for his paintings of sweetly lyrical female figures, such as *St. Cecilia* (fig. 733), the patron saint of music. Inspired by Raphael, the subject inaugurates a long line of successors through the Rococo.

RENI; GUERCINO. Lanfranco eventually vanquished his adversary Domenichino in fresco decoration, where the main development of Baroque painting was to take place through the 1630s. Their rivalry was repeated in this arena by two other pupils of the Carracci, Guido Reni (1575–1642) and Guercino (Giovanni Francesco Barbieri; 1591–1666). Reni exercised a widespread influence early on (Domenichino may have known Raphael's painting of St. Cecilia through a copy by Reni) and eventually assumed leadership of the Bolognese school. Guercino succeeded Reni upon his death, but only after making important concessions to his refined style.

To artists who were inspired by it, the Farnese Gallery seemed to offer two alternatives. Pursuing the Raphaelesque style of the mythological panels, they could arrive at a deliberate, "official" classicism; or they could take their cue from the sensuous illusionism present in the framework. The approach varied according to personal style and the conditions imposed by the actual site. Among the earliest responses to the first

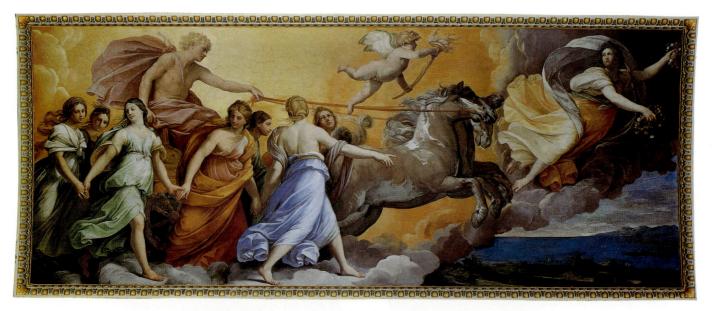

734. Guido Reni. Aurora. 1613. Ceiling fresco. Casino Rospigliosi, Rome

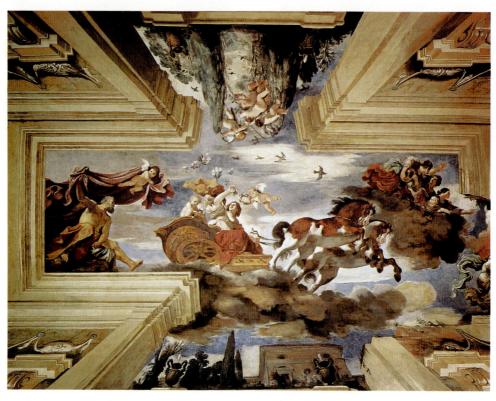

735. Guercino. Aurora. 1621–23. Ceiling fresco. Villa Ludovisi, Rome

alternative is Reni's ceiling fresco *Aurora* (fig. 734), showing Apollo in his chariot (the Sun) led by Aurora (Dawn). Here grace becomes the pursuit of perfect beauty. Nevertheless, the relieflike design would seem like little more than a pallid reflection of High Renaissance art were it not for the glowing and dramatic light, which gives it an emotional force that the figures alone could never achieve. Hence, this style is called Baroque classicism to distinguish it from all earlier forms of classicism, no matter how much it may be indebted to them.

The *Aurora* ceiling (fig. 735) painted less than ten years later by Guercino is the very opposite of Reni's. Here archi-

tectural perspective, combined with the pictorial illusionism of Correggio and the intense light and color of Titian, converts the entire surface into one limitless space, in which the figures sweep past as if propelled by stratospheric winds. With this work, Guercino started what soon became a veritable flood of similar visions characteristic of the High Baroque after 1630.

DA CORTONA. The most overpowering of these is the ceiling fresco by Pietro da Cortona (1596–1669) in the great hall of the Barberini Palace in Rome, which presents a glorification of the reign of the Barberini pope, Urban VIII (fig. 736),

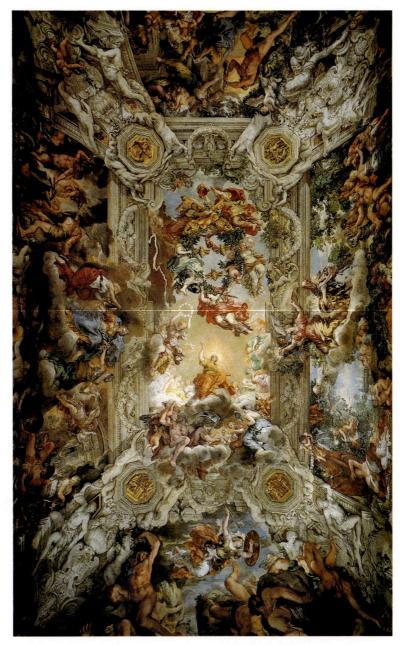

736. Pietro da Cortona. *Glorification of the Reign of Urban VIII*. 1633–39. Portion of ceiling fresco. Palazzo Barberini, Rome

couched in the traditional terms of a complex humanist allegory. As in the Farnese Gallery, the ceiling area is subdivided by a painted framework simulating architecture and sculpture, but beyond it we now see the unbounded sky, as in Guercino's *Aurora*. Clusters of figures, perched on clouds or soaring freely, swirl above as well as below this framework, creating a dual illusion: some figures appear to hover well inside the hall, perilously close to our heads, while others recede into a lightfilled, infinite distance. In the Barberini ceiling, the dynamism of the High Baroque style reaches a resounding climax. The effect is very similar to that of an illusionistic domed ceiling painted by Lanfranco in Rome nearly a decade earlier, which was based directly on Correggio's *The Assumption of the Virgin* (fig. 654).

Cortona's frescoes provided the focal point for the rift between the High Baroque and Baroque classicism that grew out of the Farnese ceiling. The classicists asserted that art serves a moral purpose and must observe the principles of clarity, unity, and decorum. And supported by a long tradition reaching back to Horace's dictum *ut pictura poesis*, they further maintained that painting should follow the example of tragic poetry in conveying meaning through a minimum of figures whose movements, gestures, and expressions can be easily read. Cortona, though not anticlassical, presented the case for art as epic poetry, with many actors and episodes that elaborate on the central theme and create a magnificent effect. He was also the first to argue that art has a sensuous appeal which exists as an end in itself.

Although it took place on a largely theoretical level, the debate over illusionistic ceiling painting represented more than fundamentally divergent approaches to telling a story and expressing ideas in art. The issue lay at the very heart of

The most important contribution of the Baroque to music and

theater was the invention of opera, which united all the theatrical elements of the period into a spectacular whole. It began modestly enough as a humanist exercise in Florence. Following the suggestion of Girolamo Mei of Rome, members of the Camerata of Florence, so called because it met in camera (behind closed doors) at the palace of Count Giorgio Bardi, set out to re-create ancient Greek drama, which they wrongly believed had been sung throughout a performance. Around 1590, Vincenzo Galilei (c. 1520–1591), the father of the astronomer Galileo, issued a polemic attacking the vocal counterpoint of madrigals as impersonal and artificial because it did not adhere to the Greek unity of text and music. Although Vincenzo experimented with monodies (short, dramatic monologues with continuo accompaniment), the first opera (short for opera in musica, "work in music") was Dafne, produced privately with a libretto (text) by Ottavio Rinuccini (1562–1621) and music mostly by Jacopo Peri (1561–1633). It was followed by *Euridice* from the same team, with arias by Giulio Caccini (c. 1546–1618), and was performed in 1600 in honor of the marriage of Henry IV and Marie de' Medici. That same year and in 1601, Caccini and Peri, who were singers and professional rivals, published separate versions of the opera. Despite its limitations, this new declamatory style, called representative or theatrical style, made an extraordinary impression on listeners.

Opera might nevertheless have remained of little more than antiquarian interest had it not been for Claudio Monteverdi (1567-1643). He has aptly been described as the "last great madrigalist and the first great opera composer." His Orfeo, produced in 1607 at Mantua with a libretto by Alessandro Striggio, enlarged the story of *Euridice* into the standard five acts demanded by the Roman poet Horace while increasing the variety of vocal music and giving a greater role to the instrumental accompaniment. This expansion required all the skills he had gained composing madrigals—the very kind of music attacked by Vincenzo Galilei! Monteverdi was openly experimental. He was acutely aware of the conflict between the earlier style of the Netherlanders and the later Italian madrigalists such as Carlo Gesualdo (see page 535), and he fended off attacks by saying that he was working in an entirely new vein so that none of the old rules applied.

From then on, music took precedence over words in opera, which often emphasized extreme emotional states of mind (*affetti*) through violent contrasts, as did Baroque art.

The future of the new form lay in Rome and Venice, which opened

the first public opera house in 1637. Operas soon became wildly popular, not only in Italy but throughout Europe, and everyone vied for the services of the leading Italians. After 1650 the court in Vienna became the main center of theater and opera. Its zenith came with The Golden Apple, a huge spectacle staged there in 1668 to celebrate the wedding of Emperor Leopold I and the Infanta Margarita of Spain, with music by Pietro Antonio Cesti (1623–1669) and scenery by Ludovico Burnacini (1636–1707). The public wanted new operas as soon as they could be mounted, while star singers required virtuoso arias, solos to which they often added florid ornamentation to showcase their talents. Combined with the increasing emphasis on spectacle, these demands conspired to dilute opera as a dramatic form while the beauty of the music itself grew. The impact of opera was nevertheless pervasive. Even church music became operatic in the solo cantatas and oratorios of Giacomo Carissimi (1605–1674). These three vocal forms reached maturity in the compositions of Alessandro Scarlatti (1660-1725), who worked in Naples and Rome, so that he holds a position analogous to that of Francesco Solimena in painting. In addition to being the outstanding Italian opera composer of his time, Scarlatti wrote religious music of great beauty. He was the pivotal figure in late Italian Baroque music, comparable in importance to Jean-Baptiste Lully of France.

The Baroque was the first period in which instrumental music equaled vocal music in stature. While continuing the practice of imitating different dance types, it also began to mimic vocal style. The two approaches are exemplified in the trio sonatas of Arcangelo Corelli (1653-1713). His chamber sonatas use dance movements, while the church sonatas in principle do not, although they were often mixed. Both employ two violins and a continuo consisting of a lower viol and a keyboard instrument. When expanded to a full string orchestra, the trio sonata became the concerto grosso (grand concerto), the most characteristic type of Baroque instrumental music, which began as overtures to and during Mass. Corelli alternated sprightly, dancelike movements with slow ones that have a uniquely plaintive, bittersweet quality similar to the laments in Monteverdi's madrigals. Virtuoso touches of ornamentation are treated discretely so as not to disrupt the singing line, which is kept well within the range of the human voice. Each movement generally has one or two alternating melodies developed in clear progressions that became the basis for modern harmony.

the Baroque. Illusionism enabled artists to overcome the apparent contradictions of the era by fusing separate levels of reality into a pictorial unity of such overwhelming grandeur as to sweep aside any differences between them. Despite the intensity of the argument, in actual practice the two sides rarely came into conflict over easel paintings, where the differences between Cortona's and Carracci's followers were not always so clear-cut. Surprisingly, Cortona found inspiration in Classical art and Raphael throughout his career. Nevertheless, the leader of the reaction against what were regarded as the

excesses of the High Baroque was neither a fresco painter, nor was he an Italian, but a French artist living in Rome: Nicolas Poussin (see page 596), who, strangely enough, moved in the same antiquarian circle early on but drew very different lessons from it.

IL GESÙ. It is a peculiar fact that few ceiling frescoes were painted after Cortona finished his *Glorification of the Reign of Urban VIII*, ironically because the new style of architecture fostered by Francesco Borromini and Guarino Guarini (see

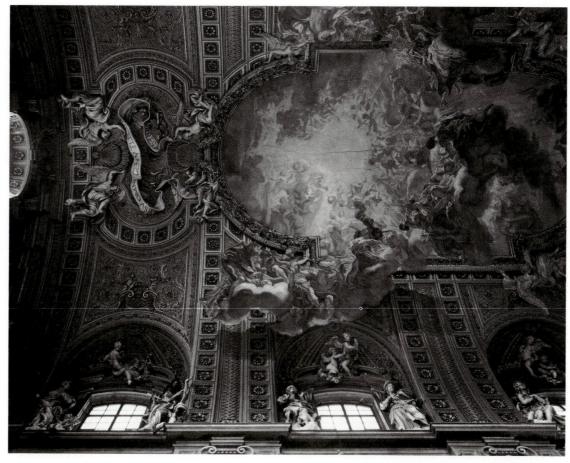

737. Giovanni Battista Gaulli. Triumph of the Name of Jesus. 1672-85. Ceiling fresco. Il Gesù, Rome

pages 560-63) provided so few opportunities for adornment. But after 1670 they enjoyed an astonishing revival in older buildings, which reached its culmination in the interior decoration of Il Gesù (fig. 737). Although his role in this case was only advisory, it is clear that the plan must be by Gianlorenzo Bernini (1598-1680), the greatest sculptor-architect of the century (see below). At Bernini's suggestion, the commission for the ceiling frescoes went to Giovanni Battista Gaulli (1639-1709), his young protégé known as Baciccia, while a talented assistant, Antonio Raggi (1624-1686), did the stucco sculpture. However, the program, which proved extraordinarily influential, is testimony to Bernini's imaginative daring. As in the Cornaro Chapel (fig. 754), the entire ceiling is treated as a single unit: the nave fresco, with its sharp contrasts of light and dark suggesting a mystical vision, spills dramatically over its frame, then turns into sculptured figures. Here Baroque illusionism achieves its ultimate expression.

GIORDANO. The Late Baroque found its greatest representative in Luca Giordano (1634–1705), a Neapolitan who began as an imitator of his teacher Ribera but became the principal heir to Pietro Cortona as the leading decorative painter in Italy. Legendary for his speed, Giordano was a virtuoso whose remarkable facility resulted in a prodigious and varied output. *The Abduction of Europa* (fig. 738) shows his spontaneous approach at its best. The composition is based on one by Veronese that also was to inspire François Boucher (see pages 614–15). The painting shares its graceful style with

738. Luca Giordano. *The Abduction of Europa.* 1686. Oil on canvas, $7'5\,^5/8" \times 6'4^1/4" \ (2.27 \times 1.93 \ m).$ Wadsworth Atheneum, Hartford, Connecticut Ella Gallup Sumner and Mary Catlin Sumner Collection

Cortona's, but instead of the latter's blond palette, it favors a rich tonalism. Although he never fully acceded to colorism, Giordano set the stage for the great Venetian painters of the eighteenth century, even in his peripatetic life-style: he became the first in a line of great Italian artists, culminating in Tiepolo (see page 626), to be called to the Spanish court.

Gaulli and Giordano mark the final flowering of Baroque exuberance. By this time, the pendulum had swung in the opposite direction. Italian painting during the third quarter of the seventeenth century was largely characterized by a conservative synthesis of the High Baroque and Baroque classicism. This yielded to an academic style that flourished in Rome and Naples, which were then closely linked. It was formulated chiefly by Carlo Maratta (1625-1713) of Rome, the most admired artist of his day, and Francesco Solimena (1657-1747), Giordano's successor in Naples. Maratta may be regarded as a less doctrinaire counterpart to Charles Lebrun in France (see page 600). In contrast to his rival Gaulli (see fig. 737), he sought to revive the grand manner of the Carracci by emphasizing individual figures through a clear, even light without entirely abandoning Cortona's color and drama. As might be expected, however, the results of such a compromise were generally unimpressive.

ARCHITECTURE IN ITALY

MADERNO. In architecture, the beginnings of the Baroque style cannot be defined as precisely as in painting. In the vast ecclesiastical building program that got under way in Rome toward the end of the sixteenth century, the most talented young architect to emerge was Carlo Maderno (1556–1629). In 1603 he was given the task of completing, at long last, the church of St. Peter's. The pope had decided to add a nave to Michelangelo's building (fig. 623), converting it into a basilica. The change of plan, which may have been prompted by the example of Il Gesù (see figs. 668 and 670), made it possible to link St. Peter's with the Vatican Palace to the right of the church (fig. 739). Maderno's design for the facade follows the pattern established by Michelangelo for the exterior of the church. It consists of a colossal order supporting an attic, but with a dramatic emphasis on the portals. The effect can only be described as a crescendo that builds from the corners toward the center. The spacing of the supports becomes closer, pilasters turn into columns, and the facade wall projects step by step.

This quickened rhythm had been hinted at a generation earlier in Giacomo della Porta's facade of Il Gesù (see fig. 670). Maderno made it the dominant principle of his facade designs, not only for St. Peter's but for smaller churches as well. In the process, he replaced the traditional concept of the church facade as one continuous wall surface, which was not yet challenged by the facade of Il Gesù, with the "facade-in-depth," dynamically related to the open space before it. The possibilities implicit in this new concept were not to be exhausted until 150 years later.

BERNINI. Maderno's work at St. Peter's was completed by Bernini, who molded the open space in front of the facade into a magnificent oval piazza. This "forecourt" acts as an immense

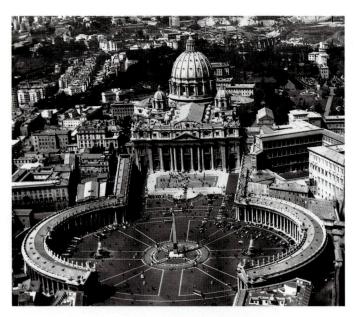

739. Aerial view of St. Peter's, Rome. Nave and facade by Carlo Maderno, 1607–15; colonnade by Gianlorenzo Bernini, designed 1657

atrium framed by colonnades which Bernini himself likened to the motherly, all-embracing arms of the Church. For sheer impressiveness, this integration of the building with such a grandiose setting of molded open space can be compared only with the ancient Roman sanctuary at Palestrina (see fig. 240).

The piazza can be thought of as a continuation on the exterior of the decoration program at St. Peter's that occupied Bernini at intervals during most of his long and prolific career. The enormous size of St. Peter's made the decoration of its interior a uniquely difficult task: how to relate its chill vastness to the human scale and imbue it with a measure of emotional warmth. He began by designing the huge bronze canopy for the main altar under the dome (fig. 740). The tabernacle is a splendid fusion of architecture and sculpture. Four ornate, spiral-shaped columns support an upper platform. At its corners are statues of angels and vigorously curved scrolls which raise high the symbol of the victory of Christianity over the pagan world, a cross above a golden orb. The entire structure is so alive with expressive energy that it strikes us as the very epitome of Baroque style. Yet its most impressive feature, the corkscrew columns, had been invented in late antiquity, and even employed, on a much smaller scale, in the old basilica of St. Peter's. Thus Bernini could claim the best possible precedent for his own use of the motif. This is not the only instance of an affinity between Baroque and ancient art. Several monuments of Roman architecture of the second and third centuries A.D. seem to anticipate the style of the seventeenth (see figs. 257-60).

BORROMINI. As a personality, Bernini represents a type we first met among the artists of the Early Renaissance, a self-assured, expansive person of the world. His great rival in architecture, Francesco Borromini (1599–1667), who also started out as an assistant to Maderno, was the very opposite: a secretive and emotionally unstable genius who died by suicide. The Baroque heightened the tension between the two types.

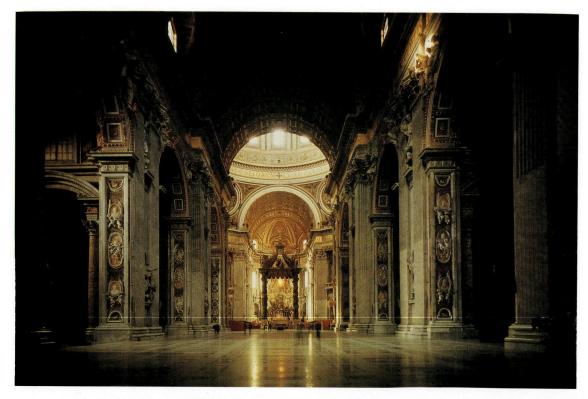

740. Carlo Maderno. Nave, with Bernini's Tabernacle (1624-33) at crossing, St. Peter's, Rome

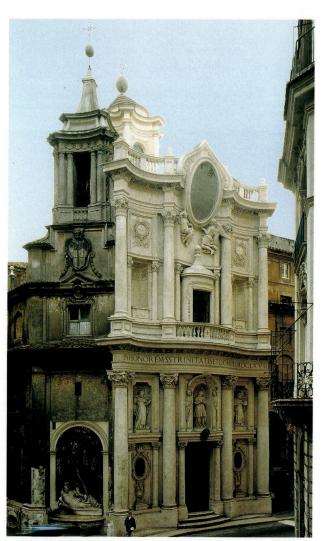

741. Francesco Borromini. Facade of S. Carlo alle Quattro Fontane, Rome. 1665–67

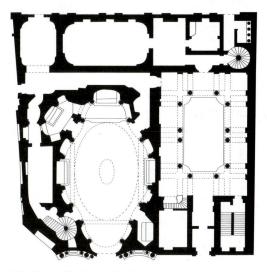

742. Plan of S. Carlo alle Quattro Fontane. Begun 1638

The temperamental contrast between the two masters would be evident from their works alone, even without the testimony of contemporary witnesses. Both exemplify the climax of Baroque architecture in Rome, yet Bernini's design for the colonnade of St. Peter's is dramatically simple and unified, while Borromini's structures are extravagantly complex. Bernini himself agreed with those who denounced Borromini for flagrantly disregarding the classical tradition, enshrined in Renaissance theory and practice, that architecture must reflect the proportions of the human body.

In Borromini's first major project, the church of S. Carlo alle Quattro Fontane (figs. 741–43), it is the syntax, not the vocabulary, that is new and disquieting. The ceaseless play of concave and convex surfaces makes the entire structure seem elastic, "pulled out of shape" by pressures that no previous

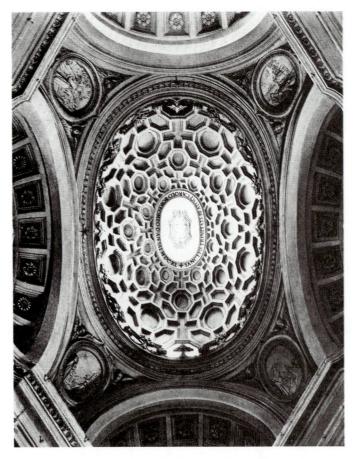

743. (above) Dome of S. Carlo alle Quattro Fontane

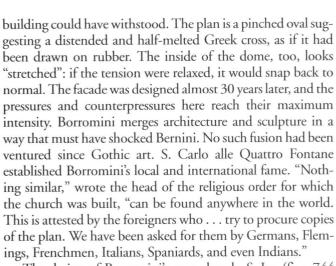

The design of Borromini's next church, S. Ivo (figs. 744 and 745), is more compact and equally daring. Its plan, a star-hexagon, belongs unequivocally to the central type. Here Borromini may have been thinking of octagonal structures, such as S. Vitale, Ravenna (compare figs. 317–20), but the result is

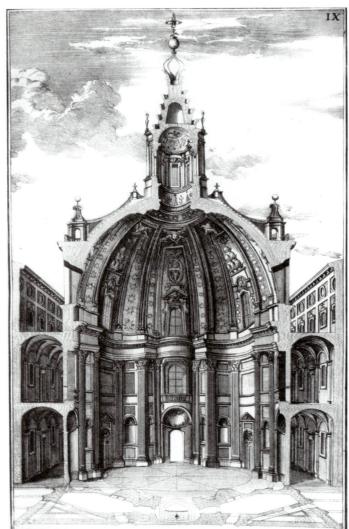

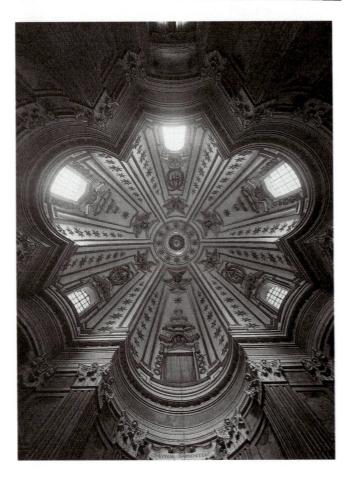

745. (right) Dome of S. Ivo

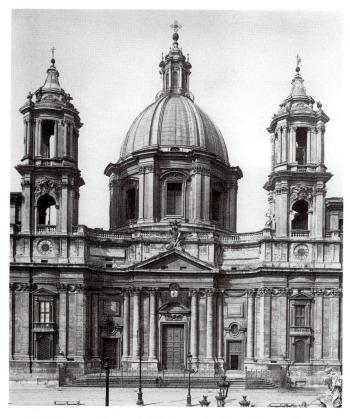

746. Francesco Borromini. S. Agnese in Piazza Navona, Rome. 1653 - 63

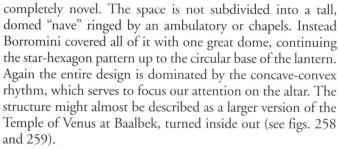

A third project by Borromini is of special interest as a High Baroque critique of St. Peter's. Maderno had found one problem insoluble: although his new facade forms an impressive unit with Michelangelo's dome when seen from a distance, the dome is gradually hidden by the facade as we approach the church. Borromini designed the facade of S. Agnese in Piazza Navona (fig. 746) with this conflict in mind. Its lower part is adapted from the facade of St. Peter's, but curves inward, so that the dome (a tall, slender version of Michelangelo's) functions as the upper part of the facade. The dramatic juxtaposition of concave and convex, always characteristic of Borromini, is further emphasized by the two towers, which form a monumental triad with the dome. (Such towers were also once planned for St. Peter's by Bernini but they would have been free-standing.) Once again Borromini joins Gothic and

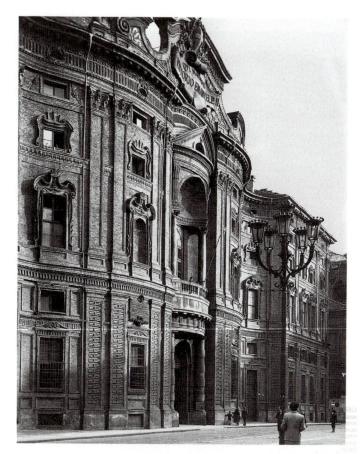

747. Guarino Guarini. Facade of Palazzo Carignano, Turin. Begun 1679

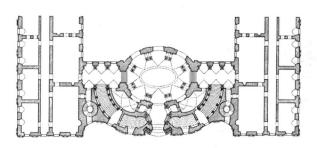

748. Plan of Palazzo Carignano

Renaissance features—the two-tower facade and the dome into a remarkably "elastic" compound.

GUARINI. The wealth of new ideas that Borromini introduced was to be exploited not in Rome but in Turin, the capital of Savoy, which became the creative center of Baroque architecture in Italy toward the end of the seventeenth century. In 1666 that city attracted Borromini's most brilliant successor, Guarino Guarini (1624-1683), a Theatine monk whose architectural genius was deeply grounded in philosophy and mathematics. His design for the facade of the Palazzo Carignano (figs. 747 and 748) repeats on a larger scale the undulating movement of S. Carlo alle Quattro Fontane (see fig. 741), using a highly individual vocabulary. Incredibly, the exterior of the building is entirely of brick, down to the last ornamental detail.

Still more extraordinary is Guarini's dome of the Chapel of the Holy Shroud, a round structure attached to Turin

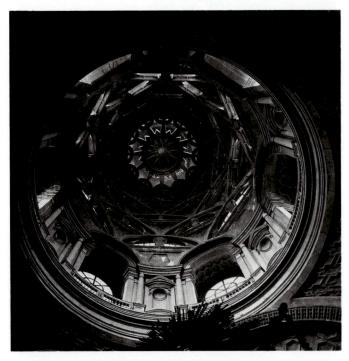

749. Guarino Guarini. Dome of Chapel of the Holy Shroud, Turin Cathedral. 1668–94

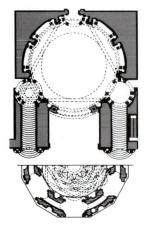

750. Plan of the Chapel of the Holy Shroud and of the dome

Cathedral (figs. 749 and 750). The tall drum, with alternating windows and tabernacles, consists of familiar Borrominian motifs, but beyond it we enter a realm of pure illusion. The interior surface of the dome of S. Carlo alle Quattro Fontane, though dematerialized by light and the honeycomb of fanciful coffers, was still recognizable (see fig. 743). But here the surface has disappeared completely in a maze of segmental ribs, and we find ourselves staring into a huge kaleidoscope. Above this seemingly endless funnel of space hovers the dove of the Holy Spirit within a bright, 12-pointed star.

So far as we know, there is only one similar dome anywhere in the history of art: that of the Ulu Mosque at Erzurum in Turkish Armenia, built about 1150 (fig. 751). How could Guarini have known about it? Or did he recapture its effect entirely by coincidence? Guarini's dome retains the old symbolic meaning of the Dome of Heaven (see pages 436–37;

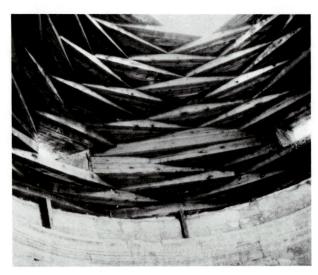

751. Wooden dome of the Ulu Mosque, Erzurum, Seljuk. c. 1150

figs. 572–74), but the objective harmony of the Renaissance has here become subjective, a compelling experience of the infinite. If Borromini's style at times suggested a synthesis of Gothic and Renaissance, Guarini takes the next, decisive step. In his theoretical writings, he contrasts the "muscular" architecture of the ancients with the opposite effect of Gothic churches, which appear to stand only by means of some kind of miracle, and he expresses equal admiration for both. This attitude corresponds exactly to his own practice. By using the most advanced mathematical techniques of his day, he achieved architectural miracles even greater than those of the seemingly weightless Gothic structures.

SCULPTURE IN ITALY

We have already encountered Gianlorenzo Bernini as an architect. It is now time to consider him as a sculptor, although the two aspects are never far apart in his work. As in the tabernacle for St. Peter's (see fig. 740), a strong relationship can often be discovered between Bernini's and Hellenistic sculpture. If we compare Bernini's *David* (fig. 752) with Michelangelo's (see fig. 607) and ask which is closer to the Pergamum frieze or *The Laocoön Group* (see figs. 213 and 215), our vote must go to Bernini. His figure shares with Hellenistic works that unison of body and spirit, of motion and emotion, which Michelangelo so conspicuously avoids. This does not mean that Bernini is more classical than Michelangelo. It indicates, rather, that both the Baroque and the High Renaissance acknowledged the authority of ancient art, but each period drew inspiration from a different aspect of antiquity.

Bernini's *David*, obviously, is in no sense an echo of *The Laocoön Group*. What makes it Baroque is the implied pres-

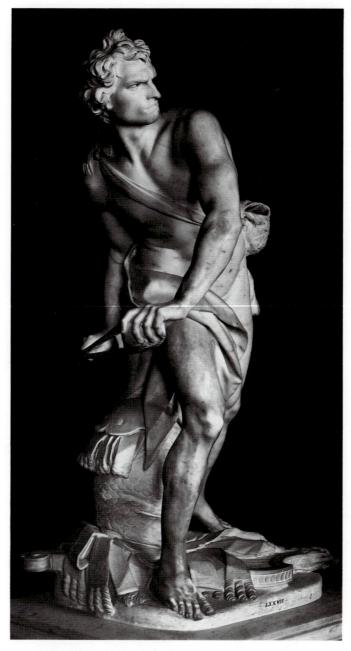

752. Gianlorenzo Bernini. *David.* 1623. Marble, lifesize. Galleria Borghese, Rome

ence of Goliath. Unlike earlier statues of David, Bernini's is conceived not as one self-contained figure but as half of a pair, his entire action focused on his adversary. Did Bernini, we wonder, plan a statue of Goliath to complete the group? He never did, for his *David* tells us clearly enough where *he* sees the enemy. Consequently, the space between David and his invisible opponent is charged with energy—it "belongs" to the statue.

Bernini's *David* shows us what distinguishes Baroque sculpture from the sculpture of the two preceding centuries: its new, active relationship with the space it inhabits. It rejects self-sufficiency for the illusion of presences or forces that are implied by the behavior of the statue. Because it so often presents an "invisible complement" (like the Goliath of Bernini's

David), Baroque sculpture is a tour de force, attempting essentially pictorial effects that were traditionally outside its province. Such a charging of space with active energy is, in fact, a key feature of all Baroque art. Caravaggio had achieved it in his *St. Matthew*, with the aid of a sharply focused beam of light. Indeed, Baroque art acknowledges no sharp distinction between sculpture and painting. And as we have seen, the two may even be combined with architecture to form a compound illusion, like that of the stage.

In fact, Bernini, who had a passionate interest in the theater, was at his best when he could merge architecture, sculpture, and painting in this fashion. His masterpiece in this vein is the Cornaro Chapel in the church of Sta. Maria della Vittoria, containing the famous group called *The Ecstasy of St.*

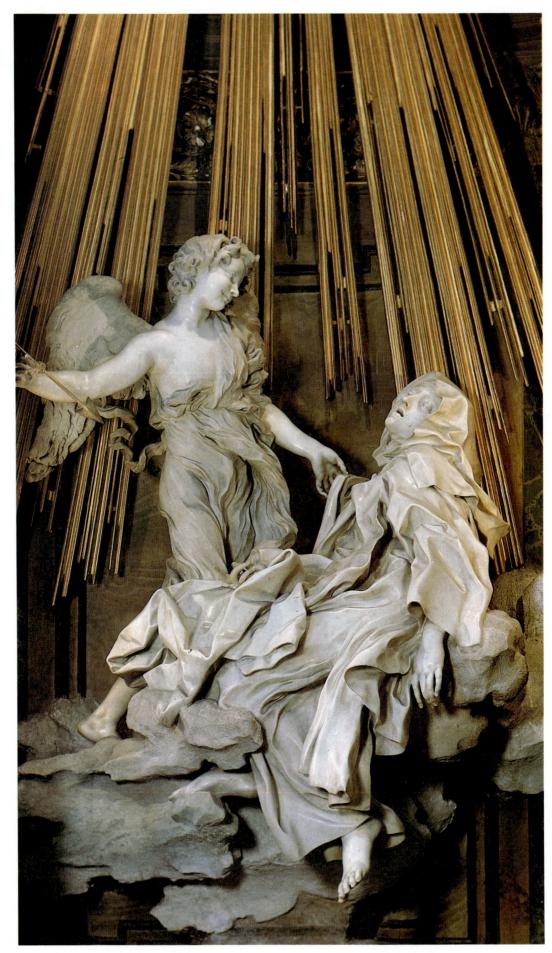

753. Gianlorenzo Bernini. *The Ecstasy of St. Theresa*. 1645–52. Marble, lifesize. Cornaro Chapel, Sta. Maria della Vittoria, Rome

Theresa (fig. 753). Theresa of Avila, one of the great saints of the Counter Reformation (see page 548), had described how an angel pierced her heart with a flaming golden arrow: "The pain was so great that I screamed aloud; but at the same time I felt such infinite sweetness that I wished the pain to last forever. It was not physical but psychic pain, although it affected the body as well to some degree. It was the sweetest caressing of the soul by God."

Bernini has made this visionary experience as sensuously real as Correggio's Jupiter and Io (see fig. 655). In a different context, the angel would be indistinguishable from Cupid, and the saint's ecstasy is palpable. The two figures on their floating cloud are illuminated (from a hidden window above) in such a way as to seem almost dematerialized in their gleaming whiteness. The beholder experiences them as visionary. The "invisible complement" here, less specific than David's but equally important, is the force that carries the figures heavenward, causing the turbulence of their drapery. Its divine nature is suggested by the golden rays, which come from a source high above the altar. In an illusionistic fresco by Guidebaldo Abbatini on the vault of the chapel, the glory of the heavens is revealed as a dazzling burst of light from which tumble clouds of jubilant angels (fig. 754). This celestial "explosion" gives force to the thrusts of the angel's arrow and makes the ecstasy of the saint believable.

To complete the illusion, Bernini even provides a built-in audience for his "stage." On the sides of the chapel are balconies resembling theater boxes, where we see marble figures, depicting members of the Cornaro family, who also witness the ecstasy. Their space and ours are the same, and thus part of everyday reality, while the ecstasy, housed in a strongly framed niche, occupies a space that is real but beyond our reach. Finally, the ceiling fresco represents the infinite, unfathomable space of Heaven. We may recall that The Burial of Count Orgaz and its setting also form a whole embracing three levels of reality (see page 492). There is nevertheless a profound difference between the two chapels. El Greco's Mannerism evokes an ethereal vision in which only the stone slab of the sarcophagus is "real," in contrast to Bernini's Baroque theatricality, where the distinction nearly breaks down altogether. It would be all too easy to dismiss The Ecstasy of St. Theresa as a superficial, melodramatic display, but Bernini also was a devout Catholic who believed (as did Michelangelo) that he received his inspiration directly from God. Like the Spiritual Exercises of St. Ignatius, which Bernini practiced, his religious sculpture is intended to help the viewer achieve complete identification with miraculous events through a vivid appeal to the senses.

Bernini was steeped in Renaissance humanism and theory. Central to his sculpture is the role played by gesture and expression in arousing emotion. While no less important to the Renaissance (compare Leonardo), these devices have an apparent abandon that seems anticlassical in Bernini's hands. However, he essentially adhered to the concept of decorum, and calculated his effects very carefully, varying them in accordance with his subject. Unlike the Frenchman Nicolas Poussin (whom he respected), Bernini did this for the sake of expressive impact rather than conceptual clarity. Their approaches were diametrically opposed as well. For Bernini, antique art served

754. *The Cornaro Chapel.* 18th-century painting. Staatliches Museum, Schwerin, Germany

as no more than a point of departure for his own fertile inventiveness, whereas for classicists such as Poussin it provided a reference point that acted as a standard of comparison. It is nevertheless characteristic of the paradoxical Baroque that Bernini's theories should be far more orthodox than his art. An admirer of Annibale Carracci, he often sided with the classicists against his fellow High Baroque artists. Thus, he attacked Pietro da Cortona, despite the fact that their work has much in common. In this regard he was perhaps motivated by professional jealousy: Cortona, like Raphael before him, also made an important contribution to architecture and was a rival in that sphere.

ALGARDI. It is no less ironic that Cortona was the closest friend of the sculptor Alessandro Algardi (1596–1654), who is generally regarded as the leading classical sculptor of the Italian Baroque and the only serious rival to Bernini in ability. *The Meeting of Pope Leo I and Attila* (fig. 755), executed while he supplanted Bernini at the papal court, represents Algardi's main contribution, for it inaugurates a new kind of high relief that soon became widely popular. It depicts the defeat of the Huns in 452, a fateful event in the early history of Christianity when its very survival was at stake. The subject revives one familiar to us from antiquity: the victory over barbarian forces (compare fig. 210), but now it is the church, not civilization, that triumphs.

755. Alessandro Algardi. The Meeting of Pope Leo I and Attila. 1646. Marble, 28'13/4" x 16'21/2" (8.5 x 4.9 m). St. Peter's, Vatican

The commission was given for a sculpture because the water condensation caused by the location in an old doorway of St. Peter's made a painting impossible. Never before had an Italian sculptor attempted such a large relief—it stands nearly 28 feet high. The problems posed by translating a pictorial conception (it had been treated by Raphael in one of the Vatican Stanze) into a relief on this gigantic scale were formidable, and if Algardi has not succeeded in resolving every detail, his achievement is stupendous nonetheless. By varying the depth of the carving, he nearly convinces us that the scene takes place in the same space as ours. The foreground figures are in such high relief as to appear detached from the background. To accentuate the effect, the stage on which they are standing projects several feet beyond its surrounding niche. Thus Attila seems to rush out toward us in fear and astonishment as he flees

the heavenly vision of the two apostles defending the faith. The result is surprisingly persuasive, both visually and expressively.

Such illusionism is, of course, quintessentially Baroque. Baroque, too, is the intense drama, worthy of Bernini himself, which is heightened by the twisting poses and theatrical gestures of the protagonists. Algardi was obviously touched by Bernini's towering genius. Only in his observance of the three traditional levels of relief carving (low, middle, and high, instead of continuously variable depth), his preference for frontal poses wherever possible, and his degree of restraint in dealing with the violent action can he be called a classicist, and then purely in a relative sense. Clearly, then, we must not insist on drawing the distinction between the High Baroque and Baroque classicism too sharply in sculpture any more than in painting.

PAINTING IN SPAIN

During the sixteenth century, at the height of its political and economic power, Spain had produced great saints and writers, but no artists of the first rank. Nor did El Greco's presence prove a stimulus to native talent. The reason is that the Catholic church, the main source of patronage, was extremely conservative, while the Spanish court and most of the aristocracy preferred to employ foreign painters, above all Titian, so that native artists were held in low esteem. Thus the main impetus came from Italy and The Netherlands.

SANCHEZ COTÁN. Stimulated by the example of Aertsen and his contemporaries in The Netherlands, Spanish artists began to develop their own versions of still life in the 1590s. We see the distinctive character of this tradition in the example (fig. 756) by Juan Sanchez Cotán (1561-1627), a minor religious artist remembered today as one of the first and most remarkable members of the Toledo school of still-life painters. In contrast to the lavish display of food or luxury objects in Northern pictures, we here find an order and an austere simplicity that give a new context to these vegetables. They are so deliberately arranged that we cannot help wondering what symbolic significance the artist meant to convey. The juxtaposition of bright sunlight and impenetrable darkness, of painstaking realism and abstract form, creates a memorable image in which even these humble fruits and vegetables become sacred examples of God's work.

Although he probably used contemporary North Italian paintings as his point of departure, Sanchez Cotán's still lifes make one think of Caravaggio, whose effect on Spanish art, however, is not found until considerably later. We do not know exactly how Caravaggism was transmitted. The likeliest

756. Juan Sanchez Cotán. Quince, Cabbage, Melon, and Cucumber. c. 1602. Oil on canvas, 271/8 x 331/4" (68.8 x 84.4 cm). San Diego Museum of Art Gift of Misses Anne R. and Amy Putnam

source was Naples, where Caravaggio had fled, which was then under Spanish rule. His principal follower there was Jusepe Ribera (see page 551), but too little is known of his activity before about 1625 for us to trace his influence on early Spanish Baroque art in detail. Be that as it may, the impact of Caravaggism was felt especially in Seville, the home of the most important Spanish Baroque painters before 1640.

VELÁZQUEZ. Diego Velázquez (1599-1660) painted in a Caravaggesque vein during his early years in Seville. His interests at that time centered on scenes of people eating and drinking rather than religious themes. Known as bodegónes, such

Baroque Theater in Italy and Spain

Besides the opera, the most popular form of Italian theater in the

seventeenth century was the commedia dell'arte, which arose after 1570 as earlier sixteenth-century written farce declined. It then spread quickly throughout Europe, especially to France. The commedia actors improvised their dialogue on a rough plot outline, taking the roles of stock characters—the innocent young girl, the impoverished youth, the braggart captain, the pedantic doctor—in age-old scenarios of love and intrigue. The comedic characters were clever servants, often called zanni ("Johnny" in the Venetian dialect—from which the English word zany is derived), who delighted their audiences by outwitting their masters and other figures of authority. The best known of these zanni were Harlequin, Mezzetin, and Pulcinella, whose name and huge nose survived into the twentieth century in the character of Punch of Punch-and-Judy puppet shows. The Italian commedia was also the source of modern slapstick and burlesque comedy. Its success depended on the close identification of the actors with their roles, which they rarely changed except in advanced age, so that they became one and the same in life and in art. Although the commedia dell'arte remained popular for 200 years, its heyday was over by 1650, when its creativity began to wane.

Under Philip III and Philip IV the seventeenth century

in Spain was the golden age of theater, as it was of art. It began

around 1580 with the plays of Juan de la Cueva (c. 1543-1610) and Miguel de Cervantes (1547-1616), the author of Don Quixote, but its greatest writer was Lope de Vega (1562–1635), who claimed to have scripted more than 1,200 dramas and comedies. In its combination of worldliness and religion, Vega's work reflects the character and social order of Spain, which centered on the often-conflicting demands of love, honor, church, and responsibility among the different social classes. The plots are lively and the writing fluid, but characters tend to be rather conventional because they conform to established codes. Tirso de Molina (1580-1648), a member of the Mercedarian order, was likewise prolific: he professed to have written 300 plays by 1621, of which 80 survive, but he is known primarily for introducing the legend of Don Juan in The Trickster of Seville. Vega's successor, Pedro Calderón de la Barca (1600–1681), wrote mainly cape-and-sword comedies for the court, which he served as Master of the Revels, as well as religious dramas (called autos sacramentales) after he was ordained a priest toward the end of his life. Throughout the century, both types were performed at court and in public theaters by professional actors employed by local municipalities.

757. Diego Velázquez. *The Water Carrier of Seville*. c. 1619. Oil on canvas, 41¹/2 x 31¹/2" (105.3 x 80 cm). Wellington Museum, London Crown copyright reserved

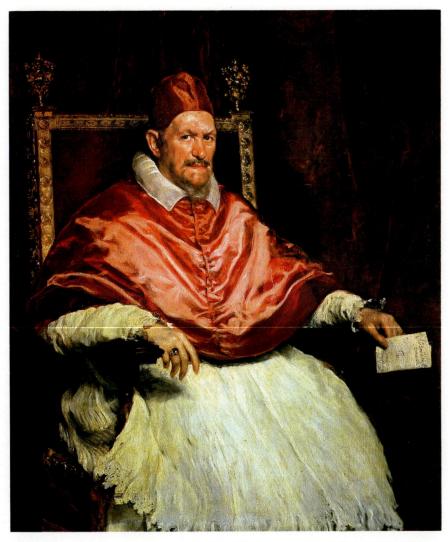

758. Diego Velázquez. *Pope Innocent X.* 1650. Oil on canvas, 55 x 45¹/4" (139.7 x 115 cm). Galleria Doria Pamphili, Rome

paintings are the distinctive Spanish counterparts of Dutch breakfast pieces, for they evolved from the paintings of tabletop displays brought to Spain by visiting Flemish artists in the early seventeenth century. *The Water Carrier of Seville* (fig. 757), which Velázquez did at the age of 20 under the apparent impress of Ribera, already shows his genius. His powerful grasp of individual character and dignity invests this everyday scene with the solemn spirit of a ritual—perhaps with good reason, for the scene is related to Giving Drink to the Thirsty, one of the Seven Acts of Mercy, a popular theme among Caravaggesque painters at the time.

A few years later, Velázquez was appointed court painter to Philip IV, whose reign from 1621 to 1665 represents the great age of painting in Spain. Much of the credit must go to the duke of Olivares, who largely restored Spain's fortunes and supported an ambitious program of artistic patronage to proclaim the monarchy's greatness. Upon moving to Madrid, Velázquez quickly displaced the mediocre Florentines who had enjoyed the favor of Philip III and his minister, the duke of Lerma. A consummate courtier, the artist quickly became a personal favorite of the king, whom he served as chamberlain. Velázquez spent the rest of his life in Madrid, doing mainly portraits of the royal family. The earlier of these still show the precise division of light and shade and the clear outlines of his

Seville period, but after the late 1620s his work acquired a new fluency and richness.

During his visit to the Spanish court on a diplomatic mission in 1628, the Flemish painter Peter Paul Rubens (see page 574) helped Velázquez to discover the beauty of the many Titians in the king's collection. The magnificent portrait of Pope Innocent X (fig. 758), painted in 1650 while Velázquez was visiting Italy, is meant to evoke the great tradition of the papal portraits of Raphael, but its fluid brushwork and glowing color derive from Titian (compare figs. 629 and 635). The sitter's gaze, sharply focused on the beholder, conveys a passionate and powerful personality so characteristic of the Baroque.

The Maids of Honor (fig. 759) displays Velázquez' mature style at its fullest. At once a group portrait and a genre scene, it might be subtitled "the artist in his studio," for Velázquez shows himself at work on a huge canvas. In the center is the little Princess Margarita, who has just posed for him, among her playmates and maids of honor. The faces of her parents, the king and queen, appear in the mirror on the back wall. They have just stepped into the room, to see the scene exactly as we do. Through their presence the canvas celebrates Velázquez' position as royal painter and his knighthood in the Order of Santiago, whose red cross he proudly wears on his tunic.

The painting shows Velázquez' fascination with light. The

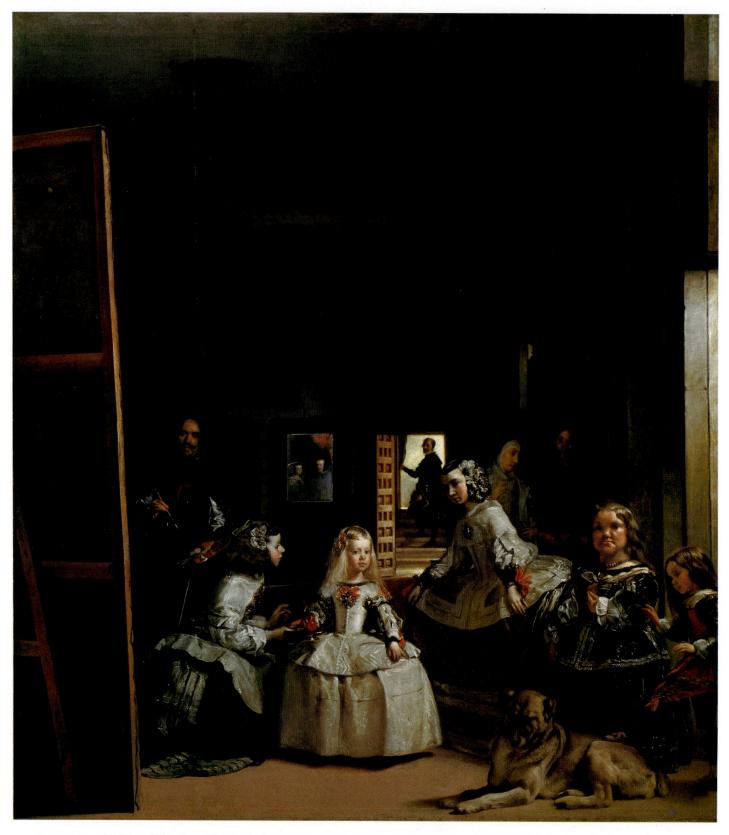

759. Diego Velázquez. The Maids of Honor. 1656. Oil on canvas, 10'5" x 9' (3.2 x 2.7 m). Museo del Prado, Madrid

varieties of direct and reflected light in *The Maids of Honor* are almost limitless. The artist challenges us to match the mirror image against the paintings on the same wall, and against the "picture" of the man in the open doorway. Although the side lighting and strong contrasts of light and dark still suggest the influence of Caravaggio, Velázquez' technique is far more varied and subtle, with delicate glazes setting off the impasto of

the highlights. The glowing colors have a Venetian richness, but the brushwork is even freer and sketchier than Titian's. Velázquez was concerned with the optical qualities of light rather than its metaphysical mysteries. These he penetrated more completely than any painter of his time. His aim is to show the movement of light itself and the infinite range of its effects on form and color. For Velázquez, as for Jan Vermeer

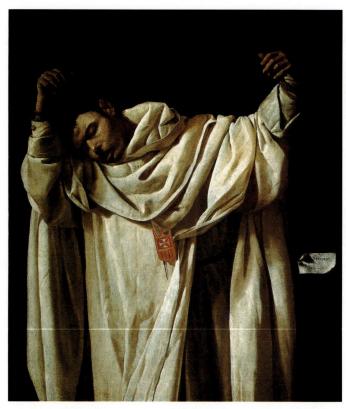

760. Francisco de Zurbarán. *St. Serapion.* 1628. Oil on canvas, 47½ x 41" (120.7 x 104.1 cm). Wadsworth Atheneum, Hartford, Connecticut

Ella Gallup Sumner and Mary Catlin Sumner Collection

in Holland (see page 592), light *creates* the visible world. Velázquez could not have known the work of Vermeer, then only 24, but he may have known scenes of domestic genre by older Dutch painters. Looking at the open, sketchy brushwork in *The Maids of Honor*, we wonder if he could also have seen works by Frans Hals (compare fig. 772). However, unlike Hals, Velázquez is not interested in capturing time on the wing, although the visual effects are fleeting. Rather, he suspends the moment for an eternity to make of the studio an ideal realm that conveys his elevated position as an artist.

ZURBARÁN. Francisco de Zurbarán (1598–1664) stands out among the painters of Seville for his quiet intensity. This artist's most important works were done for monastic orders, and consequently are filled with an ascetic piety that is uniquely Spanish. *St. Serapion* (fig. 760) shows an early member of the Mercedarians (Order of Mercy) who was brutally murdered by pirates in 1240 but canonized only a hundred years after this picture was painted. The canvas was appropriately placed as a devotional image in the funerary chapel of the order, which was originally dedicated to self-sacrifice.

The painting will remind us of Caravaggio's *David with* the Head of Goliath (see fig. 12). Each shows a single, three-quarter-length figure in lifesize. But Zurbarán's saint is both hero and martyr, and it is the viewer who now contemplates the slain monk with a mixture of compassion and awe. The sharp contrast between the white habit and dark background lends the motionless figure a heightened visual and expressive presence. Here pictorial and spiritual purity become one. The hushed stillness creates a reverential mood that counteracts the

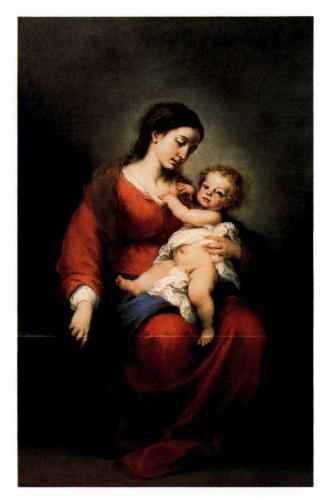

761. Bartolomé Esteban Murillo. *Virgin and Child.* c. 1675–80. Oil on canvas, 65¹/4 x 43" (165.7 x 109.2 cm). The Metropolitan Museum of Art, New York Rogers Fund, 1943

stark realism, so that we identify with the strength of St. Serapion's faith rather than with his physical suffering. The very absence of rhetorical pathos makes this timeless image profoundly moving. [See Primary Sources, no. 70, page 640.]

MURILLO. The work of Bartolomé Esteban Murillo (1617– 1682), Zurbarán's successor as the leading painter in Seville, is the most cosmopolitan, as well as the most accessible, of any Spanish artist. For that reason, he exerted a vast influence on innumerable followers, whose pale imitations have obscured his considerable achievement. He learned as much from Northern artists, including Rubens and Rembrandt, as he did from Italians such as Reni and Guercino. The Virgin and Child in figure 761 unites these influences in an image that nevertheless retains an unmistakably Spanish character. The haunting expressiveness of the faces achieves a gentle pathos that lends a more overt appeal to Zurbarán's pietism. In addition to reflecting changes in religious practice, this must be seen as part of an attempt to inject new life into standard devotional images that had been reduced to formulaic repetition in the hands of lesser artists. The extraordinary sophistication of Murillo's brushwork and the subtlety of his color show the influence of Velázquez. There is a debt as well to the great Flemish Baroque painters Peter Paul Rubens and Anthony van Dyck (see fig. 766).

CHAPTER SEVEN

THE BAROQUE IN FLANDERS AND HOLLAND

In 1581, the six northern provinces of The Netherlands, led by William the Silent of Nassau, declared their independence from Spain, capping a rebellion that had begun 15 years earlier against Catholicism and the attempt by Philip II to curtail local power. The southern Netherlands, called Flanders (now divided between France and Belgium), were soon recovered; but after a long struggle the United Provinces (today's Holland) gained their autonomy, which was recognized by the truce declared in 1609. Although hostilities broke out again in 1621, the freedom of the Dutch was ratified by the Treaty of Münster, which ended the Thirty Years' War in 1648.

The division of The Netherlands had very different consequences for the economy, social structure, culture, and religion of the north and the south. After being sacked by marauding Spanish troops in 1576, Antwerp, its leading port, lost half its population. Although Brussels was the seat of government, Antwerp gradually regained its position as Flanders' commercial and artistic capital, until the Scheldt River leading to its harbor, which had been periodically shut down during the war, was closed permanently to shipping as part of the Treaty of Münster, thereby crippling trade for the next two centuries. Because Flanders continued to be ruled by Spanish regents, who were staunchly Catholic and viewed themselves as the defenders of the true faith, its artists relied heavily on commissions from Church and State, although the patronage of the aristocracy and wealthy merchants was also of considerable importance.

Holland, in contrast, was proud of its hard-won freedom. While the cultural links with Flanders remained strong, several factors encouraged the quick development of Dutch artistic traditions. Unlike Flanders, where all artistic activity radiated from Antwerp, Holland had a number of flourishing local schools. Besides Amsterdam, the commercial capital, we find important groups of painters in Haarlem, Utrecht, Leyden, Delft, and other towns. Thus Holland produced an almost bewildering variety of masters and styles.

The new nation was one of merchants, farmers, and seafarers, and its religion was Reformed Protestant, which was iconoclastic. Hence, Dutch artists did not have the large-scale commissions sponsored by State and Church that were available throughout the Catholic world. While municipal authorities and civic bodies provided a certain amount of art patronage, their demands were limited, so that the private collector now became the painter's chief source of support. This condition had already existed to some extent before (see page 540), but its full effect can be seen only after 1600. There was no shrinkage of output. On the contrary, the general public developed so insatiable an appetite for pictures that the whole country became gripped by a kind of collector's mania. John Evelyn, during a visit to Holland in 1641, noted in his diary that "it is an ordinary thing to find a common farmer lay out two or three thousand pounds in this commodity. Their houses are full of them, and they vend them at their fairs to very great gain." The collectors' mania in seventeenth-century Holland caused an outpouring of artistic talent comparable only to Early Renaissance Florence. Pictures became a commodity, and their trade followed the law of supply and demand. Many artists produced for the market rather than for individual patrons. They were lured into becoming painters by hopes of success that often failed to materialize, and even the greatest masters were sometimes hard-pressed. (It was not unusual for an artist to keep an inn, or run a small business on the side.) Yet they survived—less secure, but freer.

FLANDERS

RUBENS. Although Rome was its birthplace, the Baroque style soon became international. The great Flemish painter Peter Paul Rubens (1577–1640) holds a place of unique importance in this process. It might be said that he finished what Dürer had started a hundred years earlier: the breakdown of the artistic barriers between north and south. Rubens' father

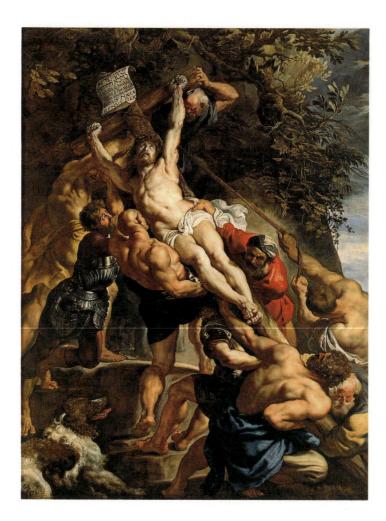

762. Peter Paul Rubens. The Raising of the Cross. 1609-10. Center panel of a triptych, 15'1" x 11'95/8" (4.6 x 3.4 m). Antwerp Cathedral, Belgium

was a prominent Antwerp Protestant who fled to Germany to escape Spanish persecution during the war of independence (see page 539). The family returned to Antwerp after his death, when Peter Paul was ten years old, and the boy grew up a devout Catholic. Trained by local painters, Rubens became a master in 1598, but developed a personal style only when, two years later, he went to Italy.

During his eight years in the south, he absorbed the Italian tradition far more thoroughly than had any Northerner before him. He eagerly studied ancient sculpture, the masterpieces of the High Renaissance (see his splendid drawing after Leonardo's Battle of Anghiari, fig. 597), and the work of Caravaggio and Annibale Carracci. Rubens competed, in fact, with the best Italians of his day on even terms, and could well have made his career in Italy. When his mother's illness in 1608 brought him back to Flanders, he meant the visit to be brief, but he received a special appointment as court painter to the Spanish regent, which permitted him to establish a workshop in Antwerp, exempt from local taxes and guild regulations. Rubens had the best of both worlds. Like Jan van Eyck before him (see page 506), he was valued at court not only as an artist, but as a confidential adviser and emissary. Diplomatic errands gave him entrée to the royal households of the major powers, where he procured sales and commissions. Aided by a growing number of assistants, he was also free to carry out a huge volume of work for the city of Antwerp, for the Church, and for private patrons.

In his life, Rubens epitomized the extroverted Baroque ideal of the virtuoso for whom the entire universe is a stage. He was, on the one hand, a devoutly religious person and, on the other, a person of the world who succeeded in every arena by virtue of his character and ability. Rubens resolved the contradictions of the era through humanism, that union of faith and learning attacked by the Reformation and Counter Reformation alike. In his paintings as well, Rubens reconciled seemingly incompatible opposites. His enormous intellect and vitality enabled him to synthesize his sources into a unique style that unites the natural and supernatural, reality and fantasy, learning and spirituality. Thus his epic canvases defined the scope and the style of High Baroque painting. They possess a seemingly boundless energy and inventiveness, which, like his heroic nudes, express life at its fullest. The presentation of this heightened existence required the expanded arena that only Baroque theatricality, in the best sense of the term, could provide, and Rubens' sense of drama was as highly developed as Bernini's. At the same time, he could be the most human of artists.

The Raising of the Cross (fig. 762), the first major altarpiece Rubens produced after his return to Antwerp, shows strikingly how much he was indebted to Italian art. The muscular figures, modeled to display their physical power and passionate feeling, recall those of the Sistine ceiling and the Farnese Gallery, while the lighting suggests Caravaggio's. The panel nevertheless owes much of its success to Rubens' remarkable

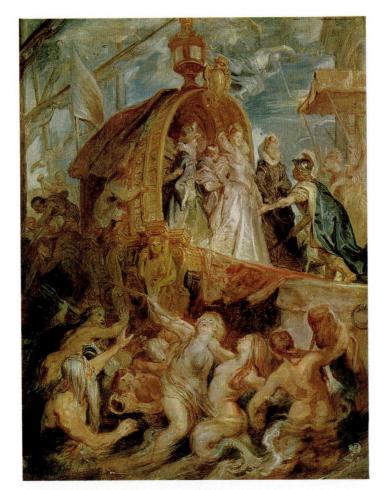

763. Peter Paul Rubens.

Marie de' Medici,

Queen of France, Landing in

Marseilles. 1622–23.

Oil on panel, 25 x 19³/4"

(63.5 x 50.3 cm).

Alte Pinakothek, Munich

ability to unite Italian influences with Netherlandish ideas, updating them in the process. The painting is more heroic in scale and conception than any previous Northern work, yet it is unthinkable without Rogier van der Weyden's *Descent from the Cross* (see fig. 679). Rubens is also a Flemish realist in such details as the foliage, the armor of the soldier, and the curly-haired dog in the foreground. These varied elements, integrated with sovereign mastery, form a composition of tremendous dramatic force. The unstable pyramid of bodies, swaying precariously, bursts the limits of the frame in a characteristically Baroque way, making the beholder feel like a participant in the action.

In the decade of the 1620s, Rubens' dynamic style reached its climax in his huge decorative schemes for churches and palaces. The most famous is the cycle in the Luxembourg Palace in Paris glorifying the career of Marie de' Medici, the widow of Henri IV and mother of Louis XIII. Our illustration shows the artist's oil sketch for one episode, the young queen landing in Marseilles (fig. 763). This is hardly an exciting subject in itself, yet Rubens has turned it into a spectacle of unprecedented splendor. As Marie de' Medici walks down the gangplank, Fame flies overhead sounding a triumphant blast on two trumpets, and Neptune rises from the sea with his fishtailed crew. Having guarded the queen's journey, they rejoice at her arrival. Everything flows together here in swirling movement: heaven and earth, history and allegory—even drawing and painting, for Rubens used oil sketches like this one to prepare his compositions. Unlike earlier artists, he preferred to

design his pictures in terms of light and color from the very start. (Most of his drawings are figure studies or portrait sketches.) This unified vision, explored but never fully achieved by the great Venetians, was Rubens' most precious legacy to subsequent painters.

Around 1630, the turbulent drama of Rubens' preceding work changes to a late style of lyrical tenderness inspired by Titian, whose work Rubens discovered anew in the royal palace while he visited Madrid. *The Garden of Love* (fig. 764), one result of this encounter, is as glowing a tribute to life's pleasures as Titian's *Bacchanal* (see fig. 632). But these celebrants belong to the present, not to a golden age of the past, though they are playfully assaulted by swarms of cupids. To understand the artist's purpose, we must first realize that this subject, the Garden of Love, had been a feature of Northern painting ever since the courtly style of the International Gothic. The early versions, however, were genre scenes showing groups of fashionable young lovers in a garden. By combining this tradition with Titian's classical mythologies, Rubens has created an enchanted realm where myth and reality become one.

The picture must have had special meaning for him, since he had just married a beautiful girl of 16. (His first wife died in 1626.) He also bought a country house, Château Steen, and led the leisurely life of a squire. This change induced a renewed interest in landscape painting, which he had practiced only intermittenly before. Here, too, the power of his genius is undiminished. In *Landscape with the Château Steen* (fig. 765), a magnificent open space sweeps from the hunter and his prey

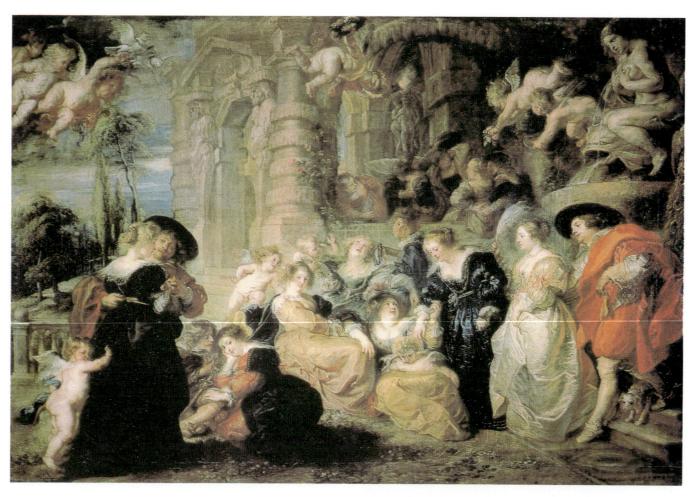

764. Peter Paul Rubens. The Garden of Love. c. 1638. Oil on canvas, 6'6" x 9'3 1/2" (2 x 2.8 m). Museo del Prado, Madrid

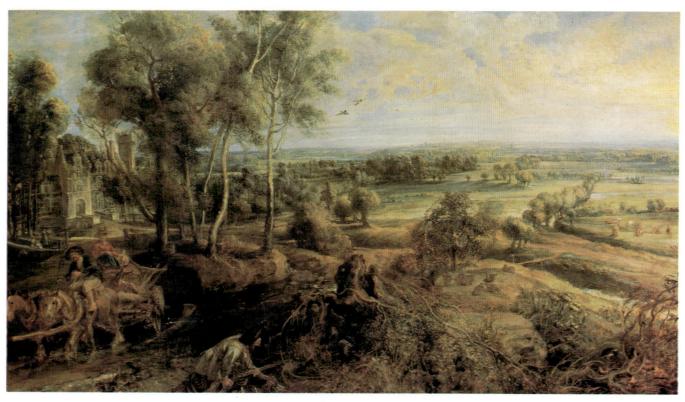

765. Peter Paul Rubens. Landscape with the Château Steen. 1636. Oil on panel, 4'5" x 7'9" (1.34 x 2.36 m). The National Gallery, London Reproduced by courtesy of the Trustees

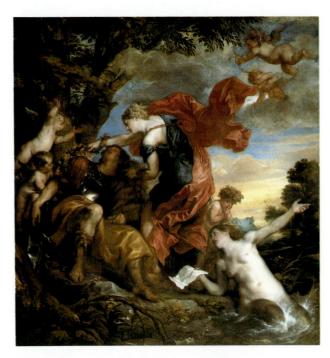

766 . Anthony van Dyck. *Rinaldo and Armida.* 1629. Oil on canvas, 7'9" x 7'6" ($2.36 \times 2.24 \text{ m}$). The Baltimore Museum of Art The Jacob Epstein Collection

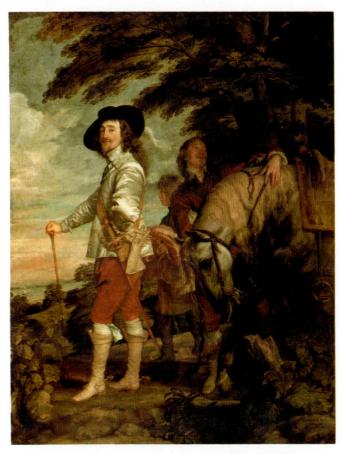

767. Anthony van Dyck. *Portrait of Charles I Hunting*. c. 1635. Oil on canvas, 8'11" x 6'11¹/2" (2.7 x 2.1 m). Musée du Louvre, Paris

in the foreground to the mist-veiled hills along the horizon. As a landscapist, Rubens again creates a synthesis from his Northern and Southern sources, for he is the heir of both Pieter Bruegel and Annibale Carracci (compare figs. 716 and 731).

VAN DYCK. Besides Rubens, only one Flemish Baroque artist won international stature. Anthony van Dyck (1599–1641) was that rarity among painters, a child prodigy. Before he was 20, he had become Rubens' most valued assistant. But like Rubens, he developed his mature style only after a formative stay in Italy.

Van Dyck's achievement as a history painter has been overshadowed by Rubens', yet it was of considerable importance in its own right. He was at his best in lyrical scenes of mythological love. Rinaldo and Armida (fig. 766), taken from Torquato Tasso's immensely popular poem Jerusalem Freed (1581) about the crusades, which gave rise to a new courtly ideal throughout Europe and inspired numerous operas as well as paintings, shows the sorceress falling in love with the Christian knight she intended to kill. The painting reflects the conception of the English monarchy, for whom it was painted. Charles I, a Protestant, had married the Catholic Henrietta Maria, sister of his rival, the king of France. Charles found parallels in Tasso's epic. He saw himself as the virtuous ruler of a peaceful realm much like the Fortunate Isle where Armida brought Rinaldo. (Ironically, Charles' reign ended in civil war and his beheading in 1649.) Van Dyck tells his story of ideal love in the pictorial language of Titian and Veronese, but with a lyrical tenderness and visual opulence that would have been the envy of any Venetian artist. The picture was so successful that it helped gain Van Dyck appointment to the English court two years later.

Van Dyck's fame rests mainly on the portraits he painted in London between 1632 and 1641. *Charles I Hunting* (fig. 767) shows the king standing near a horse and two grooms against a landscape backdrop. Representing the sovereign at ease, it might be called a "dismounted equestrian portrait"—less rigid than a formal state portrait, but hardly less grand, for the king remains fully in command of the state, symbolized by the horse. The fluid Baroque movement of the setting complements the self-conscious elegance of the king's pose, which continues the stylized grace of Hilliard's portraits (compare fig. 712). Van Dyck has brought the Mannerist court portrait up to date, using Rubens and Titian as his points of departure. In the process, he created a new aristocratic portrait tradition that continued in England until the late eighteenth century, and had considerable influence on the Continent as well.

JORDAENS. Jacob Jordaens (1593—1678) was the successor to Rubens and Van Dyck as the leading artist in Flanders. Although he was never a member of Rubens' studio, he turned to Rubens for inspiration throughout his career. His most characteristic subjects are mythological themes depicting the revels of nymphs and satyrs. Like his eating and drinking scenes, which illustrate popular parables of an edifying and moralizing sort, they reveal him to be a close observer of people. These denizens of the woods, however, inhabit an idyllic realm, untouched by the cares of human affairs. The painterly execution in *Homage to Pomona (Allegory of Fruitfulness)* (fig. 768)

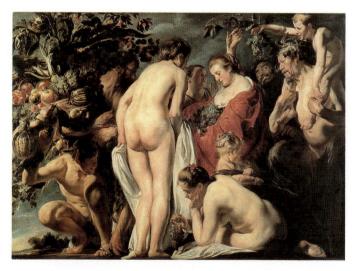

768. Jacob Jordaens. *Homage to Pomona (Allegory of Fruitfulness)*. c. 1623. Oil on canvas, 5'10⁷/8" x 7'10⁷/8" (1.8 x 2.4 m). Musée Royaux d'Art et d'Histoire, Brussels

acknowledges a strong debt to Rubens, yet the monumental figures dispense with Rubens' rhetoric and possess a calm dignity all their own.

JAN BRUEGHEL. Rubens' towering genius dominated Flemish painting. It touched every artist around him, includ-

ing Jan Brueghel the Elder (1568-1625), the leader of the preceding generation, with whom he frequently collaborated. Although he was the principal heir to the tradition of his illustrious father, Pieter Bruegel the Elder (see page 542), Jan was an innovator who occupied a position of central importance in the transition from Mannerism to the Baroque in the North. Allegory of Earth (fig. 769) shows one of his major contributions to Flemish art: the "paradise" landscape. It originally belonged to a series devoted to the four elements, a common theme in Northern seventeenth-century painting, each with an appropriate biblical or mythological subject. Barely visible in the background is the expulsion of Adam and Eve from the Garden of Eden, a remnant of the Mannerist inverted perspective (see pages 540-41). Jan's enchanting vision of this innocent realm is made convincing by his meticulous realism. The small copperplate, which he, like many older artists, preferred, offered a smooth, hard surface ideally suited to his jewellike style.

SNYDERS. Brueghel also made an important contribution to flower painting. However, the development of the Baroque still life in Flanders was largely the responsibility of Frans Snyders (1579–1657), who studied with Jan's brother, Pieter Brueghel the Younger (1564–1638). Snyders concentrated on elaborate table still lifes piled high with food that epitomize the Flemish gusto for life during the Baroque era. His

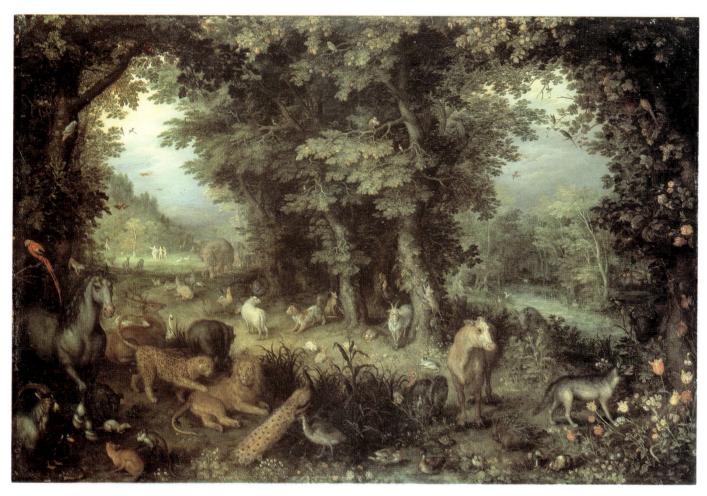

769. Jan Brueghel the Elder. Allegory of Earth. c. 1618. Oil on copper, 181/8 x 263/8" (46 x 67 cm). Musée du Louvre, Paris

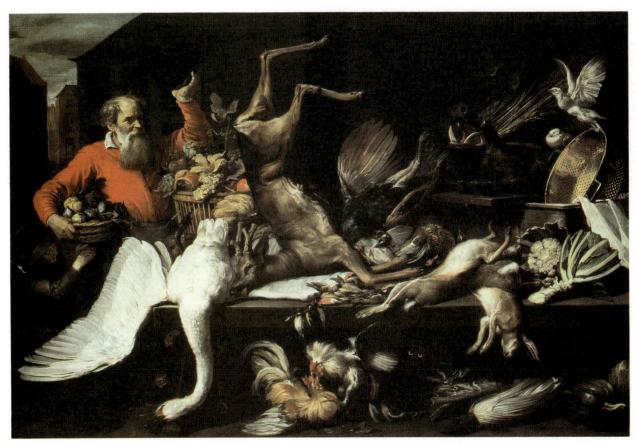

770. Frans Snyders. *Market Stall.* 1614. Oil on canvas, 6'11⁷/8" x 10'3⁵/8" (2.1 x 3 m). © 1991 The Art Institute of Chicago Charles H. and Mary F. S. Worcester Fund, 1981

771. Hendrick Terbrugghen.

The Calling of St. Matthew. 1621.

Oil on canvas, 40 x 54"

(101.5 x 137.2 cm).

Centraal Museum, Utrecht,

The Netherlands

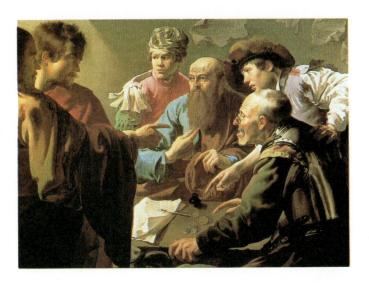

splendid *Market Stall* (fig. 770) is a masterpiece of its kind. This early picture appeals frankly to the senses. The artist revels in the bravura application of paint, as seen in the varied textures of the game. The scene is further enlivened by the little drama of the youth picking the old man's pocket and the hens fighting in the foreground as a cat looks on from its safe retreat beneath the low bench.

Even here Rubens' influence can be felt: the composition descends from one Snyders painted with Rubens based on the latter's design shortly after both returned from Italy around 1609. Market Stall updates The Meat Stall of Pieter Aertsen (fig. 715) into a Baroque idiom. Unlike Aertsen, Snyders subordinates everything to the ensemble, which has a characteristically Baroque ebullience and immediacy. There is a fundamental difference in content as well. No longer is it necessary to include a religious subject in the background of this scene of plenty. Although an emblematic meaning has been suggested, the painting also celebrates a time of peace and prosperity after the truce of 1609, when hunting was resumed in the replenished game preserves.

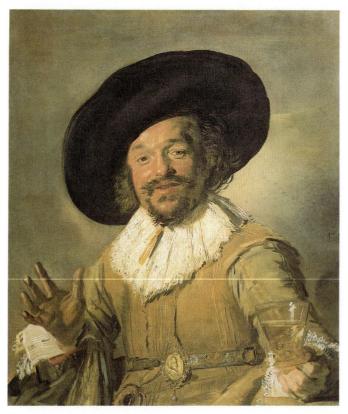

772. Frans Hals. *The Jolly Toper.* c. 1628-30. Oil on canvas, $31^{7}/8 \times 26^{1}/4$ " (81 x 66.6 cm). Rijksmuseum, Amsterdam

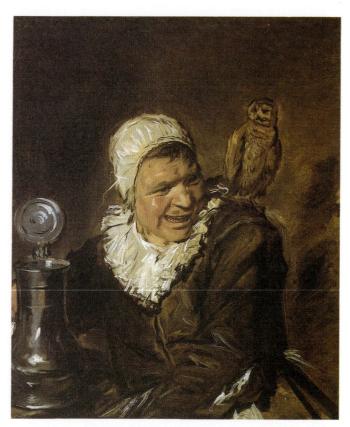

773. Frans Hals. *Malle Babbe*. c. 1650. Oil on canvas, $29^{1}/2 \times 25^{"}$ (75 x 63.5 cm). Gemäldegalerie, Berlin

HOLLAND

UTRECHT SCHOOL. The Baroque style came to Holland from Antwerp through the work of Rubens, and from Rome through direct contact with Caravaggio and his followers. Although most Dutch painters did not go to Italy, most of those who went in the early years of the century were from Utrecht, a town with strong Catholic traditions. It is not surprising that these artists were more attracted by Caravaggio's realism and "lay Christianity" than by Annibale Carracci's classicism. The Calling of St. Matthew by Hendrick Terbrugghen (1588-1629), the oldest and ablest of this group (fig. 771), directly reflects Caravaggio's earlier version (fig. 726) in the sharp light, the dramatic timing, and the everyday detail. Missing, however, is the element of grandeur and simplicity. While it produced few other major artists, the Utrecht School was important for transmitting the style of Caravaggio to other Dutch masters, who then made better use of these new Italian ideas.

HALS. One of the first to profit from this experience was Frans Hals (1580/85–1666), the great portrait painter of Haarlem. He was born in Antwerp, and what little is known of his early work suggests the influence of Rubens. His developed style, however, seen in *The Jolly Toper* (fig. 772), combines Rubens' robustness and breadth with a concentration on

the "dramatic moment" that must be derived from Caravaggio via Utrecht. Everything here conveys complete spontaneity: the twinkling eyes and half-open mouth, the raised hand, the teetering wineglass, and—most important of all—the quick way of setting down the forms. Hals works in dashing brushstrokes, each so clearly visible as a separate entity that we can almost count the total number of "touches." With this open, split-second technique, the completed picture has the immediacy of a sketch (compare our example by Rubens, fig. 763). The impression of a race against time is, of course, deceptive. Hals spent hours, not minutes, on this lifesize canvas, but he maintains the illusion of having done it all in the wink of an eye.

These qualities are even more forceful in the *Malle Babbe* (fig. 773), one of the artist's genre pictures. A lower-class counterpart of *The Jolly Toper*, this folk character, half-witch (note the owl), half-village idiot, screams invectives at other guests in a tavern. Hals seems to share their attitude toward this benighted creature, one of cruel amusement rather than sympathy, but his characterization is masterfully sharp and his lightninglike brushwork has the bravura of incredible skill.

In the artist's last canvases these pictorial fireworks are transmuted into an austere style of great emotional depth. His group portrait, *The Women Regents of the Old Men's Home at*

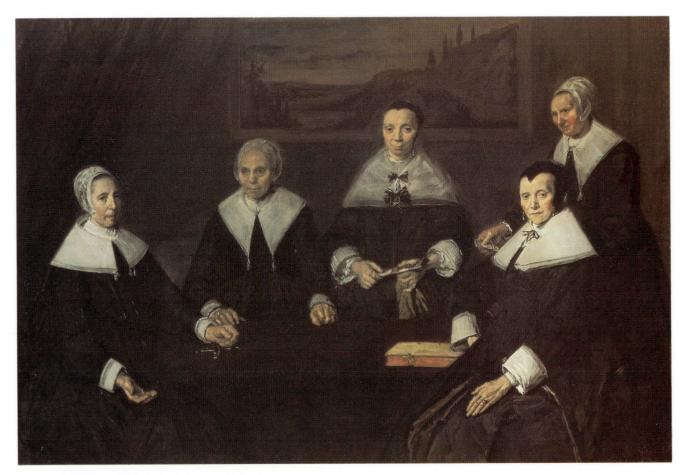

774. Frans Hals. *The Women Regents of the Old Men's Home at Haarlem.* 1664. Oil on canvas, 5'7" x 8'2" (1.70 x 2.49 m). Frans Halsmuseum, Haarlem, The Netherlands

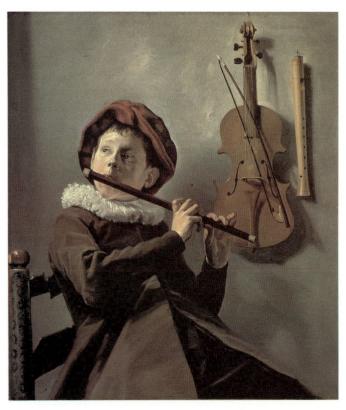

775. Judith Leyster. *Boy Playing a Flute.* 1630-35. Oil on canvas, $28^{1}/8 \times 24^{1}/8$ " (73 x 62 cm). Nationalmuseum, Stockholm

Haarlem (fig. 774), has an insight into human character matched only in Rembrandt's late style (compare figs. 779 and 780). The daily experience of suffering and death has so etched the faces of these women that they seem themselves to have become images of death—gentle, inexorable, and timeless.

LEYSTER. Hals' virtuosity was such that it could not be imitated readily, and his followers were necessarily few. The most important among them was Judith Leyster (1609–1660). Like many women artists before modern times, her career was partially curtailed by motherhood. Leyster's enchanting *Boy Playing a Flute* (fig. 775) is her masterpiece. Significantly, its style is closer to Terbrugghen's than to Hals'. The rapt musician is a memorable expression of lyrical mood. To convey this spirit, Leyster investigated the poetic quality of light with a quiet intensity that anticipates the work of Jan Vermeer a generation later (see pages 592–93).

REMBRANDT. Like Hals, Rembrandt (1606–1669), the greatest genius of Dutch art, was stimulated at the beginning of his career by indirect contact with Caravaggio through the Utrecht School. His earliest pictures, painted in his native Leyden, are small, sharply lit, and intensely realistic. Many deal with Old Testament subjects, a lifelong preference. They show both his greater realism and his new emotional attitude. Since

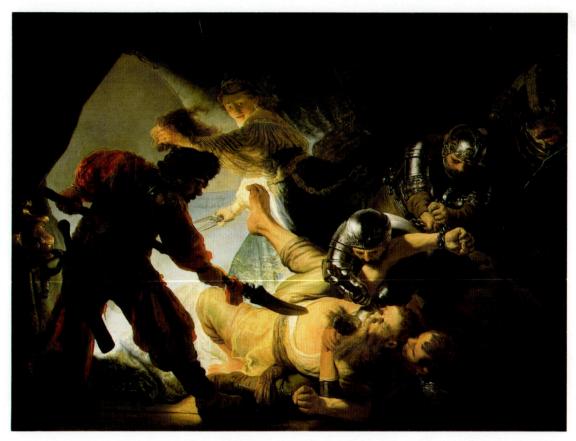

776. Rembrandt. *The Blinding of Samson.* 1636. Oil on canvas, 7'9" x 9'11" (2.4 x 3 m). Städelsches Kunstinstitut, Frankfurt

the beginning of Christian art, episodes from the Old Testament had often been represented for the light they shed on Christian doctrine, rather than for their own sake. (The Sacrifice of Isaac, for example, "prefigured" the sacrificial death of Christ.) This perspective not only limited the choice of subjects, it also colored their interpretation. Rembrandt, by contrast, viewed the stories of the Old Testament in much the same lay Christian spirit that governed Caravaggio's approach to the New Testament: as direct accounts of God's ways with his human creations.

How strongly these stories affected him is evident from *The Blinding of Samson* (fig. 776). Painted in the High Baroque style he developed in the 1630s after moving to Amsterdam, it shows Rembrandt as master storyteller. The artist depicts the Old Testament world as full of Oriental splendor and violence, cruel yet seductive. The flood of brilliant light pouring into the dark tent is unabashedly theatrical, heightening the drama to the pitch of *The Raising of the Cross* (fig. 762) by Rubens, whose work Rembrandt attempted to rival.

Rembrandt was at this time an avid collector of Near Eastern paraphernalia, which serve as props in these pictures. He was now Amsterdam's most sought-after portrait painter, as well as a man of considerable wealth. His famous group portrait known as *The Night Watch* (fig. 777), painted in 1642, shows a military company assembling for the visit of Marie de'

Medici to Amsterdam. Although its members had each contributed toward the cost of the huge canvas (originally it was even larger), Rembrandt did not give them equal weight. He was anxious to avoid the mechanically regular designs that afflicted earlier group portraits—a problem only Frans Hals had overcome successfully. Instead, he made the picture a virtuoso performance of Baroque movement and lighting, which captures the excitement of the moment and lends the scene unprecedented drama. Thus some of the figures were plunged into shadow, while others were hidden by overlapping. Legend has it that the people whose portraits he had obscured were dissatisfied. There is no evidence that they were. On the contrary, we know that the painting was much admired in its time.

Like Michelangelo and, later, Van Gogh, Rembrandt has been the subject (one might say, the victim) of many fictionalized biographies. In these, the artist's fall from public favor is usually explained by the "catastrophe" of *The Night Watch*. It is undeniable that his prosperity petered out in the 1640s, as he was replaced by other artists, including some of his own pupils. Nevertheless, his fortunes declined less suddenly and completely than his romantic admirers would have us believe. Certain important people in Amsterdam continued to be his steadfast friends and supporters, and he received some major public commissions in the 1650s and 1660s. Actually, his financial difficulties resulted largely from poor management

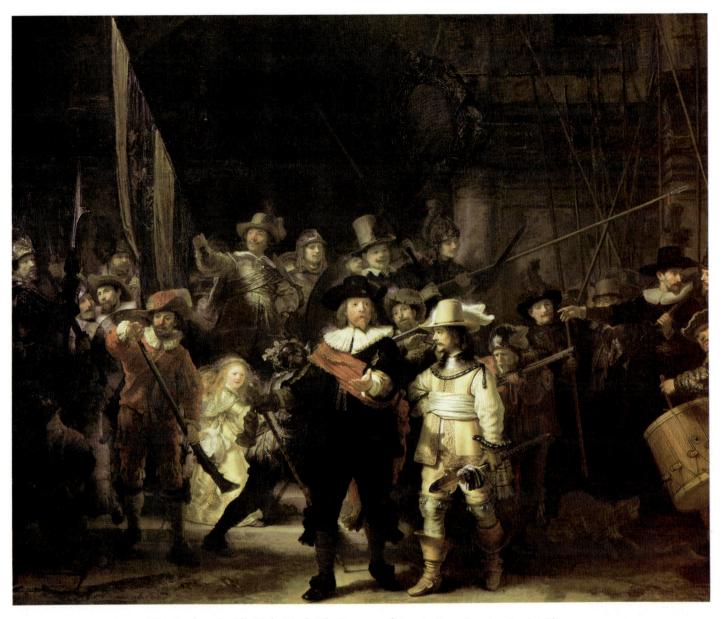

777. Rembrandt. *The Night Watch (The Company of Captain Frans Banning Cocq).* 1642. Oil on canvas, 12'2" x 14'7" (3.8 x 4.4 m). Rijksmuseum, Amsterdam

and his own stubbornness, which alienated his patrons. [See Primary Sources, no 71, pages 640–41.]

Still, the 1640s were a period of crisis, of inner uncertainty and external troubles, especially his wife's death. Rembrandt's outlook changed profoundly: after about 1650, his style eschews the rhetoric of the High Baroque for lyric subtlety and pictorial breadth. Some exotic trappings from the earlier years remain, but they no longer create an alien, barbarous world. Rembrandt's etchings from these years, such as Christ Preaching (fig. 778), show this new depth of feeling. The sensuous beauty seen in The Blinding of Samson has now yielded to a humble world of bare feet and ragged clothes. The scene is full of the artist's deep feeling of compassion for the poor and outcast who make up Christ's audience. Rembrandt had a special sympathy for the Jews, as the heirs of the biblical past and as the patient victims of persecution; they were often his models. This print, like the sketch in figure 7, strongly suggests some corner in the Amsterdam ghetto, and surely incorporates observations of life from the drawings he habitually made throughout his career. Here it is the magic of light that endows *Christ Preaching* with spiritual significance. Rembrandt's importance as a graphic artist is second only to Dürer's, although we get no more than a hint from this single example.

In the many self-portraits Rembrandt painted over his long career, his view of himself reflects every stage of his inner development: experimental in the early Leyden years, theatrically disguised in the 1630s, frank toward the end of his life. While our late example (fig. 779) is partially indebted to Titian's sumptuous portraits (compare fig. 634), Rembrandt scrutinizes himself with the same typically Northern candor found in Jan van Eyck's *Man in a Red Turban* (see fig. 676). The bold pose and penetrating look bespeak a resigned but firm resolve in the face of adversity.

This self-analytical approach helps to account for the plain dignity we see in the religious scenes that play so large a part in Rembrandt's work toward the end of his life. *The Return of the Prodigal Son* (fig. 780), created a few years before his death, is perhaps Rembrandt's most moving painting. It is also his

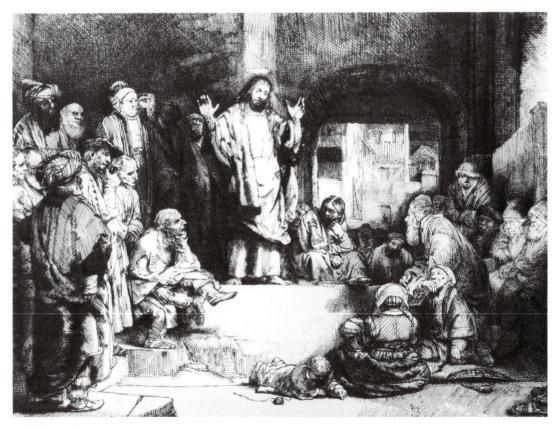

778. Rembrandt. Christ Preaching. c. 1652. Etching, $6^{1/8} \times 8^{1/8}$ " (15.6 x 20.6 cm). The Metropolitan Museum of Art, New York Bequest of Mrs. H. O. Havemeyer, 1929

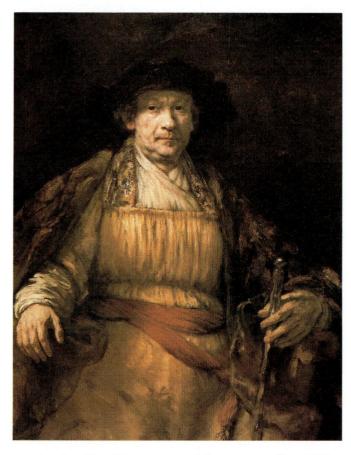

779. Rembrandt. Self-Portrait. 1658. Oil on canvas, $52^{5/8}$ x $40^{7/8}$ " (133.6 x 103.8 cm). The Frick Collection, New York Copyright The Frick Collection

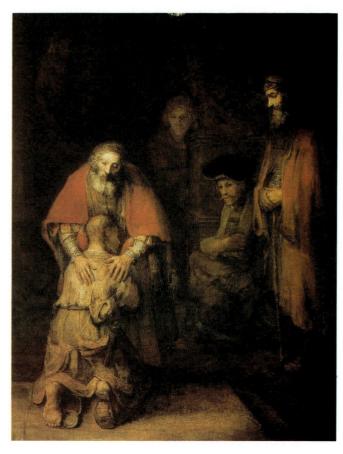

780. Rembrandt. The Return of the Prodigal Son. c. 1665. Oil on canvas, 8'8" x $6'7^3/4$ " (2.6 x 2.1 m). Hermitage Museum, St. Petersburg

quietest—a moment stretching into eternity. So pervasive is the mood of tender silence that the beholder senses a spontaneous kinship with this group. Our bond of shared experience is perhaps stronger and more intimate in this picture than in any earlier work of art. Here the wealth of human understanding accumulated over a lifetime of experience achieves a universal expression of sorrow and forgiveness.

LANDSCAPES. Rembrandr's religious pictures demand an insight that was beyond the capacity of all but a few collectors. Most art buyers in Holland preferred subjects within their own experience: landscapes, architectural views, still lifes, everyday scenes. These various types, we recall, originated in the latter half of the sixteenth century (see page 540). As they became fully defined, an unheard-of specialization began. The trend was not confined to Holland. We find it everywhere to some degree, but Dutch painting was its fountainhead, in both volume and variety.

VAN GOYEN. *Pelkus-Poort* (fig. 781) by Jan van Goyen (1596–1656) is the kind of landscape that enjoyed great popularity because its elements were so familiar: the distant town under a looming overcast sky, seen through a moisture-laden atmosphere across an expanse of water. Such a view remains characteristic of the Dutch countryside to this day, and no one knew better than Van Goyen how to evoke the special mood of these "nether lands," ever threatened by the sea.

Like other early Dutch Baroque landscapists, Van Goyen restricted his palette to grays and browns highlighted by green accents, but within this narrow range he achieved an almost infinite variety of effects. The tonal landscape style in Holland was allied to a drastic simplification of composition, which reduced the complex constructions of Northern Mannerism to orderly arrangements. Van Goyen's scene is based on a lucid scheme of parallel bands surmounted by a triangle. He discovered what Annibale Carracci had already learned from Giorgione and the Venetians: that the secret to depicting landscape lay in geometry, which enabled the artist to gain visual control over nature as it did architecture.

781. Jan van Goyen. *Pelkus-Poort.* 1646. Oil on panel, 14¹/₂ x 22¹/₂" (36.8 x 57.2 cm). The Metropolitan Museum of Art, New York

Gift of Francis Neilson, 1954

CUYP. Other Northern artists absorbed this lesson directly in Rome, where they congregated in growing numbers. The Dutch Italianates who returned home in the 1640s brought with them new ideas that were to have an invigorating effect on landscape painting. Their impact can be seen in the work of Aelbert Cuyp (1620–1691), who never left his native soil. A follower of Van Goyen, he quickly abandoned tonalism in favor of the radiant light found in their views of the Roman Campagna, which parallel the work of Claude Lorraine (see fig. 796). The golden sunlight of late afternoon imbues Cuyp's *View of the Valkhof at Nijmegen* (fig. 782) with a poetic mood that suspends the scene in time and space. The nearly classical structure of the composition and cubic handling of the architecture heighten the sense of repose created by Cuyp's grasp of even the subtlest atmospheric effects.

RUISDAEL. Although nature was enjoyed for its own sake, it could also serve as a means of divine revelation through contemplation of God's work. Such is the case with *The Jewish Cemetery* (fig. 783) by Jacob van Ruisdael (1628/9–1682), the

Dutch Protestant conservatism regarding music in the church

inhibited the development of music in the Netherlands. Indeed, the only important Dutch composer in the seventeenth century was Jan Sweelinck (1562–1621), who succeeded his father as organist of the Oude Kerk (Old Church) in Amsterdam. He was particularly noted for his psalm music, and even enjoyed the protection of the town council from church authorities. Nevertheless, Sweelinck's strongest influence was felt not in Holland, but in Germany, where his best pupils, such as Samuel Scheidt (1587–1654), Handel's distinguished predecessor in Halle, were able to find employment and where a love of church music, fostered by Lutheranism, was widespread.

By contrast, Holland enjoyed a lively theatrical life, especially in Amsterdam. Dutch theater was partly an outgrowth

Music and Theater in Holland

of the societies of Rhetoricians that had sprung up during the

fifteenth century, and partly of the Dutch Academy, which was founded in 1617 as a "Netherlandish training school." The theater also flourished because the country was fortunate to produce a number of gifted playwrights, notably Joost van den Vondel (1587–1679), at a time when rising nationalism placed new emphasis on the Dutch language. The plots often drew on the Old Testament to glorify the Dutch as a new "chosen people." These dramas were an important inspiration to artists, particularly Rembrandt. Many of his paintings, especially those from his early years, depict scenes drawn directly from these plays. Moreover, Rembrandt's use of exotic costumes and similar stage properties shows a deep love of drama that helps to account in part for the theatricality of his work.

782. Aelbert Cuyp. View of the Valkhof at Nijmegen. c. 1655-65. Oil on panel, $19^{1/4} \times 29''$ (48.9×73.7 cm). Gift of Mrs. James W. Fesler. © 1993 Indianapolis Museum of Art

783. Jacob van Ruisdael. The Jewish Cemetery. 1655–60. Oil on canvas, 4'6" x $6'2^{1/2}$ " (1.42 x 1.89 m). The Detroit Institute of Arts Gift of Julius H. Haass in memory of his brother, Dr. Ernest W. Haass

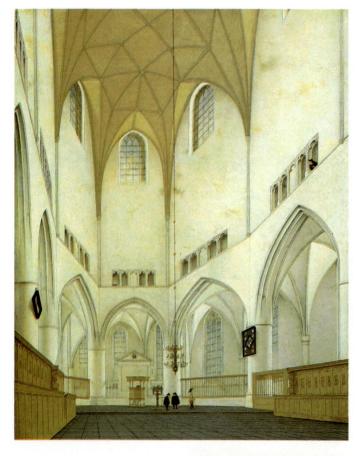

greatest Dutch landscape painter. Natural forces dominate this wild scene, which is frankly imaginary, except for the tombs, which depict the Jewish cemetery in Amsterdam. The thunderclouds passing over a deserted mountain valley, the medieval ruin, the torrent that has forced its way between ancient graves, all create a mood of deep melancholy. Nothing endures on this earth, the artist tells us: time, wind, and water grind all to dust, the trees and rocks, as well as the feeble works of human hands. Even the elaborate tombs offer no protection from the same forces that destroy the church built in God's glory. Within the context of this extended allegory, the rainbow may be understood as a sign of the promise of redemption through faith. Ruisdael's view of nature is thus the exact opposite of Annibale Carracci's "civilized" landscape (compare fig. 731). It harks back instead to Giorgione's tragic vision (see fig. 631). The Jewish Cemetery inspires that awe on which the Romantics, 150 years later, based their concept of the Sublime. The difference is that for Ruisdael, God ultimately remains separate from his creation, instead of a part of it.

SAENREDAM. Nothing at first seems further removed from The Jewish Cemetery than the painstakingly precise Interior of the Choir of St. Bavo's Church at Haarlem (fig. 784), painted by Pieter Saenredam at almost the same time. Yet it, too, is meant to serve as more than a mere topographic record. (These architectural views were often freely invented as well.) The medieval structure, stripped of all furnishings and whitewashed under Protestant auspices, has acquired a crystalline spaciousness that invites meditation.

STILL LIFES. Still lifes exist above all to delight the senses, but even they can be tinged with a melancholy air. As a result of Holland's conversion to Calvinism, these visual feasts

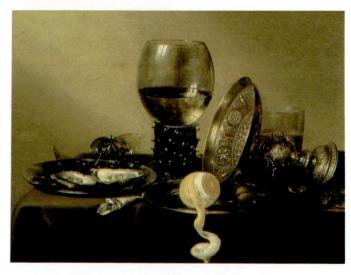

785. Willem Claesz. Heda. Still Life. 1634. Oil on panel, 16⁷/8 x 22⁷/8" (43 x 57 cm). Museum Boymans-van Beuningen, Rotterdam, The Netherlands

became vehicles for teaching moral lessons. Most Dutch Baroque still lifes treat the theme of Vanitas (the vanity of all earthly things). Overtly or implicitly, they preach the virtue of temperance, frugality, and hard work by admonishing the viewer to contemplate the brevity of life, the inevitability of death, and the passing of all earthly pleasures. The medieval tradition of imbuing everyday objects with religious significance was absorbed into vernacular culture though emblem books which, together with other forms of popular literature and prints, encompassed the prevailing ethic in words and pictures. The stern Calvinist sensibility is exemplified by such homilies as, "A fool and his money are soon parted" (a saying

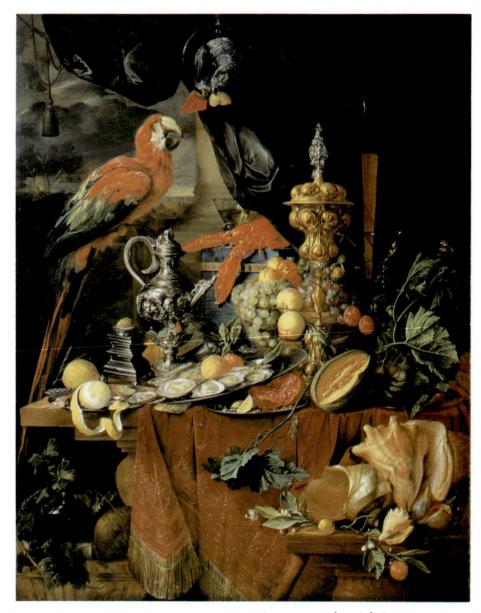

786. Jan de Heem. Still Life with Parrots. Late 1640s. Oil on canvas, $59^{1/4}$ x $45^{1/2}$ " (150.5 x 115.5 cm). John and Mable Ringling Museum of Art, Sarasota, Florida

that goes all the way back to ancient Rome), and illustrated by flowers, shells, and other exotic luxuries. The very presence in Vanitas still lifes of precious goods, scholarly books, and objects appealing to the senses suggests an ambivalent attitude toward their subject. Such symbols usually take on multiple meanings which, though no longer comprehensible to us, were readily understood at the time. In their most elaborate form, these moral allegories become visual riddles that rely on the very learning they sometimes ridicule.

HEDA. The banquet (or breakfast) piece, showing the remnants of a meal, had Vanitas connotations almost from the beginning. The message may lie in such established symbols as death's-heads and extinguished candles, or be conveyed by less direct means. *Still Life* (fig. 785) by Willem Claesz. Heda (1594–1680) belongs to this widespread type. Food and drink are less emphasized here than luxury objects, such as crystal goblets and silver dishes, which are carefully juxtaposed for their contrasting shape, color, and texture. How different this seems from the piled-up edibles of Aertsen's *Meat Stall* (see fig. 715)! But virtuosity was not Heda's only aim. He reminds us

that all is Vanity. His "story," the human context of these grouped objects, is suggested by the broken glass, the half-peeled lemon, the overturned silver dish. The unstable composition, with its signs of a hasty departure, is itself a reference to transience. Whoever sat at this table has been suddenly forced to abandon the meal. The curtain that time has lowered on the scene, as it were, invests the objects with a strange pathos. The disguised symbolism of "Late Gothic" painting lives on here in a new form.

DE HEEM. The breakfast piece soon evolved into an even more lavish display, known appropriately as the "fancy" still life for its visual splendor, which culminated in the work of Jan de Heem (1606–1684). De Heem began his career in Protestant Holland, but he soon moved to Catholic Flanders. However, he traveled back and forth between the two countries and eventually returned to his native land. His achievement was to synthesize the sober Dutch tradition with the flamboyant manner of Frans Snyders into a unique style that proved equally influential on both sides of the border. In *Still Life with Parrots* (fig. 786), De Heem has compiled delicious food,

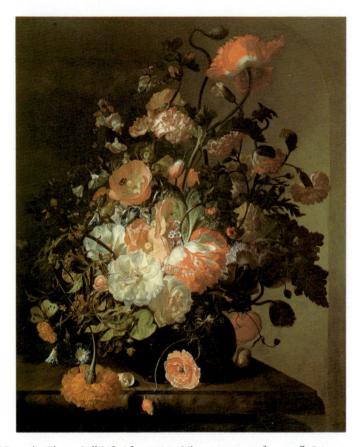

787. Rachel Ruysch. Flower Still Life. After 1700. Oil on canvas, 29³/4 x 23⁷/8" (75.5 x 60.7 cm). The Toledo Museum of Art, Ohio

Purchased with funds from the Libbey Endowment, Gift of Edward Drummond Libbey

exotic birds, and luxurious goods from around the world. The result is a stunning tour de force. Despite its profusion, the painting is unified by the balanced composition and colorful palette. In keeping with the appetitive theme, the viewer is meant to enjoy the visual abundance, which celebrates the work of the Lord and humanity. At the same time, the picture has a covert meaning. Many of these objects, including the oysters, melon, and shells (which commanded high prices), are also standard Vanitas symbols conveying an admonition to be temperate. The extravagant display further incorporates the time-honored theme of the four elements, as well as traditional Christian imagery: the parrot is identified with the Madonna as the mother of Christ, while the grapes are a reference to the Eucharistic wine and, hence, resurrection, as is the pomegranate, which stands for the Virgin's purity as well.

RUYSCH. De Heem also formulated the High Baroque floral still life so definitively that flower painters were to feel his impact for the next 200 years. Many of them were women, including his pupil Maria van Oosterwijck (1630-1693), who became a celebrated artist in her own right. Her achievements were soon outstripped by those of Rachel Ruysch (1664-1750), who shared honors with Jan van Huysum

(1682–1749) as the leading Dutch flower painters of the day. Was she aware of the significance of every blossom, and of the butterflies, moths, and snails she put into the beautiful piece in figure 787, each of which has a complex symbolic meaning? By this time it is doubtful that she assembled her bouquet to a moralizing end. Instead, the main purpose of Ruysch's painting was surely to please the eye. She imparts such a sweeping vitality to the swirling profusion of buds that they fairly leap from their vase.

STEEN. The large class of pictures termed genre is as varied as that of landscapes and still lifes. It ranges from tavern brawls to refined domestic interiors. *The Feast of St. Nicholas* (fig. 788) by Jan Steen (1625/6-1679) is midway between. St. Nicholas has just paid his pre-Christmas visit to the household, leaving toys, candy, and cake for the children. The little girl and boy are delighted with their presents. She clutches a doll of St. John the Baptist and a bucket filled with sweets, while he plays with a golf club and ball. Everybody is jolly except their brother, on the left, who has received only a birch rod (held by the young maidservant) for caning naughty children. Soon his tears will turn to joy, however: his grandmother, in the background, beckons to the bed, where a toy is hidden.

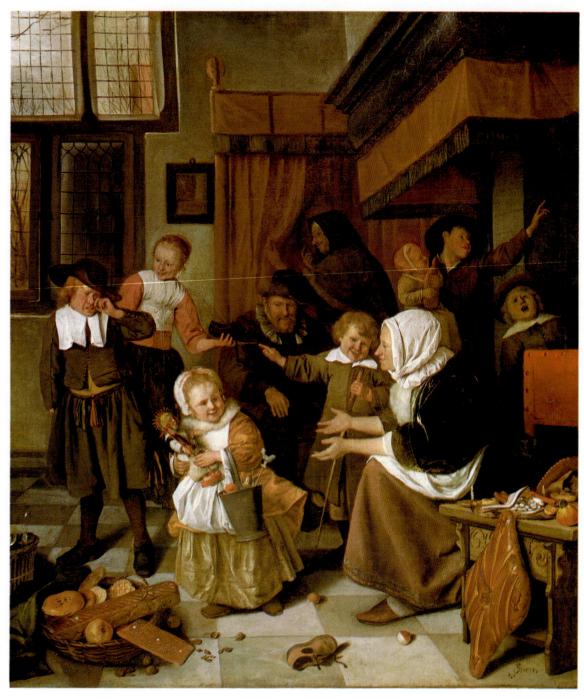

788. Jan Steen. The Feast of St. Nicholas. c. 1660–65. Oil on canvas, $32\,^1\!/4$ x $27\,^3\!/4$ " (82 x 70.5 cm). Rijksmuseum, Amsterdam

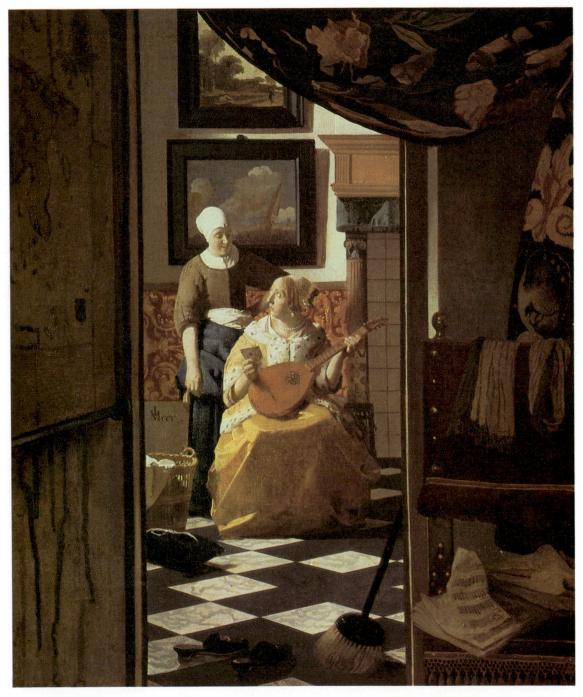

789. Jan Vermeer. The Letter. 1666. Oil on canvas, 17 1/4 x 15 1/4" (43.3 x 38.3 cm). Rijksmuseum, Amsterdam

Steen tells this story with relish, embroidering it with many delightful details. Of all the Dutch painters of daily life, he was the sharpest and the most good-humored observer. To supplement his earnings he kept an inn, which perhaps explains his keen insight into human behavior. His sense of timing and his characterization often remind us of Frans Hals (compare fig. 773), while his story-telling stems from the tradition of Pieter Bruegel the Elder (compare fig. 717). At the same time, Steen was a gifted history painter, and although his pictures often contain parodies of well-known works by Italian artists, they usually convey a serious message as well. Thus the doll of the hermit saint John is meant to remind the viewer about the importance of spiritual matters over worldly possessions, no matter how delightful or innocent the latter may be.

VERMEER. In the genre scenes of Jan Vermeer (1632– 1675), by contrast, there is hardly any narrative. Single figures, usually women, are seemingly engaged in simple, everyday tasks (see fig. 23). They exist in a timeless "still life" world, as if calmed by some magic spell. When there are two, as in The Letter (fig. 789), they do no more than exchange glances. The painting nonetheless does tell a story, but with unmatched subtlety. The carefully "staged" entrance serves to establish our relation to the scene. We are more than privileged bystanders:

we become the bearer of the letter that has just been delivered to the young woman. Dressed in sumptuous clothing, she has been playing the lute, as if awaiting our visit. This instrument, laden with erotic meaning, traditionally signifies the harmony between lovers, who play each other's heart strings. Are we, then, her lover? The amused expression of the maid suggests just such an anecdotal interest. Moreover, the lover in Dutch art and literature is often compared to a ship at sea, whose calm waters depicted in the painting here indicate smooth sailing. As usual with Vermeer, however, the picture refuses to yield a final answer, since the artist has concentrated on the moment before the letter is opened.

Vermeer's real interest centers on the role of light in creating the visible world. The cool, clear daylight that filters in from the left is the only active element, working its miracles upon all the objects in its path. As we look at *The Letter*, we feel as if a veil had been pulled from our eyes, for the everyday world shines with jewellike freshness, beautiful as we have never seen it before. No painter since Jan van Eyck *saw* as in-

tensely as this. But Vermeer, unlike his predecessors, perceives reality as a mosaic of colored surfaces—or perhaps more accurately, he translates reality into a mosaic as he puts it on canvas. We see *The Letter* not only as a perspective "window," but as a plane, a "field" composed of smaller fields. Rectangles predominate, carefully aligned with the picture surface, and there are no "holes," no undefined empty spaces. Only Pieter de Hooch (1629–1684), his contemporary in Delft, had such a feel for visual order (see fig. 14).

The interlocking shapes give to Vermeer's work a uniquely modern quality within seventeenth-century art. How did he acquire it? Despite the discovery of considerable documentary evidence relating to his life, we still know very little about his training. Some of his works show the influence of Carel Fabritius (1622–1654), the most brilliant of Rembrandt's pupils; other pictures suggest his contact with the Utrecht School. But none of these sources really explains the genesis of his style, so daringly original that his genius was not recognized until about a century ago.

CHAPTER EIGHT

THE BAROQUE IN FRANCE AND ENGLAND

FRANCE: THE AGE OF VERSAILLES

Under Henry IV (1553–1610), Louis XIII (1601–1643), and Louis XIV (1638–1715), France became the most powerful nation of Europe, militarily and culturally. In this they were aided by a succession of extremely able ministers and advisers: the Duc de Sully, Cardinal Richelieu, Cardinal Mazarin, and Jean-Baptiste Colbert. By the late seventeenth century, Paris was vying with Rome as the world capital of the major and minor arts, a position the Holy City had held for centuries. How did this change come about? Because of the Palace of Versailles and other vast projects glorifying the king of France, we are tempted to think of French art in the age of Louis XIV as the expression—and one of the products—of absolutism. This is true of the climactic phase of Louis' reign, 1660–85, but by that time seventeenth-century French art had already attained its distinctive style.

The French are reluctant to call this manner Baroque. To them, it is the Style of Louis XIV. Often they also describe the art and literature of the period as "classic." In this context, the word has three meanings. It is first of all a synonym for "highest achievement," which implies that the Style of Louis XIV corresponds to the High Renaissance in Italy or the age of Pericles in ancient Greece. The term also refers to the emulation of the form and subject matter of classical antiquity. Finally, "classic" suggests qualities of balance and restraint, shared by ancient art and the Renaissance. The second and third of these meanings describe what could more accurately be called "classicism." Since the Style of Louis XIV reflects Italian Baroque art, however modified, we may label it "Baroque classicism."

This classicism was the official court style between 1660 and 1685, but its origin was primarily artistic, not political. Sixteenth-century architecture in France, and to a lesser extent sculpture, were more intimately linked with the Italian Renaissance than in any other Northern country, although painting

continued to be governed by the Mannerist style of the later school of Fontainebleau until after 1600 (see page 496). Classicism was also nourished by French humanism, with its intellectual heritage of reason and Stoic virtue, which reflected the values of the middle-class who dominated cultural and political life. These factors retarded the spread of the Baroque in France and modified its interpretation. Rubens' Medici cycle (see fig. 763), for example, had no effect on French art until the very end of the century. In the 1620s, when he painted it, the young artists in France were still assimilating the Early Baroque.

Printmaking

CALLOT. An important transitional figure among these neglected masters was Jacques Callot (1592/3-1635), an etcher and engraver whose work was of importance for both Georges de La Tour and the young Rembrandt. Much of his early career was spent at the court of Cosimo II de' Medici in Florence, where he mainly executed prints dealing with the theater, especially the commedia dell'arte (see box page 569). After he returned in 1621 to his native town of Nancy, his work underwent a profound change. His prints now alternate between apocalyptic intensity, which allies him directly with Hieronymus Bosch, and astonishing directness, which draws close to the spirit of Pieter Bruegel the Elder, yet he belongs fully to his own time. Thus, Callot's work looks as much to past tradition as it does to the art of the present. These qualities merge in Great Miseries of War, which appeared in 1633, the year Richelieu conquered Nancy. This series of etchings represents a distillation of Callot's experience of the Thirty Years' War, but it also has a moralizing purpose. Hangman's Tree (fig. 790) depicts soldiers paying for their crimes. "Finally

790. Jacques Callot. Hangman's Tree, from Great Miseries of War. 1633. Etching, 31/2 x 9" (9 x 23 cm). The British Museum, London

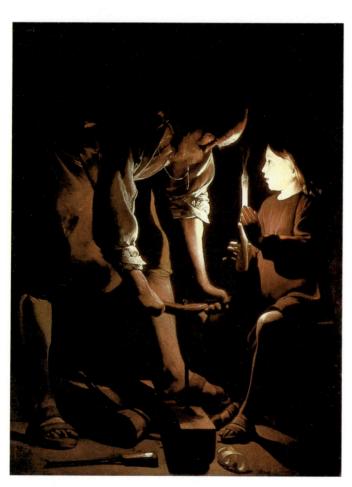

791. Georges de La Tour. *Joseph the Carpenter*. c. 1645. Oil on canvas, $51^{1}/8 \times 39^{3}/4$ " (130 x 100 cm). Musée du Louvre, Paris

these thieves, sordid and forlorn, hanging like unfortunate pieces of fruit from this tree," so the inscription tells us, "experience the justice of Heaven sooner or later." The style remains Mannerist, except in the group to the right, which participates in the same naturalism as the Le Nains'. Callot's unflinching portrayal makes this stark scene far grimmer than Bosch's vision of Hell in *The Garden of Delights* (see fig. 684). The plate has a striking immediacy, gained from the artist's experience of the theater, that in turn anticipates the vividness of Goya's imagery (see fig. 864).

Painting

DE LA TOUR. Many early French Baroque painters were influenced by Caravaggio, although how they absorbed his style is far from clear. They were for the most part minor artists toiling in the provinces, but a few developed highly original styles. The finest of them was Georges de La Tour (1593–1652), whose importance was recognized only 200 years later. Although he spent his career in Lorraine in northeast France, he was by no means a simple provincial artist. In addition to being named a painter to the king, De La Tour received important commissions from the governor of Lorraine. He began his career painting picturesque figures in the tradition of Callot, then turned to elaborate stock scenes from contemporary theater derived largely from Caravaggio's Northern followers.

Although the latter are well painted, De La Tour would arouse no more than passing interest were it not for his mature religious pictures, which possess both seriousness and grandeur. *Joseph the Carpenter* (fig. 791) might be mistaken for a genre scene, but its devotional spirit has the power of Caravaggio's *Calling of St. Matthew* (see fig. 726). De La Tour's

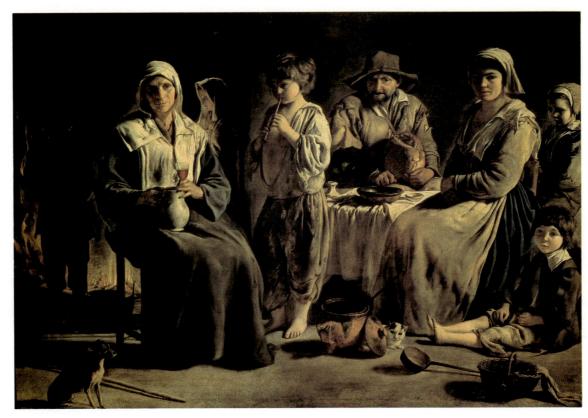

792. Louis Le Nain. Peasant Family. c. 1640. Oil on canvas, 441/2 x 621/2" (113 x 158.7 cm). Musée du Louvre, Paris

intensity of vision lends each gesture, each expression, its maximum significance within this spellbinding composition. The boy Jesus holds a candle, a favorite device with this artist, which lights the scene with an intimacy and tenderness reminiscent of the *Nativity* by Geertgen tot Sint Jans (fig. 683). De La Tour also shares Geertgen's tendency to reduce forms to a geometric simplicity that elevates them above the everyday world, despite their apparent realism.

THE LE NAINS. Like Georges de La Tour, the three Le Nain brothers—Antoine, Louis, and Mathieu—were rediscovered in modern times, but they did not have to wait quite so long. Although their birth dates are not known, all must have been born in Laon during the first decade of the century. By 1629 they were in Paris, where the eldest two died of the plague in 1648. Despite the fact that they shared the same style, signed their pictures simply "Le Nain," and worked on paintings together, each had a distinctive personality. Antoine was a miniaturist at heart, Louis the most severe, and Mathieu the most robust. Louis' Peasant Family (fig. 792) nevertheless exemplifies their "family" style and its virtues. Like the peasant scenes of seventeenth-century Holland and Flanders, with which it has much in common, the picture stems from a tradition going back to Pieter Bruegel the Elder (see fig. 717). But whereas the Netherlandish scenes of lowlife are often humorous or satirical (see fig. 773), Le Nain endows them with a human dignity and monumental weight that recall Velázquez' *Water Carrier of Seville* (see fig. 757).

POUSSIN. Why were these artists forgotten so quickly? The reason is simply that after the 1640s, classicism was supreme

in France. The clarity, balance, and restraint of their art, when measured against other Caravaggesque painters, might be termed "classical," but neither was a "classicist." The artist who did the most to bring the rise of classicism about was Nicolas Poussin (1593/4–1665). The greatest French painter of the century and the first French painter in history to win international fame, Poussin nevertheless spent almost his entire career in Rome. There, under the influence of Raphael, he formulated the style that was to become the ideal model for French painters of the second half of the century.

Poussin was initially inspired by Titian's warm, rich colors and by his approach to classical mythology. In *Cephalus and Aurora* (fig. 793) Poussin visualizes the ancient past as a poetic dream world, although the unalloyed bliss of Titian's *Bacchanal* (fig. 632) is now overcast with melancholy. Like many other early subjects by Poussin, this is a tale of frustrated love drawn from the Roman poet Ovid's *Metamorphoses*, a favorite source for Baroque artists (see also fig. 20), although the picture characteristically departs from the text. Aurora, the goddess of dawn, tries to embrace the mortal Cephalus, who spurns her love out of faithfulness to his wife, Procris. Cephalus' fidelity is shown by the charming device of a putto holding up a portrait of Procris to his gaze. The sleeping river-god to the left signifies night, as the sun-god Apollo waits by his chariot in the background for daybreak (see also fig. 734).

By contrast, *The Abduction of the Sabine Women* (fig. 794) must be seen altogether differently. It, too, shows his profound allegiance to antiquity, but in style and attitude the two works are much farther apart than the seven years' difference in date would suggest. *The Abduction of the Sabine Women* epitomizes the severe discipline of Poussin's intellectual style, which

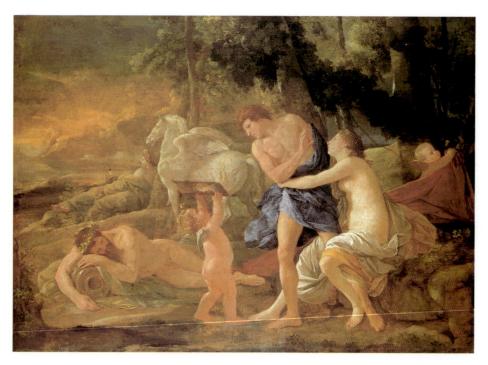

793. Nicolas Poussin. Cephalus and Aurora. c. 1630. Oil on canvas, 38 x 51" (96.7 x 129.7 cm). The National Gallery, London Reproduced by courtesy of the Trustees

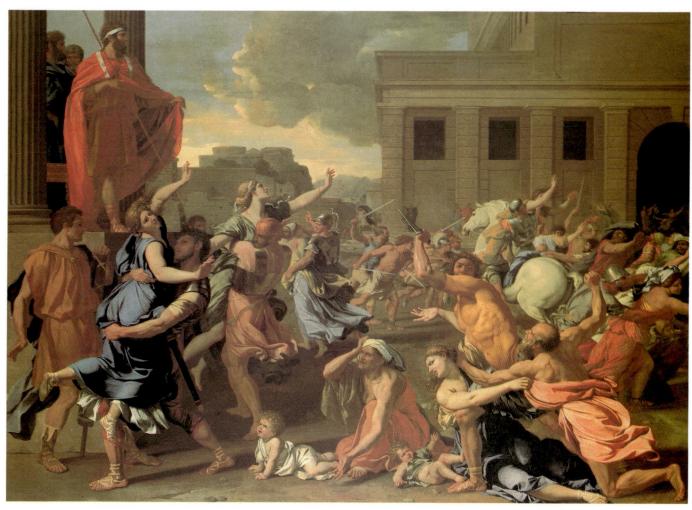

794. Nicolas Poussin. The Abduction of the Sabine Women. c. 1636-37. Oil on canvas, 5'7/8" x 6'105/8" (1.54 x 2.09 m). The Metropolitan Museum of Art, New York Harris Brisbane Dick Fund, 1946

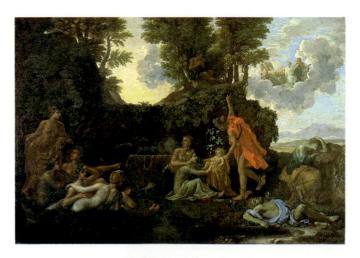

795. Nicolas Poussin. The Birth of Bacchus. c. 1657. Oil on canvas, 48¹/₄ x 70¹/₂" (122.6 x 179.1 cm). Fogg Art Museum, Harvard University Art Museums, Cambridge, Massachusetts Gift of Mrs. Samuel Sachs in memory of her husband

developed in response to what he regarded as the excesses of the High Baroque (see page 558). The strongly modeled figures are "frozen in action" like statues; many are, in fact, derived from Hellenistic sculpture. Poussin has placed them before reconstructions of Roman architecture that he believed to be archaeologically correct. The composition has an air of theatricality, and with good reason. It was worked out by moving clay figurines around a miniature stagelike setting until it looked right to the artist. Emotion is abundantly displayed, but it is so lacking in spontaneity that it fails to touch us. The attitude reflected here is clearly Raphael's (see figs. 626 and 627). More precisely, it is Raphael as filtered through Annibale Carracci and his school (compare figs. 729 and 734). The Venetian qualities that asserted themselves early in his career have been consciously suppressed.

Poussin now strikes us as an artist who knew his own mind only too well, an impression confirmed by the numerous letters in which he expounded his views to friends and patrons. The highest aim of painting, he believed, is to represent noble and serious human actions. This is true even in *The Abduction* of the Sabine Women, which, ironically, was admired as an act of patriotism that insured the future of Rome. (According to the accounts of Livy and Plutarch, the Sabines otherwise escaped unharmed, and the young women abducted as wives by the Romans later became peacemakers between the two sides.) Be that as it may, such actions must be shown in a logical and orderly way—not as they really happened, but as they would have happened if nature were perfect. To this end, art must strive for the general and typical. In appealing to the mind rather than the senses, the painter should suppress such incidentals as color, and stress form and composition. In a good picture, the beholder must be able to "read" the exact emotions of each figure and relate them to the story. [See Primary Sources, no. 72, page 641.] These ideas were not new. We recall Horace's dictum ut pictura poesis and Leonardo's statement that the highest aim of painting is to depict "the intention of man's soul" (see pages 408 and 456). Before

Poussin, however, no one made the analogy between painting and literature so close, nor put it into practice so single-mindedly. His method accounts for the cold and over-explicit rhetoric in *The Abduction of the Sabine Women*, which makes the picture seem so remote, much as we may admire its rigor.

Poussin also painted "ideal" landscapes according to this theoretical view, with surprisingly impressive results, for they have an austere beauty and somber calm. This severe rationalism lasted until about 1650, when he began to paint a series of landscapes that return to the realm of mythology he had abandoned in middle age. They unite the Titianesque style of his early work with his later, Raphaelesque classicism to produce a new kind of mythological landscape, close in spirit to Claude Lorraine's (see below) but rich in personal associations that lend them multiple levels of meaning. Indeed, the artist's late ruminations have rightly been called transcendental meditations, for they contain archetypal imagery of universal significance. The Birth of Bacchus (fig. 795), among his most profound statements, takes up the great Stoic theme (which Poussin had treated twice already as a young man) that death is to be found even in the happiest realm. The painting shows the moment when the infant, created by Jupiter's union with Semele, the moon-goddess, and born from his thigh, is delivered for safe-keeping by Mercury to the river-goddess Dirce, while the satyr Pan plays the flute in rapt inspiration. (Jupiter himself had been raised by sylvan deities.)

The picture is not beautifully executed. The act of painting became difficult for the artist in old age, so that the brushwork is shaky. He nevertheless turned this liability to his advantage, and *The Birth of Bacchus* represents the purest realization of expressive intent in painted form. It is full of serene lyricism conveying the joy of life on the one hand, and dark forebodings of death on the other: to the right, the nymph Echo weeps over the dead Narcissus, the beautiful youth who spurned her love and instead drowned kissing his reflection. Like Cephalus and Aurora, the story of Echo and Narcissus is taken from Ovid, but now it is the meaning, not the narrative, that interests Poussin. He treats it as part of the eternal cycle of nature, in which the gods embody natural forces and the myths contain fundamental truths. Although he certainly drew on the pantheistic writings of Tommaso Campanella and the learned commentaries of the Stoic Natale Conti, it is the artist's personal synthesis that brings these ideas to life.

CLAUDE LORRAINE. If Poussin developed the heroic qualities of the ideal landscape, the great French landscapist Claude Lorraine (1600–1682) brought out its idyllic aspects. He, too, spent almost his entire career in Rome. Like many Northerners, Claude explored the surrounding countryside, the Campagna, more thoroughly and affectionately than any Italian. Countless drawings made on the spot bear witness to his extraordinary powers of observation. He is also documented as having sketched in oils outdoors, the first artist known to have done so. Sketches, however, were only the raw material for his paintings, which do not aim at topographic exactitude but evoke the poetic essence of a countryside filled with echoes of antiquity. Often, as in *A Pastoral Landscape* (fig. 796), the compositions are suffused with the hazy, luminous atmosphere of early morning or late afternoon. The space

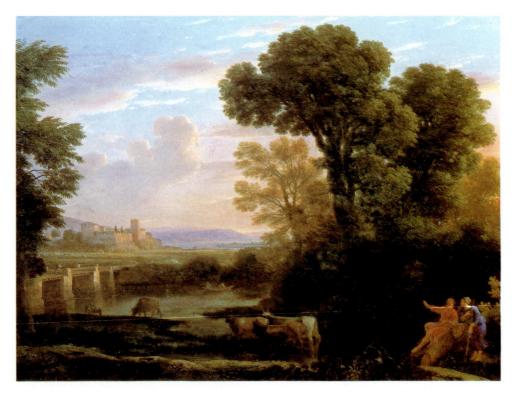

796. Claude Lorraine. *A Pastoral Landscape.* c. 1650. Oil on copper, 15¹/₂ x 21" (39.3 x 53.3 cm). Yale University Art Gallery, New Haven, Connecticut

Leo C. Hanna, Jr., Fund

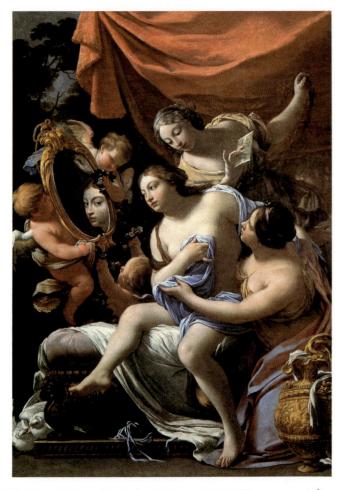

797. Simon Vouet. *The Toilet of Venus.* c. 1640. Oil on canvas, 65 \(^1/4\) x 45" (165.7 x 114.3 cm). The Carnegie Museum of Art, Pittsburgh Gift of Mrs. Horace Binney Hare

expands serenely, rather than receding step-by-step as in Poussin's landscapes. An air of nostalgia hangs over such vistas, of past experience gilded by memory. Hence they appealed especially to the English who had seen Italy only briefly or even not at all.

VOUET. At an early age Simon Vouet (1590–1649), too, went to Rome, where he became the leader of the French Caravaggesque painters; but unlike Poussin and Claude, he returned to France. Upon settling in Paris, he quickly shed all vestiges of Caravaggio's manner and formulated a colorful style based on Carracci's which won such acclaim that Vouet was named First Painter to the king. He also brought with him memories of the great North Italian precursors of the Baroque. *The Toilet of Venus* (fig. 797) depicts a subject popular in Venice from Titian to Veronese. Vouet's figure looks back as well to Correggio's Io (see fig. 655), but without her frank eroticism. Instead, she has been given an elegant sensuousness that could hardly be further removed from Poussin's disciplined art.

Ironically, *The Toilet of Venus* was painted about 1640, toward the beginning of Poussin's ill-fated sojourn in Paris, where he had gone at the invitation of Louis XIII. He met with no more success than Bernini was to have 20 years later (see page 606). After several years Poussin left, deeply disillusioned by his experience at the court, whose taste and politics Vouet understood far better. In one sense, their rivalry was to continue long afterward. Vouet's decorative manner provided the foundation for the Rococo, but it was Poussin's classicism that soon dominated art in France. The two traditions vied with each other through the Romantic era, alternating in succession without gaining the upper hand for long.

Baroque Theater and Music in France

The central fact of French culture in the seventeenth century was

the taste for classicism, which had been established 50 years earlier. The Pléiade, a group of poets led by Pierre de Ronsard (1524-1585), was founded in 1550 to develop French literature along the lines of Greek and Roman poetry and plays, which had been published and studied since early in the century. Around the same time, court festivals became popular, as did intermezzi (also called ballets de cour), which combined song, dance, drama, and spectacle in the "antique" manner. Public theater was monopolized by the Confrérie de la Passion (Confraternity of the Passion), which was given control over secular drama. (Religious plays were banned in 1548.) These three factors—classical taste, antiquarianism, and court patronage—decisively shaped French theater and music. The preference for classicism and humanism was reinforced during the regency of Henry II's Italian queen, Catherine de' Medici (1560-74). However, the development of the arts was disrupted by the Wars of Religion between Catholics and Protestants that broke out in 1562. Hostilities continued until the Protestants were defeated in 1629 by the soldiers of Louis XIII under the direction of prime minister Cardinal Richelieu (1585-1642).

The end of the Wars of Religion placed Richelieu in a position of immense power. A highly cultivated man, he now turned his attention not only to governing France, but also to patronage of the arts. In 1629, the same year that the Protestants were defeated, the French Academy, a small group of intellectuals, began to meet informally to discuss literature. At Cardinal Richelieu's behest, it became a state institution based on Italian models in 1636. The Academy required that theater teach moral lessons and adhere to the Italian concept of verisimilitude (see page 487). This was the first of a number of French academies that would be founded during the course of the seventeenth century to foster painting and sculpture, music, architecture, and even dance. These state-controlled academies oversaw the training of young artists and were responsible for awarding royal commissions. As time went on, the academies became increasingly authoritarian, eventually exercising rigid control over all of the arts.

The first important French dramatist was Alexandre Hardy (c. 1572–1632), a prolific playwright who wrote some 700 tragicomedies (plays of serious subject that end happily) and pastoral plays for the Hôtel de Bourgogne, the only permanent playhouse in Paris before the end of the wars in 1629. Otherwise, plays were performed on tennis courts (*jeux de paume*), with a platform erected as a stage. In 1640 Cardinal Richelieu had a theater erected at his palace, the

first in France to feature a proscenium (the arch separating the

stage from the auditorium), an innovation from Italy that was soon to become standard throughout Europe. Richelieu took a particular interest in drama and personally employed five playwrights to work under his supervision. The only one to achieve lasting fame was Pierre Corneille (1606–1684), whose tragedies, drawn from ancient history and mythology, center on the hero who chooses death over dishonor. They are written in the ornate, emotional language that defined French classical drama before 1650. Yet when Corneille submitted *Le Cid* to the Academy for review the year it was founded, the play met with such harsh criticism that he stopped writing for four years. Corneille's younger brother, Thomas (1625–1709), was also a noted playwright whose finest works date from the 1670s.

French drama reached its zenith in the plays of Jean Racine (1639–1699), whose tragedies in the Greek manner revolved around the conflict of desire and duty, expressed in direct, simple language that quickly replaced the elaborate language of Pierre Corneille. Racine's plays embody the theories of Nicolas Boileau-Despréaux (1636-1711), who championed the three unities of action, time, and place, and decorum in speech, manner, and moral behavior. Early in his career Racine had been befriended by Molière (Jean-Baptiste Poquelin, 1622–1673), whose plays marked the high tide of French comedy. The Misanthrope (1666) and Tartuffe (1664), influenced by the commedia dell'arte which enjoyed great success in France, are masterpieces of cynical wit written in the twelve-syllable Alexandrine couplets that had become the standard verse form of French theater. The Comédie Français, formed by royal decree in 1680 from Molière's troupe and that of the rival Hôtel Bourgogne, was granted a monopoly on all dramas in French, with the sole exception of the commedia dell'arte (see page 569), which was eventually banned in 1697 for an imagined slight of the king's mistress.

Cardinal Mazarin, Richelieu's successor who was an Italian by birth, had an abiding love of opera, which he actively promoted. Soon after taking the reins of full power upon Mazarin's death in 1661, Louis XIV began construction of a new palace at Versailles, outside Paris, where the aristocracy would be forced to live following the disastrous Fronde rebellion of 1648–52. Even before the palace was completed in 1682 Louis staged huge spectacles, such as *The Pleasure of the Enchanted Land* (1664), an allegory of his reign. The arts during the age of Louis XIV were meant to glorify the king, and classicism had an essential role to play. Classicism was favored not only because of its learned humanism and

THE ROYAL ACADEMY. When young Louis XIV took over the reins of government in 1661, Jean-Baptiste Colbert, his chief adviser, built the administrative apparatus to support the power of the absolute monarch. In this system, aimed at subjecting the thoughts and actions of the entire nation to strict control from above, the visual arts had the task of glorifying the king. As in music and theater, which shared the same task, the official "royal style" was classicism in both theory and

practice. Centralized control over the visual arts was exerted by Colbert and the artist Charles Lebrun (1619–1690), who became supervisor of all the king's artistic projects. As chief dispenser of royal art patronage, Lebrun commanded so much power that for all practical purposes he was the dictator of the arts in France. This authority extended beyond the power of the purse. It also included a new system of educating artists in the officially approved style.

elevated moral tone, but also because it suggested that France was the successor to Greece and Rome. In the debates after 1688 known as the Battle of the Ancients and the Moderns, French academicians even sought to show the supremacy of French culture by using it to replace antiquity as the new standard.

Louis XIV appeared regularly in ballets during the 1650s, when they became great spectacles. Thereafter he continued to enjoy ballets and operas by his court composer and dancing master, Jean-Baptiste Lully (1632-1687). Lully had initially collaborated with Molière on comic ballets for the court, but the two ceased to work together in 1672 because of Lully's unscrupulous practices. Lully then forged a partnership with the playwright Philippe Quinault (1635-1688) that lasted a decade, from Atys (1676) through Armide (1686), based on Torquato Tasso's Jerusalem Freed. Their work, which emphasized the unity between text and music, was comparable in character to the tragedies of Corneille and Racine. Because he clung to the Florence camerata's ideal of emphatic declamation (see page 558), Lully composed music of measured and stately simplicity. He also introduced additional choruses and ballets to the opera, which lent the performances a greater pageantry that benefited greatly from the costumes designed by Jean Bérain (1637–1711). The results were sober and pompous, but also colorful—perfectly suited to life at Versailles. Lully occupied a position in French music comparable to that of Charles Lebrun in the arts. He was instrumental in founding the Royal Academy of Dancing upon the king's retirement from active participation in ballets in 1661. In 1672, Lully merged the academies of music and dance to create the forerunner of the Opéra, the national opera company of France.

Lully was by far the most powerful force in French Baroque music. His only rival was Marc-Antoine Charpentier (1634–1704), a student of Carissimi, who as music director to the Jesuit order in Paris became the greatest French composer of religious music. Charpentier's secular music was also of high quality, particularly the opera *The Imaginary Illness* (1673), written with Molière after the latter had broken with Lully. The other major figure was the much younger François Couperin (1668–1733), organist to the king at Versailles, whose harpsichord and orchestral suites are notable for their lively invention. As a composer he straddled two eras: his most important compositions were written during the reign of Louis XV, although his music remained Late Baroque in style.

Throughout antiquity and the Middle Ages, artists had been trained by apprenticeship, and this time-honored practice still prevailed in the Renaissance. As painting, sculpture, and architecture gained the status of liberal arts, artists wished to supplement their "mechanical" training with theoretical knowledge. For this purpose, "art academies" were founded, patterned on the academies of the humanists. (The name academy is derived from the Athenian grove where Plato met

798. François Mansart. Vestibule of the Château of Maisons. 1642–50

with his disciples.) Art academies appeared first in Italy in the later sixteenth century as an outgrowth of literary academies. They seem to have been private associations of artists who met periodically to draw from the model and discuss questions of art theory. These academies later became formal institutions that took over some functions from the guilds, but their teaching was limited and far from systematic.

This was the case as well with the Royal Academy of Painting and Sculpture in Paris, founded in 1648. But when Lebrun became its director in 1663, he established a rigid curriculum of compulsory instruction in practice and theory, based on a system of "rules." This set the pattern for all later academies, including their successors, the art schools of today. Much of this doctrine was derived from Poussin, under whom Lebrun had spent several years studying in Rome, but it was carried to rationalistic extremes. The Academy even devised a method for tabulating, in numerical grades, the merits of artists past and present in such categories as drawing, expression, and proportion. The ancients received the highest marks, needless to say, then came Raphael and his school, and Poussin. The Venetians, who "overemphasized" color, ranked low, the Flemish and Dutch even lower. Subjects were similarly classified, from "history" (that is, narrative subjects, be they classical, biblical, or mythological) at the top to still life at the bottom.

Architecture

MANSART. Meanwhile, the foundations of Baroque classicism in architecture were laid by a group of designers whose most distinguished member was François Mansart (1598–1666). Apparently he never visited Italy, but other French architects had already imported and acclimatized some aspects of the Roman Early Baroque, especially in church design, so that Mansart was not unfamiliar with the new Italian style. What he owed to it, however, is hard to determine. His most important buildings are châteaux, and in this field the French Renaissance tradition outweighed any direct Italian Baroque influences. The Château of Maisons near Paris, built for a newly risen administrative official, shows Mansart's mature style at its best. The vestibule leading to the grand staircase (fig. 798) has a particularly beautiful effect, severe yet festive.

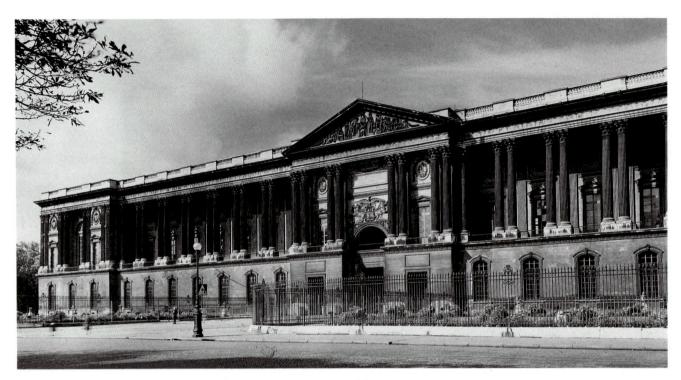

799. Claude Perrault. East Front of the Louvre, Paris. 1667-70

On seeing the classically pure articulation of the walls, one first thinks of Palladio (see page 501), whose treatise Mansart certainly knew and admired. But sculpture is used here in the characteristically French way as an integral part of architectural design. The complex curves of the vaulting further inform us that this structure, for all its classicism, belongs to the Baroque.

LOUIS XIV, COLBERT, AND THE LOUVRE. Mansart died too soon to have a share in the climactic phase of Baroque classicism. It began with the first great project Colbert directed, the completion of the Louvre. Work on the palace had proceeded intermittently for over a century, along the lines of Lescot's design (see fig. 722). What remained to be done was to close the square court on the east side with an impressive facade. Colbert, dissatisfied with the proposals of French architects, invited Bernini to Paris in the hope that the most famous master of the Roman Baroque would do for the French king what he had already done so magnificently for the Church. Bernini spent several months in Paris in 1665 and submitted three designs, all of them on a scale that would have completely engulfed the existing palace. After much argument and intrigue, Louis XIV rejected these plans and turned over the problem of a final solution to a committee of three: Charles Lebrun, his court painter; Louis Le Vau (1612–1670), his court architect, who had worked on the project before; and Claude Perrault (1613-1688), who was a student of ancient architecture, not a professional architect. All three were responsible for the structure that was actually built (fig. 799), although Perrault is usually credited with the major share. [See Primary Sources, no. 73, page 641.]

The design in some ways suggests the mind of an archaeologist, but one who knew how to select those features of classical architecture that would link Louis XIV with the glory of the Caesars and still be compatible with the older parts of the palace. The center pavilion is a Roman temple front, and the wings look like the flanks of that temple folded outward. The temple theme demanded a single order of free-standing columns, but the Louvre had three stories. This difficulty was skillfully resolved by treating the ground story as the podium of the temple and recessing the upper two behind the screen of the colonnade. The entire design combines grandeur and elegance in a way that fully justifies its fame. The East Front of the Louvre signaled the victory of French classicism over Italian Baroque as the royal style. Ironically, this great example proved too pure, and Perrault soon faded from favor.

PALACE OF VERSAILLES. The king's largest enterprise was the Palace of Versailles, located 11 miles from the center of Paris. It was begun in 1669 by Le Vau, who designed the elevation of the Garden Front (fig. 800) but died within a year. Under Jules Hardouin-Mansart (1646–1708), a great-nephew of François Mansart, the entire project was greatly expanded to accommodate the ever-growing royal household. The Garden Front, intended by Le Vau to be the main view of the palace, was stretched to an enormous length with no modification of the architectural membering, so that his original facade design, a less severe variant of the East Front of the Louvre, now looks repetitious and out of scale. The whole center block contains a single room, the famous Galerie des Glaces (Hall of Mirrors, fig. 801), with the Salon de la Guerre (War) and its counterpart, the Salon de la Paix (Peace), at either end.

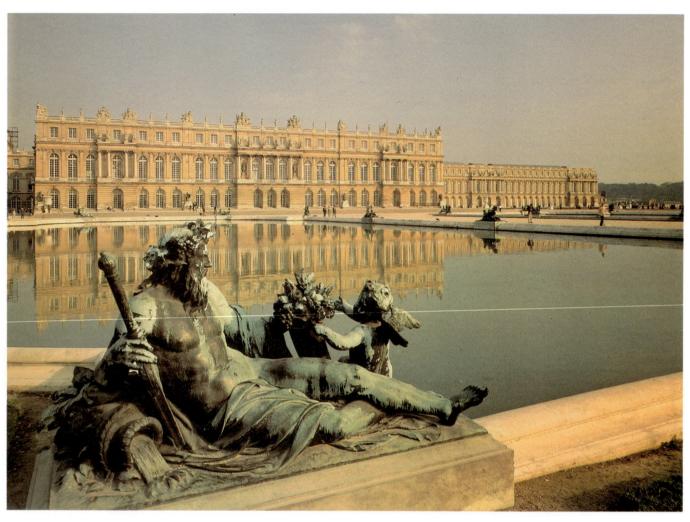

800. Louis Le Vau and Jules Hardouin-Mansart. Garden Front of the center block of the Palace of Versailles. 1669–85

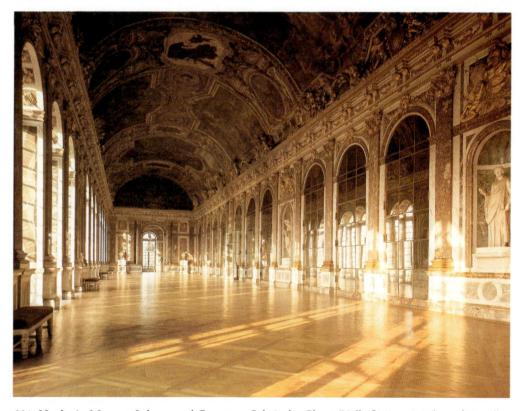

801. Hardouin-Mansart, Lebrun, and Coysevox. Galerie des Glaces (Hall of Mirrors), Palace of Versailles

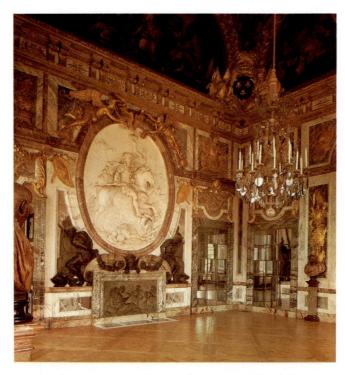

802. Hardouin-Mansart, Lebrun, and Coysevox. Salon de la Guerre, Palace of Versailles. Begun 1678

Baroque features, although not officially acknowledged, reappeared inside the Palace of Versailles. This shift corresponded to the king's own taste. Louis XIV was interested less in architectural theory and monumental exteriors than in the lavish interiors that would make suitable settings for himself and his court. Thus the man to whom he really listened was not an architect, but the painter Lebrun. Lebrun's goal was in itself Baroque: to subordinate all the arts to the glorification of Louis XIV. To accomplish it, he drew freely on his memories of Rome; the great decorative schemes of the Baroque that he saw there must also have impressed him, for they stood him in good stead 20 years later, both in the Louvre and at Versailles. Although a disciple of Poussin, he had studied first with Vouet, and became a superb decorator, utilizing the combined labors of architects, sculptors, painters, and artisans for ensembles of unheard-of splendor. The Salon de la Guerre at Versailles (fig. 802) is closer in many ways to the Cornaro Chapel than to the vestibule at Maisons (compare figs. 754 and 798). If Lebrun's ensemble is less adventurous than Bernini's, he has emphasized surface decoration just as much. And, as in so many Italian Baroque interiors, the separate ingredients are less impressive than the effect of the whole.

GARDENS OF VERSAILLES. Apart from the magnificent interior, the most impressive aspect of Versailles is the park extending west of the Garden Front for several miles (fig. 803). Its design, by André Le Nôtre (1613–1700), is so strictly correlated with the plan of the palace that it becomes a continuation of the architectural space. Like the interiors, these formal gardens, with their terraces, basins, clipped hedges, and statuary, were meant to provide an appropriate setting for the king's appearances in public. They form a series of "outdoor rooms" for the splendid fêtes and spectacles that Louis XIV so

enjoyed. The spirit of absolutism is even more striking in this geometric regularity imposed upon an entire countryside than it is in the palace itself.

HARDOUIN-MANSART. At Versailles, Jules Hardouin-Mansart worked as a member of a team, constrained by the design of Le Vau. His own architectural style can be better seen in the Church of the Invalides (figs. 804 and 805), named after the institution for disabled soldiers of which it formed one part. The building presents a combination of Italian Renaissance and Baroque features, but reinterpreted in a distinctly French manner. The plan, consisting of a Greek cross with four corner chapels, is based ultimately (with various French intermediaries) on Michelangelo's plan for St. Peter's (see fig. 623); its only Baroque element is the oval choir. The dome, too, reflects the influence of Michelangelo (figs. 622 and 624), and the classicistic vocabulary of the facade is reminiscent of the East Front of the Louvre, but the exterior as a whole is unmistakably Baroque. It breaks forward repeatedly in the crescendo effect introduced by Maderno (see fig. 739). And, as in Borromini's S. Agnese in Piazza Navona (see fig. 746), the facade and dome are closely correlated. The dome itself is the most original, and the most Baroque, feature of Hardouin-Mansart's design. Tall and slender, it rises in one continuous curve from the base of the drum to the spire atop the lantern. On the first drum rests, surprisingly, a second, narrower drum. Its windows provide light for the painted vision of heavenly glory inside the dome, but they themselves are hidden behind a "pseudo-shell" with a large opening at the top, so that the heavenly glory seems mysteriously illuminated and suspended in space. "Theatrical" lighting so boldly directed would do honor to any Italian Baroque architect.

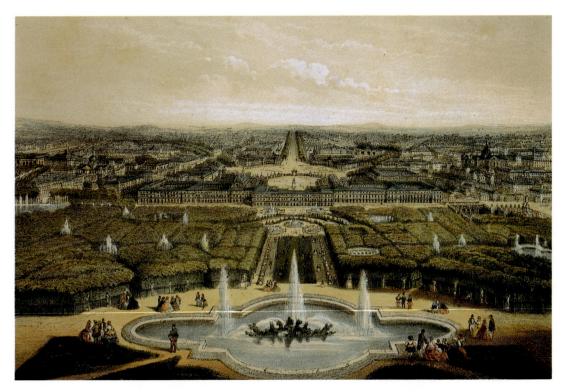

803. Charles Rivière. Perspective View of the Château and Gardens of Versailles. Lithograph after an 1860 photograph

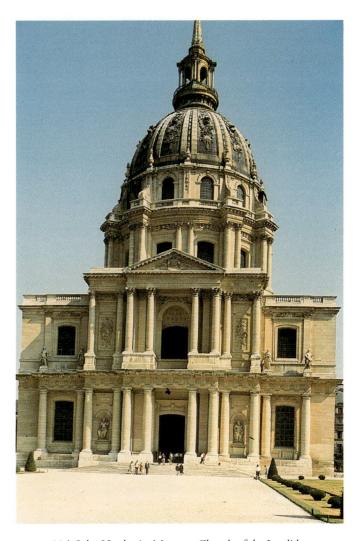

804. Jules Hardouin-Mansart. Church of the Invalides, Paris. 1680-91

805. Plan of the Church of the Invalides

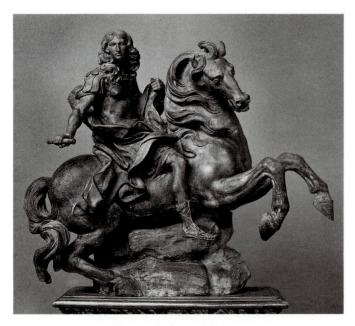

806. Gianlorenzo Bernini. *Model for Equestrian Statue of Louis XIV.* 1670. Terracotta, height 30" (76.3 cm). Galleria Borghese, Rome

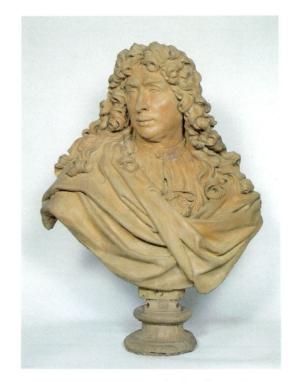

807. Antoine Coysevox. *Charles Lebrun.* 1676. Terracotta, height 26" (66 cm). The Wallace Collection, London Reproduced by permission of the Trustees

Sculpture

Sculpture arrived at the official royal style in much the same way as architecture. While in Paris, Bernini carved a marble bust of Louis XIV and was commissioned to do an equestrian statue of him. [See Primary Sources, no. 74, pages 641–42.] The latter project, for which he made a splendid terracotta model (fig. 806), shared the fate of Bernini's Louvre designs. Although he portrayed the king in classical military garb, the statue was rejected. Apparently it was too dynamic to safeguard the dignity of Louis XIV. This decision was far-reaching: equestrian statues of the king were later erected throughout France as symbols of royal authority, and Bernini's design, had it succeeded, might have set the pattern for these monuments.

COYSEVOX. Bernini's influence can nevertheless be felt in the work of Antoine Coysevox (1640–1720), one of the sculptors Lebrun employed at Versailles. The victorious Louis XIV in Coysevox's large stucco relief for the Salon de la Guerre (see fig. 802) retains the pose of Bernini's equestrian statue, albeit with a certain restraint. Coysevox is the first of a long line of distinguished French portrait sculptors. His bust of Lebrun (fig. 807) likewise repeats the general outlines of Bernini's model of Louis XIV. The face, however, shows a realism and a subtlety of characterization that are Coysevox's own.

PUGET. Coysevox approached the Baroque in sculpture as closely as Lebrun would permit. Pierre-Paul Puget (1620–1694), the most talented and most Baroque of seventeenth-century French sculptors, had no success at court until after Colbert's death, when the power of Lebrun was on the decline. *Milo of Crotona* (fig. 808), Puget's finest statue, bears comparison to Bernini's *David* (see fig. 752). Puget's composition is

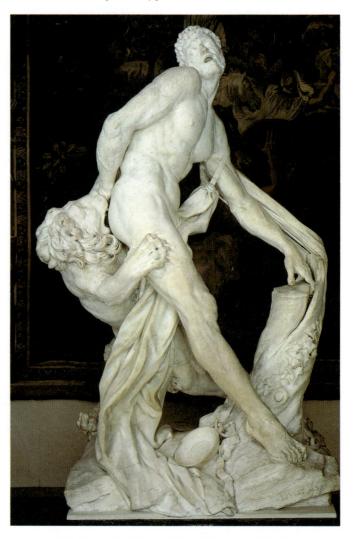

808. Pierre-Paul Puget. *Milo of Crotona*. 1671–83. Marble, height 8'10¹/2" (2.7 m). Musée du Louvre, Paris

more contained than Bernini's, but the agony of the hero has such force that its impact on the beholder is almost physical. The internal tension fills every particle of marble with an intense life that also recalls The Laocoön Group (see fig. 215). That, one suspects, is what made it acceptable to Louis XIV.

ENGLAND

The English made no significant contribution to Baroque painting and sculpture. They were content instead with feeble offshoots of Van Dyck's portraiture by imported artists like the Dutch-born Peter Lely (1618–1680) and his German successor, Godfrey Kneller (1646-1723). The English achievement in architecture, however, was of genuine importance. This is all the more surprising in light of the fact that the insular form of "Late Gothic" known as the Perpendicular style (see fig. 451) proved extraordinarily persistent.

JONES. The first English architect of genius was Inigo Jones (1573–1652), who was also the leading theatrical designer of the day. When he went to Italy about 1600 and again in 1613, he was influenced by the Baroque stage designs of Giulio Parigi; yet, surprisingly he returned a thoroughgoing disciple of Palladio (who, after all, had designed the theater of the Olympic Academy in Vicenza, one of the earliest of its kind). The Banqueting House Jones built at Whitehall Palace in London (fig. 809) to hold the masques and other entertainment he presented at the court conforms in every respect to

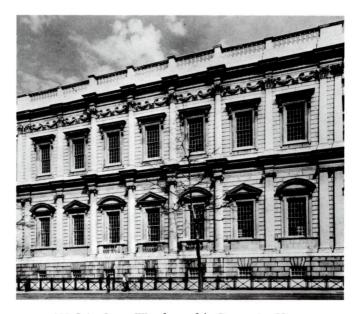

809. Inigo Jones. West front of the Banqueting House, Whitehall Palace, London. 1619-22

the principles in Palladio's treatise, yet does not copy any specific building by Palladio. Symmetrical and self-sufficient, it is, for its date, more like a Renaissance palazzo than any other building north of the Alps. Jones' spare style, supported by Palladio's authority as a theorist, stood as a beacon of classicist orthodoxy in England for 200 years.

In England, court masques adapted from Italian court pag-

eants played a similar role to the French ballets de cour in that they promoted an idealized vision of monarchy presented through allegory and myth expressed in elegant speeches, music, and dance. Many of these masques were created for James I by the playwright Ben Jonson (1572-1637) and staged by Inigo Jones, who became surveyor of the king's works in 1615. Upon the overthrow in 1642 of Charles I by the Puritans—whose religious views demanded the most austere social standards—all theaters were closed, and remained so during the Commonwealth, the Puritan period of rule led by Oliver Cromwell. Theaters were reopened only when the monarchy was restored in 1660. The Restoration, as the reign of the new king, Charles II, came to be known, was a great period of creativity for theater and music. There was an almost immediate demand for new plays, which were supplied by John Dryden (1631–1700), whose work was influenced by Shakespeare and the classical Roman authors. The later plays by Dryden and William D'Avenant (1606–1668), Jonson's successor at court, are rather stilted, moralizing tragedies about people of noble birth. Comedy fared better, while adhering to the same goal of moral instruction. The Rover: or the Banished Cavalier (1677) by Mrs. Aphra Behn (1640-1689) and The Way of the World (1700) by William Congreve (1670-1729) and John Vanbrugh (best

Baroque Theater and Music in England

known as the architect of Blenheim Palace; see fig. 813) are up-

roarious comedies of manners that reflect the cynicism—and what later critics would call the licentiousness—of the age. The Restoration marked a revolution in English theater: not only did women begin to write plays, but they also appeared on the legitimate stage for the first time. Some became sensationally successful: one, Nell Gwynn, soon retired from the stage to become Charles II's mistress.

Theater gave rise to a new class of stage music by the leading composer of the Restoration, Henry Purcell (1659-1695). During the Commonwealth, English operas were plays set to music, which managed to avoid the ban against theater because they were considered concerts. This practice continued even during the Restoration. Thus Venus and Adonis, by Henry Purcell's teacher John Blow (1649–1708), is essentially a masque in disguise. A large part of Purcell's output is theater music, such at The Fairy Queen (1692), which is a free adaptation of Shakespeare's A Midsummer Night's Dream. The closest Purcell came to opera was Dido and Aeneas (1689), which is basically a concert opera reputedly composed for a girls' boarding school but perhaps given as a court entertainment instead. Blow and Purcell also wrote numerous odes for the royal family and to celebrate other occasions, as well as many church anthems and a considerable body of chamber music and keyboard works.

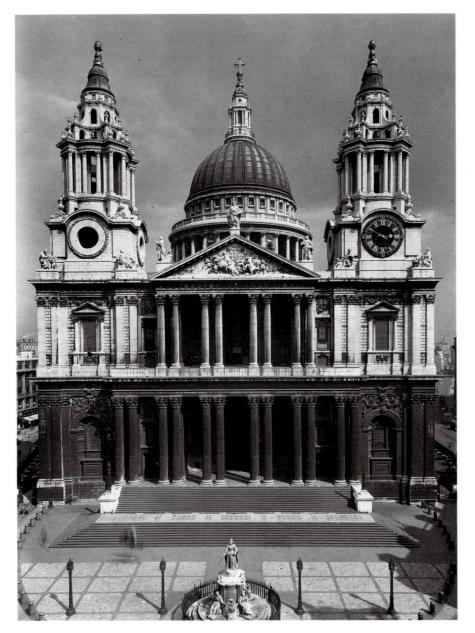

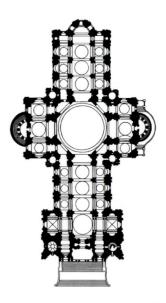

810. Sir Christopher Wren. Facade of St. Paul's Cathedral, London. 1675–1710

811. Plan of St. Paul's Cathedral

WREN. This classicism can be seen in some parts of St. Paul's Cathedral (figs. 810-12) by Sir Christopher Wren (1632-1723), the great English architect of the late seventeenth century: note the second-story windows and especially the dome, which looks like Bramante's Tempietto much enlarged (see fig. 601). St. Paul's is otherwise an up-to-date Baroque design reflecting a thorough acquaintance with contemporary architecture in Italy and France. Sir Christopher came close to being a Baroque counterpart of the Renaissance artist-scientist. An intellectual prodigy, he first studied anatomy, then physics, mathematics, and astronomy, and was highly esteemed by Sir Isaac Newton. His serious interest in architecture did not begin until he was about 30. However, it is characteristic of the Baroque as opposed to the Renaissance that there is apparently no direct link between his scientific and artistic ideas. It is hard to determine whether his technological knowledge significantly affected the shape of his buildings.

Had not the great London fire of 1666 destroyed the Gothic cathedral of St. Paul and many lesser churches, Sir Christopher might have remained an amateur architect. But following that catastrophe, he was named to the royal commission for rebuilding the city, and a few years later he began his designs for St. Paul's. [See Primary Sources, no. 75, page 642.] The tradition of Inigo Jones did not suffice for this task, beyond providing a starting point. On his only trip abroad, Sir Christopher had visited Paris at the time of the dispute over the completion of the Louvre, and he must have sided with Perrault, whose design for the East Front is clearly reflected in the facade of St. Paul's. Yet, despite his belief that Paris provided "the best school of architecture in Europe," Sir Christopher was not indifferent to the achievements of the Roman Baroque. He must have wanted the new St. Paul's to be the St. Peter's of the Church of England: soberer and not so large, but equally impressive. His dome, like that of St. Peter's, has a

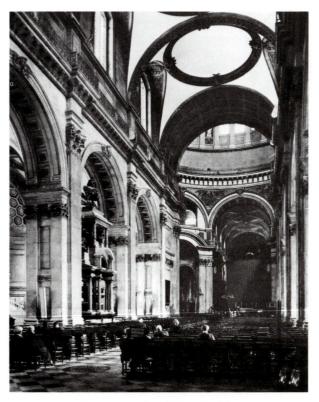

812. Interior of St. Paul's Cathedral

diameter as wide as nave and aisles combined, but it rises high above the rest of the structure and dominates even our close view of the facade. The lantern and the upper part of the clock towers also suggest that he knew Borromini's S. Agnese in Piazza Navona (see fig. 746), probably from drawings or engravings.

VANBRUGH. Italian Baroque elements are still more conspicuous in Blenheim Palace (fig. 813), the grandiose structure designed by Sir John Vanbrugh (1664-1726), a gifted amateur, with the aid of Nicholas Hawksmoore (1661-1719), Wren's most talented pupil. Vanbrugh, like Jones, had a strong interest in the theater. (He was a popular playwright.) That his kinship was even closer to Bernini can be seen when we compare the facade of Blenheim and its framing colonnade with the piazza of St. Peter's (see fig. 739). The main block uses a colossal Corinthian order to wed a temple portico with a Renaissance palace (compare fig. 621), whereas the wings rely on a low-slung Doric. Such eclecticism, extreme even by the relaxed standards of the period, is maintained throughout the welter of details. Compared to Versailles (fig. 800), the effect has a massiveness that makes Blenheim a fitting symbol of English power: it was presented by a grateful nation to the duke of Marlborough for his great victories over French and German forces in the War of Spanish Secession.

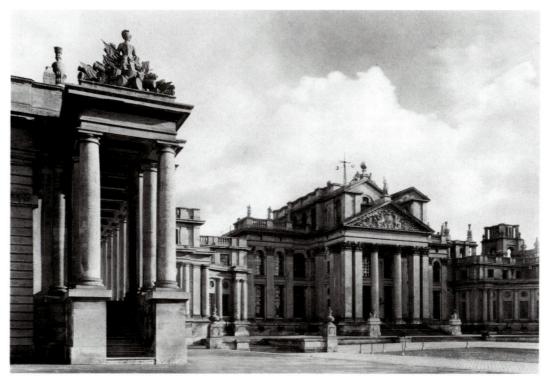

813. Sir John Vanbrugh. Blenheim Palace, Woodstock, England. Begun 1705

CHAPTER NINE

THE ROCOCO

Much as the Baroque is often considered the final phase of the Renaissance, so the Rococo has been treated as the end of the Baroque: a long twilight, delicious but decadent, that was cleaned away by the Enlightenment and Neoclassicism. In France, the Rococo is linked with Louis XV, to whose lifespan (1710–1774) it corresponds roughly in date. However, it cannot be identified with the absolutist State or the Church any more than can the Baroque, even though these continued to provide the main patronage. Moreover, the essential characteristics of Rococo style were created before the king was born. Its first symptoms begin as much as 50 years earlier, during the lengthy transition that constitutes the Late Baroque. Hence, the view of the Rococo as the final phase of the Baroque is not without basis: as the philosopher François-Marie Voltaire acknowledged, the eighteenth century lived in the debt of the past. In art, Poussin and Rubens cast their long shadows over the Rococo. The controversy between their partisans, in turn, goes back much further to the debate between the supporters of Michelangelo and of Titian over the merits of design versus color. In this sense, the Rococo, like the Baroque, still belongs to the Renaissance world.

To overemphasize the similarities and stylistic debt of the Rococo to the Baroque, however, risks ignoring a fundamental difference between them. What is it? In a word, it is fantasy. If the Baroque presents theater on a grand scale, the Rococo stage is smaller and more intimate. At the same time, the Rococo is both more lighthearted and tender-minded, marked equally by playful whimsy and wistful nostalgia. Its artifice evokes an enchanted realm that presents a temporary diversion from real life. Because the modern age is the product of the Enlightenment that followed, it is still fashionable to denigrate the Rococo for its unabashed escapism and eroticism. To its credit, however, the Rococo discovered the world of love and broadened the range of human emotion in art to include, for the first time, the family as a major theme.

FRANCE

THE RISE OF THE ROCOCO. After the death of Louis XIV in 1715, the centralized administrative machine that Colbert (see page 600) had created ground to a stop. The nobility, formerly attached to the court at Versailles, were now freer of royal surveillance. Many of them chose not to return to their ancestral châteaux in the provinces, but to live in Paris, where they built elegant town houses, known as hôtels. As state-sponsored building activity was declining, the field of "design for private living" took on new importance. These city sites were usually cramped and irregular, so that they offered scant opportunity for impressive exteriors. Hence, the layout and décor of the rooms became the architects' main concern. The hôtels demanded a style of interior decoration less grandiloguent and cumbersome than Lebrun's. They required instead an intimate, flexible style that would give greater scope to individual fancy uninhibited by classicistic dogma. French designers created the Rococo ("The Style of Louis XV," as it is often called in France) from Italian gardens and interiors to fulfill this need. The name fits well: it was coined as a caricature of coquillage and rocaille (echoing the Italian barocco), which meant the playful decoration of grottoes with irregular shells and stones.

The Decorative Arts

It was in the decorative arts that the Rococo flourished first and foremost. We have not considered the decorative arts until now, because the conservative nature of the crafts permitted only limited creativity except to a few individuals of outstanding ability. But the latter half of the seventeenth century ushered in a period of unprecedented change in French design. A central role was played by Colbert, who in the 1660s acquired the Gobelins (named after the brothers who founded them) for the crown and turned them into royal works supplying luxurious furnishings, including tapestries, to the court under the direction of the king's chief artistic adviser, Charles

Lebrun. After 1688 the War of the League of Augsburg forced major economies on the crown, including reductions at the Gobelins that gradually loosened central control of the decorative arts and opened the way to new stylistic developments. Thus the situation paralleled the decline of the Academy's tyrannical influence over the fine arts, which gave rise to the Rococo in painting (see page 600).

This does not explain the excellence of French décor, however. Critical to its development was the importance assigned to designers: their engravings established new standards of design that were expected to be followed by artisans, who thereby lost much of their independence. Let us note, too, the collaboration of architects, who became increasingly involved in the decoration of the rooms they designed. Together with sculptors, who often designed the ornamentation, they helped to elevate the decorative arts virtually to the level of the fine arts, thus establishing a tradition that continued into modern times. The decorative and fine arts intersected most clearly in major furniture. French cabinetmakers known as ébénistes (after ebony, their preferred wood veneer) helped to bring about the revolution in interior décor by introducing new materials and techniques. Many of these upstarts hailed originally from Holland, Flanders, Germany, and even Italy.

The decorative arts played a unique role during the Rococo. Hôtel interiors were more than assemblages of objects. They were total environments put together with fastidious care by discerning collectors and the talented architects, sculptors, decorators, and dealers who catered to their taste. A room, like a single item of furniture, could involve the services of a wide variety of artisans—cabinetmakers, wood carvers, gold- and silversmiths, upholsterers, porcelain makers—all dedicated to producing the ensemble, even though each craft was, by tradition, a separate specialty subject to strict regulations. Together they fueled the insatiable hunger for novelty that swept Europe.

PINEAU. Virtually none of these rooms has survived intact. Like the furniture they housed, most have been destroyed, heavily altered, or dispersed. We can nevertheless get a good idea of their appearance by the reconstruction of one such room from the Hôtel de Varengeville, Paris, designed about 1735 by Nicolas Pineau (1684–1754) for the Duchesse de Villars (fig. 814). To create a sumptuous effect, the walls and ceiling are encrusted with ornamentation, and the elaborately carved furniture is adorned with gilt bronze. Everything swims in a sea of swirling patterns united by the most sophisticated sense of design and materials the world has ever known. Here there is no clear distinction between decoration and function, for example in the clock on the mantel and the statuette in the corner of our illustration. Note, too, how the painting has been thoroughly integrated into the room.

Sculpture

CLODION. Because so much of it was done to adorn interiors, French Rococo sculpture generally took the form of small groups in a "miniature Baroque" style, which were designed to be viewed at close range. A typical example is *Satyr and Bacchante* (fig. 815) by Claude Michel (1738–1814),

814. Nicolas Pineau. Room from the Hôtel de Varengeville, Paris. c. 1735. The Metropolitan Museum of Art, New York, Wrightsman Collection

815. Claude Michel, known as Clodion. Satyr and Bacchante.
 c. 1775. Terracotta, height 23¹/4" (59 cm).
 The Metropolitan Museum of Art, New York
 Bequest of Benjamin Altman, 1913

known as Clodion. Its coquettish eroticism is a playful echo of the ecstasies of Bernini, whose work he studied during a nine-year stay in Italy (compare fig. 753). Despite the fact that he undertook several large decorative cycles, Clodion was by nature a modeler who was at his best working on a small scale. Able to work miracles with terracotta, he reigned supreme in this intimate realm.

PIGALLE. Monumental commissions for French Rococo sculptors were few. Lifesize statues were confined largely to decorative figures of nymphs, goddesses, and the like who are the counterparts to the mythological creatures in the paintings of Boucher and his followers (see below). The Tomb of the Maréchal de Saxe (fig. 816) by Jean-Baptiste Pigalle (1714-1785), Clodion's teacher and the most gifted sculptor of the era, shows that they could recapture something of Baroque grandeur when given the opportunity. The Maréchal steps unafraid from a pyramid denoting immortality toward a casket held open for him by the beckoning figure of Death, as France tries vainly to intervene. He is mourned by the griefstricken Herakles to the left, representing the French army, and, to the right, the weeping infant personifying the Genius of War, who extinguishes his torch before the fallen military standards. The strange menagerie to the left stands for the nations defeated by the Maréchal in combat: Holland, England, and the Holy Roman Empire. If the allegory strikes us as heavy-handed, there can be no denying the effectiveness of the presentation, which is among the most astonishing in all of sculpture. The poses show the classicism requisite for official French art, but the spirit of the whole is unmistakably Baroque. Pigalle has mounted a tableau worthy of Bernini, whose works he studied during several years in Rome as a young man, although the relative restraint also suggests the example of Algardi (see pages 564-68). The pyramid is not a three-dimensional structure but a low relief built against the wall of the church, while the steps leading up to it and the figures occupying them are "real," like actors performing before a backdrop. We must therefore view the monument as a kind of theatrical performance in marble. The artist has even set it apart from its surroundings by creating an elevated "stage space" that projects outward.

Painting

"POUSSINISTES" VERSUS "RUBÉNISTES." It is hardly surprising that the straitjacket system of the French Academy (see page 600) produced no significant artists. Even Charles Lebrun, as we have seen, was far more Baroque in his practice than we would expect from his classicistic theory. The absurd rigidity of the official doctrine generated, moreover, a counterpressure that vented itself as soon as Lebrun's authority began to decline. Toward the end of the century, the members of the Academy formed two warring factions over the issue of drawing versus color: the "Poussinistes" (or conservatives) against the "Rubénistes." The conservatives defended Poussin's view that drawing, which appealed to the mind, was superior to color, which appealed to the senses. The Rubénistes advocated color, rather than drawing, as being more true to nature. They also pointed out that drawing, admittedly based on reason, appeals

816. Jean-Baptiste Pigalle. Tomb of the Maréchal de Saxe. 1753–76. Marble. St. Thomas, Strasbourg, France

only to the expert few, whereas color appeals to everyone. This argument had revolutionary implications, for it proclaimed the lay person to be the ultimate judge of artistic values and challenged the Renaissance notion that painting, as a liberal art, could be appreciated only by the educated mind.

WATTEAU. By the time Louis XIV died in 1715, the dictatorial powers of the Academy had long been overcome, and the influence of Rubens and the great Venetians was everywhere. The greatest of the Rubénistes was the painter Jean-Antoine Watteau (1684–1721). Watteau's pictures violated all academic canons, and his subjects did not conform to any established category. To accommodate Watteau, the Academy invented the new category of fêtes galantes (elegant fêtes or entertainments). The term refers to the fact that the artist's work mainly shows scenes of elegant society or comedy actors in parklike settings. Watteau characteristically interweaves theater and real life so that no clear distinction can be made between the two. A Pilgrimage to Cythera (fig. 817), painted as his reception piece for the Academy, is an evocation of love that includes yet another element: classical mythology. Accompanied by swarms of cupids, these young couples have come to Cythera, the island of love, to pay homage to Venus, whose garlanded image appears on the far right. The action unfolds in the foreground, like a continuous narrative, from right to left, which informs us that they are about to board the boat: two lovers are still engaged in their amorous tryst; behind

817. Jean-Antoine Watteau. A Pilgrimage to Cythera. 1717. Oil on canvas, 4'3" x 6'41/2" (1.3 x 1.9 m). Musée du Louvre, Paris

them, another couple rises to follow a third pair down the hill as the reluctant young woman casts a wistful look back at the goddess' sacred grove.

As a fashionable conversation piece, the scene at once recalls Rubens' *Garden of Love* (compare fig. 764), but Watteau has added a touch of poignancy, lending it a poetic subtlety reminiscent of Giorgione and Titian (see figs. 631 and 10). His figures, too, lack the robust vitality of Rubens'. Slim and graceful, they move with the studied assurance of actors who play their roles so superbly that they touch us more than reality ever could. They recapture an earlier ideal of "mannered" elegance.

Many of Watteau's paintings center on the *commedia dell'-arte*. His treatment of this Italian theme is all the more remarkable because the *commedia dell'arte* was officially banned in France from 1697 until 1716, despite the fact that it had been far more popular with the middle class than the classical tragedies of the official Comédie Français (see page 628), which were favored by the court. Shortly before his death, Watteau painted perhaps his most moving work: *Pierrot* (fig. 818), known traditionally as *Gilles* after a similar stock character in

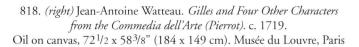

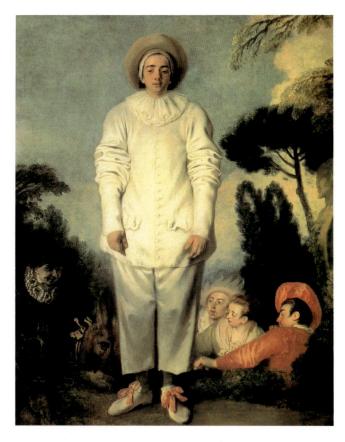

the commedia dell'arte. It was probably done as a sign for a café owned by a friend of the artist who retired from the stage after achieving fame in the racy role of the clown. The troupe's performance having ended, the actor has stepped forward to face the audience. The other characters all bear highly individualized likenesses, no doubt belonging to friends from the same circle. Yet the painting transcends portraiture and its purpose as an advertisement. Watteau approaches his subject with incomparable human understanding and artistic ability. Pierrot is lifesize, so that he confronts us as a full human being, not simply as a stock character. In the process, Watteau transforms Pierrot into Everyman, with whom he evidently identified himself—a merger of identity basic to the commedia dell'arte as a whole. The face and pose have a poignancy that suggests a subtle sense of alienation. Like the rest of the actors, except the doctor on the donkey who looks mischievously at us, he seems lost in his own thoughts. Still, it is difficult to define his mood, for the expression remains as elusive as it is eloquent.

BOUCHER. The work of Watteau signals a shift in French art as a whole to the Rococo. The term originally applied to the decorative arts (see page 610), but it suits the playful character of French painting before 1765 equally well. By about 1720 even history painting becomes intimate in scale and delightfully ebullient in style and subject. The finest painter in this vein was François Boucher (1703–1770), who epitomizes the age of Madame de Pompadour, the mistress of Louis XV. *The Toilet of Venus* (fig. 819), painted for her private retreat, is full of silk and perfume. Compared to Vouet's sensuous goddess (see fig. 797), from which she is descended, Boucher's Venus has been transformed into a coquette of enchanting beauty. In this cosmetic land, she is an eternally youthful

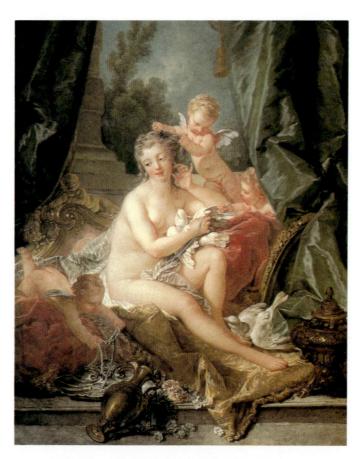

819. François Boucher. *The Toilet of Venus.* 1751. Oil on canvas, 43 x 33¹/2" (109.2 x 85.1 cm). The Metropolitan Museum of Art, New York Bequest of William K. Vanderbilt

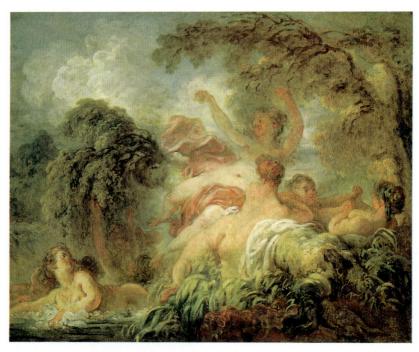

820. Jean-Honoré Fragonard. *Bathers.* c. 1765. Oil on canvas, $25^{1/4}$ x $31^{1/2}$ " (64 x 80 cm). Musée du Louvre, Paris

Venus with the same soft, rosy skin as the cherubs who attend her. If Watteau elevated human love to the level of mythology, Boucher raised playful eroticism to the realm of the divine. What Boucher lacks in the emotional depth that distinguishes Watteau's art, he makes up for in unsurpassed understanding of the world of fantasies that enrich people's lives.

FRAGONARD. *Bathers* (fig. 820), by Jean-Honoré Fragonard (1732–1806), Boucher's star pupil, shows him to be an even franker Rubéniste than Boucher. He paints with a fluid breadth and spontaneity reminiscent of Rubens' oil sketches and even paraphrases the Flemish master's figures (see fig. 763). They move with a floating grace that also links him with Tiepolo, whose work he had admired on an extended stay in Italy (compare fig. 838). Fragonard had the misfortune to outlive his era; his pictures became outmoded as the French Revolution approached. After 1789 he was reduced to poverty, supported, ironically, only by a curatorship to which he was appointed in 1793 by Jacques-Louis David (see page 639), who recognized his achievement, although their styles were antithetical. He died, virtually forgotten, in the heyday of the Napoleonic era.

CHARDIN. The style Fragonard practiced with such mastery was not the only alternative open to him and the other French painters of his generation. His art might have been different had he followed that of his first teacher, Jean-Baptiste-Siméon Chardin (1699-1779), whose style can be called Rococo only with reservations. The Rubénistes had cleared the way for a renewed interest in still-life and genre paintings by Dutch and Flemish masters. This revival was facilitated by the presence of numerous artists from The Netherlands, especially Flanders, who settled in France in growing numbers after about 1550 while maintaining artistic ties to their native lands. Chardin is the finest French painter in this vein. He is nevertheless far removed in spirit and style, if not in subject matter, from any Dutch or Flemish painter. Indeed, he is more akin to Le Nain and Sanchez Cotán (see pages 596 and 569). His paintings act as moral exemplars, not by conveying symbolic messages as Baroque art often does (see page 588), but by affirming the rightness of the existing social order and its values. To the rising middle class who were the artist's patrons, his genre scenes and kitchen still lifes proclaimed the virtues of hard work, frugality, honesty, and devotion to family.

Back from the Market (fig. 821) shows life in a Parisian mid-dle-class household with such feeling for the beauty hidden in the commonplace, and so clear a sense of spatial order, that we can compare him only to Vermeer and De Hooch (see figs. 789 and 14), but his remarkable technique is quite unlike any Dutch artist's. Devoid of bravura, his brushwork renders the light on colored surfaces with a creamy touch that is both analytical and subtly lyrical. To reveal the inner nature of things, he summarizes forms, subtly altering their appearance and texture, rather than describing them in detail.

Chardin's genius discovered a hidden poetry in even the most humble objects and endowed them with timeless dignity. His still lifes usually depict the same modest environment, eschewing the "object appeal" of their Dutch predecessors. In *Kitchen Still Life* (fig. 822), we see only the common objects

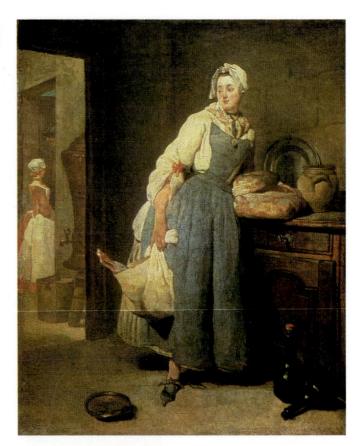

821. Jean-Baptiste-Siméon Chardin. *Back from the Market*. 1739. Oil on canvas, 18¹/₂ x 14³/₄" (47 x 37.5 cm). Musée du Louvre, Paris

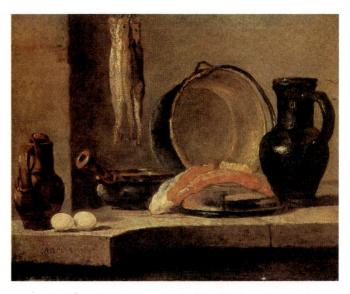

822. Jean-Baptiste-Siméon Chardin. Kitchen Still Life.
c. 1731. Oil on canvas, 12¹/₂ x 15³/₈" (32 x 39 cm).
Ashmolean Museum, Oxford
Bequeathed by Mrs. W. F. R. Weldon

that belong in any kitchen: earthenware jugs, a casserole, a copper pot, a piece of raw meat, smoked herring, two eggs. But how important they seem, each so firmly placed in relation to the rest, each so worthy of the artist's—and our—scrutiny! Despite his concern with formal problems, evident in the beautifully balanced design, Chardin treats these objects with a respect close to reverence. Beyond their shapes, colors, and textures, they are to him symbols of the life of common people.

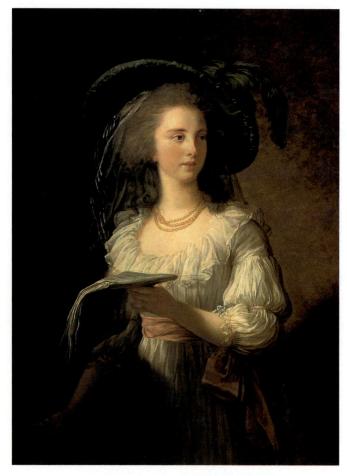

823. Marie-Louise-Elisabeth Vigée-Lebrun. The Duchesse de Polignac. 1783. Oil on canvas, 38³/4 x 28" (98.3 x 71 cm) © The National Trust Waddesdon Manor

VIGÉE-LEBRUN. It is from portraits that we can gain the clearest understanding of the French Rococo, for the transformation of the human image lies at the heart of the age. In portraits of the aristocracy, men were endowed with the illusion of character as a natural attribute of their station in life, stemming from their noble birth. But the finest achievements of Rococo portraiture were reserved for depictions of women, hardly a surprising fact in a society that idolized the cult of love and feminine beauty. Indeed, one of the finest practitioners in this vein was herself a beautiful woman: Marie-Louise-Elisabeth Vigée-Lebrun (1755–1842). [See Primary Sources, no. 76, pages 642–43.]

Throughout Vigée's long life she enjoyed great fame, which took her to every corner of Europe, including Russia, when she fled the French Revolution. *The Duchesse de Polignac* (fig. 823) was painted a few years after Vigée had become the portraitist for Queen Marie Antoinette, and it amply demonstrates her ability. We will recognize the duchesse as the descendant of Domenichino's *St. Cecilia* (fig. 733). She has the eternally youthful loveliness of Boucher's *Venus* (fig. 819), made all the more persuasive by the artist's ravishing treatment of her clothing. At the same time, there is a sense of transience in the engaging mood that exemplifies the Rococo's whimsical theatricality. Interrupted in her singing, the lyrical duchesse becomes a real-life counterpart to the poetic creatures in

Watteau's A Pilgrimage to Cythera (fig. 817) by way of the delicate sentiment she shares with the girl in Chardin's Back from the Market (fig. 821).

ENGLAND

Painting

Across the English Channel the Venetians were the predominant artists for more than a half-century (see page 628), but the French Rococo had an important, though unacknowledged, effect and, in fact, helped to bring about the first school of English painting since the Middle Ages that had more than local importance.

HOGARTH. The earliest of these painters, William Hogarth (1697–1764), was the first English artist of genius since Nicholas Hilliard (see fig. 712). A natural-born satirist, he began as an engraver and soon took up painting. Although he certainly learned something about color and brushwork from Venetian and French examples, as well as Van Dyck, his work is of such originality as to be essentially without precedence. He made his mark in the 1730s with a new kind of picture, which he described as "modern moral subjects . . . similar to representations on the stage." It follows the vogue for senti-

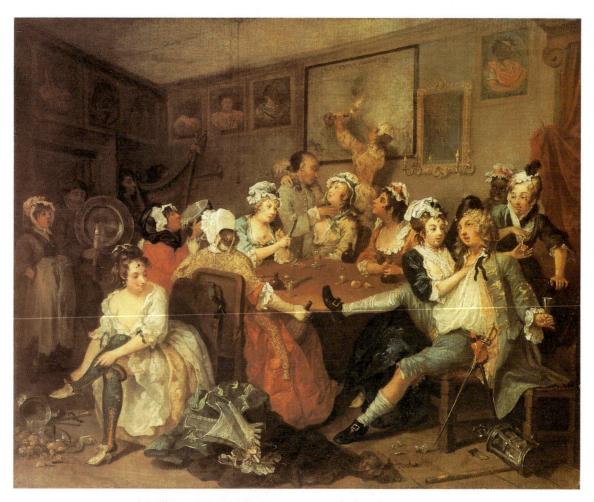

824. William Hogarth. *The Orgy,* Scene III of *The Rake's Progress.* c. 1734. Oil on canvas, 24¹/₂ x 29¹/₂" (62.2 x 74.9 cm). Sir John Soane's Museum, London

mental comedies, such as those by Richard Steele, that sought to teach moral lessons through satires of the protagonist's dissolute life. In the same vein is John Gay's The Beggar's Opera of 1728, a social and political satire which Hogarth illustrated in one of his paintings. Hogarth wished to be judged as a dramatist, he said, even though his "actors" could only "exhibit a dumb show." These pictures, and the prints he made from them for popular sale, came in sets, with details recurring in each scene to unify the sequence. Hogarth's "morality plays" teach, by horrid example, the solid middle-class virtues. They show a country girl who succumbs to the temptations of fashionable London; the evils of corrupt elections; and aristocratic rakes who live only for ruinous pleasure, marrying wealthy women of lower status for their fortunes, which they soon dissipate. Hogarth is probably the first artist in history to become a social critic in his own right.

In *The Orgy* (figs. 824 and 825), from *The Rake's Progress*, the young wastrel is overindulging in wine and women. The scene is so full of visual clues that a full account would take pages, and also constant references to the adjoining episodes. However literal-minded, the picture has great appeal. Hogarth combines some of Watteau's sparkle with Jan Steen's narrative gusto (compare figs. 817 and 788), and entertains us so well that we enjoy his sermon without being overwhelmed by its message.

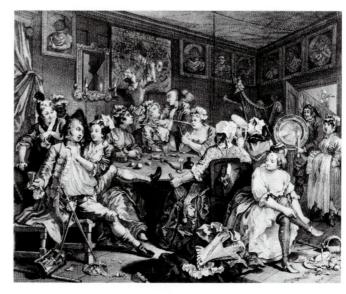

 825. William Hogarth. He Revels (The Orgy), Scene III of The Rake's Progress. 1735. Engraving.
 The Metropolitan Museum of Art, New York Harris Brisbane Dick Fund, 1932

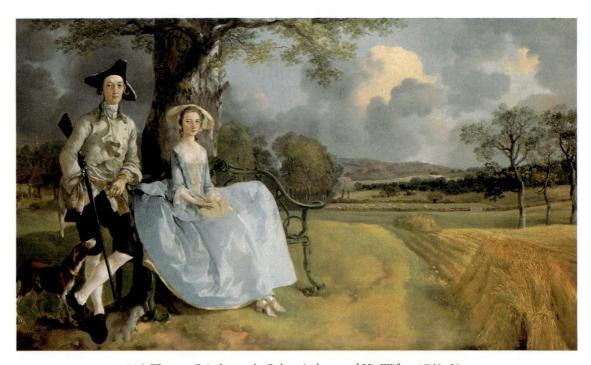

826. Thomas Gainsborough. Robert Andrews and His Wife. c. 1748–50. Oil on canvas, $27^{1/2}$ x 47'' (69.7 x 119.3 cm). The National Gallery, London Reproduced by courtesy of the Trustees

GAINSBOROUGH. Portraiture remained the only constant source of income for English painters. Here, too, eighteenthcentury England produced a style that differed from Continental traditions. Hogarth was a pioneer in this field as well. Its greatest master, Thomas Gainsborough (1727-1788), began by painting landscapes, but ended as the favorite portraitist of British high society. His early portraits, such as Robert Andrews and His Wife (fig. 826), have a lyrical charm that is not always found in his later pictures. Compared to Van Dyck's artifice in *Charles I Hunting* (see fig. 767), this country squire and his wife are unpretentiously at home in their setting. The landscape, although derived from Ruisdael and his school, has a sunlit, hospitable air never achieved (or desired) by the Dutch masters, while the casual grace of the two figures, which affects an air of naturalness, indirectly recalls Watteau's style. The newlywed couple—she dressed in the fashionable attire of the day, he armed with a rifle to denote his status as a country squire (hunting was a privilege of wealthy landowners)—do not till the soil themselves. The painting nevertheless conveys the gentry's closeness to the land, from which the English derived much of their sense of national identity. (Many private estates had been created in 1535, when Henry VIII broke with the Catholic church and redistributed its property to his supporters.) Out of this attachment to place was to develop a feeling for nature that became the basis for English landscape painting, to which Gainsborough himself made an important early contribution.

Gainsborough spent most of his career working in the provinces, first in his native Suffolk, then in the fashionable resort town of Bath. Toward the end of his career, he moved to London, where his work underwent a pronounced change. The very fine portrait of the famous actress Mrs. Siddons (fig. 827) has the virtues of Gainsborough's late style: a cool ele-

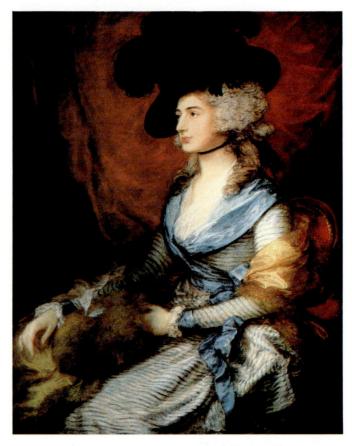

827. Thomas Gainsborough. *Mrs. Siddons.* 1785. Oil on canvas, 49½ x 39" (125.7 x 99.1 cm). The National Gallery, London Reproduced by courtesy of the Trustees

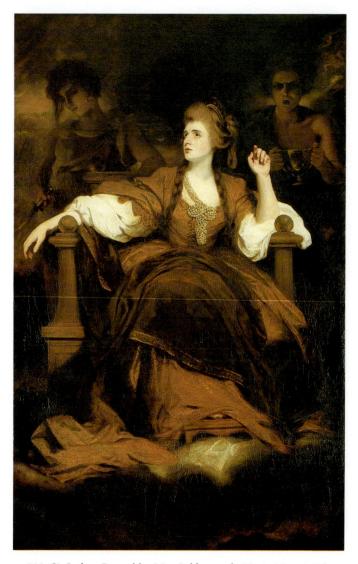

828. Sir Joshua Reynolds. *Mrs. Siddons as the Tragic Muse.* 1784. Oil on canvas, 7'9" x 4'9¹/2" (2.36 x 1.46 m). Henry E. Huntington Library and Art Gallery, San Marino, California

gance that translates Van Dyck's aristocratic poses into lateeighteenth-century terms, and a fluid, translucent technique reminiscent of Rubens' that renders the glamorous sitter, with her fashionable attire and coiffure, to ravishing effect.

REYNOLDS. Gainsborough painted Mrs. Siddons in conscious opposition to his great rival on the London scene, Sir Joshua Reynolds (1723-1792), who had portrayed the same sitter as the Tragic Muse (fig. 828). Reynolds, president of the Royal Academy since its founding in 1768, was the champion of the academic approach to art, which he had acquired during two years in Rome. In his famous Discourses he formulated what he felt were necessary rules and theories. [See Primary Sources, no. 77, page 643.] His views were essentially those of Lebrun, tempered by British common sense. Like Lebrun, he found it difficult to live up to his theories in actual practice. Although he preferred history painting in the grand style, most of his works are portraits "enabled," whenever possible, by allegorical additions or disguises like those in his picture of Mrs. Siddons. His style owed a good deal more to the Venetians, the Flemish Baroque, and even to Rembrandt (note the lighting in Mrs. Siddons) than he conceded in theory, though he often recommended following the example of earlier masters.

Reynolds was generous enough to give praise to Gainsborough, whom he outlived by a few years, and whose instinctive talent he must have envied. He eulogized him as one who saw with the eye of a painter rather than a poet. There is more truth to this statement than it might seem. Gainsborough's paintings epitomized the Enlightenment philosopher David Hume's idea that painting must incorporate both nature and art. Gainsborough himself was a simple and unpretentious person who exemplified Hume's "natural man," free of excessive pride or humility. Reynolds' approach, on the other hand, as enunciated in his *Discourses*, was based on the Roman poet Horace's dictum ut pictura poesis. His frequent borrowing of poses from the antique was intended to elevate the sitter from an individual to a universal type through association with the great art of the past and the noble ideals it embodied. This heroic model was closely related to the writings of the playwright Samuel Johnson and the practices of the actor David Garrick, both of whom were friends of Reynolds. In this,

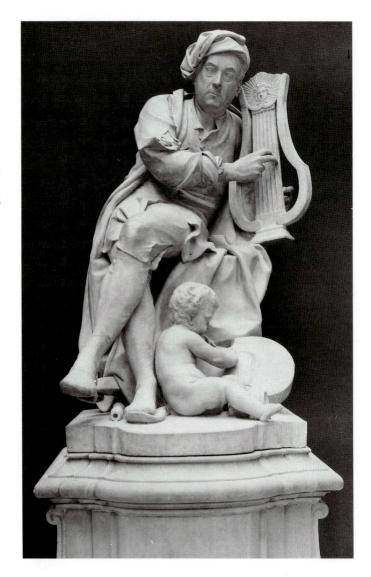

829. Louis-François Roubiliac. George Frideric Handel.1738. Marble, lifesize. Victoria & Albert Museum, London

Reynolds was the very opposite of Gainsborough. Yet, for all of the differences between them, the two artists had more in common, artistically and philosophically, than they cared to admit.

Reynolds and Gainsborough looked back to Van Dyck, drawing different lessons from his example. Both emphasized, albeit in varying degrees, the visual appeal and technical proficiency of their paintings. Moreover, their portraits of Mrs. Siddons bear an unmistakable relationship to the Rococo style of France—note their resemblance to Vigée's *Duchesse* (fig. 823)—yet remain distinctly English in character. Hume and Johnson were similarly linked by an abiding skepticism. If anything, Johnson's writings, which inspired Reynolds, were more bitterly pessimistic than Hume's, which generally advocated a tolerant and humane ethical system.

Sculpture

English sculpture has not been discussed in these pages since that of the thirteenth century (see fig. 475). During the Reformation, we will recall, there was a wholesale destruction of sculpture in England. This had so chilling an effect that for 200 years the demand for statuary of any kind was too low to sustain more than the most modest local production. With the rise of a vigorous English school of painting, however, sculp-

tural patronage grew as well, and during the eighteenth century England set an example for the rest of Europe in creating the "monument to genius": statues in public places honoring culture heroes such as Shakespeare, a privilege hitherto reserved for heads of state.

ROUBILIAC. One of the earliest and most ingratiating of these statues is the monument to the great composer George Frideric Handel (fig. 829) by the French-born Louis-François Roubiliac (1702–1762). It was also the first to be made of a culture hero within his lifetime. (The next to achieve this distinction would be Voltaire in France, a full generation later; see fig. 851). Roubiliac (who is portrayed in fig. 27) carved the figure in 1738 for the owner of Vauxhall Gardens in London, a pleasure park with dining facilities and an orchestra stand where Handel's music was often performed, so that the statue served two purposes: homage and advertising. Handel is in the guise of Apollo, the god of music, playing a classical lyre, while a putto at his feet writes down the divine music. But Handel is a most domestic Apollo, in slippers and a worn dressing gown, a soft beret on his head instead of the then-customary wig. These attributes distinguish him as a man of arts and letters. Although Roubiliac shows himself in full command of the Baroque sculptural tradition, the studied informality of his deified Handel seems peculiarly English. Touches such as the right foot resting

830. Johann Fischer von Erlach. Facade of St. Charles Borromaeus (Karlskirche), Vienna. 1716–37

upon rather than inside the slipper (a hint at the composer's gouty big toe?) suggest that he sought advice from William Hogarth, with whom he was on excellent terms (see page 616). Be that as it may, *Handel* was Roubiliac's first big success in his adopted homeland, and it became the forebear of countless monuments to culture heroes everywhere (see fig. 957).

GERMANY AND AUSTRIA

Rococo was a refinement in miniature of the curvilinear, "elastic" Baroque of Borromini and Guarini, and thus could be happily united with architecture in Central Europe, where the Italian style had taken firm root. It is not surprising that the Italian style received such a warm response there. In Austria and southern Germany, ravaged by the Thirty Years' War, the number of new buildings remained small until near the end of the seventeenth century. Baroque was an imported style, practiced mainly by visiting Italians. Not until the 1690s did native designers come to the fore. There followed a period of intense activity that lasted more than 50 years and gave rise to some of the most imaginative creations in the history of architecture. These monuments were erected for the glorification of princes and prelates who, generally speaking, deserve to be remembered only as lavish patrons of the arts. Rococo architecture in Central Europe is larger in scale and more exuberant than in France. Moreover, painting and sculpture are more closely linked with their settings. Palaces and churches are dec-

831. Plan of St. Charles Borromaeus

orated with ceiling frescoes and decorative sculpture unsuited to domestic interiors, however lavish, although they reflect the same taste that produced the Hôtel de Varengeville.

FISCHER VON ERLACH. The Austrian Johann Fischer von Erlach (1656–1723), the first great architect of the Rococo in Central Europe, is a transitional figure linked most directly to the Italian tradition. His design for the church of St. Charles Borromaeus in Vienna (figs. 830 and 831)

combines the facade of Borromini's S. Agnese and the Pantheon portico (figs. 746 and 249). Here a pair of huge columns derived from the Column of Trajan (see fig. 273) substitutes for facade towers, which have become corner pavilions reminiscent of those on the Louvre court (compare fig. 722). With these inflexible elements of Roman Imperial art embedded into the elastic curvatures of his church, Fischer von Erlach expresses, more boldly than any Italian Baroque architect, the power of the Christian faith to absorb and transfigure the splendors of antiquity.

PRANDTAUER. Even more monumental, thanks to its superb site, is the Monastery of Melk (fig. 832) by Jakob Prandtauer (1660–1726). The buildings form a tightly knit unit that centers on the church. It occupies the crest of a promontory above the Danube, rising from the rock, not like a fortress but like a vision of heavenly glory. The interior of the church (fig. 833) still reflects the plan of Il Gesù, but the abundant illumination, the play of curves and countercurves, and the weightless grace of the stucco sculpture give it an airy lightness far removed from the Roman Baroque. The vaults and wall surfaces seem thin and pliable, like membranes easily punctured by the expansive power of space.

832. Jakob Prandtauer. Monastery Church, Melk, Austria. Begun 1702

Although music after 1700 was the direct outgrowth of the previ-

ous century, it had not only a different sound but also was dominated by a handful of great composers—or so it seems to us today. They were nevertheless surrounded by many others of equal ability who began to form recognizable schools. These phenomena were interrelated. They were made possible by the international circulation of printed scores and musical treatises and the codification of the modern majorminor harmonic system (see "Modern Harmony," page 624). Of course, we have encountered great composers before; yet, when we listen to their music, it does not sound "modern" to our ears, no matter how beautiful or intricate it may be on its own terms.

The earliest of these eighteenth-century giants was Antonio Vivaldi (1678–1741). The son of a violinist at St. Mark's in Venice, he trained for the priesthood but was allowed to leave after one year for health reasons. From then on, he was employed chiefly as head of the Conservatory of the Pietà orphanage for girls. His vast body of work in virtually every instrumental and vocal form shows enormous versatility, one of the chief characteristics of the Rococo. Like the other great composers of the time, he was under constant pressure, due to his responsibilities and popularity, to write new music. He was, for example, the most successful composer of operas in Venice. He claimed to have written 90 in all; of the 20 that survive relatively intact, some show signs of haste (one of them was composed in only five days!). Nevertheless, Orlando Furioso (1727), inspired by Ariosto's epic poem, is unquestionably a masterpiece that is much superior to Handel's better-known Alcina (1735), based on the

Rococo Music

same story. Today Vivaldi is known almost exclusively for his

concertos, which number nearly 500, the large majority of them for the violin, of which *The Four Seasons*, set to verses probably written by Vivaldi himself, is justly the most famous.

Johann Sebastian Bach (1685-1750), trained as organist and violinist, spent part of his early career as a court composer, then settled down as music director at the church of St. Thomas in Leipzig, a position that made huge demands on him for new music. As an organist, he was indebted to a virtuoso tradition that began in Italy with Girolamo Frescobaldi (1583-1643) and continued in Germany with Dietrich Buxtehude (1637–1707), whom he went out of his way to hear in Lübeck. Bach was influenced early on by Italian music, which helped to shape his sense of melody and harmony. His keyboard compositions show the impact of François Couperin as well. Bach's music balances melody and polyphony, harmony and counterpoint, expressive power and supreme rationality. The instrumental works are built largely on fugues and variations, for he believed completely in his system of counterpoint, even when it forced unsatisfactory results. He is remembered chiefly for choral music, including the justly celebrated Mass in B Minor, several oratorios, which are nearly miniature operas, and voluminous cantatas. They owe their character to the revolution brought about in 1700 by Erdmann Neumeister (1671-1756) of Hamburg, a theologian and poet who introduced a new kind of sacred poetry, which he called "cantata." It effectively reconciled the difference between the Lutheran chorale and Calvinist Psalm by alternating biblical passages

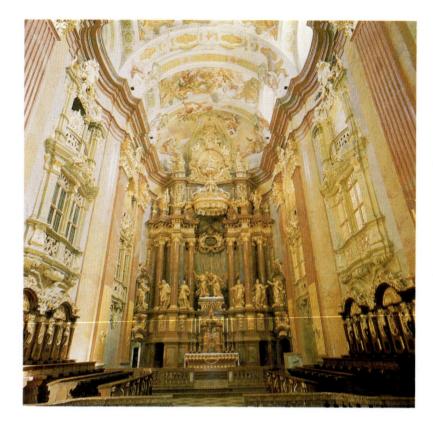

833. Prandtauer, Beduzzi, and Munggenast. Interior of the Monastery Church, Melk. Completed c. 1738

with original texts that expand on the scripture's meaning by offering personal responses and meditations.

Bach was hardly the most famous or prolific German composer of his time. That honor belonged to his friend Georg Philipp Telemann (1681–1767), who worked for a while in Leipzig but spent most of his life in Hamburg. New issues of his compositions were eagerly sought after, for they show the fertile imagination of Vivaldi, the technical mastery of Bach, and the cosmopolitan flair of Rameau. This is especially true of his overtures (which are really dance suites), chamber suites for entertainment, and concertos.

George Frideric Handel (1685-1759), too, was famous throughout almost his entire career. Born at Halle in Saxony, he first worked in Hamburg, then visited Italy between 1706 and 1710, when he met Arcangelo Corelli, Alessandro Scarlatti, and his son Domenico Scarlatti (1685–1757), a brilliant composer of harpsichord sonatas. The stay in Italy was decisive to Handel's formation, for it was there that he learned to compose operas and adopted the lyrical manner that distinguishes his work. Upon his return to Germany, he was appointed music director at Hannover, but soon went to London on a leave of absence and never really returned. As fate would have it, the elector of Hannover then became King George I of England, and he continued to support Handel in London. Handel was both composer and impresario who made and lost fortunes in Italian opera. Italian opera flourished until John Gay's The Beggar's Opera (1728), a social and political satire written in English at the suggestion of the author Jonathan Swift (1667–1745), took England by storm. The Beggar's Opera used familiar songs culled from a variety of sources (including Purcell) and arranged by the German-born

Johann Christoph Pepusch (1667–1752), who had settled in London in 1700 and no doubt enjoyed creating this spoof of his rival's music. Handel, who by this time had become an English citizen, turned to oratorios in his adopted tongue. They have a drama that makes them virtually concert operas, not church music, although many are based on biblical subjects. Their extroverted character expresses the confidence of the English as the new chosen people. His instrumental music is extremely appealing in its poetry and stateliness.

After failing to achieve success in Paris early in his career, Jean-Philippe Rameau (1683–1764) made his mark as a theorist in 1722 with the *Treatise on Harmony*, then returned the following year to Paris, where he gained the backing of a major patron and began to write operas, which established his reputation and earned him the support of the court. His style has the clarity and grace of Watteau and the intelligence of Voltaire. Despite the fact that Rameau's operas, such as The Gallant Indes (1735, a "heroic ballet" in several episodes) and Castor and Pollux (1737), are the direct descendants of Jean-Baptiste Lully's, they were attacked by the latter's supporters for their variety and drama. Ironically, the Lullyists later championed him against Italian opera, whose cause was being promoted by the Enlightenment philosopher Jean-Jacques Rousseau (1712-1778) on the grounds that French was not fit for singing! Nevertheless, the revival of Castor and Pollux in 1754, after it had been heavily reworked by the composer, was an outstanding success that marked the defeat of Italian opera. The declamatory style satisfied the Lullyists, while the brilliant inventiveness, especially of the instrumental writing, pleased Rameau's partisans, who proclaimed the opera his masterpiece.

Modern Harmony

The development of eighteenth-century music was made possible by the codification of the modern system of harmony, which, after a gradual development over approximately 300 years, was spelled out in its final form in the Treatise on Harmony (1722) by the French composer Jean-Philippe Rameau (1683-1764). This system was based on the "tempered" diatonic scale, a progression of notes derived by equally spacing ("tempering") 12 tones within an octave (in essence, the black and white keys of a piano). The tonal distance, or interval, between any two of these one-twelfth-octave tones is called a semitone or "half step." Twice that interval is called a whole tone or "whole step." The diatonic system includes two principal scales, the major scale—the familiar "do-re-mi" that music students practice—and a modification of it called the minor scale. Both major and minor scales include a specific progression of five whole tones and two semitones, which start from the tonic, the note on which the scale is based, to the same note an octave above it. Like Greek modes, the major and minor scales communicate emotional qualities. Generally, a listener experiences the major scale as positive and optimistic, and the minor scale as somber or plaintive.

The tempered scale allowed a keyboard to include a number of octaves, which in turn increased the range of music that could be written for keyboard instruments. The 48 pieces that Johann Sebastian Bach (1685–1750) wrote in his *Well-Tempered Clavier* (1722, 1744) were one of the first series of compositions that exploited the possibilities of the newly expanded keyboard.

Another feature of the system as defined by Rameau were chords, sets of notes based on specific tones of the scale, sounded together in accompaniment to the melody. The major chord, for example, is derived from the major scale. It is made up of the tonic, the third note of the scale, and the fifth note of the scale. The chords for each scale were intended to create a full multivoice sound that is pleasing to the ear. Rameau's rules defined which chords were to be used in which musical circumstances; however, it was also understood that a composer might "break" the rules to create a deliberately discordant effect, or dissonance, for expressive purposes. Such dissonances were almost always "resolved" back to the notes of the scale in which the work was being played.

We need not be schooled in music theory to appreciate the virtues of the new system, which are readily apparent to the ear: its orderliness and flexibility, which not only permitted the fullest development of counterpoint, but created new melodic possibilities as well. Modern harmony was an essential precondition for the work of the great composers of the eighteenth and nineteenth centuries, and it remained the basis of Western music composition until the end of World War I, when avantgarde composers began to seek other modes of musical expression.

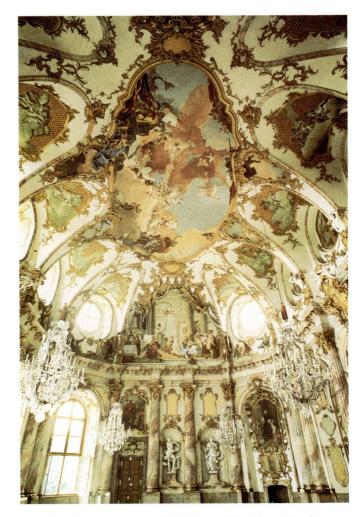

834. Balthasar Neumann. The Kaisersaal, Residenz, Würzburg, Germany. 1719–44. Frescoes by Giovanni Battista Tiepolo, 1751

NEUMANN. The architects of the next generation favored a tendency toward lightness and elegance. The Episcopal Palace in Würzburg by Balthasar Neumann (1687–1753) includes the breathtaking Kaisersaal (fig. 834), a great oval hall decorated in the favorite color scheme of the mid-eighteenth century: white, gold, and pastel shades. The number and aesthetic role of structural members such as columns, pilasters, and architraves are now minimized. Windows and vault segments are framed by continuous, ribbonlike moldings, and the white surfaces are spun over with irregular ornamental designs. This repertory of lacy, curling motifs, the hallmark of the French style (see fig. 814), is happily combined with German Rococo architecture.

ZIMMERMANN. A contemporary of Balthasar Neumann, Dominikus Zimmermann (1685–1766), created what may be the finest spatial design of the mid-eighteenth century, the Bavarian pilgrimage church nicknamed "Die Wies" (figs. 835 and 836). The exterior is so plain that its interior richness seems truly overwhelming. Like the Kaisersaal, its shape is oval, but since the ceiling rests on paired, free-standing supports, the spatial configuration is more fluid and complex. As a result, we are reminded of a German Gothic Hallenkirche (see fig. 454),

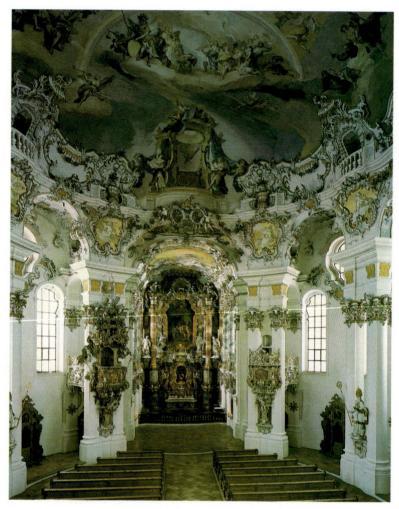

835. Dominikus Zimmermann. Interior of Die Wies, Upper Bavaria, Germany. 1745–54

despite the playful Rococo décor. Guarini's prophetic revaluation of Gothic architecture has here become reality.

ITALY

Just as the style of architecture invented in Italy achieved its climax north of the Alps, much of the Italian Rococo took place in other countries. The timid style of the Late Baroque in Italy was suddenly transformed during the first decade of the eighteenth century by the rise of the Rococo in Venice, which had been relegated to a minor outpost for a hundred years. The Italian Rococo is distinguished from the Baroque by a renewed appreciation of Veronese's colorism and pageantry, but with a light and airy sensibility that is new. The first to formulate this style was Sebastiano Ricci (1659–1734), who began his career as a stage painter and emerged as an important artist only in mid-career. Their skill at blending this painterly manner with High Baroque illusionism made Ricci and the Venetians the leading decorative painters in Europe between 1710 and 1760, and they were active in every major center throughout Europe, particularly London and Madrid. They were not alone: artists from Rome and other parts of Italy also worked abroad in large numbers.

836. Plan of Die Wies

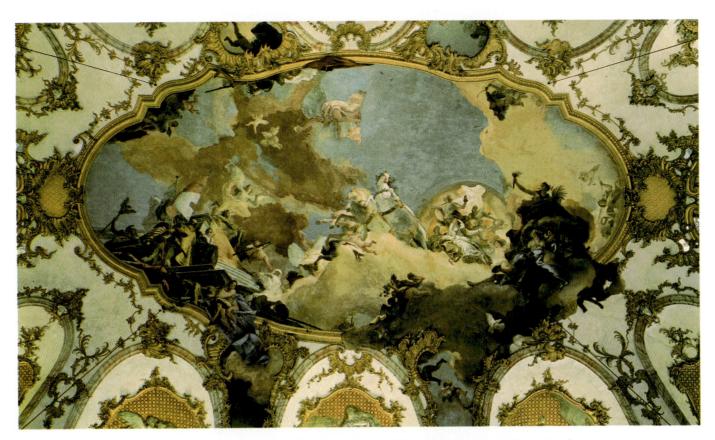

837. Giovanni Battista Tiepolo. Ceiling fresco (detail). 1751. The Kaisersaal, Residenz, Würzburg

TIEPOLO. The last and most refined stage of Italian illusionistic ceiling decoration is represented in Würzburg by its greatest master, Giovanni Battista Tiepolo (1696-1770). In his mastery of light and color, his grace and felicity of touch, and his power of invention, Tiepolo far surpassed his fellow Venetians, and these qualities made him famous far beyond his home territory. When Tiepolo painted the Würzburg frescoes (figs. 834, 837, and 838), his powers were at their height. The tissuelike ceiling so often gives way to illusionistic openings of every sort that we no longer feel it to be a spatial boundary. These openings do not, however, reveal avalanches of figures propelled by dramatic bursts of light, like those of Roman ceilings (compare fig. 737), but rather blue sky and sunlit clouds, and an occasional winged creature soaring in this limitless expanse. Only along the edges of the ceiling are there solid clusters of figures (fig. 837).

At one end, replacing a window (see fig. 834), is *The Marriage of Frederick Barbarossa* (fig. 838). As a public spectacle, it is as festive as *Christ in the House of Levi* (fig. 653) by Veronese, whose example the artist has followed by placing the event (which took place in the twelfth century) in a contemporary setting. Its allegorical fantasy is literally revealed by the carved putti opening a curtain onto the wedding ceremony in a display of theatrical illusionism worthy of Bernini. Unexpected

in this lively procession is the element of classicism, which lends an air of noble restraint to many of the figures.

Tiepolo afterward became the last in the line of Italian artists, beginning with Luca Giordano (see page 560), invited to work at the Royal Palace in Madrid. There he encountered the German painter Anton Raphael Mengs, a proponent of the classical revival whose presence signaled the effective end of the Rococo (see page 638).

GIAQUINTO. The artist replaced by Mengs was Corrado Giaquinto (1703–1765), who departed because of ill health. The only serious rival in ability to Tiepolo, he can be claimed with equal justice as the last great representative of painting in both Naples, where he trained under Francesco Solimena, and Rome, where he passed most of his career, for the two schools were intimately related (see page 560). At the Spanish court, where he exercised powers comparable to Lebrun's (see page 600), Giaquinto was hailed as the successor to Giordano, whose work in turn had a decisive impact on his art. *Justice and Peace* (fig. 839) bears an obvious resemblance to Giordano's *Abduction of Europa* (fig. 738), but with overtones of the work of Boucher that suggest an awareness of his style (see fig. 819). The painting happily unites the best of both worlds: the monumentality of Italy and the charm of France. What sets it apart

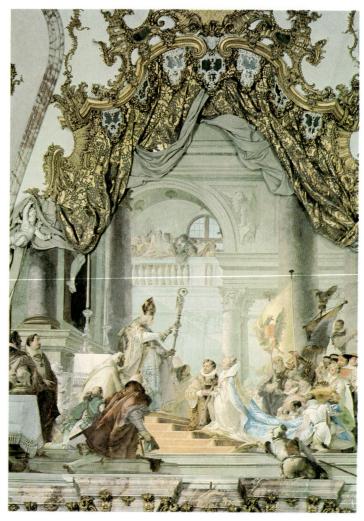

838. Giovanni Battista Tiepolo. *The Marriage of Frederick Barbarossa* (partial view). 1752. Fresco. Kaisersaal, Residenz, Würzburg

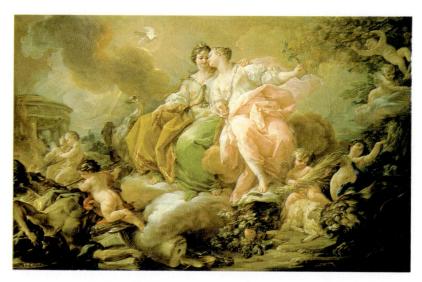

839. Corrado Giaquinto. Justice and Peace. c. 1753–54. Oil on canvas, 7'1" x 13'11 1 /4" (2.16 x 4.25 m). Museo del Prado, Madrid

Rococo Theater

Theater throughout the Rococo period was marked by sentimen-

tality, usually with a moralizing theme. In England this trend began with Love's Last Shift by Colley Cibber (1671–1757), which was presented even before the attacks of Jeremy Collier (1650-1726) in 1698 on the morality of the theater. The net result was a more conservative kind of domestic drama for the middle class, exemplified by The Conscious Lovers (1722) by Richard Steele (1672–1729), in which people recant the folly of their ways. As a result of the political satires by Henry Fielding (1707–1754), which offended the Prime Minister, Sir Robert Walpole, theater was further constrained by the Licensing Act of 1737, which imposed strict censorship. England, which had been influenced by Molière and Racine during the seventeenth century, now made an important contribution to French theater. The counterpart to Steele's plays in France were the "tearful comedies" of Philippe Destouches (1680–1754), who served as a diplomat in London in 1716, Pierre-Claude Nivelle de La Chaussée (1692-1754), and Pierre Marivaux (1688-1763). Tragedy enjoyed a final resurgence in the plays of the writer and philosopher Voltaire (François-Marie Arouet, 1694-1778), who sought to liberalize classical drama after living as a refugee in 1726-29 in England, where he came to know all the leading intellectuals and developed a superficial admiration for Shakespeare. His later plays are no less sentimental than those of his peers, but the growing emphasis on spectacle led him in 1759 to banish spectators from the stage for the first time. Comedy was left in the hands of Comédie Italienne, created in 1716 when the commedia dell'arte was invited back to France by the Duc d'Orléans upon the death of his brother, Louis XIV. In Italy, by contrast, the energies of the playwrights were absorbed by the mania for opera. The main exception was Carlo Goldoni (1707-1793), a Venetian dramatist whose vivid comedies deliberately imitated those of Molière.

The major contributions of Rococo theater thus lay not in writing but in stagecraft: scenic design and acting. With the increased demand for spectacle, many artists were trained or employed as scenographers, including François Boucher and Canaletto. The affinity was natural, since the backgrounds in many paintings came to look increasingly

Boucher's pupil Philippe-Jacques de Loutherbourg (1740-1812), who also trained under the

like set designs after 1700.

scene designer Louis-René Boquet (1717-1814), brought French practices with him to England, where many painters, including Hogarth's father-in-law James Thornhill (1676-1734), George Lambert (c. 1699–1765), and Francis Hayman (1708–1776), regularly worked for the theater.

De Loutherbourg, who became a friend of Thomas Gainsborough, had been invited to England by the actor David Garrick (1717-1779) to supervise scene painting at his Drury Lane Theater, and both men introduced a number of innovations in the theater, especially in improved lighting. Garrick, whose portrait was painted by all the leading artists of the day, including Hogarth, Reynolds, and Gainsborough, dominated the English stage after his debut in 1741, and played a major role in theatrical reform on the Continent following his visits to France in 1763 and Italy and Germany two years later. Like Voltaire, he removed spectators from the stage. Nevertheless, Garrick had several rivals, chief among them Charles Macklin (1697?–1797) and Samuel Foote (1720–1777), who established The Haymarket as a rival to Drury Lane and Covent Garden, the two legitimate theaters in London. These three men were among the first English actors to show an awareness of period dress, which was also taken up by the French theater. Voltaire's main actor, Henri-Louis Lekain (1729–1778), and his leading lady, Mademoiselle Clairon (1723–1803), became the first French actors to use authentic costumes, as part of the trend toward greater realism in theater.

Women had been acting in the Comédie Français since the 1690s, but they never achieved the status of English actresses. Thus, Adrienne Lecouvreur (1692-1730), who was the first to adopt formal court costumes for tragic heroines, was buried anonymously the same year that Anne Oldfield (1683-1730) was interred in Westminster Abbey. After 1780 the reigning actress was Sarah Siddons (1755–1831), the sister of the great impresario John Philip Kemble (1757– 1823); like Garrick, she sat for both Gainsborough and Reynolds (see figs. 827 and 828). During the early decades of the eighteenth century, a number of women in England also became successful playwrights.

is its ravishing beauty. The seemingly effortless brushwork and bold palette are unique to Giaquinto. No other painter of the Rococo could apply such a daring array of hues with such creamy consistency.

CANALETTO. During the eighteenth century, landscape in Italy evolved a new form in keeping with the character of the Rococo: veduta (view) painting. Its beginnings can be traced back to the seventeenth century with the many foreigners, such as Claude Lorraine (see fig. 796), who specialized in depicting Rome's environs, but after 1720 it acquired a specifically urban identity. The most renowned of the vedutists was Canaletto (1697–1768) of Venice. His pictures were great favorites with the British, who purchased them as souvenirs of the grand tours of Italy, then so popular. Indeed, he enjoyed such success with clients from England that he later became one of several prominent Venetian artists to spend lengthy sojourns in London. The Bucintoro at the Molo (fig. 840) was one of a series of paintings commissioned by Joseph Smith, an English entrepreneur living in Venice. These served both to decorate Smith's house and to introduce Canaletto's work to prospective buyers. Smith subsequently issued them as a suite of etchings to meet the demand for remembrances of Venice by those who could not afford an original canvas by the artist.

Canaletto's landscapes are, for the most part, topographically accurate. However, he was not above tampering with the truth, and while he usually made only slight adjustments for the sake of compositional effectiveness, he would sometimes

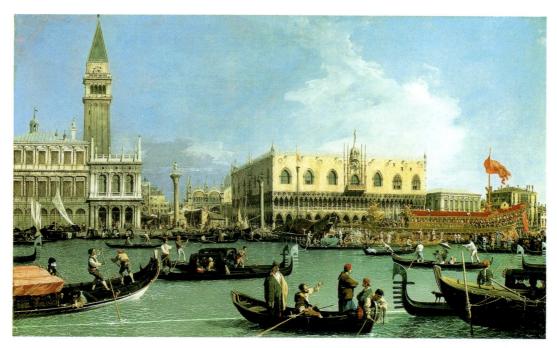

840. Canaletto. *The Bucintoro at the Molo.* c. 1732. Oil on canvas, 30¹/4 x 49¹/2" (77 x 126 cm). The Royal Collection © 1993 Her Majesty Queen Elizabeth II

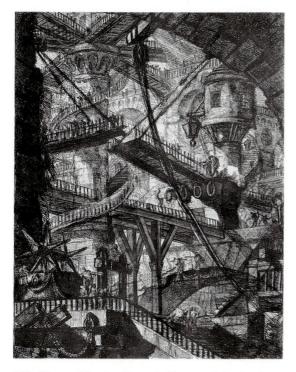

841. Giovanni Battista Piranesi. *Tower with Bridges*, from *Prison Caprices*. 1760–61. Etching, 21³/4 x 16³/8" (55.2 x 41.6 cm). The Metropolitan Museum of Art, New York Rogers Fund

treat scenes with considerable license or create composite views. He may have used a mechanical or optical device (perhaps a camera obscura, a forerunner of the photographic camera) to render some of his views, although he was a consummate draftsman who hardly needed such aids. In any

event, they fail to account for the visual sparkle of his pictures and his sure sense of composition. These features sprang in part from Canaletto's training as a scenographer. This experience in the theater also helps to explain the liveliness of his paintings. He often included vignettes of daily life in Venice that lend a human interest to his scenes and make them fascinating cultural documents as well. *The Bucintoro at the Molo* shows a favorite theme: the Doge returning on his magnificent barge to the Piazza San Marco from the Lido (the city's island beach) on Ascension Day after celebrating the Marriage of the Sea. Canaletto has captured to perfection the festive air surrounding this great public celebration, which is presented as a theatrical display of spectacular brilliance.

PIRANESI. Canaletto shared his background as a designer of stage sets with Ricci (see above) and also with Giovanni Panini (1691–1765), his fellow vedutist in Rome who had a passion for classical antiquity (see fig. 246). They, in turn, are the forerunners of another Roman artist, Giovanni Battista Piranesi (1720–1778), whose *Prison Caprices* (fig. 841) are rooted in contemporary designs for theater and opera. Unlike the prints after Canaletto's paintings, these masterful etchings were intended as original works of art from the beginning, so that they have a gripping power. In Piranesi's imagery, the play between reality and fantasy, so fundamental to the theatrical Rococo, has been transformed into a romanticized vision of despair as terrifying as any nightmare. His bold imagination appealed greatly to many artists of the next generation, on whom he exercised a decisive influence.

Primary Sources for Part Three

The following is a selection of excerpts, in modern translations, from original texts by artists, architects, religious figures, and historians from the Renaissance through the Rococo periods. These readings supplement the main text and are keyed to it. Their full citations are given in the Credits section at the end of the book.

Leone Battista Alberti (1404–1472) From *On Painting*

Alberti's On Painting, published in 1435, and his On Sculpture, which appeared in 1464, are among the most influential and revealing documents of the Early Renaissance.

The fundamental principle will be that all the steps of learning should be sought from Nature: the means of perfecting our art will be found in diligence, study and application. I would have those who begin to learn the art of painting do what I see practised by teachers of writing. They first teach all the signs of the alphabet separately, and then how to put syllables together, and then whole words. Our students should follow this method with painting. First they should learn the outlines of surfaces, then the way in which surfaces are joined together, and after that the forms of all the members individually; and they should commit to memory all the differences that can exist in those members, for they are neither few nor insignificant. Some people will have a crook-backed nose; others will have flat, turned-back, open nostrils; some are full around the mouth, while others are graced with slender lips, and so on. . . . But, considering all these parts, he should be attentive not only to the likeness of things but also and especially to beauty, for in painting beauty is as pleasing as it is necessary. The early painter Demetrius failed to obtain the highest praise because he was more devoted to representing the likeness of things than to beauty. Therefore, excellent parts should all be selected from the most beautiful bodies.

Leone Battista Alberti From *On Architecture*

Modeled on Vitruvius' treatise on architecture (1st century B.C.), On Architecture was completed in 1452 but not published until 1485, after Alberti's death.

The most expert Artists among the Ancients . . . were of [the] opinion that an Edifice was like an Animal, so that in the formation of it we ought to imitate Nature. . . . It is manifest that

in those [animals] which are esteemed beautiful, the parts or members are not constantly all the same, . . . but we find that even in those parts wherein they vary most, there is something inherent and implanted which tho' they differ extremely from each other, makes each of them be beautiful. . . . But the judgment which you make that a thing is beautiful, does not proceed from mere opinion, but from a secret argument and discourse implanted in the mind itself. . . . There is a certain excellence and natural beauty in the figures and forms of buildings, which immediately strike the mind with pleasure and admiration. It is my opinion that beauty, majesty, gracefulness and the like charms, consist in those particulars which if you alter or take away, the whole wou'd be made homely and disagreeable. . . . There is . . . something . . . which arises from the conjunction and connection of these other parts, and gives the beauty and grace to the whole: which we will call Congruity, which we may consider as the original, of all that is graceful and handsome. . . . Wherever such a composition offers itself to the mind either by the conveyance of the sight, hearing, or any of the other senses, we immediately perceive this congruity: for by Nature we desire things perfect, and adhere to them with pleasure when they are offered to us; nor does this Congruity arise so much from the body in which it is found, or any of its members, as from itself and from Nature, so that its true Seat is in the mind and in reason. . . . This is what Architecture chiefly aims at, and by this she obtains her beauty, dignity and value.

Girolamo Savonarola (1452–1498) From a sermon delivered in Florence in 1493

The monk and religious reformer Savonarola preached against the growing worldliness of Florentine culture and was highly influential in that city for a time. As a result of his unwillingness to curb his outspoken criticisms of the papacy, he was excommunicated in 1497 and burned at the stake in 1498.

The primitive Church was constructed of living stones, Jesus Christ himself being the chief corner-stone. The Church was then a garden of delights, a very heaven upon earth. How holy was the zeal which animated its pastors for the good of souls! How anxiously did they employ themselves in things divine!

. . . Alas, how changed the scene! The devil, through the instrumentality of wicked prelates, has destroyed the temple of God. . . .

The holiest festivals are devoted to worldly amusements, to indecent spectacles, and to games suited to a heathen taste. On Christmas Eve, instead of filling our churches and sharing in their sacred offices, and proffering to God their thanksgivings for his inestimable love in the redemption of the world, Christians, so called, go off to taverns, to gratify their appetites, and to practise all sorts of evil. This very day I beheld in the streets females, who know better, exercising seductive arts, and clothed with meretricious ornaments. Such are not the insignia of female purity. Priests appear in public, arrayed more pompously than laymen. They are to be found in gambling houses and taverns. . . . Go to Rome, -go through all Christendom; study what is passing in the houses of great prelates and grand masters. Poetry and oratory chiefly occupy their thoughts. They prepare themselves by the study of Virgil, and Horace, and Cicero, for the cure of souls. Will you believe it? . . . The primitive bishops . . . were poor and humble men; they could not boast of great revenues and rich abbeys like the modern. They had neither mitres nor chalices of gold; or, if they had them, they were ready to sacrifice them for the necessities of the poor. . . . In the primitive Church, the chalices were of wood, and the prelates of gold. Now-a-days the Church has prelates of wood, and chalices of gold.

Leonardo da Vinci (1452–1519) From his undated manuscripts

Leonardo, the consummate High Renaissance man, wrote on a variety of intellectual topics. The comparison of the arts, or Paragone, was a common subject in High Renaissance scholarship.

HE WHO DEPRECIATES PAINTING LOVES NEITHER PHILOSOPHY NOR NATURE

If you despise painting, which is the sole imitator of all visible works of nature, you certainly will be despising a subtle invention which brings philosophy and subtle speculation to bear on the nature of all forms—sea and land, plants and animals, grasses and flowers—which are enveloped in shade and light. Truly painting is a science, the true-born child of nature. For painting is born of nature; to be more correct we should call it the grandchild of nature, since all visible things were brought forth by nature and these, her children, have given birth to painting. Therefore we may justly speak of it as the grandchild of nature and as related to God.

A COMPARISON BETWEEN POETRY AND PAINTING The imagination cannot visualize such beauty as is seen by the eye, because the eye receives the actual semblances or images of objects and transmits them through the sense organ to the understanding where they are judged. But the imagination never gets outside the understanding; . . . it reaches the memory and stops and dies there if the imagined object is not of great beauty; thus poetry is born in the mind or rather in the imagination of the poet who, because he describes the same things as the painter, claims to be the painter's equal! . . . The object of the imagination does not come from without but is born in the darkness of the mind's eye. What a difference between forming a mental image of such light in the darkness of the mind's eye and actually perceiving it outside the darkness!

If you, poet, had to represent a murderous battle you would have to describe the air obscured and darkened by fumes from frightful and deadly engines mixed with thick clouds of dust polluting the atmosphere, and the panicky flight of wretches fearful of horrible death. In that case the painter will be your superior, because your pen will be worn out before you can fully describe what the painter can demonstrate forthwith by the aid of his science, and your tongue will be parched with thirst and your body overcome by sleep and hunger before you can describe with words what a painter is able to show you in an instant.

ON PAINTING AND POETRY

Poetry is superior to painting in the presentation of words, and painting is superior to poetry in the presentation of facts. . . . For this reason I judge painting to be superior to poetry. But as painters did not know how to plead for their own art she was left without advocates for a long time. For painting does not talk; but reveals herself as she is, ending in reality; and Poetry ends in words in which she eloquently sings her own praises.

From the *Journal* of Luca Landucci

Landucci's journal entry for January 25, 1503, records varied opinions on the placement of Michelangelo's David (fig. 607).

Considering that the statue of David is almost finished, and desiring to install it and to give it an appropriate and acceptable location, with the installation at a suitable time, and since the installation must be solid and structurally trustworthy according to the instructions of Michelangelo, master of the said Giant, and of the consuls of the [wool guild], and desiring such advice as may be useful for choosing the aforesaid suitable and sound installation, etc., they decided to call together and assemble, to decide on this, competent masters, citizens, and architects, . . . and to record their opinions, word for word. . . .

All of these [28] men . . . gave advice as to where, and in what place, the said statue was to go; their statements are recorded below verbatim in their own words.

MESSER FRANCESCO, FIRST HERALD OF THE SIGNORIA There are two places where such a statue might be erected. The first is where the Judith is [Donatello's Judith and Holofernes, then located outside the Palazzo Vecchio] and the second the center of the courtyard of the Palace, where the David is [Donatello's David, see fig. 535, then located in the courtyard of the Palazzo Vecchio]. The reason for the first is because the Judith is an emblem of death, and it is not fitting for the Republic and I say it is not fitting that the woman should kill the man. And even more important, it . . . was erected under an evil star, for . . . then we lost Pisa. The David of the courtyard is a figure that is not perfect, because the leg that is thrust backwards is faulty. For these reasons I would advise putting this statue in one of the two places . . . but with my preference for where the Judith now is.

SANDRO BOTTICELLI

Cosimo [Rosselli] has hit upon the place where I think it can best be seen by passers-by [steps of the cathedral], with a Judith at the other corner. Perhaps also in the Loggia of the Signoria [a covered, open-air assembly hall used for state ceremonies]—but preferably at the corner of [the cathedral].

GIULIANO DA SAN GALLO

My judgment too was much inclined in favor of the corner of the Duomo that Cosimo mentioned, where it would be seen by the people. But, consider that this is a public thing, and consider the weakness of the marble, which is delicate and fragile. Then, if it is placed outside and exposed to the weather, I think that it will not endure. For this reason as much as any, I thought that it would be better underneath the central arch of the Loggia of the Signoria.

LEONARDO DA VINCI

I agree that it should be in the Loggia, where Giuliano said, but on the parapet where they hang the tapestries on the side of the wall, and with decency and decorum, and so displayed that it does not spoil the ceremonies of the officials.

SALVESTRO, WORKER IN PRECIOUS STONES

Almost all the places have been talked about, and much has been said one way or the other. But I believe that the man who made it did so to be worthy of giving it the best possible location. Though for my part I favor the place outside the palace [Palazzo Vecchio].

Michelangelo Buonarroti (1475–1564) Sonnet

In addition to being a painter, a sculptor, and an architect, Michelangelo was also a prolific, although unpublished, poet. This sonnet was written in 1554.

My course of life already has attained, Through stormy seas, and in a flimsy vessel, The common port, at which we land to tell All conduct's cause and warrant, good or bad,

So that the passionate fantasy, which made Of art a monarch for me and an idol, Was laden down with sin, now I know well, Like what all men against their will desired.

What will become, now, of my amorous thoughts, Once gay and vain, as toward two deaths I move, One known for sure, the other ominous?

There's no painting or sculpture now that quiets The soul that's pointed toward that holy Love That on the cross opened Its arms to take us.

Giorgio Vasari (1511–1574)
From The Lives of the Most Excellent
Italian Architects, Painters, and Sculptors
from Cimabue to Our Times

Vasari was inspired to write the Lives by his patron, Cardinal Farnese, later Pope Paul III. The book, first published in 1550 and expanded in 1568, was based on interviews conducted throughout Italy. Vasari personally knew many of the artists about whom he wrote, including Michelangelo.

When Michelangelo had finished the statue [a portrait of Pope Julius II, later destroyed], Bramante, the friend and relation of Raphael and therefore ill-disposed to Michelangelo, seeing the Pope's preference for sculpture, schemed to divert his attention, and told the Pope that it would be a bad omen to get Michelangelo to go on with his tomb, as it would seem to be an invitation to death. He persuaded the Pope to get Michelangelo, on his return, to paint the vaulting of the Sixtine Chapel. In this way Bramante and his other rivals hoped to confound him, for by taking him from sculpture, in which he was perfect, and putting him to colouring in fresco, in which he had had no experience, they thought he would produce less admirable work than Raphael. . . . Thus, when Michelangelo returned to Rome, the Pope was disposed not to have the tomb finished for the time being, and asked him to paint the vaulting of the chapel. Michelangelo tried every means to avoid it, and recommended Raphael. . . . At length, seeing that the Pope was resolute, [he] decided to do it. . . . Michelangelo then made arrangements to do the whole work singlehanded. . . . When he had finished half, the Pope . . . daily became more convinced of Michelangelo's genius, and

wished him to complete the work, judging that he would do the other half even better. Thus, singlehanded, he completed the work in twenty months, aided only by his mixer of colours. He sometimes complained that owing to the impatience of the Pope he had not been able to finish it as he would have desired, as the Pope was always asking him when he would be done. On one occasion Michelangelo replied that he would be finished when he had satisfied his own artistic sense. "And we require you to satisfy us in getting it done quickly," replied the Pope, adding that if it was not done soon he would have the scaffolding down. . . . The work was executed in great discomfort, as Michelangelo had to stand with his head thrown back, and he so injured his eyesight that for several months he could only read and look at designs in that posture. . . . I marvel that Michelangelo supported the discomfort. However, he became more eager every day to be doing and making progress, and so he felt no fatigue, and despised the discomfort.

Giorgio Vasari
From The Lives of the Most Excellent
Italian Architects, Painters, and Sculptors
from Cimabue to Our Times

Gian. Bellini and other painters of [Venice], through not having studied antiquities, employed a hard, dry and laboured style, which Titian acquired. But in 1507 arose Giorgione, who began to give his works more tone and relief, with better style, though he imitated natural things as best he could, colouring them like life, without making drawings previously, believing this to be the true method of procedure. He did not perceive that for good composition it is necessary to try several various methods on sheets, for invention is quickened by showing these things to the eye, while it is also necessary to a thorough knowledge of the nude. . . .

On seeing Giorgione's style Titian abandoned that of Bellini, although he had long practised it, and imitated Giorgione so well that in a short time his works were taken for Giorgione's. . . . He also did a marvellous Venus and Adonis. . . . In a panel of the same size he did Perseus freeing Andromeda from the marine monster, a work of unsurpassable charm. . . .

Titian's methods in these paintings differ widely from those he adopted in his youth. His first works are executed with a certain fineness and diligence, so that they may be examined closely, but these are done roughly in an impressionist manner, with bold strokes and blobs, to obtain the effect at a distance. This is why many in trying to imitate him have made clumsy pictures, for if people think that such work can be done without labour they are deceived, as it is necessary to retouch and recolour them incessantly, so that the

labour is evident. The method is admirable and beautiful if done judiciously, making paintings appear alive and achieved without labour.

Raphael Sanzio (1485–1520) Letter to Baldassare Castiglione

Castiglione was the author of the famous book of Renaissance manners, The Courtier. This letter, probably written in 1514, suggests Raphael's familiarity with the Platonic notion that individual creatures and things are imperfect expressions of an original "ideal." The individual who wishes to glimpse that ideal can do so only through the higher powers of the mind. The concept became central to the classical idealism of Renaissance and post-Renaissance art.

I have made drawings of various types based on Your Lordship's indications, and unless everybody is flattering me, I have satisfied everybody; but I do not satisfy my own judgment, because I am afraid of not satisfying yours. I am sending these drawings to you. Your Lordship may choose any of them, if you think any worthy of your choice.

The Holy Father, in honoring me, has laid a heavy burden upon my shoulders: the direction of the work at St. Peter's. I hope, indeed, I shall not sink under it; the more so, as the model I have made for it pleases His Holiness and has been praised by many connoisseurs. But my thoughts rise still higher. I should like to revive the handsome forms of the buildings of the ancients. Nor do I know whether my flight will be a flight of Icarus. Vitruvius affords me much light, but not sufficient.

As for the Galatea, I should consider myself a great master if it had half the merits you mention in your letter. However, I perceive in your words the love you bear me; and I add that in order to paint a fair one, I should need to see several fair ones, with the proviso that Your Lordship will be with me to select the best. But as there is a shortage both of good judges and of beautiful women, I am making use of some sort of idea which comes into my mind. Whether this idea has any artistic excellence in itself, I do not know. But I do strive to attain it.

59

From the Canons and Decrees of the Council of Trent

The Catholic church responded to the growth in Northern Europe of independent "Reformed" churches (inaugurated by Martin Luther's 1517 critique of the Church) by attempting to stop the Reformation and win back the territories and peoples lost to the Roman Church. These various measures of the sixteenth and early seventeenth centuries are collectively called the Counter Reformation. One agency of this development was the Council of Trent, a series of three meetings of church leaders in 1545–47, 1551–52, and 1562–63. The following is from one of the council's last edicts, dated December 3–4, 1563, a response to ongoing Protestant attacks against religious images.

The holy council commands all bishops and others who hold the office of teaching and have charge of the cura animarum, that in accordance with the usage of the Catholic and Apostolic Church, received from the primitive times of the Christian religion, and with the unanimous teaching of the holy Fathers and the decrees of sacred councils, they above all instruct the faithful diligently in matters relating to intercession and invocation of the saints, the veneration of relics, and the legitimate use of images. . . . Moreover, that the images of Christ, of the Virgin Mother of God, and of the other saints are to be placed and retained especially in the churches, and that due honor and veneration is to be given them; not, however, that any divinity or virtue is believed to be in them by reason of which they are to be venerated, or that something is to be asked of them, or that trust is to be placed in images, as was done of old by the Gentiles who placed their hope in idols; but because the honor which is shown them is referred to the prototypes which they represent, so that by means of the images which we kiss and before which we uncover the head and prostrate ourselves, we adore Christ and venerate the saints whose likeness they bear. That is what was defined by the decrees of the councils, especially of the Second Council of Nicaea, against the opponents of images.

Moreover, let the bishops diligently teach that by means of the stories of the mysteries of our redemption portrayed in paintings and other representations the people are instructed and confirmed in the articles of faith, which ought to be borne in mind and constantly reflected upon; also that great profit is derived from all holy images, not only because the people are thereby reminded of the benefits and gifts bestowed on them by Christ, but also because through the saints the miracles of God and salutary examples are set before the eyes of the faithful, so that they may give God thanks for those things, may fashion their own life and conduct in imitation of the saints and be moved to adore and love God and cultivate piety. But if anyone should teach or maintain anything contrary to these decrees, let him be anathema.

If any abuses shall have found their way into these holy and salutary observances, the holy council desires earnestly that they be completely removed, so that no representation of false doctrines and such as might be the occasion of grave error to the uneducated be exhibited. . . . Finally, such zeal and care should be exhibited by the bishops with regard to these things that nothing may appear that is disorderly or unbecoming and confusedly arranged, nothing that is

profane, nothing disrespectful, since holiness becometh the house of God.

60

From a session of the Inquisition Tribunal in Venice of Paolo Veronese

Because of the liberal religious atmosphere of Venice, Veronese was never required to make the various changes to his painting of the Last Supper (fig. 653) asked for by the tribunal of the Inquisition in this interrogation. All parties seem to have been satisfied with a mere change of title, to Supper in the House of Levi (now Christ in the House of Levi).

Today, Saturday, the 18th of the month of July, 1573, having been asked by the Holy Office to appear before the Holy Tribunal, Paolo Caliari of Verona, . . . Questioned about his profession:

Answer: I paint and compose figures.

Q: Do you know the reason why you have been summoned? A: No, sir.

Q: Can you imagine it?

A: I can well imagine.

Q: Say what you think the reason is.

A: According to what the Reverend Father, the Prior of the Convent of SS. Giovanni e Paolo, . . . told me, he had been here and Your Lordships had ordered him to have painted [in the picture] a Magdalen in place of a dog. I answered him by saying I would gladly do everything necessary for my honor and for that of my painting, but that I did not understand how a figure of Magdalen would be suitable there. . . .

Q: What picture is this of which you have spoken?

A: This is a picture of the Last Supper that Jesus Christ took with His Apostles in the house of Simon. . . .

Q: At this Supper of Our Lord have you painted other figures? A: Yes, milords.

Q: Tell us how many people and describe the gestures of each.

A: There is the owner of the inn, Simon; besides this figure I have made a steward, who, I imagined, had come there for his own pleasure to see how the things were going at the table. There are many figures there which I cannot recall, as I painted the picture some time ago. . . .

Q: In this Supper which you made for SS. Giovanni e Paolo what is the significance of the man whose nose is bleeding?

A: I intended to represent a servant whose nose was bleeding because of some accident.

Q: What is the significance of those armed men dressed as Germans, each with a halberd in his hand? . . .

A: We painters take the same license the poets and the jesters take and I have represented these two halberdiers, one drinking and the other eating nearby on the stairs. They are placed there so that they might be of service because it seemed to me fitting, according to what I have been told,

that the master of the house, who was great and rich, should have such servants.

- Q: And that man dressed as a buffoon with a parrot on his wrist, for what purpose did you paint him on that canvas?
- A: For ornament, as is customary.
- Q: Who are at the table of Our Lord?
- A: The Twelve Apostles.
- Q: What is St. Peter, the first one, doing?
- A: Carving the lamb in order to pass it to the other end of the table.
- Q: What is the Apostle next to him doing?
- A: He is holding a dish in order to receive what St. Peter will give him.
- Q: Tell us what the one next to this one is doing.
- A: He has a toothpick and cleans his teeth. . . .
- Q: Did any one commission you to paint Germans, buffoons, and similar things in that picture?
- A: No, milords, but I received the commission to decorate the picture as I saw fit. It is large and, it seemed to me, it could hold many figures.
- Q: Are not the decorations which you painters are accustomed to add to paintings or pictures supposed to be suitable and proper to the subject and the principal figures or are they for pleasure—simply what comes to your imagination without any discretion or judiciousness?
- A: I paint pictures as I see fit and as well as my talent permits.
- Q: Does it seem fitting at the Last Supper of the Lord to paint buffoons, drunkards, Germans, dwarfs and similar vulgarities?
- A: No, milords.
- Q: Do you not know that in Germany and in other places infected with heresy it is customary with various pictures full of scurrilousness and similar inventions to mock, vituperate, and scorn the things of the Holy Catholic Church in order to teach bad doctrines to foolish and ignorant people?

A: Yes that is wrong. . . .

After these things had been said, the judges announced that the above named Paolo would be obliged to improve and change his painting within a period of three months from the day of this admonition and that according to the opinion and decision of the Holy Tribunal all the corrections should be made at the expense of the painter and that if he did not correct the picture he would be liable to the penalties imposed by the Holy Tribunal. Thus they decreed in the best manner possible.

Andrea Palladio (1518–1580)
From *The Four Books of Architecture*

Published in 1570, Palladio's Four Books of Architecture made an enormous impression on his European contemporaries.

His book provided the basis for much French and English architecture of the seventeenth and eighteenth centuries.

Guided by a natural inclination, I gave myself up in my most early years to the study of architecture: and as it was always my opinion, that the ancient Romans, as in many other things, so in building well, vastly excelled all those who have been since their time, I proposed to myself Vitruvius for my master and guide, who is the only ancient writer of this art, and set myself to search into the reliques of all the ancient edifices, that, in spight of time and the cruelty of the Barbarians, yet remain; and finding them much more worthy of observation, than at first I had imagined, I began very minutely with the utmost diligence to measure every one of their parts; of which I grew at last so sollicitous an examiner, (not finding any thing which was not done with reason and beautiful proportion) that I have very frequently not only travelled in different parts of Italy, but also out of it. . . .

Whereupon perceiving how much this common use of building was different from the observations I had made upon the said edifices, and from what I had read in Vitruvius, Leon Battista Alberti, and in other excellent writers . . . it seemed to me a thing worthy of a man, who ought not to be born for himself only, but also for the utility of others, to publish the de-signs of those edifices, (in collecting which, I have employed so much time, and exposed myself to so many dangers) and concisely to set down whatever in them appeared to me more worthy of consideration; and moreover, those rules which I have observed, and now observe, in building; that they who shall read these my books, may be able to make use of whatever will be good therein, and supply those things in which . . . I shall have failed; that one may learn, by little and little, to lay aside the strange abuses, the barbarous inventions, the superfluous expence, and (what is of greater consequence) avoid the various and continual ruins that have been seen in many fabricks....

The first part shall be divided into two books; in the first shall be treated of the preparation of the materials, and when prepared, how, and in what manner, they ought to be put to use, from the foundation up to the roof: where those precepts shall be, that are universal, and ought to be observed in all edifices, as well private as publick.

In the second I shall treat of the quality of the fabricks that are suitable to the different ranks of men: first of those of a city; and then of the most convenient situation for villas, and in what manner they are to be disposed.

62 Carel van Mander (1548–1606) From *The Painter's Treatise*

Van Mander's biographies of distinguished Dutch and Flemish painters, published in 1604, are a counterpart to the lives of

Italian artists by Giorgio Vasari, which first appeared in 1550. Van Mander, a painter himself, begins his biographies with Jan van Eyck because he was considered the inventor of oil painting and consequently the originator, with his brother Hubert, of the Netherlandish tradition of painting. Among the works described by Van Mander are the Ghent Altarpiece (see figs. 673–75) and a painting that is probably the Arnolfini Portrait (see figs. 677 and 678).

It is supposed that the art of painting with a glue and egg medium [tempera painting] was imported into the Netherlands from Italy, because, as we have noted in the biography of Giovanni of Cimabue, this method was first used in Florence, in 1250. . . .

According to the people of Bruges, Joannes [Jan] was a learned man, clever and inventive, who studied many subjects related to painting: He examined many kinds of pigment; he studied alchemy and distillation. At length, he worked out a method of varnishing his egg and glue paintings with oil, so that these shining and lustrous pictures exceedingly delighted all who saw them. . . .

Joannes had painted a panel on which he had spent much time.... He varnished the finished panel according to his new invention and placed it in the sunlight to dry.... The panel burst at the joints and fell apart. Joannes ... took a resolve that the sun should not damage his work ever again.

Accordingly, . . . he set himself to discover or invent some kind of varnish which would dry within the house, away from the sunlight. He had already examined many oils and other similar materials supplied by nature, and had found that linseed oil and nut oil had the best drying ability of them all. . . .

Joannes found, after many experiments, that colors mixed with these oils could be handled easily, that they dried well, became hard, and, once dry, could resist water. The oil made the color appear more alive, owing to a lustre of its own, without varnish. And what surprised and pleased him most was that paint made with oil could be applied more easily and mixed more thoroughly than paint made with egg and glue. . . .

Joannes . . . had created a new type of painting, to the amazement of the world. . . . This noble discovery, of painting with oil, was the only thing the art of painting still needed to achieve naturalistic rendition.

If the ancient Greeks, Apelles and Zeus [Zeuxis] had come to life again in this country and had seen this new method of painting, they would not have been any less surprised than if war-like Achilles [had] witnessed the thunder of cannon fire. . . .

The most striking work which the Van Eyck brothers did together is the altar-piece in the church of St John, in Ghent. . . .

The central panel of the altar-piece represents a scene from the Revelation of St John, in which the elders worship the Lamb. . . . In the upper part, Mary is represented; she is being crowned by the Father and the Son. . . .

Next to the figure of Mary are little angels singing from sheets of music. They are painted so exquisitely and so well that one can detect readily, from their facial expressions, who is singing the higher part, the high counter part, the tenor part, and the bass. . . .

Adam and Eve are represented. One may observe that Adam has a certain fear of breaking the command of the Lord, for he has a worried expression. . . .

The altar painting of the Van Eyck brothers was shown only to a few personages of high standing or to someone who would reward the keeper very well. Sometimes it was shown on important holidays, but then there was usually such a crowd that it was difficult to come near it. Then the chapel containing the altar-piece would be filled with all kinds of people—painters young and old, every kind of art lover, swarming like bees and flies around a basket of figs or raisins. . . .

Some Florentine merchants sent a splendid painting, made in Flanders, by Joannes to King Alphonso I of Naples. . . . A huge throng of artists came to see this marvelous painting, when it reached Italy. But although the Italians examined the picture very carefully, touching it, smelling at it, scenting the strong odor produced by the mixture of the colors with oil, and drawing all kinds of conclusions, the secret held until Antonello of Messina, in Sicily, went to Bruges to learn the process of oil-painting. Having mastered the technique, he introduced the art into Italy, as I have described in his biography. . . .

Joannes had once painted in oil two portraits in a single scene, a man and a woman, who give the right hand to each other, as if they had been united in wedlock by *Fides*. This little picture came through inheritance into the hands of a barber in Bruges. Mary, aunt of King Philip of Spain and widow of King Louis of Hungary, . . . happened to see this painting. The art loving princess was so pleased with this picture that she gave a certain office to the barber which brought him a yearly income of a hundred guilders.

63 Gaspar Ofhuys (c. 1456–1523) From an account of the illness of

Hugo van der Goes

Gaspar Ofhuys entered the "Red Cloister" monastery near Brussels together with Hugo van der Goes in 1475. Ofhuys was perhaps jealous of the special privileges Van der Goes enjoyed because of his status as a painter, and intimates that his mental illness was an affliction brought on by the sin of pride. This sin was often attributed to artists in the Middle Ages.

About five or six years after he had taken the vows it fell to our brother [Hugo van der Goes] to make a journey which—if I remember right—took him to Cologne. . . . Hugo, during one night of his journey home, was seized by a strange illness of his mind; he uttered unceasing laments about being doomed

and sentenced to eternal damnation. He even wanted to lay murderous hands on himself and had to be prevented by force from doing so. Because of this strange illness that journey came to an extremely sad end. However, thanks to efficient help, Brussels was safely reached, and prior Thomas was immediately summoned. When he saw and heard all that had happened he suspected that Hugo was vexed by the same illness which had befallen King Saul; and remembering that Saul was relieved when David played the harp he at once permitted plenty of music to be made in the presence of Hugo and also other soothing performances to be arranged in order to chase away those fantasies. But with all this, Hugo's health did not improve; he continued to rave and to pronounce himself a child of perdition. In this sad state he came home to the monastery. . . .

We can speak of two possible assumptions concerning the illness of our painter-brother converse. The first is that it was a natural one, a kind of frenzy. There exist various natural species of this disease: sometimes it is caused by "melancholy" victuals, sometimes by imbibing strong wine; then again by passions of the soul such as anxiety, sadness, overwork, or fear. . . . As regards those passions of the soul, I know for certain that this converse brother was much afflicted by them. For he was deeply troubled by the thought of how he could ever finish the works of art he wanted to paint, and it was said at that time that nine years would hardly suffice for it. . . .

The second possibility of explaining this disease is that it was sent by Divine Providence which, as it is written in the second Epistle of St. Peter, ch. 3, "is long-suffering to us-ward, not willing that any should perish, but that all should come to repentance." For this converse brother was highly praised in our order because of his special artistic achievements—in fact, he thus became more famous than he would have been outside our walls; and since he was only human—as are all of us—the various honors, visits, and accolades that came to him made him feel very important. Thus, since God did not want him to perish, He in His compassion sent him this humiliating disease which indeed made him very contrite. This our brother understood very well, and as soon as he had recovered he became most humble.

Fray José de Sigüenza (1544?–1606) From the *History of the Order of St. Jerome*

The works of Hieronymus Bosch were collected by the Spanish king Philip II (reigned 1556–98) and were displayed in his Escorial Palace near Madrid, where Sigüenza was the librarian. The interpretation of Bosch's work was as difficult then as it is today and caused just as much disagreement. This passage is Sigüenza's attempt to interpret the painting that we call The Garden of Delights (figs. 684 and 685).

Among these German and Flemish pictures . . . there are distributed throughout the house many by a certain Geronimo Bosch. Of him I want to speak at somewhat greater length for various reasons: first, because his great inventiveness merits it; second, because they are commonly called the absurdities of Geronimo Bosque by people who observe little in what they look at; and third, because I think that these people consider them without reason as being tainted by heresy. . . .

The difference that, to my mind, exists between the pictures of this man and those of all others is that the others try to paint man as he appears on the outside, while he alone had the audacity to paint him as he is on the inside. . . .

The ... painting has as its basic theme and subject a flower and the fruit of [a] type that we call strawberries. . . . In order for one to understand his idea, I will expound upon it in the same order in which he has organized it. Between two pictures is one large painting, with two doors that close over it. In the first of the panels he painted the Creation of Man, showing how God put him in paradise, a delightful place . . . and how He commands him as a test of his obedience and faith not to eat from the tree, and how later the devil deceived him in the form of a serpent. He eats and, trespassing God's rule, is exiled from that wondrous place and deprived of the high dignity for which he was created. . . . This is [shown] with a thousand fantasies and observations that serve as warnings. . . .

In the large painting that follows he painted the pursuits of man after he was exiled from paradise and placed in this world, and he shows him searching after the glory that is like hay or straw, like a plant without fruit, which one knows will be cast into the oven the next day, . . . and thus uncovers the life, the activities, and the thoughts of these sons of sin and wrath, who, having forgotten the commands of God . . . strive for and undertake the glory of the flesh. . . .

In this painting we find, as if alive and vivid, an infinite number of passages from the scriptures that touch upon the evil ways of man, . . . many allegories or metaphors that present them in the guise of tame, wild, fierce, lazy, sagacious, cruel, and bloodthirsty beasts of burden and riding animals. . . . Here is also demonstrated the transmigration of souls that Pythagoras, Plato, and other poets . . . displayed in the attempt to show us the bad customs, habits, dress, disposition, or sinister shades with which the souls of miserable men clothe themselves—that through pride they are transformed into lions; by vengefulness into tigers; through lust into mules, horses, and pigs; by tyranny into fish; by vanity into peacocks; by slyness and craft into foxes; by gluttony into apes and wolves; by callousness and evil into asses; by stupidity into sheep; because of rashness into goats...

One can reap great profit by observing himself thus portrayed true to life from the inside. . . . And he would also see in the last panel the miserable end and goal of his pains, efforts, and preoccupations, and how . . . the brief joys are transformed into eternal wrath, with no hope or grace.

65

From the contract for the St. Wolfgang Altarpiece

It took Michael Pacher ten years (1471–81) to complete this elaborate altarpiece for the pilgrimage church of St. Wolfgang. The altarpiece is still in its original location (fig. 691).

Here is recorded the pact and contract concerning the altar at St. Wolfgang, concluded between the very Reverend, Reverend Benedict, Abbot of Mondsee and of his monastery there, and Master Michael, painter of Bruneck, on St. Lucy's day of the year 1471.

Item, it is first to be recorded that the altar shall be made conforming to the elevation and design which the painter has brought to us at Mondsee, and to its exact measurements.

Item, the predella shrine shall be guilded on the inside and it shall show Mary seated with the Christ Child, Joseph, and the Three Kings with their gifts; and if these should not completely fill the predella shrine he shall make more figures or armored men, all gilt.

Item, the main shrine shall show the Coronation of Mary with angels and gilt drapery—the most precious and the best he can make.

Item, on one side St. Wolfgang with mitre, crozier, church, and hatchet; on the other St. Benedict with cap, crozier, and a tumbler, entirely gilded and silvered where needed.

Item, to the sides of the altar shall stand St. Florian and St. George, fine armored men, silvered and gilded where needed.

Item, the inner wings of the altar shall be provided with good paintings, the panels gilded and equipped with gables and pinnacles, representing four subjects, one each. . . .

Item, the outer wings—when the altar is closed—shall be done with good pigments and with gold added to the colors; the subject from the life of St. Wolfgang. . . .

Item, at St. Wolfgang, while he completes and sets up the altar, we shall provide his meals and drink, and also the iron work necessary for setting up the altar, as well as help with loading wherever necessary.

Item, the contract is made for the sum of one thousand two hundred Hungarian guilders or ducats. . . .

Item, if the altar is either not worth this sum or of higher value, and there should be some difference of opinion be-tween us, both parties shall appoint equal numbers of experts to decide the matter.

66

Martin Luther (1483–1546) From Against the Heavenly Prophets in the Matter of Images and Sacraments

Luther inaugurated the Protestant Reformation movement in

1517 with a public critique of certain church practices, especially the sale of indulgences. His actions soon inspired a number of similar reformers in the North, some of whom were more extreme in their denunciations of the conventional artistic and musical trappings of the Church. The ideas of one of these, Andreas Bodenstein, inspired this writing of 1525.

I approached the task of destroying images by first tearing them out of the heart through God's Word and making them worthless and despised.... For when they are no longer in the heart, they can do no harm when seen with the eyes. But Dr. Karlstadt [Andreas Bodenstein], who pays no attention to matters of the heart, has reversed the order by removing them from sight and leaving them in the heart....

I have allowed and not forbidden the outward removal of images, so long as this takes place without rioting and uproar and is done by the proper authorities. . . . And I say at the outset that according to the law of Moses no other images are forbidden than an image of God which one worships. A crucifix, on the other hand, or any other holy image is not forbidden. Heigh now! you breakers of images, I defy you to prove the opposite! . . .

Thus we read that Moses' Brazen Serpent remained (Num. 21:8) until Hezekiah destroyed it solely because it had been worshiped (II Kings 18:4)....

However, to speak evangelically of images, I say and declare that no one is obligated to break violently images even of God, but everything is free, and one does not sin if he does not break them with violence. . . .

Nor would I condemn those who have destroyed them, especially those who destroy divine and idolatrous images. But images for memorial and witness, such as crucifixes and images of saints, are to be tolerated. This is shown above to be the case even in the Mosaic law. And they are not only to be tolerated, but for the sake of the memorial and the witness they are praiseworthy and honorable, as the witness stones of Joshua (Josh. 24:26) and of Samuel (I Sam. 7:12).

67

Albrecht Dürer (1471–1528) From the draft manuscript for The Book on Human Proportions

Dürer made two trips to Italy and was exposed to the new art theories being discussed there, which impressed him greatly. He did not accept them uncritically, however. His rethinking of Italian ideas often appears only in preliminary form, in drafts such as this one, written in 1512–13.

How beauty is to be judged is a matter of deliberation. . . . In some things we consider that as beautiful which elsewhere would lack beauty. "Good" and "better" in respect of beauty

are not easy to discern, for it would be quite possible to make two different figures, neither of them conforming to the other, one stouter and the other thinner, and yet we scarce might be able to judge which of the two may excel in beauty. What beauty is I know not, though it adheres to many things. When we wish to bring it into our work we find it very hard. We must gather it together from far and wide, and especially in the case of the human figure. . . . One may often search through two or three hundred men without finding amongst them more than one or two points of beauty which can be made use of. You therefore, if you desire to compose a fine figure, must take the head from some and the chest, arm, leg, hand, and foot from others. . . .

Many follow their taste alone; these are in error. Therefore let each take care that his inclination blind not his judgment. For every mother is well pleased with her own child. . . .

Men deliberate and hold numberless differing opinions about these things and they seek after them in many different ways, although the ugly is more easily attained than the beautiful. Being then, as we are, in such a state of error, I know not how to set down firmly and with finality what measure approaches absolute beauty. . . .

It seems to me impossible for a man to say that he can point out the best proportions for the human figure; for the lie is in our perception, and darkness abides so heavily within us that even our gropings fail. . . .

However, because we cannot altogether attain perfection, shall we therefore wholly cease from our learning? This bestial thought we do not accept. For evil and good lie before men, wherefore it behooves a rational man to choose the better.

Artemisia Gentileschi (1593–c. 1653) From a letter to Don Antonio Ruffo

Being a woman in what was considered until very recently a man's field was not easy, as this letter of November 13, 1649, only begins to suggest. Ruffo was one of Artemisia's patrons.

I have received a letter of October 26th, which I deeply appreciated, particularly noting how my master always concerns himself with favoring me, contrary to my merit. In it, you tell me about that gentleman who wishes to have some paintings by me, that he would like a Galatea and a Judgment of Paris, and that the Galatea should be different from the one that Your Most Illustrious Lordship owns. There was no need for you to urge me to do this, since by the grace of God and the Most Holy Virgin, they [clients] come to a woman with this kind of talent, that is, to vary the subjects in my painting; never has anyone found in my pictures any repetition of invention, not even of one hand.

As for the fact that this gentleman wishes to know the price before the work is done, . . . I do it most unwillingly. . . . I never quote a price for my works until they are done. However, since Your Most Illustrious Lordship wants me to do this, I will do what you command. Tell this gentleman that I want five hundred ducats for both; he can show them to the whole world and, should he find anyone who does not think the paintings are worth two hundred *scudi* more, I won't ask him to pay me the agreed price. I assure Your Most Illustrious Lordship that these are paintings with nude figures requiring very expensive female models, which is a big headache. When I find good ones they fleece me, and at other times, one must suffer [their] pettiness with the patience of Job.

As for my doing a drawing and sending it, I have made a solemn vow never to send my drawings because people have cheated me. In particular, just today I found . . . that, having done a drawing of souls in Purgatory for the Bishop of St. Gata, he, in order to spend less, commissioned another painter to do the painting using my work. If I were a man, I can't imagine it would have turned out this way. . . .

I must caution Your Most Illustrious Lordship that when I ask a price, I don't follow the custom in Naples, where they ask thirty and then give it for four. I am Roman, and therefore I shall act always in the Roman manner.

Giovanni Pietro Bellori (1613–1696) From Lives of the Modern Painters, Sculptors, and Architects

Unlike Vasari's Lives, Bellori's book is more selective and critical. He often ignores or gives minimal treatment to those artists and architects who offended his classical taste. Bellori's account was published in Rome in 1672.

When the divine Raphael with the ultimate outlines of his art used its beauty to the summit, restoring it to the ancient majesty of all those graces and enriching the merits that once made it most glorious in the presence of the Greeks and the Romans, painting was most admired by men and seemed descended from Heaven. But since things of the earth never stay the same, and whatever gains the heights inevitably must with perpetual vicissitude fall back again, so art, which from Cimabue and Giotto had slowly advanced over the long period of two hundred and fifty years, was seen to decline rapidly and from a queen become humble and common. Thus, with the passing of that happy century, all of its beauties quickly vanished. The artists, abandoning the study of nature, corrupted art with the maniera, that is to say, with the fantastic idea based on practice and not on imitation. This vice, the destroyer of painting, first began to appear in masters of honored acclaim. It rooted itself in the schools that later followed. . . .

Thus, when painting was drawing to its end, . . . It pleased God that in the city of Bologna, the mistress of sciences and studies, a most noble mind was forged and through it the declining and extinguished art was reforged. He was that Annibale Carracci, of whom I now mean to write. . . .

Annibale continued in the [Farnese] gallery [fig. 729] . . . ordering various myths toward an end: the theme . . . is human love governed by Heaven. Thus the theme of love . . . displays its power, subjecting the breasts of the strong, the chaste, and the savage: the loves, that is to say, of Hercules, Diana, and of Polyphemus. . . . The amours of Jupiter, Juno, Aurora, and Galatea reveal its power in the universe. The white wool that Diana receives from the god Pan and the golden apples given to Paris by Mercury are the gifts by which Amor sways human minds, and the discords provoked by beauty. The Bacchanal is the symbol of drunkenness, the source of impure desires. And since the end of all irrational pleasures is sorrow and punishment, . . . he painted Andromeda bound to the rock to be devoured by the sea monster, symbolizing that the soul bound to emotion becomes the food of vice if Perseus—that is to say, reason and the love of the worthy—does not come to her assistance.

Francisco Pacheco (1564–1654) From *The Art of Painting*

Pacheco, a painter, was the most influential Spanish writer on art in the seventeenth century. For his conception of the aim of painting he relied heavily on the ideas stated by the Council of Trent. This book, which Pacheco worked on for 40 years, was published in Seville in 1649.

When dealing with the aim of painting . . . it is necessary to . . . distinguish between the aim of the work and the aim of the worker . . . [and] between the aim of the painting and the aim of the painter. The aim of the painter . . . will be by means of his art to earn a living, achieve fame or renown, to afford pleasure or service to another or to work for his own enjoyment. . . .

But considering the aim of the painter as a Christian [his] . . . principal goal will be to achieve a state of grace through the study and practice of this profession; because the Christian, born to achieve high things, is not content to restrict his activities to lower things, attending only to human rewards and earthly comfort. . . .

It would be hard to overstate the good that holy images do: they perfect our understanding, move our will, refresh our memory of divine things. They heighten our spirits . . . and show to our eyes and hearts the heroic and magnanimous acts of patience, of justice, chastity, meekness, charity and contempt for worldly things in such a way that they instantly cause us to seek virtue and to shun vice, and thus put us on the roads that lead to blessedness. . . .

Would that our painters nowadays realized these obligations; but how many of them are capable of understanding these words of mine? Oh, what a shame it is, what a terrible shame! . . .

I say that the principal goal of Christian images will always be to persuade men to be pious and to lead them to God . . . even though other specific goals may also be involved, such as leading men to penitence, to suffering with pleasure, charity, contempt of the world, or to other virtues, which are all ways of uniting men with God, which is indeed the highest end that the painting of sacred images can aspire to.

71

From the "Inventory of the Paintings,
Furniture and Other Effects Contained
in the House of Rembrandt van Rijn
Living in the Breestreet
by the St. Anthony Water-Gate"

This list, dated July 25–26, 1656, was prepared for the liquidation sale of all Rembrandt's properties, which was forced by his numerous creditors. The list provides invaluable information on Rembrandt's diverse tastes and interests.

- 1. One small picture of Adrian Brouwer, representing a pastrycook. . . .
- 13. One Nativity by Jan Lievens. . . .
- 57. One perspective by Lucas van Leyden. . . .
- 67. One head by Raphael of Urbino. . . .
- 81. One copy after Anibale Carracci. . . .
- 85. One head of an old man by van Eyck. . . .
- 93. Two small landscapes by Hercules Seghers. . . .
- 196. One ditto [book] with copper-plate engravings by [after] Raphael of Urbino. . . .
- 200. The precious book of Andrea Mantegna. . . .
- 204. One ditto containing prints of Breughel the elder. . . .
- 208. One ditto containing prints by Lucas Cranach. . . .
- 216. One ditto, very large with almost all the work of Titian. . . .
- 230. One ditto full of the work of Michelangelo Buonarotti. . . .
- 232. One book with erotica by Raphael, Rosso, Anibale Carracci and Giulio Bonasone. . . .
- 234. One ditto containing Turkish buildings by Melchior Lorch, Hendrick van Aelst and others, illustrating Turkish life. . . .
- 245. One ditto with trial proofs [after pictures] by Rubens and Jordaens. . . .
- 273. Albrecht Dürer's book on proportion with woodcuts. . . .
- 312. Thirty-three pieces of ancient weapons and wind instruments. . . .
- 313. Thirty-three pieces of ancient hand weapons, arrows,

staffs, assegais and bows. . . .

- 317. Seventeen hands and arms, cast from life. . . .
- 329. One antique Laocoön. . . .
- 333. Three or four antique heads of women. . . .
- 340. One [pair of] costumes for an Indian man and woman.

72

Nicolas Poussin (c. 1593–1665) From an undated manuscript

Poussin's ideas on art were central to the formation of the French Academy in 1648 and, because of the preeminence of that academy, therefore to the entire European academic movement of the seventeenth through the nineteenth centuries.

The magnificent manner consists of four things: subject, or topic, concept, structure and style. The first requirement, which is the basis for all the others, is that the subject or topic should be great, such as battles, heroic actions and divine matters. However, given the subject upon which the painter is engaged is great, he must first of all make every effort to avoid getting lost in minute detail, so as not to detract from the dignity of the story. He should describe the magnificent and great details with a bold brush and disregard anything that is vulgar and of little substance. Thus the painter should not only be skilled in formulating his subject matter, but wise enough to know it well and to choose something that lends itself naturally to embellishment and perfection. Those who choose vile topics take refuge in them on account of their own lack of ingenuity. Faintheartedness is therefore to be despised, as is baseness of subject matter for which any amount of artifice is useless. As for the concept, it is simply part of the spirit, which concentrates on things, like the concept realized by Homer and Phidias of Olympian Zeus who could make the Universe tremble with a nod of his head. The drawing of things should be such that it expresses the concept of the things themselves. The structure, or composition of the parts, should not be studiously researched, and not sought after or contrived with effort but should be as natural as possible. Style is a particular method of painting and drawing, carried out in an individual way, born of the singular talent at work in its application and in the use of ideas. This style, and the manner and taste emanate from nature and from the mind.

73 Charles Perrault (1628–1703) From *Memoirs of My Life*

Charles Perrault, a poet, critic, and adviser to Colbert on arts and letters, helped his brother, Claude, get the assignment to

design the East Front of the Louvre (fig. 799).

Since the Cavaliere Bernini's design was not very well conceived, and could only be carried out to the shame of France, I made a listing of only a few of the incongruities with which it was ridden, because I thought it inappropriate to point out too many of them the first time. I sent this memorandum to Monsieur Colbert, who was then at Saint-Germain. The first time he came to Paris, after having received my list, he had me step into the garden with him, and even cut short the audience he was granting to someone else, in order to talk to me. . . .

"You did well," he told me; "continue doing so, because one cannot be too well informed on a matter of this importance. I don't understand," he added, "how this man believes he can give us a design in which so many things are misunderstood."

From that moment on, Monsieur Colbert undoubtedly saw that he had approached the wrong party, but he believed he had to follow through on his gamble. Perhaps he thought also that with good advice, he could redirect the Cavaliere to the right way of doing things, and that by showing him his mistakes, he would have him produce something excellent; but he still did not know the Cavaliere. . . .

I am persuaded that as an architect he hardly excelled at all, except with the decor and machinery of the theater. . . .

Monsieur Colbert, in contrast, wanted precision, and wanted to see where and how the King would be lodged, and how he could be most easily served. He was persuaded, and with reason, that one must manage not only to accommodate the person of the King and all other royalty, but also give convenient lodging to all the household officials. . . . He was killing himself to produce and to have others produce memoranda of everything which had to be observed in the construction of all these apartments.

The Cavaliere was extremely bored with all these lists of which he understood nothing and wished to understand nothing, imagining erroneously that it was beneath the dignity of a great architect like himself to descend to the level of these *minutiae*. He complained to Monsieur de Chantelou, even doing so in a disrespectful manner. "Monsieur Colbert," he said, "treats me like a little boy" (these are the words of Monsieur de Chantelou's diary, which was shown to me after his death); "with his useless speeches about privies and underground passages, he fills up entire meetings; he wants to be the clever one and understands nothing; he's a real boaster." . . .

If the Cavaliere was unhappy with Monsieur Colbert, Monsieur Colbert for his part was no less dissatisfied with the Cavaliere, although he revealed nothing outwardly, and on the contrary, he always spoke of Bernini with remarkable respect.

74

Paul de Fréart (1609–1694) From his unpublished diary

Fréart, Sieur de Chantelou, was an art collector and student of

artistic theory. Louis XIV appointed him to assist Bernini during his stay in Paris, and Chantelou became one of Bernini's few French friends and admirers. The following passage is taken from Chantelou's dairy, dated June 6, 1665.

He [M. Colbert] went into the room where the bust stood [Bernini's unfinished portrait bust of Louis XIV]. Having looked at it for a long time, he expressed astonishment . . . at the progress of the work. . . . The Cavalier replied that there was always something to do for those who want to do well. Up until now he had almost always worked from his imagination and had looked only rarely at his drawings. He had looked principally at what was inside (pointing at his forehead) where, he said, he had his image of His Majesty (otherwise he would only have made a copy in place of an original), but this was giving him a great deal of trouble. The King, in asking him for a portrait, could not have asked him for anything more difficult. He would strive to see to it that the portrait would turn out to be the least bad of all. In this type of portrait beyond the likeness, it is necessary to render what ought to be in the face of heroes.

Sir Christopher Wren (1632–1723)
From Proposals for Rebuilding the City of
London After the Great Fire

The manner of building in the city of London, practised in the former ages, was commonly with timber, a material easily procured, and at little expense. . . . This often subjected the town to great and destructive fires, sometimes to the ruin of the whole. . . . This mode continued until the two fatal years 1665 and [166]6; but then the successive calamities of plague and fire gave all people occasion seriously to reflect on the causes of the increase of both to that excessive . . . closeness of buildings, and combustible materials; and hence the wishes for the necessary amendment of both, by widening the streets, and building with stone and brick, became universal.

Some intelligent persons went farther, and thought it highly requisite the city in the restoration should rise with beauty, by the straightness and regularity of buildings, and convenience for commerce, by the well disposing of streets and public places, and the opening of wharfs. . . . In order therefore to a proper reformation, Dr. Wren (pursuant to the royal commands) immediately after the fire, took an exact survey of the whole area . . . and designed a plan or model of a new city. . . .

The observations of a late critic (allowing for some mistakes in his description of [my] scheme for rebuilding the city) are judicious and right.

"Towards the end of King James the First's reign, . . . taste in architecture made a bold step from Italy to England at once, and scarce staid a moment to visit France by the way. From the most profound ignorance in architecture, the most consummate night of knowledge, Inigo Jones started up, a prodigy of art, and vied even with his master, Palladio himself. From so glorious an outset there was not any excellency that we might not have hoped to attain; Britain had a reasonable prospect to rival Italy. . . . But in the midst of these sanguine expectations, the fatal civil war commenced. . . .

"Wren was the next genius that arose. . . .

"The fire of London furnished the most perfect occasion that can ever happen in any city, to rebuild it with pomp and regularity. This Wren foresaw, and . . . offered a scheme for that purpose, which would have made it the wonder of the world. He proposed to have laid out one large street from Aldgate to Temple Bar, in the middle of which was to have been a large square, capable of containing the new church of St. Paul [figs. 810–12], with a proper distance for the view all round it; whereby that huge building would not have been cooped up, as it is at present, in such a manner as nowhere to be seen to advantage at all; but would have had a long and ample vista at each end. . . . He further proposed to rebuild all the parish churches in such a manner as to be seen at the end of every vista of houses. . . . Lastly, he proposed to build the houses uniform, and supported on a piazza, . . . and by the waterside . . . he had planned a long and broad wharf . . . with proper warehouses for merchants between, to vary the edifices, and make it at once one of the most beautiful and most useful ranges of structure in the world. But the hurry of rebuilding, and the disputes about property, prevented this glorious scheme from taking place."

76 Marie-Louise-Elisabeth Vigée-Lebrun (1755–1842) From the *Memoirs of Vigée-Lebrun*

Vigée-Lebrun published three volumes of memoirs (1835 and 1837) when she was in her eighties. Female portraits and the painting of flowers were considered the most appropriate subjects for women artists in the eighteenth and nineteenth centuries.

M. Le Brun asked for my hand in marriage. Nothing could have been further from my thoughts than my marrying Le

Brun.... I was then twenty years old; I had few worries about my future since I was already earning a substantial amount of money. In short, I had no inclination to wed at all.... Finally, I accepted, goaded on by the desire to escape the torment of living with my stepfather.... So little inclined was I to sacrifice my freedom, that even as I approached the church on my wedding day, I was still asking myself, "Shall I say yes or no?" Alas, I said yes and merely exchanged my old problems for new ones.... His overwhelming passion for extravagant women, combined with a love of gambling, decimated both his fortune and my own, of which he made very free use. So, by the time I left France in 1789 I had

less than twenty francs to my name, in spite of the fact that

I had earned more than a million from my work: he had

squandered the lot! . . .

When I finally announced my marriage officially . . . I was not as downcast as I might have been, for I still had my beloved painting. I was overwhelmed with commissions from every quarter and although Le Brun took it upon himself to appropriate my earnings, this did not prevent him from insisting that I take pupils in order to increase our income even further. I consented to this demand without really taking time to consider the consequences and soon the house was full of young ladies learning how to paint "eyes, noses and faces." I was constantly correcting their efforts and was thus distracted from my own work, which I found very irritating indeed. . . .

I believe the strain of having to leave my precious brushes for several hours each day only increased my eagerness to paint. I refused to leave my easel until nightfall and the number of portraits I painted at this period is quite astonishing. As I had a horror of the current fashion, I did my best to make my models a little more picturesque. I was delighted when, having gained their trust, they allowed me to dress them after my fancy. No-one wore shawls then, but I liked to drape my models with large scarves, interlacing them around the body and through the arms, which was an attempt to imitate the beautiful style of draperies seen in the paintings of Raphael and Dominichino. . . . Above all I detested the powdering of hair and succeeded in persuading the beautiful Duchesse de Grammont-Caderousse not to wear any when she sat for me. Her hair was as black as ebony and I parted it on the forehead, arranging it in irregular curls. After the sitting, which ended around dinner time, the Duchess did not alter her hair at all and left directly for the theatre; being such a pretty woman, she was quite influential and her hair style gradually insinu-ated itself into fashionable society and eventually became universal. . . .

Happy as I was at the idea of becoming a mother, after nine months of pregnancy, I was not in the least prepared for the birth of my baby. The day my daughter was born, I was still in the studio, trying to work on my *Venus Binding the Wings of Cupid* in the intervals between labour pains.

77

Sir Joshua Reynolds (1723–1792) From "A Discourse, Delivered at the Opening of the Royal Academy, January 2, 1769"

An Academy, in which the Polite Arts may be regularly cultivated, is at last opened among us by Royal Munificence. This must appear an event in the highest degree interesting, not only to the Artists, but to the whole nation.

It is indeed difficult to give any other reason, why an empire like that of Britain, should so long have wanted an ornament so suitable to its greatness, than that slow progression of things, which naturally makes elegance and refinement the last effect of opulence and power. . . .

The principal advantage of an Academy is, that . . . it will be a repository for the great examples of the Art. These are the materials on which Genius is to work, and without which the strongest intellect may be fruitlessly or deviously employed. By studying these authentick models, that idea of excellence which is the result of the accumulated experience of past ages may be at once acquired, and the tardy and obstructed progress of our predecessors, may teach us a shorter and easier way. The Student receives, at one glance, the principles which many Artists have spent their whole lives in ascertaining. . . . How many men of great natural abilities have been lost to this nation, for want of these advantages? . . .

Raffaelle, it is true, had not the advantage of studying in an Academy; but all *Rome*, and the works of Michael Angelo in particular, were to him an Academy. . . .

One advantage, I will venture to affirm, we shall have in our Academy, which no other nation can boast. We shall have nothing to unlearn. . . .

But as these Institutions have so often failed in other nations . . . I must take leave to offer a few hints, by which those errors may be rectified. . . .

I would chiefly recommend, that an implicit obedience to the *Rules of Art*, as established by the practice of the great Masters, should be exacted from the *young* Students. That those models, which have passed through the appro-bation of ages, should be considered by them as perfect and infallible Guides; as subjects for their imitation, not their criticism.

I am confident, that this is the only efficacious method of making a progress in the Arts; and that he who sets out with doubting, will find life finished before he becomes master of the rudiments. For it may be laid down as a maxim, that he who begins by presuming on his own sense, has ended his studies as soon as he has commenced them. Every opportunity, therefore, should be taken to discountenance that false and vulgar opinion, that rules are the fetters of Genius.

-	1375 1/00 1/25					
	1350-1375	1375–1400	1400-1425			
HISTORY AND POLITICS	 1356 Edward, the "Black Prince," son of Edward III of England, defeats the French at Poitiers and takes prisoner Jean le Bon, king of France c. 1358 Foundation of the powerful Hanseatic League of Baltic mercantile cities Peasant uprisings: 1358, Jacquerie revolt in France; 1381, Wat Tyler's rebellion in England, London sacked 1368 In China, the Buddhist monk Chu Yüan-chang leads a peasants' revolt, driving the Mongols out of Beijing and founding the Ming dynasty, taking the title Hungwu Timur (Tamerlane, c. 1369–1405), Mongol leader with capital at Samarkand, establishes the Timurid empire, conquering much of the Mideast and Persia and invading India 		1410 Teutonic Knights defeated by Poles and Lithuanians at battle of Tennenberg, ending their sole jurisdiction over Prussia Philip the Good of Burgundy (r. 1419–67) inherits the Northern Provinces; including Holland, Flanders, and Luxembourg, it is one of the largest and richest holdings in Europe and a threat to France			
		Sources of Renaissance Neo-Platonism Neo-Platonic ideas of harmony, balance, proportion, and spirituality appeared in Western thought throughout the Middle Ages, but the source texts of Plato, Plotinus, and their followers were little known. In 1394 the Greek scholar Manuel Chrysoloras visited Italy from Constantinople and remained to teach Greek in Florence. In 1439 other Greek scholars from the Byzantine Empire attended the ecclesiastical Council of Florence, which attempted to unite the Eastern and Western churches, and they further exposed local writers and artists to the intellectual heritage of classical Greece, especially its idealism. The work of the Early Renaissance architects				
RELIGION		 1378 Papal court returns to Rome from Avignon. Great Papal Schism begins, in which several candidates compete for the papacy c. 1382 John Wycliffe, English theologian and religious reformer, initiates first complete translation of the Bible into English 	1405–15 Jan Hus, influenced by Wycliffe, leads the Hussite movement to reform the church in Bohemia and denounces sale of indulgences; 1415, burned at the stake as a heretic at the Council of Constance 1417 Pope Martin V ends Great Schism			
	(left) BOHEMIAN MASTER Death of the Virgin, Prague, 1350–60 (right) Florence Cathedral, begun by ARNOLFO DI CAMBIO, 1296; dome by FILIPPO BRUNELLESCHI, 1420–36	CLAUS SLUTER The Moses Well, Dijon, 1395–1406	(left) DONATELLO, St. Mark, 1411–13 (right) GENTILE DA FABRIANO The Adoration of the Magi, Italy, 1423			
MUSIC, LITERATURE, AND PHILOSOPHY	1361 Foundation of the University of Pavia, in northern Italy Christine de Pisan (c. 1363–c. 1430), French writer of poems on courtly love, best known for her spirited defense of women in <i>The Book of the City of Ladies</i> , c. 1404–5 Leonardo Bruni (1370–1444), prominent humanist and classical scholar in Florence, author of <i>Praise of the City of Florence</i> , 1402–3	1395–98 Manuel Chrysoloras, a Byzantine Greek scholar, teaches Greek in Florence; translates Plato's <i>Republic</i> into Latin; author of first Greek grammar used in Western Europe	Leone Battista Alberti (1404–72) writes influential treatises <i>On Painting</i> , 1435, <i>On Architecture</i> , 1452, and <i>On Sculpture</i> , 1464			
SCIENCE, TECHNOLOGY, AND EXPLORATION	1355 Death of Jacopo Dondi (b. 1298), creator of an early clock run by weights	1375 Charles V of France commissions the <i>Carta catalana</i> , an accurate map of Europe, North Africa, and Western Asia Prince Henry the Navigator of Portugal (1394–1460) sponsors exploration, especially of the African coasts, an observatory, a school of navigation, and improvements in ship design, the compass, and cartography 1398 Cennino Cennini writes the <i>Libro dell'</i> arte, a technical manual for painters	1406 King Edward IV of England founds the Society of Merchant Adventurers to encourage trade and commerce 1407 Establishment of Bank of St. George, first public bank, in Genoa 1410 Ptolemy's Geography translated into Latin c. 1413 Pictorial perspective invented in Italy, by Filippo Brunelleschi			

1425–1450	1450–1475	1475–1500	
 1438 Hapsburg rule of the Holy Roman Empire (later Germany and Austria) begins (until 1806) By 1450 Medici family, founded by Cosimo the Elder (1389–1464), gains power in Florence; 1469–92, Lorenzo the Magnificent virtually rules the city 	1453 Constantinople falls to the Turkish army of Mohammed II; Ottoman Empire founded Matthias the Just (r. 1458–90) establishes Hungary as dominant power in central Europe 1469 Marriage of Ferdinand of Aragon and Isabella of Castile unites Spain	1477 French army defeats Charles the Bold of Burgundy at Nancy. Northern Provinces pass to Maximilian, Hapsburg emperor; 1488, Flemish cities revolt against his rule 1478 Pazzi Conspiracy in Florence; Giuliano de' Medici assassinated during Easter mass, and Pazzi family decimated in revenge; 1480, turmoil among Tuscan city-states quelled by Lorenzo's leadership 1492 Defeat of Moslem Grenada by the Span-	
influence to a certain degree. After the fall of Constantinople to the manently to the West. Their ideas, and the stimulated interest in humanist studies. ential at the erudite Florentine court of Platonic Academy. The philosopher Man	After the fall of Constantinople to the Turks in 1453, many scholars fled permanently to the West. Their ideas, and the precious manuscripts they brought, stimulated interest in humanist studies. Neo-Platonism was particularly influential at the erudite Florentine court of Lorenzo de' Medici, known as the Platonic Academy. The philosopher Marsilio Ficino (1433–99) and the artists Sandro Botticelli (1444/5–1510) and Michelangelo (1475–1564) were promi-		
1431 Joan of Arc burned at the stake in Rouen, accused of heresy and witchcraft 1439 Council of Florence attempts to reunite the Eastern Orthodox church with the Western Catholics; its success is short-lived	1464 Pope Pius II, humanist and patron of learning, dies during a failed crusade against the Turks Pope Sixtus IV (r. 1471–84) condemns the excesses of the Spanish Inquisition and tries to reunite Russian church with Rome	1494 Rise in Florence of Fra Girolamo Savo- narola (1452–98), monk and religious radi- cal advocating moral and governmental re- form; 1498, he is burned at the stake for heresy	
(left) JAN VAN EYCK Arnolfini Portrait, detail, 1434 (right) LORENZO GHIBERTI Panel of the "Gates of Paradise," c. 1435	(right) HUGO VAN DER GOES The Portinari Altarpiece, center panel, c. 1476	(right) SANDRO BOTTICELLI The Birth of Venus, c. 1480	
François Villon (born c. 1431), French poet Marsilio Ficino (1433–99), humanist and philosopher, undertakes a translation of Plato, under the patronage of the Medici in Florence Josquin Des Prés (c. 1440–1521), Flemish composer of madrigals Pope Nicholas V (r. 1447–55) founds Vatican Library	Desiderius Erasmus of Rotterdam (c. 1466–1536), scholar and satirical author (<i>Praise of Folly</i> , 1509), epitomizes the humanist intellectual concerns of the Northern Reformation	1481 A commentary on Dante's <i>Divine Comedy</i> is published, with illustrations by Botticelli and a preface by Marsilio Ficino 1494 Sebastian Brant (1458?–1521), German humanist, writes <i>The Ship of Fools</i> , a satirical poem	
 c. 1425 Discovery and proliferation in Northern Europe of the technique of painting with oil c. 1440 Earliest record of a suction pump 	c. 1450 Movable type for printing invented in Germany (by Johann Gutenberg?); books become more readily available; literacy gradually spreads Leonardo da Vinci (1452–1519) performs dissections of human cadavers; his experiments in hydraulics, mechanics, engineering, flight, and optics, recorded in coded manuscripts, address a dazzling range of intellectual and scientific problems	1487–88 Bartholomew Diaz of Portugal rounds Cape of Good Hope and circumnavigates African continent 1490 First Latin edition of Galen's works on medicine published in Venice 1492 Columbus lands in the Bahamas 1497–1501 Voyages of Vasco da Gama and Pedro Cabral establish Portuguese dominance of trade with India, utilizing both Atlantic and Pacific sea passages	

_	Timeline Three: 1350 to 1800 (continued) 1500–1525 1525–1550 1550–1575				
HISTORY AND POLITICS	Francis I of France (r. 1515–47), a popular king. His rich and cultured court introduces Italian ideas and art to the North 1519–21 The Spaniard Hernán Cortés defeats Aztecs in Mexico; 1532, Francisco Pizarro conquers Peru Charles V of Spain elected Holy Roman Emperor (r. 1519–56); founder of Hapsburg dynasty Suleiman I, Turkish sultan (r. 1520–66), raids the European continent, threatening Hungary, Austria, and Italy; begins a gradual Turkish conquest of the eastern Mediterranean islands over the next century 1524–25 Peasants' War in Germany, inspired by Martin Luther	1527 Henry VIII of England, seeking a divorce from his first wife, Catherine of Aragon, breaks with the Catholic church. 1534, his Act of Supremacy establishes the Church of England and confiscates Catholic church property 1527 Charles V of Spain sacks Rome, demoralizing the Italian states and signaling the end of Roman dominance 1533–84 Ivan the Terrible rules in Russia 1541 John Calvin (1509–64) brings Reformation to the Swiss city of Geneva. His writings establish the rigorous Calvinist branch of Protestantism 1545 Pope Paul III (r. 1534–49), in response to the threat of Protestantism, calls the Council of Trent, first major conference on church reform. Its tenets provide the basis for the Catholic Counter Reformation, including a number of rules for artists depicting religious subjects. The council meets periodically until 1563	Wars of Lutheran against Catholic princes in Germany; 1555, Peace of Augsburg lets each sovereign decide the religion of his subjects 1556 Philip II reigns in Spain; territories include lands in the Americas, Italy, France, and The Netherlands as well as the Iberian Peninsula Elizabeth I (r. 1558–1603) succeeds to the English throne, fostering a period of prosperity, international trade, and exploration 1562–98 Henry IV's persecution of Protestants in France leads to religious wars 1568–1648 Netherlands revolt against Spain. 1579, Union of Utrecht affirms the unification of the Northern Netherlands; 1581, they declare independence from Spain 1571 Battle of Lepanto, off the Greek coast. Spanish and Venetian fleets defeat the Turks, beginning the decline of Turkish naval power		
RELIGION	1517 Martin Luther (1483–1546) posts "95 Theses," against Catholic practice of selling indulgences, on door of Wittenberg church, signaling the beginning of the Protestant Reformation		1560 John Knox, Scottish minister, founds Presbyterian branch of Protestant church		
	(left) MICHELANGELO David, 1501–4 (right) HIERONYMUS BOSCH The Garden of Delights, center panel, c. 1510–15	PONTORMO Deposition, c. 1526–28	TITIAN Christ Crowned with Thorns, c. 1570		
MUSIC, LITERATURE, AND PHILOSOPHY	Sir Thomas Wyatt (1503–42), English poet and courtier under Henry VIII, translates Petrarch's sonnets and creates the English sonnet form 1516 Ludovico Ariosto (1474–1533), Italian poet and diplomat, publishes <i>Orlando Furioso</i> , an epic poem	 1528 Baldassare Castiglione (1478–1529) writes The Book of the Courtier 1532 Niccolò Machiavelli (1469–1527) writes The Prince, examining Renaissance political practice and thought 1534 François Rabelais (1483–1553) authors the satires Gargantua and Pantagruel 1547 Henry Howard translates Vergil's Aeneid into English blank verse 	1550 Giorgio Vasari (1511–74), Italian painter, publishes <i>The Lives of the Artists</i> Felix Lope de Vega (1562–1635), Spanish poet and playwright William Shakespeare (1564–1616), English dramatist and poet Ben Jonson (1572–1637); John Donne (1573–1631), English master of metaphysical poetry and prose		
SCIENCE, TECHNOLOGY, AND EXPLORATION	 1501 Amerigo Vespucci, a Florentine navigator in the service of Portugal, explores coast of Brazil 1511 First road map of Europe 1513 The Spaniard Vasco Nuñez de Balboa crosses Panama and finds the Pacific Ocean 1516 Portuguese sailors reach China; 1543, Japan 1519–22 Ferdinand Magellan of Portugal circumnavigates the globe 	 1543 Nicolaus Copernicus (1473–1543), Polish astronomer, publishes theory of the solar system in which the planets revolve around the sun; beginning of modern astronomy 1543 Andreas Vesalius (1514–64), court physician to Emperor Charles V, publishes first scientific study of human anatomy based on dissections 	 1556 Georgius Agricola (1494–1555) publishes <i>De re metallica</i>, on metallurgy 1569 Gerhard Mercator (1512–94) designs correct projection of the earth onto a flat map, for accurate navigation charts c. 1572 Tycho Brahe (1546–1601), Danish astronomer, produces a catalogue of stars; Johannes Kepler (1571–1630), German astronomer, discovers the elliptical orbits of the planets 		

1575–1600	1600-1625	1625–1650
1588 Spanish Armada, aiming to attack England, defeated by English navy The Protestant Reformation The h		1625 Charles I rules England. Disputes with Parliament and autocratic measures lead, in 1642, to Civil War. 1649, Charles beheaded, ending the war and founding the Commonwealth (1649–53), under Oliver Cromwell 1630–42 Large-scale emigration of English settlers to North American colonies: 16,000 arrive in Massachusetts 1639 Japanese enforce policy of isolation from all Europeans, except a token Dutch trading post 1648 Treaty of Westphalia ends Thirty Years' War; Spain acknowledges the sovereignty of
before the Renaissance was punctuated by periodic movements to reform corrupt practices within the Catholic church. In the Middle Ages these were usually local and short-lived. But the fifteenth century saw the spread of literacy and education, growing economic power, a much-envied rise in the wealth of the papacy, and persistent quarrels between the pope and secular princes; these forces made criticism of the Church especially fierce. In 1517, the German cleric Martin Luther proclaimed his "95 Theses" condemning abuses of the Church		the Northern Netherlands
and sparked a popular revolt, soon joi as a rival and who coveted the vast ter movement grew dramatically, especial had begun as a protest with mixed polyveloped into a detailed reformulation this restructuring is generally called Protestantism focused on the relation	ritories held by the papacy. The ally in Northern Europe. What itical, pious, and social aims deof the Christian religion itself; rotestantism.	Publications of Cornelius Jansenius (Augustinus, 1640) lead to conflict with Jesuits. Preoccupied with internal strife, the papacy loses its dominant position in European politics
to God and was characterized by an austerity of taste that signified a rejection of the corrupt and worldly opulence of Rome. Use of images in churches was strictly prohibited. Renaissance taste for the personal, the contemporary, and the material was to some degree a product of Protestant culture, which patronized secular arts. For this new market, artists began to create small images for personal use. A new vocabulary of subject matter developed: landscape, still life, and scenes of daily life. In the North such paintings were sold directly to the public in a free-market system, rather than solely by patronage or commission.		(left) ARTEMISIA GENTILESCHI, Judith and Maidservant with the Head of Holofernes, c. 1625 (right) JACQUES CALLOT, detail of Hangman's Tree,
1588 St. Theresa of Avila writes Interior Castle, a visionary text; Michel de Montaigne, French thinker, writes Essays 1590 Edmund Spenser, English poet, publishes The Faerie Queene	 1604 Carel van Mander publishes biographical history of Dutch and Flemish painting 1605 Miguel de Cervantes Saavedra (1547–1616) writes <i>Don Quixote</i> 1607 Claudio Monteverdi's <i>Orpheus</i> is performed in Mantua, one of the first operas Baruch Spinoza (1632–77), Dutch philosopher 	from Great Miseries of War, 1633 1636 Pierre Corneille (1606–84), French dramatist, writes Le Cid 1637 René Descartes (1596–1650), French philosopher and scientist, writes Discourse on Method Molière (1622–73) and Jean Racine (1639–99), French playwrights 1649 Francisco Pacheco (1564–1654), Spanish historian, publishes The Art of Painting
 c. 1575 Potatoes, maize, tobacco, cocoa, coffee imported from the Americas to Europe 1578 Li Shih-chen, Chinese physician, publishes an illustrated compendium of medicines 1582 Pope Gregory XIII reforms the calendar, aligning it more accurately with astronomy; in order to do so, he decrees that Thursday, October 4, be followed by Friday, October 15 	 c. 1600 Invention of the telescope and microscope, based on new lens-grinding techniques developed in Holland 1610 Galileo Galilei (1564–1642), in Italy, first uses the telescope to view the stars and planets; his conclusions support the Copernican system and are banned by the Catholic church in 1633 	1628 William Harvey, English physician (1575–1657), describes the circulation of blood 1636 Founding of Harvard College, Boston 1642 Blaise Pascal (1623–62) invents first adding machine Antonio Stradivari (1644–1737), Italian designer of fine stringed instruments 1648 Royal Academy of Painting and Sculpture founded in Paris

-	1650–1675	1675–1700	1700-1725
HISTORY AND POLITICS	 1652–54 Naval and mercantile competition between English and Dutch leads to war 1659 Louis XIV of France marries Maria Teresa, daughter of Philip IV of Spain; 1661, establishes autocratic regime (r. 1661–1715) with his influential adviser Jean-Baptiste Colbert 1660 Parliament proclaims Charles II king, restoring English monarchy 1666 Great Fire in London destroys over 450 acres of the city 1672–78 France and England wage war against Netherlands. William III of Orange beats back invasion of French forces 	 1679 English Parliament passes Habeas Corpus Act, which sets foundation for fair judicial procedure and prisoners' rights 1685 Louis XIV revokes Edict of Nantes (1598), which had granted Protestants some religious freedom. Mass emigration of educated Protestants ensues, a blow to French industry and commerce. In England, James II, a Catholic, succeeds to the throne and attempts to restore Catholicism 1688 The so-called Glorious Revolution in England: James II flees; Parliament passes Declaration of Rights, limiting the power of the monarchy 1689 Protestants William III of Orange and Mary rule England; new laws protect freedom of religion, establish annual parliaments, and guarantee individual liberty Peter the Great (r. 1689–1725) rules Russia, with a program of westernization 1692 Witchcraft trials in Salem, Massachusetts 	 1701 Frederick III crowns himself king of Prussia. Prussia gains international power through military strength 1702–13 War of Spanish Succession: extinction of the Hapsburg line in Spain leads to war among major European powers. At conclusion, Philip of Anjou, grandson of Louis XIV, takes the Spanish throne as Philip V; beginning of Bourbon rule in Spain 1704 Defeat of French at Blenheim by English and allies, led by John Churchill, Duke of Marlborough 1707 Union of England and Scotland as the United Kingdom of Great Britain Louis XV (r. 1715–74), king of France, consolidates absolute power of the monarchy
RELIGION	c. 1667 Russian church changes liturgy and ritual to conform to Greek practice. Secession from the church of the conservative "Old-Believers" 1668 Society of Friends (Quakers) officially established in England	1682 Louis XIV's Four Articles are adopted in France, placing secular power over reli- gious authority. Vehemently opposed by Pope Innocent XI (r. 1676–89)	1721 Peter the Great reforms Russian church government John Wesley (1703–91), with his brother, Charles, founds the Methodist branch of Protestantism in England
	(left) DIEGO VELAZQUEZ, The Maids of Honor, 1656 (right) FRANS HALS, The Women Regents of the Old Men's Home at Haarlem, 1664	(left) BARTOLOMÉ ESTEBAN MURILLO Virgin and Child, c. 1675–80 (right) SIR CHRISTOPHER WREN Facade of St. Paul's Cathedral, London, 1675–1710	RACHEL RUYSCH Flower Still Life, after 1700
MUSIC, LITERATURE, AND PHILOSOPHY	 1667 John Milton (1608–74), English poet, writes Paradise Lost Joseph Addison (1672–1719), English essayist, editor with the writer and statesman Sir Richard Steele (1672–1729) of the Spectator, a literary and satirical periodical 1672 Giovanni Pietro Bellori (1613–96), Italian commentator on Baroque art, publishes Lives of the Modern Painters 	John Locke (1632–1704), founder of English school of empirical philosophy Baroque composers: Alessandro Scarlatti (1659–1725) and Antonio Vivaldi (1678–1741), Italian; Johann Sebastian Bach (1685–1750), George Frideric Handel (1685–1759), German François-Marie Voltaire (1694–1778), French critical writer	1711 Alexander Pope (1688–1744), English poet, writes <i>The Rape of the Lock</i> David Hume (1711–76), Scottish philosopher Jean-Jacques Rousseau (1712–78), French philosopher and novelist Denis Diderot (1713–84), editor of first <i>Encyclopedia</i> , in France Johann Joachim Winckelmann (1717–68), German art theorist and antiquarian
SCIENCE, TECHNOLOGY, AND EXPLORATION	 1662 Royal Society of London founded by Charles II, a forum for scientific activity for two centuries; 1662, Boyle's Law describes the properties of gas pressure 1663 Charles Lebrun, at Royal Academy in Paris, institutes strict guidelines for art 1665 In England Robert Hooke publishes his discovery of cells and microorganisms 1673 Pendulum clock invented by the Dutchman Christiaan Huygens 	 1687 Isaac Newton (1642–1727) publishes theory of the laws of motion, including the principle of gravity, in England; 1704, his <i>Optics</i> investigates the nature and behavior of light 1698 Steam engine invented in England by Thomas Savery 	1705 Edmund Halley (1656–1742), in England, discovers similarities in the paths of comets Benjamin Franklin (1706–1790), American statesman and inventor, invents bifocal lens, lightning rod, and Franklin stove, and publishes observations on electricity in Philadelphia 1717 Temperature gradation system proposed by Gabriel Fahrenheit, in Holland

1725–1750	1750–1775	1775–1800
The Enlightenment The European en ial expansion and development of financial markets, and government, tems weakened monarchs and the chapopulations. English parliamentary democracy, and the various forms of the lution were all attempts to remake the radical discoveries in the sciences and tion of society itself. Thinkers such a Kant, and Swift sought to use reason a and took experience as the measure of cal, modernist attitude was a taste for as a commitment to the perfectibility of reforms in education, medicine, taxat	1756–66 Seven Years' War: England and Prussia fight Austria and France on land and sea and throughout the colonies; called the French and Indian Wars in North America; 1769, French defeated at Quebec Catherine the Great (r. 1762–96) increases the power, territory, and influence of Russia eighteenth century was a time of colonew methods in industry, farming, Constitutions and parliamentary systurch and offered the vote to broader monarchy, American representative the French government after the Revopolitical system more inclusively, while technology encouraged a new definites Rousseau, Hume, Voltaire, Diderot, and scientific method in their inquiries, knowledge. Coupled with this skeptisentimentality and idealism, expressed of humanity. This led, in public life, to ion, and religious tolerance, as well as feoclassical and Romantic movements	 1775–83 American Revolution: 1776, Declaration of Independence; 1787–88, United States Constitution ratified 1789 French Revolution begins. Declaration of a National Assembly dedicated to producing a constitution. Mobs storm Bastille prison and riot in Paris; 1792, French monarchy is abolished; 1793, Louis XVI is beheaded. European states declare war against the French Republic, whose radical ideas are feared to encourage unrest 1793–95 Reign of Terror in France, dominated by Maximilien Robespierre, with as many as 350 executions per month 1793–95 Partition of Poland by Russia, Prussia, and Austria completely erases the country 1796–97 Napoleon Bonaparte's Italian campaign conquers most of Italy; after his Egyptian campaign (1798–99), his reputation as soldier and diplomat is established; 1799, he controls France 1793 French government, under Robespierre, outlaws the worship of God; Cult of Reason established 1798 Napoleon abolishes papal rule and establishes a French-dominated Roman Republic in the Papal States
CANALETTO The Bucintoro at the Molo, c. 1732	(left) FRANÇOIS BOUCHER, The Toilet of Venus, 1751 (right) GIOVANNI BATTISTA TIEPOLO The Marriage of Frederick Barbarossa, 1752	(left) MARIE-LOUISE-ELISABETH VIGÉE-LEBRUN The Duchesse de Polignac, 1783 (center) JOHN HENRY FUSELI, The Nightmare, c. 1790
1726 Jonathan Swift (1667–1745), Irish political satirist, writes <i>Gulliver's Travels</i>	1755 Samuel Johnson (1709–1784) compiles a Dictionary of the English Language 1774 Johann von Goethe (1749–1832) publishes The Sorrows of Young Werther in Germany, extolling naturalism and sentimentality; it inspires numerous suicides Wolfgang Amadeus Mozart (1756–91), innovative Austrian composer of symphonies, operas, and church music	 (right) FRANCISCO GOYA, The Sleep of Reason 1776 Adam Smith (1723–90), Scottish economist, writes The Wealth of Nations 1781 Immanuel Kant (1724–1804), German critical philosopher, writes the Critique of Pure Reason 1792 Mary Wollstonecraft (1759–1836) writes Vindication of the Rights of Women, first English feminist treatise
 1744 Geographical survey of France begun, the first such topographical survey 1745 Discovery of Pompeii and Herculaneum 1749 George Leclerc (1707–88) writes a treatise on natural history in England 	 1753 Carl Linnaeus, Swedish botanist (1707–78), writes the Species Plantarum, the definitive modern classification system for plants 1764 Invention of the spinning jenny and cotton gin (1793) hastens mechanization of textile production 1768–79 Captain James Cook (1728–79) explores the islands of the Pacific 1774 Joseph Priestly (1733–1804), English chemist, isolates oxygen 	1783 First flight in a hot-air balloon, France 1789 Antoine Lavoisier (1743–94) publishes his systematic study of chemistry in France 1790–1801 Revolutionary government of France institutes metric system 1798 Edward Jenner (1749–1823) demonstrates first vaccination against smallpox 1798 Alois Senefelder (1771–1834), Hungarian inventor, develops lithography

PART FOUR

THE MODERN WORLD

rt history, according to the classical model of Johann Winckelmann,

unfolds in an orderly progression in which one phase follows another as inevitably as night follows day. In addition, the concept of period style implies that the arts march in lockstep, sharing the same characteristics and developing according to the same inner necessity. The thoughtful reader will already suspect, however, that any attempt to synthesize the history of art and place it into a broader context must inevitably mask a welter of facts that do not conform to such a systematic model and may, indeed, call it into question. So far as the art of the distant past is concerned, we may indeed have little choice but to see it in larger terms, since so many facts have been erased that we cannot possibly hope to reconstruct a full and accurate historical record. Hence it is arguably the case that any reading is an artificial construct inherently open to question. As we approach the art of our times, these become more than theoretical issues. They take on a new urgency as we try, perhaps vainly, to understand modern civilization and how it came to be this way.

It is suggestive of the difficulties facing the historian that the period which began 250 years ago has not acquired a name of its own. Perhaps this does not strike us as peculiar at first. We are, after all, still in its midst. Considering how promptly the Renaissance coined a name for itself, however, we may well wonder why no key concept comparable to the "rebirth of antiquity" has yet emerged. It is tempting to call this "The Age of Revolution," for it has been characterized by rapid and violent change. It began with revolutions of two kinds: the Industrial Revolution, symbolized by the invention of the steam engine; and the political revolution, under the banner of democracy, inaugurated in America and France.

Both of these revolutions are still going on. Industrialization and democracy are sought over much of the world. Western science and Western political thought (and, in their wake, all the other products of modern civilization: food, dress, art, music, literature) will eventually belong to all peoples, although they have been challenged by other ideologies that command allegiance—nationalism, religion, even tribalism. These two movements are so closely linked today that we tend to think of them as different aspects of one process, with effects more far-reaching than any basic shift since the Neolithic Revolution 10,000 years ago. Still, the twin revolutions are not

the same. Indeed, we cannot discern a common impulse behind these developments, despite attempts to relate them to the rise of capitalism. The more we try to explain their relationship and trace their historic roots, the more paradoxical they seem. Both are founded on the idea of progress. But whereas progress in science and technology during the past two centuries has been more or less continuous and measurable, we can hardly make this claim for our pursuit of happiness, however we choose to define it. Here, then, is a fundamental conflict that continues to this very day.

If we nevertheless accept "The Age of Revolution" as a convenient name for the era as a whole, we must still make a distinction for the century to which we belong. For lack of a better word, we shall call it *modernity*. It is a problematic term, modernity. What is it? When did it begin? These questions are not unlike those posed by the Renaissance, and so perhaps is the answer. No matter how many different opinions there may be about the nature of the beast—and scholars remain deeply divided over the issues—the modern era clearly began when people acquired "modern consciousness." Around 1900 men and women in the Western world became aware that the character of the new age in which they were living was defined by the machine, which brought with it a different sense of time and space, as well as the promise of a new kind of humanity and society.

It is difficult for us to appreciate from our vantage point just how radical the technological revolution seemed to people of the time, for it has since become commonplace and been outstripped by even more far-reaching changes. The advances that took place in science, mathematics, engineering, and psychology during the 1880s and 1890s laid the foundation for the Machine Age. The diesel and turbine engines, electric motor, tire, automobile, light bulb, phonograph, radio, box camera: all these were invented before 1900, and the airplane shortly thereafter. They forever transformed the quality of life—its very feel—but it was not until these changes reached a "critical mass" in the opening years of this century that the sweeping magnitude of these changes was fully realized. Of course, this was by no means the first time that people have felt modern, which simply means contemporary. Yet modern consciousness has been so fundamental to our identity that we can hardly hope to understand civilization for the past 100 years without it.

The word *modern* has its origins in the early medieval *modernus*, meaning that which is present, of our time, and, by extension, new, novel—in contrast to antiquity, which, surprisingly, lacked a comparable expression, even though modern derives ultimately from the Latin modo (now). As this odd and unusual fact suggests, modernity is based on the Christian view of history as a break in time (before and after Christ), instead of the concept of recurring cycles that had prevailed in Greece and Rome. It is to Petrarch that we owe the idea of history as a succession of periods, which he separated into eras of light, dark, and rebirth. For him history was linear and progressive, permitting humanity to play an active part in shaping its outcome. Petrarch's veneration for antiquity was indebted partly to Bernard of Chartres, who in the early twelfth century argued that we are puny dwarfs who see farther than our predecessors because we are standing on the shoulders of giants. However, such a position did not allow the authority of the past, no matter how great, to go unchallenged. The end of the twelfth century witnessed the first dispute between disciples of ancient versus modern poetry; ever since, literature and criticism have taken the lead in framing the central issues of modernity. The controversy was revived in late-seventeenth-century France as the Quarrel of Ancients and Moderns (satirized by the English writer Jonathan Swift in *The Battle of the Books*). Throughout the debate, modern generally held negative connotations, for it was taken as the opposite of classic, whose original antonym in Latin was "vulgar." Yet not even the most conservative voices recommended the slavish imitation of antiquity. Moreover, the moderns saw themselves as adhering to eternal values even more faithfully than had the ancients themselves! As Christians, they held the advantage over the ancients on another count as well, since religious truth was deemed superior to scientific truth or aesthetic beauty, the only area where the pagans had excelled.

The nineteenth century gave birth to two conflicting views of modernity that have continued to compete with each other to this day: one based on scientific and material progress, which arose out of the Enlightenment, with its belief in reason and freedom, and is identified with the middle class; and a radical alternative regarding the bourgeoisie as the enemy of culture—in a word, philistines. Although its roots lie in eighteenth-century German thought, the second of these is a peculiarly Romantic

notion first formulated by the French writer Stendhal (Marie-Henri Beyle). Not only did he relate modernity specifically to Romanticism as a reaction against classicism, he regarded the Romantic as a warrior in the service of modernity. But why should modernity need such a warrior in the first place? Because the times were slow to accept the new, which could therefore only be validated by the future, not the present. We will recognize in Stendhal's warrior the forerunner of the avant-garde.

It was, nevertheless, Charles Baudelaire who gave modernity its current meaning. "Modernity," he wrote, "is the transitory, the fugitive, the contingent, the half of art, of which the other half is the eternal and the immutable. . . ." And "since all centuries and all peoples have had their own form of beauty, so inevitably we have ours. The particular element in each manifestation comes from the emotions; and just as we have our own particular emotions, so we have our own beauty." Perceptively, he located the source of that beauty in urban existence: "The life of our city is rich in poetic and marvellous subjects. We are enveloped and steeped as though in an atmosphere of the marvellous; but we do not notice it." In this he relied partly on his fellow critic Théophile Gautier, who said that modern beauty is based on accepting modern civilization as it is. To do so, however, artists must go against tradition and rely on their own imaginations, which requires taking enormous risks.

Baudelaire had the distinction of being the first to use mechanical metaphors for beauty in place of the organic ones favored by the Romantics. He further denounced the material progress of modern civilization, thereby helping to create the schism between modernity and modernism. What is the difference between them? Paradoxically, modernism looks to the future, whereas modernity is concerned with the present, which can stand in the way of progress. To artists, modernism is a trumpet call that both asserts their freedom to create in a new style and provides them with the mission to define the meaning of their times—and even to reshape society through their art. To be sure, artists have always responded to the changing world around them, but rarely have they risen to the challenge as they have under the banner of modernism, or with so fervent a sense of personal cause.

This is a role for which the "avant-garde" (literally, vanguard) is hardly sufficient. Although both arose as part of the decadent movement toward the end of the nine-teenth century, the term *avant-garde*, like modernism, has a long history reaching back

to the Middle Ages. The term originated in French warfare and was first applied to the arts in the sixteenth century, but began to acquire its modern definition only under the Romantics. The Socialist reformer Comte de Saint-Simon included artists with scientists and industrialists in the elite group that would rule the ideal state, because as people of imagination they can foresee the future and therefore help to create it. As Baudelaire realized, however, there is an inherent contradiction between Romantic individualism and the discipline necessary for political action. Although its scope was subsequently limited mainly to culture, the avant-garde has sometimes played an active part in politics. Despite the fact that they are closely linked, the avant-garde is by no means synonymous with—and is even antithetical to—modernism. We shall find that the two have held very different meanings for different artists—and produced surprisingly different results in each of the visual arts. Both run counter to their times. But whereas modernism remains dedicated to a utopian vision of the future that stems from the Enlightenment, the avant-garde is bent solely on the destruction of bourgeois modernity. Judged by this standard, few of the twentieth-century's leading artists have been members of a self-styled avant-garde.

Today, having cast off the framework of traditional authority which confined and sustained us before, we can act with a latitude both frightening and exhilarating. The consequences of this freedom to question all values are everywhere around us. Our knowledge about ourselves is now vastly greater, but this has not reassured us as we had hoped. In a world without fixed reference points, we search constantly for our own identity and for the meaning of human existence, individual and collective.

Because modern civilization lacks the cohesiveness of the past, it no longer proceeds by readily identifiable periods; nor are there clear period styles to be discerned in art or in any other form of culture. Instead, we find a continuity of another kind: movements and countermovements. Spreading like waves, these "isms" defy national, ethnic, and chronological boundaries. Never dominant anywhere for long, they compete or merge with each other in endlessly shifting patterns. Hence our account of modern art is guided more by movements than by countries. Only in this way can we hope to do justice to the fact that modern art, all regional differences notwith-standing, is as international as modern science.

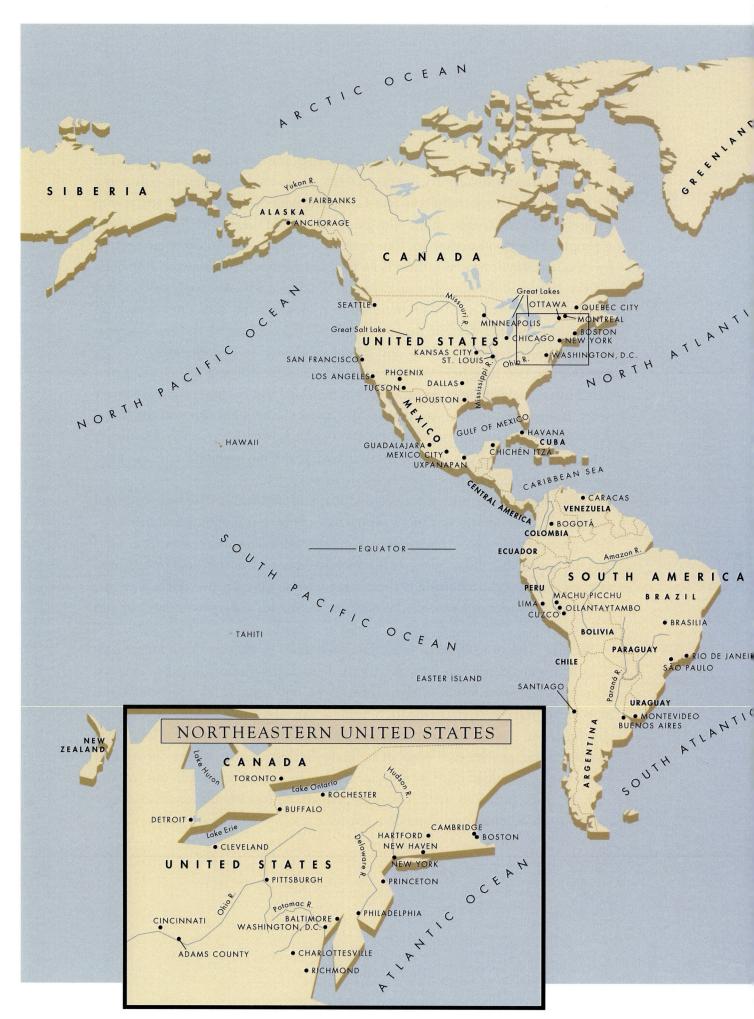

THE MODERN WORLD SIBERIA CELAND SWEDEN RUSSIA FINLAND NORWAY · OSLO ESTONIA NIZHNY NOVGOROD MOSCOW ENGLAND GERMANY BELGIUM UKRAINE KAZAKHSTAN GEORGIA A MADRID CHINA BEIJING . TOKYO MEDITERRANEAN SEA куото AFGHANISTAN SYRIA IRA LEBANON JORDAN CHINA SEA MOROCCO CAIRO ALGERIA EGYPT SĀRNĀTH TAIWAND HONG KONG CALCUTTA . SAUDI ARABIA AURITANIA CAMBODIA VIETNAM NIGERIA SOMALIA ETHIOPIA BENIN GABON NO AN OCEAN ZAIRE KINSHASA ANGOLA ZAMBIA MOZAMBIQUE MADAGASCAR AUSTRALIA CEAN SOUTH AFRICA DENMARK . HUMLEBAE GLASGOW • EDINBURGH • SCOTLAND LITHUANIA MELBOURNE . EUROPE LIVERPOOL ENGLAND MANCHESTER • ENGLAND UTRECHT | MANCHESTER | MASTERDAM | HAMBURG | HANOVER | BERLIN | LONDON | DESSAU LONDON ANTWERP GERMANY DESSAU BRIGHTON BRUSSELS FRANKFURT AMANAU AMANA GERMANY DESSAU POISSY-SUR SEINE PARIS BARBIZON ORMANS ZUNICH FRANCE BASEL BERN LUCERNE RONCHAMP SWITZERLAND SLOVENIA SLOVENIA SLOVENIA SLOVENIA UKRAINE RN • LUCERNE SWITZERLAND MILAN • ARCOLE CROATIA BOSNIA AIX-EN-PROVENCE BOSNIA-HERZEGOVINA SERBIA BULGARIA SPAIN MEDITERRANEAN SEA PORTUGAL SSOLONGHI

CHAPTER ONE

NEOCLASSICISM AND ROMANTICISM

The history of the two movements to be dealt with in this chapter covers roughly a century, from about 1750 to 1850. Paradoxically, Neoclassicism has been seen as the opposite of Romanticism on the one hand and as no more than one aspect of it on the other. The difficulty is that the two terms are not evenly matched, any more than are "quadruped" and "carnivore." Neoclassicism is a new revival of classical antiquity, more consistent than earlier classicisms, and one that was linked, at least initially, to Enlightenment thought. Romanticism, in contrast, refers not to a specific style but to an attitude of mind that may reveal itself in any number of ways, including classicism. Romanticism, therefore, is a far broader concept and is correspondingly harder to define. To compound the difficulty, the Neoclassicists and early Romantics were exact contemporaries, who in turn overlapped the preceding generation of Rococo artists. David and Goya, for example, were born within a few years of each other. And in England the leading representatives of the Rococo, Neoclassicism, and Romanticism—Reynolds, West, and Fuseli—shared many of the same ideas, although they were otherwise separated by clear differences in style and approach.

NEOCLASSICISM

The Enlightenment

If the modern era was born during the American Revolution of 1776 and the French Revolution of 1789, these cataclysmic events were preceded by a revolution of the mind that had

begun half a century earlier. Its standard-bearers were those thinkers of the Enlightenment in England, France, and Germany—David Hume, François-Marie Voltaire, Jean-Jacques Rousseau, Heinrich Heine, and others—who proclaimed that all human affairs ought to be ruled by reason and the common good, rather than by tradition and established authority. In the arts, as in economics, politics, and religion, this rationalist movement turned against the prevailing practice: the ornate and aristocratic Rococo. In the mid-eighteenth century, the call for a return to reason, nature, and morality in art meant a return to the ancients. After all, had not the classical philosophers been the original "apostles of reason"? The first to formulate this view was Johann Joachim Winckelmann, the German art historian and theorist who popularized the famous concept of the "noble simplicity and calm grandeur" of Greek art (in Thoughts on the Imitation of Greek Works . . . , published in 1755). [See Primary Sources, no. 78, page 934.] His ideas deeply impressed two painters then living in Rome, the German Anton Raphael Mengs (1728-1779) and the Scotsman Gavin Hamilton (1723-1798). Both had strong antiquarian leanings but otherwise limited artistic powers. This may explain why they accepted Winckelmann's doctrine so readily. Mengs' importance lies principally in his role as a propagator of the "Winckelmann program," since his paintings amount to little more than weak paraphrases of Italian art. He left Rome in 1761 after executing his major work, a ceiling fresco of Parnassus inspired by Raphael, and went to Spain, where he vied with the aging Tiepolo (see page 626).

It is a measure of Italy's decline that leadership should pass

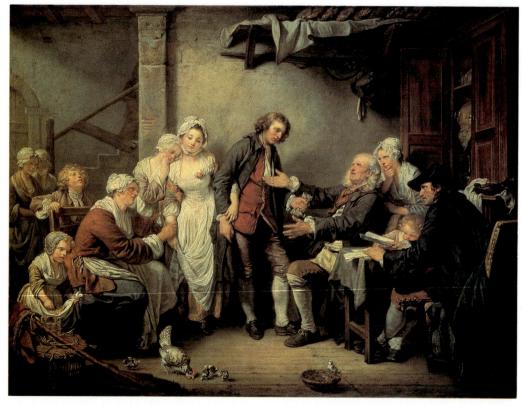

842. Jean-Baptiste Greuze. The Village Bride. 1761. Oil on canvas, 36 x 461/2" (91.4 x 118.1 cm). Musée du Louvre, Paris

to the Northerners who gathered in Rome, which remained a magnet for artists from all over Europe. The only Roman painter who could compete on even terms with the foreigners was Pompeo Batoni (1708-1787), a splendid technician who continued the eclectic classicism of Carlo Maratta (see page 560) but is remembered today chiefly for portraits of his English patrons. This vacuum helps to account for the astonishing success of Mengs and Hamilton. Toward the end of Batoni's career the Italian school was eclipsed once and for all by the French Academy in Rome under Joseph-Marie Vien (1716-1809), its head from 1775 to 1781. To French artists, a return to the classics meant, of course, the style and "academic" theory of Poussin, combined with a maximum of archaeological detail newly gleaned from ancient sculpture and the excavations of Pompeii. Vien himself was a minor artist, who reduced history painting to genre scenes of ancient life, but he was a gifted teacher, and it was his pupils who were to establish French painting as the inheritor and self-proclaimed guardian of the great tradition of Western art.

PAINTING

France

GREUZE. In France, the anti-Rococo trend in painting was at first a matter of content rather than style, which accounts for the sudden fame around 1760 of Jean-Baptiste Greuze (1725–1805). *The Village Bride* (fig. 842), like his other pictures of those years, is a scene of lower-class family life. What

distinguishes it from earlier genre paintings (compare fig. 788) is its contrived, stagelike character, borrowed from Hogarth's "dumb show" narratives (see figs. 824 and 825). But Greuze had neither wit nor satire. His pictorial sermon illustrates the social gospel of Jean-Jacques Rousseau that the poor, in contrast to the immoral aristocracy, are full of "natural" virtue and honest sentiment. Everything is intended to remind us of this, from the declamatory gestures and expressions of the actors to the smallest detail, such as the hen with her chicks in the foreground: one chick has left the brood and sits alone on a saucer, like the bride who is about to leave her "brood." The Village Bride was acclaimed a masterpiece; the loudest praise came from Denis Diderot, that apostle of Reason and Nature. Here at last was a painter with a social mission who appealed to the beholder's moral sense, instead of merely giving pleasure like the frivolous artists of the Rococo! In his first flush of enthusiasm, Diderot accepted the narrative of Greuze's pictures as "noble and serious human action" in Poussin's sense. Diderot's extravagant praise of Greuze is understandable. The Village *Bride* is a pictorial counterpart to Diderot's own melodramas.

DAVID. Diderot modified his views later, when a far more gifted and rigorous "Neo-Poussinist" appeared on the scene: Jacques-Louis David (1748–1825). A disciple of Vien, David had developed his Neoclassical style in Rome during the years 1775–81. Upon his return to France, he quickly established himself as the leading Neoclassical painter, overshadowing all others by far, so that our conception of the movement is largely based on his accomplishments. In *The Death of Socrates*

843. Jacques-Louis David.

The Death of
Socrates. 1787.
Oil on canvas,
4'3" x 6'5¹/4"
(1.3 x 1.96 m).
The Metropolitan Museum of
Art, New York.
Wolfe Fund,
1931
Catherine Lorillard
Wolfe Collection

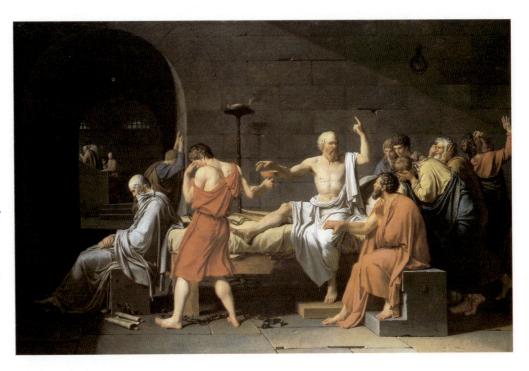

(fig. 843) of 1787, he seems more "Poussiniste" than Poussin himself (compare fig. 794). The composition unfolds parallel to the picture plane like a relief, and the figures are as solid and immobile as statues. David has added one unexpected element: the lighting, sharply focused and casting precise shadows. It is derived from Caravaggio, as is the firmly realistic detail. (Note the hands and feet, the furniture, the texture of the stone surfaces.) Consequently, the picture has a quality of life rather astonishing in so doctrinaire a statement of the new ideal style. The very harshness of the design suggests that its creator was passionately engaged in the issues of his age, artistic as well as political. Socrates, refusing to compromise his principles, was convicted of a trumped-up charge and sentenced to death. About to drink poison from the cup, he is shown not only as an example of Ancient Virtue, but also as the founder of the "religion of Reason." Here he is a Christlike figure amid his 12 disciples.

David took an active part in the French Revolution, and for some years he had controlling power over the artistic affairs of the nation comparable only to Lebrun's a century before (see pages 600-1). During this time he painted his greatest picture, The Death of Marat (fig. 844). David's deep emotion has made a masterpiece from a subject that would have embarrassed any lesser artist, for Marat, one of the political leaders of the Revolution, had been murdered in his bathtub. A painful skin condition required immersion, and he did his work there, with a wooden board serving as his desk. One day a young woman named Charlotte Corday burst in with a personal petition, and plunged a knife into his chest while he read it. David has composed the scene with a stark directness that is awe-inspiring. In this canvas, which was planned as a public memorial to the martyred hero, classical art coincides with devotional image and historical account. However, classical art could offer little specific guidance here, even though the slain figure probably derives from an antique source, and the artist has drawn on the Caravaggesque tradition of religious art far more than in *The* Death of Socrates. It is no accident that his Marat reminds us so strongly of Zurbarán's St. Serapion (see fig. 760).

England

WEST. The martyrdom of a secular hero was first immortalized by Benjamin West (1738–1820) in *The Death of General Wolfe* (fig. 845). West traveled to Rome from Pennsylvania in 1760 and caused something of a sensation, since no American painter had appeared in Europe before. He relished his role of frontiersman. On being shown the *Apollo Belvedere* (see fig. 208) he reportedly exclaimed, "How like a Mohawk warrior!" He also quickly assimilated the lessons of Neoclassicism, so that when he left a few years later, he was in command of the most up-to-date style. West stopped in London for what was intended to be a brief stay on his way home, but stayed on to became first a founding member of the Royal Academy, then, after the death of Reynolds, its president. His career was thus European rather than American, but he always took pride in his New World background.

We can sense this in *The Death of General Wolfe*, his most famous work. Wolfe's death in 1759, which occurred in the siege of Quebec during the French and Indian War, had aroused considerable feeling in London. When West, among others, decided to represent this event, two methods were open to him. He could give a factual account with the maximum of historic accuracy, or he could use "the grand manner," Poussin's ideal conception of history painting (see pages 557-58), with figures in "timeless" classical costume. Although he had absorbed the influence of Mengs and Hamilton, he did not follow them in this painting—he knew the American scene too well for that. Instead, he merged the two approaches. His figures wear contemporary dress, and the conspicuous figure of the Indian places the event in the New World for those unfamiliar with the subject. Yet all the attitudes and expressions are "heroic." The composition, in fact,

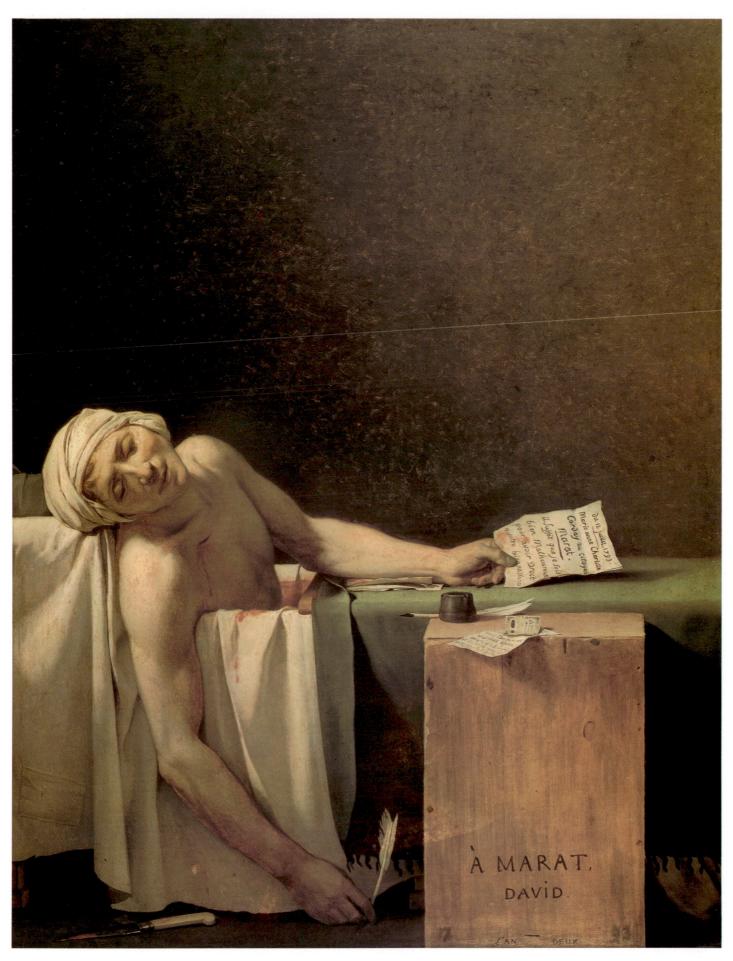

844. Jacques-Louis David. *The Death of Marat.* 1793. Oil on canvas, $65 \times 50^{1}/2$ " (165×128.3 cm). Musées Royaux des Beaux-Arts de Belgique, Brussels

845. Benjamin West. The Death of General Wolfe. 1770. Oil on canvas, 4'11¹/2" x 7' (1.51 x 2.13 m). National Gallery of Canada, Ottawa Gift of the Duke of Westminster

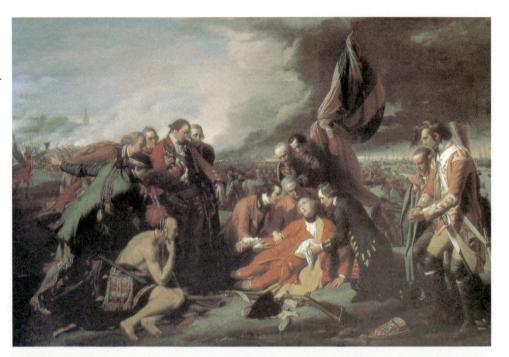

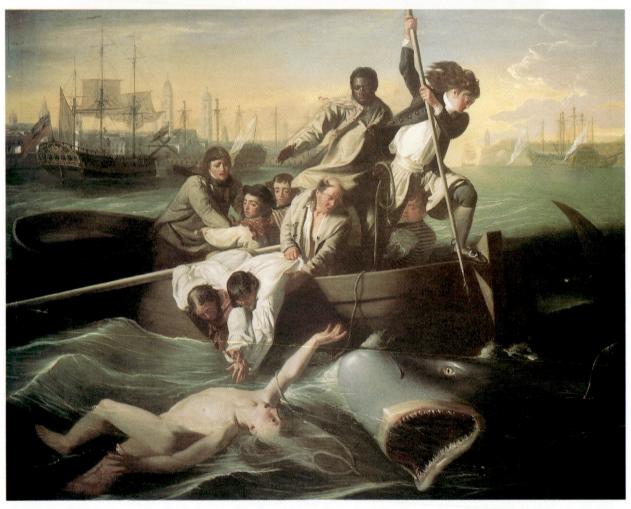

846. John Singleton Copley. Watson and the Shark. 1778. Oil on canvas, 7'61/4" x 6'1/2" (2.29 x 1.84 m). Museum of Fine Arts, Boston Gift of Mrs. George von Lengerke Meyer

recalls an old and hallowed theme, the lamentation over the dead Christ (see fig. 506), dramatized by Baroque lighting (see fig. 762). West thus endowed the death of a modern military hero with both the rhetorical pathos of "noble and serious human actions," as defined by academic theory, and the trappings of a real event. He created an image that expresses a phenomenon basic to modern times: the shift of emotional allegiance from religion to nationalism. No wonder his picture had countless successors during the nineteenth century.

COPLEY. West's gifted compatriot, John Singleton Copley of Boston (1738–1815), moved to London just two years before

the American Revolution. As New England's outstanding portrait painter, he had adapted the formulas of the British portrait tradition to the cultural climate of his hometown. In Europe, Copley was at last able to attain his ideal of history painting in the manner of West. His most memorable work is Watson and the Shark (fig. 846). As a young man, Watson had been dramatically rescued from a shark attack while swimming in Havana harbor, but not until he met Copley did he decide to have this gruesome experience memorialized. Perhaps he thought that only a painter newly arrived from America would do full justice to the exotic flavor of the incident. Copley, in turn, must have been fascinated by the task of translating the story into pictorial terms. Following West's example, he made every detail as authentic as possible (here the black man has the purpose of the Indian in The Death of General Wolfe) and utilized all the expressive resources of Baroque painting to invite the beholder's participation. Copley may have remembered representations of Jonah and the Whale, which include the elements of his scene, except that the action is reversed: the prophet is thrown overboard into the jaws of the sea monster. The shark becomes a monstrous embodiment of evil; the man with the boat hook recalls an Archangel Michael fighting Satan; and the nude youth, resembling a fallen gladiator, flounders helplessly between the forces of doom and salvation. This kind of moral allegory is typical of Neoclassicism as a whole, and despite its charged emotion, the picture has the same logic and clarity found in David's Death of Socrates.

KAUFFMANN. One of the leading Neoclassicists in England was the Swiss-born painter Angelica Kauffmann (1741–1807). A founding member of the Royal Academy, she spent 15 years in London among the group that included Reynolds and West, whom she had met in Winckelmann's circle in Rome (see page 658). From the antique this disciple of Mengs developed a delicate style admirably suited to the interiors of Robert Adam (see page 651), which she was often commissioned to adorn. Nevertheless, Kauffmann's most ambitious works are narrative paintings, of which the artist John Henry Fuseli (see page 666) observed, "Her heroines are herself." *The Artist in the Character*

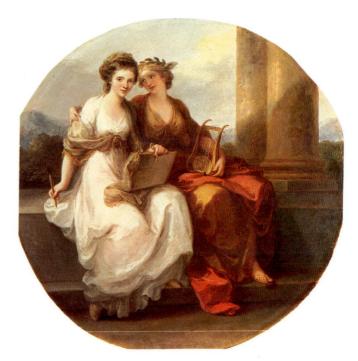

847. Angelica Kauffmann. *The Artist in the Character of Design Listening to the Inspiration of Poetry.* 1782. Oil on canvas, diameter 24" (61 cm). The Iveagh Bequest, Kenwood, London

of Design Listening to the Inspiration of Poetry (fig. 847), one of her finest paintings, combines both aspects of her art. The subject must have held particular meaning for her. The prototype of the allegorical "friendship" pictures showing two female figures that remained popular into the Romantic era (see fig. 896), it is eloquent testimony to women's struggle to gain recognition in the arts. The artist has assumed the guise of Design, attesting to her strong sense of identification with the muse.

STUBBS. George Stubbs (1724–1806), who painted portraits of racehorses (and sometimes their owners) for a living, developed a new type of animal picture full of feeling for the grandeur and violence of nature. On a visit to North Africa, he is said to have seen a horse killed by a lion. Certainly this image haunted his imagination. *Lion Attacking a Horse* (fig. 848) can

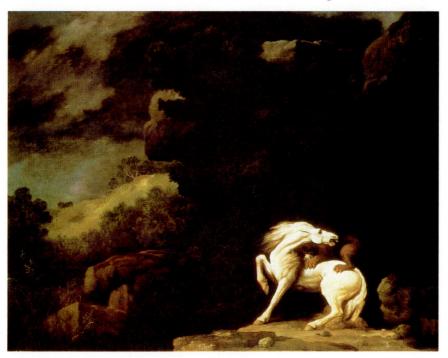

848. George Stubbs.

Lion Attacking a Horse.
1770. Oil on canvas,
40¹/8 x 50¹/4"
(102 x 127.6 cm). Yale
University Art Gallery,
New Haven,
Connecticut
Gift of the Yale University Art
Gallery Associates

Neoclassicism and Romanticism 663

849. Alexander Cozens. Landscape, from A New Method of Assisting the Invention in Drawing Original Compositions of Landscape.
 1784–86. Aquatint. The Metropolitan Museum of Art, New York Rogers Fund, 1906

be seen as an animal counterpart to Copley's *Watson and the Shark*, and it has similar allegorical overtones as well. People have no place in this realm, and the artist identifies himself emotionally with the horse, whose pure whiteness contrasts so dramatically—and symbolically—with the sinister rocks of the lion's domain. Thunderclouds racing across the sky reinforce the mood of doom. The poor horse, frightened also by the approaching storm, seems doubly defenseless against these forces of destruction. We respond to the horse in the same way as to the unfortunate Watson: with mixed fascination and horror.

Although it looks forward to Romanticism, Stubbs' effort at endowing his animals with nearly human action and emotion was the beginning of a larger investigation that was characteristic of the Enlightenment. He later made a series of drawings for a book of comparative anatomy—including one that could well be used to illustrate Plato's dictum of human beings as featherless bipeds—which emphasizes the similarities in physiology and psychology between people and animals. His scientific curiosity and comprehensive approach relate him to the attempt by Diderot in his massive *Encyclopédie* to unite knowledge and philosophy into a single, coherent system.

THE PICTURESQUE AND THE SUBLIME. Picturesque landscape painting was as distinctive to the Enlightenment as the English garden (see pages 668–69), to which it was closely related. As the term implies, the picturesque was a way of looking at nature through the eyes of landscape painters. The scenery of Italy and the idyllic landscapes of Claude contributed to the English appreciation of nature. In articulating sentiments inspired by these examples, English nature poets such as James Thomson further validated the aesthetic response to nature, often through references to mythology. The picturesque was soon joined by wilder scenes reflecting a taste for the sublime—that delicious sense of awe experienced before grandiose nature, as defined by Edmund Burke in *Inquiry into the Origin of Our Ideas of the Sublime and the*

Beautiful of 1756. After touring the rugged lake region of England in 1780, William Gilpin claimed, however, that the picturesque lay somewhere between Burke's extremes, since it is neither vast nor smooth but finite and rough. The picturesque later came to include a topographical mode and a rustic mode, but remained fundamentally a way of manipulating nature to conform to artistic examples.

COZENS. Alexander Cozens (c. 1717–1786), who helped to originate the picturesque, soon tired of these models, which he felt could produce only stereotyped variations on an established theme. The direct study of nature, important though it was, could not be the new starting point either, for it did not supply the imaginative, poetic quality that for him constituted the essence of landscape painting. As a teacher, Cozens developed what he called "a new method of assisting the invention in drawing original compositions of landscapes," which he published, with illustrations such as figure 849, shortly before his death. What was this method? Leonardo da Vinci, Cozens noted, had observed that an artist could stimulate his imagination by trying to find recognizable shapes in the stains on old walls. Why not then produce such chance effects on purpose, to be used in the same way? Crumple a sheet of paper, smooth it; then, while thinking generally of landscape, blot it with ink, using as little conscious control as possible. (Our example is such an "ink-blot landscape.") With this as the point of departure, representational elements may be picked out in the configuration of blots, and then elaborated into a finished picture. Cozens' blotscape, then, is not a work of nature but a work of art. Even though only half-born, it shows, if nothing else, a highly individual graphic rhythm.

Because it relies on art, the Cozens method still falls within the picturesque, while the sweeping nature of his attempt places it within the Enlightenment, with its love of systems. Needless to say, however, it has far-reaching implications, theoretical as well as practical, but these could hardly have been understood by his contemporaries, who regarded the "blotmaster" as ridiculous. Nevertheless, the "method" was not forgotten, its memory kept alive partly by its very notoriety. The two great masters of Romantic landscape in England, John Constable and William Turner, both profited from it, although they differed in almost every other way.

SCULPTURE

The history of Neoclassical sculpture does not simply follow that of painting. The phenomenon of Neoclassicism, which in painting is sometimes hard to distinguish from Romanticism, stands out far more clearly in sculpture. Unlike painters, Neoclassical sculptors were overwhelmed by the authority accorded since Winckelmann to ancient statues such as the *Apollo Belvedere* (see fig. 208), praised as being supreme manifestations of the Greek genius, although in fact most of them were mechanical Roman copies of no great distinction after Hellenistic pieces. (Goethe, upon seeing the newly discovered late Archaic sculpture from Aegina, pronounced it clumsy and inferior; see figs. 160 and 161.)

When Winckelmann published his essay advocating the imitation of Greek works, enthusiasm for the virtues of classi-

cal antiquity was already well established among the intellectuals of the Enlightenment. In Rome from 1760 on, the restoring of ancient sculpture and its sale, especially to wealthy visitors from abroad, was a flourishing business. To these patrons, "classics" such as the Apollo Belvedere or The Laocoön Group (fig. 215), to cite only two of the most famous, belonged to a different world. They were venerated as embodiments of an aesthetic ideal, undisturbed by the demands of time and place. To enter this world, the modern sculptor set himself the goal of creating "modern classics," that is, sculpture demanding to be judged on a basis of equality with its ancient predecessors. This was not merely a matter of style and subject matter. It meant that the sculptor had to find a way of creating monumental sculpture in the hope that critical acclaim would establish such works as modern classics and attract buyers. The solution to this problem was the original plaster, which permitted him to present major works to the public without a ruinous investment in expensive materials. We first encounter it at the Salons, the exhibitions sponsored by the French Academy, where success was crucial for young artists. Without the original plaster, the Neoclassic revolution in sculpture would have been impossible to accomplish.

If Paris was the artistic capital of the Western world, Rome during the second half of the eighteenth century became the birthplace and spiritual home of Neoclassicism. However, as we have seen, the new style was pioneered by the resident foreigners from north of the Alps, rather than Italians. That Rome should have been an even stronger magnet for sculptors than for painters is hardly surprising. After all, it was in ancient sculpture that the "noble simplicity and calm grandeur" praised by Winckelmann were most strikingly evident, and Rome offered an abundance of sculptural monuments but only a meager choice of ancient painting. (The city also had many skilled artisans in both marble and bronze.) In the shadow of these monuments, Northern sculptors trained in the Baroque tradition awakened to a new conception of what sculpture ought to be and thus paved the way for Antonio Canova, whose success as the creator of modern classics was the ultimate fulfillment of their aspirations (see pages 699-700).

England

The leading role of Anglo-Roman artists prior to 1780 in the formulation of Neoclassicism was a result of England's enthusiasm for classical antiquity since the early years of the century. This precocious appreciation was political, philosophic, and literary, with a new nationalism as its common denominator, but this soon turned into a demand that England become "the principal seat of the arts" as well.

BANKS. Thomas Banks (1735–1805) came closest to establishing the creation of modern classics as the sculptor's true goal. Little is known of Banks' career before he went to Rome in 1772 for seven years on a traveling fellowship from the Royal Academy. *The Death of Germanicus* (fig. 850) of 1774, a large relief, shows his close study of classical sources, yet it is not in the least archaeological in flavor. While the facial types and drapery treatment derive from classical sources, the strained poses, the pronounced linear rhythms, and the emo-

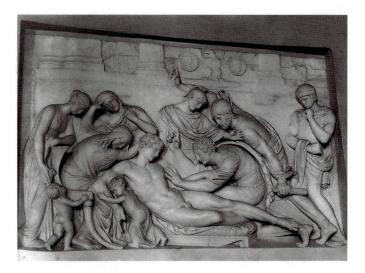

850. Thomas Banks. The Death of Germanicus. 1774. Marble, height 30" (76.2 cm). Holkham Hall, Norfolk, England By kind permission of The Earl of Leicester and the Trustees of the Holkham Estate

tional intensity of the scene have no counterpart in ancient sculpture. They reflect, rather, Banks' admiration for the two chief Anglo-Roman painters, Gavin Hamilton (who had treated the same subject, but with much less originality) and Henry Fuseli (see page 686).

On his return to England, Banks found little demand for his "new classics," although they were enthusiastically received by the recently established Royal Academy. Devoted to the nude and to heroic drama, he nevertheless sought commissions for funerary monuments, which were the main source of steady employment for sculptors in England.

France

HOUDON. Jean-Antoine Houdon (1741–1828), unlike most of his contemporaries, built his career on portrait sculpture. He would have been glad to accept state commissions had they been available. However, he discovered quite soon his special gift for portraits, for which there was a growing demand. Portraiture proved the most viable field for Neoclassic sculpture. How else could modern artists rise above the quality of the Greek and Roman classics, which they were everywhere assured were the acme of sculptural achievement?

Houdon's portraits still retain the acute sense of individual character introduced by Coysevox (see fig. 807). Indeed, they established entirely new standards of physical and psychological verisimilitude that reflect Enlightenment ideals. Houdon, more than any other artist of his time, knew how to give them visible form. His portraits have an apparent lack of style that is deceptive: his style consists of the uncanny ability to make all his sitters into Enlightenment personalities while remaining conscientiously faithful to their individual physiognomies. He even managed this on the rare occasions when he had to make portrait busts of figures long dead, or when he had to work from a death mask only.

With Voltaire, he was more fortunate, modeling him from life a few weeks before the famous author's death in May 1778, and then making a death mask as well. From these he created

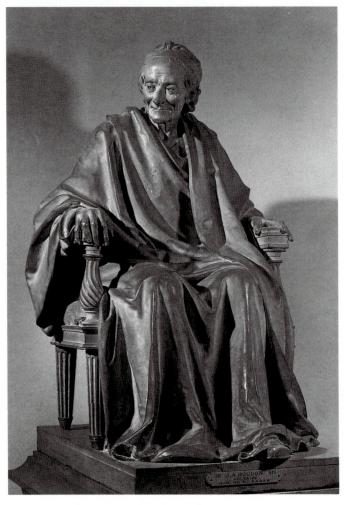

851. Jean-Antoine Houdon. *Voltaire Seated.* 1781. Terracotta model for marble original, height 47" (119.3 cm). Musée Fabre, Montpellier, France

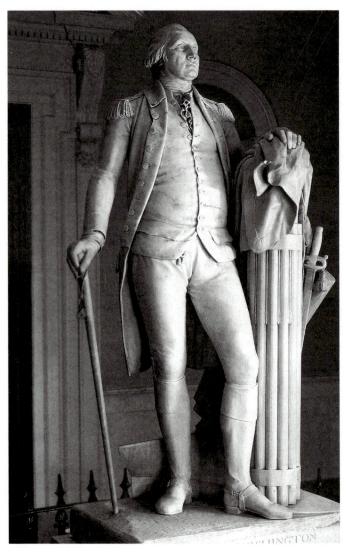

852. Jean-Antoine Houdon. *George Washington*. 1788–92. Marble, height 6'2" (1.88 m). State Capitol, Richmond, Virginia

Voltaire Seated (fig. 851), which was immediately acclaimed as towering above all others of its kind. The original plaster has not survived, but a terracotta cast from it, retouched by Houdon, offers a close approximation. As contemporary critics quickly pointed out, the Voltaire Seated was a "heroicized" likeness, enveloping the frail old man in a Roman toga and even endowing him with some hair he no longer had so as to justify the classical headband. Yet the effect is not disturbing, for Voltaire wears the toga as casually as a dressing gown, and his facial expression and the turn of his head suggest the atmosphere of an intimate conversation. Thus Voltaire is not cast in the role of classical philosopher—he becomes the modern counterpart of one, a modern classic in his own right! In him, we recognize ourselves. Voltaire is the image of modern man: unheroic, skeptical, with his own idiosyncratic mixture of rationality and emotion. That is surely why Voltaire strikes us as so "natural." We are, after all, the heirs of the Enlightenment, which coined this ideal type.

Aside from his *Voltaire Seated*, the Virginia *George Washington* (fig. 852) is Houdon's finest effort. In 1778, the year he

portrayed Voltaire, Houdon became a Freemason and modeled Benjamin Franklin. Replicas of the Franklin bust spread the artist's fame in the New World. American colonial sculpture hardly existed aside from weathervanes, tombstone carvings, and cigar-store Indians. Public monuments were few, and imported from England rather than produced at home. Thus the newborn republic had to look to France for a sculptor to immortalize its Founding Father (see pages 699–704). It could not be entrusted to an Englishman, for obvious reasons, and there was, it seems, no contact with British sculpture from 1776 until after the fall of Napoleon. Thus when the Virginia legislature decided to commission a marble statue of George Washington, the natural choice was Houdon. Houdon insisted on coming over to model his sitter directly, and in October 1785, he spent two weeks at Mount Vernon as Washington's guest. The figure was finally erected in the rotunda of the State Capitol 11 years later.

Houdon initially made two versions, one in classical and one in modern costume, the final form of the statue. Even the latter, though meticulously up-to-date in detail, has a classiIn France, around the middle of the eighteenth century, the

philosopher and encyclopedist Denis Diderot (1713–1784) attempted to add domestic tragedy and the comedy of virtue (the so-called middle genres) to the accepted classifications of theater through his sentimental plays *The Illegitimate Son* (1757) and *The Father of a Family* (1758). They were quickly forgotten, with good reason. The only important French playwright of the later Enlightenment was Pierre-Augustin Caron de Beaumarchais (1732–1799), whose comedies *The Barber of Seville* (1775) and *The Marriage of Figaro* (1783) became the basis for operas by Rossini and Mozart. While the *Barber* is a lighthearted farce about the triumph of young lovers over lecherous old men, *Figaro* was a critique of the aristocracy, whose ranks Beaumarchais joined, thanks to the wealth he amassed through his inventions and business ventures.

Neoclassicism in German theater was represented chiefly by the playwright, critic, and university professor Johann Christoph Gottsched (1700–1766), who modeled his plays on French examples and who based his ideas on those of Nicolas Boileau (1636–1711); however, their success depended heavily on his close association with the actress Caroline Neuber (1697–1760). His theories were attacked by Gotthold Ephraim Lessing (1729–1781) in Laokoon (1766) and in the journal Hamburgische Dramaturgie (1767–68) by arguing that the goal of drama is to arouse compassion, thereby fulfilling an important moral and social function. Although he belittled his own work, Lessing's plays, such as Minna von Barnhelm (1767), embody his principles very capably.

Lessing helped pave the way for the *Sturm und Drang* (Storm and Stress) period (1770–87), which constituted a rebellion against the restrictions of the Neoclassical drama and Enlightenment philosophy and were the first attempt to create a distinctive German form of theater. Although this literary movement took its name from a play of that title (1776) by F. M. Klinger, it centered on the young poet Johann Wolfgang von Goethe (1749–1832), whose drama

Goetz van Berlichingen (1773), inspired by the memoirs of a

famous sixteenth-century German knight, launched the movement in theater. Its extreme subjectivity was epitomized by his novel *The Sorrows of Young Werther*, published the following year. *Sturm und Drang* in theater was poorly received but widely discussed; it was finally legitimized by August von Kotzebue (1761–1819), who became the most popular playwright in Europe. The late eighteenth century was notable for the establishment of national theaters throughout Germany, as well as Austria: the Hamburg National Theater, which employed Lessing as its artistic adviser (dramaturge) when it opened in 1767, and the Burgtheater in Vienna in 1776.

After the publication of The Sorrows of Young Werther, which established his reputation, Goethe was invited to the court in Weimar, where he spent the rest of his career and even served as minister of state for ten years. During a sojourn to Italy in 1786-88 he became a convert to classicism and rejected Sturm und Drang. In 1791 he was appointed director of the theater at Weimar, in which he showed little interest until his friendship with the poet Friedrich von Schiller (1759-1805). Schiller had written some early dramas before turning to the study of history, which led to a professorship at the university in Jena, not far from Weimar. The two men became such close friends that Schiller moved to Weimar in 1799. From then until his death Schiller wrote his great dramas, which were a direct outgrowth of his abiding interest in history. They center on the Thirty Years' War, about which he wrote the first major treatise, particularly General Albrecht Wallenstein (1583-1634). His other plays concern William Tell, Mary Stuart, and Joan of Arc. Under Goethe and Schiller, Weimar became home to the leading theater on the Continent. They argued that theater should transform experience through harmony and grace rather than create an illusion of real life; hence, they instituted stylized conventions designed to lead the viewer to ideal truth. After Schiller's death, however, Goethe lost interest in the theater.

cal pose, and we can feel the chill breath of the Apollo Belvedere (fig. 208), as it were, on the becalmed, smooth surfaces. By this time, Washington no longer held public office; he was simply a gentleman farmer. Houdon has given him a general's uniform, but the sword, no longer needed in peacetime, is suspended from a bundle of 13 rods (the fasces, representing the original states of the Union) and his right hand rests on a cane. Behind his feet is a plow, the symbol of peace. These attributes, with their classical allusions, blend easily with the contemporary dress, and the contrapposto stance of the figure is so well motivated that the beholder is hardly aware of its antique origin. Above all, Houdon has created a powerful impression of Washington's character along with a meticulous record of his physical appearance, in the framework of the personality type of the Enlightenment. Far more than any other portrait, Houdon's statue, and the busts associated with it, determined how the nation visualized the Father of His Country.

ARCHITECTURE

England

THE PALLADIAN REVIVAL. England was the birthplace of Neoclassicism in architecture, as it had been in the forefront of painting and sculpture. The earliest sign of this attitude was the Palladian revival in the 1720s, sponsored by the wealthy amateur Richard Boyle, Lord Burlington (1694–1753). Chiswick House (figs. 853 and 854), adapted from the Villa Rotonda (see figs. 664 and 665), is compact, simple, and geometric—the antithesis of the Baroque pomp of Blenheim Palace (see fig. 813). What distinguishes this style from earlier

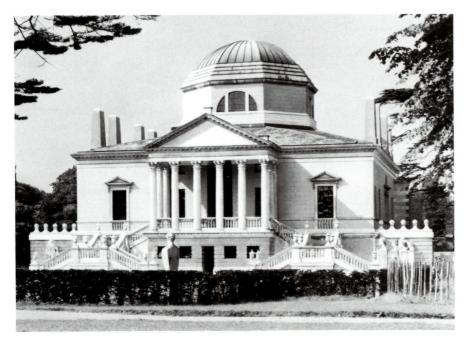

853. Lord Burlington and William Kent. Chiswick House, near London. Begun 1725

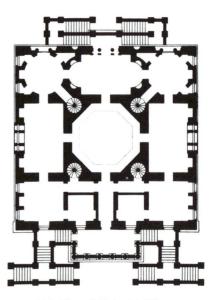

854. Plan of Chiswick House

classicisms is less its external appearance than its motivation. Instead of merely reasserting the superior authority of the ancients, it claimed to satisfy the demands of reason, and thus to be more "natural" than the Baroque, which at the time was identified with Tory policies by the Whig opposition, thus beginning an association between Neoclassicism and liberal politics that was to continue through the French Revolution. This rationalism helps to explain the abstract, segmented look of Chiswick House. The surfaces are flat and unbroken, the ornament is meager, and the temple portico juts out abruptly from the blocklike body of the structure.

THE ENGLISH GARDEN. Should such a villa be set in a geometric, formal garden, like Le Nôtre's at Versailles (see fig. 800)? Indeed not, Lord Burlington and his circle maintained. That would be unnatural, hence contrary to reason, so they invented what became known all over Europe as "the English landscape garden." Carefully planned to look unplanned, with winding paths, irregularly spaced clumps of trees, and little lakes and rivers instead of symmetrical basins and canals, the "reasonable" garden must seem as unbounded, as full of surprise and variety, as nature itself. It must, in a word, be "picturesque," like the landscapes of Claude Lorraine (fig. 796), which English landscape architects now took as their source of inspiration. A standard feature was the inclusion of little temples half concealed by the shrubbery, or artificial ruins, "to draw sorrowful reflections from the soul."

Such sentiments were not new. They had often been expressed before in poetry and painting. But to project them onto nature itself, through planned irregularity, was a new idea. The landscape garden, a work of art intended not to look like a work of art, blurred the long-established demarcation between artifice and reality, and thus set an important precedent for the revival styles to come. After all, the landscape garden stands in the same relation to nature as a synthetic ruin to an authentic one, or a Neoclassic or Neo-Gothic building to

855. Henry Flitcroft and Henry Hoare. Landscape garden with Temple of Apollo, Stourhead, England. 1744-65

its ancient or medieval model. When the fashion spread to the other side of the Channel, it was welcomed not only as a new way to lay out gardens but as a vehicle of Romantic emotion.

STOURHEAD. Of all the landscape gardens laid out in England in the mid-eighteenth century, the one at Stourhead most nearly retains its original appearance. Its creators, the banker Henry Hoare and the designer Henry Flitcroft (1697–1769), were both enthusiastic followers of Lord Burlington and William Kent. Stourhead is unique not only for its fine preservation but also for the owner's active role in planning every detail of its development. Our view (fig. 855) is across a small lake made by damming the river Stour. High on the far shore is the Temple of Apollo modeled on the Temple of Venus at Baalbek (see fig. 258), which became known in the West only

856. Jacques-Germain Soufflot. The Panthéon (Ste.-Geneviève), Paris. 1755–92

after 1757. Occupying other focal points at Stourhead are a grotto, a Temple of Venus, a Pantheon, a genuine Gothic cross, and a neo-medieval tower built to commemorate King Alfred the Great, the "Father of His People."

France

SOUFFLOT. The rationalist movement came somewhat later in France. Its first great monument, the Panthéon in Paris (fig. 856), by Jacques-Germain Soufflot (1713-1780), was built as the church of Ste.-Geneviève, but secularized during the Revolution. As with so much else in eighteenth-century France, the building looks back to the preceding century, in this case Hardouin-Mansart's Church of the Invalides (fig. 804). Its dome, interestingly enough, is derived from St. Paul's Cathedral in London (see fig. 810), indicating England's new importance for Continental architects. The smooth, sparsely decorated surfaces are abstractly severe, akin to those of Chiswick House (an effect further emphasized by having to wall in the windows later because the architect miscalculated the stresses), while the huge portico is modeled directly on ancient Roman temples. From this coolly precise exterior we would never suspect that Soufflot also had a strong interest in Gothic churches. He admired them, not for the seeming miracles they perform but for their structural elegance—a rationalist version of Guarini's point of view (see fig. 749). His ideal, in fact, was "to combine the classic orders with the lightness so admirably displayed by certain Gothic buildings," although he did not study them in detail.

BOULLÉE. Étienne-Louis Boullée (1728–1799) was half a generation younger than Soufflot and far more daring. He began as a painter and retired early, but though he built little, his teaching at the Royal Academy helped to create a tradition of visionary architecture that flourished during the last third of the century and the early years of the next. [See Primary Sources, no. 79, pages 934–35.] Boullée's ideal was an architecture of "majestic nobility," an effect he sought to achieve by combining huge, simple masses. Most of his designs were for structures on

857. Étienne-Louis Boullée. Project for a Memorial to Isaac Newton. 1784. Ink and wash drawing, 15½ x 25½ " (39.3 x 64.7 cm). Bibliothèque Nationale, Paris

858. Claude-Nicolas Ledoux. Barrière de Villette (after restoration), Paris. 1785–89

a scale so enormous that they could hardly be built even today.

He hailed the sphere as the perfect form, since no trick of perspective can alter its appearance (except, of course, its apparent size). Thus he projected a memorial to Isaac Newton as a gigantic hollow sphere, mirroring the universe (fig. 857). "O Newton!" he exclaimed, "I conceived the idea of surrounding you with your discovery, and thus, somehow, of surrounding you with yourself." The interior was to be bare, apart from an empty sarcophagus symbolizing the mortal remains of the great man, but the surface of its upper half was pierced by countless small holes, points of light meant to give the illusion of stars. Bathed in deep shadow, Boullée's plan for the memorial to Newton has a striking pictorialism inspired in part by the Prison Caprices of Piranesi (see fig. 841). Plans such as this have a utopian grandeur that dwarfs the boldest ambitions of earlier architects. Largely forgotten during most of the nineteenth century, Boullée was rediscovered in the early twentieth, when architects again dared to "think the unthinkable."

LEDOUX. Claude-Nicolas Ledoux (1736–1806) was the opposite of Boullée: an architect who built much and turned to theory only late in his career. Yet his work quickly developed visionary qualities that are readily apparent in his most important achievement, the 50 tollgates he designed for the new walls around Paris in 1785–89, of which only four still exist. (The rest were dismantled during the French Revolution.) Our example (fig. 858) shows a remarkable sense of geometry placed at the

Neoclassicism and *Sturm und Drang* (see box page 667) were

also important to music. The leading representative of the former was Christoph Willibald Glück (1714-1787). Gluck wrote two operas, Orfeo ed Euridice (1762) and Alceste (1767) with the poet Raniero Calzabigi (1714-1795), who was influenced by Rameau's operas during a sojourn in Paris. They sought to correct the excesses of Italian opera through "a beautiful simplicity" and to "confine music to its proper function of serving the poetry for the expression and the situation of the plot." Though originally produced in Vienna, which had become the opera capital of Europe, the two operas enjoyed greater success in Paris, where classicism was an uninterrupted tradition. Glück's operas have a nobility and depth of feeling that hark back to Monteverdi but with a classicism and pageantry worthy of Lully and Rameau. The subject of both works is the immortality of love, which conquers even death. Alceste, who was willing to die so that her husband, King Admetes, could live, was seen as a paradigm of conjugal love. Thanks in good measure to the opera's popularity, Jean-François Peyron (1744– 1814), the only serious rival of Jacques-Louis David (see pages 559-60), made it the subject of his first important commission from Louis XVI in 1785. (The painting is now in the Louvre.)

Carl Philipp Emanuel Bach (1714-1788), a son of Johann Sebastian Bach, served for nearly 30 years at the Berlin court of Frederick the Great (1712–1786), himself a very able composer. Unlike his illustrious father, he loathed counterpoint. The widespread reaction against counterpoint, with its complexities, may be likened to the call for natural morality by Bach's exact contemporary, the philosopher Jean-Jacques Rousseau (1712-1778). Bach nevertheless adopted a conservative style that suited his patron's taste. Upon being appointed music director of Hamburg, one of the most important posts in Germany, he felt free to pursue a direct, expressive style that sometimes shows a debt to his predecessor there, Georg Philipp Telemann. His first Hamburg symphonies exemplify the Sturm und Drang in music: they are full of extremes, with brooding, sighing, slow movements sandwiched between dynamic fast ones characterized by irregular rhythms and emotional outbursts that startle the listener. Their limitation, and it is a significant one, is the composer's disregard for form, which prevented him from developing them further.

Sturm und Drang influenced the middle symphonies written by Franz Joseph Haydn (1732–1809) in 1771–74. He spent almost his entire career at the estate of the Esterházys

south of Vienna, where he had a small but excellent ensemble of

instrumentalists and singers in the service of an enlightened if demanding patron. Haydn became the most famous composer of his era and was called to Paris (1785–86) and London (1790, 1794), where he created symphonies of unrivaled sophistication and richness. He was no less a master of the string quartet, which he wrote in large numbers, all of them marked by unprecedented variety, formal mastery, and refined feeling. Haydn remained a person of his times: the late oratorios—*The Creation* (1798), based on Milton's *Paradise Lost*, and *The Seasons* (1801), adapted from James Thomson's poem (1726–30) of the same name—maintain the late-eighteenth-century view of an orderly cosmos created by a benevolent god.

Haydn became a close friend of Wolfgang Amadeus Mozart (1756-1791), despite their great differences in age, temperament, and outlook. A child prodigy, Mozart received a rigorous training from his father, Leopold (1719–1787), who paraded him around the great courts of Europe, where he was exposed to the full range of contemporary music. Mozart failed in his efforts to gain a major court appointment; deprived of this measure of security, he became a prolific composer for the open market who put the stamp of his individual genius on everything he wrote. His finest quartets are the six dedicated to Haydn, who declared him the greatest composer alive, while the late symphonies blaze new territory that foreshadow those of the young Beethoven. His numerous concertos for piano, of which he was a virtuoso, combine enchanting lyricism with brilliant technical display. Mozart was a supreme vocal composer, and it is the singing quality of the human voice that underlies his mature work, regardless of instrument. He was also a master of compositional technique, including counterpoint (he had discussed Bach's music with his successor at Leipzig), and his compositions depend for much of their success on their formal perfection. Indeed, for Mozart form was the vehicle of expression, which it served to contain, so that there was an ideal, "classical" balance between the two. He was fully sympathetic to the Enlightenment. Its philosophy both informs and burdens his operas, including his acknowledged masterpieces The Marriage of Figaro (1787), based on the play by Beaumarchais, and Don Giovanni (1787). Both are a new type of comic opera, called *opera buffo* to distinguish it from traditional serious operas (opera seria), but unlike others of their kind, they have a wonderful humanity and substantial content, thanks in part to the librettos by Mozart's collaborator, Lorenzo Da Ponte (1749–1838).

service of a singular imagination. Ledoux has mounted a huge rotunda on a square base, which is entered through a Greek portico supported by pillars instead of columns. (All four sides are identical in appearance.) Although the structure derives from antiquity, the effect is anything but classical. Visually the portico seems almost crushed by the burden of the rotunda, whose massiveness is barely relieved by the strangely medieval-looking screen of arches over paired columns (compare fig. 397). Implicit in the radically simplified forms and decidedly odd proportions is a critique of all earlier examples of the same type,

from the Pantheon (fig. 249) through Soufflot's Ste.-Geneviève (fig. 856). (See also figs. 544, 665, 804, and 853.) The building, nearly Mannerist in its gestures, is among the most peculiar of any before Wright's Guggenheim Museum (fig. 21), which may be regarded as its descendant.

Neoclassicism and the Antique

The mid-eighteenth century was greatly stirred by two experiences: the rediscovery of Greek art as the original source of

859. Robert Adam. The Library, Kenwood, London. 1767-69

classic style, and the excavations at Herculaneum and Pompeii, which for the first time revealed the daily life of the ancients and the full range of their arts and crafts. Richly illustrated books about the Acropolis at Athens, the temples at Paestum, and the finds at Herculaneum and Pompeii were published in England and France. Archaeology caught everyone's imagination. From this came a new style of interior decoration. The Greek phase of this revival proved necessarily limited, as only a narrow range of household furnishings was known at second hand from paintings and sculpture, such as our *Grave Stele of Hegeso* (fig. 197). When they wanted to work in a Greek style, designers turned chiefly to architecture, whose vocabulary could be readily adapted to large pieces of furniture where it was commingled with Roman elements. Thus it was, for the most part, a classicism of particulars.

ADAM. The Neoclassical style was epitomized by the work of the Englishman Robert Adam (1728–1792). His friendship with Piranesi in Rome reinforced Adam's goal of arriving at a personal style based on the antique without slavishly imitating it. His genius is seen most fully in the interiors he designed in the 1760s for palatial homes. Because he commanded an extraordinarily wide vocabulary, each room is different; yet the syntax remains distinctive to him. The library wing he added to Kenwood (fig. 859) shows Adam at his finest. Clearly Roman in inspiration (compare fig. 255), it is covered with a barrel vault connected at either end to an apse that is separated by a screen of Corinthian columns. (The basic scheme had been anticipated more than 40 years earlier by Johann Fischer von Erlach; see pages 621–22.) Adam was concerned above all with movement, but this must be understood

860. Thomas Jefferson. Monticello, Charlottesville, Virginia. 1770–84; 1796–1806

861. Plan of Monticello

not in terms of Baroque dynamism or Rococo ornamentation but the careful balance of varied shapes and proportions. The play of semicircles, half-domes, and arches lends an air of festive grace. The library thus provides an apt setting for "the parade, the convenience, and the social pleasures of life," since it was also a room "for receiving company." This intention was in keeping with Adam's personality, which was at ease with the aristocratic milieu in which he moved. The room owes much of its charm to the paintings by Antonio Zucchi (1762–1795), later the husband of Angelica Kauffmann, who also worked for Adam, and the stucco ornament by Adam's plasterer Joseph Rose, which was adapted from Roman examples (compare fig. 270). The color, too, was in daring contrast to the stark white that was widely preferred for interiors at the time. The effect, stately yet intimate, echoes the delicacy of Rococo interiors (Adam had stayed in Paris in 1754 before going to Rome) but with a characteristically Neoclassic insistence on planar surfaces, symmetry, and geometric precision.

JEFFERSON. Meanwhile, the Palladianism launched by Lord Burlington had spread overseas to the American Colonies, where it became known as the Georgian style. An example of great distinction is Thomas Jefferson's house, Monticello (figs. 860 and 861). Built of brick with wood trim,

it is not so doctrinaire in design as Chiswick House. (Note the less compact plan and the numerous windows.) Instead of using the Corinthian order, Jefferson (1743–1826) chose the Roman Doric, which Adam had helped to legitimize as an alternative to the stark simplicity favored by Lord Burlington, although the late eighteenth century came to favor the heavier and more austere Greek Doric.

THE ROMANTIC MOVEMENT

Of all the "isms" that populate Western art of the past two centuries, Romanticism has always been the most difficult to define. It deserves to be termed an "ism" only because its practitioners (or at least some of them) thought of themselves as being part of a movement. But none has left us anything approaching a definition. Romanticism, it seems, was a certain state of mind rather than the conscious pursuit of a goal. If we try to analyze this state of mind, it breaks down into a series of attitudes, none of which, considered individually, is unique to Romanticism. It is only their peculiar combination that seems characteristic of the Romantic movement.

How did Romanticism come about? The Enlightenment, paradoxically, liberated not only reason but also its opposite: it helped to create a new wave of emotionalism that was to last for the better part of a half-century, and came to be known as Romanticism. The word derives from the late-eighteenthcentury vogue for medieval tales of adventure (such as the legends of King Arthur or the Holy Grail), called "romances" because they were written in a Romance language, not in Latin. This interest in the long-neglected "Gothick" past was symptomatic of a general trend. Those who shared a revulsion against the established social order and religion-against established values of any sort—could either try to found a new order based on their faith in the power of reason, or they could seek release in a craving for emotional experience. Their common denominator was a desire to "return to Nature." The rationalist acclaimed nature as the ultimate source of reason, while the Romantic worshiped it as unbounded, wild, and ever-changing. The Romantic believed that evil would disappear if people were only to behave "naturally," giving their impulses free rein. In the name of nature, the Romantics acclaimed liberty, power, love, violence, the Greeks, the Middle Ages, or anything else that aroused them, although actually they exalted emotion as an end in itself. This attitude has motivated some of the noblest, as well as vilest, acts of our era. In its most extreme form, Romanticism could be expressed only through direct action, not through works of art. No artist, then, can be a wholehearted Romantic, for the creation of a work of art demands some detachment, self-awareness, and discipline. What William Wordsworth, the great Romantic poet, said of poetry in 1798—that it is "emotion recollected in tranquility"—applies also to the visual arts.

To cast fleeting experience into permanent form, Romantic artists needed a style. But since they were in revolt against the old order, this could not be the established style of the time. It had to come from some phase of the past to which they felt linked by "elective affinity" (another Romantic concept). Romanticism thus favored the revival not of one style,

but of a potentially unlimited number of styles. In fact, the rediscovery and utilization of forms hitherto neglected or scorned evolved into a stylistic principle in itself, so that revivals became the "style" of Romanticism in art, as it did, to a degree, in literature and music.

Seen in this context, Neoclassicism was simply the first phase of Romanticism, a revival that continued all the way through the nineteenth century, although it came to represent conservative taste. Perhaps it is best, then, to think of them as two sides of the same modern coin. If we maintain the distinction between them, it is because, until about 1800, Neoclassicism loomed larger than the other Romantic revivals, and because of the Enlightenment's dedication to the cause of liberty as against the cult of the individual represented by the Romantic hero.

PAINTING

It is one of the many apparent contradictions of Romanticism that it became, despite the desire for untrammeled freedom of individual creativity, art for the rising professional and commercial class, which effectively dominated nineteenthcentury society and which replaced state commissions and aristocratic patronage as the most important source of support for artists. Painting remains the greatest creative achievement of Romanticism in the visual arts precisely because, being less expensive, it was less dependent than architecture or sculpture on public approval. It held a correspondingly greater appeal for the individualism of the Romantic artist. Moreover, it could better accommodate the themes and ideas of Romantic literature. Romantic painting was not essentially illustrative; but literature, past and present, now became a more important source of inspiration for painters than ever before, and provided them with a new range of subjects, emotions, and attitudes. Romantic poets, in turn, often saw nature with a painter's eye. Many had a strong interest in art criticism and theory. Some, notably Johann Wolfgang von Goethe and Victor Hugo, were capable draftsmen; and William Blake cast his visions in both pictorial and literary form (see page 687). Art and literature thus have a complex, subtle, and by no means one-sided relationship within the Romantic movement.

Spain

GOYA. We must begin with the great Spanish painter Francisco Goya (1746–1828), David's contemporary and the only artist of the age who may unreservedly be called a genius. When Goya first arrived in Madrid in 1766, he found both Mengs and Tiepolo working there. He was much impressed with the latter (see page 626), whom he must have recognized immediately as the greater of the two. Goya's early works, in a delightful late Rococo vein, reflect the influence of Tiepolo, as well as the French masters of the Rococo. (Spain had produced no painters of significance for over a century.) Nor did he respond to the growing Neoclassic trend during his brief visit to Rome five years later.

In the 1780s, however, Goya became more of a libertarian. His involvement with Enlightenment thought is best seen in his etchings, which made him the most important printmaker

862. Francisco Goya. The Sleep of Reason Produces Monsters, from Los Caprichos. c. 1798. Etching and aquatint, 8¹/₂ x 6"
(21.6 x 15.2 cm). The Metropolitan Museum of Art, New York Gift of M. Knoedler & Co., 1918

since Rembrandt. Published in series at intervals throughout his career, they ridicule human folly from the same moral viewpoint as Hogarth. But what a vast difference separates the two artists! Although suggested by proverbs and popular superstitions, many of Goya's prints defy exact analysis. He creates terrifying scenes such as The Sleep of Reason Produces Monsters from the series Los Caprichos of the late 1790s (fig. 862). The subtitle, added later, elaborates its meaning: "Imagination abandoned by reason produces impossible monsters; united with her, she is the mother of the arts." The artist, shrinking from the assault of his visions, suffers from the same affliction as Dürer's Melencolia I (see fig. 704), but his paralysis is psychological rather than conceptual. The image belongs to that realm of subjectively experienced horror which we will meet in Fuseli's The Nightmare (see fig. 884), but is infinitely more compelling. Goya's etching owes part of its success to the technique of aquatint, whose potential he was the first to exploit fully, although he did not invent it (see box page 674).

Goya surely sympathized with the French Revolution, and not with the king of Spain, who had joined other monarchs in war against the young Republic. Yet he was much esteemed at court, where he was appointed painter to the king in 1799. Goya now abandoned the Rococo for a Neo-Baroque style based on Velázquez and Rembrandt, the masters he had come to admire most. It is this Neo-Baroque style that announces the arrival of Romanticism.

The Family of Charles IV (fig. 863), Goya's largest royal portrait, deliberately echoes Velázquez' The Maids of Honor (see fig. 759). The entire clan has come to visit the artist, who is painting in one of the picture galleries of the palace. As in the earlier work, shadowy canvases hang behind the group and the light pours in from the side, although its subtle gradations owe as much to Rembrandt as to Velázquez. The brushwork, too, has an incandescent sparkle rivaling that of The Maids of

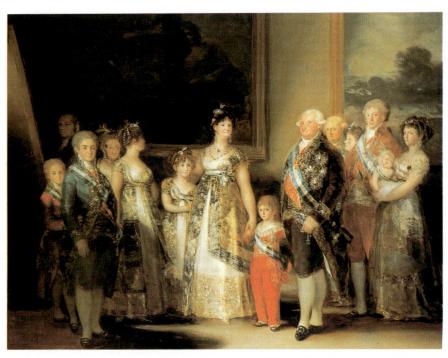

863. Francisco Goya. The Family of Charles IV. 1800. Oil on canvas, 9'2" x 11' (2.79 x 3.35 m). Museo del Prado, Madrid

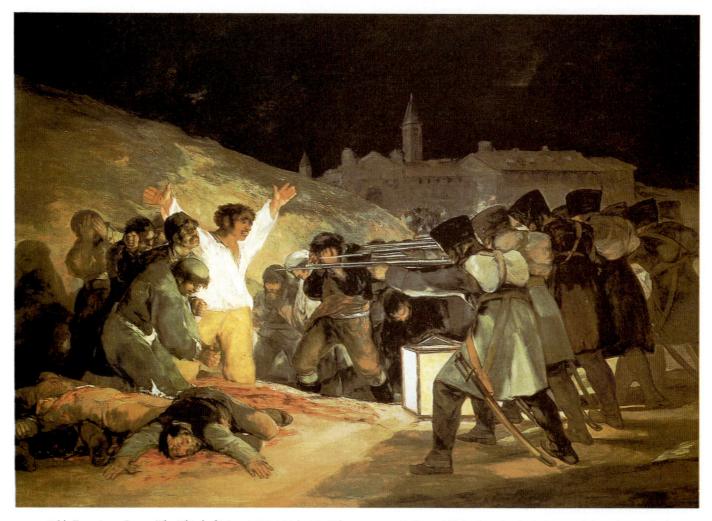

864. Francisco Goya. The Third of May, 1808. 1814–15. Oil on canvas, 8'9" x 13'4" (2.67 x 4.06 m). Museo del Prado, Madrid

Honor. Goya does not utilize the Caravaggesque Neoclassicism of David, yet his painting has more in common with David's work than we might think. Like David, he practices a revival style and, in his way, is equally devoted to the unvarnished truth: he uses the Neo-Baroque of Romanticism to unmask the royal family.

Psychologically, The Family of Charles IV is almost shockingly modern. No longer shielded by the polite conventions of

Baroque court portraiture, the inner being of these individuals has been laid bare with pitiless candor. They are like a collection of ghosts: the frightened children, the bloated king, and—in a master stroke of sardonic humor—the grotesquely vulgar queen, posed like Velázquez' Princess Margarita. (Note the left arm and the turn of the head.) How could Goya get away with this? Was the royal family so dazzled by the splendid painting of their costumes that they failed to realize what

During the eighteenth century, the range of printmaking was

enlarged by the addition of two techniques on copperplates. The first, aquatint, is an extension of etching. It involves melting resin powder on the plate, which leaves a fine crackle pattern exposed to the acid bath. The result is an even, medium tone similar to that of a wash drawing. The other, called mezzotint, is found almost exclusively in portrait and other reproductive engravings. It utilizes a cylindrical rocker covered with tiny teeth to pit the surface, providing velvety grays and rich blacks.

The first completely new print medium, however, was lithography. Invented in Germany shortly before 1800 by Alois Senefelder, it is the most important of the plano-

New Printmaking Techniques

graphic processes, meaning that the print is made on a flat sur-

face. Using a greasy crayon or ink, called tusche, the artist draws or brushes the design onto a special lithographic stone; alternatively, it can be transferred from paper. (Metals such as zinc and aluminum have also been used as plates.) Once the design is fixed by an acid wash, the surface is dampened, then rolled with oily ink, which adheres to the greasy design but is repelled by water. The print is made by rubbing moistened paper under light pressure against the stone. Because a limitless number of prints can be pulled relatively cheaply, lithography has been closely associated from the beginning with commercial printing and the popular press.

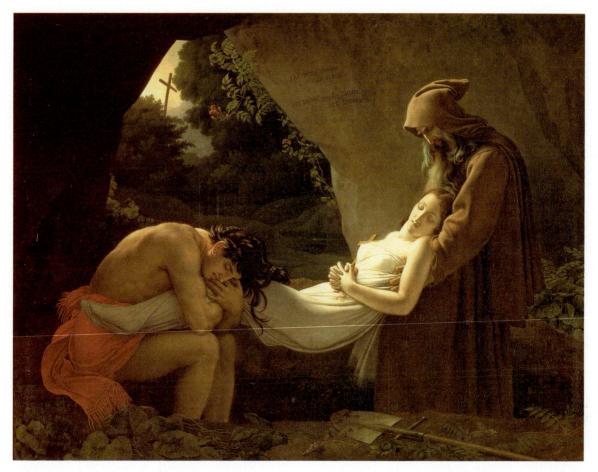

865. Anne-Louis Girodet-Trioson. The Funeral of Atala. 1808. Oil on canvas, 5'53/4" x 6'105/8" (1.67 x 2.10 m). Musée du Louvre, Paris

he had done to them? Goya, we realize, must have painted them as they saw themselves, while unveiling the truth for all the world to see.

When Napoleon's armies occupied Spain in 1808, Goya and many other Spaniards hoped that the conquerors would bring the liberal reforms so badly needed. The barbaric behavior of the French troops crushed these hopes and generated a popular resistance of equal savagery. Many of Goya's works from 1810 to 1815 reflect this bitter experience. The greatest is The Third of May, 1808 (fig. 864), commemorating the execution of a group of Madrid citizens. Here the blazing color, broad, fluid brushwork, and dramatic nocturnal light are more emphatically Neo-Baroque than ever. The picture has all the emotional intensity of religious art, but these martyrs are dying for Liberty, not the Kingdom of Heaven. Nor are their executioners the agents of Satan but of political tyranny: a formation of faceless automatons, impervious to their victims' despair and defiance. The same scene was to be reenacted countless times in modern history. With the clairvoyance of genius, Goya created an image that has become a terrifying symbol of our era.

After the defeat of Napoleon, the restored Spanish monarchy brought a new wave of repression, and Goya withdrew more and more into a private world. Finally, in 1824, he went into voluntary exile. After a brief stay in Paris, Goya settled in Bordeaux, where he died. His importance for the Neo-Baroque Romantic painters of France is well attested by the greatest of them, Eugène Delacroix (see pages 678–81), who said that the ideal style would be a combination of Michelangelo's and Goya's art.

France

GIRODET. By 1795 Neoclassicism had largely run its course, and rapidly lost its purity and rigor. Thus within a few years French Romantic painting began to emerge among the Primitif faction of Jacques-Louis David's studio. These rebellious students simplified his stringent Neoclassicism still further by reverting to the linear designs of Greek and Etruscan vase painting, and the unadorned manner of the Italian Early Renaissance. At the same time, they subverted its content by preferring subjects whose appeal was primarily emotional rather than intellectual. Their sources were not the classical authors such as Horace or Ovid but the Bible, Homer, Ossian (the legendary Gaelic bard whose poems were forged by James Macpherson in the eighteenth century), and Romantic literature—anything that excited the imagination. The ablest, as well as most radical, member of the group was Anne-Louis Girodet-Trioson (1767–1824), whose Funeral of Atala (fig. 865) has all the hallmarks of the Primitif style. Without abandoning his teacher's exacting technique, he reduces the composition to a rhythmic play of lines across the picture plane by emphasizing simple shapes with strong contours, which are further accentuated by the selective highlighting. The scene is taken from the wildly popular Atala, or The Love of Two Savages in the Desert by François-René de Chateaubriand, one of the first Romantic authors and later foreign minister of France. The unfinished novel, published as excerpts in 1801, unites the character of a classical idyll and the taste for the exotic with a religious theme at a time of resurgent Catholicism. These elements are conspicuously present in Girodet's canvas, which treats the burial

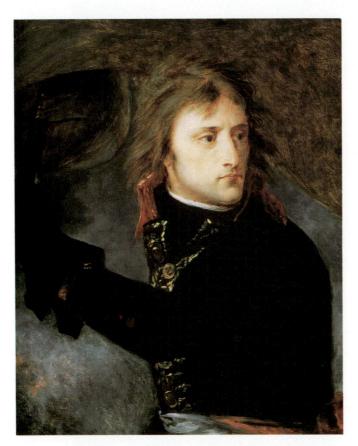

866. Antoine-Jean Gros. *Napoleon at Arcole*. 1796. Oil on canvas, 29¹/2 x 23" (74.9 x 58.4 cm). Musée du Louvre, Paris

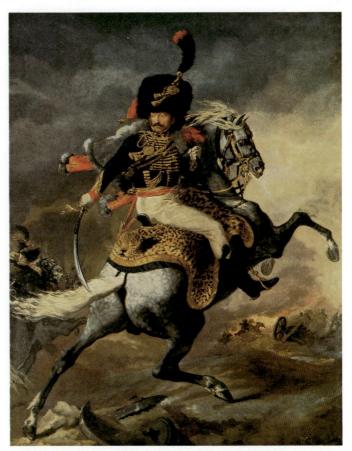

867. Théodore Géricault. *Mounted Officer of the Imperial Guard.* 1812. Oil on canvas, 9'7" x 6'4¹/2" (2.9 x 1.9 m). Musée du Louvre, Paris

of the virtuous young woman in the cave as the entombment of a Christian martyr. (Note the cross on the hillside.) Yet unlike the secular martyrdom memorialized by David in *The Death of Marat*, the painting is a celebration of sentiment. Girodet uses an eerie light to evoke an elegiac mood that is his real aim.

GROS. With its glamour and its adventurous conquests in remote parts of the world, the reign of Napoleon (which lasted from 1799 to 1815, with one interruption) gave rise to French Romanticism. David became an ardent admirer of Napoleon and executed several large pictures glorifying the emperor. As a portrayer of the Napoleonic myth, however, he was partially eclipsed by artists who had been his students. They felt the style of David too confining and fostered a Baroque revival to capture the excitement of the age. Antoine-Jean Gros (1771–1835), David's favorite pupil, shows us Napoleon as a 27-year-old general leading his troops at the Battle of Arcole in northern Italy (fig. 866). Painted in Milan, soon after the series of victories that gave the French the Lombard plain, it conveys Napoleon's magic as an irresistible "man of destiny," with a Romantic enthusiasm David could never match.

After Napoleon's empire collapsed, David spent his last years in exile in Brussels, where his major works were playfully amorous subjects drawn from ancient myths or legends and painted in a coolly sensuous Neo-Mannerist style he had initiated in Paris. He turned his pupils over to Gros, urging him to return to Neoclassic orthodoxy. Much as Gros respected his teacher's doctrines, his emotional nature impelled him toward the color and drama of the Baroque. He remained torn between his pic-

torial instincts and these academic principles. Consequently, he never achieved David's authority and ended his life by suicide.

GÉRICAULT. The Neo-Baroque trend initiated in France by Gros aroused the imagination of many talented younger artists. The chief heroes of Théodore Géricault (1791-1824), apart from Gros, were Michelangelo and the great Baroque masters. Mounted Officer of the Imperial Guard (fig. 867), painted by Géricault at the astonishing age of 21, offers the same conception of the Romantic hero as Gros' Napoleon at Arcole (see fig. 866), but on a large scale and with a Rubenslike energy. For Géricault, politics no longer had the force of a faith. All he saw in Napoleon's campaigns was the thrill irresistible to the Romantic—of violent action. Ultimately, the ancestors of this splendid figure are the equestrian soldiers in Leonardo's Battle of Anghiari (see fig. 597); as in Leonardo's equestrian image, the rider becomes one with his animal, whose frenzy he shares. Géricault, himself an enthusiastic horseman, later became interested in the British animal painters such as George Stubbs (see pages 663–64).

Géricault painted his most ambitious work, *The Raft of the* "*Medusa*" (fig. 868), in response to a political scandal and a modern tragedy of epic proportions. The *Medusa*, a government vessel, had foundered off the West African coast with hundreds of men on board. Only a handful were rescued, after many days on a makeshift raft which had been set adrift by the ship's heartless captain and officers. The event attracted Géricault's attention because, like many French liberals, he opposed the monarchy that was restored after Napoleon. He went to extra-

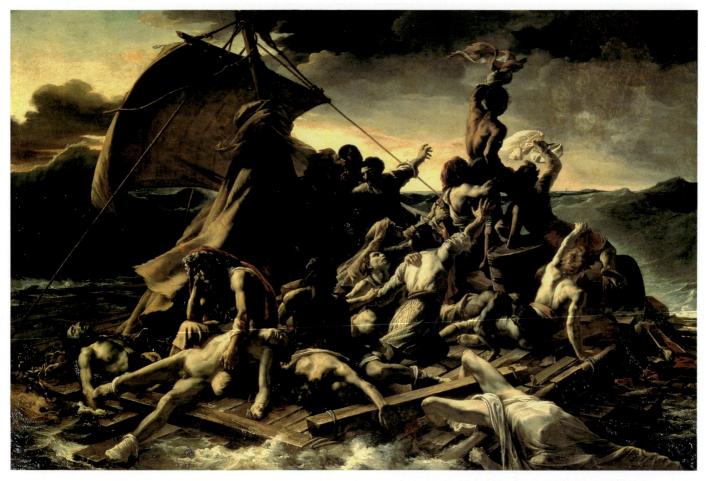

868. Théodore Géricault. The Raft of the "Medusa." 1818-19. Oil on canvas, 16'1" x 23'6" (4.9 x 7.16 m). Musée du Louvre, Paris

ordinary lengths in trying to achieve a maximum of authenticity. He interviewed survivors, had a model of the raft built, even studied corpses in the morgue. This search for uncompromising truth is like David's, and The Raft is indeed remarkable for its powerfully realistic detail. Yet these preparations were subordinate in the end to the spirit of heroic drama that dominates the canvas. Géricault depicts the exciting moment when the rescue ship is first sighted. From the prostrate bodies of the dead and dying in the foreground, the composition is built up to a climax in the group that supports the frantically waving black man, so that the forward surge of the survivors parallels the movement of the raft itself. Sensing, perhaps, that this theme of "man against the elements" would have strong appeal across the Channel, where Copley had painted Watson and the Shark 40 years before (fig. 846), Géricault took the monumental canvas to England on a traveling exhibit in 1820.

His numerous studies for The Raft of the "Medusa" had taught him how to explore extremes of the human condition scarcely touched by earlier artists. He went now not only to the morgue, but to the insane asylum of Paris. There he became a friend of Dr. Georget, a pioneer in modern psychiatry, and painted for him a series of portraits of individual patients to illustrate various types of derangement, such as that in figure 869. The conception and execution of this oil sketch has an immediacy that recalls Frans Hals, but Géricault's sympathy toward his subject makes his work contrast tellingly with Malle Babbe (see fig. 773). This ability to see the victims of mental disease as fellow human beings, not as accursed or bewitched outcasts, is one of the noblest fruits of the Romantic movement.

869. Théodore Géricault. The Madman. 1821-24. Oil on canvas, 24 x 20" (61 x 50.8 cm). Museum voor Schone Kunsten, Ghent, Belgium

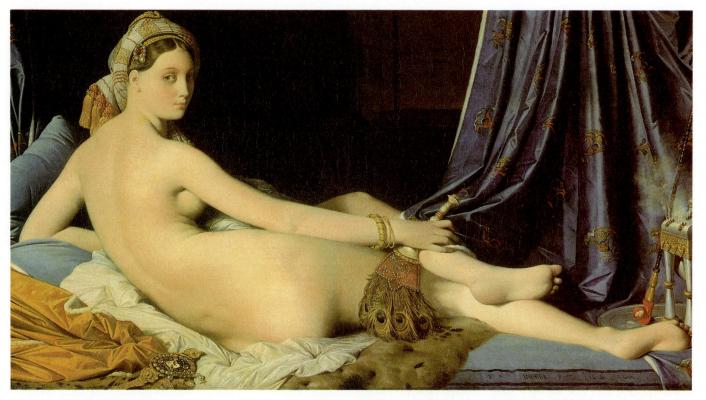

870. Jean-Auguste-Dominique Ingres. Odalisque. 1814. Oil on canvas, 351/4 x 633/4" (89.7 x 162 cm). Musée du Louvre, Paris

INGRES. The mantle of David finally descended upon his pupil Jean-Auguste-Dominique Ingres (1780–1867). Too young to share in the political passions of the Revolution, Ingres never was an enthusiastic Bonapartist. In 1806 he went to Italy and remained for 18 years, so that he largely missed out on the formation of Romantic painting in France. Thus after his return he became the high priest of the Davidian tradition, defending it from the onslaughts of younger artists. [See Primary Sources, no. 80, page 935.] What had been a revolutionary style only half a century before now congealed into rigid dogma, endorsed by the government and backed by the weight of conservative opinion.

Ingres is usually called a Neoclassicist, and his opponents Romantics. Actually, both factions stood for aspects of Romanticism after 1800: the Neoclassic phase, with Ingres as the last important survivor, and the Neo-Baroque, first announced in France by Gros' Napoleon at Arcole. Indeed, the two seem so interdependent that we should prefer a single name for both if we could find a suitable one. ("Romantic Classicism," which is appropriate only to the classical camp, has not won wide acceptance.) The two sides seemed to revive the old quarrel between Poussinistes and Rubénistes (see page 612). The original Poussinistes had never quite practiced what they preached, and Ingres' views, too, were far more doctrinaire than his pictures. He always held that drawing was superior to painting, yet a canvas such as his Odalisque (fig. 870) reveals an exquisite sense of color. Instead of merely tinting his design, he sets off the petal-smooth limbs of this Oriental Venus (odalisque is a Turkish word for a harem slave girl) with a dazzling array of rich tones and textures. The exotic subject, redolent with the enchantment of the Thousand and One Nights, is characteristic of the Romantic movement. (It would be perfectly at home in the Royal Pavilion at Brighton; see fig. 912.) Despite Ingres' professed worship of Raphael, this nude embodies no classical ideal of beauty. Her elongated proportions, languid grace, and strange mixture of coolness and voluptuousness

remind us, rather, of Parmigianino's figures (compare fig. 640).

History painting as defined by Poussin remained Ingres' lifelong ambition, but he had great difficulty with it, while portraiture, which he pretended to dislike, was his strongest gift and his steadiest source of income. He was, in fact, the last great professional in a field soon to be dominated by the camera. Ingres' Louis Bertin (fig. 871) at first glance looks like a kind of "super-photograph," but this impression is deceptive. Comparing it with the preliminary pencil drawing (fig. 872), we realize how much interpretation the portrait contains. The drawing, quick, sure, and precise, is a masterpiece of detached observation, but the painting endows the sitter with a massive force of personality. Bertin's pose is shifted slightly to the left, his jacket open to lend the figure greater weight. The position of his powerful hands, which are barely indicated in the drawing, has been adjusted to convey an almost leonine strength. Ingres further applies the Caravaggesque Neoclassicism he had inherited from David to introduce slight changes of light and emphasis in the face, subtly altering its expression, which now manifests a frightening intensity.

Among the Romantics, only Ingres could so unify psychological depth and physical accuracy. His followers focused on physical accuracy alone, competing vainly with the camera. The Neo-Baroque Romantics, in contrast, emphasized the psychological aspect to such a degree that their portraits tended to become records of the artist's private emotional relationship with the sitter. Often these are interesting and moving, but they are no longer portraits in the proper sense of the term.

DELACROIX. The year 1824 was crucial for French painting. Géricault died after a riding accident. Ingres returned to France from Italy and had his first public success. The first showing in Paris of works by the English Romantic painter John Constable was a revelation to many French artists (see pages 667–70). *The Massacre at Chios* (fig. 873) established

871. Jean-Auguste-Dominique Ingres. *Louis Bertin.* 1832. Oil on canvas, $46 \times 37^{1/2}$ " (116.8 x 95.3 cm). Musée du Louvre, Paris

872. Jean-Auguste-Dominique Ingres. *Louis Bertin.* 1832. Pencil drawing. Musée du Louvre, Paris

873. Eugène Delacroix. *The Massacre at Chios*. 1822-24. Oil on canvas, 13'10" x 11'7" (4.2 x 3.5 m). Musée du Louvre, Paris

874. Eugène Delacroix. *Odalisque*. 1845–50.

Oil on canvas, 14⁷/8 x 18¹/4" (37.3 x 46.5 cm). Fitzwilliam Museum, Cambridge, England Reproduction by permission of the Syndics of the Fitzwilliam Museum

Eugène Delacroix as the foremost Neo-Baroque Romantic painter. An admirer of both Gros and Géricault, Delacroix (1798–1863) had been exhibiting for some years, but *The Massacre* made his reputation. Conservatives called it "the massacre of painting," others acclaimed it enthusiastically. For the next quarter-century, he and Ingres were acknowledged rivals, and their polarity, fostered by partisans, dominated the artistic scene in Paris. [See Primary Sources, no. 81, page 935.]

Like The Raft of the "Medusa," The Massacre at Chios was inspired by a contemporary event: the Greek war of independence against the Turks, which stirred a wave of sympathy throughout western Europe. (The full title of the painting is Scenes of the Massacre at Chios: Greek Families Awaiting Death or Slavery.) Delacroix, however, aimed at "poetic truth" rather than at recapturing a specific, actual event. In this, he relied on tradition to a surprising degree, for he has conjured up a scene as brutal as The Abduction of the Sabine Women by Nicolas Poussin (compare fig. 794). The picture is treated as the kind of secular martyrdom already familiar to us from Benjamin West's The Death of General Wolfe (fig. 845). Now, however, the victims are as nameless as those in The Raft of the "Medusa."

Such sources have been combined into an intoxicating mixture of sensuousness and cruelty. Delacroix does not entirely succeed, however, in forcing us to suspend our disbelief. While we revel in the sheer splendor of the painting, we do not quite accept the human experience as authentic. We react instead much as we do to J. M. W. Turner's *Slave Ship* (see fig. 890). One reason may be the discontinuity of the fore-

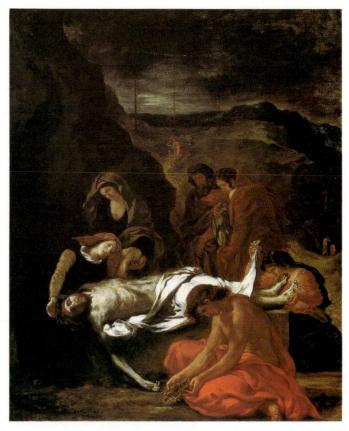

875. Eugène Delacroix. *The Entombment of Christ.* 1848. Oil on canvas, 64 x 52" (162.6 x 132.1 cm). Museum of Fine Arts, Boston Gift by contribution in memory of Martin Brimmer

ground, with its dramatic contrasts of light and shade, and the luminous sweep of the landscape behind. Delacroix is said to have hastily repainted part of the background after seeing Constable's *The Haywain* (see fig. 888). Originally, the background of *The Massacre* was probably like that in Géricault's *Mounted Officer* (fig. 867), and the Turkish horseman, too, directly recalls the rider in the earlier picture.

Delacroix's sympathy with the Greeks did not prevent him from sharing the enthusiasm of fellow Romantics for the Near East. He was enchanted by a visit to North Africa in 1832, finding there a living counterpart of the violent, chivalric, and picturesque past evoked in Romantic literature. His sketches from this trip supplied him with a large repertory of subjects for the rest of his life: harem interiors, street scenes, lion hunts. It is fascinating to compare his *Odalisque* (fig. 874) with Ingres' (fig. 870). Sonorous color and the energetically fluid brushwork show Delacroix to be a Rubéniste of the first order. In his version, Ingres also celebrates the exotic world of the Near East—alien, seductive, and violent—but how different the result! Reclining in ecstatic repose, Delacroix's *Odalisque* exudes passionate abandon and animal vitality—the exact opposite of Ingres' ideal.

The Entombment of Christ (fig. 875), painted in 1848, marks a shift in Delacroix's art. The painting has a new grandeur and an air of almost classical restraint. This change was perhaps an outgrowth of a decorative cycle Delacroix did over the previous several years in the Bourbon Palace, which brought him into renewed contact with the tradition of Western art: his work shows a preference for literary and biblical themes, without abandoning his earlier subjects. This may be seen as part of a larger crisis of tradition that gripped French art beginning in 1848, when revolution was in the air everywhere. Delacroix was now seen, with Ingres, as the last great representative of the mainstream of European painting. As the critic Charles Baudelaire wrote in his Salon of 1846: "Delacroix is . . . heir to the great tradition. . . . But take away Delacroix, and the great chain of history is broken and slips to the ground. It is true that the great tradition has been lost, and that the new one is not yet established." The Entombment suggests Delacroix's awareness of his new status. The painting combines overtones of Titian and Rubens with Poussinesque nobility to make it that rarity in nineteenth-century art—a truly moving religious image.

DAUMIER. The later work of Delacroix reflects the attitude that eventually doomed the Romantic movement: its growing detachment from contemporary life. History, literature, the Bible, and the Near East were the domains of the imagination where he sought refuge from the turmoil of the Industrial Revolution. It is ironic that Honoré Daumier (1808–1879), one of the few Romantic artists who did not shrink from reality, remained in his day practically unknown as a painter. He turned to painting in the 1840s but found no public for his work. Only a few friends encouraged him and, a year before his death, arranged his first solo exhibition. Thus his pictures had little impact during his lifetime. A biting political cartoonist, Daumier contributed satirical drawings to various Paris weeklies for most of his career. Nearly all of Daumier's cartoons were done with lithography (see box page 674).

876. Honoré Daumier. *It's Safe to Release This One!* 1834. Lithograph

Although Daumier is sometimes called a realist, his work falls entirely within the range of Romanticism. The neat outlines and systematic crosshatching in Daumier's early cartoons (fig. 876) show his conservative training. He quickly developed a bolder and more personal style of draftsmanship, however, and his paintings of the 1850s and 1860s have the full pictorial range of the Neo-Baroque. Their subjects vary widely. Many show aspects of everyday urban life that also occur in his cartoons, now viewed with a painter's eye rather than from a satirist's angle. In The Third-Class Carriage (fig. 877), Daumier's forms reflect the compactness of Millet's (compare fig. 882), but are painted so freely that they must have seemed raw and "unfinished" even by Delacroix's standards. Yet its power derives from this very freedom. Daumier's concern is not for the tangible surface of reality but for the emotional meaning behind it. In The Third-Class Carriage, he has captured a peculiarly modern human condition: "the lonely crowd." These people have in common only that they are traveling together in a railway car. Though they are physically crowded, they take no notice of one another, for each is alone with his or her own thoughts. Daumier explores this state with an insight into character and a breadth of human sympathy worthy of Rembrandt, whose work he revered. His feeling for the dignity of the poor also suggests the Le Nains, who had recently been rediscovered by French critics. Indeed, the old woman on the left in Louis Le Nain's Peasant Family (fig. 792) seems the direct ancestor of the central figure in *The* Third-Class Carriage.

Other paintings by Daumier have subjects more characteristic of Romanticism. The numerous canvases and drawings of the adventures of Don Quixote, from Cervantes' sixteenth-century novel, show the fascination this theme had for him. The lanky knight-errant, vainly trying to live his dream of noble deeds, and Sancho Panza, the dumpy materialist, seemed to embody for Daumier a tragic conflict within human nature that forever pits the soul against the body, ideal

877. Honoré Daumier. The Third-Class Carriage. c. 1862. Oil on canvas, $25^3/4 \times 35^1/2$ " (65.4 x 90.2 cm). The Metropolitan Museum of Art, New York Bequest of Mrs. H. O. Havemeyer, 1929. The H. O. Havemeyer Collection

878. Honoré Daumier. Don Quixote Attacking the Windmills. c. 1866. Oil on canvas, 22¹/4 x 33" (56.5 x 83.7 cm). Collection Mr. Charles S. Payson, New York

aspirations against harsh reality. In Don Quixote Attacking the Windmills (fig. 878), this polarity is forcefully realized. The mock hero dashes off in the noonday heat toward an invisible, distant goal, while Panza helplessly wrings his hands, a monument of despair. The sculptured simplicity of Daumier's shapes, and the expressive freedom of his brushwork, make Delacroix's art seem almost conventional by comparison.

French Landscape Painting

Thanks to the cult of nature, landscape painting became the most characteristic form of Romantic art. The Romantics believed that God's laws could be seen written in nature. While it arose out of the Enlightenment, their faith, known as pantheism, was based not on rational thought but on subjective experience, and the appeal to the emotions rather than the intellect made those lessons all the more compelling. In order to express the feelings inspired by nature, the Romantics sought to transcribe landscape as faithfully as possible, in contrast to the Neoclassicists, who subjected landscape to prescribed ideas of beauty and linked it to historical subjects. At the same time, the Romantics felt equally free to modify nature's appearance as a means of evoking heightened states of mind in accordance with dictates of the imagination, the only standard they ultimately recognized. Landscape inspired the Romantics with passions so exalted that only in the hands of the greatest history painters could humans equal nature in power as protagonists. Hence, the Romantic landscape lies outside the descriptive and emotional range of the eighteenth century.

COROT. The first and undeniably greatest French Romantic landscape painter was Camille Corot (1796-1875). In 1825 he went to Italy for two years and explored the countryside around Rome, like a latter-day Claude Lorraine. What Claude recorded in his drawings—the quality of a particular place at a particular time—Corot made into paintings, small canvases done on the spot in an hour or so (fig. 879). In size and immediacy, these quickly executed pictures are analogous to Constable's oil sketches (see fig. 887), yet they stem from different traditions. If Constable's view of nature, which emphasizes the sky as "the chief organ of sentiment," is derived from Dutch seventeenth-century landscapes, Corot's instinct for architectural clarity and stability recalls Poussin and

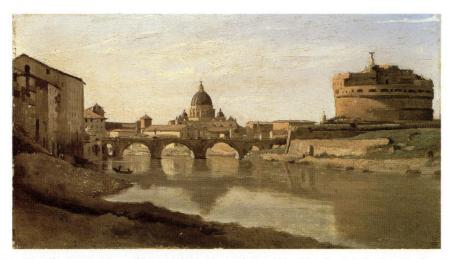

879. Camille Corot. View of Rome: The Bridge and Castel Sant'Angelo with the Cupola of St. Peter's.

1826–27. Oil on paper mounted on canvas, 10½ x 17" (22 x 38 cm). Fine Arts Museums of San Francisco

Museum Purchase, Archer M. Huntington Fund

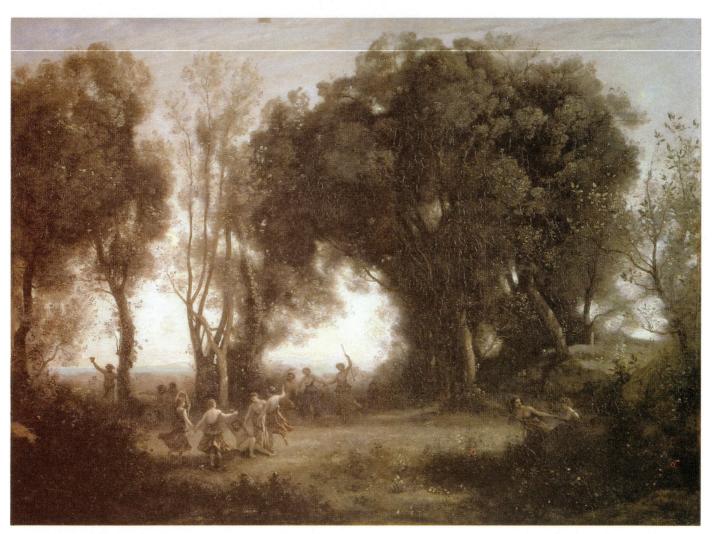

880. Camille Corot. Morning: Dance of the Nymphs. 1850. Oil on canvas, 385/8 x 515/8" (97.1 x 130 cm). Musée d'Orsay, Paris

Claude. But he, too, insists on "the truth of the moment." His exact observation and his readiness to seize upon any view that attracted him during his excursions show the same commitment to direct visual experience that we find in Constable. The Neoclassicists had also painted oil sketches out-of-doors. Unlike them, Corot did not transform his sketches into idealized pastoral visions. His willingness to accept them as inde-

pendent works of art marks him unmistakably as a Romantic.

After returning from his second visit to Italy in 1834, Corot began to paint historical landscapes which combine stylistic and topographical features from Italy and the North in eclectic fashion. But during the 1840s he gradually developed a unique style that appears in its definitive form in *Morning: Dance of the Nymphs* (fig. 880). The painting has rightly

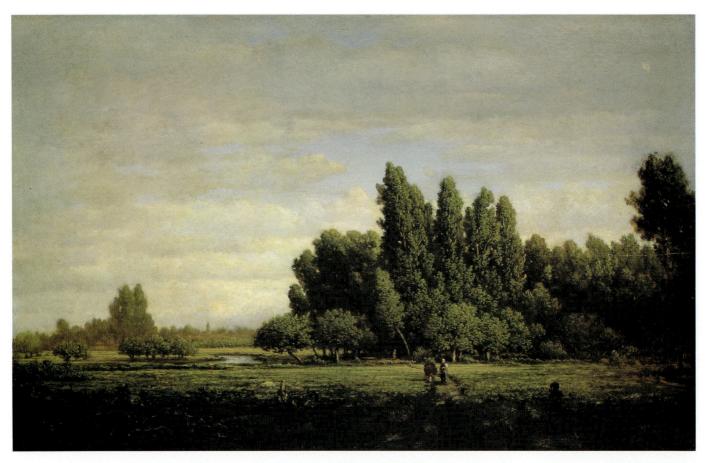

881. Théodore Rousseau. A Meadow Bordered by Trees. c. 1840-45. Oil on panel, $16^3/8 \times 24^3/8$ " (41.6 x 61.9 cm). The Metropolitan Museum of Art, New York Bequest of Robert Graham Dun, 1911

been called a souvenir of the opera, especially the ballets traditional in Parisian productions which he habitually sketched. He found in them a common bond of feeling with painting that provided inspiration for his work. The landscape shows a new unity between the figures and their setting. The silvery light creates a veiled atmosphere that envelops the forms and lends the painting an elusive mood reminiscent of that in Poussin's late works (see fig. 795). In this way, Corot reconciles romantic sentiment and classical content.

Morning: Dance of the Nymphs was the outgrowth of the crisis of tradition in French art and of a personal crisis: when he painted it, Corot was approaching old age with considerable anxiety, and in Poussin he discovered a kindred spirit burdened with similar fears. Thus it was Corot's own development that enabled him to unlock the secret of late Poussin and learn how to interpret nature in a deeply poetic way.

ROUSSEAU. Coror's early fidelity to nature was an important model for the Barbizon School, though he was not actually a member. This group of younger painters, centering on Théodore Rousseau (1812–1867), settled in the village of Barbizon on the edge of the forest of Fontainebleau near Paris to paint landscapes and scenes of rural life. Enthused, however, by Constable, whose work had been exhibited in Paris in 1824, they turned to the Northern Baroque landscape as an alternative to the Neoclassical tradition. From Ruisdael's

example (fig. 783), Rousseau learned how to imbue his encrusted forms and gnarled trees with a sense of inner life, but it was the hours of solitary contemplation in the forest of Fontainebleau that enabled him to penetrate nature's secrets. *A Meadow Bordered by Trees* (fig. 881) is a splendid representative of his landscapes, which are filled with a simple veneration that admirably reflects the rallying cry of the Romantics—sincerity.

MILLET. Jean-François Millet (1814–1875) became a member of the Barbizon School in 1848, the year revolution swept France and the rest of Europe. Although he was no radical, *The* Sower (fig. 882) was championed by liberal critics, because it was the very opposite of the Neoclassical history paintings sanctioned by the establishment. Millet's archetypal image nonetheless has a self-consciously classical flavor that reflects his admiration for Poussin. Blurred in the hazy atmosphere, this "hero of the soil" is a timeless symbol of the ceaseless labor that the artist viewed as the peasant's inexorable fate. (Could Millet have known the pathetic sower from the October page of Les Très Riches Heures du Duc de Berry? Compare fig. 522.) Ironically, the painting monumentalizes a rural way of life that was rapidly disappearing under the pressure of the Industrial Revolution. For that very reason, however, the peasant was seen as the quintessential victim of the evils arising from the Machine Age.

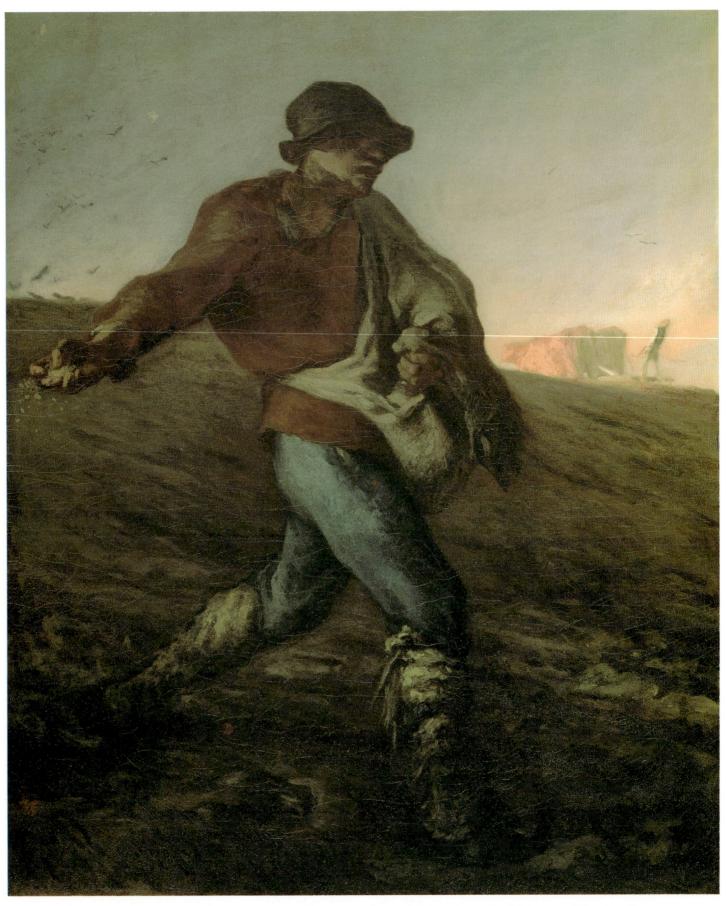

882. Jean-François Millet. *The Sower.* c. 1850. Oil on canvas, 40 x 32¹/2" (101.6 x 82.6 cm). Museum of Fine Arts, Boston Gift of Quincy Adams Shaw through Quincy A. Shaw, Jr., and Mrs. Marion Shaw Haughton

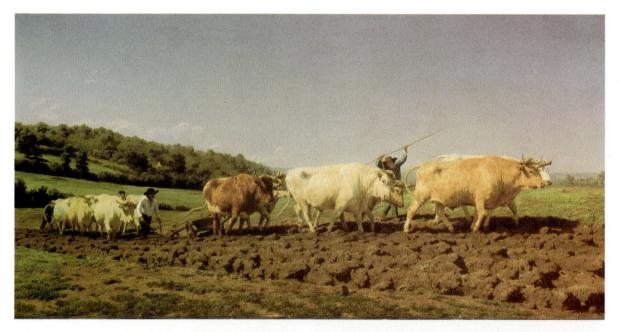

883. Rosa Bonheur. Plowing in the Nivernais. 1849. Oil on canvas, 5'9" x 8'8" (1.75 x 2.64 m). Musée d'Orsay, Paris

BONHEUR. The Barbizon School generally advocated a return to nature as a way of fleeing the social ills attendant to industrialization and urbanization. Despite their conservative outlook, these artists were elevated to a new prominence in French art by the popular revolution of 1848. That same year Rosa Bonheur (1822-1899), also an artist who worked outof-doors, received a French government commission that led to her first great success and helped to establish her as a leading painter of animals—and eventually as the most famous woman artist of her time. [See Primary Sources, no. 82, page 936.] Her painting *Plowing in the Nivernais* (fig. 883) was exhibited the following year, after a winter spent making studies from life. The theme of humanity's union with nature had already been popularized in the country romances of George Sand, among others. Bonheur's picture shares Millet's reverence for peasant life, but the real subject here, as in all her work, is the animals within the landscape. These she depicts with a convincing naturalism that later placed her among the most influential realists.

England

FUSELI. England was as precocious in nurturing Romanticism as it had been in promoting Neoclassicism. In fact, one of its first representatives, John Henry Fuseli (1741–1825), was a contemporary of West and Copley. This Swiss-born painter (originally named Füssli) had an extraordinary impact on his time, more perhaps because of his adventurous and forceful personality than the merits of his work. Ordained a minister at 20, he had left the Church by 1764 and gone to London in search of freedom. Encouraged by Reynolds, he spent the 1770s in Rome. There he encountered Gavin Hamilton, but Fuseli based his style on Michelangelo and the Mannerists, not on Poussin and the antique. A German acquaintance of those years described him as "extreme in everything, Shakespeare's painter." Shakespeare and Michelangelo were indeed his twin

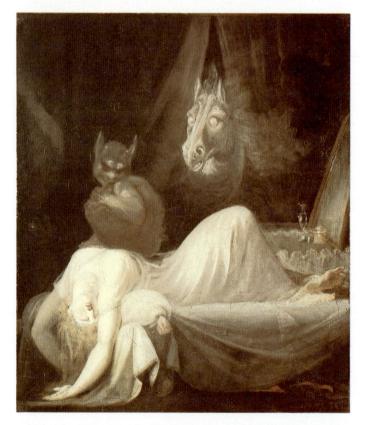

884. John Henry Fuseli. *The Nightmare*. c. 1790. Oil on canvas, 29¹/2 x 25¹/4" (74.9 x 64.1 cm). Freies Deutsches Hochstift-Frankfurter Goethe-Museum, Frankfurt

gods. He even visualized a Sistine Chapel with Michelangelo's figures transformed into Shakespearean characters where the sublime would be the common denominator for "classic" and "Gothic" Romanticism. Such fusion marks Fuseli as a transitional figure. He espoused many of the same Neoclassical theories as Reynolds, West, and Kauffmann, but bent their rules virtually to the breaking point.

885. William Blake. *The Ancient of Days*, frontispiece of *Europe, A Prophesy.* 1794. Metal relief etching, hand-colored illustration, 9¹/8 x 6⁵/8" (23.2 x 16.8 cm). Library of Congress, Washington, D.C.

Lessing J. Rosenwald Collection

We see this in *The Nightmare* (fig. 884). The sleeping woman, more Mannerist than Michelangelesque, is Neoclassical. The grinning devil and the luminescent horse, however, come from the demon-ridden world of medieval folklore, while the Rembrandtesque lighting reminds us of Reynolds (compare fig. 828). Here the Romantic quest for terrifying experiences leads not to physical violence but to the dark recesses of the mind. What was the genesis of *The Nightmare*? Nightmares often have a strongly sexual connotation, sometimes quite openly expressed, at other times concealed behind a variety of disguises. We know that Fuseli originally conceived the subject not long after his return from Italy, when he had fallen violently in love with a friend's niece who soon married a merchant, much to the artist's distress. We can see in the picture a projection of his "dream girl," with the demon taking the artist's place while the horse, a well-known erotic symbol, looks on.

BLAKE. Later, in London, Fuseli befriended the poet-painter William Blake (1757–1827), who possessed an even greater creativity and stranger personality than his own. A recluse and visionary, Blake produced and published his own books of poems with engraved text and hand-colored illustrations. Though he never left England, he acquired a large repertory of Michelangelesque and Mannerist motifs from engravings, as well as through the influence of Fuseli. He also conceived a

886. Taddeo Zuccaro. *The Conversion of St. Paul* (detail). c. 1555. Oil on canvas. Galleria Doria Pamphili, Rome

tremendous admiration for the Middle Ages, and came closer than any other Romantic artist to reviving pre-Renaissance forms. (His books were meant to be the successors of illuminated manuscripts.)

These elements are all present in Blake's memorable image *The Ancient of Days* (fig. 885). The muscular figure, radically foreshortened and fitted into a circle of light, is derived from Mannerist sources (see fig. 886), while the symbolic compasses come from medieval representations of the Lord as Architect of the Universe. With these precedents, we would expect the Ancient of Days to signify Almighty God, but in Blake's esoteric mythology, he stands rather for the power of reason, which the poet regarded as ultimately destructive, since it stifles vision and inspiration. To Blake, the "inner eye" was all-important; he felt no need to observe the visible world around him.

English Landscape Painting

CONSTABLE. It was nevertheless in landscape rather than in narrative scenes that English painting reached its fullest expression. During the eighteenth century, landscape paintings had been, for the most part, imaginative exercises conforming to Northern and Italian examples. John Constable (1776–1837) admired both Ruisdael and Claude, yet he strenuously opposed all flights of fancy. Landscape painting, he believed, must be based on observable facts. It should aim

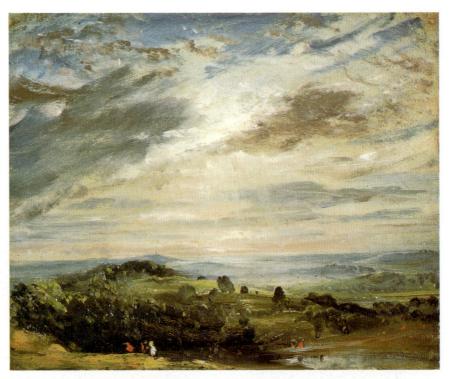

887. John Constable. *Hampstead Heath.* 1821. Oil sketch on paper, mounted on canvas, 10×12 " (25.3 x 30.5 cm). City Art Galleries, Manchester, England

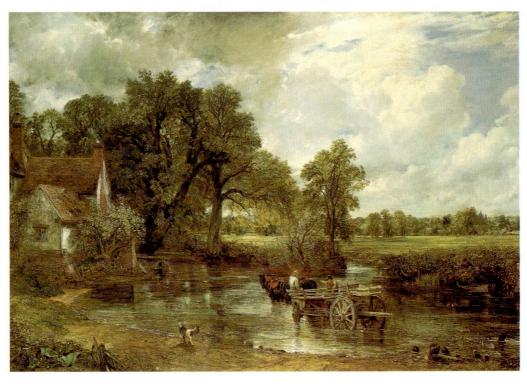

888. John Constable. *The Haywain.* 1821. Oil on canvas, 4'3¹/4" x 6'1" (1.3 x 1.85 m). The National Gallery, London Reproduced by courtesy of the Trustees

at "embodying a pure apprehension of natural effect." Toward that end, he painted countless oil sketches outdoors. These were not the first such studies, but, more than his predecessors, he was concerned with the intangible qualities—conditions of sky, light, and atmosphere—rather than the concrete details of the scene. Often, as in *Hampstead Heath* (fig. 887), the land serves as no more than a foil for the ever-changing drama over-

head, which he studied with a meteorologist's accuracy, the better to grasp its infinite variety. In endeavoring to record these fleeting effects, he arrived at a painting technique as broad, free, and personal as that of Cozens' "ink-blot landscapes," even though his point of departure was the exact opposite.

All of Constable's pictures show familiar views of the English countryside. It was, he later claimed, the scenery around

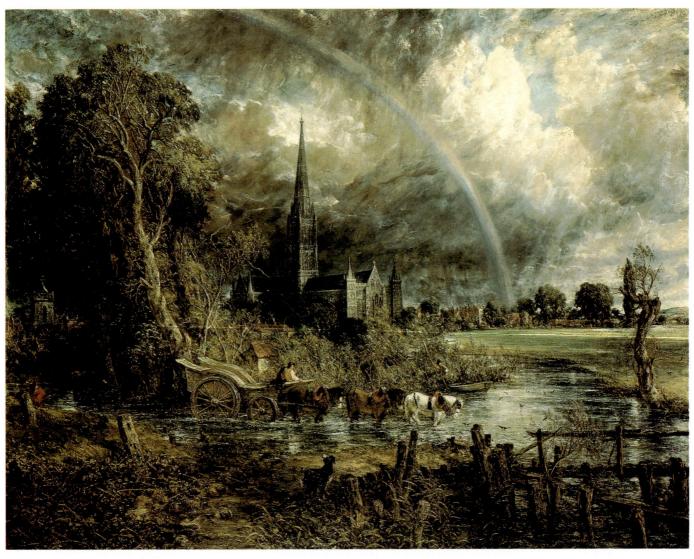

889. John Constable. *Salisbury Cathedral from the Meadows*. 1829–34. Oil on canvas, 59³/4 x 74³/4" (151.8 x 189.9 cm). Private collection, on loan to the National Gallery, London

his native Stour Valley that made him a painter. [See Primary Sources, no. 83, page 936.] Although he painted the final versions in his studio, he prepared them by making oil studies based on sketches from nature. The sky, to him, remained "the key note, standard scale, and the chief organ of sentiment," as a mirror of those sweeping forces so dear to the Romantic view of nature. In The Haywain (fig. 888), painted the same year as Hampstead Heath, he has caught a particularly splendid moment: a great expanse of wind, sunlight, and clouds over the spacious landscape. The earth and sky have both become organs of sentiment informed with the artist's poetic sensibility. At the same time, there is an intimacy in this monumental composition that reveals Constable's deep love of the countryside. This new, personal note is characteristically Romantic. Since Constable has painted the landscape with such conviction, we see the scene through his eyes and believe him, even though it perhaps did not look quite this way in reality.

In 1829 a marked change came over Constable's work. Deeply affected by his wife's death a year earlier, he was subject to darkened moods. *Salisbury Cathedral from the Meadows* (fig. 889), begun that summer, stands as his most personal state-

ment. When the canvas was exhibited two years later, he appended nine lines from *The Seasons* by the eighteenth-century poet James Thomson that reveal its meaning: the rainbow is a symbol of hope after a storm that follows on the death of the young Amelia in the arms of her lover Celadon. Although a political intent has sometimes been seen in the landscape, there can be little doubt of its autobiographical significance. To the left of the huge ash tree, a symbol of life, is a cenotaph; to the right the great church, one of his major themes, a symbol of faith and resurrection. The rainbow, added late in the composition's development, suggests the artist's renewed optimism. Thus the painting reflects his changing frame of mind.

Constable continued to work on *The Rainbow*, as he called it, on and off for several more years. He attached great importance to the painting, which he regarded as the fullest expression of his art and felt would be considered his finest work by future generations. It is indeed an astonishing achievement. The amazingly free application of paint (much of it done with a palette knife) and rich, somber color evoke an agitation not seen before in his landscapes. All nature is caught up in the fury of a cataclysmic event beyond human comprehension.

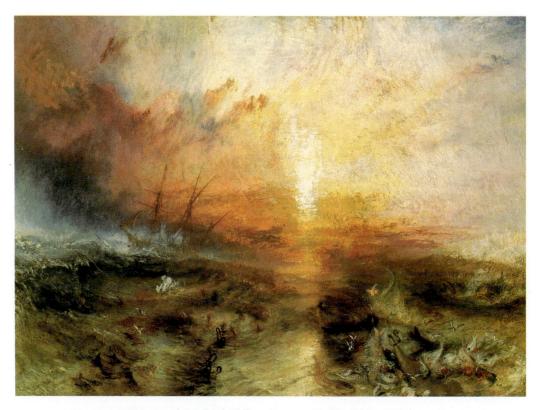

890. Joseph Mallord William Turner. *The Slave Ship.* 1840. Oil on canvas, $35^3/4 \times 48$ " (90.8 x 121.9 cm). Museum of Fine Arts, Boston Henry Lillie Pierce Fund (Purchase)

Every leaf, every branch acts as an index of feeling, expressing the artist's turbulent emotions. Once again it is the sky that provides the keynote: now the storm has clearly passed. No other painter before or since was able to capture the play of the elements with such power. Even paintings by his great rival Joseph Mallord William Turner seem tame by comparison.

TURNER. Joseph Mallord William Turner (1775–1851) arrived at a style that Constable deprecatingly but accurately described as "airy visions, painted with tinted steam." Turner began as a watercolorist; the use of translucent tints on white paper may help to explain his preoccupation with colored light. Like Constable, he made copious studies from nature (though not in oils), but the scenery he selected satisfied the Romantic taste for the picturesque and the sublime—mountains, the sea, or sites linked with historic events. In his full-scale pictures he often changed these views so freely that they became quite unrecognizable.

Many of Turner's landscapes are linked with literary themes and bear such titles as *The Destruction of Sodom*, or *Snowstorm: Hannibal Crossing the Alps*, or *Childe Harold's Pilgrimage: Italy.* When they were exhibited, he would add appropriate quotations from ancient or modern authors to the catalogue, or he would make up some lines himself and claim to be "citing" his own unpublished poem, "Fallacies of Hope." Yet these canvases are the opposite of history painting as defined by Poussin: the titles indeed indicate "noble and seri-

ous human actions," but the tiny figures, who are lost in the seething violence of nature, suggest the ultimate defeat of all endeavor—"the fallacies of hope."

The Slave Ship (fig. 890) is one of Turner's most spectacular visions and illustrates how he transmuted his literary sources into "tinted steam." First entitled Slavers Throwing Overboard the Dead and Dying—Typhoon Coming On, the painting compounds several levels of meaning. Like Géricault's The Raft of the "Medusa" (see fig. 868), which had been exhibited in England in 1820, it has to do, in part, with a specific incident that Turner had recently read about.

When an epidemic broke out on a slave ship, the captain jettisoned his human cargo because he was insured against the loss of slaves at sea, but not by disease. Turner also thought of a relevant passage from James Thomson's poem *The Seasons* that describes how sharks follow a slave ship during a typhoon, "lured by the scent of steaming crowds, or rank disease, and death." But what is the relation between the slaver's action and the typhoon? Are the dead and dying slaves being cast into the sea against the threat of the storm, perhaps to lighten the ship? Is the typhoon nature's retribution for the captain's greed and cruelty? Of the many storms at sea that Turner painted, none has quite this apocalyptic quality. A cosmic catastrophe seems about to engulf everything, not merely the "guilty" slaver but the sea itself, with its crowds of fantastic and oddly harmless-looking fish.

While we still feel the force of Turner's imagination, most

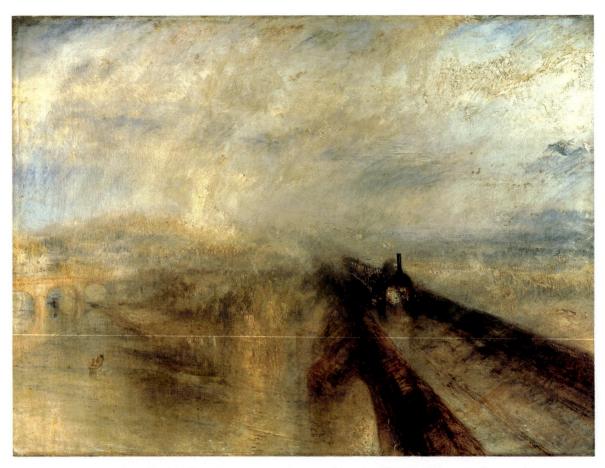

891. Joseph Mallord William Turner. Rain, Steam and Speed—The Great Western Railway. 1844. Oil on canvas, $35^3/4 \times 48$ " (90.8 x 122 cm). The National Gallery, London Reproduced by courtesy of the Trustees

of us enjoy, perhaps with a twinge of guilt, the tinted steam for its own sake rather than as a vehicle of the awesome emotions the artist meant to evoke. Even in terms of the values he himself acknowledged, Turner strikes us as "a virtuoso of the Sublime," led astray by his very exuberance. He must have been pleased by praise from the theorist John Ruskin, that protagonist of the moral superiority of Gothic style, who saw in *The* Slave Ship, which he owned, "the true, the beautiful, and the intellectual"—all qualities that raised Turner above older landscape painters. Still, Turner may have come to wonder if his tinted steam had its intended effect on all beholders. Soon after finishing The Slave Ship, he read in his copy of Goethe's Color Theory, recently translated into English, that yellow has a "gay, softly exciting character," while orange-red suggests "warmth and gladness." Surely these would not be the emotions aroused by *The Slave Ship* in a viewer who did not know its title. Interestingly enough, Turner soon modified his approach to take Goethe's ideas into account. He even painted a pair of canvases about the Deluge that were meant to illustrate Goethe's theory of positive (light and warm) and minus (dark and cold) colors; yet they hardly differ in appearance from the rest of his work.

Many of Turner's paintings had their origin in watercolors called "color beginnings" that are as abstract as American Color Field Painting (see pages 826–27). Nevertheless, they always retained a basis in the artist's actual experiences. Indeed, Turner seems to have sought them out. *Rain, Steam and*

Speed—The Great Western Railway (fig. 891) shows the recently completed Maidenhead railway bridge looking across the Thames River toward London. It was painted after Turner stuck his head out of a window on the Exeter express for some nine minutes during a rainstorm. One could hardly ask for a more vivid impression of speed and atmospheric turbulence! Yet, in a touch of delicious irony, he has added a hare (hardly visible in our illustration) racing ahead of the oncoming train.

WATERCOLORS. Turner was the preeminent watercolorist of his time. Watercolors were first introduced into Britain by visiting Northerners, who had used them as a means of recording on-the-spot observations since the time of Dürer (see fig. 699), but the English made the medium their own. Because they became an indispensable part of the genteel person's education, watercolors are often thought of as an amateur's medium. After the middle of the eighteenth century, however, they emerged as a vehicle of serious artistic expression in the hands of gifted painters like Thomas Gainsborough (see page 618). There was a direct lineage from them to Turner and Constable, who turned to them late in his career. It descended through Cozens' equally talented son, John Robert Cozens (1752–1797), the first to introduce poetic melancholy into watercolors, and Thomas Girtin (1752-1802), Turner's brilliant contemporary, who during his brief career revolutionized the English landscape by investing it with a Romantic mood. The full potential of watercolors was realized only in the

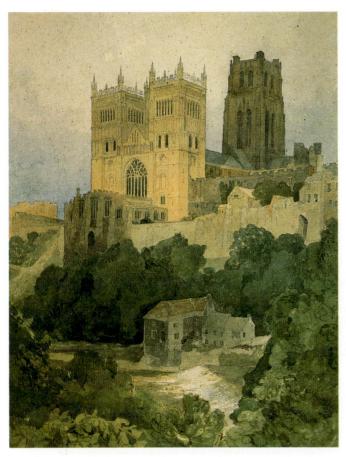

892. John Cotman. *Durham Cathedral*. 1805. Watercolor on paper, $17^{1/4} \times 13^{\circ}$ (43.8 x 33 cm). The British Museum, London

nineteenth century, when artists like Turner greatly extended the range of subjects, techniques, and expression. Many of its most famous practitioners are all but forgotten today, while others, such as John Sell Cotman (1782–1842), who were largely ignored, are now seen as having made important contributions.

COTMAN. Cotman started out in London, where he moved in the same circles as Turner, but spent most of his career as a drawing master in the north of England, as much out of a weakness in his character as the force of circumstances. Although he achieved modest local recognition as a leader of the Norwich landscape school, he died in obscurity and was only rediscovered in the 1920s, when his highly unusual style suddenly seemed remarkably modern. Cotman's watercolors are distinguished by an economy of means that endows even the simplest subject with monumentality and dignity. His formalism grew out of the landscape tradition of Nicolas Poussin and Claude Lorraine, yet he was no classicist. And although he was affected by the Dutch and Flemish Baroque artists who so influenced Constable, Cotman's watercolors are among the most original creations of the English Romantic landscape school during its formative phase.

Durham Cathedral (fig. 892), a finished watercolor painted in the studio from nature studies, bears the individual stamp of his genius. The artist has concentrated on the essential elements, reducing the scene to a flat, nearly abstract pat-

tern. The result is an expressiveness of astonishing intensity. Cotman emphasizes the sheer massiveness of the great church, which looms over the house below, as if threatening to crush it. The landscape bespeaks the English Romantic fascination with the Gothic. It inspired him with much the same sentiment found in Ruisdael's *The Jewish Cemetery* (fig. 783), while the picture has the elemental power of Constable's *Salisbury Cathedral from the Meadows* (fig. 889). Did Cotman intend it as a testimony of his personal faith? Of man's works, he seems to say, only the cathedral, a house of worship, will endure. Yet we know surprisingly little about his beliefs.

Germany

FRIEDRICH. In Germany, as in England, landscape was the finest achievement of Romantic painting, and the underlying ideas, too, were often strikingly similar. About 1800 German artists rediscovered the Gothic, which they regarded as their native heritage. For the most part, this "Gothic Revival" remained limited in subject matter and scope, but in the hands of Caspar David Friedrich (1774–1840), the most important German Romantic artist, it acquired a haunting mystery. A devout Protestant, he had a pantheistic love of nature that became a vehicle of profound religious sentiment. In Abbey in an Oak Forest (fig. 893) all is death—the ancient graves, the barren trees, and ruined church silhouetted against the somber winter sky at twilight. Yet we contemplate the forlorn scene with the same hushed reverence as the solemn procession of monks. Hardly distinguishable from the tombstones, they seek the crucifix enshrined in the arched portal, which offers eternal life to the faithful. The frozen stillness is in marked contrast to the painting by Ruisdael that probably inspired it (similar to fig. 783). Infinitely lonely, the bleak landscape is a reflection of the artist's own melancholy.

When Friedrich painted *The Polar Sea* (fig. 894), he may have known of Turner's "Fallacies of Hope," for in an earlier picture on the same theme (now lost) he had inscribed the name "Hope" on the crushed vessel. In any case, he shared Turner's attitude toward human fate. The painting, as so often before, was inspired by a specific event which the artist endowed with symbolic significance: a dangerous moment in William Parry's Arctic expedition of 1819–20.

One wonders how Turner might have depicted this scene. Perhaps it would have been too static for him, but Friedrich was attracted by this very immobility. He has visualized the piled-up slabs of ice as a kind of megalithic monument to human defeat built by nature itself. There is no hint of tinted steam—the very air seems frozen—nor any subjective handwriting. We look right through the paint-covered surface at a reality that seems created without the painter's intervention.

This technique, impersonal and meticulous, is peculiar to German Romantic painting. It stems from the early Neoclassicists, but the Germans, whose tradition of Baroque painting was weak, adopted it more wholeheartedly than the English or the French. Friedrich absorbed this approach at the Royal Academy in Copenhagen, and although in his hands it yielded extraordinary effects, the results proved disappointing for most German artists, who lacked his compelling imagination.

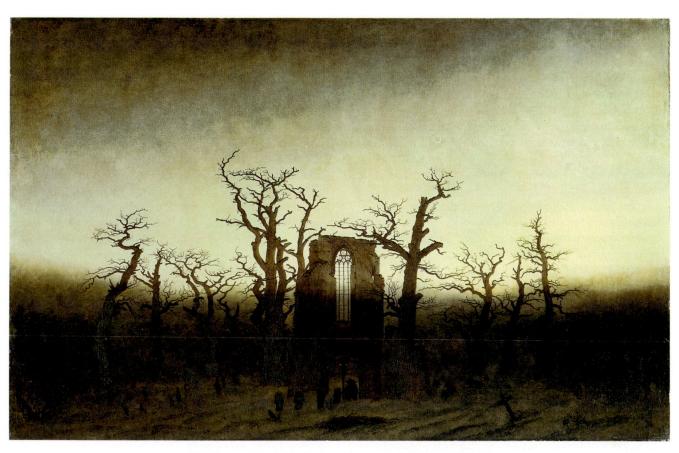

893. Caspar David Friedrich. Abbey in an Oak Forest. 1809–10. Oil on canvas, $44 \times 68^1/2$ " (111.8 x 174 cm). Schloss Charlottenburg, Berlin

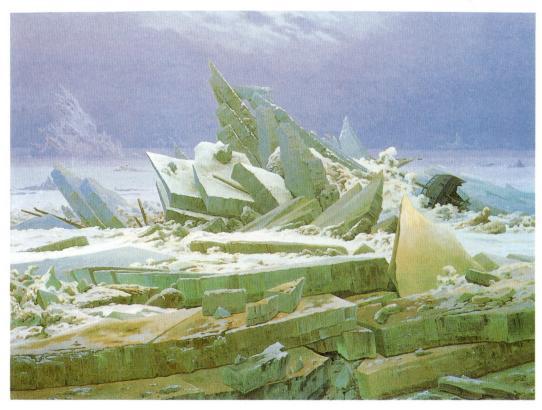

894. Caspar David Friedrich. *The Polar Sea.* 1824. Oil on canvas, $38^1/2$ x $50^1/2$ " (97.8 x 128.3 cm). Kunsthalle, Hamburg, Germany

The Romantic Movement in Literature and the Theater

Romanticism in art had an exact counterpart in literature and the theater. It was inextricably en-

twined with Johann Wolfgang von Goethe, whose dramatic poem *Faust* (Part 1, 1808; Part 2, 1832) remains the greatest monument of the Romantic movement. Goethe was interested in a vast range of subjects, including botany and architecture. His book on color theory (1810), which constituted an attack on Newtonian optics, exercised widespread influence on painters. He was also a gifted amateur musician who conducted operas and wrote librettos, as well as lyrical poems that inspired some of the finest songs by Beethoven and Schubert.

Romanticism in the theater began in Germany just before the turn of the nineteenth century as an outgrowth of Friedrich von Schiller and Goethe. It centered on August Wilhelm von Schlegel (1767-1845), the editor of the literary journal Athenäum from 1798-1800, and his brother Friedrich (1772-1829), a noted philosopher. Together they promoted Romanticism as an all-embracing vision. An early admirer of Shakespeare, whose plays he began to translate, August Schlegel emphasized mood and character over plot in literature, and championed the revival of such medieval works as the twelfth-century German epic Nibelungenlied (The Song of the Niebelungs). The Schlegels were part of a small, tightly knit group that included Ludwig Tieck (1773-1853), who completed the job of translating Shakespeare after August's death. Tieck, who wrote both comedies and tragedies, was also an important theorist, especially later in life, and exercised considerable influence on German Romantic painting through his friendship with Philipp Otto Runge. In the heady early days of Romanticism he collaborated with Wilhelm Heinrich Wackenroder (1773-1798), who stated that "the Gothic church and the Greek temple are equally pleasurable in the sight of God." Medievalism, with its reverence for Christian ideals, was also taken up in 1799 by the writer Novalis (Friedrich von Hardenberg, 1772-1801). The writings of the Schlegel circle inspired not only the landscape painter Caspar David Friedrich but also the Nazarenes, who were to establish the mainstream of German Romantic art. Though he was generally overlooked during his lifetime, the finest playwright of the early nineteenth century in Germany was Heinrich von Kleist (1777-1811), a poet and novelist, whose tragedies and comedies are filled with the conflict of extreme emotions typical of Romanticism.

German ideas were first introduced into France by

Madame de Staël (Germain Necker, 1760–1817), the daughter of Louis XVI's finance minis-

ter and the wife of the Swedish ambassador to France, who detested Napoleon. She went into exile in Germany, where she wrote *Of Germany*, which presented many of the Schlegels' theories. The book, initially suppressed upon its publication in 1810, was reissued after Napoleon's exile to Elba in 1813. Even more important for French Romanticism was the enthusiasm for all things English, which reached its height during the following decade. The novels of Sir Walter Scott sparked the taste for medieval legends, while an English troupe caused a sensation in Paris with its performances of Shakespeare four years after his plays had been declared superior to Racine's by Marie-Henri Beyle, known as Stendhal (1783–1842), in 1823.

The central figure among the French Romantics was the novelist Victor Hugo (1802-1885). The introduction to his play about Oliver Cromwell (1827), the puritan who ruled England after the execution of King Charles II, was a broadside attack on classical drama. In 1830 his drama Hernani announced the triumph of Romanticism. It reversed the shopworn triumph of young lovers (so dear to classical French theater) by ending in tragedy, and broke from the stilted literary conventions of French drama by altering the length of the poetic line. Perhaps fittingly, it was the failure of Hugo's The Burgraves in 1843 that signaled the end of Romantic theater. The other leading dramatist of the 1830s was Alexandre Dumas the Elder (1802–1870), who wrote a number of successful historical and domestic plays before turning to the novels for which he is best known today: The Three Musketeers (1844) and The Count of Monte Cristo (1845). George Sand (Amandine-Aurore-Lucile Dupin Dudevant, 1804-1876), who adopted a male pen name to help gain acceptance of her work, was a favorite novelist as well as a prolific playwright.

It was popular theater that enjoyed the greatest success, fueled by the huge growth of cities spawned by the Industrial Revolution. Much of it took the form of bourgeoise melodramas, which owed their appeal to their simple plots and morality. New kinds of spectacle were made possible by the same technology that gave rise to the Industrial Revolution itself, for example, the invention in 1816 of gaslight and limelight, which involved heating lime with compressed oxygen and compressed hydrogen. They were superseded by Thomas Edison's invention of the electric light in 1879, which made possible the improved carbon arc lamp a year

RUNGE. Philipp Otto Runge (1777–1810), who attended the Copenhagen academy soon after Friedrich, shared many of the same ideas but expressed them very differently. His most important work was a series of four allegorical landscapes devoted to the times of day that occupied him throughout his brief career and was left incomplete at his death. The paintings incorporate an ambitious program having several levels of meaning. They stand for, among other things, the seasons and

the ages of life. The set was intended for a Gothic chapel of Runge's own design, where poetry and music by his friends would be heard.

Morning, the only picture to be finished, was later cut up and survives only in fragments, but a slightly earlier, smaller version (fig. 895) gives a good idea of its appearance. The land-scape represents spring and childhood. Within Runge's program, it also signifies "the boundless illumination of the

later. Among the favorite spectacles were large paintings of panoramas and dioramas, which created special effects through changes of light and color. The leader in this field was Louis Daguerre, who was also an important scene designer before he turned to the invention of photography (see pages 713–14).

In England, all the important Romantic poets tried their hand at plays but with little success: Samuel Taylor Coleridge (1772-1834), William Wordsworth (1770-1850), John Keats (1795-1821), Percy Bysshe Shelley (1792–1822), and even Robert Browning (1812–1889). The most important among them was Lord Byron (George Gordon, 1788–1824), the very prototype of the Romantic writer. His impact was immediate—Delacroix painted canvases inspired by Byron's dramas Marino Faliero and Sardanapalus—and lasted well beyond his own brief lifetime. The novelist Sir Walter Scott (1771– 1832) also wrote plays, but mainly his novels were adapted to the stage by others to great acclaim. The most popular productions in England were translations of middle-class plays by the German Kotzebue; these were superseded by the works of George Bulwer-Lytton (1803-1873)—famous for "It was a dark and stormy night"—who invented the "gentlemanly" melodrama that gave an air of Victorian respectability to the theater.

Philadelphia was the theater capital in the United States, as it was of art, before 1815. The most important house, the Chestnut Street Theater, was designed by the great English architect Inigo Jones. New York City soon superseded Philadelphia. The close ties between art and theater in America are illustrated by William Dunlap (1766–1839), who was the nation's leading playwright before turning to painting in 1812; toward the end of his long life he also wrote the first histories of American theater and art. Many artists, especially aspiring younger ones along the frontier, found their first employment painting stage scenery. As in Europe, the growth of cities in America created a demand for larger and more numerous theaters around the country. Especially popular were Native American and Yankee plays as symbols of the young nation. They were soon joined by African-American minstrel shows (the term Jim Crow comes from a song introduced by Thomas D. Rice in 1829), which featured the "end men" Tambo and Bones, and a "middle" man who functioned as a master of ceremonies. The 1840s saw the rise of a new type, the city boy, who was often pitted against his country cousin.

universe." Aurora-Venus (compounding the rising sun and the morning star) hovers over the Christlike infant as child genii sprout from a lily above. (Flowers in Runge's highly personal system become symbols of universal life through emotional identification with their forms.) The decorated frame, inspired by medieval manuscripts (compare fig. 418), expands on the meaning of the central image. The light of revelation, eclipsed by darkness below, liberates the soul trapped beneath

895. Philipp Otto Runge. *Morning*. 1808. Oil on canvas, $42^{7/8}$ x $33^{5/8}$ "(109 x 85.4 cm). Kunsthalle, Hamburg

the earth within the roots of the bulb. Above, the soul rises transcendent as a genius from the lily to the heavens and is transformed into an angel.

Morning is an extraordinary synthesis of Classical mythology and Christian faith, Romantic attitudes and Neoclassical technique. Painting for Runge was a deeply spiritual act revealing the divinity of nature. To him, this elevated conception required abstraction to express the poetic idea. Thus the artist communicates his intent through the stylized forms and symmetrical composition. More generally, Morning represents the mystical yearning of the soul for the infinite so dear to the German Romantic. This ecstatic vision, the "chord" of harmony as he put it, is depicted using the same method as Friedrich's. Every detail has been precisely observed. The picture surface, transparent as glass, makes us look at nature with the same innocence as the newborn child. As a result, the landscape has a disarming simplicity, despite the complexity of its program. In the end, it is the painting technique that validates Runge's ideas and makes them convincing.

THE NAZARENES. In 1808 a group of young German painters at the Vienna Academy banded together to form the Guild of St. Luke, after the artists' guilds of old. They equated

896. Friedrich Overbeck. *Italia and Germania*. 1811–28. Oil on canvas, 37³/4 x 41⁷/8" (96 x 106.4 cm). Bayerische Staatsgemäldesammlungen, Neue Pinakothek, Munich

897. William Sidney Mount. *Dancing on the Barn Floor.* 1831. Oil on canvas, 25 x 30" (63.5 x 76.2 cm). Collection of The Museums at Stony Brook Gift of Mr. and Mrs. Ward Melville

simplicity with pious virtue, as against virtuosity, which precluded the heartfelt sincerity that was their goal. Two years later they decided to lead the life of artists-monks at an abandoned monastery near Rome, where they became known as the Nazarenes. Although their work at first had a striking purity, the painstaking precision of the old German masters and the style of the Early Renaissance they also affected reinforced the Neoclassic emphasis on form at the expense of color, which was put to the service of an increasingly inflated rhetoric. The Nazarene movement gradually petered out as its members died or returned to Germany, where they established the mainstream of German Romanticism.

OVERBECK. The Nazarenes were at their best in intimate subjects, such as *Italia and Germania* (fig. 896) by Friedrich Overbeck (1789–1869). This manifesto by the movement's "priest" expresses the North's long-standing love-hate relationship with the South. It shows personifications of the two countries, so different in every respect, reconciled in tender friendship. The painting is at once a nostalgic reminiscence of the artist's homeland and a celebration of the beauty he found around him in Rome, both united in harmony and mutual respect. Its source, we recognize, is Angelica Kauffmann's self-portrait (fig. 847), by way of German portraiture.

United States

Painting following the American Revolution was dominated by protégés of Benjamin West, who took every young artist arriving in London from the New World under his wing. Strangely enough, the only ones to enjoy much success were portraitists such as Gilbert Stuart (1755–1828). Using the fashionable conventions of Joshua Reynolds, they conferred the aura of established aristocracy on the Federalists, who were only too eager to forget the recent revolutionary past enshrined by the history painters. What Americans wanted was an art based not on the past but on the present. Romantic painting in the United States rode the tidal wave of cultural nationalism fostered by Jacksonian democracy. Collectors now began to support artists who could articulate their vision of the United States. For perhaps the only time in the country's history, artists, patrons, and intellectuals came to share a common point of view.

MOUNT. During the 1820s, America found its history painting in genre scenes descended from Dutch and English examples. The first native genre painter of real talent, William Sidney Mount (1808–1868), spent his career on rural Long Island, which provided him with a rich vein of subjects. Although he began as a history painter and was associated with the leading ones in New York City, Mount quickly turned to subjects of everyday life, which he imbued with the humor of

898. Thomas Cole. *View of Schroon Mountain, Essex County, New York, After a Storm.* 1838. Oil on canvas, 39³/8 x 63" (100 x 160 cm). The Cleveland Museum of Art Hinman B. Hurlbut Collection

Jan Steen. *Dancing on the Barn Floor* (fig. 897), one of his first efforts, projects the ideal of America as a land of contentment in which its fun-loving people enjoy a simple, happy life as the fruit of their honest labor. The carefully observed violinist testifies to the artist's love of music, his favorite theme. Indeed, this ingenious inventor and theoretician wrote considerable "fiddle" music himself, and later patented a violin of unusual design.

THE HUDSON RIVER SCHOOL. At about the same time, Americans began to discover landscape painting. Before then, settlers were far too busy carving out homesteads to pay much attention to the poetry of nature's moods. The attitude toward landscape began to change only as the surrounding wilderness was gradually tamed, allowing Americans for the first time to see nature as the escape from civilization that inspired European painters. As in England, the contribution of the poets proved essential to shaping American ideas about nature. By 1825, they were calling on artists to depict the wilderness as the most conspicuous feature of the New World and its emerging civilization. Pantheism virtually became a national religion during the Romantic era. While it could be frightening, nature was everywhere, and was believed to play a special role in determining the American character. Led by Thomas Cole (1801–1848), the founder of the Hudson River School, which flourished from 1825 until the Centennial celebration in 1876, American painters elevated the forests and mountains to symbols of the United States.

COLE. Like many early American landscapists, Cole came from England, where he was trained as an engraver, but learned the rudiments of painting from an itinerant artist in the Midwest. Following a summer sketching tour up the Hudson River, he invented the means of expressing the elemental power of the country's primitive landscape by transforming the formulas of the English picturesque into Romantic hymns based on the direct observation of nature. Because he also wrote poetry, Cole was able to create a visual counterpart to the literary rhetoric of the day. His painting View of Schroon Mountain, Essex County, New York, After a Storm (fig. 898) shows the peak rising majestically, like a pyramid, from the forest below. It is treated as a symbol of permanence surrounded by death and decay, signified by the autumnal foliage, passing storm, and lightning blasted trees. Stirred by sublime emotion, the artist has heightened the dramatic lighting, so that the broad landscape becomes a revelation of God's eternal laws.

BINGHAM. Fur Traders Descending the Missouri (fig. 899) by George Caleb Bingham (1811–1879) shows this close identification with the land in a different way. The picture, both a landscape and a genre scene, is full of the vastness and silence of the wide-open spaces. The two trappers in their dugout canoe, gliding downstream in the misty sunlight, are entirely at home in this idyllic setting. The assertion of a human presence portrays the United States as a benevolent Eden in which settlers assume their rightful place. Rather than being

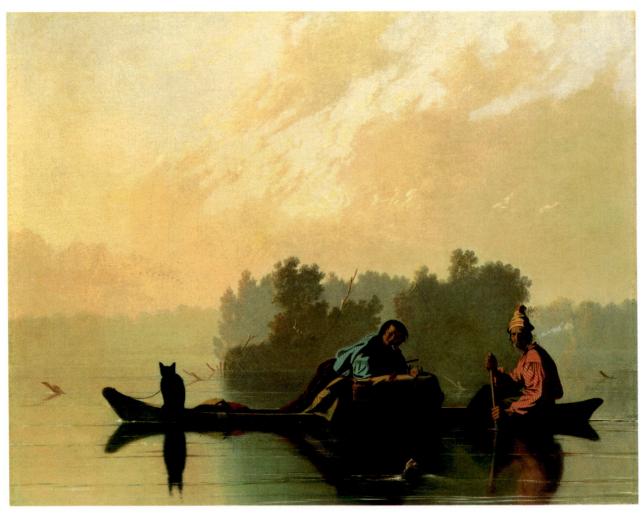

899. George Caleb Bingham. Fur Traders Descending the Missouri. c. 1845. Oil on canvas, 29 x 36¹/2" (73.7 x 92.7 cm). The Metropolitan Museum of Art, New York Morris K. Jesup Fund, 1933

dwarfed by a vast and often hostile continent, these hardy pioneers live in an ideal state of harmony with nature, symbolized by the waning daylight. The picture reminds us of how much Romantic adventurousness went into the westward expansion of the United States. The scene owes much of its haunting charm to the silhouette of the black cub chained to the prow and its reflection in the water. This masterstroke adds a note of primitive mystery that we shall not meet again until the work of Henri Rousseau (see pages 764–65).

SCULPTURE

In attempting to define Romanticism in sculpture, we are immediately struck by one rather extraordinary fact: in contrast to the abundance of theoretical writings that accompanied Neoclassical sculpture from Winckelmann on, there exists only one piece of writing that sets forth a general theory of sculpture from the Romantic point of view: Baudelaire's essay of 1846, "Why Sculpture is Boring," which occupies only a few pages of his long review of the Salon of that year. Actually, Baudelaire is less concerned with the state of French

sculpture at that moment, which strikes him as deplorable, than he is with the limitations of sculpture as a medium. To him, there can be no such thing as Romantic sculpture, because every piece of sculpture is to him a "fetish" whose objective existence prevents the artist from making it a vehicle of his subjective view of the world, his personal sensibility. It can transcend this limitation only if it is placed in the service of architecture, enhancing a larger whole such as a Gothic cathedral, but as soon as it detaches itself from this context, sculpture reverts to its primitive status. Fortunately, Baudelaire's theory was not taken at face value by either artists or patrons, but it does suggest the difficulty Romantic sculptors (or at least those who thought of themselves as part of the Romantic movement) had in establishing a self-image they could live with. Indeed, the unique virtue of sculpture—its solid, space-filling reality (its "idol" quality)—was not congenial to the Romantic temperament. The rebellious and individualistic urges of Romanticism could find expression in rough, small-scale sketches but rarely survived the laborious process of translating the sketch into a permanent, finished monument.

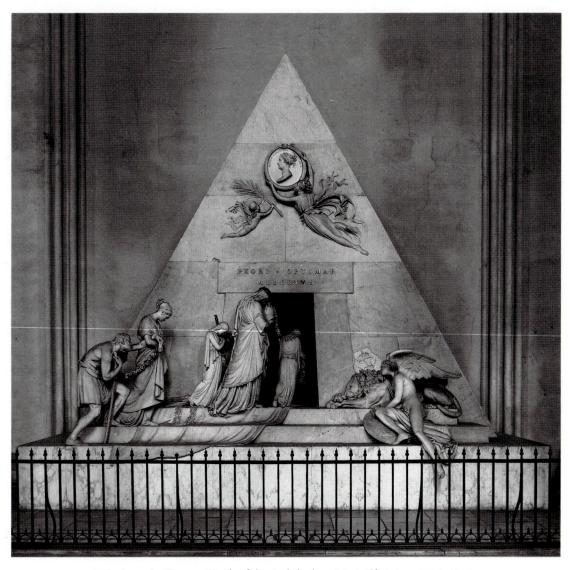

900. Antonio Canova. Tomb of the Archduchess Maria Christina. 1798–1805. Marble, lifesize. Augustinerkirche, Vienna

Italy

CANOVA. At the beginning of the Romantic era, we find an adaptation of the Neoclassical style to new ends by sculptors, led by Antonio Canova (1757-1822). He was not only the greatest sculptor of his generation, he was the most famous artist of the Western world from the 1790s until long after his death. Both his work and his personality became a model for every sculptor during those years. Canova's meteoric rise is well attested by his numerous commissions. The Tomb of Maria Christina, archduchess of Austria, in the Church of the Augustinians in Vienna (fig. 900) is remarkable as much for its "timeless" beauty as for its gently melancholy sentiment. It was commissioned by her husband soon after her death in 1798, although its framework had been anticipated in a monument to Titian planned by Canova several years before. This ensemble, in contrast to the tombs of earlier times (such as fig. 577), does not include the real burial place. Moreover, the deceased appears only in a portrait medallion framed by a snake biting its own tail, a symbol of eternity, and sustained by two floating genii. Presumably, but not actually, the urn carried by the woman in the center contains her ashes. This is an ideal burial service performed by classical figures, mostly allegorical: a mourning winged genius on the right, and the group about to enter the tomb on the left, who represent the Three Ages of Life. The slow procession, directed away from the beholder, stands for "eternal remembrance." All references to Christianity are conspicuously absent.

It is readily apparent that Canova must have known of Pigalle's tomb for the Maréchal de Saxe (fig. 816), which looks forward to it in so many respects. The differences are equally striking, however. Canova's design looks surprisingly like a very high relief, for most of the figures are seen in strict profile, so that they seem to hug the wall plane despite the deep space. Gestures are kept to a minimum, and the allegorical trappings that clutter Pigalle's monument have been swept away, so that nothing distracts us from the solemn ritual being acted out before us. It is this intense concentration that distinguishes Canova's classicism from the Rococo of Pigalle.

Canova's friends included Jacques-Louis David (see pages 659–60), who helped to spread his fame in France. In 1802, Canova was invited to Paris by Napoleon, who wanted his

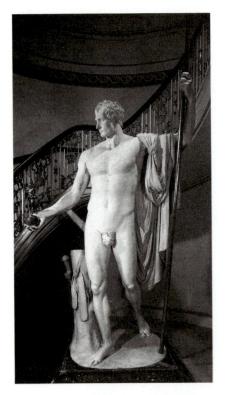

901. Antonio Canova. *Napoleon.* 1806. Marble, over-lifesize. Apsley House, London

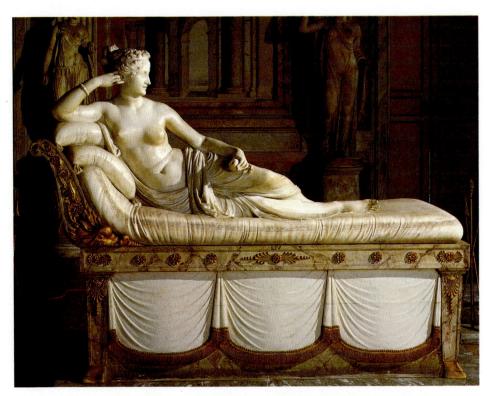

902. Antonio Canova. *Pauline Borghese as Venus.* 1808. Marble, lifesize. Galleria Borghese, Rome

portrait done by the greatest sculptor of the age. With Napoleon's approval, he made a colossal nude figure in marble showing the conqueror as a victorious and peace-giving Mars (fig. 901). The head is an idealized but thoroughly recognizable portrait of Napoleon, while the figure is based on statues of ancient rulers in the guise of nude classical deities. The elevation of the emperor to a god marks a decisive shift away from the noble ideals of the Enlightenment that had given rise to Neoclassicism. The glorification of the hero as a noble example, seen in Houdon's statue of George Washington (fig. 852), is abandoned in favor of the Romantic cult of the individual. There is no longer any higher authority—neither religion, nor reason is invoked—only the imperative of Greek art remains unquestioned as a style divorced from content. Fittingly enough, the statue was given to the Duke of Wellington after he defeated Napoleon at Waterloo.

Not to be outdone, Napoleon's sister Pauline Borghese permitted Canova to sculpt her as a reclining Venus (fig. 902). The statue is so obviously idealized as to still any gossip. We recognize it as a precursor, more classically proportioned, of Ingres' *Odalisque* (see fig. 870). She is equally typical of early Romanticism, which incorporated Rococo eroticism but in a less sensuous form. Strangely enough, Pauline Borghese seems less three-dimensional than the painting. She is designed like a "relief in the round," for front and back view only, and her very considerable charm radiates almost entirely from the fluid grace of her contours.

THORVALDSEN. Canova remained the model for every sculptor of ambition for most of the nineteenth century. Yet the Napoleonic era was not a propitious one for sculptors who wanted to be like him: independent, beholden to no single patron, free to create "modern classics." The only one who

succeeded, and the sculptor on whom Canova's mantle ultimately descended, was Bertel Thorvaldsen (1770–1844), a Dane who came to Rome in 1797 on a scholarship from the Royal Academy in Copenhagen. Although he established his reputation early, he had to live through some difficult years before he could feel artistically and financially secure.

Thorvaldsen became the first to revive the most heroic phase of Greek art, but soon underwent a basic change not only of style but of outlook. His *Venus* (fig. 903) is closer to a living model than to any ancient source, though its immediate precedent is a statue by Houdon. Thorvaldsen shows her in a moment of triumph, holding the golden apple awarded by Paris in the beauty contest that started the Trojan War, yet she contemplates the apple in a way that might lead us to mistake her for an Eve tempted, were it not for the garment in her left hand. The statue shows Thorvaldsen's new emphasis on poetic sentiment, as well as his reawakened religious feeling, which he shared with the young German painters in Rome known as the Nazarenes, many of whom were his friends (see page 696). Thus his *Venus* is far more Romantic than Neoclassic, despite its style.

For all of Europe except France and Spain, Thorvaldsen remained the model of sculptural perfection until the 1850s. Germans, Scandinavians, and many Italians viewed him as more "truly Greek" than Canova, and for the English he became the heir of John Flaxman as well.

France

It was in France that the main development of Romantic sculpture took place. Although the doctrine of the Academy came to be broadened and modified in the course of time, its core lasted until Rodin. This core might be defined as the

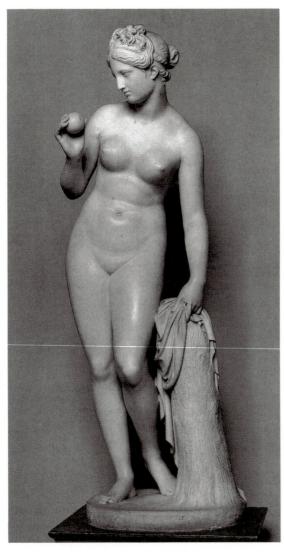

903. Bertel Thorvaldsen. *Venus.* 1813–16. Marble, lifesize. Thorvaldsens Museum, Copenhagen

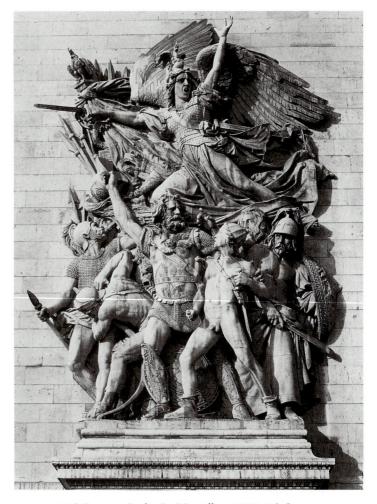

904. François Rude. *La Marseillaise*. 1833–36. Stone, approx. 42 x 26' (12.8 x 7.9 m). Arc de Triomphe, Paris

belief that the human body is nature's noblest creation and, hence, the sculptor's noblest subject. Translated into practice, this meant that every student of sculpture at such academies as the Paris École des Beaux-Arts received a rigorous training. Since the level of teaching was far higher than it was in painting, the limitations of the academic sculptural tradition became apparent much later. The Romantic reaction against the ideal of the "modern classic" asserted itself in the sculpture sections of the French Salons right after the Revolution of 1830, which brought the fall of the ancient regime of the Bourbons, but the antiacademic tradition did not become dominant until the last two decades of the century, when Michelangelo, Rodin's ideal, at last won out over Canova. What ultimately destroyed it was the cult of the fragmentary and the unfinished.

That the Romantic "rebellion" started so much later than in painting also attests to how closely sculpture and politics were linked in nineteenth-century France. Artists were often passionately involved in politics during an era when political feelings were especially intense, but because the state remained the largest single source of commissions, the fortunes of the sculptors were more directly affected than those of the painters by changes in regime. This is not meant to suggest that French

sculpture was dominated by its social and political environment. Yet, to the extent that it was a public art, sculpture responded to the pressure of these forces, directly or indirectly, far more than did painting, and was shaped by them in varying degrees, depending on local circumstances. Thus we cannot understand its development without reference to the changing politics around it.

RUDE. François Rude (1784–1855), who enthusiastically took Napoleon's side after the emperor's return from Elba, sought refuge in Brussels from Bourbon rule, as had Jacques-Louis David, whom he knew and revered. Following his return to Paris, Rude must have felt that artistically he had reached a dead end and decided to strike out in new directions. He conceived a new interest in the French Renaissance tradition of the School of Fontainebleau and Giovanni Bologna (see pages 496–98), which would eventually lead him back to Claus Sluter. This rediscovery of national sculptural traditions, so characteristic of Romantic revivalism, was part of a new nationalism, which was also exemplified by a passion for historic portraits as "morally elevating for the public."

These concerns are manifest in Rude's masterpiece, *The Departure of the Volunteers of 1792*, commonly called *La*

Music became the ideal Romantic art form because it was widely

believed to allow the fullest expression of pure feeling, without the hindrance of literal meaning or the reality of appearance. The archetype of the early Romantic composer was Ludwig van Beethoven (1770-1827). He sympathized strongly with the American and French Revolutions, which fed his restless Romantic spirit, and in his personal relations he bowed to no one, least of all to his aristocratic patrons. Nevertheless, he was closest spiritually to Goethe, a member of the previous generation. His early works properly belong to the Neoclassical period of music (see box page 670), but his style has greater affinities with that of C. P. E. Bach than of Mozart or Haydn, with whom he studied for four years. Beethoven greatly expanded the expressive range of the forms he inherited. His works are more explosive and dynamic, louder and more grandiose. Like Mozart, Beethoven was a universal genius. By emphasizing content over form, he pushed the boundaries of classical music to their limits, and sometimes beyond. Mercilessly self-critical, he composed far fewer works than his predecessors, but with few exceptions they are substantial contributions to the literature. In addition to the famous nine symphonies, on which his public reputation rests, there are 31 sonatas for piano, an instrument that was at once personal and symphonic, and 17 quartets that are the most profound utterances in all of chamber music. The most striking aspect of Beethoven's music is its novelty, which made it controversial to many of his contemporaries. It features heroic expression counterbalanced by melting lyricism. No other composer could scale the heights or plumb the depths of the soul to such stirring effect. Extremely public during his youth and early maturity, his music became increasingly private over time, perhaps as the result of his growing deafness, which was largely complete by 1816, as well as his troubled personal life. Yet its complexity was a consistent outgrowth of the composer's personality, and makes the late works demanding for interpreter and listener alike.

Beethoven was the essential point of departure for most Romantic composers of the next generation. Yet, no matter how awed they were by his commanding presence, they remained independent personalities determined to make their own contributions.

Franz Schubert (1797–1828), in contrast to Beethoven, was a man of gentle temperament. His dreamy sensibility found its ideal outlet in German art songs (*Lieder*; singular, *Lied*), inspired by the poetry of Goethe and Schiller among others, which he wrote in great quantity and variety. Although he had some difficulty handling extended symphonic form, Schubert's piano sonatas present an ideal

combination of intimate lyricism and large scale.

Orchestral writing presented no difficulties to Felix Mendelssohn-Bartholdy (1809–1847). Like Mozart, he was a child prodigy who was writing significant music by late adolescence. (His sister, Fanny, was also gifted and remains unjustly neglected.) His five symphonies and numerous overtures are notable for their vitality and colorism, which "paint" vivid images in sound. Mendelssohn, too, was stirred by literature, above all by the plays of Shakespeare. For an 1843 production by Ludwig Tieck he set Shakespeare's A Midsummer Night's Dream to music that perfectly captures its impish spirit. Mendelssohn, like Schubert, succumbed early to syphilis (the AIDS of the time), which also claimed the lives of numerous other people in the arts.

The most characteristic music of Robert Schumann (1810–1856) was piano and vocal music. But although he lacked the facility for orchestration of his friend Mendelssohn, his four symphonies were of major importance for the next generation of German composers. They breathe an innocence and love of nature that make them the musical counterparts of Romantic landscape paintings. Schumann was also inspired by Romantic writers, and undertook a series of large-scale vocal works: incidental music for Manfred (1849), incorporating the poem by Lord Byron; the opera Genoveva (1850), taken from Ludwig Tieck's drama; and Scenes from Faust (1853), based on Goethe's poetry. Schumann's wife, Clara Wieck (1819–1896), was also an excellent pianist and composer, but she put her career second to her husband's, so that only recently has her music come to the fore. Schumann died young after suffering from two years of madness, perhaps brought on by syphilis.

The only composer to equal Beethoven's heroic stature was the Frenchman Hector Berlioz (1803-1869), whose music employs the full force of a very large orchestra. Despite being mainly self-taught, Berlioz was a masterful composer in command of orchestration—the technique of specifying which instruments should play which parts of a musical composition. Berlioz's music is programmatic, that is, it tells a story, or at least suggests a sequence of incidents, and this emphasis on story line over pure form is one of his most Romantic qualities. Berlioz's Symphonie fantastique (Fantastic Symphony, 1830) is a morbid account of unrequited love. Shakespeare made a deep impression on him, and his most successful work is a dramatic realization of Romeo and Juliet (1839). No one, not even Verdi and Tchaikovsky later in the century, understood better the magic of love or the power of tragedy in Shakespeare. Although they were little performed during his lifetime, Berlioz's operas were of great importance for successfully reviving the grand tradition of Lully and Rameau.

Marseillaise (fig. 904), for Napoleon's unfinished triumphal arch on the Place de l'Étoile. Louis-Philippe and his energetic minister of the interior Adolphe Thiers saw its completion as an opportunity to demonstrate that the new government was one of national reconciliation. Hence, the sculptural program had to offer something to every segment of the French political spectrum. Rude was fortunate in getting a commission for

one of the four groups that flank the opening. He raised his subject—the French people rallying to defend the Republic against attack from abroad—to the level of mythic splendor. The volunteers surge forth, some nude, others in classic armor, inspired by the great forward movement of the winged genius of Liberty above them. No wonder the work engendered an emotional response that made people identify the group with

Paris was the opera capital of Europe during the first half of the nineteenth century. The most prolific and popular composer of opera was Giacchino Rossini (1792-1868), who adapted his Italian style to suit the French taste. While his operas generally have ridiculous plots, the music itself is glorious and, given a libretto of quality, the result is a masterpiece: The Barber of Seville (1816), based on Beaumarchais' play, and William Tell (1829), his last opera, inspired by Schiller's drama of 1804. The classical antithesis of Rossini's unabashed Romanticism was another Italian, Luigi Cherubini (1760-1842), who settled in Paris in 1788. A later academic counterpart to Glück, he was regarded as the equal of Beethoven, whose lone opera was influenced by Cherubini's Medea (1797), taken from the Greek tragedy by Euripides.

When Rossini departed for Paris in 1824, Italian opera was left in the capable hands of Gaetano Donizetti (1797–1848). Most of his 70 operas are potboilers, but the finest ones, notably *Lucia di Lammermoor* (1835), have spirited drama and appealing music. Donizetti's style largely determined the character of Italian opera before Giuseppe Verdi. His chief rival, Vincenzo Bellini (1801–1835), died too young to achieve his full potential a few years after writing *Norma* and *La Somnambula* in 1831.

Among the most unusual musical personalities of the Romantic movement was the Polish composer Frédéric Chopin (1810–1849), who was drawn to Paris. A great virtuoso of the piano, Chopin introduced a wide range of new types of composition for the keyboard, most of them—such as the *polonaise* and the *mazurka*—based on the national music of Poland, although John Field (1782–1837) helped to pave the way for his nocturnes. These compositions are so free and inventive that they seem to be entirely new forms spun as if by magic from Chopin's endlessly fertile imagination. Though mostly small in scale, they yielded not only poetic intimacy, at which he excelled, but also heroic grandeur. Chopin and his companion, the novelist George Sand, sat for a famous portrait by Delacroix.

For Chopin, music remained an expressive vehicle first, a technical display second. With the Italian violinist Niccolò Paganini (1782–1840), who also spent much of his life in Paris, virtuosity became an end in itself, which greatly enlarged the scope of violin playing. He was one of the first great music stars to be idolized by an adoring public. Paganini became the model in turn for the Hungarian pianist Ferenc Liszt (1811–1886), a friend of Chopin who came to Paris for a while, but later traveled widely.

the national anthem itself. For Rude, the group had a deeply felt personal meaning: his father had been among those volunteers. When the arch was officially unveiled in 1836, there was almost unanimous agreement that Rude's group made the other three pale into insignificance. Despite its great public acclaim, *The Departure* failed to gain Rude the official honors he so clearly deserved. He found himself more and more

905. Antoine-Louis Barye. *Tiger Devouring a Gavial of the Ganges*. 1831–32. Bronze, length 39¹/2" (100.3 cm). Musée du Louvre, Paris

in opposition to the regime, and his most important works between 1836 and 1848 were direct expressions of his Bonapartist political beliefs.

BARYE. The ultimate source of *La Marseillaise* is pictorial. In a similar way, Stubbs' Lion Attacking a Horse (see fig. 848) is the sire of animal groups by Antoine-Louis Barye (1795-1875). Barye followed in his father's footsteps as a goldsmith, but spent all his free hours at the Paris zoo, sketching live animals and studying their anatomy. He also became a friend of Delacroix, who shared these interests and sometimes treated the same themes. Barye scored his first public success at the Salon of 1831 with the plaster model of Tiger Devouring a Gavial of the Ganges (see fig. 905). His group displays a realism based on thorough zoological knowledge, but what really impressed critics and public alike was the ferocity of the tiger, the pitiless display of "nature red in tooth and claw" so exciting to the Romantic imagination. Animal combats had a long tradition in Western art going all the way back to classical antiquity, but these followed well-established formal conventions that governed both the choice of animals and their compositional relationship. Barye disregarded all such precedents. Not only did he study his animals directly from nature, he chose exotic species and combinations. What mattered was not the zoological implausibility of the group (gavials are unlikely prey for tigers) but its expressive power, intensified by the monumental compactness of design.

PRÉAULT. The Salons of the early 1830s, besides bringing Rude and Barye into prominence, served as showcases for sculptors then still in their twenties. What separated them from the generation of their teachers was that none was old enough to have experienced the Napoleonic era. As it happened, there was not a single first-rate artist in this group. Auguste Préault (1809–1879), the most interesting of them, may have been the first to earn the epithet "a genius without talent," as he was termed by one of his contemporaries. His ambitious relief titled Tuerie (Slaughter) (fig. 906), sent to the Salon of 1834, indicates that his interest centered on extreme physical and emotional states. He submitted the panel as the fragment of a larger composition, but this, one suspects, was merely for the purpose of easing it past the jury. The design is actually quite self-contained, even though every figure in it is a fragment, except for the baby. The style of Tuerie must be termed Neo-Baroque, yet it is brimming with a physical and

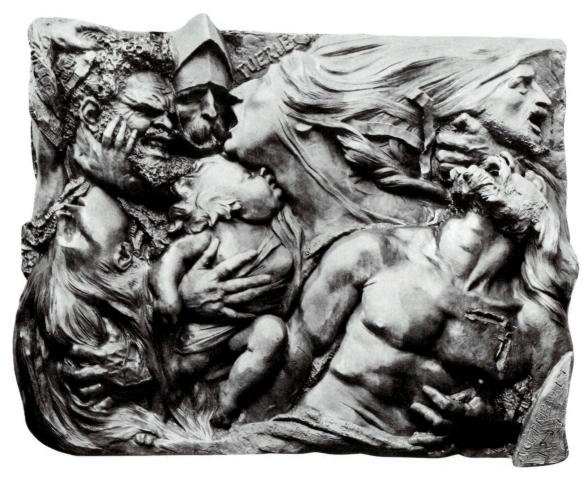

906. Auguste Préault. Tuerie (Slaughter). 1834. Bronze, 43 x 55" (109.2 x 139.7 cm). Musée des Beaux-Arts, Chartres, France

emotional violence far beyond anything found in Baroque art, and its expressive distortions, its irrational space filled to the bursting point with writhing shapes, evoke memories of Gothic sculpture (compare fig. 488). In fact, the helmeted knight's face next to that of the screaming mother hints that the subject itself—some dread apocalyptic event beyond human control—is medieval. But in true Romantic fashion, Préault does not define this event.

Tuerie established Préault's reputation as the archetypal Romantic sculptor. As a radical attack on the rules of classical relief, it was acclaimed by avant-garde critics. (What the other side thought of it can easily be imagined.) Its very extremism, however, condemned *Tuerie* to being a dead end. Neither Préault nor anyone else could make it the starting point of a new development.

CARPEAUX. If the high tide of Romanticism is to be found among the French sculptors born during the first decade of the century, those born during the second may, with some hesitation, be designated late (or belated) Romantics, but we again look in vain for a major talent among them. The third decade,

in contrast, saw the birth of several important sculptors. Of these, the greatest and best known was Jean-Baptiste Carpeaux (1827–1875). Carpeaux's masterpiece came at the end of the Second Empire, which succeeded the short-lived Second Republic in 1852. In 1861 his old friend the architect Charles Garnier began the Paris Opéra (see pages 710-12) and entrusted him with one of the four sculptural groups across the facade. The Dance (fig. 907) perfectly matches Garnier's Neo-Baroque architecture. (The plaster model in our illustration is both livelier and more precise than the final stone group, visible in fig. 920, lower right). The group created a scandal after the unveiling in 1869. The nude dancing bacchantes around the winged male genius in the center were denounced as drunk, vulgar, and indecent—and small wonder, for their coquettish gaiety derives from small Rococo groups such as Clodion's (see fig. 815). But unlike Clodion's, Carpeaux's enormous figures (they are 15 feet tall) look undressed rather than nude, so that we do not accept them as legitimate denizens of the realm of mythology. Public opinion insisted that it be replaced, but after the war with Germany ended in 1871 the old complaints were forgotten and *The Dance* was

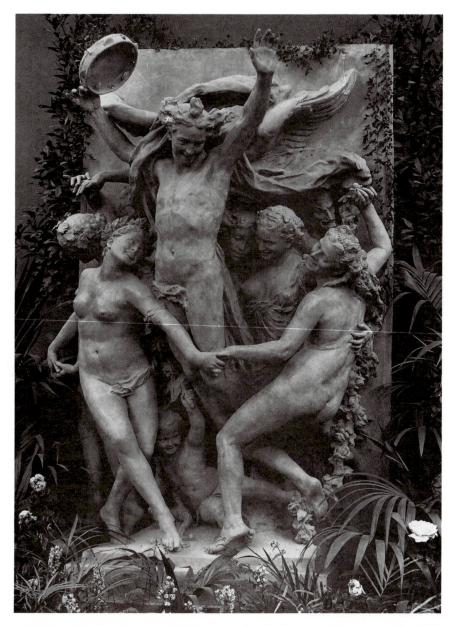

907. Jean-Baptiste Carpeaux. *The Dance.* 1867–69. Plaster model, approx. 15' x 8'6' (4.6 x 2.6 m). Musée de l'Opéra, Paris

acclaimed as a masterpiece. It is as obviously superior to the other three Opéra groups by more conservative authors as Rude's *Marseillaise* is to its neighbors on the Arc de Triomphe.

BARTHOLDI. To defy established society, its values and institutions, was easier for writer and painters than for sculptors. To the latter, the late nineteenth century offered vast opportunities for official commissions. Of the total of such monuments in the Western world, it is a safe guess that the great majority were erected, or at least begun, between 1872 and 1905. The most ambitious of these was the *Statue of Liberty* (or, to use its official title, *Liberty Enlightening the World*; fig. 908) by Auguste Bartholdi (1834–1904).

This monument in memory of French assistance to America during the War of Independence was a gift of the French people, not of the government. Hence, its enormous cost was raised by public subscription, which took ten years. Bartholdi

conceived the Statue of Liberty out of a previous one for a gigantic lighthouse in the form of a woman holding a lamp to be erected at the northern entry to the Suez Canal. All he had to do was exchange the Egyptian headdress for a radiant crown and the lantern for a torch. The final model shows an austere, classically draped young woman holding the torch in her raised right hand and a tablet in her left. With her left foot, on which her weight rests, she steps on the broken shackles of tyranny. The right leg (the "free" one in accordance with the rules of classical contrapposto) is set back, so that the figure seems to be advancing when viewed from the side but looks stationary in the frontal view. As a piece of sculpture, the Statue of Liberty is less original than one might think. Formally and iconographically, it derives from a well-established ancestry reaching back to Canova and beyond. Its conservatism is, however, Bartholdi's conscious choice. He sensed that only a "timeless" statue could embody the ideal he wanted to glorify.

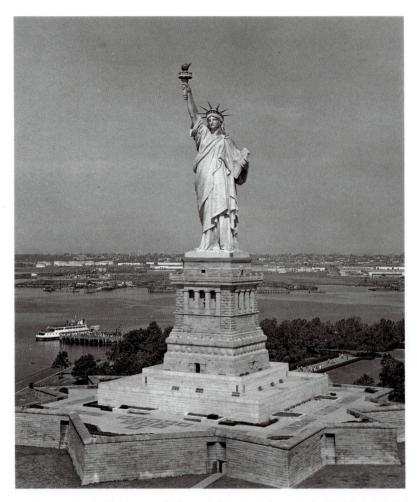

908. Auguste Bartholdi. *Statue of Liberty (Liberty Enlightening the World).* 1875–84. Copper sheeting over metal armature, height of figure 151'6" (46 m). Liberty Island, New York Harbor

The figure, which stands over 150 feet tall, presented severe structural problems that called for the skills of an architectural engineer. Bartholdi found the ideal collaborator in Gustave Eiffel, the future builder of the Eiffel Tower (see pages 742–43 and fig. 964). The project took more than a decade to complete. The *Statue of Liberty* was inaugurated at last in the fall of 1886, having been placed on a tall pedestal built with funds raised by the American public. Its fame as the symbol—one is tempted to say "trademark"—of the United States has been worldwide ever since.

ARCHITECTURE

Given the individualistic nature of Romanticism, we might expect the range of revival styles to be widest in painting, the most personal and private of the visual arts, and narrowest in architecture, the most communal and public. Yet the opposite is true. Painters and sculptors were unable to abandon Renaissance habits of representation, and never really revived medieval art or ancient art before the Classical Greek era. Architects were not subject to this limitation, however, and the revival styles persisted longer in architecture than in the other arts.

The Classic and Gothic Revivals

The late eighteenth century, as we noted before, had come to favor the heavier and more austere Greek Doric over the Roman. This "Greek revival" phase of Neoclassicism was pioneered on a small scale in England, but was quickly taken up everywhere, since it was believed to embody more of the "noble simplicity and calm grandeur" of classical Greece than did the later, less "masculine" orders. Greek Doric was also the least flexible order, hence particularly difficult to adapt to modern tasks even when combined with Roman or Renaissance elements. Only rarely could Greek Doric architecture furnish a direct model for Neoclassic structures. We instead find adaptations of it combined with elements derived from the other Greek orders.

SCHINKEL. The Altes Museum (Old Museum; fig. 909) by Karl Friedrich Schinkel (1781–1841) is a spectacular example of the Greek revival. The main entrance looks like a Doric temple seen from the side (see fig. 166), but with Ionic columns strung across a Corinthian order (compare figs. 162 and 177). The building is notable for its bold design and

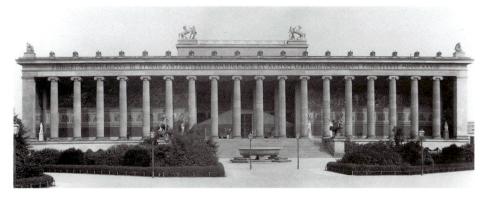

909. Karl Friedrich Schinkel. Altes Museum, Berlin. 1824-28

refined proportions. Schinkel, an architect of great ability, began as a painter in the style of Caspar David Friedrich (see pages 692–93) and also worked as a stage designer before joining the Berlin public works office, which he later headed. Hence, he knew well how to infuse architecture with Romantic associations and a theatrical flair worthy of Piranesi. Schinkel's first love was the Gothic, and although most of his public buildings are in a Greek style, they retain a strong element of the picturesque. Here the measured cadence of the monumental facade is intended to establish a contemplative mood appropriate to viewing art in a repository of antiquities.

Schinkel set a precedent that was soon taken up everywhere. He was the first to treat a museum as a temple of the arts. Such an association could find sanction in the classical past: the small *pinakotheke* (picture gallery) at the entrance to the Acropolis (fig. 173). The Altes Museum expresses the veneration of ancient Greece in the land of Winckelmann and Mengs. To the poet Goethe, it remained the pinnacle of civilization. The Altes Museum is, furthermore, testament to the Enlightenment attitude that gave rise to art museums, galleries, and academies on both sides of the Atlantic after 1760. At the same time, the Greek style served the imperial ambitions of Prussia, which emerged as a major power at the Congress of Vienna in 1815. The imposing grandeur of the Altes Museum proclaims Berlin as the new Athens, with Kaiser Wilhelm III as a modern Pericles.

It is characteristic of Romanticism that at the time architects launched the classical revival, they also started a Gothic revival. England was far in advance here, as it was in the development of Romantic literature and painting. Gothic forms had never wholly disappeared in England. They were used on occasion for special purposes, even by Sir Christopher Wren and Sir John Vanbrugh (see pages 608–9), but these were survivals of an authentic, if outmoded, tradition. The conscious revival, by contrast, was linked with the cult of the picturesque, and with the vogue for medieval (and pseudomedieval) romances.

WALPOLE. In this spirit Horace Walpole (1717–1797), midway in the eighteenth century, enlarged and "gothicized" his country house, Strawberry Hill (figs. 910 and 911), a process that took some two decades and involved his circle of friends (including Robert Adam, who was responsible for the round tower). On the exterior, the rambling structure has a

910. Horace Walpole, with William Robinson and others. Strawberry Hill, Twickenham, England. 1749–77

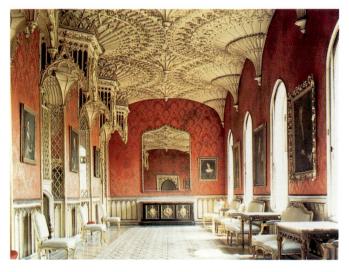

911. Interior of Strawberry Hill

studied irregularity that is decidedly picturesque. Inside, most of the elements were copied or faithfully adapted from authentic Gothic sources. The interior in figure 911 is a splendid imitation of the English Perpendicular style found in the chapel of Henry VII at Westminster Abbey (compare fig. 452), with its conical vaults. The richly brocaded, yet dainty wall surfaces look almost as if they were decorated with lace-paper doilies. Although Walpole associated the Gothic with the pathos of

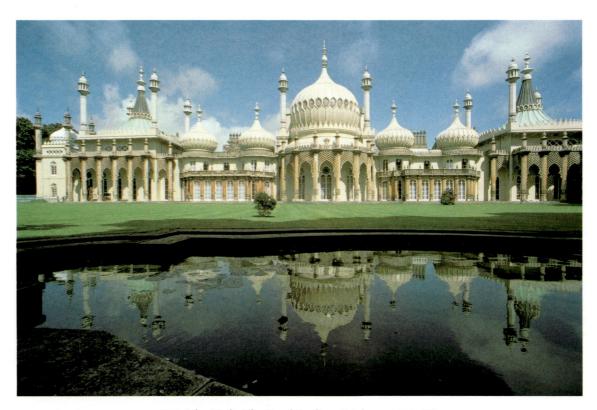

912. John Nash. The Royal Pavilion, Brighton. 1815–18

the Sublime, he acknowledged that the house is "pretty and gay." This playfulness, so free of dogma, gives Strawberry Hill its special charm. Gothic here is still an "exotic" style. It appeals because it is strange, but for that very reason it must be "translated," like a medieval romance, or like the Chinese motifs that crop up in Rococo decoration.

NASH. The Romantic imagination saw the Gothic and the mysterious East in much the same light. The masterpiece in this vein is the Royal Pavilion at Brighton (fig. 912), created half a century later by John Nash (1752–1835). The greatest architect of the English picturesque, he commanded the full range of revival styles, which here have been combined to brilliant effect. The style of this "stately pleasure dome" is a creampuff version of the Taj Mahal. Over a Neo-Palladian building Nash imposed a facade of cast-iron domes, minarets, and lacy screens, with Chinese and even Gothic motifs thrown in for good measure; hence, it was known as Indian Gothic.

LATROBE. By 1800 the Gothic was a fully acceptable alternative to the Greek revival as a style for major churches. Benjamin Latrobe (1764–1820), an Anglo-American who under Jefferson became the most influential architect of "Federal" Neoclassicism, submitted a design in each style for the Cathedral in Baltimore. In this he may be called a disciple of the English architect John Soane (1753–1837), who also worked in a variety of revival styles. The Neoclassic one was chosen, but it might well have been the Neo-Gothic. The exterior of the present building (fig. 913) has walls that resemble Soufflot's Panthéon (see fig. 856), a dome of more severe design, a

temple front, and bell towers of disguised Gothic-Baroque ancestry. (The bulbous crowns are not his work.)

Far more distinguished is the interior (fig. 914). Although inspired by the domed and vaulted spaces of ancient Rome, especially the Pantheon (see fig. 246), Latrobe was not interested in archaeological correctness. The "muscularity" of Roman structures has been suppressed. The delicate moldings, profiles, and coffers are derived straight from Robert Adam (compare fig. 859); they are no more than linear accents that do not disturb the continuous, abstract surfaces. Here Latrobe shows how much he had learned from Soane's masterpiece, the Bank of England in London, before his departure from that city in 1796. Unfortunately, the bank was largely destroyed in 1927, but it is still known from photographs (see fig. 916). Like Adam, Soane was enthused by Piranesi's epic architectural fantasies, which he joined with the latest French theories. In Latrobe's Romantic interpretation, the spatial qualities of ancient architecture have acquired the visionary quality of Boullée's memorial to Isaac Newton (see fig. 857)vast, pure, sublime. The strangely weightless interior presents almost that combination of classic form and Gothic lightness first postulated by Soufflot. It also shows the free and imaginative look of the mature Neoclassic style, when handled by a gifted architect. Had the Gothic design (fig. 915) been chosen, the exterior might have been more striking, but the interior probably less impressive. Like most Romantic architects seeking the sublime, Latrobe viewed Gothic churches "from the outside in"—as mysterious, looming structures silhouetted against the sky-but nourished his spatial fantasy on Roman monuments.

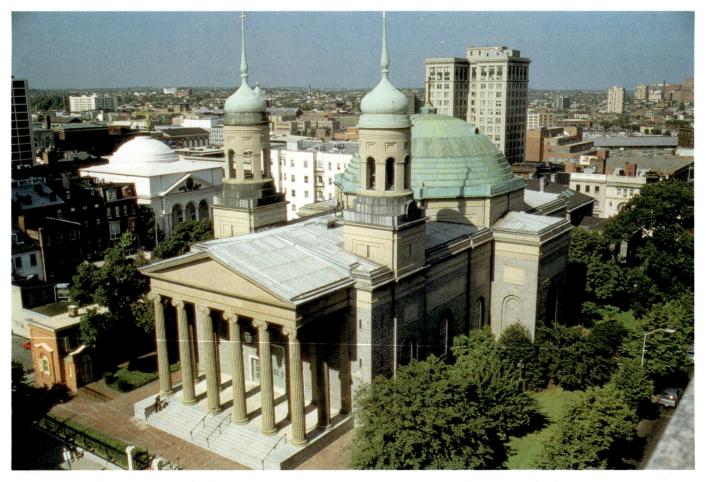

913. Benjamin Latrobe. Baltimore Cathedral (Basilica of the Assumption), Baltimore, Maryland. Begun 1805

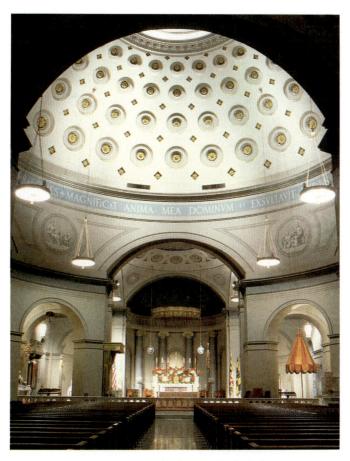

914. Interior of Baltimore Cathedral

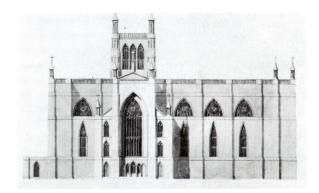

915. Benjamin Latrobe. Alternative design for Baltimore Cathedral

After 1800, the choice between classical and Gothic modes was more often resolved in favor of Gothic. Nationalist sentiments, strengthened in the Napoleonic wars, became important factors. England, France, and Germany each tended to think that Gothic expressed its particular national genius. Certain theorists (notably John Ruskin) also regarded Gothic as superior for ethical or religious reasons on the grounds that it was "honest" and "Christian." [See Primary Sources, no. 84, pages 936-37.]

BARRY AND PUGIN. All these considerations lie behind the design by Sir Charles Barry (1785-1860) and A. N. Welby

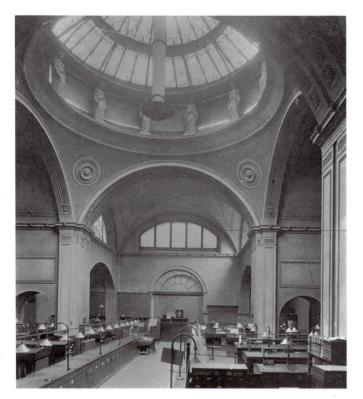

916. Sir John Soane. Consols' Office, Bank of England, London. 1794. Destroyed

Pugin (1812–1852) for the Houses of Parliament in London, the largest monument of the Gothic revival (fig. 917). As the seat of a large and complex governmental apparatus, but at the same time as a focus of patriotic feeling, it presents a curious mixture: repetitious symmetry governs the main body of the structure and picturesque irregularity its silhouette. The building is indeed a contradiction in terms, for it imposes Pugin's Gothic vocabulary, inspired by the later English Perpendicu-

lar (compare fig. 452), onto the classically conceived structure by Barry, with results that satisfied neither. Nevertheless the Houses of Parliament admirably convey the grandeur of Victorian England at the height of its power.

Neo-Renaissance and Neo-Baroque Architecture

GARNIER. Meanwhile the stylistic alternatives were continually increased for architects by other revivals. When, by midcentury, the Renaissance, and then the Baroque, returned to favor, the revival movement had come full circle: Neo-Renaissance and Neo-Baroque replaced the Neoclassical. This final phase of Romantic architecture, which dominated the years 1850–75 and lingered through 1900, is epitomized in the Paris Opéra (figs. 918-20), designed by Charles Garnier (1825–1898). The Opéra was the culmination of Baron Georges-Eugène Haussmann's plan to modernize Paris under Napoleon III, for it is the focal point for a series of main avenues that converge on it from all sides. Although the building was not completed until after the fall of the Second Empire, the opulence of its Beaux-Arts style typified the new Paris. The building is a masterpiece of eclecticism. The fluid curves of the Grand Staircase, for example, recall the Vestibule of the Laurentian Library (see fig. 617). The massing of the main entrance is reminiscent of Lescot's Square Court of the Louvre (see fig. 722). But the paired columns of the facade, "quoted" from Perrault's East Front of the Louvre (see fig. 799), are combined with a smaller order, in a fashion suggested by Michelangelo's Palazzo dei Conservatori (see fig. 621). The other entrance consists of a temple front.

The totality consciously suggests a palace of the arts combined with a temple of the arts. The theatrical effect projects the festive air of a crowd gathering before the opening curtain. Its Neo-Baroque quality derives more from the profusion of

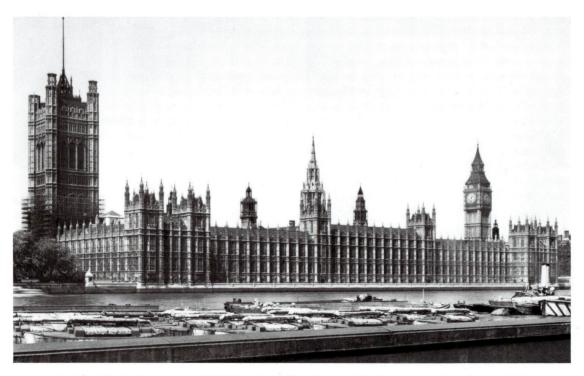

917. Sir Charles Barry and A. N. Welby Pugin. The Houses of Parliament, London. Begun 1836

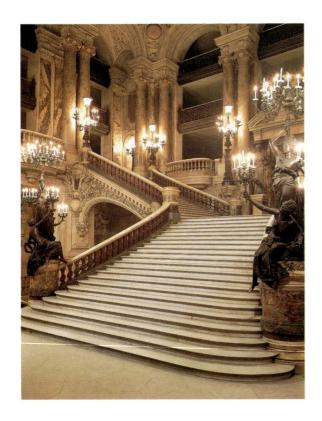

918. (left) Charles Garnier. Grand Staircase, the Opéra, Paris. 1861–74

919. (below) Plan of the Opéra

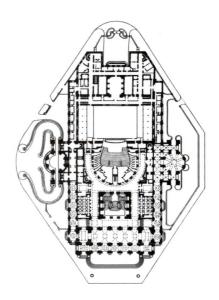

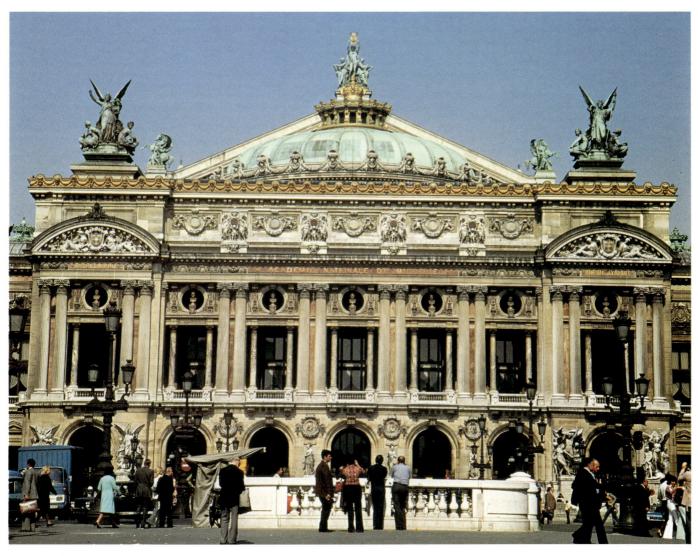

920. The Opéra

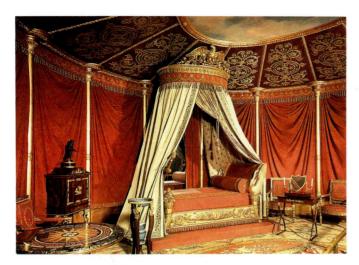

921. François-Honoré Jacob-Desmalter (after a design by Charles Percier and Pierre-François Fontaine). Bedroom of Empress Joséphine Bonaparte. c. 1810. Château de Malmaison, Rueil-Malmaison, France

sculpture—including Carpeaux's *The Dance* (see fig. 907)—and ornament than from its architectural vocabulary. The whole building looks "overdressed," its luxurious vulgarity so naïve as to be disarming. It reflects the taste of the beneficiaries of the Industrial Revolution, newly rich and powerful, who saw themselves as the heirs of the old aristocracy. For a comparably extravagant display, we must turn to Sansovino's Library of St. Mark's (fig. 663), which celebrates the wealth of Venice. Small wonder, then, that magnates found the styles predating the French Revolution more appealing than Neoclassical or Neo-Gothic.

DECORATIVE ARTS

THE EMPIRE STYLE. The decorative arts followed much the same course as architecture during the Romantic era, but they were, if anything, more eclectic still. The revival sparked by the discoveries at Pompeii and Herculaneum reached its climax during the early nineteenth century with the Empire style, that late form of Neoclassicism which spread throughout Europe in the wake of Napoleon's conquests. As the term suggests, the style drew heavily on Roman art, which associated Napoleon with the Caesars by borrowing imperial attributes. Initially Roman prototypes had been copied more or less faithfully, but such imitations are among the least interesting products of the Empire style. Far more significant are the free adaptations of these sources to glorify the Bonapartes. These often incorporate Egyptian motifs to commemorate Napoleon's invasion in 1798 which opened up the Middle East.

PERCIER AND FONTAINE. We have already caught a glimpse of the Empire style in the bed of Canova's Pauline Borghese as Venus (fig. 902). We see it at its fullest in the Château de Malmaison, Napoleon's private residence near Paris, which was remodeled after 1798 by the architects Charles Percier (1764–1838) and Pierre-François Fontaine (1762–1853). They were also entrusted with its furnishings, and their book on interior decoration, printed in 1812, set the

standard for the Empire style. The bedroom of Napoleon's wife, Joséphine, reveals her taste for the ostentatious, which was so characteristic of the Empire style as a whole (fig. 921). Thus its lavish splendor tells us a great deal about the First Empire and its ambitions. The décor here serves the same propagandistic purpose as at Versailles (see fig. 802), for this is a state bedroom. (She usually slept in an ordinary one nearby.) Although ordered previously, the remarkable bed—made by François-Honoré Jacob-Desmalter (1770–1841), the preeminent furniture manufacturer under Napoleon, after a design by Percier and Fontaine—became the centerpiece of a total redecoration in 1810 that continues to proclaim Joséphine as empress after their marriage was annulled earlier that year. It incorporates swans and cornucopias, standard Napoleonic devices, with a traditional canopy that evokes a military tent surmounted by an imperial eagle. Nearby is a tripod washstand, with basin and jug, based on Pompeiian examples. Like everything else about the bedroom, it adheres to archaeological fact in details. Yet nothing in antiquity looked like this, and the effect is surprisingly close to the style of Louis XVI on the eve of the French Revolution.

THE INDUSTRIAL REVOLUTION. The rise of the Industrial Revolution led to the debasement of the decorative arts as everything from porcelain and silverware to drapery and furniture became mass-produced to meet the needs of the rapidly expanding middle class. Despite attempts to preserve the craftsmanship of the past, the machine won out after the Revolution of 1848. This was accompanied by a corresponding decline in the standards of design, which catered to the largest possible clientele. During the Restoration and Second Empire, the decorative arts were intended to evoke the earlier glory of France through indiscriminate imitation. There were even revivals of revival styles! By 1840 furnishings began to disappear in a welter of eclectic bric-a-brac that provided an opulent setting for the new captains of industry. In consequence, only rarely did the decorative arts manage to rise above the pedestrian. Among the few exceptions are the enormous torchères for the Grand Staircase of the Paris Opéra (see fig. 918) by the gifted sculptor Albert-Ernest Carrier-Belleuse (1824–1887). In the end, however, the only thing that could reverse the trend was another revolution in the decorative arts: the Arts and Crafts Movement (see pages 744–45).

PHOTOGRAPHY

Is photography art? The fact that we still pose the question testifies to the continuing debate. The answers have varied with the changing definition and understanding of art. In itself, of course, photography is simply a medium, like oil paint or pastel, used to make art but having no inherent claim to being art. After all, what distinguishes an art from a craft is why, not how, it is done. But photography shares creativity with art because, by its very nature, its performance necessarily involves the imagination. Any photograph, even a casual snapshot, represents both an organization of experience and the record of a mental image. The subject and style of a photograph thus tell us about the photographer's inner and outer worlds. Furthermore, like painting and sculpture, photography participates in

922. Joseph Nicéphore Niépce. View from His Window at Le Gras. 1826. Heliograph, 6½ x 7½ (16.5 x 20 cm). Gernsheim Collection, Harry Ransom Research Center, University of Texas at Austin

aspects of the same process of seek-and-find. Photographers may not realize what they respond to until after they see the image that has been printed.

Like woodcut, etching, engraving, and lithography, photography is a form of printmaking that is dependent on mechanical processes. But in contrast to the other graphic mediums, photography has always been tainted as the product of a new technology. Apart from pushing a button or lever, or setting up special effects, no active intervention is required of the artist's hand to guide an idea. For this reason, the camera has usually been considered to be little more than a recording device. Photography, however, is by no means a neutral medium; its reproduction of reality is never completely faithful. Whether we realize it or not, the camera alters appearances. Photographs reinterpret the world around us, making us literally see it in new terms.

Photography and painting represent parallel responses to their times and have generally expressed the same world view. Sometimes the camera's power to extend our way of seeing has been realized first by the painter's creative vision. The two mediums nevertheless differ fundamentally in their approach and temperament. Painters communicate their understanding through techniques that represent their cumulative response over time, whereas photographers recognize the moment when the subject before them corresponds to the mental image they have formed of it.

It is hardly surprising that photography and art have enjoyed an uneasy relationship from the start. Artists have generally treated the photograph as something like a preliminary sketch, as a convenient source of ideas or record of motifs to be fleshed out and incorporated into a finished work. Academic painters found the detail provided by photographs to be in keeping with their own precise naturalism. Many other kinds of artists resorted to photographs, though not always admitting it. Photography has in turn been heavily influenced

throughout its history by the painter's mediums, and photographs may still be judged according to how well they imitate paintings and drawings. To understand photography's place in the history of art, we must recognize the medium's particular strengths and inherent limitations.

The Founders of Photography

In 1822 a French inventor named Joseph Nicéphore Niépce (1765–1833) succeeded, at the age of 57, in making the first permanent photographic image, although his earliest surviving example (fig. 922) dates from four years later. He then joined forces with a younger man, Louis-Jacques-Mandé Daguerre (1789–1851), who had devised an improved camera. After ten more years of chemical and mechanical research, the daguerreotype, using positive exposures, was unveiled publicly in 1839, and the age of photography was born. The announcement spurred the Englishman William Henry Fox Talbot (1800–1877) to complete his own photographic process, involving a paper negative from which positives could be made, that he had been pursuing independently since 1833.

What motivated the earliest photographers? They were searching for an artistic medium, not for a device of practical utility. Though Niépce was a research chemist rather than an artist, his achievement was an outgrowth of his efforts to improve the lithographic process. Daguerre was a skilled painter, and he probably turned to the camera to heighten the illusionism in his huge painted dioramas, which were the sensation of Paris during the 1820s and 1830s. Fox Talbot saw in photography a substitute for drawing, as well as a means of reproduction, after using a camera obscura as a tool to sketch landscapes while on a vacation. The interest that all of the founders had in the artistic potential of the medium they had created is reflected in their photographs. Daguerre's first

923. Louis-Jacques-Mandé Daguerre. *Still Life.* 1837. Daguerreotype, 6½ x 8½"(16.5 x 21.7 cm). Société Française de Photographie, Paris

924. William Henry Fox Talbot. *Sailing Craft.* c. 1845. Calotype. Science Museum, London

picture (fig. 923) imitates a type of still life originated by Chardin while Fox Talbot's *Sailing Craft* (fig. 924) looks like the English marine paintings of his day.

That the new medium should have a mechanical aspect was particularly appropriate. It was as if the Industrial Revolution, having forever altered civilization's way of life, now had to invent its own method for recording itself, although the transience of modern existence was not captured by "stopping the action" until the 1870s. Photography underwent a rapid series of improvements, including inventions for better lenses, glass-plate negatives, and new chemical processes, which provided faster emulsions and more stable images. Since many of the initial limitations of photography were overcome around mid-century, it would be misleading to tell the early history of the medium in terms of technological developments, important though they were.

The basic mechanics and chemistry of photography, moreover, had been known for a long time. The camera obscura, a box with a small hole in one end, dates back to antiquity. In the sixteenth century it was widely used for visual demonstrations. The camera was fitted with a mirror and then a lens in the Baroque period, which saw major advances in optical science culminating in Newtonian physics. By the 1720s it had become an aid in drawing architectural scenes. At the same time, silver salts were discovered to be light-sensitive.

Why, then, did it take another hundred years for someone to put this knowledge together? Much of the answer lies in the nature of scientific revolutions, which as a rule combine old technologies and concepts with new ones. (They do this in response to changing world views that they, in turn, influence.) Photography was neither inevitable in the history of technology, nor necessary to the history of art; yet it was an idea whose time had clearly come. If we try for a moment to imagine that photography was invented a hundred years earlier, we will find this to be impossible simply on artistic, apart from technological, grounds: the eighteenth century was too devoted to fantasy to be interested in the literalness of photography. Rococo portraiture, for example, was more concerned with providing a flattering image than an accurate likeness, so that the camera's straightforward record would have been totally out of place. Even in architectural painting, extreme liberties were willingly taken with topographical truth (see pages 628–29).

The invention of photography was a response to the artistic urges and historical forces that underlie Romanticism. Much of the impulse came from a quest for the True and the Natural. The desire for "images made by Nature" can already be seen, on the one hand, in Cozens' ink-blot compositions (see fig. 849), which were "natural" because they were made by chance; and, on the other, in the late-eighteenth-century vogue for silhouette portraits (traced from the shadow of the sitter's profile), which led to attempts to record such shadows on light-sensitive materials. David's harsh realism in *The Death of Marat* (fig. 844) had already proclaimed the cause of unvarnished truth. So did Ingres' *Louis Bertin* (fig. 871), which established the standards of physical reality and character portrayal that photographers would follow. [See Primary Sources, no. 85, page 937.]

925. Nadar. *Sarah Bernhardt*. 1859. George Eastman House, Rochester, New York

926. Honoré Daumier. *Nadar Elevating Photography to the Height of Art.* 1862. Lithograph. George Eastman House, Rochester. New York

Portraiture

Like lithography, which was invented in 1797, photography met the growing middle-class demand for images of all kinds. By 1850, large numbers of the bourgeoisie were having their likenesses painted, and it was in portraiture that photography found its readiest acceptance. Soon after the daguerreotype was introduced, photographic studios sprang up everywhere, especially in America, and multi-image *cartes de visites*, invented in 1854 by Adolphe-Eugène Disdéri, became ubiquitous. Anyone could have a portrait taken cheaply and easily. In the process, the average person became memorable. Photography thus became an outgrowth of the democratic values fostered by the American and French revolutions. There was also keen competition among photographers to get the famous to pose for portraits.

NADAR. Gaspard Félix Tournachon (1820–1910), better known as Nadar, managed to attract most of France's leading personalities to his studio. Like many early photographers, he started out as an artist but came to prefer the lens to the brush. He initially used the camera to capture the likenesses of the 280 sitters whom he caricatured in an enormous lithograph, *Le Panthéon Nadar*. The actress Sarah Bernhardt posed for him several times, and his photographs of her (fig. 925) are the direct ancestors of modern glamour photography (compare fig. 1210). With her romantic pose and expression, she is a counterpart to the soulful maidens who inhabit much of nineteenth-century painting. Nadar has treated her in remarkably

sculptural terms. Indeed, the play of light and sweep of drapery are reminiscent of the sculptured portrait busts that were so popular with collectors at the time.

The Restless Spirit

Early photography reflected the outlook and temperament of Romanticism, and indeed the entire nineteenth century had a pervasive curiosity and an abiding belief that everything could be discovered. While this fascination sometimes manifested a serious interest in science—witness Darwin's voyage on the *Beagle* from 1831 to 1836—it more typically took the form of a restless quest for new experiences and places. Photography had a remarkable impact on the imagination of the period by making the rest of the world widely available, or by simply revealing it in a new way. Sometimes the search for new subjects was close to home. Nadar, for example, took aerial photographs of Paris from a hot-air balloon. This feat was wittily parodied by Daumier (fig. 926), whose caption, "Nadar Elevating Photography to the Height of Art," expresses the prevailing skepticism about the aesthetics of the new medium.

A love of the exotic was fundamental to Romantic escapism, and by 1850 photographers had begun to cart their equipment to faraway places. The same restless spirit that we saw in George Caleb Bingham's *Fur Traders Descending the Missouri* (see fig. 899) also drew photographers to the frontier, where they documented the westward expansion of the United States, often for the U.S. Geological Survey, with pictures that have primarily historical interest today.

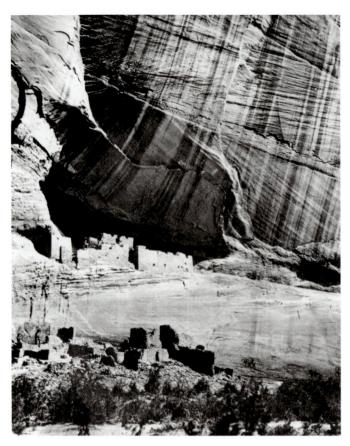

927. Timothy O'Sullivan. Ancient Ruins in the Cañon de Chelle, N.M., in a Niche 50 Feet Above the Present Cañon Bed (now Canyon de Chelly National Monument, Arizona). 1873. Albumen print. George Eastman House, Rochester, New York

O'SULLIVAN. An exception is the landscape photography of Timothy O'Sullivan (c. 1841–1882), who often preferred scenery that contemporary painters had overlooked. He practically invented his own aesthetic in photographing the *Cañon de Chelle* (fig. 927), for it conforms to no established pictorial type. The view fills the entire photograph, allowing no visual relief and lending it awesome force. The composition is held together by the play of lines of the displaced strata of the rock, which creates a striking abstract design. O'Sullivan's control of tonal relations is so masterful that even color photographs taken since then of the same site have far less impact.

Stereophotography

The unquenchable thirst for vicarious experiences accounts for the expanding popularity of stereoscopic daguerreotypes. Invented in 1849, the two-lens camera produced two photographs that correspond to the slightly different images perceived by our two eyes. When seen through a special viewer called a stereoscope, the stereoptic photographs fuse to create a remarkable illusion of three-dimensional depth. Two years later, stereoscopes became the rage at the Crystal Palace exposition in London (see fig. 962). Countless thousands of double views were taken, such as that in figure 928. Virtually every corner of the earth became accessible to practically any household, with a vividness second only to being there.

Stereophotography was an important breakthrough, for its binocular vision marked a distinct departure from perspective in the pictorial tradition and demonstrated for the first time photography's potential to enlarge vision. Curiously enough, this success waned, except for special uses. People were simply too habituated to viewing pictures as if with one eye. Later on, when the halftone plate was invented in the 1880s for reproducing pictures on a printed page, stereophotographs revealed another drawback. As our illustration shows, they were unsuitable for this process of reproduction. From then on, single-lens photography was inextricably linked with the mass media of the day.

Photojournalism

Fundamental to the rise of photography was the pervasive nineteenth-century sense that the present was already history in the making. Only with the advent of the Romantic hero did great acts other than martyrdom become popular subjects for contemporary painters and sculptors, and it can hardly be surprising that photography was invented a year after the death of Napoleon, who had been the subject of more paintings than any secular leader ever before. At about the same time, Géricault's *The Raft of the "Medusa"* (fig. 868) and Delacroix's *The Massacre at Chios* (fig. 873) signaled a decisive

928. Tsar Cannon Outside the Spassky Gate, Moscow (cast 1586; presently inside the Kremlin). Second half of 19th century. Stereophotograph Courtesy Culver Pictures

929. Alexander Gardner. Home of a Rebel Sharpshooter, Gettysburg. July 1863. Wet-plate photograph. Chicago Historical Society

shift in the Romantic attitude toward representing contemporary events. This outlook brought with it a new kind of photography: photojournalism.

BRADY. Its first great representative was Mathew Brady (1823-1896), who covered the Civil War in the United States. Other wars had already been photographed, but Brady and his 20 assistants (including Timothy O'Sullivan), using cameras too slow and cumbersome to show actual combat, nevertheless were able to bring home the horrors of that war with unprecedented directness.

GARDNER. Home of a Rebel Sharpshooter, Gettysburg (fig. 929) by Alexander Gardner (1821-1882), who left Brady to form his own photographic team in 1863, is a landmark in the history of art. Never before had both the grim reality and the significance of death on the battlefield been conveyed so inexorably in a single image. Compared with the heroic act celebrated by Benjamin West (see fig. 845), this tragedy is as anonymous as the slain soldier himself. The photograph is all the more persuasive for having the same harsh realism found in David's *The Death of Marat* (see fig. 844), and the limp figure, hardly visible between the rocks framing the scene, is no less poignant. In contrast, the paintings and engravings by the artists—notably Winslow Homer (see pages 732-33)—who illustrated the Civil War for magazines and newspapers were mostly genre scenes that kept the reality of combat safely at arm's length.

CHAPTER TWO

REALISM AND IMPRESSIONISM

PAINTING

France

"Can Jupiter survive the lightning rod?" asked Karl Marx, not long after the middle of the century. The question, implying that the ancient god of thunder and lightning was now in jeopardy through science, sums up the dilemma we felt in the sculptor Carpeaux's *The Dance* (fig. 907). The French poet and art critic Charles Baudelaire was addressing himself to the same problem when, in 1846, he called for paintings that expressed "the heroism of modern life." [See Primary Sources, no. 86, page 937.] At that time only one painter was willing to make an artistic creed of this demand: Baudelaire's friend Gustave Courbet (1819–1877).

COURBET AND REALISM. Courbet was born in Ornans, a village near the French-Swiss border, and remained proud of his rural background. He had begun as a Neo-Baroque Romantic in the early 1840s. But by 1848, under the impact of the revolutionary upheavals then sweeping over Europe, he had come to believe that the Romantic emphasis on feeling and imagination was merely an escape from the realities of the time. The modern artist must rely on direct experience—"I cannot paint an angel because I have never seen one," he said—they must be Realists. [See Primary Sources, no. 87, page 938.] As a descriptive term, "realism" is not very precise. For Courbet, it meant something akin to the "naturalism" of Caravaggio (fig. 726). As an admirer of Louis Le Nain and Rembrandt he had, in fact, strong links with the Caravaggesque tradition, and his work, like Caravaggio's, was denounced for its supposed vulgarity and lack of spiritual content. What ultimately defines Courbet's Realism, however, and distinguishes it from Romanticism is his allegiance to radical politics. His Socialist views colored his entire outlook, and although it did not determine the specific content or appearance of his pictures, it does help to account for his choice of subject matter and style, which went against the grain of tradition.

The storm broke in 1849, when Courbet exhibited *The* Stone Breakers (fig. 930), the first canvas fully embodying his programmatic Realism. Here, for the first time, was a picture that treated an apparent genre scene with the same seriousness and monumentality as a history painting, in disregard of the academic hierarchy, and with a heavy impasto that violated accepted standards of finish. Courbet had seen two men working on a road, and had asked them to pose for him in his studio. He painted them lifesize, solidly and matter-of-factly. The picture is very much larger than anything by Millet, and with none of his overt pathos or sentiment (compare fig. 882). The young man's face is averted, the old one's half hidden by a hat. Yet he cannot have picked them casually. Their contrast in age is significant: one is too old for such heavy work, the other too young. Endowed with the dignity of their symbolic status, they do not turn to us for sympathy. Courbet's friend, the Socialist Pierre-Joseph Proudhon, likened them to a parable from the Gospels.

During the 1855 Paris Exposition, where works by Ingres and Delacroix were prominently displayed, Courbet brought his pictures to attention by organizing a private exhibition in a large shed and by distributing a "manifesto of Realism." The show centered on a huge canvas, the most ambitious of his career, entitled *Studio of a Painter: A Real Allegory Summarizing My Seven Years of Life as an Artist* (fig. 931). "Real allegory" is something of a teaser. Allegories, after all, are unreal by definition. Courbet meant either an allegory couched in the terms of his particular Realism, or one that did not conflict with the "real" identity of the figures or objects embodying it.

The framework is familiar: Courbet's composition clearly belongs to the type of Velázquez' *The Maids of Honor* and Goya's *The Family of Charles IV* (see figs. 759 and 863). But now the artist has moved to the center, and the visitors here are his guests, not royal patrons who enter whenever they wish.

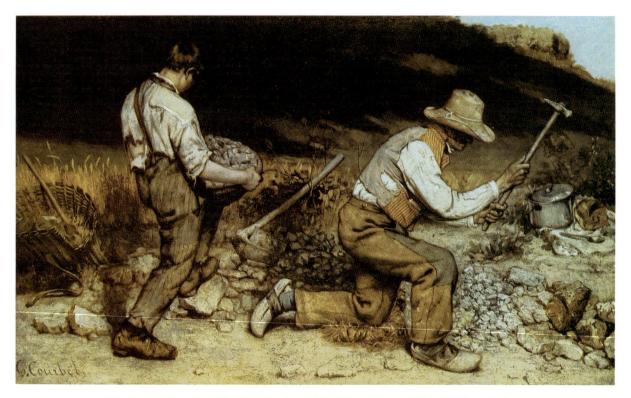

930. Gustave Courbet. The Stone Breakers. 1849. Oil on canvas, 5'3" x 8'6" (1.6 x 2.6 m). Formerly Gemäldegalerie, Dresden. Destroyed 1945

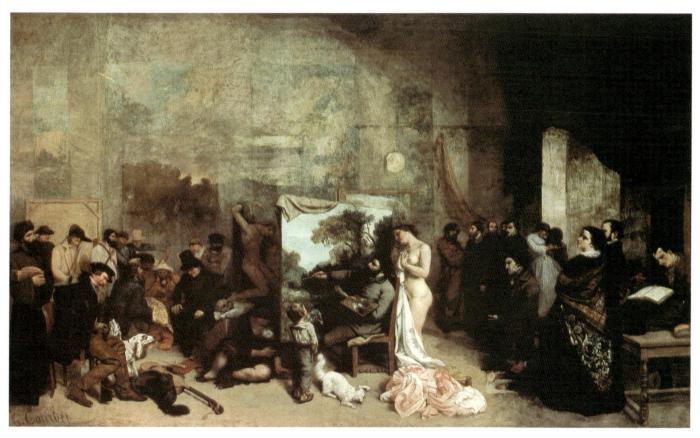

931. Gustave Courbet. Studio of a Painter: A Real Allegory Summarizing My Seven Years of Life as an Artist. 1854–55. Oil on canvas, 11'10" x 19'7" (3.6 x 6 m). Musée d'Orsay, Paris

He has invited them specially for a purpose that becomes evident only upon thoughtful reflection. The picture does not yield its full meaning unless we take the title seriously and inquire into Courbet's relation to this assembly.

There are two main groups. On the left are "the people." They are types rather than individuals, drawn largely from the artist's home environment at Ornans: hunters, peasants, workers, a Jew, a priest, a young mother with her baby. On the right, in contrast, we see groups of portraits representing the Parisian side of Courbet's life: clients, critics, intellectuals. (The man reading is Baudelaire.) All of these people are strangely passive, as if they were waiting for we know not what. Some are quietly conversing among themselves, others seem immersed in thought. Yet hardly anybody looks at Courbet. They are not his audience, but a representative sampling of his social environment.

Only two people watch the artist at work: a small boy, intended to suggest "the innocent eye," and the nude model. What is her role? In a more conventional picture, we would identify her as Inspiration, or Courbet's Muse, but she is no less "real" than the others here. Courbet probably meant her to be Nature, or that undisguised Truth which he proclaimed to be the guiding principle of his art. (Note the emphasis on the clothing she has just taken off.) Significantly enough, the center group is illuminated by clear, sharp daylight, but the background and the lateral figures are veiled in semidarkness, to underline the contrast between the artist—the active creator—and the world around him that waits to be brought to life.

MANET AND THE "REVOLUTION OF THE COLOR PATCH." Courbet's *Studio* helps us to understand a picture that shocked the public even more: *Luncheon on the Grass* (see fig. 4), showing a nude model accompanied by two gentlemen in frock coats, by Édouard Manet (1832–1883). Manet was the first to grasp Courbet's full importance; his *Luncheon*, among other things, is a tribute to the older artist. He particularly offended contemporary morality by juxtaposing the nude and nattily attired figures in an outdoor setting, the more so since the noncommittal title offered no "higher" significance. Yet the group has so formal a pose that Manet certainly did not intend to depict an actual event. (For its classical source, see figs. 5 and 6.) Perhaps the meaning of the canvas lies in this denial of plausibility, for the scene fits neither the plane of everyday experience nor that of allegory.

The *Luncheon*, as a visual manifesto of artistic freedom, is much more revolutionary than Courbet's. It asserts the painter's privilege to combine whatever elements he pleases for aesthetic effect alone. The nudity of the model is "explained" by the contrast between her warm, creamy flesh tones and the cool black-and-gray of the men's attire. Or, to put it another way, the world of painting has "natural laws" that are distinct from those of familiar reality, and the painter's first loyalty is to his canvas, not to the outside world. Here begins an attitude that was later summed up in the doctrine of Art for Art's Sake and became a bone of contention between progressives and conservatives for the rest of the century (see page 731). Manet himself disdained such controversies, but his work attests to his lifelong devotion to "pure painting": to the belief that brushstrokes and color patches themselves—not what they stand for—are the artist's

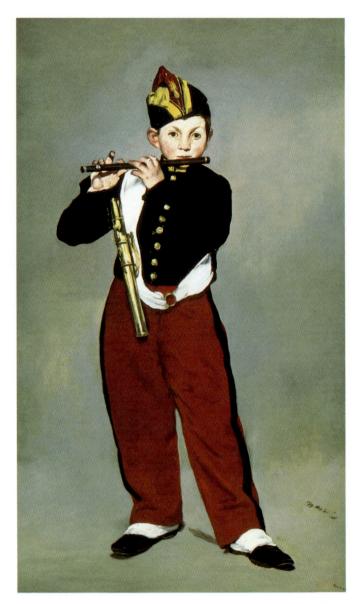

932. Édouard Manet. *The Fifer.* 1866. Oil on canvas, 63 x 38¹/4" (160 x 97.5 cm). Musée d'Orsay, Paris

primary reality. Among painters of the past, he found that Hals, Velázquez, and Goya had come closest to this ideal. He admired their broad, open technique, their preoccupation with light and color values. Many of his canvases are, in fact, "pictures of pictures": they translate into modern terms those older works that particularly challenged him. Yet he always took care to filter out the expressive or symbolic content of his models, lest the beholder's attention be distracted from the pictorial structure itself. His paintings, regardless of subject, have an emotional reticence that can easily be mistaken for emptiness unless we understand its purpose.

Courbet is said to have remarked that Manet's pictures were as flat as playing cards. Looking at *The Fifer* (fig. 932), we can see what he meant. Done three years after the *Luncheon*, it is a painting with very little modeling, no depth, and hardly any shadows. (There are a few, actually, but it takes a real effort to find them.) The figure looks three-dimensional only because its contour renders the forms in realistic fore-

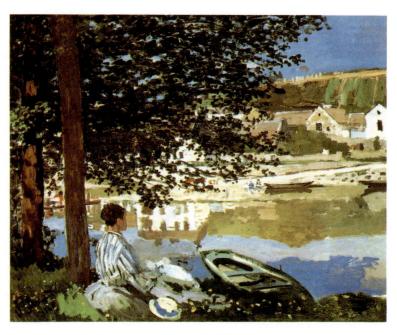

933. Claude Monet. *On the Bank of the Seine, Bennecourt.* 1868. Oil on canvas, 32½8 x 395/8" (81.5 x 100.7 cm). The Art Institute of Chicago Mr. and Mrs. Potter Palmer Collection

shortening. Otherwise, Manet eschews all the methods devised since Giotto's time for transforming a flat surface into a pictorial space. The undifferentiated light-gray background seems as near to us as the figure, and just as solid. If the fifer stepped out of the picture, he would leave a hole, like the cutout shape of a stencil.

Here, then, the canvas itself has been redefined. It is no longer a "window," but a screen made up of flat patches of color. How radical a step this was can be readily seen if we match *The Fifer* against Delacroix's *The Massacre at Chios* (fig. 873), and a Cubist work such as Picasso's *Three Dancers* of 1925 (fig. 1049). The structure of Manet's painting obviously resembles that of Picasso's, whereas Delacroix's—or even Courbet's—still follows the "window" tradition of the Renaissance. In retrospect, we realize that the revolutionary qualities of Manet's art could already be seen in the *Luncheon*, even if they were not yet so obvious. The three figures lifted from Raphael's group of river-gods form a unit nearly as shadowless and stencillike as *The Fifer*. They would be more at home on a flat screen, for the chiaroscuro of their present setting, which is inspired by the landscapes of Courbet, no longer fits them.

MONET AND IMPRESSIONISM. What brought about this "revolution of the color patch"? We do not know, and Manet himself surely did not reason it out beforehand. It is tempting to think that he was impelled to create the new style by the challenge of photography. The "pencil of nature," then known for a quarter-century, had demonstrated the objective truth of Renaissance perspective, but it established a standard of representational accuracy that no handmade image could hope to rival. Painting needed to be rescued from competition with the camera. This Manet accomplished by insisting

that a painted canvas is, above all, a material surface covered with pigments—that we must look at it, not through it. Unlike Courbet, he gave no name to the style he had created. When his followers began calling themselves Impressionists, he refused to adopt the term for his own work. His aim was to be accepted as a Salon painter, a goal that eluded him until late in life.

The word Impressionism had been coined in 1874, after a hostile critic had looked at a picture entitled Impression: Sunrise by Claude Monet (1840–1926), and it certainly fits Monet better than it does Manet. Monet had adopted Manet's concept of painting and applied it to landscapes done outdoors. Monet's On the Bank of the Seine, Bennecourt of 1868 (fig. 933) is flooded with sunlight so bright that conservative critics claimed it made their eyes smart. In this flickering network of color patches, shaped like mosaic tesserae, the reflections on the water are as "real" as the banks of the Seine. [See Primary Sources, no. 88, page 938.] Even more than The Fifer, Monet's painting is a "playing card." Were it not for the woman and the boat in the foreground, the picture would be just as effective upside-down. The mirror image here serves a purpose contrary to that of earlier mirror images (compare fig. 686). Instead of adding to the illusion of real space, it strengthens the unity of the actual painted surface. This inner coherence sets On the Bank of the Seine, Bennecourt apart from Romantic "impressions" such as Constable's Hampstead Heath (see fig. 887) or Corot's View of Rome (see fig. 879), even though all three share the same on-the-spot immediacy and fresh perception.

In the late 1860s and early 1870s Monet and his friend Auguste Renoir (1841–1919) worked together to develop Impressionism into a fully mature style, one that proved ideally

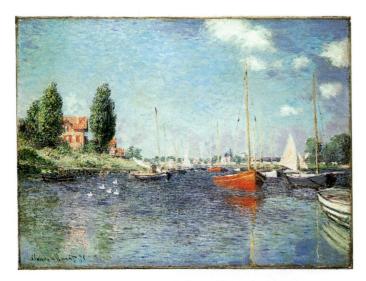

934. Claude Monet. Red Boats, Argenteuil. 1875. Oil on canvas, $23^{1/2} \times 31^{5/8}$ " (59.7 x 80.3 cm). Fogg Art Museum, Harvard University Art Museums, Cambridge, Massachusetts Bequest of Collection of Maurice Wertheim, Class of 1906

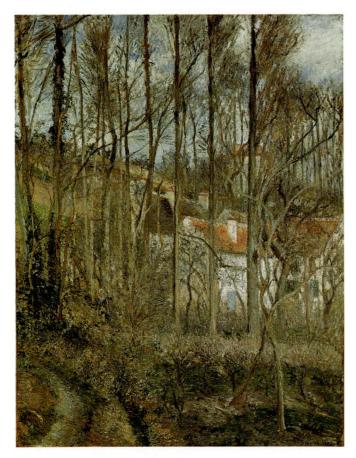

935. Camille Pissarro. The Côte des Boeufs at l'Hermitage, near Pontoise. 1877. Oil on canvas, $45^{1/4} \times 34^{1/2}$ " (114.9 x 87.6 cm). The National Gallery, London Reproduced by courtesy of the Trustees

suited to painting outdoors. Monet's Red Boats, Argenteuil (fig. 934) captures to perfection the intense sunlight of Argenteuil along the Seine near Paris, where the artist was spending his summers. Now the flat brushstrokes have become flecks of paint, which convey an extraordinary range of visual effects.

The amazingly free brush weaves a tapestry of rich color inspired by the late paintings of Delacroix. Despite its spontaneity, Monet's technique retains an underlying logic in which each color and brushstroke has its place. As an aesthetic, then, Impressionism was hardly the straightforward realism it first seems. It nevertheless remained an intuitive approach, even in its color, although the Impressionists were familiar with many of the optical theories that were to provide the basis for Seurat's Divisionism (see pages 750–51).

PISSARRO. The method that Monet and Renoir evolved was soon adopted by other members of the group. The landscapes of Camille Pissarro (1830-1903) have an unaffected naturalism that places him close to the Barbizon School, and a firm, almost classical structure that was shared only by his friend Paul Cézanne (see pages 746-49). We see these qualities in The Côte des Boeufs at l'Hermitage, near Pontoise (fig. 935). The painting has a real feel for rural life and scenery, which concerned Pissarro more than any other Impressionist. The artist makes no attempt to beautify the overgrown landscape, yet the stately procession of trees and blocklike buildings lend the picture a timeless dignity. The surprisingly abstract composition establishes a complex rhythm across the picture plane. This structure lends order to the tangled network of forms embedded in the dense surface texture, which evokes the rebirth of life in early springtime.

RENOIR. The Impressionist painters answered Baudelaire's call to artists to capture the "heroism of modern life" by depicting its dress and its pastimes. Scenes from the world of entertainment—dance halls, cafés, concerts, the theater—were favorite subjects for them. These carefree vignettes of bourgeois pleasure are flights from the cares of daily life. Renoir filled his work with the *joie de vivre* of a singularly happy temperament. The flirting couples in Le Moulin de la Galette (fig. 936), dappled with sunlight and shadow, radiate a human warmth that is utterly entrancing, even though the artist permits us no more than a fleeting glance at any of them. Our role is that of the casual stroller, who takes in this slice of life in passing.

MANET AND IMPRESSIONISM. Such spontaneity came less easily to the austere, deliberate Manet; it appears in his work only after about 1870, under Monet's influence. Manet nevertheless remained the finest painter of all the Impressionists. His last major picture, A Bar at the Folies-Bergère, of 1881–82 (fig. 937), is an unequaled tour de force. The canvas shows a single figure as calm and as firmly set within the rectangle of the canvas as the fifer, but the background is no longer neutral. A huge shimmering mirror image now fills four-fifths of the picture. The mirror, close behind the barmaid, shows the whole interior of the nightclub, but deprives it of three-dimensionality, in part by taking liberties with the scene. (Note how the barmaid's reflection is shown off to one side, something that is impossible in reality.) The serving girl's attitude, detached and touched with melancholy, contrasts poignantly with the gaiety of her setting, which she is not permitted to share. For all its urbanity, the mood of the canvas reminds us oddly of Daumier's The Third-Class Carriage (see fig. 877).

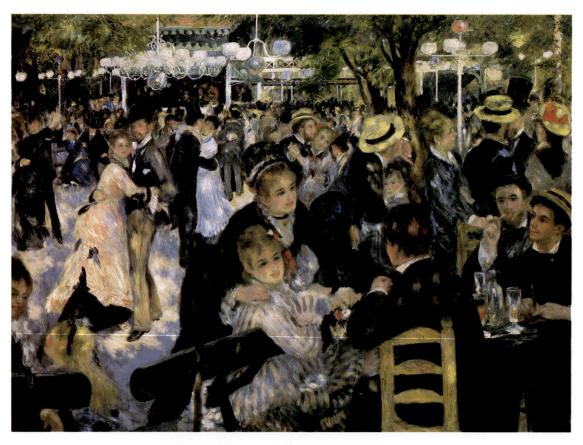

936. Auguste Renoir. Le Moulin de la Galette. 1876. Oil on canvas, $51^{1}/2 \times 69''$ (130.7 x 175.3 cm). Musée d'Orsay, Paris

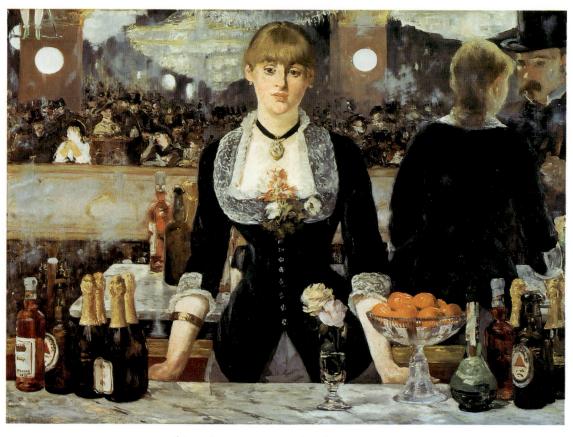

937. Édouard Manet. A Bar at the Folies-Bergère. 1881–82. Oil on canvas, $37^{1/2}$ x 51" (95.3 x 129.7 cm). Courtauld Institute Galleries, Home House Trustees, London

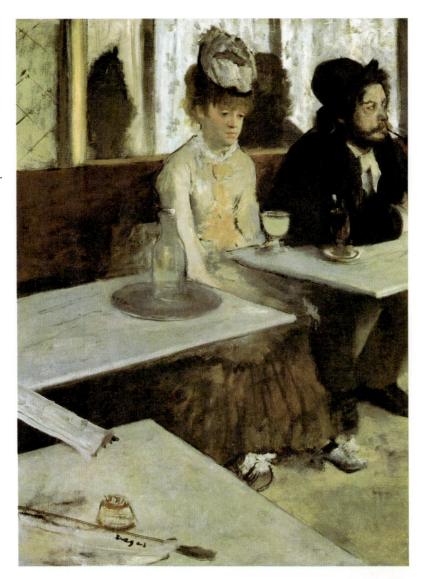

938. Edgar Degas. The Glass of Absinthe. 1876. Oil on canvas, 36 x 27" (91.3 x 68.7 cm). Musée d'Orsay, Paris

939. (opposite): Edgar Degas. Prima Ballerina. c. 1876. Pastel, 23 x 16¹/2" (58.3 x 42 cm). Musée d'Orsay, Paris

DEGAS. Edgar Degas (1834-1917), too, had a profound sense of human character that lends weight even to seemingly casual scenes such as that in The Glass of Absinthe (fig. 938). He makes us look steadily at the disenchanted pair in his café scene, but out of the corner of our eye, so to speak. The design of this picture at first seems as unstudied as a snapshot—Degas practiced photography—yet a longer look shows us that everything here dovetails precisely. The zigzag of empty tables between us and the luckless couple reinforces their brooding loneliness, for example. Compositions as boldly calculated as this set Degas apart from other Impressionists.

A wealthy aristocrat by birth, he had been trained in the tradition of Ingres, whom he greatly admired. When he joined the Impressionists, Degas did not abandon his early allegiance to draftsmanship. His finest works were often done in pastels (powdered pigments molded into sticks), which had a strong appeal for him since they yielded effects of line, tone, and color simultaneously. Prima Ballerina (fig. 939) well demonstrates this flexible medium. The oblique view of the stage, from a box near the proscenium arch, has been shaped into another deliberately off-center composition. The dancer floats above the steeply tilted floor like a butterfly caught in the glare of the footlights.

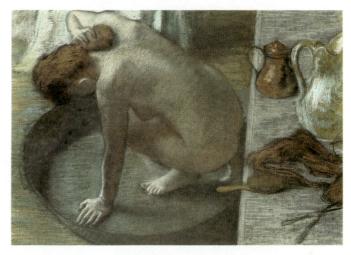

940. Edgar Degas. The Tub. 1886. Pastel, 23¹/₂ x 32³/₈"(59.7 x 82.3 cm). Musée d'Orsay, Paris

A decade later, *The Tub* (fig. 940) is again an oblique view, but now severe, almost geometric, in design. The tub and the crouching woman, both vigorously outlined, form a circle within a square, and the rest of the rectangular format is filled by a shelf so sharply tilted that it almost shares the plane of the picture. Yet on this shelf Degas has placed two pitchers that are

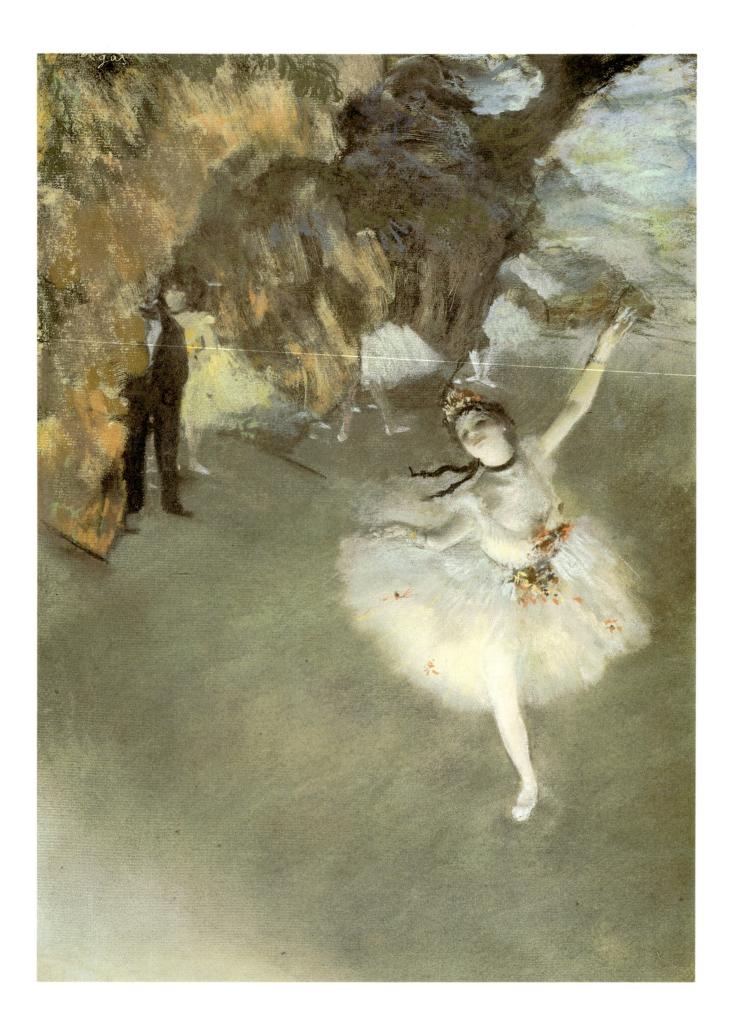

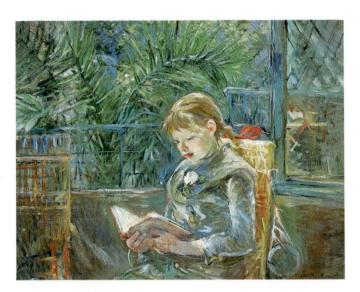

941. Berthe Morisot. *La Lecture (Reading)*. 1888. Oil on canvas, 29¹/4 x 36¹/2" (74.3 x 92.7 cm). Museum of Fine Arts, St. Petersburg, Florida Gift of Friends of Art in Memory of Margaret Acheson Stuart

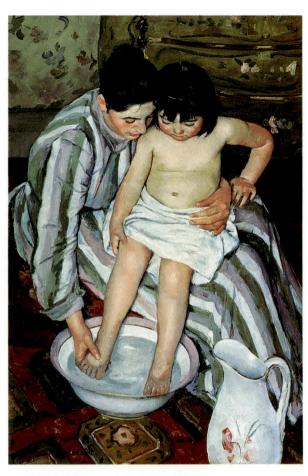

942. Mary Cassatt. *The Bath.* 1891–92. Oil on canvas, $39^{1/2} \times 26$ " (100.3 x 66 cm). The Art Institute of Chicago Robert A. Waller Collection

hardly foreshortened at all. (Note how the curve of the small one fits the handle of the other.) Here the tension between "two-D" and "three-D" surface and depth comes close to the breaking point. *The Tub* is Impressionist only in its shimmering, luminous colors. Its other qualities are more characteristic of the 1880s, the first Post-Impressionist decade, when many artists showed a renewed concern with problems of form (see Chapter 3).

MORISOT. The Impressionists' ranks included several women of great ability. The subject matter of Berthe Morisot (1841–1895), a member of the group from its inception, was the world she knew: the domestic life of the French upper middle class, which she depicted with authentic understanding. Morisor's early paintings, centering on her mother and her sister Edma, were influenced at first by Manet, whose brother she later married, but they have a subtle sense of alienation distinctive to her. Her mature work is altogether different in character. The birth of her daughter Julie in 1878 signaled a change in her art, which reached its height during the following decade. Her painting of a little girl reading in a room overlooking the artist's garden (fig. 941) shows a light-filled style

of her own making. Morisot applied her virtuoso brushwork with a sketchlike brevity that omits nonessential details yet conveys a complete impression of the scene. The figure is fully integrated within the formal design, whose appeal is enhanced by the pastel hues she favored. Morisot's painting radiates an air of contentment free of the sentimentality that often affects genre paintings of the period.

CASSATT. Surprisingly, Americans were the first patrons of the Impressionists, responding to the new style sooner than Europeans did. At a time when no French museum would have them, Impressionist works entered public collections in the United States, and American painters such as Whistler and Mary Cassatt (1845–1926) were among the earliest followers of Manet and his circle. Cassatt joined the Impressionists in 1877, becoming a tireless champion of their work. [See Primary Sources, no. 89, page 938.] She had received a standard academic training in her native Philadelphia, but had to struggle to overcome traditional barriers. Like Morisot, she was able to pursue her career as an artist, an occupation regarded as unsuitable for women, because she was independently wealthy. Cassatt was instrumental in gaining early acceptance of Impres-

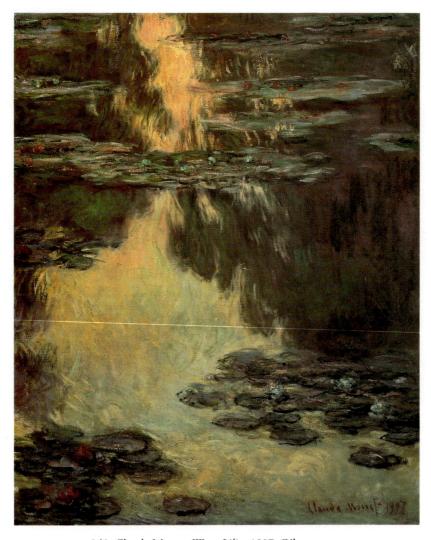

943. Claude Monet. Water Lilies. 1907. Oil on canvas, 361/2 x 29" (92.7 x 73.7 cm). Kawamura Memorial Museum of Art, Sakura City, Chiba Prefecture, Japan

sionist paintings in the United States through her social contacts with wealthy private collectors. Although she never married, maternity provided the thematic and formal focus of most of her work. Cassatt developed a highly accomplished individual style, seen at its best in *The Bath* (fig. 942), which is characteristic of her mature work around 1890. The oblique view, simplified color forms, and flat composition show the impact of her mentor Degas, as well as her study of Japanese prints. Despite the complexity of its design, the painting has a directness that lends simple dignity to motherhood.

MONET'S LATER WORKS. By the mid-1880s Impressionism became widely accepted, its technique imitated by conservative painters and practiced as a fusion style by a growing number of artists worldwide. Ironically, the movement now underwent a deep crisis. Manet died in 1883. Renoir, already beset by doubts, moved toward a more classical style. Racked by internal dissension, the group held its last show in 1886. At that time Pissarro abandoned Impressionism altogether in favor of Seurat's Divisionism for several years (see pages 750–51). Among the major figures of the movement, Monet alone remained faithful to the Impressionist view of nature. Nevertheless, his work became more subjective over time, although he never ventured into fantasy, nor did he forsake the basic approach of his earlier landscapes.

About 1890, Monet began to paint pictures in series, showing the same subject under various conditions of light and atmosphere. These tended increasingly to resemble Turner's "airy visions, painted with tinted steam" as Monet concentrated on effects of colored light. (He had visited London and knew Turner's work; see pages 690-91.) His Water Lilies (fig. 943) is a fascinating sequel to On the Bank of the Seine (fig. 933) across a span of almost 40 years. The surface of the pond now takes up the entire canvas, so that the effect of a weightless screen is stronger than ever. The artist's brushwork, too, has greater variety and a more individual rhythm. While the scene is still based on nature, this is no ordinary landscape but one entirely of his making. On the estate at Giverny given to him late in life by the French government, the artist created a self-contained world for purely personal and artistic purposes. The subjects he painted there are as much reflections of his imagination as they are of reality. They convey a very different sense of time as well. Instead of the single moment captured in *On the Bank of the Seine*, his *Water Lilies*, painted at Giverny,

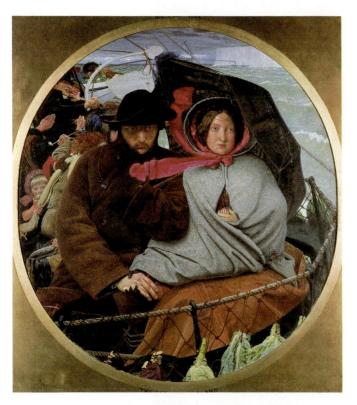

944. Ford Madox Brown. The Last of England. 1852-55. Oil on panel, 32¹/₂ x 29¹/₂" (82.5 x 74.9 cm). City Museum and Art Gallery, Birmingham, England By permission Birmingham Museum and Art Gallery

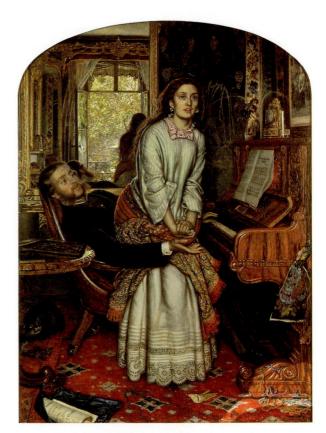

945. William Holman Hunt. The Awakening Conscience. 1853. Oil on canvas, 30 x 20" (76.2 x 50.8 cm). The Tate Gallery, London

summarizes a shifting impression of the pond in response to the changing water as the breezes play across it.

England

REALISM. By the time Monet came to admire his work, Turner's reputation was at a low ebb in his own country. In 1848, when Courbet launched his revolutionary doctrine of Realism, a concern with "the heroism of modern life" asserted itself quite independently in English painting as well, although the movement lacked a leader of Courbet's stature and assertiveness.

Perhaps the best-known example of English Realism is *The* Last of England (fig. 944) by Ford Madox Brown (1821-1893), a picture that enjoyed enormous popularity throughout the latter half of the century in the English-speaking world. The subject—a group of emigrants as they set out on their long overseas journey—may be less obvious today than it once was; nor does it carry the same emotional charge. Nonetheless, there can be no question that the artist has treated an important theme taken from modern experience, and that he has done so with touching seriousness.

The painting is intended to dramatize the conditions that made the emigrants decide to leave England. The pathos of the scene may strike us as a bit theatrical: note the contrast between the brooding young family in the foreground (Brown used himself, his wife, and daughter as the models) and the "good riddance" gesture of the man at the upper left. We recognize its source in the "dumb shows" of Hogarth, whom Brown revered (see fig. 824). Brown's style, however, has nothing in common with Hogarth's. Its extreme precision of detail strikes us as almost photographic. No hint of subjective "handwriting" is permitted to intervene between us and the scene depicted. Brown had acquired this painstaking technique some years earlier, after he met the Nazarenes, the group of German painters in Rome who practiced what they regarded as a "medieval" style (see page 696). He in turn transmitted it to his three pupils who together in 1848 helped to found an artists' society called the Pre-Raphaelite Brotherhood: William Holman Hunt (1827–1910), John Everett Millais (1829–1896), and Dante Gabriel Rossetti (1828–1882).

THE PRE-RAPHAELITES. Brown himself never actually joined the Pre-Raphaelites, but he shared their basic aims: to do battle against the frivolous art of the day by having "genuine ideas to express" and by producing "pure transcripts . . . from nature," an objective inspired by the writings of John Ruskin. As the name of the Brotherhood proclaims, its members took their inspiration from the "primitive" masters of the fifteenth century. To that extent, they belong to the Gothic revival, which had long been an important aspect of the Romantic movement. What set the Pre-Raphaelites apart from Romantics like the Nazarenes was an urge to reform the ills of modern civilization through their art. In this they were aroused by Chartism, the democratic working-class movement that reached its peak in the revolutionary year 1848.

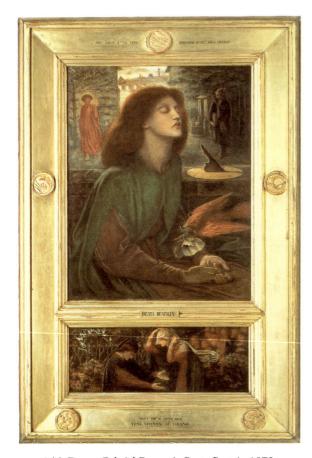

946. Dante Gabriel Rossetti. Beata Beatrix. 1872. Oil on canvas, 34¹/₂" x 27¹/₄" (87.5 x 69.3 cm); predella $10^{1/2}$ x $27^{1/4}$ " (26.5 x 69.3 cm). The Art Institute of Chicago Charles L. Hutchinson Collection

The Awakening Conscience (fig. 945) by William Holman Hunt, the artist who remained truest to the Brotherhood's ideals, stands as perhaps the quintessential Pre-Raphaelite statement. It, too, is a morality play in the tradition of Hogarth. Inspired by an episode in Charles Dickens' David Copperfield, the picture shows a young woman stirred to the realization by the music she sings that she has been living in sin. The scene is presented in obsessive detail, which is laden with symbolic meaning: the print above the piano, for example, shows Christ and the Woman Taken into Adultery, while the light reflected in the mirror is that of religious revelation. Here the artist looked to the example of Jan van Eyck's Arnolfini Portrait (fig. 677), which had recently been acquired by the National Gallery in London. Although he treated it as a personal moral crisis, The Awakening Conscience addresses a very real social problem of the time.

Rossetti, unlike Hunt, was not concerned with social issues. He thought of himself, rather, as a reformer of aesthetic sensibility. The vast majority of his work consists of watercolors or pastels showing women taken from literary sources who bear a striking resemblance to his wife, Elizabeth Siddal. Beata Beatrix (fig. 946), created as a memorial to Siddal, imposes her features on the wife of his namesake, the Italian poet Dante, whose account of her death inspired the painting. Rossetti explained the program in considerable detail: "The picture illustrates the 'Vita Nuova,' embodying symbolically the death of Beatrice as treated in that work. The picture is not intended at all to represent death, but to render it under the

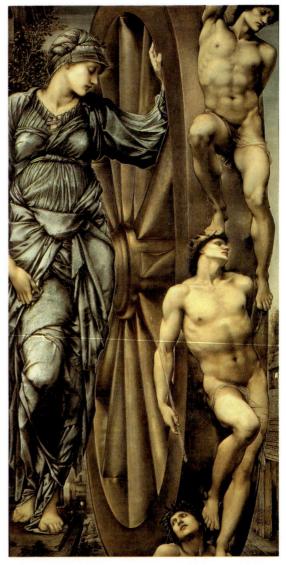

947. Edward Burne-Jones. The Wheel of Fortune. 1877–83. Oil on canvas, 6'63/4" x 3'33/8" (2 x 1 m). Musée d'Orsay, Paris

semblance of a trance. . . . I have introduced . . . the figures of Dante and Love passing through the street and gazing ominously on one another, conscious of the event; while the bird, a messenger of death, drops the poppy between the hands of Beatrice. She, through her shut lids, is conscious of a new world." In this version, the artist has expressed the hope of seeing his beloved Elizabeth again by adding a second panel showing Dante and Beatrice meeting in Paradise and inscribing the dates of their deaths on the frame. For all its apparent spirituality, the painting radiates an aura of repressed eroticism that is the hallmark of Rossetti's work and exerted a powerful influence on other Pre-Raphaelites.

BURNE-JONES. We can sense it again in the work of Rossetti's pupil Edward Burne-Jones (1833-1898), who, although he was too young to have been a member, came to be identified most completely with the Brotherhood in the public's mind. The Wheel of Fortune (fig. 947) was initially planned as part of a large pseudo-triptych devoted to the story of Troy. Although the project was never realized, its content was allegorical, rather than illustrative, in character. Based on a poem by William Morris that likewise remained unfinished, it

Nationalism in Mid-Nineteenth-Century Music

Instead of Realism, composers turned for inspiration to their native heritages. The fascination

with folk music, as well as folklore, was an outgrowth of nationalism, an intrinsic part of Romanticism that became nearly universal after the mid-nineteenth century. Among the first to take up this interest was Johannes Brahms (1833-1897), a pupil of Robert Schumann, for whose widow, Clara, he developed an abiding but unrequited love. Brahms' development was slow: his first symphony was not completed until 1876, but it is cast in the heroic mold of Beethoven. No other composer of his generation wrote masterpieces in such a wide range of music. The works are characteristically intense, with writing high in the string sections, but the slow movements are of astonishingly tender lyricism. They are nevertheless without the bombast found in that of other composers from the same time, and are held together by a thorough command of composition and strong, classical structure.

Brahms was one of the first to appreciate the Czech composer Antonin Dvořák (1841-1904), whose career he encouraged. Whereas Brahms' music is alternately brooding and rapturous, Dvořák's is almost uniformly sunny and uniquely Czech in flavor-he called himself proudly "a happy Bohemian." Love of nature and homeland fill his music. Dvořák was proud of his national music, but he was affected by the music of other cultures, especially during his sojourn in New York as head of the National Conservatory of Music (1892-95), when he produced his celebrated New World Symphony and American Quartet. He left behind a body of chamber music even more substantial than Brahms', and a splendid cello concerto that is the greatest of its kind. The late tone poems, inspired mostly by folk tales, became important models for the next generation of Czech composers centering on Leoš Janáček (1854–1928).

Perhaps the most distinctive national school was to be found in Russia. The group known as "The Five" sought to infuse their music with the sound of their country and often took folk melodies as the basis for their work. They also revived the system of modes, which had remained intact in Orthodox music and was indigenous to large parts of Russia. The most original member of the Russian school was Modest Moussorgsky (1839–1881), despite being the least trained. His opera Boris Godunov (1868-72), written about the same time as Aleksei Tolstoy's drama but taken from an earlier play by Aleksandr Pushkin (1799-1837) and the history of Russia by Nikolai Karamzin, is the undisputed masterpiece of the entire movement.

The greatest Russian composer remains Peter Ilyich Tchaikovsky (1840-1893), who began as a student of the traditionalist Anton Rubinstein (1829-1894) but was decisively influenced early in his career by "The Five." The tone poems, all based on literature, pulsate with Romantic yearning and adventure, while the six symphonies, several of which incorporate Russian themes, are programmaticespecially the last three, which are virtually autobiographical. Indeed, the final one (the Pathétique) is a valedictory statement of the composer's life, with its struggles and tri-

umphs. Its undeniable Russian elements notwithstanding, Tchaikovsky's music owes its enduring

appeal to its internationalism. Despite its physical isolation, Russia was closely linked to the musical capitals of western Europe. Thus, Tchaikovsky's three great ballets build on the French tradition and possess a sophistication that is extraordinarily cosmopolitan. Two of them are based on folk tales retold by the brothers Grimm, and were written for Marius Petipa (1819–1910), under whom Russian ballet reached its zenith.

With Richard Wagner (1813–1883), nationalist rhetoric came to express the growing expansionist mood of Germany that led ultimately to the rise of Nazism during the 1930s. He manned the barricades in Dresden during the revolutionary upheavals that struck Europe throughout 1848–49, and was forced into exile for 13 years, until he won the support of Ludwig II of Bavaria. His operas, such as Tristan and *Isolde* (1859), written under the influence of the philosophy of Arthur Schopenhauer (1788-1860), and the enormous four-part cycle The Ring of the Niebelungen (1853-74), which dates from about the same time as Christian Hebbel's plays, expand greatly on medieval Germanic legends. Wagner's goal was a total work of art that united music, literature, and theater. His texts reflect the influence of Goethe in their literary, declamatory style. One of Wagner's characteristic devices is the leitmotif (pronounced "light moteef," from German, "leading motif"), a melodic line that represents a person, idea, or situation. If, for example, the music brings together the leitmotif for Tristan with one that signifies Fate, the informed listener understands that Tristan is being drawn toward his destiny. Add the motif for Isolde, and we know that his fate is intertwined with hers. Music of such sophistication demanded a highly educated audience, which the prosperous cities of nineteenth-century Europe could readily supply.

Despite the enormous demands Wagner placed on singers, it was the orchestra that carried the largest part of the musical burden. His highly unconventional orchestration techniques and integrated drama set an important example for the Italian composer Giuseppe Verdi (1813–1901), who nevertheless denied their influence. His early operas often have patriotic subjects espousing the cause of Italian independence (the risorgimento). Although Verdi's arias remained vehicles of virtuoso singing, the last five operas broke decisively with the style of Donizetti and Bellini. Dating from 1862 to 1893, they are the finest in the entire Italian tradition stretching back to Monteverdi. Like Berlioz and Tchaikovsky, Verdi was attracted above all to the plays of Shakespeare—Macbeth, Othello, and The Merry Wives of Windsor—which brought out the best in him.

As in art and architecture, revivalism was an important factor in music, although it never became a guiding principle. Mendelssohn resuscitated Bach's St. Matthew Passion, Wagner rediscovered Palestrina and Glück (his very antitheses as composers), while Brahms helped to prepare complete editions of the works of Handel, C. P. E. Bach, and Mozart that mark the beginning of modern musicology.

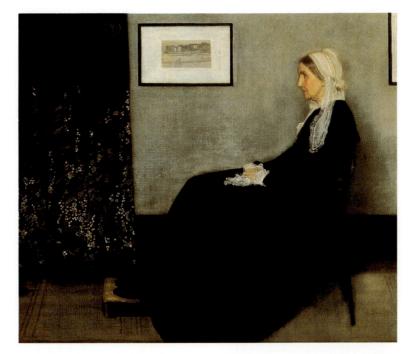

948. James Abbott McNeill Whistler. Arrangement in Black and Gray: The Artist's Mother. 1871. Oil on canvas, 57 x 64¹/2" (144.6 x 163.8 cm). Musée d'Orsay, Paris

was divided into four sections representing Fortune, Fame, Oblivion, and Love. The figures chained to the wheel of fortune, from which they cannot escape, include a slave, a king, and a poet. The composition was inspired by an altarpiece by Mantegna, while the figures show the impact of the sibyls and nudes that populate the ceiling of the Sistine Chapel (see figs. 9 and 613), which the artist studied in detail during a visit to Rome, as well as Michelangelo's "Captives" (compare figs. 609 and 610). Dame Fortune also reflects his admiration for Botticelli's figures, such as those in figure 583. The artist's principal interest lies in the decorative design, inspired by Early Renaissance paintings, which has the flatness and luxuriance of a tapestry. Even more than Whistler's, Burne-Jones' work represents an escape from reality into a dreamlike world of heightened beauty and attenuated feeling.

WHISTLER. James Abbott McNeill Whistler (1834–1903) came to Paris from America in 1855 to study painting; four years later he moved to London, where he spent the rest of his life, but he visited France during the 1860s and was in close touch with the rising Impressionist movement. His bestknown picture, Arrangement in Black and Gray: The Artist's Mother (fig. 948), reflects the influence of Manet in its emphasis on flat areas, and the likeness has the austere precision of Degas. Its fame as a symbol of our latter-day "mother cult" is a paradox of popular psychology that would have dismayed Whistler, who wanted the canvas to be appreciated for its formal qualities alone.

A witty, sharp-tongued advocate of Art for Art's Sake, he thought of his pictures as analogous to pieces of music, calling them "symphonies" or "nocturnes." [See Primary Sources, no. 90, page 939.] The boldest example, painted about 1874, is Nocturne in Black and Gold: The Falling Rocket (fig. 949). Without an explanatory subtitle, we would have real difficulty making it out. No French painter had yet dared to produce a picture so "nonrepresentational," so reminiscent of Cozens' "blotscapes" and Turner's "tinted steam" (see figs. 849 and 890). It was this canvas, more than any other, that prompted John Ruskin to accuse Whistler of "flinging a pot of paint in the

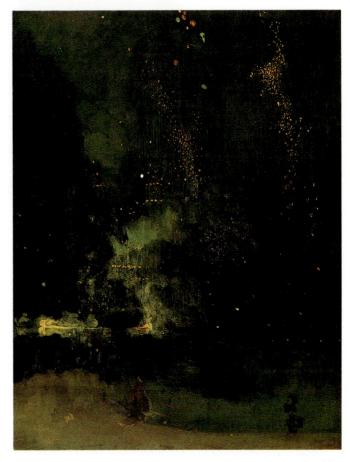

949. James Abbott McNeill Whistler. Nocturne in Black and Gold: The Falling Rocket. c. 1874. Oil on panel, $23^{3}/4 \times 18^{3}/8$ " (60.2 x 46.8 cm). The Detroit Institute of Arts Gift of Dexter M. Ferry, Jr.

public's face." (Since the same critic had highly praised Turner's The Slave Ship, we must conclude that what Ruskin admired was not the tinted steam itself but the Romantic sentiment behind it.)

During Whistler's subsequent suit for libel, he offered a definition of his aims that seems to be particularly applicable

950. George Inness. The Rainbow. c. 1878-79. Oil on canvas, 301/4 x 451/4' (76.8 x 114.9 cm). © 1993 Indianapolis Museum of Art Gift of George E. Hume

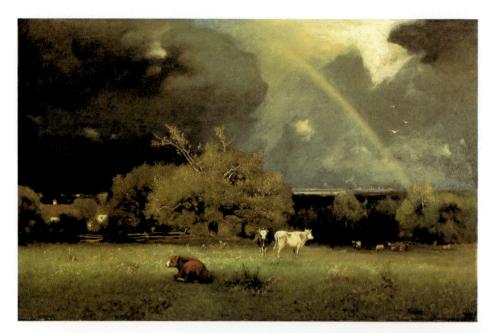

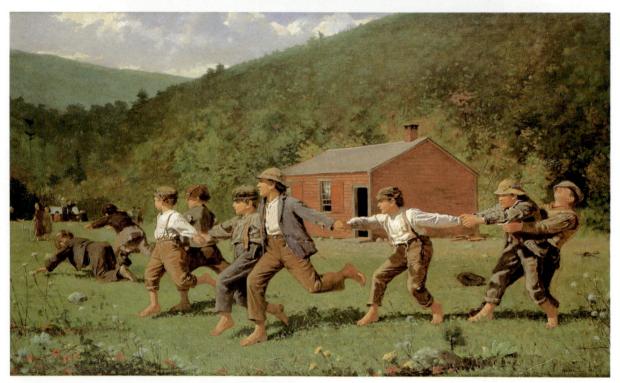

951. Winslow Homer. Snap the Whip. 1872. Oil on canvas, 221/4 x 361/2" (56.5 x 92.7 cm). The Butler Institute of Art, Youngstown, Ohio

to The Falling Rocket: "I have perhaps meant rather to indicate an artistic interest alone in my work, divesting the picture from any outside sort of interest. . . . It is an arrangement of line, form, and color, first, and I make use of any incident of it which shall bring about a symmetrical result." The last phrase has special significance, since Whistler acknowledges that in utilizing chance effects, he does not look for resemblances but for a purely formal harmony. While he rarely practiced what he preached to quite the same extent as he did in The Falling Rocket, his statement reads like a prophecy of American abstract painting (see fig. 1079).

United States

THE AMERICAN BARBIZON SCHOOL. After the Civil War, the United States underwent unprecedented industrial growth, immigration, and westward expansion. These changes led to not only a new range of social and economic problems but a different outlook and taste. As the United States became more like the Old World, Americans traveled abroad in growing numbers, seeking their cultural models in Europe, particularly France, which promoted a new cosmopolitanism in art. There was an equally dramatic shift in the attitude toward nature. The uneasy balance between civilization and nature shifted irrevocably in favor of progress by the end of the Centennial Celebration in 1876. The loss of the twin Romantic visions of the virgin wilderness and a pastoral Eden left nature as little more than a sentimental vestige to be preserved in parks. Since landscape ceased to be a teacher of moral truths as well, the viewer was left only with a personal reaction to a total impression of the scenery at hand. Through this resonance, the mystery of nature retained its spiritual

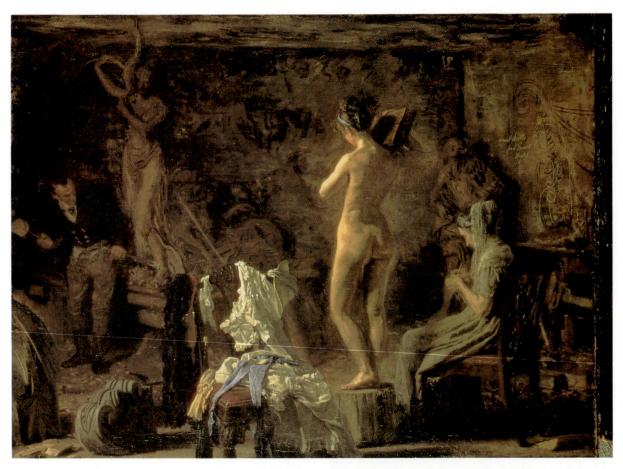

952. Thomas Eakins. William Rush Carving His Allegorical Figure of the Schuylkill River. 1877. Oil on canvas, $20^{1/8}$ x $26^{1/2}$ " (51.1 x 67.3 cm). Philadelphia Museum of Art Given by Mrs. Thomas Eakins and Miss Mary A. Williams

significance but required an alternative mode of expression. The American Barbizon painters answered the need for a new form of landscape: they responded to the transformation of America by turning inward. Their canvases embody the altered mentality of the United States by evoking a poetic state of mind with ever-increasing freedom.

INNESS. The leader of the American Barbizon School was George Inness (1825–1894), who had been deeply impressed by the work of Théodore Rousseau and his followers during a visit to France. The Rainbow (fig. 950) shows one of the storm scenes so characteristic of this artist. The contrast of nature's beneficence with the tumultuous sweep of cosmic forces is reminiscent of Cole's View of Schroon Mountain (see fig. 898), but instead of depicting the wilderness, this former member of the Hudson River School has followed a rustic scene by Millet. Inness imbued his landscape with a sense of divine presence by freely rearranging nature according to formulas that act as indexes of personal feelings. Deeply religious, he had converted to the spiritualism of Emanuel Swedenborg, who believed in an immaterial but light-filled realm inhabited by departed souls that is visually similar and parallel to our own. Although only a few of his landscapes have a specific symbolic content, rainbows had spiritual significance for Inness. Swedenborg's ideas confirmed and intensified his approach, which relied increasingly on light and color to impart his vision of a deeper reality lying hidden from people's eyes but not their souls.

HOMER. The far more gifted Winslow Homer (1836-1910) was a pictorial reporter throughout the Civil War and continued as a magazine illustrator until 1875. He went to Paris in 1866, but though he left too soon to receive its full impact, French art did have an important effect on his work. Snap the Whip (fig. 951) conveys a nostalgia for the simpler era of America before the Civil War (see fig. 899). The picture carries us back to the innocent era of Mark Twain's Tom Sawyer and Huckleberry Finn. The sunlit scene might be called "pre-Impressionist." Its fresh delicacy lies halfway between Corot and Monet (compare figs. 879 and 933). The air of youthful innocence relies equally on the composition, which was undoubtedly inspired by the bacchanals then popular in French art (compare fig. 907). The sophisticated design shows the same subtle understanding of motion as Bruegel's The Blind Leading the Blind (see fig. 718), which also terminates in a fallen figure.

EAKINS. Thomas Eakins (1844–1916) arrived in Paris from Philadelphia about the same time as Homer. He went home four years later, after receiving a conventional academic training but with decisive impressions of Velázquez and Courbet. Elements from both these artists are combined in *William Rush Carving His Allegorical Figure of the Schuylkill River* (fig. 952; compare figs. 759 and 931). Eakins had encountered stiff opposition for advocating traditional life studies at the Pennsylvania Academy of the Fine Arts. To him, Rush was a hero for basing his 1809 statue for the Philadelphia Water Works on the nude

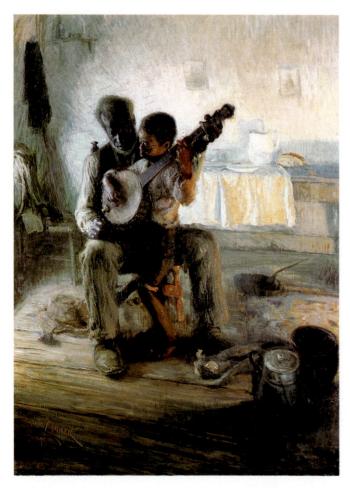

953. Henry O. Tanner. *The Banjo Lesson*. c. 1893. Oil on canvas, 48 x 35" (121.9 x 88.9 cm). Hampton University Museum, Hampton, Virginia

model, though the figure itself was draped in a classical robe. Eakins no doubt knew contemporary European paintings of sculptors carving from the nude; these were related to the theme of Pygmalion and Galatea popular at the time among academic artists. Conservative critics nevertheless denounced *William Rush Carving His Allegorical Figure of the Schuylkill River* for its nudity, despite the presence of the chaperon knitting quietly to the right. To us the painting's declaration of unvarnished truth seems a courageous fulfillment of Baudelaire's demand for pictures that express the heroism of modern life.

TANNER. Thanks in large part to Eakins' enlightened attitude, Philadelphia became the leading center of minority artists in the United States. Eakins encouraged women and blacks to study art seriously at a time when professional careers were closed to them. African-Americans had no chance to enter the arts before Emancipation, and after the Civil War the situation improved only gradually. Henry O. Tanner (1859–1937), the first important black painter, studied with Eakins in the early 1880s. Tanner's masterpiece, *The Banjo Lesson* (fig. 953), painted after he moved permanently to Paris, bears Eakins' unmistakable impress. Avoiding the mawkishness of similar subjects by other American painters, the scene is rendered with the same direct realism as *William Rush Carving His Allegorical Figure of the Schuylkill River*.

SCULPTURE

Impressionism, it is often said, revitalized sculpture no less than painting. The statement is at once true and misleading. Auguste Rodin (1840–1917), the first sculptor of genius since Bernini, redefined sculpture during the same years that Manet and Monet redefined painting. In so doing, however, he did not follow these artists' lead. How indeed could the effect of such pictures as *The Fifer* or *On the Bank of the Seine* be reproduced in three dimensions and without color?

RODIN. What Rodin did accomplish is already visible in the first piece he tried to exhibit at the Salon, The Man with the Broken Nose of 1864 (fig. 954). (It was rejected, as we might expect, on the grounds that it conformed to no established category of sculpture.) Earlier, he had worked briefly under Carrier-Belleuse and Barye, whose influence may help to explain the vigorously creased surface (compare fig. 905). These welts and wrinkles produce, in polished bronze, an ever-changing pattern of reflections. But is this effect borrowed from Impressionist painting? Does Rodin actually dissolve three-dimensional form into flickering patches of light and dark? These fiercely exaggerated shapes pulsate with sculptural energy, and they retain this quality under whatever conditions the piece is viewed. Rodin did not work directly in bronze; he modeled in wax or clay. How, then, could he calculate in advance the reflections on the bronze surfaces of the casts that would ultimately be made from these models?

He worked as he did, we must assume, for an altogether different reason: not to capture elusive optical effects, but to emphasize the process of "growth"—the miracle of dead matter coming to life in the artist's hands. As the color patch for Manet and Monet is the primary reality, so are the malleable lumps from which Rodin builds his forms. Conservative critics rejected *The Man with the Broken Nose* and Impressionist painting on the same grounds: it was "unfinished," a mere sketch.

The Man with the Broken Nose was Rodin's confession of aesthetic faith. Later on, he said of it: "That mask determined all my future work." The head, on which he had worked for about a year, represented a revolutionary insight. What matters in sculpture is not whether it is "finished" or "complete" but whether it conveys to the beholder the way it grew. The Man with the Broken Nose certainly does, and that is why Rodin thought of it as the cornerstone of his entire future oeuvre. He was the first to make of unfinishedness an aesthetic principle that governed both his handling of surfaces and the whole shape of the work. (The Man with the Broken Nose is not a bust, but a head "broken off" at the neck.) By discovering what might be called the autonomy of the fragment, he rescued sculpture from mechanical verisimilitude just as Manet rescued painting from photographic realism.

Despite the sculptural revolution proclaimed with such daring by Rodin at 24, he still believed that the sculptor's noblest task is to show the nude human form, although it could now be done in fragmentary form, and he persisted in the claim that the sculptor's vocation is to create "new classics"—that is, works free from the dictates of the patron and demanding to be judged on their own terms. [See Primary Sources, no. 91, page 939.] When in 1880 he was at last entrusted with a major

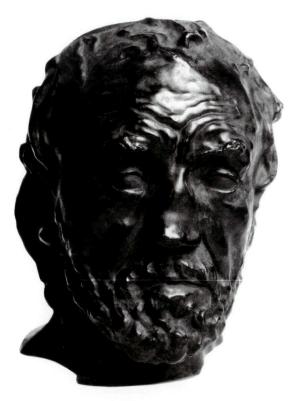

954. Auguste Rodin. *The Man with the Broken Nose.* 1864. Bronze, height 9¹/2" (24 cm). Rodin Museum, Philadelphia Museum of Art

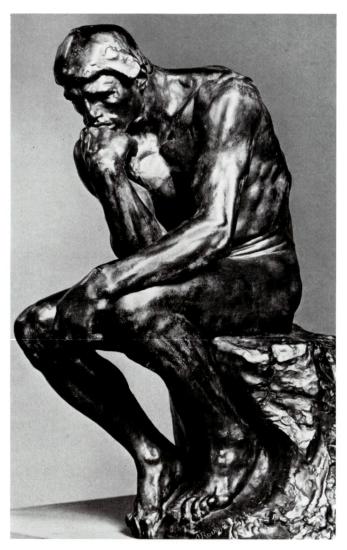

955. Auguste Rodin. *The Thinker.* 1879–89. Bronze, height 27¹/2" (69.8 cm). The Metropolitan Museum of Art, New York
Gift of Thomas F. Ryan, 1910

task, the entrance of the École des Arts Décoratifs in Paris, Rodin elaborated the commission into an ambitious ensemble called *The Gates of Hell*, which, characteristically, he never finished. The symbolic program was inspired by Dante's *Inferno*, but it was equally indebted to Baudelaire's *The Flowers of Evil*. Its common denominator is a tragic view of the human condition—guilty passions, desire forever unfulfilled here and in the beyond, the vain hope of happiness. The perceptive critic Gustave Geffroy, writing of *The Gates of Hell* in 1889, defined their subject as the endless reenactment of the sufferings of Adam and Eve. Indeed, Rodin had tried in 1881 to persuade the government to let him flank *The Gates* with statues of the two.

The Gates served as a matrix for countless smaller pieces that he eventually made into independent works. The most famous of these autonomous fragments is *The Thinker* (fig. 955), intended for the lintel of the *Gates*, whence the figure was to contemplate the panorama of despair below him. It descends partly from a statue by Carpeaux of another subject from *The Inferno*, Ugolino and his sons. The ancestry of *The Thinker* can be traced back much further, however. It goes back, indirectly, to the first phase of Christian art. (The pen-

sive man seated at the left in the Byzantine ivory in figure 346 reflects an Early Christian source.) It also includes the action-in-repose of Michelangelo's superhuman bodies (see figs. 610, 613, and 616), the tension in Puget's *Milo of Crotona* (see fig. 808, especially the feet), and the expressive dynamism of *The Man with the Broken Nose*.

Who is *The Thinker*? In the context of *The Gates of Hell,* he was originally conceived as a generalized image of Dante, the poet who in his mind's eye sees what goes on all around him. Once Rodin decided to detach him from *The Gates,* he became *The Poet-Thinker,* and finally just *The Thinker.* But what kind of thinker? Partly Adam, no doubt (though there is also a different Adam by Rodin, another "outgrowth" of the Gates), partly Prometheus, and partly the brute imprisoned by the passions of the flesh. Rodin wisely refrained from giving him a specific name, for the statue fits no preconceived identity. In this new image of a man, form and meaning are one, instead of cleaving apart as in Carpeaux's *The Dance* (see fig. 907). Carpeaux's naked figures pretend to be nude, while *The Thinker,* like the nudes of Michelangelo, is free from subservience to the undressed model.

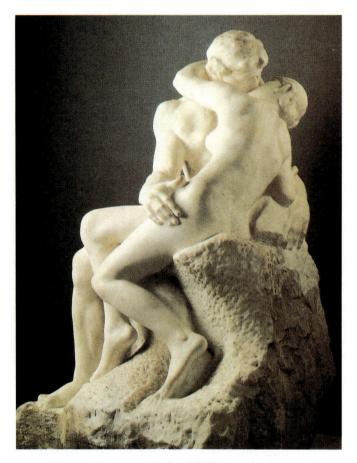

956. Auguste Rodin. *The Kiss.* 1886–98. Marble, over-lifesize. Rodin Museum, Paris

The Kiss (fig. 956), an over-lifesize group in marble, also derives from The Gates. It was meant to be Dante's Paolo and Francesca, but Rodin rejected it as unsuitable. Evidently he realized that *The Kiss* shows the ill-fated pair succumbing to their illicit desire for each other here on earth, not as tortured souls in Hell. Knowing its original title helps us to understand a salient aspect of the group: passion reigned in by hesitancy, for the embrace is not yet complete. Less powerful than The Thinker, it exploits another kind of artful unfinishedness. Rodin had been impressed by the struggle of Michelangelo's "Slaves" against the remnants of the blocks that imprison them. The Kiss was planned from the start to include the mass of roughhewn marble to which the lovers are attached, and which thus becomes symbolic of their earthbound passion. The contrast of textures emphasizes the veiled, sensuous softness of the bodies.

But Rodin was by instinct a modeler, not a carver like Michelangelo. His greatest works were intended to be cast in bronze. Even these, however, reveal their full strength only when we see them in plaster casts made directly from Rodin's clay originals. The *Monument to Balzac*, his last, as well as most daring and controversial creation (fig. 957), remained in plaster for many years, rejected by the writers' association that had commissioned it. He had been asked at the insistence of the author Émile Zola to take over the project when the first sculptor died after producing only a sketch. He declared it to be "the sum of my whole life. . . . From the day of its conception, I

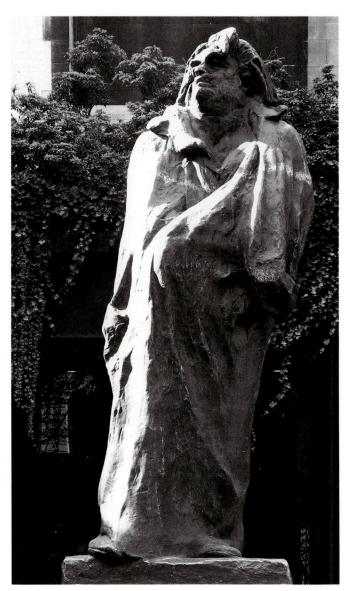

957. Auguste Rodin. *Monument to Balzac.* 1897–98. Bronze (cast 1954), height 9'3" (2.82 m). The Museum of Modern Art, New York

Presented in memory of Curt Valentin by his friends

was a changed man." Outward appearance did not pose a problem (Balzac's features were well known). But Rodin desired far more than that. He was searching for a way to cast Balzac's whole personality into visible form, without the addition of allegorical figures, the habitual props of monuments to genius. The final version gives no hint of the many alternative solutions he tried. (More than 40 have survived.) The element common to them all is that Balzac is standing, in order to express the virile energy Rodin saw in his subject.

The final sculpture shows the writer clothed in a long dressing gown—described by his contemporaries as a "monk's robe"—which he liked to wear while working at night. Here was a "timeless" costume that permitted Rodin to conceal and simplify the contours of the body. Balzac awakens in the middle of the night, seized by a sudden creative impulse, and hastily throws the robe over his shoulders without putting his arms through the sleeves, before he settles down to record his thoughts on paper. But, of course, Balzac is not about to write.

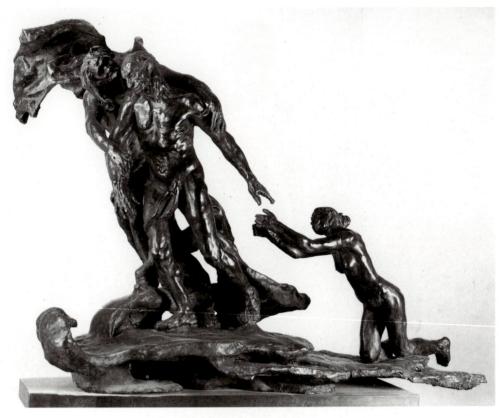

958. Camille Claudel. Ripe Age. c. 1907. Bronze, 341/2 x 201/2" (87.6 x 21.9 cm). Musée d'Orsay, Paris

He looms before us with the frightening insistence of a specter, utterly unaware of his surroundings—the entire figure leans backward to stress its isolation from the beholder.

The statue is larger than life, physically and spiritually: it has an overpowering presence. Like a huge monolith, the man of genius towers above the crowd. He shares "the sublime egotism of the gods" (as the Romantics put it). From a distance we see only the great bulk of the figure. From the mass formed by the shroudlike cloak, the head thrusts upward—one is tempted to say, erupts—with elemental force. When we are close enough to make out the features clearly, we sense beneath the disdain an inner agony that stamps *Balzac* as the kin of *The* Man with the Broken Nose.

To this day, the Balzac remains a startling sight. Rodin had indeed reached the outer limits of his art, as he himself realized. The question remains, Why did he never have it cast in bronze, even though a wealthy private collector offered to pay for it? Its compact shape certainly lent itself to a marble statue, and it may be that he visualized the monument as one all along.

CLAUDEL. Rodin employed various assistants throughout his career. One of them, Camille Claudel (1864-1943), has emerged as an important artist. Claudel entered Rodin's studio as a 19-year-old, and for the next decade she was his artistic collaborator and his mistress. Her work is strongly in her mentor's mode, and her best sculptures might be mistaken for his. Much of her work is autobiographical. Ripe Age (fig. 958) depicts a grisly Rodin, whose features are clearly recognizable, being led away with apparent reluctance by his longtime companion, Rose Beuret, whom Claudel sought to replace in his affections. Beuret is shown as a sinister, shrouded figure who first appears in Claudel's work as Clotho, one of the three Fates, ironically caught in the web of life she has woven. The nude figure is a self-portrait of Claudel, likewise evolved from an earlier work, Entreaty.

DEGAS. It is significant of the fundamental difference between painting and modeling that only Degas among the Impressionists tried his hand at sculpture, producing dozens of small-scale wax figurines that explore the same themes as his paintings and drawings. These are private works made for his own interest; few of them were exhibited during the artist's lifetime, and none were cast until after his death in this century. During the 1870s, there was a growing taste for casts made from artists' working models, reflecting the same appreciation for the qualities of spontaneity and inspiration found in drawings and oil sketches, which had long appealed to collectors. For the first time sculptors felt emboldened to violate time-honored standards of naturalism and craftsmanship for statuettes, and to leave the impress of their fingers on the soft material as they molded it. Nevertheless, when Degas showed the wax original of *The Little Fourteen-Year-Old Dancer* at the Impressionist exhibitions of 1880 and 1881, the public was scandalized by its lack of traditional finish and uncompromising adherence to unvarnished truth, although the response from critics was less harsh. The sculpture, reproduced here in

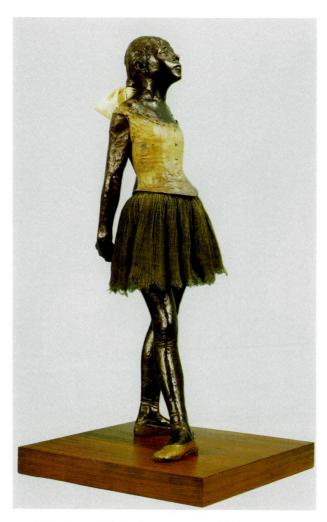

959. Edgar Degas. *The Little Fourteen-Year-Old Dancer.* 1878–80. Bronze with gauze tutu and satin hair ribbon, height 38" (96.5 cm). Norton Simon Art Foundation, Pasadena, California

ARCHITECTURE

a posthumous cast (fig. 959), is nearly as rough in texture as the slightly smaller nude study from life on which it is based.

Instead of sculpting her costume, Degas used real cotton and silk, a revolutionary idea for the time but something the Romantics, with their emphatic naturalism, must often have felt tempted to do. Degas was intrigued by the tension between the concrete surface and the abstract but powerfully directional forces beneath it. The ungainliness of the young adolescent's body is subtly emphasized by her pose, that of a dancer at "stage rest," which becomes in his hands an extremely stressful one, so full of sharply contrasting angles that no dancer could maintain it for more than a few moments. Yet, rather than awkwardness, the statuette conveys a simple dignity and grace that are irresistible. The openness of the stance, with hands clasped behind the back and legs pointing in opposite directions, demands that we walk around the dancer to arrive at a complete image of it. As we view the sculpture from different angles, the surface provides a constantly shifting impression of light comparable to that in Degas' numerous paintings and pastels of the ballet (compare fig. 939).

For more than a century, from the mid-eighteenth to the late nineteenth, architecture had been dominated by a succession of "revival styles" (see pages 706-12). This term, we will recall, does not imply that earlier forms were slavish copies; the best work of the time has both individuality and high distinction. Yet the architectural wisdom of the past, however freely interpreted, proved in the long run to be inadequate for the practical demands of the Industrial Age: the factories, warehouses, stores, and city apartments that formed the bulk of building construction. After about 1800, in the world of commercial architecture, we find the gradual introduction of new materials and techniques that were to have a profound effect on architectural style by the end of the century. The most important was iron, never before used as an actual structural member. Within a few decades of their first appearance, cast-iron columns and arches had become the standard means of supporting roofs over the large spaces required by railroad stations, exhibition halls, and public libraries.

LABROUSTE. A famous early example is the Bibliothèque Ste.-Geneviève in Paris by Henri Labrouste (1801–1875).

960. Henri Labrouste. Bibliothèque Ste.-Geneviève, Paris. 1843-50

961. Henri Labrouste. Reading Room, Bibliothèque Ste.-Geneviève

The exterior (fig. 960) represents the historicism prevailing at mid-century. It is drawn chiefly from Italian Renaissance banks, libraries, and churches. To identify the building as a library, Labrouste used the simple but ingenious device of inscribing the names of great writers around the facade. The reading room (fig. 961), on the other hand, recalls the nave of a French Gothic cathedral (compare fig. 439). But why did Labrouste choose cast-iron columns and arches, hitherto used exclusively for railroad stations? Cast iron was necessary not to

provide structural support for the two barrel roofs—this could have been done using other materials—but to complete the building's symbolic program. The library, Labrouste suggests to us, is a storehouse of something even more valuable and sacred than material wealth: the world's literature, which takes us on a journey not to faraway places but of the mind.

Labrouste chose to leave the interior iron skeleton uncovered, and to face the difficulty of relating it to the massive Renaissance revival style of the exterior of his building. If his

Realism was the dominant style in mid-nineteenth-century the-

ater, as it was in painting. In part, theatrical realism was a reflection of the pragmatic character of the Industrial Revolution. Its principal theorist was the French philosopher Auguste Comte (1798–1857), the founder of a system of thought known as Positivism, which called for a material explanation of truth based on objective observation and scientific analysis. As in art, Realism in drama covered a wide range of tendencies, from simple adherence to historic fact, social reality, or physical appearance, to highly emotional treatments that have much in common with Romanticism.

The Realist playwright best known today is Alexandre Dumas the Younger (1824-1895), whose drama Camille (1852) was the first to treat the now-familiar theme of the prostitute with a heart of gold. While a modern audience might find Camille somewhat melodramatic, in its own time the play was considered an unflinching depiction of life at the fringes of Parisian society. In response to the criticism of Camille contained in Olympe's Marriage by Émile Augier (1820–1889), Dumas abandoned Realism three years later in The Demi-Monde, his first attempt at social and moral criticism. The most popular playwright of the period was Victorien Sardou (1831-1908), whose drama La Tosca (1887) was later turned into a well-known opera by the Italian composer, Giacomo Puccini (see box page 758). This story of love, treachery, and revenge during the Italian struggle for independence was an important starring role for the great British tragic actress, Sarah Bernhardt (1844-1923; see fig. 925). A gifted sculptor as well, Bernhardt specialized in tragic heroines such as Camille and Adrienne Lecouvreur. Her only rival was Ellen Terry (1847–1928), who came from a long line of actors. She was the leading lady to Henry Irving (1838-1905), by far the most important actor and manager in England during the later nineteenth century, who commissioned Edward Burne-Jones and other prominent artists to design stage sets for him. Irving was knighted in 1895, while Terry was made a Dame Commander of the British Empire only in 1925.

Germany produced few major dramatists during the third quarter of the century. Instead, it was content to rely on the plays of Shakespeare, Goethe, and Schiller, and on translations of Sardou and the younger Dumas. Vienna became the main theater center under Heinrich Laube (1806–1884), a former member of Young Germany, and Franz Dingelstedt (1814–1881), who had produced Chris-

tian Friedrich Hebbel's (1813–1863) trilogy *The Niebelungen* in

1861 at Weimar. A fascination with old Germanic legends that was fueled by growing nationalism helped to make historical accuracy the goal of German theater. The chief contributors to theater in Germany at this time were Duke George II of Saxe-Meiningen (1826–1914) and his wife, the actress Helene Franz (1839–1923), who elevated the quality of acting through careful preparation and emphasis on ensemble. Attention was also paid to costumes and scenery.

Russian authors of the time had a particular affinity for psychological Realism. The first Russian professional playwright, Aleksandr Ostrovsky (1823-1886), had an abiding interest in characters and their relationships. However, the major plays were written by the great novelists of the era. Ivan Turgenev (1818–1883) wrote a number of dramas that are remarkable for their portrayal of their characters' inner lives and complex relationships. Leo Tolstoy (1828-1910) also tried his hand at plays, notably The Power of Darkness, which was produced in 1895, some 30 years after it was written. Aleksei Tolstoy (1817-1875), a distant relative, established himself as the leading Realist with a strong interest in the history of Russia. The Death of Ivan the Terrible and Tsar Boris, both of 1870, were based on the historical research of Nikolai Karamzin (1766–1826), which did much to stimulate Russian nationalism.

In the United States, the favorite dramas before the Civil War were various adaptations of the novel *Uncle Tom's Cabin* by Harriet Beecher Stowe (1811-1896). This portrayal of the life of slaves on southern plantations helped fuel abolitionist sentiment. It was also a time of great actors. The Englishman William Burton (1804-1860) headed the finest company in New York, the undisputed theater capital of America, although the Boston Museum also staged many plays after 1850. Burton had been preceded by another English performer, Junius Booth (1796–1852), whose son Edwin Booth (1833-1893) became the greatest actor America has ever produced. Unfortunately, the family remains notorious for another son, John Wilkes Booth (1838-1865), the assassin of President Abraham Lincoln. The most popular form of theater was the burlesque extravaganza. Over time it came to appeal mainly to men by featuring beautiful women, although striptease was added only in 1929. Vaudeville, a more genteel form of family entertainment that reached its height between 1890 and 1930, was defined largely by Tony Pastor (1837-1908).

solution does not fully integrate the two systems, it at least lets them coexist. The iron supports, shaped like Corinthian columns, are as slender as the new material permits. Their collective effect is that of a space-dividing screen, belying their structural importance. To make them weightier, Labrouste has placed them on tall pedestals of solid masonry, instead of directly on the floor. Aesthetically, the arches presented greater difficulty, since there was no way to make them look as powerful as their masonry ancestors. Here Labrouste has gone to the other

extreme, perforating them with lacy scrolls as if they were pure ornament. This architectural (as against merely technical) use of exposed iron members has a fanciful and delicate quality that links it, indirectly, to the Gothic revival. Later superseded by structural steel and ferroconcrete, it is a peculiarly appealing final chapter in the history of Romantic architecture.

The authority of historic modes had to be broken if the industrial era was to produce a truly contemporary style. It nevertheless proved extraordinarily persistent. Labrouste, pio-

962. Sir Joseph Paxton. The Crystal Palace, London. 1851; reerected in Sydenham 1852; destroyed 1936

neer though he was of cast-iron construction, could not think of architectural supports as anything but columns having proper capitals and bases, rather than as metal rods or pipes (see pages 768–70). The "architecture of conspicuous display" espoused by Garnier (see pages 710-11) was divorced, even more than were the previous revival styles, from the needs of the present. It was only in structures that were not considered "architecture" at all that new building materials and techniques could be explored without these inhibitions.

PAXTON. Within a year of the completion of the Bibliothèque Ste.-Geneviève, the Crystal Palace (fig. 962) was built in London. A pioneering achievement far bolder in conception than Labrouste's library, the Crystal Palace was designed to house the first of the great international expositions that continue in our day. Its designer, Sir Joseph Paxton (1801–1865), was an engineer and builder of greenhouses. The Crystal Palace was, in fact, a gigantic greenhouse—so large that it enclosed

some old trees growing on the site—with its iron skeleton freely on display. Paxton's design was such a success that it set off a wave of similar buildings for commercial purposes, such as public markets. Still, the notion that there might be beauty, and not merely utility, in the products of engineering made headway very slowly, even though the doctrine "form follows function" found advocates from the mid-nineteenth century on. Hence most such edifices were adorned with decorations that follow the eclectic taste of the period.

ROEBLING. Only rarely could an engineering feat express the spirit of the times. One of the few to do so was the Brooklyn Bridge, built by John and Washington Roebling (fig. 963), which was referred to, appropriately enough, as America's Arch of Triumph. It remains one of the outstanding achievements of the Industrial Revolution. The massive towers nevertheless incorporate aspects of Egyptian, Roman, and Gothic architecture (note the pointed arches) to express a

963. John and Washington Roebling. The Brooklyn Bridge, New York. 1867–83

combination of eternal strength, civic pride, and soaring spirituality. Small wonder it was celebrated by poets and artists alike (see fig. 1056).

EIFFEL. What was needed for products of engineering to be accepted as architecture was a structure that would capture the world's imagination through its bold conception. The breakthrough came with the Eiffel Tower, named after its designer, Gustave Eiffel (1832-1923). As shown in a contemporary photograph (fig. 964), it was erected at the entrance to the Paris World's Fair of 1889, where it, too, served as a triumphal arch of science and industry. It has become such a visual cliché beloved of tourists—much like the Statue of Liberty, which also involved Eiffel (see fig. 908)—that we can hardly realize what a revolutionary impact it had at the time. [See Primary Sources, no. 92, pages 939-40.] The tower, with its frankly technological aesthetic, so dominates

the city's skyline even now that it provoked a storm of protest by the leading intellectuals of the day. Eiffel used the same principles of structural engineering that he had already applied successfully to bridges. Yet it is so novel in appearance and so daring in construction that nothing like it has ever been built, before or since.

The Eiffel Tower owed a good measure of its success to the fact that for a small sum anyone could ascend its elevators to see a view of Paris previously reserved for the privileged few able to afford hot-air balloon rides (see fig. 926). It thus helped to define a distinctive feature of modern architecture, one that it shares with modern technology as a whole: it acts on large masses of people, without regard to social or economic class. Although this capacity, shared only by the largest churches and public buildings of the past, has also served the aims of political extremists at both ends of the spectrum, modern architecture has tended by its very nature to function as a vehicle of democracy. We can

964. Gustave Eiffel. The Eiffel Tower, Paris. 1887-89

readily understand, then, why the Eiffel Tower quickly became a popular symbol of Paris itself. It could do so, however, precisely because it serves no practical purpose whatsoever.

OTHER FIELDS

MORRIS. We must take note of the unusually important role played by the decorative arts in England during the second

half of the nineteenth century. William Morris (1834–1896), the early leader in what came to be known as the Arts and Crafts Movement, started out with William Holman Hunt as a student of the Pre-Raphaelite painter Rossetti but soon shifted his interest to "art for use"—domestic architecture and interior decoration such as furniture, tapestries, and wallpapers. He wanted to displace the shoddy products of the Machine Age by reviving the handicrafts of the preindustrial

965. William Morris (Morris & Co.). Green Dining Room. 1867. Victoria & Albert Museum, London

past, an art "made by the people, and for the people, as a happiness to the maker and the user."

Morris was an apostle of simplicity. Architecture and furniture ought to be designed in accordance with the nature of their materials and working processes; surface decoration must be flat rather than illusionistic. His interiors (fig. 965) are total environments that create an effect of quiet intimacy. Despite Morris' self-proclaimed championship of the medieval tradition, he never imitated its forms directly but sought to capture its spirit. His achievement was to invent the first original system of ornament since the Rococo.

Through the many enterprises he sponsored, as well as his skill as a writer and publicist, Morris became a tastemaker without peer in his day. Toward the end of the century, his influence had spread throughout Europe and America. Nor was he content to reform the arts of design alone. He saw them, rather, as a lever by which to reform modern society as a whole. As a consequence, he played an important part in the early history of Fabian socialism (the gradualist variety invented in England as an alternative to the revolutionary socialism of the Continent).

CRANE. Many of Morris' artist friends came to share his convictions, and some contributed their artistic talents to the cause. A political cartoon (fig. 966) by the illustrator and book designer Walter Crane (1845–1915) shows the genius of Liberty, strongly reminiscent of the style of Botticelli (see fig. 583), bringing the glad tidings of socialism to a sleeping

966. Walter Crane. Political cartoon from *Cartoons for the Cause*. 1886. Woodcut

967. James Abbott McNeill Whistler. Harmony in Blue and Gold: The Peacock Room. 1876-77. Oil color and gold on leather and wood. Courtesy of the Freer Gallery of Art, Smithsonian Institution, Washington, D.C.

worker who is being oppressed by capitalism in the shape of a nightmarish vampire. Shades of Henry Fuseli!

WHISTLER. In the 1860s the reform ideas of William Morris began to bear fruit in domestic architecture and decoration. The boldest innovations, however, came not from members of his immediate circle but from Whistler and his entourage. Whistler himself created one of the masterpieces of nineteenth-century design: the Peacock Room (fig. 967), which housed the blue-and-white porcelain collection of his patron Frederick Leyland. What began as a modest project to remedy the previous decorations soon escalated into an ambitious

overhaul by Whistler, who spared no expense to realize his lavish scheme while the unwitting Leyland was away. The results were inevitably mixed, as the preexisting room embodies fundamentally the same sensibility as Morris' Green Dining Room (see fig. 965). The fanciful decorations, with gilt everywhere, nevertheless epitomize the Aesthetic Movement, which sought refuge from the tawdry reality of the Industrial Revolution by retreating into a realm of pure beauty. The peacock motif, which reflects Whistler's fascination with Japanese art, seems a singularly apt symbol of his aestheticism, which regarded beauty as an end in itself, without regard to social responsibility.

CHAPTER THREE

POST-IMPRESSIONISM, SYMBOLISM, AND ART NOUVEAU

PAINTING

Post-Impressionism

In 1882, just before his death, Manet was made a chevalier of the Legion of Honor by the French government. This event marks the turn of the tide: Impressionism had gained wide acceptance among artists and the public—but by the same token it was no longer a pioneering movement. When the Impressionists held their last group show four years later, the future already belonged to the "Post-Impressionists." Taken literally, this colorless label applies to all painters of significance in the 1880s and 1890s. In a more specific sense, it designates a group of artists who passed through an Impressionist phase but became dissatisfied with the limitations of the style and pursued a variety of directions. Because they did not share one common goal, we have no more descriptive term for them than Post-Impressionists. In any event, they were not "anti-Impressionists." Far from trying to undo the effects of the "Manet Revolution," they wanted to carry it further. Thus Post-Impressionism is in essence just a later stage, though a very important one, of the development that had begun in the 1860s with such pictures as Manet's Luncheon on the Grass.

CÉZANNE. Paul Cézanne (1839–1906), the oldest of the Post-Impressionists, was born in Aix-en-Provence, near the Mediterranean coast, where he formed a close friendship with the writer Émile Zola, later a champion of the Impressionists. A man of intensely emotional temperament, he came to Paris in 1861 imbued with enthusiasm for the Romantics. Delacroix was his first love among painters, and he never lost his admiration for him. Cézanne, however, quickly grasped the nature of the "Manet Revolution," but utterly transformed it. A Modern Olympia (fig. 968) was painted in response to an Olympia by Manet featuring a prostitute whose frank naked-

ness scandalized the art world. As in Luncheon on the Grass (fig. 4), executed by Manet the same year as the Olympia, Cézanne's nude is in the company of a man wearing contemporary garb; his features are plainly those of Cézanne himself (see fig. 969). Like many of his early works, A Modern Olympia is sexually charged, albeit in a curiously ambivalent way that suggests why he never formed a durable relationship. While the setting is a boudoir, the picture is one of the first to treat what was to become one of the recurring themes in modern art: the artist and his model, a subject often fraught with erotic overtones. He sits in mute adoration of the young woman, whose sumptuous surroundings suggest that she is indeed a modern goddess. Yet the juxtaposition of the two figures is strange indeed. Although separated in space, they are placed so near each other on the picture plane that she seems almost to recoil from his dark presence! Equally disturbing is the brushwork, which communicates the turbulent passion repressed by the seemingly impassive artist. Never before have we seen such brusqueness, not even in Cézanne's ideal, Delacroix. The subtitle The Pasha pays homage to the Orientalism of Delacroix, whose Odalisque (fig. 874) nevertheless has a sensuousness absent from Cézanne's Olympia. This artist-as-potentate can admire, but not possess, his "harem girl."

After passing through this Neo-Baroque phase, Cézanne began to paint bright outdoor scenes with Pissarro, but he never shared his fellow Impressionists' interest in "slice-of-life" subjects, in movement and change. About 1879, when he painted the *Self-Portrait* in figure 969, he had decided "to make of Impressionism something solid and durable, like the art of the museums." His Romantic impulsiveness of the 1860s has now given way to a patient, disciplined search for

968. Paul Cézanne. A Modern Olympia (The Pasha). Early 1870s. Oil on canvas, 22 x 21⁵/8" (56 x 55 cm). Private collection

harmony of form and color. Every brushstroke is like a building block, firmly placed within the pictorial architecture, which creates a subtle balance of "two-D" and "three-D." (Note how the pattern of wallpaper in the background frames the rounded shape of the head.) The colors, too, are deliberately controlled so as to produce "chords" of warm and cool tones that reverberate throughout the canvas.

In Cézanne's still lifes, such as Still Life with Apples in a Bowl (fig. 970), this quest for the "solid and durable" can be seen even more clearly. Not since Chardin have simple everyday objects assumed such importance in a painter's eye. Again the ornamental backdrop is integrated with the three-dimensional shapes, and the brushstrokes have a rhythmic pattern that gives the canvas its shimmering texture. We also notice aspects of Cézanne's mature style that are more conspicuous here than in the Self-Portrait and may puzzle us at first. The forms are deliberately simplified and outlined with dark contours, and the perspective is "incorrect" for both the fruit bowl and the horizontal surfaces, which seem to tilt upward. The longer we study the picture, the more we realize the rightness of these apparently arbitrary distortions. When Cézanne took these liberties with reality, his purpose was to uncover the permanent qualities beneath the accidents of appearance. All forms in nature, he believed, are based on the cone, the sphere, and the cylinder. This order underlying the external world was the true subject of his pictures, but he had to interpret it to fit the separate, closed world of the canvas.

To apply this method to landscape became the greatest challenge of Cézanne's career. From 1882 on, he lived in isolation near his hometown of Aix-en-Provence, exploring its environs as Claude Lorraine and Corot had explored the Roman countryside. One feature, the distinctive shape of a mountain called Mont Ste.-Victoire, seemed almost to obsess him. Its craggy profile looming against the blue Mediterranean sky appears in a long series of compositions, such as the monumental late work in figure 971. There are no hints of human presence here—houses and roads would only disturb the lonely grandeur of this view. Above the wall of rocky cliffs that bar our way like a chain of fortifications, the mountain rises in triumphant clarity, infinitely remote yet as solid and palpable as the shapes in the foreground. For all its architectural stability, the scene is alive with movement; but the forces at work here have been brought into equilibrium, subdued by the greater power of the artist's will. This disciplined energy, distilled from the trials of a stormy youth, gives the mature style of Cézanne its enduring strength.

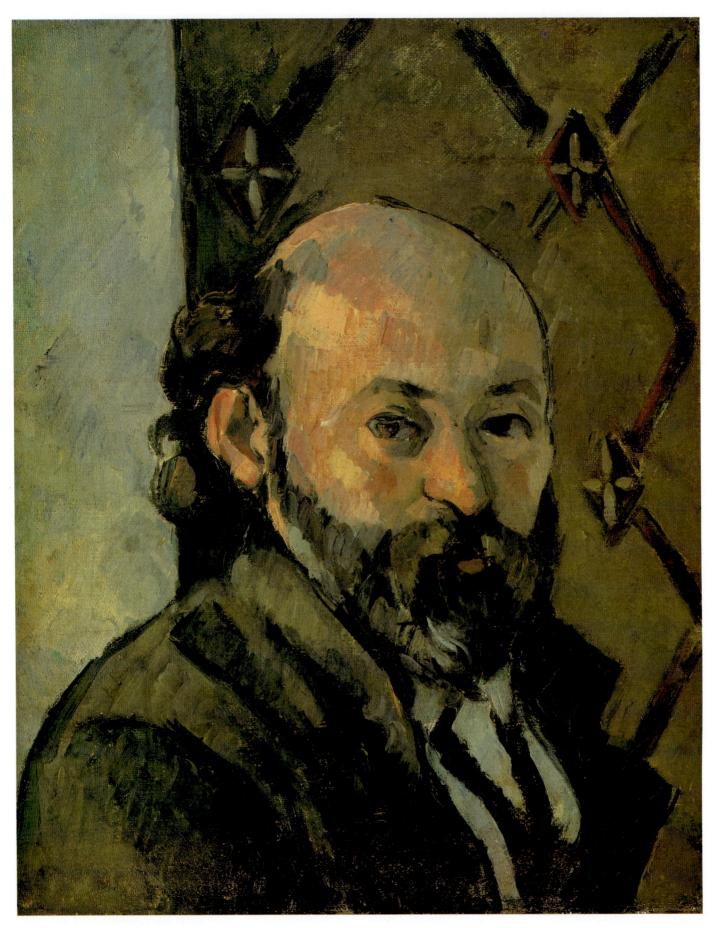

969. Paul Cézanne. Self-Portrait. c. 1879. Oil on canvas, $13^3/4 \times 10^5/8$ " (35 x 27 cm). The Tate Gallery, London

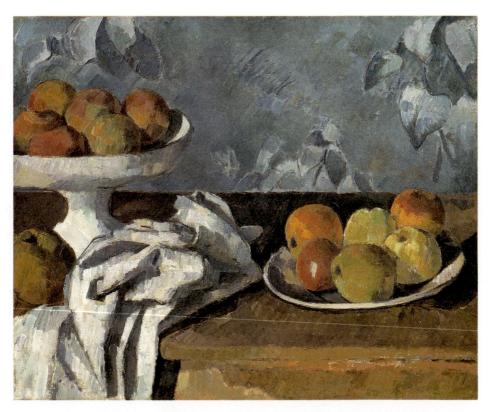

970. Paul Cézanne. Still Life with Apples in a Bowl. 1879–82. Oil on canvas, $17^{1/8} \times 21^{1/4}$ " (43.5 x 54 cm). Ny Carlsberg Glyptotek, Copenhagen, Denmark

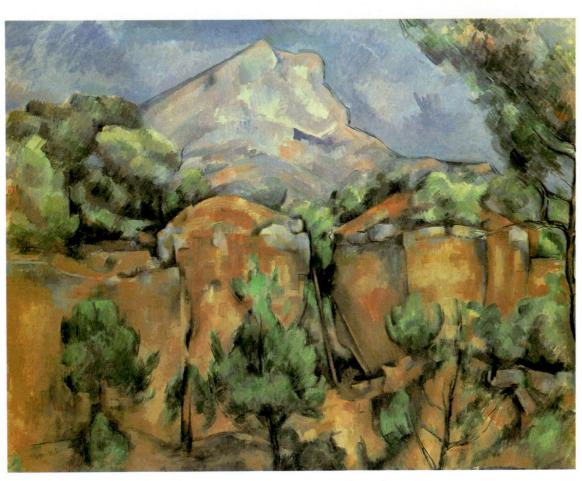

971. Paul Cézanne. Mont Ste.-Victoire seen from Bibemus Quarry. c. 1897-1900. Oil on canvas, $25^{1/2}$ x $31^{1/2}$ " (65.1 x 80 cm). The Baltimore Museum of Art The Cone Collection, formed by Dr. Claribel Cone and Miss Etta Cone of Baltimore, Maryland

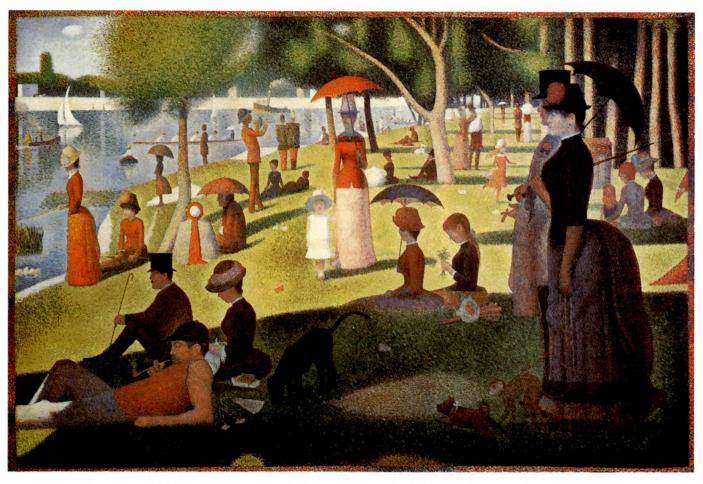

972. Georges Seurat. A Sunday Afternoon on the Island of La Grande Jatte. 1884–86.
Oil on canvas, 6'10" x 10'1¹/4" (2.08 x 3.08 m). The Art Institute of Chicago
Helen Birch Bartlett Memorial Collection

SEURAT. Georges Seurat (1859–1891) shared Cézanne's aim to make Impressionism "solid and durable," but he went about it very differently. His goal, he once stated, was to make "modern people, in their essential traits, move about as if on friezes, and place them on canvases organized by harmonies of color, by directions of the tones in harmony with the lines, and by the directions of the lines." Seurat's career was as brief as those of Masaccio, Giorgione, and Géricault, and his achievement just as astonishing. Although he participated in the last Impressionist show, it is an indication of the Post-Impressionist revolution that thereafter he exhibited with an entirely new group, the Society of Independents.

Seurat devoted his main efforts to a few very large paintings, spending a year or more on each of them and making endless series of preliminary studies before he felt sure enough to tackle the definitive version. A Sunday Afternoon on the Island of La Grande Jatte (fig. 972), his greatest masterpiece, had its genesis in this painstaking method. The subject is of the sort that had long been popular among Impressionist painters. Impressionist, too, are the brilliant colors and the effect of intense sunlight. Otherwise, however, the picture is the very opposite of a quick "impression." The firm, simple

contours and the relaxed, immobile figures give the scene a stability that recalls Piero della Francesca (see fig. 562) and shows a clear awareness of Puvis de Chavannes (see pages 579–60).

In the *Grande Jatte*, modeling and foreshortening are reduced to a minimum, and the figures appear mostly in either strict profile or frontal views, as if Seurat had adopted the rules of ancient Egyptian art. Moreover, he has fitted them within the composition as tightly as the pieces of a jigsaw puzzle. So exactly are they fixed in relation to each other that not a single one could be moved by even a millimeter. Frozen in time and space, they act out their roles with ritualized gravity, in contrast to the joyous abandon of the relaxed crowd in Renoir's *Le Moulin de la Galette* (fig. 936), who are free to move about in the open air. Thus despite the period costumes, we read this cross section of Parisian society as timeless. Small wonder the picture remains so spellbinding more than a century after it was painted.

Even the brushwork demonstrates Seurat's passion for order and permanence. The canvas surface is covered with systematic, impersonal "flicks" that make Cézanne's architectural brushstrokes seem temperamental and dynamic by comparison. These tiny dots of brilliant color were supposed to

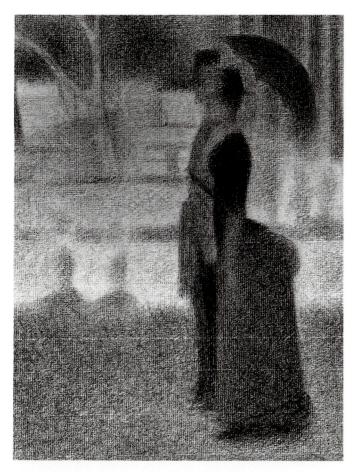

973. Georges Seurat. The Couple. c. 1884-85. Conté crayon on paper, 11¹/₂ x 9" (29.2 x 22.8 cm). Private collection, Paris

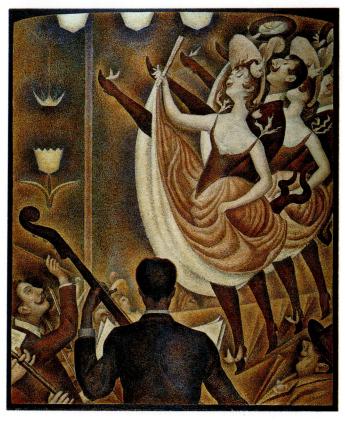

974. Georges Seurat. Chahut. 1889-90. Oil on canvas, 66¹/₂ x 54³/₄" (169 x 139 cm). Rijksmuseum Kröller-Müller, Otterlo, Holland

merge in the beholder's eye and produce intermediary tints more luminous than those obtainable from pigments mixed on the palette. This procedure was variously known as Neo-Impressionism, Pointillism, or Divisionism (the term preferred by Seurat). The actual result, however, did not conform to the theory. Looking at the Grande Jatte from a comfortable distance (seven to ten feet from the original), we find that the mixing of colors in the eye remains incomplete; the dots do not disappear, but are as clearly visible as the tesserae of a mosaic (compare figs. 321 and 322). Seurat himself must have liked this unexpected effect, which gives the canvas the quality of a shimmering, translucent screen. Otherwise he would have reduced the size of the dots.

The painting has a dignity and simplicity suggesting a new classicism, but it is a distinctly modern classicism based on scientific theory. Seurat adapted the laws of color discovered by Eugène Chevreul, O. N. Rood, and David Sutter, as part of a comprehensive approach to art. Like Degas, he had studied with a follower of Ingres, and his theoretical interests grew out of this experience. He came to believe that art must be based on a system. With the help of his friend Charles Henry (who was, like Rood and Sutter, an American), he formulated a series of artistic "laws" based on early experiments in the psychology of visual perception. These principles helped him to control every aesthetic and expressive aspect of his paintings. But, as with all artists of genius, Seurat's theories do not really explain his pictures. It is the pictures, rather, that explain the theories.

Strange as it may seem, color was an adjunct to form in Seurat's work—the very opposite of the Impressionists' technique. Most of his output consists of drawings done in conté crayon, made of graphite and clay, which provides rich, velvety blacks (fig. 973). These have a haunting mystery all their own, in contrast to the festive colors of his paintings. In sheets such as ours, Seurat's forms achieve a machinelike quality through rigorous abstraction. This is the first expression of a peculiarly modern outlook leading to Futurism (see page 794). Seurat's systematic approach to art has the internal logic of modern engineering, which he and his followers hoped would transform society for the better. This social consciousness was allied to a form of anarchism descended from Courbet's friend Proudhon, and contrasts with the general political indifference of the Impressionists. The fact that Seurat shares the same subject matter as the Impressionists serves only to emphasize further the fundamental difference in attitude.

Toward the end of his brief career, Seurat's paintings acquired a new liveliness, seen in Chahut (fig. 974). True, everything is held very precisely in place by a system of vertical and horizontal coordinates that defines the canvas as a self-contained rectilinear field. Only in the work of Vermeer have we encountered a similar "area-consciousness" (compare fig. 789). But while these dancers move in lockstep, the decorative arabesques within the flat design possess an unexpected energy. Consciously or unconsciously, Seurat here moves close to the world of commercial art. The speckled surface resembles the cheap offset printing then coming into use. The subject and composition, too, directly anticipate the posters of Henri de Toulouse-Lautrec—even in the marvelous wit and insight with which the facial expressions are observed.

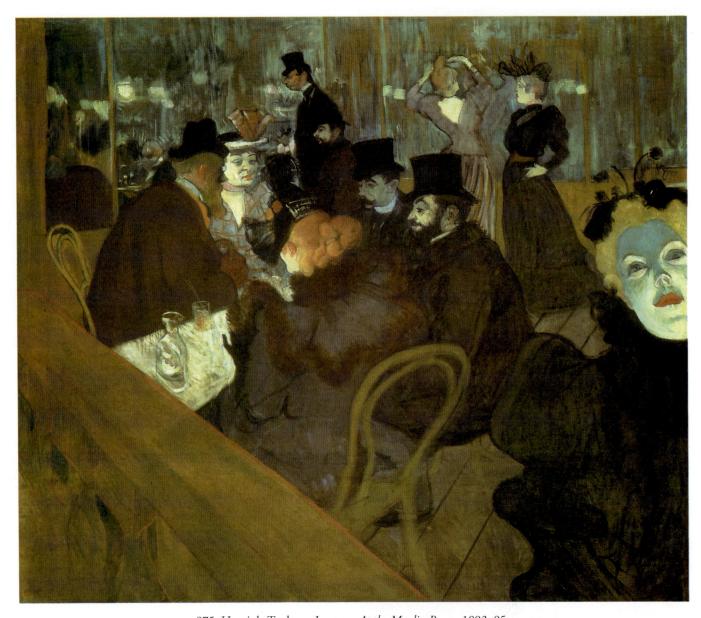

975. Henri de Toulouse-Lautrec. At the Moulin Rouge. 1893-95. Oil on canvas, $48^3/8 \times 55^1/2$ " (123 x 141 cm). The Art Institute of Chicago Helen Birch Bartlett Memorial Collection

TOULOUSE-LAUTREC. Physically a dwarf, Henri de Toulouse-Lautrec (1864–1901) was an artist of superb talent who led a dissolute life in the night spots and brothels of Paris and died of alcoholism. He was a great admirer of Degas, and his At the Moulin Rouge (fig. 975) recalls the zigzag pattern of Degas' The Glass of Absinthe (see fig. 938). Yet this view of the well-known nightclub is no Impressionist "slice of life." Toulouse-Lautrec sees through the gay surface of the scene, viewing performers and customers with a pitilessly sharp eye for their character—including his own: he is the tiny bearded man next to the very tall one in the back of the room. The large areas of flat color, however, and the emphatic, smoothly curving outlines, reflect the influence of Gauguin (compare fig. 980). The Moulin Rouge that Toulouse-Lautrec shows here has an atmosphere so joyless and oppressive that we have to wonder if the artist did not regard it as a place of evil.

If his paintings inevitably bring to mind Degas and Gauguin, Toulouse-Lautrec is without precedent as a graphic artist. His posters, done in a distinctive style of his own invention, are ideally suited to inexpensive lithography, which enforces an equal economy of form and color. His first poster, La Goulue (fig. 976), which established his fame, lends this seedy demimonde an air of glamour that is at once captivating and mysterious. As advertising it sets a standard that has rarely been matched. The design is wed to the text so seamlessly that they cannot live without each other.

VAN GOGH. While Cézanne and Seurat were converting Impressionism into a more severe, classical style, Vincent van Gogh (1853–1890) pursued the opposite direction. He believed that Impressionism did not provide the artist with enough freedom to express his emotions. Since this was his main

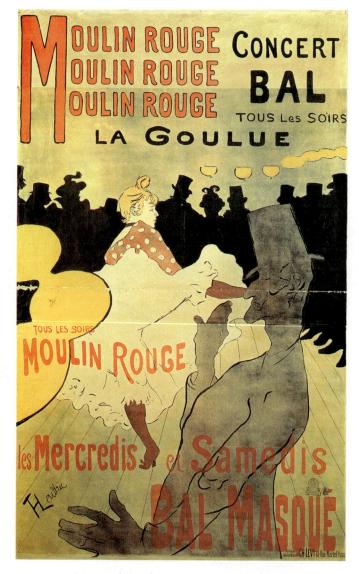

976. Henri de Toulouse-Lautrec. La Goulue. 1891. Colored lithographic poster, 6'3" x 3'10" (1.90 x 1.16 m)

concern, he is sometimes called an Expressionist, although the term ought to be reserved for certain later painters (see page 780). Van Gogh, the first great Dutch master since the seventeenth century, did not become an artist until 1880; as he died only ten years later, his career was even briefer than Seurat's. His early interests were in literature and religion. Profoundly dissatisfied with the values of industrial society and imbued with a strong sense of mission, he worked for a while as a lay preacher among poverty-stricken coal miners in Belgium. This same intense feeling for the poor dominates the paintings of his pre-Impressionist period, 1880–85. In *The Potato Eaters* (fig. 977), the last and most ambitious work of those years, there remains a naïve clumsiness that comes from his lack of conventional training, but this only adds to the expressive power of his style. [See Primary Sources, no. 93, page 940.] We are reminded of Daumier and Millet (see figs. 877 and 882), and of Rembrandt and Le Nain (see figs. 780 and 792). For this peasant family, the evening meal has the solemn importance of a rite.

When he painted *The Potato Eaters*, Van Gogh had not yet discovered the importance of color. A year later in Paris, where his brother Theo had a gallery devoted to modern art, he met

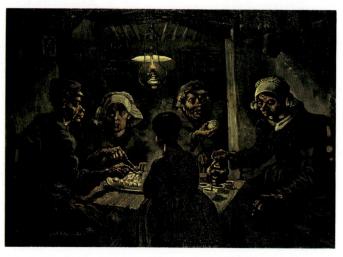

977. Vincent van Gogh. The Potato Eaters. 1885. Oil on canvas, 321/4 x 45" (82 x 114.3 cm). Vincent van Gogh Foundation/ Van Gogh Museum, Amsterdam

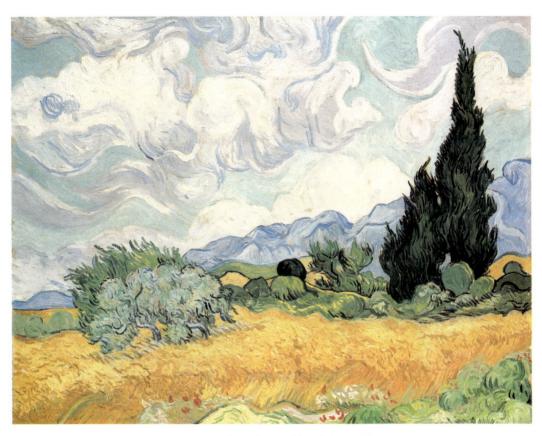

978. Vincent van Gogh. Wheat Field and Cypress Trees. 1889. Oil on canvas, $28^{1/2} \times 36^{\circ}$ (72.4 x 91.4 cm). The National Gallery, London Reproduced by courtesy of the Trustees

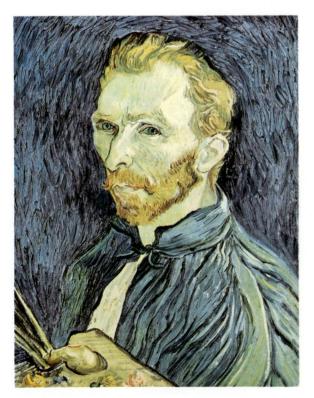

979. Vincent van Gogh. Self-Portrait. 1889. Oil on canvas, 221/2 x 17" (57.2 x 43.2 cm). Collection Mrs. John Hay Whitney, New York

Degas, Seurat, and other leading French artists. Their effect on him was electrifying. His pictures now blazed with color, and he even experimented briefly with the Divisionist technique of Seurat. This Impressionist phase, however, lasted less than two years. Although it was vitally important for his development, he had to integrate it with the style of his earlier years before his genius could fully unfold. Paris had opened his eyes to the sensuous beauty of the visible world and had taught him the pictorial language of the color patch, but painting continued to be nevertheless a vessel for his personal emotions. To investigate this spiritual reality with the new means at his command, he went to Arles, in the south of France. It was there, between 1888 and 1890, that he produced his greatest pictures.

Like Cézanne, Van Gogh now devoted his main energies to landscape painting, but the sun-drenched Mediterranean countryside evoked a very different response in him: he saw it filled with ecstatic movement, not architectural stability and permanence. In Wheat Field and Cypress Trees (fig. 978), both earth and sky pulsate with an overpowering turbulence. The wheat field resembles a stormy sea, the trees spring flamelike from the ground, and the hills and clouds heave with the same undulant motion. The dynamism contained in every brushstroke makes of each one not merely a deposit of color, but an incisive graphic gesture. The artist's personal "handwriting" is here an even more dominant factor than in the canvases of Daumier (compare figs. 877 and 878). Yet to Van Gogh himself it was the color, not the form, that determined the expressive content of his pictures. The letters he wrote to his brother include many eloquent descriptions of his choice of hues and the emotional meanings he attached to them. He

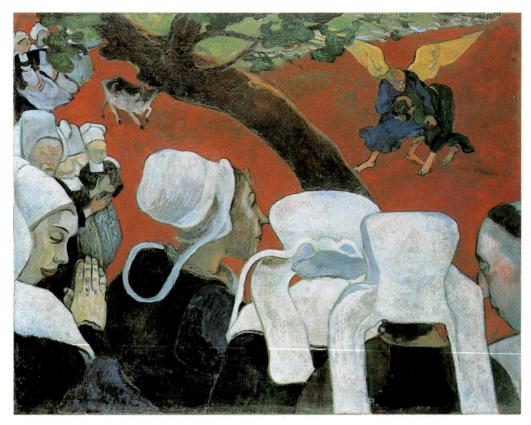

980. Paul Gauguin. The Vision After the Sermon (Jacob Wrestling with the Angel). 1888. Oil on canvas, $28^{3}/4 \times 36^{1}/2$ " (73 x 92.7 cm). The National Galleries of Scotland, Edinburgh

had learned about Impressionist color from Pissarro, but his personal color symbolism probably stemmed from discussions with Paul Gauguin (see below), who stayed with Van Gogh at Arles for several months. (Yellow, for example, meant faith or triumph or love to Van Gogh, while carmine was a spiritual color, cobalt a divine one; red and green, on the other hand, stood for the terrible human passions.) Although he acknowledged that his desire "to exaggerate the essential and to leave the obvious vague" made his colors look arbitrary by Impressionist standards, he nevertheless remained deeply committed to the visible world. [See Primary Sources, no. 94, page 940.]

Compared to Monet's On the Bank of the Seine (see fig. 933), the colors of Wheat Field and Cypress Trees are stronger, simpler, and more vibrant, but in no sense "unnatural." They speak to us of that "kingdom of light" Van Gogh had found in the South, and of his mystic faith in a creative force animating all forms of life—a faith no less ardent than the sectarian Christianity of his early years. His Self-Portrait (fig. 979) will remind us of Dürer's (fig. 701), and with good reason: the missionary had now become a prophet. His emaciated, luminous head with its burning eyes is set off against a whirlpool of darkness. "I want to paint men and women with that something of the eternal which the halo used to symbolize," Van Gogh had written, groping to define for his brother the human essence that was his aim in pictures such as this. At the time of the Self-Portrait, he had already begun to suffer fits of a mental illness that made painting increasingly difficult for him. Despairing of a cure, he committed suicide a year later, for he felt very deeply that art alone made his life worth living.

GAUGUIN. The quest for religious experience also played an important part in the work, if not in the life, of another great Post-Impressionist, Paul Gauguin (1848-1903). He began as a prosperous stockbroker in Paris and an amateur painter and collector of modern pictures. At the age of 35, however, he became convinced that he must devote himself entirely to art. He abandoned his business career, separated from his family, and by 1889 was the central figure of a new movement called Synthetism or Symbolism.

Gauguin started out as a follower of Cézanne and once owned one of his still lifes. He then developed a style that, though less intensely personal than Van Gogh's, was in some ways an even bolder advance beyond Impressionism. Gauguin believed that Western civilization was "out of joint," that industrial society had forced people into an incomplete life dedicated to material gain, while their emotions lay neglected. To rediscover for himself this hidden world of feeling, Gauguin left Paris in 1886 to live among the peasants of Brittany at Pont Aven in western France. There two years later he met the painters Émile Bernard (1868–1941) and Louis Anquetin (1861-1932), who had rejected Impressionism and began to evolve a new style which they called Cloissonism (after an enamel technique), for its strong outlines. Gauguin incorporated their approach into his own, and emerged as the most forceful member of the Pont-Aven group, which quickly came to center on him.

The Pont-Aven style was first developed fully in the works Gauguin and Bernard painted at Pont Aven during the summer of 1888. Gauguin noticed particularly that religion was still part of the everyday life of the country people, and in pictures such as The Vision After the Sermon (Jacob Wrestling with the Angel) (fig. 980), he tried to depict their simple, direct faith. Here at last is what no Romantic artist had achieved: a style based on pre-Renaissance sources. Modeling and

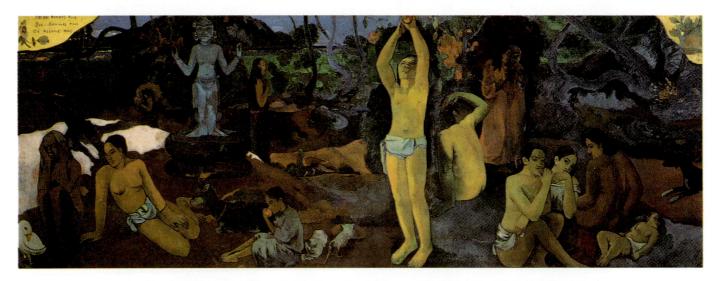

981. Paul Gauguin. Where Do We Come From? What Are We? Where Are We Going? 1897. Oil on canvas, 4'6³/4" x 12'3¹/2"(1.3 x 3.7 m). Museum of Fine Arts, Boston Arthur Gordon Tompkins Residuary Fund

perspective have given way to flat, simplified shapes outlined heavily in black, and the brilliant colors are equally "unnatural." This style, inspired by folk art and medieval stained glass, is meant to re-create both the imagined reality of the vision and the trancelike rapture of the peasant women. The painting fulfills the goal of Synthetism: by treating the canvas in this decorative manner, the artist has turned it from a representation of the external world into an aesthetic object that projects an internal idea without using narrative or literal symbols. Yet we sense that although he tried to share this experience, Gauguin remains an outsider. He could paint pictures about faith, but not from faith.

Two years later, Gauguin's search for the unspoiled life led him even farther afield. He went to Tahiti—he had already visited Martinique in 1887—as a sort of "missionary in reverse," to learn from the natives instead of teaching them. [See Primary Sources, no. 95, page 940.] Although he spent the rest of his life in the South Pacific (he returned home only once, from 1893 to 1895), he never found the virgin Eden he was seeking. Indeed, he often had to rely on the writings and photographs of those who had recorded its culture before him. Nonetheless his Tahitian canvases conjure up an ideal world filled with the beauty and meaning he sought so futilely in real life.

His masterpiece in this vein is Where Do We Come From? What Are We? Where Are We Going? (fig. 981), painted as a summation of his art shortly before he was driven by despair to attempt suicide. Even without the suggestive title, we would recognize the painting's allegorical purpose from its monumental scale, the carefully thought out poses and placement of the figures within the tapestrylike landscape, and their pensive air. Although Gauguin intended the surface to be the sole conveyer of meaning, we know from his letters that the huge can-

vas represents an epic cycle of life. The scene unfolds from right to left, beginning with the sleeping girl, continuing with the beautiful young woman (a Tahitian Eve) in the center picking fruit, and ending with "an old woman approaching death who seems reconciled and resigned to her thoughts." In effect, the picture constitutes a variation on the three ages of life found in *Death and the Maiden* by Hans Baldung Grien (see fig. 708). The enigmatic Maori god overseeing everything acts as a counterpart to the figure of Death in Baldung Grien's painting. Gauguin has cast the answer to his title in distinctly Western terms. Moreover, he painted the composition in response to Puvis de Chavannes' classical allegories, such as those in the Lyons museum—especially *The Sacred Grove* (fig. 984, left). In this primitive Eden, Gauguin tell us, lies the real secret to the central mystery of life, not in some mythical past.

The works that come closest in flavor to Tahitian culture are Gauguin's woodcuts. *Offerings of Gratitude* (fig. 982), like the *Vision*, presents the theme of religious worship, but the image of a local god replaces the biblical subject. In its frankly "carved" look and its bold white-on-black pattern, we can feel the influences of the native art of the South Seas and of other non-European styles. The renewal of Western art and civilization as a whole, Gauguin believed, must come from "the Primitives." He advised other Symbolists to shun the Greek tradition and to turn instead to Persia, the Far East, and ancient Egypt.

The idea of primitivism itself was not new. It stems from the Romantic myth of the Noble Savage, propagated by the thinkers of the Enlightenment more than a century before, and its ultimate source is the age-old tradition of an earthly paradise where human societies once dwelled—and might perhaps live again—in a state of nature and innocence. But no one before Gauguin had gone as far to put the doctrine of

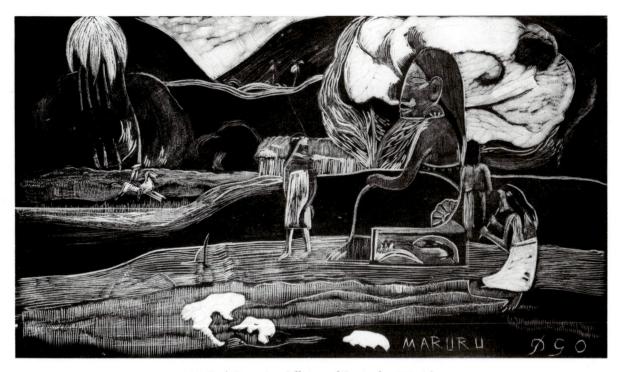

982. Paul Gauguin. *Offerings of Gratitude.* 1893–94. Wood engraving, 8¹/16 x 14" (20.4 x 35.5 cm). The Museum of Modern Art, New York Lillie P. Bliss Collection

primitivism into practice. His pilgrimage to the South Pacific had more than a purely private meaning. It symbolizes the end of the 400 years of colonial expansion which had brought almost the entire globe under Western domination. The "white man's burden," once so cheerfully and ruthlessly shouldered by the empire builders, was becoming unbearable.

Symbolism

Van Gogh's and Gauguin's discontent with the spiritual ills of Western civilization was part of a sentiment widely shared at the end of the nineteenth century. It reflected an intellectual and moral upheaval that rejected the modern world and its materialism in favor of irrational states of mind. A self-conscious preoccupation with decadence, evil, and darkness pervaded the artistic and literary climate. Even those who saw no escape analyzed their predicament in fascinated horror. Yet, somewhat paradoxically, this very awareness proved to be a source of strength, for it gave rise to the remarkable movement known as Symbolism. (The truly decadent, we may assume, are unable to realize their plight.)

Symbolism in art was at first an outgrowth of the literary movement that arose in 1885–86, with Jean Moréas and Gustave Kahn at its helm. Reacting against the Naturalism of the novelist Émile Zola, they reasserted the primacy of subjective ideas and championed the *poètes maudits* (the doomed poets) Stéphane Mallarmé and Paul Verlaine. There was a natural sympathy between the Pont-Aven painters and the Symbolist poets, and in a long article defining Symbolism published in April 1892, the writer G. Albert Aurier insisted on Gauguin's leadership. Nevertheless, unlike Post-Impressionism, which

was a stylistic tendency, Symbolism was a general outlook, one that allowed for a wide variety of styles—whatever would embody its peculiar frame of mind.

THE NABIS. Gauguin's Symbolist followers, who called themselves Nabis (from the Hebrew word for "prophet"), were less remarkable for creative talent than for their ability to spell out and justify the aims of Post-Impressionism in theoretical form. One of them, Maurice Denis, coined the statement that was to become the first article of faith for modernist painters of the twentieth century: "A picture—before being a war horse, a female nude, or some anecdote—is essentially a flat surface covered with colors in a particular order." He added that "every work of art is a transposition, a caricature, the passionate equivalent of a received sensation." The theory of equivalents gave the Nabis their independence from Gauguin. "We supplemented the rudimentary teaching of Gauguin by substituting for his over-simplified idea of pure colors the idea of beautiful harmonies, infinitely varied like nature; we adapted all the resources of the palette to all the states of our sensibility; and the sights which caused them became to us so many signs of our own subjectivity. We sought equivalents, but equivalents in beauty!"

VUILLARD. We can now understand why paintings by the Nabis soon came to look so different from Gauguin's. They became involved with decorative projects which, like Whistler's Peacock Room (see fig. 967), participate in the late-nineteenth-century's retreat into a world of beauty. The pictures of the 1890s by Édouard Vuillard (1868–1940), the most gifted member of the Nabis, share this quality. They consist mainly of domestic scenes, small in scale and intimate in effect, like

Music in the Post-Impressionist Era

The late nineteenth century presents a welter of musical tenden-

cies no less perplexing than the diversity found in Post-Impressionism. Strictly speaking, the term Impressionism cannot be applied to music, because music, by its very nature, cannot describe, it can only evoke. The term has nevertheless often been used to characterize the works of the Frenchman Claude Debussy (1862-1918), such as La Mer (1905), which successfully conveys the contrasting moods of the sea. In reality, however, his compositions are much closer in spirit to Symbolist poetry. (His closest friends, such as Pierre Louÿs, were writers.) This is especially evident in his lone opera, Pelléas et Mélisande (1893-1902), which was derived from a play by the Franco-Belgian Symbolist Maurice Maeterlinck (1862-1949); despite the vast difference between them, the opera reveals a debt to Wagner's music, which Debussy first heard at Bayreuth in 1888. Early in his career, Debussy summered in Russia as the guest of Tchaikovsky's patron, Madame von Meck, and it must have been at that time that he first became interested in modes, as well as other "lost" and exotic musical forms. This interest was reinforced by hearing Javanese music at the Universal Exposition in Paris in 1889. As a consequence, he began to employ such unusual devices as the pentatonic scale (the five black notes on the piano), which in his later years push conventional tonalism virtually to its breaking point.

Symbolism also touched Debussy's fellow "Impressionist," Maurice Ravel (1875–1937), particularly in such early works as Gaspard de la nuit (1908) for piano, which was inspired by a poem by Aloysius Bertrand (1807-1841). It also underlies the enchanting Mother Goose, originally composed that same year as a piano duet for the daughters of a close friend and later orchestrated as a ballet: the choice of stories and their musical treatment revels in the realm of dreams and other emanations of the subconscious, despite the air of childlike innocence.

The music of Debussy and Ravel was in many respects the conscious antithesis of Neo-Romanticism, that late phase of Romanticism which is identified particularly with the German composers Gustav Mahler (1866-1911) and Richard Strauss (1864–1949). Strauss started out as a classicist but through his friendship with the poet Alexander Ritter (1833-1896) became a disciple of Wagner and Liszt. While pursuing a career as a conductor, he first gained fame for his tone poems, such as Death and Transfiguration (1889). From 1905 on, however, Strauss devoted himself primarily to operas, notably Der Rosenkavalier (The Cavalier of the Rose; 1911), which, like all his finest efforts, was the result of his collaboration with the Austrian Neo-Romantic poet and dramatist Hugo von Hofmannsthal (1874–1929). The composer later supported the Nazis and served for a while as head of musical affairs under Hitler, although he was officially exonerated of collaboration shortly before his death.

If Strauss represents the final glory of German Romanticism,

the symphonies and orchestrated song cycles by his friend and fellow conductor Gustav Mahler of Vienna can be seen as the musical counterpart to the morbid sensitivity of Gustav Klimt and the Vienna Secession movement. Their enormous scale makes huge demands on orchestra and chorus alike, while the extremes of hypersensitive introspection and almost hysterical bombast go beyond the expressive limits of Romanticism. Mahler's late works, sparser in character, were the point of departure for the next generation of Viennese composers, whose work he encouraged: Arnold Schoenberg, Anton Webern, and Alban Berg, who were to revolutionize twentieth-century music.

This fact points to an anomaly, namely, that a number of late Romantics had the unfortunate fate of living well beyond the advent of modern music. Both Ravel and the Finnish composer Jean Sibelius (1865–1957) responded by virtually ceasing to write music after 1925. Sibelius was a throwback to the nationalist composers of the mid-nineteenth century. His early works are tone poems, based on Nordic legends, that are filled with a brooding melancholy. His major contribution, however, lies in the seven symphonies, which build short motifs into large structures of decidedly unconventional form that nearly stand Romanticism on its ear. Although passionate at times, his compositions lack the lush, sentimental appeal of those by the other great nationalist composer of the era, the Russian Sergei Rachmaninov (1873–1943), who wrote piano concertos as showcases for his virtuosity, in addition to three symphonies that follow in a direct line of descent from Tchaikovsky's.

Just as there was no true Impressionism in music, so the term realism in late-nineteenth-century opera is something of a misnomer. It was applied to a small group of operas including Carmen (1875) by Georges Bizet (1838–1875) and Pagliacci (1892) by Ruggiero Leoncavallo (1858-1919), which is often produced on the same bill with Cavalleria Rusticana (1889) by Pietro Mascagni (1863-1945)—set in contemporary Europe that are nonetheless sentimental melodramas. La Bohème (1896) and Tosca (1900) by Giacomo Puccini (1858–1924), Verdi's successor as the leading composer of this genre in Italy, partake of this verismo, as it was called, although they are set earlier in the century; however, they owe their success much more to their combination of melting lyricism and pungent drama. The later operas, such as Madame Butterfly (1904) and Girl of the Golden West (1910), based on successful melodramas by the American playwright David Belasco (c. 1853–1931), exploit the European taste for the exotic, although they were failures initially. Belasco's plays, however, were considered examples of realism by audiences in the United States, to whom their setting and moral meaning were instantly recognizable. Their realism was heightened by spectacular staging and special effects.

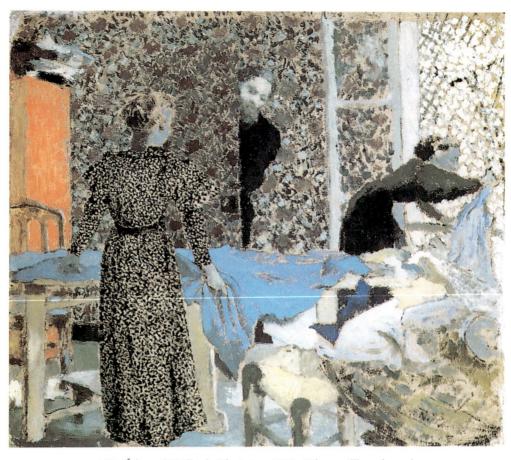

983. Édouard Vuillard. The Suitor. 1893. Oil on millboard panel, 12¹/2 x 14" (31.8 x 35.6 cm). Smith College Museum of Art, Northampton, Massachusetts Purchased, Drayton Hillyer Fund, 1938

The Suitor (fig. 983). These combine into a remarkable new entity the flat planes and emphatic contours of Gauguin (fig. 980) with the shimmering Divisionist "color mosaic" and the geometric surface organization of Seurat (see fig. 974). This seemingly casual view of his mother's corset-shop workroom has a delicate balance of "two-D" and "three-D" effects. Indeed, Vuillard probably derived his flat patterns from the fabrics themselves. The picture's quiet magic makes us think of Vermeer and Chardin (compare figs. 789 and 821), whose subject matter, too, was the snug life of the middle class.

In both subject and treatment, the painting has counterparts as well in Symbolist literature and theater: the poetry of Paul Verlaine, the novels of Stéphane Mallarmé, and the productions of Aurélian-Marie Lugné-Poë, for whom Vuillard designed stage sets. It evokes a host of feelings through purely formal means that could never be conveyed by naturalism alone. The Nabis established an important precedent for Matisse a decade later (see fig. 1022). By then, however, the movement had disintegrated as its members became more conservative. Vuillard himself turned more to naturalism, and he never recaptured the delicacy and daring of his early canvases.

PUVIS DE CHAVANNES. The Symbolists discovered that there were some older artists, descendants of the Romantics, whose work, like their own, placed inner vision above the observation of nature. Many of them, as well as other Post-

Impressionists, took their inspiration from the classicism of Pierre-Cécile Puvis de Chavannes (1824–1898), a follower of Ingres who succeeded in becoming the leading muralist of his day. Rejecting academic conventions, he sought a radical simplification of style, which at first seemed anachronistic but was soon hailed by the critics and artists of all persuasions. The effectiveness of the murals he executed in the 1880s for the museum at Lyons (fig. 984) depends in large part on Puvis' formal devices—the compressed space, schematic forms, and restricted palette, which imitates in oil the chalky surface of old frescoes. The antinaturalism of his style emphasizes the allegorical character of the scene, lending it a gravity and mystery absent from other decorative paintings by his contemporaries. Anecdotal interest is replaced by nostalgia for an idealized, mythical past. The stiff, ritualistic poses serve both to freeze time and to convey a poetry that is at once elegiac and serene. Puvis' economy of means was intended to present his ideas with maximum clarity, but it has just the opposite effect: it heightens their suggestiveness. His popularity resulted precisely from this ambiguity, which permitted a wide variety of interpretation. Symbolists from Gauguin through the young Picasso could thus claim him as one of their own; nevertheless, he vehemently protested any association with the Symbolist movement, although he reciprocated an admiration with the English Pre-Raphaelite Burne-Jones (see pages 728-29).

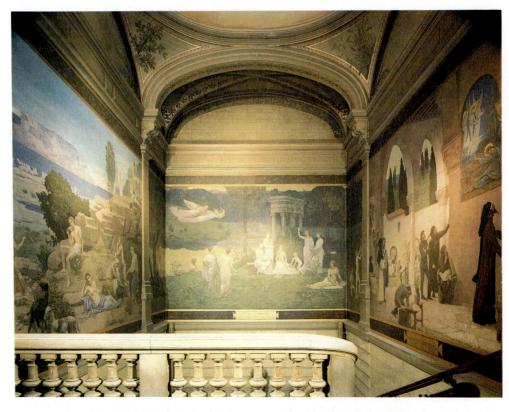

984. Pierre-Cécile Puvis de Chavannes. *The Sacred Grove.* c. 1883–84; Vision of Antiquity. c. 1888–89; and Christian Inspiration. c. 1888–89. Painting cycle, grand staircase, Musée des Beaux-Arts, Lyons, France

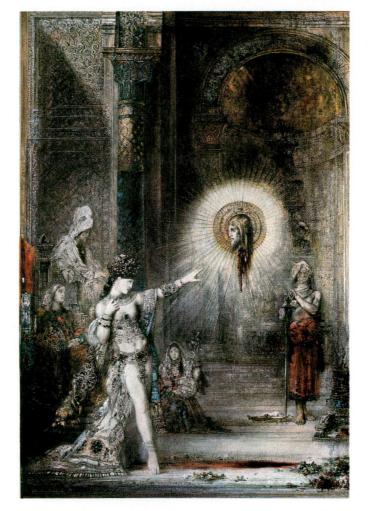

985. Gustave Moreau. *The Apparition (Dance of Salome)*. c. 1876. Watercolor, 41³/4 x 28³/8" (106 x 72 cm). Musée du Louvre, Paris

760 Post-Impressionism, Symbolism, and Art Nouveau

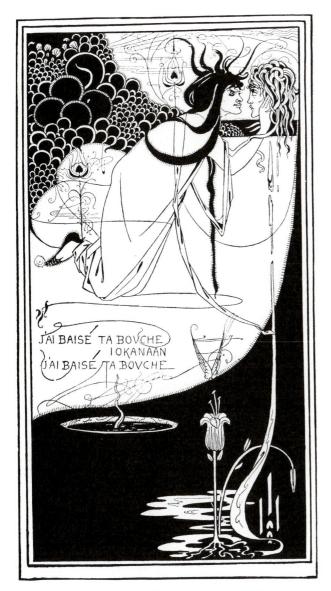

986. Aubrey Beardsley. *Salome*. 1892. Pen drawing, 10¹⁵/₁₆ x 5¹³/₁₆" (27.8 x 14.8 cm). Aubrey Beardsley Collection. Manuscripts Division, Department of Rare Books and Special Collections, Princeton University Library, New Jersey

MOREAU. One of the Symbolists, Gustave Moreau (1826– 1898), a recluse who admired Delacroix, created a world of personal fantasy that has much in common with the medieval reveries of some of the English Pre-Raphaelites. The Apparition (fig. 985) shows one of his favorite themes: the head of John the Baptist, in a blinding radiance of light, appears to the dancing Salome. Her odalisquelike sensuousness, the stream of blood pouring from the severed head, the vast, mysterious space of the setting suggestive of an exotic temple rather than of Herod's palace, all these summon up the dreams of Oriental splendor and cruelty so dear to the Romantic imagination, combined with an insistence on the reality of the supernatural. Only late in life did Moreau achieve a measure of recognition. Suddenly, his art was in tune with the times. During his last six years, he even held a professorship at the conservative École des Beaux-Arts, the successor of the official art academy that had been founded under Louis XIV (see page 600). There he attracted the most gifted students, among them such future modernists as Matisse and Rouault.

987. Odilon Redon. *The Eye Like a Strange Balloon Mounts Toward Infinity*, from the series *Edgar A. Poe.* 1882. Lithograph, $10^{1/4} \times 7^{11}/16$ " (25.9 x 19.6 cm). The Museum of Modern Art, New York

Gift of Peter H. Deitsch

BEARDSLEY. How prophetic Moreau's work was of the taste prevailing at the end of the century is evident from a comparison with Aubrey Beardsley (1872-1898), a gifted young Englishman whose elegantly "decadent" black-and-white drawings were the very epitome of that taste. They include a Salome illustration (fig. 986) that might well be the final scene of the drama depicted by Moreau: Salome has taken up John's severed head and triumphantly kissed it. Whereas Beardsley's erotic meaning is plain—Salome is passionately in love with John and has asked for his head because she could not have him in any other way—Moreau's remains ambiguous. Nevertheless, the parallel is striking, and there are formal similarities as well, such as the "stem" of trickling blood from which John's head rises like a flower. Yet Beardsley's Salome cannot be said to derive from Moreau's. The sources of his style are English the graphic art of the Pre-Raphaelites (see fig. 966)—with a strong mixture of Japanese influence.

REDON. Another solitary artist whom the Symbolists discovered and claimed as one of their own was Odilon Redon (1840–1916). Like Moreau, he had a haunted imagination, but his imagery was even more personal and disturbing. A master of etching and lithography, he drew inspiration from the fantastic visions of Goya (see fig. 862) as well as Romantic literature. The lithograph shown in figure 987 is one of a

988. James Ensor. Christ's Entry into Brussels in 1889. 1888. Oil on canvas, 8'6'1/2" x 14'1'1/2" (2.6 x 4.3 m). Collection of the J. Paul Getty Museum, Malibu, California

set he issued in 1882 and dedicated to Edgar Allan Poe. The American poet had been dead for 33 years; but his tormented life and his equally tortured imagination made him the very model of the poète maudit, and his works, excellently translated by Baudelaire and Mallarmé, were greatly admired in France. Redon's lithographs do not illustrate Poe. They are, rather, "visual poems" in their own right, evoking the macabre, hallucinatory world of Poe's imagination. In our example, the artist has revived an ancient device, the single eye representing the all-seeing mind of God. But, in contrast to the traditional form of the symbol, Redon shows the whole eyeball removed from its socket and converted into a balloon that drifts aimlessly in the sky.

ENSOR. The disquieting visual paradoxes in Redon's lithographs express the pessimism of a troubled mind struggling to find itself; only after 1900 did his outlook give way to a new serenity laden with spiritual overtones. In the art of the Belgian painter James Ensor (1860-1949), a cynical view of the human condition reaches obsessive intensity, and for much the same reason. In Christ's Entry into Brussels in 1889 (fig. 988) the demon-ridden world of Bosch and Schongauer has come to life again in modern guise (compare figs. 685 and 694). The painting, showing the Second Coming of Christ in contemporary Belgium, is a grotesque parody of a subject familiar to us since the Late Gothic (compare figs. 502 and 504). Here Christ is virtually lost in a sea of leering faces, which are treated as the epitome of evil. As we scrutinize these masks we become aware that they are the crowd's true faces, revealing the depravity ordinarily hidden behind the facade of everyday appearances. At the time, Ensor identified with Christ, whose suffering he felt paralleled his own at the hands of hostile critics and an indifferent public. Later, when his art began to gain wide acceptance, he abandoned this bitter attitude.

MUNCH. Something of the same macabre quality pervades the early work of Edvard Munch (1863-1944), a far more gifted artist who came to Paris from Norway in 1889 and based his starkly expressive style on Toulouse-Lautrec, Van Gogh, and Gauguin. The Scream (fig. 989) shows the influences of all three. It is an image of fear, the terrifying, unreasoned fear we feel in a nightmare. Unlike Goya and Fuseli (see figs. 862 and 884), Munch visualizes this experience without the aid of frightening apparitions, and his achievement is the more persuasive for that very reason. The rhythm of the long, wavy lines seems to carry the echo of the scream into every corner of the picture, making of earth and sky one great sounding board of fear.

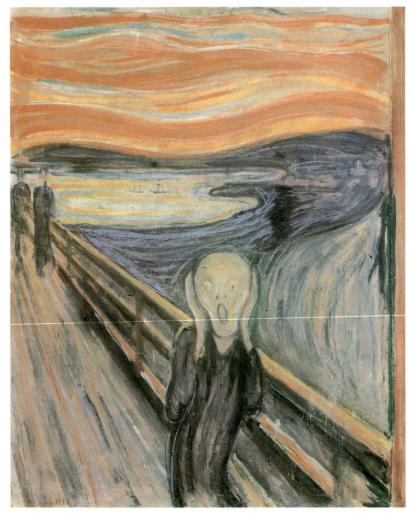

989. Edvard Munch. The Scream. 1893. Tempera and casein on cardboard, 36 x 29" (91.4 x 73.7 cm). Nasjonalgalleriet, Oslo, Norway

KLIMT. Munch's works generated such controversy when they were exhibited in Berlin in 1892 that a number of young radicals broke from the artists association and formed the Berlin Secession, which took its name from a similar group that had been founded in Munich earlier that year. The Secession quickly became a loosely allied international movement. In 1897 it spread to Austria, where Gustav Klimt (1862-1918) established the Vienna Secession with the purpose of raising the level of the arts and crafts in Austria through close ties to Art Nouveau (see pages 768-69). The Kiss (fig. 990) by Klimt expresses a different kind of anxiety from Munch's The Scream. The image will remind us of Beardsley's Salome (fig. 986), but here the barely suppressed eroticism has burst into desire. Engulfed in mosaiclike robes that create an illusion of rich beauty, the angular figures steal a moment of passion whose brevity emphasizes their joyless existence.

PICASSO'S BLUE PERIOD. When he came to Paris from his native Spain in 1900, Pablo Picasso (1881-1973) felt the spell of the same artistic atmosphere that had generated the style of Munch. His so-called Blue Period (the term refers to the prevailing color of his canvases as well as to their mood) consists almost exclusively of pictures of beggars and derelicts,

990. Gustav Klimt. The Kiss. 1907-8. Oil on canvas, 70⁷/8 x 70⁷/8" (180 x 180 cm). Österreichische Galerie, Vienna

991. Pablo Picasso. *The Old Guitarist*. 1903. Oil on panel, 48³/8 x 32¹/2" (122.9 x 82.6 cm). The Art Institute of Chicago Helen Birch Bartlett Memorial Collection

such as *The Old Guitarist* (fig. 991). These outcasts or victims of society have a pathos that reflects the artist's own sense of isolation. Yet they convey poetic melancholy more than outright despair. The aged musician accepts his fate with a resignation that seems almost saintly, and the attenuated grace of his limbs reminds us of El Greco (compare fig. 649). *The Old Guitarist* is a strange amalgam of Mannerism and of the art of Gauguin and Toulouse-Lautrec (note the smoothly curved contours), imbued with the personal gloom of a 22-year-old genius.

ROUSSEAU. A few years later, Picasso and his friends discovered a painter who until then had attracted no attention, although he had been exhibiting his work since 1886. He was Henri Rousseau (1844–1910), a retired customs collector who had started to paint in his middle age without training of any sort. His ideal—which, fortunately, he never achieved—was the arid academic style of the followers of Ingres. Rousseau is that paradox, a folk artist of genius. How else could he have done a picture like *The Dream* (fig. 992)? What goes on in the enchanted world of this canvas needs no explanation, because none is possible. Perhaps for that very reason its magic becomes believably real to us. Rousseau himself described the scene in a little poem:

992. Henri Rousseau. *The Dream.* 1910. Oil on canvas, 6'8¹/2" x 9'9¹/2" (2.05 x 2.96 m). The Museum of Modern Art, New York Gift of Nelson A. Rockefeller

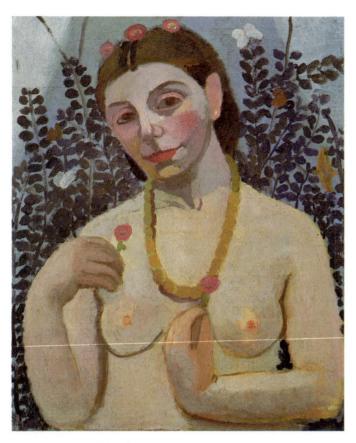

993. Paula Modersohn-Becker. Self-Portrait. 1906. Oil on canvas, 24 x 19³/4" (61 x 50.2 cm). Öffentliche Kunstsammlung Basel, Kunstmuseum, Switzerland

Yadwigha, peacefully asleep Enjoys a lovely dream: She hears a kind snake charmer Playing upon his reed. On stream and foliage glisten The silvery beams of the moon. And savage serpents listen To the gay, entrancing tune.

Here at last was an innocent directness of feeling that Gauguin thought was so necessary for the age. Picasso and his friends were the first to recognize this quality in Rousseau's work. They revered him as the godfather of twentieth-century painting.

MODERSOHN-BECKER. The inspiration of primitivism that Gauguin had traveled so far to find was discovered by Paula Modersohn-Becker (1876-1907) in the village of Worpswede, near her family home in Bremen, Germany. Among the artists and writers who congregated there was the Symbolist lyric poet Rainer Maria Rilke, Rodin's friend and briefly his personal secretary. Rilke had visited Russia and been deeply impressed with what he viewed as the purity of Russian peasant life. His influence on the colony at Worpswede affected Modersohn-Becker, whose last works are direct precursors of modern art. Her gentle but powerful Self-Portrait (fig. 993), painted the year before her early death, presents a transition from the Symbolism of Gauguin and his followers, which she absorbed during several stays in Paris, to Expressionism. The

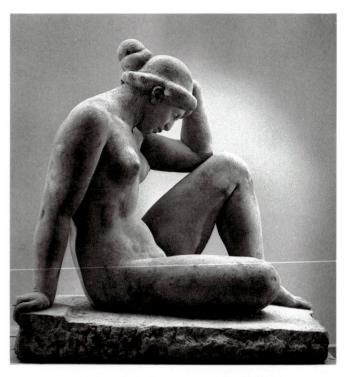

994. Aristide Maillol. Seated Woman (La Méditerranée). c. 1901. Stone, height 41" (104.1 cm). Collection Oskar Reinhart, Winterthur, Switzerland

color has the intensity of Matisse and the Fauves (see page 781). At the same time, her deliberately simplified treatment of forms parallels the experiments of Picasso, which were to culminate in Les Demoiselles d'Avignon (fig. 1033).

SCULPTURE

MAILLOL. In sculpture, there are no tendencies to be equated with Post-Impressionism, but a form of Symbolism makes its appearance about 1900. Sculptors in France of a younger generation had by then been trained under the dominant influence of Rodin and were ready to go their own ways. The finest of these, Aristide Maillol (1861-1944), began as a Symbolist painter, although he did not share Gauguin's anti-Greek attitude. Maillol might be called a "classic primitivist": admiring the simplified strength of early Greek sculpture, he rejected its later phases. The Seated Woman (fig. 994) evokes memories of the Archaic and Severe styles rather than of Phidias and Praxiteles. The solid forms and clearly defined volumes also recall Cézanne's statement that all natural forms are based on the cone, the sphere, and the cylinder. But the most notable quality of the figure is its harmonious, self-sufficient repose, which the outside world cannot disturb. A statue, Maillol thought, must above all be "static," structurally balanced like a piece of architecture. It must represent a state of being that is detached from the stress of circumstance, with none of the restless, thrusting energy of Rodin's work. In this respect, the Seated Woman is the exact opposite of The Thinker (see fig. 955). Maillol later gave it the

The major competing tendencies of the late nineteenth century

were Realism and Symbolism, which were sometimes found in the work of the same author. The most important Realist was the French novelist Émile Zola (1840–1902). Inspired by Charles Darwin's theory of evolution and Auguste Comte's socialism, he argued that the dramatist should observe the human condition with the detachment of the scientist and illustrate the "inevitable laws of heredity and environment." However, his plays, like those of the Goncourt brothers, were more important in theory than in practice, and Realism found its main expression in the plays of Henri Becque (1837-1899), which are pessimistic to the point of cynicism. Even so, Realism's success depended in the end on the determination of André Antoine (1858–1943), who established the Théâtre Libre (Free Theater) in 1887 and then the Théâtre Antoine a decade later, which became proving grounds for Realist drama and experimental staging techniques until Antoine was appointed head of the statesupported Odéon in 1906.

Antoine also mounted productions of foreign playwrights, notably the Norwegian Henrik Ibsen (1828–1906), who first established his reputation with verse-dramas about the legendary past, notably Peer Gynt (1867), which is still considered the great national saga of Norway. In the 1870s, however, he turned to Realism in such plays as The Doll's House (1879), then began making greater use of Symbolism beginning with The Wild Duck (1884). The basic theme of his mature works nevertheless remained the same: the conflict between duty and self, which finally sees the consequences of its actions in a moment of revelation. However, Ibsen's treatment of this theme changed considerably over time, almost reversing itself, whereas at first he condemned excessive devotion to duty, in the end he came to criticize unbridled self-interest.

Like the Norwegian painter Edvard Munch, Ibsen enjoyed considerable influence in Germany, thanks in part to the productions mounted by Otto Brahm (1856–1912), who was president of the Freie Bühne (Free Theater) in Berlin in 1889-94 and then director of the Deutsches Theater (German Theater) for a decade before taking over the Lessing Theater until his death. The most important Germany playwright associated with the Freie Bühne was Gerhart Hauptmann (1862-1946), whose drama The Weavers (1892) shows the same social conscience as the early paintings of Van Gogh and the sculpture of Constantin Meunier.

Psychological, not social, realism was the particular interest of

Arthur Schnitzler (1862-1931), whose major play, Anatol (1893), follows the ideas of his friend Sigmund Freud, the founder of modern psychiatry, in treating human sexuality through a series of affairs that inevitably give way to boredom because ego gratification cannot give rise to enduring love. Thanks in good measure to heavy government funding, it was in Germany where most of the major technical innovations in stagecraft were devised, including the revolving stage, the elevator stage, the rolling platform, and the sliding platform.

In England, the counterpart of the Théâtre Libre and the Freie Bühne was the Independent Theater, where George Bernard Shaw (1856-1950) first achieved critical acclaim in 1892. Shaw used sharp wit to illustrate philosophical propositions in the guise of national and social issues. His belief in human progress through moral persuasion and exercise of free choice found its highest expression in Man and Superman (1901), in which a socialist intellectual representing man as spiritual creator outwits his rivals but succumbs to a woman who exemplifies the life force.

The leading Realist in Russia at the turn of the century was Anton Chekhov (1860–1904), whose fame rests on the four plays about ennui in the upper class he wrote for the Moscow Art Theater during the last five years of his life, especially *The Three Sisters* (1901). Like Chekhov, who befriended him, Maxim Gorky (1868-1936) was at first better known as a writer of short stories; his plays, likewise written mainly for the Moscow Art Theater and centering on class conflict, reflect his political activism.

The antithesis of Zola's Realism was the Symbolism of Stéphane Mallarmé (1842-1898), a poet who was inspired by Edgar Allan Poe's macabre writings, Charles Baudelaire's art criticism, and Richard Wagner's operas. He proposed theater that evoked the mystery of life through poetic metaphor. Symbolism was championed first by the short-lived Théâtre d'Art of Paul Fort (1872–1962), and then by the Théâtre de l'Oeuvre under Aurélian-Marie Lugné-Poë (1869–1940). Lugné-Poë drew many of his ideas about scenery from his friends Édouard Vuillard, Maurice Denis, and Pierre Bonnard, whom he also employed to create sets, along with Odilon Redon and Henri de Toulouse-Lautrec. The most important French dramatist associated with Lugné-Poë was the Belgian-born Maurice Maeterlinck (1862-1949), whose masterpiece, Pelléas and Mélisande (1892), which was to

title La Méditerranée—The Mediterranean—to suggest the source from which he drew the timeless serenity of his figure.

MEUNIER. If Maillol sought to transcend his epoch, the Belgian Constantin Meunier (1831-1905) was thoroughly immersed in it. Politically and socially, Belgium exemplified all the tensions of the later nineteenth century: a conservative government, insensitive to the extremes of wealth and poverty in the country, seemed determined to suppress all protest or attempts at reform. The workers' movement had a late start in such a setting; it was not until 1885 that labor unions were strong enough to found the Belgian Workers' Party. By that time, many writers and artists had become partisans of social reform. Meunier began as a painter but soon began to model in clay. From 1885 until the end of his life, his output consisted almost entirely of sculpture. The change was motivated by his search for a more "heroic" medium. The heroism of labor, its pride and its pathos, was to be his theme as a sculptor. He treated it with a solemnity carried over from his earlier religious subjects—a concern that he shared with Vincent van Gogh, who had an unforgettable experience of human misery in the mining district of Belgium (see page 753). His lifesize Bust of a Puddler (fig. 995) has an air of pathos, of noble suffering such as befits a "martyr of labor." It also betrays

inspire Debussy's opera 10 years later, relies heavily on symbolic devices to create an air of mystery. Lugné-Poë also staged Ubu Roi by Alfred Jarry (1873-1907), which sparked a riot on opening night in 1896. Originally written as a schoolboy satire of a chemistry teacher, this play about an unscrupulous bourgeois king and his wife who give in to every appetitive and depraved whim later exercised great influence on the absurdist theater of the Surrealists. A year later Lugné-Poë abandoned Symbolism out of admiration for Ibsen, whose dramas offered far richer content.

After establishing his reputation as a Realist in the late 1880s with Miss Julie, the Swedish playwright August Strindberg (1849-1912) began to write "dream plays" in which he tried, as he put it, "to imitate the disconnected but seemingly logical form of the dream. Anything may happen; everything is possible and probable. Time and space do not exist. But one consciousness reigns above them all—that of the dreamer." Unlike Schnitzler's plays, they arose not from Freudian theory but from the dramatist's own bout with madness during the 1890s, when he was living in Berlin, from which he recovered with the aid of Emanuel Swedenborg's spiritualist belief in a higher reality.

Closely related to Strindberg as a dramatist was the German Benjamin Franklin Wedekind (1864-1918), whose two major plays, Earth Spirit and Pandora's Box (both 1895), deal with frankly sexual themes through the prostitute Lulu, who inspired Alban Berg's unfinished opera. After becoming disillusioned with the power of words, Hugo von Hofmannsthal (1874-1929) actually gave up theater almost entirely to write librettos for Richard Strauss' operas. Another leader in the reaction against Realism was the Swiss-born Adolphe Appia (1861–1928), who emphasized the staging of Wagner's operas through three-dimensional scenery and carefully calculated light effects that made full use of the recent advantages in lighting technology.

The only serious experiment with Symbolism by an English dramatist was Salomé (1892) by Oscar Wilde (1856-1900), but it can hardly be called an English play. It had been written in French during the previous decade and was published in Paris with illustrations by Aubrey Beardsley. Moreover, the work, which was banned in England until 1931, was first produced in Paris by Lugné-Poë in 1896 with Sarah Bernhardt in the lead role. Wilde was otherwise a writer of extremely clever, albeit conventional, comedies, whose main connection to Symbolism was his involvement with the Aesthetic Movement, whose dandyism he personified.

Meunier's considerable debt to Rodin, for whom he always expressed the greatest admiration.

MINNE. The youngest of Belgian nineteenth-century sculptors and, during the first dozen years of his career, the most original was George Minne (1866–1941). Minne contributed woodcut illustrations to books by his friends the Belgian Symbolist writers Maurice Maeterlinck and Émile Verhaeren, who introduced him to Les Vingt (The Twenty), a group of Belgian avant-garde artists, and it was at their annual exhibition in 1890 that Minne first presented his sculpture. Kneeling Boy (fig. 996), on which his fame rests, shows a state of brooding

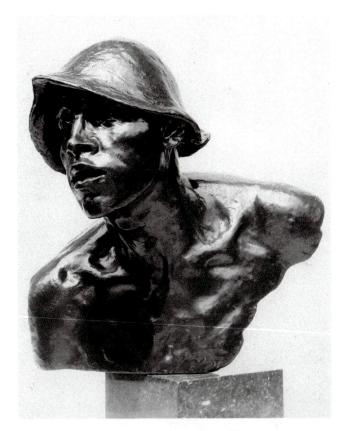

995. Constantin Meunier. Bust of a Puddler. c. 1885-90. Bronze, lifesize. Private collection

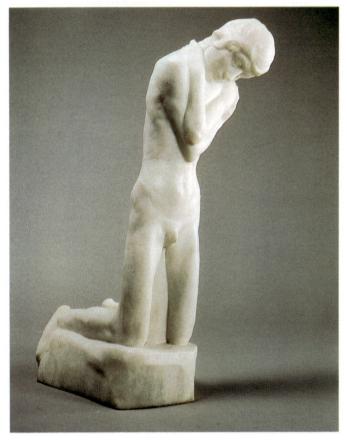

996. George Minne. Kneeling Boy. 1898. Marble, height 31" (78.7 cm). Museum voor Schone Kunsten, Ghent, Belgium

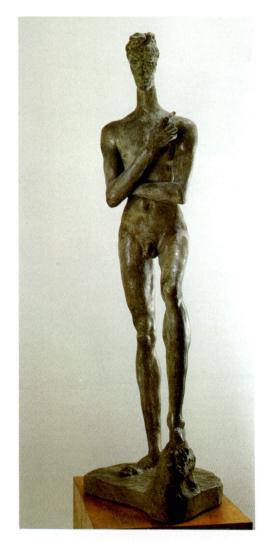

997. Wilhelm Lehmbruck. Standing Youth. 1913. Cast stone, height 7'8" (2.33 m); base $33^{1/2} \times 26^{3/4}$ " (85.1 x 68 cm). The Museum of Modern Art, New York Gift of Abby Aldrich Rockefeller

calm, but the haggard, angular limbs reflect Gothic, not classical, influence, and the trancelike rigidity of the pose suggests religious meditation. The statue became the basis for a fountain design with five kneeling boys grouped around a circular basin as if engaged in a solemn ritual. By treating the figure as an anonymous member of a rhythmically repeated sequence, Minne heightened its mood of ascetic withdrawal.

LEHMBRUCK. Minne's art attracted little notice in France, but was admired in Germany. His influence is apparent in Standing Youth (fig. 997) by Wilhelm Lehmbruck (1881-1919). Here a Gothic elongation and angularity are combined with a fine balance derived from Maillol's art, as well as with some of Rodin's expressive energy. The total effect is a looming monumental figure well anchored in space, yet partaking of that poetic melancholy we observed in Picasso's Blue Period.

BARLACH. Ernst Barlach (1870–1938), another important German sculptor who reached maturity in the years before World War I, seems the very opposite of Lehmbruck. He is a "Gothic primitivist," and more akin to Munch than to the Western Symbolist tradition. What Gauguin had experienced in Brittany and the tropics, Barlach found by going to Russia: the simple humanity of a preindustrial age. His figures, such

998. Ernst Barlach. Man Drawing a Sword. 1911. Wood, height 31" (78.7 cm). Private collection

as Man Drawing a Sword (fig. 998), embody elementary emotions—wrath, fear, grief—that seem imposed upon them by invisible presences. When they act, they are like somnambulists, unaware of their own impulses. Human beings, to Barlach, are humble creatures at the mercy of forces beyond their control; they are never masters of their fate. Characteristically, these figures do not fully emerge from the material substance (often, as here, a massive block of wood) of which they are made. Their clothing is like a hard chrysalis that hides the body, as in medieval sculpture. Barlach's art has a range that is severely restricted in both form and emotion, yet its mute intensity within these limits is not easily forgotten.

ARCHITECTURE

Art Nouveau

During the 1890s and early 1900s a movement now usually known as Art Nouveau arose throughout Europe and America. It takes its name from the shop opened in Paris in 1895 by the entrepreneur Siegfried Bing, who employed most of the leading designers of the day and helped to spread their work everywhere. By that time, however, the movement had already been in full force for several years. Art Nouveau has various other names as well: it is called *Jugendstil* (literally Youth Style) in Germany and Austria, Stile Liberty (after the well-known London store that helped to launch it) in Italy, and Modernista in Spain. Like Post-Impressionism and Symbolism, Art Nouveau is not easy to characterize. It was primarily a new style of decoration based on sinuous curves, nominally inspired by Rococo forms, that often suggest organic shapes. Its favorite pattern was the whiplash line, its typical shape the lily. Yet there was a severely geometric side as well that in the long run proved of even greater significance. The ancestor of Art Nouveau was the ornament of William Morris and the Japonist enthusiasm of Whistler. It was also related to the styles of Gauguin, Beardsley, Munch, and Klimt, among others. In turn it was allied to such diverse outlooks as aestheticism, socialism, and symbolism.

The avowed goal of Art Nouveau was to raise the crafts to the level of the fine arts, thereby abolishing the distinction between them. In this respect, it was meant to be a "popular" art, available to everyone. Yet it often became so extravagant as to be affordable only by the wealthy few. Art Nouveau had a profound impact on public taste, and its pervasive influence on the applied arts can be seen in wrought-iron work, furniture, jewelry, glass, typography, and even women's fashions. Historically Art Nouveau may be regarded as a prelude to modernism, but its preciousness was perhaps the most conspicuous symptom of the malaise that afflicted the Western world at the end of the nineteenth century. Hence it is uniquely worthy of our attention as our own culture passes through a similar transition.

Although it is usually thought of in terms of the decorative arts, Art Nouveau had perhaps its most important impact on architecture. As a style of decoration it did not lend itself easily to translation on a large scale. Indeed, it was aptly called book-decoration architecture by wags, for the origin of its designs, which were best suited to two-dimensional surface effects. But in the hands of architects of greatness, Art Nouveau yielded impressive results. Thus the authority of the "revival styles" was undermined once and for all in Europe.

HORTA. The first architect to explore the full potential of Art Nouveau was Victor Horta (1861-1947), the founder of the movement in Brussels. The stairwell in Tassel House (fig. 999), built in 1892–93, has a fluid grace that is truly amazing. Horta has made maximum use of wrought iron, which could be drawn out into almost any shape. The supporting role of the column is frankly acknowledged, although it has been made as slender as possible. But in a charming play on the Corinthian capital (compare fig. 176), it sprouts ribbonlike tendrils that dissolve the conjoining arches—an effect amplified by continuing the vegetable motif in the vault above. Similarly the bannister, which is light and supple, uncoils with taut springiness. This extends to the linear patterns on the floor and walls, which serve to integrate the space visually. The entire ensemble has a litheness and airiness that make the grand staircase of Garnier's Opéra seem utterly ponderous and vulgar by comparison (see fig. 918).

GUIMARD. Despite the use of iron, Horta's interior presents no structural advance. And although they lie largely on the

999. Victor Horta. Interior Stairwell of the Tassel House, Brussels.

1000. Hector Guimard. Métro Station, Paris. 1900

surface, the same devices could be translated readily into independent three-dimensional forms whose role was essentially sculptural. The entrances for the Métro (the Paris subway) designed in 1900 by Hector Guimard (1867-1942) present just such a case (see fig. 1000). Like Horta, whose work he clearly admired, Guimard was a designer of universal scope,

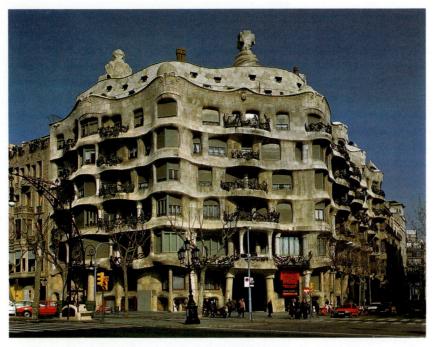

1001. Antoní Gaudí. Casa Milá apartments, Barcelona. 1905-7

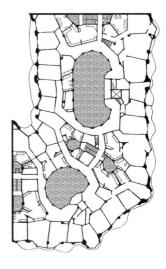

1002. Floor plan of typical floor, Casa Milá

rather than an engineer, and it is this background in the applied arts that renders these stations appealing even today. The functional purpose is so thoroughly disguised by the fanciful forms that we readily overlook their role in providing safety and light, which comes from the plantlike posts springing like strange hybrids from the sidewalk.

GAUDÍ. The most remarkable instance of Art Nouveau in architecture is the Casa Milá in Barcelona (figs. 1001 and 1002), a large apartment house by Antoní Gaudí (1852-1926). It shows an almost maniacal avoidance of all flat surfaces, straight lines, and symmetry of any kind, so that the building looks as if it had been freely modeled of some malleable substance. (The material is not stucco or cement, as we might suppose, but cut stone.) The softly rounded openings anticipate the "eroded" shapes of Henry Moore's sculpture (see fig. 1127), the roof has the rhythmic motion of a wave, and the chimneys seem to have been squeezed from a pastry tube. The Casa Milá expresses one man's fanatical devotion to the ideal of "natural" form. It could never be repeated, let alone developed further. Structurally, it is a tour de force of old-fashioned craftsmanship, an attempt at architectural reform from the periphery, rather than from the center.

MACKINTOSH. Gaudí represents one extreme of Art Nouveau architecture. The Scot Charles Rennie Mackintosh (1868-1928) represents another. Although they stood at opposite poles, both strove for the same goal—a contemporary style independent of the past. Mackintosh's basic outlook is so close to the functionalism of Louis Sullivan (see below) that at first glance his work hardly seems to belong to Art Nouveau at all. The north facade of the Glasgow School of Art (fig. 1003) was designed as early as 1896, but might be mistaken for a building done 30 years later. Huge, deeply recessed studio windows have replaced the walls, leaving only a framework of massive, unadorned cut-stone surfaces except in the center

1003. Charles Rennie Mackintosh. North facade of the Glasgow School of Art, Glasgow, Scotland. 1896-1910

bay. This bay, however, is "sculptured" in a style not unrelated to Gaudi's, despite its preference for angles over curves. Another Art Nouveau feature is the wrought-iron grillwork (here with a minimum of ornament). Even more surprising than the exterior is the two-story library (fig. 1004), with its rectangular wooden posts and lintels supporting the balcony.

VAN DE VELDE. Through architectural magazines and exhibitions, Mackintosh's work came to be widely known abroad. Its structural clarity and force had a profound effect on one of the leaders of Art Nouveau in Belgium, Henry van de Velde (1863–1957). He began as a Divisionist painter but, under the influence of William Morris, became a designer of posters, furniture, silverware, and glass. Then, after 1900, he worked mainly as an architect. Van de Velde founded the

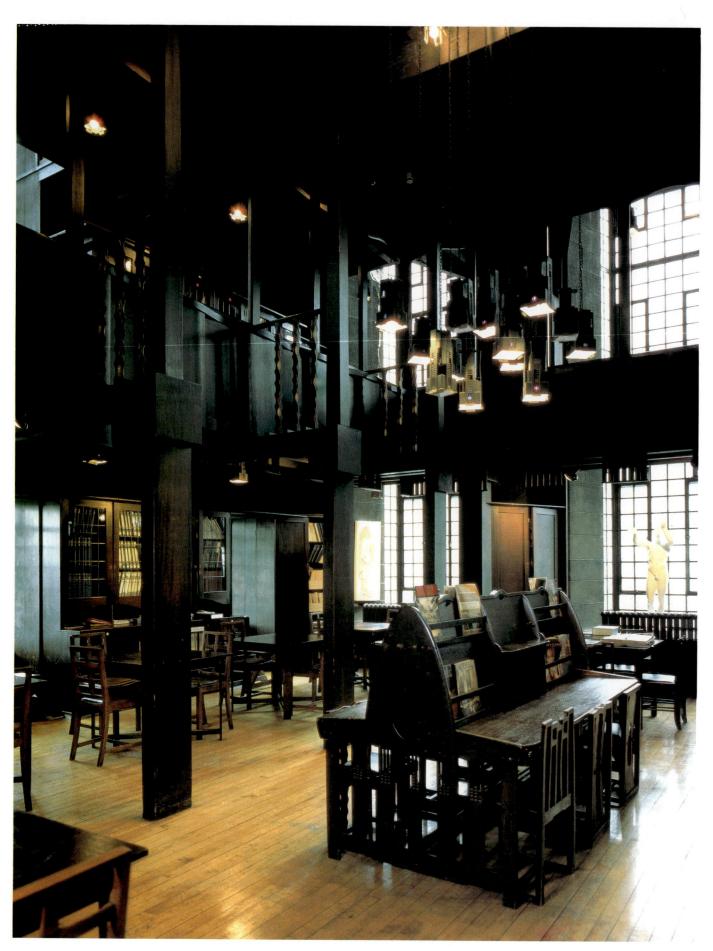

1004. Interior of the Library, Glasgow School of Art

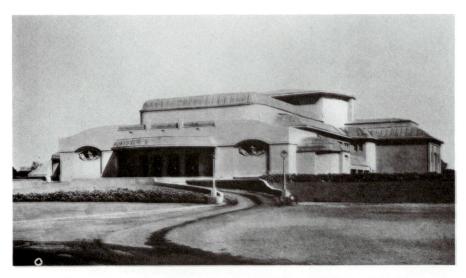

1005. Henry van de Velde. Theater, Werkbund Exhibition, Cologne. 1914. Destroyed

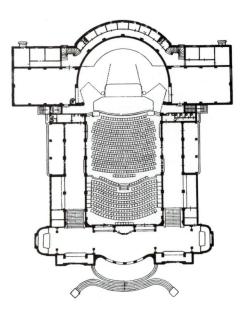

1006. Plan of the Theater, Werkbund Exhibition

Weimar School of Arts and Crafts in Germany, which became famous after World War I as the Bauhaus (see page 876). His most ambitious building (figs. 1005 and 1006), the theater he designed in Cologne for an exhibition sponsored by the Werkbund (arts and crafts association) in 1914, makes a telling contrast with the Paris Opéra (figs. 919 and 920). Whereas the older building tries to evoke the splendors of the Louvre Palace, Van de Velde's exterior is a tightly stretched, unadorned "skin" that covers—and reveals—the individual units of which the internal space is composed. So vast is the difference that it seems almost incredible that the Opéra should have been completed only 40 years before.

United States

The search for a modern architecture first began in earnest around 1880. It required wedding the ideas of William Morris and a new machine aesthetic, tentatively explored some 15 years earlier in the decorative arts, to new construction materials and techniques. The process itself took several decades, during which architects experimented with a variety of styles. It is significant that the symbol was the skyscraper, and that its first home was Chicago, then a burgeoning metropolis not yet encumbered by allegiance to the styles of the past.

RICHARDSON. The Chicago fire of 1871 had opened enormous opportunities to architects from older cities such as Boston and New York. Among them was Henry Hobson Richardson (1838–1886), who profited as a young man from contact with Labrouste in Paris (see fig. 961). Most of his work along the eastern seaboard shows a massive Neo-Romanesque style. There are still echoes of this in his last major project for Chicago, the Marshall Field Wholesale Store designed in 1885 (fig. 1007). The huge structure filled an entire city block. In its symmetry and the treatment of masonry, it may remind us of Italian Early Renaissance palaces (see fig. 550). Yet the complete lack of ornament proclaims its utilitarian purpose.

Warehouses and factories as commercial building types had a history of their own dating to the later eighteenth century. Richardson must have been familiar with this tradition, which

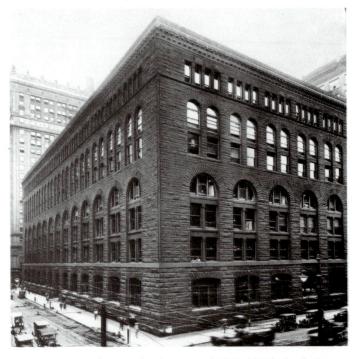

1007. Henry Hobson Richardson. Marshall Field Wholesale Store, Chicago. 1885-87. Demolished 1930

on occasion had produced remarkably impressive "strippeddown" designs (see fig. 1008). In contrast to these earlier structures, however, the walls of the Marshall Field Wholesale Store do not present a continuous surface pierced by windows. Except for the corners, which have the effect of heavy piers, they show a series of superimposed arcades, like a Roman aqueduct (see fig. 243), an impression strengthened by the absence of ornament and the thickness of the masonry. (Note how deeply the windows are recessed.) These arcaded walls are as functional and self-sustaining as their ancient predecessors. They invest the building with a strength and dignity unrivaled in any earlier commercial structure. Behind them is an iron skeleton that actually supports the seven floors, but the exterior does not depend on it, either structurally or aesthetically.

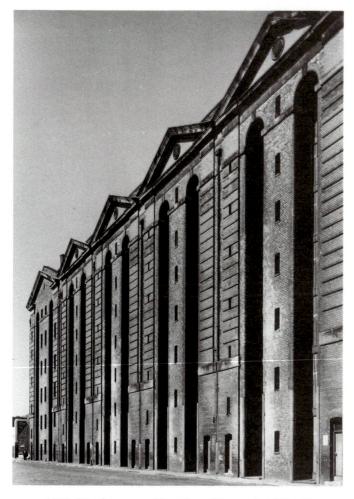

1008. Warehouses on New Quay, Liverpool. 1835-40

SULLIVAN. Richardson's Marshall Field building thus stands midway between the old and the new. It embodies, with utmost severity and logic, a concept of monumentality derived from the past, but its opened-up walls, divided into vertical "bays," look forward to the work of Louis Sullivan (1856–1924). The Wainwright Building in St. Louis (fig. 1009), his first skyscraper, is only five years after the Marshall Field Store. It, too, is monumental, but in a very untraditional way. The organization of the exterior reflects and expresses the internal steel skeleton, in the slender, continuous brick piers that rise between the windows from the base to the attic. Their collective effect is that of a vertical grating encased by the corner piers and by the emphatic horizontals of attic and mezzanine.

This is, of course, only one of the many possible "skins" that could be stretched over the structural framework. What counts is that we immediately feel this wall is derived from the skeleton underneath, that it is not self-sustaining. "Skin" is perhaps too weak a term to describe this brick sheathing. To Sullivan, who often thought of buildings as analogous to the human body, it was more like the "flesh" and "muscle" that are attached to the "bone" yet are capable of an infinite variety of expressive effects. When he insisted that "form ever follows function," he meant a flexible relationship between the two, not rigid dependence. [See Primary Sources, no. 96, pages 940–41.]

The range of Sullivan's invention becomes evident if we compare the Wainwright Building with his last building, the department store of Carson Pirie Scott & Company in Chicago, begun nine years later (fig. 1010). The sheathing of white

1009. Louis Sullivan. Wainwright Building, St. Louis, Missouri. 1890–91. Destroyed

1010. Louis Sullivan. Carson Pirie Scott & Company Department Store, Chicago. 1899–1904

1011. Detail of facade, showing window, Carson Pirie Scott & Company Department Store

1012. Jacob Riis. Bandits' Roost. c. 1888. Gelatin-silver print. Museum of the City of New York

PHOTOGRAPHY

Documentary Photography

During the second half of the nineteenth century, the press played a leading role in the social movement that brought the harsh realities of poverty to the public's attention. The camera became an important instrument of reform through the photodocumentary, which tells the story of people's lives in a pictorial essay. It responded to the same conditions that had stirred Courbet (see pages 718–20), and its factual reportage likewise fell within the Realist tradition. Before then, photographers had been content to present the romanticized image of the poor like those in genre paintings of the day. The first photodocumentary was John Thomson's illustrated sociological study *Street Life in London*, published in 1877. To get his pictures, he had to pose his figures.

RIIS. The invention of gunpowder flash ten years later allowed Jacob Riis (1849–1914) to rely for the most part on the element of surprise. Riis was a police reporter in New York City, where he learned at first hand about the crime-infested slums and their appalling living conditions. He kept up a steady campaign of illustrated newspaper exposés, books, and lectures which in some cases led to major revisions of the city's housing codes and labor laws. His photographs' unflinching realism has lost none of its force. Certainly it would be difficult to imagine a more nightmarish scene than *Bandits' Roost* (fig. 1012). With good reason we sense a pervasive air of

terracotta here follows the grid of the steel frame far more closely, and the overall effect, enhanced by the simple molding around the windows (fig. 1011), is one of lightness and crispness rather than of harnessed energy. The contrast between the horizontal continuity of the flanks and the vertical accent at the corner has been subtly calculated to provide a clear terminus to the facade.

Paradoxically, Sullivan's buildings are based on a lofty idealism and adorned with a type of ornamentation that remain firmly rooted in the nineteenth century, even as they point the way to the architecture of our own era. From the beginning his geometry carried a spiritual meaning, inspired partly by Emanuel Swedenborg, that centered on birth, flowering, decay, and regeneration. It was tied to a highly original style of decoration in accordance with Sullivan's theory that ornament must give expression to structure—not by reflecting it literally but by interpreting the same concepts through organic abstraction. The soaring verticality of the Wainwright Building, for example, stands for growth, which is elaborated by the vegetative motifs of the moldings along the cornice and between the windows. Likewise the clean articulation of the windows on the upper stories of the Carson Pirie Scott building gives way on the ground floor and mezzanine to a lavish display of ironwork (designed largely by George G. Elmslie using Sullivan's system), enhancing the store-front's appeal to shoppers.

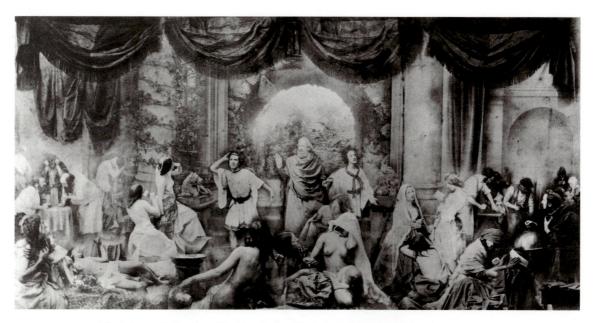

1013. Oscar Rejlander. The Two Paths of Life. 1857. Combination albumen print, 16 x 31" (40.6 x 78.7 cm). George Eastman House, Rochester, New York

danger in the eerie light. The notorious gangs of New York City's Lower East Side sought their victims by night, killing them without hesitation. The motionless figures seem to look us over with the practiced casualness of hunters coldly sizing up potential prey.

Pictorialism

The raw subject matter and realism of documentary photography had little impact on art and were shunned by most other photographers as well. England, through such organizations as the Photographic Society of London, founded in 1853, became the leader of the movement to convince doubting critics that photography, by imitating painting and printmaking, could indeed be art. To Victorian England, beauty above all meant art with a high moral purpose or noble sentiment, preferably in a classical style.

REJLANDER. The Two Paths of Life (fig. 1013) by Oscar Rejlander (1818-1875) fulfills these ends by presenting an allegory clearly descended from Hogarth's Rake's Progress series (figs. 824 and 825). This tour de force, almost three feet wide, combines 30 negatives through composite printing: a young man (in two images) is choosing between the paths of virtue or of vice, the latter represented by a half-dozen nudes. The picture created a sensation in 1857 and Queen Victoria herself purchased a print. Rejlander, however, never enjoyed the same success again. He was the most adventurous photographer of his time and soon turned to other subjects less in keeping with prevailing taste.

ROBINSON. The mantle of art photography fell to Henry Peach Robinson (1830–1901), who became the most famous photographer in the world. He established his reputation with Fading Away (fig. 1014), which appeared a year after Rejlander's The Two Paths of Life. With six lines from Shelley's

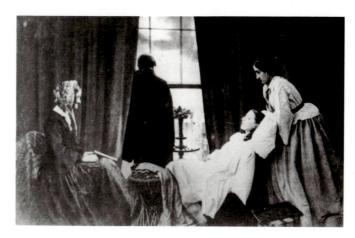

1014. Henry Peach Robinson. Fading Away. 1858. Combination print. Royal Photographic Society, London

"Queen Mab" printed below on the mat, it is typical of Robinson's sentimental scenes. Like The Two Paths of Life, it is a photomontage, but of only five negatives, and the scene is as carefully staged as any Victorian melodrama. At first Robinson made detailed drawings of his scenes before photographing the individual components. He later renounced multiple-negative photography, but still contrived to imitate contemporary genre painting in his pictures. When treating elevated subject matter he continued to distinguish between fact and truth, which to him was a mixture of the real and the artificial.

CAMERON. The photographer who pursued ideal beauty with the greatest passion was Julia Margaret Cameron (1815-1879). An intimate of leading poets, scientists, and artists, she took up photography at the age of 48 when she was given a camera. She went on to create a remarkable body of work. In her own day Cameron was known for her allegorical and narrative

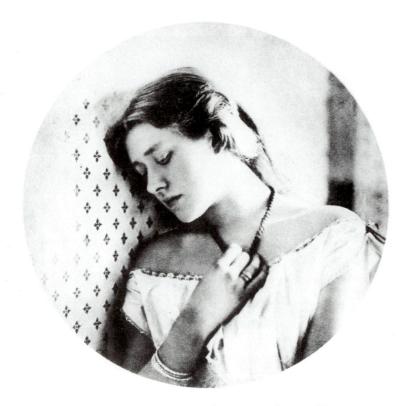

1015. Julia Margaret Cameron. *Ellen Terry, at the Age of Sixteen.* c. 1863. Carbon print, diameter 9¹/2" (24 cm). The Metropolitan Museum of Art, New York Alfred Stieglitz Collection, 1949

Photo-Secession

pictures, but now she is remembered primarily for her portraits of the men who shaped Victorian England. Many of her finest photographs, however, are of the women who were married to her closest friends. An early study of the actress Ellen Terry (fig. 1015) has the lyricism and grace of the Pre-Raphaelite aesthetic that shaped Cameron's style (compare fig. 946).

Naturalistic Photography

EMERSON. The cudgel against art photography was taken up by Peter Henry Emerson (1856–1936), who became the bitter enemy of Robinson. Emerson espoused what he called naturalistic photography, based on scientific principles and Constable's landscapes. Nevertheless, he too contrasted realism with truth, defining truth in terms of sentiment, aesthetics, and the selective arrangement of nature. Using a single negative, Emerson composed his scenes with the greatest care, producing results that were sometimes similar to Robinson's, though of course he never acknowledged this. Most of Emerson's work was devoted to scenes of rural and coastal life which are not far removed from early documentary photographs.

In his best prints, nature predominates. He was a master at distributing tonal masses across a scene, and his photographs (fig. 1016) are equivalent to fine English landscape paintings of the period. Although the effect is rarely apparent in his work, Emerson advocated putting the lens slightly out of focus, in the belief that the eye sees sharply only the central area of a scene. When he gave up this idea a few years later, he decided that photography was indeed science instead of art because it was machine-made, not personal.

The issue of whether photography could be art came to a head in the early 1890s with the Secession movement (see page 763), which was spearheaded in 1893 by the founding in London of the Linked Ring, a rival group to the renamed Royal Photographic Society of Great Britain. Stimulated by Emerson's ideas, the Secessionists sought a pictorialism independent of science and technology. They steered a course between academicism and naturalism by imitating every form of late Romantic art that did not involve narrative. Equally antithetical to their aims were Realist and Post-Impressionist painting, then at their zenith. In the group's approach to photography as Art for Art's Sake, the Secession had the most in common with Whistler's aestheticism.

To resolve the dilemma between art and mechanics, the Secessionists tried to make their photographs look as much like paintings as possible. Rather than resorting to composite or multiple images, however, they exercised total control over the printing process, chiefly by adding special materials to their printing paper to create different effects. Pigmented gum brushed on coarse drawing paper yielded a warm-toned, highly textured print that in its way approximated Impressionist painting. Paper impregnated with platinum salts was especially popular among the Secessionists for the clear grays in their prints. Their subtlety and depth lend a remarkable ethereality to *The Magic Crystal* (fig. 1017) by Gertrude Käsebier (1854–1934), in which spiritual forces are almost visibly sweeping across the photograph.

STEICHEN. Through Käsebier and Alfred Stieglitz, the Linked Ring had close ties with America, where Stieglitz

1016. Peter Henry Emerson. Haymaking in the Norfolk Broads. c. 1890. Platinum print. Société Française de Photographie, Paris

opened his Photo-Secession gallery in New York in 1905. [See Primary Sources, no. 97, page 941.] Among his protégés was the young Edward Steichen (1879-1973), whose photograph of Rodin in his sculpture studio (fig. 1018) is without doubt the finest achievement of the entire Photo-Secession movement. The head in profile contemplating The Thinker

1017. Gertrude Käsebier. The Magic Crystal. c. 1904. Platinum print. Royal Photographic Society, Bath

1018. Edward Steichen. Rodin with His Sculptures "Victor Hugo" and the "Thinker." 1902. Gum print, $14^{1/4}$ x $12^{3/4}$ " (36.3 x 32.4 cm). The Art Institute of Chicago Alfred Stieglitz Collection

1019. Eadweard Muybridge. Female Semi-Nude in Motion, from Human and Animal Locomotion, vol. 2, pl. 271. 1887. George Eastman House, Rochester, New York

expresses the essence of the confrontation between the sculptor and his work of art. His brooding introspection hides the inner turmoil evoked by the ghostlike monument to Victor Hugo which rises dramatically like a genius in the background. Not since *The Creation of Adam* by Michelangelo (fig. 612), who was Rodin's ideal, have we seen a more telling use of space or an image that penetrates the mystery of creativity so deeply.

The Photo-Secession movement achieved its goal of gaining wide recognition for photography as an art form, but by 1907 its artifices were regarded as stilted. Though the movement lasted for a few more years, it was becoming clear that the future of photography did not lie in the imitation of painting, for painting was then being drastically reformed by modernists. Yet the legacy of the Photo-Secession was valuable, its limitations notwithstanding, for it taught photographers much about the control of composition and the response to light.

Motion Photography

MUYBRIDGE. An entirely new direction was charted by Eadweard Muybridge (1830–1904), father of motion photog-

raphy. He wedded two different technologies, devising a set of cameras capable of photographing action at successive points. Photography had grown from such marriages. Another instance had occurred earlier when Nadar used a hot-air balloon to take aerial shots of Paris (fig. 926). After some trial efforts, Muybridge managed in 1877 to get a set of pictures of a trotting horse which forever changed artistic depictions of the horse in movement. Of the 100,000 photographs he devoted to the study of animal and human locomotion, the most astonishing were those taken from several vantage points at once (fig. 1019). The idea was surely in the air, for the art of the period occasionally shows similar experiments, but Muybridge's photographs must nevertheless have come as a revelation to artists. The simultaneous views present an entirely new treatment of motion across time and space that challenges the imagination. Like a complex visual puzzle, they can be combined in any number of ways that are endlessly fascinating.

Muybridge left it to others to pursue these possibilities further. Much of his later work was conducted at the University of Pennsylvania in Philadelphia with the support of Eakins, then the head of the Academy of the Fine Arts. Eakins was already adept at using a camera, and it provided the subjects for several of his paintings; soon his interest in science led him

1020a, b. Étienne-Jules Marey. Man in Black Suit with White Stripes Down Arms and Legs, Walking in Front of a Black Wall. c. 1884. Chronophotograph

to take up motion photography. Unlike Muybridge's succession of static images, Eakins' multiple exposures show sequential motion on one plate. In the end, photography for Eakins was simply a means of depicting figures more realistically.

MAREY. It was Étienne-Jules Marey (1830-1904) who developed motion photography into an art. A noted French physiologist, Marey, like Muybridge, with whom he was in direct contact, saw the camera as a tool for demonstrating the mechanics of bodily movement, but he soon began to use it so creatively that his photographs have a perfection not equaled for another 60 years (compare fig. 1222). Indeed, his multiple exposure of a man walking (fig. 1020a, b) satisfies both scientific and aesthetic truth in a way that Emerson and the Secessionists never imagined.

The photographs of Muybridge and Marey convey a peculiarly modern sense of dynamics reflecting the new tempo of life in the Machine Age. However, because the gap was then so great between scientific fact on the one hand and visual perception and artistic representation on the other, their farreaching aesthetic implications were to be realized only by the Futurists (see page 794).

CHAPTER FOUR

TWENTIETH-CENTURY PAINTING

PAINTING BEFORE WORLD WAR I

In our account of art in the modern era, we have already discussed a succession of "isms": Neoclassicism, Romanticism, Realism, Impressionism, Post-Impressionism, Divisionism, and Symbolism. There are many more to be found in twentieth-century art—so many, in fact, that nobody has made an exact count. These "isms" can form a serious obstacle to understanding: they may make us feel that we cannot hope to comprehend the art of our time unless we immerse ourselves in a welter of esoteric doctrines. Actually, we can disregard all but the most important "isms." Like the terms we have used for the styles of earlier periods, they are merely labels to help us sort things out. If an "ism" fails the test of usefulness, we need not retain it. This is true of many "isms" in contemporary art. The movements they designate either cannot be seen very clearly as separate entities, or have so little importance that they can interest only the specialist. It has always been easier to invent new labels than to create a movement in art that truly deserves a new name.

Still, we cannot do without "isms" altogether. Since the start of the modern era, the Western world (and, increasingly, the rest of the world) has faced the same basic problems everywhere, and local artistic traditions have steadily given way to international trends. Among these we can distinguish three main currents, each comprising a number of "isms," that began among the Post-Impressionists and have developed greatly in our own century: Expressionism, Abstraction, and Fantasy. The first stresses the artist's emotional attitude toward himself and the world; the second focuses on the formal structure of the work of art; the third explores the realm of the imagination, especially its spontaneous and irrational qualities. We must not forget, however, that feeling, order, and imagination are all present in every work of art. Without imagination, it would be deadly dull; without some degree of order, it would be chaotic; without feeling, it would leave us

These currents are not mutually exclusive, and we shall find them interrelated in many ways. An artist's work often belongs to more than one, which may in turn embrace a wide range of approaches, from the realistic to the completely nonrepresentational (or non-objective). Our three currents, then, do not correspond to specific styles but to general attitudes. They represent parallel responses to the realization, intuitive as well as intellectual, that after 1900 people were living in a different age. The primary concern of Expressionism is the human community; of Abstraction, the structure of reality; and of Fantasy, the labyrinth of the mind. And we shall find that Realism, which is concerned with the appearance of the world around us, has continued to exist independently of the other three, especially in the United States, where art has often pursued a separate course. These strands bear a shifting relation to each other that reflects the complexity of modern life. To be understood, they must be seen in their proper historical context. Beginning in the mid-1930s, however, the distinction between them begins to break down, so that after 1945 it is no longer meaningful to trace their evolution separately.

In examining twentieth-century art, we shall find it anything but tidy. On the contrary, we quickly discover the visual arts are like soldiers marching to different drummers. A purely chronological approach would reveal just how out of step they have generally been with each other—but at the cost of losing sight of their internal development. Does this mean that the other visual arts have shared none of the same concerns? No, that is not the case either. The three main currents we outlined in painting—Expressionism, Abstraction, and Fantasy-may be found as well in sculpture, architecture, and photography before 1945. But they are present in

1021. Henri Matisse. *The Joy of Life.* 1905-6. Oil on canvas, $5'8^{1/2} \times 7'9^{3/4}$ " (1.74 x 2.38 m). The Barnes Foundation, Merion, Pennsylvania

different measure and do not always carry the same meaning. For that reason, the parallelism between them should not be emphasized.

EXPRESSIONISM

The Fauves

The twentieth century may be said to have begun five years late, so far as painting is concerned. Between 1901 and 1906, several comprehensive exhibitions of the work of Van Gogh, Gauguin, and Cézanne were held in Paris, as well as Germany. For the first time the achievements of these masters became accessible to a broad public. The young painters who had grown up in the "decadent," morbid mood of the 1890s (see page 761) were profoundly impressed by what they saw. Several of them formulated a radical new style, full of the violent color of Van Gogh and bold distortions of Gauguin, which they manipulated freely for pictorial and expressive effects. When their work first appeared in 1905, it so shocked critical opinion that they were dubbed the Fauves (wild beasts), a label they wore with pride. Actually, it was not a common program that brought them together, but their shared sense of liberation and experiment. As a movement, Fauvism comprised a number of loosely related individual styles, and the group dissolved after a few years, most of its members unable to sustain their inspiration or adapt successfully to the challenges posed by Cubism. It was nevertheless a decisive breakthrough, for it constituted the first unequivocably modern movement of the twentieth century in both style and attitude, one to which every important painter before World War I acknowledged a debt.

MATISSE. Its leader was Henri Matisse (1869-1954), the oldest of the founders of twentieth-century painting. The Joy of Life (fig. 1021), probably the most important picture of his long career, sums up the spirit of Fauvism better than any other single work. It obviously derives its flat planes of color, heavy undulating outlines, and the "primitive" flavor of its forms from Gauguin (see fig. 981). Even its subject suggests the vision of humanity in a state of Nature that Gauguin had pursued in Tahiti. But we soon realize that Matisse's figures are not Noble Savages under the spell of a native god. The subject is a pagan scene in the classical sense: a bacchanal like Titian's (compare fig. 632). The poses of the figures have for the most part a classical origin, and in the apparently careless draftsmanship resides a profound knowledge of the human body. (Matisse had been trained in the academic tradition.) What makes the picture so revolutionary is its radical simplicity, its

1022. Henri Matisse. *The Red Studio*. 1911. Oil on canvas, $5'11^1/4" \times 7'2^1/4"$ (1.81 x 2.19 m). The Museum of Modern Art, New York Mrs. Simon Guggenheim Fund

"genius of omission." Everything that possibly can be has been left out or stated by implication only, yet the scene retains the essentials of plastic form and spatial depth. What holds the painting together is its firm underlying structure. (Matisse venerated Cézanne and owned one of his paintings.)

Painting, Matisse seems to say, is not a representation of observed reality but the rhythmic arrangement of line and color on a flat plane. But it is not only that. How far can the image of nature be pared down without destroying its basic properties and thus reducing it to mere surface ornament? "What I am after, above all," he once explained, "is expression . . . [But] . . . expression does not consist of the passion mirrored upon a human face. . . . The whole arrangement of my picture is expressive. The placement of figures or objects, the empty spaces around them, the proportions, everything plays a part." [See Primary Sources, no. 98, pages 941-42.] What, we wonder, does *The Joy of Life* express? Exactly what its title says. Whatever his debt to Gauguin, Matisse was never stirred by the same agonized discontent with the decadence of our civilization. He instead shared the untroubled outlook of the Nabis, with whom he had previously associated, and the canvas derives its decorative quality from their work (compare fig. 983). He was concerned above all with the act of painting. This to him was an experience so profoundly joyous that he wanted to transmit it to the beholder.

Matisse's "genius of omission" is again at work in *The Red Studio* (fig. 1022). By reducing the number of tints to a minimum, he makes color an independent structural element. The result is to emphasize the radical new balance he struck between the "two-D" and "three-D" aspects of painting. Ma-

tisse spreads the same flat red color on the tablecloth and wall as on the floor, yet he distinguishes the horizontal from the vertical planes with complete assurance using only a few lines. Equally bold is Matisse's use of pattern. By repeating a few basic shapes, hues, and decorative motifs in seemingly casual, but perfectly calculated, array around the edges of the canvas, he harmonizes the relation of each element with the rest of the picture. Cézanne had pioneered this integration of surface ornament into the design of a picture (see fig. 969), but Matisse here makes it a mainstay of his composition.

ROUAULT. The other important member of the Fauves, Georges Rouault (1871–1958), would hardly have agreed with Matisse's definition of "expression." For him this had still to include, as it had in the past, "the passion mirrored upon a human face"—as we can tell from his *Head of Christ* (fig. 1023). But the expressiveness does not reside only in the "image quality" of the face. The savage slashing brushstrokes speak equally eloquently of the artist's rage and compassion. If we cover the upper third of the picture, it is no longer a recognizable image. Yet the expressive effect is hardly diminished.

Rouault was the true heir of Van Gogh's and Gauguin's concern for the corrupt state of the world. However, he hoped for spiritual renewal through a revitalized Catholic faith. His pictures, whatever their subject, are personal statements of that ardent hope. Trained in his youth as a stained-glass worker, he was better prepared than the other Fauves to share Gauguin's enthusiasm for medieval art. Rouault's later work, such as *The Old King* (fig. 1024), has glowing colors and compartmented, black-bordered shapes inspired by Gothic stained-glass win-

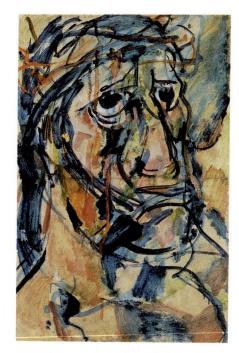

1023. Georges Rouault. Head of Christ. 1905. Oil on paper, mounted on canvas, 39 x 251/4" (99.1 x 64.2 cm). The Chrysler Museum, Norfolk, Virginia Gift of Walter P. Chrysler, Jr.

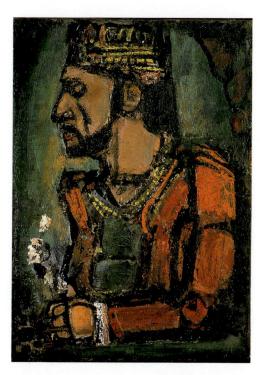

1024. Georges Rouault. The Old King. 1916-37. Oil on canvas, $30^{1/4} \times 21^{1/4}$ " (76.8 x 54 cm). The Carnegie Museum of Art, Pittsburgh Patrons Art Fund

dows (compare fig. 494). Within this framework he retains a good deal of the pictorial freedom we saw in the Head of Christ, which he uses to express his profound understanding of the human condition. The old king's face conveys a mood of resignation and inner suffering that reminds us of Rembrandt, Daumier, and Van Gogh.

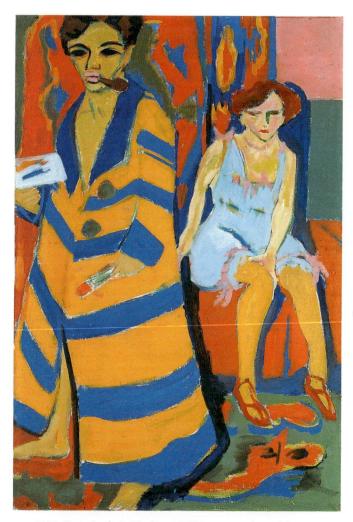

1025. Ernst Ludwig Kirchner. Self-Portrait with Model. 1907. Oil on canvas, 59¹/4 x 39³/8" (150.5 x 100 cm). Kunsthalle, Hamburg

German Expressionism

Fauvism exerted a decisive influence on the Expressionist movement that arose at the same time in Germany. Because Expressionism had deep historical roots that made it especially appealing to the Northern mind, it lasted far longer in Germany, where it proved correspondingly broader and more diverse than in France. For these reasons, Expressionism is sometimes applied to German art alone, but such a limit ignores the close ties and numerous similarities between them. To be sure, Fauvism was generally less neurotic and morbid, but although German Expressionism was characterized by greater emotional extremes and a more spontaneous approach, the two branches were not separated by any fundamental difference in style or content.

DIE BRÜCKE. Expressionism in Germany began with Die Brücke (The Bridge), a group of like-minded painters who lived in Dresden in 1905. Through its totally bohemian lifestyle, Die Brücke cultivated a sense of immanent disaster that is one of the hallmarks of the modern avant-garde. Their early work not only reveals the direct impact of Van Gogh and Gauguin but also shows elements derived from Munch, who was then living in Berlin and deeply impressed the German Expressionists. Self-Portrait with Model (fig. 1025) by Ernst

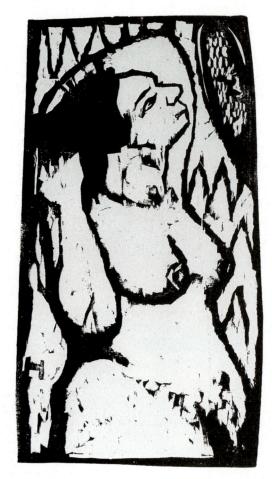

1026. Erich Heckel. *Woman Before a Mirror.* 1908. Woodcut, 16⁵/8 x 8⁷/8" (42.2 x 22.5 cm). Brücke Museum, Berlin

Ludwig Kirchner (1880–1938), the group's leader, reflects Matisse's simplified, rhythmic line and loud color. Yet the contrast between the coldly aloof artist and the brooding model, who looks as if she has been violated, has a peculiar expressiveness that can have come only from Munch, whose work was often fraught with a palpable sexual tension.

HECKEL. The artists of *Die Brücke* were idealists who sought to revive German art. Toward that end, they took up woodcuts, which they regarded as a uniquely national medium. The first to do so was Kirchner, but the finest printmaker of the group was Erich Heckel (1883–1970). Under the influence of ethnographic art and Gauguin's woodcuts (see fig. 982), Heckel's prints, such as our *Woman Before a Mirror* (fig. 1026), imitate the straightforward manner of the early German "primitives" (compare figs. 692 and 700) rather than the example of Dürer that had originally inspired *Die Brücke*. Heckel's woman before a mirror is "primitive" in another sense as well: her ponderous fleshiness lends her the primeval quality of ancient fertility goddesses (compare figs. 43 and 44), but with a sensuous charm that is utterly disarming.

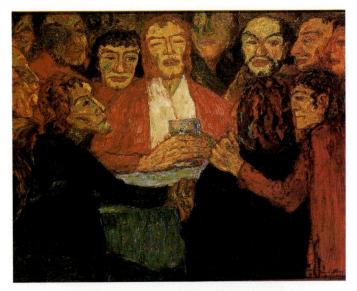

1027. Emil Nolde. *The Last Supper.* 1909. Oil on canvas, 32¹/2 x 41³/4" (82.6 x 106.1 cm). Stiftung Seebull Ada und Emil Nolde, Neukirchen, Schleswig, Germany

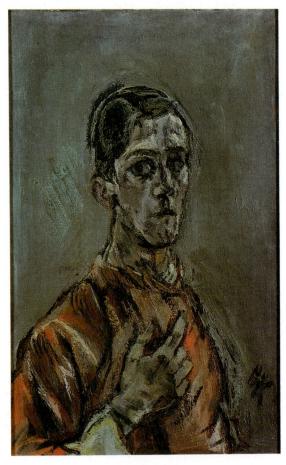

1028. Oskar Kokoschka. *Self-Portrait.* 1913. Oil on canvas, 32 x 19¹/2" (81.7 x 49.7 cm). The Museum of Modern Art, New York

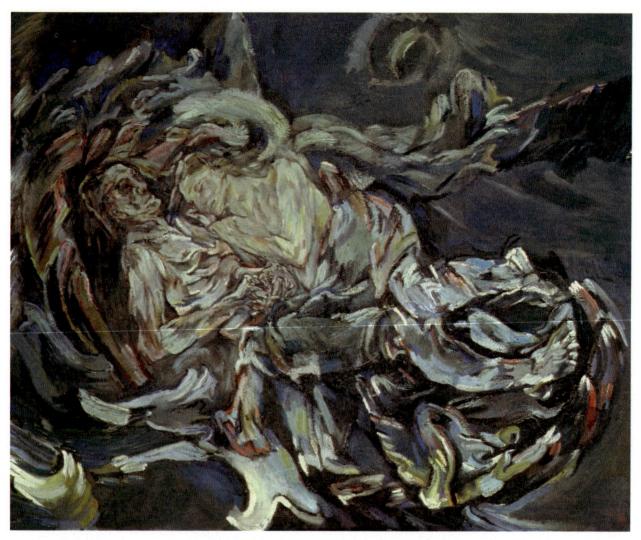

1029. Oskar Kokoschka. The Bride of the Wind. 1914. Oil on canvas, 5'11¹/4" x 7'2⁵/8" (1.81 x 2.20 m). Öffentliche Kunstsammlung Basel, Kunstmuseum, Switzerland

NOLDE. One Brücke artist, Emil Nolde (1867–1956), stands somewhat apart. Older than the rest, he was already working in an Expressionist style when he was invited to join the movement in 1906. Nolde shared Rouault's preference for religious themes, and his figures show a like sympathy for the suffering of humanity. The thickly encrusted surfaces and deliberately clumsy draftsmanship of The Last Supper (fig. 1027) reject pictorial refinement in favor of a primeval, direct expression inspired by Gauguin. Ensor's grotesque masks, too, come to mind (see fig. 988), as does the blocklike monumentality of Barlach's peasants (see fig. 998).

KOKOSCHKA. Another artist of highly individual talent was the Austrian painter Oskar Kokoschka (1886-1980). In 1910, he was invited to Berlin by the publisher of Der Sturm (The Storm), which soon attracted members of Die Brücke and Der Blaue Reiter (see below). His main contribution is the portraits he painted before World War I, such as the moving Self-Portrait in figure 1028. Like Van Gogh, Kokoschka sees himself as a visionary, a witness to the truth and reality of his inner experiences (compare fig. 979). The hypersensitive features seem lacerated by a great ordeal of the imagination. We may find in this tortured psyche an echo of the cultural climate that also produced Sigmund Freud.

Kokoschka's most memorable work is The Bride of the Wind (fig. 1029). Based on Romantic paintings of Dante's tragic lovers Paolo and Francesca, it shows the artist with Alma Mahler, the "muse" who inspired so many of Germany and Austria's leading cultural figures. The awesome canvas is a monument to the power of love: echoing the impassioned brushwork, the entire universe resounds in a great chord of exaltation at their embrace.

KANDINSKY. The most daring and original step beyond Fauvism was taken in Germany by a Russian, Wassily Kandinsky (1866–1944), the leading member of a group of Munich artists called Der Blaue Reiter (The Blue Rider) after one of his early paintings. Formed in 1911, it was a loose alliance united only by its mystical tendencies. Kandinsky began to forsake representation as early as 1910 and abandoned it altogether several years later. Using the rainbow colors and the free, dynamic brushwork of the Paris Fauves, he created a completely non-objective style. These works have titles as abstract as their forms: our example, one of the most striking, is called

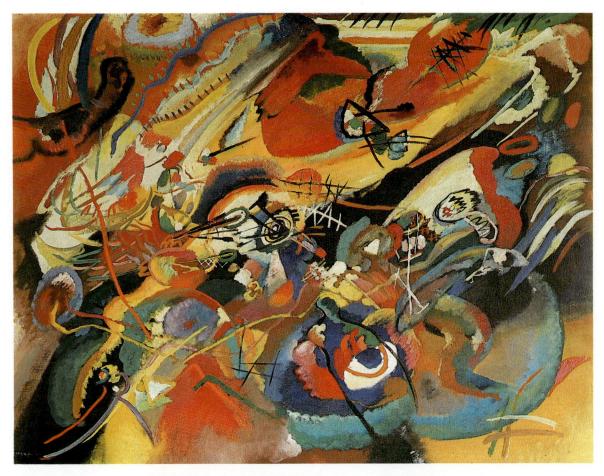

1030. Wassily Kandinsky. *Sketch I for "Composition VII."* 1913. Oil on canvas, 30³/4 x 39³/8" (78 x 100 cm). Private collection

Sketch I for "Composition VII" (fig. 1030). Perhaps we should avoid the term abstract, because it is often taken to mean that the artist has analyzed and simplified visible reality into geometric forms. (Compare Cézanne's dictum that all natural forms are based on the cone, sphere, and cylinder.) Kandinsky did indeed derive his shapes from the world around him—landscapes that he freely invented—but by transforming rather than reducing them.

As the first part of his book *Concerning the Spiritual in Art*, published in 1912, makes clear, Kandinsky's aim was to charge form and color with a purely spiritual meaning (as he put it), one that expressed his deepest feelings, by eliminating all resemblance to the physical world. [See Primary Sources, no. 99, page 942.] To him, the only reality that mattered was the artist's inner reality. Kandinsky acknowledged the Symbolists as his ancestors. Like Gauguin, he wanted to create an art of spiritual renewal. But in contrast to Rouault or Nolde, his was an art without a specific spiritual program, though it has close affinities with the theosophy of Rudolf Steiner, which influenced many early modern artists in Germany. Kandinsky, like Steiner, believed that humanity had lost touch with its spirituality through attachment to material things, and he sought to rekindle that dreamlike consciousness through his art.

The second part of the book is concerned exclusively with the formal aspects of painting, above all color. Kandinsky studied the color theories of Seurat and his followers (see page 751), as did many other Expressionists, but the meaning he attached to specific hues was no less individual than Van Gogh's. However, not until after his return from Russia in 1922 were the implications of his discussion of form fully realized when he adopted geometric abstraction (see page 759).

What does all this have to do with Kandinsky's paintings themselves? The character of his art is best summed up by his later statement: "Painting is the vast, thunderous clash of many worlds, destined, through a mighty struggle, to erupt into a totally new world, which is creation. And the birth of a creation is much akin to that of the Cosmos. There is the same vast and cataclysmic quality belonging to that mighty symphony—the Music of the Spheres."

Kandinsky's antinaturalism was inherent in Expressionist theory from the very beginning. Whistler, too, had spoken of "divesting the picture from any outside sort of interest." He even anticipated Kandinsky's "musical" titles (fig. 949). But it was the liberating influence of the Fauves that permitted Kandinsky to put this approach into practice: when the upper third of Rouault's *Head of Christ* (fig. 1023) is covered, we recall, the rest becomes a nonrepresentational composition strangely similar to Kandinsky's in its slashing brushwork and charged forms.

How valid is the analogy between painting and music? Although Kandinsky was careful to acknowledge the differences between the two art forms, he sought a painting that,

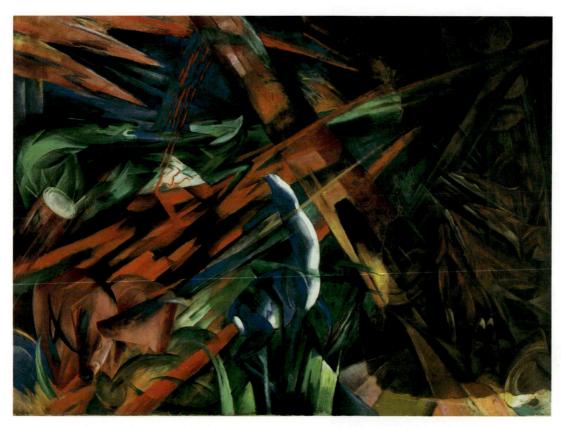

1031. Franz Marc. Animal Destinies. 1913. Oil on canvas, 6'41/2" x 8'7" (1.94 x 2.62 m). Öffentliche Kunstsammlung Basel, Kunstmuseum, Switzerland

like music, was an absolute because it was divorced entirely from the "objective," material realm. When a painter like Kandinsky carries it through so uncompromisingly, does he really lift his art to another plane? Or could it be that his declared independence from representational images now forces him instead to "represent music," which limits him even more severely? Kandinsky's advocates like to point out that representational painting has a "literary" content, and they deplore such dependence on another art. But they do not explain why the "musical" content of non-objective painting should be more desirable. Is painting less alien to music than to literature? They seem to think music is a higher art than literature or painting because it is inherently nonrepresentational. This point of view has an ancient tradition that goes back to Plato and includes Plotinus, St. Augustine, and their medieval successors. The attitude of the non-objectivists might thus be termed "secular iconoclasm." They do not condemn images as wicked, but denounce them as non-art.

The case is difficult to argue, and it does not matter whether this theory is right or wrong, for the proof of the pudding is in the eating, not in the recipe. Kandinsky's—or any artist's—ideas are not important to us unless we are convinced of the importance of the work itself. The painting reproduced here has such density and vitality that it impresses us with its radiant freshness of feeling, even though we may be uncertain what exactly the artist has expressed.

MARC. The subject matter of Franz Marc (1880–1916) was the unconscious life of animals in nature. Motivated by the pantheistic feeling of the Romantics, which was heightened by his association with Kandinsky, the artist's paintings represent humanity's desire to return to a state of harmony with the universe—a central concept of Rudolf Steiner's theosophy. Marc devised a color symbolism as personal as that of Van Gogh, who had inspired his early work (see page 757). He wrote: "Blue is the masculine principle, robust and spiritual. Yellow is the feminine principle, gentle, serene, sensual. Red is matter, brutal and heavy." But it was the Orphism of Robert Delaunay (see page 793), with whom he formed a friendship in 1912, that showed Marc the full potential of color to express his mystical beliefs. Later that year, Futurism enabled him to depict the dynamism of nature by creating rhythms that echo those of the cosmos, or so he believed. In Animal Destinies (fig. 1031), Marc's poetic vision has attained apocalyptic intensity. With its interpenetrating crystalline forms looking like so many pieces of jagged stained glass, the picture is even more terrifying than Stubbs' Lion Attacking a Horse (fig. 848) in evoking the cataclysmic forces that overwhelm these uncomprehending beasts. Here the artist was indeed on the verge of depicting a "higher" symbolic reality. A year later he abandoned representation almost entirely for an abstract style no less advanced than Kandinsky's. Soon, however, he was drafted into the war, which claimed his life.

1032. Marsden Hartley. *Portrait of a German Officer.* 1914.

Oil on canvas, 68¹/4 x 41³/8" (173 x 104 cm). The Metropolitan Museum of Art, New York

The Alfred Stieglitz Collection, 1949

HARTLEY. Americans became familiar with the Fauves through exhibitions from 1908 on. After the pivotal Armory Show of 1913, which introduced the latest European art to New York, there was a growing interest in the German Expressionists as well (see page 783). The driving force behind the modernist movement in the United States was the photographer Alfred Stieglitz (see page 898), who almost singlehandedly supported many of its early members. To him, modernism meant abstraction and its related concepts. Among the most significant works by the Stieglitz group are the canvases painted by Marsden Hartley in Munich during the early years of World War I under the direct influence of Kandinsky. Portrait of a German Officer (fig. 1032) is a masterpiece of design from 1914, the year Hartley (1887-1943) was invited to exhibit with Der Blaue Reiter. He had already been introduced to Futurism and several offshoots of Cubism (see page 794), which he used to discipline Kandinsky's supercharged surface. The emblematic portrait is testimony to the militarism he encountered everywhere in Germany. It incorporates the insignia, epaulets, Maltese cross, and other details from an officer's uniform of the day.

ABSTRACTION

The second of our main currents is Abstraction. When discussing Kandinsky, we said that the term is usually taken to mean the process (or the result) of analyzing and simplifying observed reality into geometric shapes. Literally, it means "to draw away from, to separate." Actually, abstraction goes into the making of any work of art, whether the artist knows it or not, since even the most painstakingly realistic portrayal can never be an entirely faithful replica. The process was not conscious and controlled, however, until the Early Renaissance, when artists first analyzed the shapes of nature in terms of mathematical bodies (see page 432). Cézanne and Seurat revitalized this approach and explored it further. They are the direct ancestors of the abstract movement in twentiethcentury art. The difference, as one critic has noted, is that for the latter, abstraction has been both a premise and a goal, not simply a reductive refinement. Abstraction has been the most distinctive and consistent feature of modern painting to which even its most vocal opponents have responded.

PICASSO'S DEMOISELLES D'AVIGNON. It is difficult to imagine the birth of modern abstraction without Pablo Picasso. About 1905, stimulated as much by the Fauves as by the retrospective exhibitions of the great Post-Impressionists, he gradually abandoned the melancholy lyricism of his Blue Period (see fig. 991) for a more robust style. He shared Matisse's enthusiasm for Gauguin and Cézanne, but he viewed these masters very differently. In 1907 he produced his own counterpart to The Joy of Life, a monumental canvas so challenging that it outraged even Matisse (fig. 1033). The title, Les Demoiselles d'Avignon ("The Young Ladies of Avignon"), does not refer to the town of that name, but to Avignon Street in a notorious section of Barcelona. When Picasso started the picture, it was to be a temptation scene in a brothel, but he ended up with a composition of five nudes and a still life. But what nudes! Matisse's generalized figures in The Joy of Life (see fig. 1021) seem utterly innocuous compared to this savage aggressiveness.

The three on the left are angular distortions of classical figures, but the violently dislocated features and bodies of the other two have all the barbaric qualities of ethnographic art. Following Gauguin's lead, the Fauves had discovered the aesthetic appeal of African and Oceanic sculpture and had introduced Picasso to this material. Nonetheless it was Picasso, not the Fauves, who used primitivist art as a battering ram against the classical conception of beauty. Not only the proportions, but the organic integrity and continuity of the human body are denied here, so that the canvas (in the apt description of one critic) "resembles a field of broken glass."

Picasso, then, has destroyed a great deal. What has he gained in the process? Once we recover from the initial shock, we begin to see that the destruction is quite methodical. Everything—the figures as well as their setting—is broken up into angular wedges or facets. These, we will note, are not flat, but shaded in a way that gives them a certain three-dimensionality. We cannot always be sure whether they are concave or convex. Some look like chunks of solidified space, others like fragments of translucent bodies. They constitute a unique kind of

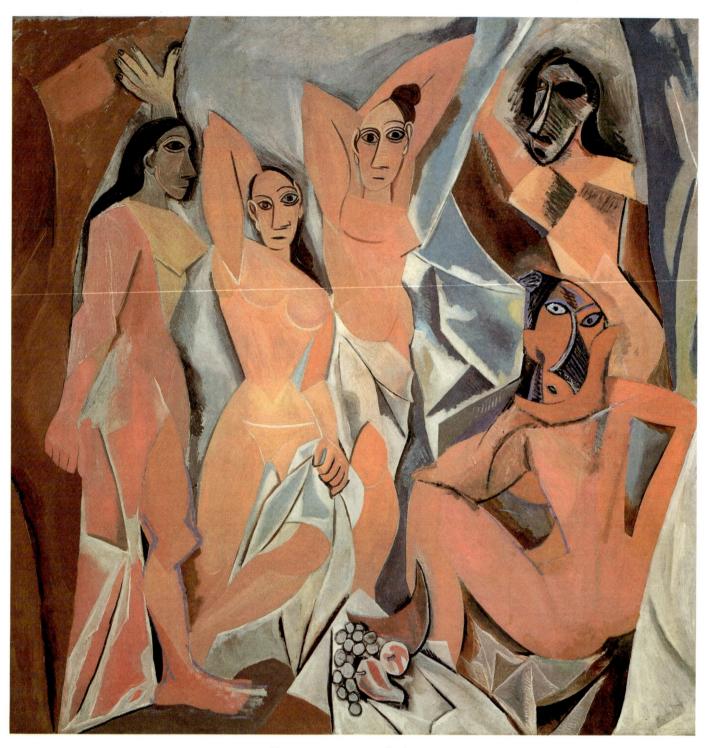

1033. Pablo Picasso. Les Demoiselles d'Avignon. 1907. Oil on canvas, 8' x 7'8" (2.44 x 2.34 m). The Museum of Modern Art, New York Acquired through the Lillie P. Bliss Bequest

If any one event announced the arrival of twentieth-century mu-

sic, it was the ballet The Rite of Spring (1913) by the Russianborn composer Igor Stravinsky (1882-1971), the last of three scores commissioned in 1910-13 by the impresario Sergei Diaghilev for his Ballets Russes (see box page 795). While a pupil of the nationalist composer Nikolai Rimsky-Korsakov (1844–1908) in St. Petersburg, Stravinsky had revealed a striking gift for melody in the Russian tradition and an unusual sense of rhythm. These were evident in his first two ballets, The Firebird and Petrushka, which created a sensation in Paris because of their exoticism. The primitivism and eroticism of the Rite of Spring caused a famous riot at its premiere, although there is evidence that it was staged. Stravinsky was the musical counterpart to Picasso as a giant of his time. Indeed, the Rite may be compared to Picasso's Demoiselles d'Avignon (fig. 1033) in its impact. Like Picasso, Stravinsky turned to classicism after 1920. Finally, toward the end of his long life, he successfully adopted the serialism of Arnold Schoenberg.

Just as the art of the twentieth century was distinguished by abstraction from an early date, so its music has often been marked by atonality, a rejection of the major and minor diatonic scales, the rules of harmony in general, and especially the importance of the tonic (the first tone of the scale in which a given piece was written; see box page 624). From about 1550, most European music had centered around the tonic note, in effect a musical "home base" to which the melody tended to return. However, a frequent return to the tonic note is not actually required by the rules of harmony or the tempered scale (see page 624)—a fact that had already been exploited by a number of German composers, starting with Wagner. It was almost inevitable that the final break with tonality—the importance of the tonic—would be made by a Post-Romantic.

The final step was taken by Arnold Schoenberg (1874–1951). The hypersensitive content of his early work, like Mahler's, sometimes brings to mind the world of neurosis explored by his great contemporary in Vienna Sigmund Freud, the pioneer of modern psychology. His *Transfigured Night* (1899) has the sensuality of the famous *Liebestod* duet in Wagner's opera *Tristan and Isolde*. Schoenberg, an Expressionist by inclination, later became a friend of Kandinsky and a capable artist in his own right. Schoenberg, however, moved almost immediately into complete atonality. In 1912 he took the further step of abandoning the pitches used in

normal singing for "speech-song" (German, *Sprechstimme*). Schoen-

berg nevertheless continued to make use of other traditional techniques of composition, which he built into pieces of extraordinary complexity. Finally, in 1923, he took another step when he produced his first "serial" works based on the so-called "twelve-tone row" (also called the "series") utilizing the same devices he had been working with for some time. Each row uses all the notes of the tempered scale just once, except for a few "free" notes that do not conform to the sequence. It thus constitutes a self-contained musical realm representing the final overthrow of tonalism. By subjecting it to various techniques for modifying and extending it (including such as devices as retrogrades, inversions, and transpositions), the row can be built into a large-scale composition without repeating any sequence. Serialism was, then, simply a means of organizing Schoenberg's compositions, and although others were to extend its principles, he

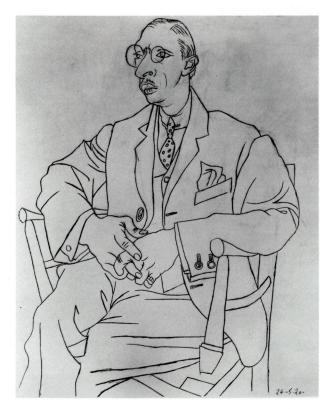

Pablo Picasso. *Portrait of Igor Stravinsky*. 1920. Pencil on paper, $24^3/8 \times 19^1/8$ " (62 x 48.5 cm). Musée Picasso, Paris

matter, which imposes a new integrity and continuity on the entire canvas. The *Demoiselles*, unlike *The Joy of Life*, can no longer be read as an image of the external world. Its world is its own, analogous to nature but constructed along different principles. Picasso's revolutionary "building material," compounded of voids and solids, is hard to describe with any precision. The early critics, who saw only the prevalence of sharp edges and angles, dubbed the new style Cubism.

Analytic Cubism

That the *Demoiselles* owes anything to Cézanne may at first seem incredible. However, Picasso had studied Cézanne's late work (such as fig. 971) with great care, finding in Cézanne's abstract treatment of volume and space the translucent structural units from which to derive the faceted shapes of Analytic (or Facet) Cubism. The link is clearer in *Portrait of Ambroise Vollard* (fig. 1034)—Vollard was one of the leading print publishers and dealers of the time—which Picasso painted three

always stressed the personal nature of his work, which was no less individual than that of his contemporaries. He remained an Expressionist at heart. *A Survivor from Warsaw* (1948), written after the composer had fled Austria and settled in California (as did Stravinsky), conveys the nightmare of the Holocaust with almost unbearable anguish.

Needless to say, Schoenberg's music made extraordinary demands on musician and listener alike. Yet he was able to attract talented disciples almost as soon as he settled in Vienna in 1903. Chief among them was Anton Webern (1883-1945), who, like Gustav Mahler before him, was better known as a conductor during his lifetime. Webern's mature compositions, all small in scale, are miracles of rigor, conciseness, and purity. For over a decade his music retained aspects of Schoenberg's expressionism, making it a counterpart to the hypersensitive manner of his friend Oscar Kokoschka. Hence, serialism initially had little impact on his style and, as with Schoenberg, was little more than a convenient means of organizing his music more coherently. However, he gradually began to apply its principles to other aspects of music, not just tone rows. Much of Webern's work consists of songs and choral music that treat the voice as simply another instrument, for he was as devoted to his serial system as Bach had been to counterpoint. At first Webern's literary sources differed little in character from Mahler's, but his terse atonality can be regarded as the antidote to the inflated rhetoric of his predecessor's song cycles, such as *The* Youth's Magic Horn. Despite their serial technique, Webern's later songs are remarkably successful settings of mystical poems by his friend Hildegard Jone.

The main contributions of Alban Berg (1885-1935), Schoenberg's other important pupil, are the Expressionist operas Wozzeck (1923), based on the play by Georg Büchner, and the unfinished Lulu (1935), derived from two plays of 1895 by Franklin Wedekind. Both are emotionally harrowing explorations of the dark side of human existence in a world of unrelenting evil: Wozzeck becomes a terrifying symbol of modern man trapped by forces he cannot comprehend that ultimately destroy him, while Lulu traces the descent of the protagonist into prostitution and her murder at the hands of Jack the Ripper as a tragic metaphor for the unbridled lust and avarice in contemporary society. In Berg's vocal writing one can still hear the last vestiges of Wagnerian opera, but stripped of its mythical trappings so that it evokes a disturbing, yet haunting, vision of twentiethcentury life.

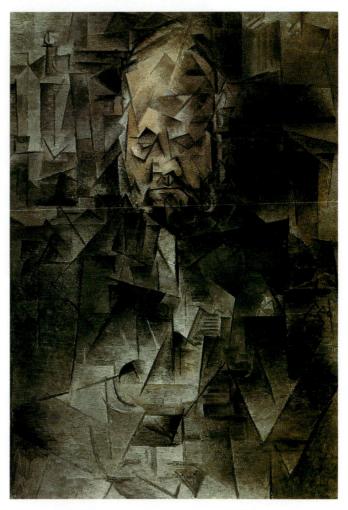

1034. Pablo Picasso. *Portrait of Ambroise Vollard.* 1910. Oil on canvas, 36¹/4 x 25⁵/8" (92 x 65 cm). The Pushkin State Museum of Fine Arts, Moscow

years later. The facets are now small and precise, more like prisms, and the canvas has the balance and refinement of a fully mature style.

Contrasts of color and texture, so pronounced in the *Demoiselles*, are now reduced to a minimum; the subdued tonality of the picture approaches monochrome, so as not to compete with the design. The structure has become so complex and systematic that it would seem wholly cerebral if the

"imprismed" sitter's face did not emerge with such dramatic force. Indeed, this is as commanding a portrait as Ingres' *Louis Bertin* (fig. 871), one that fully conveys the power of his complex personality. Of the "barbaric" distortions in the *Demoiselles* there is no trace; they had served their purpose. Cubism has become an abstract style within the purely Western sense, but its distance from observed reality has not significantly increased. Picasso may be playing an elaborate game of hideand-seek with nature, but he still needs the visible world to challenge his creative powers. The non-objective realm held no appeal for him, then or later.

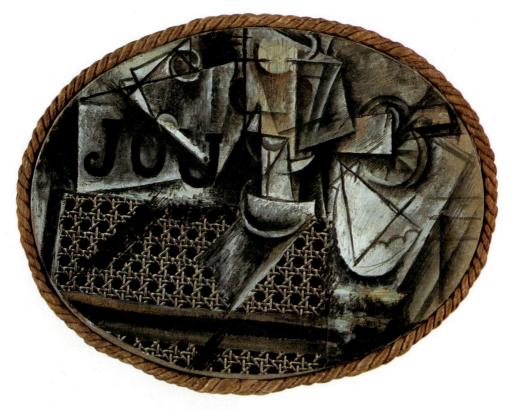

1035. Pablo Picasso. Still Life with Chair Caning. 1912. Collage of oil, oilcloth, and pasted paper simulating chair caning on canvas, $10^{1/2} \times 13^{3/4}$ " (26.7 x 35 cm). Musée Picasso, Paris

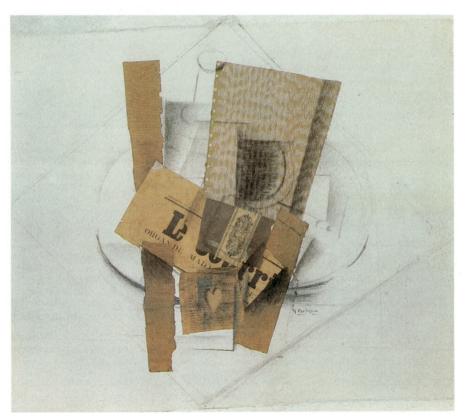

1036. Georges Braque. *Newspaper, Bottle, Packet of Tobacco (Le Courrier).* 1914.

Collage of charcoal, gouache, pencil, ink, and pasted paper on cardboard, 20⁵/8 x 25" (52.4 x 63.5 cm).

Philadelphia Museum of Art

A. E. Gallatin Collection

Synthetic Cubism

By 1910 Cubism was well established as an alternative to Fauvism, and Picasso had been joined by a number of other artists, notably Georges Braque (1882–1963), with whom he collaborated so intimately that their work at that time is difficult to tell apart. Both of them (it is not clear to whom the chief credit belongs) initiated the next phase of Cubism, which was even bolder than the first. Usually called Synthetic Cubism because it puts forms back together, it is also known as Collage Cubism, after the French word for "paste-up," the technique that started it all. We see its beginnings in Picasso's Still Life with Chair Caning of 1912 (fig. 1035). Most of the painting shows the now-familiar facets, except for the letters; these, being already abstract signs, could not be translated into prismatic shapes. But from beneath the still life emerges a piece of imitation chair caning, which has been pasted onto the canvas, and the picture is "framed" by a piece of rope. This intrusion of alien materials has a most remarkable effect: the abstract still life appears to rest on a real surface (the chair caning) as if it were on a tray, and the substantiality of this tray is further emphasized by the rope.

Within a year, Picasso and Braque were producing still lifes composed almost entirely of cut-and-pasted scraps of material, with only a few lines added to complete the design. In Le Courrier by Braque (fig. 1036) we recognize strips of imitation wood graining, part of a tobacco wrapper with a contrasting stamp, half the masthead of a newspaper, and a bit of newsprint made into a playing card (the ace of hearts). Why did Picasso and Braque suddenly prefer the contents of the wastepaper basket to brush and paint? In wanting to explore their new concept of the picture as a tray on which to "serve" the still life, they found the best way was to put real things on the tray. The ingredients of a collage actually play a double role. They have been shaped and combined, then drawn or painted upon to give them a representational meaning, but they do not lose their original identity as scraps of material they remain "outsiders" in the world of art. Their function is both to represent (to be a part of an image) and to present (to be themselves). In this latter capacity, they endow the collage with a self-sufficiency that no Analytic Cubist picture can have. A tray, after all, is a self-contained area, detached from the rest of the physical world. Unlike a painting, it cannot show more than is actually on it.

The difference between the two phases of Cubism may also be defined in terms of picture space. Analytic Cubism retains a certain kind of depth, so that the painted surface acts as a window through which we still perceive the remnants of the familiar perspective space of the Renaissance. Though fragmented and redefined, this space lies behind the picture plane and has no visible limits. Potentially, it may even contain objects that are hidden from our view. In Synthetic Cubism, on the contrary, the picture space lies in front of the plane of the "tray." Space is not created by illusionistic devices, such as modeling and foreshortening, but by the actual overlapping of layers of pasted materials. The integrity of the nonperspective space is not affected when, as in Le Courrier, the apparent thickness of these materials and their distance from each other are increased by a bit of shading here and there. Synthetic Cubism, then,

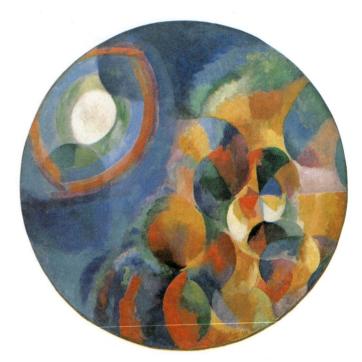

1037. Robert Delaunay. Simultaneous Contrasts: Sun and Moon. 1913. Oil on canvas, diameter 53" (134.5 cm). The Museum of Modern Art, New York Mrs. Simon Guggenheim Fund

offers a basically new space concept, the first since Masaccio. It is a true landmark in the history of painting.

Before long Picasso and Braque discovered that they could retain this new pictorial space without the use of pasted materials. They only had to paint as if they were making collages. World War I, however, put an end to their collaboration and the further development of Synthetic Cubism, which reached its height in the following decade.

Orphism

THE DELAUNAYS. The Cubism of Picasso and Braque was little concerned with color—an issue addressed finally by Robert Delaunay (1885–1941) and his wife, Sonia Delaunay-Terk (1885–1979). They evolved a totally abstract style, called Orphism, after the legendary Orpheus, by the poet Apollinaire (1880–1918), the chief theorist of the movement. Following the concepts of Chevreul, Seurat, and Gauguin, they sought to produce pure color harmonies as independent of nature as music. Late in 1912, Delaunay began to paint his series Simultaneous Contrasts (fig. 1037), in which the swirling movement is meant to evoke the rhythms pulsating throughout the universe. The idea was in the air: at almost the same time the Czech painter Frantisek Kupka (1871-1957), working independently in Paris, came to the identical solution. It was soon taken up as well by the Americans Stanton Macdonald-Wright (1890-1973) and Morgan Russell (1886-1953), also active in Paris, who called their movement Synchromism. Orphism proved to be short-lived, however. Even the Delaunays were able to maintain this non-objective style for only a few years and soon turned to Futurism. Nevertheless, the movement proved of great importance. Among its early members were Marcel

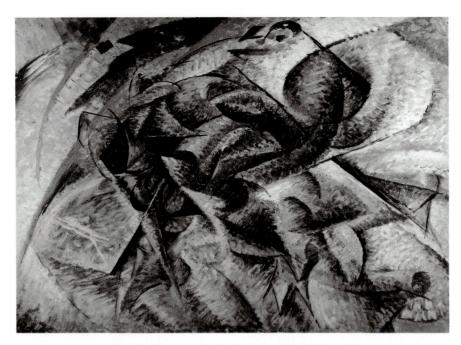

1038. Umberto Boccioni. *Dynamism of a Cyclist.* 1913. Oil on canvas, 27⁵/8 x 37³/8" (70 x 95 cm). Collection Gianni Mattioli, Milan

Cubo-Futurism

Duchamp and his brother Raymond Duchamp-Villon. In addition to Franz Marc, it also affected Fernand Léger, Marc Chagall, and even Paul Klee.

Futurism

As originally conceived by Picasso and Braque, Cubism was a formal discipline of subtle balance applied to traditional subjects: still life, portraiture, the nude. Other painters, however, saw in the new style a special affinity with the geometric precision of engineering that made it uniquely attuned to the dynamism of modern life. The short-lived Futurist movement in Italy exemplifies this attitude. In 1909–10 its disciples, led by the poet Filippo Tommaso Marinetti, issued a series of manifestos violently rejecting the past and exalting the beauty of the machine. [See Primary Sources, no. 100, pages 942–43.]

BOCCIONI. At first they used techniques developed from Post-Impressionism to convey the surge of industrial society, but these were otherwise static compositions, still dependent upon representational images. By adopting the simultaneous views of Analytic Cubism in *Dynamism of a Cyclist* (fig. 1038), Umberto Boccioni (1882-1916), the most original of the Futurists, was able to communicate the energy of furious pedaling across time and space far more tellingly than if he had actually depicted the human figure, which could be seen in only one time and place in traditional art. In the flexible vocabulary provided by Cubism, Boccioni found the means of expressing the twentieth century's new sense of time, space, and energy that Albert Einstein had defined in 1905 in his special theory of relativity. Moreover, Boccioni suggests the unique quality of the modern experience. With his pulsating movement, the cyclist has become an extension of his environment, from which he is now indistinguishable.

As its name implies, Cubo-Futurism, which arose in Russia a few years before World War I as the result of close contacts with the leading European art centers, took its style from Picasso and based its theories on Futurist tracts. The Russian Futurists were, above all, modernists. They welcomed industry, which was spreading rapidly throughout Russia, as the foundation of a new society and the means for conquering that old Russian enemy, nature. Unlike the Italian Futurists, however, the Russians rarely glorified the machine, least of all as an instrument of war.

Central to Cubo-Futurist thinking was the concept of zaum, a term which has no counterpart in English. Invented by Russian poets, zaum was a trans-sense (as opposed to the Dadaists' nonsense; see page 806) language based on new word forms and syntax. In theory, zaum could be understood universally, since it was thought that meaning was implicit in the basic sounds and patterns of speech. When applied to painting, zaum provided the artist with complete freedom to redefine the style and content of art. The picture surface was now seen as the sole conveyer of meaning through its appearance. Hence, the subject of a work of art became the visual elements and their formal arrangement. However, because Cubo-Futurism was concerned with means, not ends, it failed to provide the actual content that is found in modernism. Although the Cubo-Futurists were more important as theorists than artists, they provided the springboard for later Russian movements.

The new world envisioned by the Russian modernists led to a broad redefinition of the roles of man and woman, and it was then in Russia that women emerged as artistic equals to an extent not achieved in Europe or America until considerably later. The finest painter of the group was Liubov Popova (1889–1924), who studied in Paris in 1912 and visited Italy in 1914. The combination of Cubism and Futurism that she

By far the most adventurous theater before World War I was to be

found in Russia, thus preparing the way for even more radical experiments after the Russian Revolution of 1917. The most famous of the Russian reformers remains Konstantin Stanislavsky (1863-1938), who was a co-founder of the Moscow Art Theater with Vladimir Nemirovich-Danchenko (1858–1943). His legacy is clouded by a lack of fully authentic texts, but in general he placed greatest emphasis on the actor, despite the fact that he never adopted the "star" system. Stanislavsky insisted on a rigorous training of body, voice, and mind based on a thorough understanding of stagecraft, reality, and the drama itself, so that the action would unfold naturally and convincingly, though he was by no means a Realist. Stanislavsky's theories were later practiced in America as "method acting" (see box page 825).

The key figure in early Russian modernism, however, was Vsevelod Meyerhold (1874-1940), who considered the director to be the main creative force in the theater. He was employed by every Russian avant-garde theater, including Stanislavsky's Moscow Art Theater, but never lasted very long in any position because his experiments were regarded as too bold. For example, he dispensed with the theatrical curtain and set his productions in symbolic scenery or even on a bare stage. Alexander Tairov (1885-1950) adopted a centrist position: like Stanislavsky, he stressed the importance of the actor but followed Meyerhold in treating the play as the point of departure for the director's creativity. At the same time, he maintained that there is no relationship between art and life and that theater should be like the sacred dances of ancient temples. The ritual effect of his productions, which stressed unity of word, music, and dance, was similar in intent to Classical Greek theater. At the opposite end of the spectrum was the equally innovative Nikolai Evreinov (1879-1953), whose "monodramas," such as The Theater of the Soul (1912), sought to lead the audience to a greater understanding by drawing on what he believed was humanity's innate theatricality, which leads people to seek a

The Russians had a great impact on French theater. The first to exercise his influence was Sergei Diaghilev (1872-1929), whose publication The World of Art promoted Symbolist art, literature, and theater. The ballet company he took to Paris in 1909 met with such success that he formed the Ballets Russes, featuring the great dancer Vasily Nijinsky (1890-1950), the choreography of Mikhail Fokine (1880-1942), the music of Igor Stravinsky and his teacher Nikolai Rimsky-Korsakov, and the designs of Aleksandr Benois (1870-1960) and Léon Bakst (1866-1924). With the onset of the Russian Revolution the company remained in Paris; it later employed Picasso, Braque, and De Chirico among

other artists as stage and costume designers.

Under Russian influence, Jacques Rouché (1862–1957) launched the periodical Modern Theater simultaneously with the Théâtre des Arts in 1910. His ideas were to bear fruit at the Paris Opéra, where he was appointed director four years later and remained until 1936. It was at the Théâtre des Arts that Jacques Copeau (1879-1949), who became the leading figure in French theater between the wars, got his start. He adopted the opposite position of Meyerhold's in arguing that only the actor was essential and that the director's primary responsibility was the faithful translation of the script into a "poetry of the theater." And whereas Rouché thought primarily in visual terms, Copeau argued for a return to the bare

For all of its inventiveness, early-twentieth-century theater contributed little in the way of new plays. The main impetus in dramatic writing came from Ireland. There plays with a Gaelic focus were produced by the Irish National Theater Society, better known as the Abbey Theater, where it was housed after 1904. The most important playwrights were the poet William Butler Yeats (1865-1939), Lady Augusta Gregory (1863-1935), and John Synge (1871-1909). Yeats' early work sprang from the writing of the French Symbolists he had met in Paris. He was primarily concerned with restoring the importance of writing to theater; thus, his poetic-mythic approach was the opposite of Lady Gregory's, whose style was realistic-domestic. It was Yeats who convinced Synge to return from Paris to write about Irish peasant life. Synge successfully synthesized the best features of Yeats and Lady Gregory in the two finest dramas staged by the Abbey: Riders to the Sea (1904) and The Playboy of the Western World (1907). Synge was fearless in tackling controversial subjects that went against customary beliefs—Playboy caused riots wherever it played—but the real secret of his success was his unique form of poetic prose.

In England, the most important theorist was the director and designer Edward Gordon Craig (1872-1966), the son of Ellen Terry and Edward Goodwin, whose thinking laid the ground for many of the key concepts of modern directing. Like Meyerhold, he conceived of the director as an artist who created theater as a work of art independent of the drama itself by utilizing lights and simply painted screens. No one, however, had more impact on theater than Max Reinhardt (1873-1943), who succeeded Brahm as director of the Deutsches Theater in Berlin. He realized that each play demanded a different approach, without adhering to any single system. In place of the conventions of the day he insisted that the director rethink and control every detail of the production, which was prepared in close collaboration with his actors and designers.

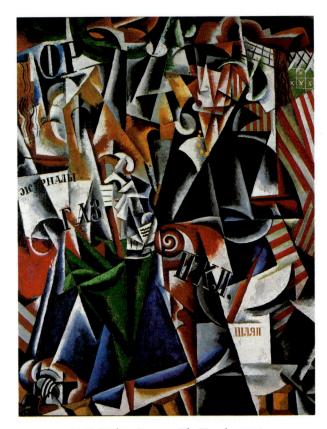

1039. Liubov Popova. *The Traveler.* 1915. Oil on canvas, 56 x 41¹/2" (142.2 x 105.4 cm). Norton Simon Art Foundation, Pasadena, California

absorbed abroad is seen in *The Traveler* (fig. 1039). The treatment of forms remains essentially Cubist, but the painting shares the Futurist obsession with representing dynamic motion in time and space. The jumble of image fragments creates the impression of objects seen in rapid succession. The furious interaction of forms with their environment across the plane threatens to extend the painting into the surrounding space. At the same time, the strong modeling draws attention to the surface, lending it a relieflike quality that is enhanced by the vigorous texture.

Suprematism

The first purely Russian art of the twentieth century, however, was Suprematism. In one of the greatest leaps of the symbolic and spatial imagination in the history of art, Kazimir Malevich (1878–1935) invented the Black Quadrilateral, as seen in figure 1040. How is it that such a seemingly simple image should be so important? By limiting art to a few elements—a single shape repeated in two tones and fixed firmly to the picture plane—he emphasized the painting as a painting even more radically than had his predecessors. Simultaneously, he transformed it into a concentrated symbol having multiple layers of meaning, thereby providing the content missing from Cubo-Futurism. The inspiration for Black Quadrilateral came in 1913 while Malevich was working on designs for the opera Victory over the Sun, with music by the composer-painter Mikhail Matiushin and libretto by the poetpainter Alexei Kruchenykh. This production was one of the

most important artistic collaborations in the modern era. In the context of the opera, the black quadrilateral represents the eclipse of the sun of Western painting and of everything based on it. Further, the work can be seen as the triumph of the new order over the old, the East over the West, humanity over nature, idea over matter. The black quadrilateral (which is not even a true rectangle) was intended to stand as a modern icon. It supersedes the traditional Christian trinity and symbolizes a "supreme" reality, because geometry is an independent abstraction in itself; hence the movement's name, Suprematism.

According to Malevich, Suprematism was also a philosophical color system constructed in time and space. His space was an intuitive one, with both scientific and mystical overtones. The flat plane replaces volume, depth, and perspective as a means of defining space. Each side or point represents one of the three dimensions, while the fourth side stands for the fourth dimension, time. Like the universe itself, the black surface would be infinite were it not delimited by an outer boundary, the white border and shape of the canvas. Black Quadrilateral thus constitutes the first satisfactory redefinition, visually and conceptually, of time and space in modern art. Like Einstein's formula E=mc² for the theory of relativity, it has an elegant simplicity that belies the intense effort required to synthesize a complex set of ideas and reduce them to a fundamental "law." When it first appeared, Suprematism had much the same impact on Russian artists that Einstein's theory had on scientists: it unveiled a world never seen before, one that was unequivocally modern. The relation between art and science is closer than we might think, for despite the differences in approach, they are united by the imagination. In fact, the key to solving the theory of relativity came to Einstein as a visual image.

Later, Malevich began to tilt his quadrilaterals and simplify his paintings still further in search of the ultimate work of art. Malevich's efforts culminated in *Suprematist Composition:* White on White (fig. 1041), his most famous composition, which limits art to its fewest possible components. It is all too tempting to dismiss such a radical extreme as a reductio ad absurdum. Seen in person, however, the canvas is surprisingly persuasive. The shapes, created by two subtly different shades of white, have a revelatory purity that makes even Black Quadrilateral seem needlessly complex.

The heyday of Suprematism was over by the early 1920s. Reflecting the growing diversity and fragmentation of Russian art, its followers defected to other movements, above all to the Constructivism led by Vladimir Tatlin (see pages 847–48).

FANTASY

Our third current, Fantasy, follows a less clear-cut course than the other two, since it depends on a state of mind more than on any particular style. The one thing all painters of fantasy have in common is the belief that imagination, "the inner eye," is more important than the outside world. We must be careful how we use the term *fantasy*. It originated in psychoanalytic theory, and meant something very different in the early twentieth century than it does now. It was thought of as mysterious and profound, anything but the lighthearted and superficial view we take of it today.

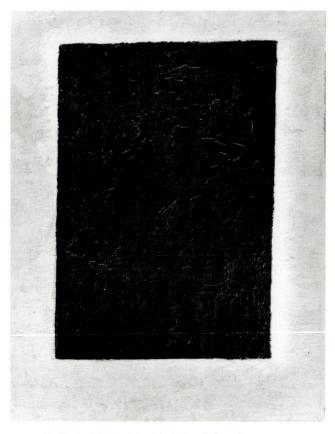

1040. Kazimir Malevich. Black Quadrilateral. c. 1913–15. Oil on canvas, 24 x 17" (61 x 43.3 cm). Copyright the George Costakis Collection, Athens

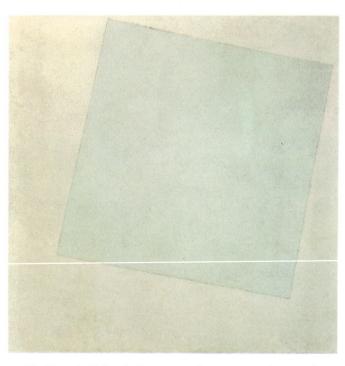

1041. Kazimir Malevich. Suprematist Composition: White on White. 1918. Oil on canvas, $31^{1/4} \times 31^{1/4}$ " (79.4 x 79.4 cm). The Museum of Modern Art, New York

Why did private fantasy come to loom so large in twentieth-century art? We saw the trend beginning at the end of the eighteenth century in the art of Goya and Fuseli (see figs. 862 and 884); perhaps this suggests part of the answer. In fact, there seem to be several interlocking causes. First, the cleavage that developed between reason and imagination in the wake of rationalism tended to dissolve the heritage of myth and legend that had been the common channel of private fantasy in earlier times. Second, the artist has a greater freedom—and insecurity—within the social fabric, giving him a sense of isolation and favoring an introspective attitude. Then, too, the Romantic cult of emotion prompted the artist to seek out subjective experience, and to accept its validity. Needless to say, this process took time, so that in early-nineteenth-century painting, private fantasy was still a minor current, but by 1900 it had become a major one, thanks to Symbolism on the one hand and the naïve vision of artists like Henri Rousseau on the other.

DE CHIRICO. The heritage of Romanticism can be seen most clearly in the astonishing pictures painted in Paris just before World War I by Giorgio de Chirico (1888–1978), such as Mystery and Melancholy of a Street (fig. 1042). This deserted square with endless diminishing arcades, nocturnally illuminated by the cold full moon, has all the poetry of Romantic reverie—but it has also a strangely sinister air. This is an "ominous" scene in the full sense of the term: everything here suggests an omen, a portent of unknown and disquieting significance. The artist himself could not explain the

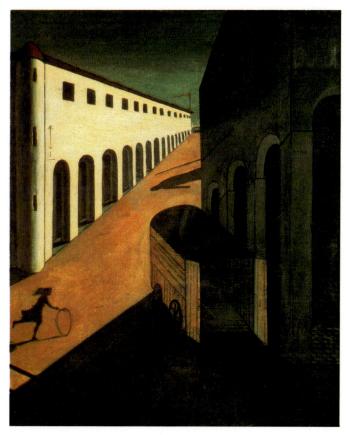

1042. Giorgio de Chirico. Mystery and Melancholy of a Street. 1914. Oil on canvas, $34^{1/4} \times 28^{1/2}$ " (87 x 72.4 cm). Private collection

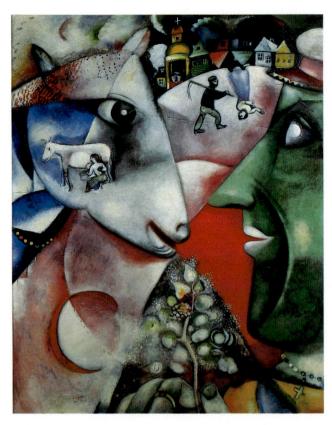

1043. Marc Chagall. I and the Village. 1911. Oil on canvas, $6'3^5/8" \times 4'11^1/2"(1.92 \times 1.51 \text{ m})$. The Museum of Modern Art, New York

Mrs. Simon Guggenheim Fund

incongruities in these paintings—the empty furniture van, or the girl with the hoop—that trouble and fascinate us. De Chirico called this *Metaphysical Painting:* "We who know the signs of the metaphysical alphabet are aware of the joy and the solitude which are enclosed by a portico, by the corner of a street, or even in a room, on the surface of a table, or between the sides of a box. . . . The minutely accurate and prudently weighed use of surfaces and volumes constitutes the canon of the metaphysical aesthetic." Later, after he had returned to Italy, he adopted a conservative style and repudiated his early works, as if he were embarrassed at having put his dream world on display, even though he secretly continued to paint copies to meet the commercial demand for them.

CHAGALL. The power of nostalgia, so evident in *Mystery and Melancholy of a Street*, also dominates the fantasies of Marc Chagall (1887–1985), a Russian who went to Paris in 1910. *I and the Village* (fig. 1043) is a Cubist fairy-tale, weaving dreamlike memories of Russian folk tales, Jewish proverbs, and the look of Russia into one glowing vision. Here, as in many later works, Chagall relives the experiences of his childhood. These were so important to him that his imagination shaped and reshaped them for years without their persistence being diminished.

DUCHAMP. In Paris shortly before World War I we encounter yet another artist of fantasy, the Frenchman Marcel

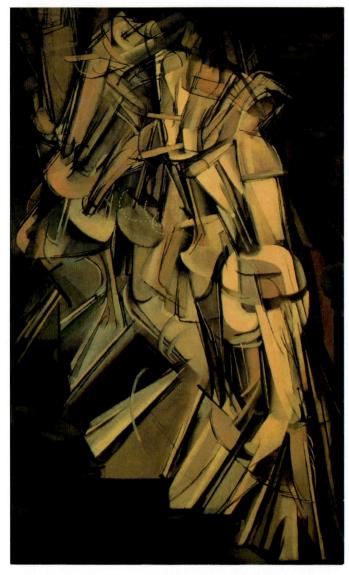

1044. Marcel Duchamp. *Nude Descending a Staircase No. 2.* 1912. Oil on canvas, 58 x 35" (147.3 x 89 cm). Philadelphia Museum of Art Louise and Walter Arensberg Collection

Duchamp (1887–1968). After basing his early style on Cézanne, he initiated a dynamic version of Analytic Cubism, similar to Futurism, by superimposing successive phases of movement on each other, much as in multiple-exposure photography (see fig. 1020a, b). His *Nude Descending a Staircase* (fig. 1044), done in this vein, caused a scandal at the Armory Show of modern art in New York in 1913 because it went against all traditional notions of what a nude should look like. Although his objective was simply to paint "a static representation of movement," this parody of the human figure already shows the ironic wit that was to underlie his work.

Soon, however, Duchamp's development took a far more disturbing turn. In *The Bride* (fig. 1045), we look in vain for any resemblance, however remote, to the human form. What we see is a mechanism that seems part motor, part distilling apparatus. It is beautifully engineered to serve no purpose whatever. The title cannot be irrelevant: by lettering it right onto the canvas, Duchamp has emphasized its importance. Yet it causes us real perplexity. Evidently the artist intended the machine as a kind of modern fetish that acts as a metaphor of

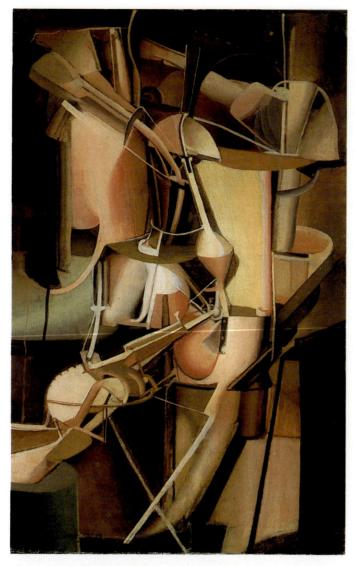

1045. Marcel Duchamp. *The Bride.* 1912. Oil on canvas, $35^{1/8}$ x $21^{3/4}$ " (89.4 x 55.2 cm). Philadelphia Museum of Art Louise and Walter Arensberg Collection

human sexuality. By "analyzing" the bride until she is reduced to a complicated piece of plumbing that seems utterly dysfunctional, physically and psychologically, he satirized the scientific outlook on humanity. Thus the picture represents the negative counterpart of the glorification of the machine, so stridently proclaimed by the Futurists. We may further see in Duchamp's pessimistic outlook a response to the gathering forces that were soon to be unleashed in World War I, toppling the political order that had been created 100 years earlier at the Congress of Vienna.

REALISM

THE ASH CAN SCHOOL. In America, the first wave of change was initiated not by the Stieglitz circle but by the Ash Can School, which flourished in New York just before World War I. Centering on Robert Henri, who had studied with a pupil of Thomas Eakins at the Pennsylvania Academy, this group of artists consisted mainly of former illustrators for Philadelphia and New York newspapers. They were fascinat-

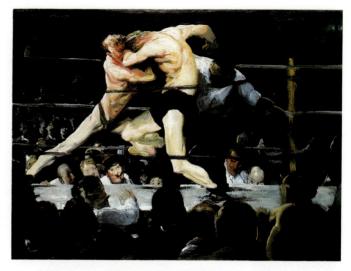

1046. George Bellows. *Stag at Sharkeys*. 1909. Oil on canvas, 36¹/4 x 48¹/4" (92.1 x 122.6 cm). The Cleveland Museum of Art Hinman B. Hurlbut Collection

ed with the teeming life of the city slums, and found an endless source of subjects in the everyday urban scene, to which they brought the reporter's eye for color and drama. Despite the socialist philosophy that many of them shared, theirs was not an art of social commentary, but one that felt the pulse of city life, discovering in it vitality and richness while ignoring poverty and squalor. To capture these qualities they relied on rapid execution, inspired by Baroque and Post-Impressionist painting, which lends their canvases the immediacy of spontaneous observation.

BELLOWS. Although not among its founders, George Bellows (1882–1925) became the leading representative of the Ash Can School in its heyday. His masterpiece, Stag at Sharkey's (fig. 1046), shows why: no painter in America before Jackson Pollock expressed such heroic energy. Stag at Sharkey's reminds us of Eakins' William Rush Carving His Allegorical Figure of the Schuylkill River (see fig. 952), for it continues the same Realist tradition. Both place us in the scene as if we were present, and both use the play of light to pick out the figures against a dark background. Bellows' paintings were fully as shocking as Eakins' had been. Most late-nineteenth-century American artists had all but ignored urban life in favor of land-scapes, and compared with these, the subjects and surfaces of the Ash Can pictures had a disturbing rawness.

THE ARMORY SHOW. The Ash Can School was quickly eclipsed by the rush toward a more radical modernism set off by the Armory Show held in New York in 1913. It was an outgrowth of the Independents Show three years earlier, which had showcased the talents of a group of rising young artists known as the Eight, who soon founded the American Association of Painters and Sculptors. The Armory Show was intended to foster a "new spirit in art" by introducing Americans to the latest trends from Europe and the United States.

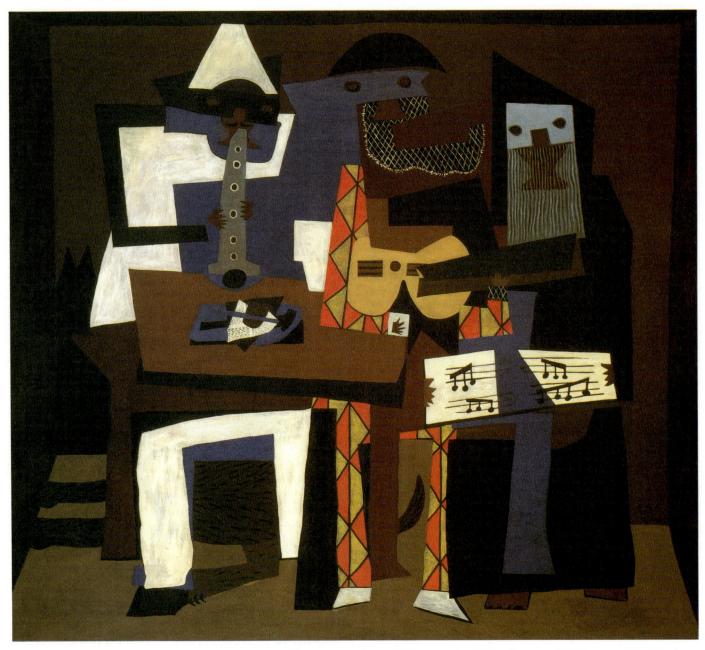

1047. Pablo Picasso. *Three Musicians*. Summer 1921. Oil on canvas, 6'7" x 7'3³/4"(2 x 2.3 m). The Museum of Modern Art, New York Mrs. Simon Guggenheim Fund

The exhibition began with a survey of French painting from the Romantics to the Post-Impressionists, especially the Symbolists. Needless to say, the modern section was also heavily French, with a major emphasis on Matisse and Picasso. There were curious lapses as well: German Expressionism was poorly represented, while Futurism was omitted completely, although Orphism had a prominent place. The selection of sculpture was haphazard at best. The American art, which made up by far the largest part of the exhibition, included works by members of the Ash Can School, the Stieglitz Group, and the Eight. While it failed to promote the interests of its organizers, the Armory Show did succeed in its goal of introducing a new cosmopolitanism into the American art

scene. It proved a *succès de scandale* with the public, who bought an astonishing number of works from the exhibition.

PAINTING BETWEEN THE WARS

The Founders

As we examine painting between the wars, we shall find anything but an orderly progression. World War I had totally disrupted the further evolution of modernism, and its end unleashed an unprecedented outpouring of art after a four-year creative lull. The responses were correspondingly diverse.

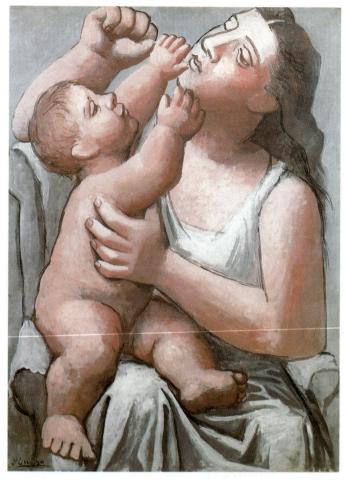

1048. Pablo Picasso. *Mother and Child.* 1921–22. Oil on canvas, 38 x 28" (96.7 x 71 cm). The Alex L. Hillman Family Foundation, New York

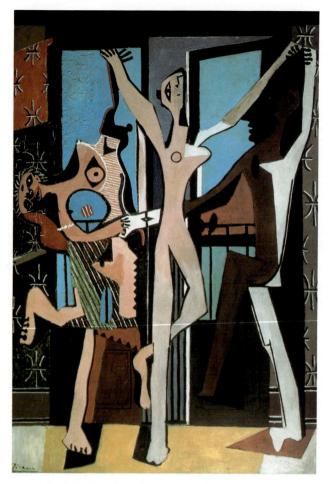

1049. Pablo Picasso. *Three Dancers*. 1925. Oil on canvas, $7'^{1}/^{2}$ " x $4'8^{1}/^{4}$ " (2.15 x 1.43 m). The Tate Gallery, London

Because they were already fully formed artists, the founders of modern painting—Picasso, Braque, Matisse, Kirchner, and Kandinsky—followed very different paths from those of younger ones who had not yet emerged into maturity by 1914. They broke the "rules" they had established earlier, responding only to the dictates of their sovereign imaginations; hence, their evolution transcends ready categorization. Rather than a simple linear development, we must therefore think in terms of multiple layers of varying depth that bear a shifting relation to each other.

PICASSO. We begin with Picasso, whose genius towers over the period. As a Spanish national living in Paris he was not involved in the conflict, unlike many French and German artists who served in the military and even sacrificed their lives. This was a time of quiet experimentation that laid the foundation for Picasso's art over the next several decades. The results did not become fully apparent, however, until the early 1920s, following a period of intensive cultivation. *Three Musicians* (fig. 1047) shows the fruit of that labor. It utilizes the "cut-paper style" of Synthetic Cubism so consistently that we cannot tell from the reproduction whether it is painted or pasted.

By now, Picasso was internationally famous. Cubism had spread throughout the Western world. It influenced not only other painters, but sculptors and even architects. Yet Picasso was already striking out in a new direction. Soon after the invention of Synthetic Cubism, he had begun to do drawings in a realistic manner reminiscent of Ingres, and by 1920 he was working simultaneously in two quite separate styles: the Synthetic Cubism of the Three Musicians, and a Neoclassical style of strongly modeled, heavy-bodied figures such as his Mother and Child (fig. 1048). To many of his admirers, this seemed a kind of betrayal, but in retrospect the reason for Picasso's double-track performance is clear: chafing under the limitations of Synthetic Cubism, he needed to resume contact with the classical tradition, the "art of the museums." The figures in Mother and Child have a mock-monumental quality that suggests colossal statues rather than flesh-and-blood human beings, yet the theme is treated with surprising tenderness. The forms, however, are carefully dovetailed within the frame, not unlike the way the *Three Musicians* is put together.

A few years later the two tracks of Picasso's style began to converge into an extraordinary synthesis that was to become the basis of his art. The *Three Dancers* of 1925 (fig. 1049) shows how he accomplished this seemingly impossible feat. Structurally, the picture is pure Synthetic Cubism. It even includes painted imitations of specific materials, such as patterned wallpaper and samples of various fabrics cut out with pinking shears. The figures, a wildly fantastic version of a classical scheme (compare the dancers in Matisse's *The Joy of Life*,

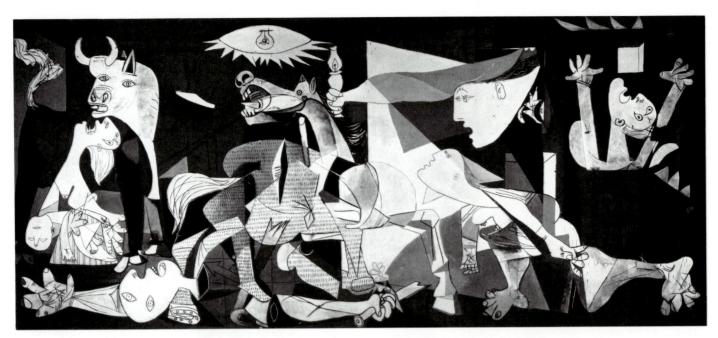

1050. Pablo Picasso. Guernica. 1937. Oil on canvas, 11'6" x 25'8" (3.5 x 7.8 m). Museo Nacional Centro de Arte Reina Sofía, Madrid. On permanent loan from the Museo del Prado, Madrid

fig. 1021), are an even more violent assault on convention than the figures in Les Demoiselles d'Avignon. Human anatomy is here simply the raw material for Picasso's incredible inventiveness. Limbs, breasts, and faces are handled with the same sovereign freedom as the fragments of external reality in Braque's Le Courrier (fig. 1036). Their original identity no longer matters. Breasts may turn into eyes, profiles merge with frontal views, shadows become substance, and vice versa, in an endless flow of metamorphoses. They are "visual puns," offering wholly unexpected possibilities of expression—humorous, grotesque, macabre, even tragic.

Three Dancers marks a transition to Picasso's experiment with Surrealism (see page 807). Because he did not practice automatism, he never developed into a true adherent of the movement. Nevertheless, the impact of his fellow Spaniard Joan Miró (see page 808) can be seen in the biomorphism of his mural Guernica (fig. 1050). Picasso did not show any interest in politics during World War I or the 1920s, but the Spanish Civil War stirred him to ardent partisanship with the Loyalists. The mural, executed in 1937 for the Pavilion of the Spanish Republic at the Paris International Exposition, has truly monumental grandeur. It was inspired by the terrorbombing of Guernica, the ancient capital of the Basques in northern Spain. The painting does not represent the event itself. Rather, it evokes the agony of total war with a series of powerful images.

The destruction of Guernica was the first demonstration of the technique of saturation bombing that was later employed on a huge scale during the course of World War II. The mural was thus a prophetic vision of doom—the doom that threatens us even more in this nuclear age. The symbolism of the scene resists precise interpretation, despite its several traditional elements: the mother and her dead child are the descendants of the Pietà (see fig. 479), the woman with the lamp recalls the Statue of Liberty (see fig. 908), and the dead fighter's hand, still clutching a broken sword, is a familiar emblem of heroic resistance. We also sense the contrast between the menacing, human-headed bull, surely intended to represent the forces of darkness, and the dying horse.

These figures owe their terrifying eloquence to what they are, not to what they mean. The anatomical dislocations, fragmentations, and metamorphoses, which in the Three Dancers seemed willful and fantastic, now express a stark reality, the reality of unbearable pain. The ultimate test of the validity of collage construction (here shown in superimposed flat "cutouts" restricted to black, white, and gray) is that it could serve as the vehicle of such overpowering emotions.

MATISSE. From 1911 on Matisse was influenced increasingly by Cubism, but after the war he, like Picasso, returned to the classical tradition. The lessons he absorbed from Cubism nevertheless had far-reaching consequences for his style. We see this in Decorative Figure Against an Ornamental Background (fig. 1051), which has a new luxuriance. At the same time, there is an underlying discipline resulting from his study of Cubism. The carpet provides a firm geometric structure for organizing the composition, so that everything has its place, although the system itself is entirely intuitive. Only in this way could Matisse control all the elements of his elaborate picture. It is among the finest in a long series of odalisques that Matisse painted during the 1920s and 1930s. In them the artist emerges as the titular heir of the French tradition, which he had absorbed through his teacher Gustave Moreau (see page 761). The visual splendor would be worthy of Delacroix himself. Yet in the calm pose and strong contours of the figure, Matisse reveals himself to be a classicist at heart, more akin to Ingres than the Romantics (compare figs. 870 and 874). The picture has overtones of Degas (see fig. 940), who had been trained by a disciple of Ingres and thus formed an important link in the chain of tradition. It breathes the classical serenity of Seated Woman by Matisse's friend Maillol (see fig. 994), who early in his career had likewise been inspired by Gauguin. Nevertheless, Matisse's is a distinctly modern classicism.

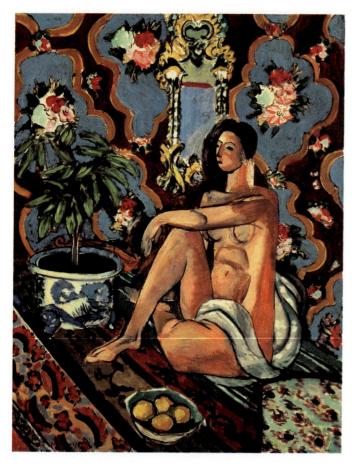

1051. Henri Matisse. *Decorative Figure Against an Ornamental Background.* 1927. Oil on canvas, 51¹/8 x 38¹/2" (129.9 x 97.8 cm). Musée National d'Art Moderne, Paris

KIRCHNER. Kirchner, too, was affected by Cubism after 1911, when he joined the other members of *Die Brücke* in Berlin. Four years later he was drafted into World War I, which ruined his physical and mental health. Released from the army after six months to recuperate from tuberculosis, he moved to Switzerland, where he turned increasingly to landscapes, as did many other German Expressionists following the war. *Winter Landscape in Moonlight* (fig. 1052), painted in the Swiss Alps, resounds with a sense of peace and wonderment before nature. The painting rivals the ecstatic rhythms of the young Kandinsky (compare fig. 1030), whose work Kirchner came to know while participating in the exhibitions of *Der Blaue Reiter* following the dissolution of *Die Brücke*.

KANDINSKY. Kandinsky himself spent the war years in Russia, where he participated enthusiastically in the Revolution and played an important role in shaping artistic policy. When his pedagogical reforms met with growing hostility, he returned to Germany in 1921 and soon accepted an invitation from Walter Gropius to teach at the Bauhaus (see page 874). Although he had begun to experiment with a more geometric style in Russia under the influence of Constructivism and other related avant-garde movements (see page 847), some of which shared his mystical tendencies, his output was surprisingly small, and it was only after he assumed his position at Weimar that he adopted geometric abstraction once and for all. The lessons and exercises he developed for his students no doubt helped to crystallize his theories of form and structure.

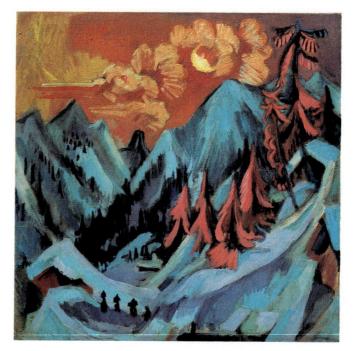

1052. Ernst Ludwig Kirchner. Winter Landscape in Moonlight.
 1919. Oil on canvas, 47⁵/8 x 47⁵/8" (121 x 121 cm).
 The Detroit Institute of Arts

Gift of Curt Valentin in memory of the artist on the occasion of Dr. William R. Valentiner's sixtieth birthday

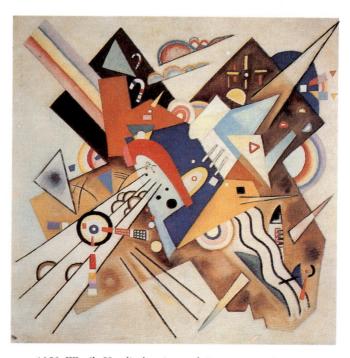

1053. Wassily Kandinsky. *Accented Corners, No. 247.* 1923. Oil on canvas, $51^{1}/4 \times 51^{1}/4$ " (130 x 130 cm). Private collection

These he set out systematically in *Point and Line to Plane*, published in 1926, which elaborates concepts that were only nascent in his earlier book *Concerning the Spiritual in Art* (see page 786). His development was perhaps reinforced by the presence at the Bauhaus after 1923 of Laszlo Moholy-Nagy, who came from a Constructivist background, although his approach was otherwise the opposite of Kandinsky's (see page 906). Looking at a typical example of his work from this time (fig. 1053), we seem to have entered a different world from that of his earlier work (fig. 1030). Only when we analyze the

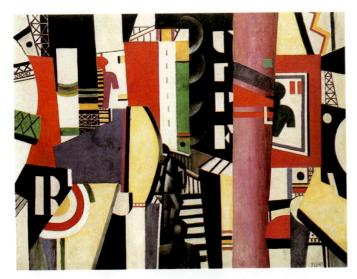

1054. Fernand Léger. *The City.* 1919. Oil on canvas, 7'7" x 9'9" (2.31 x 2.98 m). Philadelphia Museum of Art A. E. Gallatin Collection

painting do we realize that it embodies the same titanic clash of forces. The artist has clarified the shapes and lines of force that had been buried in a sea of swirling forms. Yet the attitude is still the same, and he admitted that he remained a Romantic to the end.

Abstraction

Picasso's abandonment of strict Cubism signaled the broad retreat of abstraction after 1920 because the utopian ideals associated with it had been largely dashed by "the war to end all wars." In retrospect, abstraction can be seen as a necessary phase through which modern painting had to pass, but it was not essential to modernism as such, even though it has been perhaps the dominant tendency of the twentieth century.

LÉGER. The Futurist spirit nevertheless continued to find adherents on both sides of the Atlantic. Buoyant with optimism and pleasurable excitement, *The City* (fig. 1054) by the Frenchman Fernand Léger (1881–1955) conjures up a mechanized utopia. This beautifully controlled industrial landscape is stable without being static, and reflects the clean geometric shapes of modern machinery. In this instance, the term *abstraction* applies more to the choice of design elements and their manner of combination than to the shapes themselves, since these are "prefabricated" entities, except for the two figures on the staircase.

DEMUTH. The modern movement in America proved short-lived. One of the few artists to continue working in this vein after World War I was Charles Demuth (1883–1935). A member of the Stieglitz group (see pages 898–90), he had been friendly with Duchamp and exiled Cubists in New York during World War I. A few years later, under the impact of Futurism, he developed a style known as Precisionism to depict urban and industrial architecture. We can detect influences from all of these movements in *I Saw the Figure 5 in Gold* (fig. 1055). The title is taken from the poem "The Great Figure" by Demuth's friend William Carlos Williams, whose name also forms part of the design as "Bill," "Carlos," and

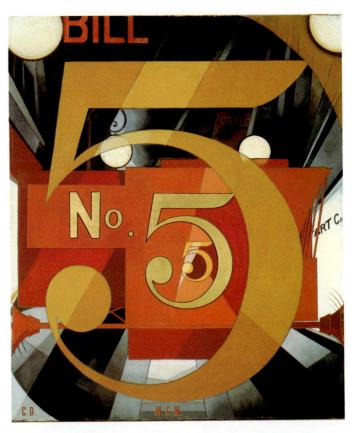

1055. Charles Demuth. *I Saw the Figure 5 in Gold.* 1928. Oil on composition board, 36 x 29³/4" (91.4 x 75.6 cm). The Metropolitan Museum of Art, New York

The Alfred Stieglitz Collection, 1949

"W. C. W." In the poem the figure 5 appears on a red fire truck, while in the painting it has become the dominant feature, thrice repeated to reinforce its echo in our memory as the fire truck rushes on through the night:

Among the rain and lights
I saw the figure 5 in gold on a red firetruck moving tense unheeded to gong clangs siren howls and wheels rumbling through the dark city

STELLA. Poetry was central as well to *Brooklyn Bridge* (fig. 1056) by the Italian-American Joseph Stella (1877–1946). To Stella, who emigrated to America as a young man, the bridge became a symbol of his adopted land, which provided his boldest theme. He wrote in his autobiography: "To realize this towering imperative vision in all its integral possibilities . . . I appealed for help to the soaring verse of Walt Whitman and to the fiery Poe's plasticity. Upon the swarming darkness of the night, I rung all the bells of alarm with the blaze of electricity scattered in lightnings down the oblique cables, the dynamic pillars of my composition, and to render more pungent the mystery of the metallic apparition, through the green and red

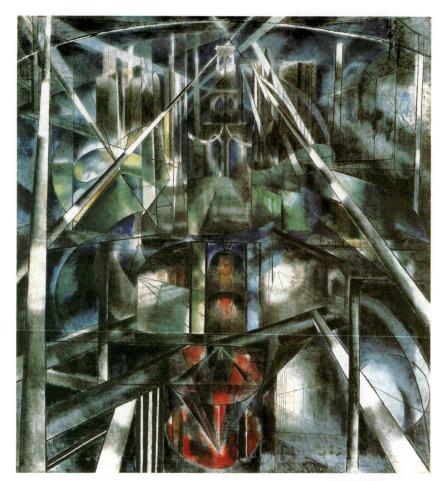

1056. (left) Joseph Stella. Brooklyn Bridge. 1917. Oil on bedsheeting, 7' x 6'4" (2.13 x 1.93 m). Yale University Art Gallery, New Haven, Connecticut Gift of Collection Société Anonyme

1057. (below) Piet Mondrian. Composition with Red, Blue, and Yellow. 1930. Oil on canvas, 20 x 20" (50.8 x 50.8 cm). Private collection Courtesy of the Mondrian Estate/Holtzman Trust/MBI NY

glare of the signals I excavated here and there caves as subterranean passages to infernal recesses." His painting achieves what a contemporary critic perceptively called the apotheosis of the bridge, through a synthesis of Futurism, which he had been exposed to during a visit to Paris in 1912, and Precisionism, which he experimented with as early as 1917. With its maze of luminescent cables, vigorous diagonal thrusts, and crystalline cells of space, the painting is a striking visual counterpart to Hart Crane's famous hymn of 1930, "To Brooklyn Bridge":

O harp and altar, of the fury fused, (How could mere toil align thy choiring strings!) Terrific threshold of the prophet's pledge, Prayer of pariah, and the lover's cry,— Again the traffic lights that skim thy swift Unfractioned idiom, immaculate sigh of stars, Beading thy path—condense eternity: And we have seen night lifted in thine arms.

MONDRIAN. The most radical abstractionist of our time was a Dutch painter nine years older than Picasso, Piet Mondrian (1872-1944). He arrived in Paris in 1912 as a mature Expressionist in the tradition of Van Gogh and the Fauves. Under the impact of Analytic Cubism, his work soon underwent a complete change, and within the next decade Mondrian developed an entirely nonrepresentational style that he called Neo-Plasticism. The short-lived movement as a whole is also known as De Stijl, after the Dutch magazine advocating his ideas, which were formulated with Theo van Doesburg (1883-1931) and Bart van der Leck (1876-1958). Mondrian became the center of the

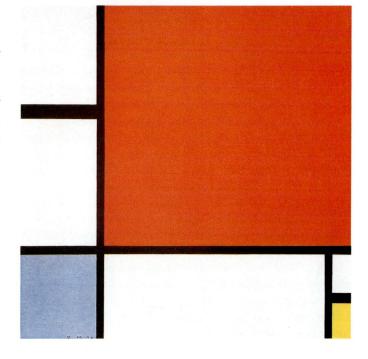

abstract movement in Paris, where he returned in 1919 and remained until the onset of World War II. Indeed, the School of Paris in the 1930s was made up largely of foreigners like him—especially the Abstraction-Création group, which included artists of every persuasion. As a result, the differences between the various movements soon became blurred, although Mondrian himself consistently adhered to his principles.

Composition with Red, Blue, and Yellow (fig. 1057) shows Mondrian's style at its most severe. He restricts his design to

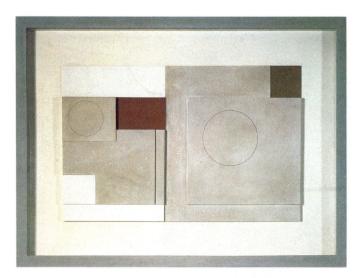

1058. Ben Nicholson. *Painted Relief.* 1939. Synthetic board mounted on plywood, painted, 32⁷/8 x 45" (83.5 x 114.3 cm). The Museum of Modern Art, New York

Gift of H. S. Ede and the artist by exchange

horizontals and verticals and his colors to the three primary hues, plus black and white. Every possibility of representation is thereby eliminated. Yet Mondrian sometimes gave to his works such titles as Trafalgar Square or Broadway Boogie Woogie (fig. 13) that hint at some degree of relationship, however indirect, with observed reality. Like Kandinsky, Mondrian was affected by theosophy, albeit the distinctive Dutch branch founded by M. J. H. Schoenmaekers. Unlike Kandinsky, however, he did not strive for pure, lyrical emotion. His goal, he asserted, was "pure reality," and he defined this as equilibrium "through the balance of unequal but equivalent oppositions." [See Primary Sources, no. 101, page 943.] For all of their analytic calm, Mondrian's paintings are highly idealistic: "When we realize that equilibriated relationships in society signify what is just, then we shall realize that in art, likewise, the demands of life press forward when the spirit of the age is ready."

Perhaps we can best understand what he meant by equilibrium if we think of his work as "abstract collage" that uses black bands and colored rectangles instead of recognizable fragments of chair caning and newsprint. He was interested solely in relationships and wanted no distracting elements or fortuitous associations. By establishing the "right" relationship among his bands and rectangles, he transforms them as thoroughly as Braque transformed the snippets of pasted paper in Le Courrier (fig. 1036). How did he discover the "right" relationship? And how did he determine the shape and number for the bands and rectangles? In Braque's collage, the ingredients are to some extent "given" by chance, but apart from his self-imposed rules, Mondrian constantly faced the dilemma of unlimited possibilities. He could not change the relationship of the bands to the rectangles without changing the bands and rectangles themselves. When we consider his task, we begin to realize its infinite complexity.

Looking again at *Composition with Red, Blue, and Yellow,* we find that when we measure the various units, only the proportions of the canvas itself are truly rational, an exact square. Mondrian has arrived at all the rest "by feel," and must have undergone agonies of trial and error. How often, we wonder, did he change the dimensions of the red rectangle to bring it and the other elements into self-contained equilibrium?

Strange as it may seem, Mondrian's exquisite sense for nonsymmetrical balance is so specific that critics well acquainted with his work have no difficulty in distinguishing fakes from genuine pictures. Designers who work with nonfigurative shapes, such as architects and typographers, are likely to be most sensitive to this quality, and Mondrian has had a greater influence on them than on artists (see Chapter 6).

NICHOLSON. Mondrian nevertheless did produce a number of followers among the painters. By far the most original was the English artist Ben Nicholson (1894–1982). A rigorous abstractionist, he bent Mondrian's rules without breaking them in his painted reliefs (fig. 1058), which also show the inspiration of his wife, the sculptor Barbara Hepworth (see page 854). The overlapping shapes violate the integrity of the rectangle and overcome the tyranny of the grid maintained by Mondrian. The geometry is further enlivened by the introduction of the circle. Yet his work, too, relies on the delicate balance of elements. The effect is enhanced by the subdued palette and matte finish, which create harmonies of the utmost refinement. Indeed, compared to Nicholson's, Mondrian's primary colors seem astonishingly bright and exuberant.

Fantasy

DADA. Out of despair over the mechanized mass killing of World War I, a number of artists in Zurich and New York (including Marcel Duchamp) simultaneously launched in protest a movement called Dada (or Dadaism), which then spread to other cities in Germany and France. The term, which means hobbyhorse in French, was reportedly picked at random from a dictionary, although it had actually been used as the title of a Symbolist journal. As an infantile, all-purpose word, however, it perfectly fitted the spirit of the movement. Dada has often been called nihilistic, and its declared purpose was indeed to make clear to the public at large that all established values, moral or aesthetic, had been rendered meaningless by the catastrophe of the Great War. During its short life (c. 1915-22) Dada preached nonsense and antiart with a vengeance. As Hans Arp wrote, "Dadaism carried assent and dissent ad absurdum. In order to achieve indifference, it was destructive." Marcel Duchamp once "improved" a reproduction of Leonardo's *Mona Lisa* with a moustache and the letters LHOOQ, which when pronounced in French, make an offcolor pun. Not even modern art was safe from the Dadaists' assaults: one of them exhibited a toy monkey inside a frame with the title "Portrait of Cézanne." Yet Dada was not a completely negative movement. In its calculated irrationality there was also liberation, a voyage into unknown provinces of the creative mind. The only law respected by the Dadaists was that of chance, and the only reality, that of their own imaginations.

ERNST. Although their most characteristic art form was the ready-made (see page 850), the Dadaists adopted the collage technique of Synthetic Cubism for their purposes. Figure 1059 by the German Dadaist Max Ernst (1891–1976), an associate of Duchamp, is largely composed of snippets from illustrations of machinery. The caption pretends to enumerate these mechanical ingredients which include (or add up to)

1059. Max Ernst. 1 Copper Plate 1 Zinc Plate 1 Rubber Cloth 2 Calipers 1 Drainpipe Telescope 1 Piping Man. 1920. Collage, 12 x 9" (30.5 x 23 cm). Estate of Hans Arp

"1 Piping Man." Actually, there is also a "piping woman." These offspring of Duchamp's prewar Bride (see fig. 1045) stare at us blindly through their goggles.

SURREALISM. In 1924, after Duchamp's retirement from Dada, a group led by the poet André Breton founded Dada's successor, Surrealism. They defined their aim as "pure psychic automatism . . . intended to express . . . the true process of thought . . . free from the exercise of reason and from any aesthetic or moral purpose." [See Primary Sources, no. 102, page 943.] Surrealist theory was larded with concepts borrowed from psychoanalysis, and its rhetoric cannot always be taken seriously. The notion that a dream can be transposed by "automatic handwriting" directly from the unconscious mind to the canvas, bypassing the conscious awareness of the artist, did not work in practice. Some degree of control was unavoidable. Nevertheless, Surrealism stimulated several novel techniques for soliciting and exploiting chance effects.

ERNST'S DECALCOMANIA. Max Ernst, the most inventive member of the group, often combined collage with "frottage" (rubbings from pieces of wood, pressed flowers, and other relief surfaces—the process we all know from the children's pastime of rubbing with a pencil on a piece of paper covering, say, a coin). In La Toilette de la Mariée (fig. 1060), he has obtained fascinating shapes and textures by another technique: "decalcomania" (the transfer, by pressure, of oil paint to the canvas from some other surface). This procedure is in essence anoth-

1060. Max Ernst. La Toilette de la Mariée. 1940. Oil on canvas, 51 x 37⁷/8" (129.5 x 96.2 cm). Peggy Guggenheim Collection, Venice

1061. Salvador Dalí. The Persistence of Memory. 1931. Oil on canvas, $9^{1/2} \times 13''$ (24.1 x 33 cm). The Museum of Modern Art, New York Given anonymously

er variant of that recommended by Alexander Cozens (see fig. 849) and Leonardo da Vinci. Ernst certainly found, and elaborated upon, an extraordinary wealth of images among his stains. The end result has some of the qualities of a dream, but it is a dream born of a strikingly Romantic imagination.

DALI. The same can be said of *The Persistence of Memory* (fig. 1061) by Salvador Dali (1904-1989). The most notorious of

1062. René Magritte. Les Promenades d'Euclid. 1955. Oil on canvas, $64^{1}/8 \times 51^{1}/8$ " (163 x 130 cm). The Minneapolis Institute of Arts The William Hood Dunwoody Fund

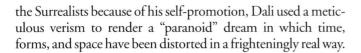

MAGRITTE. The Belgian artist René Magritte (1898–1967) also employed detailed realism, but for completely different ends. Although he found his early inspiration in the work of De Chirico, his naturalism stems from the tradition of Magic Realism that flourished in Belgium in the late nineteenth and early twentieth centuries. Magritte's goal was "poetic painting": illusionistic pictures that transform objects into images having completely different meaning through astonishing transformations, changes in scale, juxtapositions, and the like. Les Promenades d'Euclid (fig. 1062) shows one of his favorites devices, the picture within a picture. The title, added after the fact through free association, only compounds the mystery of the painting by failing to explain it. This divorce of word and image prevents us from finding any literal (or literary) meaning. The painting's charm lies not simply in this visual and verbal puzzle but in the presentation itself: the beautifully simple, abstract design, and the artist's way of subtly heightening reality while ultimately denying its plausibility.

KAHLO. A number of women, including Meret Oppenheim (see page 850), were associated with the Surrealist movement. Today the best known is Frida Kahlo (1910–1954), who was first discovered by the poet André Breton during a visit to Mexico in 1938 and then rediscovered in recent years by feminist art historians. [See Primary Sources, no. 103, pages 943–44.]

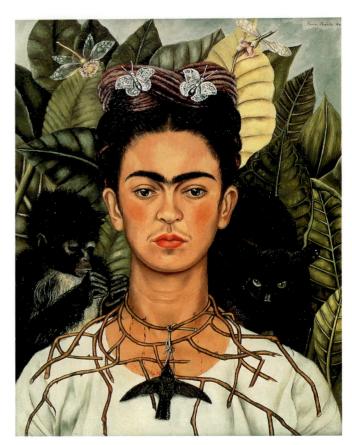

1063. Frida Kahlo. Self-Portrait with Thorn Necklace. 1940. Oil on canvas, $24^{1/2} \times 18^{3/4}$ " (62 x 47.5 cm). Art Collection, Harry Ransom Research Center, University of Texas at Austin

She owes her reputation as much to her troubled life as to her work, for they are inseparable. Her paintings are frankly autobiographical, yet so laden with personal meaning and couched in such enigmatic terms that the exact circumstances must be known in order to decipher their content. Self-Portrait with Thorn Necklace (fig. 1063) is similar in style to traditional Mexican devotional images. It was painted in 1940, when her tempestuous marriage to the painter Diego Rivera (1886–1957) was interrupted for a year by divorce. The necklace, an allusion to the crown of thorns worn by Christ during the Passion, is a symbol of her humiliation by her husband. From it hangs a dead hummingbird, a traditional amulet worn in Mexico by people seeking love. On her shoulders are two demons in the guise of the artist's pets: death, who appears as a black cat, and the devil, seen as a monkey. In context, it is clear that Kahlo must have been contemplating suicide: she has been a martyr to love while hoping for a resurrection like the Lord's, as signified by the butterflies overhead.

MIRÓ. Surrealism also has a boldly imaginative branch. Some works by Picasso, such as *Three Dancers* (fig. 1049), have affinities with it, and its greatest exponent was also Spanish: Joan Miró (1893–1983), who painted the striking *Composition* (fig. 1064). His style has been labeled "biomorphic abstraction," since his designs are fluid and curvilinear, like organic forms, rather than geometric. Actually, "biomorphic concretion" might be a more suitable name, for the shapes in Miró's pictures have their own vigorous life. They seem to change before our eyes, expanding and contracting like amoebas

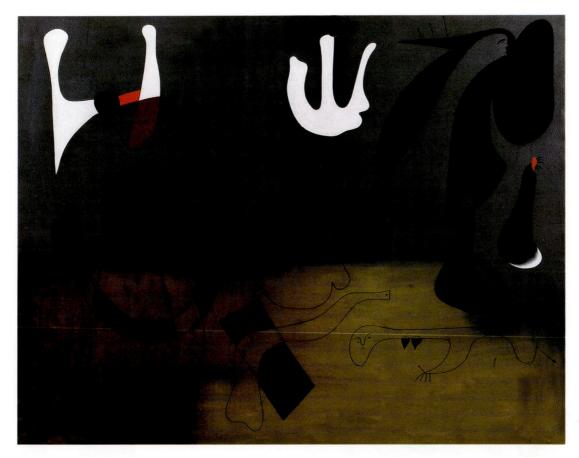

1064. Joan Miró. Composition. 1933. Oil on canvas, 51¹/4 x 63¹/2" (130.5 x 161.3 cm). Wadsworth Atheneum, Hartford, Connecticut Ella Gallup Sumner and Mary Catlin Sumner Collection

until they approach human individuality closely enough to please the artist. Their spontaneous "becoming" is the very opposite of abstraction as we defined it above (see page 788), though Miró's formal discipline is no less rigorous than that of Cubism. (He began as a Cubist.)

KLEE. The German-Swiss painter Paul Klee (1879–1940) was decisively influenced early in his career by Der Blaue Reiter, and shared many of the same ideas as his friends Kandinsky and Marc. He was, for example, fascinated with music and was himself a talented violinist. His theories of art also have much in common with those of Kandinsky. (They were colleagues at the Bauhaus.) He nevertheless went in the opposite direction. Instead of a higher reality, he wanted to illuminate a deeper one from within the imagination which parallels nature but is independent of it. Thus natural forms are essential to his work, but as pictorial metaphors filled with hidden meaning rather than as representations of nature. He was affected, too, by Cubism and Orphism, but ethnographic art and the drawings of small children held an equally vital interest for him.

During World War I, he molded these disparate elements into a pictorial language of his own, marvelously economical and precise. Twittering Machine (fig. 1065), a delicate penand-ink drawing tinted with watercolor, demonstrates the

1065. (right) Paul Klee. Twittering Machine. 1922. Watercolor and pen and ink on oil transfer drawing on paper, mounted on cardboard, 251/4 x 19" (64.1 x 48.3 cm). The Museum of Modern Art, New York

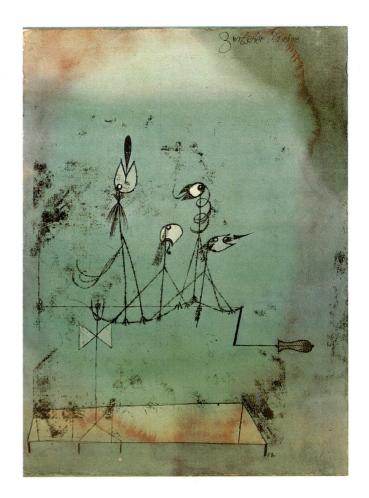

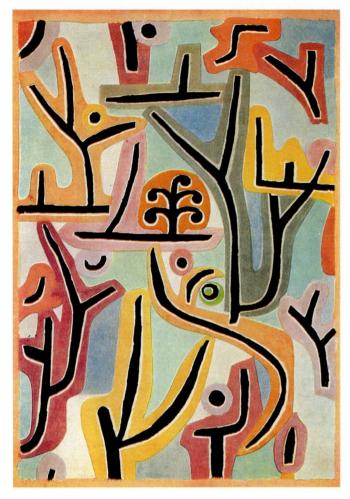

1066. Paul Klee. Park near Lu(cerne). 1938. Oil and newsprint on burlap, 39¹/₂ x 27¹/₂" (100.3 x 69.7 cm). Fondation Paul Klee, Musée des Beaux-Arts de Berne, Bern, Switzerland Copyright 1986 COSMOPRESS, Geneva

unique flavor of Klee's art. With a few simple lines, he has created a ghostly mechanism that imitates the sound of birds, simultaneously mocking our faith in the miracles of the Machine Age and our sentimental appreciation of bird song. The little contraption is not without its sinister aspect: the heads of the four sham birds look like fishermen's lures, as if they might entrap real birds. It thus condenses into one striking invention a complex of ideas about present-day civilization.

The title has an indispensable role. It is characteristic of the way Klee worked that the picture itself, however visually appealing, does not reveal its full evocative quality unless the artist tells us what it means. The title, in turn, needs the picture: the witty concept of a twittering machine does not kindle our imagination until we are shown such a thing. This interdependence is familiar to us from cartoons, but Klee lifts it to the level of high art without relinquishing the playful character of these verbalvisual puns. To him art was a "language of signs," of shapes that are images of ideas as the shape of a letter is the image of a specific sound, or an arrow the image of the command, "This way only." He also realized that in any conventional system the sign is no more than a "trigger." The instant we perceive it, we automatically invest it with meaning, without stopping to ponder its shape. Klee wanted his signs to impinge upon our awareness as visual facts, yet also to share the quality of "triggers."

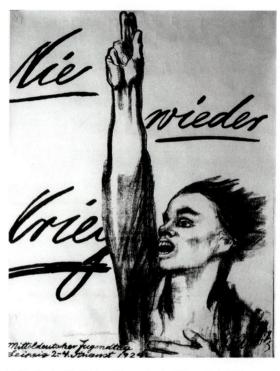

1067. Käthe Kollwitz. *Never Again War!* 1924. Lithograph, 37 x 27¹/2" (94 x 70 cm). Courtesy Galerie St. Etienne, New York

Toward the end of his life, he immersed himself in the study of ideographs of all kinds, such as hieroglyphics, hex signs, and the mysterious markings in prehistoric caves— "boiled-down" representational images that appealed to him because they had the twin quality he strove for in his own graphic language. This "ideographic style" is clearly articulated in figure 1066, *Park near Lu(cerne)*. As a lyric poet may use the plainest words, these deceptively simple shapes sum up a wealth of experience and sensation: the innocent gaiety of spring, the clipped orderliness peculiar to captive plant life in a park. Has it not also a relationship, in spirit if not in fact, with the Romanesque Summer Landscape in the manuscript of Carmina Burana (fig. 422)? Klee's attitude soon changed. Shortly before his death, the artist's horror at World War II led him to abandon this lighthearted vein in favor of a bleakly pessimistic manner that drew close to Miró's darkest fantasies of the same time.

Expressionism

KOLLWITZ. The experience of World War I filled German artists with a deep anguish at the state of modern civilization, which found its principal outlet in Expressionism. The work of Käthe Kollwitz (1867–1945) consists almost exclusively of

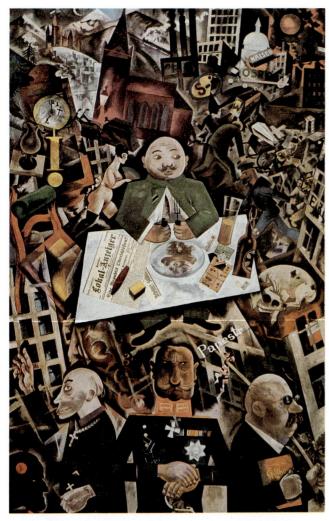

1068. George Grosz. Germany, a Winter's Tale. 1918. Formerly Collection Garvens, Hannover, Germany

prints and drawings that parallel those of Kokoschka, whose work she admired. Her graphics had their sources in the nineteenth century. Munch, Klimt, and the German artist Max Klinger (1857–1920) were early inspirations, as was her friend Ernst Barlach (see page 768). Yet Kollwitz pursued a resolutely independent course, devoting her art to themes of inhumanity and injustice. To articulate her social and ethical concerns, she adopted an intensely expressive, naturalistic style that is as unrelenting in its bleakness as her choice of subjects. Gaunt mothers and exploited workers provided much of Kollwitz's thematic focus, but her most eloquent statements were reserved for war. World War I, which cost her oldest son his life, made her an ardent pacifist. Her lithograph Never Again War! (fig. 1067) is an unforgettable image of protest.

GROSZ. George Grosz (1893–1959), a painter and graphic artist who had studied in Paris in 1913, joined the Dadaist movement in Berlin after the end of the war. Inspired by the Futurists, he used a dynamized form of Cubism to develop a bitter, savagely satiric style that expressed the disillusionment of his generation. In Germany, a Winter's Tale (fig. 1068), the city of Berlin forms the kaleidoscopic and chaotic background for several large figures, which are superimposed on it as in a

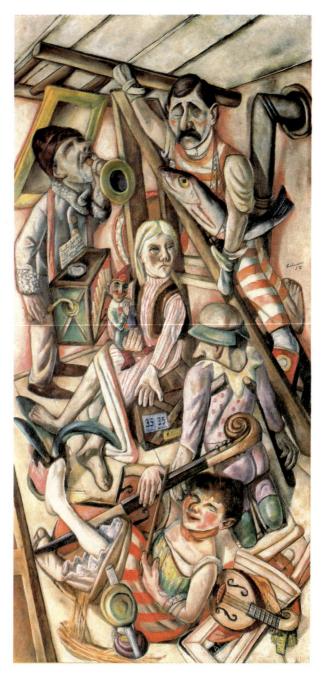

1069. Max Beckmann. The Dream. 1921. Oil on canvas, 71 x 35" (180.3 x 89 cm). Collection Morton D. May, St. Louis, Missouri

collage. They include the marionettelike "good citizen" at his table, and the sinister forces that molded him: a hypocritical clergyman, a general, and a schoolmaster.

BECKMANN. Max Beckmann (1884-1950), a robust descendant of Die Brücke artists, did not become an Expressionist until after he had lived through World War I, which filled him with such despair at the state of modern civilization that he took up painting to "reproach God for his errors." The Dream (fig. 1069) is a mocking nightmare, a tilted, zigzag world as disquieting as those in Bosch's Hell (see fig. 684). It is crammed with maimed, puppetlike figures that reflect his experience in the army medical corps: the handless swimmer, carrying a fish, who climbs a ladder that leads only to another

German Expressionism in art had a counterpart in Expression-

ist drama, which compressed as much emotion as possible into a play, eliminating anything not needed to convey the central message of the piece. It initially took the form of subjective truth and utopian vision in *The Beggar* (1912) by Reinhard Sorge (1892–1916) but soon turned to antiwar sentiment in *One Race* (1918) by Fritz von Unruh (1885–1970). Expressionist theater was also promoted by Herwarth Walden (1878–1941), publisher of the journal *Der Sturm*, which attracted many of the leading painters to Berlin, including Oskar Kokoschka, who was also a dramatist. The trilogy *Gas* (1917–20) by Georg Kaiser (1878–1945) characteristically expressed utopian ideals by reducing its characters to symbols of social forces, such as the Engineer and the Billionaire's Son.

Under the Weimar Republic (1920-33), Germany was the most vibrant center of theater in all of Europe, with a dazzling variety that reflected the turmoil of the postwar years. The most important German drama produced between the wars was Man and the Masses (1921) by Ernst Toller (1893–1939), featuring a kaleidoscopic production by the director Jürgen Fehling (1890–1968). It already shows the pessimism that led to the decline of Expressionism a few years later. In its place rose Epic Theater, promoted by Erwin Piscator (1893–1966), who championed proletarian theater. He instituted a deliberately episodic style of drama that, in contrast to Expressionism, encouraged psychological distance in the viewer through using divided stages, incorporating film clips, and having characters speak to the audience directly. These devices, later to become standard, thus broke the traditional theatrical illusion that the audience is watching actual events as they are taking place.

The main exponent of Epic Theater was Bertholt Brecht (1898–1956), a confirmed communist who spent much of his career in exile in America. He remains best known for *The Three Penny Opera* (1928), with cabaret-style music by Kurt Weill (1900–1950), that is even more profoundly cynical than the original opera by John Gay on which it is based (see page 623). Brecht's best play, however, is *Mother Courage and Her Children* (1938–39), the story of the destruction of a family during the Thirty Years' War. It provoked viewers to think about its meaning by setting contemporary events in the past (a process known as historification) and presenting them as a series of disjointed episodes, while adding strange effects to induce a sense of alienation. Thus, theater would illuminate the action by commenting on it.

The 1920s were also a time of technical innovation in Germany. The Bauhaus conducted important experiments under Walter Gropius, its longtime director, who devised a stage that could be reconfigured to place the audience in the center of the action. Oskar Schlemmer (1888–1943), head of the theater workshop, designed abstract costumes that made actors into architectural units to be placed at will with-

in the stage space by rigorously controlling their every move-

ment. *Neue Sachlichkeit* (New Objectivity) also found an outlet in theater in documentary dramas dealing with a variety of social issues, but the only playwright of note was Ferdinand Bruckner (1891–1958).

In France, the major contribution was Surrealist theater. In addition to Jarry's *Ubu Roi*, *The Breasts of Tiresias* (1903–17) by Guillaume Apollinaire (1880–1918) was the early prototype of Surrealist drama, mingling popular theater with music and dance in an illogical free form. The poet Jean Cocteau (1892–1963) used many of these devices in *Parade* (1917), a ballet presented by Diaghilev's Ballets Russes that was one of the great collaborations of the time, with costumes by Picasso and music by Erik Satie (1866–1925). Cocteau's finest efforts were restatements of Classical Greek dramas transposed to modern times and treated with all kinds of Surrealist effects. He also worked for the Ballet Suédois (Swedish Ballet), a rival company active in the early 1920s that attracted the painters Léger and De Chirico.

Although the Surrealists mounted numerous absurdist events in the 1920s and 1930s, the most important work was done by André Breton's disciple Antonin Artaud (1896-1948) after he abandoned Surrealism in 1931. Rather than appealing to the mind, his Theater of Cruelty rejected language as impotent and mounted a concerted assault on all the senses to drain the "abscesses" of civilization by "providing the spectator with the true sources of his dreams, in which his taste for crime, his erotic obsessions, his savagery . . . would surge forth." Surrealism also stimulated Henri-René Lenormand (1882-1951) to write Time is a Dream (1919) and The Eater of Dreams (1922), whose distortions of time and space anticipate effects seen later in Dali's The Persistence of Memory (fig. 1061). Perhaps the most interesting Surrealist play was No Exit (1944), written during World War II by the existentialist philosopher Jean-Paul Sartre (1905–1980). It is a drama about interpersonal relations in which a man and two women pursue each other vainly as they seek self-validation in the eyes of others, whom they try to control but who in turn have their own agenda. Sartre's "theater of situations" sought to "explore the state of man in its entirety, and to present to modern man a portrait of himself" through his choices and actions.

Although it was short-lived, Italian Futurism was notable for its extreme rejection of traditional staging through the use of multimedia techniques to promote its glorification of the machine, achieve simultaneous effects, and break down barriers between the arts. World War I saw the equally brief Theater of the Grotesque in the plays of Luigi Chiarelli (1880–1947). By far the greatest Italian playwright of the century was Luigi Pirandello (1867–1936), a novelist who turned his hand to drama only after 1910. Six Characters in Search of an Author (1921) intermixes fantasy and reality so completely that truth becomes

entirely subjective and unknowable, since it varies according to the perspective of each character and spectator. The finest dramatist in Spain was the novelist and poet Federico García Lorca (1898–1936). He worked with the theater group La Barraca in the early 1930s to create updated versions of popular theater dealing with the time-honored Spanish themes of love and honor, as did Alejandro Casona (1903-1966), who directed a similar touring group, The People's Theater.

After the Revolution, theater in Russia continued to be a hotbed of experimentation. The most powerful director was Meyerhold, who now emphasized biomechanics: machinelike movement as the chief means of expression. His sets, designed by the Constructivists, were the most boldly imaginative the world has ever seen. Meyerhold collaborated with Vladimir Mayakovsky (1893–1930), the only true literary genius produced by the Communist Revolution, in which he, like Tatlin, believed wholeheartedly. However, his last plays, such as The Bedbug (1929), were acerbic satires on Soviet bureaucracy which were received so badly that he committed suicide. Yevgeny Vakhtangov (1883–1922), who trained many of the leaders of the next generation, managed to successfully combine the seemingly opposite approaches of Meyerhold and Stanislavsky.

Theater thrived in England after World War I. Not since the Elizabethan era were there so many great directors and actors, or so many major theaters. The list of legendary stars includes Tyrone Guthrie, Barry Jackson, Laurence Olivier, John Gielgud, Michael Redgrave, Alec Guinness, Elsa Lanchester, Charles Laughton, and Sybil Thorndike, to name only the most famous. English playwriting of the time is remembered now chiefly for comedies by the novelist W. Somerset Maugham (1874–1965) and Noël Coward (1899-1973), who was a consummate man of the theater. There was considerable dramatic writing by serious authors as well. A notable example is *I Have* Been Here Before (1937) by the novelist J. B. Priestley (1894-1984), which deals with the effect of previous incarnations on the present. The poet W. H. Auden (1907-1973) and the novelist Christopher Isherwood (1904-1986) collaborated on several plays in expressionistic verse, including The Dog Beneath the Skin (1935), which was presented at the Group Theater. The Americanborn poet T. S. Eliot (1888–1965) was also a founder of the Group Theater, which staged his Sweeney Agonistes (1932), an "Aristophanic melodrama" which he considered a poem in dialogue, and Murder in the Cathedral (1935), about the death of Thomas à Becket. Both were attempts to restore verse to theater using popular forms and music-hall techniques, though Eliot abandoned this approach toward the end of the decade. The early dramas written for the Abbey Theater in the mid-1920s by Sean O'Casey (1880-1964) dealt with the impact of the Irish rebellion on people's lives, but his style later veered toward

Expressionism in the pacifist play The Silver Tassie (1928), which led to a break with the Abbey, despite support from

In the United States, new groups sprang up everywhere, many of them later subsidized by the government during the Depression under the Federal Theater Project. Stagecraft underwent radical changes at the hands of the designers Lee Simonson (1888–1967) and Robert Jones (1887–1954) and the producers Arthur Hopkins (1878-1950) and Norman Bel Geddes (1893-1958), all of whom were well versed in the latest European techniques. The Group Theater, begun in 1931 by Lee Strasberg (1901-1982) and others along the lines of the Moscow Art Theater, included such stars as Stella Adler (1904-1992) and Elia Kazan (born 1909). It was also the golden age of Hollywood films. Orson Welles, Laurence Olivier, his wife, Vivien Leigh, John Gielgud, Elsa Lanchester, Vincent Minelli, and his wife, Judy Garland, were among the actors and directors who were equally successful on stage and screen.

For the first time in its history, America had writers who were fully the equal of those in Europe, and many of them wrote for the stage. The finest was unquestionably Eugene O'Neill (1888–1953), the son of the actor James O'Neill (1846-1920), whose powerful dramas Desire Under the Elms (1925), Mourning Becomes Electra (1931), and The Iceman Cometh (1940/46) remain the great American classics of the era. Their only rivals are the plays written by Clifford Odets (1906–1963) in 1935 for the Group Theater— Waiting for Lefty, Awake and Sing!, and Paradise Lost—all scripted in intense, graphic language. Odets' most popular work remains Golden Boy (1937), about a young violinist who becomes a boxer to earn money, which is a thinly veiled reference to his own decision to move to Hollywood, where his talents soon petered out. The novelist John Steinbeck (1902–1968) adapted three of his books for the stage; much the best is Of Mice and Men, done in collaboration with George S. Kaufman (1889-1961), a story of strength, weakness, and human dignity among migrant workers in a Midwest farming town during the Depression. Maxwell Anderson (1888–1959) achieved critical acclaim during the 1930s, when he won the Pulitzer Prize for Both Your Houses (1933) and the Drama Critics' Circle Award for Winterset (1935). Much of his work dealt with war or the great monarchs and political leaders of the past. Other notable contributions to the American theater were Street Scene (1929) by Elmer Rice (1892-1967), about oppression and dehumanization; The Time of Your Life (1939) by William Saroyan (1908-1981), a witty and colorful story about life in San Francisco; Mulatto (1935) by Langston Hughes (1902–1967), the great writer of the Harlem Renaissance; and The Cradle Will Rock (1937) by Marc Blitzstein (1905-1964), whose rejection by the Federal Theater Project led Welles and John Houseman (1902-1988) to form the Mercury Theater.

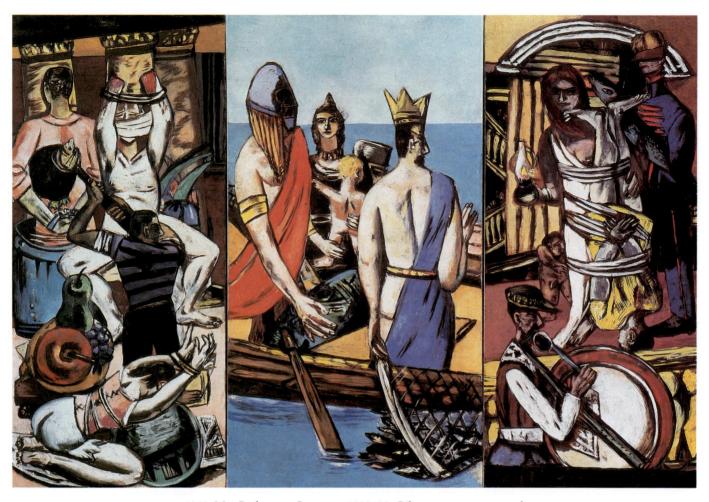

1070. Max Beckmann. *Departure*. 1932–33. Oil on canvas, center panel 7'3/4" x 3'9³/8" (2.15 x 1.15 m); side panels each 7'³/4" x 3'3¹/4" (2.15 x 1 m). The Museum of Modern Art, New York Given anonymously by exchange

ladder on the ceiling; the crippled clown whose open hat protects his eyes but not his head from the nonexistent sun; the woman singing ecstatically to herself as she plays a stringless cello; and the beggar frantically cranking his hurdy-gurdy and blaring his trumpet to this unreceptive audience. All are blind except the blond girl in the center. (Note the mirror that reflects nothing and the lantern that illuminates nothing.) Evidently a recent arrival, to judge from her trunk, she observes everything with detachment and gestures as if to say, "Behold this Ship of Fools," while the puppet she holds mockingly applauds the absurd performance. Her innocence is underscored by the plant, which rudely pushes aside her dress as she tries to stop its advance with one foot. The forms show the inspiration of early German prints, which Beckmann shared with the members of *Die Brücke* (compare figs. 692–95).

The claustrophobic space, which comes from the same source, is essential to the image, which radiates an oppressive aura. It was, he said, "how I defend myself against the infinity of space... the great spatial void and uncertainty that I call God." Beckmann has created a powerful image whose meaning is conveyed by evocative symbolism which is necessarily subjective. How indeed could Beckmann have expressed the chaos in Germany after that war with the worn-out language of traditional symbols? "These are the creatures that haunt my imagination," he seems to say. "They show the true nature of

the modern condition—how weak we are, how helpless against ourselves in this proud era of so-called progress."

Some elements from this grotesque and sinister sideshow recur in altered guise more than a decade later in the wings of Beckmann's triptych Departure (fig. 1070), a painting that reflects Beckmann's admiration for Grünewald. The right panel incorporates a blind man holding the fish, a lantern, and a mad musician. The left panel shows a scene of almost unimaginable torture. What are we to make of these brutal images? We know from letters written by the artist and a close friend that they represent life itself as endless misery filled with all manner of physical and spiritual pain. The woman trying to make her way in the dark with the aid of the lamp is carrying the corpse of her memories, evil deeds, and failures, from which no one can ever be free so long as life beats its drum. The center panel signifies the departure from life's illusions to the reality behind appearances. The crowned figure seen from behind perhaps represents the legendary Fisher King from the legend of the Holy Grail, whose health and that of his land is restored by Parsifal.

In the hindsight of today, *Departure* acquired the force of prophecy. It was completed when, under Nazi pressure, the artist was on the verge of leaving his homeland. The topsyturvy quality of the two wing scenes, full of mutilations and meaningless rituals, well captures the flavor of Hitler's Ger-

1071. Arthur G. Dove. Foghorns. 1929. Oil on canvas, 18 x 26" (42.7 x 66 cm). Colorado Springs Fine Arts Center Anonymous gift

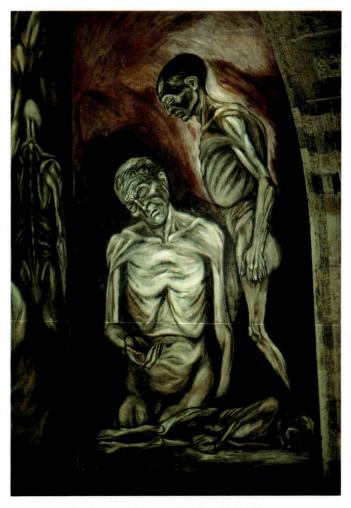

1072. José Clemente Orozco. Victims. Detail of fresco cycle. 1936. University of Guadalajara, Mexico

many. The stable design of the center panel, in contrast, with its expanse of blue sea and its sunlit brightness, conveys the hopeful spirit of an embarkation for distant shores. [See Primary Sources, no. 104, page 944.] After living through World War II in occupied Holland under the most trying conditions, Beckmann spent the final three years of his life in America.

DOVE. After 1920 in the United States, most of the original members of the Stieglitz group concentrated on landscapes, which they treated in representational styles derived from Expressionism. Alone among them, Arthur G. Dove (1880– 1946) consistently maintained a form of abstraction, one based loosely on Kandinsky's style. The difference between the two artists is that Dove sought to reveal the inner life of nature, whereas Kandinsky tried to rid his images of readily recognizable subject matter. Dove's paintings possess a monumental spirit that belies their typically modest size. Foghorns (fig. 1071) epitomizes the intelligence and economy of his mature landscapes. To evoke the diffusion of sound, Dove utilized the simple but ingenious device of irregular concentric circles of color that grow paler as they radiate outward.

OROZCO. During the 1930s, the center of Expressionism in the New World was Mexico. The Mexican Revolution began in 1911 with the fall of the dictator Porfirio Díaz and continued for more than two decades. It inspired a group of young painters to search for a national style incorporating the great native heritage of Pre-Columbian art. They also felt that their art must be "of the people," expressing the spirit of the Revolution in large mural cycles in public buildings. Although each developed his own distinctive style, they shared a common point of departure: the Symbolist art of Gauguin, which had shown how non-Western forms could be integrated with the Western tradition. The flat, decorative quality of this art was particularly suited to murals. However, the involvement of these artists in the political turmoil of the day often led them to overburden their works with ideological significance. The artist least subject to this imbalance of form and subject matter was José Clemente Orozco (1883-1949), a passionately independent artist who refused to get embroiled in factional politics. The detail from the mural cycle at the University of Guadalajara (fig. 1072) illustrates his most powerful trait: a deep humanitarian sympathy with the silent, suffering masses.

Realism

DIX. In 1923 the director of the Mannheim museum organized an exhibition with the title Die Neue Sachlichkeit (The New Objectivity; sometimes also known as Magic Realism).

The most important composer to emerge between the world

wars was Béla Bartók (1881-1945). In 1905 he met the composer Zoltán Kodály (1882–1967); together they began to collect the ethnic music of Hungary and ran the Budapest Academy of Music. While utilizing folk melodies, rhythms, and modes, Bartók incorporated the complex rhythms and the percussive effects of Stravinsky, as well as the dissonance and atonality of Schoenberg. His music was intensely personal, uniting Expressionism and Surrealism to convey the searing emotionalism apparent in the opera Bluebeard's Castle (1918), the ballet The Mandarin Prince (1926), and especially the six string quartets (1908-39), which equal Beethoven's in profundity and innovation. Bartók was a famous piano virtuoso, whose three concertos (1926–45) exploit the full potential of that instrument. The final piano concerto and the Concerto for Orchestra (1943) are more melodic and accessible to a wide audience, without diluting the composer's unique vision.

The Russian piano virtuoso Sergei Prokoviev (1891–1953) began his career as a member of the avant-garde with two dissonant concertos for piano, although the heart of his music remained melody. He left for Europe following the Russian Revolution of 1917. Soon after his return to Russia in 1934, he composed his great ballet *Romeo and Juliet* and an orchestral fairy tale for children, *Peter and the Wolf.* Although he tried his best to meet the demands of Soviet authorities for propaganda music in such works as the Fifth Symphony (1944), he suffered terrible privation and repression, as did the younger Dmitri Shostakovich (1906–1975), whose private works are uncompromising in their integrity. Fittingly enough, no one today listens to the composers who were approved by Russian officials.

The United States produced two composers of note during the first part of the twentieth century: Charles Ives (1874–1954) and Henry Cowell (1897–1965). Ives received a conventional academic music training at Yale University, but even before then he had begun to experiment with effects that were to become the hallmarks of his music. They reach their height in *Symphony No. 4* (1916), which employs several themes played simultaneously in different keys by different groups under separate conductors that create a clashing, kaleidoscopic effect; and in the *Concord Sonata* for piano (1920), which uses elbows as well as wood blocks to play the notes. He was nevertheless a gifted melodist. *Three Places in New England* (1914) is a consciously American piece in its choice of themes and alternately festive and haunting atmosphere.

Ives did little composing after 1918. He spent the rest of his life

as a successful insurance salesman, and shared his music with only a few friends, such as Cowell and Carl Ruggles (1876– 1971). Cowell, like Ives, was a pioneer in experimental music for the piano. He wrote several pieces for "prepared piano," an instrument made ready for performance by having objects attached to or placed on its strings, some of which might also be tuned unconventionally. He was the first American composer to show a consistent interest in the music of other cultures, which he incorporated into his numerous symphonies. Ruggles was a resolute individualist whose few works, such as Sun Treader (1932), deal with Symbolist themes. Although their treatment sometimes has a nearly post-Romantic massiveness, they consistently show an obsession with perfection of form and sound achieved through the most concentrated means. (He once spent the afternoon repeating the same note on the piano in search of "the perfect C.")

Aaron Copland (1900-1990) studied under Nadia Boulanger (1887-1979) during the early 1920s in Paris, where he came under the influence of Stravinsky. Upon his return to the United States, he adopted themes and rhythms inspired by jazz. Enthused by liberal ideology, he sought to create music that would speak to all the people, not simply those of one region. As a result, Copland, more than any other composer, defined our concept of "American" music across a wide spectrum, including Latin, Mexican, Appalachian, and Western. His three ballets-Billy the Kid (1838), Rodeo (1942), and above all Appalachian Spring (1944)—are justifiably popular works that combine touching lyricism with rhythmic vivacity in almost irresistible combination. Copland's work also includes a number of challenging serious works, such as Variations for piano (1930) and the Third Symphony (1946), composed in the Neoclassical manner of Stravinsky.

England also had an important school of composers before 1945, starting with the Victorian Romantic Edward Elgar (1857–1934). Elgar's cantata, *A Dream of Gerontius* (1900), based on a poem about a soul's journey to heaven by the theologian John Henry Newman, conveys the idealism of the English school. Equally characteristic was the love of nature found in the work of Gustav Holst (1874–1934), best-known for *The Planets* (1916). Perhaps the finest composer was Ralph Vaughan Williams (1872–1958), whose compositions, such as the *Serenade to Music* (1938), set to a text from Shakespeare's *Othello*, epitomize English lyricism.

This, he explained, was "a label for the new realism bearing a socialist flavor. Cynicism and resignation are the negative side of New Objectivity; the positive side expresses itself in the enthusiasm for immediate reality." Its principal representatives were George Grosz, who by this time had abandoned his slashing style for a more realistic manner no less biting in its sarcasm, and Max Beckmann, whose naturalism was simply a vehicle for expressing his disillusionment. But it was the

meticulous verism of Otto Dix (1891–1969), another Expressionist who had also been a member of Dada, that defined the essential characteristics of the New Objectivity. Its roots lay in German Renaissance art and the Romanticism of Runge, which Dix used to expose the ills of modern Germany with obsessive detail. Dix's best works are his portraits, such as that of Dr. Mayer-Hermann (fig. 1073). The image has a supernatural clarity that lends an almost nightmarish intensity to

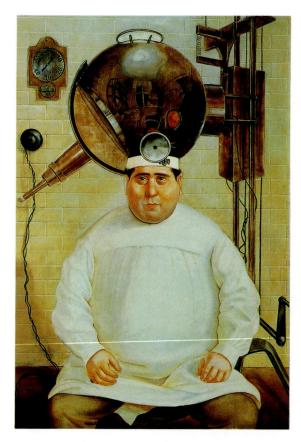

1073. Otto Dix. Dr. Mayer-Hermann. 1926. Oil and tempera on wood, 58³/4 x 39" (149.2 x 99.1 cm). The Museum of Modern Art, New York Gift of Philip Johnson

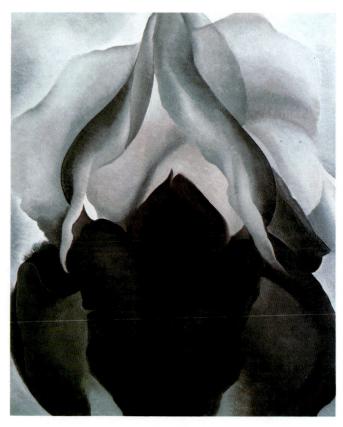

1074. Georgia O'Keeffe. Black Iris III. 1926. Oil on canvas, $36 \times 29^{7/8}$ " (91.4 x 75.9 cm). The Metropolitan Museum of Art, New York The Alfred Stieglitz Collection, 1949

this seemingly straightforward image of the doctor seated impassively before his instruments, which echo his bulbous shape. In the process, they have acquired the alien character of the devices in Max Ernst's 1 Piping Man (fig. 1059), so that they become strangely menacing. For a comparably overwhelming portrayal, we must turn to Ingres' Louis Bertin (fig. 871). That Dix fares remarkably well in the comparison is testimony to his powers of characterization.

O'KEEFFE. The New Objectivity soon succumbed to realism for its own sake tinged with Romantic nostalgia as part of a widespread conservative reaction on both sides of the Atlantic. The naturalism that characterized American art as a whole during the 1920s found its most important representative in Georgia O'Keeffe (1887-1986). Throughout her long career, she covered a wide range of subjects and styles. Like Arthur Dove, she practiced a form of organic abstraction indebted to Expressionism, but she also adopted the Precisionism of Charles Demuth (see page 804), so that she is sometimes considered an abstract artist. Her work often combined aspects of both approaches: as she assimilated a subject into her imagination, she would alter and simplify it to convey a personal meaning. Nonetheless, O'Keeffe remained a realist at heart. Black Iris III (fig. 1074) is the kind of painting for which she is best known. The image is marked by a strong

sense of design uniquely her own. The flower, however, is deceptive in its decorative treatment. Observed close up and magnified to large scale, it is a thinly disguised symbol of female sexuality.

AMERICAN SCENE PAINTING. The dominance of realism during the 1930s signaled the retreat of progressive art everywhere in response to the economic depression and social turmoil that gripped both Europe and the United States. Often realism was linked to the reassertion of traditional values. Most American artists split into two camps, the Regionalists and the Social Realists. The Regionalists sought to revive idealism by updating the American myth, defined, however, largely in midwestern terms. The Social Realists, on the other hand, captured the dislocation and despair of the Depression era, and were often concerned with social reform. But both movements, although bitterly opposed, drew freely on the Ash Can School (see page 799).

HOPPER. The one artist who appealed to all factions alike, including that of the few remaining modernists, was a former pupil of Robert Henri, Edward Hopper (1882-1967). He focused on what has since become known as the "vernacular architecture" of American cities—store fronts, movie houses, all-night diners—which no one else had thought worthy of an

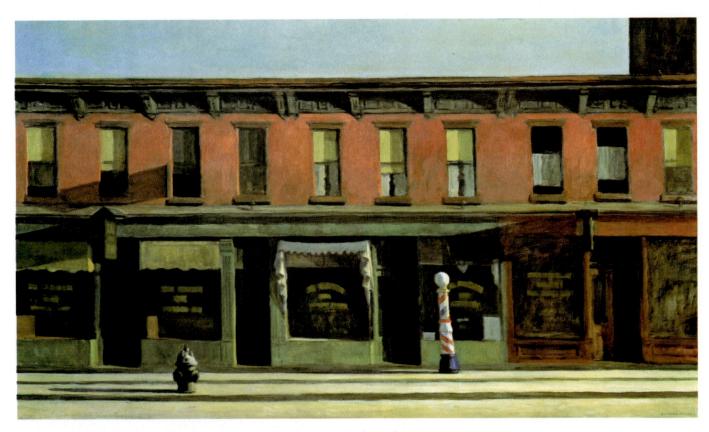

1075. Edward Hopper. *Early Sunday Morning*. 1930. Oil on canvas, 35 x 60" (88.9 x 152.4 cm). Whitney Museum of American Art, New York

artist's attention. *Early Sunday Morning* (fig. 1075) distills a haunting sense of loneliness from the all-too-familiar elements of an ordinary street. Its quietness, we realize, is temporary; there is hidden life behind these facades. We almost expect to see one of the window shades raised as we look at them. Apart from its poetic appeal, the picture also shows an impressive formal discipline. We note the strategy in placing the fireplug and barber pole, the subtle variations in the treatment of the row of windows, the precisely calculated slant of sunlight, the delicate balance of verticals and horizontals. Obviously, Hopper was not unaware of Mondrian.

LAWRENCE. The 1920s brought about a cultural revival among African-Americans known as the Harlem Renaissance. Although its promise was dashed by the economic catastrophe of the Depression, this brief flowering did produce the first black artists to gain national recognition. By far the most famous remains Jacob Lawrence (born 1917), who rose to prominence around 1940. Motivated by rage at the injustices inflicted on African-Americans, Lawrence treated historical themes and the major social issues of the day. His series "From Every Southern Town . . ." (see fig. 1076) focuses on the great exodus of blacks from the south. Despite its small size, our panel has an impressive monumentality, thanks to the simplified forms and flat color, which express his intent with admirable directness. So powerful was Lawrence's impact that

his art continues to define the prototype of African-American painting for many people, although he retired in 1983.

PAINTING SINCE WORLD WAR II

Abstract Expressionism: Action Painting

The world, having survived the most serious economic calamity and the greatest threat to civilization in all of history, now faced a potentially even greater danger: nuclear holocaust. This central fact conditioned the entire Cold War era, which has only recently come to an end. Ironically, it was also a period of unprecedented prosperity in much of the West, but not in the rest of the world, which, with the notable exception of Japan, has struggled until recently to compete successfully.

The painting that prevailed for about 15 years following the end of World War II arose in direct response to the anxiety brought on by these historical circumstances. The term *Abstract Expressionism* is often applied to this style, which was initiated by artists living in New York City. Under the influence of Surrealism and existentialist philosophy, Action painters, the first of the Abstract Expressionists, developed a new approach to art. Painting became a counterpart to life itself, an ongoing process in which artists face comparable risks and overcome the dilemmas confronting them through a

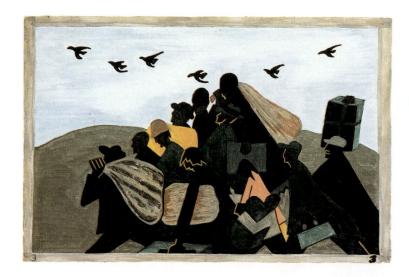

1076. Jacob Lawrence. The Migration of the Negro, panel 3, "From Every Southern Town Migrants Left by the Hundreds to Travel North." 1940-41. Tempera on masonite, 11¹/2 x 17¹/2" (29.2 x 44.4 cm). The Phillips Collection, Washington, D.C.

series of conscious and unconscious decisions in response to both inner and external demands. The Color Field painters in turn coalesced the frenetic gestures and violent hues of the Action painters into broad forms of poetic color that partly reflect the spirituality of Oriental mysticism. In a sense, Color Field Painting resolved the conflicts expressed by Action Painting. They are, however, two sides of the same coin, separated by the thinnest differences of approach.

GOTTLIEB. During World War II, the poet André Breton and other Surrealists found refuge in New York, where their work was enthusiastically received by critics and exhibited at museums and galleries such as Peggy Guggenheim's Art of This Century. Soon the early Abstract Expressionists evolved their own form of Surrealism that allowed them to express their sense of horror at the pervasive evil of a chaotic world. Distraught by the carnage, which threatened the very existence of civilization, they became myth-makers who sought to evoke images that expressed their sense of impending disaster. In this they were strongly affected by the theory of the collective subconscious formulated by Freud's disciple Carl Jung, who believed that universal archetypes are imbedded in our psyches.

The breakthrough came in a discussion between Adolph Gottlieb (1903–1974) and Mark Rothko (1903–1970), who suggested they try Classical themes. Gottlieb consequently began to paint pictographs based on Sophocles and the other Greek tragedians. Pictographs are a form of picture writing found in prehistoric art; no longer intelligible to us, they continue to exercise a mysterious, instinctive appeal. Few prehistoric images, however, have the impact of Gottlieb's pictographs (fig. 1077), which conjure up something more elemental than even the most ancient relic. The canvas owes its power to his uncanny ability to cast the viewer back into the dark, primitive realm of the subconscious. Painted in an uncompromisingly severe style, it radiates a menacing evil that is a truly frightening evocation of the war. Composed in a grid system derived from Mondrian, it contains Surrealist forms influenced by the grimmest works of Picasso, Miró, and Klee from the same years. At face value the picture seems a confusing jumble of human anatomy cut up and reassembled by a

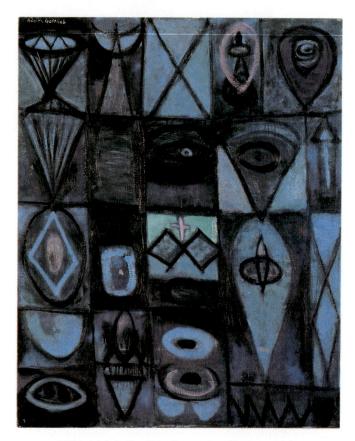

1077. Adolph Gottlieb. Descent into Darkness. 1947. Oil on masonite, 30 x 25" (76.2 x 63.5 cm). Smith College Museum of Art, Northampton, Massachusetts Acquired by exchange, 1951

lunatic. It demands to be read section by section, yet it does not yield a literal meaning. Instead, the accumulation of intuitive responses through free association to this enigmatic image provides an experience at once overwhelming and profoundly disturbing.

GORKY. Arshile Gorky (1904–1948), an Armenian who came to America at 16, was the pioneer of the movement and the single most important influence on its other members. It

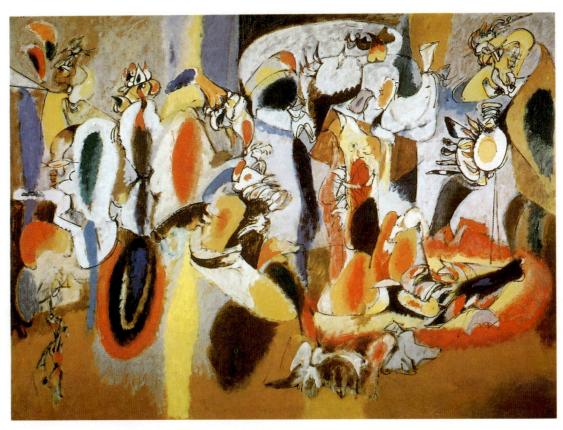

1078. Arshile Gorky. *The Liver Is the Cock's Comb.* 1944. Oil on canvas, 6'1¹/4" x 8'2" (1.86 x 2.49 m). Albright-Knox Art Gallery, Buffalo, New York Gift of Seymour H. Knox, 1956

took him 20 years, painting first in the manner of Cézanne, then in the vein of Picasso, to arrive at his mature style. We see it in *The Liver Is the Cock's Comb* (fig. 1078), his greatest work. The enigmatic title suggests Gorky's close contact with the Surrealists during the war. Gorky developed a personal mythology that underlies his work; each form represents a private symbol within this hermetic realm. Everything here is in the process of turning into something else. The treatment reflects his own experience in camouflage, gained from a class he conducted earlier. The biomorphic shapes clearly owe much to Miró, while their spontaneous handling and the glowing color reflect Gorky's enthusiasm for Kandinsky (see figs. 1064 and 1030). Yet the dynamic interlocking of the forms, their aggressive power of attraction and repulsion are uniquely his own.

POLLOCK. The most important of the Action painters proved to be Jackson Pollock (1912–1956). His huge canvas entitled *Autumn Rhythm: Number 30, 1950* (fig. 1079) was executed mainly by pouring and spattering the colors, instead of applying them with a brush. [See Primary Sources, no. 105, page 944.] The result, especially when viewed at close range, suggests both Kandinsky and Max Ernst (compare figs. 1030 and 1060). Kandinsky's nonrepresentational Expressionism and the Surrealists' exploitation of chance effects are indeed the main sources of Pollock's work, but they do not sufficiently

account for his revolutionary technique and the emotional appeal of his art. Why did Pollock "fling a pot of paint in the public's face," as Ruskin had accused Whistler of doing? It was surely not to be more abstract than his predecessors, for the strict control implied by abstraction is exactly what Pollock relinquished when he began to dribble and spatter. Rather, he came to regard paint itself not as a passive substance to be manipulated at will but as a storehouse of pent-up forces for him to release.

The actual shapes visible in our illustration are largely determined by the internal dynamics of his material and his process: the viscosity of the paint, the speed and direction of its impact upon the canvas, its interaction with other layers of pigment. The result is a surface so alive, so sensuously rich, that all earlier painting looks pallid in comparison. When he "aims" the paint at the canvas instead of "carrying" it on the tip of his brush—or, if you will, releases the forces within the paint by giving it a momentum of its own—Pollock does not simply "let go" and leave the rest to chance. He is himself the ultimate source of energy for these forces, and he "rides" them as a cowboy might ride a wild horse, in a frenzy of psychophysical action. He does not always stay in the saddle, yet the exhilaration of this contest, which strains every fiber of his being, is well worth the risk. Our simile, though crude, points up the main difference between Pollock and his predecessors: his total commitment to the act of painting. Hence his pref-

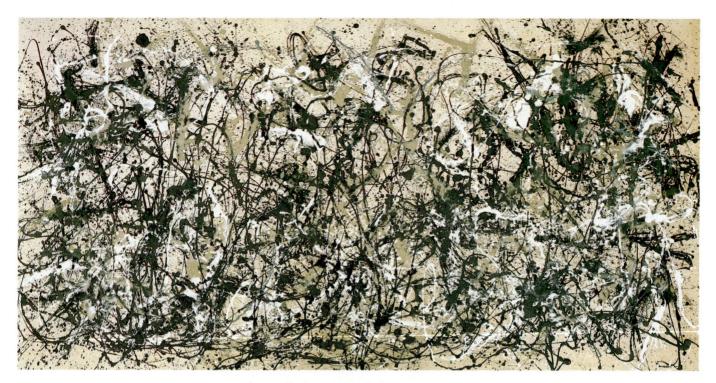

1079. Jackson Pollock. Autumn Rhythm: Number 30, 1950. 1950. Oil on canvas, 8'8" x 17'3" (2.64 x 5.26 m). The Metropolitan Museum of Art, New York George A. Hearn Fund, 1957

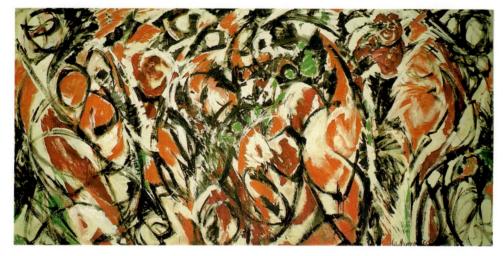

1080. Lee Krasner. Celebration. 1959-60. Oil on canvas, 7'81/4" x 16'41/2" (2.3 x 4.9 m). Private collection Courtesy Robert Miller Gallery, New York

erence for huge canvases that provide a "field of combat" large enough for him to paint not merely with his arms, but with the motion of his whole body.

The term Action Painting conveys the essence of this approach far better than does Abstract Expressionism. To those who complain that Pollock was not sufficiently in control of his medium, we reply that this loss is more than offset by a gain the new continuity and expansiveness of the creative process that gave his work its distinctive mid-twentieth-century stamp. Pollock's drip technique, however, was not in itself essential to Action Painting, and he stopped using it in 1953.

KRASNER. Lee Krasner (1908–1984), who was married to Pollock, never abandoned the brush, although she was unmistakably influenced by Pollock. She struggled to establish her artistic identity, emerging from his shadow only after undergoing several changes in direction and destroying much of her early work. After Pollock's death, she succeeded in doing what he had been attempting to do for the last three years of his life: to reintroduce the figure into Abstract Expressionism while retaining its automatic handwriting. The potential had always been there in Pollock's work: in Autumn Rhythm, we can easily imagine wildly dancing people. In Celebration (fig. 1080),

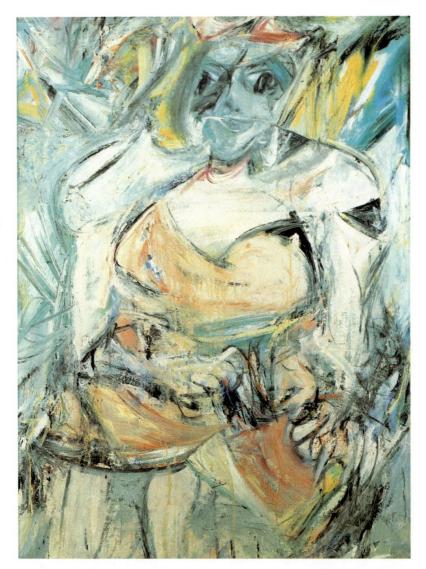

1081. Willem de Kooning.

Woman II. 1952. Oil on
canvas, 59 x 43"
(149.9 x 109.2 cm).
The Museum of Modern
Art, New York
Gift of Mrs. John D. Rockefeller 3rd

Krasner defines these nascent shapes from within the tangled network of lines by using the broad gestures of Action Painting to suggest human forms without actually depicting them.

DE KOONING. The work of Willem de Kooning (born 1904), another prominent member of the group and a close friend of Gorky, always retains a link with the world of images, whether or not it has a recognizable subject. In some paintings, such as Woman II (fig. 1081), the image emerges from the jagged welter of brushstrokes as insistently as it does in Rouault's Head of Christ (see fig. 1023). De Kooning has in common with Pollock the furious energy of the process of painting, the sense of risk, of a challenge successfully—but barely—met. In reality, the artist worked on the canvas for two years, constantly repainting it until he got it right. What are we to make of his wildly distorted Woman II? It is as if the flow of psychic impulses in the process of painting has unleashed this nightmarish specter from deep within the artist's subconscious, much as it did in Adolph Gottlieb's pictographs (compare fig. 1077). For that reason, he has sometimes been accused of being a woman-hater, a charge he denied. Rather, she is like a primordial goddess, cruel yet seductive, who represents the dark, primitive side of our makeup. We have met her before, for example in "The Mistress of the Animals" from Thera (fig. 123). At the same time, De Kooning's woman is

intended as a humorous caricature of modern movie stars such as Marilyn Monroe. Yet he shared with Max Beckmann an Old World horror of empty space, which to him signified the existential void. Only after he moved to Long Island from the confines of New York City was he able to overcome this deep-seated anxiety.

Expressionism in Europe

Action Painting marked the international coming-of-age for American art. The movement had a powerful impact on European art, which in those years had nothing to show of comparable force and conviction. One French artist, however, was of such prodigal originality as to constitute a movement all by himself: Jean Dubuffet, whose first exhibition soon after the Liberation electrified and antagonized the art world of Paris.

DUBUFFET. As a young man Dubuffet (1901–1985) had formal instruction in painting, but he responded to none of the various trends he saw around him, nor to the art of the museums. All struck him as divorced from real life, and he turned to other pursuits. Only in middle age did he experience the breakthrough that permitted him to discover his creative gifts. Dubuffet suddenly realized that for him true art had to

1082. Jean Dubuffet. Le Métafisyx, from the Corps de Dames series. 1950. $45^3/4 \times 35^1/4$ " (116.2 x 89.5 cm). Private collection

1083. Karel Appel. *Burned Face.* 1961. Oil on canvas, 9'10" x 6'6³/4" (3 x 2 m). Private collection

come from outside the ideas and traditions of the artistic elite, and he found inspiration in the art of children and the insane. The distinction between "normal" and "abnormal" struck him as no more tenable than established notions of "beauty" and "ugliness." Not since Marcel Duchamp (see page 798) had anyone ventured so radical a critique of the nature of art.

Dubuffet made himself the champion of what he called l'art brut, "art-in-the-raw," but he created something of a paradox besides: while extolling the directness and spontaneity of the amateur as against the refinement of professional artists, he became a professional artist himself. Duchamp's questioning of established values had led him to cease artistic activity altogether, but Dubuffet became incredibly prolific, second only to Picasso in output. Compared with Klee, who had first utilized the style of children's drawings (see pages 809-10), Dubuffet's art is "raw" indeed. Its stark immediacy, its explosive, defiant presence, are the opposite of the older painter's formal discipline and economy of means. Did Dubuffet perhaps fall into a trap of his own making? If his work merely imitated the art brut of children and the insane, would not these self-chosen conventions limit him as much as those of the artistic elite?

We may be tempted to think so at our first sight of *Le Métafisyx* (fig. 1082) from his *Corps de Dames* series. Even De Kooning's wildly distorted *Woman II* (fig. 1081) seems gentle when matched against this shocking assault on our inherited sensibilities. The paint is as heavy and opaque as a rough coating of plaster, and the lines articulating the blocklike body are

scratched into the surface like graffiti made by an untrained hand. Appearances are deceiving, however. The fury and concentration of Dubuffet's attack should convince us that his demonic female is not "something any child can do." In an eloquent statement the artist has explained the purpose of images such as this: "The female body . . . has long . . . been associated with a very specious notion of beauty which I find miserable and most depressing. Surely I am for beauty, but not that one . . . I intend to sweep away everything we have been taught to consider—without question—as grace and beauty [and to] substitute another and vaster beauty, touching all objects and beings, not excluding the most despised . . . I would like people to look at my work as an enterprise for the rehabilitation of scorned values, and . . . a work of ardent celebration."

APPEL. *L'art brut* and Abstract Expressionism provided the mainsprings for the COBRA group in Denmark, Belgium, and Holland, which took its name from Copenhagen, Brussels, and Amsterdam, the capitals of those countries. The Dutch artist Karel Appel (born 1921), one of the group's co-founders, soon distinguished himself as the finest pure painter of his generation in postwar Europe. To the subject matter of Dubuffet he added the slashing brushwork and vivid colors of De Kooning. During several extended visits to the United States in the late 1950s and early 1960s, Appel was directly exposed to the Action painters and inspired by jazz musicians. As a result, his palette became even more sonorous, the texture more sensuous, and the space more complex. *Burned Face* (fig. 1083), one of

The end of World War II brought an explosion of theater

in response to pent-up cultural energy and popular demand. In Europe heavy government subsidies were used to restore national theaters and establish new ones. French theater initially adhered to concepts and practices that had been developed during the war years. Most new dramas were by established writers, such as Jean Anouilh (1910-1987), the most popular playwright in France through the 1970s, whose work centered on the dilemma of maintaining youthful integrity in an adult world based on compromise. But the essential contribution of postwar France was the Theater of the Absurd, which, appropriately enough, was never an organized movement and was named by the critic Martin Esslin only in 1961, when its heyday was over. The term derives from the essay "The Myth of Sisyphus" written in 1943 by Albert Camus (1913–1960), who considered the universe to be chaotic and irrational and considered the search for meaning to be as "absurd" as the futile task of the Corinthian king who was condemned to pushing the same boulder up a hill in Hades forever. Camus' outlook was closely related to the existentialism of Jean-Paul Sartre, which held that truth in any absolute sense is unknowable, and that meaning must be self-created by each individual. Camus, however, rejected Sartre's call for political engagement as a necessary, albeit irrational, act, thereby prompting a long and bitter feud between the two men.

This attitude was a response to the horrors of the war and the anxiety created by the ensuing Cold War, with its omnipresent threat of nuclear holocaust. In fact, End Game (1957) by Samuel Beckett (1906–1989), the greatest of the absurdists, takes place at the end of the world and uses the metaphor of chess to represent the human condition through four characters who alternately torment and console each other in their incomprehensible predicament, over which they have no control. Although he was Irish, Beckett spent much of his career in Paris, and End Game was originally written in French. Paris was also home to the Romanian-born Eugène Ionesco (1912-1994), whose early one-act dramas, such as The Bald Soprano (1949), which was inspired by an English phrase book, were "antiplays" using the conventions of language to convey irrational, anguished states of mind. His later works, notably *Rhinoceros* (1960), are more conventional in form and character delineation, but they are no less hallucinatory in their effect. Of all the absurdists, the most disturbing was Jean Genet (1910-1986). Like many of his plays, Genet's masterpiece *The Bal*cony (1956) deals with outcasts—he himself was a criminal and a homosexual—caught in a web of perverse and destructive relationships, but nevertheless reveals a surprisingly compassionate, if pessimistic, view of humanity. Genet's plays are extremely powerful in their impact on the viewer. In this he reveals himself a disciple of Artaud's Theater of Cruelty, which exercised a pervasive influence on French theater after the war, including the director Roger Blin (1907-1984), who staged numerous absurdist plays in experimental theaters across the country. By far the most important recent development has come from the Théâtre du Soleil, founded in 1964, with Ariane Mnouchkine (born

1940) at its helm. Her productions of Shakespeare, Euripides,

and Aeschylus freely incorporate elements from India, Japan, and Asia to striking effect.

In Germany, the most powerful influence came from Bertholt Brecht, whose Berlin Ensemble, directed by his wife, Helene Weigel (1900-1971), was widely regarded as among the finest of the time in Europe. Despite heavy state support on both sides of the iron curtain, not until the 1960s did Germany produce its first postwar dramatist of note: Peter Weiss (1916-1982), whose Marat/Sade (the customary shortened title) unites Brecht and Artaud to treat an insane asylum as a metaphor of the world. Of the German playwrights born around the end of the war, the foremost is Botho Strauss (born 1944), whose drama Big and Little (1978), in which characters try unsuccessfully to establish contact with one another, are close to absurdist theater but replete with political overtones. Throughout the 1970s German theater was heavily leftist in its orientation, especially the productions of director Peter Stein (born 1937), which were critiques of the ideologies underlying traditional plays and examinations of their historical roots. Since then a more conventional ideology and approach have been adopted, as much out of self-preservation as conviction.

England rebuilt its fabled theater system, including the Old Vic and the Stratford Festival Company, and reestablished the important festivals such as Glyndebourne. Experimental theater, however, came only in the mid-1950s, when the English Stage Company, under George Devine (1910-1966), was established and produced two epoch-making plays by John Osborne (1929-1994): Look Back in Anger (1956), an attack on the inherited class system and its injustices, and *The Entertainer* (1957), starring Laurence Olivier as the fading music-hall actor Archie Rice, who symbolizes the decline of England. At about the same time, the Theatre Workshop began to reach its height under Joan Littlewood (born 1914), its director until 1961, who wanted to create a working-class theater. Her most famous productions were The Quare Fellow, written in 1945 by the Irish poet and novelist Brendan Behan (1923-1964), about the impending execution of an Irish Republican Army sympathizer; and A Taste of Honey (1958), written at the age of 17 by Shelagh Delaney (born 1939), about a teen-aged mother who rears her child with the help of a gay man. Under Peter Hall (born 1930) and Peter Brook (born 1925), the most experimental of all English directors, the newly chartered Royal Shakespeare Company became the leading venue for avant-garde theater in the 1960s. By far the most significant English playwright of the postwar era has been Harold Pinter (born 1930), whose enigmatic "comedies of menace," such as The Caretaker (1960), have more than a little in common with Beckett's dramas but are filled with a sense of mystery and fear that makes them psychologically gripping. The generation born in the 1930s continues to dominate English drama. Typically their work is radical, both socially and morally. Among them, Edward Bond (born 1935) gained particular notoriety for the shock value of his early plays written in 1965-68, which use violence and bizarre plots to emphasize the moral depravity of modern existence.

Poland's contribution to contemporary theater has been no less important than in music. Jerzy Grotowski (born 1933) emerged as a leading director in the mid-1960s, when the Polish Laboratory Theater toured Europe, but it was as a theorist that he made his mark with the publication in 1968 of Towards a Poor Theater, which advocated eliminating every nonessential element from theater, until it was reduced to the only components that could not be omitted without destroying theater itself-the actor and the audience. The heavy physical and psychic demands of his acting method drew mainly on the Russians, while his approach to stagecraft makes the audience play a role in the drama unself-consciously through its psychological response. Eventually he took the final step of eliminating theater itself in favor of rituals re-creating the archetypal experiences on which he believed theater was ultimately based.

In contrast to Europe, the United States government gave little support to theater after the war. American theater nonetheless prospered in small houses across the land, thanks to a revival of the Little Theater movement, which had struggled during the Great Depression. In New York experimental theater thrived off-Broadway. Major new regional companies were formed as well, particularly the Tyrone Guthrie Theater in Minneapolis, established in 1963. The most prominent organization was the Actors Studio, which was co-founded in 1947 by the director Elia Kazan, although Lee Strasberg soon became the key figure. It was the first theater to promote the "method acting" of Stanislavsky (see page 795), which dominated the American stage into the 1960s. It also staged the first classics of American postwar drama: A Streetcar Named Desire (1947) by Tennessee Williams (1911–1983), and Death of a Salesman (1949) by Arthur Miller (born 1916). The former, featuring the actor Marlon Brando in his first important role as the brutish Stanley Kowalski, is an unforgettable play about sex, madness, and violence in the South, while the latter, which focuses on the American dream of success, was written as a classical tragedy about the common man. As in the other arts, the period since 1945 has witnessed the high tide of writing for the American stage.

The most important playwright of the 1960s was Edward Albee (born 1928), who began as an absurdist, then turned to dramas (Who's Afraid of Virginia Woolf, 1962) about how people deal psychologically with inner and external reality, before becoming an iconoclast whose meanings are ambiguous (The Marriage Play, 1987). In 1964 Sam Shepard (born 1943) won an Obie Award for his first play, Cowboy, centering on his favorite theme, the American West, treated in archetypal terms. The late 1960s and early 1970s were a time of turmoil everywhere. In addition to student riots in France and America in 1968, there were protests against the Vietnam War, which found expression in such plays as America Hurrah! (1967) by Jean-Claude van Itallie (born 1936) and Sticks and Bones (1971) by David Rabe (born 1940).

1084. Francis Bacon. Head Surrounded by Sides of Beef. 1954. Oil on canvas, $50^3/4 \times 48''$ (129 x 122 cm). The Art Institute of Chicago Harriott A. Fox Fund

the personages that inhabits Appel's work from that period, is an explosion of color applied with a brilliant technique that at first hides the figural elements lurking within the painting. In maintaining the importance of content while thoroughly integrating it with the style of Abstract Expressionism, Appel established a precedent which was followed by many other European artists, as well as by a number of American painters who have become preoccupied with the same problem.

BACON. The English artist Francis Bacon (1909–1992) was allied not with Abstract Expressionism, though he was clearly related to it, but with the Expressionist tradition. For his power to transmute sheer anguish into visual form he had no equal among twentieth-century artists unless it be Rouault (see pages 482-83). Bacon often derived his imagery from other artists, freely combining several sources while transforming them so as to infuse them with new meaning. Head Surrounded by Sides of Beef (fig. 1084) reflects Bacon's obsession with Velázquez' Pope Innocent X (compare fig. 758), a picture that haunted him for some years. It is, of course, no longer Innocent X we see here but a screaming ghost, inspired by a scene from Sergei Eisenstein's film Alexander Nevsky, that is materializing out of a black void in the company of two luminescent sides of beef taken from a painting by Rembrandt. Knowing the origin of the canvas does not help us to understand it, however. Nor does comparison with earlier works such as Grünewald's The Crucifixion, Fuseli's Nightmare, Ensor's Christ's Entry into Brussels in 1889, or Munch's The Scream (see figs. 696, 884, 988, and 989), which are its antecedents. Bacon was a gambler, a risk taker, in real life as well as in the way he worked. What he sought are images that, in his

1085. Mark Rothko. *Orange and Yellow.* 1956. Oil on canvas, 7'7" x 5'11" (2.31 x 1.8 m). Albright-Knox Art Gallery, Buffalo, New York

Gift of Seymour H. Knox, 1956

1086. Helen Frankenthaler. *The Bay.* 1963. Acrylic on canvas, 6'8³/4" x 6'9³/4" (2.05 x 2.08 m). The Detroit Institute of Arts Gift of Dr. and Mrs. Hilbert H. DeLawter

own words, "unlock the deeper possibilities of sensation." Here he competes with Velázquez, but on his own terms, which are to set up an almost unbearable tension between the shocking violence of his vision and the luminous beauty of his brushwork.

Color Field Painting

By the late 1940s, a number of artists began to transform Action Painting into a style called Color Field Painting, in which the canvas is stained with thin, translucent color washes. These may be oil or even ink, but the favored material quickly became acrylic, a plastic suspended in a polymer resin, which can be thinned with water so that it flows freely.

ROTHKO. In the mid-1940s Mark Rothko worked in a style derived from the Surrealists, then adopted the gestures of early Action Painting, but within a few years his forms began to coalesce, until he subdued the aggressiveness of Action Painting so completely that his mature pictures breathe the purest contemplative stillness. *Orange and Yellow* (fig. 1085) consists of two rectangles with blurred edges on a pale red ground. The lower rectangle seems immersed in the red ground, while the upper rectangle stands out more assertively in front of the red. The canvas is very large, over seven and one-half feet high, and the thin washes of color permit the texture of the cloth to be seen. This description hardly begins to touch the essence of the

work, or the reasons for its mysterious power to move us. These are to be found in the delicate equilibrium of the shapes, their strange interdependence, and the subtle variations of hue, which seem to immerse the beholder in the painting. For those attuned to the artist's special vision, the experience can be akin to a trancelike rapture. Yet Rothko sought to convey not a mystical experience but a tragic outlook, for he possessed a melancholy, philosophical cast of mind. The overarching theme of his paintings is the tragedy of the human condition in the face of inevitable death. His bold, simplified forms are intended to function as universal symbols that express the most elemental meaning of life by condensing the drama of existence to its very essence.

FRANKENTHALER. The stained canvas was also pioneered by Helen Frankenthaler (born 1928), who was inspired by Rothko's example as early as 1952. In *The Bay* (fig. 1086) Frankenthaler uses the same biomorphic forms basic to early Action Painting but eliminates the personal handwriting found in the brushwork of Gorky and De Kooning. The results are reminiscent of O'Keeffe's paintings in their lyrical and decorative qualities, and no less impressive (compare fig. 1074).

LOUIS. A visit to Frankenthaler's studio in 1953 proved decisive for Morris Louis (1912–1962), perhaps the most gifted of all the Color Field painters. The following year he painted his first "veil" paintings, then struggled unsuccessfully for several

1087. Morris Louis. Blue Veil. 1958-59. Acrylic resin paint on canvas, 7'73/4" x 13' (2.3 x 4 m). Fogg Art Museum, Harvard University Art Museums, Cambridge, Massachusetts Gift of Lois Orswell and Purchase from the Gifts for Special Uses Fund

1088. Ellsworth Kelly. Red Blue Green. 1963. Oil on canvas, 7'8" x 11'4" (2.34 x 3.45 m). Museum of Contemporary Art, San Diego, La Jolla, California Gift of Jack and Carolyn Farris

years before inaugurating a second series that proved even more majestic. The successive layers of color in Blue Veil (fig. 1087) have been "floated on" without visible marks of the brush. Their harmonious interaction creates a delicately shifting balance, like the aurora borealis, that gives the picture its mysterious beauty. How did Louis achieve this mesmerizing effect, so akin to late paintings by Monet (see fig. 943)? We do not know for certain, but he seems to have poured his gossamer-thin paints down the canvas, which he tilted and turned to give direction to their flow. Needless to say, it took a great deal of experimentation to arrive at the seemingly effortless perfection seen in our example.

Late Abstract Expressionism

KELLY. Many artists who came to maturity in the 1950s turned away from Action Painting altogether in favor of hardedge painting. Red Blue Green (fig. 1088) by Ellsworth Kelly

1089. Frank Stella. *Empress of India.* 1965. Metallic powder in polymer emulsion on canvas, 6'5" x 18'8" (1.9 x 5.7 m). The Museum of Modern Art, New York Gift of S. I. Newhouse, Jr.

African-American Painting

(born 1923), an early leader of this tendency, abandons Rothko's impressionistic softness. Instead, flat areas of color are circumscribed within carefully delineated forms as part of the formal investigation of color and design problems for their own sake.

This radical abstraction of form is known as Minimalism, which implies an equal reduction of content. It was a quest for basic elements representing the fundamental aesthetic values of art, without regard to issues of content. Minimalism was a necessary, even valuable phase, of modern art. At its most extreme, it reduced art not to an eternal essence but to an arid simplicity. In the hands of a few artists of genius like Kelly, however, it yielded works of unprecedented formal perfection.

STELLA. The brilliant and precocious Frank Stella (born 1936) began as an admirer of Mondrian, then soon evolved a nonfigurative style that was even more self-contained. Unlike Mondrian (see pages 805–6), Stella did not concern himself with the vertical-horizontal balance that relates the older artist's work to the world of nature. Logically enough, he also abandoned the traditional rectangular format, to make quite sure that his pictures bore no resemblance to windows. The shape of the canvas had now become an integral part of the design. In one of his largest works, the majestic Empress of India (fig. 1089), this shape is determined by the thrust and counterthrust of four huge chevrons, identical in size and shape but sharply differentiated in color and in their relationship to the whole. The paint, moreover, contains powdered metal which gives it an iridescent sheen. This is yet another way to stress the impersonal precision of the surfaces and to remove the work from any comparison with the "handmade" look of easel pictures. In fact, to call *Empress of India* a picture is something of a misnomer. It demands to be thought of as an object, sufficient unto itself.

Following World War II, blacks began to attend art schools in growing numbers, at the very time that Abstract Expressionism marked the coming of age of American art. The civil rights movement helped them to establish their artistic identities and find appropriate styles for expressing them. The turning point proved to be the assassinations of Malcolm X in 1965 and Martin Luther King, Jr., in 1968, which provoked an outpouring of African-American art.

Since then, black artists have pursued three major tendencies. Mainstream Abstractionists, particularly those of the older generation, tend to be concerned primarily with seeking a personal aesthetic, maintaining that there is no such thing as African-American, or black, art, only good art. Consequently, they have been denounced by activist artists who, stirred by social consciousness as well as by political ideology, have adopted highly expressive representational styles as the means for communicating a distinctive black perspective directly to the people in their communities. Mediating between these two approaches is a more decorative form of art that frequently incorporates African, Caribbean, and even Mexican motifs. Abstraction has proved the most fruitful path, for it has opened up avenues of expression that allow black artists, however private their concerns may be, to achieve a universal, not only an ethnic, statement.

BEARDEN. No hard-and-fast rules separate these alternatives, however, and aspects of each have often been combined into individual styles. Certainly the most successful synthesis was realized by Romare Bearden (1911–1988). [See Primary Sources, no. 106, pages 944–45.] Although he got his start in the 1930s, it was not until the mid-1950s that he decided to devote his career entirely to art. Over the course of his long life, he pursued interests in mathematics, philosophy, and

1090. Romare Bearden. The Prevalence of Ritual: Baptism. 1964. Collage of photochemical reproduction, synthetic polymer, and pencil on paperboard, 91/8 x 12" (23.2 x 30.5 cm). Hirshhorn Museum and Sculpture Garden, Smithsonian Institution, Washington, D.C. Gift of Joseph H. Hirshhorn, 1966

music that enriched his work. Bearden was inevitably affected by Abstract Expressionism but, dissatisfied with the approach, abandoned it in favor of a collage technique, although abstraction remained the underpinning of his art. His reputation was established during the mid-1960s by photomontages such as The Prevalence of Ritual: Baptism (fig. 1090). Bearden's aim, as he put it, was to depict "the life of my people as I know it, passionately and dispassionately as Brueghel. My intention is to reveal through pictorial complexities the life I know." He had a full command of the resources of Western and African art. Our example is as intricate in its composition as Terbrugghen's The Calling of St. Matthew (fig. 771), but it is couched in the familiar forms of tribal masks. The picture fulfills Bearden's goals so completely that it exercises an immediate appeal to people of all races. His widespread popularity was a breakthrough that inspired other African-American artists.

WILLIAMS. William T. Williams (born 1942) belongs to the generation of African-Americans born around 1940 who have brought black painting and sculpture to artistic maturity. He was initially a member of the "lost" generation of the lyrical Expressionists from the early 1970s whose contribution has been largely overlooked. After a period of intense self-scrutiny, he developed the sophisticated technique seen in Batman (fig. 1091). His method can be compared to jazz improvisation, a debt that the artist himself has acknowledged. He interweaves his color and brushwork within a contrasting two-part structure that permits endless variations on the central theme. Although Williams is concerned primarily with formal issues, the play of color across the encrusted surface evokes the light,

1091. William T. Williams. Batman. 1979. Acrylic on canvas, 6'8" x 5' (2.03 x 1.52 m). Collection the artist

1092. Raymond Saunders. White Flower Black Flower. 1986. Mixed media on canvas, 6'7" x 8'9³/4" (2.00 x 2.53 m). Private collection

Op Art

patterns, and texture of a landscape, one that is deeply rooted in the artist's memory of the rural South where he spent his childhood.

SAUNDERS. With Williams, it is the intense effort to build up meaning through dense layers of paint within a clear framework that impresses. By contrast, the work of Raymond Saunders (born 1934) has a spontaneous creativity that emanates equally from his reservoir of memories. He was among the first artists to explore the urban African-American environment. Graffiti, church facades, store signs, restaurant menus, and other commercial images—these and like motifs are grist for his mill. The specific combination in White Flower Black Flower (fig. 1092) holds no literal meaning and arises purely through free association. By the same token, there is no precise order, despite the formal presentation. A brilliant technician, Saunders feels at liberty to juxtapose the representational and the abstract, "real" collage elements and "imitation" graffiti, pure geometry and painterly gesture. These components are nevertheless related thematically and aesthetically through their origin in Saunders' experience. We may see this approach as a stratagem that permits him to have the best of both worlds by fusing the unique features of black culture with a singular form of abstraction in a way that resists ready categorization.

A trend that gathered force in the mid-1950s was known as Op Art because of its concern with optics: the physical and psychological process of vision. Op Art has been devoted primarily to optical illusions. Needless to say, all representational art from the Old Stone Age onward has been involved with optical illusion in one sense or another. What is new about Op Art is that it is rigorously nonrepresentational. It evolved partly from hard-edge abstraction, although its ancestry can be traced back still further to Mondrian (see page 904). At the same time, it seeks to extend the realm of optical illusion in every possible way by taking advantage of the new materials and processes constantly supplied by science, including laser technology. Much Op Art consists of constructions or "environments" (see page 867) that are dependent for their effect on light and motion and cannot be reproduced satisfactorily in a book.

Because of its reliance on science and technology, Op Art's possibilities appear to be unlimited. The movement nevertheless matured within a decade of its inception and developed little thereafter. The difficulty lies primarily with its subject. Op Art seems overly cerebral and systematic, more akin to the sciences than to the humanities. Op Art often involves the beholder with the work of art in a truly novel, dynamic way. But although its effects are undeniably fascinating, they encompass a relatively narrow range of concerns that lie for the

1093. Josef Albers. Apparition, from Homage to the Square series. 1959. Oil on masonite, $47^{1/2} \times 47^{1/2}$ " (120.7 x 120.7 cm). Solomon R. Guggenheim Museum, New York

1094. Richard Anuszkiewicz. Entrance to Green. 1970. Acrylic on canvas, 9' x 6' (2.74 x 1.83 m). Collection the artist

most part outside the mainstream of modern art. Only a handful of artists have enriched it with the variety and expressiveness necessary to make it a viable tradition.

ALBERS. Josef Albers (1888–1976), who came to America after 1933, when Hitler closed the Bauhaus school at Dessau (see page 874), became the founder of the mainstream of Op Art. He preferred to work in series that allowed him to explore each theme fully before moving on to a new subject. Albers devoted the latter part of his career to color theory. Homage to the Square (fig. 1093), his final series, is concerned with subtle color relations among simple geometric shapes, which he reduced to a few basic types. Within these confines, he was able to invent almost endless combinations based on rules he devised through ceaseless experimentation. Basically, Albers relied on color scales in which primary hues are desaturated in perceptually even gradations by giving them higher values (that is, by diluting them with white or gray). A step from one color scale can be substituted for the same step in another; these in turn can be combined by following the laws of color mixing, complementary colors, and so forth. This approach requires the utmost sensitivity to color, and even though the paint is taken directly from commercially available tubes, the colors bear a complex relation to each other. In our example, the artist creates a strong optical push-pull through the play of closely related colors of contrasting value. The exact spatial effect is determined not only by hue and intensity of the pigments but by their sequence and the relative size of the squares.

ANUSZKIEWICZ. Albers was an important teacher as well as theorist. His gifted pupil Richard Anuszkiewicz (born 1930) developed his art by relaxing Albers' self-imposed restrictions. In Entrance to Green (fig. 1094), the ever-decreasing series of rectangles creates a sense of infinite recession toward the center. This is counterbalanced by the color pattern, which brings the center close to us by the gradual shift from cool to warm tones as we move inward from the periphery. Surprising for such an avowedly theoretical work is its expressive intensity. The resonance of the colors within the strict geometry heightens the optical push-pull, producing an almost mystical power. The painting can be likened to a modern icon, capable of providing a deeply moving experience to those attuned to its vision.

Pop Art

Other artists who made a name for themselves in the mid-1950s rediscovered what the public continued to take for granted despite all efforts to persuade otherwise: that a picture is not "essentially a flat surface covered with colors," as Maurice

1095. Richard Hamilton. *Just What Is It That Makes Today's Home So Different, So Appealing*?
1956. Collage on paper, 10¹/4 x 9¹/4" (26 x 24.8 cm).
Kunsthalle Tübingen. Sammlung Zundel, Germany

Denis had insisted, but an image wanting to be recognized. If art was by its very nature representational, then the modern movement, from Manet to Pollock, was based on a fallacy, no matter how impressive its achievements. Painting, it seemed, had been on a kind of voluntary starvation diet for the past hundred years, feeding upon itself rather than on the world around us. It was time to give in to the "image-hunger" thus built up—a hunger from which the public at large had never suffered, since its demand for images was abundantly supplied by photography, advertising, magazine illustrations, and comic strips.

The artists who felt this way seized on the products of commercial art catering to popular taste. Here, they realized, was an essential aspect of our century's visual environment that had been entirely disregarded as vulgar and antiaesthetic by the representatives of "highbrow" culture, a presence that cried out to be examined. Only Marcel Duchamp and some of the Dadaists, with their contempt for all orthodox opinion, had dared to penetrate this realm (see page 806). It was they who now became the patron saints of Pop Art, as the new movement came to be called.

HAMILTON. Pop Art actually began in London in the mid-1950s with the Independent Group of artists and intellectuals. They were fascinated by the impact on British life of the American mass media, which had been flooding England ever since the end of World War II. The first work that can be called an unequivocal statement of Pop Art was a small collage (fig. 1095) made in 1956 by Richard Hamilton (born 1922), a follower of Marcel Duchamp, which already incorporates most of the themes that were taken up by later artists: comic

strips, cinema, commercial design, nudes, cheap décor, appliances, all tokens of modern materialistic culture.

It is not surprising that the new art had a special appeal for America, and that it reached its fullest development there during the following decade. In retrospect, Pop Art in the United States was an expression of the optimistic spirit of the 1960s that began with the election of John F. Kennedy and ended at the height of the Vietnam War. Unlike Dada, Pop Art was not motivated by despair or disgust at contemporary civilization. It viewed commercial culture as its raw material, an endless source of pictorial subject matter, rather than as an evil to be attacked. Nor did Pop Art share Dada's aggressive attitude toward the established values of modern art.

JOHNS. The work of Jasper Johns (born 1930), one of the pioneers of Pop Art in America, raises questions that go beyond the boundaries of the movement. Johns began by painting, meticulously and with great precision, such familiar objects as flags, targets, numerals, and maps (see fig. 24). His Three Flags (fig. 1096) presents an intriguing problem: just what is the difference between image and reality? We instantly recognize the Stars and Stripes, but if we try to define what we actually see here, we find that the answer eludes us. These flags behave "unnaturally." Instead of waving or flopping they stand at attention, as it were, rigidly aligned with each other in a kind of reverse perspective. Yet there is movement of another sort: the reds, whites, and blues are not areas of solid color but subtly modulated. Can we really say, then, that this is an image of three flags? Clearly, no such flags can exist anywhere except in the artist's head. The more we think about it, the more we begin to recognize the picture as a feat of the

1096. Jasper Johns. *Three Flags.* 1958. Encaustic on canvas, 30⁷/8 x 45¹/2 x 5" (78.4 x 115.6 x 12.7 cm). Whitney Museum of American Art, New York

imagination—probably the last thing we expected to do when we first looked at it.

LICHTENSTEIN. Revolutionary though it was, Johns' use of flags, numerals, and similar elements as pictorial themes had to some extent been anticipated 30 years before by another American painter, Charles Demuth, in such pictures as *I Saw the Figure 5 in Gold* (fig. 1055). Roy Lichtenstein (born 1923), in contrast, has seized on comic strips—or, more precisely, on the standardized imagery of the traditional strips devoted to violent action and sentimental love, rather than those bearing the stamp of an individual creator. His paintings, such as *Drowning Girl* (fig. 1097), are greatly enlarged copies of single frames, including the balloons, the impersonal, simplified black outlines, and the dots used for printing colors on cheap paper. [See Primary Sources, no. 107, page 845.]

These pictures are perhaps the most paradoxical in the entire field of Pop Art. Unlike any other paintings past or present, they cannot be accurately reproduced in this book, for they then become indistinguishable from real comic strips. Enlarging a design meant for an area only a few inches square to one several hundred times greater must have given rise to a host of formal problems that could be solved only by the most intense scrutiny: how, for example, to draw the girl's nose so it would look "right" in comic-strip terms, or how to space the colored dots so they would have the proper weight in relation to the outlines.

Clearly, our picture is not a mechanical copy, but an interpretation. In fact, it is excerpted from the original panel. It nevertheless remains faithful to the spirit of the original because of the countless changes and adjustments of detail that

1097. Roy Lichtenstein. *Drowning Girl.* 1963. Oil and synthetic polymer paint on canvas, 67⁵/8 x 66³/4" (171.6 x 169.5 cm).

The Museum of Modern Art, New York

Philip Johnson Fund and Gift of Mr. and Mrs. Bagley Wright

the artist has introduced. How is it possible for images of this sort to be so instantly recognizable? Why are they so "real" to millions of people? What fascinates Lichtenstein about comic strips—and what he makes us see for the first time—are the rigid conventions of their style, as firmly set and as remote from life as those of Byzantine art.

1098. Andy Warhol.

Gold Marilyn Monroe. 1962.

Synthetic polymer paint, silkscreened, and oil on canvas, 6'11¹/4" x 4'7" (2.12 x 1.4 m).

The Museum of Modern Art, New York

Gift of Philip Johnson

WARHOL. Andy Warhol (1928-1987) used this very quality in ironic commentaries on modern society. A former commercial artist, he made the viewer consider the aesthetic qualities of everyday images, such as soup cans, that we readily overlook. He did much the same thing with the subject of death, an obsession of his, in silk-screened pictures of electric chairs and gruesome traffic accidents, which demonstrate that dying has been reduced to a banality by the mass media. Warhol had an uncanny understanding of how media shape our view of people and events, creating their own reality and larger-than-life figures. He became a master at manipulating the media to project a public persona that disguised his true character. These themes come together in his Gold Marilyn Monroe (fig. 1098). Set against a gold background, like a Byzantine icon, she becomes a modern-day Madonna. Yet Warhol conveys a sense of the tragic personality that lay behind the famous movie star's glamorous facade. The color, lurid and off-register like a reproduction in a sleazy magazine, makes us realize that she has been reduced to a cheap commodity. Through mechanical means, she is rendered as impersonal as the Virgin that stares out from the thousands of icons produced by hack artists through the ages.

Photorealism

Although Pop Art was sometimes referred to as "the new realism," the term hardly seems to fit the painters we have discussed. They are, to be sure, sharply observant of their sources. However, their chosen material is itself rather abstract: flags, numerals, lettering, signs, badges, comic strips. A more recent offshoot of Pop Art is the trend called Photorealism because of its fascination with camera images. Photographs had been utilized by nineteenth-century painters soon after the "pencil of nature" was invented (one of the earliest to do so, surprisingly, was Delacroix) but they were no more than a convenient substitute for reality. For the Photorealists, in contrast, the photograph itself is the reality on which they build their pictures.

EDDY. Their work often has a visual complexity that challenges the most acute observer. *New Shoes for H* (fig. 1099) by

1099. Don Eddy. New Shoes for H. 1973-74. Acrylic on canvas, 44 x 48"(111.7 x 121.9 cm). The Cleveland Museum of Art Purchased with a grant from the National Endowment for the Arts and matched by gifts from members of The Cleveland Society for Contemporary Art

Don Eddy (born 1944), shows Photorealism at its best. Eddy grew up in southern California. As a teenager he learned to do fancy paint jobs on cars and surfboards with an air brush, then worked as a photographer for several years. When he became a painter, he used both earlier skills. In preparing New Shoes for H, Eddy took a series of pictures of the window display of a shoe store on Union Square in Manhattan. One photograph (fig. 1100) served as the basis for the painting. What intrigued him, clearly, was the way glass filters and alters everyday reality. Only a narrow strip along the left-hand edge offers an unobstructed view. Everything else—the shoes, bystanders, street traffic, buildings—is seen through one or more layers of glass, all of them at oblique angles to the picture surface. The familiar scene is transformed into a dazzlingly rich and novel visual experience by the combined displacement, distortion, and reflection of these panes.

When we compare the painting with the photograph, we realize that they are related in much the same way as Lichtenstein's *Drowning Girl* (fig. 1097) is to the original comic-strip frame from which it derives. Unlike the photograph, Eddy's canvas shows everything in uniformly sharp focus, articulating details lost in the shadows. Most important of all, he gives pictorial coherence to the scene through a brilliant color scheme whose pulsating rhythm plays over the entire surface. At the time he painted New Shoes for H, color had become newly important in Eddy's thinking. The H of the title pays homage to Henri Matisse and to Hans Hofmann, an Abstract Expressionist whom Eddy had come to admire.

ESTES. The acknowledged grand master of Photorealism is Richard Estes (born 1936). His work is marked by its technical perfection, which turns Photorealism into a form of Magic Realism. Masterful though it be, this ability is no better than that of any competent illustrator; nor does it distinguish him from the earlier Precisionists who often used

1100. Don Eddy. Photograph for New Shoes for H. 1973-74. The Cleveland Museum of Art Gift of the artist

1101. Richard Estes. Food Shop. 1967. Oil on linen, 65⁵/8 x 48¹/2" (166.7 x 123.2 cm). Museum Ludwig, Cologne

photographs as the basis for their paintings. What, then, is the key to his success? It lies in his choice of subject and composition. Estes has a predilection for store fronts of an earlier time that evoke nostalgic memories. In this he is like an archaeologist of modern urban life. His best paintings, such as Food Shop (fig. 1101), show the same uncanny ability to

1102. Audrey Flack. *Queen.* 1975–76. Acrylic on canvas, 6'8" (2.03 m) square. Private collection Courtesy Louis K. Meisel Gallery, New York

strike a responsive chord as Hopper's *Early Sunday Morning* (see fig. 1075). The more we look at it, the more we realize that the gridlike composition is as subtly balanced as a painting by Mondrian (compare fig. 1057). In this way Estes elevates his humble store front to an arresting visual experience fully worthy of our attention.

FEMINISM. Photorealism was part of a general tendency that marked American painting in the 1970s: the resurgence of realism. It took on a wide range of themes and techniques, from the most personal to the most detached, depending on the artist's vision of objective reality and its subjective significance. Its flexibility made realism a sensitive vehicle for the feminist movement that came to the fore in the same decade. Beyond the organizing of groups dedicated to a wider recognition for women artists, feminism in art has shown little of the unity that characterizes the social movement. Many feminists, for example, turned to "traditional" women's crafts, particularly textiles, or incorporated crafts into a collage approach known as Pattern and Decoration. In painting, however, the majority pursued different forms of realism for a variety of ends.

FLACK. Women artists such as Audrey Flack (born 1931) have used realism to explore the world around them and their relation to it from a personal as well as a feminist viewpoint. Like most of Flack's paintings, *Queen* (fig. 1102) is an extended allegory. The queen is the most powerful figure on the chessboard yet she remains expendable in defense of the king.

Equally apparent is the meaning inherent to the queen of hearts, but here the card also refers to the passion for gambling in members of Flack's family, who are present in the locket with photos of the artist and her mother. The contrast of youth and age is central to *Queen:* the watch is a traditional emblem of life's brevity, and the dewy rose stands for transience of beauty, which is further conveyed by the makeup on the dressing table. The suggestive shapes of the bud and fruits can also be taken as symbols of feminine sexuality.

Queen is successful not so much for its statement, however provocative, as for its imagery. Flack creates a purely artistic reality by superimposing two separate photographs. Critical to the illusion is the gray border, which acts as a framing device and also establishes the central space and color of the painting. The objects that seem to project from the picture plane are shown in a different perspective from those on the tilted tabletop behind. The picture space is made all the more active by the play of its colors within the neutral gray.

LATE MODERNISM

Neo-Expressionism

The art we have looked at since 1945, although distinctive to the postwar era, is so closely related to what came before it that it was clearly cut from the same cloth, and we do not hesitate to call it modernist. At long last, however, twentieth-century painting, to which everything from Abstract Expressionism to

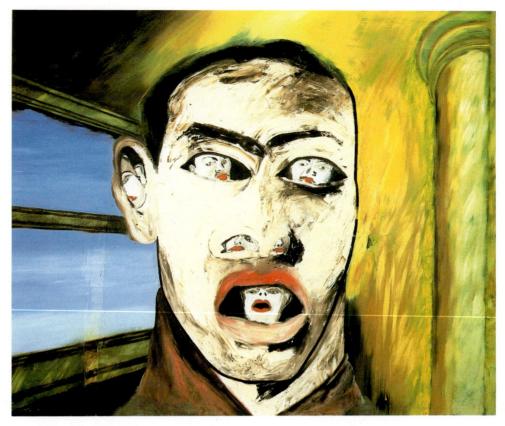

1103. Francesco Clemente. Untitled. 1983. Oil and wax on canvas, 6'6" x 7'9" (1.98 x 2.36 m) Courtesy Thomas Ammann, Zurich

Photorealism made such a vital contribution, began to lose vigor. The first sign of decline came in the early 1970s with the widespread use of "Neo-" to describe the latest tendencies, which came and went in rapid succession and are all but forgotten today. Only one of these movements has made a lasting contribution: Neo-Expressionism, which arose toward the end of the decade and became the dominant current of the 1980s. Indeed, imagery of all kinds completely overshadowed Neo-Abstraction (also known as "Neo-Geo"), to the point that abstraction itself was declared all but dead by the critics. In its place was left a feeble imitation, which signified that modern art had turned its back to the mainstream. And despite the fact that Neo-Expressionism is deeply rooted in modernism, there can be little question that it represents the end of the tradition we have traced throughout this chapter.

Europe

CLEMENTE. The Italian Francesco Clemente (born 1952) is representative in many respects of his artistic generation in Europe. His association with the Arte Povera ("Poor Art") movement in Italy led him to develop a potent Neo-Expressionist style. His career took a decisive turn in 1982 when he decided to go to New York in order "to be where the great painters have been," but he also spends much of his time in India, where he has been inspired by Hinduism. His canvases and wall paintings sometimes have an ambitiousness that can assume the form of allegorical cycles addressed directly to the Italian painters who worked on a grand scale, starting with Giotto. His most compelling works, however, are those having as their subject matter the artist's moods, fantasies, and appetites. Clemente is fearless in recording urges and memories that the rest of us repress. Art becomes for him an act of cathartic necessity that releases, but never resolves, the impulses that assault his acute self-awareness. His self-portraits (fig. 1103) suggest a soul bombarded by drives and sensations that can never be truly enjoyed. Alternately fascinating and repellent, his pictures remain curiously unsensual, yet their expressiveness is riveting. Since his work responds to fleeting states of mind, Clemente utilizes whatever style or medium seems appropriate to capturing the transient phenomena of his inner world. He is unusual among Italians in being influenced heavily by Northern European Symbolism and Expressionism with an occasional reminiscence of Surrealism. Here indeed is his vivid nightmare, having the masklike features of Ensor, the psychological terror of Munch, and the haunted vision of De Chirico.

KIEFER. The German artist Anselm Kiefer (born 1945) is the direct heir to Northern Expressionism, but rather than investigating personal moods he confronts moral issues posed by Nazism that have been evaded by other postwar artists in his country. By exploring the major themes of German Romanticism from a modern perspective, he has attempted to reweave the threads broken by history. That tradition, which began as a noble ideal based on a similar longing for the mythical past, ended as a perversion at the hands of Hitler and his followers because it lent itself readily to abuse.

At first glance, postwar music, like postwar art, seems almost

chaotic in its diversity. Composers after 1945 have vastly extended the experiments of their early-twentieth-century predecessors. Many have resorted to extreme dissonance, incorporated chance (aleatory, from the Latin work for dice) events, treated music as a form of noise, and abandoned traditional notation. Others have written for newly invented electronic instruments, turned to repetitive motifs, or looked to non-Western music for inspiration. While these innovations have widened the scope of contemporary music, they often, like Abstract Expressionist painting, place extreme demands on the audience, requiring that it discard traditional standards to judge each work on its own terms. Nevertheless, certain sounds, textures, intervals, and rhythms are so widely used as to be virtual signatures of later twentiethcentury music. Moreover, contemporary music is no more alien to twentieth-century ears than that of the late Middle Ages or Early Renaissance.

The most important composer of the postwar era was the Frenchman Olivier Messiaen (1908-1992). Like his predecessor Francis Poulenc (1899–1963), Messiaen was a devout Catholic, and his music bears witness to his faith, which remained remarkably pure even in the face of great adversity. Despite his position as a leader of the avant-garde, Messiaen created music of a haunting beauty that makes it remarkably accessible. Nowhere is Messiaen's cosmic vision more fully realized than in Colors of the Heavenly City (1963) for piano and ensemble, a kaleidoscopic yet ethereal evocation of the Apocalypse that uses exotic instruments and compositional modes from India and the Orient to suggest a universal spirituality. His music radiates an enchantment with God's creation that led him to incorporate transcriptions of bird songs in the delightful Exotic Birds (1955-56), for he delighted in and revered these simple creatures much as St. Francis of Assisi had before him. There is an intimate connection between these works: Messiaen associated the colors of the heavenly city with the brilliant plumage of birds, whose songs provided the inspiration for his music.

Messiaen was one of the first composers to apply the principles of serialism to timbre (tone color), time, rhythm, and dynamic level. His interest in twelve-tone techniques was stimulated by his pupils Pierre Boulez (born 1925) and Karlheinz Stockhausen (born 1928), on whom he in turn exerted a decisive influence. Boulez, the most intellectual composer on the scene today, has likewise extended serialism in all directions, but came to reject the twelve-tone row for a themeless (athematic) style that also permits carefully calculated "chance" effects and sometimes incorporates "concrete" (recorded) music (see below). The Hammer Without a Master (1954), inspired by the Surrealist poetry of René Char (1907–1988), has a rhythmic liveliness that belies its highly theoretical conception; by contrast, Pli selon pli (Fold by Fold; 1957-62), a sustained work for soprano and orchestra utilizing poems by Mallarmé, demands the utmost concentration to absorb its subtleties. The choice of Mallarmé is significant in itself. Not only was his Symbolist poetry the point of

departure for Surrealists such as Char, but he was the first to allow reciters the opportunity to vary the choice and sequence of poems at will, a technique which Boulez used in *Pli selon pli* and which Stockhausen exploited around the same time.

Stockhausen's compositions, though no less complex than Boulez's, are more visceral in their power. He became associated early on with Pierre Schaeffer (born 1910), the leader of "concrete" music consisting of recorded natural sounds. Soon after it was invented in Germany in 1950, Stockhausen turned to the electronic synthesizer while continuing to compose for traditional instruments. These strands merged in the mid-1950s, when he experimented with multiple orchestras and choruses placed in different arrays under separate conductors. He also explored a succession of moments in time as a replacement for form, which he subsequently abandoned for free form that allowed players to improvize on brief texts.

The Polish composer Witold Lutoslawski (1913–1994) turned to serialism and aleatory music in 1958, despite the fact that such Western techniques were officially frowned on by Communist authorities. His mature instrumental and orchestral works, such as Venetian Games (1961), accord well with the music of Messiaen and Boulez, and he became among the most respected composers of the European avantgarde. After 1975 he pursued a more personal style that culminated in his fourth and final symphony, written in 1992, which begins with an evocation of haunting mystery and ends with a thunderous climax. Lutoslawski began his career in the mold of Bartók, who exercised considerable influence on the Polish school. Krzysztof Penderecki (born 1933) is a miniaturist at heart noted for his discrete use of dissonance. He shares spiritual concerns with Henryk Górecki (born 1933), whose tonalism and traditional religious emphasis have made him very popular in the West in recent years.

From the beginning the French-born composer Edgar Varèse (1883-1965) was a consummate maverick. Influenced by the "Brutism" of the Futurists, he became fascinated by sounds of all sorts, and soon began to utilize sirens and unusual percussion instruments to create novel effects. His major early contribution was three works written between 1918 and 1927 after he emigrated to the United States-Amériques, Arcana, and Intégrales—that treat the orchestra as a form of organized noise. All are marked by extreme dynamism in rhythm and volume. It is suggestive of Varèse's role in overturning tradition that Arcana is the kind of music Sibelius would have written if he had been a modernist composer in the vein of Stravinsky. Though he was a ceaseless experimenter, he never developed a system, which he considered a sign of impotence. It was not until the invention of the tape recorder in 1948 and the synthesizer two years later that Varèse found a medium ideally suited to his extraordinary vision. (He had tried to convince Bell Laboratories to set up an experimental research center around 1930, and even stopped composing around 1937 because he could not

achieve the sounds he wanted.) Electronics allowed him to create and mix sounds of every conceivable sort into a new kind of total sound experience: the poème électronique, for the 1958 Brussels World's Fair, which stands as the first great masterpiece of American electronic music.

Varèse was precocious not only in coming to America at an early date but also in advocating experimental techniques far in advance of their time. American music reached maturity simultaneously with American art in the early 1950s and for many of the same reasons. During World War II many of Europe's leading composers—Stravinsky, Bartók, and Schoenberg among them—came to the United States, where they exercised considerable influence. The most important American composer of the postwar era was John Cage (1912-1992), who studied with Cowell, Varèse, and Schoenberg. Cage nevertheless owed his unique approach to music primarily to his wide range of interests: he made prints, composed scores for and toured with the avant-garde choreographer Merce Cunningham (born 1919), and organized light shows, among his many activities. During the 1940s he extended Cowell's use of the "prepared" piano by adding bits of "debris" from everyday life to produce unusual sounds. Like many American intellectuals during the 1950s he became interested in Zen Buddhism, which helped stimulate his fascination with chance events. "Chance" for Cage, however, must be understood not as total randomness but as improvisation within a defined context, since Cage considered music a kind of organized noise within the stream of life itself. For example, Imaginary Landscape No. 4 (1951) uses 12 radios tuned to different frequencies established by the score, though the final result was unpredictable because what each radio was playing could not be predetermined. Such an attitude, we realize, comes very close to that of the Abstract Expressionists, particularly Jackson Pollock, who also relied on chance as a reflection of life. Like Messiaen, Cage sought a spiritual experience in his music; toward that end, silence—what is not there—is often just as important as the sounds themselves.

The foremost disciple of the synthesizer in America has been Milton Babbitt (born 1916), who helped to found the Columbia-Princeton Electronic Music Center in 1959. Like Boulez, he seeks to apply serialism to all aspects of music, including his quartets and compositions for orchestra, which incorporate synthesized sounds. Despite its profoundly logical basis, his music can be surprisingly expressive, almost in spite of itself. Babbitt studied under Roger Sessions (1896-1985), an early pioneer of modernism with Copland. The symphonies and chamber music Sessions composed after adopting the twelve-tone system in 1953 established him as one of America's leading composers. His masterpiece is the cantata When Lilacs Last in the Dooryard Bloom'd (1970), a haunting evocation of verses by Walt Whitman (1819-1892), the greatest of all American poets, dedicated to John F. Kennedy and Martin Luther King. Of equal stature is Time Cycle (1960) by Lukas Foss (born 1922), who was born in Europe and educated in Paris but came at the age of 15 to the United States, where he completed his training in

Philadelphia. Commissioned for the soprano Adele Addison, it consists of four extended songs based on English and German poetry that includes improvised interludes. Perhaps the most gifted member of the American school to emerge since World War II is Elliott Carter (born 1908). His four quartets are the finest since Bartok's, while Variations for Orchestra is the outstanding contribution to orchestral music in the United States from the 1950s.

The compositions of Luciano Berio (born 1925), a former associate of Stockhausen who emigrated to the United States, are mini-dramas (he often composes for the stage as well), which utilize every available modernist technique. He often treats the human voice as another instrument while employing speechlike sounds to suggest different emotional states. Of particular interest are the works he wrote for his wife, the soprano Cathy Berberian (1925-1983), notably Recital (1971), which deals with the nervous collapse of a singer. George Crumb (born 1929) has also used the human voice in new ways. Ancient Voices of Children (1970), inspired by the poetry of Federico García Lorca, is one of the great masterpieces of the twentieth century. It utilizes motifs similar to those of South and Central American Indians to conjure up a primeval state with unforgettable power. Crumb's work belongs to no school. Neither did that of Samuel Barber (1910-1981), a romantic with an extraordinary gift for melody. Although he felt the influence of Stravinsky's Neoclassicism, Barber's compositions for voice use dissonance discreetly to emphasize the text, to which he had a unique sensitivity. Knoxville: Summer of 1915 (1947), commissioned by the soprano Eleanor Steber and set to a famous poem by James Agee, is surely the most purely beautiful vocal work by any American composer of the twentieth century.

The main tendency to emerge in recent years has been dubbed Minimalism, which uses many of the same devices as the art movement of the same name, albeit for different ends. It relies on the repetition of simple motifs that are gradually varied over time to create a hypnotic, almost mystical, effect, as in Drumming (1970-71) by Steve Reich (born 1936) and *In C* (1964) by Terry Riley (born 1943). These techniques were first explored by Stockhausen, whose music shares an inspiration in Eastern religion with Riley's. The most sophisticated products of Minimalism are the operas of Philip Glass (born 1937), above all Satyagraha ("truthforce," a Sanskrit word that refers to the philosophy of nonviolent resistance practiced by Mahatma Gandhi and Martin Luther King). Minimalism is ideally suited to the text, which is drawn from the Bhagavad-Gita that forms part of the major Hindu religious epic known as the Mahabharata. Minimalism responds to the music and philosophy of other cultures, from Africa to Asia, but it also represents a "crossover" music that incorporates jazz and popular music, including rock and roll. It reinvests contemporary music with a tonality and accessibility that have won new audiences for the concert hall. In the process, it has enjoyed increasing influence—the recent symphonies of Górecki use Minimalist devices, for example.

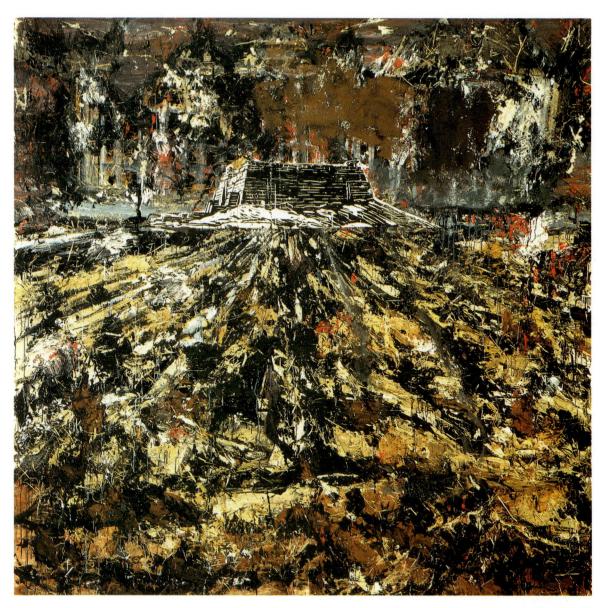

1104. Anselm Kiefer. *To the Unknown Painter.* 1983.

Oil, emulsion, woodcut, shellac, latex, and straw on canvas, 9'2" (2.79 m) square. The Carnegie Museum of Art, Pittsburgh Richard M. Scaife Fund; A. W. Mellon Acquisition Endowment Fund

To the Unknown Painter (fig. 1104) is a powerful statement of the human and cultural catastrophe presented by World War II. Conceptually as well as compositionally it was inspired by the paintings of Caspar David Friedrich (see page 692), of which it is a worthy successor. To express the tragic proportions of the Holocaust, Kiefer works on an appropriately epic scale. Painted in jagged strokes of predominantly earth and black tones, the charred landscape is made tangible by the inclusion of pieces of straw. Amid this destruction stands a somber ruin: it is shown in woodcut to proclaim Kiefer's allegiance to the German Renaissance and to Expressionism. The fortresslike structure is a suitable monument for heroes in recalling the tombs and temples of ancient civilizations (see figs. 56 and 87). But instead of being dedicated to soldiers who died in combat, it is a memorial to the painters whose art was equally a casualty of Fascism.

United States

ROTHENBERG. Neo-Expressionism has found its most gifted American representative in Susan Rothenberg (born 1945). In the mid-1970s the contours of the horse seen in profile provided a thematic focus and personal emblem for her highly formal paintings, but toward the end of the decade she turned to more emotive subjects. The sheer beauty of the surface in *Mondrian* (fig. 1105) belies the intensity of her vision. The figure emerges from the welter of feathery brushstrokes like an apparition from a nightmare. The face, which bears Mondrian's unmistakable features, conjures up a vision of madness. We have seen its like before in Bacon's Head Surrounded by Sides of Beef (fig. 1084). The picture, then, announces Rothenberg's allegiance to Expressionism and constitutes a highly charged commentary on Mondrian, whose rigorous discipline is so antithetical to her painterly freedom.

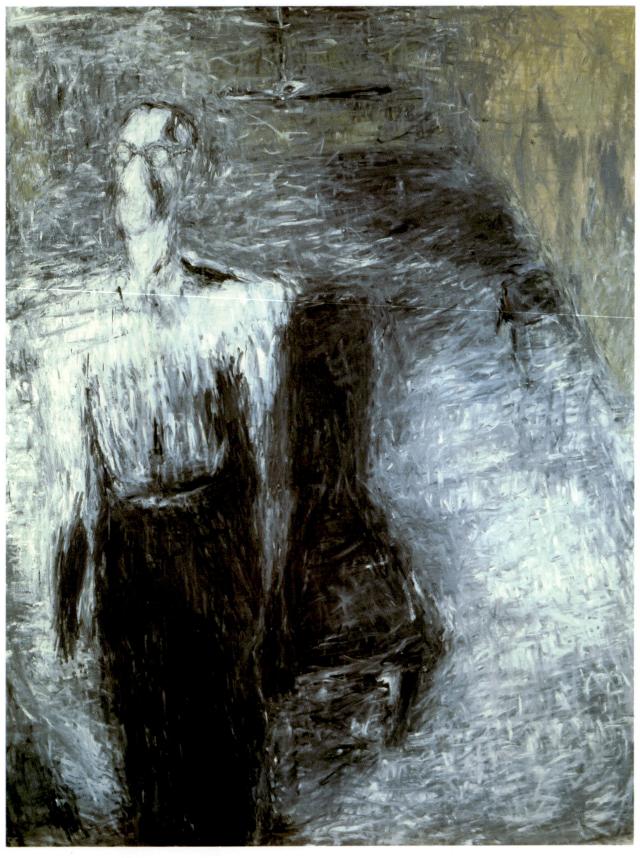

1105. Susan Rothenberg. Mondrian. 1983–84. Oil on canvas, 9'1" x 7' (2.8 x 2.1 m). Private collection Courtesy Sperone Westwater Gallery, New York

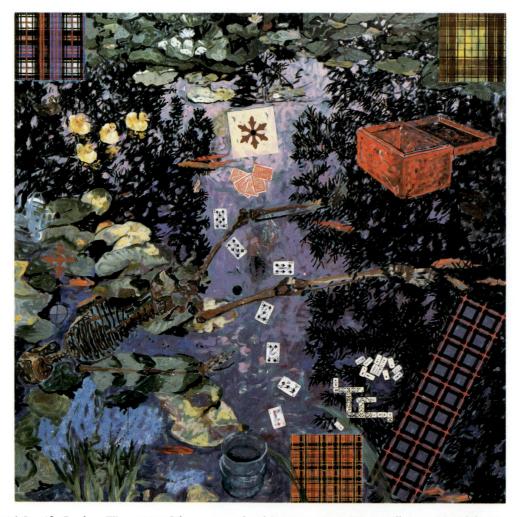

1106. Jennifer Bartlett. Water. 1990. Oil on canvas, 7' x 7' (2.13 x 2.13 m). Private collection, Honolulu, Hawaii

BARTLETT. Jennifer Bartlett (born 1941) has long been recognized as a talented painter; absent, however, was content worthy of her ability. Like Audrey Flack before her (see page 836), she recently turned to a traditional motif which supplies that missing material. The four elements, a popular subject with artists during the Baroque and Rococo, has provided the focus for an extensive series that is as rich in meaning as it is in appearance. Water (fig. 1106), though reminiscent of Monet's Water Lilies (fig. 943), is no mere evocation of nature: floating half-in, half-above the water is a skeleton. Indeed, the real subject here is Vanitas, another theme associated with the elements and, in turn, the senses and the seasons (see pages 588-90). References to Fate, inexorable and quixotic, are found in the cards, dominoes, and other devices used in games and fortune-telling. These are seemingly "stuck" onto the canvas, along with illusionistic swatches of plaid material, which serve to deny the illusionism of the scene and emphasize the surface as an independent, formal entity; hence, too, the red container that seems to hover nonsensically in midair. This play between "two-D" and "three-D" has much the same effect as in Flack's Queen (fig. 1102), and it shares a similar meaning: it both enlivens the painting and places it at one remove from everyday reality, so that we are forced to contemplate its message instead of seeing it simply as a picture.

1107. Elizabeth Murray. *More Than You Know.* 1983.
Oil on ten canvases, 9'3" x 9' x 8" (2.8 m x 2.7 m x 20.3 cm).
The Edward R. Broida Trust
Courtesy PaceWildenstein, New York

1108. Kay WalkingStick. On the Edge. 1989. Acrylic, wax, and oil on canvas, $32 \times 64 \times 3^{1/2}$ " (81.3 x 162.6 x 9 cm) Courtesy M-13 Gallery, New York

MURRAY. Neo-Expressionism has a counterpart in Neo-Abstraction, which has yielded less impressive results thus far. The greatest success in the Neo-Abstractionist vein has been achieved by those artists seeking to infuse their formal concerns with the personal meaning of Neo-Expressionism. Elizabeth Murray (born 1940) has emerged since 1980 as the leader of this crossover style in America. More Than You Know (fig. 1107) makes a fascinating comparison with Audrey Flack's Queen (fig. 1102), for both are replete with autobiographical references. While it is at once simpler and more abstract than Flack's, Murray's composition seems about to fly apart under the pressure of barely contained emotions. The table will remind us of the one in Picasso's *Three Musicians* (fig. 1047), a painting she has referred to in other works from the same time. The contradiction between the flattened collage perspective of the table and chair and the allusions to the distorted three-dimensionality of the surrounding room establishes a disquieting pictorial space. The more we look at the painting, the more we begin to realize how eerie it is. Indeed, it seems to radiate an almost unbearable tension. The table threatens to turn into a figure, surmounted by a skull-like head, that moves with the explosive force of Picasso's Three Dancers (fig. 1049). What was Murray thinking of? She has said that the room reminds her of the place where she sat with her ill mother. At the same time, the demonic face was inspired by Munch's The Scream (fig. 989), while the sheet of paper

recalls Vermeer's paintings of women reading letters (fig. 789), which to her express a combination of serenity and anxiety.

WALKINGSTICK. An artist who has managed to combine Neo-Expressionism and Neo-Abstraction in a particularly fruitful way is Kay WalkingStick (born 1935). Part Cherokee, she was deeply affected by her Indian spiritual heritage, especially its reverence for the earth, although she was raised in white culture. The death of her husband in 1989 brought forth the literal outpouring of grief seen in On the Edge (fig. 1108), which combines two separate landscape forms in a format that she had experimented with briefly several years earlier. The two halves respond to entirely different impulses. The left panel, built up in thick coats of paint applied mainly with her hands, pursues the abstract manner she had developed successfully for more than a decade. In the center is a fan shape, which both suggests a man-made feature in a primitive landscape, like those of the ancient mound builders, and acts as a sign, investing the canvas with mysterious emblematic significance. The right half, painted in an Expressionist style, unleashes a torrent of anguish that is further expressed by the violent color. This duality has several layers of meaning. It can be seen as describing the contrasting aspects of nature as spiritual center and generative force, of order and chaos, of calm contemplation and powerful emotion. Thus both parts of the diptych are necessary to give the painting its full import.

CHAPTER FIVE

TWENTIETH-CENTURY SCULPTURE

SCULPTURE BEFORE WORLD WAR I

Sculpture, the most conservative of the arts throughout most of the nineteenth century, found it difficult to cast off the burden of tradition. It has remained far less adventurous on the whole than painting, which often influenced it. Indeed, the American sculptor David Smith (see page 856) claimed that modern sculpture was created by the painters, and to a remarkable degree he was right. Sculpture has successfully challenged the leadership of painting in our time only by following a separate path.

France

MATISSE. Some of the most important experiments in sculpture were conducted by Matisse in the years 1907-14, when he was inspired by ethnographic sculpture, although there had been a growing interest in "primitive" art on the part of painters like Gauguin even before the first major public collections began to be formed in 1890. At first glance, Reclining *Nude I* (fig. 1109) seems utterly removed from Matisse's paintings. Yet sculpture was a natural complement to his pictures, which often share its "savage" element. It allowed him to investigate problems of form that in turn provided important lessons for his canvases. While the bulging distortions in the anatomy of the *Nude* create an astonishing muscular tension, the artist was concerned above all with "arabesque": the rhythmic contours that define the nude. We will recognize the statuette's kinship with the recumbent figures in *The Joy of Life* (fig. 1021), which were also conceived in outline. But now these rhythms are explored plastically and manipulated for expressive effect. Remarkably, Matisse accomplishes this without diminishing the fundamentally classical character of the nude.

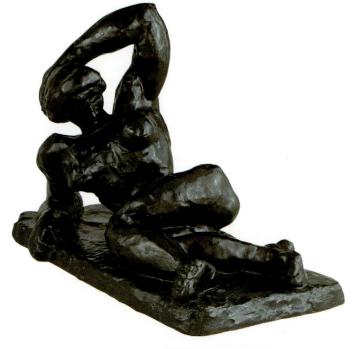

1109. Henri Matisse. *Reclining Nude I*. 1907.

Bronze, 13⁹/16 x 19⁵/8 x 11" (34.5 x 49.9 x 28 cm).

The Baltimore Museum of Art

The Cone Collection, formed by Dr. Claribel Cone and

Miss Etta Cone of Baltimore, Maryland

BRANCUSI. Sculpture remained only a sideline for Matisse. Perhaps for that reason, Expressionism was a much less important current in sculpture than in painting. This may seem surprising, since the rediscovery of ethnographic sculpture by the Fauves might have been expected to evoke a strong response among sculptors. Yet the only one who shared in this interest was Constantin Brancusi (1876-1957), a Romanian who went to Paris in 1904. However, he was more concerned with the formal simplicity and coherence of primitive carvings than with their savage expressiveness. This is evident in *The Kiss* (fig. 1110), executed in 1909 and now placed over a tomb in a Parisian cemetery.

The compactness and self-sufficiency of this group are a radical step beyond Maillol's Seated Woman (see fig. 994), to which it is related much as the Fauves are to Post-Impressionism. Brancusi has a "genius of omission" not unlike Matisse's. And his attitude toward art expresses the same optimistic faith so characteristic of early modernism: "Don't look for mysteries," he said. "I give you pure joy." To him, a monument is a permanent marker, like the steles of the ancients: an upright slab, symmetrical and immobile, and he disturbs this basic shape as little as possible. The embracing lovers are differentiated just enough to be separately identifiable, and seem more primeval than primitive. They are a timeless symbol of generation, innocent and anonymous—the exact opposite of Rodin's The Kiss (see fig. 956), where the contrast of flesh and stone mirrors the dualism of guilt and desire. Herein lies the genius of Brancusi: he posed the first successful alternative to Rodin, whose vast authority overwhelmed the creativity of many younger sculptors. In the process, Brancusi gave modern sculpture its independence.

Brancusi's work took another daring step about 1910, when he began to produce nonrepresentational pieces in marble or metal. (He reserved his "primeval" style for wood and stone.) The former fall into two groups: variations on the egg shape and soaring, vertical "bird" motifs. In concentrating on two basic forms of such uncompromising simplicity, Brancusi strove for essences, not for Rodin's illusion of growth. He was fascinated by the antithesis of life as potential and as kinetic energy: the self-contained perfection of the egg, which hides the mystery of all creation, and the pure dynamics of the creature released from this shell. The Newborn (fig. 1111) is a marvelously concise and witty, yet surprisingly sympathetic, portrayal of an infant's first cry upon entering the world.

Bird in Space (fig. 1112), made more than a decade later, is the culmination of Brancusi's art. It began as the figure of a mythical bird that talks, which he gradually simplified until it is no longer the abstract image of a bird. Rather, it is flight itself, made visible and concrete: "All my life I have sought the essence of flight," Brancusi stated, and he repeated the motif in variants of ever greater refinement. Its disembodied quality is emphasized by the high polish that gives the surface the reflectivity of a mirror, thus establishing a new continuity between the molded space within and the free space without.

CUBISM. In the second decade of the century a number of artists tackled the problem of body-space relationships with the formal tools of Cubism—no simple task, since Cubism was a painter's approach more suited to shallow relief and not

1110. Constantin Brancusi. The Kiss. 1909. Stone, height 351/4" (89.5 cm). Tomb of T. Rachevskaia, Montparnasse Cemetery, Paris

1111. Constantin Brancusi. The Newborn. 1915. Marble, length 81/8" (20.7 cm). Philadelphia Museum of Art Louise and Walter Arensberg Collection

1112. Constantin Brancusi. *Bird in Space* (unique cast). 1928. Bronze, 54 x 8 ¹/₂ x 6 ¹/₂" (137.2 x 21.6 x 16.5 cm). The Museum of Modern Art, New York

Given anonymously

1113. Raymond Duchamp-Villon. *The Great Horse*. 1914. Bronze, height 39¹/4" (99.7 cm). The Art Institute of Chicago Gift of Miss Margaret Fisher in memory of her parents, Mr. and Mrs. Walter L. Fisher

easily adapted to objects in the round. Most of the Cubist painters essayed at least a few sculptures, but the results were generally timid. Picasso's tentative efforts at sculpture attest to the difficulties he faced, yet they were of fundamental importance nonetheless. His attempts to translate the Analytic Cubism seen in *Portrait of Ambroise Vollard* (fig. 1034) into three-dimensional form succeeded only partially in breaking up the solid surface. Precisely because its facets are ambiguous in density and location, painting afforded an infinitely richer experience both visually and expressively.

DUCHAMP-VILLON. The boldest solution to the problems posed by Analytic Cubism in sculpture was achieved by the sculptor Raymond Duchamp-Villon (1876–1916), an elder brother of Marcel Duchamp, in *The Great Horse* (fig. 1113). He began with abstract studies of the animal, but his final version is an image of "horsepower," wherein the body has become a coiled spring and the legs resemble piston rods. Because of this very remoteness from their anatomical model, these quasi-mechanical shapes have a dynamism that is altogether persuasive.

Italy

BOCCIONI. In 1912 the Futurists suddenly became absorbed with making sculpture, which they sought to redefine as radically as painting. They used "force-lines" to create an "arabesque of directional curves" as part of a "systematization of the interpenetration of planes." Hence, as Umberto Boccioni declared, "We break open the figure and enclose it in

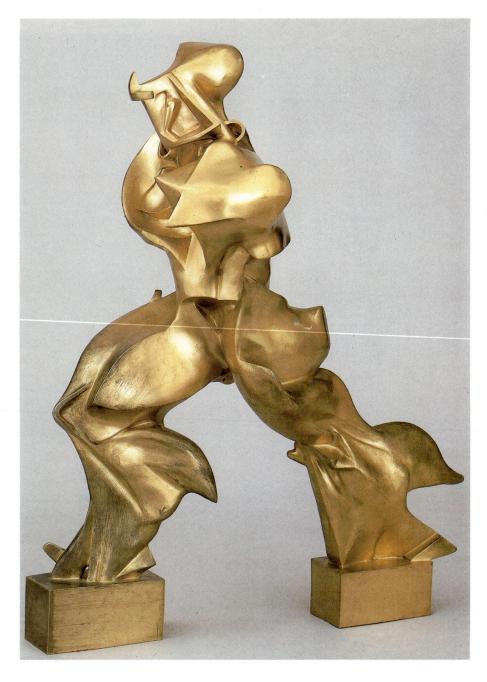

1114. Umberto
Boccioni. Unique
Forms of Continuity in
Space. 1913.
Bronze (cast 1931),
43⁷/8 x 34⁷/8 x 15³/4"
(111.4 x 88.6 x 40 cm).
The Museum of
Modern Art, New York
Acquired through the
Lillie P. Bliss Bequest

SCULPTURE BETWEEN THE WARS

Russia

environment." His running figure entitled *Unique Forms of Continuity in Space* (fig. 1114) is as breathtaking in its complexity as Brancusi's *Bird in Space* is simple. Boccioni has attempted to represent not the human form itself, but the imprint of its motion upon the medium in which it moves. The figure itself remains concealed behind its "garment" of aerial turbulence. The picturesque statue recalls the famous Futurist statement that "the roaring automobile is more beautiful than the Winged Victory," although it obviously owes more to the *Winged Victory* (the *Nike of Samothrace*, fig. 214) than to the design of motor cars. (Fins and streamlining, in 1913, were still to come.)

CONSTRUCTIVISM. In Analytic Cubism, concave and convex were postulated as equivalents. All volumes, whether positive or negative, were "pockets of space." The Constructivists, a group of Russian artists led by Vladimir Tatlin (1895–1956), applied this principle to relief sculpture and arrived at what might be called three-dimensional collage.

TATLIN. Eventually the final step was taken of making the works free-standing. According to Tatlin and his followers, these "constructions" were actually four-dimensional: since they implied motion, they also implied time. Suprematism (see page 796) and Constructivism were therefore closely

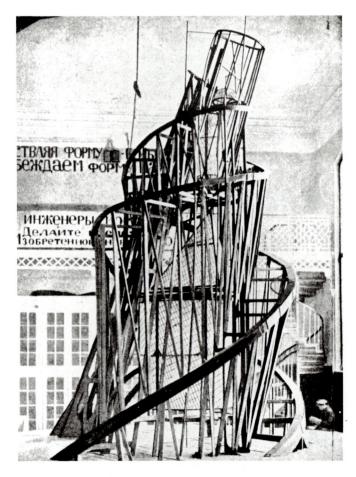

1115. Vladimir Tatlin. Project for *Monument to the Third International.* 1919–20. Wood, iron, and glass, height 20' (6.1 m).

Destroyed; contemporary photograph

related, and in fact overlapped, for both had their origins in Cubo-Futurism. They were nonetheless separated by a fundamental difference in approach. For Tatlin, art was not the Suprematists' spiritual contemplation but an active process of formation that was based on material and technique. He believed that each material dictates specific forms that are inherent in it, and that these must be followed if the work of art was to be valid according to the laws of life itself. In the end, Constructivism won out over Suprematism because it was better suited to the post-Revolution temperament of Russia, when great deeds, not great thoughts, were needed.

Cut off from artistic contact with Europe during World War I, Constructivism developed into a uniquely Russian art that was little affected by the return of some of the country's most important artists, such as Kandinsky and Chagall. The Revolution galvanized the modernists, who celebrated the overthrow of the old regime with a creative outpouring throughout Russia.

Tatlin's model for a *Monument to the Third International* (fig. 1115) captures the dynamism of the technological utopia envisioned under Communism. Pure energy is expressed as lines of force that establish new time-space relationships as well. The work also implies a new social structure, for the Constructivists believed in the power of art literally to reshape society. This extraordinary tower revolving at three speeds was conceived on a monumental scale, complete with Communist

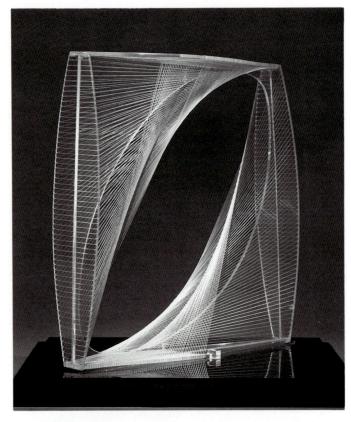

1116. Naum Gabo. *Linear Construction #1* (smaller version). 1942–43. Plexiglass and nylon thread on plexiglass base, 12¹/4 x 12¹/4 x 2³/4" (31.1 x 31.1 x 6.9 cm). Hirshhorn Museum and Sculpture Garden, Smithsonian Institution, Washington, D.C. Gift of Joseph H. Hirshhorn, 1966

Party offices. Like other such projects, however, it was wildly impractical in a society still recovering from the ravages of war and revolution and was never built.

Constructivism subsequently proceeded to a Productivist phase, which ignored any contradiction between true artistic creativity and purely utilitarian production. After the movement had been suppressed as "bourgeois formalism," a number of its members emigrated to the West, where they joined forces with the few movements still espousing abstraction.

GABO. The most important of these was Naum Gabo (1890–1977), who went first to Berlin, then to England, before settling in America after World War II. His main contribution to modern art came in the early 1940s, when he created a new kind of plastic construction strung with nylon filament (fig. 1116) that comes very close to mathematical models. Although he arrived at it through intuition, the parallels to contemporary scientific theory are astonishing, for his work embodies much the same spatiality as modern physics. Gabo was fascinated by the links between art and science, which, he said, "arise from the same creative source and flow into the same ocean of the common culture." Like Kandinsky's, his motives were purely spiritual, and he saw Constructivism as a vehicle of change. None of this, however, accounts for the elegance of Gabo's linear constructions, which embody an entirely modern sensibility.

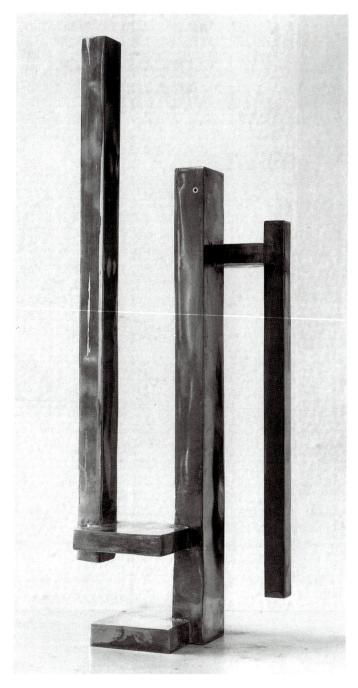

1117. Georges Vantongerloo. *Métal: y=ax³-bx³+cx.* 1935. Argentine, height 15" (38 cm). Emanuel Hoffmann Foundation, Basel, on loan to Kunstmuseum Basel

France

VANTONGERLOO. Soon after arriving in Berlin, Gabo was in touch with *De Stijl*, the Dutch group. Its only true sculptor was the Belgian Georges Vantongerloo (1886–1965), who settled in Paris. He, too, was obsessed with the problem of how to represent space. *Métal:* $y=ax^3-bx^3+cx$ (fig. 1117) is a daring prefiguration of Minimalist sculpture of the 1950s and 1960s. Whereas Mondrian's grids were never governed by strict ratios, Vantongerloo used the same bands to articulate space by establishing precise relationships as defined by the algebraic formula. The artist, however, saw this method as a means of expressing an intuition of creation, which is infinite

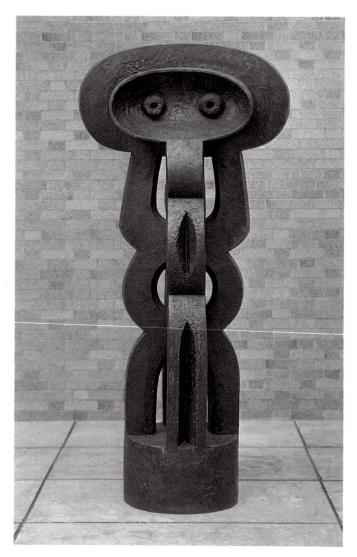

1118. Jacques Lipschitz. *Figure*. 1926–30 (cast 1937). Bronze, height 7'1¹/4" (2.17 m). The Museum of Modern Art, New York Van Gogh Purchase Fund

and is perceived only through our sensitivity. His was indeed an ecstatic vision: "O! The incommensurable is never the same; if it were, it would be commensurable. And as the universe is incommensurable, what we need is an expression that would have neither end nor beginning; and this too exists." Ultimately this realization led him to abandon his sparse geometry for a curvilinear approach, based not on classical Euclidian geometry but on Cartesian analytical geometry, to describe parabolic equations.

LIPSCHITZ. Contrary to what one might have expected, the everyday materials of Synthetic Cubism proved of far greater interest to painters than to the Cubist sculptors, who maintained a traditional allegiance to bronze. After World War I sculptors in France largely forsook abstraction and abandoned Expressionism altogether. Only the Lithuanian-born Jacques Lipschitz (1891–1973), a friend of both Picasso and Matisse, continued to explore the possibilities offered by Cubism. He also shared in Brancusi's primevalism, and in the mid-1920s he achieved a remarkable synthesis of these two tendencies. With its intently staring eyes, *Figure* (fig. 1118) is a haunting

1119. Marcel Duchamp. *In Advance of the Broken Arm.* 1945, from the original of 1915. Snow shovel, length 46³/4" (118.7 cm). Yale University Art Gallery, New Haven, Connecticut Gift of Katherine S. Dreier for the Collection Société Anonyme

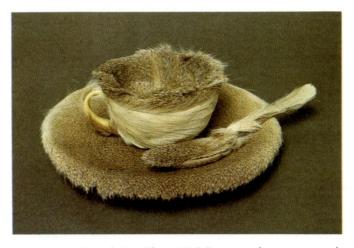

1120. Meret Oppenheim. *Object.* 1936. Fur-covered cup, saucer, and spoon; diameter of cup 4³/4" (12.1 cm); diameter of saucer 9³/8" (23.8 cm); length of spoon 8" (20.3 cm).

The Museum of Modern Art, New York

Purchase

evocation in Cubist terms of African sculpture. Consisting of two interlocking figures, it creates a play of open and closed forms that relieves Brancusi's austere simplicity through arabesque rhythms akin to those of Matisse. Not surprisingly, the patron who commissioned it as a garden sculpture found it difficult to live with *Figure*. No other sculptor at the time was able to rival Lipschitz for sheer power, and he set an important example for the generation of sculptors that reached maturity a decade later (see pages 853–55).

DUCHAMP. Lipschitz's disciplined abstraction was the very antithesis of Dada, which fostered nontraditional approaches that have both enriched and confounded modern sculpture ever since. Playfulness and spontaneity are the impulses behind the ready-mades of Marcel Duchamp, which he created by shifting the context of everyday objects from the utilitarian to the aesthetic. The artist would put his signature, and a provocative title, on ready-made objects such as bottle racks and snow shovels and exhibit them as works of art. In Advance of the Broken Arm (fig. 1119) pushed the spirit of ready-mades to a new height: Duchamp "re-created" the lost original version of 1915 with this one made in 1945. Some of Duchamp's examples consist of combinations of found objects. These "assisted" ready-mades approach the status of constructions or of three-dimensional collage. This technique, later baptized "assemblage" (see pages 863-67), proved to have unlimited possibilities, and numerous younger artists have explored it since, especially in junk-ridden America (see fig. 1144).

SURREALISM. Ready-mades are certainly extreme demonstrations of a principle: that artistic creation depends neither on established rules nor on manual craftsmanship. The principle itself was an important discovery, although Duchamp abandoned ready-mades after only a few years. The Surrealist contribution to sculpture is harder to define. It was difficult to apply the theory of "pure psychic automatism" to painting, but still harder to live up to it in sculpture. How indeed could solid, durable materials be given shape without the sculptor being consciously aware of the process?

OPPENHEIM. A breakthrough came in 1930, when the Surrealists met in response to a growing crisis within the movement. They issued a new manifesto drafted by André Breton that called for the "profound and veritable occultation of Surrealism." It further required "uncovering the strange symbolic life of the most ordinary and clearly defined objects." The result was a new class of Surrealist object: neither ready-made nor sculpture, it constituted a kind of three-dimensional collage assembled not out of aesthetic concerns using traditional techniques but according to "poetic affinity" following dictates of the subconscious. Like *Object* (fig. 1120) by Meret Oppenheim (1913–1985), which created a sensation when it was exhibited in 1936, many were intended to be repulsive and unsettling in the extreme, yet proved all the more fascinating for that very reason.

ARP. Perhaps the purest form of Surrealist sculpture, however, was created by Hans Arp (1887–1966). Around 1930 he began to translate his reliefs, which arose from his experiments

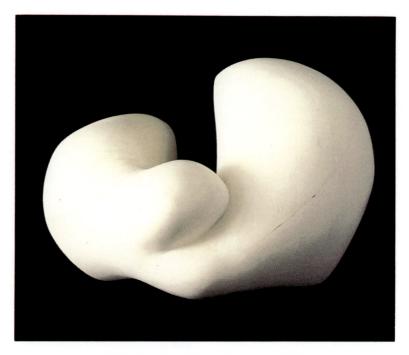

1121. Hans Arp. Human Concretion. 1935. Original plaster, $19^{1/2} \times 18^{3/4} \times 25^{1/2}$ " (49.5 x 47.6 x 64.7 cm). The Museum of Modern Art, New York Gift of the Advisory Committee

with collage, into three-dimensional forms. These evolved a few years later into the Human Concretion series (fig. 1121), a term that aptly describes their character (see also page 808). In contrast to Brancusi's abstractions, which reduce things to their absolute essence, Arp's biomorphic forms seem to grow organically as they are built up. Regardless of medium, the concretions are notable for their perfection. (They were almost always modeled in clay or plaster, although many were later carved in marble and wood, or sometimes cast in bronze, by skilled artisans.) Small wonder they have influenced countless sculptors since then.

PICASSO. As in painting, Picasso's sovereign genius provided much of the impetus for sculpture during the 1930s. In 1928 it emerged as a serious interest for him, and for the next five years he concentrated intensively on making sculptures of all sorts. They demonstrate an amazing variety that testifies to the fertility of his imagination. Head of a Woman (fig. 1122) is an especially appealing example of his work from this period. This arresting figure, made from a colander and other discarded materials, shows Picasso's fascination with ethnographic sculpture in its "primitive" quality. Its kinship with the head in Girl Before a Mirror of about the same time (see fig. 11) suggests why the artist turned to sculpture in the first place. On the one hand, his painted shapes have a solidity that practically demands to be translated into three-dimensional form.

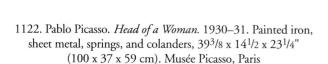

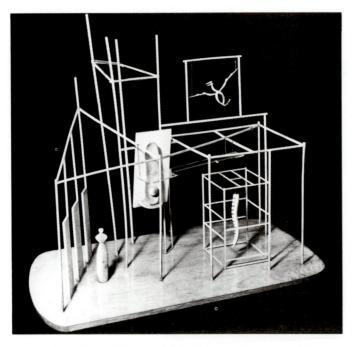

1123. Alberto Giacometti. *The Palace at 4 A.M.* 1932–33. Construction in wood, glass, wire, and string, 25 x 28¹/4 x 15³/4" (63.5 x 71.8 x 40 cm). The Museum of Modern Art, New York

1124. Julio González. *Head.* c. 1935. Wrought iron, 17³/4 x 15¹/4" (45.1 x 38.7 cm). The Museum of Modern Art, New York

Purchase

On the other, his work is so replete with startling transformations that the process of metamorphosis involved in sculpture became highly intriguing. Here there can be little doubt that Picasso's involvement with Surrealism stimulated his imagination and allowed him to approach sculpture without preconception. As he put it, "One should be able to take a bit of wood and find it's a bird." That is what allowed him to see the possibilities in the debris of modern civilization—an attitude that culminated in *Bull's Head* (fig. 2).

GIACOMETTI. Picasso's impact can be seen in *The Palace at 4 A.M.* (fig. 1123) by Alberto Giacometti (1901–1966), a Swiss sculptor and painter who lived in Paris. In 1928 Picasso had made a number of wire constructions, including a maquette for a monument to the poet Apollinaire, that are its immediate forerunners. Giacometti, however, has transformed them into an airy cage that is the three-dimensional equivalent of a Surrealist picture. Unlike earlier pieces of sculpture, it creates its own spatial environment that clings to it as though this eerie miniature world were protected from everyday reality by an invisible glass bell. The space thus trapped is mysterious and corrosive and gnaws away at the forms until only their skeletons are left. And even they, we feel, will disappear before long.

GONZÁLEZ. Picasso also stimulated the astonishing sculptural imagination of Julio González (1872–1942). Trained as a wrought-iron craftsman in his native Catalonia, González had gone to Paris in 1900. Although he was a friend of both Brancusi and Picasso, he produced little of consequence until the 1930s, when his creative energies suddenly came into focus after Picasso called him for technical advice in working with wrought iron. It was González who established this medi-

um as an important one for sculpture, taking advantage of the very difficulties that had discouraged its use before. *Head* (fig. 1124) combines extreme economy of form with an aggressive reinterpretation of anatomy that is derived from Picasso's work after the mid-1920s. As in the head of the figure on the left in Picasso's *Three Dancers* (see fig. 1049), the mouth is an oval cavity with spikelike teeth, the eyes two rods that converge upon an "optic nerve" linking them to the tangled mass of the "brain." González has produced a gruesomely expressive metaphor, as if the violence of his working process mirrored the violence of modern life.

CALDER. The early 1930s, which brought Giacometti and González to the fore, produced still another important development: the mobile sculpture of the American Alexander Calder (1898–1976). Called mobiles for short, they are delicately balanced constructions of metal wire, hinged together and weighted so as to move with the slightest breath of air. They may be of any size, from tiny tabletop models to the huge Lobster Trap and Fish Tail (fig. 1125). Kinetic sculpture had been conceived by the Constructivists, and their influence is evident in Calder's earliest mobiles, which were motordriven and tended toward abstract geometric configurations. Calder was also affected early on by Mondrian, but it was his contact with Surrealism that made him realize the poetic possibilities of "natural" rather than fully controlled movement. He borrowed biomorphic shapes from Miró and began to think of mobiles as analogues of organic structures: flowers on flexible stems, foliage quivering in the breeze, marine animals floating in the sea. Unpredictable and ever-changing, such mobiles incorporate the fourth dimension as an essential element of their structure. Infinitely responsive to their environment, they are more truly alive than any fabricated thing.

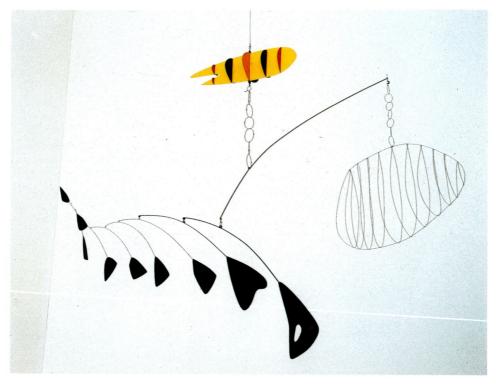

1125. Alexander Calder. *Lobster Trap and Fish Tail.* 1939. Painted steel wire and sheet aluminum, approx. 8'6" x 9'6" (2.6 x 2.9 m). The Museum of Modern Art, New York

Commissioned by the Advisory Committee for the stairwell of the Museum

England

The effects produced by Calder can be compared directly with those of Surrealist painting. The same cannot be said of two English sculptors who represent the culmination of the modern sculptural tradition before 1945: Henry Moore (1898-1986) and Barbara Hepworth (1903-1975), the preeminent woman sculptor of the twentieth century. The presence of Gabo, Kokoschka, Mondrian, Gropius, and other émigrés helped give rise to modern art in England during the mid-1930s, when Moore and Hepworth were emerging as mature artists. In consequence, they absorbed the full spectrum of earlier twentieth-century sculpture, but in different measure, reflecting their contrasting personalities. Moore was the more boldly inventive artist, but Hepworth may well have been the better sculptor. However, the two were closely associated as leaders of the modern movement in England, and influenced one another.

MOORE. The majestic *Two Forms* (fig. 1126), an early work by Moore, may be regarded as the second-generation offspring of Brancusi's *The Kiss* done a quarter-century earlier (see fig. 1110), although there is no direct connection between them. [See Primary Sources, no. 108, page 946.] Abstract and subtle in shape, they are nevertheless "persons" in much the same vein

1126. (right) Henry Moore. Two Forms. 1936. Stone, height approx. 42" (106.7 cm). Collection Mrs. H. Gates Lloyd, Haverford, Pennsylvania

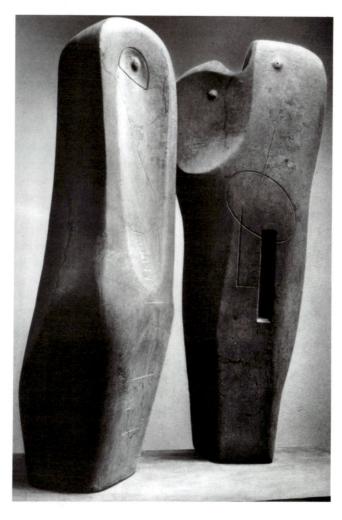

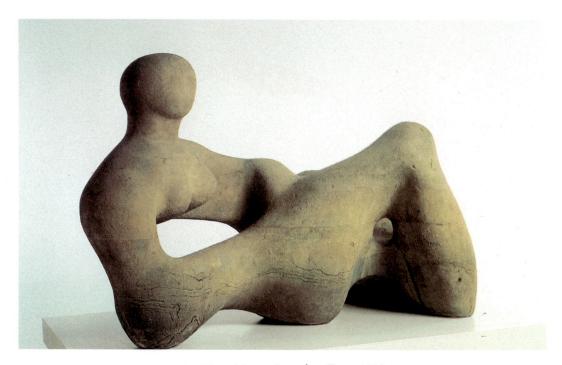

1127. Henry Moore. *Recumbent Figure*. 1938. Green Hornton stone, length approx. 54" (137.2 cm). The Tate Gallery, London

as Lipschitz's *Figure* (fig. 1118), even though they can be called "images" only in the metaphoric sense. This family group—the forked slab evolved from the artist's studies of the mother-and-child theme—is mysterious and remote like the monoliths of Stonehenge, which greatly impressed the sculptor (see fig. 47). And like Stonehenge, Moore's figures are meant to be placed in a landscape, so architectural are they in character.

Through biomorphic abstraction, his Recumbent Figure (fig. 1127) retains both a classical motif—one thinks of a reclining river-god (see fig. 6)—and a primeval look. The design is in complete harmony with the natural striations of the stone, as if the forms had resulted from slow erosion over a thousand years. Moore has evoked the essence of the human figure so successfully that if we were to succumb to the natural temptation to run our hand over the sculpture, it would seem filled with inner life, so convincingly do the forms swell and undulate. Moore was originally inspired by a Mayan statue of the rain spirit Chac Mool. Interestingly enough, the nearest relative of Brancusi's The Kiss is a Pre-Columbian pottery figurine group, which, however, the artist cannot have known, since it was a later discovery. The coincidence nevertheless serves to underscore the fundamental kinship between Brancusi and Moore. Moore's figure also suggests an awareness of Arp's Human Concretions from about the same time (see fig. 1121). The difference is that Arp suggests anatomical forms without specifically referring to them, as Moore does. The total effect is not unlike the arabesques achieved by Matisse in Reclining Nude I (fig. 1109). In addition, the liberties Moore takes with the human figure are unthinkable without Picasso (compare fig. 1050). In this way, Moore unites the strands of early modern sculpture into a seamless whole of incomparable beauty and subtlety.

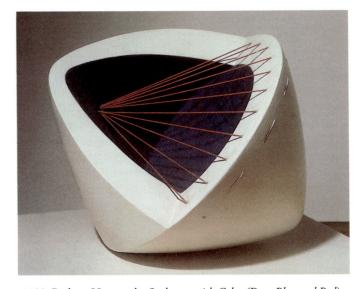

1128. Barbara Hepworth. *Sculpture with Color (Deep Blue and Red)*. 1940–42. Wood, painted white and blue, with red strings, on a wooden base, 11 x 10¹/4" (27.9 x 26 cm). Collection Alan and Sarah Bowness, London

HEPWORTH. In common with Moore's, Hepworth's sculpture had a biological foundation, but her style became more abstract after her marriage to the painter Ben Nicholson (see page 806), her association with the Constructivist Naum Gabo, and her contact in Paris with Brancusi and Arp. For a time she was practicing several modes at once under these influences. With the onset of World War II, she moved to St. Ives in Cornwall, where she initiated an individual style that emerged in the early 1940s. *Sculpture with Color (Deep Blue and Red)* flawlessly synthesizes painting and sculpture, Surrealist biomorphism and organic abstraction, and the molding of space and shaping of mass (fig. 1128). Carved from wood and immaculately finished, it modifies the shape of an egg

to a timeless ideal that has the lucid perfection of a classical head, yet the elemental expressiveness of a primitive mask. Hepworth's egg undoubtedly owes something to Brancusi's (see fig. 1111), although their work is very different. The colors accentuate the play between the interior and exterior of the hollowed-out form, while the strings, a device first used by Moore, seem to suggest a life force within. As a result of its open forms, Sculpture with Color enters into an active relationship with its surroundings. Like Moore, Hepworth was concerned with the relationship of the human figure in a landscape, but in an unusually personal way. After moving to a house overlooking St. Ives Bay, she wrote, "I was the figure in the landscape and every sculpture contained to a greater or lesser degree the ever-changing forms and contours embodying my own response to a given position in that landscape. I used colour and strings in many of the carvings of this time. The colour in the concavities plunged me into the depth of water, caves, or shadows deeper than the carved concavities themselves. The strings were the tension I felt between myself and the sea, the wind or the hills.'

SCULPTURE SINCE 1945

Primary Structures and Environmental Sculpture

Like painting, sculpture since 1945 has been notable for its epic proportions. Indeed, scale assumed fundamental significance for a sculptural movement that extended the scope—the very concept—of sculpture in an entirely new direction. "Primary Structure," the most suitable name suggested for this type, conveys its two salient characteristics: extreme simplicity of shapes and a kinship with architecture. Another term, "Environmental Sculpture" (not to be confused with the mixed-medium "environments" of Pop), refers to the fact that many Primary Structures are designed to envelop the beholder, who is invited to enter or walk through them. It is this space-articulating function that distinguishes Primary Structures from all previous sculpture and relates them to architecture. They are the modern successors, in structural steel and concrete, to such prehistoric monuments as Stonehenge (see figs. 46 and 47).

GOERITZ. The first to explore these possibilities was Mathias Goeritz (born 1915), a German working in Mexico City. As early as 1952-53, he established an experimental museum, The Echo, for the display of massive geometric compositions, some of them so large as to occupy an entire patio (fig. 1129). His ideas have since been taken up on both sides of the Atlantic.

BLADEN. Often, these sculptors limit themselves to the role of designer and leave the execution to others, to emphasize the impersonality and duplicability of their invention. If no patron is found to foot the bill for carrying out these costly structures, they remain on paper, like unbuilt architecture. Sometimes such works reach the mock-up stage. The X (fig. 1130), by the Canadian Ronald Bladen (1918-1988), was originally built with painted wood substituting for metal for an exhibition inside the two-story hall of the Corcoran Gallery in Washington, D.C. Its commanding presence, dwarfing the Neoclassic

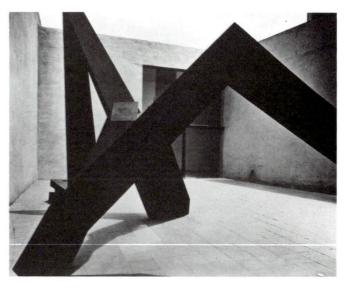

1129. Mathias Goeritz. Steel Structure. 1952-53. Height 14'9" (4.5 m). The Echo (Experimental Museum), Mexico City

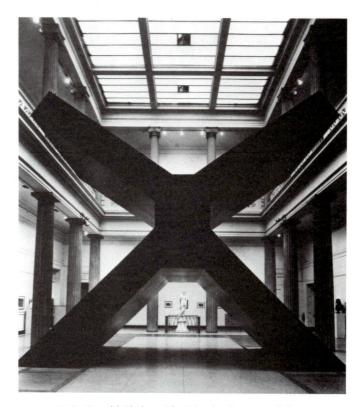

1130. Ronald Bladen. The X (in the Corcoran Gallery, Washington, D.C.). 1967. Painted wood, later constructed in steel, 22'8" x 24'6" x 12'6" (6.9 x 7.3 x 3.8 m) Courtesy Fischbach Gallery, New York

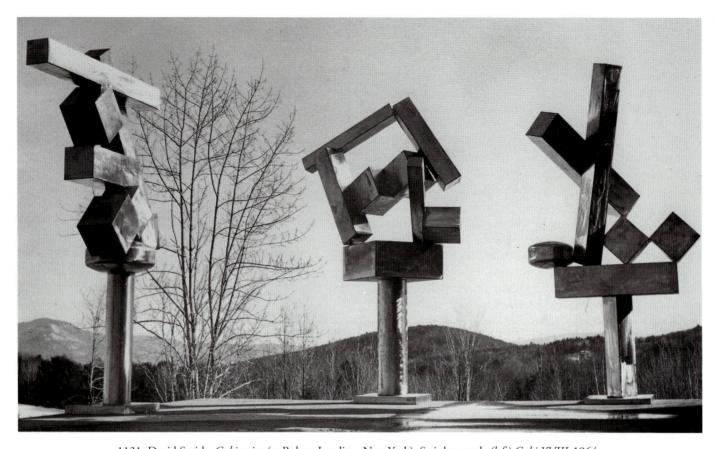

1131. David Smith. *Cubi* series (at Bolton Landing, New York). Stainless steel. *(left) Cubi XVIII.* 1964. Height 9'8" (2.9 m). Museum of Fine Arts, Boston; *(center) Cubi XVII.* 1963. Height 9'2" (2.7 m). Dallas Museum of Fine Arts; *(right) Cubi XIX.* 1964. Height 9'5" (2.9 m). The Tate Gallery, London

colonnade of the hall, seems doubly awesome in such a setting.

SMITH. Not all Primary Structures are Environmental Sculptures, of course. Most are free-standing works independent of the sites that contain them. Bladen's *The X*, for example, was later constructed of painted steel as an outdoor sculpture. They nevertheless share the same monumental scale and economy of form. The artist who played the most influential role in defining their character was David Smith (1906-1965). His earlier work had been strongly influenced by the wrought-iron constructions of Julio González (fig. 1124), but during the last years of his life he evolved a singularly impressive form of Primary Structure in his Cubi series. Figure 1131 shows three of these against the open sky and rolling hills of the artist's farm at Bolton Landing, New York. (All are now in major museums.) Only two basic components are employed: cubes (or multiples of them) and cylinders. Yet Smith has created a seemingly endless variety of configurations. The units that make up the structures are poised one upon the other as if they were held in place by magnetic force, so that each represents a fresh triumph over gravity. Unlike many members of the Primary Structure movement, Smith executed these pieces himself, welding them of sheets of stainless steel whose shiny surfaces he finished and controlled with exquisite care. As a result, his work

displays an "old-fashioned" subtlety of touch that reminds us of the polished bronzes of Brancusi.

JUDD. Donald Judd (1928–1994) carries the implications of Primary Structures to their logical conclusion: Minimalism. Unlike Environmental Sculpture, his works serve to articulate interior space without shaping it. In search of the ultimate unity, he separated Smith's Cubi into its two components, reducing the geometry to a single cube or cylinder. Judd established the proportions through precise mathematical formulas and eliminated any hint of personal intervention by contracting the work out to industrial fabricators. Having gained total control over all his elements, he soon began to elaborate on them. The most involved pieces produce a decorative opulence by repeating the shape serially at set intervals and adding an intense primary color to one or more sides (fig. 1132). Judd's strict guidelines permit few variations, only greater refinement, but within these limitations the results are often impressive. Why this should be so is not easily explained, although the artist is an eloquent spokesman. In the end, the success of his work depends on its subtle proportions and flawless finish, which enable him to achieve a degree of perfection attained by few other sculptors who share the same approach.

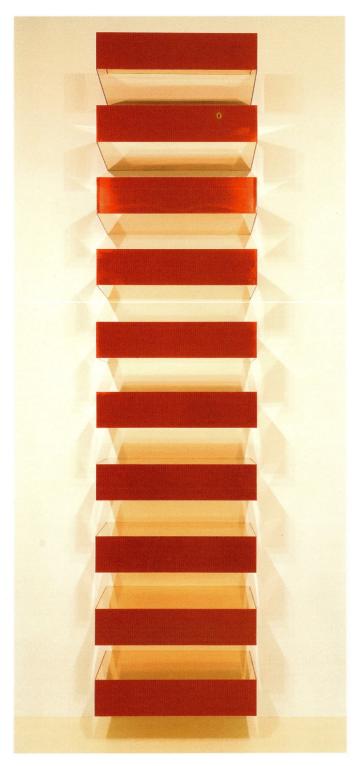

1132. Donald Judd. Untitled. 1989. Copper with red plexiglass; ten units, each 9 x 39¹/2 x 31" (23 x 100.3 x 78.8 cm) Courtesy The Pace Gallery, New York

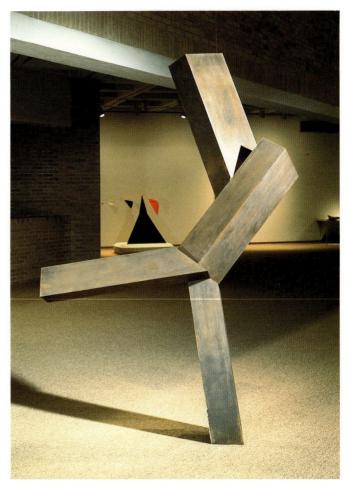

1133. Joel Shapiro. Untitled. 1989-90. Bronze, 8'5¹/₂" x 3'6" x 6'6" (2.57 x 1.06 x 1.98 m). North Carolina Museum of Art, Raleigh Purchased with funds from various donors, by exchange

SHAPIRO. A number of sculptors gradually began to move away from Minimalism without entirely renouncing it. This trend, called Post-Minimalism to denote its continuing debt to the earlier style, has as its leading exponent Joel Shapiro (born 1941). After fully exploring the possibilities of small pieces having great conceptual intensity and aesthetic power, he suddenly began to produce sculptures of simple wood beams that refer to the human figure but do not directly represent it. They assume active "poses," some standing awkwardly off-balance, others dancing or tumbling, so that they charge the space around them with energy. Shapiro soon began casting them in bronze, which retains the impress of the rough wood grain (fig. 1133). These are hand-finished with a beautiful patina by skilled artisans, reasserting the craftsmanship traditional to sculpture. By freely rearranging the vocabulary of David Smith, who actually experimented with a similar figure before his death, Shapiro has given Minimalist sculpture a new lease on life. Nevertheless, his remains one of the few successful attempts at reviving contemporary sculpture, which as a whole has found it especially difficult to seek a new direction.

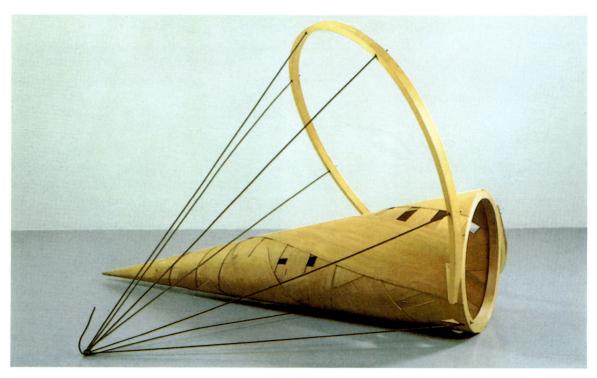

1134. Martin Puryear. *The Spell.* 1985. Pine, cedar, and steel, $4'8" \times 7' \times 5'5" (1.42 \times 2.13 \times 1.65 \text{ m})$. Collection the artist

African-American Sculpture

Minimalism was also a decisive influence on a group of talented African-American sculptors who came to maturity in the 1960s, although their contribution has only recently begun to receive critical attention. Their work has helped to make the late twentieth century the first great age of African-American art. While the artists themselves show a variety of style, subject matter, and approach, all address the black experience in America within a contemporary abstract aesthetic. Thus they have the advantage over African-American painters, who have often been burdened by representationalism and traditional styles.

PURYEAR. Martin Puryear (born 1941), the leading black sculptor on the scene today, draws on his experience with the woodworkers of both Sierra Leone in western Africa, where he spent several years in the Peace Corps, and Sweden, where he attended the Royal Academy. Puryear manages to weld these disparate sources into a seamless unity. He adapts African motifs and materials to the modern Western tradition, relying on meticulous craftsmanship to bridge the gap. His forms, at once bold and refined, have an elegant simplicity that contrasts the natural and man-made, the finished and unfinished. They may evoke a saw, bow, fishnet, anthill, or in this case a basket (fig. 1134)—whatever his memory suggests—each restated in whimsical fashion.

MITCHELL. Tyrone Mitchell (born 1944), like Puryear, spent a pivotal sojourn in Africa, where Dogon culture had a profound impact on him. His mature work, too, presents a flawless synthesis of Western and African sources. *Horn for Wifredo* (fig. 1135) reduces an antelope to its essence using Minimalist forms and the spare simplicity of Brancusi, who

influenced him at the beginning of the 1980s. Yet the diversity of materials creates a rich array of textures and colors that shows the artist's respect for time-honored materials and craftsmanship. This compound object, we realize, is suffused with a vital energy that makes of it a Surrealist creature. Indeed, the title refers to the Cuban-born Surrealist Wifredo Lam (1902–1982), an important early inspiration for Mitchell.

EDWARDS. Melvin Edwards (born 1937), who has also paid homage to Lam, was equally affected by his visits to Africa. He may be regarded as the purist among contemporary African-American sculptors. An artist in the mold of David Smith, he continues to maintain an allegiance to the Primary Structure and the vocabulary of Minimalism, but invests them with uniquely personal meaning and social content. To Listen (fig. 1136) is a totemic figure reminiscent of Moore's *Two Forms* (fig. 1126) in its elemental shape but with the rugged strength that defines Edwards' work. Attached to it is the fragment of a chain, a favorite motif which recurs in his "Lynch Fragment Series"—small works that radiate a truly frightening menace. In addition to denoting slavery, however, the chain has a positive meaning for the artist, to whom it signifies links with the past and the larger community. Likewise, abstraction helps him get in touch with his roots while providing a common ground of experience. In this he is close to the painter William T. Williams (see page 829), a personal friend. Edwards revels in the labor of sculpture, the very feel of metal, which is reflected in the vigorous, handmade finish, a further debt to Smith. The result is a powerful monument to the African-American struggle for freedom and equality that possesses the dignity of the man himself and reflects the artist's strong sense of social responsibility.

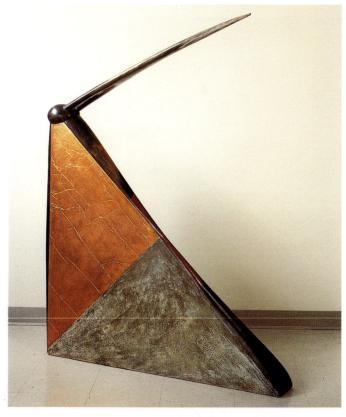

1135. Tyrone Mitchell. Horn for Wifredo. 1987. Wood, copper, plaster, and pigment, 65 x 49 x 7" (165 x 124.5 x 17.8 cm). Collection of the Schomburg Center for Research in Black Culture, The New York Public Library, Art and Artifacts Division

1136. Melvin Edwards. To Listen. 1990. Stainless steel, 7'51/2" x 1'31/2" x 3'1" (2.27 x .39 x .93 m) Courtesy CDS Gallery, New York

Monuments

OLDENBURG. On a large scale, most Primary Structures are obviously monuments. But just as obviously they are not monuments commemorating or celebrating anything except their designer's imagination. To the uninitiated, they offer no ready frame of reference, nothing to be reminded of, even though the original meaning of "monument" is "a reminder." Monuments in the traditional sense died out when contemporary society lost its consensus of what ought to be publicly remembered; yet the belief in the possibility of such monuments has not been abandoned altogether.

The Pop artist Claes Oldenburg (born 1929) has proposed a number of unexpected and imaginative solutions to the problem of the monument. He is, moreover, an exceptionally precise and persuasive commentator on his ideas. All his monuments are heroic in size, though not in subject matter. And all share one feature: their origin in humble objects of every-

In 1969 Oldenburg conceived his most unusual project. For a piece of outdoor sculpture he wanted a form that combined hard and soft and did not need a base. An ice bag met these demands, so he bought one and started playing with it. He soon realized, he says, that the object was made for manipulation, "that movement was part of its identity and should be used." He then executed a work shaped like a huge ice bag (fig. 1137) with a mechanism inside to make it produce "movements caused by an invisible hand," as the artist described them. He sent the Giant Ice Bag to the U.S.

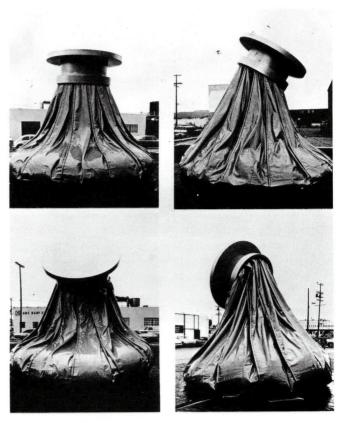

1137. Claes Oldenburg. Ice Bag-Scale B. 1970. Programmed kinetic sculpture of polyvinyl, fiberglass, wood, and hydraulic and mechanical movements, 16 x 18 x 18' (4.9 x 5.5 x 5.5 m). National Gallery of Art, Washington, D.C.

1138. Barnett Newman. *Broken Obelisk.* 1963–67. Steel, height 25'1" (7.7 m). Rothko Chapel, Houston

Pavilion at EXPO 70 in Osaka, Japan, where crowds were endlessly fascinated to watch it heave, rise, and twist like a living thing, then relax with an almost audible sigh.

What do such monuments celebrate? Part of their charm, which they share with ready-mades and Pop Art, is that they reveal the aesthetic potential of the ordinary and all-too-familiar. But they also have an undeniable grandeur.

NEWMAN. There is one dimension, however, that is missing in Oldenburg's monuments. They delight, astonish, amuse—but they do not move us. Wholly secular, wedded to the here and now, they fail to touch our deepest emotions. In our time, one of the rare monuments successful in this is *Broken Obelisk* (fig. 1138) by Barnett Newman (1905–1970). An artist inspired by profound religious and philosophical concerns which he struggled throughout his life to translate into visual form, Newman conceived *Broken Obelisk* in 1963 but could not have it executed until four years later, when he found the right steel fabricator. Rising from the center of a shallow reflecting pool, it consists of a square base plate sup-

porting a four-sided pyramid whose tip meets and supports that of the up-ended broken obelisk.

Obelisks are slender, four-sided pillars of stone erected by the ancient Egyptians. The Romans brought many of them to Italy; one marks the center of the colonnaded piazza of St. Peter's (see fig. 739). These gave rise to a number of later monuments in Europe and America. The two tips in Newman's sculpture have exactly the same angle (53 degrees, borrowed from that of the Egyptian pyramids, which had long fascinated the artist) so that their juncture forms a perfect X. Why this monument has such power to stir our feelings is difficult to put into words. Is it the daring juxtaposition of two age-old shapes that have contrary meanings, the one symbolizing timeless stability, the other a thrust toward the heavens? Surely, but what if the obelisk were intact? Would that not reduce the whole to an improbable balancing feat? The brokenness of the obelisk, then, is essential to the pathos of the monument. It speaks to us of our unfulfilled spiritual yearnings, of a quest for the infinite and universal that persists today as it has for thousands of years.

1139. Isamu Noguchi. Fountain for the John Hancock Insurance Company, New Orleans. 1961–62. Granite, 16' (4.88 m)

1140. (below) Maya Lin. Vietnam Veterans Memorial. 1982. Black granite, length 500' (152 m). The Mall, Washington, D.C.

NOGUCHI. The search for meaning also preoccupied the Japanese-American sculptor Isamu Noguchi (1904–1988). Influenced early on by the Surrealists, as well as by Brancusi, he did not confront Oriental culture until a prolonged stay in Japan in 1952 that proved decisive to his formation. From then on, he developed into one of the most diverse sculptors of this century whose rich imagination fed on both heritages. His role in mediating between East and West was of incalculable importance. To the Japanese he introduced modern Western ideas of style; to Americans he rendered traditional Japanese concepts of art visually comprehensible at a time when there was a growing fascination with Zen Buddhism. We see this fusion in his fountain for the John Hancock Insurance Company in New Orleans (fig. 1139). Like much of Zen thought, it is an elegantly simple statement of a paradoxical idea. Atop a grooved column recalling the primitive Doric of ancient Greece, where the Western sculptural tradition of which Noguchi felt himself a part originated, sits a "capital" rather like the wood-beam supports in a Japanese temple. Except for the flat faces on either side of the capital, the finish has been left rough, out of the age-old Japanese respect for the natural materials and the unadorned in the crafts. It gives the fountain a primeval look that emphasizes the stone's origin in the earth, for which Noguchi acquired an Oriental veneration. The contrast to the sleek modern lines of the Hancock building could hardly be greater. Yet the placement of the fountain shows not only a Japanese sensitivity to space but a fundamental understanding of the logic of modern architecture that Japanese critics recognized as distinctly Western.

LIN. Part of the problem confronting the monument maker in our era is that, unlike a century ago, there is so little worth commemorating in the first place—no event, no cause unites our fragmented world, despite the momentous changes going on everywhere—and no artistic vocabulary that we readily agree on. It is all the more ironic that the memorial to American soldiers killed in Vietnam should turn out to be not an embarrassing reminder of one of the most bitterly divisive chapters in recent history, but eloquent testimony to the universal tragedy of war (fig. 1140). Designed by Maya Lin (born

1141. Robert Smithson. Spiral Jetty. As built in 1970. Total length 1,500' (457.2 m); width of jetty 15' (4.6 m). Great Salt Lake, Utah

1959), it casts a spell on all those who see it. What is its secret? The very simplicity of the architectural form and its setting are disarming. By comparison, all other war memorials of recent times seem trite and needlessly elaborate, especially those incorporating realistic figures. It evokes a solemn mood while precluding the inflated rhetoric that mars most memorials. The triangular shape, although embedded in tradition and fraught with historical connotations (compare fig. 900), permits viewers to form their own associations because of its abstractness. Moreover, the reflective quality of the polished granite draws the viewer into the work. Yet these attributes alone cannot account for the extraordinary impact. Like Labrouste before her (see page 738), Lin seized on the simple but brilliant idea of inscribing names—thousands of them whose cumulative effect is to bring home the full enormity of the tragedy with awesome power. This device does not tell the story either, since names inscribed on walls or tombs rarely move us, least of all those of people we never knew. In the end, the Vietnam Veterans Memorial is that rare instance of perfect consonance between form and idea. So unique is this achievement that no artist has been able to duplicate its success.

Earth Art

Because of its space-articulating function we might be tempted to call the *Vietnam Veterans Memorial* a work of architecture, like Stonehenge; yet it is so sculptural that it belongs equally well to Primary Structures. The two categories merge in "Earth Art," which is the ultimate medium

for Environmental Sculpture, since it provides complete freedom from the limitations of the human scale. Logically enough, some designers of Primary Structures have turned to it, inventing projects that stretch over many miles. These latter-day successors to the mound-building Indians of Neolithic times have the advantage of modern earth-moving machinery, but this is more than outweighed by the problem of cost and the difficulty of finding suitable sites on our crowded planet.

SMITHSON. The few projects of theirs that have actually been carried out are mostly found in remote regions of western America, so that the finding is itself often difficult enough. *Spiral Jetty*, the work of Robert Smithson (1938–1973), jutted out into Great Salt Lake in Utah (fig. 1141) and is now partly submerged. Its appeal rests in part on the Surrealist irony of the concept: a spiral jetty is as self-contradictory as a straight corkscrew. But it can hardly be said to have grown out of the natural formation of the terrain like the Great Serpent Mound (see fig. 49). No wonder it has not endured long, nor was it intended to. The process by which nature is reclaiming *Spiral Jetty*, already twice submerged, was integral to Smithson's design from the start. The project nevertheless lives on in photographs.

CHRISTO. By way of contrast, the projects of Christo (Christo Javacheff, born 1935), who first gained notoriety for wrapping things, are deliberately short-lived. They enhance the environment only temporarily instead of altering it per-

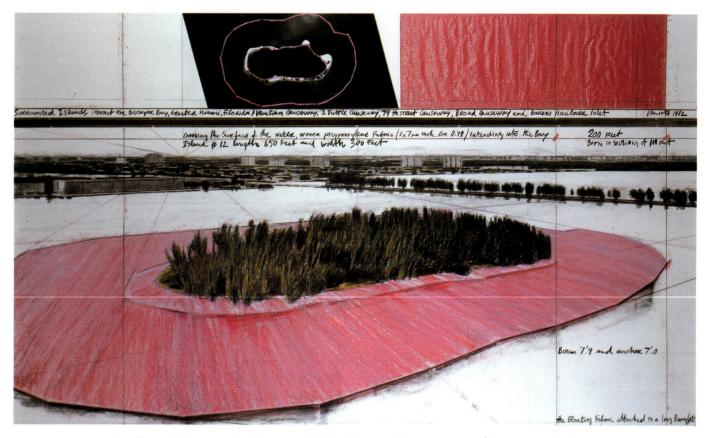

1142. Christo (Christo Javacheff). Surrounded Islands, Project for Biscayne Bay, Greater Miami, Florida. 1982.

Drawing in two parts, 1'3" x 8' (.38 x 2.44 m) and 3'6" x 8' (1.06 x 2.44 m).

Pencil, charcoal, pastel, crayon, enamel paint, aerial photograph, and fabric sample. Private collection

Copyright Christo 1982

manently. Surrounded Islands, Biscayne Bay, Miami, his most satisfying project to date, was installed for all of two weeks in the spring of 1983. Part Conceptual Art, part Happening (see pages 870–71), this ambitious repackaging of nature was a public event involving a small army of assistants. While the emphasis was on the campaign itself, the outcome was a triumph of epic fantasy.

Photographs hardly do justice to the results. Our collage of Christo's drawings, an aesthetic object in its own right, gives a clearer picture of the artist's intention by presenting the project in different ways and conveying the complexity of the experience it provided (fig. 1142). (Drawings such as this helped to fund the project.) In effect, Christo turned the islands into inverse lily pads of pink fabric. If Smithson's *Spiral Jetty* suggests the futility of grandiose undertakings, Christo's visual pun is as festive and decorative as Monet's water-lily paintings (fig. 943), an inspiration the artist has acknowledged.

Constructions and Assemblage

Constructions present a difficult problem. If we agree to restrict the term *sculpture* to objects made of a single substance, then we must put "assemblages" (that is, constructions using mixed mediums) in a class of their own. This is probably a useful distinction, because of their kinship with ready-mades. But what of Picasso's *Bull's Head* (fig. 2)? Is it not an instance of

assemblage, and have we not called it a piece of sculpture? Actually, there is no inconsistency here. The *Bull's Head* is a bronze cast, even though we cannot tell this by looking at a photograph of it. Had Picasso wished to display the actual handlebars and bicycle seat, he would surely have done so. Since he chose to have them cast in bronze, this must have been because he wanted to "dematerialize" the ingredients of the work by having them reproduced in a single material. Apparently he felt it necessary to clarify the relation of image to reality in this way—the sculptor's way—and he used the same procedure whenever he worked with ready-made objects.

Nevertheless, we must not apply the "single-material" rule too strictly. Calder's mobiles, for instance, often combine metal, string, wood, and other substances. Yet they do not strike us as being assemblages, because these materials are not made to assert their separate identities. Conversely, an object may deserve to be called an assemblage even though composed of essentially homogeneous material. Such is often true of works known as "junk sculpture," made of fragments of old machinery, parts of wrecked automobiles, and similar discards, which constitute a broad class that can be called sculpture, assemblage, or environment, depending on the work itself.

RAUSCHENBERG. Robert Rauschenberg (born 1925) pioneered assemblage as early as the mid-1950s. Much like a composer making music out of the noises of everyday life, he

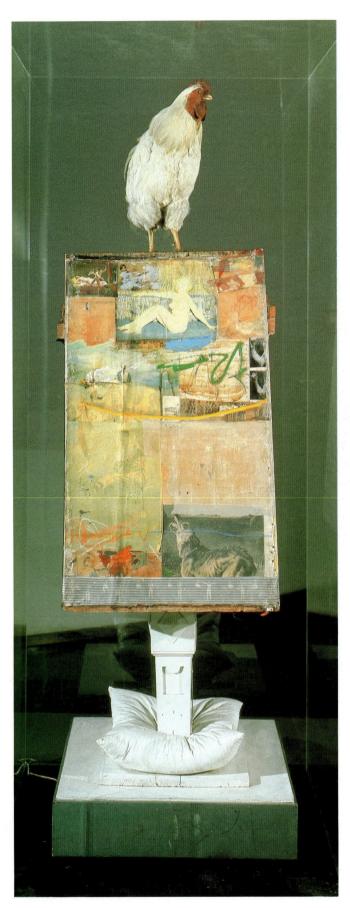

1143. Robert Rauschenberg. *Odalisk.* 1955–58. Construction, 6'9" x 2'1" x 2'1" (2.06 x .64 x .64 m). Museum Ludwig, Cologne

constructed works of art from the trash of urban civilization. *Odalisk* (fig. 1143) is a box covered with a miscellany of pasted images—comic strips, photos, clippings from picture magazines—held together only by the skein of brushstrokes the artist has superimposed on them. The box perches on a foot improbably anchored to a pillow on a wooden platform and is surmounted by a stuffed chicken.

The title, a witty blend of "odalisque" and "obelisk," refers both to the nude girls among the collage of clippings as modern "harem girls" and to the shape of the construction as a whole, for the box shares its verticality and slightly tapering sides with real obelisks. Rauschenberg's unlikely "monument" has at least some qualities in common with its predecessors: compactness and self-sufficiency. We will recognize in this improbable juxtaposition the same ironic intent as the readymades of Duchamp, whom Rauschenberg had come to know well in New York.

CHAMBERLAIN. A most successful example of junk sculpture, and a puzzling borderline case of assemblage and sculpture, is *Essex* (fig. 1144) by John Chamberlain (born 1927). The title refers to a make of car that has not been on the market for many years, suggesting that the object is a kind of homage to a vanished species. But we may well doubt that these pieces of enameled tin ever had so specific an origin. They have been carefully selected for their shape and color, and composed in such a way that they form a new entity, evoking Duchamp-Villon's *The Great Horse* (fig. 1113) rather than the crumpled automobiles to which they once belonged. Whether we prefer to call *Essex* assemblage or sculpture is of little importance, but in trying to reach a decision we gain a better insight into the qualities that constitute its appeal.

NEVELSON. Although it is almost always made entirely of wood, the work of Louise Nevelson (1900–1988) must be classified as assemblage, and when extended to a monumental scale, it acquires the status of an environment. Before Nevelson, there had not been any important women sculptors in twentieth-century America. Sculpture had traditionally been reserved for men because of the manual labor involved. Thanks to the women's suffrage movement in the second half of the nineteenth century, Harriet Hosmer (1830–1908) and her "White Marmorean Flock" (as the novelist Henry James called her and her followers in Rome) had succeeded in legitimizing sculpture as a medium for women. This school of sculpture lapsed, however, when the sentimental, idealizing Neoclassical style fell out of favor after the Philadelphia Centennial of 1876.

In the 1950s Nevelson rejected external reality and began to construct a private one from her collection of found pieces of wood, both carved and rough. At first these self-contained realms were miniature cityscapes, but they soon grew into large environments of free-standing "buildings," encrusted with decorations that were inspired by the sculpture on Mayan ruins. Nevelson's work generally took the form of large wall units that flatten her architecture into reliefs (fig. 1145). Assembled from individual compartments, the whole is always painted a single color, usually a matte black to suggest the shadowy world of dreams. Each compartment is elegantly

1144. John Chamberlain.

Essex. 1960. Automobile
body parts and other metal,
9' x 6'8" x 3'7"
(2.74 x 2.03 x 1.09 m).
The Museum of Modern
Art, New York
Gift of Mr. and Mrs. Robert C. Scull
and purchase

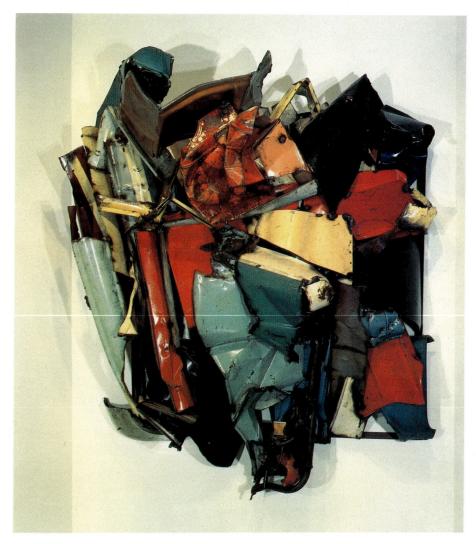

1145. Louise Nevelson.

Black Chord. 1964.

Painted wood,
8' x 10' x 11¹/2"

(2.44 x 3.05 x .29 m).

Collection Joel
Ehrenkranz

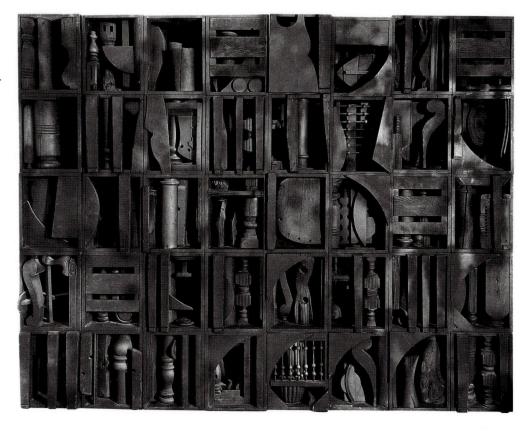

1146. (right) Barbara Chase-Riboud. Confessions for Myself. 1972.
Bronze, painted black, and black wool, 10' x 3'4" x 1'
(3.05 x 1.02 x .30 m). University Art Museum, University of California at Berkeley

Purchased with funds from the H. W. Anderson Charitable Foundation

designed and is itself a metaphor of thought or experience. While the organization of the ensemble is governed by an inner logic, the entire statement remains an enigmatic monument to the artist's fertile imagination.

CHASE-RIBOUD. Nevelson's success has encouraged other American women to become sculptors. Barbara Chase-Riboud (born 1939), a prize-winning poet who lives in Paris, belongs to a generation of remarkable black women who have made significant contributions to several of the arts at once. She is heir to a unique American tradition. It is a paradox that whereas black women never carve in traditional African cultures, in America they found their first artistic outlet in sculpture. They were attracted to it by the example set by Harriet Hosmer at a time when abolitionism and feminism were closely allied liberal causes.

Chase-Riboud received a traditional training in her native Philadelphia, the first center of minority artists. The monumental sculpture she developed in the early 1970s makes an indelible impression. In Confessions for Myself (fig. 1146) she has conjured up a demonic archetype of awesome power. Her highly individual aesthetic utilizes a combination of bronze, either polished or with a black patina, and braided fiber. Similar qualities can be found in cast bronze figures from Benin and in carved wooden masks by the Senufo tribe, which are sometimes embellished with textiles. The form can be compared to a poem: each fold is like a strophe that contributes to the total meaning of the work. Nor is the analogy an accident, for Chase-Riboud's progress as an artist was in tandem with her development as a poet. The title, too, is deliberate in this case; she began the sculpture with it in mind, which accounts for the extremely personal nature of the work. On the one hand, her sculpture expresses a distinctly ethnic sensibility and feminist outlook. On the other, she is like an archaeologist, peeling back layer after layer of personal memory to reveal a human meaning from deep within our collective subconscious that transcends limitations of race and culture. Thus, she achieves a universality in keeping with her cosmopolitan view of art and life. Ironically, her art has found wider acceptance in Europe than in the United States, where her sophisticated vision does not meet preconceived stereotypes of black art.

HESSE. A special case is formed by Eva Hesse (1936–1970). Although her work stands on its own, she had just begun to hit her stride when her life was cut short by cancer. Moreover, it is impossible to separate her work from her life, which is known in considerable detail, thanks to her diaries and many

1147. Eva Hesse. Accession II. 1967. Steel and rubber tubes, $30^3/4 \times 30^3/4 \times 30^3/4$ " (78 x 78 x 78 cm). The Detroit Institute of Arts Founders Society Purchase, Friends of Modern Art and Miscellaneous Gifts Fund

interviews. [See Primary Sources, no. 109, page 946.] While not a feminist, she has been treated as a heroine by the women's liberation movement because of her inner and artistic struggles. In many respects she represented the very prototype of the feminist artist, one who was later to provide inspiration to others. Her sculpture, too, defies convenient categories. It began to develop rapidly only in 1966 as the result of a stay in Germany, where she was influenced by Joseph Beuys and his Zero Group (see page 871). For her as for Beuys, art had healing powers through its revelatory function, only they were private rather than social in nature. Her artistic milieu was nevertheless the New York circle of Minimalists that included her closest friends. Her work derives its best features from both, but restates matters in an entirely individual way.

To look at Hesse's sculpture is to see a central mystery unveiled through its often paradoxical, mythic character. Thus *Accession II* (fig. 1147) has aptly been described as "suggesting a stylistic collision between one of Donald Judd's minimalist aluminum boxes and Meret Oppenheim's Surrealist furcovered teacup of 1936." (Compare figs. 1132 and 1120.) Aesthetically it has the spareness of Minimalist art, but with infinitely richer content, for Hesse has reinvested her industrial object with personal meaning. It at once possesses all the enigma of Pandora's box and the piquancy of an erotic fetish, a quality found throughout her mature work, which is laden with unmistakable sexual overtones.

Environments and Installations

A number of artists associated with Pop Art have also turned to assemblage because they find the flat surface of the canvas too confining. In order to bridge the gap between image and reality, they often introduce three-dimensional objects into their pictures. Some even construct full-scale models of everyday things and real-life situations, utilizing every conceivable kind of material in order to embrace the entire range of their physical environment, including the people, in their work. These "environments" combine the qualities of painting, sculpture, collage, and stagecraft. Being three-dimensional, they can claim to be considered sculpture, but the claim rests on a convention which Pop Art itself has helped to make obsolete. According to this convention, a flat or smoothly curved work of art covered with colors is a painting (or, if the surface is not covered, a drawing). Everything else is sculpture, whether or not the surface is colored and regardless of the material, size, or degree of relief-unless we can enter it, in which case we call it architecture.

Our habit of using the term *sculpture* in this sense is only a few hundred years old. Antiquity and the Middle Ages had separate terms to denote various kinds of sculpture according to the materials and working processes involved, but no single term that covered them all. Maybe it is time to revive such distinctions and to modify the all-inclusive definition of sculpture by acknowledging "environments" as a separate category, distinct from both painting and sculpture in its use of heterogeneous materials ("mixed mediums") and blurring of the borderline between image and reality. The differences are underscored by "installations," which are expansions of environments into room-size settings.

1148. George Segal. *Cinema*. 1963. Plaster, metal, plexiglass, and fluorescent light, 9'10" x 8' x 3'3" (3 x 2.4 x .99 m). Albright-Knox Art Gallery, Buffalo, New York

Gift of Seymour H. Knox

SEGAL. George Segal (born 1924) creates three-dimensional lifesize pictures showing people and objects in everyday situations. The subject of *Cinema* (fig. 1148) is ordinary enough to be instantly recognizable: a man changing the letters on a movie-theater marquee. Yet the relation of image and reality is far more subtle and complex than the obvious authenticity of the scene suggests. The man's figure is cast from a live model by a technique of Segal's invention and retains its ghostly white plaster surface. Thus it is one crucial step removed from our world of daily experience, and the neon-lit sign has been carefully designed to complement and set off the shadowed figure. Moreover, the scene is brought down from its natural context, high above the entrance to the theater, where we might have glimpsed it in passing, and is presented at eye level, in isolation, so that we grasp it completely for the first time.

THE KIENHOLZES. Some environments can have a shattering impact on the viewer. This is certainly true of *The State Hospital* (fig. 1149) by the West Coast artists Edward Kienholz (1927–1994) and Nancy Kienholz (born 1944), which shows a cell in a ward for senile patients with a naked old man strapped to the lower bunk. He is the victim of physical cruelty, which has reduced what little mental life he had in him almost to the vanishing point. His body is little more than a skeleton covered with leathery, discolored skin, and his head

1149. Edward and Nancy Kienholz. *The State Hospital.* 1966. Mixed mediums, $8 \times 12 \times 10^{\circ}$ (2.4 x 3.7 x 3.1 m). Moderna Museet, Stockholm

is a glass bowl with live goldfish, of whom we catch an occasional glimpse. The horrifying realism of the scene even has an olfactory dimension. When the work was displayed at the Los Angeles County Museum of Art, it exuded a sickly hospital smell. But what of the figure in the upper bunk? It almost duplicates the one below, with one important difference: it is a mental image, since it is enclosed in the outline of a comic-strip balloon rising from the goldfish bowl. It repre-

sents, then, the patient's awareness of himself. The abstract devices of the balloon and the metaphoric goldfish bowl are both alien to the realism of the scene as a whole; yet they play an essential part in it, for they help to break the grip of horror and pity. They make us think as well as feel. The Kienholzes' means may be Pop, but their aim is that of Greek tragedy. As witnesses to the unseen miseries beneath the surface of modern life, they have no equal.

1150. Judy Pfaff. *Dragons*. Installation at the Whitney Biennial, February–April 1981. Mixed mediums. Whitney Museum of American Art, New York
Courtesy Holly Solomon Gallery, New York

1151. Joseph Kosuth. One and Three Chairs. 1965. Wooden folding chair, photographic copy of chair, and photographic enlargement of dictionary definition of chair; chair 32³/8 x 14⁷/8 x 20⁷/8" (82.2 x 37.8 x 53 cm); photo panel 36 x 24¹/8" (91.5 x 61.1 cm); text panel 24 x 24¹/8" (61 x 61.3 cm). The Museum of Modern Art, New York
Larry Aldrich Foundation Fund

PFAFF. The installations of Judy Pfaff (born 1946) can be likened to exotic indoor landscapes. The inspiration of nature is apparent in the junglelike density of *Dragons* (fig. 1150), aptly named for its fiery forms and colors. Pfaff uses painting together with sculptural and other materials to activate architectural space. The treatment of the wall surface will remind us of the collage in Rauschenberg's *Odalisk* (fig. 1143), but Pfaff's work is characterized by playfulness rather than ironic wit. The nearest equivalent to Pfaff's spontaneous energy is the Action Painting of Jackson Pollock. It is as if the poured paint had been released from the canvas and left free to roam in space. The swirling profusion around the viewer makes for an experience that is at once pleasurable and vertiginous.

Conceptual Art

Conceptual Art has the same "patron saint" as Pop Art: Marcel Duchamp. It arose during the 1960s out of the Happenings staged by Alan Kaprow (born 1927) in which the event itself became the art. Conceptual Art challenges our definition

of art more radically than Pop, insisting that the leap of the imagination, not the execution, is art. According to this view, works of art can be dispensed with altogether, since they are incidental by-products of the imaginative leap. So too can galleries and, by extension, even the artist's public. The creative process need only be documented in some way. Sometimes this is in verbal form, but more often it is by still photography, video, or cinema displayed within an installation.

Conceptual Art, we will recognize, is akin to Minimalism as a phenomenon of the 1960s, but instead of abolishing content, it eliminates aesthetics from art. This deliberately antiart approach, stemming from Dada (see page 806), poses a number of stimulating paradoxes. As soon as the documentation takes on visible form, it begins to come perilously close to more traditional forms of art (especially if it is placed in a gallery where it can be seen by an audience), since it is impossible fully to divorce the imagination from aesthetic matters.

KOSUTH. We see this in *One and Three Chairs* (fig. 1151) by Joseph Kosuth (born 1945), which is clearly indebted to Duchamp's ready-mades (fig. 1119). It "describes" a chair by

ART HISTORY

A young artist had just finished art school. He asked his instructor what he should do next. "Go to New York," the instructor replied, "and take slides of your work around to all the galleries and ask them if they will exhibit your work." Which the artist did.

He went to gallery after gallery with his slides. Each director picked up his slides one by one, held each up to the light the better to see it, and squinted his eyes as he looked. "You're too provincial an artist," they all said. "You are not in the mainstream." "We're looking for Art History."

He tried. He moved to New York. He painted tirelessly, seldom sleeping. He went to museum and gallery openings, studio parties, and artists' bars. He talked to every person having anything to do with art; travelled and thought and read constantly about art. He collapsed.

He took his slides around to galleries a second time. "Ah," the gallery directors said this time, "finally you are historical.

Moral: Historical mispronounced sounds like hysterical.

1152. John Baldessari. Art History, from Ingres and Other Parables. 1972. Photograph and typed text.

Collection Angelo Baldassarre, Bari, Italy

combining in one installation an actual chair, a full-scale photograph of that chair, and a printed dictionary definition of a chair. Whatever the Conceptual artist's intention, this making of the work of art, no matter how minimal the process, is as essential as it was for Michelangelo. In the end, all art is the final document of the creative process, because without execution, no idea can ever be fully realized. Without such "proof of performance," the Conceptual artist becomes like the emperor wearing new clothes that no one else can see. And, in fact, Conceptual Art has embraced all of the mediums in one form or another.

BALDESSARI. Like Dada, Conceptual Art is notable for its ironic humor—whose bark is admittedly worse than its bite, however. It reached its high point with *Art History*, from *Ingres and Other Parables* by John Baldessari (born 1931), which is both a witty spoof on art-history texts such as this book and a

telling commentary on the difficulties young artists face in finding acceptance (fig. 1152). The juxtaposition of a great monument, mock-serious narrative, and absurd moral is meant to deride traditional value judgments about art. Yet it remains strangely innocuous, as if the artist were too self-consciously aware of his mischievous role.

Performance Art

Performance art, which originated in the early decades of this century, belongs to the history of theater, but the form that arose in the 1970s combines aspects of Happenings and Conceptual Art with installations. In reaction to Minimalism, artists now sought to assert their presence once again by becoming, in effect, living works of art. The results, however, have relied mainly on the shock value of irreverent humor or explicit sexuality. Nonetheless, Performance art

1153. Joseph Beuys. *Coyote.* Photo of performance at Rene Block Gallery, New York, 1974. Photograph © 1974 Caroline Tisdall Courtesy Ronald Feldman Fine Arts, New York

emerged as perhaps the most characteristic art form of the 1980s.

BEUYS. The German artist Joseph Beuys (1921–1986) managed to overcome these limitations, though he, too, was a controversial figure who incorporated an element of parody into his work. Life for Beuys was a creative process in which everyone is an artist. He assumed the guise of a modern-day shaman intent on healing the spiritual crisis of contemporary life caused, he believed, by the rift between the arts and sciences.

To find the common denominator behind such polarities, he created objects and scenarios which, though often baffling at face value, were meant to be accessible to the intuition. In 1974, Beuys spent one week caged up in a New York gallery with a coyote (fig. 1153), an animal sacred to the American Indian but persecuted by the white man. His objective in this "dialogue" was to lift the trauma caused to an entire nation by the schism between the two opposing world views. That the attempt was inherently doomed to failure does not in any way reduce the sincerity of this act of conscience.

CHAPTER SIX

TWENTIETH-CENTURY ARCHITECTURE

ARCHITECTURE BEFORE WORLD WAR I

Modernism in twentieth-century architecture has meant first and foremost an aversion to decoration for its own sake, without a trace of historicism. Instead, it favors a clean functionalism, which expresses the Machine Age, with its insistent rationalism. Yet modern architecture demanded far more than a reform of architectural grammar and vocabulary. To take advantage of the expressive qualities of the new building techniques and materials that the engineer had placed at the architect's disposal a new philosophy was needed. The leaders of modern architecture have characteristically been vigorous and articulate thinkers, in whose minds architectural theory is closely linked with ideas of social reform to meet the challenges posed by industrial civilization. To them, architecture's ability to shape human experience brings with it the responsibility to play an active role in molding modern society for the better.

WRIGHT. The first indisputably modern architect in this sense was Frank Lloyd Wright (1867–1959), Louis Sullivan's great disciple. If Sullivan, Gaudí, Mackintosh, and Van de Velde could be called the Post-Impressionists of architecture, Wright took architecture to its Cubist phase. This is certainly true of his brilliant early style, which he developed between 1900 and 1910 and had broad international influence. (For an example of his late work, see figs. 21 and 22). In the beginning Wright's main activity was the design of suburban houses in the upper Midwest. These were known as Prairie School houses, because their low, horizontal lines were meant to blend with the flat landscape around them.

Frank Lloyd Wright's last, and most accomplished, example in this series is the Robie House of 1909 (figs. 1154 and 1155). The exterior, so unlike anything seen before, instantly proclaims the building's modernity. However, its "Cubism" is not merely a matter of the clean-cut rectangular elements composing the structure, but of Wright's handling of space. It is designed as a number of "space blocks" around a central core, the chimney. Some of the blocks are closed and others are open, yet all are defined with equal precision. Thus the space that has been architecturally shaped includes the balconies, terrace, court, and garden, as well as the house itself. Voids and solids are regarded as equivalents, analogous in their way to Analytic Cubism in painting, and the entire complex enters into an active and dramatic relationship with its surroundings.

Wright did not aim simply to design a house, but to create a complete environment. In the Francis W. Little House (fig. 1156), he even took command of the details of the interior and designed stained glass, fabrics, and furniture. The controlling factor here was not so much the individual client's special wishes as Wright's conviction that buildings have a profound influence on the people who live, work, or worship in them, making the architect, consciously or unconsciously, a molder of people. [See Primary Sources, no. 110, page 947.]

LOOS. In Europe modern architecture developed more slowly and unevenly, and came to a head only on the eve of World War I, which effectively halted its further growth for nearly a decade. One of the first priests of modernism, Adolf Loos (1870–1933), spent several years working in Chicago

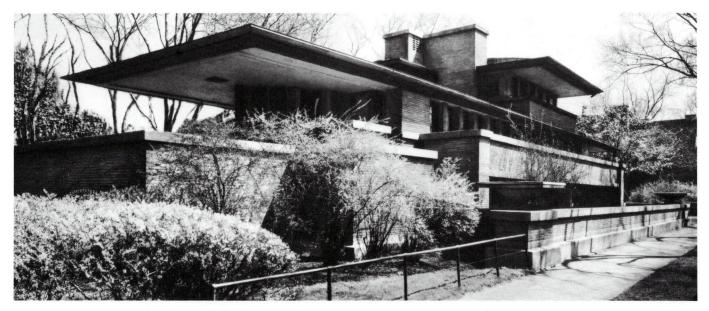

1154. Frank Lloyd Wright. Robie House, Chicago. 1909

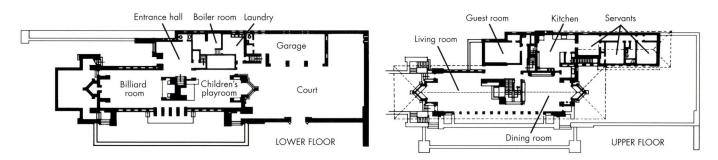

1155. Plan of the Robie House

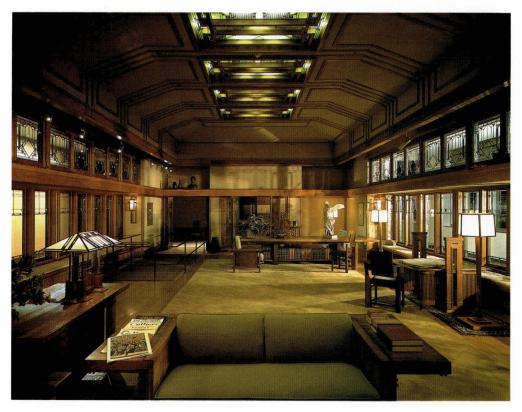

1156. Frank Lloyd Wright. Installation of the living room from the Francis W. Little House. 1913. The Metropolitan Museum of Art, New York

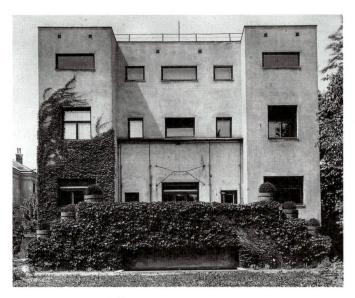

1157. Adolf Loos. Steiner House, Vienna. 1910

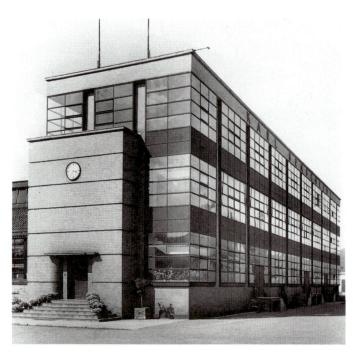

1159. Walter Gropius and Adolf Meyer. Fagus Shoe Factory, Alfeld, Germany. 1911–14

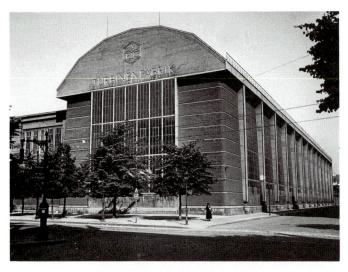

1158. Peter Behrens. A.E.G. Turbine Factory, Berlin. 1909-10

during the 1890s and returned to Vienna a convert to functionalism. The garden side of his Steiner House of 1910 (fig. 1157), one of the first private houses built of ferroconcrete (concrete reinforced with steel), is free of decoration, and retains its striking modern appearance to this very day. (The front represents an awkward compromise with local building authorities.)

DEUTSCHER WERKBUND. Central to the early development of modernism in Germany was the Deutscher Werkbund, an alliance of "the best representatives of art, industry, crafts and trades" founded in 1907 by Hermann Muthesius (1861–1927). His mission was to translate the Arts and Crafts Movement into a machine style using the most advanced techniques of industrial design and manufacturing.

BEHRENS. The way was led by Peter Behrens (1869–1940), the chief architect and designer for the electrical firm A.E.G. His Turbine Factory of 1909-10 (fig. 1158) transforms the factory shed into a monument to industry through the unmistakable reference to Greek temples (compare fig. 169). Yet it does so without resorting merely to a historicist veneer. Rather, it articulates a modern aesthetic stemming from Mackintosh's Glasgow School of Art (fig. 1003). The result is an austere simplicity surpassing that of Sullivan's Carson Pirie Scott & Company store (fig. 1010). Structurally there is little new here. Reinforced concrete had been in use since the later nineteenth century; even the wall of glass does not advance beyond Paxton's Crystal Palace (see fig. 962). Yet the building was of critical importance for Behrens' three disciples, who became the founders of modern architecture: Walter Gropius, Ludwig Mies van der Rohe, and Le Corbusier.

GROPIUS. The first to cross that threshold fully was Gropius (1883–1969). The Fagus Shoe Factory (fig. 1159), designed with Adolf Meyer (1881-1929), represents the crucial step toward modernism in European architecture. The most dramatic feature is the walls, which are a nearly continuous surface of glass. This radical innovation had been possible ever since the introduction of the structural steel skeleton several decades before, which relieved the wall of any load-bearing function. Sullivan had approached it, but he could not yet free himself from the traditional notion of the window as a "hole in the wall." Far more radically than Sullivan or Behrens, Gropius frankly acknowledged, at last, that in modern architecture the wall is no more than a curtain or climate barrier, which may consist entirely of glass if maximum daylight is desirable. Only in the classically conceived entrance did he pay a nod to the past.

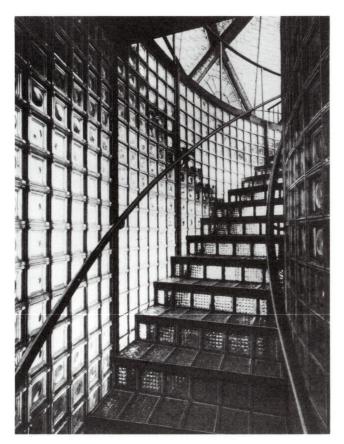

1160. Bruno Taut. Staircase of the "Glass House," Werkbund Exhibition, Cologne. 1914

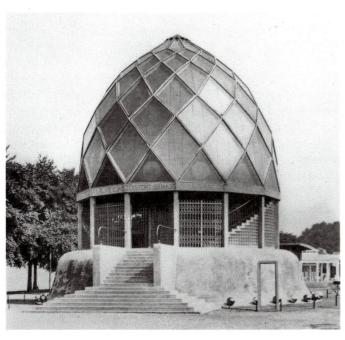

1161. Bruno Taut. The "Glass House," Werkbund Exhibition, Cologne. 1914

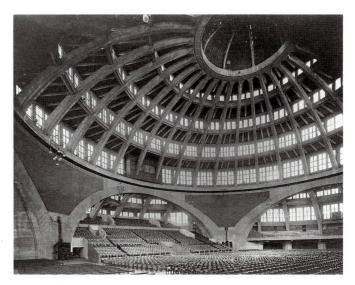

1162. Max Berg. Interior of the Centennial Hall, Breslau, Germany. 1912–13

TAUT. The Werkbund exhibition of 1914, which featured Van de Velde's theater (fig. 1005), was a showcase for a whole generation of young German architects who were to achieve prominence after World War I. Many of the buildings they designed for the fairgrounds anticipate ideas of the 1920s. Among the most adventurous is the staircase of the "Glass House" (fig. 1160) by Bruno Taut (1880–1938), made magically translucent by the use of glass bricks, then a novel material. The structural steel skeleton is as thin and unobtrusive as the great strength of the metal permits. The total effect precociously suggests Stella's *Brooklyn Bridge* (see fig. 1056) translated into three dimensions.

If the interior seems astonishingly prophetic, the exterior of the "Glass House" (fig. 1161) was shaped like a multifaceted bulbous crystal not unlike those on John Nash's Brighton pavilion (fig. 912). It was inspired, oddly enough, not by technology but by the widespread mystical fascination with crystal. To Taut, architecture "consists exclusively of powerful emotions and addresses itself exclusively to the emotions." We may call this approach Expressionism, because it stresses the artist's emotional attitude toward himself and the world (see page 781). Taut's mysticism was shared by the members of *Der* Blaue Reiter. Does modern architecture not incorporate the spontaneous and irrational qualities of Fantasy as well? Indeed it does. But because the modern architect shares the Expressionist's primary concern with the human community, rather than the labyrinth of the imagination, Fantasy plays a much lesser role than Expressionism, which has subsumed it.

BERG. The visionary side that distinguishes Expressionist architecture is best seen in the Centennial Hall (fig. 1162) built by Max Berg (1870–1948) in Breslau to celebrate Germany's liberation from Napoleon in 1812. Berg, for the first time, has taken full advantage of reinforced concrete's incredible flexibility and strength. The vast scale is not simply an engineering marvel but a visionary space that fulfills the grandest dream of Boullée (compare fig. 857). The immediate ancestry of Centennial Hall can be traced back to the Bank

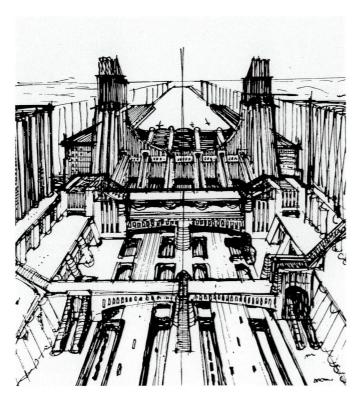

1163. Antonio Sant'Elia. Central Station project for Città Nuova (after Banham). 1914

of England by John Soane (see fig. 916), while the exterior is strangely reminiscent of Ledoux's tollgate (fig. 858). Ultimately, the interior looks back to the Pantheon (fig. 246), but with the solids and voids in reverse, so that we are reminded of nothing so much as the interior of Hagia Sophia (fig. 328). That Centennial Hall further recalls the soaring spirituality of a Gothic cathedral (such as our fig. 439) is not a coincidence: Berg shared with Rouault and Nolde an intense religiosity, which later led him to abandon his profession for Christianity.

SANT'ELIA. The final component of modernist architecture—its utopian side—was added by the Futurist Antonio Sant'Elia (1888–1916), who declared that "we must invent and reconstruct the Futurist city as an immense, tumultuous yard and the Futurist house as a gigantic machine." The Central Station project for his Città Nuova (New City; fig. 1163) is treated in terms of circulation patterns that determine the relationships between buildings, establishing a restless perpetual motion that fulfills the Futurist vision announced in Boccioni's work (see figs. 1038 and 1114). But it is the enormous scale, dwarfing even the most grandiose complexes of the past, that makes this a uniquely modern conception. It even includes a runway for airplanes, impractical as that may seem.

ARCHITECTURE BETWEEN THE WARS

By the onset of World War I, the stage was set for a modern architecture. But which way would it go? Would it follow the impersonal standard of the machine aesthetic advocated by Muthesius or the artistic creativity espoused by Van de Velde? Ironically, the issue was decided by Van de Velde's choice of

Behrens' disciple Walter Gropius as his successor at Weimar. Yet the beginning of the war effectively postponed the further development of modern architecture for nearly a decade. When this development resumed in the 1920s, the outcome of the issues posed at the Cologne Werkbund exhibition in 1914 was no longer clear-cut. Rather than a simple linear progression, we find a complex give-and-take between modernism and competing tendencies representing traditional voices and alternative visions. This varied response has its parallel in the art of the period, which largely rejected abstraction in favor of Fantasy, Expressionism, and Realism.

RIETVELD. The work of Frank Lloyd Wright attracted much attention in Europe by 1914. Among the first to recognize its importance were some young Dutch architects who, a few years later, joined forces with Mondrian in the De Stijl movement (see page 805). Among their most important experiments is the Schröder House, designed by Gerrit Rietveld (1888-1964) in 1924. The facade looks like a Mondrian painting transposed into three dimensions, for it utilizes the same rigorous abstraction and refined geometry (fig. 1164). The lively arrangement of floating panels and intersecting planes is based on Mondrian's principle of dynamic equilibrium: the balance of unequal but equivalent oppositions, which expresses the mystical harmony of humanity with the universe. Steel beams, rails, and other elements are painted in bright, primary colors to articulate the composition. Unlike the elements of a painting by Mondrian, the exterior parts look as if they can be shifted at will, though in fact they fit as tightly as interlocking pieces of a jigsaw puzzle. Not a single element could be moved without destroying the delicate balance of the whole.

Rietveld's approach to the interior (figs. 1165 and 1166) reveals his background as a cabinetmaker in his use of unadorned "boxes" of space. However, the upper story can be left open or configured into different work and sleeping areas through a system of sliding partitions that fit neatly together when moved out of the way. While this flexible treatment of the living quarters was devised with the owner, herself an artist, to suit her individual life-style, the decentralized plan also incorporates a continuous, "universal" space which is given a linear structure by the network of panel dividers.

Despite the fact that it retains an allegiance to traditional materials and craftsmanship, which were equated by *De Stijl* with the self-indulgent materialism of the past, Schröder House proclaims a utopian ideal widely held in the early twentieth century. The machine would hasten our spiritual development by liberating us from nature, with its conflict and imperfection, and by leading us to the higher order of beauty reflected in the architect's clean, abstract forms. The harmonious design of Schröder House owes its success to the insistent logic of this aesthetic, which we respond to intuitively even without being aware of its ideology. Yet the design, far from being impersonal, is remarkably intimate.

THE BAUHAUS. Schröder House was recognized immediately as one of the classic statements of modern architecture. The *De Stijl* architects represented the most advanced ideas in European architecture in the early 1920s. They had a decisive

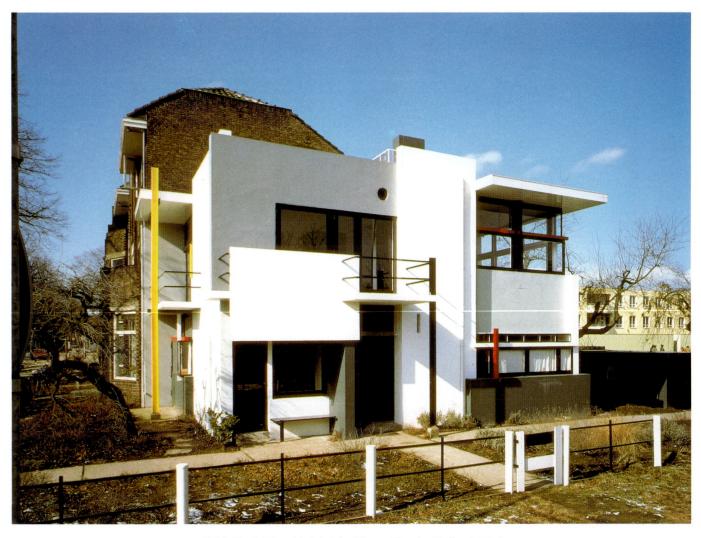

1164. Gerrit Rietveld. Schröder House, Utrecht, Holland. 1924

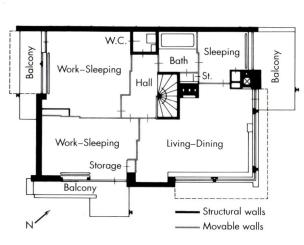

1165. Plan of the Schröder House

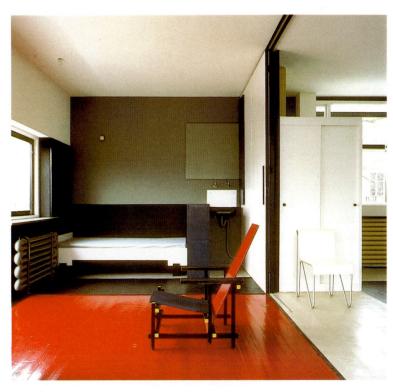

1166. Interior, Schröder House

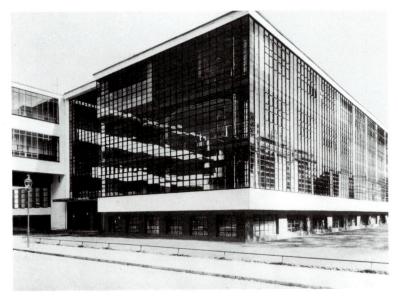

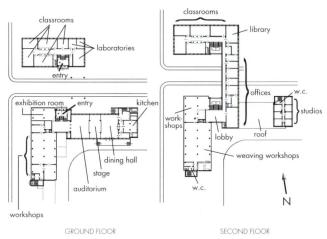

1168. Plan of the Bauhaus

influence on so many architects abroad that the movement soon became international. The largest and most complete example of this International Style of the 1920s is the group of buildings created in 1925-26 by Walter Gropius for the Bauhaus in Dessau, the famous German art school of which he was the director. [See Primary Sources, no. 111, page 947.] The most dramatic is the shop block, which is a fully mature statement of the principles announced ten years earlier in Gropius' Fagus Shoe Factory (see fig. 1159). The structure is a four-story box with walls that are a continuous surface of glass (fig. 1167). The result is rather surprising: since the glass walls reflect as well as transmit light, their appearance depends on the interplay of these two effects. They respond, as it were, to any change of conditions without and within and thus introduce a strange quality of life into the structure. In this way, the facade serves a similar purpose to the mirrorlike finish of Brancusi's Bird in Space (fig. 1112).

More important than this individual structure, however, is the complex as a whole and what it stood for. Initially during its Weimar phase, the Bauhaus (which was the result of merging two separate schools) tried to fulfill the goals of the Arts and Crafts Movement, but the traditional attitudes toward the arts and crafts were too different for this romantic dream to succeed, and there developed a deep split between the Workshop Masters, who were responsible for practical crafts, and the Masters of Form, whom Gropius invited to teach theory, such as Kandinsky and Klee. The arrival of László Moholy-Nagy (see page 907), a Hungarian follower of Tatlin's Constructivism (see page 847), and then Josef Albers (see page 831) gave the curriculum a far more rational basis. But it was the move to Dessau, which invited the school to transfer there when it was closed down for a while by Weimar, that proved decisive. The definitive character of the Bauhaus is reflected in Gropius' design. The plan consists of three major blocks (fig. 1168) for classrooms, shops, and studios, and a student center, the first two linked by a bridge of ferroconcrete containing offices. Its curriculum embraced all the visual arts, linked by the root concept of "structure" (Bau). It included, in addition to an art school, departments of industrial design under Marcel Breuer (see page 883), graphic art under Herbert Bayer (see page 907), and architecture, whose chief representative was Mies van der Rohe (see below), the Bauhaus' last director.

Gropius' buildings at Dessau incorporate elements of De Stijl and Constructivism, just as the school accommodated a range of temperaments and approaches. The Shop Block proclaims the Bauhaus' frankly practical approach, yet the complex as a whole promoted a remarkable community spirit, both of which were entirely different in character from what Gropius had inherited from Van de Velde at Weimar. The Bauhaus thus embodied Gropius' tolerant, yet unified vision. Not surprisingly, the school did not long outlast his departure in 1929 to pursue architecture full time. After his hand-picked successor, Hannes Meyer (1889-1954), was forced to resign because of his Marxist leanings, Mies van der Rohe tried vainly to revive the school's fortunes, but it was shut down by the Dessau parliament. By then, most of its leaders had left, and after a final attempt to reopen it as a private school in Berlin, the Bauhaus was closed by the Nazis in 1933.

MIES VAN DER ROHE. Equally prophetic was the German Pavilion designed by Ludwig Mies van der Rohe (1886–1969) for the International Exposition of 1929 in Barcelona (figs. 1169 and 1170), unfortunately dismantled soon after the fair closed. The structure was a daringly low-slung affair elevated on a marble base, with enclosed courtyards at the front and rear, and even more radically simple in appearance than Wright's Robie House (see figs. 1154 and 1155), out of which it clearly developed. Its walls were constructed of different-colored marble slabs, arranged like so many "dominoes" in a grid system with such precision that not a single element could be moved without disturbing the balance. Here is the great spiritual counterpart to Mondrian among contemporary

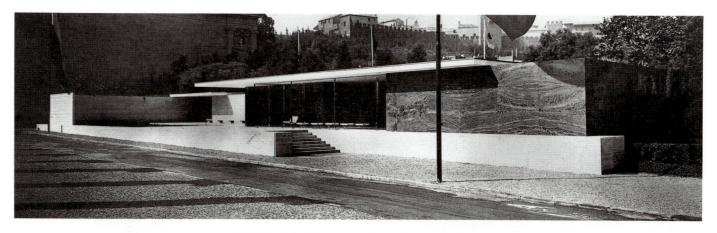

1169. Ludwig Mies van der Rohe. German Pavilion, International Exposition, Barcelona. 1929

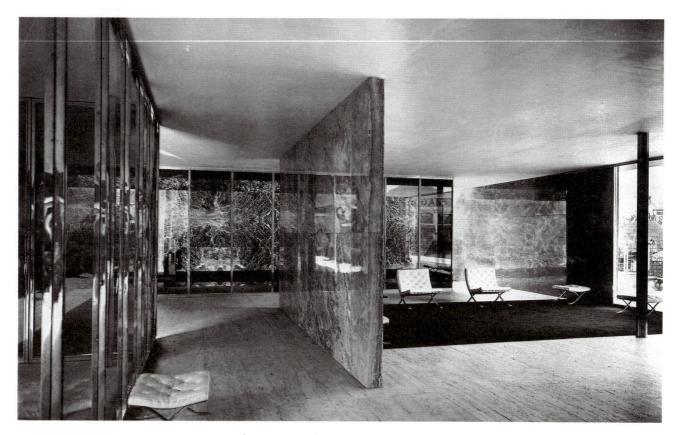

1170. Ludwig Mies van der Rohe. Interior, German Pavilion, International Exposition, Barcelona. 1929

designers, possessed of the same "absolute pitch" in determining proportions and spatial relationships. Flooded with light from the great expanse of windows, the interior was wonderfully open and fluid, yet with a sparse cleanness that still seems irrepressibly modern.

LE CORBUSIER'S EARLY WORK. In France, the most distinguished representative of the International Style during the 1920s was the Swiss-born architect Le Corbusier (Charles Édouard Jeanneret, 1886–1965). At that time he built only private houses—from necessity, not choice—but these are as

important as Wright's Prairie School houses. Le Corbusier called them *machines à habiter* (machines to be lived in), a term intended to suggest his admiration for the clean, precise shapes of machinery, not the Futurist desire for "mechanized living." (The paintings of his friend Fernand Léger during those years reflect the same attitude; see fig. 1054. Le Corbusier was himself an excellent painter in this vein.) Perhaps he also wanted to imply that his houses were so different from conventional homes as to constitute a new species.

Such is indeed our impression as we approach the most famous of them, the Savoye House at Poissy-sur-Seine (fig.

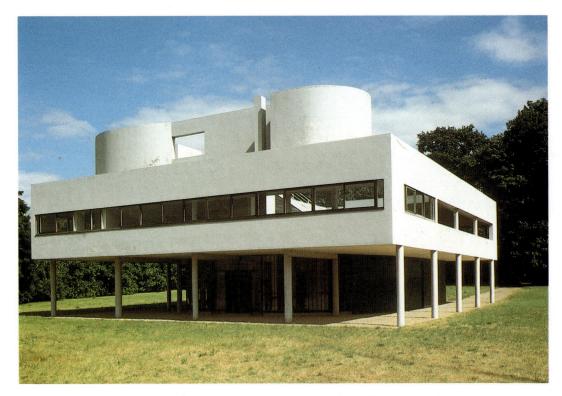

1171. Le Corbusier. Savoye House, Poissy-sur-Seine, France. 1929-30

1172. Interior, Savoye House

1171). It resembles a low, square box resting on stilts—pillars of reinforced concrete that form part of the structural skeleton and reappear to divide the "ribbon windows" running along each side of the box. The flat, smooth surfaces deny all sense of weight and stress Le Corbusier's preoccupation with abstract "space blocks."

In order to find out how the box is subdivided, we must enter it (fig. 1172). We then realize that this simple "package" contains living spaces that are open as well as closed, separated by glass walls. Within the house, we are still in communication with the outdoors: views of the sky and the surrounding terrain are everywhere to be seen. Yet we enjoy complete privacy, since an observer on the ground cannot see us unless we stand next

to a window. The functionalism of the Savoye House thus is governed by a "design for living," not by mechanical efficiency.

AALTO. Although its style and philosophy were codified about 1930 by a committee of Le Corbusier and his followers, the International Style was by no means monolithic. Soon all but the most purist among them began to depart from this standard. One of the first to break ranks was the Finnish architect Alvar Aalto (1898–1976), whose Villa Mairea (figs. 1173 and 1174) reads at first glance like a critique of Le Corbusier's Savoye House of a decade earlier. Like Rietveld's Schröder House, Villa Mairea was designed for a woman artist; her second-story studio, covered with wood slats, dominates the view of the house from three directions. This time, however, the architect was given a free hand by his patron, and the building is a summation of ideas Aalto had been developing for nearly ten years. He adapted the International Style to the traditional architecture, materials, life-style, and landscape of Finland. Aalto took the opposite approach of Le Corbusier's in order to arrive at a similar end. Aalto's primary concern was human needs, both physical and psychological, which he sought to harmonize with functionalism. The modernist heritage, which extends back to Wright, is unmistakable in his vocabulary of forms and massing of elements; yet everywhere there are romantic touches that add a warmth absent from the Savoye House. Wood, brick, and stone are employed in various combinations throughout the interior and exterior, in contrast to Le Corbusier's pristine classicism. Free forms are introduced at several places to inject an element of playfulness, as well as to break up the cubic geometry and smooth surfaces favored by the International Style.

1173. Alvar Aalto. Villa Mairea, Noormarkku, Finland. 1937-38

1174. Interior, Villa Mairea

Aalto's importance is undeniable, but his place in twentieth-century architecture remains unclear. His infusion of nationalist elements in Villa Mairea has been interpreted both as a rejection of modernism and as a fruitful regional variation on the International Style. Today his work can be seen as a direct forerunner of Late Modern architecture (see pages 890–93).

EXPRESSIONISM. Architecture between the wars is sometimes labeled Expressionist if it does not conform to the International Style. Such a view is valid only insofar as it represents

the assertion of the right of the individual to express a personal point of view against the norms of modernism. The International Style based its ideals on standardization for the sake of universality. As such, it represents the triumph of classicism. In reality, however, it was never the dominant approach after 1917, any more than abstraction was in painting. It seems best, then, to limit Expressionism in architecture following World War I to the few years around 1920.

MENDELSOHN. Inspired by the Arts and Crafts Movement's liberal politics and utopian ideals, a number of German

1175. Erich Mendelsohn. Einstein Tower, Potsdam. 1921

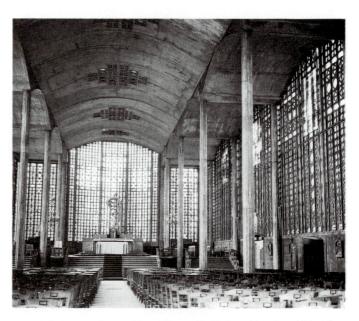

1176. Auguste Perret. Notre Dame, Le Raincy, France. 1923–24

architects gave free rein to their imaginations. The most eccentric building from this period is the Einstein Tower at Potsdam (fig. 1175) by Erich Mendelsohn (1887–1953), which has an organic quality that looks back to the Art Nouveau architecture of Antoní Gaudí and Henry van de Velde (see figs. 1001 and 1005). Despite this retrospective element, Mendelsohn was no reactionary, and the Einstein Tower, which functioned as an observatory, has also been hailed as the forerunner of Le Corbusier's later work (see fig. 1183).

PERRET. Even more important for Le Corbusier was the precedent set by Auguste Perret (1874-1954). Early in the century he had been among the first to make effective use of recent advances in reinforced concrete and to define its architectural character. His greatest achievement is the Church of Notre Dame at Le Raincy outside Paris (fig. 1176). It is an astonishingly successful translation of Romanesque architectural forms (compare fig. 385) into ferroconcrete, while the vast expanses of glass "walls" are counterparts to the stainedglass windows of Gothic cathedrals (see fig. 423). This feat is not important in itself—it could, after all, readily be dismissed as mere historicism. Yet Perret has brilliantly solved one of the thorniest problems facing the modern architect: how to create a suitable expression of traditional spirituality in our secular Machine Age using a twentieth-century vocabulary. Le Raincy is so pivotal that all later church architecture in the West is indebted to its example, no matter how different the results.

THE SKYSCRAPER IN AMERICA. The United States, despite its early position of leadership, did not share the exciting growth that took place in European architecture during the 1920s. The impact of the International Style did not begin to be felt on its side of the Atlantic until the very end of the decade. A pioneer example is the Philadelphia Savings Fund Society Building of 1931–32 (fig. 1177) by George Howe (1886–1954) and William E. Lescaze (1896–1969). It is the

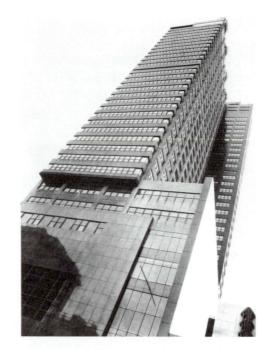

1177. George Howe and William E. Lescaze. Philadelphia Savings Fund Society Building, Philadelphia. 1931–32

first skyscraper built anywhere to incorporate many of the features evolved in Europe after the end of World War I. The skyscraper was of compelling attraction to modernist architects in Europe as the embodiment of the idea of America, and during the 1920s Gropius and Mies van der Rohe designed several prototypes that were remarkably advanced for their time. Yet none were erected, while those constructed in the United States were sheathed in a variety of revivalist styles. (The Gothic was preferred.) Although they quickly became the most characteristic form of American architecture, even the skyscrapers of the 1930s—when many of the most famous ones, such as the Empire State Building, were built—are in the tradition of Sullivan, and do little to expand on the Wainwright Building (fig. 1009) except to make it bigger. Despite

the fact that it is not entirely purist, the skyscraper of Howe and Lescaze is a landmark in the history of architecture that, remarkably enough, was not to be surpassed for 20 years (compare fig. 1181).

DESIGN

Like their predecessors in the Rococo, many of the great architects since Gaudí and Mackintosh have also been important designers who exercised an incalculable influence on others. The reason is not hard to find: they have had a unique, even privileged, understanding of modernism, its meaning, materials, and techniques. Their designs, like their buildings, have generally expressed the Machine Age through clean lines and cubic shapes bereft of unnecessary decoration. This was particularly true of the Bauhaus, where architecture and design were closely linked. The Bauhaus nevertheless failed in its goal of unifying the arts and putting the decorative arts on the same level as the fine arts. The main reason was that its members were far more gifted in architecture and painting than in design, despite the considerable emphasis placed on this area.

Gropius himself considered Bauhaus designs as models for the future that would fulfill his goal of providing high-quality wares to everyone through mass-manufacturing techniques, although only under Hannes Meyer was design placed at the service of people's practical needs. The interiors of the Masters' Houses designed by Marcel Breuer (1902–1981) reflect the school's outlook (fig. 1178). They have an almost monastic asceticism that is further emphasized by the stark simplicity of the furnishings. Breuer's famous chair in the right foreground is a marvel of elegant geometry for its own sake—without regard to comfort, as anyone who has ever sat in it can attest. Here, then, is the chief limitation of so much of twentieth-century design: the tyranny of form over human considerations.

Art Deco

The Bauhaus style was not the only major form of early-twentieth-century design, however. Art Deco is the name commonly given to the style that dominated the decorative arts between the world wars. In France it was called Le Style Moderne. Like the Bauhaus, Art Deco arose out of the work of the Glasgow school. Charles Rennie Mackintosh (see page 770), his wife Margaret Macdonald-Mackintosh (1865–1933), and her sister Frances Macdonald (1874–1921) had a great impact after 1900 on the Secession movements in Munich and especially Vienna, where the next phase of modern design took place (see page 763). Art Deco received its official baptism at the Exhibition of Decorative and Industrial Arts held in Paris in 1925, two years after the Bauhaus scored a great success at its initial design show in Weimar. The Paris exposition had actually been conceived ten years earlier, but like the progress of the style itself, it was postponed by World War I, when the movement was already well under way. The hit of the show was the Hôtel du Collectionneur pavilion assembled by Emil-Jacques Ruhlmann (1879-1933), the last of the truly great French furniture designers (fig. 1179).

In common with the Bauhaus, Art Deco attempted to resolve the dilemma between quality design and mass

1178. Marcel Breuer. The living room of Josef and Anni Albers, Masters' house, Dessau, Germany. c. 1929

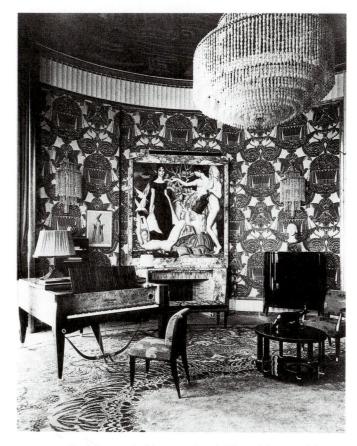

1179. Emil-Jacques Ruhlmann. Grand Salon of the Hôtel du Collectionneur at the 1925 Exposition, Paris

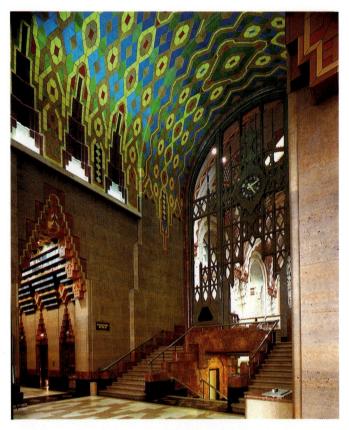

1180. Wirt Rowland, with Smith, Hinchman & Grylls, Associates Inc. (Tiles designed by Thomas Dilorenzo and made by Rookwood, Cincinnati). Main Lobby, Union Trust Company, Detroit. 1929

production, which both the Arts and Crafts Movement and Art Nouveau had also failed to reconcile. It, too, created a geometric style that could be applied to anything from teacups to building facades, a tendency that reached its climax in the following decade when everything became streamlined. The difference is that Art Deco never made the decisive break from Art Nouveau, of which it was a direct outgrowth.

Because it never developed the fully defined machine aesthetic that distinguishes the International Style, Art Deco cannot be called a modernist movement in the same sense, although they evolved in parallel to each other and sometimes achieved strikingly similar results. With its idealistic program of social and artistic reform, the International Style proved far bolder in redefining the decorative arts, despite its failure to achieve those goals. Art Deco, in contrast, was a decorative veneer that did not address the substance of modern existence. Instead, it responded to the changing taste of society during the "Jazz Age," without consciously intending to shape it. Whereas the Bauhaus came to adhere to a rigorous machine style, Art Deco was broadly eclectic in its scope, which included a taste for the exotic ranging from the art of ancient Egypt and Native American to the Russian Ballet of Sergei Diaghilev—whatever could be incorporated into its geometric framework. The virtue of Art Deco is that it embodied the very feature so conspicuously lacking in the International Style: fantasy, which permitted highly individual expression. Perhaps for that reason, it proved widely popular. Moreover, it enjoyed the commercial backing of the major manufacturers and department stores. Needless to say, much of what filtered down to everyday objects catered to the lowest common denominator. But at its finest Art Deco could be brilliantly innovative.

Because it was essentially a decorative "skin," Art Deco lent itself readily to architecture. (Even the streamlined style associated with it was adapted from Dutch architecture of the early 1920s.) It proved especially popular in the United States, where it reached its most flamboyant phase during the 1930s. A spectacular example is the interior of the Union Trust Company in Detroit (fig. 1180). Resembling a gigantic Indian feather headdress, the ceiling of ceramic tiles has the honeycomb pattern of a beehive to symbolize Thrift and Industry.

ARCHITECTURE FROM 1945 TO 1980

High Modernism

Following the rise of the Nazis, the best German architects, whose work Hitler condemned as "un-German," came to the United States and greatly stimulated the development of American architecture. Gropius, who was appointed chairman of the architecture department at Harvard University, had an important educational influence. Ludwig Mies van der Rohe, his former colleague at Dessau, settled in Chicago as a practicing architect. Following the war, they were to realize the dream of modern architecture, contained in germinal form in their buildings of the 1930s but never fully implemented. We may call the style that dominated architecture for 25 years after World War II "High Modernism," for it was indeed the culmination of the developments that had taken place during the first half of the twentieth century. High Modernism was never monolithic even at its zenith. Yet its unified spaces, be they geometric or organic, embodied a harmonious vision that developed in a consistent way as the style was disseminated in countless buildings throughout the world. Like the International Style before it, High Modernism permitted considerable local variation within established guidelines, although the process of elaboration led almost inevitably to its dissolution.

MIES VAN DER ROHE. The crowning achievement of American architecture in the postwar era was the modern skyscraper, defined largely by Mies van der Rohe. The Seagram Building in New York, designed with his disciple Philip Johnson (fig. 1181), carries the principles announced in Gropius' design for the Bauhaus to their ultimate conclusion by using the techniques developed by Louis Sullivan and Frank Lloyd Wright, Mies van der Rohe's great predecessors in Chicago, to extend the structure to a vast height. Yet the building looks like nothing before it. Though not quite a pure box, it exemplifies Mies van der Rohe's famous dictum that "less is more." This alone does not explain the difference, however. Mies van der Rohe discovered the perfect means to articulate the skyscraper in the I-beam, its basic structural member, which rises continuously along nearly the entire height of the facade. (The actual skeleton of the structure remains completely hidden from view.) The effect is as soaring as the responds inside a Gothic cathedral (compare fig. 435)—and with good reason, for Mies van der Rohe believed that "structure is spiritual." He achieved it through the lithe proportions, which create a perfect balance between the play of horizontal and vertical forces.

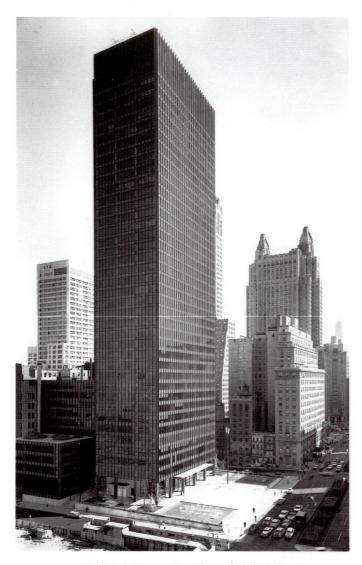

1181. Ludwig Mies van der Rohe and Philip Johnson. Seagram Building, New York. 1954–58

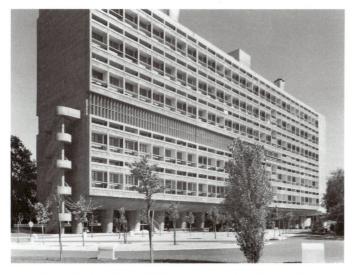

1182. Le Corbusier. Unité d'Habitation Apartment House, Marseilles, France. 1947–52

This harmony expresses the idealism, social as well as aesthetic, that underlies High Modernism in architecture.

LE CORBUSIER'S LATER WORK. Abandoning the abstract purism of the International Style, Le Corbusier's postwar work shows a growing preoccupation with sculptural, even anthropomorphic, effects. Thus the Unité d'Habitation, a large apartment house in Marseilles (fig. 1182), is a "box on stilts" like the Savoye House, but the pillars are not thin rods. Their shape now expresses their muscular strength in a way that makes us think of Doric columns. The exposed staircase on the flank, too, is vigorously sculptural, and the flat plane of the all-glass facade has a honeycomb screen of louvers and balconies that forms a sunbreak but also enhances the threedimensional quality of the structure. This projecting screen has proved to be an invention of great importance, practically and aesthetically: it is now a standard feature of modern architecture throughout the tropics. (Le Corbusier himself introduced it in India and Brazil.)

The most revolutionary building of the mid-twentieth century, however, is Le Corbusier's church of Notre-Damedu-Haut at Ronchamp in eastern France (figs. 1183–85). Rising like a medieval fortress from a hillcrest, its design is so irrational that it defies analysis, even with the aid of perspective diagrams. The play of curves and countercurves is here as insistent as in Gaudí's Casa Milá, though the shapes are now simple and more dynamic. The massive walls seem to obey an unseen force that makes them slant and curl like paper. And the overhanging roof suggests the brim of an enormous hat, or the bottom of a ship split lengthwise by the sharp-edged buttress from which it is suspended.

This evocation of the dim, prehistoric past is quite intentional: asked to create a sanctuary on a hilltop, Le Corbusier must have felt that this was the primeval task of architecture, placing him in a direct line of succession with the builders of Stonehenge, the ziggurats of Mesopotamia, and the Greek temples. Hence, he also consciously avoids any correlation between exterior and interior. The doors are concealed; we must seek them out like clefts in a hillside. To pass through them is much like entering a secret—and sacred—cave.

Only inside do we sense the specifically Christian aspect of Ronchamp. The light, channeled through stained-glass windows so tiny that they seem hardly more than slits or pinpricks on the exterior, cuts widening paths through the thickness of the wall, and thus becomes once more what it had been in medieval architecture: the visible counterpart of the Light Divine. There is true magic in the interior of Ronchamp, but also a strangely disquieting quality, a nostalgia for the certainties of a faith that is no longer unquestioned. Ronchamp mirrors the spiritual condition of the modern age, which is a measure of its greatness as a work of art.

KAHN. Le Corbusier belongs to the same heroic generation as Gropius and Mies van der Rohe: all were born in the 1880s. It was these giants who in the course of their long, fruitful careers coined the language of twentieth-century architecture. Their successors continued to employ many aspects of its vocabulary in new building types and materials. Nor did they forget its fundamental logic.

1183. Le Corbusier. Notre-Dame-du-Haut (from the southeast), Ronchamp, France. 1950–55

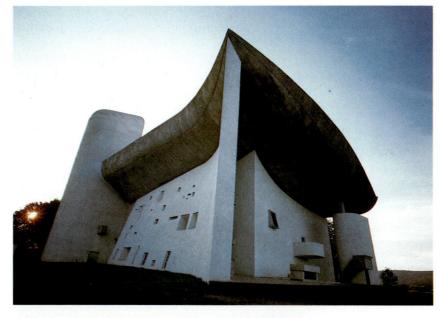

1184. Interior, Notre-Dame-du-Haut

1185. Bird's-eye perspective diagram of Notre-Dame-du-Haut (from the northeast)

Louis Kahn (1901–1974) used bare concrete to great effect in the Jonas Salk Institute of Biological Studies in La Jolla (fig. 1186). Salk, inventor of the first polio vaccine, had been deeply impressed by his visit to Assisi and conceived of the center as analogous to the Franciscan monastery there. Kahn, who was in complete sympathy with his patron's views, carried out this scheme brilliantly. He treated the offices as a series of monastic cells attached to the central work spaces formed by the laboratories—or, as he put it, servant and server spaces. Like so many others, the ambitious project proved too costly (it included, among other things, separate living quarters for the scientists and their families) and was halted before it could be completed. It nevertheless remains the fullest statement of Kahn's principles.

1186. Louis Kahn. Jonas Salk Institute of Biological Studies, La Jolla, California. 1959–65

1187. Eero Saarinen. Trans World Airlines Terminal, John F. Kennedy Airport, New York. 1956–63

1188. Interior, Trans World Airlines Terminal, John F. Kennedy Airport

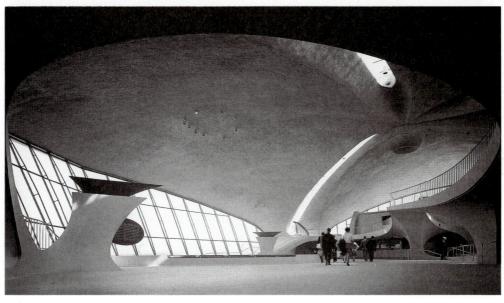

SAARINEN. There is, however, an alternate tradition of reinforced concrete dating back to Berg's Centennial Hall (see fig. 1162). This Expressionist vision continued to provide a dialogue with the International Style that enriched modern architecture. The Trans World Airlines Terminal at Kennedy Airport in New York (figs. 1187 and 1188) by Eero Saarinen (1910–1961) is the great statement of postwar Expressionism. Saarinen, whose father had been a well-known architect in his own right, was a skilled practitioner of the International Style. Here he has used the full potential of concrete in order to express the very essence of flight. Yet the inspiration, rather than mechanical, was purely organic. The swelling, saillike

forms of the four "flying" roofs create the impression of a gigantic bird, while the free-flowing spaces conduct the visitor through the graceful interior with astonishing force, as if pulled along by a vortex.

NERVI. Saarinen is linked to Berg by Pier Luigi Nervi (1891–1979), who during the 1930s and 1940s pioneered the investigation of ferroconcrete in designs for aircraft hangars that provided the point of departure for all future developments in this vein. Nervi was the twentieth-century counterpart to Gustave Eiffel: a structural engineer with a bold sense of form and an even more daring vision. The culmination of

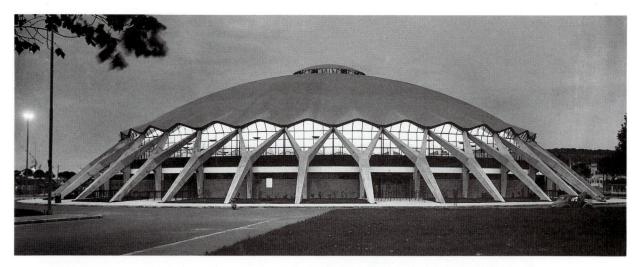

1189. Pier Luigi Nervi and Annibale Vitellozzi. Sports Palace, Rome. 1956-57

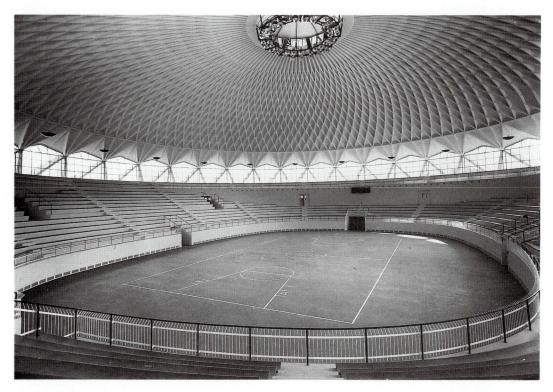

1190. Interior, Sports Palace, Rome

Nervi's efforts was the Sports Palace designed with Annibale Vitellozzi for the 1960 Olympics in Rome (figs. 1189 and 1190). From the outside, the roof appears as a thin covering whose light weight and flexibility are emphasized by the scalloped edges, so that it seems to have been draped over the Y-shaped supports radiating outward like flying buttresses. The effect inside is even more remarkable. The honeycombed roof, nearly 200 feet in diameter, recalls the interior of the Pantheon, with its great oculus (see fig. 246). A marvel of engineering, it seems to float effortlessly, like the dome of Hagia Sophia, in a pool of light without visible support (compare fig. 328).

URBAN PLANNING. To some architects, the greatest challenge is not the individual structure but urban design. Urban

planning is probably as old as civilization itself (which, we recall, means "city life"). We have caught only occasional glimpses of it in this book, since its history is difficult to trace by direct visual evidence. Cities, like living organisms, are everchanging, and to reconstruct their pasts from their present appearances is not an easy task.

With the advent of the industrial era two centuries ago, cities began to grow explosively and have continued to do so ever since. Much of this growth was uncontrolled, beyond the laying out of a network of streets. Worse, housing standards were poor or poorly enforced. The unfortunate result can be seen in the overcrowded, crumbling apartment blocks that are the blight of huge urban areas. They were taken over by the poor, while those who could afford it fled to the dormitory

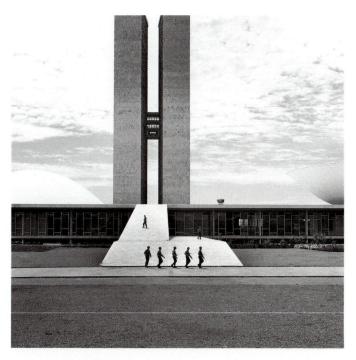

1191. Oscar Niemeyer. Brasilia, Brazil. Completed 1960

towns of suburbia. This exodus, accelerated by the automobile, has produced the dangerous tensions that lend urgency to the cry for urban renewal today. Such renewal, needless to say, must involve the political, social, and economic resources of an entire society, rather than the architect alone. Yet the architect has an essential role in the process, that of translating the schemes of the planning agencies into reality. However, they have generally failed in their social mandate to replace the slums of our

decaying cities with housing that will provide a socially healthful environment for very large numbers of people.

NIEMEYER. Nowhere are the issues facing modern civilization put into sharper relief than in the grandiose urban projects conceived by twentieth-century architects. These utopian visions may be regarded as laboratory experiments which seek to redefine the role of architecture in shaping our lives and to pose new solutions. Limited by their very scope, few of these ambitious proposals make it off the drawing board. Among the rare exceptions is Brasilia, the inland capital of Brazil built entirely since 1960. Presented with an unparalleled opportunity to design a major city from the ground up and with vast resources at its disposal, the design team, headed by the Brazilian Oscar Niemeyer (born 1907), achieved undeniably spectacular results (fig. 1191). Like most projects of this sort, Brasilia has a massive scale and insistent logic that make it curiously oppressive, so that despite the lavish display, the city provides a chilling glimpse of the future (compare fig. 1163).

SAFDIE. One particularly thorny problem is how to develop an alternative to the conventional high-rise apartment block in densely populated areas: a housing pattern that will be less deadeningly uniform (but no more expensive) and provide more light and air, safer access, and a multitude of other desirable features. A promising approach, by the Israeli architect Moshe Safdie (born 1938), was demonstrated in the Habitat complex at the Montreal EXPO 67 (fig. 1192). The individual apartments consist of prefabricated "boxes" that can be combined into units of several sizes and shapes, attached to a zigzagging concrete framework that can be extended to fit any site. Nevertheless, this lead, which proceeds from the work of Louis Kahn, has hardly been pursued by other architects.

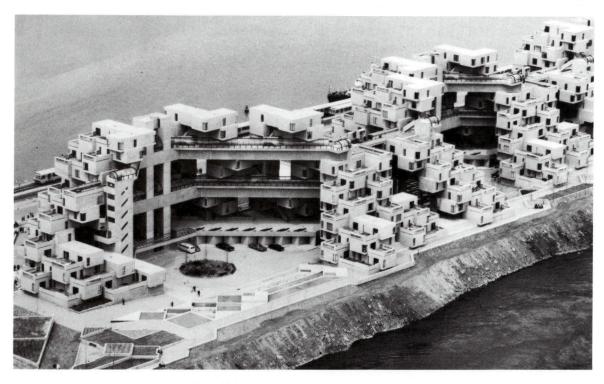

1192. Moshe Safdie and others. Habitat, EXPO 67, Montreal. 1967

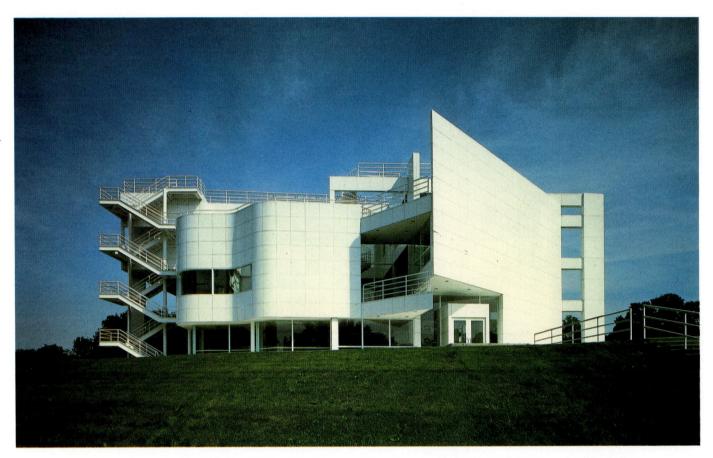

1193. Richard Meier. The Atheneum, New Harmony, Indiana. 1975-79

Late Modernism

Since 1970 architecture has been obsessed with breaking the tyranny of the cube—and the High Modernism it stands for. In consequence, a wide range of tendencies has arisen, representing almost every conceivable point of view. They have made architecture perhaps the most vital of the arts in the last quarter of the twentieth century. Like so much else in contemporary art, architecture has become theory-bound. Yet once the dust has settled, we may simplify these bewildering categories, with their equally confusing terminology, into Late Modernism, Postmodernism, and Deconstructivism (see Chapter 8). They are separated only by the degree to which they challenge the basic principles of High Modernism.

MEIER. Late Modernism began innocuously enough as an attempt to introduce greater variety of form and material, but ended in the segmentation of space and use of "high-tech" finishes that are the hallmarks of late-twentieth-century buildings. An important early example of this process is The Atheneum at New Harmony, Indiana (fig. 1193), by Richard Meier (born 1934). In its departure from the idealism of High Modernism, it seemingly constitutes an ironic commentary on the utopian vision of this historic settlement, which was founded in 1815 by George Rapp and sold ten years later to the Scottish reformer Robert Owen, who established a short-lived Socialist society. The Atheneum reflects Meier's principal

concerns: program and site, entry and circulation, structure and enclosure. Its placement within the landscape has been judiciously calculated, with equally careful consideration given to its function as a visitors' center. The inspiration of Le Corbusier's Savoye House (fig. 1171) of nearly a half-century earlier is evident in the pristine white surfaces, which lend the building a sense of clarity. The vocabulary, too, remains essentially Cubist (compare fig. 1047).

To that extent, the Atheneum falls well within the modern tradition. Yet it looks like Le Corbusier's classic statement exploded from within. The building fairly bristles with external stairways and ramps, intersecting planes and jutting walls, and false structural elements that "frame" the view. These conspire to disrupt the facade and dissolve the boundary with the surrounding environment, so that the structure lacks the self-containment of the International Style. As we might expect, the interior is an equally dynamic play on Savoye House: spatial relations are skewed by distorting forms and rotating them off-axis. Clearly Meier has pushed the syntax of High Modernism to its limits. Beyond this lies only Postmodernism.

PEICHL. In contrast to the centralized authority proclaimed by the Seagram Building, Late Modernist corporate architecture may be seen as a reflection of today's global economy, in which the major companies are based on rapid technological

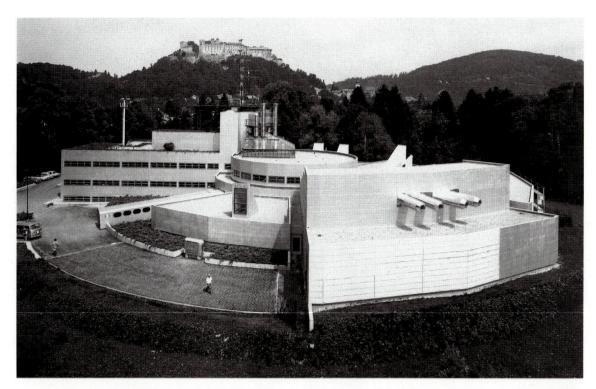

1194. Gustav Peichl. Austrian Radio and Television Studio, Salzburg. 1970-72

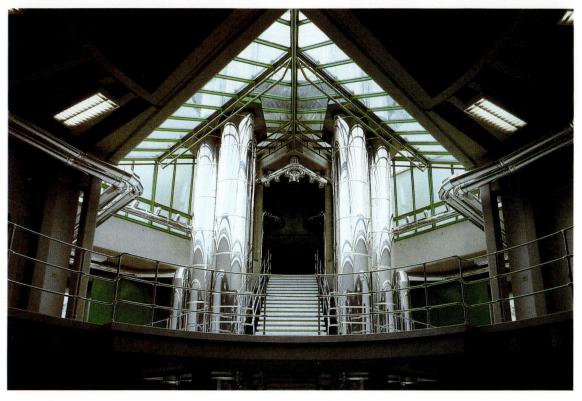

1195. Interior, Austrian Radio and Television Studio, Salzburg

advances and dispersed in far-flung smaller units. The Austrian Radio and Television studios designed by Gustav Peichl (born 1928) in 1970 have sharply contrasting wings radiating out from a central core to suggest their different functions (fig. 1194). The core itself has been conceived as a witty parody of spaceships, while the astonishing interior (fig. 1195) looks like

a futuristic movie set. Everything gleams with polished metal tubing clustered like the pipes of a rocket, which "blasts off" above the skylight. This space-age motif is continued on the rear of the auditorium, which sports exhaust pipes that curiously resemble the artillery of an aircraft carrier, as if to protect its flanks from some imaginary attack.

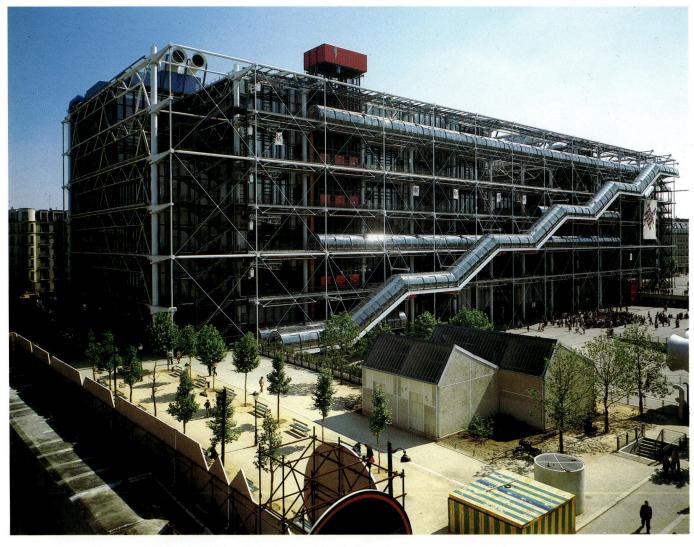

1196. Richard Rogers and Renzo Piano. Centre National d'Art et Culture Georges Pompidou, Paris. 1971–77

ROGERS AND PIANO. Among the freshest, as well as most controversial, results of Late Modernism is the Centre Georges Pompidou, the national arts and cultural center in Paris, which rejects the formal beauty of the International Style without abandoning its functionalism (fig. 1196). Selected in an international competition, the design by the Anglo-Italian team of Richard Rogers (born 1933) and Renzo Piano (born 1937) looks like a building turned inside-out. The architects have eliminated any trace of Le Corbusier's elegant facades (fig. 1171), exposing the building's inner mechanics while disguising the underlying structure. The interior itself has no fixed walls, so that temporary dividers can be arranged to meet any need. This stark utilitarianism expresses a populist sentiment current in France. Yet it is enlivened by eye-catching colors, each keyed to a different function. The festive display is as vivacious and imaginative as Léger's The City (fig. 1054), which, with Paris' Eiffel Tower (fig. 964), can be regarded as the Pompidou Center's true ancestor.

FOSTER. Rogers helped to bring Late Modernism to a head in a series of buildings around London that inspired the wrath of Prince Charles. We can see why in the Hongkong Bank, designed by Norman Foster (born 1935), one of Rogers' former associates (figs. 1197 and 1198). It testifies to the bank's desire to have the most beautiful building in the world. (It is certainly the most expensive that money can buy.) Everything about the structure is extreme. The huge scale represents the megalomania of today's corporations and the architects who work for them. The edifice was intended quite consciously as a cathedral of banking. Like a Gothic cathedral, the reinforcing members of this capitalist "church" are located on the exterior in the form of bizarre struts (compare fig. 429). The cavernous interior, with its elaborately articulated structural skeleton, may likewise be compared to that of a Gothic cathedral (see fig. 451), although the immediate antecedents of the vast atrium lie in the early work of Frank Lloyd Wright. The Hongkong Bank has been hailed as a brilliant architectural feat, and condemned as a monstrosity that offers a nightmarish vision of the future. In any event, there can be little doubt that both the principles and the vocabulary of the International Style have been abandoned so completely that it may be considered an example of Late Modernism or Postmodernism with equal justification. Whatever we choose to call it, we have clearly reached the end of High Modernist architecture.

1197. Foster Associates. Hongkong Bank, Hong Kong. 1979–86

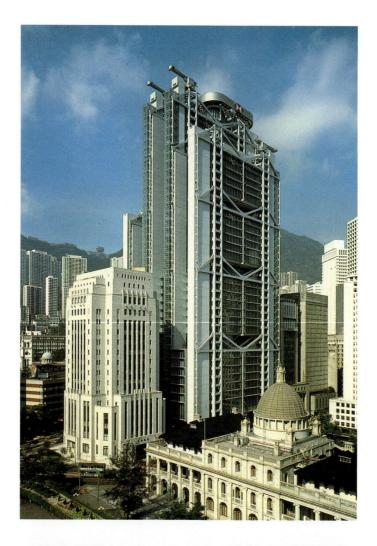

1198. Interior, Hongkong Bank, Hong Kong

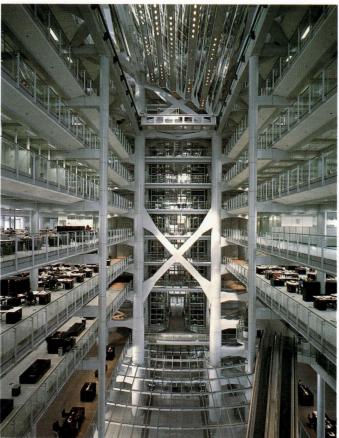

Twentieth-Century Architecture 893

CHAPTER SEVEN

TWENTIETH-CENTURY PHOTOGRAPHY

THE FIRST HALF-CENTURY

During the nineteenth century, photography struggled to establish itself as art but failed to find an identity. Only under extraordinary conditions of political upheaval and social reform did it address the most basic subject of art, which is life itself. In forming an independent vision, photography would combine the aesthetic principles of the Secession and the documentary approach of photojournalism with lessons learned from motion photography. At the same time, modern painting, with which it soon became allied, forced a decisive change in photography by undermining its aesthetic assumptions and posing a new challenge to its credentials as one of the arts. Like the other arts, photography responded to the three principal currents of our time: Expressionism, Abstraction, and Fantasy. But because it has continued to be devoted for the most part to the world around us, modern photography has adhered largely to realism and, hence, has followed a separate evolution. We must therefore discuss twentieth-century photography primarily in terms of different schools and how they have dealt with those often-conflicting currents.

The course pursued by modern photography was aided by technological advances. It must be emphasized, however, that these have increased but not dictated the photographer's options. George Eastman's invention of the hand-held camera in 1888 and the advent of 35mm photography with the Leica camera in 1924 made it easier to take pictures that had been difficult but by no means impossible to take with the traditional view camera.

Surprisingly, even color photography did not have such revolutionary importance as might be expected. It began in 1907 with the introduction of the "autochrome" by Louis Lumière (1864–1948), who with his brother had created a new art form, the cinema, in 1894. The autochrome was a glass plate covered with grains of potato starch dyed in three colors which acted as color filters, over which was applied a coating of silver bromide emulsion; it yielded a positive color transparency upon development and was not superseded until Kodak began to make color film in 1932, using the same principles but more advanced materials. The autochrome was based on the color theories used by Seurat and even achieved

Divisionist effects, as we can see if we look hard enough at *Young Lady with an Umbrella* (fig. 1199), an early effort. Except for its color, the picture differs little from photographs by the Photo-Secessionists, who were the first to turn to the new process. Color, in fact, had little immediate impact on the content, outlook, or aesthetic of photography, even though it removed the last barrier cited by nineteenth-century critics of photography as an art.

The School of Paris

ATGET. Modern photography began quietly in Paris with Eugène Atget (1856–1927), who turned to the camera only in 1898 at the age of 42. From then until his death, he toted his heavy equipment around Paris, recording the city in all its variety. Atget was all but ignored by the art photographers, for whom his commonplace subjects had little interest. He himself was a humble man whose studio sign read simply, "Atget—Documents for Artists," and, indeed, he was patronized by the fathers of modern art: Braque, Picasso, Duchamp, and Man Ray, to name only the best known. It is no accident that these artists were also admirers of Henri Rousseau, for Rousseau and Atget had in common a naïve vision, though Atget found inspiration in unexpected corners of his environment rather than in magical realms of the imagination.

Atget's pictures are marked by a subtle intensity and technical perfection that heighten the reality, and hence the significance, of even the most mundane subject. Few photographers have equaled his ability to compose simultaneously in two- and three-dimensional space. Like *Versailles* (fig. 1200),

1199. *(opposite, above)* Louis Lumière. *Young Lady with an Umbrella.* 1906–10. Autochrome. Société Lumière

1200. (opposite, below) Eugène Atget. Versailles. 1924.

Albumen-silver print, 7 x 9³/8" (17.8 x 23.9 cm). The Museum of Modern Art, New York

Abbott-Levy Collection. Partial gift of Shirley C. Burden

TWENTIETH-CENTURY PHOTOGRAPHY 895

1201. André Kertész. *Blind Musician*. 1921. Gelatin-silver print, 16³/8 x 13¹/4" (41.6 x 33.7 cm). The Museum of Modern Art, New York

1202. Brassaï. *"Bijou" of Montmartre.* 1933. 11⁷/8 x 9¹/4" (30.2 x 23.5 cm). The Museum of Modern Art, New York The Ben Schultz Memorial Collection. Gift of the artist

his scenes are often desolate, bespeaking a strange and individual outlook. The viewer has the haunting sensation that time has been transfixed by the stately composition and the photographer's obsession with textures. While Atget's work is marginally in the journalistic tradition of Nadar, Brady, and Riis (see pages 715, 717, and 774), its distinct departure from that earlier photography can only be explained in relation to late-nineteenth-century art. His pictures of neighborhood shops and street vendors, for example, are virtually identical with slightly earlier paintings by minor realists whose names are all but forgotten. Moreover, his photographs are directly related to a strain of Magic Realism that was a forerunner of Surrealism. Atget has been called a Surrealist, and while this characterization is misleading, it is easy to understand why he was rediscovered by Man Ray, the Dada and Surrealist artist-photographer, and championed by Man Ray's assistant, Berenice Abbott (see page 907). As a whole, however, Atget's work is simply too varied to permit convenient classification.

KERTÉSZ. Atget's direct successors were two East Europeans. The older of them, André Kertész (1894–1985), began photographing in his native Hungary as early as 1915, and his style was already defined when he came to Paris ten years later. *Blind Musician* (fig. 1201), made in Hungary in 1921, is the kind of picture Atget sometimes took, and it uses much the same

devices, above all the careful composition that isolates the subject within just enough of its surroundings to set the scene.

BRASSAÏ. The photographic style of Gyula Halasz, known simply as Brassaï (1899–1984), Atget's other successor, was also conditioned by Paris, its views and its habits. He was born in Transylvania and studied art in Budapest, but was a Frenchman at heart even before arriving in Paris in 1923. Several years later, while working there as a journalist, he borrowed a camera from Kertész and took a series of evocative photographs of the city by night. He soon turned to the nightlife of the Parisian cafés, where he had an unerring eye for the exotic characters who haunt them. "Bijou" of Montmartre (fig. 1202) shows the same sense of the typically aberrant as At the Moulin Rouge (see fig. 975) by Toulouse-Lautrec, whose art certainly influenced him.

CARTIER-BRESSON. The culmination of this Paris school is Henri Cartier-Bresson (born 1908), the son of a wealthy thread manufacturer. He studied under a Cubist painter in the late 1920s before taking up photography in 1932. Strongly affected at first by Atget, Man Ray (see page 906), Kertész, and even the cinema, he soon developed into the most influential photojournalist of his time, and he still thinks of himself primarily as one. His purpose and technique are nevertheless those of an artist.

1203. Henri Cartier-Bresson. Mexico, 1934. 1934. Gelatin-silver print

Cartier-Bresson is the master of what he has termed "the decisive moment." This to him means the instant recognition and visual organization of an event at the most intense moment of action and emotion in order to reveal its inner meaning, not simply to record its occurrence. Unlike other members of the Paris school, he seems to feel at home anywhere in the world and always to be in sympathy with his subjects, so that his photographs have a nearly universal appeal. His photographs are distinguished by an interest in composition for its own sake, derived from modern abstract art. He also has a particular fascination with motion, which he invests with all the dynamism of Futurism and the irony of Dada.

The key to his work is his use of space to establish relations that are suggestive and often astonishing. Indeed, although he deals with reality, Cartier-Bresson is a Surrealist at heart and has admitted as much. The results can be disturbing, as in *Mexico*, 1934 (fig. 1203). By omitting the man's face, Cartier-Bresson prevents us from identifying the meaning of the gesture, yet we respond to its tension no less powerfully.

DOISNEAU. If Cartier-Bresson has a peer in any area, it is in the ironic wit of Robert Doisneau (1912–1994). His subject matter is human foibles, which he unmasks with the best of humor. Who has not seen the man in *Side Glance* (fig. 1204), sneaking a glimpse of the voluptuous nude while his wife comments on the more serious painting before them?

1204. Robert Doisneau. Side Glance. 1953. Gelatin-silver print

1205. Alfred Stieglitz. *The Steerage*. 1907. Chloride print, $4^3/8 \times 3^5/8$ " (11.1 x 9.2 cm). The Art Institute of Chicago Alfred Stieglitz Collection

The Stieglitz School

STIEGLITZ. The founder of modern photography in the United States was Alfred Stieglitz, whose influence remained dominant throughout his life (1864–1946). From his involvement with the Photo-Secession onward (see page 776), he was a tireless spokesman for photography-as-art, although he defined this more broadly than did other members of the movement. He backed up his words by publishing the magazine *Camera Work* and supporting the other pioneers of American photography by exhibiting their work in his New York galleries, especially the first one, known as "291." The bulk of his early work adheres to Secessionist conventions, treating photography as a pictorial equivalent to painting. During the mid-1890s, however, he took some pictures of street scenes that are harbingers of his mature photographs.

His classic statement, and the one he regarded as his finest photograph, is *The Steerage* (fig. 1205), taken in 1907 on a trip to Europe. Like Ford Madox Brown's *The Last of England* (see fig. 944), painted more than a half-century earlier, it captures the feeling of a voyage, but does so by letting the shapes and composition tell the story. The gangway bridge divides the

scene visually, emphasizing the contrasting activities of the people below in the steerage, which was reserved for the cheapest fares, and the observers on the upper deck. If the photograph lacks the obvious sentiment of Brown's painting, it possesses an equal drama by remaining true to life.

This kind of "straight" photography is deceptive in its simplicity, for the image mirrors the feelings that stirred Stieglitz. For that reason, it marks an important step in his evolution and a turning point in the history of photography. Its importance emerges only in comparison with earlier photographs such as Steichen's *Rodin* (see fig. 1018) and Riis' *Bandits' Roost* (see fig. 1012). *The Steerage* is a pictorial statement independent of painting on the one hand and free from social commentary on the other. It represents the first time that documentary photography achieved the level of art in America.

Stieglitz' straight photography formed the basis of the American school. It is therefore ironic that it was Stieglitz, with Steichen's encouragement, who became the champion of abstract art against the urban realism of the Ash Can school (see page 799), whose paintings were at face value often simi-

1206. Alfred Stieglitz. Equivalent. 1930. Chloride print. The Art Institute of Chicago Alfred Stieglitz Collection

lar in content and appearance to his photographs. The resemblance is misleading. For Stieglitz, photography was less a means of recording things than of expressing his experience and philosophy of life, much as a painter does.

This attitude culminated in his "Equivalents." In 1922 Stieglitz began to photograph clouds to show that his work was independent of subject and personality. A remarkably lyrical cloud photograph from 1930 (fig. 1206) corresponds to a state of mind waiting to find full expression rather than merely responding to the moonlit scene. The study of clouds is as old as Romanticism itself, but no one before Stieglitz had made them a major theme in photography. As in Käsebier's The Magic Crystal (see fig. 1017), unseen forces are evoked that make *Equivalent* a counterpart to Kandinsky's *Sketch I for* "Composition VII" (see fig. 1030).

WESTON. Stieglitz' concept of the Equivalent opened the way to "pure" photography as an alternative to straight photography. The leader of this new approach was Edward Weston (1886-1958), who, although not Stieglitz' protégé, was decisively influenced by him. During the 1920s he pursued abstraction and realism as separate paths, but by 1930 he fused them in images that are wonderful in their design and miraculous for their detail.

Pepper (fig. 1207) is a splendid example that is anything but a straightforward record of this familiar fruit. Like Stieglitz' "Equivalents," Weston's photography makes us see the mundane with new eyes. The pepper is shown with preternatural sharpness and so close up that it seems larger than life. [See Primary Sources, no. 112, pages 947–48.] Thanks to the tightly cropped composition, we are forced to contemplate the

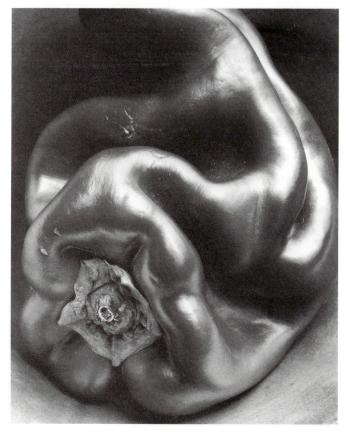

1207. Edward Weston. Pepper. 1930. Center for Creative Photography, Tucson, Arizona

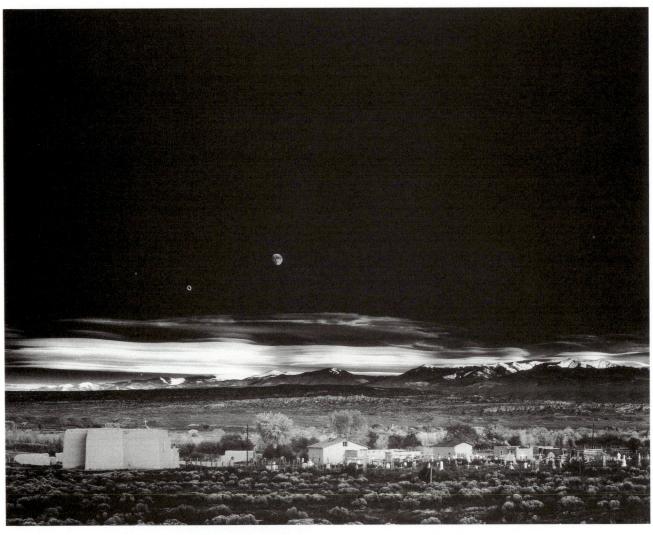

1208. Ansel Adams. *Moonrise, Hernandez, New Mexico.* 1941. Gelatin-silver print, $15 \times 18^{1/2}$ " (38.1 x 47 cm). The Museum of Modern Art, New York Gift of the photographer

form, whose every undulation is revealed by the dramatic lighting. *Pepper* has the sensuousness of *Black Iris III* by O'Keeffe (see fig. 1074) that lends the Equivalent a new meaning. Here the shapes are intentionally suggestive of the photographs of the female nude that Weston also pioneered.

ADAMS. To achieve uniform detail and depth, Weston worked with the smallest possible camera lens openings, and his success led to the formation, in 1932, of the West Coast society known as Group f/64, for the smallest lens opening. Among the founding members was Ansel Adams (1902–1984), who soon became the foremost nature photographer in America. He can rightly be regarded as the successor to Timothy O'Sullivan (see fig. 927), for his landscapes hark back to nineteenth-century American painting and photography.

Adams was a meticulous technician, beginning with the composition and exposure and continuing through the final printing. His justifiably famous work *Moonrise, Hernandez, New Mexico* (fig. 1208) came from pure serendipity which could never be repeated, a perfect marriage of straight and Equivalent photography. As in all of Adams' pictures, there is a full range of tonal nuances, from clear whites to inky blacks. The key to the photograph lies in the low cloud that divides

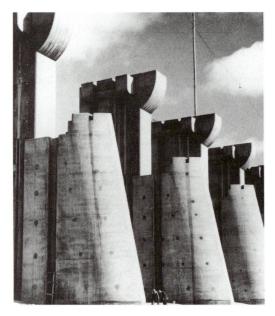

1209. Margaret Bourke-White. Fort Peck Dam, Montana. 1936. Time-Life, Inc.

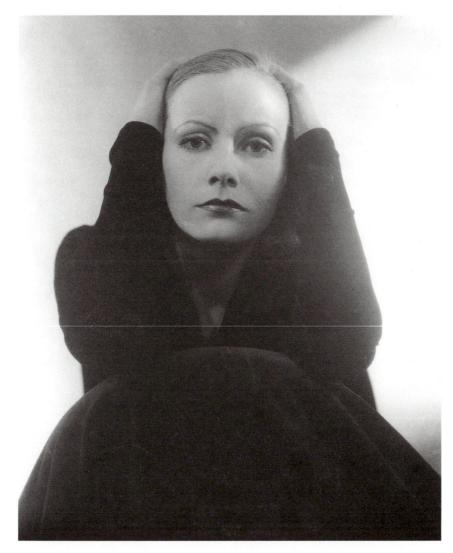

1210. Edward Steichen. *Greta Garbo*. 1928 (for *Vanity Fair* magazine). The Museum of Modern Art, New York
Gift of the photographer

the scene into three zones, so that the moon appears to hover effortlessly in the early evening sky.

BOURKE-WHITE. Stieglitz was among the first to photograph skyscrapers, the new architecture that came to dominate the horizon of America's growing cities. In turn, he championed the Precisionist painters (see pages 804-5) who began to depict urban and industrial architecture around 1925 under the inspiration of Futurism. Several of them soon took up the camera as well. Thus, painting and photography once again became closely linked. Both were responding to the revitalized economy after World War I which led to an unprecedented industrial expansion on both sides of the Atlantic. During the subsequent Depression, industrial photography continued surprisingly to grow with the new mass-circulation magazines that ushered in the great age of photojournalism and, with it, of commercial photography. In the United States, most of the important photographers were employed by the leading journals and corporations.

Margaret Bourke-White (1904–1971) was the first staff photographer hired by *Fortune* magazine and then by *Life* magazine, both published by Henry Luce. Her cover photograph of Fort Peck Dam in Montana for the inaugural

November 23, 1936, issue of *Life* remains a classic example of the new photojournalism (fig. 1209). The decade witnessed enormous building campaigns, and with her keen eye for composition, Bourke-White drew a visual parallel between the dam and the massive constructions of ancient Egypt (compare fig. 74), an idea that had already appeared in a painting of 1927 by Charles Demuth, *My Egypt*. In addition to their architectural power, Bourke-White's columnar forms have a remarkable sculptural quality and an almost human presence, looming like colossal statues at the entrance to a temple. But unlike the pharaohs' passive timelessness, these "guardian figures" have the spectral alertness of Henry Moore's abstract monoliths (see fig. 1126). Bourke-White's rare ability to suggest multiple levels of meaning made this cover and her accompanying photo essay a landmark in photojournalism.

STEICHEN. The flourishing magazine business also gave rise to fashion and glamour photography, which was developed into an art in its own right by Edward Steichen, America's most complete photographer to date. Steichen's talent for portraiture, seen in his early Photo-Secession photograph of Rodin (see fig. 1018), makes *Greta Garbo* (fig. 1210) a worthy successor to Nadar's *Sarah Bernhardt* (see fig. 925). The young

1211. Wayne Miller. Childbirth. "Family of Man" exhibition. 1955

film actress would have her picture taken countless times, despite her desire "to be alone," but none captures better the magnetic presence and complex character seen in her movies. The photograph owes much to its abstract black-and-white design, which focuses attention on her wonderfully expressive face. But Steichen's stroke of genius was to have Garbo put her arms around her head in order to suggest her enigmatic personality.

MILLER. One of Steichen's contributions to photography was to organize the "Family of Man" exhibition, which opened in New York in 1955. Wayne Miller's picture of childbirth (fig. 1211) from this epoch-making show captures the miracle of life in one dramatic image. It records with shocking honesty the newborn infant's abrupt entry into the world we all share. At the same time, the hands that reach out to help him are a moving affirmation of human existence.

VAN DER ZEE. The nature of the Harlem Renaissance, which flourished in the 1920s (see page 818), was hotly debated by black critics even in its own day. While its achievement

1212. James Van Der Zee. At Home. 1934. James Van Der Zee Estate

in literature is beyond dispute, the photography of James Van Der Zee (1886–1983) is often regarded today as its chief contribution to the visual arts. Much of his work is commercial and variable in quality, yet it remains of great documentary value and, at its best, provides a compelling portrait of the era. Van Der Zee had an acute understanding of settings as reflections of people's sense of place in the world, which he used to bring out a sitter's character and dreams. Though posed in obvious imitation of fashionable photographs of white society, his picture of the wife of the Reverend George Wilson Becton (fig. 1212), taken two years after the popular pastor of the Salem Methodist Church in Harlem was murdered, shows Van Der Zee's unique ability to capture the pride of African-Americans during a period when their dreams seemed on the verge of being realized.

Germany

With the New Objectivity movement in Germany during the late 1920s and early 1930s (see page 815), photography achieved a degree of excellence that has not been surpassed. Fostered by the invention of superior German cameras and the boom in publishing everywhere, this German version of straight photography emphasized materiality at a time when many other photographers were turning away from the real world. The intrinsic beauty of things was brought out through the clarity of form and structure in their photographs. This approach accorded with Bauhaus principles except with regard to function (see page 876).

RENGER-PATZSCH. Potter's Hands (fig. 1213) by Albert Renger-Patzsch (1897-1966), New Objectivity's leading exponent, is a marvel of technique and design that deliberately avoids any personal statement by reducing the image to an abstraction; the content lies solely in the cool perfection of the presentation and the orderly world it implies.

SANDER. When applied to people rather than things, the New Objectivity could have deceptive results. August Sander (1876–1964), whose Face of Our Time was published in 1929, concealed the book's intentions behind a disarmingly straightforward surface. The 60 portraits provide a devastating survey of Germany during the rise of the Nazis, who later suppressed the book. Clearly proud of his position, the man in Sander's Pastry Cook, Cologne (fig. 1214) is the very opposite of the timid figure in George Grosz' Germany, a Winter's Tale (see fig. 1068). Despite their curious resemblance, this "good citizen" seems oblivious to the evil that Grosz has depicted so vividly. While the photograph passes no individual judgment, in the context of the book the subject's unconcern stands as a strong indictment of the era as a whole.

Czechoslovakia

SUDEK. Josef Sudek (1896-1976) was the most diverse photographer of his time. The work of this one-armed photographer (he lost his right arm in World War I and had to struggle to take his pictures) incorporated nearly the full range of modern photography before 1945, except photojournalism,

1213. Albert Renger-Patzsch. Potter's Hands. 1925. Gelatin-silver print, $11^{3}/4 \times 15^{1}/8$ " (29.8 x 38.2 cm). The Museum of Modern Art, New York Gift of the photographer

1214. August Sander. Pastry Cook, Cologne. 1928. August Sander Archiv/SK-Stiftung Kultur, Cologne, Germany

1215. Josef Sudek. View from Studio Window in Winter. 1954. Gelatin-silver print, $8^{1}/2 \times 11^{1}/16$ " (21.6 x 28.1 cm). The Museum of Modern Art, New York Gift of Harriette and Noel Levine

which is concerned with passing moments that to him were merely incidental. Sudek was the Atget of Prague, which provided his main subject matter. From pictorialism, he learned to become a master of light, which he invested with the poetry of Vermeer, while the New Objectivity taught him to photograph simple objects with the reverence of Chardin. A romantic at heart, he sought to reveal the secret life of nature. Sudek preferred to work in series over the years and would often return to the same place to document its changing face and uncover new meanings. He was a recluse who became even more secretive during World War II, when his movement was severely restricted by the German occupation of Czechoslovakia. The most characteristic photographs from his later years are of private worlds, be they the cluttered studio where he lived, or gardens, his own as well as those of the artists, writers, and musicians who were his friends. Branches of a tree in snow seen through his window (fig. 1215) may be taken as a metaphor of the photographer himself. To Sudek, trees were primordial symbols of life that weather life's difficulties, much as he had survived personal tragedy.

The Heroic Age of Photography

CAPA. The period from 1930 to 1945 can be called the heroic age of photography for its photographers' notable response to the challenges of their times. Their physical bravery was exemplified by the combat photographer Robert Capa (1913–1954), who covered wars around the world for 20 years before being killed by a land mine in Vietnam. While

barely adequate technically, his picture of a Loyalist soldier being shot during the Spanish Civil War (fig. 1216) captures fully the horror of death at the moment of impact. Had it been taken by someone else, it might seem a freak photograph, but it is altogether typical of Capa's battle close-ups; he was as fearless as Civil War photographer Mathew Brady.

LANGE. Photographers in those difficult times demonstrated moral courage as well. Under Roy Stryker, staff photographers of the Farm Security Administration compiled a comprehensive photodocumentary archive of rural America during the Depression. While the FSA photographers presented a balanced and objective view, most of them were also reformers whose work responded to the social problems they confronted daily in the field. The concern of Dorothea Lange (1895–1965) for people and her sensitivity to their dignity made her the finest documentary photographer of the time in America.

At a pea-pickers' camp in Nipomo, California, Lange discovered 2,500 virtually starving migrant workers and took several pictures of a young widow with her children, much later identified as Florence Thompson; when *Migrant Mother*, *California* (fig. 1217) was published in a news story on their plight, the government rushed in food, and eventually migrant relief camps were opened. More than any Social Realist or Regionalist painting (see page 817), *Migrant Mother*, *California* has come to stand for that entire era. Unposed and uncropped, this photograph has an unforgettable immediacy no other medium can match.

1216. Robert Capa. Death of a Loyalist Soldier. September 5, 1936

1217. Dorothea Lange. *Migrant Mother, California.* February 1936. Gelatin-silver print. Library of Congress, Washington, D.C.

Fantasy and Abstraction

"Impersonality," the very liability that had precluded the acceptance of photography in the eyes of many critics, became a virtue in the 1920s. Precisely because photographs are produced by mechanical devices, the camera's images now seemed to some artists the perfect means for expressing the modern era. This change in attitude did not stem from the Futurists who, contrary to what might be expected, never fully grasped the camera's importance for modern art, despite Marey's in-

fluence on their paintings (see page 779). The new view of photography arose as part of the Berlin Dadaists' assault on traditional art.

Toward the end of World War I, the Dadaists "invented" the photomontage and the photogram, although these completely different processes had been practiced early in the history of photography. In the service of antiart they lent themselves equally well to fantasy and to abstraction, despite the apparent opposition of the two modes.

PHOTOMONTAGE. Photomontages are simply parts of photographs cut out and recombined into new images. Composite negatives originated with the art photography of Rejlander and Robinson (see page 775), but by the 1870s they were already being used in France to create witty impossibilities that are the ancestors of Dada photomontages. Like 1 Piping Man (see fig. 1059) by Max Ernst (who, not surprisingly, became a master of the genre), Dadaist photomontages utilize the techniques of Synthetic Cubism to ridicule social and aesthetic conventions.

These imaginative parodies destroy all pictorial illusionism and therefore stand in direct opposition to straight photographs, which use the camera to record and probe the meaning of reality. Dada photomontages might be called "ready-images," after Duchamp's ready-mades. Like other collages, they are literally torn from popular culture and given new meaning. Although the photomontage relies more on the laws of chance, the Surrealists later claimed it to be a form of automatic handwriting on the grounds that it responds to a stream of consciousness.

Most Surrealist photographers have been influenced by the Belgian painter René Magritte, whose mystifying fantasies (see fig. 1062) are treated with a magic realism that is the opposite of automatic handwriting. Since Magritte's pictorial style was already highly naturalistic, he only experimented with the camera. Nevertheless, he had a considerable impact on photography because his illusionistic paradoxes can be readily emulated in photographs, such as the photomontage

1218. Herbert Bayer. *lonely metropolitan*. 1932. Photomontage, 14 x 11" (35.6 x 28 cm). Collection the artist (copyright)

1220. Man Ray. *Untitled* (Rayograph). 1928. Gelatin-silver print, $15^{1}/2 \times 11^{5}/8$ " (39.4 x 29.5 cm). The Museum of Modern Art, New York Gift of James Thrall Soby

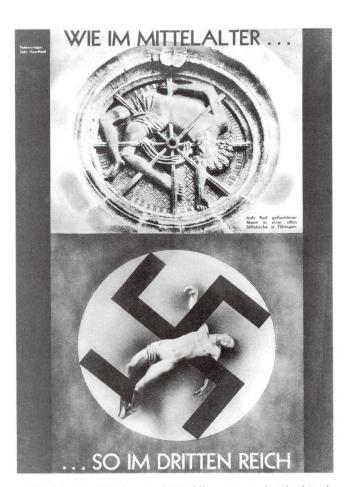

1219. John Heartfield. *As in the Middle Ages, so in the Third Reich.* 1934. Poster, photomontage. Akademie der Künste, John Heartfield Archiv, Berlin

1221. László Moholy-Nagy. *Untitled.* Photogram, silver bromide print, $19^{1/2}$ x $15^{3/4}$ " (49.5 x 40 cm). The Art Institute of Chicago Gift of George Bancroft, 1968

1222. Berenice Abbott. Transformation of Energy. 1939–58 Courtesy Parasol Press

lonely metropolitan (fig. 1218) by the German-born Herbert Bayer (1900–1985). The purpose of such visual riddles is to challenge our conception of reality, showing up the discrepancy between our perception of the world and our irrational understanding of its significance.

POSTERS. Photomontages were soon incorporated into carefully designed posters as well. In Germany, posters became a double-edged sword in political propaganda, used by Hitler's sympathizers and enemies alike. The most acerbic anti-Nazi commentaries were provided by John Heartfield (1891–1968), who changed his name from the German Herzfeld as a sign of protest. His horrific poster of a Nazi victim crucified on a swastika (fig. 1219) appropriates a Gothic image of humanity punished for its sins on the wheel of divine judgment. Obviously, Heartfield was not concerned about misinterpreting the original meaning in his montage, which communicates its new message to powerful effect.

PHOTOGRAMS. The photogram does not take pictures but makes them: objects are placed directly onto photographic paper and exposed to light. Nor was this technique new. Fox Talbot (see pages 713–14) had used it to make negative images of plants which he called "photogenic drawings." The Dadaists' photograms, however, like their photomontages, were intended to alter nature's forms, not to record them, and to substitute impersonal technology for the work of the individual. Since the results in the photogram are so unpredictable, making one involves even greater risks than does a photomontage.

Man Ray (1890–1976), an American working in Paris, was not the first to make photograms, but his name is the most closely linked to them through his "Rayographs." Fittingly enough, he discovered the process by accident. The amusing face in figure 1220 was made according to the laws of chance

by dropping a string, two strips of paper, and a few pieces of cotton onto the photographic paper, then coaxing them here and there before exposure. The resulting image is a witty creation that shows the playful, spontaneous side of Dada and Surrealism as against Heartfield's grim satire.

THE CONSTRUCTIVISTS. Because the Russian Constructivists had a comparably mechanistic conception of society, they soon followed Dada's lead in using photograms and photomontages as a means to integrate industry and art, albeit for quite different purposes. László Moholy-Nagy (1895–1946), a Hungarian teaching at the Bauhaus who was deeply affected by Constructivism, successfully combined the best features of both approaches. By removing the lens to make photograms, he transformed his camera from a reproductive into a productive instrument; photography could now become, at least in theory if not in practice, a technological tool for fostering creativity in mass education.

Like many of the Russian artists in the 1920s, Moholy-Nagy also saw light as the embodiment of dynamic energy in space. The effects conjured up by the superimposition and interpenetration of forms in his photographs are fascinating (fig. 1221). We feel transported in time and space to the edges of the universe, where the artist's imagination gives shape to the play of cosmic forces created by a supreme cosmic will.

ABBOTT. One of the principal educational purposes of Moholy-Nagy's images was to extend sense perception in new ways. Similar goals have been achieved by taking pictures through microscopes and telescopes. Such photographs have helped to open our eyes to the invisibly small and the infinitely far. Wondrous scientific photographs were taken from 1939 to 1958 by Berenice Abbott (1898–1991), Man Ray's former pupil and assistant, to demonstrate the laws of physics (fig. 1222).

1223. Aaron Siskind. New York 2. 1951. Collection the artist

Like Marey's motion photographs of 50 years earlier (see fig. 1020a, b), they are arresting images, literally and visually. Their formal perfection makes them aesthetically compelling and scientifically valid, and they have proved to be even more educational than Moholy-Nagy's photograms.

PHOTOGRAPHY SINCE 1945

Abstraction

SISKIND. Photography after World War II was marked by abstraction for nearly two decades, particularly in the United States. Aaron Siskind (1903–1991), a close friend of the Abstract Expressionist painters, recorded modern society's debris and decaying signs. Hidden in these details he discovered cipherlike figures (fig. 1223) that are ironically similar to the ideographs of some forgotten civilization no longer intelligible to us.

WHITE. Minor White (1908–1976) approached even closer to the spirit of Abstract Expressionism. An associate of Adams and Weston, he was decisively influenced by Stieglitz' concept of the Equivalent. During his most productive period, from the mid-1950s to the mid-1960s, White evolved a highly individual style, using the alchemy of the darkroom to transform reality into a mystical metaphor. His *Ritual Branch* (fig. 1224) evokes a primordial image: what it shows is not as important as what it stands for, but the meaning we sense there remains elusive.

Documentary Photography

SMITH. The continuing record of misery that photography provides has often been the vehicle for making strong personal statements. W. Eugene Smith (1918-1978), the foremost photojournalist of our time, was a compassionate cynic who commented on the human condition with "reasoned passion," as he put it. Tomoko in Her Bath (fig. 1225), taken in 1971 in the Japanese fishing village of Minamata, shows a child crippled by mercury poisoning being bathed by her mother. Not simply the subject itself but Smith's treatment of it makes this an intensely moving work. The imagery lies deep in our heritage: the mother holding her child's body goes back to the theme of the German Gothic Pietà (see fig. 479), while the dramatic lighting and vivid realism recall a painting of another martyr in his bath, Jacques-Louis David's The Death of Marat (see fig. 844). But what engages our emotions above all in making the photograph memorable is the infinite love conveyed by the mother's tender expression.

FRANK. The birth of a new form of straight photography in the United States was largely the responsibility of one man, Robert Frank (born 1924). His book *The Americans*, compiled from a cross-country odyssey made in 1955–56, created a sensation upon its publication in 1959, for it expressed the same restlessness and alienation as *On the Road* by his traveling companion, the Beat poet Jack Kerouac, published in 1957. As this friendship suggests, words have an important role in Frank's photographs, which are as loaded in their meaning as Demuth's *I Saw the Figure 5 in Gold* (fig. 1055). Yet Frank's

1224. Minor White. Ritual Branch. 1958. Gelatin-silver print, $10^3/8 \times 10^5/8$ " (26.4 x 27 cm). The International Museum of Photography at George Eastman House, Rochester, New York

1225. W. Eugene Smith. Tomoko in Her Bath. December 1971. Gelatin-silver print. Aileen and W. Eugene Smith-Black Star

1226. Robert Frank. Santa Fe, New Mexico. 1955–56. Gelatin-silver print. Collection Pace-MacGill Gallery, New York

1227. Bill Brandt. *London Child.* 1955 Copyright Mrs. Noya Brandt

social point of view is often hidden behind a facade of disarming neutrality. It is with shock that we finally recognize the ironic intent of *Santa Fe, New Mexico* (fig. 1226): the gas pumps face the sign save in the barren landscape like members of a religious

1228. Jerry Uelsmann. *Untitled.* c. 1972. Collection the artist

cult vainly seeking salvation at a revival meeting. Frank, who subsequently turned to film, holds up an image of American culture that is as sterile as it is joyless. Even spiritual values, he tells us, become meaningless in the face of vulgar materialism.

1229. Joanne Leonard.

Romanticism Is

Ultimately Fatal, from

Dreams and Nightmares.

1982. Positive transparency selectively
opaqued with collage,
93/4 x 91/4"

(24.8 x 23.5 cm).

Collection M. Neri,
Benicia, California

Fantasy

Fantasy gradually reasserted itself on both sides of the Atlantic in the mid-1950s. Photographers first manipulated the camera for the sake of extreme visual effects by using special lenses and filters to alter appearances, sometimes virtually beyond recognition. Since about 1970, however, they have employed mainly printing techniques, with results that are frequently even more startling.

BRANDT. Manipulation of photography was pioneered by Bill Brandt (1904–1983). Though regarded as the quintessential English photographer, he was born in Germany and did not settle in London until 1931. He decided on a career in photography during psychoanalysis and was apprenticed briefly to Man Ray. Consequently, Brandt remained a Surrealist who manipulated visual reality in search of a deeper one, charged with mystery. His work was marked consistently by a literary, even theatrical, cast of mind which drew on the cinema for some of its effects. His early photodocumentaries were often staged as re-creations of personal experience for the purpose of social commentary based on Victorian models. Brandt's fantasy images manifest a strikingly romantic imagination. Yet, there is an oppressive anxiety implicit in his landscapes, portraits, and nudes. London Child (fig. 1227) has the haunting mood of novels by the Brontë sisters, Charlotte, Emily, and Anne. At the same time, this is a classic dream image fraught with troubling psychological overtones. The spatial dislocation, worthy of De Chirico, expresses the malaise of a person who is alienated from both himself and the world.

UELSMANN. The American Jerry Uelsmann (born 1934), a more recent leader of this movement, was inspired by Oscar Rejlander's multiple-negative photographs, as well as by Stieglitz' Equivalents. While Uelsmann's work also has a playful side, for the most part he involuntarily expresses archetypal images from deep within the subconscious. [See Primary Sources, no. 113, page 948.] The nude lying within the soil in *Untitled* (fig. 1228) identifies the fecundity of nature, signified by the tree of life, with woman as earth goddess. At the same time, the photograph seemingly conveys a dream in which the psyche retreats into the womblike sanctuary of primal nature. Each part of the print is a faithful record; it is their astonishing juxtaposition that gives the image a new reality.

Uelsmann once participated in one of Minor White's classes, and their photographs are not as far removed visually or expressively from each other's as they might seem. The principal difference lies in their approach to the Equivalent as a means of achieving a poetical inner truth: White, like Stieglitz, recognizes his symbols in received images from nature, whereas Uelsmann creates his symbols from the imagination in the dark room. Paradoxically, it is Uelsmann's imagery, not *Ritual Branch*, that is instantly recognizable, but, like the paintings of René Magritte (see fig. 1062) that inspired him, it refuses to yield an ultimate meaning.

LEONARD. Contemporary photographers have often turned to fantasy as autobiographical expression. Both the image and the title of *Romanticism Is Ultimately Fatal* (fig. 1229) by Joanne Leonard (born 1940) suggest a meaning

1230. David Wojnarowicz. *Death in the Cornfield.* 1990. Silver print, 26 x 38" (66 x 96.5 cm) Courtesy of P.P.O.W. Gallery, New York

that is personal in its reference; it was made during the breakup of her marriage. We will recognize in this disturbing vision something of the tortured eroticism of Fuseli's *The Nightmare* (see fig. 884). The clarity of the presentation turns the apparition at the window into a real and frightening personification of despair. This is no romantic knight in shining armor, but a grim reaper whose ancestors can be found in Dürer's woodcut *The Four Horsemen of the Apocalypse* (see fig. 700).

WOJNAROWICZ. Even more shocking is *Death in the Cornfield* (fig. 1230) by David Wojnarowicz (1954–1992). Gifted with a singularly bizarre imagination, he was obsessed with the horrific, which consistently informs his work. At the time of this photograph, Wojnarowicz was already afflicted with AIDS, which claimed his life two years later. Of the countless images devoted to this dread disease by painters and pho-

tographers, none so fully captures its nightmarish terror. The macabre costume, made by Wojnarowicz himself, conjures up an awesome demon of death from some primitive tribal ritual that appears out of nature as if by magic. Like Munch's *The Scream* (fig. 989), here is an expression of irrational fear so gripping in its power as to lift personal suffering to a universal plane. It serves as an unforgettable reminder that, just as in the art world, soon virtually everyone will have been touched by the loss of cherished friends and colleagues to AIDS.

Artists as Photographers

HOCKNEY. The most recent demonstrations of photography's power to extend our vision have come, fittingly enough, from artists. The photographic collages that the English painter David Hockney (born 1937) has been making since 1982 are like revelations that overcome the traditional limita-

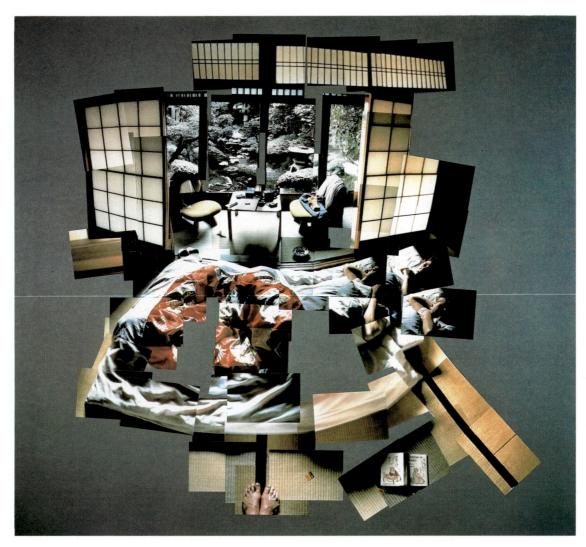

1231. David Hockney. *Gregory Watching the Snow Fall, Kyoto, Feb. 21, 1983.* 1983. Photographic collage, 43¹/₂ x 46¹/₂" (110.5 x 118 cm). Collection the artist © 1983 David Hockney

tions of a unified image, fixed in time and place, by closely approximating how we actually see. In Gregory Watching the Snow Fall, Kyoto, Feb. 21, 1983 (fig. 1231), each frame is analogous to a discrete eye movement containing a piece of visual data that must be stored in our memory and synthesized by the brain. Just as we process only essential information, so there are gaps in the matrix of the image, which becomes more fragmentary toward its edges, though without the loss of acuity experienced in vision itself. The resulting shape of the collage is a masterpiece of design. The scene appears to bow curiously as it comes toward us. This ebb and flow is more than simply the result of optical physics. In the perceptual process, space and its corollary, time, are not linear, but fluid. Moreover, by including his own feet as reference points to establish our position clearly, Hockney helps us to realize that vision is less a matter of looking outward than an egocentric act that defines the viewer's visual and psychological relationship to the surrounding world. The picture is as expressive as it is opulent. Hockney has recorded his friend several times to suggest his reactions to the serene landscape outside the door.

Hockney's approach is embedded in the history of modern painting, for it shows a self-conscious awareness of earlier art. It combines the faceted views of Picasso (see fig. 1034) and the sequential action of Duchamp (see fig. 1044) with the dynamic energy of Popova (see fig. 1039). *Gregory Watching the Snow Fall* is nonetheless a distinctly contemporary work, for it incorporates the fascinating effects of Photorealism and the illusionistic potential of Op Art. Hockney has begun to explore further implications inherent in these photo collages, such as continuous narrative. No doubt others will be discovered as well. Among these is the possibility of showing an object or scene simultaneously from multiple vantage points to let us see it completely for the first time.

CHAPTER EIGHT

POSTMODERNISM

We began Part Four with a discussion of modernism. It is appropriate that we end, for now, with its antithesis: post-modernism. We live in the postmodern era. How can that be, if modern is what is today? The term itself suggests the quizzical nature of the trend, which seeks out incongruity. To resolve this paradox, we must understand modern in a dual sense: modernity and modernism. Postmodernism as a trend not only supersedes modernism but, as we shall see, is opposed to the world order as it exists today and to the values that created it.

What, then, is postmodernism and when did it begin? Critics are in little agreement on these questions, which is hardly surprising, given how recent the phenomenon is. Generally speaking, postmodernism is marked by an abiding skepticism that rejects modernism as an ideal defining twentieth-century culture as we have known it. In challenging tradition, however, postmodernism resolutely refuses to provide a new meaning or impose an alternative order in its place. It represents a generation consciously not in search of its identity. Hence, it is not a coherent movement at all, but a loose collection of tendencies which, all told, reflect a new sensibility. Each country has a somewhat different outlook and terminology; nevertheless all may be grouped under the rubric of postmodernism. We must therefore resort to a composite picture. Though broadly painted as a matter of necessity, it will provide us with a general idea of postmodernism's peculiar character. Our treatment of postmodern art is likewise intended to be suggestive by discussing representative examples, albeit at the cost of omitting a great deal that is also of interest.

As the term *post* suggests, our world is in a state of transition—without telling us where we will land. Although "post-modern" was coined by a historian in the late 1940s to denote a late stage of the civilization initiated by the Renaissance, it has been used mainly by literary critics since the mid-1960s, a significant fact in itself. We may indeed trace the first symptoms back to that time, but in retrospect they appear to have been essentially a late phase of modernism, without making a decisive break from the mainstream of the twentieth century.

What is the difference? Postmodernism springs from postindustrial society, which is passing rapidly into the Information Age (the so-called "Third Wave"). According to this view, the political, economic, and social structures that have governed the Western world since the end of World War II are either changing, undergoing attack from within, or breaking down altogether, ironically at the same time as the collapse of Communism in eastern Europe. This institutional erosion has resulted in a corresponding spiritual crisis that reflects the disarray of people's lives. Postmodernism is a product of the disillusion and alienation afflicting the middle class. At the same time, bourgeois culture has exhausted its possibilities by absorbing its old nemesis, the avant-garde. Strangely enough, the avant-garde's mission was ended by its very success. During the 1950s the media made the avant-garde so popular that the middle class accepted it and began to hunger for ceaseless change for its own sake. By the following decade, modernism was reduced to a "capitalist" mode of expression by large corporations, which adopted it not just in architecture but in painting and sculpture.

Postmodernism celebrates the death of modernism, which it regards as not only arrogant in its claim to universality but also responsible for the evils of contemporary civilization. Democracy, based on Enlightenment values, is seen in turn as a force of oppression to spread the West's hegemony throughout the world. In common with most earlier avant-garde movements (including existentialism) postmodernism is antagonistic to humanism, which it dismisses as bourgeois. Reason, with its hierarchies of thought, is abandoned in order to liberate people from the established order. This opens the way for nontraditional approaches, especially those from the Third World, emphasizing emotion, intuition, fantasy, contemplation, mysticism, and even magic. Science is no better than any other system, since it has failed to solve today's problems. And because scientific reality does not conform to human experience, it is useless in daily life.

Truth is rejected as neither possible nor desirable on the grounds that it is used by its creators for their own power ends. Subjective and conflicting interpretations are all that can be offered, and these may vary freely according to the context. Since no set of values can have more validity than any other, everything becomes relative. Bereft of all traditional guidelines, the postmodernist drifts aimlessly in a sea without meaning or reality. To the extent that the world makes any sense, it is at the local level, where the limited scale makes understanding possible in human terms.

The only escape from an existence in which nothing has intrinsic worth is inaction or hedonism on the one hand and spirituality on the other. The latter is rarely an option, however, since religions impose their own authority and self-discipline; thus, only the most extreme forms of mysticism, lacking all rational control, are acceptable. Postmodern people are thus fated to become pleasure-seeking narcissists without any strong identity, purpose, or attachments. Avowedly cynical and amoral, they live for the moment, unburdened by any concern for larger issues, which are imponderables in the first place. Rather than vices, however, these traits are considered virtues, for they grant postmodernists a flexible approach to life that allows them to pursue new modes of existence, free from all restraints or authority.

In the brave new world of postmodernism, the individual is no longer anchored in time or space. Both have been rendered obsolete in life as they have in science, because they are beyond normal human comprehension and based on assumptions that are subject to doubt. Traditional definitions of time and space, moreover, were based on hierarchies of thought that served the purposes of colonialism, but the new "hyper-space" created by global communication makes it impossible to position oneself within customary boundaries.

Just as time and space have lost all meaning, so has history. The view of history as progressive was likewise tied to the established power centers of the capitalist system and used as a tool to oppress the Third World. Furthermore, its very premise is fallacious: if linear logic is inherently invalid, there can be no linear history either. Since conventional knowledge and structures are suspect, nothing can be learned from history in the first place, and its "facts" are therefore of little interest.

Postmodernism, of course, makes no attempt to pose new answers to replace the old certitudes it destroys. Instead it substitutes pluralism in the name of multicultural diversity. Pluralism leads inevitably to eclecticism, with which it is virtually interchangeable, since no one aesthetic is better than any other. Not only are they functions of each other, they become ends in themselves.

By the same token, postmodernism does not try to make the world a better place. In its resolute antimodernism, it is socially and politically ambivalent at best, self-contradictory at worst. Its operating principle is anarchism. But although it is surpassingly liberal in its range of possibilities—witness the rise of "political correctness" in the United States—to Marxists it is simply a decadent late phase of capitalism, while to conservatives it goes against traditional values. To the extent that it does offer an alternative, postmodernism espouses any new doctrine as superior to the one it seeks to displace. Radical politics becomes a game that is played for its own sake. In the end, however, postmodernism remains essentially a form of cultural activism motivated by intellectual theory, not political causes, to which it is ill-suited.

Postmodernism has all the classic earmarks of a self-appointed avant-garde, despite the fact that it vigorously disavows any such connection. Its resolute opposition to modernity makes it the latest adversary of conventional authority, which it is dedicated to overthrowing. Like all avant-gardes, postmodernism is a "degenerate" movement that foments an atmosphere of crisis in order to sustain and

justify itself. In character it comes closest to Dada and Surrealism, but lacks their high-pitched hysteria. Its antielitism is simply another means of attacking the cultural establishment, which it desires to supplant. The relativism and anarchism of postmodernism are patently subversive in their intent. This nihilism reflects the prevailing skepticism of the late twentieth century, when very little is deemed to have any significance or worth.

Postmodernism might well take its credo from Edgar Allan Poe:

All that we see or seem Is but a dream within a dream.

Such a position is not without its problems. As we examine it, we realize that the postmodernist rejection of reality is a philosophical construct, just as its rejection of truth is an *a priori* value judgment. Even if we grant that everything is ultimately unknowable, reality must nonetheless be capable of being apprehended in a functional sense; otherwise people could not survive. Postmodernism, then, is comparable to that higher understanding sought by mystics, for whom reason alone is insufficient.

Because it has so many meanings, postmodernism itself becomes a meaningless term, posing the kind of hopeless double bind that it delights in. In fact, postmodernism as a whole is riddled with contradictions. But if nothing is valid, then the values it often espouses—feminism, pluralism, and the like—must be fallacious as well. Seen in this light, postmodernism is a sterile philosophy that reflects the impotence of the intelligentsia to act.

In the end, postmodernism cannot escape the very laws of history it claims to deny. As a parody of modernity, it has its parallels—indeed, its origins—in the avant-garde of a hundred years ago. The same "decadence" and nihilism can be found toward the end of the nineteenth century in the Symbolist movement, with its apocalyptic vision of despair. Like pluralism, for example, Gauguin's quest for the spiritual presumed the superiority of "alternative" knowledge systems and asserted a belief in magic, which was widely shared by other Symbolists. More generally, postmodernism espouses the same destructive values as the German philosopher Friedrich Nietzsche, who was one of the principal sources of the avant-garde. Although it offers nothing in exchange, people will no doubt devise a new system to replace the old one that postmodernism strives to overturn.

SEMIOTICS AND DECONSTRUCTION. The Information Age is obsessed with meaning—and the lack thereof. Like the intellectual disciplines, nearly all branches of culture have come under the spell of semiotics—the study of signs—also known as semiology (though a distinction is sometimes made between the two). And with good reason, for semiotics is part of philosophy, linguistics, science, sociology, anthropology, communications, psychology, art, literature, cinema: any sphere of human endeavor that involves symbols. (There are other classes of signs that are the subject of semiotic inquiry as well.) Semiotics in turn has been attacked from within by Deconstruction, which constitutes undoubtedly the most

potent attack mounted to date by postmodernism. As the term suggests, deconstruction is destructive, not constructive. It tears a text apart by using the text against itself, until the text finally "deconstructs" itself. For those interested in exploring the issues further, we have supplied a brief overview in the Postscript at the end of this chapter. For our purposes it is not the theories, interesting though they may be, but their effect on art that counts.

POSTMODERN ART

We are, in a sense, the new Victorians. A century ago, Impressionism underwent a like crisis, from which Post-Impressionism emerged as the direction for the next 20 years. Behind its elaborate rhetoric, postmodernism can be seen as a strategem for sorting through the past while making a decisive break with it that will allow new possibilities to emerge. Having received a rich heritage, artists are faced with a wide variety of alternatives. The principal features of the new art are a ubiquitous eclecticism and a bewildering array of styles. Taken together, these pieces provide a jigsaw puzzle of our times. Another indication of the state of flux is the reemergence of many traditional European and regional American art centers.

Art since 1980 has been called postmodern, but not all of it fits under this umbrella. We shall find that the participation of the visual arts in the postmodern adventure has varied greatly and taken some surprising turns. In particular, the traditional mediums of painting and sculpture have played a secondary role. Much of the reason is that painting and sculpture are closely identified with the modernist tradition; by extension they are tainted as tools of the ruling class. Meanwhile, non-traditional forms, such as installations and photography, have come to the forefront and become highly politicized in the process.

Much of the basis for postmodern art can be traced back to Conceptualism, which led the initial assault on modernism (see pages 869–70). Indeed, it has been argued that the beginnings of postmodernism can be dated to the rise of Conceptualism in the mid-1960s. The two, however, are products of two distinctly different generations. Furthermore, Conceptualism itself derived from Dada, which has provided an "antimodern" alternative since early in the twentieth century. In the context of the 1960s, it was simply part of that ongoing dialogue, in which Pop also participated. Such a date, moreover, seems decidedly too early for the onset of what is fundamentally a late-twentieth-century phenomenon.

Installations and performance art have been around that long as well. What has clearly changed is the content of these art forms as part of a larger shift in viewpoint. Focused as it was on matters of art, early Conceptualism seems almost innocent in retrospect. Postmodernists, in contrast, attack modern art as part of a larger offensive against contemporary society. They are far more issue-oriented than their predecessors, and their work cuts across a much wider spectrum of concerns than ever before.

From all the recent ferment a new direction in art has begun to appear, at least for the time being. The principal manifestation of postmodernism is appropriation, which looks back self-consciously to earlier art, both by imitating previous styles and by taking over specific motifs or even entire images. Artists, of course, have always borrowed from tradition, but rarely so systematically as now. Such plundering is nearly always a symptom of deepening cultural crisis, suggesting bankruptcy. (The same thing is going on in popular culture, with its perpetual "retro" revivals.) Unbound as it is to any system, postmodernism is free not only to adopt earlier imagery but also to alter its meaning radically by placing it in a new context. The traditional importance assigned to the artist and object is furthermore de-emphasized in this approach, which stresses content and process over aesthetics. The other main characteristic of postmodernism is the merging of art forms. Thus there is no longer a clear difference between painting, sculpture, and photography, and we maintain the distinction mainly as a matter of convenience.

Although it has an anti-intellectual side, postmodernism is preoccupied with theory. In consequence, art (and, along with it, art history) has become theory-bound. Yet, despite a growing body of writing and criticism, it lags far behind literature and poetry in developing a postmodern approach. Compared to language, the visual arts are traditionally poor vehicles for theory. Perhaps they have become so word-oriented of late in an attempt to keep pace with other disciplines.

Postmodernism is undeniably a fascinating phenomenon. Yet it has an Achilles' heel: it has produced little art that is memorable—it is merely "symptomatic" of our age. But for that very reason it is worthy of our interest. Fittingly enough, the most devastating critique of postmodernism comes from that apostle of modernism, Charles Baudelaire: "Eclecticism has at all periods and places held itself superior to past doctrines because, coming last on to the scene, it finds the remotest horizons already open to it; but this impartiality only goes to prove the impotence of the eclectics. People who are so lavish with their time for reflection are not complete men: they lack the element of passion. No matter how clever he may be, an eclectic is but a feeble man; for he is a man without love. Therefore he has no ideal . . . ; neither star nor compass. Doubt has led certain artists to beg the aid of all the other arts. Experiment with contradictory means, the encroachment of one art upon another, the importation of poetry, wit, and sentiment into painting—all these modern miseries are vices peculiar to the eclectics.

ARCHITECTURE

We begin with architecture, which not only initiated the postmodern dialogue in the arts but also puts the issues literally in concrete form.

Postmodernism

Postmodernism in art was first coined to denote an eclectic mode of architecture that arose around 1980. Because it is a style, we shall capitalize it to distinguish it from the larger phenomenon of postmodernism, to which it is intimately related. As the term implies, Postmodernism constitutes a broad repudiation of the mainstream of twentieth-century architecture. Although it uses the same construction techniques, Postmodernism rejects not only the vocabulary of

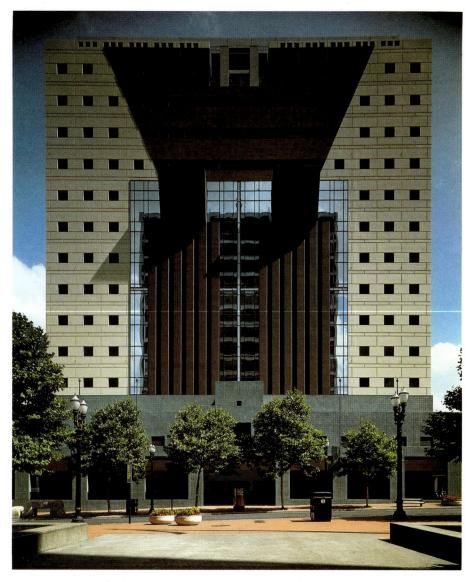

1232. Michael Graves. Public Services Building, Portland, Oregon. 1980-82

Gropius and his followers, but also the social and ethical ideals implicit in their lucid proportions. Looking at the Seagram Building (fig. 1181), we can well understand why: as a statement, it is overwhelming in its authority, which is so immense as to preclude deviation and so cold as to be lacking in appeal. The Postmodernist critique of the International Style was, then, essentially correct: in its search for universal ideals, it failed to communicate with people, who neither understood nor liked it. Postmodernism represents an attempt to reinvest architecture with the human meaning so conspicuously absent from the self-contained designs of High Modernism. It does so by reverting to what can only be called premodernist architecture.

The chief means of introducing greater expressiveness has been to adopt elements from historical styles rich with association. All traditions are assumed to have equal validity, so that they can be combined at will; but in the process, the compilation itself becomes a conscious parody characterized by ironic wit. This eclectic historicism is nevertheless highly selective in its sources. They are restricted mainly to various forms of classicism (notably Palladianism) and some of the more exotic strains of Art Deco, which, as we have seen (page 883), pro-

vided a viable alternative to modernism during the 1920s and 1930s. Architects have repeatedly plundered the past in search of fresh ideas. What counts is the originality of the final result.

VENTURI AND BROWN. The immediate antecedents of Postmodernism can be found in the work of Robert Venturi (born 1925) and his wife, Denise Scott Brown (born 1931). They realized that architecture in America had become so laden with pictorial and commercial imagery that they advocated overturning the modernist credo of "form follows function" by divorcing the symbolic quality of a facade from the building's purpose and structure. To accomplish that end, they created an architecture of banality, whose very triteness was proclaimed by ironic paraphrases of historical clichés from both the recent and distant past. Although few architects followed their lead in design, the theories of Venturi and Brown were important for opening the debate that led to Postmodernism.

GRAVES. The Public Services Building in Portland, Oregon (fig. 1232), by Michael Graves (born 1934) is exemplary of

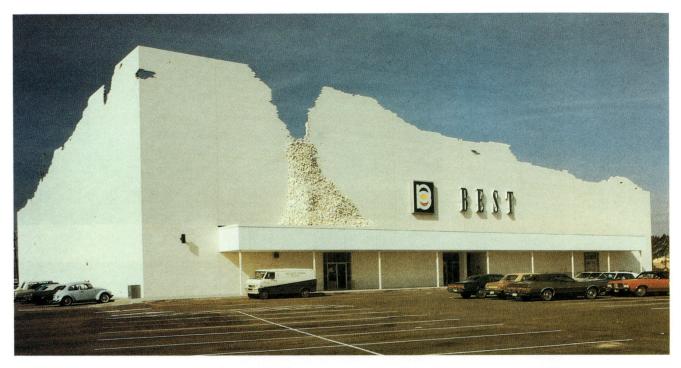

1233. SITE Projects Inc. with Maple-Jones Associates. Best Stores Showroom, Houston. 1975

Postmodernism. Elevated on a pedestal, it mixes classical, Egyptian, and assorted other motifs in a whimsical buildingblock paraphrase of Art Deco, which shared an equal disregard for historical propriety. In this way, Graves relieves the building of the monotony imposed by the tyranny of the cube that afflicts so much modern architecture. Although the lavish sculptural decoration was never added, the exterior has a surprising warmth that continues inside. At first glance, it is tempting to dismiss the Public Services Building as mere historicism. To do so, however, ignores the fact that no earlier structure looks at all like it. What holds this historical mix together is the architect's personal style. [See Primary Sources, no. 114, pages 948-49.] It is based on a mastery of abstraction that is as systematic and inimitable as Mondrian's. Indeed, Graves was a skilled Late Modernist who first earned recognition in 1969 at the same exhibition held by the Museum of Modern Art in New York that showcased Richard Meier (see page 890).

Today Postmodern buildings are being erected everywhere. They are instantly recognizable by their ubiquitous reliance on keyhole arches, round "Palladian" windows, and other relics from the architectural past. They are also marked by their ostentation. Postmodernism may be characterized as architecture for the rich that has since been translated downward to the middle class, surrounding it with an aura of luxury bespeaking the egocentricity and hedonism that spawned the "me" generation of the 1980s, one of the most prosperous and extravagant decades in recent history. Nevertheless, the retrospective eclecticism of Postmodernism soon became dated through the repetitious quotation of standard devices that were reduced to self-parodies lacking both wit and purpose. In a larger sense, however, this quick passage reflects the restless quest for novelty and, more important, a new modernism that has yet to emerge to replace the old.

SITE. In its playfulness and complexity Postmodernism has rightly been compared to Mannerist architecture, which similarly introduced a note of decadence into the classical vocabulary inherited from the Renaissance. Both share an element of self-conscious burlesque as well that reaches a climax in the designs by SITE Inc. for Best Stores, such as one in a Houston mall (fig. 1233) that looks for all the world to be crumbling into ruins (compare fig. 660). This droll takeoff on standard commercial architecture is enhanced by the bleakness of the location itself.

The differences are equally profound, however. Postmodernism arises out of the general sense of disillusionment that bedevils our age and prevents the architect from seeing either the past or the present with innocent eyes. Such a claim might well be made of Mannerist architecture, of course. But because architects today must design for different "taste-cultures," the eclecticism of Postmodernism is intended as a reflection of our "social and metaphysical reality." Historicism, then, is part of the new pluralism, which can even incorporate a parody of modernism itself. But such parodies also change old meanings into new ones through "double-coding," which combines modernist techniques and traditional styles to communicate on a new plane with the public and architects alike. The result is a content that is entirely up-to-date, despite the apparent familiarity of its hybrid style.

STIRLING. The Postmodernist critique of Late Modernism is that the latter is committed to the tradition of the new and therefore maintains modernism's integrity of invention and usage. Moreover, it lacks both pluralism and a complex relation to the past, so that it fails to transform meaning. We may test this for ourselves by comparing the Pompidou Center (fig. 1196) with the Neue Staatsgalerie in Stuttgart (fig. 1234), which was immediately recognized as a classic example of

1234. James Stirling, Michael Wilford and Associates. Neue Staatsgalerie, Stuttgart, Germany. Completed 1984

1235. Coop Himmelblau. Roof Conversion Project, Vienna. 1983–88

Postmodernism. The latter has the grandiose scale befitting a "palace" of the arts, but instead of the monolithic cube of the Pompidou Center, English architect James Stirling (born 1926) incorporates a greater variety of shapes within more complex spatial relationships. There is, too, an overtly decorative quality that will remind us, however indirectly, of Garnier's Paris Opéra (fig. 920). The similarity does not stop there. Stirling has likewise invoked a form of historicism through paraphrase that is far more subtle than Garnier's opulent revivalism, but no less self-conscious. The primly Neoclassical masonry facade, for example, is punctured by a narrow arched window recalling the Italian Renaissance (compare fig. 566) and by a rusticated portal that has a distinctly Mannerist look. At the same time, there is an exaggerated quoting of modernism through the use of such "hightech" materials as painted metal. This eclecticism is more than a veneer—it lies at the heart of the building's success. The site, centering on a circular sculpture court, is designed along the lines of ancient temple complexes from Egypt through Rome, complete with a monumental entrance stairway. This plan enables Stirling to solve a wide range of practical problems with ingenuity and to provide a stream of changing vistas that fascinate and delight the visitor. The results have been compared not inappropriately to the Altes Museum of Karl Friedrich Schinkel (fig. 909), among the most insistently classical structures of the nineteenth century. By comparison, the Pompidou Center is arguably a far more radical building!

1236. Behnisch and Partner. Hall between Laboratory Wings, Hysolar Research Institute, University of Stuttgart. 1987

Deconstructivism

Although it claims to deal with the substance as well, in the end Postmodernist historicism addresses only the decorative veneer of the International Style. Spurred by more radical theories, Deconstructivism, another tendency that has been gathering momentum since 1980, goes much farther in challenging its substance. It does so by likewise engaging in appropriation. Oddly enough, it returns to one of the earliest sources of modernism: the Russian avant-garde. The Russian experiment in architecture proved short-lived, and few of its ideas ever made it beyond the laboratory stage. Recent architects, inspired by the bold sculpture of the Constructivists and the graphic designs of the Suprematists, seek to violate the integrity of modern architecture by subverting its internal logic, which the Russians themselves did little to undermine. Nevertheless, Deconstructivism does not abandon modern architecture and its principles altogether, and remains an architecture of the possible based on structural engineering.

Deconstructivism is a new term that combines Constructivism and deconstruction. Strictly speaking there can be no architecture of deconstruction, because building puts things together instead of taking them apart. Deconstructivism nevertheless follows similar principles and is symptomatic of post-modernism as a whole. It does so by dismembering modern architecture, then reassembling it again in new ways. Although it claims Michelangelo, Bernini, and Guarini as its ancestors, Deconstructivism goes far beyond anything that can be found in earlier architecture. We will find little common ground among its practitioners. The main devices they have in common are superimpositions of clashing systems or layers of space, and distortions from within that subvert the normal vocabulary and purposes of modern architecture.

COOP HIMMELBLAU. Although Deconstructivist designs have won major awards, their experimental approach and ambitious scale have discouraged actual construction. The most advanced designs to get off the drawing board have generally been relatively modest affairs, but no less exciting for that fact. The roof conversion for a Viennese lawyer's office by Coop Himmelblau (fig. 1235) has well been described as "a writhing, disruptive, animal breaking through the corner." The internal disturbances are incorporated into the structure itself: "It is as if some kind of parasite has infected the form and distorted it from the inside." This is directly akin to how deconstruction uses language.

BEHNISCH AND PARTNER. An equally brilliant example is the Hysolar Research Institute at the University of Stuttgart (fig. 1236) by the firm of Behnisch and Partner. The hall between the laboratory wings both reflects and parodies the scientific work being carried on. The materials suggest the "high-tech" purpose of the project, which is to investigate energy based on hydrogen produced by solar power, while the free-flowing passage indicates the collaborative exchange of ideas. Yet the sensation produced by the collision of twisted forms is not unlike careening down a roller coaster. Nothing, it seems, works the way it should in the orderly world of modern science!

1237. Bernard Tschumi Architects. Plan of Parc de La Villette, Paris. 1983

TSCHUMI. One of the first architects avowedly influenced by deconstruction is Bernard Tschumi (born 1944). The most complete embodiment of his Deconstructivism is the Parc de La Villette in Paris, for which the founder of deconstruction, Jacques Derrida (see Postscript), later wrote an essay in the brochure explaining the project. The park's program was set by the fact that it had to include a variety of functions (workshop, baths, gymnasium, playground, concert facilities) and other parks and buildings already on the site. Tschumi's solution is directly related to this fact and presents an intelligent solution to what could have been a hopelessly complex problem that would have overwhelmed any traditional approach.

To describe the Parc de La Villette, we must resort to the coded terminology of Deconstructivism itself. The architect began by laying out the grounds in a simple abstract grid to provide a strong, yet flexible conceptual framework for change, improvisation, and substitution; he then subverted it by superimposing two other grid systems on it (fig. 1237), so as to

1238. Bernard Tschumi Architects. Folie P6, Parc de La Villette, Paris. 1983

prevent any dominant hierarchy or clear relation between the program and the solution. This multiple grid is deliberately antifunctional, anticontextual, and infinite. (In principle, it could be extended in any direction indefinitely.) Tschumi creates highly unorthodox relationships through decentralization, fragmentation, combination, and superimposition of elements, so that the architecture appears to serve no purpose. He further supplants form, function, and structure with contiguity, substitution, and permutation. To undermine the traditional rules of composition, hierarchy, and order, he uses crossprogramming (using space for a different purpose than intended), transprogramming (combining two incompatible programs and spaces), and disprogramming (combining two programs to create a new one from their contradictions). The functions are dispersed through a series of buildings (folies) whose components, appearance, and uses are interchangeable. The play between free and rigid form within this multiplicity leads to ambiguity, disorder, impurity, imperfection. The result denies any inherent meaning to the forms, structure, or organization.

What does all this theory have to do with the actual experience? Surprisingly little. The ensemble is meant to induce a sense of disassociation, both within and between its elements, that conveys an unstable programmatic madness (*folie*) through a form of cinematic montage inspired by the films of the Russian Sergei Eisenstein and others. However, the visitor is hardly aware of this effect. On the contrary, the system creates an order and rhythm of its own, whether Tschumi intended it or not. We are left only with a feeling of enchantment, which suggests the more playful meaning of *folie*, not just madness. The *folies* themselves resemble large-scale sculptures extended almost to the breaking point (fig. 1238). Yet the tension between the reality of the built structures and their "impossibility" results in an architecture of rare vitality. It is especially fitting that two of the most captivating *folies* are for

use by children. Although the architect insists that he was not expressing himself, this effect is perhaps the ultimate test of the park's success. Tschumi himself acknowledges the fact indirectly by speaking of affirmative deconstruction—a self-contradiction if ever there was one!

We may yet see one Deconstructivist deconstructing the work of another Deconstructivist. Peter Eisenman (born 1932) has designed a second garden for the Parc de La Villette that poses what might be called "the battle of the grids": Tschumi's versus Eisenman's version of Deconstructivist point grid, which the latter claims to have discovered first. And in this case, it was designed with Derrida's collaboration from the start. To pull it off, Eisenman has added new layers of ever more complex rhetoric (called "tropes" in the current parlance) to justify what amounts to skillful one-upmanship. Since the plan has yet to be built, it remains to be seen whether the results will support the dense verbiage.

POSTMODERN VS. DECONSTRUCTIVISM. Try as their adherents might to deny it, Postmodernism and Deconstructivism are really two sides of the same postmodernist coin, which has pushed modern architecture to its limits. As a style Postmodern challenges it from the outside, while Deconstructivism as an approach corrupts it from within. It is a measure of how far things have proceeded that in 1988 Philip Johnson, who helped to design the interior of the Seagram Building and was himself the architect of one of the most controversial Postmodern buildings (the AT&T Building in New York), declared modern architecture to be dead and mounted an exhibition of Tschumi, Eisenman, and several other Deconstructivists. This sort of questioning has gone on before. Postmodernism is a transition much like Art Nouveau at the turn of the century, which provided part of the foundation for modern architecture. It is a necessary part of the process that will redefine architecture as we have come to know it.

1239. Luciano Fabro. *The Birth of Venus.* 1992. Onyx and marble, 8'7¹/2" x 2'3¹/2"x 3'10¹/2" (2.63 x .70 x 1.18 m). Courtesy of Galerie Durand-Dessert, Paris

1240. Nam June Paik. *TV Buddha.* 1974. Video installation with statue. Stedelijk Museum, Amsterdam

SCULPTURE

FABRO. Traditional sculpture has such a little role in postmodernism that it seems almost out of place when it does make an appearance. A rare example is *The Birth of Venus* (fig. 1239) by Luciano Fabro (born 1936), an original member of the Arte Povera movement (see page 837) who works in a wide variety of styles and techniques. The roughed-out "figure" is attached like a misshapen cocoon to the eroded capital atop the smooth column drums, all of contrasting color. What might she look like? Unlike Michelangelo's Awakening Slave (fig. 3), Fabro's Venus remains imprisoned within the marble forever, with no more than the barest outlines to hint at her possible shape. Curiously enough, the column more closely resembles a statue, the Archaic Greek "Peplos" Kore in figure 152, than does this strange appendage. Although some would deny it, The Birth of Venus is clearly a postmodern work. What makes it so is the improbable juxtaposition, which is a knowing misquotation of the past. Yet the ironic takeoff is accomplished with all the gravity of an artist for whom sculpture is both a living tradition and a dead language to be revived—a serious business that nevertheless does not preclude an element of irreverence for this vestigial relic. The real surprise is that the piece is so effective, for in its muteness it contains a spellbinding mystery.

PAIK. Sculpture today descends mainly from the work of Joseph Beuys, who, with Andy Warhol and John Baldessari, may be regarded as the patron saint of postmodern art (see pages 871, 834, and 870). The notes and photographs that document Beuys' performances and installations hardly do them justice. His chief legacy today lies perhaps in the stimulation he provided his many students and collaborators. Among them was Nam June Paik (born 1932). The sophisticated video displays of the Korean-born Paik fall outside the scope of this book; but his installation with a Buddha contemplating himself on television (fig. 1240) is a memorable image uniquely appropriate to the Information Age, in which the fascination with electronic media has replaced transcendent spirituality as the focus of life.

LONGO. The work of Robert Longo (born 1953) is the direct outgrowth of his experience in Performance art. Longo addresses disturbing issues in his large tableaux. These usually consist of wall pieces incorporating a variety of mediums, sometimes sound as well, but may also extend into space, so that they fall somewhere between assemblage and environments. Notable for their formal elegance, they are produced with the aid of collaborators, though the conception generally

1241. Robert Longo. *Now Everybody (For R. W. Fassbinder)*. 1982–83. Charcoal, graphite, and ink on paper, 8 x 16' (2.4 x 4.8 m); cast bronze, 6'7" x 2'4" x 3'9" (2.01 x .71 x 1.14 m). National Gallery, Budapest, Hungary

remains his. The effect produced by these conflicting elements can be unsettling, in keeping with the provocative subject matter. Longo's characteristic theme is violence and alienation in the artificial world of the urban middle class. The figure in *Now Everybody* (fig. 1241) is seen in a pose inspired by discothèques that, upon closer inspection, is strangely contorted, as if he had been shot or struck by an unseen force. He is engaged, we realize, in the universal dance of death that belies his sheltered life. Despite Longo's attempt to give the subject a larger meaning, it seems strangely characteristic of the 1980s, a decade memorable chiefly for its shallowness.

INSTALLATIONS. Why have installations become such a focal point of postmodernism? They may be regarded as the ideal manifestations of the deconstructionist idea of the world as "text," whose intent can never be fully known even by its author so that "readers" are free to interpret it in light of their own understanding (see Postscript). The installation artist creates a separate world that is a self-contained universe, at once alien and familiar. Left to their own devices to wander this microcosm, viewers bring their own understanding to bear on the experience in the form of memories that are elicited by the novel environment. In effect, then, they help to write the "text." In themselves, installations are empty vessels: they may contain anything that "author" and "reader" wish to put into them. Hence, they serve as ready vehicles for expressing social, political, or personal concerns, especially those that satisfy the

postmodern agenda. The installation as text can become deliberately literal: it is often linked to a text that makes the program explicit.

KABAKOV. Russian artists have a special genius for installations. Cut off for decades from contemporary art in the West, they developed mostly provincial forms of painting and sculpture. Yet that very isolation allowed them to cultivate a unique brand of Conceptual Art that in turn provided the foundation for their installations. The first to gain international acclaim was Ilya Kabakov (born 1933), who now keeps his studio in New York. "Ten Characters" was a suite of rooms like those of a seedy communal apartment, each inhabited by an imaginary person possessed of an "unusual idea, one all-absorbing passion belonging to him alone." The most spectacular was *The* Man Who Flew into Space from His Apartment (fig. 1242): he achieved his dream of flying into space by being hurled from a catapult suspended by springs while the ceiling and roof are blown off at the precise moment of launching. Like the other rooms, it was accompanied by a text of Dostoyevskian darkness written by the artist, reflecting the Russian talent for story-telling. The installation was more than an elaborate realization of this bizarre fantasy, however. The extravagant clutter was a sardonic commentary encapsulating a wealth of observations that reflect the peculiar dilemmas of life in the former Soviet Union—its tawdry reality, its broken dreams, the pervasive role of central authority.

1242. Ilya Kabakov. *The Man Who Flew into Space from His Apartment*, from "Ten Characters." 1981–88. Mixed-media installation at Ronald Feldman Fine Arts, New York, 1988 Courtesy Ronald Feldman Fine Arts

1243, 1244. Ann Hamilton. *parallel lines.* Two parts of an installation in two rooms, São Paulo Bienal, September–December 1991. Mixed media

Courtesy Richard Ross

HAMILTON. Kabakov was inspired in part by the example of Beuys, who was also an influence on the young American installation artist Ann Hamilton (born 1956). Her work is about loss, be it from personal tragedy or distortion of a natural relationship. Unlike Beuys, she seeks only to raise issues, not to resolve them, a matter that is left to the visitor. Yet she uses many of the same means: her installations involve all of the senses through the use of unusual materials, often in disturbing ways, in order to present a paradox that lies at the center of each work. She exercises these choices through a train of free association until the idea crystallizes. Her installations are labor-intensive—obsessively, even ritualistically, so. Thus parallel lines for the 1991 São Paulo Bienal (figs. 1243 and 1244) began with assistants coating the walls of one gallery with soot from burning candles, then attaching sequentially numbered copper tags to the floor (an interest in seriality that is basic to Conceptual Art). Finally, a huge bundle of candles was placed in the room, so as to dominate it. A second room, covered entirely in the same copper tags, held nothing but two glass library cases containing turkey carcasses that were slowly devoured by beetles. This assault on the viewer's senses—and sensibilities—was intended to pose a number of questions. What is collected, why, and by whom? What is the moral difference between showing candles made by people from the fat of dead animals and exhibiting a dead bird with beetles carrying out their natural role as scavengers? Although death was treated matter-of-factly, there was a strangely mournful air to the entire installation, which invited viewers to ponder these matters and to arrive at their own conclusions.

HOWARD. Mildred Howard (born 1945) uses many of the same principles as Hamilton, but constructs her installations as specifically African-American statements. A social activist, she draws chiefly on her own life to define the black experience. To her, memory is both individual and ethnic. Thus *Tap: Investigation of Memory* (fig. 1245) resonates with multiple layers of personal and cultural meaning. It celebrates the importance of this dance form to the artist's family during her childhood, as well as the special contribution African-Americans have made to it. The taps, labeled "Traveler" significantly enough, are lined up ritualistically in rows, with

1245. Mildred Howard. *Tap: Investigation of Memory.* 1989. Travelers' shoe taps, in antique 3-seat shoeshine stand, assorted painted shoes, and delayed playback of an ambient sound, 10' x 13'6" x 51'6" (3 x 4 x 15.5 m). Collection the artist Courtesy Gallery Paule Anglim, San Francisco

shoes in solemn procession down the center aisle, before a beat-up shoeshine stand which becomes a shrinelike altar. The spiritual references are intentional. Movement is closely identified in Howard's mind with African-American worship—especially as practiced in store-front churches, the subject of another of her installations—in contrast to the somber introspection traditional to Western churches. Yet *Tap* succeeds precisely because of the contemplative atmosphere, which evokes a broad range of associations.

1246. David Salle. *Miner.* 1985. Oil, wood, metal tables, and fabric, 8' x 13'7" (2.4 x 4.1 m). Collection Philip Johnson, New Canaan

Courtesy Gagosian Gallery, New York

1247. A. R. Penck. The Demon of Curiosity. 1982. Acrylic on canvas, 9'2¹/4" x 9'2¹/4" (2.8 x 2.8 m). The Rivendell Collection of Late-Twentieth Century Art on permanent loan to the Center for Curatorial Studies, Bard College, Annandale-on-Hudson, New York Courtesy Michael Werner Gallery, New York and Cologne

PAINTING

Painting, like sculpture, is a traditional medium that does not lend itself well to postmodernism. Indeed, it is arguable that most of what passes as postmodern painting is really late modernism in disguise. In any event, there is no fixed boundary between the two. To the extent that it can be said to exist at all, however, postmodern painting is an outgrowth of Conceptualism, Pop Art, and Neo-Expressionism. Yet it differs from them in a fundamental respect: now painting acts like a deconstructed text gutted of all significance, except for whatever we choose to add by way of free association from the reservoir of our own experience.

How did painting come to be so barren of content? Traditional vehicles such as allegory require a shared culture. However, this is hardly possible in the postmodern age, despite the concept of the "global village," for our civilization is more fractured than ever. Deconstruction, moreover, proclaims the death of the author and subject matter as unnecessary vestiges of humanism, thus rendering meaning null and void. It argues instead that representation in its broadest sense is both unnecessary and undesirable on the grounds that it strives to re-create a fraudulent reality, and therefore can never provide an authentic experience. Such an attitude is not confined to deconstruction, however. It is inherent in postmodernism as a whole.

SALLE. The postmodern approach to painting is demonstrated by the work of David Salle (born 1952), a controversial figure who often incorporates racy images of nude women. (He worked for a while as a layout artist for a pornographic magazine.) An appropriation artist by nature, he derived everything in *Miner* (fig. 1246) from other sources: the

Depression-era picture of a miner with two diamond rings superimposed on his jacket, and the bust of a girl hovering like a neon sign in front of the partial view of an interior. Although his technique is conventional enough, the treatment is novel. The miner's head, for example, is flanked by two smashed metal tables, as if to represent his "thoughts." By combining different objects and materials, the diptych becomes a pictorial counterpart to installations by his friend Robert Longo (see fig. 1241), and in principle there is very little difference between them. Salle's disregard for art-historical decorum in juxtaposing unrelated elements is as great as Michael Graves' (see fig. 1232), and reflects his training under the Conceptual artist John Baldessari, for whom anything goes (compare fig. 1152). Salle is clearly a gifted painter, so that we are forced to take him seriously, despite reservations that his reputation (like that of so many other artists in the 1980s) was driven by the art market's need to find a new "star." Yet the syntax is so disjunctive that Miner refuses to yield a satisfactory meaning, try as we might to discover one.

PENCK. Salle had much in common with a group of post-modern artists from the former German Democratic Republic who have helped to make Germany the leading school of painting in the West today. Perhaps the most interesting among them is A. R. Penck (born 1939). Penck is the pseudonym adopted by Ralf Winkler from a famous geologist whose specialty was the Ice Age. In fact, the artist lived in East Germany throughout most of the Cold War, a political "ice age" of its own, before emigrating to the West in 1980. The "primitive" and "childish" quality in *The Demon of Curiosity* (fig. 1247), with its colorful directness, is deceptive. Although

1248. Mark Tansey.

Derrida Queries De Man.
1990. Oil on canvas,
6'11" x 4'7"
(2.13 x 1.4 m).

Collection Michael and
Judy Ovitz,
Los Angeles

Courtesy Curt Marcus Gallery,
New York

to discuss Postmodernism in Music and Theater

It is hardly possible to discuss Postmodernism in music, which

to date has not yielded significant results on matters of appropriation and deconstruction. The closest it has come to is Minimalism. The composer Lukas Foss, who has been practicing a form of Minimalism since the late 1970s, describes his Quintets for Orchestra (1979) in terms very similar to deconstruction: "A five-note chord dominates the composition. It is endlessly repeated, varied, permutated, transposed, and inverted, invading the entire piece . . . like a wound." Theater, by contrast, is ideally suited to appropriation and deconstruction, especially the latter, since it readily permits viewers to participate actively in creating the text as they perceive it. The main tendency has been to reinterpret existing classics, as well as works of recent vintage, in extremely untraditional ways that challenge conventional ("received") ideas about their content and meaning. Such is the case with the Romanian director Andrei Serban (born 1943), who was strongly affected by

Peter Brook; Peter Sellars (born 1957), former director of the

American National Theater at the Kennedy Center in Washington, D.C.; Les Breuer (born 1937), director of the Mabou Mines company, who was influenced by Beckett, Brecht, and Grotowski, among others; and Robert Wilson (born 1942), who worked with Philip Glass and the choreographers Andrew de Groat and Lucinda Childs on Einstein on the Beach (1976). Wilson's own works, stemming from his collaboration with the autistic teen-ager Christopher Knowles, juxtapose elements of different cultures and media in surreal fashion. Perhaps the most important contribution has been made by the Environmental Theater of Richard Schechner (born 1934), who conceives of theater as a public event that can take place in any environment and assigns an active role to the audience. Every element of theater becomes independent of text-indeed, there need not be any text at all. None of these ideas is new in itself. Rather, it is the combination that matters.

largely self-taught, Penck uses a fluid technique that is, in fact, very sophisticated, making it a wonderfully sensitive vehicle for expressing every possible meaning. But what are we to make of the picture's content? At first glance, it seems as bewildering as the rock engraving at the Cave of Addaura. Upon closer inspection we realize that the artist's "code" can be broken, at least enough for us to understand the basic intent. The demon, as fierce as anything conjured up by Gauguin (compare fig. 980), is surmounted by a bird looking both ways that signifies inquisitiveness, to which the small crucified figure at the left has been sacrificed. The figures swim in a sea of hexlike signs, letters, and numbers, symbolizing knowledge, which fills up the man to the point where he seems literally "pregnant (or at least bloated) with meaning." The painting reflects Penck's fascination with cybernetics, the science of information systems. Indeed, to him the artist is a kind of scientist, and he sees little difference between the two.

TANSEY. If Penck follows in the footsteps of artists such as Paul Klee by inventing a personal vocabulary of pictographs, Mark Tansey (born 1949) uses the Roman alphabet to accomplish the seemingly impossible: construct representational images that are literally made up of texts following the principles of deconstruction. Derrida Queries De Man (fig. 1248) shows the founder of deconstruction with his chief American disciple, Paul de Man. If we look closely, we see that the landscape consists of typeset lines that merge to form the steep cliffs. Here the texture of the paint serves to bridge the gap between text and illustration by embedding the idea within the image. In this sense, the painting functions as an illustration of a metaphor. But what is it saying? Certainly it makes a serious point about the relation between content, picture, and reality. Yet it does so with surprising wit, beginning with the very idea of building a painting out of words. And, in a gesture of supreme irony, Tansey has appropriated the image from a famous illustration showing the death of Sherlock Holmes at the hands of his archenemy, Professor Moriarty! We have seen such humor before, in the work of René Magritte (see fig. 1062), who served as an early inspiration for Tansey. By precluding a literal reading of the painting, this astonishing juxtaposition opens up new lines of questioning for the viewer that never fully resolve themselves.

PHOTOGRAPHY

Photography, too, has taken up the theme of image as "text." Given the close association of words and photographs in Conceptual Art, such a move was perhaps inevitable. It was abetted, however, by the new importance attached to semiotics, which has opened up fruitful new avenues of investigation for the artist. How do signs acquire public meaning? What is the message? Who originates it? What (and whose) purpose does it serve? Who is the audience? What are the means of disseminating the idea? Who controls the media?

Photographers, especially in the United States, raise these questions in order to challenge our received notions of the world we live in and the social order it imposes. Unlike Joanne Leonard or David Hockney, postmodern photographers are "re-photographers" who for the most part do not take their

1249. Barbara Kruger. *You Are a Captive Audience*. 1983. Gelatin-silver print, 48 x 37³/4" (122 x 96 cm). Courtesy the artist and Annina Nosei Gallery, New York

own pictures but appropriate them from other mediums. To convey their message, these new Conceptualists often follow the formula established by Baldessari of placing image and text side by side (compare fig. 1152). Sometimes their pictures are intended as counterparts to paintings, and are enlarged on an unprecedented scale, using commercial processes developed for advertisements, which may also serve as sources. Here it is the choice of image that matters, since the act of singling it out and changing its context from billboard to gallery wall constitutes the comment. In both cases, however, we are asked to base our judgment on the message; the means of delivery deliberately shows so little individuality that it is often impossible to tell the work of one artist from another. In the process, however, the message often becomes equally forgettable.

KRUGER. That is not a problem with Barbara Kruger (born 1945), whose pictures are instantly recognizable for their confrontational approach. *You Are a Captive Audience* (fig. 1249) exemplifies her style. It usually involves a tightly cropped close-up in black and white taken from a magazine or newspaper and blown up as crudely as possible to monumental proportions, so that the viewer cannot escape its presence or the message, which is stenciled in white letters against a red background. The conjoining of unrelated text and image is clearly intended for radical ends. The challenging statement is intended to provoke acute anxiety by playing on people's latent fears in our society of being controlled by nameless forces, especially such large, impersonal power centers as the government, the military, or corporations.

1250. Annette Lemieux. Truth. 1989. Latex and acrylic on canvas, $7' \times 11'1" \times 1^1/2"$ (213.4 x 337.8 x 3.8 cm) Courtesy Josh Baer Gallery, New York

LEMIEUX. Kruger's work is like a sharp blow to the solar plexus: the message is direct, the response immediate, especially the first time around. The themes of Annette Lemieux (born 1957) are quieter but correspondingly more thoughtprovoking. Centering on social issues, they address the human condition without engaging in polemic. Lemieux has a particular gift for perceiving new possibilities of meaning in old photographs and illustrations. Truth (fig. 1250) is an image about sound—or, rather, the lack of it. The photograph, derived from a book on the history of radio, is a visual counterpart to the saying, "Hear no evil, speak no evil, see no evil." Transferred to canvas, it acquires a very different meaning in its new context. Stenciled in bold letters is the Russian proverb, "Eat bread and salt but speak the truth," which means roughly, "Be frank when accepting someone's hospitality." The lettering transforms the image from an amusing publicity photograph into an ominous-looking propaganda poster. Contrary to initial impressions, the issue is neither Russia nor Communism—the photograph features the famous American entertainer Jack Benny—but the role of the media in modern life. They enter our homes as guests without being candid: here the performer covers his mouth in order to speak no evil. Shielded by the medium itself, he distorts truth by selectively concealing information, not by telling a deliberate falsehood. Truth emerges as a matter of relative perspective, determined both by who controls it and who hears it.

SHERMAN. Not all postmodern photography is attached to words, nor is it taken simply from other sources. A curious in-between case is provided by Cindy Sherman (born 1954). [See Primary Sources, no. 115, page 949.] Among her best works are the early photographs that were staged in imitation of old movie stills. They are so skillfully realized that they look like the real thing. In them she fulfills the secret American dream of being star, caster, set designer, producer, and photographer, except that she does so almost vicariously. As her own star, she can assume any role she wants, and the choice is illuminating. Figure 1251 shows her predilection for 1940s and 1950s movies portraying beautiful women as vulnerable heroines. The picture is a perfect period piece, down to the last detail of costume, setting, and lighting. Only after we have looked at it for a while do we realize that the photograph raises intriguing questions about the image of women projected on the silver screen. Whether the message is feminist has been the subject of considerable debate. Is Sherman's use of herself merely an exercise in narcissism and her reliance on stereotypes no more than an example of shallow consumerism? Or is there a feminist sense of irony in her posing? However we choose to interpret it, the photograph is strangely affecting in its aura of nostalgia and the sense of mystery it communicates. Here the timeless image of the woman looking in the mirror is updated to receive among its most provocative—and puzzling—expressions ever. Sherman

1251. Cindy Sherman. *Untitled Film Still #2.* 1977. Photograph, 18 x 10" (45.5 x 25.5 cm)

Courtesy Metro Pictures, New York

offers voyeurism at second hand, so to speak, a fantasy compounded that forever precludes authentic experience. In that sense, it is a paradigm of postmodernism.

POSTSCRIPT: POSTMODERN THEORY

SEMIOTICS. Semiotics (the study of signs) may be regarded ultimately as a branch of philosophy. It has its foundations in ancient philosophy, as well as medieval theology, and its modern form is a direct outgrowth of Enlightenment rationalism. Moreover, the American school of semiotics was founded by a philosopher, Charles Sanders Pierce. Despite its seemingly endless diversity, semiotics retains some key features of all philosophical systems: it seeks a universal understanding, and its theoretical constructs frequently follow classical exemplars. It typically acts as a closed body of ideas, one that is concerned primarily with its inner logic, rather than presenting a corpus of knowledge.

It is impossible to summarize such a vast field here: to do so would require a book as long as this, since there are virtually innumerable permutations. In essence, semiotics provides a stimulating approach to the age-old conundrum: What does the mind know, and how does it know it? In an ultimate sense, the mind is elusive. To a Buddhist, for example, the mind cannot grasp itself, since it lacks physical substance and is ever-

changing; hence, it also has an almost endless capacity for self-delusion. Like most hermetic systems, semiotics generally assumes that the mind can know only itself through the concepts it builds. These act as filters through which all experience, internal as well as external, is interpreted. Semiotics is therefore little concerned with objective reality—if it exists at all—since it remains inherently unknowable and meaningless in itself, although some semiologists postulate meaning stemming from God or some form of pure Idea.

Modern semiotics begins with Ferdinand de Saussure. Like many revolutionary intellectuals, he came late in life to rebel against the very ideas he had devoted much of his career to in his case, philology, the study of language. His contribution lay in the intuitive realization that language cannot be explained simply in terms of its development, because it always functions as a coherent system. For the dynamic (diachronic) paradigm of philology he substituted a static (synchronic) model. At the center of Saussure's system is his definition of a sign as consisting of a concept (signified) and its sound-image (signifier), which is a purely mental impression, not the sound itself. Identity is defined purely by difference, a philosophically suspect approach. Most are binary oppositions (for example, good and evil), built up into larger structures of increasing complexity. As against traditional grammar, meaning is determined by structure and the relationships it imposes. Thus context becomes critical to understanding. Saussure further

distinguished between the everyday speech of the individual (parole) and language as a socially shared linguistic system (langue). Because there are no concrete objects in language, external reality has no place in his analysis—it is simply assumed to lie parallel to, or else to be unknowable outside of, langue. The problem with Saussure's semiology is that it proves incapable of dealing with language as an evolving system, which requires a more organic model, and thus with time in general, both as past and as future.

Semiotics constitutes a form of system analysis that in principle can be applied to almost anything. (Saussure's theories, for example, are comparable to those of Talcott Parsons in sociology; interestingly enough, both are indebted partly to the sociologist Émile Durkheim.) What counts is the coherence of the theory itself, not its basis in reality, which, as we have seen, is of secondary importance at best. Data are merely the point of departure for constructing the conceptual model, thus raising the question whether it has any relevance to real life. This suggests the main weakness of the structuralist approach to semiology: if the structure is undermined, then its related concepts are deprived of meaning, which is only an abstraction without independent existence. Logically the result must inevitably be chaos, an important point that we shall soon return to. We may nevertheless wonder whether this is necessarily so in actual fact.

In most cases, the relationship between sign and meaning is extremely complex. In human society it is arbitrary at face value and assigned only as a matter of convention; otherwise most symbols could not possibly be understood and would remain entirely private. This points to a fundamental difficulty besetting semiotics. Like most bodies of theory, it is encumbered by a torturous thought process and tedious jargon. Even granting the inadequacy of normal language to express the formal rhetoric of intellectual disciplines, it functions as a need-

lessly complex code system deliberately accessible only to "those in the know." The same critique may be taken to apply to the role of semiotics in contemporary art and art history.

DECONSTRUCTION. The assault on structuralist semiology that began in the late 1960s by the French philosopher Jacques Derrida soon blossomed into a wholesale war on traditional learning in all fields. Similar controversies have raged in philosophy before. The antecedents of deconstruction can be traced back to medieval Scholasticism, both the nominalism of thinkers like William of Ockham, which rejected universals, and supposition theory, in which context determines meaning. In fact, virtually all of its lines of argumentation are to be found in the catalogue of Scholasticism's infamous errors in logic, which are familiar to every student of philosophy. More intriguing still is the relation to music of the fourteenth century, which featured tropes (added pieces of texts and music), as well as suspensions and ambiguities of rhythm, that exactly parallel Derrida's usage. Deconstruction nonetheless has a peculiar flavor that is specifically postmodern.

Derrida considered the structuralist approach to be inadequate to explain the human condition, which he investigated by exploring his own consciousness. As we have seen, Saussure's semiotics contains the seeds of its own destruction. To Derrida language is structure to be dismantled. Against the structuralists, he asserted the primacy of the written word over the spoken, which it at first supplements, then supplants. Since all cultural products are texts in the sense of documents, everything—history, life itself—becomes a text. However, texts never mean what they seem to say, because sign and meaning are entirely separate. This contradicts the fundamental assumption of all semiotics; yet it is a possibility that semiotics itself allows, because of the arbitrary relation between sign and meaning in the first place. In deconstruction theory, everything is intertextual; that is, it is dependent on everything else, to the point where no trait can be isolated and no order or causality can exist. Furthermore, any term ("supplement") can be substituted for any other, so that it can pass for the original one, which it "infects" from inside. Because they are free to recombine, no element can be a self-sufficient sign and must refer to another one that is not present. This gives the reader a new latitude to create his or her own meaning by mixing fragments of text and varying their context, regardless of the author's intent, which can never be truly ascertained anyway. Language thus becomes "meaning-less," and truth a mere linguistic convention that implies an author and a subject, both of which deconstruction also rejects.

Deconstruction is adamantly against all forms of logocentrism (the belief that there are abstract truths that have a basis in reality), which is seen as an instrument of ethnocentrism (the belief that one's own culture is superior to others). It also rejects standard binary oppositions like good versus evil. To undermine such beliefs, it seeks out words that have multiple, even contradictory, meanings that are "undecidables," although these in turn sometimes become binary oppositions themselves!

Deconstruction relies on exceptions to disprove a principle. By focusing on weak points around the fringes where everything can be doubted and become unknowable, it creates an unending series of questions that cannot be answered. In addition to using obscure terms, a favorite technique of deconstruction is to invent new words ("neologisms") that combine bits of old ones to create unusual, often illogical meanings. A case in point is "différance," which compounds "to differ" and "to defer" to produce an "undecidable" by "suspending" between the two. Différance in this sense requires uniqueness of parts rather than coherence of whole. It ostensibly means the implicit reference to other "texts" which change or postpone indefinitely the meaning of the original one. This slip-

pery concept of time exploits, we will recall, an intrinsic limitation of structuralism, which is turned against itself.

As this suggests, deconstruction is subversive in its methodology. By destabilizing time and, with it, meaning, suspending permits deconstructionists to change the rules at will to suit their purpose, which is ultimately to overturn the structure of language in order to subvert logical thought. Not only does it go against all the accepted laws of reason, it disallows all exceptions or criticisms. It furthermore utilizes (and openly advocates) the deliberate misuse of terms, inappropriate synonyms, willful misquotes, irrational positions, extreme interpretations, and even personal attacks against its opponents.

To a deconstructionist, texts, not facts, are what count. Reality is at best a mental construct whose apparent meaning is determined by context (as opposed to structure). As a result, everything becomes ultimately unknowable—including one's own feelings, even though the individual is left to arrive at a purely subjective understanding. Hence, every understanding or interpretation is inherently false. Deconstruction denies the priority of any viewpoint, but implicitly holds its own above all others. It conveniently ignores the fact that despite its relativism, even deconstruction cannot fully escape the inherent authoritarianism of language, which creates its own logic structures. Moreover, it rarely, if ever, deconstructs its own texts, for it claims to be a "logic beyond all forms of reason."

Needless to say, deconstruction has provoked a storm of outrage from traditional intellectuals. It has been condemned as everything from irrational sophistry and contrived obscurantism to arid nihilism. Nevertheless deconstruction has had an extraordinary impact on contemporary thought, and remains a fascinating historical phenomenon. Of all the critiques mounted against deconstruction, perhaps the most telling is its predictability: once its unwritten rules are understood, the game is simple to play and each step easy to anticipate.

Primary Sources for Part Four

The following is a selection of excerpts from original texts by writers, critics, artists, architects, and photographers from the late eighteenth to the twentieth century. These readings are intended to supplement the main text and are keyed to it. Full citations are given in the Credits section at the end of the book.

78

Johann Joachim Winckelmann (1717–1768)

From Thoughts on the Imitation of Greek Works in Painting and Sculpture

Winckelmann's influential publications on classical antiquities, including Thoughts . . . (1755) and the History of Ancient Art (1764), laid the foundation for modern scientific archaeology.

To take the ancients for models is our only way to become great. . . . Their masterpieces reveal not only nature in its greatest beauty, but . . . certain ideal beauties of nature which . . . exist only in the intellect.

The most beautiful bodies found among us today might, perhaps not be more similar to the Greek bodies than Iphicles was to Hercules, his brother. . . . Take a young Spartan, bred, by a hero and heroine, never bound by swaddling clothes, who has slept on the bare ground from the age of seven and has been trained in wrestling and swimming from earliest infancy; put him beside a young Sybarite of our day and then decide which one the artist would choose as a model for a youthful Theseus. . . .

Through these exercises the bodies, free from superfluous fat, acquired the noble and manly contours that the Greek masters gave to their statues. . . . Everything that disfigured the body was carefully avoided; Alcibiades refused to play the flute in his youth because it might distort his face. . . . Furthermore, the clothing of the Greeks was so designed as not to interfere with the natural growth of the body, while today our tight and binding dress makes the natural beauty of our bodies suffer, especially at the neck, waist, and thighs. Even the fair sex of the Greeks refused any restricting fashions. . . .

The school of the artist was the gymnasium, where the youths, ordinarily clothed because of modesty, exercised quite naked. It was the gathering place of philosophers as well as artists: Socrates visited it to teach Charmides, Artolycus and Lysis; Phidias went there to enrich his art with these magnificent figures. There one learned the movement of muscles, and studied the contours of the body. . . . The most beautiful aspects of the nude revealed themselves here in many varied and noble poses unattainable by hired models such as are used in our academies. . . .

These frequent opportunities for observing nature caused the Greek artists to go even further: they began to form general concepts of beauty for the individual parts of the body as well as for its proportions: concepts that were meant to rise above nature, being taken from a spiritual realm that existed only in the mind.

In this way Raphael formed his Galathea. As he says in his letter to Count Balthasar Castiglione, "Since beauty is rare among women, I follow a certain idea formed in my imagination. . . ."

The imitation of natural beauty either focuses upon a single model or it collects data from many models and combines them. The first produces a faithful copy, a portrait; it leads to the shapes and figures of Dutch art. The second, however, leads to universal beauty and its ideal images, and this is the path taken by the Greeks.

79

Étienne-Louis Boullée (1728–1799) From *Architecture*, *Essay on Art*

Boullée's philosophy was in the Romantic tradition of Jean-Jacques Rousseau. In this introduction to an undated manuscript, he set down his visionary ideas on architecture.

TO MEN WHO CULTIVATE THE ARTS

Dominated by an excessive love for my profession, I have surrendered myself to it completely. But although I have yielded to this overweaning passion, I have made it a rule that I shall work for the benefit of society and thus merit public esteem.

I should confess straightaway that I have refused to confine myself to the exclusive study of our ancient masters and have instead tried, through the study of Nature to broaden my ideas on my profession which, after much thought, I consider to be still in its infancy.

What little attention has been paid in the past to the poetry of architecture, which is a sure means of adding to man's enjoyment and of bestowing on artists the fame they deserve!

That is my belief. Our buildings—and our public buildings in particular—should be to some extent poems. The impression they make on us should arouse in us sensations that correspond to the function of the building in question. It seemed to me that if I was to incorporate in my Architecture all the poetry of which it was capable, then I should study the

theory of volumes and analyse them, at the same time seeking to understand their properties, the power they have on our senses, their similarities to the human organism. I flattered myself that if I went back to the source of all the fine arts I should find new ideas and thus establish principles that would be all the more certain for having their source in nature.

You who are fascinated by the fine arts, surrender yourselves completely to all the pleasure that this sublime passion can procure! No other pleasure is so pure. It is this passion that makes us love to study, that transforms our pain into pleasure and, with its divine flame, forces genius to yield up its oracles. In short, it is this passion that summons us to immortality.

It is to you who cultivate the arts that I dedicate the fruits of my long vigils; to you who, with all your learning, are persuaded—and doubtless rightly so—that we must not presume that all we have left is to imitate the ancients!

80

Jean-Auguste-Dominique Ingres (1780–1867) From "The Doctrine of Ingres"

Maurice Denis, a member of the Nabis, compiled these aphorisms from Ingres' notebooks and from the reminiscences of his students.

Art should only depict beauty. . . .

Do you believe that I send you to the Louvre to find ideal beauty, something different from that which is nature? Similar idiocies in ill-fated epochs brought about the decadence of art. I send you there because you will learn from the ancients to see nature because they are themselves nature; one must be nourished by them. . . .

And no matter what your genius, if you paint to the last stroke not according to nature, but your model, you will always be its slave; your manner of painting will smack of servitude. The proof of the contrary is seen in Raphael. He tamed the model to such a point and possessed it so thoroughly in his memory, that instead of the model giving him orders, one would say that the model obeyed him. . . .

To form yourself in beauty, . . . walk with your head raised to the sky instead of keeping it toward the earth like pigs searching in the mud. . . .

The figures of antiquity are only beautiful because they resemble the beauty of nature. . . . And nature will always be beautiful when it resembles the beauties of antiquity. . . .

Study vases, it was with them that I began to understand the Greeks. . . .

I will write on the door of my studio: School of drawing, and I will make painters.

Drawing is the probity of art. . . .

Smoke itself should be expressed by a line.

Drawing is everything; it is all of art. The material processes of painting are very easy and may be learned in eight days. . . .

There is neither correct nor incorrect drawing; there is only beautiful or ugly drawing. That is all! . . .

Colour [is] one of the ornaments of painting, the lady with her sister's finery, because it is colouring which brings the amateurs and the admirers to the more important perfections of art.

In front of Rubens, put on blinders like those a horse wears.

Eugène Delacroix (1798–1863) From his *Journal*

Delacroix began his Journal in 1822 and maintained it irregularly until his death in 1863. He wrote it, he said, "for myself alone" in the hope that it would "do me a lot of good." This entry, dated October 20, 1853, was recorded at Champrosay.

What an adoration I have for painting! The mere memory of certain pictures, even when I don't see them, goes through me with a feeling which stirs my whole being. . . .

The impressions produced by the arts on sensitive organisms are a curious mystery: confused impressions, if one tries to describe them, clear-cut and full of strength if one feels them again, and if only through memory! I strongly believe that we always mix in something of ourselves with feelings which seem to come from the objects that strike us. It is probable that the only reason why these works please me so much is that they respond to feelings which are my own. . . .

The type of emotion peculiar to painting is, so to speak, tangible; poetry and music cannot give it. You enjoy the actual representation of objects as if you really saw them, and at the same time the meaning which the images have for the mind warms you and transports you. These figures, these objects, which seem the thing itself to a certain part of your intelligent being are like a solid bridge on which imagination supports itself to penetrate to the mysterious and profound sensation for which the forms are, so to speak, the hieroglyph, but a hieroglyph far more eloquent than a cold representation, a thing equivalent to no more than a character in the printer's font of type. . . .

They are strangely deceived if they think that when they have written: a foot or a hand, they have given to my mind the same emotion as the one I experience when I see a beautiful foot or a beautiful hand. The arts are not algebra, in which the abbreviation of the figures contributes to the success of the problem; success in the arts is by no means a matter of abridging, but of amplifying, if possible, and prolonging the sensation by all possible means. What is the theater? One of the most certain witnesses to man's need for experiencing the largest possible number of emotions at one time. It gathers together all the arts so that each may make us feel their combined effect more strongly.

Rosa Bonheur (1822–1899) From *Reminiscences of Rosa Bonheur*

Bonheur's father, Raymond, was a landscape painter and a disciple of the utopian socialist Henri de Saint-Simon, who considered the artist the priest of his "new Christianity" and thought the Messiah of the future would be, as Bonheur states here, a woman. These reminiscences were published in 1910.

I have never counseled my sisters of the palette to wear men's clothes in the ordinary circumstances of life.

If, however, you see me dressed as I am, it is not in the least in order to make me into an original, but simply to facilitate my work. Consider that, at a certain period in my life, I spent whole days at the slaughterhouse. . . . I also had the passion for horses. Now where better to study these animals than in the fairs. . . . I was forced to recognize that the clothing of my sex was a constant bother. That is why I decided to solicit the authorization to wear men's clothing from the prefect of police.

But the suit I wear is my work attire, and nothing else. The epithets of imbeciles have never bothered me. . . .

Two years ago (October 8, 1896) on the occasion of the reception of the Russian royalty in Paris, the minister of the fine arts had the desire to introduce to them the leading figures of French art. . . . I wore my beautiful suit of black velvet and my little feathered bonnet. . . .

From the moment I arrived at the Louvre, I would have given I do not know what to have had on my head my gray felt hat. I was the only woman, in the middle of a crowd of men. . . . All the eyes turned toward me; I didn't know where to hide myself. This was a harsh test, and that day I really missed my masculine attire, I can assure you. . . .

In spite of my metamorphosis of costume, there is no daughter of Eve who appreciates more than I the nuances; my brusque and almost savage nature never prevented my heart from always remaining perfectly feminine. . . .

Why wouldn't I be proud of being a woman? My father, that enthusiastic apostle of humanity, repeated to me many times that woman's mission was to uplift the human race, that she was the Messiah of future centuries. I owe to his doctrines the great and proud ambition that I conceived for the sex to which I take glory in belonging and whose independence I will uphold until my last day. Moreover, I am persuaded that the future belongs to us.

83

John Constable (1776–1837) From a letter to John Fisher

Fisher, the archdeacon of Salisbury Cathedral, was a lifelong friend of the artist. This letter of October 23, 1821, reflects How much I wish I had been with you on your fishing excursion in the New Forest! What river can it be? But the sound of water escaping from mill-dams, etc., willows, old rotten planks, slimy posts, and brickwork, I love such things. Shake-speare could make everything poetical; he tells us of poor Tom's haunts among "sheep cotes and mills." As long as I do paint, I shall never cease to paint such places. They have always been my delight, and I should indeed have been delighted in seeing what you describe, and in your company, "in the company of a man to whom nature does not spread her volume in vain." Still I should paint my own places best; painting is with me but another word for feeling, and I associate "my careless boyhood" with all that lies on the banks of the Stour; those scenes made me a painter, and I am grateful; that is, I had often thought of pictures of them before I ever touched a pencil.

John Ruskin (1819–1900)

The Stones of Venice, from Chapter 6,

"The Nature of the Gothic"

Ruskin's Stones of Venice, published in 1853, praised Venetian Gothic architecture while condemning its Renaissance buildings. The Gothic was very popular in the nineteenth century.

It is verily this degradation of the operative into a machine, which, more than any other evil of the times, is leading the mass of the nations everywhere into vain, incoherent, destructive struggling for a freedom of which they cannot explain the nature to themselves. . . .

For observe, I have only dwelt upon the rudeness of Gothic, or any other kind of imperfectness, as admirable, where it was impossible to get design or thought without it. . . . In art, delicate finish is desirable from the greatest masters, and is always given by them. . . . But lower men than these cannot finish, for it requires consummate knowledge to finish consummately, and then we must take their thoughts as they are able to give them. . . . Above all, demand no refinement of execution where there is no thought, for that is slaves' work. . . .

We are always in these days endeavoring to separate the two; we want one man to be always thinking, and another to be always working, and we call one a gentleman, and the other an operative; whereas the workman ought often to be thinking, and the thinker often to be working, and both should be gentlemen, in the best sense. As it is, we make both ungentle, the one envying, the other despising, his brother; and the mass of society is made up of morbid thinkers, and miserable workers. Now it is only by labor that thought can be made healthy, and only by thought that labor can be made happy, and the two cannot be separated with impunity. . . .

Enough, I trust, has been said to show the reader that the

rudeness or imperfection which at first rendered the term "Gothic" one of reproach is indeed, when rightly understood, one of the most noble characters of Christian architecture, and not only a noble but an essential one. It seems a fantastic paradox, but it is nevertheless a most important truth, that no architecture can be truly noble which is *not* imperfect. . . .

Wherever the workman is utterly enslaved, the parts of the building must of course be absolutely like each other; for the perfection of his execution can only be reached by exercising him in doing one thing, and giving him nothing else to do. The degree in which the workman is degraded may be thus known at a glance, by observing whether the several parts of the building are similar or not; and if, as in Greek work, all the capitals are alike, and all the mouldings unvaried, then the degradation is complete; . . . if, as in Gothic work, there is perpetual change both in design and execution, the workman must have been altogether set free.

85

Charles Baudelaire (1821–1867)
"The Modern Public and Photography,"
from Part 2 of *The Salon of 1859*

Baudelaire, now known for his controversial poems The Flowers of Evil (1857), was an important Parisian art critic at mid-century. The photographer Nadar was one of his close friends.

In this country, the natural painter, like the natural poet, is almost a monster. Our exclusive taste for the true . . . oppresses and smothers the taste for the beautiful. Where only the beautiful should be looked for . . . our people look only for the true. They are not artistic, naturally artistic. . . .

In the domain of painting and statuary, the present-day credo of the worldly wise, especially in France . . . is this: I "believe in nature, and I believe only in nature. . . . I believe that art is, and can only be, the exact reproduction of nature. . . . Thus if an industrial process could give us a result identical to nature, that would be absolute art." An avenging God has heard the prayers of this multitude; Daguerre was his messiah. And then they said to themselves: "Since photography provides us with every desirable guarantee of exactitude . . . art is photography." From that moment onwards, our loathsome society rushed, like Narcissus, to contemplate its trivial image on the metallic plate. . . .

I am convinced that the badly applied advances of photography, like all purely material progress for that matter, have greatly contributed to the impoverishment of French artistic genius. . . . Poetry and progress are two ambitious men that hate each other, with an instinctive hatred, and when they meet along a pathway one or other must give way. If photography is allowed to deputize for art in some of art's activities, it will not be long before it has supplanted or corrupted art altogether, thanks to the stupidity of the masses, its natural

ally. Photography must, therefore, return to its true duty, which is that of handmaid of the arts and sciences. . . . Let photography quickly enrich the traveller's album, and restore to his eyes the precision his memory may lack; let it adorn the library of the naturalist, magnify microscopic insects, even strengthen, with a few facts, the hypotheses of the astronomer; let it, in short, be the secretary and record-keeper of whomsoever needs absolute material accuracy for professional reasons. . . . But if once it be allowed to impinge on the sphere of the intangible and the imaginary, on anything that has value solely because man adds something to it from his soul, then woe betide us!

86

Charles Baudelaire "On the Heroism of Modern Life," from Part 18 of *The Salon of 1846*

Baudelaire thought that painters and sculptors should reject subjects drawn from history and choose those from contemporary life. His ideas influenced the work of a number of later painters, including his close friend Édouard Manet.

To return to our principal and essential problem, which is to discover whether we possess a specific beauty, intrinsic to our new emotions, I observe that the majority of artists who have attacked modern life have contented themselves with public and official subjects—with our victories and our political heroism. Even so, they do it with an ill grace, and only because they are commissioned by the government which pays them. However, there are private subjects which are very much more heroic than these.

The pageant of fashionable life and the thousands of floating existences—criminals and kept women—which drift about in the underworld of a great city . . . all prove to us that we have only to open our eyes to recognize our heroism.

Suppose that a minister, baited by the opposition's impertinent questioning, has given expression once and for all—with that proud and sovereign eloquence which is proper to him—to his scorn and disgust for all ignorant and mischiefmaking oppositions. The same evening you will hear the following words buzzing around you on the Boulevard des Italiens: "Were you in the Chamber today? And did you see the minister? Good Heavens, how handsome he was! I have never seen such scorn!"

So there *are* such things as modern beauty and modern beroism!

All these words that fall from your lips bear witness to your belief in a new and special beauty, which is neither that of Achilles nor yet of Agamemnon.

The life of our city is rich in poetic and marvellous subjects. We are enveloped and steeped as though in an atmosphere of the marvellous; but we do not notice it. 87

Gustave Courbet (1819–1877) From his letter to a group of students

A band of students who had withdrawn in protest from the staterun École des Beaux-Arts had invited Courbet to direct the alternative school they were hoping to open. In this letter dated December 25, 1861, he rejected their offer, but did agree to give instruction and criticism for about a year in a rented studio, where the model was usually a peasant with a farm animal.

I do not have, and I can not have, students.

I who believe that every artist should be his own master. . . .

I can not teach my art . . . because I deny that art can be taught and because . . . I maintain that art is completely individual, and the talent of each artist is only the result of his own inspiration and his own study of tradition. . . .

Especially, art in painting can only consist of the representation of objects that are visible and tangible to the artist.

No age can be depicted except by its own artists. . . . I believe that the artists of one century are completely incompetent when it comes to depicting the objects of a preceding or future century. . . .

It is in this sense that I deny the term historical art as applied to the past. Historical art is, by its very essence, contemporary. Every age should have its artists, who will express it and depict it for the future. . . .

The true artists are those who take up their epoch at exactly the point to which it has been carried by preceding ages. To retreat is to do nothing. . . . This explains why all archaic schools have always ended by reducing themselves to the most useless compilations.

I also believe that painting is an essentially CONCRETE art and can only consist of the representation of REAL AND EXISTING objects. . . . Imagination in art consists in knowing how to find the most complete expression of an existing object, but never in imagining or in creating the object itself.

Beauty is in nature, and in reality is encountered under the most diverse forms. As soon as it is found, it belongs to art, or rather to the artist who is able to perceive it. . . . The beauty based on nature is superior to all artistic conventions.

88

Lilla Cabot Perry (1848?–1933) From "Reminiscences of Claude Monet from 1889 to 1909"

Perry was an American expatriate painter. Monet, a strict empiricist, had a horror of artistic theory and therefore refused to systematize his ideas on art. Perry's reminiscences, published in 1927, provide our best evidence of those ideas.

He never took any pupils, but he would have made a most inspiring master if he had been willing to teach. I remember his once saying to me:

"When you go out to paint, try to forget what objects you have before you—a tree, a house, a field, or whatever. Merely think, here is a little square of blue, here an oblong of pink, here a streak of yellow, and paint it just as it looks to you, the exact color and shape, until it gives your own naïve impression of the scene before you."

He said he wished he had been born blind and then had suddenly gained his sight so that he could have begun to paint in this way without knowing what the objects were that he saw before him. He held that the first real look at the motif was likely to be the truest and most unprejudiced one, and said that the first painting should cover as much of the canvas as possible, no matter how roughly, so as to determine at the outset the tonality of the whole. . . .

Monet's philosophy of painting was to paint what you really see, not what you think you ought to see; not the object isolated as in a test tube, but the object enveloped in sunlight and atmosphere, with the blue dome of Heaven reflected in the shadows.

89

Mary Cassatt (1845–1926) From a letter to Harrison Morris

Between 1874 and 1886 a loosely affiliated group of artists in France, who became known as the Impressionists, organized eight exhibitions outside the official Salon. These "independent" exhibitions soon inspired other artists in western Europe, thereby contributing significantly to the demise of the academic system that had dominated European art since the mid-seventeenth century. Cassatt's letter of March 15, 1904, to Morris, Managing Director of the Pennsylvania Academy of the Fine Arts, is in response to a prize she had been awarded.

Our first exhibition was held in 1879 and was a protest against official exhibitions and not a grouping of artists with the same art tendencies. We have been since dubbed "Impressionists" a name which might apply to Monet but can have no meaning when attached to Degas' name.

Liberty is the first good in this world and to escape the tyranny of a jury is worth fighting for, surely no profession is so enslaved as ours. Gérôme [an academic painter] who all his life was on the Jury of every official exhibition said only a short time before his death that if Millet were then alive, he, Gérôme would refuse his pictures, that the world has consecrated Millet's genius made no difference to him. I think this is a good comment on the system. . . . When I was at home a few years ago it was one of the things that disheartened me the most to see that we were slavishly copying all the evils of the French system, evils which they deplore and are trying to remove.

90

James Abbott McNeill Whistler (1834–1903)

From The Gentle Art of Making Enemies

Whistler's book, published in 1893, also contains his account of the famous libel suit he brought against John Ruskin in 1878.

As music is the poetry of sound, so is painting the poetry of sight, and the subject-matter has nothing to do with harmony of sound or of colour.

The great musicians knew this. Beethoven and the rest wrote music—simply music; symphony in this key, concerto or sonata in that.

On F or G they constructed celestial harmonies . . . as combinations, evolved from the chords of F or G and their minor correlatives.

This is pure music as distinguished from airs—commonplace and vulgar in themselves, but interesting from their associations, as, for instance, "Yankee Doodle. . . ."

Art should be independent of all clap-trap—should stand alone, and appeal to the artistic sense of eye or ear, without confounding this with emotions entirely foreign to it, as devotion, pity, love, patriotism, and the like. All these have no kind of concern with it, and that is why I insist on calling my works "arrangements" and "harmonies."

Take the picture of my mother, exhibited at the Royal Academy as an "Arrangement in Grey and Black." Now that is what it is. To me it is interesting as a picture of my mother; but what can or ought the public to care about the identity of the portrait?

91

Auguste Rodin (1840–1917) From "Conversations" with Paul Gsell

The following remarks, recorded in 1911, reveal Rodin as an exponent of the unconventional idea that the beauty or ugliness of a work of art centers on its inherent "character," or "truth."

The vulgar readily imagine that what they consider ugly in existence is not fit subject for the artist. They would like to forbid us to represent what displeases and offends them in nature.

It is a great error on their part.

What is commonly called *ugliness* in nature can in art become full of great beauty.

In the domain of fact we call *ugly* whatever is deformed, whatever is unhealthy, whatever suggests the ideas of disease, of debility, or of suffering, whatever is contrary to regularity, which is the sign and condition of health and strength: a

hunch-back is *ugly*, only who is bandy-legged is *ugly*, poverty in rags is *ugly*. . . .

But let a great artist or a great writer make use of one or the other of these uglinesses, instantly it is transfigured. . . .

To the great artist, everything in nature has character. . . . And that which is considered ugly in nature often presents more *character* than that which is termed beautiful, because in the contractions of a sickly countenance, in the lines of a vicious face, in all deformity, in all decay, the inner truth shines forth more clearly than in features that are regular and healthy.

And as it is solely the power of *character* which makes for beauty in art, it often happens that the uglier a being is in nature, the more beautiful it becomes in art.

There is nothing ugly in art except that which is without character, that is to say, that which offers no outer or inner truth.

Whatever is false, whatever is artificial, whatever seeks to be pretty rather than expressive, whatever is capricious and affected, whatever smiles without motive, bends or struts without cause, is mannered without reason; all that is without soul and without truth; all that is only a *parade* of beauty and grace; all, in short, that lies, is *ugliness* in art.

92

Joris-Karl Huysmans (1848–1907) From "Iron"

Huysmans, author of the radical antinaturalist novel Against the Grain (1884), was also an important art critic in Paris at the end of the nineteenth century. The following is taken from a selection of his art criticism entitled Certaines (1889).

In architecture, the situation is now this.

The architects build absurd monuments whose parts, borrowed from all ages, constitute in their ensemble the most servile parodies that one could see. . . .

One fact is certain: the age has produced no architect and is characterized by no style.... Another undoubted fact is that stone, considered until now the fundamental material of building, has foundered, drained by repetition....

But our period may yet incarnate itself in buildings that symbolize its activity and its sadness, its cunning and its money, in works sullen and hard, in any case, new.

And the material is here named, it is iron.

Since the reign of Louis Philippe [1830–48], iron structure has been attempted many times, but . . . no new form has been discovered; the metal remains . . . linked to stone, a subordinate agent, incapable of creating by itself a monument that is not a railway station or a greenhouse, a monument that aesthetic criticism may cite. . . .

Iron's role is thus practical and limited, purely internal.

This was the state of architecture when the exposition of 1889 was resolved upon.

It is interesting to see if, in . . . the Eiffel Tower [fig. 964], iron-making has come out of its gropings, and . . . has finally invented a new style. . .

In a touching unanimity, . . . the entire press, flat on its stomach, exalts the genius of M. Eiffel.

And yet his tower resembles a factory chimney under construction, a carcass that waits to be filled with cut stone or bricks. One cannot imagine that [it] is finished, that this solitary suppository riddled with holes will remain as it is....

The Eiffel Tower is truly of a disconcerting ugliness, and it is not even enormous! Seen from below, it does not seem to attain the height cited for it. . . .

From afar, from the center of Paris, from the depths of the suburbs, the effect is identical. The emptiness of this cage diminishes it; the lathing and the meshwork make of this trophy of iron a horrible bird cage. . . .

It is 300 meters tall and appears one hundred; it is finished and appears barely begun. . . .

Finally, one must ask oneself, what is the fundamental purpose for the existence of this tower?

93

Vincent van Gogh (1853–1890) From a letter to his brother, Theo

Theo, who worked for an art dealer in Paris, provided Vincent's chief emotional and economic support. This letter, dated April 30, 1885, was written from their father's house in Neunen.

I have tried to emphasize that those people, eating their potatoes in the lamplight, have dug the earth with those very hands they put in the dish, and so it speaks of *manual labor*, and how they have honestly earned their food [fig. 977].

I have wanted to give the impression of a way of life quite different from that of us civilized people. Therefore I am not at all anxious for everyone to like it or to admire it at once. . . .

It would be wrong, I think, to give a peasant picture a certain conventional smoothness. If a peasant picture smells of bacon, smoke, potato steam—all right, that's not unhealthy; if a stable smells of dung—all right, that belongs to a stable; if the field has an odor of ripe corn or potatoes or of . . . manure—that's healthy, especially for city people.

94

Vincent van Gogh From an undated letter to Theo

I am returning to the ideas I had in the country before I knew the impressionists. And I should not be surprised if the impressionists soon find fault with my way of working, for it has been fertilized by Delacroix's ideas rather than by theirs. Because instead of trying to reproduce exactly what I see before my eyes, I use color more arbitrarily, in order to express myself forcibly. . . .

I should like to paint the portrait of an artist friend, a man who dreams great dreams, who works as the nightingale sings, because it is his nature. He'll be a blond man. I want to put my appreciation, the love I have for him, into the picture. So I paint him as he is, as faithfully as I can, to begin with.

But the picture is not yet finished. To finish it I am now going to be the arbitrary colorist. I exaggerate the fairness of the hair, I even get to orange tones, chromes and pale citron-yellow.

Behind the head, instead of painting the ordinary wall of the mean room, I paint infinity, a plain background of the richest, intensest blue that I can contrive, and by this simple combination of the bright head against the rich blue background, I get a mysterious effect, like a star in the depths of an azure sky

95

Paul Gauguin (1848–1903) From a letter to J. F. Willumsen

The Danish painter J. F. Willumsen was a member of Gauguin's circle in Brittany. Gauguin wrote this letter in the autumn of 1890, before his departure for the South Seas.

As for me, my mind is made up. I am going soon to Tahiti, a small island in Oceania, where the material necessities of life can be had without money. I want to forget all the misfortunes of the past, I want to be free to paint without any glory whatsoever in the eyes of the others and I want to die there and to be forgotten there. . . . A terrible epoch is brewing in Europe for the coming generation: the kingdom of gold. Everything is putrefied, even men, even the arts. There, at least, under an eternally summer sky, on a marvellously fertile soil, the Tahitian has only to lift his hands to gather his food; and in addition he never works. When in Europe men and women survive only after unceasing labor during which they struggle in convulsions of cold and hunger, a prey to misery, the Tahitians, on the contrary, happy inhabitants of the unknown paradise of Oceania, know only sweetness of life. To live, for them, is to sing and to love. . . . Once my material life is well organized, I can there devote myself to great works of art, freed from all artistic jealousies and with no need whatsoever of lowly trade.

96

Louis Sullivan (1856–1924)
From "The Tall Office Building
Artistically Considered"

Sullivan had already completed several skyscrapers, including the

Wainwright Building (fig. 1009) and the Guaranty Building, when he recorded these ideas in an essay of 1896.

The architects of this land and generation are now brought face to face with something new under the sun—namely, . . . a demand for the erection of tall office buildings. . . .

Offices are necessary for the transaction of business; the invention and perfection of the high-speed elevators make vertical travel, that was once tedious and painful, now easy and comfortable; development of steel manufacture has shown the way to safe, rigid, economical constructions rising to a great height; continued growth of population in the great cities, consequent congestion of centers and rise in value of ground, stimulate an increase in number of stories. . . . Thus has come about that form of lofty construction called the "modern office building. . . ."

Problem: How shall we impart to this sterile pile, . . . this stark, staring exclamation of eternal strife, the graciousness of those higher forms of sensibility and culture that rest on the lower and fiercer passions? . . .

What is the chief characteristic of the tall office building? . . . It is lofty. This loftiness is to the artist-nature its thrilling aspect. . . . It must be every inch a proud and soaring thing, rising in sheer exultation that from bottom to top it is a unit without a single dissenting line. . . .

Certain critics . . . have advanced the theory that the true prototype of the tall office building is the classical column, consisting of base, shaft and capital. . . .

Other theorizers, assuming a mystical symbolism as a guide, quote the many trinities in nature and art, and the beauty and conclusiveness of such trinity in unity. . . .

Others, seeking their examples and justification in the vegetable kingdom, urge that such a design shall above all things be organic. . . . They point to the pine-tree, its massy roots, its lithe, uninterrupted trunk, its tuft of green high in the air. Thus, they say, should be the design of the tall office building: again in three parts vertically.

Others still, more susceptible to the power of a unit than to the grace of a trinity, say that such a design should be struck out at a blow, as though by a blacksmith or by mighty Jove. . . .

I shall, with however much of regret, dissent from [these critics] as touching not at all upon . . . the quick of the entire matter, upon the true; the immovable philosophy of the architectural art. . . .

Unfailingly in nature [its] shapes express the inner life, the native quality, of the animal, tree, bird, fish, that they present to us; they are so characteristic, so recognizable, that we say, simply, it is "natural" it should be so. . . .

It is the pervading law of all things organic, and inorganic, . . . that form ever follows function. . . .

Shall we, then, daily violate this law in our art? . . .

Does this not . . . conclusively show that the lower one or two stories [of the tall office building] will take on a special character suited to the special needs, that the tiers of typical offices, having the same unchanging function, shall continue in the same unchanging form, and that as to the attic, . . . its function shall equally be so in force, in . . . outward expression? From this results, naturally, . . . a three-part division, not from any theory, symbol, or fancied logic.

Georgia O'Keeffe (1887–1986) From "Stieglitz: His Pictures

Collected Him"

O'Keeffe met Alfred Stieglitz in 1908, and had her first show at his gallery in 1916. She married him in 1924. These remarks, published in 1949, were made after his death.

Stieglitz grew up during the period when photography was young, began working at it while studying mechanical engineering at the Berlin Polytechnic. . . . He soon decided to make himself an authority on photography and went about it by sending his photographs everywhere to exhibitions to get all the medals that were given in the world at that time. . . .

Although the photographs that he was making at this time were very much admired by painters and artists generally, the artists seemed to have the idea that photography could never be accepted as one of the arts. Stieglitz denied this. As he was naturally a fighter, he began to work for its recognition as one of the arts, not particularly for himself but for the idea of photography. . . . Painters would often say they wished they had painted what he had photographed. He always said he never regretted that he had not photographed what they were painting.

In 1890 Stieglitz returned to America from his European student period, twenty-six years old. Years of feverish activity with photography followed. He finally decided that for photography to be recognized as one of the arts, the work of a group could bring about this recognition better than the work of an individual. . . .

The Photo-Secession group was formed in 1902, . . . Stieglitz . . . was the leader. In 1905 they began having photographic exhibitions at the little gallery known as "291". . . . Here the beginnings of modern art were also shown. . . .

I was sent, like all the other students, by the instructors of the Art Students League to see the first showing of Rodin drawings at "291."...

I very well remember the fantastic violence of Stieglitz's defense when the students with me began talking with him about the drawings.

Henri Matisse (1869–1954) From "Notes of a Painter"

This 1908 article, Matisse's most complete statement on his art,

reflects the transition from his early Fauve phase to his mature, post-Fauve period.

Often when I settle down to work I begin by noting my immediate and superficial color sensations. Some years ago this first result was often enough for me—but today if I were satisfied with this, my picture would remain incomplete. I would have put down the passing sensations of a moment; they would not completely define my feelings and the next day I might not recognize what they meant. I want to reach that state of condensation of sensations which constitutes a picture. . . .

There are two ways of expressing things; one is to show them crudely, the other is to evoke them artistically. In abandoning the literal representation of movement it is possible to reach toward a higher ideal of beauty. . . .

Suppose I set out to paint an interior: I have before me a cupboard; it gives me a sensation of bright red-and I put down a red which satisfies me; immediately a relation is established between this red and the white of the canvas. If I put a green near the red, if I paint in a yellow floor, there must still be between this green, this yellow and the white of the canvas a relation that will be satisfactory to me. But these several tones mutually weaken one another. It is necessary, therefore, that the various elements that I use be so balanced that they do not destroy one another. To do this I must organize my ideas; the relation between tones must be so established that they will sustain one another. A new combination of colors will succeed the first one and will give more completely my interpretation. . . . I cannot copy nature in a servile way; I must interpret nature and submit it to the spirit of the picture. When I have found the relationship of all the tones the result must be a living harmony of tones, a harmony not unlike that of a musical composition. . . .

What I dream of is an art of balance, of purity and serenity devoid of troubling or depressing subject matter, an art which might be for every mental worker, be he businessman or writer, like an appeasing influence, like a mental soother, something like a good armchair in which to rest from physical fatigue.

99

Wassily Kandinsky (1866–1944)

Concerning the Spiritual in Art, from Chapter 5, "The Effect of Color"

Kandinsky hoped to inaugurate a new spiritual era for modern man through his art. These remarks first appeared in 1912.

If you let your eye stray over a palette of colors, you experience two things. In the first place you receive *a purely physical effect*, namely the eye itself is enchanted by the beauty and other qualities of color. You experience satisfaction and delight, like a gourmet savoring a delicacy. Or the eye is stimulated as the tongue is titillated by a spicy dish. But then it

grows calm and cool, like a finger after touching ice. These are physical sensations, limited in duration. They are superficial, too, and leave no lasting impression behind if the soul remains closed. Just as we feel at the touch of ice a sensation of cold, forgotten as soon as the finger becomes warm again, so the physical action of color is forgotten as soon as the eye turns away. On the other hand, as the physical coldness of ice, upon penetrating more deeply, arouses more complex feelings, and indeed a whole chain of psychological experiences, so may also the superficial impression of color develop into an experience. . . .

And so we come to the second result of looking at colors: their psychological effect. They produce a correspondent spiritual vibration, and it is only as a step towards this spiritual vibration that the physical impression is of importance. . . .

Generally speaking, color directly influences the soul. Color is the keyboard, the eyes are the hammers, the soul is the piano with many strings. The artist is the hand that plays, touching one key or another purposively, to cause vibrations in the soul.

It is evident therefore that color harmony must rest ultimately on purposive playing upon the human soul.

100

Filippo Tommaso Marinetti (1876–1944) From "The Foundation and Manifesto of Futurism"

After Marinetti's example of 1908, the manifesto became a popular device for innovative twentieth-century artists to publicize their views.

We declare our primary intentions to all living men of the earth:

- 1. We intend to glorify the love of danger, the custom of energy, the strength of daring. . . .
- 3. Literature having up to now glorified thoughtful immobility, ecstasy, and slumber, we wish to exalt the aggressive movement, the feverish insomnia, running, the perilous leap, the cuff, and the blow.
- 4. We declare that the splendor of the world has been enriched with a new form of beauty, the beauty of speed. A race-automobile adorned with great pipes like serpents with explosive breath . . . a race-automobile which seems to rush over exploding powder is more beautiful than the Victory of Samothrace. . . .
- 7. There is no more beauty except in struggle. No masterpiece without the stamp of aggressiveness. Poetry should be a violent assault against unknown forces to summon them to lie down at the feet of man. . . .
- 9. We will glorify war—the only true hygiene of the world—militarism, patriotism, the destructive gesture of anarchist, the beautiful Ideas which kill, and the scorn of woman.
 - 10. We will destroy museums, libraries, and fight against

moralism, feminism, and all utilitarian cowardice. . . .

It is in Italy that we hurl this overthrowing and inflammatory declaration, with which today we found Futurism, for we will free Italy from her numberless museums which cover her with countless cemeteries.

Museums, cemeteries! . . . Identical truly. . . .

To admire an old picture is to pour our sentiment into a funeral urn instead of hurling it forth in violent gushes of action and productiveness. . . .

The oldest among us are thirty; we have thus at least ten years in which to accomplish our task. When we are forty, let others—younger and more daring men—throw us into the wastepaper basket like useless manuscripts!

101

Piet Mondrian (1872–1944) From "Plastic Art and Pure Plastic Art"

This essay, published in 1937, is the culmination of Mondrian's attempts to work out his aesthetic theories in written form.

Although Art is fundamentally everywhere and always the same, nevertheless two main human inclinations, diametrically opposed to each other, appear in its many and varied expressions. One aims at the *direct creation of universal beauty*, the other at the *esthetic expression of oneself...* The first aims at representing reality objectively, the second subjectively.... This latter attempt must of necessity result in an individual expression which veils the pure representation of beauty. Nevertheless, both the two opposing elements (universal-individual) are indispensable if the work is to arouse emotion. Art had to find the right solution. . . . For the artist the search for a unified expression through the balance of two opposites has been, and always will be, a continual struggle. . . .

The only problem in art is to achieve a balance between the subjective and the objective. . . .

Gradually art is purifying its plastic means and thus bringing out the relationships between them. Thus, in our day two main tendencies appear: the one maintains the figuration, the other eliminates it. While the former employs more or less complicated and particular forms, the latter uses simple and neutral forms, or, ultimately, the free line and the pure color. It is evident that the latter (nonfigurative art) can more easily and thoroughly free itself from the domination of the subjective than can the figurative tendency.

102

André Breton (1896–1966) From "What is Surrealism?"

The first Surrealist manifesto appeared in 1924, the second in

1930, and this one, considered the third, in 1934. Although the Surrealist movement was dedicated to the freedom of the individual, its founder, Breton, was both moralistic and highly authoritarian. Because he sometimes excommunicated members of the group, he became known as "the Pope of Surrealism."

We still live under the reign of logic, but the methods of logic are applied nowadays only to the resolution of problems of secondary interest. The absolute rationalism which is still the fashion does not permit consideration of any facts but those strictly relevant to our experience. Logical ends, on the other hand, escape us. Needless to say that even experience has had limits assigned to it. It revolves in a cage from which it becomes more and more difficult to release it. Even experience is dependent on immediate utility, and common sense is its keeper. Under color of civilization, under the pretext of progress, all that rightly or wrongly may be regarded as fantasy or superstition has been banished from the mind, all uncustomary searching after truth has been proscribed. It is only by what must seem sheer luck that there has recently been brought to light an aspect of mental life-to my belief by far the most important-with which it was supposed that we no longer had any concern. All credit for these discoveries must go to Freud. Based on these discoveries a current of opinion is forming that will enable the explorer of the human mind to continue his investigations, justified as he will be in taking into account more than mere summary realities. The imagination is perhaps on the point of reclaiming its rights. If the depths of our minds harbor strange forces capable of increasing those on the surface, or of successfully contending with them, then it is all in our interest to canalize them, to canalize them first in order to submit them later, if necessary, to the control of the reason. . . .

I am resolved to render powerless that *hatred of the mar-velous* which is so rampant. . . . Briefly: The marvelous is always beautiful, anything that is marvelous is beautiful; indeed, nothing but the marvelous is beautiful.

The admirable thing about the fantastic is that it is no longer fantastic: there is only the real.

103

Frida Kahlo (1910–1954) From a letter to Nickolas Muray

Kahlo, wife of the muralist Diego Rivera, met André Breton when he came to Mexico in 1938 to give some lectures and visit the exiled Russian Communist Leon Trotsky. Kahlo, who had looked forward to meeting Breton, found him pretentious, boring, vain, and arrogant. This letter of February 16, 1939, recounts the Paris exibition Breton arranged for her.

The question of the exhibition is all a damn mess. . . . Until I came the paintings were still in the custom house, because the s. of a b. of Breton didn't take the trouble to get them out.

... So I had to wait days and days just like an idiot till I met Marcel Duchamp... who is the only one who has his feet on the earth, among all this bunch of coocoo lunatic sons of bitches of the surrealists. He immediately got my paintings out and tried to find a gallery. Finally there was a gallery called "Pierre Colle" which accepted the damn exhibition...

[A] few days ago Breton told me that the associate of Pierre Colle, an old bastard and son of a bitch, saw my paintings and found that only two were possible to be shown, because the rest are too "shocking" for the public!! I could of kill[ed] that guy and eat it afterwards, but I am so sick and tired of the whole affair that I have decided to send every thing to hell, and scram from this rotten Paris before I get nuts myself. . . . You have no idea the kind of bitches these people are. They make me vomit. They are so damn "intellectual" and rotten that I can't stand them any more. . . . They sit for hours in the "cafes" warming their precious behinds, and talk without stopping about "culture," "art," "revolution," and so on and so forth, thinking themselves the gods of the world, dreaming the most fantastic nonsenses, and poisoning the air with theories and theories that never come true. . . . I never seen Diego [Rivera, her husband] or you wasting their time on stupid gossip and "intellectual" discussions. That is why you are real men and not lousy "artists."

Max Beckmann (1884–1950) From "On My Painting"

This excerpt is from a lecture delivered in London in July of 1938.

In my opinion all important things in art since Ur... have always originated from the deepest feeling about the mystery of Being. Self-realization is the urge of all objective spirits. It is this self which I am searching in my life and in my art.

Art is creative for the sake of realization, not for amusement; for transfiguration, not for the sake of play. It is the quest of our self that drives us along the eternal and neverending journey we must all make. . . .

I have always on principle been against the artist speaking about himself or his work. Today neither vanity nor ambition causes me to talk about matters which generally are not to be expressed even to oneself. But the world is in such a catastrophic state, and art is so bewildered that I, who have lived the last thirty years almost as a hermit, am forced to leave my snail's shell to express these few ideas which, with much labor, I have come to understand in the course of the years.

The greatest danger which threatens mankind is collectivism. Everywhere attempts are being made to lower the happiness and the way of living of mankind to the level of termites. I am against these attempts with all the strength of my being. . . .

And for this reason I am immersed in the phenomenon of

the Individual, the so-called whole Individual, and I try in every way to explain and present it. What are you? What am I? Those are the questions that constantly persecute and torment me and perhaps also play some part in my art.

Jackson Pollock (1912–1956) From "My Painting"

In 1947, when these remarks were recorded, Pollock rejected the usual easel format by placing his unstretched canvases directly on the floor. Using ordinary house paint, he claimed that he was not just throwing paint but delineating some real thing in the air above the canvas.

My painting does not come from the easel. I hardly ever stretch my canvas before painting. I prefer to tack the unstretched canvas to the hard wall or the floor. I need the resistance of a hard surface. On the floor I am more at ease. I feel nearer, more a part of the painting, since this way I can walk around it, work from the four sides and literally be *in* the painting. This is akin to the method of the Indian sand painters of the West.

I continue to get further away from the usual painter's tools such as easel, palette, brushes, etc. I prefer sticks, trowels, knives and dripping fluid paint or a heavy impasto with sand, broken glass and other foreign matter added.

When I am *in* my painting, I'm not aware of what I'm doing. It is only after a sort of "get acquainted" period that I see what I have been about. I have no fears about making changes, destroying the image, etc., because the painting has a life of its own. I try to let it come through. It is only when I lose contact with the painting that the result is a mess. Otherwise there is pure harmony, an easy give and take, and the painting comes out well.

The source of my painting is the unconscious. I approach painting the same way I approach drawing. That is direct—with no preliminary studies. The drawings I do are relative to my painting but not for it.

Romare Bearden (1911–1988) From two interviews

In interviews conducted by Myron Schwartzman in 1983 and 1986, Bearden discussed the wide range of artistic influences on his working methods and ideas.

MYRON SCHWARTZMAN: So [collage] gets improvisational. . . .

ROMARE BEARDEN: Well, it's like jazz; you do this and then you improvise. You know Manet (I think) said, "A painting isn't finished; sometimes you get on the surface." He

meant, "Well, you've got it under control." Maybe sometimes a third of the way through [a painting], I'll say, "I know this is coming out." You get that feeling that the thing is going to be all right. And other things you just have to surrender. As my friend Carl Holty used to say, "Don't close your picture too quickly; keep it open until the very last, and that gives you room to maneuver." You reach a point when all the elements seem to focus, so that the colors and the forms will set. And at that point you can relinquish the painting. . . .

MS: What triggers [a] series, Romie?

RB: Well, the memories are just there; they're just really with me. It's strange, the memories are there. For instance, you see the Vermeer [reproduction of *The Concert*] up there on the wall? I'll say, "Well, I saw something like this; this used to be so-and-so." Because I guess art is made from other art. Yes, I've been in places like this; I've gone in with the same kind of stillness, and the light coming in from this source.

Those people [of Vermeer's time] moved on, and the people from Mecklenburg [North Carolina, Bearden's birthplace] have come in there; they stayed a while and now there is something else.

MS: Let's explore the theme of relationships. What does it mean to you in painting?

RB: In discussing relationships, we have to consider many disparate factors, or seemingly disparate factors, in the way a painting is put together, such as scale, space, line, and so forth. And the idea of my thinking is that everything has a certain correspondence. . . . For instance, a Chinese painter, in the classic days, when he looked at the rocks and trees, felt a certain oneness with them. . . . I think this is one of the most important things that Matisse talks about—the relationships, how one does things—and it changes. . . .

In the Cloisters [museum] I saw some old Spanish frescoes, and I thought—Picasso. In the icons, and in African sculpture, they bring everything to a very beautiful shape. So long as you can get everything in a nice shape, the picture will be all right—you're just shaping it, not worrying so much about the anatomy. If you do that and it all moves in the right rhythms, you have a painting. We get deceived so much by appearances. You sometimes just have to forget about that, because you are working in another world here. And so you could easily take these [canvases] as being completely non-representational.

Take Vermeer's drawings—you turn them upside down, and there's real, great abstraction. The wrinkles in the clothes, for instance; you turn the drawing upside down, and you see something else, the great relationships. This is the abstracting of things. People think abstraction means that you don't have figurative objects in a work. So a more accurate word is "non-representational" rather than "abstract," because Poussin, Ingres are great abstractionists. . . .

The thing is that the artist confronts chaos. The whole thing of art is, how do you organize chaos? . . . Probably, if you take it symbolically, there is no greater chaos than in the inferno, down in hell. Dante, in his *Inferno*, meets Virgil. . . .

He's lost and confused there, and Virgil says, "I'll guide you, . . . " to me he is like the artist. This is the help that he needs in understanding what is going on, . . . some kind of organization that he finds. And he's talking about sin, and the rest of these things. But he needs that guide.

So I think it's the same thing with the artist.

107

Roy Lichtenstein (born 1923) From "What is Pop Art?"

This interview with Gene R. Swenson appeared in 1963, the same year as Lichtenstein's Drowning Girl (fig. 1097).

GENE R. SWENSON: What is Pop Art?

ROY LICHTENSTEIN: I don't know—the use of commercial art as subject matter in painting, I suppose. It was hard to get a painting that was despicable enough so that no one would hang it. . . . The one thing everyone hated was commercial art; apparently they didn't hate that enough either.

GRS: Is Pop Art despicable?

RL: . . . Well, it is an involvement with what I think to be the most brazen and threatening characteristics of our culture, things we hate, but which are also powerful in their impingement on us. I think art since Cézanne has become extremely romantic and unrealistic, feeding on art. . . . It has had less and less to do with the world. . . . Outside is the world; it's there. Pop Art looks out into the world; it appears to accept its environment. . . .

I suppose I would still prefer to sit under a tree with a picnic basket rather than under a gas pump, but signs and comic strips are interesting as subject matter. There are certain things that are usable, forceful and vital about commercial art. We're using those things—but we're not really advocating stupidity, international teenagerism and terrorism. . . .

I think my work is different from comic strips—but I wouldn't call it transformation. . . . What I do is form, whereas the comic strip is not formed in the sense I'm using the word; the comics have shapes but there has been no effort to make them intensely unified. The purpose is different, one intends to depict and I intend to unify. And my work is actually different from comic strips in that every mark is really in a different place, however slight the difference seems to some. The difference is often not great, but it is crucial. . . .

GRS: A curator at the Modern Museum has called Pop Art fascistic and militaristic.

RL: The heroes depicted in comic books are fascist types, but I don't take them seriously in these paintings—maybe there is a point in not taking them seriously, a political point. I use them for purely formal reasons, and that's not what those heroes were invented for. . . .

The techniques I use are not commercial, they only appear to be commercial—and the ways of seeing and composing and unifying are different and have different ends. 108

Henry Moore (1898–1986) From "The Sculptor Speaks"

Moore's sculpture in the 1930s began to reveal the tension between solid and void. His interest in the human figure and in natural forms remained paramount, however, as is evident in these comments published in 1937.

It is a mistake for a sculptor or a painter to speak or write very often about his job. It releases tension needed for his work. By trying to express his aims with rounded-off logical exactness, he can easily become a theorist whose actual work is only a caged-in exposition of conceptions evolved in terms of logic and words.

But though the nonlogical, instinctive, subconscious part of the mind must play its part in his work, he also has a conscious mind which is not inactive. . . .

Since the Gothic, European sculpture had become overgrown with moss, weeds—all sorts of surface excrescences which completely concealed shape. It has been Brancusi's special mission to get rid of this overgrowth, and to make us once more shape-conscious. To do this he has had to concentrate on very simple direct shapes, to keep his sculpture, as it were, one-cylindered, to refine and polish a single shape to a degree almost too precious. Brancusi's work, apart from its individual value, has been of historical importance in the development of contemporary sculpture. But it may now be no longer necessary to close down and restrict sculpture to the single (static) form unit. We can now begin to open out. To relate and combine together several forms of varied sizes, sections, and directions into one organic whole.

Although it is the human figure which interests me most deeply, I have always paid great attention to natural forms, such as bones, shells, and pebbles, etc. Sometimes for several years running I have been to the same part of the seashore—but each year a new shape of pebble has caught my eye, which the year before, though it was there in hundreds, I never saw. . . . A different thing happens if I sit down and examine a handful one by one. I may then extend my form-experience more, by giving my mind time to become conditioned to a new shape.

There are universal shapes to which everybody is subconsciously conditioned and to which they can respond if their conscious control does not shut them off.

Pebbles show nature's way of working stone.

Eva Hesse (1936–1970) From an interview

An abbreviated version of this interview with Cindy Nemser was

published in 1970, shortly before her death. Hesse resisted the impersonal formalism of 1960s art.

CINDY NEMSER: Tell me about your family background.

EVA HESSE: . . . I was told by the doctor that I have the most incredible life he ever heard. . . . It's not a little thing to have a brain tumor at thirty-three. Well my whole life has been like that. I was born in Hamburg, Germany. My father was a criminal lawyer. He had just finished his two doctorates and I had the most beautiful mother in the world. She looked like Ingrid Bergman and she was manic depressive. She studied art in Hamburg. My sister was born in 1933 and I was born in 1936. Then in 1938 there was a children's pogrom. I was put on a train with my sister. We went to Holland where we were supposed to be picked up by my father's brother and his wife in Amsterdam but he couldn't do it, so we were put in a Catholic children's home and I was always sick. So I was put in a hospital and I wasn't with my sister. My parents were hidden somewhere in Germany and then they came to Amsterdam and had trouble getting us out. Somehow they got us to England. My father's brother and his wife ended up in concentration camps. No one else in my family made it. . . . No one in my family has lived. I have one healthy sister. There's not been one normal thing in my life—not one—not even my art. . . .

CN: . . . Looking at your works they seem, to me, to be filled with sexual impulses or organic feeling. I feel there are anthropomorphic inferences.

EH: It's not a simple question for me. First when I work it's only the abstract qualities that I'm really working with, which is to say the material, the form it's going to take, the size, the scale, the positioning. . . . However, I don't value the totality of the image on these abstract or esthetic points. For me it's a total image that has to do with me and life. It can't be divorced as an idea or composition or form. I don't believe art can be based on that. . . . I don't want to make that my problem. . . . Those problems are solvable, I solve them, can solve them beautifully. In fact, my idea now is to discount everything I've ever learned or been taught about those things and to find something else. So it is inevitable that it is my life, my feelings, my thoughts. And there I'm very complex. I'm not a simple person and the complexity . . . is the total absurdity of life. I guess that's where I relate, if I do, to certain artists who I feel very close to, and not so much through having studied their writings or works, but because, for me, there's this total absurdity in their work.

CN: Which artists are they?

EH: Duchamp, Yvonne Rainer, Ionesco, Carl Andre.

CN: Let's talk about some of your early sculptures.

EH: There was a piece I did for that show in the Graham Gallery . . . in 1965 or '66. It was called Hang-Up—a dumb name . . . but I can't change it. I think it was about the fifth piece I did and I think the most important statement I made. It's close to what I feel I achieve now in my best pieces. It was the first time where my idea of absurdity or extreme feeling came through.

110

Frank Lloyd Wright (1867–1959) From "A Philosophy of Fine Art"

Wright delivered these remarks at a meeting of the Architectural League of the Art Institute of Chicago in 1900.

We feel and find in Nature always, an accord of form and function with Life principle. . . . But, however much we love the oak and pine in a state of nature in pristine freedom, their freedom is not for us. It does not belong to us now, however much the relic of barbarism within us may yearn for it. Civilization means for us a conventionalizing of our original state of nature. . . . For Art is the great conservator of the finer sensibilities of a people. . . . I wish I might use another word than "conventionalizing," to convey the idea of this magic process, for only an artist or one with some genuine artistic training, will realize precisely what that means. To know a thing, what we can call knowing, a man must first love the thing, sympathize with it. So the Egyptians "knew" the Lotus and translated the Lotus to the dignified stone forms of their Architecture: this was the Lotus "conventionalized!" The Greeks "knew" and idealized the Acanthus in stone translations. This was the Acanthus conventionalized. Of all Art, whatsoever, perhaps Architecture is the Art best fitted to teach this lesson, for in its practices this problem of "conventionalizing" Nature is worked out at its highest and best. . . . A work of Architecture is . . . in no sense naturalistic—it is the highest, most subjective, conventionalization of Nature known to man, and at the same time it must be organically true to Nature.

Walter Gropius (1883–1969) From Scope of Total Architecture

Gropius was interested in the social and aesthetic implications of housing and city planning, as these remarks of 1943 suggest.

Every thinking contemporary searches his mind now trying to figure out what may be the ultimate value of our stupendous scientific progress. We roar with new techniques and new inventions for speedier means of transportation. But what do we do with all the time saved? Do we use it for contemplation of our existence? No, we plunge instead into an even more hectic current of activity, surrendering to that fallacious slogan: time is money. We obviously need a clarification as to what exactly our spiritual and intellectual aims are. . . .

I should like, therefore, to attempt to outline the potential strategic aim of planning for my own profession, architecture, within the cultural and political context of our industrial civilization. . . .

Our scientific age, by going to extremes of specialization, has obviously prevented us from seeing our complicated life as an entity. The average professional man, driven to distraction by the multiplicity of problems spread out before him, seeks relief from the pressure of general responsibilities by picking out one single, rigidly circumscribed responsibility in a specialized field and refuses to be answerable for anything that may happen outside this field. A general dissolution of context has set in and naturally resulted in shrinking and fragmentating life. As Albert Einstein once put it: "Perfection of means and confusion of aims seem to be characteristic of our age. . . . "

But there are indications that we are slowly moving away from overspecialization and its perilous atomizing effect on the social coherence of the community. . . . In the gigantic task of its reunification, the planner and architect will have to play a big role. He must be well trained not ever to lose a total vision, in spite of the infinite wealth of specialized knowledge which he has to absorb and integrate. He must comprehend land, nature, man and his art, as one great entity. In our mechanized society we should passionately emphasize that we are still a world of men, that man in his natural environment must be the focus of all planning. We have indulged our latest pets, the machines, to such an extent that we have lost a genuine scale of values. Therefore, we need to investigate what makes up the really worthwhile relationships among men, and between men and nature, instead of giving way to the pressure of special interests or of shortsighted enthusiasts who want to make mechanization an end in itself. . . .

There is no other way toward progress but to start courageously and without prejudice new practical tests by building model communities in one stroke and then systematically examining their living value. What a wealth of new information for the sociologist, the economist, the scientist and the artist would be forthcoming, if groups, formed of the most able planners and architects available, should be commissioned to design and build completely new model communities! Such information would also offer most valuable preparatory data to solve the complicated problem of rehabilitating our existing communities.

Edward Weston (1886–1958) From "Photographic Art"

Weston insisted that the photographer should previsualize the final print before making the exposure and not crop or trim the print. This excerpt from an encyclopedia entry published in 1942 attempts to synthesize some of the reflections on photography that he kept in his Daybooks.

The camera lens sees too clearly to be used successfully for recording the superficial aspects of a subject. . . .

But if the camera's innate honesty works any hardship on the photographer by limiting his subject matter in one direction, the loss is slight when weighed against the advantages it provides. For it is that very quality that makes the camera expressly fitted for examining deeply into the meaning of things. The discriminating photographer . . . can reveal the essence of what lies before his lens with such clear insight that the beholder will find the recreated image more real and comprehensible than the actual object.

The photograph isolates and perpetuates a moment of time: an important and revealing moment, or an unimportant and meaningless one, depending upon the photographer's understanding of his subject and mastery of his process. The lens does not reveal a subject significantly of its own accord. On the contrary, its vision is completely impartial and undiscriminating. It makes no distinction between important detail and meaningless detail. Selection, emphasis, and meaning must be provided by the photographer in his composition. . . . To compose a subject well means no more than to see and present it in the strongest manner possible. . . . Its capacity for rendering fine detail and tone makes photography excel in recording form and texture. Its subtlety of gradation makes it admirably suited to recording qualities of light or shadow. . . . The photographer cannot depend on rules deduced from finished work in another medium. He must learn to see things through his own eyes and his own camera; only then can he present his subject in a way that will transmit his feeling for it to others.

An intuitive knowledge of composition in terms of the capacities of his process enables the photographer to record his subject at the moment of deepest perception; to capture the fleeting instant when the light on a landscape, the form of a cloud, the gesture of a hand, or the expression of a face momentarily presents a profound revelation of life.

The appeal to our emotions manifest in such a record is largely due to the quality of authenticity in the photograph. The spectator accepts its authority and, in viewing it, perforce believes that he would have seen that scene or object exactly so if he had been there. We know that the human eye is capable of no such feat, and furthermore that the photographer has not reproduced the scene exactly; quite possibly we would not even be able to identify the original scene from having seen the photograph. Yet it is this belief in the reality of the photograph that calls up a strong response in the spectator and enables him to participate directly in the artist's experience.

113

Jerry Uelsmann (born 1934) From "Some Humanistic Considerations of Photography"

Uelsmann's approach to photography—postvisualization—is the opposite of Edward Weston's previsualization. This excerpt is

from a speech given by Uelsmann to the Royal Photographic Society of Great Britain in 1971.

As you may know the dominant aesthetic in photography has been called previsualization. This means that the image is essentially fully previsioned at the time the shutter is clicked. Now I propose that photographers keep themselves open to in-process discovery. . . .

It seems to me that all other areas of art allow for in-process discovery. The painter does not begin with a fully-conceived canvas, the sculptor with a fully-conceived piece. They allow for a dialogue to evolve, to develop, and as far as I'm concerned the darkroom is truly capable of being a visual research laboratory, a place for discovery, observation and meditation. . . .

Some of my photographs I don't understand. This disturbs some people. I would like to think that today we are sophisticated enough to realize that first of all there are systems of knowledge which are not necessarily verbal. There are levels of consciousness that we can engage ourselves in when we are encountering the world of photography that are not easy to talk about. . . . I think many times we are pressured into a verbalization of things that we don't fully understand but somehow the words are important. . . .

One recent photograph disturbs me a great deal. Literally I know what's happening: there is a wave and an organic form that was washed up on the beach after a hurricane. . . . But there is some strange thing happening, some strange statement within that I am in no way capable of articulating. I think the sooner that we as photographers become aware of this phenomenon that we can perhaps address each other visually at times, I think the happier we'll all be, because so many times I am pressed to have verbal responses to things that I can't defend verbally.

114

Michael Graves (born 1934) From "What is the Focus of Post-Modern Architecture?"

This 1981 interview with Michael McTwigan appeared while Graves was designing the Public Services Building (fig. 1232), which was dubbed the "Post-Modern building of the year."

MICHAEL McTWIGAN: It's interesting that you use the word "figural." By that, do you mean related to human scale . . . ?

MICHAEL GRAVES: Those things, as well as a range of architectonic ideas—elements like a door or a window, a configuration of space that is anthropomorphically related. For instance, if I make a Greek cross plan . . . there's no doubt where the primary space is for us in a room like that. If you look at De Stijl architecture, on the other hand, there is no clear identity of the human body within the plan. I can't locate the figure of myself within the work.

MM: That is presumably why so many people have felt alienated by modern architecture; it stands on its own and doesn't really have a relationship to the human being. . . .

Architect Robert Stern said not too long ago, "We're not in the business of educating and transforming human nature; we're in the business of responding to the human condition. We're not reformers or revolutionaries." That seems to be quite a statement, quite a change from the Bauhaus days. . . .

MG: . . . In part, what Robert is saying is that this is not a time of manifestos. I remember in the early '60s, when Peter Eiseman and I were working together, we wanted to write a manifesto. We wanted to be modern architects and say, "This is what ought to be, not what is. . . ."

We wanted to make clear our own ideas in a general sense, rather than in the peculiarities of site or client or whatever. It's not that one has softened today, but the manifesto is much more gentle now. I would not say we are not reformers, however. We are, in the best sense of the word, re-formers. We are trying to establish form as it relates to us more than to the machine. . . . We are reformers in the sense that we don't want to return to something, but, rather, to reestablish the language of architecture. That's where the manifesto comes.

Although literature can use the window as a metaphor, architecture possesses the window. It's the modern architect who wants to throw the window out. It's people like myself who want to say simply, "The window exists, and I will use the window." The window relates to the human body and it relates to the wall for very specific aesthetic, technical, and cultural reasons. It's not for nothing that the window existed for 2,000 years or more. That's a crucial issue.

So I would vary that rather dramatic statement of Robert's and say I'm interested in reestablishing the language of architecture. . . .

MM: So it's not just a matter of reeducating. It's a matter of teaching old skills as well. . . . It could be said that people almost forgot how to paint in the '60s, and the same could be said about architecture.

MG: Sure. There's an architect by the name of Leo Krier in London who says he won't build, because there's no craft tradition from which to build his buildings. His political standing is that we must dissolve the Industrial Revolution. So he does his drawings. He says, "Let's go back to the craft tradition."

Cindy Sherman (born 1954) From an interview

In these excerpts from a 1988 interview with Jeanne Siegel, Sherman discusses her photographic role-playing.

CINDY SHERMAN: I still wanted to make a filmic sort of image, but I wanted to work alone. I realized that I could make a picture of a character reacting to something outside the frame so that the viewer would assume another person.

Actually, the moment that I realized how to solve this problem was when Robert [Longo] and I visited David Salle, who had been working for some sleazy detective magazine. Bored as I was, waiting for Robert and David to get their "art talk" over with, I noticed all these 8 by 10 glossies from the magazine which triggered something in me. (I was never one to discuss issues—after all, at that time I was "the girlfriend.")

JEANNE SIEGEL: In the "Untitled Film Stills," what was the influence of real film stars? It seems that you had a fascination with European stars. You mentioned Jeanne Moreau, Brigitte Bardot and Sophia Loren in some of your statements. Why were you attracted to them?

CS: I guess because they weren't glamorized like American starlets. When I think of American actresses from the same period, I think of bleached blonde, bejeweled and furred sex bombs. But, when I think of Jeanne Moreau and Sophia Loren, I think of more vulnerable, lower-class types of characters, more identifiable as working-class women.

At that time I was trying to emulate a lot of different types of characters. I didn't want to stick to just one. I'd seen a lot of the movies that these women had been in but it wasn't so much that I was inspired by the women as by the films themselves and the feelings in the films.

JS: And what is the relationship between your "Untitled Film Stills" and real film stills?

CS: In real publicity film stills from the 40s and 50s something usually sexy/cute is portrayed to get people to go see the movie. Or the woman could be shown screaming in terror to publicize a horror film.

My favorite film images (where obviously my work took its inspiration) didn't have that. They're closer to my own work for that reason, because both are about a sort of brooding character caught between the potential violence and sex. However, I've realized it is a mistake to make that kind of literal connection because my work loses in the comparison. I think my characters are not quite taken in by their roles so that they couldn't really exist in any of their so-called "films," which, next to a real still, looks unconvincing. They are too aware of the irony of their role and perhaps that's why many have puzzled expressions. My "stills" were about the fakeness of role-playing as well as contempt for the domineering "male" audience who would mistakenly read the images as sexy. . . .

JS: Another critical issue attached to the work was the notion that the stereotypical view was exclusively determined by the "male" gaze. Did you see it only in this light or did it include the woman seeing herself as well?

CS: Because I'm a woman I automatically assumed other women would have an immediate identification with the roles. And I hoped men would feel empathy for the characters as well as shedding light on their role-playing. What I didn't anticipate was that some people would assume that I was playing up to the male gaze. I can understand the criticism of feminists who therefore assumed I was reinforcing the stereotype of woman as victim or as sex object.

	1800-1820	1820-1840	1840 –1850
HISTORY AND POLITICS	1802 First child labor laws, in England 1803 United States purchases Louisiana from France for \$15 million 1804 Napoleon crowned emperor of France, ending the republic established by the French Revolution; 1805–9, occupies Italy and Spain. He wins battles against allied England, Austria, Russia, and Sweden until he retreats from Moscow, 1812, losing the bulk of his army; 1814, successes of allies force him to abdicate; he is exiled to Elba War of 1812 (European allies against Napoleon) draws United States into conflict with Britain; 1814, Washington, D.C. burned 1814 Allies at Congress of Vienna redivide Europe. Louis XVIII, Bourbon king of France (r. 1814–24), establishes a constitutional monarchy; 1815, Napoleon returns; allies defeat him at Waterloo; he abdicates again and, 1821, dies a prisoner of war. Bourbon kings return to power until 1830 1819–21 Spain sells Florida to United States	 1822 Simon Bolívar (1783–1830) leads revolution in Latin America: six countries gain independence from Spain 1823 Monroe Doctrine claims United States sphere of influence in the Western Hemisphere 1833 Factory Act abolishes slavery in British colonies 1830 July Revolution in France; republican mobs riot against the monarchy; Louis Philippe, nominated as new king (r. 1830–48, the July Monarchy), continues conservative policies. This change of power mandated by popular acclaim spawns revolutionary movements across Europe Queen Victoria (r. 1837–1901) rules Great Britain 1838 "Trail of Tears": Thousands of Cherokee and other Indians are moved by United States government on a forced march from the Southeast to Indian Territory (now Oklahoma); one in four dies 	1842 Oregon Trail opens western lands of North America for settlement 1846–48 War between United States and Mexico over territories of Texas and New Mexico Revolution of 1848 in France; 1848–52, Second Republic declared after abdication of Louis Philippe. Bloody insurrection leads to the election of Louis Napoleon, nephew of Napoleon I, as constitutional monarch; 1852, he overthrows republic and becomes Emperor Napoleon III (Second Empire, 1852–70); 1861–67, disastrous attempt by France to annex Mexico 1848 Revolutions throughout Europe; 1848–61, unification of Italy begins with a revolt led by Giuseppe Garibaldi against Austrian and French rule 1848 Discovery of gold in American West encourages westward expansion
RELIGION	Pope Pius X (r. 1803–14) reforms church law, music, texts, and administration		
	THÉODORE GÉRICAULT The Raft of the "Medusa," 1818–19	JOHN CONSTABLE Salisbury Cathedral from the Meadows, 1829–34	JOSEPH MALLORD WILLIAM TURNER Rain, Steam and Speed—The Great Western Railway, 1844
MUSIC, LITERATURE, AND PHILOSOPHY	 1800s English Romantic poets: Wordsworth, Byron, Shelley, Keats; novelists: Thackeray, Austen, Dickens, Trollope, the Brontës, Eliot, Kipling 1807 Georg Wilhelm Friedrich Hegel (1770–1831) writes <i>Phenomenology of Mind</i> 1819–37 Jacob and Wilhelm Grimm, brothers, collect authoritative versions of German folktales and myths 	Emily Dickinson (1830–86), American poet 1833 Carl von Clausewitz, a general in the Napoleonic Wars, writes <i>On War</i> , a treatise on modern warfare 1840 Edgar Allan Poe publishes suspenseful and macabre short stories in United States	1842 Honoré de Balzac completes <i>The Human Comedy</i> , a series of novels and stories Modern economic theories: 1848, Karl Marx and Friedrich Engels write <i>The Communist Manifesto</i> and John Stuart Mill publishes <i>Principles of Political Economy</i> , 1867, Marx's <i>Capital</i>
SCIENCE, TECHNOLOGY, AND EXPLORATION	1800 Estimated world population nears 1 billion; that of Europe is 180 million; Alessandro Volta (1745–1827) constructs the first battery and demonstrates electric currents 1804–6 Lewis and Clark cross the American continent to the Pacific Ocean 1811 Invention of tin cans for food storage 1814 Steam locomotive, in England, used to power early railroad travel 1819 First steamship crossing of the Atlantic	 1825 Opening of the Erie Canal, allowing passage of ships from the Atlantic Ocean to the Great Lakes 1831 Invention of mechanical McCormick reaper; 1837, John Deere plow c. 1837 Development of armaments: rifles, artillery, shrapnel, revolvers, and torpedoes by the 1880s 1839 First forms of photography: daguerreotype and negative-positive system 	1844 Samuel Morse's telegraph transforms communications by allowing transmission and reception of a coded signal through wires; 1866, transatlantic cable laid 1846 Sewing machine invented by Elias Howe; William Morton uses ether anesthesia in surgery 1847 First Law of Thermodynamics formulated by Julius von Mayer and James Joule; 1850, Second Law, by Rudolf Clausius

CAMILLE COROT

Morning: Dance of the Nymphs, 1850

HONORÉ DAUMIER The Third-Class Carriage, c. 1862

EDWARD BURNE-JONES

The Wheel of Fortune, 1877–83

Mid-1800s Russian literature: Gogol (1809–52), Turgenev (1818–83), Dostoyevsky (1821–81), Tolstoy (1828–1910), Chekhov (1860–1904)

1851 Melville's Moby Dick; Stowe's antislavery novel Uncle Tom's Cabin; 1853, Ruskin's The Stones of Venice; 1857, Madame Bovary, by Flaubert; The Flowers of Evil, by Baudelaire Impressionist composers: Claude Debussy (1862–1918), Maurice Ravel (1875–1937); Romantics: Frédéric Chopin (1810–49), Robert Schumann (1810–56), Franz Liszt (1811–86), Johannes Brahms (1833–97). The Romantic work of Richard Wagner (1813–83) transforms opera

1862 Victor Hugo's novel Les Misérables

Carl G. Jung (1875–1961), Swiss psychologist, explores the concept of the collective unconscious

Thomas Mann (1875–1955), German novelist **1878–80** Friedrich Nietzsche, German philosopher, develops idea of an *Übermensch* (superman)

1855 First plastic material, celluloid, discovered by Alexander Parkes

c. 1856–63 Steel manufacturing processes invented; experimentation with alloys proliferates; 1890, first steel-frame skyscraper built, in Chicago

1859 Charles Darwin publishes *The Origin of Species*, formulating the theory of evolution

1863 First subways built, in London

1864 In France, Louis Pasteur's germ theory alters medical research and practice; 1865, antiseptic techniques introduced in surgery

1865 Genetic experiments of Gregor Mendel published in Austria

1866 Invention of dynamite by Alfred Nobel 1869 American transcontinental railroad completed; Suez Canal opens; periodic table of el-

ements formulated by Dmitri Mendeleev

1872 Heinrich Schliemann excavates Troy1876 Alexander Graham Bell patents the tele-

phone

1876-85 In Germany, internal-combustion engine, running on gasoline fuel, developed

1877 Thomas Edison invents phonograph; 1879, incandescent bulb; 1894, motion pictures

1879 Ivan Pavlov explores the relationship between psychology and physiology

-	1880-1890	1890-1900	1900-1910		
HISTORY AND POLITICS	 1881–82 First pogroms against Jews in Russia 1886 Labor unrest in United States: Haymarket riot, Chicago, leads to the foundation of the American Federation of Labor, first national labor union; 1892, Carnegie steel strike, Pennsylvania 1886 Zionism, a doctrine calling for the establishment of a Jewish state in Palestine, appears in Europe; 1897, first Zionist Congress called by Theodor Hertzl, in Basel, Switzerland 	 1890 Battle of Wounded Knee, between Sioux nation and United States Army, effectively ends Indian resistance 1893 World's Columbian Exposition, Chicago 1894–1906 Dreyfus Affair: a charge of treason brought fraudulently against a Jewish army officer stirs antisemitism and popular unrest in France 1895–98 Wars in Cuba and America weaken Spanish kingdom and result in losses in territory and prestige 1899–1902 Boer War in South Africa; British defeat South Africans and annex territory 	Edward VII of England (r. 1901–10), whose government passes sweeping education reforms (1902) 1904–5 Russian–Japanese War over territory on the Pacific coast ends in humiliating defeat for the Russians and heightened unrest among the population; 1905, Bloody Sunday massacre of demonstrating workers in St. Petersburg leads to first Russian revolution; the Great General Strike gives birth to organized labor movement and the first soviets, or workers' councils		
RELIGION HIST	Early Modernism In Europe and America around the turn of the nineteenth century, just as visual artists were beginning to experiment with the concepts of collage and abstraction, and composers were testing unusual tonal systems and atonality in music, a number of writers were trying something parallel in prose and poetry: stream of consciousness, rhythmic language, fragmentation of form, and radical play with grammatical structures. Many were explicitly interested in the connections among art forms: the relationship between sound and color, for example, fascinated both the poet Charles Baudelaire and, later, the painter Wassily Kandinsky. Arthur Rimbaud shocked France in 1873 with the publication of the poem A Season in Hell; in 1896, Alfred Jarry's absurdist play King Ubu caused a riot in a Paris theater. In England in the 1880s Gerard Manley Hopkins invented "sprung rhythm" in poetry. The American Gertrude Stein, also in Paris, wrote Three Lives in 1908; Ezra Pound, in London, published the poems Personae in 1909. Thus, the pre—World War I radicalism of such artists as the painters Kandinsky, Pablo Picasso, and Kazimir Malevich and the architect Frank Lloyd Wright may be seen in the broader context of other revolutionary and visionary creative ideas.				
	(left) AUGUSTE BARTHOLDI, Statue of Liberty (Liberty Enlightening the World), 1875–84	PAUL GAUGUIN Where Do We Come From? What	CLAUDE MONET Water Lilies, Giverny, 1907		
MUSIC, LITERATURE, AND PHILOSOPHY	(right) GEORGES SEURAT A Sunday on La Grande Jatte—1884, 1884–86 French Symbolist poets: Stéphane Mallarmé (1842–98), Paul Verlaine (1844–96), Arthur Rimbaud (1854–91) 1881 Portrait of a Lady, by Henry James 1884 The Adventures of Huckleberry Finn, by Mark Twain; Against the Grain, by Joris-Karl Huysmans	Are We? Where Are We Going?, detail, 1897 1890–1903 Erik Satie composes Three Small Pieces in the Form of a Pear 1891 Oscar Wilde writes The Picture of Dorian Gray 1897 Bram Stoker publishes Dracula Jorge Luis Borges (1899–1986), Argentine Surrealist author 1900 Joseph Conrad publishes Lord Jim	Pablo Neruda (1904–73), Chilean poet 1906 Upton Sinclair publishes <i>The Jungle</i> , an American documentary novel that exposes the injustices of the industrial system 1908 Filippo Tommaso Marinetti writes the Futurist Manifesto; the composer Arnold Schoenberg uses atonality in composition Ferdinand de Saussure (1857–1913), French philologist, founds modern linguistics		
SCIENCE, TECHNOLOGY, AND EXPLORATION	c. 1880 Barbed-wire fences of galvanized iron patented and used to fence in much of the open range in American West c. 1885 First automobiles invented, by Karl Benz and Gottlieb Daimler, in Germany	 c. 1890 Reinforced concrete begins to be used as a primary building material 1892–95 Sigmund Freud, Austrian physician, formulates the theory and method of psychoanalysis 1895 X-rays discovered by Wilhelm Röntgen; Guglielmo Marconi invents wireless telegraph, a precursor of radio 1897 Joseph Thomson discovers the electron 1898 Marie Curie discovers radium 	1903 First aircraft flight, made by Orville and Wilbur Wright, in North Carolina 1905 Albert Einstein (1879–1955), pioneering physicist, formulates the theory of relativity, radically changing modern views of space and time; 1953, Unified Field Theory 1909 American Robert Peary reaches North Pole; 1912, Robert Scott's American expedition reaches the South Pole (discovered by the Norwegian Roald Amundsen, 1911)		

1910-1920	1920 –1930	1930 –1940
1911 Revolution in China: emperor deposed, Sun Yat-sen establishes a republic 1912 British ocean liner <i>Titanic</i> sinks 1914 Outbreak of World War I: assassination of Archduke Ferdinand of Austria in Sarajevo leads to war between Germany, Austro-Hungarian Empire, and allies on one side, and Serbia, Russia, France, England, and allies on the other; most of Europe and its colonies become involved; 1917, United States enters; 1918, defeat of Germany. Yugoslavia, Poland, Turkey, Czechoslovakia, Hungary, and Austria become independent nations; Syria, Iraq, and Palestine become mandates controlled by France and Britain 1916 Easter Rebellion in Ireland attempts to gain independence from Britain, but fails 1917 Bolshevik Revolution in Russia, under Lenin, inaugurates first communist state 1919 Foundation of the League of Nations, an international congress to promote peace, forerunner of the modern United Nations	1920 Women enfranchised in the United States; 1928, in England; 1945, in France 1920 With the passage of the Home Rule Bill, the British concede autonomy to southern Ireland; Mohandas Gandhi initiates peaceful mass protests (satyagraha, or passive resistance) in India against British rule 1922 Fascists under Benito Mussolini seize power in Italy 1926–53 Joseph Stalin controls Soviet Union; his government is a rigid totalitarian state marked by purges, pogroms, and radical collectivization of farms and industries 1929 Stock-market crash in United States inaugurates the Great Depression, worldwide economic crisis, during the 1930s	1931–41 Japanese wage undeclared war on China, annexing Manchuria 1933 In United States: the New Deal, a program of government spending to end the Depression; in Germany: Adolf Hitler's National Socialist (Nazi) Party seizes power 1934–35 Long March: 90,000 communist rebels led by Mao Tse-tung flee Chiang Kaishek across China; less than half survive 1936–39 Spanish Civil War, won by Fascists 1938 Germany annexes Austria; 1939, occupies Czechoslovakia 1939–45 World War II: 1939, Germany invades Poland; 1940, Belgium and France; Italy enters war as ally of Germany. 1941, Germany attacks Russia. Japan, allied with Germany, bombs American fleet at Pearl Harbor; United States enters war. Holocaust in Europe: Nazis systematically exterminate over 6 million Jews, communists, homosexuals, gypsies, and others. 1945, defeat of Germans and Japanese by Allies
1917 British government, in control of much of the Middle East following World War I, promulgates the Balfour Declaration supporting the establishment of a Jewish state in Palestine	1923 Martin Buber, German Jewish theologian, writes <i>I and Thou</i>	1939–43 Rampant persecution of Orthodox church in Soviet Union
(left) PABLO PICASSO Still Life with Chair Caning, 1912 (right) FRANZ MARC Animal Destinies, 1913	PABLO PICASSO Three Dancers, 1925	(left) MÉRET OPPENHEIM Object, 1936 (right) FRIDA KAHLO Self-Portrait with Thorn Necklace, 1940
 1910 Wassily Kandinsky publishes Concerning the Spiritual in Art c. 1912–15 John Dewey (1859–1952) and Maria Montessori (1870–1952) pioneer new ideas about education 1913–28 Marcel Proust, French critic and novelist, writes Remembrance of Things Past 1919 The Cabinet of Dr. Caligari, innovative German Expressionist silent film 	1920s American free-verse and modernist poets: Robert Frost (1874–1963), Ezra Pound (1885–1972), T. S. Eliot (1888–1965) 1926 Franz Kafka's <i>The Castle</i> ; Ernest Hemingway's <i>The Sun Also Rises</i> ; 1927, Virginia Woolf's <i>To the Lighthouse</i> ; Abel Gance makes the film <i>Napoléon</i> ; 1928, D. H. Lawrence's <i>Lady Chatterly's Lover</i> ; 1929, William Faulkner's <i>The Sound and the Fury</i>	Russian modernist composers: Rachmaninoff (1873–1943), Stravinsky (1882–1971), Prokoviev (1891–1953), Shostakovich (1906–1975) 1932 Aldous Huxley's <i>Brave New World</i> describes a pseudo-utopian future 1930s Gertrude Stein explores the forms and structure of language; 1939, James Joyce publishes <i>Finnegans Wake</i> , further experimenting with language
 1911 First model of atomic structure made, by Ernest Rutherford, in Britain By 1913 Diesel engines replace steam locomotives on many railways 1914 Henry Ford's fully mechanized massproduction plant for the Model T car marks the beginning of American industrialization 1915 Birth-control movement, led by Margaret Sanger in the United States, advocates family planning 	 1920 Radio programs broadcast, Pittsburgh 1922 Howard Carter discovers the tomb of Tutankhamen in Egypt 1925–26 Werner Heisenberg and Erwin Schrödinger's theories of quantum mechanics 1926 Sound motion pictures and television demonstrated 1927 Charles Lindbergh flies an aircraft solo across the Atlantic 1929 Alexander Fleming discovers penicillin 	1931 Radio waves from space detected by the American electrical engineer Karl Jansky: beginning of radio astronomy, using radio waves to trace objects; c. 1935–36, radar discovered by the Scottish physicist Robert Watson-Watt, and others 1935 C. F. Richter, American, devises scale for measuring earthquakes

-	1940-1950	1950-1960	1960-1970
HISTORY AND POLITICS	1945 United Nations founded as an international advisory and peacekeeping council; Yalta Conference: British prime minister Winston Churchill, American president Franklin D. Roosevelt, and Marshal Joseph Stalin of the Soviet Union plan division of Germany into zones of occupation and Europe into spheres of influence 1947 Marshall Plan, proposed to aid recovery of European states devastated by World War II, enacted by the United States. Division of Germany into East and West states 1948 Israel achieves nationhood with recognition by the United Nations; India gains independence from Britain 1949 Communist People's Republic of China founded, under Mao Tse-tung	1954 American civil-rights movement begins: United States Supreme Court outlaws racial segregation in public schools; 1955, Montgomery, Alabama, bus boycott by African-Americans, led by Martin Luther King, Jr. c. 1955–c. 1989 Cold War among Soviet Union, China, and United States: a period of mutual hostilities, espionage, arms escalation, and political maneuvering for influence in other countries by the three world powers; most other nations align themselves with one of the three. Conflicts center upon the opposition between communism and democracy; 1961, Berlin Wall built, isolating West Berlin within East Germany; 1962, Cuban Missile Crisis, Soviet Union attempts to install missiles in Cuba, threatening United States 1959 Fidel Castro establishes communist government in Cuba	1963 Assassination of United States President John F. Kennedy 1965 America enters Vietnam War 1965–76 Cultural Revolution in China: hardline Maoist Red Guards formed; educators, local governments, and other elements seen as "enemies of the Revolution" attacked; thousands are killed, millions sent to reeducation camps; many artworks and religious sites are destroyed 1967 Egypt and Israel at war; Egypt is defeated, Israel controls Sinai peninsula 1968 Prague Spring, an attempt by Czechoslovakia to win freedom from Soviet control, crushed by Soviet troops; in United States, presidential candidate Robert F. Kennedy and civil-rights leader Martin Luther King, Jr., assassinated; mass protests in United States against Vietnam War
RELIGION	1948 Thomas Merton, American Trappist monk, poet, and philosopher, writes <i>The Seven Story Mountain</i>	1950s In some Protestant and Jewish denominations, women become ministers. Chinese invade Tibet and destroy over 6,000 ancient temples and monasteries; 1959, Dalai Lama, head of state and of Tibetan Buddhism, forced into exile in India	1962–65 Pope John XXIII's Second Vatican Council institutes use of vernacular in church ritual and other reforms 1964 Pope Paul VI and Patriarch Athenagoras attempt to resolve differences between East- ern and Western Christian churches
	ADOLPH GOTTLIEB Descent into Darkness, 1947	MARK ROTHKO Orange and Yellow, 1956	(left) ROY LICHTENSTEIN Drowning Girl, 1963 (right) ROMARE BEARDEN The Prevalence of Ritual: Baptism, 1964
MUSIC, LITERATURE, AND PHILOSOPHY	 1941 Charlie Chaplin makes the film <i>The Great Dictator</i> 1942 Albert Camus publishes <i>The Stranger</i> 1943 Jean-Paul Sartre writes <i>Being and Nothingness</i>, statement of Existentialism 1949 George Orwell's novel <i>1984</i> creates a futuristic totalitarian world 1949–50 Simone de Beauvoir authors the key feminist text <i>The Second Sex</i> 	1950s Beat Generation: artists influenced by jazz whose works criticize American postwar materialism and complacency: 1952, John Cage composes 4'33", 1956, Allen Ginsberg writes the narrative poem <i>Howl</i> ; 1957, Jack Kerouac writes <i>On the Road</i> 1955 <i>Lolita</i> , by Vladimir Nabakov, humorously explores the erotic relationship between an older man and a young girl	 1960 Richard Wright writes Native Son, on the African-American experience c. 1965 British Invasion in popular music: the Beatles, the Rolling Stones, and other rockand-roll groups sell millions of albums 1967 In Colombia, Gabriel Garcia-Marquez writes One Hundred Years of Solitude 1969 Woodstock Festival in New York draws 500,000 fans of rock and roll
SCIENCE, TECHNOLOGY, AND EXPLORATION	The Atomic Age: 1942, in United States, first nuclear chain reaction; 1943, first nuclear fission bomb; 1945, United States drops atomic bombs on Japanese cities, killing over 100,000 instantly. 1949, first Soviet nuclear bomb; 1956, first nuclear electrical generators built in England; by 1970s, nuclear power in widespread commercial use 1946 Radio-carbon dating 1947 Dead Sea Scrolls discovered in Israel	 c. 1950 Nuclear-powered submarines and ships in United States and Soviet Union 1953 In England, James Watson and Francis Crick publish a model of the structure of DNA and hypothesize the transmission of genetic codes 1954 Jonas Salk invents polio vaccine Space Age begins: 1957, Sputnik, first satellite, launched by Soviet Union; 1961, first human orbit of the earth by Yuri Gagarin 	 1960 Laser technology developed 1963 Research in genetic engineering begins in United States; 1976, synthesis achieved 1967 First human heart transplant, by Dr. Christiaan Barnard, in South Africa 1969 United States' Apollo XI mission: Neil Armstrong and Edwin Aldrin walk on the moon; 1976, solar probe launched

1970 –1980	1980 –1990	1990 –2000
 1973 Egypt and Syria attack Israel and are defeated. United States withdraws from Vietnam War, having failed militarily and in response to increasing public criticism. In Chile, Salvador Allende, a socialist, becomes president; he is murdered and a military dictatorship under Augusto Pinochet takes power, until 1989. In Washington, D.C., Watergate scandal: President Richard Nixon is implicated in illegal activities; 1974, he resigns 1975 South Vietnam falls, ending the war; nation is unified under a communist regime 1978 Iranian revolution: Islamic fundamentalists rebel against the shah; the Ayatollah Khomeini takes power 1979 Afghan War: Soviet troops invade Afghanistan; they are forced to withdraw ten years later. Camp David Accords brokered by United States: Egypt formally recognizes Israel and regains Sinai territory 1979–81 Iran holds 52 Americans hostage 	1981 Assassination of President Anwar Sadat of Egypt, advocate for peace in the Middle East; 1982, Israel invades Lebanon, whose government falls, causing war among Lebanese and Palestinian factions 1985 Mikhail Gorbachev is premier of Soviet Union: policies of glasnost and perestroika permit economic, political, and cultural liberalization 1986 In United States, Iran-contra scandal: secret, illegal sale of arms to Iran and diversion of funds to Nicaraguan rebels implicates high government officials 1989 Berlin Wall torn down; 1989–90, Soviet Union breaks up into independent states, with mostly noncommunist governments, along old ethnic and political boundaries; Yugoslavia and Czechoslovakia divide; student demonstrations (estimated over 1 million) in favor of democracy, in Tiananmen Square, Beijing, China, suppressed violently by Chinese military	 1990–91 Gulf War: Iraq invades Kuwait, is repulsed by combined United Nations and United States armies 1990 Nelson Mandela, leader of the African National Congress and South African antiapartheid movement, is freed from jail after 27 years; Germany reunifies 1991 Boris Yeltsin elected premier of Russia 1992 Civil war in states of the former Yugoslavia: ethnic and territorial disputes, some of ancient origin, in Bosnia, Croatia, and Serbia 1993 Israeli–Palestinian peace accord ratified; threatened by extremist terrorist activity 1994 South Africa holds first multiracial elections: Nelson Mandela is president; apartheid laws are abandoned; civil war in Rwanda kills over 500,000 civilians in a few months; Palestine Liberation Organization, under Yasir Arafat, gains self-rule from Israel in Jericho and Gaza
1977 End of Catholicism as state religion of Italy 1978 Pope John Paul II of Poland elected, first non-Italian pope in 455 years	1980s Rise of religious fundamentalism, especially among Moslems in the Middle East and Central Asia, Hindus in India, and some Christian sects in the United States	AIDS and Art The disease known as Acquired Immune Deficiency Syndrome was first noticed in the United States in about 1981, and first identified by its current name in 1985. Its rapid spread throughout the world population in the succeeding ten years, its fatal nature, and its resistance to treatment or cure make it a powerful and terrible force in culture at the end of the second millennium, comparable in some ways (if not in scale) to the devastating bubonic plague (Black Death) that swept through Europe in 1348–49. Like that plague, AIDS has become a key subject for the art world in the 1990s. Many in the fields of visual arts, dance, theater, music, and film have died of AIDS by mid-decade.
1974 Aleksandr Solzhenitsyn (b. 1918), Russian writer whose novels describe life in a Soviet prison camp and criticize the government, is exiled to the United States	1981 MTV (music television), introduced on cable television, brings the new medium of video music to a mass audience 1989 Anglo-Indian novelist Salman Rushdie's Satanic Verses outrages Islamic fundamentalists, who place him under a death threat and force him into hiding	
1973 Three babies born in England through invitro fertilization c. 1978 Personal computers widely available 1979 Near-meltdown of nuclear reactor at Three Mile Island electrical-power plant, in Pennsylvania; 1986, explosion of Chernobyl nuclear-power plant in Ukraine devastates the area and causes severe radiation poisoning, as well as contamination of atmosphere over much of Europe	 1981 First Space Shuttle, a reusable manned rocket, launched by United States 1982 First artificial heart implanted c. 1985 AIDS, identified as a new, incurable disease, spreads throughout the world and begins to claim thousands of lives; by 1995, HIV infection levels reach epidemic proportions 1989 Voyager II space probe passes Neptune and discovers a new moon 	1990s New office technology: fax for transmission of documents; modem for electronic transmission of information; rapid development of computer programs with many applications; fiber-optic technology in widespread use 1990 Hubble space telescope launched

BOOKS FOR FURTHER READING

by Max Marmor

In the literature of art—as in art itself—the best is not always the newest. We have, therefore, sought to achieve a judicious balance between standard works and current publications. Some works listed here are valuable chiefly for their reproductions, the text being outdated. We have not tried to indicate which titles are currently in print. But most listed here should be available in the art section of a local public or academic library. Your librarian can help you determine whether any specific title is readily available for purchase.

In the literature of art, the best is not always a book. But this list is limited to books, despite the fact that much important art-historical literature appears in periodicals and other types of publications. We have listed below a few of the standard indexes to art periodicals. These, too, should be available in a local library.

In the literature of art, the best is not always written in English. This list is, however, limited to books published in English. If, therefore, some areas of art history seem less well served here than others, readers may assume that the appropriate English literature on those subjects is similarly limited. In an era of multiculturalism and global scholarship, the student of art history is obliged to learn to read foreign languages.

In the literature of art, the best is not always obvious. To help the interested reader explore beyond the self-imposed limits of this list, we include below a list of several general art bibliographies; and more specialized bibliographies may be found throughout, in their appropriate places. We also include a list of standard art dictionaries and encyclopedias.

In the literature of art, the best is not infrequently the artists' own words or those of their contemporaries. We have therefore included a selective list of anthologies of "sources and documents" readily available in English translation.

In the literature of art, the best is not always printed at all. We therefore include a brief list of some electronic resources of interest to the student of art history.

A final note. Monographs on individual artists are legion, and only a handful are included here. Because greatness is established over time, we have been especially economical about listing monographs on individual twentieth-century artists. Your librarian can help you identify scholarly books on artists not included here.

REFERENCE RESOURCES IN ART HISTORY

1. ANTHOLOGIES OF SOURCES AND DOCUMENTS

- Documents of Modern Art. 14 vols. Wittenborn, New York, 1944–61. A series of specialized anthologies.
- The Documents of Twentieth-Century Art. G. K. Hall, Boston. A new series of specialized anthologies, individually listed below.
- Goldwater, R., and M. Treves, eds. Artists on Art, from the Fourteenth to the Twentieth Century. 3rd ed. Pantheon, New York, 1974.
- Holt, E. G., ed. A Documentary History of Art. Vol. 1, The Middle Ages and the Renaissance. Vol. 2, Michelangelo and the Mannerists. The Baroque and the Eighteenth Century. Vol. 3, From the Classicists to the Impressionists. 2nd ed. Princeton University Press, Princeton, 1981.
- Sources and Documents in the History of Art Series. General ed. H. W. Janson. Prentice Hall, Englewood Cliffs, N.J. Specialized anthologies, listed individually below.

2. BIBLIOGRAPHIES AND RESEARCH GUIDES

- Arntzen, E., and R. Rainwater. Guide to the Literature of Art History. American Library Association, Chicago, 1980.
- Barnet, S. A Short Guide to Writing About Art. 4th ed. HarperCollins College, New York, 1993.
- Chiarmonte, P. Women Artists in the United States: A Selective Bibliography and Resource Guide to the Fine and Decorative Arts, 1750–1986. G. K. Hall, Boston, 1990
- Ehresmann, D. Architecture: A Bibliographical Guide to Basic Reference Works, Histories, and Handbooks. Libraries Unlimited, Littleton, Colo., 1984.
- Fine Arts: A Bibliographical Guide to Basic Reference Works, Histories, and Handbooks. 3rd ed. Libraries Unlimited, Littleton, Colo., 1990.
- Freitag, W. Art Books: A Basic Bibliography of Monographs on Artists. Garland, New York, 1985.
- Goldman, B. Reading and Writing in the Arts: A Handbook. Wayne State Press, Detroit, 1972.
- Kleinbauer, W., and T. Slavens. Research Guide to Western Art History. American Library Association, Chicago, 1982
- Reference Publications in Art History. G. K. Hall, Boston. Specialized bibliographies, individually listed below.

3. DICTIONARIES AND ENCYCLOPEDIAS

- Baigell, M. Dictionary of American Art. Harper & Row, New York, 1979.
- Chilvers, I., and H. Osborne, eds. *The Oxford Dictionary of Art.* Oxford University Press, New York, 1988.
- Dictionary of Art, The. 34 vols. Grove's Dictionaries, New York, 1996.
- Duchet-Suchaux, G., and M. Pastoureau. The Bible and the Saints. Flammarion Iconographic Guides. Flammarion, Paris and New York, 1994.
- Encyclopedia of World Art. 14 vols., with index and supplements. McGraw-Hill, New York, 1959–68.
- Fleming, J., and H. Honour. A Dictionary of Architecture. 4th ed. Penguin, Baltimore, 1991.
- ——. The Penguin Dictionary of Decorative Arts. New ed. Viking, London, 1989.
- Hall, J. Illustrated Dictionary of Symbols in Eastern and Western Art. HarperCollins, New York, 1994.
- ——. Subjects and Symbols in Art. 2nd ed. Harper & Row, New York, 1979.
- Havlice, P. P. World Painting Index. 2 vols. Scarecrow Press, Metuchen, N.J., 1977. 2 vols. supplement, 1982.
- Hutchinson Dictionary of the Arts, The. Helicon, London, 1994
- Janson, H. W., and D. J., eds. Key Monuments of the His-
- tory of Art. Harry N. Abrams, New York, 1959.Lever, J., and J. Harris. Illustrated Dictionary of Architecture, 800–1914. Faber & Faber, Boston, 1993.
- Mayer, Ralph. *The HarperCollins Dictionary of Art Terms & Techniques*. 2nd ed. HarperCollins, New York, 1991.
- ——. The Artist's Handbook of Materials and Techniques. 5th ed. Viking, New York, 1991.
- McGraw-Hill Dictionary of Art. Ed. B. S. Myers. 5 vols. McGraw-Hill, New York, 1969.
- Millon, H. A., ed. Key Monuments of the History of Architecture. Harry N. Abrams, New York, 1964.
- Murray, P. and L. A Dictionary of Art and Artists. 5th ed. Penguin, New York, 1988.
- Osborne, H., ed. Oxford Companion to Art. Oxford, Clarendon Press, 1970.
- Pierce, J. S. From Abacus to Zeus: A Handbook of Art History. 5th ed. Prentice Hall, Englewood Cliffs, N.J., 1995.

- Placzek, A. K., ed. Macmillan Encyclopedia of Architects. 4 vols. Macmillan, New York, 1982.
- Reid, J. D., ed. The Oxford Guide to Classical Mythology in the Arts 1300–1990. 2 vols. Oxford University Press, New York. 1993.
- Teague, E. World Architecture Index: A Guide to Illustrations. Greenwood Press, New York, 1991.
- Worldwide Bibliography of Art Exhibition Catalogues, 1963–1987, The. 3 vols. Kraus, Millwood, N.Y., 1992.
- West, S., ed. *The Bulfinch Guide to Art History.* Little, Brown and Company, Boston, 1996.
- Wright, C., comp. The World's Master Paintings: From the Early Renaissance to the Present Day: A Comprehensive Listing of Works by 1,300 Painters and a Complete Guide to Their Locations Worldwide. 2 vols. Routledge, New York, 1991.

4. INDEXES, PRINTED AND ELECTRONIC

- Increasingly, the standard indexes to art literature are being made available by computer.
- Art Index. 1929 to present. A standard quarterly index to more than 200 art periodicals. Data since 1984 also available electronically.
- ART bibliographies MODERN. 1969 to present. A semiannual publication indexing and annotating more than 300 art periodicals, as well as books, exhibition catalogues, and dissertations. Data since 1984 also available electronically.
- Avery Index to Architectural Periodicals. 1934 to present. 15 vols., with supplementary vols. G. K. Hall, Boston, 1973. Also available electronically.
- BHA: Bibliography of the History of Art. 1991 to present. The merger of two standard indexes: RILA (Répertoire International de la Littérature de l'Art/International Repertory of the Literature of Art, vol. 1, 1975) and Répertoire d'Art et d'Archéologie (vol. 1, 1910). Like those indexes, scheduled to be available electronically in the near future.

5. GENERAL SOURCES

- Barasch, M. *Theories of Art: From Plato to Winckelmann*. New York University Press, New York, 1985.
- Baxandall, M. Patterns of Intention: On the Historical Explanation of Pictures. Yale University Press, New Haven, 1985.
- Bois, Y.-A. Painting as Model. MIT Press, Cambridge, 1990.Broude, N., and M. Garrard, eds. Feminism and Art History: Questioning the Litany. Harper & Row, New York, 1982.
- The Expanding Discourse: Feminism and Art History. Harper & Row, New York, 1992.
- Bryson, N., ed. Vision and Painting: The Logic of the Gaze. Yale University Press, New Haven, 1983.
- ——, et al., eds. Visual Theory: Painting and Interpretation. Cambridge University Press, New York, 1991.
- Cahn, W. Masterpieces: Chapters on the History of an Idea. Princeton University Press, Princeton, 1979.
- Chadwick, W. Women, Art, and Society. Thames and Hudson, New York, 1990.
- Freedberg, D. *The Power of Images: Studies in the History and Theory of Response.* University of Chicago Press, Chicago, 1989.
- Gage, J. Color and Culture: Practice and Meaning from Antiquity to Abstraction. Little, Brown, Boston, 1993.
- Gombrich, E. H. *Art and Illusion*. 4th ed. Pantheon, New York, 1972.
- Harris, A. S., and L. Nochlin. Women Artists, 1550–1950. Knopf, New York, 1976.
- Kemal, S., and I. Gaskell. The Language of Art History.

- Cambridge Studies in Philosophy and the Arts. Cambridge University Press, New York, 1991.
- Kleinbauer, W. E. Modern Perspectives in Western Art History: An Anthology of Twentieth-Century Writings on the Visual Arts. Reprint of 1971 ed., University of Toronto Press, Toronto, 1989.
- Kostof, S. A. History of Architecture: Settings and Rituals. 2nd ed. Oxford University Press, New York, 1995.
- Kris, E. Psychoanalytic Explorations in Art. International Universities Press, New York, 1962.
- ——, and O. Kurz. Legend, Myth, and Magic in the Image of the Artist: A Historical Experiment. Yale University Press, New Haven, 1979.
- Kultermann, U. The History of Art History. Abaris Books, New York, 1993.
- Nochlin, L. Women, Art, and Power, and Other Essays. Harper & Row, New York, 1988.
- Panofsky, E. *Meaning in the Visual Arts.* Reprint of 1955 ed., University of Chicago Press, 1982.
- Parker, R., and G. Pollock. Old Mistresses: Women, Art, and Ideology. Pantheon, New York, 1981.
- Penny, N. *The Materials of Sculpture*. Yale University Press, New Haven, 1993.
- Podro, M. The Critical Historians of Art. Yale University Press, New Haven, 1982.
- Pollock, G. Vision and Difference: Feminity, Feminism, and the Histories of Art. Routledge, New York, 1988.
- Rees, A. L., and F. Borzello. The New Art History. Humanities Press International, Atlantic Highlands, N.J., 1986.
- Roth, L. Understanding Architecture: Its Elements, History, and Meaning. Harper & Row, New York, 1993.
- Shikes, R. E. The Indignant Eye: The Artist as Social Critic in Prints and Drawings from the Fifteenth Century to Picasso. Beacon Press, Boston, 1969.
- Summerson, J. *The Classical Language of Architecture*. MIT Press, Cambridge, 1963.
- Tagg, J. Grounds of Dispute: Art History, Cultural Politics, and the Discursive Field. University of Minnesota Press, Minneapolis, 1992.
- Trachtenberg, M., and I. Hyman. Architecture: From Prehistory to Post-Modernism. Harry N. Abrams, New York, 1986.
- Watkin, D. *The Rise of Architectural History.* University of Chicago Press, Chicago, 1980.
- Wittkower, R. and M. Born Under Saturn: The Character and Conduct of Artists: A Documented History from Antiquity to the French Revolution. Norton, New York, 1963.
- Wölfflin, H. Principles of Art History: The Problem of the Development of Style in Later Art. Dover, New York, 1932.
- Wolff, J. The Social Production of Art. 2nd ed. New York University Press, New York, 1993.
- Wollheim, R. Art and Its Objects. Cambridge University Press. New York, 1980.

PART ONE: THE ANCIENT WORLD

GENERAL REFERENCES

- Groenewegen-Frankfort, H. A., and B. Ashmole. Art of the Ancient World: Painting, Pottery, Sculpture, Architecture from Egypt, Mesopotamia, Crete, Greece, and Rome. Harry N. Abrams, New York, 1975.
- Lloyd, S., H. Müller, and R. Martin. Ancient Architecture: Egypt, Mesopotamia, Greece. Harry N. Abrams, New York, 1974.
- Van Keuren, F. Guide to Research in Classical Art and Mythology. American Library Association, Chicago, 1991.
- Wolf, W. The Origins of Western Art: Egypt, Mesopotamia, the Aegean. Universe Books, New York, 1989.

1. PREHISTORIC ART

Bandi, H.-G., and H. Breuil. The Art of the Stone Age: Forty Thousand Years of Rock Art. 2nd ed. Methuen, London, 1970.

- Breuil, H. Four Hundred Centuries of Cave Art. Reprint of 1952 ed., Hacker, New York, 1979.
- Chauvet, J.-M., É. B. Deschamps, and C. Hilaire. *Dawn of Art: The Chauvet Cave.* Harry N. Abrams, New York. 1995.
- Gimbutas, M. The Gods and Goddesses of Old Europe, 7000–3500 B.C.: Myths, Legends, and Cult Images. University of California Press, Berkeley, 1974.
- Graziosi, P. Paleolithic Art. McGraw-Hill, New York, 1960.
- Leroi-Gourhan, A. The Dawn of European Art: An Introduction to Palaeolithic Cave Painting. Cambridge University Press, New York, 1982.
- Powell, T. G. E. *Prehistoric Art*. The World of Art. Oxford University Press, New York, 1966.
- Ruspoli, M. *The Cave of Lascaux: The Final Photographs.* Harry N. Abrams, New York, 1987.
- Sandars, N. Prehistoric Art in Europe. 2nd ed. Yale University Press, New Haven, 1985.
- Sieveking, A. *The Cave Artists*. Thames and Hudson, London, 1979.
- Twohig, E. S. *The Megalithic Art of Western Europe*. Oxford University Press, New York, 1981.

2. EGYPTIAN ART

- Aldred, C. The Development of Ancient Egyptian Art, from 3200 to 1315 B.C. 3 vols. in 1. Academy Editions, London, 1972.
- Badawy, A. A History of Egyptian Architecture. 3 vols. University of California Press, Berkeley, 1954–68.
- Davis, W. *The Canonical Tradition in Ancient Egyptian*Art. Cambridge University Press, New York, 1989.
- Edwards, I. E. S. *The Pyramids of Egypt.* Rev. ed., Penguin, Harmondsworth, England, 1991.
- Lange, K., and M. Hirmer. Egypt: Architecture, Sculpture, Painting in Three Thousand Years. 4th ed. Phaidon, London, 1968.
- Mahdy, C., ed. The World of the Pharaohs: A Complete Guide to Ancient Egypt. Thames and Hudson, London, 1990.
- Mendelssohn, K. *The Riddle of the Pyramids*. Thames and Hudson, New York, 1986.
- Panofsky, E. Tomb Sculpture: Four Lectures on Its Changing Aspects from Ancient Egypt to Bernini. Introduction by M. Kemp. Harry N. Abrams, New York, 1992.
- Schaefer, H. *Principles of Egyptian Art.* Clarendon Press, Oxford, 1986.
- Smith, W., and W. Simpson. The Art and Architecture of Ancient Egypt. Pelican History of Art. Reprint of 1981 2nd ed., Yale University Press, New Haven, 1993.
- Wilkinson, R. Reading Egyptian Art: A Hieroglyphic Guide to Ancient Egyptian Painting and Sculpture. Thames and Hudson, New York, 1992.

3. ANCIENT NEAR EASTERN ART

- Akurgal, E. Art of the Hittites. Harry N. Abrams, New York, 1962.
- Amiet, P. Art of the Ancient Near East. Harry N. Abrams, New York, 1980.
- Collon, D. First Impressions: Cylinder Seals in the Ancient Near East. University of Chicago Press, Chicago, 1987.
- Crawford, H. Sumer and the Sumerians. Cambridge University Press, New York, 1991.
- Frankfort, H. The Art and Architecture of the Ancient Orient. Pelican History of Art. 4th ed. Yale University Press, New Haven, 1970.
- Ghirshman, R. Persian Art, the Parthian and Sassanian Dynasties, 249 B.C.–A.D. 651. The Arts of Mankind. Golden Press, New York, 1962.
- The Arts of Ancient Iran: From Its Origins to the
 Time of Alexander the Great. The Arts of Mankind.
- Golden Press, New York, 1964.Leick, G. A Dictionary of Ancient Near Eastern Architecture. Routledge, New York, 1988.
- Lloyd, S. The Art of the Ancient Near East. Oxford University Press, New York, 1963.

- Stone Age to the Persian Conquest. Rev. ed. Thames and Hudson, New York, 1984.
- Mellaart, J. Earliest Civilizations of the Near East. McGraw-Hill, New York, 1965.
- Moscati, S. *The Phoenicians*. Abbeville, New York, 1988.Oates, J. *Babylon*. Rev. ed. Thames and Hudson, London, 1986.
- Parrot, A. *The Arts of Assyria.* Braziller, New York, 1961.

 ——. *Sumer: The Dawn of Art.* Golden Press, New York, 1961.
- Porada, E. The Art of Ancient Iran: Pre-Islamic Cultures. Crown, New York, 1965.
- Reade, J. Mesopotamia. British Museum, London, 1991.

4. AEGEAN ART

- Barber, R. *The Cyclades in the Bronze Age.* University of Iowa Press, Iowa City, 1987.
- Boardman, J. Pre-Classical: From Crete to Archaic Greece. Penguin, Harmondsworth, England, 1967.
- Demargne, P. Aegean Art: The Origins of Greek Art. The Arts of Mankind. Thames and Hudson, London, 1964.
- Getz-Preziosi, P. Sculptors of the Cyclades. University of Michigan Press, Ann Arbor, 1987.
- Graham, J. *The Palaces of Crete*. Rev. ed. Princeton University Press, Princeton, 1987.
- Hampe, R., and E. Simon. The Birth of Greek Art from the Mycenean to the Archaic Period. Oxford University Press, New York, 1981.
- Higgins, R. *Minoan and Mycenaean Art.* The World of Art. Rev. ed. Oxford University Press, New York, 1981.
- Hood, S. The Arts in Prehistoric Greece. Pelican History of Art. Penguin, Harmondsworth, England, 1978.
- ——. The Minoans: The Story of Bronze Age Crete. Praeger, New York, 1981.
- Hurwit, J. *The Art and Culture of Early Greece, 1100–480*B.C. Cornell University Press, Ithaca, 1985.
- McDonald, W. *Progress into the Past: The Rediscovery of Mycenaean Civilization.* 2nd ed. Indiana University Press, Bloomington, 1990.
- Mylonas, G. *Mycenae and the Mycenaean Age.* Princeton University Press, Princeton, 1966.
- Renfrew, C. The Emergence of Civilization: The Cyclades and the Aegean in the Third Millennium B.C. Methuen, London, 1972.
- Vermeule, E. *Greece in the Bronze Age.* University of Chicago Press, Chicago, 1972.

5. GREEK ART

- Arias, P., and M. Hirmer. History of 1000 Years of Greek Vase Painting. Harry N. Abrams, New York, 1963.
- Beazley, J. D. Attic Black-Figure Vase-Painters. Reprint of 1956 ed., Hacker, New York, 1978.
- The Development of Attic Black-Figure. Rev. ed. University of California Press, Berkeley, 1986.
- Boardman, J. Greek Gems and Finger Rings: Early Bronze Age to Late Classical. Harry N. Abrams, New York, 1970.
- ——. Athenian Black Figure Vases: A Handbook. Thames and Hudson, New York, 1985.
- Greek Sculpture: The Archaic Period: A Handbook. New ed. The World of Art. Thames and Hudson, New York, 1985.
- Greek Sculpture: The Classical Period: A Handbook. New ed. The World of Art. Thames and Hudson, New York, 1985.
- Athenian Red Figure Vases: The Classical Period: A Handbook. The World of Art. Thames and Hudson, New York, 1989.
- Athenian Red Figure Vases: The Archaic Period: A Handbook. The World of Art. Thames and Hudson, New York, 1991.
- ——, ed. *The Oxford History of Classical Art.* Oxford University Press, New York, 1993.
- Carpenter, T. H. Art and Myth in Ancient Greece: A Handbook. The World of Art. Thames and Hudson, New York, 1991.
- Charbonneaux, J., R. Martin, and F. Villard. *Archaic Greek Art.* The Arts of Mankind. Braziller, New York, 1971.

- ——. Classical Greek Art. The Arts of Mankind. Braziller, New York, 1972.
- ——. Hellenistic Greek Art. The Arts of Mankind. Braziller, New York, 1973.
- Coulton, J. J. Ancient Greek Architects at Work: Problems of Structure and Design. Cornell University Press, Ithaca, 1977.
- Dinsmoor, W. The Architecture of Ancient Greece. Reprint of 1950 ed., Norton, New York, 1975.
- Kraay, C., and M. Hirmer. *Greek Coins*. Harry N. Abrams, New York. 1966.
- Lawrence, A. Greek Architecture. Pelican History of Art. 4th ed., rev. Penguin, Harmondsworth, England, 1983.
- Moon, W., ed. Ancient Greek Art and Iconography. University of Wisconsin Press, Madison, 1983.
- Papaioannou, K. *The Art of Greece*. Harry N. Abrams, New York, 1989.
- Pedley, J. *Greek Art and Archaeology.* 2nd ed. Harry N. Abrams, New York, 1997.
- Pollitt, J. Art and Experience in Classical Greece. Cambridge University Press, New York, 1972.
- The Ancient View of Greek Art: Criticism, History, and Terminology. Yale University Press, New Haven, 1974.
- ——. Art in the Hellenistic Age. Cambridge University Press, New York, 1986.
- ——, ed. Art of Greece, 1400–31 B.C.: Sources and Documents. 2nd ed. Prentice-Hall, Englewood Cliffs, N.J., 1990.
- Richter, G. M. A. The Sculpture and Sculptors of the Greeks. 4th ed., rev. Yale University Press, New Haven, 1970.
- ——. Portraits of the Greeks. Ed. R. Smith. Oxford University Press, New York, 1984.
- —. A Handbook of Greek Art. 9th ed. Da Capo, New York, 1987.
- Ridgway, B. S. *The Severe Style in Greek Sculpture*. Princeton University Press, Princeton, 1970.
- ——. The Archaic Style in Greek Sculpture. Princeton University Press, Princeton, 1976.
- Fifth Century Styles in Greek Sculpture. Princeton University Press, Princeton, 1981.
- ——. Hellenistic Sculpture. Vol. 1, The Styles of ca. 331–200 B.C. Bristol Classical Press, Bristol, 1990.
- Robertson, D. Greek and Roman Architecture. 2nd ed. Cambridge University Press, Cambridge, 1969.
- Robertson, M. *History of Greek Art.* 2 vols. Cambridge University Press, Cambridge, 1975.
- The Art of Vase Painting in Classical Athens. Cambridge University Press, New York, 1992.
- Schefold, K. Myth and Legend in Early Greek Art. Harry N. Abrams, New York, 1966.
- Gods and Heroes in Late Archaic Greek Art. Cambridge University Press, New York, 1992.
- Smith, R. *Hellenistic Sculpture*. The World of Art. Thames and Hudson, New York, 1991.
- Stewart, A. F. *Greek Sculpture: An Exploration.* Yale University Press, New Haven, 1990.

6. ETRUSCAN ART

- Boethius, A. Etruscan and Early Roman Architecture. Pelican History of Art. 2nd ed. Penguin, Harmondsworth, England, 1978.
- Bonfante, L., ed. Etruscan Life and Afterlife: A Handbook of Etruscan Studies. Wayne State University Press, Detroit, 1986.
- Brendel, O. Etruscan Art. Pelican History of Art. Yale University Press, New Haven, 1995.
- Pallottino, M. Etruscan Painting. Skira, Geneva, 1953.
- Richardson, E. The Etruscans: Their Art and Civilization. Reprint of 1964 ed., with corrections, University of Chicago Press, Chicago, 1976.
- Sprenger, M., G. Bartoloni, and M. Hirmer. *The Etrus*cans: Their History, Art, and Architecture. Harry N. Abrams, New York, 1983.
- Steingräber, S., ed. Etruscan Painting: Catalogue Raisonné of Etruscan Wall Paintings. Johnson Reprint, New York. 1986.

7. ROMAN ART

- Andreae, B. *The Art of Rome*. Harry N. Abrams, New York, 1977.
- Bianchi-Bandinelli, R. *Rome: The Center of Power.* The Arts of Mankind. Braziller, New York, 1970.
- ——. Rome: The Late Empire. The Arts of Mankind. Braziller, New York, 1971.
- Brilliant, R. Roman Art from the Republic to Constantine. Phaidon, London, 1974.
- Jenkyns, R., ed. *The Legacy of Rome: A New Appraisal.* Oxford University Press, New York, 1992.
- Kent, J., and M. Hirmer. Roman Coins. Harry N. Abrams, New York, 1978.
- Kleiner, D. *Roman Sculpture*. Yale University Press, New Haven, 1992.
- Ling, R. Roman Painting. Cambridge University Press, New York, 1991.
- L'Orange, H. Art Forms and Civic Life in the Late Roman Empire. Princeton University Press, Princeton, 1965.
- Macdonald, W. *The Architecture of the Roman Empire*. 2 vols. Rev. ed. Yale University Press, New Haven, 1982–86.
- Maiuri, A. Roman Painting. Skira, Geneva, 1953.
- Nash, E. Pictorial Dictionary of Ancient Rome. 2 vols. Reprint of 1968 2nd ed., Hacker, New York, 1981.
- Pollitt, J. The Art of Rome and Late Antiquity: Sources and Documents. Prentice-Hall, Englewood Cliffs, N.J., 1966.
- Ramage, N. and A. The Cambridge Illustrated History of Roman Art. Cambridge University Press, Cambridge, 1991.
- Strong, D. E. *Roman Art.* Pelican History of Art. 2nd ed. Penguin, Baltimore, 1976.
- Vitruvius, the Ten Books on Architecture. Trans. M. H. Morgan. Reprint of 1914 ed., Dover, New York, 1960.
- Ward-Perkins, J. B. Roman Architecture. Harry N. Abrams, New York, 1977.
- ——. Roman Imperial Architecture. Pelican History of Art. 2nd ed. Penguin, New York, 1981.
- Zanker, P. The Power of Images in the Age of Augustus. University of Michigan Press, Ann Arbor, 1988.

PART TWO: THE MIDDLE AGES

GENERAL REFERENCES

- Alexander, J. J. G. Medieval Illuminators and Their Methods of Work. Yale University Press, New Haven, 1992.
- Calkins, R. G. *Illuminated Books of the Middle Ages*. Cornell University Press, Ithaca, 1983.
- Monuments of Medieval Art. Reprint of 1979 ed., Cornell University Press, Ithaca, 1985.
- Cassidy, B., ed. *Iconography at the Crossroads*. Princeton University Press, Princeton, 1993.
- Katzenellenbogen, A. Allegories of the Virtues and Vices in Medieval Art. Reprint of 1939 ed., University of Toronto Press, Toronto, 1989.
- Pächt, O. Book Illumination in the Middle Ages: An Introduction. Miller, London, 1986.
- Pelikan, J. Mary through the Centuries: Her Place in the History of Culture. Yale University Press, New Haven, 1996.
- Schapiro, M. Late Antique, Early Christian, and Mediaeval Art. Meyer Schapiro, Selected Papers, 3. Braziller, New York, 1979.
- Schiller, G. *Iconography of Christian Art.* 2 vols. New York Graphic Society, Greenwich, 1971–72.
- Snyder, J. Medieval Art: Painting, Sculpture, Architecture, 4th–14th Century. Harry N. Abrams, New York, 1989.
- Tasker, E. Encyclopedia of Medieval Church Art. Batsford, London, 1993.

1. EARLY CHRISTIAN AND BYZANTINE ART

Beckwith, J. The Art of Constantinople: An Introduction to Byzantine Art (330–1453). 2nd ed. Phaidon, New York, 1968.

- Early Christian and Byzantine Art. Pelican History of Art. 2nd ed. Penguin, New York, 1979.
- Demus, O. *Byzantine Art and the West.* New York University Press, New York, 1970.
- Grabar, A. *The Beginnings of Christian Art, 200–395.* The Arts of Mankind. Odyssey, New York, 1967.
- —. Christian Iconography: A Study of Its Origins. Princeton University Press, Princeton, 1968.
- Kitzinger, E. *Byzantine Art in the Making*. Harvard University Press, Cambridge, 1977.
- Kleinbauer, W. Early Christian and Byzantine Architecture: An Annotated Bibliography and Historiography. G. K. Hall, Boston, 1993.
- Krautheimer, R. *Rome: Profile of a City, 312–1308.* Princeton University Press, Princeton, 1980.
- Early Christian and Byzantine Architecture. Pelican History of Art. 4th ed. Yale University Press, New Haven, 1986.
- Maguire, H. Art and Eloquence in Byzantium. Princeton University Press, Princeton, 1981.
- Mango, C. *Byzantine Architecture*. Harry N. Abrams, New York, 1974.
- The Art of the Byzantine Empire, 312–1453: Sources and Documents. Reprint of 1972 ed., University of Toronto Press, Toronto, 1986.
- Mark, R., and A. Ş. Çakmak, eds. Hagia Sophia from the Age of Justinian to the Present. Cambridge University Press. New York. 1992.
- Mathews, T. The Byzantine Churches of Istanbul: A Photographic Survey. Pennsylvania State University Press, University Park, Pa., 1976.
- The Clash of Gods: A Reinterpretation of Early Christian Art. Princeton University Press, Princeton, 1993
- Milburn, R. Early Christian Art and Architecture. University of California Press, Berkeley, 1988.
- Rodley, L. *Byzantine Art and Architecture: An Introduction*. Cambridge University Press, New York, 1994.
- Simson, O. G. von. Sacred Fortress: Byzantine Art and Statecraft in Ravenna. Reprint of 1948 ed., Princeton University Press, Princeton, 1987.
- Talbot Rice, D. *The Beginnings of Christian Art.* Abingdon Press, Nashville, Tenn., 1957.
- ——. Art of the Byzantine Era. The World of Art. Thames and Hudson, London, 1963.
- Volbach, W. Early Christian Art. Harry N. Abrams, New York, 1962.
- Weitzmann, K. Late Antique and Early Christian Book Illumination. Braziller, New York, 1977.

2. EARLY MEDIEVAL ART

- Alexander, J. J. G. Insular Manuscripts, Sixth to the Ninth Century. Survey of Manuscripts Illuminated in the British Isles. Miller, London, 1978.
- Backhouse, J., ed. *The Lindisfarne Gospels*. Phaidon, Oxford, 1981.
- ——. The Golden Age of Anglo-Saxon Art, 966–1066. Indiana University Press, Bloomington, 1984.
- Conant, K. Carolingian and Romanesque Architecture, 800–1200. Pelican History of Art. 3rd ed. Penguin, Harmondsworth, England, 1973.
- Davis-Weyer, C. Early Medieval Art, 300–1150: Sources and Documents. Reprint of 1971 ed., University of Toronto Press, Toronto, 1986.
- Deshman, R. Anglo-Saxon and Anglo-Scandinavian Art: An Annotated Bibliography. G. K. Hall, Boston, 1984.
- Dodwell, C. R. *Anglo-Saxon Art: A New Perspective.* Cornell University Press, Ithaca, 1982.
- The Pictorial Arts of the West, 800–1200. Pelican History of Art. New ed. Yale University Press, New Haven, 1993.
- Henry, F., ed. *Irish Art in the Early Christian Period, to 800*A.D. Cornell University Press, Ithaca, 1965.
- Irish Art During the Viking Invasions, 800–1020
 A.D. Cornell University Press, Ithaca, 1967.
- Horn, W., and E. Born. *The Plan of St. Gall.* 3 vols. University of California Press, Berkeley, 1979.

- Hubert, J., J. Porcher, and W. Volbach. Europe of the Invasions. The Arts of Mankind. Braziller, New York, 1969.
- Hubert, J. The Carolingian Renaissance. The Arts of Mankind. Braziller, New York, 1970.
- Kitzinger, E. Early Medieval Art, with Illustrations from the British Museum. Rev. ed. Indiana University Press, Bloomington, 1983.
- Lasko, P. Ars Sacra, 800–1200. Pelican History of Art. 2nd ed. Yale University Press, New Haven, 1994.
- Mayr-Harting, M. Ottonian Book Illumination: An Historical Study. 2 vols. Miller, London, 1991–93.
- Mütherich, F., and J. Gaehde. Carolingian Painting. Braziller, New York, 1976.
- Nees, L. From Justinian to Charlemagne: European Art, 567–787: An Annotated Bibliography. G. K. Hall, Boston, 1985.
- Nordenfalk, C. Celtic and Anglo-Saxon Painting: Book Illumination in the British Isles, 600–800. Braziller, New York, 1977.
- Palol, P. de, and M. Hirmer. *Early Medieval Art in Spain*. Harry N. Abrams, New York, 1967.
- Rickert, M. Painting in Britain: The Middle Ages. Pelican History of Art. 2nd ed. Penguin, Harmondsworth, England, 1965.
- Stone, L. Sculpture in Britain: The Middle Ages. Pelican History of Art. 2nd ed. Penguin Books, Harmondsworth, England, 1972.
- Temple, E. Anglo-Saxon Manuscripts, 900–1066. Survey of Manuscripts Illuminated in the British Isles. Miller, London, 1976.
- Werner, M. Insular Art: An Annotated Bibliography. G. K. Hall, Boston, 1984.
- Wilson, D. M. Anglo-Saxon Art: From the Seventh Century to the Norman Conquest. Overlook Press, Woodstock, N.Y., 1984.
- Wormald, F. Collected Writings, Vol. 1, Studies in Medieval Art from the Sixth to the Twelfth Centuries. Oxford University Press, New York, 1984.

3. ROMANESQUE ART

- Aubert, M. Romanesque Cathedrals and Abbeys of France. House and Maxwell, New York, 1966.
- Bizzarro, T. Romanesque Architectural Criticism: A Prehistory. Cambridge University Press, New York, 1992.
- Boase, T. S. R. *English Art, 1100–1216.* Oxford History of English Art. Clarendon Press, Oxford, 1953.
- Cahn, W. Romanesque Bible Illumination. Cornell University Press, Ithaca, 1982.
- Chapman, G. Mosan Art: An Annotated Bibliography, Reference Publications in Art History. G. K. Hall, Boston, 1988.
- Davies, M. Romanesque Architecture: A Bibliography. G. K. Hall, Boston, 1993.
- Demus, O. Romanesque Mural Painting. Harry N. Abrams, New York, 1970.
- Focillon, H. The Art of the West in the Middle Ages. Ed. J. Bony. 2 vols. Reprint of 1963 ed., Cornell University Press, Ithaca, 1980.
- Glass, D. F. Italian Romanesque Sculpture: An Annotated Bibliography. Reference Publications in Art History. G. K. Hall, Boston, 1983.
- Grabar, A., and C. Nordenfalk. Romanesque Painting from the Eleventh to the Thirteenth Century: Mural Painting. Skira, Geneva, 1958.
- Hearn, M. F. Romanesque Sculpture: The Revival of Monumental Stone Sculpture. Cornell University Press, Ithaca, 1981.
- Kaufmann, C. Romanesque Manuscripts, 1066–1190. Survey of Manuscripts Illuminated in the British Isles. Miller, London, 1978.
- Kubach, H. E. *Romanesque Architecture*. Harry N. Abrams, New York, 1975.
- Lyman, T. W. French Romanesque Sculpture: An Annotated Bibliography. Reference Publications in Art History. G. K. Hall, Boston, 1987.
- Måle, E. Religious Art in France, the Twelfth Century: A Study of the Origins of Medieval Iconography. Bollingen series, 90:1. Princeton University Press, Princeton, 1978.

- Nichols, S. Romanesque Signs: Early Medieval Narrative and Iconography. Yale University Press, New Haven, 1983.
- Pächt, O. The Rise of Pictorial Narrative in Twelfth-Century England. Clarendon Press, Oxford, 1962.
- Petzold, A. *Romanesque Art.* Perspectives. Harry N. Abrams, 1995.
- Platt, C. The Architecture of Medieval Britain: A Social History. Yale University Press, New Haven, 1990.
- Porcher, J. French Miniatures from Illuminated Manuscripts. Collins, London, 1960.
- Porter, A. K. Romanesque Sculpture of the Pilgrimage Roads. 10 vols. Reprint of 1923 ed., Hacker, New York, 1969.
- Schapiro, M. Romanesque Art. Braziller, New York, 1977. Stoddard, W. Art and Architecture in Medieval France. Harper & Row, New York, 1972.
- Swarzenski, H. Monuments of Romanesque Art: The Art of Church Treasures in North-Western Europe. 2nd ed. University of Chicago Press, Chicago, 1967.

4. GOTHIC ART

- Avril, F. Manuscript Painting at the Court of France: The Fourteenth Century, 1310–1380. Braziller, New York, 1978
- Belting, H. The Image and Its Public: Form and Function of Early Paintings of the Passion. Caratzas, New Rochelle, 1990.
- Blum, P. Early Gothic Saint-Denis: Restorations and Survivals. University of California Press, Berkeley, 1992.
- Bomford, D. Art in the Making: Italian Painting Before 1400. Exh. cat. National Gallery of Art, London, 1989
- Bony, J. The English Decorated Style: Gothic Architecture Transformed, 1250–1350. Cornell University Press, Ithaca, 1979.
- French Gothic Architecture of the Twelfth and Thirteenth Centuries. University of California Press, Berkeley, 1983.
- Bowie, T., ed. The Sketchbook of Villard de Honnecourt. Reprint of 1968 ed., Greenwood, Westport, Conn., 1982.
- Branner, R. St. Louis and the Court Style in Gothic Architecture. Zwemmer, London, 1965.
- -----. Chartres Cathedral. Norton, New York, 1969.
- Brieger, P. English Art, 1216–1307. Oxford History of English Art. Clarendon Press, Oxford, 1957.
- Camille, M. Gothic Art: Glorious Visions. Perspectives. Harry N. Abrams, New York, 1997.
- The Gothic Idol: Ideology and Image Making in Medieval Art. Cambridge University Press, New York, 1989.
- Caviness, M. H. Stained Glass Before 1540: An Annotated Bibliography. G. K. Hall, Boston, 1983.
- Sumptuous Arts at the Royal Abbeys of Reims and Braine. Princeton University Press, Princeton, 1990. Cennini, C. The Crafisman's Handbook (Il Libro dell'Arte).
- Dover, New York, 1954. Erlande-Brandenburg, A. *Gothic Art.* Harry N. Abrams,
- New York, 1989. Frankl, P. *Gothic Architecture.* Pelican History of Art. Pen-
- guin, Harmondsworth, England, 1962. Frisch, T. G. Gothic Art, 1140-c. 1450: Sources and Doc-
- uments. Reprint of 1971 ed., University of Toronto Press, Toronto, 1987.
- Gerson, P., ed. Abbot Suger and Saint-Denis: A Symposium. Metropolitan Museum of Art, New York, 1986.
- Grodecki, L. Gothic Architecture. Harry N. Abrams, New York, 1977.
- ———, and C. Brisac. *Gothic Stained Glass*, 1200–1300. Cornell University Press, Ithaca, 1985.
- Jantzen, H. High Gothic: The Classic Cathedrals of Chartres, Reims, Amiens. Reprint of 1962 ed., Princeton University Press, Princeton, 1984.
- Katzenellenbogen, A. The Sculptural Programs of Chartres Cathedral. Johns Hopkins University Press, Baltimore, 1959.
- Krautheimer, R., and T. Krautheimer-Hess. *Lorenzo Ghiberti*. 2nd ed. Princeton University Press, Princeton, 1970.

- Lord, C. Royal French Patronage of Art in the Fourteenth Century: An Annotated Bibliography. G. K. Hall, Boston, 1985.
- Mâle, E. Religious Art in France, the Thirteenth Century: A Study of Medieval Iconography and Its Sources. Ed. H. Bober. Princeton University Press, Princeton, 1984.
- Meiss, M. Painting in Florence and Siena After the Black Death. Princeton University Press, Princeton, 1951.
- French Painting in the Time of Jean de Berry: The Late Fourteenth Century and the Patronage of the Duke. Braziller, New York, 1967.
- ———, and E. Beatson. *The "Belles Heures" of Jean, Duke of Berry.* Braziller, New York, 1974.
- Meulen, J. van der. Chartres: Sources and Literary Interpretation: A Critical Bibliography. Reference Publications in Art History. G. K. Hall. Boston, 1989.
- Morgan, N. Early Gothic Manuscripts. Survey of Manuscripts Illuminated in the British Isles. 2 vols. Miller, London, 1982–88.
- Murray, S. Beauvais Cathedral: Architecture of Transcendence. Princeton University Press, Princeton, 1989.
- Panofsky, E. Gothic Architecture and Scholasticism. Reprint of 1951 ed., New American Library, New York, 1985.
- ——, ed. and trans. Abbot Suger on the Abbey Church of Saint-Denis and Its Art Treasures. 2nd ed. Princeton University Press, Princeton, 1979.
- Pope-Hennessy, J. *Italian Gothic Sculpture*. 3rd ed. Oxford University Press, New York, 1986.
- Sandler, L. Gothic Manuscripts, 1285–1385. Survey of Manuscripts Illuminated in the British Isles. Miller, London, 1986.
- Sauerländer, W. Gothic Sculpture in France, 1140–1270. Harry N. Abrams, New York, 1972.
- Simson, O. von. The Gothic Cathedral: Origins of Gothic Architecture and the Medieval Concept of Order. 3rd ed. Princeton University Press, Princeton, 1988.
- Stubblebine, J. Assisi and the Rise of Vernacular Art. Harper & Row, New York, 1985.
- Dugento Painting: An Annotated Bibliography. G. K. Hall, Boston, 1985.
- Vigorelli, G. *The Complete Paintings of Giotto.* Harry N. Abrams, New York, 1966.
- White, J. *Duccio: Tuscan Art and the Medieval Workshop.*Thames and Hudson, New York, 1979.
- Art and Architecture in Italy, 1250–1400. Pelican History of Art. 3rd ed. Yale University Press, New Haven, 1993.
- Williamson, P. Gothic Sculpture, 1140–1300. Yale University Press, New Haven, 1995.
- Wilson, C. The Gothic Cathedral. Thames and Hudson, New York, 1990.

PART THREE: THE RENAISSANCE THROUGH THE ROCOCO

GENERAL REFERENCES

- De Winter, P. European Decorative Arts, 1400–1600: An Annotated Bibliography. G. K. Hall, Boston, 1988.
- Hartt, F. Italian Renaissance Art. 4th ed. Harry N. Abrams, New York, 1993.
- Haskell, F., and N. Penny. Taste and the Antique: The Lure of Classical Sculpture, 1500–1900. Yale University Press, New Haven, 1981.
- Held, J., and D. Posner. Seventeenth and Eighteenth Century: Baroque Painting, Sculpture, Architecture. Harry N. Abrams, New York, 1971.
- Hind, A. *History of Engraving and Etching*. Reprint of 1923 3rd ed., Dover, New York, 1963.
- An Introduction to a History of Woodcut. 2 vols. Reprint of 1935 ed., Dover, New York, 1963.
- Ivins, W. M., Jr. *How Prints Look: Photographs with a Com*mentary. Beacon Press, Boston, 1987.
- Landau, D., and P. Parshall. The Renaissance Print. Yale University Press, New Haven, 1994.
- Martin, J. R. Baroque. Penguin, Harmondsworth, England, 1989.
- Millon, H. Baroque and Rococo Architecture. Braziller, New York, 1961.

- Norberg-Schultz, C. Baroque Architecture. Harry N. Abrams, New York, 1971.
- Late Baroque and Rococo Architecture. Harry N. Abrams, New York, 1983.
- Snyder, J. Northern Renaissance Art: Painting, Sculpture, the Graphic Arts, from 1350–1575. Harry N. Abrams, New York, 1985.
- Wiebenson, D., ed. Architectural Theory and Practice from Alberti to Ledoux. 2nd ed. University of Chicago Press, Chicago, 1983.
- Wittkower, R. Architectural Principles in the Age of Humanism. 4th ed. St. Martin's, New York, 1988.

1. THE EARLY RENAISSANCE IN ITALY

- Alberti, L. B. On Painting. Trans. C. Grayson, introduction and notes M. Kemp. Penguin, New York, 1991.
- On the Art of Building, in Ten Books. Trans. J. Rykwert, et al. MIT Press, Cambridge, 1991.
- Ames-Lewis, F. Drawing in Early Renaissance Italy. Yale University Press, New Haven, 1981.
- Battisti, E. Filippo Brunelleschi: The Complete Works. Rizzoli, New York, 1981.
- Baxandall, M. Painting and Experience in Fifteenth-Century Italy. A Primer in the Social History of Pictorial Style. 2nd ed. Oxford University Press, New York, 1988.
- Blunt, A. Artistic Theory in Italy, 1450–1600. Reprint of 1940 ed., Oxford University Press, New York, 1983.
- Bober, P., and R. Rubinstein. Renaissance Artists and Antique Sculpture: A Handbook of Sources. Oxford University Press, New York, 1986.
- Borsook, E. The Mural Painters of Tuscany: From Cimabue to Andrea del Sarto. 2nd ed. Oxford University Press, New York, 1980.
- Campbell, L. Renaissance Portraits: European Portrait-Painting in the 14th, 15th, and 16th Centuries. Yale University Press, New Haven, 1990.
- Chambers, D. S., comp. and trans. Patrons and Artists in the Italian Renaissance. University of South Carolina Press, Columbia, 1971.
- Dunkelman, M. Central Italian Painting, 1400–1465: An Annotated Bibliography. G. K. Hall, Boston, 1986.
- Edgerton, S. The Renaissance Rediscovery of Linear Perspective. Basic Books, New York, 1975.
- Gilbert, C. E. Italian Art, 1400–1500: Sources and Documents. Prentice-Hall, Englewood Cliffs, N.J., 1980.
- Goldthwaite, R. Wealth and the Demand for Art in Italy, 1300–1600. Johns Hopkins University Press, Baltimore, 1993.
- Gombrich, E. H. Norm and Form: Studies in the Art of the Renaissance. Phaidon, London, 1966.
- ——. Symbolic Images: Studies in the Art of the Renaissance. 3rd ed. Phaidon, London, 1972.
- The Heritage of Apelles: Studies in the Art of the Renaissance. Phaidon, London, 1976.
- Heydenreich, L., and W. Lotz. Architecture in Italy. 1400– 1600. Pelican History of Art. Penguin, Harmondsworth, England, 1974.
- Humfreys, P., and M. Kemp, eds. The Altarpiece in the Renaissance. Cambridge University Press, New York, 1990.
- Huse, N., and W. Wolters. The Art of Renaissance Venice: Architecture, Sculpture, and Painting, 1460–1590. University of Chicago Press, Chicago, 1990.
- Janson, H. W. The Sculpture of Donatello. 2 vols. Princeton University Press, Princeton, 1957.
- Joannides, P. Masaccio and Masolino: A Complete Catalogue. Harry N. Abrams, New York, 1993.
- Jones, R., and N. Penny. Raphael. Yale University Press, New Haven. 1983.
- Karpinsky, C. Italian Printmaking, Fifteenth and Sixteenth Centuries: An Annotated Bibliography. G. K. Hall, Boston, 1987.
- Kempers, B. Painting, Power, and Patronage: The Rise of the Professional Artist in the Italian Renaissance. Penguin, New York, 1992.
- Lavin, M. A. Piero della Francesca. Harry N. Abrams, New York. 1992.
- Lightbown, R. Sandro Botticelli. 2 vols. University of California Press, Berkeley, 1978.

- Mantegna: With a Complete Catalogue of the Paintings. University of California Press, Berkeley, 1986.
- Murray, P. *The Architecture of the Italian Renaissance.* The World of Art. Rev. ed. Thames and Hudson, New York, 1986.
- Panofsky, E. Renaissance and Renascences in Western Art. Humanities Press, New York, 1970.
- ——. Perspective as Symbolic Form. Zone Books, New York, 1991.
- Pope-Hennessy, J. *The Portrait in the Renaissance*. Pantheon, New York, 1966.
- ——. Italian Renaissance Sculpture. 3rd ed. Oxford University Press, New York, 1986.
- ——. Donatello. Abbeville, New York, 1993.
- Rosenberg, C. Fifteenth-Century North Italian Painting and Drawing: An Annotated Bibliography. G. K. Hall, Boston, 1986.
- Seymour, C. Sculpture in Italy, 1400–1500. Pelican History of Art. Penguin, Harmondsworth, England, 1966.
- Turner, A. R. The Vision of Landscape in Renaissance Italy. Princeton University Press, Princeton, 1974.
- Vasari, G. The Lives of the Painters, Sculptors, and Architects. Trans. G. du C. De Vere. 2 vols. Everyman's Library. Knopf, New York, 1996.
- Wackernagel, M. The World of the Florentine Renaissance Artist: Projects and Patrons, Workshop and Art Market. Princeton University Press, Princeton, 1981.
- Wilk, S. Fifteeenth-Century Central Italian Sculpture: An Annotated Bibliography. G. K. Hall, Boston, 1986.

2. THE HIGH RENAISSANCE IN ITALY

- Ackerman, J., and J. Newman. The Architecture of Michelangelo. 2nd ed. Penguin, Harmondsworth, England, 1986.
- Boase, T. S. R. Giorgio Vasari: The Man and the Book. Princeton University Press, Princeton, 1979.
- Brown, P. Venice and Antiquity: The Venetian Sense of the Past. Yale University Press, New Haven, 1997.
- Bruschi, A. *Bramante*. Thames and Hudson, New York, 1977.
- Clark, K. *Leonardo da Vinci*. Revised and introduced by M. Kemp. Viking, New York, 1988.
- Cole, A. Virtue and Magnificence: Art of the Italian Renaissance Courts. Perspectives. Harry N. Abrams, New York, 1995.
- De Tolnay, C. *Michelangelo.* 4 vols. 2nd ed. Princeton University Press, Princeton, 1969–71.
- Freedberg, S. Painting of the High Renaissance in Rome and Florence. 2 vols. Harvard University Press, Cambridge, 1961.
- ——. Painting in Italy, 1500–1600. Pelican History of Art. 3rd ed. Yale University Press, New Haven, 1993.
- Hibbard, H. Michelangelo. 2nd ed. Harper & Row, New York, 1985.
- Kemp, M. Leonardo da Vinci: The Marvellous Works of Nature and Man. Harvard University Press, Cambridge, 1981.
- ———, ed. Leonardo on Painting: An Anthology of Writings. Yale University Press, New Haven, 1989.
- Klein, R., and H. Zerner. *Italian Art, 1500–1600: Sources and Documents.* Reprint of 1966 ed., Northwestern University Press, Evanston, Ill., 1989.
- Panofsky, E. Studies in Iconology: Humanist Themes in the Art of the Renaissance. Harper & Row, New York, 1972.
- Partridge, L. *The Art of Renaissance Rome.* Perspectives. Harry N. Abrams, New York, 1997.
- Pietrangeli, C., et al. *The Sistine Chapel: A Glorious Restoration*. Harry N. Abrams, New York, 1992.
- Pope-Hennessy, J. Italian High Renaissance and Baroque Sculpture. 3 vols. 3rd ed. Oxford University Press, New York, 1986.
- Rosand, D. Painting in Cinquecento Venice: Titian, Veronese, Tintoretto. Yale University Press, New Haven, 1982.
- Wölfflin, H. Classic Art: An Introduction to the High Renaissance. Reprint of 1952 ed., Cornell University Press, Ithaca, 1980.

3. MANNERISM AND OTHER TRENDS

- Ackerman, J. *Palladio*. 2nd ed. Penguin, Harmondsworth, England, 1977.
- Cellini, B. The Life of Benvenuto Cellini. Ed. J. Pope-Hennessy. 3rd. ed. Phaidon, London, 1960.
- Friedlaender, W. Mannerism and Anti-Mannerism in Italian Painting. Reprint of 1957 ed., Columbia University Press, New York, 1990.
- Gould, C. H. M. The Paintings of Correggio. Cornell University Press, Ithaca, 1976.
- Kaufmann, T. DaCosta. Art and Architecture in Central Europe, 1550–1620: An Annotated Bibliography. Reference Publications in Art History. G. K. Hall, Boston, 1988.
- Mann, R. El Greco and His Patrons: Three Major Projects. Cambridge University Press, New York, 1986.
- Rearick, W. R. The Art of Paolo Veronese, 1528–1588. Cambridge University Press, Cambridge, 1988.
- Shearman, J. Mannerism. Penguin, Harmondsworth, England, 1967.
- Smyth, C. H. *Mannerism and Maniera*. 2nd ed. IRSA, Vienna, 1992.
- Tavernor, R. *Palladio and Palladianism*. The World of Art. Thames and Hudson, New York, 1991.
- Valcanover, F., and T. Pignatti. *Tintoretto*. Harry N. Abrams, New York, 1984.

4. "LATE GOTHIC" PAINTING, SCULPTURE, AND THE GRAPHIC ARTS

- Blum, S. Early Netherlandish Triptychs: A Study in Patronage. University of California Press, Berkeley, 1969.
- Davies, M. Rogier van der Weyden: An Essay with a Critical Catalogue of Paintings. Phaidon, New York, 1972.
- Dhanens, E. *Hubert and Jan van Eyck*. Alpine Fine Arts Collection, New York, 1980.
- Friedländer, M. Early Netherlandish Painting. 14 vols. Praeger, New York, 1967–73.
- ------. From Van Eyck to Bruegel: Early Netherlandish
 Painting. 3rd ed. Cornell University Press, Ithaca,
 1981.
- Frinta, M. S. *The Genius of Robert Campin.* Studies in Art, 1. Mouton, The Hague, 1966.
- Gibson, W. Hieronymus Bosch. Praeger, New York, 1973.
 Mâle, E. Religious Art in France, the Late Middle Ages: A Study of Medieval Iconography and Its Sources. Princeton University Press, Princeton, 1986.
- Mellinkoff, R. Outcasts: Signs of Otherness in Northern European Art of the Late Middle Ages. University of California Press, Berkeley, 1993.
- Muller, T. Sculpture in the Netherlands, Germany, France, and Spain, 1400–1500. Pelican History of Art. Penguin, Harmondsworth, England, 1966.
- Panofsky, E. Early Netherlandish Painting. 2 vols. Harvard University Press, Cambridge, 1958.
- Scott, K. Later Gothic Manuscripts, 1395–1495. Survey of Manuscripts Illuminated in the British Isles. 2 vols. Miller, London. Forthcoming.

5. THE RENAISSANCE IN THE NORTH

- Baxandall, M. The Limewood Sculptors of Renaissance Germany. Yale University Press, New Haven, 1980.
- Benesch, O. The Art of the Renaissance in Northern Europe. Rev. ed. Phaidon, London, 1965.
- Bialostocki, J. The Art of the Renaissance in Eastern Europe. The Wrightsman Lectures, 8. Cornell University Press, Ithaca, 1976.
- Chastel, A., et al. The Renaissance: Essays in Interpretation. Methuen, London, 1982.
- Ganz, P. The Paintings of Hans Holbein the Younger. Phaidon, London, 1956.
- Harbison, C. The Mirror of the Artist: Northern Renaissance Art in Its Historical Context. Perspectives. Harry N. Abrams, New York, 1995.
- Hitchcock, H.-R. German Renaissance Architecture. Princeton University Press, Princeton, 1981.
- Hutchison, J. C. Albrecht Dürer: A Biography. Princeton University Press, Princeton, 1990.

- Koerner, I. The Moment of Self-Portraiture in German Renaissance Art. University of Chicago Press, Chica-
- Lane, B. Flemish Painting Outside Bruges, 1400-1500: An Annotated Bibliography. G. K. Hall, Boston, 1986.
- Melion, W. Shaping the Netherlandish Canon: Karel van Mander's Schilder-Boeck. University of Chicago Press, Chicago, 1991.
- Moxey, K. Peasants, Warriors, and Wives: Popular Imagery in the Reformation. University of Chicago Press, Chicago, 1989.
- Mundy, E. Painting in Bruges, 1470-1550: An Annotated Bibliography. G. K. Hall, Boston, 1985.
- Osten, G. von der, and H. Vey. Painting and Sculpture in Germany and the Netherlands, 1500-1600. Pelican History of Art. Penguin, Harmondsworth, England, 1969.
- Panofsky, E. The Life and Art of Albrecht Dürer. 4th ed. Princeton University Press, Princeton, 1971.
- Parshall, L. and P. Art and the Reformation: An Annotated Bibliography. G. K. Hall, Boston, 1986.
- Stechow, W. Northern Renaissance Art, 1400-1600: Sources and Documents. Prentice-Hall, Englewood Cliffs, N.J., 1966.
- Pieter Bruegel, the Elder. Harry N. Abrams, New York, 1969.
- Van Mander, K. Lives of the Illustrious Netherlandish and German Painters. Ed. H. Miedema. 6 vols. Forth-
- Wood, C. Albrecht Altdorfer and the Origins of Landscape. University of Chicago Press, Chicago, 1993.

6. THE BAROQUE IN ITALY AND SPAIN

- Blunt, A. Borromini. Harvard University Press, Cambridge, 1979
- Brown, J. Velázquez: Painter and Courtier. Yale University Press, New Haven, 1986.
- Francisco de Zurbaran. Harry N. Abrams, New York, 1991.
- The Golden Age of Painting in Spain. Yale University Press, New Haven, 1991.
- Enggass, R., and J. Brown. Italy and Spain, 1600-1750: Sources and Documents. Reprint of 1970 ed., Northwestern University Press, Evanston, Ill., 1992.
- Freedberg, S. Circa 1600: A Revolution of Style in Italian Painting. Harvard University Press, Cambridge, 1983.
- Haskell, F. Patrons and Painters: A Study in the Relations Between Italian Art and Society in the Age of the Baroque. Rev. ed. Yale University Press, New Haven, 1980.
- Hibbard, H. Bernini. Reprint of 1965 ed., Penguin Books, Baltimore, 1980.
- Caravaggio. Harper & Row, New York, 1983.
- Kubler, G., and M. Soria. Art and Architecture in Spain and Portugal and Their American Dominions, 1500-1800. Pelican History of Art. Penguin, Harmondsworth, England, 1959.
- Levey, M. Giambattista Tiepolo: His Life and Art. Yale University Press, New Haven, 1986.
- Montagu, J. Roman Baroque Sculpture: The Industry of Art. Yale University Press, New Haven, 1989.
- Nicolson, B. Caravaggism in Europe. Ed. L. Vertova. 2nd ed., rev. and enl. 3 vols. Allemandi, Turin, 1989.
- Posner, D. Annibale Carracci. 2 vols. Phaidon, London,
- Smith, G. Architectural Diplomacy: Rome and Paris in the Late Baroque. MIT Press, Cambridge, 1993.
- Spear, R. Caravaggio and His Followers. Harper & Row, New York, 1976.
- Varriano, J. Italian Baroque and Rococo Architecture. Oxford University Press, New York, 1986.
- Waterhouse, E. Italian Baroque Painting. 2nd ed. Phaidon, London, 1969.
- Wittkower, R. Art and Architecture in Italy, 1600-1750. Pelican History of Art. 3rd ed. Penguin, Harmondsworth, England, 1980.
- . Gian Lorenzo Bernini: The Sculptor of the Roman Baroque. 3rd ed. Cornell University Press, Ithaca, 1981.

7. THE BAROQUE IN FLANDERS AND HOLLAND

- Alpers, S. The Art of Describing: Dutch Art in the Seventeenth Century. University of Chicago Press, Chicago,
- Blankert, A. Vermeer of Delft: Complete Edition of the Paintings. Dutton, New York, 1978.
- Bruyn, J., et al. A Corpus of Rembrandt Paintings. 3 vols. (to date). Nijhoff, The Hague, 1982-.
- Gerson, H., and E. Ter Kuile, Art and Architecture in Belgium, 1600-1800. Pelican History of Art. Penguin, Baltimore, 1960.
- Haak, B. The Golden Age: Dutch Painters of the Seventeenth Century. Harry N. Abrams, New York, 1984.
- Rembrandt: The Master and His Workshop. Ed. S. Salvesen. 2 vols. Exh. cat. Yale University Press, New Haven,
- Rosenberg, J., S. Slive, and E. Ter Kuile. Dutch Art and Architecture, 1600-1800. 3rd ed. Yale University Press, New Haven, 1997.
- Rosenberg, J. Rembrandt: Life and Work. Rev. ed. Cornell University Press, Ithaca, 1980.
- Schama, S. The Embarrassment of Riches. University of California Press, Berkeley, 1988.
- Schwartz, G. Rembrandt: His Life, His Paintings. Viking, New York, 1985.
- Slive, S. Dutch Painting, 1600-1800. Pelican History of Art. Yale University Press, 1995.
- Frans Hals. 3 vols. Phaidon, New York, 1970-74. Stechow, W. Dutch Landscape Painting of the Seventeenth Century. Reprint of 1966 ed., Cornell University Press, Ithaca, 1980.
- Strauss, W. L., et al., comps. The Rembrandt Documents. Abaris, New York, 1979.
- Sutton, P. The Age of Rubens. Exh. cat. Museum of Fine Arts, Boston, 1993.
- Walford, F. Jacob van Ruisdael and the Perception of Landscape. Yale University Press, New Haven, 1992.
- Westermann, M. A Worldly Art: The Dutch Republic 1585-1718. Perspectives. Harry N. Abrams, New York, 1996.
- Wheelock, A. K., et al. Anthony van Dyck. Exh. cat. Harry N. Abrams, New York, 1990.
- Wheelock, A K., ed. Johannes Vermeer. Exh. cat. Yale University Press, New Haven, 1995.
- White, C. Peter Paul Rubens. Yale University Press, New Haven, 1987.

8. THE BAROQUE IN FRANCE AND ENGLAND

- Blunt, A. Nicolas Poussin. 2 vols. Princeton University Press, Princeton, 1967.
- . Art and Architecture in France, 1500-1700. Pelican History of Art. 4th ed. Penguin, Harmondsworth, England, 1981.
- Downes, K. The Architecture of Wren. Rev. ed. Redhedge, Reading, England, 1988.
- Garreau, M. Charles Le Brun: First Painter to King Louis XIV. Harry N. Abrams, New York, 1992.
- Liechtenstein, J. The Eloquence of Color: Rhetoric and Painting in the French Classical Age. University of California Press, Berkeley, 1993.
- Mérot, A. French Painting in the Seventeenth Century. Yale University Press, New Haven, 1995.
- Nicolas Poussin, Abbeville, New York, 1990.
- Röthlisberger, M. Claude Lorrain: The Paintings. 2 vols. Yale University Press, New Haven, 1961.
- Summerson, J. Architecture in Britain, 1530-1830. Pelican History of Art. 6th ed., rev. Penguin, Harmondsworth, England, 1977.
- Waterhouse, E. K. Painting in Britain, 1530-1790. Pelican History of Art. 4th ed. Penguin, Harmondsworth, England, 1978.
- . The Dictionary of Sixteenth and Seventeenth Century British Painters. Antique Collectors' Club, Woodbridge, Suffolk, 1988.
- Whinney, M. English Art, 1625-1714. Oxford History of English Art. Clarendon Press, Oxford, 1957.

9. THE ROCOCO

- Baillio, J. Elisabeth Louise Vigée Le Brun, 1755-1842. Exh. cat. Kimbell Art Museum, Fort Worth, 1982.
- Brunel, G. Boucher. Vendome, New York, 1986.
- Brusatin, M., et al. The Baroque in Central Europe: Places, Architecture, and Art. Marsilio, Venice, 1992.
- Conisbee, P. Painting in Eighteenth-Century France. Cornell University Press, Ithaca, 1981.
- -. Chardin. Bucknell University Press, Lewisburg, Pa., 1985
- Cormack, M. The Paintings of Thomas Gainsborough. Cambridge University Press, New York, 1991.
- Cuzin, J. P. Jean-Honoré Fragonard: Life and Work: Complete Catalogue of the Oil Paintings. Harry N. Abrams, New York, 1988.
- Gaunt, W. The Great Century of British Painting: Hogarth to Turner. 2nd ed. Phaidon, London, 1978.
- Levey, M. Rococo to Revolution: Major Trends in Eighteenth-Century Painting. The World of Art. Reprint of 1966 ed., Thames and Hudson, New York, 1985.
- Painting and Sculpture in France, 1700-1789. Pelican History of Art. New ed. Yale University Press, New Haven, 1993.
- Links, J. Canaletto. Oxford University Press, New York, 1982.
- Paulson, R. Hogarth: His Life, Art, and Times. 2 vols. Yale University Press, New Haven, 1971.
- Penny, N., ed. Reynolds. Exh. cat. Harry N. Abrams, New York, 1986.
- Pointer, M. Hanging the Head: Portraiture and Social Formation in Eighteenth-Century England. Yale University Press, New Haven, 1993.
- Posner, D. Antoine Watteau. Cornell University Press, Ithaca, 1984.

PART FOUR: THE MODERN WORLD

GENERAL REFERENCES

- Arnason, H. H. History of Modern Art. 3rd ed., rev. and enl. Harry N. Abrams, New York, 1988.
- Baigell, M. A Concise History of American Painting and Sculpture. Harper & Row, New York, 1984.
- Barasch, M. Modern Theories of Art. Vol. 1, From Winckelmann to Baudelaire. New York University Press, New York, 1990.
- Battcock, G., and R. Nickas, eds. The Art of Performance: A Critical Anthology. Dutton, New York, 1984.
- Benevolo, L. History of Modern Architecture. MIT Press, Cambridge, 1971.
- Boime, A. A Social History of Modern Art. 2 vols. (5 vols. planned). University of Chicago Press, Chicago, 1987-
- Brown, M., et al. American Art: Painting, Sculpture, Architecture, Decorative Arts, Photography. Prentice-Hall, Englewood Cliffs, N.J., 1979.
- Campbell M., et al. Harlem Renaissance: Art of Black America. Harry N. Abrams, New York, 1987.
- Castelman, R. Prints of the Twentieth Century: A History. Oxford University Press, New York, 1985.
- Chipp, H., ed. Theories of Modern Art: A Source Book by Artists and Critics. University of California Press, Berkeley, 1968.
- Crary, J. Techniques of the Observer: On Vision and Modernity in the Nineteenth Century. MIT Press, Cambridge, 1990.
- Crook, J. The Dilemma of Style: Architectural Ideas from the Picturesque to the Post Modern. University of Chicago Press, Chicago, 1987.
- Crow, T. Modern Art in the Common Culture. Yale University Press, New Haven, 1996.
- Documents of Modern Art. 14 vols. Wittenborn, New York, 1944-61.
- The Documents of Twentieth-Century Art. G. K. Hall, Boston. Cited individually below.
- Driskell, D. Two Centuries of Black American Art. Exh. cat. Knopf, New York, 1976.
- Eitner, L. An Outline of Nineteenth-Century European

- Painting: From David through Cézanne. 2 vols. Harper & Row, New York, 1986.
- Frampton, K. Modern Architecture: A Critical History. 3rd ed. Thames and Hudson, New York, 1992.
- ———, and Y. Futagawa. *Modern Architecture, 1851–1945.* 2 vols. Rizzoli, New York, 1983.
- Frascina, F., ed. Modern Art and Modernism: A Critical Anthology. Harper & Row, New York, 1982.
- ———. Pollock and After: The Critical Debate. Harper & Row, New York, 1985.
- ——, and J. Harris, eds. Art in Modern Culture: An Anthology of Critical Texts. Harper & Row, New York, 1992.
- Gernsheim, H. and A. The History of Photography: From the Camera Obscura to the Beginning of the Modern Era. McGraw-Hill, New York, 1969.
- Goddard, D. American Painting. Macmillan, New York, 1990.
- Goldberg, R. Performance Art: From Futurism to the Present. Rev. and enl. ed. Harry N. Abrams, New York, 1988
- Goldberg, V., ed. *Photography in Print: Writings from 1816* to the Present. Simon & Schuster, New York, 1981.
- Goldwater, R. *Primitivism in Modern Art.* Enl. ed. Harvard University Press, Cambridge, 1986.
- Hamilton, G. H. Nineteenth and Twentieth Century Art: Painting, Sculpture, Architecture. Harry N. Abrams, New York, 1970.
- Harrison, C., and P. Wood, eds. Art in Theory, 1900– 1990: An Anthology of Changing Ideas. Blackwell, Oxford, 1992.
- Hertz, R., ed. *Theories of Contemporary Art.* Prentice-Hall, Englewood Cliffs, N.J., 1985.
- —, and N. Klein, eds. Twentieth-Century Art Theory: Urbanism, Politics, and Mass Culture. Prentice-Hall, Englewood Cliffs, N.J., 1990.
- Hitchcock, H. R. Architecture: Nineteenth and Twentieth Centuries. Pelican History of Art. 2nd ed. Penguin, Harmondsworth, England, 1971.
- Hunter, S., and J. Jacobus. Modern Art: Painting, Sculpture, Architecture. Harry N. Abrams, New York, 1992.
- Janson, H. W. Nineteenth-Century Sculpture. Harry N. Abrams, New York, 1985.
- ——, and R. Rosenblum. *Nineteenth-Century Art.* Harry N. Abrams, New York, 1984.
- Joachimides, C., et al. American Art in the Twentieth Century: Painting and Sculpture, 1913–1933. Exh. cat. Prestel, Munich, 1993.
- Johnson, W. Nineteenth-Century Photography: An Annotated Bibliography, 1839–1879. G. K. Hall, Boston, 1990.
- Kaplan, P., and S. Manso, eds. Major European Art Movements, 1900–1945: A Critical Anthology. Dutton, New York, 1977.
- Licht, F. Sculpture, Nineteenth and Twentieth Century. New York Graphic Society, Greenwich, 1967.
- McCoubrey, J. American Art, 1700–1960: Sources and Documents. Prentice-Hall, Englewood Cliffs, N.J., 1965.
- McShine, K. An International Survey of Recent Painting and Sculpture. Exh. cat. Museum of Modern Art, New York, 1984.
- Newhall, B. The History of Photography from 1830 to the Present Day. 5th ed., rev. New York Graphic Society, Greenwich, 1982.
- Nochlin, L. The Politics of Vision: Essays on Nineteenth-Century Art and Society. Harper & Row, New York,
- Norman, G. Nineteenth-Century Painters and Painting: A Dictionary. University of California Press, Berkeley, 1977.
- Osborne, H., ed. Oxford Companion to Twentieth-Century Art. Oxford University Press, New York, 1981.
- Phaidon Dictionary of Twentieth-Century Art. Phaidon, Oxford, 1973.
- Pierson, W., and W. Jordy. American Buildings and Their Architects. 4 vols. Doubleday, Garden City, N.Y., 1970–78.
- Pingeot, A., et al. Sculpture: The Adventure of Modern

- Sculpture in the Nineteenth and Twentieth Centuries. Rizzoli, New York, 1986.
- Prown, J. D., and B. Rose. American Painting: From the Colonial Period to the Present. New ed. Rizzoli, New York, 1977.
- Robins, C. *The Pluralist Era: American Art, 1968–1981.* Harper & Row, New York, 1984.
- Rose, B., ed. Readings in American Art Since 1900: A Documentary Survey. Praeger, New York, 1968.
- ——., American Art Since 1900. Rev. ed. Praeger, New York, 1975.
- Rosen, C., and H. Zerner. Romanticism and Realism: The Mythology of Nineteenth-Century Art. Viking, New York. 1984.
- Rosenblum, N. A World History of Photography. Rev. ed. Abbeville, New York, 1989.
- Roth, L. A Concise History of American Architecture. Harper & Row, New York, 1980.
- Sayre, H. The Object of Performance: The American Avant-Garde Since 1970. University of Chicago Press, Chicago, 1990.
- Schapiro, M. Modern Art: Nineteenth and Twentieth Centuries. Braziller, New York, 1982.
- Scharf, A. Art and Photography. Rev. ed. Penguin, Harmondsworth, England, 1974.
- Scully, V. Modern Architecture. Rev. ed. Braziller, New York, 1974.
- Selz, P. Art in Our Times: A Pictorial History, 1890–1980. Harry N. Abrams, New York, 1981.
- Stangos, N. Concepts of Modern Art. 2nd ed. Harper & Row, New York, 1981.
- Row, New York, 1981. Tafuri, M. *Modern Architecture*. 2 vols. Rizzoli, New York,
- 1986. Taylor, J. *The Fine Arts in America*. University of Chicago
- Press, Chicago, 1979.
 ——, ed. *Nineteenth-Century Theories of Art.* Universi-
- ty of California Press, Berkeley, 1991. Tomkins, C. *Post to Neo: The Art World of the 1980s.* Holt,
- New York, 1988.
- Walker, J. Glossary of Art: Architecture and Design Since 1945. 3rd ed. G. K. Hall, Boston, 1992.
- Weaver, M. *The Art of Photography, 1839–1989.* Exh. cat. Yale University Press, New Haven, 1989.
- Weintraub, L. Art on the Edge and Over. Art Insights, Litchfield, Connecticut; dist. D.A.P., 1997.
- Weiss, J. *The Popular Culture of Modern Art.* Yale University Press, New Haven, 1994.
- Wilmerding, J. American Art. Pelican History of Art. Penguin, Harmondsworth, England, 1976.
- Witzling, M., ed. Voicing Our Visions: Writings by Women Artists. Universe Books, New York, 1991.
- Wood, P., et al. *Modernism in Dispute: Art Since the Forties.* Yale University Press, New Haven, 1993.

1. NEOCLASSICISM AND ROMANTICISM

- Bindman, D. Blake as an Artist. Dutton, New York, 1977.Boime, A. The Academy and French Painting in the Nineteenth Century. New ed. Yale University Press, New Haven, 1986.
- Braham, A. *The Architecture of the French Enlightenment*. University of California Press, Berkeley, 1980.
- Cambridge University Press, Cambridge, 1984.
- Crow, T. Painters and Public Life in Eighteenth-Century Paris. Yale University Press, New Haven, 1985.
- Eitner, L. E. A. Géricault: His Life and Work. Cornell University Press, Ithaca, 1982.
- . Neoclassicism and Romanticism, 1750–1850: Sources and Documents. Reprint of 1970 ed., Harper & Row, New York, 1989.
- Fried, M. Absorption and Theatricality: Painting and Beholder in the Age of Diderot. University of Chicago Press, Chicago, 1980.
- Friedlaender, W. From David to Delacroix. Reprint of 1952 ed., Schocken Books, New York, 1968.
- Gaunt, W. The Restless Century: Painting in Britain, 1800–1900. Phaidon, London, 1972.

- Goncourt, E. and J. de. French Eighteenth-Century Painters. Reprint of 1948 ed., Cornell University Press, Ithaca, 1981.
- Goya and the Spirit of Enlightenment. Exh. cat. Little, Brown, Boston, 1989.
- Herrmann, L. British Landscape Painting of the Eighteenth Century. Oxford University Press, New York, 1974.
- Honour, H. *Neoclassicism.* Reprint of 1968 ed., Penguin, London, 1991.
- . Romanticism. Harper & Row, New York, 1979. Johnson, E. *The Paintings of Eugène Delacroix: A Critical Catalogue, 1816–1831.* 4 vols. Clarendon Press,
- Oxford, 1981–86. Koerner, J. Caspar David Friedrich and the Subject of Landscape. Yale University Press, New Haven, 1990.
- Licht, F. Canova. Abbeville, New York, 1983.
- . Goya: The Origins of the Modern Temper in Art. Harper & Row, New York, 1983.
- Mainardi, P. Art and Politics of the Second Empire: The Universal Expositions of 1855 and 1867. Yale University Press, New Haven, 1987.
- The End of the Salon: Art and the State in the Early Third Republic. Cambridge University Press, Cambridge, 1993.
- Middleton, R., and D. Watkin. *Neoclassical and Nine*teenth-Century Architecture. Rizzoli, New York, 1977.
- Miles, E. G., ed. *The Portrait in Eighteenth-Century America*. University of Delaware Press, Newark, 1993.
- Novotny, F. Painting and Sculpture in Europe, 1780– 1880. Pelican History of Art. Penguin, Harmondsworth, England, 1971.
- Pelles, G. Art, Artists, and Society: Origins of a Modern Dilemma: Painting in England and France, 1750– 1850, Preptice-Hall, Englewood Cliffs, N.J., 1963.
- 1850. Prentice-Hall, Englewood Cliffs, N.J., 1963. Prown, J. D. *John Singleton Copley*. 2 vols. Exh. cat. Har-
- vard University Press, Cambridge, 1966. Reynolds, G. *Turner*. The World of Art. Thames and
- Hudson, New York, 1985. Rosenblum, R. *Transformations in Late Eighteenth Centu-*
- ry Art. Princeton University Press, Princeton, 1967.
- ——. Jean-Auguste-Dominique Ingres. Harry N. Abrams, New York, 1990.
- Saisselin, R. G. The Enlightenment Against the Baroque: Economics and Aesthetics in the Eighteenth Century. University of California Press, Berkeley, 1992.
- Solkin, D. Painting for Money: The Visual Arts and the Public Sphere in Eighteenth-Century England. Yale University Press, New Haven, 1993.
- Tomlinson, J. *Goya in the Twilight of Enlightenment.* Yale University Press, New Haven, 1992.
- Vaughan, W. German Romantic Painting. Yale University Press, New Haven, 1980.
- Watkin, D., and T. Mellinghoff. German Architecture and the Classical Ideal. MIT Press, Cambridge, 1987.
- Wilton, A. J. M. W. Turner: His Life and Art. Rizzoli, New York, 1979.

2. REALISM AND IMPRESSIONISM

- Adler, K., and T. Garb. Manet. Phaidon, Oxford, 1986.Broude, N. Impressionism: A Feminist Reading. Rizzoli, New York, 1991.
- Clark, T. J. The Absolute Bourgeois: Artists and Politics in France, 1848–1851. Princeton University Press, Princeton, 1982.
- The Painting of Modern Life: Paris in the Art of Manet and His Followers. Princeton University Press, Princeton, 1984.
- Denvir, B. *The Impressionists: A Documentary Study.* Thames and Hudson, New York, 1986.
- tory of Impressionist Art. Little, Brown, Boston, 1993. Fried, M. Courbet's Realism. University of Chicago Press, Chicago, 1990.
- Goodrich, L. *Thomas Eakins*. 2 vols. Exh. cat. Harvard University Press, Cambridge, 1982.
- Hamilton, G. H. *Manet and His Critics*. Reprint of 1954 ed., Yale University Press, New Haven, 1986.

- Herbert, R. Impressionism: Art, Leisure, and Parisian Society. Yale University Press, New Haven, 1988.
- Higonnet, A. Berthe Morisot. Harper & Row, New York, 1990.
- Hilton, T. *The Pre-Raphaelites*. The World of Art. Reprint of 1970 ed., Thames and Hudson, London, 1985.
- House, J. Monet: Nature into Art. Yale University Press, New Haven, 1986.
- Jenkyns, R. Dignity and Decadence: Victorian Art and the Classical Inheritance. Harvard University Press, Cambridge, 1991.
- Kendall, R., and G. Pollock, eds. Dealing with Degas: Representations of Women and the Politics of Vision. Universe, New York, 1992.
- Lipton, E. Looking into Degas. University of California Press, Berkeley, 1986.
- Miller, D., ed. American Iconology: New Approaches to Nineteenth-Century Art and Literature. Yale University Press, New Haven, 1993.
- Mosby, D. Henry Ossawa Tanner. Exh. cat. Rizzoli, New York, 1991.
- Needham, G. *Nineteenth-Century Realist Art.* Harper & Row, New York, 1988.
- Nochlin, L. Realism and Tradition in Art, 1848–1900: Sources and Documents. Prentice-Hall, Englewood Cliffs, N.J., 1966.
- Impressionism and Post-Impressionism, 1874– 1904: Sources and Documents. Prentice-Hall, Englewood Cliffs, N.J., 1976.
- Novak, B. American Painting of the Nineteenth Century: Realism and the American Experience. Harper & Row, New York, 1979.
- Nature and Culture: American Landscape Painting, 1825–1875. Oxford University Press, New York, 1980.
- Pollock, G. Mary Cassatt. Harper & Row, New York, 1980.
- Reff, T. Manet and Modern Paris. Exh. cat. National Gallery of Art, Washington, D.C., 1982.
- Rewald, J. *The History of Impressionism.* 4th ed., rev. New York Graphic Society, Greenwich, 1973.
- Spate, V. Claude Monet: Life and Work. Rizzoli, New York, 1992.
- Tucker, P. Monet at Argenteuil. Yale University Press, New Haven, 1981.
- ——. Monet in the '90s: The Series Paintings. Exh. cat. Yale University Press, New Haven, 1989.
- Walther, I., ed. *Impressionist Art*, 1860–1920. 2 vols. Forthcoming.
- Weisberg, G. Beyond Impressionism: The Naturalist Impulse. Harry N. Abrams, New York, 1992.
- Wilmerding, J. Winslow Homer. Praeger, New York, 1972. Wood, C. *The Pre-Raphaelites*. Viking, New York, 1981.

3. POST-IMPRESSIONISM, SYMBOLISM, AND ART NOUVEAU

- Brettell, R., et al. *The Art of Paul Gauguin*. Exh. cat. Little, Brown, Boston, 1988.
- Broude, N. Georges Seurat. Rizzoli, New York, 1992.
- Cachin, F., I. Cahn, et al., *Cézanne*. Exh. cat. Harry N. Abrams, New York, 1995.
- Denvir, B. *Post-Impressionism*. The World of Art. Thames and Hudson, New York, 1992.
- Gaunt, W. *Renoir.* Notes by K. Adler. Rev. and enl. ed. Phaidon, Oxford, 1982.
- Goldwater, R. Symbolism. Harper & Row, New York, 1979.
 ———. Paul Gauguin. Concise ed. Harry N. Abrams, New York, 1983.
- Hamilton, G. H. Painting and Sculpture in Europe, 1880–1940. Pelican History of Art. 6th ed. Yale University Press, New Haven, 1993.
- Hulsker, J. The Complete Van Gogh. Harry N. Abrams, New York, 1980.
- Rewald, J. Post-Impressionism: From Van Gogh to Gauguin. 2nd ed. Museum of Modern Art, New York, 1962.
- Roskill, M. Van Gogh, Gauguin, and the Impressionist Circle. New York Graphic Society, Greenwich, 1970.
- Schapiro, M. Van Gogh. Rev. ed. Harry N. Abrams, New York, 1982.

- ------. Paul Cézanne. Concise ed. Harry N. Abrams, New York, 1988.
- Shiff, R. Cézanne and the End of Impressionism: A Study of the Theory, Technique, and Critical Evaluation of Modern Art. University of Chicago Press, Chicago, 1984.
- Silverman, D. Art Nouveau in Fin-de-Siècle France. University of California Press, Berkeley, 1989.
- Varnedoe, K. Vienna 1900: Art, Architecture, and Design. Exh. cat. Museum of Modern Art, New York, 1986.

4. TWENTIETH-CENTURY PAINTING

- Ades, D., et al., eds. *In the Mind's Eye: Dada and Surrealism.* Abbeville, New York, 1986.
- Ashton, D. American Art Since 1945. Oxford University Press, New York, 1982.
- Baker, K. Minimalism. Abbeville, New York, 1989.
- Battcock, G., comp. *Minimal Art: A Critical Anthology*. Dutton, New York, 1968.
- Idea Art: A Critical Anthology. New ed. Dutton, New York, 1973.
- Beardsley, J., and J. Livingston. *Hispanic Art in the United States: Thirty Contemporary Painters and Sculptors.* Exh. cat. Abbeville, New York, 1987.
- Breton, A. *Manifestoes of Surrealism*. Trans. R. Seaver and H. R. Lane. University of Michigan Press, Ann Arbor, 1969.
- Brown, M. *The Story of the Armory Show.* Rev. ed. Abbeville, New York, 1988.
- Celant, G. Unexpressionism: Art Beyond the Contemporary. Rizzoli, New York, 1988.
- Chadwick, W. Women Artists and the Surrealist Movement. Thames and Hudson, New York, 1991.
- Crane, D. The Transformation of the Avant-Garde: The New York Art World, 1940–1985. University of Chicago Press, Chicago, 1987.
- Crow, T. The Rise of the Sixties: American and European Art in the Era of Dissent. Perspectives. Harry N. Abrams, New York, 1996.
- Duchamp, M. Marcel Duchamp, Notes. Trans. P. Matisse. The Documents of Twentieth-Century Art. G. K. Hall, Boston, 1983.
- Fer, B., et al. Realism, Rationalism, Surrealism: Art Between the Wars. Modern Art—Practices and Debates. Yale University Press, New Haven, 1993.
- Gilbaut, S. *How New York Stole the Idea of Modern Art.* University of Chicago Press, Chicago, 1983.
- ——, ed. Reconstructing Modernism: Art in New York, Paris, and Montreal, 1945–1964. MIT Press, Cambridge, 1990.
- Golding, J. Cubism: A History and an Analysis, 1907– 1914. 3rd ed. Harvard University Press, Cambridge, 1988.
- Goldwater, R. *Primitivism in Modern Art.* Enl. ed. Belknap Press, Cambridge, Mass., 1986.
- Gordon, D. *Expressionism: Art and Idea.* Yale University Press, New Haven, 1987.
- Gray, C. The Russian Experiment in Art, 1863–1922. Harry N. Abrams, New York, 1970.
- Green, C. Cubism and Its Enemies. Yale University Press, New Haven, 1987.
- Greenberg, C. Clement Greenberg, The Collected Essays and Criticism. Ed. J. O'Brian. 4 vols. University of Chicago Press, Chicago, 1986–93.
- Herbert, J. Fauve Painting: The Making of Cultural Politics. Yale University Press, New Haven, 1992.
- Hoffman, K., ed. Collage: Critical Views. UMI Research Press, Ann Arbor, 1989.
- Kandinsky, W. Kandinsky, Complete Writings on Art. Eds. K. C. Lindsay and P. Vergo. The Documents of Twentieth-Century Art. 2 vols. G. K. Hall, Boston, 1982
- Krauss, R. The Originality of the Avant-Garde and Other Modernist Myths. MIT Press, Cambridge, 1986.
- Kuspit, D. *The Cult of the Avant-Garde Artist*. Cambridge University Press, New York, 1993.
- Langer, C. Feminist Art Criticism: An Annotated Bibliography. G. K. Hall, Boston, 1993.
- Leggio, J., and S. Weiley, eds. American Art of the 1960s.

- Studies in Modern Art, 1. Museum of Modern Art, New York, 1991.
- Leja, M. Reframing Abstract Expressionism: Subjectivity and Painting in the 1940s. Yale University Press, New Haven, 1993.
- Lewis, H. The Politics of Surrealism. Paragon, New York, 1988.
- Lippard, L. R., et al. *Pop Art.* Praeger, New York, 1966.

 ———, ed. *From the Center: Feminist Essays on Women's Art.* Dutton, New York, 1976.
- ——. Overlay: Contemporary Art and the Art of Prehistory. Pantheon, New York, 1983.
- Livingstone, M. *Pop Art: A Continuing History.* Harry N. Abrams, New York, 1990.
- Lodder, C. Russian Constructivism. Yale University Press, New Haven, 1983.
- Martin, M. Futurist Art and Theory, 1909–1915. Clarendon Press, Oxford, 1968.
- Meisel, L. K. *Photorealism*. Harry N. Abrams, New York,
- Miró, J. Joan Miró: Selected Writings and Interviews. Ed. M. Rowell. The Documents of Twentieth-Century Art. G. K. Hall, Boston, 1986.
- Mitchell, W. J. T. The Reconfigured Eye: Visual Truth in the Post-Photographic Era. MIT Press, Cambridge, 1992.
- Mondrian, P. *The New Art, the New Life: The Complete Writings.* Eds. and trans. H. Holtzmann and M. James. The Documents of Twentieth-Century Art. G. K. Hall, Boston, 1986.
- Motherwell, R., ed. The Dada Poets and Painters: An Anthology. 2nd ed. Harvard University Press, Cambridge, 1989.
- Collected Writings. Ed. Stephanie Terenzio. Oxford University Press, New York, 1992.
- Nadeau, M. History of Surrealism. Harvard University Press, Cambridge, 1989.
- Pincus-Witten, R. Postminimalism into Maximalism: American Art, 1966–1986. UMI, Ann Arbor, 1987.
- Polcari, S. Abstract Expressionism and the Modern Experience. Cambridge University Press, New York, 1991.
- Richter, H. *Dada: Art and Anti-Art.* McGraw-Hill, New York, 1965.
- Rosen, R., and C. Brawer, eds. Making Their Mark: Women Artists Move into the Mainstream, 1970–85. Exh. cat. Abbeville, New York, 1989.
- Rosenblum, R. *Cubism and Twentieth-Century Art.* Prentice-Hall, Englewood Cliffs, N.J., 1976.
- Roskill, M. Klee, Kandinsky, and the Thought of Their Time: A Critical Perspective. University of Illinois Press, Urbana, 1992.
- Ross, C. Abstract Expressionism: Creators and Critics: An Anthology. Harry N. Abrams, New York, 1990.
- Rubin, W. S. *Dada and Surrealist Art.* Harry N. Abrams, New York, 1968.
- ——. Picasso and Braque: Pioneering Cubism. Exh. cat. Museum of Modern Art, New York, 1989.
- Sandler, I. The Triumph of Participant Advances Expression of Participant Advances Exp
- Abstract Expressionism. Praeger, New York, 1970.

 The New York School: The Painters and Sculptors
- of the Fifties. Harper & Row, New York, 1979. Seitz, W. Abstract Expressionist Painting in America. Harvard University Press, Cambridge, 1983.
- Silver, K. E. Esprit de Corps: The Art of the Parisian Avant-Garde and the First World War, 1914–1925. Princeton University Press, Princeton, 1989.
- Varnedoe, K., and A. Gopnik. High and Low: Modern Art/ Popular Culture. Harry N. Abrams, New York, 1990.
- Washton, R.-C., ed. German Expressionism: Documents from the End of the Wilhelmine Empire to the Rise of National Socialism. The Documents of Twentieth-Century Art. G. K. Hall, Boston, 1993.

5. TWENTIETH-CENTURY SCULPTURE

- Bach, F., T. Bach, and A. Temkin. *Constantin Brancusi*. Exh. cat. MIT Press, Cambridge, 1995.
- Beardsley, J. Earthworks and Beyond: Contemporary Art in the Landscape. Enl. ed. Abbeville, New York, 1989.

- Beaumont, M., et al. Sculpture Today. St. Martin's, New York, 1987.
- Elsen, A. Origins of Modern Sculpture. Braziller, New York, 1974.
- Krauss, R. Passages in Modern Sculpture. MIT Press, Cambridge, 1977
- Kultermann, U. The New Sculpture: Environments and Assemblages. Praeger, New York, 1968.
- Lucie-Smith, E. Sculpture Since 1945. Universe Books, New York, 1987
- Read, H. Modern Sculpture: A Concise History. The World of Art. Reprint of 1964 ed., Thames and Hudson, London, 1987.
- Selz, J. Modern Sculpture: Origins and Evolution. Braziller, New York, 1963.
- Senie, H. Public Sculpture: Tradition, Transformation, and Controversy. Oxford University Press, New York, 1992
- Tucker, W. The Language of Sculpture. Reprint of 1974 ed., Thames and Hudson, New York, 1985.
- Waldman, D. Collage, Assemblage, and the Found Object. Harry N. Abrams, New York, 1992.

6. TWENTIETH-CENTURY ARCHITECTURE

- Bayer, H., et al., eds. Bauhaus, 1919-1928. Reprint of 1938 ed., New York Graphic Society, Boston, 1986.
- Collins, G. R. Antonio Gaudí. The Masters of World Architecture, Braziller, New York, 1960.
- Curtis, W. Modern Architecture Since 1900. 2nd ed. Prentice-Hall, Englewood Cliffs, N.J., 1987.
- Fitch, J. American Building: The Historical Forces that Shaped It. 2 vols. 2nd ed. Houghton Mifflin, Boston, 1966-72.
- Franciscono, M. Walter Gropius and the Creation of the Bauhaus in Weimar. University of Illinois Press, Urbana, 1971.
- Hitchcock, H. R. In the Nature of Materials: The Buildings of Frank Lloyd Wright, 1887-1941. Duell, Sloane & Pierce, New York, 1942.
- , and P. Johnson. The International Style. 2nd ed. Norton, New York, 1966.
- Jencks, C. Le Corbusier and the Tragic View of Architecture. Harvard University Press, Cambridge, 1973.
- Johnson, P. Mies van der Rohe. 3rd ed., rev. New York Graphic Society, Greenwich, 1978.
- Kultermann, U. Architecture in the Twentieth Century. Van Nostrand Reinhold, New York, 1993.
- Lane, B. Architecture and Politics in Germany, 1918-1945. New ed. Harvard University Press, Cambridge, 1985.
- Le Corbusier. Towards a New Architecture. Dover, New York, 1986.
- Magnago Lampugnani, V. Encyclopedia of Twentieth-Cen-

- tury Architecture. Harry N. Abrams, New York, 1986. Ockman, J., ed. Architecture Culture, 1943-1968: A Documentary Anthology. Rizzoli, New York, 1993.
- Pehnt, W. Expressionist Architecture. Thames and Hudson, London, 1973.
- Pevsner, N. The Sources of Modern Architecture and Design. Oxford University Press, New York, 1977
- Russell, J. Art Nouveau Architecture. Rizzoli, New York, 1979.
- Sharp, D. Modern Architecture and Expressionism. Braziller, New York, 1966.
- Troy, N. J. Modernism and the Decorative Arts in France: Art Nouveau to Le Corbusier. Yale University Press, New Haven, 1991.
- Wright, F. L. Frank Lloyd Wright, Collected Writings. 2 vols. Rizzoli, New York, 1992.

7. TWENTIETH-CENTURY PHOTOGRAPHY

- Ades, D. Photomontage. Pantheon, New York, 1976. Ansel Adams: Images, 1923-1974. Foreword W. Stegner.
- New York Graphic Society, Boston, 1974.
- August Sander: Photographs of an Epoch, 1904-1959. Aperture, Millerton, N.Y., 1980.
- Burgin, V., ed. Thinking Photography. Communications and Culture. Macmillan Education, Houndsmills, England, 1990.
- Callahan, S., ed. The Photographs of Margaret Bourke-White. New York Graphic Society, Boston, 1972.
- Coke, V. D. The Painter and the Photograph: From Delacroix to Warhol. Rev. ed. University of New Mexico Press, Albuquerque, 1972.
- Dorothea Lange: Photographs of a Lifetime. Aperture, Millerton, N.Y., 1982.
- Ducrot, N., ed. André Kertész: Sixty Years of Photography, 1912-1972. Grossman, New York, 1972.
- Gidal, T. Modern Photojournalism: Origin and Evolution, 1910-1933. Collier, New York, 1972.
- Green, J. American Photography: A Critical History, 1945 to the Present. Harry N. Abrams, New York, 1984.
- Greenough, S., and J. Hamilton. Alfred Stieglitz, Photographs and Writings. National Gallery of Art, Washington, D.C., 1983.
- Haus, A. Moholy-Nagy: Photographs and Photograms. Pantheon, New York, 1980.
- Henri Cartier-Bresson, Photographer. Foreword E. Bonnefoy. New York Graphic Society, Boston, 1979.
- Krauss, R. L'Amour Fou: Photography and Surrealism. Abbeville, New York, 1985.
- Longwell, D. Steichen: The Master Prints, 1895-1914. New York Graphic Society, Boston, 1978.
- Maddow, B. Edward Weston: Fifty Years. Aperture, Millerton, N.Y., 1973.

- Marzona, E., and R. Fricke. Bauhaus Photography. MIT Press, Cambridge, 1987.
- Naef, W. Fifty Pioneers of Modern Photography: The Collection of Alfred Stieglitz. Viking Press, New York,
- Petruck, P., ed. The Camera Viewed: Writings on Twentieth-Century Photography. 2 vols. Dutton, New York,
- Phillips, C., ed. Photography in the Modern Era: European Documents and Critical Writings, 1913-1940. Metropolitan Museum of Art, New York, 1989.
- Sontag, S. On Photography. Farrar, Straus and Giroux, New York, 1973.
- Szarkowski, J., and M. Hambourg. The Work of Atget. 4 vols. Museum of Modern Art, New York, 1981-84.
- Walsh, G., et al. Contemporary Photographers. St. Martin's Press, New York, 1983.

8. POSTSCRIPT: POSTMODERN THEORY

- Barthes, R. The Pleasure of the Text. Blackwell, Oxford, 1990.
- Brunette, P., and D. Wills, eds. Deconstruction and the Visual Arts: Art, Media, Architecture. Cambridge University Press, New York. Forthcoming.
- Derrida, J. Writing and Difference. University of Chicago Press, Chicago, 1978.
- Eco, U. A Theory of Semiotics. Indiana University Press, Bloomington, 1976.
- Foster, H., ed. The Anti-Aesthetic: Essays on Postmodern Culture. Bay Press, Seattle, 1983.
- Jameson, F. The Prison House of Language. Princeton University Press, Princeton, 1972.
- Jencks, C. Post-Modernism: The New Classicism in Art and Architecture. Rizzoli, New York, 1987.
- . Architecture Today. Rev. and enl. ed. Harry N. Abrams, New York, 1988.
- What is Post-Modernism? 3rd ed. St. Martin's Press, New York, 1989.
- Norris, C., and A. Benjamin. What is Deconstruction? St. Martin's Press, New York, 1988.
- Papadakes, A., et al., eds. Deconstruction: The Omnibus Volume. Rizzoli, New York, 1989.
- Portoghesi, P. Postmodern: The Architecture of the Post-Industrial Society. Rizzoli, New York, 1983.
- Risatti, H., ed. Postmodern Perspectives. Prentice-Hall, Englewood Cliffs, N.J., 1990.
- Tafuri, M. Contemporary Architecture. Harry N. Abrams, New York, 1977.
- Wallis, B., ed. Art After Modernism: Rethinking Representation. Documentary Sources in Contemporary Art, 1. Godine, Boston, 1984.

GLOSSARY

ABACUS. A slab of stone at the top of a classical CAPITAL, just beneath the ARCHITRAVE (figs. 162, 164).

ABBEY. 1) A religious community headed by an abbot or abbess. 2) The buildings which house the community. An abbey church often has an especially large CHOIR to provide space for the monks or nuns (fig. 423).

ACADEMY. A place of study, the word coming from the Greek name of a garden near Athens where Plato and, later, Platonic philosophers held philosophical discussions from the 5th century B.C. to the 6th century A.D. The first academy of fine arts was the Academy of Drawing, founded 1563 in Florence by Giorgio Vasari. Later academies were the Royal Academy of Painting and Sculpture in Paris, founded 1648, and the Royal Academy of Arts in London, founded 1768. Their purpose was to foster the arts by teaching, exhibitions, discussion, and occasionally by financial aid.

ACANTHUS. 1) A Mediterranean plant having spiny or toothed leaves. 2) An architectural ornament resembling the leaves of this plant, used on MOLDINGS, FRIEZES, and Corinthian CAPITALS (figs. 162, 176, 407).

ACRYLIC. A plastic binder MEDIUM for pigments that is soluble in water. Developed about 1960 (fig. 1086).

AERIAL PERSPECTIVE. See PERSPECTIVE.

AISLE. See SIDE AISLE.

ALLA PRIMA. A painting technique in which pigments are laid on in one application with little or no underpainting.

ALTAR. 1) A mound or structure on which sacrifices or offerings are made in the worship of a deity. 2) In a Catholic church, a tablelike structure used in celebrating the Mass.

ALTARPIECE. A painted or carved work of art placed behind and above the ALTAR of a Christian church. It may be a single panel (fig. 525) or a TRIP-TYCH or a POLYPTYCH having hinged wings painted on both sides (figs. 671, 675). Also called a reredos or retable.

ALTERNATE SYSTEM. A system developed in Romanesque church architecture to provide adequate support for a GROIN-VAULTED NAVE having BAYS twice as long as the SIDE-AISLE bays. The PIERS of the nave ARCADE alternate in size; the heavier COMPOUND piers support the main nave vaults where the THRUST is concentrated, and smaller, usually cylindrical, piers support the side-aisle vaults (figs. 388, 394).

AMBULATORY. A covered walkway. 1) In a BASILICAN church, the semicircular passage around the APSE (fig. 423). 2) In a CENTRAL-PLAN church, the ring-shaped AISLE around the central space (fig. 318). 3) In a CLOISTER, the covered COLONNADED or ARCADED walk around the open courtyard.

AMPHITHEATER. A double THEATER. A building, usually oval in plan, consisting of tiers of seats and access corridors around the central theater area (figs. 180, 244).

AMPHORA (pl. AMPHORAE). A large Greek storage vase with an oval body usually tapering toward the base; two handles extend from just below the lip to the shoulder (figs. 140, 143).

ANDACHTSBILD. German for devotional picture. A picture or sculpture with a type of imagery intended for private devotion, first developed in Northern Europe (fig. 479).

ANNULAR. From the Latin word for ring. Signifies a ring-shaped form, especially an annular barrel VAULT (fig. 303).

ANTA (pl. ANTAE). The front end of a wall of a Greek temple, thickened to produce a PILASTER-like member. Temples having COLUMNS between the antae are said to be "in antis" (fig. 163).

APSE. 1) A semicircular or polygonal niche terminating one or both ends of the NAVE in a Roman BASILICA (fig. 254). 2) In a Christian church, it is usually placed at the east end of the nave beyond the TRANSEPT or CHOIR (figs. 667, 811). It is also sometimes used at the end of transept arms.

AQUATINT. A print processed like an ETCHING, except that the ground or certain areas are covered with a solution of asphalt, resin, or salts which, when heated, produces a granular surface on the plate and rich gray tones in the final print (fig. 849). Etched lines are usually added to the plate after the aquatint ground is laid.

AQUEDUCT. Latin for duct of water. 1) An artificial channel or conduit for transporting water from a distant source. 2) The overground structure which carries the conduit across valleys, rivers, etc. (fig. 243).

ARCADE. A series of ARCHES supported by PIERS or COLUMNS (fig. 299). When attached to a wall, these form a blind arcade (fig. 399).

ARCH. A curved structure used to span an opening. Masonry arches are built of wedge-shaped blocks, called voussoirs, set with their narrow side toward the opening so that they lock together (fig. 235). The topmost voussoir is called the keystone. Arches may take different shapes, as in the pointed Gothic arch (fig. 450), but all require support from other arches or BUTTRESSES.

ARCHITRAVE. The lowermost member of a classical ENTABLATURE, i.e., a series of stone blocks that rest directly on the COLUMNS (fig. 162).

ARCHIVOLT. A molded band framing an ARCH, or a series of such bands framing a TYMPANUM, often decorated with sculpture (fig. 403).

ARIANISM. Early Christian belief, initiated by Arius, a 4th-century A.D. priest in Alexandria. Now largely obscure, it was later condemned as heresy and suppressed.

ARRICCIO. See SINOPIA.

ATMOSPHERIC PERSPECTIVE. See PERSPECTIVE.

ATRIUM. 1) The central court of a Roman house (fig. 255), or its open entrance court. 2) An open court, sometimes COLONNADED or ARCADED, in front of a church (figs. 298, 393).

ATTIC. A low upper story placed above the main CORNICE or ENTABLATURE of a building, and often decorated with windows and PILASTERS (fig. 622).

AUTOCHROME. A color photograph invented by Louis Lumière in 1903, using a glass plate covered with grains of starch dyed in three colors to act as filters, then a silver bromide emulsion (fig. 1199).

BALUSTRADE. 1) A railing supported by short pillars called balusters (fig. 617). 2) Occasionally applied to any low parapet (figs. 196, 430).

BAPTISTERY. A building or a part of a church, often round or octagonal, in which the sacrament of baptism is administered (fig. 399). It contains a baptismal font, a receptacle of stone or metal which holds the water for the rite (fig. 411). **BARREL VAULT.** See **VAULT.**

BASE. 1) The lowermost portion of a COLUMN or PIER, beneath the SHAFT (figs. 162, 177). 2) The lowest element of a wall, DOME, or building, or occasionally of a statue or painting (see PREDELLA).

BASILICA. 1) In ancient Roman architecture, a large, oblong building used as a hall of justice and public meeting place, generally having a NAVE, SIDE AISLES, and one or more APSES (fig. 254). 2) In Christian architecture, a longitudinal church derived from the Roman basilica, and having a nave, apse, two or four side aisles or side chapels, and sometimes a NARTHEX (fig. 543). 3) One of the seven main churches of Rome (St. Peter's, St. Paul Outside the Walls, St. John Lateran, etc.), or another church accorded the same religious privileges.

BATTLEMENT. A parapet consisting of alternating solid parts and open spaces designed originally for defense and later used for decoration (fig. 464). BAY. A subdivision of the interior space of a building, usually in a series bounded by consecutive architectural supports (fig. 443).

BLIND ARCADE. See ARCADE.

BLOCK BOOKS. Books, often religious, of the 15th century, containing WOODCUT prints in which picture and text were usually cut into the same block (compare fig. 693).

BOOK OF HOURS. A private prayer book containing the devotions for the seven canonical hours of the Roman Catholic church (matins, vespers, etc.), liturgies for local saints, and sometimes a calendar (figs. 40, 522). They were often elaborately ILLUMINATED for persons of high rank, whose names are attached to certain extant examples (fig. 516).

BRACKET. A stone, wooden, or metal support projecting from a wall and having a flat top to bear the weight of a statue, CORNICE, beam, etc. (fig. 407). The lower part may take the form of a SCROLL: it is then called a scroll bracket.

BROKEN PEDIMENT. See PEDIMENT.

BURIN. See ENGRAVING.

BUTTRESS. 1) A projecting support built against an external wall, usually to counteract the lateral THRUST of a VAULT or ARCH within (fig. 428). 2) FLYING BUTTRESS. An arched bridge above the aisle roof that extends from the upper nave wall, where the lateral thrust of the main vault is greatest, down to a solid pier (figs. 429, 443).

CALLIGRAPHY. From the Greek word for beautiful writing. 1) Decorative or formal handwriting executed with a quill or reed pen, or with a brush (fig. 310). 2) A design derived from or resembling letters, and used to form a pattern (fig. 352).

CAMERA OBSCURA. Latin for dark room. A darkened enclosure or box with a small opening or lens on one wall through which light enters to form an inverted image on the opposite wall. The long-known principle was not used as an aid in picture making until the 16th century.

CAMPANILE. From the Italian word *campana*, meaning bell. A bell tower, either round or square, and sometimes freestanding (figs. 300, 393).

CAMPOSANTO. Italian word for holy field. A cemetery near a church, often enclosed.

CANOPY. In architecture, an ornamental, rooflike projection or cover above a statue or sacred object (figs. 468, 740).

CAPITAL. The uppermost member of a COLUMN or PILLAR supporting the ARCHITRAVE (figs. 162, 176).

CARTOON. From the Italian word *cartone*, meaning cardboard. 1) A full-scale DRAWING for a picture or design intended to be transferred to a wall, panel, tapestry, etc. (fig. 597). 2) A drawing or print, usually humorous or satirical, calling attention to some action or person of popular interest (fig. 876).

CARVING. 1) The cutting of a figure or design out of a solid material such as stone or wood, as contrasted to the additive technique of MODELING. 2) A work executed in this technique (figs. 609, 610).

CARYATID. A sculptured female figure used as an architectural support (figs. 157, 178). A similar male figure is an atlas (pl. atlantes).

CASTING. A method of duplicating a work of sculpture by pouring a hardening substance such as plaster or molten metal into a mold. See CIRE-PERDU PROCESS.

CATACOMBS. The underground burial places of the early Christians, consisting of passages with niches for tombs, and small chapels for commemorative services.

CELLA. 1) The principal enclosed room of a temple, to house an image (fig. 163). Also called the naos. 2) The entire body of a temple as distinct from its external parts.

CENTERING. A wooden framework built to support an ARCH, VAULT, or DOME during its construction.

CENTRAL-PLAN CHURCH. 1) A church having four arms of equal length. The CROSSING is often covered with a DOME (figs. 572–74). Also called a Greek-cross church. 2) A church having a circular or polygonal plan (figs. 318, 602).

CHANCEL. See CHOIR.

CHAPEL. 1) A private or subordinate place of worship (figs. 544–47). 2) A place of worship that is part of a church, but separately dedicated (figs. 561, 611).

CHASING. 1) A technique of ornamenting a metal surface by the use of various tools. 2) The procedure used to finish a raw bronze cast.

CHÂTEAU (pl. CHÂTEAUX). French word for castle, now used to designate a large country house as well (fig. 720).

CHEVET. In Gothic architecture, the term for the developed and unified east end of a church, including CHOIR, APSE, AMBULATORY, and RADIATING CHAPELS (fig. 436).

CHIAROSCURO. Italian word for light and dark. In painting, a method of modeling form primarily by the use of light and shade (figs. 594, 726).

CHOIR. In church architecture, a square or rectangular area between the APSE and the NAVE or TRANSEPT (fig. 424). It is reserved for the clergy and the singing choir, and is usually marked off by steps, a railing, or a CHOIR SCREEN. Also called the chancel. See PILGRIMAGE CHOIR.

CHOIR SCREEN. A screen, frequently ornamented with sculpture and sometimes called a rood screen, separating the CHOIR of a church from the NAVE or TRANSEPT (figs. 336, 476). In Orthodox Christian churches it is decorated with ICONS, and thus called an iconostasis (fig. 334).

CIRE-PERDU PROCESS. The lost-wax process of CASTING. A method in which an original is MODELED in wax or coated with wax, then covered with clay. When the wax is melted out, the resulting mold is filled with molten metal (often bronze) or liquid plaster.

CLERESTORY. A row of windows in the upper part of a wall that rises above an adjoining roof; built to provide direct lighting, as in a BASILICA or church (figs. 437, 442, 542).

CLOISTER. 1) A place of religious seclusion such as a monastery or nunnery. 2) An open court attached to a church or monastery and surrounded by a covered ARCADED walk or AMBULATORY. Used for study, meditation, and exercise.

CODEX (pl. CODICES). A manuscript in book form made possible by the use of PARCHMENT instead of PAPYRUS. During the 1st to 4th centuries A.D., it gradually replaced the roll or SCROLL previously used for written documents.

COFFER. 1) A small chest or casket. 2) A recessed, geometrically shaped panel in a ceiling. A ceiling decorated with these panels is said to be coffered (figs. 246, 743, 914).

COLLAGE. A composition made of cut and pasted scraps of materials, sometimes with lines or forms added by the artist (fig. 1036).

COLONNADE. A series of regularly spaced COLUMNS supporting a LINTEL or ENTABLATURE (figs. 74, 601).

COLOSSAL ORDER. COLUMNS, PIERS, or PILASTERS which extend through two or more stories (figs. 567, 621).

COLUMN. An approximately cylindrical, upright architectural support, usually consisting of a long, relatively slender SHAFT, a BASE, and a CAPITAL (figs. 162, 164). When imbedded in a wall, it is called an engaged column (fig. 179). Columns decorated with spiral RELIEFS were used occasionally as freestanding commemorative monuments (fig. 273).

COMPOUND PIER. See PIER.

CONTRAPPOSTO. Italian word for set against. A method developed by the Greeks to represent freedom of movement in a figure. The parts of the body are placed asymmetrically in opposition to each other around a central axis, and careful attention is paid to the distribution of the weight (figs. 182, 183, 539).

CORBELING. Roofing technique in which each layer of stone projects inward slightly over the previous layer (corbel) until all sides meet (figs. 130, 131).

CORINTHIAN ORDER. See ORDER, ARCHITECTURAL.

CORNICE. 1) The projecting, framing members of a classical PEDIMENT, including the horizontal one beneath and the two sloping or "raking" ones above (figs. 162, 164). 2) Any projecting, horizontal element surmounting a wall or other structure, or dividing it horizontally for decorative purposes (fig. 550).

CROMLECH. From the Welsh for concave stone. A circle of large upright stones, or DOLMENS, probably the setting for religious ceremonies in prehistoric Britain (figs. 46, 47).

CROSSHATCHING. See HATCHING.

CROSSING. The area in a church where the TRANSEPT crosses the NAVE, frequently emphasized by a DOME (figs. 397, 548), or crossing tower (fig. 380).

CROSS SECTION. See SECTION.

CRYPT. In a church, a VAULTED space beneath the CHOIR, causing the floor of the choir to be raised above the level of that of the NAVE.

DAGUERREOTYPE. Originally, a photograph on a silver-plated sheet of copper which had been treated with fumes of iodine to form silver iodide on its surface and, after exposure, was developed by fumes of mercury. The process, invented by L. J. M. Daguerre and made public in 1839, was modified and accelerated as daguerreotypes gained popularity.

DEËSIS. From the Greek word for entreaty. The representation of Christ enthroned between the Virgin Mary and St. John the Baptist, frequent in Byzantine MOSAICS and depictions of the Last Judgment (fig. 672); refers to the roles of the Virgin Mary and St. John as intercessors for humankind.

DENTIL. A small, rectangular toothlike block in a series, used to decorate a classical entablature (fig. 162).

DIPTYCH. 1) Originally a hinged two-leaved tablet used for writing. 2) A pair of ivory CARVINGS or PANEL paintings, usually hinged together (figs. 314, 315).

DIPYLON VASE. A Greek funerary vase with holes in the bottom through which libations were poured to the dead (fig. 139). Named for the cemetery near Athens where the vases were found.

DISGUISED SYMBOLISM. "Hidden" meaning in the details of a painting that carry a symbolic message (fig. 671).

DOLMEN. A structure formed by two or more large, upright stones capped by a horizontal slab; thought to be a prehistoric tomb (fig. 45).

DOME. A true dome is a VAULTED roof of circular, polygonal, or elliptical plan, formed with hemispherical or ovoidal curvature (fig. 249). May be supported by a circular wall or DRUM (fig. 337), and by PENDENTIVES (fig. 320) or related constructions. Domical coverings of many other sorts have been devised (fig. 459).

DOMUS. Latin word for house. A Roman detached, one-family house with rooms grouped around one, or frequently two, open courts. The first, the ATRIUM, was used for entertaining and conducting business; the second, usually with a garden and surrounded by a PERISTYLE or COLONNADE, was for the private use of the family (fig. 255).

DONOR. The patron or client at whose order a work of art was executed; the donor may be depicted in the work (figs. 671, 687).

DORIC ORDER. See ORDER, ARCHITECTURAL.

DRAWING. 1) A work in pencil, pen and ink, charcoal, etc., often on paper (fig. 986). 2) A similar work in ink or WASH, etc., made with a brush and often called a brush drawing. 3) A work combining these or other techniques. A drawing may be large or small, a quick sketch or an elaborate work. Among its various forms are: a record of something seen (fig. 597); a study for another work (figs. 590, 872; see also OIL SKETCH; SINOPIA); an illustration associated with a text (fig. 599); a technical aid.

DRÔLERIES. French word for jests. Used to describe the lively animals and small figures in the margins of late medieval manuscripts (fig. 516) and occasionally in wood CARVINGS on furniture.

DRUM. 1) A section of the SHAFT of a COLUMN (figs. 172, 253). 2) A wall supporting a DOME (fig. 249).

DRYPOINT. See ENGRAVING.

ECHINUS. In the Doric or Tuscan ORDER, the round, cushionlike element between the top of the SHAFT and the ABACUS (figs. 162, 165).

ELEVATION. 1) An architectural drawing presenting a building as if projected on a vertical plane parallel to one of its sides (fig. 442). 2) Term used in describing the vertical plane of a building.

ENCAUSTIC. A technique of painting with pigments dissolved in hot wax (fig. 293).

ENGAGED COLUMN. See COLUMN.

ENGRAVING. 1) A means of embellishing metal surfaces or gemstones by incising a design on the surface. 2) A PRINT made by cutting a design into a metal plate (usually copper) with a pointed steel tool known as a burin. The burr raised on either side of the incised line is removed; ink is then rubbed into the V-shaped grooves and wiped off the surface; the plate, covered with a damp sheet of paper, is run through a heavy press (fig. 694). The image on the paper is the reverse of that on the plate (figs. 824, 825). When a fine steel needle is used instead of a burin and the burr is retained, a drypoint engraving results, characterized by a softer line (fig. 695). 3) These techniques are called, respectively, engraving and drypoint.

ENTABLATURE. 1) In a classical ORDER, the entire structure above the COLUMNS; usually includes ARCHITRAVE, FRIEZE, and CORNICE (figs. 162, 164). 2) The same structure in any building of a classical style (fig. 855).

ENTASIS. A swelling of the SHAFT of a COLUMN (figs. 165, 169).

ETCHING. 1) A PRINT made by coating a copperplate with an acid-resistant resin and drawing through this ground, exposing the metal with a sharp instrument called a STYLUS. The plate is bathed in acid, which eats into the lines; it is then heated to remove the resin, and finally inked and printed on paper (fig. 778). 2) The technique itself is also called etching.

FACADE. The principal face or the front of a building.

FINIAL. A relatively small, decorative element terminating a GABLE, PINNACLE, or the like (fig. 403).

FLUTING. In architecture, the ornamental grooves channeled vertically into the SHAFT of a COLUMN or PILASTER (fig. 172). They may meet in a sharp edge, as in the Doric ORDER, or be separated by a narrow strip or fillet, as in the Ionic, Corinthian, and Composite orders.

FLYING BUTTRESS. See BUTTRESS.

FONT. See BAPTISTERY.

FORESHORTENING. A method of reducing or distorting the parts of a represented object which are not parallel to the PICTURE PLANE, in order to

convey the impression of three dimensions as perceived by the human eye (figs. 794, 871).

FORUM (pl. FORA). In an ancient Roman city, the main public square which was the center of judicial and business activity, and a public gathering place (fig. 242).

FRESCO. Italian word for fresh. 1) True fresco is the technique of painting on moist plaster with pigments ground in water so that the paint is absorbed by the plaster and becomes part of the wall itself (fig. 505). Fresco secco is the technique of painting with the same colors on dry plaster. 2) A painting done in either of these techniques.

FRIEZE. 1) A continuous band of painted or sculptured decoration (figs. 157, 267). 2) In a classical building, the part of the ENTABLATURE between the ARCHITRAVE and the CORNICE. A Doric frieze consists of alternating TRIGLYPHS and METOPES, the latter often sculptured (fig. 169). An Ionic frieze is usually decorated with continuous RELIEF sculpture (fig. 162).

GABLE. 1) The triangular area framed by the CORNICE or eaves of a building and the sloping sides of a pitched roof (fig. 371). In classical architecture, it is called a PEDIMENT. 2) A decorative element of similar shape, such as the triangular structures above the PORTALS of a Gothic church (figs. 403, 441), and sometimes at the top of a Gothic picture frame.

GALLERY. A second story placed over the SIDE AISLES of a church and below the CLERESTORY (figs. 427, 443), or, in a church with a four-part ELE-VATION, below the TRIFORIUM and above the NAVE ARCADE which supports it on its open side.

GENRE. French word for kind or sort. A work of art, usually a painting, showing a scene from everyday life represented for its own sake (fig. 821).

GESSO. A smooth mixture of ground chalk or plaster and glue, used as the basis for TEMPERA PAINTING and for oil painting on PANEL.

GILDING. 1) A coat of gold or of a gold-colored substance that is applied mechanically or chemically to surfaces of a painting, sculpture, or architectural decoration (figs. 541, 834). 2) The process of applying same.

GLAZE. 1) A thin layer of translucent oil color applied to a painted surface or to parts of it in order to modify the tone. 2) A glassy coating applied to a piece of ceramic work before firing in the kiln, as a protective seal and often as decoration. GLORIOLE or GLORY. The circle of radiant light around the heads or figures of God, Christ, the Virgin Mary, or a saint. When it surrounds the head only, it is called a halo or nimbus (fig. 518); when it surrounds the entire figure with a large oval (figs. 349, 466), it is called a *mandorla* (the Italian word for almond). It indicates divinity or holiness. Originally it was placed around the heads of kings and gods as a mark of distinction.

GOLD LEAF, SILVER LEAF. 1) Gold beaten into very thin sheets or "leaves" and applied to ILLUMINATED MANUSCRIPTS and PANEL paintings (figs. 418, 518), to sculpture, or to the back of the glass TESSERAE used in MOSAICS (figs. 302, 322). 2) Silver leaf is also used, though ultimately it tarnishes (fig. 311). Sometimes called gold foil, silver foil.

GOSPEL. 1) The first four books of the New Testament. They tell the story of Christ's life and death, and are ascribed to the evangelists Matthew, Mark, Luke, and John. 2) A copy of these, usually called a Gospel Book, often richly ILLUMINATED (figs. 365, 367).

GREEK-CROSS CHURCH. See CENTRAL-PLAN CHURCH. GROIN VAULT. See VAULT.

GROUND PLAN. An architectural drawing presenting a building as if cut horizontally at the floor level.

GUTTAE. In a Doric ENTABLATURE, small peglike projections above the FRIEZE; possibly derived from pegs originally used in wooden construction (figs. 162, 164).

HALLENKIRCHE. German word for hall church. A church in which the NAVE and the SIDE AISLES are of the same height. The type was developed in Romanesque architecture, and occurs especially frequently in German Gothic churches (figs. 385, 454).

HALO. See GLORIOLE.

HATCHING. A series of parallel lines used as shading in PRINTS and DRAW-INGS (fig. 590). When two sets of crossing parallel lines are used, it is called crosshatching.

HIEROGLYPH. A picture of a figure, animal, or object, standing for a word, syllable, or sound. These symbols are found on ancient Egyptian monuments as well as in Egyptian written records (fig. 71).

HIGH RELIEF. See RELIEF.

ICON. From the Greek word for image. A PANEL painting of one or more sacred personages, such as Christ, the Virgin, a saint, particularly venerated in the Orthodox Catholic church (fig. 347).

ICONOSTASIS. See CHOIR SCREEN.

ILLUMINATED MANUSCRIPT. A MANUSCRIPT decorated with drawings (fig. 368) or with paintings in TEMPERA colors (figs. 377, 418).

ILLUSIONISM. In artistic terms, the technique of manipulating pictorial or other means in order to cause the eye to perceive a particular reality. May be used in architecture (fig. 749) and sculpture (figs. 753, 754), as well as in painting (figs. 286, 291).

IMPASTO. From the Italian word meaning "in paste." Paint, usually oil paint, applied very thickly (figs. 759, 978).

IN ANTIS. See ANTA.

INSULA (pl. INSULAE). Latin word for island. 1) An ancient Roman city block. 2) A Roman "apartment house": a CONCRETE and brick building or chain of buildings around a central court, up to five stories high. The ground floor had shops, and above were living quarters (fig. 256).

IONIC ORDER. See ORDER, ARCHITECTURAL.

JAMBS. The vertical sides of an opening. In Romanesque and Gothic churches, the jambs of doors and windows are often cut on a slant outward, or "splayed," thus providing a broader surface for sculptural decoration (figs. 466, 467).

KEEP. 1) The innermost and strongest structure or central tower of a medieval castle, sometimes used as living quarters, as well as for defense. Also called a donjon (fig. 522). 2) A fortified medieval castle.

KEYSTONE. See ARCH.

KORE (pl. KORAI). Greek word for maiden. An Archaic Greek statue of a clothed, standing female (fig. 152).

KOUROS (pl. KOUROI). Greek word for male youth. An Archaic Greek statue of a standing, nude youth (fig. 148).

KRATER. A Greek vessel, of assorted shapes, in which wine and water are mixed. Calyx krater—a bell-shaped vessel with handles near the base; volute krater—a vessel with handles shaped like scrolls (fig. 144).

KYLIX. In Greek and Roman antiquity, a shallow drinking cup with two horizontal handles, often set on a stem terminating in a foot (fig. 142).

LABORS OF THE MONTHS. The various occupations suitable to the months of the year. Scenes or figures illustrating these were frequently represented in ILLUMINATED manuscripts (figs. 40, 522); sometimes with the symbols of the ZODIAC signs, CARVED around the PORTALS of Romanesque and Gothic churches (figs. 466, 474).

LANTERN. A relatively small structure crowning a DOME, roof, or tower, frequently open to admit light to an enclosed area below (figs. 249, 622).

LAPITH. A member of a mythical Greek tribe that defeated the Centaurs in a battle, scenes from which are frequently represented in vase painting and sculpture (fig. 187).

LEKYTHOS (pl. **LEKYTHOI**). A Greek oil jug with an ellipsoidal body, a narrow neck, a flanged mouth, a curved handle extending from below the lip to the shoulder, and a narrow base terminating in a foot. It was used chiefly for ointments and funerary offerings (fig. 200).

LIBERAL ARTS. Traditionally thought to go back to Plato, they comprised the intellectual disciplines considered suitable or necessary to a complete education, and included grammar, rhetoric, logic, arithmetic, music, geometry, and astronomy. During the Middle Ages and the Renaissance, they were often represented allegorically in painting, engravings, and sculpture (fig. 466).

LINTEL. See POST AND LINTEL.

LITHOGRAPH. A PRINT made by drawing a design with an oily crayon or other greasy substance on a porous stone or, later, a metal plate; the design is then fixed, the entire surface is moistened, and the printing ink which is applied adheres only to the oily lines of the drawing. The design can then be transferred easily in a press to a piece of paper. The technique was invented c. 1796 by Aloys Senefelder and quickly became popular (figs. 876, 987). It is also widely used commercially, since many impressions can be taken from a single plate.

LOGGIA. A covered GALLERY or ARCADE open to the air on at least one side. It may stand alone or be part of a building (fig. 661).

LONGITUDINAL SECTION. See SECTION.

LOUVERS. A series of overlapping boards or slats which can be opened to admit air, but are slanted so as to exclude sun and rain (fig. 1182).

LOW RELIEF. See RELIEF.

LUNETTE. 1) A semicircular or pointed wall area, as under a VAULT or above a door or window. When it is above the PORTAL of a medieval church, it is called a TYMPANUM (fig. 45). 2) A painting (fig. 731), relief sculpture (fig. 576), or window of the same shape (fig. 853).

MAESTÀ. Italian word for majesty, applied in the 14th and 15th centuries to representations of the Madonna and Child enthroned, and surrounded by her celestial court of saints and angels (fig. 32).

MAGUS (pl. MAGI). 1) A member of the priestly caste of ancient Media and Persia. 2) In Christian literature, one of the three Wise Men or Kings who came from the East bearing gifts to the newborn Jesus (fig. 41).

MANDORLA. See GLORIOLE.

MANUSCRIPT. From the Latin word for handwritten. 1) A document, scroll, or book written by hand, as distinguished from such a work in print (i.e., after c. 1450). 2) A book produced in the Middle Ages, frequently ILLU-MINATED.

MASTABA. An ancient Egyptian tomb, rectangular in shape, with sloping sides and a flat roof. It covered a chapel for offerings and a shaft to the burial chamber (fig. 54).

MAUSOLEUM. 1) The huge tomb erected at Halicarnassus in Asia Minor in the 4th century B.C. by King Mausolus and his wife Artemisia (fig. 202). 2) A generic term for any large funerary monument.

MEANDER. A decorative motif of intricate, rectilinear character, applied to architecture and sculpture (figs. 269, 407).

MEDIUM. 1) The material or technique in which an artist works. 2) The vehicle in which pigments are carried in paint, PASTEL, etc.

MEGALITH. A huge stone such as those used in CROMLECHS and DOL-MENS.

MEGARON (pl. MEGARONS, or MEGARA). From the Greek word for large. The central audience hall in a Minoan or Mycenaean palace or home (fig. 120).

METOPE. In a Doric FRIEZE, one of the panels, either decorated or plain, between the TRIGLYPHS. Originally it probably covered the empty spaces between the ends of the wooden ceiling beams (figs. 162, 169).

MINIATURE. 1) A single illustration in an ILLUMINATED manuscript (figs. 352, 353). 2) A very small painting, especially a portrait on ivory, glass, or metal.

MODEL. 1) The preliminary form of a sculpture, often finished in itself but preceding the final CASTING or CARVING (figs. 806, 807, 907). 2) Preliminary or reconstructed form of a building, made to scale (fig. 363). 3) A person who poses for an artist.

MODELING. 1) In sculpture, the building up of a figure or design in a soft substance such as clay or wax (fig. 231). 2) In painting and drawing, producing a three-dimensional effect by changes in color, the use of light and shade, etc.

MOLDING. In architecture, any of various long, narrow, ornamental bands having a distinctive profile, which project from the surface of the structure and give variety to the surface by means of their patterned contrasts of light and shade (figs. 157, 270).

MOSAIC. Decorative work for walls, VAULTS, ceilings, or floors, composed of small pieces of colored materials (called TESSERAE) set in plaster or concrete. The Romans, whose work was mostly for floors, used regularly shaped pieces of marble in its natural colors (fig. 199). The early Christians used pieces of glass whose brilliant hues, including gold, and slightly irregular surfaces produced an entirely different, glittering effect (figs. 321, 322). See also GOLD LEAF.

MURAL. From the Latin word for wall, *murus*. A large painting or decoration, either executed directly on a wall (FRESCO) or done separately and affixed to it (fig. 984).

NAOS. See CELLA.

NARTHEX. The transverse entrance hall of a church, sometimes enclosed but often open on one side to a preceding ATRIUM (fig. 298).

NAVE. 1) The central aisle of a Roman BASILICA, as distinguished from the SIDE AISLES (fig. 254). 2) The same section of a Christian basilican church extending from the entrance to the APSE or TRANSEPT (fig. 298).

OBELISK. A tall, tapering, four-sided stone shaft with a pyramidal top. First constructed as MEGALITHS in ancient Egypt (fig. 74); certain examples since exported to other countries (fig. 739).

OIL PAINTING. 1) A painting executed with pigments mixed with oil, first applied either to a panel prepared with a coat of GESSO (as also in TEMPERA PAINTING), later to a stretched canvas primed with a coat of white paint and glue. The latter method has been usual since the late 15th century. Oil painting also may be executed on paper, parchment, copper, etc. 2) The technique of executing such a painting.

OIL SKETCH. A work in oil painting of an informal character, sometimes preparatory to a finished work (figs. 763, 887).

ORCHESTRA. 1) In an ancient Greek theater, the round space in front of the stage and below the tiers of seats, reserved for the chorus (fig. 180). 2) In a Roman theater, a similar space reserved for important guests.

ORDER, **ARCHITECTURAL**. An architectural system based on the COLUMN and its ENTABLATURE, in which the form of the elements themselves (CAPITAL, SHAFT, BASE, etc.) and their relationships to each other are specifically defined. The five classical orders are the Doric, Ionic, Corinthian, Tuscan, and Composite (fig. 162). See also SUPERIMPOSED ORDER.

ORDER, MONASTIC. A religious society whose members live together under an established set of rules.

PALAZZO (pl. PALAZZI). Italian word for palace (in French, *palais*). Refers either to large official buildings (fig. 464), or to important private town houses (fig. 550).

PALETTE. 1) A thin, usually oval or oblong board with a thumbhole at one end, used by painters to hold and mix their colors. 2) The range of colors used by a particular painter. 3) In Egyptian art, a slate slab, usually decorated with sculpture in low RELIEF. The small ones with a recessed circular area on one side are thought to have been used for eye makeup. The larger ones were commemorative objects (figs. 51, 52).

PANEL. 1) A wooden surface used for painting, usually in TEMPERA, and prepared beforehand with a layer of GESSO. Large ALTARPIECES require the joining together of two or more boards (fig. 690). 2) Recently, panels of Masonite or other composite materials have come into use (fig. 1093).

PANTHEON. A temple dedicated to all the gods (figs. 246, 247), or housing tombs of the illustrious dead of a nation, or memorials to them (fig. 856). PANTOCRATOR. A representation of Christ as ruler of the universe which appears frequently in the DOME or APSE MOSAICS of Byzantine churches (fig. 340).

PAPYRUS. 1) A tall aquatic plant that grows abundantly in the Near East, Egypt, and Abyssinia. 2) A paperlike material made by laying together thin strips of the pith of this plant, and then soaking, pressing, and drying the whole. The resultant sheets were used as writing material by the ancient Egyptians, Greeks, and Romans. 3) An ancient document or SCROLL written on this material.

PARCHMENT. From Pergamum, the name of a Greek city in Asia Minor where parchment was invented in the 2nd century B.C. 1) A paperlike material made from thin bleached animal hides, used extensively in the Middle Ages for MANUSCRIPTS (fig. 354). Vellum is a superior type of parchment, made from calfskin. 2) A document or miniature on this material (fig. 377).

PASTEL. 1) A color of a soft, subdued shade. 2) A drawing stick made from pigments ground with chalk and mixed with gum water. 3) A drawing executed with these sticks (fig. 939).

PEDESTAL. An architectural support for a statue, vase, column, etc.

PEDIMENT. 1) In classical architecture, a low GABLE, typically triangular, framed by a horizontal CORNICE below and two raking cornices above; frequently filled with relief sculpture (fig. 159). 2) A similar architectural member, either round or triangular, used over a door, window, or niche (fig. 616). When pieces of the cornice are either turned at an angle or broken, it is called a broken pediment (fig. 257).

PELIKE. A Greek storage jar with two handles, a wide mouth, little or no neck, and resting on a foot (fig. 201).

PENDENTIVE. One of the spherical triangles which achieves the transition from a square or polygonal opening to the round BASE of a DOME or the supporting DRUM (figs. 328, 334).

PERIPTERAL. An adjective describing a building surrounded by a single row of COLUMNS or COLONNADE (figs. 163, 169).

PERISTYLE. 1) In a Roman house or DOMUS, an open garden court sur-

rounded by a COLONNADE (fig. 260). 2) A colonnade around a building or court (fig. 163).

PERSPECTIVE. A technique for representing spatial relationships and three-dimensional objects on a flat surface so as to produce an effect similar to that perceived by the human eye. In "atmospheric" or aerial perspective, this is accomplished by a gradual decrease in the intensity of local color and in the contrast of light and dark, so that everything in the far distance tends toward a light bluish-gray tone (fig. 672). In one-point linear perspective, developed in Italy in the 15th century, a mathematical system is used, based on orthogonals (all lines receding at right angles to the picture plane) that converge on a single vanishing point on the horizon. Since this presupposes an absolutely stationary viewer and imposes rigid restrictions on the artist, it is seldom applied with complete consistency (figs. 534, 563).

PHOTOGRAM. A shadowlike photograph made without a camera by placing objects on light-sensitive paper and exposing them to a light source (fig. 1220). PHOTOGRAPH. The relatively permanent or "fixed" form of an image made by light that passes through the lens of a camera and acts upon light-sensitive substances. Often called a PRINT.

PHOTOMONTAGE. A photograph in which prints in whole or in part are combined to form a new image (fig. 1219). A technique much practiced by the Dada group in the 1920s.

PIAZZA (pl. PIAZZE). Italian word for public square (in French, *place*; in German, *Platz*).

PICTURE PLANE. The flat surface on which a picture is painted.

PIER. An upright architectural support, usually rectangular, and sometimes with CAPITAL and BASE (fig. 229). When COLUMNS, PILASTERS, or SHAFTS are attached to it, as in many Romanesque and Gothic churches, it is called a compound pier (fig. 388).

PIETÀ. Italian word for both pity and piety. A representation of the Virgin grieving over the dead Christ (fig. 479). When used in a scene recording a specific moment after the Crucifixion, it is usually called a Lamentation (fig. 506). PILASTER. A flat, vertical element projecting from a wall surface, and normally having a BASE, SHAFT, and CAPITAL. It has generally a decorative rather than a structural purpose (figs. 569, 572).

PILGRIMAGE CHOIR. The unit in a Romanesque church composed of the APSE, AMBULATORY, and RADIATING CHAPELS (figs. 381, 424).

PILLAR. A general term for a vertical architectural support which includes COLUMNS, PIERS, and PILASTERS.

PINNACLE. A small, decorative structure capping a tower, PIER, BUT-TRESS, or other architectural member, and used especially in Gothic buildings (figs. 444, 446).

PLAN. See GROUND PLAN.

PODIUM. 1) The tall base upon which rests an Etruscan or Roman temple (fig. 236). 2) The ground floor of a building made to resemble such a base (fig. 799). **POLYPTYCH.** An ALTARPIECE or devotional work of art made of several panels joined together (fig. 673), often hinged.

PORCH. General term for an exterior appendage to a building which forms a covered approach to a doorway (fig. 441). See PORTICO for porches consisting of columns.

PORTAL. A door or gate, usually a monumental one with elaborate sculptural decoration (figs. 466, 480).

PORTICO. A columned porch supporting a roof or an ENTABLATURE and PEDIMENT, often approached by a number of steps (fig. 236). It provides a covered entrance to a building, and a link with the space surrounding it.

POST AND LINTEL. A basic system of construction in which two or more uprights, the posts, support a horizontal member, the lintel. The lintel may be the topmost element (fig. 47), or support a wall or roof (fig. 135).

PREDELLA. The base of an ALTARPIECE, often decorated with small scenes which are related in subject to that of the main panel or panels (fig. 525).

PRINT. A picture or design reproduced, usually on paper and often in numerous copies, from a prepared wood block, metal plate, or stone slab, or by photography. See AQUATINT, ENGRAVING, ETCHING, LITHOGRAPH, PHOTOGRAPH, WOODCUT.

PRONAOS. In a Greek or Roman temple, an open vestibule in front of the CELLA (fig. 163).

PROPYLAEUM (pl. **PROPYLAEA**). 1) The entrance to a temple or other enclosure, especially when it is an elaborate structure. 2) The monumental entry gate at the western end of the Acropolis in Athens (fig. 172).

PSALTER. 1) The book of Psalms in the Old Testament, thought to have been written in part by David, king of ancient Israel. 2) A copy of the Psalms, sometimes arranged for liturgical or devotional use, and often richly ILLUMI-NATED (fig. 339).

PULPIT. A raised platform in a church from which the clergy deliver a sermon or conducts the service. Its railing or enclosing wall may be elaborately decorated (fig. 482).

PUTTO (pl. PUTTI). A nude, male child, usually winged, often represented in classical and Renaissance art. Also called a cupid or *amoretto* when he carries a bow and arrow and personifies Love (fig. 628).

PYLON. Greek word for gateway. 1) The monumental entrance building to an Egyptian temple or forecourt, consisting of either a massive wall with sloping sides pierced by a doorway, or of two such walls flanking a central gateway (fig. 74). 2) A tall structure at either side of a gate, bridge, or avenue, marking an approach or entrance.

QUATREFOIL. An ornamental element composed of four lobes radiating from a common center (figs. 474, 492).

RADIATING CHAPELS. Term for CHAPELS arranged around the AMBU-LATORY (and sometimes the TRANSEPT) of a medieval church (figs. 380, 424, 444).

RELIEF. 1) The projection of a figure or part of a design from the background or plane on which it is CARVED or MODELED. Sculpture done in this manner is described as "high relief" or "low relief" depending on the height of the projection (figs. 53, 273). When it is very shallow, it is called *schiacciato*, the Italian word for flattened out (fig. 532). 2) The apparent projection of forms represented in a painting or drawing.

RESPOND. 1) A half-PIER, PILASTER, or similar element projecting from a wall to support a LINTEL, or an ARCH whose other side is supported by a free-standing COLUMN or pier, as at the end of an ARCADE (fig. 302). 2) One of several pilasters on a wall behind a COLONNADE (fig. 257) which echoes or "responds to" the columns, but is largely decorative. 3) One of the slender shafts of a COMPOUND PIER in a medieval church which seems to carry the weight of the VAULT (figs. 392, 438).

RHYTON. An ancient drinking horn made from pottery or metal, and frequently having a base formed by a human or animal head (fig. 113).

RIB. A slender, projecting archlike member which supports a VAULT either transversely (fig. 383), or at the GROINS, thus dividing the surface into sections (fig. 392). In Late Gothic architecture, its purpose is often primarily ornamental (fig. 451).

RIBBED VAULT. See VAULT.

ROOD SCREEN. See CHOIR SCREEN.

ROSE WINDOW. A large, circular window with stained glass and stone TRACERY, frequently used on FACADES and at the ends of TRANSEPTS of Gothic churches (figs. 430, 433).

ROSTRUM. 1) A beaklike projection from the prow of an ancient warship, used for ramming the enemy. 2) In the Roman FORUM, the raised platform decorated with the beaks of captured ships, from which speeches were delivered. 3) A platform, stage, or the like used for public speaking.

RUSTICATION. A masonry technique of laying rough-faced stones with sharply indented joints (figs. 550, 662).

SACRA CONVERSAZIONE. Italian for holy conversation. A composition of the Madonna and Child with saints in which the figures all occupy the same spatial setting, and appear to be conversing or communing with each other (figs. 593, 633).

SACRISTY. A room near the main altar of a church, or a small building attached to a church, where the vessels and vestments required for the service are kept. Also called a vestry.

SALON. 1) A large, elegant drawing or reception room in a palace or a private house. 2) Official government-sponsored exhibition of paintings and sculpture by living artists held in the Louvre at Paris, first biennially, then annually. 3) Any large public exhibition patterned after the Paris Salon.

SANCTUARY. 1) A sacred or holy place or building. 2) An especially holy place within a building, such as the CELLA of a temple, or the part of a church around the altar.

SARCOPHAGUS (pl. SARCOPHAGI). A large stone coffin usually decorated with sculpture and/or inscriptions (figs. 225, 312). The term is

derived from two Greek words meaning flesh and eating, which were applied to a kind of limestone in ancient Greece, since the stone was said to turn flesh to dust.

SCRIPTORIUM (pl. **SCRIPTORIA**). A workroom in a monastery reserved for copying and illustrating MANUSCRIPTS.

SCROLL. 1) An architectural ornament with the form of a partially unrolled spiral, as on the CAPITALS of the Ionic and Corinthian ORDERS (figs. 162, 177). 2) A form of written text.

SECTION. An architectural drawing presenting a building as if cut across the vertical plane, at right angles to the horizontal plane. Cross section: a cut along the transverse axis. Longitudinal section: a cut along the longitudinal axis.

SEXPARTITE VAULT. See VAULT.

SFUMATO. Italian word meaning gone up in smoke, used to describe very delicate gradations of light and shade in the MODELING of figures; applied especially to the work of Leonardo da Vinci (fig. 598).

SHAFT. In architecture, the part of a COLUMN between the BASE and the CAPITAL (fig. 162).

SIDE AISLE. A passageway running parallel to the NAVE of a Roman BASILICA or Christian church, separated from it by an ARCADE or COLONNADE (figs. 254, 298). There may be one on either side of the nave, or two, an inner and outer.

SILVER LEAF. See GOLD LEAF.

SILVER SALTS. Compounds of silver—bromide, chloride, and iodide—which are sensitive to light and are used in the preparation of photographic materials. This sensitivity was first observed by Johann Heinrich Schulze in 1725.

SINOPIA (pl. SINOPIE). Italian word taken from Sinope, the ancient city in Asia Minor which was famous for its brick-red pigment. In FRESCO paintings, a full-sized, preliminary sketch done in this color on the first rough coat of plaster or "arriccio" (fig. 514).

SKETCH. See DRAWING, OIL SKETCH.

SPANDREL. The area between the exterior curves of two adjoining ARCHES, or, in the case of a single arch, the area around its outside curve from its springing to its keystone (figs. 284, 403).

SPHINX. 1) In ancient Egypt, a creature having the head of a man, animal, or bird, and the body of a lion; frequently sculpted in monumental form (fig. 62). 2) In Greek mythology, a creature usually represented as having the head and breasts of a woman, the body of a lion, and the wings of an eagle. It appears in classical, Renaissance, and Neoclassical art.

STELE. From the Greek word for standing block. An upright stone slab or pillar with a CARVED commemorative design or inscription (fig. 95).

STEREOBATE. The substructure of a classical building, especially a Greek temple (fig. 162).

STEREOSCOPE. An optical instrument which enables the user to combine two pictures taken from points of view corresponding to those of the two eyes into a single image having the depth and solidity of ordinary binocular vision (fig. 928). First demonstrated by Sir Charles Wheatstone in 1838.

STILTS. Term for pillars or posts supporting a superstructure; in 20th-century architecture, these are usually of ferroconcrete (figs. 1171, 1182). Stilted, as in stilted arches, refers to tall supports beneath an architectural member.

STOA. In Greek architecture, a covered COLONNADE, sometimes detached and of considerable length, used as a meeting place or promenade.

STUCCO. 1) A concrete or cement used to coat the walls of a building. 2) A kind of plaster used for architectural decorations such as CORNICES, MOLDINGS, or for sculptured RELIEFS (fig. 229).

STUDY. See DRAWING.

STYLOBATE. A platform or masonry floor above the STEREOBATE forming the foundation for the COLUMNS of a classical temple (fig. 162).

STYLUS. From the Latin word *stilus*, the writing instrument of the Romans. 1) A pointed instrument used in ancient times for writing on tablets of a soft material such as clay. 2) The needlelike instrument used in drypoint or etching. See ENGRAVING, ETCHING.

SUPERIMPOSED ORDERS. Two or more rows of COLUMNS, PIERS, or PILASTERS placed above each other on the wall of a building (fig. 245).

TABERNACLE. 1) A place or house of worship. 2) A CANOPIED niche or recess built for an image (fig. 530). 3) The portable shrine used by the ancient Jews to house the Ark of the Covenant (fig. 295).

TABLINUM. From the Latin word meaning writing tablet, or written record. In a Roman house, a room at the far end of the ATRIUM, or between it and the second courtyard used for keeping family records.

TEMPERA PAINTING. 1) A painting made with pigments mixed with egg yolk and water. In the 14th and 15th centuries, it was applied to PANELS which had been prepared with a coating of GESSO; the application of GOLD LEAF and of underpainting in green or brown preceded the actual tempera painting (figs. 508, 525). 2) The technique of executing such a painting.

TERRACOTTA. Italian word for baked earth. 1) Earthenware, naturally reddish-brown but often GLAZED (fig. 576) in various colors and fired. Used for pottery, sculpture, or as a building material or decoration. 2) An object made of this material. 3) Color of the natural material.

TESSERA (pl. TESSERAE). A small piece of colored stone, marble, glass, or gold-backed glass used in a MOSAIC (fig. 338).

THEATER. In ancient Greece, an outdoor place for dramatic performances, usually semicircular in plan and provided with tiers of seats, the ORCHESTRA, and a support for scenery (fig. 180). See also AMPHITHEATER.

THOLOS. In classical architecture, a circular building ultimately derived from early tombs (fig. 179).

THRUST. The lateral pressure exerted by an ARCH, VAULT, or DOME, which must be counteracted at its point of greatest concentration either by the thickness of the wall or by some form of BUTTRESS.

TRACERY. 1) Ornamental stonework in Gothic windows. In the earlier or "plate tracery" the windows appear to have been cut through the solid stone (fig. 403). In "bar tracery" the glass predominates, the slender pieces of stone having been added within the windows (fig. 444). 2) Similar ornamentation using various materials and applied to walls, shrines, facades, etc. (fig. 509).

TRANSEPT. A cross arm in a BASILICAN church, placed at right angles to the NAVE, and usually separating it from the CHOIR or APSE (fig. 298).

TREE OF KNOWLEDGE. The tree in the Garden of Eden from which Adam and Eve ate the forbidden fruit which destroyed their innocence.

TREE OF LIFE. A tree in the Garden of Eden whose fruit was reputed to give everlasting life; in medieval art it was frequently used as a symbol of Christ.

TRIFORIUM. The section of a NAVE wall above the ARCADE and below the CLERESTORY (fig. 437). It frequently consists of a BLIND ARCADE with three openings in each bay. When the GALLERY is also present, a four-story ELEVATION results, the triforium being between the gallery and clerestory. It may also occur in the TRANSEPT and the CHOIR walls.

TRIGLYPH. The element of a Doric FRIEZE separating two consecutive METOPES, and being divided by channels (or glyphs) into three sections. Probably an imitation in stone of wooden ceiling beam ends (figs. 162, 169). **TRIPTYCH.** An ALTARPIECE or devotional picture, either CARVED or painted, with one central panel and two hinged wings (fig. 345).

TRIUMPHAL ARCH. 1) A monumental ARCH, sometimes a combination of three arches, erected by a Roman emperor in commemoration of his military exploits, and usually decorated with scenes of these deeds in RELIEF sculpture (fig. 284). 2) The great transverse arch at the eastern end of a church which frames ALTAR and APSE and separates them from the main body of the church. It is frequently decorated with MOSAICS or MURAL paintings (figs. 299, 302).

TRUMEAU. A central post supporting the LINTEL of a large doorway, as in a Romanesque or Gothic PORTAL, where it was frequently decorated with sculpture (figs. 401, 480).

TRUSS. A triangular wooden or metal support for a roof which may be left exposed in the interior (figs. 299, 457), or be covered by a ceiling (figs. 374, 398). TURRET. 1) A small tower, part of a larger structure. 2) A small tower at an angle of a building, often beginning some distance from the ground.

TYMPANUM. 1) In classical architecture, the recessed, usually triangular area, also called a PEDIMENT, often decorated with sculpture (fig. 164). 2) In medieval architecture, an arched area between an ARCH and the LINTEL of a door or window, frequently carved with RELIEF sculpture (figs. 406, 470).

 $m V\!AULT$. An arched roof or ceiling usually made of stone, brick, or concrete. Several distinct varieties have been developed; all need BUTTRESSING at the point where the lateral THRUST is concentrated. 1) A barrel vault is a semicylindrical structure made up of successive ARCHES (fig. 235). It may be straight or ANNULAR in plan (fig. 303). 2) A groin vault is the result of the intersection of two barrel vaults of equal size which produces a BAY of four compartments with sharp edges, or "groins," where the two meet (fig. 235). 3) A ribbed groin vault is one in which RIBS are added to the groins for structural strength and for decoration (fig. 391). When the diagonal ribs are constructed as half-circles, the resulting form is a domical ribbed vault (fig. 394). 4) A sexpartite vault is a ribbed groin vault in which each bay is divided into six compartments by the addition of a transverse rib across the center (figs. 391, 392). 5) The normal Gothic vault is quadripartite with all the arches pointed to some degree (fig. 438). 6) A fan vault is an elaboration of a ribbed groin vault, with elements of TRACERY using conelike forms. It was developed by the English in the 15th century, and was employed for decorative purposes. VEDUTA (pl. VEDUTE). A view painting, generally a city landscape (fig. 840). VELLUM. See PARCHMENT.

VESTRY. See SACRISTY.

VILLA. Originally a large country house (fig. 665), but in modern usage also a detached house or suburban residence.

VOLUTE. A spiral architectural element found notably on Ionic and Composite CAPITALS (figs. 162, 177, 236), but also used decoratively on building FACADES and interiors (fig. 670).

VOUSSOIR. See ARCH.

WASH. A thin layer of translucent color or ink used in WATERCOLOR PAINTING and brush drawing, and occasionally in OIL PAINTING.

WATERCOLOR PAINTING. Painting, usually on paper, in pigments suspended in water (figs. 699, 1065).

WESTWORK. From the German word *Westwerk*. In Carolingian, Ottonian, and German Romanesque architecture, a monumental western front of a church, treated as a tower or combination of towers, and containing an entrance and vestibule below, and a CHAPEL and GALLERIES above. Later examples often added a TRANSEPT and a CROSSING tower (fig. 371).

WING. The side panel of an ALTARPIECE which is frequently decorated on both sides, and also hinged, so that it may be shown either open or closed (figs. 673, 675).

WOODCUT. A PRINT made by carving out a design on a wooden block cut along the grain, applying ink to the raised surfaces which remain, and printing from those (figs. 694, 700, 966).

ZIGGURAT. From the Assyrian word *ziqquratu*, meaning mountaintop or height. In ancient Assyria and Babylonia, a pyramidal tower built of mud brick and forming the BASE of a temple; it was either stepped or had a broad ascent winding around it, which gave it the appearance of being stepped (figs. 84, 87).

ZODIAC. An imaginary belt circling the heavens, including the paths of the sun, moon, and major planets, and containing 12 constellations and thus 12 divisions called signs, which have been associated with the months. The signs are: Aries, the ram; Taurus, the bull; Gemini, the twins; Cancer, the crab; Leo, the lion; Virgo, the virgin; Libra, the balance; Scorpio, the scorpion; Sagittarius, the archer; Capricorn, the goat; Aquarius, the water-bearer; and Pisces, the fish. They are frequently represented around the PORTALS of Romanesque and Gothic churches in conjunction with the LABORS OF THE MONTHS (figs. 406, 474).

ART AND ARCHITECTURE WEB SITE GAZETTEER

The directory below is comprised mainly of the significant museum collections and monuments illustrated in this book. A few additional non-illustrated art sites are also listed. All efforts have been made to gather up-to-date addresses, phone numbers, and Web sites. Contact information is current as of time of printing.

UNITED STATES

ARIZONA

The Heard Museum, 22 E. Monte Vista Rd., Phoenix 85004. (602)252–8840. hanksville.phast.umass.edu/defs/independent/Heard/Heard.html

Phoenix Art Museum, 1625 N. Central Ave., Phoenix 85004. (602)257–1880. aztec.asu.edu/AandE/phoenix.art

Center for Creative Photography, University of Arizona, 843 E. University Blvd., Tuscon 85721. (520)621–7968. www.library.arizona.edu/branches/ccp/ccphome.html

CALIFORNIA

University Art Museum and Pacific Film Archive, University of California, 2626 Bancroft Way, Berkeley 94704. (510)642–0808. www.uampfa.berkeley.edu

Los Angeles County Museum of Art, 5905 Wilshire Blvd., Los Angeles 90036. (213)857–6111. www.lacma.org

The Museum of Contemporary Art, Los Angeles, 250 S. Grand Ave. at California Plaza, Los Angeles 90012. (213)382–6622, 621–2766. www.MOCA-LA.org

University of California, Los Angeles, Frederick S. Wright Art Gallery, 405 Hilgard Ave., Los Angeles 90024. (213)825–1461

The J. Paul Getty Museum, 17985 Pacific Coast Hwy., Malibu 90265. (310)458–2003. ca.living.net/trav/ museums/caripgm.htm

Stanford University Museum and Art Gallery, Lomita Dr. & Museum Way, Palo Alto 94305. (415)725–4177. www.leland.stanford.edu/dept/ SUMA/

Norton Simon Museum, 411 W. Colorado Blvd., Pasadena 91105. (818)449–6840; 449–3730. www.citycet.com/CCC/Pasadena/nsmuseum.htm

Crocker Museum of Art, 216 O St., Sacramento 95814. (916)264–5423

Museum of Contemporary Art, San Diego, 1001 Kettner Blvd., San Diego 92101, 700 Prospect St., La Jolla 92037. (619)454–3541

San Diego Museum of Art, Balboa Park, 1450 El Prado, San Diego 92101. (619)232–7931. www.sddt.com/sdma.html

The Fine Arts Museums of San Francisco, www.famsf.org: California Palace of the Legion of Honor, Lincoln Park, near 34th Ave. and Clement St., San Francisco 94121. (415)863–3330; M. H. de Young Memorial Museum, Golden Gate Park, San Francisco 94118. (415)221–4811

San Francisco Museum of Modern Art, 151 3rd St., San Francisco 94103. (415)357–4000. www.sfmoma.org/

San Jose Museum of Art, 110 S. Market St., San Jose 95113. (408)294–2787. www.sjliving.com/sja

Huntington Library, Art Collections, and Botanical Gardens, 1151 Oxford Rd., San Marino 91108. (818)405–2141

Santa Barbara Museum of Art, 1130 State St., Santa Barbara 93101. (805)963–4364. www.artdirect.com/sbma/

COLORADO

The Denver Art Museum, 100 W. 14th Ave. Pkwy., Denver 80204. (303)640–2793

Colorado Springs Fine Arts Center, 30 W. Dale St., Colorado Springs 80903. (719)634–5581

CONNECTICUT

Wadsworth Atheneum, 600 Main St., Hartford 06103. (203)278–2670

Yale Center for British Art, 1080 Chapel St., New Haven 06520. (203)432–2800

Yale University Art Gallery, 1111 Chapel St. at York, New Haven 06520. (203)432–0600

DELAWARE

Delaware Art Museum, 2301 Kentmere Pkwy., Wilmington 19806. (302)571–9590. www.udel.edu/delart

DISTRICT OF COLUMBIA The Corcoran Gallery of Art, 500 17th St. NW, 20006. (202)638–1903. www.corcoran.org

Freer Gallery of Art, Smithsonian Institution, Jefferson Dr. at 12th St. SW, 20560. (202)357–4880. www.si.edu/

Hirshhorn Museum and Sculpture Garden, Smithsonian Institution, Independence Ave. at 7th St. SW, 20560. (202)357–2700. www.si.edu/

National Gallery of Art, 4th St. at Constitution Ave. NW, 20565. (202)737–4215; (202)842–6176 (TDD). www.nga.gov

National Museum of American Art, 8th and G Sts., 20560 (202)357–2700. www.nmaa.si.edu

National Museum of American Art, Renwick Gallery, Pennsylvania Ave. at 17th St. NW. 20006. (202)357–2700

National Museum of Women in the Arts, 1250 New York Ave. NW, 20005, (202) 783–5000. www.nmwa.org

National Portrait Gallery, 8th and F Sts. NW, 20560. (202)357–2700. www.npg.si.edu

The Phillips Collection, 1600 21st St. NW, 20009. (202)387–0961

Vietnam Veterans Memorial, The Mall

FLORIDA

Lowe Art Museum, University of Miami, 1301 Stanford Dr., Coral Gables 33124. (305)284–3535

John and Mable Ringing Museum of Art, 5401 Bay Shore Rd., Sarasota 34243. (813)359–5700. www.sarasota online.com/ringling/welcome.html

Museum of Fine Arts, Saint Petersburg, Florida, 255 Beach Dr. NE, Saint Petersburg 33701. (813)896–2667

GEORGIA

Georgia Museum of Art, University of Georgia, Jackson St., North Campus, Athens 30602. (706)542–GMOA or 4662

High Museum of Art, 1280 Peachtree St. NE, Atlanta 30309. (404)733–HIGH or 4444. www.high.org

HAWAII

Honolulu Academy of Arts, 900 S. Beretania St., Honolulu 96814. (808)532–8700; 532–8701

ILLINOIS

Krannert Art Museum, University of Illinois, 500 E. Peabody Dr., Champaign 61820. (217)333–1861. www.art.uiuc.edu/kam/

The Art Institute of Chicago, 111 S. Michigan Ave. at Adams St., Chicago 60603. (312)443–3600; 443–3500. www.artic.edu/aic/firstpage.html

Museum of Contemporary Art, 220 E. Chicago Ave., Chicago 60611. (312)280–2660; 280–5161. www.web core/chicago/thingsplaces/museums/mca/mca-home.html

Oriental Institute Museum, The University of Chicago, 1155 E. 58th St., Chicago 60637. (773)702–9520

Terra Museum of American Art, 666 N. Michigan Ave., Chicago 60611. (312)664–3939

INDIANA

Indianapolis Museum of Art, 1200 W. 38th St., Indianapolis 46208. (317)923–1331. web.ima-art.org/ima

IOWA

Des Moines Art Center, 4700 Grand Ave., Des Moines 50312. (515)277–4405

University of Iowa Museum of Art, 150 N. Riverside Dr., Iowa City 52242. (319)335–1727

KANSAS

Spencer Museum of Art, University of Kansas, 1301 Mississippi St., Lawrence 66045. (913)864–4710

Wichita Art Museum, 619 Stackman Dr., Wichita, 67203. (316)268–4921

KENTUCKY

J. B. Speed Art Museum, 2035 S. 3rd St., Louisville 40208. (502)636–2920. www.gatech.edu/CARLOS/AAMDO/ Speedext.htm

LOUISIANA

New Orleans Museum of Art, 1 Collins Diboll Circle, City Park, New Orleans 70124. (504)488–2631

MAINE

Bowdoin College Museum of Art, Walker Art Building, Brunswick 04011. (207)725–3275

Portland Museum of Art, 7 Congress Sq., Portland 04101. (207)775– 6148

MARYLAND

The Baltimore Museum of Art, Art Museum Dr. at North Charles and 31st Sts., Baltimore 21218. (410)396–7100. www.world-arts-resources.com/ cgi-bin/access?mu269

Walters Art Gallery, 600 N. Charles St., Baltimore 21201. (410)547–9000; 547–ARTS

MASSACHUSETTS

Mead Art Museum, Amherst College, Amherst 01002. (413)542–2335

Addison Gallery of American Art, Phillips Academy, Andover 01810. (508)749–4015. www.andover.edu/ addison/home.html

Isabella Stewart Gardner Museum, 280 The Fenway, Boston 02115. (617)566–1401. www.boston.com/ gardner

Museum of Fine Arts, Boston, 465 Huntington Ave., Boston 02115. (617)267–9300. www.mfa.org

Harvard University Art Museums, Cambridge 02138. (617)495–9400 www.fas.harvard.edu/~artmuseums/: Busch-Reisinger Museum, 32 Quincy St.; Fogg Art Museum, 32 Quincy St.; The Arthur M. Sackler Museum, 485 Broadway

Smith College Museum of Art, Elm St. at Bedford Terrace, Northampton 01063. (413)585–2760

Peabody Essex Museum, East India Sq., Salem 01970. (508)745–1876. www.pem.org

Mount Holyoke College Art Museum, South Hadley 01075. (413)538–2245

Rose Art Museum, Brandeis University, 415 South St., Waltham 02254. (617)736–3434

Davis Museum and Cultural Center, Wellesley College, 106 Central St., Wellesley 02181. (617)283–2051

Sterling and Francine Clark Art Institute, 225 South St., Williamstown 01267. (413)458–9545

Williams College Museum of Art, Main St., Williamstown 01267. (413)597–2429

Worcester Art Museum, 55 Salisbury St., Worcester 01609. (508)799–4406

MICHIGAN

The University of Michigan Museum of Art, 525 S. State St., Ann Arbor 48109. (313)764–0395

The Detroit Institute of Arts, 5200 Woodward Ave., Detroit 48202. (313)833–7900. www.dia.org

Grand Rapids Art Museum, 155 Division North, Grand Rapids 49503. (616)459–4677

MINNESOTA

The Minneapolis Institute of Arts, 2400 3rd Ave. S., Minneapolis 55404. (612)870–3131; 870–3200. www.artsMIA.org

Walker Art Center, Vineland Pl., Minneapolis 55403. (612)375–7622. www.walkerart.org

MISSOURRI

The Nelson-Atkins Museum of Art, 4525 Oak St., Kansas City 64111. (816)561–4000

The Saint Louis Art Museum, 1 Fine Arts Dr., Forest Park, St. Louis 63110. (314)721–0072. www.slam.org

NEBRASKA

University of Nebraska-Lincoln/Sheldon Memorial Art Gallery and Sculpture Garden, 12th and R Sts., Lincoln 68588. (402)472–2461

Joslyn Art Museum, 2200 Dodge St., Omaha 68102. (402)342–3300. www.gatech.edu/CARLOS/AAMDO. cenreg.htm

NEW HAMPSHIRE

Hood Museum of Art, Dartmouth College, Wheelock St., Hanover 03755.

NEW JERSEY

The Montclair Art Museum, 3 S. Mountain Ave. at Bloomfield Ave., Montclair 07042. (201)746–5555. www.interactive.net/~upper/mam.html

The Newark Museum, 49 Washington St., Newark 07101. (201)596–6500

Jane Zimmerli Art Museum, Rutgers The State University of New Jersey, Hamilton and George Sts., New Brunswick 08903 (201)932–7237

The Art Museum, Princeton University, Princeton 08544. (609)258–3788

NEW MEXICO

Millicent Rogers Museum, 1504 Millicent Rogers Rd., Taos 87571. (505)758–2462

NEW YORK

The Brooklyn Museum, 200 Eastern Pkwy., Brooklyn 11238. (718)638–5000. wwar.com/brooklyn_museum/index.html

Albright-Knox Art Gallery, 1285 Elmwood Ave., Buffalo 14222. (716)882–8700

Herbert F. Johnson Museum of Art, Cornell University, Ithaca 14853. (607)255–6464

Storm King Art Center, Old Pleasant Hill Rd., Mountainville 10953. (914)534–3115

American Craft Museum, 40 W. 53rd St., New York 10019, (212)956–3535

The Cloisters, Fort Tryon Park, New York 10040. (212)923–3700

Cooper-Hewitt National Museum of Design, Smithsonian Institution, 2 E. 91st St., New York 10128. (212) 860–6868

The Frick Collection, 1 E. 70th St., New York 10021. (212)288–0700

The Grey Art Gallery and Study Center, New York University Art Collection, 33 Washington Pl., New York 10003. (212)998–6780

Guggenheim Museum SoHo, 575 Broadway, New York 10012. (212)423–3500

International Center of Photography, 1130 5th Ave., New York 10028. (212)860–1777

International Center of Photography Midtown, 1133 6th Ave., New York 10036. (212)860–1783

The Jewish Museum, 1109 5th Ave., New York, 10128. (212)423–3200

The Metropolitan Museum of Art, 5th Ave. at 82nd St., New York 10028. (212)879–5500. www.metmuseum.org

The Museum of Modern Art, 11 W. 53rd St., New York 10019. (212)708–9400. www.moma.org

The New Museum of Contemporary

Art, 583 Broadway, New York 10012. (212)219–1222. www.newmuseum.org

The Pierpont Morgan Library, 29 E. 36th St., New York 10016. (212)685–0008

Solomon R. Guggenheim Museum, 1071 5th Ave., New York 10128. (212)423–3500.www.mediabridge.com/ nyc/museums/guggenheim.html

The Studio Museum in Harlem, 144 W. 125th St., New York 10027. (212)864–4500

Whitney Museum of American Art, 945 Madison Ave., New York 10021. (212)570–3676. www.echonyc.com/~whitney

Neuberger Museum of Art, Purchase College, State University of New York at Purchase, 735 Anderson Hill Rd., Purchase 10577. (914)251–6133

George Eastman House/International Museum of Photography and Film, 900 E. Ave., Rochester 14607. (716)271–3361

Memorial Art Gallery of the University of Rochester, 500 University Ave., Rochester, NY 14607. (716)473– 7720

Everson Museum of Art of Syracuse and Onondaga County, 401 Harrison St., Syracuse 13202. (315)474– 6064

Munson-Williams-Proctor Institute Museum of Art, 310 Genesee St., Utica 13502. (315)797–0000

The Hudson River Museum of Westchester, 511 Warburton Ave., Yonkers 10701. (914)963–4550

NORTH CAROLINA

The Ackland Art Museum, University of North Carolina, Chapel Hill, Columbia and Franklin Sts., Chapel Hill 27599. (919)966–5736

Duke Univerisity Museum of Art, Buchanan Blvd. at Trinity, East Campus, Durham 27708. (919)684–5135. www.duke.edu/duma

Weatherspoon Art Gallery, University of North Carolina, Greensboro, Spring Garden and Tate Sts., Greensboro 27412. (910)334–5770

North Carolina Museum of Art, 2110

Blue Ridge Rd., Raleigh 27607. (919)833–1935

OHIO

Great Serpent Mound, Adams County

Cincinnati Art Museum, Eden Park, Cincinnati 45202. (513)721–5204

The Taft Museum, 316 Pike St., Cincinnati 45202. (513)241–0343

The Cleveland Museum of Art, 11150 E. Blvd., Cleveland 44106. (216)421–7340. www.clemusart.com

The Columbus Museum of Art, 480 E. Broad St., Columbus 43215. (614)221–6801

Wexner Center for the Arts, The Ohio State University, North High St. at 15th Ave., Columbus 43210. (614)292–3535

Dayton Art Institute, 456 Belmonte Park North, Dayton 45405. (513)223–5277. www.gatech.edu/ CARLOS/AAMDO/Daytext.htm

Allen Memorial Art Museum, Oberlin College, 87 N. Main St., Oberlin 44074. (216)775–8665.

www.oberlin.edu/wwwmap/allen_art.html

The Toledo Museum of Art, 2445 Monroe St., Toledo 43620. (419)255–8000; (800)644–6862

The Butler Institute of America, 524 Wick Ave., Youngstown 44502. (216)743–1711. www.butlerart.com

OKLAHOMA

Gilcrease Museum, 1400 Gilcrease Museum Rd., Tulsa 74127. (918)596–2700

The Philbrook Museum of Art, 2727 S. Rockford Rd., Tulsa 74114. (918)749–7941

OREGON

Portland Art Museum, 1219 SW Park Ave, Portland 97205. (503)226–2811. www.pam.org/~pam/index.html

PENNSYLVANIA

Brandywine River Museum, Brandywine Conservancy, Rt. 1 at PA Rt. 100, Chadds Ford 19317. (610)388–2700

Barnes Foundation, 300 North Natch's Ln., Merion Station 19066. (610)667–0290

Institute of Contemporary Art, University of Pennsylvania, 118 S. 36th St., Philadelphia 19104. (215)898–7108

Museum of American Art of the Pennsylvania Academy of the Fine Arts, 118 N. Broad St., Philadelphia 19102. (215)972–7600. www.pond.com/~pafa

Philadelphia Museum of Art, 26th St. and Benjamin Franklin Pkwy., Philadelphia 19130. (215)763–8100. liber tynet.org/~pma/pmahome.html

University of Pennsylvania Museum,

33rd and Spruce Sts., Philadelphia 19104. (215)895–4000

The Andy Warhol Museum, 117 Sandunsky St., Pittsburgh 15212. (412)237–8300. www.clpgh.org/warhol

The Carnegie Museum of Art, 4400 Forbes Ave., Pittsburgh 15213. (412)622–3131. www.clpgh.org/moa

The Frick Art Museum, 7227 Reynolds St., Pittsburgh 15208. (412)371–0600

RHODE ISLAND

Museum of Art, Rhode Island School of Design, 224 Benefit St., Providence 02903. (401)454–6500. www/gatech.edu/CARLOS?AAMDO/ RISDext.htm

SOUTH CAROLINA

Greenville County Museum of Art, 420 College St., Greenville 29601. (803)271–7570

TENNESSEE

Knoxville Museum of Art, 410 10th Ave., World's Fair Park, Knoxville 37916. (615)525–6101. www.esper.com/kma/index.html

Memphis Brooks Museum of Art, Overton Park, 1934 Poplar, Memphis 38104. (901)722–3500

TEXAS

Dallas Museum of Art, 1717 N. Harwood, Dallas 75201. (214)922–1200. www.unt.edu/dfw/dma/www/dma.htm

Amon Carter Museum, 3501 Camp Bowie Blvd., Fort Worth 76107. (817)738–1933. cartermuseum.org

Kimbell Art Museum, 3333 Camp Bowie Blvd., Fort Worth 76107. (817)332–8451. www.corbis.com/ features/secure/kimbell

Modern Art Museum of Fort Worth, 1309 Montgomery St. at Camp Bowie Blvd., Fort Worth 76107. (817)738–9215

Contemporary Arts Museum, 5216 Montrose Blvd., Houston 77006. (713)526–0773. riceinfo.rice.edu/ projects/cam

The Menil Collection, 1515 Sul Ross, Houston 77006. www.menil.org/~menil

The Museum of Fine Arts, Houston, 1001 Bissonnet St., Houston 77005. (713)639–7300. www.mfah.org

Rothko Chapel, 1409 Sul Ross, Houston 77006. (713)524–9839

Marion Koogler McNay Art Museum, 6000 N. New Braunfels Ave., San Antonio 78209. (210)824–5368

San Antonio Museum of Art, 200 W. Jones St., San Antonio 78215. (210)978–8100. www.samuseum.org

VIRGINIA

Monticello, Charlottesville. www.monticello.org/ Hampton University Museum, Hampton 23668. (804)727–5308

The Chrysler Museum, 245 W. Olney Rd., Norfolk 23510. (804)664–6200. www.whro.org/cl/cmhh

Virginia Museum of Fine Arts, 2800 Grove Ave., Richmond 23221. (804)367–0844

WASHINGTON

Seattle Art Museum, 100 University St., Seattle 98101. (206)625–8900; 654–3100. www.pan.ci.seattle.wa.us/sam

Tacoma Art Museum, 12th and Pacific Ave., Tacoma 98402. (206)272–4258

WISCONSIN

Milwaukee Art Museum, 750 N. Lincoln Memorial Dr., Milwaukee 53202. (414)224–3200. www.mam.org

OUTSIDE THE UNITED STATES

AUSTRIA

Graphische Sammlung Albertina, Augustinerstr. 1, Vienna 1010. (0222)534830

Kunsthistoriches Museum, Burgring 5, Vienna 1010. (0222)525240

Church of St. Wolfgang, Vienna

Österreichische Galerie Belvedere, Prinz. Eugen. Str. 27, Vienna 1037. (01)79557

BELGIUM

Antwerp Cathedral

Musées Royaux des Beaux-Arts de Belgique: Musée d'Art Ancien, 3 Rue de la Régence, Brussels 1000. (32)25083211; Musées d'Art Moderne, 1-2, Place Royale, Brussels 1000. (32)25083211

Musée Royaux d'Art et d'Histoire, Parc du Cinquantenaire 10, Brussels 1040. (02)7417211

Church of St. Bavo, Ghent

CANADA

Edmonton Art Gallery, 2 Sir Winston Churchhill Sq., Edmonton, Alberta T5J 2C1. (403)422–6223

Glenbow, 130 9th Ave., Southeast, Calgary, Alberta T2G 0P3. (403)268–4100. www.glenbow.org

Vancouver Art Gallery, 750 Hornby St., Vancouver, British Columbia V6Z 2H7. (604)682–4668. www.vanartgallery.bc.ca

National Gallery of Canada, 380 Sussex Dr., Ottawa, Ontario K1N 9N4. (800)319–ARTS; (613)990–1985. national.gallery.ca

Art Gallery of Ontario, 317 Dundas St. W., Toronto, Ontario M5T 1G4. (416)977–6648. www.ago.on.ca

Royal Ontario Museum, 100 Queen's Park, Toronto, Ontario M5S 2C6. (416)586–5551. www.rom.on.ca/

Canadian Center for Archictecture, 1920, rue Baile, Montréal, Quebec H3H 2S6. (514)939–7000; 939–7026

Montréal Museum of Fine Arts, 1379-80 Sherbrook St. W., Montréal, Quebec H36 2T9. (514)285–1600; 285–2000. www.mmfa.qc.ca

CZECH REPUBLIC

National Gallery in Prague. (42)2 53 08 95. (43)5132782

Sternberg Palace, Hradcanske namesti 15, Prague 1-Hradcany. (42)23524413

DENMARK

Ny Carlsberg Glyptotek, Dantes Plads 7, Copenhagen 1556. (45)33418141. www.europe-today.com/denmark/ museum2.html#carlsberg2

Louisiana Museum of Modern Art, Gl. Strandvej 13, Humlebaek 3050 (nr. Copenhagen). (45)42190719. www.europe-today.com/denmark/museum2.html#Louisiana

EGYPT

Tomb of Khnum-hotep, Beni Hasan

Egyptian Museum, Cairo University. Midan el Tahrir, Cairo. (2)760390

Funerary Temple of Queen Hatshepsut, Deir el-Bahari

The Great Sphinx, Giza

Pyramids of Menkaure, Khafre, Khufu, Giza

Temple complex of Amun-Mut-Khonsu, Luxor

Funerary district of King Djoser, Saqqara

Tomb of Ti, Saqqara

Tomb of Ramose, Thebes

ENGLAND

Birmingham Museum and Art Gallery, Chamberlain Sq., Birmingham B3 3DH. (0121)2352834

Durham Cathedral, Durham

Banqueting House, Whitehall Palace, London

British Library Exhibition Galleries, Great Russell St., London WC1B 3DG. (0171)4127595

British Museum, Great Russell St., London WC1B 3DG. (0171)6361555

Westminster Abbey, London

Courtauld Institute Galleries, Somerset House, Strand, London WC2R ORN. (0181)8732538

The Houses of Parliament, London

The National Gallery, Trafalgar Sq., London WC2N 5DN. (0171)8393321

Royal Academy of Arts, Burlington House, Picadilly, London WIV ODS. (0171) 439-7438

St. Paul's Cathedral, London

Sir John Soane's Museum, 13 Lincoln's Inn, London WC2A 3BP. (0171)4052107

Tate Gallery, Millbank, London SWIP 4RG. (0171)8878000

Victoria and Albert Museum, Cromwell Rd., South Kensington, London SW7 2RL. (0171)9388500. www.vam.ac.uk

Wellington Museum, Apsley House, 149 Piccadilly, Hyde Park Corner, London N1V 9FA. (0171)4995676

Ashmolean Museum of Art and Archaeology, Beaumont St., Oxford 0X1 2PH. (01865)278000. www.ashmol.ox.ac.uk

Salisbury Cathedral, Salisbury

Stonehenge, Salisbury Plain (Wiltshire)

Blenheim Palace, Woodstock 0X7 1PX. (01993)811325

FRANCE

Chauvet cave, Vallon-pont-d'Arc

Amiens Cathedral, Amiens

Autun Cathedral, Autun

Chartres Cathedral, Chartres

Musée Unterlinden, 1 rue des Unterlinden, Colmar 68000. 89201550

Lascaux cave, Montignac, Dordogne

Château de Fontainebleau, Fontainebleau. (1)60715070

Musée Claude Monet, rue Claude Monet, Giverny 27620. 32512821. giverny.org/monet/welcome.htm

Musée des Beaux-Arts de Lyon, Palais St. Pierre, 20 place des Terreaux, 69001 Lyon. 78280766

Pont du Gard, Nîmes

Abbey Church of St.-Denis, Paris

Bibliothèque Nationale de France, 25 rue de Richelieu, Paris 75002. (1)47038126

Bibliothèque Ste. Geneviève, Paris

The Eiffel Tower, Paris

Galeries Nationales du Grand Palais, 3 avenue du Général Eisenhower, Paris 75008. (1)42895410

Musée Auguste Rodin, 77 rue de Varenne, Paris 75007. (1)47050134

Musée du Louvre, rue de Rivoli, 75001 Paris. (1)40205009. www.Louvre.fr Musée National d'Art Moderne—Centre National d'Art et de Culture Georges Pompidou, Centre Beaubourg, Paris 75191. (1)781233. www.paris.org/Musees/Beaubourg

Musée d'Orsay, 1 rue de Bellechasse, Paris 75007. (1)40494814. www.paris.org.:80/Musees/Orsay/

Musée Picasso, Hôtel Salé, 5 rue de Varenne, Paris 75003. (1)42712521

Notre-Dame, Paris

The Opéra, Paris

Rodin Museum, Paris

Riems Cathedral, Reims

Notre-Dame-du-Haut, Ronchamp

Musée des Antiquités Nationales, Château de Saint-Germaine-en-Laye, Saint-Germain-en-Laye 78100

Château de Versailles, Versailles. (1)30847400

GERMANY

Palace Chapel of Charlemagne, Aachen

Brücke-Museum, Bussardsteig 9, Berlin 14195. (030)8312029. www/dhm.de/museen/bruecke/

Ägyptisches Museum und Papyrussammlung, Staatliche Museeun zu Berlin-Preussischer Kulturbesitz, Schlossstr. 70, Berlin 14059. (030)32091261. fub46.zedat.fuberlin.de:8080/~kurtwagn/gendir/ aegy-pap/aegychar.html

Schloss Charlottenburg, Berlin. peri.pericont.in-berlin.de/cgi-bin/ cg/museummuseumshow.pl?80; land=Berlin

Staatliche Museen zu Berlin, Gemäldegalerie. peri.pericont.in-berlin.de/cgibin/cg/museummuseumshow.pl?80; land=Berlin

Staatliche Museen zu Berlin, Preussischer Kulturbesitz, Stauffenbergstr. 41, Berlin 10785. (030)2666. peri.pericont.in-berlin.de/cgi-bin/ cg/museummuseumshow.pl?80; land=Berlin

Museum Ludwig, Bischofsgartenstr. 1, Cologne 50667. (0221)2212379. www.blackbox.de/kunst/museen/ mlu.htm

St. Pantaleon, Cologne

Städelsches Kunstinstitut und Städtische Galerie, Schaumainkai 63, Frankfurt 60596. (069)6050980. peri.pericont.in berlin.de/cgi-bin/cg/museumcity search.pl?city=Frank furt_am_Main

Hamburger Kunsthalle, Glockengiesserwall, 20095 Hamburg. (040)24862612. www.hamburg.de/Behoerden/Museen/kh/

Hildesheim Cathedral, Hildesheim

Staatliche Kunsthalle, Hans-Thoma-Str. 2, Karlsruhe 76133. 1353370. www.rz.uni- karlsruhe.de/Nick/Karlsruhe/

Alte Pinakothek, Barer Str. 27, Munich 80333. (089)238050. server.StMUK WK.bayern.de/kunst/museen/pinalt.html

Bayerische Staatsgemäldesammlungen, Barrer Str. 29, Munich 80799. (089)238050

Staatliche Graphische Sammlung, Meiserstr. 10, Munich 80333. (089)5591490

Staatliche Antikensammlungen und Glyptothek, Konigspl 1–3, Munich 80333. (089)1598359

Staatsbibliothek, Munich

Staatsgalerie Stuttgart, Konrad-Adenauer Str. 30, Stuttgart 70173. (0711) 212 4050. macserver.zedat.fu-berlin. de:1080/index.html

The Episcopal Palace, Würzburg

GREECE

Acropolis, Athens

Acropolis Museum, Athens. www.cul ture.gr

National Archaeological Museum, Od Tosita 1, Athens 10682. (01)8217717. www.culture.gr

Archaeological Museum, Corfu. www.culture.gr

Archaeological Museum, Heraklion, Crete. www.culture.gr

Palace of Minos, Knossos, Crete

Archaeological Museum, Delphi 33054. (0265)82313. www.culture.gr

Archaeological Museum, Eleusis. www.culture.gr

Monastery of Hosius Loukas (St. Luke of Stiris)

HUNGARY

National Gallery, Budapest

IRAN

Archaeological Museum, Teheran

IRAQ

Iraq Museum, Karkh Museum Sq., Baghdad. 361215

Ziggurat of King Urnammu, Ur (El Muqeiyar)

"White Temple", Uruk (Warka)

IRELAND

National Gallery of Ireland, Merrion Sq. W., Dublin 2. (01)6615133

ITALY

Museo Civico Archeologico, Via dell'Archiginnasio 2, Bologna 40124. (051)233849. www.dsnet.it/Bologna/engl_ musei.html Museo Civico Cristiana, Via Musei, 81, Brescia 25100. (030)44327

Museo Etrusco, Piazza della Cattedrale, Chiusi 53043

Florence Cathedral and Baptistery of S. Giovanni, Florence

Galleria dell'Academia, Via Ricasoli 60, Florence 50122. (055)214375

Galleria degli Uffizi, Piazza degli Uffizi 6, Florence 50122. (055)2388651. www.televisual.it/uffizi/

Museo Archeologico Nazionale du Firenze, Via della Colonna 38, Florence 50121. (055)23575

Museo Nazionale del Bargello, Via del Proconsolo 4, Florence 50122. 055210801

S. Lorenzo, Florence

Sta. Maria delle Grazie, Milan

Museo Archeologico Nazionale, Via Museo 19, Naples 80135. (081) 440166

Museo e Gallerie Nazionale di Capodimonte, Palazzo di Capodimonte, Naples 80136. (081)7410801

"Basilica" and "Temple of Poseidon", Paestum

Parma Cathedral

House of the Vettii, Pompeii

Villa of the Mysteries, Pompeii

S. Apollinare in Classe, Ravenna

S. Vitale, Ravenna

Arch of Constantine, Rome

Arch of Titus, Rome

Casino Rospogliosi, Rome

The Colosseum, Rome

Column of Trajan, Rome

Galleria Borghese, Piazzale Scipione Borghese 5, Rome 00197. (06) 858577

Galleria Nazionale d'Arte Antica, Via delle Quattro Fontane 13, Rome 00184. (06)4824184

Il Gesù, Rome

Musei Capitolini, Piazza del Campidoglo, Rome 00186. (06)67102475

Museo dei Conservatori, Piazza del Campidoglio, Rome 00186. (06)67102475

Museo di Antichità Etrusche e Italiche, Piazza Aldo Moro, Rome 00185

Museo delle Terme, Rome

Museo Nazionale di Villa Giulia, Piazza di Villa Giulia 9, Rome 00195. (06)350719

Museum of the Ara Pacis, Rome

Palazzo Barberini, Rome

Palazzo Farnese, Rome

The Pantheon, Rome

S. Carlo alle Quattro Fontane, Rome

S. Luigi dei Francesi, Rome

St. Peter's, Rome

Sta. Maria Maggiore, Rome

Sta. Maria della Vittoria, Rome

Vatican Museums, Viale Vaticano, Città del Vaticano 00120, Rome. (06)69883333

Villa Medici, Rome

Cave of Addaura, Monte Pellegrino (Palermo), Sicily

Tombs, Tarquinia

Peggy Guggenheim Collection, Palazzo Venier dei Leoni, 701 Dorsoduro, 30123 Venice. (041)5206288

Galleria dell'Academia, Campo della

Carità, Venice 30121. (041)22247

S. Giorgio Maggiore, Venice

St. Marks, Venice

Villa Rotonda, Vicenza

JORDAN

Jordan Archaeological Museum, Amman. 638795

THE NETHERLANDS

Rijksmuseum, Stadhouderskade 42, Amsterdam 1070. (020)6732121. www.nbt.nl/holland/museums/home.htm

Rijksmuseum Vincent van Gogh, Paulus Potterstr. 7, Amsterdam 1070. (020)5705200. www.nbt.nl/holland/museums/home.htm

Stedelijk Museum of Modern Art, Paulus Potterstraat 13, Amsterdam 1070. (020)5732911. art.cwi.nl

Frans Halsmuseum, Groot Heiligland 62, Haarlem 2001. (023)164200. www.nbt.nl/holland/museums/home.htm

Kröller-Müller Museum, Otterlo 6730. 08382. www.nbt.nl/holland/museums/ home.htm

Museum Boymans-van Beuningen, Museumpark 18-20, Rotterdam 3015. 010441400. www.nbt.nl/holland/ museums/home.htm Centraal Museum Utrecht, Agnietenst. 1, Utrecht 3500. (030)362362. www.nbt.nl/holland/museums/ home.htm

NORWAY

Nasjonalgalleriet, Universitestsgaten 13, Oslo 0033. 22200404

ROMANIA

National Museum, Str. Stirbei Vida, nr. 1–3, Bucharest 70733. (01)6155193

RUSSIA

Cathedal of St. Basil, Moscow

Pushkin Museum of Fine Arts, Ul. Volkhonka 12, Moscow. (095)2037412. www.rosprint.ru/art/museum/pushkin

Hermitage Museum, 36 Dvortsovaya Naberezhnaya, Saint Petersburg, (812)3113420

SCOTLAND

National Gallery of Scotland, The Mound, Edinburgh EH2 2EL. (0131)5568921

SPAIN

Altamira cave

Church of the Sagrada Familia, Barcelona

Museo Nacional del Prado, Paseo del Prado, Madrid 28014. (91)4680950

Museo Nacional Centro de Arte Reina

Sofía, Santa Isabel 52, Madrid 28012. (1)4675062

Toledo Cathedral, Toledo

SWEDEN

Moderna Museet, Spårvagnshallarna, Box 16382, Stokholm 10327. (08)6664250

Nationalmuseum, S. Blasieholmshamnen, Stockholm 10324. (08)6664250

University Art Gallery, Uppsala University

SWITZERLAND

Öffentliche Kunstsammlung Basel, Kunstmuseum, St. Alban-Graben 16, Basel 4010. (41)612710828. www.access.ch/bsweb/museum/e/kusa_ku/index.htm

Musée des Beaux-Arts de Berne, Bern

Musée d'Art et d'Histoire, 2 Rue Charles Gallard, Geneva 1211. (022)3114340

TURKEY

Archaeological Museum, Ankara

Archaeological Museum of Istanbul, Gülhane Sultanahmet, Istanbul 34400. (520)7742

Hagia Sophia, Istanbul

Kariye Camii (Church of the Saviour in Chora), Istanbul

INDEX

Works ascribed to a specific artist are indexed under the artist's name, shown in SMALL CAPITAL letters. Insofar as possible, works, including buildings and archeological remains, are also indexed by site of origin. Buildings whose name begins with "Palace," "Villa," "Cathedral," and such generic names are listed under the next significant part (e.g., Versailles, France, Palace). Illustration references, shown in *italic* type, are to *figure numbers*, not page numbers.

Aachen, Germany, Palace Chapel of Charlemagne (Odo of Metz), 276–77, 280; 357, 358, 359 AALTO, ALVAR, 880–81; Villa Mairea (Noormarkku, Finland), 880; 1173, 1174

ABBATINI, GUIDEBALDO, fresco (Cornaro Chapel, Sta. Maria della Vittoria, Rome), 559, 567, 604; 754

abbey churches, 316

Abbey in an Oak Forest (Friedrich), 692; 893

ABBOTT, BERENICE, 896, 907–8; *Transformation of Energy*, 779, 907–8; *1222*

Abduction of Europa (Giordano), 559–60, 626; 738 Abduction of Prosperine (Vergina, Macedonia), 151–52; 198

Abduction of the Sabine Women (Bologna), 498; 659 Abduction of the Sabine Women (Poussin), 596–98, 660, 680; 794

Abstract Expressionism, 28, 818–22; late, 827–28 abstraction, 780, 788–96; between the wars, 804–6; in photography, 894, 905–8

Abstraction-Création group, 805

Abu Temple, Tell Asmar, Iraq, statues, 80–81, 88; 89 Accented Corners, No. 247 (Kandinsky), 803–4; 1053 Accession II (Hesse), 867; 1147

Achaemenid culture, 94-96

"ACHILLES PAINTER," *Muse and Maiden,* lekythos, 152–53, 214; 200

Acropolis, Athens, Greece, 131, 133–34, 136; *171*Erechtheum, 134–37, 706; *177*; Porch of the Maidens, 137: *178*

Parthenon, 130-33, 148-50, 874; 169

east pediment, 149; 193; Dionysus, 148; 191; Three Goddesses, 133, 148, 150, 162; 192

frieze, 131–33, 149, 192–93; 170; Procession, 192–93, 241, 413; 268; The Sacrifice of King Erechtheus' Daughters, 149; 194

metopes, *Lapith and Centaur*, 150, 155, 192; *195* Propylaea, 133–34, 136, 707; *172, 173, 174*

Temple of Athena Nike, 134, 136; *174*; *Nike*, sculpture, 150, 247; *196*

Action Painting, 818-22

ADAM, ROBERT, 663, 671; Kenwood, The Library (London, England), 671, 708; 859

Adam and Eve (Dürer), 530, 534, 536; 702

Adam and Eve (Eyck, Ghent Altarpiece, St. Bavo Chapel, Ghent, Belgium), 506, 509–10; 674

Adam and Eve Reproached by the Lord (from Bronze Doors of Bishop Bernward, St. Michael's Cathedral, Hildesheim, Germany), 289, 311, 312, 318; 376

Adam in Paradise, diptych (Early Christian), 418, 427; 541

ADAMS, ANSEL, 900–901; Moonrise, Hernandez, New Mexico, 900–901; 1208

Addaura Cave, Monte Pellegrino (Palermo), Sicily, Ritual Dance (?), rock engraving, 53; 33

Adoration of the Magi, portal sculpture (St.-Pierre, Moissac, France), 306, 309, 310, 386; 402

Adoration of the Magi (Gentile da Fabriano), altarpiece, 380–81, 423, 429, 506; 525; Nativity from, 381, 493, 515; 526

Adoration of the Magi (Leonardo), 453–54; 594 Adoration of the Shepherds (Bassano), 493–94; 652 Aegean art, 98–109

Aegina, Greece, Temple of Aphaia, 124, 130-31; 159,

168; Dying Warrior, 124, 139, 145, 147, 158; 160; Herakles, 124, 139, 145; 161

A.E.G. Turbine Factory, Berlin, Germany (Behrens), 874; 1158

Aeolian capital (from Larissa, Greece), 136, 173; 175 AERTSEN, PIETER, 541–42; The Meat Stall, 542, 580, 589, 715

aesthetics, 16, 25

African-American art, 828-30, 858

AGESANDER, ATHENODORUS, POLYDORUS OF RHODES, attr., *Laocoön Group*, 162, 462, 564, 607, 665; 215

Agnolo di Tura del Grasso, History, 393

Agony in the Garden, The (El Greco), 34, 265; 17

Akhenaten (Amenhotep IV), 72, 75–76; relief of, 75; 78 Akkadian culture, 83–84

Akrotiri, Thera (Santorini), Greek island: Crocus Girl, mural, 102–3, 822; 123; Landscape, mural, 103–4, 209; 124; "The Mistress of the Animals," mural, 102–3, 822; 123

Albers, Josef, 831, 878; Homage to the Square, Apparition from, 831; 1093

Alberti, Leone Battista, 434–37, 458–59, 500 On Architecture (book), 420, 437, 446; excerpt, 630 On Painting (book), 434; excerpt, 630

Palazzo Rucellai (Florence), 434, 468, 546, 920; 566 S. Andrea (Mantua, Italy), 434–37, 438–39, 470, 502; 569, 570, 571

S. Francesco (Rimini, Italy), 434; 567, 568

Alexander the Great with Amun Horns, coin (Lysimachus), 165, 191; 221

Alfeld, Germany, Fagus Shoe Factory (Gropius), 874, 878; 1159

ALGARDI, ALESSANDRO, 567–68; *The Meeting of Pope Leo I and Attila* (St. Peter's, Rome), 567–68; *755*

Alkestis Leaving Hades, relief (Temple of Artemis, Ephesus, Anatolia), 35; 18

Allegory of Earth (Brueghel), 579; 769

Allegory of Venus (Bronzino), 486-87; 642

Altamira, Spain, Wounded Bison, 51; 29

ALTDORFER, ALBRECHT, 534–36; *The Battle of Issus*, 534–35, 536; 707

Altes Museum, Berlin, Germany (Schinkel), 706-7, 920: 909

alto (high) relief, 35

Amenhotep III, 72; court of, Temple of Amun-Mut-Khonsu, Luxor, Egypt, 72–75, 95; 74

American art, see Colonial American art; United States,

American Association of Painters and Sculptors, 799 American Barbizon school, 732–33

American Scene Painting, 817-18

Amiens, France, Cathedral, 297, 331–32, 739, 876;
438, 439, 440, 442; Labors of the Months (July, August, September), sculpture, 348, 349, 378, 379; 474; Signs of the Zodiac, sculpture, 348, 349, 378, 379; 474

Ammanati, Bartolommeo, 499; Palazzo Pitti (Florence), 499–500, 546; 662

Ammianus Marcellinus, History, excerpt, 219

Amorgos, Greek island: figure from, 98–99; 117; Harpist (Orpheus), 17; 1

amphora, 111

Amun, Temple of, Luxor, Egypt, 75, 79, 235; 76

Amun-Mut-Khonsu, Temple of, Luxor, Egypt, 72–75, 95, 901; 74; court of Amenhotep III, 72–75, 95; 74; court of Ramesses II, 72–75, 95; 74, 75; pylon of Ramesses II, 72–75, 95; 74, 75

Analytic Cubism, 790-91, 798, 805, 846

Anastasis, fresco (Kariye Camii [Church of the Saviour in Chora]), Istanbul, Turkey), 269, 314, 366; 349 anatomical studies, 26

Ancient of Days, The, illustration, from Europe, A Prophecy (Blake), 687; 885

Ancient Ruins in the Cañon de Chelle, N.M., in a Niche

50 Feet Above the Present Cañon Bed (O'Sullivan), 716; 927

Andachtsbild, 351, 529

ANGELICO, FRA, 428-29; Deposition, 429; 559

Angilbert, Saint: Customary for the Different Devotions, excerpt, 385; Inventory of the Treasury of Centula, excerpt, 385

ANGUISSOLA, SOFONISBA, 488; Portrait of the Artist's Sister Minerva, 488; 645

Animal Destinies (Marc), 787; 1031

Animal Head (from ship burial, Oseberg, Norway), 270–71; 351

Animal Hunt (Çatal Hüyük, Turkey), 55–56; 40 animals, sacred, in art, 81–83, 92

animal style: Celtic-Germanic, 270–71; Persian, 92–94,

Ankh-haf, Vizier, *Bust of*, Giza, Egypt, 70; 67 *Annunciation* (Broederlam), altar panel, 377–78, 505,

506; 519

Annunciation (Daret), Woodcut of St. Christopher shown as detail in, 525, 814; 693

Annunciation (Grünewald), from Isenheim Altarpiece, 527–29, 535; 697

Annunciation (Lanfranco), 555; 732

Annunciation (Pucelle), from Hours of Jeanne d'Evreux, 358, 375; 516

Annunciation (Reims Cathedral), sculpture, 332, 347–48, 350, 353, 354, 410; 471

Annunciation (St.-Pierre, Moissac, France), portal sculpture, 306, 309, 310, 386; 402

Annunciation of the Death of the Virgin, detail (Duccio, Maestà Altar, Siena Cathedral), 365, 375, 393; 501

Anquetin, Louis, 755

ANTELAMI, BENEDETTO, 311–12; King David (Cathedral, Fidenza), 311–12, 355, 357; 410

Anthemius of Tralles, 252, 308

Antimachus of Bactria, coin (Hellenistic), 165; 222

antiquity, art of, see Graeco-Roman art

Antwerp Mannerism, 539

Anuszkiewicz, Richard, 831; Entrance to Green, 831; 1094

APELLES OF KOS, 151

Aphaia, Temple of, Aegina, Greece, 124, 130–31; *159*, *168: Dying Warrior*; 124, 139, 145, 147, 158; *160: Herakles*, 124, 139, 145; *161*

Apollo, coin (Herakleidas, Catana, Sicily), 164; 220

Apollo, Sanctuary of, Delphi, Greece, *Charioteer*, 143–44, 189; *186*

Apollo, statue (Temple of Apollo, Veii, Italy), 173, 174;

Apollo, statue (Temple of Zeus, Olympia, Greece), 144–45, 149, 150, 152, 164, 432; *187*

Apollo, Temple of, Veii, Italy, 173–74; *Apollo* statue, 173, 174; *231*

Apollo and Daphne (Bernini), 36, 596; 20

Apollo Belvedere (Graeco-Roman), 157–58, 162, 231, 660, 664, 665, 667; 208

APOLLODORUS OF ATHENS, 151

Apostle, sculpture (St.-Sernin, Toulouse, France), 305, 309, 311: 400

Apostles (Masegne, St. Mark's, Venice, Italy), 357; 491 Apotheosis of Sabina, relief (Rome, Italy), 197; 274

Apparition, from Homage to the Square (Albers), 831;

Apparition (Dance of Salome) (Moreau), 761; 985 APPEL, KAREL, 823–25; Burned Face, 823–25; 1083

applied arts, 23 apprentices, 276

apprentices, 27

Ara Pacis, Rome, Italy, 192–94, 198; 266; Imperial Procession from, 192–93, 198, 241, 245, 348, 413, 414, 437, 448, 551; 267; panels, 194, 413; 269

Arc de Triomphe, Paris, France, La Marseillaise (Depar-

ture of the Volunteers of 1792) from (Rude), 701-3, 705; 904

arch, types and parts of, 177, 182, 185; 235

Archaic smile, 120, 123, 140

Archangel Michael, The, leaf of diptych (Early Christian), 246–47, 250, 254, 291, 305, 316; 315

Architectural View, wall painting (Boscoreale [near Naples], Italy), 204, 206, 240, 289, 365, 367, 370; 286

architecture, 23, 25, 36-37

cultures: Archaic Greek, 118–19; Byzantine, 257–58, 260–63; Early Christian, 234–37; Early Medieval, 275–80, 285–86; Egyptian, 64–65, 72–75; Etruscan, 175; Greek, 114, 124–39; Minoan, 99–101; Mycenaean, 109; neolithic, 58–59; Roman, 177–88; Romanesque, 293–304; Sumerian, 78, 79–80

periods: from 1945 to 1980, 884–92; before World War I, 872–76; between the wars, 876–83; 19th century, 738–43; 16th century, 500–502; 20th century, 872–92

styles: Art Nouveau, 768–72; Baroque, 560–64, 601–4, 607–9; Classic Revival, 706–10; Early Renaissance, 418–22, 434–37; Expressionist, 887; Gothic, 321–43; Gothic Revival, 706–10; Mannerist, 498–500, 918; Modern, 772–74, 884–92; Neo-Baroque, 710–12; Neoclassic, 667–72; Neo-Renaissance, 710–12; Postmodern, 916–20; Proto-Baroque, 502–3; Renaissance, 457–59, 544–47; Romantic, 706–12

types: domestic, 186; interiors, 182–86; secular, 181–82, 335–36, 343

Arch of Constantine, Rome, Italy, 197, 202–3, 434, 446; 284; medallions and frieze, 197, 202–3, 232, 244, 254, 415; 285

Arch of Titus, Rome, Italy, 198

reliefs: Spoils from the Temple in Jerusalem, 152, 194, 196, 281, 413; 271; Triumph of Titus, 97, 152, 195–96, 413; 272

Arena Chapel, Padua, Italy, murals (Giotto), 366, 391, 467; 505; Christ Entering Jerusalem, 366–68, 391, 762; 504; The Lamentation, 358, 362, 368–69, 390, 391, 662; 506

Aristotle, Politics, excerpt, 218

Armory Show of 1913, 788, 799-800

Arnolfini Portrait, The (Eyck), 484, 510–12, 537, 729; 677, 678

Arnolfo di Cambio, 341, 342–43, 349, 356–57, 366; Tomb of Guglielmode Braye, S. Domenico, Orvieto, Italy, 357, 438; 490

ARP, HANS, 806, 850–51, 854; Human Concretion, 851, 854; 1121

Arrangement in Black and Gray: The Artist's Mother (Whistler), 731; 948

Arrest of Christ, The, mural (S. Angelo in Formis, Capua, Italy), 315; 417

Arrezzo, Italy, S. Francesco, frescoes (Piero della Francesca), 431, 432, 549; 561; The Discovery and Proving of the True Cross, 431; 562

art: appreciation of, 25; creation of, 16; meaning of, 37–43; visual elements of, 25

art brut, l' (art-in-the-raw), 823

Art Deco, 883-84, 917, 918

Artemis, Temple of, Corfu, Greek island, 123, 125; *155*; pediment, 123, 139, 147, 164; *154*

Artemis, Temple of, Ephesus, Anatolia, *Alkestis Leaving Hades*, relief, 35; 18

Arte Povera (Poor Art), 837, 923

Art for Art's Sake, 720

art history, 24, 41, 45

Art History, from Ingres and Other Parables (Baldessari), 870, 927, 929; 1152

artisans, 19, 41

Artist in the Character of Design Listening to the Inspiration of Poetry, The (Kauffmann), 663, 696; 847

artists, 17, 41; signing of work by, 115 Art Nouveau, 763, 768–72, 884

arts: major, 25; minor, 23

Arts and Crafts Movement, 712, 743–44, 874, 878, 881, 884

Ash Can School, 799, 800, 898-99

Ashurbanipal, Palace of, Nineveh (Kuyunjik), Iraq, *The Sack of the City of Hamanu by Ashurbanipal*, 90–91, 124, 192, 196; *102*

Ashurnasirpal II Killing Lions (Palace of Ashurnasirpal II, Nimrud (Calah), Iraq), 91, 96, 122; 103

As in the Middle Ages, so in the Third Reich (Heartfield),

Assemblage, 863-67

assembled sculpture, Sumerian, 81-83

Assumption, Basilica of the, Baltimore, Md. (Latrobe), 708; 913, 914, 915

Assumption of the Virgin, The, fresco (Correggio, Cathedral, Parma, Italy), 495–96, 557; 654

Assyrian art, 88-92, 95, 122

ATGET, EUGÈNE, 894–96; Versailles, 894–96; 1200 Athena and Alcyoneus (Great Frieze, Great Pergamum Altar, Pergamum, Anatolia), 137, 160, 162, 192, 214, 217, 461, 498, 564; 213

Athena Nike, Temple of, Acropolis, Athens, Greece, 134, 136; 174; Nike, sculpture, 150, 247; 196

Atheneum, The, New Harmony, Indiana (Meier), 890;

ATHENODORUS, 162

Athens, Greece, 130-33

Acropolis, 131, 133-34, 136; 171

Erechtheum, 134–37, 706; *177;* Porch of the Maidens, 137; *178*

Parthenon, 130–33, 148–50, 874; 169
east pediment, 149; 193; Dionysus, 148; 191;
Three Goddesses, 133, 148, 150, 162; 192
frieze, 131–33, 149, 192–93; 170; Procession, 192–93, 241, 413; 268; The Sacrifice of King Erechtheus' Daughters, 149; 194
metopes, Lapith and Centaur, 150, 155, 192;

Propylaea, 133–34, 136, 707; *172, 173, 174* Temple of Athena Nike, 134, 136; *174; Nike,* sculpture, 150, 247; *196*

Dipylon cemetery, vase, 111–12, 113, 114; *139* Monument of Lysicrates, 137; *179*

At Home (Van Der Zee), 903; 1212

Atreus, Treasury of, Mycenae, Greece, 106, 109, 166; 130, 131

AT&T building, New York, N.Y. (Johnson), 922 At the Moulin Rouge (Toulouse-Lautrec), 752, 896; 975 audience for art, 24

Augustine, Saint, 379

Augustinerkirche, Vienna, Austria, Tomb of Archduchess Maria Christina (Canova), 699; 900

Augustus, statue of (Primaporta, Italy), 190–92, 198, 199, 254, 448; 264, 265

Aulus Metellus (L'Arringatore) (Roman), 189, 191; 261 Aurignacian art, 51

Aurora, ceiling fresco (Guercino, Villa Ludovisi, Rome), 556, 557; 735

Aurora, ceiling fresco (Reni, Casino Rospigliosi, Rome), 556, 596, 598; 734

Austria, Rococo in, 621–25

Austrian Radio and Television Studio, Salzburg, Austria (Peichl), 891; 1194, 1195

autochrome, 894

automatism, 802

Autumn Rhythm: Number 30, 1950 (Pollock), 732, 820–21; 1079

Autun, France, Cathedral, 295–97; 384; Eve (Giselbertus), 308; 405; Last Judgment (Giselbertus), 306, 356, 467, 509; 404

Avignon, France, Palace of the Popes, Scenes of Country Life (Martini), 376; 517

Avignon Pietà (Quarton), 520; 690

Awakening Conscience, The (Hunt), 729; 945

Awakening Slave (Michelangelo), 19, 36, 460, 461, 923; 3

Baalbek, Lebanon, Temple of Venus, 187–88, 560, 563, 668; 258, 259

Babylon, Iraq, Ishtar Gate, 91-92; 105

Babylonian art, 86-88, 122

Bacchanal (Titian), 477–79, 493, 496, 542, 554, 576, 596, 781; 632

Back from the Market (Chardin), 615, 616, 759; 821

Bacon, Francis, 825–26; Head Surrounded by Sides of Beef, 825, 840; 1084

BALDESSARI, JOHN, 870, 923, 927, 929; Ingres and Other Parables, Art History from, 870, 927, 929; 1152 BALDUNG GRIEN, HANS, 536–37; Death and the Maiden,

536–37, 756; 708 Baltimore, Md., Cathedral (Basilica of the Assumption,

Baltimore, Md., Cathedral (Basilica of the Assumption Latrobe), 708; 913, 914, 915 Bandit's Roost (Riis), 774–75, 898; 1012

Banjo Lesson, The (Tanner), 734; 953

Bank of England, London, England, Consols' Office (Soane), 708, 876; 916

Banks, Thomas, 665; The Death of Germanicus, 665; 850

Baptism of Christ (Andrea da Pisano, doors, Florence Baptistery), 358; 493

Baptism of Christ (Verrocchio and Leonardo), 441 Bar at the Folies-Bergère, A (Manet), 722; 937

Barberini, Palazzo, Rome, Italy, Glorification of the Reign of Urban VIII, ceiling fresco (Cortona), 556– 57: 736

Barbizon School, 684, 686, 722

Barcelona, Spain

Casa Milá apartments (Gaudí), 770, 882, 885; 1001, 1002

International Exposition (1929), 878; German Pavilion (Mies van der Rohe), 878–79; *1169*, *1170*

BARLACH, ERNST, 768, 811; Man Drawing a Sword, 768, 785; 998

Baragua 549, 609; Baragua classicism, 556, 557, 560

Baroque, 549–609; Baroque classicism, 556, 557, 560, 568, 594; in England, 607–9; in Flanders, 574–80; in France, 594–607; High, 555, 556, 557, 560, 568, 575, 583, 584, 590; in Italy, 549–68; Late, 610; in music and theater, 569, 607; in Netherlands, 574, 581–93; in Spain, 548–49, 569–73

barrel vault, 177, 182, 185; 235

Barrière de Villette, Paris, France (Ledoux), 669-70, 876; 858

BARRY, SIR CHARLES, 709–10; Houses of Parliament (London, England), 710; 917

BARTHOLDI, AUGUSTE, 705–6; *Statue of Liberty* (New York, N.Y.), 705–6, 742, 802; 908

BARTLETT, JENNIFER, 842; Water, 842; 1106

BARYE, ANTOINE-LOUIS, 703; Tiger Devouring a Gavial of the Ganges, 703; 905

bas (low) relief, 35

"Basilica," Paestum, Italy, 126, 128–30, 131; *164, 165* basilicas: Early Christian, 234–36; Roman, 185–86

BASSANO (JACOPO DA PONTE), 493; The Adoration of the Shepherds, 493–94; 652

Bath, The (Cassatt), 727; 942

Bathers (Fragonard), 615; 820

Batman (Williams), 829; 1091

BATONI, POMPEO, 659

Battista, Giovanni, 559

Battle of Anghiari, The, cartoon (Leonardo da Vinci, for Palazzo Vecchio, Florence, Italy, copy by Rubens), 456, 575, 676; 597

Battle of Hastings, from Bayeux Tapestry (French Romanesque), 314, 315; 415

Battle of Issus (Altdorfer), 534-35, 536; 707

Battle of Issus (Battle of Alexander and the Persians) (Pompeii, Italy), 142, 152, 192, 209, 238, 314, 535; 199

Battle of San Romano (Uccello), 432, 456; 563

Battle of the Gods and Giants (from Treasury of the Siphnians, Delphi, Greece), 123–24, 139, 149, 155, 160; 158

Battle of the Greeks and Amazons (Scopas (?), Mausoleum, Halicarnassus, Anatolia), 137, 155, 192, 198, 231, 203

Battle of the Lapiths and Centaurs (Temple of Zeus,

Olympia, Greece), 144-45, 149, 150, 152, 164, 432; 187

Battle of the Ten Naked Men (Pollaiuolo), 440-41, 443;

Baudelaire, Charles: "The Modern Public and Photography," excerpts, 937; "On the Heroism of Modern Life," 937

Bauhaus, Dessau, Germany (Gropius), 772, 803, 876-78, 883, 884; 1168; Masters House, interior (Breuer), 883; 1178; Shop Block (Gropius), 878: 1167

Bay, The (Frankenthaler), 826; 1086

BAYER, HERBERT, lonely metropolitan, 907; 1218

Bayeux Tapestry (French Romanesque), Battle of Hastings, 314, 315; 415

beaker, painted (from Susa, Iran), 92-93; 106

BEARDEN, ROMARE, 828-29; interviews with, excerpts, 944-45; The Prevalence of Ritual: Baptism, 829;

Beardsley, Aubrey, 761, 769; Salome, 761, 763; 986 Beata Beatrix (Rossetti), 729, 776; 946

Beaux-Arts style, 710

BECKMANN, MAX, 811-15, 816; Departure, 814-15; 1070; The Dream, 811-14; 1069; lecture, "On My Painting," excerpt, 944

Bedroom, The (Hooch), 33, 593, 615; 14 beehive tombs, 166

BEHNISCH AND PARTNER, 921; Stuttgart University, Hysolar Research Institute (Stuttgart, Germany), 921; 1236

BEHRENS, PETER, 874; A.E.G. Turbine Factory (Berlin, Germany), 874; 1158

Bellechose, Henri, 378

Belle Jardinière, La (Raphael), 471-72; 625

BELLINI, GIOVANNI, 449-50; Madonna and Saints (S. Zaccaria, Venice, Italy), 450, 479; 593; St. Francis in Ecstasy, 429, 449-50, 476, 541; 592

Bellori, Giovanni Pietro, Lives of the Modern Painters, Sculptors, and Architects, extract, 639-40

Bellows, George, 799; Stag at Sharkey's, 799; 1046 Benedict of Nursia, Saint, The Rule, 385-86

Beni Hasan, Egypt: Tomb of Khnum-hotep, Feeding the Oryxes, 72; 71; tombs, 72

BERG, MAX, 875-76; Centennial Hall (Breslau, Germany), 875-76, 887; 1162

Berlin, Germany: A.E.G. Turbine Factory (Behrens), 874; 1158; Altes Museum (Schinkel), 706-7, 920: 909

BERNARD, ÉMILE, 755

Bernard of Clairvaux, Saint, Apologia to Abbot William of St.-Thierry, 387-88

Bernhardt, Sarah, photograph (Nadar), 715, 901; 925 Bernini, Gianlorenzo, 559, 560, 561, 564-67, 602 Apollo and Daphne, 36, 596; 20

David, 564-65, 606-7; 752

Model for Equestrian Statue of Louis XIV, 606; 806

Sta. Maria della Vittoria, Cornaro Chapel (Rome), 559, 567, 604; 754; The Ecstasy of St. Theresa, 442, 565–67, 612; 753

St. Peter's (Rome): colonnade, 560, 604, 609, 860; 739; Tabernacle, 560, 564; 740

BERRUGUETE, ALONSO, 496; St. John the Baptist (Cathedral, Toledo, Spain), 496; 656

Best Stores Showroom, Houston, Tex. (SITE Projects, Inc.), 918; 1233

Betrayal of Christ (Pucelle), from Hours of Jeanne d'Evreux, 358, 375; 516

Betrayal of Christ (S. Apollinare Nuovo, Ravenna), 241,

BEUYS, JOSEPH, 867, 871, 923; Coyote, performance, 871; 1153

Bible: characters of, 248; excerpt from, 382; versions of, 241

"Bijou" of Montmartre (Brassaï), 896; 1202

Bing, Siegfried, 768

BINGHAM, GEORGE CALEB, 697-98; Fur Traders Descending the Missouri, 697-98, 715, 733; 899 Bird in Space (Brancusi), 845, 878; 1112

Birth of Bacchus, The (Poussin), 598; 795

Birth of the Virgin (Lorenzetti), 370, 377, 427, 510; 509 Birth of Venus (Botticelli), 442, 443-44, 474, 487, 731, 744; 583

Birth of Venus (Fabro), 923; 1239

Bison (La Madeleine, near Les Eyzies (Dordogne), France), 54, 93; 36

Black Chord (Nevelson), 864-66; 1145

Black Death, 373

black-figured style, Greek vase painting, 115-17 Black Iris III (O'Keeffe), 817, 826, 900; 1074

Black Quadrilateral (Malevich), 796; 1040

BLADEN, RONALD, 855-56; The X (Corcoran Gallery, Washington, D.C.), 855-56; 1130

BLAKE, WILLIAM, 687; Europe, A Prophecy, The Ancient of Days illustration from, 687; 885

Blaue Reiter group, 785, 788, 803, 809, 875

Blenheim Palace, Woodstock, England (Vanbrugh), 609, 667; 813

Blinding of Polyphemus, The, amphora (Eleusis, Greece), 113-14, 115, 123; 140

Blinding of Samson, The (Rembrandt), 583, 584; 776 Blind Leading the Blind, The (Bruegel), 544, 733; 718 Blind Musician (Kertész), 896; 1201 Blue Veil (Louis), 827; 1087

Boccaccio, Giovanni, 373, 408-9; Decameron, 394-95 BOCCIONI, UMBERTO, 794, 846-47; Dynamism of a Cyclist, 794, 876; 1038; Unique Forms of Continuity in Space, 847, 876; 1114

Bogazköy, Anatolia, The Lion Gate, 88, 90, 109, 122; 99 BOHEMIAN MASTER, Death of the Virgin, 377, 506; 518 BOLOGNA, GIOVANNI (JEAN DE BOLOGNE), 498, 701; The Abduction of the Sabine Women, 498; 659

Bologna, Italy, S. Petronio, The Creation of Adam (Quercia), 418, 427, 464; 540

BONHEUR, ROSA, 686; Plowing in the Nivernais, 686; 883; Reminiscences, excerpt, 936

Book of Kells (Hiberno-Saxon), Chi-Rho Monogram Page, 273-74; 353

Book of the Dead (Egyptian), 66

Book of the Popes, excerpts from, 382

book covers, 241-42, 280-82

BORROMINI, FRANCESCO, 558-59, 560-63, 621; Sta. Agnese in Piazza Navona (Rome), 563, 604, 609, 622; 746; S. Carlo alle Quattro Fontane (Rome), 561-62, 563, 564; 741, 742, 743; S. Ivo (Rome), 562-63; 744, 745

BOSCH, HIERONYMUS, 380, 516-18, 594; The Garden of Delights, 447, 516-18, 541, 595, 637, 762, 811; 684, 685

Boscoreale (near Naples), Italy, Architectural View, wall painting, 204, 206, 240, 289, 365, 367, 370; 286

BOTTICELLI, SANDRO, 443-44, 446; The Birth of Venus, 442, 443-44, 474, 487, 731, 744; 583; Primavera, 444-45; 584

BOUCHER, FRANÇOIS, 559, 614-15; The Toilet of Venus, 614-15, 616, 626; 819

BOUCICAUT MASTER, 378-79, 508; Boucicaut Hours, The Story of Adam and Eve, from Boccaccio's Des cas des nobles hommes et femmes, 378-79, 505, 514: 521

BOULLÉE, ÉTIENNE-LOUIS, 669; Architecture, Essay on Art, excerpt, 934-35; Project for a Memorial to Isaac Newton, 669, 708, 875; 857

Bourges, France, House of Jacques Coeur, 336; 447 BOURKE-WHITE, MARGARET, 901; Fort Peck Dam, Montana, 901; 1209

BOWLAND, WIRT (Union Trust Company, Detroit, Mich., with Smith, Hinchman & Grylls, Associates), 884; 1180

Boy Playing a Flute (Leyster), 582; 775

Brady, Mathew, 717, 896, 904

Bramante, Donato, 458-59, 462, 470, 473; St. Peter's (Rome), 458, 459, 470; 603, 604; S. Pietro in Montorio, Tempietto (Rome), 458-59, 470, 608; 601, 602

Brancacci Chapel, Sta. Maria del Carmine, Florence, Italy, frescoes

Lippi, 425, 427; 554

Masaccio, 425; 553; The Expulsion from Paradise, 427, 441, 464; 556; The Tribute Money, 425-27: 555

Masolino, 425, 427; 554

Brancusi, Constantin, 845, 854; Bird in Space, 845, 878; 1112; The Kiss, 845, 853, 854; 1110; The Newborn, 845, 855; 1111

Brandt, Bill, 911; London Child, 911; 1227

Braque, Georges, 793, 801; Newspaper, Bottle, Packet of Tobacco (Le Courrier), 793, 802, 806; 1036

Brasilia, Brazil (Niemeyer), 889; 1191

Brassaï (Gyula Halasz), "Bijou" of Montmartre, 896; 1202

Breslau, Germany, Centennial Hall (Berg), 875-76, 887; 1162

Breton, André, 807, 819, 850; manifesto, "What is Surrealism?" excerpt, 943

Breuer, Marcel, 878; Bauhaus, Masters House, interior (Dessau, Germany), 883; 1178

Bride, The (Duchamp), 798-99, 807; 1045

Bride of the Wind, The (Kokoschka), 785; 1029

Brighton, England, Royal Pavilion (Nash), 678, 708, 875; 912

Broadway Boogie Woogie (Mondrian), 31, 33, 806; 13 Broederlam, Melchior, 377-78, 381; Annunciation, Visitation, Presentation in the Temple, and Flight into Egypt, altar panels, 377-78, 505, 506; 519

Broken Obelisk (Newman), 860; 1138 Bronze Age, 47; Sumerian, 78

Bronze Doors of Bishop Bernward, St. Michael's Cathedral, Hildesheim, Germany, 286-89, 304, 310-11; 375; Adam and Eve Reproached by the Lord from, 289, 311, 312, 318; 376

Bronzino, Agnolo, 486-87; Allegory of Venus, 486-87; 642; Eleanora of Toledo and Her Son Giovanni de' Medici, 488, 538; 644

Brooklyn Bridge, New York, N.Y. (Roebling), 741-42; 963

Brooklyn Bridge (Stella), 742, 804-5, 875; 1056

Brown, Denise Scott, 917

Brown, Ford Madox, 728; The Last of England, 728, 898; 944

Brücke, Die (The Bridge), 783-85, 803, 811, 814

BRUEGEL, PIETER, THE ELDER, 542-44, 579, 594; The Blind Leading the Blind, 544, 733; 718; Peasant Wedding, 542-44, 592, 596; 717; The Return of the Hunters, 542, 554, 578; 716

Brueghel, Jan, the Elder, 579; Allegory of Earth, 579; 769

Brueghel, Pieter, the Younger, 579

Brunelleschi, Filippo, 349, 409, 418-19, 456, 457-59; Sta. Croce, Pazzi Chapel (Florence), 421-22, 434, 437, 470, 499, 670; 544, 545, 546, 547; S. Lorenzo (Florence), 419-20, 459, 467; 542, 543, 605; Sta. Maria degli Angeli (Florence), 422, 437, 457, 458; 549; Sto. Spirito (Florence), 422, 436; 548

Brunswick, Germany, Lion Monument, 312; 412 Brussels, Belgium, Tassel House, stairway (Horta), 769;

BRYAXIS (?), Mausolus, statue (Mausoleum, Halicarnassus, Anatolia), 137, 155, 162, 190, 214; 204

Bucintoro at the Molo (Canaletto), 628, 629; 840 Building of the Tower of Babel (St.-Savin-sur- Gartempe, France), murals, 297, 314, 520; 416

bull capital (Palace of Darius and Xerxes, Persepolis), 95, 96, 134; 111

Bull's Head (Picasso), 18-19, 21, 38, 852, 863; 2

Burgundy, 295, 306-9

burial customs, see funerary customs; tombs

Burial of Count Orgaz, The (Greco, Sto. Tomé, Toledo, Spain), 490-92, 567, 764; 648, 649

Burke, Edmund, Inquiry into the Origin of Our Ideas of the Sublime and the Beautiful (book), 664

BURLINGTON, LORD (RICHARD BOYLE) (and WILLIAM KENT), Chiswick House (near London, England), 667-68, 669, 670; 853, 854

Burned Face (Appel), 823-25; 1083

Burne-Jones, Edward, 729–31; The Wheel of Fortune, 729–31; 947

Bust of a Puddler (Meunier), 766-67; 995

Byzantine art, 249–69; early, 249–57; Late, 267–69; Middle, 257–67

Ca' d'Oro, Venice, Italy, 343, 500; 465

Caen, France: St.-Étienne, 298, 300, 326; 387, 392; St.-Pierre, choir (Sohier), 544–45; 719

CALDER, ALEXANDER, 852, 863; Lobster Trap and Fish Tail, 852; 1125

Calf-Bearer, Greek, 120, 121, 130–31, 234; 149 CALLICRATES, 131, 136

Calling of St. Matthew (Caravaggio, Contarelli Chapel, S. Luigi dei Francesi, Rome), 38, 549–51, 565, 581, 595–96, 718; 726

Calling of St. Matthew (Terbrugghen), 581, 829; 771
CALLOT, JACQUES, 594–95; Great Miseries of War, 594–95; Hangman's Tree from, 549; 790

camera obscura, 714

Camera Work (magazine), 898

Cameron, Julia Margaret, 775–76; Ellen Terry, at the Age of Sixteen, 776; 1015

Campidoglio, Rome, Italy (Michelangelo), 469–70; 619, 620; Palazzo dei Conservatori, 470, 609, 710; 621

CANALETTO, 628–29; *The Bucintoro at the Molo*, 628, 629; 840

canon, 21

Canova, Antonio, 665, 699; Napoleon, 700; 901; Pauline Borghese as Venus, 700, 712; 902; Tomb of the Archduchess Maria Christina, Augustinerkirche, Vienna, Austria, 699; 900

CAPA, ROBERT, 904; Death of a Loyalist Soldier, 904; 1216

Capua, Italy, S. Angelo in Formis, *The Arrest of Christ*, mural, 315; 417

CARADOSSO, medal with St. Peter's, 458, 470; 604

Caravaggio (Michelangelo Merisi), 30, 38, 549–51, 569, 572, 581, 582, 595, 660, 718

David with the Head of Goliath, 30-31, 573; 12

paintings for Contarelli Chapel, S. Luigi dei Francesi, Rome, Italy, 549; *725; The Calling of St. Matthew*, 549–51, 565, 581, 595–96, 718; *726*

Carignano, Palazzo, Turin, Italy (Guarini), 563; 747, 748

Carmina Burana, manuscript (Romanesque), Summer Landscape from, 318, 810; 422

Carnac (Brittany), France, dolmen, 57; 45

Carolingian art, 275–82

Carpeaux, Jean-Baptiste, 704–5, 735; *The Dance* (façade sculpture, Opéra, Paris), 704–5, 712, 718, 733, 735; *907*

Carracci, Annibale, 552–55, 567, 581, 586, 599; Landscape with the Flight into Egypt, 554–55, 578, 588; 731; Palazzo Farnese (Rome), 553–54, 555, 557, 598; 729, 730

Carson Pirie Scott & Company Department Store, Chicago, Ill. (Sullivan), 773–74, 874; 1010, 1011

cartes de visites, 715

Cartier-Bresson, Henri, 896–97; Mexico, 897; 1203 Cartoons for the Cause, political cartoon (Crane), 744–45, 761; 966

carving, 36; paleolithic, 53-54

Casa Milá apartments, Barcelona, Spain (Gaudí), 770, 882, 885; *1001*, *1002*

Casino Rospigliosi, Rome, Italy, *Aurora*, ceiling fresco (Reni), 556, 596, 598; 734

Cassatt, Mary, 726–27; *The Bath,* 727; 942; letter to Harrison Morris, excerpt, 938

Castagno, Andrea del, 432–33, 440, 448; *David*, 433, 440; *565; Last Supper* (S. Apollonia, Florence), 432–33, 455; *564*

catacombs, 233-34

Çatal Hüyük, Turkey, 55–57; Animal Hunt, 55–56; 40; Fertility Goddess, 56; 41; town design, 55; 39;

View of Town and Volcano, 56-57; 42

cathedrals, Gothic: comparison of nave elevations, 331–32; 442; parts of, 323, 331–32; 425, 443

Cattle Fording a River (Tomb of Ti, Saqqara, Egypt), 61, 71, 124; 69

CAVALLINI, PIETRO, 365–66; The Last Judgment (Sta. Cecilia in Trastevere, Rome), Seated Apostles, detail, 366; 503

cave art, 51-53

Celebration (Krasner), 821-22; 1080

cella, 79

Cellini, Benvenuto, 496; Saltcellar of Francis I, 496, 547: 657

Celtic-Germanic style (Early Medieval), 270-71

Centennial Hall, Breslau, Germany (Berg), 875–76, 887; 1162

Central Station Project for Cittá Nuova (Sant'Elia), 876, 889; 1163

Centre National d'Art et Culture Georges Pompidou, Paris, France (Rogers), 892, 918; 1196

Cephalus and Aurora (Poussin), 596; 793

Cernavoda, Romania, Fertility Goddess, 57, 784; 43, 44 Cerveteri, Italy: sarcophagus, 169, 170, 174; 224, 225; Tomb of the Reliefs, 173; 229

CÉZANNE, PAUL, 722, 746–47, 781, 798; A Modern Olympia (The Pasha), 746; 968; Mont Ste-Victoire Seen from Bibémus Quarry, 747, 790; 971; Self-Portrait, 746–47, 782; 969; Still Life with Apples in a Bowl, 747; 970

CHAGALL, MARC, 794, 798; I and the Village, 798; 1043

Chahut (Seurat), 751, 759; 974

Chamberlain, John, 864; Essex, 850, 864; 1144

Chambord, France, Château, 545–46; 720, 721 Channel region, Romanesque painting, 316–18

Chapel of Henry VII, Westminster Abbey, London, England, 338: 452, 453

CHARDIN, JEAN-BAPTISTE-SIMEON, 615; Back from the Market, 615, 616, 759; 821; Kitchen Still Life, 615; 822; Soap Bubbles, 33; 15

Charioteer (Sanctuary of Apollo, Delphi, Greece), 143–44, 189; 186

Charlemagne, Palace Chapel of, Aachen, Germany (Odo of Metz), 276–77, 280; *357*, *358*, *359*

Charles I, of England, portrait of (Dyck), 578, 618; 767 Charles Lebrun (Coysevox), 606, 665; 807

Charlottesville, Va., Monticello (Jefferson), 671–72; 860, 861

Chartres, France, Cathedral, 297, 329–32, 336, 884; 432, 433, 434, 435, 436, 437, 442

portal sculpture, 327–31, 344–47, 359, 360; 466, 467; Dormition and Assumption of the Virgin, 318, 347; 469; St. Theodore, 347, 351, 353, 413; 468

stained-glass window, *Notre-Dame de la Belle Verrière*, 330–31, 359, 523, 783; 494

west facade, 327-31, 389; 431

Chartreuse de Champmol, Dijon, France: *The Moses Well* (Sluter), 353, 378, 414; 481; portal sculpture (Sluter), 352–53, 510; 480

Chase-Riboud, Barbara, 866; Confessions for Myself, 866; 1146

Chateaubriand, François-René de, *Atala, or The Love of Two Savages in the Desert* (book), 675

Chauvet cave, France, Horse, 51; 28

Chevreul, Eugène, 751

chiaroscuro, 30

Chicago, Ill.: Carson Pirie Scott & Company Department Store (Sullivan), 773–74, 874; 1010, 1011; Marshall Field Wholesale Store (Richardson), 772, 773; 1007; Robie House (Wright), 872, 878; 1154, 1155

Childbirth (Miller), 902; 1211

Childe Harold's Pilgrimage: Italy (Turner), 690

children's art, 16

China, 47

Chios, Greek island (?), Kore, 121–22, 130–31, 456; 153 Chi-Rho: insignia, 201, 230; Monogram Page, Book of Kells (Hiberno-Saxon), 273–74; 353 CHIRICO, GIORGIO DE, 797–98, 808; Metaphysical Painting, 798; Mystery and Melancholy of a Street, 797–98; 1042

Chiswick House, near London, England (Burlington), 667–68, 669, 670; 853, 854

Christ Before Pilate (Tintoretto, Scuola di San Rocco, Venice, Italy), 489; 646

Christ Carrying the Cross (Master Francke), 380; 524 Christ Crowned with Thorns (Titian), 480, 489; 636

Christ Entering Jerusalem (Duccio, from Maestà Altar, Siena Cathedral), 365, 370, 393, 762; 502

Christ Entering Jerusalem (Giotto, Arena Chapel, Padua, Italy), 366–68, 391, 762; 504

Christ Enthroned, from Sarcophagus of Junius Bassus, 243, 317; 313

Christian art, see Early Christian art

Christian Inspiration, mural (Puvis de Chavannes, museum, Lyons, France), 756, 759; 984

Christianity, 548; biblical, church, and celestial beings, 248; monastic orders in, 296–97

Christ in the Garden of Gethsemane (Cathedral, Monreale, Italy), 265; 344

Christ in the House of Levi (Veronese), 494–95, 626, 634; 653

CHRISTO (CHRISTO JAVACHEFF), 862–63; Surrounded Islands, Project for Biscayne Bay, Greater Miami, Florida, drawing for, 863; 1142

Christ Preaching (Rembrandt), 584; 778

Christ's Entry into Brussels in 1889 (Ensor), 762, 785, 825; 988

churches: central plan, 236, 437; facades, 355–56; Gothic, 355–56; hall churches, 297–98; Romanesque, 297–98; *see also* cathedrals

Church of the Eremitani, Padua, Italy, Ovetari Chapel, St. James Led to His Execution (Mantegna), 448, 530: 589

Church of the Invalides, Paris, France (Hardouin-Mansart), 604, 670; 804, 805

CIMABUE, 363–64; *Madonna Enthroned*, 363–64, 370, 427; 499

Cinema (Segal), 867; 1148

cinerary urn (Etruscan), 167; 223

City, The (Léger), 804, 879, 892; 1054

city planning: ancient Greek, 137–38; Etruscan, 175; modern, 888–89

Cividale, Italy, Cathedral Baptistery, relief (inscribed by Sigvald), 274, 304; 356

classical art, see Graeco-Roman art

Classical orders, 124–26, 127, 134, 137, 182, 186–88, 215, 706; *162*

Classical style, Gothic, 347–49

Classic Revival, in architecture, 706–10

CLAUDEL, CAMILLE, 737; Entreaty, 737; Ripe Age, 737; 958

Claude Lorraine, 598–99, 683, 687, 692; A Pastoral Landscape, 586, 598–99, 628, 668; 796

CLEMENTE, FRANCESCO, 837; Untitled (self-portrait), 837; 1103

CLODION (CLAUDE MICHEL), 611–12; Satyr and Bacchante, 611–12, 704; 815

Cloissonism, 755

CLOUET, JEAN, Francis I, 538; 711

Cluny, France, abbey church at, 316

Cnidian Aphrodite (Praxiteles), 99, 156, 157, 244, 443; 206

Cnidus, Anatolia, Demeter, 156; 205

CoBrA group, 823

Coeur, Jacques, House, Bourges, France, 336; 447

coins, Greek, 162–65 Colbert, Jean-Baptiste, 594, 600, 602, 610

COLE, THOMAS, 697; View of Schroon Mountain, Essex County, New York, After a Storm, 697, 733; 898 Collage Cubism, 793

Colleoni, Bartolommeo, equestrian monument of (Verrocchio), 442–43; 582

Cologne, Germany

Cathedral, *The Gero Crucifix*, 284–85, 304; *370* St. Pantaleon, Westwork, 285–86; *371*

Werkbund Exhibition (1914), 875, 876; "Glass House" (Taut), 875; 1160, 1161; Theater (Velde), 772, 875, 882; 1005, 1006

Colonial American art, 41

color, 28-30; pre-Impressionist, 720-22

Color Field Painting, 691, 826-27

Colosseum, Rome, Italy, 97, 181–82, 295, 434, 500; 244, 245

Column of Trajan, Rome, Italy, 152, 196, 198, 240, 475, 622: 273

columns: Egyptian, 64–65, 75; Greek, 124–26, 127, 134, 137, 182, 186–88, 215, 706; *162*; Minoan, 101; Persian, 95

commedia dell'arte, 613-14

Commune of Siena, The, frescoes (Lorenzetti, Palazzo Pubblico, Siena, Italy), 370–73, 381; 510

composition, 31-34

Composition (Miró), 808-9, 820; 1064

Composition with Red, Blue, and Yellow (Mondrian), 805–6, 836; 1057

Conceptualism, 869-70, 916, 926, 927; in photography, 929

Confessions for Myself (Chase-Ribaud), 866; 1146

Consecration of the Tabernacle and Its Priests, The, murals (assembly hall, synagogue, Dura-Europos, Syria), 232–33, 234, 239, 242; 295

Conservatori, Palazzo dei, Campidoglio, Rome, Italy (Michelangelo), 470, 609, 710; 621

Constable, John, 664, 678, 683, 687–90; Hampstead Heath, 682, 688, 721; 887; The Haywain, 681, 689; 888; letter to John Fisher, excerpt, 936; Salisbury Cathedral from the Meadows (The Rainbow), 689–90, 692; 889

Constantine, Basilica of, Rome, Italy, 185–86, 200–201, 254; 250, 251, 252

Constantine the Great, Roman emperor, *Head of*, 185, 200–201, 247; 283

Constructions, 863-67

Constructivism, 796, 803, 847–48, 878, 921; in photography, 907

Contarelli Chapel, S. Luigi dei Francesi, Rome, Italy, paintings for (Caravaggio), 549; 725; The Calling of St. Matthew, 38, 549–51, 565, 581, 595–96, 718; 726

contrapposto, 139-43, 202, 348, 410

Conversion of St. Paul (Zuccaro), 687; 886

Copernicus, 549

COPLEY, JOHN SINGLETON, 662–63; Nathaniel Hurd, 42–43; 26; Paul Revere, 41–43; 25; Watson and the Shark, 663, 664, 677; 846

Corbie, France, *Gospel Book, St. Mark* from, 305, 313, 314, 316; 414

Corcoran Gallery, Washington, D.C., *The X* (Bladen), 855–56; *1130*

Corfu, Greek island, Temple of Artemis, 123, 125; *155*; pediment, 123, 139, 147, 164; *154*

Corinthian capital, 137; from Tholos, Epidaurus, Greece, 137, 769; 176

Corinthian order, 124, 182, 215

Cornaro Chapel, Sta. Maria della Vittoria, Rome, Italy (Bernini), 559, 567, 604; 754; The Ecstasy of St. Theresa (Bernini), 442, 565–67, 612; 753; fresco (Abbatini), 559, 567, 604; 754

COROT, CAMILLE, 682–84; Morning: Dance of the Nymphs, 683–84; 880; View of Rome: The Bridge and Castel Sant'Angelo with the Cupola of St. Peter's, 682, 721, 733; 879

Corps de Dames series (Dubuffet), Le Métafisyx from, 823; 1082

Corpus Hermeticum (book), 536

CORREGGIO (ANTONIO ALLEGRI), 495, 554; *The Assumption of the Virgin,* fresco (Cathedral, Parma, Italy), 495–96, 557; 654; *Jupiter and Io*, 495–96, 540, 567, 599; 655

CORTONA, PIETRO DA, 556–58, 559, 567; Glorification of the Reign of Urban VIII, ceiling fresco (Palazzo Barberini, Rome), 556–57; 736 Côte des Boeufs at l'Hermitage, near Pointoise, The (Pissarro), 722; 935

COTMAN, JOHN SELL, *Durham Cathedral*, 692; 892 Council of Trent, 483; excerpt from Canons and Decrees of, 633–34

Counter Reformation, 483, 548

Couple, The (Seurat), 751; 973

COURBET, GUSTAVE, 718–20, 733; letter of, excerpt, 938; The Stone Breakers, 718; 930; Studio of a Painter: A Real Allegory Summarizing My Seven Years of Life as an Artist, 718–20, 733; 931

Coyote, performance (Beuys), 871; 1153

Coysevox, Antoine, 606

Charles Lebrun, bust, 606, 665; 807

Versailles: Galerie des Glaces, 602; 801; Salon de la Guerre, 604, 606, 712; 802

COZENS, ALEXANDER, 664; A New Method of Assisting the Invention . . . Landscape from, 664, 714, 731, 807; 849

Cozens, John Robert, 691

craftsmen, see artisans

CRANACH, LUCAS, THE ELDER, 533–34; The Judgment of Paris, 533–34; 706

CRANE, WALTER, 744–45; Cartoons for the Cause, political cartoon, 744–45, 761; 966

Creation of Adam (ceiling fresco, Michelangelo, Sistine Chapel, Vatican), 462–64, 551, 778; 612

Creation of Adam (Quercia, S. Petronio, Bologna, Italy), 418, 427, 464; 540

creativity, 16, 18-21

Crete, 108-9

Crocus Girl, mural (Akrotiri, Thera (Santorini), Greek island), 102–3, 822; 123

cromlechs, 57-59

Crossing of the Red Sea, from Klosterneuburg Altar (Nicholas of Verdun), 318, 347, 524; 421

Cross Page, *Lindisfarne Gospels* (Hiberno-Saxon), 31, 273, 281, 316, 360; *352*

Crucifixion (Daphnē, Greece, monastery church), mosaic, 263, 264–65, 266, 285, 316, 318, 347; 340

Crucifixion (Eycks), 449, 506-9, 541; 672

Crucifixion (Grünewald), from Isenheim Altarpiece, 527–29, 825; 696

Crucifixion (Naumburg Master, Cathedral, Naumburg, Germany), 350, 352, 360, 365, 514; 476

Crucifixion, plaque (Hiberno-Saxon), 274; 355

Crystal Palace, London, England (Paxton), 716, 741, 874; 962

Ctesiphon, Iraq, Palace of Shapur I, 97; 115

Cubi series: Cubi XVII, XVIII, and XIX (from Smith), 856; 1131

Cubism, 788, 801, 802, 809, 845-46, 849

Cubo-Futurism, 794-96, 848

CUYP, AELBERT, 586; View of the Valkhof at Nijmegen, 586; 782

Cycladic art, 98-99

Czechoslovakia, modern photography in, 903-4

Dada, 806, 869, 870, 916 dadaism, 905

Daguerre, Louis-Jacques-Mandé, 713–14; *Still Life*, 714; *923*

Dalí, Salvador, 807–8; The Persistence of Memory, 807–8; 1061

Damned Cast into Hell (Signorelli, S. Brizio Chapel, Cathedral, Orvieto, Italy), 447–48; 588

Danaë (Gossaert), 540; 713

Danaë (Titian), 28, 480, 613; 10

Dance, The (sculpture, Carpeaux, Opéra, Paris), 704–5, 712, 718, 733, 735; 907

Dancing on the Barn Floor (Mount), 697; 897

Dante Alighieri, 356, 369; *Divine Comedy,* extracts, 390–91

Danube school, 534

Daphnē, Greece, monastery church: *The Crucifixion*, mosaic, 263, 264–65, 266, 285, 316, 318, 347; 340; *Pantocrator*, mosaic, 234, 263–64; 341

DARET, JACQUES (?), Annunciation, Woodcut of St. Christopher, detail in, 525, 814; 693

Darius and Xerxes, Palace of, Persepolis, 95; 109; audience hall, 95, 100, 134; 110; bull capital, 95, 96, 134; 111; Darius and Xerxes Giving Audience, relief, 95–96, 122, 192; 112

Daughters of Akhenaten, The (Egyptian), 76; 80

DAUMIER, HONORÉ, 681–82; Don Quixote Attacking the Windmills, 682, 754; 878; It's Safe to Release This One! 681; 876; Nadar Elevating Photography to the Height of Art, 715, 742, 778; 926; The Third-Class Carriage, 681, 722, 753, 754; 877

David, Jacques-Louis, 659–60, 674, 676, 699, 701; The Death of Marat, 660, 676, 714, 717, 908; 844; The Death of Socrates, 659–60, 663; 843

David (Bernini), 564-65, 606-7; 752

David (Castagno), 433, 440; 565

David (Donatello), 415, 632; 535

David (Michelangelo), 461, 564, 631; 607

David and Goliath, from Prayer Book of Philip the Fair (Master Honoré), 362, 375; 498

David Composing the Psalms, from Paris Psalter (Byzantine), 260-63, 269, 317; 339

David with the Head of Goliath (Caravaggio), 30–31, 573: 12

Dead Sea Scrolls, 231

Death and the Maiden (Baldung Grien), 536–37, 756; 708 Death in the Cornfield (Wojnarowicz), 912; 1230

Death in the Cornfleta (Wojnarowicz), 912; 1 Death of a Loyalist Soldier (Capa), 904; 1216

Death of a Loyalist Solaler (Capa), 904; 1216 Death of General Wolfe, The (West), 660–62, 663, 680,

717; 845 Death of Germanicus, The (Banks), 665; 850

Death of Marat (David), 660, 676, 714, 717, 908; 844 Death of Socrates (David), 659–60, 663; 843

Death of the Virgin (Bohemian Master), 377, 506; 518 Death of the Virgin (Strasbourg Cathedral), portal sculpture, 318, 347, 350, 377, 513; 470

Decalcomania, 807

Deconstruction, 915–16, 921–22, 932–33

decorative arts: England, 19th century, 743–44; France, Rococo, 610–11; Romantic, 712

Decorative Figure Against an Ornamental Background (Matisse), 802; 1051

Degas, Edgar, 724–26, 737–38; The Glass of Absinthe, 724, 752; 938; The Little Fourteen-Year-Old Dancer, 737–38; 959; Prima Ballerina, 724, 738; 939; The Tub, 724–26, 802; 940

Deir el-Bahari, Egypt, funerary temple of Queen Hatshepsut, 72, 180; 72, 73

DE KOONING, WILLEM, 822; Woman II, 822, 823; 1081
DELACROIX, EUGENE, 678–81, 722; The Entombment of
Christ, 681; 875; Journal of, excerpt, 935; The
Massacre at Chios, 678–81, 716–17, 721; 873;
Odalisque, 681, 746, 802; 874

Delaunay, Robert, 787, 793; Simultaneous Contrasts: Sun and Moon, 793: 1037

DELAUNAY-TERK, SONIA, 793

Delivery of the Keys (Perugino, Vatican), 446, 447, 462, 471: 586

Delos, Greek island, *Portrait Head*, 155, 162, 165, 189, 199, 200; *216*

Delphi, Greece

Sanctuary of Apollo, *Charioteer*, 143–44, 189; *186*Treasury of the Siphnians, 123–24, 126, 136, 137, 149; *156, 157; Battle of the Gods and Giants* from, 123–24, 139, 149, 155, 160; *158*

de Man, Paul, 929 Demeter (Cnidus, Anatolia), 156; 205

Demoiselles d'Avignon, Les (Picasso), 765, 788–91, 802;

Demon of Curiosity, The (Penck), 927-29; 1247

DEMUTH, CHARLES, 804, 817; *I Saw the Figure 5 in Gold*, 804, 833, 908; *1055; My Egypt*, 901

Denis, Maurice, 757

Departure (Beckmann), 814-15; 1070

Deposition (Angelico), 429; 559

Deposition (Pontormo, Sta. Felicita, Florence), 484, 493; 638

Derrida, Jacques, 921, 922, 932 Derrida Queries De Man (Tansey), 929; 1248

Descartes, René, 549

Descent from the Cross (Rosso Fiorentino), 483, 484, 485, 489, 496, 499; 637

Descent from the Cross (Weyden), 512-13, 576; 679 Descent into Darkness (Gottlieb), 819, 822; 1077

DESIDERIO DA SETTIGNANO, St. John the Baptist, 439-40; 578

design, 883-84

Dessau, Germany, Bauhaus (Gropius), 1168; Masters House, interior (Breuer), 883; 1178; Shop Block (Gropius), 878; 1167

Destruction of Sodom or Snowstorm (Turner), 690 Detroit, Mich., Union Trust Company (Bowland), 884; 1180

Deutscher Werkbund, 874

Diana, House of, Ostia, Italy, insula, 186; 256

Die Wies, Germany, pilgrimage church (Zimmermann), 624; 835, 836

Dijon, France, Chartreuse de Champmol: The Moses Well (Sluter), 353, 378, 414; 481; portal sculpture (Sluter), 352-53, 510; 480

Diocletian, Palace of, Spalato, Balkans, 188, 560; 260 Dionysus (Parthenon, east pediment, Acropolis, Athens, Greece), 148; 191

Dionysus in a Boat, kylix (Exekias), 115, 169; 142 diptychs: Early Christian, 245-47; Early Medieval, 291 Dipylon cemetery, Athens, Greece, vase, 111-12, 113, 114; 139

Discobolus (Discus Thrower) (Myron), 146, 214; 189 Discovery and Proving of the True Cross, fresco (Piero della Francesca, S. Francesco, Arrezzo, Italy), 431; 562

DISDÉRI, ADOLPHE-EUGÈNE, 715

divination, Etruscan, 174-75

Divisionism (Seurat), 722, 727, 751, 754, 894

DIX, OTTO, 816-17; Dr. Mayer-Hermann, 816-17;

Djoser, King: funerary district of, Saqqara, Egypt, 64, 65, 75, 136; 57, 58; Step Pyramid of, 64, 65, 66, 127, 840; 55, 56

Doesburg, Theo van, 805

DOISNEAU, ROBERT, 897; Side Glance, 897; 1204 dolmen (Carnac (Brittany), France), 57; 45

dolmens, 57-59 Domenichino, 555; St. Cecilia, 555, 616; 733

DOMENICO VENEZIANO, 430-31; Madonna and Child with Saints, 430, 450, 479; 560

domes: Early Christian, 236; parts of, 177, 254; 325 DONATELLO, 409, 410-14, 416, 418, 440, 448, 460 David, 415, 632; 535

Equestrian Monument of Gattamelata (Piazza del Santo, Padua, Italy), 415; 536

The Feast of Herod (Siena Cathedral, baptismal font), 414, 418, 428, 441; 534

Mary Magdalen, 416, 440, 441; 537

Or San Michele, Florence, Italy, sculptures

St. George tabernacle: St. George, 413, 442-43, 461; 531; St. George and the Dragon, 413, 425; 532

St. Mark, 410; 530

Prophet (Zuccone) (Florence Cathedral, Campanile), 413-14, 416, 430; 533

Don Quixote Attacking the Windmills (Daumier), 682, 754; 878

Dorchester (Oxfordshire), England, Abbey, Tomb of a Knight, 350, 620; 475

Doric order, 124, 125-26, 182, 215; temples, 126-34 Dormition and Assumption of the Virgin, portal sculpture (Cathedral, Chartres, France), 318, 347; 469

Doryphorus (Spear Bearer) (Canon of Polyclitus, Polyclitus), 140, 141, 146, 191, 213, 415; 183

Doubting of Thomas (Sto. Domingo de Silos, Spain), 309–10; 408

Doubting of Thomas (Trier, Germany [?]), 291; 379 Doubting of Thomas (Verrocchio), 441-42, 454; 581 DOURIS, Eos and Memnon, Attic kylix, 117, 147, 265; 145 DOVE, ARTHUR G., 815, 817; Foghorns, 815; 1071

Dragons (Pfaff), 869; 1150

drawing, 26

Dream, The (Beckmann), 811-14; 1069

Dream, The (Rousseau), 764; 992

Dreams and Nightmares (Leonard), Romanticism Is Ultimately Fatal from, 911-12; 1229

Dr. Mayer-Hermann (Dix), 816-17; 1073 drôlerie, 375-76

Drowning Girl (Lichtenstein), 833, 835, 945; 1097 drypoint, 524

DUBUFFET, JEAN, 822-23; Corps de Dames series, Le Métafisyx from, 823; 1082

DUCCIO OF SIENA, 364-65, 408; Maestà Altar, Siena Cathedral, 380; details: Annunciation of the Death of the Virgin, 365, 375, 393; 501; Christ Entering Jerusalem, 365, 370, 393, 762; 502; Madonna Enthroned, 364-65, 366, 367-68, 393; 500

DUCHAMP, MARCEL, 793-94, 798-99, 806, 823, 850, 869; The Bride, 798-99, 807; 1045; In Advance of the Broken Arm, 850, 869; 1119; Nude Descending a Staircase No. 2, 798, 913; 1044

DUCHAMP-VILLON, RAYMOND, 794, 846; The Great Horse, 846, 864; 1113

Duchesse de Polignac, The (Vigée-Lebrun), 616, 620; 823 Dura-Europos, Syria, 231-33; synagogue, assembly hall, The Consecration of the Tabernacle and Its Priests, murals, 232-33, 234, 239, 242; 295

DÜRER, ALBRECHT, 529-33; Adam and Eve, 530, 534, 536; 702; The Book on Human Proportions, extract, 638-39; The Four Apostles, 532-33; 705; The Four Horsemen of the Apocalypse, woodcut, 530, 784, 912; 700; Italian Mountains, 493, 529, 536, 691; 699; Knight, Death, and Devil, 530-31; 703; Melencolia, 531-32, 673; 704; Self-Portrait, 530, 538, 755; 701; St. Jerome in His Study, 531

Durham, England, Cathedral, 299, 325, 336; 388, 389, 390

Durham Cathedral (Cotman), 692; 892

Dur Sharrukin (Khorsabad), Iraq, citadel of Sargon II, 89-90, 91-92, 95, 100, 122; 100, 101

DYCK, ANTHONY VAN, 578, 620; Portrait of Charles I Hunting, 578, 618; 767; Rinaldo and Armida, 573, 578; 766

Dying Lioness (Nineveh (Kuyunjik), Iraq), 91, 96, 231;

Dying Niobid (Greek), 147-48; 190

"Dying Slave, The" (Michelangelo, Tomb of Julius II, S. Pietro in Vincoli, Rome), 461-62, 464, 468, 731, 736; 609

Dying Trumpeter (Epigonos of Pergamum (?), Roman copy), 158-59, 192, 350, 567; 210

Dying Warrior (Temple of Aphaia, Aegina, Greece), 124, 139, 145, 147, 158; 160

Dynamism of a Cyclist (Boccioni), 794, 876; 1038

LAKINS, THOMAS, 733-34, 778-79; William Rush Carving His Allegorical Figure of the Schuylkill River, 733-34, 799; 952

Early Christian art, 233-49

Early Renaissance, 408-51, 504, 526-27

Early Sunday Morning (Hopper), 818, 836; 1075

Earth Art, 862-63

Eastman, George, 894

Echo, The (museum), Mexico City, Steel Structure (Goeritz), 855; 1129

Echternach Gospels (Hiberno-Saxon), Symbol of St. Mark from, 274, 281, 360; 354

École des Beaux-Arts (Paris), 701

Ecstasy of St. Theresa, The (Bernini, Cornaro Chapel, Sta. Maria della Vittoria, Rome), 442, 565-67, 612; 753

EDDY, DON, 834-35; New Shoes for H, 834-35; 1099, 1100

Edgar A. Poe series (Redon), The Eye Like a Strange Balloon Mounts Toward Infinity from, 761-62; 987

EDWARDS, MEIVIN, 858: To Listen, 858: 1136

Egypt, 47, 108-9; Middle Kingdom, 71-72; New Kingdom, 72-77; Old Kingdom, 60-71; religion, 60-61; Upper and Lower, 63, 71

Egyptian art, 60-77, 91, 95, 103, 105-6, 112-13, 114, 118-19, 122; compared to Graeco-Roman, 60; compared to Sumerian, 78

EIFFEL, GUSTAVE, 742-43, 887; Eiffel Tower (Paris), 742-43, 892; 964

Eight, The, 799, 800

Einstein Tower, Potsdam, Germany (Mendelsohn), 882; 1175

Eisenman, Peter, 922

Ekkehard and Uta, sculpture (Naumburg Master, Cathedral, Naumburg, Germany), 351, 366; 478

Elamites, 86

Eleanora of Toledo and Her Son Giovanni de' Medici (Bronzino), 488, 538; 644

Eleusis, Greece: The Blinding of Polyphemus, amphora, 113-14, 115, 123; 140; Gorgons, amphora, 113-14, 115, 123; 140

Elgin Marbles, 148, 150

Elizabeth at the Well, mosaic (Kariye Camii, Istanbul, Turkey), 268-69, 365; 348

Ellen Terry, at the Age of Sixteen (Cameron), 776; 1015 Elmslie, George G., 774

Embryo in the Womb (Leonardo), 456; 599

EMERSON, PETER HENRY, 776; Haymaking in the Norfolk Broads, 776: 1016

Emperor Justinian and His Attendants (mosaics, S. Vitale, Ravenna), 250, 254, 256, 263, 751; 321

Empire style, 712

Empress of India (Stella), 828; 1089

Empress Theodora and Her Attendants (mosaics, S. Vitale, Ravenna), 250, 254, 263, 751; 322

England, art: Baroque, 607-9; decorative arts, 743-44; Gothic, 336-38, 349-50; modern sculpture, 853-55; Neoclassicism, 660-64, 665, 667-69; Realism, 728-32; Rococo, 616-21; Romanesque, 298-300; Romanticism, 686-92

engraving, 23, 524, 525

Enlightenment, 658-59

ENSOR, JAMES, 762; Christ's Entry into Brussels in 1889, 762, 785, 825; 988

Entombment, The (Parmigianino), 485-86, 493; 641 Entombment of Christ, The (Delacroix), 681; 875

Entrance to Green (Anuszkiewicz), 831; 1094

Entreaty (Claudel), 737

Environmental Sculpture, 855-57

Environments, 867-69

Eos and Memnon, Attic kylix (Douris), 117, 147, 265; 145

Ephesus, Anatolia, Temple of Artemis, Alkestis Leaving Hades, relief, 35; 18

Epidaurus, Greece: theater, 138; 180, 181; Tholos, Corinthian capital from, 137, 769; 176

EPIGONOS OF PERGAMUM (?), 158; Dying Trumpeter (Roman copy), 158-59, 192, 350, 567; 210

Equestrian Monument of Colleoni (Verrocchio), 442-43; 582

Equestrian Monument of Gattamelata (Donatello, Piazza del Santo, Padua, Italy), 415; 536

Equestrian Statue of Can Grande della Scala (Verona, Italy), 356, 390, 415, 443; 489

Equestrian Statue of Marcus Aurelius, 199, 243, 254, 356, 415, 469; 279

Equivalent series (Stieglitz), 899-900, 908, 911; Equivalent from, 899: 1206

Erasmus of Rotterdam, 531

Erasmus of Rotterdam (Holbein, the Younger), 537; 709 Erechtheum, Acropolis, Athens, Greece, 134-37, 706; 177; Porch of the Maidens, 137; 178

ERNST, MAX, 806-7; 1 Copper Plate 1 Zinc Plate 1 Rubber Cloth 2 Calipers 1 Drainpipe Telescope 1 Piping Man, 806–7, 817, 905; 1059; La Toilette de la Mariée, 807, 820; 1060

Erzurum, Turkey, Ulu Mosque, 564; 751 Essex (Chamberlain), 850, 864; 1144

ESTES, RICHARD, 835-36; Food Shop, 835-36; 1101 etching, 524

Étienne Chevalier and St. Stephen, from Melun Diptych (Fouquet), 519, 538; 687

Etruscan art, 166-75

Euphronios, Herakles Wrestling Antaios, Attic krater, 117; 144

Europe, A Prophecy (Blake), The Ancient of Days, illustration from, 687; 885

Eutropios, portrait of, 247-49; 316

Evans, Sir Arthur, 98

Eve (Giselbertus, Cathedral, Autun, France), 308; 405 ewer (Mosan), 312; 413

EXEKIAS, 115; Dionysus in a Boat, kylix, 115, 169; 142 Expressionism, 753, 765, 780, 781-88, 800, 815, 817, 845; in architecture, 881-83, 887; between the wars, 810-15; in photography, 894; after World War II, 822-26

Expulsion from Paradise, fresco (Masaccio, Brancacci Chapel, Sta. Maria del Carmine, Florence), 427, 441, 464; 556

Expulsion from the Garden of Eden, ceiling fresco (Michelangelo, Sistine Chapel, Vatican), 464, 731, 735; 613

EYCK, HUBERT VAN, 506–12, 519, 540–41

EYCK, JAN VAN, 506-12, 519, 540-41

The Arnolfini Portrait, 484, 510-12, 537, 729; 677,

The Crucifixion (with or by Hubert van Eyck?), 449, 506-9, 541; 672

Ghent Altarpiece (St. Bavo Chapel, Ghent, Belgium, with Hubert van Eyck), 506, 509-10; 673, 675; Adam and Eve, 506, 509-10; 674

Last Judgment (with or by Hubert van Eyck?), 449, 506-9, 541; 672

Man in a Red Turban (Self-Portrait?), 510, 514, 530, 584; 676

Eye Like a Strange Balloon Mounts Toward Infinity, The, from Edgar A. Poe series (Redon), 761-62; 987

 ${f F}_{
m ABRIANO}$, Gentile Da, 427

FARRITIUS, CARFL. 593

FABRO, LUCIANO, 923; The Birth of Venus, 923; 1239 Fading Away (Robinson), 775; 1014

Fagus Shoe Factory, Alfeld, Germany (Gropius), 874, 878; 1159

Faiyum, Egypt, Portrait of a Boy, Roman era, 211, 256;

Fall of Jerusalem (Fouquet, illustration in Josephus, Antiquités Judaïques), 520; 689

Fall of Man, ceiling fresco (Michelangelo, Sistine Chapel, Vatican), 464, 731, 735; 613

Family of Charles IV (Goya), 673-75, 718; 863

Family of Man exhibition, 902

Fantasy, 780, 796-99; between the wars, 806-10; in photography, 894, 905-8, 911-12

Farnese, Palazzo, Rome, Italy, ceiling fresco (Carracci), 553-54, 555, 557, 598; 729, 730

Farnesina, Villa, Rome, Italy, Galatea (Raphael), 474, 477-79, 485, 488, 554; 628

Fauves, 765, 781-83, 785, 805, 845

Feast of Herod (Donatello, baptismal font, Siena Cathedral), 414, 418, 428, 441; 534

Feast of St. Nicholas (Steen), 590, 617, 659; 788

Feeding the Oryxes (Tomb of Khnum-hotep, Beni Hasan, Egypt), 72; 71

Female Figure (Kore), Greek, 119, 121; 146

Female Head (Uruk (Warka), Iraq), 54, 80, 109; 88

Female Semi-Nude in Motion, Human and Animal Locomotion (Muybridge), 778; 1019

Feminism, 836

Fertility Goddess (Çatal Hüyük, Turkey), 56; 41 Fertility Goddess (Cernavoda, Romania), 57, 784; 43, 44

fertility goddesses, 99, 101-2

Ficino, Marsilio, 444, 452, 460, 532 Fidenza, Cathedral, King David (Antelami), 311-12, 355, 357; 410

Fifer, The (Manet), 720-21; 932

Figure (Lipschitz), 849-50, 854; 1118 fine arts, 23

FISCHER VON ERLACH, JOHANN, 621-22, 671; St. Charles Borromaeus (Karlskirche) (Vienna, Austria), 621-22; 830, 831

Flack, Audrey, 836; Queen, 836, 842, 843; 1102 Flanders: Baroque in, 574-80; music in, 517 Flemish painting, 430

Flight into Egypt, altar panel (Broederlam), 377–78, 506;

FLITCROFT, HENRY, 668; landscape garden with Temple of Apollo (Stourhead, England), 668-69; 855 Florence, Italy

art: Early Renaissance, 409-33; Mannerist, 483-88 Laurentian Library (Michelangelo), 468, 499, 710; 617, 618

Or San Michele

Four Saints (Quattro Coronati) (Nanni di Banco), 410, 437, 441; 527, 528

St. George tabernacle (Donatello): St. George, 413, 442-43, 461; 531; St. George and the Dragon, 413, 425; 532

St. Mark (Donatello), 410; 530

Palazzo degli Uffizi (Vasari), 498-99; 661

Palazzo Medici-Riccardi (Michelozzo), 422, 434, 772.550

Palazzo Pitti (Ammanati), 499-500, 546; 662 Palazzo Rucellai (Alberti), 434, 468, 546, 920; 566

Palazzo Vecchio, 343, 422, 461; 464

S. Apollonia, The Last Supper (Castagno), 432-33, 455; 564

Sta. Croce, 340, 341, 342, 419; 457, 458; Pazzi Chapel (Brunelleschi), 421-22, 434, 437, 470, 499, 670; 544, 545, 546, 547; Tomb of Leonardo Bruni (Rossellino), 409, 438-39, 468, 699; 577

Sta. Felicita, Deposition (Pontormo), 484, 493; 638

S. Giovanni (Baptistery), 304, 341, 364, 420; 399; doors: The Baptism of Christ (Andrea da Pisano), 358; 493; "Gates of Paradise" (Ghiberti), 416; 538; The Story of Jacob and Esau from, 416-18, 420, 423, 428; 539; The Sacrifice of Isaac (Ghiberti), 357-58, 378, 392, 410, 413, 414, 416-18: 492

S. Lorenzo (Brunelleschi), 419-20, 459, 467; 542, 543, 605; New Sacristy, Tomb of Giuliano de' Medici (Michelangelo), 467-68, 487, 496, 735; 616

Sta. Maria degli Angeli (Brunelleschi), 422, 437, 457, 458; 549

Sta. Maria del Carmine, Brancacci Chapel, frescoes Lippi, 425, 427; 554

Masaccio, 425; 553; The Expulsion from Paradise, 427, 441, 464; 556; The Tribute Money, 425-27: 555

Masolino, 425, 427; 554

Sta. Maria del Fiore Cathedral, 340-43, 419; 460, 461; Campanile, Prophet (Zuccone) (Donatello), 413-14, 416, 430; 533; Cantoria, Trumpet Players (Robbia), 437; 575; dome, 340-43, 413, 419, 458, 470-71; 459; west facade, 342, 355; 462

Sta. Maria Novella, The Holy Trinity with the Virgin, St. John, and Two Donors, fresco (Masaccio), 423, 425, 427-28, 429, 430, 448, 473, 492; 551, 552

Sto. Spirito (Brunelleschi), 422, 436; 548 Flower Still Life (Ruysch), 590; 787

Foghorns (Dove), 815; 1071

Folie P6, from Parc de la Villette, Paris, France (Tschumi), 922; 1238

Fontaine, Pierre-François, 712

Fontainebleau, France, Château, stucco figures (Primaticcio), 496, 539, 547; 658

Fontainebleau, School of, 594, 701

Fontaine des Innocents, Paris, France, reliefs (Goujon), 547; 723, 724

Food Shop (Estes), 835-36; 1101 form, 34-36

"form follows function," 127-28

Fortitude (Pisano, Pisa Baptistery pulpit, detail), 354, 461; 484

Fort Peck Dam, Montana (Bourke-White), 901; 1209 Fortuna Primigenia, Sanctuary of, Praeneste (Palestrina), Italy, 179-80, 560; 240, 241

"Fortuna Virilis, Temple of," Rome, Italy, 177-78, 183; 236, 237

Fortune magazine, 901

Forums, Rome, Italy, plans of, 181; 242

Fossanova, Italy, Abbey Church, 339, 419; 455, 456 FOSTER, NORMAN, 892; Hongkong Bank (Hong Kong), 892; 1197, 1198

FOUQUET, JEAN, 519-20

The Fall of Jerusalem (illustration in Josephus, Antiquités Judaïques), 520; 689

Melun Diptych: Étienne Chevalier and St. Stephen, 519, 538; 687; Madonna and Child, 519; 688

Four Apostles, The (Dürer), 532-33; 705

Four Horsemen of the Apocalypse, woodcut (Dürer), 530, 784, 912; 700

Four Saints (Quattro Coronati) (Nanni di Banco, Or San Michele, Florence), 410, 437, 441; 527, 528

Fragonard, Jean-Honoré, 615; Bathers, 615; 820

France, art: Baroque, 594-607; Gothic, 321-36, 344-49, 358-62; Impressionism, 721-28; "Late Gothic," 518-20; Neoclassicism, 659-60, 665-67, 669-70; Realism, 718-20; Renaissance, 544-47; Rococo, 610-16; Romanesque, 293-98, 304-6, 313-16; Romanticism, 675-86, 700-706; sculpture, 844-46, 849-53

Francesco d'Este (Weyden), 514; 681

Francis I (Clouet), 538; 711

Francis W. Little House, interior (Wright), 872; 1156 FRANK, ROBERT, 908-10; The Americans (book), 908; Santa Fe, New Mexico, 910; 1226

Frankenthaler, Helen, 826; The Bay, 826; 1086 Fray Felix Hortensio Paravicino (Greco), 492-93; 650

Fréart, Paul de, diary, excerpt, 641-42 fresco painting, Gothic, 374, 376-77

Freud, Sigmund, 17-18

FRIEDRICH, CASPAR DAVID, 692, 707, 840; Abbey in an Oak Forest, 692; 893; The Polar Sea, 692; 894 frieze, 123-24

"From Every Southern Town Migrants Left by the Hundreds to Travel North" (Lawrence), The Migration of the Negro from, 818; 1076

Front View of a Lion, from sketchbook of Villard de Honnecourt, 360, 393; 496

Funeral of Atala, The (Girodet-Trioson), 675; 865

funerary customs: Egyptian, 64; Etruscan, 166-67, 170-73; Greek, 112; Roman, 190; see also

Fur Traders Descending the Missouri (Bingham), 697-98, 715, 733; 899

FUSELI, JOHN HENRY, 665, 686-87; The Nightmare, 673, 687, 762, 797, 825, 912; 884

Futurism, 787, 788, 794, 800, 804, 805, 846

GABO, NAUM, 848, 853, 854; Linear Construction 1, 848: 1116

GAINSBOROUGH, THOMAS, 618-20, 691; Mrs. Siddons, 618-19, 620; 827; Robert Andrews and His Wife, 826

Galatea (Raphael, Villa Farnesina, Rome), 474, 477-79, 485, 488, 554; 628

Galla Placidia, Mausoleum of, Ravenna, Italy, Good Shepherd mosaic, 239; 306

garden, English landscape, 668

Garden of Delights (Bosch), 447, 516-18, 541, 595, 637, 762, 811; 684, 685

Garden of Love (Rubens), 576, 613; 764

GARDNER, ALEXANDER, 717; Home of a Rebel Sharpshooter, Gettysburg, 717; 929 Garnier, Charles, 704, 710–12

Opéra (Paris), 704, 772, 920; 919, 920; Grand Staircase, 712, 769; 918

Gates of Hell, The (Rodin), 735-36

- "Gates of Paradise" (Ghiberti, Florence Baptistery doors), 416; 538; The Story of Jacob and Esau from, 416–18, 420, 423, 428; 539
- Gattamelata, equestrian monument of (Donatello), 415; 536
- GAUDÍ, ANTONÍ, 770, 882; Casa Milá apartments (Barcelona, Spain), 770, 882, 885; 1001, 1002
- GAUGUIN, PAUL, 755–57, 762, 764, 769, 781, 782; letter to J. F. Willumsen, excerpt, 940; Offerings of Gratitude, 756, 784; 982; The Vision after the Sermon (Jacob Wrestling with the Angel), 752, 755–56, 759, 929; 980; Where Do We Come From? What Are We? Where Are We Going? 756, 781; 981
- GAULLI, GIOVANNI BATTISTA, 559, 560; Triumph of the Name of Jesus, ceiling fresco (Il Gesù, Rome), 502, 559, 560, 626; 737
- Gay, John, The Beggar's Opera, 617
- Geertgen tot Sint Jans, 515–16; *Nativity*, 515–16, 596; 683
- genre painting: Dutch, 615; Netherlands Renaissance, 540–41
- GENTILE DA FABRIANO, 380-81
 - The Adoration of the Magi, altarpiece, 380–81, 423, 429, 506; 525; Nativity from, 381, 493, 515; 526
- GENTILESCHI, ARTEMISIA, 551–52; Judith and Maidservant with the Head of Holofernes, 552; 728; letter to Don Antonio Ruffo, excerpt, 639
- geometric style, in Greek art, 111-12, 115
- George Frideric Handel (Roubiliac), 620–21; 829 George Washington (Houdon), 666–67, 700; 852
- Georgian style, 671–72
- GÉRICAULT, THÉODORE, 676–77; The Madman, 677; 869; Mounted Officer of the Imperial Guard, 676, 681; 867; The Raft of the "Medusa," 676–77, 680, 690, 716–17; 868
- German Pavilion, Barcelona, Spain, International Exposition (1929, Mies van der Rohe), 878–79; 1169, 1170
- Germany, art: Expressionism, 783–88, 800; Gothic, 338, 350–52; "Late Gothic," 518–20; Northern Renaissance, 527–39; photography, 903; Rococo, 621–25; Romanesque, 302–3, 312; Romantic, 692–96
- Germany, a Winter's Tale (Grosz), 811, 903; 1068
- Gero Crucifix, The (Cathedral, Cologne, Germany), 284–85, 304; 370
- Gesù, Il, Rome, Italy (Vignola), 502–3, 558–59, 560; 668, 669; facade (Porta), 502–3, 560; 670
- Ghent, Belgium, St. Bavo Chapel, *Ghent Altarpiece* (Eyck), 506, 509–10; *673, 675; Adam and Eve* from, 506, 509–10; *674*
- GHIBERTI, LORENZO, 357–58, 410, 416–18 *The Commentaries*, extracts, 392
 - Florence Baptistery doors
 - "Gates of Paradise," 416; 538; The Story of Jacob and Esau from, 416–18, 420, 423, 428; 539
 - The Sacrifice of Isaac, 357–58, 378, 392, 410, 413, 414, 416–18; 492
- GHIRLANDAIO, DOMENICO, 445, 446; *An Old Man and His Grandson*, 445, 474; 585
- GIACOMETTI, ALBERTO, 852; The Palace at 4 A.M., 852; 1123
- GIAQUINTO, CORRADO, 626–28; Justice and Peace, 626–28; 839
- Gilles and Four Other Characters from the Commedia dell'-Arte (Pierrot) (Watteau), 613–14; 818
- GIORDANO, LUCA, 559–60; *The Abduction of Europa*, 559–60, 626; *738*
- GIORGIONE, 475–77, 479; *The Tempest*, 476–77, 480, 542, 554, 588, 613; *631*
- Giotto, 276, 342, 365-70, 408-9, 460
- Arena Chapel, Padua, Italy, murals, 366, 391, 467; 505; Christ Entering Jerusalem, 366–68, 391, 762; 504; The Lamentation, 358, 362, 368–69, 390, 391, 662; 506
- Madonna Enthroned, 369–70, 377, 427, 433; 507 GIOVANNI DA MILANO, 374; Pietà, 374, 378, 429; 515

- Girl Before a Mirror (Picasso), 29-30, 851; 11
- GIRODET-TRIOSON, ANNE-LOUIS, 675–76; The Funeral of Atala, 675; 865
- GIRTIN, THOMAS, 691
- GISELBERTUS, 308; Eve (Cathedral, Autun, France), 308; 405; Last Judgment (Cathedral, Autun, France), 306, 356, 467, 509; 404
- Giuliano de' Medici, Tomb of (Michelangelo, New Sacristy, S. Lorenzo, Florence), 467–68, 487, 496, 735: 616
- GIULIO ROMANO, Palazzo del Te (Mantua, Italy), 498, 918; 660
- Giza, Egypt: Bust of Vizier Ankh-haf, 70; 67; The Great Sphinx, 67; 62; Khafre, 67–68, 86; 63; Menkaure and His Wife, Queen Khamerernebty, 68, 119; 64; Prince Rahotep and His Wife Nofret, 68, 86, 170; 65; Pyramid of Khafre, 66–67; 59, 60; Pyramid of Khufu, 66–67; 59, 60, 61; Pyramid of Menkaure, 66–67; 59, 60
- Glasgow, Scotland, School of Art (Mackintosh), 770, 874, 883; 1003, 1004
- Glass of Absinthe, The (Degas), 724, 752; 938 glazes, 29
- Glorification of the Reign of Urban VIII, ceiling fresco (Cortona, Palazzo Barberini, Rome), 556–57; 736
- Gloucester, England, Cathedral, 336–38, 607, 892; 451 Gobelins factory, 610–11
- gods and goddesses, of ancient Greece, 113
- GOERITZ, MATHIAS, 855; Steel Structure (The Echo (museum), Mexico City), 855; 1129
- GOES, HUGO VAN DER, 515; *The Portinari Altarpiece*, 454, 494, 515; 682
- GOGH, VINCENT VAN, 28, 752–55, 762, 781, 782; letters to Theo, quoted, 940; *The Potato Eaters*, 753; 977; Self-Portrait, 755, 785; 979; Wheat Field and Cypress Trees, 754–55; 978
- gold cups (Vaphio, Greece), 106–8, 124, 231; *133, 134 Gold Marilyn Monroe* (Warhol), 834; *1098*
- González, Julio, 852; *Head*, 852, 856; *1124*
- Good Government in the City, fresco (Lorenzetti, Palazzo Pubblico, Siena, Italy), 370–73, 381, 394, 427, 429: 510, 511
- Good Government in the Country, fresco (Lorenzetti, Palazzo Pubblico, Siena, Italy), 370–73, 381, 394, 429; 510, 512
- Good Shepherd, mosaic (Mausoleum of Galla Placidia, Ravenna), 239; 306
- Gorgons, amphora (Eleusis, Greece), 113–14, 115, 123; 140
- GORKY, ARSHILE, 819–20; The Liver Is the Cock's Comb, 820: 1078
- Gospel Book (Corbie, France), St. Mark from, 305, 313, 314, 316; 414
- Gospel Book of Abbot Wedricus, St. John the Evangelist from, 316–17, 695; 418
- Gospel Book of Archbishop Ebbo of Reims (Early Medieval), St. Mark from, 281, 291, 312, 313, 318; 367
- Gospel Book of Charlemagne (Early Medieval), St. Matthew from, 280–81, 291, 317; 365
- Gospel Book of Otto III (Early Medieval): Jesus Washing the Feet of Peter from, 289–91, 295, 310, 313, 317; 377; St. Luke from, 289–91, 313; 378
- GOSSAERT, JAN (MABUSE), 539–41; *Danaë*, 540; *713* Gothic art, 320–81; classicism in, 347–49; flamboyant, 334–35
- "Gothic primitivism," 768
- Gothic Revival, in architecture, 706-10
- GOTTLIEB, ADOLPH, 819; Descent into Darkness, 819, 822; 1077
- GOUJON, JEAN, 547; Fontaine des Innocents, reliefs (Paris), 547; 723, 724
- Goulue, La (Toulouse-Lautrec), 752; 976
- GOYA, FRANCISCO, 672–75, 720; The Family of Charles IV, 673–75, 718; 863; Los Caprichos, The Sleep of Reason Produces Monsters from, 673, 761, 762, 797; 862; The Third of May, 1808, 595, 675; 864

- GOYEN, JAN VAN, 586; Pelkus-Poort, 586; 781
- Graeco-Roman art, 60, 239–40; influence on Early Christian, 239–40, 244–45; and Neoclassicism, 670–72; see also Greek art; Hellenistic art; Roman art
- graphic arts, 23, 25, 26; "Late Gothic," 523-25
- Graves, Michael, 917–18; interview, "What is the Focus of Post-Modern Architecture?" excerpt, 948–49; Public Services Building (Portland, Ore.), 917–18, 927, 948; 1232
- Grave Stele of Hegeso (Greek), 151, 152, 170, 193, 413, 671; 197
- Great Horse, The (Duchamp-Villon), 846, 864; 1113 Great Miseries of War series (Callot), Hangman's Tree from, 549, 594–95; 790
- Great Pergamum Altar, Pergamum, Anatolia, 137, 159–60, 192; 211; Great Frieze, Athena and Alcyoneus from, 137, 160, 162, 192, 214, 217, 461, 498, 564; 213; plan of, 137, 160; 212
- Great Serpent Mound, Adams County, Ohio, 59, 862;
- Great Sphinx, The (Giza, Egypt), 67; 62
- Greco, El (Domenikos Theotocopoulos), 490–93, 551; The Agony in the Garden, 34, 265; 17; The Burial of Count Orgaz (Sto. Tomé, Toledo, Spain), 490–92, 567, 764; 648, 649; Fray Felix Hortensio Paravicino, 492–93; 650
- Greece, Greeks, 109-13, 137-38, 142-43
- Greek art, 110–65, 670–71; Archaic, 114–24, 765; Classical, 124–54; geometric, 112, 115; influence on Roman, 208–11; late Classical, 154; orientalizing, 112–15; see also Hellenistic art; Mycenaean art
- Greek Revival (19th c.), 157-58
- "Greek style" (Gothic), 265, 362–65
- Green Dining Room, Victoria and Albert Museum, London, England (Morris), 744, 745; 965
- Gregory I, Pope, letter about iconoclasm, excerpt, 382
- Gregory Watching the Snow Fall, Kyoto, Feb. 21, 1983 (Hockney), 913; 1231
- Greta Garbo (Steichen), 715, 901-2; 1210
- Greuze, Jean-Baptiste, 659; *The Village Bride*, 659; 842
- grisaille, 375
- groin vault, 177, 182, 185; 235
- GROPIUS, WALTER, 853, 874, 876, 878, 882, 883, 884 Bauhaus (Dessau, Germany), 1168; Shop Block, 878;
- essay, Scope of Total Architecture, excerpt, 947
- Fagus Shoe Factory (Alfeld, Germany), 874, 878;
- GROS, ANTOINE-JEAN, 676; Napoleon at Arcole, 676, 678: 866
- GROSZ, GEORGE, 811, 816; Germany, a Winter's Tale, 811, 903; 1068
- Grünewald, Matthias (Mathis Gothart Nithart), 527–29, 535–36, 814
 - Isenheim Altarpiece, 527-29
 - details: The Annunciation, 527–29, 535; 697; The Crucifixion, 527–29, 825; 696; Lamentation, 527–29, 825; 696; Madonna and Child with Angels, 527–29, 535; 697; The Resurrection, 527–29, 535; 697, 698; St. Anthony Abbot, 527–29, 825; 696; St. Sebastian, 527–29, 825; 696
- Guadalajara, Mexico, University, *Victims*, fresco (Orozco), 815; *1072*
- GUARINI, GUARINO, 558–59, 563–64, 621; Cathedral (Turin, Italy), 563–64, 669; *749, 750*; Palazzo Carignano (Turin, Italy), 563; *747, 748*
- Gudea, king of Lagash, 84–86; *Cylinder A*, excerpt, 212–13
- Gudea (Lagash, Iraq), 86; 96
- GUERCINO (GIOVANNI FRANCESCO BARBIERI), 555–56; *Aurora*, ceiling fresco (Villa Ludovisi, Rome), 556, 557; 735
- Guernica (Picasso), 802, 854; 1050 Guggenheim, Peggy, 819

Guglielmode Braye, Tomb of, S. Domenico, Orvieto, Italy (Arnolfo di Cambio), 357, 438; 490
Guild of St. Luke, 695–96
guilds, masters and apprentices, 276
GUIMARD, HECTOR, 769–70; Metro station entrance (Paris), 769; 1000

Habitat, EXPO 67, Montreal, Canada (Safdie), 889;

Hagia Sophia, Istanbul, Turkey, 252–54, 265, 383, 876, 888; 323, 324, 326, 327, 328; Virgin and Child Enthroned, mosaic, 252, 260, 359, 363; 338 Hagia Triada, Crete, Harvester Vase, 105, 108, 124; 129

Hagia Triada, Crete, Harvester Vase, 105, 108, 124; 129
Halicarnassus, Anatolia, Mausoleum, 137, 155; 202;
Battle of the Greeks and Amazons (Scopas [?]), 137, 155, 192, 198, 231; 203; Mausolus, statue (Bryaxis [?]), 137, 155, 162, 190, 214; 204
hall churches, 297–98, 338

Hals, Frans, 581–82, 677, 720; The Jolly Toper, 573, 581; 772; Malle Babbe, 581, 592, 596, 677; 773; The Women Regents of the Old Men's Home at Haarlem, 581–82; 774

 HAMILTON, ANN, 926; parallel lines installation (São Paolo, Brazil, Bienal [1991]), 926; 1243, 1244
 HAMILTON, GAVIN, 658, 659, 665, 686

Hamilton, Richard, 832; Just What Is It That Makes Today's Home So Different, So Appealing?, 832; 1095

Hammurabi, king of Babylon, stele with Law Code of, 88, 109; 98

Hampstead Heath (Constable), 682, 688, 721; 887 Handel, George Frideric, statue of (Roubiliac), 620–21; 829

Hangman's Tree, from Great Miseries of War series (Callot), 549, 594–95; 790

Hannibal Crossing the Alps (Turner), 690

Happenings, 869, 870

Harbaville Triptych, The (Byzantine), 265–66; 345 HARDOUIN-MANSART, JULES, 602, 604

Church of the Invalides (Paris), 604, 670; 804, 805 Versailles: Galerie des Glaces, 602; 801; Garden Front, 602, 609, 668; 800; Salon de la Guerre, 604, 606, 712; 802

Hariulf, *History of the Monastery of St.-Riquier*, 384–85 Harlem Renaissance, 818, 902–3

Harmony in Blue and Gold: The Peacock Room (Whistler), 745, 757; 967

Harpist (Orpheus) (Amorgos, Greek island), 17; 1

HARTLEY, MARSDEN, 788; Portrait of a German Officer, 788; 1032

Harvester Vase (Hagia Triada, Crete), 105, 108, 124; 129 Hatshepsut, Queen, funerary temple of, Deir el-Bahari, Egypt, 72, 180; 72, 73

Haussmann, Georges-Eugène, 710

Hawksmoore, Nicholas, 609

Haymaking in the Norfolk Broads (Emerson), 776; 1016 Haywain, The (Constable), 681, 689; 888

Head (González), 852, 856; 1124

Head of an Akkadian Ruler (Nineveh (Kuyunjik), Iraq), 84; 94

Head of a Woman (Picasso), 851-52; 1122

Head of Christ (Rouault), 782, 786, 822; 1023

Head Surrounded by Sides of Beef (Bacon), 825, 840; 1084 HEARTFIELD (HERZFELD), JOHN, 907; As in the Middle Ages, so in the Third Reich, 1219

HECKEL, ERICH, 784; Woman Before a Mirror, 784; 1026 HEDA, WILLEM CLAESZ., 589; Still Life, 589; 785

НЕЕМ, JAN DE, 589–90; Still Life with Parrots, 589–90; 786

Hellenistic art, 154, 158-62

HENRI, ROBERT, 799

Henry, Charles, 751

Henry VII, Chapel of, Westminster Abbey, London, England, 707, 710

Henry VIII (Holbein), 538; 710

Hepworth, Barbara, 806, 853, 854–55; Sculpture with Color (Oval Form), Pale Blue and Red, 854–55;

"Hera" (Samos, Greek island), 121, 122, 123; 151 HERAKLEIDAS, 164; Apollo, coin (Catana, Sicily), 164;

Herakles (Temple of Aphaia, Aegina, Greece), 124, 139, 145; 161

Herakles Strangling the Nemean Lion, Attic amphora (Psiax), 114-15, 120, 152, 354; 143

Herakles Wrestling Antaios, Attic krater (Euphronios), 117; 144

Herculaneum, Italy, 186, 203, 671, 712; Hercules and Telephus, wall painting, 210, 256, 366; 292; Peaches and Glass Jar, wall painting, 208, 211; 291

Hercules and Antaeus (Pollaiuolo), 440, 498; 579

Hercules and Telephus, wall painting (Herculaneum, Italy), 210, 256, 366; 292

He Revels (The Orgy), The Rake's Progress, engraving (Hogarth), 617, 659, 775; 825

Hermes (Praxiteles), 156–57, 191, 198, 214, 354; 207 hero, in Greek Legend, 117

HESSE, EVA, 866–67; Accession II, 867; 1147; interview with, excerpt, 946

Hesy-ra, *Portrait Panel of*, Saqqara, Egypt, 63–64, 70; *53* Hiberno-Saxon style, Early Medieval, 271–74

Hierakonpolis, Egypt: *Palette of King Narmer*, 62–63, 65, 68, 82; 51, 52; *People, Boats, and Animals*, 61, 123, 270, 305; 50

hieroglyphics, Egyptian, 61

High Renaissance, 452–81, 483, 526–27, 594; music and theater, 464

Hildegard of Bingen, 316

Hildesheim, Germany, St. Michael's Cathedral, 286, 293; *372*, *373*, *374*

Bronze Doors of Bishop Bernward, 286–89, 304, 310–11; 375; Adam and Eve Reproached by the Lord from, 289, 311, 312, 318; 376

HILLIARD, NICHOLAS, 538–39; A Young Man Among Roses, 539, 578, 616; 712

HIMMELBLAU, COOP, 921; roof conversion project (Vienna, Austria), 921; 1235

Hittites, 47, 88

HOARE, HENRY, 668

HOCKNEY, DAVID, 912–13, 929; Gregory Watching the Snow Fall, Kyoto, Feb. 21, 1983, 913; 1231

HOGARTH, WILLIAM, 616–17; The Rake's Progress, The Orgy from, 617, 659, 728, 775; 824; The Rake's Progress, engraving, He Revels (The Orgy), 617, 659, 775; 825

Holbein, Hans, the Younger, 537–38; Erasmus of Rotterdam, 537; 709; Henry VIII, 538; 710

Holland, see Netherlands

Holy Family by the Rosebush (Master of the Housebook), 493, 525, 814; 695

Holy Trinity with the Virgin, St. John, and Two Donors, The, fresco (Masaccio, Sta. Maria Novella, Florence), 423, 425, 427–28, 429, 430, 448, 473, 492; 551, 552

Homage to Pomona (Allegory of Fruitfulness) (Jordaens), 578–79; 768

Homage to the Square (Albers), Apparition from, 831; 1093

Home of a Rebel Sharpshooter, Gettysburg (Gardner), 717;

Homer, Homeric writings, 98, 112, 113–14, 127; Hymn to Aphrodite, 443

HOMER, WINSLOW, 733; Snap the Whip, 733; 951 Hongkong Bank, Hong Kong (Foster), 892; 1197, 1198 HOOCH, PIETER DE, The Bedroom, 33, 593, 615; 14 HOPPER, EDWARD, 817–18; Early Sunday Morning, 818, 836; 1075

Horemheb, Tomb of, Saqqara, Egypt, Workmen Carrying a Beam, 76, 105, 122; 81

Horn for Wifredo (Mitchell), 858; 1135

Horse (Chauvet cave, France), 51; 28

Horse (Vogelherd Cave, Germany), 53; 34

HORTA, VICTOR, 769; Tassel House, stairway (Brussels, Belgium), 769; 999

Hosios Loukas (St. Luke of Stiris), Greece

monastery churches, 257–58; *332*, *333*; Katholikon, 257–58; *334*

Nativity, mosaic, 264; 342

HOSMER, HARRIET, 864

Hôtel du Collectionneur exhibit, Paris, France, Exposition (1925, Ruhlmann), 883; 1179

HOUDON, JEAN-ANTOINE, 665–67; George Washington, 666–67, 700; 852; Voltaire Seated, 620, 666; 851

Hours of Jeanne d'Evreux (Pucelle): Annunciation from, 358, 375; 516; Betrayal of Christ from, 358, 375; 516

Houses of Parliament, London, England (Barry), 710; 917

Houston, Tex., Best Stores Showroom (SITE Projects, Inc.), 918; 1233

HOWARD, MILDRED, 926; Tap: Investigation of Memory installation, 926; 1245

Howe, George, Savings Fund Society Building (Philadelphia, Pa.), 882, 883; 1177

Hudson River School, 697, 733

Human and Animal Locomotion (Muybridge), Female Semi-Nude in Motion, 778; 1019

Human Concretion (Arp), 851, 854; 1121

HUNT, WILLIAM HOLMAN, 728, 743; The Awakening Conscience, 729; 945

Hunting and Fishing, Tomb of, Tarquinia, Italy, 115, 169: 226

Huysmans, Joris-Karl, essay, "Iron," excerpt, 939–40 Huysum, Jan van, 590

Hyksos, 71, 72

Hysolar Research Institute, University, Stuttgart, Germany (Behnisch and Partner), 921; 1236

 $m{I}$ and the Village (Chagall), 798; 1043

Ice Age, 45-46

Ice Bag - Scale B (Oldenburg), 859-60; 1137

Iconoclastic Controversy, 256, 257, 260

iconography, 23

icons, Byzantine, 254-57, 267-68

ICTINUS, 131, 133

Ignatius of Loyola, Saint, 483

illustrated manuscripts: Early Christian, 241–42; Goth-

ic, 360–62, 375–77; Hiberno-Saxon, 272–74 illustration, 23

imagination in art, 16–18

Imdugud and Two Stags (Iraq), 82; 91

Імнотер, 64–65

Imperial Procession (from Ara Pacis, Rome), 192–93, 198, 241, 245, 348, 413, 414, 437, 448, 551; 267

Impressionism, 734–38, 746; in France, 721–28; in the United States, 732–34

In Advance of the Broken Arm (Duchamp), 850, 869; 1119

Inanna-Ishtar (Babylonian), 86–88, 102, 231; 97

Independent Group, 832

industrial design, 23

Industrial Revolution, 712

Indus Valley, 47

Information Age, 914–15

Ingres, Jean-Auguste-Dominique, 678, 801

"The Doctrine of Ingres," excerpts from, 935 *Louis Bertin*, 678, 714, 791, 817; 871; drawing for, 678; 872

Odalisque, 678, 681, 700, 802; 870

Ingres and Other Parables, from Art History (Baldessari), 870, 927, 929; 1152

inlaywork, Sumerian, 83

INNESS, GEORGE, 733; The Rainbow, 733; 950

Installations, 30, 867-69, 916, 924

interior design, 23, 182–86

Interior of the Choir of St. Bavo's Church at Haarlem (Saenredam), 588; 784

Interior of the Pantheon (Panini), 182, 183, 304, 437, 629, 708, 876, 888; 246

International Style (Gothic), 352-53, 357, 377-81,

448, 504, 505, 506, 514, 515, 521, 523 International Style (20th-century architecture), 878, 879, 880, 881, 882, 884, 885, 887, 892, 917, 921

Ionian Greeks, 95, 96, 110, 123

Ionic order, 124, 182; temples, 134-38

Iron Age, 47

I Saw the Figure 5 in Gold (Demuth), 804, 833, 908;

Isenheim Altarpiece (Grünewald), 527-29

details: The Annunciation, 527–29, 535; 697; The Crucifixion, 527–29, 825; 696; Lamentation, 527–29, 825; 696: Madonna and Child with Angels, 527–29, 535; 697; The Resurrection, 527–29, 535; 697, 698; St. Anthony Abbot, 527–29, 825; 696; St. Sebastian, 527–29, 825; 696

Ishtar Gate, Babylon, Iraq, 91–92; 105 ISIDORUS OF MILETUS, 252, 308

Istanbul, Turkey

Hagia Sophia, 252–54, 265, 383, 876, 888; 323, 324, 326, 327, 328; Virgin and Child Enthroned, mosaic, 252, 260, 359, 363; 338

Kariye Camii (Church of the Saviour in Chora): Anastasis, fresco, 269, 314, 366; 349; Elizabeth at the Well, mosaic, 268–69, 365; 348

Italia and Germania (Overbeck), 663, 696; 896

Italian Mountains (Dürer), 493, 529, 536, 691; 699

Italy, art: Baroque, 548–68, 569; Early Renaissance, 434–51; Gothic, 338–43, 353–57, 362–74; High Renaissance, 452–81; modern sculpture, 846–47; Rococo, 625–29; Romanesque, 309–12; Romanticism, 699–700

See also Roman art

It's Safe to Release This One! (Daumier), 681; 876 ivories, 245–47, 265–67, 291

JACOB-DESMALTER, FRANÇOIS-HONORÉ, 712; Château of Malmaison, bedroom in (Rueil-Malmaison, near Paris), 712; *921*

Jacob Wrestling the Angel, from Vienna Genesis (Early Christian), 242; 311

Jefferson, Thomas, 671–72; Monticello (Charlottesville, Va.), 671–72; 860, 861

Jericho, Palestine, 54–55; Neolithic plastered skull, 54; 37; wall and tower, 55, 78; 38

Jerome, Saint, 41, 320

Jesuits, 483

Jesus, life of, 246–47

Jesus Washing the Feet of Peter, from Gospel Book of Otto III (Early Medieval), 289–91, 295, 310, 313, 317; 377

Jewish Cemetery, The (Ruisdael), 586–88, 684, 692; 783 John Hancock Insurance Company, New Orleans, La., fountain for (Noguchi), 861; 1139

Johns, Jasper, 832–33; *Target with Four Faces*, 38–41, 832; *24*; *Three Flags*, 832–33; *1096*

JOHNSON, PHILIP, AT&T building (New York, N.Y.), 922

Jolly Toper, The (Hals), 573, 581; 772

Jonas Salk Institute of Biological Studies, La Jolla, Calif. (Kahn), 886; 1186

JONES, INIGO, Whitehall Palace (London, England), 607; 809

JORDAENS, JACOB, 578–79; Homage to Pomona (Allegory of Fruitfulness), 578–79; 768

Joseph the Carpenter (La Tour), 595-96; 791

Joy of Life, The (Matisse), 781–82, 788–90, 801–2, 844; 1021

JUDD, DONALD, 856; *Untitled*, 856, 867; 1132

Judgment of Paris (Cranach), 533–34; 706 Judgment of Paris (Raphael, copy by Raimondi), 21, 23, 477, 720; 5

Judith and Maidservant with the Head of Holofernes (Gentileschi), 552; 728

jug, beaked (Kamares style, Phaistos, Crete), 105; 126 Jugend stil, 769

Julius II, Tomb of, S. Pietro in Vincoli, Rome, Italy (Michelangelo): "The Dying Slave," 461–62,

464, 468, 731, 736; 609; Moses, 461–62, 468; 608; "The Rebellious Slave," 461–62, 464, 468, 731, 735, 736; 610

Junius Bassus, Sarcophagus of, 239, 243-44, 263, 317, 354, 366; 312, 313

Jupiter and Io (Correggio), 495–96, 540, 567, 599; 655 Justice and Peace (Giaquinto), 626–28; 839

Justinian as Conqueror (Byzantine), 254, 291; 330 Just What Is It That Makes Today's Home So Different, So Appealing? (Hamilton), 832; 1095

KABAKOV, ILYA, 924; "Ten Characters" installation, *The Man Who Flew into Space from His Apartment*from, 924; 1242

KAHLO, FRIDA, 808; letter to Nickolas Muray, excerpt, 943–44; Self-Portrait with Thorn Necklace, 808; 1063

Kahn, Louis, 886; Jonas Salk Institute of Biological Studies (La Jolla, Calif.), 886; *1186*

Kamares ware, 105

excerpt, 942

Kandinsky, Wassily, 785–87, 801, 803–4, 809, 815, 878

Accented Corners, No. 247, 803–4; 1053 Concerning the Spiritual in Art (book), 786, 803;

Point and Line to Plane (book), 803

Sketch I for "Composition VII," 786, 803–4, 820; 1030 Kaprow, Alan, 869

Kariye Camii (Church of the Saviour in Chora), Istanbul, Turkey: *Anastasis*, fresco, 269, 314, 366; 349; Elizabeth at the Well, mosaic, 268–69, 365; 348

KARPION, 131

KASÉBIER, GERTRUDE, The Magic Crystal, 776, 899; 1017Katholikon, monastery church, Hosios Loukas (St. Luke of Stiris), Greece, 257–58; 334

Kato Zakro, Crete, *Leaping Mountain Goat*, vase carving, 105, 108; 128

KAUFFMANN, ANGELICA, 663, 686; The Artist in the Character of Design Listening to the Inspiration of Poetry, 663, 696; 847

Kelly, Ellsworth, 827–28; *Red Blue Green*, 827–28; *1088*

Kenwood, London, England, The Library (Adam), 671, 708; 859

Kertész, André, 896; *Blind Musician*, 896; *1201 Khafre* (Giza, Egypt), 67–68, 86; *63*

Khafre, Pyramid of, Giza, Egypt, 66-67; 59, 60

Khnum-hotep, Tomb of, Beni Hasan, Egypt, Feeding the Oryxes, 72; 71

Khufu, Pyramid of, Giza, Egypt, 66–67; 59, 60, 61 KIEFER, ANSELM, 837–40; *To the Unknown Painter*, 840;

KIENHOLZ, EDWARD AND NANCY, 867–68; The State Hospital, 867–68; 1149

King David (Antelami, Cathedral, Fidenza), 311–12, 355, 357; 410

KIRCHNER, ERNST LUDWIG, 801, 803; Self-Portrait with Model, 783–84; 1025; Winter Landscape in Moonlight, 803; 1052

Kiss, The (Brancusi), 845, 853, 854; 1110

Kiss, The (Klimt), 763; 990

Kiss, The (Rodin), 736, 845; 956

Kiss of Judas, The, sculpture (Naumburg Master, Cathedral, Naumburg, Germany), 350–51, 380; 477

Kitchen Still Life (Chardin), 615; 822

KLEE, PAUL, 794, 809–10, 878; Park near Lu(cerne), 810; 1066; Twittering Machine, 809–10; 1065

KLIMT, GUSTAV, 763, 769, 811; *The Kiss*, 763; 990 KLINGER, MAX, 811

Klosterneuburg Altar (Nicholas of Verdun), 317–18, 347; 420; Crossing of the Red Sea from, 318, 347, 524; 421

Kneeling Boy (Minne), 767-68; 996

Kneller, Godfrey, 607

Knight, Death, and Devil (Dürer), 530-31; 703

Knight, Tomb of a, Abbey, Dorchester (Oxfordshire), England, 350, 620; 475 Knossos, Crete

Palace of Minos, 100–101; *118;* The Queen's Megaron, 101, 104, 169; *120;* staircase, 101; *119* rhyton from, 102; *122*

Snake Goddess (Priestess?), 102, 109; 121

KOKOSCHKA, OSKAR, 785, 853; The Bride of the Wind, 785; 1029; Self-Portrait, 785; 1028

KOLLWITZ, KÄTHE, 810–11; Never Again War!, 811; 1067

Kore, 119-22

Kore (Chios, Greek island [?]), 121–22, 130–31, 456; 153

Kore in Dorian Peplos (Greek), 121, 130–31, 456, 923; 152

Kostromskaya, Russia, *Stag* (Scythian), 93, 96, 270; *108* Kosuth, Joseph, 869–70; *One and Three Chairs*, 869–70; *1151*

Kouros, 119-22

Krasner, Lee, 821–22; *Celebration*, 821–22; *1080* Kritios, attr., *Standing Youth (Kritios Boy)*, 139–40, 144,

415; 182 Kroisos (Kouros from Anavysos), Greek, 119–20, 139; 148

Kruchenykh, Alexei, 796 Kruger, Barbara, 929; You Are a Captive Audience,

907, 929; *1249* Kupka, Frantisek, 793

Labors of Herakles paintings (Pollaiuolo; lost), 444 Labors of the Months (July, August, September), sculpture (Cathedral, Amiens, France), 348, 349, 378, 379; 474

LABROUSTE, HENRI, 738–41; Bibliothèque Ste.-Geneviève (Paris), 738–41, 772; 960, 961

Laestrygonians Hurling Rocks at the Fleet of Odysseus, The, wall painting (from a house on the Esquiline Hill, Rome), Odyssey Landscapes, 204, 216, 289, 373; 287

Lagash (Telloh), Iraq, 84-86; Gudea, 86; 96

La Jolla, Calif., Jonas Salk Institute of Biological Studies (Kahn), 886; 1186

LAM, WIFREDO, 858

La Madeleine, near Les Eyzies (Dordogne), France, Bison, 54, 93; 36

Lamentation (murals, Giotto, Arena Chapel, Padua, Italy), 358, 362, 368–69, 390, 391, 662; 506

Lamentation (Grünewald), from Isenheim Altarpiece, predella, 527–29, 825; 696

Lamentation (fresco, St. Panteleimon, Nerezi, Macedonia), 264–65, 347, 368; 343

landscape: Dutch Baroque, 586–88; English Romantic, 687–91; French Romantic, 682–86; Netherlands Renaissance, 540–41; in photography, 715–16; picturesque, 664

Landscape, from A New Method of Assisting the Invention . . . (Cozens), 664, 714, 731, 807; 849

Landscape, mural (Akrotiri, Thera (Santorini), Greek island), 103–4, 209; 124

Landscape with St. Jerome Removing the Thorn from the Lion's Paw (Patinir), 541; 714

Landscape with the Château Steen (Rubens), 576–78; 765 Landscape with the Flight into Egypt (Carracci), 554–55, 578, 588; 731

Landucci, Luca, excerpts from Journal of, 631-32

Lanfranco, Giovanni, 555, 557; Annunciation, 555; 732

LANGE, DOROTHEA, 904; Migrant Mother, California, 904; 1217

Laocoön Group (Agesander, Athenodorus, Polydorus of Rhodes, attr.), 162, 462, 564, 607, 665; 215

Lapith and Centaur (Parthenon, netopes, Acropolis,

Athens, Greece), 150, 155, 192; 195 Larissa, Greece, Aeolian capital from, 136, 173; 175

Lascaux, near Montignac (Dordogne), France, cave art, 51–52; 30, 31; map of, 52; 32

Last Judgment (Cavallini, Sta. Cecilia in Trastevere, Rome), Seated Apostles, detail, 366; 503

Last Judgment (Eyck, with or by Hubert van Eyck?), 449, 506–9, 541; 672

Last Judgment (Giselbertus, Cathedral, Autun, France), 306, 356, 467, 509; 404

Last Judgment (Maitani, Cathedral, Orvieto, Italy), 355–56, 704; 488

Last Judgment (wall fresco, Michelangelo, Sistine Chapel, Vatican), 467, 471, 495; 614; detail, with selfportrait, 467; 615

Last of England, The (Brown), 728, 898; 944

Last Supper (Castagno, S. Apollonia, Florence), 432–33, 455; 564

Last Supper (Leonardo), 455–56, 472, 473, 490; 596 Last Supper (Nolde), 785; 1027

Last Supper (Tintoretto, S. Giorgio Maggiore, Venice, Italy), 490, 492, 494; 647

"Late Gothic": compared to Renaissance art, 504–21, 526, 527; painting, 529

La Tour, Georges de, 594, 595–96; *Joseph the Car*penter, 595–96; 791

LATROBE, BENJAMIN, 708–9; Cathedral (Basilica of the Assumption) (Baltimore, Md.), 708; *913*, *914*, *915*

Laurentian Library, Florence, Italy (Michelangelo), 468, 499, 710; 617, 618

LAWRENCE, JACOB, 818; "From Every Southern Town Migrants Left by the Hundreds to Travel North," The Migration of the Negro from, 818; 1076

Leaping Mountain Goat, vase carving (Kato Zakro, Crete), 105, 108; 128

Lebrun, Charles, 560, 600, 601, 602, 604, 610–11, 612, 619

Charles Lebrun, bust, 606, 665; 807

Versailles: Galerie des Glaces, 602; *801;* Salon de la Guerre, 604, 606, 712; *802*

LECK, BART VAN DER, 805

LE CORBUSIER (CHARLES ÉDOUARD JEANNERET), 879–80, 885; Notre-Dame-du-Haut (Ronchamp, France), 882, 885; 1183, 1184, 1185; Savoye House (Poissy-sur-Seine, France), 879– 80, 890, 892; 1171, 1172; Unité d'Habitation Apartment House (Marseilles, France), 885; 1182

Lecture, La (Reading), (Morisot), 726; 941

LEDOUX, CLAUDE-NICOLAS, 669–70; Barrière de Villette (Paris), 669–70, 876; 858

Léger, Fernand, 794, 804; *The City*, 804, 879, 892; 1054

LEHMBRUCK, WILHELM, 768; Standing Youth, 768; 997 Lely, Peter, 607

Lemieux, Annette, 930; Truth, 930; 1250

Le Nain, Antoine, 596

LE NAIN, LOUIS, 596, 615, 718; Peasant Family, 596, 681, 753; 792

Le Nain, Mathieu, 596

LE NOTRE, ANDRÉ, 604; Versailles, gardens, 604; 803 LEONARD, JOANNE, 911–12, 929; Dreams and Nightmares, Romanticism Is Ultimately Fatal from, 911–12; 1229

LEONARDO DA VINCI, 441, 442, 453–59, 461, 475, 494, 807; Adoration of the Magi, 453–54; 594; The Battle of Anghiari, cartoon (for Palazzo Vecchio, Florence), 456, 575, 676; 597; Embryo in the Womb, 456; 599; The Last Supper, 455–56, 472, 473, 490; 596; manuscripts, excerpts from, 631; Mona Lisa, 21, 456, 471–72, 474, 529; 598; Project for a Church, 457–58; 600; The Virgin of the Rocks, 454, 472; 595

Leo X, portrait of (Raphael), 474, 480, 571; 629 Leptis Magna, North Africa, basilica, 185–86, 235; 253, 254

Le Raincy, France, Notre-Dame (Perret), 882; 1176 LESCOT, PIERRE, 546; Louvre, facade (Paris), 546, 602, 622, 710; 722

Letter, The (Vermeer), 592–93, 615, 751, 759; 789 Le Vau, Louis, 602; Versailles, Garden Front, 602, 609, 668: 800

LEYSTER, JUDITH, 582; Boy Playing a Flute, 582; 775 Library of St. Mark's, Venice, Italy (Sansovino), 500, 712; 663 Libyan Sibyl (Michelangelo, ceiling fresco, Sistine Chapel, Vatican), 28, 464, 731; 9; studies for, 26–28; 8

LICHTENSTEIN, ROY, 833; *Drowning Girl*, 833, 835, 945; *1097;* interview, "What is Pop Art?," excerpt, 945

Liège, France, St. Barthélemy, baptismal font (Renier of Huy), 312, 317, 347, 444; 411

Life magazine, 901

light, 30

light installations, 30

LIMBOURG BROTHERS, 379, 508; Les Très Riches Heures du Duc de Berry, calendar page, 335–36, 379, 429, 505, 520, 684; 522

LIN, MAYA, 861–62; Vietnam Veterans Memorial (Washington, D.C.), 861–62; 1140

Lindau Gospels (Early Medieval), book cover, 282, 284, 289; 369

Lindisfarne Gospels (Hiberno-Saxon): colophon, 384; Cross Page, 31, 273, 281, 316, 360; 352

line, 25-28; vs. color, 28

Linear Construction 1 (Gabo), 848; 1116

Linked Ring, 776

Lion Attacking a Horse (Stubbs), 663–64, 703, 787; 848 Lionesses, Tomb of the, Tarquinia, Italy, Musicians and Two Dancers, 115, 169–70; 227

Lion Gate, Bogazköy, Anatolia, 88, 90, 109, 122; 99 Lion Gate, Mycenae, Greece, 109, 122, 177, 305; 135 lion hunts, as Assyrian subject matter (motif), 91 Lion Monument, Brunswick, Germany, 312; 412 LIPPI, FILIPPINO, Sta. Maria del Carmine, Brancacci

Chapel (Florence), frescoes, 425, 427; 554 LIPPI, FRA FILIPPO, 428, 429, 448; *Madonna Enthroned*, 428, 443; 558

LIPCHITZ, JACQUES, 849; *Figure*, 849–50, 854; *1118* lithography, 674

Little Fourteen-Year-Old Dancer, The (Degas), 737–38; 959

liturgy, Christian, 235

Liver Is the Cock's Comb, The (Gorky), 820; 1078 Liverpool, England, warehouses on New Quay, 772; 1008

Livia, Villa of, Primaporta, Italy, View of a Garden, mural, 204-6, 289: 288

Livy, Founding of the City, excerpt, 218 Lobster Trap and Fish Tail (Calder), 852; 1125 Lombard style (Early Medieval), 274

Lombardy, 300-302

London, England: Bank of England, Consols' Office (Soane), 708, 876; 916; Crystal Palace (Paxton), 716, 741, 874; 962; Houses of Parliament (Barry), 710; 917; Kenwood, The Library (Adam), 671, 708; 859; St. Paul's Cathedral (Wren), 608–9, 669; 810, 811, 812; Sanctuary of Mithras, 177; Victoria and Albert Museum, Green Dining Room (Morris), 744, 745; 965; Westminster Abbey, Chapel of Henry VII, 338, 707, 710; 452, 453; Whitehall Palace (Jones), 607; 809

London, England (near), Chiswick House (Burlington), 667–68, 669, 670; 853, 854

London Child (Brandt), 911; 1227

lonely metropolitan (Bayer), 907; 1218

LONGO, ROBERT, 923–24; Now Everybody (For R. W. Fassbinder), 924, 927; 1241

Loos, Adolf, 872–74; Steiner House (Vienna, Austria), 874; 1157

LORENZETTI, AMBROGIO, 370–73, 374; frescoes (Palazzo Pubblico, Siena, Italy): The Commune of Siena, 370–73, 381; 510; Good Government in the City, 370–73, 381, 394, 427, 429; 510, 511; Good Government in the Country, 370–73, 381, 394, 429; 510, 512

LORENZETTI, PIETRO, 370–73; Birth of the Virgin, 370, 377, 427, 510; 509

Los Caprichos (Goya), The Sleep of Reason Produces Monsters from, 673, 761, 762, 797; 862

Louis, Morris, 826–27; Blue Veil, 827; 1087

Louis Bertin (Ingres), 678, 714, 791, 817; 871; drawing for, 678; 872

Louis XIV, of France, 594, 600; statue of (Bernini), 606; 806; style of, 594

Louis XV, of France, style of, 610

Louis XVI, of France, style of, 712

Louvre, second, Paris, France, 335–36, 379, 429, 505, 520, 684; 522

Louvre, third, Paris, France: east front (Perrault), 602, 640, 710; 799; facade (Lescot), 546, 602, 622, 710; 722

Ludovisi, Villa, Rome, Italy, *Aurora*, ceiling fresco (Guercino), 556, 557; 735

LUMIÈRE, LOUIS, 894; Young Lady with an Umbrella, 894; 1199

Luncheon on the Grass (Le Déjeuner sur l'Herbe) (Manet), 21, 720–21, 746; 4

Luristan (?), pole-top ornament, 93, 95, 270; 107

Luther, Martin, 482–83; Against the Heavenly Prophets in the Matter of Images and Sacraments, excerpt, 638

Luxembourg Palace, Paris, France, Medici Cycle, Marie de' Medici, Queen of France, Landing in Marseilles (Rubens), 576, 581, 594, 615; 763

Luxor, Egypt

Temple of Amun, 75, 79, 235; 76

Temple of Amun-Mut-Khonsu, 72–75, 95, 901; 74; court of Amenhotep III, 72–75, 95; 74; court of Ramesses II, 72–75, 95; 74, 75; pylon of Ramesses II, 72–75, 95; 74, 75

Lyons, France, Musée des Beaux-Arts, murals, *The Sacred Grove, Vision of Antiquity*, and *Christian Inspiration* (Puvis de Chavannes), 756, 759; *984*

lyre, inlay panel of a (Ur (El Muqieyar), Iraq), 61, 82, 93, 115, 123, 231, 305; *92*

Lysicrates, Monument of, Athens, Greece, 137; 179 Lysimachus, coin issued by, Alexander the Great with Amun Horns, 165, 191; 221

Lysippus, 158, 176; Apoxyomenos (Scraper), 158; 209

Macdonald, Frances, 883

Macdonald-Mackintosh, Margaret, 883

MacDonald-Wright, Stanton, 793

MACKINTOSH, CHARLES RENNIE, 770, 883; School of Art (Glasgow, Scotland), 770, 874; 1003, 1004 MADERNO, CARLO, 560; St. Peter's (Rome): facade, 560,

604, 609, 860; 739; nave, 560, 564, 604, 609, 860; 739, 740

Madman, The (Géricault), 677; 869

Madonna (Pisano, Prato Cathedral), 355, 366; 486, 487 Madonna and Child, from Melun Diptych (Fouquet), 519; 688

Madonna and Child with Angels (Grünewald), from Isenheim Altarpiece, 527–29, 535; 697

Madonna and Child with Saints (Domenico Veneziano), 430, 450, 479; 560

Madonna and Saints (Bellini, S. Zaccaria, Venice, Italy), 450, 479; 593

Madonna Enthroned (Byzantine), 267–68, 363; 347 Madonna Enthroned (Cimabue), 363–64, 370, 427; 499 Madonna Enthroned (Duccio, from Maestà Altar, Siena Cathedral), 364–65, 366, 367–68, 393; 500

Madonna Enthroned (Giotto), 369-70, 377, 427, 433; 507

Madonna Enthroned (Lippi), 428, 443; 558

Madonna Enthroned (Masaccio, panel from polyptych for Carmelite Church, Pisa, Italy), 427, 428, 429, 431, 450; 557

Madonna with Members of the Pesaro Family (Titian), 479, 489; 633

Madonna with the Long Neck, The (Parmigianino), 485, 488, 493, 496, 678; 640

Maestà Altar (Duccio), Siena Cathedral: Annunciation of the Death of the Virgin, 365, 375, 393; 501; Christ Entering Jerusalem, 365, 370, 393, 762; 502; Madonna Enthroned, 364–65, 366, 367– 68, 393; 500

Magdalenian art, 51

magic, paleolithic, 53

Magic Crystal, The (Kasëbier), 776, 899; 1017 Magic Realism, 835, 896

MAGRITTE, RENÉ, 808, 905; Les Promenades d'Euclid, 808, 905, 911; 1062

Mai and His Wife Urel (Tomb of Ramose, Thebes, Egypt), 75; 77

Maids of Honor, The (Velázquez), 571–73, 673–74, 718, 733; 759

MAILLOL, ARISTIDE, 765–66, 768; Seated Woman (La Méditerranée), 765–66, 802, 845; 994

Mairea, Villa, Noormarkku, Finland (Aalto), 880; 1173,

Maisons, near Paris, France, Château (Mansart), 601–2, 604; 798

Mattani, Lorenzo, *The Last Judgment* (Cathedral, Orvieto, Italy), 355–56, 704; 488

MALEVICH, KAZIMIR, 796; Black Quadrilateral, 796; 1040; Suprematist Composition: White on White, 796; 1041

Malle Babbe (Hals), 581, 592, 596, 677; 773

Malmaison, Château of, Rueil-Malmaison, near Paris, France (Percier), 712; 921; bedroom in (Jacob-Desmalter), 712; 921

MALOUEL, JEAN, 378; Martyrdom of St. Denis (with Bellechose, Henri), 378; 520; Martyrdom of St. Denis (with Henri Bellechose), 505

MANDER, CAREL VAN, *The Painter's Treatise*, excerpt, 635–36

Man Drawing a Sword (Barlach), 768, 785; 998

Manet, Édouard, 720–21, 722, 727, 746; A Bar at the Folies-Bergère, 722; 937; The Fifer, 720–21; 932; Luncheon on the Grass (Le Déjeuner sur l'Herbe), 21, 720–21, 746; 4; Olympia, 746

Man in a Red Turban (Self-Portrait?) (Eyck), 510, 514, 530, 584; 676

Man in Black Suit with White Stripes Down Arms and Legs, Walking in Front of a Black Wall (Marey), 779, 798, 908; 1020

Mannerism, 483–500, 526–27, 539, 548, 594, 595, 686, 764; in architecture, 498–500, 918; court portraiture, 578; in Florentine and Roman painting, 483–88; in sculpture, 496–98; in music, 486–87; in Venetian painting, 489–93

Man Ray, 896, 907; *Untitled* (Rayograph), 907; *1220*Mansart, François, 601–2; Château (Maisons, near Paris), 601–2, 604; *798*

Mantegna, Andrea, 441, 444, 448, 494

St. James Led to His Execution (Ovetari Chapel, Church of the Eremitani, Padua, Italy, destroyed), 448, 530; 589; drawing for, 448–49; 590

St. Sebastian, 449; 591

Mantua, Italy: Palazzo del Te (Giulio Romano), 498, 918; 660; S. Andrea (Alberti), 434–37, 438–39, 470, 502; 569, 570, 571

manuscripts: Early Medieval, 280–82, 289–91; Gothic, 360–62, 375–77; Hiberno-Saxon, 272–74; see also illustrated manuscripts

Man Who Flew into Space from His Apartment, The, from "Ten Characters" installation (Kabakov), 924; 1242

Man with the Broken Nose, The (Rodin), 734, 735, 737; 954

Man with the Glove (Titian), 479–80, 493, 584; 634 MARATTA, CARLO, 560, 659

MARC, FRANZ, 787, 794, 809; Animal Destinies, 787;

Marcus Aurelius, Roman emperor, *Equestrian Statue of*, 199, 243, 254, 356, 415, 469; *279*

Marey, Étienne-Jules, 779, 798, 908; Man in Black Suit with White Stripes Down Arms and Legs, Walking in Front of a Black Wall, 779, 798, 908;

Maria Christina, Archduchess, Tomb of, Augustinerkirche, Vienna, Austria (Canova), 699; 900

Marie de' Medici, Queen of France, Landing in Marseilles, Medici Cycle (Rubens, Luxembourg Palace, Paris), 576, 581, 594, 615; 763

Marinetti, Filippo Tommaso, 794; "The Foundation

and Manifesto of Futurism," excerpt, 942-43

Market Gate, Miletus, Anatolia, 187, 208, 470, 560; 257 Market Stall (Snyders), 580; 770

Marriage of Frederick Barbarossa, The, fresco (Tiepolo, Kaisersaal, Residenz, Würzburg, Germany), 615, 626; 838

Marseillaise (Departure of the Volunteers of 1792), La (Rude, Arc de Triomphe, Paris), 701–3, 705; 904

Marseilles, France, Unité d'Habitation Apartment House (Le Corbusier), 885; 1182

Marshall Field Wholesale Store, Chicago, Ill. (Richardson), 772, 773; 1007

"Marsyas Painter," Peleus and Thetis, 153, 214, 440; 201

MARTINI, SIMONE, 370, 377, 408; *The Road to Calvary*, 370, 377, 506; 508

MARTINI, SIMONE, ITALIAN FOLLOWER OF (MATTEO GIOVANNETTI?), Scenes of Country Life (Palace of the Popes, Avignon, France), 376; 517

Martyrdom of St. Denis (Malouel and Bellechose), 378, 505; 520

Mary Magdalen (Donatello), 416, 440, 441; 537 MASACCIO, 409, 423, 429, 460

Brancacci Chapel, Sta. Maria del Carmine, Florence, Italy, frescoes, 425; 553; The Expulsion from Paradise, 427, 441, 464; 556; The Tribute Money, 425–27; 555

The Holy Trinity with the Virgin, St. John, and Two Donors, fresco (Sta. Maria Novella, Florence), 423, 425, 427–28, 429, 430, 448, 473, 492; 551, 552

Madonna Enthroned (from polyptych for Carmelite Church, Pisa, Italy), 427, 428, 429, 431, 450; 557

MASEGNE, JACOBELLO AND PIERPAOLO DALLE, *Apostles* (St. Mark's, Venice, Italy), 357; 491

MASOLINO, 427; Sta. Maria del Carmine, Brancacci Chapel (Florence), 425, 427; 554

Massacre at Chios, The (Delacroix), 678–81, 716–17, 721; 873

mastaba (Egyptian tomb), 64; 54

MASTER FRANCKE, 380; Christ Carrying the Cross, 380; 524

MASTER HONORÉ, Prayer Book of Philip the Fair, David and Goliath from, 362, 375; 498

Master of Flémalle (Robert Campin?), 505–6, 508, 512, 519, 521, 540; *Mérode Altarpiece,* 430, 505–6, 510, 512, 540–41; *671*

MASTER OF THE HOUSEBOOK, 525; Holy Family by the Rosebush, 493, 525, 814; 695

masters (craftsmen), 276

Matisse, Henri, 761, 765, 781–82, 801, 802, 844; Decorative Figure Against an Ornamental Background, 802; 1051; essay, "Notes of a Painter," excerpt, 941–42; The Joy of Life, 781–82, 788–90, 801–2, 844; 1021; Reclining Nude I, 844, 854; 1109; The Red Studio, 759, 782; 1022 Matiushin, Mikhail, 796

Mausoleum, Halicarnassus, Anatolia, 137, 154–55; 202;

Battle of the Greeks and Amazons (Scopas [?]),
137, 155, 192, 198, 231; 203

Mausolus, statue (Bryaxis [?], Mausoleum, Halicarnassus, Anatolia), 137, 155, 162, 190, 214; 204

Mazarin, Cardinal, 594

Meadow Bordered by Trees, A (Rousseau), 684; 881 meaning in art, 23–24

Meat Stall, The (Aertsen), 542, 580, 589; 715

Medici, Giuliano de', Tomb of, Night, 28-29

Medici Cycle (Rubens, Luxembourg Palace, Paris), Marie de' Medici, Queen of France, Landing in Marseilles (sketch for), 576, 581, 594, 615; 763

Medici-Riccardi, Palazzo, Florence, Italy (Michelozzo), 422, 434, 772; 550

medieval art, 270–91, 320–81; see also Byzantine art; Gothic art; Romanesque art

Meditations on the Life of Christ, 389-90

Meeting of Pope Leo I and Attila, The (Algardi, St. Peter's, Rome), 567–68; 755

megalithic monuments, 57-59

megaron (Mycenaean), plan, 109, 127; 136

MEIER, RICHARD, 890, 918; The Atheneum (New Harmony, Indiana), 890; 1193

Melchizedek and Abraham, sculpture (Reims Cathedral), 332, 348, 360, 365; 472

Meleager, Sarcophagus of (Rome), 197-98; 275

Melencolia (Dürer), 531-32, 673; 704

Melk, Austria, Monastery Church (Prandtauer), 622; 832; interior (Prandtauer, Beduzzi, Munggenast), 622; 833

Melun Diptych (Fouquet): Étienne Chevalier and St. Stephen, 519, 538; 687; Madonna and Child, 519: 688

Menander, House of, Pompeii, Italy, Portrait of Menander, 281; 366

MENDELSOHN, ERICH, 882; Einstein Tower (Potsdam, Germany), 882; 1175

Mengs, Anton Raphael, 626, 658, 659

Menkaure, Pyramid of, Giza, Egypt, 66–67; 59, 60 Menkaure and His Wife, Queen Khamerernebty (Giza,

Menkaure and His Wife, Queen Khamerernebty (Giza, Egypt), 68, 119; 64

Mérode Altarpiece (Master of Flémalle), 430, 505–6, 510, 512, 540–41; 671

Mesarites, Nicholas, Description of the Church of the Holy Apostles, excerpt, 384

Mesopotamia, 47, 78; *Imdugud and Two Stags*, 82; 91; see also Sumerian art

Mesopotamian art, 102, 109, 112–14, 118; see also Assyrian art; Babylonian art

Métafisyx, Le, from Corps de Dames series (Dubuffet), 823; 1082

metalwork: Etruscan, 174–75; Ottonian (Early Medieval), 286–89; Romanesque, 313, 317–18

Métal: y equals ax3 - bx3 + cx (Vantongerloo), 849; *1117*

Metaphysical Painting (de Chirico), 798 Métro Station entrance (Guimard, Paris), 769; 1000

Meunier, Constantin, 766–67; Bust of a Puddler, 766–67; 995

Meuse Valley, Romanesque sculpture in, 312

Mexico (Cartier-Bresson), 897; 1203

Mexico City, The Echo (museum), Steel Structure (Goeritz), 855; 1129

Meyer, Adolf, 874

MEYER, HANNES, 878, 883

mezzo (middle) relief, 35

mezzotint, 674

Michelangelo, 19, 162, 446, 452, 459–71, 472, 475, 483, 487, 488, 686

Awakening Slave, 19, 36, 460, 461, 923; 3

Campidoglio (Rome), 469–70; 619, 620; Palazzo dei Conservatori, 470, 609, 710; 621

David, 461, 564, 631; 607

Laurentian Library (Florence), 468, 499, 710; 617, 618 Pietà, 460–61, 485; 606

St. Peter's (Rome), 459, 470–71, 502, 560, 604; 622, 623, 624

Sistine Chapel, Vatican

ceiling frescoes, 462–67, 554; 611; The Creation of Adam, 462–64, 551, 731, 778; 612; The Expulsion from the Garden of Eden, 464, 731, 735; 613; The Fall of Man, 462–64, 551, 731, 735, 778; 613; Libyan Sibyl, 28, 464, 731, 735; 9; studies for, 26–28; 8

wall fresco, *The Last Judgment*, 467, 471, 495; 614; detail, with self-portrait, 467; 615

Sonnet, quoted, 632

Tomb of Giuliano de' Medici (New Sacristy, S. Lorenzo, Florence), 467–68, 487, 496, 735; *616; Night*, 28–29

Tomb of Julius II, S. Pietro in Vincoli, Rome, Italy: "The Dying Slave," 461–62, 464, 468, 731, 736; 609; Moses, 353, 461–62, 468; 608; "The Rebellious Slave," 461–62, 464, 468, 731, 735, 736; 610

Triumph of Love, 486

MICHELOZZO, 422; Palazzo Medici-Riccardi (Florence), 422, 434, 772; 550

MIES VAN DER ROHE, LUDWIG, 878–79, 882, 884–85; German Pavilion (Barcelona, Spain, International Exposition [1929]), 878–79; 1169, 1170; Seagram Building (New York, N.Y.), 883, 884–85, 917, 922; 1181

Migrant Mother, California (Lange), 904; 1217

Migration of the Negro, The, from "From Every Southern Town Migrants Left by the Hundreds to Travel North" (Lawrence), 818; 1076

MIKON OF ATHENS, 151

Milan, Italy: Cathedral, 343, 357; 463; S. Ambrogio, 300–302; 393, 394

Miletus, Anatolia, Market Gate, 187, 208, 470, 560; *257* MILLAIS, JOHN EVERETT, 728

MILLER, WAYNE, 902; Childbirth, 902; 1211

MILLET, JEAN-FRANÇOIS, 684, 733; *The Sower*, 681, 684, 718, 753; 882

Milo of Crotona (Puget), 606-7, 735; 808

Miner (Salle), 927; 1246

Minimalism, 828, 849, 857, 858, 867, 869, 870

MINNE, GEORGE, 767–68; *Kneeling Boy*, 767–68; *996* Minoan art, 98, 99–108, 109

Minos, Palace of, Knossos, Crete, 100–101; 118; The Queen's Megaron, 101, 104, 169; 120; staircase, 101; 119

Mint, Venice, Italy (Sansovino), 500, 712; 663

Miraculous Draught of Fishes, The, altarpiece (Witz), 518-19, 721; 686

Miraflores Altarpiece, The (Weyden), 513; 680

MIRÓ, JOAN, 802, 808–9; Composition, 808–9, 820; 1064

mirror, engraved (Etruscan), 174, 524; 234

Mission of the Apostles, The, portal sculpture (Ste-Madeleine, Vézelay, France), 308–9, 314, 345, 386; 406

"Mistress of the Animals, The," mural (Akrotiri, Thera (Santorini), Greek island), 102–3, 822; 123

Mitannians, 88

MITCHELL, TYRONE, 858; *Horn for Wifredo*, 858; *1135* Mithras, sanctuary of, London, England, 177

Mithras Slaying the Sacred Bull (Roman), 231, 535; 294 MNESICLES, 133–34, 136

Model for Equestrian Statue of Louis XIV (Bernini), 606;

modeling, sculptural, 35-36

Modena, Italy, Cathedral, Scenes from Genesis (Wiligelmo), 310–11; 409

modern architecture, 772–74, 881–83, 890–92; International Style, 878, 879, 880, 881, 882, 884–92, 917, 921

modern art, 37, 836-43

Modernista style, 769

Modern Olympia (The Pasha), A (Cézanne), 746; 968 MODERSOHN-BECKER, PAULA, 765; Self-Portrait, 765; 993

MOHOLY-NAGY, László, 803, 878, 907; *Untitled*, Photogram, 907; *1221*

Moissac, France, St.-Pierre, portal sculpture, 305–6, 344, 386; 401; Annunciation, Visitation, and Adoration of the Magi, 306, 309, 310, 386; 402

Mona Lisa (Leonardo), 21, 456, 471–72, 474, 529; *598* monasteries, standard plan, 278, 286; *362*, *363* monasticism, 257–58, 296–97

MONDRIAN, PIET, 31, 805–6, 853, 876; Broadway Boogie Woogie, 31, 33, 806; 13; Composition with Red, Blue, and Yellow, 805–6, 836; 1057; essay, "Plastic Art and Pure Plastic Art," excerpt, 943

Mondrian (Rothenberg), 840; 1105

Monet, Claude, 721–22, 727–28; On the Bank of the Seine, Bennecourt, 721, 727, 733, 755; 933; Red Boats, Argenteuil, 722; 934; Water Lilies, 727–28, 827, 842, 863; 943

Monreale, Italy, Cathedral, Christ in the Garden of Gethsemane, 265; 344

Monte Cassino, Italy, monastery, mosaics, 314–15 Monticello, Charlottesville, Va. (Jefferson), 671–72;

Montreal, Canada, Habitat, EXPO 67 (Safdie), 889; 1192

Mont Ste-Victoire Seen from Bibémus Quarry (Cézanne), 747, 790; 971

Monuments, 859-62

Monument to Balzac (Rodin), 736-37; 957

Monument to the Third International, model (Tatlin), 848; 1115

Moonrise, Hernandez, New Mexico (Adams), 900–901; 1208

Moore, Henry, 853–54; essay, "The Sculptor Speaks," excerpt, 946; *Recumbent Figure*, 770, 854; 1127; Two Forms, 853–54, 858, 901; 1126 moralizing portraiture, 42

MOREAU, GUSTAVE, 761, 802; The Apparition (Dance of Salome), 761; 985

More Than You Know (Murray), 843; 1107

Morisot, Berthe, 726; *La Lecture (Reading)*, 726; 941 *Morning* (Runge), 694–95; 895

Morning: Dance of the Nymphs (Corot), 683–84; 880

MORRIS, WILLIAM, 743–44, 769, 772; Victoria and
Albert Museum, Green Dining Room (London, England), 744, 745; 965

mosaics: Byzantine, 268-69, 314-15; Early Christian, 238-41

Mosan art, 312

Moscow, Russia, St. Basil Cathedral, 258–60; 337 Moses (Michelangelo, Tomb of Julius II, S. Pietro in Vin-

coli, Rome), 353, 461–62, 468; 608 Moses Receiving the Law (Trier, Germany [?]), 291; 379 Moses Well, The (Sluter, Chartreuse de Champmol,

Dijon, France), 353, 378, 414; 481 Mother and Child (Picasso), 801; 1048

Moulin de la Galette, Le (Renoir), 722, 750; 936

Mound Builders, 59

Mount, William Sidney, 696–97; Dancing on the Barn Floor, 697; 897

Mounted Officer of the Imperial Guard (Géricault), 676, 681; 867

Mrs. Siddons (Gainsborough), 618–19, 620; 827

Mrs. Siddons as the Tragic Muse (Reynolds), 619, 620, 687; 828

Munch, Edvard, 762, 769, 811; *The Scream,* 21, 762, 763, 825, 843, 912; *989*

murals: Byzantine, 268–69; Early Christian, 238–41; Greek, 115, 151–52; *see also* fresco painting

Murillo, Bartolomé Esteban, 573; Virgin and Child, 573; 761

Murray, Elizabeth, 843; More Than You Know, 843; 1107

Muse and Maiden, lekythos ("Achilles Painter"), 152-53, 214; 200

Musée des Beaux-Arts, Lyons, France, murals, The Sacred Grove, Vision of Antiquity, and Christian Inspiration (Puvis de Chavannes), 756, 759; 984

museums, 37

music: Baroque, 558, 600–601, 607; before World War I, 790–91; between the wars, 816; Early Renaissance, 442; 18th century harmony, 624; in 15th-century Flanders, 517; Greek, 142–43; High Renaissance, 464; in the Mannerist age, 480–87; Medieval, 326–27; nationalism in mid-19th-century, 730; Neoclassical, 670; in the Netherlands, 586; in the Northern Renaissance, 535; and painting (Kandinsky), 787; in the Post-Impressionist era, 758; Postmodernism in, 928; Rococo, 622–24; Roman, 209; Romanticism in, 702–3; since World War II, 838–39

Musicians and Two Dancers (Tomb of the Lionesses, Tarquinia, Italy), 115, 169–70; 227

Muthesius, Hermann, 874, 876

Muybridge, Eadweard, 778–79; Human and Animal Locomotion, Female Semi-Nude in Motion, 778; 1019

Mycenae, Greece, 108–9; Lion Gate, 109, 122, 177, 305; 135; rhyton, 106, 109; 132; Three Deities, carving, 109; 137; Treasury of Atreus, 106, 109, 166; 130, 131

Mycenaean art, 98, 106-9, 112, 122, 123

My Egypt (Demuth), 901

MYRON, Discobolus (Discus Thrower), 146, 214; 189

Mysteries, Villa of the, Pompeii, Italy, Scenes of a Dionysiac Mystery Cult, 206, 209, 232; 289

Mystery and Melancholy of a Street (Chirico), 797–98; 1042

mythology: Etruscan, 174; Greek, 109, 113, 117

Nabash the Ammonite Threatening the Jews at Jabesh, from Psalter of St. Louis (French Gothic), 360, 365; 497

Nabis, 757

Nadar (Gaspard Félix Tournachon), 896; Le Pantheon Nadar, 715; Sarah Bernhardt, 715, 901; 925

Nadar Elevating Photography to the Height of Art (Daumier), 715, 742, 778; 926

Naksh-i-Rustam (near Persepolis), Iran, Shapur I Triumphing over the Emperors Philippus the Arab and Valerian, 97, 200; 114

NANNI DI BANCO, 410; Four Saints (Quattro Coronati) (Or San Michele, Florence), 410, 437, 441; 527, 528

Napoleon (Canova), 700; 901

Napoleon at Arcole (Gros), 676, 678; 866

Naram-Sin, king of Akkad, Victory Stele of Naram-Sin, King of Akkad, 84, 88, 192; 95

Narmer, King, *Palette of King Narmer*, Hierakonpolis, Egypt, 62–63, 65, 68, 82; *51*, *52*

narrative art: Greek, 113–14; Roman, 192; Sumerian, 90–91; Renaissance, 475

Nash, John, 708; Royal Pavilion (Brighton, England), 678, 708, 875; *912*

Nathaniel Hurd (Copley), 42-43; 26

Nativity (Geertgen tot Sint Jans), 515-16, 596; 683

Nativity (Gentile da Fabriano, from *The Adoration of the Magi* altarpiece), 381, 493, 515; *526*

Nativity (Hosios Loukas, Greece), mosaic, 264; 342

Nativity (N. Pisano, from Pisa Baptistery pulpit), 353–54, 410; 483

Nativity (G. Pisano, from Pisa Cathedral pulpit), 354–55, 358, 390; 485

naturalism, 24; in photography, 776

nature in art, 103-5

Naumburg, Germany, Cathedral, sculpture (NAUMBURG MASTER), 350–51; *Crucifixion*, 350, 352, 360, 365, 514; 476; *Ekkehard and Uta*, 351, 366; 478; *The Kiss of Judas*, 350–51, 380; 477

Naxos, Greek island, Silenus, coin, 164; 219

Nazarenes, 695–96, 700, 728

Near East: ancient art of, 78-97; Neolithic art, 54-57

Neo-Abstraction, 843

Neo-Babylonian culture, 91–92

Neo-Baroque architecture, 710–12

Neoclassicism, 658–72, 801; and the Antique, 670–72

Neo-Expressionism, 836-43, 927

Neolithic art, 46-47, 54-59, 98

Neo-Palladian style, 708 Neo-Plasticism, 805

Neo-Platonism, 443–44, 452, 460

Neo-Renaissance architecture, 710–12

Neo-Romanesque style, 772

Nerezi, Macedonia, St. Panteleimon, *Lamentation*, fresco, 264–65, 347, 368; 343

Nervi, Pier Luigi, 887–88; Sports Palace (Rome), 888; *1189*, *1190*

Netherlandish painting, 505-18

Netherlands

art: Baroque, 574, 581–93; genre and still life, 588–90, 615; landscape, 588–90; Renaissance, 539–44; Romanesque, 302–3

music and theater, 586

Neue Sachlichkeit (New Objectivity), 815–16, 903

Neue Staatsgalerie, Stuttgart, Germany (Stirling), 918;

NEUMANN, BALTHASAR, 624; Residenz, Kaisersaal (Würzburg, Germany), 624, 626; 834

NEVELSON, LOUISE, 864–66; *Black Chord*, 864–66; *1145 Never Again War!* (Kollwitz), 811; *1067*

Newborn, The (Brancusi), 845, 855; 1111

New Harmony, Indiana, The Atheneum (Meier), 890; 1193

Newman, Barnett, 860; Broken Obelisk, 860; 1138 New Method of Assisting the Invention . . ., A (Cozens), Landscape from, 664, 714, 731, 807; 849

New Orleans, La., John Hancock Insurance Company, fountain for (Noguchi), 861; 1139

New Sacristy, S. Lorenzo, Florence, Italy, Tomb of Giuliano de' Medici (Michelangelo), 467–68, 487, 496, 735; 616

New Shoes for H (Eddy), 834–35; 1099, 1100 Newspaper, Bottle, Packet of Tobacco (Le Courrier) (Braque), 793, 802, 806; 1036

Newton, Sir Isaac, 549

New York, N.Y.: Brooklyn Bridge (Roebling), 741–42; 963; Seagram Building (Mies and Johnson), 883, 884–85, 917, 922; 1181; Solomon R. Guggenheim Museum (Wright), 37, 670, 872; 21, 22; Statue of Liberty (Bartholdi), 883, 884–85, 917, 922; 1181; Trans World Airlines Terminal (Saarinen), 887; 1187, 1188

New York 2 (Siskind), 908; 1223

NICHOLAS OF VERDUN, 317–18

Klosterneuburg Altar, 317–18, 347; 420; Crossing of the Red Sea from, 318, 347, 524; 421

NICHOLSON, BEN, 806, 854; *Painted Relief,* 806; *1058* NIEMEYER, OSCAR, 889; Brasilia, Brazil, 889; *1191*

NIÉPCE, JOSEPH NICÉPHORE, 713; View from His Window at Le Gras, 713; 922

Night, Michelangelo, Tomb of Giuliano de' Medici, 28–29

Nightmare, The (Fuseli), 673, 687, 762, 797, 825, 912; 884

Night Watch (The Company of Captain Franz Banning Coca) (Rembrandt), 549, 583; 777

Nike (Temple of Athena Nike, Acropolis, Athens, Greece), 150, 247; 196

Nike of Samothrace (Pythokritos of Rhodes [?]), 160–62, 847; 214

NIKOMACHOS OF ATHENS, 151, 152

Nile River, 67

Nîmes, France, Pont du Gard, 181, 772; 243

Nimrud (Calah), Iraq, Palace of Ashurnasirpal II, Ashurnasirpal II Killing Lions, 91, 96, 122; 103

Nineveh (Kuyunjik), Iraq, 90–91; Dying Lioness, 91, 96, 231; 104; Head of an Akkadian Ruler, 84; 94; Palace of Ashurbanipal, The Sack of the City of Hamanu by Ashurbanipal, 90–91, 124, 192, 196; 102

Nocturne in Black and Gold: The Falling Rocket (Whistler), 731–32, 786; 949

NOGUCHI, ISAMU, 861; John Hancock Insurance Company, fountain (New Orleans, La.), 861; *1139*

NOLDE, EMIL, 785; *The Last Supper*, 785; *1027* nomadic peoples, art, 92–93

Noormarkku, Finland, Villa Mairea (Aalto), 880; 1173,

Normandy, Romanesque architecture in, 298-300

Northern Expressionism, 837

Northern Mannerism, 540-44

Northern Renaissance, 526-47

Notre-Dame, Le Raincy, France (Perret), 882; 1176

Notre-Dame, Paris, France, 322, 325–27, 329, 331–32, 892; 426, 427, 428, 429, 442; The Virgin of Paris, sculpture, 348–49, 352, 355; 473; west facade, 325, 544; 430

Notre-Dame de la Belle Verrière, stained-glass window (Cathedral, Chartres, France), 330–31, 359, 523, 783; 494

Notre-Dame-du-Haut, Ronchamp, France (Le Corbusier), 882, 885; *1183*, *1184*, *1185*

Notre-Dame-la-Grande, Poitiers, France, 297–98, 326; 386

Now Everybody (For R. W. Fassbinder) (Longo), 924, 927; 1241

Nude Descending a Staircase No. 2 (Duchamp), 798, 913; 1044

nudes: female, 99; male, 26; Medieval, 354 Nuremberg, Germany, St. Sebald, 338, 624–25; 454

Object (Oppenheim), 850, 867; 1120
"Octopus Vase" (Palaikastro, Crete), 105; 127
Odalisk (Rauschenberg), 864, 869; 1143
Odalisque (Delacroix), 681, 746, 802; 874
Odalisque (Ingres), 678, 681, 700, 802; 870

Odo of Metz, Palace Chapel of Charlemagne (Aachen, Germany), 276–77, 280; 357, 358, 359

Odyssey Landscapes, The Laestrygonians Hurling Rocks at the Fleet of Odysseus, wall painting (from a house on the Esquiline Hill, Rome), 204, 216, 289, 373: 287

Offerings of Gratitude (Gauguin), 756, 784; 982 oil paint, 428

O'KEEFFE, GEORGIA, 817; Black Iris III, 817, 826, 900; 1074; essay, "Stieglitz: His Pictures Collected Him," excerpt, 941

Oldenburg, Claes, 859–60; *Ice Bag - Scale B*, 859–60; 1137

Old Guitarist, The (Picasso), 764, 788; 991

Old King, The (Rouault), 782-83; 1024

Old Man and His Grandson, An (Ghirlandaio), 445, 474;

Old St. Peter's basilica, Rome, Italy, 234, 235, 278, 293, 421; 297, 298

Old Stone Age, 46

Olympia, Greece, Temple of Zeus: *Apollo*, 144–45, 149, 150, 152, 164, 432; *187; Battle of the Lapiths and Centaurs*, 144–45, 149, 150, 152, 164, 432; *187*

Olympia (Manet), 746

One and Three Chairs (Kosuth), 869-70; 1151

1 Copper Plate 1 Zinc Plate 1 Rubber Cloth 2 Calipers 1 Drainpipe Telescope 1 Piping Man (Ernst), 806–7, 817, 905; 1059

On the Bank of the Seine, Bennecourt (Monet), 721, 727, 733, 755; 933

On the Edge (WalkingStick), 843; 1108

Oosterwijck, Maria van, 590

Op Art, 28, 830-31, 913

Oppenheim, Meret, 808, 850; *Object*, 850, 867; *1120 Orange and Yellow* (Rothko), 826; *1085*

orders, see Classical orders

Orgy, The, from The Rake's Progress (Hogarth), 617, 659, 728, 775; 824

orientalizing style, in Greek art, 112-15

originality in art, 21-23

Orozco, José Clemente, 815; *Victims*, fresco (University, Guadalajara, Mexico), 815; *1072*

Orphism, 787, 793-94, 800, 809

Or San Michele, Florence, Italy

Four Saints (Quattro Coronati) (Nanni di Banco), 410, 437, 441; 527, 528

St. George tabernacle: St. George (Donatello), 413, 442–43, 461; 531; St. George and the Dragon (Donatello), 413, 425; 532

St. Mark (Donatello), 410; 530

Orvieto, Italy

Cathedral

The Last Judgment (Maitani), 355–56, 704; 488 S. Brizio Chapel: The Damned Cast into Hell (Signorelli), 447–48; 588; The Rule of the Antichrist (Signorelli), 446–47, 467; 587

S. Domenico, Tomb of Guglielmode Braye (Arnolfo di Cambio), 357, 438; 490

Oseberg, Norway, ship burial, *Animal Head* from, 270–71; 351

Ostia, Italy, House of Diana, insula, 186; 256

O'SULLIVAN, TIMOTHY, 716, 717; Ancient Ruins in the Cañon de Chelle, N.M., in a Niche 50 Feet Above the Present Cañon Bed, 716; 927

Ottonian art, 282-91

Overbeck, Friedrich, 696; *Italia and Germania*, 663, 696; *896*

Ovetari Chapel, Church of the Eremitani, Padua, Italy, St. James Led to His Execution (Mantegna), 448, 530: 589

Ovid, 443; *Metamorphoses*, 596 Oviedo, Spain, Sta. Maria de Naranco, 280; *364* Owen, Robert, 890

Pacheco, Francisco, *The Art of Painting*, excerpt, 640 Pacher, Michael, *St. Wolfgang Altarpiece*, 521–23, 527, 638; *691*; contract for, excerpt, 638

Padua, Italy, 448

Arena Chapel, murals (Giotto), 366, 391, 467; 505; Christ Entering Jerusalem, 366–68, 391, 762; 504; The Lamentation, 358, 362, 368–69, 390, 391, 662; 506

Church of the Eremitani, Ovetari Chapel, St. James Led to His Execution (Mantegna), 448, 530; 589 Piazza del Santo, Equestrian Monument of Gattamela-

ta (Donatello), 415; 536

Paestum Italy: "Basilica" 126, 128–30, 131: 164, 165

Paestum, Italy: "Basilica," 126, 128–30, 131; 164, 165; "Temple of Poseidon," 128–30, 131, 706; 164, 166, 167

PAIK, NAM JUNE, 923; TV Buddha, 923; 1240 Painted Relief (Nicholson), 806; 1058

painting, 23, 25, 28-34

cultures: Egyptian, 72, 77; Graeco-Roman, 239–40; Greek, 111–18, 151–53, 208–11; Minoan, 102–6; Roman, 203–11; Romanesque, 313–18

styles: American Realist, 732–34; Baroque, 549–60, 569–73, 595–601; Early Renaissance, 423–33, 443–50; Gothic, 358–81; Impressionism, 721–28, 732–34; Mannerism, 483–93; Neoclassicism, 659–64; Northern Renaissance, 527–37, 539–44; Post-Impressionism, 746–57; Postmodern, 927–29; Proto-Baroque, 495–96; Realism, 718–20, 728–32; Rococo, 612–20; Romantic, 672–98; Symbolism, 757–65

20th century, 780–843; before World War I, 780–81; between the wars, 800–818; since World War II, 818–36

See also murals; panel painting

Palace at 4 A.M., The (Giacometti), 852; 1123

Palace of the Popes, Avignon, France, Scenes of Country

Life (Martini), 376; 517

palaces: Assyrian, 89-91; Minoan, 99-102

Palaikastro, Crete, "Octopus Vase", 105; 127

Palazzo Pubblico, Siena, Italy, frescoes (Lorenzetti): *The Commune of Siena*, 370–73, 381; 510; *Good Government in the City*, 370–73, 381, 394, 427, 429; 510, 511; *Good Government in the Country*, 370–73, 381, 394, 429; 510, 512

Palazzo Vecchio, Florence, Italy, 343, 422, 461; 464

Paleolithic art, 46, 50-54, 98, 99

Palette of King Narmer (Hierakonpolis, Egypt), 62–63, 65, 68, 82; 51, 52

Palladian revival, 667-68

PALLADIO, ANDREA, 500–502, 602

The Four Books of Architecture, 501; excerpt, 635 S. Giorgio Maggiore (Venice, Italy), 501–2; 666, 667 Villa Rotonda (Vicenza, Italy), 501, 667, 670; 664, 665 panel painting, Gothic, 376–77

Panini, Giovanni, 629; *Interior of the Pantheon*, 182, 183, 304, 437, 629, 708, 876, 888; 246

Pantheon, Rome, Italy, 182–85, 341, 437, 438, 622, 670; 247, 248, 249; painting of (Panini), 182, 183, 304, 437, 629, 708, 876, 888; 246

Panthéon (Ste.-Geneviève), Paris, France (Soufflot), 669, 670, 708; 856

Pantheon Nadar, Le (Nadar), 715

Pantocrator, mosaic (monastery church, Daphnē, Greece), 234, 263–64; 341

papyrus half-columns, 64, 65

parallel lines installation (Hamilton, São Paolo, Brazil, Bienal [1991]), 926; 1243, 1244

Parc de la Villette, Paris, France (Tschumi), 921–22; 1237; Folie P6, 922; 1238

Parigi, Giulio, 607

Paris, France

Arc de Triomphe, La Marseillaise (Departure of the Volunteers of 1792) (Rude), 701–3, 705; 904

Barrière de Villette (Ledoux), 669–70, 876; 858 Bibliothèque Ste.-Geneviève (Labrouste), 739, 772; 960, 961

Centre National d'Art et Culture Georges Pompidou (Rogers), 892, 918; 1196

Church of the Invalides (Hardouin-Mansart), 604, 670: 804, 805

Eiffel Tower (Eiffel), 742-43, 892; 964

Exposition (1855), 718

Exhibition of Decorative and Industrial Arts (1925), 883

Fontaine des Innocents, reliefs (Goujon), 547; 723, 724 Hôtel de Varengeville, room (Pineau), 611, 624; 814 Louvre, second, 335–36, 379, 429, 505, 520, 684; 522

Louvre, third: east front (Perrault), 602, 640, 710; 799; facade (Lescot), 546, 602, 622, 710; 722

Luxembourg Palace, Medici Cycle, *Marie de' Medici*, *Queen of France, Landing in Marseilles* (Rubens), 576, 581, 594, 615; 763

Métro Station entrance (Guimard), 769; 1000

Notre-Dame, 322, 325–27, 329, 331–32, 892; 426, 427, 428, 429, 442; The Virgin of Paris, sculpture, 348–49, 352, 355; 473; west facade, 325, 544; 430

Opéra (Garnier), 704, 772, 920; 919, 920; façade sculpture, *The Dance* (Carpeaux), 704–5, 712, 718, 733, 735; 907; Grand Staircase (Garnier), 712, 769; 918

Panthéon (Ste.-Geneviève, Soufflot), 669, 670, 708; 856

Parc de la Villette (Tschumi), 921–22; *1237; Folie P6*, 922; *1238*

St.-Denis Abbey Church, 321–23, 359–60, 882; 423, 424

Paris, School of, in photography, 894-97

Paris Psalter (Byzantine), 263; David Composing the Psalms from, 260-63, 269, 317; 339

Park near Lu(cerne) (Klee), 810; 1066

Parma, Italy, Cathedral, *The Assumption of the Virgin*, fresco (Correggio), 495–96, 557; 654

Parmigianino, 484–86, 493; The Entombment, 485–86, 493; 641; The Madonna with the Long Neck, 485, 488, 493, 496, 678; 640; Self-Portrait, 484–85; 639

Parrhasios of Ephesus, 151

Parthenon, Acropolis, Athens, Greece, 130–33, 148–50, 874; 169, 193

east pediment: Dionysus, 148; 191; Three Goddesses, 133, 148, 150, 162; 192

frieze, 131–33, 149, 192–93; 170; Procession, 192–93, 241, 413; 268; The Sacrifice of King Erechtheus Daughters, 149; 194

metopes, Lapith and Centaur, 150, 155, 192; 195
Parting of Lot and Abraham, The, mosaic (Sta. Maria Maggiore, Rome), 240, 241, 291; 308

Pastoral Landscape, A (Claude Lorraine), 586, 598–99, 628, 668; 796

Pastry Cook, Cologne (Sander), 903; 1214

PATINIR, JOACHIM, 541; Landscape with St. Jerome Removing the Thorn from the Lion's Paw, 541; 714

Paul III, portrait of (Titian), 480, 571; 635

Pauline Borghese as Venus (Canova), 700, 712; 902 Paul Revere (Copley), 41–43; 25

PAXTON, SIR JOSEPH, 741; Crystal Palace (London, England), 716, 741, 874; 962

Pazzi Chapel, Sta. Croce, Florence, Italy (Brunelleschi), 421–22, 434, 437, 470, 499, 670; 544, 545, 546, 547

Peaches and Glass Jar, wall painting (Herculaneum, Italy), 208, 211; 291

Peasant Family (Le Nain), 596, 681, 753; 792 Peasant Wedding (Bruegel), 542–44, 592, 596; 717 pediment, 123–24

PEICHL, GUSTAV, 891; Austrian Radio and Television Studio (Salzburg, Austria), 891; 1194, 1195 Peleus and Thetis ("Marsyas Painter"), 153, 214, 440; 201

Pelkus-Poort (Goyen), 586; 781

Penck, A. R. (Ralf Winkler), 927–29; *The Demon of Curiosity*, 927–29; *1247*

People, Boats, and Animals (Hierakonpolis, Egypt), 61, 123, 270, 305; 50

Peparethus, Greek island, Winged God, coin, 164; 218 Pepper (Weston), 899–900; 1207

Percier, Charles, 712; Château of Malmaison (Rueil-Malmaison, near Paris) (and Pierre-François Fontaine), 712; *921*

Performance Art, 870-71, 916

perfume vase (Proto-Corinthian), 114, 167; 141

Pergamum, Anatolia, Great Pergamum Altar, 137, 159–60, 192; 211; Great Frieze, Athena and Alcyoneus, 137, 160, 162, 192, 214, 217, 461, 498, 564; 213; plan of, 137, 160; 212

Pericles, 130-33

period styles, 24

perpendicular style (Gothic), 336-38, 707, 710

Perrault, Charles, Memoirs, excerpt, 641

Perrault, Claude, 602; east front, third Louvre (Paris), 602, 640, 710; 799

Perret, Auguste, 882; Notre-Dame (Le Raincy, France), 882; 1176

PERRY, LILLA CABOT, "Reminiscences of Claude Monet," excerpt, 938

Persepolis, Palace of Darius and Xerxes, 95; 109; audience hall, 95, 100, 134; 110; bull capital, 95, 96, 134; 111; Darius and Xerxes Giving Audience, relief, 95–96, 122, 192; 112

Perseus and Andromeda (Vasari), 487–88, 496, 499; 643 Persia, Persians, 92, 93

Persian art, 92–97, 122; *see also* Sassanian art *Persistence of Memory, The* (Dalí), 807–8; *1061* perspective: atmospheric, 508; linear, 31–33, 414

PERUGINO, PIETRO, 445–46; *The Delivery of the Keys* (Vatican), 446, 447, 462, 471; 586

Petrarch, 276, 404, 408

PFAFF, JUDY, 869; Dragons, 869; 1150

Phaistos, Crete, beaked jug (Kamares style), 105; 126

pharaohs, 60, 67, 72

Phidias, 150-51, 176

Philadelphia, Pa., Savings Fund Society Building (Howe), 882, 883; 1177

Philippus the Arab, Roman emperor, statue of, 200, 414; 280

PHILOXENUS OF ERETRIA, 152

Phoenicia, 118

photograms, 905, 907

Photographic Society of London, 775

photography: artists' use of, 912–13; documentary, 774–75, 908–12; heroic age of, 904; landscape frontiers, 715–16; motion, 778–79; naturalistic, 776; 19th century, 774–79, 894–97; portraiture, 715; postmodern, 929–31; Romantic period, 712–17; 20th- century, 894–913

photojournalism, 716-17, 894

photomontage, 905-7

Photorealism, 834-36, 913

Photo-Secession, 776–78, 894, 898, 901; gallery (New York), 777

PIANO, RENZO, 892

Piazza del Santo, Padua, Italy, Equestrian Monument of Gattamelata (Donatello), 415; 536

PICASSO, PABLO, 763–64, 788–93, 794, 801–2, 851–52; Blue period, 763–64; Bull's Head, 18–19, 21, 38, 852, 863; 2; Les Demoiselles d'Avignon, 765, 788–91, 802; 1033; Girl Before a Mirror, 29–30, 851; 11; Guernica, 802, 854; 1050; Head of a Woman, 851–52; 1122; Mother and Child, 801; 1048; The Old Guitarist, 764, 788; 991; Portrait of Ambroise Vollard, 790–91, 846, 913; 1034; Portrait of Igor Stravinsky, 790; Still Life with Chair Caning, 793; 1035; Three Dancers, 721, 801–2, 808, 843, 852; 1049; Three Musicians, 801, 843, 890; 1047

pictorialism, 775-76

pictorial space, 31-34

Pierce, Charles Sanders, 931

Piero della Francesca, 431–32, 446 S. Francesco, Arrezzo, Italy, fresco, 431, 432, 549;

Francesco, Arrezzo, Italy, fresco, 431, 432, 549; 561; The Discovery and Proving of the True Cross from, 431; 562

Piero di Cosimo, 444–45; The Discovery of Honey, 444–45; 584

pietà, 351-52

Pietà (Giovanni da Milano), 351–52, 374, 378, 429; 515

Pietà (Michelangelo), 460-61, 485; 606

PIGALLE, JEAN-BAPTISTE, 612; St. Thomas, Tomb of the Maréchal de Saxe (Strasbourg, France), 612, 699; 816

Pilgrimage to Cythera, A (Watteau), 612–13, 616, 617;

Pilgrim's Guide to Santiago de Compostela, 386–97

PINEAU, NICOLAS, 611; Hôtel de Varengeville (Paris), room in, 611, 624; 814

PIRANESI, GIOVANNI BATTISTA, 629, 708; Prison Caprices, Tower with Bridges, 629, 669; 841
Pisa, Italy

Baptistery, 303-4, 434, 670; 397

pulpit (N. Pisano), 353–54; 482; Fortitude from, 354, 461; 484; Nativity from, 353–54, 410; 483

Campanile (Leaning Tower), 303–4, 434, 670; 397 Camposanto, *The Triumph of Death* (Traini), 373–74, 448; 513; drawing for, 374, 449; 514

Cathedral, 303–4, 434, 670; 397; interior, 303, 420; 398; pulpit (G. Pisano), *Nativity* from, 354–55, 358, 390; 485

PISANO, ANDREA DA, 276, 358; *The Baptism of Christ* (from Florence Bapistery doors), 358; 493

PISANO, GIOVANNI, 354-55, 365, 366

Madonna (Prato Cathedral), 355, 366; 486, 487 Pisa Cathedral pulpit: inscriptions on, 390; Nativity from, 354–55, 358, 390; 485

Pisano, Nicola, 358, 366

Pisa Baptistery pulpit, 353–54; 482; Fortitude from, 354, 461; 484; Nativity from, 353–54, 410; 483 PISSARRO, CAMILLE, 722, 727; The Côte des Boeufs at

l'Hermitage, near Pointoise, 722; 935 Pitti, Palazzo, Florence, Italy (Ammanati), 499–500, 546; 662

Pizan, Christine de, *The Book of the City of Ladies*, 395 plans, architectural, Greek, 124–26

Plato, 60, 140, 245; *The Republic*, excerpt, 216–17 Pliny the Elder, 162

Natural History (book), 488; excerpts, on Graeco-Roman art, 213–14

Plotinus, 245; Enneads, excerpt, 219

Plowing in the Nivernais (Bonheur), 686; 883

Plutarch, Parallel Lives of Greeks and Romans, excerpt, 216

POCCETTI, BERNARDINO, 342; drawing of Florence Cathedral, 342, 355; 462

Pointillism, 751, 754

Poissy-sur-Seine, France, Savoye House (Le Corbusier), 879–80, 890, 892; 1171, 1172

Poitiers, France, Notre-Dame-la-Grande, 297–98, 326; 386

Polar Sea, The (Friedrich), 692; 894

pole-top ornament (Luristan [?]), 93, 95, 270; 107

Poliziano, Angelo, 443–44, 474

POLIAIUOLO, ANTONIO DEL, 440, 441, 443, 446; *Battle of the Ten Naked Men*, 440–41, 443; *580; Hercules and Antaeus*, 440, 498; *579*; Labors of Herakles paintings (lost), 444

POLLOCK, JACKSON, 820–21; *Autumn Rhythm: Number* 30, 1950, 732, 820–21; 1079; interview, "My Painting," excerpt, 944

Polybius, Histories, excerpt, 218-19

POLYCLITUS, 140, 158, 176; Doryphorus (Spear Bearer) (Canon of Polyclitus), 140, 141, 146, 191, 213, 415; 183 POLYDORUS OF RHODES, 162 POLYGNOTOS OF THASOS, 151 Pompeii, Italy, 186, 203, 671, 712; The Battle of Issus (Battle of Alexander and the Persians), 142, 152, 192, 209, 238, 314, 535; 199; House of Menander, Portrait of Menander, 281; 366; House of the Silver Wedding, atrium, 175, 186, 235, 671; 255; House of the Vettii, The Ixion Room, 194, 206-8, 209-10, 216, 240, 365, 367, 370; 290; Villa of the Mysteries, Scenes of a Dionysiac Mystery Cult, 206, 209, 232: 289 Pond in a Garden, A (Tomb of Ramose, Thebes, Egypt), 33; 16 Pont-Aven group, 755, 757 Pont du Gard, Nîmes, France, 181, 772; 243 PONTORMO, 483-84; Deposition (Sta. Felicita, Florence), 484, 493; 638 Pop Art, 831-34, 916, 927; British, 832 Pope Innocent X (Velázquez), 571, 825; 758 Pope Leo X with Giulio de' Medici and Luigi de' Rossi (Raphael), 474, 480, 571; 629 Pope Paul III and His Grandsons (Titian), 480, 571; 635 POPOVA, LIUBOV, 794–96; The Traveler, 796, 913; 1039 PORTA, GIACOMO DELLA, 502-3; Il Gesù, facade (Rome), 502-3, 560; 670; St. Peter's, dome (Rome), 459, 470-71, 502, 604; 622 portal, Romanesque and Gothic, parts of, 305; 403 Portinari Altarpiece (Goes), 454, 494, 515; 682 Portland, Ore., Public Services Building (Graves), 917-18, 927, 948; *1232* Portrait Head (Delos, Greek island), 155, 162, 165, 189, 199, 200; 216 Portrait Head (probably Plotinus) (Roman), 200, 245, 247, 414; 281 Portrait of a Boy (Etruscan), 174; 233 Portrait of a Boy (Faiyum, Egypt), 211, 256; 293 Portrait of a German Officer (Hartley), 788; 1032 Portrait of a Lady (Roman), 198-99; 277 Portrait of Ambroise Vollard (Picasso), 790-91, 846, 913; 1034 Portrait of a Physician (Romanesque miniature), 317; 419 Portrait of a Roman (Late Roman), 410; 529 Portrait of a Roman (Roman), 189-90; 262 Portrait of Charles I Hunting (Dyck), 578, 618; 767 Portrait of Igor Stravinsky (Picasso), 790 Portrait of Louis-François Roubiliac (Vispré, attr.), 42, 620: 27 Portrait of Menander (House of Menander, Pompeii, Italy), 281; 366 Portrait of the Artist's Sister Minerva (Anguissola), 488; Portrait Panel of Hesy-ra (Saqqara, Egypt), 63-64, 70; 53 portraiture, 41; Akkadian, 84; Early Christian, 247-49; Egyptian, 67-70, 71-72, 75-76; Etruscan, 174-75; German Renaissance, 537-39; Hellenistic, 162; in photography, 715; Mannerist, 488; moralizing, 42; Roman, 189-90, 198-201, 211; Sumerian, 80-81 "Poseidon, Temple of," Paestum, Italy, 128-30, 131, 706; 164, 166, 167 Post-Impressionism, 28, 800, 845; in music and theater, 758, 766-67; in painting, 746-57 Post-Minimalism, 857 Postmodernism, 914-33

Potato Eaters, The (Gogh), 753; 977

excerpt, 641

Potter's Hands (Renger-Patzsch), 903; 1213

Poussinistes, compared to Rubenistes, 612

pottery, 23; Greek, 111–18; Minoan, 102–6

Potsdam, Germany, Einstein Tower (Mendelsohn), 882;

Poussin, Nicolas, 558, 567, 596-98, 610, 682, 692;

The Abduction of the Sabine Women, 596-98,

660, 680; 794; The Birth of Bacchus, 598; 795;

Cephalus and Aurora, 596; 793; manuscript of,

Praeneste (Palestrina), Italy, Sanctuary of Fortuna Primigenia, 179-80, 560; 240, 241 Prairie School Style, 872, 879 PRANDTAUER, JAKOB, 622; Monastery Church (Melk, Austria), 622; 832 Prato, Italy: Cathedral, Madonna (G. Pisano), 355, 366; 486, 487; Sta. Maria delle Carceri (Sangallo), 437, 564; 572, 573, 574 PRAXITELES, 155-57, 176; Cnidian Aphrodite, 99, 156, 157, 244, 443; 206; Hermes, 156-57, 191, 198, 214, 354; 207 PRAXITELES, attr., Standing Youth, 35-36; 19 Prayer Book of Philip the Fair (Master Honoré), David and Goliath from, 362, 375; 498 PRÉAULT, AUGUSTE, 703-4; Tuerie (Slaughter), 703-4; 906 Precisionism, 804, 805, 817, 835, 901 prehistoric societies, 45; art of, 17, 50-51 pre-Impressionism, 720-22 Pre-Raphaelite Brotherhood, 728-29, 761 Presentation in the Temple, altar panel (Broederlam), 377-78, 506; 519 Prevalence of Ritual: Baptism (Bearden), 829; 1090 Priestess of Bacchus, leaf of diptych (Early Christian), 245-46, 250, 418; 314 Prima Ballerina (Degas), 724, 738; 939 Primaporta, Italy: Augustus, statue, 190-92, 198, 199, 254, 448; 264, 265; Villa of Livia, View of a Garden mural, 204-6, 289; 288 Primary Structures, 855-57 PRIMATICCIO, FRANCESCO, 496; stucco figures (Château, Fontainebleau, France), 496, 539, 547; 658 Primavera (Botticelli), 444-45; 584 primitive art, 17 Prince Rahotep and His Wife Nofret (Giza, Egypt), 68, 86, 170:65 prints, 23, 524; Baroque, 594-95; Romantic, 674 Prison Caprices (Piranesi), Tower with Bridges, 629, 669; 841 Procession (Parthenon, frieze, Acropolis, Athens, Greece), 192-93, 241, 413; 268 Procopius of Caesarea, Buildings, excerpt, 383 profile, Egyptian, 63 Project for a Church (Leonardo), 457-58; 600 Project for a Memorial to Isaac Newton (Boullée), 669, 708, 875; 857 Promenades d'Euclid, Les (Magritte), 808, 905, 911; 1062 Prophet (Zuccone) (Donatello, Campanile, Florence Cathedral), 413-14, 416, 430; 533 Propylaea, Acropolis, Athens, Greece, 133-34, 136, 707; 172, 173, 174 Protestantism, 482, 548 Proto-Baroque, 495–96, 502–3 Provence, Romanesque classicism in, 309 Psalter of St. Louis (French Gothic), Nabash the Ammonite Threatening the Jews at Jabesh from, 360, 365; PSIAX, 115, 117; Herakles Strangling the Nemean Lion, Attic amphora, 114-15, 120, 152, 354; 143 Public Services Building, Portland, Ore. (Graves), 917-18, 927, 948; 1232 PUCELLE, JEAN, Hours of Jeanne d'Evreux: Annunciation from, 358, 375; 516; Betrayal of Christ from, 358, 375; 516 PUGET, PIERRE-PAUL, 606-7; Milo of Crotona, 606-7,

Quarton, Enguerrand, 520; Avignon Pietà, 520; 690 Queen (Flack), 836, 842, 843; 1102 Queen Nefertiti (Egyptian), 75; 79 Queen's Megaron, Palace of Minos, Knossos, Crete, 101, 104, 169; 120 QUERCIA, JACOPO DELLA, 418, 460, 461; The Creation of Adam (S. Petronio, Bologna, Italy), 418, 427, Quince, Cabbage, Melon, and Cucumber (Sanchez Cotán), 569; 756 Raft of the "Medusa," The (Géricault), 676-77, 680, 690, 716-17; 868 RAGGI, ANTONIO, 559; sculpture for ceiling fresco (Il Gesù, Rome), 502, 559, 560, 626; 737 RAIMONDI, MARCANTONIO, The Judgment of Paris (after Raphael), 21, 23, 477, 720; 5 Rain, Steam and Speed - The Great Western Railway (Turner), 691; 891 Rainbow, The (Inness), 733; 950 Raising of the Cross (Rubens), 575-76, 583, 662; 762 Rake's Progress, The (Hogarth): He Revels (The Orgy), engraving, 617, 659, 775; 825; The Orgy from, 617, 659, 728, 775; 824 Ram and Tree (Ur (El Muqieyar), Iraq), 81-82, 93, 102; Ramesses II, 75; court of, Temple of Amun-Mut-Khonsu, Luxor, Egypt, 72-75, 95; 74, 75; pylon of, Temple of Amun-Mut-Khonsu, Luxor, Egypt, 72-75, 95; 74, 75 Ramose, Tomb of, Thebes, Egypt: Mai and His Wife Urel, 75; 77; A Pond in a Garden, 33; 16 Rampin Head, The (Greek), 120, 130-31; 150 Raphael (Raffaello Sanzio), 446, 471–75, 488, 494, 554 La Belle Jardinière, 471-72; 625 Galatea (Villa Farnesina, Rome), 474, 477-79, 485, 488, 554; 628 The Judgment of Paris, 21, 23, 477, 720; 5 letter to Castiglione, excerpt, 633 Pope Leo X with Giulio de' Medici and Luigi de' Rossi, 474, 480, 571; 629 The Sacrifice at Lystra, 475; 630 Stanza della Segnatura, Vatican, frescoes, 472, 598; 626; The School of Athens, 442, 472-73, 474, 598; 627 Rapp, George, 890 RAUSCHENBERG, ROBERT, 863-64; Odalisk, 864, 869; 1143 Ravenna, Italy Mausoleum of Galla Placidia, Good Shepherd, mosaic, S. Apollinare in Classe, 235-36, 238, 249, 263, 280, 301, 302, 303; 300, 301, 302 S. Apollinare Nuovo: The Betrayal of Christ, 241, 376; 309; wall mosaics, 240-41 S. Vitale, 249-50, 257, 276, 301, 562; 317, 318, 319, 320; mosaics: Emperor Justinian and His Attendants, 250, 254, 256, 263, 751; 321; Empress Theodora and Her Attendants, 250, 254, 263, Throne of Maximianus, 254; 329 Rayographs, 907 Ready-mades, 850 realism, 24, 493-95, 780, 799-800; between the wars, 735; 808 Pugin, A. N. Welby, 709-10 815-18; in England, 728-32; in France, pure painting, 720 718-20; in theater, 740; in the United States, Puryear, Martin, 858; The Spell, 858; 1134 732-34; see also naturalism Puvis de Chavannes, Pierre-Cécile, 756, 759; murals "Rebellious Slave, The" (Michelangelo, Tomb of Julius II, for museum, Lyons, France, The Sacred Grove, S. Pietro in Vincoli, Rome), 461-62, 464, 468, Vision of Antiquity, and Christian Inspiration, 731, 735, 736; 610 756, 759; 984 Reclining Nude I (Matisse), 844, 854; 1109 pyramids, Egyptian, 65-67 Recumbent Figure (Moore), 770, 854; 1127

Red Blue Green (Kelly), 827-28; 1088

Red Boats, Argenteuil (Monet), 722; 934

red-figured style, Greek vase painting, 117-18

Redon, Odilon, 761-62; Edgar A. Poe series, The Eye

PYTHOKRITOS OF RHODES (?), 162; Nike of Samothrace,

Pyramid Texts, The (Egyptian), 66; excerpt, 212

PYTHEOS OF PRIENE, 154–55

160-62, 847; 214

Like a Strange Balloon Mounts Toward Infinity from, 761–62; 987

Red Studio, The (Matisse), 759, 782; 1022 Regionalists (American), 817

Reims, France, Cathedral, 331-32; 441, 442

sculpture: Annunciation, 332, 347–48, 350, 353, 354, 410; 471; Melchizedek and Abraham, 332, 348, 360, 365; 472; Visitation, 332, 347–48, 350, 353, 354, 410; 471

REJLANDER, OSCAR, 775, 905; The Two Paths of Life, 775; 1013

relief, 35; Egyptian, 72; Minoan, 102–6; narrative, 192; Persian, 95–96; Roman, 192

Reliefs, Tomb of the, Cerveteri, Italy, 173; 229

religion: eastern, 230–33; Egyptian, 60–61; Minoan, 101–2; Mycenaean, 109; neolithic, 55–57; paleolithic, 52–53; Persian, 94–95; Roman, 177–81; Sumerian, 78–79

REMBRANDT, 582–86, 594, 718; The Blinding of Samson, 583, 584; 776; Christ Preaching, 584; 778; inventory of paintings owned by, excerpts, 640–41; The Night Watch (The Company of Captain Franz Banning Cocq), 549, 583; 777; The Return of the Prodigal Son, 582, 584–86, 753; 780; Self-Portrait, 582, 584; 779; The Star of the Kings, 26, 584; 7

Renaissance: compared to "Late Gothic," 504–21; Early, 408–51, 504, 526–27; High, 452–81, 483, 526–27, 594; Late, 482; music and theater, 464; Northern, 526–47

RENGER-PATZSCH, ALBERT, 903; Potter's Hands, 903; 1213 RENI, GUIDO, 555–56; Aurora, ceiling fresco (Casino Rospigliosi, Rome), 556, 596, 598; 734

RENIER OF HUY (baptismal font, St. Barthélemy, Liège, France), 312, 317, 347, 444; 411

RENOIR, AUGUSTE, 721–22, 727; Le Moulin de la Galette, 722, 750; 936

Restoration style, 712

Resurrection, The (Grünewald), from Isenheim Altarpiece, 527–29, 535; 697, 698

Resurrection, The (Robbia), 438; 576

Return of the Hunters (Bruegel), 542, 554, 578; 716
Return of the Prodigal Son (Rembrandt), 582, 584–86,
753; 780

REYNOLDS, SIR JOSHUA, 619–20, 686, 696; *Discourses* (book), 619; *Mrs. Siddons as the Tragic Muse*, 619, 620, 687; *828*; Royal Academy speech by, excerpt, 643

rhyton: Achaemenid, 96; 113; Knossos, Crete, 102; 122; Mycenae, Greece, 106, 109; 132

Riace Warriors (Greek), 140-43; 184, 185

RIBERA, JUSEPE, 551, 569; St. Jerome and the Angel of Judgment, 551; 727

RICCI, SEBASTIANO, 625, 629

RICHARDSON, HENRY, 772; Marshall Field Wholesale Store (Chicago, Ill.), 772, 773; 1007

Richelieu, Cardinal, 594

RIETVELD, GERRIT, 876; Schröder House (Utrecht, Netherlands), 876; 1164, 1165, 1166

RIIS, JACOB, 774–75, 896; *Bandit's Roost*, 774–75, 898; 1012

Rimini, Italy, S. Francesco (Alberti), 434; 567, 568 Rinaldo and Armida (Dyck), 573, 578; 766

Ripe Age (Claudel), 737; 958

Ritual Branch (White), 908; 1224

Ritual Dance (?), rock engraving (Addaura Cave, Monte Pellegrino (Palermo), Sicily), 53; 33

Rivera, Diego, 808

River-Gods (Roman), detail of sarcophagus, 21, 464, 468, 720, 854; 6

Road to Calvary (Martini), 370, 377, 506; 508

ROBBIA, LUCA DELLA, 437–38; The Resurrection, 438; 576; Trumpet Players (Cantoria, Florence Cathedral), 437; 575

Robert Andrews and His Wife (Gainsborough), 826 Robert de Torigny, Chronicle, 389

Robie House, Chicago, Ill. (Wright), 872, 878; 1154,

Robinson, Henry Peach, 775, 905; Fading Away, 775; 1014

Rococo, 610–29; in Austria, 621–25; in England, 616–21; in France, 610–16; in Germany, 621–25; in Italy, 625–29

RODIN, AUGUSTE, 734–37, 768; "Conversations" with Paul Gsell, excerpt, 939; The Gates of Hell, 735–36; The Kiss, 736, 845; 956; The Man with the Broken Nose, 734, 735, 737; 954; Monument to Balzac, 736–37; 957; The Thinker, 21, 735, 765; 955

Rodin with His Sculptures "Victor Hugo" and the "Thinker" (Steichen), 777-78, 898, 901; 1018

Roebling, John and Washington, 741–42; Brooklyn Bridge (New York, N.Y.), 741–42; 963

Roettgen Pietà (German), 117, 351–52, 374, 390, 416, 461, 514, 529, 802, 908; 479

ROGERS, RICHARD, 892; Centre National d'Art et Culture Georges Pompidou (Paris), 892, 918; 1196 rolls, Early Christian, 241–42

Roman art: ancient, 97, 176–211; Mannerist, 483–88 Romanesque art, 292–318; classicism in, 309 Romanism, 539

Roman Patrician with Busts of His Ancestors, A (Roman), 190, 414; 263

Romanticism, 672–712, 800; architecture, 706–12; compared to Neoclassicism, 658; music and theater, 694–95, 702–3; painting, 672–98; photography, 712–17; sculpture, 698–706

Romanticism Is Ultimately Fatal, from Dreams and Nightmares (Leonard), 911–12; 1229

Rome, Italy

ancient, 190, 209

Apotheosis of Sabina, relief, 197; 274

Ara Pacis, 192–94, 198; 266; Imperial Procession from, 192–93, 198, 241, 245, 348, 413, 414, 437, 448, 551; 267; panels, 194, 413; 269

Arch of Constantine, 197, 202–3, 434, 446; 284; medallions and frieze, 197, 202–3, 232, 244, 254, 415; 285

Arch of Titus, 198; Spoils from the Temple in Jerusalem from, 152, 194, 196, 281, 413; 271; Triumph of Titus from, 97, 152, 195–96, 413; 272

Basilica of Constantine, 185–86, 200–201, 254; 250, 251, 252

Campidoglio (Michelangelo), 469–70; 619, 620; Palazzo dei Conservatori, 470, 609, 710; 621

Casino Rospigliosi, *Aurora*, ceiling fresco (Reni), 556, 596, 598; 734

Colosseum, 97, 181–82, 295, 434, 500; 244, 245 Column of Trajan, 152, 196, 198, 240, 475, 622; 273 Forums, plans of, 181; 242

Il Gesù (Vignola), 502–3, 558–59, 560; 668, 669; facade (Porta), 502–3, 560; 670; sculpture for ceiling fresco (Raggi), 502, 559, 560, 626; 737; Triumph of the Name of Jesus, ceiling fresco (Gaulli), 502, 559, 560, 626; 737

a house, stucco decoration from, 194, 204, 413, 671; 270

a house on the Esquiline Hill, The Laestrygonians Hurling Rocks at the Fleet of Odysseus, wall painting, Odyssey Landscapes from, 204, 216, 289, 373; 287

Old St. Peter's basilica, 234, 235, 278, 293, 421; *297*, 298

Palazzo Barberini, Glorification of the Reign of Urban VIII, ceiling fresco (Cortona), 556–57; 736

Palazzo Farnese (Carracci), ceiling fresco, 553–54, 555, 557, 598; 729, 730

Pantheon, 182–85, 341, 437, 438, 622, 670; 247, 248, 249; painting of (Panini), 182, 183, 304, 437, 629, 708, 876, 888; 246

Sta. Agnese in Piazza Navona (Borromini), 563, 604, 609, 622; 746

S. Carlo alle Quattro Fontane (Borromini), 561–62, 563, 564; *741*, *742*, *743*

Sta. Cecilia in Trastevere, *The Last Judgment, Seated Apostles*, detail (Cavallini), 366; 503

Sta. Costanza, 236, 249, 341, 437; *303*, *304*, *305* S. Ivo (Borromini), 562–63; *744*, *745*

S. Luigi dei Francesi, Contarelli Chapel, paintings for (Caravaggio), 549; 725; The Calling of St. Matthew, 38, 549–51, 565, 581, 595–96, 718; 726

Sta. Maria della Vittoria, Cornaro Chapel (Bernini), 559, 567, 604; *754; The Ecstasy of St. Theresa* (Bernini), 442, 565–67, 612; *753;* fresco (Abbatini), 559, 567, 604; *754*

Sta. Maria Maggiore, *The Parting of Lot and Abraham*, mosaic, 240, 241, 291; 308

St. Paul's Outside the Walls, 186, 234, 235, 293, 303, 315, 420; *299*

St. Peter's (Bramante and Michelangelo), 459, 470–71, 502, 604; 622; colonnade (Bernini), 560, 604, 609, 860; 739; dome (Porta), 459, 470–71, 502, 604; 622; facade (Maderno), 560, 604, 609, 860; 739; The Meeting of Pope Leo I and Attila, sculpture (Algardi), 567–68; 755; nave (Maderno), 560, 564, 604, 609, 860; 739, 740; plan of Bramante, 458, 459, 470; 603, 604; plan of Michelangelo, 470, 560, 604; 623, 624; Tabernacle (Bernini), 560, 564; 740

SS. Pietro e Marcellino, catacomb, ceiling painting, 233–34, 239, 244, 250; *296*

S. Pietro in Montorio, Tempietto (Bramante), 458–59, 470, 608; 601, 602

S. Pietro in Vincoli, Tomb of Julius II: "The Dying Slave" (Michelangelo), 461–62, 464, 468, 731, 736; 609; Moses (Michelangelo), 461–62, 468; 608; "The Rebellious Slave" (Michelangelo), 461–62, 464, 468, 731, 735, 736; 610

Sarcophagus of Meleager, 197–98; 275

Sports Palace (Nervi), 888; 1189, 1190

"Temple of Fortuna Virilis," 177–78, 183; 236, 237 Vatican Palace

Sistine Chapel

ceiling frescoes (Michelangelo), 462–67, 554; 611; The Creation of Adam, 462–64, 551, 731, 778; 612; The Expulsion from the Garden of Eden, 464, 731, 735; 613; Fall of Man, 462–64, 551, 731, 735, 778; 613; Libyan Sibyl, 28, 464, 731, 735; 9; studies for, 26–28; 8

wall frescoes (Michelangelo), *The Last Judgment*, 467; 614; detail, with self-portrait, 467, 471, 495; 615

wall frescoes (Perugino), *The Delivery of the Keys*, 446, 447, 462, 471; 586

Stanza della Segnatura, frescoes (Raphael), 472, 598; 626; The School of Athens, 442, 472–73, 474, 598; 627

Villa Farnesina, *Galatea* (Raphael), 474, 477–79, 485, 488, 554; *628*

Villa Ludovisi, *Aurora*, ceiling fresco (Guercino), 556, 557; *735*

Ronchamp, France, Notre-Dame-du-Haut (Le Corbusier), 882, 885; 1183, 1184, 1185

Rood, O. N., 751 Rose, Joseph, 671

Rossellino, Antonio, 439, 441

468, 699; 577

ROSSELLINO, BERNARDO, 438–39; Tomb of Leonardo Bruni, Sta. Croce (Florence), 409, 438–39,

Rossetti, Dante Gabriel, 728; *Beata Beatrix*, 729, 776; *946*

ROSSO FIORENTINO, 483; Descent from the Cross, 483, 484, 485, 489, 496, 499; 637

ROTHENBERG, SUSAN, 840; Mondrian, 840; 1105

ROTHKO, MARK, 819, 826; Orange and Yellow, 826; 1085

ROUAULT, GEORGES, 761, 782–83; *Head of Christ*, 782, 786, 822; *1023; The Old King*, 782–83; *1024*

ROUBILIAC, LOUIS-FRANÇOIS, 620–21; George Frideric Handel, 620–21; 829

Rouen, France, St.-Maclou, 334–35, 336; 446 ROUSSEAU, HENRI, 764–65, 797; *The Dream*, 764; 992

- Rousseau, Théodore, 684, 733; A Meadow Bordered by Trees, 684; 881
- Royal Academy of Painting and Sculpture (Paris), 601 Royal Pavilion, Brighton, England (Nash), 678, 708, 875, 912
- Royal Photographic Society of Great Britain, 776 Rubenistes, 612
- Rubens, Peter Paul, 28, 573, 574–78, 581, 610; The Battle of Anghiari (after Leonardo), 456, 575, 676; 597; The Garden of Love, 576, 613; 764; Landscape with the Château Steen, 576–78; 765; Medici Cycle (Luxembourg Palace, Paris), Marie de' Medici, Queen of France, Landing in Marseilles (sketch for), 576, 581, 594, 615; 763; The Raising of the Cross, 575–76, 583, 662; 762
- Rucellai, Palazzo, Florence, Italy (Alberti), 434, 468, 546, 920; 566
- RUDE, FRANÇOIS, 701–3; La Marseillaise (Departure of the Volunteers of 1792) (Arc de Triomphe, Paris), 701–3, 705; 904
- Rueil-Malmaison, near Paris, France, Château of Malmaison (Percier), 712; 921; bedroom in (Jacob-Desmalter), 712; 921
- RUHLMANN, EMIL-JACQUES, Hôtel du Collectionneur exhibit (Paris, France, Exposition [1925]), 883; 1179
- RUISDAEL, JACOB VAN, 687; *The Jewish Cemetery*, 586–88, 684, 692; *783*
- Rule of the Antichrist (Signorelli, S. Brizio Chapel, Cathedral, Orvieto, Italy), 446–47, 467; 587
- RUNGE, PHILIPP OTTO, 694–95, 816; *Morning*, 694–95; 895
- Ruskin, John, 691, 709, 731; *The Stones of Venice*, excerpt, 936–37
- Russell, Morgan, 793
- Russia, sculpture in, between the wars, 847–48 RUYSCH, RACHEL, 590; *Flower Still Life*, 590; 787
- Saarinen, Eero, 887; Trans World Airlines Terminal (New York, N.Y.), 887; 1187, 1188
- Sacchetti, Franco, Three Hundred Stories, 393–94
- SACCHI, ANDREA (and JAN MIEL), *Urban VIII Visiting Il*Gesù, 502; 669
- Sack of the City of Hamanu by Ashurbanipal, The (Palace of Ashurbanipal, Nineveh, Iraq), 90–91, 124, 192, 196; 102
- Sacred Grove, The, mural (Puvis de Chavannes, museum, Lyons, France), 756, 759; 984
- Sacrifice at Lystra (Raphael), 475; 630
- Sacrifice of Iphigenia, detail of casket (Byzantine), 266–67; 346
- Sacrifice of Isaac (Ghiberti, Florence Baptistery doors), 357–58, 378, 392, 410, 413, 414, 416–18; 492
- Sacrifice of King Erechtheus' Daughters, The (Parthenon, frieze, Acropolis, Athens, Greece), 149; 194
- SAENREDAM, PIETER, 588; Interior of the Choir of St. Bavo's Church at Haarlem, 588; 784
- SAFDIE, MOSHE, 889; Habitat, EXPO 67 (Montreal, Canada), 889; 1192
- Sailing Craft (Talbot), 714; 924
- Saint: in the following list of places, churches, and artworks, S., SS., St., Sta., Sta., and Sto. are alphabetized as if spelled Saint; entries for sainted persons are listed elsewhere by first name (e.g., Jerome, Saint)
- Sta. Agnese in Piazza Navona, Rome, Italy (Borromini), 563, 604, 609, 622; 746
- S. Ambrogio, Milan, Italy, 300-302; 393, 394
- S. Andrea, Mantua, Italy (Alberti), 434–37, 438–39, 470, 502; 569, 570, 571
- S. Angelo in Formis, Capua, Italy, *The Arrest of Christ*, mural, 315; 417
- St. Anthony Abbot (Grünewald), from Isenheim Altarpiece, 527–29, 825; 696
- S. Apollinare in Classe, Ravenna, Italy, 235–36, 238, 249, 263, 280, 301, 302, 303; 300, 301, 302
- S. Apollinare Nuovo, Ravenna, Italy, wall mosaics, 240–41; *The Betrayal of Christ*, 241, 376; 309

- S. Apollonia, Florence, Italy, *The Last Supper* (Castagno), 432–33, 455; 564
- St. Barthélemy, Liège, France, baptismal font (Renier of Huy), 312, 317, 347, 444; 411
- St. Basil Cathedral, Moscow, Russia, 258–60; 337
- St. Bavo Chapel, Ghent, Belgium, Ghent Altarpiece (Eyck), 506, 509–10; 673, 675; Adam and Eve from, 506, 509–10; 674
- S. Brizio Chapel, Cathedral, Orvieto, Italy, frescoes (Signorelli): *The Damned Cast into Hell*, 447–48; 588; *The Rule of the Antichrist*, 446–47, 467; 587
- S. Carlo alle Quattro Fontane, Rome, Italy (Borromini), 561–62, 563, 564; 741, 742, 743
- St. Catherine, Monastery of, Sinai Peninsula, Virgin and Child Enthroned with Saints and Angels, 256–57, 260; 331
- St. Cecilia (Domenichino), 555, 616; 733
- Sta. Cecilia in Trastevere, Rome, Italy, *The Last Judgment,* Seated Apostles, detail (Cavallini), 366; 503
- St. Charles Borromaeus (Karlskirche), Vienna, Austria (Fischer von Erlach), 621–22; *830*, *831*
- Sta. Costanza, Rome, Italy, 236, 249, 341, 437; 303, 304, 305
- Sta. Croce, Florence, Italy, 340, 341, 342, 419; 457, 458;
 Pazzi Chapel (Brunelleschi), 421–22, 434, 437,
 470, 499, 670; 544, 545, 546, 547; Tomb of
 Leonardo Bruni (Rossellino), 409, 438–39,
 468, 699; 577
- St.-Denis Abbey Church, Paris, France, 321–23, 359–60, 882; 423, 424
- S. Domenico, Orvieto, Italy, Tomb of Guglielmode Braye (Arnolfo di Cambio), 357, 438; 490
- Sto. Domingo de Silos, Spain, monastery, 309–10; *The Doubting of Thomas*, 309–10; 408
- St. Dorothy, woodcut ("Late Gothic"), 523, 530, 784, 814; 692
- St.-Étienne, Caen, France, 298, 300, 326; 387, 392
- Sta. Felicita, Florence, Italy, Deposition (Pontormo), 484,
- S. Francesco, Arrezzo, Italy, frescoes (Piero della Francesca), 431, 432, 549; 561; The Discovery and Proving of the True Cross, 431; 562
- S. Francesco, Rimini, Italy (Alberti), 434; 567, 568
- St. Francis in Ecstasy (Bellini), 429, 449–50, 476, 541; 592
- St. Gall, Switzerland, monastery plan, 278, 286; *362*, *363*
- Ste.-Geneviève, Bibliothèque, Paris, France (Labrouste), 739, 772; 960, 961
- St. George, Salonica, Greece, dome mosaic, 239, 268; 307
- St. George tabernacle, Or San Michele, Florence, Italy (Donatello): St. George, 413, 442–43, 461; 531; St. George and the Dragon, 413, 425; 532
- St.-Gilles-du-Gard, France, Church, portal sculpture, 305, 309–11, 344, 386; 407
- S. Giorgio Maggiore, Venice, Italy (Palladio), 501–2; 666, 667; The Last Supper (Tintoretto), 490, 492, 494; 647
- S. Giovanni (Baptistery), Florence, Italy, 304, 341, 364, 420; 399; doors: The Baptism of Christ (Andrea da Pisano), 358; 493; "Gates of Paradise" (Ghiberti), 416; 538; The Story of Jacob and Esau from, 416–18, 420, 423, 428; 539; The Sacrifice of Isaac (Ghiberti), 357–58, 378, 392, 410, 413, 414, 416–18; 492
- S. Ivo, Rome, Italy (Borromini), 562-63; 744, 745
- St. James Led to His Execution (Mantegna, Ovetari Chapel, Church of the Eremitani, Padua, Italy, destroyed), 448, 530; 589; drawing for, 448– 49; 590
- St. Jerome and the Angel of Judgment (Ribera), 551; 727 St. Jerome in His Study (Dürer), 531
- St. John the Baptist (Berruguete, Cathedral, Toledo, Spain), 496; 656
- St. John the Baptist (Desiderio da Settignano), 439-40;

- St. John the Evangelist, from Gospel Book of Abbot Wedricus, 316–17, 695; 418
- S. Lorenzo, Florence, Italy (Brunelleschi), 419–20, 459, 467; 542, 543, 605; New Sacristy, Tomb of Giuliano de' Medici (Michelangelo), 467–68, 487, 496, 735; 616
- St. Louis, Mo., Wainwright Building (Sullivan), 773–74, 882, 941; 1009
- S. Luigi dei Francesi, Rome, Italy, Contarelli Chapel, paintings for (Caravaggio), 549; 725; The Calling of St. Matthew, 38, 549–51, 565, 581, 595–96, 718; 726
- St. Luke, from Gospel Book of Otto III (Early Medieval), 289–91, 313; 378
- St.-Maclou, Rouen, France, 334-35, 336; 446
- Ste.-Madeleine, Vézelay, France, The Mission of the Apostles, portal sculpture, 308–9, 314, 345, 386; 406
- Sta. Maria degli Angeli, Florence, Italy (Brunelleschi), 422, 437, 457, 458; 549
- Sta. Maria del Carmine, Florence, Italy, Brancacci Chapel, frescoes
- Lippi, 425, 427; 554
- Masaccio, 425; 553; The Expulsion from Paradise, 427, 441, 464; 556; The Tribute Money, 425–27; 555 Masolino, 425, 427; 554
- Sta. Maria del Fiore (Cathedral), Florence, Italy, 340–43, 419; 460, 461; dome, 340–43, 413, 419, 458, 470–71; 459; west facade, 342, 355; 462
- Sta. Maria della Vittoria, Rome, Italy, Cornaro Chapel (Bernini), 559, 567, 604; 754; The Eestasy of St. Theresa (Bernini), 442, 565–67, 612; 753; fresco (Abbatini), 559, 567, 604; 754
- Sta. Maria delle Carceri, Prato, Italy (Sangallo), 437, 564; 572, 573, 574
- Sta. Maria de Naranco, Oviedo, Spain, 280; 364
- Sta. Maria Maggiore, Rome, Italy, The Parting of Lot and Abraham, mosaic, 240, 241, 291; 308
- Sta. Maria Novella, Florence, Italy, *The Holy Trinity with*the Virgin, St. John, and Two Donors, fresco
 (Masaccio), 423, 425, 427–28, 429, 430, 448,
 473, 492; 551, 552
- St. Mark, from Gospel Book (Corbie, France), 305, 313, 314, 316; 414
- St. Mark, from Gospel Book of Archbishop Ebbo of Reims (Early Medieval), 281, 291, 312, 313, 318; 367
- St. Mark (Donatello, Or San Michele, Florence), 410; 530
- St. Mark's, Venice, Italy, 258, 343, 437; 335, 336; Apostles (Masegne), 357; 491; The Tetrarchs, 200; 282
- St. Matthew, from Gospel Book of Charlemagne (Early Medieval), 280–81, 291, 317; 365
- St. Matthew and the Angel (Savoldo), 493, 549; 651
- St. Michael's Cathedral, Hildesheim, Germany, 286, 293; 372, 373, 374
- Bronze Doors of Bishop Bernward, 286–89, 304, 310–11; *375; Adam and Eve Reproached by the Lord* from, 289, 311, 312, 318; *376*
- St. Pantaleon, Cologne, Germany, Westwork, 285–86; 371
- St. Panteleimon, Nerezi, Macedonia, *Lamentation*, fresco, 264–65, 347, 368; 343
- St. Paul's Outside the Walls, Rome, Italy, 186, 234, 235, 293, 303, 315, 420; *299*
- St. Paul's Cathedral, London, England (Wren), 608–9, 669; 810, 811, 812
- St. Peter's, Rome, Italy (Bramante and Michelangelo), 459, 470–71, 502, 604; 622; colonnade (Bernini), 560, 604, 609, 860; 739; dome (Porta), 459, 470–71, 502, 604; 622; facade (Maderno), 560, 604, 609, 860; 739; The Meeting of Pope Leo 1 and Attila, sculpture (Algardi), 567–68; 755; nave (Maderno), 560, 564, 604, 609, 860; 739, 740; plan of Bramante, 458, 459, 470; 603, 604; plan of Michelangelo, 470, 560, 604; 623, 624; Tabernacle (Bernini), 560, 564; 740

S. Petronio, Bologna, Italy, *The Creation of Adam* (Quercia), 418, 427, 464; 540

St.-Pierre, Caen, France, choir (Sohier), 544–45; 719
St.-Pierre, Moissac, France, portal sculpture, 305–6, 344, 386; 401; Annunciation, Visitation, and Adoration of the Magi, 306, 309, 310, 386; 402

SS. Pietro e Marcellino, Rome, Italy, catacomb, ceiling painting, 233–34, 239, 244, 250; *296*

S. Pietro in Montorio, Rome, Italy, Tempietto (Bramante), 458–59, 470, 608; 601, 602

S. Pietro in Vincoli, Rome, Italy, Tomb of Julius II: "The Dying Slave" (Michelangelo), 461–62, 464, 468, 731, 736; 609; Moses (Michelangelo), 461–62, 468; 608; "The Rebellious Slave" (Michelangelo), 461–62, 464, 468, 731, 735, 736; 610

St.-Riquier (Centula), near Abbeville, France, Abbey Church, 278–79, 286, 293, 303; *360, 361*

St.-Savin-sur-Gartempe, France, Church, 297, 314, 338, 882; 385; The Building of the Tower of Babel, murals, 297, 314, 520; 416

St. Sebald, Nuremberg, Germany, 338, 624–25; 454

St. Sebastian (Grünewald), from Isenheim Altarpiece, 527–29, 825; 696

St. Sebastian (Mantegna), 449; 591

St. Serapion (Zurbarán), 573, 660; 760

St.-Sernin, Toulouse, France, 293–95, 303, 322, 325, 386; 380, 381, 382, 383; Apostle, sculpture, 305, 309, 311; 400

Sto. Spirito, Florence, Italy (Brunelleschi), 422, 436; 548
St. Theodore, portal sculpture (Cathedral, Chartres, France), 347, 351, 353, 413; 468

St. Thomas, Strasbourg, France, Tomb of the Maréchal de Saxe (Pigalle), 612, 699; 816

Sto. Tomé, Toledo, Spain, *The Burial of Count Orgaz* (Greco), 490–92, 567, 764; 648, 649

St.-Urbain Cathedral, Troyes, France, 334–35; 444, 445
S. Vitale, Ravenna, Italy, 249–50, 257, 276, 301, 562; 317, 318, 319, 320

mosaics: Emperor Justinian and His Attendants, 250, 254, 256, 263, 751; 321; Empress Theodora and Her Attendants, 250, 254, 263, 751; 322

St. Wolfgang Altarpiece (Pacher), 521–23, 527, 638; 691 S. Zaccaria, Venice, Italy, Madonna and Saints (Bellini), 450, 479; 593

Salisbury, England, Cathedral, 336; 448, 449, 450
Salisbury Cathedral from the Meadows (The Rainbow)
(Constable), 689–90, 692; 889

SALLE, DAVID, 927; Miner, 927; 1246

Salome (Beardsley), 761, 763; 986

Salonica, Greece, St. George, dome mosaic, 239, 268; 307

Saltcellar of Francis I (Cellini), 496, 547; 657

Salzburg, Austria, Austrian Radio and Television Studio (Peichl), 891; 1194, 1195

Samos, Greek island, "Hera," 121, 122, 123; 151

SANCHEZ COTÁN, JUAN, 569, 615; Quince, Cabbage, Melon, and Cucumber, 569; 756

SANDER, AUGUST: Face of Our Time (book), 903; Pastry Cook, Cologne, 903; 1214

Sangallo, Antonio da, the Younger, 470

SANGALLO, GIULIANO DA, 437; Sta. Maria delle Carceri (Prato, Italy), 437, 564; *572*, *573*, *574*

Sansovino, Jacopo, 499–500; Library of St. Mark's (Venice, Italy), 500, 712; *663*; Mint (Venice, Italy), 500, 712; *663*

Santa Fe, New Mexico (Frank), 910; 1226

SANT'ELIA, ANTONIO, 876; Central Station Project for Cittá Nuova, 876, 889; 1163

Saqqara, Egypt

funerary district of King Djoser, 64, 65, 75, 136; *57*, *58 Portrait Panel of Hesy-ra*, 63–64, 70; *53*

Seated Scribe, 68-70; 66

Step Pyramid of King Djoser, 64, 65, 66, 127, 840; 55, 56

Tomb of Horemheb, Workmen Carrying a Beam, 76, 105, 122; 81

Tomb of Ti: Cattle Fording a River, 61, 71, 124; 69;

Ti Watching a Hippopotamus Hunt, 61, 70, 122, 169; 68

Sarah Bernhardt (Nadar), 715, 901; 925

sarcophagus (Cerveteri, Italy), 169, 170, 174; 224, 225 Sarcophagus of Junius Bassus, 239, 243–44, 263, 354, 366; 312; Christ Enthroned from, 243, 317; 313

Sargon II, 89; citadel of, Dur Sharrukin (Khorsabad), Iraq, 89–90, 91–92, 95, 100, 122; *100, 101*

Sargon of Akkad, 83-84

Sassanian art, 96-97

Satyr and Bacchante (Clodion), 611–12, 704; 815

Saunders, Raymond, 830; White Flower Black Flower, 830; 1092

Saussure, Ferdinand de, 931-32

Savings Fund Society Building, Philadelphia, Pa. (Howe), 882, 883; 1177

SAVOLDO, GIROLAMO, 493; St. Matthew and the Angel, 493, 549; 651

Savonarola, Girolamo, 444, 460; a sermon of, quoted, 630–31

Savoye House, Poissy-sur-Seine, France (Le Corbusier), 879–80, 890, 892; 1171, 1172

Saxe, Maréchal de, Tomb of, St. Thomas, Strasbourg, France (Pigalle), 612, 699; 816

Scenes from Genesis (Wiligelmo, Cathedral, Modena, Italy), 310–11; 409

Scenes of a Dionysiac Mystery Cult (Villa of the Mysteries, Pompeii, Italy), 206, 209, 232; 289

Scenes of Country Life (Martini, Palace of the Popes, Avignon, France), 376; 517

SCHINKEL, KARL FRIEDRICH, 706–7; Altes Museum (Berlin, Germany), 706–7, 920; 909

Schliemann, Heinrich, 98

Schongauer, Martin, 493, 525; *The Temptation of St. Anthony*, 525, 527, 530, 762, 814; *694*

School of Athens, The, fresco (Raphael, Stanza della Segnatura, Vatican), 442, 472–73, 474, 598; 627

Schröder House, Utrecht, Netherlands (Rietveld), 876; 1164, 1165, 1166

SCOPAS, 155, 156

SCOPAS (?), Battle of the Greeks and Amazons (Mausoleum, Halicarnassus, Anatolia), 137, 155, 192, 198, 231; 203

Scream, The (Munch), 21, 762, 763, 825, 843, 912; 989 sculpture, 23, 25, 34–36

cultures: Akkadian, 84; Archaic Greek, 118–24; Early Christian, 242–49; Early Medieval, 284–85; Egyptian, 67–70; Greek, 114, 154–58; Hellenistic, 158–62; Minoan, 101–2, 105–6; Mycenaean, 109; Roman, 188–203; Romanesque, 304–12; Sumerian, 80–81

styles: Baroque, 564–68, 606–7; classical, 139–51; Cubist, 845–46; Early Renaissance, 410–18, 437–43; Gothic, 344–58; Impressionist, 734–38; "Late Gothic," 521–23; Mannerist, 496–98; Neoclassic, 664–67; Postmodern, 923–26; Renaissance, 19, 544–47; Rococo, 611–12, 620–21; Romantic, 698–706; Surrealist, 850–52; Symbolist, 765–68

20th-century, 844–71; before World War I, 844–47; between the wars, 847–55; since 1945, 855–71 See also relief; statues

Sculpture with Color (Oval Form), Pale Blue and Red (Hepworth), 854–55; 1128

Scuola di San Rocco, Venice, Italy, Christ Before Pilate (Tintoretto), 489; 646

Seagram Building, New York, N.Y. (Mies and Johnson), 883, 884–85, 917, 922; 1181

Seated Apostles, detail, The Last Judgment (Cavallini, Sta. Cecilia in Trastevere, Rome), 366; 503

Seated Scribe (Saqqara, Egypt), 68-70; 66

Seated Woman (La Méditerranée) (Maillol), 765–66, 802, 845; 994

Secession movements, 763, 776, 883, 894, 898 Second Empire style, 710, 712

SEGAL, GEORGE, 867; Cinema, 867; 1148

self-expression, 24 Self-Portrait (Cézanne), 746–47, 782; 969 Self-Portrait (Dürer), 530, 538, 755; 701

Self-Portrait (Gogh), 755, 785; 979

Self-Portrait (Kokoschka), 785; 1028

Self-Portrait (Modersohn-Becker), 765; 993

Self-Portrait (Parmigianino), 484-85; 639

Self-Portrait (Rembrandt), 582, 584; 779

Self-Portrait with Model (Kirchner), 783–84; 1025 Self-Portrait with Thorn Necklace (Kahlo), 808; 1063

semiotics, 915–16, 931–32 Semites, 83–84

Sesostris III, pharaoh, portrait of, 71–72; 70

SEURAT, GEORGES, 28, 750–51; Chahut, 751, 759; 974; The Couple, 751; 973; A Sunday on the Island of La Grande Jatte, 750–51, 900; 972

Severe style, 140, 141, 143-44, 164, 765

shamans, 17

Shapiro, Joel, 857; Untitled, 857; 1133

Shapur I, Palace of, Ctesiphon, Iraq, 97; 115

Shapur I Triumphing over the Emperors Philippus the Arab and Valerian (Naksh-i-Rustam (near Persepolis), Iran), 97, 200; 114

SHERMAN, CINDY, 930–31; interview with, excerpt, 949; Untitled Film Still 2, 930; 1251

She-Wolf (Etruscan), 174, 218, 312; 232

"Sibyl, Temple of the," Tivoli, Italy, 179, 182, 188, 437; 238, 239

Side Glance (Doisneau), 897; 1204

367-68, 393; 500

Siena, Italy

Cathedral

baptismal font, *The Feast of Herod* (Donatello), 414, 418, 428, 441; 534

Maestà Altar (Duccio): Annunciation of the Death of the Virgin from, 365, 375, 393; 501; Christ Entering Jerusalem from, 365, 370, 393, 762; 502; Madonna Enthroned from, 364–65, 366,

Palazzo Pubblico

frescoes (A. Lorenzetti): The Commune of Siena, 370–73, 381; 510; Good Government in the City, 370–73, 381, 394, 427, 429; 510, 511; Good Government in the Country, 370–73, 381, 394, 429; 510, 512

inscriptions on frescoes in, 394

SIGNORELLI, LUCA, 446; S. Brizio Chapel, Cathedral, Orvieto, Italy, frescoes: *The Damned Cast into Hell*, 447–48; 588; *The Rule of the Antichrist*, 446–47, 467; 587

Signs of the Zodiac, sculpture (Cathedral, Amiens, France), 348, 349, 378, 379; 474

Sigüenza, Fray José de, from the *History of the Order of St. Jerome*, 637

Silenus, coin (Naxos, Greek island), 164; 219

silk, woven (Sassanian), 97, 274; 116

Silver Wedding, House of the, Pompeii, Italy, atrium, 175, 186, 235, 671; 255

Simultaneous Contrasts: Sun and Moon (Delaunay), 793;

Sinai Peninsula, Monastery of St. Catherine, Virgin and Child Enthroned with Saints and Angels, 256– 57, 260; 331

sinopie, 374

Siphnians, Treasury of the, Delphi, Greece, 123–24, 126, 136, 137, 149; *156, 157; Battle of the Gods and Giants* from, 123–24, 139, 149, 155, 160;

Siskind, Aaron, 908; New York 2, 908; 1223

Sistine Chapel, Vatican Palace, Rome, Italy

ceiling frescoes (Michelangelo), 462–67, 554; 611; The Creation of Adam, 462–64, 551, 731, 778; 612; The Expulsion from the Garden of Eden, 464, 731, 735; 613; The Fall of Man, 462–64, 551, 731, 735, 778; 613; Libyan Sibyl, 28, 464, 731, 735; 9; studies for, 26–28; 8

wall frescoes (Michelangelo), *The Last Judgment*, 467; 614; detail, with self-portrait, 467, 471, 495; 615

wall frescoes (Perugino), *The Delivery of the Keys*, 446, 447, 462, 471; 586

SITE Projects, Inc., 918; Best Stores Showroom (Houston, Tex.), 918; *1233*

Sketch I for "Composition VII" (Kandinsky), 786, 803–4, 820; 1030

skyscrapers, 882-83

Slave Ship, The (Turner), 680, 690-91, 731; 890

Sleep of Reason Produces Monsters, The, from Los Caprichos (Goya), 673, 761, 762, 797; 862

SLUTER, CLAUS, 352–53, 357; The Moses Well (Chartreuse de Champmol, Dijon, France), 353, 378, 414; 481; portal sculpture (Chartreuse de Champmol, Dijon, France), 352–53, 510; 480

SMITH, DAVID, 844, 856; *Cubi* series: *Cubi* XVII, XVIII, and XIX from, 856; 1131

SMITH, W. EUGENE, 908; Tomoko in Her Bath, 908; 1225

SMITHSON, ROBERT, 862; Spiral Jetty, 862; 1141 Snake Goddess (Priestess?) (Knossos, Crete), 102, 109; 121 Snap the Whip (Homer), 733; 951

SNYDERS, FRANS, 579–80; Market Stall, 580; 770

SOANE, JOHN, 708; Bank of England, Consols' Office (London, England), 708, 876; 916

Soap Bubbles (Chardin), 33; 15

Social Realists (American), 817

Soest, Konrad von, 380; *The Wildungen Altarpiece*, 380; 523

SOHIER, HECTOR, 544–45; St.-Pierre, choir (Caen, France), 544–45; 719

SOLIMENA, FRANCESCO, 560

Solomon R. Guggenheim Museum, New York, N.Y. (Wright), 37, 670, 872; 21, 22

SOUFFLOT, JACQUES-GERMAIN, 669; Panthéon (Ste.-Geneviève, Paris), 669, 670, 708; 856

Sower, The (Millet), 681, 684, 718, 753; 882 space, 36–37

Spain, art: Baroque, 548–49, 569–73; Early Medieval, 278–80; Romanesque, 309–12; Romantic, 672–75

Spalato, Balkans, Palace of Diocletian, 188, 560; 260 Spell, The (Puryear), 858; 1134

Speyer, Germany, Cathedral, 302; 395

Spiral Jetty (Smithson), 862; 1141

Spoils from the Temple in Jerusalem, reliefs (Arch of Titus, Rome), 152, 194, 196, 281, 413; 271

Sports Palace, Rome, Italy (Nervi), 888; 1189, 1190 Stag (Kostromskaya, Russia, Scythian), 93, 96, 270; 108 Stag at Sharkey's (Bellows), 799; 1046

stained glass, French Gothic, 358–59

Standard of Ur, inlay panel (Ur (El Muqieyar), Iraq), 83: 93

Standing Youth (Kouros), Greek, 119–20, 139; 147 Standing Youth (Kritios Boy) (Kritios, attr.), 139–40, 144, 415; 182

Standing Youth (Lehmbruck), 768; 997

Standing Youth (Praxiteles, attr.), 35-36; 19

Stanza della Segnatura, Vatican, frescoes (Raphael), 472, 598; 626; The School of Athens from, 442, 472–73, 474, 598; 627

Star of the Kings, The (Rembrandt), 26, 584; 7 State Hospital, The (Kienholz), 867–68; 1149

Statue of Liberty, New York, N.Y. (Bartholdi), 705–6, 742, 802; 908

statues: freestanding, 35–36, 119, 123; Greek, movement in, 145–46

statuettes, Hellenistic, 162

Steel Structure (Goeritz, The Echo (museum), Mexico City), 855; 1129

STEEN, JAN, 590–92, 697; The Feast of St. Nicholas, 590, 617, 659; 788

Steerage, The (Stieglitz), 898; 1205

STEICHEN, EDWARD, 776–78, 901–2; Greta Garbo, 715, 901–2; 1210; Rodin with His Sculptures "Victor Hugo" and the "Thinker," 777–78, 898, 901; 1018

Steiner House, Vienna, Austria (Loos), 874; 1157 STELLA, FRANK, 828; Empress of India, 828; 1089

STELLA, JOSEPH, 804–5; *Brooklyn Bridge*, 742, 804–5, 875; 1056

stereophotography, 716

STIEGLITZ, ALFRED, 776–77, 788, 898–99; Equivalent scries, *Equivalent* from, 899; *1206; The Steerage*, 898: *1205*

Stieglitz Group, 800, 804, 815, 898-903

Stijl, De, 805, 849, 876, 878

Stile Liberty, 769

still life: Dutch Baroque, 588–90, 615; Netherlands Renaissance, 540–41

Still Life (Daguerre), 714; 923

Still Life (Heda), 589; 785

Still Life with Apples in a Bowl (Cézanne), 747; 970 Still Life with Chair Caning (Picasso), 793; 1035

STIRLING, JAMES, 919–20; Neue Staatsgalerie (Stuttgart, Germany), 918; 1234

Stone Age, see Neolithic art; Paleolithic art Stone Breakers, The (Courbet), 718; 930

Still Life with Parrots (Heem), 589-90; 786

Stone Breakers, The (Courbet), 718; 930 Stonehenge, Salisbury Plain (Wiltshire), England, 58,

126, 854, 855; 46, 47, 48 Story of Adam and Eve, The, illustration for Boccaccio's

Des cas des nobles hommes et femmes (Boucicaut Master), 378–79, 505, 514; 521

Story of Jacob and Esau, The, from "Gates of Paradise" (Chibarri, Florance Reprinterer deors), 416, 18

(Ghiberti, Florence Baptistery doors), 416–18, 420, 423, 428; 539

Story of Sinuhe, The, Egyptian, excerpt, 212

Stourhead, England, landscape garden with Temple of Apollo (Flitcroft), 668–69; 855

Strasbourg, France: Cathedral, *Death of the Virgin*, portal sculpture, 318, 347, 350, 377, 513; 470; St.

Thomas, Tomb of the Maréchal de Saxe (Pigalle), 612, 699; 816

Strawberry Hill, Twickenham, England (Walpole), 707–8; 910, 911

Street Life in London (Thomson), 774

Stryker, Rov, 904

STUART, GILBERT, 696

STUBBS, GEORGE, 663–64; Lion Attacking a Horse, 663–64, 703, 787; 848

stucco decoration, Roman, 194

Studio of a Painter: A Real Allegory Summarizing My Seven Years of Life as an Artist (Courbet), 718–20, 733; 931

Sturm, Der (The Storm), 785

Stuttgart, Germany: Neue Staatsgalerie (Stirling), 918; 1234; University, Hysolar Research Institute (Behnisch and Partner), 921; 1236

style, 23-24

Style Moderne, Le, 883

sublime, the, 664

SUDEK, JOSEF, 903–4; View from Studio Window in Winter, 904; 1215

Suger of St. Denis, Abbot, 321–23, 358–59; writings: On the Consecration of the Church of St.-Denis, 388; On What Was Done Under His Administration, 389

Suitor, The (Vuillard), 759, 782; 983

SULLIVAN, LOUIS, 770, 773–74, 884; Carson Pirie Scott & Company Department Store (Chicago, Ill.), 773–74, 874; 1010, 1011; essay, "The Tall Office Building Artistically Considered," excerpt, 940–41; Wainwright Building (St. Louis, Mo.), 773–74, 882, 941; 1009

Sumerian art, 78-88; narrative, 90-91

Summer Landscape, from Carmina Burana, manuscript (Romanesque), 318, 810; 422

Sunday on the Island of La Grande Jatte, A (Seurat), 750–51, 900; 972

Suprematism, 796, 847-48, 921

Suprematist Composition: White on White (Malevich), 796; 1041

Surrealism, 802, 807–9, 819; in photography, 896, 905, 911; in sculpture, 850–52

Surrounded Islands, Project for Biscayne Bay, Greater Miami, Florida, drawing for (Christo), 863;

Susa, Iran, painted beaker from, 92-93; 106

Sutter, David, 751

Sutton Hoo, England, ship burial, purse cover from, 270: 350

Switzerland, "Late Gothic" painting in, 518-20

Symbolism, 755, 757–68, 797, 800; in painting, 757–65; in sculpture, 765–68

Symbol of St. Mark, from Echternach Gospels (Hiberno-Saxon), 274, 281, 360; 354

Synthetic Cubism, 793, 801, 806, 849 Synthetism, 755

 $T_{aj\ Mahal,\ 708}$

TALBOT, WILLIAM HENRY FOX, 713–14; Sailing Craft, 714; 924

talent, artistic, 21-23

Talenti, Francesco, 276, 341, 342

Tanagra figures, 162

TANNER, HENRY O., 734; The Banjo Lesson, 734; 953

Tansey, Mark, 929; Derrida Queries De Man, 929; 1248

Tap: Investigation of Memory installation (Howard), 926; 1245

Target with Four Faces (Johns), 38-41, 832; 24

Tarquinia, Italy: Tomb of Hunting and Fishing, 115, 169; 226; Tomb of the Lionesses, Musicians and Two Dancers, 115, 169–70; 227

Tassel House, Brussels, Belgium, stairway (Horta), 769;

Tasso, Torquato, *Jerusalem Freed* (poem), 578 taste, 24–25

TATLIN, VLADIMIR, 796, 847–48; Monument to the Third International, model, 848; 1115

TAUT, BRUNO, 875; "Glass House" (Cologne, Germany, Werkbund Exhibition [1914]), 875; 1160,

Te, Palazzo del, Mantua, Italy (Giulio Romano), 498, 918; 660

Tell Asmar, Iraq, Abu Temple, statues, 80–81, 88; *89* tempera, 363, 428

Tempest, The (Giorgione), 476–77, 480, 542, 554, 588, 613; 631

Tempietto, S. Pietro in Montorio, Rome, Italy (Bramante), 458–59, 470, 608; 601, 602

temples: Archaic Greek, 122–24; Etruscan, 173–74; 230; Greek, 126, 138; 163; Mycenaean, 109; Sumerian, 79–80

Temptation of St. Anthony (Schongauer), 525, 527, 530, 762, 814; 694

"Ten Characters" installation (Kabakov), The Man Who Flew into Space from His Apartment from, 924; 1242

Terbrugghen, Hendrick, The Calling of St. Matthew, 581, 829: 771

Tetrarchs, The (St. Mark's, Venice, Italy), 200; 282 textiles, Sassanian, 97

theater

cultures: Greek, 137–38, 146; Medieval, 326–27; Roman, 209

styles: Baroque, 569, 600–601, 607; Early Renaissance, 442; High Renaissance, 464; in the Mannerist age, 486–87; Neoclassical, 667; in the Netherlands, 586; in the Northern Renaissance, 535; in the Post-Impressionist era, 766–67; Postmodernism in, 928; Realist, 740; Rococo, 628; Romantic Movement in, 694–95

20th century: before World War I, 795; between the wars, 812–13; since World War II, 824–25

Theater, Cologne, Germany, Werkbund Exhibition (1914) (Velde), 772, 875, 882; 1005, 1006

Thebes, Egypt, 72

Tomb of Ramose: Mai and His Wife Urel, 75; 77; A Pond in a Garden, 33; 16

Tomb of Tutankhamen: coffin cover, 76–77, 106, 211; 82; Tutankhamen Hunting, 61, 77, 91; 83

Theodore the Studite, Refutation of the Iconoclasts, excerpt, 383

Theophilus Presbyter, On Divers Arts: The Art of the Worker in Glass, 392–93

Thinker, The (Rodin), 21, 735, 765; 955 Third-Class Carriage, The (Daumier), 681, 722, 753,

Third of May, 1808, The (Goya), 595, 675; 864 Tholos, Epidaurus, Greece, Corinthian capital from, 137, 769; 176

Thomas Aquinas, Saint, 275-76, 320 THOMSON, JOHN, Street Life in London, 774

THORVALDSEN, BERTEL, 700; Venus, 700; 903

Three Dancers (Picasso), 721, 801-2, 808, 843, 852; 1049

Three Deities, carving (Mycenae, Greece), 109; 137 Three Flags (Johns), 832-33; 1096

Three Goddesses (Parthenon, east pediment, Acropolis, Athens, Greece), 133, 148, 150, 162; 192

Three Musicians (Picasso), 801, 843, 890; 1047 Throne of Maximianus (Ravenna), 254; 329

Ti, Tomb of, Saqqara, Egypt: Cattle Fording a River, 61, 71, 124; 69; Ti Watching a Hippopotamus Hunt, 61, 70, 122, 169; 68

TIEPOLO, GIOVANNI BATTISTA, 626, 658, 672; frescoes (Kaisersaal, Residenz, Würzburg, Germany), 624, 626; 834, 837; The Marriage of Frederick Barbarossa, 615, 626; 838

Tiger Devouring a Gavial of the Ganges (Barye), 703; 905 TINTORETTO, JACOPO, 489-90; Christ Before Pilate (Scuola di San Rocco, Venice, Italy), 489; 646; The Last Supper (S. Giorgio Maggiore, Venice, Italy), 490, 492, 494; 647

 $Titian,\ 28-29,\ 477-80,\ 493,\ 494;\ \textit{Bacchanal},\ 477-79,$ 493, 496, 542, 554, 576, 596, 781; 632; Christ Crowned with Thorns, 480, 489; 636; Danaë, 28, 480, 613; 10; Madonna with Members of the Pesaro Family, 479, 489; 633; Man with the Glove, 479-80, 493, 584; 634; Pope Paul III and His Grandsons, 480, 571; 635

Tivoli, Italy, "Temple of the Sibyl," 179, 182, 188, 437; 238, 239

Ti Watching a Hippopotamus Hunt (Tomb of Ti, Saqqara, Egypt), 61, 70, 122, 169; 68

Toilet of Venus (Boucher), 614-15, 616, 626; 819

Toilet of Venus (Vouet), 599, 614; 797

Toilette de la Mariée, La (Ernst), 807, 820; 1060 Toledo, Spain: Cathedral, St. John the Baptist (Ber-

ruguete), 496; 656; Sto. Tomé, The Burial of Count Orgaz (Greco), 490-92, 567, 764; 648, 649

To Listen (Edwards), 858; 1136

tombs: Egyptian, 60-61, 64, 70-71; Etruscan, 166-73; Gothic, 356; Mycenaean, 106-9

Tomoko in Her Bath (Smith), 908; 1225

tonalism, 28

tools, 50-51

"Toreador Fresco" (Minoan), 104, 105, 108; 125

To the Unknown Painter (Kiefer), 840; 1104

Toulouse, France, St.-Sernin, 293-95, 303, 322, 325, 386; 380, 381, 382, 383; Apostle, sculpture, 305, 309, 311; 400

Toulouse-Lautrec, Henri De, 752, 762, 764; At the Moulin Rouge, 752, 896; 975; La Goulue, 752; 976

Tournai, Flanders, Cathedral, 303; 396

Tower of Babel, 79 Tower with Bridges, Prison Caprices (Piranesi), 629, 669;

tradition in art, 21-23

TRAINI, FRANCESCO, 373-74; The Triumph of Death (Camposanto, Pisa, Italy), 373-74, 448; 513; drawing for, 374, 449; 514

Trajan, Roman emperor, Head of, 199; 278

Transformation of Energy (Abbott), 779, 907-8; 1222 Trans World Airlines Terminal, New York, N.Y. (Saari-

nen), 887; 1187, 1188

Traveler, The (Popova), 796, 913; 1039 Très Riches Heures du Duc de Berry, Les (Limbourg Brothers), 542; calendar page, 335-36, 379, 429, 505, 520, 684; 522

Tribute Money, The, fresco (Masaccio, Brancacci Chapel,

Sta. Maria del Carmine, Florence), 425-27; 555 Trier, Germany (?): The Doubting of Thomas, 291; 379; Moses Receiving the Law, 291; 379

Triumph of Death, The (Traini, Camposanto, Pisa, Italy), 373-74, 448; 513; drawing for, 374, 449; 514 Triumph of Love (Michelangelo), 486

Triumph of the Name of Jesus (Gaulli, Il Gesù, Rome), ceiling fresco, 502, 559, 560, 626; 737

Triumph of Titus, reliefs (Arch of Titus, Rome), 97, 152, 195-96, 413; 272

Troyes, France, St.-Urbain, 334-35; 444, 445 Trumpet Players (Robbia, Cantoria, Florence Cathedral), 437; 575

Truth (Lemieux), 930; 1250

Tsar Cannon Outside the Spassky Gate, Moscow, stereophotograph (19th century), 716; 928

TSCHUMI, BERNARD, 921-22

Parc de la Villette (Paris), 921-22; 1237; Folie P6 from, 922; 1238

Tub, The (Degas), 724-26, 802; 940

Tuerie (Slaughter) (Préault), 703-4; 906

Turin, Italy: Cathedral (Guarini), 563-64, 669; 749, 750; Palazzo Carignano (Guarini), 563; 747, 748

TURNER, JOSEPH MALLORD WILLIAM, 664, 690-91, 692; Childe Harold's Pilgrimage: Italy, 690; The Destruction of Sodom or Snowstorm, 690; Fallacies of Hope (poem), 690, 692; Hannibal Crossing the Alps, 690; Rain, Steam and Speed - The Great Western Railway, 691; 891; The Slave Ship, 680, 690-91, 731; 890

Tuscany, Romanesque architecture in, 303-4 Tutankhamen, 76-77

Tomb of, Thebes, Egypt: coffin cover, 76-77, 106, 211; 82; Tutankhamen Hunting, 61, 77, 91; 83 TV Buddha (Paik), 923; 1240

Twickenham, England, Strawberry Hill (Walpole), 707-8; 910, 911

Twittering Machine (Klee), 809-10; 1065 Two Forms (Moore), 853-54, 858, 901; 1126 291 (New York gallery), 898 Two Paths of Life, The (Rejlander), 775; 1013 typographic design, 23

UCCELLO, PAOLO, 432, 448; Battle of San Romano, 432, 456; 563

UELSMANN, JERRY, 911; speech, "Some Humanistic Considerations of Photography," excerpt, 948; Untitled, 911: 1228

Uffizi, Palazzo degli, Florence, Italy (Vasari), 498-99;

Ulu Mosque, Erzurum, Turkey, 564; 751

Union Trust Company, Detroit, Mich. (Bowland), 884;

Unique Forms of Continuity in Space (Boccioni), 847, 876; 1114

d'Habitation Apartment House, Marseilles, Unité France (Le Corbusier), 885; 1182

United States, art: architecture, 772-74, 882-83; Neo-Expressionism, 840-43; Realism and Impressionism, 732-34; Romanticism, 696-98

Untitled (Clemente, self-portrait), 837; 1103

Untitled (Judd), 856, 867; 1132

Untitled (Man Ray, Rayograph), 907; 1220

Untitled (Moholy-Nagy, Photogram), 907; 1221

Untitled (Shapiro), 857; 1133

Untitled (Uelsmann), 911; 1228

Untitled Film Still 2 (Sherman), 930; 1251

Ur (El Muqieyar), Iraq, 78, 84-86; inlay panel from the soundbox of a lyre, 61, 82, 93, 115, 123, 231, 305; 92; Ram and Tree, 81-82, 93, 102; 90; Standard of Ur, 83; 93; ziggurat of King Urnammu, 79-80, 840; 87

Urban VIII Visiting Il Gesù (Sacchi and Miel), 502; 669 Urnammu, King, ziggurat of, Ur (El Muqieyar), Iraq, 79-80, 840; 87

Uruk (Warka), Iraq: Female Head, 54, 80, 109; 88; "White Temple," 79; 84, 85, 86

Utrecht, Netherlands, Schröder House (Rietveld), 876; 1164, 1165, 1166

Utrecht Psalter (Early Medieval), 281, 312, 313, 318; 368 Utrecht School, 581, 582, 593

 ${f V}$ AN: many names with ${\it van, van de, van der}$, or ${\it von are}$ listed under next element of name (e.g., GOGH,

VANBRUGH, SIR JOHN, 609, 707; Blenheim Palace (Woodstock, England), 609, 667; 813

VAN DER ZEE, JAMES, 903; At Home, 903; 1212

Vanitas, theme of, 588–89

Vantongerloo, Georges, 849; Métal: y equals ax3 bx3 + cx, 849; 1117

Vaphio, Greece, gold cups, 106-8, 124, 231; 133, 134 Varengeville, Hôtel de, Paris, France, room (Pineau), 611, 624; 814

Vasari, Giorgio, 362, 487–88, 498–99

Lives of the Painters (book), 452; excerpts from, 632-33

Palazzo degli Uffizi (Florence), 498-99; 661 Perseus and Andromeda, 487-88, 496, 499; 643 vase (Dipylon cemetery, Athens, Greece), 111-12, 113,

Greek, 114; painting on, 114-18, 152-53; shapes of, 111: 1.38

Proto-Corinthian, 114, 167; 141

Vatican Palace, Rome, Italy

114; 139

Sistine Chapel

ceiling frescoes (Michelangelo), 462-67, 554; 611; The Creation of Adam, 462-64, 551, 731, 778; 612; The Expulsion from the Garden of Eden, 464, 731, 735; 613; The Fall of Man, 462-64, 551, 731, 735, 778; 613; Libyan Sibyl, 28, 464, 731, 735; 9; studies for, 26-28; 8

wall frescoes (Michelangelo), The Last Judgment, 467; 614; detail, with self- portrait, 467, 471, 495; 615

wall frescoes (Perugino), The Delivery of the Keys, 446, 447, 462, 471; 586

Stanza della Segnatura, frescoes (Raphael), 472, 598; 626; The School of Athens, 442, 472-73, 474, 598; 627

Vatican Vergil (Graeco-Roman manuscript), 218, 242; 310

vaults: ribbed groin, 299, 300; 391; types and parts of, 177, 182, 185; 235

Veii, Italy, Temple of Apollo, 173-74; Apollo statue, 173, 174; 231

Veiled Dancer (Hellenistic), 162, 213, 440; 217

VELÁZQUEZ, DIEGO, 569-73, 720, 733; The Maids of Honor, 571-73, 673-74, 718, 733; 759; Pope Innocent X, 571, 825; 758; The Water Carrier of Seville, 571, 596; 757

VELDE, HENRY VAN DE, 770-72, 876, 882; Theater (Cologne, Germany, Werkbund Exhibition [1914]), 772, 875, 882; 1005, 1006

Vendramin, Gabriele, 476

Venice, Italy

art: Early Renaissance, 448; Mannerist, 489-93 Ca' d'Oro, 343, 500; 465

Library of St. Mark's (Sansovino), 500, 712; 663 Mint (Sansovino), 500, 712; 663

S. Giorgio Maggiore (Palladio), 501-2; 666, 667; The Last Supper (Tintoretto), 490, 492, 494;

St. Mark's, 258, 343, 437; 335, 336; Apostles (Masegne), 357; 491; The Tetrarchs, 200; 282

S. Zaccaria, Madonna and Saints (Bellini), 450, 479; 593 Scuola di San Rocco, Christ Before Pilate (Tintoretto), 489: 646

VENTURI, ROBERT, 917

Venus, Temple of, Baalbek, Lebanon, 187-88, 560, 563, 668; 258, 259

Venus (Thorvaldsen), 700; 903

"Venus" of Willendorf (Paleolithic), 54, 99; 35 Vergil, Aeneid, excerpt, 217-18

Index 997

Vergina, Macedonia, The Abduction of Prosperine, 151–52: 198

VERMEER, JAN, 572–73, 592–93; The Letter, 592–93, 615, 751, 759; 789; Woman Holding a Balance, 38, 592; 23

Verona, Italy, Equestrian Statue of Can Grande della Scala, 356, 390, 415, 443; 489

VERONESE, PAOLO (PAOLO CALIARI), 494–95; Christ in the House of Levi, 494–95, 626, 634; 653; Inquisition testimony, excerpt, 634–35

VERROCCHIO, ANDREA DEL, 441–43, 446, 453, 461;

Baptism of Christ (with Leonardo), 441; The

Doubting of Thomas, 441–42, 454; 581; Equestrian Monument of Colleoni, 442–43; 582

Versailles, France, Palace, 594, 602–4; Galerie des Glaces (Hardouin-Mansart, Lebrun, Coysevox), 602; 801; Garden Front (Hardouin-Mansart, Le Vau), 602, 609, 668; 800; gardens (Le Nôtre), 604; 803; Salon de la Guerre (Hardouin-Mansart, Lebrun, Coysevox), 604, 606, 712; 802

Versailles (Atget), 894–96; 1200 Vespasian, Roman emperor, Head of, 198; 276

Vettii, House of the, Pompeii, Italy, The Ixion Room, 194, 206–8, 209–10, 216, 240, 365, 367, 370;

194, 200–8, 209–10, 216, 240, 363, 367, 370; 290 Vézelay, France, Ste.-Madeleine, *The Mission of the Apos*-

tles, portal sculpture, 308–9, 314, 345, 386; 406 Vicenza, Italy, Villa Rotonda (Palladio), 501, 667, 670;

664, 665 Victims, fresco (Orozco, University, Guadalajara, Mexi-

co), 815; *1072* Victoria and Albert Museum, London, England, Green Dining Room (Morris), 744, 745; *965*

Victory over the Sun (opera), 796

Victory Stele of Naram-Sin, king of Akkad, 84, 88, 192; 95 Vien, Joseph-Marie, 659

Vienna, Austria: Augustinerkirche, Tomb of the Archduchess Maria Christina (Canova), 699; 900; roof conversion project (Himmelblau), 921; 1235; St. Charles Borromaeus (Karlskirche, Fischer von Erlach), 621–22; 830, 831; Steiner House (Loos), 874; 1157

Vienna Academy, 695

Vienna Genesis (Early Christian), Jacob Wrestling the Angel from, 242; 311

Vienna Secession, 763

Vietnam Veterans Memorial, Washington, D.C. (Lin), 861–62; 1140

View from His Window at Le Gras (Niépce), 713; 922 View from Studio Window in Winter (Sudek), 904; 1215 View of a Garden mural (Villa of Livia, Primaporta, Italy), 204–6, 289; 288

View of Rome: The Bridge and Castel Sant'Angelo with the Cupola of St. Peter's (Corot), 682, 721, 733; 879

View of Schroon Mountain, Essex County, New York, After a Storm (Cole), 697, 733; 898

View of the Valkhof at Nijmegen (Cuyp), 586; 782 View of Town and Volcano (Çatal Hüyük, Turkey), 56–57; 42

VIGÉE-LEBRUN, MARIE-LOUISE-ELISABETH, 616; The Duchesse de Polignac, 616, 620; 823; Memoirs of, excerpt, 642–43

VIGNOLA, GIACOMO, 502–3; Il Gesù (Rome), 502–3, 558–59, 560; 668, 669

Village Bride, The (Greuze), 659; 842

VILLARD DE HONNECOURT, 359–60

Sketchbook: excerpts, 393; Front View of a Lion, 360, 393; 496; Wheel of Fortune, 360, 393, 432; 495

Villa Rotonda, Vicenza, Italy (Palladio), 501, 667, 670; 664, 665

Vingt, Les (The Twenty), 767 Virgin and Child (Murillo), 573; 761 Virgin and Child Enthroned, mosaic (Hagia Sophia, Istanbul, Turkey), 252, 260, 359, 363; 338

Virgin and Child Enthroned with Saints and Angels (Monastery of St. Catherine, Sinai Peninsula), 256–57, 260; 331

Virgin of Paris, The, sculpture (Notre-Dame, Paris), 348–49, 352, 355; 473

Virgin of the Rocks (Leonardo), 454, 472; 595

Vision after the Sermon (Jacob Wrestling with the Angel) (Gauguin), 752, 755–56, 759, 929; 980

Vision of Antiquity, mural (Puvis de Chavannes, museum, Lyons, France), 756, 759; 984

Visitation (Broederlam), altar panel, 377–78, 506; 519 Visitation (Reims Cathedral), sculpture, 332, 347–48, 350, 353, 354, 410; 471

Visitation (St.-Pierre, Moissac, France), portal sculpture, 306, 309, 310, 386; 402

VISPRÉ, FRANCIS XAVIER, attr., Portrait of Louis-François Roubiliac, 42, 620; 27

Vitellozzi, Annibale, 888

VITRUVIUS, 133, 204, 275, 276; On Architecture, excerpts, 215–16

Vogelherd Cave, Germany, Horse, 53; 34 Voltaire Seated (Houdon), 620, 666; 851

VOUET, SIMON, 599; *The Toilet of Venus*, 599, 614; 797 VUILLARD, ÉDOUARD, 757–59; *The Suitor*, 759, 782; 983

Wainwright Building, St. Louis, Mo. (Sullivan), 773–74, 882, 941; 1009

WALKINGSTICK, KAY, 843; On the Edge, 843; 1108 wall painting, see murals

WALPOLE, HORACE, 707–8; Strawberry Hill (Twickenham, England), 707–8; 910, 911

Warhol, Andy, 834, 923; Gold Marilyn Monroe, 834; 1098

Washington, D.C.: Corcoran Gallery, *The X* (Bladen), 855–56; *1130*; Vietnam Veterans Memorial (Lin), 861–62; *1140*

Water (Bartlett), 842; 1106

Water Carrier of Seville, The (Velázquez), 571, 596; 757 watercolors, 691–92

Water Lilies (Monet), 727–28, 827, 842, 863; 943 Watson and the Shark (Copley), 663, 664, 677; 846

WATTEAU, JEAN-ANTOINE, 612–14; Gilles and Four Other Characters from the Commedia dell'Arte (Pierrot), 613–14; 818; A Pilgrimage to Cythera, 612–13, 616, 617; 817

Weimar School of Arts and Crafts, 772

Werkbund, 874

West, Benjamin, 660–62, 686, 696; *The Death of General Wolfe,* 660–62, 663, 680, 717; 845

Westminster Abbey, London, England, Chapel of Henry VII, 338, 707, 710; 452, 453

WESTON, EDWARD, 899–900; essay, "Photographic Art," excerpt, 947–48; *Pepper*, 899–900; *1207*

WEYDEN, ROGIER VAN DER, 512–14, 521; Descent from the Cross, 512–13, 576; 679; Francesco d'Este, 514; 681; The Miraflores Altarpiece, 513; 680

Wheat Field and Cypress Trees (Gogh), 754–55; 978 Wheel of Fortune, from sketchbook of Villard de Hon-

necourt, 360, 393, 432; 495 Wheel of Fortune, The (Burne-Jones), 729–31; 947 Where Do We Come From? What Are We? Where Are We

Going? (Gauguin), 756, 781; 981
WHISTLER, JAMES ABBOTT MCNEILL, 731–32, 745, 769;
Arrangement in Black and Gray: The Artist's
Mother, 731; 948; The Gentle Art of Making

Arrangement in Black and Gray: The Artists Mother, 731; 948; The Gentle Art of Making Enemies (book), excerpt, 939; Harmony in Blue and Gold: The Peacock Room, 745, 757; 967; Nocturne in Black and Gold: The Falling Rocket, 731–32, 786: 949

WHITE, MINOR, 908; *Ritual Branch*, 908; *1224*

White Flower Black Flower (Saunders), 830; 1092 Whitehall Palace, London, England (Jones), 607; 809 Wildungen Altarpiece, The (Soest), 380; 523

WILIGELMO, 310–11; Scenes from Genesis (Cathedral, Modena, Italy), 310–11; 409

William Rush Carving His Allegorical Figure of the Schuylkill River (Eakins), 733–34, 799; 952

WILLIAMS, WILLIAM T., 829–30, 858; Batman, 829; 1091 Winckelmann, Johann Joachim, 664

Thoughts on the Imitation of Greek Works in Painting and Sculpture (book), 658; excerpt, 934

Winged God, coin (Peparethus, Greek island), 164; 218 Winter Landscape in Moonlight (Kirchner), 803; 1052 WITZ, CONRAD, 518–19, 520; altarpiece, The Miracu-

lous Draught of Fishes from, 518–19, 721; 686 WOJNAROWICZ, DAVID, 912; Death in the Cornfield, 912; 1230

Woman Before a Mirror (Heckel), 784; 1026

Woman Holding a Balance (Vermeer), 38, 592; 23

Woman II (de Kooning), 822, 823; 1081

women artists, 488, 551, 590, 663, 686, 726, 765 Women Regents of the Old Men's Home at Haarlem, The (Hals), 581–82; 774

Woodcut of St. Christopher, detail in Annunciation (Daret), 525, 814; 693

woodcuts, 23, 524; "Late Gothic," 523-25

Woodstock, England, Blenheim Palace (Vanbrugh), 609, 667; 813

Workmen Carrying a Beam (Tomb of Horemheb, Saqqara, Egypt), 76, 105, 122; 81

Wounded Bison (Altamira, Spain), 51; 29

Wren, Sir Christopher, 608, 707; Proposals for Rebuilding the City of London After the Great Fire, excerpt, 642; St. Paul's Cathedral (London, England), 608–9, 669; 810, 811, 812

WRIGHT, FRANK LLOYD, 872, 876, 884; Francis W. Little House, interior, 872; 1156; Robie House (Chicago, Ill.), 872, 878; 1154, 1155; Solomon R. Guggenheim Museum (New York, N.Y.), 37, 670, 872; 21, 22; speech, "A Philosophy of Fine Art," excerpt, 947

writing, 45

Würzburg, Germany, Residenz, Kaisersaal (Neumann), 624, 626; 834; frescoes (Tiepolo), 624, 626; 834, 837; The Marriage of Frederick Barbarossa, 615, 626; 838

X, The (Bladen, Corcoran Gallery, Washington, D.C.), 855–56; 1130

You Are a Captive Audience (Kruger), 907, 929; 1249 Young Lady with an Umbrella (Lumière), 894; 1199 Young Man Among Roses, A (Hilliard), 539, 578, 616; 712

Youth and Demon of Death, cinerary container (Etruscan), 170, 174; 228

Zero Group, 867

Zeus (Greek), 141, 145; 188

Zeus, Temple of, Olympia, Greece: *Apollo*, statue, 144–45, 149, 150, 152, 164, 432; *187*; *Battle of the Lapiths and Centaurs*, 144–45, 149, 150, 152, 164, 432; *187*

ZEUXIS OF HERAKLEIA, 151

ziggurat, 79-80

ZIMMERMANN, DOMINIKUS, 624–25; pilgrimage church (Die Wies, Germany), 624; 835, 836

ZUCCARO, TADDEO, The Conversion of St. Paul, 687; 886

Zucchi, Antonio, 671

Zurbarán, Francisco de, 573; *St. Serapion*, 573, 660; 760

Zwingli, Huldreich, 482-83

PHOTOGRAPH CREDITS and COPYRIGHTS

The author and publisher wish to thank the libraries, museums, galleries, and private collections for permitting the reproduction of works of art in their collections and for supplying the necessary photographs. Photographs from other sources are gratefully acknowledged below. All numbers refer to figure numbers.

PHOTOGRAPH CREDITS and COPYRIGHTS

J. S. Ackerman, The Architecture of Michelangelo: 618; ACL, Brussels: 396, 411, 673-75, 693; Adros Studio, Rome: 416; Alison Frantz Collection, American School of Classical Studies, Athens: 69, 172, 177, 332; Archivi Alinari, Florence: 111, 228, 238, 271, 272, 274, 279, 280, 344, 393, 409, 461, 463, 484, 490, 491, 530, 540, 541, 542, 550, 566, 569, 574, 578, 589, 594, 621, 635, 661, 662, 670, 732, 743, 746, 755; Ronald Sheridan's Ancient Art & Architecture Collection, Pinner, England: 343, 405; Arcaid/David Churchill, Kingston upon Thames, U.K.: 910, 911; Art Co. Limited, Nassau, Bahamas: 1040; Artothek/Joachim Blauel, Peissenberg, Germany: 561, 636, 701, 705, 707, 713, 763, 776, 896; Cameraphoto-Arte, Venice/Art Resource, New York: 465, 633, 653, 663; Erich Lessing/Art Resource, New York: 342; Foto Marburg/Art Resource, New York: 176, 357, 387, 392, 407, 430, 431, 435, 445, 472, 473, 477, 719, 745, 798, 960-62, 1158, 1159, 1162, 1169; The Pierpont Morgan Library/Art Resource, New York: 369; Scala/Art Resource, New York: 20, 282, 309, 343, 504, 505, 544, 562, 588, 606, 627, 631; The Tate Gallery, London/Art Resource, New York: 945, 969, 1049, 1127; Bank of England, London: 916; Foto Barsotti, Florence: 486, 487; Herbert Bayer Studio, Montecito, California: 1218; Bayerische Staatsbibliothek, Munich: 377, 378, 422; M. Beazley, Atlas of World Architecture: 259, 382; Jean Bernard, Aix-en-Provence: 433, 437; Constantin Beyer, Weimar, Germany: 478; Bildarchiv Preussischer Kulturbesitz, Berlin: 78, 79, 105, 211, 213, 257, 379, 529, 680, 687, 773, 893, 909; Paul Bitjebier, Brussels: 1034; Black Star, New York: 1225; Erwin Böhm, Mainz: 87; Lee Boltin Photo Library, Croton-on-Hudson: 108; Boyan & Shear, Glasgow: 1003; W. Braunfels, Mittelalterliche . . . Toskana: 419; The Bridgeman Art Library, London: 803; Brisighelli-Undine, Cividale, Italy: 356; The British Museum, London: 202; British National Tourist Office, New York: 912; F. Bruckmann Verlag, Munich: 930; Jutta Brüdern, Braunschweig: 374, 375, 412; Martin Bühler, Basel: 993, 1117; Photographie Bulloz, Paris: 404, 426, 723, 724, 906; Bundesdenkmalsamt, Vienna: 900; Studio C.N.B. & C., Bologna, Italy: 81; Caisse Nationale des Monuments Historiques et des Sites/© Arch.Phot.Paris: 45, 384, 385, 401, 402, 438, 444, 447, 466, 480, 481, 609, 610, 907; F. Camard, Ruhlmann, Master of Art Deco: 1194; Canali Photobank, Capriolo: page 316, 10, 12, 116, 164, 165, 183, 189, 223, 231, 232, 236, 238, 250, 255, 263, 266, 267, 270, 277, 278, 285, 287–92, 302, 303, 306, 308, 310, 317, 320–22, 329, 394, 398, 399, 417, 457, 482, 483, 485, 489, 492, 500, 503, 506, 509–13, 532, 534, 538, 551, 558, 561, 564, 567, 572, 581, 586, 587, 596, 601, 617, 622, 626, 628, 637, 638, 644, 646, 647, 654, 659, 660, 682, 710, 718, 725–27, 729, 731, 734–36, 740, 741, 753, 756, 758, 886, 902; Canali Photobank/Bertoni, Capriolo: 261, 515, 525, 531, 537, 560, 579, 607; Canali Photobank/Codato: 336, 536, 582, 593; Canali Photobank/Rapuzzi, Capriolo: 143; Chicago Historical Society: 929; Cinématique Française, Paris: 1020; Editions Citadelles & Mazenod, Paris: 68; Peter Clayton: 62, 65, 71, 83; Collection Colonel Norman Colville: 97; Colorphoto Hans Hinz, Alschwill-Basel: 30, 993; K. J. Conant, Carolingian and Romanesque Architecture, 850-1200: 381, 389; Paula Cooper Gallery, New York: 1106, 1107; Costa and Lockhart, Persia: 115; The Conway Library/Courtauld Institute of Art, University of London: 364, 469, 850, 937; Culver Pictures, New York: 928; Photo Daspet, Villeneuve-les-Avignon: 517; D. James Dee, New York: 1242; Eric De Maré, © Gordon Fraser Gallery, London: 1008; Deutsches Archäologisches Institut, Baghdad: 84, 86; Deutsches Archäologisches Institut, Rome: 6, 253, 262, 275, 276, 284; Jean Dieuzade [YAN], Toulouse: 380, 400; Dom-und Diözesanmuseum, Hildesheim: 376; M.

Droste, Bauhaus 1919-1933: 1178; Du Atlantis, Zurich (September 1965): 966; E. Du Cerceau, Les Plus Excellent Batissement . . . : 721; Dumbarton Oaks Washington, D.C. © Byzantine Visual Resources: 338, 340; Galerie Durand-Dessert, Paris: 1239; Editoriale Museum/Pedicini, Rome: 249; Nikos Kontos Courtesy of Ekdotike Athenon, Athens: 331; English Heritage Photograph Library, London: 47, 847, 859; ESTO/© Peter Aaron, Mamaroneck, N.Y.: 1232; ESTO/© Peter Mauss, Mamaroneck, N.Y.: 1238; ESTO/© Ezra Stoller, Mamaroneck, N.Y.: 1139, 1181, 1186-88, 1193; Ronald Feldman Fine Arts, New York: 1242; Fischbach Gallery, New York: 1130; B. Fletcher, A History of Architecture: 168; Fotocielo, Rome: 739; Fototeca Unione, American Academy, Rome: 166, 240, 242, 258, 269; Peter Fowles, Glasgow: 1004; © Klaus Frahm, Hamburg: 1236; G. De Francovich, Rome: 410; H. Frankfort, The Art and Architecture of the Ancient Orient: 85; John R. Freeman, Limited, London: 590; French National Tourist Board, Paris: 904; Gabinetto Fotografico Nazionale, Rome: 624, 669, 730, 752, 806; Gabinetto Nazionale delle Stampe, Rome: 619, 620; Henry Gaud, Molsenay: 441; G.E.K.S., New York: 21, 22, 245, 273, 747, 1173, 1174, 1182, 1206; Philip Gendreau, New York: 963; G. Gherardi/A. Fioretti, Rome: 1189, 1190; Photographie Giraudon, Paris: 406, 446, 467, 522, 600, 722, 816, 851, 856, 918, 921, 964, 976; P. Gössel and G. Leuthäuser: Architecture in the Twentieth Century: 1195, 1233; © Gianfranco Gorgoni, New York: 1141; Edward V. Gorn, New York: 337; Foto Grassi, Siena: 483, 485; The Green Studio, Limited, Dublin: 353; Peter Grosz, Princeton, N.J.: 1068; Dr. Reha Günay, İstanbul: 348, 349; Hedrich-Blessing/Bill Engdahl, Chicago: 1154, 1170; Lucien Hervé, Paris: 1172; Hirmer Fotoarchiv, Munich: 35, 53, 130, 149, 154, 158, 160, 161, 170, 175, 179, 184, 185, 187, 190–92, 218–22, 224, 225, 229, 268, 283, 307, 312, 313, 327, 527, 533, 575, 608, 616, 663, 694; H. R. Hitchcock, Architecture: Nineteenth and Twentieth Century. 919, 1002; Foto Karl Hoffmann, Speyer: 395; Walter Horn: 363; © Angelo Hornak Library, London: 665; Christian Huelsen, *Il Libro* di Giuliano da Sangallo: 547; Timothy Hursley: 1234; L'Institut de France, Paris: 600; Instituto di Etruscologia e Antichità Italiche, University of Rome: 33; The Iveagh Bequest, Kenwood, London: 847; Jahrbuch des Deutschen Werkbundes (1915): 1005, 1006, 1160, 1161; Anthony Janson: 858, 1092; H. W. Janson: 455, 552, 995, 1094; Bruno Jarrett/ARS, New York/ADAGP, Paris: 956, 958; S. W. Kenyon, Wellington, U.K.: 37, 38; A. F. Kersting, London: 388, 452, 799, 809; Jörg Klam, Berlin: 1026; © Studio Kontos, Athens: 1, 19, 120, 121, 126, 127, 129, 133–35, 137, 140, 148, 152, 153, 173, 174, 178, 182, 186, 188, 198, 207, 216; Balthazar Korab, Troy, Michigan: 1138; S. N. Kramer, Studio Koppermann, Gauting, Germany: 142, 200, 212; History Begins at Sumer. 94; R. Krautheimer: Early Christian and Byzantine Architecture: 297, 298; Ian Lambot, Haslemere, Surrey: 1197, 1198; Kurt Lange, Oberstdorf, Allgäu, Germany: 51, 52, 528; Jacques Lathion, Oslo: 989; Lautman Photography, Washington, D.C.: 860; A.W. Lawrence: Greek Architecture: 171; William Lescaze, New York: 1177; Library of Congress, Washington, D.C.: 885; Ralph Liberman: 464; Lichtbildwerkstätte Alpenland, Vienna: 311, 316, 385, 591, 639, 655, 657, 708, 716, 717; Maya Lin, New York: 1140; Tony Linck, Fort Lee, N.J.: 47; Jannes Linders, Rotterdam: 1164, 1166; Magnum, New York: 1203, 1211, 1216; Barbara Malterm, Rome: 210; Marlborough Gallery, New York: 1146; Alexander Marshak, New York: 34, 43, 44; Maryland Historical Society, Baltimore: 915; Arxiu MAS, Barcelona: 684, 685, 649, 759, 764, 863, 864, 876; Foto Mayer, Vienna: 691; © Rollie McKenna, Stonington, Connecticut: 548; Arlette and James Mellaart, London: 39-41, 42; H. Millon, Key Monuments in the History of Art: 456, 568, 605, 623, 748; Ministry of Culture/Archaeological Receipts Fund (Service T.A.P.) Athens: 196, 197; Ministry of Public Buildings and Works, London: 46, 47, 853, 854; Monumenti, Musei, e Gallerie Pontificie, Vatican City, Rome: 206, 234, 265; André Morin, Paris: 1239; © Museum of Modern Art, New York: 1167, 1168; Ann Münchow, Domkapitel Aachen: 358; National Buildings Record, London: 450, 451, 810, 812, 917; Otto Nelson, New York: 1091; Richard Nickel, Chicago: 1007, 1009-11; Nippon Television Network Corporation, Tokyo: 9, 611-15; © Takashi Okamura, Shizuoka City,

Japan: 494, 525, 526, 539, 545, 559, 576, 577, 629; Bill Orcutt Studios, New York: 1248; The Oriental Institute of the University of Chicago: 89, 100, 101, 110, 112; Oroñoz, Madrid: 632, 714, 839, 1001; Pace Wildenstein Gallery/Bill Jacobsen, New York: 1132; Gustav Peichl, Vienna: 1194; Robert Perron, New York: 1192; N. Pevsner, Outline of European Architecture: 549; G. Picard, The Roman Empire, © Benedikt Taschen Verlag, Cologne, Germany: 241; Erich Pollitzer, New York: 979; Winslow Pope/Michigan Consolidated Gas Company, Detroit, Michigan: 1180; Port Authority, New York: 908; Foto Positiv, Vienna: 833; Josephine Powell, Rome: 341; © Museo del Prado: 679; Provinciebestuur van Antwerpen: 777; Pubbli Aer Foto, Milan: 237, 335; Antonio Quattrone (Courtesy of Olivetti), Florence: 553-56; Mario Quattrone Fotostudio, Florence: 499, 507, 583, 640, 643; Rapho, Paris: 1204; Carl Reiter: 751; Studio Rémy, Dijon, France: 519; © Réunion des Musées Nationaux, Paris: 4, 36, 66, 95, 96, 98, 106, 111, 141, 144, 145, 146, 150, 151, 214, 330, 345, 508, 520, 585, 595, 597, 598, 625, 634, 690, 709, 711, 733, 767, 784, 791, 792, 808, 817, 818, 820, 821, 842, 865–68, 870–73, 880, 883, 905, 931, 932, 936, 938, 939, 947, 948, 984, 985, 1035, 1051; Rheinisches Bildarchiv, Cologne: 370, 371, 1101, 1143; Ekkehard Ritter, Vienna: 420, 421; Photographie Roger-Viollet, Paris: 720, 803, 920, 1000, 1176; Richard Ross: 1243, 1244; Jean Roubier, Paris: 243, 383, 427, 468, 470, 471, 474; Routhier/Studio Lourmel, Paris: 940; The Royal Collection Enterprises, Windsor Castle: 599, 652, 840; Sächsische Landesbibliothek, Deutsche Fotothek, Dresden: 477, 1190; Galerie St. Etienne, New York: 1067; Armando Salas, Portugal: 1129; Toni Schneiders, Lindau, Germany: 835, 837; Fotostudio Schoenen & Junger, Aachen: 1241; Silvestris Photo-Service, Kastl, Germany: 832; Aaron Siskind: 1223; Haldor Sochner, Munich: 648; Société Archeologique et Historique, Avesnes-sur-Helpe: 418; Société Française de Photographie, Paris: 923; Holly Solomon Gallery, New York: 1150; Soprintendenza alle Antichità, Palermo: 33; Soprintendenza Archaeologica, Ministero per i Beni Culturali Ambientali, Rome: 233; Soprintendenza Archaeologica all'Etruria Meridionale, Tarquinia: 226, 227; Soprintendenza dei Monumenti, Pisa: 514; Sperone Westwater Gallery, New York: 1105; Stiftsbibliothek, St. Gallen, Switzerland: 362; Franz Stoedtner, Düsseldorf: 999; A. Stratton: Life. . . : 811; Adolph Studley, Pennsburg, Pennsylvania: 998; Wim Swaan: 3, 56, 58, 59, 63, 69, 72, 74, 75, 77, 82, 99, 114, 386, 397, 423, 428, 429, 439, 448, 454, 462, 488, 656, 737, 749, 800-02, 830; © Jean Clothes, SYGMA, New York: 28; J. W. Thomas, Oxford: 475; © 1974 Caroline Tisdall: 1168; Marvin Trachtenberg, New York: 180, 328, 334, 459, 570, 666, 804, 834, 1171, 1183, 1184; Bernard Tschumi Architects, New York: 1237; University Library, Uppsala, Sweden: 715; © University Museum of National Antiquities, Oslo: 351; Jean Vertut, Issy-les-Moulineaux: 29, 31; Robert Villani: 1155, 1165; John B. Vincent, Berkeley, California: 668; Foto Vitullo, Rome: 297; Wolfgang Volz © Christo: 1142; Leonard von Matt, Buochs, Switzerland: 128, 366, 408; © Elke Walford, Hamburg: 524, 894, 895, 1025; Denise Walker, Baltimore: 913, 914; Clarence Ward: 426; © Lewis Watts, Anselmo, California: 1245; Etienne Weil, Jerusalem: 1110, 1196; Whitaker Studios, Richmond, Virginia: 852; Joachim Wilke, Stuttgart: 855; David Wilkins, Pittsburgh: 535; Ole Wodbye, Copenhagen: 903; © CORBIS/Roger Wood, Bellevue, Washington: 119; Woodfin Camp & Associates, New York: 432; (former) Yugoslav State Tourist Office, New York: 260; © Arq. Sergio Zepeda C., Guadalajara, Mexico: 1072; O. Zimmerman, Colmar, France: 696, 697; © Gerald Zugmann, Vienna: 1235; Foto Zwicker-Berberich, Gerchsheim/Würzburg, Germany: 823.

ARTIST COPYRIGHTS

© 1997 by the Trustees of the Ansel Adams Publishing Rights Trust. All Rights Reserved: 1208; © 1997 Richard Anuszkiewicz/Licensed by VAGA, New York, N.Y.: 1094; © 1997 Artists Rights Society (ARS), N.Y./ADAGP, Paris: 994, 1023, 1024, 1030, 1036, 1043–45, 1053,

1054, 1059, 1060, 1064-67, 1078, 1082, 1110-12, 1119, 1121, 1123, 1124, 1125, 1214, 1220; © 1997 Artists Rights Society (ARS), N.Y./ ADAGP, Paris/FLC: 1171, 1172, 1182-84; © 1997 Artists Rights Society (ARS), N.Y./DACS, London: 1058, 1095; © 1997 Artists Rights Society (ARS), N.Y./Beeldrecht, Amsterdam: 1083, 1164, 1166; © 1997 Artists Rights Society (ARS), N.Y./Pro Litteris, Zurich: 1028, 1029, 1117, 1120; Artists Rights Society (ARS), N.Y./VBK, Vienna: 1157; © 1997 Artists Rights Society (ARS), New York/V.G. Bild-Kunst, Bonn: 942, 1026, 1069, 1070, 1073, 1093, 1153, 1158, 1169, 1170, 1181, 1213, 1218, 1219, 1221; © 1997 Demart Pro Arte ®, Geneva/Artists Rights Society (ARS), N.Y.: 1061; © Ernst und Hans Barlach Lizenzverwaltung, Ratzeburg, Germany: 99; © 1997 Romare Bearden Foundation/Licensed by VAGA, New York, N.Y.: 1090; © Black Star, New York: 1240; © Mrs. Noya Brandt, London: 1227; © Gilberte Brassaü, Paris: 1202; © Robert Capa/Magnum, New York: 1216; © Cartier-Bresson/ Magnum, New York: 1203; © 1997 Center for Creative Photography, Arizona Board of Regents, Tucson, Arizona: 1207; © 1997 John Chamberlain/Artists Rights Society (ARS), N.Y.: 1144; © 1997 Foundacion Giorgio de Chirico/Licensed by VAGA, New York, N.Y.: 1042; © 1982 Christo, New York: 1142; © Condé Nast Publications, New York: 1210; © 1997 Estate of James Ensor/Licensed by VAGA, New York, N.Y.: 988; © 1997 Richard Estes/Licensed by VAGA, New York, N.Y./Marlborough Gallery, N.Y.: 1101; © Anna Farovà, Prague: 1215; © Helen Frankenthaler, New York: 1086; © 1997 Adolph and Esther Gottlieb Foundation/ Licensed by VAGA, New York, N.Y.: 1077; © 1997 Estate of George Grosz/Licensed by VAGA, New York, N.Y.: 1068; Hepworth Estate, © Alan Bowness, London: 1128; © 1997 Charly Herscovici/Artists Rights Society (ARS), N.Y.: 1062; © 1997 Estate of Eva Hesse: 1147; © David Hockney, Los Angeles: 1231; © Instituto Nacional de Bellas Artes, Mexico City: 1063; © 1997 Jasper Johns/Licensed by VAGA, New York, N.Y.: 24, 1096; © 1997 Donald Judd Estate/Licensed by VAGA, New York, N.Y.: 1132: © Ministère de la Culture (AFDPP), Paris: 1201; © Anselm Kiefer: 1104; Ernst Ludwig Kirchner, Dr. Wolfgang and Ingeborg Henze-Ketterer, Wichtrach, Bern: 1025, 1052; © 1997 Willem de Kooning Revocable Trust/Artists Rights Society (ARS), N.Y.: 1081; © 1997 Joseph Kosuth/Artists Rights Society (ARS), N.Y.: 1151; © Barbara Kruger: 1249; © Roy Lichtenstein, New York: 1097; © 1997 Estate of Jacques Lipchitz/Licensed by VAGA, New York, N.Y./Marlborough Gallery, N.Y.: 1118; © 1997 Succession H. Matisse, Paris/Artists Rights Society (ARS), N.Y.: 1021, 1022, 1051, 1109; © Wayne Miller/Magnum, New York: 1211; © Mondrian Estate/Holtzman Trust: 13, 1057; © The Henry Moore Foundation, Much Hadham, Hertfordshire, U.K.: 1126, 1127; © 1997 The Munch Museum/The Munch-Ellingsen Group/ Artists Rights Society (ARS), N.Y.: 989; © 1997 Barnett Newman Foundation/Artists Rights Society (ARS), N.Y.: 1138; © Stiftung Ada und Emil Nolde, Seebüll, Germany: 1027; © 1997 The Georgia O'Keeffe Foundation/Artists Rights Society (ARS), N.Y.: 1074; © 1997 Estate of Pablo Picasso, Paris/Artists Rights Society (ARS), N.Y.: 2, 11, 991, 1033-35, 1047-50, 1122; © 1997 The Pollock-Krasner Foundation/ Artists Rights Society (ARS), N.Y.: 1079, 1080; © 1997 Robert Rauschenberg/Licensed by VAGA, New York, N.Y.: 1143; © 1997 Kate Rothko-Prizel and Christopher Rothko/Artists Rights Society (ARS), N.Y.: 1085; © 1997 David Salle/Licensed by VAGA, New York, N.Y.: 1246; © 1997 George Segal/ Licensed by VAGA, New York, N.Y.: 1148; © 1997 Estate of David Smith/Licensed by VAGA, New York, N.Y.: 1131; © The Estate of Edward Steichen, New York. Reprinted with permission of Joanna T. Steichen: 1018, 1210; © 1997 Frank Stella/Artists Rights Society (ARS), N.Y.: 1089; © 1997 Estate of Vladimir Tatlin/ Licensed by VAGA, New York: 1115; © 1997 The Andy Warhol Foundation for the Visual Arts/Artists Rights Society (ARS), N.Y.: 1098; © Margaret Bourke-White, LIFE Magazine © Time Inc., New York: 1209; © The Minor White Archive, Princeton University, Princeton, New Jersey: 1224.

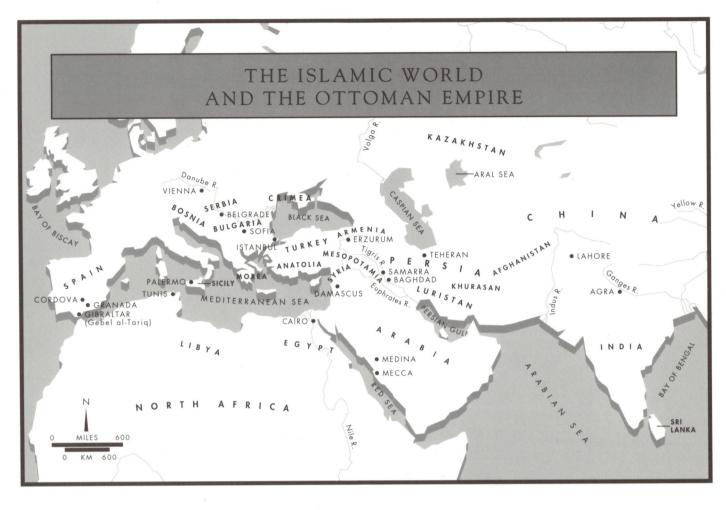

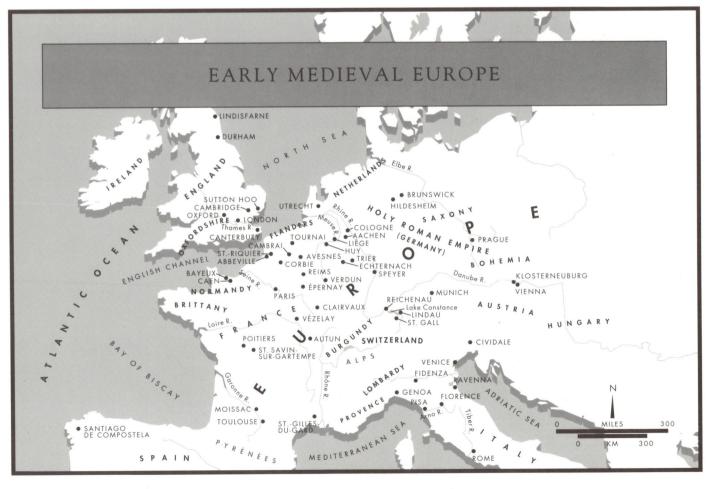